THE OXFORD COMPANION TO
WESTERN ART

THE OXFORD
COMPANION TO
WESTERN
ART

EDITED BY

HUGH BRIGSTOCKE

OXFORD
UNIVERSITY PRESS

OXFORD
UNIVERSITY PRESS

Great Clarendon Street, Oxford OX2 6DP

Oxford University Press is a department of the University of Oxford.
It furthers the University's objective of excellence in research, scholarship,
and education by publishing worldwide in

Oxford New York

Athens Auckland Bangkok Bogotá Buenos Aires Kolkata
Cape Town Chennai Dar es Salaam Delhi Florence Hong Kong Istanbul
Karachi Kuala Lumpur Madrid Melbourne Mexico City Mumbai
Nairobi Paris São Paulo Shanghai Singapore Taipei Tokyo Toronto Warsaw
with associated companies in Berlin Ibadan

Oxford is a registered trade mark of Oxford University Press
in the UK and in certain other countries

Published in the United States
by Oxford University Press Inc., New York

British Library Cataloguing in Publication Data

Data available

Library of Congress Cataloging in Publication Data

Data available

ISBN 0-19-866203-3

1 3 5 7 9 10 8 6 4 2

Typeset by Interactive Sciences Ltd, Gloucester
Printed in Great Britain
on acid-free paper by
Butler and Tanner Ltd
Frome, Somerset

CONTENTS

LIST OF COLOUR PLATES

INTRODUCTION

WHEN the Oxford University Press first visited me to seek advice on how they might best replace Harold Osborne's *Oxford Companion to Art*, first published in 1970, I never for one moment entertained the idea that I might myself one day agree to plan and edit a new Companion. After four intensive years devoted to planning the 34-volume Macmillan *Grove Dictionary of Art*, which was conceived on a global basis, I had moved to the more object-oriented world of Sotheby's old master paintings department and had little appetite for more editorial work. On the other hand, I did have strong views as to how Oxford should proceed. Osborne's work had courageously attempted to bring together the study of Western and Eastern cultures at a time when most art historical work was far more insular and chauvinistic than it is today. Yet my experience at Macmillan's, grappling with the methodological issues involved in implementing such a comprehensive approach, convinced me that this could not possibly be achieved adequately within the scope of a single-volume Companion. Accordingly, I recommended that both non-western art and all architecture should be treated in separate works, and that a Companion to Western Art, focused primarily on painting, sculpture, and the graphic arts, should be set in motion to replace the principal aspect of Osborne's work. The Oxford University Press agreed and I was persuaded to take it on.

When, in the company of my advisory editors, I initiated the debate on the range of our coverage of Western art, we all agreed that the book should, so far as possible, cover all cultures speaking a European language and be object-orientated in its approach. Our notional reader is perceived to be first and foremost someone who travels and visits ancient sites and cities, galleries and exhibitions, churches and libraries, country houses and palaces, and who therefore is likely to look for biographical details about artists and to need contextual information on patronage, collecting, and changing aspects of taste. Both in range and depth, we have greatly expanded the coverage of artists provided by Osborne. We have included articles on the *fortuna critica* of the art of the major European countries, rather than adopt the more obvious approach of surveying each country's patrons. Thus, instead of an article on Italian patronage, there is an article on the patronage and collecting of Italian art, not only in Italy, but in Spain, France, Germany and central Europe, Britain, and the USA.

The articles on major cities, ancient and modern, are determined by their history as centres of patronage, collecting, and the art market; and major museums and academies are discussed in articles under the city heading. We have endeavoured to provide lucid explanations of styles and movements and art historical methodology, with articles on individual writers and theorists, as well as on recent approaches to art involving new concepts and new language. Harold Osborne had given considerable emphasis to aesthetic and scientific issues, and here, exceptionally, we have retained much of his material, for instance the legendary articles on colour, perspective, and proportion. Arguably these long essays disrupt the balance of the present *Companion*, but we could not bring ourselves to mutilate or cut them. Osborne was also exceptionally diligent in his coverage of materials and techniques and the scientific examination of art. While following his example, we restructured the headings and recommissioned all the articles in this field to take account of the enormous advances made in recent years.

The principal differences between the present volume and its predecessor are all reflections of the radical changes in taste and the range of investigative scholarship that have taken place over the last 30 years. For instance, the coverage of medieval illuminated manuscripts has been expanded both in absolute and relative terms. Much Italian and Spanish Baroque art, especially outside mainstream activity in Rome, was virtually ignored by Osborne and is now given its due place. The coverage of 19th- and 20th-century art has been fundamentally reconsidered. Although living artists have been included, we have concentrated on figures whose careers have already taken shape. We have not attempted to predict next year's movements.

In compiling our headword lists and in making subsequent revisions to it, we have incurred debts to several notable scholars. Many are also listed as authors but particular acknowledgement is due to the following: Jill Dunkerton and Ashok Roy, National Gallery, London, for planning the coverage of painting materials and techniques; Paul Goldman, University of London, for advice on drawing techniques; Richard Godfrey of Sotheby's for devising the coverage of prints; John Gage, recently retired from Cambridge University, for advice on colour and other scientific and aesthetic issues; Gabriele Finaldi, National Gallery, London, for advice on 16th–18th-century Spanish coverage; Susan Foister, National Gallery, London, for advice

on 16th–18th-century German coverage; Jon Whiteley, Ashmolean Museum, Oxford, for advice on 19th-century coverage; and Elizabeth Cowling of Edinburgh University, and Christine Lodder of St Andrew's University for suggestions on 20th-century coverage. Others who helped check our list of articles for oversights include Nigel Morgan, Ann Sutherland Harris, Kirk Savage, David Cohen, Peter Draper, Janet Huskisson, Antony Spawforth, and the late Michael Kitson. Christopher Brown and Lorne Campbell helped to vet a number of articles on Dutch and Flemish artists; and Anthony Langdon helped to rationalize and edit some of the more complex country and city articles.

It remains for me to thank the advisory and commissioning editors and other editorial advisers for their vision, patience, and perseverance; the staff at the Oxford University Press, especially Pam Coote, Wendy Tuckey, and Rebecca Collins; the copyeditors Edwin and Jackie Pritchard; and, above all, our authors, on whom the character of this book ultimately depends. We hope our readers find it a true Companion, both informative and entertaining. This book is not designed as an all-inclusive dictionary like the Macmillan/Grove, to which many of our writers extend appreciative acknowledgement, but as a stimulating point of departure; and the bibliographical references at the foot of most articles are intended to lead the reader on to more comprehensive or specialized sources. However, art history is not a subject which can be studied exclusively in a reference library. We hope that with this *Companion* readers will travel around and study works of art at first hand; wherever possible we have indicated the present whereabouts of pictures discussed in the text. For that reason too, we have not sought to illustrate the full range of Western art, and nor have the colour plates been chosen as illustrations to specific articles; instead, they are intended as a taster, and reflect two general themes: the human form and the face, as interpreted from antiquity to the present day.

HUGH BRIGSTOCKE

York
1 April 2000

ADVISORY EDITORS

DR LORI-ANN TOUCHETTE was principal adviser on coverage of the classical world and responsible for commissioning and vetting the entries in this area. She is a Research Fellow in Ancient Art History at the British School at Rome. She has taught ancient art history and classical archaeology at Johns Hopkins University (1989–95), University College Dublin (1995–7), and The British School at Rome (1997–8). A specialist in Roman copies of Greek sculpture, her interests extend to broader issues of mimesis and the reception of diverse visual traditions in the ancient world. She has published a book on the Dancing Maenad Reliefs (1995) and articles on various aspects of Greek and Roman art, iconography, and production, as well as on the reception of antiquity in the 18th century.

DR KAY SUTTON was editorial adviser on coverage of all the arts of the post-classical period up to and including the 15th century and was responsible for commissioning and vetting most of the entries in this area and also the biographies of 16th-century sculptors. She also helped to plan and commissioned the general articles on sculpture materials, techniques, and conservation. She is Consultant for Medieval and Renaissance Manuscripts in the International Book Department, Christie's, London.

DAVID RODGERS (1942–99) was principal adviser on coverage of the art of the 19th and 20th centuries, and of post-medieval British art; and he commissioned and vetted most of the entries in these areas. He was a former Director of Wolverhampton Art Gallery and Museums (1969–81), Exeter Museums and Art Gallery (1981–6), and of the Geffrye Museum, London (1986–90). In 1967 he organized a pioneering exhibition on Charles Conder in Sheffield, and has written works on Rossetti (1996) and William Morris (1996). At the time of his sudden death, he was working on Oscar Wilde. As a museum director he championed British and American Pop Art.

OTHER EDITORIAL ADVISERS

Helen Langdon helped prepare the list of entries for the *Companion*, and continued to advise the General Editor on methodological issues, especially relating to art historical writers and art theory. After the death of David Rodgers, Julian Bell gave additional advice on coverage of 20th-century general issues and methodology. Both have also generously contributed entries to the *Companion*.

CONTRIBUTORS

Text entries are signed with the initials listed below. A small number of entries has been reused from the *Oxford Companion to Art*, edited by Harold Osborne. In these cases entries are signed HO, since there is no record of the individual contributors to that work. Where an entry has been reused from Osborne's *Companion* with only minor revision, the entry is signed HO followed by the initials of the revising contributor. Entries that are unsigned are based on the text of Ian Chilvers, *Dictionary of Twentieth-Century Art* (1998).

AA Andrew Ayers is an architectural historian and is currently preparing a guide to the architecture of Paris, due for publication in 2001.

JA Jaynie Anderson, Professor and Head of the School of Fine Arts, Classical Studies, and Archaeology at the University of Melbourne, has published widely in the Italian Renaissance.

KWA Karim Arafat, Reader in Classical Archaeology, King's College London, with special interest in Greek art and the 2nd-century AD traveller and writer Pausanias.

RRAM Richard Aronowitz-Mercer is a poet and freelance writer on art, specializing in modern and contemporary German painting.

AB Antonia Boström, Assistant Curator, Department of European Sculpture and Decorative Arts, Detroit Institute of Arts. She is Editor of the *Encyclopedia of Sculpture* (2001) and her research concentrates on 16th-century Italian sculpture and collecting.

CB Christopher Baker, Assistant Curator of the Christ Church Picture Gallery, Oxford; he has a special interest in 17th-century painting and sculpture.

CFB Christopher F. Black, Senior Lecturer in Modern History at the University of Glasgow, with special interests in social, religious, and cultural history of early modern Italy.

DB David Bomford, Senior Restorer of Paintings, National Gallery, London. He was Slade Professor of Fine Art, Oxford University, 1996–7.

DB-O Diana Buitron-Oliver, Adjunct Professor of Liberal Studies at Georgetown University, and author of *Douris A Master Painter of Athenian Red-figure Vases* (1995).

FB Flavio Boggi is a freelance art historian with special interest in Italian Renaissance and Baroque art.

FGB Francesca G. Bewer, Associate Curator for Research, Straus Center for Conservation, Harvard University Art Museums. Her special interest is the history of technology of sculpture.

HB Hugh Brigstocke, General Editor.

JB Julian Bell is a painter and the author of *What is Painting? Representation and Modern Art* (1999).

JBl John P. Black, Department of History of Art, University of Glasgow. His particular interests are 13th- and 14th-century Italian painting and the influence on this of Classical and Antique art.

JBB John Bernard Bury, author of *Arquitectura e arte no Brasil colonial* (1991) and contributor to *Cultural links between Portugal and Italy* (2000).

KB Kathryn Barron, The Royal Collection, London.

KLB Kristin Lohse Belkin is a Rubens specialist and author of *Rubens* (Art and Ideas) (1998).

MB Michael Bury, Senior Lecturer in the Department of Fine Art at the University of Edinburgh.

MBe Marina Belozerskaya is a historian of Renaissance art and culture and the author of *Perceiving the Renaissance: Burgundian Arts Across Europe* (forthcoming).

MPB Michelle P. Brown is Curator of Illuminated Manuscripts at the British Library, and author of *Understanding Illuminated Manuscripts* (1994) and *The British Library Guide to Writing and Scripts* (1998).

PAHB Peter Bower is a forensic paper historian and analyst, and author of *Turner's Papers 1787–1820* (1990) and *Turner's Late Papers 1820–1851* (1990).

PB Paul Binski, Lecturer in the History of Art, Cambridge University.

RB Rachel Billinge, Rausing Research Associate, Conservation Department, National Gallery, London.

XB Xavier Bray specializes in Spanish art. He was Assistant Curator at the National Gallery in London, and now works as the curator of European paintings in the Museum of Fine Arts of Bilbao in Spain.

CC Chloe Catán is a freelance art historian currently based in Mexico. Specialized in modern art, she has co-ordinated various exhibitions and books on Mexican art, architecture, and photography.

DC Diané Collinson, freelance writer on aesthetics and composer of vocal music. She was formerly Senior Lecturer and Staff Tutor in Philosophy at the Open University, specializing in aesthetics.

DSC David Chambers, Emeritus Reader in Renaissance Studies at the Warburg Institute, University of London.

FC Fenella Crichton teaches at the University of Brighton, with special interest in contemporary art.

HC Helen Carron, Emmanuel College Library, Cambridge. Her special research interest is Scandinavia.

HCh Hugo Chapman, Assistant Keeper, Department of Prints and Drawings, British Museum, responsible for Italian old master drawings.

IC Ian Chilvers, author and editor. His publications include *Dictionary of Twentieth-Century Art* (1998) and the *Concise Oxford Dictionary of Art and Artists* (2nd edn 1996).

JNC Nicolas Coldstream, Professor Emeritus of Classical Art and Archaeology at University College London. His special interest is the archaeology of the Early Greek World.

KC Kate Challis is a doctoral student at the University of Melbourne, researching early 16th-century Flemish manuscript illumination.

MC Martin Clayton, Assistant Curator in the Print Room of the Royal Library, Windsor Castle.

MFC Meta Chavannes is an art historian and trainee paintings conservator at the Hamilton Kerr Institute, Cambridge.

NC Nicola Coldstream is an independent scholar, author of *The Decorated Style. Architecture and Ornament 1240–1360* (1994).

PC Peter Cooke, Lecturer in French Studies at the University of Manchester, with special interest in 19th-century French painting and literature.

PCo Peter Collingridge, Consultant, Russian Dept, Christie's, London.

SC Sharon Cather, Conservation of Wall Painting Department, Courtauld Institute of Art, University of London. She is a specialist in the study and conservation of wall paintings.

TPC Thomas Campbell, Associate Curator of European Sculpture and Decorative Arts at the Metropolitan Museum of Art, specializes in European tapestry production and patronage.

ID Ian Dunlop is an independent art expert and author of *The Shock of the New* (1972) and *Degas* (1979).

JD Jill Dunkerton is a restorer in the Conservation Department of the National Gallery, London.

KD Kerry Downes, Emeritus Professor of History of Art, University of Reading.

RD Roger Diederen, Associate Curator at the Dahesh Museum, New York, specialist in 19th-century European painting.

JRE Jesús Escobar, Assistant Professor of Art History at Fairfield University, Connecticut, with special interest in Spanish architecture and urbanism.

MLE Mark Evans, Head of Paintings at the Victoria and Albert Museum, London, has a special interest in Renaissance painting and manuscript illumination, and cultural exchange between Italy and northern Europe.

MF Morgan Falconer is a freelance journalist with interests in contemporary art and social affairs.

MLF Margaret Lane Ford is a Director in the Book Department at Christie's, London.

CFW Clare Ford-Wille is a lecturer and writer with a special interest in 16th- and 17th-century Dutch and Flemish painting.

JG John Goodman, a freelance translator and specialist in 18th- and 19th-century European art with a particular interest in Paris.

JGa John Gage, formerly Reader in the History of Western Art at Cambridge University, and author of *Colour and Culture* (1993) and *Colour and Meaning* (1999).

JG-S John Glaves-Smith is Senior Lecturer in History of Art and Design at Staffordshire University.

PG Pierre Géal, Professor of Spanish Civilization at the University of Provence, Aix-en-Provence, wrote his doctoral thesis on the history of museums in Spain.

PHJG Paul Goldman is an Associate Fellow at the Institute of English Studies in the University of London. He is the author of *Victorian Illustrated Books 1850–1870* (1994) and *Victorian Illustration* (1996).

RG Robert Gibbs, Senior Lecturer in History of Art at Glasgow University; his particular interest is 13th- and 14th-century Bolognese painting and illumination.

RGo Richard Godfrey, Specialist, Old Master Prints Department, Sotheby's, London, and author of *Printmaking in Britain* (1978), and *Wenceslaus Hollar* (1994).

CMH Carola Hicks teaches History of Art at the University of Cambridge, and has specialized in the arts of the early Middle Ages, and in stained glass of all periods.

ILH Inge Lyse Hansen, freelance researcher with a special interest in Roman art and the imaging of women in the classical world.

JEH John Harrison is a psychologist working within the pharmaceutical industry. He is the author of *The Strangest Thing: The Science of Synaesthesia* (2001).

JH Justine Hopkins is a writer and freelance lecturer in History of Art, with special interest in 19th- and 20th-century painting and sculpture. She is the author of *Michael Ayrton: A Biography* (1994).

JHo John House, Professor of the History of Art at the Courtauld Institute of Art, University of London, with special interest in French 19th-century art.

KH Karen Hearn is Curator of 16th- and 17th-century British Art at the Tate Gallery.

LH Lucinda Hawkins is co-author of *Michelangelo* (1991) and was an Area Editor of Macmillan's *Grove Dictionary of Art*.

PBH Peter Humfrey, Professor of Art History at the University of St Andrews, with special interest in the art of Renaissance Venice.

PH Paul Hetherington, a freelance art historian, has special interests in Byzantine art and architecture, and in the art of late medieval Rome. His publications include *Byzantine and Medieval Greece, churches, castles and art* (1991) and *Pietro Cavallini, a study in the art of late medieval Rome* (1979).

PHo Paul Holberton is an art historian and a book publisher, known for his work on Renaissance iconography and Venetian painting.

TJH Timothy Hunter lectured in Medieval History and History of Art at the University of Oxford, and is now a Director of Christie's, London.

OI O. H. Irvine is an art historian and antiquarian bookseller.

AWJ Alan Johnston, Reader in Classical Archaeology, University College London, with special interest in Archaic Greece and Greek Epigraphy.

DJ David Jackson, Lecturer in the Department of Fine Art at the University of Leeds, specializing in 19th- and 20th-century Russian and Soviet art.

DJa David Jaffé, Senior Curator at the National Gallery, London, and former Curator of Paintings at the J. Paul Getty Museum, Los Angeles. His specialization is Flemish art, 1600–1800.

LJ Liz James, Senior Lecturer in the History of Art, School of European Studies, University of Sussex, with a special interest in Byzantine art.

MJ Marc Jordan is an art historian and writer who has spent most of his career as an editor and publisher of art books. He is currently Managing Director of Acoustiguide, the audio tours provider.

TJ Tom Jones is a Professor and Head of Department at Birmingham Institute of Art and Design, University of Central England.

YJ Yvonne Jones is a Lecturer and researcher in the fine and applied arts, and formerly Head of Arts & Museums, Wolverhampton.

CEK Catherine Ellen King is Senior Lecturer and Head of Department in Art History at the Open University,

Milton Keynes. She is author of *Renaissance Women Patrons; wives and widows in Italy c.1300–1550* (1998) and editor of *Views of Difference: different views of art* (1999).

JK Jon Kear, Lecturer in the History and Theory of Art, University of Kent at Canterbury, with special interests in 19th-century painting and sculpture.

MK Michael Kitson taught at the Courtauld Institute of Art from 1955, and was Deputy Director, 1980–5. He was also Director of Studies at the Paul Mellon Centre (1986–92) and Vice-Chairman of the Turner Society (1984–93). He has written books on Turner, Rembrandt, and Caravaggio, as well as exhibition catalogues and articles on the Italian baroque, British painting, Salvator Rosa, and Claude Lorrain.

AJL Anthony Langdon, formerly a Deputy Secretary at the Home Office, is co-author (with Ian Dunbar) of *Tough Justice* (1998).

HL Helen Langdon is the author of *Claude Lorrain* (1989) and *Caravaggio: a Life* (1998).

JL John Langton is a painter.

KDSL Kenneth D. S. Lapatin teaches ancient art at Boston University; he is the author of *Chryselephantine Statuary in the Ancient Mediterranean World* (2001).

LL Louise Leates, freelance teacher of art history with special interest in French arts from the Renaissance to the later 19th century.

PL Patrick Lenaghan is currently Curator of Prints and Photographs at the Hispanic Society of America, New York. His original training was in sculpture and painting of the Spanish Golden Age.

PLe Paul Lewis, formerly Head of Media and Cultural Studies at the University of Wolverhampton, is a freelance lecturer in the history of art and photography.

RJL Roger Ling, Professor of Classical Art and Archaeology at the University of Manchester, with special interest in Roman archaeology.

RL Riccardo Lattuada, Professor of History of Modern Art at the Seconda Università degli Studi di Napoli, with special interest in Italian Baroque painting.

SL Susan Loppert, art historian, critic and consultant, is currently Director of Chelsea & Westminster Hospital Arts. She is co-editor of *The Arts in Health Care: Learning from Experience* (1999).

AM Aimée Marcereau, Assistant Curator, Department of European Paintings, Detroit Institute of Arts, with special interest in 18th-century British painting.

AMo Andrew Morrall is Associate Professor at the Bard Graduate Center for the Decorative Arts and Culture, New York, where he teaches Northern Renaissance and Baroque art and culture. He is the author of *Jörg Breu the Elder, Reformation and Renaissance in early 16th-century Augsburg* (forthcoming).

CCM Carol C. Mattusch, Mathy Professor of Art History at George Mason University in Fairfax, Virginia, studies Greek and Roman art and archaeology, and has a special interest in bronze technology.

CEM Christine Morris, Leventis Lecturer in Greek Archaeology and History, School of Classics, Trinity College Dublin; her special area of research is the art and archaeology of the Aegean Bronze Age.

CJM Christopher Masters is a lecturer and journalist and author of *Dalí* (1995).

DM Duncan Macmillan is Professor of the History of Scottish Art at the University of Edinburgh and author of *Scottish Art 1460–2000* (2000).

GMcK-S Gridley McKim-Smith, Andrew W. Mellon Professor in Humanities, Bryn Mawr College, Pennsylvania, with special interest in Spanish and Latin American Art.

KM Kirk Marlow, Lecturer of Art History, Fine Art Program, Grant MacEwan Community College, Edmonton, Alberta, with special interest in Canadian Art History.

NAM Nina Ayala Mallory, Professor Emeritus of Art History at the University of the State of New York, with special interests in Spanish and Flemish 17th-century painting.

NM Nicholas Mann, Director of the Warburg Institute, University of London, is a long-standing student of Petrarch and early humanism.

NMcA Nick McAdoo has a Ph.D. in the Philosophy of Art and has published widely in the field. He has taught aesthetics at the Universities of London and Kent and now works for the Open University, Milton Keynes.

PM Paul Mitchell, a frame historian and frame consultant, is co-author of *Frameworks* (1997) and *A History of European Picture Frames* (1996).

PMcC Patrick McCaughey, Director of the Yale Center for British Art since 1996; Director of the Wadsworth Atheneum, Hartford, 1988–96, and National Gallery of Victoria, Melbourne, 1981–7.

WMO William Mostyn-Owen, formerly assistant to Bernard Berenson 1952–8, after a spell at the Metropolitan, New York, joined Christie's, London, as Director of the Old Masters Department, 1968–87.

GN Geraldine Norman is the Director of the Hermitage Development Trust and a long-standing author and journalist.

NWN Nancy Ward Neilson lives in Milan and has written on the painting and draughtsmanship of the early 17th-century Lombard school.

AO Anna Orlando is a freelance art historian. Her main research interest is 17th-century Genoese painting.

CIRO'M Claire I. R. O'Mahony, Visiting Lecturer at the Courtauld Institute of Art, London, and at the University of Bristol. Her specialism is mural painting.

HO Harold Osborne (1905–87) was joint founder with Sir Herbert Read of the British Society of Aesthetics, whose journal he edited for many years. He wrote many books on aesthetics and art, and edited the *Oxford Companions to Art* (1970), *Twentieth-Century Art* (1981), and the *Decorative Arts* (1975). See also Note above.

SO'C Sheila O'Connell, Assistant Keeper, Department of Prints and Drawings, British Museum.

CP Cecilia Powell, editor of *Turner Society News* since 1986, is the author of four books and exhibition catalogues on Turner and his travels in Europe, including the prize-winning *Turner in the South* (1987).

MP Michael Pidgley is a freelance art historian with a special interest in 19th-century British painting, watercolours, and printmaking.

OP Olga Palagia, Professor of Classical Archaeology at the University of Athens, with special interest in Greek sculpture.

OPa Oliver Parfitt is a musician and freelance art historian whose main area of research is British art of the 19th and 20th centuries.

RJP Robin Plummer, painter and interviewer, formerly Dean and Professor at Brighton Polytechnic.

RP Roy A. Perry, Head of Tate Conservation, with special interest in 20th-century and contemporary painting.

VGP Véronique Gerard Powell, Assistant Professor (Maître de Conférences) in Modern Art History in the University of

Paris-IV Sorbonne, specializes in Spanish art of the 16th to the 18th centuries.

WP Wolfgang Prohaska, Curator of later Italian and Flemish Paintings, Kunsthistorisches Museum, Vienna, and Professor and Lecturer at the Institute of Fine Arts, Vienna University.

FQ François Quiviger, Librarian at the Warburg Institute, University of London; part-time lecturer at the Victoria & Albert Museum, London.

AR Ashok Roy, Head of the Scientific Department at the National Gallery, London, with a special interest in the materials and techniques of old master painting.

DER David Rodgers, Advisory Editor. See description above.

JR John C. Richards, Lecturer in History of Art, University of Glasgow.

LR Lynn Roberts is a frame historian and co-author of *Frameworks* (1997) and *A History of European Picture Frames* (1996).

AS Amanda Simpson is author of *English and Bohemian Painting during the second half of the fourteenth century* (1984) and now works on 14th-century English sculpture.

ASt Alexander Sturgis is the Director's Curatorial Assistant at the National Gallery, London.

CS Claudia Schnitzer is the Curator for German Prints and Drawings from 1500 to 1800 at the Kupferstich-Kabinett Dresden (Collection of Prints and Drawings, Dresden).

CALS-M Charles Sebag-Montefiore, Hon. Treasurer of the London Library, and Trustee of the Samuel Courtauld Trust, with special interest in the history of the British as collectors.

GS Gudrun Schubert, currently subject leader for Visual Culture BA at the University of Brighton. She has a particular interest in the careers and work of women artists in 19th-century France and England.

JCS Jeffrey Chipps Smith, Ruth Head Centennial Professor of Fine Arts at the University of Texas at Austin, specializes in Renaissance and Baroque art in Germany and the Low Countries.

KS Kay Sutton, Advisory Editor. See description above.

LS Luke Syson, Curator of Medals at the British Museum, with special interest in the Italian Renaissance.

LSt Lesley Stevenson, Senior Lecturer in Art History, Thames Valley University, has written a number of books and articles on 19th-century French art.

MLS Maria Santangelo, Assistant Curator of European Sculpture and Decorative Arts at the Detroit Institute of Arts, with special interest in early Italian Renaissance sculpture, decorative arts, and painting.

MS Marilyn Smith, Associate Lecturer with the Open University, Milton Keynes, with special interest in Renaissance Art and Architecture.

PCS Peter C. Sutton is a Vice-President in Citibank's Art Advisory Service. He is a specialist in Northern Baroque painting who has written about Dutch and Flemish art.

PS Pippa Shirley, Head of Collections, Waddesdon Manor, Buckinghamshire.

PSt Paul Stirton is Senior Lecturer in the History of Art at Glasgow University and Visiting Professor at the Bard Graduate Center, New York.

SS-P Suzanne Stratton-Pruitt is an independent art historian whose area of expertise is Spanish Renaissance and Baroque art and its reflections in the Americas.

AT Achim Timmermann, Getty Postdoctoral Fellow (2000–1), with particular interest in medieval art and the historiography of art history.

BT Belinda Thomson is a freelance author, lecturer, and exhibition curator, with special interests in Impressionism, Post-Impressionism, and the Nabi group.

DT Duncan Thomson was Keeper of the Scottish National Portrait Gallery from 1982 to 1997.

GT Grady T. Turner is Director of Exhibitions at the New York Historical Society, and an art critic for publications including *Art in America*, *ARTnews*, *Flash Art*, and *The Village Voice*.

GyT Gyöngyi Török, Chief Curator of Medieval Art in the Hungarian National Gallery, Budapest, with special interest in central European altarpieces, the Hungarian Renaissance, book illumination, and iconography.

JT Janis Tomlinson is the Director of Arts in the Academy, National Academy of Sciences, Washington DC. She is the author of *El Greco to Goya: Painting in Spain 1561–1828* (1997).

JTo Judith Toms, Research Associate, Institute of Archaeology, University of Oxford.

KT Karen Trentelman is an Associate Research Scientist at the Detroit Institute of Arts.

L-AT Lori-Ann Touchette, Advisory Editor. See description above.

MT Michelle Thomas, freelance writer.

TT Thomas Tolley, Senior Lecturer in Fine Art, University of Edinburgh, with special interest in northern European visual culture of the 14th and 15th centuries.

JV Jutta Vinzent, Honorary Research Fellow at the University of Birmingham, with special interest in 20th-century German art and literature.

OEV Oscar E. Vázquez, Associate Professor of Art History, Binghamton University, New York, has published on Spanish and Latin American visual cultures, academies, and collections.

WV William Vaughan, Professor of the History of Art at Birkbeck College, University of London, with special interests in British and German art of the 19th century.

AJW Julia Weiner is art critic of the *Jewish Chronicle* and writes regularly about Jewish art and artists.

AW Alexander Wied, Curator at the Gemäldergalerie of the Kunsthistorisches Museum in Vienna, with special interest in Netherlandish painting of the 16th century.

HW Humphrey Wine, Curator of 17th- and 18th-century French paintings, National Gallery, London.

JW Joanna Woodall is Senior Lecturer at the Courtauld Institute of Art, University of London, with special interests in western portraiture and early modern Netherlandish painting.

JW-E John Wilton-Ely, Emeritus Professor in the History of Art, University of Hull, with special interests in 18th-century European art and architecture, and author of *G. B. Piranesi. The Complete Etchings* (1994).

MW Mariët Westermann, Associate Professor of Art History at Rutgers University, with special interest in 17th-century Netherlandish art.

RW Ruth Webb is Assistant Professor in the Department of Classics at Princeton University. Her special interest is in word and image in the literature of the Roman Empire and Byzantium.

RWh Raymond White, Principal Scientific Officer, Scientific Department, National Gallery, London, specializes in the chemistry, analysis, and use of organic natural products in European easel paintings.

SAW Sally Woodcock works as a paintings conservator, both independently and at the Guildhall Art Gallery, London,

with special interest in British 19th-century artists' colourmen.

SVW Susan Verdi Webster, Associate Professor of Art History at the University of St Thomas, St Paul, Minnesota, with special focus on the art of Spain and Latin America.

CWZ Catherine Wilkinson Zerner, Professor of the History of Architecture at Brown University in Providence, Rhode Island, works on architecture of the Renaissance.

EZ Eric Myles Zafran, Curator of European Painting and Sculpture at the Wadsworth Atheneum, with special interest in the history of collecting.

ABBREVIATIONS

AG	Art Gallery
ARA	Associate of the Royal Academy
Arch.	Archaeological, Archeologico
Bib.	Bibliothèque, Biblioteca, Bibliothek
Bib. Nat.	Bibliothèque Nationale
BL	British Library
BM	British Museum
c.	*circa*
Coll.	Collection
destr.	destroyed
exhib. cat.	exhibition catalogue
Gal.	Gallery, Galerie, Galleria
Inst.	Institute, Institut
J.	Journal
Kunsthist. Mus.	Kunsthistorisches Museum
Lib.	Library
Met. Mus.	Metropolitan Museum of Art
MoMa	Museum of Modern Art
MS	manuscript
Mus.	Museum, Musée, Museo
Mus. Arch. Naz.	Museo Archeologico Nazionale
Mus. Naz. Romano	Museo Nationale Romano
NG	National Gallery
NPG	National Portrait Gallery
Pin.	Pinacoteca, Pinakothek
priv. coll.	private collection
Prop.	Proposition
RA	Royal Academy, Royal Academician
S.	Saint (English and all Romance languages)
s.d.	signed and dated
SS	Saints (English and all Romance languages); also Santissima
V&A	Victoria and Albert Museum

NOTE TO THE READER

This book is designed for ease of use, but the following notes may be helpful to the reader.

Alphabetical arrangement Entries are arranged in letter-by-letter alphabetical order of their headwords, which are shown in bold type. There are two exceptions to a strictly alphabetical arrangement, for reasons of logic:

1. Entries on the anonymous masters (all beginning with the headword 'Master') are ordered by their significant words, disregarding the words 'of' and 'the', so that the sequence runs, for example:

 > Master, Bedford
 > Master of the Boqueteaux
 > Master, Boucicaut
 > Master of the Brunswick Diptych

2. Entries on museums, galleries, and exhibiting societies have the relevant city as an initial headword (e.g. Florence, Uffizi) and in these cases, the general entry on the city precedes entries on individual galleries regardless of alphabetical rules, e.g.

 > Florence: patronage and collecting
 > Florence, Bargello
 > Florence, Palazzo Pitti
 > Florence, Uffizi

Cross-references An asterisk (*) within the text indicates a cross-reference to another relevant headword. Similarly 'see' or 'see also' followed by a headword in SMALL CAPITALS is used to cross-refer when the precise form of headword to which the reader is being pointed does not occur naturally in the text. An item is normally marked with an asterisk only at its first occurrence in any entry; and if the reference is merely incidental it is not marked.

Gallery and museum entries As mentioned above, entries on galleries, museums, and exhibiting societies include their city as the first word of their headword, so that readers can find all entries relating to a particular city in one place. Thus, on looking up Paris, the reader will find the general entry on patronage and collecting in Paris, followed by a sequence of entries from Paris, Académie Royale, to Paris, Salon du Champ de Mars. To avoid undue clutter, parenthetical cross-references to gallery entries generally refer only to the city name, e.g. (see under PARIS).

Uncertain dates An oblique stroke between two dates is used to indicate alternate dates, not a sequence, e.g. 1589/95 means 'in either 1589 or 1595'. A multiplication sign is used to signal a range of dates, e.g. 1530×9 means 'at some time between 1530 and 1539'. *Circa* is used in the normal way to indicate an approximate date, e.g. *c*.1382 means 'around 1382'; and a question mark following a date indicates a probable date.

Titles of works of art We have aimed to use the title by which a work is most commonly known, thus on occasion departing from a fuller or more strictly correct title. Capitalization of titles follows the normal rules for capitalization of the language in question, thus fewer capitals are used for Italian and Spanish titles than English ones.

Saints For reasons of space S. and SS have been used in all references to saints, both in English and all Romance languages, with the exception of place-names.

Index of artists and writers on art At the back of the book (see pp. 811–820) a select index allows the reader to follow up references to artists and writers on art mentioned in the course of other entries, but without an entry of their own. People mentioned solely in the context of an entry on the art of one country have not been indexed.

Contributors' initials are given at the end of each entry, and a key to these initials is provided on pp. xiii–xvii.

AACHEN, HANS VON (1552–1615). Much-travelled German artist who worked mainly in Italy and Bohemia, where he was one of the foremost artists at the court of Emperor Rudolf II at Prague. After training in Cologne, he visited Venice, Rome, and Florence, receiving commissions from Italian patrons and making copies of *Antique and Italian works of art. In Prague, von Aachen worked not only as a painter but also as an art agent and, occasionally, diplomat, making frequent journeys abroad. In 1605 Rudolf II conferred a knighthood on him. Along with Bartholomäus *Spranger, von Aachen was the main representative of the late *Mannerist, internationally influenced style of art practised at the court of Rudolf II. His works—portraits, paintings of religious and historical subjects, genre pictures, and allegories—combine Roman and Florentine Mannerist forms with Venetian colour and Netherlandish realism. Among his finest paintings are those of mythological and allegorical content, in which sensuous nudes in the guise of Greek gods are subtly linked to Rudolf II's qualities as a ruler (*Bacchus, Ceres and Cupid*, c.1600; Vienna, Kunsthist. Mus.).

KLB

Da Costa Kaufmann, T., *The School of Prague* (1988).

AALTONEN, WÄINÖ (1894–1966). Finnish sculptor born near Turku. He studied at the School of Drawing of the Turku Art Association. His first significant works were commemorative monuments produced after the civil war of 1918, the most ambitious being *The Hero's Grave* at Savonlinna. A large exhibition of his work was held in Stockholm in 1927, which strengthened his reputation as the outstanding representative of the Finnish national character and way of life. Among his most famous monuments are: the five allegorical figures on the theme *Work and the Future* for the assembly hall of the new House of Parliament opened in 1931; and the statue to the author *Alexis Kivi* in front of the Finnish National Theatre in Helsinki. Other works include a bronze monument to the runner *Paavo Nurmi* (1925; Turku and Helsinki), his series of granite nudes *Young Girls Paddling* (1925; Turku, Aaltonen Mus.) and *The Tax Collector* (1929; Tampere). He also did portrait busts of *Sibelius* (1928) and *Queen Louise of Sweden* (1942).

OPa

Okkonen, O., *Wäinö Aaltonen* (1941).

ABILDGAARD, NICOLAI ABRAHAM (1743–1809). Danish painter, designer, and architect. He was one of the leading Scandinavian artists of *Neoclassicism. Born and trained in Copenhagen, he spent 1772–7 in Italy, chiefly Rome and Naples, at a time when the discoveries of ancient art at *Herculaneum and *Pompeii were beginning to make their full impact. Through the sculptor *Sergel he was introduced to *Fuseli, whose intensely personal style and choice of subject matter influenced Abildgaard's painting in the 1780s. During this decade he was also involved in the decoration of the Palace of Christiansborg, Copenhagen, and the applied arts were his main interest in the 1790s. The chairs that he designed for his own house on the model of the Greek *Klismos* were widely influential in Scandinavia well into the 19th century. In the last decade of his life Abildgaard returned to painting, taking as his subject scenes from the writers Terence and Apuleius (examples Copenhagen, Statens Mus. for Kunst). He was director of the Danish Royal Academy in 1789–91 and 1801–9. *Thorvaldsen was among his pupils.

MJ

Skovgaard, B., *Maleren Abildgaard* (1961).
Swane, L., *Abildgaard: arkitektur og dekoration* (1926).

ABRAMTSEVO COLONY, artistic commune established north of Moscow on the estate of the industrialist Savva Mamontov (1841–1918). Between the 1870s and the

1890s it was an important influence on the late 19th-century Slavic revival in its preservation and revival of national culture, antiquities, and indigenous art forms, particularly folk art, including a unique collection of everyday peasant objects. Many prominent Russian artists lived and worked on the estate, including Ilya *Repin, Viktor Vasnetsov (1848–1926), Vasiley Polenov (1844–1927) and Yelena Polenova (1850–98), Mikhail Vrubel (1856–1910), Valentin Serov (1865–1911), and Mikhail Nesterov (1862–1942). The architects Viktor Gartman and Ivan Ropet designed a number of revivalist projects, some functional—a communal bathhouse, studios, workshops, a school and hospital for the local peasantry—others, like the fairytale hut on hen's legs, conceived in fun. The latter, along with the church of the Saviour (1880–2), an ambitious archaeological reconstruction in a purer 14th-century style, were designed and decorated by Vasnetsov. Working with local craftsmen the estate produced a variety of wares: furniture, ceramics, tableware, embroideries. A similar interest in national culture occurred at Princess Tenisheva's estate at Talashkino. The Abramtsevo estate is now a national museum. DJ

Beloglazova, N., *Abramtsevo* (1981).

ABSTRACT ART. Before the 20th century, the term 'abstract' covered the aspects of artists' work that 'draw out' (Latin *abstrahere*) from the visible particulars of 'concrete' reality their general or essential form; in this sense, every line sketched from life is an 'abstraction'. But the most familiar use of the term in a contemporary context is as a minimal negative definition, to denote works of art that are not 'representational', that is, which do not seem to represent other bodily objects. Abstraction, however, can be seen as a major or even a dominant aspiration of 20th-century art, and as such it bears a large content of substantial meanings and intentions, which though sometimes seemingly at odds are nonetheless historically interrelated. An attempt at a positive consensus definition might be that an abstract work of art is a production that creates a highly singular and effectively unprecedented visual experience.

The factors that led to the innovatory creation of works of this sort in the 1910s could be described in many ways. There was the yearning to give specific visual form to the inward life of the spirit—which had resulted in the earliest exhibition of non-representational paintings, by Georgiana Houghton (1814–84) in London in 1871. There was the urge, pushed forward by *Gauguin and the *Expressionists, to 'liberate' colour from the task of description and make it a vehicle for such spiritual expression—one

which prompted *Kandinsky's *Compositions* from *c.*1910, commonly seen as the first abstract art. There was the aspiration for an art that, like instrumental music, was devoted exclusively to form—one pursued by Frantisek *Kupka in the rhythmically organized colours of paintings entitled *Fugues* from the same date, and by Robert *Delaunay and the *Orphist group in 1912–14. There was the aim of systematically 'abstracting' from appearances their underlying essence, seen in the sculptures of *Brancusi and understood by *Mondrian to be the logical conclusion from *Cubism that he was delivering in his geometrical reductions of landscape scenes *c.*1916.

Besides these paired concerns with spiritual expression and with form, there was also Kasimir *Malevich's defiant rejection of all foregoing pictorial material in his *Black Square* of 1915, an impulse planted in the utopian revolutionary hopes of the era. The non-objective art that followed in the 1920s generally related to such hopes: El *Lissitzky, Naum *Gabo, Wladyslaw Strzeminski, and other *Constructivists sought to create radically new realities from fresh combinations of basic abstract forms. A common and paradoxical insistence in the inter-war thinking of Constructivism and *Neo-plasticism was that such new realities must be 'concrete': thus 'abstraction' joined hands with its logical opposite.

New elements entered abstract art in the 1940s, when components of the European scene took root in America. The hope of unfolding a new visual language for the inward life of the spirit (seen in 'informal' and 'gestural', rather than in 'formal' and 'geometric' abstraction) was reinterpreted in the light of *Surrealism to suggest an agenda of expressing the unconscious and, beyond that, of producing a visual equivalence for the bodily being of the artist. Both aspirations might be read into the celebrated career of Jackson *Pollock. In the abstraction of the *New York School, which introduced to such painting a fresh component of scale, the defiant wish not to represent (seen in Barnett *Newman) coexisted with Mark *Rothko's belief that to represent contemporary experience adequately, a work must surpass all representation of particulars.

The period from the end of the Second World War to the mid-1960s marked the heyday of 20th-century abstract art: in this period, representational work became positively marginalized in the art world, as powerful historical arguments for the necessity of abstraction were brought forth by critics like Clement *Greenberg. A generation of American artists—the youthful Frank *Stella, the practitioners of *Post-Painterly Abstraction, the *Minimalists—acted on these visions of an 'autonomous' art that was entirely, and as never before, about itself, and

that was exactly the sum of its own formal relations. This appeal to the viewer's intellectual appreciation would lead away from the customary abstractionist emphasis on primary visual encounters, towards the *Conceptual art of the 1970s. Meanwhile, the generation of new forms of visual experience was a project explored in ever-multiplying ways, including the *Op art of painters like Bridget *Riley.

Abstraction since the mid-1960s, when *Pop art galvanized critical attention, has to some extent lost the historical impetus that propelled it earlier. A vastly extended, diffuse activity, the making of abstract work has been absorbed into a continuity with the figurative tradition; both being materials for re-appropriation in postmodernist painting of the 1980s and 1990s, so that seemingly non-representational canvases by Peter Halley or Fiona Rae may equally be seen as allusive representations of the abstract tradition that precedes them. JB

Lynton, N., *The Story of Modern Art* (1980).

ABSTRACT EXPRESSIONISM. The origins of the term are obscure, but it is used to describe the ethos shared by a group of artists in New York during the 1940s and early 1950s. This group knew and supported each other, discussed and argued about their ideas, and had at least some beliefs in common. A generally shared belief was that trying to clear their minds of initial preconceptions and anticipation of the end result would allow them greater expressive freedom, as the work developed mark by mark.

Arshile *Gorky, Philip *Guston, Adolph *Gottlieb, Franz *Kline, Willem *de Kooning, Robert *Motherwell, Barnett *Newman, Jackson *Pollock, Mark *Rothko, and Clyfford *Still, are regarded as the core of the group but other artists, including William *Baziotes, Hans *Hofmann, Lee *Krasner, and David *Smith, were also involved. In 1946, when they started to gain recognition as a group, they were mostly already artists of some reputation, and in their forties; most had worked on the *Federal Art Project (1935–43). Many of them were encouraged by the patronage of Peggy Guggenheim (1898–1979), whose New York gallery, Art of this Century, opened in 1941. Through Guggenheim (who was married to Max *Ernst), they came into close contact with *Surrealist painting and theory. Surrealist influence appeared in the biomorphic forms adopted by Gorky and Baziotes and in the early work of de Kooning, Pollock, and Rothko; but it was the 'psychic *automatism' of the Surrealists, the random marks intended to free the unconscious from the fetters of logic, that had the

more lasting and profound effect. This was reinforced by the influence of the west coast artist Mark *Tobey with his interest in Zen and his 'white writing' paintings. Motherwell and Gorky both practised automatic techniques but it was Pollock, with his 'drip' paintings of 1947, e.g. *Cathedral* (1947; Dallas, Mus. of Fine Arts), who fully developed its potential and broke the ice of dealers and collectors' indifference to the work of contemporary American artists.

Other, subsidiary influences on Abstract Expressionist practice included Marcel *Duchamp (at that time living in New York), Hans Hofmann, *Dada, *Monet, *Miró, *Kandinsky, *Malevich, John *Marin, *Matta, the Mexican Muralists, *Picasso, and *Matisse. The group rejected American styles of the 1930s like the Regionalism of Grant *Wood and Thomas Hart *Benton, and symbolic abstraction; but transcendent beliefs were an important part of the movement, in particular to Barnett Newman, Mark Rothko, and Pollock. Pollock and Guston were influenced by Krishnamurti during their late teens in California.

The work produced by the Abstract Expressionists became increasingly individual as they matured: from the figurative paintings of de Kooning, through the biomorphic forms of Gorky and Baziotes, to the non-figurative work of Kline, Motherwell, Newman, Pollock, Rothko, and Still. The work of some artists was very large: an interest in attempting mural scale may have been a legacy from their work on murals with the Federal Art Project. With others, like Pollock or Kline, the large scale came from the whole body being involved in the act of painting; while for Newman or Rothko size was a way of immersing the spectator in the painting.

By 1948 the most successful painters had begun to establish international reputations and were on their way to earning substantial sums. They had gained support from major critics, notably Clement *Greenberg, Harold Rosenberg and Thomas Hess (who became immensely influential through his editorship of *Art News*) and from patrons in particular Peggy Guggenheim, and the state. The CIA regarded them as the perfect representatives, during the Cold War, of rugged American values—freedom, individuality, and machismo as opposed to Communist conformity—and channelled money into international promotion of their reputations.

In an article in *Art News* in December 1952, Harold Rosenberg described them as 'Action Painters', a label which was rapidly taken up, and which signalled the end of Abstract Expressionism as a term applied to a specific group of artists working in New York. 'Abstract Expressionism' is now a stylistic label used generically like 'Impressionism'.　RJP

Anfam, D., *Abstract Expressionism* (1990).

ABSTRACTION-CRÉATION, an association of abstract painters and sculptors formed in Paris in February 1931 in succession to the short-lived Cercle et Carré group, whose mailing list the new association took over. The prime movers behind Abstraction-Création were Jean Hélion, Auguste Herbin, and Georges *Vantongerloo, who all practised the type of abstract art in which works are constructed from completely non-representational, usually geometrical, elements, rather than derived from natural appearances. Although geometrical abstraction was especially well represented in the association, it was open to abstract artists of all persuasions and the membership at one time rose to as many as 400. Artists of numerous nationalities joined, among them *Arp, *Gabo, *Kandinsky, *Lissitzky, *Mondrian, and *Pevsner. Many members had left the totalitarian regimes in Nazi Germany and Stalinist Russia, where avant-garde art was outlawed, and their presence in Paris helped to make it an important centre for abstract art in the 1930s. Also included in the membership were artists who were never permanently resident in Paris, such as Barbara *Hepworth and Ben *Nicholson. The association operated by arranging group exhibitions and by publishing an illustrated annual entitled *Abstraction-Création: art non-figuratif*, which appeared from 1932 to 1936 with different editors for each issue. The first issue explained the choice of name of the association and the annual: 'abstraction, because certain artists have come to the concept of non-figuration by the progressive abstraction of forms from nature'; 'creation, because other artists have attained non-figuration direct, purely via geometry, or by the exclusive use of elements commonly called abstract, such as circles, planes, bars, lines, etc.'; and 'non-figuration, that is to say a purely plastic culture which excludes every element of explication, anecdote, literature, naturalism, etc.' In the later 1930s the association dwindled, but after the Second World War its ideals were carried on by the Salon des Réalités Nouvelles.　IC

ACADÉMIE ROYALE. See under PARIS.

ACADEMIES. The Academy was an olive grove outside Athens where *Plato and his successors taught philosophy. His school of philosophy was therefore known as 'The Academy'. In the Italian *Renaissance the word began to be applied to almost any philosophical or literary circle. In the 16th century academies became more formal, with established rules of procedure, and began to cover a greater range of activities. It was in this atmosphere that there appeared the first academies of art.

By a natural extension of current Renaissance terminology the word 'academy' was sometimes employed of groups of artists who discussed theoretical as well as practical problems—in this sense it was used somewhat ironically of *Botticelli's studio c.1500. Similarly the famous Accademia of Leonardo da Vinci—the reference has come down to us in engravings of the first years of the 16th century—almost certainly implied no more than a group of men who discussed scientific and artistic problems with Leonardo. Another premature 'academy' is the one attributed by *Vasari to Lorenzo de Medici under the direction of the sculptor *Bertoldo di Giovanni. In fact Vasari is here finding a suitable ancestor for the one that he himself had promoted in 1561; all the evidence suggests that while Lorenzo allowed artists and others easy access to his collections, there was no organized body of any kind concerned with the arts in the Florence of his day. Finally there is an engraving of 1531 by Agostino Veneziano which shows the *Accademia di Baccio Bandin in Roma in luogo detto Belvedere*. Although this portrays sculptors drawing a small statue in *Bandinelli's studio, it probably represents no more than a group of friends discussing the theory and practice of art.

The first art academy proper was set up some 30 years later when Duke Cosimo de' Medici founded the Accademia del Disegno in Florence in 1562. The prime mover was Giorgio Vasari, whose aim was to emancipate artists from control by the guilds, and to confirm the rise in social standing they had achieved in the previous hundred years. *Michelangelo, who more than any other embodied this change of status in his own person, was made one of the two heads and Duke Cosimo himself was the other. Thirty-six artist members were elected, and amateurs and theoreticians were also eligible for membership. Lectures in geometry and anatomy were planned, but there was no scheme of compulsory training to replace regular workshop practice. The Academy quickly won great international authority, but in Florence itself it soon degenerated into a sort of glorified artists' guild.

The next important step was taken in Rome, where in 1593 was founded the Accademia di S. Luca, of which Federico *Zuccaro was elected president. Though more stress than at Florence was laid on practical instruction, theoretical lectures were also prominent in the Academy's plans, for once again the the motives for its foundation had been largely ones of social prestige. As in Florence, these plans proved to be far too ambitious and nothing remotely approaching an academic doctrine emerged in these early years. Nor was the Academy at all successful in its war against the guilds until it achieved powerful support from Pope Urban

VIII in 1627 and 1633. Thereafter it grew in wealth and prestige. All the leading Italian artists and many foreign artists in Rome were members; debates on artistic policy were held; some influence over important commissions was wielded; and everything was done to make the lives of those who were not members (such as many of the Flemish freelance artists in Rome) as unpleasant as possible.

The only other similar organization in Italy was the Academy established in Milan by Cardinal Federico Borromeo in 1620. But meanwhile the word was very frequently used of private institutions where artists met either in a studio or in some patron's palace to draw from life. The most famous example of this kind was the Accademia degli Incamminati, which was organized by the *Carracci in Bologna.

In France a group of painters, moved by the same reasons of prestige as had earlier inspired the Italians, persuaded the king to found the Académie Royale de Peinture et de Sculpture (see under PARIS) in 1648. Here too the guilds put up a powerful opposition, and its supremacy was not assured until Colbert was elected vice-protector in 1661 and found in the Académie an instrument for imposing the official standards and principles of taste. Colbert and Charles *Le Brun, the director, envisaged dictatorship of the arts, and for the first time in history the expression 'academic art' acquired a precise significance. The Académie arrogated to itself a virtual monopoly of teaching and of exhibition and by applying rigidly its own standards of membership came to wield an important, if not decisive, economic influence on the profession of artist. For the first time an orthodoxy of artistic and aesthetic doctrine obtained official sanction. Implicit in the academic theory and teaching was the assumption that everything to do with the practice and appreciation of art, or the cultivation of taste, can be brought within the scope of rational understanding and reduced to logical precepts that can be taught and studied. The phenomenon of academicism in the arts, in so far as it fell within the Académie of Le Brun, was perhaps the most extraordinary manifestation of that ubiquitous rationalism which marked the Age of Enlightenment. Even a theory of *Expression was elaborated for the rational and logical expression of emotions by visual means. Though much of the systematization of rule and precept was derived from handbooks of the late *Mannerist writers such as *Lomazzo and *Zuccaro, academic theory adopted in principle the *classicism of the Renaissance and in 1666 a branch of the Académie was set up in Rome in order to give prize students opportunity to study the *Antique on the spot. The monolithic character of Académie doctrine was to some extent shattered in the last years of Louis XIV by a splinter group who attacked certain aspects of the official theory. There was, for example, the controversy associated with de *Piles about the relative importance of colour and design. Nonetheless the Académie succeeded in creating and imposing an official orthodoxy for France which persisted through subsequent centuries with the result that from the date of its formation most of the creative movements in French art took place outside the ambit of the artistic establishment.

Other art academies were founded in Germany, Spain, and elsewhere between the middle and end of the 17th century, and it has been estimated that in 1720 there were nineteen of them active in Europe. But though they differed fairly widely among themselves and were of varying importance for the art of the countries concerned, none calls for special comment. The great change did not occur until the middle of the 18th century—a change indicated by the fact that by 1790 well over 100 art academies were flourishing throughout Europe. Among these was the Royal Academy in *London, which was founded in 1768. For the most part these academies were the product of a new awareness on the part of the state of the place that art might be expected to play in the life of society. The Church and the court were no longer the chief patrons of art. But with the growth of industry and commerce the economic importance attached to good design led to official support for teaching academies. Inseparably linked to this motive was the promotion of *Neoclassicism in opposition to the surviving styles of *Baroque and *Rococo. Everywhere the academies made themselves the champions of the new return to the Antique. As far as instruction went the copying of casts and life drawing were paramount, and classical subjects were particularly encouraged.

There was some opposition to these bodies from the start. Towards the end of the 18th century French revolutionary sentiment was especially bitter about the exclusive privileges enjoyed by members of the Académie, and many artists, with *David in the lead, demanded its dissolution. This step was taken in 1793, but after various experiments had been tried and and substitute bodies set up, the Académie was reinstated in 1816 as the École des Beaux-Arts (see under PARIS).

In fact the real threat to academies came from the Romantic notion of the artist as a genius who produces his masterpieces by the light of inspiration which cannot be taught or subjected to rule. The concept of the artistic genius made headway first among English 18th-century aesthetic writers. It was formalized by *Kant and gained impetus from *Goethe and the German Romantics. Opposition to academies was accentuated by the widening breach between creative artists and the bourgeois public after aristocratic patronage declined. Virtually all the finest and most creative artists of the 19th century stood outside the academies and sought alternative channels for exhibiting their works. When the revaluation of 19th-century art took place with the final recognition of the *Impressionists this contrast was too blatant to be ignored. Academies were condemned out of hand by the adventurous, though they still retained prestige among those who were too confused in the prevailing breakdown of taste to risk supporting what they did not understand. Gradually compromises were made on both sides, facilitated by the liberalization of the academies and the increasing number of art schools which have finally broken academic monopolies. Academies now generally hold the view that they should at least insist on certain standards of sheer craftsmanship which any artist, however personal his vision, is expected to display. During the 20th century the pace has quickened. Most of the aesthetic movements, however revolutionary they seemed at the time, have rapidly produced their own 'academicism' as minor artists of no more than moderate endowment have aped the mannerisms of the few geniuses who have shaped each movement. Creative art becomes academic in the hands of its followers and an opposition between the original creative and the derivative academic has persisted. HO/MJ

Blunt, A., *Artistic Theory in Italy 1450–1600* (1962).
Fontaine, A., *Les Doctrines de l'art en France de Poussin à Diderot* (1909).
Goldstein, C., *Teaching Art: Academies and Schools from Vasari to Albers* (1996).
Pevsner, N., *Academies of Art Past and Present* (1940).
Sparkes, J. C. L., *Schools of Art* (1884).

ACADEMY. An 'academy', or more properly 'academy figure', is a drawn, painted, or modelled study from life of the posed human figure. The beginnings of the academy figure may be traced back to the revival of life drawing in 15th-century Italy. What distinguishes it from pure life drawing, however, which can be an informal pursuit by the artist of an unposed or unaware model, is its formal and institutionalized character, with the model set, often in the stance of a classical statue and with appropriate accessories, as an exercise by a master for a group of pupils. Not surprisingly the 'academy' reached its apogee in 18th- and 19th-century France where it was regarded as an essential preparation for a career as a history painter and regularly set and judged as a student essay at the Académie Royale and the École des Beaux-Arts (see both under PARIS), with notable examples being painted by *David, *Géricault, and *Delacroix in their student days. This period also saw the publication of books of engravings of academy

figures for the use of students who did not have access to the life class of an art school. Most galleries of old masters contain examples of these finely observed, dramatically lit, and handsome male and female figures. Some artists, notably *Rembrandt, used the genre as a vehicle for ironic commentary on the discrepancies between the ideals of classical art and the faulty human clay of which we are made. MJ

Bignamini, I., and Postle, M., *The Artist's Model: Its Role in British Art from Lely to Etty*, exhib. cat. 1991 (London, Kenwood House).

Roland-Michel, M., *Le Dessin français au XVIIIe siècle* (1987).

ACCADEMIA. See under relevant city.

ACRYLIC PAINT. A recent discovery for artists, these paints depend on acrylic *resins only produced commercially since the 1930s. Methyl methacrylate in mineral spirits forms a pigment medium, directly applied or thinned with turpentine. Polymerized, it produces a milky emulsion used in polymer colours, which are thinned with water, drying quickly to an insoluble finish, and colour of great brilliance. Both types have become popular; David *Hockney is one artist who has effectively exploited their special qualities. JH

Mayer, R., *The Artist's Handbook of Material and Techniques* (1982).

ACTION PAINTING. See ABSTRACT EXPRESSIONISM.

ADA SCHOOL, also known as the Court School, the products of the first major scriptorium of the *Carolingian Renaissance, dating from 790 to 814. The patronage of the imperial court at Aachen is exemplified in the Ada Gospels (Trier, Municipal Lib.), named after their donor, who may have been a sister of Charlemagne. The intention of the artists was to follow the early Christian models advocated by Charlemagne, rather than seeking to create new styles. Manuscript illuminations (see ILLUMINATED MANUSCRIPTS) include full-page portraits of the Evangelists. A majestic and solemn effect is obtained by heavily outlined figure drawing, and a linear, geometric quality is achieved through the structure of architectural frames and backgrounds. Colours are vivid and symbolic, including rich purple parchment and gold lettering. A typical example is the Gospels of S. Medard-de-Soissons, c.800 (Paris, Bib. Nat.). These antique reconstructions represent the more monumental style of late *Roman art, in contrast to the *Hellenistic manner of the contemporary 'Palace School'. However, later examples show more truth to nature and better rendering of space.

Court School ivories, such as the Lorsch Gospels cover (London, V&A) which imitates 5th-century *Byzantine work, also show the strength of early Christian sources. CMH

Hollander, H., *Early Medieval* (1990).

ADAM FAMILY. French sculptors originating in Lorraine, of whom the most important were **Lambert-Sigisbert** (1700–59) and his brother **Nicolas-Sébastien** (1705–78). They both trained in their father's workshop in Nancy before studying in Rome, where they were influenced by *Bernini's style. After settling in Paris they collaborated on the extravagantly Baroque fountain group *The Triumph of Neptune and Amphitrite* (1740) for Versailles. Lambert-Sigisbert continued to produce similarly rhetorical decorative sculpture even though the tide of taste was turning towards the delicacy of the *Rococo style. His brother proved more adaptable and his funerary monument to Catharina Opalinska, wife of Duke Stanislas of Lorraine (1749), in Notre-Dame de Bon Secours, Nancy, is one of the most affecting of its period. Another brother, **François-Gaspard** (1710–61), worked for Frederick the Great making sculpture for Sans-Souci, Potsdam. *Clodion was their nephew. MJ

Thirion, H., *Les Adam et Clodion* (1885).

ADDISON, JOSEPH (1672–1719). English writer and statesman. Addison, a precocious scholar, was educated at Charterhouse and Oxford, becoming a fellow of Magdalen College in 1698. From 1706 he was an active diplomat and politician in the Whig cause. He contributed to the *Tatler*, owned by his school friend Richard Steele (1672–1729) from 1709–11, and was joint proprietor, with Steele, of the *Spectator* in 1711–12. Between them they virtually invented a new literary form, the periodical essay, which was much admired and highly influential. Reacting against Restoration coarseness, Addison adopted an urbane and elegant style to express reasonable and civilized views which appealed to a sophisticated readership. In 1712, in the *Spectator*, he published *On the Pleasures of the Imagination* in which he analysed the appeal of visible objects seen and recalled. Despite considering imagination inferior to reason and art inferior to nature he postulated that the contemplation of actual and remembered images produced an 'inner sense of beauty', passively received, which laid the basis for the concept of sensibility, an important element in the formation of 18th-century taste. DER

Smithers, P., *Joseph Addison* (1954).

ADORNO, THEODOR (1903–69). German philosopher. The leading member of the Marxist-oriented 'Frankfurt School' that had a major presence in German intellectual life

both before and after the Nazi era, he combined revolutionary political sympathies with a profound respect for traditional European forms of art. He held that art must be understood within an always fluctuating historical context, and that its autonomy expresses the individual's demand for freedom in the face of social forces exerting repression for financial gain; yet he believed that art could redeem, by providing experience of the unveiled and truthful presence of the object. Adorno was sceptical in the 1930s as to the hopes of his friend Walter *Benjamin for a new mass art, and his later remark that after Auschwitz, poetry could no longer be written reflected his persuasion that an art attempting to engage with the circumstantial detail of 20th-century life would inevitably lapse into bathos; nonetheless he defended the necessity for a high art of aesthetic autonomy. Much of his copious written output is concerned with music, which he regarded as art par excellence, insofar as it is form rather than content. DC

Adorno, T., *Minima moralia* (1951).

AELST, WILLEM VAN (1627–after 1682). Dutch *still-life painter. He was born in Delft, spent four years in France from 1645, and was then in Italy where he worked as court painter to Ferdinand II, Grand Duke of Tuscany, who presented him with a gold medal and chain of which he remained inordinately proud. In 1657 he established himself in Amsterdam, where he built up a hugely successful and lucrative career. He painted a range of still-life subjects, including banquet pieces and game pieces featuring hunting equipment and dead game, and he was particularly famous for his *flower painting. His work shows an impressive, but rather chilly, control of line and colour. In flower painting his distinctive contribution was to break away from the symmetrical arrangements that had been conventional hitherto, and to distribute the bouquet in a stylish curve (*Flowers in a Silver Vase*, 1663; The Hague, Mauritshuis). Together with the luxury accessories that he introduced, van Aelst's innovations in design produced an effect of refined aristocratic elegance that was new to Dutch flower painting. AJL

Taylor, P., *Dutch Flower Painting 1600–1720* (1993).

AERIAL PERSPECTIVE, a term invented by *Leonardo. Because the word 'perspective' was already in use for the linear method of creating the appearance of depth or receding picture space, he gave the name 'aerial perspective' to the means of producing pictorial depth through scaled variation of colour that imitated the effect of atmosphere on *colours at different distances. Modern analysis shows that the presence in the atmosphere of dust and large moisture

particles causes some scattering of light as it passes through it. The amount of scattering depends on the wavelength (hence colour) of the light. Short wavelength (blue) light is scattered most and long wavelength (red) is scattered least. This is the reason why the sky is blue and why distant dark objects appear to lie behind a veil of blue. Distant bright objects tend to appear redder than they would be if near because some blue is lost from the light by which we see them.

Aerial perspective as we may see it used in paintings from *Pompeii and southern Campania (see ROMAN ART, ANCIENT) was discussed by Ptolemy (2nd century AD), who said (11. 24): 'When painters of architectural scenes wish to show colours of things seen at a distance they employ veiling airs.' It is also treated at some length in the fragment of a papyrus roll of Alexandrian origin by an unknown writer on optics from the pre-Christian era, who explains how the air can change the perception not only of shape but also of colour: shape loses its distinctness and colour becomes dull. Earlier still, the Aristotelian pamphlet *De coloribus* (794) states that a colour may be changed by being seen through a transparent medium, such as air or water. In Europe atmospheric perspective remained in abeyance for 1,000 years, to be rediscovered by the early 15th-century, Flemish painters. Leonardo relates aerial to linear perspective and in the *Trattato* (s.231) he wrote: 'The diminution or loss of colours is in proportion to their distance from the eye that sees them. But this happens only with colours that are at an equal elevation; those which are at unequal elevations do not observe the same rule because they are in airs of different densities which absorb these colours differently.' An attempt to systematize aerial perspective and relate it to linear perspective was made by A. *Bosse in his once important work *Manière universelle de M. Desargues pour pratiquer la perspective par petit-pied comme le géométral ensemble des places et proportions des forts et faibles touches, teintes ou couleurs* (1648). Aerial perspective helps to achieve the spaciousness and luminous harmony of the landscapes of *Claude or *Cuyp, and plays a part in the powerfully planned landscapes of *Rubens. No one exploited it more thoroughly than *Turner, who included it in his perspective lectures. In *Dido Building Carthage* (London, NG) he used it to give a sense of infinitely extended space, and in his late works, such as *Rain, Steam, and Speed* (London, NG), the 'haze' and the pictorial structure are as indivisible as in the most atmospheric paintings of *Monet and the *Impressionists. HO

AERTSEN, PIETER (1508–75). Amsterdam painter who moved to Antwerp, where he became a member of the guild in 1535. In 1542 he married Kathelijne Bueckelaer, an aunt of Joachim *Bueckelaer, who became his apprentice and the inheritor of his style. In 1557 he returned to Amsterdam and remained there for the rest of his life. Aertsen painted numerous altarpieces which were largely destroyed during the iconoclastic riots. Today his importance rests mainly on his still-life and genre paintings which are the direct forerunners of the 17th-century kitchen and market scenes of the Flemish artists *Snyders and *Fyt. Especially noteworthy are the works which combine monumental still lifes in the foreground with small religious scenes in the background. Thus the famous *Butcher's Stall* (1551; Uppsala University) occludes the Flight into Egypt; the biblical story of Christ in the House of Martha and Mary justifies the display of foodstuffs and kitchen utensils. This 'inversion' of religious theme and genre influenced the *bodegónes* of the young *Velázquez who was familiar with Aertsen's works through engravings. KLB

Nederlands Kunsthistorisch Jaarboek, 40 (1989).

AESTHETICISM, the 19th-century theory that art, whether visual or literary, is self-sufficient and need have no moral or social purpose. The doctrine is most succinctly expressed in the phrase 'l'art pour l'art' (art for art's sake) attributed to the French philosopher Victor Cousin (1792–1867) in his lectures on *Le Vrai, le beau et le bien* (1818, published 1836). Wider dissemination came with the publication of *Madamoiselle de Maupin* (1835) by Théophile *Gautier who, in the preface, goes further than Cousin by suggesting that any moral purpose is injurious to art. Aestheticism flourished in England from the 1870s to the 1890s, its principal theorists being Walter *Pater, in the conclusion to *The Renaissance* (1873), and Oscar *Wilde. The latter's assertion, under cross-examination, that there was no such thing as an immoral book was probably one of the factors that led to his imprisonment and his subsequent disgrace signalled the movement's decline. The foremost practitioners in painting were *Whistler and Albert *Moore. The former's habit of giving his works musical titles (*Nocturne in Black and Gold*, 1877; Detroit, Inst. of Arts) is symbolic of the Aesthetic movement's desire to emulate music, the most abstract, and therefore purest, of the arts. The excesses of the movement, usually expressed in affected speech and dress, were satirized in Gilbert and Sullivan's opera *Patience* (1881) and by George du Maurier (1834–96) in the pages of *Punch*. A more serious and convincing attack on the doctrine was provided by Leo Tolstoy (1828–1910) in *What is Art?* (1898), which promotes moral worth at the expense of beauty, a position directly opposed to that of the Aesthetes. DER

Lambourne, L., *The Aesthetic Movement* (1995).
Spencer, R., *The Aesthetic Movement* (1972).

AESTHETICS, a term used to describe thinking about the nature of art, particularly that which treats it as a singular and independent field of human experience. Generalizations about art may be traced back through European culture to Plato and Aristotle, and engaged many writers from the 15th century onwards, such as *Alberti, *Leonardo, *Vasari, and *Bellori. But the idea that art should be treated as a distinct area of philosophical enquiry stems from the writing of Alexander Baumgarten, who in 1735 proposed a term from the Greek *aisthetika* (matters of perception) to distinguish thought about our sensuous responses from thought on alternative themes such as logic or ethics. Baumgarten, a pupil of Leibniz, wrote in the context of contemporary discussions of taste by authors like Francis *Hutcheson, and included responses to natural as well as artistic beauty in his material. *Kant, who took up the growing fashion for the term in 1790, set responses to nature over those to art; but from the writings (1802–3) of Friedrich *Schelling onwards, the tradition of writing on aesthetics has chiefly revolved around the visual arts, literature, and music. *Hegel's *Lectures on Aesthetics* (1828) added weight to this tradition, ensuring it a firm place in subsequent philosophic systems.

The distinction proposed by Baumgarten, however, has been as controversial as it has been influential. Can art be separated from all other forms of experience ('art for art's sake' is a doctrine that issues from the circle of Schelling), or is this special pleading to promote the status of social groups such as the 'Aesthetes' of the later 19th century? (See AESTHETICISM.) Proponents of aesthetics—notably George Santayana (1863–1952), Benedetto *Croce (writing in 1898), Clive *Bell (in 1914), and John Dewey (1859–1952)—argued against this suspicion, voiced in Tolstoy's *What is Art?* (1898), by rooting 'aesthesis', the experience of artistic beauty, deep in their differing accounts of human nature.

The ramifications of such arguments led to increasingly complex and discriminatory accounts of art in later 20th-century writers, who related the aesthetic field to contemporary intellectual concerns such as Marxism—as in the work of György Lukács (1885–1971)—phenomenology—explored by Maurice *Merleau-Ponty—existentialism, psychoanalysis, and analytic philosophy, in writings by Jean-Paul *Sartre, Suzanne Langer, and Richard Wollheim. Aesthetics, as an academic study, could be separated into various types of enquiry: those about the nature of taste and the basis of evaluation; those about the nature of *representation and the *semiotics of art; equally, questions about the

psychology of creativity and the sociology of art. In the context of these increasingly sophisticated approaches, the urgency of the need to state a primary case for the existence of aesthetics receded. JB

Dewey, J., *Art as Experience* (1934).
Langer, S., *Aesthetics in a New Key* (1969).
Santayana, G., *The Sense of Beauty* (1896).
Wollheim, R., *Art and its Objects* (rev. edn., 1980).

AFFETTI (Italian: movements of the soul). The concept of the *affetti*, derived from ancient rhetoric and poetic theory, was central to Renaissance art theory, and meant human passion and feelings conveyed through physical gesture and the movements of the body. In the 17th century, when the rendering of heightened emotion was a major concern, the term 'passions' became more common. Related to the *affetti* are the *moti*, an ambiguous word which suggests both action and feeling. See also EXPRESSION AND GESTURE. HL

AFONSO, JORGE (documented 1507–40). Portuguese court painter and official in the College of Heralds. He was brother-in-law of the Flemish painter Francisco Henriques (active in Portugal 1500–18), father-in-law and master of Gregorio *Lopes, and uncle of another prominent painter, who was also his pupil, namely Garcia Fernandes (active 1514–d. 1565). Another distinguished pupil was the painter Cristóvão de Figueiredo (active 1515–40). Works attributed to Afonso, all of patently Flemish inspiration, include a *Last Supper* (c.1520; Viseu Mus.) and a retable of 1510/20 in the Lisbon Madre de Deus convent. The prestige of his large workshop ensured the continuity of Netherlandish influence on Portuguese religious painting until at least the mid-16th century. JBB

AGAR, EILEEN (1904–91). English artist born in Argentina. Agar studied at the Slade School of Art, London, 1925–6 and in Paris where she met the poet Paul Éluard in 1929 and was introduced to *Surrealist painting. On Éluard's recommendation, Roland Penrose (1900–84) and Herbert *Read selected her work for the 1936 International Surrealist Exhibition, London. Agar became instantly successful, and was exhibited and published along with the Surrealists in England and abroad. Her trips to Dorset during the 1930s where she met Paul *Nash inspired photographs of eclectic but delicate collections of marine objets, collages, and assemblages such as *The Wings of Augury* (c.1936; priv. coll.). Her pieces of the 1930s are among the most novel of that period. Some, like *Angel of Anarchy* (1936; London, Tate), are subversive and disturbing, others, including paintings, have an imaginative network of references to past

(especially classical) civilizations, nature, and myth. Agar described her work as 'the mystical communion between nature and human sensibility'. CC

Eileen Agar: Retrospective Exhibition, exhib. cat. 1971 (London, Commonwealth AG).

AGASSE, JACQUES-LAURENT (1767–1849). Geneva-born Swiss painter who spent most of his career in England as a painter of horses and other animals for an aristocratic sporting clientele. From 1786 to 1789 Agasse trained under *David in Paris, where he also studied anatomy. Following the Revolution he was brought to England by the racehorse owner Lord Rivers and he finally settled there in 1800. At first he enjoyed fame and success but his style became unfashionable and he died in poverty. Agasse was a powerful draughtsman and his best horse paintings, such as *White Horse in Pasture* (Winterthur, Oskar Reinhart Foundation) have an impressive presence. In addition to his animal paintings he produced portraits and highly finished genre scenes of English life that have the sweetness and unthreatened tranquillity of *Biedermeier painting. AJL

Jacques-Laurent Agasse, exhib. cat. 1988 (London, Tate).

AGATHARCHUS, (active late 5th century BC). Greek painter. Although from Samos, Agatharchus achieved fame in Athens, primarily from his development of *perspective. The fullest account of his work is by the Augustan writer Vitruvius, who says (*De architectura* 7 praef. 11) that Agatharchus painted scenery for Aeschylus (c.525–456 BC). Although we know no more of these paintings, we are told that Agatharchus wrote an accompanying book which prompted Democritus and Anaxagoras to develop a theory of linear perspective. Thus it appears that Agatharchus' scenery for Aeschylus was thought later to include perspective, although surviving plays give no support for this. Indeed, innovation in scene painting is associated with Sophocles, albeit in a passage of Aristotle which may be interpolated. Plutarch (*Pericles* 13. 2) records a story that Agatharchus boasted of the speed and ease with which he painted, provoking *Zeuxis to reply that his own figures both took and lasted a long time. The most frequently told anecdote about Agatharchus (by Plutarch, Demosthenes, and Andocides) concerns how Alcibiades (451–403 BC) imprisoned him in his house until he had decorated it. Painting private houses was exceptional, although whether he painted it with perspective scenes is not stated. KWA

AGOSTINO DI DUCCIO (1418–81). Italian sculptor, born in Florence. His style owed little to the prevailing influence of classical art; if anything, his slant-eyed, inscrutable figures have closer affinities with *Piero della Francesca's style. His earliest recorded work, an antependium relief for Modena Cathedral (1442), also suggests familiarity with Jacopo della *Quercia's work. He was in Venice in 1446, and is next recorded at Rimini, where from 1449 to 1456 he was engaged on his most important sculptural commission for Sigismondo Malatesta at the Tempio Malatestiano. Some of the *Liberal Arts* reliefs included in the chapel decoration there inspired Adrian Stokes's *Stones of Rimini* (1934). His next major work was for the polychrome sculpted façade of the oratory of S. Bernardino in Perugia (1457–61). The *Virgin and Child with Five Angels* (c.1450s; London, V&A) can be compared to the Rimini sculptures, and displays his characteristic linear design and low calligraphic relief style. AB

Pope-Hennessy, J., *The Virgin and Child by Agostino di Duccio* (1952).

AGUCCHI, GIOVANNI BATTISTA (1570–1632). Art theorist. Born at Bologna, Agucchi pursued a distinguished ecclesiastical career in Rome, where, as a highly cultivated connoisseur, he influenced the taste of official art circles at the papal court. He was a fervent admirer of Annibale *Carracci, and *Domenichino lived in his house for some years. Probably between 1607 and 1615 he wrote his *Trattato della pittura*, of which only a fragment survives. Here he formulated a classical-idealist doctrine that was to influence *Bellori and the development of 17th- and 18th-century *classicism. He believed that the artist, seeking an Ideal of beauty, must perfect and idealize the imperfect works of nature. To him the art of *Caravaggio represented an exact imitation of nature, enjoyed only by the vulgar; the educated viewer, however, in contemplating an Ideal of Beauty, moved towards the divine. Agucchi wrote the only surviving programme for a 17th-century ideal landscape, of Erminia and the Shepherds. He advised the artist to show a place of quiet retreat and blissful Arcadia. Annibale Carracci probably painted an unusually intimate and direct portrait of Agucchi (York, AG) (see also under DOMENICHINO). HL

Mahon, D., *Studies in Seicento Art and Theory* (1947).

AIR BRUSH, a painting implement which sprays paint from a small integral reservoir through a hand-held nozzle by means of a hose connected to a compressor. It was first patented in 1893, by Charles Burdick, as an Aerograph. The variable pressure produces subtle gradations of colour and a smooth stroke-free finish. It was used to great effect

by *Pop and *Photo-realist painters and is often used in commercial graphic design.

DER

AIX, MUSÉE GRANET, founded in 1821. It takes its name from the local painter and museum administrator François-Marius *Granet, who was made an honorary director of the museum in 1844 and who left it his collection and the contents of his studio when he died in 1849. The museum consequently contains a large collection of Granet's work, including two characteristic examples of his lugubrious convent scenes, a typical piece from the series depicting episodes from the life of an admired artist (in this case, the death of *Poussin), and many of the oil sketches that are by far his most convincing work to a modern eye.

This homage to Granet is in poignant contrast to the municipality's treatment of the far greater Aixois *Cézanne. Even in Cézanne's last years the museum's director, Pontier, was vowing that for as long as he was alive none of Cézanne's works would enter the museum, and the painter was greatly wounded by this hostility. As late as 1939 the municipality deliberately decided to ignore Cézanne's centenary, and (apart from a student drawing and a watercolour that was presented by an Englishman in memory of the painter) there was nothing by Cézanne in the museum until the state placed eight of his paintings from the Pellerin Collection on deposit in 1984.

The most celebrated paintings in the Granet bequest are certainly two by *Ingres—a moody, romantic portrait of Granet painted in Rome in 1809 and the monumental *Jupiter and Thetis* of 1811. From various sources, however, the museum contains an interesting collection of Italian 17th-century pictures, a good display of French portraits, and a strong section of Dutch and Flemish work. The collection of sculpture includes several maquettes by *Puget, who came from Marseille. There is a large archaeological section.

AJL

Cabanne, P., *Nouveau Guide des musées de France* (1997).

ALABASTER, a form of gypsum, varying in colour from pure white to streaky, widely used in England from the early 14th century. Deposits are found in Nottinghamshire, Lincolnshire, and Yorkshire, but the main quarries were in Derbyshire and Staffordshire. Its solubility renders it unsuitable for external use, but the ease with which it could be cut made it an ideal material for tomb sculpture and devotional images. Following its use in the 1330s for the effigies of Edward II in Gloucester, and his brother John of Eltham in Westminster, alabaster soon became as popular as stone for tombs; by the late 14th century the figures become increasingly standardized, with much emphasis laid on the virtuoso detailing of costume and armour. It was also used for retables, small individual panels, and statuettes; a considerable number were made for export and are found as far afield as Spain, Italy, and Iceland. Its relative cheapness and availability resulted in mass production, and by the late 15th century the main workshops, in London, York, and Nottingham, were producing stereotyped works of little merit. The Reformation killed the market for religious images, although alabaster continued to be used for tombs.

AS

Stone, L., *Sculpture in Britain: The Middle Ages* (1972).

ALBANI, FRANCESCO (1578–1660). Italian painter and draughtsman, who worked in Bologna and Rome and was one of the principal followers of Annibale *Carracci. At Bologna he trained initially under Denys *Calvaert, after which he moved to the Accademia degli Incamminati and studied with Ludovico *Carracci. This led to his first commissions, notably a fresco of the *Repentance of S. Peter* (c.1598) at the oratory of S. Colombano, Bologna, which was praised by *Malvasia. In 1601 Albani moved to Rome with Guido *Reni and found a place in the studio of Annibale Carracci, where he was involved in fresco decorations for the church of S. Giacomo degli Spagnoli, Rome. He was also involved with Annibale and other artists in the series of lunettes, commissioned for the chapel of the Palazzo Aldobrandini, comprising six scenes from the life of Christ set in classical landscapes (now Rome, Doria Pamphili Gal.). Under Annibale's influence Albani's style, both in figure composition and landscape, had developed in a classical direction. As an independent painter in Rome, c.1606–17, Albani went on to secure major commissions for fresco decorations, in particular at the Palazzo Mattei, the Palazzo Giustiniani at Bassano di Sutri, the Chapel of the Annunciation at the Palazzo Quirinale, the Palazzo Verospi, and S. Maria della Pace. He also painted small cabinet pictures, often on copper, such as the *Holy Family* (priv. coll., Brocklesby, Lincs.).

Albani was back in Bologna in 1617; he established a studio and turned his attention away from fresco painting, concentrating instead on painting altarpieces for local churches, in a monumental classical style. However his most attractive works were landscapes and mythological *poesie*: these include a series of the *Loves of Venus and Diana* (Rome, Borghese Gal.); a series of the *Four Elements* (c.1625–8; Turin, Sabauda Gal.); and a further series on the *Loves of the Gods* (Paris, Louvre) with prominent landscape backgrounds reminiscent of Annibale Carracci and *Domenichino. Two landscapes of *Erminia and the Shepherds* (Rome, Colonna Gal.) are less structured and classical, with a more naturalistic vision, inspired perhaps by *Tassi and *Claude, although Albani himself, in his own writings, expressed little respect for the northern *Bamboccianti painters he had met in Rome.

HB

Puglisi, C., *Francesco Albani* (1999).
Volpe, C., in *L'ideale classico del seicento in Italia e la pittura di paesaggio*, exhib. cat. 1962 (Bologna, Palazzo dell'Archiginnasio).

ALBERS, JOSEF (1888–1976). German-American geometric abstract painter and designer who, until 1950, was best known as an influential teacher. He studied at various German art schools and at the *Bauhaus, where he progressed from student to teacher and, ultimately, to head of its furniture workshops. When the Bauhaus closed in 1933, Albers taught in America, at *Black Mountain College, NC, and later at Yale and Harvard Universities, and developed his celebrated course of colour studies. He worked empirically throughout his career, always questioning, refining, and simplifying forms. His earliest American paintings were free abstracts, but later groups like *Structural Constellations* (1950), based on optical phenomena, presaged the long and now famous series *Homage to the Square* (1950–76). Quietly monumental, these paintings of squares within squares of flat colour induce subtle ever-changing spatial illusions and vibrant simultaneous contrasts, *Departing in Yellow* (1964; London, Tate) being typical. They formed the research for his seminal text *Interaction of Colour* (1963), and influenced *Op-artists. *Despite Straight Lines* (1977) was published posthumously.

YJ

Josef Albers: A Retrospective, exhib. cat. 1988 (New York, Guggenheim).

ALBERTI, LEON BATTISTA (1404–72). Italian architect, sculptor, painter, theorist, and humanist, born in Genoa, the son of a Florentine exile. His treatises on painting, sculpture, and architecture were the first of their type since the classical age, and they proved to be immensely influential. As well as studying the visual arts, he wrote about a wide variety of topics, including ships of Antiquity, horses, and family ethics.

Alberti studied in Padua and later attended Bologna University; in these years he immersed himself in the classics and in 1424 wrote a Latin comedy, *Philodoxeos*. He held a secretarial post at the papal court in 1432–64 and in 1434 was in Florence as a member of the papal curia. Here he came into contact with the innovative work of *Brunelleschi, *Donatello, Luca della *Robbia, and *Masaccio, and to them he dedicated his first treatise on the arts, *De pictura* (1435; trans. into Italian

as *Della pittura* in 1436), which contains an early description of *perspective construction. In 1452 he presented his treatise on architecture, *De re aedificatoria*, to the Pope. Influenced by Vitruvius, Alberti wrote about architecture as a civic art and gave a theoretical exposition of the orders. His treatise on sculpture, *De statua*, probably followed later.

From the 1440s Alberti worked as an architect in various Italian cities. In the Palazzo Rucellai (Florence; begun *c*.1453) he articulated the façade with superimposed orders of pilasters, a device that was widely taken up subsequently. Equally influential were his designs for the façade of S. Maria Novella (Florence; *c*.1458–70), the Latin-cross plan of S. Andrea (Mantua; 1470), and the Greek-cross plan of S. Sebastiano (Mantua; 1459–60).

In accordance with the new status of the artist as an exponent of liberal art and not a mere manual worker, Alberti placed great emphasis on the necessity for the artist to have a thorough grounding in such sciences as history, poetry, and mathematics. His definitions of the various arts were no longer in religious function, but entirely in human terms with a strong admiration for classical *Antiquity. In certain contexts he defines painting in terms of unqualified naturalism, but elsewhere he recognizes that the artist will search for an ideal of beauty that cannot be achieved simply by accurate reproduction of nature but involves selection. Sometimes he identifies the beautiful with the typical in nature, but in *De re aedificatoria* he constructs a theory of beauty around mathematical symmetry and proportion of parts. FB

Rykwerk, J., and Engel, A. (eds.), *Leon Battista Alberti*, exhib. cat. 1994 (Mantua, Palazzo del Te).

ALBERTINELLI, MARIOTTO (1474–1515). Florentine painter whose work reflects the *classicism of early cinquecento art in Florence. Born the son of a goldsmith, he is thought to have trained in Cosimo *Rosselli's shop alongside Fra *Bartommeo, with whom he collaborated at various moments in his life. Albertinelli's *Virgin and Child with Saints* (1500; Milan, Mus. Poldi Pezzoli), one of his earlier independent works, is painted in an elegant style and displays an eccentric combination of influences from Flemish painting, *Perugino, and early Renaissance art. In 1501 he finished Fra Bartommeo's fresco of the *Last Judgement* (Florence, Mus. S. Marco), and in 1503 he dated the *Visitation* (Florence, Uffizi); the monumentality of this altarpiece is influenced by Bartommeo's suave classicism, and the work's subtle tonalities and gentle colours are indebted to Perugino. In 1510 he completed an *Annunciation* (Florence, Accademia), which displays grand figures in a dramatic setting, and exhibits a forceful and expressive use of *chiaroscuro

and colour. In his final years he visited Viterbo and Rome. FB

Padovani, S. (ed.), *L'età di Savonarola: Fra' Bartolomeo e la scuola di San Marco* (1996).

ALBRIGHT, IVAN (1897–1983). American painter, sculptor, and lithographer, born in Chicago. Albright was employed as a medical draughtsman in France (1918–19). This experience was reflected in his own work, with its meticulous detail and its recurrent preoccupation with decay, human degradation, and death. His work remained consistently figurative and heavily loaded with symbolism, and was seen as a literary art, especially since he also wrote poetry. Between the late 1920s and early 1930s he painted a number of portraits of local people around his studio in Illinois. *Into the World There Came a Soul Called Ida* (1920–30; Chicago, Art Inst.) is typical of the period in its melancholic tone and concentration on rugged and lumpy flesh. Between 1931 and 1941 he worked on a major painting of a door, decorated with a funeral wreath, with a characteristic lengthy, suggestive title and melancholic tone: *That Which I Should Have Done I Did Not Do* (Chicago, Art Inst.). MF

Kun, K., *The Artist's Voice* (1962).

ALDEGREVER, HEINRICH (*c*.1502–55×61?). German engraver, painter, and designer of woodcuts, active in Soest (Westphalia). He is usually grouped with the so-called *'Little Masters' (see also PENCZ, GEORG and BEHAM, SEBALD), since he liked working on a small scale. His numerous prints betray the all-pervading influence of *Dürer. His ornamental designs, which make up about one-third of his *c*.300 engravings, were intended as models for metalworkers, but were also adapted by other craftsmen for such decorative arts as enamel, intarsia, and book illustration. Only two paintings are firmly attributed to him: the wings and predella of an altarpiece of *c*.1525/6 (Soest, S. Maria zur Wiese) and the *Portrait of Count Philip III of Waldeck* of 1537 (Arolsen, Residenzschloss). A number of his preparatory drawings for engravings have survived, of which the largest single collection is in the Rijksmuseum, Amsterdam. KLB

Goddard, S. H. (ed.), *The World in Miniature*, exhib. cat. 1988 (Lawrence, University of Kansas, Spencer Mus. of Art).

ALDINE PRESS, an influential press founded at Venice in 1495 by the scholar-printer Aldus Manutius and Andrea Torresani. The press was important for publishing educational and classical works, beginning with its first publication, a volume containing Constantine Lascaris's *Erotemata* in Greek and Latin, Aldus' *De literis graecis et diphthongis*, and other texts. Among its innovations were

the introduction of italic type, first used in the *Epistolae* of S. Catherine (1499), and the publication of classical texts in octavo editions as pocket books. The press was the first to print extensively in Greek, mostly *editiones principes* edited by scholars such as Marcus Musurus, Angelo Poliziano, Marsilio Ficino, and Aldus himself. The roman, Greek, and italic types were cut by Francesco Griffo, modelled on contemporary hands, including Aldus', and much influenced later type design. After Aldus' death in 1515 the press continued under Torresani (d. 1529) and, later, their heirs. The Aldine dolphin-and-anchor device, introduced in 1501–2, is perhaps the most famous of all printers' devices. MLF

Lowry, M., *The World of Aldus Manutius* (1978).
Renouard, A.-A., *Annales de l'Imprimerie des Alde* (3rd edn., 1834).

ALECHINSKY, PIERRE (1927–). Belgian painter and graphic artist. He was born in Brussels, where he studied book illustration and typography at the École Supérieure d'Architecture et des Arts Décoratifs, 1944–8. In 1947 he became a member of the Jeune Peinture Belge association and in 1949 he joined the *COBRA group. He organized a COBRA exhibition in Liège in 1951, but soon after this the group disbanded and in the same year Alechinsky moved to Paris to study printmaking under a French government grant. In 1952 he studied with S. W. Hayter at Atelier 17 and at about this time he became fascinated by Japanese calligraphy—in 1955 he visited the Far East and produced a prizewinning film entitled *Calligraphie japonaise*. From 1960 he travelled widely in Europe, the USA, and Mexico, but he continued to live and work mainly in France. His paintings are in a style of vigorous, even violent, expressive abstraction. They retain residual figurative motifs and their vein of turbulent fantasy shows a strong debt to his countryman *Ensor. Alechinsky is regarded as one of the leading Belgian artists of the 20th century and has an international reputation; in 1976 he was the first recipient of the Andrew W. Mellon Prize and this award was accompanied by a major retrospective exhibition at the Museum of Art, Carnegie Institute, Pittsburgh, in 1977. IC

ALGARDI, ALESSANDRO (1598–1654). Italian sculptor, with *Bernini one of the two most accomplished artists in that medium of the 17th century. He was born and trained in Bologna, but in 1625 went to Rome where he worked at first restoring *Antique sculpture. His earliest important works were a pair of stucco statues of *S. John the Evangelist* and *S. Mary Magdalene* (*c*.1629) for S. Silvestro al Quirinale. These already represent a moderated, classicizing contrast to the full-blooded *Baroque of Bernini. The avoidance

of extremes in composition and use of contrasting materials became characteristic of Algardi's art. His early connections with the painters *Domenichino and Pietro da *Cortona, also representatives of the more restrained and noble strand of the Baroque, may be regarded as significant in this respect. In 1634 Algardi began the major monumental commission for the tomb in S. Peter's of Pope Leo XI (completed 1644). Although composed in a similar manner to Bernini's tomb of Urban VIII (1628), the scale is smaller, the poses of the statues less demonstrative, and the whole is executed in white marble, eschewing the use of bronze and gilding employed by his rival. At the same time Algardi was working on another of his better works, the free-standing marble group of The Beheading of S. Paul (finished 1644; Bologna, S. Paolo Maggiore). Despite these and other important commissions much of Algardi's time was spent on relatively small-scale sculpture in bronze and silver, a reflection of the pre-eminence in artistic life of Bernini throughout the reign of Urban VIII. The election in 1644 of Innocent X Pamphili began a decade of ascendancy for Algardi, favoured by the more austere tastes of the new papal court. He was busily involved in the rebuilding and decorating of the Pamphili houses. His two monumental sculptural projects of this time were the great bronze statue of Innocent X (1646–50) in the Museo dei Conservatori, Rome, and his marble relief of The Encounter of Leo the Great and Attila (1646–53) in S. Peter's. The latter, with its main figures carved almost in the round, is one of the finest reliefs of the 17th century. Algardi was also a highly accomplished portrait sculptor, preferring a dignified naturalism to the more rhetorical treatment of expression and character favoured by Bernini. Outstanding among his portraits are those of Cardinal Mellini (1637–8; Rome, S. Maria del Popolo) and the terracotta model for that of Cardinal Zacchia (London, V&A), a late work. Almost inevitably Algardi's achievement and the character of his art must be measured against Bernini's, but in 17th-century Rome they enjoyed equal reputations, and although Algardi's forays into architecture and planning were not successful, it can be fairly claimed that as a sculptor he should be valued as highly as his rival.　　　　MJ

Montagu, J., Alessandro Algardi (1985).
Vitzthum, W., Alessandro Algardi (1966).

ALGAROTTI, FRANCESCO (1712–64). The foremost Italian art critic of his day, who amassed a notable collection of paintings and drawings. He was a cosmopolitan snob of great charm, who spent several years in Prussia, and whose friendship with some of the leading men of Europe—notably Voltaire and Frederick the Great—promoted the culture of his native city, Venice. He advised August of Saxony on purchases for the gallery in *Dresden, and for this he commissioned *history paintings from the leading painters of the day. He set out his views on aesthetics in letters and in his Saggio sopra la pittura. In these he proclaimed a watered-down version of the *Neoclassicism which was gaining ground in Europe (though not in Venice). For some years he influenced the practice of G. B. *Tiepolo ('restraining his wilder fantasies' as he claimed), *Canaletto (encouraging architectural *capricci), as well as *Piazzetta and other painters. His real importance lies in his having helped to make acceptable the bolder ideas of other men and thus to break down the cultural isolation of Italy.　　　　HO/HL

Haskell, F., Patrons and Painters (1963).

ALLAN, DAVID (1744–96). Scottish painter. Allan was the outstanding student at the Foulis Academy, Glasgow (1754–75), and the recipient of one of its pioneering travel scholarships which assisted his journey to Rome in 1764 to study with Gavin *Hamilton. He practised as a *history painter, winning a prize for The Departure of Hector in 1773 (Rome, Accademia di S. Luca), and a portraitist. In 1775 he presented his portrait of the connoisseur Sir William Hamilton, full-length, surrounded by his Antique vases and with a view of Vesuvius, to the British Museum (1774; London, NPG). During his Italian stay Allan made a large number of lively pen and wash drawings of daily life and on his return to London in 1777 he exhibited drawings of the Roman Carnival (Windsor Castle, Royal Coll.) at the RA in 1779 which earned him the sobriquet 'the Scottish Hogarth'. From 1780 he worked as a painter of portraits and *conversation pieces in Edinburgh but continued to paint and draw rustic genre, including the illustrations to Allan Ramsay's Gentle Shepherd (1788), which influenced the young *Wilkie during his training in Edinburgh (1799–1804).　　　　DER

The Indefatigable Mr Allan, exhib. cat. 1973 (Scottish Arts Council).

ALLSTON, WASHINGTON (1779–1843). American painter and writer. Born in Georgetown, SC, Allston read classics at Harvard but his interests were already Romantic and artistic when he graduated in 1800. A Tragic Figure in Chains (c.1800; Andover, Mass., Phillips Academy) reveals a knowledge of Gothic literature and *Fuseli. In 1801 he enrolled in the RA Schools, *London, where he enthusiastically absorbed *Reynolds's theory of the *Grand Manner. In Paris, in 1803, he was influenced by the Venetian masters. From 1804 to 1808 he lived in Rome, where his friends included Washington Irving and Coleridge, evidence of his Romantic, literary sensibility. After three unsuccessful years in Boston he returned to London where *sublimity was still appreciated. His exhibition at Bristol in 1814, which included Rising of a Thunderstorm at Sea (1804; Boston, Mus. of Fine Arts), probably influenced *Danby. In 1820 he returned to Boston with Belshazzar's Feast (Detroit, Inst. of Arts) which preoccupied him, tragically, until his death. However he now began to paint lyrical imaginary landscapes, for instance Moonlit Landscape (1819; Boston, Mus. of Fine Arts), his most original works, which anticipate the *Luminists.　　　　DER

Gerdts, W., and Stebbins, T., A Man of Genius: The Art of Washington Allston, exhib. cat. 1979 (Boston, Mus. of Fine Arts).

ALMA-TADEMA, SIR LAWRENCE (1836–1912). Dutch-born English painter. Alma-Tadema learnt the foundations of his meticulous technique in the Low Countries, ending his studies under Baron Leys, whose medieval subject matter he adopted during his early career. In 1863 he visited *Pompeii and thenceforward daily life in Greece and Rome became his preoccupation. In 1869 he exhibited The Pyrrhic Dance (London, Guildhall) at the RA and its rapturous reception encouraged him to settle in London. His highly detailed, illusionistic paintings were immensely popular and often afforded the enjoyment of nudity. Occasionally, as in A Coign of Vantage (1895; Los Angeles, Getty Mus.), his compositions are daringly original and are said to have influenced early Hollywood directors. All his work attempts archaeological accuracy, based on site drawings and his photographic archive (Birmingham University), but there is an undeniable bathos in his smaller pictures of classical domestic bliss, painted in his magnificent Roman villa in St John's Wood. *Whistler's description of meeting him at a party in laurel wreath, toga, and iron-rimmed spectacles has a definitely Pooterish quality.　　　　DER

Swanson, V. G., Alma-Tadema (1977).

ALMEIDA, JOSÉ DE (1700–69). Portuguese Baroque sculptor. He belonged to a family of artists and was trained in Rome in the studio of Carlo Monaldi. He worked there, and subsequently in Lisbon, on the decoration of state coaches. Several marble sculptures, and woodcarved figures, for churches in and around Lisbon are attributed to him. His Christ Adored by Angels (1730), the wooden model for an intended marble group for the high altar at Mafra, is preserved in the Lisbon church of S. Estevão. He was the leading Portuguese sculptor of the mid-18th century, and master of Joaquim *Machado de Castro.　　　　JBB

ALTARPIECE, a screenlike structure, usually carved or painted, which stands behind and above the altar in a Christian church or chapel. It may also be called a *retable, or reredos, a term originally describing a decorative hanging.

In the early Church, as in the Synagogue, the altar was a sacred table upon which were placed the books and instruments used to celebrate the Eucharistic sacrament, or Mass. The altar often stood above the tomb of a saint or martyr, and relics of these saints were housed in the altar, which became boxlike to accommodate them. In 787 the Council of Nicaea ordained that every altar should contain a relic. As the importance of saints and their relics increased, reliquaries and image-bearing objects, such as small statues, began to be placed upon the altar. An additional source of imagery was the altar *frontal, or antependium, a rectangular cloth or metal covering usually decorated with figures within an arcade. These, too, were sometimes transferred to the top of the altar, as in the case of the gold one presented to the church of S. Denis by Charles the Bold in the 9th century (illustrated in the *Mass of S. Giles* (London, NG) by the *Master of S. Giles).

The autonomous image upon or behind the altar thus grew in importance as a focus for worship. This was reinforced when it became customary for the priest to stand in front of, rather than behind, the altar, obscuring the altar frontal and allowing for more visible and sumptuous images as a backdrop to the service. The earliest of these continued to resemble the altar frontal, the horizontal frame with arched compartments housing the figures of saints. The Pala d'Oro (*c.*1105) on the high altar at S. Mark's, Venice, consists of gold and enamel panels showing Christ in Majesty with angels, saints, and narrative scenes. Painted examples such as that by *Margarito of Arezzo (1260s; London, NG), or the Westminster Abbey retable (1270s), have a similar format. In other cases venerated icons of the early Church were adapted as altarpieces, for example the *Madonna Avvocata* of S. Maria Aracoeli, Rome, believed to date from the 6th century.

Byzantine icons influenced an alternative form of altarpiece, popular in Italy. These were vertical, gabled images like *Cimabue's *S. Trinita Madonna* (1280s; Florence, Uffizi) which also followed the type of the hieratic, enthroned Virgin used by the Greek Church. The basis for development was, however, the compartmented, horizontal form which was placed at the back of the altar and appeared to be unified with it.

The role of the altarpiece was to identify the dedication of the altar, and reinforce its sacramental function. The Synod of Trier in 1310 required every altar to carry a label, either text or image, indicating this dedication. The Trinity, Holy Spirit, or the Cross might,

therefore, be prominent depending on the popularity of particular cults or the influence of the mendicant orders. The cult of the Virgin, which reached a peak in the 13th century, is reflected by the countless number of altarpieces featuring her as the central devotional image. As well as those depicting her as Queen of Heaven, there are examples which focus on her Annunciation (*Simone Martini and Lippo *Memmi; 1333; Florence, Uffizi), her Coronation (*Lorenzo Monaco; London, NG), and the popular image of the tender Mother of Christ, particularly appropriate for private worship (*Duccio's triptych of the *Virgin and Child with Saints*; London, NG). These central images may also be amplified by additional scenes, as in Duccio's great *Maestà* for the high altar of the Duomo, Siena (1308–11; Museo del Opera del Duomo, but some parts dispersed), which combines devotional and complex narrative elements.

The titular saint usually occupies a prominent position, either close to the central image or even taking over the whole altarpiece, as in the retable of *S. George* (1410; London, V&A), by *Marzal de Sax. Local saints are frequently included, as well as figures of general importance, apostles, and doctors of the Church. S. Zenobius, Bishop of Florence, appears in many Florentine works, while S. Ursula is a favourite figure in altarpieces from Cologne, where she was believed to have died. When a donor is portrayed, he or she is usually presented by a name saint, such as S. George who presents Canon van der Paele to the Virgin and Child in van *Eyck's altarpiece (1436; Bruges, Groeningemus.). Like the Virgin, these saints were expected to intercede on behalf of the donor and the worshipper.

Scenes from the life and Passion of Christ served as a reminder of his sacrifice, and of the promise of salvation. Rogier van der *Weyden's triptych of the *Last Judgement* (Beaune, Hôtel-Dieu) is a powerful image, designed for the contemplation of the sick and dying. Certain unusual themes occur, for example, Rogier's altarpiece of the *Seven Sacraments* (Antwerp, Koninklijk Mus. voor Schone Kunsten) and Dieric *Bouts's altarpiece of *The Holy Sacrament* (1464; Louvain, S. Pierre) each depict an aspect of Christian doctrine, while the Ghent altarpiece by van Eyck has, as its central image, an event from the Book of Revelation, the *Adoration of the Lamb* (*c.*1432; Ghent, S. Bavo).

The structure, materials, and development of the altarpiece varied widely throughout Europe. In Italy, the horizontal panel painting of Christ or the Virgin flanked by saints grew increasingly elaborate and architectonic. Decorative gilt frames, gabled and arcaded, were carved into twisted columns, cusps, and pinnacles, and a growing number of separate compartments led to the polyptych of the 14th century. The most complex of

these had several tiers of vertical compartments, their weight supported by a *predella painted with narrative scenes. *Taddeo di Bartolo's *Virgin of the Assumption and Saints* (*c.*1394–1401; Montepulciano Cathedral) is one such monumental altarpiece. These proliferated largely as a result of the endowment of altars by individuals, confraternities, and guilds who thus ensured that Masses would be said on their behalf.

Pictorial developments led, in the 15th century, to a shift from the polyptych to a more unified picture space; the number of compartments or panels decreased and the narrative scenes merged into a single composition, or at most a triptych. *Domenico Veneziano's *S. Lucy* altarpiece (Florence, Uffizi) is an important early example of the realistic form of composition, known as the *sacra conversazione*, in which the Virgin and other figures appear to exist in the same space. Progressively harmonious and lucid spatial compositions, like Giovanni *Bellini's S. Zaccaria altarpiece (1505; Venice, S. Zaccaria), had classicizing, rather than Gothic, architectural frames. Increasingly illusionistic or dramatic visions, such as *Titian's *Assunta* (1518; Venice, Frari), were created, and in time the single-panel framed altarpiece, or *pala*, differed little in form from other easel paintings.

In northern Europe altarpieces were often carved, either in wood or in stone, as was the high altar of Marburg's Elisabethkircke (1290). The winged altar was the most usual form and this could combine sculpture and painting, the central carved panel in early examples deriving from reliquary shrines which would have been preserved behind hinged doors. Even when no relic was present it was customary for the wings to remain closed on all but special feast days. The altarpiece of the *Crucifixion* for the Charterhouse of Champmol (1390–9; Dijon, Mus. des Beaux-Arts), by Jacques de *Baerze and Melchior *Broederlam, consists of a fantastic Gothic interior of gilt and polychromed sculpture whose outer wings, when closed, display painted narrative scenes. Sometimes a second pair of wings was included, painted on the outside in grisaille, for use on days of penance. The additional wings allowed for extended pictorial programmes, such as in *Conrad van Soest's massive altarpiece of the *Crucifixion* (1403; Bad Wildungen, parish church).

As in Italy the proliferation of separate scenes gave way to pictorial centralization, particularly in the Netherlands where paint superseded sculpture. In Hugo van der *Goes's monumental Portinari altarpiece (1470s; Florence, Uffizi), the landscape unifies all three panels, while Hans *Memling's Donne Triptych (*c.*1477; London, NG) is a peaceful *sacra conversazione* set in a similarly unified interior.

In Germany and Austria woodcarving continued to predominate, culminating in late 15th-century altarpieces of dramatic scale and complexity, notably the *S. Wolfgang* altarpiece (1471–81) by Michael *Pacher (S. Wolfgang im Salzkammergut, S. Wolfgang). Stone was a popular medium in the making of French altarpieces, such as the simple 14th-century *Passion* retable from S. Denis (Paris, Mus. Cluny).

Spain produced large retables, both painted and carved, featuring extensive programmes and complex frames. Often the whole apse of the church is filled by a carved reredos of wood and stone, for example at Toledo Cathedral (1504; Capilla Mayor). A special kind of reredos also evolved in England, consisting of a series of figures in niches which cover the wall behind the altar (Oxford, New College).

The Reformation of the 16th century put an end to the production of religious works of art in many Protestant areas, and in others restricted their imagery. As well as reinforcing the Eucharistic significance of the altarpiece, the Catholic Reformation imposed an overall unity of church design and decoration. The altarpiece was, increasingly, conceived as part of an architectural scheme, such as Andrea Palladio's (1508–80) design for the church of the Redentore, Venice. It was unified with the altar, its frame echoed the architecture of the building and in some cases, like the high altar in S. Peter's, Rome, was given a ciborium (*Bernini).

The altarpieces of the Baroque period are theatrical, and designed, like the frescoes around them, to arouse the spiritual feelings of the viewer. Paintings are vertically composed and dynamic, and three-dimensional settings of sculpture and fictitious architecture add to the overall dramatic illusion. Sculptural elements frequently provide the focus for the altar, as in Alessandro *Algardi's *Beheading of S. Paul* (1644; Bologna, S. Paolo Maggiore), and—most dramatic and mystical—Bernini's carving of S. Teresa's ecstatic vision (1647–52; Rome, S. Maria della Vittoria).

The Baroque churches of Rome were imitated throughout Europe, their ornate altars enclosing a single painting or sculptural group providing a model for many years. More romantic images marked 19th-century altars, often reminiscent of the altarpieces of an earlier age. Caspar David *Friedrich's *Cross in the Mountains* (1807–8; Dresden, Gemäldegal.) is set in a landscape which takes on some of the spirituality of the altarpiece genre. Twentieth-century churches require simpler furnishings and their altars are often positioned in the body of the church, so a return to the values of the early Church has resulted in the replacement of the altarpiece

with a simple image or symbol. MS

Humfrey, P., and Kemp, M. (eds.), *The Altarpiece in the Renaissance* (1991).

ALTDORFER, ALBRECHT (c.1482×5–1538). German painter, draughtsman, printmaker, and architect. He was the most important exponent of the 'Danube School', whose main characteristics are the importance of landscape as an expressive element, even in narratives, and a poetic feeling for nature. Most of Altdorfer's life was spent in Regensburg, where his presence is first recorded in 1505, and where he achieved both financial success and influence. He was on the town council in 1519 when the entire Jewish community was expelled and the synagogue demolished. Two etchings of the building have been interpreted as the artist's celebration of the event, especially in light of the inscription on one of them, which refers to the destruction as a just act of God. Beyond this however nothing is known of Altdorfer's position. In place of the synagogue was erected a pilgrimage chapel dedicated to the cult of the Virgin for which Altdorfer designed and executed various images. He was still a council member when the city adopted Lutheranism in 1533.

Altdorfer's earliest known works are drawings and prints, and the early paintings (first dated pictures 1507) are small in scale. In these works, nature provides the dramatic content; humans and animals are virtually submerged in forest vegetation (*S. George in a Wood*, 1510; Munich, Alte Pin.). From c.1510 the artist began to receive commissions for altarpieces, adopting a larger scale and more monumental figure style. The major works of this type were executed from c.1518 for the monastery of S. Florian near Linz. He continued however to paint cabinet pictures, including pure landscape with no human figures (see DANUBE SCHOOL), and landscapes with architectural fantasies (*Susanna at the Bath*, 1526; Munich, Alte Pin.). Altdorfer's most famous painting, the *Victory of Alexander the Great over Darius* (1529; Munich, Alte Pin.), displays at its height his capacity to organize an infinity of detail within an overall visual unity. The personal fate of the individual combatants, whether Alexander or Darius, is of secondary importance to the wild agitation of the armies within the immense, cosmic landscape bathed in mysterious light.

KLB

Goldberg, G., *Albrecht Altdorfer: Meister von Landschaft, Raum Licht* (1988).

ALTICHIERO (active c.1364; d. by 1393). Italian painter. Altichiero was the most significant Italian painter of the later trecento and the greatest of all north Italian artists of the century. Though Veronese his artistic language was founded on *Giotto's later work

and that of his followers *Maso di Banco and Puccio *Capanna. Altichiero's wider importance rests on his connections with the *humanist culture of *Petrarch and his associates in the signorial courts of Verona and Padua. At some stage after 1364 he painted the Sala Grande of the Scaligeri Palace in Verona with frescoes of Josephus' *Jewish Wars*. Surviving fragments of a window-border sequence of *Roman Emperors* reveal an erudite and precocious *all'antica* style. In the early 1370s Altichiero decorated the Sala Virorum Illustrium of the Carrarese Palace in Padua with frescoes after the *De viris illustribus* of Petrarch (d. 1374). Of these, only the *Portrait of Petrarch* survives. Altichiero's two extant sets of Paduan frescoes, in the chapel of S. Giacomo in the Santo (c.1376–9) and the adjacent oratory of S. Giorgio (1379–84), also contain images of Petrarch, pointedly juxtaposed with presumed portraits of the commissioning Lupi family and the Carrara court. These frescoes, New Testament scenes and narratives of S. James (S. Giacomo) and SS George, Catherine, and Lucy (S. Giorgio), represent a sustained development of the Giottesque pictorial language, richly coloured and displaying a remarkable range of characterization and observation. The great three-bay *Crucifixion* in S. Giacomo, filled with incident and genre detail but controlled by a compositional rigour looking both to Giotto and to Roman relief sculpture (see ROMAN ART, ANCIENT), is representative. Five of the S. Giacomo lunettes may be attributed to Jacopo *Avanzi, with whom Altichiero may have worked on the Sala Grande, though their professional relationship is problematic. JR

Richards, J., *Altichiero* (1998).

AMBERGER, CHRISTOPH (1500×5–61/2). German painter from Augsburg, primarily known for his portraits. He was admitted to the guild as a master in 1530 and probably trained by Leonhard Beck, whose daughter he married. Augsburg, the most cosmopolitan German city of the Renaissance, had close cultural and economic ties to Italy. Even before Amberger's meeting with *Titian at the Reichstag in Augsburg in 1547–8, and again in 1550–1, his portraits betray Venetian influence; a trip to Venice and northern Italy is likely (*Christoph Baumgartner*, 1543; Vienna, Kunsthist. Mus.). He also seems to have been familiar with the works by the Netherlandish court painter Jan Vermeyen who visited Innsbruck and Augsburg in 1530. One of Amberger's most ambitious religious paintings is the high altar of the *Virgin and Child with SS Ulrich and Afra*, signed and dated 1554, in Augsburg Cathedral. He also designed some of the bronze statues on the tomb of Emperor Maximilian I of c.1548 in the

Hofkirche, Innsbruck. KLB

Welt im Umbruch, exhib. cat. 1980 (2 vols.; Augsburg, Zeughaus und Rathaus).

AMBO (Latin: both), term in Christian church architecture for one of two lecterns or pulpits, usually positioned on either side of the choir, dating from the early Middle Ages. They could take various forms and were normally made of stone or marble. Good examples of 12th-century marble ambos can be seen at S. Clemente, Rome, and another two very similar at S. Maria in Cosmedin, Rome. Others were elaborately decorated with metalwork and enamelled panels, such as Henry II's magnificent ambo (*c.*1002–14; Aachen, palace chapel), or the ambo designed by *Nicholas of Verdun for Klosterneuburg in 1181 (later dismantled and used as a retable). During Mass the northern ambo was used for reading the Epistle and that on the south for reading the Gospel. They were superseded later in the Middle Ages, being replaced by a single movable lectern. TJH

AMERICAN ART OF THE USA (1) *Painting;* (2) *Sculpture*

1. PAINTING

Art in the United States begins with the native Americans. Their carvings, rock paintings, and weaving represent a cultural heritage rooted in religion, tribal ritual, and magic. This legacy the colonialists preferred to ignore; almost lost through years of persecution, it has comparatively recently re-emerged as a substantial thread in American art.

The 16th-century watercolours of John *White and Jacques Le Moyne, including coastal charts, native American settlements, and wildlife, demonstrate the eagerness of the first artists confronting their uncharted country. The gravestones and portraits of the early settlers have a forceful simplicity inspiring a continuing tradition of primitives; from 1660 John Foster's Boston printing press added the stark influence of woodcut.

Few professional painters survived the rigours of the early colonies; English influence was strong, portraiture paramount. The Baroque style became fashionable in the 18th century, notably through Justus Kuhn (active *c.*1711) and Gustavus *Hesselius. Wider subject matter reflected greater security and affluence: historical, mythological, and religious painting emerged, and landscape developed, as the colonialists found in their surroundings more than a challenge to survive.

John *Smibert, arriving in Boston from England in 1729, brought a greater sophistication and natural grace to portraiture. Also impressive was the native-born Robert Feke, of whom virtually nothing is certain, but whose *Isaac Royall and his Family* (1728–9; New Haven, Yale University AG) displays perceptive imagination and decorative sense. The outstanding figures of the period, John Singleton *Copley and Benjamin *West, both made their names in London, West becoming president of the RA (see under LONDON). Copley's boldly realistic portraits were admired, but his imaginative scenes of contemporary drama, including *Watson and the Shark* (1778; Washington, NG), were his most powerful innovation. With West, he began a Romantic historical tradition which continued through succeeding centuries. West's authoritative combination of history and portraiture, as in *The Death of General Wolfe* (1770; Ottawa, NG Canada), made a lasting impression.

West's chief pupil, Washington *Allston interpreted American landscape in the Romantic idiom. The Colonial Wars broke America's strong English links and artists turned to Europe and to their own land for inspiration. Charles Willson *Peale and Gilbert *Stuart developed the portraiture of the new republic, with Allston's friend Samuel *Morse, whose promising portrait career was disrupted by the success of his inventions. Thomas *Birch and Robert Salmon (1775–*c.*1845) painted the developing urban life with imaginative flair.

Natural science, art, and morality came together in the folk painting which flourished in the early 19th century, often through the works of self-taught, anonymous amateurs. *The Peaceable Kingdom* paintings of the Quaker Edward *Hicks and the work of Erastus Salisbury Field (1805–1900) are notable for an unsophisticated directness and sincerity continued into the next century by Grandma *Moses. The popularity of regional painting reflected developing nationalism: William Mount (1807–68), Eastman *Johnson, and George Caleb *Bingham were acclaimed for their interpretations of provincial America.

Close observation of the natural world was fostered by the talents of Alexander Wilson (1766–1813) and John James *Audubon, whose watercolours, published 1845–54, represent a high point in wildlife painting, equalled by George *Catlin's outstanding studies of native American tribes. The writings of a talented group including Fenimore Cooper, Emerson, Thoreau, and Irving promoted a belief in transcendental landscape, influencing the work of the *Hudson River School, who found in its gorges and rapids a focus for spiritual inspiration. Thomas Doughty (1793–1856). Thomas *Cole, Asher Brown *Durand, and John *Kensett articulated the symbolic power of landscape, reaching a climax in Cole's *The Voyage of Life* (1850; New York, Utica). Significant among younger painters were Jasper Cropsey (1823–1900), John Chapman (1808–89), and Frederic *Church, whose *Cotopaxi* (1855; Washington, Smithsonian) combines scientific curiosity, complex detail, and exalted celebration. Albert *Bierstadt painted native Americans in a similar spirit.

The *Luminists explored light and atmosphere. Led by Kensett, their works are quieter than Hudson River paintings; less concerned with scenic grandeur than transient sunlight, often across water. Sanford Gifford (1823–80), George Loring Brown (1814–89), and Fitz Hugh Lane (1804–65) produced evocative visions of this intimate side of landscape. George *Inness, Ralph Blakelock (1847–1919), and Albert Pinkham *Ryder transformed Hudson River Romantic realism at deeper levels of mysticism and imagination: Ryder's *Toilers of the Sea* (New York, Met. Mus.), metamorphosing reality into symbol, spans the gulf between the 19th and 20th centuries.

At the turn of the century three great expatriate painters, James McNeill *Whistler, John Singer *Sargent, and Mary *Cassatt, carried the reputation of American painting into Europe, as continental influences dominated the art scene at home. Against this cosmopolitanism, Winslow *Homer resolutely presented his unsentimental visions of New England rural life, while Thomas *Eakins blended portraiture, science, and nationalism in *The Agnew Clinic* (1898; Philadelphia, University of Pennsylvania), and a series of penetrating portraits. William *Harnett's *trompe l'œil* still lifes popularized an obsession with everyday minutiae beginning earlier in the century with Raphael Peale (1774–1825) and Charles Bird King (1785–1862), whose *Poor Artist's Cupboard* (1815; Washington, Corcoran Gal.) is outstanding. Harnett, John Peto, and John Haberle (1856–1933) brought the aggrandizement of commonplace objects to a climax which anticipated *Pop art by more than a century.

At the beginning of the 20th century, the photographer Alfred Stieglitz (1864–1946) challenged established authority at his New York '291' gallery. Chief among his exhibitors were The *Eight, led by Robert *Henri, and including George *Luks, William *Glackens, John *Sloan, and Everett Shinn (1876–1953). These young artists favoured urban scenes, painted with a gritty vigour which gained them the name of Ashcan Realists: the seedy customers of Sloan's *McSorley's Bar* (1912; Detroit, Inst. of Arts) are typical. The Association of American Painters and Sculptors, founded in 1911, provided a modernist forum for The Eight and their associates, including Ernest Lawson (1873–1939), George *Bellows, famous for his energetic paintings of prizefighters, and Arthur *Davies, whose lyrical landscapes laid the way for the *magic realism of Charles *Burchfield and Andrew *Wyeth.

In 1913 the New York *Armory Show brought together American and European

avant-garde artists, a watershed exhibition establishing the vitality of American *modernism. American artists experimented with *Cubism and *abstraction: Stanton MacDonald-Wright (1890–1973) and Morgan *Russell developed *Synchronism, related to the experiments of *Delaunay and *Kandinsky, while Max *Weber and *Man Ray evolved an Expressionist fragmentation of form recalling *Dada. Formal analysis and the fascination of technology inspired the *Precisionists, or Immaculates: the prismatic brilliance of Charles *Demuth, Charles Sheeler's (1883–1965) lucid industrial landscapes, and the dynamic kaleidoscopes of Joseph *Stella. Stuart Davis and James Rosenquist used geometric forms, words, and fragmented images to convey the sensations of modern America.

Equally austere, but inspired by the natural world, is the cool, intense geometry of Georgia *O'Keeffe's flowers, bones, and mountains. She shared with John *Marin, Arthur *Dove, and Marsden *Hartley the ability to perceive and recreate abstract and symbolic essences of natural forms. Another artist who shared their concerns with naturally derived organic pattern was Milton *Avery, whose textural and tonal modulations express the modernist awareness of the tensions between reality and illusion.

In the aftermath of the First World War came a renewed interest in folk-art and regional history (see REGIONALISM), exemplified by the paintings of John Steuart *Curry, Thomas *Benton, and Grant *Wood, whose American Gothic (1930; Chicago, Art Inst.) testifies to the continuing power of early Puritan aesthetics and morality.

After the Second World War New York became established as modernism's centre as the avant-garde fled Europe, adding their talents and discoveries to the explorations of native artists. *Surrealism, *Constructivism, *Op art, and *abstraction all influenced art from the 1950s, artists now confident of their own identity. The Surrealism of Ivan *Albright owes its intensity partly to a passionate realism, as do the distinctive paintings of Morris Graves (1910–). Graves brought the formal inspiration of oriental calligraphy to his mystical, emblematic compositions; Mark *Tobey developed similar influences in the abstract context of his 'white writing'.

Edward *Hopper linked Ashcan objectivity with modernist alienation, creating enigmatic situations through meticulous painting and implicit narrative, as in Office at Night (1940; Minneapolis, Art Mus.). A still more sinister atmosphere informs the harsh social realism of Ben *Shahn, while Andrew Wyeth's magic realism adds a lyrical vein of fantasy to this understated style of detached observation: the painstaking natural detail of

Christina's World (1948; New York, MoMa) being used to suggest psychological complexity and poetic mystery.

Surrealism's fascination with psychoanalysis, mythology, and *automatism, allied with an intense awareness of landscape and the city's conflicting rhythms, inspired monumental canvases where technique and spirituality interact in vibrant abstract images. From 1930, largely through the example and teaching of Hans *Hofmann, artistic initiative centred on New York and the Abstract Expressionists, internationally promoted by the critic Clement *Greenberg, a crucial figure in the developing reputation of modern American art. The work divides roughly into two aspects: the vigorous Action Paintings of Franz *Kline, Jackson *Pollock and Willem *de Kooning, and the haunting colour field images created by Mark *Rothko, Clyfford *Still, and Barnett *Newman. Pollock's hectic Lavender Mist (1950; Washington, NG) encapsulates the energies of the first, while Rothko's Houston Chapel (1964–7), at once serene and starkly disturbing, brought the second to a physical and spiritual climax. Robert *Motherwell combined the powers of contemplation and explosion, using organic shapes in fields of stark colour, as in The Voyage (1949; New York, MoMa). Second-generation colour field painters included Helen Frankenthaler, Morris *Louis, and Kenneth *Noland; Cy *Twombly continues to develop idiosyncratic combinations of staining and images.

From the 1960s American art's hallmark has been an energetic diversity. The 'Post-Painterly Abstraction' of Ellsworthy Kelly (b. 1923) and Frank *Stella looks back to the hard-edged subtleties of Ad *Reinhardt's orchestrated, monochromatic squares, and forward to the *Minimalists, including sculptor Carl André (1935–) and, in painting, Sol *Lewitt, Brice Marden (1938–), and Robert Ryman (1930–). Jasper *Johns magnified and recontextualized familiar images as art objects, most famously the American flag itself, as in Three Flags (1958; New York, Whitney Mus.). In his wake the Pop Artists Roy *Lichtenstein, with his hugely magnified cartoons, Andy *Warhol, mass-reproduced commercial images, and Jim *Dine encapsulated the anxieties and excesses of the consumer generation. Jean-Michel Basquiat (1960–88) provided an anarchic climax, asserting street graffiti as a potent art form. Op art was briefly popular; both Larry Poons (1937–) and Richard Anuszkiewicz (1930–) producing striking examples of visual illusion. More recently Bruce Nauman (1941–) and others have refocused attention on the artist-performer with 'body art' creations, an idea

developed in the video works of Bill Viola (1951–): *Conceptualism remains paramount in expressive art development.

2. SCULPTURE

A vital gulf separates native tribal carving traditions and the establishment of an immigrant school. The incomers were principally craftsmen, carving ships' figureheads and occasional portrait busts; serious commissions went to foreigners, as with *Houdon's busts of Lafayette and Washington. Not until the 19th century did sculpture become significant, even then remaining dominated by European *Neoclassicism. The work of Hiram *Powers, Horatio *Greenough, and Thomas *Crawford is typical: trained in Italy, their work echoes the classical simplicity of *Canova and *Thorvaldsen. Greenough's George Washington (1832–9; Washington, Smithsonian) and Crawford's huge bronze Armed Freedom (1857), crowning the Capitol dome, are the central examples. Clark Mills's contemporary Andrew Jackson (1853; Washington, Lafayette Square) demonstrates an opposing realist tradition advanced by John Quincy Adams *Ward and William *Rimmer.

Twentieth-century American sculptors sought a distinctive contemporary style. The death of Augustus *Saint-Gaudens allowed an escape from classical idealism: among others, George Grey *Barnard took up the challenge with monumental marbles inspired by *Michelangelo. Daniel Chester *French's Minute Man (Concord, Mass.) established a style of symbolic and monumental realism reaching its peak with Gutson *Borglum, whose presidential portrait busts, carved into the 150-m (500-ft) side of Mount Rushmore, South Dakota, were unfinished at his death, but remain the largest carvings in the world. Another realist was Frederic *Remington, whose lively representations of the picturesque Old West brought him popularity in sculpture, painting, and illustration. Jo Davidson (1883–1952) combined intense observation with massive simplicity in portraits of international figures.

After the Armory Show sculpture, with painting, explored abstraction. Max Weber and Robert Laurent (1890–1970) extended Cubism into three dimensions, encouraged by European immigrants including *Arp, *Moholy-Nagy, *Gabo, and *Zadkine. *Brancusi influenced many young sculptors, notably John Flannagan (1859–1942) and Isamu *Noguchi. The semi-organic abstractions of Theodore Roszak (1907–81) and David *Smith followed Gabo's bold use of modern materials, while Alexander *Calder allied engineering and sculpture in the first mobiles, an innovation which rapidly gained popularity: there are fine examples at Kennedy Airport, New York, and in Washington.

A surreal element entered American sculpture with Pop art sculptors Robert

*Rauschenberg and Claes *Oldenburg, whose outlandish constructions carry *Duchamp's irony to extremes of cultural satire, for example *Monogram* (1955–9; Stockholm, Moderna Mus.), Rauschenberg's tyre-ringed goat, and Oldenburg's gigantic hamburgers. Joseph *Cornell developed the Surrealist *collage in his curious boxed collections, John Chamberlain (1927–) arranged automobile debris as celebration and indictment of modern culture, while George *Segal's plaster images unite traditional realism with the poignantly surreal. Figurative sculpture continued, for example in the work of Leonard Baskin (1922–), whose bronze and wooden figures, hieratic and immobile, have an expressive, often anguished, dignity.

Modern materials continue their fascination. The neon tubes and plexiglas boxes of *Chryssa link art and advertising, while Eva *Hesse exploited latex and fibreglass in free-hanging works (*Right After*, 1969; Milwaukee, AG), expressively connecting structures within and around the body. Recent sculptors have returned to the oldest American obsession: creating designs or performing actions linking human activity with natural landscape. Among the most spectacular are *Christo, wrapping sections of landscape and public buildings, and Robert *Smithson, whose *Spiral Jetty* (1970), projecting 460 m (1,500 ft) into Salt Lake, Utah, parallels primeval geological forces. Walter De Maria's (1935–) *Lightning Field* (1971–7; New Mexico) combines monumental sculpture with an Impressionist manipulation of light, and the thrilling potential of electrical power; an ultimate fusion of nature, art, and technology.

JH

Hughes, R., *American Visions* (1997).
McLanathan, R., *The American Tradition in the Arts* (1968).
Rosenthal, N. (ed.) *American Art in the 20th Century*, exhib. cat. 1993 (London, RA).
Wilmerding, J., *American Art* (1976).
The Britannica Encyclopedia of American Art (1973).

AMIGONI, JACOPO (*c*.1685–1752). Italian painter and etcher, specializing in decorative frescoes and paintings in a *Rococo style. His place of birth is unknown but he was probably brought up in Venice and was a member of the Venetian painters' guild in 1711. *Zanetti describes a picture of *S. Andrew and S. Catherine* (Venice, S. Stae); but otherwise little is known about his early development until he arrived in Germany, where he remained *c*.1715–29, and painted decorative ceiling frescoes for the Elector of Bavaria in Munich and the Benedictine monastery at Ottobeuren. His style, influenced initially by Antonio Bellucci (1654–1726), from whom he probably received his early training in Venice, and by Sebastiano *Ricci, reached maturity with his fresco cycle in two rooms at Schloss Schleissheim on the *Life of Aeneas*,

which achieve a fluid light-hearted spirit that distinguishes them from the academic weight and dramatic designs of the Venetian tradition of history painting. He moved to England in 1729 where he enjoyed equal success. For Benjamin Styles at Moor Park (Herts.) he painted a magnificent sequence of large canvases of *Jupiter and Io* which were set in the Neo-Palladian plasterwork. In the lightness of their tone and their softness of touch they achieve a delicacy that sets them apart from the decorative work of other Italians who had already worked in Britain earlier in the century, such as S. Ricci and *Pellegrini. A later invitation to work at Castle Howard for Charles Howard, 3rd Earl of Carlisle, *c*.1736, ran into difficulties but another Yorkshireman, Thomas Bellasyse, acquired a magnificent *Mars and Venus* (London, National Trust). Amigoni also worked as a portrait painter and was particularly successful with portraits of the family and court of George II. He was a printmaker and took steps to open a print shop with his pupil Joseph Wagner. In 1739 he returned to Venice but was overshadowed there by G. B. *Tiepolo's more imaginative *illusionism. In 1747 Amigoni became court painter to Ferdinand VI of Spain and decorated a ceiling at Aranjuez (Palacio Real) with an *Allegory of the Virtues of the Spanish Monarchy* (1748–50). One of his last works was the intimate *Self-Portrait with Friends* (*c*.1750; Melbourne, NG Victoria).

HB

Croft-Murray, E., *Decorative Painting in England 1537–1837*, vol. 2 (1970).
Hennesy, L., *Jacopo Amigoni: An Artistic Biography with a Catalogue of his Venetian Painting* (1985).
Holler, W., *Jacopo Amigoni: Frühwerk in Süddeutschland* (1986).

AMMAN, JOST (1539–91). Swiss engraver and designer of woodcuts. Born in Zurich, he spent most of his career in Nuremberg, where he worked with Virgil *Solis, the chief illustrator for the Frankfurt publisher Sigmund Feyerabend. After the latter's death in 1562, Amman continued the association with Feyerabend. He was perhaps the most prolific illustrator of his day and one of his pupils boasted that he produced more drawings in four years than could be carted away in a hay wagon. On the whole, his woodcuts and engravings are perhaps more important as documents of contemporary life than for their artistic value, as in his so-called *Ständebuch* of 1568 (*Eygentliche Beschreibung aller Stände auff Erden*), with illustrations of the work of various trades. They were very popular however and some of his biblical illustrations served as models to the young *Rubens.

KLB

Pilz, K., 'Jost Amman', in *Allgemeines Künstlerlexikon*, vol. 2 (1986).

AMMANATI, BARTOLOMEO (1511–92). Italian sculptor and architect. Probably trained in Pisa, where he worked in the cathedral, he contributed to the Sannazaro monument in Naples (1536–8), before moving to Urbino. He returned to Florence in 1540 to execute the reclining figure for the Nari tomb (Florence, Bargello), soon after moving to Venice to assist Jacopo *Sansovino on the Libreria. However, he was mainly active in Padua, carving a lumpen *Hercules* (1544; Padua, Palazzo Mantova Benavides) for Bernardo Benavides, for whose architectural tomb in the Eremitani church (1546) he was also inspired by *Michelangelo. Arriving in Rome in 1550, he received the commission from Julius III for the del Monte chapel in S. Pietro in Montorio (1550–3), among his most successful sculptures, and contributed to the decoration of the Pope's Villa Giulia (1552–5). Returning to Florence in 1555, he became a Medici court artist. His fountain for the Palazzo Vecchio (*c*.1555; Florence, Bargello) illustrates a lyrical sculptural vision, and both the bronze *Hercules and Antaeus* (1560) and the *Apennine* (1563–5; Castello, Villa Medici) are ingeniously designed. His Neptune Fountain (1560–75) for the Piazza della Signoria had a hostile reception and the *Neptune* was nicknamed 'Biancone' on account of its colossal size and ungainly design. He modified the Palazzo Pitti and the Boboli Gardens (1560–77), and designed the graceful Ponte S. Trinita (1567–70). In old age, influenced by Counter-Reformation theory, he recanted his youthful works.

AB

Utz, H., 'A Note on Ammannati's Apennine and on the Chronology for the Figure for his Fountain of Neptune', *Burlington Magazine*, 115 (1973).

AMSTERDAM: PATRONAGE AND COLLECTING. *See overleaf.*

AMSTERDAM, RIJKSMUSEUM. It was a Frenchman, Louis Bonaparte, who established a Royal Museum in 1808. At first it was housed in the royal palace on the Dam; then, with the accession of King William I, it moved to the Trippenhuis before a final move in 1885 to its large, distinctive, red-brick present home designed by P. J. H. Cuijpers (1885). The primary importance of the collection is in the extensive holding of Dutch painting from the 15th to 18th centuries, particularly outstanding in painters of the 17th-century Golden Age. *Rembrandt's *Nightwatch* formed part of the collection from the beginning, joined later by *The Syndics* and *Jewish Bride*. Landscape, genre, still life, and portraiture by Dutch artists are without parallel and include Frans *Hals, Jacob van *Ruisdael, Pieter de *Hooch, Willem Claesz. *Heda, and *Vermeer. The remainder of the museum is devoted to a fine collection of sculpture and decorative art, again predominantly with Dutch associations.

CFW

· AMSTERDAM: PATRONAGE AND COLLECTING ·

CAPITAL and largest city of the province of North Holland and of the Netherlands (the seat of government is at The Hague), Amsterdam's greatest period of prosperity and artistic output was during the 17th century, the so-called Golden Age. Amsterdam's earliest origins were as a fishing village near the rivers Amstel and IJ. By the end of the 12th century the river Amstel was dammed, closing access to the IJ, and the resulting land now forms the heart of the city, Dam Square.

Up to the beginning of the 16th century little is known of art in Amsterdam. Evidence of religious art is scanty, possibly because of its destruction by Protestant iconoclasts at the end of the century, but *portraiture seems to have occupied a position of importance. One of the earliest artists to emerge was Jacob *Cornelisz. van Oostsanen. His son Dirck Jacobsz. specialized in portraiture and his *Crossbowmen* (1529; Amsterdam, Rijksmus.) is one of the earliest surviving militia group portraits. Cornelis Anthonisz. was also an early exponent of the militia portrait, such as the *Banquet of the Copper Coin* (1533; Amsterdam, Historical Mus.). By the mid-16th century Dirk *Barendsz. emerged as the leading painter. He visited Italy, where he may have studied with *Titian. The painter Pieter *Aertsen returned to his native Amsterdam after some years in Antwerp, where he had developed new large-scale compositions of genre figures and arrangements of still life. For the remainder of the century painters such as Jan van *Scorel and Maerten van *Heemskerck, from outside Amsterdam, were receiving the most important commissions.

It was at the beginning of the 17th century that Amsterdam was transformed very rapidly into the leading port of northern Europe, a mercantile centre and hub of artistic production. In 1578 the city authorities had sided with the Protestant house of Orange in the war against the Southern Netherlands. Amsterdam's increasing prosperity resulted in an ever-expanding market for paintings, prints, and books.

The period 1630–75 marks a peak in the artistic fortunes of Amsterdam. *Rembrandt was drawn to Amsterdam from Leiden in 1631 to benefit from the greater opportunities of patronage there. There is no recognizable Amsterdam school of painting but portraiture remained the predominant subject, the leading exponents at the beginning of the 17th century being Nicolaes Eliasz. called Pickenoy and Thomas de *Keyser. De Keyser had injected an informality and liveliness into his portraits as in *Constantin Huygens and his Secretary* (1627; London, NG) which may have influenced Rembrandt. New aspects were developed such as an enthusiasm for group portraits of famous medical doctors, for instance those of *Dr Tulp* (1632; The Hague, Mauritshuis) and *Dr Deyman* (Amsterdam, Historical Mus.), both by Rembrandt, or of Protestant preachers, as in Rembrandt's *Mennonite Preacher C. C. Anslo* (1641; Berlin, Gemäldegal.). Militia company portraits remained popular but the novel dramatic qualities of Rembrandt's *Nightwatch* (1642; Amsterdam, Rijksmus.) was not favoured as much as the static standing or seated approach as in the examples by van der *Helst and Pickenoy in the Amsterdam Historical Museum. Gradually these were replaced by group commissions from charitable institutions such as orphanages as in *Four Regentesses of the Burgher Orphanage* by Adriaen Backer (1683; Amsterdam, Historical Mus.). Civic patronage was dominated by commissions to, among others, Govaert *Flinck and Ferdinand *Bol, former pupils of Rembrandt, for the interior decoration of the new town hall. Wealthy individuals also commissioned portraits such as the East India Company official Philips Lucasz. (London, NG) or the merchant Jan Six (Amsterdam, Six Coll.), both by Rembrandt.

After the mid-century taste in Amsterdam shifted towards a greater elegance and demanded that painters emphasize sumptuous fabrics and interiors, influenced by the Flemish painter Anthony van *Dyck and French fashion. This is apparent in the work of genre painters such as Willem *Duyster, Pieter Codde (1599–1678), and Eglon van der *Neer.

In the 18th century the importance of Amsterdam as an artistic centre declined and painters such as Jacob de *Wit, Jurriaan Andriessen (1742–1819), and Jacob *Cats concentrated on interior decoration and wallpaper designs. Cornelis *Troost brought a new liveliness and informality to genre painting in his favourite technique of pastel and watercolour.

Until 1765 when the Amsterdamse Stadstekenacademie was founded, training for painters was in individual masters' academies, a well-known master being the classicizing painter and theorist Gérard de *Lairesse.

From 1806 to 1810 Napoleon's brother Louis Bonaparte became king of Holland. He made a considerable contribution to the arts in Amsterdam, organizing exhibitions and a system of grants. In 1808 he founded the Koninklijk Museum, a predecessor of the Rijksmuseum which, after 1813, was developed by William I of Orange.

Towards the end of the 19th century Amsterdam became a focus of new ideas in art and architecture which were spread through the new periodical *De Stijl*, founded by Piet *Mondrian and Theo van *Doesburg in 1917.

CFW

ANAMORPHOSIS. Anamorphic images are distorted so that they appear correctly from one viewpoint only. Such distortions were intended to mystify, amuse, hide, or accentuate the whole or parts of a work of art. Ancient Greek painters and sculptors understood the principle of negative optical perspective and used it in works which though viewed from below would nevertheless appear to be in proportion (Plato, *Sophist* 235–6). The distortion of images as a spatial conceit for its own end was most popular during the 17th century. Treatises and manuals started appearing in the 16th century, by Daniel Barbero among others, but the most influential works were published in the 17th century—François Noceron's *La Perspective curieuse ou magie artificielle* (1638), Emmanuel Maignan's *Perspective boraria, sive de horographia gnomica* (1648), and the Jesuit manual *La Perspective practique par un religieux de la Compagnie de Jésus* (3, 5, 6, and 7; 1649). Examples of anamorphosis include the skull in *Holbein's *The Ambassadors* (1533; London, NG), and a portrait of Edward VI (1546; London, NPG). OI

ANATOMY. The study of human anatomy was and is a part of the education of the art student. The artists of the *Renaissance, and in particular *Leonardo da Vinci, were helped by the work of physicians and surgeons in this branch of science, who in turn encouraged artistic endeavour by their ever-increasing need for good-quality illustrations. The greatest contribution to this field, and one of the most widely disseminated works on anatomy, was the first and illustrated edition of Andreas Vesalius' *De humani corporis fabrica libri septem* (1543). This work is of seminal importance in the history of medicine and book design, in particular for the high quality of its illustrations, reproduced in many works until well into the 19th century. There has been much speculation as to the identity of the artist, but according to *Vasari the illustrations are the work of Jan Steven van Calcar. The sort of dissection lectures that Vesalius gave in the famous lecture theatre at Padua were seen as suitable subject matter for a number of Renaissance artists. Parts of human skeletons are depicted in the engravings of Baccio *Bandinelli's so-called academies and *Lomazzo in his celebrated *Trattato* (1584) gives a minute account of the structure of the body. The study of anatomy became an institutionalized and fundamental component of artistic training from the middle of the 17th century with the foundation of the *academies; for example the *Paris Académie Royale de Peinture et de Sculpture employed a surgeon to lecture to students and the Royal Academy (see under LONDON) a professor of anatomy. In attempts to arrive at a standard, or ideal, form anatomical study was of obvious importance.

Artistic anatomy is superficial in the sense of being confined to the form and proportion of the human body, the bone structure, and those muscles visible beneath the skin. For purposes of demonstration casts from the Antique and from life, the skeleton and the flayed figures were usually employed; actual work upon the subjects in the dissecting room was far less common. This branch of study has seldom been pursued with enthusiasm by teachers or pupils. *Ingres objected to the presence of a skeleton in the life room, and remarked that although he was acquainted with the muscles of the body, he did not care to know their names. The most fervent supporter of anatomical training was *Haydon, who maintained staunchly—and it would seem mistakenly—that the Greek sculptors dissected the body; he believed that through the study of comparative anatomy the student could perceive what was essentially human, and therefore essentially divine, in our bodies.

Throughout the 19th century anatomy continued to be taught in academies of art and two authorized textbooks, Dr Paul Richer's *Anatomie artistique* (1890) and Prof. Arthur Thomason's *Anatomy for Art Students* (1896), met a continuing demand. Anatomy was irrelevant to the main aesthetic preoccupations of the age and has to an increasing extent been abandoned in art schools. In some cases it was replaced by a more general morphological course dealing with the structure of both animate and inanimate objects. OI

Roberts, K. B., and Tomlinson, J. D. W., *The Fabric of the Body: European Traditions of Anatomical Illustration* (1992).

ANCIENT ART, POST-ANTIQUE COLLECTING. *See overleaf.*

ANDACHTSBILD. See DEVOTIONAL IMAGE.

ANDREA (BONAIUTI) DA FIRENZE (active 1346–77). Italian painter. Andrea Bonaiuti spent most of his career in Florence, where he was moderately successful, although, 'miserabilis et impotens', unable to pay his debts in 1370. In 1365 he was contracted to decorate the chapter house (later known as the Spanish chapel) of S. Maria Novella. These frescoes comprise an encyclopedic statement of Dominican theology. Their didactic nature has been too easily interpreted, like *Orcagna's work for the same order, as testimony to a supposedly reactionary shift in Florentine painting. Within the necessarily diagrammatic format of a fresco like the *Way to Salvation*, Andrea's powers of observation and description are revealed to

be considerable. Much doctrinal information is provided, but couched in a detailed and vivid narrative language representing the intelligent adaptation of early trecento naturalism, not its rejection. The fresco includes a remarkable image of the cathedral, imaginatively completed but in reality still subject to the deliberations of a commission on which Andrea himself served in 1366–7. In 1377 he was paid for frescoes of the life of S. Ranieri in the Camposanto at Pisa. JR

Offner, R., and Steinweg, K., *A Corpus of Florentine Painting*, vol. 4/6 (1931–).

ANDREA DEL SARTO (Andrea d'Agnolo) (1486–1531). Florentine painter, called Sarto (tailor) after his father's profession. He studied probably with *Piero di Cosimo, but his early works were more directly influenced by Fra *Bartolommeo and, to a gradually increasing degree, by both *Leonardo and *Michelangelo. The five frescoes of the life of Filippo Benizzi painted for the church of SS Annunziata, Florence (1510), also attest to del Sarto's adherence to traditional 15th-century Florentine painting, most notably Domenico *Ghirlandaio. Del Sarto's attainment of a grander and more expressive style can be seen in slightly later works, such as the *Annunciation* (c.1512; Florence, Pitti) and the *Marriage of S. Catherine* (c.1512; Dresden, Gemäldegal.).

It is likely that Andrea visited Rome during this period, where he was deeply affected by the idealized beauty and monumentality of Roman High *Renaissance art. He lacked, however, the impulse for abstraction found in Michelangelo and *Raphael for his *classicism was always tempered by a naturalism rooted in the Florentine tradition. The integration of naturalistic detail within compositions of rigorous compositional clarity is apparent in his fresco of the *Birth of the Virgin* (1514) in SS Annunziata, and in his celebrated series of grisailles in the cloister of the Florentine confraternity of the Scalzo illustrating the life of John the Baptist, which were executed during several periods of activity from 1509/10 to 1526, interrupted by del Sarto's brief period in France in 1518–19.

In contrast to the febrile emotions expressed in the work of his pupils *Rosso and *Pontormo, the mood of del Sarto's painting is almost always meditative and contained, and this classical restraint, which was largely unaffected by *Mannerism, has often been wrongly interpreted as a vacuity of feeling. Although his emotional range is limited, del Sarto's classicism is often enlivened by an engaging human sympathy, as shown in the *Pietà* (1523/4; Florence, Pitti), or in his most celebrated works the *Madonna of the Harpies* (1517; Florence, Uffizi) and the *Madonna della*

continued on page 19

· ANCIENT ART, POST-ANTIQUE COLLECTING ·

COLLECTING of antiquities began in the ancient period itself with the art collections of the Hellenistic dynasts and Romans of the republican and imperial periods (see ART MARKET, ANCIENT). The beginning of post-Antique collecting can perhaps be best set within the late Antique period, when older monuments and statuary were reused for the decoration of new monuments such as the Arch of Constantine (see TRIUMPHAL ARCHES) (AD 315) in Rome. The Emperor Constantine's foundation of the 'New Rome' in Constantinople (AD 324) was characterized by an explosion of collecting of antiquities from Rome, Athens, and other Graeco-Roman cities for the embellishment of this capital of the Greek East. Charlemagne too fitted out his new capital with monuments constructed with *spolia* from Rome and Ravenna; his own tomb was an ancient sarcophagus. The use and display of *spolia* should however be set within the broader context of the late Antique and early medieval periods with their extremely limited production of new building and sculptural material.

If it was once thought that interest in the Antique was reborn solely in the *Renaissance, a much earlier classical revival can be reconstructed in the *Carolingian period. A further revival of interest in ancient art and literature is found among the humanists of the 12th and 13th centuries. In the mid-12th century, Henry of Blois, the Bishop of Winchester, acquired an impressive collection of antiquities under the pretence of removing statues in order to protect the Romans from the cult of images. Medieval writers, Magister Gregorius, John of Salisbury, and others, produced detailed chronicles of their visits to Rome complete with descriptions of ancient works of art and inscriptions. The colossal statues of the *Dioscuri* on the Quirinal and other ancient works were recorded in the *Mirabilia urbis Romae* of the mid-12th century.

Already in the medieval period, ancient art attracted the interest of collectors and patrons as well as artists and craftsmen. These two elements coincided in the early pattern books filled with a compendium of Antique motifs characteristic of late Gothic realism of *c.*1400. The Porta della Mandorla of the cathedral in Florence (1390–1400) is but one example of these quotations *all'antica*. The first comprehensive set of drawings after the Antique is a sketchbook from the studio of *Gentile da Fabriano in which the dual goals of imitation of ancient art and naturalism intertwine. A more direct response to ancient art is represented by the medieval practice of reusing Roman marble sarcophagi and ash urns as tombs, fountain or holy-water basins, or set into the wall as decoration. The collection of marbles, bronzes, gems, and engraved gems amassed by Oliviera Forzetta (1335–73) was the first on the scale of its Renaissance counterparts.

The Renaissance was characterized by an explosion in the discovery and reception of ancient statuary, wall painting, and minor arts. At the same time, collecting of antiquities commenced on a large scale with *humanist collectors such as Niccolò Niccoli and Poggio and artists such as Lorenzo *Ghiberti and *Mantegna. Pope Paul II (1464–71) amassed a collection of ancient gems, coins, and small bronzes that after his death were acquired by Lorenzo de' Medici (1449–92). Lorenzo's collection was to become the richest of Renaissance Italy; it also included bronze and marble statues and portraits, vases of semi-precious stones, as well as terracotta and glyptic works. In the same period, Pope Sixtus IV (1471–84) presented a collection of bronze statues including the *She-Wolf* and the *Spinario* to the Conservatori in 1471; these statues constituted the first objects in what was to become the oldest public collection of art in the world (see ROME, CAPITOLINE MUSEUMS).

The public collection on the Capitoline was later matched by the Belvedere court of the Vatican of Pope Julius II (1503–13), the first purpose-built site for the display of antiquities. The court gave its name to two of its most important early occupants, the *Apollo Belvedere* and the *Belvedere Torso*. It was nearly completed in 1506 when the *Laocoön* was discovered and subsequently installed there. The *Belvedere Antinous*, the statue that stood in the sole remaining niche of Bramante's design, was added in 1545. Private collections such as that of the Farnese Pope Paul III (1534–49), which included the *Farnese Hercules* and *Farnese Bull*, competed with the public ones on both a qualitative and quantitative level. Collecting was not restricted to Italy however. François I's hunting lodge at *Fontainebleau was fitted out with bronze statues cast from moulds of the most famous Antique works in Rome obtained by the court artist *Primaticcio as well as more than 125 marble statues.

By the middle of the 16th century, plaster casts produced from the moulds of Primaticcio adorned the studio of the sculptor Leone *Leoni. The importance of drawing after the Antique, either originals or plaster casts, was increasingly emphasized. Casts are associated with the earliest art *academies at Florence (1562), Rome (1593), and Milan (1620). One of the express purposes for the foundation of the French Academy in Rome in 1666 was for the holders of the *Prix de Rome to produce marble copies or plaster casts of the principle Antique statues in the city. Conceived to adorn the extensive grounds of *Versailles, these copies were not intended as exact replicas but improvements on their Antique models, adapted to suit the site as the copy of the *Crouching Venus* by *Coysevox demonstrates. In 1707, the director of the Academy suggested that it be closed down since there were already sufficient copies in France, but the Academy survived and became renowned for its collection. Reproductions after the

Antique, although no longer requested by the French royal family, found a new market amongst connoisseurs and travellers on the *Grand Tour.

The Grand Tour coincided with extensive excavations in Italy centred in Rome and its environs and the discovery of *Pompeii and *Herculaneum at the foot of Vesuvius. English, Scottish, and Irish travellers were those most interested in the Antique; they purchased originals as well as copies after ancient sculpture and painting. The wealthiest of them, Richard Payne *Knight, Charles Townley, the Marquess of Lansdowne, and the like, amassed significant collections for the decoration of their London houses and country homes. Artists/art dealers such as Gavin *Hamilton and Thomas Jenkins were instrumental in procuring the masses of antiquities demanded by the connoisseurs. At the same time, the dispersal of the collections of Roman families such as the Altemps, Barberini, and Borghese greatly enriched the market. In Naples, Sir William Hamilton collected an extraordinary range of vases, bronze and marble statuary, glass, gems, jewellery, and glyptic art.

Damaged or fragmentary antiquities were restored in the workshops of Cavaceppi, Albacini, and others; their restorations covered a broad range from the replacement of missing limbs using plaster casts to the creation of pastiches of ancient fragments and fakes. During the second half of the 18th century, attitudes to restoration shifted from free adaptation and creation to a more academic approach. *Winckelmann was central to this debate. By the beginning of the next century, *Canova enforced a more restricted approach to restoration through his position as inspector general for the Papal States.

Reproductions after the most famous works were also collected. The production of bronzes after the Antique should in theory be more exact. Thus, the 17th-century sculptor Massimiliano Soldani emphasized that marble copies are not, and can never be, as correct as those of bronze. Soldani's own works belie this principle, as they are highly personal interpretations. Full-scale bronzes were among the most valued objects in 17th-century royal collections. Even small-scale bronzes after the Antique were luxuries in the 17th and most of the 18th centuries. The largest collection belonged to Louis XIV's court sculptor, François *Girardon; illustrations of his collection were published in 1709. Bronze copies produced in the Florentine workshops of *Susini and others served first the needs of sovereigns and later graced German palaces and English country houses. The tide shifted even further with the introduction of the economical technique of sand casting in the 1780s. The workshops of Giovanni Zoffoli, Francesco Righetti, and Giuseppe Boschi took up the commercial production of sets of small bronze copies at a price attractive to the gentleman traveller.

Already in the early 18th century, Count *Algarotti envisioned porcelain figures after the most beautiful statues of Antiquity. This vision was fulfilled in the mid-18th century by the production of copies of the models of Soldani and Foggiani after famous statues in Florence in the Marchese Carlo Ginoro's factory. Algarotti's foresight was brought to further fruition by establishment (1785) of the factory of the engraver Giovanni Volpato in Rome that specialized in biscuit porcelain reproductions on the same scale and subjects as the statuettes sold by Righetti and Zoffoli. The English porcelain workshop of Josiah Wedgwood produced copies after the Antique and 'Etruscan' vases, thereby making the Antique accessible to an even broader range of society.

Napoleon's desire to create a new Rome in Paris led to a massive exodus of Antique art from Rome and other defeated cities (1796–8). The *Apollo Belvedere*, *Laocoön*, *Spinario*, and many other famous statues were carried in triumphal procession to *Paris. The collection of antiquities was further enriched over the next decade by the arrival of the *Medici Venus* and the collection of Napoleon's brother-in-law Prince Camillo Borghese. In 1815, Canova was entrusted with the restitution of the papal collections to Rome. The beginning of the 19th century was also characterized by important discoveries in Greece that led to a devaluation of Roman art in comparison to the art of Classical Greece. The 'Elgin Marbles' stripped from the *Parthenon in Athens and transferred to the British Museum in *London in 1818 and the purchase in 1812 of the pedimental sculptures of the temple of Aphaia at Aegina by Prince Ludwig of Bavaria confirmed Winckelmann's views concerning the superiority of Greek art. Ludwig I, who adorned *Munich with the most famous of Roman and Greek antiquities, also signals the end of the great age of collecting of the Antique. L-AT

Bober, P. P., and Rubinstein, R., *Renaissance Artists and Antique Sculpture* (1986).

Haskell, F., and Penny, N., *Taste and the Antique* (1981).

Weiss, R., *The Renaissance Discovery of Classical Antiquity* (1969).

Scala (c.1522/3; Madrid, Prado). The lucid harmony of his compositions and the naturalism of expression of his figures was achieved through a rigorous process of preparatory studies. His chalk figure *drawings display an immediacy, both in their execution and in the observation of the model, seldom found in his painted work.

Sarto was the dominant influence on the generation of reforming Counter-Reformation Florentine painters at the end of the century, such as *Santi di Tito and Jacopo da Empoli, who reacted against the mannered, unreal elegance of *Vasari and his school. HCh

Freedberg, S. J., *Andrea del Sarto* (1963).

Shearman, J., *Andrea del Sarto* (1965).

ANGEL (Greek: messenger). Spiritual beings, intermediaries between God and man, angels are part of the Judaeo-Christian tradition, appearing in the Old and New Testaments. Angelic literature, concerning their nature and such stories as the *Fall of the Rebel Angels* (illustrations to *Paradise Lost*, by William *Blake), is derived from the apocryphal Book of Enoch (1st–2nd centuries BC). Medieval angelology is based on the writings of, among others, Dionysius the Pseudo-Areopagite, S. Augustine, and S. Thomas Aquinas. Dionysius established the celestial hierarchy of nine choirs: seraphim, cherubim, and thrones; dominations, virtues, and powers; principalities, archangels, and angels, the last two having a direct mission to

men. The 16th- and 17th-century cult of the guardian angel produced many representations of the archangels Raphael and Michael (statue atop Castel S. Angelo, Rome, 1570s, replaced 1752).

In the Old Testament angels appear in the guise of humans, and in *Byzantine art they can be wingless (*Jacob Wrestling with the Angel*, 4th-century ivory casket; Brescia, Mus. Civico Cristiano). The angel of Western art can be traced to classical Victories; angels are shown winged, usually with haloes and in loose draperies that occasionally show their feet. In medieval painting, seraphim were often red, with six wings; cherubim were blue, sometimes with two or three pairs of wings; the sacred function of the childlike cherubs that appear from the 16th century should not be confused with the profane putti, or small cupids.

All the Bible stories that include angels, from the Expulsion from Paradise to the Revelation, were illustrated, along with the apocryphal stories of the Virgin Mary (*Assumption of the Virgin*, by Guido *Reni, 1616–17; Genoa, S. Ambrogio). Angels are also depicted in theophanies based on the visions of Isaiah (6: 1–2) and Ezekiel (1: 4–13; *c*.1155; Chartres Cathedral, central west door). In paintings they often appear as heavenly choirs, and in late medieval England the nine orders became popular on wooden screens (Barton Turf, Norfolk), and were sculpted in the Beauchamp chapel, S. Mary's, Warwick. Angels were carved on tombs (Bishop Mortival, *c*.1333; Salisbury Cathedral; Montmorency tomb, Moulins, by François *Anguier, *c*.1650; Queen Victoria and Prince Albert, by Marochetti, 1864–8; Windsor Castle, Royal Coll.). *Bernini provided sculptured angels for the Ponte S. Angelo (Rome, 1668–9; now in S. Andrea delle Frate, Rome), the Scala Regia (1663–6; Vatican), and the baldacchino (1624–33) in S. Peter's.

Angels enjoyed a revival in the 19th century, particularly in stained glass; that they have survived contemporary religious scepticism is attested by the gigantic bronze *Angel of the North* by Antony Gormley (1950–) sculpted on a hillside near Gateshead, Northumberland (1998). NC

Cross, F. L., and Livingstone, E. A. (ed.), *Oxford Dictionary of the Christian Church* (3rd edn., 1997).
Hall, J., *Hall's Dictionary of Subjects and Symbols in Art* (rev. edn., 1993).

ANGELICO, FRA (Fra Giovanni di Fiesole; Guido di Piero da Mugello) (active 1417–55). Italian painter and illuminator of the Florentine School who has been admired both for his intense spirituality and for his understanding of the innovative methods of his day. *Ruskin shared the view of *Vasari, writing in 1845 that he was 'not an artist properly so called but an inspired

saint', who produced edifying devotional works.

He entered the Dominican order and was a friar at S. Domenico, Fiesole, by 1423, eventually becoming prior there. After 1436 he worked extensively at the priory of S. Marco in Florence, and from *c*.1445 was a good deal occupied in Rome, also painting in Orvieto in 1447. His prolific artistic career, the size of his workshop, and the status of his patrons, who included two popes, reflect his sophistication and professionalism, which he combined with a devotion to the teaching of the Dominican order and the tradition of art in the service of religion.

Although there is evidence of the influence of *Gentile da Fabriano in some works, for example the *predella (London, NG) of the altarpiece for S. Domenico, Fiesole, Fra Angelico's paintings from the 1430s onwards utilize the most advanced developments of Florentine artists, notably *Masaccio and *Ghiberti. The *Coronation of the Virgin* (*c*.1435; Paris, Louvre) shows a mastery of perspective and spatial rhythms of volumetric forms, while the fresco of the *Crucifixion* in the Dominican convent at Fiesole refers to Masaccio's *Trinity* (Florence, S. Maria Novella). Even the Linaiuoli Tabernacle, (1433–9; Florence, Mus. S. Marco), although patterned and more decorative with its background of sumptuous hangings, and acknowledging a debt to Gentile's handling of colour and light, shows an emphasis on the plasticity of the Virgin and Child and especially the sculptural figures of saints on the wings.

Fra Angelico's combination of modern realistic techniques and traditional images of corporate devotion is apparent in the frescoes for the restored convent of S. Marco, which represent a celebration of the disciplined life of the convent in their delicate coloration and economy of composition, as in the two versions of the *Annunciation*. These are very different from the later scenes from the lives of SS Stephen and Laurence (1448–9; Vatican), which emphasize dignified narrative elements and ornate detail, more appropriate for their location and clearly the work of the leading painter in Rome at that time. They are the only surviving fresco cycle from the four papal commissions undertaken by Fra Angelico.

The *Deposition* (1443; Florence, Mus. S. Marco) is a serene vision of an extensive, evenly lit landscape suggestive of one-point perspective. The spatial disposition and varied poses and gestures of the figures (especially the kneeling figure who links the viewer and the picture space), and the decorative trees and flowers, would have fulfilled *Alberti's requirements of variety and ornateness, described in his treatise on painting. Fra Angelico's influence can be seen in the work of his pupil Benozzo *Gozzoli, and in the spatial and tonal harmonies

of *Domenico Veneziano and *Piero della Francesca. MS

Hood, W., *Fra Angelico at San Marco* (1993).
Pope-Hennessy, J., *Fra Angelico* (1972).

ANGLO-SAXON ART. The Anglo-Saxons stemmed from the pagan Germanic peoples who invaded and settled post-Roman Britain during the 5th and 6th centuries, and had carved out a number of kingdoms by 600; the most notable ('the Heptarchy') were Kent, Sussex, Wessex, Essex, East Anglia, Mercia, and Northumbria. They had brought with them a highly developed abstract and animal art that adorned their artefacts. Many of these have been preserved in pagan burials, the most renowned being the Sutton Hoo ship burial in East Anglia (*c*.625; London, BM) which features intricate pieces of gold, garnet, inlay, and enamelwork, some of it influenced by Roman and Frankish pieces. Upon settling in Britain they were increasingly exposed to the influence of the sophisticated abstract and zoomorphic styles of *Celtic art, the legacy of Antiquity (see ANTIQUE) expressed through Romano-British survivals, the missionary activities of the Roman and Celtic Christian Churches, as well as through continuing trade links. Because the early medieval culture of Britain was essentially a fusion of these varied influences, the 6th to 9th centuries are often termed the Insular period—being the cultural product of the British Isles and Ireland. The ornamental fusion of Germanic, Celtic, and Pictish motifs was particularly marked in the Celtic areas of the north and west, and in the north of England (Northumbria), and is sometimes also termed 'Hiberno-Saxon'. It is expressed in masterpieces of metalwork such as the Tara Brooch and Ardagh Chalice, both now considered to be of Irish manufacture (8th century; Dublin, National Mus. Ireland) and in the luxury Insular Gospel books such as the Book of Durrow for which the origin is contested between Iona, Ireland, and Northumbria (late 7th century?; Dublin, Trinity College Lib., MS 57), the Lindisfarne Gospels, made at Lindisfarne (*c*.698; London, BL, Cotton MS Nero D. IV), and the Book of Kells (*c*.800; Dublin, Trinity College Lib., MS 58). Along with the conversion, from the late 6th century, of the Anglo-Saxons to Christianity came an awe for its vehicles—writing and the book. A major Insular contribution to medieval art was the elevation of the written word to the status of an icon in its own right, with the introduction of the fully decorated initial and incipit page and of the historiated initial (the earliest example of which is in the Vespasian Psalter made in Canterbury *c*.725 (London, BL, Cotton MS Vespasian A. I). These devices were designed to articulate the text and, by integrating text, script, and image, bestowed mutual validation and

overcame issues of idolatry. Similarly, inscriptions often accompany narrative images, as on the Franks Casket and the Ruthwell (Dumfries and Galloway) and Bewcastle (Cumbria) Crosses, works of Northumbrian manufacture which synthesize northern and Mediterranean cultures. Narrative images are also found in manuscripts, notably Evangelist miniatures, Crucifixion and Last Judgement scenes, scenes from the life of King David, and also complex symbolic pictures, such as the scenes depicting the Temptation and the Arrest of Christ in the Book of Kells.

Alongside Germanic and Celtic styles and motifs was an ever-increasing input from the Mediterranean. Many Anglo-Saxon ecclesiastics, such as Wilfrid and Benedict Biscop, were Romanophiles and are known to have imported books and panel paintings, as well as choral personnel, from Rome during the 7th century, founding Romanizing monasteries such as Monkwearmouth/Jarrow, Hexham, and Ripon. These were to produce works such as the Codex Amiatinus (Florence, Bib. Laurenziana, MS Am. I), a Bible which was made at Monkwearmouth/ Jarrow before 716 as a present for the Pope, and which until the 1880s was thought to be the work of Italo-Byzantine craftsmen because of its naturalistic, illusionistic painting style, its Romanizing uncial script, and the purity of its Vulgate text. In the south the missionizing Roman Church had taken Canterbury as its base and under the learned Archbishop Theodore of Tarsus and Abbot Hadrian from Africa its school became the envy of the West, paving the way for the scholarship of Aldhelm, Bede and Alcuin of York. Kent and Mercia gave rise to an influential group of 8th- to 9th-century manuscripts termed the 'Tiberius group' (formerly the 'Canterbury group') including the Vespasian Psalter, the Stockholm Codex Aureus (Royal Lib., MS A. 135), the Book of Cerne (Cambridge, University Lib., MS Ll. I. 10), and the Royal Bible (London, BL, Royal MS I. E. VI), along with the Tiberius Bede (London, BL, Cotton MS Tiberius C. II) from which the group takes its name. A style of metalwork known as the 'Trewhiddle style' was also much in vogue in Southumbria at this time especially for pieces in silver-niello, and features the same whimsical animal ornament as the southern manuscripts.

Viking raids from the late 8th century onwards and the ensuing partition of unoccupied England and the Danelaw caused a dislocation of production and many losses of art and libraries. The period of disruption was largely confined to the mid-9th century, however. From this time onwards the Celtic peoples and the Anglo-Saxons engaged in less cultural collaboration and, following the spiritual, educational, and cultural revival

initiated by Alfred the Great and his successors from the late 9th century we speak of Anglo-Saxon art proper. Insular styles of art continued to be practised in Celtic areas for many centuries. As a part of the 'Alfredian' revival earlier Southumbrian sources acted as models, leading to the survival of zoomorphic initials, and *Carolingian influence (already experienced in England during the early 9th century) increased, with the introduction of acanthus-like ornament and of a monumental but animated drawing style. The ecclesiastical reforms of the later 10th century, implemented by clerics such as Archbishop Dunstan, and Bishops Æthwold and Oswald, under the patronage of King Edgar, occasioned a flowering of the arts. They were conducted under continental Benedictine influence and this is clearly seen in the 'First' or 'Winchester' style of Anglo-Saxon art which is characterized by monumental figures with flying drapery hems, indebted to Carolingian drawing styles, and by opulent acanthus ornament in borders and initials. In manuscripts this may occur in fully painted form or in outline/tinted drawings, or even in a fusion of the two. Its greatest manuscript representatives are the Benedictional of S. Æthelwold (c.980; London, BL, Add. MS 49598) and the New Minster Charter (966; London, BL, Cotton MS Vespasian A. VIII). The style is also found in *ivories such as the Winchester angels panel and the V&A pyx, and in metalwork. It was by no means confined to Winchester.

Renewed political instability and Viking intervention in the early 11th century does not appear to have been detrimental to the arts, with many of the most opulent manuscripts being commissioned at this time, such as the York Gospels, the Grimbald Gospels, the Copenhagen Gospels (late 10th century and c.1020; Copenhagen, Koningen Bib., MS G.I), the Eadui Gospels, the Bury Gospels, and the Missal of Robert of Jumièges (c.1020; Rouen, Bib. Municipale, MS Y. 6). It has been suggested that the patronage of the Danish King of England Cnut and his wife may have stimulated such production. One scribe/ artist who worked on many of these books, the Christ Church Canterbury monk Eadui Basan, enjoyed royal patronage. He also worked on one of the major artistic endeavours of the later Anglo-Saxon age, the Harley Psalter (London, BL, Harley MS 603). This was made at Christ Church in the early 11th century, perhaps for the Archbishop as a response to one of the great icons of medieval art, the Utrecht Psalter (9th century; Utrecht, Bib. Ryksuniversiteit, MS 32). This monument of Carolingian art had been made in the diocese of Reims around 820 and is thought to have been modelled on an early Christian exemplar. The Utrecht Psalter's agitated, sketchy, illusionistic outline drawings inspired the second later Anglo-Saxon style,

the 'Utrecht style'. Its elongated figures and agitated drapery are also found in other media, notably ivories such as the S. Omer *Virgin and S. John*.

During the first half of the 11th century the 'first' or 'Winchester' style and the 'Utrecht' style merged, producing a monumental but impressionistic and often expressionistic style, as seen in S. Margaret's Gospels (Oxford, Bodleian Lib., MS lat. liturg. F5) and the Tiberius Psalter (London, BL, Cotton MS Tiberius C. VI), and on objects such as the Musée de Cluny portable altar. In metalwork and sculpture *Scandinavian styles of animal art and foliate interlace (especially Ringerike and Urnes style) are increasingly influential and occur on a variety of metalwork pieces, including the Sutton Isle of Ely disc brooch, and on sculpture such as the S. Paul's churchyard slab and the numerous Anglo-Scandinavian crosses and hog-back tombs. Here images from Norse mythology are often juxtaposed with Christian iconography, as on the Gosforth Cross. Around the mid-11th century a harsh, metallic figure style is found in manuscripts such as the Caligula Troper (London, BL, Cotton MS Caligula A. X. IV) and in objects such as the Cleveland Museum casket, perhaps under German or Flemish influence, as part of the transition to *Romanesque art. Anglo-Saxon artistic influence survived the Norman Conquest of 1066 and may be seen in later 11th-century books from Normandy, such as the Préaux and Jumièges Gospels), and also in the Bayeux Tapestry (c.1066–97; Bayeux, Mus. de la Tapisserie) which records events surrounding the Conquest. Through the two-way street of exchange of influences and through the high regard in which its culture was held, Anglo-Saxon art played an influential role in the arts of the early Middle Ages and of the Romanesque period.　MPB

Backhouse, J., et al. (eds.), *The Golden Age of Anglo-Saxon Art, 966–1066*, exhib. cat. 1984 (London, BM/BL).

Brown, M. P., *Anglo-Saxon Manuscripts* (1991).

Webster, L., and Backhouse, J. (eds.), *The Making of England: Anglo-Saxon Art and Culture AD 600–900*, exhib. cat. 1991 (London, BM/BL).

Wilson, D., *Anglo-Saxon Art* (1984).

ANGUIER BROTHERS. French sculptors. **François** (c.1604–69) and **Michel** (1612–86) were both in Rome in the 1640s. There they came under the influence of *Algardi, and it was his moderate and dignified *Baroque style that they·brought with them on their return to France (François before 1643, Michel in 1651). This Roman style is evident in the tomb for Henri de Montmorency (Moulins, Lycée), begun by François in 1648 and to which Michel contributed also. Michel's later work developed in a more classicizing direction than that of his brother, though his well-known *Nativity* of 1665 in S. Roch, Paris, sets

up a dramatic interplay between the three separate figures that make up the group. Michel was still active in the 1670s, when he carved the decoration of the Porte S. Denis in Paris to the designs of Charles *Le Brun. But by then his work must have looked old-fashioned compared to that of *Girardon, *Coysevox, and the younger generation of sculptors working for Louis XIV. MJ

Black, B., and Nadeau, H., *Michel Anguier's 'Pluto': The Marble of 1669* (1990).
Blunt, A., *Art and Architecture in France, 1500–1700* (rev. edn., 1988).
Sanson, A., *Les Frères Anguier* (1889).

ANGUISSOLA, SOFONISBA (c.1535–1625). The eldest of a noble Italian family of five sisters, all painters, whose rarity as a woman artist brought her immense fame; *Vasari visited her home in Cremona. Her career was skilfully managed by her father, and she studied first with Bernardino *Campi, then with Bernardino Gatti (c.1495–1576). Her popular self-portraits, round-eyed, grave, show her reading, seated at the clavichord, or painting a devotional work, and convey an ideal of the highly cultivated gentlewoman; in the *Chess Game* (1555; Poznań, National Mus.) the sisters display their skill and grace. Sofonisba specialized in *Leonardesque studies of laughter and weeping, and a drawing, *Boy Bitten by a Crab* (Naples, Capodimonte), was praised by *Michelangelo. In 1559 she went to Spain, where she painted the Spanish royal family. Later she married twice, and worked in Sicily and Genoa, painting devotional works influenced by *Cambiaso. Her sisters' lives, by contrast, were wan and short; they too painted portraits and devotional works, and a handful of pictures have been attributed to them. HL

Caroli, F., *Sofonisba Anguissola e le sue sorelle*, exhib. cat. 1994 (Cremona, Centro Culturale).

ANQUETIN, LOUIS (1861–1932). French painter, born in Normandy, who played a small but significant role in the development of pictorial *Symbolism in Paris in the 1880s. He entered the Atelier Cormon in 1884, where he met van *Gogh, *Toulouse-Lautrec, and *Bernard, and in the mid-1880s concentrated on insistently modern Parisian subjects. In 1886–7 he and Bernard were together developing a new style, *Cloisonnism, which rejected naturalism and explored the symbolic power of colour and line; Anquetin's *Street: Five O'Clock in the Evening* (1887; Hartford, Conn., Wadsworth Atheneum) represents this style. Anquetin later moved away from Cloisonnism, and sought new inspiration in the art of *Rubens. HL

ANTAL, FRIGYES (Frederick) (1887–1954). Hungarian art historian. Antal studied art history in Berlin and Vienna under *Wölfflin and *Dvořák, and in 1919 became involved in the cultural politics of the Hungarian Communist regime. His chief contributions to the discipline of art history were made after his emigration to England in 1934, including *Florentine Painting and its Social Background* (1948), a study which provoked much criticism from conservative scholars because of its decidedly Marxist approach and language. His theoretical outlook is expounded in *Remarks on the Methods of Art History* (1949). AT

ANTELAMI, BENEDETTO (active 1178–96, possibly 1233). 'Antelami' is a 12th-century term for masons originating in the region of Como. This outstanding 12th-century Italian sculptor is known from two signed and dated works: a relief of the *Deposition* (1178; Parma Cathedral), and the north portal of Parma Baptistery (1196) for which Benedetto was probably the architect. The *Deposition* is a majestic, repetitive composition of figures in classicizing drapery that describes the body with sober vertical pleats underscoring the gravity of mood. Its style has been compared to S. Gilles-du-Gard in Provence but is closer to the west portals of Chartres, whose later transept sculpture or that of Mantes may also have been known to Antelami, for the baptistery's wall structure is related to that found in eastern French Gothic architecture. The baptistery's sumptuous sculptural programme includes *Virgin* and *Last Judgement* portals and interior niches, simplifying but also monumentalizing their French sources. Other works by his workshop or his followers include the monumental cycles of the *Labours of the Months* in Parma (baptistery) and Ferrara cathedrals (Porta dei Mesi), S. Andrea, Vercelli (begun 1219), and perhaps the equestrian portrait of Oldrado da Trasseno (1233; Milan, Palazzo della Ragione). RG

Crichton, G. H., *Romanesque Sculpture in Italy* (1954).
Quintavalle, A. C., *Benedetto Antelami* (1990).

ANTEPENDIUM. See FRONTAL.

ANTICO, L' (c.1460–1528). Italian sculptor, perhaps from Mantua, properly named Pier Jacopo di Antonio Alari Bonacolsi. His pseudonym refers to his ability to interpret *Antique sources and recreate small-scale versions of the statuary of Antiquity. As well as producing bronzes and medals, he was a goldsmith, and is known to have restored ancient marble sculpture, possibly part of the *Dioscuri* of Monte Cavallo, Rome.

He was employed alongside Andrea *Mantegna at the Gonzaga court in *Mantua, both as artist and adviser on the purchasing of antiques, and complements this painter in the clearly defined anatomy and smooth muscularity of his figures. Among his small bronzes are versions of the *Spinario* (Rome, Capitoline Mus.), and the *Apollo Belvedere*. Of the latter, the example in Venice (Ca' d'Oro) omits the tree trunk which was the support necessary for the marble original, itself a copy of an earlier bronze. This understanding of his sources is seen in numerous *all'antica* subjects, such as *Hercules and Antaeus* (Vienna, Kunsthist. Mus.), and *Meleager* (London, V&A), and is often combined with the use of decorative gilded and silver detail, resulting in a rich, yet erudite effect. MS

Radcliffe, A. F., 'Antico and the Mantuan Bronze', in *Splendours of the Gonzaga*, exhib. cat. 1981–2 (London, V&A).

ANTIPHONAL. See CHOIR BOOK.

ANTIQUE, THE, art of the ancient *Greek and *Roman periods, up to the beginning of the Middle Ages. During the Middle Ages a few detached Antique works had been publicly preserved outside the Lateran in Rome and in the squares of other Italian cities, also around several palaces of the Holy Roman Emperor, and there is visual evidence (from its use by Gothic sculptors) or written report of more—especially engraved *gems and cameos, which were widely prized. Then from around 1450 (among a few even earlier) the vogue became universal in Italy for accessories (including art) *all'antica*—displacing the fashions that hitherto had been set by foreign princely courts. Perhaps its first manifestation was the production of medals, presumably meant to imitate classical coins, though bearing little resemblance to them. During the course of the 15th century rising *humanist interest, though centred on matters textual or historical or, at best, *iconographical, accompanied the more widespread collection, discussion, and depiction of ancient works of art; a leading figure in this last was the widely connected Ciriaco d'Ancona. Reference to the Antique became more common in contemporary art, and sculptural installations such as *Donatello's bronze *equestrian *Gattamelata* in Padua (1443–7) may be regarded as having been set up in conscious emulation. The Antique also gave good precedent for depicting the nude, and set a standard of scale to be matched. Displays such as Lorenzo de' Medici's garden in Florence or the Belvedere court installed by Pope Julius II in the Vatican in the first decade of the 16th century, and several other 'gardens' displaying statuary in Rome, aroused general interest. An important number of albums of *Renaissance drawings after the Antique have survived, notably those by *Aspertini. The

practice grew up of copying or pastiching Antique works of art notably in small bronzes of a type to adorn shelves or desks (reported in Isabella d'Este's *studioli* for instance, and depicted in *Carpaccio's *S. Augustine's Vision of S. Jerome* in the Scuola di S. Giorgio, Venice). Indeed the medieval and Renaissance treasuring of small Antique or *anticheggiante* items (among other things) in *studioli* gave way in the 16th century to the institution of *gallerie* ('long galleries') in which especially Antique marble statuary and busts were displayed *de rigueur* (see under GALLERY). Notably François I of France from about 1540 began to receive or have made, and to display, bronze copies of the most highly prized Antique marbles in Rome. This practice in turn facilitated the formation of a range of canonical works (mostly in marble; seldom Classical Greek originals) in which the principles of the *classicist tradition might be instructively exemplified.　　　　　PH

Bober, P. P., and Rubinstein, R., *Renaissance Artists and Antique Sculpture* (1986).

Haskell, F., and Penny, N., *Taste and the Antique* (1981).

Howard, S., *Antiquity Restored: Essays on the Afterlife of the Antique* (1990).

Settis, S. (ed.), *Memoria dell'antico nell'arte italiana* (3 vols., 1984–6).

ANTOLÍNEZ, JOSÉ (1635–75). Spanish painter, born in Madrid and pupil of Francisco *Rizi. There are many signed and dated works by him, the earliest of 1658. The subject he painted most frequently is the *Immaculate Conception*, in which the Virgin's active, angular pose is complemented by the movement of her windblown, swirling mantle. The abundance of lively cherubs carrying Marian emblems is also characteristic.

Antolínez also painted some small mythological scenes, a few portraits, and a genre picture. His *Portrait of the Danish Ambassador and his Friends* (1662; Copenhagen, Statens Mus. for Kunst) is a rare instance of group portraiture in Spain. Besides *Murillo's and *Velázquez's examples, genre paintings were rare in Spain. The setting of Antolínez's large *Itinerant Painter* (Munich, Alte Pin.)—an interior that opens into a succession of spaces beyond—is closer to Dutch or Flemish genre than to those Spanish prototypes, but its unusual subject, a character who proffers a Madonna's image to the viewer, is one of those 'travelling and tattered painters' often mentioned in *Palomino's biographies of Spanish artists.　　　　　NAM

Brown, J., *The Golden Age of Painting in Spain* (1991).

Mallory, N. A., *El Greco to Murillo: Spanish Painting in the Golden Age: 1556–1700* (1990).

ANTONELLO DA MESSINA (c.1430–79). Italian painter. Born in Sicily, he was the most important south Italian painter of the 15th century. He is traditionally credited with introducing into northern Italy the Netherlandish technique of oil painting, which he perhaps learned in Naples. He combined this oil technique and north European delight in detail with an Italian taste for simplified forms. Northern influence reminiscent of Jan van *Eyck is suggested by the exquisite still-life elements and Gothic setting of one of his earliest works, *S. Jerome in his Study* (1460s; London, NG). The unusual expressiveness of his portraits (Paris, Louvre; London, NG) derives in part from his use of the three-quarter view, another Netherlandish import. Even in a small work such as the *Crucified Christ* (1475; London, NG), he created a surprising sense of space. By 1475 he was in Venice, where he executed an important altarpiece for S. Cassiano (fragments: Vienna, Kunsthist. Mus.), one of the first to be specifically related to its architectural setting. He influenced Venetian artists, particularly Giovanni *Bellini, as well as *Piero della Francesca.　　　　　LH

Sricchia Santoro, F., *Antonello e l'Europa* (1986).

ANTWERP: PATRONAGE AND COLLECTING. *See overleaf.*

ANTWERP, GUILD OF S. LUKE, a guild dedicated to S. Luke, patron saint of artists, to which artists had to belong in order to practise their craft in the city. The guild of S. Luke in Antwerp seems to have been founded early, by the year 1453, in comparison to those in other cities. From this year records begin and run continuously until 1795, when the organization closed. They form an important body of information on Netherlandish artists. Thirty-five names were listed in the first year, increasing to over 300 by 1500. During the 16th century, 1,925 names are listed, not all of them artists, since from 1550 onwards bookbinders, printers, engravers, and harpsichordists were also members. Once artists were members, not only could they practise their profession in Antwerp, but they could also sell sculptures, altarpieces, and paintings through the guild's booth in the forecourt of Antwerp Cathedral.　　　　　CFW

Honig, E. A., *Painting and the Market in Early Modern Antwerp* (1998).

ANTWERP MANNERISM, term invented by Max *Friedlaender in 1915 in an article 'Die Antwerper Manieristen von 1520', written as a result of his researches into the *Adoration of the Magi* (Munich, Alte Pin.) which bore the false signature of Herri met de *Bles; Friedlaender called the unknown master the Pseudo-Bles. The somewhat confusing term 'Antwerp Mannerism' is now used to describe a number of mainly anonymous artists active in Antwerp about 1500–30 such as Master of the Antwerp Adoration, Master of Amiens, Master of the von Groote Adoration, and the Master of 1518 (now identified as Jan Mertens). The main identifiable artists include Jan de Beer (c.1475–before 1528), Adriaen van Overbeke (active 1508–29), Jan Wellens de Cock (c.1490–before 1527), and Jan *Gossaert in his early works. The Mannerism of these artists is not associated with Italian or later 16th-century Netherlandish developments, but is more related to the intricate and highly wrought characteristics of late *Gothic art and sculpture. Compositions are exclusively religious with crowded, theatrical figure groupings, combined with fantastical architecture, elegant costumes, and an exaggerated use of colour and a self-conscious technical virtuosity. Jan de Beer's *Nativity* (Birmingham, Barber Inst.) is a typical example.　　　　　CFW

Friedlaender, M. J., 'Die Antwerpener Manieristen von 1520', *Jahrbuch Konig. Preuss. Kunstsamml.* 36 (1915).

APELLES (active late 4th–early 3rd century BC). Painter, of Colophon, later of Ephesus. Considered the supreme ancient painter, Apelles explained the principles of painting in several treatises. He was inventive, creating a secret varnish which not only protected his paintings, but brought out the brilliance of the colours. Apelles' work was renowned for *charis* (charm). He said that he knew when to finish a picture, but was self-critical, secretly listening to the comments of viewers of his work. Horses neighed at his horses; his portraits, too, were famously life-like. He frequently painted Philip II and Alexander the Great, who allowed only Apelles to paint him. Apelles showed Alexander victorious over War; and mounted, with a thunderbolt, he portrayed the one-eyed Antigonus (King of Macedonia 306–301 BC) in three-quarter view to hide the defect. Of some 30 known works by Apelles, his *Aphrodite Anadyomene* (rising from the sea) was particularly famous, becoming the subject of many epigrams, and was later dedicated by Augustus in Rome. *Lucian describes *Calumny*, an allegorical painting, which inspired Renaissance artists, notably *Botticelli's *Calumny of Apelles*.　　　　　KWA

APHRODISIAS, a city in Caria (modern Turkey) whose name reflects the city's worship of Aphrodite from its foundation in the 2nd century BC. The claim by Caesar and Augustus of descent from the Roman Venus led to a special relationship between the city and Rome from the Julio-Claudian period to the late 3rd century AD; it later became the capital of Caria under the Emperor Diocletian. Excavations carried out at the site since 1961 have revealed continued vitality through to the early *Byzantine period. The importance of Aphrodisias as a centre of sculptural production was noted even before

continued on page 24

· ANTWERP: PATRONAGE AND COLLECTING ·

NOW a province of Belgium (formerly part of the old duchy of Brabant), during the 16th century, partly because of its situation on the river Scheldt, Antwerp became the greatest port and trade centre of Europe with over 1,000 merchants of all nationalities resident by 1560.

Antwerp's emergence at the beginning of the 16th century to a position of outstanding importance as a centre of trade resulted in a vigorous development of artistic life. Not only did it become an important centre of painting, but it also occupied a foremost position in printing, map-making, tapestry production, and luxury goods such as glass and metalwork. Painters like Quentin *Massys, Joachim *Patinir, Pieter *Aertsen, and Frans *Pourbus opened studios there and helped to establish Antwerp as a place of new artistic ideas. Besides commissioned works of art there were a host of workshops engaged in the mass production of altarpieces, for example the *Passion retable* (Philadelphia Mus.). Visitors were numerous and included the German artist *Dürer, his fellow countryman Erasmus, and the Italian writer Guiccardini.

Antwerp became a refuge for heretics and their ideas were spread through its printing presses, in particular that of Christophe Plantin. Books and prints became an important vehicle for the dissemination of artistic ideas as well: for example the influence of Italian *Renaissance decorative detail in the graphic work of Pieter *Coecke and Hans Vredeman de Vries (1527–1606?).

However, this early 16th-century period of artistic dominance was short-lived, and the religious upheavals under the Spanish King Philip II caused a swift decline in Antwerp's fortunes during the second half of the century. Much religious art was destroyed and the population fell by half with the emigration of large numbers of wealthy and skilled families to the northern Netherlands, such as the parents of Frans *Hals or the landscape painter Gillis van *Coninxloo.

A revival in Antwerp's artistic fortunes took place at the beginning of the 17th century with the Twelve Year Truce of 1609 which gave a much needed period of stability. Antwerp, with its close proximity to the Dutch Protestant border, was used by the Spanish governors as a spearhead of Catholicism against the influence of Dutch Calvinism, with the building of new churches and the commissioning of altarpieces in the Counter-Reformation spirit. One of the crucial factors in this artistic revival was the return of *Rubens in 1608 from Italy. He opened a studio in Antwerp rather than joining the court in Brussels and provided outstanding altarpieces such as the *Raising of the Cross* and *Deposition* (1609–11; Antwerp Cathedral). A new generation of painters, including van *Dyck, Frans *Snyders, and Lucas van *Uden, were attracted to his studio for training or employment. Although the Church now played a less significant role as patron, the Jesuits were an exception and commissioned from Rubens a large cycle of paintings for the Jesuit church. Important members of Antwerp society once more became patrons, for example Nicolas Rockox and Cornelis van der Geest, whose art collection is recorded in a painting by Willem van der Haecht (Antwerp, Rubenshuis). Such paintings of *Kunstkammer* collections and also the production of objects for them such as the Ptolemaic Armillary Sphere (Chicago, Adler Planatarium) or Cabinet with Landscapes (The Hague, Gemeentemus.) was a speciality of Antwerp artistic production. The city was an important centre for precious metals and gems, and goldsmiths trained there were highly sought after at international courts; for example Hans Vermeyen was invited to Prague by the Emperor Rudolf II.

With the deaths of Antwerp's greatest painters Rubens and van Dyck in 1640 and 1641 respectively, followed in 1678 by that of Jacob *Jordaens, the city began to decline again as an artistic and economic centre, despite the foundation of an Academy by David *Teniers II in 1663. An exception was the continuance of a spectacular sculptural revival in the decoration of churches with elaborate black and white marble church furnishings, in particular the work of the *Quellinus family (Antwerp, S. Jacob's).

Not until the 19th century was Antwerp again to make a distinctive artistic contribution with the establishment of the Koninklijk Museum voor Schone Kunsten (1878–90) and smaller museums like the Museum Mayer van den Bergh. A group of painters including Nicaise de Keyser and Henri Leys developed a romantic historicism which began by harking back to Antwerp's 16th-century glory exemplified by the *Visit of Dürer* by Henri Leys (1855; Antwerp, Koninklijk Mus. voor Schone Kunsten) and developed towards a vigorous realism in the work of Leys's nephew Henri de Braekeleer. CFW

Stock, J. van der (ed.), *Antwerp: The Story of a Metropolis*, exhib. cat. 1993 (Antwerp).

the excavations commenced, on the basis of signed sculptures in Roman and other museums that gave the ethic of the artist as 'Aphrodisian'. Quarries nearby provided the working material, a fine white marble as well as grey, striated white and grey, and dark grey or blue-black marble. In addition to the rich sculptural decoration of the monuments and the series of portrait and ideal sculpture on the site, sculpture in various states of unfinish provides further information concerning marble production in this important school, operative from the 1st century BC/AD to the late Antique period. Noteworthy are the mid-1st-century AD panel reliefs of the triple-storeyed portico leading to the Sebasteion, dedicated to the cult of the emperor, with historical reliefs including members of the imperial family, mythological reliefs, and personifications of cities and ethnics. Ideal sculpture is represented by series of copies in small and large scale, such as a satyr with a baby Dionysus and a Hellenistic fisherman. Sarcophagi were another form of local production; more than 300 are preserved. An important late Antique series is represented by inscribed shield portraits of Greek

philosophers and writers such as Pythagoras and Pindar, associated with the philosophical school based there. Finally, a small-scale statuette of a priestess and miniature cult images of Cybele and perhaps Asclepius testify to the shift in pagan worship practices as Christians gained hold in the late Antique period. L-AT

Erim, K., *Aphrodisias: City of Venus Aphrodite* (1986).
Rouché, C., and Erim, K. T. (eds.), *Aphrodisias Papers* (1990).
Rouché, C., and Smith, R. R. R. (eds.), *Aphrodisias Papers 3* (1996).
Smith, R. R. R., *Journal of Roman Studies*, 77 (1987); 78 (1988); 80 (1990).
Smith, R. R. R., and Erim, K. T. (eds.), *Aphrodisias Papers 2* (1991).

APHRODITE OF CNIDUS, or *Aphrodite Euploia*, the most admired of *Praxiteles' works, sculpted in marble *c*.350 BC. The lost statue's appearance can be recovered from ancient descriptions and representations in diverse media (e.g. Vatican Mus.): the goddess of love was depicted in a contrapposto pose, nude, bathing: while lifting her garment from a water jar at her left, she apparently turns to respond to an unseen intruder; her right hand casually masks her pudenda in what is commonly considered a gesture of modesty, but thereby directs the viewers' attention to the source of her power. Allegedly modelled on the sculptor's mistress Phryne, this statue established the ideal for feminine beauty. It brought great fame to the city of Cnidus, on the south-western coast of Asia Minor, and was frequently praised, reproduced, and adapted throughout Antiquity and thereafter. KDSL

Ajootian, A., 'Praxiteles', *Yale Classical Studies*, 30 (1996).
Havelock, C. M., *The Aphrodite of Knidos and her Successors* (1995).

APOCALYPSE MANUSCRIPT. The last book of the New Testament, known in the Authorised Version as 'The Revelation of S. John the Divine', describes a series of S. John the Evangelist's eschatological visions commonly known as the Apocalypse. The earliest illuminated manuscript of the Apocalypse appeared in the 9th century and contained coloured ink drawings (*c*.820; Trier, Stadbib., MS 31). The Beatus manuscripts produced in Spain from the 10th to the 13th centuries are illustrated commentaries on the Apocalypse—a compilation of visionary texts written about 776 by an Asturian monk, Beatus of Liébana. It is believed that they were designed for liturgical use, possibly even to be placed on the altar. Illuminated apocalypses achieved great popularity in England in the 13th century. The abbreviated text could be in Latin or Anglo-Norman French and was usually accompanied by a

commentary. All of these examples were extensively and dramatically illustrated, with large miniatures often on every folio as in the Dyson Perrins Apocalypse (*c*.1255–60; Los Angeles, Getty Mus., MS Ludwig III 1). Although apocalypses were made for liturgical usage, or for monks' private reading, these luxurious manuscripts seem likely to have been made for rich lay patrons and some were certainly owned by aristocrats, such as the Apocalypse of Blanche of Castile, Queen of France (*c*.1260; Paris, Bib. nat., MS lat. 8865). KC

Emmerson, R. K., and McGinn, B. (eds.), *The Apocalypse in the Middle Ages* (1992).
van der Meer, F., *Apocalypse: Visions from the Book of Revelation in Western Art* (1978).

APOLLINAIRE, GUILLAUME (1880–1918). French writer. A poet of lasting appeal, he was also the leading art critic of the Parisian avant-garde in the decade before the First World War. He arrived in Paris in 1899, the illegitimate son of a Polish noblewoman. In 1904 he met *Picasso. Mutual admiration led the latter to paint in response to Apollinaire's verse during his 'Rose' period, while the poet was the first to praise Picasso in print (1905). Apollinaire vigorously promoted the developing *Cubist painting of Picasso and *Braque, alongside that of his lover Marie *Laurencin, but went on to make new associates: in 1911 Raoul *Dufy illustrated his book *Bestiaire*, while in 1912 he kept company with Francis *Picabia and Marcel *Duchamp, but also helped launch Robert *Delaunay's new movement, coining for it the label *Orphism. A year later his enthusiasms were with the *Futurism of *Marinetti. On active service through the war, Apollinaire died of influenza two days before its close, being widely mourned. A year earlier he had invented the term *'Surrealism', subsequently adopted by the post-war avant-garde.

MF/JB

APOLLO BELVEDERE (Vatican Mus.), a marble sculpture of the god Apollo, thought to be a Roman copy of a Classical Greek bronze. Excavated at the end of the 15th century, it is recorded from 1509 in the Vatican Museum; by 1511 it stood in the Belvedere statue court there, hence its name. The statue soon became one of the most famous survivals of ancient art, considered until the 19th century as a paradigm of Greek, rather than Roman, achievement. It was reproduced in various media and prompted homages by artists and writers, such as *Reynolds and *Winckelmann. The latter's description (G. Winckelmann, *Storia delle arti del disegno presso gli antichi*, ed. C. Fea, 1783/4) proved an important influence on Neoclassical artists, including *Canova. The sculpture was ceded to France in 1797 and taken to

Paris; it returned to Rome in 1816. CB

Haskell, F., and Penny, N., *Taste and the Antique* (1981).

APOLLONIO DI GIOVANNI (*c*.1416–65). Florentine painter and illuminator whose thriving workshop produced many of the finest *cassoni* (marriage chests) and painted furniture panels for the Florentine mercantile elite of the mid-15th century. Apollonio's style, as seen in the *Aeneid Cassone* (*c*.1455; New Haven, Yale University AG), combined recent developments in Florentine monumental painting with a sense of narrative and emotional expressiveness that animated his decorative panels. Responding to the aspirant classical interests of his patrons, he was responsible for introducing many new subjects from Antique and modern literature (Homer, Virgil, and *Petrarch) into contemporary Renaissance art. PSt

Callmann, E., *Apollonio di Giovanni* (1974).

APOXYOMENUS. See LYSIPPUS.

APPEL, KAREL (1921–). Dutch abstract painter, sculptor, graphic artist, designer, ceramicist, and poet, regarded as the most powerful of the post-war generation of Netherlandish artists. He was born in Amsterdam, where he studied at the Academy, 1940–3, and he had his first one-man exhibition at Het Beerenhuis in Groningen in 1946. At this time he was influenced by *Dubuffet and was attempting to work in the spirit of children's drawings. In 1948 he helped to found Reflex, the experimental group of Dutch and Belgian artists from which the *COBRA group sprang, and in 1949 he painted a fresco in the cafeteria of Amsterdam City Hall which caused such controversy that it was covered for ten years. The following year he settled in Paris, where he found an influential supporter in the critic Michel Tapié (1907–87), who organized exhibitions of his work. By the end of the decade he had an international reputation, having travelled widely and won the Unesco Prize at the Venice Biennale in 1954, the International Painting Prize at the São Paulo Bienal in 1959, the Guggenheim International Award in 1960, and several other honours. He first visited New York in 1957 and subsequently divided his time mainly between there, Paris, and Monaco.

His most characteristic paintings are in an extremely uninhibited and agitated *Expressionist vein, with strident colours and violent brushwork applied with very thick impasto. The images usually look purely abstract at first glance, but they often retain suggestions

of human masks or of animal or fantasy figures, sometimes fraught with terror as well as a childlike naivety: Herbert *Read wrote that in looking at his pictures one has the impression of 'a spiritual tornado that has left these images of its passage'. Such works were influential on *Neo-Expressionism. In 1968 Appel began to make relief paintings, followed by painted sculptures in wood and then aluminium. He has also made ceramics, and done a varied range of design work, including carpets, stained glass, and the scenery for a ballet, *Can we Dance a Landscape?*, for which he also wrote the plot; it was performed at the Paris Opéra in 1987.　　IC

APPIANI, ANDREA (1754–1817). The leading *Neoclassical painter in Italy. Based in his native Milan, he worked chiefly in fresco, contributing large decorative schemes to S. Maria presso S. Celso (1792–8) and the Palazzo Reale (1808). His attempt to create a neo-Greek style, as exemplified in such canvases as *The Toilet of Juno* (c.1806; Brescia, Gall. d'Arte Moderna) compares unfavourably with the contemporary efforts of *David and *Ingres. This did not, however, prevent him from being a favourite of both Pope Pius VI and Napoleon, the latter of whom made him his official painter in Italy. To modern taste Appiani's most sympathetic works are his portraits.　　MJ

Neppi, A., *Andrea Appiani* (1952).

AQUATINT, a method of etching tone which creates an effect akin to a wash drawing. It is usually combined with etched line, and the tones are created by biting the copper plate through a porous ground of granulated resin.

The aquatint ground is usually formed by covering the plate with a fine dust of powdered resin, which is then fused to the plate by heat. The plate is bitten in the same way as an etching, but the acid bites the exposed copper through the reticulations of the hardened resin, creating a myriad of tiny dots which print as a fine tone. The texture is dependent on the varying size of grains used, while the depth of tone is varied by the greater or lesser amount of time the plate is immersed in acid, as in regular etching. It is a delicate technique, and the most subtle tones wear out very quickly. The artist makes his design, and varies the tones, by the use of stopping out, namely by painting varnish over those areas of the plate to be protected from the acid.

The several variants of the method include sugar aquatint, which was used by *Gainsborough in the 18th century but neglected until the 20th century, when it has been used by many artists, including, notably, *Picasso. The artist established his dark tones directly, by drawing on the copper with a solution of black watercolour and sugar. The plate is varnished, and immersed in water, where the sugar swells, lifts off the plate, and bursts through the varnish. The result is a plate covered with varnish, excepting the marks made with the sugar solution, which have the freedom of lines drawn on paper. All methods of aquatint are printed in the same manner as regular etching, but frequently aquatints were printed in brown as well as black.

The principles of aquatint were established in the 17th century by Jan van de Velde IV (c.1610–86), who etched an extraordinary portrait of *Oliver Cromwell* in a mixture of aquatint and engraving. It then lay dormant until revived by Jean-Baptiste Le Prince (1733–81), whose first plates are dated 1768. In France the most interesting development of aquatint went largely in harness with colour printing from multiple plates, notably in the work of François Janinet (1752–1814) and Philibert Louis Debucourt (1755–1832), and the latter's *La Promenade publique* (1792) is one of the most effective of all French prints. One obvious application of the method was its use to copy or imitate wash *drawings, and a pioneer in this field was Cornelis Ploos van Amstel, who made accurate facsimiles of drawings by *Rembrandt, van *Ostade, and others.

It was in England that aquatint found its most natural partner in the national school of watercolour painting. It was initially popularized by the landscape prints of Paul Sandby (1731–1809), who was experimenting with the technique from about 1775. Thereafter countless artists used the technique, principally for purposes of topography, where it was the perfect supplement to the British tradition of watercolour. Such prints, often assembled in book form, were frequently hand coloured, or printed in colour by the superimposition of different plates. It was also used with great brilliance by *Gillray. However it reached its apogee in the prints of *Goya, notably in the 80 plates of *Los caprichos* (1799), and he also expanded the technique by scraping the grounded surface of an aquatint plate with a *mezzotint scraper in his rare print *The Colossus*.

The history of the technique is fundamentally workaday, but it received great impetus late in the 19th century by the work of Degas and Camille *Pissarro, who vied with each other to create new effects. The influence of Japanese prints was also adapted to aquatint in the colour prints of Mary *Cassatt.

In the 20th century aquatint has been part of the armoury of many printmakers, but none has used it with more brilliance and variety than Picasso, some of his most virtuoso sugar aquatints being created in his extreme old age.　　RGo

Prideaux, S. T., *Aquatint Engraving* (1909).

ARA PACIS, the Altar of Augustan Peace (Rome). Dedicated on 30 January 9 BC, the altar was erected in the Campus Martius by the Roman Senate to commemorate Augustus' return from Spain and Gaul on 4 July 13 BC. The best-known exemplar of Augustan art (see ROMAN ART, ANCIENT: SCULPTURE), it is typified by its eclectic mix of *Classical and *Hellenistic elements and skilful amalgam of Roman myth-history and contemporary events. A small frieze on the altar depicts the annual sacrifice. The interior of the walled precinct surrounding the altar monumentalizes the temporary enclosure set up for Augustus' return and is hung with garlands and ox-heads. The location of the altar meant that the visitor approached from the east end and then followed the procession to the entrance on the west. Its exterior is decorated in two registers, with a stylized acanthus scroll peopled with animals and birds in the lower tier. The upper section is divided into mythological and allegorical panels on the short east and west sides. On the right panel of the east side, the seated figure of Rome personified barely survives; she was joined by personifications of military courage and its reward. The identification of the better-preserved seated goddess on the left is more complex. Her iconography, with twins on her lap and slipping drapery, suggests Venus Genetrix, the ancestress of the Julian family. The obvious identification would be Peace, but Mother Earth, Land, Italy, and the Empire have all been suggested. On the right-hand panel of the west side, Aeneas sacrifices at Lanuvium, accompanied by Ascanias-Iulus, the ancestor of the Julian family, faithful Achates, and a slave-boy. The Lupercal, with the she-wolf suckling the twins Romulus and Remus, appears on the left-hand panel; Mars and the shepherd Faustulus survive. The long north and south sides contain a procession of the Emperor and his entourage, including his family, officials, priests, senators, and fraternities. The festive thanksgiving for Augustus' return or the dedication of the altar may be represented. The whole is tied together through internal references that emphasize the fecundity and prosperity of the new 'Golden Age' of Augustan Peace.　　L-AT

Castriota, D., *The Ara Pacis Augustae* (1995).
Torelli, M., *Typology and Structure of Roman Historical Reliefs* (1982).

ARCHAIC GREEK ART (c.700–480 BC). By the late 8th century regular contact was renewed with Near Eastern cultures, with an influx of artefacts and probably artisans into

Greece (hence the 7th century is labelled the Orientalizing period); art and thought were strongly influenced by this trend, brought mainly via metalwork, ivories, and, assumedly, textiles. Preserved material consists largely of decorated vases, while marble, terracotta, and bronze sculpture and figurines form a substantial secondary body, together with gems, coins (from c.550), and rarely paintings. Much was grafted onto previous styles, notably in painting, while monumental sculpture was heavily indebted to Egyptian and north Syrian models, especially in standing and seated individual figures. Increasing wealth and a rise in civic consciousness were spurs to commissioning ever bigger, or more numerous, temples, dedications, and grave monuments ('civic' and 'domestic' art are scarcely apparent), facilitated by contemporary technical advances such as the mastery of hollow casting in bronze. Style was somewhat formulaic, but vivid; increasing interest in anatomy led by the end of the period to bold experimentation and general mastery. Subject matter in art was richly expanded, though any direct form of historical representation is extremely rare. Specificity is clear when names are added as labels to artefacts, a common habit. The actions of heroes and deities prevail, often narrated in a synoptic manner, collapsing the temporal dimension. AWJ

Charbonneaux, J., Martin, R., and Villard, F., *Archaic Greek Art* (1971).
Hurwit, J., *The Art and Culture of Early Greece* (1985).
Robertson, C. M., *A Shorter History of Greek Art* (1981).

ARCHIPENKO, ALEXANDER (1887–1964). Russian sculptor. Born in Kiev, he studied at the Kiev Academy of Art (1902–5) and in 1906 moved to Moscow where he contributed to exhibitions. In 1908 he moved to Paris where, from 1910, he played an important role in the development of *Cubist sculpture, combining primitivism and sophistication to telling effect, as in *Walking Woman* (1912; Denver, Art Mus.). Although he later observed, 'I did not take from Cubism but added to it', his Cubist work has close affinities to that of *Lipchitz and *Laurens. *Apollinaire introduced his first one-man show in 1912; in 1913 he exhibited in the *Armory Show, New York, and in 1914 showed with Der *Sturm. After the First World War he had an international reputation showing at the Venice Biennale (1920) and MoMa, New York (1921). In 1923 he settled in the USA and taught before establishing his own sculpture school in New York in 1939. Archipenko pioneered many of the techniques of 20th-century sculpture including the use of holes—*Standing Figure* (1920; Darmstadt, Hessisches Landesmus.).—*polychromy and illuminated plexiglas sculptures (c.1946), all of which were attempts to bring light and movement to the medium. DER

Karshan, D. H., *Archipenko* (1974).

ARCH OF ... See TRIUMPHAL ARCHES.

ARCIMBOLDO, GIUSEPPE (c.1530–93). Milanese painter, poet, musician, costume and theatre designer, who was celebrated for his fantastic heads, composed of fruits or animals, landscapes, or implements. Many symbolize the seasons or the elements, among them *Summer* (1563), made up of corn and harvest fruits, and *Water* (1566) a mass of fish, shellfish, and corals (both Vienna, Kunsthist. Mus.). He began his career as a designer of stained-glass windows for Milan Cathedral, but from 1562 he was court painter in *Vienna and *Prague to successive Habsburg kings. The rich and erudite symbolism of his heads, which glorified Habsburg power, appealed to a courtly Mannerist taste for the rare and curious, and Rudolf II commissioned him to collect objects for his *Kunstkammer*. He also designed court festivities, and in 1585 presented Rudolf II with a sketchbook (Florence, Uffizi) containing 148 drawings of costumes and allegorical figures. After his return to Milan in 1587 he continued to paint for the Habsburgs. His reputation was revived by the *Surrealists, who admired his visual punning. HL

Kriegeskorte, W., *Giuseppe Arcimboldo* (1993).

ARELLANO, JUAN DE (1614–76). Spanish flower painter. He turned to flower painting late but by 1652 he was producing delicate and original work such as *Festoon of Flowers with Cartouche Surrounding a Landscape* (1652; Madrid, Prado) developed from the style of Daniel *Seghers. In his later work the influence of Roman *Baroque flower painting, notably that of Mario Nuzzi (1603–73), was increasingly evident and his work became more robust and dramatic. His final style is exemplified by a series depicting openwork baskets packed solid with blossoms. The brilliance of the colours, the dense profusion of the flowers, and the energy of the handling make an overwhelming impact of vitality and abundance. AJL

Jordan, W. B., and Cherry, P., *Spanish Still Life from Velazquez to Goya*, exhib. cat. 1995 (London, NG).

ARETINO, PIETRO (1492–1556). Lecher, pornographer, extortioner, journalist, poet, satirist, and writer of religious compositions, with a good claim to be regarded as the first art critic. From humble origins, he launched his public career in Rome but was forced to leave following the scandal caused by his sixteen obscene sonnets to accompany Marcantonio *Raimondi's engravings of positions of sexual intercourse. From 1525 he was settled in Venice where he collected pictures and had many artist friends, including *Titian and *Sansovino, with whom he formed a sort of private dining club. He was famous for his published letters, 600 of which are about art and artists. They include both technical comments and extended passages of verbal analogue for the metaphors of visual art. The most famous example of that kind—which is often seen as a revival of the classical literary genre of *ekphrasis*—is his letter to Titian describing the view of the Grand Canal outside his window in terms of an imagined painting by Titian himself. His shameless letter to *Michelangelo, criticizing the nudity of figures in the Last Judgement for being irreligious while claiming that the language of his own brothel dialogues was appropriate to its subject, is notorious. AJL

Land, N., *The Viewer as Poet* (1995).

ARGENTINE ART. Argentina has little trace of pre-Hispanic art and thus largely depended on European models until the 20th century when its artists deliberately adopted an internationalist policy. Examples of early colonial art are also scarce. The Jesuit missions played a large part in encouraging Christian painting, engraving, and sculpture by establishing schools and workshops in the 17th and 18th centuries but following their expulsion in 1767 many works were auctioned or dispersed. Non-religious colonial art, which was mostly restricted to portraiture, echoed European styles and conventions although, due to the distance, prototypes were hard to come by. The painter Tomás Cabrera (c.1740–1810/20) was the first to depict Argentine historical subjects.

During the 19th century, following the May Revolution of 1810, many European artists visited Argentina where they not only painted Argentine subjects but also transmitted new styles and techniques to indigenous painters. Typical of them was the Englishman Emeric Essex Vidal (1791–1861) who painted a series of watercolours of Argentinian life and customs which were published in London as *Picturesque Illustration of Buenos Ayres and Montevideo* (1820). The best-known native painter, Prilidiano Paz Puerredón (1813–94), painted portraits and landscapes in a wholly European academic style. Towards the end of the century Argentinian artists began to study abroad, broadening their horizons and forging contacts with their European contemporaries.

The 1920s heralded a change which was to single out Argentina as one of the foremost forces in modern Latin American art. The turning point was marked by the publication of the modernist review *Martin Fierro* (1924) which, unlike its Mexican counterparts, rejected exaggerated nationalism and called

instead for a new American yet cosmopolitan art. Inspired by *Dada and *Futurism, most of the *martinfierrista* artists spent many years in Europe and, apart from their basic credo, differed widely in style. Emilio *Pettorutti was influenced by *Cubism and *Purism; Pedro Figari (1861–1938) executed paintings of the Argentinian pampas and gauchos said to be partly inspired, stylistically, by *Bonnard and *Vuillard, and Alejandro Xul Solar (1887–1963) depicted mystical, fantastic, imaginary landscapes.

In 1944 the review *Arturo* began an innovative movement of non-figurative art which has lasted until today. Following the ideas expounded in *Arturo* a number of artists founded the Arte Concreto-Invención group, inspired by the *Bauhaus, De *Stijl, and *Constructivism. They used the word 'concrete' to mean non-figurative art, which is invented, rather than abstract art which they felt was 'abstracted' from reality. In their aim to produce rather than reproduce they emphasized that a painting should have no other meaning than itself and rejected the conventions of presentation, such as the frame. Their exhibitions were interdisciplinary and combined poetry, dance, and music with painting and sculpture. The Arte Concreto-Invención group soon divided and those who left formed the Madi group, centred around Tomás Maldonaldo (1922–), who continued to explore multi-disciplinary work with an even greater emphasis on movement. Gyula Kosice's (1924–) neon light works, Diyi Laan's (1927–) articulated paintings of the 1940s and the movable sculptures of Arden Quin (1913–) all questioned formal artistic categories and means of representation. The prevailing internationalism of 20th-century Argentinian art may be seen in the work of Lucio *Fontana, a member of the Madi group who later formulated his influential *spazialismo* principles in Italy, the *Surrealist Roberto Aizenberg (b. 1928), Antonio Berni (1905–81) whose *collages raised fundamental questions about Latin American culture and society, and the women artists Raquel Forner (1902–88) and Sarah Grillo (1921–). CC

Brughetti, R., *Historia del arte en la Argentina* (1965).

ARIKHA, AVIGDOR (1929–). Romanian-born Israeli painter, draughtsman, printmaker, designer, and writer on art who has worked mainly in France. He moved to Israel in 1944, and from 1949 to 1951 studied at the École des Beaux-Arts in *Paris, where he settled in 1954. Initially he made his name as a book illustrator, then from 1957 to 1965 he was primarily an abstract painter, working in an *Art Informel vein. Between 1965 and 1973 he abandoned painting for drawing and etching, his work of this period including a series of portraits of the writer Samuel Beckett, who was a close friend. When he resumed painting in 1973, he concentrated on working from the life, his subjects including landscapes, interiors, still lifes, and portraits, among which are a few commissioned portraits (*Queen Elizabeth, the Queen Mother*, 1983; Edinburgh, Scottish NPG). With such works Arikha has won a reputation as one of the leading figurative painters of his day. He has also written on art and has organized exhibitions on the work of *Poussin and *Ingres.
IC

ARISTOTLE (384–322 BC). Greek philosopher. A pupil of *Plato, Aristotle's work is fundamental for its questioning of his master's theory of Forms. In his *Poetics*, he recognized three kinds of imitation in both poetry and the visual arts, of 'things as they were or are, or things as they are said or appear to be or things as they should be'. Aristotle's view, by introducing the concept that art can represent 'imitation by process', and thus a more natural form of creation, led to a somewhat more positive interpretation of the role of art in society (especially reflected in the *Politics*). L-AT

Pollitt, J. J., *The Ancient View of Greek Art* (1974).

ARMATURE, a framework or skeleton in metal or wood, which forms the internal support around which a clay, wax, or plaster figure can be modelled. AB

ARMENIAN ART. One of the first Christian nations; the early period is dominated by religious art. A few wall paintings in churches survive from before the 10th century, the best preserved are in the Tat'ev Monastery and at Aght'amar. In these and other churches there are also sculptures of distinct design which illustrate scenes from the Bible, donors, and animals and which reflect local architectural tradition. *Illuminated manuscripts of religious texts, principally the Gospels, were made for individuals as well as churches from the 7th century with the Edjmiadzin Gospels (Erevan, Matenadaran Inst. Anc. Armen. MSS, MS 2374) as the best surviving example; further fine examples were produced under the Bagratids from the 9th to 11th centuries and again in Lesser Armenia in the 13th century (many examples Erevan, Matenadran Inst.). Hostile invasions caused an interruption in creative expression and the conquest of Armenia by the Ottomans resulted in some of the population emigrating and the appearance of pockets of their culture surviving in Constantinople, the Crimea, Persia, and elsewhere. Domestic crafts of carpet weaving, ceramics, and jewellery often show external influences, but the study of decoration and inscriptions has revealed particular centres of Armenian manufactures. After the union of eastern Armenia with the Russian Empire Western influence increased, for example in the works of the portraitist Akop Hovnat'anian the younger (1806–81), of the seascape painter I. K. Aivazovskii (1817–1900) in the Crimea, of the landscape artist Martiros Saryan (1880–1972), and others, before the development of the 20th-century Armenian School dominated by the Soviet Socialist Realist philosophy. PCo

Stepanian, N. S., *Iskusstvo Armenii* (Art of Armenia) (1989).

ARMORY SHOW, the International Exhibition of Modern Art held in New York in 1913 in a former armoury. Conceived as a showcase for contemporary American art, it soon evolved into an eclectic survey of American and European modern art beginning with *Goya and ending with *Cubism. It was organized by the Association of American Painters and Sculptors under the sophisticated Arthur B. *Davies. The 1,600-plus exhibits were seen by over 300,000 visitors in New York, Chicago, and Boston and although it attracted an inevitable popular backlash it proved a major factor in establishing modernism in America. DER

Brown, M., *The Story of the Armory Show* (1963).

ARNOLFO DI CAMBIO (active 1265; d. by 1310). Italian sculptor and architect. Arnolfo was one of the two great pupils of Nicola *Pisano. He is first recorded with the other, Nicola's son Giovanni, working on the Siena Cathedral pulpit in 1265. Were it not for the loss or rearrangement of much of his work he would be more widely recognized as a seminal figure in the transformation of Italian art in the early *Renaissance. What can be identified as his work while still in Nicola's workshop, on the tomb of S. Dominic (1264–7; Bologna, S. Domenico) and at Siena, establishes the stocky classicism of Nicola's early style as the basis for Arnolfo's monumental formal language. In the 1270s Arnolfo, now independent, entered the service of Charles of Anjou, secular ruler of Rome under the papacy, of whom he carved a seated figure of openly imperial character for the exterior tribunal of S. Maria in Aracoeli, from where the statue (Rome, Capitoline Mus.) once looked down upon the Capitol. The tomb of Cardinal de Braye (d. 1282) in S. Domenico, Orvieto, though rearranged, is perhaps the masterpiece of this period. Arnolfo reinvents the concept of tomb design in terms of a theatrical contrast between the effigy of the dead Cardinal, across whom two deacons draw curtains, and his rebirth above, presented to a sturdy group of the *Madonna and Child*, possibly using reworked sections of an Antique carving. The twin deacons, their draperies pulling revealingly across their bodies, demonstrate

Arnolfo's seamless combination of classicizing form with the expressive fluidity of Gothic sculpture. Also in Rome Arnolfo made two surviving and signed altar canopies: for S. Paolo fuori le mura (1285) and S. Cecilia in Trastevere (1293). These subject the Rayonnant *Gothic language associated with the patronage of Charles of Anjou's brother, Louis IX of France, to the spirit, at least, of classical architectural discipline. Arnolfo's name is associated with larger-scale architecture after his move to Florence in 1294 as a consultant on the plans for the new cathedral. While his responsibility for the Franciscan church of S. Croce (1294/5) is undocumented, recent research has established that the cathedral, even as redesigned throughout the trecento and completed by *Brunelleschi, owes its basic format to Arnolfo, *capomaestro* from 1296. For its projected façade Arnolfo carved a large body of sculpture, including a *Nativity* and a *Dormition* (destr.) which reveal a profound debt to the study of the *Antique, and a majestic seated *Madonna and Child* (Florence, Mus. dell'Opera del Duomo). JR

Pope-Hennessy, J., *Italian Gothic Sculpture* (4th edn., 1996).

ARP, HANS (or Jean) (1886–1966). German-born artist and poet, celebrated for his 'biomorphic' abstraction. Native to Strasbourg, at the intersection of French and German culture, Arp studied art in both countries but found academic training deeply dissatisfying. He persevered alone, and around 1910 began to explore abstraction. That year he co-founded the Moderne Bund, which later collaborated with the *Blaue Reiter group after Arp met *Kandinsky in 1912. At the outbreak of war he fled to Paris and moved in a circle which included *Apollinaire, *Modigliani, and *Picasso. Expelled from France, he arrived in Zurich in 1915 where he met his future wife, the Swiss artist Sophie Taeuber (1889–1943). Her influence on his work was profound, and their careers were entangled thereafter. Arp was a founder member of Zurich Dada in 1916, and later befriended German Dadaists, including *Ernst and *Schwitters. In the 1920s he developed his 'biomorphic' vocabulary—abstract forms of organic inspiration (e.g. *Navel-Torso*, about 1924–6; Clamart, Fondation Arp), in contrast to earlier geometric abstraction—and was involved with *Surrealism. The Arps began construction of a studio at Meudon in 1928, to Taeuber's design. During the early 1930s they participated in the Cercle et Carré and *Abstraction-Création groups, and Arp began producing his now best-known work: sensuous, biomorphic sculpture in stone, plaster, or bronze (e.g. *Human Concretion*, 1934; Clamart, Fondation Arp). The war years were spent first at Grasse and then in Switzerland, where

Taeuber died. The post-war period was marked by eminent public commissions, honours, and retrospectives. AA

Read, H., *arp* (1968).

ARPINO, CAVALIERE D'. See CAVALIERE D'ARPINO.

ART AND LANGUAGE, a movement in British art which started in 1968 with the founding of the Art and Language Press. The first issue of its journal, *Art-Language*, was published in May 1969. The founder members were Terry Atkinson (1939–), Michael Baldwin (1945–), David Bainbridge (1941–), and Harold Hurrell (1940–). The forms taken by the works of the group—printed texts, and paintings done by brushes held in the artists' mouths—were united by their expression of the belief that all visual art is conceptually dependent on language. OPa

Harrison, C., *A Provisional History of Art and Language* (1982).

ART BRUT (French: Raw Art), term coined by Jean *Dubuffet for the art produced by people outside the established art world—people such as solitaries, the maladjusted, patients in psychiatric hospitals, prisoners, and fringe-dwellers of all kinds. In English the term 'outsider art' (the title of a book by Roger Cardinal, 1972) is generally used to cover this type of work. Dubuffet claimed that such art—'springing from pure invention and in no way based, as cultural art constantly is, on chameleon- or parrot-like processes'—is evidence of a power of originality that all people possess but which in most has been stifled by educational training and social constraints. He may have become interested in the subject as early as 1923, but he did not begin collecting Art Brut until 1945, following a visit to Switzerland, where there were already collections of works by the mentally ill in psychiatric hospitals. Thereafter he devoted a good deal of his energies to promoting Art Brut, through writing, lecturing, and organizing exhibitions. From 1948 to 1951 he ran an association called the Compagnie de l'Art Brut, the aims of which he specified as 'To seek out the artistic productions of humble people that have a special quality of personal creation, spontaneity, and liberty with regard to convention and received ideas; to draw the public's attention towards this sort of work, to create a taste for it and encourage it to flourish'. The best known of the exhibitions he organized was probably *L'Art Brut préféré aux arts culturels* at the Galerie René Drouin, Paris, in 1949; it featured more than 200 works by 63 artists.

In 1972 Dubuffet presented his own collection (by then numbering more than 5,000 items) to the city of Lausanne, where it was

opened to the public at the Château de Beaulieu in 1976. Among the artists represented were the French painter, draughtsman, sculptor, and writer Gaston Chaissac (1904–64), who used rough and ready materials and was influenced by child art; Madge Gill (see AUTOMATISM); the Swiss draughtsman and painter Louis Soutter (1871–1942), who after contracting typhoid was plagued by years of ill health and eccentric behaviour; Scottie *Wilson; and the Swiss draughtsman, collage maker, writer, and musician Adolf Wölfli (1864–1930), who was institutionalized in 1895 after committing a series of sex offences. Nearly half the collection was produced by patients in psychiatric hospitals, usually schizophrenics, but Dubuffet repudiated the concept of psychiatric art, claiming that 'there is no art of the insane any more than there is an art of the dyspeptics or an art of people with knee complaints'. IC

ART DECO, the most fashionable style of design and decoration in the 1920s and 1930s in Europe and the USA, characterized by sleek geometrical or stylized forms and bright, sometimes garish colours. The name comes from the *Exposition Internationale des Arts Décoratifs et Industriels Modernes* held in Paris in 1925—the first major international exhibition of decorative art since the end of the First World War (it was originally planned for 1915). The emphasis of the exhibition was on individuality and fine craftsmanship (at the opposite extreme from the contemporary doctrines of the *Bauhaus), and Art Deco was originally a luxury style, with costly materials such as ivory, jade, and lacquer much in evidence. However, when the exhibition *Machine Art*—another great showcase of the style—was held at the Museum of Modern Art, New York, in 1934, the emphasis was on the general style and impression of an interior rather than upon the individual craft object. Perhaps partly because of the effects of the Depression, materials that could be easily mass produced—such as plastics—were adapted to the style.

Art Deco may have owed something to several of the major art movements of the early 20th century—the geometry of *Cubism (it has been described as 'Cubism tamed'), the bold colours of *Fauvism, and the machine forms of *Constructivism and *Futurism. Similarly, although the term is not often applied to painting or sculpture, the Art Deco style is clearly reflected in the streamlined forms of certain artists of the period, for example the Polish-born painter Tamara de Lempicka and the American sculptor Paul Manship. There was a revival of interest in Art Deco during the 1960s (it was then that the name was coined) and its bold, bright forms have a kinship with *Pop art.

 IC

ART EDUCATION. Despite historical changes in the nature of artists' work, how they have acquired the knowledge, skills, and experience appropriate to professional practice has remained surprisingly constant. Whether art education consists in courses of institutionalized study or working alongside an established artist, it can be seen as forming a continuing dialogue between the instrumentalist view that art serves socio-economic purposes and the humanistic belief that it leads to cultural and personal emancipation.

During the Middle Ages, the scriptoria and workshops of European religious houses took a strictly instrumental approach. Suitable novices were taught the skills of calligraphy, manuscript illumination, and other crafts required for producing liturgical artefacts and church furnishings. Rooted in iconographic regulations, this rich but circumscribed educational tradition failed to survive the combined impact of mechanized printing and the Reformation. Correspondingly, secular art education was controlled by medieval guilds but directed towards protecting urban trades. Painters evolved their own guilds, while sculptors belonged to organizations associated with building the great cathedrals. A boy would be apprenticed to a guild master who housed the trainee and taught him his trade; in return, the apprentice agreed to work, often unpaid, for a set period, traditionally seven years. When fully trained, he could submit an example of his work—his 'master piece'—for officials to decide whether his skills and conduct were of sufficient standard for him to be admitted to the guild and be allowed to take his own apprentices. Painters learnt their craft the hard way, starting with menial studio employment and progressing to more responsible technical tasks, such as grinding pigments. At an appropriate stage, the apprentice was taught how to prepare paintings and eventually would be entrusted with executing whole commissions in the style of the workshop master. By the 15th century, a basic method for learning the craft skills necessary to become a painter or sculptor had been evolved. Practice in progressively complex processes under the guidance of an expert was to become a standard feature of European art education. Though education through formal apprenticeship steadily disappeared, artists continued to take pupils into the 19th century and even today's ex-students occasionally continue to learn through employment in artists' studios or workshops. While medieval guilds ensured continuity of craftsmanship, they provided a training that recognized little distinction between ephemeral decoration, functional images, and works of art. *Vasari's anecdotes recounting how young painters astounded their masters with precocious talents reflect a new concern with personalized creativity. Renaissance apprentices were in a position to challenge the anonymous conservatism of skill-based education and began to self-consciously identify themselves as potential artists.

In 1562, Vasari was active in founding the Accademia del Disegno in Florence. Established as an alternative to guild apprenticeship and to perpetuate the techniques of Renaissance artists, the school also provided students with classical standards. The purpose of art education had now become a matter of teaching students how to knowingly produce paintings and sculpture that society would recognize as works of art. The attraction of teaching canons of excellence in fine art spread through Italy, across Europe, and later to America as comparable *academies were established under royal or state patronage. Colbert, the indefatigable minister of Louis XIV, characteristically regarded such institutions as potential agents of cultural control. By the 1670s, the French Académie Royale in *Paris under the virtual dictatorship of *Le Brun had developed a pedagogical system that formed an enduring model for academic art education. Young men—the few women who aspired to be artists were taught within family businesses—followed an instructional regime directed by artists who themselves were academicians. Before being allowed to paint or sculpt, students learnt to draw, initially from plaster casts of classical sculptures and later, when they were considered sufficiently adept, from life models. As well as continuing the traditional hierarchy of skill development, academies ranked media and subjects according to cultural value. *Drawing, *watercolour, and *clay modelling were private or preparatory studio processes, whereas oil paintings and stone carvings dominated the grand public exhibitions organized by academies. Similarly, landscapes and still lifes were valued less than portraits and narrative figure compositions. Art education, based on Renaissance ideals of humanistic emancipation and professional excellence, had become an instrument of cultural conservatism—ironically, directed by artists.

While the history of 19th-century European and American art education largely consists of national or localized reactions against academic orthodoxies, the sequence of changes in British art education can be seen as typical. Despite being founded by artists in 1768 and being guided by the ideals of *Reynolds, the Royal Academy of Arts schools in *London offered an education that had ossified by the early 1800s. Many alternative sources of diverse instruction were available including semi-public drawing schools, watercolour artists reluctantly pursuing careers as private tutors, and free tuition in drawing from the new Mechanics' Institutes. In 1837 and concerned over commercial challenges posed by well-designed European industrial products, the government founded a School of Design in London. Through the bureaucratic genius of Sir Henry Cole, a national structure of art education was eventually imposed on all the numerous institutes, societies, and proto-art schools that had developed. The Royal Society of Arts had long awarded certificates for success in art examinations, but the examination system emanating from Cole's South Kensington schools adopted a quasi-design ethos and stipulated meticulous copying as a way of learning. Regional art schools however veered towards fine art and often became sources of municipal pride, especially in larger cities such as Birmingham, Manchester, and Glasgow. Tension within the curriculum was partly resolved through subordinating design to art in the concept of 'fine and applied art' which arose in conjunction with Arts and Crafts philosophies. The belief that drawing, painting, and sculpture formed a creative power house from which students engaged in craft and design could draw inspiration was the keystone of art school thinking for many years.

Victorian art education echoed British social divisions in that fine art tended to be studied by middle-class women destined to become consumers of art and craft products, while working-class men were more likely to be trained as artisans or potential industrial employees. A different social dimension was introduced mid-century with *Ruskin's passionate advocacy of liberal art education. His teaching at the Working Men's College proved an early example of the life-enriching practical art experience that later featured in adult education classes and university extramural studies, and his opposition to the South Kensington examination system eventually lessened its rigidity. Inauguration of Slade professorships at Oxford, Cambridge, and at London university in 1871, introduced practical fine art at degree level, though it found root more readily in American institutions and took another century to feature substantially in British universities. The importance of London University Slade School in early 20th-century British art was due as much to critical reactions by students who became influential artists as to the renowned quality of its teaching. This ambivalent relationship with art as a profession was typical of art schools as they became identified with cultural rebellion and bohemianism during the inter-war years. Meanwhile, applied art gradually gave way to more industrially relevant concepts of design. TJ

Efland, A. D., *A History of Art Education* (1990).
Macdonald, S., *The History and Philosophy of Art Education* (1970).

ARTE POVERA. See MINIMAL ART.

ART FOR ART'S SAKE. See AESTHETICISM.

ART HISTORY AND ITS METHODS. *See overleaf.*

ART INFORMEL, term coined by the French critic Michel Tapié to describe a type of spontaneous abstract painting popular among European artists in the 1940s and 1950s, roughly equivalent to *Abstract Expressionism in the USA. Tapié popularized the term in his book *Un art autre* (1952), and these two terms—Art Autre and Art Informel—are sometimes used more or less synonymously. They are rarely used with any precision, but some critics regard Art Informel as a narrower term, representing only one aspect of the broader trend of Art Autre (which includes figurative as well as abstract work). In English the term 'Informalism' is sometimes used as an equivalent to Art Informel, but the word 'informel' (which Tapié himself devised) might be translated as 'without form' rather than 'informal'. Following suggestions made by *Kandinsky, Tapié argued that expressive, non-geometrical abstract art is a method of discovery and of communicating intuitive awareness of the fundamental nature of reality. See also TACHISME. IC

ARTISTS, ANCIENT, SOCIAL STATUS OF. The issue of the social status of ancient artists is multifaceted and complex. Ancient art covers an immense chronological period, from the prehistoric art of the Cyclades and Cyprus of the 4th millennium through to the late Antique images of the 3rd and 4th centuries of our era. Nonetheless, the majority of evidence comes from the Greek and Roman periods.

The term artist is a misnomer, anachronistically applied in response to the *Renaissance distinction between artists and artisans. No such differentiation in terminology existed in the ancient world. The carver of stone blocks and the sculptor of monumental figures and even a farm labourer were all artisans. Thus, in *The Dream* (9) of the 2nd-century essayist *Lucian, the writer abandoned his potential career as a sculptor's apprentice in favour of rhetoric in response to these words of Education: 'You will be just a worker, one of the masses, cowering before the distinguished, truckling to the eloquent . . . You may turn out to be a *Phidias or a *Polyclitus, to be sure, and create a number of wonderful works; but even so, though your art will be generally commended, no sensible observer will be found to wish himself like you. Whatever your real qualities, you will always rank as a common craftsman who makes his living with his hands.' Or again, the 1st-century AD Greek biographer Plutarch (*Pericles* 2. 1): 'No generous youth, when contemplating the Zeus of Olympia or the Hera of Argos, will desire to become a Phidias or Polyclitus.'

But Lucian and Plutarch do not reveal the entire story nor can their perception of the social status of sculptors be taken reasonably to span the millennia of ancient art. The Linear B tablets from the Mycenaean palaces demonstrate the vast specialization of labour and division of artisans in the palace structure. For literary evidence concerning artists in Bronze and Iron Age Greece, we must turn to the 'bible' of the Greeks: the works of Homer. Here, the professional artist holds no social position and is comparable with non-citizens and slaves. Yet, artists can create magical objects, such as the automata of *Daedalus. At the same time, Odysseus himself can double as an artisan, as both the singing bard and the builder of his marital bed in olive wood and ivory.

Dedications by sculptors and potters from *Archaic Greece testify to the wealth of at least some of these artisans. The earliest surviving sculptor's signature appears on a base of a Greek *kouros statue (*c*.650 BC; Delos Mus.): 'Euthycartides the Naxian dedicated me, having made [me].' This inscription adds another dimension to the question of social status. Euthycartides was wealthy enough to devote the equivalent of a man-year to the production of this statue. Similarly, the largest of the Acropolis dedications, *Antenor's Kore*, is traditionally thought to have been dedicated by the potter Nearchus (*c*.525 BC; Athens, Acropolis Mus.). At the same time, the itinerant nature of artisans' lives contributed to the amalgam of diverse cultural elements evident in art of the Archaic period. Thus, the models for Greek monumental sculpture came from Egypt (kouroi) and Syria and the Near East (korai) respectively. In sculpture, metalwork, and painted pottery, fantastic beasts, such as sphinxes, and other Eastern iconography enter the repertoire. At the same time, the geography and political fragmentation of Greece asserted its influence in the development of regional styles specific to particular city-states.

In the *Classical period, the supposed interpersonal relationship and collaboration posited in the ancient sources between the Greek statesman Pericles and the 5th-century BC sculptor Phidias in the design and completion of the massive building programme on the Athenian Acropolis may demonstrate that some master sculptors attained a social position commensurate with their talent. The ancient sources note ways in which artists could celebrate their art. The treatise or *Canon* written by Polyclitus, another major Classical Greek sculptor, suggests that like architects, a group normally accorded a greater importance in the sources, sculptors could sometimes record their working methods for posterity. On another level, artists' workshops in Athens seem to have functioned as a forum for the exchange of ideas between philosophers and artisans. The influence of Pythagorean philosophy on the *Canon* of Polyclitus and vice versa is clear. The sculptor Apollodorus, baptized the 'Madman', even appears in a Platonic dialogue.

The Golden Age of Greece in the second half of the 5th century BC was characterized by an influx of artists from all over the Greek world into *Athens, as the city-state decked itself out with the proceeds of its new empire. Art in the Classical period was in the service of the state, with contracts decided by the citizens of the individual city-states. The Erechtheion inscriptions (409–406 BC), with their detailed accounts of the name of each artist, what he produced, and his payment, also provide evidence for both resident aliens and citizens working on the frieze of the Erechtheion, Athens. Similar inscriptions from Athens (late 5th-4th centuries BC), *Delos (late 4th-2nd centuries BC), as well as *Delphi and Epidaurus provide crucial information concerning work organization and payment of artists across a long chronological range. These inscriptions also serve as reminders of the public nature of building and artistic production in the Greek world.

Despite the negative connotations of physical labour in the eyes of the Greeks, *Pliny (*Natural History* 35. 77) records that by the first half of the 4th century, painting had become part of the education system for noble youths. It is precisely in the period of Alexander the Great and his successors that a further shift in the status of artists is evident. No longer practised for the glorification of city-states, art became an expression of the personal power of the Hellenistic dynasts, with a concomitant increase in the status of the individual artist. Greek artists are attested in the service of Hellenistic rulers and satraps throughout the empire, continuing the tradition that began in the 4th century with the Nereid Monument at Xanthos (London, BM) and the Mausoleum at *Halicarnassus (London, BM). The higher status of artists is best recorded in the court of Alexander the Great. *Apelles and *Lysippus were the favoured artists in his court; the sources record the King's visits to their studios and suggest (wrongly) that he only allowed his portrait to be produced in paint or sculpted by Apelles and Lysippus respectively.

In the Roman imperial period, even emperors practised the arts of painting and sculpture. Nero (AD 54–68; Suetonius, *Nero* 52) and Hadrian (AD 118–38; Aurelius Victor, *On the Caesars* 14. 2) were recognized as skilled sculptors and painters. Marcus Aurelius learned painting from the Greek master Diogenes (Scriptores Historiae Augustae, *Marcus Aurelius* 4. 9); Elagabalus and Alexander Severus were skilled painters (Scriptores

continued on page 33

· ART HISTORY AND ITS METHODS ·

GENERALLY the term 'art history' refers to the study of the visual arts within a historical framework. A formal academic subject since the 19th century, art history has become a dynamic and richly developed discipline, generating varied and complex methodologies. The range of its material, traditionally comprising architecture, sculpture, painting, and the applied arts, has recently been broadened to include media such as *photography, film, and certain computer applications, e.g. virtual reality. One problem frequently addressed by art historians concerns the nature and breadth of the discipline's interpretative framework: should art mainly be analysed from the standpoint of a visual or formal history, or should the aim of any investigation be to place it in the broader context of cultural history?

The expression 'history of art' was first used by Pierre Mosnier in his *Histoire des arts . . .* (1698), but interest in the development of the visual arts goes back to classical Antiquity. The chapters on painting and sculpture in the elder *Pliny's *Natural History* (1st century AD), which describe art in terms of progress, formed a model used during the Italian Renaissance for chronicling recent artistic achievements. Chief examples of this tradition are the *Commentarii* written by the sculptor Lorenzo *Ghiberti (c.1450), but, above all, the *Vite* by *Vasari (1550, enlarged edn., 1568). Vasari develops a comprehensive theory of the history of Italian art between c.1250 and c.1550. According to this concept, the visual arts evolve in three successive stages progressing towards perfection, the summit of this perfection being attained in Vasari's own time. Whereas Vasari's *Lives* provide a series of artists' histories to account for the unfolding of art, the first scholar to write a history of art in the modern sense was the archaeologist Johann Joachim *Winckelmann, who emphasized the dependence of the visual arts on factors such as politics, society, or education, and thus made one of the first attempts to consider art within the broader framework of cultural history.

In the 19th century art history became an academic discipline—the first chair being established at Berlin University in 1844. Throughout the century the study of art oscillated between an idealist position advanced by the philosopher Georg Wilhelm Friedrich *Hegel, according to whom the forms assumed by works of art were manifestations of *Geist* (the world spirit, or mentality) at a particular stage of its self-realization, and an empirical view derived from the physical sciences. Empiricism was applied to the analysis of art in various ways: while scholars such as Karl Friedrich von *Rumohr or Anton Springer critically examined a wide range of written sources to place a work of art into its historical or iconographical context, others, in particular

Giovanni *Morelli, focused on the collection of facts gleaned from the close scrutiny of paintings or sculptures, and thereby developed the method of *connoisseurship later refined by Bernard *Berenson. The increasing knowledge of monuments gained through empirical research fostered the writing of general accounts of *iconography and style, dictionaries of artists, and artistic inventories, culminating at the turn of the century in the works of Émile *Mâle, and Adolfo *Venturi and the colossal encyclopedia of *Thieme and Becker, begun 1907.

Indispensable though these compendia were—and still are—for the study of particular fields, they were criticized by some for their lack of theoretical rigour and philosophical vision. A turning point towards more universal approaches to the study of art was marked by the formalistic models of Alois *Riegl and Heinrich *Wölfflin. Drawing on Hegel as well as experimental psychology, Riegl considered the history of art as being subject to overarching laws (the concept of *Kunstwollen*) which determined artistic change and formal order. He also introduced antithetical sets of terms to characterize the formal features of art, a method which was also chosen by Wölfflin in his attempt to analyse the mechanisms behind the internal evolution of form.

The trend to emphasize the autonomy of form and dismiss subject matter was sharply criticized by Erwin *Panofsky, whose iconological method—developed from the late 1920s—represented a highly sophisticated version of culturally contextualized art history. Owing much to the impetus of Aby *Warburg, Panofsky proposed to uncover the various layers of meaning of a work of art by means of a three-step procedure. Panofsky's model long ranked as paradigmatic, especially in the Anglo-Saxon world, which since the 1930s had become the refuge of many German-speaking art historians. A corrective to Panofsky's somewhat limited contextual framework—mostly philosophy, literature, and religion—was provided by an approach known as the social history of art developed during the 1940s and 1950s, with the Marxist art historians Arnold *Hauser and Frederick *Antal as its principal exponents.

From the early 1970s onwards the methodology and indeed the entire discipline of art history were subject to considerable revision. Major points of criticism included the monolithic dominance of certain methods, such as *iconology, as well as the failure to take into account more recent approaches pioneered in the neighbouring disciplines, for instance *structuralism, which since the 1960s had played a seminal role in the study of linguistics. Alternatives were suggested by what became known as *'New Art History', which is characterized by a high level of theory and a diversity of new perspectives

on the subject; these include *feminism, *semiotics, and psychoanalysis. This methodological pluralism was regarded by some as heralding the 'end of art history' (Hans Belting) while others have stressed its intellectual potential (Eric Fernie). AT

Belting, H., *The End of the History of Art* (1984; English trans., 1987).

Fernie, E., *Art History and its Methods: A Critical Anthology* (1995).

Minor, V. H., *Art History's History* (1994).

Historiae Augustae, *Elagabalus* 30. 1; Herodian 5. 5; Scriptores Historiae Augustae, *Alexander Severus* 27. 7); the late Antique Emperor Valentinian I was renowned as both a painter and sculptor (Aurelius Victor 45. 7; Ammianus Marcellinus, 30. 9. 4).

Yet most art production in the Roman world was relegated to slaves and foreigners whether freeborn or slaves. Rarely is the social status of the artist mentioned in the literary or epigraphic sources. An exception in sculpture occurs on two *Pan* statues signed by Marcus Cossutius Kerdon, who defines himself as a freedman (1st century BC; London, BM). Most artists were male. We know of only one female painter. Pliny (*Natural History* 35. 147–8) notes that Iaia, a Greek from Cysicus (in Rome, *c*.100 BC), was renowned for painting, in particular portraits of women on ivory. A wall painting from Pompeii may preserve the image of such a painter at work (1st century AD; Naples, Mus. Arch. Naz.).

Art production was largely the province of the Greek artists who first arrived in Italy en masse in the mid-2nd century BC, contemporary with Roman expansion in the Greek East. Triumphant generals returned from Greek campaigns with artists who served as tutors to their sons. Over the course of the late republican and imperial periods, Greek sculptors set up workshops in Rome as well as in centres in the Greek world in close proximity to marble quarries, such as Athens, Rhodes, *Pergamum, Delos (before 88 BC), and *Aphrodisias. In Italy, Roman copyists congregated near ports, at first around the bay of Naples. After the opening of Claudius' port in AD 42, the workshops moved to *Ostia. These sculptors imported from Greece not only marble but also plaster casts of Greek originals (e.g. *Baiae).

Painters too were largely Greeks, although the epigraphic and literary record is more sparse. Pliny (*Natural History* 35. 118) records that a painter was the common property of the world. Evidence for specialization of labour in artistic production is provided by the late Antique Price Edict of Diocletian (AD 301). The wall painter is differentiated from the figure painter not only in name, but also in payment. The *pictor imaginarius* (figure painter) made 150 denarii a day, double the daily wage of a wall painter and six times that of a field labourer.

The vast majority of ancient artists remain anonymous, lost in the shroud of the intervening centuries; yet the names of others are preserved through the medium of signatures on the works they produced, by their funerary monuments, or in the literary record. Signatures, of both potters and painters, first appear on Greek painted pottery in the late 8th century BC. The François Vase (*c*.570 BC; Florence, Mus. Arch.) is signed by the potter Ergotimus and the painter Clitias; more than 200 additional inscriptions name all the figures and some of the objects portrayed. The practice seems to have been most common in late 6th-century BC Athens.

Sculptors' signatures appear predominantly on free-standing sculpture, inscribed on bases or on the sculpture itself from the late 7th century BC. Yet signatures on architectural relief do exist as demonstrated by the sculptor's signature preserved on the shield of one of the combatants of the frieze of the Siphnian Treasury at Delphi (525 BC; Delphi Mus.). Another example is represented by the *Gigantomachy* frieze of the Altar of Zeus from Pergamum, where the names of the sculptors responsible for each section are carved below the inscribed names of the giants (*c*.180 BC; Berlin, Pergamum Mus.). The bronze portrait sculpture of Hellenistic Rhodes is unusual in including the names of both the artist and the bronze caster. In the Roman period, signatures appear predominantly on Roman copies after Greek prototypes from the 1st century BC to the 4th century AD.

Sculptors' signatures often provide further details important for our understanding of workshop organization and the peregrinations of artists. The handing down of sculptural expertise through families over generations is testified to by the inclusion of the father's name in many cases; by the same token, it is clear that not only profession but also names were duplicated, leading to confusion over which of several artists with the same name is to be recognized as the sculptor of a particular work. Signatures in which the artist identifies himself as the pupil of another sculptor record the possible disruption of this dynastic system in the Roman period. Thus Stephanus defines himself as Pasiteles' pupil on the so-called *Stephanus Athlete* (1st century AD; Rome, Villa Albani); Menelaus signed his *Orestes and Electra* as the pupil of Stephanus (1st century AD; Rome, Mus. Naz. Romano). The addition of ethnics demonstrates the presence of artists from a range of cities operative in the major centres of the Greek and Roman world. On the Athenian Acropolis, Athenian sculptors are joined by sculptors from Paros, Miletus, and Sparta.

From the 4th century BC, mosaicists signed their work, sometimes identifying the workshop within which they worked. Fathers' names and ethnics can appear, although they are rare. On a mosaic from Lillebonne, both master and pupil signed; the latter is indicated by the addition of the Latin term *discipulus* after his name. Grave inscriptions as well as the Price Edict of Diocletian (AD 301) provide evidence for trade specialization in mosaic workshops.

Minor arts may also be signed. Bronze and silver vases bear the marks of their maker. The Ficoroni Cista is signed by Novius Plautius (4th century BC; Rome, Villa Giulia Mus.). Even miniature art such as gems and coins testifies to the identity of their creators. Wall painting of the Greek period is largely lost to us; while on Roman wall painting, signatures make the rarest of appearances. Lucius signed in Latin a wall painting in the House of D. Octavianus at *Pompeii (pre-AD 79); a wall painting in the House of Livia on the Palatine in Rome has a Greek graffito: 'Seleucus made [it]' (1st century BC/AD). Sometimes the inscription is spoken by the object, thus, so and so made me. One of the earliest Latin inscriptions appears on a vase. 'Duenus med feced' (Duenus made me or caused me to be made). This capacity to speak can be exploited by the artist in other ways. The statue might compare the statue's execution to that of another artist (Thus so and so, never so well!). A Boeotian stela bears the inscription: 'Alxenor of Naxos made me: just look!' (*c*.490 BC; Athens, Nat. Arch. Mus.). A relationship between the inscription and the potential market may be indicated here. Alternatively, we may be witnesses to internal competition within a workshop or a Panhellenic site. At *Olympia, Paionius not only signed the *Nike* he created but also noted in the inscription that he had won the competition to produce the acroteria of the temple of Zeus as well (post-425 BC; Olympia Mus.).

Inscriptions in public places can also indicate the social status of the artist. At Delos, an inscription records honours awarded to the 3rd-century BC sculptor Telesinus of Athens in recompense for his production of two statues, the restoration of other statues in the sanctuary, and his actions as a benefactor of the city. Interestingly, Telesinus is praised not only for his expertise in making the statues but also for his punctuality. Several sculptors

in 3rd- and 2nd-century Rhodes were given residents' privileges, as testified by their boastful addition of the award to their signatures. The mosaicist P. Aelius Harpocration, alias Proclus, was honoured by the erection of a statue in Thrace. His son, also a mosaicist, was a member of the local senate. L-AT

Blagg, T. F. C., 'Society and the Artist', in J. Wachter (ed.), *The Roman World* (1987).

Burford, A., *Craftmen in Greek and Roman Society* (1972).

Stewart, A., *Greek Sculpture: An Exploration* (1990).

Toynbee, J. M. C., *Some Notes on Artists in the Roman World*, Coll. Latomus 6 (1951).

ART MARKET, ANCIENT. The evidence for the organization of the art market in the ancient world is fragmentary. The archaeological evidence for workshops includes, for example, the potters' quarter (Kerameikos) and bronze statue kilns in Athens, the workshop of *Phidias at *Olympia, and plaster casts from Greek originals found in a sculptor's workshop in *Baiae. New evidence is emerging, such as the sculpture 'training pieces' from *Aphrodisias. Other evidence comes from representations of workshops on vases (Foundry Cup, 490–80 BC; Berlin, Altes Mus.), reliefs, and funerary monuments. Signatures of potters and painters on Greek vases demonstrate that different painters signed works by the same potter. For sculpture, signatures provide evidence for a system of apprenticeship based on transmission from father to son. The Hellenistic bronzes from Rhodes parallel the Greek ceramic evidence with their recording of both sculptor and caster. Inscriptions on mosaics and Roman ceramics sometimes indicate the workshop rather than the specific artist.

Shipwrecks with cargoes of sculpture and architectural elements also provide tantalizing clues to the organization of the art market. Scattered finds attest to the market in Greek bronzes. A shipwreck off Cape Artemisium yielded the bronze 'Artemesium Zeus' (c.460 BC; Athens, Nat. Arch. Mus.) and a Hellenistic bronze horse and boy rider (Athens, Nat. Arch. Mus.). Two ships foundered on the coast of Italy. The first, of about 400 BC, included two bearded 'philosopher' heads and the two *Riace Bronzes that represent striking evidence for early *Classical Greek style (Reggio di Calabria, Mus. Nazionale). The Mahdia wreck (first half of 1st century BC) with its mixed cargo of bronzes and marbles hints at the decoration of an elaborate Roman villa (Tunis, Mus. National du Bardo). Marble columns are joined by bronze statues, an Archaic herm, a winged Eros, bronze statuettes of dwarfs, 'Neo-Attic' marble craters, Greek votive reliefs, and inscriptions. They include Greek originals and contemporary creations. By the Hadrianic period (AD 117–38), cargoes had become more homogeneous, if the evidence from the Piraeus shipwreck is indicative; the ship was filled with the products of a single workshop, marble relief panels of the same dimensions in diverse styles (Piraeus, Arch. Mus.). Ships carrying sarcophagi provide evidence for the unfinished state in which these objects were shipped and verify the existence of diverse markets for Attic and Asiatic sarcophagi.

Finds from the ancient sites verify the testimony of the shipwrecks. Often, our evidence is enriched by natural and human destruction. As a result of the Persian sack of Athens in 480 BC, a series of damaged Archaic statues were preserved through their burial on the Acropolis (Athens, Acropolis Mus.). The eruption of Vesuvius in AD 79 provides a fascinating record of the wall painting, sculpture, and luxury goods that embellished the temples, fora, and private houses and villas of Romans of the late republican and early imperial periods (much of the material now in Naples, Mus. Arch. Naz.). The survival of inscriptional evidence such as the building accounts from Epidaurus and the ancient sources, in particular *Pliny and *Cicero, fill out the bare bones provided by the archaeological evidence. L-AT

Burford, A., *Craftsmen in Greek and Roman Society* (1972).

ART NOUVEAU, a decorative style spreading through Europe around the turn of the century, briefly essentializing the dynamic and *avant-garde in the fine and applied arts. A conscious break with tradition and establishment values, it asserted the community and equality of all the visual arts, rejecting the classical historicism of academic orthodoxy for more exotic alternatives. The Japanese art becoming increasingly popular in western Europe was a significant influence, as were *Celtic art, Gothic architecture, and organic forms, abstracted and idealized. Unlike most major contemporary art movements, including the closely related *Symbolism, which originated in France, Art Nouveau spread from England. Its development can be traced back through William Morris (1834–96) and the romantic fantasies of *Rossetti and the later *Pre-Raphaelites, to the illuminated writings of William *Blake. Morris's Arts and Crafts movement established the principles on which the style was based, while Aubrey *Beardsley developed its characteristic sinuous linearity. His drawings, many published in periodicals including the *Yellow Book* (1894–5) and the *Savoy* (1896–8), encouraged the spread of its influence. Other notable exponents included the architect Arthur Mackmurdo (1851–1942), and the painter-illustrators Walter Crane (1845–1915) and Charles Ricketts (1866–1931). Crucially important was the input of the Glaswegian architect and designer Charles Rennie *Mackintosh, and the *Macdonald sisters, Margaret and Frances. With the architect Herbert MacNair (1868–1955) they formed an internationally recognized group, 'The Four', whose experiments in interior design (for example, the Turin Exhibition Scottish Pavilion, 1902) were fundamental in promoting Art Nouveau forms and ideas. The fabrics and prints produced by Liberty of London popularized the style.

The first continental manifestation of Art Nouveau appeared in Brussels; Victor Horta (1861–1947) and Henry van de Velde (1863–1957) became its principal exponents, while the Symbolist painters James *Ensor and Jan *Toorop added a distinctive *Expressionist aspect. It rapidly acquired its own character, encouraged by the avant-garde exhibiting society Les *Vingt, which showed applied arts and illustrated books with paintings from 1884. Horta's innovative cast iron staircase for the Tassel house (1892–3) in Brussels originated the 'Belgian line', and established Art Nouveau use of modern materials.

In France the impact of Art Nouveau was limited, although René Lalique (1860–1945) and Émile Gallé (1846–1904) produced some fine work. Lalique explored its use of asymmetry and organic form in jewellery and metalwork, while Gallé's use of etched relief in his glassware made a distinctive contribution. The designs for the Paris metro stations by Hector Guimard (1867–1942) are a lasting reminder of the attractions of Art Nouveau architecture. In Spain the movement centred in Barcelona, where the architect-designer Antoni Gaudí (1852–1926) exploited natural forms to surreal extremes in the Casa Mila (1905–10), and the Sagrada Familia church (1883–1926). In Italy the *Stile Anglese*, or *Stile Liberty*, achieved a great vogue, but no distinctive character, remaining heavily indebted to English and Austrian examples, although Giuseppe Sommaruga (1857–1932) developed his *Stile Floreale* under its influence.

In Austria and Germany, Art Nouveau became the catalyst for an artistic liberation which produced some of the most exciting avant-garde work of the period. In Germany it became known as *Jugendstil*, from the progressive periodical *Jugend* (Youth); although the style itself produced no outstanding work, many of the artists who later led the German Expressionist movement began under its influence. *Barlach, *Kandinsky, and *Kirchner all worked in *Jugendstil* before establishing their personal idioms. The movement began in Munich with a tapestry exhibition by Hermann Obrist (1863–1927), whose *Whiplash* wallhanging (1895; Munich, Historisches Stadtmus.) typifies the Art Nouveau vision. It developed two aspects: the floral style of Otto Eckmann (1865–1902) and August Endell (1871–1925), and a more abstract form, beginning in Berlin around 1900 under the influence of Henry van de Velde,

and developed by the architect Peter Behrens (1868–1940) and in Munich by Kandinsky.

Austria came late to Art Nouveau, but from 1895 established a near-geometric version of its linear sinuosity, influenced by Mackintosh, and by Mackmurdo's follower Charles Voysey (1857–1941). The architects Otto Wagner (1841–1918), Joseph Olbrich (1867–1908), and Koloman Moser (1868–1918) made it the touchstone of their rebellion against Viennese establishment conservatism; with Gustav *Klimt they founded the breakaway Vienna *Sezession, the style itself becoming known as *Sezessionstil*. Chiefly propagated by the avant-garde periodical *Ver sacrum*, *Sezessionstil* represented a new energy in Austrian art which, through Klimt and his protégé Egon *Schiele, gained international recognition. Klimt and Wagner's pupil Josef Hoffmann (1870–1956) opened the Wiener Werkstätte, in the Arts and Crafts tradition, which also promoted Art Nouveau design.

In the USA Louis Sullivan (1856–1924) used Art Nouveau forms in bands of organic decoration on his buildings, although not in their fundamental design, while Louis Comfort Tiffany (1848–1933) developed a highly original use of flower forms in his window designs and opalescent glassware.

Even in the early years of the new century the *fin de siècle* artificiality of the Art Nouveau aesthetic was criticized and eventually undermined by the robust vigour of *modernism; none of its diverse manifestations survived the First World War, and its reputation declined until interest was revived by the *Surrealists in Paris in the 1930s. After the war a series of exhibitions, beginning in Zurich in 1952, and culminating at the Museum of Modern Art, New York, in 1960, brought an artistic and scholarly reappraisal of its forms, principles, and history, and the renewed popularity of its decorative flourishes continues in contemporary design. JH

Barilli, R., *Art Nouveau* (1969).

Pevsner, N., *Pioneers of Modern Design* (1960).

ART UNIONS, subscription societies whose members received specially commissioned prints or reproductions and entered an annual lottery for a work of art purchased by the Union from a specified exhibition. They were established throughout Europe and America, the oldest being the Berlin Kunstverein, founded in 1814; the London Union originated in 1836. Although their intentions were admirable, for they increased patronage of contemporary artists, they were susceptible to charges of corruption and often, as in America, fell foul of anti-gambling legislation. Although most disappeared by 1900 the Glasgow Union was still active in the 1930s. DER

ARUNDEL SOCIETY. The Society, named after Thomas Howard, 2nd Earl of Arundel, was founded in 1848 to publish writings on art and engravings after paintings, sculpture, and architecture. Its purpose was to interest a wider public in early Italian art through the publication of cheap *reproductions that were intended to be true to the original, rather than merely decorative. The founding members included Giovanni Aubrey Bezzi, the secretary; the poet and collector Samuel Rogers; John *Ruskin; and Lord *Lindsay, who had just published a pioneering book *Sketches of the History of Christian Art* (1847). Early Arundel Society prints included engravings of Fra *Angelico's frescoes in the chapel of Nicholas V at the Vatican in Rome; and wood engravings of *Giotto's frescoes in the Arena Chapel, Padua. The moving force in the society was the politician and art collector Sir Henry Layard (1817–94) who while travelling in Italy in 1855 had on his own account commissioned tracings of various early fresco cycles and later claimed to have gathered 'a pretty complete illustration of the history of fresco painting from Giotto to Fra Bartolomeo' (*Autobiography and Letters*, ed. W. Bruce, 1903). It was through his publicly voiced concern, echoing earlier pleas by Lord Lindsay in his book, that the society accepted the mission of having records made of early Renaissance frescoes in Italy before neglect led to decay and loss. A Copying Fund was established in 1857, and with a still expanding membership the society was able to afford to commission copies of all the frescoes in the upper church at *Assisi, although only a few were ever published. On Layard's initiative the society turned to chromolithography (see LITHOGRAPHY) after 1857 and produced popular colour reproductions after watercolours of *Perugino's *Martyrdom of S. Sebastian* (Panicale, S. Sebastiano), the interior of the Arena chapel, Padua, the frescoes by *Masolino, *Masaccio, and Filippino *Lippi in the Brancacci chapel, S. Maria del Carmine, Florence, and *Giorgione's Castelfranco altarpiece. The society also published popular monographs, most notably Ruskin's *Giotto and his Works at Padua* (3 parts, 1853–60). By 1897, when the Arundel Society ceased to function, the rediscovery of the Italian primitives was complete, while photography had superseded chromolithography as a method of reproduction. HB

Cooper, R., 'The Popularization of Renaissance Art in Victorian England', *Art History*, (no. 3) (1978).

Harrod, T., 'John Ruskin and the Arundel Society', *Apollo*, 94 (1988).

Lloyd, C., and Ledger, T., *Art and its Images*, exhib. cat. 1975. (Oxford, Bodleian Lib.).

ASAM FAMILY. German painters, stuccoists, and architects active in central Europe in the late Baroque and Rococo periods. The brothers **Cosmas Damian** (1686–1739) and **Egid Quirin** (1692–1750) were initially trained by their father **Hans Georg** (1649–1711), but later worked in Rome in the circle of Carlo *Maratti and the followers of *Bernini. Although Cosmas Damian was principally a fresco painter and Egid Quirin a stuccoist and architect they were essentially monumental decorators for whom the boundaries between the different media were blurred in the concept of the *Gesamtkunstwerk*. Their principal collaborations—at Weltenburg monastery (1716–35), S. Johann Nepomuk in Munich (1729–45), and the Ursulinenkirche at Straubing (1736–9)—are among the most accomplished examples of the *Rococo style in southern Germany. MJ

Hitchcock, H.-R., *Rococo Architecture in Southern Germany* (1968).

Rupprecht, B., *Die Brüder Asam* (1980).

Weichslgartner, A. J., and Molodovsky, N., *Die Familie Asam* (1977).

ASHCAN SCHOOL. See EIGHT, THE.

ASPERTINI, AMICO (1474/5–1552). Bolognese painter, sculptor, draughtsman, and illuminator. Aspertini's eccentric style, considered a forerunner of *Mannerism, contrasts with the *Raphaelesque current of contemporary Bolognese painting. He probably trained with his father in Bologna, and in 1500–3 he resided in Rome, where he perhaps worked on a sketchbook after the Antique and was in touch with *Pinturicchio. In Lucca in 1508–9 he decorated the chapel of S. Agostino (S. Frediano); these frescoes imaginatively combine Antique motifs with influences from northern art, and their lively narrative is enriched with an expressive use of colour. Back in Bologna in 1519 he executed a *Pietà* (1519; S. Petronio) which, with its gloomy colours and broad forms, is filled with an intensity of feeling. His *Holy Family* (Paris, S. Nicolas-des-Champs) was almost certainly executed at a later moment, to judge from the fullness of the forms, the dissolving colours, and the sheer emotional force of the whole. Aspertini's many façade decorations, considered to be particularly inventive in design by *Vasari, are virtually all destroyed. FB

ASPETTI, TIZIANO (c.1559–1606). Paduan sculptor, probably trained under Girolamo Campagna, with whom he collaborated on a pair of colossal figures for the entrance to the Public Mint in Venice (1590). His works also display a knowledge of Alessandro *Vittoria. The impressive telamons and relief for the fireplace of the Sala del Anticollegio in the Doge's palace in Venice show his early marble-carving skills. Moving back to Padua, he was engaged on a group of bronze saints, allegorical figures, and angels

for the shrine of S. Anthony in the Santo (1591–1603), and executed reliefs of scenes from the life of Daniel (1592–3; shrine of S. Daniel, Padua Cathedral) which are his most representative bronze works. He moved to Pisa in 1604 in the service of Antonio Grimani, Bishop of Torcello, where he remained until his death. His late relief of the *Martyrdom of S. Laurence* (Florence, S. Trinita) is one of his most successful. AB

Pope-Hennessy, J., *Italian High Renaissance and Baroque Sculpture* (4th edn., 1996).

ASSELIJN, JAN (*c*.1615–52). Leading member of the 'second generation' of Dutch Italianate painters. He started as a battle painter in the style of his presumed master Jan Martszen the Younger but he travelled to Italy in 1639–40 and was active in Rome until 1643–4. During his return he worked in Paris with Nicolaes de Helt Stockade, whose sister-in-law he had married. By 1647 he was in Amsterdam where he stayed until his death in 1652. *Rembrandt etched his portrait.

His repertoire included evocations of the Campagna featuring classical ruins and *contadini*, winter scenes, Roman street scenes in the manner of van *Laer, Mediterranean harbour scenes, and landscapes featuring panoramic views that were to be influential on later Dutch Italianate painters such as *Berchem. He used a bright palette and his landscapes are suffused with a light, silvery tonality. His painting of repairs to the S. Anthony Dyke following the dyke break in May 1651 (Berlin; Gemäldegal.) depicts this quintessentially Dutch scene with Mediterranean light and staffage. AJL

Duparc, F. L., and Graif, L. L., *Italian Recollections: Dutch Painters of the Golden Age*, exhib. cat. 1990 (Montreal, Mus. of Fine Arts).

ASSEMBLAGE. Though applicable as a term to a wide variety of artistic objects, this is essentially a development and extension of the *Cubist collage, in which found objects and man-made materials are combined in three-dimensional structures that have no obvious artistic significance. Thus *Picasso's and *Braque's Cubist experiments during the 1910s with cards, tickets, and other objects affixed to the surface of their paintings led to the dissociation of objects from their original context. The term 'assemblage' was coined by Jean *Dubuffet in 1953. The disconnected character of *Surrealist compositions, and the anti-art of *Dadaism, are related to assemblage. A typical early example of this style, in which objects are literally 'assembled', is Joseph *Cornell's boxes, the earliest of which was made in 1936 (*Untitled (Soap Bubble Set)*; Hartford, Conn., Wadsworth Atheneum). The incorporation of newspaper, fragments of glass, or other found objects also characterizes the painting of the American *Abstract Expressionists, especially Robert *Rauschenberg's 'combine paintings'. The French sculptor César's sculptures and reliefs, made up of compressed car body parts, and the American John Chamberlain's assemblages of junkyard and discarded car parts extend this style to incorporate the detritus of the modern machine age. The compositions of Edward *Kienholz, in which physical and technological data are arranged in disturbing tableaux, illustrate the extent to which this art form can be taken. The continuing preoccupation with assemblage to this day underlines its adaptability to different artistic contexts and philosophies. AB

ASSISI, BASILICA OF S. FRANCESCO. The church of S. Francesco in Assisi is of exceptional significance, not only as one of the first major examples of Italian Gothic architecture, but because of its surviving late duecento and early trecento fresco cycles. As most contemporary Roman painting has been lost, the Assisi cycles constitute the most significant corpus of large-scale fresco painting from this key period of early *Renaissance art. The decoration of the main body of the double church, including a series of stained-glass windows which were installed from *c*.1250 onwards, remains the most extensive visual statement of early Franciscan theology, calculated to establish Francis's quasi-apostolic status and emphasize his intense self-identification with Christ's Passion. It suffered badly in the earthquake of 1997; major works by *Cimabue and the Isaac *Master were lost, and others were damaged. A number of subsidiary chapels have fresco and glass decorations more tangentially related to the main themes of Franciscan ideology, but of great art historical interest.

Construction of the church began less than two years after the death of S. Francis (3 Oct. 1226) and shortly after his canonization (16 Apr. 1228); the foundation ceremony took place in July 1228. Dramatically perched on the edge of a long spur of rock on the western extremity of the town, the basilica is built on three levels: an aisleless, transepted upper church; a lower church, to which was later added a pair of chapels at each end of the transept and a number flanking the nave; and a crypt housing the saint's tomb. This complexity of format, together with the imposing scale of the church and its ancillary buildings, testifies to the convent's exceptional triple role as mother house of the Franciscan order, pilgrimage site, and papal palace. The church was consecrated by Pope Innocent IV in 1253.

The earliest fresco decoration, only parts of which survive, consists of the S. Francis *Master's twin cycles (*c*.1260–5) of the life of S. Francis and the Passion in the lower church nave. From *c*.1275 a painting campaign in the western parts (= liturgical east; the church is occidented) of the upper church began. This comprises frescoes in the right transept of the *Transfiguration, Christ in Glory,* and six *Apostles* by the so-called Gothic Master (perhaps a northerner), six more *Apostles* by a Roman painter, and a series of apostolic, apocalyptic, and Marian scenes in the apse and left transept, with four *Evangelists* in the crossing vault, all by Cimabue and his workshop. A cropped but securely attributable fresco of the *Madonna and Child with Angels and S. Francis* in the south transept of the lower church may be a survivor of an otherwise overpainted campaign by Cimabue. Decoration of the upper church nave, following Cimabue's work, took place in two phases. The first (*c*.1290 and after) consists of Old and New Testament scenes along the upper parts of the side and entrance walls, and two (of four) of the bays of the vault: a *Deësis* vault (second bay from the crossing) and a *Doctors of the Church* vault (fourth from the crossing). The sections nearest the crossing were painted by a Roman workshop associated with the name of Jacopo *Torriti; the entrance wall (and *Doctors* vault) and some of the eastern nave walls are by the Isaac Master. On completion of the upper sections an expansive series of frescoes of the legend of S. Francis was painted (by 1307 at the latest; perhaps before 1300) on the lower part of the nave and inner façade walls. This second S. Francis cycle, contained within a fictive architectural frame of powerfully illusionistic nature, has long been attributed to Giotto, chiefly on the basis of Lorenzo Ghiberti's assertion that Giotto painted in the 'lower part' (*parte di sotto*) of S. Francesco. Serious doubts have been cast on this attribution in recent years on stylistic and historical grounds (see MASTER OF THE S. FRANCIS LEGEND; MASTER OF S. CECILIA; GIOTTO DI BONDONE). That Ghiberti may instead have been referring to the lower *church* is suggested by the next campaign: infancy of Christ (with a *Crucifixion*) and Franciscan miracle cycles on the north transept walls and vault and four Franciscan allegories in the crossing vault; and by the frescoes in the chapels of S. Nicola (painted *c*.1305–7) and S. Maria Maddalena (frescoed after 1307/8), all in the lower church and all fundamentally Giottesque in style. The transept campaign continued with a Passion cycle in the south arm by the Sienese workshop of Pietro *Lorenzetti (*c*.1325–35, or perhaps before 1320; the dating is contentious). The early trecento decoration of S. Francesco was completed with frescoes by *Simone Martini in the chapels of S. Martino (*c*.1312–19) and S. Elisabetta, and by Puccio *Capanna in the cantoria of the lower church and in the chapter house. Andrea de' Bartoli's *Life of S. Catherine* cycle in the chapel of S. Caterina (completed by 1368) is the only significant

later addition to the great fresco campaigns from the period 1260–1330 for which S. Francesco is so renowned. JR

Belting, H., *Die Oberkirche von San Francesco in Assisi: ihre Dekoration als Aufgabe und die Genese einer neuen Wandmalerei* (1977).

Poeschke, J., *Die Kirche San Francesco in Assisi und ihre Wandmalereien* (1985).

Ruf, G., *Das Grab des hl.Franziskus* (1981).

Smart, A., *The Assisi Problem and the Art of Giotto* (1971).

AST, BALTHASAR VAN DER (1593/4–1657). Dutch still-life painter, probably born in Middelburg. He was the brother-in-law of Ambrosius *Bosschaert the elder, with whom he went to train as a flower painter when he was orphaned in 1609. He joined the painters' guild in Utrecht in 1619 and moved permanently to Delft in 1632. While he retained Bosschaert's bright, clear colour, he was also influenced by Roelandt *Savery's innovations, especially the use of *chiaroscuro to create an illusion of space. He developed highly original compositions of fruit and flowers, sometimes in combination, as in his *Still Life with Fruit and Flowers* (dated 1620 and 1621; Amsterdam, Rijksmus.). Here he spreads out, against a gleaming table cloth, a rich array of precious objects, flowers in a vase, reminiscent of Bosschaert, a bowl of fruit, shells, and spiky winged insects. Such motifs recur in simpler paintings, which may show a carafe of flowers, or a line of exotic shells. His distinctive work is characterized by a softness of outline unusual in Dutch flower painting. AJL

Taylor, P., *Dutch Flower Painting 1600–1750*, exhib. cat. 1996 (Dulwich, Gal.).

ATHENADORUS. See HAGESANDER, ATHENADORUS, AND POLYDORUS.

ATHENS, ANCIENT. Athens was one of the great cultural centres of the ancient world. Although a centre of art production since the Bronze Age, its reputation rests primarily on its schools of architecture, painting, and sculpture which flourished under the patronage of the democracy (508–322 BC). After the repulsion of two Persian invasions in 490 and 480/479 BC, Athens became head of a maritime empire and commanded immense resources. The allied tribute was used in part to finance a number of building programmes, commemorative of the military triumphs against the invaders.

Religious and political art flourished in Athens. In the 5th century political symbolism was couched in mythological terms, and the battles of gods and giants, Greeks and Amazons or Trojans, and Lapiths and centaurs stood for the historical battles of the Persian Wars. Portraiture was largely confined to posthumous statues of statesmen, military commanders, men of letters, or heroes of the democracy. In the 4th century the Athenian state did not hesitate to commission historical paintings or portraits of living benefactors and allies. Personification and allegory were also introduced as a new means of expression, although the Athenian School remained famous for its traditional handling of heroic subjects; near the end of the 4th century it is marked by retrospection.

The second quarter of the 5th century saw the creation of three important landmarks. The bronze statues of the *Tyrant-Slayers*, symbols of the democracy, were a state commission, made by Critius and Nesiotes (copies in Naples, Mus. Arch. Naz.). The Athenian painters Micon and Panainus and the Thasian *Polygnotus embellished the Painted Stoa, a private donation, with famous panel paintings. Panainus' picture of the victory of the Athenians over the Persians at Marathon in that Stoa was the most famous of all Athenian paintings. Proceeds from the booty of that battle financed *Phidias' colossal bronze *Athena Promachos* on the Acropolis. Phidias the Athenian was much admired as the unsurpassed creator of divine images. He greatly contributed to the creation of the classical style by his gold and ivory cult statue of *Athena Parthenos* (446–438 BC) inside the *Parthenon (copy in Athens, Nat. Arch. Mus.) and by his influence on the architectural sculptures of that temple.

The third quarter of the 5th century was the Golden Age of Athenian art, when the sanctuaries of the Acropolis were rebuilt and embellished with statuary under the political tutelage of Pericles. The Athenian architects Ictinus, Callicrates, and Mnesicles were responsible for the Parthenon, the Propylaia, the temple of Athena Nike, and the temple of Athena Polias (also known as the Erechtheion) on the Acropolis. They introduced new blends of Doric and Ionic styles, of white and grey marbles, bronze and lead attachments, and wax colouring, along with new construction methods (including the experimental use of structural iron). The Propylaia served as a picture gallery housing famous panels with Homeric subjects by Polygnotus.

Phidias and his pupils, Alcamenes of Athens and Agoracritus of Paros, were the main proponents of the high classical Athenian School of sculpture and were responsible for a number of cult statues in the city and countryside, all dating from the 450s and 420s. Phidias created *Aphrodite Ourania* (copy in Naples, Mus. Arch. Naz.), Alcamenes *Aphrodite in the Gardens* (copy in Naples, Mus. Arch. Naz.), *Athena* (copy in Paris, Louvre), and *Hephaistus* (copy in Vatican), as well as *Dionysus*, while Agoracritus made the *Mother of the Gods* and *Nemesis* (copy in Athens, Nat. Arch. Mus.). Their statues were often set up on sculptured bases with divine birth scenes after the model of Phidias' *Athena Parthenos*.

In the 4th century the School is represented by the Athenian sculptors Cephisodotus and his son Praxiteles, as well as by Euphranor of Isthmos. Praxiteles lived in Athens but made statues mostly for export. He was famous for his choice of intimate subjects, his use of live models, and his virtuosity in the representation of women and children. In his native city he was responsible for a *Satyr* (copy in Dresden, Albertinum) on the Street of the Tripods and the cult statue of *Aphrodite Brauronia* (copy in Paris, Louvre) on the Acropolis. Euphranor was both sculptor and painter and served as state artist of the democracy like his predecessor Phidias. The most famous painter of his studio was Nicias, responsible for a painting of *Odysseus' Descent into the Underworld*, which was probably set up inside a monument dedicated by himself near the theatre of Dionysus after a victory in a dramatic festival. Versions of his *Perseus and Andromeda*, *Odysseus and Calypso*, and *Io and Argos* are known from Pompeian frescoes (Naples, Mus. Arch. Naz.). Both Nicias and Euphranor wrote technical treatises and advocated the use of lofty subjects in a suitably robust style. OP

Buitron-Oliver, D. (ed.), *The Interpretation of Architectural Sculpture in Greece and Rome.* (1997).

Castriota, D., *Myth, Ethos and Actuality* (1992).

Jenkins, I., *The Parthenon Frieze* (1994).

Miller, M. C., *Athens and Persia in the Fifth Century BC* (1997).

Palagia, O., *Euphranor* (1980).

Palagia, O., *The Pediments of the Parthenon* (1993).

Palagia, O., and Pollitt, J. J. (eds.), *Personal Styles in Greek Sculpture* (1996).

Robertson, M., *A History of Greek Art* (1975).

Travlos, J., *Pictorial Dictionary of Ancient Athens* (1971).

Wycherley, R. E., *The Stones of Athens* (1978).

ATHENS, NATIONAL ARCHAEOLOGICAL MUSEUM. The principal archaeological museum in Greece, the Athens National Museum contains one of the most important collections of ancient Greek art from the prehistoric to the Roman period. The construction of the original building dates to 1866–89; expansions over the next 50 years resulted in the addition of north, south, east, and west wings and a two-storey building.

All of the significant periods of Greek art are represented by an extraordinary number of objects of high quality. The canonical *Cycladic female figurines with folded arms (e.g. an early Cycladic example from Amorgus, 2800–2300 BC) as well as the *Harp-Player* from Keros (2800–2300 BC) convey the richness of expression in this period. The finds from the Shaft Graves at *Mycenae (1600–1500 BC) contained massive quantities of gold and silver plate, including the gold death mask of Agamemnon. The tombs were marked by the martial character of the finds within (whether objects associated with the

activities of warriors, such as daggers decorated in niello technique, or visual representations of battles, such as the Siege Rhyton). The frescoes and pottery of the lost city of Thera, buried in a volcanic eruption (*c*.1550 BC), provide important evidence for the existence of regional variation in this period.

The *Geometric period is most clearly characterized by the monumental amphora of the *Dipylon Painter (mid-8th century BC) that stood as a grave marker in the Kerameikos cemetery in Athens. Small-scale figurines in bronze repeat the calligraphic figural forms of the vase painters. In the *Archaic period, monumental *kouroi such as the *Sounion Kouros* (600 BC) and *Aristodicus* (500 BC) stood in Greek sanctuaries as offerings to the gods or in cemeteries where they functioned as grave markers. The Hegeso Stele (end of 5th century BC) is an excellent example of the grave stelae that were also used to mark tombs in the Archaic and *Classical periods. The bronze *Artemision Poseidon/Zeus* (460 BC) is a rare survival in bronze of early Classical statuary. The Classical sculptor *Polyclitus, in contrast, is represented not in the original bronze, but in a marble copy of the *Diadoumenus* from Delos (early 1st century BC). For painting of the period, only the Pitsa Tablets (*c*.540–500 BC) survive of what was once a common genre of painting on wood.

A number of important monumental bronzes come from finds in the sea. Thus a shipwreck off Anticythera yielded the *Hellenistic *Head of a Philosopher* (250–200 BC) and the *Anticythera Youth* (340 BC). Like the *Artemesion Poseidon/Zeus*, the *Jockey of Artemision* (140 BC) came from a shipwreck off Cape Artemision. Recently, an extraordinary equestrian statue of Augustus has been recovered off the coast of Attica (end of the 1st century BC).

L-AT

ATTAVANTE DEGLI ATTAVANTI (1452–before 1525). Florentine illuminator. His elegant, idealized compositions and use of *Antique sources epitomize *Renaissance manuscript illustration and were an essential element of the finest Florentine production in the decades around 1500.

Throughout his career he collaborated with the most influential illuminators of his day and worked for the most important and discriminating patrons. He contributed to the Bible of Federigo da Montefeltro, Duke of Urbino (1477–8; Vatican, Bib. Apostolica, MSS Urb. lat. 1–2) and to a number of manuscripts, both liturgical and secular, made for Matthias Corvinus, King of Hungary (e.g. the Missal of 1487; Brussels, Bib. Royale, MS 9008). Attavante undertook equally lavish and extensive commissions for the Medici, collaborating on the Hours of Laudomia de' Medici (1502; London, BL, Yates Thompson MS 30) and illuminating choir books for Leo X's use in the Sistine chapel (e.g. *Preparatio ad missam pontificale* of 1520; New York, Pierpont Morgan Lib., MS H. 6). His final certain work was on the series of choir books made for the Cathedral of Florence (now Mus. dell'Opera del Duomo and Bib. Laurenziana). KS

The Painted Page: Italian Renaissance Book Illumination 1450–1550, exhib. cat. 1994/5 (London, RA; New York, Pierpont Morgan Lib.).

ATTRIBUTES are objects or symbols which have come to characterize, or are associated with, a particular figure. For example the thunderbolts of Jove, the keys of S. Peter, the wheel of S. Catherine, the anchor of Hope, and the scales of Justice. Such attributes are often held, but they may also appear as background decoration, decorative conceits, or heraldic devices. Attributes can be found in both religious and secular art. They had various sources, most obviously a key element in the martyrdom of a saint, but some attributes were enigmatic and esoteric in nature. Some came to stand as personifications of the subject. OI

AUDRAN, CLAUDE (1658–1734). French painter and draughtsman. He was the third artist of this name in a large family of engravers and painters. He is best known for his imaginative and exotic designs for painted wall decorations. These are an elaborate mélange of arabesques and grotesques, consisting of ribbons, trelliswork, and barely recognizable architectural elements through which clamber and caper human figures in fancy dress with birds, monkeys, and animals of all kinds. Audran worked at Meudon, Anet, Fontainebleau, and the Ménagerie at Versailles, as well as in the Paris houses of the rich, but most of this light-hearted decoration has disappeared, and much is likely to have been executed by assistants. A large collection of his drawings is, however, preserved at the Nationalmuseum in Stockholm. They give a good idea of the grace and fluidity of his style that made him preferred in the fashionable world to his older rival Jean *Berain. Together the two designers have been credited with laying the foundations of the *Rococo style in decoration. From 1704 Audran was keeper of the art collection at the Luxembourg Palace in Paris and encouraged *Watteau to study *Rubens's *Marie de Médicis* cycle. MJ

Duplessis, G., *Les Audran* (1892).

AUDUBON, JOHN JAMES (1785–1851). French-born American naturalist and artist. Born in Haiti, Audubon was educated in France where he reportedly received drawing lessons from *David. He appears to have visited America in 1803, before settling there in 1806. He led a peripatetic life as merchant and portrait painter before working as a taxidermist in Ohio. After 1820 he devoted himself to painting birds with the intention of publication. Having failed to find an American publisher he visited England in 1826 where *The Birds of America* was issued in four volumes (1827–38) of hand-tinted aquatints by Robert Havell, whose son Robert Jr. (active 1820–50) engraved the plates. He completed the text (5 vols., 1831–9) in Edinburgh with the assistance of William MacGillivray (1796–1852) before returning to New York in 1839. He now began work on *The Quadrupeds of America* (2 vols., 1842–5) assisted by his sons. *The Birds of America*, which is generally considered to be among the finest of colour-print books, contains engravings of 435 watercolours (New York, Historical Society) which combine scientific accuracy with dramatic composition and great artistry. DER

Foshay, E., *John James Audubon* (1997).

AURIER, ALBERT (1865–92). French *Symbolist poet and art critic. In his brief career Aurier championed certain isolated individuals and anti-naturalist tendencies within *Post-Impressionist painting. He was the first to promote van *Gogh during his lifetime. In 'Le Symbolisme en peinture: Paul Gauguin' (*Mercure de France*, Mar. 1891), he proclaimed *Gauguin the leader of Symbolism, which he distinguished sharply from *Impressionism and characterized as a cerebral art form founded on ideas and involving decorative, synthetic techniques. BT

Mathews, P. Townley, *Aurier's Symbolist Art Criticism* (1986).

AUSTRALIAN ART. The art of European origin in Australia can be traced back to 1788, when a British penal colony was established at Sydney Cove. The first non-Aboriginal examples of graphic art were records of native plants, animals, and human inhabitants created to help English scientists. However, landscape, and the problems of its interpretation by European colonists, soon emerged as the most important theme of Australian painting. The first landscape in oil was painted by a convict, Thomas Watling (1762–*c*.1810). *Sydney in 1794* (Sydney, Mitchell Lib.) is an example of picturesque topography, a manner also used by Joseph Lycett (active 1810–24) in his depictions of views of Tasmania and New South Wales. Many early landscapes are characterized by a potentially incongruous placing of groups of Aborigines within idyllic, pastoral settings, as in *A Corroboree of Natives in Mills Plain* (*c*.1833; Adelaide, AG South Australia) by John Glover (1769–1849). Landscape remained the main subject of colonial art until the end of the 19th century, and reflected the influence of German Romanticism. Its manifestations encompassed a wide range of genres and styles, and appear to have served a number of purposes.

Many pictures were of topographical interest, with accurate depictions of mountain ranges like *North-East View from the Northern Tip of Mount Kosciusko* (1863; Melbourne, NG Victoria) by Eugene von Guerard (1811–1901). Others were more overtly colonial in outlook, in their representations of Australia as an untamed wilderness, for example *Country North-West of Tableland* (1846; Canberra, National Lib. Australia) by S. T. Gill (1818–80). Still others showed the ostentatious mansions of colonial landholders, whose wealth was further indicated by the Romantic nature of the landscapes in which they were set. Towards the end of the 19th century, many landscapes were painted in an *Impressionist manner. The principles of Impressionism had been gathered by the artist Tom Roberts (1856–1931) when he toured through England, France, and Spain between 1883 and 1885. Along with other artists such as Frederick McCubbin (1855–1917), Charles Conder (1868–1909), and Arthur Streeton (1867–1943), Roberts was credited with creating the first authentic school of Australian painting, in which *plein air* and Impressionist principles were applied to the interpretation of the light, colour, and atmosphere of the landscape, often including the expression in heroic terms of certain aspects of Australian life and history, as in Roberts's *Shearing the Rams* (1890; Melbourne, NG Victoria). This group, known as the *Heidelberg School, first exhibited in Melbourne in 1889. A more conservative, academic approach continued to have a strong presence during the first 20 years of the 20th century, exemplified by the paintings and theories of Max Meldrum (1875–1955), who believed in the scientific emulation of the old masters, and that modern art indicated social decadence. Such conservatism is also apparent, though to a lesser degree, in the portraiture of George Lambert (1873–1930), and the landscapes of Elioth Gruner (1882–1939). Amongst the works of contemporaries such as Roland Wakelin (1887–1971), Grace Cossington Smith (1892–1984), and Roy de Maistre (1894–1968), however, an interest in *Post-Impressionism and *Orphism can be discerned. De Maistre and Wakelin experimented with colour and its relationship to music; they held an exhibition of 'Synchromies' in Sydney in 1919. By 1925 the influence of Post-Impressionism was apparent in the work of many artists, including Arnold Shore (1897–1963), George Bell (1878–1966), and William Frater (1890–1974). Bell and Shore established an art school in Melbourne in 1932, and the Contemporary Group had been founded in Sydney in 1925; both encouraged the development of modern art. Despite the existence of these groups, and the formation in Sydney of the Contemporary Art Society in 1937, the range and diversity of contemporary art in Europe was not clearly demonstrated until an exhibition

held in Adelaide and Melbourne in 1939, and organized by the *Melbourne Herald*, presented over 200 'French and British' paintings, ranging from *Cézanne to *Dalí. Interest in *Surrealism grew as a result, notably in the works of James Gleeson (1915–) and Eric Thake (1904–98), but after 1940 it was *Expressionism, in various forms, which took hold as the dominant style of Australian *modernism, for example: the caricatural portraiture of William Dobell (1899–1970); landscapes of drought and rural poverty by Russell Drysdale (1912–81); and the naive paintings of Australian folk history and myth by Sidney *Nolan and Arthur Boyd (1920–99). In Melbourne, a circle of Expressionist painters associated with the journal *Angry Penguins* (1941–6) created a form of figurative art in which Surrealistic, social, and regional interests were combined. Two of them, Arthur Boyd and John Perceval (1923–), were among those who formed the Antipodean Group, in defence of the figurative image against abstraction, in 1959. In historiographical terms, post-war art in Australia has been characterized by an opposition between abstract art in Sydney, and figurative art in Melbourne. This has probably been somewhat overstated, however. In the 1960s, landscape continued to dominate, but was mediated through various abstract forms which reflected contemporary trends in European and American art. Paintings by John Olsen (1928–) such as *Journey into You Beaut Country* (1961; Melbourne, NG Victoria) attempted to apply the principles of lyrical abstraction to the Australian landscape. This kind of work was known as Abstract Impressionism, and was also practised by John Passmore (1904–84), Eric Smith (1919–) and the sculptor Robert Klippel (1920–). Olsen's paintings, whilst ostensibly abstract, did not entirely renounce figuration, and, as such, exemplify a sense of uneasiness towards non-representational art which characterized much Australian art in the 1960s, 1970s, and 1980s, including the emblematic method of *abstract painting developed by Roger Kemp (1908–87). From about 1965, however, a form of hard edge, non-figurative art did develop. Known as colour field painting, its exponents included Alun Leach-Jones (1937–), Robert Rooney (1937–), and Michael Johnson (1938–). Thus, all the dominant modes of late modernist art in Europe and America were reflected to some degree in Australia, with the notable exception of *Pop art, which never really took hold. This has been accounted for by the theory that Pop art is essentially urban, whereas Australian art has been concerned mainly with the expression of either the desolation of the outback, or the 'placelessness' of suburban existence. Since the 1980s, however, in the installation works of artists such as Imants Tillers (1950–) and Lindy Lee (1954–), Australian art has defined

itself in terms of *postmodernism, many of the associated ideas of which seem peculiarly appropriate to the country's cultural and historical concerns. OPa

Allen, C., *Art in Australia* (1997).
Smith, B., *Australian Painting* (1991).

AUSTRIAN ART has been shaped by the country's position astride one of the main routes between the north and Italy, and on the fringe of eastern Europe and the Balkans. Until the 19th century the main patrons remained the circle of the Habsburg rulers, and the Church.

In the medieval period there were several regional schools of religious wall painting, sculpture, and manuscript illumination, including the notable scriptorium of the abbey of S. Florian in the 14th century. During the next century the influence of Netherlandish realism slowly became apparent, but the first major artist to come to terms with the Italian *Renaissance was the Tyrolese painter and sculptor *Pacher, some of whose painting achieves an extraordinarily powerful synthesis between the fantasy of Gothic and the intellectual rigour of *Mantegna (*The Four Doctors of the Church*; Munich, Alte Pin.).

In the early 16th century the Danube School of painting, with its feeling for wild Alpine scenery, spread to Austria, and artists such as *Huber and *Altdorfer painted important works in the area. The most successful local painter to be influenced by this development was Rueland *Frueauf the younger whose altar panels include spacious landscape backgrounds.

The Emperor Charles V, who ruled over the entire Habsburg territories in central and western Europe from 1519 to 1556, gave employment to Austrian artists such as the portraitist *Seisenegger. Charles, who fully understood the use of art to project an image of majesty, was also able to call on *Titian, however, and Seisenegger's modest talent was quite outgunned. With the partition of the empire following Charles's abdication, the Austrian Habsburgs became increasingly involved in dealing with both the Reformation and the Turks, and the area was in turmoil for long periods. Several Habsburgs established *Kunstkammers* of the minor arts as part of their image as rulers, but no significant Austrian artists emerged until the 18th century.

After the Turks were finally defeated before Vienna in 1683 Austria embarked on a huge and confident building boom of town development, palace building, and the establishment of churches and monasteries. Architects such as Fischer von Erlach established a recognizably Austrian 'imperial style' and Austrian artists similarly created a national vocabulary in the decoration of these major 18th-century projects. While

promulgation of the ascendancy of the Catholic Church was certainly one strong element in the enterprise, this was not an evangelical Counter-Reformation programme as seen in Italy or parts of Germany a century before. In particular, most of the religious foundations were by the old orders such as the Benedictines.

At the outset of this phase Italian artists were very influential. *Pozzo came to work in Vienna and *Solimena provided work for the Belvedere of Prince Eugène of Savoy. Other successful Italian decorators were Carlo *Carlone and Gregorio Guglielmi (1714–73). *Rottmayr, however, soon established himself as a local painter capable of taking on the largest commissions, and Paul Troger (1698–1762), who was a professor in the Vienna Academy from 1751, was an especially influential figure. Troger, who had visited Venice, favoured strong effects of luminosity, high colour, and free painterly handling, and these are the characteristics that distinguish the generation of Austrian painters who dominated major decorative painting schemes in the third quarter of the century. The unquestioned leader of this group was *Maulbertsch, whose explosive colouristic pyrotechnics and vivid expressiveness epitomize the Austrian *Rococo. Appreciation of the spontaneity of drawings and sketches for its own sake was but one way in which Austrian art circles took their lead from Italy in this period, and Maulbertsch was acknowledged as a master of the minor modes, especially the oil-sketch medium.

During Maulbertsch's active career the Austrian court and intelligentsia came under the influence of the Neoclassical doctrines of *Winckelmann, who was honoured by the Empress Maria Theresa, and patrons came to demand more emphasis on clarity and rationality. Maulbertsch tried to adjust his heady art to the new environment, but increasingly found that he could only find work in bucolic Austrian commissions and in Hungary, and his leading place was taken by artists like Martin Johann Schmidt (1718–1801), whose work was more subdued.

In the first half of the 19th century several movements coexisted in Austria, as elsewhere. The *Nazarene group was founded in Vienna in 1809 as the Lukasbrüder (Brotherhood of S. Luke), though its main activity was in Germany and Rome. The most characteristic art movement of the period, reflecting the newly emerging bourgeois clientele, was that of the painters who produced meticulously crafted, unthreatening, landscapes, portraits, and genre pieces in the so-called *Biedermeier style. *Waldmüller, whose landscapes were notably fresh in observation and feeling, was the quintessential exponent of this type of painting but his

advocacy of the study of nature was regarded as heretical by the stiflingly rigid establishment at the Academy and he was dismissed from his post of professor there in 1857.

The ultra-conservatism of the Academy was typical of the official social and political structures of 19th-century Austria, but Vienna was also the city of *Freud and, in music, the city of Alban Berg and Arnold Schoenberg. It was, in fact, a hotbed of the ideas that were to govern the intellectual explorations of the 20th century and, while these ideas were anathema to the ruling class, there was a cadre of adventurous art patrons among the, largely Jewish, population of entrepreneurs and financiers. In 1897 a group of avant-garde artists under the leadership of *Klimt resigned from the establishment exhibiting society, the Künstlerhausgenossenschaft, and set up the Austrian *Sezession group which proceeded to publish its magazine Ver sacrum and to hold exhibitions in a purpose-built building designed by Joseph Maria Olbrich. The Sezession did not pursue a specific stylistic agenda of its own, but among the foreign artists whose work it exhibited there was a good proportion of those such as *Khnopff and *Klinger who were interested in exploring themes of psychological ambiguity.

Klimt himself had obtained several public commissions for mural paintings in buildings such as the Opera and the Kunsthistorisches Museum in Vienna but the controversy surrounding his work eventually forced him to withdraw the paintings (now destr.) for his final public commission, for Vienna University. He specialized in allegorical scenes in which erotically charged female figures are set off against elaborate flat patterning in iridescent colours. One of the most elaborate of these, the Beethoven-frieze, was made to accompany a statue of Beethoven by Klinger in the 1902 Sezession show, and it is now once more exhibited in the Sezession building.

The Sezession broke the ice for the Expressionist painters Richard *Gerstl (who committed suicide after running off with Schoenberg's wife), *Kokoschka, and *Schiele. While Klimt's art was saturated with decadent fin de siècle elegance, however, these painters—especially Schiele—depicted a harsh and angst-filled post-Freudian world of psychic turbulence that still looks startlingly modern.

Following the Second World War Austrian art explored many directions. Arnulf *Rainer and Joseph Mikl painted in a severe abstract mode. Anton Lehmden and Ernst *Fuchs were leading members of the Phantastischer Realismus (Fantastic Realism) movement in Vienna. The sculptor Fritz *Wotruba made

figures and reliefs that owed much to primitive art.　　　　　　　　　　AJL

Kaufmann, T. DaC., Court, Cloister and City (1995).

AUTOMATISM, method of producing paintings or drawings (or writing or other work) in which the artist suppresses conscious control over the movements of the hand, allowing the unconscious mind to take over. There are various precedents for this kind of work, most notably the 'blot drawings' of the 18th-century English watercolourist Alexander *Cozens, who stimulated his imagination by using accidental blots on the paper to suggest landscape forms. Cozens himself remarked that 'something of the same kind had been mentioned by *Leonardo da Vinci', and slightly before Leonardo, Leon Battista *Alberti (in his treatise De statua, c.1460) gives an imaginative account of the origins of sculpture, describing ancient peoples observing 'in tree trunks, clumps of earth, or other objects of this sort, certain outlines which through some slight changes could be made to resemble a natural shape'. Alberti's version of events may be not far from the truth, for scholars of prehistoric art have found examples of such spontaneous discovery of representational images in chance natural formations of cave walls. However, automatism in its fully developed form is a 20th-century phenomenon. The *Dadaists made some use of the idea, although they were more interested in chance effects than in automatism as such. In 1916–17, for example, *Arp made a series of Collages with Squares Arranged According to the Laws of Chance, in which he said he arranged the pieces of paper 'automatically, without will', and in 1920 *Picabia published an ink blot labelled La Sainte Vierge in his magazine 391. However, it was the *Surrealists who first made automatism an important part of their creative outlook; for whereas the Dadaists used the idea dispassionately, the Surrealists regarded exploration of the unconscious through such methods as deeply personal.

In the first Surrealist manifesto (1924) André *Breton discussed automatism in a passage that refers to literary composition but could equally well apply to drawing or painting: 'Secrets of Surrealist magical art … have someone bring you writing materials, once you have got into a position as favourable as possible to your mind's concentration on itself. Put yourself in the most passive, or receptive, state you can. Detach yourself from your genius, your talent, and everyone else's talent and genius.' Later, in Le Surréalisme et la peinture (1928), he wrote: 'The fundamental discovery of Surrealism' is that 'without any preconceived intention, the pen which hastens to write, or the pencil which hastens to draw, produces an infinitely precious substance all of which is not perhaps

immediate currency but which at least seems to bear with it everything emotional that the poet harbours within him'.

By 1924 André *Masson was producing spontaneous automatic drawings with 'wandering lines' and he soon developed a more elaborate technique in which he drew on the canvas with an adhesive substance, then added colour by sprinkling coloured sands. Other Surrealists devised different methods, and some of them regarded the use of dream imagery (as in the work of *Dalí) as a kind of psychological—as opposed to mechanical—automatism. Sometimes they used chance—rather than strictly automatic—methods to provide the initial image (see DECALCOMANIA; FROTTAGE). The Surrealist interest in automatism had a strong influence on the *Abstract Expressionists, some of whom took their ideas further. With Surrealists, once an image had been formed by automatic or chance means, it was often exploited deliberately with fully conscious purpose, but with Action Painters such as Jackson *Pollock, automatism in principle permeated the whole creative process.

Other types of automatism are those in which the artist works under the influence of drugs or by alleged occult means. The offbeat British painter Austin Spare (1886–1956) claimed to be able to conjure up horrific survivals of man's pre-human ancestry from deep within his mind, but more usually the artist is said to work under the inspiration of a beneficent spirit guide (a notion not necessarily to be taken lightly, as no less an artist than William *Blake claimed to have direct inspiration from his dead brother). The British painter Georgiana Houghton (1814–84) gave up conventional art because of grief at the death of her sister in 1851, but in 1861 she began to produce 'spirit drawings', using coloured pencils and later watercolour and ink. She held an exhibition of them at the New British Gallery, London, in 1871, and examples are preserved in the Victorian Spiritualists' Union, Melbourne; they have been claimed as the earliest abstract pictures.

Unlike Blake and Houghton, most psychic artists of this kind have no particular artistic gifts or inclinations in their 'normal' life. An example is Madge Gill (1882–1961), an uneducated British housewife who became interested in spiritualism after a series of traumatic events (two of her children died tragically and she lost an eye through illness). From 1919 she produced hundreds of ink drawings whilst in a trancelike state, allegedly directed by her spirit guide 'Myrninerest' (one acquaintance said unkindly that the spirit which really guided her was gin). From 1932 she exhibited regularly at shows for amateur artists at the Whitechapel Art Gallery, London. Her drawings ranged from postcard-sized sketches to works more than 6 m (20 ft) wide. In 1926 her son Laurie issued

a broadsheet entitled *Myrninerest, the Spheres*, in which he described the range of his mother's automatic activities: 'Spiritual or Inspirational drawings, Writings, Singing, Inspired Piano-Playing, making knitted woollen clothes and weaving silk mats in beautifully blended colours'. IC

AUTOMATISTES, LES, a group of seven Montreal abstract painters active in the late 1940s, who adopted the technique of automatic painting from the *Surrealists. The oldest and most influential was Paul-Émile *Borduas. In 1946, in Montreal, they held Canada's first group exhibition of abstract painters. The name was coined by the critic Tancrède Marsil, in a review of this show, from the title of Borduas's painting *Automatisme 1.47*. In 1947 members of the group exhibited in Paris and later published a manifesto, *Refus global* (1948), but the association soon afterwards dissolved. DER

Robert, G., *Borduas* (1972).

AVANT-GARDE, a term taken from the French which originally applied to the foremost part of an army, or vanguard, and was used in this sense in English from the 15th to 19th century. However, since the early 20th century (*Daily Telegraph*, 1 July 1910) it has been used to describe contemporary pioneers or innovators in any of the arts and also signifies work which challenges accepted standards. HO

AVANZI, JACOPO (active *c*.1363–*c*.1384). Bolognese painter whose œuvre is based around a signed *Crucifixion* panel (Rome, Gal. Colonna) done for the Malatesta family. The same decisive qualities of draughtsmanship and foreshortening can be detected in a fresco of the *Massacre of the Idolaters* from S. Apollonia at Mezzaratta (now Bologna, Pin. Nazionale), a recently discovered *Battle Scene* in the Malatesta castle at Montefiore, and the illustrations of a manuscript of Statius' *Thebaid* (Dublin, Chester-Beatty Lib.). Avanzi may also be identified as the painter of five frescoes of the life and miracles of S. James in the chapel of S. Giacomo in the Santo at Padua. His professional relationship with *Altichiero, the painter of the other frescoes there, is unclear. It is also unclear which of the two documented Bolognese painters called Jacopo Avanzi is the author of this group of paintings. The pattern of his career, working for the Malatesta and for the courtiers of Carrarese Padua, contrasts with those of his Bolognese contemporaries. His art is less disciplined than that of his putative colleague Altichiero, but it is vivid, expressive, and adventurous in the Bolognese tradition. JR

Benati, D., *Jacopo Avanzi* (1992).

AVED, JACQUES-ANDRÉ-JOSEPH-CAMELOT (1702–66). French portrait painter. Born in Douai, he trained in Amsterdam before settling in Paris. He is known to have owned pictures by *Rembrandt, and it may be correct to see something of the northern, naturalist tradition in his portraits. Although he had royal patrons, he seems to have been most at home with sitters from the higher bourgeoisie, and with his familiars from the world of artists and collectors. Aved's portraits are among the most engaging of the 18th century and share something of the directness of *Chardin, whose friend he was. His masterpiece is *Mme Antoine Crozat* (1741; Montpellier, Mus. Fabre), which depicts a plain, old lady looking up quizzically from her embroidery. Its character and quality can be gauged from the fact that it was once attributed to Chardin, who painted Aved as *The Chemist in his Laboratory*. MJ

Lespes, M., 'Catalogue des œuvres du peintre Jacques Aved', dissertation, Montpellier University (1985).
Wildenstein, G., *Le Peintre Aved* (1922).

AVERCAMP, HENDRICK (1585–1634). Dutch painter who specialized in landscapes. He was born in Amsterdam but worked in Kampen, and became known as 'de stom (stomme) van Campen', as he was dumb. He concentrated on the production of winter scenes, with skaters, sleighs, tobogganers, and people playing *kolf* (an early form of golf), which convey a sense of delight in the picturesque aspects of Dutch leisure in the 17th century. They often include innumerable small figures from all social classes, as well as comic details. Dated paintings by him range from 1608 to 1632. Some of his most appealing works are round in format.

Avercamp may have been taught by Pieter Isaacsz. (*c*.1560–1625), and was probably inspired by the work of Flemish followers of Pieter *Bruegel the elder. A number of his drawings, which are often tinted with watercolour and focus on genre details, survive (e.g. Windsor Castle, Royal Coll.). Hendrick's nephew Barent Avercamp (1612–79) continued working in his style in Kampen, as did Arent Arentsz. CB

Welcker, C. J., *Hendrick Avercamp en Barent Avercamp* (2nd edn., 1979).

AVERLINO, ANTONIO DI PIETRO. See FILARETE.

AVERY, MILTON (1885–1965). American painter. He was born in Altmar, New York, spent most of his early life in Connecticut, and settled in New York City in 1925. Although he studied briefly at the Connecticut League of Art Students, he was essentially self-taught as an artist, and in his early years he supported himself with a variety of night

jobs so he could paint during the day. It was only after his marriage in 1926 that his wife's earnings (she was an illustrator) allowed him to concentrate full-time on painting. (Avery's wife Sally Michel was considerably younger than him and it was perhaps to improve his chances in courting her that he took eight years off his age; his date of birth is usually given as 1893, but there is good evidence to indicate that he was born in 1885.)

Avery was an independent figure. At a time when most of his leading contemporaries were working in fairly sober, naturalistic styles he followed the example of *Matisse in using flat areas of colour within flowing outlines. He was the main and practically only channel through whom this subtle colouristic tradition was sustained in America until it engaged the interest of younger artists such as *Rothko (his close friend) and *Gottlieb in the 1940s. Rothko in particular acknowledged the debt that he and other abstract painters owed to the 'sheer loveliness' of Avery's work, in which he had 'invented sonorities never seen nor heard before'. Although Avery himself never abandoned representation (his favourite subjects included landscapes and beach scenes), some of his later works are so broadly conceived and ethereally painted that they can at first glance be mistaken for abstracts (*Spring Orchard*, 1959; Washington, National Mus. of American Art). IC

AVIGNON, MUSÉE CALVET. It originated in 1810 when Esprit Calvet, a local professor of medicine, left to the city of Avignon his library and collections of antiques, natural history, and curiosities. The municipal collection was joined with the Calvet bequest and in 1855 the museum opened in the elegant Hôtel Villeneuve-Martignan, where it remains.

Calvet, together with some of the subsequent benefactors, was at least as interested in archaeology as in the fine arts. While he did own some excellent small bronzes, his collection was not strong on painting. The museum managers therefore soon bought some local collections, and several works were placed on deposit by the state. Two more recent developments have been the gift of 20th-century paintings (*Soutine, *Vlaminck, *Utrillo) from the Joseph-Rignault Collection, and the loss of early Italian paintings to the Petit Palais museum in Avignon when the latter was founded in 1976.

In addition to local art of most periods the display now includes a miscellaneous but interesting collection of northern painting and Italian old masters together with a strong 18th- and early 19th-century section—with much Hubert *Robert, *Panini, and Joseph *Vernet. The most striking work is the iconic *Death of Joseph Bara* (1794), the last of *David's three Jacobin memorials to revolutionary martyrs. AJL

Musée Calvet, *Peintures et sculptures d'Italie: collections du XVe au XIXe siècle* (1998).

AVIGNON, MUSÉE DU PETIT PALAIS. A new museum, installed in the old Archbishop's Palace in 1976, to house some 300 pictures from the collection of early Italian primitives formed in Italy by the Marchese Giovanni Pietro Campana (1808–80), a Roman banker and respected archaeologist. In 1861 after he had been arrested in Rome in 1857 for financial irregularities, much of his collection—12,000 works including antiquities and Italian paintings—was sold to the French nation and was then installed in Paris the following year at the Musée Napoléon III. In 1863 the Musée Napoléon, including the best Campana pictures (works by *Uccello, Cosimo *Tura), was absorbed into the Louvre.

Many of the Campana pictures were then dispersed to French provincial centres. The Avignon museum brings together many of these works including examples by *Botticelli, *Carpaccio, *Crivelli, Pietro di Domenico, Marco Palmezzano, Cosimo *Rosselli, and Lorenzo *Vecchietta. HB

Laclotte, M., and Mognetti, E., *Avignon—Musée du Petit Palais, Peinture Italienne* (1976).

AYRTON, MICHAEL (1921–75). British artist. Painter, sculptor, and writer, Ayrton preferred to describe himself by the phrase *image-maker*. From 1935 he attended various London art schools, but was largely self-taught, working in Vienna, Paris, and Provence. Invalided out of the RAF, he worked as stage designer, radio broadcaster, and art critic, associating with other London Neo-Romantics. Later he travelled in Italy; influenced by the 15th-century artists, his early linearity (*The Temptation of S. Anthony*, 1947; London, Tate) gave way to spatial articulation and monumental form. From 1955 sculpture replaced painting as his principal medium.

From 1956 Ayrton explored the mythology of Daedalus, Icarus, and the Minotaur: *Icarus III* (1960; London, RAF Mus., Hendon), and the huge *Arkville Minotaur* (1969; London, Postman's Park) are among his best-known works. In America he designed a full-size maze, based on his novel *The Maze Maker* (1967); he published novels, essays, and a scholarly monograph and was a successful and prolific illustrator, also producing etchings and lithographs. Fragile health rarely curtailed his work: he continued exploring new ideas until his early death. His illustrated edition of Archilochus' poems appeared posthumously. JH

Hopkins, J., *Michael Ayrton: A Biography* (1994).

BABUREN, DIRCK (JASPERSZ.) VAN (c.1594/5–1624). Dutch painter who was apprenticed to Paulus *Moreelse in Utrecht and then went to Italy, probably c.1612. In Rome he was influenced by *Caravaggio and became part of the circle of artists grouped around *Manfredi who (in 1619) was living in the same parish. He collaborated with David de Haen (d. 1622), about whom little else is known, in decorating the chapel of the Pietà in S. Pietro in Montorio, Rome, with scenes of the Passion (1617–20; *in situ*). His altarpiece for this chapel, an *Entombment* (said to have formerly carried a signature and the date 1617), shows an obvious debt to Caravaggio's picture of the same subject (Vatican Mus.). His *Uriah's Death in Battle* (ex-London art market, reproduced *Burlington Magazine*, Nov. 1987) takes up a figure from a *Cain and Abel* attributed to Orazio Riminaldi (Florence, Pitti). Other Roman works include the *Capture of Christ* (Rome, Borghese Gal.), painted for Cardinal Scipione Borghese; and *Christ Washing the Feet of the Apostles* (Berlin, Gemäldegal.), painted for Vincenzo Giustiniani.

Baburen was probably back in Utrecht by 1621. His work there continued to reflect the influence of Manfredi, notably in *Christ among the Doctors* (s.d. 1622; Oslo, NG Norway) and the *Crowning with Thorn* (Utrecht, Cathar- ijneconvent; and Kansas City, Mo., Nelson Atkins Mus. of Art). And he also became closely associated with other Caravaggesque artists working in Utrecht, above all ter *Brugghen with whom he probably shared a workshop. Baburen's importance now rested not only on his Caravaggesque style of painting but also on his seminal role in introducing fresh subject matter and new approaches to the Dutch traditions of moral- izing genre painting, history painting, and religious imagery that were quickly taken up by such artists as Jan van Bijlert (1597?–1671), Gerrit van *Honthorst, Jan Janssens (1590– c.1650), as well as ter Brugghen. His theatrical *Youth Playing a Small Whistle* (1621; Utrecht,

Centraal, Mus.) was one of the first of its kind in Utrecht. And his *Procuress* (Boston, Mus. of Fine Arts), *Backgammon Players* (Bamberg, Res- idenzgal.; and other versions) and *S. Sebastian Tended by Irene* (Hamburg, Kunsthalle) all had an equally immediate effect on the vocabu- lary of art in Utrecht. HB

Nicolson, B., *Caravaggism in Europe* (2nd edn., 1990).
Slatkes, L. J., *Dirck van Baburen: A Dutch Painter in Utrecht and Rome* (1965).

BACICCIO, IL. See GAULLI, GIOVANNI BAT- TISTA.

BACKER, JACOB ADRIAENSZ. (1608– 51). Dutch artist of some distinction who was born in Harlingen in Friesland. Backer is chiefly known as a fairly prolific portrait painter, although he also produced later in life some religious and historical scenes. His parents settled in Amsterdam in 1611, and he trained with Lambert Jacobsz. in Leeuwar- den. By 1633 Backer was working independ- ently in Amsterdam; his portraits of this period are quite close stylistically, although smoother in finish, to some of the works of *Rembrandt from the period of 1632 to 1636, and it was at one time incorrectly thought that he worked for a period in Rembrandt's studio. Pictures of this type include the *Por- trait of a Boy in Grey* (1634; The Hague, Maurits- huis) and the *Portrait of an Elderly Woman* (London, Wallace Coll.), which bears a false Rembrandt signature. His *history paintings by contrast draw on the precedent of the work of Pieter *Lastman. When Backer died a commemorative medal was struck in his honour. CB

Ingamells, J., *The Wallace Collection Catalogue of Pic- tures, 4: Dutch and Flemish* (1992).

BACKHUYZEN, LUDOLF (1630/1–1708). Leading Dutch *marine painter. Back- huyzen was born in Emden in east Friesland. He arrived in Amsterdam in 1650, having

been trained as a clerk and calligrapher, but soon turned to drawing shipping. He learned to paint by studying with Allart van *Everdingen and Hendrik Dubbels (1621–1707). The artist enjoyed considerable success: in 1665 he was commissioned by the burgomasters of Amsterdam to paint a view of the city which was to be presented to one of Louis XIV's ministers, and later he was patronized by Peter the Great and a number of German princes. Most of his seascapes show a view from the shore with rough conditions and stormy skyscapes; there are six such works in the National Gallery, London. A few paintings in other genres by him, including landscapes and town views, survive; and Backhuyzen also produced a number of etchings. CB

Nannen, H., *Ludolf Backhuysen (Emden 1630–Amsterdam 1708)* (1985).

BACKOFFEN, HANS (c.1460–1519). Late Gothic German sculptor. He probably studied with Tilman *Riemenschneider in Würzburg. He is documented in Mainz between 1500 and his death in 1519. The most important works attributed to him are the monuments of the Archbishops Johann von Liebenstein (c.1508) and Uriel von Gemmingen (c.1515/16; Mainz Cathedral). Although he is documented as a *Bildschnitzer*—a term implying work in wood—these monuments are in stone. Backoffen's style here has affinities with Hans Syfer (d. 1509) and with Riemenschneider. KLB

Baxandall, M., *The Limewood Sculptors of Renaissance Germany* (1980).

BAÇO, JAIME, or Jacomart (c.1411–61). Valencian-born Spanish painter who signed documents as 'alias Jacomart' or 'Mestre Jacomart'. He worked for King Alfonso V of Aragon, and, when the King was laying siege to Naples in 1440, he summoned Jacomart to join him. The artist left Valencia for Italy in 1442, was named court painter in 1444, returned to Valencia in 1446, and in 1447 accompanied Alfonso on another Italian military campaign. Jacomart's presence back in Valencia is documented from 1451 until his death. Jacomart's biography is much better known than his work, which was highly regarded during his lifetime. The several altarpieces he painted for the Cathedral of Valencia before his departure for Italy do not survive, nor do any of the works he created while in the King's entourage in Italy. The few extant works that may be said to reflect Jacomart's style are largely the work of his assistants; for example: *SS Laurence and Peter* retable (Cati, parish church), which Jacomart was commissioned to paint in 1460 but which was probably carried out by his assistants. His collaborators included Pere Rexach and Juan Rexach. SS-P

BACON, FRANCIS (1909–92). English painter, born in Dublin. His childhood asthma prevented a conventional education and as a teenager he worked for his father, a racehorse trainer. From 1925 he worked as a furniture designer and interior decorator in London, stayed in Berlin and Paris (1927–9), and began to draw and paint in watercolour. In 1929, settled in London, he first experimented with oil painting. Apart from the encouragement of his friend Roy De Maistre (1894–1968) Bacon had no training and later to claim that intuition was the key to painting. In 1934 he held a one-man show in London which attracted the notice of the critic Herbert *Read but, discouraged by commercial failure, he virtually ceased painting until 1945 when his strikingly original triptych, *Three Studies for Figures at the Base of a Crucifixion* (London, Tate), won him fame and notoriety. He now committed himself to painting and also destroyed most of his early work.

Throughout his career Bacon drew upon an eclectic mixture of sources ranging from *Rembrandt, *Grünewald, and *Velázquez, the latter inspiring his *Screaming Pope* series of the early 1950s, to *Degas, van *Gogh, and *Picasso. He was also influenced by the time-lapse photography of *Muybridge and the films of Eisenstein, illustrated medical textbooks, and newspapers. Widely although idiosyncratically well read, he was intensely responsive to verbal imagery; especially important were T. S. Eliot's poems and the plays of Aeschylus and Euripides. His highly original style incorporates elements of *Surrealism and *Expressionism and his deformed naked figures and anguished heads are usually contained within a characteristic perfunctory scaffolding or inner frame. Bacon was a noted portraitist who preferred to work from photographs although his subjects were usually intimate friends. Aiming not for a likeness but an equivalent, his portraits, like that of *Isabel Rawsthorne* (1966; London, Tate), are painfully distorted, powerful, and disturbing paraphrases on life and death.

From the 1950s Bacon's reputation was international and he was generally considered the greatest of modern British painters, unflinchingly revealing the essential loneliness and vulnerability of the human condition. Since his death, however, some critics have discerned a trend towards the formulaic in his later paintings, particularly the large triptychs, and a lack of the passion which energizes his work from the 1950s to the 1970s. His notorious homosexuality and bohemianism excluded him from official honours. JH

Russell, J., *Francis Bacon* (1979).
Sylvester, D., *Interviews with Francis Bacon* (1975).

BACON, JOHN (1740–99). English sculptor. He worked first as a modeller in a porcelain factory and then at the Coade Artificial Stone Manufactory, both experiences leaving a mark on his prettily detailed and somewhat soft interpretation of the *Neoclassical style. He early attracted the attention of George III, his marble bust of the King (version of 1774; Oxford, Christ Church) being repeated several times. His finest work is the monument to *Thomas Guy* (1779; London, Guy's Hospital), showing the founder in contemporary dress succouring a sick man draped in vaguely classical sheets. The favour of the King gained him the important commission for the monument to William Pitt, Earl of Chatham (1779–83; London, Westminster Abbey), the design and symbolism of which show his talents stretched beyond their limits. His classically draped statue of *Dr Johnson* (1796; London, S. Paul's Cathedral) has been widely criticized for its clumsy interpretation of the *Antique (Bacon never went to Rome) and his strengths clearly lay with figures in modern dress and in architectural sculpture such as that which he contributed to Somerset House, London. Bacon's practice was continued by his son John Bacon the younger (1777–1859). HO/MJ

Cecil, R., *Memoirs of John Bacon Esq, RA* (1801).
Cox-Johnson, A. L., *John Bacon, RA, 1740–1799* (1961).
Whinney, M., *Sculpture in Britain 1530–1830* (rev. edn., 1988).

BACON, SIR NATHANIEL (1585–1627). English painter of portraits and market pieces. Fewer than a dozen pictures survive by this highly accomplished gentleman-amateur, a kinsman of the politician and philosopher Sir Francis Bacon. They include his rather Dutch-looking self-portraits (London, NPG, and priv. colls.) and three large kitchen or market pieces, each depicting a servant girl with a still life of fruit and vegetables, dead birds, or game (1620–5; London, Tate, and priv. coll.). No other British artist of the period worked in this genre, for which Bacon's compositions, but not his handling, are indebted to the Antwerp painter Frans *Snyders. Nothing is known of Bacon's training, although surviving letters indicate that he visited the Low Countries, including Antwerp, from his Suffolk home. A tiny imaginary landscape painted on copper and inscribed 'NB' (Oxford, Ashmolean) is also attributed to Bacon. He experimented with varnishes and pigments, devising a special 'pink' (that is, yellow). Appointed a Knight of the Bath in 1626, he died the following year, perhaps of tuberculosis. KH

Hearn, K. (ed.), *Dynasties*, exhib. cat. 1995 (London, Tate).

BAERZE, JACQUES DE (c.1384–99). Southern Netherlandish sculptor who is best known for the two altarpieces commissioned by Philip the Bold, Duke of Burgundy in 1390 for the Charterhouse of Champmol that were to be gilt and painted by Melchior *Broederlam (1390–9; Dijon, Mus. des Beaux-Arts). The carved interiors have intricate and complex architectural framing housing central narratives with standing saints on the wings. In November 1399 one was placed on the altar endowed by John, Duke of Berry, whilst the smaller of the two was installed in the chapter house. For Philip the Bold, Baerze completed numerous other *tables entaillées*. Earlier he had made two carved altarpieces for Philip's father-in-law Louis II de Mâle, Count of Flanders and Duke of Brabant, for the castle of Dendermonde and the hospice of the abbey of Bijloke (untraced). KC

Roggen, D., 'De twee retabels van De Baerze te Dijon', *Gentsche bijdragen tot de Kunstgeschiedenis*, 1 (1934).

BAGLIONE, GIOVANNI (1566–1644). Italian painter and writer on art, whose volume of artists' biographies, *Le vite de pittori, scultori et architetti* (1642), is a major source for early 17th-century Roman artists. Born in Rome, he worked first with Sixtus V's and Clement VIII's vast teams of fresco painters at the Biblioteca Vaticana and the Lateran, but around 1600 underwent a dramatic conversion to the naturalism of *Caravaggio. His *S. Francis in Ecstasy* (1601; priv. coll.) is one of the earliest Caravaggesque works, and his *Divine Love* (1602; two versions; Rome, Barberini Gal., and Berlin, Gemäldegal.) is a response to Caravaggio's *Victorious Love* (Berlin, Gemäldegal.). But Caravaggio mocked his art, and the enmity between them resulted in the celebrated trial of 1603, when Baglione sued Caravaggio for slander. His later art wavers between the traditions of late *Mannerism and the innovations of the *Carracci, but his career flourished, and he was knighted. In 1639 he published *Le nove chiese di Roma*, an artistic guidebook which set new standards of precision and inclusiveness. His *Vite* concentrate on the period 1572–1642. Baglione disclaimed any desire to describe or to judge, limiting himself to the role of chronicler, but his work is rarely impartial; nonetheless its freshness, reliability, and richness of anecdote render it indispensable. HL

BAIAE PLASTER CASTS. Almost 300 fragments of *plaster casts of ancient statuary were excavated in a cellar-like area forming the substructure of a hall or terrace within the great bath complex at Baiae, the Roman seaside resort near Naples. Dated to the early 1st century AD, the casts seem to have served a copyist workshop for more than a century and a half. The quality of the casts is so high that it has been suggested that they are primary casts taken directly from the Greek bronze originals; the positive casts, in small sections, were imported directly from Greece. Of the almost 300 fragments preserved, perhaps 24–35 are significant. Fragments from twelve originals have been identified. Many of the statues best known from Roman copies are represented: e.g. *Westmacott Athlete* of *Polyclitus, three *Wounded Amazons* associated with Ephesus. Yet, comparison between the casts and surviving copies reveals that Greek sculpture was rarely copied exactly. Moreover, variations exist between copies that were made at the same time. L-AT

Landwehr, C., *Die antiken Gipsabüsse aus Baiae: griechische Bronzestatuen in Abgüssen römischer Zeit*, DAI Forschungen 14 (1985).

BAKST, LEON (Lev) (c.1886–1925). Russian painter and stage designer. Bakst grew up in St Petersburg where he became a society painter, book illustrator, and interior decorator. He became famous with his designs for the theatre, particularly those for Diaghilev at the Ballets Russes between 1909 and 1921, introducing a new grandeur of scale, energy, and detail. He was particularly attracted to the exotic and drew on ancient Greece and the Orient in his designs. MF

Spencer, C., *Leon Bakst* (1973).

BALDACCHINO, or baldachin. Term in Christian church architecture for a canopy hung over an altar or sacred object, such as holy relics. These could take the form of permanent fixtures in a church, where they were either supported on columns (as in the case of the bronze baldacchino above the high altar at S. Peter's in Rome designed by *Bernini, with huge spirally twisted column supports), or else suspended from the ceiling, usually by ropes or chains. Alternatively they could be portable and were carried in processions above a reliquary. TJH

BALDINUCCI, FILIPPO (1624–96). Florentine art historian and connoisseur who, despite his turbulent and tormented character, his modest origins, and brief education, rose to prominence in artistic circles at the Medici court (see FLORENCE: PATRONAGE AND COLLECTING). He was adviser to Cardinal Leopoldo de' Medici (1617–75) and helped to form his collection of drawings. He also selected and bought pictures for Grand Duke Cosimo III. His main claim to fame is as author of the monumental *Notizie de' professori del disegno* (appearing in six volumes from 1681 to 1728), lives of artists from *Cimabue to his own time, which is valuable for the information he gives about 16th-century Florentine artists as well as his own contemporaries. He saw himself as a second *Vasari, and his passionate support of the supremacy of Tuscan painting, a theme dear to the Medici, involved him in bitter controversies. He had an expert's knowledge of techniques, and wrote the first history of engraving on copper (1686) (see PRINTS) primarily for the use of collectors, and the first dictionary of artistic terms. HL

Goldberg, E. L., *After Vasari: History, Art and Patronage in Late Medici Florence* (1988).

BALDOVINETTI, ALESSO (1425–99). Italian painter and mosaicist, a characteristic representative of the Florentine School of the second half of the 15th century. He inherited standards of economy in design and of scrupulous execution from *Domenico Veneziano and Fra *Angelico, though he lacked the imaginative powers of either. He had a taste for popular decorative devices, such as fruit, flowers, and brocades, which resulted in a curious and engaging blend of naivety and sophistication. His works include a *Sacra Conversazione* painted for the Medici villa at Cafaggiolo, an *Annunciation* (Florence, Uffizi), a ruined fresco of the *Nativity* in the forecourt of the SS Annunziata, and a *Madonna* now in the Louvre, Paris; the last two contain extensive background landscapes after the Flemish manner. He has also been credited with the *Portrait of a Lady in Yellow* (London, NG), a severe profile portrait with interesting technique and decoration which has become his best-known work.

From 1450 he worked as a decorator and mosaicist at the baptistery in Florence and became one of the leading mosaicists of his time. There is a mosaic by him of *S. John the Baptist* over the south door of the cathedral at Pisa (1467). His diary of commissions is one of the few that are known from the 15th century. PSt

Kennedy, R., *Alesso Baldovinetti* (1938).

BALDUNG, HANS, called Grien (1484/5–1545). Painter, draughtsman, printmaker, and designer of stained glass. Born of an academic family in Schwäbisch-Gmünd in south-west Germany, he entered *Dürer's workshop in Nuremberg c.1503 as a journeyman rather than apprentice (together with Hans *Schäufelein and, slightly later, Hans von *Kulmbach). While in Nuremberg, he painted two altarpieces for Halle (1507; Berlin, Gemäldegal.; Nuremberg, Germanisches Nationalmus.). By 1509 he was in Strasbourg, where he spent most of his working life, although his greatest extant work was executed in Freiburg (*Coronation of the Virgin*, 1512–16; Freiburg Cathedral). The most outstanding follower of Dürer, Baldung nonetheless did not share the latter's rational humanism but tended more closely towards northern mysticism. More than any other artist of the time, he expressed the period's

ambivalence towards sensuality: *woodcuts of witches' sabbaths, with their emphasis on the female nude, and small painted pictures on the theme of *Death and the Woman*, in which a naked woman is embraced by a half-skeletal Death (1517; Basle, Kunstmus.). In addition to altarpieces and small cabinet pictures, Baldung also painted portraits. Among his woodcuts, those of wild horses in the forest (1534) are almost certainly meant to allude to man's bestial passions, and his most famous print, *The Bewitched Groom*, combines the subject of horse and witchcraft to mysterious effect, aided by strong foreshortening derived from *Mantegna. KLB

Osten, G. von der, *Hans Baldung Grien: Gemälde und Dokumente* (1983).

BALEN, HENDRIK VAN (1575–1632). Antwerp painter of small cabinet pictures, often with multi-figured mythological scenes, which allowed him to display his nudes in paradisaical settings (*Wedding Banquet of Peleus and Thetis*, 1608; Dresden, Gemäldegal.). He went to Italy after becoming a free master in 1592/3, where he may have met the German painter Hans *Rottenhammer, whose work shows similar qualities. In Antwerp he ran a busy and successful workshop. He often collaborated with other artists, among them Jan *Brueghel I and II and Joost de *Momper. Among his pupils were van *Dyck and *Snyders; his daughter married Theodoor van *Thulden. KLB

Sutton, P., *The Age of Rubens*, exhib. cat. 1993 (Boston, Mus. of Fine Arts).

BALLA, GIACOMO (1871–1958). Italian painter, born in Turin. A visit to Paris in 1900 caused him to adopt Divisionism (see NEO-IMPRESSIONISM), which he passed on to *Boccioni and *Severini on his return to Rome. His conversion to *Futurism by *Marinetti in 1910 led him to produce paintings characterized by a strong sense of movement, exemplified by *Girl Running on a Balcony* (1912; Milan, Civica Gal. d'Arte Moderna), which shows the successive positions taken up by its subject's legs. From *c*.1912 he created works of great *abstraction, including *Abstract Speed: The Car has Passed* (1913; London, Tate), which nonetheless originated in observations of external reality. He remained associated with Futurism during the inter-war period, although his painting returned to a more naturalistic style. CJM

Lista, G., *Giacomo Balla* (1982).

BALTIMORE, WALTERS ART GALLERY, America's pre-eminent family-founded museum. Its extensive original holdings represent the achievements of two generations. The first was William Thompson Walters (1819–94) who moved from Pennsylvania to Baltimore in 1841. He prospered in the liquor business and then moved on to banking and railroads, so that he could dabble in the emerging art market. His taste was conservative, and he acquired American landscapes and European genre scenes, most notably *Gérôme's renowned *The Duel after the Masquerade*. With the outbreak of the Civil War, Mr Walters found it expedient to take his family to Paris. There, advised by another expatriate Baltimorean, George A. Lucas, he continued his collecting activities, assembling works by such living artists as *Millet, *Corot, *Meissonier, and especially the sculptor Antoine-Louis *Barye. Following his return to Baltimore Mr Walters opened his collection to the public in 1874 and built a picture gallery adjoining his house in Mt. Vernon Place.

When William Walters died in 1894, his son Henry (b. 1848) not only took over and expanded the family business but also became an even greater collector than his father. Purposely adding to its historical range, he extended the collection back to include *Ingres, as well as *Géricault and *Delacroix, and forward to incorporate the *Impressionists. However, he much preferred the old masters, and he began this pursuit in 1898 with van *Dyck's *Virgin and Child* formerly belonging to the Duke of Marlborough. He would also add single masterpieces by Hugo van der *Goes, *Veronese, and in 1900 the first *Raphael Madonna to come to America, but his greatest coup came in 1902 when in Rome he bought for $1 million the extensive collection of antiquities and paintings assembled by a minor papal official, Don Marcello Massarenti. Among the ancient marbles the highlight was a group of seven marble sarcophagi; and the collection of over 500 paintings ranges from the anonymous *View of an Ideal City* to pictures by *Strozzi, *Tiepolo, and *Panini. The Massarenti Collection also brought examples of other schools, including El *Greco, *La Hyre, and most notably *Heemskerck's gigantic *Panoramic Landscape*. To house his now much expanded collection, the younger Mr Walters acquired more land adjacent to his father's home in Baltimore and commissioned the architect William Adams Delano to design a suitable museum, modelled after a Genoese *palazzo*, which opened in 1909. In addition to paintings Henry Walters also loved precious objects, bronze sculpture, and above all, like his friend J. Pierpont Morgan, rare illuminated manuscripts. The collection includes the 13th-century Italian Conradin Bible, the Flemish Beaupré Antiphonary, and Simon *Bening's Stein Quadriptych of *c*.1530.

On his death in 1931 Henry Walters bequeathed his entire collection, the museum building, and his private home to the city of Baltimore. Additional acquisitions in all fields have continued. EZ

Johnston, W. R., *The Nineteenth Century Paintings in the Walters Art Gallery* (1982).

Zeri, F., *Italian Paintings in the Walters Art Gallery* (1976).

BAMBOCCIANTI, a group of mainly Dutch artists, working in Rome, who took their name from their leader, Pieter van *Laer, who was dubbed 'Bamboccio' (clumsy doll or puppet). In the early 1630s his small pictures of Roman street life, which *Passeri compared to an 'open window' onto everyday reality, introduced a new type of genre. His followers, among them *Cerquozzi, *Miel, Jan Lingelbach (1622–74), and *Sweerts, developed favourite themes; they painted rustic taverns, limekilns, travellers attacked by brigands, street vendors, charlatans, and carnivals. Their vision is poetic, and their pictures of a contented peasantry were popular with noble Italian collectors, while their portrayal of a picturesque Italian life held a romantic appeal for northern Europe. Much of its effect, as in Jan *Both's *Street Scene with the Colosseum* (Amsterdam, Rijksmus.), depends on the contrast between a trivial and fleeting moment from contemporary life, and the crumbling grandeur of ancient Rome. Classicizing artists, such as *Reni, *Sacchi, and *Rosa, deeply resented the popularity of such low subjects. HL

Briganti, G., Trezzani, L., and Laureati, L., *I Bamboccianti: The Painters of Everyday Life in 17th-Century Rome* (1983).

BANDINELLI, BARTOLOMMEO (or Baccio) (1493–1560). Florentine sculptor and draughtsman whose bellicose temperament and career is among the best documented of his period thanks to the accounts of *Vasari, *Cellini, and his own *Memoriale*. Trained as a goldsmith by his father, Bandinelli enjoyed the continuous patronage of the Medici family. His first commissions included a pompous *Orpheus and Cerberus* (1519; Florence, Palazzo Medici) and a copy of the *Laocoön (*c*.1520–2; Florence, Uffizi). His crude sculptural skills and taste for the colossal are best illustrated by the *Hercules and Cacus* (1527–34; Florence, Piazza della Signoria), carved as a challenge to *Michelangelo, but the object of ridicule from the moment of its unveiling. He carved the tombs of Leo X and Clement VII (1536–42; Rome, S. Maria sopra Minerva), and the monument to Giovanni delle Bande Nere (1540–54; Florence, Piazza S. Lorenzo). The marble reliefs for the choir of Florence Cathedral (1547–55) are attractively designed and demonstrate his linear skills, while the *Dead Christ Supported by Nicodemus* (1534–54) for his own memorial chapel in SS Annunziata, Florence, is his most successful sculptural group. Bandinelli's academy played an important role in training younger artists in

carving, bronze-casting, and drawing skills. AB

Ward, R. (ed.), *Baccio Bandinelli 1493–1560: Drawings from British Collections*, exhib. cat. 1988 (Cambridge, Fitzwilliam).

BANKS, THOMAS (1735–1805). English sculptor. He trained with Peter *Scheemakers and in 1772 won a scholarship from the Royal Academy to study in Rome. He remained in Italy until 1779, absorbing the emotionally charged *Neoclassicism prevalent in *Fuseli's circle and learning Italian marble-carving techniques. His highest ambition was to produce gallery sculpture. But even in Rome he found it hard to sell such works as *Achilles Arming* (London, V&A). In London he had to turn to less elevated work such as portrait *busts and chimney pieces. A journey to St Petersburg in 1781 to search for major commissions was not a success, but on his return to London he began to receive a steady stream of commissions for *funerary monuments. Among them is the touching memorial to Penelope Boothby (1793; Ashbourne, Derbys.) and the magnificent tombs of Capt. Richard Burgess (1802) and Capt. Westcott (1802–5) in St Paul's Cathedral. Had circumstances in Britain been more encouraging to ideal sculpture Banks's seriousness of purpose, his technical excellence, and his intense style might have made him one of the great sculptors of European *Neoclassicism. MJ

Bell, C. F., *Annals of Thomas Banks* (1938).
Whinney, M., *Sculpture in Britain 1530–1830* (rev. edn., 1988).

BARBARI, JACOPO DE' (1460×70–before 17 July 1516). Venetian painter and printmaker active from c.1497. He was a most original artist whose work shows the influence of Alvise *Vivarini, with whom Barbari probably trained in Venice in the 1490s, Andrea *Mantegna, the residual use of whose parallel hatching can be seen in Barbari's woodcuts, and Albrecht *Dürer, in his use of curvilinear modelling to render the nude. His earliest dated work is his celebrated *View of Venice* of 1500, an enormous bird's-eye view of the city (12 extant copies, e.g. London, BM; original blocks in Venice, Mus. Correr). It was published by the Nuremberg merchant Anton Kolb, through whom it is likely that Barbari became court artist to Emperor Maximilian I in 1500. Between 1503 and 1506 Barbari was in the service of Friedrich III, Elector of Saxony, and thereafter in the Netherlands at the court of Philip of Burgundy. Most of his paintings date from his residence in Germany, including *Still Life with a Dead Partridge* (1504; Munich, Alte Pin.), a *trompe l'œil* and the earliest known independent still life of the Renaissance. He influenced van *Orley, *Cranach the elder, *Altdorfer, von *Kulmbach, and *Gossaert. Nearly all his works are signed with a caduceus (a herald's staff). OI

Schulz, J., 'Jacopo d' Barabari's *View of Venice*: Mapmaking, City Views and Moralised Geography before the Year 1500', *A. Bull.* 60 (1978).

BARBERINI FAUN, marble statue (Munich, Glyptothek) of a handsomely muscular satyr sprawled asleep on a rock in an openly erotic pose: his identity is revealed by pointed ears, tail, ivy wreath, and pantherskin. The statue masterfully conveys the abandoned relaxation of one heavily asleep under the influence of wine, reversing its subject's habitual predatory sexuality as he himself unwittingly provides an arousing sight. The baroque style and fine workmanship suggest a *Hellenistic original of c.200 BC, if not a Roman replica. Discovered in Rome before 1628, it was acquired by Cardinal Francesco Barberini, nephew of the reigning Pope Urban VIII, and restored by *Bernini, among others. Much admired thereafter, it was keenly sought by various collectors and purchased by Ludwig of Bavaria in 1814. The statue's mystique was enhanced by its reported findspot, Castel S. Angelo (Hadrian's Mausoleum) in Rome, whence, Procopius reports, besieged Romans hurled statues onto the Goths in 537, a service which may have cost the Faun his limbs. MBe

Haskell, F., and Penny, N., *Taste and the Antique* (1981).

BARBIERI, GIAN-FRANCESCO. See GUERCINO.

BARBIZON SCHOOL, a group of 19th-century French painters who took their name from a village on the edge of the forest of Fontainebleau. Painters began to use Barbizon in the 1820s and Pierre-Étienne-Théodore *Rousseau—generally seen as the central figure of the group—regularly worked there from 1836. The other leading members of the school were *Diaz, *Daubigny, and Constant Troyon (1810–65). The group's fortunes fluctuated but by the time the leading members died in the 1860s and 1870s they had all won official recognition and their work was popular with the nouveau riche clientele that French economic expansion had produced.

The Barbizon painters were a loose group and several of them, such as Diaz, were happy to turn their hands to many genres. They were, however, united in rejecting the classicizing idea of landscape prescribed by the French academic hierarchy, and in concentrating on simple French rural images, usually without much staffage. All this led to Rousseau's notorious exclusion from the *Salon, where he did not show between 1836 and 1849. Formally, the group owed much to the naturalism of *Constable, *Bonington, and Dutch 17th-century landscape. There was, however, a great difference between, for example, Rousseau's massively deliberate forest scenes and the spontaneous effects that Daubigny pursued from his studio boat on the Seine and the Oise. They all worked extensively en *plein air* but their exhibition pictures were usually worked up in the studio.

In general, the Barbizon painters had a *Romantic view of timeless nature, quite different from the consciously modern eye of the *Impressionists, and this touched a popular mood. By the late 1840s the forest of Fontainebleau was packaged as a romantic tourist attraction and it was flooded by city-dwellers taking the short train-ride from Paris.

Two of the biggest names associated with Barbizon had aims that lay apart from the group as a whole. *Millet was the only significant painter to make his permanent home at Barbizon, where he lived from 1849, but he made his colossal reputation not with landscape but with message-burdened peasant scenes set in the featureless plain to the west of the village. *Corot made naturalist studies of the forest in the early 1820s and was involved with the group in the 1830s, but his art moved towards a highly personal amalgam of nostalgic reverie and Neoclassicism. Corot's visits to Italy also set his work apart from that of the Barbizon painters, who all stayed determinedly in France. AJL

Adams, S., *The Barbizon School and the Origins of Impressionism* (1994).

BARENDSZ., DIRK (1534–92). Netherlandish painter. After an early training with his father in Amsterdam, he travelled to Italy in 1552, visiting Rome and Venice. Venetian painters such as *Titian, with whom he may have worked, and Jacopo *Bassano had the greatest impact upon Barendsz. On his return to Amsterdam by c.1562, he became one of the earliest artists to introduce to the Netherlands the rich colours and painterly brushwork of Venetian painting. This can clearly be seen in a major work *Triptych with Adoration of the Shepherds* (1566; Gouda, Stedelijk Mus.). His surviving work is rare, but shows that besides his religious work, much of which must have perished due to the later iconoclasm in the Netherlands, he was an early and accomplished painter of group portraits such as *Fourteen Crossbowmen of Company G* (1562; Amsterdam, Historical Mus.). Here the natural skin tones, modelling, and characterization of the heads are particularly skilful and show a continuing Venetian influence. Barendsz. also provided designs for engravers such as *Goltzius. For the engraver Jan *Sadeler I he designed some unusual chiaroscuro sketches in oil for a series of the

Passion (various collections). CFW

Judson, J. R., *Dirck Barendsz. 1534–1592* (1970).

BARLACH, ERNST (1870–1938). German sculptor and writer. Born in Holstein, Barlach studied in Hamburg (1888–91), Dresden (1891–5), and at the Académie Julian in Paris (1895–6). Barlach, who was originally active as a ceramicist, discovered his personal style and subject matter during a visit to Russia in 1906 after which he carved and modelled expressionistic sculptures of peasants, beggars, and allegorical figures typified by planar angularity, dynamic movement, simplification, and intensity, as in the fierce, agitated *Avenger* (1914; London, Tate). His dynamism has affinities with the work of the *Futurists which he admired in Florence in 1909 and his subjects and linearity owe a debt to German *Gothic examples, particularly in his emotionally powerful woodcut illustrations. His Expressionist play *The Dead Day* (1912) was illustrated with his own lithographs. Barlach lived in Berlin 1905–10 where he was associated with the artists of the Berlin *Sezession, exhibiting with them from 1907. In 1910 he moved to Güstrow, which was to remain his home, where, after the First World War, he executed one of a number of memorials, *The Angel of Death* (Güstrow Cathedral), for which his austere yet dramatic style was well suited. It was dismantled in 1938 when his art was declared degenerate by the Nazi regime but subsequently restored. JH

Werner, A., *Ernst Barlach* (1966).

BARNA (DA SIENA) (active *c*.1330–50). Supposed Sienese painter, whose existence is based on conflicting passages in *Ghiberti's *Commentarii* and *Vasari's *Vite*, and who may be the artist Berna Bertini cited in a document of 1340.

The core of the works generally attributed to him is the fresco cycle of the *Infancy and Passion of Christ* in the Collegiata of San Gimignano, probably dating from the middle of the century. While anatomical and spatial description is often minimal, the overall narrative organization and pace of the scenes is dramatic, culminating in the powerful *Crucifixion* which takes up the main space of an entire bay.

Stylistic variation could support the view that the scheme, and panels associated with it, are collaborative works produced by Lippo *Memmi's circle after *Simone Martini left for Avignon in 1334–5. The combination of simplicity of design with dramatic effects of scale and gesture which is associated with the group, workshop, or individual known as Barna can be seen in the panel of the *Carrying of the Cross* (New York, Frick Coll.) MS

Martindale, A., *Simone Martini* (1988).
Ventroni, D., *Barna da Siena* (1972).

BARNABA (AGOCCHIARI) DA MODENA (active 1361–83). A native of Modena who resided in Genoa and dominated its painting till around 1420, notably through his follower Nicolò da Voltri. Barnaba's style shows as much influence of Sienese taste and style as of local Emilian art. His work is characterized by a series of half-length Madonnas, often on a large scale and notable for the chrysography of Mary's mantle, her full features and sweet expression. Particularly fine is the *Madonna* in Frankfurt (Städelsches Kunstinst.), signed and dated 'barnabas de mutina pinxit in Janua. mccclxvii'. Most later examples show Mary breastfeeding a wide-eyed child. A complete polyptych of *S. Bartholomew* survives in Genoa (S. Bartolomeo del Fossato). His three works in Pisa are probably all late commissions, though his style is very consistent throughout. His majestic narrative idiom is demonstrated in *Pentecost* (London, NG) and *The Coronation of the Virgin; The Trinity; The Virgin and Child; The Crucifixion* (4 scenes and a predella; (London, NG). RG

Davies, M., *The Early Italian Schools before 1400*, rev. D. Gordon (1988).

BARNARD, GEORGE GREY (1863–1938). American sculptor, an independent, original, and controversial figure. He was born in Bellefonte, Pennsylvania, and after studying briefly at the Art Institute of Chicago he moved to Paris in 1883. After years of hardship there he had a sensational success with his over-life-size marble group *Struggle of the Two Natures in Man* (New York, Met. Mus.), when it was exhibited at the Salon de la Nationale in 1894. In the same year he returned to the USA (against the advice of *Rodin, to whom his vigorous style was much indebted) and settled in New York. Initially he made little impact there, but in 1902 he received the largest commission given to an American sculptor up to that date—a vast scheme of allegorical decorations for the Pennsylvania State Capitol at Harrisburg. He returned to France to work on this. In 1906 there was a scandal in Harrisburg over misuse of public funds, bringing payment to Barnard to an end, but he continued the project at his own expense and it was unveiled—on a much smaller scale than originally envisaged—in 1911. His final major work was a bronze statue of *Abraham Lincoln*, set up in Lytle Park, Cincinnati, in 1917. It caused a furore; Barnard had attempted to show the national hero as an ordinary man in deep thought, but some thought it made him look like a 'dishevelled dolt' and Lincoln's son described the statue as 'grotesque and defamatory'. However, it also had strong supporters, including the former President Theodore Roosevelt, who said, 'The greatest statue of our age has revealed the greatest soul of our age.' During his many years in France Barnard made a superb collection of medieval art; this was bought for the Metropolitan Museum, New York, in 1925 and forms the basis of its out-station, The Cloisters, opened in 1938. Barnard devoted his final years to a visionary project for a colossal Rainbow Arch (to be dedicated to the mothers of war dead), which he hoped to erect near The Cloisters. IC

BAROCCHETTO, term describing a mainly Roman style of late 17th- and early 18th-century painting and sculpture. It falls between *Baroque and *Rococo, and is characterized by open compositions and flowing drapery patterns, and by a high-keyed palette of rose, pale green, violet, and pink; less powerful than the Baroque, it has a new tenderness and grace. The style is displayed in the decorative sculpture ensemble in S. John Lateran, Rome (early 1730s). HL

BAROCCI, FEDERICO (*c*.1535–1612). Italian painter, draughtsman, and occasional printmaker who trained in Urbino. His principal patron was Duke Francesco Maria II della Rovere. In the mid-1550s he went to Rome and returned there again in 1560, when he decorated a ceiling for the Casino of Pius IV in the Vatican gardens. He went back to Urbino, having studied *Raphael and the Roman *Mannerist style practised by the *Zuccaro family. From this time onwards he painted mainly religious works which combine the influence of *Correggio and Raphael in an individual and sensitive manner. His *Deposition* (1567–9; Perugia Cathedral) is a highly emotional interpretation, proto-Baroque in its unity of action and expression. Many of his paintings in the next two decades are crowded Mannerist compositions with spiralling movement within a restricted and sometimes ambiguous spatial structure—for instance the *Vision of S. Francis* (*c*.1577; Urbino, S. Francesco), with its unreal two-tier design and precariously posed central figure, and the *Madonna del popolo* (1579; Florence, Uffizi). At other times, for instance in the relatively early intimate *Madonna with the Cat* (before 1577; London, NG) or the altarpiece of the *Circumcision* (1590; Paris, Louvre), Barocci achieves more naturalistic effects, enhanced by a *sfumato* which brings a soft tonal unity to the design and reinforces the dramatic impact. In his final works Barocci became boldly experimental, moving in the direction of the Baroque and finally freeing himself from the persistent influences of Roman Mannerist artifice. The *Madonna del rosario* (*c*.1593; Senigallia, Palazzo Vescovile), the *Blessed Michelina* (*c*.1606; Vatican Mus.), the *Crucifixion* (1604; Madrid, Prado), with its remarkable background showing the city of Urbino, and the *Assumption of the Virgin* (priv.

coll.) radiate a new intensity of intimate mystical experience that seems highly personal. Barrocci was a prolific draughtsman, using his life studies to explore all aspects of his paintings, including light, colour, and perspective, as well as to establish poses and articulate draperies. He often worked on blue paper with coloured pastels and sometimes made oil sketches of individual heads.　HB

Emiliani, A., *Mostra di Federico Barocci*, exhib. cat. 1975 (Bologna, Mus. Civico).
Emiliani, A., *Federico Barocci* (1985).
Pillsbury, E., and Richards, L., *The Graphic Art of Federico Barocci: Selected Drawings and Prints*, exhib. cat. 1978 (Cleveland, Mus. of Art).

BAROQUE. *See overleaf.*

BARRET, GEORGE (1728×32–84). Hiberno-British landscape painter, born and trained in Dublin. He worked first for the Earl of Miltown at Russborough House, Co. Wicklow, and consolidated his reputation with views of other locations outside Dublin, such as Powerscourt and Castletown. In 1763, he moved to London where he was equally successful with English aristocratic patrons, notably the dukes of Portland and Buccleuch. In 1768, he became a founding member of the RA. Barret's style, whether in views of country estates or scenes in the Lake District and north Wales, was a watered-down, less refined, and more easily assimilable version of Richard *Wilson's. Several of Barret's children were also painters, especially George Barret Jr. (1767–1842), who was chiefly a watercolourist.　MK

Crookshank, A., and the Knight of Glin, *The Painters of Ireland 1660–1920* (1978).

BARRY, JAMES (1741–1806). Irish painter. Born in Cork, he moved to Dublin in 1763 where he met Edmund *Burke who encouraged him to travel to London and financed Barry's continental studies 1765–71. After ten months in Paris he arrived in Rome and was overwhelmed by the beauty of *Antique art and the *Renaissance masters. He returned to London in 1771 when his *Temptation of Adam* (Dublin, NG Ireland) was exhibited to acclaim at the RA. Success seemed assured when he was elected an Academician in 1773 but in order to achieve his ambition to paint elevated works with universal moral messages Barry undertook a cycle of vast pictures *The Progress of Human Culture* (1777–85; London, Royal Society of Arts) for the Society of Arts. This was barely remunerative and he supported himself by the sale of prints. The paintings were greatly admired and he was appointed professor of painting at the RA in 1782, until his expulsion, for slander against Academicians, in 1799. His paranoia, aggressiveness, and arrogance militated against financial success and from 1788 he lived in extreme squalor.　DER

Pressly, W., *The Life and Art of James Barry* (1981).

BARTHES, ROLAND (1915–80). French theorist. His writings of the 1950s and 1960s, alongside those of the anthropologist Claude Lévi-Strauss, prompted an international enthusiasm for *structuralism, thanks to their literary flair and conceptual elegance. This structuralism was primarily derived from the linguistic semiology of Ferdinand de Saussure, which distinguishes *parole*, the unit of meaning, from *langue*, the encompassing structure which makes meaning possible. Barthes's essays in *Mythologies* (1957) expanded such an approach to cover the surfaces and artefacts of contemporary culture, exploring the codes of signification behind films, photographs, car design, etc.: his interests in mass imagery coincided with those of *Pop art, and his analyses of ideological assumptions stimulated some Conceptual art of the 1970s and 1980s. Barthes's later writings shifted from an emphasis on underlying structures of signification, towards an acknowledgement that the viewer or reader may himself construct a constellation of meaning from an open-ended 'galaxy of signifiers'. In the light of this new 'post-structuralist' approach, he wrote in *Image, Music, Text* (1977) about 'The Death of the Author', insofar as the writer cannot determine the meanings taken from the text he produces. Barthes returned eloquently to his discussion of photography in *Camera lucida* (1980).　JB

Culler, J., *Barthes* (1983).

BARTOLO, SEBASTIANO DI. See MAINARDI, BASTIANO.

BARTOLO DI FREDI CINI (active 1353–1410). Member of a family of Sienese painters and father of Andrea di Bartolo, he ran a successful practice in Siena and its subject towns. He also held a number of civic offices in Siena.

Frescoes in San Gimignano display his eclecticism; his scenes from the life of the Virgin (S. Agostino) appear to be influenced by Lippo *Memmi, and the Old Testament cycle (1367) in the Collegiata by the work there associated with the name *Barna da Siena. The *Presentation in the Temple* altarpiece, also for S. Agostino (Paris, Louvre), shows his continuation of Ambrogio *Lorenzetti's narrative style, but considerably flattened and more decorative, a development typical of the second half of the century.

The complex, ornate *Coronation of the Virgin* polyptych for S. Francesco, Montalcino (1388; dismembered, now various collections) combined extensive, detailed narrative on the wings, pinnacles, and *predella with a central visionary effect created by linear rhythms and harmonious colour transitions. Perhaps his most attractive features are his individualized figures, and animated scenes set against a combination of gold and warm tones.　MS

Harpring, P., *The Sienese Painter Bartolo di Fredi* (1993).
van Os, H. W., 'Tradition and Innovation in some Altarpieces by Bartoli di Fredi', *Art Bulletin*, 67 (1985).

BARTOLOMEO VENETO (active 1502; d. 1531). Italian painter who worked in the Veneto and Lombardy. He specialized in small devotional works and portraits. Much of what is now known about him is based on the inscriptions, dates, and signatures of his surviving pictures. His earliest known painting, a *Madonna and Child* of 1502 (last recorded in Venice, priv. coll.), carries an inscription with his name and the detail that he was half-Venetian, half-Cremonese. His first works are influenced by Gentile and Giovanni *Bellini, and Bartolomeo's early style, therefore, is characterized by tightly painted forms articulated by crisp modelling and sharp outlines, and a widespread attention to detail. From the mid-1510s he was based mostly in Lombardy, where he worked predominantly in the field of portraiture. His portrait of *Ludovico Martinengo* (1530; London, NG) displays an interest in rich surface textures and elaborate costume details, as well as a *Leonardesque awareness of the psychology of the sitter.　FB

BARTOLOMMEO, FRA (Baccio della Porta) (1472–1517). Florentine painter, a key figure in the development of the High *Renaissance style. He was trained in the studio of Cosimo *Rosselli, where *Piero di Cosimo was the senior assistant, but his own work of the 1490s, such as the *Madonna and Child with S. John the Baptist* (New York, Met. Mus.) or the *Last Judgement* (Florence, S. Marco), shows a greater affinity with *Leonardo da Vinci. Inspired by the preaching of Savonarola, he entered the Dominican order in 1500 and renounced painting. This affected both the *iconography and the spirit of his subsequent work. On his return in 1504 he was commissioned by Bernardo del Bianco to paint an *altarpiece for the Badia in Florence. Instead of a conventional *sacra conversazione, Fra Bartolommeo produced the *Vision of S. Bernard* (Florence, Uffizi), shifting the orientation of the scene and emphasizing transcendental qualities through the emotional responses of the figures. From 1504 to 1509 he developed in parallel with *Raphael, each artist contributing to the High Renaissance concept of a dynamic yet unified altarpiece. After Raphael's departure Fra Bartolommeo and his partner *Albertinelli

continued on page 51

· BAROQUE ·

PROPERLY, Baroque is the leading style in art and architecture of the 17th and early 18th centuries. Loosely extended, stylistically, to music and other arts and crafts of that period and to the date bracket *c.*1600–1750, it is primarily the style of *Caravaggio, the *Carracci, *Rubens, Frans *Hals, *Velázquez, Pietro da *Cortona, *Gaulli, *Giordano, and *Thornhill, of *Rembrandt's earlier paintings, and the sculpture of *Bernini and *Puget. When late 19th-century historians and critics sought to identify, characterize, and explain styles as entities, it was both logical and convenient to look for a consistent character in the whole culture of any period: Baroque was the obvious name for the art produced between the late *Renaissance and ¹Neoclassicism. Wherever historical styles are discussed or differentiated the concept remains useful, although recent scholarship has broadened and modified it. Distinguishing early, high (*c.*1625–75), and late Baroque now seems needlessly artificial, but the paradoxical notion of *Baroque classicism*, including such diverse artists as *Poussin, *Claude, *Sacchi, *Algardi, Jacob van *Ruisdael, *Vermeer, and the late Rembrandt, is realistic and takes account of the rich variety of pictorial imagination which the Baroque era inherited and further developed from Renaissance theory and practice.

Baroque art addresses the beholder's senses, and thereby the emotions as much as the intellect. Forms, actions, and compositions are to be taken in at first glance, however long the eye may linger thereafter over details. However laborious the preparation, however permanent the material, the work suggests one instant, as if in the next moment all would have changed. Appearances take precedence over essences: things not as they are but as they *seem to be*. However, although the appearance of reality is usually a means in Baroque art, actual illusionism is seldom the end: most paintings unequivocally remained coloured surfaces, just as the magical actuality of Bernini's figures is inseparable from the physical qualities of marble. Baroque decorative painters were skilled in *trompe l'œil* architecture, but they did not invent it.

The etymology of the term is obscure—and some of it fanciful—but for the history of art what is important to note is that *baroque* entered the language of art as a term of abuse, rather than the name of a style, when in 1755 *Winckelmann, mindful of 'pearls and teeth of unequal size', applied it to certain aspects of a recently outmoded taste. Neoclassical writers soon extended it to anything bizarre, ridiculous, or excessive in the art of the preceding era, most often in architecture and particularly that of Borromini; it can still be found as a more general—and sometimes abusive—synonym for a florid style. But when, a century after Winckelmann, the Renaissance historian *Burckhardt found aspects of *Michelangelo's architecture both baroque and unintelligible, Baroque was still not seen as a coherent historical style: Burckhardt still accepted and categorized painters like Caravaggio and the Carracci as 'modern, partly eclectic, partly naturalistic'.

*Bellori wrote in 1672 of Annibale Carracci as 'the renewer and the principal of art, restored and raised anew by him to life in '*disegno e colore*'. Although Bellori's theoretical bias implies a contrast between the studious Annibale and the maverick Caravaggio, who admitted to no teacher but Nature, earlier critics including the Roman patron Vincenzo Giustiniani (1564–1637), who wrote a series of discourses on the visual arts, gave equal honours to both artists. Perceptive contemporaries indeed recognized both painters as leaders and reformers of an art which reconciled, rather than opposed, *disegno* and *colore*, *maniera* and nature, essence and appearance, reason and intuition.

Such antithetical pairs are rooted in the diversity of human vision, thought, and behaviour, and they underlie the fundamental critical studies of the Baroque by Heinrich *Wölfflin (see also ART HISTORY AND ITS METHODS). In Wölfflin's youth the norms of artistic excellence were the *Antique and the Renaissance; other periods were considered somehow inferior, their study exciting but intellectually risky. His concern was not to identify the conditions or trace the events that brought the style into being, but to elucidate its character by the formal analysis of individual artefacts. In his first book, *Renaissance und Barock* (1888), he looked not at painting but at architecture of the 'late Renaissance'; subsequently, in *Kunstgeschichtliche Grundbegriffe* (1915), Wölfflin sought, by careful comparison of selected pairs of images, to exemplify what he termed the 'double root of style'. In *Renaissance und Barock* he had introduced—albeit into architectural criticism—the general concept of 'painterly' (*malerisch*) and its opposite, *linear*.

Painterly is probably the most important of the terms Wölfflin introduced in connection with the style; it is certainly the most used and the most misused. In Wölfflin's sense it implies not only the fluidity of the oil sketch or the clay *bozzetto* but more generally the freedom of the brush stroke as against the restrictions of the pen or the graver. It implies *colore* in the sense of tones as well as hues; it also implies the representation of things 'as they seem to be'. It involves the suggestion, or the sensation, of movement, be it in light and shade, in composition, in actions, or in the brushmarks themselves; movement implies change or impermanence, and subsequent critics termed Baroque an art of becoming (*werden*). While Wölfflin understood that no single set of principles could encompass the variety of the period, his book came to be seen (especially after translation into English) as a guide to the understanding of Baroque as a style of movement, transience, immediacy, and sensory appearance.

It is significant that Wölfflin began with architecture: the conditions which produced the Baroque are easier to trace in an art of abstract forms than in one of representation in which we normally perceive medium and message simultaneously. From later studies these conditions can be codified as (1) the existence of an established and accepted formal language whose vocabulary, syntax, and range of expression were generally familiar; (2) the Renaissance conception of the ideas and artefacts of ancient Greece and Rome—'the Antique'—as a diverse but homogeneous package; (3) the Renaissance belief in a system of aesthetic rules, actually or supposedly based largely on the precedent and authority of the Antique; (4) what we know as the Western concept of individual personality and liberty, which entitles the artist to follow, adapt, or disregard earlier prototypes at will; (5) the extreme consequences of these ideas in *Mannerism, in which rules or a 'manner' could be followed exclusively, or alternatively all rules could be subverted or rewritten at will; (6) an attempt to reconcile and synthesize the Mannerist extremes with the underlying *'classical' principles well understood—although not formulated—at the time.

For the fine arts the conditions could not be identical: the reconstruction of the Antique was based on other kinds of evidence or supposition, although the human body was seen as the basis of both art and architecture. On the other hand, technical discoveries—the optical laws underlying *perspective and the invention of oil painting—made it possible for the first time to represent a pictorial world comparable to, but distinct from, the world of reality; thus *Vasari could define painting as 'nothing but the imitation of all the living things in Nature with *disegno* and *colore*'. The conjunction of all these conditions in the late 16th century was unique; thus, although late Graeco-Roman art shows similar qualities of realism, expression, and movement, no equivalent of the Baroque did, or could, exist in Antiquity.

The generation after Wölfflin made great advances in understanding. Detailed study of both artefacts and original written sources moved the watershed from c.1550 to c.1590 in Italy, somewhat later beyond the Alps. Increasingly during the 1920s scholars tried, abandoning formalist criticism, to enhance understanding of 17th-century art through its social, economic, and political context and the study of patronage. Their success was limited, if for no further reason than that interdisciplinary studies of this kind depend heavily on generalizations which become unsustainable in the face of individual examples; as Nikolaus Pevsner wrote in 1928, 'few periods leave such an impression of complexity and diversity'. Seventy years on, it is clear that in the post-Renaissance world aesthetic considerations were factors for change as significant as the political and demagogic usefulness of the arts. Towards the end of the 16th century the decline of *maniera* as an ideal, and the renewed study of nature in all its aspects were common to religious and secular, private and public art alike. As Pevsner showed in 1925, neither the doctrinal and moral reforms of the Council of Trent in general nor the rhetoric and missionary evangelism of the Society of Jesus in particular can be tied to the establishment of the Baroque.

However, the new style was not formed in a cultural vacuum. The regeneration of Rome as the papal capital, begun in the 15th century, was completed during the 17th, as the city became the centre of the art world for artists, patrons, and collectors alike. There the artistic optimism of critics like Giustiniani (and half a century later, in retrospect, of Bellori) coincided with the second, optimistic and expansionist phase of the Catholic Counter-Reformation and the realization by rulers, both religious and secular, that an art that was not only both naturalistic and expressive but also elegant and technically brilliant could be used to convey many kinds of message to all sorts and conditions of people. This was true both of absolute monarchies like France and of republics like Venice and the Netherlands. Rubens worked for the Spanish viceroys in Brussels and other princes, but also for the burghers of Antwerp. Rembrandt's dramatic religious pictures were for Protestant collectors, not for Catholic churches. In England Thornhill's decoration of the great hall of Greenwich Hospital exhibits all the devices of full Baroque allegory, but its subject is the triumph of liberty in the bloodless revolution that made Great Britain a constitutional monarchy. KD

Martin, J. R., *Baroque* (1977).
Pevsner, N., 'The Counter-Reformation and Mannerism' (German orig. 1925); 'Early and High Baroque' (German orig. 1928), in N. Pevsner, *Studies in Art, Architecture and Design*, vol. 1 (1968).
Wittkower, R., *Art and Architecture in Italy 1600–1750* (1958).
Wölfflin, H., *Principles of Art History* (1932; German orig. 1915).
Wölfflin, H., *Renaissance and Baroque* (1964; German orig. 1888).

received some of the most important commissions in Florence, including the *Mystic Marriage of S. Catherine* for S. Marco (1511; Paris, Louvre) and the Ferry Carondolet altarpiece (1513; dispersed; main panel Besançon Cathedral), works which demonstrated their repertoire of complex, idealized figures in rhythmic compositions. Visits to Venice (1508) and Rome (1513) gave Fra Bartolommeo experience of current work by Giovanni *Bellini, *Michelangelo, and Raphael. Although responsive to these new influences he continued to reveal a distinctive manner of considerable originality right up to the time of his final work the *Noli me tangere* fresco at the hospice of Le Caldine, near Florence. His influence persisted mostly in Florence where his large corpus of *drawings was much admired and copied by later artists. PSt

BARTSCH, ADAM VON (1757–1821). Austrian engraver, museum administrator, and writer, primarily remembered for his substantial contributions to the critical study of *prints. Having first worked as a librarian in the Imperial Library, Vienna, he was appointed keeper of the imperial print collection in 1791. For the rest of his life he applied himself to the enlargement of this collection, focusing in particular on the acquisition of early prints, especially German. Between 1803 and 1821 he published his monumental *Peintre graveur* (21 vols.), a critical print catalogue which still provides the model for such works. AT

BARYE, ANTOINE-LOUIS (1796–1875). French sculptor of animals (*animalier*), whose works combine rigorous attention to naturalistic detail with a Romantic humanization of emotion. Barye was a contemporary of *Delacroix and Berlioz and one of the great sculptors of French *Romanticism. Though he had a conventional academic training, which he supplemented with studies of living and dissected animals in the Paris Jardin des Plantes, his aim was to depict the grandeur and savage nobility of the natural world and, by transference, the extremes of human emotion. He sometimes worked on a large scale, as with *Lion Crushing a Serpent* (Paris, Louvre), which was bought by King Louis-Philippe in 1836. But he preferred his small-scale bronzes, which include many groups with titles like *Python Killing a Gnu* (c.1834). Barye's models were reproduced in bronze editions in his own workshops using the lost-wax method (see CASTING). He also made more conventional monumental sculptures, including allegorical groups for Napoleon III's rebuilt Louvre and an equestrian statue of *Napoleon I* for Ajaccio in Corsica. MJ

Benge, G. F., *Antoine-Louis Barye: Sculptor of Romantic Realism* (1984).

Pivar, S., *The Barye Bronzes: A Catalogue Raisonné* (1974).

BASCHENIS, EVARISTO (1617–77). Italian painter who introduced a new type of *still-life picture. Ordained a priest at an early age, he probably always lived at Bergamo. He painted some kitchen scenes, but most of his works, such as *Still Life with Musical Instruments and a Statuette* (Bergamo, Gal. Accademia Carrara), show musical instruments, globes, small sculptures, books, pieces of fruit, arranged on tables covered with carpets; they are meditative, intensely poetic pictures, which unite a detailed surface realism with geometric forms and a complex analysis of space. Their sources lie in *Renaissance intarsia and in 16th-century treatises on *perspective, and they suggest the influence of the north European *vanitas painting. A turning globe, a spent candle, dust on the backs of instruments, evoke the passage of time. His early works were simply composed, but he moved towards an increasing richness and complexity and more brilliant colour. Immensely popular with cultivated collectors, Baschenis ran a studio which produced repetitions and variants of his works. HL

Rosci, M., 'Evaristo Baschenis', in *I pittori bergameschi dal XIII al XIX secolo: il seicento*, vol. 3 (1985).

BASELITZ, GEORG (1938–). German painter, printmaker, draughtsman, and sculptor, born at Deutschbaselitz, Saxony. He began his training in East Berlin, but moved to West Berlin in 1956 and studied at the Academy. It was at this time that he gave up his original surname, Kern, and adopted a name derived from his place of birth. In the 1960s he became controversial for producing deliberately crude paintings that give him a place as one of the pioneers of Neo-Expressionism. The most notorious of these pictures is *The Great Piss-up* (also called *Big Night down the Drain*, 1962–3; Cologne, Ludwig, Mus.); it shows a man, with an enormous, lewdly displayed penis, and the painting was seized by the police when it was first shown in Berlin in 1963. Baselitz attracted more controversy in 1969 when he began painting the images in his pictures upside down. Jonathan Fineberg (*Art Since 1940*, 1995) describes 'the idea of turning whole paintings upside down' as 'a signature device to take the focus off the subject matter and redirect it toward the expressive surface'. Since 1979 Baselitz has also made sculptures; in these the figures are the normal way up. He has become one of the best-known European artists of his generation, but critical opinion on him is divided.

BASSA, FERRER (active c.1315–48×50). Founder of 14th-century Catalan painting and court artist of King Pedro. His style is strongly influenced by Sienese painting, perhaps the result of a sentence of exile in 1320, and may be identified with the dominant manner in the illumination of the Hours of Maria of Navarre (Venice, Bib. Nazionale Marciana, Lat. I, 104), whose lyrical Sienese idiom recurs in the *S. Mark* Polyptych (1346 for Barcelona Cathedral, now Manresa, S. María) and in most later Catalan painting. Pictorial space, emotive gestures, and crisply geometric architectural settings reflect his Italian sources, while his rich *Gothic polyptych structures, stylish drawing, and perhaps a distinctive intensity of facial type are unmistakably Iberian. Traditionally his name is associated with the oil-painted murals of the S. Miguel chapel at Pedralbes, commissioned from him in 1344 but only completed in 1346. Its roughly effective version of Pietro *Lorenzetti's idiom is not Ferrer's, however, but the work of an Italian assistant or his son Arnau (active 1346/7). RG

Yarza, J., Marcon, S., et al., *Libro de Horas de María de Navarra* (1996).

BASSANO (da Ponte) FAMILY. Italian painters from Bassano del Grappa, known as da Ponte because of the proximity of their workshop to the bridge over the Brenta. The leading artistic personality was **Jacopo** (c.1510–92), son of the moderate painter **Francesco the elder** (c.1475–1539). His own sons **Francesco the younger** (1549–1592), **Leandro** (1557–1622), and **Gerolamo** (1566–1621) all trained in his workshop.

Detailed information about the organization of the Bassano workshop is recorded in the surviving and recently published volume of accounts (*Il libro secondo di Francesco e Jacopo dal Ponte*, ed. M. Muraro, 1992). Jacopo was apprenticed to his father and then trained in Venice under Bonifazio de' Pitati (1487–1553). He was also influenced by *Pordenone as well as prints by or after northern artists, including *Dürer. And he was responsive to the work of Tuscan Mannerists including Francesco *Salviati. These sources are evident in the brightly coloured naturalistic *Adoration of the Kings* (Burghley House, Lincs.) which shows clear compositional links back to Pordenone's picture of the same subject in the Cappella Malchiostro, Treviso Cathedral, while the horse and rider apparently derive from a Pordenone drawing at Chantilly (Mus. Condé). Pordenone's influence is equally apparent in J. Bassano's picture of the same subject at Edinburgh (NG Scotland) dating from the early 1540s. A change of figure style, following constructive study of *Parmigianino, probably through reproductive prints by *Schiavone, is apparent in the *Flight into Egypt* (Pasadena, Calif., Norton Simon Mus.) and *The Way to Calvary* (London, NG) of c.1545. And here the strong local colours of Bassano's early work give way to a more acidic and discordant tonality. This Mannerist style continues in *The Virgin in Glory* (1548–9; Asolo Cathedral) and another *Adoration of the Kings* (c.1555; Vienna, Kunsthist. Mus.). Jacopo also experimented with chiaroscuro in pictures such as the *Way to Calvary* (c.1552; Budapest, Szépművészeti Mus.) where the rhythm of strong light and shade adds impetus to the figures who move laterally as in a frieze across the picture plane. Jacopo virtually invented the concept of the biblical pastoral journey, most notably in *Jacob's Journey* (London, Royal Coll.), perhaps dating from c.1560, which anticipates the Genoese *Castiglione's exploitation of this theme from the 1630s. As Jacopo's career reached its peak, and the demand for altarpieces from churches in the Veneto and Trentino pressed upon his time, he collaborated increasingly with Francesco and this was acknowledged in the *S. Paul Preaching* (1574; Marostica, S. Antonio Abate), which they signed jointly. When Francesco moved to Venice in 1578, Leandro also helped his father until he too set up on his own in Venice in 1588. Leandro painted religious and history paintings but he exploited a particular talent for portraiture, evident in his *Doge Marino Grimani* (c.1575; Dresden, Gemäldegal.). Meanwhile Jacopo in the final years of his life became increasingly absorbed in emulating the expressive qualities of *Titian's late style, above all in his *Martyrdom of S. Lawrence* (1571; Belluno Cathedral) and the *Entombment* (1574; Padua, S. Maria in Vanzo). HB

Brown, B., and Marini, P., *Jacopo Bassano*, exhib. cat. 1992–3 (Bassano del Grappa, Mus. Civico; Fort Worth, Kimbell Mus.).

BASTIEN-LEPAGE, JULES (1848–84). French painter. He was of peasant origin, and most celebrated for his large, *plein air* paintings of peasant subjects, set in the flat countryside of north-eastern France around his birthplace Damvillers. He also painted portraits and landscapes. Although he was a pupil of the academic French painter *Cabanel, the dominant influence on his art is the peasant paintings of *Millet; yet his stark depictions of beggars, of ragged children, such as *Poor Fauvette* (1881; Glasgow, AG), and of old wood gatherers, such as *Le Père Jacques* (1882; Milwaukee, Art Mus.), make a stronger sentimental appeal. His pictures are muted in colour, and freely handled distances are contrasted with the meticulous finish of the figures, and with sharply detailed wild flowers and trees. In the 1880s Bastien-Lepage was immensely celebrated, and had followers throughout the world; he was particularly admired in the then flourishing artists' colonies, especially in Brittany, Denmark, and Great Britain, where his influence was strongest in Scotland. HL

BATONI, POMPEO (1708–87). Italian painter and draughtsman. He was the son of a goldsmith of Lucca and one of the most ostentatiously wealthy and successful painters of 18th-century Rome. He arrived there in 1727 and for the next three years dedicated himself to copying the classical antiquities as well as the paintings of *Raphael, Annibale *Carracci, and other classicizing artists. Fifty-three drawings after the Antique, made for Richard Topham (Eton College library), are among the finest known records of the classical sculpture to be seen in Rome at the time. By the 1740s he had established his reputation for religious and history paintings. The *Sacrifice of Iphigenia* (1741–2; Edinburgh, NG Scotland) is the masterpiece of his early style, echoing the designs of such artists as *Poussin and *Testa. He was also much in demand for religious work, ranging from *Christ Delivering the Keys to S. Peter* (1742; Rome, Palazzo Quirinale) to the *Martyrdom of S. Bartholomew* (1749; Lucca, Villa Giunigi). However, his most important challenge, *The Fall of Simon Magus*, commissioned for S. Peter's in 1746, met with a disastrous reception when unveiled in 1755 and was transferred to S. Maria degli Angeli, Rome, in 1757. This setback unquestionably propelled him towards his expanding practice as a portrait painter which had been gathering momentum since 1750. During the 1750s he painted some 60 British *Grand Tourists, including

John, Lord Brudenell (1758; Duke of Buccleuch, priv. coll.), and made a speciality of incorporating within his portraits well-known antiquities or views of ancient Rome to enhance their significance and the sense of occasion. One particularly incongruous image is the full-length *Portrait of Colonel William Gordon* (1766; Fyvie Castle, Grampian) dressed in tartan and posed before the classical figure of *Roma* (Rome, Capitoline Mus.).

Batoni also painted European royalty—most notably the *Emperor Joseph II and his Brother Leopold I, Grand Duke of Tuscany* (1769; Vienna, Kunsthist. Mus.). However his most sensitive portraiture involved Italian sitters, whom he approached in a more direct manner, with a psychological intimacy that anticipates *Goya. His portrait of *Princess Cecilia Mahony Giustiniani* (1785; Edinburgh, NG Scotland) movingly conveys with cruel honesty the suffering of a lady who had first lost a daughter in childbirth in 1783 and then suffered a still-birth in the very year the picture was painted. HB

Clark, A., *Pompeo Batoni: A Complete Catalogue of his Works*, ed. E. P. Bowron (1985).

BATTEUX, CHARLES, ABBÉ (1713–80). French cleric and writer. His treatise *Les Beaux-Arts réduits à un seul principe* (1747) was a highly influential text on aesthetics throughout Europe until well into the 19th century. Brushing aside non-aesthetic standards for the judgement of works of art, such as the moral instruction they might offer, he argued that artists were ultimately guided in their practices and routines only by the imitation of nature. It is in the light of this sole principle that art should be judged. MJ

Danckelmann, E. von, *Charles Batteux: sein Leben und sein aesthetisches Lehrergebäude* (1902).

BATTISTELLO, See CARACCIOLO, GIOVANNI BATTISTA.

BATTLE PAINTING. *See overleaf.*

BAUDELAIRE, CHARLES (1821–67). French poet and critic who, like Sainte-Beuve and Taine, in his aesthetic outlook came within the ambit of the scientific *naturalism of the second half of the 19th century. His criticism and his views on the nature and principles of art are expressed in *L'Art romantique* (1899) and in various essays collected in 1923 under the title *Curiosités esthétiques*. In common with the sociological school Baudelaire held that there is no absolute and universal beauty but a different beauty for different peoples and cultures. Beauty arises from the emotions, and therefore every man has his personal beauty. Moreover the individuality of the artist is essential to the creation of beauty and if it is suppressed or

regimented, art becomes banal. 'Le beau est toujours bizarre.' Despite this kinship with the sociological school, Baudelaire resisted the claims that art should serve social or moral purposes and was one of the leaders of the 'art for art's sake' school with Flaubert, *Gautier, and the *Goncourt brothers. In his views of literature he owed much to Edgar Allan Poe. Believing that beauty is indifferent to good and evil, he set himself the task of 'extracting beauty from evil' and gave to his poems the title *Fleurs du mal*. In the 'Hymn to Beauty' he exclaims: 'Whether thou comest from Satan or from God, what does it matter?' Yet while he maintained the primacy of art over everything else including morality, he stopped short of the view that there is any essential antipathy between the beautiful and the good. In his poetry he was obsessed with the idea of *synaesthesia, or the correspondence of sensations of different kinds: 'Les parfums, les couleurs et les sons se répondent.' The later Symbolist poets Rimbaud, Verlaine, and *Mallarmé owed much to this aspect of his work.

In his criticism of art he sought to assess the stature of an artist by his ability to portray the 'heroism' of modern life. *Delacroix, to whom he devoted some of his most perceptive essays, he found unsuitable owing to his predilection for Romantic and exotic subject matter. *Courbet seemed to him too materialistic and he finally chose the relatively minor painter Constantin *Guys as the representative par excellence of contemporary society and wrote a long appreciation of his work entitled *Le Peintre de la vie moderne* (1863). He was a friend and supporter of *Manet and he is one of the persons depicted in Manet's *Musique aux Tuileries* (1863; London, NG) as well as in Courbet's *L'Atelier du peintre* (1855; Paris, Mus. d'Orsay). HO/MJ

Baudelaire, C., *The Mirror of Art*, trans. J. Mayne (1955).
Baudelaire, C., *The Painter of Modern Life and Other Essays*, trans. J. Mayne (2nd edn., 1995).
Brookner, A., *The Genius of the Future: Essays in French Art Criticism* (1971).

BAUDOLF, JAN (Jean Bondol) (active 1368–81). Flemish painter and illuminator, chiefly active in France at the court of Charles V (d. 1380), where he received a considerable salary as court painter and *valet de chambre* 1368–80. This position enabled Baudolf to be a significant influence upon *manuscript illumination in France in the transition from a traditional mannered style to a more realistic approach. His most famous work is a miniature in a *Bible historiale* made for Charles V (1371; The Hague, Rijksmus. Meermanno-Westreenianum, MS 10 B 23, fo. 2ʳ), which shows the manuscript being presented to the King by his adviser Jean de Vaudetar. Exceptionally, this leaf is not only signed but dated. Baudolf also worked for

continued on page 55

· BATTLE PAINTING ·

THE vocabulary of the classical battle piece was set by the Greeks, who generally depicted legendary combats rather than real ones, though there are several references to *Hellenistic paintings of Alexander's historical exploits. One of these, depicting the *Battle of Issus*, is preserved in a virtuoso Roman mosaic copy (c.100 BC; Naples, Mus. Arch. Naz.) This shows Alexander confronting Darius, and it exploits every technical device to emphasize Alexander's energy and psychological domination of his enemy.

Elaborately interlaced battle scenes became popular on Roman sarcophagi, and their rhythmic compositions were to have immense influence in the *Renaissance. The great sources of visual information on Roman warfare, however, were public monuments, especially Trajan's Column (AD 113; Rome) and the more emotionally dramatic Column of Marcus Aurelius (180–93; Rome). These detailed campaign records deploy great narrative skill and accurate observation to depict the Roman army in every kind of military activity.

While the spiral narrative strip formula of the Roman columns possibly influenced tiered commemorative public works like *Spinello Aretino's frescoes of 1408 in the Sala di Balía, Palazzo Pubblico, Siena, the full classical influence only appeared later. *Bertoldo di Giovanni's bronze *Battle Scene* (late 1480s; Florence, Bargello), modelled on a sarcophagus in the Camposanto, Pisa, epitomizes the Renaissance idea of a distilled image of energy and conflict. This theme was taken to a higher pitch of intensity in *Leonardo da Vinci's lost cartoon for the *Battle of Anghiari* (1503–6). Michelangelo's contemporaneous cartoon for the *Battle of Cascina* exploited an incidental episode in the battle for a bravura display of nude figure studies. Neither artist was interested in verisimilitude of the Florentine battles being commemorated.

The Renaissance heroic battle piece finally emerged fully developed in *Giulio Romano's *Battle of Constantine and Maxentius* (1523–4; Vatican, Sala di Costantino). In this huge painting of the victory that established the first Christian Roman emperor the classical quality of the artist's vision is part of the statement being made about the papacy's claim to unbroken legitimacy. Giulio Romano's erudite quotations from Roman sculpture are reinvented in the language of the project, which combines academic authority with explosive emotional and political force. Giulio Romano's masterpiece was the basis of da *Cortona's Baroque paraphrase, the *Battle of Issus* (1643; Rome, Capitoline Mus.) and of *Le Brun's vast series of the *Battles of Alexander* (1662–8; Paris, Louvre) that established Lebrun's position under Louis XIV and were the models for numerous paintings and tapestries well into the 18th century.

A different tradition was created by *Titian's *Battle of Spoleto* (1537–8; destr.). This work depended on a composition of violent foreshortening echoing Leonardo's *Battle of Anghiari*. *Rubens's battle pieces are within this tradition.

In the second quarter of the 17th century the Neapolitan painter Aniello Falcone (1607–56) established a new non-referential genre of 'the battle scene without a hero', which was the title of an influential article on Falcone by Fritz Saxl (*Journal of the Warburg and Courtauld Institutes*, 3, 1938–9). These are usually cavalry mêlées set in a landscape, in which the ephemeral violence is veiled by swirling smoke and dust. This style of romantic genre piece was developed by Salvator *Rosa and Il *Borgognone, and by Dutch artists such as Philip and Pieter *Wouverman. Rosa's most ambitious battle pieces such as that of 1652 (Paris, Louvre) are, however, more *classicizing paintings that make a serious statement about the cruelty and passion of war.

The Italian tradition was conditioned by theoretical ideas of what art ought to look like, rather than by concern with what battles ought to look like. There was also a pragmatic, realist northern tradition that delighted in describing social types and in depicting technology. There are innumerable Burgundian and Flemish 14th- and 15th-century manuscript illustrations of battles and sieges, and in the first half of the 16th century there was a great output of German and Swiss prints featuring the swashbuckling mercenary pikeman—the *Landesknecht* and the *Reisläufer*. The most ambitious records of contemporary battles in this period are the *Triumphzug* of Maximilian I (c.1515; Vienna, Albertina). These large miniatures by *Altdorfer and others present a startlingly convincing panoramic impression of great forces in engagement. Later, Altdorfer contributed a masterpiece to the battle series commissioned by Wilhelm of Bavaria: his *Battle of Issus* (1529; Munich, Alte Pin.) contains inexhaustible detail of interlocked hordes in a sublime mountain setting and it creates a cosmic image of unending and timeless conflict.

One type of battle painting developed in the 18th and early 19th centuries by painters like Horace *Vernet was the topographically accurate record of a large-scale action, but much art of the Napoleonic Wars was unashamedly Romantic. The 19th century's increasingly nationalistic attitudes are reflected in the popular taste for reassuring, stereotyped tableaux of cavalry charges or episodes of steadfastness against overwhelming odds. The leading English battle painter was Lady *Butler, who abstained from depicting hand-to-hand combat because of its savagery. Her hugely successful *Roll Call* (1874; London, St James's Palace) celebrates the stoical discipline of a unit of the Grenadier Guards shown mustering after a costly engagement in the Crimean War. Her concern for the experience of the ordinary soldier was shared by the French painter Alphonse de Neuville (1835–85), though much of his work was violently sensational.

Lady Butler lived long enough to paint imaginary, conventional scenes of British cavalry in Flanders but, for those who were actually there, the experience of total war in 1914–18 soon swept away any possibility of depicting the conflict in routine upbeat terms. The art by which the war is now remembered is typified by the nightmare visions of Otto *Dix's 50 etchings *War* (1924), and the tormented landscapes of Paul *Nash. AJL

Hale, J. R., *Artists and Warfare in the Renaissance* (1990).

Charles's brothers; he completed a painting for Philip the Bold, Duke of Burgundy (d. 1404), and between 1377 and 1381 was paid for designs for tapestries with scenes from the Apocalypse (Angers Castle) made for Louis I, Duke of Anjou (d. 1384). He may also have worked for Pedro IV, King of Aragon (ruled 1336–87). KC

Avril, F., *Manuscript Painting at the Court of France: The Fourteenth Century (1310–1380)* (1978).

BAUGIN, LUBIN (c.1612–63). French painter. He became a master painter in the corporation of S. Germain-des-Prés in Paris in 1629 and seems to have spent a period in Italy from about 1636. As increasing numbers of his surviving works have been identified, an attractive artistic personality has begun to emerge. He seems to have practised mainly as a painter of religious scenes in an elegantly mannered style that filters his *Raphaelesque prototypes through memories of the School of *Fontainebleau. Examples are *The Dead Christ* (Orléans, Mus. des Beaux-Arts) and *The Virgin and Child* (Norfolk, Va., Chrysler Mus.) Scholars now generally agree that a group of austere still lifes signed 'Baugin' (among them *Dessert with Gaufrettes* in the Louvre) are by the same artist and probably painted before his Italian journey. MJ

Thuillier, J., 'Lubin Baugin', *L'Œil*, 102 (1963).

BAUHAUS, a school of architecture and applied art, established in Weimar in 1919 by the architect Walter Gropius (1883–1969). He believed that architecture, as the mother of the arts, creates a unity between art, design, and craft, an ideal he once equated with that of William Morris (1834–96). The *Expressionist leanings of early staff, like *Kandinsky and *Klee, were overshadowed by changes in The Bauhaus's doctrine: first in 1923 by a mission to unite art and industry; then again in 1925 when, moving to Dessau, it adopted the *Constructivist and *functionalist ideas of teachers like László *Moholy-Nagy and Josef *Albers. Gropius was succeeded by Hannes Meyer (1889–1954) in 1928 and Ludwig Mies van der Rohe (1886–1969) in 1930. Although Nazi opposition forced the Bauhaus to move to Berlin in 1932 and forced its closure in 1933, its ideals were perpetuated throughout the 1930s and 1940s by staff and students. Moholy-Nagy, for example, founded the New Bauhaus in Chicago (1937). The disciplined style of the school, based on the cube, rectangle, and circle, and its belief in truth to materials, widely influenced European architecture and design, re-emerging in later developments like *Op art. YJ

Westphal, U., *The Bauhaus* (1991).

BAUMEISTER, WILLI (1889–1955). German artist. Born in Stuttgart, Baumeister studied at the Stuttgart Academy, where he was influenced by *Post-Impressionism. He began to work in an abstract manner in 1919 and continued to do so for the rest of his life, although his work became more figurative for a time in the mid-1920, in the *Machine Pictures* and *Sport Pictures*, which made him famous in Paris. Baumeister's interests have ranged from geometric and Constructivist concerns to the primitive and archaic, but he always stood apart from German *Expressionism. MF

Grohmann, W., *Willi Baumeister: Life and Work* (1966).

BAYEU Y SUBÍAS, FRANCISCO (1734–95). Spanish painter, who after training as a young artist in his native Saragossa, in 1758 submitted to the Academia de S. Fernando, *Madrid, a competition piece, *The Tyranny of Gerion*. The painting won him a stipend to study in Madrid, which was soon withdrawn due to Bayeu's differences with his professors. He returned to Saragossa where his work was seen in 1762 by *Mengs. Mengs invited Bayeu to assist him in fresco decorations for the new royal palace of Madrid, where Bayeu would paint the *Surrender of Granada* (1763), the *Fall of the Giants* (1764), and the *Apotheosis of Hercules* (1768–9). In 1768, he became court painter. His major works include frescoes for S. María el Pilar (Saragossa); for the cathedral in Toledo (1776 87); as well as tapestry cartoons for the royal factory and the high altar of S. Francisco el Grande, Madrid (1781–4). The most senior painter at court after the 1776 departure of Mengs, Bayeu was never granted the position of First Court Painter, which went after his death to Francisco *Goya and Bayeu's colleague Mariano *Maella. JT

Morales y Marin, José Luis, *Francisco Bayeu: vida y obra* (1995).

BAYONNE, MUSÉE BONNAT. It houses the magnificent collection formed by the Third Republic portraitist Léon Bonnat. Bonnat (1833–1922) was virtually France's official portrait painter from the 1870s to the end of the century, and he became extremely rich. He was also an obsessive collector of paintings, drawings, and Antique sculpture, and he built up a huge collection during the 1880s and 1890s.

Bonnat suggested leaving his collection to his home town, Bayonne, in 1891. It was then decided to mount a joint project in which Bonnat's collection would initially share a new building with the town library and with a natural history collection. The building was finished by 1901 and Bonnat immediately placed part of his collection in it. The rest followed after his death and the museum re-opened in 1923 with the entire building made over to the fine arts. The bulk of the collection comes from the Bonnat bequest, with some important works on deposit from the state. A further significant acquisition was a bequest in 1921 by General Derrecageix, including six superb *Rubens sketches for the series of mythological paintings commissioned from him by Philip IV of Spain for the Torre de la Parada (a hunting lodge in the Prado woods).

The collection is characterized by a strong personal taste, albeit not a very adventurous one, and consistently high quality. In addition to the splendid section of Rubens and van *Dyck sketches, there are very notable groups of works by *Ingres, *Géricault, and (especially) *Goya, who had spent his last years at Bayonne. The collection of drawings, including works by *Michelangelo, *Titian, and *Rembrandt, is altogether exceptional. AJL

Ducourdu, V., *Le Musée Bonnat à Bayonne* (1988).

BAZILLE, FRÉDÉRIC (1841–70). One of the core group of early French *Impressionist painters; killed in action in the Franco-Prussian War. Bazille came from a well-to-do family in Montpellier who sent him to Paris in 1862 to study medicine but allowed him to attend the studio of Charles Gleyre (1808–74), where he met *Sisley, *Monet, and *Renoir. In 1864 he started to paint full-time, and he exhibited in every *Paris Salon from 1866 to 1870. In the years 1863 to 1865 he made painting trips with Monet to Chailly and Honfleur. In addition

to landscapes, he painted at this time a vivid picture (Paris, Mus. d'Orsay) of Monet recuperating in bed at Chailly with an injured leg. Later he turned to large outdoor figure compositions under a strong southern light (*Family of the Artist on a Terrace*, 1868–9; Paris, Mus. d'Orsay). These are like Monet's contemporary picnic scenes (for which Bazille posed) in suggesting the attractions of bourgeois leisure in the summer, and in exploring the effects of dappled shade under trees. Bazille was, however, a less spontaneous or experimental painter than Monet or Renoir and he prepared his major compositions with traditional deliberation and preparatory studies.

AJL

Daulte, F., *Frédéric Bazille* (1992).

BAZIOTES, WILLIAM (1912–63). American painter. Born in Pittsburg, he moved to New York in 1933 to study at the National Academy of Design, before joining the *Federal Art Project 1936–41. He came to prominence in 1944 when exhibited at Peggy Guggenheim's New York gallery (Art of this Century). Although associated with the *Abstract Expressionists (he was co-founder of the Subjects of the Artist School (1948–9) in New York with *Motherwell, *Newman, *Rothko, and *Still), Baziotes's work was always distanced from them by his introspective use of biomorphic forms and 'psychic-automatism' deriving from his long interest in *Surrealism, as in *The Pond* (1955; Detroit, Inst. of Arts).

RJP

William Baziotes: A Retrospective Exhibition, exhib. cat. 1978 (Newport Beach, Calif., Harbor Art Mus.).

BAZZI, GIOVANNI ANTONIO. See SODOMA.

BEALE, MARY (née Cradock) (1632/3–99). English portrait painter. A Suffolk clergyman's daughter, Beale first trained with Robert Walker, (1599–1658), was influenced by the portrait painter Peter *Lely, and then herself became the first Englishwoman to be a portrait painter of distinction. By the age of 27 her work was much in demand from aspiring artists, literati, and, above all, from the clergy. The height of her popularity came in the 1670s, when, in 1677 alone, 83 portraits were painted. Ten years later, however, demand for her work declined, so that she had to use cheap materials and copy her own and Lely's work. Married at 19, her husband Charles (1632–1705), who was also a painter, encouraged her by working for her, mixing colours, priming canvases, and keeping valuable records of all her commissions. Examples of her work include *Thomas Sydenham* (1688; London, NPG) and *Self-Portrait* (c.1666; London, NPG), which incorporates portraits of her two sons and was painted in

Hampshire where the family moved to avoid the Great Plague.

GS

The Excellent Mrs. Mary Beale, exhib. cat. 1975 (London, Geffrye Mus.).

BEARDSLEY, AUBREY (VINCENT) (1872–98). British illustrator. His undoubted genius for black and white drawing seems to have been innate for he received no formal training. After a brief period as a clerk he was introduced to J. M. Dent who commissioned him to illustrate *Le Morte d'Arthur* (1893–4), which established his reputation. Whereas these early drawings reveal a small debt to *Burne-Jones, his designs for Oscar *Wilde's *Salome* (1894), arguably his finest achievement, show a marked Japanese influence. They are elegant and witty and subtly undermine the pretentiousness of Wilde's text. He was employed by John Lane as the art editor of the *Yellow Book* from 1894 until 1895 when he was dismissed in the wake of Wilde's conviction for homosexuality, an ironic fate given their antipathy. In 1896 he worked for the disreputable publisher Leonard Smithers for whom he illustrated a highly rococo *Rape of the Lock* and the *Lysistrata* of Aristophanes. The drawings for the latter, amusingly naughty rather than truly erotic, show a return to the standard set by *Salome*. He died aged 26, of tuberculosis.

DER

Reade, B., *Aubrey Beardsley*, exhib. cat. 1966 (London, V&A).

Snodgrass, C., *Aubrey Beardsley: Dandy of the Grotesque* (1995).

BEAUMETZ, JEAN DE (active by 1361, d. 1396). French painter from Arras. As a citizen of Valenciennes, Beaumetz is documented in 1361 painting and gilding a statue recently repaired by André *Beauneveu. By 1371 he was based in Paris, where he entered the service of Philip the Bold, Duke of Burgundy, receiving the title *valet de chambre*. In 1375 he travelled to Dijon, where he spent most of the remainder of his career, establishing a thriving workshop (he had nineteen assistants in 1388) with a wide range of responsibilities, including the painting of chairs, carriages, chapels, devotional hangings, altarpieces, and pageantry for tournaments. His main activities were centred on the decoration of the Charterhouse of Champmol, the Duke's monastic foundation. Two surviving panel paintings, both depicting Calvary scenes (1390–5; Paris, Louvre; Cleveland, Mus. of Art), may be identified as belonging to a series of devotional works he painted for the monks' cells. Their style indicates that Beaumetz was well acquainted with earlier Sienese painting, particularly

works by *Simone Martini.

TT

Winter, P. M. de, 'Art from the Duchy of Burgundy', *Bulletin of the Cleveland Museum of Art*, 74 (1987).

BEAUNEVEU, ANDRÉ (1335?–1401×3). Franco-Netherlandish sculptor and painter from Valenciennes. By 1364 he was in Paris, working for Charles V on four *tombs for the abbey of S. Denis. These have not all survived, but the effigy from the King's own tomb is notable for being the earliest such figure apparently portrayed from life. After a period possibly spent in England, he was at Kortrijk by 1374, engaged on the (unfinished) tomb of the Court of Flanders. A documented statue of *S. Catherine* survives from this church (Kortrijk, Onze Lieve Vrouwkerk), indicating Beauneveu's mastery of the French tradition of elegant monumental sculpture. From 1386 he was in service to John, Duke of Berry, supervising extensive decoration at the château at Mehun-sur-Yèvre and the S. Chapelle at Bourges (both destr.). Beauneveu's hand has been identified in survivals from the latter (e.g. the stained-glass *Prophets*, now in the crypt of Bourges Cathedral) by comparison with his documented illuminations in the Duke's Psalter (Paris, Bib. Nat., MS lat. 13091).

TT

Péleguin, G. (ed.), *Les Fastes du Gothique: le siècle de Charles V*, exhib. cat. 1981 (Paris, Grand Palais).

BECCAFUMI, DOMENICO (DI GIACOMO DI PACE) (c.1484–1551). Sienese painter and sculptor. His training and artistic contacts are not clear, though his work clearly springs from Florentine art of the first decade of the 16th century, and contains echoes of later developments in Rome. *Vasari, who knew Beccafumi and admired him, states that he visited Rome early in his career and studied *Michelangelo's and *Raphael's work there. However, although visits to Rome are plausible, there is no documentary evidence for them. Generally, Beccafumi was firmly based in Siena and seems to have been seen as the leading artist there, despite the presence of *Sodoma. His highly distinctive artistic personality is already apparent in his first documented works (1513) for the Capella della Madonna del Manto in the Spedale di S. Maria della Scala, Siena, and he continued to develop an individual and highly emotional style of religious painting with a strong element of fantasy, characterized by vibrant luminosity, hazy *sfumato, and a distinctive palette of shot colours, as in the *Nativity* (c.1522–4; Siena, S. Martino). His frescoes in the Sala del Concistoro in the Palazzo Pubblico, Siena (1529–35), combine decorative illusionism with figures and gestures clearly derived from Michelangelo. A major public commitment for much of his life was the design of sections of the inlaid marble

floor of the cathedral, and many of these (e.g. 1531; *Moses on Mount Sinai*) are powerful compositions. His final commission, in the last years of his life, was for the eight bronze torch-bearing angels in the choir of the Cathedral. AJL

Agosti, G., *Domenico Beccafumi e il suo tempo*, exhib. cat. 1990 (Siena, Pin.).

BECERRA, GASPAR (1520?–70). Spanish Mannerist sculptor and painter. Born in Baeza, Andalusia, to a family of painters, he travelled to Italy as a young man. He had arrived there by 1545 when he is documented in Rome as one of *Vasari's assistants for the decoration of the Cancelleria. Soon after 1556 he returned to Spain, where his work provided a source of contemporary Mannerist and *Michelangelesque compositions. In 1558 he received the commission for the main retable of Astorga Cathedral; he later sculpted the figure of the *Dead Christ* for the convent of the Descalzas Reales (Madrid). As a painter, he created many altars, now unfortunately destroyed, and made frescoes for the royal palaces of El Pardo (scenes of Perseus) and the Alcázar in Madrid (destr. 1734). In recognition of these achievements he was appointed court painter to Philip II in 1563. PL

Fracchia, C., 'El retablo mayor de la catedral de Astorga: un concurso escultórico en la España del Renacimiento', *Archivo español de arte*, 282 (1988).
Fracchia, C., 'Gaspar de Becerra: A Spaniard in the Workshop of Daniele da Volterra', *Sculpture Journal*, 3 (1999).
Fracchia, C., 'La herencia italiana de Gaspar Becerra en el retablo mayor de la Catedral de Astorga', *Annuario del Departamento de Historia y Teoría del Arte, Universidad Autónoma de Madrid*, 9–10 (1997–8).

BECKMANN, MAX (1884–1950). German painter. Beckmann was born in Leipzig and studied at the Weimar Akademie (1900–3) before spending six months in Paris. Influenced by the *Impressionists, particularly *Manet, he established a reputation as a leading German Impressionist, critical of contemporary trends, including *Expressionism. In 1914 he volunteered for military service and served as a medical orderly in Flanders recording his experiences in many drawings. Sickened and traumatized by the futility of war, he was discharged with a nervous breakdown in 1915 and settled in Frankfurt where he taught 1916–33, when he was dismissed by the Nazis as degenerate. Beckmann's post-war paintings and graphics differ completely from his earlier work; his palette is subdued, his forms angular, his subjects disturbing, and his compositions often claustrophobic. Disillusioned by Weimar politics, his work became overtly critical although, unlike *Dix and *Grosz, more symbolic than satirical. His over-life-size painting

Night (1918/19; Düsseldorf, Kunstsammlung Nordrhein-Westfalen), inspired by the murder of the Communists Liebknecht and Rosa Luxemburg, is also an allegory of inhumanity in general. Its twisted puppet-like figures, frozen in a shallow artificial space, owe as much to the German *Gothic tradition as they do to Expressionism, the movement with which he is most often associated. Apparently innocuous subjects, like *The Trapeze* (1923; Toledo, Oh., Mus.), are also invested with the ominous quality which permeates his post-war work. In 1918 he described his aim in art as 'transcendental objectivity', and his work was included in the *Neue Sachlichkeit (New Objectivity) exhibition of 1925, although his aims transcend the movement. In 1937, proscribed from working in Germany, he moved to Amsterdam and from 1947 taught in Washington and New York. DER

Gopel, E., *Max Beckmann* (2 vols., 1976).

BEDOLI, GIROLAMO MAZZOLA (c.1505–c.1570). Emilian painter working mainly at Parma in *Parmigianino's manner. Bedoli was probably trained by Parmigianino's uncle Pier'Ilario Mazzola, whose daughter he married in 1529. His first documented work is the *Allegory of the Immaculate Conception* (1533–7; Parma, Gal. Nazionale), but there are others which can be dated earlier on stylistic grounds. These include a *Holy Family with SS John the Evangelist, Francis, and Anthony* (Naples, Capodimonte), and *The Virgin and Child with the Infant Baptist, Francis, and Sebastian* (Dresden, Gemäldegal.), which reflect Parmigianino's most mannered style but with a harder and more brittle linearity. Even after Parmigianino's death in 1540 Bedoli continued working in a style superficially like that of his kinsman, although in certain works, such as the S. Martino Polypytch (c.1540; Parma, Gal. Nazionale) he affected a softer, more *Correggesque manner. His frescoes in S. Maria della Steccata, Parma (1547–67) are generally laboured in execution and composition. Bedoli's elegant drawing style was closely modelled on that of Parmigianino. HCh

Milstein, A., *The Paintings of Girolamo Mazzola Bedoli* (1978).

BEECHEY, SIR WILLIAM (1753–1839). English portrait painter. Beechey entered the RA Schools (see under LONDON) in 1772 and first exhibited at the RA four years later. In 1787 his portraits were rejected by the Academy, probably because of their framing. Despite this setback Beechey became an Associate in 1793, the year of his appointment as portrait painter to Queen Charlotte, and an Academician in 1798. He was knighted in the same year, probably as a reward for his enormous painting *A Review of the Horse Guard with King George III and the Prince of Wales* (1798; London, Royal Coll.). His diploma work was a

further portrait of *The Prince of Wales* (1798; London, RA) in a pose clearly derived from *Reynolds.) His finest work, including an arresting head of the actor *John Philip Kemble* (c.1798; London, Dulwich, Gal.) dates from this period. Although he continued to receive royal patronage until the 1830s when he painted *Queen Adelaide* (c.1831; London, NPG), he was eclipsed by *Lawrence by 1800. Beechey was an uninspired but conscientious painter noted for his craftsmanship and the accuracy of his likenesses rather than originality. DER

Roberts, W., *Sir William Beechey* (1907).

BEERBOHM, SIR MAX (1872–1956). English caricaturist and writer. Beerbohm was born in London and educated at Charterhouse and Oxford where he displayed the urbanity, detachment, and dandyism which remained the principal characteristics of his life and work. A meeting with the artist William Rothenstein (1872–1945) in 1893 introduced him to the milieu of the *Yellow Book* for which he wrote an ironic *Defence of Cosmetics* in 1894 which ensured his notoriety. In the same year he made his debut as a caricaturist and in 1896 *Twenty-Five Gentlemen* was issued by *Beardsley's publisher Leonard Smithers. In 1904 he exhibited *The Poets' Corner* at the Carfax Gallery and for the rest of his life made a living from writing and regular exhibitions. Beerbohm's finest caricatures are of literary and artistic subjects and he is at his best when satirizing the dead, for he hated to wound. His masterpiece is *Rossetti and his Circle*, published in 1922, which wickedly and wittily anatomizes the foibles of the *Pre-Raphaelites. His spare and elegant line, perfunctorily filled in with washes of colour, aims less for physical likeness than character. DER

Hart-Davis, R., *Catalogue of the Caricatures of Max Beerbohm* (1972).

BEERT, OSIAS (c.1580–1623). Probably born in Antwerp, he was a leading figure in the first generation of Flemish *still-life painters. He became a master in the Antwerp guild of S. Luke in 1602, and is especially noted for his paintings of oysters and confectionery goods, in orderly arrangements on tabletops together with precious wine glasses and Chinese porcelain (*Still Life with Oysters and Sweetmeats*; Brussels, Mus. Royaux). He collaborated with *Rubens or his studio on at least one occasion, supplying the floral garlands to the former's *Pausias and Glycera* (Sarasota, Fla., Ringling Mus.). KLB

Sutton, P., *The Age of Rubens*, exhib. cat. 1993 (Boston, Mus. of Fine Arts).

BEGA, CORNELIS (1631–64). Dutch painter, draughtsman, and etcher, from a prosperous Catholic background in Haarlem.

Bega's mother was the daughter of Cornelisz. van *Haarlem, one of the leading painters of the previous generation, whose collection of drawings she inherited. Bega was a *genre painter with a wide range of subject matter including tavern and village scenes and domestic interiors, as well as single figures such as quack doctors and gamblers. In some cases these have a moralizing content which may have influenced Jan *Steen. Bega was probably a pupil of Adriaen van *Ostade. In 1653 he travelled extensively throughout Germany, Switzerland, and France. Much of his work survives including 160 paintings, over 80 drawings, and 34 etchings. A small number of monotypes are also extant; Bega was one of the earliest exponents of this process. Bega's early works are freely painted compositions with many figures. Later works of the 1660s such as *The Duet* (1663; Stockholm, Nationalmus.) become more finely detailed with an increased richness of colour and have more in common with the Leiden *fijnschilders* such as *Dou. CFW

Sutton, P., *Masters of 17th Century Dutch Genre Painting*, exhib. cat. 1984 (Philadelphia, Berlin, London).

BEGGARSTAFF BROTHERS. See PRYDE, JAMES.

BEHAM BROTHERS. German engravers. **Hans Sebald** (1500–50) and **Barthel** (1502–40) were amongst the most distinguished of the *Little Masters. In 1525 they were expelled from Nuremberg for blasphemy. They were highly productive, engraving biblical scenes, *genre, ornamental, and allegorical subjects that are sometimes seasoned by mild eroticism, and they added a quirky humour to a technique that owed much to *Dürer. After his banishment from Nuremberg Barthel became the court painter to Wilhelm IV of Bavaria in Munich. Both artists designed a number of *woodcuts, and a few paintings are known by Hans Sebald, but their significance resides in their engraved work. RGo

BEKE, JOOS VAN DER. See CLEVE, JOOS VAN.

BELBELLO DA PAVIA, Luchino di Giovanni di Belbello (active c.1430–after 1473). Italian illuminator whose colourful and individual style found most favour at the courts of northern Italy, especially the Visconti/Sforza court in Milan, around the middle of the 15th century. For Filippo Maria Visconti, Duke of Milan, he undertook the completion of the Book of Hours begun for Giangaleazzo Visconti by Giovannino de *Grassi (Florence, Bib. Nazionale, MS Landau Finaly 22). Although likely to be among the earliest of his surviving works it shows all the features that remained characteristic of his illumination—the intense, saturated palette, the full forms and rounded contours, and the dark and idiosyncratic shading of flesh tones; these combine to dramatic and exotic effect divorced from any interest in realism.

Importuning letters from Belbello to the Marchioness of Mantua, for whom he had worked intermittently from 1448, and to the Duchess of Milan suggest that by the late 1450s his style no longer coincided with court taste. The latest work attributed to him is from a series of choir books made in Venice or the Veneto (e.g. Venice, S. Giorgio Maggiore, Corale M). He had returned to Pavia by 1473 where he was taken in by the Carthusians. KS

Meiss, M., and Kirsch, E., *The Visconti Hours* (1972).

BELGIAN ART. See FLEMISH ART.

BELL, CLIVE (1881–1964). English art critic. With his wife, the painter Vanessa *Bell, and his fellow critic Roger *Fry, he was a leading member of the *Bloomsbury Group. Bell and Fry introduced the work of *Cézanne and the *Fauves to London with their two Post-Impressionist exhibitions (1910, 1912). Advocacy of such painters led Bell to write a short book, *Art* (1914). In it he asserts that 'significant form' is the quality that distinguishes art. 'Lines and colours combined in a particular way, certain forms and relations of forms' induce a distinct aesthetic emotion in those attuned to art—who range from the mosaicists of Ravenna, through Chinese ceramicists, to Cézanne. Art thus understood is distinct from representational content, and suffers when irrelevant representational demands intrude—as in the anecdotal painting of Bell's Victorian forebears. This influential statement of *formalism was followed by further writings on French painting, and an argument for the maintenance of social elites, *Civilization* (1928). JB

Beechey, J., *Clive Bell* (2000).

BELL, VANESSA (1879–1961). British painter and designer, born in London into a distinguished literary family: her father was Sir Leslie Stephen, the first editor of the *Dictionary of National Biography*, and her younger sister became famous as the novelist Virginia Woolf. She studied at the Royal Academy Schools (see under LONDON), 1901–4, and in 1905 founded the Friday Club as a discussion group for artists. In 1907 she married Clive *Bell, and their house at 46 Gordon Square became one of the focal points of the *Bloomsbury Group. Her early work, up to about 1910, and her paintings produced after the First World War are tasteful and fairly conventional, in the tradition of the New English Art Club (see under LONDON), but in the intervening period she was briefly in the vanguard of progressive ideas in British art. At this time, stimulated by the *Post-Impressionist exhibitions organized by Roger *Fry (with whom she had an affair), she worked with bright colours and bold forms, and by 1914 she was painting completely abstract pictures. Her designs for Fry's *Omega Workshops include a folding screen (V&A, London, 1913–14) clearly showing the influence of *Matisse (Gertrude Stein had introduced her to Matisse and *Picasso in Paris in January 1914).

From 1916 Bell lived with Duncan *Grant, by whom she had a daughter in 1918. However, she remained on good terms with her husband, who was lavish in his praise of both her and Grant's work. Bell and Grant spent a good deal of time in London and travelling abroad, but they lived mainly at Charleston Farmhouse, at Firle, Sussex, and did much painted decoration in the house; it has been restored as a Bloomsbury memorial and is open to the public (the couple are buried together nearby at Firle churchyard). In addition to the work at Charleston, they collaborated on other decorative schemes, including a series of murals at Berwick church, Sussex, a few miles away. Bell's independent work included portraits, landscapes, interiors, and figure compositions. She also did a good deal of design work, including covers for books published by the Hogarth Press, founded by Virginia Woolf and her husband Leonard Woolf in 1917. After the Second World War, her work—like that of Grant—went out of fashion, but she continued painting vigorously into her old age, even though the death of her son, the poet Julian Bell (1908–37), in the Spanish Civil War was 'the end of all real happiness' (Richard Shone, *Bloomsbury Portraits*, 1976). Throughout her life Bell was a voluminous correspondent. About 3,000 of her letters survive, providing a rich source of information on the Bloomsbury circle; some 600 of them appear in *Selected Letters of Vanessa Bell*, edited by Regina Marler (1993). IC

BELLA, STEFANO DELLA (1610–64). Italian *etcher and draughtsman. He was born in Florence but lived in Rome 1633–9 and in Paris 1639–50. He returned to Florence in 1650 but continued to make visits to Rome. He was an extremely prolific artist, producing innumerable drawings and over 1,000 prints of festivals, battles, theatrical extravaganzas, landscapes, and scenes of everyday life. In style his etchings are close to *Callot whose prints he copied; and he was influenced too by the naturalism of the Dutch landscape artists in Rome as well as the vigour and technical freedom of Italian Baroque artists such as *Castiglione, another brilliant etcher. HB

de Vesme, A., rev P. Massar as *Stefano della Bella: Catalogue Raisonné* (1971).

BELLANGE, JACQUES (c.1575–1616). French painter, etcher, and draughtsman, from what was then the independent duchy of Lorraine. He was active at Nancy and was employed there by Duke Charles III (ruled 1545–1608). Much of his work consisted of ephemeral decorations for festivities, but his reputation today is based on his *etchings. He had a highly individual *Mannerist style, more bizarre in its imagery and its technical linear vocabulary than that of any earlier artists whose work may have influenced him, including Hendrik *Goltzius, Bartholomäus *Spranger, *Parmigianino and the Second School of *Fontainebleau, Federico *Barocci, and Ventura Salimbeni (1568–1613). He builds up volume by laying one area of parallel lines over another and uses stippling for flesh tones. Bellange's sinuous figures have elongated bodies and adopt highly affected contorted poses (*The Holy Women at the Sepulchre*); they sport fantastic coiffures (*The Annunciation*) and theatrical costumes; and they are usually grouped tightly together in crowded compositions with dramatic foreshortening or other disconcerting spatial effects (*Adoration of the Magi*; *Martyrdom of S. Lucy*). Although his subjects are mainly religious, the effect is erotic as well as devotional, dreamlike and surreal as well as mystical. Only in the *Blind Hurdy-gurdy Player* and *The Hurdy-gurdy Player Attacking a Pilgrim* does he approach realistic subject matter head on with a vigorous and violent intensity. Although he was probably equally active as a painter, only two pictures have been satisfactorily attributed to him. A *Lamentation* (St Petersburg, Hermitage), in which the source of light is a candle in the left foreground, has dramatic chiaroscuro and expressive forms, although it is quite crudely executed. There is a portrait of Cardinal Charles of Lorraine (d. 1607), son of the Duke, in the right foreground. A *Stigmatization of S. Francis* (Nancy, Mus. Historique) is set out of doors and lacks the artifice of most of Bellange's engraved work; it too may be an early work, although it is difficult to reconcile it stylistically with the *Lamentation*. HB

Griffiths, A., and Hartley, C., *Jacques Bellange, Printmaker of Lorraine*, exhib. cat. 1997 (London, BM).
Thuillier, J., and Pétry, C. (eds.), *L'Art en Lorraine au temps de Jacques Callot*, exhib. cat. 1992 (Nancy, Mus. des Beaux-Arts).

BELLECHOSE, HENRI (active by 1415, d. 1440×45?). Netherlandish painter, active in Burgundy. In 1415 he succeeded *Malouel as court painter in Dijon to the Duke of Burgundy, with the title *valet de chambre*. Much of his work seems to have been decorative or heraldic in character, including the painting of banners, coats-of-arms, sculpture, and items in connection with the funerals of members of the ducal family. By the 1420s he ran a large workshop and in 1426 the Duke commissioned an altarpiece from him. Yet, soon afterwards, he disappears from ducal records, perhaps because the focus of the Duke's activity had moved to the Netherlands, where another more celebrated court painter, Jan van *Eyck, was available. In 1429 Bellechose began a *Christ and the Twelve Apostles* and an *Annunciation* for S. Michel in Dijon. The only surviving work clearly associated with him is the ornate *Martyrdom of S. Denis* (Paris, Louvre), completed c.1416, although the extent of his work on it is unclear. TT

Troescher, G., *Burgundische Malerei* (1966).

BELLEGAMBE, JEAN (c.1470–1535/6). Franco-Netherlandish painter and designer. He was principally a painter of altarpieces for churches in the vicinity of his native Douai, many of which are documented. His technical mastery and feeling for iconographic innovation show him to have been one of the most distinctive painters working in a Netherlandish idiom in the early 16th century. A highly developed sense of fantasy, particularly evident in architectural settings, and a brilliant handling of colour relationships, distinguish him from Netherlandish contemporaries like Quentin *Massys, with whom he shares many characteristics. Bellegambe delighted in realizing in paint very complicated theological programmes, often employing eye-catching devices initially developed by *Memling and his followers. Yet his stiff, expressionless figures, and over-burdened pictorial language reveal him essentially as old-fashioned, his patrons far removed from the central developments in contemporary Franco-Netherlandish culture. His most ambitious work is the magnificent, double-winged *Credo* altarpiece made for the abbey at Anchin (1508–13; Douai, Mus. de la Chartreuse), which fuses visions of heaven and earth with notions of redemption, faith, and purity. TT

Genaille, R., 'L'Œuvre de Jean Bellegambe', *Gazette des beaux-arts*, 87 (1976).

BELLINI, FATHER AND SONS. Painters dominant in Venice from about 1440 to the death of Giovanni in 1516. The workshop was founded by Jacopo, with whom his two sons Gentile and Giovanni collaborated from mid-century; on his death in 1470/1 it was inherited by Gentile, and on his death in 1507 by Giovanni. Jacopo's nephew Leonardo was an illuminator and his daughter Nicolasia married *Mantegna. The estate included two remarkable albums of drawings, now in the British Museum and the Louvre.

Jacopo (c.1400–70/1) was trained by *Gentile da Fabriano, with whom he was in Florence in 1425. Testament to his wide reputation is a humanist's report of a contest with *Pisanello in 1441 to paint the portrait of Lionello d'Este, lord of Ferrara. Unfortunately the paintings by him that survive represent a small proportion of his output, are all small panels, and are much damaged. He signed a *Christ on the Cross* (Verona, Mus. Civico) and Madonnas in Venice (Accademia), Milan (Brera), and Lovere (Accademia). The half-length Madonnas have distinctively graceful yet forceful silhouettes and (still) a soft luminosity of rich colour out of which Giovanni's art directly develops; though dry and reticent by comparison, they also anticipate the meditative absorption of Giovanni's Madonnas. Again, Jacopo's *S. Jerome* in Verona (Mus. Civico) is set in a rocky landscape more individually conceived than was usual for its date, even in Pisanello's work.

These surviving works contrast with the variety and, not infrequently, monumentality of Jacopo's drawings in the two books in the Louvre and British Museum. The drawings include strikingly elaborate compositions in perspective, in which the surroundings (whether urban or landscape) dwarf the religious subject, and some drawings after the *Antique. Jacopo's preferred medium was silverpoint, but many of the drawings have been gone over (not long after his death) in pen. The earlier book, in Paris, on parchment, has drawings dating from c.1430 to c.1455; the London book, on paper, drawings from c.1450.

Gentile (c.1429–1507) enjoyed at least a local reputation no less than his father's. He was evidently well connected with the highest political circles in Venice and even served as a kind of ambassador to the court of the Great Turk in Constantinople from 1479 to 1481. Besides portraiture—though few portraits by him survive, and these, if indeed they are original, are of rather indifferent quality—and some religious work (notably his *Madonna* in London, NG), he specialized in large canvases for public halls such as the Great Council Room of the Doge's palace and the *porteghe* of *scuole*. Now in the Accademia, Venice, his cycle of pictures for the Scuola di S. Giovanni includes a famous representation of S. Mark's in its square as it was in 1496. The many portraits with which these pictures are filled remain unidentified.

Giovanni (d. 1516) seems to have been born very close in time to Gentile, and was perhaps his illegitimate stepbrother rather than his junior. Painting initially in a style very close to his father's, during his long career he steadily refined his modelling and deepened and enriched his colours, using oil glazes, at the same time absorbing influences from both Lombardy and Tuscany, until, in the 16th century, he laid the foundations of High Renaissance Venetian colourism.

His *Crucifixion* in Venice (c.1460; Mus. Correr) shows him very much in his father's workshop. The series of surviving half-length Madonnas that he or his workshop or his followers or his imitators—the *belliniani*—

produced in incredible numbers (one doubts that by 1510 there can have been a respectable household in Venice without one) starts shortly afterwards: the *Davis Madonna* (New York, Met. Mus.) shows still Jacopo's line, also already the ever-present influence of the slightly older Mantegna. Such works as *The Agony in the Garden* (mid- or late 1460s; London, NG) show him exploiting the feeling for light in landscape that his father had perhaps transmitted from Gentile da Fabriano (actually two lights, the natural and the supernatural); an even more brilliant example, especially considering its date (c.1475–80), is the *Resurrection* in Berlin (Gemäldegal.); this is followed by the dazzling *Transfiguration* (c.1485) in Naples (Capodimonte), and by *S. Francis in Ecstasy* (New York, Frick Coll.; perhaps c.1490, though commonly dated earlier). Meanwhile, under the influence of Netherlandish art, he deepened the emotional pungency of his devotional works (*Dead Christ Supported by Mary and John*, c.1470; Milan, Brera), gradually tempering this to a compelling meditative stillness (altarpiece; Venice, Frari; *Madonna and Two Female Saints*, c.1490; Venice, Accademia), and by this time was rivalling *Leonardo for finesse in the modelling of light. His altarpieces evolved from triptychs to *sacre conversazioni* that fictively extended the architecture of their classicizing frames from the space of the church, under stimulus both from *Antonello da Messina and from *Piero della Francesca—the most monumental and definitive of these is the S. Giobbe altarpiece (1480s; Venice, Accademia). Most famous of his exquisite portraits (all surviving are male) is *Doge Leonardo Loredan* (London, NG), glistening as real as a reliquary. From around 1500 the wonderfully deep colours of his sitters' increasingly ample garments dominate his compositions—colours in a limited range of red, blue, white, and gold, also orange and violet, which *Titian will take over directly (as in *S. Mark Enthroned*; Venice, Salute); Titian's 'Gypsy' *Madonna* (Vienna, Kunsthist. Mus.) is based on such superb late Madonnas as that signed and dated 1510 in the Brera, Milan. Giovanni was not 'a man to do stories', as a contemporary remarked—despite his 1514 *Feast of the Gods* (Washington, NG). But the haunting stillness and glowing colours of the later purely autograph religious icons (if well preserved) are unsurpassed.　　PHo

Eisler, C., *The Genius of Jacopo Bellini: The Complete Paintings and Drawings* (1989).

Goffen, R., *Giovanni Bellini* (1989).

Meyer zur Capellen, J., *Gentile Bellini* (1985).

Tempestini, A., *Giovanni Bellini: catalogo completo* (1992).

BELLMER, HANS (1902–75). Polish-born artist. Bellmer trained in Germany and worked as a typographer and illustrator before, in 1933, embarking on his most famous work, *The Doll*. Photographs he took of this articulated life-size mannequin, in the form of an adolescent girl, were published in the *Surrealist magazine *Minotaur* in 1935. He joined the Surrealists in Paris in 1938 and, after the war, turned to etching to explore his continuing erotic obsession with the female body.　　MF

Webb, P., and Short, R., *Hans Bellmer* (1985).

BELLORI, GIOVANNI PIETRO (1615–96). Italian antiquarian, biographer, and art theorist. He was the most powerful Roman art critic in the later 17th century, whose support for *classicizing artists was immensely influential. In 1664 he delivered a lecture on the 'Ideal' in art at the Accademia di S. Luca, *Rome, which became the seminal statement of idealist art theory, and the forerunner of the *Neoclassicism preached by *Winckelmann. To Bellori the *Idea that the artist should imitate was formed from images in nature, but nature selected and embellished. This lecture was published as a preface to his *Vite de' pittori, scultori et architetti moderni* (1672), which remains a basic source, and in the preparation of which he was inspired by *Poussin. In contrast to former art historians his method was to concentrate on artists whose classical qualities he admired; he disliked *Caravaggio's naturalism, and gave prominence to *Raphael, Annibale *Carracci, *Poussin, and *Maratti. He wrote the text to some of Pietro Sante Bartoli's illustrated books on ancient art, and he was librarian to Queen Christina of Sweden.　　HL

Panofsky, E., *Idea* (1924).

BELLOTTO, BERNARDO (1722–80). Italian painter, nephew, pupil, and assistant of *Canaletto in Venice. Initially, Bellotto was strongly influenced by his uncle and their respective work is sometimes confused. On occasion they evidently worked side by side, painting the same views from marginally different positions—for instance Bellotto's *View of the Campo Santo Stefano, Venice* (1739–40; Castle Howard, North Yorks.) appears to have been made from a viewpoint just to the left of Canaletto's in his picture, now at Woburn Abbey (Duke of Bedford Coll.). During the 1740s Bellotto also travelled with his uncle along the Brenta canal to Padua and went independently to Florence, Lucca, Rome, and Verona. It was at this time that he developed his own individual style in work such as the *View of the Arno towards the Ponte alla Carraia* (Cambridge, Fitzwilliam); the *Piazza di S. Martino, Lucca* (York, AG); the *Castel S. Angelo* (Detroit, Inst. of Arts); the *View of Verona with the Ponte delle Navi* (on loan, Edinburgh, NG of Scotland). Bellotto left Italy for good in 1747, to spend the rest of his life working at the courts of Dresden (1747–58 and 1761–7), Vienna (1758–61), Munich (1761), and Warsaw, where he died. He called himself Canaletto and this caused confusion (perhaps deliberate) between his work and his uncle's, particularly in views of Venice. Bellotto's style is, however, quite distinct, marked by an interest in massed clouds, cast shadows, and rich foliage, reminiscent of Dutch artists such as Jacob van *Ruisdael, as well as precise architectural drawing, and a distinctive cool clarity and tone. The figures populating his streets form lively scenes of high and low life, characteristic of the widespread growth of genre painting in Europe. These qualities are particularly evident in his series of views of the fortress at Königstein, near Dresden (Washington, NG; Manchester, AG; Knowsley, Earl of Derby Coll.), commissioned c.1756 by the Elector of Saxony, Frederick Augustus II, for whom he had already painted fourteen scenes of Dresden and eleven of Pirna (all now Dresden, Gemäldegal.). In his observation of the atmospheric light on the distant landscape beyond the castle of Königstein in the Washington picture, in the vigorous naturalism of the shepherds in the foreground, and in the overall grandeur of design, Bellotto here demonstrates talents quite distinct from those of his renowned mentor.　　HB

Kowalczkyk Trupiano, B. A., in *Splendori del Settecento Veneziano*, exhib. cat. 1995 (Venice).

Kozakiewicz, S., *Bernardo Bellotto* (1972).

BELLOWS, GEORGE WESLEY (1882–1925). American painter. Born in Columbus, Ohi., Bellows attended Ohio University before studying under Robert *Henri in New York. His choice of proletarian and sporting subjects and adoption of a loose, impressionistic style allies him firmly with the Ashcan School (see EIGHT, THE) the first generation of New York realists, so called because of their uncompromisingly urban themes, for which Henri was the spokesman. He achieved recognition with the bravura *Stag at Sharkey's* (1907; Cleveland, Mus. of Art), a vivid representation of an illegal prizefight. In paintings like *Cliff Dwellers* (1913; Los Angeles, County Mus.), an incident-packed depiction of working-class tenements, Bellows captured the bustle and energy of city life. In 1913 he helped to organize the *Armory Show and exposure to contemporary European painting introduced a greater formality into his compositions, furthered around 1917 by his study of Hambidge's theory of Dynamic Symmetry, a mathematical analysis of composition. A later boxing painting, *Dempsey and Firpo* (1924; New York, Whitney Mus.), lacks some of his earlier spontaneity. He produced many lithographs after 1916 and some admired portraits from 1920.　　DER

Young, M. S., *The Paintings of George Bellows* (1973).

BELVEDERE TORSO (1st century BC; Vatican Mus.), a spectacular fragment from an ancient Roman marble figure, recently identified as the Trojan hero Ajax. The figure is seated on an animal skin; the rock below is inscribed with the name of the 1st-century BC sculptor Apollonius, son of Nestor, the Athenian. Only the muscular torso and part of the legs survive. The torso is first recorded in Cardinal Colonna's collection in the 1430s. Housed in the Vatican Museum since the early 16th century, like the *Apollo Belvedere*, it takes its name from its display in the statue court there. The heavy musculature and subtleties of modelling inspired numerous homages, including *Rodin's *Thinker*. It owes its fame to the fact that *Michelangelo admired it, and it thereby became known as 'the school of Michelangelo'. The sculpture was ceded to France in 1797 and taken to Paris; it returned to Rome in 1816. CB

Haskell, F., and Penny, N., *Taste and the Antique* (1981).

BEMBO, BONIFACIO (active 1444; d. before 1482). Lombard painter first mentioned in Cremona. He was in the service of the Sforza family for much of his life: he worked for Francesco Sforza in Pavia (1456), Milan (1461), and Cremona (c.1462); from 1468 he was employed by Galeazzo Maria Sforza in Pavia and elsewhere. The characteristics of Bembo's style are difficult to define since his only secure works are two poorly conserved fresco portraits of *Francesco and Maria Sforza* (Cremona, S. Agostino). These figures are defined by flattened surfaces and sharp outlines. The depiction of the Duke's face, however, indicates that Bembo was an able portrait painter, who paid attention to small details such as a mole on Francesco Sforza's cheek. Other works, including frescoes in Cremona (Cavalcabò chapel, S. Agostino), illuminated manuscripts, and sets of tarot cards, have been attributed to him with varying degrees of success. The decorative style of these items, characterized by bright colour, refined figure types, and Gothicizing line, does not entirely resemble the manner of the Cremona portraits. FB

Dummett, M., *The Visconti–Sforza Tarot Cards* (1986).

BENEFIAL, MARCO (1684–1764). Leading Roman painter, though partnerships with the less distinguished artists Filippo Germisoni and Filippo Evangelisti affected his reputation. He was taught by the Bolognese painter Bonaventura Lamberti (1652–1721), and the naturalistic element in his style distanced him from the *Maratti-dominated Roman art establishment. Nevertheless, in 1718 he painted a *Jonah* in S. John Lateran, for which he was made a *cavaliere*. Two years later he led the successful campaign against a papal decree that had sought to protect the Accademia di S. Luca (see under ROME) by various restrictive practices, including the prohibition of non-academicians from teaching art. He embarked on a busy period of church commissions in Rome and elsewhere, constantly experimenting with devices to emphasize dramatic immediacy, and reaching a peak of narrative verismo in the frescoes at Città di Castello Cathedral (1747–9).

Having been blackballed for many years, he was eventually admitted to the Accademia di S. Luca, Rome in 1741, but was expelled in 1755 for criticizing the mediocrity of both the Academy and his fellow academicians during a life-drawing class. His reaction can be gauged from a contemporary caricature portraying him leering at the expulsion order with ostentatious scorn, but *Panini (the Accademia's president) nevertheless secured his readmission the same year. His later work became increasingly coarse. AJL

Briganti, G. (ed.), *La pittura in Italia: il settecento* (1989).

BENING, FATHER AND SON. Flemish illuminators. **Sanders** (Alexander) (active 1469–1519) entered the Ghent guild of illuminators on 19 January 1469 sponsored by Hugo van der *Goes, whose sister or niece he later married. Although his name appears frequently in contemporary documents, no certain surviving work by him has been recognized. Attempts have been made to identify him as the Master of Mary of Burgundy or the Master of the Older Prayer Book of Maximilian, yet both attributions have their weaknesses. **Simon** (1483?–1561), the son of Sanders, was active in Ghent, Bruges, and Antwerp. He was recognized as one of the finest, if not the finest illuminator (see ILLUMINATED MANUSCRIPTS) of his time. The Portuguese chronicler Damião de Góis described Simon as 'the principal master in this art [illumination] in all Europe'. Góis commissioned Bening's largest and most magnificent work, in the unfinished *Genealogy of the Infante Dom Fernando of Portugal* (1530–4; London, BL, Add. MS 12531). There are numerous references to Bening in primary sources as well as many dated and documented works. He carried out commissions for prominent families, high-ranking members of the clergy, and the aristocracy in Flanders, Spain, Portugal, Italy, and Germany. Usually they were for the illumination of devotional books. Simon's miniatures often appear like small panel paintings, a quality he exploited by abandoning the typical flowered borders of the time and replacing them with fictive picture frames, as in the Beatty Rosarium (Dublin, Chester Beatty Lib., Codex, MS Western 99). His *landscapes are of exceptional quality as shown by the sequence of calendar cycles he painted. Four leaves with scenes of the occupations for eight months (London, BL, Add. MS 18855, fos. 108–9, and V&A, Salting Ms 2538) are the culmination of his achievement in this genre; small figures are integrated into extensive and varied terrains where both spatial and atmospheric recession is convincingly depicted. These characteristics influenced landscape painters such as Joachim *Patinir. Two self-portraits survive (1558; London, V&A; New York, Met. Mus., Lehman Coll.). KC

Góis, Damião de, *Crónica do Felicissimo Rei D. Manuel* (1619; repr. 1953).
Kren, T. (ed.), *Renaissance Painting in Manuscripts: Treasures from the British Library*, exhib. cat. 1983–4 (Los Angeles, Getty Mus.; New York, Pierpont Morgan Lib.; London, BL).

BENJAMIN, WALTER (1892–1940). German critic. His writings, reflecting his Jewishness, his Marxist allegiances, and his aesthetic passions in a highly individual manner, only came to prominence after his friend Theodor *Adorno published a selection in 1955. Among other things, they explore German Romantic literature, the contemporary cultural predicament, and the Paris of Charles *Baudelaire. 'The Work of Art in the Age of Mechanical Reproduction' (1936) has become the most famous of Benjamin's essays, as an exemplary meditation on 20th-century tensions between high art and mass culture. It argues that major works of the past have come to us each with a specific 'aura', stemming from their unique handmade quality and their origins in ritual function; but that such an aura must wither as mass copying techniques are perfected. Yet new artistic possibilities may arise when 'quantity has been transmuted into quality'. Other writings talk of those possibilities in terms of the 'dialectical image', the shock juxtaposition of contrasted materials that reveals to viewers the fragmented nature of their modern experience: Benjamin's thinking here parallels that of another friend, the playwright Bertolt Brecht. JB

Eagleton, T., *Walter Benjamin* (1981).

BENOIS, ALEXANDRE (1870–1960). Russian-born theatre designer, art historian, and book illustrator. He is credited with opening Diaghilev's eyes to the enchantments of ballet, and later produced designs for him, mixing Russian folk style with elements of the French *Rococo. However, when Diaghilev left for Paris, Benois remained in Russia, acting as curator of the Hermitage Museum, St Petersburg, 1918–25, only moving to Paris permanently in 1926, by which time his former pupil had dismissed him as old-fashioned. MF

Benois, A., *Reminiscences of the Russian Ballet*, trans. M. Britnieva (1941).

BENSON, AMBROSIUS (c.1495–1550). Flemish painter born in Italy (Lombardy), who worked in Bruges. Initially he was in the studio of Gerard *David, by whom he was strongly influenced, but after a few months the relationship went wrong, and the younger painter brought a suit against David. Benson became a master in the local guild in 1519. He was an affluent and successful man: he received commissions from city magistrates to decorate their new county hall and was a member of the city council. However, there are no documents confirming his works, and none remains in Bruges. It seems that many of his paintings were exported, notably to Spain. Benson executed altarpieces and other religious paintings in a somewhat eclectic style which combined elements of the works of his great Flemish predecessors with Italian monumentality and symmetry (*S. Anthony of Padua*, c.1532; Brussels, Mus. Royaux). From his later years there are also mythological scenes and paintings of classical subjects. KLB

Grössinger, C., *North-European Panel Painting* (1992).

BENTON, THOMAS HART (1889–1975). American painter. Born in Neosho, Mo., Benton attended the Art Institute of Chicago in 1907. In 1908 he went to Paris where he was deeply influenced by Stanton *MacDonald-Wright. Returning to New York in 1912 he adopted Wright's theories in paintings like *Constructivist Still Life: Synchromist Colour* (1917; Columbus, Oh., Gal. of Fine Arts). Around 1920, he abandoned *modernism, which he later opposed vehemently, and from 1924 travelled in the south and midwest recording rural, small town life. By 1929 he was associated with Grant *Wood and John *Curry as a *Regionalist, extolling the virtues and values of non-metropolitan America. Like earlier generations of American social realists Benton was anxious to democratize art and to this end conceived an ambitious pictorial history of the United States in 64 panels, sixteen of which were completed. However his desire for accessibility was achieved at the expense of subtlety, and his murals of contemporary America (1930–1; New York, School for Social Research), compartmentalized into irregular individual scenes, are only saved from banality by their raw energy. By the 1940s his reactionary views made him increasingly isolated. DER

Baigell, M., *Thomas Hart Benton* (1973).

BENTVUEGHELS. See SCHILDERSBENT.

BÉRAIN, JEAN (1640–1711). He was the most notable and prolific designer of his time, producing drawings for tapestries, furniture, silver, interior decoration, the theatre, and royal and aristocratic festivities. Among his specialisms were arabesques, *grotesques, and *singeries. Bérain's designs were widely disseminated through suites of engravings, such as the *Œuvre de Jean Bérain* of 1711. They provided inspiration to the painters, sculptors, decorators, and cabinetmakers of the *Rococo period. MJ

Gorce, J. de la, *Bérain: dessinateur du Roi Soleil* (1986).

BERCHEM, NICOLAES (1620–83). Dutch painter, draughtsman, and son of the still-life painter Pieter *Claesz, Berchem was one of the second generation of Dutch Italianate landscape painters. Except for an early training with his father, there is no further documented evidence. After joining the Haarlem painters' guild in 1642, he travelled with Jacob van *Ruisdael to Bentheim near the German border c.1650. His early works are tonal landscapes influenced by van *Goyen but his style changed significantly during the 1650s, either in response to a journey to Italy, or to other artists, such as Jan *Both or Pieter van *Laer. Landscapes become grander, suffused by a clear Mediterranean light, in which elegant peasants tend their cattle and gossip in the tranquil evening as in *Herd of Cattle Crossing a Ford* (1656; Amsterdam, Rijksmus.). Some of his genre subjects cater to a mid-17th-century taste for the exotic such as *Moor Presenting a Parrot to a Lady* (Hartford, Conn., Wadsworth Atheneum). Berchem was highly productive and well paid, with many pupils, including Pieter de *Hooch and Jacob *Ochtervelt. CFW

Salerno, L., *Landscape Painters of the 17th Century in Rome* (3 vols., 1977–80).

BERCKHEYDE, GERRIT ADRIAENSZ. (1638–98). Dutch painter of architectural views. From a family of painters, Berckheyde trained under his brother Job, whose subject matter is so similar that confusion often arises between their work. During the 1650s the brothers travelled along the Rhine and worked at Heidelberg for the Elector Palatine, Karl Ludwig. By 1660 Gerrit Berckheyde returned to Haarlem for the remainder of his life. He specialized mainly in townscapes, many of Haarlem and Amsterdam, often repeating certain landmarks of both cities in compositions throughout his career. *The Market Place at Haarlem with the Town Hall* (1671; Haarlem, Frans Hals Mus.) has the low viewpoint and dramatic sunlight and shadow effects which are so characteristic of Berckheyde's work. Figures, although dwarfed by the architecture, are important vertical accents which enhance the tranquillity and grandeur of the architectural vistas. Interior scenes such as *Interior of S. Bavo, Haarlem* (1668; Haarlem, Frans Hals Mus.) owe a debt to *Saenredam or de *Witte yet Berckheyde's sweeping shadows interspersed with strong shafts of sunlight give his work a powerful individuality. CFW

Lawrence, C., *Gerrit Berckheyde: Haarlem Cityscape Painter* (1991).

BERENSON, BERNARD (1865–1959). Art historian and *connoisseur. A child of Lithuanian Jews who emigrated to America in 1875, Berenson graduated from Harvard University in 1887. From his student days onwards he was in contact with wealthy art collectors, in particular Isabella Stewart Gardner (see BOSTON, ISABELLA STEWART GARDNER MUSEUM), who sponsored his first extensive trip to Europe. There he soon established a reputation as an expert in Italian Renaissance art and in 1895 entered into partnership with the art dealer Joseph Duveen (1869–1939). His collaboration with dealers and patrons was extremely lucrative and enabled him to purchase the Villa I Tatti near Florence, now a private institute for the study of Renaissance art. A spiritual heir to Giovanni *Morelli, Berenson became the connoisseur par excellence and made the principle of tactile values the touchstone of assessment and interpretation. For him the power to stimulate the tactile imagination was especially strong in the Florentine painters, to whom he dedicated two of his chief works, *The Florentine Painters of the Renaissance* (1896) and the critical catalogue *The Drawings of the Florentine Painters* (1903).

See also ITALIAN ART AS OBJECTS OF PATRONAGE AND COLLECTING: USA. AT

Samuels, E., *Bernard Berenson: The Making of a Legend* (1987).

BERG, CLAUS (1470×80?–1532×5?). North German woodcarver, probably born in Lübeck. His work betrays the influence of Veit *Stoss and it is likely that he spent time in south Germany. In 1504–5 he was invited to Odensee by Christina of Saxony, Queen of Denmark. Among her commissions was the high altar (1517–22) for the Franciscan church, Odensee (parts of which are in what is now S. Canute), in which Berg combined the *Tree of Life (Crucifixion)*, *All Saints*, the *Passion of Christ*, and the *Veneration of the Virgin*. He also carved altarpieces for other Danish churches, and tomb slabs, pulpits, epitaphs, and choir stalls are attributed to him. After leaving Denmark in 1532, he went to Mecklenburg. Berg excelled in figures of dramatic pathos and energetic movement, as in the series of *Apostles* he carved for the cathedral at Güstrow (*in situ*). He was one of the last exponents of the Baltic late Gothic style on the eve of the Reformation. KLB

Baxandall, M., *The Limewood Sculptors of Renaissance Germany* (1980).

BERGHE, FRITS VAN DEN (1883–1939). Belgian painter, born in Ghent, where he studied (1897–1904) and later taught (1907–11) at the Academy. While teaching in Ghent he lived at the nearby village of Laethem–St Martin, where he was a member of a colony of artists including *Permeke and de *Smet. He also worked with de Smet in Holland when they fled there during the First World War. It was at this time that his work turned decisively from *Impressionism to *Expressionism, and he is regarded as one of Belgium's leading exponents of the style. He returned to Belgium in 1922 and settled permanently in Ghent in 1925. Initially his Expressionist work was vaguely derived from *Cubism, with blocklike forms and matt surfaces, but from the mid-1920s his paintings took on a more fantastic quality in the tradition of *Ensor and Hieronymus *Bosch. These works have been seen by some as an anticipation of *Surrealism. His subjects included landscapes, portraits, nudes, and allegories of the human condition. IC

BERGMÜLLER, JOHANN GEORG (1688–1762). German painter. He trained in Munich, but from 1713 was resident in Augsburg. There he became the city's most ubiquitous painter and influential teacher in the 18th century. His work is almost exclusively religious and he worked on the decoration of most of Augsburg's churches, Protestant and Catholic, in a solemn late *Baroque style sometimes lightened with *Rococo touches. Most of his fresco decorations were destroyed in the Second World War (those in S. Anna, 1748, and the Residenz, 1754, survive), but he is well represented by altarpieces, such as *S. Amandus Threatening King Dagobert with Punishment for his Sins* (1724; Donauwirth, Heiliges Kreuz). MJ

Johann Georg Bergmüller, 1688–1762, exhib. cat. 1988 (Turkheim, Sieben-Schwaben Mus.).

BERGOGNONE (Borgognone), AMBROGIO, also called Ambrogio di Stefano da Fossano (1453?–1523). Italian painter born in Milan and active there during most of his career. Mentioned as a master in the Milanese painters' register of 1481 he began to call himself Bergognone or Borgognone from 1495. He was a pupil of Vincenzo *Foppa to whose serene style and composition he remained true. His careful rendition of background detail also suggests a Flemish influence, while Provencal painting may be seen as a source for his figure style. His silvery colouring known as his 'grey style' and fine nuances in light and shade are unique qualities. From 1488 to 1494 he worked at the Certosa at Pavia not only producing frescoes, altarpieces, and processional banners but designing stained glass and choir stalls there.

Around 1490 he painted the altarpiece depicting *The Virgin and Child with SS Catherine of Siena and Catherine of Alexandria* (London, NG). MFC

BERLIN: PATRONAGE AND COLLECTING. *See overleaf.*

BERLIN, ANTIKENSAMMLUNG: ALTES MUSEUM AND PERGAMUM MUSEUM. The Antikensammlung of the Staatliche Museen in Berlin is divided between the Altes Museum and the Pergamum Museum. The erection of the Berlin Wall not only separated the territory and people of Berlin, but also resulted in the creation of museums of Antiquity on either side of the wall: the Antiken Museum in West Berlin and the Pergamum Museum in East Berlin. After the fall of the Wall, work began in 1990 on the reinstallation of the antiquities collection in these two sites in the area called the 'Museum Island'.

Founded in 1830 as the first German Museum, the Altes Museum contains Greek and Roman sculpture, vase painting, and minor arts. The origin of the collection dates even earlier, to the collection of the Roman archaeologist Giovanni Pietro *Bellori that was displayed in the Berlin Schloss from 1698. The new installation is organized according to provenance and period, with thematic subdivisions. The museum contains an impressive collection of *Greek vases, including the name vase of the Berlin Painter (active 500–c.460 BC) and works by *Euphronius and *Exekias. The Roman marble *Portrait of Cleopatra* (40 BC) and the *Berlin Athlete* (c.340–330 BC) are just two examples from the rich sculpture collection. A highlight of the *Roman collection is the Hildesheim Treasure, a hoard of gold and silver vessels of Augustan date (1st century BC–1st century AD).

The Pergamum Museum was founded in 1930 to house the extensive finds from German excavations at *Olympia (1875–81), Samos (1910–14), *Pergamum (1878–86), and other east Greek sites (now Turkey). An extraordinary feature of the museum is the reconstruction of architectural elements. Most impressive is the *Hellenistic Great Altar of Zeus from Pergamum (c.180 BC), an extraordinary tour de force with its marble frieze depicting the *Gigantomachy* (120×2.3 m/390×7½ ft). Other examples include the temple of Athena Polias and the North Hall of the Agora at Priene. The sculpture collection covers the entire chronological and iconographical range, with provenances closely connected to German excavations of the last century (e.g. the *Archaic *Berlin Goddess*, 575 BC; colossal head identified as the Pergamene King Attalus I (200 BC)). L-AT

BERLIN, GEMÄLDEGALERIE. The outstanding collection of old master paintings in Berlin has been finally brought together in one permanent building, the fourth in the history of the collection, and opened in the summer of 1998. Constant growth of the collection had necessitated its move in 1905 from the first building, the purpose-built Altes Museum on Museum Island designed by Karl Friedrich Schinkel, to the Kaiser-Friedrich-Museum. After the Second World War and division of Berlin, the collection was split between the East, where the Kaiser-Friedrich-Museum was re-established and renamed the Bode-Museum, and the West, where temporary space was given to the pictures in the former Asian Gallery at Berlin-Dahlem. Founded in 1830, the Berlin Gemäldegalerie, unlike the museums at Munich or Dresden, did not emerge from a royal collection. Only a quarter of the 1,198 paintings first put on display were drawn from the royal palaces. Instead, two major collections acquired shortly before the foundation of the gallery form the core of the collection. One was the Giustiniani Collection from Rome, purchased in 1815 by King Friedrich Wilhelm III and immediately presented to the public. The other was a collection of over 600 pictures, including many Italian primitives, purchased in 1821 from an English timber merchant, Edward Solly. A guaranteed annual acquisitions budget enabled certain purchases to be made, although the money had to be shared between all the other divisions of the museum. However, in 1841, Gustav Friedrich Waagen, the outstanding first director, travelled for a year throughout Italy and purchased over 100 *Renaissance paintings, drawings, and sculptures, preparing the way for the eventual purchase of *Raphael's *Madonna Terranuova*. Waagen was committed to the principle of historicism in the presentation of the collection, backed up by scholarly catalogues and explanatory labels. After the founding of the German Empire in 1870–1, more money was made available with the purpose of creating a collection of imperial stature and international renown. This was achieved in great part during the remarkable curatorial career of Wilhelm von Bode which spanned half a century from 1872 to 1920.

In 1939, the museum was closed and the paintings were first deposited in the vault of the National Mint, later being transferred to a bunker in the the Friedrichshain district and thence to salt mines in Thüringia. More than 400 larger paintings, mainly of the Italian and Flemish Baroque, remained in Berlin and almost certainly were destroyed in May 1945. Few acquisitions have been made in the later 20th century, as resources have been concentrated on amalgamating the dispersed painting collection in a new building, designed by the Bauhaus-trained architect

continued on page 65

· BERLIN: PATRONAGE AND COLLECTING ·

BERLIN'S reputation as an artistic centre springs from its political significance as the capital, successively, of Brandenburg, Prussia, and modern Germany. Founded during the late 12th century, the medieval city was undistinguished, eliciting the observation 'Berliners are good but altogether uncultured' from a visitor in 1505. Berlin became the principal residence of the Hohenzollern electors of Brandenburg during the reign of Joachim I (ruled 1499–1535), who commissioned his father's tomb from the Nuremberg workshop of Peter *Vischer, and had his portrait painted by Lucas *Cranach. The Reformation in Brandenburg was promulgated in 1540 in the name of Joachim II (ruled 1535–71), who employed the Saxons Hans Krell and Hans Schenck as his court portrait painter and sculptor. Although Brandenburg was united with the duchy of Prussia in 1618, Berlin remained small, and the Thirty Years War reduced its population to around 6,000.

The city's fortunes were revived by the Great Elector, Friedrich Wilhelm (ruled 1640–88). He encouraged the immigration of French Huguenots, including painters such as Abraham Romandon and the weaver Pierre Mercier, who transformed its cultural and economic life. Friedrich Wilhelm favoured Dutch painters, of whom the most distinguished was Jan *Lievens, and in 1678 established a Delftware factory. Following the coronation of his heir Friedrich III (ruled 1688–1713) as Friedrich I of Prussia in 1701, the city acquired an increasingly *Baroque character. The first major sculptor to work there was Andreas *Schlüter, from Danzig (Gdańsk), between 1694 and 1714. Other court artists included the Dutch painters Abraham Jansz. Begeyn (1637/8–97) and Augustin Terwesten (1649–1711), and the distinguished Parisian portraitist Antoine Pesne (1683–1757). The earliest significant native artists were the fresco painters Christoph Joseph Werner and Samuel Theodor Gericke, both of whom had studied in Italy. The latter, and Schlüter, were leading lights in the Prussian Royal Academy of Arts, founded in 1696 in imitation of Louis XIV's Académie Royale (see under PARIS).

By 1709 Berlin had grown into one of the largest cities in central Europe, with a population of over 50,000. The 'soldier king' Friedrich Wilhelm I (ruled 1713–40) was himself an amateur artist, but he preferred Dutch genre scenes to Italian mythologies, and cautioned his agent in the Hague that he would prefer numerous acceptable paintings to a few expensive major works. His son Frederick the Great (1740–86) was culturally Francophile; an enthusiastic collector of compositions by *Watteau, *Pater, and *Lancret, as well as paintings by *Rubens, Guido *Reni, and *Rembrandt. Frederick employed French sculptors, retained Antoine Pesne and commissioned works from Louis XV's painter Carle van *Loo. The French painter Blaise Nicolas Le Sueur (1714–83) and the Flemish sculptor J. P. Antoine Tassaert (1727–88) also held senior positions at court and the Academy. In 1743 Daniel Nikolaus Chodowiecki (1726–1801) moved from Danzig to Berlin, where he captured its cultural life in fresh and informal drawings and engravings. Twenty years later Frederick the Great established the Berlin royal porcelain factory, which intitially produced wares in a *Rococo style derived from Meissen.

Under Friedrich Wilhelm II (ruled 1786–97), the Berlin Academy was reorganized to provide systematic provision for the fine and applied arts. A chaste *Neoclassicism, exemplified by the work of the Berlin sculptor Johann Gottfried *Schadow, emerged as the preferred Prussian style. During the long reign of Friedrich Wilhelm III (ruled 1797–1840), the architect and designer Karl Friedrich Schinkel explored a range of styles, from pure Grecian to late Gothic. Napoleon's defeat of Prussia and the French occupation of 1806–8 fostered a patriotic and introspective mood: qualities explored by the landscapes of Caspar David *Friedrich, purchased by Friedrich Wilhelm and the Crown Prince of Prussia in 1810–12. The Italianate landscapes of *Blechen and the panoramic views of Berlin by Eduard Gaertner were collected by middle-class collectors, as well as the King. From 1815 the government acquired art collections for the new Berlin Museum, which opened in 1830 on a site adjacent to the cathedral and the royal palace, with the objective to 'delight, then educate' the public. Its first director Gustav Waagen sought to make its holdings more comprehensive, with the objective of providing an universal survey of European art.

A consensus similar to the political alignment of the upper middle classes and nobility, which provided the foundation for Bismarck's unification of Germany, is visible in Adolf von *Menzel's industrial scenes, *history paintings, and official commissions. Prussia's victory in the Franco-Prussian War and the subsequent unification of Germany was accompanied by a huge increase in the wealth and prestige of Berlin. Its population doubled from 500,000 in 1861 to over 1,000,000 in 1877, and the city was ornamented with massive public sculptures glorifying the Hohenzollern dynasty.

By the 1850s the Berlin Museum had assembled one of the principal Egyptian collections in Europe. During the second half of the 19th century, German archaeologists excavated the spectacular antiquities from Babylon, *Olympia, *Pergamum, Baalbek, and other Antique sites, now housed in the Pergamum Museum. In a professional career of over half a century, which culminated in his appointment as director in 1905, Wilhelm von Bode established Berlin's great collection of Italian *Renaissance sculpture, and transformed its holdings of Italian, German, Dutch, and Flemish old master paintings. By his retirement in 1920, the German Empire had collapsed, leaving as one of its most enduring monuments the complex of art museums on the 'Museum Island' in central Berlin.

Although the Prussian museums were forbidden to collect progressive French art by the conservative Wilhelm II (ruled 1888–1918), Max *Liebermann was profoundly influenced by the *Barbizon School and private collectors such as Carl Bernstein assembled significant collections of *Impressionist pictures. From the 1890s, the tight control which the state exercised over artistic life faltered in the face of opposition from innovative art dealers including Bruno and Paul Cassirer, liberal curators such as Hugo von Tschudi, and the unofficial exhibiting society, the Berlin Sezession. By 1911, when the *Expressionist group Die *Brücke moved from Dresden to Berlin, the German capital was home to a thriving modern art movement.

Many artists who survived the First World War regarded Germany's political and cultural institutions with profound scepticism. Following the abdication of the Kaiser in November 1918, the Novembergruppe sought a synthesis between *Cubism and Expressionism and sympathized with revolutionary politics. Berlin *Dada was established as early as 1917 under the leadership of Richard Huelsenbeck, John *Heartfield, and George *Grosz, and from 1919 it became increasingly antagonistic towards the government. In 1922 the First Russian Art Exhibition established Berlin as a centre for *Constructivist artists oriented towards Soviet Russia. From the early 1920s, the 'New Realism' of Grosz, Otto *Dix, and Christian Schad expressed a trenchant social criticism comparable with the plays of Bertolt Brecht. In 1932 Mies van de Rohe sought to re-establish the *Bauhaus at Berlin; its forced closure in 1933 signalled the defeat of modernism, leaving a void which the 'New German Painting' of the Nazis was powerless to fill.

In 1945 Berlin lay in ruins, its art collections scattered and its best artists in exile. After the proclamation of the Soviet-backed German Democratic Republic in 1949, the artistic life of East Berlin was dominated by *Socialist Realism. In the western sector, survivors of the pre-war *avant-garde looked to the *École de Paris and *Abstract Expressionism. From the 1960s the government of West Berlin invested heavily in cultural provision, and the city regained eminence as an international artistic centre. The reunification of Berlin in 1990 permitted the reorganization of its art collections and encouraged the migration of experimental art activity towards the former eastern sector. In 1995 the impending return of the German government provided the sculptor *Christo with the opportunity to realize his long-cherished project of the *Wrapped Reichstag*.　　　　　　　　　　　　　　　　MLE

Hans Scharoun, in 1964, forming part of the Kulturforum complex in the Tiergarten district. In 1987 the competition for the present gallery building was won by Heinz Hilmer and Christoph Sattler, whose restrained design offers no distractions from the paintings themselves.

Of the 2,902 pictures listed in the 1996 catalogue, about 1,000 paintings are arranged throughout 45 rooms of the new building, with 500 more displayed in sixteen reserve galleries.

The original intention in 1830 was to form a comprehensive and didactic collection, covering the art of the 13th to the 18th centuries. This was achieved in 1998 with the unification of this exceptional collection.

German Romantic paintings are at Schloss Charlottenburg; 19th and early 20th-century paintings are in the old Nationalgalerie on Museum Island; the 20th-century works are in the Neue Nationalgalerie in Tiergarten. The German national sculpture collection, together with Italian Renaissance sculpture, will be at the Bode-Museum (closed until 2004)　　　　　　　　　　　　CFW

BERLINGHIERO (c.1190–c.1237, active 1228), and his sons **Bonaventura Berlinghieri** (active 1228–74), **Barone** (active 1228–82), and **Marco** (active 1232–59). A family of Lucchese painters whose vigorously linear *Romanesque idiom is often erroneously described as a Byzantine manner, reflecting its debt to *Byzantine conventions. The static figures, devoid of contrapposto and with out-of-scale heads, on the *Crucifix* signed by Berlinghiero (Lucca, Mus. Nazionale di Villa Guinigi) would have been quite unacceptable to Byzantine patrons, but its imposing drawing undoubtedly influenced later pictorial technique in Tuscany. His son Bonaventura signed the most important early panel of *S. Francis and his Life* (1235; Pescia, S. Francesco), whose two-dimensional settings caricature Byzantine pictorial space, but with a vigorous chiaroscuro. Marco illuminated a Lucchese Bible in 1150 (probably Lucca, Bib. Capit., cod. 1) and was in Bologna, 1253–9, where the mural of the *Massacre of the Innocents* in S. Stefano shows a related Italo-Byzantine idiom. The family workshop is also credited with an important mosaic of *Christ and the Apostles* on the façade of S. Frediano, Lucca, epitomizing their influence on painting in Tuscany between 1190 and 1270.　　　　　　　　　　　　　　　　RG

Boskovits, M. (Offner, R.), *A Corpus of Florentine Painting*, 1: *The Origins* (1993).
Concioni, G., Ferri, C., and Ghilarducci, G., *Arte e pittura nel medioevo lucchese* (1994).

BERMEJO, BARTOLOMÉ (active 1468–95). Bermejo ('red') is the nickname by which the Spanish painter Bartolomé de Cárdenas is known. Bermejo, active in Aragón in the late 15th century, may have learned how to paint in oils in Flanders, but his earliest known work, a panel representing S. Michael (1468; London, NG), reflects the style of the school of Valencia. In 1474 Bermejo was in Daroca painting an altarpiece dedicated to S. Domingo de Silos; the central panel represents the titular saint in a hieratic pose (Madrid, Prado), his realistic, albeit imaginary, countenance framed by the planar but luxurious treatment of the surface. Bermejo's extensive use of gold, minute depiction of the richly detailed robes, and the deep tones of jewel-like colours perfectly suited the taste of his Spanish patrons. A considerably later *Pietà* including figures of S. Jerome and the patron, Cardinal Lluís Desplà (1490; Barcelona, Cathedral Mus.), is more emotional than Bermejo's earlier works. The anguish expressed in the face of the Virgin Mary is echoed in the darkened landscape and reflected with due sobriety on the strikingly unidealized countenance of Desplà.　　SS-P

Young, E., *Bartolomé Bermejo: The Great Hispano-Flemish Master* (1975).

BERNARD, ÉMILE (1868–1941). French painter, printmaker, decorative artist, and critic. His works, with their simplified forms and distortions of drawing and scale, stimulated the development of pictorial *Symbolism, while his letters and critical writings are an early discussion of the theoretical issues raised by the modern movement. He met *Anquetin as a fellow student, and together, in 1886–7, they evolved a decorative, anti-naturalistic style known as *Cloisonnism characterized by flat colour areas and bold black outlines. Van *Gogh, a close friend in the mid-1880s, admired his Cloisonnist portraits. From 1886, attracted by the contemporary interest in a primitive way

of life, he painted many Breton subjects; his *Breton Women in a Meadow* (1888; Paris, priv. coll.), with its folk subject, flat patterning, and irrational space and colour, inspired *Gauguin, with whom he worked between 1888 and 1891. Later he was associated with the *Nabis, and taught in Egypt (1893–1904). On his return he continued to promote Symbolist theories of art in his periodical *La Renovation esthétique* and an article on *Cézanne, translated by Roger *Fry, was published in the *Burlington Magazine* (1910). HL

Émile Bernard, exhib. cat. 1990 (Mannheim, Kunsthalle).

BERNINI, GIANLORENZO (1598–1680). Italian sculptor, architect, and painter, the outstanding figure of the Italian *Baroque and the greatest formative influence within it. He was the son of the *Mannerist sculptor Pietro Bernini (1562–1629), now best remembered for his fountain in the form of a sunken ship at the bottom of the Spanish Steps in Rome. Pietro passed on to his son not only his remarkable facility in carving marble, but also his connection with the powerful Roman Borghese and Barberini families, who fostered and employed Gianlorenzo's talent. The younger Bernini's earliest surviving work, said to have been carved when he was 16, is the group *The Goat Amalthea Nursing the Infant Zeus and a Young Satyr* (Rome, Borghese Gal.), which long passed for a *Hellenistic original, a tribute to his precocious virtuosity. By the early 1620s, in a series of statues made for Cardinal Scipione Borghese, Bernini had already demonstrated how he could reinvigorate the exhausted tradition of sculpture practised by the last followers of *Michelangelo. The statues, still in the Borghese Gallery in Rome, are *Aeneas and Anchises* (1618–19), *The Rape of Proserpine* (1621–2), *David* (1623), and *Apollo and Daphne* (1622–4). In each case Bernini chose to represent a moment of action rather than repose, and to design them to be seen from a single viewpoint. In form as well as dramatic vigour the figures open out to the surrounding space, involving the spectator not just in an act of aesthetic contemplation, but in a moment of theatre. In these qualities and in the superb handling of marble they represent a decisive break with the then current tradition of late Mannerism and instantly established a benchmark against which contemporary sculpture had to be judged.

On the accession of Maffeo Barberini as Pope Urban VIII in 1623 Bernini soon became the principal artist at the papal court, entrusted with the Pope's ambitious plans to embellish Rome and commemorate his pontificate. Bernini's first project was to provide a new façade for the little church of S. Bibiana and to carve for the high altar a statue of the saint, whose body had been discovered in 1624. Much more ambitious in scale was his involvement with S. Peter's as its official architect, an association that continued with some interruptions for 56 years, and resulted in some of his most famous works. For Urban VIII he provided a colossal statue of *S. Longinus* (1629–38) for one of the piers under the dome (a project that involved the tricky task of hollowing out a giant niche in Michelangelo's supporting structure), a dramatic bronze and marble tomb for the Pope (1628–47; the model for many funerary monuments across Europe in the 17th and 18th centuries) and, most importantly, the great bronze baldacchino or canopy (1624–33) over the tomb of S. Peter. The latter, colossal in size and supported by four twisted columns inspired by those thought to have been in the temple of Solomon in Jerusalem, was as much a tribute to Bernini's skills as an engineer as to those as an architect and sculptor.

These works secured Bernini a European reputation. But on Urban's death in 1644 he fell under a cloud, in part because of structural failures in his lateral towers for S. Peter's and partly because the austere new Pope, Innocent X Pamphili, preferred the more restrained style of *Algardi. During Innocent's papacy Bernini worked mainly for private clients. His principal work from this period is the Cornaro chapel in S. Maria della Vittoria, Rome (1645–52). Though small, this work is perhaps the most perfect example of Bernini's attempts to fuse sculpture, architecture, and painting into a dramatic and emotionally charged whole in accord with Counter-Reformation ideas of spirituality. The centrepiece of the ensemble is the famous marble group of *S. Teresa in Ecstasy*, which the spectator, accompanied by members of the Cornaro family carved as if in theatre boxes in relief on the side walls, views through an architectural screen like a proscenium arch. Saint and accompanying angel, poised to penetrate, are bathed in a divine radiance achieved with coloured glass in a hidden skylight. The whole bears witness not only to Bernini's original artistic mastery, but also to the personal piety of a regular reader of the *Spiritual Exercises* of Ignatius Loyola.

Bernini was not, however, entirely cut off from papal patronage during this period. From 1648 to 1651 he designed and in part executed the Four Rivers Fountain in the Piazza Navona, Rome, a commission originally intended for his rival, the architect Francesco Borromini (1599–1667). Incorporating an Antique obelisk supported by artificial rockwork and personifications of the rivers Danube, Nile, Ganges, and Plate, which represent the four quarters of the globe, it is one of the most spectacular of Rome's many fountains and stands on Pamphili territory near Borromini's Palazzo Pamphili and S. Agnese.

With the election of Alexander VII as pope in 1655 Bernini was returned to full favour. At Alexander's order he decorated the apse of S. Peter's with a bronze setting for fragments of the throne of S. Peter. In effect a reliquary on a colossal scale, the Cathedra Petri incorporates many of the effects which Bernini had used so successfully in the Cornaro chapel. Viewed as intended through the earlier baldacchino it is intensely dramatic. Also from this time date Bernini's first plans for arranging the square in front of S. Peter's with its oval colonnade, one of the most impressive pieces of townscape in Europe. In 1663 he designed the adjoining Scala Regia, connecting the square with the Vatican Palace above. Here he made ingenious use of perspective effects to counteract the awkwardness of the site and placed at its foot his equestrian statue (1654–70) of the Christian Emperor Constantine I. Creative and highly expressive use of geometry and subtle visual effects are also characteristics of Bernini's third Roman architectural masterpiece, the elliptical church of S. Andrea al Quirinale (1658–70). Although on a relatively modest scale this Jesuit building displays a resourcefulness in the manipulation of the classical language of architecture that only Borromini among his contemporaries could match.

In 1665 Bernini was invited to *Paris by Louis XIV to make designs for a new main block for the Louvre. Intrigue by French artists and the inexorable drift of the French King's statecraft towards a national French style meant that Bernini's Italianate ideas were not, eventually, accepted—those of Claude Perrault and Louis Le Vau being preferred. He did, however, execute a fine bust of the king (Versailles), and his conversations on art and other topics were recorded by Fréart de Chantelou, the court official in charge of his welfare. A few years after his visit Bernini delivered to Versailles an equestrian statue of Louis XIV modelled on that of Constantine. So far was its Baroque vigour from the classicizing style by then in favour in France that it was recarved by François *Girardon as *Marcus Curtius Throwing Himself into the Flames* and banished to a remote part of the park.

Notable later works by Bernini include a series of over-life-size angels displaying the instruments of the Passion for the Ponte S. Angelo (1668–71), the recumbent figure of *The Blessed Lodovica Albertoni* (1671–4) in the Altieri chapel of S. Francesco a Ripa, and the tomb of Alexander VII in S. Peter's (1671–8). The last is even more theatrical in its effect than the earlier tomb of Urban VIII.

In addition to being the best monumental sculptor of his century, Bernini was also the foremost portrait sculptor of his day, bringing a sense of grandeur, drama, and forceful characterization to even the most official likenesses of popes and kings, and introducing a welcome note of lively informality to those of his friends. Outstanding *busts are

those of his early patron *Cardinal Scipione Borghese* (1632; Rome, Borghese Gal.), of the English cavalier *Thomas Baker* (1638; London, V&A), and of *Gabriele Fonseca* (c.1670; Rome, S. Lorenzo in Lucina). So great was Bernini's reputation in this field that he was sometimes asked to work from paintings provided by foreigners who could not travel to Rome: a triple portrait of Charles I of England by van *Dyck survives, painted especially for Bernini to carve the marble bust of the King that was destroyed later in the century in the Whitehall fire. As in so many areas of his activity, Bernini set patterns and standards that were still being followed in the mid-18th century.

Besides being the official entrepreneur of the papacy in its last great period of political and economic ascendency, Bernini was also a witty conversationalist, a writer of comedies, a caricaturist, and a painter. Argument still rages among scholars as to which of the surviving paintings associated with him are actually by his hand. A painting in the Barberini Collection of *SS Andrew and Thomas* in the manner of Andrea *Sacchi and a scattered group of portraits and self-portraits influenced by *Velázquez, whom Bernini had met in Rome, are the likeliest candidates. It seems certain, however, that despite his appreciation of the uses of painting by others in his decorative ensembles, it always remained in his own output a tertiary activity largely indulged in for his own amusement.

Bernini continued to be the dominant influence on sculpture in Italy and to some degree in France, the Netherlands, and Germany until the mid-18th century. With the advent of *Neoclassicism, however, his fall from favour was speedy and complete. Neither the dramatic realism of his style, the virtuosity of his technique, nor the enthusiasm with which he displayed his piety was palatable to critics or amateurs in the later 18th and 19th centuries, particularly Protestant ones who regarded the Baroque as vulgar and insincere. It is only since the revival of interest in the art of the Baroque in the secular second half of the 20th century that Bernini has taken his rightful place among the greatest artists in the Western canon.

HO/MJ

Avery, C., *Bernini* (1998).
Baldinucci, F., *Vita del Cavaliere Gio. Lorenzo Bernini*, trans. C. Enggass (1966).
Gould, C., *Bernini in France* (1981).
Hibbard, H., *Bernini* (1965).
Wittkower, R., *Gian Lorenzo Bernini: The Sculptor of the Roman Baroque* (3rd rev. edn., 1981).

BERRUGUETE, FATHER AND SON. Castilian painters. **Pedro** (c.1450–1503) and his son **Alonso** (c.1488–1561) were associated with the introduction of *Renaissance and *Mannerist styles in Spain. According to some writers court painter to Ferdinand and Isabella, Pedro may have been the 'Pietro Spagnuolo' active at the court of Federigo da Montefeltro at *Urbino who collaborated with *Joos van Wassenhove and *Melozzo da Forlì on the decoration of the *studiolo*. Alonso probably trained under his father, before spending some years in Florence and Rome (c.1508–16) where he absorbed the lessons of sculptors like *Donatello, della *Quercia, and *Michelangelo. He completed Filippino *Lippi's *Coronation of the Virgin* (Paris, Louvre), but other paintings executed from this period reflect the anguished Mannerism of *Rosso and *Pontormo. By 1518 he had returned to Spain, where he sought work from Emperor Charles V and embarked on a series of important composite altarpieces incorporating painting and free-standing and relief sculpture. One was commissioned for S. Benito in Valladolid (1526; Valladolid, Mus. Nacional de Escultura Religiosa). Another retable of the *Adoration of the Magi* (1537; Valladolid, Santiago), with its dynamic composition and figure style, displays his close familiarity with Michelangelo's work. His marble tomb of Cardinal Tavera (1559; Toledo, Hospital Tavera) is indebted to *Sansovino's Roman tomb design.

AB

Azcárate, J. M. (ed.), *Alonso Berruguete: cuatro ensayos*, exhib. cat. 1963 (Valladolid, Mus. Nacional de Escultura).

BERTOLDO DI GIOVANNI (c.1440–91). Italian sculptor. Famous for his association at Florence with the Medici family, for whom he became court sculptor, Bertoldo began his career as an assistant to *Donatello on the pulpits for S. Lorenzo (c.1455–70). He was instrumental in developing the genre of small bronze statuette intended for a private collector, particularly with his energetic *Bellerophon and Pegasus* (c.1480–5; Vienna, Kunsthist. Mus.) and the lyrical *Apollo* (1470s; Florence, Bargello). His interest in classical sculpture is evident in the *Battle Scene* bronze relief (c.1480; Florence, Bargello), based on an Antique sarcophagus in the Camposanto in Pisa. Traditionally supposed to have taught *Michelangelo at the Medici sculpture garden at Piazza S. Marco, it is more likely that he played the role of curator and restorer of the Medici Antique collections housed there, where younger artists also came to draw and learn. He also designed a medal of *Mohammed II* (1480–1) after a portrait by Gentile *Bellini.

AB

Draper, J. D., *Bertoldo di Giovanni, Sculptor of the Medici Household* (1992).

BERTRAM, MASTER (active 1367–1414/15). German painter and illuminator from Minden, Westphalia, who worked in Hamburg from 1367 onwards. Documentary evidence suggests that he may have gone on a pilgrimage to Rome in 1390. His main work is the *S. Peter* altarpiece, the so-called Grabow altarpiece, a huge polyptych completed 1383 for the high altar of S. Petri in Hamburg (now Kunsthalle). The double-winged altar includes a carved shrine, *predella, headpiece, and 24 painted panels. The sculptural parts consist of a *Crucifixion*, flanked on either side by double rows of prophets, saints, and apostles. The painted wings display narratives in two rows, one on top of the other, beginning with the Creation and closing with the infancy of Christ. The scenes are painted in bright colours against a golden background. The figures are large and bulky, softly modelled with single drapery folds, which recall the *Bohemian School of painting. It has been suggested that Bertram was trained in Prague.

KLB

Beutler, C., *Meister Bertram: der Hochaltar von Sankt Petri* (1984).

BESTIARY, a medieval natural history text designed to transmit the Christian message through moralizing tales from the animal kingdom. It is believed that bestiaries derive from the 2nd-century Greek text *Physiologus* which combined Hebrew, Egyptian, and Indian animal legends. The bestiary contains on average 100 sections, each comprising a brief description of an individual animal, a lesson, and an accompanying image. The earliest known illustrated bestiary is dated c.1120 and contains pen drawings (Oxford, Bodleian Lib., MS Laud. Misc. 247). With the increase in their popularity in the late 12th and early 13th centuries, particularly in England, more attention was lavished on the illumination which became more detailed and larger in scale; they became one of the leading picture books of the Middle Ages. One of the most lavish examples contains 120 illuminations of animals and eight Creation scenes (c.1210; Oxford, Bodleian Lib., MS Ashmole 1511). After the mid-13th century the popularity of the bestiary declined, yet its images exerted a great influence on medieval art as seen in decorated initials and *misericords.

KC

White, T., *The Bestiary: The Book of Beasts* (1954).

BEUYS, JOSEPH (1921–86). German sculptor. Beuys was born in Krefeld but moved to Kleve in the same year. He served as a pilot in the Luftwaffe during the Second World War before studying woodcarving at the Düsseldorf Academy (1947–51). Possibly the most influential post-war German artist, Beuys was both artistically and politically provocative, as acknowledged by his multiple print self-portrait *We are the Revolution* (1972), and always worked at the cutting edge of the avant-garde. His sculptures, frequently created in the form of enigmatic assemblages, used a variety of non-conventional materials including both felt (*Felt Suit*, 1970;

London, Tate) and lard, which he claimed had saved him from hypothermia when shot down over the Crimea during the war. The attribution of magical and personal properties to the contents of his work is consistent with his belief in the artist as shaman and art as revelatory. He himself became a guru figure, particularly when he was dismissed from the chair of sculpture at Düsseldorf in 1971, after ten years, for offering places in his classes to unqualified students. Like *Warhol, whom he resembled in no other way, Beuys exemplifies the artist as personality, his behaviour and philosophy being as important as his work. Indeed much of his œuvre was intentionally ephemeral, whether as *performance, like *How to Explain Pictures to a Dead Hare* (performed 1965; Düsseldorf, Schmela Gal.), or because of the organic nature of his materials, like tallow and lard, which would necessarily dissolve or disintegrate. Beuys was also a pacifist, conservationist, and political activist who originated the Organization for Direct Democracy (1972) and was a founder member of the German Green Party. DER

Szeeman, H. (ed.), *Beuys*, exhib. cat. 1993 (Zurich, Kunsthaus).

BEWICK, THOMAS (1753–1828). British *wood engraver, best known for his representations of animals and birds. By electing to work with a burin (rather than a knife) on the end-grain of the boxwood, Bewick demonstrated the possibilities of wood engraving as a cheap and accurate alternative to copper engraving that could be conveniently printed in conjunction with letterpress. Among his other innovations were to emphasize the 'white line' (the part of the wood cut away) and to shave down the surface of the block in the areas corresponding to the background, so that they received less ink and printed grey.

With such refinements at his command and by designing as well as engraving his own compositions, Bewick helped to revive printmaking in the Romantic period as a creative, as distinct from merely reproductive, medium. Preceded by some collections of fables, his two principal works were *A General History of Quadrupeds* (1790) and—his masterpiece—*A History of British Birds* (2 vols., 1797–1804). The latter depended on Bewick's own observations as a naturalist, and the book is memorable for its narrative tailpieces—vignettes in which aspects of north-country life are rendered with humour and a deep love of nature. His last publications were produced with the help of pupils, who included his brother John and son Robert. Bewick lived throughout his working life and published his books in Newcastle upon Tyne, in a period when the city had a flourishing literary and scientific, as well as industrial, culture. MK

Bain, I., *Thomas Bewick: An Illustrated Record of his Life and Work* (1979).
Bain, I., *The Watercolours and Drawings of Thomas Bewick and his Workshop Apprentices* (2 vols., 1981).

BIBIENA (Galli-Bibiena) FAMILY. Italian architects and stage designers based in Bologna; eight members practised from 1670 to 1787 in practically every country of Europe. They provided fantastically elaborate stage settings in a late Baroque style for operas, balls, state occasions, and religious ceremonies, mainly in the service of the Austrian imperial family in Vienna and various German princelings. They also built several theatres in Italy and Germany, one of which survives: the Opera House at Bayreuth, decorated by **Giuseppe** (1696–1756) in 1748. About 200 engravings of their designs are known, including **Ferdinando's** (1659–1739) *Architettura civile* (Parma, 1711). The Theatre Collection of the Austrian National Library in Vienna has a large collection of drawings by family members. HO/MJ

Hadamowsky, F., *Die Familie Galli-Bibiena in Wien* (1962).
Mayor, A. Hyatt, *The Bibiena Family* (1945).

BIBLE HISTORIALE, a popular medieval text combining biblical narrative, legend, and religious commentary. It was written by Guiart des Moulins (*c.*1295) and based on Peter Comestor's 12th-century *Historia scholastica*. Even the earliest copies were quite often illustrated and in France during the 14th and 15th centuries many luxury copies were made; one of the most extensively illuminated is the manuscript presented to Charles V of France by his counsellor Jean de Vaudetar in March 1372 (The Hague, Rijksmus. Meermanno-Westreenianum, MS 10 B 23) that has a dedicatory miniature showing the King receiving the book that is signed by Jan *Baudolf. A version of the text was printed but from the Reformation such legendary glosses to the central biblical text were discouraged. KC

McGerr, R., 'Guyart Desmoulins, the Vernacular Master of Histories and his "Bible historiale"', *Viator*, 14 (1983).

BIBLE ILLUSTRATION. In the early Christian period single books or groups of books, rather than complete bibles, tended to be illustrated. The most commonly illustrated were the Pentateuch (the five books of Moses), the Octateuch (the first eight books), the psalter, the Gospels, and the Apocalypse. These remained the most fully illustrated sections in the complete bibles of the early Middle Ages. The earliest surviving manuscripts are the fragmentary leaves from Quedlinburg (*c.*400; Berlin, Staatsbib. zur Preussischer Kulturbesitz, MS theo. Lat. fo. 485) with text and illustrations to the Books of Kings; the 6th-century Vienna Genesis (Vienna, Österreichische Nationalbib., Cod. theol. Gr. 31) and Cotton Genesis (London, BL, Cotton MS Otho B. VI) which contained a fuller series of pictures than any subsequent Genesis illustrations; and the Ashburnham Pentateuch (early 7th century; Paris, Bib. Nat., MS nouv. acq. lat. 2334). Octateuchs with illustrations based on early Christian models appeared in 11th- to 13th-century Byzantium (Mt. Athos, Vatopedhi monastery, Cod. 602).

Complete bibles with illustrations, principally for Genesis and Exodus, were produced in the scriptorium of S. Martin, Tours, during the Carolingian period; the Montier-Grandval Bible (*c.*840; London, BL, Add. MS 10546) is the oldest of these. Nothing similar has survived from the Ottonian period. *Romanesque art produced some of the most splendid of decorated bibles such as the Nury Bible (*c.*1135; Cambridge, Corpus Christi College, MS 2) and the Winchester Bible (*c.*1160–90; Winchester, Cathedral Lib.). Illustration tended to play a smaller role than decoration and was on the whole limited to one miniature or historiated initial to each book. Gothic bibles were smaller and had still fewer illustrations, but at the same time large, sumptuously illustrated picture bibles, often combining illustrations with scenes of historical or typological content, were produced for laymen. Most important of these are the *Bible moralisée* which contains over 5,000 small pictures (*c.*1240; Oxford, Bodleian Lib., Bodley MS 270b; Paris, Bib. Nat., MS lat. 11560); the *Bible historiale* such as the one made for Charles V (1371; The Hague, Rijksmus. Meermanno-Westreenianum, MS 10 B 23); and subsequently the great typological books such as the *Biblia pauperum*. Among the most lavishly illuminated bibles is the Bohemian Wenceslas Bible (*c.*1390–5; Vienna, Österreichische Nationalbib. Cods. 2759–64), which is only half finished, (nevertheless it contains close to 600 miniatures), and the two-volume Bible of Borso d'Este (1455–61; Modena, Bib. Estense, MS V.G. 12). Despite these magnificently illuminated codices, by the end of the Middle Ages illustrated bibles had become a rarity.

Ordinary illustrated bibles reappeared following the introduction of printing with movable type in the mid-15th century. Woodcuts and engraving were used to illustrate the text. In 1478–9 Heinrich Quentell designed two bibles in Cologne which featured over 100 double-column illustrations. Quentell's designs later became prototypes for subsequent editions. The publication of Martin Luther's German translation was accompanied by illustrations by Lucas *Cranach the younger. The rise of Protestantism encouraged the widespread use of German translations, and Zurich and Basle became

the centres for printing. Hans *Holbein also designed woodcuts for Bible illustrations, such as those in the 1538 *Historiarum Veteris Testamenti icones* published by Johannes Treschel. Numerous illustrated editions of the Bible were published in the following centuries, of which the 19th century produced the most outstanding examples such as Gustave *Doré's in 1866 and William *Blake's personal vision of the *Book of Job*. Several modern artists, including Georges *Rouault and Marc *Chagall, have made series of etchings of biblical illustrations. In 1931 Eric *Gill's *Four Gospels of our Lord Jesus Christ* blended elegant text design with illustration. A complete illustrated Old Testament was published by the Oxford University Press in 1968–9, with work by a group of contemporary artists. KC

Cahn, W., *Romanesque Bible Illustration* (1982).
Hamel, C. de, *Glossed Books of the Bible and the Origins of the Paris Booktrade* (1984).
Hamel, C. de, *Illuminated Manuscripts* (1986).
Smalley, B., *The Study of the Bible in the Middle Ages* (1952, 1970).
Strachan, J., *Early Bible Illustrations* (1957).

BIBLE MORALISÉE, a type of Bible developed in 13th-century France for use by the laity. It contains short biblical passages with explanatory commentaries, often in the form of moralizations, allegories, and analogies. The texts are secondary to the detailed pictorial programmes and these manuscripts count among the most elaborately illuminated books (see ILLUMINATED MANUSCRIPTS) of the medieval period. One of the most lavish versions contains over 5,000 small miniatures and is divided into several volumes (c.1240; Oxford, Bodleian Lib., Bodley MS 270b; Paris, Bib. Nat., MS lat. 11560; London, BL, Harley MSS 1526–7). The manuscripts were created in workshops experienced in producing large manuscripts and with access to the theological knowledge necessary to devise the vast illustrative programmes. It is thought that they originated in the Parisian monastic houses of S. Germain-des-Prés or S. Victor. It seems likely that these early examples were made for members of the French royal family; this was certainly the case with two later copies that were modelled on them, one made for John the Good, King of France (1350–55; Paris, Bib. Nat., MS fr. 167) and the copy for which his son Philip the Bold, Duke of Burgundy employed the de *Limburgs (c.1402–4; Paris, Bib. Nat., MS fr. 166). KC

Branner, R., *Manuscript Painting in Paris during the Reign of S. Louis* (1977).

BICCHERNE. From 1257 to circa 1682 the registers of the Biccherna, the exchequer of the city-state of Siena, were bound in wooden boards on which small panel paintings were executed. These were of exceptional quality compared with other centres, reflecting the importance of painting as both craft and industry in the city. The earliest to survive is for 1258, by Gilio di Pietro, succeeded by those of Dietisalvi di Speme for 1264, 1270, 1282. Originally they depicted the chief clerk or/ and the current arms of the office, but later showed religious and civic subjects. The term is extended to similarly decorated registers of other Sienese offices. The greatest Sienese painters were among their executants, including *Duccio (lost commissions between 1279 and 1295) and Ambrogio *Lorenzetti (*Good Government* for the Gabella office, 1344). RG

Borgia, L., and Carli, E., *Le biccherne* (1984).

BICCI DI LORENZO (1373–1452). Florentine painter and architect from a dynasty of artists whose workshop thrived despite indifference to current developments in *Renaissance art. His early work is derived from the trecento manner of his father, Lorenzo di Bicci, but the first quarter of the 15th century saw Bicci's art develop into a popular, workmanlike style that was in great demand. The ornate triptych of the *Virgin and Child with Saints* (1435; Bibbiena, SS Ippolito e Donato) is typical of Bicci's taste for decorative qualities and the deployment of stock figures against a gold background. The studio was employed on several major projects in Florence, notably the cathedral and the hospital of S. Maria Nuova for which Bicci provided fresco decorations, altarpieces, and architectural models. By the 1440s, Bicci's son Neri took over the running of the workshop, ensuring the continuation of his father's manner into the next generation. PSt

BIEDERMEIER, a term applied to bourgeois life and art in German dominated Europe between the Congress of Vienna (1815) and the revolution of 1848. It derives from Gottlieb Biedermeier, the pseudonym adopted by Ludwig Eichrodt (1827–92) and Adolf Kussmaul (1822–1902) when writing his fictional adventures in mildly satirical verse for a Munich journal, *Fliegende Blätter*; *bieder* meaning solid and unpretentious in German. Despite regional variations Biedermeier style is therefore staid, sober, and particular, eschewing heroics and drama. Opposed to academic and religious subjects, Biedermeier painters usually worked on a small scale in a detailed naturalistic style. Although applied to portraits, unpretentious and highly finished, and landscapes, particularly those of the Austrian painter Ferdinand *Waldmüller, it is primarily associated with interiors which often contain the furniture with which the term is more commonly associated. After 1830 Biedermeier painting became less spare and formal and more sentimental and anecdotal, a typical example being the gently humorous *Poor Poet* (1839; Munich, Neue Pin.) by the Munich landscape and genre artist Carl Spitzweg (1808–85). DER

Wilkie, A., *Biedermeier* (1987).

BIERSTADT, ALBERT (1830–1902). German-born American painter. Bierstadt was born in Solingen, near Düsseldorf, but emigrated to America as a child. In 1853 he returned to Düsseldorf to study at the Academy, popular with American painters at this time. During his European stay he visited Rome, with negligible effect on his subsequent work which remains resolutely Germanic and Romantic. He returned to America in 1857 and in the following year joined a surveying expedition, under General Lander, to the Rocky Mountains and the west. This was the first of many similar journeys during which he made sketches which he later worked up into paintings. His highly finished and atmospheric pictures of the awesome scenery of this unknown territory, like the *Rocky Mountains* (1863; New York, Met. Mus.) or the equally sublime *Lake Tahoe* (1868; Cambridge, Mass., Fogg Art Mus.) proved massively popular to a society which still saw the west as its destiny. Occasionally, as in *The Last of the Buffalo* (Washington, Corcoran Mus.), Bierstadt acknowledged that the conquest of the west would inevitably destroy its natural harmony. DER

Anderson, N., and Ferber, L., *Albert Bierstadt: Art and Enterprise*, exhib. cat. 1991 (New York, Brooklyn Mus.).

BIGARNY, FELIPE. See VIGARNY, FELIPE.

BIGOT, TROPHIME (c.1579–1650). French painter. Bigot, who came from Arles, is documented in Rome throughout the 1620s and may well have been there for many years previously. J. von *Sandrart (*Teutsche Academie*, 1675–9) noted that he had painted *Caravaggesque nocturnal half-lengths. From 1634 Bigot was back at Arles, and then at Aix and Avignon, painting and signing large altarpieces in a coarsely realistic provincial style. These works are not compatible with the bulk of the corpus of Caravaggesque half-lengths that the English art historian Benedict Nicolson had associated first with an unnamed 'Candlelight Master' and then with Bigot. There is, however, a 1708 engraving of a (lost) nocturnal half-length piece by Bigot in the manner of *Honthorst, and a closely related painting is in a private collection in Aix.

In the present state of knowledge, Bigot remains a shadowy figure as regards his Caravaggesque manner. A clearer view may emerge from current efforts to analyse the corpus of work once attributed to the 'Candlelight Master'. AJL

Cuzin, J.-P., 'Trophime Bigot in Rome: A Suggestion', *Burlington Magazine*, 121 (1979).
Nicolson, B., *Caravaggism in Europe*, ed. L. Vertova (1989).

BILL, MAX (1908–94). Swiss artist, architect, designer, writer, and teacher. He studied silversmithing in Zurich (1924–7), and architecture at the *Bauhaus (1927–9) where *Kandinsky, *Klee, and *Schlemmer were formative influences, as were van *Doesburg's *Constructivism and theory of *Concrete art. Bill used mathematics and geometry to create an impersonal art, spiritually accessible to everyone. His paintings of geometric *colour progressions within mathematical grids rely for effect on the interaction of colour and form: *Condensation towards Yellow* (1965; Belfast, Ulster Mus.). His stone or polished brass or copper sculptures are similarly dependent, one of the best known *Endless Loop* (1947–9; New York, Hirshorn Coll.), being based on the curious Möbius strip. A member of *Abstraction-Création, he organized the first exhibition of Concrete art (1944, Basle), and, through his writings, was influential in Italy, Germany, and South America. Bill was rector of the Ulm Hochschule für Gestaltung (1951–5) which, built to his design, stands as his most ambitious architectural project. His writings include essays on Kandinsky and 'Die Mathematische' (*Werk*, 3, 1949), which advanced a mathematical approach in contemporary art. YJ

Hüttinger, E., *Max Bill* (rev. edn., 1978).

BINDING MEDIUM. See MEDIUM.

BINGHAM, GEORGE CALEB (1811–79). American painter. Bingham was born in Virginia but, after 1819, spent most of his life in Missouri. He began to paint portraits *c*.1833, after an apprenticeship to a cabinet-maker; his *Self-Portrait* (1835; St Louis, Art Mus.) is provincially unsophisticated. During 1838 he studied in Philadelphia, amassing a repertoire of poses for subsequent compositions. He flourished from the mid-1840s with paintings of Missouri life, the finest of which, *Fur Traders Descending the Missouri* (*c*.1845; New York, Met. Mus.), is a conceptualized composition of figures in a canoe, parallel to the picture plane, set against a luminescent, atmospheric dawn. These local paintings achieved national distribution and fame, as engravings, through the American Art Union. In 1848 he began a political career, reflected in such pictures as *The Verdict of the People* (1855; St Louis, Boatmen's National

Bank). A period in Düsseldorf (1856–9) affected some of his later paintings with European sentimentalism. In his finest work, despite using formulas, he showed great originality and endowed American subject painting with the dignity of universality. DER

Bloch, E. M., *George Caleb Bingham* (2 vols., 1967).

BIRAGO, GIOVANNI PIETRO (active *c*.1470–1513). Italian illuminator (see ILLUMINATED MANUSCRIPTS). His earliest works are three signed choir books from Brescia Cathedral (Brescia, Pin. Civica Tosio-Martinengo, MSS 22, 23, and 25) but by 1490 he was the most favoured illuminator at the Sforza court in *Milan, and it is for this work that he is best known. Next to the Hours of Bona Sforza (left unfinished by Birago in 1494; London, BL, Add. MS 34294) the most impressive survivors of these commissions are the illuminated frontispieces of luxury copies of Giovanni Simonetta's *Life of Francesco Sforza* (1490), made for Francesco's son Ludovico il Moro (Ludovico's own copy *c*.1490–5; London, BL, Grenville bequest). Birago's style is accomplished and animated and made especially distinctive by the sculptural crispness of form and the prevalence of intense red, blue, and green; a type of plump, curly-haired putto makes an almost signature-like appearance in many borders and miniatures. KS

The Painted Page: Italian Renaissance Book Illumination 1450–1550, exhib. cat. 1994/5 (London, RA; New York, Pierpont Morgan Lib.).

BIRCH, THOMAS (1779–1851). English-born American painter. Birch, who was born in Warwickshire, emigrated to America with his father William (1755–1834), a painter and engraver, in 1794. They settled in Philadelphia where William, who taught his son, established a drawing school. Taking their cue from English practice and working in collaboration they painted accurate, clearly defined townscapes, public buildings both civic and industrial, and the estates of the wealthy; these works were sold as engravings. In 1812, on the outbreak of war with Britain, Birch took up marine subjects including major naval engagements in a style based on Anglo-Dutch tradition. These proved understandably popular as prints and he extended his range to include dramatic shipwrecks which reveal a knowledge of *Vernet and de *Loutherbourg. In paintings like *The 'Wasp' and the 'Frolick'* (1820; Boston, Mus. of Fine Arts), a collision at sea, Birch catches the peculiar clarity of light which was to fascinate the *Luminists in the 1840s. He continued to paint landscapes usually including large expanses of water, as in *View on the Delaware* (1831; Washington, Corcoran

Gal.), which also anticipate Luminism. DER

Thomas Birch, exhib. cat. 1966 (Philadelphia, Maritime Mus.).

BIRD, EDWARD (1772–1819). English painter. Bird's only formal training was as an apprentice painter in the japanning industry of his home town, Wolverhampton. In 1794, determined to be an artist, he left the Midlands for Bristol where he established a Drawing Academy in 1797. Bird flourished in the artistic circle surrounding the gentleman-amateur George Cumberland (1754–1848) and in 1810 his painting of *The Country Choristers* (London, Royal Coll.) was purchased from the RA by the Prince Regent. For the next three years he rivalled David *Wilkie as the principal exponent of genre painting. In 1813, following the acclamation of his *Day after the Battle of Chevy Chase* (1812; lost), he was appointed historical painter (see HISTORY PAINTING) to Princess Charlotte and success seemed assured. However, the Prince Regent's refusal to purchase his paintings of the *Embarkation* (1816; Bristol, AG) and *Landing of Louis XVIII* (1817; Wolverhampton, AG) seems to have obsessed him and subsequently he devoted his considerable talents to religious subjects which became increasingly unsaleable. He died in poverty in 1819, self-sacrificed on the altar of High Art. DER

Richardson, S., *Edward Bird*, exhib. cat. 1982 (Wolverhampton, AG).

BIROLLI, RENATO (1905–59). Italian painter, who initially worked in an impressionistic figurative style, under the influence of the critic Edoardo Persico. His dislike both of Fascism and the classicism of the Novecento Italiano movement led him to co-found the left-wing Corrente group (1938–43). During the 1940s his work was characterized by bright, expressive colours and broad brushwork, as in *Peasant with Corncobs* (1946; Parma, Mus. del Premio Guzzara). In the post-war period he joined the Fronte Nuovo delle Arti (1947) and opposed the realism supported by the Italian Communist Party. His own work moved towards an expressive abstraction that was related to French *Art Informel. CJM

Renato Birolli, exhib. cat. 1989–90 (Milan, Palazzo Reale).

BLACK MOUNTAIN COLLEGE. Founded in the mountains of North Carolina in 1933 by John Andrew Rice and a group of dissident, progressive academicians, Black Mountain College came to be a symbol of academic freedom and the experimental spirit in American culture. The tiny college, which had less than 1,200 students before its closure in 1957, evolved into a mixture of a liberal arts school, summer camp, farm school, pioneering village, refugee

camp, and religious retreat. It survived on little money and few facilities, but its faculty included some of the finest minds from Europe, many having fled to America as refugees. In this way the college was significant in reinterpreting and assimilating European modernist thought in America. Josef *Albers, who arrived in 1933, brought with him *Bauhaus ideas, and was to be a significant influence on Kenneth *Noland and Robert *Rauschenberg, who were both students. In the 1960s the college became associated mainly with two groups: the Black Mountain Poets, and the circle of artists, dancers, musicians, and performers around John Cage (1912–) and Merce Cunningham (1919–).

MF

Harris, M. E., *The Arts at Black Mountain College* (1987).

BLAKE, PETER (1932–). British painter, sculptor, and designer, a leading exponent of *Pop art. He was born in Dartford, Kent, and studied at Gravesend School of Art, 1949–51, then after two years in the RAF at the Royal College of Art, 1953–6. In 1956–7 a Leverhulme scholarship enabled him to travel extensively on the Continent studying folk and popular art (this had been an interest since his teenage years, stimulated by visits to fairgrounds). His early work was meticulously painted and often featured items of popular ephemera, particularly magazine covers (*On the Balcony*, 1955–7; London, Tate). From 1959 he moved more into the mainstream of Pop with pictures of pop singers and film stars, painted in a much broader manner and often featuring collage elements, and within a few years had become established as one of the leading figures of the movement in England (in 1961 he won first prize in the Junior Section of the John Moores Liverpool Exhibition and in the same year he was featured in Ken Russell's television film *Pop Goes the Easel*, which did as much as anything to arouse public interest in Pop art). During the 1960s the pop music world continued to be a major source of inspiration (his most famous work is the cover design for the Beatles LP *Sergeant Pepper's Lonely Hearts Club Band*, 1967), and his other favourite images of the time included fairground wrestlers and striptease dancers.

In 1969 Blake moved to Wellow, near Bath, and in 1975 he was one of the founders of the Brotherhood of Ruralists, a seven-strong group of painters who took as their inspiration 'the spirit of the countryside'. A series of winsome fairy paintings are characteristic of his Ruralist phase. They show something of the combination of sophistication and naivety that often occurs in his work as well as his penchant for imagery drawn from childhood (his two daughters have often featured in his work). He returned to London in 1979 and since then he has continued to

paint both contemporary and fantasy subjects. In 1983 he had a major retrospective exhibition at the Tate Gallery, London; it proved a great popular success, showing how fondly his early work is regarded by many people for its colourful evocation of the 'swinging sixties'. In 1994–6 he was Associate Artist at the National Gallery, London.

IC

BLAKE, WILLIAM (1757–1827). Blake was a visionary, nonconformist English painter and poet of mystical and prophetic themes conveyed in complex figurative imagery. His innovative methods included 'illuminated printing' which combined image and text printed together from relief-etched copper plates. His small books thus produced were hand printed and finished in *watercolour, making each a unique work. Famous examples include themes of childhood and the loss of innocence in a materialist world: *Songs of Innocence* (1789) and *Songs of Experience* (1794). He also made prophetic books inspired by revolutionary politics, including *America: A Prophecy* (1793) and *Europe: A Prophecy* (1794). Blake's *colour printing found its full expression in twelve large modified *monotype prints of 1795, including *God Judging Adam* and *Newton* (London, Tate). Blake's original works had few, if dedicated, admirers and he supplemented his meagre income by undertaking commercial engraving from the works of other artists such as *Hogarth, *Flaxman, and *Fuseli. He was apprenticed to the engraver James Basire from 1772 to 1779 and then briefly attended the RA Schools in London. Although he exhibited his watercolours at the Academy from 1780 he railed against academic art and its systems, insisting instead on individual inspiration. His own style was formed from a knowledge of *Gothic sculpture, which he studied in Westminster Abbey, and of the muscular figures of *Michelangelo, studied only from engravings. A typical Blake watercolour is a lyrical composition of finely drawn, agile, elongated figures, naked, or semi-clad, floating in a non-material world, as in *The Last Judgement* (1808; Petworth House, Sussex). In the 1790s Blake lived in Lambeth and was helped in the printing of his books by his wife. In 1800 he moved to Felpham in Sussex and was aided by the poet William Hayley and by his major patron Thomas Butts, who commissioned a series of 50 biblical pictures, and who also owned many more of his works. In 1809 Blake held an ambitious solo exhibition in Soho, describing his aims and works in a *Descriptive Catalogue*. He defended his use of tempera (see MEDIUM) (which he called fresco) over oil which he associated with decadent academic art.

In his later years Blake was lauded by a group of young artists, including Samuel

*Palmer and Edward *Calvert who were inspired by his *wood engravings for *The Pastorals of Virgil* (1821) and by his engravings of *The Book of Job* (1825), commissioned by the artist John Linnell (1792–1882). Later in the century new devotees of Blake's art and poetry included *Rossetti.

MP

Bindman, D., *William Blake: His Art and Times* (1982).

BLANCHARD, JACQUES (1600–38). French painter who was brought up by the painter Nicolas Bollery, his uncle, in the late *Mannerist tradition and later studied in Italy (1624–8). He drew his inspiration mainly from the Venetians, particularly *Veronese, making delicate use of reflected light in his treatment of flesh (*Charity*; London, Courtauld Inst. Gal.). The earlier *Medor and Angelica* (New York, Met. Mus.) is more Mannerist in style. *Cimon and Iphigenia* (Paris, Louvre) and other paintings show the influence of *Rubens. As a minor painter of small religious and mythological subjects in a sensitive but sentimental manner, he achieved a certain success.

HB

BLAST. See VORTICISM.

BLAUE REITER, DER, a loose association of artists formed in Germany in 1911. When the committee of Munich's *Neue Kunstlervereinigung*, founded in 1909 by *Kandinsky and *Jawlensky, rejected one of Kandinsky's own pictures in 1911, he organized an opposing exhibition at Munich's Gallery Thannhauser with Franz *Marc. Kandinsky and Marc went on to form the Blaue Reiter as an extension of the exhibition and drew in its other prominent members, August *Macke and Paul *Klee. A second exhibition of the Blaue Reiter was held in Munich in 1912, later touring to Cologne and the gallery Der *Sturm in Berlin. It was there that the Blaue Reiter last exhibited together, in the German Salon d'Automne of 1913. The group was broken up by the outbreak of war; Marc and Macke died in action, while Kandinsky returned to his native Russia for the war's duration.

The Blaue Reiter can be seen as a more theoretically programmatic group than Die *Brücke. Both Kandinsky and Marc brought to it powerful intellectual impulses, combined with the former's native Russian folk heritage and an increasing tendency towards abstraction after 1910. *The Blaue Reiter Almanac* (1912) included a wealth of influences, ranging from Bavarian glass painting and children's art to African and Oceanic tribal artefacts. Their exhibitions also demonstrated a breadth of interests, drawing in an

international array of artists including the *Cubists, Henri *Rousseau, and Robert *Delaunay.

Blaue Reiter painting is less consistent in style than that of Die Brücke, reflecting the diversity of its artists' cultural backgrounds and influences. However, a harmony of psychologically charged colours, a focus on the spiritual and an empathetic identification with the animal kingdom, and an increasing tendency towards a non-objective idiom are all common elements in the Blaue Reiter œuvre. RRAM

Vergo, P., *The Blue Rider* (1977).

BLECHEN, KARL (1798–1840). German landscape painter who depicted dramatic themes in a vivid and naturalistic manner. At times he resembles *Turner (an artist he admired), particularly in the verve and painterly brilliance of his *plein air* studies. His finished works show an affinity with the more fantastic and ironic writings of German *Romanticism. Trained in Berlin, he worked first as a scene painter in the Royal Theatre, designing sets for plays by E. T. A. Hoffmann and other fashionable writers of the period. His paintings at this point were influenced by Caspar David *Friedrich. In 1828 he went to Rome, where his experience of Italian light encouraged him to develop his own striking form of naturalism based on direct observation. On returning to Berlin in 1830, he startled both critics and public with such masterful pictures as *Building the Devil's Bridge* (1830; Munich, Neue Pin.). Many of these, for example *Women Bathing in the Park at Terni* (1830; Berlin, Nationalgal.), were based on his experiences in Italy. He had an immense influence upon the development of Berlin naturalism, in particular on Adolphe von *Menzel. WV

Carl Blechen: zwischen Romantik und Realismus, exhib. cat. 1990 (Berlin, Nationalgal.).
Vaughan, W., *German Romantic Painting* (2nd edn., 1994).

BLES, HERRI MET DE (c.1510–50?). Poorly documented Flemish painter of landscapes with figures, usually of religious content. He was a close follower of Joachim *Patinir, and may be identical with the latter's nephew Herry Patinir, who became a master in Antwerp in 1535/6. He may have travelled in Italy, although this is not documented. His works were undoubtedly popular in Italy, where he was known as 'Civetta' because of the little owl that often appears in his paintings. Like Patinir's, his panoramic landscapes with their fantastic rock formations dominate the figure groups, but they are more crowded with detail than those of the older

master (*Landscape with Christ on the Road to Emmaus*; Vienna, Kunsthist. Mus.). KLB

Gibson, W. S., *'Mirror of the Earth': The World Landscape in Sixteenth-Century Flemish Painting* (1989).

BLOCKBOOKS. A fairly short-lived phenomenon, blockbooks were mainly produced in the Netherlands and Germany in the 1460s, some time after the invention of movable type, with which they attempted to compete. A blockbook is composed of leaves which have been printed from wooden blocks on which the text and pictorial design have been cut together, often in two divided compartments. They were often printed by hand rubbing, and printed in pale brown ink, frequently augmented by crude hand colouring. The most frequent texts were the Apocalypse, and the *Biblia pauperum* (simple instructional compendia of Old and New Testament themes), which were popular at the time. Generally they consist of very simple linear designs, characterized by Gothic loops and hooks in the folds of the garments. The finest examples are generally considered to be Netherlandish, and they usually survive in only a handful of individual sheets. RGo

Hind, A., *An Introduction to a History of Woodcut* (1935).

BLOEMAERT, ABRAHAM (1566–1651). Dutch painter and teacher. A prominent painter in the Catholic city of Utrecht, Bloemaert was one of the founders of the painters' guild in 1611. His work passes through various transitions both in style and subject matter. After a fragmentary training, he went to Paris in 1581/2 where he was influenced by the School of *Fontainebleau. *The Death of Niobe's Children* (1591; Copenhagen, Statens Mus. for Kunst) is a large and dramatic composition, full of stylish, twisting, and elongated figures, consciously modelled on classical and Renaissance forms. This early example of Dutch *Mannerism impressed his contemporaries, attracting many pupils, such as Gerrit van *Honthorst and Hendrick ter *Brugghen, who were in turn to influence their master. The *Adoration of the Kings* (1624; Utrecht, Centraal Mus.) is a bold, light-flooded composition with large, realistic figures prominently in the foreground. It owes a debt not only to the Utrecht, *Caravaggisti but also to *Rubens, who visited Bloemaert three years later. Bloemaert turned towards pastoral scenes, probably influenced by the current pastoral tradition in Dutch literature. Bloemaert's *Shepherd and Shepherdess* (1627; Hanover, Niedersächsische Landesgal.) is an early example of this type in Utrecht. CTW

Roethlisberger, M. G., and Bok, M. J., *Abraham Bloemaert and his Sons* (1993).

BLOEMEN, VAN. Family of Flemish painters. The Arcadian landscapes of the immensely productive Flemish painter **Jan Frans van Bloemen** (or Orizzonte) (1662–1749) were fundamental to the development of landscape in Rome in the early 18th century. Born in Antwerp, he and his brother **Pieter** (or Stendardo) (1657–1720) worked together in Rome, from c.1688 until Pieter's return to Antwerp in 1692. They collaborated in scenes of the the Roman countryside, enlivened by horsemen and bandits, and in Antwerp Pieter produced market scenes and military encampments. Jan painted such tranquil landscapes as *Arcadian Scene beside the Tiber, with the Vatican Belvedere* (1737; Rome, Accademia di S. Luca) which create an idealized vision of the Roman Campagna and were popular with *Grand Tourists and noble Italian families. Such scenes, with stone pines and Antique fragments, classically structured, with forts and hill towns patterned in sharp cubes against the landscape, are intensely evocative of ancient Rome. They look back to *Poussin and *Dughet, but lack their grandeur and mythology, suggesting rather a timeless pastoral serenity. Another brother, **Norberto** (1670–1746), also worked in Rome, and painted *Bamboccianti scenes. HL

Busiri Vici, A., *Jan Frans Van Bloemen: Orizzonte* (1974).

BLONDEEL, LANCELOT (1498–1561). Flemish artist who entered the painters' guild in Bruges in 1519. He also worked as an architect and designed sculpture, tapestries, and pageant decorations. He was a friend of Jan van *Scorel, together with whom he was engaged, in 1550, on restorations on the Ghent altarpiece, the *Adoration of the Lamb*, by Hubert and Jan van *Eyck (c.1423–32; Ghent, S. Bavo). Among his pupils was Pieter *Pourbus who married his daughter. Blondeel was a committed Renaissance artist who used decorative constructions in his compositions of grotesques, scrollwork, and Antique building elements, worked out in grisaille on a ground of gold leaf. For his figures he employed a restrained tonal palette, with a preference for dramatic highlights (*Virgin and Child with SS Luke and Giles*, 1545; Bruges, S. Salvatorskerk). KLB

Marlier, G., *Le Siècle de Bruegel*, exhib. cat. 1963 (Brussels, Mus. Royaux).
Martens, M. P. J. (ed.), *Bruges and the Renaissance: Memling to Pourbus*, exhib. cat. 1998 (Bruges, Memlingmus.).

BLOOMSBURY GROUP. The artists, theorists, and writers at the core of the Bloomsbury Group came together through the elitist Cambridge University group The Apostles, in which Thoby Stephens, brother of Vanessa (*Bell) and Virginia (Woolf), was a

prominent member. The three hosted literary gatherings at their home in north London from which the Bloomsbury Group evolved. Roger *Fry's arrival in 1911 broadened their interests; from then on the visual arts were as important to Bloomsbury as literature. The Bloomsbury Group pioneered a new approach to painting, based on the decorative arabesques and expressive colour of *Matisse, the spatial awareness of *Cézanne, and the vitality they found in ethnic art. They considered painting a language, with its own visual 'grammar'. Under the influence of Clive *Bell they also developed the use of 'significant form': certain combinations of lines, colours, and shapes which were especially aesthetically moving. Three members of the group were important as painters: Roger Fry, Duncan *Grant, and Vanessa Bell. The latter studied at the RA Schools, then briefly at the Slade. She was introduced to the work of *Gauguin and Cézanne by Clive Bell, whom she married in 1907; her painting from 1911 shows their influence, together with Matisse, as in *Studland Beach* (1912; London, Tate). From 1915 she painted mainly abstracts and portraits, returning after 1920 to a more figurative style. She also worked as a textile designer, in theatre design, and on book jackets for Bloomsbury's private Hogarth Press.

Bell worked closely with Duncan Grant; they lived and painted together in the south of France. Grant studied in Paris (1906–7), and was also influenced by *Post-Impressionism from 1911. His work evolved distinct styles: realism in landscapes and portraits, and a decorative abstraction blending figurative and formal elements in complex designs. His subjects varied widely, including myth, (*The Queen of Sheba*, 1912; London, Tate) and still life (*The Mantelpiece*, 1914; London, Tate). Other artists associated with the group included Frederick Etchells (1886–1973), Henry Lamb (1883–1960), Dora Carrington (1893–1932) and the designer Nina Hamnett (1890–1956). The group also sponsored Fry's Omega Workshops, initiated in July 1913. Inspired by the Arts and Crafts movement, Fry declared that all items were made by hand to designs based on 'significant form' and expressing spiritual experience. Various young artists worked there, although many became dissatisfied with his insistence on anonymity, brought to a violent head by Wyndham *Lewis, who formed the rival Rebel Art Centre in 1914. Although Omega survived it was considerably damaged, while Fry's attempts to combine aesthetic integrity with practical design limited his outlets and popularity. The company was wound up in June 1919. JH

Anscombe, I., *Omega and After* (1981).
Shone, R., *Bloomsbury Portraits* (1976).

BLOT DRAWING. See COZENS, FATHER AND SON.

BLUE ROSE (Golubaya Roza), group of Russian painters active in the first decade of the 20th century, named after an exhibition held in Moscow in 1907. Their acknowledged inspiration was *Borisov-Musatov and their style was essentially *Symbolist, although there was also influence from *Fauvism and an interest in *primitivism. The origin of the name is uncertain, but the colour blue was particularly significant for Symbolists, associated with the sky and spirituality, and the rose has many symbolic associations: in 1904 an exhibition called the *Crimson Rose* or *Scarlet Rose* (Alaya Roza) had been held in Saratov, Borisov-Musatov's home town, and the Blue Rose was a successor to this. Borisov-Musatov's most talented follower was Pavel Kuznetsov (1878–1968); other members of the group included the Armenian Martiros Saryan (1880–1972) and the Greek-born Milioti brothers, Nikolai (1874–1955) and Vasily (1875–1943). Georgy Yakulov (1882–1928), best known as a stage designer, was not a formal member, but he shared the group's concerns and was invited to contribute to their retrospective exhibition in 1920. The group was promoted by the journal Golden Fleece and exhibited under its auspices. IC

BOCCACCIO, GIOVANNI (1313–75). Italian writer. Boccaccio is now best known for his vernacular *Decameron*, which refers to many contemporary artists. This interest in artists as individuals achieves added significance in conjunction with the Latin texts on which his contemporary reputation as a humanist rested. Boccaccio, with *Petrarch and his followers, initiated the acceptance of the visual arts as the equal of the established liberal arts. Central to this was the insistence on *Giotto's supremacy among trecento painters, a position requiring the development of a vocabulary by means of which this could be demonstrated in terms of the rhetorical concepts of literary *humanism. Boccaccio cited three aspects of Giotto's work in support of this: that it was supremely realistic; that through it the artist had restored painting to a position it had lost during the Dark Ages, and that it appealed to the knowledgeable rather than the ignorant. Notwithstanding the many fine illustrated copies of Boccaccio's works produced from the trecento onwards, it is on his contribution to this reappraisal of what had formerly been a mere 'mechanical' art that his art historical significance lies. JR

Baxandall, M., *Giotto and the Orators* (1971).

BOCCIONI, UMBERTO (1882–1916). Italian painter and sculptor. Born in Reggio Calabria, he spent his childhood in various parts of Italy, before moving in 1899 to Rome, where, together with *Severini, he was taught the technique of Divisionism (see NEO-IMPRESSIONISM) by *Balla. In 1910 he began to work in a *Futurist style. As well as representing movement by rendering the successive positions of a body in motion, he developed the concept of simultaneity, attempting to create 'a synthesis of what is remembered and what is seen' (introd., exhib. cat., Paris, Bernheim-Jeune Gal., 1912), most notably in the second series of three paintings entitled *States of Mind* (1911; New York, Met. Mus.). He also was a gifted sculptor, often combining in one work such different materials as iron, wood, and glass, while also working in the more conventional medium of bronze. Like his painting, his sculpture is strongly dynamic, expressing the interaction between the object represented and the space that surrounds it. Boccioni himself analysed the principles on which such works were based in various writings, most notably the *Manifesto della scultura futurista* (1912) and the book *Pittura e scultura futurista* (1914). Like the other Futurists, Boccioni was a passionate supporter of Italian intervention in the First World War. In 1915 he joined an artillery regiment, and died soon after, following a fall from a horse. CJM

Boccioni, exhib. cat. 1988 (New York, Met. Mus.).

BÖCKLIN, ARNOLD (1827–1901). Swiss painter. Born in Basle, Böcklin trained in Germany, Flanders, and Paris before a prolonged stay in Rome (1850–7). His early work, characterized by lyrical naturalism, owed much to *Corot but in Italy his emphasis shifted to the creation of mood, in landscapes, figure compositions, and mythological subjects, like *Pan in the Reeds* (1857; Munich, Neue Pin.) which established his reputation and gained him the sobriquet 'great Pan'. During a visit to *Pompeii in the 1860s he was inspired by the frescoes to experiment with harsh colours, flattened perspective, and classical subjects. Settling in Munich in 1871, he influenced a new generation of painters, many of whom worked in his studio. In 1874 he returned to Italy where he began to paint a series of haunting imaginary landscapes including *Villa by the Sea* (1877; Stuttgart, Staatsgal.) and his best-known picture, the sombre and evocative *Isle of the Dead* (1880; Basle, Öffentliche Kunstsammlung), a *Symbolist masterpiece which nonetheless is deeply indebted to the Romantic imaginary landscapes of Caspar David *Friedrich. His mythological paintings of the 1880s, when he was arguably the most famous contemporary artist in the German-speaking world, are usually sentimental but include some violent conflicts between fauns and nymphs which profoundly influenced the Munich *Sezessionist painter Franz von *Stuck. JH

Andree, R., *Arnold Böcklin: die Gemälde* (1977).

BODEGÓN, Spanish term meaning tavern, or shop where common foods are served. Used since the 17th century for paintings of still lifes and genre scenes in which elements such as foodstuffs and kitchen- and tableware are prominent. *Zurbarán's *Still Life with Cidras, Oranges, Cup, and Rose* (1633; Pasadena, Calif., Norton Simon Mus.), *Velázquez's *Old Woman Cooking Eggs* (1618; Edinburgh, NG Scotland), and Pereda's *Kitchen Still Life* (1650; Lisbon, Mus. Nacional de Arte Antiga) are examples of *bodegones*. NAM

Jordan, W. B., *Spanish Still Life in the Golden Age* (1985).
Jordan, W. B., and Cherry, P., *Spanish Still Life from Velázquez to Goya* (1995).

BODYCOLOUR. This term is used to describe any kind of opaque pigment which is water soluble. In the late 15th century when it was first employed by *Dürer in combination with pure watercolour the medium employed was lead white. However, in 1834 Winsor and Newton introduced Chinese white (zinc oxide) and this was sold widely as a substitute for lead white.

Although artists such as *Rubens and van *Dyck made extensive use of bodycolour it became much more frequently a part of *watercolour art in England during the 1820s and 1830s. *Turner in particular was highly successful in combining the delicacy of pure watercolour with the additional strength offered by bodycolour. Some artists made drawings in bodycolour alone. Drawings described simply as 'watercolours' are often found to be executed in a combination of both transparent and opaque pigments. PHJG

BOHEMIAN MEDIEVAL ART. Following the destruction of the Greater Moravian Empire by the Magyars in 906, the centre of power moved from Moravia to Bohemia, and the ruling Přemyslid family made Prague its capital. Although the Eastern Church had been responsible for the conversion of Moravia and Bohemia, by the 10th century both duchies had turned to the Western, Latin liturgy. In 973 S. Adalbert was created bishop of Prague and founded the first Benedictine monastery in Bohemia, at Břevnov. The 11th and 12th centuries saw an enormous expansion in monastic building; such foundations created a demand for books, and by the end of the 11th century the Břevnov scriptorium could produce a magnificent Gospel Book (the Codex Vysehradensis, Prague University Lib., MS XIV A 13). Made for the coronation of Wratisław II in 1085, it marks his elevation to the kingship, a reward from the Emperor Henry IV. Cistercian foundations during the 13th century introduced elements of *Burgundian architecture to the region, although the figure style of one of the rare portals to have incorporated sculpture in its decoration, the west portal of the Cistercian church at Předklášteří, c.1240–50, is entirely German. In 1306 the last Přemyslid, Wacław III, was murdered, to be succeeded in 1310 by John of Luxembourg. His connections with the French court brought a new orientation to Bohemian art. A group of manuscripts made for the Dowager Queen Eliska Rejčka 1315–23 show first-hand knowledge of Franco-Flemish illumination, while a passional illuminated for the Abbess Kunhuta in about 1320 (Prague, University Lib. MS XIV A 17) is close to contemporary English illumination. John's son Charles, later Emperor Charles IV, transformed Prague into one of the major cultural centres of Europe. His ambitious building schemes employed artists from all parts of Europe, most importantly *Peter *Parler*, enriching an already sophisticated native culture. He was succeeded by his son Wacław IV in 1378, a passionate bibliophile who commissioned a number of superbly illuminated books, during whose reign the 'Beautiful Style' in both painting and sculpture reached full maturity. For nearly 50 years following his death in 1419 the country was devastated by the Hussite Wars. Churches were destroyed, while painting and sculpture stagnated. Before the Habsburg takeover in 1526 the Polish Jagiellonian princes, Władysław II, who ruled from 1471, and his son Ludwig, brought some stability to Bohemia. They employed, among others, the German architect Benedict Ried; his rebuilding of Prague Castle, with its brilliant combination of Gothic and Renaissance detail, brought the era to a spectacular close. AS

Bachmann, E. (ed.), *Gothic Art in Bohemia* (1977).

BOILLY, LOUIS-LÉOPOLD (1761–1845). French painter. A native of Flemish-influenced north-east France, he settled in Paris in 1785. He made his reputation as a painter of small-scale portraits and genre scenes of contemporary city life. During the Reign of Terror he came under suspicion because of the alleged frivolity of his subjects; only the discovery at his home of drawings for a painting of *The Triumph of Marat* (c.1794; Versailles) saved him from prison, or worse. He continued his very productive career (he claimed to have executed 5,000 portraits) recording fashionable Parisian life through the Revolution, the Directory, the Empire, and on into the Restoration period. Among his best-known works is the *Gathering of Artists in Isabey's Studio* (1798; Paris, Louvre), which depicts meticulously the most successful artists of the day. Boilly's precisely detailed and smoothly finished style owes much to the Dutch and Flemish genre painters of the 17th century, whose works were widely collected during his lifetime. In the 1820s he was one of the first French artists to experiment with *lithography as a way to reproduce his paintings. MJ

Marmottan, P., *Le Peintre L. Boilly* (1913).
Siègfried, S. L., *The Art of Louis-Léopold Boilly: Modern Life in Napoleonic France*, exhib. cat. 1995 (Washington, NG).

BOIZOT, LOUIS-SIMON (1743–1809). French sculptor. He was a prizewinning pupil of Michel-Ange *Slodtz who suceeded *Falconet as director of the sculpture studio at the Sèvres porcelain factory. He held the post from 1773 until 1800, and was responsible for some of its most characteristic and prestigious designs. These include the famous toilet set for the 'Comtesse du Nord' (St Petersburg, Hermitage) and the so-called 'large Medici vases' (Paris, Louvre). His soft, graceful, and backward-looking style was admirably suited to this kind of object, but less so to full-scale sculpture at a time when *Neoclassicism was becoming the fashion. Nevertheless, he was regularly employed on portrait busts (including Napoleonic generals) and made a marble statue of *S. John* (1785) for S. Sulpice, Paris, and a statue of *Racine* (1785–7) now in the Louvre. MJ

Lami, S., *Dictionnaire des sculpteurs de l'école française du 18e siècle* (1910).

BOL, FERDINAND (1616–80). Dutch painter, born in Dordrecht, who entered *Rembrandt's studio, probably 1635–c.1642, and became a successful painter in Amsterdam. His history paintings and portraits of the 1640s are indebted to Rembrandt, both in composition and lighting; his *Governors of the Leper Hospital* (1649; Amsterdam, Rijksmus.) displays his skill in rendering varied poses and expressions, uniting formality with warmth. From 1650 Bol also responded to the fashionable van der *Helst, and his later portraits are more colourful and elegant, often incorporating landscape and architectural motifs. In 1669 he married a wealthy widow and seems to have stopped painting. HL

Blankert, A., *Ferdinand Bol* (1982).

BOL, HANS (1534–93). Flemish painter and draughtsman, principally of landscapes. He was trained in the technique of tempera painting on linen, a speciality of his home town Malines. After a sojourn in Germany, including two years in Heidelberg, he settled in Malines, where he became a master in 1560. In 1572, after the Spaniards occupied the town, he moved to Antwerp and entered the guild there in 1574. War and religious unrest drove him to the Northern Netherlands in 1584, and he finally settled in Amsterdam in 1591. Little of Bol's work in the perishable medium of tempera on linen has survived. He is known for his miniature-like pictures in gouache on paper or parchment and for his

drawings, many of which were made into prints. KLB

Luijten, G., et al. (eds.), *Dawn of the Golden Age*, exhib. cat. 1994 (Amsterdam, Rijksmus.).

BOLDINI, GIOVANNI (1842–1931). Italian painter, mainly of portraits. Boldini vied with *Sargent as the most successful international portrait painter of his day. In 1862 he moved to *Florence where he associated with the *Macchiaioli, developing a light fresh style, achieved by the subtle application of individual touches of paint, used to great effect in his later Parisian street scenes. An early portrait, *The Laskaraki Sisters* (1867; Ferrara, Mus. Boldini), is painterly and informal. By 1867 he was working in Paris where he greatly admired the panache of *Manet, whose dramatic use of white pigment influenced his own work. He worked in London for three years before settling in Paris *c*.1872. Here he painted *Whistler* (New York, Brooklyn Mus.) but the majority of his clients came from the international *beau monde*. *Lady Colin Campbell* (*c*.1897; London, NPG) reveals a typical originality of composition which enhances the soigné elegance of the sitter. His urbane style, which was ideally suited to his clientele, was becoming dated by the 1920s and, among the bright young things, his name became a byword for superficiality and flattery. DER

Fiorio, M. T., *Leonardeschi in Lombardia* (1982).

BOLOGNA, GIOVANNI. See GIAMBOLOGNA.

BOLTRAFFIO, GIOVANNI ANTONIO (1467–1516). Milanese painter of aristocratic origin; he was a pupil of *Leonardo and a highly regarded portrait painter. In the 1490s he collaborated with Marco d'Oggiono (*c*.1467–1524) on an altarpiece of the *Resurrection with Saints* (Berlin, Gemäldegal.). Boltraffio reveals his debt to Leonardo in the polished surfaces and subtle shadows of his share of the work. In 1500 he executed an altarpiece of the *Virgin and Child with Saints and Donors* (Paris, Louvre) for S. Maria della Misericordia, Bologna; the heightened luminosity and serenity of the landscape testify to Boltraffio's contact with the art of *Perugino and Francesco *Francia. His skill as a portrait painter was clearly recognized in 1498 when Isabella of Aragon commissioned him to copy a portrait of her brother. Among his surviving portraits from around this date is the *Portrait of a Gentleman* (London, NG). This work, typical of his other portraits, shows clearly drawn contours which help to define the sitter's profile against a dark background. He also made use of light to bring about greater psychological suggestiveness in his subjects. FB

BOMBERG, DAVID (1890–1957). English painter. Bomberg studied with *Sickert at the Westminster School and at the Slade (1911–13). He joined the *London Group in 1914, and exhibited with the *Vorticists, although he refused to join their organization. Paintings such as *In the Hold* (1913–14; London, Tate) and *The Mud Bath* (1915; London, Tate) show the influence of Vorticist ideas in their abstracted, geometrical forms. After the war, Bomberg's reputation collapsed, and he began to travel widely, particularly in Spain (Ronda), developing a more naturalistic style, based on the expressive use of bright colour and thick paint, violently applied. Landscapes and flowers pieces dominated his work, for example *Valley of La Hermida* (1935; Sheffield, AG). He also painted portraits, of which *Lilian* (1932; London, Tate) is a fine example. From 1945 to 1953 he taught at the Borough Polytechnic, where he was extremely influential: his doctrines of the centrality of drawing, and the organization of compositions in terms of mass and lines of force, still persist in art schools today, carried on by his pupils, including Frank Auerbach (1931–) and Leon Kossoff (1926–). His insistence on figurative painting during the domination of abstraction is now recognized as a major contribution to modern British painting. JH

Cork, R., *David Bomberg* (1988).

BONDOL, JEAN. See BAUDOLF, JAN.

BONE/IVORY CARVING: MATERIALS AND TECHNIQUES. Ivory is dentine, and is commonly derived from the teeth or tusks of the upper incisor teeth of the African or Asiatic elephant, and from other mammals, such as the narwhal, the walrus (or morse), the sperm whale, the hippopotamus, and the pig or boar. The characteristically curved African tusk is larger than the Asiatic, can vary in weight up to 70 kg (150 lb), and examples are known to have measured longer than 3 m (10 ft). The tusk has a hollow pulp cavity which narrows towards a nerve cavity at the tip; this is surrounded by dentine, which in turn is covered by a brittle cementum. This is the dentine that is valued for carving, and its dense grain allows for subtle carving in most directions. The collagen in the dentine imparts an oil which contributes to the sheen when the ivory is polished.

Mammoth ivory (commonly from Siberia) is similar to elephant ivory though its colour is often yellower. Ivory derived from the teeth of the lower jaw of the hippopotamus is whiter and denser than elephant, though triangular in small transverse sections, as are walrus ivory carvings. Pigs' or boars' tusks are markedly curved but small in cross-section and with no visible grain. The tusk of whale or narwhal is spirally curved, and can measure up to 2.5 m (8 ft) in length. Since most of the tusk is hollow, only the tip will be carved. Walrus ivory is derived from the male animal and usually has a much smaller cross-section. The colour of ivory differs markedly from creamy white to a rusty brown, especially if it has been exposed to light, or treated with a stain. Bone has the same properties as ivory, though its grain is less even and it does not retain a sheen to the same extent. Usually small convex pieces are carved.

During the 19th century synthetic ivory was developed by John Hyatt in New York in 1865, and this was a cellulose mixed with pigment. Other similar products then followed. In the 1920s and 1930s a less fragile form of synthetic ivory was produced, which was sold under the name of Ivorine and Ivorite. Epoxy and polyester resins are currently used to imitate ivory

Ivory is carved with similar tools to those used by the woodworker, and the ivory carver will usually carve in the direction of the grain. It is easily worked with saws, chisels, drills, files, rasps, scrapers, drills, abrasives, all of which approximate the tools used since ancient times. The size and shape of a three-dimensional carving are usually limited to the dimensions of a tusk rarely exceeding 18 cm (7 in) in diameter. Being close-grained, ivory lends itself particularly well to low relief and engraving, but it has also been used successfully for statuettes in the round, whose compositions are often dictated by the curve of the tusk itself.

If a section of tusk is to be used for relief, a portion is sawed from the tusk, and the design roughed out using the saw. Detailed work is undertaken with chisels and knives, and the layers are pared away, though undercutting for sharp detail will also be done with drills. Drills can also be used for pierced work, and the hole allows access for different blades according to the degree of refinement of the decoration.

Ivory is also used for turned work, and a bow lathe or an ornamental lathe, and scrapers of different profiles and shapes, are used for this. Given its flexibility it can also be split from the longitudinal section of the tusk into thin laminates and veneers, which can also be bent into curved or circular shapes with steam. These can be used for boxes, whose bases will be formed by the circular cross-section of the hollow base of the tusk. Small sections of ivory veneers are used in inlaid furniture and occasionally stained.

The surfaces of ivory can be left bare, simply polished to a high sheen, enhancing the creamy, translucent whiteness of the material. Alternatively, it can be stained, or polychromed and gilded, a practice common in medieval ivories, though little survives today of this original decoration. It has been pointed out that the *polychromy of ivories

has many parallels with manuscript illumination, and illuminators may be responsible for painting on ivory writing tablets, for instance. The gilding was normally applied over an intermediate layer of glue, bole, or egg white. In addition to polychromy, incrustations of jewels or gold pins might enhance the decorative feature of a statuette, usually along the borders of a mantle or a garment. On relief sculptures, gilding might enhance the architectural features and polychromy might be applied to the figures, for instance in the small bone panels carved for altarpieces and coffers by the Embriachi workshop in Venice during the late 14th and 15th centuries. A revival of ivory carving in the 19th century also included a revival in the use of polychromy, as well as the unscrupulous 'restoration of polychromy' on medieval ivories. AB

Barnet, P. (ed.), *Images in Ivory: Precious Objects of the Gothic Age*, exhib. cat. 1997 (Detroit, Inst. of Arts).

BONHEUR, ROSA (1822–99). Celebrated French animal painter, whose powerful and unconventional character made her an object of curiosity. She was born in Bordeaux, and trained by her painter father, Raymond Bonheur. In the 1840s and 1850s, following the tradition established by *Géricault, she drew in the slaughterhouses of Paris and at horse fairs; in 1857, apparently to avoid undue attention while working, she obtained police permission to wear men's dress in public places. A vast, *Romantic canvas, the *Horse Fair* (1853; New York, Met. Mus.), won her immense popular success, particularly in England, where the picture was exhibited and engraved. In 1856 she toured England and Scotland, where she met *Landseer, and moved towards more highly finished works; in 1872 she began a series of panthers, lions, and tigers. She was visited by Buffalo Bill, and painted his portrait on a white horse (1889; Cody, Wyo., Whitney Gal. of Western Art). The Château de By, near Fontainebleau, which Bonheur and her intimate friend Nathalie Micas bought in 1860, and where they kept a menagerie, is now the Musée de l'Atelier de Rosa Bonheur. HL

Ashton, D., *Rosa Bonheur* (1981).

BONINGTON, RICHARD PARKES (1802–28). English painter. Bonington's family moved in 1817 from Nottingham to Calais where he studied watercolour painting with Louis Francia (1772–1839). In Paris 1819–22 he studied with *Gros. He sketched around Paris and in northern France and elsewhere, selling through dealers, making lithographs, and working for print publishers. In London in 1825 he sketched Gothic architecture and medieval armour with *Delacroix. A trip to Italy in 1826 provided colourful new subjects. He exhibited with great success in Paris and London between 1822 and 1828. With his reputation increasing he died in September 1828, not quite 26 years old. His brilliant, fluid landscape sketches in oils and watercolour were inspirational and he helped create a vogue for 'troubadour' subjects. These were fancy historical costume pieces built on studies made from the old masters seen in Paris, London, and Venice and inspired by Walter Scott's writings and by orientalist fashions, e.g. *Amy Robsart and Leicester*, (Oxford, Ashmolean). His Venetian subjects, like *The Piazetta, Venice* (1827; London, Tate), were much imitated. He was a major figure in the Anglo-French art world of the 1820s and is well represented in London in the Wallace Collection (see under LONDON). MP

Ingamells, J., *Bonington* (1980).

BONNARD, PIERRE (1867–1947). French painter. In 1888, although a law student, he became one of the *Nabis group at the Académie Julian, Paris, whose influences were *Gauguin and Japanese prints. He became a professional artist after selling a poster for champagne in 1889 and revealed a great flair for decoration and design in fans, furniture, *lithography, theatre decor, and book illustration. He painted interiors in dark tones and sophisticated scenes of Parisian life, such as *The Croquet Game* (1892; Paris, Mus. d'Orsay), becoming known as the 'Nabi très japonard', simultaneously developing a quick, flickering drawing style, closely related to his painting method. Painting became his primary interest after 1900, his principal subjects being still lifes, landscapes, and nudes (Marthe de Méligny, his partner, and later his wife). Influenced by *Monet but not following the precepts of *Impressionism, he painted in the Seine valley until discovering the Midi in 1910, his preoccupations thereafter being light and colour. Bonnard revised his painting method in 1915, feeling that he had sacrificed form for colour. In 1926, a year after marrying, he bought the Villa du Bosquet above Le Cannet (Midi). It became his centre of activity and he remained there throughout the Second World War; Marthe died there in 1940. Bonnard's achievement is to make paint itself and the act of painting parts of the spectator's experience, creating transfigurations of perceived reality so luminous and so elusive that a mysterious, incandescent symbolism seems to emerge, giving the work a visionary quality: *La Palme* (1926; Washington, Phillips Coll.). He has been very influential. JL

Pierre Bonnard: The Graphic Art, exhib. cat. 1990 (New York, MoMa).

Watkins, N., *Bonnard* (1994).

BONTEMPS, PIERRE (c.1505–c.1568). French sculptor working with *Primaticcio at *Fontainebleau from 1536, first as a stuccoist and later making casts after the *Antique. By 1549 he was one of a number of sculptors working on the tomb of François I (Paris, S. Denis) directed by Philibert de L'Orme, whose elegant triumphal arch dominates the scheme. Bontemps certainly carved the gisants and bas-reliefs of military victories. He and de L'Orme also collaborated on the small monument to the heart of François I (1550–60; Paris, S. Denis), an Antique urn covered with strapwork and exquisite reliefs celebrating the King's patronage of the arts and letters. *Charles de Maigny* (1557; Paris, Louvre) sits, apparently asleep, but in reality guards his master, the King, to eternity. His richly damascened armour also suggests Bontemps's decorative ability. Similarly robust elderly gentlemen may be from his workshop, the most likely being *Jean d'Humières* (d. 1550; Paris, Louvre). A Protestant, Bontemps spent the last years of his life in a Huguenot community at Verneuil. LL

BONVICINO, ALESSANDRO. See MORETTO DA BRESCIA.

BOOK OF HOURS or *horae*. A collection of devotional texts that from the 13th century came to replace the psalter as the most popular prayer book for secular use; it is the type of medieval manuscript that survives in greatest numbers. The central text is the little office of the Blessed Virgin Mary, a devotion that from the 11th century had been added to the divine office for recital throughout the day (and night) by religious communities. With the rise of the cult of the Virgin and the medieval acceptance of her as the most effective intercessor between man and God it was adopted for lay use, and the division of the office into eight canonical hours led to the popular name for the collection of devotions of which the office was the central element. The other essential texts included in a book of hours were a calendar, the Gospel extracts, the seven penitential psalms and litany, and the office of the dead. Pious recital of these, either by encouraging moral conduct or invoking forgiveness, was intended to minimize the length of time spent in purgatory by the devotees or their loved ones. Additional elements were added according to local tradition or the personal preference of the intended owner. The suffrages to individual saints could be petitions for protection against more immediate ills or risk: S. Margaret for childbirth, SS Sebastian or Roch for plague, S. Apollonia for toothache, S. Christopher for travel.

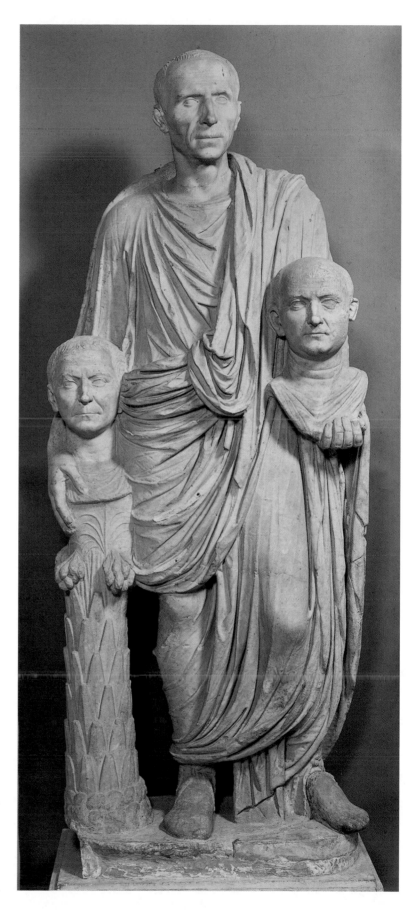

THIS PAGE: *Barberini togatus* (50–25 BC), marble, 1.65 m (65 in) high, Rome, Capitoline Museum.

OVERLEAF LEFT: Book of Kells (Iona?) (8th or early 9th century), Dublin, Trinity College, MS 58, fol. 114r.

OVERLEAF RIGHT: *Christ Pantocrator* (1174–82), mosaic, apse of Monreale Cathedral, Sicily.

nd also be prayeth to his father that it were possible
he may of this cuffen to paffe otherwise if tho best of
his father to be done

Gcamo dicco
ecerunc
Summorcem auufu

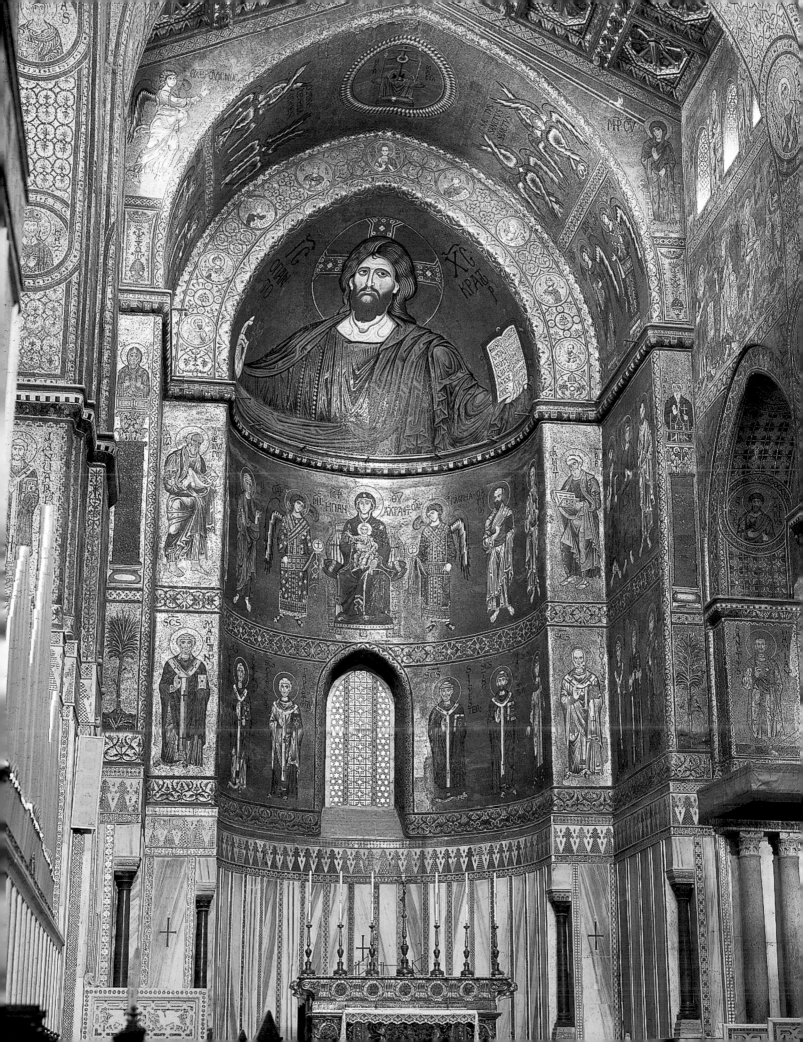

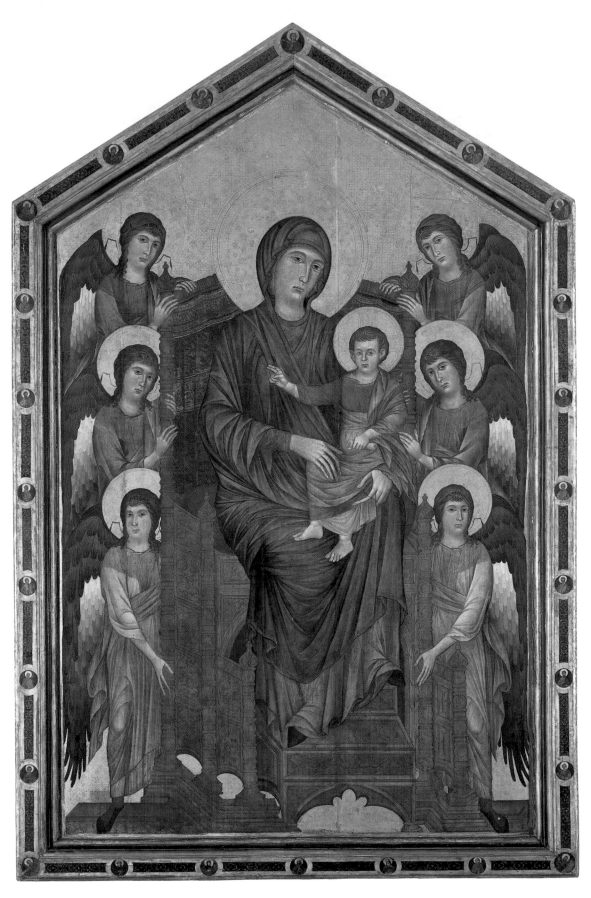

Cimabue (active 1272–1302), *Maestà. Madonna and Child in Majesty surrounded by Six Angels* (The Pisa Madonna), wood panel, 4.27 × 2.80 m (14 ft × 9 ft 2½ in), Paris, Louvre.

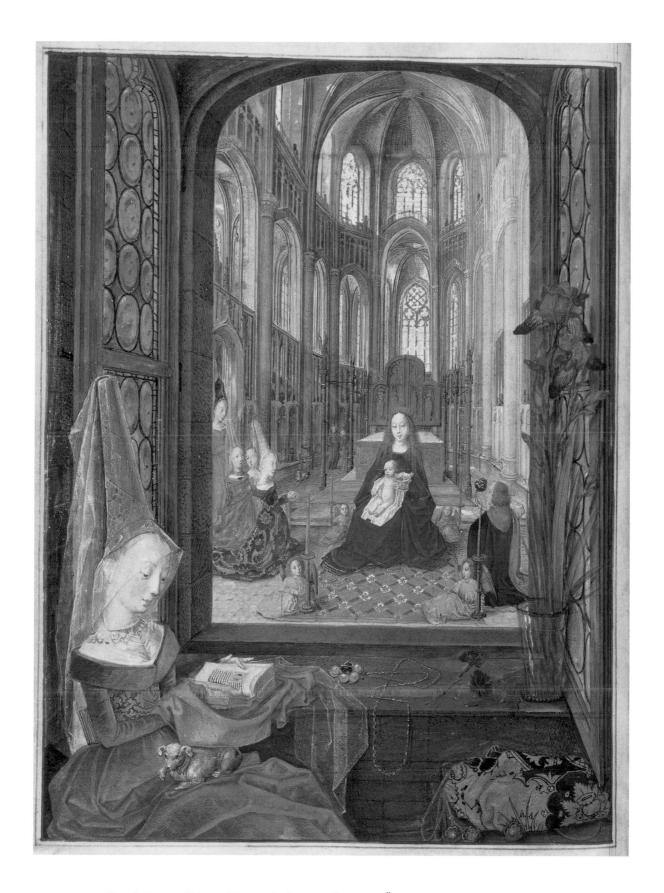

Ghent?, Hours of Mary of Burgundy (late 1470s), Vienna, Österreichische Nationalbibliothek.

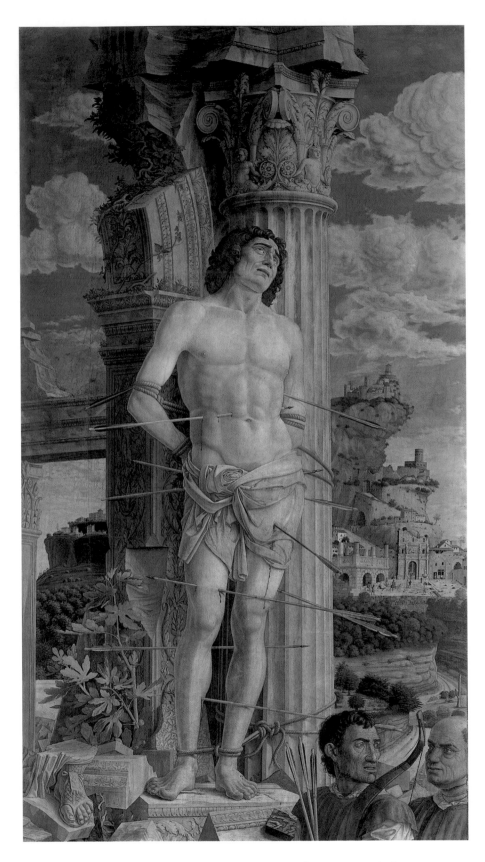

Andrea Mantegna (1431–1506), *S. Sebastian*, tempera on panel, 2.75 × 1.42 m (108 × 55⅞ in), Vienna, Kunsthistorisches Museum.

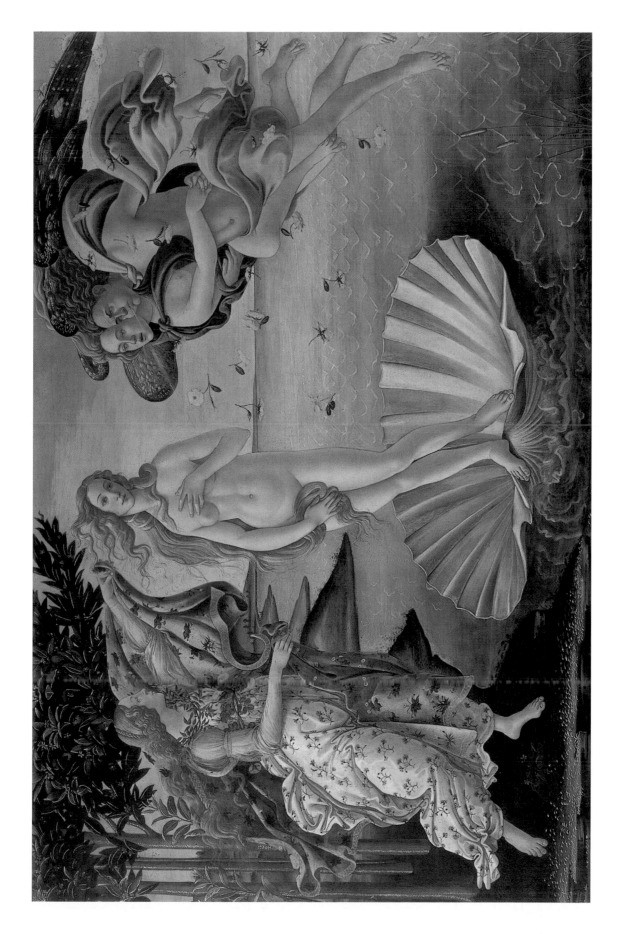

Sand·o Botticelli (1445–1510), *Birth of Venus*, tempera on canvas, 1.73 × 2.79 m (68 × 109½ in), Florence, Uffiz_

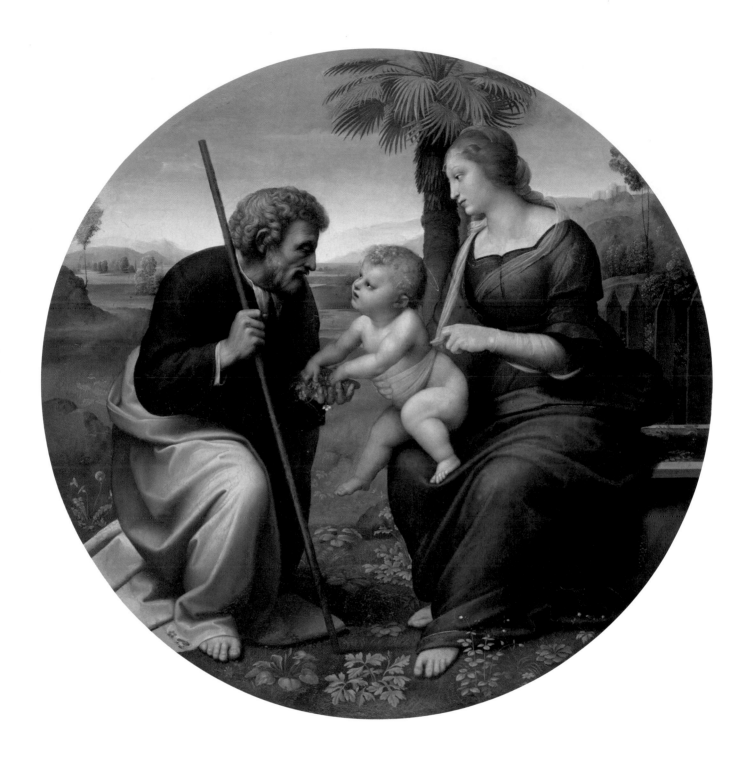

Raphael (1483–1520), *Holy Family with a Palm Tree*, oil and gold on canvas transferred from panel, 101.5 cm (40 in) (circular), Duke of Sutherland Collection on loan to National Gallery of Scotland, Edinburgh.

No doubt an element of display and aesthetic pleasure also figured in the commissioning of the most personalized and luxurious copies, none more so than in the case of—probably the most famous of all books of hours—the *Très Riches Heures* (Chantilly, Mus. Condé) that the de *Limburg brothers were working on until 1416 for John, Duke of Berry, and which was completed in 1485 by Jean *Colombe for Charles, Duke of Savoy. Even modest, routine productions were usually extensively decorated or illustrated. The programme of illustration was relatively standardized: the office of the Virgin, for example, was most commonly illustrated with a series of miniatures surrounding the infancy of Christ, from the *Annunciation* at matins to the *Flight into Egypt* at vespers, and ended with the *Death* or *Coronation of the Virgin* at compline. As well as providing an aid to meditation the illustrations and decorated initials helped to identify texts. In some cases the miniature was an integral component of the devotion, for example the indulgences attached to the prayer to the holy face of Christ, especially popular in Flanders during the 15th and 16th centuries, were only gained if the prayer was said while contemplating an image of Christ's face. Books of hours continued to be made well into the 16th century and ranged from modest mass-produced printed editions to highly individualized luxury manuscript commissions such as the Hours illuminated by Giulio *Clovio for Cardinal Alessandro Farnese (1546; New York, Pierpont Morgan Lib., MS M. 69). The Farnese Hours was described at length and with wonder by *Vasari in his life of Clovio (1568 edn.). KS

Wieck, R. S., *Painted Prayers: The Book of Hours in Medieval and Renaissance Art* (1997).

BORCH, TER (Terborch), GERARD THE YOUNGER (1617–81). One of the most distinguished of Dutch *genre painters, who also explored portraiture. He was born in Zwolle, visited Amsterdam and Haarlem, and was renowned for his precocity. He trained with his father Gerard the elder and Pieter de *Molyn. Ter Borch travelled widely: he was recorded in London in 1635 and from about 1636 to 1640 probably visited Italy. He also went to Spain, Flanders, and Germany, and in the Netherlands is recorded in Delft and Deventer (where he remained from 1654 until his death). His small genre paintings often concentrate on richly dressed women and the detailed depiction of sumptuous textiles, particularly satin. He also proved to be a very accomplished portraitist, developing a new type of small full-length portrait; in addition he recorded in an impressive group portrait a defining moment in the history of the United Provinces—*The Swearing of the Oath of the Ratification of the Treaty of Münster* (1648; London, NG), which he had witnessed. CB

Gudlaugsson, S. J., *Gerard ter Borch*, (2 vols., 1959).

BORDON, BENEDETTO (active *c.*1480–1530). Italian illuminator. He is mentioned as an illuminator in Padua from 1480 and this has led to his identification with the Benedetto Padovano who signed two incunabula owned by Peter Ugelheimer, financial backer to the Venetian printer Nicolaus Jensen (Gotha, Landesbib., Mon. Typ. 1477 and Mon. Typ. 1479). From 1492 Bordon is known to have been in Venice and around 1494 he published and illuminated a Latin translation of the *Dialogues* of Lucian (Vienna, Österreichische Nationalbib., Inc. 4. G. 27) for a member of the Mocenigo family. Two manuscripts, an evangeliary (Dublin, Chester Beatty Lib., MS W. 107), which is signed Benedetto Bordonus, and an epistolary (London, BL, Add. MS 15815) have been identified as those contracted from Bordon for the monastery of S. Giustina in Padua in 1523. He is believed to have been responsible for a number of Venetian *woodcuts produced in the 1490s, and his work as an engraver (see LINE ENGRAVING) survives in his *Isolario* (1528).

Bordon was also recognized as a scholar and author, and was the father of the humanist Giulio Cesare Scaligero. KS

BORDONE, PARIS (1500–71). Italian painter whose reputation in his own day approached that of *Titian, under whom he probably studied. He was from Treviglio but had settled in Venice by 1518. His *Presentation of the Ring of S. Mark to the Doge* (*c.*1534–5; Venice, Accademia) is a large ceremonial picture in Titian's grand manner; the elaborate architectural setting was inspired by his friend Sebastiano Serlio's unpublished treatise. He received commissions from as far afield as the King of Poland; and in the 1540s he was in Augsburg working for the Fugger family. According to Vasari he had also visited Paris in 1538. He specialized in *sacre conversazioni*; mythological pictures, some overtly erotic; and portraits in the style of Titian (*Knight in Armour*; Raleigh, North Carolina Mus.). He had little capacity for self-renewal and his late style marks a period of decline and self-repetition. HO/HB

Manzato, E. (ed.), *Paris Bordone*, exhib. cat. 1984 (Treviso, Palazzo Trecento).

BORDUAS, PAUL-ÉMILE (1905–60). Canadian painter. Borduas was born in St Hilaire, Quebec, and was apprenticed to the church decorator Ozias Leduc (1864–1955) at 16. He studied at the École des Beaux-Arts, Montreal (1923–7), and Les Ateliers d'Art Sacrée, Paris (1928–30), under Maurice *Denis. Returning to Canada he failed to establish himself as a decorator and, in 1933, decided to work as a painter. By 1937 he was teaching in Montreal and active in artistic circles. In 1942, inspired by *Surrealist art and writings, Borduas abandoned Denis-influenced figuration and exhibited 45 abstract automatist gouaches which attracted a group of younger artists, including Jean-Paul Riopelle, who became known as Les *Automatistes and worked together in the late 1940s. In his preface to their manifesto *Refus global* (1948), Borduas attacked both State and Church resulting in his dismissal and subsequent physical and mental suffering. His mature, *tachiste work has much in common with *Abstract Expressionism and in 1953 he moved to New York but, although befriended by *Motherwell and influenced by *Kline, he followed Riopelle to Paris, where he was to remain, in the same year. DER

Gagnon, F.-M., *Paul-Émile Borduas* (1978).

BORGHINI, RAFFAELE (*c.*1537–88). Florentine man of letters. His *Il Riposo* (1584) is a treatise on painting and sculpture, cast as a dialogue between a group of art enthusiasts meeting at the villa Il Riposo, which was owned by the collector Bernardo Vecchietti. The theoretical discussion is lifted wholesale from *Vasari, but the book contains useful information about contemporary artists and artistic activity in Florence. It is particularly good on *Giambologna, vividly describing Vecchietti's large collection of statuettes and models displayed at the villa, and the discussions over the title of the *Rape of the Sabines* (Florence, Loggia dei Lanzi). It is also notable for being specifically aimed at a new audience of cultured amateurs, rather than at other artists as had been the case with earlier treatises. AJL

Blunt, A., *Artistic Theory in Italy 1450–1600* (1940).

BORGHINI, VINCENZO MARIA (1515–80). Florentine historian, Benedictine churchman, and courtier. He was a friend of *Vasari, whom he provided with the iconographical programme for the ceiling paintings in the Salone dei Cinquecento (1563; Florence, Palazzo Vecchio). He also drew up the programme for the *studiolo* of Francesco I de' Medici (1570; Florence, Palazzo Vecchio) and acted as iconographic adviser to the Medici court for many public ceremonials in the 1560s and 1570s. He left a large body of writing on the history of Florence and the Italian language. AJL

Lo stanzino del principe in Palazzo Vecchio, exhib. cat. 1980 (Florence, Palazzo Vecchio).

BORGIANNI, ORAZIO (*c.*1575–1616). Italian painter and etcher. He was born in Rome, but the presence in Catania (Villa Cerami) of his earliest known painting *S. Gregory in his Study*, signed and dated 1593, might suggest he was in Sicily during his youth. He

went twice to Spain, c.1598–1603 and again 1605–7; otherwise he appears to have been based at Rome. His style reflects the combined influence of *Caravaggio, *Lanfranco, and Jacopo *Bassano. After an initial Caravaggesque phase, during which he may have painted the violent *David Beheading Goliath* (Madrid, Academia de S. Fernando), his palette becomes more varied and colourful in such pictures as the *Birth of the Virgin* (Savona, Sanctuary of Nostra Signora della Misericordia) probably painted c.1612. In 1613 he sent an important group of paintings, including a vast altarpiece of the *Assumption of the Virgin*, from Rome to the monastery of Porta Coeli, Valladolid, in Spain. His late style from c.1614 reverts to a stark Caravaggism: the *Pietà* (Rome, Palazzo Venezia and other versions); and the *S. Christopher* (Edinburgh, NG Scotland, and other versions); and his etchings of these two designs, that of the *Pietà* dated 1615.

HB

Wethey, H., 'Orazio Borgianni in Italy and Spain', *Burlington Magazine*, 106 (1964).

BORGLUM, GUTZON (1867–1941). American sculptor. Borglum was born in Idaho, studied in Paris, and lived and worked in England 1896–1901. After returning to America he began a successful career as an academic sculptor. In 1911 he joined the Association of American Painters and Sculptors but resigned in 1913 as a protest about the poor representation of sculpture in the *Armory Show. Shortly afterwards he began to work on the colossal scale for which he is famous, creating gigantic reliefs on mountain sides, using pneumatic drills and dynamite. The first of these, on Stone Mountain in Georgia, commemorating the Confederate army, was worked on 1915–25 but was never completed. In 1930 he began his best-known work, the relief carving of four presidents heads on Mount Rushmore, South Dakota. Washington's head was completed in 1930, Jefferson's in 1936, Lincoln's in 1937 (he also commemorated his hero Lincoln with a massive head in the Rotunda of the US Capitol), and Theodore Roosevelt's in 1939. His son Lincoln completed the work in 1941 after Borglum's death. The cost, of over $1 million, was borne by the government. His brother Solon (1868–1922) was a sculptor of Wild West subjects.

DER

BORGOGNONE, AMBROGIO. See BERGOGNONE, AMBROGIO.

BORGOGNONE, IL. See COURTOIS BROTHERS.

BORGOÑA, JUAN DE (active 1495–d. 1536). Spanish name of a painter probably from Burgundy, as reflected in the style of works he painted for the Cathedral of Toledo between 1495 and 1502. Beginning in 1508, Juan de Borgoña worked to complete the main altarpiece of the Cathedral of Ávila, left incomplete when the painter Pedro *Berruguete died in 1503. The paintings Borgoña undertook in Ávila are so markedly Italianate in their understanding of *perspective that it can be assumed that he made a trip to Rome, probably about 1505–6. In 1508 Cardinal Francisco Ximénez de Cisneros, Archbishop of Toledo, called Borgoña back to Toledo to decorate the chapter house of the cathedral. The resulting series of frescoes, painted between 1509 and 1511, are Borgoña's finest achievement. A fictive gallery with views into the distant landscape frames scenes from the life of the Virgin and the Passion of Christ. The painting on the entrance wall represents the *Last Judgement*. Juan de Borgoña's large workshop, mostly occupied working for Cisneros, was busy until the painter's death in 1536. His influence continued in Toledan painting in the hands of followers such as Antonio de Comontes.

SS-P

Brown, J., *The Golden Age of Painting in Spain* (1991).

BORISOV-MUSATOV, VIKTOR (1870–1905). Russian *Symbolist painter. He studied at the Moscow School of Art 1890–1 and 1893–5, the Imperial Academy 1891–3, and in the Parisian studio of Fernand Cormon 1895–8. Familiar with Western developments, he adopted a bright *Neo-Impressionist style influenced by the decorative works of *Gauguin and *Puvis de Chavannes. On his return to Russia in 1898 he concentrated on the depiction of a remote and melancholic dream world populated by introspective female figures in period costume. Typically, as in *Portrait of the Artist with his Sister*, (1898; St Petersburg, Russian State Mus.) figures are posed in formal gardens, evoking an air of romantic ennui, a nostalgia for a vanished age similar to that of the Symbolist poets Bryusov and Bely with whom he was friendly. Later works in tempera, watercolour, and pastel, such as *The Pool* (1902; Moscow, Tretyakov Gal.) are similarly static and uneventful, painted in broad, muted tones that accentuate decorative qualities. He was a member of the Union of Russian Artists 1904–5 and exhibited with World of Art in 1906. His work was influential in Russian Symbolist circles, particularly with the *Blue Rose group.

DJ

Gofman, I. (ed.), *V. Borisov-Musatov: Album* (1989).
Rusakova, A., *Borisov-Musatov* (1975).

BORMAN (or Borreman, Borremans) FAMILY. Southern Netherlandish sculptors active in Brussels. **Jan I** (d. 1498) is recorded as standing surety with his son **Jan II** (active c.1479–1520) for the bronze caster Jan van Thienen in the making of a door (untraced) for S. Pieterskerk, Louvain. Many wooden altarpieces have been attributed to the Borman family, which also included **Jan III** (active c.1491–1522) and his elder brother **Passchier** (active c.1491–1537). The quality of their large output is varied, suggesting workshop assistance. Little has been identified as the work of Jan I, but Jan II's most important work was probably the altarpiece comprising seven scenes from the life of S. George (Brussels, Mus. Royaux), commissioned for the chapel of Onze Lieve Vrouw Buiten de Mauren, in Louvain. Each scene is composed of up to twelve figures, originally with polychromy, each with unusually varied facial characterization, meticulously carved details, and heavy, folded drapery. In 1511 Jan II was commissioned to make wooden figures of the dukes and duchesses of Brabant, which were to be cast by Reinier van Thienen. In the same year he was described in the royal accounts as 'the best sculptor'. Carvings attributed to the family may be found in Swedish, German, as well as Belgian churches.

OI

BORRASSÀ, LLUÍS (active 1380–1424/5). Catalan painter from Girona, first mentioned for his repairs to stained-glass windows in Girona Cathedral in 1380. From 1385 Borrassà worked in both Girona and Barcelona and other Catalan centres; he was the most prolific Catalan painter of his generation. Eleven altarpieces by him are documented and a further 20 or so have been attributed to his hand. Examples characteristic of his style include the altarpieces of the *Virgin* and *S. George* (Vilafranca del Penedès, San Francisco) and the altarpiece of *S. Peter* for S. Pedro, Terrassa (1411–13). Rich in anecdotal detail, brightly coloured, and peopled with active, gesturing figures, his work was an influential departure from the softer and more static paintings of the preceding generation.

OI

Gudiol, J., and Alcolea Blanch, S., *Pintura Gótica catalana* (1986).

BOSCH, HIERONYMUS (or Jeroen) (c.1450–1516). North Netherlandish painter whose family name was van Aken (from the German city of Aachen) but who took the name by which he is known from the Dutch town of 's-Hertogenbosch, where he was born, lived, and worked. Bosch is celebrated for panel paintings, among them several triptychs, peopled with grotesque forms and nightmarish visions. His painting technique, using translucent oil glazes, gives a semblance of reality to his strange creations, frequently set in vast landscapes or across night scenes lit by the fires of hell. Bosch's preference for metamorphosis has been explained by the influence of late

medieval manuscript illumination (see ILLU-MINATED MANUSCRIPTS) or Italian grotesque ornaments, but his forms are more gruesome and threatening.

Fanciful theories have grown up around the creation of these paintings, offering explanations from the psychological to hypotheses of Bosch's involvement with heretical sects, magic, alchemy, astrology, and witchcraft. However, Bosch was an orthodox Christian, a member of the Brotherhood of our Lady, a pious religious confraternity. It can be demonstrated that Bosch's pictures were designed to impart certain moral and spiritual truths, and that their monstrous imagery derived from visual translations of verbal puns and metaphors. Bosch's sources, in fact, should rather be sought in the language and folklore of his day—in proverbs, sermons, and popular devotional literature. Nonetheless, the fact remains that much of his art defies any rational description or explanation.

It is probable that Bosch's most dreamlike allegories, the large triptychs with the *Garden of Earthly Delights* (c.1504) and the *Haywain* (c.1500; both Madrid, Prado; the latter in another version in the Escorial) were painted for nobles at the Burgundian courts at *Brussels and Malines who delighted in his jewel-like execution and rich imagination but who, at the same time, desired moral instruction. He also painted traditional Christian subjects, especially episodes from the birth and Passion of Christ, the Last Judgement, and the lives of the saints (e.g. several versions of the *Temptation of S. Anthony*; Lisbon, Mus. Nacional de Arte Antiga; Madrid, Prado; Venice, Doge's palace). Bosch's inventions were imitated by innumerable successors, among them Pieter *Bruegel the elder whose painted allegories and, especially, prints had a wide, popular appeal. But ultimately it was Bosch's sensitive depiction of landscape that was of the greatest significance for Bruegel. KLB

Gibson, W. S., *Hieronymus Bosch* (1973).

BOSCHINI, MARCO (1605–81). Venetian polemical poet, painter, art dealer, and engraver. His main work was *La carta del navagar pittoresco* (1660), a 680-page poem in Venetian dialect which mounts an extravagant defence of Venetian painting against the ideals of Tuscan and Roman art, with *Vasari treated as the butt of much violently caustic satire. The poem takes the form of a dialogue, conducted during gondola trips over the course of several days, between a senator 'Ecelenza' and a painter 'Compare' who educates the other's taste and advises him about forming an art collection.

Boschini was passionately devoted to the freedom of Venetian colour and brushwork; the whole poem is, in fact, a 'paean to the brush-stroke, glaze and scumble' (Rosand).

As a poet Boschini was strongly influenced by Marino. The *Carta* is bursting at the seams with hyperbolic metaphor and bizarre sensory imagery, and Boschini exploits the local dialect by every kind of rhythmic device so as to reflect the immediacy and spontaneity that he valued above all other qualities in Venetian painting. He also wrote a more conventional history, *Le ricche minere della pittura veneziana* (1674) in normal (i.e. Tuscan) Italian. As an art dealer he exported much Venetian painting while maintaining the public posture of complaining about such practices as depleting the artistic patrimony. AJL

Rosand, D., *Painting in Cinquecento Venice* (1982).
Sohm, P., *Pittoresco* (1991).

BOSSCHAERT, AMBROSIUS, THE ELDER (1573–1621). Antwerp-born founder of a dynasty of Dutch fruit and flower painters (though few fruit pieces by Ambrosius have survived). Like many Protestant Flemish artists he left Antwerp for religious reasons to seek refuge in Holland, where he is recorded in Middelburg 1593–1613; thereafter he moved around the country, settling for a while in Utrecht. He specialized in bright, symmetrical bouquets of flowers, individually observed at different times of the year, flanked by insects and sea shells. His most original compositions are placed in arched windows opening on distant vistas of imaginary landscapes (*Vase of Flowers in a Window*, c.1619; The Hague, Mauritshuis). His three sons, Ambrosius the younger (1609–45), Johannes (either 1606–8 or 1610/11–28 or later), and Abraham (c.1612/13–43), as well as his brother-in-law Balthasar van der *Ast, continued in the same tradition. Of these Johannes was the most talented. He may also have been the eldest, as suggested by recent research which places his birth 1606–8. KLB

Taylor, P., *Dutch Flower Painting* (1995).

BOSSE, ABRAHAM (1602–76). One of the finest printmakers in 17th-century France. His many series of *etchings on biblical subjects, such as *The Prodigal Son* and *The Wise and Foolish Virgins*, or on traditional themes including *The Five Senses* and *The Four Seasons*, invariably show their figures in contemporary dress in elaborately descriptive interiors, thus making them valuable evidence of bourgeois life in the mid-17th century. Bosse was also inspired by his friendships with the mathematician Gérard Desargues and the etcher Jacques *Callot to publish the first manual for printmakers. His influential *Traité des manières de graver en taille-douce* was first published in 1645 and went through many subsequent printings. Bosse was an honorary member of the Académie Royale (see under PARIS) and a lecturer on *perspective, but his independent character

and unorthodox theories led to his expulsion in 1661. Much of his later life was devoted not to printmaking but to increasingly bitter attempts to promote his views against academic doctrine. MJ

Duplessis, G., *Catalogue de l'œuvre d'Abraham Bosse* (1859).
Villa, N., *Le XVIIe Siècle vu par Abraham Bosse* (1967).

BOSTON: PATRONAGE AND COLLECTING. *See overleaf.*

BOSTON, ISABELLA STEWART GARDNER MUSEUM. More than any other American museum it is the permanent record of its founder's taste and achievements. Born in New York in 1840, Isabella Stewart married John Gardner of Boston at age 20, and, following the early death of their son in 1865, they turned their interest to travel and collecting. After her husband's death in 1898, Mrs Gardner forged ahead with their plans to build a private museum. Her Venetian-inspired *palazzo* on the Fenway with its glorious light- and flower-filled central court opened in 1903, and remained a lively centre of art and music until her death in 1924. Mrs Gardner's will stipulated that Fenway Court was to be for 'the education and enjoyment of the public forever', and nothing could be added or changed. The remarkable collection which she formed comprises nearly 3,000 works. There are a small number of Far Eastern pieces, but the vast majority is Western art, including Romanesque sculpture, medieval stained glass, and many tapestries. Of ancient antiquities there is a Graeco-Roman sculptural fragment of *Odysseus*, a mosaic with the head of Medusa, and most notably a fine Roman sarcophagus of satyrs and maenads from the Palazzo Farnese, Rome. Although Mrs Gardner did not intend her house museum to provide a chronological survey, many of the rooms concentrate on certain schools of painting. The best represented is the Italian, and in forming this she had the expert advice of Bernard *Berenson, whom she had first known as a Harvard student. Representing the early Italians are panels by *Giotto, *Daddi, *Pesellino, *Simone Martini, *Giovanni di Paolo, *Crivelli, and the only fresco outside Italy by *Piero della Francesca. Continuing into the Renaissance there are two *Botticellis, *Bandinelli's *Self-Portrait*, *Pollaiuolo's *Woman in Profile*, and two *Raphaels—a portrait and a small predella panel. The Venetian School is well represented with works by *Tintoretto, *Veronese, and *Bordone, and above all *Titian's *Rape of Europa*. A *Christ Carrying the Cross*, purchased as a *Giorgione, is now given to the school of Giovanni *Bellini. Spanish art also interested Mrs Gardner, and she acquired a large *Bermejo as well as pictures by

continued on page 81

· BOSTON: PATRONAGE AND COLLECTING ·

ALTHOUGH the Massachusetts Bay Colony founded by Puritans had a famous aversion to visual seduction, Boston has long quietly produced avid patrons and collectors of art. The painter John *Smibert arrived in town as early as 1729, bringing with him a collection of copies of old masters. The Boston area's favourite colonial-period portraitist was John Singleton *Copley, who depicted many of the region's leading citizens. Founded in 1807, the Boston Athenaeum held regular exhibitions after 1827, showing the works not only of Copley but also of local artists like Washington *Allston, Gilbert *Stuart, William *Rimmer, and William Morris Hunt (1824–79). It was also during these years that the architect Charles Bulfinch (1763–1844) left his mark on the city, crowning Beacon Hill with the golden dome of his State House. Late 18th-century and early 19th-century collectors, such as the Codmans in nearby Lincoln and Harrison Gray Otis (1765–1848), had a few minor European old masters, but most carried dubious attributions. However, the furnishings and paintings in some early Boston homes, such as the Deacon Mansion in the South End which housed François *Boucher's Halt at the Spring and Returning from Market (the two earliest old master paintings to be donated to the Museum of Fine Arts, Boston) attest to an aspiration to opulence which comes as a surprise to those familiar with the more restrained tastes of the Museum's founders. These men, who included Martin Brimmer (1829–96), William Babcock (1826–99), Thomas Gold Appleton (1812–84), and Quincy Adams Shaw (1825–1908), were usually Harvard graduates and often amateur artists themselves. The painter William Morris Hunt was a member of this circle and championed the French *Barbizon School, particularly the art of Jean-François *Millet. While the 60 paintings by Copley in the museum might be regarded as an indigenous legacy, the more than 150 works by Millet speak to a truly distinctive local taste. Boston Brahmins admired Barbizon landscapes but were drawn even more strongly to the moral dimension of Millet's peasant genre scenes and a mid-19th-century concept of social realism. Quincy Adams Shaw, who installed 60 Millets in his Chestnut Hill mansion, also boasted a broad range of American and European paintings and sculpture, notably a superb *Donatello marble relief (Boston, Mus. of Fine Arts). At the same time the learned Denman Waldo Ross (1853–1935), who taught art theory at Harvard, collected in an astonishing variety of fields, from great oriental and Egyptian art to old master and *Impressionist paintings, donating objects to virtually every curatorial department of the museum. Gridley G. F. Bryant (1816–99), Arthur Gilmore (1821–82), and H. H. Richardson (1830–86) were the architects who shaped the face of Boston in the second half of the 19th century, with the last mentioned's serenely Romanesque Trinity church dominating Copley Square.

There were a few noted collectors of old masters, such as Stanton Blake and Mrs Samuel D. Warren, in Boston's 'Brown Decades' or 'Gilded Age', but during the prosperous years following the Civil War, most Bostonians collected contemporary American paintings. The master of bravura brushwork, John Singer *Sargent, created a suitably understated yet elegant version of the 'swagger' portrait which flattered local sitters, while simultaneously undertaking large municipal decorations, including murals for the Public Library (McKim, Mead & White of New York) as well as the Museum of Fine Arts. Beginning in the 1880s, Isabella Stewart Gardner assembled an impressive collection of old master and 19th-century paintings, often relying on the advice of Bernard *Berenson, and installed them with flair in an Italianate palazzo on the Fenway (see BOSTON, ISABELLA STEWART GARDNER MUSEUM).

As Philadelphians embraced *Cézanne more passionately than Parisians, so Bostonians made Claude *Monet a special obsession, acquiring literally scores of his pictures. Today more than three dozen are still housed at the Museum of Fine Arts. Peter Chardon Brooks, Desmond FitzGerald, and the Edwards and Kimball families were some of the leading Impressionist collectors. Just as the artist W. M. Hunt provided a direct personal contact with the earlier Barbizon painters, so too the local Boston painters Lilla Cabot Perry (1848–1933) and Dennis Bunker (1861–90) made the pilgrimage to study with Monet at Giverny and, returning, promoted his art. The city's Impressionist collectors also patronized local artists working in an Impressionist manner, including Frank Benson (1862–1951), Edmund Tarbell (1862–1938), Philip Leslie Hale (1865–1931) and Lilian Westcott Hale (1881–1963), and William Paxton (1896–1941), all of whom were associated with the newly founded School of the Museum of Fine Arts. Robert Treat Paine (1861–1943) is an excellent example of a Boston collector from this era of extraordinarily catholic tastes and distinguished eye. Grandson of a great benefactor of Harvard and leader of the building committee of Trinity church, Paine was a Harvard-educated lawyer and businessman who collected everything from medieval tapestries to old master drawings and paintings, as well as Impressionist and *Post-Impressionist paintings, notably *Manet, *Degas, Cézanne, Monet, *Renoir, and van *Gogh. Still another inspired collector of Impressionist and Post-Impressionist paintings was John Taylor Spaulding (1870–1948), who assembled a peerless group of Japanese prints before turning to the more recent French masters, and especially to still lifes.

In part the museum's strengths in 19th-century French paintings have to do with Bostonians' general scepticism about 20th-century and contemporary art. The citizenry has been far less receptive to *Cubism and its offspring than to Impressionism; indeed until quite recently Bostonians continued to collect the art of the last century

rather than of their own. Nonetheless, in this century early American paintings and decorative arts were sought avidly by the flamboyant Maxim Karolik (1893–1963) and his wife Martha Codman Karolik (1858–1948), including colonial portraits, furniture and silver, *Hudson River School and *Luminist landscapes, as well as works by many hitherto underestimated American masters. William H. and Saundra B. Lane assembled an outstanding collection of *modernist American paintings, now donated, like William Coolidge's old masters and Impressionists, to the museum. In the late 20th century, I. M. Pei was often the architect of choice, building both the Hancock Tower and the new wing on the MFA. There continue to be local collectors of earlier art, notably prints, drawings, and French and Dutch paintings, but these have been supplemented successively with collectors of *Abstract Expressionism, *colour field painting, *Conceptual art, modern design, and many other recent movements. Programmes and exhibitions of contemporary art now abound at the Museum of Fine Arts, Fogg Art Museum, Institute of Contemporary Art, and other public and commercial galleries; however, an undercurrent of conservatism still tempers taste in Boston. PCS

*Zurbarán and *Velázquez. The greatest rarity among the 17th-century northern masters was the *Vermeer The Concert purchased at the Thoré Burger sale in 1892, but sadly stolen in 1990. By Americans there are several fine *Whistlers, and works by *Hassam, Thomas Dewing, and Mrs Gardner's protégé, the Boston Impressionist Dennis Miller Bunker. Mrs Gardner was keenly interested in the art of her time and was herself painted by both Anders *Zorn and John Singer *Sargent, whose masterpiece, El jaleo of 1882, is given pride of place in the alcove of the Spanish Court. More adventurous was her acquisition of *Matisse's 1904 Terrace at St Tropez, the first work by the artist to enter an American museum. EZ

Goldfarb, H. T., The Isabella Stewart Gardner Museum: A Companion Guide and History (1995).

BOSTON, MUSEUM OF FINE ARTS.

Founded by a group of civic-minded patrons in 1870. At that time the collection was a very modest one of a few old masters from the Boston Athenaeum and prints from Harvard. A building was erected on city land at Copley Square in 1876, but in 1909 the museum moved to a new larger Neoclassical building designed by Guy Lowell on Huntington Avenue not far from Mrs Gardner's Fenway Court. In 1914 the Evans wing for paintings was added, and in 1967 a new west wing was designed by I. M. Pei to house special exhibitions and contemporary art.

Known for its great holdings of Asian, Indian, and Egyptian art, the museum, befitting Boston's role as the Athens of America, also became a major repository for classical art. In 1872 a portion of the Cesnola collection of antiquities was purchased. Local connoisseurs, such as Edward Perry Warren, captured major finds like the Mantiklos Apollo. Later came the Minoan Snake Goddess of ivory and gold. There are also notable examples of Greek vase painting, including one by *Exekias, Roman portraiture, and an extraordinary collection of coins and cameos. The Department of European Paintings began with the donation in 1871 of two immense *Bouchers, and through both gifts and purchases it has grown into an extraordinarily rich holding. In the Italian School this includes a *Duccio triptych, a *Crivelli, and the Mannerist *Rosso Fiorentino's Dead Christ. Spanish works commence with a monumental 12th-century Catalonian fresco and continue with a an early El *Greco portrait, two paintings by *Velázquez, and a pair of *Meléndez still lifes. Northern European highlights are Rogier van der *Weyden's S. Luke Painting the Virgin, and from the 17th century outstanding examples by *Baburen, *Rubens, *Ruisdael, *Hals, and *Rembrandt. The French classical tradition is strongly represented, with important paintings by *Poussin, *Claude, and more unusually two major *Le Sueurs. The French 18th century, greatly enhanced by the Forsythe Wickes bequest in 1965, includes works by *Watteau, *Lancret, *Greuze, and *Chardin. Boston had a long love affair with French painting of the 19th century: first with *Corot, *Delacroix, and *Courbet, and also the Barbizon School, best represented by *Millet. However, it is the *Impressionists who predominate in Boston. *Monet is represented by 39 works, primarily landscapes but also his magnificent early La Japonaise. Other notable acquisitions from this period include *Renoir's Le Bal à Bougival and *Gauguin's enormous D'où venons-nous? English art is well represented, including *Turner's great Slave Ship, once owned by *Ruskin. The Department of Prints and Drawings has outstanding holdings in *Dürer, Rembrandt, *Goya, Turner, and *Blake. One of the most outstanding aspects of the museum is its holding of American paintings. Unsurpassed is the large group of *Copleys, mainly portraits, but also the historical Watson and the Shark. There are in addition Gilbert *Stuart's Portraits of George and Martha Washington (now shared with the National Gallery in Washington). Other significant American painters on view are *Sully, *Homer, *Hassam, *Cassatt, and above all John Singer *Sargent. EZ

Kanter, L., Italian Paintings in the Museum of Fine Arts, Boston, vol. 1 (1994).

Whitehill, W. M., Museum of Fine Arts: A Centennial History (2 vols., 1970).

Zafran, E. M., French Paintings in the Museum of Fine Arts, Boston, vol. 1 (1998).

BOTH, JAN

(c.1618–52). Dutch painter, draughtsman, and etcher, who made an important contribution to the development of Dutch Italianate landscape painting. Jan Both's training is uncertain, although Abraham *Bloemaert and Gerrit van *Honthorst have been suggested as teachers. By 1638 Jan had joined his brother Andries in Rome where, in 1639, he collaborated with Herman van Swanevelt and *Claude Lorrain on a project for the Buen Retiro Palace in Madrid. Certainly by 1646 Jan had returned to Utrecht, where he refined further his expansive, imaginary landscapes drenched with a Mediterranean golden light. In Landscape with Bandits Leading Prisoners (Boston, Mus. of Fine Arts) the sandy road makes a sweeping diagonal from the left. Touches of realism in the down-to-earth figures and detailed vegetation of the foreground contrast with the idyllic golden distance. Occasionally Both peoples his landscapes with religious or mythological figures as in Judgement of Paris (London, NG) where the figures were painted by a fellow Utrecht artist, Cornelis van *Poelenburch. Jan's brother Andries (c.1612–41), who specialized in peasant scenes, died in Venice on their return to Utrecht. CFW

Burke, J. D., Jan Both (1976).

BOTTICELLI, SANDRO (Alessandro di Mariano Filipepi)

(1445–1510). Today perhaps the most famous painter of the early *Renaissance period; in his own time one of the leading painters in Florence. He almost certainly trained with Filippo *Lippi, whose sweetness, delicacy, and finesse he took over while adding a more wiry vigour of draughtsmanship comparable to that of Antonio *Pollaiuolo. His earliest documented work, Fortitude for the Florentine Mercanzia

(1470; Florence, Uffizi), shows the fusion clearly.

Throughout his career he produced Madonnas of half-length or *tondo format, deriving initially from Filippo Lippi's models; these are some of his best-loved works (*Madonna of the Magnificat*; Florence, Uffizi). He also produced portraits, some of great charm and admirable in their depiction of a typically Florentine physiognomy, but never 'psychological', even though he moved from the hitherto prevailing pure profile to frontal and three-quarter views under Netherlandish influence. Early in his career, too, he produced some exquisite small-scale figure scenes (two panels of *Judith*; Florence, Uffizi; *Adoration of the Magi*; Florence, Uffizi, well known for its Medici portraits in the figures of the Kings and for its supposed self-portrait among the bystanders), and the extraordinary *Primavera* (Florence, Uffizi), in which the figures are three-quarter life size. The significance of this picture has been unfortunately distorted by its pairing, since *Vasari's time, with the *Birth of Venus*, a different commission which must date from the 1480s; the *Primavera* is commonly supposed to have been painted for the young Lorenzo di Pierfrancesco de' Medici, but the facts are only that he possessed it before 1495, while on grounds of style it must have been painted perhaps before Lorenzo was even adolescent. It is one of the earliest known *classicizing allegories of the Renaissance, in which the mythical gods are introduced to stand for abstract qualities: Chloe raped by Zephyr and metamorphosing into Flora for sexuality; the Graces for beauty; Mercury for eloquence and wisdom. All these are qualities associated with the ideal beloved of contemporary *Petrarchizing love poetry (the more modern view); alternatively, they convey a message from contemporary *Neoplatonic philosophy (the older view); in either case the central figure, whether Venus or not, represents an ideal. Scholars have tended to read into this beautiful picture classicistic values they associate with the Renaissance spirit, but its 'Garden of Love' convention and abundant bright ornament are, equally, late medieval.

In 1481–2 Botticelli, together with *Perugino, *Ghirlandaio, and Cosimo *Rosselli, was painting matching Old and New Testament scenes on the walls of the newly completed Sistine chapel in Rome: these above all show the 'aria virile', 'optima ragione', and 'integra proportione' for which he was praised in a report to Ludovico il Moro of Milan a few years later. On his return to Florence further secular commissions followed, including *Mars and Venus* (London, NG) and the Medicean *Camilla and the Centaur* (otherwise known as *Pallas and the Centaur*; Florence, Uffizi) and the very well-known *Birth of Venus*,

both less elaborate allegories than the *Primavera*, and large altarpieces such as the *S. Barnaba* (Florence, Uffizi). By the end of the 1480s his style was becoming more mannered, however, as in the 1489 Cestello *Annunciation* (Florence, Uffizi), with its exaggerated gestures, or in the *Calumny of Apelles* (Florence, Uffizi), with its elongated figures.

In the last years of the century Botticelli's style may have come to seem rather dry, especially since he seldom used oil glazes. It is unlikely, in contrast to *Mantegna, that he devised his own allegories, though he was well known in Medicean humanist circles. But, if he did not invent, he was a consummate illustrator, as is shown, too, by his series of illustrations to *Dante, drawn on *parchment. PHo

Lightbown, R., *Sandro Botticelli: Life and Work* (rev. edn., 1989).

BOTTICINI, FRANCESCO (Francesco di Giovanni di Domenico) (c.1446–98).

A minor Florentine painter of the later 15th century who, despite his dependence on the examples of *Botticelli, Filippino *Lippi, and *Verrocchio, produced some original and distinctive works. The son of an artisan painter of playing cards, he achieved the status of a master relatively early. The *Three Archangels* altar for S. Spirito (c.1470; Florence, Uffizi) is an example of his early maturity. His most important work is the Tabernacle of the Sacrament, commissioned for the Collegiate church at Empoli in 1484 but still unfinished when installed in 1491. Botticini's workshop concentrated on panel paintings (no frescoes are known), two of which in London (NG) are unusual: *The Assumption* (c.1476) is thought to illustrate a heresy, while *S. Jerome in Penitence with Saints and Donors* (1484–91) has the attendants adoring a picture of the saint; a picture within a picture. PSt

BOUCHARDON, EDMÉ (1698–1762).

French sculptor, draughtsman, and medallist. For many of his contemporaries (most notably his champion the antiquary the Count *Caylus) Bouchardon was not only the most eminent sculptor of public monuments in mid-18th-century France but also its most distinguished draughtsman. In both media he preferred classical forms and details studied from nature to the *Rococo contrivances of the period. Nevertheless, for all his admiration for Antiquity Bouchardon belongs to the tradition of the academy rather than being a *Neoclassicist *avant la lettre*. He studied with Guillaume I *Coustou and was then a star pupil at the French Academy in Rome, where his models were as much influenced by *Algardi and *Duquesnoy as by the Antique. Bouchardon's large-scale works in Paris include a series of statues of the apostles in S. Sulpice and the vast wall fountain

(1739–45) in the Rue de Grenelle, with its much-copied relief panels of putti representing the activities of the seasons. His most ambitious work was the bronze equestrian statue of *Louis XV* (1748–63), which before the French Revolution was the centrepiece of what is now the Place de la Concorde. For this work he made a series of red chalk studies of horses (Paris, Louvre), which are rivalled only by those of George *Stubbs. Bouchardon's main commissions came from the city of Paris, and his seriousness was not always appreciated at court: his royal statue of *Cupid Making a Bow from the Club of Hercules* (finished 1750; Paris, Louvre) depicts a rather gawky adolescent and was much criticized for its 'excessive' naturalism. MJ

Colin, O. (ed.), *Edmé Bouchardon*, exhib. cat. 1962 (Chaumont, Mus. Municipal).

Roserot, A., *Edmé Bouchardon* (1910).

BOUCHER, FRANÇOIS (1703–70). French

painter. At least since the publication in the mid-19th century of the *Goncourt brothers' famous essay, Boucher has seemed to many to be the quintessential painter of 18th-century France. His voluptuous mythologies and elegant pastorals have been admired or abused according to the regard in which the *Rococo style is held.

Boucher was born in Paris and trained with the engraver Cars, contributing to the scheme to engrave the works of *Watteau, whose art was thus a formative influence. He also worked in the studio of François *Lemoyne, one of the chief protagonists of the colouristic, Rubéniste tendency in France. In 1723 Boucher won the Académie Royale's Grand Prix (see under PARIS), but it was not until 1727 that he left for Rome, at his own expense and in the company of Carle and Louis-Michel van *Loo. There he fell under the spell of the decorative painters of the *Baroque—*Albani, Pietro da *Cortona, and Luca *Giordano. Returning to Paris in 1731, he was received as a member of the Academy in 1734 on presentation of *Rinaldo and Armida* (Paris, Louvre). By 1736 his mature style was formed, altering little during his long career.

Boucher worked successfully in several genres. He treated mythological themes either with a delicate and very modern eroticism—as in *The Bath of Diana* (1742; Paris, Louvre)—or with robust splendour—as with *The Rising of the Sun* (1753; London, Wallace Coll.). He painted scenes of contemporary fashionable life, including the delightful *La Marchande de modes* (1746; Stockholm, Nationalmus.). He was a stylish if not very penetrating portrait painter—his images of his most famous patron Mme de Pompadour are the best. He also painted landscapes in a sweetened version of 17th-century Dutch

style. And he occasionally painted devotional subjects, among them the graceful *Nativity* painted for Mme de Pompadour's chapel at Bellevue (1750; Lyon, Mus. des Beaux-Arts). In all of these modes the predominant atmosphere is one of happy escapism, supported by an easy grace of style, a luscious touch, and shimmering, nacreous colouring.

In a career supported by wealthy private clients, Louis XV, and Mme de Pompadour, Boucher produced not only easel paintings, but also cartoons for the Beauvais and Gobelins tapestry factories, made designs for Sèvres porcelain, painted decorative schemes for *Versailles and Fontainebleau, and designed sets for theatre and opera. By his own reckoning he made more than 10,000 drawings and 1,000 paintings and oil sketches. During the 1760s Boucher's art, which had dominated mid-century fashionable taste in France (and as far away as Sweden and Russia), came under attack from critics looking for morally uplifting subjects expressed in a dignified and temperate style. The most intemperate criticism came from *Diderot, who fumed and raged at what he saw as Boucher's pictorial slovenliness and personal turpitude. Despite this, and despite an impairment of vision that gave a curious reddish tonality to his last paintings, Boucher remained popular to the end with his powerful patrons, and was granted the title of Premier Peintre du Roi on the death of Carle van Loo in 1765. MJ

Ananoff, A., and Wildenstein, D., *François Boucher* (1976).
Laing, A., et al., *Boucher*, exhib. cat. 1986 (Paris, Grand Palais).

BOUDIN, EUGÈNE (1824–98). French painter of coastal and beach scenes. He was the son of a sailor from Honfleur and ran a picture-framing and stationery business at Le Havre, where his customers included *Millet, who encouraged him to paint. He specialized in painting the coasts of northern France and became a strong advocate of painting direct from nature in the open air, a method that he encouraged the young *Monet to adopt when he befriended him. His (generally small) paintings are characterized by a spontaneous, lively, touch, and he paid particular attention to recording the luminous skies of the region. He was on good terms with the *Impressionists and exhibited at the first Impressionist *exhibition in 1874. Many of Boudin's paintings show groups of well-dressed bourgeois holidaymakers strung out along the beach (especially the beach at Trouville). The charm of these scenes masks the fact that Boudin was disturbed by the development of the Channel resorts, such as Trouville, and regretted the way in which the new tourism had suppressed the old coast life with which he had grown up. AJL

Hamilton, V., *Boudin at Trouville* (1992).

BOUGUEREAU, ADOLPHE WILLIAM (1825–1905). French painter. Bouguereau was born in La Rochelle and studied in Bordeaux before attending the Académie Royale in *Paris. In 1850 he won the *Prix de Rome and on his return to Paris in 1854 found immediate success with *The Body of S. Cecilia Borne to the Catacombs* (Paris, Luxembourg). This launched an enormously successful and prolific career as an academic portrait painter, religious artist, and, above all, master of the female nude. The latter was saved from impropriety by classical antecedents and archaeological accuracy, as in the Dionysiac and orgiastic *La Jeunesse de Bacchus* (1884; priv. coll.) which also demonstrates his compositional expertise, much praised in his lifetime. A staunch academic and influential teacher, Bouguereau was vehemently anti-modernist and was ridiculed by *Cézanne and *Renoir among others. His formulaic paintings, in which transparent and knowing eroticism masquerades as High Art, were derided and neglected after his death but the recent revival of critical interest in 19th-century academic art has led to a largely favourable reappraisal of his work. DER

Wissman, F., *Bouguereau* (1996).

BOULLOGNE, LOUIS DE (1654–1733). French painter of decorative and religious pictures. He was trained by his father, also Louis, and by his elder brother Bon de Boullogne (1649–1717). He spent five years in Italy, where he was influenced by the classicizing painters of Rome and Bologna, such as *Albani and *Domenichino. After his return to Paris in 1680 he was employed by the Crown for decorative works at Marly and Fontainebleau. At the latter he replaced some of *Rosso Fiorentino's works considered too lascivious by the elderly and pious Louis XIV with more modest ones of his own. In such paintings as *Diana's Repose* (1707; Tours, Mus. des Beaux-Arts) Boullogne, like his older contemporary Charles de *La Fosse, introduced a lighter and more delicate note into French painting which prefigures the *Rococo style of the next generation. MJ

Saint-Aymour, C. de, *Les Boullogne* (1919).
Schnapper, A., and Guicharnaud, H., *Louis de Boullogne, 1654–1733* (1986).

BOURDELLE, ÉMILE-ANTOINE (1861–1929). French monumental sculptor, born at Montauban, son of a cabinetmaker. After studying at the École des Beaux-Arts, Toulouse, in 1884 he joined the studio of Alexandre Falguière in Paris and from 1893 to 1908 he worked in *Rodin's studio. In 1909 he joined the Académie de la Grande Chaumière and was a respected teacher there for the rest of his life. His early bronzes, such as his studies for the Monument to the Fallen of 1870 (Montauban; 1893–1901) and his *Tragic Mask of Beethoven* (1901; Paris, Mus. Bourdelle) are dramatic and expressive, with massive forms and rough surfaces. Around 1909 he developed a more classical style, influenced by Archaic Greek sculpture, as in the *Head of Apollo* (1909; Paris, Mus. Bourdelle), which he developed in the rhythmic linear reliefs for the Théâtre des Champs-Élysées in Paris (finished 1912). There followed a series of portentous public commissions that brought Bourdelle enormous praise, and by the time of his death he had become a national institution. AJL

Jianou, I., and Dufet, M., *Bourdelle* (2nd edn., 1975).

BOURDICHON, JEAN (1457–1521). French painter and illuminator active in Tours. The vast quantity and exceptional quality of his surviving work suggests a large workshop with many assistants. From the early 1480s until his death he was *peintre du roi* and *valet de chambre* to a succession of French kings including Louis XI, Charles VIII, Louis XII, and François I. At court his responsibilities extended beyond illuminating and painting to the decorations at festivities, designs for coins, stained-glass windows, and plate. In return he was paid a generous salary and Charles VIII gave him land, as well as providing substantial dowries for Bourdichon's two daughters. Many of his manuscripts survive, including his earliest known work, a book of hours (c.1480–5; Los Angeles, Getty Mus., MS 6) and the extensively illuminated *Grandes Heures* of Anne Brittany (1503–8; Paris, Bib. Nat., MS lat. 9474) contains 49 miniatures. A triptych of the *Virgin with S. John the Baptist and S. John the Evangelist* (c.1500; Naples, Capodimonte) is his only known surviving panel painting. Bourdichon's style was influenced by Jean *Fouquet, his predecessor at the court of Louis XI, and features large figures placed in the foreground, rich colours with delicate highlighting in liquid gold, and Renaissance architectural settings. KC

Avril, F., and Reynaud, N. (eds.), *Les Manuscrits à peintures en France, 1440–1520*, exhib. cat. 1993 (Paris, Bib. Nat.).
Kren, T. (ed.), *Renaissance Painting in Manuscripts: Treasures from the British Library*, exhib. cat., 1985–4 (Los Angeles, Getty Mus.; New York, Pierpont Morgan Lib.; London, BL).

BOURDON, SÉBASTIEN (1616–71). French painter, draughtsman, and engraver. Born in Montpellier, he trained in Paris, and worked briefly in Bordeaux and Toulouse before travelling to Rome, where he is recorded in 1634. His closest associates probably were Pieter van *Laer and Jan *Miel and like them he too produced naturalistic genre scenes such as *The Limekiln* (Munich, Alte Pin.) and the tondo of an *Encampment*

(Oberlin, Allen Memorial Mus.). He was obliged to leave Rome in 1637, after being denounced to the Inquisition as a heretic, and returned to France via Venice. He continued to paint in an Italianate style that sometimes reflects knowledge of *Castiglione's Roman work, evident for instance in the *Departure of Jacob* (Houston, Mus. Fine Arts) and the *Pastoral Landscape* (Northampton, Pa., Smith College Mus. of Art), and sometimes reverts to his *Bamboccianti manner. He also attempted more ambitious history paintings in a Baroque style, including *Solomon Sacrificing to the Idols* (Paris, Louvre). In 1643 he was commissioned to paint the *Martyrdom of S. Peter* (Paris, Notre-Dame); and c.1645 painted the *Meeting of Anthony and Cleopatra* (Paris, Louvre), which has a decorative opulence surely inspired by Venetian artists such as *Veronese. The arrival at Paris of Nicolas *Poussin in 1641 may have prompted yet another change in Bourdon's stylistic development, reflected in *Christ and the Little Children* (Chicago, Art Inst.), the *Massacre of the Innocents* (St Petersburg, Hermitage) and the *Finding of Moses* (Washington, NG). In 1648 he participated in the creation of the Académie Royale de Peinture et de Sculpture (see under PARIS), and appeared to have associated himself with the Poussinesque style of classicism practised above all by Charles *Le Brun. Under the influence of Poussin, whose work had reached many Parisian collections, Bourdon developed his interest in landscape, but now forsaking his early Roman Bamboccianti style, he sought to construct an idealized interpretation of the natural world. His finest work in this tradition is the *Landscape with Mill* (Providence, Rhode Island School of Design), although it displays an immediacy and freshness, indeed flamboyance, in its execution that distinguishes it from Poussin's more controlled, calculated, and self-effacing manner of painting.

In 1652 Bourdon was invited to Sweden by Queen Christina and appears to have been required to spend much of his time painting portraits, for which he adopted a style that was inspired by van *Dyck. He returned to Paris two years later, and in 1657 went back to Montpellier, where he continued to work as a portraitist. Here too he executed the *Fall of Simon Magus* for the high altar of the cathedral (*in situ*). In 1663 he decorated the gallery of the Hôtel Bretonvilliers, Paris, with scenes from the story of Phaethon (destr.). His death intervened before he could complete his only royal commission to decorate the ceiling of the Chambre des Rois in the Tuileries.

Bourdon was not an original artist and never quite succeeded in formulating a distinctive stylistic language, although his work is easily recognizable and has a personal touch. He attempted to make a virtue of this eclecticism and advised younger artists at the Académie Royale accordingly. He was greatly admired by his contemporary, the writer André *Félibien. HB

Rosenberg, P., *France in the Golden Age*, exhib. cat. 1982 (Paris, Grand Palais; New York, Met. Mus.).

BOUTS, DIERIC (Dierick, Dirk) (c.1415–75). Netherlandish painter, born in Haarlem, but working mainly in Louvain. He contributed to the development of landscape representation. His influence and large workshop resulted in the production of many works in his style. His sons Dieric and Aelbrecht were painters.

Bouts's early paintings, such as the altarpiece of the Virgin (Madrid, Prado) combine northern Netherlandish characteristics such as stocky, homely figures located in deep spatial settings, with increasing compositional influence from Rogier van der *Weyden.

The altarpiece of the *Holy Sacrament* (1464–7; Louvain, S. Pierre) with its unusual central subject of the *Last Supper*, flanked by Old Testament scenes, typifies Bouts's mature style. Action is frozen and timeless, and gestures are restrained. Perspective and high viewpoints are used, the settings are brightly lit and detailed, possibly incorporating portraits, while the spacious landscapes, especially in the *Gathering of the Manna* panel, recede in parallel and tonally graduated planes.

This skilled use of landscape is notable in the *Portrait of a Man* (inscribed 1462; London, NG), one of the earliest Netherlandish portraits to include a landscape viewed through a window, a device which reinforces the unidealized realism of the sitter by placing him firmly in a real place and time rather as van *Eyck did in his *Arnolfini Portrait*.

In *The Ordeal by Fire* (Brussels, Mus. des Beaux-Arts), a large-scale work commissioned for Louvain Town Hall in 1468, Bouts combines spacious interior and exterior settings, enriched by glowing local colour and textures. Its elongated courtly figures, however, display little emotion. Far more realistic and lively are the popular half-length Virgins which were a speciality of Bouts's workshop. MS

Châtelet, A., *Early Dutch Painting* (1981).
Dirck Bouts een vlaams primites te leuven, exhib. cat. 1998 (Louvain, Stedelijk Mus. van der Kelen-Mertins).
Smeyers, M., *Dirck Bouts: Peintre du silence* (1998).

BOYDELL, JOHN (1719–1804). Boydell was a major entrepreneurial printseller and publisher in London, first in the Strand (1740s), and then in Cheapside. He was trained as an engraver (see LINE ENGRAVING) and sold cheap topographical prints and imported engravings. As a publisher he commissioned work from, amongst others, the leading British engraver William Woollett (1735–85), whose print (1776) after Benjamin *West's *Death of General Wolfe* helped to make Boydell's fortune. Export sales boomed until the continental market collapsed during the hostilities with France. In 1786 he formed his plans for the Shakespeare Gallery, housed eventually in purpose-built showrooms in Pall Mall, with over 100 commissioned paintings by British artists; among them dramatic works by *Fuseli. These were engraved in two sizes: folio, and a smaller series as book illustrations. The whole project cost him dearly and the pictures were disposed of in 1805. Boydell was Lord Mayor of London in 1790–1, having been both alderman and sheriff. Boydell also published *An History of the River Thames* (1794–6) with fine coloured aquatints after Joseph *Farington, which was a landmark in topographical printmaking. MP

BOYS, THOMAS SHOTTER (1803–74). English watercolour painter and *lithographer. Boys was apprenticed to an engraver before moving to Paris in the mid-1820s. He was befriended by *Bonington whose style influenced his most important work, a series of elegant views of Paris executed 1830–5. Having learned lithography in France he returned to London in 1837 to work on the chromolithographs *Picturesque Architecture in Paris* etc. (1839), followed by *London as it is* (1842), in monochrome lithography. He continued to work until his death but never again achieved the refinement of his Parisian period. HO/DER

Roundell, J., *Boys* (1974).

BOZE, JOSEPH (1745–1826). French painter and inventor. He studied with Maurice-Quentin de *Latour and had a successful career as a society pastellist and miniature painter before the Revolution. His works from this time include the beautiful portrait of Marie-Antoinette's lady-in-waiting *Mme Campin* (1786; Versailles). He later depicted a number of the revolutionary leaders before going into exile because of his royalist connections. The end of his career was overshadowed by accusations that he had tried to pass off the work of more talented painters as his own. Among his inventions was a quick-release harness for four-horse wagons. MJ

Volcy-Boze, J.-A., *Le Comte Joseph de Boze, peintre de Louis XVI* (1873).

BOZZETTO (Italian: sketch), a sculptor's small sketch, usually in wax or clay, which serves as a preliminary model for a larger work in a more durable material. *Bernini's clay *bozzetti* are renowned for their vivid spontaneity and ability to capture the sculptor's artistic genius. HO/AB

BRAMANTINO (Bartolomeo Suardi) (c.1465–1530). Italian painter and architect, leading figure of the Lombard High Renaissance. His early work is influenced by the linearity of the *Mantegna School and by Donato Bramante (1443/4?–1514), after whom he took his assumed name. His life was spent mostly in Milan, with a period in Rome in 1508–9. His major pre-Roman work is the series of twelve tapestries of *The Months* for the Sforza *condottiere* Giovanni Giacomo Trivulzio (1501–8; Milan, Castello Sforzesco), for whom Bramantino later designed a funerary chapel at S. Nazaro Maggiore in Milan. Paintings of this period, like the *Adoration of the Magi* (c.1500–5; London, NG), combine an ostentatiously studied display of linear *perspective, a symmetrical and monumental design, and a dreamlike quality of narrative presentation. This latter characteristic dominates later paintings like the large *Crucifixion* (Milan, Brera), in which the graphic sharpness of his early drapery style gives way to a softer and more painterly manner, influenced, directly or indirectly, by *Leonardo's Milanese works. JR

Muzzalani, G., and dell'Acqua, G. A., *Bramantino e Bramante pittore: opera completa* (1978).

BRAMER, LEONARD (1596–1674). Dutch painter. He was born and died in Delft, but spent the years 1614–27 in France and Italy, mostly in Rome. While in Italy he was influenced by *Elsheimer and *Fetti, and developed a personal speciality of small pictures showing figures in weirdly lit nocturnal settings of Antique buildings, sinister woods, or crumbling ruins (*Scene of Witchcraft*, c.1630; Bordeaux, Mus. des Beaux-Arts). On his return to Delft he was also patronized as a fresco painter, but none of his work in that medium survives. AJL

BRANCUSI, CONSTANTIN (1876–1957). Romanian-born sculptor. Raised in a rural, artisanal community, Brancusi received an academic training in Bucharest, then moved to Paris in 1904. He briefly worked with *Rodin (1906), but left the apprenticeship exclaiming: 'Nothing grows in the shadow of great trees.' The following year he broke free from Rodinesque influences and started exploring abstraction. Simplification of form to its Platonic essence became his lifelong preoccupation; for example, a 1911 depiction of a Romanian mythological bird, *Maiastra* (London, Tate), still recognizably derived from nature, was later superseded by the immaculate abstraction of his series of *Birds in Space* (1923 onwards), one of which earned notoriety in 1926 when US customs refused to recognize it as art and taxed it as raw metal. Unlike his avant-garde

friends (*Duchamp was his US agent), Brancusi was not enamoured of the machine age; he drew on Romanian traditions of craftsmanship—his feeling for materials was superb—and continually reworked a small number of themes, including *Le Coq*, *The Kiss*, and the *Colonnes sans fin*. The contents of his studio are housed at the Centre Georges Pompidou in Paris. AA

Miller, S., *Constantin Brancusi* (1995).

BRANGWYN, SIR FRANK (1867–1956). English decorative artist, much honoured in his lifetime, whose sheer versatility and productivity may have damaged his posthumous reputation. Brangwyn was born in Bruges and largely self-taught although he studied briefly at the South Kensington Schools, London. From 1882 to 1884 he worked for William Morris's Company developing his considerable skills as a designer in a variety of media. After leaving he travelled widely, including a visit to Japan, and his early paintings reveal a romantic passion for sailing ships and exotic foreign ports. In 1895 he designed the fittings and façade of Samuel Bing's Parisian shop L'Art Nouveau after which his career was international and included the Occidental Museum in Tokyo (1922) and murals in Winnipeg, Cleveland, and New York (Rockefeller Center). His best-known murals, the *British Empire* panels (1924–33; Swansea, Guildhall), were designed for the House of Lords. His finest paintings, often still lifes like *The Brass Pot* (1924; Wolverhampton, AG), show a strong sense of design and are painted vigorously in bold, glowing colours. He was also a gifted and prolific etcher and book illustrator. DER

Frank Brangwyn, exhib. cat. 1967 (Cardiff, National Mus. Wales).

BRAQUE, GEORGES (1882–1963). French painter. He was revered by all who knew him for his personal grace and nobility, his intellectual honesty and exquisite taste, qualities which are evident in his work and which, allied to masterly craftsmanship, make him one of the greatest painters of the 20th century. He embodied a French ideal: he was seen as aristocrat and artisan. Born in Argenteuil into a family of painters and decorators, he was for three years an apprenticed house painter, learning techniques including combing, graining, and marbling, all of which he employed with wit and affection throughout his career. Braque became a full-time artist in 1904, and between 1906 and 1914 he was at first connected with *Fauvism and then, more importantly, with *Cubism, which *Picasso and he developed 'as if we

were two climbers roped together'. Braque contributed several of the motifs and stylistic devices of Cubism, musical instruments, such as *Clarinet* (1913; New York, MoMa), stencilled numbers and letters on the surface, foreign matter in the paint-mix (sand, ashes, tobacco), and *trompe l'œil* effects. The first *papier collé was made by him in 1912.

Called to the war in 1914, Braque served with gallantry, suffering a severe head wound in 1915. After field-hospital trepanning, he recovered but was discharged, with the Croix de Guerre and the Legion of Honour, in 1916. He emerged from convalescence to paint again, briefly taking up where he had left off, but now developed an individual, personal style in which subtlety of composition, richness of colour, and variety of handling marked him as a modern master: *Café Bar* (1919; Basle, Kunstmus.). Braque, a brilliant decorative artist, had a lifelong interest in ancient Greek and Etruscan art, and in the 1920s he painted *Canephorae*, large, semi-draped female figures carrying baskets of fruit, and began a series of Greek heroes, nymphs, and gods engraved into plaster through black-painted surfaces. For Ambroise Vollard he illustrated Hesiod's *Theogony* with sixteen etchings. Also at this time, 1931, he built a house at Varengeville, Normandy, and summered there, painting coastal scenes.

Braque's great achievement is revealed, however, in the still lifes on pedestal tables (*guéridons*), the interiors with figures, the billiard tables, and the studios. In his final phase, a great bird enters his work (he decorated a ceiling in the Etruscan Gallery of the Louvre with birds in 1952–3), bringing emphasis to his space/form devices and lending them a haunting, visionary aura: *The Studio V* (1948–9; London, Tate). JI

Hope, H. R., *Georges Braque* (1949).
Richardson, J., *Georges Braque* (1959).

BRASS, a yellow alloy of copper and zinc. The most usual form of brass, known as red or common brass, has a zinc content of 25–30%. The properties of brass—colour, pouring, and casting qualities—depend upon the zinc content and the addition of trace amounts of other metals. The greater the zinc content the greyer and more brittle the metal. Brass rose to prominence in the 1st millennium BC. By the 1st century BC brass coins were being minted using a method akin to the cementation process—a means of producing brass from copper and zinc ore in a crucible. This method was superseded in the 19th century in England by the downward distillation or 'English' process, and by similar developments in Europe. The majority of brass produced in the 20th century was

made electrolytically. OI

Craddock, P. T. (ed.), '2000 Years of Zinc and Brass' *BM Occasional Papers*, 50 (1990).

BRASSES, MONUMENTAL. These are engraved, commemorative brass plates, usually found in churches as a focus of prayers for the soul of the deceased. A substitute for a built tomb, they were made in north-western and central Europe from the 13th to the 17th centuries, being particularly popular in England, Flanders, and south Germany. The earliest known brasses were made for bishops; brasses made for royalty are uncommon, but they were rapidly adopted by the gentry (brasses of the Cobham family, c.1310–1408; Cobham, Kent).

Brasses were made of latten plate, an alloy of copper and about 18% zinc, and set into a slab to lie flush with the floor surface. The engraved lines were filled in with black, but colours were used for heraldic tinctures (Hugh Hastings, c.1347; Elsing, Norfolk). Patterns of lost brasses can often be recovered from the matrix. Brasses were produced in both metropolitan and provincial workshops: the main centres were Paris, Tournai, and London. Workshop types can be established: two important early 14th-century English series are the Camoys and Seymour groups, named from the brasses of those families at Trotton, West Sussex, and Higham Ferrers, Northants. The simplest brasses were inscribed with the name of the deceased; most show half- or full-length representations, and the grandest have canopy-like frames, following funeral effigies or carved figures in niches. Identification was by inscription, heraldry and, later, a rebus. As with effigies, knights were shown fully armed; brasses provide useful evidence of developments in medieval armour.

Styles followed monumental sculpture and painting, the two-dimensional field often resembling the layout of a manuscript page, with small figures in niches flanking the main representation (Roger L'Estrange, 1506; Hunstanton, Norfolk). Later brasses included representations of the deceased's children. Angels supporting cushions and lion and dog footrests were taken over from tomb designs. Canopies were composed of micro-architectural motifs derived from metalwork and buildings (Bishop Louis de Beaumont, c.1333; Durham Cathedral); in the elaborate late medieval Franco-Flemish brasses the entire background to the figure could be engraved with micro-architecture and small figures (Bishops Serken and Mul, 1350; Lübeck Cathedral). In 14th-century England, simpler brasses, based on designs for incised slabs, took the form of a cross with a foliate centre, enclosing a representation of the deceased (Robert de Paris, 1408; Hildersham, Cambs.).

Monumental brasses were revived by A. W. N. Pugin as part of the 19th-century Gothic Revival. NC

Cameron, H. K., *A List of Monumental Brasses on the Continent of Europe* (rev. edn., 1973).
Coales, J. (ed.), *The Earliest English Brasses: Patronage, Style and Workshops, 1270–1350* (1987).

BRAY, FATHER AND SON. Dutch painters. **Salomon Bray** (1597–1664) was born in Amsterdam but moved to Haarlem where he probably trained with Hendrik *Goltzius and Cornelisz. van *Haarlem. Of great versatility, Salomon was not only a painter, draughtsman, and poet but was also involved in architectural and urban planning projects. In 1627 he provided sketches for the Zeylpoort in Haarlem and later provided plans for the enlargement of the city and the Nieuwe Kerk. In 1644 he was called to Nijmegen to design an orphanage there. As a painter his style shows the impact of the Utrecht *Caravaggisti in its realism and strong lighting of his large and prominent figure compositions such as *Jael, Deborah, and Barak* (1635; on loan Utrecht, Catharijnconvent). Salomon's son **Jan** (1627–97), after training with his father, specialized in portraiture and history painting. Both are combined in *A Couple Represented as Ulysses and Penelope* (1668; Louisville, Ky., Speed Mus.) while in *The Banquet of Antony and Cleopatra* (1669; Manchester, NH, Currier Gal.; London, Royal Coll.) Jan's parents and siblings appear as historical figures in the strongly lit, polished composition which reveals Jan's increasing enthusiasm for an academic classicism characteristic of later 17th-century Dutch painting. CFW

Blankert, A., *Gods, Saints and Heroes*, exhib. cat. 1980–1 (Washington, Detroit, Amsterdam).

BRAZILIAN ART. Until the proclamation of Independence in 1822 the development of Brazilian art was dictated by the tastes of the Portuguese colonists. Initially, as in Argentina, most art was Christian, fostered and promoted by the Jesuit missionaries, later decorative and portrait painting predominated. Stylistically this colonialist art followed European conventions. In 1637 the Dutch painter Frans *Post accompanied the Count of Nassau's expedition to Brazil and remained there until 1644. His paintings of Brazilian scenes, several of which are in the Rijksmuseum, Amsterdam, were largely responsible for spreading knowledge of Brazilian life and landscape in Europe. From 1807 to 1822 João VI, ousted from Lisbon by Napoleon, made Rio de Janeiro his capital and after the fall of Napoleon (1815) welcomed a group of French artists to Rio in 1816, among them were Nicholas Taunay (1755–1830) and Jean-Baptiste Debret (1768–1848) who each trained a large number of Brazilian artists in the *Neoclassical manner. Following Independence they were among the founders of the Academy of Fine Arts in 1826. Republicanism and rapid industrialization during the rest of the 19th century boosted nationalistic and political themes in painting but the intellectual focus remained French.

The most intense period of artistic reorientation occurred during the 1920s when Brazilian *modernism fused cosmopolitan stylistic developments with essentially national themes. Triggered by an exhibition of Anita Malfatti's (1896–1964) Fauvist paintings in 1917, which was poorly received by conservative critics, the painter Emiliano Cavalcanti (1897–1976) organized the Modern Art Week of 1922 where artists and intellectuals debated the directions and objectives of contemporary art. The leading modernists were Tarsila do Amaral (1886–1973), who had studied in Paris unde *Léger, *Gleizes, and André Lhote, Anita Malfatti, and the poet Mario de Andrade (1893–1945). Inspired by Amaral's painting *Black Woman* (1923; São Paulo, Mus. de Arte Contemporanea da Universidade) the writer Oswald de Andrade (1890–1954) wrote the *Pau-Brasil Poetry Manifesto* (1924) and the *Anthropophagite Manifesto* (1928), both concerning a specific Brazilian approach to European culture. The latter introduced the idea of consuming and digesting European art to produce something new and also advocated the representation of Afro-Brazilian culture. These two manifestos define the essence of Brazilian modernism. Important artists of the period included the muralist Candido Portinari, Vincente Do Rego Monteiro (1899–70), the Expressionist Lasar Segall (1891–1957), Alfredo Volpi (1896–1988), known first for his colourful geometric paintings of houses in São Paulo and later for his increasingly abstract work, and the Portuguese painter Maria Helena Viera da Silva (1902–92), who lived in Brazil for a decade.

The first São Paulo Bienal was held in 1951 since when it has regularly brought international contemporary work to Brazil and encouraged a lively avant-garde in the city. From the 1950s movements in Brazilian art have reflected international activity, from geometric abstraction to *Abstract Expressionism and beyond. The Neo-Concrete group, Lygia Clark (1920–88), Hélio Oiticica (1937–80), and Lygia Pape (1929–), is particularly renowned. Closely linked to Brazil's urbanization, they applied a social and political dimension to their critique of representation. They experimented with subjective and organic dimensions, in particular the human body's relationship to space, the inversion and interrelation of interior and exterior space, audience participation, and kineticism. Important 20th-century artists outside the Neo-Concrete movement include Maria Schendel (1919–88), Tomie Ohtake (1913–), and Sergio de Camargo (1930–76). CC

Zanini, W., *História geral do arte no Brasil* (1983).

BREENBERGH, BARTHOLOMEUS (1598–1657). Dutch *landscape painter, draughtsman, and etcher, who, with *Poelenburch, led the first generation of Dutch Italianates. Born in Deventer, he worked in Rome 1619–29, then in Amsterdam until his death. In Rome, influenced by the followers of *Elsheimer and by *Filippo Napoletano, he painted small landscapes, such as the *Landscape with Ruins* (Cambridge, Fitzwilliam) with desolate, overgrown ruins set against melting distances; underlying his early naturalism are dramatic pen and wash studies of the Roman countryside made out of doors, which capture the bright southern sun on masonry and rocks. In Amsterdam his landscapes remained Italianate, but he began to paint religious and classical subjects, suggesting the influence of *Lastman. Many are crowd scenes set in elaborate landscapes, such as *View of Ruins with Christ Healing the Sick* (1635; Paris, Louvre) in which small, highly individual figures, some exotically turbaned, create a lively narrative through vivid gesture and expression. In his final years he turned to mythological and pastoral subjects, and the figures became larger in relation to the format. HL

Roethlisberger, M., *Bartholomeus Breenbergh* (1981).

BREGNO, ANDREA (1418–1503). Italian sculptor born in Osteno in Lombardy, where he probably trained. He worked in Rome, where he was the most important *funerary monument and *tomb sculptor at the end of the 15th century. He was a friend of Giovanni Antonio Platina, and a noted collector of Antique sculpture. He frequently collaborated with *Mino da Fiesole, and with Giovanni Dalmata, with whom he worked on the Tebaldi monument in S. Maria sopra Minerva, Rome (1466). With his large workshop he produced his masterpiece, the Piccolomini altar in Siena Cathedral (1481–5), and worked extensively at S. Maria del Popolo, Rome, for instance on the altar for Cardinal Alessandro Borgia (1473), and perhaps on the design for the façade. His tomb and altar designs, often featuring a triumphal arch with niche figures and central reclining figure, are characterized by their brittle perfection and use of *classicizing motifs, perhaps drawn from his own archaeological research. AB

Zander, G., *L'arte a Roma nel sec. XV* (1968).

BREITNER, GEORGE HENDRIK (1857–1923). Dutch painter. Breitner was born in Rotterdam and studied in his home town and The Hague and Amsterdam. His early work, often of cavalry manœuvres, such as *Mounted Artillery* (1880s; Amsterdam, Rijksmus.), was influenced by the *Hague School painters, particularly *Mesdag and Willem *Maris, who was one of his teachers. From 1881 to 1883 he encouraged van *Gogh, who had determined to become a painter and had just embarked on his training. A visit to Paris in 1884 introduced him to *Impressionism, which had a profound effect on his work and led to his eventual reputation as the leading Dutch Impressionist. In 1886 he settled in Amsterdam where he painted street and harbour scenes often, like *Degas and *Toulouse-Lautrec in France, using unconventional compositional devices which reflect his interest in photography, as in *Paleisstraat* (c.1896; Amsterdam, Rijksmus.). In common with his French contemporaries, and *Whistler and *Moore in England, he was also fascinated by Japanese art and painted a number of pictures of women in Japanese dress: *Young Woman in Kimono* (1904; Amsterdam, Rijksmus.). Illness forced him to cease painting after 1910. DER

Hefting, P. H., *G. F. Breitner* (1968).

BRESDIN, RUDOLPH (1822–85). Eccentric French *lithographer whose sinister and fantastic forest scenes, and claustrophobic interiors, were executed in a densely finished style that sometimes involved the transfer of etchings to lithography. *The Comedy of Death* (1854) is a typically morbid example of a large print where insignificant figures are overwhelmed and threatened by a dense landscape, choked with rotting vegetation and menacing branches. His lifestyle was strange and reclusive, and he is the original inspiration of Champfleury's novel *Chien-Caillou*, by which name he is sometimes known. His work has much of the morbid sensibility that is found in the street scenes of Charles *Meryon. He was a very fine draughtsman, and prepared his prints by exquisitely finished pen drawings. He was admired by Baudelaire, and had a profound influence on the early works of *Redon. RGo

van Gelder, D., *Rodolph Bresdin* (1976).

BRETON, ANDRÉ (1896–1966). French writer, the chief exponent of *Surrealism. From 1919 to 1924 he co-edited the periodical *Littérature*, initially supporting the Paris branch of *Dada. His poetic ambitions were, however, inconsistent with the nihilistic qualities of Dada, from which he dissociated himself in 1922. Two years later Breton brilliantly expressed his ideas in the first *Manifesto of Surrealism*. This document, heavily influenced by the ideas of *Freud, promoted the concept of *automatism which he described as 'thought's dictation, in the absence of all control exercised by reason'. Although the manifesto was principally concerned with poetry, Breton edited a magazine, *La Révolution surréaliste* (1924–9), which promoted the 'automatic' art of such figures as André *Masson and Joan *Miró.

Breton modified his views in the *Second Manifesto of Surrealism* (1930), in which he placed less stress on 'automatism': at this time he was particularly impressed by the highly contrived dream narratives of Salvador *Dalí. During the following decades Breton played an important role in publicizing Surrealism abroad, especially in the USA, where he spent the Second World War, returning to France in 1946. He remained extremely energetic in the post-war period, issuing only a year before his death the final edition of *La Surréalisme et la peinture*, originally published in 1928. CJM

André Breton: la beauté convulsive, exhib. cat. 1991 (Paris, Centre Georges Pompidou).

BRETT, JOHN (1831–1902). English painter. He entered the RA Schools (see under LONDON) in 1854 and, as a student, admired the *Pre-Raphaelites and worshipped the writings of John *Ruskin. In 1856, inspired by the passage *Of Mountain Beauty* in volume 4 of *Modern Painters* (1856), he travelled to Switzerland to paint *The Glacier of Rosenlaui* (London, Tate), using Ruskin's text as a virtual manual. While there he was influenced by J. W. Inchbold (1830–88) and developed his characteristic practice of intense, illusionistic realism. On his return *Rossetti showed the picture to Ruskin who recognized it as embodying his teachings. He was particularly impressed by Brett's ability to reveal the underlying structure of natural appearances which arose from the painter's serious study of geology. In 1858, while praising Brett's *Stonebreaker* (Liverpool, Walker AG), Ruskin exhorted him to paint the *Val d'Aosta* (priv. coll.), which the obliging painter immediately did. When shown at the Academy in 1859 it was criticized as being photographic and in 1862 his panoramic *Florence from Bellosguardo* (London, Tate) was rejected. From 1863 Brett specialized in coast scenes, his friendship with Ruskin over. DER

Staley, A., *The Pre-Raphaelite Landscape* (1973).

BREU, JÖRG, FATHER AND SON. German painters. **Jörg the elder** (c.1475/6–1537) was a painter and designer of stained glass and woodcuts from Augsburg who, together with *Altdorfer, *Cranach, and *Huber, was the most important representative of the so-called *Danube School. During his journeyman years in Austria, c.1500–2, he evolved a type of altarpiece in which directly observed landscape and landscape motifs are an important and emotionally expressive component of the narrative, as in the altarpiece for the Stiftskirche, Zwettl (1500; *in situ*), which depicts the *Life of S. Bernard* with realistically observed landscape motifs and natural phenomena. Later works from this period (altarpieces for the Carthusian monastery at Aggsbach and the abbey church at Melk) derive their force from powerfully

modelled figures with expressive features, though landscape backgrounds are less dominant. From 1502 until his death Breu worked in Augsburg where he increasingly made use of Italian Renaissance motifs, some derived directly from 15th-century Italian art, others adopted from *Dürer and *Burgkmair. But he lacked Dürer's ability to synthesize classical forms and northern realism; his strength lay in the depiction of emotional extremes, violence, and movement. Like Dürer and Altdorfer, Breu contributed to the marginal illustrations of the Emperor Maximilian I's Prayer Book (1513; Munich, Staatsbib.) and designed woodcuts on the entry of Charles V into Augsburg in 1530 and the tremendous sheet of the *Battle of Pavia*. Breu's son **Jörg the younger** (after 1510–47) was his pupil. After his journeyman years, which took him as far as Venice, he registered as a master painter in Augsburg in 1534. In addition to the type of work executed by his father, he was much employed as a wall painter (Castle Grünau, near Neuburg on the Danube). KLB

von der Osten, G., and Vey, H., *Painting and Sculpture in Germany and the Netherlands* (1969).

BREUGHEL FAMILY. See BRUEGEL FAMILY.

BRIL (Brill) BROTHERS. Flemish painters. Both **Matthijs** (1550–83) and his younger brother **Paul** (c.1554–1626) started training with their father in Antwerp before departing for Rome within a few years of each other. Rome was an important artistic centre at the end of the 16th century and the Bril brothers were among many Netherlanders to seek work there. They became the most important northern *landscape painters in Italy. They contributed to a tradition for both imaginary and topographical landscape which made a lasting impact upon 17th-century painters. *Baglione records Matthijs as working in the Vatican Palace painting a series of frescoed views of Rome for the Galleria Geografica in c.1575, probably to celebrate the translation of the remains of S. Gregory Nazianus in June 1580. To commemorate the reform of the Gregorian Calendar (1582), he decorated the Torre dei Venti papal apartments, some being imaginary landscapes, some topographical views of Rome placed within an illusionistic framework. Although Matthijs died young and his Roman projects were never easily visible, his reputation was enhanced by two series of prints made soon after.

Paul Bril may have worked with Daniel Wortelmans in Antwerp before journeying to Rome via Lyon. Paul is documented there by 1582. His earliest works were large frescoes, a *Jonah and the Whale* (1588; Vatican, Scala Santa) and *Martyrdom of S. Clement* (Vatican, Sala Clementina). Landscape began to

dominate in the 1590s, for example in a fresco cycle in S. Cecilia in Trastevere. At this time Paul turned to small works on copper or wooden panels, in which hunters, hermits, or fishermen are dwarfed by lush landscapes of Roman ruins, harbours, or fantastic mountain vistas. From about 1605 his style changed significantly, perhaps in reponse to Annibale *Carracci and *Elsheimer. His compositions became more expansive, less concerned with meticulous detail, and moved towards a greater degree of atmospheric unity. *Landscape with Hunters and Waterfall, Tivoli* (1626; Hanover, Niedersächsische Landesgal.) is a supreme late example. CFW

Salerno, L., *Painters of the Seventeenth Century* (1977).

BRIULOV, KARL PAVLOVICH. See BRYULOV, KARL PAVLOVICH.

BROEDERLAM, MELCHIOR (d. c.1411). Southern Netherlandish painter from Ypres. By 1381 he was official painter to Louis de Mâle, Count of Flanders (ruled 1346–84), decorating furniture, pennants, and banners. On Louis's death Broederlam was appointed *valet de chambre* to the Count's heir and son-in-law Philip the Bold, Duke of Burgundy, and for the remainder of his career part of his output concerned the production of the decorative, ephemeral, or heraldic work that was a standard requirement of most painters employed at court. He spent periods over the next four years working at the castle, now destroyed, at Hesdin, Artois, where he not only painted narrative cycles but was in charge of the mechanical devices, including the weather machine. Between 1393 and 1399 he painted the outer sides of the wings of Jacques de *Baerze's carved altarpieces for the Charterhouse at Champmol, near Dijon, the Duke's major religious foundation. One pair of wings survives, showing the *Annunciation*, *Visitation*, *Presentation*, and *Flight into Egypt* (Dijon, Mus. des Beaux-Arts). They are a key work of Franco-Flemish painting. He is regarded as the predecessor of the *Master of Flémalle and Jan van *Eyck in the development of early Netherlandish painting. OI

Comblem-Sonkes, M., *Le Musée des Beaux-Arts de Dijon, les primitifs flamands.* (1986).
Panofsky, E., *Early Netherlandish Painting* (1953).

BROKOF, FERDINAND MAXIMILIAN (1688–1731). The most important sculptor working in central Europe in the late Baroque period. The son of a Bohemian sculptor, he trained with him and later in Vienna, returning to spend most of his career in Prague. There he carved many of the complex stone groups on religious themes that give the Charles bridge its flamboyant appearance. Best among these is *SS Vincent Ferrer*

and Procopius (1712). He also made woodcarvings for numerous Prague churches and provided many of the ubiquitous stone statues of *S. John Nepomuk* to be found in what is now the Czech Republic. Although the quality of the output of what must have been a large workshop is variable, Brokof's designs are always florid and imaginative. MJ

Blažíček, O. J., *Ferdinand Brokof* (1986).

BRONZE is an alloy of copper and tin, sometimes having traces of other non-ferrous metals. Bronze with low tin content (less than 16%) is called 'alpha' bronze and is soft and malleable, with a melting point varying from 1083 °C (that of copper) to c.950 °C. The hardness of bronze with low tin content can be increased by cold hammering. 'Delta' bronze (with 32% tin) is hard and brittle, and the danger of it cracking during cold hammering increases with the greater proportion of tin. Bronze is easier to cast than copper because it has a lower melting point and is more liquid than copper at a given temperature. Its colour, ranging from golden to grey, is affected by the proportion of tin or other metals present in the alloy (zinc, lead, silver, arsenic) and these also affect patination. Lead especially assists in the fluidity of the molten metal. Bronze is a very responsive, strong, and enduring substance, readily workable by a variety of processes. Its great tensile strength makes possible free extension or protrusion of unsupported parts and the easy balance of large masses over a narrow base. It may be given a surface texture to suggest the flow of the molten metal or it may be wrought and chiselled to suggest sharp and hard-edged metallic planes. It can convey the effect of *plastic* (modelling), *glyptic* (carving), or *toreutic* (metalworking). HO/AB

Tylecote, R. F., *A History of Metallurgy* (1976).

BRONZE SCULPTURE. See CASTING.

BRONZINO, AGNOLO TORI DI COSIMO DI MARIANO (1503–72). Florentine *Mannerist painter best known for his portraits. The classical restraint and emotional detachment of Bronzino's work reveal a temperament quite unlike that of his master *Pontormo. His refined draughtmanship and interest in surface detail is seen to best effect in his supremely elegant portraits of Florentine aristocrats, such as that of *Ugolino Martelli* (1536; Berlin, Gemäldegal.) and that of the wife of Duke Cosimo de' Medici, *Eleonora of Toledo with her Son Giovanni* (1545; Florence, Uffizi). Bronzino worked extensively for the Medici court both as a portraitist and on larger projects such as the chapel of Eleonora of Toledo in the Palazzo Vecchio. In Bronzino's best-known work, the *Allegory of Venus and Cupid* (c.1545; London, NG), the polished

brilliance of the colours and the unnatural elegance of the figures are ideally suited to the icy eroticism of the subject. HCh

McCorquodale, C., Bronzino (1981).

BROOKING, CHARLES (c.1723–59). British marine painter, said to have been brought up in the Deptford dockyard. Though much influenced by the 17th-century Dutch masters, his work shows an imaginative response to natural effects and an informed knowledge of maritime practice and naval architecture. In 1754, he completed a large sea piece for the Foundling Hospital, London (still in situ), and there are also paintings by him in the National Maritime Museum, London, and elsewhere. MK

BROUWER, ADRIAEN (1605/6–38). Flemish painter and draughtsman active in the Northern Netherlands. He was a *genre painter, the most creative artist of low life in the early 17th century. Brouwer had a strong influence on other painters such as the *Ostade brothers. Probably born in Flanders, he is first documented in 1625 living in an Amsterdam inn. In the following year he is said to have been a pupil of Frans *Hals in Haarlem, for which there is no further evidence other than an adventurous and lively technique. By 1631/2 he had returned to Antwerp where he spent the remainder of his short life. Scarcely 60 paintings are attributed to him, none of them dated. Highly regarded by *Rubens and *Rembrandt, who collected his work, Brouwer invested his rough peasants with a down-to-earth realism which gives an outstanding immediacy to his work. In Tavern Scene (Rotterdam; Boymans-van Beuningen Mus.), as in all his works, a lively brushwork and a subtle range of tones infuse the composition with an atmospheric unity and unequalled naturalism, which makes him a fitting heir to Pieter *Bruegel the elder. CFW

Renger, K., Adriaen Brouwer und das niederlandische Bauerngenre 1600–60, exhib. cat. 1986 (Munich, Alte Pin.).
Sutton, P. (ed.), Age of Rubens, exhib. cat. 1993 (Boston, Toledo).

BROWN, FORD MADOX (1821–93). English painter. Brown was born in Calais and trained in Belgium. In Rome, in 1845, he studied the work of the German *Nazarenes and was inspired by their seriousness and clarity. On returning to England he adopted a lighter palette and a white ground for greater luminosity. His 'early Christian' style first appears in his paintings of Wycliffe (1847/8; Bradford, AG) and Chaucer (1851; Sydney, AG). In 1848 he was introduced to the *Pre-Raphaelite circle by *Rossetti who was briefly his pupil. Under Pre-Raphaelite influence he

painted en plein air (Pretty Baa Lambs, 1851; Birmingham, AG) and from 1852 shared their concern with the 'modern' subject, painting The Last of England (1852–5; Birmingham, AG) on the problem of emigration, and Work (1852–63; Manchester, AG), which celebrated 'British excavators'. In 1865 Brown held a successful and pioneering solo exhibition but by 1878 he was only saved from poverty by a commission to paint historical pictures for Manchester Town Hall which occupied him until 1893. From 1861 to 1874 he was a partner in William Morris's Company for which he designed some distinctive stained glass. DER

Newman, T., and Watkinson, R., Ford Madox Brown (1991).

BROWN, MATHER (1761–1831). American painter. He was born in Boston to an influential family and studied under Gilbert *Stuart in 1773 during Stuart's brief return to America. He arrived in London in 1781 and was accepted as a free student by *West on Benjamin Franklin's recommendation. He entered the RA Schools in 1782 and exhibited four portraits the following year, in a style influenced by Stuart and *Reynolds. By 1786 he was painting portraits of popular figures, like John Howard (n.d.; London, NPG), the prison reformer, and military heroes, such as Lord Heathfield (1788), for engraving. In 1788 he painted the Prince of Wales (London, Royal Coll.) and was appointed historical and portrait painter to the Duke of York, but his success was short-lived. Disinherited by his father and increasingly obsessed by history painting, which proved unsaleable, he left London in 1809 and worked in Bristol (his Baptism of Henry VIII is in Bristol AG), Bath, and Lancashire until 1824 when he returned to London. By now he was financially independent but continued to work incessantly, surrounded by his ambitious unsold canvases. DER

Evans, D., Mather Brown: Early American Painter in England (1982).

BRÜCKE, DIE, a Group of German artists formed in Dresden in 1905 by *Schmidt-Rottluff, *Kirchner, *Heckel, and Fritz Bleyl (1880–1966). The group was augmented in 1906 by *Pechstein and *Nolde, although the latter was to maintain only a loose relationship to Die Brücke. Otto *Müller was the last to join in 1910, the year which saw Die Brücke's move to Berlin. By 1913, the group had disbanded to pursue independent careers.

Schmidt-Rottluff chose the group's name, 'The Bridge', to symbolize both the link that held its members together and an art acting as a bridge to the future. Late Gothic *woodcuts, German craft traditions, *Cézanne, van *Gogh, *Munch, and *Gauguin all exerted a

strong influence on the young Brücke artists, while the ethnological collection in Dresden provided ready sources for the assimilation of African and Oceanic art traditions.

Die Brücke demonstrated in both their Dresden and Berlin periods a particular interest in the theme of man in nature and in studies of the modern city, combined with powerful evocations of studio life. Using angular, rhythmical areas of flat and often violently clashing colours in a unified pictorial space which collapsed the boundaries between foreground and background, the Brücke artists thrust towards a dynamic and challenging idiom that was greeted by the public at first with dismissive scorn. The group's first positive critical reception came for their graphic works and in particular for their bold, primitivistic woodcuts. However, Brücke painting has increased in stature over the course of the 20th century to stand today as a true and intensely invigorating departure from the *realism and *Impressionism which had dominated the later 19th century, and against which the Brücke artists reacted so forcefully. RRAM

BRUEGEL FAMILY. Dynasty of Flemish artists from Antwerp, of whom the most original and influential figure was **Pieter Bruegel the elder** (1525×30?–69), followed by his younger son **Jan Brueghel**, nicknamed Velvet Brueghel (1568–1625). Pieter's elder son **Pieter Brueghel the younger**, nicknamed Hell Brueghel (1564–1638), mostly produced copies and variations of his father's compositions. This tradition was continued by his son and pupil Pieter Brueghel III. The son of Jan Brueghel, Jan Brueghel II (1601–78), was, in his turn, an imitator of his father's work.

Pieter Bruegel the elder is chiefly known for his *landscapes and scenes of peasant life. The belief that he had been a peasant himself was emphatically disproven when it became known that his patrons were to be found among Antwerp's intellectuals and rich merchants, and even the court at Brussels. The humour in his works is that of the educated townsman laughing at, not with, the peasants, and of the moralist who points out their follies. At the same time, he was aware that the land and those who tilled it were the source of the country's wealth and the well-being of its inhabitants, not only in economic terms but also in relation to the forces of nature. Pictorially, Bruegel drew both on the tradition of early Netherlandish art and, in his mature work, on Italian *Renaissance masters. It is the richness of these references, combined with his visual mastery, that inspired generations of artists, well into the 17th century (among them *Rubens), and helped to create works of universal appeal.

Little is known of Bruegel's beginnings. He was probably trained by Pieter *Coecke van Aelst, whose daughter he later married. He joined the Antwerp painters' guild in 1551/2, leaving almost immediately for Italy, where he travelled as far south as Sicily. Unlike other northern artists, he recorded no works of art while in Italy, only views of cities and landscapes. Among his landscape drawings, those of Alpine views, long regarded as the most spectacular record of his journey south, have now been reattributed to Jacob and Roelandt *Savery, who may have produced them as deliberate forgeries or as virtuoso emulations of a famous old master whose work enjoyed a tremendous revival of interest c.1595–c.1610.

After Bruegel's return to Antwerp in 1555, a set of twelve prints, the *Large Landscapes*, were issued by the publishing house of Hieronymus *Cock. The surviving drawings related to these prints (London, BM; Paris, Louvre) are held to be autograph by contemporary Bruegel scholars. Bruegel continued to work for Cock, producing designs for engravings in the manner of Hieronymus *Bosch: moralizing allegories, such as the series of the *Seven Deadly Sins*, and illustrations of Netherlandish proverbs, such as *Big Fish Eat Little Fish*. In the *Seven Virtues* series of c.1559/60 Bruegel no longer imitated Bosch's demonic imagery but drew more heavily on examples from daily life. From this date also stem his paintings of proverbs: *Netherlandish Proverbs* (1559; Berlin, Gemäldegal.), *The Battle between Carnival and Lent* and *Children's Games* (1559 and 1560 respectively; both Vienna, Kunsthist. Mus.). These were followed by three paintings recreating Bosch's nightmarish visions: *Fall of the Rebel Angels* (1562; Brussels, Mus. Royaux), *Dulle Griet* (c.1562–4; Antwerp, Mus. Mayer van den Bergh) and *The Triumph of Death* (c.1562–4; Madrid, Prado), the latter two containing allusions to the harsh conditions of Spanish rule in the Netherlands.

In 1563 Bruegel moved to Brussels. He now began to paint religious subjects, drawing on both early Netherlandish art, especially Rogier van der *Weyden (*Christ Carrying the Cross*, 1564; Vienna, Kunsthist. Mus.), and Italian models, especially *Michelangelo's Bruges *Madonna*, in Bruges since 1506, and *Raphael's tapestry cartoons, in Brussels since 1517 (*Adoration of the Magi*, 1564; London, NG; *Christ and the Woman Taken in Adultery*, 1565; London, Courtauld Inst. Gal.). Bruegel's study of Raphael led him to concentrate on the human form. Though never sharing the Renaissance interest in the nude, from about 1565 on, Bruegel's figures become larger and more massive; they are often densely arranged within a restricted space, thus filling the entire composition. This compositional device becomes particularly evident in the

large-scale paintings of the artist's last years: *Peasant Kermis* and *Peasant Wedding Feast* (both c.1567/8; Vienna, Kunsthist. Mus.), *Parable of the Blind* (1568; Naples, Capodimonte), and *The Peasant and the Nest Robber* (1568; Vienna, Kunsthist. Mus.). Paradoxically, these compositions, inspired, as they are, by Italian models, are some of Bruegel's most Flemish in content.

The new monumentality also affected Bruegel's landscape style, as is evident in the great *Labours of the Months* series, which he painted in 1565 for the wealthy Antwerp merchant Nicolaas Jonghelinck. Only five panels are known, and it is not certain whether twelve were ever painted (three panels Vienna, Kunsthist. Mus.; one, Prague, Národní Gal.; one, New York, Met. Mus.). Ultimately, the subject is dependent on Burgundian and early Netherlandish calendar illuminations in books of hours, but Bruegel's emphasis is not on seasonal labours but on the transformation of the landscape itself. Man and his activities are subordinate to the cycles of nature.

Bruegel had many imitators who were mainly drawn to his popular *genre scenes. Among them, his son Pieter Brueghel the younger was most productive. Throughout his life, he painted copies and variations on his father's work. His nickname 'Hell' refers to his pictures of the underworld with Bosch-like monsters. He was the master of Frans *Snyders.

Jan Brueghel the elder became a major artist in his own right, foremost as a painter of small cabinet pictures of landscapes and flower still lifes. About 1589 he went to Italy where he met Cardinal Federico Borromeo, Archbishop of Milan from 1595, who became his great patron. For him he painted, among others, four allegorical pictures of the *Elements* (Milan, Ambrosiana; Paris, Louvre). Pictures of this type, which also include allegories of the Five Senses and the Seasons, were a speciality of the artist's. They show a mythological figure or personification surrounded by naturalistic details, symbolically reinforcing the central theme. Brueghel's landscapes are magical vistas of woodlands in the manner of *Coninxloo, and his flower pieces are noted for their variety and delicate rendering of surfaces, which earned him the nickname 'Velvet'. Brueghel often collaborated with other artists, foremost Rubens, who was also a close friend. The latter provided the figures of Adam and Eve in Brueghel's *Garden of Eden* (The Hague, Mauritshuis) and the 'picture' of the Madonna and Child in his *Madonna and Child in a Garland of Flowers*, of which Brueghel painted several versions. Other artists who collaborated with him were Joost de *Momper, Hendrik de Clerck, Hendrik van *Balen, Sebastian *Vrancx, and

the Milanese painter G. C. *Procaccini. KLB

Bruegel: une dynastie de peintres, exhib. cat. 1980 (Brussels, Palais des Beaux-Arts).
Gibson, W., *Bruegel* (1977).
Kavaler, E. M, *Pieter Bruegel: Parables of Order and Enterprise* (1999).

BRUGGHEN, HENDRICK TER (1588–1629). Dutch painter who was brought up at The Hague and Utrecht and received his training under Abraham *Bloemaert. He then went to Italy, possibly as early as 1606 when *Caravaggio was still active there. His Italian work has never been identified and his activity is not adequately documented. The influence of Caravaggio and *Saraceni is evident in his paintings dating from shortly after his return to Utrecht in 1614: for instance, the *Supper at Emmaus* (1616; Toledo, Oh., Mus.) and the *Adoration of the Magi* (s.d. 1619; Amsterdam, Rijksmus.). In 1621 he probably began to share a studio with *Baburen, who had just returned from Rome with fresh ideas acquired in the circle of *Manfredi in the years after ter Brugghen's return to Holland. This new impetus is reflected in ter Brugghen's numerous pictures exploring picaresque themes including two paintings of a *Flute-Player* (both Kassel, Schloss Wilhelmshöhe) and the *Gamblers* (s.d. 1623; Minneapolis, Inst. of Arts). He also painted numerous pictures of boys and girls with candles that may derive from J. *Bassano. Following the death of Baburen in 1624, ter Brugghen's style made a further significant advance toward a far more personal idiom that transcends its Caravaggesque sources, and is notable for its very distinctive figure types, especially the turbaned women. The most personal and expressive of these works of his maturity is the *Crucifixion* (c.1625; New York, Met. Mus.); this was followed by the tender and refined *S. Sebastian Tended by Women* (Oberlin, Oh., Allen Memorial Art Mus.); the *Musical Company* (London, NG); the *Allegory of Time* (s.d. 1627; Los Angeles, Getty Mus.); and the *Annunciation* (s.d. 1629; Diest, Openbaar Centrum), distinguished by its richly patterned draperies and more delicate chiaroscuro. HB

Blankert, A., and Slatkes, L., *Hollandische malerei in neuem Licht: Hendrik ter Brugghen und seine Zeitgenossen*, exhib. cat. 1986–7 (Utrecht, Centraal Mus.; and Brunswick, Herzog-Anton-Ulrich Mus.).
Nicolson, B., *Hendrick Terbrugghen* (1958).

BRULLOFF, KARL PAVLOVICH. See BRYULLOV, KARL PAVLOVICH.

BRUNELLESCHI, FILIPPO DI SER BRUNELLESCO (1377–1446). Florentine architect and sculptor credited with initiating the revival of the architectural principles of ancient Rome. Trained as a goldsmith, he

competed in 1401 for the prestigious commission of the bronze doors for the baptistery, submitting a relief of the *Sacrifice of Isaac* (Florence, Bargello). After losing to *Ghiberti he probably visited Rome with *Donatello, investigating the construction and proportions of ancient buildings. Consequently, in his own buildings in Florence such as the loggia of the Foundling Hospital (begun 1429), he adapted classical architectural elements to Tuscan Romanesque forms, and employed a system of proportioning based on a module usually represented, as in the churches of S. Lorenzo and S. Spirito, by the square crossing. With his design for the Scolari oratory, S. Maria degli Angeli (begun 1434), he initiated the centrally planned Renaissance building, based on the circle—according to humanists the perfect geometric form. This interest in mathematics and geometry may have led Brunelleschi to formulate around 1413 the kind of system of linear perspective used by *Masaccio. His biographer Antonio Manetti (1480s?) described two demonstration panels he had painted of the baptistery and the Palazzo Vecchio. The construction of the dome of Florence Cathedral brought him immense fame, being a civic symbol as well as a remarkable engineering feat. MS

Battisti, E., *Filippo Brunelleschi: The Complete Work* (1982).

Saalman, H., *Filippo Brunelleschi: The Buildings* (1993).

B RUSHES have been used for drawing since ancient times. During the medieval period brushes were almost invariably made of squirrel hair and were slim and pointed. They were usually fixed into the ends of quills which had themselves been narrowed for this purpose. Although it is common to refer to drawings as having been made in pen it is often found on a close examination that they have been executed using a fine brush. PHJG

B RUSSELS: PATRONAGE AND COLLECTING. The capital of modern Belgium, but originally the capital of the former duchy of Brabant, Brussels received its first charter in the early 15th century from Henry I, Duke of Brabant, and became an important centre of the cloth trade, lying on a major trade route from Bruges to Cologne.

By the 15th century increasing wealth through trade encouraged patronage of the arts, especially during the rule of the Burgundian dukes when their court was resident there (1374–1480) and Brussels became known for the production of altarpieces, pottery, glass, and weapons and, particularly in the 16th century, tapestries and lace. Little survives of artistic production before the 15th century with the exception of the sculptural decoration of churches such as S. Gudule (now Cathédrale S. Michel) by anonymous teams of craftsmen.

The first well-known painter to settle in Brussels was Rogier van der *Weyden, appointed painter to the city in 1436. The city authorities commissioned a pair of Justice scenes (now lost) for the Brussels Town Hall which were to have an important influence on later painters of similar scenes for the town halls of Louvain by Dieric *Bouts (Brussels, Mus. Royaux) and Bruges by Gerard *David (Bruges, Groeningemus.). Van der Weyden was also in demand as a portrait painter of the ducal and noble inhabitants such as Philippe de Croy (Antwerp, Koninklijk Mus. voor Schone Kunsten). Towards the end of the 15th century Brussels had become well known as a centre for the production of altarpieces. Created mainly by anonymous craftsmen, the quality was raised further by Jan *Borman the younger and his son Passchier, an example being the retable of *Our Lady* (Louvain, S. Pierre). Manuscripts were also produced in Brussels. During the 15th century the most flourishing workshops were those of Willem *Vrelant, Loyset *Liédet, and Sanders *Bening.

In 1531 Brussels replaced Malines as the centre of Netherlands government which had now passed to the Habsburgs, who ruled there through governors. At first, this increased both artistic patronage and production. As Arras and Tournai declined as centres of tapestry weaving, the workshops of Brussels began a domination that was to last well into the 17th century. In 1516 *Raphael's cartoons for the Sistine chapel were sent to the tapestry workshop of Pieter van Aelst. Bernaert van *Orley and his pupils Michiel *Coxcie and Pieter *Coecke van Aelst ran the leading workshops in the early 16th century producing altarpieces, portraits, and tapestry designs. Pieter *Bruegel the elder moved there in 1563.

During the 1560s however, the importance of Brussels as an artistic centre began to decline as a result of unrest amongst local merchants against Spanish Habsburg rule, resulting in insurrections and the destruction of religious art.

A vigorous revival of the arts came with the stable rule 1599–1621 of the Spanish Governors, the Archdukes Albert and Isabella. Although *Rubens remained in Antwerp which was dominant as an artistic centre compared with Brussels, nevertheless as the centre of tapestry and lace production Brussels was unrivalled. An important development was the emergence of Brussels as a centre of *landscape painting with the work of Denijs van Alsloot (before 1573–1625/6) and Lodewijk de Vadder (1605–55) followed later by Jacques d'Arthois (1613–86). David *Teniers the younger became court painter to the Spanish Governors and his painting depicting the collection of the Archduke Leopold Wilhelm (Vienna, Kunsthist. Mus.) represents an important record of collecting and taste towards the end of the 17th century.

In 1695 Brussels was severely damaged from the heavy bombardment by Marshal Villeroi during the war against France and during the 18th century the city saw a period of rapid artistic decline.

In 1792 Belgium was annexed by the French and Brussels received fresh impetus under Napoleon. The fortifications and streets of the old city were demolished and replaced by Neoclassical buildings and wide boulevards. In 1816 the French painter Jacques-Louis *David arrived in Brussels and a significant group of portraits date from this last period of his life such as *Three Ladies of Ghent* (Paris, Louvre). An important follower was François-Joseph Navez (1787–1869).

In 1830, Brussels became the capital of an independent kingdom of Belgium which contributed a certain nationalistic character to the paintings emanating from the Académie des Beaux-Arts (established 1711) and the Société Libre des Beaux-Arts (1868). Towards the end of the 19th century painters and architects in Brussels showed their awareness of new developments, for example the work of Antoine *Wiertz, Constantin Meunier (1831–1905) and Victor Horta (1861–1947), all commemorated by museums in Brussels. CFW

B RUSTOLON, ANDREA (1662–1732). Italian sculptor and woodcarver. He trained in Venice with Filippo *Parodi and went on to become one of the most admired sculptors in wood of the early 18th century. He worked in a florid late Baroque style, and among his outstanding works are a boxwood and ebony reliquary of S. Innocent (1715; Hamburg, Mus. Kunst und Gewerbe) and a large altarpiece of *The Death of S. Francis Xavier* (1723–8; Belluno, Mus. Civico) for a church in his home town. Brustolon was equally famous for his elaborate carved furniture made for the Venetian patriciate, of which there are examples in the Ca' Rezzonico, Venice. MJ

Alberici, C., *Il mobile veneto* (1980).

Biasuz, G., and Buttignon, M. G., *Andrea Brustolon* (1969).

B RUYN FAMILY. German painters. **Bartholomäus** (or Barthel) **Bruyn I** (1493–1555) had three sons, of whom two also became painters: **Arnt** (1520s–1577) and **Bartholomäus II** (c.1530–1607×10). Bartholomäus I entered the workshop of Jan *Joest at Kalkar and assisted him in painting the high altar for the Nikolaikirche (1505–8) together with Joest's other pupil, Joos van *Cleve. In 1512 he went to Cologne, where he remained for the rest of his life. He painted

altarpieces for churches in and around Cologne in an essentially conservative style. In 1547 he was commissioned to paint scenes from the New Testament (all but one destroyed) for Cologne's Karmelitenkloster, which he completed with the assistance of his sons. In the early and middle period, Bruyn's works reflect the influence of Jan Joest, Joos van Cleve, and local Cologne artists. Around 1525–8 his religious paintings show Italianate ornamentation, which he absorbed from the neighbouring Netherlandish artists Jan van *Scorel and Maerten van *Heemskerck. Bruyn was also an excellent portraitist who depicted many of Cologne's patrician citizens. Bartholomäus II, the more successful of the two sons, inherited his father's shop in 1555. Though he painted altarpieces and other religious panels (the only signed work is a diptych with the *Carrying of the Cross and Vanitas*, 1560; Bonn, Rheinisches Landesmus.), he is best known for his portraits. KLB

Hand, J. O., *German Paintings of the Fifteenth through Seventeenth Centuries*, exhib. cat. 1993 (Washington, NG).

B RYULLOV, KARL PAVLOVICH (1799– 1852). Russian painter. Son of an Italian sculptor he studied at the Imperial Academy 1815–21 under Andrei Ivanov (1772–1848). He settled in Rome 1823–4 and had a major success with *The Last Day of Pompeii*, (1830–3; St Petersburg, Russian State Mus.), inspired by archaeological researches, Pliny's account, and Pacini's opera (1825); it reputedly moved Bulwer-Lytton to write his novel *The Last Days of Pompeii* (1834). A combination of *Raphael's classicism (it includes references to the *Fire in the Borgo*), realistic accuracy, and melodramatic Romanticism, it was admired by Sir Walter Scott and shown to great acclaim in Rome, Milan, and Paris. Bryullov visited Greece, Turkey, and Asia Minor, returning to Russia 1835 to become an academic professor. He undertook decorations for S. Isaak's Cathedral, St Petersburg, 1843–7, and executed a huge history subject, *The Siege of Pskov by Stepan Batory in 1581* (1836–43; Moscow, Tretyakov Gal.). He was a gifted and psychologically incisive portraitist: *Nestor Kukolnik* (1836; Tretyakov Gal.). In 1849 he returned to Rome. Bryullov eroded the severity of academic classicism with a new and vital attention to the emotional possibilities of colour, becoming the first Russian artist to win an international reputation. DJ

Leontiyeva, G., *Karl Bryullov: The Painter of Russian Romanticism* (1996).

B UECKELAER, JOACHIM (or Beuckelaer) (c.1534–c.1574). Flemish painter of large market and kitchen pieces in Antwerp. He was the nephew (by marriage) and pupil of Pieter *Aertsen, and became a master himself in 1560. Greatly influenced by Aertsen in style, manner of painting as well as choice of subject matter, it is sometimes difficult to distinguish between the two hands. Bueckelaer, however, was no slavish imitator. As regards execution, he fully bears comparison with Aertsen; as to subject matter, he expanded the repertoire by introducing the topic of fish stalls to the genre (1569; Ghent, Mus. voor Schone Kunsten). KLB

Joachim Beuckelaer, exhib. cat. 1986 (Ghent, Mus. voor Schone Kunsten).

B UFFALMACCO (Bonamico, Buonamico di Martino) (active c.1315–36). Italian painter and shadowy figure by whom no authenticated works exist. Boccaccio refers to his reputaion for practical jokes, hence the nickname by which he is known, but he is recorded among members of the Florentine guild of Medici and Speziali in 1320 as Bonamichus Magistri Martini.

He is first recorded in Florence in 1315, at which time, according to *Ghiberti, he painted frescoes in the Cappella Spina at Settimo. The style of these, their solid yet lively figures and detailed architecture, has linked them to the three scenes in the upper church, Assisi, ascribed by some to the *Master of S. Cecilia.

Buffalmacco is recorded in Pisa in 1336 where he lived in lodgings provided for cathedral employees. Ghiberti ascribes to him numerous frescoes in the Camposanto there. He could, therefore, be identified with the Master of the Triumph of Death. A document of 1341 indicates that he had painted a fresco in Arezzo Cathedral. This may be the fragment showing the Virgin and Child on the south wall, which displays 'some stylistic similarities with the Pisa frescoes. MS

Bellosi, L., *Buffalmacco e il Trionfo della Morte* (1974). Smart, A., *The Dawn of Italian Painting* (1978).

B UON (or Bon) BARTOLOMMEO (c.1400×10–c.1464×7). One of the most important Venetian sculptors and architects of the first half of the 15th century, whose work epitomizes the survival of the *Gothic style in Venice. Trained under his father Giovanni, he became head of the workshop after his father's death (1443). Bartolommeo carved an elaborately decorated well-head for the Ca' d'Oro, Venice (1427). His imposing Istrian stone *tympanum relief of *The Madonna della Misericordia* was carved for the Scuola Vecchia di S. Maria della Misericordia in Venice (c.1445–50; London, V&A), and a second is over the entrance to the Scuola di S. Marco (1437). Other commissions include the Porta della Carta at the Doge's palace (c.1438–42). AB

Pope-Hennessy, J., *Catalogue of Italian Sculpture in the Victoria and Albert Museum* (1964).
Wolters, W., *La scultura gotica veneziana* (1976).

B UONTALENTI, BERNARDO (1531– 1608). Florentine architect, military engineer, designer, painter, and sculptor. His training is unknown, but he was taken under the protection of the Medici family, and he probably learned painting and architecture in the circle of *Salviati, *Bronzino, and *Vasari. He was appointed tutor to Francesco de' Medici, whose passion for scientific studies he shared, and later engineer to the Medici, also compiling two books on engineering and fortifications. He designed and supervised the creation of the gardens, grottoes, and fountains at many of their Florentine villas, including Pratolino (1569–80), the Casino di S. Marco (1574–80), and the Grotta Grande in the Boboli Gardens (1583–93). Other activities involved the provision of decorations and pyrotechnics for ceremonial events, and he created the Tribuna in the Uffizi (c.1580). Buontalenti's distinctive auricular style pervades both his designs for architecture, especially notable at the Palazzo Nonfinito (1593–1600), and for hardstone vessels and porcelain for the grand ducal factory (1575–87). AB

Botto, I. M. (ed.), *Mostra di disegni di Bernardo Buontalenti (1531–1608)*, exhib. cat. 1968 (Florence, Uffizi).

B URCHFIELD, CHARLES (1893–1967). American painter. Burchfield was raised in Salem, Oh., to which he returned after training at Cleveland School of Art (1912–16). While working in a local factory he painted a series of small symbolic watercolours (1915–18) which either externalized his inner fears, as in *Noontide in Late May* (1917; New York, Whitney Mus.), or represented natural sounds (*The Insect Chorus*, 1917; Utica, NY, Munson-Williams-Proctor Inst.). The latter are highly decorative, painted in arbitrary expressive colour, with a debt to oriental art. After war service (1918–19) he became a wallpaper designer in 1921 and moved to Buffalo, where he remained, in 1925. He became a full-time artist in 1929 by which time he had abandoned fantasy for realistic portrayals of urban and industrial Buffalo, frequently, as in *Rainy Night* (1929–30; San Diego, Mus. of Art), evocative and melancholy. Now classed as an American scene painter, in 1936–7 he was commissioned by *Fortune* magazine to paint the Pennsylvania railway yards and the West Virginia coalfields. From 1943–67 he returned to his earlier expressionism with pantheistic and highly personal landscapes (*An April Mood*, 1946–55; New York, Whitney Mus.). DER

Baigell, M., *Charles Burchfield* (1976).

BURCKHARDT, JACOB (1818–97). Swiss cultural historian and art historian. Of patrician origin, Burckhardt studied at the universities of Berlin and Bonn and in 1844 took up a teaching post at Basle University. Following a brief interlude as professor of art history in Zurich, he was called back to Basle in 1858, where he was succeeded by his pupil Heinrich *Wölfflin in 1893. Although he published on a variety of subjects, such as early Christian art and *Rubens, Burckhardt is primarily known for his powerful evocation of Italian *Renaissance culture. His most influential book, *Die Cultur der Renaissance in Italien* (1860), paints a colourful picture of art and life at the Italian courts and city-states. Burckhardt considered the Renaissance as a rebirth of Western culture deriving from the spirit of classical Antiquity. Among the most significant changes brought about by this development he numbers the emergence of an essentially secular view of the world and the genesis of a new self-reflective consciousness. Burckhardt's remarkable gift for vivid artistic description is evident in his *Cicerone* (1855), intended as a 'Guide to the Enjoyment of Italian Art Works'. AT

Guggisberg, H. R. (ed.), *Umgang mit Jacob Burckhardt: zwölf Studien* (1994).

BURGKMAIR, HANS, ELDER AND YOUNGER. German painters and designers of woodcuts in Augsburg. **Hans Burgkmair I** (1473–1531) was trained by his father, the painter Thoman Burgkmair (1444/6–1525), but may also have worked under *Schongauer in Colmar around 1490. In 1498 he married the sister of Hans *Holbein the elder. He almost certainly visited Italy and the Netherlands. His paintings after 1505 show his study of Venetian colour and monumental figure types indebted to Italian models. In addition to altarpieces (*S. John* altarpiece, 1518; *Crucifixion* altarpiece, 1519; both Munich, Alte Pin.) and smaller devotional panels, Burgkmair executed many portraits. From 1510 he was employed on projects for the Emperor Maximilian I, including the woodcuts for the *Triumphal Arch and Procession* as well as the *Theuerdanck* and *Weisskunig*, Maximilian's essays in autobiography. He played a seminal role in the development of the *chiaroscuro woodcut (*S. George and the Dragon* and *Maximilian I*, 1508). **Hans Burgkmair II** (c.1500–62) took over the family workshop in 1531, but his only known works are mostly copies after his father's works (e.g. a series of tournament participants, Munich, Graphische Sammlung). KLB

Schade, W., *Hans Burgkmair*, exhib. cat. 1974 (Berlin, Staatliche Mus.).

BURGUNDY, an area of eastern France. In 1361 the last Capetian Duke of Burgundy, Philippe de Rouvres, died and the duchy reverted to the French Crown. The Valois King John II (the Good) of France in 1363 rewarded his younger son Philip with the gift of the duchy in gratitude for Philip's loyalty to him during the battle of Poitiers. In this way Burgundy became an independent duchy from 1363 to 1477. It is during this period that the arts flourished and Burgundian styles and fashions had wide-ranging influence throughout the rest of Europe.

In 1369 Philip the Bold, the first Duke (1363–1404), married Margaret, the daughter and heiress of the Count of Flanders, Louis de Mâle, and in 1384, on the death of his father-in-law, Philip added Flanders and some nearby territories to his kingdom. Under the subsequent dukes further areas were added including Luxembourg, Brabant, Hainaut, and Holland.

The wealth derived from the wool trade in the Netherlands enabled the Burgundian dukes to become prolific and enthusiastic collectors and patrons of the arts. Philip the Bold's artistic aspirations were wide-ranging. Little is left of his two main architectural projects, the palace at Dijon and the nearby Carthusian monastery of Champmol, founded in 1385 as his mausoleum. The only exception is some sculptural work by the remarkable Claus *Sluter. Painters and woodcarvers were also employed by Philip to produce altarpieces for Champmol, including the painters Melchior *Broederlam, Jean de *Beaumetz, Jean *Malouel, and the woodcarver Jacques de *Baerze. Inventories describe a collection of more than 100 tapestries such as the *Nine Heroes* (Dijon, Mus. des Beaux-Arts) and a library of 200 illuminated books, an enormous number for the period, some of which were commissioned by Philip the Bold from artists such as the *Limburg brothers, for example a *Bible moralisée* (Paris, Bib. Nat.).

The second Duke John the Fearless (1404–19) continued to follow his father's patronage of the arts as a means of supporting his political ambitions. Sluter had died leaving Philip the Bold's tomb unfinished so his nephew Claus de *Werve completed it and also probably designed that of John the Fearless (both tombs in Dijon, Mus. des Beaux-Arts). Duke John continued to add to the library and retained artists such as Jean Malouel to work on the Champmol monastery. *The Martyrdom of S. Denis* by Henri *Bellechose (Paris, Louvre) is the only surviving painting commissioned by Duke John.

Philip the Good, the third and longest reigning Burgundian duke, was in many ways the most wide-ranging in his interests as a patron, employing painters, sculptors, and tapestry designers as well as commissioning works of literature and music. His love of ceremonial and sumptuous festivities not only prompted him to found the order of the Golden Fleece in 1430 but also influenced his patronage of the luxury industries. Indeed for his wedding to Isabella of Portugal in 1430 fifteen cartloads of tapestries, 50 loads of furnishings and jewels, and fifteen more of arms and armour were brought to Bruges for the wedding.

Little remains of the many projects with which Philip the Good was involved. Louis de Mâle's tomb in S. Pierre, Lille, by Jacques de Gerennes of Brussels (1455) was destroyed by the French in 1793 and Philip's portrait by Rogier van der *Weyden survives only in copies. It is known that his library grew to number more than 1,000 books for which Philip commissioned numerous works, for example *Chronicles of Hainaut* (1448; Brussels, Bib. Royale) illuminated by Willem *Vrelant and Loyset *Liédet. Most significant was Philip the Good's patronage of Jan van *Eyck who became court painter and *valet de chambre* in 1425. He was highly esteemed by the Duke, who visited him in his studio; but nothing survives of the work commissioned by the Duke from van Eyck. A number of Burgundian courtiers followed the Duke's lead, in particular his Chancellor, Nicolas Rolin, for whom not only van Eyck painted a *Virgin and Child* (Paris, Louvre) but Rogier van der Weyden painted a *Last Judgement* (Beaune, Hôtel-Dieu).

Charles the Bold, the fourth and final duke, whose death in 1477 at the battle of Nancy resulted in the end of Burgundy, both as an independent kingdom and as an artistic entity, continued the patronage of his predecessors. An important surviving object commissioned by Duke Charles in 1467 from Gerard Loyet, his goldsmith, is a magnificent gold and enamel reliquary representing the kneeling Duke with his patron saint (Liège, Diocesan Mus.). Other survivals are fragments of a set of eleven tapestries depicting the *History of Troy* (New York, Met. Mus.), woven by Pasquier Grenier in Tournai. CFW

Vaughan, R., *Valois Burgundy* (1975).

BURIN, or graver, the line engraver's principal tool. It is a short steel rod, lozenge shaped in section, and shaped obliquely at the end to provide a tool. It is fixed into a mushroom-shaped wooden handle, which is held in the palm of the engraver's hand while he guides the tool with his fingers. Mainly associated with engraving on copper, it can also be used in wood engraving. RGo

BURKE, EDMUND (1729–97). British statesman and writer. Burke was educated at Trinity College, Dublin, and the Middle Temple, in London, but soon abandoned his legal studies and embarked on a glittering parliamentary career in 1765. In 1756 he published *A Philosophical Enquiry into the Origin*

of our Ideas of the Sublime and Beautiful in which he differentiated between the two by associating the sublime with horror. He further suggested, in opposition to previous writers, that both were perceived emotionally and not by objective criteria. He added an *Essay on Taste* to the second edition (1759) which argued that taste is a product of the imagination, reacting to sensibility and tuned by experience. These ideas, which anticipate *Romanticism, had a profound influence on artists, writers, and landscape gardeners not only in Britain but throughout Europe. Burke furthered the careers of his fellow Irishmen George *Barret and James *Barry. The latter, who was supported financially by Burke during his studies in Rome 1765–70, painted his portrait (Dublin, Trinity College) around 1771. DER

BURLYUK BROTHERS. Ukrainian artists. **David** (1882–1967) and **Vladimir** (1887–1917) were particularly influential in the development of the Russian avant-garde as painters, graphic artists, and organizers. Self-styled artistic 'savages', they were from middle-class backgrounds and received a conventional training at Odessa, Munich, and the Académie Cormon, Paris. Fervent iconoclasts, they rejected the realist and academic styles, drawing instead on an eclectic fusion of *Post-Impressionist influences, including *Cézanne, *Cubism, German *Expressionism, and *abstraction, embracing also the primitive arts and Russian folk art. The results, seen in David's *Portrait of the Futurist Poet Vasiley Kamensky* (1917; St Petersburg, Russian State Mus.) were essentially Neoprimitivist, characterized consistently only by their inventiveness and bold experimentation. They exhibited widely in avant-garde circles in Russia, Germany (including Der *Blaue Reiter), France, and Italy, and were active in forming the *Knave of Diamonds and Union of Youth. David's polemical, intemperate, and not always coherent writings, such as *A Slap in the Face of Public Taste* (1912), published with the poets Mayakovsky and Kruchenykh, were of seminal influence in the formation of Russian *Futurism. He settled in New York in 1922. DJ

Compton, S., *The World Backwards: Russian Futurist Books 1912–16* (1978).

BURNE-JONES, SIR EDWARD (1833–98). English painter. He was born in Birmingham and educated at Exeter College, Oxford, where he met his lifelong friend William Morris (1834–96), with whom he shared a passionate love of Arthurian chivalry. He studied briefly under his hero D. G. *Rossetti but soon outgrew his influence despite retaining great respect for his master. In 1861 he was a founder member of Morris, Marshall, Faulkner, & Co. for which he designed stained glass and tapestries until his death. In the following year he visited Italy with John *Ruskin, seeing works by *Botticelli and *Mantegna which had a profound influence on him. His mature style is essentially linear and characterized by a flowing sinuosity which is applied to both drapery and foliage. His subjects were either mythological (e.g. *The Beguiling of Merlin*, 1874; Port Sunlight, Lady Lever Gal.) or personal inventions like *The Golden Stairs* (1875–80; London, Tate), which he claimed were autonomous. From 1878, when he exhibited in Paris, he gained a European reputation and influenced both continental *Symbolism and *Art Nouveau. DER

Christian, J., *Burne-Jones*, exhib. cat. 1975 (London, Hayward).
Harrison, M., and Waters, B., *Burne-Jones* (1973).

BURR, the dense, slightly clotted effect of inking created by the raised furrows of copper at the side of lines formed by the *drypoint needle. The same effect can be found in very early impressions of line engravings. RGo

BURRA, EDWARD (1905–76). English painter. Burra, born to wealthy parents, had little formal education because of illness. He studied art at Chelsea and, in 1923, the Royal College. Despite infirmity he lived a bohemian life, assumed the persona of an Edwardian tart, and was irresistibly drawn to the louche and dangerous. Throughout his life, possibly because of crippling arthritis, his preferred medium was watercolour, painted in luminous washes within tight well-defined outlines. His early work portrays fashionable and near-criminal society in a manner reminiscent of *Grosz but without his moral standpoint. In 1933, during his third visit to France, he painted Genet-like characters in Marseilles and in 1934, in America, the street life of Harlem (*Harlem*, 1934; London, Tate). Spanish and Mexican journeys during the 1930s, combined with involvement with *Surrealism from 1933, resulted in macabre and powerful allegorical works, like *Dancing Skeletons* (1934; London, Tate), and scenes of unspecified atrocities inspired by the Spanish Civil War, but he was equally capable of imbuing still lifes with considerable menace. In later years he turned increasingly to melancholy landscapes; *Valley and River, Northumberland* (1972; London, Tate). DER

Causey, A., *Edward Burra* (1985).

BURRI, ALBERTO (1915–95). Italian artist. Burri's work was influenced by the example of Kurt *Schwitters, although it has a strong poetic quality alien to *Dada. He developed the theme of metamorphosis by burning the surfaces of some works, while in *Sacking and Red* (1954; London, Tate) he used an unconventional material, exploiting its physical properties with an expressiveness characteristic of contemporary *Art Informel. He was extremely influential on the development of Arte Povera (see MINIMAL ART) in Italy, and received considerable recognition throughout Europe and North America. CJM

Burri, exhib. cat. 1985 (Milan, Brera).

BUSH, JACK HAMILTON (1909–77). Canadian painter. Born in Toronto, he was one of Canada's foremost abstract painters. In the early 1950s he was influenced by *Matisse and American *Abstract Expressionists, painting non-representational, gestural works. In his mature style (from the late 1950s), 'stacks' of brilliant colours are arranged in lyrical configurations, as in *Signal* (1968; Calgary, Glenbow Mus.), and his paintings are usually grouped in series. The works of the 1970s have a looser, more calligraphic composition and are often influenced by jazz music. KM

Jack Bush: A Retrospective, exhib. cat. 1976–7 (Toronto, AG Ontario).

BUSHNELL, JOHN (d. 1701). The most accomplished English sculptor of the Restoration period, a position he held by virtue of his understanding of Italian *Baroque style. This was the result of a prolonged period of self-exile in Venice to avoid the consequences of his enforced marriage to a servant seduced by his master, the sculptor Thomas Burman. Bushnell returned to London at the end of the 1660s and carved royal figures for Temple Bar, made busts influenced by *Bernini, among them that of *Charles II* (Cambridge, Fitzwilliam), as well as tomb effigies such as that to Lord Mordaunt (Fulham, London, All Saints), which demonstrate his superior grasp of European models. In old age he was taken by *folie de grandeur* and bankrupted himself with ventures that included building a mansion at Hyde Park Corner and a huge reconstruction of the Trojan Horse. He died mad and penniless. MJ

Esdaile, K. A., 'John Bushnell Sculptor', *Walpole Society*, 15 (1927).
Whinney, M. D., *Sculpture in Britain 1530–1830* (rev. edn., 1988).

BUST, a sculptured representation of the head and upper portion of the body. The word is of uncertain origin, but it is sometimes explained as derived from the Latin *bustum*, 'sepulchral monument'. The forms of busts have varied a good deal; the term covers many types ranging from those which only show the head, the neck, and part of the collarbone to those which include shoulders, arms, and even hands. Such parts of the body as are shown may serve simply as a base for

the portrait head and be so shaped as to give a straight line downward, or they may be draped to serve a decorative purpose, or dressed in garments which indicate the sitter's status.

The history of the bust is closely linked with that of the portrait. It was natural that the Egyptians, convinced of life after death, should make vivid polychrome busts of the dead. The Greeks (see GREEK ART, ANCIENT), once they began to make portraits (in the 5th century BC), often combined them with herms, as in the helmeted *Pericles* (Vatican Mus.). *Hellenistic busts always demonstrate that the chief interest of later Greek artists was in the head, which might be ideal, as in the famous portrait of blind *Homer* (Boston, Mus. of Fine Arts), or realistic, as in Alexandrian art of the 1st century BC. It is very different with the Romans (see ROMAN ART, ANCIENT), who from republican times onwards varied and elaborated the bust form so inventively and so often that archaeologists are able to date a Roman bust from its shape.

During the Middle Ages, when there was little interest in individual portraiture, the bust almost vanished from art, although the form was sometimes used for those images of saints which served as *reliquaries; and for these precious metals were often employed. Friedrich II (d. 1251), conscious of his role as emperor, reintroduced the bust with other forms of classical art.

Artists of the *Renaissance, especially those of the 15th century in Florence, achieved a true revival of the classical bust in all its variety. Their portraits ranged from highly realistic representations sometimes based on life or *death masks (Antonio *Rossellino, *Giovanni Chellini*; London, V&A) to formal idealizations (Francesco *Laurana, *Ippolita Sforza*; Berlin, Staatliche Mus.). The 16th century turned from the simple bust forms used in the quattrocento to a more elaborate imitation of Roman late imperial types (*Cellini, *Cosimo I*; Florence, Bargello). New and richer forms were developed in the *Baroque period, in particular by *Bernini; again these were sometimes highly realistic (*Scipione Borghese*; Rome, Borghese Gal.) and sometimes consciously idealized (*Louis XIV*; Versailles). Later ages have added little to the store of forms, though in the 18th century the bust as a lively portrayal of individual character was brought to a high level of refinement in the work of artists such as *Lemoyne in France and *Roubiliac in England; the *Neoclassicist sculptors of Europe and America returned to the simpler types of Roman republican busts (*Houdon, *Voltaire*; London, V&A; Paris, Louvre). In the 19th and 20th centuries artists such as *Rodin, Charles Despiau, and *Epstein used the form of the bust, but their interest in characterization has led

them away from subservience to any traditional formulas. Epstein sometimes emphasized the character of his portraits by the addition of arms and hands (*Ellen Ballon*; Montreal, Mus. of Fine Arts). The convention of the portrait bust is still retained by academic sculptors in the modern period, but the form is used only as a point of departure by more experimental sculptors. HO/MJ

BUTINONE, BERNARDINO (c.1450–before 6 Nov. 1510). Italian painter. He was born at Treviglio in Lombardy and was influenced by *Mantegna, Cosimo *Tura, Francesco del *Cossa, and Vincenzo *Foppa. He often worked in Milan and Treviglio in collaboration with Bernardo Zenale (c.1464–1526), as in the case of the polyptych which was commissioned for the church of S. Martino at Treviglio in 1485. Two works signed by Butinone alone are known: a triptych in the Brera, Milan, dated 1484; and a *Madonna and Child Enthroned with S. John the Baptist and S. Justina* in the Borromeo Collection at Isola Bella. HB

BUTLER, ELIZABETH (Lady Butler, née Thompson) (1850–1933). English painter. Elizabeth Thompson was born in Lausanne, the daughter of a wealthy Englishman and his wife, a talented amateur musician and artist, and spent her childhood on the Continent, mainly in Italy. In 1873, inspired by watching manœuvres, she began painting military subjects and in the following year had an unprecedented success with several Crimean War paintings at the RA, particularly the sombre *Roll Call* (London, Royal Coll.) which, despite having been purchased, was ceded by royal request to Queen Victoria, who commissioned further works. She greatly admired academic French military painters, including *Meissonier and *Gérôme, and was determinedly conservative; her own works were not only highly popular with a patriotic public but also praised by *Millais and *Ruskin. In 1877 she married a soldier, William Butler (knighted 1886), and for the rest of her highly successful career painted both past and contemporary battles including those of the First World War. Disregarded after her death, some of her works, like *Scotland for Ever!* (1881; Leeds, AG), have considerable panache. DER

Butler, E., *An Autobiography* (1922).

BUTLER, REG (1913–81). British sculptor, draughtsman, and printmaker, born at Buntingford (Herts.). He was an architect by training (his work included the clocktower of Slough Town Hall, 1936), but he began making sculpture in 1944, without formal training. Architecture remained his main activity until 1950, when he gave up his practice and became the first Gregory Fellow in sculpture

at Leeds University, 1950–3. In 1953 he suddenly came to prominence on being awarded the first prize in the international competition for a Monument to the Unknown Political Prisoner (defeating *Calder, *Gabo, and *Hepworth among other established artists). The competition, financed by an anonymous American sponsor and organized by the Institute of Contemporary Arts, was intended to promote interest in contemporary sculpture and 'to commemorate all those unknown men and women who in our time have been deprived of their lives or their liberty in the cause of human freedom'. Butler's design was characterized by harsh, spindly forms, suggesting in his own words 'an iron cage, a transmuted gallows or guillotine on an outcrop of rock'. The monument was never built (one of the models is in the Tate Gallery, London), but the competition established Butler's name and he won a high reputation among the British sculptors of his generation.

Butler had learned iron forging when he worked as a blacksmith during the Second World War (he was a conscientious objector) and iron was his favourite material. His early sculpture is remarkable for the way in which he used his feeling for the material to create sensuous textures. His later work, which was more traditional (and to many critics much less memorable), included some bronze figures of nude women, realistically painted and with real hair, in contorted poses looking as if they had strayed from the pages of 'girlie' magazines. Butler was a sensitive draughtsman and made drawings as independent works. He also produced a few lithographs and wood engravings. An articulate writer and radio broadcaster, he vigorously argued the case for modern sculpture; five lectures he delivered to students at the Slade School, London, in 1961 were published in book form the following year as *Creative Development* (he taught at the Slade from 1951 to 1980). He was a widely read man, who numbered leading intellectuals among his friends, and his liberal sympathies were shown by his donation of works to such causes as the campaign against capital punishment. IC

BUYS, CORNELIS. See MASTER OF ALKMAAR.

BUYTEWECH, WILLEM (1591/2–1624). Dutch painter, draughtsman, and etcher. Although Buytewech lived for most of his short life in Rotterdam, his artistic background is closely linked with developments in Haarlem where he entered the painters' guild in 1612, the same year as Esias van de *Velde and Hercules *Segers. Nicknamed 'Geestige' (witty), he is an early exponent, with his light-filled and broadly painted merry company scenes, of a fresh approach

to realism in Dutch art. None of the ten paintings now attributed to him are signed or dated but Buytewech's style is distinctive. In *Merry Company* (Budapest, Szépmüvészeti Mus.) four elaborately dressed figures balance one another in a somewhat crowded space resembling a small stage. A bright golden light floods over the composition, emphasizing the jewel-like colours. Buytewech's drawings and etchings are more numerous than his paintings and show a wide range of subject matter from religious and historical narratives to allegories, genre, and landscape scenes. Ten of his innovative etchings were published in 1616 entitled *Various Little Landscapes*, showing the influence of *Elsheimer. CFW

Giltay, J., et al. (eds.), *Willem Buytewech*, exhib. cat. 1974–5 (Rotterdam, Boymans-van Beuningen Mus.).

BYZANTINE ART.

BYZANTINE ART. Byzantine is the term applied from the 19th century onwards to the history and culture of the Christian East Roman Empire whose capital was Constantinople (modern Istanbul). It derives from the classical name of that city, Byzantium. The Byzantines themselves never used that term, calling themselves Romans and perceiving their state as the continuation, without pause, of the Roman Empire. The 'start' of the Byzantine period is therefore debatable; some take it as 330 when Constantine the Great refounded the city of Byzantium as Constantinople, and moved his capital there from Rome; others prefer a later, more 'medieval' date in the 6th or 7th centuries. Whenever it began, the empire came to an end in 1453 when Constantinople was captured by the Turks and became the capital of the Ottoman Empire. During its 1,100 years of existence, the territories of Byzantium varied as the empire expanded and contracted, but took in Italy, Greece, the Balkans, Asia Minor, and the eastern Mediterranean as far as North Africa. During the Middle Ages, Byzantium was the major Christian power in eastern Europe. It was the centre of enlightenment and learning, a dominant influence across Europe and the Middle East and western Europe's protection against the growth of Islam. All Christian powers looked towards Byzantium for culture and civilization. From the 6th century on, Greek was the language of the empire and Byzantium kept the language and literature of the classical past alive. This learning was passed on to the West, which had largely forgotten it.

The art that survives from Byzantium is essentially religious. This is partly chance of survival, for much of the secular Byzantine world lies under modern towns or was ignored in excavations as archaeologists hastened to uncover the classical past. However, it also relates to the fact that a great deal of what was made in Byzantium was Christian, in terms both of monuments and of portable objects. Many of these portable objects, especially manuscripts, found their way into the West and were treasured. The Christian remains of Byzantium were of relatively little significance to their Islamic conquerors. However, Byzantine art was not restricted to the empire alone but influenced developments both to East and West. It did not come to an end in 1453 but continued—and continues—to be produced where the Orthodox religion flourished, above all in Greece and the Slav countries, and most obviously in the form of the *icon.

A style history of Byzantine art, tracing developments and influences from the 4th to the 15th century, is possible. Prior to *Iconoclasm, in iconographical and formal terms, art was as diverse as the cities it came from in the Roman world; lively scenes from everyday life form a part of both religious and secular imagery: the wildlife scrolled round the mosaics of the church of S. Vitale, Ravenna (6th century—consecrated in 547); circus dancing girls on the obelisk of Theodosius I in the remains of the Hippodrome of Constantinople (390–1); the kicking donkey in the floor mosaics of the Great Palace of the emperors (?6th century; Istanbul, Mosaic Mus.). As questions about the nature of images became more pressing, subject matter and its style became more formalized and, in the centuries after Iconoclasm, frontality and symmetry, which had both always been present, became dominating characteristics in both monumental (the mosaics of the 10th- and 11th-century Greek churches of Hosios Loukas, Daphni, and Nea Moni Chios) and small-scale arts (the enamels of the Pala d'Oro, (Venice, S. Mark's) or the saints in the *menologium*—collection of saints' lives—of the Emperor Basil II). During the late 11th and 12th centuries, greater emotionalism is apparent (the wall painting of the *Dead Christ and Mourners* at Nerezi from *c.*1164, for example). It is from this period that Byzantine art seems to have been particularly widespread in influence, ranging from the churches of Serbia and Georgia to the monuments of Norman Sicily and the mosaics of S. Mark's, Venice, and apparent in manuscripts (the illustrated chronicle of the historian John Skylitzes, now in Madrid, was probably produced in Sicily but looks almost completely Byzantine) and other portable art forms. In 1204, the Fourth Crusade sacked Constantinople and huge amounts of artistic treasures were taken to the West in the form of plunder, to fill cathedral treasuries and decorate cities across western Europe. After the 60-year occupation of Constantinople by the Latins, a final phase of more wideranging and less formal artistic activity is apparent, typified in the mosaics of the Kariye Camii in Istanbul (after 1321) or the wall paintings of Mistra in the Peloponnese (13th and 14th centuries).

Such a history of style is, however, limited, acting primarily as a means of categorizing and dating art objects. Medium, use, and function need also to be considered to understand Byzantine art more fully. Wall *mosaic became perhaps the medium most closely associated with Byzantine art. Wall painting was less highly rated than mosaic in terms of both expense and craftsmanship. Three-dimensional sculpture became increasingly less significant than in the Roman world, though classical statues continued to be displayed and marvelled at. Small-scale art was produced in great quantities, from illuminated manuscripts, ivories, metalwork, and enamels at the top end of the scale to amulets and bronze crosses, lead and even clay pilgrim tokens, and icons ranging in quality from the very good to the extremely crude. Ivories representing religious themes or commemorating individuals, especially imperial figures, were one high-cost, highly prestigious form of art. Byzantine silks were renowned and coveted throughout Europe, as their presence in so many cathedral treasuries testifies. Garments incorporating the imperial purple were particularly valued, and at all times their sale and export was fiercely supervised. Metalwork and enamels were also highly prized.

*Illuminated manuscripts were another costly form of art requiring expensive materials as well as intensive labour from scribes and painters. Manuscripts played a major role in spreading Byzantine culture. Both secular, in the form of histories, scientific treatises, and literary books, and religious manuscripts in the form of bibles, psalters, Gospel books, and collections of saints' lives survive. These were illuminated perhaps through full-page miniatures, or part-page representations or even illustrations in the margins, the pictures serving to draw attention to and comment on the text. The fantastic beasts and interlace of European manuscript illumination are barely present; rather figures and scenes dominate. For some reason connected with the treatment of the parchment, many Byzantine miniatures have rubbed badly, but enough survives to indicate the bright, clear colours and the extensive use of expensive pigments. On completion, manuscripts were then expensively bound in leather and precious materials. One splendid example of the 10th century was made of silver gilt plaques decorated with enamel medallions, mounted gems, and pearls framing a central gold cloisonné plaque of the crucifixion (Venice, Bib. Nazionale Marciana).

In considering these smaller-scale, often luxury objects, we should remember the distinction between public and private art.

Monuments such as churches and their decorations were designed to be visible to thousands; objects such as illuminated manuscripts or personal icons might be seen only by their owner. This distinction affected what was portrayed and the ways in which it might be shown. A manuscript might have all sorts of personal allusions and comments in the margins, as is the case with the anti-Iconoclast propaganda of the Khludov Psalter (Moscow, State Russian Lib., MS 129D), in a way in which a mosaic would not.

Little is known of individual Byzantine artists—perhaps 100 names, all male, are known over the entire period—and their working practices. Few works are signed, next to nothing is known about workshop practices, master–pupil relations, or even how long it took to make a mosaic, an icon, a manuscript, a wall painting. As far as artistic creativity goes, the Church Council of 787, which restored the place of images in religious worship after the period of Iconoclasm, stated that 'The making of icons is not the invention of painters, but [expresses] the approved legislation of the Catholic church . . . The conception and the tradition [of painting, that is] belong to the [Holy Fathers of the Church] and not the painter; for the painter's domain is limited to his art whereas the disposition manifestly pertains to the Holy Fathers.' Clearly, the artist was not regarded as culturally significant but was seen as a craftworker; rather, emphasis lies with the patrons of art and the audiences for art—the person who paid, the person depicted, and the person who saw the image. Where we often stress the primacy of the artist's intentions and genius, this had little significance in Byzantium: Byzantine art is what Byzantine beholders made it.

In artistic terms, Constantine's most significant move was to make Christianity the official religion of the Roman Empire. Christian art became official and Christian buildings and objects spread throughout the Roman Christian world. The nature and form of these works changed over time: churches moved from the basilica plan (like S. Apollinare Nuovo, Ravenna; early 6th century) to the typical Byzantine domed cross-in-square type, like Hosios Loukas (mid-10th century) or Nea Moni. The church was the dominating intellectual and moral institution; it attempted to control the patronage of art and to limit its range of subject matters to Christian themes. Art was a medium through which the Church could promote and allow values and emotions. Much art, from churches down to portable wooden icons, was commissioned by individual patrons as an offering to God, a bid to stay on the right side of God and to win his favour. Christians had always been uneasy about the place of images in church worship: the 8th-century Iconoclastic dispute established the role of

images in man's interaction with God, fixing them as an intrinsic and crucial part of religious devotion. So Byzantine art deals with the paradox of representing a physically unknown but very real God 'realistically'. Byzantine art and the Byzantines' discussions about their art always essentially come back to the crucial question for the Christian believer: how can man represent God? This was a genuine issue. In a world where no ideological framework existed outside of God, the issue of the individual's relationship to and with God was of paramount importance. The future held the Last Judgement where all would be assessed according to their merits and would either experience everlasting joy with God or eternal damnation.

As it had been for the Romans, art in Byzantium was a vital tool of government. Images were powerful because they were scarce; the average Byzantine perhaps saw as many different images in their lifetime as we see in one day. Art was a useful vehicle for imperial propaganda and the ideas behind imperial art remained constant. For the majority of the population, the image of their ruler was the most they would ever see of him, so it was crucial that he was portrayed in all his glory, God's regent on earth, his court mirroring the heavenly court, responsible for the well-being of the world. An image of the emperor represented, indeed was, the emperor himself and was to be treated with the same respect and devotion as him. Such images dominate in all media from the changing images on coins to the representation of rulers in monumental mosaic panels in important churches throughout the Byzantine period. The 6th-century Emperor Justinian and his wife Theodora are represented in two mosaic panels in S. Vitale, Ravenna; the 11th-century Empress Zoe and her third husband Constantine IX are present in the South Gallery of Hagia Sophia, Istanbul, as are the 12th-century Emperor John II and his wife Eirene. In these images and in the majority of surviving imperial imagery, the imperial figures are seen in interaction with the divine. Justinian and Theodora celebrate the Eucharist, surrounded by their courts; Zoe and Constantine offer gifts to a blessing Christ; John and Eirene perform the same action with the Virgin and Christ child. God and emperor were intrinsically and eternally linked, human power verified and supported by the divine.

Ceremonial also played a key part in Byzantine public life and here, again, art was used to convey the message. The great church of Constantinople, Hagia Sophia, with its 33-m (107-ft) dome encompassing a vast open space below, was the heart of religious and imperial ritual, of great processions through the city, commemorating victories over enemies, feasts of the Church,

and deeds of the emperors. Churches and buildings reflected these ceremonies in their decoration, becoming increasingly detailed in content. In religious terms, as the celebration of the liturgy developed and became more elaborate, so too did the appearance and role of icons, vestments, and the fixtures and fittings of church worship. Silver church vessels survive from across the empire, from both village churches and major city churches.

Art had various functions assigned to it. It might be educative or inspirational; it was frequently described as having a function parallel to but more vivid than words. It allowed the individual access to the divine and a way of expressing gratitude and supplication to God. Works of art were proper gifts. However, Byzantine descriptions of their art are frustrating for the modern reader. Their stress lies less on describing what is visible to the audience and more on what the inner meaning of the image is. In a way incomprehensible to us, they emphasize the lifelike qualities of the image. They are explanations of art rather than descriptions, whose focus lies on the truths, usually religious, conveyed through art. Function not form, message rather than medium, are what mattered.

The effects of art and its magnificence are stressed in Byzantine writings. Byzantine aesthetics lie with light and brilliance. Both in the physical nature of their art, the use of mosaic, precious burnished metals, bright colours, and in their writings, it is clear that it was the scintillating play of light, its reflection on a multitude of surfaces, variegated colours that attracted the Byzantine beholder. Even ivories may well have been painted brightly and gilded to enhance their beauty and value. Moreover, colour also had a conceptual significance, for it was colour that defined the image, making its identity clear and its form visible. The monochrome had no place in Byzantine art. Coupled to aesthetic beauty was a very clear perception of cost; the value of a work of art enhanced its beauty considerably. The bigger and more lavish the church, the greater the patron and the more worthy the work of art.

Byzantine art is often criticized as flat, two-dimensional, hieratic, and unchanging. These are all accurate terms but to employ them as criticisms is to misunderstand the nature and role of art in Byzantium. The primary purpose of art was not aesthetic but pragmatic; it was not intended to be naturalistic as we understand that term. Such criticisms derive from 19th- and 20th-century beliefs in the primacy of classical and of Renaissance art as the height of human artistic endeavour; anything not in this model has been perceived as falling short of this standard. Within the study of Byzantine art, this has led to art historians examining the use of

the classical in Byzantium, defining periods such as the 10th and 14th centuries as eras of 'renaissance' because of their use of classical forms and styles. Such a privileging of the classical is an essentially subjective value judgement. There were good reasons why Byzantine art developed as it did, tied above all to its desire to picture the divine appropriately. The Iconoclastic dispute established that pictures did not lie but were an accurate reflection of the truths of the Christian message; they showed Christ as he was. Consequently, it is inevitable that all images must look alike.

So the aims and ambitions of Byzantine art are far from those of the classical period, as its rejection and utilization of the classical shows. Novelty for its own sake was a non-existent concept; innovations appeared in the form of ancient tradition. Many works have a close dependence on earlier examples, sometimes a direct derivation, sometimes a shared visual vocabulary of poses, gestures, backgrounds. Older models are constantly used and reused, details employed interchangeably. There is a limited iconographical corpus and a homogeneity to Byzantine art but it was devised by choice on the part of the Byzantines in line with their views on art and the nature of art. Iconoclasm established that holy images were true images and transmitted the presence and power of the divine. LJ

Cormack, R. S., *Writing in Gold* (1985).

Kazhdan, A., et al. (eds.), *The Oxford Dictionary of Byzantium* (1991).

Lowden, J., *Early Christian and Byzantine Art* (1997).

Mango, C., *The Art of the Byzantine Empire 330–1453: Sources and Documents* (1974).

Mathew, G., *Byzantine Aesthetics* (1963).

Rodley, L., *Byzantine Art and Architecture: An Introduction* (1994).

CABANEL, ALEXANDRE (1823–89). French painter. Born in Montpellier, Cabanel's precocious talent won him a scholarship to study at the École des Beaux-Arts in *Paris in 1839 and in 1845 he went to Italy as joint winner of the *Prix de Rome. On his return to Paris he received a number of commissions including the *Triumph of Flora* for the ceiling of the Cabinet des Dessins in the Louvre (see under PARIS). His decorative paintings, in which he combined the classical smoothness of *Ingres with the *Rococo composition of *Boucher, won him official recognition, fame, and fortune in the later 1850s and in 1862 his *Birth of Venus* (1862; Paris Mus. d'Orsay) dominated the Salon. This painting, in which a voluptuous naked Venus, attended by jubilant putti, reclines languorously on the waves, is typical of his highly finished, slick, and titillating works and was purchased by Napoleon III (1808–73), who commissioned several other paintings including portraits. Like *Bouguereau, his rival as the leading academic painter, he was vehemently anti-Impressionist and, like Bouguereau, his reputation dissolved after his death. DER

Alexandre Cabanel, exhib. cat. 1975 (Montpellier, Mus. Fabre).

CABINET PICTURES are small paintings that are intended to be viewed from a short distance. The term originally referred to the cabinets, or small rooms, that wealthy 16th-century connoisseurs throughout Europe would cram with paintings and other art objects. It is, however, used more broadly to denote any small painting intended for domestic display. The smaller 17th-century Dutch genre scenes and flower pieces are typical cabinet paintings. AJL

CADES, GIUSEPPE (1750–99). Italian copyist. Regarded by his contemporaries as a prodigy because of his extraordinary ability as a draughtsman, Cades was born in Rome of a French father and trained at an early age under Domenico Corvi (1721–1803). Though his independent attitude led to his expulsion from his master's studio, he went on to establish himself as a copyist, winning custom from British travellers on the *Grand Tour who wanted to return home with copies after old master drawings. His abilities were such that one of his early drawings after *Raphael was bought by the director of the Dresden cabinet under the impression that it was the original. In the late 1770s, his studio became a prominent attraction for visitors to Rome. His compositions reflect an intimate understanding of the old masters, from *Michelangelo and *Leonardo da Vinci to *Tibaldi, fused with the more solid *Neoclassical taste in fashion at the time. His deep religious convictions, remarked on by his contemporaries, are reflected in a style foreshadowing that of the proto-Romantics. In his way of blending different styles to suit the spirit of the age in which he was working he has often been compared to *Fuseli. XB

CAFFA, MELCHIORRE (1658–67). Maltese sculptor and draughtsman who by 1690 was attached to the workshop of Ercole *Ferrata in Rome. During his short life, he became the most important *Baroque sculptor in the city in the generation after *Bernini, by whom he was strongly influenced. His first major commission was the marble relief of *The Martyrdom of S. Eustace* in the Pamphili family church of S. Agnese in Agone, Rome, which was completed after his untimely death by Giovanni Francesco Rossi (active 1640–77). Other major projects, also left incomplete, included the *Charity of S. Thomas of Villanova* for S. Agostino, Rome; the *Baptism of Christ* for the high altar of Valletta Cathedral, Malta; the *Ecstasy of S. Catherine of Siena* for the high altar of S. Caterina da Siena a Monte Magnapoli, Rome (1667). He also showed a capacity for intimate and psychologically

penetrating portraiture, for instance the bust of *Alexander VII* (bronze version, New York, Met. Mus.). His capacity for stylistic innovation, and in particular the freedom of his modelling to produce painterly effects, is best appreciated through his terracotta sketch models, many of which are to be found at the Palazzo Venezia, Rome, the National Museum at Valletta, and the Hermitage, St Petersburg. Some of his drawings have been identified (Paris, Louvre; London, BM; Vienna, Albertina). HB

Montagu, J., 'The Graphic Work of Melchior Cafa', *Paragone*, 413 (1984).

CAFFIÉRI, JEAN-JACQUES (1725–92).

French sculptor. He came from a long line of sculptors and bronze-founders and became one of the most eminent sculptors of the second half of the 18th century. After training with *Lemoyne he won the *Prix de Rome in 1748. In Rome he executed a Baroque-inspired stucco group of the *Trinity* for the high altar of S. Luigi dei Francesi. He returned to Paris in 1754 and became a member of the Académie Royale (see under PARIS) in 1759. He worked for influential private clients in the prevailing sentimental *Rococo style. The group *Friendship Surprised by Love* made for Mme du Barry is typical, and its popularity is attested by numerous small-scale replicas, such as that of 1777 in the Ohio Museum of Art. Caffiéri also made notable contributions to the series of statues of great Frenchmen commissioned by the Crown, among them *Corneille* (1779; Paris, Louvre) and *Molière* (1787; Paris, Inst. de France). His skills, however, found their finest expression in his vivacious and naturalistic portraits. The best of his busts, such as that in terracotta of *Canon Pingré* (1788) in the Louvre, rival those of his younger contemporary *Houdon. Caffiéri also specialized in posthumous portraits: his busts of famous actors and dramatists in the foyer of the Comédie-Française in Paris were donated by the sculptor in return for free admission to the theatre during his lifetime. MJ

Guiffrey, J.-J., *Les Caffiéri* (1877).

CAILLEBOTTE, GUSTAVE (1848–94). A

member of a wealthy bourgeois Parisian family, Caillebotte both promoted the *Impressionists, and himself made an original contribution to their art. His *Self-Portrait at an Easel* (1879/80; priv. coll.) with, on his studio wall, Renoir's *Dance at the Moulin de la Galette* (Paris, Mus. d'Orsay) symbolizes this dual role. He painted characteristic Impressionist scenes of bourgeois leisure, of gardens, boating, and canoeing, but his most inventive works are large, modern history paintings of urban Paris. More traditional in technique, they are linked to Impressionism through insistently modern subjects. In *Pont de l'Europe*

(Geneva, Mus. de Petit Palais) the stark metal spans of the bridge, steep perspective, and taut social contrasts convey the bleak modern city recently created by Baron Haussmann. Its labourers form the theme of the *Floor Scrapers* (1875; Paris, Mus. d'Orsay) where the grave figures are presented without comment or pathos. These works suggest parallels with naturalist literature, as do the stifling interiors of such portraits as *Luncheon* (1876; priv. coll.). Caillebotte left over 60 Impressionist works to the French state. HL

Distel, A., et al., *Gustave Caillebotte*, exhib. cat. 1996 (London, RA).

CAIRO, FRANCESCO (1607–65). Italian

painter, born in Milan, who became court painter to Victor Amadeus I, Duke of Savoy, at Turin, in 1633. He may have trained under *Morazzone. His early works represent the culmination of the artistic revival initiated by *Cerano and G. C. *Procaccini in Milan in the early years of the century and are remarkable for their emotional intensity and for their depictions of half-length figures, ranging from *Herodias* to the *Magdalene* to *S. Francis*, in extreme states of ecstasy. His earliest known altarpieces, *S. Teresa's Vision of S. Peter and S. Paul* (Pavia, Certosa) and *The Death of the Blessed Andrea Avellino* (Milan, S. Antonio Abate), are conceived in a similar spirit, albeit within a more clearly defined architectural interior and with dramatic effects of chiaroscuro. There was no immediate change in style following Cairo's transfer to *Turin. Pictures, listed in a 1635 inventory of the Savoy Collection, which may well date from the period 1633–5, include an *Agony in the Garden*, a *Herodias with the Head of S. John the Baptist*, a *Martyrdom of S. Agnes*, and a *Death of Lucretia* (all Turin, Sabauda Gal.); they are all characterized by an almost erotic morbidity and a theatrical projection of light which lies at the opposite extreme to *Caravaggio's use of chiaroscuro to achieve a more naturalistic sense of dramatic engagement. Cairo's success at Turin led to his election to the Order of SS Maurice and Lazarus in 1634 and the grant of a regular stipend by the Duke of Savoy in 1635. Two years later he was sent to Rome for a year but was back in Turin by 1639. The experience of Rome caused Cairo to break free from his Lombard influences and to adopt a more conventional and painterly Baroque style loosely derived from Pietro da *Cortona and van *Dyck. In such works as the *Mystic Marriage of S. Catherine* (Toulouse, Mus. des Augustins) and the *Madonna and Child with S. Catherine of Siena and S. Alessandria* (Pavia, Certosa), which is documented as completed by 1645, the well-modelled, robust, unemotive figures adopt frozen static positions, against a landscape background, set in natural light. By 1648 Cairo had returned to Milan. Late documented works in a Baroque style, suggestive of Venetian 16th-

century influences, include an *Ecstasy of S. Teresa* (1654; Venice, S. Maria di Nazareth) and the *Assumption* (1662; S. Giulio di Orta, Basilica di S. Giulio all'Isola). But by now Cairo's art had lost all its fire and intensity, and it is for the excesses of his early *Mannerist style that he is now esteemed. HB

Testori, G., et al., *Francesco Cairo*, exhib. cat. 1983 (Varese, Mus. Civici).

CALABRESE, IL CAVALIERE. See PRETI, MATTIA.

CALDER, ALEXANDER (1898–1976).

American sculptor and painter, celebrated as the originator of the *mobile. Calder's father and grandfather were sculptors, and his mother a painter. The young Calder, however, studied mechanical engineering before enrolling at art school in 1923. He spent seven years in Paris, from 1926. His first mobile (a term coined by Marcel *Duchamp) dates from 1932; *Calderberry Bush* (1932; New York, Whitney Mus.) exhibits the attenuated form and abstract vocabulary characteristic of such pieces. Conversely his static sculptures were christened 'stabiles'. Calder's later work increasingly featured large-scale pieces made for public spaces. AA

Marter, J. M., *Alexander Calder* (1991).

CALIARI, PAOLO. See VERONESE, PAOLO.

CALLCOTT, SIR AUGUSTUS WALL

(1779–1844). English painter. Callcott entered the RA Schools in 1797 while simultaneously studying under *Hoppner. Although his earliest works were portraits he soon turned to picturesque landscapes, and by 1805 he had an established reputation and an aristocratic clientele. In 1815 he began to specialize in marine subjects of which *The Pool of London* (1816; Bowood, Wilts.), commissioned by Lord Lansdowne, is among the first and finest. He painted slowly, judiciously exhibiting only one picture a year, in a luminous style influenced by Dutch old masters and by his close friend J. M. W. *Turner. In 1827 he married Maria Graham, a pioneer writer on early Italian art, and spent a prolonged continental honeymoon studying pictures and meeting leading European artists. Sketches he made were developed into paintings, including *The Entrance to Pisa from Leghorn* (1833; London, Tate), over the next few years. His respected position in artistic society was acknowledged by his appointment to the board of the Government Schools of Design in 1836 and knighthood in 1837. After his death his reputation was undeservedly overshadowed by that of Turner. DER

Brown, D., *Augustus Wall Callcott*, exhib. cat. 1981 (London, Tate).

CALLISTRATUS (3rd or 4th century AD). Author of a collection of rhetorical descriptions of statues in Greek entitled *Ekphraseis*. Like the *Imagines* of the two *Philostrati, Callistratus' work is an example of the later classical rhetorical writers' interest in describing the visual arts in words. Like his predecessors, Callistratus often identifies the artist responsible for the work he describes and occasionally gives information about its location. Certain of the sculptures are known from other sources: the statue of *Kairos* (opportunity) at Sicyon and Scopas' *Maenad* are celebrated in epigrams in the *Greek Anthology*. Like the authors of the *Greek Anthology*, Callistratus is interested in the sculptors' paradoxical ability to create an impression of life and emotion from stone or bronze. His *Ekphraseis* were first published by Aldus Manutius in 1503 and translated into French by Blaise de Vigenère in 1597. RW

Philostratus, *Imagines*, and Callistratus, *Descriptions*, trans. A. Fairbanks (1931).

CALLOT, JACQUES (1592/3–1635). French draughtsman and print-maker from *Nancy, who perfected a method of etching by progressive biting of the plate, augmented by engraved work. He trained in Rome before moving to Florence in 1612, absorbing the sophisticated style of late *Mannerism, and responding in many witty plates to the ceremonies, masques, and carnivals which flourished under the Medici court. He excelled in drawing tiny strutting figures, often set against carefully observed townscapes, as in the *Capricci di varie figure* (1617).

He returned to Nancy in 1621, and, apart from brief spells in Paris in 1629 and 1630, remained there until his death. He was enormously productive, making more than 1,000 prints and hundreds of drawings. The grotesquerie of such plates as the *Temptation of S. Anthony* (1617) is counterbalanced by the harsh realism of his etchings of beggars, and he excelled in amassing teeming crowds in fairs and market places, while his enormous *battle scenes such as *The Siege of Breda* (1628) accommodate whole fleets and armies. His most famous prints are *Les Misères et les malheurs de la guerre* (1633), their atrocious imagery recording the horrors of the Thirty Years War. RGo

Choné, P., *Jacques Callot*, exhib. cat. 1992 (Nancy, Mus. Historique).

CALVAERT, DENYS, also called Dionisio Fiammingo (c.1540–1619). Flemish artist from Antwerp who, after an early training with the landscape painter Kerstiaen van Queboorn (1515–78), emigrated to Italy and remained there for the rest of his life. About 1560 he was in Bologna, where he studied with Prospero *Fontana and Lorenzo Sabatini (1530–76). In 1572 he accompanied the latter to Rome and assisted him in the decoration of the Sala Regia in the Vatican. Around 1575 he returned to Bologna, where he founded a successful Academy which was attended by, among others, Guido *Reni, *Domenichino, and Francesco *Albani. It lost some of its popularity after the establishment of the Accademia degli Incamminati of the *Carracci, which encouraged drawing from life rather than the copying from prints and other works of art as practised in Calvaert's school. Calvaert continued, however, to be a successful painter, essentially faithful to the *Mannerist style he had adopted in the studios of his Bolognese teachers (*Mystic Marriage of S. Catherine*, 1590; Rome, Capitoline Mus.). KLB

Dacos Crifò, N., and Meijer, B. W. (eds.), *Fiamminghi a Roma, 1508–1608*, exhib. cat. 1995 (Brussels, Palais des Beaux-Arts; Rome, Palazzo delle Esposizioni).

CALVERT, EDWARD (1799–1883). English painter and engraver who was born in north Devon and studied drawing in Plymouth after a spell in the navy. In 1824 he moved to London to enter the RA Schools and soon met Samuel *Palmer, George Richmond (1809–96), and other members of the 'Ancients', all deeply imbued with the spirit of William *Blake. Blake's *wood engravings for the *Pastorals* of Virgil (1821) inspired Calvert who, between 1827 and 1831, made a series of eleven minute and brilliant prints, mostly wood engravings, with a few copper engravings and lithographs. His delicate technique and vignette format give to some of his prints the quality of Antique cameos densely packed with an intense emotional response to landscape and figures. His world is that of Arcadia, e.g. *The Chamber Idyll* (1831), and *The Cyder Feast* (1828). These works are mostly seen in posthumous impressions in the *Memoir* produced by the artist's son (1893). Following the death of Blake in 1827, Calvert's work lost much of its poetic fervour and intense imaginative quality. With independent means, he spent much of his later life as a recluse, although he visited Greece in 1844. His work, now often painted in oil on paper, was of uneven quality, as he became obsessed with theories of *colour and music. MP

Lister, R., *Edward Calvert* (1962).

CAMARÓN Y BORONAT, JOSÉ (1731–1803). Spanish painter born in Segorbe, near Valencia, to a family of artists, Camarón began his apprenticeship with his father, a local sculptor. He moved to Valencia in 1753 to join the newly founded Academia de S. Barbara, and later to Madrid, where he became Academician of Merit at the Academia de S. Fernando (see under MADRID) in 1762. He is known for his cartoons for the Royal Tapestry Works and his small cabinet pictures, inspired by his cartoons or depicting scenes from Spanish life and local customs, in a vein similar to that of *Watteau's pastoral scenes.

Painted in rich pastel colours and a light feathery brush, his works reflect the taste of the Spanish nobility of the time for Spanish *Rococo scenes. His subjects, wearing costumes typical of the *majos* and *majas* of Madrid in contrast with the more Frenchified dress of Spanish society in this period, are often shown performing local dances such as the *seguidilla*, or engaged in other typical social pastimes. In 1768, Camarón was one of the founding members of the Valencian Academia de S. Carlos. XB

CAMBIASO, LUCA (1527–85). Italian painter and draughtsman. He was the principal artist in Genoa during the 16th century and the major formative influence on the Genoese School of the 17th century. Born in Moneglia, Liguria, he trained under his father Giovanni, and was already active as a painter in Genoa by 1544. His style shows a wide variety of influences including *Perino del Vaga, Pellegrino *Tibaldi, *Giulio Romano, *Pordenone, Domenico *Beccafumi, *Correggio, and Renaissance artists from Venice. He probably visited Rome c.1547–50. His early style was prone to *Mannerist excess, with exaggerated forms and bold foreshortening (for instance the *Adoration of the Magi*, Turin, Sabauda Gal.). During the 1560s he simplified his drawings, using characteristic cubist shapes to delineate form; and his paintings too show more restraint, as in the frescoes of the *Marriage of the Virgin* and the *Purification of the Virgin* (Genoa Cathedral). By the 1570s his style had been pared down to the stark austerity of the moving *Pietà* in S. Maria in Carignano, Genoa. He now embarked on a sequence of night scenes, many on a relatively small scale, designed for private use: *Madonna with a Candle* (Genoa, Palazzo Bianco), and *Christ before Caiaphas* (Genoa, Accademia Ligustica). In 1581 he was invited to submit a *Martyrdom of S. Lawrence* to the Escorial in Spain; and this led to an invitation from King Philip II of Spain to work for him there. He was commissioned to decorate the monastic church of S. Lorenzo and painted a rigidly schematic and theologically didactic *Gloria* for the sacristy vault (1584; Escorial). HB

Magnani, L., *Luca Cambiaso: da Genova all'Escorial* (1995).
Suida Manning, B., and Suida, W., *Luca Cambiaso: la vita e le opere* (1958).

CAMBRIDGE, FITZWILLIAM MUSEUM. The fine art museum and art gallery of the University of Cambridge, the

Fitzwilliam, named after its founder the 7th Viscount Fitzwilliam (1745–1816), was established in 1816. Fitzwilliam's collection, typical of that of an 18th-century English gentleman, included Italian High Renaissance paintings and the finest collection of *Rembrandt etchings then in England. Like the Ashmolean Museum, *Oxford, the collections have been largely built up through private benefactions, the most noteworthy being the bequest of Charles Brinsley Marlay (1831–1912) which greatly enriched all departments. By the beginning of the 20th century the museum was in some decay, starved of funds, and generally neglected by the university authorities. The reversal of this decline was achieved by the formidable Sir Sidney Cockerell (1867–1962), bibliophile and sometime secretary to William Morris, who held the directorship 1908–37. Cockerell was amongst the first museum curators to show fine and applied art together, placing excellent furniture, rugs, and carpets in the picture galleries which also benefited from bowls of flowers provided and arranged by devoted lady admirers. His considerable and influential contacts, in Britain and America, enabled him to make important acquisitions with the minimum of funds. The museum's collections are wide ranging, particular strengths being Greek coins (the Maclean Gift, 1906–12) and Italian paintings.

The building, on Trumpington Street, paid for by Fitzwilliam's bequest of £100,000, was begun in 1837 by George Basevi (1794–1845), continued by C. R. Cockerell (1788–1863), and completed by E. M. Barry (1830–80) in 1875, since when there have been several extensions. DER

CAMBRIDGE, MASS., WILLIAM HAYES FOGG MUSEUM OF ART,

founded in 1891 by a bequest of $200,000 to Harvard University from Elizabeth P. Fogg in memory of her husband, a very successful merchant. A building designed by Richard Morris Hunt opened in 1895 to house her collection of American landscapes and a selection of plaster casts after the Antique. The first director, an Englishman, Prof. C. H. Moore, added drawings by his teacher, *Ruskin, as well as *Turner. An extensive *Pre-Raphaelite collection was to become one of the Fogg's special strengths. The formation of a true museum, however, began with the appointment of Edward W. Forbes as director in 1909. Six years later he appointed as his assistant Paul J. Sachs, and together they served the Fogg until 1944, transforming it into a major museum and teaching institution. A new building constructed to their specifications opened in 1927. Mr Forbes's interest in the early Italian School led to the creation of a collection with notable works by *Spinello Aretino, *Giovanni di Paolo, Fra *Angelico, and *Botticelli. Two significant bequests

greatly augmented the 19th-century holdings. Among the nearly 4,000 works received from Grenville L. Winthrop in 1943 were paintings by *David, *Delacroix, *Ingres, *Géricault, and *Moreau and a cast of *Degas's *Petite Danseuse*. In 1950 the Maurice Wertheim Collection brought works by most of the *Impressionists and *Post-Impressionists as well as *Matisse and *Picasso.

Paul Sachs's taste was for drawings, and he left his extensive personal collection to the museum, where it has formed the basis of a world-famous collection, ranging from *Mantegna to *Mondrian. EZ

Bowron, E. P., *European Paintings before 1900 in the Fogg Art Museum* (1990).
Grenville L. Winthrop: Retrospective for a Collector, exhib. cat. 1969 (Cambridge, Mass., Fogg Art Mus.).

CAMDEN TOWN GROUP. See under LONDON.

CAMERA LUCIDA (Latin: light chamber), an apparatus for drawing and copying, patented in 1807 by William Hyde Wollaston, a well-known man of science. It received this misleading name (for it is not a chamber at all) because it performed the same function as the *camera obscura, but in full daylight. It consists essentially of a prism on an adjustable stand. The draughtsman sets the prism between his eye and the paper in such a way that light from the object is reflected into his eye at the same time as light from the paper. Thus he has the illusion of seeing the image on the paper and can trace its outline. The apparatus has been adapted for use with the microscope. HO

CAMERA OBSCURA (Latin: dark chamber), an apparatus which projects the image of an object or scene onto a sheet of paper or ground glass so that the outlines can be traced. It consists of a shuttered box or room with a small hole in one side through which light from a brightly lit scene enters and forms an inverted image on a screen placed opposite the hole. It is in this respect identical with the photographic camera. For greater convenience a mirror is usually installed, which reflects the image the right way up onto a suitably placed drawing surface.

*Aristotle noted the principle on which the camera obscura depends, having observed how the round image of the sun passed undistorted through the angular interstices of wickerwork. Early astronomers found it helpful to observe the solar eclipse with the aid of a camera obscura; it is described in this connection by the Arabian Alhazen (d. 1038). Roger Bacon (1214–94) appears to have known the mirror device. *Vasari refers to an invention of *Alberti's which sounds like the

earliest camera obscura as an instrument for *drawing. He compares it with the invention of printing, which he puts in the same year (1457). *Leonardo was the first to connect the camera obscura with the way the eye functions. To Giambattista della Porta, a physician of Naples, must be ascribed the first written account of its use for drawing and his description in his work on popular science, *Magia naturalis* (1558), did much to make the device widely known. Girolamo Cardano of Milan appears to have preceded della Porta in suggesting the fitting of a lens. In the early 1600s Johann Kepler, who gave the camera obscura its name, used it to record astronomical phenomena and also had a portable tent apparatus for drawing landscapes. The 17th-century Dutch painter Johannes Torrentius (1589–1644), who used a dark chamber for his *still-life painting, was suspected of witchcraft. *Vermeer experimented with this device and took pains to replicate the optical distortions observed through the apparatus, such as discrepancies of scale, collapsed perspective, halations, and blurred focus. In 1679 Robert Hooke built a transportable apparatus for landscape painters. By the 18th century the camera obscura had become a craze. Both amateurs and professionals, such as *Canaletto, were using it for topographical painting, and we hear of an apparatus, somewhat like a sedan chair, inside which the artist could sit and draw, at the same time actuating bellows with his feet to improve the ventilation. HO

CAMPAGNOLA FAMILY. Italian printmaker and draughtsman, **Giulio Campagnola** (c.1482–c.1516) was born in Padua, at the Ferrarese court in 1499, and was active in Venice in 1507. His figure style is sometimes influenced by *Mantegna, while his landscape backgrounds lift motifs from *Dürer's prints, but his most perfect engravings, such as the *Young Shepherd* and *Venus Reclining in a Landscape*, are inspired by the idyllic landscape style, with soft light and shade, and rustic buildings, of *Giorgione's *Sunset Landscape with S. Roch, S. George, and S. Anthony Abbot* ('Il Tramonto') (London, NG). His invention of a technique of *stipple engraving, in which shadows are created by dots, enabled him to convey the soft tones of Giorgione's pictures. Celebrated as a musician, and with a knowledge of Greek and Latin, Campagnola moved in highly cultivated literary circles, and his prints perfectly convey the mood of the then newly fashionable pastoral poetry.

Painter, printmaker, and draughtsman, **Domenico Campagnola** (c.1500–64) stimulated the development of landscape as an independent genre, and his prints and drawings spread an awareness of the Venetian landscape style to northern Europe. The son of a German artisan, he was probably born in Venice, and apprenticed to his

adoptive father Giulio. His early prints and signed landscape drawings, intended for collectors, reflect the delicate pastoral vision of Giorgione; *Titian inspired a series of more powerful works, such as the woodcut *Landscape with Wandering Family*, where small figures are set in the deep space of a rugged and mountainous terrain. He was established at Padua by 1523, where, as the city's leading artist, he painted altarpieces and frescoes, influenced by Titian and *Pordenone. HL

CAMPAÑA, PEDRO DE (c.1503–80). The Spanish name of a Brussels-born painter, Pieter Kempeneer, first documented in Bologna in 1529 working on the temporary decorations for the triumphal entry of the Emperor Charles V. From there he travelled to Venice in the service of Cardinal Grimani. In 1537 he moved to Seville, perhaps drawn by the presence there of a substantial Flemish community. His *Descent from the Cross* (1547; Seville Cathedral) reveals the impact of Campaña's Italian sojourn, particularly the influence of the followers of *Raphael, and also his Flemish background. The composition is based on a Roman engraving, but the angular figure of Christ and the hard edges of the draperies are northern in feeling. A later work, the impressive *Purification of the Virgin* (1555; Seville Cathedral) is more Italianate, marked by a spacious composition, masterful drawing of the human figure, and more natural treatment of the drapery. Campaña's other surviving Sevillian work is the enormous altarpiece painted for the church of S. Ana, begun in 1557. In 1562 Campaña left Spain to succeed Michiel *Coxcie as director of the tapestry factory in Brussels; he was active there designing tapestry cartoons throughout his old age. SS-P

Angulo Iñiguez, D., *Pedro de Campaña* (1951).

CAMPI FAMILY. Italian painters who dominated 16th-century Cremona, and also worked in Milan. **Galeazzo** (1477?–1536) painted devotional works, such as the *Virgin with S. Antony and S. Blaise* (1517; Milan, Brera), indebted to *Perugino and Giovanni *Bellini. Of his sons, **Giulio** (d. 1573) was a versatile, dazzlingly eclectic artist, who at S. Sigismondo, Cremona, created frescoes (1539–67) indebted to *Giulio Romano, while the cycle at S. Margherita, Cremona (1547), is an elegant, sumptuously decorative work inspired by *Raphael and *Parmigianino. **Antonio** (1523–87) collaborated on these projects, and his *Christ in the House of the Pharisees* (1577; Cremona, S. Sigismondo) is a blend of *Mannerist splendour with naturalistic detail. Later, he created starker, more concentrated works, and explored effects of light in highly theatrical night scenes, such as the *S. Catherine in Prison* (1583; Milan, S. Angelo). **Vincenzo**

(1530×5?–91) was indebted to Lombard naturalism, and such works as *Christ Nailed to the Cross* (1577; Madrid, Prado) are dramatically lit and violent narratives. He also painted *still life and *genre (kitchen scenes, fruit and fish vendors), which are rich in erotic and comic allusions and were often intended for foreign patrons (*Kitchen Scene*; Milan, Brera).

Bernardino Campi (1522–91) was not related to this family, but was initially a pupil of Giulio. He was a more refined and colder Mannerist artist, who became fashionable in Milan and Cremona, where his most famous works are the *S. Cecilia and S. Catherine* (1566; Cremona, S. Sigismondo), an elegant, sumptuous picture, indebted to Parmigianino, and the decoration of the dome of the church (1570). HL

Gregori, M. (ed.), *I Campi e la cultura artistica cremonese del cinquecento*, exhib. cat. 1985 (Cremona, Mus. Civico).

CAMPIGLI, MASSIMO (1895–1971). Italian painter, born in Florence. He trained as a journalist in Milan (where he associated with the *Futurists) and was self-taught as a painter. In the First World War he fought in the Italian army and was taken a prisoner of war; after his release he settled in Paris, where he lived from 1919 to 1933. As Campigli himself said, *Léger and *Picasso were major influences on his early work, but after seeing an exhibition of Etruscan art on a visit to Rome in 1928 his style was completely transformed: he abandoned perspective and his figures became two-dimensional and hieratic (although they have an air of dolls rather than of ancient presences). In the 1930s he began to establish an international reputation and received several commissions for large murals, to which his flat figures with their exaggerated gestures were well suited; examples are in the Palace of the League of Nations in Geneva (1937), the Palazzo di Giustizia, Milan (1938), and the Palazzo del Liviano, Padua (1939–40). In 1933 Campigli had returned to Milan; he spent the Second World War there and in Venice, and afterwards lived variously in Milan, Paris, Rome, and St Tropez (where he died). By the middle of the century he was perhaps the best-known internationally among contemporary Italian painters, and his work is represented in many public collections of Europe and America. His reputation has faded somewhat since his death. IC

CAMPIN, ROBERT (c.1375×79–1444). Netherlandish painter, possibly born in Valenciennes, who was active in Tournai from 1405/6. He purchased citizenship there in 1410 and was involved in municipal and guild affairs, although at times earning the disapproval of the authorities for his political sympathies and behaviour.

Campin's studio was highly productive, securing civic and private commissions—a mural for Tournai's Halle des Jurez and polychromed sculptures for the church of S. Brice. Little survives which can be identified with these commissions to provide a basis for attribution, although damaged fragments of an *Annunciation* mural found in S. Brice may be related to a payment of 1406–7 to 'Mestre Robert le pointre'.

Campin trained several apprentices, including Jacques *Daret and 'Rogelet de la Pasture', probably identifiable with Rogier van der *Weyden. On the strength of these associations Campin is now widely supposed to be identifiable as the *Master of Flémalle, whose work shows strong similarities with the style of van der Weyden and Daret. MS

Campbell, L., 'Robert Campin, the Master of Flémalle and the Master of Merode', *Burlington Magazine*, 116 (1974).
Châtelet, A., *Robert Campin: le maître de Flémalle: la fascination du quotidien* (1996).
Foister, S., and Nash, S., *Robert Campin: New Direction in Scholarship*, proceedings of symposium, 1996 (London, NG).

CAMPIONESI, a term that refers to a group of sculptors and architects, not always related to one another, from Campione di Lugano. They were active in and around northern Italy from the mid-1100s to the late 1300s. An early document relating to them mentions that a certain **Anselmo** was Master of Works at Modena Cathedral from the mid-12th century, and that Anselmo's descendants continued to work there after 1244; their sculptural style is distinguished by the large heavy forms of figures that are designed with a lively realism. Related works are attributed to their circle in Milan, Bologna, Parma, and Switzerland. By the late 13th century their distinctive style had merged with the work of other north Italian sculptors. Among the most important Campionesi of the 14th century was **Giovanni da Campione**, who worked in Bergamo on various projects, including an equestrian statue of *S. Alexander* (1353; S. Maria Maggiore), characterized by solid forms and a lack of movement. In 1370–6 **Bonino da Campione** signed the *tomb of Cansignorio della Scala (Verona, S. Maria Antica). FB

Bossaglia, R., et al., *I maestri campionesi* (1992).

CANADIAN ART (1) *Painting;* (2) *Sculpture*

1. PAINTING
Canada's art reflects divided roots in the Catholic French and Puritan British colonies. *La France apportant la foi aux Hurons de la Nouvelle France* (c.1670; Quebec, Ursuline Monastery), attributed to Frère Luc, typifies popular naively painted allegories often used by Jesuit missionaries. Frère Luc (1614–85), and

Abbé Jean Guyon (1659–87) stand out among early clerical painters; secular artists emerged during the 18th century, including Michel Dessailliant de Richeterre (active 1701–23) and Paul Malepart de Beaucourt (1700–56), although religious subject matter remained paramount.

Puritan iconoclasm initially restricted British-Canadian painting to portraiture and topography. However, landscape painting quickly developed, Thomas Davies (c.1737–1812) and George Heriot (1759–1839) being the most accomplished celebrants of the wilderness, while Robert Todd (1809–66) illustrated favoured beauty spots in the naive style. William Berczy (1744–1813) painted portraits in Montreal, as did George Berthon (1806–92) in Toronto; Robert Field (1769–1819) established a successful provincial practice in Halifax.

In Quebec Joseph Légaré (1795–1855) painted dramatic natural and urban landscapes and Antoine Plamondon (1804–95) developed French *classicism in austere but sensitive portraits; his late *genre scenes extended Canadian subject matter; Théophile Hamel (1817–70) painted acutely characterized portraits in primitive style. Paul Kane (1810–71), inspired by the American George Catlin, painted among the native Canadians, producing 1845–8 a powerful record of a dying lifestyle. Cornelius Krieghoff's (1815–72) anecdotal landscapes portrayed native Canadians and settlers with equal animation, as in Merrymaking (1860; New Brunswick, The Beaverbrook AG).

After Confederation (1867) landscape painting reflected new interest in the reintegrated country. Otto Jacobi (1812–1901), William Raphael (1833–1914), and Adolphe Vogt (1842–71) emphasized Nature's heroic qualities, as in Vogt's Niagara Falls (1869; Ottawa, NG Canada). Montreal became an artistic centre through the Art Association of Montreal (1860) and the Society of Canadian Artists (1867); from 1873 this focus shifted to Toronto and the Ontario Society of Artists. One notable member was Lucius O'Brien (1832–99), first president of the Royal Canadian Academy of Arts (1880). His work follows American *Luminism, expressing spirituality in landscape through light and colour; Sunrise on the Saguenay (1880) instantly entered the new National Gallery in Ottawa. John Fraser (1858–98) and Frederick Verner (1836–1928) also developed this vein of sublime landscape.

From 1890 Canadian artists, especially the realists, looked to France. William Brymner (1855–1925) and Robert Harris (1849–1919) established an influential objective *realism: Harris's iconographic The Fathers of Confederation (1886; destr.) was typical. Harmony (1886; Ottawa, NG Canada) shows the sensitivity the style also achieved. His pupil George Reid (1860–1947) painted monumental genre

scenes, while experimenting with *Impressionist landscape.

The Canadian Art Club provided a *modernist forum from 1907. The first president, Homer Watson (1855–1936), painted closely observed landscapes, including The Stone Road (1881; Ottawa, NG Canada), earning him international fame as 'the Canadian Constable'. Later works, lyrical, but lacking intensity, reflect his self-conscious awareness of the comparison. His friend and successor Horatio Walker (1858–1938) painted, with a sombre poetry, peasant scenes influenced by *Millet.

Impressionism thrived in evocative snowscapes by Maurice Cullen (1866–1934) and the atmospheric compositions of James Wilson Morrice (1865–1924), whose The Ferry, Quebec (1907; Ottawa, NG Canada) exemplifies his decorative harmonies of colour and form. Morrice associated with the *Fauves in Paris, bringing the concept of 'pure' painting back to Canada, to be taken up by John Lyman (1886–1967) from the 1940s.

Against the Canadian Art Club's cosmopolitan ambitions, the *Group of Seven proposed a nationalist art based on native traditions. Led by Lawren Harris (1885–1970), and including Arthur Lismer (1885–1969), J. E. H. MacDonald (1873–1932), Frederick Varley (1881–1969), and A. Y. Jackson (1882–1974), they exhibited in Toronto in 1920, establishing a distinctive style related to *Art Nouveau and *Post-Impressionism, but also to native folk art and natural landscape. Harris's Maligne Lake, Jasper Park (1924; Ottawa, NG Canada) and Jackson's Early Spring, Quebec (1926; Toronto, AG Ontario) are outstanding.

Linked with the Group was Tom Thomson (1877–1917), whose magnificent paintings of the Algonquins celebrate the metaphysical power of nature through colour and texture: the economical rhythms of Petawawa Gorges (1916; Ottawa, NG Canada) strikingly convey the wilderness spirit. Emily *Carr, Lionel LeMoine FitzGerald (1890–1956), and David Milne (1882–1953) painted independently of the Group, but shared their fierce nationalist attachment. Carr, inspired by native Canadian culture, painted atmospheric rainforest studies; Milne's delicate still lifes brought an imaginative intimacy to Canadian painting.

In 1933 the Group of Seven expanded to form the Canadian Group of Painters, including A. J. Casson (1898–1992) and Carl Schaefer (1903–95), whose Storm over the Fields, Hanover (1937; Toronto, AG Ontario) demonstrates a development of the original group style, bringing emotional force into starkly organized landscape. Charles Comfort's (1900–94) emphatic landscapes, the decoratively symbolic murals of Will Ogilvie (1901–89), and the genre paintings of Henri Masson (1907–) continued this native-based tradition.

Bertram Brooker (1888–1955), the first Canadian *abstract painter, produced geometric constructions influenced by *Stella and *Kandinsky. Later stylized figuration aligned him with the Montreal-based Beaver Hall (Hill) Group, boldly original figure painters including Prudence Heward (1896–1947), Lilias Newton (1896–1980), and Sarah Robertson (1891–1948).

Modernist painters rejected the Canadian Group's determined provincialism. The Contemporary Art Society brought the European avant-garde to Montreal in 1939, eagerly welcomed by native artists. Marian Scott (1906–93) developed a powerful biomorphic abstraction; Alfred Pellan (1906–88) gave an idiosyncratic twist to *Surrealism, contrasting with Goodridge Roberts's (1904–74) grave classicism.

Paul-Émile *Borduas organized the *Automatistes, a radical group of young painters including Marcel Barbeau (1925–), Fernand Leduc (1916–), and Jean-Paul Riopelle (1923–), whose work gained international acclaim, from Borduas's abstract figuration to Riopelle's richly coloured non-objective dream-images. In Toronto, Jock Macdonald (1897–1960) and William Ronald (1926–99) assembled Painters Eleven, developing an enigmatic abstraction of strong-coloured, biomorphic forms: Macdonald's Nature Evolving (1960; Toronto, AG Ontario) and Oscar Cahén's (1916–56) Painting on Olive Ground (1956; Sarasota, Ringling Mus.) are evocative examples.

Regional centres flourished: the stark figure paintings of Alex Colville (1920–) in New Brunswick established a school of *magic realism; in the West the 'Regina Five', including Kenneth Lochhead (1926–), Arthur McKay (1926–), and Ronald Bloore (1925–), created hallucinogenic abstractions of colour and animistic form. B. C. Binning (1909–76) developed decorative formal abstraction in Vancouver, contrasting with the nature-based, abstract Surrealism of Jack Shadbolt (1909–). Hard-edged abstraction continued with Roy Kiyooka (1926–94), and the Plasticiens, led by Guido Molinari (1933–) and Claude Tousignant (1932–). Joyce Wieland (1931–98) investigates female sexuality through colour-articulated space. The work of Michael Snow (1929–) and Greg Curnoe (1936–92) recalls elements of *Dadaism and *Pop art.

2. SCULPTURE

Sculpture in Canada developed slowly, beginning in woodcarving for church decoration, the 18th-century work of the Levasseur and Baillairgé families being typical. François Baillairgé (1759–1830) also undertook secular commissions; his portrait busts show the influence of French classicism into the 19th century, as do works by Louis-Philippe Hébert (1850–1917) and his son Henri (1884–

1950). Walter Allward (1876–1955) and Alfred Laliberté (1878–1953) produced competent if unadventurous memorial statues, while Marc-Aurèle Suzor-Coté (1869–1932), who experimented with Impressionist painting, made interesting small sculptures inspired by rural life. More recently Louis Archambault (1915–) combined archaic and modern European influences, tautly balancing the primitive and lyrical, while the inclined painted planes and bronze columns of Robert Murray (1936–) herald a vital abstract tradition.

A preoccupation with modern materials emerges in abstract constructions by Ed Zelenak (1940–), Nobuo Kubota (1932–), and the Rabinowitch brothers (1943–), balancing George Sawchuk's carved trees, which reshape the living wilderness. Geoffrey Smedley's (1927–) complex constructions and Murray Favro's (1940–) installations demonstrate a *postmodernist impetus continued by Marcel Gosselin (1948–) and Robert Wiens (1953–) among others; Joe Fafard's (1942–) ceramic figures assert the vitality of Canadian Primitivism. JH

Bringhurst, R., et al. (eds.), *Contemporary Art in Canada* (1983).
Burnett, D., and Schiff, M., *Contemporary Canadian Art* (1983).
Harper, J. R., *Painting in Canada: A History* (1966).
Lerner, L. R., *Art and Architecture in Canada* (1991).
Reid, D., *A Concise History of Canadian Painting* (2nd edn., 1988).
Townsend, W. (ed.), *Contemporary Canadian Painting* (1970).

CANALETTO (Giovanni Antonio Canal) (1697–1768). Venetian painter. He worked in the theatre with his father Bernardo and went with him to Rome in 1719. There he turned to topography under the influence of Roman *topographical painters and engravers. Returning to Venice, he collaborated in producing a series of decorative canvases for the Duke of Richmond; but by 1723 he was painting dramatic and picturesque views of Venice, marked by strong contrasts of light and shade and free handling. Often he combined more than one viewpoint in the same composition. Examples are four pictures commissioned by Stefano Conti of Lucca (priv. coll.) which can be dated 1725 and 1726 from documents in Canaletto's own hand. This phase of Canaletto's work culminated in the splendid so-called *Stonemason's Yard* (1727–8; London, NG). Meanwhile, partly under the influence of Luca *Carlevaris, the first painter in Venice to practise topography systematically, and largely in rivalry with him, Canaletto began to turn out views which were more topographically accurate, set in a higher key, and with smoother, more precise handling—characteristics that mark most of his later

work. At the same time he became more prolific as a draughtsman, mainly in pen and ink; and began painting the ceremonial and festival subjects which ultimately formed an important part of his work. His patrons were chiefly English collectors, for whom he sometimes produced series of views in uniform size, a notable example being in the collection of the Duke of Bedford (Woburn), painted in the early 1730s.

Conspicuous among his patrons was Joseph Smith, an English merchant in Venice, appointed British consul there in 1744, who brought together a remarkable collection of 18th-century Venetian painting and a fine library. He is often said to have exploited Canaletto to his own advantage, though the evidence is inconclusive. In any event he seems to have been Canaletto's main support in the early 1740s, when the outbreak of the war of the Austrian Succession greatly reduced the number of visitors to Venice. Perhaps at the instance of Smith, Canaletto at this time enlarged his repertory to include subjects from the Venetian mainland and from Rome (probably based on drawings made during his visit as a young man) and by producing numerous *capricci, arbitrary groupings of material drawn from different places, and *vedute ideate* or imaginary landscapes. He also gave increased attention to the graphic arts, making a magnificent series of etchings, and many drawings in pen and pen and wash as independent works of art and not as preparation for paintings. This led to changes in his manner of painting, increasing an already well-established tendency to become stylized and mechanical in handling and encouraging the use of dark shadows with sharply dotted lights. In 1746 he went to England, apparently at the suggestion of Jacopo *Amigoni, one of the many Italian painters who had sought their fortunes there. For a time he was very successful, painting views of London and of various country houses for, among others, the Duke of Richmond (Goodwood) and Sir Hugh Smithson, later Duke of Northumberland (Alnwick, Northumb.). Subsequently, with declining demand, his work became increasingly lifeless and mannered, so much so that rumours were put about, probably by rivals, that he was not in fact the famous Canaletto but an impostor. About 1755 he was finally back in Venice and remained active as painter and draughtsman with undiminished skill, though still highly mannered. A notable work of this period was the set of twelve elaborate drawings (c.1763) of ceremonies in which the Doge took part, best known from reproductive engravings from which paintings were made by *Guardi. In 1763, after an earlier unsuccessful candidature, he was elected a member of the Venice Academy. Legends of his having amassed a

fortune in Venice are disproved by the official inventory of his estate on his death. Before this, Joseph Smith had sold his library and the major part of his paintings to George III, thus bringing into the royal collection (see under LONDON) an unrivalled group of Canaletto's paintings and drawings. Added to examples in English public and private collections this makes England incomparably richer in his work than any other country. HO/HB

Baetjer, K., and Links, J., *Canaletto*, exhib. cat. 1989 (New York, Met. Mus.).
Bomford, D., and Finaldi, G., *Venice through Canaletto's Eyes* (1998).
Constable, W., and Links, J., *Canaletto* (1989).

CANDID, PETER, also called Pietro Candido or Pieter de Witte (c.1548–1628). Flemish painter, tapestry designer, and draughtsman, active in Italy and Germany. He was one of several Italian-trained *Mannerist artists employed by the courts of Europe, and was the leading figure in Munich 1600–28. His early works, mostly altarpieces, were done in Florence, in a manner close to *Bronzino and Alessandro Allori (1535–1607). In 1586 he was summoned to the court at Munich (upon the recommendation of the sculptor *Giambologna), where he remained for 40 years. As in Italy, he produced mainly altarpieces, which are distinguished by large figures, symmetrically arranged, and by luminous colours and iridescent hues (*Assumption of the Virgin*; Munich, Frauenkirche). Under Duke (later Elector) Maximilian I, Candid's main occupation was as designer of tapestries (*The Months*; Munich, Residenz). He was also responsible for all interior paintings at the new buildings added by Maximilian to the Residenz in Munich and the Altes Schloss at Schleissheim. KLB

Um Glauben und Reich, exhib. cat. 1980 (Munich, Residenz).

CANGIANTISMO (Italian *cangiare*: to change), a system of modelling, described in *Cennini's *Libro dell'arte*, in which shifts of hue create the midtones and the lights. A green robe, for example, may have yellow highlights, and be shaded with ultramarine blue. It was perhaps invented by *Giotto, and was widely used by Florentine and Paduan painters in the 14th and 15th centuries, in both tempera and fresco painting. It is antinaturalistic, and such works as *Lorenzo Monaco's *Coronation of the Virgin* (London, NG) create a sense of celestial beauty through a decorative display of shot or *cangiante* fabrics. *Michelangelo's Sistine ceiling (Vatican) displayed brilliant effects of *cangiantismo* with new power and variety, and his turquoise-violet and orange-blue hue-shifts fascinated the *Mannerist painters, as revealed by *Pontormo's *Deposition* (Florence, S. Felicita) or *Rosso Fiorentino's *Deposition* (Volterra, Pin.).

With the Counter-Reformation demand for naturalism such extravagant colour became outmoded, although *Barocci employed a modified form of *cangiantismo*.　　HL

Hall, M. B., *Color and Meaning: Practice and Theory in Renaissance Painting* (1992).

CANO, ALONSO (1601–67). Spanish painter, sculptor, and architect, born in Granada. He trained as a painter with *Pacheco in Seville and entered its guild in 1626. His early paintings are tenebrist and naturalistic. In the early 1620s he joined the workshop of the sculptor Juan Martínez *Montañés, and most of his youthful works are sculptural (retable for the church of Lebrija, 1629–31). Cano's painting became luminous c.1635/7 and his sculpturesque figures are idealized and elegant (*Vision of S. John the Evangelist*; London, Wallace Coll.). In 1638, he went to Madrid as painter to the Count-Duke of Olivares, where his style became more painterly (*Miracle of the Well*, c.1648; Madrid, Prado). In 1652 he moved to Granada as prebendary of the cathedral and started a series of monumental canvases of the life of the Virgin for its rotunda. In the following years he also produced some of his best sculpture (*S. Anthony with the Christ Child*, 1653–7; Granada Mus.; *Immaculate Conception*, 1655–6; Granada Cathedral sacristy). After a three-year stay in Madrid, he finally settled in Granada in 1660. His last work was the design for the façade of its cathedral, of which he was appointed architect in 1667.　　NAM

Wethey, H. E., *Alonso Cano, Painter, Sculptor, Architect* (1955).

CANOVA, ANTONIO (1757–1822). Italian sculptor who was possibly the most accomplished and certainly the most famous sculptor of the *Neoclassical movement, his rivals being *Thorvaldsen and *Flaxman. He trained in and near Venice and his earliest works are typical of the late *Baroque. But by the time of *Daedalus and Icarus* (1778–9; Venice, Mus. Correr) he had already moved towards a synthesis of the naturalistic and the classical. The decisive event in Canova's career was his move to Rome in 1779, where he fell under the influence of *Antique art and the group of artists, scholars, and archaeologists inspired by *Winckelmann. The unveiling in 1787 of his monument to Pope Clement IV in S. Peter's brought him instant acclaim with its austere and monolithic reinterpretation of its Baroque prototypes. He continued to refine and simplify his concept of the funerary monument for the rest of his career, the culminating and most radical example being that to Maria Christina of Austria in the Augustinian church, Vienna (1798–1805). With its line of marble mourners moving towards the entrance of a pyramidal sepulchre it is the benchmark of Neoclassical simplicity

and *larmoyante* sensibility in the same way that *Bernini's monument to Urban VIII in S. Peter's is the high-water mark of Baroque complexity and drama.

Alongside these funerary works Canova carved many ideal marble groups, most prominent among them *Cupid Awakening Psyche* (1783–93; Paris, Louvre) and *The Three Graces* (1812–16; St Petersburg, Hermitage). The latter shows the extent to which Canova in his later career moved away from close imitation of his Antique prototypes to create an entirely modern sculpture of exquisite refinement of conception, touch, and sensibility. Such an achievement was the result of a long process of abstraction from the vigour and passion of his first drawings and sketch models: the marble works were mainly carved by assistants from full-size plaster models, Canova himself then adding the final refinements of surface and patination.

By 1800 Canova was the most famous sculptor in Europe and much in demand for portraits as well as large-scale commissions. Particularly striking among them are those of members of the Bonaparte family. These include a colossal nude statue of *Napoleon as Mars the Pacifier* (1803–6; London, Apsley House) and a reclining one of *Paolina Borghese Bonaparte as Venus Victorious* (1804–8; Rome, Borghese Gal.), which posterity has judged transcendent and absurd by turns. In his last years Canova used part of his accumulated wealth in building a circular Neoclassical church at his native Possignano (1819–30). This serves as his mausoleum and nearby stands the Gipsoteca Canoviana, housing his drawings and terracotta and plaster models.　　MJ

Licht, F., *Canova* (1983).
Pavanello, G., *L'opera completa del Canova* (1976).
Pavanello, G., and Romanelli, G., *Antonio Canova*, exhib. cat. 1992 (Venice, Mus. Correr).

CANVAS. See SUPPORTS.

CAPANNA, PUCCIO (active c.1330–50). Italian painter, the major practitioner of a developed Giottesque style in the mid-trecento. The relatively recent identification and assessment of Puccio's œuvre has been made on the basis of a fragmentary but documented fresco of the *Virgin and Child with SS Francis and Clare* of 1341 (Assisi, Pin.). Most of his surviving work is located in Assisi, and he is likely to have emerged from one of *Giotto's teams decorating the lower church of S. Francesco there (see under ASSISI). His own frescoes of scenes from the life of S. Stanislaus in the lower church cantoria (c.1330) reveal a fundamental debt to the plasticity and spatial daring of *Giotto's mature style, together with a refinement of colour and modelling and volumetric weight reminiscent of the art of *Maso di Banco. The tonal blending

and smoky modulation of surfaces in the Pinacoteca fresco's Christ child and in the figures of the frescoed *Crucifixion* in the former chapter house of S. Francesco can scarcely be matched in the trecento.　　JR

Zanardi, B., 'Da Stefano Fiorentino a Puccio Capanna', *Storia dell'arte*, 22 (1978).

ČAPEK, JOSEF (1887–1945). Czech painter and writer. Born in Schwadonitz, he studied weaving (1901–3) before attending the School of Applied Arts in Prague (1904–10) where he was influenced by the decorative qualities of Secessionist art (see SEZESSION). In 1910 he went to Paris with his brother Karel, the writer (1890–1938), with whom he later collaborated on the allegorical anti-totalitarian *Insect Play* (1921). Returning to Prague in 1911 the brothers founded the *Cubist-inclined Group of Plastic Artists, with Otto *Gutfreund and *Filla, but he left in 1912 over his attempts to combine Cubist form with *Expressionist content. By c.1915, when he painted *Man in the Hat* (Hradec Králové, Regional Gal.) he had achieved a personal synthesis of Cubism, *classicism, and *Symbolism. His work of the 1920s is more expressive and reveals his growing concern with the state of society and by the end of the decade he had introduced elements of Czech folk art, with simplified figures in bold colours. *Fire I* (1938; Prague, Národní Gal.) is the first of a series of dramatic Expressionist anti-war paintings. A fervent anti-Nazi, he was arrested by the Germans in 1939 and died in Belsen.　　DER

Pecirka, J., *Josef Čapek* (1961).

CAPPELLE, JAN VAN DE (1626–79). Dutch businessman, collector, painter, and draughtsman. In 1674 van de Cappelle inherited his father's dyeworks in Amsterdam, giving him the financial freedom to pursue his painting. He was never considered a professional artist, neither did he join a guild, nevertheless he owned an outstanding art collection and is considered to be an exceptional *marine painter. The inventory of his collection comprised 200 paintings including works by *Rubens and *Rembrandt. Of the more than 6,000 drawings, many were by Simon de *Vlieger and Rembrandt, particularly nearly all of the latter's landscape sketches. As an artist, van de Cappelle was thought to have been self-taught, using his pleasure yacht as an opportunity to sketch from nature. *Shipping Scene with a Dutch Yacht Firing a Salute* (1650; London, NG) reveals van de Cappelle's novel approach. The horizon is low, the masts and hulks of the ships making a series of horizontals and verticals receding far into the distance. In particular, van de Cappelle brought new subtlety to his treatment of light and reflections, at first cool and silvery

and later more golden. Besides marine subjects, van de Cappelle also painted winter scenes. CFW

Russell, M., *Jan van de Cappelle* (1979).

CAPRICCIO, an Italian term meaning caprice or fancy. According to *Baldinucci, writing in the 17th century, it meant an 'idea or invention' and could thus apply to any fanciful subject. However, during the 18th century and since, it has been used to describe architectural fantasies which combine real and imaginary buildings, ruins, or monuments in one composition, such as *Canaletto's *The Colleoni Monument in a Caprice Setting* (1744; London, Royal Coll.). They were sought by *Grand Tourists and were often used in decorative schemes as overmantels and over-doors (*sopraporte*). Venetian artists, including Antonio Visentini (1688–1782), *Marieschi, and Marco and Sebastiano *Ricci, excelled at capricci and they were considered superior to view paintings (*vedute*) as being works of the imagination. Canaletto's reception piece on his election to the Venetian Academy in 1763 was a *Capriccio with Colonnade* (c.1765; Venice, Accademia). Capriccio subjects were also popular as *etchings, *Piranesi's *Invenzioni capricciose di carceri* (c.1745) and Giambattista *Tiepolo's *Capricci* and *Scherzi* of the 1740s and 1750s being among the finest. By the end of the century, in *Goya's *Los caprichos* (1799), the architectural element has been replaced by the macabre. DER

CARACCIOLO, GIOVANNI BATTISTA (Battistello) (1578–1635). Italian painter. His style was formed on close study of *Caravaggio, whose work he studied not only in Naples but also in Rome; yet, unlike Caravaggio, he also painted in fresco. Born in Naples, he probably trained under Belisario Corenzio (1590–1646). His signed *Immaculate Conception with SS Dominic and Francis of Paola* (1607; Naples, S. Maria della Stella) marks a major landmark in the development of Neapolitan painting towards Caravaggesque naturalism. His *Baptism of Christ* (Naples, Pin. Girolamini) clearly reflects the extent to which he had embraced Caravaggio's expressive approach and spontaneous technique, with no hint of Mannerist artifice. The *Liberation of S. Peter* (1615; Naples, Pio Monte della Misericordia) continues this development although there are echoes too of the more polished and refined manner of Orazio *Gentileschi, whom he had met in Rome the previous year. In 1618 Caracciolo, whose reputation had now spread beyond Naples, visited *Florence to work for the Grand Duke Cosimo II de' Medici; and he was frequently in *Genoa between 1618 and 1624. He was one of the artists employed there by Marcantonio Doria to paint frescoes for his villa at Sampierdarena (now destr.). A hint of the expressive late *Mannerism associated with the Lombard painter *Cerano is evident in Caracciolo's tender *Agony in the Garden* (Vienna, Kunsthist. Mus.) and a second version in the parish church at Rho. Caracciolo's mature masterpiece is *Christ Washing the Feet of the Disciples* (1622; Naples, Certosa di S. Martino), executed in fresco. Here he breaks free from Caravaggesque tenebrism and places the still realistic figures within a clearly defined and dramatically lit architectural interior; and both through gesture and expressive form explores the individual emotions of the protagonists in the tradition of *Baroque classicism that runs from *Raphael to *Poussin. This may explain the otherwise surprising commission for history paintings for five sections of the vaulted ceiling of the Palazzo Reale, Naples, representing *Exploits of the Great Captain Consalvo de Cordova* (1625–30; *in situ*). HB

Whitfield, C., and Martineau, J. (eds.), *Painting in Naples 1606–1705: From Caravaggio to Giordano*, exhib. cat. 1982 (London, RA).

CARAVAGGIO (Michelangelo Merisi) (1571–1610). Italian painter, born at Caravaggio, near Bergamo, and apprenticed in 1584 in Milan to Simone Peterzano, who claimed to be a pupil of *Titian. By 1592, with both parents dead, he had run through his inheritance. Soon afterwards he left for Rome, where he lived in poverty, did various hack work, and then painted fruits and flowers in the studio of *Cavaliere d'Arpino. Two highly finished early half-lengths of youths with prominent *still lifes are the *Sick Bacchus* and the *Boy with a Basket of Fruit* (both Rome, Borghese Gal.). Later, he sold his work through a dealer and the *Cardsharpers* (Fort Worth, Kimbell Mus.) attracted the attention of Cardinal del Monte who took Caravaggio into his household, probably around 1595–6. The *Cardsharps* and the contemporary *Gypsy Fortune-Teller* (Rome, Capitoline Mus.) were a new *genre in which contemporary types, painted from life, enact anecdotal tableaux of deceit.

Del Monte was at the centre of the most cultured circles in *Rome and Caravaggio made contact with advanced patrons such as Vincenzo Giustiniani and with leading poets such as Gaspare Murtola and Giambattista Marino who both celebrated his paintings. Music was especially important and it provided the theme for the *Musicians* (New York, Met. Mus.) and the *Lute-Player* (St Petersburg, Hermitage), in both of which lightly draped androgynous musicians embody an unattainable world of beauty and refinement.

Caravaggio's first major Roman religious commission was for the Contarelli chapel in S. Luigi dei Francesi where the two lateral paintings (both *in situ*) were unveiled in 1600.

In these works Caravaggio first made expressive use of extreme *chiaroscuro and (especially in the *Calling of S. Matthew*) he depicted the story as a contemporary scene. Their realism and dramatic power created a sensation, making Caravaggio overnight the most celebrated painter in Rome. Nevertheless, the church authorities rejected his first version of the chapel's altarpiece depicting the *Inspiration of S. Matthew* (destr., formerly Berlin, Kaiser Friedrich Mus.). This was snapped up for his private collection by Giustiniani, who arranged for Caravaggio to make a more conventional replacement (*in situ*).

The Contarelli chapel paintings were the first of six major Roman church commissions. In four of these Caravaggio was asked to change his first efforts, or his work was rejected. These episodes included the rejection of his deeply moving masterpiece the *Death of the Virgin* (Paris, Louvre), which was then bought by the Duke of Mantua on the advice of *Rubens. Differing circumstances lay behind these setbacks but the core problem was Caravaggio's insistent realism and his use of humble models. While this antagonized the more conservative clergy it was completely in line with much Counter-Reformation feeling as expressed, for example, by the Oratorians.

Caravaggio's quarrelsome and antisocial behaviour spiralled out of control during this period. He was sued and imprisoned for circulating obscene doggerels about a rival painter, *Baglione, and according to *Malvasia he threatened to knock Guido *Reni's head off for 'stealing his style'. He was also involved in a string of violent incidents with the swordsmen and whores of the Roman streets, ending with his killing of Ranuccio Tomassoni in a gang fight in May 1606. Fleeing Rome, he was sentenced to death *in absentia*.

He arrived in Naples in October 1606 and by the following January he had completed the *Seven Acts of Mercy* for the Pio Monte della Misericordia (*in situ*). This astonishing composite depiction of the works of mercy being enacted by very diverse protagonists shows his intellectual and imaginative powers at full stretch, and he kept up a busy output, mostly of religious work, until he left Naples for Malta in July 1607. His objective was to become a knight of the prestigious Order of S. John, and he achieved this in July 1608. Probably as his payment for entry he painted the enormous, desolate *Beheading of S. John* (Valletta, oratory of S. Giovanni) which he prominently signed in the blood streaming from the Baptist's wound. By October, however, he had quarrelled with another knight, been thrown into prison, and escaped to Sicily. In December he was expelled from the

order in his absence. The ceremony of expulsion was held in front of his own mighty altarpiece.

He spent a year in Sicily, inventing yet a further style of religious painting and leaving great, sombre altarpieces in Syracuse and Messina. These bleak masterpieces continue the trend of the Malta altarpiece in having large areas of almost empty dark background against which the figures enacting the human experience appear isolated and reduced. The *Burial of S. Lucy* (Syracuse, Mus. Regionale di Palazzo Bellomo) was originally above an altar on the spot of the saint's death and burial and it powerfully re-creates the spirit of the primitive church. The *Raising of Lazarus* (Messina, Mus. Regionale) is a frightening image in which the tension between Christ and the resurrected Lazarus is at fever pitch. The *Adoration of the Shepherds* (Messina, Mus. Regionale) is a massive meditative statement on the mystery, without any of the interest in charm and sentiment that is usually associated with the subject. The last of the Sicilian series, the *Adoration of the Shepherds with SS Lawrence and Francis* (formerly Palermo, oratory of S. Lorenzo), was a much more conventional, sweet image. (It was stolen in 1969, allegedly by the Mafia.)

By 24 October 1609 Caravaggio was back in Naples, for he was then attacked and disfigured in a tavern there. In the next few months he painted many urgent, spare works, often depicting scenes of execution and martyrdom. By July 1610 he knew that a pardon was being obtained for him from the Pope, and he set out to return to Rome. At Palo he was imprisoned, and when he had bought his way out he found that the boat containing his belongings had left without him. He hurried up the coast after the boat but collapsed and died at Porto Ercole.

The early biographers stress the illusionistic realism of Caravaggio's work and make it clear that he ostentatiously sold himself as following nature rather than the example of other artists or of classical Antiquity. They also describe his working method of painting directly from the model onto the canvas, without preparatory drawings, and emphasize his common use of illumination by a single source of direct light, from a high window or a lamp suspended high in the studio. The classical theorist *Bellori, writing in 1672, recognized the importance of Caravaggio's rebellion against the frigid formulas of late 16th-century *classicism, but presented him as being bereft of any traditional values and compositional skills, and consequently as a bad influence. It is now realized that Caravaggio's work refers to the art of the past much more than he—or Bellori—was prepared to acknowledge, and that the emotional authority of his work owes a lot to this.

Caravaggio was an unstable, violent man who lived in a violent age. His life story, his image as a rebel against conservative values, and the powerful immediacy of his art have made him by far the best-known Italian 17th-century painter, but it is not always appreciated that he was a highly intellectual painter. Even his deceptively simple *Basket of Fruit* (c.1598; Milan, Ambrosiana) exists within a rigorous controlling scheme and throughout his life, as he explored new subject matter, he developed his native Lombard realism in radically new and unpredictable ways. Above all, he was one of the greatest painters ever to have found new ways of reinventing images of Christian feeling. AJL

Marini, M., *Caravaggio: Michelangelo da Caravaggio 'pictor Praestantissimus'* (1989).

CARAVAGGISM. Caravaggio had no known pupils or collaborators, but in the two or three decades after his death there flourished in Italy and northern Europe a type of painting that responded to his realism. While his example represented the main alternative to *classicism, the extent to which Italian patrons consciously took sides in a polemical debate is a controversial issue.

Caravaggio himself took violent exception to Guido *Reni's short-lived adoption of his style, and other Italian painters who soon showed his passing influence were *Saraceni and Orazio *Gentileschi. *Manfredi, however, based his product on the systematic exploitation of elements from Caravaggio. In the decade from 1610 he had a successful Roman studio turning out half-lengths painted from life, usually applying Caravaggio's *chiaroscuro to secular subjects such as feasts, guardroom scenes, card-players, and musicians.

For many northern visitors to Rome Manfredi was probably as influential as the work of Caravaggio himself. The French painter *Valentin de Boulogne settled in Rome and painted Manfredian subjects in a more polished and organized version of his style until his death in 1632. Many French painters in Rome, led by *Vouet, went through a similar Caravaggesque phase.

The most notable centre of Caravaggism in northern Europe was the Catholic city of Utrecht, where ter *Brugghen, van *Honthorst, and van *Baburen were active. All had been in Rome, where van Honthorst had been retained in the household of Caravaggio's patron Vincenzo Giustiniani and had developed the speciality of candlelit scenes, which became a characteristic feature of northern Caravaggesque painting. The genre scenes of van Honthorst and van Baburen became steadily coarser and mechanistic, and further removed from the subtly enigmatic quality of Caravaggio's own genre pieces. Most Caravaggism derived from Caravaggio's Roman period, but in Naples it was the impact of his work there in 1606–7 and 1609–10 that was decisive. In particular, *Caracciolo was unique in his deeply felt understanding of Caravaggio's use of chiaroscuro to convey religious meanings, and he produced several very personal masterpieces within that idiom. AJL

Nicolson, B., *The International Caravaggesque Movement* (1979).

CARDIFF, NATIONAL MUSEUM OF WALES. The museum was founded in 1907 following a parliamentary resolution of 1903; however, the present building, by Smith and Brewer, in a classical revival style, was not completed until 1927. The nucleus of the collection are the contents of Cardiff's municipal museum, the Welsh Museum of Natural History, Arts, and Antiquities, transferred to the National Museum in 1912. As its purpose is to record the story of Wales from earliest times, paintings, drawings, and prints were initially acquired for their subjects, with Welsh landscape, portraits, and scenes of Welsh life predominating. Fortunately this policy led to the acquisition of many important works by Richard *Wilson and subsequent collecting has been international, although there is naturally a strong Welsh bias. The art collections were transformed by the bequests of Gwendoline and Margaret Davies in 1951 and 1963 of old master, British, and French paintings, the latter including a large and outstanding group of late 19th-century works by *Corot, *Daumier, *Monet, and *Cézanne, among others. These magnificent gifts provided the impetus for a more ambitious acquisitions policy which has resulted in one of the finest holdings of foreign paintings in Britain. Additional space was provided in 1932 and 1960 with the opening of the east and west wings and there have since been further extensions. DER

CARDUCHO BROTHERS. Italian painters. **Vicencio** (1576–1658) was born in Florence; he arrived in Spain in 1585 with his brother **Bartolomé** (c.1560–1608), who had been invited by Philip II to work on the decoration of the *Escorial under the direction of Federico *Zuccaro. Bartolomé remained in Spain after Zuccaro's departure, continuing to serve Philip II and Philip III as Painter to the King. At his death, Vicencio, who had participated in his brother's decorative projects for the royal palaces, succeeded him in his post and continued as Painter to the King under Philip IV. After *Velázquez's arrival at the court in 1623, however, the only major works he painted for Philip were three battle pictures for the Salón de Reinos in the Buen Retiro Palace (1634; Madrid, Prado).

Vicencio was in great demand as painter of religious works throughout his life. The cycle of 54 pictures for the Carthusian monastery of El Paular (1626–32; Segovia), his

largest commission, attests to his prolific imagination.

Vicencio's ideas on art, expressed in his *Diálogos de la pintura* (1633), adhere to the doctrine of idealization prevalent in Italian artistic theory since the 16th century.　NAM

Brown, J., *The Golden Age of Painting in Spain* (1991).
Volk, M. C., *Vicencio Carducho and Castilian Painting* (1977).

CARICATURE. The term is normally understood today to refer to a portrait in which certain features are exaggerated for satirical effect, often for political purposes. Until recently it was commonly used to describe the whole genre of satirical printmaking whether or not prints contained caricatured likenesses.

Deliberately distorted figures appear in the margins of medieval manuscripts and *Leonardo da Vinci made drawings of grotesque heads, but the term 'caricature' (from the Italian *caricare*, to load) was used for the first time only in the late 16th century. It described the witty sketches of their contemporaries made by the *Carracci and other Bolognese artists, and by Roman and Venetian artists of the following generation, in particular Gianlorenzo *Bernini. Such caricatures made for private consumption are found in the work of many artists better known for more serious productions: an example is a group of amusing sketches by Dante Gabriel *Rossetti and Edward *Burne-Jones (London, BM) showing William and Jane Morris in relaxed moments, sometimes with a wombat.

A market for caricatured portraits was developed by Pier Leone *Ghezzi in early 18th-century Rome, and George, Marquess Townshend (1724–1807), returning from the *Grand Tour, introduced the genre into British political satirical printmaking.

Caricature was carried to its height, both artistically and as a weapon in national affairs, in the hands of James *Gillray. Even when working outside the satirical form Gillray's sharp eye for the physical feature that can define character brought his portraits to the verge of caricature (see, for instance, his engraved portrait of William Pitt the younger, 1789). Thomas *Rowlandson, Gillray's great contemporary, employed caricatured types rather than individuals in his satires on English society. The genre deteriorated in England during the 19th century and by the 1870s it came to be identified with the comic portraits of celebrities in *Vanity Fair*.

In continental Europe political caricature continued to flourish. There is a touch of caricature in the work of *Goya, who was certainly influenced by the English satirists, but the genre reached another peak in France with Honoré *Daumier's *lithographs in the journals *La Caricature* and *Le Charivari*, published in the 1830s, by Charles Philipon, himself a caricaturist. Daumier also produced a series of caricatured clay busts of members of the French parliament which were later cast in bronze.

In the period after the First World War George *Grosz expressed his disgust with German society in his depictions of bloated bourgeois and Berlin cabaret life. In recent decades Gerald Scarfe has revived caricature as a force in British political satire; the genre is almost entirely freed from naturalistic representation in his extreme exaggerations of the features of recent political leaders.

SO'C

CARLEVARIS, LUCA (1663–1730). Born in Udine and trained as a mathematician, Carlevaris is regarded as the true father of 18th-century Venetian view painting. After a period in Rome when he studied the careful *topographical work of *Vanvitelli, he settled in Venice in 1698 and specialized in painting views of the city in rigorous perspective settings. These, and his set of over 100 engraved views of the city published in 1703, are the foundation on which *Canaletto and *Guardi built. Carlevaris was patronized by Venetians, including the Zenobio family. In 1707 he was commissioned to record the *Arrival of the 4th Earl of Manchester in Venice* (1707; Birmingham, Mus. and AG), a crowded and colourful scene, with well-defined figures. He was also supported by Christopher Crowe, the British consul at Livorno (1705–16), who commissioned four exceptionally colourful and animated views of Venice (two on loan, Cardiff, National Mus. Wales); and by the Duke of Marlborough. A number of oil sketches from nature in the Victoria and Albert Museum, London, reveal his powers of lively observation.

HB

Brigstocke, H., et al., *Masterpieces from Yorkshire Houses*, exhib. cat. 1994 (York, AG).
Rizzi, A., *Luca Carlevaris* (1967).

CARLONE, CARLO INNOCENZO (1686–1775). Member of an extensive north Italian family of painters, architects, and sculptors he became one of the best-known fresco painters of central Europe in the first half of the 18th century. He trained first in Venice and later with Francesco *Trevisani in Rome, where he absorbed the work of Pietro da *Cortona, Luca *Giordano, and Francesco *Solimena. By 1716 he was at work on decorations at the Belvedere in Vienna, and from that time his colourful and light-hearted *Rococo allegories spread across the Habsburg territories, Germany, and north Italy. Notable works are the frescoes at the Clam-Gallas Palace, Prague (1727–9), and in the music room and chapel at Schloss Brühl (1750–2). He was also active as a religious painter, particularly on his annual summer visits to Italy, for instance the nave frescoes of Monza Cathedral (1738–45). A large number of his attractive oil sketches for decorations survive.

MJ

Barrigozzi Brini, A., and Garas, K., *Carlo Innocenzo Carlone* (1967).

CARLONE BROTHERS. Italian painters. **Giovanni Andrea** (1584–1630) and **Giovanni Battista** (1603–84) were active mainly as fresco painters in their native Genoa. A period in Rome from about 1616 exposed them to the influence of Pietro da *Cortona, the most innovative decorator of the early *Baroque. They adapted his sumptuous style to the needs of their Genoese clients, religious and secular, and together established a busy workshop which continued to produce fresco decorations in a similar manner long after the elder brother's death. Among the religious output of the workshop are decorations in S. Ambrogio (c.1619) and S. Siro (1652–70), Genoa, and among their secular work decorations at the Villa Spinola di S. Pietro at Sampierdarena (before 1620) and in the Palazzo Airoli-Negrone, Genoa (after 1650).

MJ

Marangoni, M., *I Carloni* (1925).
Pesenti, F. R., *La pittura in Liguria: artisti del primo seicento* (1986).

CARO, SIR ANTHONY (1924–　). British sculptor, one of the most influential figures in post-war British art. He was born in London and studied engineering at Christ's College, Cambridge, 1942–4. After war service in the Fleet Air Arm, he studied sculpture at Regent Street Polytechnic, 1946, and the Royal Academy, *London, 1947–52. From 1951 to 1953 he worked as part-time assistant to Henry *Moore. Caro's early works were figures modelled in clay, but a radical change of direction came after he visited the USA and met David *Smith in 1959. In the following year he began making abstract metal sculpture, using standard industrial parts such as steel plates and lengths of aluminium tubing, as well as pieces of scrap, which he welded and bolted together and then generally painted a single rich colour. The colour helped to unify the various shapes and textures and often set the mood for the piece, as with the bright and optimistic red of *Early One Morning* (1962; London, Tate). This, like many of Caro's sculptures, is large in scale and open and extended in composition; it rests directly on the ground, and Caro has been one of the leading figures in moving away from the 'pedestal' tradition: 'I think my big break in 1960 was in challenging the pedestal, killing statuary, bringing sculpture into our own lived-in space. And doing that involved a different kind of looking. These sculptures of mine incorporated space and

interval so that you could not grasp them from a single view; you had to walk along to take them in.'

Caro taught part-time at St Martin's School of Art, 1953–79, and he had a major influence on several of the young sculptors who trained under him, initiating a new school of British abstract sculpture. In the 1970s his work became much more massive and rougher in texture, sometimes incorporating huge chunks of metal. In the 1980s he returned to more traditional materials and techniques and began making figurative (or semi-abstract) works in bronze, including (in the early 1990s) a series inspired by the Trojan War. IC

CAROLINGIAN ART. See opposite.

CARON, ANTOINE (c.1520×7–1599). French court painter best known now for paintings such as The Massacre of the Triumvirate (1566; Paris, Louvre), which encapsulates the atmosphere of the Valois court at the start of the Wars of Religion. Tiny, neatly painted, brightly coloured figures converse and slaughter against a stagelike setting of Roman buildings and sculpture. Massacre subjects were owned by both Catholics and Protestants. His Astrologers Studying an Eclipse (Los Angeles, Getty Mus.) and The Tiburtine Sibyl (Paris, Louvre) illustrate the court's fascination with magic and prediction. First recorded at Beauvais making cartoons for stained glass, he was employed at *Fontainebleau from 1540 and became the archetypal court artist, designing entertainments and ephemeral decorative schemes, such as that for the entry of Henri III into Paris in 1573. In 1562 he provided drawings to accompany sonnets written in honour of Catherine de Médicis telling the story of Artemisia, the devoted wife of Mausolus, upon whom Catherine modelled herself. These were later woven as tapestries. LL

Ehrmann, J., Antoine Caron, peintre des fêtes et des massacres (1986).

CARPACCIO, VITTORE (c.1460–1525/6). Venetian painter best known for the freshness and splendour of his narrative scenes, although he did produce works in other genres. His early work is influenced by Giovanni *Bellini, but he seems to have ignored the radical innovations of Bellini's circle after 1500, preferring to concentrate on the popular narrative cycles commissioned by the Venetian religious societies or scuole. Carpaccio emerges as a distinct personality in his first major cycle, Scenes from the Life of S. Ursula (Venice, Accademia) painted for the Scuola di S. Orsola in the 1490s. His distinguishing characteristics, a taste for anecdote

and an eye for the crowded detail of the Venetian cityscape, found their happiest expression in scenes like the Arrival of the English Ambassadors (1496–8). A similar vitality can be observed in Miracle at the Rialto (1494; Venice, Accademia), a single scene contributed by Carpaccio to a cycle on the Legend of the True Cross. The famous Dream of S. Ursula (Venice, Accademia) reveals another aspect of Carpaccio's art, a vein of poetic fantasy suggested in the delicate light and still-life details of the saint's bedchamber. His other cycle, Scenes from the Lives of SS George and Jerome (1502–8; Venice, Scuola degli Schiavoni), combines fantasy with minutely observed detail but there is a falling off in the overall quality. Carpaccio's altarpieces, all painted towards the end of his career, are somewhat derivative but he was a highly regarded portraitist. The Portrait of a Young Knight (1510; Madrid, Thyssen Mus.) is the first known full-length portrait in Italian art, a type that was developed by *Titian with spectacular results. PSt

Brown, P. Fortini, Venetian Narrative Painting in the Age of Carpaccio (1988).

CARPEAUX, JEAN-BAPTISTE (1827–75). The pre-eminent French sculptor of the Second Empire. His allegorical group representing Dance on the façade of Charles Garnier's Paris Opera is one of the epoch's most characteristic works. Carpeaux's early years were poverty-stricken and he struggled to support himself during his training at the École des Beaux-Arts (see under PARIS) from 1844. After a number of setbacks he was awarded a scholarship to the French Academy in Rome, where he worked from 1855 to 1862. Dating from this period are the statue Fisherboy Listening to a Shell and the bronze group from Dante's Inferno, Ugolino and his Children (both Paris, Mus. d'Orsay). On his return to Paris Carpeaux was given a number of official commissions, including the touching statue of The Prince Imperial with his Dog Nero (1867; Paris, Mus. d'Orsay) and the ebullient high relief of The Triumph of Flora on the Pavillon de Flore of Napoleon III's new Louvre. He was also much in demand as a society portraitist, and nearly all the famous personages of the period were modelled by him in bust format, among them Dumas, Gounod, and Princesse Mathilde, the Emperor's art patron sister. If the group Dance (1866–9) now seems in its exuberant, fleshly naturalism the very epitome of the spirit of the Second Empire, it produced shock and outrage when it was first unveiled. One protester threw a bottle of ink over it and only the outbreak of the Franco-Prussian War in 1870 put paid to moves to replace it with a less sexy work. A similar reaction greeted Carpeaux's bronze Observatory Fountain for the Luxembourg Gardens in Paris (1867–74),

in which the quarters of the world are represented by buxom female nudes of different ethnic types. Carpeaux's romanticizing statue of the painter.*Watteau (1869; inaugurated 1884) for Valenciennes, of which they were both natives, was uncontroversial. The museum at Valenciennes has a large collection of terracotta models and plaster casts of his work. MJ

Wagner, A., Jean-Baptiste Carpeaux (1985).

CARR, EMILY (1871–1945). Canadian landscape painter. Born in Victoria, British Columbia, Carr received a thorough and varied training in painting in San Francisco (1889–95), London (1899–1904), and Paris (1910–11) where she was impressed by the *Fauves and, in all probability, by Frances Hodgkins (1869–1947). She returned to the Pacific northwest, painting the native Canadian villages and their totem poles. Whilst this isolation ensured highly personal subject matter and style, her work went almost completely unnoticed. This changed in the 1920s, when she met Mark *Tobey and the Canadian *Group of Seven in Toronto. Not formally a member, she showed with them, starting in 1927 with the exhibition 'Canadian West Coast Art: Native and Modern'. She later adopted a more austere manner, as in Blunden Harbour (1928; Ottawa, NG Canada). Monumental nature, now distilled to its essential form and devoid of any reference to the moral, anecdotal, or sentimental, was her main inspiration, and this made her, with Georgia *O'Keeffe, a leading North American landscape painter. She wrote several autobiographical works. GS

Shadbolt, D., The Art of Emily Carr (1988).

CARRÀ, CARLO (1881–1966). Italian painter. After an academic training in Milan, he became involved with the *Futurists in 1910. Although his work initially remained Divisionist in style (see NEO-IMPRESSIONISM), a trip to Paris in 1911 brough him under the influence of *Cubism. He gave his dynamic Futurist paintings a Cubist conception of space, often combined with the extremely restrained colours that characterized the work of *Picasso and *Braque at this time. He also used the technique of *collage, including writing inspired by the 'words in freedom' of *Marinetti, as in the Interventionist Manifesto (1914; Milan, Mattioli Coll.). During the First World War he became interested in *Giotto's representation of space and mass, which appears in the *Metaphysical paintings that Carrà produced following his meeting with *de Chirico in Ferrara (1917). These works, which employ de Chirico's disquieting imagery, his faceless mannequins, and pictures within pictures, were accompanied by Carrà's book, Pittura

continued on page 112

· CAROLINGIAN ART ·

THE art produced in the Frankish Empire under Charlemagne and his immediate successors, from 768, when he came to power, until around 900, when the empire fragmented into separate states. Distribution covers most of north-west Europe, from the Netherlands, modern France, and Germany to Italy south of Rome; it was Charlemagne's conquest of Italy, including Rome, that provided the inspiration and foundations for his aim to re-create the Roman Empire—not the earlier one of the Caesars, but that of the early Christian period, of the 4th and 5th centuries AD. Although the art produced by the Carolingians has been described as compilation rather than creation, their assimilation and transformation of the styles and subject matter of early Christian art was to become the first major art style of medieval Europe. And despite the processes of imitation, what was produced was something quite different: the so-called legacy of Rome was not merely the emulation of Roman culture but, through the use of varied sources, the making of a new and distinctively Carolingian one.

Charlemagne's revival of classical art and learning was a crucial element in his *renovatio Romanorum imperii*, or renewal of the Roman Empire, a programme of wide-ranging political, ecclesiastical, and educational reforms. Art also functioned as a means of welding Church and State together: although most surviving Carolingian art was produced in the service of the Church, it was through court patronage. Secular and ecclesiastical items are made in identical styles.

So the deliberate re-creation of the arts of the early Christian Roman Empire, through the production of manuscripts, ivories, metalwork, and other decorative arts, is evidence of the official policy of *renovatio*, centred on the 'new Rome', Charlemagne's capital at Aachen. Here, his great palace imitated and even incorporated examples of late classical art and architecture. The palace chapel copies the octagonal plan of the 6th-century church of S. Vitale, Ravenna, and includes marble columns imported from Rome. Also fetched from Ravenna was the typically Roman equestrian statue of the 5th-century Emperor Theodoric, which served as the model for a bronze statue of Charlemagne (Paris, Louvre).

It is the various schools of manuscript painting and ivory carving, two closely linked media, which reveal the ways in which Carolingian artists reinterpreted late Roman and early Christian prototypes, including the *By-zantine art of the eastern Mediterranean area. Manuscripts imported from the capital, Constantinople, preserving the illusionistic style of late Greek art (see GREEK ART, ANCIENT), directly inspired the manuscript painters of the early Carolingian 'Palace School', as in the Aachen Gospels of *c*.800 (Aachen, Munsterschatz), while the *Ada School followed late Roman prototypes. These were succeeded by the artists of the Reims School of the early to mid-9th century: the lightly sketched, mobile figures of the Utrecht Psalter (Utrecht, University Lib.) retains the Greek drawing style and inspires the ivory carving of the later 9th-century 'Liuthard Group'. Other regional centres and schools, such as that of *Tours, were based on monasteries as well as the court, and show the divergent paths of classical influence.

However, the revival was not completely founded on the arts of the more distant past, since there was already continuity between Carolingian artists and their *Merovingian Frankish predecessors, who had already tried to reconcile late classical narrative naturalism and Christian subject matter with more abstract Germanic decorative principles. This blurring of boundaries between past and present, religious and secular, can be recognized in the survival of the ornate designs and rich colours of Merovingian jewellery into the intricate decoration of some Carolingian manuscripts. And the magnificent chalices, altars, and reliquaries incorporate both Frankish and late Roman techniques, implying direct descent rather than revival. The high status of Carolingian jewellers is confirmed by the reputation of Einhard, who designed fine bronzework for Aachen, as well as other lost gold and silver masterpieces.

Another significant influence was from the arts of the British Isles, where imports from the Mediterranean world and Rome had already been blended with native Celtic-Germanic tradition. Insular manuscripts combining figural and decorative designs were taken by English and Irish missionaries to the Continent: early Carolingian manuscripts, such as the Corbie Psalter (Amiens, Bib. Nat.) reveal Insular features such as entwined animals and angular interlace.

Other media also demonstrate the very great technical skills of Carolingian artists. The exquisite art of engraving on rock crystal referred back to Roman cameos and *gem carving, but could depict biblical material: the Lothar Crystal (London, BM) shows the Old Testament story of Susanna in the narrative style of the Reims manuscript school. On a far more monumental scale, there was mural painting in gold and other vivid colours, an essential part of the lavish decoration of churches, combining instruction and ornament: surviving examples consist of narrative cycles of Bible scenes or saints' lives in styles which reflect the court and regional manuscript schools. There is also evidence that secular buildings such as the palace at Aachen were decorated. Another form of mural decoration with Roman and Byzantine precedents was that of *mosaic; the sole surviving example is at Germigny-des-Prés, Loiret, France (apse of the oratory), consecrated 806.

CMH

Hollander, H., *Early Medieval* (1990).
Kitzinger, K., *Early Medieval Art* (3rd edn., 1985).
McKitterick, R. (ed.), *Carolingian Culture: Emulation and Innovation* (1994).

metafisica, in 1918. From the 1920s he concentrated on creating timeless landscapes and seascapes, partly influenced by *Cézanne, although he did also paint some figurative frescoes during the inter-war period. CJM

Carlo Carrà: mostra antologica, exhib. cat. 1987 (Milan, Palazzo Reale).

CARRACCI FAMILY. Italian artists from Bologna. Three members of the family, **Ludovico** (1555–1619), and his cousins **Agostino** (1557–1602) and **Annibale** (1560–1609), who were brothers, together instigated a fundamental reform of late 16th-century Italian painting, replacing *Mannerist refinement and artifice with the vigour, naturalism, and sentiment of the early *Baroque. Their approach was rooted in the mastery of drawing and a direct engagement with the visual imagery of the natural world. This concern with truth to nature not only stimulated a fresh approach to portraiture, *genre, and *landscape, but also reinvigorated religious paintings with a persuasive power and a capacity to engage the viewer's emotion that was in tune with Bologna's position as a centre of post-Tridentine theology under its archbishop, Cardinal Gabriele Paleotti, who was the author of a treatise on religious art.

The influence of the Carracci was felt at Bologna from c.1582 when Agostino and Annibale opened an academy of art in the studio of Ludovico. The Accademia degli Desidcrosi, renamed c.1590 the Accademia degli Incamminati, attracted numerous commissions, which were allocated among the family by Ludovico, although sometimes the three Carracci collaborated on decorative projects, notably the *Stories of the Founding of Rome* in the Palazzo Magnani-Salem c.1589–90. The Academy was clearly effective as a painters' workshop with a distinctive style, but it is less certain to what extent it also offered an intellectual centre for theoretical debate which conceived and propounded a teachable method. At the time contemporary writers were more concerned with the question of which artist was the principal stimulus of reform. The Bolognese writer *Malvasia emphasized Ludovico's seminal role as well as the north Italian origin of the new naturalistic style. *Bellori, on the other hand, insisted on Annibale's fundamental and central role, and argued that it was largely by going to Rome in 1595 that the artist was able to perfect a classical style derived from the *Antique and *Raphael and build upon the reform that had been initiated at Bologna.

Ludovico had trained initially under Prospero *Fontana and then travelled widely in north Italy visiting Florence, Parma, Mantua, and Venice. The influence of *Barocci predominates in his early *Annunciation* (1583–4?; Bologna, Pin. Nazionale) as well as in the *Vision of S. Francis* (Amsterdam, Rijksmus.). On the other hand his *Madonna and Child Adored by Saints and a Donor*, painted for the Bargellini family chapel (1588; Bologna, Pin. Nazionale), is conceived in the tradition of the masters of the Venetian Renaissance, especially *Titian and *Veronese. The more vigorous naturalism associated with the Carracci academy is apparent in the period c.1587–90 in his *Flagellation* (Douai, Mus. de la Chartreuse) and the portrait of his sister and her family, the *Tacconi Family* (Bologna, Pin. Nazionale); while the *Conversion of S. Paul* (Bologna, Pin. Nazionale) displays a proto-Baroque sense of drama and movement and vivid chiaroscuro which is developed in slightly later works including the *Martyrdom of S. Ursula* (1592; Bologna, Pin. Nazionale) and the *Preaching of S. John the Baptist* (1592; Bologna, Pin. Nazionale). Following the departure of Annibale and Agostino in 1594, Ludovico began to conceive his paintings on a bolder and larger scale: in the *Ascension* (1597; Bologna, S. Cristina) and ultimately in his frescoes for the vault of the cathedral at Piacenza, as well as two large canvases for the choir, representing the *Funeral of the Virgin* and the *Apostles at the Tomb of the Virgin* (Parma, Gal. Nazionale) all dating from c.1605–8. In the meantime he had visited Rome, seen his cousin Annibale's monumental decorations at the Palazzo Farnese, and completed his own decorative fresco cycle of the *Story of S. Benedict* for the cloister of S. Michele in Bosco, Bologna (1602–5). In the final decade of his career Ludovico surrendered his pre-eminent position in Bologna to younger rivals, notably Guido *Reni, who had returned from Rome in 1613. Ludovico's masterpiece from this late period is the exuberant and richly coloured *Paradiso* (1617; Bologna, S. Paolo Maggiore). Yet, although his work seen as a whole marks a decisive break from the artifice of north Italian Mannerism, Ludovico never achieved the irreversible and seminal breakthrough associated with Annibale's Roman style.

If only with hindsight, it is now clear that Bellori was right when he singled out Annibale as the true innovator who defined the classical Baroque style and changed the future direction of painting in 17th-century Rome. Annibale's initial training at Bologna had been from Ludovico, and he had then embarked on a tour of northern Italy to study *Correggio and the Venetian Renaissance masters. The influence of pastoral painting in Venice is immediately apparent in Annibale's early landscapes, such as *Hunting* and *Fishing* (Paris, Louvre) and his *River Landscape* (Washington, NG) which all probably date from the 1580s. His astoundingly original early genre paintings (dating c.1581–4), characterized by vigorous but summary brushwork and acutely observed naturalism—the *Bean Eater* (Rome, Gal. Colonna) and the *Butcher's Shop* (Oxford, Christ Church)—mark a decisive break from the far more self-conscious work of a similar type by *Passarotti. The same freshness of vision is apparent in his first major religious work, the *Crucifixion* (1583; Bologna, S. Maria della Carità). The design of the *Baptism of Christ* (1583–5; Bologna, S. Gregorio) is more complex and reflects his knowledge of Correggio and Barocci.

Annibale's fundamental achievement over the next five years was to develop a style which was not only true to nature but also interpreted religious subject matter with exceptional clarity and emotional power, the two most fundamental qualities associated with the Baroque. The evolution of this revolutionary process can be traced from his *Pietà with S. Francis and S. Clare* (1585; Parma, Gal. Nazionale) to the *Assumption of the Virgin*, painted for the confraternity of S. Roch in Reggio Emilia (1587; Dresden, Gemäldegal.) and the *Martyrdom of S. Matthew* (Dresden, Gemäldegal.). These were followed by the frescoes in the Palazzo Magnani-Salen, executed with Agostino and Ludovico c.1589–90, as already described above. During the 1590s Annibale's altarpieces became increasingly monumental, but without any sacrifice of naturalism or vigour: the *Assumption of the Virgin* (Bologna, Pin. Nazionale); the *Resurrection of Christ* (1593; Paris, Louvre); and *S. Roch Distributing Alms* (c.1595; Dresden, Gemäldegal.), a densely crowded and animated narrative scene with numerous groups of figures welded together into a coherent and rhythmic surface design.

Annibale finally settled and established himself in Rome in 1595, at the invitation of Cardinal Odoardo Farnese. During the ten years he worked there he developed his style in the fields of fresco decoration in the Grand Manner, history painting, and landscape painting, and in all these aspects he exerted a strong impact on succeeding generations of artists. In the Farnese Palace he first decorated the Camerino with stories of Hercules, and in 1597 undertook the ceiling of the larger Galleria where the theme was the *Loves of the Gods*. He drew inspiration for this carefully planned system of feigned architecture, sculpture, and gilt-framed pictures from the Sistine ceiling and Raphael's decorations in the Vatican Loggias and the Farnesina. He made over 1,000 preparatory drawings to clarify his intricate but logical scheme, among them many studies from the life. Although the ceiling is rich in the interplay of various illusionistic elements, it retains fundamentally the self-contained and unambiguous character of High Renaissance decoration. The full untrammelled stream of Baroque illusionism was still to come in the works of Pietro da *Cortona and *Lanfranco.

Annibale's work in history painting received fresh stimulus from Raphael's Stanze and tapestries: his *Domine, quo vadis?* (London, NG); *Stoning of S. Stephen* (Paris, Louvre); and *Christ and the Samaritan Woman* (Vienna, Kunsthist. Mus.) reveal a striking economy in figure composition and a force and precision of gesture that had a profound influence on *Poussin and through him on the whole language of expression and gesture in painting. He developed landscape painting along similar lines, giving great thought to its planar construction and the telling accentuation of figures; e.g. *Flight into Egypt* (1604; Rome, Doria Pamphili Gal.). In his last years Annibale was overcome by melancholia and he gave up painting almost entirely after 1606. His late work, particularly the *Three Marys* (London, NG) and the *Pietà with S. Francis* (1603–7; Paris, Louvre), originally painted for the Mattei chapel in S. Francesco a Ripa, has an expressive emotional force that breaks the bounds of classical decorum and underlines the intuitive and self-generating powers of Annibale's stylistic progression.

Agostino, whose early reputation was based on reproductive engravings and who was arguably the most didactic of the three Carracci at the Bolognese Accademia degli Incamminati, worked only intermittently as a painter. His most celebrated picture in Bologna, *The Communion of S. Jerome*, dating from the 1590s (Bologna, Pin. Nazionale), would later attract the attention of *Domenichino. However, in Rome, at the Palazzo Farnese, where he painted *Glaucus and Scylla* (1598) and *Cephalus and Aurora* on the long walls of the Galleria, he was totally overshadowed by Annibale. In 1599 he moved to Parma and decorated a room in the Palazzo del Giardino. He died in the city and was buried in Parma Cathedral. His funeral at the church of the Ospedale della Morte in Bologna was also the pretext for a celebration of the Academy he had helped to establish.

The fame of all the Carracci declined with the advent of *Romanticism and the anti-academic bias of 19th-century art criticism. Paradoxically, the concepts underlying the Carracci reforms and their renewal of the Grand Manner—the reconciliation of *disegno* and *colore*, clarity of design and expressive form—were now rejected as academic, technical, eclectic, and unfeeling. Only in the mid-20th century, above all with the publication of Denis Mahon's *Studies in Seicento Art and Theory* (1947), was this profound critical misunderstanding effectively refuted and the path cleared for a full re-evaluation of the Baroque style that the Carracci had initiated.

HB

Bohlin, D. DeGrazia, *Prints and Related Drawings by the Carracci Family*, exhib. cat. 1979 (Washington, NG).
Cavalli, G. C., et al. (eds.), *Mostra dei Carracci*, exhib. cat. 1956 (Bologna, Palazzo dell'Archiginnasio).
Emiliani, A., *Ludovico Carracci*, exhib. cat. 1993 (Bologna, Pin. Nazionale; Fort Worth, Kimbell Mus.).
Posner, D., *Annibale Carracci* (1971).

CARREÑO DE MIRANDA, JUAN (1614–85). Spanish painter born in Asturias but trained and active in Madrid. His first signed work dates from 1646. His pictures of the late 1640s are strongly influenced by Venetian painting, *Rubens, and van *Dyck, but an *Annunciation* of 1653 already shows a distinct personal style. His largest and most brilliant canvas is the *Foundation of the Trinitarian Order* (1666; Paris, Louvre).

Carreño is best known for his portraits, of which the *Duke of Pastrana* is the first datable one (c.1666; Madrid, Prado). It also shows his assimilation and transformation of Venetian and Flemish sources. Carreño had worked for Philip IV since 1659, but was given the post of Painter to the King only in 1669 by the widowed Queen Mariana, whom he portrayed numerous times. The first of his many portraits of *Charles II* (Oviedo, Mus. de Bellas Artes de Asturias) dates from 1671, the year he was named *Pintor de Cámara*. The figure's setting, the Alcázar's Hall of Mirrors, expresses a symbolic content; the imperial eagles and the paintings reflected in the mirrors affirm the position of the future king as a powerful monarch and defender of the faith. NAM

Brown, J., *The Golden Age of Painting in Spain* (1991).
Mallory, N. A., *El Greco to Murillo: Spanish Painting in the Golden Age: 1556–1700* (1990).
Pérez Sánchez, A. E., *Juan Carreño de Miranda* (1985).

CARRIERA, ROSALBA (1675–1757). Italian painter from Venice and in her day one of the most celebrated women artists. She was a sister-in-law of *Pellegrini. As a portrait painter working mainly in pastels, she achieved spectacular success throughout the capital cities of Europe, and was a member of the Roman and French academies. Her visits to Paris (1720–1) and to Vienna (1730) were in the nature of royal progresses. Her light-hearted and essentially lightweight portraits and fancy pictures struck a chord both with fashionable society in Paris and with artists and were an influence in the formation of the *Rococo style. She painted *Watteau's portrait and converted Maurice-Quentin de *La Tour to the pastel medium. Her work is characterized by a delicate style and an air of spontaneity. She had the power to impart graciousness without obvious flattery. She kept a journal in which she recorded her work and her impressions of her sitters. HO/MJ

Giornale di Rosalba Cariera (1793), French trans. by A. Sensier (1865).
Sani, B., *Rosalba Carriera* (1988).

CARRIÈRE, EUGÈNE (1849–1906). French *Symbolist painter and printmaker, who trained as a lithographer, but then entered *Cabanel's painting studio at the École des Beaux-Arts in Paris in 1869. In addition to portraits and some religious works, he produced a large number of studies of his wife and children, illustrating the deeply felt theme of motherhood. In such works as *Maternity* (c.1892; New York, MoMA), painted in a narrow range of umbers, he cultivated a technique in which form was dissolved in a mysterious and misty haze. This quality of mystery greatly appealed to the Symbolists, with whom Carrière had close relations. He exchanged portraits with *Gauguin, and produced a memorable lithographic image of *Verlaine* (1896). *Rodin greatly admired him, and his lithograph *Rodin Sculpting* (1900), with its seer-like figure conjured from the shadows, seems a metaphor for the mystery of the creative process. Carrière's art epitomizes a *fin de siècle* spirituality, and he was a celebrated artist. HL

Eugène Carrière; Anders Zorn, exhib. cat. 1983 (Geneva, Mus. d'Art et d'Histoire).

CARSTENS, ASMUS JAKOB (1754–98). Danish *Neoclassical painter and draughtsman. He trained at the Copenhagen Academy under *Abildgaard before going to Rome in 1783. He soon ran out of money and was obliged to spend several years as a portrait painter and muralist in Berlin. In 1792 he was able to go back to Rome, the fountainhead of ancient art, at the expense of the Berlin Academy, where he had a teaching post. In Rome he gave up painting almost entirely in favour of what he considered to be the purer and more serious discipline of drawing. Typical of his severe style and elevated subjects is *Night with her Children Sleep and Death* (c.1795; Weimar, Schlossmus.), which combines in equal measure the influence of Antique reliefs and *Michelangelo. Carstens's gift to the next generation, among them the *Nazarenes, was less his austere style than his uncompromising view of the role of the artist. He famously responded to a letter recalling him to his duties in Berlin by writing, 'I belong not to the Berlin Academy but to mankind . . . I renounce all benefits, preferring poverty, an uncertain future and perhaps a hopelessly infirm old age . . . so that I may do my duty to art and fulfil my calling as an artist.' MJ

Fernow, K. L., *Leben des Künstlers Asmus Jakob Carstens* (1806).
Rosenblum, R., 'German Romantic Painting in International Perspective', *Yale University Art Gallery Bulletin*, 33/3 (1972).

CARTOON, a drawing of the chief outlines of a work which is made to the same scale as the *fresco or painting for which it is preparatory. In certain cases of fresco painting the cartoon was applied in sections to the damp wall itself and the outlines were cut through onto the wet plaster

beneath. This process invariably led to the destruction of the cartoon. On occasion the original cartoon was preserved by transferring the design to another sheet of paper known as a secondary cartoon. This was achieved in two ways—by pricking the paper (see POUNCE) or by indenting it with a *stylus. The secondary cartoon would hence take the place of the first and be placed directly on the wall. Cartoons have also been used as preparations for *tapestries and for *stained glass. Important examples of the former usage are the *Raphael Cartoons in the V&A, London.

The German art historian Oskar Fischel (*Raphaels Zeichnungen*, 8 vols., 1913–41) was the first to describe as 'auxiliary cartoons' detailed subsidiary studies made by Raphael based on outlines traced through from complete cartoons. These details were of heads, arms, and hands which the artist was determined to depict with special care. He would retain them for reference when he came to execute the relevant sections in the painting.

Today the word 'cartoon' almost invariably denotes a comic or sarcastic drawing dealing with a current situation often political. This usage dates from 1843 when an exhibition was held in Westminster Hall of cartoons from which a design was to be chosen for the fresco decoration in the new Houses of Parliament. In a mocking mood *Punch* pretended to take part in the competition and published a drawing by John Leech which was the first *caricature to be termed a 'cartoon'. It was called 'Substance and Shadow: The Poor Ask for Bread, and the Philanthropy of the State Accords an Exhibition'. PHJG

CARTOUCHE, an ornamental tablet with edges simulating a scroll of cut parchment usually framing an inscription or shield with coat of arms. HO

CARUCCI, JACOPO. See PONTORMO, JACOPO DA.

CARYATIDS, female figures employed as weight-bearing elements in architecture and decorative arts. According to Vitruvius (*De architectura* 1. 1. 5) they symbolized the punishment of the women of Caryae, a town near Sparta, for betrayal in the Graeco-Persian Wars (480–479 BC). Female supports appear considerably earlier, however, in the Near East, at Delphi and Athens, and on *perirrhanteria* (ritual basins), bronze mirrors, and other implements, all belying Vitruvius' account of their origins. Their nomenclature may, nonetheless, derive from postures assumed at the festival of Artemis Caryatis. Most famous are those of the Erechtheion at Athens (421–406 BC), which contemporary inscriptions call *korai* ('maidens'). Romans copied these in the Forum Augustum and Agrippa's Pantheon in Rome, and Hadrian's Villa at *Tivoli. Lord Elgin's agents removed one c.1804 (now London, BM); the remaining five, corroded by atmospheric pollution, were transferred to the Acropolis Museum in 1979 and replaced by casts.

See also ROMAN ART, ANCIENT: SCULPTURE. KDSL

Lawrence, A. W., *Greek Architecture* (1996).

CASORATI, FELICE (1883–1963). Italian painter, born at Novara. He was a talented musician and took a law degree in 1906, but he decided to become a painter and studied at the Academies of Padua, Naples, and Verona. After serving in the Italian army during the First World War he began to teach at the Turin Academy in 1918 and soon became a leading figure in the city's intellectual and artistic circles. His early work, influenced by *Art Nouveau, was dominated by hard outlines and strong colours. In the 1920s he was influenced by *Metaphysical Painting, producing pictures emphasizing the volume and substance of the figures and often using strange perspective effects to heighten the air of unreality (*Midday*, 1922; Trieste, Gal. d'Arte Moderna). As well as figure paintings he did numerous commissioned portraits. In the 1930s he adopted a lighter and less harsh palette and a more rhythmic type of composition. By the 1940s he had an international reputation; he won a prize at the Venice Biennale in 1938 and again in 1952. In addition to painting, Casorati did much set and costume design, notably for La Scala, Milan, and also made prints and sculpture. IC

CASSATT, MARY (1844–1926). American expatriate painter who worked mainly in Paris and made a significant contribution to the *Impressionist movement both as painter and promoter in America. After studying at the Pennsylvania Academy of the Fine Arts, she pursued her art studies in Paris and Italy, absorbing lessons from the old masters. She showed at the *Paris Salon but after 1879 transferred allegiance to the Impressionists, exhibiting with them regularly and missing only one show. Her champion, *Degas, appreciated her gifts as a draughtsman and encouraged her concentration on the modern figure and on everyday scenes and gestures. Paintings such as *Five O'Clock Tea* (1880; Boston, Mus. of Fine Arts) and *Two Young Ladies in a Loge* (1882; Washington, NG) evoke the elaborate refinement of the society described by Henry James. Her suite of Japanese-inspired coloured etchings (1891) demonstrate the compositional boldness and intimate feminine themes that remain the hallmarks of her reputation. BT

Breeskin, A., *Mary Cassatt: A Catalogue Raisonné of Paintings, Watercolours and Drawings* (1970).
Breeskin, A., *The Graphic Work of Mary Cassatt* (2nd edn., 1979).

CASSONE (Italian), a large marriage chest which frequently contained the bride's trousseau. Decorated *cassoni* became the fashion in Renaissance Italy, and quattrocento Florence saw the development of the painted *cassone* front. These paintings usually represented episodes from classical or biblical history or mythology appropriate for the newly wed. The surviving records of the flourishing *cassone* workshop run by Marco del Buono Giamberti and Apollonio di Giovanni show that they delivered an average of one pair of *cassoni* a fortnight during prosperous periods: such as the panels with scenes from Virgil's *Aeneid* (New Haven, Yale University AG). Major artists such as *Domenico Veneziano and *Botticelli may have decorated *cassoni* on occasion. Painted *cassoni* went out of fashion towards the end of the 15th century when carved oaken chests came into vogue. MLS

CASTAGNO, ANDREA DEL (Andrea di Bartolo di Bargilla) (before 1419–57). Italian painter, based in Florence, notable for his depiction of the human form as three-dimensional, almost sculptural, defined by strong contours and emphatic line. He thus fused the influence of *Masaccio, as seen in early works like *The Crucifixion with Saints* for S. Maria Novella, Florence, with that of sculptors, particularly *Donatello, to produce a relief effect which verges on illusionism. Some works, such as the frescoes of *Famous Men and Women* (Florence, Uffizi), and his grisaille, equestrian portrait of *Niccolò da Tolentino* (1456–7; Florence Cathedral) are indeed painted representations of sculpture.

In 1442 Andrea collaborated on frescoes in S. Zaccaria, Venice, contributing to the introduction of Florentine innovations into Venice, and perhaps himself absorbing elements of the style of *Domenico Veneziano and *Piero della Francesca, who were working there. Frescoes in the refectory of S. Apollonia, Florence, represent a synthesis of his sources. The remarkable, albeit ambiguous, perspective of the *Last Supper* is combined with sophisticated *all'antica* detail, painted porphyry and marble and grave, stonelike apostles. *The Trinity* (c.1453–7; Florence, SS. Annunziata), incorporates dramatic foreshortening and a harsh, expressive vitality, features which were further explored by the generation of *Mantegna, *Verrocchio, and *Pollaiuolo. MS

Horster, M., *Andrea del Castagno* (1980).
Salmi, M., *Andrea del Castagno* (1961).

CASTELLO, VALERIO (1624–59). He was born in Genoa and worked under Domenico Fiasella (1589–1669) and Giovanni Andrea de' Ferrari (1598–1669). His style was based on a synthesis of various *Mannerist and *Baroque influences: *Perino del Vaga and *Beccafumi, Lombards such as *Cerano or G. C. *Procaccini, Flemings most notably *Rubens and van *Dyck. His dramatic Mannerist sense of composition and chiaroscuro is displayed in his *Baptism of S. James and S. John* (1646–7) in the Oratorio di S. Giacomo della Marina, Genoa; on the other hand his *Rape of Proserpine* (Rome, Palazzo Madama) shows the extent to which he developed a more fluid Baroque style, which is also apparent in his fresco cycles at the Palazzo Balbi-Senarega, Genoa (c.1657–9), representing mythological scenes and, in the principal *salone*, an *Allegory of Time*. He produced many fine oil sketches, perhaps inspired by van Dyck and Procaccini, some of which were made as preparatory studies for large-scale projects, perhaps for consideration by the patron, while others may have been conceived as autonomous works of art. In one such picture, *The Marriage of the Virgin* (Genoa, Palazzo Spinola), the figures are placed in an architectural setting with a sure sense of dramatic choreography, yet the overall effect is one of fluidity and movement, due to the artist's assured technique and vibrant use of colour. HB

Manzitti, C., *Valerio Castello* (1972).

CASTIGLIONE, BALDASSARE (1478–1529). Italian humanist, a nobleman from Mantua, and famous for his prose dialogues, the *Book of the Courtier* (1528), in which he defined the attributes of the perfect courtier. The courtier should be well versed in all the arts, should unite intellectual gifts with military and sporting distinction, and yet exhibit these skills with an effortless grace (*sprezzatura*). This courtly ideal was influential throughout Europe; it appealed to musicians, writers, and artists, such as *Raphael, *Giulio Romano, *Rosso, and *Vasari, who aspired to a noble lifestyle; the dialogues on painting educated the gentleman amateur in what to look for, and whom to admire. Vasari's theory of grace in painting is indebted to Castiglione's concept of social grace. Castiglione was a friend of Raphael in Rome, and Raphael's portrait (1517; Paris, Louvre) of him, modest and at ease, shows Castiglione as the perfect gentleman. It was copied by *Rembrandt, *Rubens, and *Sandrart, all of whom responded to the painting as an image of the noble virtuoso as well as to its formal distinction. Castiglione assisted Raphael with a letter to Pope Leo X, lamenting the destruction of ancient Rome, and he wrote an elegy on Raphael's death. HL

Burke, P., *The Fortunes of the Courtier* (1995).

CASTIGLIONE, GIOVANNI BENEDETTO (1609–64). Italian painter, draughtsman, and printmaker. He was born in Genoa and trained under *Paggi. The animal paintings and naturalistic landscapes of *Scorza were another formative influence. In 1632 he went to Rome, and *Sandrart, the German writer, describes him adopting the 'antiche Manier'. This is confirmed by a painting of *Jacob's Journey*, signed and dated 1633 (priv. coll.), which in both the principal figures and the warm neo-Venetian landscape was clearly directly inspired by Nicolas *Poussin's early *poesie*. Drawings by Castiglione based on Poussin's *Saving of Pyrrhus* (1634; Paris, Louvre) and *Adoration of the Golden Calf* (c.1634; London, NG) confirm this artistic link. By 1635 Castiglione was in Naples. By now he was even being described as a painter of Jacob's journeys and he clearly influenced Andrea di Leone who also took up the genre and indeed comes dangerously close to producing pastiches of Castiglione's concept. By 1639 Castiglione was back in Genoa. He then produced a remarkable sequence of *etchings that reflect the esoteric and learned antiquarianism he encountered in Rome with Poussin and probably other artists such as *Testa working on Cassiano dal Pozzo's paper museum (see under POUSSIN, NICOLAS; TESTA, PIETRO). Other etchings are derived from ancient mythology, or obscure incidents such as the discovering of the bodies of S. Peter and S. Paul in the Roman catacombs. Many such prints were conceived as nocturnal scenes, illuminated by torchlight, and reflect Castiglione's close study of *Rembrandt's etchings.

In 1645 Castiglione completed his first major altarpiece, *The Adoration of the Shepherds*, for the church of S. Luca, Genoa. It is painted with *Rubensian vigour, with a backward glance at Jacopo *Bassano. This was followed by the *Battle of S. James* for the Oratorio di S. Giacomo della Marina, Genoa, which was directly inspired by a G. C. *Procaccini painting of the same subject in the collection of Gian Carlo Doria (1621; priv. coll.); *The Miracle of S. Dominic at Soriano* at S. Maria di Castello, Genoa; and the *Vision of S. Bernard* painted for S. Martino at Sampierdarena (but now in S. Maria della Cella), where the artist is already moving towards the devotional *Baroque style of his full maturity. This point is finally reached with the *Immaculate Conception*, formerly in the Capuchin church at Osimo (now Minneapolis, Inst. of Arts), which was completed in 1650. In the 1650s Castiglione was patronized by the Gonzaga court at Mantua. This led to the commission for an *Allegory* in honour of the Duchess of Mantua (priv. coll.) and its companion *Temporalis aeternitas* (Los Angeles, Getty Mus.), both essentially Poussinesque meditations on the fragility of life. Castiglione was for ever experimenting with new techniques on a more intimate

scale: wash drawings and oil sketches of exceptional freedom reflecting similar efforts in Genoa by Procaccini; and above all his *monotypes, where the freedom of the oil sketch is transformed into a unique printed image. HB

Brigstocke, H., 'Castiglione: Two Recently Discovered Paintings and New Thoughts on his Development', *Burlington Magazine*, 122 (May 1980).
Dillon, G., *Il genio di G. B. Castiglione*, exhib. cat. 1990 (Genoa, Accademia Ligustica).
Percy, A., *Giovanni Battista Castiglione: Master Draughtsman of the Italian Baroque*, exhib. cat. 1971 (Philadelphia Mus.).

CASTILLO, JOSÉ DEL (1737–93). Spanish painter. Castillo enjoyed an unusually distinguished artistic apprenticeship, by comparison with most of his contemporaries. At age 14, in 1751 he was sponsored by Spain's minister of state, José de Caravajal y Lancaster, to study under *Giaquinto in Rome. When Giaquinto was summoned by Ferdinand VI to Madrid in 1753 to decorate the royal palace, Castillo returned to study at the newly founded Academia de S. Fernando (see under MADRID). His talents won him numerous prizes, including a royal pension in 1758 to study at the Spanish Academy in Rome under Preciado de la Vega, who encouraged him to copy after the Antique and late Baroque compositions. In 1764, he was called back to Madrid, where he was employed by *Mengs to paint cartoons for the Royal Tapestry Factory of S. Barbara. His courtly scenes, taken from contemporary Madrid life, are characterized by elegant figures painted with bright colours and set in idealized landscapes. An excellent imitator of *Giordano, he was commissioned to copy many of the Neapolitan painter's compositions in the royal collection and restore his frescoes in the Buen Retiro Palace. XB

CASTING. *See overleaf.*

CATENA, VINCENZO (c.1480–1531). Venetian painter whose manner and technique preserved the spirit of *Bellini in a period which saw the effects of *Giorgione, *Titian, and *Palma Vecchio revolutionize Venetian art. This conservatism in Catena's art is surprising since he is mentioned in an inscription on the back of Giorgione's *Laura* (1506; Vienna, Kunsthist. Mus.) as a friend of the artist and his circle is known to have included leading humanists like Marcantonio Michiel and Pietro Bembo. Catena's work falls into two categories; altarpieces and portraits. His altarpieces, particularly the Madonnas, are closest to Bellini in their colour and tonal effects but lack the master's poetic sensibility and emotional depth. This is evident in his masterpiece, *Christ Saving S. Christina from Drowning* (1520–2; Venice, S. Maria Mater Domini), in which the action remains

continued on page 119

· CASTING ·

CASTING is a process by which a liquid or molten material is shaped by pouring into a mould that contains the negative impression of a desired model. Metal alloys are among the numerous materials that are often formed by casting. 'Bronze' is a blanket term used to refer to a range of copper alloys in which the major second element traditionally is tin. However, bronze may also include smaller amounts of other elements, such as zinc and lead. The term 'bronze' is also often used in art historical literature to describe copper–zinc alloys (technically these are 'brasses') and copper with antimony or arsenic used in early times; there is no standard nomenclature.

Pure copper, an element, is very ductile, has a relatively high melting point of 1100 °C, and easily retains gases. By selectively combining it with metallic elements that have lower melting points, such as tin, zinc, and lead, one can obtain a variety of stronger alloys with broader melting ranges and a variety of colours. This process, known as alloying, also allows more control over the metal's shrinkage as it solidifies. Typically, bronze used for sculpture contains between 5% and 10% tin. The melting range of a bronze, for example, can be lowered to around 1000 °C by adding 10% tin, and to 900 °C with c.20% tin. High-tin bronze—often used to cast bells because of its acoustic properties—is very fluid. However, it is very brittle and difficult to rework, and therefore not generally used to cast statues. Furthermore, tin has always been rare, so other, less expensive elements such as lead have often been used in lieu of some portion of tin. Lead helps to lower the melting range of the alloy and to soften it; however, it dulls the metal's sheen. Zinc enhances the alloy's fluidity and affords better resistance to corrosive atmospheric agents. Historically it also provided a good base for mercury gilding—a process outlawed in most countries today because of the hazardous mercury vapours. Recently, the use of 'silicon bronze' has increased in art foundries. This alloy contains 90–5% copper, 3–4% silicon, 1% manganese, and up to 5% zinc, and can be poured very smoothly because it oxidizes less than traditional alloys. However, it is more brittle than the often-used gunmetal (c.85% copper, 5% tin, 5% zinc, and 5% lead).

Casting sculpture in bronze is usually achieved by one of two methods: lost-wax (from the French *cire perdue*) and sand casting. (Slush casting, a third method used primarily for decorative objects, consists of rolling liquefied metal around in metal moulds so that it coats the objects as it cools and solidifies.) Lost-wax casting has been practised since the third millennium BC in different cultures around the world and although the conditions may have varied, the principles and basic stages of the process have remained the same. A wax model (i) is produced by hand or by mould. The wax model is then outfitted with a network of wax rods or 'sprues' (j) that will create the 'gates' and 'vents'—passageways for the wax, metal, and air to flow through the fire-resistant or 'refractory' mould in which it is embedded. The finished mould is heated (k) to dry it thoroughly and melt out the wax (and to fuse the ceramic shell). Meanwhile, the bronze is liquefied in a crucible or furnace, and poured through the funnel created by the casting cup at the apex of the gating system into the cavity left by the wax in the mould (l). Once the metal has solidified, the newly cast figure is broken out of the mould and freed of its 'fireskin' of oxidized metal, excess network of sprues, chaplets, and other disfigurements (m). It is repaired and cleaned up (n)—the part of the process called 'fettling'. Any separately cast parts are joined at this point either by mechanical or metallurgical means. Subsequently, selected areas of the surface may be highly polished with abrasives, while other parts may be textured with punches or sharpened with chisels or engraving tools—the part of the process referred to as 'chasing'. Finally, the outer metal surface may be 'patinated' or treated with chemicals or a variety of organic or metal coatings to unify it and to enhance its colour (o). Waxes and varnishes are often applied for protection.

The lost-wax process can generally be subdivided into 'direct' and 'indirect' casting. Yet both written evidence and technical studies indicate that numerous variations incorporating elements of each have been used over the years. The 'direct' method is a simple translation of an original and unique wax model into a unique metal cast. In the 'indirect' method, the wax model used for casting is fashioned from an intermediary reusable mould distinct from the investment mould, which introduces another step in the procedure (e–h). The indirect process permits the efficient production of multiple casts. (The metal-casting stage of the indirect method is identical to that of the direct one.)

Over the centuries, moulding materials and methods have varied, as alloys have, due to: the knowledge and materials available to sculptors and founders in a given time and place; the size and complexity of the sculpture; the material of the original model; and whether the model was meant to be reproduced as a unique cast or in multiples. For example, plaster of Paris has been commonly used through the centuries to make both waste moulds and piece-moulds. Waste moulds are used once to produce a more permanent plaster replica of an ephemeral model, which will be used in turn to create intermediary moulds (a–d). Plaster piece-moulds, by contrast, are designed for casting multiples of three-dimensional sculpture with undercuts. Their component parts are created much like a three-dimensional jigsaw puzzle that keys together and can be taken apart and reassembled without damage to either the model or the mould (f–h). They require two or more pieces. The separate pieces are held together by an outer 'mother mould'. Moulds made

Fig. 1. Lost–wax process

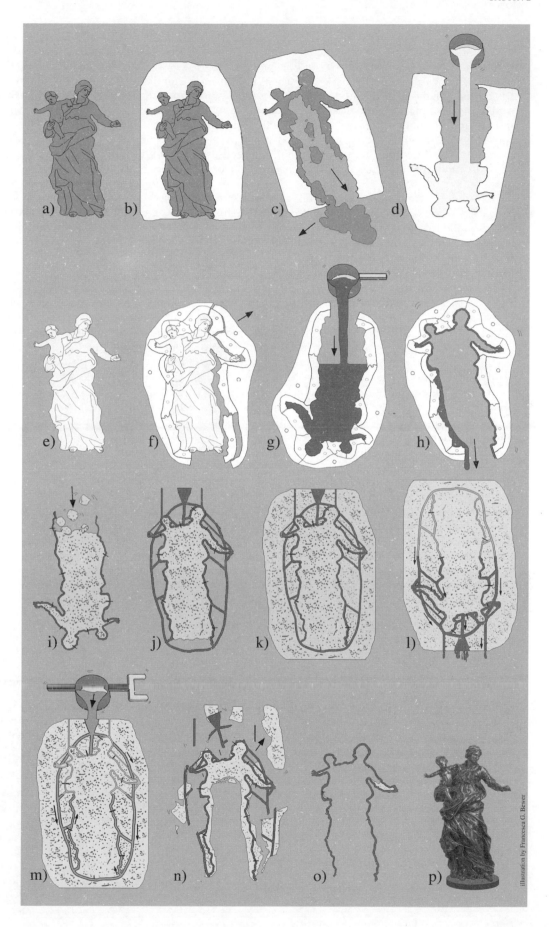

illustration by Francesca G. Bewer

of flexible materials such as gelatin—and more recently of synthetic rubbers—simplify the moulding process. Such materials can easily be peeled back in larger sections from the surface of the original model, while preserving the undercuts. Like plaster piece-moulds, they require a rigid mother mould made of plaster or a synthetic resin. Because flexible moulds are easier to make than plaster piece-moulds, they have, to a large extent, replaced the latter in modern foundries, despite their shorter useful life.

Piece-moulds can be used repeatedly to produce multiple casts in wax for bronze casting. In order to achieve this, liquefied casting wax is slushed around in the re-assembled moulds and allowed to coat all the surfaces to the desired thickness as it sets (g–h). Wax may also be formed into sheets and pressed into sections of the mould and then assembled.

A variety of materials such as stone, metal, and sandy clays have been used to form the mould in which metal is cast. For lost-wax sculpture, the latter material has been preferred for its plastic qualities. The more traditional 'investment' moulds are composed of ceramic powder and sand, bound with plaster, which is formed into a bulky mass. Increasingly, more modern, lighter, form-hugging, and stronger ceramic shell moulds are being used. Such forms were originally developed for industrial casting and subsequently adopted by art foundries, much as sand moulds had been in the 19th century.

While small sculptures may be solid, most casts are hollow shells. This reduces the weight and cost of the sculpture and allows better control over the casting. Additionally, large volumes of metal may shrink unevenly as they cool and solidify, thereby trapping gases and producing retraction porosity and cracks, which can mar both the cast's structure and appearance. In the lost-wax process, the thickness of the wax walls determines the thickness of the metal cast and the hollow is created by an internal extension of the refractory mould, called a 'core'. There are various ways of producing a core, depending upon how the wax model is made. The sculptor might start by forming a slightly smaller and less detailed version of the sculpture out of refractory material and then modelling an even layer of wax with the finer details over it. Alternatively, core material may be pressed or poured into the hollow of a moulded wax replica (i). The even thickness is ensured during the pour by anchoring the core in relation to the outer mould. To this end numerous metal 'core pins' or 'chaplets' are pushed through the wax shell to span the gap between the core and the outer mould.

Sand casting is a variation of the piece-moulding process. It involves a reusable mould made of a hard material such as plaster, metal, or wood, which can withstand the pressure applied to it during this process. Sand moulds can only be used once as they are destroyed in the casting process. Iron or wooden 'flasks'—called 'drag' and 'cope'—serve as outer containers in which sand and a binding agent such as clay or resin is packed around the model. The 'drag' is placed on a board and filled with coarse sand to the rim. The model is embedded halfway into the sand. The exposed part is tightly packed with the special mixture of sand. When thus compressed, the sand mixture preserves a negative impression of the model. When the top portion of the mould is complete, the other flask, or 'cope', is set on top of the drag. Coarse sand is carefully rammed around the piece-mould and in the empty spaces in the cope, thus holding the piece-mould together. The clamped flasks are then turned over; the drag is now on top. The coarse sand is removed to expose the other half of the model. The smoothed horizontal surface of sand in line with the top of the drag is coated with a separating agent and, for a simple form without undercuts, the same process is repeated for the other half of the model. Forms with undercuts require a more elaborate moulding procedure with smaller pieces made by packing or 'ramming' the special sand mixture around carefully defined sections of the exposed model. Smaller mould pieces are held in place by long pins and keys. Once finished, the flasks are carefully parted in order to remove the model. Gates and vents are carved into the sand and the flasks are reassembled for casting. Hollow sculptures require a core made of the same casting sand. This core is formed over an iron armature in the mould. The thickness of the metal is defined by the space obtained by paring down the core. Chaplets and other core supports are used to firmly suspend the core in the mould.

Both in lost-wax and sand casting, complex or large models may be divided into smaller components, moulded and cast separately, and joined in the metal. Such sectioning simplifies the moulding and casting process and also reduces the extent of eventual casting flaws. Furthermore, it facilitates the removal of the core material. In ancient Greece in the 6th century BC, many large sculptures were moulded indirectly, cast in parts, and flow-welded. However, during the Renaissance in Florence—perhaps in response to the *Michelangelesque challenge to carve sculptures from one piece of marble—sculptors took great pride in casting sculptures in one piece. The majority of French and American 19th-century bronzes were made in smaller sections by the sand-casting method. These were then skilfully reassembled by some form of mechanical join (e.g. mortise and tenon or pinned sleeve join). Today, most sculptures, whether cast by the lost-wax or sand-casting method, are made in parts and welded.

Casting is considered a reproductive process, mimicking the appearance of the material of the original model, whether carved, modelled, or hammered sheet. As such, it facilitates the production of multiples and also of 'surmoulages' or 'aftercasts'—replicas cast from moulds taken from existing bronzes. These are generally distinguished from the first generation of casts by a loss of detail and slightly smaller dimensions, due to the metal's shrinkage in cooling. The notion of 'originality' of a bronze sculpture might, therefore, be reconsidered in terms of (1) the artist's

intention to produce a given model in this material; (2) to what extent the artist had a hand in achieving this; and (3) whether the artist approved of its production and finish.

In order to provide the artist with some control over the production of bronze sculptures, limited editions were introduced, beginning in the 19th century (in contrast to the large editions of industrial casts). Legislation was passed regarding output in the late 20th century.

Most often, the artist does not have the equipment or skill to produce a bronze sculpture on his own—especially monumental pieces—and will therefore hand over his model to others for translation into bronze. The accuracy of this translation is a reflection of the sensitivity and skill of all of those involved in such a collaborative process. Specialized mould makers often make the moulds of the artist's model; other skilled craftsmen prepare, sprue, and invest the wax replicas; founders prepare and cast the liquefied metal into the pre-heated mould; adroit metal smiths may reclaim the original form with chisels, hammers, files, and saws, eliminating artefacts of the casting process, repairing imperfections, and enhancing the surface by chasing in order to present the sculpture as a pristine form; another expert patinates the surface with the aid of chemicals, heat, and sometimes coloured waxes and varnishes.

The final and much appreciated visual element of a cast bronze is its surface coloration. The bright golden hue of a freshly polished bronze cast may be preserved and even enhanced by protective coatings. However, the surface is often intentionally treated with chemicals to obtain a specific chromatic effect at the time of its production. 'Patina' refers to the alteration of a material's surface, whether induced by natural or artificial means. The environment in which a bronze sculpture is displayed and interventions throughout its lifetime inevitably contribute to its appearance. Unless it is protected and maintained, the metal will try to revert back to the more stable mineralized state of the alloy's elements. As with other works of art, it is a challenge for those responsible for a sculpture's preservation to identify the sculptor's original intention and to find the right balance in choosing how to re-present a surface altered by time. FGB

Beale, Arthur, 'Materials and Techniques', in *Daumier Sculpture: A Critical and Comparative Study*, exhib. cat. 1969 (Cambridge, Mass., Fogg Art Mus.).

Mattusch, Carol, et al., *The Fire of Hephaistos: Large Classical Bronzes from North American Collections*, exhib. cat. 1996 (Cambridge, Mass., Harvard University Art Mus.).

Shapiro, Michael E., *Bronze Casting and American Sculpture 1850–1900* (1985).

static and dull despite the sensitive colour of the open landscape. Catena's skills of observation and description were better applied to portraiture and in the 1520s he produced many fine *portraits of Venetian humanists, merchants, and dignitaries. PSt

Robertson, G., *Vincenzo Catena* (1954).

CATLIN, GEORGE (1796–1872). American painter. Born in Wilkes-Barre, Pa., Catlin practised as a lawyer until his thirties when he was able to earn a living as a portrait painter. In 1830, prophetically aware of the fate of native Americans, he resolved 'to rescue from oblivion the looks and customs of the vanishing races of the native man in America'. Over the next eight years he travelled throughout the west, often alone, and painted over 600 pictures of the life of 48 tribes including many full-length portraits. He subsequently toured his paintings, accompanied by native American companions, throughout America (1838–9) and Europe, including London (1845) and Paris (1846). *Baudelaire, who described him as 'the impresario of the red-skins', greatly admired his work, partly for its unaffected immediacy and partly because of the nobility of Catlin's subjects. He reproduced many of his paintings and wash drawings in *Manners of the North American Indians* (2 vols., 1841) and later publications. His valuable record of native American life transcends ethnography for, although accurate, his paintings are lively and dignified. The Smithsonian Institution,

Washington, holds the largest collection of his work. DER

Mann, D., *George Catlin (1796–1872)*, exhib. cat. 1992 (Washington, NG).

CATS, JACOB (1577–1660). Dutch statesman and poet. After training as a lawyer in France and England, Cats became Pensionaris, then Raadspensionaris, of Holland, one of the most important political posts. He became wealthy through marriage and land speculation. Apart from his official position, he was well known as a poet and playwright. His poetic emblem books in particular, written in alexandrine verse and with a moralizing tone, brought him international renown. Translated into French, German, and English, the influence of 'Father Cats' lasted well into the 19th century. The first emblem book, *Sinn'- en minne-beelden* (1618), contains emblems, written in Dutch, Latin, and French. Each emblem is illustrated and has a threefold text commenting upon the themes of love, religion, and social custom. The illustrations by Adriaen van de *Venne contributed to the book's success. The second book, *Spieghel van den ouden en de nieuwen Tijdt* (1632), is also divided into three. This time, each saying corresponds to the themes of childhood/youth, married life, and old age. CFW

Berge, D. ten., *De hooggeleerde en zoet vloeiende dichter Jacob Cats* (The Learned and Fluent Poet Jacob Cats) (1979).

CAVACEPPI, BARTOLOMEO (?1716–99). Italian sculptor, restorer, and dealer. Trained by Pierre-Étienne *Monnot, he executed a small number of original statues. But most of the energies of his big Roman workshop were devoted to the restoration of Antique sculptures to supply his century's insatiable thirst for classical art. Almost every collector of note, from Charles Townley to Catherine the Great, bought pieces from him. In a situation in which demand outstripped supply the boundaries between restored sculptures, copies, and outright fakes were blurred and Cavaceppi was expert at the conjectural reconstruction of entire statues or elaborate marble candelabra from the suggestion offered by an insignificant original fragment. Pieces by him are to be found in most of the older public art collections in Europe. MJ

Howard, S., *Bartolomeo Cavaceppi: Eighteenth-Century Restorer* (1982).

CAVALIERE D'ARPINO (Giuseppe Cesari) (1568–1640). Italian painter, the favourite artist of Pope Clement VIII, who dominated the official art world in Rome in the years around 1600. Born in Arpino, the son of an inferior painter of ex-votos, he came to Rome as a young boy, and almost immediately entered the team of fresco painters working in the Vatican Loggias, where he was acclaimed as a prodigy. There followed swift success as a fashionable painter of elegant frescoes; his small, highly

finished cabinet paintings of erotic mythological subjects were also much in demand. In the 1590s commissions poured into his busy studio, where he employed many specialist artists, among them *Caravaggio, who there painted flowers and fruit. His frescoed decoration of the Olgiati chapel in S. Prassede (1593–5) brought a new sense of brilliant colour and decorative opulence to Roman art. From 1599 to 1601 he directed the decoration of the transept of S. John Lateran, and here attempted to restore the grandeur and clarity of *Raphael. These years marked the summit of his success, and later, melancholy and dissatisfied, he stood apart from the developing *Baroque. His brother Bernardino (1571–1622) worked in his studio, but was better known as a draughtsman. HL

Röttgen, H., *Il Cavaliere d'Arpino*, exhib. cat. 1973 (Rome, Palazzo Venezia).

CAVALLINI, PIETRO (active c.1270–c.1330). Late medieval artist who worked in fresco and mosaic, chiefly in Rome. Between c.1275 and c.1289 Cavallini repainted the huge *Early Christian fresco cycles in the nave of S. Paolo fuori le mura; the destruction of the basilica in 1823 means that these are known only from copies, but a commission for such a prominent work would only have been given to an established artist. From c.1293 parts of a fresco scheme which originally covered the interior of S. Cecilia in Trastevere still survive; most of the *Last Judgement* was protected, and it provides the best evidence for his fresco style at this time. In the later 1290s he created a *mosaic cycle of six scenes of the life of the Virgin, with a donor panel, in the apse of S. Maria in Trastevere; it is the principal complete surviving work of the artist. Between 1296 and 1308, besides some smaller works, he painted the apse fresco in S. Giorgio in Velabro. From the early 1320s there survive some areas of a fresco scheme in the church of S. Maria Donna Regina in Naples; this is his only work outside Rome. His final major commission, given him by Pope John XXII from Avignon, was for a mosaic on the façade of S. Paolo fuori le mura, Rome; he worked on it from 1325 to 1330, and its appearance is known from copies.

Cavallini's career and œuvre are important for two reasons. He became the first artist to emerge from the late medieval tradition of central Italy and establish a completely original and personal figure style. This has great plastic power and presence, which was later associated with the younger artist *Giotto, and reflects an interest in contemporary sculptural values. Although surrounded in Rome by classical and Early Christian art, his work also shows an ability to create a synthesis of contemporary art of both the Byzantine world and northern Europe; it is

impossible to explain his work without reference both to French *Gothic art and to that of the Palaeologus phase (1261–1453) of *Byzantine art.

Secondly, he achieved a social position that (for an artist) had not previously existed in Italy. Invited to Naples by the Angevin King, his status, with a pension and a house for his family, was exceptional. His burial in a prominent tomb in S. Paolo fuori le mura, Rome, where a lamp was kept burning for centuries after his death, was also unprecedented. PH

Hetherington, P., *Pietro Cavallini: A Study in the Art of Late Medieval Rome* (1979).

CAVALLINO, BERNARDO (1616–56?). Italian painter, from Naples, who specialized in intimate *cabinet pictures, sometimes on copper, for a sophisticated clientele. He trained under *Stanzione, according to his Neapolitan biographer, de *Dominici (1742–3), but was also influenced by other painters in Naples including *Ribera, Aniello Falcone (1607–56), and the anonymous Master of the Annunciation to the Shepherds. The refined elegance of his figures suggests he also drew inspiration from French and Netherlandish prints of the late 16th and early 17th centuries. His subjects ranged from biblical scenes to a variety of literary themes taken from Ovid, Livy, Tasso, and Marino, as well as single half-length figures of saints and singers. Only eight of Cavallino's surviving works are signed, which has limited attempts to analyse his stylistic development: a *S. Peter* and *S. Paul* (ex-art market), which are strongly reminiscent of Ribera; *S. Cecilia in Ecstasy* (1645; Florence, Palazzo Vecchio), which shows the characteristic grace and spiritual refinement of the artist's mature style; a *Pietà* (Molfetta, Vescovile Diocesano) of great emotional intensity; an *Adoration of the Shepherds* (Cleveland, Mus. of Art) notable for its mastery of design and delicate orchestration of tone; *Judith with the Head of Holofernes* (Stockholm, Nationalmus.), a Caraveggesque work reminiscent of *Vouet; the *Expulsion of Heliodorus* (Moscow, Pushkin Mus.) painted on copper, a highly finished work in a classicizing style, where the Roman tradition of history painting is reinterpreted with disconcerting originality in a highly theatrical manner. Cavallino's only identifiable large painting in the grand manner is the unsigned *Triumph of Galatea* (priv. coll.) which reinterprets *Raphael's Galatea (Rome, Farnesina; engraved by Raimondi) with an exuberance and joy that anticipates *Tiepolo and the *Rococo. HB

Percy, A., et al., *Bernardo Cavallino of Naples*, exhib. cat. 1984 (Cleveland, Mus. of Art; Fort Worth, Kimbell Mus.).

CAYLUS, CLAUDE-PHILIPPE DE TUBIÈRES, COUNT DE (1692–1765). French antiquarian and collector. He abandoned a promising military career to fulfil his lifelong passion for the arts and the *Antique. In 1714 he spent a year in Italy and travelled through Greece to Constantinople and the Near East. Returning to Paris in 1717 he took drawing lessons from *Watteau (of whom he wrote a life in 1748), learned engraving, and threw himself with enthusiasm into the reproduction of old master drawings, coins and gems, and antiquities. In 1722 he visited the great collections of Holland and England. In 1731 he was elected honorary counsellor of the Academy of Painting and Sculpture and in 1742 a member of the Academy of Inscriptions. He was an active, if somewhat interfering and overbearing, champion of the younger artists working in the classical style, notably *Bouchardon, of whom he published a life in 1762. He supported the ideals of classical purity and simplicity in contrast to the more decorative *Rococo and was among the most important influences for the emergence of the Louis XVI style, which combined the language of Antiquity with naturalness in a way that gracefully avoided the somewhat self-conscious and frigid archaeological exactitude of the *Neoclassicism of the early 19th century. Caylus is credited with being the first to conceive archaeology as a scientific discipline and in this respect *Winckelmann acknowledged indebtedness to him. His own collection of antiques, which he began in 1729, formed the basis of his *Recueil d'antiquités égyptiennes, étrusques, grecques, romaines et gauloises* (7 vols., 1752–67), the most serious work of antiquarian research in the 18th century and one of the most influential in spreading knowledge and enthusiasm for the works of classical Antiquity. HO/MJ

Rocheblave, S., *Le Comte de Caylus* (n.d.).

CÉAN BERMÚDEZ, JUAN AGUSTÍN (1749–1829). Spanish writer, collector, and amateur artist. His reputation is based on his six-volume *Diccionario historico de los mas ilustres profesores de las bellas artes en España* (1800), which surveys artists working in Spain from the Middle Ages until his own time. It incorporated information derived from unpublished archives, and achieved new standards of historical judgement and objectivity. It was an essential source of reference for pioneer British travellers visiting Spain in the 1830s, such as Richard *Ford, and later in the 1840s, Sir William *Stirling. Céan Bermúdez attributed the revival of Spanish art to *Mengs and he himself valued good drawing and ideal beauty in preference to the more spontaneous *fa presto* manner of *Giordano and other *Baroque painters. Yet he admired the naturalism of *Velázquez.

This internal conflict is reflected in Céan Bermúdez's *Dialogo sobre el arte de la pintura* (1819) where *Murillo and Mengs, meeting after death, debate the relative merits of naturalism and idealism as artistic ideals. Céan Bermúdez was a friend of *Goya, who became involved in an unfulfilled project to provide portrait engravings to illustrate the *Diccionario*. He owned many of the drawings after Velázquez which Goya made for his series of reproductive etchings; including a red chalk drawing after *Las meninas*. The artist also gave him the only complete set of proof impressions, with autograph titles, of the etchings of the *Disasters of War* (now London, BM). Much of his extensive print collection, including works by *Rembrandt, is now in the Biblioteca Nacional, Madrid. HB

Gassier, P., and Wilson, J., *The Life and Complete Works of Francisco Goya* (1971).
Sayre, E., *The Changing Image: Prints by Francisco Goya*, exhib. cat. 1974 (Boston, Mus. of Fine Arts).

CELLINI, BENVENUTO

CELLINI, BENVENUTO (1500–71). Florentine goldsmith and sculptor. Thanks largely to shameless self-promotion in his autobiography, a vivid and amusing account written in the vernacular, he is one of the best documented and most widely reputed *Mannerist artists after *Michelangelo.

He trained initially as a goldsmith, only turning later to marble sculpture. His career can be divided roughly into three periods. The earlier period was spent mainly in Rome, where he produced precious tableware, jewellery, and cast medals and coins. The Sack of Rome (1527) forced him to abandon the city and, after short stays in northern Italy, in 1540 he entered the court of François I of France. There he produced his most renowned goldsmith's work, the Salt Cellar (1540–3; Vienna, Kunsthist. Mus.), a virtuoso design in gold and enamel. He worked on architecture at *Fontainebleau, and cast the large semicircular bronze relief of the languid *Nymph of Fontainebleau* (1543; Paris, Louvre), surrounded by beasts. A lost colossal *Mars* was his last work in France. The remainder of his career was spent in *Florence, principally in the service of Cosimo I de' Medici, for whom his first and most significant commission was for his elegant masterpiece, the bronze *Perseus* (1545–53; Florence, Loggia de' Lanzi). The intricate decorative detailing of its principal figures and the statuettes decorating the base illustrates his goldsmith's training. To this period belong his marble sculptures, including the *Apollo and Hyacinth* (c.1548–57) and the effete *Narcissus* (c.1548–57; both Florence, Bargello), as well as the *Crucifix* (1562; Escorial). The bronze *Ganymede* (1548–50; Florence, Bargello) is an antique restored by Cellini. As a portraitist, Cellini displays incisive characterization and precise chiselling in his bronze *Cosimo I* (1548; Florence, Bargello) and the *Bindo Altoviti*

(c.1550; Boston, Isabella Stewart Gardner Mus.). The autobiographical *Vita* was translated into English by Thomas Nugent in 1771, and into German by Goethe in 1798; the preferred English version is the edition by John Addington Symonds (1st edn., 1887). In the mid-1560s he composed the *Trattato dell'oreficeria* and the *Trattato della scultura*, both translated into English by C. R. Ashbee, and these still remain valuable technical texts today.
 AB

Cellini, B., *The Life of Benvenuto Cellini Written by Himself*, trans. J. A. Symonds (1949).
Pope-Hennessy, J., *Cellini* (1985).

CELTIC ART

CELTIC ART, the style of ornament and imagery produced by the Celtic-speaking peoples of central and western Europe between the 5th century BC and 8th century AD. Exuberant and complex decoration was applied to a range of portable possessions, including ornate secular metalwork and items of religious significance. An essential design characteristic is the rhythmical distortion and almost unrecognizable abstraction of ultimately natural forms, in which there is deliberate ambiguity and shape-shifting—spirals end in birds' heads, an animal face appears or disappears like the Cheshire cat. This is a functional art, but the objects it decorates are an integral expression of Celtic society and beliefs.

Described by contemporary Greek and Roman writers as aggressive, wandering, horse-riding barbarians, the Celts were unified by their language and by their material culture; their art survives substantially in the form of the decorated equipment made of bronze, gold, or iron required by an Iron Age warrior-aristocracy. Helmets, shields, swords, scabbards, harness, and chariot gear demonstrate warfare, display, and mobility; brooches, neck-rings, armlets, buckles, and other jewellery express rank and status; while bowls, flagons, cups, cauldrons, and fire-dogs confirm the written evidence of epic drinking, feasting, and hospitality. The techniques involved, including repoussé relief, inlays, enamelling, filigree, engraving, and hatching, are those of exceptionally skilled designer-craftsmen, who held a deservedly important position in society. There are also three-dimensional figures, probably of ritual significance, including bronze animals, carved stone human heads, and wooden effigies.

This society commences in the 7th to 6th centuries BC, a phase named Hallstatt after its Austrian type site where richly furnished chieftains' graves contain Greek and Italian bronze and pottery wine vessels, avidly imported from the Mediterranean area in return for salt and metal ores. Indeed it has been claimed that Celtic art was created by Celtic thirst; for the geometric, floral, and foliate decoration found on these ancient wine

containers was a crucial source of inspiration for Celtic patrons and craftsmen, who transformed these elements into their own characteristic sinuous linear designs.

The main phase of continental Celtic culture is called La Tène after the type site in Switzerland; it lasts from the 5th to the 2nd centuries BC and reflects a prosperous, hierarchical, and tribal society whose aristocratic families were buried with lavish grave goods. The custom of ritually depositing weapons and other items in lakes and rivers has also preserved much vital evidence for the development of Celtic art. This has been divided into four main phases, neither chronologically nor geographically exclusive. The 'early' style emerges quite suddenly in the 5th century BC, as a confident adaptation into symmetrical scrolls and border designs of the natural motifs of tendrils and palmettes on the imported wine vessels, together with stylized animal and human masks. The 'Waldalgesheim' phase, which dates from the mid-4th century, is named after a rich German burial site containing wine flagon, chariot, and jewellery. The jewellery, decorated in a more advanced and coherent style employing continuous scroll patterns, foliate and petal-like motifs, triquetra designs, and with the first use of coloured inlays of enamel or coral, may reflect the influence of eastern as well as classical sources. The subsequent 'Sword' style is called after the linear, more asymmetrical scroll patterns seen particularly on scabbards; it dates from the 3rd to 2nd centuries BC, and overlaps with the 'Plastic' style, characterized by ornament in deep relief.

The independent society creating such art forms ended on the Continent in the 1st century BC as a result of its subjugation by the Roman Empire. In the British Isles, however, there was quite a different sequence. The first artefacts decorated in a recognizably Celtic manner date from around 300 BC. Regional and local schools of craftsmen then produced continually evolving decoration, marked by its vigour and asymmetry; among their superb products are many objects and designs exclusive to Britain. These include a series of bronze mirrors with engraved trumpet-scrolls (e.g. mirror from Holcombe, Devon; London, BM); horse equipment with complex curvilinear enamel inlays; gold torcs and massive inlaid bronze armlets providing evidence of the high rank of their wearers. It was only the south-east of Britain which really felt the impact of Roman art, whose realist traditions can be detected through the introduction of gods portrayed in human form, and more recognizable images of animals. This style is known as Romano-Celtic.

In the north-west and Ireland purer Celtic features were retained and preserved, the products of jewellers and smiths during the

five centuries of the Roman occupation. Then, in response to the new religion of Christianity, there was an extraordinary renaissance of Celtic art in the 7th century AD, when craftsmen, now employed by monastic workshops, applied their long-established designs and techniques to the embellishment of illuminated Gospel books, gold and silver chalices, and carved stone crosses.

CMH

Green, M., *Celtic Art* (1996).

Kruta, W., et al., *The Celts* (1991).

Megaw, R. and V., *Celtic Art from its Beginnings to the Book of Kells* (1989).

Stead, I. M., *Celtic Art in Britain before the Roman Conquest* (1985).

CENNINI, CENNINO (D'ANDREA) (c.1370–c.1440). Italian painter and writer. Cennino was the pupil of Agnolo *Gaddi, the embodiment, for him, of the continuing legacy of *Giotto in Florentine painting. No securely attributable paintings by Cennino are known, either in Florence or in Padua, where he was recorded in 1398 and 1400. His fame rests instead on his treatise, the *Libro dell'arte*, perhaps written in Padua in the 1390s. It is primarily a practical manual for artists, describing in sometimes pithy detail the elaborate processes underlying all kinds of painting. The *Libro*, important as the first Italian text of its kind, is also significant for the context in which Cennino sets his art, anticipating the later acceptance of painting as the equal of the ancient liberal arts. He emphasizes the importance of a moral approach to artistic activity, the exercise of imagination based on natural observation, and the forging of a personal style. The *Libro* thus contributed to the developing sense of artists as individuals, and to the modern reading of art as an intellectual as well as a manual activity.

JR

Cennini, Cennino, *Il libro dell'arte*, trans. D. V. Thompson (1933).

CERANO. See CRESPI, GIOVANNI BATTISTA.

CEROPLASTICS. This is the art of sculpture in wax, such as, for instance, Mme Tussaud's waxwork figures, which she exhibited in London from the 1830s and which formed the foundation for the present-day Mme Tussaud's in London.

AB

CERQUOZZI, MICHELANGELO (1602–60). Italian painter who was active in his native city of Rome. Cerquozzi may have begun his career as a *battle painter, and was nicknamed 'Michelangelo delle Battaglie'; but he became best known as a painter of *Bambocciante, small scenes from popular life, a genre created by the Dutch artist van *Laer. Cerquozzi's *Artist with a Group of Friends* (Kassel, Staatliche Kunstsammlungen) is fresh and lively, and vividly evokes an everyday Rome of crumbling ruins, strewn with fragments of Antique sculpture. He painted some religious scenes, with small figures, and, probably in his mature years, produced large still lifes, with landscape settings, and often with figures, which introduced a new Baroque splendour to the Italian still life. His works were popular with aristocratic Italian collectors, and his most celebrated and unusual picture, the *Revolt of Masaniello* (1647; Rome, Gal. Spada), which presents a momentous historical event as unheroic genre, was in the collection of Cardinal Bernardino Spada. This marked the beginnings of a collaboration with the perspectival specialist Viviano *Codazzi, and Cerquozzi's later genre scenes lose their early freshness and are set in grand architectural vistas.

HL

Briganti, G., Trezzani, L., and Laureati, L., *The Bamboccianti: The Painters of Everyday Life in 17th Century Rome* (1983).

CERUTI, GIACOMO (Il Pitocchetto) (1698–1767). Italian painter, born in Milan, but active mainly in Bergamo and Brescia. Although he painted religious works and history paintings, his main activity was in portrait painting and genre. His portraits have a striking objectivity and an engaging if provincial lack of artifice. His genre paintings consist of somewhat prettified but essentially realistic and sympathetic scenes of vagabonds (*pitocchi*), peasants, beggars, and other humble types—for instance *I due disgraziati* (Brescia, Pin. Civ. Tosio-Martinengo). In 1726–8 Ceruti was commissioned by Andrea Memmo, Governor of Brescia, to paint seventeen pictures of important local worthies to decorate the Palazzo di Broletto, Brescia, but these were dispersed at the end of the century. In 1736 he delivered a series of portraits, beggar pictures (including *Tre pitocchi*; Madrid, Thyssen Mus.), to Johann Mattias von Schulenburg, Marshal of the Venetian Republic. More unusually, Schulenburg's commission also included two vividly executed still lifes: a *Still Life of Fish, Lobster, and Oysters* (priv. coll.) and a *Still Life with Game* (Kassel, Staatliche Kunstsammlungen). Ceruti worked in Milan and Piacenza during the 1740s, but his later years are not well documented.

HB

Gregori, M., *Ceruti* (1982).

Gregori, M., et al., *Giacomo Ceruti il Pitocchetto*, exhib. cat. 1987 (Brescia, Monasterio di S. Giulia).

CESARI, GIUSEPPE. See CAVALIERE D'ARPINO.

CÉZANNE, PAUL (1839–1906). French painter widely considered to be a crucial figure in the development of modern art. Born in Aix-en-Provence, the son of a prosperous banker and schoolfellow of Émile Zola, he initially studied law, but after enrolling at the Academy at Aix began to pursue a career as a painter. Having won a second-class medal in life-class drawing he left Provence for Paris with the aim of enrolling at the École des Beaux-Arts. In Paris he was reunited with Zola, who introduced him to *Manet and *Courbet. In 1861, having failed to gain entry to the École, he studied at the Académie Suisse, where he met *Pissarro and Armand Guillaumin and was later introduced to *Monet, *Bazille, *Sisley, and *Renoir.

His painting during these early years represents a highly original blend of *Romanticism and *Realism that explored the range of genres typical of the *Paris Salon. Cézanne's painting drew on an eclectic range of sources from the high art of the old masters to the low art of popular *caricature and the *canards*. His style and subject matter of the 1860s constitutes a critical set of dialogues with the work of other painters. Among the most significant of these are the work of Manet, Courbet, *Delacroix, and *Daumier, but equally the work of fellow southern painters such as *Monticelli, Paul Guigou (1834–71), and Émile Loubon.

In the mid-1860s Cézanne was to develop a brusque and rapid manner of painting that placed an emphasis on composing through the direct application of thick slabs of paint, often applied with only a palette knife. Exemplary of this style is his *Uncle Dominic* series (1866), a group of portraits, each executed in a single sitting. These paintings have very little in the way of preparatory sketches and bring to the fore the painter's distinctive brushwork and his privileging of the compositional role of colour over line, reversing thereby many of the hierarchical values of academic composition. Cézanne was later to refer to this period as his 'manière cuillarde' which is evidently indebted not only to Courbet but to the style associated with the Provençal tradition. Around the same time he began painting direct from nature under the influence of the *Barbizon painters *Corot, *Daubigny, and Théodore *Rousseau. During these years Cézanne placed an emphasis on painting with *naïveté* and *sincérité* and using his motifs as vehicles to express his strong *sensations* and *tempérament*. These terms were to remain as the bedrock of his artistic principles even though his manner and procedures of painting were to change quite radically. In the early 1870s, working closely with Pissarro and also Guillaumin in Pontoise, Cézanne's style and pictorial concerns gradually moved closer to those of the *Impressionists. During this decade he exhibited in the Impressionist exhibitions of 1874 and 1877. Though continuing to see the motif as a channel for the expression of his

subjective *sensations*, Cézanne now placed a greater emphasis on patient observation and the visual aspect of sensation. His palette lightened and expanded, exhibiting a greater inclination toward primary colours, and his handling gradually showed more finesse. Yet, as his *La Maison du pendu* (1873; Paris, Mus. d'Orsay), one of his more complete landscapes, reveals, his painting placed a greater emphasis on form and structure and showed less interest in the atmospheric and contingent effects of nature than is characteristic of Impressionism. Indeed, during the late 1870s Cézanne was to develop a manner of painting characterized by a small patchwork of coloured brush strokes that model the form without tonal gradation. This 'constructive stroke' is evident in *Le Château de Medan* (*c*.1880; Glasgow, Burrell), but as the painting reveals this manner was far from systematic. Cézanne retrospectively indicated to Maurice *Denis that he was unable to render his *sensation* of a motif all at once and had devised this method as a way of initially developing his paintings which he would later refine and adjust with a more varied form of realization in response to his perception of the motif. This is very evident in his still lifes of the 1870s and 1880s, works which often reveal a higher degree of completion and resolution and which reveal his concern to unlearn inherited and formulaic ways of looking and composing. Though landscape arguably became the dominant subject matter of his painting during this period, he continued to work in a wider range of genres than the other Impressionists and continued to produce a high proportion of figure works, particularly on the theme of Bathers. At the 1877 Impressionist show the centrepiece of his submissions was the Barnes version of *Les Baigneurs au repos* (1876–7; Merion, Pa., Barnes Foundation), a large ambitious painting set in his native Provence, which indicates his concern to interweave references from the work of the old masters with contemporary pictorial concerns for greater 'naturalness' in painting.

In the late 1870s Cézanne resettled in Provence and, though still visiting Paris regularly, became an increasingly remote figure within the Paris art world. Except for showing a portrait at the Salon in 1882 he did not exhibit again in Paris until 1895, when the dealer Vollard staged the first of three important retrospectives of the painter that were to bring his work to the forefront of the attention of the Parisian avant-garde and consolidate the interest in his painting that had been growing during the 1880s. In the same year he had two works accepted by the Musée Luxembourg as part of the *Caillebotte bequest. During the years leading up to the Vollard show Cézanne had progressively expanded the range of his landscape motifs, taking in both rustic subjects and fragments

of nature, but also more contemporary motifs such as the bay at L'Estaque, a busy industrial port. In this period Cézanne sought to find a synthesis between Impressionist *naïveté* and empiricism with references to the classical past. In works such as *La Montagne Sainte-Victoire au grand pin* (1887; London, Courtauld Inst. Gal.), he features the mountain that was a symbol of Provençal history and chooses to frame his motif with a repoussoir tree, features that allude to the association of Provence with the perpetuation of *classical traditions. Cézanne's interest in archaic classicism and his constant references particularly in his nudes to *Baroque and *Rococo art, styles associated with the south, reflected his commitment to his native Mediterranean culture; and during the 1890s he was to establish a friendship with Joachim Gasquet, a leading figure in the Provençal Félibrige movement. During the late 1880s and early 1890s Cézanne began to work on a more ambitious scale in many different genres. Whilst continuing to construct his paintings out of pictorial equivalents for his sensations, these works reveal an increasingly complicated compositional structure, a new emphasis on mood through the use of a dominant warm or cool tone, and show him self-consciously exploring the relationship between the codes and conventions of different genres. His work henceforth revealed a greater concern with pictorial harmony, compositional finesse, and achieving a greater degree of resolution. During the 1890s Cézanne's painting showed a greater range of pictorial effect which could vary from a tightly controlled and patiently built up facture to a more fluid and delicately worked compositional format, sometimes using the medium of watercolour. Cézanne's work at this time also revealed a greater range of pictorial reference, with clear allusions to the work of Courbet, Daumier, Corot, *Poussin, *Tintoretto, *Veronese, Delacroix, and *Rubens, by all accounts his favourite painter, as well as to Provençal painters such as *Granet. In the last twelve years of his life his major work centred on the representation of the female nude. Between 1895 and 1907 Cézanne produced the three *Grande Baigneuses* (London, NG; Philadelphia Mus.; Merion, Pa., Barnes Foundation) and numerous preparatory oil sketches on the subject.

Reaction to Cézanne in his own lifetime was divided. Cézanne's painting was either seen by contemporaries as an idiosyncratic variant of Impressionism or as a form of primitive *Neoclassicism in line with the concerns of the *Symbolists. Many of the most important early writings on the painter came from artists like *Bernard or Denis who were at the forefront of the Neoclassical tendencies within the Symbolist movement. Their characterization of the painter shaped

the understanding of Cézanne by later generations. Between 1904 and 1907 Cézanne's work was shown in a series of retrospectives at the Salon d'Automne (see under PARIS) where it was seen as leading the way to the experiments of the *Fauves. Soon after Cézanne's work was also seen as providing a model for the development of *Cubism. Influenced by Bernard's reading of Cézanne as having progressively moved away from the Impressionist depiction of natural forms in favour of exploring the inherent geometric structure of things, the Cubists saw Cézanne's painting as a model for their own concerns with form. In the second decade of the 20th century the British critics Roger *Fry and Clive *Bell, drawing on Maurice Denis's observations about the self-reflexivity of Cézanne's painting, characterized Cézanne as 'a great classic master', providing an account of the painter that emphasized his overriding interest in formal concerns. This view of Cézanne became central to the understanding of the painter as having initiated the movement towards abstraction in modern painting. This was challenged by interpretations which stressed the empirical nature of Cézanne's endeavour and later by accounts which stress psychological conflicts within Cézanne's painting. Recent interpretations of the painter, whilst continuing to affirm Cézanne's place in the history of modern art, have provided a less essentialist account of his work, stressing the importance of his subject matter and providing a fuller account of his critical engagement with other contemporary painters and old masters as well as examining the way his art responded to contemporary issues and debates in French social and cultural life.　　　JK

Fry, R., *Cézanne: A Study of his Development* (1927).
Schapiro, M., *Cézanne* (1952).
Shiff, R., *Cézanne and the Ends of Impressionism* (1984).
Wechsler, J., *Cézanne in Perspective* (1975).

CHADWICK, HELEN (1953–96). English artist. Chadwick was born in Croydon and trained at Brighton Polytechnic and the Chelsea School of Art. All her work, in a variety of media, was biological in inspiration and, as with several female artists of her generation, much was an exploration of her own body and its functions. As she wrote, 'my apparatus is a body × sensory systems with which to correlate experience'. In the 1970s she produced edible body casts and followed these with *Piss Flowers*, casts of patterns of urine in snow. In the series *Of Mutability* (1984–6) she collaged photographs of her naked body amongst organic matter, the sort of disturbing juxtaposition she returned to in *Wreaths of Paradise* (1992–4) in which unnaturally coloured flowers are photographed floating in incongruous domestic fluids. Controversy surrounded *Cacao* (1994), a fountain of molten chocolate, an ambiguous

image of desire and repulsion, at her *Effluvia* exhibition at the Serpentine Gallery, London. Before her death she was working on photographs of human embryos, the outcome of a residency at King's College Hospital, London.

DER

CHAGALL, MARC (1887–1985). Painter of the *École de Paris, born to Jewish parents in Vitebsk, Russia. He went to St Petersburg in 1907, studied under Leon *Bakst and moved to Paris in 1910. Here his memories of Vitebsk became transposed into a fantastic, poetic world depicted with *Cubist form and bright *Orphic colour, as in *To Russia, Asses and Others* (1911; Paris, Centre Georges Pompidou). Returning to Russia in 1914, he founded an art school in Vitebsk and designed for the Jewish theatre in Moscow. He returned to Paris in 1923 and produced illustrations for luxury editions of Gogol's *Dead Souls* (1923–5) and La Fontaine's *Fables* (1927–30). In the late 1930s Chagall began to produce dramatic and visionary works such as the *White Crucifixion* (1938; Chicago, Art Inst.) in response to the rise of Fascism and anti-Semitism in Europe. He fled to the United States in 1941 and designed decor and costumes for Stravinsky's *Firebird* (1945), returning to Paris in 1947 to be honoured with a major retrospective.

MF

Baal-Teshuva, J. (ed.), *Chagall: A Retrospective*. (1995).

CHALK. Natural chalks, usually red, grey, black, and white, are derived from earth substances. Natural red chalk is obtained from the red ochre variety of haematite, natural grey chalk from brick clay, natural white chalk from the chalk variety of calcite or soapstone, and natural black chalk from carbonaceous shale. In order to use these materials in *drawing, lumps were cut down and inserted into metal holders and the ends shaved to points.

Red chalk was in use by the 16th century and many *Renaissance artists employed it. Among the most notable practitioners in this medium were *Correggio, *Leonardo da Vinci, and *Michelangelo. Red chalks obtained from different deposits often varied in hue and variation could also be achieved by damping the chalk before use. Red chalk is frequently referred to as 'sanguine' in older reference books.

Black chalk was discovered at about the same time as red chalk and was used regularly in drawing until the early 19th century. It declined in importance largely because of the variability in quality and the fact that it began to be replaced by *crayon. Natural white chalk has been frequently employed since Renaissance times chiefly to heighten drawings executed in other media. Because of its softness it proved easy to cut it into convenient shapes for insertion into metal holders.

French artists of the 18th century, especially *Watteau, favoured a technique involving the use of red, black, and white chalks in combination and this was known as 'aux trois crayons'. Fabricated chalks or pastels are made from powdered pigments which are combined with non-greasy binders—they are essentially dry drawing media and are usually employed as short sticks. The marks left by pastels are opaque and since the 18th century special papers, sometimes ribbed or tinted, have been made for pastel drawing. Mixing the colours on the support can be done by smudging with the fingers or by the use of a *stump.

Pastel drawing started in northern Italy during the 16th century and was popular with many artists including Jacopo *Bassano and *Barocci. Elsewhere it was favoured for portrait drawing, most notably by Hans *Holbein the younger and Jean *Clouet. It continued to be used during the 18th century also for portraiture—some of the greatest exponents of the medium were Rosalba *Carriera, Jean-Étienne *Liotard, and *Chardin. In the late 19th century interest in pastels revived especially in the hands of *Degas, *Vuillard, *Redon, *Renoir, and *Toulouse-Lautrec.

PHJG

CHAMPAIGNE, PHILIPPE DE (1602–74). Flemish painter who trained in Brussels with Jacques Fouquières, but who settled in Paris in 1621 and was naturalized in 1629. In Paris Champaigne met Nicolas *Poussin, who was on the point of setting off for Italy (a journey Champaigne never made), and quickly attracted the attention of Louis XIII and Cardinal Richelieu. For the King he executed two allegorical portraits, a genre with which he was not entirely comfortable. In more naturalistic and austere mode he was a formidable, and original, portrait painter: his portraits of Richelieu in the Louvre and the National Gallery, London, bring the Cardinal vividly to life, while his masterpiece is the votive picture of 1662 (Paris, Louvre), which commemorates in the form of a double portrait the miraculous recovery from paralysis of his daughter, a nun at the Port-Royal convent in Paris. For his contemporaries, however, Champaigne's principal achievement was as a painter of altarpieces. Such early works as *The Adoration of the Shepherds* (c.1630; London, Wallace Coll.) retain traces of the *Baroque style of *Rubens, but his involvement from the 1640s with the austere religious teachings of the Jansenists of Port-Royal changed his art, inclining some of his religious pictures to the cold and hard, without quite attaining the *classicism of Poussin. Nevertheless, in such late works as *The Crucifixion* of 1674 (Paris, Louvre) there exists a profoundly moving tension between the economy of artistic means and the tragic subject matter. There also survive a number of landscapes, mostly with biblical themes, by the artist. In all, Champaigne was one of the most original and creative figures in French painting of the middle of the 17th century, his portraits and later religious works reflecting the passionate rationalism of French thought in the age of Pascal, Descartes, and Corneille.

HO/MJ

Dorival, B., *Philippe de Champaigne: catalogue raisonné* (1976).
Dorival, B., *Supplément au catalogue raisonné de l'œuvre de Philippe de Champaigne* (1992).

CHAMPFLEURY, pseudonym of Jules-Husson Fleury (1821–89). French novelist and art historian. A close friend and ally of *Courbet, he played a major role in the early development of French *Realism. His novels deal with social themes, and *Les Aventures de Mademoiselle Mariette* (1853) is set in the bohemian Paris of destitute and aspiring artists. Courbet's *The Artist's Studio* (Paris, Mus. d'Orsay) contains his portrait, and Champfleury's *Realist Manifesto* of 1885 accompanied a private exhibition of Courbet's paintings. He studied popular imagery, and collected folk songs, engravings, old plates, and peasant faience. Later, he turned to art history and published studies of the *Le Nain brothers (1862), caricature (1865–80), and *Daumier (1878).

HL

Flanary, D. A., *Champfleury: The Realist Writer as Art Critic* (1980).

CHANTERENE, NICOLAU (active c.1516–50). French sculptor among the foreign artists lured to 16th-century Portugal, then wealthy from its overseas colonies. Chanterene's first documented work in Portugal, a royal commission for the convent of S. Maria de Belém (c.1517), evinces the quintessentially French style through which he dominated Portuguese sculpture during his lifetime. In 1522 he began the limestone altarpiece for the important Silva family at the church of S. Marcos de Tentúgal. The theme and composition are *Gothic, with Aires Gomes da Silva and his wife kneeling in reverence with their saints before the deposition of Christ; the setting, however, is fantastic classical architecture covered with dense Renaissance ornament. Another version of this altarpiece in the convent of Nossa Senhora da Pena at Sintra (1529–32) is larger and more monumental, yet simpler. The alabaster wall tomb that Chanterene created for the Archbishop of Évora (1537) is his most classical work, with a simplified architectural setting and the elimination of ornate decoration. From 1533 to 1540 Chanterene lived in Évora among a circle of humanists with close ties to Spain and Italy. He was awarded the title of royal

herald by King João III. SS-P

Smith, R. C., *The Art of Portugal 1500–1800* (1968).

CHANTILLY, MUSÉE CONDÉ, one of the great 19th-century collections, formed by men of vast wealth. The Duke of Aumale was the fifth son of the French King Louis-Philippe. When the monarchy fell in 1848 he was exiled and lived in England, at Orleans House, Twickenham, where he devoted himself to connoisseurship and collecting Greek sculpture, books, manuscripts, 18th-century furniture, drawings, paintings, and objets d'art. He bought both entire collections and individual pieces of special quality, and had a network of correspondents throughout Europe. He was heir to the Condé and Montmorency collections and to the Condé estate at Chantilly. After the fall of the Second Empire he returned to France and had a new château built at Chantilly in Renaissance revival style on the foundations of the château that had been razed in the Revolution. Here he continued to expand his collection, with the intention of presenting it to the Institut de France for the benefit of the nation. This he did in 1886, despite having been exiled yet again under an anti-monarchist law of that year.

The collection reflects a conventional mid-19th-century connoisseur's taste at a level of superb quality. In addition to splendid *Poussins and Italian old masters, including three fine *Raphaels, there is an excellent collection of French portraits of all periods and a number of works by contemporaries such as *Meissonier and *Delaroche who appealed to this kind of collector. The collections of old master drawings and of manuscripts equal the paintings; the most celebrated object in the collection, albeit one that is not normally on show to the public, is doubtless the *Très Riches Heures du Duc de Berry* (1410–16) (see also under DE LIMBURG). AJL

Lefébure, A., *Chantilly* (1986).

CHANTREY, SIR FRANCIS LEGATT (1781–1841). English sculptor. He was apprenticed to a woodcarver in Sheffield but went to London around 1802 and worked at the RA Schools (see under LONDON). Marriage to a well-off cousin helped to launch his independent career and he secured his first public success with his marble bust of *The Revd J. Horne Tooke* (Cambridge, Fitzwilliam) at the Royal Academy in 1811. Thereafter he succeeded *Nollekens as the most popular portrait sculptor in England. A mature work such as the bust of *John Raphael Smith* (1825; London, V&A) demonstrates the psychological acuity and vigorous *naturalism of his style, which was little affected by the prevailing *Neoclassicism, even after his belated journey to Italy in 1819. In addition to portraits Chantrey also produced commemorative statues and funerary monuments, scoring a particular success with those that included children, such as those to the Robinson children (1817; Lichfield Cathedral) and to *David Pike Watts* (1826; Ilam, Staffs., parish church). In these a muted Neoclassicism is combined with naturalism in a way that seems to have suited the pragmatic English temperament of the 19th century. Chantrey's busy practice brought him great wealth, and besides being very generous during his life he left a bequest of £105,000 to be administered by the RA, the interest to be used to buy 'works of Fine Art of the highest merit executed within the shores of Great Britain'. These are now housed at the Tate Gallery, London. HO/MJ

Holland, J., *Memorials of Sir Francis Chantrey* (1851).
Jones, G., *Sir Francis Chantrey, R.A.: Recollections of his Life, Practice and Opinions* (1849).
Potts, A., *Sir Francis Chantrey, 1781–1841*, exhib. cat. 1981 (London, NPG).

CHANTRY, a religious foundation, permanently endowed with money or lands, to pay for daily masses and prayers for the souls of the founders. The most notable involved the erection of a special chapel within a church, usually containing the tombs of the deceased beneficiaries and an altar where the Masses could be celebrated. Many elaborately decorated chantry chapels were built after the Black Death (1348–9) and functioned until 1545 when 2,000 were suppressed. Lincoln Cathedral had at one time 36 chantries, Ely 29, and six now survive at Winchester. Henry VII's chapel at Westminster was the most elaborate foundation of all. KC

Duffy, E., *The Stripping of the Altars: Traditional Religion in England 1400–1500* (1992).

CHARCOAL. In order to manufacture charcoal, wood is reduced to carbon in heated chambers and oxygen excluded from these containers to prevent combustion. Charcoal was cut into pieces and inserted into holders like chalk. In the main it was employed as a preparatory substance for drawings which were to be completed in other media, but it has also been used by some artists on its own. A disadvantage of charcoal was that it was easily rubbed away and no means of fixing it seems to have been discovered before the first quarter of the sixteenth century.

Nevertheless, it was clearly well known at this period since combining it with white chalk on blue paper was a favourite medium of the Venetian artists, notably *Titian and *Tintoretto. In order to render charcoal drawings more permanent a new method of producing 'oiled charcoal' was developed from about the middle of the 16th century. Sticks of charcoal were soaked in linseed oil, wiped dry, and then used for drawing before the oil hardened through oxidization. The line left was indelible and in time it hardened like oil paint. Unfortunately the oil left behind on either side of the line tended to remain as a yellow streak. *Guercino was an artist who drew with this variety of charcoal. PIIJG

CHARDIN, JEAN-SIMÉON (1699–1779). French painter of *still life and *genre. He was the exact contemporary of *Boucher but his contrast in every way, representing the naturalistic tendency that persisted through the 18th century alongside the more fashionable *Rococo. Chardin was born in Paris and trained with the minor painter Pierre-Jacques Cazes (1676–1754). He had his first public success in 1728 when he exhibited *The Rayfish* (Paris, Louvre) at the annual open-air exhibition in the Place Dauphine. This led to his acceptance into the Académie Royale (see under PARIS) later that year as a painter of 'animals and fruit'. His early still lifes depict simple groups of game, fruit, and humble household utensils arranged on a stone shelf or plain linen cloth. They are soberly painted and use a limited palette. This simplicity contrasts with the lavish abundance and rich objects in the pictures of such Flemish and French still-life practitioners as Jan Weenix and *Oudry. It is less a reflection of the relatively modest milieu that Chardin undoubtedly moved in at this time than a function of his search for architectonic strength of composition and the technical means to express as directly as possible the physicality of the things he depicted. A fine example of this early phase of Chardin's still-life style is *The Copper Cistern* (c.1734; Paris, Louvre).

From the mid-1730s Chardin began to paint *genre scenes depicting the small events of bourgeois domestic life in unadorned interiors. These pictures, usually with no more than two figures—typically a female servant and a child—are in the tradition of the Dutch 17th-century cabinet paintings that were so avidly collected in 18th-century France. But their atmosphere of calm and order, Chardin's eschewal of the anecdotalism and elaborate symbolism of their Dutch prototypes, and an unmistakably French elegance give them a uniquely attractive character. Such works as *The Housekeeper* (1738; Ottawa, NG Canada) and *Grace* (1740; Paris, Louvre) point their gentle morals with simplicity and understatement. They quickly attracted royal and aristocratic patrons and through engravings by Charles-Nicolas *Cochin and others became Chardin's most popular works in his lifetime, a status that grew rather than diminished in the 20th century.

From 1748 Chardin returned to an almost exclusive concentration on still life. In this

third phase of his career his compositions were more ambitious, the array of objects more complex, and their nature more expensive. At the extreme, in such elaborate paintings as *The Attributes of the Arts* and *The Attributes of Music* (1765; Paris, Louvre), this reflected the demands of his rich (in this case royal) patrons for works to fit into sumptuous Rococo decorative schemes. Nevertheless in the smaller pictures that comprised the generality of his output, though the food was more expensive and pottery had been replaced by porcelain and glass, Chardin was still exploring with great subtlety both the effects of composition and the painterly means to express the different materialities of the objects in front of him. It was paintings such as *The Jar of Olives* (1760; Paris Louvre) that *Diderot praised with enthusiasm, regarding Chardin as one of the best colourists and most adroit manipulators of paint of the 18th century. This is an assessment that subsequent critics, collectors, and, above all, artists have endorsed, giving Chardin his place as the greatest French still-life painter at least until *Cézanne, and as one of the greatest pure painters of realistic form that the world has known.

At the end of his long life, suffering from eye troubles, Chardin turned to pastel as a medium, executing a number of portraits of family and friends. These include two self-portraits (1771 and 1775; Paris, Louvre) and exhibit the same qualities of direct, unflattering observation and probity of technical means as do the best of the still lifes. Throughout his career Chardin was a regular exhibitor at the *Paris Salon, and from 1755 in his twin roles as treasurer and *tapissier* of the Académie Royale was responsible for the difficult task of hanging the pictures at the exhibition. HO/MJ

Conisbee, P., *Chardin* (1986).
Naughton, G., *Chardin* (1996).
Roland Michel, M., *Chardin* (1996).
Rosenberg, P. (ed.), *Chardin 1699–1779*, exhib. cat. 1979 (Paris, Grand Palais; Boston, Mus. of Fine Arts).

CHARONTON, ENGUERRAND. See QUARTON, ENGUERRAND.

CHASE, WILLIAM MERRITT (1849–1916). American painter, born in Indiana. From 1873 to 1878 he studied in Munich under *Piloty, from whom he learnt technical virtuosity. On returning to America he settled in New York, where he developed a brighter palette influenced by French *Impressionism. He soon became a successful and influential teacher, first at the Art Students' League and, after 1896, at the eponymous Chase School. He encouraged his students, who included *Demuth, *O'Keeffe, and Charles *Sheeler to paint outdoors. Speed and spontaneity were of paramount importance to Chase; he painted over 2,000 works, portraits, still lifes, landscapes, and interiors, and his tour de force was to paint a finished figure study, before his pupils, in under three hours. His work, with its emphasis on surface and finish, is superficial but decorative, concerned less with subject than technique. *In the Studio* (c.1880; New York, Brooklyn Mus.) is a study in textural contrasts in which gleaming brass, golden silk, polished wood, and Persian rug are vividly represented in lively brush strokes. From 1902 he exhibited with the New York and Boston Impressionist group, The Ten, founded in 1898. DER

Dayer Sallati, B. *William Merritt Chase* (1995).

CHASSE, a box or casket, often with a gabled roof, usually containing relics of a saint or holy person. See RELIQUARY. PS

CHASSÉRIAU, THÉODORE (1819–56). French painter, who successfully adapted the techniques of *classicism to the aims of *Romanticism. He was one of the most gifted pupils of *Ingres, and worked with him in Rome; his portrait drawings are close to those of Ingres. Later, after visits to North Africa in 1840 and 1846, he conceived an admiration for *Delacroix, and began to paint Romantic subjects, among them scenes from North African life, Shakespeare, and the Bible, in more brilliant and freely handled colour. The exotic figures of his *Toilet of Esther* (1841; Paris, Louvre) suggest both the voluptuousness of Delacroix and the decorative pattern and line of Ingres. His chief work was the decoration of the Cour des Comptes in the Palais d'Orsay, Paris, with allegorical scenes of Peace and War. The palace was destroyed, and a few fragments of the paintings are in the Louvre, Paris. HL

Sandoz, M., *Théodore Chassériau* (1974).

CHEERE, SIR HENRY (1703–81). English sculptor, possibly of French descent. He was in partnership with Henry Scheemakers (see under SCHEEMAKERS, PETER) until the latter left England about 1733. More interesting than their jointly signed work is that by Cheere alone, such as the statue of *Christopher Codrington* in Antique dress at All Souls, Oxford (1732). In his later works he moved beyond the Baroque classicism of *Rysbrack and the other leading sculptors of his youth to achieve a *Rococo delicacy of design, well exemplified in a drawing for a small monument to Capt. Philip de Sausmarez (after 1747; London, V&A). He was knighted in 1760 when he presented an address to George III on behalf of the County of Middlesex. His brother John (1709–87) had a yard near Hyde Park Corner which turned out large quantities of lead garden sculpture (e.g. Stourhead, Wilts., Longford Castle, Wilts.) in both Antique and Rococo styles, much of it originally painted naturalistically. HO/MJ

Gunnis, R., *Dictionary of British Sculptors 1660–1851* (rev. edn., 1968).
Whinney, M., *Sculpture in Britain 1530–1830* (rev. edn., 1988).

CHÉRET, JULES (1836–1932). French printmaker who set a new style for Parisian poster art with his exuberant designs and printing in brilliant multiple colours. Through him colour lithography (see COLOUR PRINTS) attained a new popularity and power. After starting as a commercial artist in Paris he spent eight years in London, where he studied lithographic printing techniques; here he met the perfume manufacturer Eugène Rimmel, for whom he made floral designs, and with whom he travelled widely. He set up his own studio in Paris in 1866, and over the next decade became recognized as the leading French poster designer. His frothy poster girls, rendered with a rapid, flamelike line, in brilliant reds, yellows, oranges, against sharp greens and blues, entice with the pleasures of the latest novel or glass of Dubonnet. Others symbolize the frivolous charm of those popular Parisian entertainments which they advertise—the music hall and *café-concert*, the circus and skating rink. His art was widely admired, and influenced *Seurat and *Toulouse-Lautrec, as well as *Art Nouveau designers. HL

Broido, L., *The Posters of Jules Chéret* (2nd edn., 1992).

CHEVALIER, GUILLAUME-SULPICE. See GAVARNI, PAUL.

CHEVREUL, MICHEL-EUGÈNE (1786–1889). French chemist and *colour theorist. Born in Angers, Chevreul studied chemistry at the Collège de France, Paris. He was a polymath whose early inventions and discoveries included margarine; he wrote on a wide variety of scientific subjects and had a distinguished career which included the directorship of the Museum of Natural History in Paris. His study of colours arose from his work as technical director of the Gobelins tapestry works from 1828. Practical difficulties in weaving, the unsatisfactory combination of certain threads, led him to observe that colours were perceived differently in combination and isolation and that in juxtaposition one colour altered another. His experiments proved that these optical effects were general rather than individual and thus subject to formulation. He continued his researches until 1864 but published his major discoveries in *De la loi du contraste simultané des couleurs* (1839), translated as *The Principles of Harmony and Contrast in Colours* in 1872. Although few painters probably read his work its influence may be seen in the work of the *Impressionists and *Pointillists and it had a

profound effect on the use of colour by later artists. DER

CHIARI, GIUSEPPE BARTOLOMEO

(1654–1727). Italian painter who was trained in the studio of *Maratti at Rome from 1666. He established his reputation with his *Birth of the Virgin* and *Adoration of the Magi* in S. Maria del Suffragio, Rome, commissioned in 1782. In 1686 Jacopo Montinioni (d. 1687), treasurer to Pope Innocent XII, commissioned an *Assumption* for the vault of the Montinioni chapel in S. Maria di Montesanto, Rome, as well as two extremely ambitious *history paintings of *Tullia Driving her Chariot over the Body of her Father Servilius Tullius* and *Ventura and Volumnia Imploring Coriolanus not to take up Arms against Rome* (both Burghley House, Lincs.). Both of the Burghley pictures are inspired by drawings produced by artists in the circle of Pietro da *Cortona and Chiari transforms these Cortonesque prototypes into more cohesive and clearly articulated classical designs. However, Chiari's classicism is never rigid or severe; indeed, in developing Maratti's ideas, he lightens the tone and softens the forms, as can be readily appreciated in his series of small and elegant mythological scenes from Ovid's *Metamorphoses* (1708; Rome, Gal. Spada). On an altogether larger scale he had painted in fresco *Hercules Introducing Marcantonio Colonna to Olympus* (c.1700; Rome, Palazzo Colonna). Pope Clement XI became his most important patron during the second decade of the century and commissioned work at S. Clemente and S. John Lateran, as well as an *Allegory on the Papacy* (Frascati, Episcopio), of which a second version was made as a gift for the Old Pretender, James Francis Stuart (now Rome, Accademia di S. Luca). Chiari's work was popular among British collectors and tourists including the 5th Earl of Exeter of Burghley House, Lord Burlington, John Talman (1677–1726), and Earl Harrold of Wrest Park (Beds.). HB

Dreyer, P., in *Zeitschrift für Kunstgeschichte*, 34 (1971). Waterhouse, E., *Roman Baroque Painting* (1976).

CHIAROSCURO (Italian: bright-dark).

The term was used by *Baldinucci to describe purely tonal monochrome paintings which rely for their effect only on gradations between brightness and darkness. De *Piles in his *Cours de peinture* (1708), on the other hand, defines it as 'the art of advantageously distributing the lights and shades which ought to appear in a picture, as well for the repose and satisfaction of the eye, as for the effect of the whole together In order to understand thoroughly the meaning of this word, we must know that *claro* implies not only any thing exposed to a direct light, but also all such colours as are luminous in their natures; and *obscuro* . . . all the colours which are naturally brown . . . deep velvets, brown stuffs, a black horse, polished armour, and the like, which preserve their natural or apparent obscurity in any light whatever.' In this application the term described an essential department of the painter's art to which, for instance, James *Barry, John *Opie, and Henry *Fuseli each in turn devoted one of his lectures in the Royal Academy (see under LONDON). The acknowledged master of chiaroscuro was, of course, *Rembrandt.
 HO

CHIAROSCURO WOODCUT, a relief

technique in which different tones are added by the successive printing of separate wood blocks. One block is cut for each tone, sometimes with the addition of a key block to print the main outlines of the design in black. Typically a chiaroscuro woodcut would be printed from three or four blocks, very carefully superimposed. From the early 15th century it was used with much vigour in Germany and Italy, the earliest dated work being *Burgkmair's *Emperor Maximilian on Horseback* (1508), and other fine German exponents were *Baldung Grien and Lucas *Cranach. They made more use of the key block than the Italians, and their work includes a much higher proportion of original designs. The Italians, led by *Ugo da Carpi, concentrated mainly on translating drawings or paintings, often by *Raphael and *Parmigianino, into the new medium.

The Italians used a more restrained range of tones, blending brown, pink, and mushroom to create a subtle play of tone, and a pronounced sense of the third dimension. At the end of the 16th century the technique flourished in Holland, and a group of prints by *Goltzius are some of the last important examples. The technique overlaps greatly with the history of the colour woodcut.
 RGo

Bialler, N., *Chiaroscuro Woodcuts* (1992).

CHICAGO ART INSTITUTE. In 1866 the

Chicago Academy of Design was formed by a group of artists. Despite the election in 1878 of a group of businessmen to help manage the new institution, all resigned after a year and formed a new institution called the Chicago Academy of Fine Arts in 1879. In 1882 the name was changed to the Art Institute and a new building, designed by John Wellborn Root, was built in Michigan Avenue and opened in 1887. After only five years this building proved inadequate and it was arranged that one of the buildings erected for the World's Columbian Exposition of 1893 would, at the end of the Exposition, be taken over by the Art Institute. This building, designed by Shepley, Rutan, and Coolidge, remains at the heart of the Institute's complex.

A number of bequests have contributed to the outstanding collection of paintings and graphic works of all periods. The Art Institute also has select collections of ancient Greek vases, medieval European sculpture, oriental artefacts, and pre-Columbian objects. The first important painting to be acquired was in 1892, the *Family Concert* by Jan *Steen, followed by other Dutch paintings from the Demidoff sale in Florence in 1895. Two early bequests moulded the present character of the collection, that of Henry Field of pictures mainly by *Barbizon artists and Mrs Potter Palmer's remarkable collection of *Impressionist paintings. *Post-Impressionist and early 20th-century holdings were greatly enhanced by the Helen Birch-Bartlett and Arthur Jerome Eddy collections respectively. The former includes one of the best-known pictures in the collection, Gustave *Caillebotte's *Paris Street: Rainy Day*. El *Greco's *Assumption of the Virgin*, acquired in 1906, has often been considered the highlight of the collection. It was discovered in Spain by the painter Mary *Cassatt, and, finding its way to the Paris gallery of Durand-Ruel, was sent to Chicago on approval. CFW

CHINARD, JOSEPH (1756–1813). French

sculptor. He spent much of his career in his native Lyons, and was probably the best sculptor working outside Paris in late 18th-century France. From 1784 to 1787 Chinard was in Rome. He was there again in 1791, when he was imprisoned in the Castel S. Angelo, his terracotta models for candelabra representing *Reason Trampling Superstition* and *Liberty Striking down Aristocracy* (Paris, Mus. Carnavalet) being thought subversive by the papal authorities shocked by the French Revolution. Ironically he was again imprisoned on his return to Lyons—because of a lack of revolutionary fervour. Chinard's small-scale figures and groups combine *Neoclassical themes with a grace of style reminiscent of *Clodion. Although he designed large sculptures for revolutionary and Napoleonic celebrations his best works are his portrait *busts, most remarkable among them that in marble of the sphinx without a riddle, the mysterious and seductive Mme Récamier (1801; Lyons, Mus. des Beaux-Arts).
 MJ

Rocher-Jauneau, M., *L'Œuvre de Chinard au Musée des Beaux-Arts de Lyon* (1978).

CHINNERY, GEORGE (1774–1852). Eng-

lish expatriate artist. Chinnery, the son of an amateur painter, first exhibited a portrait at the RA in 1791, when a student. He practised portraiture in London until moving to Dublin c.1795. While in Ireland he married and from 1802, when they returned to England, his life was dictated by a desire to escape his family. He deserted them immediately by sailing to India where, during a stay of over 20 years, he prospered as a

portrait painter and made many observant, sympathetic, and delicate drawings of Indian life and scenery (London, BM, V&A) for pleasure. When his family arrived, c.1825, he fled to Macao followed by his indefatigable wife, who died on ship c.1830 when Chinnery had taken refuge in Canton. He returned to Macao, where he painted English nabobs and Chinese officials, employing Chinese assistants as copyists, and made thousands of further drawings. *Dent's Verandah, Macao* (c.1842; priv. coll.) is typical of his fluid, relaxed style, redolent with oriental languor. His *Self-Portrait* (c.1840; London, NPG), seated at his easel, shows a prosperous Pickwickian figure. DER

George Chinnery, exhib. cat. 1957 (London, Arts Council).

CHINOISERIE, a European style in the fine and decorative arts reflecting fanciful and poetic notions of China which from the time of Marco Polo have been conjured up from travellers' tales and from exports of ceramics, lacquer, textiles, and objets d'art. Objects in the Chinese style became fashionable in the 17th century when ceramics, textiles, and lacquer were produced in imitation of Chinese designs. This vogue in the decorative arts reached its apogee in the Trianon de Porcelaine built by Louis Le Vau for Louis XIV in the park at Versailles (1670–1), which became the prototype of innumerable Chinese pagodas and pavilions built across Europe in the later 17th and early 18th centuries. Towards the end of the 17th century Jean *Bérain introduced Chinese motifs into his arabesques and originated that peculiar offshoot of chinoiserie, the *singerie. It was during the period of the French *Rococo that artists of prominence other than decorators lent themselves to chinoiserie. Antoine *Watteau painted around 1709 a series of *figures chinoises et tartares* for the Cabinet du Roi at the Château de La Muette, which are now known only through engravings. The spirit of delicate fantasy which enlivened Watteau's work was further developed by the chinoiseries and singeries of Christophe Huet, while a more original concept of the voluptuous Orient imbued the chinoiserie of *Boucher in his tapestry designs (the *tentures chinoises* woven at Beauvais about the middle of the 18th century), his decor for Noverre's ballet *Les Fêtes chinoises*, drawings engraved and published as *Livre des chinois*, and also easel paintings such as *The Chinese Fishing Party* and *The Chinese Fair* (both 1742; Besançon, Mus. des Beaux-Arts). In Germany and England the style was employed more in porcelain, furniture, decoration, and architecture than in the two-dimensional arts, receiving a scholarly imprimatur with William Chambers's *Designs of Chinese Buildings, Furniture etc.* (1757) and reaching an extravagant early 19th-century climax in the Brighton Pavilion designed by John Nash for the Prince Regent. HO/MJ

Honour, H., *Chinoiserie: The Vision of Cathay* (1961).
Impey, O., *Chinoiserie* (1977).
Jarry, M., *Chinoiserie: Chinese Influence on European Decorative Art* (1981).

CHOIR BOOK, a liturgical book containing the music and texts to be sung during the celebration of the Mass or divine office. Choir books are usually large format in order to be visible when placed on a lectern in front of the choir. The most common types are the gradual and the antiphonal (or antiphonary). The gradual, used during the Mass, contains the gradual responses, hymns sung after the Epistle and before the Gospel. The antiphonal, on the other hand, contains the chants sung antiphonally in the divine office. Their large format, with relatively few words to a page, could necessitate several volumes being made to cover the feasts of the liturgical year: for example the six-volume Beaupré Antiphonal (c.1290; Baltimore, Walters AG, MSS W 759–62).

It was during the 14th and 15th centuries that particularly lavishly illuminated series of choir books were undertaken; each feast opening with a suitably historiated initial. One of the most impressive of all such series was that begun for the Cathedral of Siena in 1457. The project continued over the next two decades and, in addition to Sienese artists, attracted two of the greatest northern Italian illuminators: *Liberale da Verona and *Girolamo da Cremona. Twenty-nine of the resulting volumes are displayed in the Piccolomini Library, Siena. In 1491 the first printed antiphonal was produced in Seville. KC

Calkins, R., *Illuminated Books of the Middle Ages* (1983).
Plummer, J. (ed.), *Liturgical Manuscripts for the Mass and Divine Office*, exhib. cat. 1964 (New York, Pierpont Morgan Lib.).

CHRISTIAN ART, EARLY. See EARLY CHRISTIAN ART.

CHRISTO (Christo Javacheff) (1935–). Bulgarian-born sculptor and experimental artist who settled in New York in 1964 and became an American citizen in 1973. He was born in Gabrovno, the son of an engineer-chemist who ran a textile factory, and studied at the Academy in Sofia, 1952–6. After brief periods in Prague, Vienna (where he studied sculpture with *Wotruba), and Geneva, he moved to Paris, where he lived from 1958 to 1964. Initially he earned his living there as a portrait painter, but soon after his arrival he invented 'empaquetage' (packaging), a form of expression he has made his own and for which he has become world famous. It consists of wrapping objects in materials such as canvas or semi-transparent plastic and dubbing the result art. He began with small objects such as paint tins from his studio (in this he had been anticipated by *Man Ray), but they increased in size and ambitiousness through trees and motor cars to buildings and sections of landscape. His first one-man exhibition was at the Galerie Haro Lauhus, Cologne, in 1961 and in the same year he made his first project for a wrapped public building. He spends a great deal of time and effort negotiating permission to carry out such work and then (if negotiations are successful) in planning the operations, which can involve teams of professional rock-climbers as well as construction workers. He finances such massive enterprises through the sale of his smaller works. The buildings that he has succeeded in wrapping include the Kunsthalle, Berne (1968), the Museum of Contemporary Art, Chicago (1969), the Pont Neuf in Paris (1985, after nine years of negotiations), and the Reichstag in Berlin (1995). Among the landscape projects he has carried out are the packaging of 1.6 km (1 mile) of coastline near Sydney, Australia (1969), *Valley Curtain* across Rifle Gap, Colorado (1972), and *Running Fence*, something like a fabric equivalent of the Great Wall of China, undulating through 40 km (24 miles) of Sonoma and Marin Counties, California (1976). Christo's wife Jeanne-Claude (née de Guillebon) (1935–) collaborates with him in his work. See also ENVIRONMENTAL ART. IC

CHRISTUS, PETRUS (c.1410–75/6). Netherlandish painter, active in Bruges from 1444, and the leading painter there after the death of Jan van *Eyck. He follows closely the style of his contemporaries, particularly van Eyck, whose works he may have copied or completed. Several works are signed and dated.

His intimate *Portrait of a Man* (London, NG) is detailed with microscopic precision and the sitter is, unusually, placed by an open window overlooking a landscape. A portrait of a Carthusian (1446; New York, Met. Mus.) is a dramatically lit close-up of a figure whose gaze engages directly with the spectator; the intervening space is bridged, in the manner of van Eyck, by a *trompe l'œil fly placed on an illusionistic parapet.

Petrus Christus' skilled depiction of familiar settings and interiors is seen in the *Virgin and Child in an Interior* (Kansas City, Mo., Nelson Atkins Mus. of Art), which recalls van Eyck's *Arnolfini Portrait* (London, NG) while employing deep perspectival recession and airy spaciousness.

His debt to Rogier van der *Weyden is evident from his *Lamentation* (Brussels, Mus. Royaux). Here he takes over motifs from Rogier's emotional and tightly constructed *Descent from the Cross* in the Prado, Madrid, but produces a composition which is restrained,

even stiff, but with beautifully observed details, and a panoramic, distantly receding landscape. MS

Ainsworth, M. W., *Petrus Christus: Renaissance Master of Bruges*, exhib. cat. 1994 (New York, Met Mus.).
Sterling, C., 'Observations on Petrus Christus', *Art Bulletin* (1971).

CHROMA. See COLOUR.

CHROMOLITHOGRAPHY. See LITHOGRAPHY.

CHRYSELEPHANTINE, a prestigious combination of gold (*khrusos*) and ivory (*elephas*) used in Greece, from the 6th century BC, for cult figures of deities, especially for the colossal statues in major sanctuaries. A wooden framework carried carved ivory, representing the exposed flesh of body and face, along with contoured gold sheeting for clothing and decoration. The most celebrated examples were *Phidias' *Athena* for the Parthenon (440s BC), and his later *Zeus* at Olympia (430s BC). A life-sized ivory head discovered at Delphi is the most notable original that has survived, but there are some images of Phidias' statues on contemporary coins and gems, together with some small copies of the *Athena*, and numerous references and descriptions by ancient commentators, like Pausanias. There are, too, indications of the procedures involved due to the recovery from Phidias' workshop, at Olympia, of some of the large terracotta moulds on which his gold sheeting was hammered to shape. JBl

CHRYSSA (Chryssa Vardea Mavromichaeli) (1933–). Greek-born American sculptor, a leading exponent of Light art. She was born in Athens, studied at the Académie de la Grande Chaumière, Paris (1953–4), and the California School of Fine Arts, San Francisco (1954–5), then settled in New York. There she experimented with various kinds of avant-garde work, and she was one of the first to explore the kind of banal subject matter associated with Jasper *Johns and Andy *Warhol, sometimes using words or letters as the entire content of a piece. During her early years in New York she was 'utterly alone, broke and very happy', and she became fascinated with the bright lights of Times Square. In 1962 she began incorporating neon tubing in her work (she is said to have been the first American to do this) and she soon moved on to pieces that consisted entirely of neon tubing apart from the necessary wiring and casing. In 1964–6 she produced *The Gates to Times Square* (Buffalo, Albright-Knox Gal.), a huge, brilliantly coloured work that is generally regarded as one of the most impressive light sculptures ever made; it is in the shape of a giant letter 'A', symbolizing America. Her work is sometimes categorized as *Minimal art, and it is also placed within the orbit of *Pop art because it takes its inspiration from advertising signs. IC

CHURCH, FREDERIC EDWIN (1826–1900). American painter. Church was born in Hartford, Conn., and studied under Thomas *Cole, 1844–6, from whom he learnt not only technique but the concept of landscape as history. His work, however, is less subjective than Cole's and aims for accurate, if heightened, representation. Superficially his enormous canvases resemble *Bierstadt's but Church had a deeper purpose. His reading of *Kosmos* (1845–62) by Alexander von Humboldt (1769–1859) encouraged a pantheistic belief that God was revealed by his works, most particularly in extreme natural wonders. Following Humboldt's exhortations he visited South America (1853 and 1857), painting several views of the volcanic *Cotopaxi* (c.1863; Reading, Pa., AG), and Newfoundland (1859) where he painted *Floating Icebergs* (New York, Cooper-Hewitt). *Niagara* (1857; Washington, Corcoran Gal.), with which he made his reputation, he saw as a potent symbol of America as the chosen country. The Wagnerian *Twilight in the Wilderness* (1860; Cleveland, Mus. of Art), with dramatic blood red clouds rolling westward, is a triumphant hymn to America's destiny. Church, who was a popular and financially successful painter, travelled and worked in Europe and the Near East 1867–9. DER

Kelly, F., et al., *Frederic Edwin Church* (1989).

CHURRIGUERA, JOSÉ DE (1665–1725). Head of a family of altarpiece makers, he moved to Madrid from Barcelona with his brother Joaquín in the early 1760s. The Churriguera family's surname came to designate their deliriously decorative surface carvings combining twisted ('Solomonic') columns, foliate ornament, gilded imitations of tasselled fabrics, and pyramidal forms standing on their apexes (called *estípites*). The altarpieces of S. Esteban in Salamanca (1693) and that of S. Salvador, Leganés (1707) exemplify Churrigueresque formulas. The style fell out of favour in 18th-century Spain, but continued to flourish on the altarpieces and church façades of Spanish America. SS-P

Kubler, G., and Soria, M., *Art and Architecture in Spain and Portugal and their American Dominions 1500 to 1800* (1959).

CICERO (106–43 BC). Roman orator and statesman, important as a source for collecting and connoisseurship in late republican Rome. His letters to Atticus and to the art dealer Gallus provide the best surviving evidence for the concerns of a Roman patron in ordering sculpture with which to decorate his villas (see ROMAN ART, ANCIENT: PATRONAGE AND COLLECTING). His primary concern is with its suitability to various parts of his villa and to his nature. There is no mention of statues by particular Greek artists or of particular periods. Yet, in *Brutus* 70 and *Orator* 9, Cicero presents a tradition of art criticism that sees the classicism of *Phidias as the pinnacle of achievement; this view is preserved to a greater extent in *Quintilian. The speeches against Verres, a provincial governor in Sicily renowned for his avarice in acquiring works of art, also provide an overview of the kinds of material desired and the relative values of works of art. L-AT

Leen, A., 'Cicero and the Rhetoric of Art', *American Journal of Philology*, 112 (1991).
Marvin, M., 'Copying in Roman Sculpture: The Replica Series', in *Retaining the Original: Multiple Originals, Copies, and Reproductions* (1989).
Pollitt, J. J., *The Ancient View of Greek Art* (1974).

CICOGNARA, (FRANCESCO) LEOPOLDO, COUNT (1767–1834). Italian art historian and critic. Born to aristocratic parents in Ferrara, Cicognara was educated at the Collegio dei Nobili in Modena (1776–85). A stay in Rome (1788–90) introduced him to classical architecture and contemporary *Neoclassical art and after 1807, when he settled in Venice, he devoted himself to scholarship, painting, and administration. From 1808 to 1826 he was president of the Accademia and was largely responsible for public access to the collection in 1817. His treatise *Del bello* (1808) expounds standard Neoclassical aesthetic theories but his most important work, *Storia della scultura* (1813–18), which describes the development of Italian sculpture from the 13th century to his own times, praises originality and progress. His marble bust, by his friend *Canova (1822; unfinished, Ferrara, Certosa), was placed on his tomb. Although attacked by Romantic writers his work established the concept of the professional academic critic. DER

CIGOLI, LUDOVICO (1559–1613). Italian painter and draughtsman; also active as an architect. He was responsible for introducing a new spirit of naturalism to Florentine art, based on study of very similar sources to those that inspired Annibale *Carracci, and in particular the art of *Barocci and the Venetians. He was apprenticed to Alessandro Allori and later studied under *Santi di Tito. His style oscillates between a proto-Baroque concern with interlocking figures and diagonal movement, as for instance in the *Martyrdom of S. Stephen* (Florence, Pitti) and the more classical grandeur of the *Adoration of the Kings* (Stourhead, Wilts.) enriched by finely characterized figures wearing opulent draperies. In 1604 Cigoli went to Rome; his *Ecce Homo* (1604–6; Florence, Pitti) is a direct challenge to

Caravaggio, and was painted there in competition with him. His best pupil was Giovanni Bilivert (1585–1644). HB

Chiarini, M., and Chappell, M., *Ludovico Cigoli: tra manierismo e barocco*, exhib. cat. 1992 (Florence, Pitti).

CIMABUE (Cenni di Pepo) (active 1272–1302).

Italian painter. Cimabue's significance was recognized as early as *Dante's time, but has been distorted by a tendency to define him as a mere pathfinder: forerunner to *Giotto and *Renaissance painting proper. For *Vasari, his was the first, albeit embryonic, attempt to shake off the supposed crudity of medieval style and begin the long march to a fully achieved Renaissance. He should instead be seen as an artist of tremendous dramatic and emotive power in his own right, inventive, alert to *classical as well as *Byzantine influence.

Only one work, the *S. John* mosaic of 1301–2 in Pisa Cathedral, is documented, but a reasonably settled attributional history allows Cimabue's progress to be studied. His earliest work is probably the *Crucifix* in S. Domenico, Arezzo. Byzantine anatomical conventions are observed, but subjected to vivid and naturalistic modelling of the forms, the whole controlled by a remarkably firm sense of proportion and composition. The tragic grandeur of Cimabue's conception is echoed in one of the two versions of the *Crucifixion* included in his choir and transept frescoes in the upper church of S. Francesco in Assisi. These (of c.1280, or rather earlier) comprise the *Life of the Virgin* (choir), *Evangelists* (crossing vault), and apostolic and apocalyptic scenes (transept). Their near-ruinous condition cannot obscure the intensity of the drama or the rapidity of Cimabue's own development. The south transept *Crucifixion* has a visionary and expressive intensity scarcely equalled in the period. In the lower church at Assisi Cimabue painted a frescoed altarpiece of the *Madonna and Child with S. Francis*, probably before the upper church frescoes. The oblique throne, echoed in *Duccio's *Rucellai Madonna* (1285; Florence, Uffizi) and Cimabue's own *Pisa Madonna* (Paris, Louvre), contrasts with the majestic frontality of his *Madonna* for S. Trinita in Florence (now Florence, Uffizi). Here the throne recedes coherently into space; distance is established by the passage from the foreground busts of *David* and *Prophets* placed beneath the throne's plinth to the angels supporting the rear. The Madonna is clothed in the fine classicizing pleats already seen in the loincloth of the Arezzo *Crucifix*. A second *Crucifix* (Florence, Mus. dell'Opera di S. Croce), perhaps from the mid-1280s, was seriously damaged in the 1966 floods. It marks a further advance in naturalism. The modelling of flesh is more fluid, running the stylized graphic motifs of Cimabue's Italian and Byzantine sources into a continuous and modulated surface, with a fine sense of chiaroscuro. A new grasp of light is evident in the superbly painted translucent loincloth. JR

Chiellini, M., *Cimabue* (1988).

CIMA DA CONEGLIANO, GIOVANNI BATTISTA (1459/60?–1517/18).

A leading painter in Venice in the generation between G. *Bellini and *Titian. His principal activity was in producing altarpieces, usually of the *Virgin and Child with Saints*, although he supplied smaller pictures, mainly half-length Virgins, for private use. Influenced by Bellini, his conservative style showed little development and did not even keep up with new directions in his mentor's work. His early activity is not well documented; his first dated work is the *Virgin and Child with SS James and Jerome* (Vicenza, Mus. Civico) painted for S. Bartolomeo, Vicenza, in 1489, by which date he must already have been well established. Much of his patronage came from the small towns of the Veneto, around his birthplace, Conegliano, near Treviso, including the *Madonna with Saints and Music-Making Angels* in the cathedral at Conegliano (s.d. 1493) which shows an obvious debt to G. Bellini. His earliest Venetian altarpiece, *S. John the Baptist with SS Peter, Mark, Jerome and Paul* in the church of the Madonna del Orto (c.1493) is notable for its rusticated architecture, with a tree twisting between the columns supporting an open vault. A more elaborate landscape background, full of natural detail, characterizes his *Baptism of Christ* in S. Giovanni in Bragora, Venice (commissioned in 1492 but probably completed a little later). However the artist's essential conservatism is apparent from such late works as the *Virgin and Child with S. John and Mary Magdalene* (Paris, Louvre) painted for S. Domenico, Parma c.1511–13, where the figures in the foreground, crafted with meticulous attention, still remain essentially detached from the carefully constructed landscape background. A polyptych for S. Anna, Capodistria (s.d. 1513) (missing since 1946) further underlines the *retardataire* quality of Cima's late work. Cima employed several assistants. The slow careful method of painting practised in his workshop, usually involving a wood panel with a gesso ground, underdrawing with a brush in black iron-gall ink, elaborate hatching and shading particularly in the modelling of draperies, and the application of an oil-based paint, can be studied in an unfinished painting of the *Virgin and Child with S. Andrew and S. Peter* (Edinburgh, NG Scotland) which reflects the design of Cima's *Madonna of the Orange Tree* (Venice, Accademia), dating from the 1490s, but which may have been painted later by one of his assistants. HB

Humfrey, P., *Cima da Conegliano* (1983).

Humfrey, P., *The Altarpiece in Renaissance Venice* (1993).

CIONE, ANDREA DI, called Orcagna (active 1343, d. 1368).

Italian painter and sculptor, the dominant Florentine artist of the period following the 1348 Black Death. His style has been frequently, perhaps too easily, interpreted as a response to that catastrophe and a reaction against the advances of *Giotto's school. The signed altarpiece of *Christ in Majesty with Saints* (1357) which Orcagna painted for the Strozzi chapel in S. Maria Novella displays his formidable powers. The language of pictorial space is inverted, not abandoned, in the interests of a highly cerebral and specific exposition of Dominican politico-theology employing a pointed reworking of *Traditio Legis* iconography. The hot colours, sharp outlines, and the unrelenting frontal stares of the central figure of Christ and the flanking S. John the Baptist combine in an image of unforgettable force. In 1359 Orcagna signed a large and elaborate tabernacle for the chapel of the Florentine guildhall, Or San Michele. The marble reliefs of the *Life of the Virgin* combine elements of the Strozzi altarpiece's style with others reflecting a profound grasp of the *stil nuovo* of Giotto and his contemporaries. Surviving fragments of a frescoed trilogy of the *Triumph of Death, Last Judgement and Hell*, of uncertain date, from the nave of S. Croce (now in the former refectory), framed by muscular fictive spiral columns, reveal a narrative style of great dramatic power. A more lyrical version of Orcagna's style informs the work of his brother Nardo, the painter of the vast frescoes of the *Last Judgement, Paradise*, and *Hell* which decorate the walls of the Strozzi chapel. Another brother, Jacopo, completed Orcagna's *S. Matthew* altarpiece (Florence, Uffizi) after his death. JR

Offner, R., and Steinweg, K., *A Corpus of Florentine Painting* (1931–79), vol. 4/6.

CIPRIANI, GIOVANNI BATTISTA (1727–85).

Italian-born decorative and history painter. Cipriani studied at the Accademia del Disegno in Florence, his birthplace, before moving to Rome in 1750. Here he met the architect Sir William Chambers (1723–96) and *Wilton, the sculptor, and returned to England with them in 1755. Chambers's position as architectural tutor to the future George III was a key to Cipriani's success, but in addition to his decorative schemes he was also an accomplished designer and illustrator. In 1776 he was engaged by Chambers to provide designs and decorations for Somerset House, London, including *Nature, History, Allegory*, and *Fable*, to surround *Reynolds's *Theory* on the library

ceiling, grisaille panels for the staircase, and key stones, carved by *Nollekens, for the façade. He became a founder member of the RA (1768) and designed the diploma which was engraved by his friend Francesco Bartolozzi (1727–1815), a fellow student in Florence. The two of them are shown, together with a third émigré, Agostino Carlini (d. 1790), in a *Group Portrait* by J. F. Rigaud (1777; London, NPG).　　　　　　　　　　　　　DER

Croft-Murray, E., *Decorative Painting in England*, vol. 2 (1970).

CIRE-PERDU. See CASTING.

CIVETTA. See BLES, HERRI MET DE.

CLAESZ., PIETER (1596/7–1661). Still-life painter, born in Burgsteinfurt, Westphalia. By May 1617, when he married, he was living in Haarlem and stayed there for the remainder of his career. Here, in 1620, his son Nicolaes *Berchem was born. He and Willem Claesz. *Heda are considered the most important representatives of the monochromatic style of Dutch still-life painting. As with Heda, Claesz. came to specialize in *ontbijtjes* (breakfast pieces). He chose less sumptuous objects than Heda and arranged them in simple compositions which are admirably balanced on a strong diagonal against pale beige backgrounds. *Still Life with Glass and Lemon* (1638; Kassel, Staatliche Kunstsammlungen) is also characteristic of Claesz.'s virtuoso technique in painting reflections in glass and a soft atmospheric light gleaming on silver against a plain background. Other still lifes allude to mortality, such as *Vanitas* (1630; The Hague, Mauritshuis) with the prominent watch, skull, and recently extinguished candle. In the later 1640s Claesz.'s compositions become grander. In *Still Life* (1647; Budapest, Szépmüvészeti Mus.) the folds of large napkins are draped over the edge of the table, glowing curves of lemon peel and precious knife-handles catch the light.　　　　　　　　　　　　　　CFW

Segal, S., *A Prosperous Past: The Sumptuous Still Life in the Netherlands* (1988).

CLARK, KENNETH (Lord Clark of Saltwood) (1903–83). English art historian and collector. Through his television series *Civilisation* (1969) Clark brought to millions his discerning and humane view of the central role of the visual arts in Western culture. His urbane television presence was the culmination of many years as a sought-after popular lecturer on the history of art. Yet beneath his easy, patrician manner lay wide-ranging scholarship of real distinction. Clark began his first book *The Gothic Revival* (1928) while still an Oxford undergraduate. Two years in Florence studying Italian art, his abiding passion, with Bernard *Berenson

were followed by his appointment in 1931 as Keeper of Fine Art at the Ashmolean Museum, *Oxford. From 1934 until the outbreak of war he was director of the National Gallery in *London, and from 1951 he was chairman of the Arts Council of Great Britain. His publications include the catalogue of the *Leonardo drawings in the Royal Collection at Windsor Castle (1935), *Landscape into Art* (1949), *The Nude* (1956), and *Rembrandt and the Italian Renaissance* (1966), the last three being reworkings of important lecture series. A connoisseur's eye and private wealth enabled Clark to assemble an important collection of old master art and also to help contemporary British artists at critical moments in their early careers. Among them were Henry *Moore, Graham *Sutherland, and Victor *Pasmore.　　　　　　　MJ

Clark, K., *Another Part of the Wood* (1974).
Clark, K., *The Other Half* (1977).
Secrest, M., *Kenneth Clark: A Biography* (1984).

CLASSICAL GREEK ART (c.480–336 BC). The traditional beginning of the Classical period is 480 BC; thus the Persian sack of Athens is seen as a decisive turning point, both politically and culturally. The creation of the Athenian Empire, established to confront the Persian initiatives, resulted in the flowering of the arts in a 'Golden Age' of *Athens. As the centre of the empire, the city was embellished with buildings, sculpture, and painting. In its most narrow sense, 'Classical' has come to refer to this period above all. But the Classical period encompasses a much broader range, from experimentation in early Classical sculpture at the temple of Zeus at *Olympia to the innovations of the sculptors of the 4th century BC, *Praxiteles and *Lysippus. In painting and sculpture, the period is marked by advances in the portrayal of 'historical' events by reference to mythology and allegory. Representation of daily life is restricted to pottery and funerary art. In the 4th century BC, a greater interest in characterization of god and man is evidenced. Political instability is reflected in new types for the gods. Apollo and Dionysus become sexually ambiguous youths; the austerity of the maiden goddess Athena is replaced by a sensuous Aphrodite, captured in stone, naked in the bath.　　　　　　L-AT

Boardman, J., *Greek Sculpture, Classical Period* (1985).
Charbonneaux, J., Martin, R., and Villard, F., *Classical Greece* (1973).
Pollitt, J. J., *Art and Experience in Classical Greece* (1972).

CLASSICISM. *See overleaf.*

CLAUDE GLASS, a small black convex glass used for reflecting landscapes in miniature. It abstracts the artist's subject from its surroundings, simplifies it, and subdues the colours so that it is seen in terms of

light and shade. It also reduces the intervals between the lights and darks, and by concentration enables the painter to see his subject broadly and to assess the relative tonality of the various parts. It was popular in the 17th and 18th centuries, and not only with artists, for the poet Gray carried one with him in his travels round Britain in search of the *picturesque. *Claude Lorrain was said to have used such a glass. An Italian artist whom Mrs Merrifield interviewed (*Practice of the Old Masters*, 1849) told her that he possessed a black glass which had once belonged to *Dughet and N. *Poussin, and before them to Pieter van *Laer. A view reflected in this glass, he said, looked 'just like a Flemish landscape'. In the 19th century a similar device was used by *Corot, who regarded tonal unity in painting as supremely important.　　　　　　　　　　　　　　HO

Ashwin, C., *Encyclopaedia of Drawing* (1982).

CLAUDE LORRAIN (Claude Gelée) (c.1604/5–82). French painter, draughtsman, and etcher who specialized in *landscape. He was born at Chamagne (Toul) in the duchy of Lorraine. He trained initially as a pastrycook and it was probably in that capacity that he moved to Rome, maybe as early as 1617. Shortly afterwards he seems to have turned to painting and moved to Naples, working there for two years under the German artist Goffredo Wals (c.1600–38/40). This was followed by further training back at Rome with Agostino *Tassi who specialized in painting landscape, coastal scenes, and illusionistic architecture. Claude returned briefly to Lorraine in 1625 and was assistant at Nancy to the court painter Claude *Deruet whose figure style made a lasting impact on him. He may also have met *Callot and copied several of his etchings. By 1627 Claude was back at Rome and he settled there for the rest of his life. He now fell under the influence of the northern painters living in the city who specialized in scenes of everyday life, often set against scenes of ancient ruins: Bartholomeus *Breenbergh, Herman van Swanevelt (c.1600–55), with whom he shared lodgings, and Pieter van *Laer, one of the Bamboccianti artists. Above all he responded to Paul *Bril's imaginary mythological landscapes.

Claude's great achievement as a landscape artist was to transform the Venetian *Renaissance concept of the pastoral landscape into a more natural but no less poetic genre, based on his capacity to perceive Rome and its surrounding landscape with the eyes of a foreigner, intoxicated by its classical associations and the Italian light. Conscious through close observation of nature of changing patterns in the landscape, especially at sunrise and sunset, he found a beauty that was atmospheric and objectively perceived

continued on page 133

· CLASSICISM ·

CLASSICISM is a term to describe reference or commitment to a canonical ('classic') art of the past or its values, in particular the art of Antiquity (the *Antique). In theory the values of classical art are constant; in practice they vary with the 'period eye' and tend to alter with what they may be opposed to—*Gothic, *Baroque, *Rococo, *Romantic, even *Realist. Principles typically associated with classicism include order, proportion, balance, harmony, decorum, avoidance of excess. Though classicism is posited on the imitation of nature, classicist artists manipulate and select their natural material in a manner involving both the application of reason and the instruction of previous example.

Opposed to Gothic, classicism may stand for a new conception of the figure involving contrapposto and a style of architectural ornament deriving from the Antique. Once the *Renaissance style has been established, it becomes a matter more of handling—'Baroque', like 'Rococo', originally implying an anti-classical tendency, although the Baroque style is founded on the canon established by the High Renaissance, and Baroque artists not regarded as 'classicist' were extremely well versed in classical example (the architect Borromini is one case; *Rubens, when opposed in the late 17th-century debate to *Poussin, another). Opposed to Rococo, 'classicism' may mean not much more than the prevailing orthodoxy of the waning Louis XIV Baroque.

Classicist values have always resided not simply in canonical Antique art but also in post-medieval art that is regarded as having successfully imitated or emulated the canon, and itself become canonical; thus, although there has been a continuing classicist tradition in Western art, it has been subject to accretions, discards, and revised codifications. Through time the visually far more impressive canon of post-Raphaelite art has in practice far outweighed the Antique example it was supposed to be keeping alive. Although *Vasari rejected *Titian and contemporary Venetian artists because 'they had not seen Rome' and did not practise *disegno*, Venetian Renaissance art was accepted into the canon soon afterwards, for instance by the *Carracci. The academic principle of learning art by drawing after the Antique (thus supposedly inculcating classicism) remained long ensconced, but one may doubt that the nature of the plaster casts of classical statuary before which the students sat made much difference to their technique: the emphasis on drawing was the important one, and effectively classicism became reduced to the current standards of naturalism, or to these standards as represented in careful drawing as opposed to 'looser' colourism, or as contrasted with any contemporary 'avant-garde' realism. Indeed in recent times classicism has become a concept quite detached from its basis in previous instances, for example in the appropriation of the term in the early 20th century to describe the art of *Cézanne (or *Gauguin!), standing now only for the

principles behind the perceived excellence. One may perhaps distinguish between a 'high' classicism consciously continuing the values enumerated above—order etc.— but with little specific reference to the Antique and a 'low' classicism which may amount to no more than the casual revival of a Greek or Roman motif but without commitment to an ideal proportion or principle.

At least since the 19th century, the achievement of classic or canonical status has implied a preceding period of formation and a later period of degeneration or at least diversification: in ancient Greek art, *Archaic precedes the Classical, *Phidian, period which gives way to *Hellenistic; in early modern art, early Renaissance precedes High Renaissance which 'breaks up' into *Mannerism; in the Baroque period, Poussin, in contrast to his predecessors, achieved a coherent synthesis of the elements of art which became a touchstone for later artists. Particularly in the history of French art, in which classicism has been more firmly enshrined, there have been constant appeals to principles or a 'return to order', although the proliferation of classicist reference has also permitted both parties to an argument to claim to be classicist—for example, both *Ingres and *Delacroix regarded themselves as classicist.

By contrast to classicism, *Neoclassicism suggests not simply a revival in adherence to the classic which may have waned but a renewed examination or shifting of the canonical heritage and a changing perception of the values found there. In the late 18th and early 19th centuries, the Neoclassical period, changing ideals and new archaeology fuelled the revision of perceptions to the extent of dissolving the canon and permitting the paradox of 'Romantic Classicism' (better called Romantic Neoclassicism). And once it had been unbuilt, the canon could never be re-established with its old authority: 'classicism' became a style among other styles. However, Neoclassicism may produce oddities, which classicism cannot do.

In modern usage the notion of 'classicism' has become further bedevilled by the free use of the word 'classic': an early Marvel comic, for example, might be called 'classic' and so become an example to follow. Classicism, however, is not simply the pursuit of the values inherent in 'the classic', despite its common etymological root in late Latin as a term denoting 'textbook' excellence. Perhaps one may say that the 'classic' is timeless, like a Corbusier *objet-type*, but classicism refers back to a precedent model and implicitly to the principles by which it is informed. PHo

Bauch, K., 'Klassik-Klassizität-Klassizismus', in *Das Werk des Künstlers*, vol. 1 (1939–40).

Burger, H. (ed.), *Begriffsbestimmung der Klassik und der Klassischen* (1972).

Boehm, G., Mosch, U., and Schmidt, K. (eds.), *Canto d'amore: Classicism in Modern Art and Music*, exhib. cat. 1996 (Basle, Kunstmus.).

Haskell, F., and Penny, N., *Taste and the Antique* (1981).

Lloyd-Jones, H., *Blood for the Ghosts: Classical Influences in the Nineteenth and Twentieth Centuries* (1982).

as well as poetic and idealized. His earliest Roman work includes a *Pastoral Landscape* (1629; Philadelphia Mus.); an etching, *The Storm* (1630); and *The Mill* (Boston, Mus. of Fine Arts), which successfully combines a precision of naturalistic observation with a well-ordered and idealized composition, these elements unified and the mood intensified by the early morning light that is filtered through the trees, from the left.

Claude's capacity for observation was nurtured by his frequent sketching expeditions, both in the immediate countryside around Rome, along the left bank of the Tiber, and along the ancient Via Appia, and further afield at Tivoli or Subiaco. The survival of hundreds of drawings in pen and ink, wash and black chalk, recording open-air views, trees, rocks, plants, and streams, and exploring patterns of light and shade and *contre jour* effects of trees silhouetted against the sun, confirm the impression that Claude used drawings made out of doors as an essential point of reference when back in the studio. He may also have found the process of making the drawings served to focus his mind and memory on both the changing and the permanent aspects of the natural world. The outcome is reflected in such pictures as *Landscape with a Goatherd* (1637; London, NG) and *View of La Crescenza* (New York, Met. Mus.). The German writer *Sandrart suggests Claude also made oil paintings or oil sketches on the spot, although apparently none has survived.

One of Claude's most striking innovations was to include the sun as the direct source of light at the focal point of his paintings, thereby throwing into relief all the features of the foreground and middle ground. Although this idea probably originated from his sketching out of doors, it was a technique he employed most effectively in his more contrived scenes of harbours and seaports, which became one of his most celebrated subjects, inspired perhaps by Tassi's seascapes (for instance, Rome, Doria Pamphili Gal.). Among Claude's earliest pictures of this kind is the *Harbour Scene* (1634; St Petersburg, Hermitage) and he persisted with this category of subject matter in the *Seaport with Setting Sun* (1639; Paris, Louvre), the *Seaport with the Embarkation of S. Ursula* (1641, London, NG), and many other works.

By the late 1630s, Claude had begun to introduce figures drawn from mythological or biblical sources to add *gravitas* or emotional force to his landscapes. At the same time his approach to nature became less detached and he imposed a new sense of grandeur through a more complex spatial structure, emulating the *classicizing landscapes of Annibale *Carracci and *Domenichino. A series of four *Landscapes* of vertical format, commissioned by King Philip IV of Spain in 1639 for the Buen Retiro, mark a decisive step in this direction. They represent *The Finding of Moses* and *Tobias and the Angel*, from the Old Testament, together with the *Embarkation of S. Paula* and the *Burial of S. Serapia*. Claude took advantage of the required vertical format to allow trees and architectural columns a dominant place in defining the structure and perspective of the designs, and the figures too are heroically conceived.

As Claude's style gravitated towards a more idealized vision of nature, his choice of subject matter also brought a new level of empathy with the ancient world. His *Landscape with Narcissus and Echo* (1645; London, NG) reflects the lyrical description in Ovid of the spot where Narcissus fell in love with his own reflection in a 'clear pool with shining silvery waters'. Equally, his *Landscape with Procession to Delphi* (1650; Rome, Doria Pamphili Gal.) evokes the temple of Apollo but in an imaginary reconstruction that transcends nostalgic concerns with the ruins of Antiquity. This elevated tone continues during the next decade with such heroic large scale canvases as *Landscape with Apollo and the Muses* (1652; Edinburgh, NG Scotland); *Landscape with the Adoration of the Golden Calf* (1653; Karlsruhe, Kunsthalle), where the figures are inspired by Raphael's fresco of the same subject in the vault of the Vatican Loggias; a *Coast Scene with Acis and Galatea* (1657; Dresden, Gemäldegal.), based on Ovid. In some respects, Claude appears to be emulating the heroic style of his compatriot Nicolas *Poussin, especially in his concern for scholarly detail, noble subject matter, and conceptual clarity. Yet there is a fundamental gulf that separates them. For Poussin, in his maturity, landscape is a vehicle for suggesting or reflecting mood and clarifying his subject matter; the figures always remain dominant. With Claude, on the other hand, his northern eye for natural detail and atmospheric effects dominates every painting, and the figures, even when exceptionally large, as in the *Apollo and the Muses*, are always secondary to his vision of nature.

Some of Claude's very late work achieves an epic or heroic quality, most notably in his *Landscape with Aeneas at Pallanteum* (1675; Anglesey Abbey, Cambs.), where the landscape matches the description in Virgil's *Aeneid*. Other work, particularly the *Enchanted Castle* (1664; London, NG), which shows Psyche waking outside the Palace of Cupid in anticipation of the consummation of her passion, creates a mood of mystery and romance that anticipates 19th-century Romanticism and transcends Claude's otherwise quite limited emotional range.

During his lifetime Claude enjoyed enormous success and as early as 1634 was apparently forged or plagiarized by *Bourdon. Such incidents may have prompted him to keep his *Libro d'invenzioni* or *Liber veritatis*, recording his designs and the names of buyers (now London, BM). Far more than Poussin, he was patronized by the Roman nobility and above all by Pope Urban VIII. Of the cardinals, Rospigliosi and Massimi supported them both. Yet Claude's work also appealed to contemporary French collectors as well as to travellers, including the Marquis de Fontenay Mareuil; and it could without exaggeration be claimed that, through the choice of locations with classical associations in his landscapes, he pioneered the concept behind the *Grand Tour, and the itineraries on which it would be based in the 18th century. Later artists, from Britain in particular, would transform his intense vision into a more relaxed topographical genre, or more literary and nostalgic capricci, or even into landscape gardens; but the original idea, the close association of natural landscape with the ruins of the classical past and the ancient but still vibrant poetry of Ovid, Virgil, and Horace, was first conceived from very different standpoints, by Poussin and Claude. HB

Kitson, M., *The Art of Claude Lorrain*, exhib. cat. 1969 (London, Hayward).

Kitson, M., *Liber veritatis* (1978).

Langdon, H., *Claude Lorrain* (1989).

Russell, H. Diane, *Claude Lorrain*, exhib. cat. 1982 (Washington, NG).

Whiteley, J., *Claude Lorrain: Drawings from the Collections of the British Museum and the Ashmolean Museum*, exhib. cat. 1998 (London, BM).

CLAY is composed of ground-up rock, and is classified as primary (feldsparthic) and secondary (deposited by rivers), and that deposited by glaciers, which is the most coarse. Clay goes through stages before it is ready for use: weathering, souring or stinking (to produce a fine clay), wedging or kneading elutriation, in which water is added. This allows the clay to form a malleable material. Kaolin is added to clay to form porcelain. Clay can be used in a number of different ways: for modelling the preparatory model or sketch for a marble or bronze sculpture; for casting in plaster or wooden moulds, particularly relief and architectural sculpture, and for stamping. Clay can be left to dry naturally, or fired in a kiln. The surface can be left unglazed, which means that it remains porous, or it can be glazed, as in glazed figural and relief sculptures made in the 15th-century Florentine workshop of the della *Robbia. Meissen porcelain figures of animals, such as Johann Joachim Kändler's *Crane* (1732; Dresden, Porzellansammlung), show how fine clay, mixed with kaolin, could be used in the sculpture made for the court of Augustus the Strong in Dresden. In the 18th century a fine unglazed porcelain clay, biscuit, was used frequently for sculptural figurines and portrait busts by sculptors such as *Falconet, who worked for the Sèvres factory, and the same unglazed matt clay, known as Parian ware, was employed for the

miniature reproductions of large-scale sculpture in the 19th century. AB

CLÉRISSEAU, CHARLES-LOUIS (1722–1820). French architectural draughtsman and painter of ruins. He trained in Paris under Jacques-François Blondel (1705–74). After winning the *Prix de Rome for architecture he went to Italy in 1749. There he moved in the Roman circles of *Panini and *Piranesi, becoming successively drawing tutor to William Chambers and Robert Adam, the two most successful architects in later 18th-century England. Clérisseau specialized in dramatic views of ancient ruins—he supplied the drawings from which were made the engraved plates for Adam's influential publication *The Ruins of the Palace of the Emperor Diocletian at Spalatro* (1764). In 1766 he showed his skills as a painter of ruins on a larger scale by decorating the famous Ruin Room in the convent of S. Trinità dei Monti in Rome. His later drawings, much admired in England, were *capricci of Italian sites, often highly finished in gouache. Clérisseau spent the years 1771–5 working in England for the Adam brothers and is thought to have inspired such projects as the Etruscan Room at Osterley Park (Middx.). He subsequently entered the service of Catherine the Great of Russia. There are a number of his drawings in the collections of the Royal Institute of British Architects and the Soane Museum, London. MJ

Gäbler, B., *Charles-Louis Clérisseau, 1722–1820: Ruinmalerei* (1984).
McCormick, T. J., 'Piranesi and Clérisseau's Vision of Classical Antiquity', *Actes du colloque Piranèse et les Français* (1978).

CLEVE, JOOS VAN (c.1485–1540/1). Formerly known as the Master of the Death of the Virgin (after two paintings on this theme: Cologne, Wallraf-Richartz-Mus.; Munich, Alte Pin.), his real name was Joos van der Beke, but he was called after his native town of Cleve. He probably entered the workshop of Jan Joest about 1505 and assisted in painting the wings of the high altar for the Nikolaikirche in Kalkar, a town not far from Cleve (1505–8; *in situ*). He most likely visited Bruges before settling in Antwerp where he became a master in 1511. Joos was one of the most prolific of the city's painters. His style was eclectic, showing the influence of earlier Flemish art, especially that of Quentin *Massys and *Patinir, with whom he collaborated. Later he came into contact with the work of *Leonardo da Vinci, which he may have seen during his stay at the French court (1530–1), where he was invited by François I to paint portraits of the King and his entourage (e.g. Philadelphia Mus.). He may also have visited Italy during 1528/9–35 when there is no record of him in Antwerp. Joos created several types of slender, slightly sentimental depictions of the *Madonna and Child* and the *Holy Family* (e.g. c.1518–20; New York, Met. Mus.). These images must have been very popular, for they were produced in quantity by the artist and his workshop. KLB

Ainsworth, M. W., and Christiansen, K. (eds.), *From Van Eyck to Bruegel*, exhib. cat. 1998 (New York, Met. Mus.).

CLEVELAND MUSEUM OF ART. Cleveland enjoyed great prosperity at the end of the 19th and in the early 20th centuries. The wills of civic-minded individuals, Hinman Hurlbut, John Huntington, and Horace Kelly, provided for a future art museum that was incorporated in 1913. Built on land donated for the purpose in 1892 by Jeptha Wade, a Neoclassical building designed by the local firm Hubbell & Benes opened its doors in 1916. As in other American museums founded at the time, an attempt was made to present the most important areas of art history. Due to benefactors such as Leonard C. Hanna—whose 1957 bequest made it then one of the richest museums in the country—the institution grew considerably in size and collections. Consequently, the museum not only provides one of the great surveys of Western art (both geographically and chronologically) in the United States, but also displays Islamic, African, and South American art, and has world-renowned Asian holdings. Unlike most American museums, however, the growth of the Cleveland collections usually resulted from purchases rather than donations of works of art. Directors have thus been able to make strong personal stands in shaping the collection. Frederic Whiting, who associated with the Arts and Crafts movement, thought an armour collection befitted a city of steelworkers. His successor William Milliken laid the foundation for a strong medieval department by purchasing objects from the Guelph Treasure (c.1040) in 1930, a formidable coup in a Depression year. Other directors have continued to expand upon the museum's broad collecting activities with certain emphases: Sherman Lee focused on Asian art, but also showed great flair in his acquisition of European old masters, while Evan Turner gave a strong impulse to *photography. Otherwise, as far as Western art is concerned, the museum has built impressive collections of European and American paintings, prints, and drawings, textiles, and decorative arts, including the following: a Byzantine textile, *Icon of the Virgin* (6th century AD), Filippino *Lippi, *Holy Family* (c.1495), *Andrea del Sarto, *Sacrifice of Isaac* (c.1537), *Caravaggio, *Crucifixion of S. Andrew* (1609), *Zurbarán, *Holy House of Nazareth* (c.1635–40), *Poussin, *Madonna on the Steps* (1648), *Copley, *Portrait of Nathaniel Hurd* (c.1765), *David, *Cupid and Psyche* (1817), *Turner, *Burning of the Houses of Parliament* (1835), *Church, *Twilight in the Wilderness* (1860), *Eakins, *Biglin Brothers Turning the Stake* (1873), *Picasso, *La Vie* (1903), *Warhol, *Marilyn × 100* (1962). RD

Turner, E. (ed.), *Object Lessons: Cleveland Creates an Art Museum* (1991).

CLICHÉS-VERRE. See GLASS PRINTS.

CLODION (1738–1814). French sculptor. His real name was Claude Michel, but he was known by the diminutive form of his first name. Trained in Paris by his uncle Lambert-Sigisbert *Adam and then, briefly, by *Pigalle, Clodion spent the years 1762–71 in Rome, much of the time as a pupil of the French Academy there. Before his return to Paris he had already begun to specialize in the small-scale terracotta statuettes and reliefs of satyrs, bacchantes, and other mythological figures for which he is famous. Although he made a number of large-scale, public works, including a fine statue of *Montesquieu* for Louis XVI (1783; Paris, Institut de France), he preferred working for private collectors. His erotic sculptures of naked adolescent girls and priapic satyrs are among the finest expressions of late *Rococo taste in France, yet were easily assimilated to the chic *Neoclassicism of the 1780s. Clodion's career was brought to a halt by the French Revolution, though he found work again under Napoleon. So popular has his work remained that the terracottas were widely faked in the 19th and early 20th centuries. Nevertheless there are securely attributed examples in the V&A, London, the Louvre, Paris, and the Metropolitan Museum of Art, New York. MJ

Poulet, A., and Scherf, G., *Clodion, 1738–1814*, exhib. cat. 1992 (Paris, Louvre).
Thirion, H., *Les Adam et Clodion* (1885).

CLOISONNISM, a painting technique involving the demarcation of bold, flat colour areas with bounding lines of black; pioneered by *Anquetin and *Bernard in 1887 and named by the critic Édouard Dujardin, by analogy with enamelling. BT

CLOUET, FATHER AND SON. Painters of Netherlandish origin, active in France. **Jean** (c.1480–1541?) is first clearly documented in 1516 working for François I. He eventually became the King's chief painter with the title *valet de chambre ordinaire*, a large income, and a reputation matching him with *Michelangelo. Known exclusively as a portraitist, he recorded the appearances of members of the French court in a striking series of drawings, oil paintings, and illuminations. The practice of using quickly sketched likenesses as the basis of panel portraits is

characteristic of earlier French portraiture. Jean probably developed his own approach, notable for stylish draughtsmanship, from drawings by *Perréal (court portraitist of the previous generation) and *Leonardo. His only documented work is a portrait of the humanist Guillaume Budé (c.1536; New York, Met. Mus.), a splendid study of scholarly integrity. **François** (c.1516×20–1571), known like his father as 'Janet', succeeded his father as court painter, expanding the same repertory of forms through contact with Italian portraitists like *Bronzino. TT

Mellen, P., *Jean Clouet* (1971).

CLOVIO, GIULIO (1498–1578). Italian painter of Croatian origin, he was the most important miniaturist of the 16th century, a 'Michelangelo of small works', according to *Vasari. He trained in Venice, where he served the Grimani family, and with *Giulio Romano in Rome, where he studied the work of *Michelangelo. After being imprisoned during the Sack of Rome in 1527, he fled to Mantua and joined a monastery. He continued to paint there and later in Padua, where he executed a book of hours for Marino Grimani (London, BM) which shows the influence of *Raphael and Roman *Mannerism. By 1540 he had returned to Rome and entered the service of the powerful Cardinal Alessandro Farnese, who commissioned his masterpiece, the Farnese Book of Hours (New York, Pierpont Morgan Lib.), in which Venetian, Roman, and northern influences were integrated in his mature style. Surprisingly bold and sensual, its biblical scenes are monumental compositions in miniature and, unlike medieval miniatures, are separate from the text, elaborately framed by figures recalling Michelangelo's Sistine chapel nudes. LH

Cionini Visani, M., and Gamulin, G., *Giorgio Clovio, Miniaturist of the Renaissance* (1980).

COADE STONE, an artificial buff coloured stone, named after its most successful manufacturer, Mrs Eleanor Coade, who ran the factory in Lambeth from 1770, and where production continued until c.1820. It was referred to as 'lithodipyra', the Greek for 'twice-fired stone', on account of the mixture of grog and pre-fired clay ground up with flint to form a paste. Unlike natural stone, this stoneware is both resistant to frost and hard enough to retain extremely sharp detail and contours. Using moulds, it was cast hollow for architectural ornament, and the sculptor John Bacon the elder was closely associated with the firm for which he designed sculptures for gardens and grottoes. Monuments in Coade stone survive in many English churches, including those to Capability Brown and his children at Fenstanton (Huntingdonshire). HO/AB

Penny, N., *The Materials of Sculpture* (1993).

COBRA, a Marxist-based association of painters founded in the Café Notre-Dame, Paris, on 8 November 1948, which was active until 1951. The title is an acronym for Copenhagen, Brussels, and Amsterdam, reflecting the nationalities of the principal founder members, the Danish Asger *Jorn, the Belgians Corneille (1922–) and Pierre Alechinsky (1927–), and the Dutch Karel *Appel. Determined to produce a new Art for the People they emphasized spontaneity, while repudiating *Surrealist automatism, and based their work on children's drawings, primitive art, and the doodles of *Klee. Their imagery, frequently crude and violent, was developed from Nordic myth and Jungian symbolism and they shared childlike forms and brash colour. The group, which soon included writers and poets, first exhibited together in 1949, at the 1st Exposition d'Art Expérimental in Amsterdam, to a hostile reception. A change of name to Internationale des Artistes Expérimentaux reflected the inclusion of French and German artists in the movement. They published their ideas in the *COBRA Review* (eight issues) and held a further exhibition at Liège in 1951 after which COBRA was dissolved. DER

Lambert, J. C., *COBRA: un art libre* (1983).

COCHIN, CHARLES-NICOLAS (1715–90). French designer and engraver of vignettes, frontispieces, and decorations for books. Among many other works he designed the frontispiece for *Diderot and d'Alembert's *Encyclopédie* and was one of the great engravers of other artists' work, following in the footsteps of his father who made many prints after *Watteau. Cochin brought *etching, his preferred medium, to a very high level of skill, as is demonstrated by the large plates he made to record the court festivities of Louis XV's reign. In 1749 he went to Italy as artistic tutor to Mme de Pompadour's brother, the future Marquis de Marigny, who was being groomed for the post of minister of the arts. Cochin was also a popular and ubiquitous administrator. From 1755 he was secretary to the Académie Royale (see under PARIS) and played a crucial role as intermediary between the royal administration responsible for official commissions and the artists. He published a number of books and articles, including a *Voyage en Italie* from which Diderot claimed to have learnt all he knew about art techniques. In his writings and in the drawings that he exhibited regularly at the Salon Cochin was a staunch advocate of *classicism against the *Rococo style. MJ

Cochin, C.-N., *Recueil de quelques pièces concernant les arts* (1757).
Michel, C., *Charles-Nicolas Cochin et l'art des lumières* (1993).
Rocheblave, S., *Charles-Nicolas Cochin, graveur et dessinateur* (1927).

COCK, HIERONYMUS (c.1510–70). Etcher, print publisher, and dealer in Antwerp. He became a member of the guild of S. Luke in 1546 and probably left for Italy before 1550 when he etched and published a series of views of Roman ruins. More than 1,100 prints were issued by his publishing house Aux Quatre Vents (At the Sign of the Four Winds). A few drawings can be attributed to Cock, and some etchings, but his reputation rests largely on his publishing activities. He was the most important print publisher of his time in northern Europe, and a key figure in the transformation of printmaking from an activity of individual artists and craftsmen into an industry based on division of labour between the artist who invented a composition and the engraver who turned it into a print. Working for Cock were the engravers Giorgio Ghisi, Dirck Volkertsz. Coornhert, Cornelis Cort, and Philipp *Galle who reproduced designs by famous Italian Renaissance masters, but more often those by Dutch and Flemish artists, foremost among them Pieter *Bruegel I. KLB

Riggs, T., *Hieronymus Cock* (1977).

COCK, PIETER. See COECKE VAN AELST, PIETER.

CODAZZI, VIVIANO (c.1606–70). The most important 17th-century painter of architectural views and *capricci. Born in the valley of the Valsassina north of Bergamo, he arrived in Naples in the 1620s, already skilled in the techniques of *quadratura painting. Here he collaborated with *Micco Spadaro, whose elegant figures grace his decorative capricci, such as *Palace with Rustic Portico*, and *Baldacchino with Solomonic Columns* (1641; Naples, Palazzo Reale). He also assisted his compatriot Cosimo Fanzago, contributing architectural perspectives to the decoration of the Certosa di S. Martino (1644–6). In Rome by 1648, he collaborated with *Bamboccianti painters, especially *Cerquozzi. His repertory broadened; he painted both ruin pieces and displays of ideal architecture which are related to theatre sets; capricci, and harbour scenes. In the 1660s his pictures became grander and more scenographic. Such works as *Travellers Resting at an Inn* (early 1650s; Hartford, Conn., Wadsworth Atheneum), with

figures by Cerquozzi, show his prowess in uniting a realism of surface and picturesque detail, with architectural inventiveness and a display of perspectival skill. HL

Marshall, D. R., *Viviano and Niccolo Codazzi* (1993).

CODICOLOGY, the study of the physical structure of books, which, when used in conjunction with palaeography, reveals a great deal about the date, place of origin, and subsequent history of a particular codex. The term was first used in conjunction with listing texts in catalogue form, but later in the 20th century came to be associated primarily with the structural aspects of manuscript production, which had been studied in a coherent fashion since the late 19th century.

The basic structure of a codex consists of a number of sheets, usually of *parchment or vellum but sometimes of *paper, folded in half to form two leaves, known as bifolia. Each leaf or folio has two pages and these were normally marked out for the text and any illumination by a process of pricking and ruling using a variety of instruments. The bifolia are gathered and sewn to form a quire. These quires are then bound together in the correct order to produce the book. This process varied in significant ways over time and from place to place, so that a close examination of these features can shed much light on the provenance of a manuscript. In particular codicologists are interested in the nature and preparation of the parchment (especially the disposition of the hair and flesh sides), the manner in which pricking and ruling was carried out and the templates used for this, the way the book was bound (or in most cases rebound), as well as in matters of collation, such as the number of leaves in each quire, and the absence of bifolia or whole quires. The codicologist's task is made more difficult by the fact that manuscripts were frequently rebound throughout their life, with the result that a particular codex could often incorporate works of differing dates and origins, and thus with totally different internal structures. Further obfuscation could occur if these structures were altered and unified by a later binder to ensure a better fit for his new binding.

In the 13th century book production underwent important changes due to the increasing secularization of the book trade. A group of middlemen, known as stationers or *libraires*, emerged. They would receive commissions for particular texts, which they would then subcontract out to scribes, illuminators, and binders, to whom they also supplied materials and tools. Some of the resulting changes in practice, such as the systematic marking up of quires by scribes for assembly by the *libraire*, are of great value to the codicologist in reconstructing the original order of the manuscript. TJH

COECKE (also Cock or Coeke) VAN AELST, PIETER (1502–50). South Netherlandish painter, architect, sculptor, designer of woodcuts, tapestries, and stained glass, and writer. According to Karel van *Mander, he was trained in Brussels by Bernaert van *Orley before he entered the Antwerp Guild in 1527. He visited Rome, probably between 1524 and 1525, and in 1533 he was in Constantinople. A series of drawings made on his journey was later published in woodcuts by his widow Mayken Verhulst: *Ces mœurs et fachons de faire de Turcz* (1553). Coecke moved to Brussels in 1546 and was named court painter to Charles V in 1550, a few months before his death. He had a large and productive workshop with many pupils, among them Willem *Key and Gillis van *Coninxloo (Pieter *Bruegel the elder was his son-in-law but probably not his pupil). Coecke established a style that was much imitated. One particularly popular composition was his *Last Supper* (e.g. 1531; Brussels, Mus. Royaux) which survives in 41 copies, the last one of which was painted thirteen years after his death. His translations of Vitruvius and Serlio helped bring to the Netherlands a greater understanding of Italian Renaissance architecture. KLB

Dacos Crifò, N., and Meijer, B. W. (eds.), *Fiamminghi a Roma, 1508–1608*, exhib. cat. 1995 (Brussels, Palais des Beaux-Arts).

COELLO, CLAUDIO (1642–93). Spanish painter born in Madrid, apprenticed to Francisco *Rizi until 1660. The *Triumph of S. Augustine* (1664; Madrid, Prado) and the monumental *Annunciation* for the church of S. Plácido (1668) are typical of Coello's mature work and perfect examples of the Spanish High *Baroque style.

After 1668, Coello's style underwent a change that parallels the Baroque classicism in contemporary Italian art (*Virgin of the Pillar Appearing to S. James*, 1677; San Simeon, Calif., Hearst–San Simeon State Historical Mus.). Coello's most important late work is *La sagrada forma* (*Charles II Adoring the Host*), an enormous altarpiece in the sacristy of the basilica of the *Escorial (1685–90). *Velázquez's *Las meninas* is the only precedent for its evocation of the light and atmosphere of the very space that houses the picture.

A small fraction of Coello's frescoes are extant: the illusionistic ceilings of the vestry of the Cathedral of Toledo (1671–4) and of the Casa de la Panadería in Madrid (1672–3), in which he makes use of *quadratura*. NAM

Brown, J., *The Golden Age of Painting in Spain* (1991).
Mallory, N. A., *El Greco to Murillo: Spanish Painting in the Golden Age: 1556–1700* (1990).
Sullivan, E. J., *Baroque Painting in Madrid* (1986).

COLE, THOMAS (1801–48). American landscape painter. Cole, the most prominent member of the *Hudson River School, was born in England and emigrated to America in 1819 where he worked as an engraver before settling in New York in 1825. Inspired by the grandeur of American scenery, the concept of sublimity, and the teachings of *Reynolds, Cole began painting both dramatic Romantic landscapes; *Landscape with Dead Tree* (1827–8; Providence, Rhode Island School of Design); and equally sensational histories: *Expulsion from Eden* (1827–8; Boston, Mus. of Fine Arts). He twice visited Europe, 1831–2 and 1841–2, and during his first visit to Rome occupied the studio traditionally used by *Claude, an artist he much admired, his other hero being *Turner. Unsatisfied by 'the mere imitation of nature', albeit much heightened in his own work, he turned increasingly to vast allegorical cycles, *The Course of Empire* (1836; New York, Historical Society), *The Voyage of Life* (1840), and *The Cross and the World* (1848) which, although admired for their moral content, were considerably less popular than his 'native' landscapes painted to subsidize his more ambitious works. DER

Truettner, W., and Wallach, A., *Thomas Cole: Landscape into History* (1994).

COLLAGE (French: sticking or pasting). The term has come to be used of any work made up of pieces of paper or other materials which have been painted, drawn, or printed and which are then stuck onto a support.

Often assumed to have been used first in the 20th century, collage was employed in the 18th century to great effect by the flower artist Mrs Mary Delany (1700–88). The method she invented was known as 'paper mosaic' or 'plant collage' and she cut out the leaves and petals from sheets of coloured paper which she then pasted on a black paper background. She sometimes used papers on which the colours had run or applied discreet touches of watercolour herself. On occasion she even made use of real leaves. In the present century more artists have taken to using collage, perhaps most notably Kurt *Schwitters, who employed fabrics, printed ephemera, and various small objects in his collages. More recently other practitioners such as the Mexican Rafael Cauduro (1950–) and the American Paul Sarkisian (1928–) have also produced collages of distinction. PHJG

COLLECTING. The assembly of works of art, sometimes at great expense, has since classical times conveyed an element of prestige associated with power, wealth, and *connoisseurship. Private collecting on a significant scale is recorded in *Hellenistic

times, for example the collection of pictures made by King Attalus II of Pergamum (d. 138 BC). The treasuries attached to temples constituted the first museum collections: these were formed by ex-voto gifts from the faithful and contained sculpture and objects made of gold, silver, and bronze. The classical Greeks (see GREEK ART, ANCIENT) placed their paintings in *pinakothekai*, a word deriving from *pinas* meaning plank.

Through contact with Greece, conquered in the 2nd-century BC, the Romans acquired a taste for works of art. The spoils of plunder were divided between temples, with the victor keeping his share. Originals or copies of Greek statues, objects of gold or silver, ivory or tortoiseshell, intaglios, cameos, and vases of precious stone accumulated in Roman palaces and villas, and statuary adorned their gardens. The best preserved of the suburban villas is that built by the Emperor Hadrian at *Tivoli. The Emperor Nero was blamed for the inaccessibility of his works of art in his *Domus Aurea*. Other prominent collectors included Atticus, Lucullus, Varro, Pompey, and Julius Caesar.

The Middle Ages cover the long period of Christian history from Constantine, the first Christian emperor (311–37), to the beginning of the *Renaissance. Collecting was taken over by the Church. The monasteries became repositories of treasures which included paintings, sculptures, manuscripts, ivories, bronzes, reliquaries, precious stones, and textiles. One of the oldest is the treasury of the Cathedral of Monza, Italy, founded in the early 7th century. Charlemagne, crowned emperor in AD 800, acquired many precious objects by gift or booty, and encouraged sculpture in ivory. Cameos, Antique intaglios, Byzantine or Muslim ivories, silks, gems, and other objects filled his thesaurus in Aachen. Other great treasuries were formed in Reichenau, Hildesheim, Quedlinburg, Reims, and Sens. At S. Denis, the 12th-century Abbot Suger, minister of Louis VII, enriched the treasury with objects of the utmost preciousness: this collection is now in Paris, divided between the Bibliothèque Nationale and the Louvre. Collections of precious objects and illuminated manuscripts were made by the grandees of Gothic Europe such as the dukes of Burgundy, and by John, Duke of Berry (1340–1416), brother of Charles V.

The dawn of *humanism, which sought to recover the standards of ancient culture, brought about a greater interest in objects from classical Antiquity, foreshadowing the enthusiasm for Antiquity which was a feature of the Renaissance. Examples of those early collections include those of Friedrich of Hohenstauffen (1220–50), Cola di Rienzo (1313–54), and *Petrarch (1304–74). In sculpture, this trend was manifested by Giovanni *Pisano, who used classical precedents for his pulpit for the Cathedral of Pisa. One of the earliest records of a cabinet of antiquities is an itemized bill of purchases made in *Venice by one Oliviero Forza or Forzetta, a citizen of Treviso, dated about 1335. He acquired manuscripts by Sallust, Seneca, Ovid, Cicero, and Livy, 50 medallions, intaglios, pottery, bronzes, and marble statues. Interest in the *Antique world continued to be a central feature of collecting.

In *Florence, the great bourgeois families, the Strozzi, the Rucellai, the Pazzi, the Tornabuoni, and the Capponi, filled their palaces not only with works of art from the Antique world but also with manuscripts, paintings, and sculpture commissioned from contemporary artists. The most important Florentine collections in this tradition were put together by the Medici, whose power was founded on the greatest banking wealth of the time. This taste was echoed in the collections of other great Italian humanist princes: Montefeltro of *Urbino, Este of Ferrara, and Gonzaga of *Mantua. Many artists, for instance *Mantegna, followed in this tradition.

In *Rome, the spirit of the Renaissance was kindled by Pope Nicholas V, who had been librarian for Cosimo the elder. The first pope to be a real collector was the Venetian Pietro Barbo (Paul II) who built the immense Palazzo Venezia in Rome to house his collections of gems, cameos, series of coins, small bronzes, paintings with gold backgrounds, reliquaries, and Byzantine objects. The capture of Constantinople by the Turks in 1453 placed great quantities of pillaged works onto the market, with Venice serving as the intermediary in their resale. Sixtus IV founded the Capitoline Museum for Antiquities in 1471, but the most determined collector of antiquities in Rome was the Farnese Pope Paul III, who excavated many sites in Rome: the enormous collections he amassed did not enrich the papal collections, but eventually in 1787 reached the Museo Nazionale in *Naples.

North of the Alps, collecting continued to follow more or less the medieval pattern. One of the most famous collections was that of the Habsburg Rudolf II (1552–1612) at *Prague: he collected Venetian pictures and works by *Brughel and patronized the Mannerist painters *Arcimboldo, *Spranger, and *Savery, and the sculptor Adriaen de *Vries, who came from The Hague. In 1648, his collection was plundered by the Swedes, and taken to Stockholm. The French King François I (1494–1547) lured *Leonardo da Vinci to Amboise, where the artist died in 1519. The artist's atelier formed the nucleus of the royal collection of paintings which the King augmented by commission (e.g. *Titian and *Primaticcio) and by diplomatic gift: he also collected Antique sculpture and bronzes, and patronized Benvenuto *Cellini.

Overflowing with Antique and Renaissance treasures, Italy proved to be an inexhaustible source of supply for collectors in the 17th century. The Reynst brothers of Amsterdam acquired the picture collection formed by the Doge Vendramin at Venice. The entire Gonzaga cabinet of paintings and antiquities was bought from Mantua in 1627 by King Charles I of England, who attracted *Rubens and van *Dyck to *London, and was an active patron of contemporary artists. Save for his statuary, the Earl of Arundel's famous collection, including in particular paintings by *Holbein, was moved to the Netherlands after his exile in 1642, and sold after his death. However, the greatest sale of works of art in the 17th century was the dispersal under the Commonwealth of the collection of pictures, miniatures, statues, bronzes, and medals formed by Charles I. The purchasers included Philip IV of Spain, the Archduke Leopold Wilhelm, Cardinal Mazarin, and M. Jabach, a banker from *Paris who afterwards sold his collection to Louis XIV.

The greatest artists made fortunes and lived in a princely fashion. Van Dyck owned nineteen Titians, and Rubens, who had ten, built a palace in Antwerp, which contained a rotunda to house his antiquities. Small collecting spread to the middle classes especially in the Netherlands, where there was a plentiful supply.

In Great Britain, the 18th century was characterized by the import from the Continent of vast quantities of paintings, sculpture, prints, drawings, and other works of art, many purchased on the *Grand Tour and sent home. Horace Walpole recorded in the introduction to *Aedes Walpolianae* (1747) that 'most of the Pallavicini collection has been brought over; many of them are actually at Houghton. When I was in Italy, there were to be sold the Sagredo collection at Venice, those of the Zambeccari and San Pieri collections at Bologna; and at Rome those of the Sacchetti and Cardinal Ottoboni, and . . . the Barbarini.' The Houghton Gallery in turn was itself sold to the Empress Catherine of Russia in 1779. In the second half of the century, the growing financial and political crisis in France made Paris a place for selling rather than buying: English milords, German princes, and Dutch merchants mined France for art treasures. The greatest collection sold was that of the Duke of Orléans, dispersed chiefly to aristocratic collectors in London in the 1790s. The effect of Napoleon's activities in Spain and Italy uprooted many private and monastic collections, and made both countries net sellers, chiefly to British collectors, over this period. (See SPANISH ART AS OBJECTS OF PATRONAGE AND COLLECTING; ITALIAN ART AS OBJECTS OF PATRONAGE AND COLLECTING.)

For much of the century, British collections

were kept in London houses, but these were gradually moved to their owner's country house erected on each estate: the majority of the pictures recorded at Devonshire House in 1761 were removed to Chatsworth. The great Duke of Marlborough at Blenheim, Sir Robert Walpole at Houghton, and Thomas Coke at Holkham filled their houses with pictures by Rubens and van Dyck, *Claude and *Poussin, Italian pictures, and commissioned portraits of themselves and their families by *Gainsborough and *Reynolds to adorn their dining rooms.

The collecting of old masters was given fresh stimulus at the turn of the century by the continuous arrival in London of pictures from the Continent, mainly through the London-based dealers Buchanan, Colnaghi, Nieuwenhuys, John Smith, and the Woodburn brothers, who had a leading role in forming the unrivalled collections of drawings formed by Sir Thomas *Lawrence. In the 19th century, a new collecting trend became apparent: it was no longer necessary to acquire connoisseurship of old masters in order to form a collection. The emerging Victorian middle class, with fortunes built on industrial success, combined collecting with patronage of contemporary British artists.

Private collecting of old masters in America began in earnest in the second half of the 19th century by industrialists and bankers, of whom Henry Clay Frick, Andrew Mellon, Isabella Stewart Gardner, the Havemeyers, and Pierpont Morgan may serve as examples—see Frick Collection and Metropolitan Museum under NEW YORK, National Gallery of Art under WASHINGTON, and Isabella Stewart Gardner Museum under BOSTON. One feature of American collections is their tendency not to become family collections as in Europe: instead, many were converted into self-contained museums or were bequeathed to existing public museums.

The *Impressionist painters found many French patrons, including Victor Choquet, Count Isaac de Camondo, and the dealer Paul Durand-Ruel: the principal early collectors outside France were German (Hugo von Tschudi and Oscar Schmitz), Russian (Sergei Shchukin and Ivan Morozov; see also under MOSCOW), and many in America. In Britain, a few collectors such as Sir Hugh Lane, the Misses Davies, and Samuel Courtauld owned superb examples of French Impressionist pictures, which public collections were slow to accept (see National Museum of Wales under CARDIFF, and Courtauld Institute and Gallery under LONDON).

The public museum came into being as many of the great continental private collections began to be made accessible to the public. In 1743, Anna Maria Ludovica, the last of the Medici family, decreed that the collections should pass to the people of Tuscany and at about the same time the Empress

Maria Theresa opened the Habsburg collections at *Vienna to the public. In *Paris the French national museum at the Louvre opened to the public in 1793, a year after the fall of the monarchy. The National Gallery was established in *London in 1824, late by continental European standards, based in the first instance on the private collection recently formed by John Julius Angerstein.

Some trends in collecting by public museums were adopted only after a lead by private collectors. The taste for Italian gold-backed 'primitives' began with private collectors at the end of the 18th century, yet was adopted by public galleries only 50 years later. In Britain these pioneers included the Earl-Bishop of Bristol, William Roscoe, and the Prince Consort; continental collectors in this vein included Artaud de Montor, Cardinal Fesch, and the British-born Edward Solly, whose astonishing collection was acquired for *Berlin in 1821. The revival of interest during the second half of the 20th century in Italian seicento pictures that had been shunned since the mid-19th century is due to British private collectors, chiefly Sir Denis Mahon.

In the late 20th century, aggressive collecting by museums in America and Europe means the finest objects will never again come on the market, and escalating prices have limited the scope for the private collector. The governments of many European countries have placed restrictions on the free export of works of art, especially France and Italy, whereas Britain is more liberal in export procedures. A major feature of the 1990s has been the collecting activity in the USA of the Getty (*Los Angeles) and Kimbell (Fort Worth, Texas) Museums, munificently endowed, paying top prices, and seeming to dominate the art market, save occasionally in Britain where significant acquisitions for public collections can be made by offsetting capital tax liabilities against part or all of the purchase price. CALS-M

Bazin, G., *The Museum Age*, trans. Jane van Nuis Cahill (1967).
Cooper, D., *The Courtauld Collection: A Catalogue and Introduction* (1954).
Taylor, F. H., *The Taste of Angels: A History of Art Collecting from Rameses to Napoleon* (1948).

COLMAN, SAMUEL (1780–1845). English painter. Colman's birthplace is unknown but he lived and worked in Bristol (1816–38) as a portrait painter and drawing master. Although only a peripheral member of the Bristol School, Colman's genre paintings were influenced by Edward *Bird and his pupil E. V. Rippingille (1798–1859); his *S. James's Fair* (1824; Bristol, AG) appearing one year after the exhibition of Rippingille's *Bristol Fair* (priv. coll.). However, Colman is best known for his enormous, sensational biblical pictures, in the manner of John *Martin and

the Bristol-based Francis *Danby who anticipated Colman's *Delivery of Israel out of Egypt* (1830; Birmingham, Mus. and AG) with his own treatment in 1825 (Preston AG). Colman's apocalyptic works were inspired by religious motives, for he was a dedicated Nonconformist Christian, and refer, allegorically, to the struggle for the emancipation of slaves. DER

Greenacre, F. (ed.), *The Bristol School of Artists*, exhib. cat. 1973 (Bristol AG).

COLOGNE: PATRONAGE AND COLLECTING. Since its designation in AD 50 as Colonia Claudia Ara Agrippinensium, the capital of Lower Germany, the artistic life of Cologne has been conditioned by its location on major international trade routes at Germany's western border. Until the departure of the Romans in AD 457, the city was one of the most important commercial centres in northern Europe. It subsequently came under Frankish rule, but fell into ruins during the 9th century and was refounded in 883. Cologne became a principality in 925, when Otto I invested its Archbishop, his brother Bruno, with the authority of count. The Archbishop lost control of the city in 1288, but retained the right to crown German kings and was acknowledged as one of the seven imperial electors by the Emperor Charles IV in 1356. Cologne's strategic location on the Rhine, and rights to store and tax goods in transit, made it one of the largest and most influential cities of the Holy Roman Empire and the Hanseatic League. Its university, the first in northern Germany, was founded in 1388. The guilds gained control of the city council in 1396, and in 1475 Cologne became an imperial free city. It remained a city-state until it was seized and incorporated into the French Republic in 1797. In 1814 Cologne was ceded to Prussia, with which it became part of united Germany in 1871.

Roman Cologne had numerous artists' workshops and, after its refounding, the city benefited from the patronage of the Ottonian emperors. By the late 10th century its cathedral scriptorium was a leading school of manuscript illumination, demonstrating a mixture of court and Byzantine influences. Numerous large *Romanesque parish churches, richly decorated with wall paintings, mosaic floors, stained glass, and ecclesiastical metalwork, reflect the growing power and prosperity of the citizenry of Cologne. The translation of the relics of the Magi to its cathedral gave rise to the greatest of all the city's reliquaries: the monumental golden shrine of the Three Kings, constructed around 1181–1230. In 1248 Archbishop Konrad von Hochstaden initiated the rebuilding of the cathedral in the latest French *Gothic style and on a colossal scale; a project which

dragged on for three centuries before lapsing, and was only completed in 1880. The bronze tomb of its founder (d. 1261), the dainty stone figures added to its choir piers around 1290, and its choir stalls of 1508–11 all reflect recent French models.

The guild of painters was one of many craft associations which emerged in Cologne during the 15th century. Illuminated manuscripts and small panels produced there during the earlier 14th century are closely aligned with the Franco-Flemish School, and suggest contacts with English art. The series of paintings on the cathedral choir stalls, produced around 1330, have links with Italian trecento art. During the last quarter of the 14th century, when the mason Heinrich Parler von Gmünd was periodically active in Cologne, the sculptural decoration of the cathedral, and the stone *Beautiful Madonnas* and *Pietà* groups carved in the city, reveal the distinct influence of the *Parler workshop in Prague. By the end of the 14th century, Cologne was a major centre for the production of precious metalwork, with over 100 goldsmiths, including the mysterious Master Gusmin praised by Lorenzo *Ghiberti as 'of the highest genius . . . equal to the ancient Greek sculptors'.

The *Passion* retables in the Wallraf-Richartz-Museum and Berlin, painted in Cologne around 1410–20, are analogous with paintings from the Meuse valley, and it is likely that the art of this region provided a common denominator between Parisian *International Gothic and the soft style in Cologne. The first fully-fledged exponent of this gently modelled and luminous mode, the *Master of S. Veronica, takes his name from a panel of *S. Veronica with the Sudarium* now in Munich (Alte Pin.). The most celebrated painter of the Cologne School, Stefan *Lochner, was born near Lake Constance, and probably studied in the Netherlands before arriving by 1442 in his adoptive city. His greatest work, the *Adoration of the Magi* triptych now in Cologne Cathedral, was commissioned for the town hall chapel around 1440–5.

Lochner's death in 1451 left a void, and Rogier van der *Weyden was commissioned to paint the *Adoration of the Magi* altarpiece, now in Munich, for the church of S. Columba. Thereafter, imported Netherlandish paintings became increasingly dominant. At the turn of the 15th century, the Master of the Holy Kindred renovated the precepts of Lochner by reference to Hans *Memling, and the Master of S. Bartholomew mounted a spirited revival of Rogier's compositional ideas. In 1515–25 the Antwerp painter Joos van *Cleve supplied the Hackeney family of Cologne with two altarpieces of *The Death of the Virgin*, now divided between the Wallraf-Richartz-Museum and Munich (Alte Pin.). Around 1515 Joos's student Bartholomäus *Bruyn settled in the city, where he and his son maintained the principal painter's workshop until the second half of the 16th century.

Although Cologne remained one of Germany's largest and most prosperous cities, it had few artists of significance from the Renaissance until the 20th century. In 1638 *Rubens was commissioned to produce an altarpiece for the church of S. Peter, and also painted a *Stigmatization of S. Francis* in the Capuchin church (both now in the Wallraf-Richartz-Mus.). An art dealer appears for the first time at the Cologne spring fair in 1546, and a number of later painters and engravers combined the production of works of art with dealing. During the 18th century bourgeois collectors such as Wilhelm Friedrich Wolfgang von Kaas assembled collections of largely Netherlandish paintings. Clemens August (1700–61), the last Wittelsbach elector-archbishop, was a major patron of Italian painters, including *Amigoni, Rosalba *Carriera, *Pittoni, *Piazzetta, and G. B. *Tiepolo, but his principal residences were at Bonn and Brühl.

From 1804 the dissolution of the Cologne religious houses allowed the merchants Sulpiz and Melchior Boisserée to form a spectacular collection of early northern paintings, which they sold to Ludwig I of Bavaria. In 1824 Ferdinand Franz Wallraf bequeathed to Cologne his extensive art collections, which formed the basis of the Wallraf-Richartz-Museum in 1861. The foundation of a series of civic museums and art schools followed between 1879 and 1909.

The international *Sonderbund* exhibition in 1912 was the first international exhibition of *avant-garde art in Cologne, and a precursor of the celebrated *Armory Show in New York. It was followed in 1914 by the Deutscher Werkbund exhibition, which included applied art and architecture. In 1919–21 several influential Dadaist reviews and exhibitions were mounted in Cologne under the leadership of Max *Ernst and Hans *Arp, who were oriented towards Paris, where they subsequently joined the *Surrealists. After the Second World War, major donations of German Expressionist art transformed the Wallraf-Richartz-Museum. During the 1960s, Cologne became one of the principal European centres for the modern art trade. In 1968–79, Irene and Peter Ludwig established the Museum Ludwig as the leading museum of modern art in Germany, and the principal collection of American *Pop art in Europe.

MLE

COLOGNE, WALLRAF-RICHARTZ-MUSEUM. The name of the museum housing Cologne's main collection of paintings is a combination of the names of the two founders of the collection, Ferdinand Franz Wallraf (1748–1824) and Johann Heinrich Richartz (1797–1861). The core of the collection was formed by Wallraf and, although it was put on public display as early as 1827, was later housed in a special building, begun in 1855, with money offered for the purpose by Richartz. He then provided a further sum of money for the acquisition of pictures. Wallraf, the son of a tailor, became a priest and embarked upon a successful academic career in the field of natural science in the University of Cologne, eventually becoming rector in 1793. Opportunities for the acquisition of paintings were much increased with the Decree of Secularization of religious works of art in 1802 and, by 1818, Wallraf had amassed 1,712 paintings and over 40,000 prints and drawings, which he bequeathed to the city of Cologne. The strength of the collection lies in works by artists of the school of Cologne from the 14th to 16th centuries, including the *Master of S. Veronica and Stefan *Lochner. German artists of the 16th century, including *Dürer and Lucas *Cranach the elder, are also well represented. The Dutch, Flemish, and Italian collections, although smaller, are important and include a pair of portraits by Frans *Hals, a self-portrait by *Rembrandt, and *Piazzetta's mysterious *Idyll on the Seashore*. The Wallraf-Richartz-Museum has recently moved to a new building which it shares with the Ludwig Museum housing a significant modern and contemporary collection, including 216 works given by Peter and Irene Ludwig in 1976.

CFW

COLOMBE BROTHERS. French brothers active in Bourges and *Tours in the late 15th century. **Michel** (c.1430–1514) was a successful sculptor who is documented receiving many commissions, the majority of which cannot be traced. He is best known today for his monumental *tomb of François II, Duke of Brittany, and Marguerite de Foix (1502–7; Nantes Cathedral), commissioned by their daughter Anne of Brittany after a design by Jean *Perréal synthesizing late Gothic and Renaissance elements. **Jean** (active 1463–d. 1498) was an illuminator who established a thriving workshop in Bourges with the help of André Rousseau, a scribe, manuscript agent, and the librarian of the university. The demand for Jean's work was such that, either through haste or the use of assistants, his attributed output is of variable quality. Despite this, many highly accomplished works survive, such as the Hours of Louis de Laval (c.1483–9; Paris, Bib. Nat., MS lat. 920) comprising 1,200 illuminations. His most renowned, and perhaps most artistically important, commission was undertaken for Charles I, Duke of Savoy, in Chambéry in 1486, when Colombe was given the task of completing the illumination of the *Très Riches Heures* of the Duke of Berry (Chantilly, Mus. Condé, MS 65) begun by the de *Limburg brothers seventy years earlier. His style can be characterized by its restricted tonal range,

idyllic landscapes, mannered figures, and the use of gold hatching over elaborate costumes. His son Philbert (d. 1505) and grandson François (d. 1512) were also illuminators.
KC

Avril, F., and Reynaud, N. (eds.), *Les Manuscrits à peintures en France, 1460–1520*, exhib. cat. 1993 (Paris, Bib. Nat.).

Pradel, P., *Michel Colombe: le dernier imagier gothique* (1953).

COLONIA, DE. Family of architects and sculptors active in Spain from the mid-15th to the mid-16th centuries. **Juan** (active 1449–81), of German descent, arrived in Burgos in the 1440s, bringing with him a northern late *Gothic style that would dominate in the region well into the 16th century. Juan's son **Simón** (active c.1482–1511) succeeded his father as Master of the Works of Burgos Cathedral and was also active as a sculptor. Simón's masterpiece, the Capilla del Condestable at the east end of the cathedral, is characterized by his affection for sculptural embellishment. **Francisco** (active 1511–42) became Master of the Works of Burgos Cathedral in 1511 following the death of his father Simón, with whom he had worked on the façade of the Colegio de S. Pablo, Valladolid; façade designs by the Colonia family were enormously influential in Spain. Francisco's work as a sculptor includes the altarpiece of S. Nicolás, Burgos, and the carving of the Puerta de la Pellejería of Burgos Cathedral (1516).
SS-P

Proske, B. G., *Castilian Sculpture: Gothic to Renaissance* (1951).

COLOSSUS OF RHODES. See SEVEN WONDERS OF THE ANCIENT WORLD.

COLOUR (1) *Psychological approach;* (2) *Physical approach;* (3) *Psychophysical approach*
The study of colour falls within the fields of physics, physiology, and psychology. *Physics* studies the radiant energy of the light which stimulates vision and in general the objective physical characteristics of the stimulus situation. A special branch is the study of the *chemical* aspects of such substances as pigments and dyes in relation to their colour-producing properties. *Physiology* studies the electro-chemical activity in the nerves and in general the processes which take place in the eye and brain when a stimulus situation results in an experience of colour. *Psychology* studies the awareness of colour as an element of visual experience. Different concepts of colour are used in these fields and the difficulties of the subject have often been complicated by failure to keep them distinct. All three approaches have a bearing on the problems of colour in relation to art.

1. PSYCHOLOGICAL APPROACH
For psychology colour is a part of what is perceived and the concept at its widest may be defined as that aspect of visual experience which remains when you abstract the spatial and temporal aspects.

(a) Colours have three modes of appearance in experience:
Film colours are colours such as are seen in a spectroscope or a patch of blue or uniformly grey sky. They appear at a certain, though somewhat indefinite, distance from the observer as if providing a back wall to the intervening space. They have a spongy quality without precise texture and there is a sense that one can penetrate more or less deeply into them. They always appear in a plane frontal to the eye. Film colours are not seen as qualities of objects or the surfaces of objects.
Volume colours may be seen in a transparent medium such as a glass of wine or an illuminated cloud of smoke. They are transparent, that is, objects can be seen through them, and they permeate the three-dimensional space which they occupy, that is, they are voluminous. They cannot change their plane in relation to the eye.
Surface colours appear to lie on the surface of objects, to be localized at a definite distance from the observer and in a plane which may be at any angle to the direction of vision. They take on the surface texture of the object and provide a resistant barrier beyond which the eye cannot penetrate. They are ordinarily seen as qualities of the object in which they inhere. Sometimes surface colours may appear on things such as non-transparent clouds or smoke which we do not usually think of as objects.
Certain other qualities of colour appearance are derivatives of the above modes:
Lustre is a variation of brightness which exceeds the brightness of the surface colour of an object and seems to be superimposed upon the surface, breaking up and destroying the surface texture. There are various characteristic kinds of lustre, such as the lustre of silk, the lustre of glazed pottery, the lustre of metal.
Metallic colours seem to lie *behind* the perceived surface of the object and as with film colours the eye seems to penetrate to some extent into the colour. In metallic objects there is a marked difference of brightness between the lustrous and the non-lustrous parts.
Luminosity and *glow*. A coloured object is said to be luminous when it exceeds in brightness the surrounding visual field and appears to emit light. Luminous colours have affinities in appearance with film colours or voluminous colours (e.g. a flame). An object is said to *glow* when it is seen as luminous throughout its mass.

Artists work predominantly with surface colours. Part of the craft of the painter consists in producing the appearance of film colours and volume colours, of lustre or glow or luminosity, by means of pigments which do not in fact have these qualities. The representation of other modes of colour appearance by means of surface colours is a contributory factor in enabling the observer to enjoy the aesthetic experience of being simultaneously aware of a picture as a flat pigmented canvas and seeing objects depicted in picture space with different colour and textural qualities. Volume colours are sometimes used by modern abstract sculptors who work in transparent plastic and similar materials.

(b) All colours have three independently variable aspects or dimensions. These are hue, saturation, and brightness.
Hue is the dimension of colour which is referred to a scale ranging through red, yellow, green, blue, corresponding to the sensations experienced from stimulation by light of various wavelengths and ranging over the visible section of the spectrum. There are said to be approximately 150 discernible differences of hue, not distributed evenly over the range of visible wavelengths since we have greater powers of hue discrimination in the longer wavelengths. The longest wavelengths are in the red area, decreasing through yellow, green, blue, to violet.
There are four psychological primary hues, each of which has no resemblance to the others. They are blue, green, yellow, and red. (These psychological primaries are not to be confused with the three primary colours recognized in the physical study of colour.) In general they correspond to the hues which remain constant with change of intensity and saturation.
Saturation is the term used to describe the *purity* of a colour in the sense of the amount of apparent colour in contrast with an achromatic area of equal brightness.
Brightness is the dimension of colour referred to a scale running from dim to bright (sometimes termed the black-grey-white scale or the dark-light scale). The term 'lightness' is sometimes used in a sense similar to 'brightness' when opaque objects are compared on a scale ranging from black to white or when transparent objects are compared on a scale ranging from black to clear. (The former is more appropriate to body pigments, the latter to dye colours.) Sometimes 'brightness' is applied to differences resulting from changes in the intensity of the illumination and 'lightness' to differences among colours in uniform illumination. Painters, however, usually refer to this dimension as 'tone'.
Hue, saturation, and brightness constitute a unique system of co-ordinates in terms of

which all variations of colour experience can be described. These dimensions of colour are sometimes represented schematically by a three-dimensional figure, the hues being ranged in a circle, degree of saturation being represented by the distance of any colour from the centre of the circle and brightness by its position on a vertical scale at right angles to the plane of the circle.

Many other 'terms' are used, particularly in the literature of art criticism, to describe the qualities of colour experience and the lack of precision or generally agreed application has been a major cause of obscurity. *Brilliance* can legitimately be used to describe a quality of colour which combines saturation and brightness. *Chroma* or *chromatic quality* has often been used to name the aspect of colour which includes hue and saturation but abstracts from brightness. *Tone* has been used indifferently to refer to variations in the dimensions of hue and brightness. Such expressions as 'warm' or 'cool' tonality refer to hue. But 'tone values' or 'tone relations' often refer to differences of brightness and when artists are said to be interested in tonality the words are usually intended in this sense. This was the meaning when *Corot said that drawing comes first, then tone, and finally colour. The purpose of the *Claude glass, which Corot used, was to help artists distinguish brightness contrast in the object depicted to the exclusion of other aspects of visual experience. Emphasis on *chiaroscuro, as in the paintings of *Caravaggio, *Rembrandt, *Velázquez, who all substantially extended the proportion of dark in the whole composition, was largely a matter of concentration on or exaggeration of brightness differences.

Shade has been used with a similar ambiguity and even less precision. It sometimes refers to hue, sometimes to differences on the brightness scale, and sometimes appears to include also saturation. In the Wilhelm Ostwald (1853–1932) Colour System, following traditional practice of oil painting, 'shade' was defined as a degree of black in excess of the maximum saturation and brightness (i.e. brilliance) achievable with any pigment.

Tint has usually been applied to a light hue at a low degree of saturation, particularly where the degree of pigmentation is low in relation to white.

Intensity is reserved by scientists for the strength of illumination, but in the literature of the arts it is applied to colour with a variety of imprecise meanings. Sometimes it may be indistinguishable from saturation. More usually, however, it refers to the insistence or prominence which a patch of colour acquires in a particular context owing to enhancement by simultaneous contrast with neighbouring colours. In this sense it is possible to speak of 'intense black'. So too *Titian is supposed to have maintained that the test of a good colourist is whether he can make Venetian red appear to have the intensity and brilliance of vermilion. The concepts of intensity and brilliance have often been linked, and the technique of painting thin *glazes over light *grounds is commonly said to produce greater intensity, luminosity, and brilliance than painting opaquely. Artists who have been interested in the depiction of form by means primarily of colour have concerned themselves with colour intensity. Thus *Cézanne asserted a close link between intensity of colour and plenitude of form, although it is not quite clear in what sense he used the words.

Hues have a natural and circular order. Thus orange lies *between* red and yellow, purples *between* red and blue, and so on, and the primaries are ordered from red through yellow, green, and blue back to red. *Complementary* colours are those which are the greatest distance apart when the hues are arranged in their natural order around the circumference of a circle. Such complementary colours produce the greatest reciprocal enhancement by simultaneous contrast when juxtaposed; also when negative after-images are produced, these will be of the colour complementary to that which produces them. (A different concept of complementary colours is used in physics.) Colour circles have sometimes been used by artists in connection with scaled palettes where a restricted number of paints, including black and white, are arranged systematically on the palette in such a way that by mixing them on definitive principles the artist can obtain the sequences and variations of intensity and hue which he requires and avoid random and untried mixtures. They have the disadvantage, however, that two systems of constructing a colour circle cannot be combined. If the complementary primaries are set at opposite sides of the circle, the intervening sections cannot be divided into an equal number of discriminable hues. If the discriminable hues are set at equal distances round the circumference, the complementaries do not fall opposite each other. Moreover the pigment colours available to the artist do not enable him to do more than approximate roughly to an ideal arrangement of hues at equal brightness and saturation.

(c) Psychology has also been concerned to study certain derivative qualities of colour, such as temperature, weight, and size, and affective responses to colour. Since Theodor Fechner (1834–87) the preferred method has been experimental and the study commonly goes by the name of Experimental *Aesthetics.

Warm and cool colours. It has long been a commonplace of studio tradition and the literature of the visual arts that colours may be divided as to 'warm' and 'cool', the warmest lying in the orange sector of the colour circle and the coolest in the blue-green sector. Experiment has borne out this belief and has confirmed that the 'warm-cool' aspect of colour is linked with hue rather than brightness or saturation.

Advancing and receding colours. There is an equally authentic artists' tradition that warm colours tend to advance and cool colours to recede when situated in the same plane at equal distances from the eye. In order to account for this effect of colour on apparent distance, theories have been advanced suggesting that different colours focus at different distances from the eye. Experiment during the 1940s, however, suggests that this impression may be due rather to brightness or luminance than to hue. The successful use of this phenomenon in landscape painting from the 17th century onwards, when a picture was organized in three zones of colour (brown in the foreground, yellow to green in the middle distance, and blue in the far distance), was closely linked with *aerial perspective and may therefore have been an effect of representation rather than a distancing quality of hue as such.

Weight. Experiment has revealed a general measure of agreement as to the apparent heaviness of dark colours and weightlessness of light colours.

Size. There has been some experimental support for the impression that lighter objects tend to look larger than darker objects of the same size. But the belief that certain hues seem to expand and others to contract within their boundaries apart from luminance has not obtained experimental confirmation. It has, however, often been affirmed by artists. *Kandinsky, for example, alleged that a yellow circle reveals a spreading movement outwards from the centre which almost markedly approaches the spectator, while a blue circle develops a concentric movement (like a snail hiding in its shell) and moves away from the spectator.

The term 'affective response' is used for the feeling and emotional qualities of experience generally. The main purpose of the scientific study of affective response to colour has been to learn how to utilize colour so as to have a predictable effect on people. During the first half of the 20th century experimental psychology of colour has been devoted to investigating colour preferences; results have been expressed in terms of statistical averages for single colours under laboratory conditions. Even so they have been inconclusive. In 1941 H. J. Eysenck stated that little agreement had been reached on the fundamental points, the existence of a general order of preference for colours, the relative popularity of saturated colours and differences between the sexes as regards colour preferences.

In our natural everyday attitude to life we

regard colours as properties of the objects in the surrounding world, useful as clues to help us recognize the things we see and the materials of which they are made. People do not ordinarily make colours the object of special consideration or easily dwell on or recall the colours they have just seen. To attend to colour on its own account is a highly sophisticated attitude, very recent even in the field of the arts. Throughout the greater part of the history of painting colour was regarded as no more than a decorative adjunct to the essential delineation of shape. *Kant was expressing the common opinion of his day when he wrote: 'In painting, sculpture, and in fact in all the formative arts, in architecture and horticulture, so far as fine arts, the *design* is what is essential The colours which give brilliancy to the sketch are part of the charm. They may no doubt, in their own way, enliven the object for sensation, but make it really worth looking at and beautiful they cannot.' (*Critique of Judgement*, 14.) The contemporary interest in the subleties and minutiae of colours, whether in the fine arts or in fashion fabrics or interior decoration and so on, reveals a shift of attitude in the whole outlook on colour. Modern painting, in particular, often treats colour as the very substance and structure of form rather than a supererogatory embellishment to it. Affective reactions in laboratory conditions to isolated single colours divorced from practical significance are necessarily artificial and their bearing, if any, on the artistic problems of colour is problematical.

2. PHYSICAL APPROACH

From the point of view of physics colour is a function jointly of illumination and an object which serves as a stimulus to produce a colour experience in some percipient. The amount of radiant energy or intensity of light determines the brightness of a seen surface. The different wavelengths of light falling upon the eye constitute the physical basis of hue discrimination. Ordinary daylight comprises all the wavelengths of the visible spectrum and is seen as white. Objects reflect, transmit, or absorb the light which falls upon them. Most objects reflect or transmit to the eye a greater proportion of light of some wavelengths than others and appear coloured in relation to the wavelengths which they reflect or transmit. Objects which transmit or reflect all wavelengths equally appear in normal illumination achromatic, that is neutral black, white, or grey.

In 1672 Sir Isaac Newton communicated to the Royal Society his experimental discovery that a beam of white light passed through a refracting prism may be dispersed into its component chromatic rays and that these may be recombined into white light. (Rays of light are of course not themselves coloured

any more than sounds exist in the source of sound apart from an organ of hearing and a conscious percipient. The concept of colour in physics represents the coefficient of the reflectance index of an object and certain aspects of a light source: when light is said to be coloured or chromatic, the implication is that in certain conditions such light would cause such and such a colour experience in a normal observer.) It is now known that any colour in the visible spectrum and also white light can be matched by mixing different amounts of light from the red, green, and blue sectors of the spectrum. These are therefore called primary colours (a different concept from the four psychological primaries). An indefinite number of sets of primaries may be chosen (always from the same general regions of the spectrum): in any set of primaries no one of them can be matched by combining the other two. Some but not all spectral colours can be matched by combining two other colours. Two colours from widely separated parts of the spectrum (e.g. yellow and blue) may be combined to produce white light. Such colours are called *complementaries*, a concept not wholly identical with psychological complementaries. (It is worth mentioning that from the point of view of physics there are no 'steps' in the wavelength spectrum but a continuum of evenly varying wavelengths. The different 'colours' (red, blue, green, etc.) which we experience are due to factors in our optical receptors.)

Colour mixture. When chromatic lights are combined the resultant colour is that which corresponds with the combined wavelengths of the lights which are mixed. This is called *additive mixture*. When colouring substances, such as dyes or pigments, are mixed the reverse process occurs. For the colour of a pigment corresponds with the wavelengths of the light which it reflects upon the eye and this in turn may be equated roughly with those wavelengths from the complete visible range which it does not absorb.

When two substances are combined each still absorbs its appropriate wavelengths and the light reflected (and consequently the colour seen) is reduced to those wavelengths which neither of the substances absorbs when not mixed. This is called *subtractive mixture*. The amount of light reflected by two substances mixed is less than each reflects separately since their absorption range is combined. Artists therefore tend to avoid unnecessary mixture of pigments since this causes a lowering of brightness and a 'muddy' effect. The *Pointillists tried to get the best of both worlds by obtaining an additive mixture with the use of pigments. The pigments are placed on the canvas without mixture in small dots which when seen from the appropriate distance away are no

longer visible as separate dots. The chromatic lights reflected from the several dots are combined by the eye additively in the manner of admixture of light. The technique gives a high key but a reduced range of brightness.

Many artists, including Pointillists and *Mosaicists, have applied their pigments in small patches in such a way that from the ideal viewing distance an ambiguous effect is produced, the colour patches simultaneously combining to give a third colour by additive mixture but also being seen as separate patches. There is an oscillation which causes an impression of scintillation over the area. The term *vibration* is used to describe this effect and painters have often sought after it as being more 'lively' or 'vibrant' than unambiguous colours.

In the (subtractive) mixture of pigments primary colours are said to be those three colours other than black, white, and grey, no two of which can be mixed to produce the third but which together can produce all possible hues. There is no unique set of primaries but different sets differ in the saturations and brightnesses of the colours resulting from their admixture. This is of importance to the artist since he is concerned with saturation and brightness as well as hue. Indeed some hues give rise to psychologically different colours with special colour names at different levels of saturation and brightness (e.g. yellow-brown). The three pigment colours which are usually thought to produce the greatest workable range of subtractive mixtures are those which are known in colour photography as magenta, yellow, and cyan. Much, however, depends upon the chemical constitution of the actual pigments used.

Because pigments are not pure colours, in pigment mixture, unlike additive mixture of chromatic lights, many different pigments can usually be combined with any one other pigment to produce a neutral grey. There is therefore no one complementary to any hue in pigment colours as in spectral colours. The concept of complementaries is useful in regard to pigment colours chiefly in its psychological sense of colours which give each other's negative after-image or which when juxtaposed give the maximum enhancement by simultaneous contrast.

Texture. Many objects which transmit or reflect light are composed of small particles differing in their refractive index. The light entering the object and striking upon these particles suffers directional changes and is said to be *diffused*. Light which is diffused within an object may be transmitted or reflected. When most of the light reflected by an object is diffused light, the object has a characteristic appearance called a matt surface. An object which transmits principally diffused light is called *translucent*. When an

object reflects light with little diffusion it is said to have a *glossy* or optically smooth surface. Objects which transmit light with little diffusion are said to be *transparent*. Most objects in everyday life are intermediate, having both diffusing and non-diffusing components. The pigments and dyes which artists use have their own characteristic diffusion structure. By devices of technique artists represent by their means objects in the surrounding world which have different and even contrasting diffusion qualities. One of the sources of aesthetic enjoyment in the contemplation of works of pictorial art consists in the simultaneous awareness of the actual diffusion qualities of the pigmented canvas and of the apparent diffusion qualities of the objects represented in the created picture space.

3. PSYCHOPHYSICAL APPROACH.

The physiological study of the organs of vision, the optical pathways, brain processes, and colour vision theories will not be dealt with in this article. Certain psychophysical considerations, however, combinations of the physical study of the stimulus situation and psychological study of the subjective response in visual experience, are essential to an understanding of colour in the context of the arts.

Simultaneous contrast. The position of a colour area in relation to other colour areas in the visual field can cause changes of colour analogous to those which would be produced by changes in the character of the light coming from the area to the eye. As a general rule the visual mechanism accentuates differences in juxtaposed areas. The effect applies to hue, saturation, and brightness, either concurrently or separately. A great deal of illustrative work has been done on it by colour scientists and psychologists, particularly of the *Gestalt School, and it will be dealt with briefly here.

(i) Juxtaposed areas of high and low brightness appear respectively brighter and darker than they would in separation.
(ii) Apparent saturation varies according to juxtaposed or background areas.
(iii) Juxtaposed areas of adjacent hues appear to be more different in hue than if seen separately.
(iv) Juxtaposed objects of complementary hues appear more saturated than they would if seen in separation.

A high degree of brightness contrast reduces contrast of hue. For this reason artists who have been principally interested in hue (commonly referred to as 'colour') usually avoid dramatic effects of *chiaroscuro and paint for the most part at a medium level of brightness where the range of hue is greatest.

Artists interested in saturation effects usually paint in a fairly narrow range of hues.

Spatial factors. The foregoing principles of contrast are modified by certain spatial factors.

(i) A large area appears brighter and more saturated than a small area of the same hue. But a small bright area in a large dark field appears brighter than an area of identical brightness against an uncontrasted background.
(ii) When the contrasted areas interlock in complicated linear patterns the phenomenon of *assimilation* reverses the foregoing effects of simultaneous contrast. These two factors might account for the fact that most artists agree that the dynamics of shape cannot be separated from what might be called the integral dynamic of colour.
(iii) Brightness and saturation are enhanced by sharpness of outline or generally by what is called 'good gestalt', a definite and recognizable shape.
(iv) An area which is seen as a single conformation may appear uniform despite being seen against contrasting backgrounds in different parts of its extent.

Artists have in the past been intuitively familiar with the above principles of colour combination and interaction in their practical application and by this knowledge they have been able to achieve a surprising variety and subtlety of effects with relatively few pigments and with a minimum of pigment admixture.

Such effects and many others depend on a fundamental peculiarity of colour vision in which it differs basically from the perception of sound. When several musical notes are sounded simultaneously a new emergent sound (the chord) is heard which is identical with none of them; a trained ear can as it were analyse the vibration and hear simultaneously the constituent notes and the chord sound. But when chromatic lights or colouring substances are mixed the eye sees only one colour and does not analyse out the components.

Constancy. Colour constancy is a phenomenon akin to constancy effects in regard to shape and size (see PERSPECTIVE). Briefly, surface colours of objects, particularly familiar objects, tend to be seen not in exact accordance with the light which is reflected by them upon the eye but nearer to the colour which they would have in normal daylight illumination. Thus in ordinary everyday vision most colour perceptions are relatively independent of changes in illumination and viewing conditions. Colour constancy is a complex and variable phenomenon, not perfectly understood, and seems to combine a tendency to see things the colours they are

remembered to be and a tendency to compensate for changes of illumination and viewing conditions. Colour constancy is favoured by the 'object attitude' of perception when colours are noticed incidentally to the perception of objects rather than by the aesthetic attitude when they are attended to for themselves. For this reason colour constancy is usually stronger when viewing natural objects in real scenes than when seeing them depicted in pictures, and painters have difficulty in duplicating the colour impressions of ordinary vision for this reason.

In the language of painting the term *local colour* is used for the 'natural' colours of objects towards which colour constancy vision tends to approximate. Local colour is not a precise concept but it may be practically defined as the colour which an object is seen to have against white in clear diffused daylight. For example a neutrally grey road surface illuminated by sunlight falling through green foliage may be violet; but its local colour remains grey. Some artists have been content to paint in colours approximating to local colours, giving the objects in their pictures as nearly as possible the colours which they are seen to have in ordinary everyday vision. Others, and notably the *Impressionists, have striven to discount colour constancy and to see and depict each area of the visual field in exact accordance with the constitution of the light actually reflected from it upon the eye. This is a way of looking at the environment which requires considerable effort to counteract ingrained habits of practical 'object-recognition' seeing, and the much-debated phrase 'innocent eye' has a legitimate application to it. It is, of course, a highly sophisticated way of seeing and comes naturally to artists who are principally interested in illumination, atmosphere, and in colours as such rather than the objects to which they adhere. It leads to a manner of painting in which the shapes of objects in the visual field are apt to be broken up and to disappear into unfamiliar areas of colour.

Most objects in the daily scene are illuminated not only by the main source of light but wholly or in part also by light reflected upon them from neighbouring objects. In the literature of painting the modifications of local colour caused by such reflections are called *reflected* or *accidental* colours. The early Italian artists paid little attention to them and *Ingres, under the influence of such 'primitives', said: 'Le reflet est indigne du peintre d'histoire.' The importance of reflected colours in European painting increased with the growth of naturalism and was closely studied by such masters as *Rubens, *Rembrandt, and *Velázquez. *Delacroix wrote: 'Dans la nature tout est reflet.' But when combined with rejection of local colours, as

with the Impressionists, attention to reflected colours has a contra-naturalistic effect. *Ruskin was quoted by *Signac as saying: 'We must consider nature purely as a mosaic of different colours which we ought to imitate quite simply one alongside the other.'

The operation of colour constancy is particularly intractable in the dimension of brightness. A painter can, theoretically, match all the hues of nature and has a pretty wide range of saturation. But his range of brightness is many times less than that of nature. A black in sunlight may be much brighter than a white in shadow, yet the former continues to look black and the latter white. The painter cannot reproduce this, literally. He must scale down all brightness contrasts to fit the resources available to him, transferring the relationships into a reduced key. Moreover the closer proximity of the colours in a painting, the smaller areas, the greater uniformity of texture, and the attitude of the ordinary observer who when looking at a picture tends to pay more attention to colour as such than he does in the ordinary 'object vision' of practical life, all operate to enhance the effects of interaction and simultaneous contrast. At every point he must compromise, adjust, distort, and use effects which are not identical with those in the scene he is depicting in order to convey an impression of that scene. It is only the non-naturalistic painter who can afford to 'match' area by area. The painter, whether naturalistic or not, goes beyond naturalistic matching and seeks a certain harmony of colour within a limited range. This is partly why a fine painting which is reproduced however accurately in a small book illustration looks garish and untrue. Size plays an important part both as regards the picture in relation to the scene depicted and as regards the reproduction in relation to the picture.

Colour harmony. There have been a number of attempts from *Aristotle to *Goethe to evolve scientific principles of harmony in the combination of colours, abstracting from their representative functions. One of the most influential was that of *Chevreul, whose interest stemmed from his work as chief of the dyeing department at the Gobelins tapestry workshop, Paris. In *De la loi du contraste simultané des couleurs et de l'assortiment des objets colorés* (1839), translated into English as *The Principle of Harmony and Contrast of Colours* (1980), he distinguished two kinds of colour harmony, harmonies of analogous colours and harmonies of contrasts. He was followed by the critic and art historian Charles Blanc, who in *Grammaire des arts du dessin* (1867), and in an essay on Delacroix (1864) enunciated 'mathematical' and 'infallible' means of obtaining harmony which, however, required delicate sensibilities and experience on the part of the artist. In *Modern*

Chromatics (1879) the American Ogden N. Rood, an amateur painter, tried to discover harmonious principles of colour combination by arranging them in pairs and triads. David Sutter in *Les Phénomènes de la vision* (1880) affirmed the belief that 'the laws of aesthetic harmony of colours are learned as one learns the rules of musical harmony'. *Seurat, though probably most indebted to *Delacroix, studied these scientific theories of colour harmony and in his pictures *Une baignade* (London, NG) and *La Grande Jatte* (New York, Met. Mus.) applied the principles of harmony by analogy and contrast enunciated by Chevreul and Rood. In his later years, following the 'scientific aesthetics' of Charles Henry, he evolved a theory of colour harmony based on the supposed emotional significance of colours. A modern attempt to find a system of measuring the aesthetic quality of colour combinations is contained in G. D. Birkhoff's *Aesthetic Measure* (1933), but it has not stood up to criticism.

No precise concept of colour harmony has been worked out in these studies. Colour harmonies are reducible to combinations which are found empirically to be pleasant and as the findings have not been adequately supported by controlled experiment they remain suspect. Scientific theories of colour harmony fall short of the intuitive grasp of principles which most competent artists display.

Colour measurement and naming. (See also COLOUR LANGUAGE.) Different colour vocabularies have become current in the diverse fields of art, science, and industry, and workers in one field are often unable to understand the nomenclature used in another. The American Inter-Society Color Council of the National Bureau of Standards has compiled a dictionary of colour names co-ordinating 7,500 colour names current in fourteen recognized systems of nomenclature.

Systems of colour naming cannot be universalized or compared unless the names can be referred to standard samples. Colour measurement or colorimetry is a technique of measuring colour stimuli (e.g. standard samples) and relating them to the calculated response of a standard observer. It is a psychophysical technique leading to a system of colour specification necessary to systematic naming. Colour measurement presupposes a method of organizing colour samples for systematic standards. Three methods are in use. (i) By the mixture of a limited number of dyes or pigments in varying proportions to produce the whole gamut of colour. (ii) By combining systematically a few standard colours or dyes as in three-colour photography to produce the whole range of colour. (iii) By grouping samples according to minimum discriminable intervals of hue, saturation, and brilliance. That most frequently used is the Munsell Colour System, which is

related to a set of 1,200 samples contained in the Munsell Book of Colour. HO

Burnham, R., et al., *Colour: A Guide to Basic Facts and Concepts* (1963).
Evans, R. M., *An Introduction to Colour* (1948).
Galifret, Y. (ed.), *Mechanisms of Colour Discrimination* (1960).
Itten, J., *The Art of Color* (1961).
Katz, D., *The World of Colour* (1935).
Kornerup, A., and Wanscher, J. H., *Methuen Handbook of Colour* (1967).

COLOUR FIELD PAINTING, abstract painting characterized by large expanses of barely modulated colour, with no strong contrasts of tone or obvious focus of attention. The forerunner of such painting in America was Yves *Klein, who, in 1946, began producing 'monochromes', canvases painted in one colour. Leading exponents included Barnett *Newman and Mark *Rothko. Although the hard-edged abstraction of Newman's work can be seen to have anticipated *Minimal art, by contrast with the *Abstract Expressionist facture in Rothko's paintings, their styles are comparable in creating areas of intense, saturated colour. In paintings such as *Adam* (1951; London, Tate) by Newman, and *Earth and Green* (1955; Cologne, Ludwig Mus.) by Rothko, colour appears almost to have overwhelmed elements of shape and drawing, thereby acquiring a specific pictorial autonomy, in which the works' mesmerizing effects, and the senses of scale which they impart, are attributable entirely to chromatic contrasts, rather than to strictly formal qualities. From 1952 Helen Frankenthaler (1928–2000) developed colour field painting by soaking or staining very thin paint into unprimed canvas, so that the paint is integral rather than superimposed. This variation is known as 'colour stain painting'. OPa

COLOUR LANGUAGE. *Colour has been seen since at least the 19th century as the most 'grammatical' of the formal elements in art, offering the visual language most independent of words. Modern colour systems identify the intersecting co-ordinates of *hue*, *saturation*, and *brightness* by numbers, and only an infinitesimal proportion of the millions of perceptible colours has been named in any language. Colour names nevertheless perform a vital function, and it has been found that naming and recalling colours tends to push the nuances of perceived colour towards a standardized norm. The classification of colour perceptions into sets of 'primary' or 'basic' colours has, indeed, been a dominant feature of colour theory since the 17th century, and in the art of the *Constructivist movements has formed an intrinsic part of visual ideology. But the notion of 'primary' may depend on several conflicting criteria: two of the three 'primary' colours used to print the colour plates in this

Companion, magenta and cyan, are unlikely to be known by name to any but specialists and do not occur in the sets of 'basic' colour terms identified in the hundred contemporary languages studied by the ethno-linguists Berlin and Kay. Their controversial work was an attempt to use colour vocabularies as an index of the evolution of languages themselves: they identified the introduction of a basic series, beginning with 'black' and 'white', followed by 'red', and developing to their full set of eleven terms, ending with the equally ranked purple, pink, orange, and grey. Their World Color Survey of spoken languages and surveys of some historical colour vocabularies are now under way.

The concept 'red' is particularly interesting for the understanding of the functions of colour symbolism: in ancient Greek and Latin it included 'purple', but by at least the 17th century 'purple' had moved away from red towards 'violet', although *Goethe's 'Purpur' (carmine) still had—unknown to him—the ancient connotation. The symbolic connotations of 'red' and 'purple' are now, of course, widely divergent. The primary and secondary colours have lent themselves most readily to a standard terminology; the tertiaries and other nuances have been given far more idiosyncratic names ('pink' has gravitated in English from 'yellow' to 'pale red' over the past four centuries), and 'unnameable' colours have become part of the mysterious language of *Symbolism itself.

JGa

B. Berlin, B., and Kay, P., *Basic Color Terms: Their Universality and Evolution* (2nd edn., 1991).

Grossmann, M., *Colori e lessico: studi sulla struttura semantica degli aggettivi di colore in Catalano, Castigliano, Italiano, Romeno, Latino e Ungherese* (1988).

Meier, C., and Suntrup, R., 'Zum Lexikon der Farbenbedeutungen im Mittelalter: Einführung zu Gegenstand und Methoden sowie Probeartikel aus dem Farbenbereich "Rot"', *Frühmittelalterlichen Studien*, 21 (1987).

Tornay, S. (ed.), *Voir et nommer les couleurs* (1978).

COLOUR PRINTS AND COLOURED PRINTS. From the earliest times woodcuts were issued with bright simple colouring, sometimes applied through stencils. By the Renaissance however, many artists, such as *Dürer, abjured colour, while others experimented with the restricted range of colours possible in *chiaroscuro woodcuts. During the 17th century colour was seldom used, apart from cheap popular prints, with the astonishing exception of *Seghers, who used both colour printing, coloured supports, and hand colouring. The earliest and most sustained attempt to establish a sophisticated technique of colour printing is found in the work of Jacob Cristoff Le Blon (1667–1741), who applied the principles of Newton by printing blue, yellow, and red from separate *mezzotint plates, often augmented by some hand touching. He established a firm in London, but it went bankrupt in 1732, probably due to the excessive slowness and complication of his method. His assistant Jacques Gautier d'Agoty inherited the method, and it was used by successive generations, notably in large and rather grisly anatomical plates.

The 18th century is the golden age of colour printing, notably in England and France, and mainly in the manufacture of sophisticated reproductive prints. *Aquatint and *stipple engraving were the most frequent foundations for colour printing, but mezzotint plates, particularly when slightly worn out, were frequently printed in colours in England, generally from sentimental or genre subjects such as the many plates after George *Morland. Line engraving remained a predominantly black and white medium, austere and high minded.

The most seductive and technically advanced colour prints were made in Paris, particularly by Philibert Louis Debucourt and François Janinet. They used aquatint, often supplemented with work by the *roulette, composing their designs by the use of carefully registered multiple plates, often of subjects that were of a decorative and mildly amorous nature. The crayon manner, usually used to imitate chalk drawings, was a satisfactory technique with which to print a limited range of colours, such as brown or red.

London was the other great home of colour printing in the second half of the century. Stipple engravings, usually of sentimental or rustic subjects, were often issued both plain and coloured. A time-consuming but effective method of inking the plate was the method *à la poupée*, whereby the printer inked up the different colours by the use of selective dabbing, sometimes finished by hand touching. Sporting subjects after George *Stubbs, particularly by his son George Townly, are especially effective examples of this type.

Throughout this period, and well into the 19th century, a legion of hand colourists were at work, sometimes young apprentice painters such as *Turner and *Girtin, supplementing their income by this tiresome work. Aquatints, although sometimes printed in colour, were more frequently hand coloured in England, as were the great mass of caricatures by such artists as *Gillray, which were issued with bright gaudy colours to attract the passer-by. The most remarkable of all English colour prints are those of William *Blake, particularly his large *monotypes, which exist in a world of their own.

During the 19th century a host of different methods of colour printing were used with greater or lesser success, often with strictly commercial applications. The fundamental instrument for colour printing was however the *lithograph. A pioneering and very beautiful set of views by Thomas Shotter *Boys, the *Picturesque Architecture in Paris, Ghent, Antwerp, Rouen* (1839), printed from several stones, match the full chromatic range of a *watercolour, and are a high point of the art in England. They anticipate the many chromolithographs of the Victorian period, highly finished images with a plethora of garish colours, that gave the word 'chromo' a pejorative flavour. More notable for their technique than their artistic value are the numerous popular subjects by George Baxter (1804–67), who used ingenious combinations of technique and inking to achieve his effects.

In France as the century drew to a close so did colour printing have its greatest triumphs. The new-found splendours of Japanese prints were a profound influence on a generation of French artists, notably on *Toulouse-Lautrec whose lithographs, particularly the huge *posters, reflect Japanese influence in their use of simplified shapes, large flat areas of colour, and simplified contours. Japanese prints also had their effect on the colour lithographs of *Bonnard and *Vuillard in their early period, and perhaps most memorably in a set of ten colour-printed drypoints with aquatint by Mary *Cassatt of *c*.1891 showing women in different domestic activities. Predictably *Degas had an interest in colour printing, although it was mainly confined to his odd rather anthropomorphic landscape monotypes. In many publications of this period the contribution, not often acknowledged, of expert printers can scarcely be exaggerated.

In the 20th century the contribution of *Picasso to the history of the colour print was predictably incisive, especially in his large *linocuts. The German *Expressionists also made dramatic use of harsh bright colours in their *woodcuts, influenced by Edvard *Munch. Many artists of the *École de Paris made colour prints, aided to a greater or lesser degree by their printers. It was in the 1960s with the emergence of *Pop art that a new chapter was written with the dominance of the *screen print, a technique that was exploited by such artists as *Warhol, *Lichtenstein, and *Johns to brilliant effect in huge prints that can dominate a wall like a painting. It is this search for wall power that has dominated much recent printmaking, and guaranteed the almost total dominance of colour prints over black and white images. A chasm now exists between the collector of modern colour prints and the collector of old master prints, intended for perusal in a box or portfolio.

RGo

COLUMN STATUES, sometimes known as column figures, characterize early *Gothic church doorways, particularly in the Île de France and areas under its

influence. Carved from the same blocks of stone as the columns of the embrasure, they were adumbrated in such *Romanesque buildings as S. Madeleine, Vézelay (late 1120s).

The earliest column statues (destr.) appeared at S. Denis Abbey in the late 1130s, rapidly followed by the west front of Chartres Cathedral, and at the cathedrals of Bourges and Le Mans (all probably 1150s). They became common on great churches throughout the Île de France, and in the first half of the 13th century huge ensembles were produced for Notre-Dame, Paris, the transepts at Chartres, and the cathedrals of Reims and Amiens. Outside France there are French-inspired column statues in Spain (e.g. Santiago de Compostela and S. Vicente, Ávila), Germany (cathedrals of Münster and Bamberg), and England (Rochester Cathedral). Column statues were not favoured in Italy, although Romanesque doorways at Verona, Ferrara, and Cremona have figures carved into columns and jambs in door embrasures.

At S. Denis, Chartres, and other mid-12th-century buildings column statues adorn royal portals, so-called from the belief of 18th-century antiquaries that the figures depicted kings and queens of France. They are, in fact, part of larger programmes of sculpture encompassing the whole door or group of doors, which expounded the Christian message through narrative, allegory, and symbolism. At first they represented Old Testament kings and queens, prophets, and patriarchs; later, especially at Senlis Cathedral c.1165, the selection of figures foreshadowed the Incarnation and life of Christ. As programmes expanded, subjects were more widely sought, and included local and universal saints, martyrs, and witnesses to the faith.

Column statues vary in quality, the larger programmes showing signs of mass production. The earliest resemble vertical, stiff planks, respecting the qualities of the columns they replace; but their style began to reflect sculptors' growing interest in naturalism and movement through space, until on the north transept of Chartres (c.1215–20) in scenes of the *Annunciation* and *Visitation*, the statues are almost fully three-dimensional and turn as if to address one another.

Column statues were occasionally used in cloister arcading—for example at Notre-Dame-en-Vaux, Châlons-sur-Marne, in the 1160s. Figures adorned doorways until the late 13th century, but they were increasingly freed from the column to stand against flat jambs or in niches. Their demise followed the new tendency to display monumental sculptures in interiors, rather than exteriors. NC

Sauerlaender, W., *Gothic Sculpture in France, 1140–1270* (1970).
Williamson, P., *Gothic Sculpture, 1140–1300* (1995).

COMPOSITION. The Latin word *compositio* usually represented the Greek *synthesis*, the most general term for structure or arrangement. Both terms were applied in all the arts in a neutral sense with no necessary implication for beauty or aesthetic value. Thus Demetrius uses synthesis almost as an equivalent for 'style', as for example: 'Smoothness of composition (*synthesis*) . . . is not altogether suited to forcible vocabulary' (*On Style*, 299). Sometimes 'composition' was used with a meaning fairly close to *dispositio*, or the arrangement of the subject matter. The last usage became rather common in the Middle Ages, but otherwise medieval practice showed little divergence from the classical. For example, Aquinas (1225–74) (*Summa theologiae*) said: 'The forms of art works derive from the conception of the artist; for they are nothing else than *compositio*, arrangement (*ordo*) and shape (*figura*).'

Hugo (1096–1141) used 'composition' for the arrangement of the parts of a single thing and 'disposition' for the arrangement of a number of things in a group. Bonaventura (1221–74), discussing whether the artist *creates*, distinguished between the activity of imitation (of which the portrait is a paradigm) and the activity of imagination. The latter, he asserted, does not create new things but does create new compositions. The word *compositio* came into use during the Middle Ages, particularly in music and architecture, with a special reference to purely formal beauty.

At the *Renaissance the word *compositio* did not acquire a much more specific connotation. In his *Poetica Horatiana* (1561), the most detailed commentary of the century on *Horace's *Ars poetica*, Giovanni Battista Pigna distinguished the matter (*rem*) of a poem from the words (*verba*) and the combination of the two, which was composition (*compositionem*). 'To the composition', he says, 'belong the whole form of the poem and the entire power of the poet.' But Torquato Tasso in his early *Lezione sopra un sonetto di Monsignor della Casa* (c.1565) said: 'It is clear that the concepts are the end and therefore the form of discourse, and the words and composition of the verse are the material and instrument.' During the 16th century and still more in the 17th the terminology which had its source in classical theory of rhetoric became formalized in art theory. As an illustration Franciscus Junius said in *The Painting of the Ancients* (1638) that the five components of painting are *invention, *proportion, *colour, motion, disposition.

Disposition, or 'the ordering of the whole worke', became in the language of the *academies roughly the equivalent of *compositio* in Antiquity and the Middle Ages—the ordered plan or structure of a work of art. Thus *Fréart de Chambray, who was influenced by Junius, defines 'disposition' in his *Idée de la perfection de la peinture* (1662) as 'la collocation ou la position regulière des figures'.

From classical Greek times theories of composition by proportion and harmony among the parts and between the parts and the whole have envisaged the classical ideal of a work of art as an organic whole—a metaphor first used by *Plato. The formulation in *Aristotle's *Poetics* that the unity of a work of art should be such that 'if any of the parts be either transposed or taken away, the whole will be destroyed or changed' has been very influential through the ages. Among others Roger de *Piles emphasized the importance of harmony throughout the whole in his *Cours de peinture par principes* (1708). HO

Osborne, H., *Theory of Beauty* (1952).

COMPUTER ART. Experiments with the aesthetic possibilities of computer design began in the early 1950s, and were focused around industrial companies with large research sections, such as the Boeing Company and the Bell Telephone Company. During this time, a small number of people were using computers specifically for artistic purposes, for example Ben Laposky (1928–), who, in 1952, used an analogic computer to create his *Electronic Abstractions*.

Interest in computer-generated art gathered momentum during the 1960s. The first exhibition of computer graphic art was held at the Howard Wise Gallery, New York, in 1965. The organization American Experiments in Art and Technology (EAT), established in New York in 1966, held an exhibition of computer art, called *The Machine*, at MoMa, New York, in 1968. The Computer Arts Society was formed in England in 1968 following the exhibition *Cybernetic Serendipity*, held at the Institute of Contemporary Arts and curated by Jasia Reichardt. In 1969, the society held another exhibition, *Computers and Visual Research*, in Zagreb. Prominent among early exponents of computer art were Frieder Nake (1924–) and Gustav Metzger (1926–).

The forms taken by computer art since the early 1970s have been increasingly diverse, and have touched upon many other aspects of contemporary art. These forms include: the techniques devised by Charles Csuri (1931–) and Robert Mallory (1929–) for generating sculpture by computer; the kinetic works of Jim Pallas (1947–), such as *Electromechanical Heart* (1985; video installation); video-digitized images such as *Victims* (1985–8; video installation) by Thomas Porett (1949–); and films, such as *Mutations* (1992) by William Latham (1961–). Despite such formal diversity, these works are linked by the nature of their production; that they are computer generated is their conceptual essence. Jasia Reichardt wrote that 'the computer . . . is devoid of the prime forces

behind creativity—imagination, intuition and emotion' (*Cybernetic Serendipity*, exhib. cat.), and it is the precise role of such a machine in relation to the production of art, as either mediator or creator, about which computer art invites speculation.

A distinction can be drawn between artists who use computers simply as design tools, like David Youngerman (1929–), and those who consider the stages involved in the generation of certain computer images to be analogous to human intellectual thought processes, like Harold Cohen (1928–). The latter approach appears to grant a degree of aesthetic autonomy to the computer, in that the patterns emerging from it will not necessarily have been imaginable to the person programming their creation. The most startling and significant examples of computer art to have been produced in this way are the fractal images by the scientist Benoît Mandelbrot.

In many ways, computer art constitutes a rejection of the *Modernist interpretation of *abstract art which asserts its self-referential nature. While most computer-generated abstractions appear to have this quality, the exhibition of them actually draws attention to their subordination to the machines which created them, and which can create an unlimited number of identical images. OPa

CONCA, SEBASTIANO (1680–1764). Italian painter. Born at Gaeta, he trained under *Solimena at Naples before coming to Rome in 1707. Inspired by the classicism of *Maratti he quickly evolved a lyrical *Rococo style which reached fulfilment in his *Coronation of S. Cecilia* (1721–4), frescoed on the vault of S. Cecilia, Trastevere. The success of this prestigious project led to an unending flow of commissions from all over Europe that was matched by his tireless output. His *Pool of Bethesda*, frescoed in the church of the Ospedale della Scala, Siena (1731–2), his altarpiece of the *Assumption of the Virgin and S. Sebastian* (1740; Rome, S. Martina and S. Luca), and the ceiling fresco of *The Allegory of the Sciences* (1747; Rome, Bib. Corsini) are subsequent landmarks in the development of his soft and decorative style. Around 1752, following the election of Pope Benedict XIV, he moved to Naples, where he worked at S. Chiara (1752–5; destr.). By this time his illusionistic manner was falling out of fashion and his late work is somewhat rhetorical and repetitive. HB

Clark, A., 'Sebastiano Conca and the Roman Rococo', *Apollo*, 85 (1967).

CONCEPTUAL ART, a term which emerged in the 1960s to describe art designed to draw attention to the intellectual processes involved in its construction, and implicitly to question the critical judgements made of it. Works such as Marcel *Duchamp's *Bottle Rack* (1914; Paris, Centre Georges Pompidou) have been cited as precedents for Conceptual art. An important difference is that the creators of such 'ready-mades' were making conventional aesthetic and formal decisions in their choice of objects; displaced from its usual surroundings, *Bottle Rack* is revealed as a mysterious, sculpturally enthralling object. Conceptual art, however, is characterized by a suppression of formal peculiarities, denying the possibility of interest in any physical aspect of the work itself, as in *Joint* (1968, various locations) by Carl André (1935–), a photograph of 183 units of baled hay. Other exponents of Conceptual art include Sol *Lewitt, Bruce Nauman (1941–), Dennis Oppenheim (1938–), Keith Arnatt (1930–), and Michael Craig-Martin (1941–).

While it is concerned with the negation of formal interest in a work, the forms Conceptual art has taken have been very diverse. Texts, maps, diagrams, X-rays, audiocassettes, and videotape have all been used as communicative media. This diversity stems from the importance attached by Conceptual artists to such things as photographs and working notes. Regarded as relatively incidental and ephemeral in relation to more conventional kinds of art production, every stage in the creation and dissemination of a piece of Conceptual art is equally important in suggesting the intellectual and communicative processes of which it is a part. Consequently, in a work such as *Duration Piece #7* (1969, various locations) by Douglas Huebler (1943–), the verbal explanation that fifteen photographs were made, at one-minute intervals, of an area occupied by eleven ducks and a pigeon is, in terms of conceptual importance, equal to the event itself.

Contemporary accounts of Conceptual art often found it difficult to explain its 'objectless' nature; the Tate Gallery's *Biennial Report* (1972–4) contained a 'Note on Conceptual Art' which related it inappropriately to earlier art by claiming that it 'develops with a new vitality [art's] traditional preoccupations with the human figure and with its setting in interiors and in landscape'. In rejecting the basic forms by which art is recognized—a painting or sculpture installed in a gallery—Conceptual art was seriously disruptive to *modernist critical practices, in which divisions such as those between painting and gallery, artist and spectator, were taken for granted. It could thus be considered as a form of *Postmodernism. OPa

Battcock, G. (ed.), *Idea Art: A Critical Anthology* (1973).
Meyer, U. (ed.), *Conceptual Art* (1972).

CONCRETE ART, term applied to abstract art that is intended to be totally autonomous, repudiating all figurative references and symbolic associations. The name was coined by Theo van *Doesburg, who in Paris in 1930 issued a manifesto called *Art concret* (it took the form of the first number of a periodical with this title, but no other numbers were issued). In this he declared: 'The work of art … should receive nothing from nature's formal properties or from sensuality or sentimentality … A pictorial element has no other significance than "itself" and therefore the picture has no other significance than "itself". The construction of the picture, as well as its elements, should be simple and controllable visually. Technique should be mechanical, that is to say exact, anti-impressionistic.' Van Doesburg died the following year, but his ideas were developed by the *Abstraction-Création group. One of its members, Max *Bill, was a major force in helping Concrete art survive beyond the Second World War (he lived in neutral Switzerland). After the war, several new associations of Concrete art were formed, notably in Italy and in South America (which Bill visited in the 1950s), and it was later influential on *Minimal art and *Op art. Bill, who organized international exhibitions of Concrete art in Basle in 1944 and in Zurich in 1960, gave the following definition: 'Concrete painting eliminates all naturalistic representation; it avails itself exclusively of the fundamental elements of painting, the colour and form of the surface. Its essence is, then, the complete emancipation of every natural model: pure creation.' Although Concrete art is typically austerely geometrical, it is not necessarily so; Bill's sculpture, for example, often uses graceful spiral or helix shapes. IC

CONDER, CHARLES (1868–1909). English painter. After a conventional education Conder emigrated to Australia in 1883 to become a surveyor. By 1885 he was studying art in Sydney, where he met the Australian Impressionists Tom Roberts (1856–1931) and Arthur Streeton (1867–1943). Early in 1890, following his sale of *The SS Orient* (1888; Sydney, AG), he sailed to Europe. By August he was in Paris sharing a studio with William Rothenstein (1872–1945), who became a lifelong friend despite disapproving of Conder's notorious debauchery. For the next decade he divided his time between England and France, living off his art, his wits, and his friends. His oils are fresh, impressionistic landscapes often, like *Blossom at Dennemont* (1893; Oxford, Ashmolean), of considerable beauty, but the works which made his reputation were fanciful pastorals painted in watercolour on silk (e.g. *Hommage à Watteau Fan*, c.1899; Oxford, Ashmolean) which have a melancholy charm. A fortunate marriage in December 1901 solved his financial worries but his work and his health both deteriorated and the last three years of his life were

spent as an invalid. DER

Rodgers, D., *Charles Conder*, exhib. cat. 1967 (Sheffield, AG).
Rothenstein, J., *Conder* (1938).

CONINXLOO, GILLIS VAN III (1544–1607).

South Netherlandish painter, the most distinguished member of at least six generations of artists active from the late 15th century to the early 17th. After finishing his apprenticeship (according to van Mander, with Pieter *Coecke van Aelst, Leonaert Kroes, an artist about whom nothing else is known, and Gillis Mostaert), he visited France *c*.1562. He became a master in the Antwerp guild in 1570. As a Calvinist, he escaped Antwerp in 1585, first to Zeeland and then to Frankenthal in Germany, where he was the leader of a small group of landscape painters. In 1595 he settled in Amsterdam and became a citizen in 1597. Coninxloo is known for his luxurious forest scenes. Although not the inventor of the genre, he is its most important practitioner. His landscapes are seen close to eye level; foreground, middleground, and background are no longer marked by the traditional three-colour division but are interwoven through the distribution of light and shade (*Forest Landscape*, 1598; Vaduz, Liechtenstein Coll.). Coninxloo ran a large workshop; Hercules *Seghers and Esias van de *Velde probably were his pupils. KLB

Luijten, G., et al. (eds.), *Dawn of the Golden Age*, exhib. cat. 1994 (Amsterdam, Rijksmus.).

CONNOISSEUR, CONNOISSEURSHIP. See *opposite*.

CONRAD VON SOEST (*c*.1360–1422).

One of the most important German painters of the late Middle Ages. His style amalgamates Westphalian and Parisian traditions. Born in Dortmund, Germany, it is probable that he completed his apprenticeship in Westphalia and then travelled to Paris in the 1380s. Von Soest's œuvre has been reconstructed on the basis of the massive Niederwildung altarpiece (1403; Bad Wildungen, SS Maria, Elisabeth, and Nikolaus) which bears an inscription attesting to his authorship. The altar features thirteen scenes of the life of Christ and reveals von Soest's narrative skill. His is an elegant style, but this does not detract from the humanity of his characters as seen in *Adoration of the Magi*, where Melchior is moved to touch the newborn Christ child with tenderness and adoration. Von Soest also painted an altar for the confraternity of the Marienkirche in Dortmund (*c*.1420; *in situ*), to which he and his wife belonged. The altar was severely reduced in size for reframing, and has been heavily overpainted. Although it is difficult to discern von Soest's hand a comparison with the Niederwildung altar shows significant changes in his sense of composition and space. Where the Niederwildung altar features multi-figured scenes, the Dortmund altar places the compositional emphasis on fewer, more monumental figures. Typical features of his style are the brilliant palette and the cloud motif, punched into the gold ground of the panel. Von Soest has been traditionally viewed as representative of *International Gothic art in Germany. KC

Conrad von Soest und sein Kreis, exhib. cat. 1950 (Cappenberg-Selm, Schloss Cappenberg).
Corley, B., *Conrad von Soest, Painter among Merchant Princes* (1996).

CONSERVATION AND RESTORATION

(1) *Paintings*; (2) *Sculpture*; (3) *Modern paintings*

1. PAINTINGS

The conservation of paintings is generally understood to mean the stabilization of their existing state by means that may or may not involve active intervention. Restoration implies returning the appearance of a painting to a state as close as possible to that which the artist originally intended.

In the past, the term 'restoration' has been used for all types of repair—as well as cleaning, retouching, and wholesale repainting. As many documents record, early restorations were carried out by painters. *Sodoma's repainting of the child—damaged by damp—in *Signorelli's *Circumcision* (London, NG), recorded by *Vasari; Jan van *Scorel's restoration of Hubert and Jan van *Eyck's Ghent altarpiece (Ghent, S. Bavo) in 1550; and *Navarrete el Mudo's work on Rogier van der *Weyden's *Descent from the Cross* (Madrid, Prado), ordered by Philip II in 1566, are notable examples. The 18th century saw the emergence of specialist restorers, followed by disillusionment in some quarters with their activities. A purely aesthetic debate about the cleaning of paintings—enthusiastically endorsed by *Hogarth in his *Analysis of Beauty* (1753), but opposed by others such as Joseph Addison (for example, in his well-known article in the *Spectator* in 1711 in which he imagined the personification of Time at work in a picture gallery)—became submerged by justifiable outrage at the destruction of paintings by unskilled picture cleaners. In the 19th century, the first sustained cleaning controversies arose as a result of *Eastlake's programme of cleaning paintings at the National Gallery, London, at a time when the deep brown tone of so-called 'gallery' varnishes was much admired. Periodic controversies have occurred right up to the present time as well-known paintings have been cleaned in Britain, Europe, and the United States.

Modern conservation of paintings in a museum or private collection begins with the control of the conditions in which the works are kept: generally agreed levels of relative humidity and light exposure—and secure methods of storage or display—should be maintained if the materials of a painting are not to deteriorate. Such passive measures are grouped together under the term 'preventive conservation'. Conservation may also involve active treatment if the structure of a painting begins to break down or if it is physically damaged by accident or attack. Much present-day conservation treatment consists of replacing or reversing interventions by previous restorers.

Techniques of structural conservation vary according to the type of *support, the main structural layer of the painting. The problems of panel paintings—on poplar, oak, fir, beech, mahogany, and other species depending on their place of origin—are those of wooden artefacts in general, compounded by the fact that the wood is painted usually on one side only. Warping, splitting along the grain, the breaking apart of joins, the flaking of paint and ground from the wooden substrate, and insect damage are all commonly encountered. Rigid secondary supports such as wooden or metal battens or gridlike structures known as *cradles* were, from the 18th century until recent times, frequently applied to the backs of thinned panel paintings in order to keep them flat and to reinforce splits and joins. These often had destructive effects, causing worse problems of distortion, splitting, and cracking than those they were designed to counteract and they now have to be removed. The most extreme form of panel treatment was *transfer*, in which the wood of the original panel was removed altogether and the paint mounted on a new support. There was a vogue for transfer—beginning in late 18th-century Paris (practised most notoriously at first by the restorer Picault and later by the Hacquin family) and later spreading to Russia—in which many important Italian Renaissance panels were unnecessarily transferred to canvas, often with disastrous results. The tragedy of transfer mania was that it was usually the most important paintings that were chosen for 'immortality' (as the restorers of the time described the process). Panels by *Raphael and *Leonardo in the Louvre (e.g. Leonardo's *Madonna of the Rocks*) and others brought back to Paris by Napoleon's imperial adventures (e.g. Raphael's *Foligno Madonna*, now back in the Vatican Museums) were among those changed for the worse and for ever by the transfer process.

The modern approach to conservation is to intervene as little as possible. For panels, this means mending splits where necessary, but accepting a moderate degree of warp and minimizing it as much as possible by environmental measures and correct framing—if necessary sealing the panel in a clear vitrine

continued on page 150

· CONNOISSEUR, CONNOISSEURSHIP ·

THE development of aesthetic appreciation in Renaissance Italy gave rise to the term *conoscitore* and later in 17th-century France to *connoisseur* (now *connaisseur*), which is found in La Bruyère, Racine, and Molière. It was imported in its French form into England early in the 18th century (Mandeville, Berkeley). *Connoisseurship* is first found around 1750 (Fielding, Richardson, Sterne). The word is derived from the Latin *cognoscere*, to get to know (Greek root in *gignōskō*), but neither the Greeks nor the Romans had a corresponding noun. The adjective *philokalos* in Greek and *aestimator* in Latin expressed the idea, with a marked utilitarian emphasis in Latin as the money term *aes* indicates.

Early in the 18th century the influential drawings collector Jonathan *Richardson, in his Two Discourses (*An Essay on the Whole Art of Criticism as it Relates to Painting and an Argument in Behalf of the Science of a Connoisseur*), first published in 1719, argued that the attributes of a connoisseur were a proper accomplishment of the cultivated man and that the necessary grounding ought to be a recognized part of the ordinary education of an English gentleman. He stressed the social importance of a 'Gentleman of Taste' and the civilizing influence of the fine arts on a nation by 'the reformation of our manners, refinement of our pleasure and increase of our fortunes and reputation'. Richardson used the term in a sense which combined a degree of sensibility and discrimination with the basic knowledge and understanding which might be expected of an interested amateur. As the century advanced the word acquired a rather more specialized implication. In 1752 the *Dictionnaire universel* ('de Trevoux') defined 'connoisseur' as a person completely knowledgeable about the qualities of any object submitted to his judgement and distinguished a connoisseur from an amateur, observing that although it is not possible to be a connoisseur without being an amateur, it is possible to be an amateur without being a connoisseur. Johnson (*Dictionary*, 1754) defined 'connoisseur' as: 'a judge, a critick. It is often used of a pretended critick.' He does not give 'amateur', which was described in 1805 (Rees, *Cyclopedia*) as 'a foreign term introduced and now passing current among us to denote a person understanding and loving or practising the polite arts of painting, sculpture or architecture without any regard to pecuniary advantage'.

In the 19th century the term 'connoisseurship', without losing its more general connotation of sensibility and discrimination, became current also in a narrower sense linked with the specialized disciplines of the art historian and the museum man—the apparatus which in Germany was designated by the term *Kunstwissenschaft*. Influential in promoting this usage was Sir Charles *Eastlake, who in his essay 'How to Observe' defined 'connoisseurship' as follows: 'The connoisseur, as the name implies, is he who more especially professes to *know*. The designation perhaps indicates an acquaintance with facts rather than truths, with appearance and results rather than with their causes. In its general acceptance it comprehends a familiarity with the characteristics of epochs, schools, and individual masters, together with a nicer discrimination which detects imitations from original works. The chief distinction between the connoisseur and the amateur is that the knowledge of the first assists the exercise of judgement, while that of the latter tends to kindle the imagination. The studies of the connoisseur may, however, take a wider range, and be directed not only to recognise excellence in works of art, but to investigate the nature and principles of that excellence; in short, in addition to a practical and habitual acquaintance with specimens, and a discrimination of their relative claims, to penetrate the causes of the world's admiration. On the whole, therefore, he may be said to combine the views of the philosophical artist with an erudition to which the artist seldom aspires.'

Eastlake, a practising artist who was also destined to become director of the National Gallery, London, with a responsibility for selecting and buying old master paintings, including the little studied Italian primitives, was well qualified to define the role of the connoisseur in such broad terms. A similar synthesis of visual observation of significant detail, more general stylistic analysis, combined with a historical sense of context and a respect for documentary evidence, characterizes the volumes of the Englishman Joseph Arthur Crowe and the Italian Giovanni Battista Cavalcaselle, whose three-volume *A New History of Painting in Italy* was first published in 1864–6.

However with the Italian connoisseur Giovanni *Morelli, who knew both Cavalcaselle and Eastlake, we find a narrowing of the concept which links the term more particularly to problems of attribution. He believed that each painter had a characteristic use of *schema* and techniques which can be regarded as a kind of handwriting and which the eye of a trained connoisseur can identify. His method, based on an analysis of anatomical details and other habitual elements of an artist's visual vocabulary, was reflected in his writings—translated into English as *Italian Painters: Critical Studies of their Works* (1892–3)—and had a direct influence on *Berenson, who in his *Rudiments of Connoisseurship* (1894, published 1902) insisted on the supremacy of visual evidence in addressing a work of art and formulated a theory that those elements of a picture which are not employed as a means of expression offer the most reliable evidence of authorship—ears and hands, drapery and landscape, for instance.

Although Berenson, in the tradition of Walter *Pater, was also able to write lyrically about art from a more general aesthetic viewpoint—for instance, characterizing Florentine art in terms of 'tactile values' which give rise to a sense of form, volume, and texture—his reputation ultimately depended on his status as an expert on

attribution, assigning names of artists to sometimes quite secondary works of art. He published lists, divided by regional schools, *Venetian Painters* (1894), *Florentine Painters* (1896), *Central Italian Painters* (1897), *North Italian Painters* (1907), defining the work of individual hands, sometimes using pseudonyms where the actual name of a recognizable hand eluded him. He applied the same methodology to drawings, and in his *Drawings of the Florentine Painters* (1903) offers not only a catalogue of all known and identified drawings but also a text that penetrates the creative intent of each artist. Here he was building on a long tradition of collector connoisseurs ranging from Jabach and Crozat in France to Sir J. C. Robinson, whose *Critical Account of the Drawings of Michel Angelo and Raffaello in the University Galleries, Oxford, 1870* broke new ground through his methodical study of an artist's drawings as an essential element in understanding his work as a whole (see ITALIAN ART AS OBJECTS OF PATRONAGE AND COLLECTING: FRANCE and LONDON, VICTORIA AND ALBERT MUSEUM).

Unfortunately Berenson's close association with the British New York art dealer Joseph Duveen provoked a reaction against the idea of connoisseurship as an academic discipline and during the last 35 years has led to the demise of almost all object-oriented art history. This stems from a failure to differentiate both morally and methodologically between commercial expertise, often an instant judgement based on informed memory and knowledge of the art market, and creative connoisseurship. The connoisseur in the traditional sense derives his authority from a wide-ranging appreciation of historical context as a basis for understanding the evolution of style and appreciating the originality, vision, and imagination of an individual artistic personality. As John Gere, himself a notable connoisseur of old master drawings, has explained: 'Connoisseurship, in the technical sense of identifying the authors of works of art, is not exactly a science, in the sense of being a rational system of inference from verifiable data, nor is it exactly an art. It stands somewhere between the two and it calls for a particular combination of qualities of mind, some more scientific than artistic, and others more artistic than scientific: a visual memory for compositions and details of compositions, exhaustive knowledge of the school or period in question, an awareness of all the possible answers, a sense of artistic quality, a capacity for assessing evidence, and a power of empathy with the creative processes of each individual artist and a positive conception of him as an individual artistic personality.' This imaginative capacity to follow an artist into unknown territory is well exemplified by an occasion when Philip Pouncey (1910–90), a notable connoisseur of our own era who developed his skills at the British Museum, examined a drawing at Christ Church, Oxford, which for 200 years had been preserved unnoticed among the anonymous drawings, and observed that if Bastianino (1532×4–1602), an obscure Ferrarese imitator of Michelangelo, had ever made drawings, this was exactly the kind of drawing one would have expected from him. This observation was subsequently confirmed following the discovery of a painting by Bastianino with a figure based on the Oxford drawing. By such sensitive and ultimately verifiable judgements connoisseurs eventually define correctly the corpus of an artist's work, thus enabling us to make valid critical observations of a more general kind.

Connoisseurs have no quarrel with those who prefer to study art in terms of social context, iconography, or the history of taste. However, their respect for the artist and the identification of his work is fundamental to the discipline of art history and the informed appreciation of works of art.

HB/HO

Brown, D. A., *Berenson and the Connoisseurship of Italian Painting*, exhib. handbook 1979 (Washington, NG).

Eastlake, Charles, 'How to Observe' (1835), repr. in *Contributions to the Literature of the Fine Arts*, 2nd ser. (1870).

Gere, J., in J. Stock and D. Scrase (eds.), *Philip Pouncey: The Achievement of a Connoisseur*, exhib. cat. 1985 (Cambridge, Fitzwilliam).

to buffer it from the humidity changes that place it under strain. Flaking paint is routinely secured with small quantities of adhesive and heated spatulas.

Canvases are more vulnerable than panels, easily dented, torn, and becoming weaker as they age. The traditional method of reinforcing them is *lining* in which a second canvas is stuck to the back of the original one before remounting on the stretcher: this adds strength and, moreover, the adhesive used to join them can be made to penetrate to the back of the paint layers to secure them if they are flaking. Although it was indeed often necessary for strengthening weakened canvases, the practice of lining was indiscriminate and very few pre-19th-century canvas paintings remain unlined. The portraits of *Juan de Pareja* (New York, Met. Mus.) and *Philip IV in Brown and Silver* (London, NG), both by *Velázquez, are notable examples of 17th-century paintings that have escaped lining and the crispness of their paint surfaces is striking. The process of lining, although frequently unavoidable and often expertly done, has undoubtedly changed the texture and translucency of many paintings. In the worst cases, paint surfaces have been burned and scraped by the use of hot hand-irons: much damage uncovered by today's restorers and blamed on overcleaning was, in fact, caused by past liners. The choice of adhesive, too, can have negative effects. The once widespread use of wax-resins for consolidation has irretrievably darkened the delicate tonalities of many *Impressionist and *Cubist works.

The modern approach to the conservation of canvas paintings is—as with panels—to treat them only for what is actually wrong with them. The replacement of old, perished linings (*relining*) is still often necessary but the qualities of unlined paintings are so highly valued that lining is avoided if at all possible. If consolidation is required, adhesives are carefully chosen that do not alter the optical qualities of the paint. The use of low-pressure suction tables now permits the treatment of weakened or distorted canvases and flaking paint by methods that interfere minimally with the structure and appearance of the work.

The cleaning of paintings is the most visible and controversial of the processes of restoration. It may be defined as the removal of dirt, discoloured varnishes, and non-original overpaints from the surface. Many paintings are considerably obscured by the natural yellowing and darkening of the resins that make up old varnishes and by artificial toning or repaints put on by previous restorers. Most old master paintings have been cleaned and retouched a number of times since they

were painted. Present-day restorers are the inheritors of a confused legacy of change, deterioration, and multiple intervention by their predecessors. The decision whether and how much to clean a painting is a complex one that depends on the condition of the work and the aesthetic objectives of those responsible for the cleaning. An assessment has to be made of the likely results. If a painting is extensively damaged and repainted, cleaning may not be considered desirable: it may be better to preserve the previous restoration than to expose the fragmentary nature of the original paint. On the other hand, if large amounts of well-preserved authentic paint are obscured, it is usually worthwhile revealing them and regaining the tonality of the original colours.

The processes of cleaning have been subject to much scrutiny in recent years. In the past, cleaning with caustic reagents or abrasive cleaners frequently caused damage to paint surfaces that becomes apparent only when subsequently applied varnishes and overpaints are removed. The use of organic solvents—applied on small swabs and chosen specifically to soften varnishes and more recent repaints, but not original paint—remains the usual cleaning method. Recent developments include the use of resin soaps and solvent gels, tailored to interact only with specific resin varnishes and leave oil formulations unaffected.

The key factor in cleaning paintings is that the restorer should have control over the level to which dirt, varnish, and overpaint are removed. This is important, since different degrees of cleaning may be appropriate in different cases. Three common approaches to varnish removal have been identified as (i) *partial*, (ii) *selective*, and (iii) *total* cleaning, in which the varnish is (i) thinned and lightened, (ii) removed in some areas but not others, or (iii) totally removed. There are sound reasons why total cleaning may not be attempted—principally the possible vulnerability of some colours to cleaning solvents. *Glazes—thin veils of transparent colour—are often considered to be especially sensitive to cleaning—but caution should be exercised with all areas of a painting. Each of the three approaches listed above is ethically valid, provided it can be safely achieved, but the aesthetic results are very different and demonstrate the inherent subjectivity of the cleaning process and the need for sensitive judgement on the part of the restorer.

The removal of discoloured varnish and overpaint reveals previous damages and changes that have taken place within the paint layers. A decision then has to be made as to the extent and nature of any *retouching* or *inpainting*. Generally, paint losses are filled with an inert filler, textured to match the adjoining surface, and then retouched with the

colours necessary to complete the surrounding design. There are strict rules for retouching that should be observed: new paint must not overlap original paint (in the past, retouchings were frequently much more extensive than the damages they were put on to conceal); the materials used should be stable but also readily reversible (that is, easily removable with mild solvents); and a full photographic record should be made of the state of the painting after cleaning so that the extent of the retouching is clear.

Although fully matched (or deceptive) retouching is generally attempted, visible inpainting may also be used. There is a great range of methods for rendering retouching discreet but discrete. The simplest type of visible inpainting is a plain colour—a so-called 'neutral' tone—chosen to blend unobtrusively with the overall tone of the painting. Various other schemes have been tried—mainly in Italy—that use successions of hatched or striped brush strokes, either in abstract gradations of colour or in more direct reconstructions of the missing form. The aim in all cases is to allow the painting to appear complete from a distance but to permit the damaged areas to be visible on closer inspection. The success of these methods depends—as do all the processes of restoration—on the skill and sensitivity of the restorer. The final stage of restoration is to apply a clear varnish—when appropriate. However, it should be recognized that some paintings were not intended to be varnished—many Impressionist and Cubist works, for example—and that the intentions of the artists may be compromised if the surfaces of their paintings are altered in this way.

All paintings begin to age, change, and deteriorate from the moment they are finished and one of the most difficult judgements for the restorer to make is how to balance the conflicting requirements of what Alois Riegl in his *Modern Cult of Monuments* of 1903 defined as a series of values: age value, historical value, artistic value, and so on. Is it acceptable for a deteriorating painting to be stabilized at the cost of its aesthetic appearance? Are old varnishes and repaints essential components of the historical object—or can they be discarded to regain what we choose to define as the artist's intent? Is it better to disguise old damages or to leave them showing as a signifier of age? Should the restorer take account of the context in which a painting is viewed—museum, church, or house—and restore accordingly? All restoration is a compromise and present-day philosophy is to intervene much less than our predecessors. But the aesthetic and practical consequences of these questions are profound and are the reason why conservation and restoration will continue to

provoke controversy. DB

Sitwell, C., and Staniforth, S. (eds.), *Studies in the History of Painting Restoration* (1998).
Stanley Price, N., Kirby Talley, M., and Melucco Vaccaro, A. (eds.), *Historical and Philosophical Issues in the Conservation of Cultural Heritage* (1996).

2. SCULPTURE

The distinction between conservation and restoration of sculpture has in recent years assumed greater significance than in earlier centuries, since conservation ethics, especially in the conservation departments of museums and galleries, have become ever more codified. A move towards preservation of the original work of art, rather than restoration, characterizes modern conservation methods, and today conservators are highly qualified professionals, trained in studio art, art history, and scientific analysis. By contrast, during the 16th to 19th centuries a restorer of Antique sculpture might be a creative sculptor practising 'restoration' as a means of supplementing his income. Such sculptors abounded in Rome, especially fulfilling the demands of the clergy and *Grand Tourists for Antique sculpture for their collections. Examples of these often unidentified restorers' works, usually involving the freely interpreted addition of a missing limb or fragment, abound in collections. Today more circumspect and scientific approaches are taken both to conservation, that is, preservation, and to restoration, that is reproducing the lost structure or surface. Each case study is evaluated on its own merits, and conservation only undertaken after careful assessment of the risks and requirements involved. In all cases, photographic and written documentation records the various stages of conservation, and remains on file as part of the history of the object. Wherever possible the conservation materials are reversible, and compatible with the sculpture. Restorations should either be clearly visible or, if not, are thoroughly documented for the file.

One of the principles of conservation is preventive action, since the environment in which an object is stored or displayed has a fundamental effect on its long-term well-being. Objects kept out of doors are subject to weathering from rain, wind, sunshine, and the disintegrating action of frost, as well as to attack by pollutants from industrial atmospheres and vibration. The removal of sculpture indoors, or to protection out of doors, will remove some immediate danger. Wooden covers or tents can protect fountains and outdoor sculpture, and for extra insulation against frost, hessian and straw can be packed within the covers. Material kept in these environments, even if partly protected, is still susceptible to exterior forces, and the replacement of originals with copies is one way of arresting further deterioration. The

placement of sculpture in controlled environments, such as modern museums and galleries, in which air temperature and humidity are regulated, contributes to the halt in this disintegration. Conditions indoors are regarded as satisfactory when the atmosphere can be maintained at an equable temperature and humidity. However, if it is impossible to remove an object from its exterior setting, repeated preventive treatment can lessen the effects of environmental attack.

The conservation of stone can encompass either structural work and/or surface cleaning. Structural work can consist of joining broken elements with adhesives or dowels, or removing previous repairs which have deteriorated and are no longer stable. Surface cleaning can be achieved by any number of methods, including the use of water, air-abrasives, laser, and various chemical cleaning agents.

The conservation of outdoor stone is largely a preventive treatment, arresting further deterioration of the stone in a hostile outdoor environment. This usually takes the form of periodic washing by water during the warm seasons. Abrasion, using abrasive dust, can also aid in cleaning dirt; or a slaked lime poultice can be applied to the surfaces, and the caustic properties of the lime poultice will soften the black encrusted surfaces of the stone, drawing impurities to the top of the stone, which can then be washed off with water. Lime-saturated water is then applied as a sealant to the surfaces.

Over the last decades much study has been made of stone consolidants, with greater and lesser degrees of success achieved in their use on exterior sculpture. The so-called consolidants do not penetrate the stone but merely harden the powdery surface to form a skin which is not durable when exposed to rain and damp. Where sculpture is protected from exposure to weathering these preservatives are more effective. Mixtures of modern synthetic waxes, silanes, and lime-based putty may provide the ideal solution.

Breaks in sculpture can be joined by glue with a filler or a cement of marble dust. Larger parts of sculpture will need dowelling with stainless steel, since this is more stable than iron, copper, or brass, which corrode and expand. Dowels can also be used for wood, ivory, and other materials. The insertion of a dowel along a crack, together with adhesive, will prevent the crack from enlarging. Such cracks appear in response to exposure to extremes of temperature and humidity, and susceptible objects must be protected from direct sources of heat and light. Sunlight also bleaches materials, such as wood and ivory.

The worst threat to wood is pest infestation which can be treated either through chemical pesticides, or through fumigation, but is now more commonly treated by closure in an oxygen-starved environment (see WOOD-CARVING).

Metal should ideally be stored in conditions of relative humidity. Preventive treatment includes wiping the surfaces with a silicone wax or with clear lacquer using a soft cloth. For outdoor metal sculpture waxing at least once a year is essential to protect the metal from chemical action. Without protection, metal sculpture will develop a natural patina through oxidization with the air and moisture, and this may lead to tarnishing or corrosion, which may or may not be desirable. The green mineral patinas on bronze are often considered to enhance the aesthetic value of the object, but white powdery patinas on lead are unstable and are a sign of active corrosion, which can only result in the ultimate destruction of the work. Where corrosion is discovered to be active, treatment must be given and the choice of method depends on the nature of the metal. Though the corrosion that occurs on a metal object kept in one place may be stable, its removal to another environment will reactivate the process. Bronze disease, as it is colloquially referred to, consists of the deterioration of metals by the action of chloride minerals.

X-radiography is normally used to determine if decoration is hidden under layers of corrosion. Before conservation, readily removable areas of deterioration are removed by mechanical tools. If active, however, the corrosion will need to be treated with chemicals. If a hollow casting is cracked or flawed, allowing moisture to enter, corrosion may occur within the piece at a point where it is inaccessible for cleaning. In this event the sculpture must be dried thoroughly before the cracks are repaired. Subsequent repair work should be carried out using metal of the same composition as the object. This is done by welding or soldering, but where the metal is deformed by innumerable cracks or blow-holes it may be preferable to make good the surface by using one of the organic reversible adhesives for use with metals. Whichever method is adopted, no acidic or alkaline residue should be allowed to remain on the metal, as otherwise corrosion will ensue. HO/AB

Plenderleith, H. J., and Werner, A. E. A., *The Conservation of Antiquities and Works of Art* (1971).

3. MODERN PAINTINGS

Conservation's priority is prevention rather than cure. Conserving a modern painting presents the opportunity to preserve it in a condition close to its original state. Protecting a painting from accidents and combating the rate of inevitable degradation reduces the need for future treatments to repair structural damage and restore lost appearance. A restored work, no matter how expertly done, can never have the same intrinsic value as a well-preserved one.

Knowledge of artists' materials and how they interact with one another and their environment underpins all effective conservation. It enables decisions to be made about suitable environmental conditions and appropriate treatments when the need arises. Many new artists' materials for *supports, primers, paints, and varnishes were introduced in the 20th century. Cotton canvas has become more popular than linen, being particularly suited to the use of *acrylic primers and paints, and plywood and compressed wood fibre boards, such as hardboard, have largely replaced timber for making panels. Synthetic *resins, which include alkyds, cellulose esters, ketone resins, polyvinyl acetates, and acrylics, have been used for artists' materials since the 1930s but it was not until the 1950s that developments in the production of water-borne acrylic 'emulsions' allowed the commercial production of the artists' acrylic paints, media, and primers that are now in common use. These have the advantage of being fast drying and may be used on a wide variety of unprimed or acrylic-primed supports. Alkyd and acrylic primers, pigmented with titanium white, have largely replaced white lead in oil as *grounds for oil painting. Acrylic and ketone resins are used in place of the traditional dammar, mastic, and copal resins for the manufacture of many oil painting media and picture varnishes.

New *pigments have greatly extended the range of colours available, from the ubiquitous titanium white and pthalocyanine blue to countless organic dye pigments. Artists have also seized on the creative potential of everyday industrial and decorative products. House paints and cuttings from glossy magazines are used alongside the latest development in artists' acrylics.

Recording the materials and techniques used is a prerequisite to conservation. A technical dossier of information supplied by the artist can be supplemented with details of products from suppliers and manufacturers, before it is forgotten or lost. Without this information, future identification of the materials requires sophisticated, scientific analysis to unravel the often novel and complex concoctions used.

The physical and chemical properties of a painting are dependent on understanding how the materials were used and have aged as well as their inherent properties. Thus, paint that was excessively thinned without the addition of *medium will form a film vulnerable to abrasion and solvents whatever the medium. Acrylic resin remains more flexible than aged oil or alkyd; so that acrylic primers and paints are less prone to developing brittle cracks unless overloaded with pigments and fillers. Acrylic paints, like oil paints that are rich in medium, become soft and vulnerable to damage and dirt retention

at high temperatures and humidities or brittle and friable at low temperatures.

Conservation aims to protect the painting from the harmful effects of its environment as well as accidental damage. A clean and stable environment is essential to guard against airborne pollution, excesses of humidity, temperature, and light. The environmental conditions required for a painting are determined by the most vulnerable components. A painting incorporating highly photosensitive paper *collage or exposed canvas will require lower levels of lighting than a painting in acrylic or oil alone. Paper, cotton, and linen canvases are made from natural organic fibres that are susceptible to degradation initiated by light as well as acidic pollution.

A well-constructed glazed frame, sealed with a board covering the back, provides effective and constant protection against accidents, dirt, and short-term fluctuations in humidity. For many modern paintings fitting a glazed frame or applying a protective varnish are not acceptable. Displaying them in a clean area without exposure to heat sources, such as radiators, or high light levels, such as direct sunlight, will help preserve them. They can be protected in storage by fitting simple, deep-sided, storage frames wrapped in polythene. The glazing in the frame or wrapping must not be in contact with the surface of the painting.

However well protected, paintings may require cleaning or treatment to counteract inevitable deterioration or restore accidental damages. Cleaning modern paintings is often hampered by the presence of intricately textured, soft, absorbent, or solvent-sensitive paint films. Even traditional oil paint can be sensitive to water. Contemporary artists seldom varnish their paintings so that the dirt has to be removed directly from the paint surface. This can be as difficult as the removal of old varnishes. The presence of exposed canvas, collage, and materials that can be easily dislodged, such as lead paint, charcoal, or pastel, will severely limit the extent to which a painting can be safely cleaned.

Changes in the appearance and solubility of paint can be particularly rapid during its early years. This compromises the restoration of a damage to a new painting. An accurate retouching can quickly become visible as the surrounding original paint continues to change. Particular care is needed in selecting restoration materials that can be safely removed in the future. Paintings containing mixed media are likely to age in visibly erratic ways. The inconsistent ageing of different materials produces visual discontinuities rather than the harmonious surface of a traditional painting in one medium. However, this is often an integral part of the artist's intention.

The ultimate limitations of durability for a painting or any artefact are determined by the physical characteristics of the materials from which it is made. A rainbow will cease with the rain and a sculpture in ice will melt when its temperature rises above freezing. Maintaining the special conditions of storage and display required to preserve artefacts that are unstable in normal conditions requires specialist technical knowledge, constant attention, and often considerable resources.

Artists have sometimes incorporated visible decay as a key component of their works, resulting in rapid changes in appearance and disintegration. It is the artist's decision as to whether such works should be repeatedly remade or the remains of the work left to become a relic of its original form and subsequent decay. The artist may provide a specification from which the work can be recreated, within acceptable parameters, like performing a piece of music from a score. The work and its history can also be recorded in a more a durable medium, such as *photography.

It is essential, when dealing with reproducible media such as photography or electronic media, that the artist states what constitutes the original work. A *video may always need to be displayed in its original format on designated equipment or it may be desirable to transfer it to new formats as the original technology becomes superseded. One artist will welcome the enhanced picture quality that technological developments bring while for another it may be the precise visual qualities of the original technology that it is essential to preserve.

Conserving modern art involves preserving rapidly changing and ephemeral materials as well as those of proven durability. Understanding their properties, and providing appropriate protection and environmental conditions, helps to ensure their survival for the enjoyment of many generations. RP

CONSTABLE, JOHN (1776–1837). Along with *Turner, recognized as the greatest English landscape painter of the 19th century. Born in East Bergholt, Suffolk, the son of a well-to-do miller, Constable entered the RA schools, London, in 1799 and first exhibited in 1802. He acquired an eye for the picturesque through study of J. T. Smith's rustic etchings, and for wooded scenery through the example of *Gainsborough and Dutch 17th-century masters. He was a lifelong admirer of *Claude's poetic landscapes, especially those in the collection of Sir George Beaumont. Critical success came slowly; he became an ARA in 1819 and a full RA as late as 1829. Genuine enthusiasm for his work came in the 1820s, notably from the French, culminating in a gold medal at the *Paris Salon in 1824 for his *Haywain* (London, NG), by far his best-known work. As *Landscape, Noon* Constable had first exhibited it at the RA in 1821. It was one of a series of large Suffolk subjects of river and farm scenes which he continued to paint even after he married and settled in London in 1816. Others include *Flatford Mill* (1816–17; London, Tate), called by Constable *Scene on a Navigable River*, and *The Leaping Horse* (1825; London, RA).

His knowledge of the farming year and its seasonal activities is seen in numerous small pencil sketches and in directly painted oil studies in which he accurately recorded the changing face of the cultivated landscape of the Stour valley and those who worked there. His attention to fleeting weather effects can be seen in his cloud studies, sketched from 1819 in the summer months at Hampstead, where he rented a house. Constable's techniques were designed to inject life and vibrancy into his large exhibited pictures. He made full-size preparatory oil sketches in the studio as a way of retaining the freshness and spontaneity of his on-the-spot sketches. Flickering light on moving leaves was rendered with deft touches of white, while a palette knife created rich textural effects. The critics sometimes saw this as lack of finish and unsophisticated handling. Without recourse to mythology or allegory Constable aimed to give meaning to his landscapes. His art was a quest involving experimentation into natural phenomena akin to scientific enquiry and containing moral, philosophical, and religious dimensions. He was widely read in the literature of landscape, especially English poets such as James Thomson, William Cowper, and Robert Bloomfield, himself a Suffolk poet. His ideas were explored in many letters, especially in those to his friend John Fisher, who acquired Constable's *The White Horse* (1819; New York, Frick Coll.). Constable lectured on the history and progress of landscape painting at the Hampstead Literary and Scientific Society in 1830 and at the Royal Institution in 1836. In 1830 he also began publishing a series of *mezzotints entitled *English Landscape Scenery*, engraved by David Lucas from Constable's oil sketches and intended to show the 'chiaroscuro of nature'. Constable died in 1837 feeling that his ambitions had not been realized. The publication in 1843 of *Memoirs of the Life of John Constable* by his friend, the artist C. R. Leslie (1794–1859), began a new assessment of his life and art. A body of subscribers bought his *Cornfield* for the National Gallery. Real appreciation of his drawings, watercolours, and oil sketches began with the bequest of Isabel Constable to the V&A (see under LONDON) in 1888. MP

Parris, L., et al. (eds.), *Constable: Paintings, Drawings and Watercolours*. exhib. cat. 1976 (London, Tate).

CONSTRUCTIVISM, a Russian abstract movement, founded by the sculptors Antoine *Pevsner and Naum *Gabo in 1920. Dedicated to producing widely accessible sculpture from industrial anti-art materials like sheet-metal, glass, and plastic, it developed alongside and owed much to Vladimir *Tatlin's collage constructions of 1914–17. Tatlin's Constructivism, based on socially useful 'production art' and rooted in Communist ideologies, was short-lived because its artists, like Alexander *Rodchenko, turned to typography and other design disciplines where Constructivist goals were more achievable. Pevsner's and Gabo's Constructivism, expounded in their *Realist Manifesto* (1920) was of greater consequence; they stated that sculpture should be about movement in space, rather than volume and political values. Oppressed by the dominance of 'production art', Pevsner and Gabo moved to Western Europe in 1922 and 1923 respectively, and with others, like van *Doesburg at the *Bauhaus (1921–8) and *Lissitzky with his contacts with *Dada and De *Stijl artists, developed an International Constructivism. Based on mathematics and aesthetics instead of politics, and concerned mainly with painting and sculpture, the movement influenced Western architecture and developments like *Concrete and *kinetic art. YJ

Rickey, G., *Constructivism: Origins and Evolution* (1968).

CONTÉ CRAYON. This was the invention of Nicolas Jacques Conté (1755–1805) and it was a mixture of refined *graphite and clay. A shortage of graphite for drawing purposes occurred in France during the Napoleonic Wars and Conté's product both used less graphite and improved the quality of drawing pencils by achieving several degrees of hardness.

*Seurat made a celebrated series of studies for his painting *La Grande Jatte* in Conté crayon in which he demonstrated the delicate effects of texture which could be obtained using this medium. The 'Conté crayons' available commercially today are different in their composition, being a type of fabricated *chalk. PHJG

CONTRAPPOSTO, the Italian term for a pose in which one part of the body is turned in the opposite direction from another. In particular, it is used to denote the asymmetrical, but balanced, posture of the standing human figure that first appeared in 5th-century Greek sculpture (see GREEK ART, ANCIENT: SCULPTURE) and was developed and elaborated in the *Renaissance.

In Egyptian and earlier Greek sculpture standing figures were always represented with the weight evenly distributed on both feet and with the pelvis horizontal, so that the frontal view of the figure was essentially symmetrical. During the 5th century BC Greek sculptors freed the standing figure from this rigid frontality and developed a new scheme in which the centre of gravity remained in the middle, but in which most of the weight of the body was carried on one leg that was held obliquely, so that the pelvis on the weight-bearing side was thrust outwards and higher than on the non-weight-bearing side, while the free leg was bent at the knee. Above, the torso and shoulders were tilted out of the vertical in the opposite direction from the pelvis, and the head was inclined sideways. The total effect is of a rhythm of strong curves on the supporting side, contrasting with a relaxed fall on the free side.

This scheme of balancing and offsetting the masses of the body is one of the great achievements of Greek art, since it greatly enriched the plastic possibilities and expressive range of the sculpted figure. The sculptor who is most closely associated with the development of the scheme is *Polyclitus, who wrote a lost treatise on proportion and whose nude male sculptures (notably the *Doryphorus* and the *Diadoumenus*) were widely copied in Antiquity. A bronze statuette in Munich shows that by *c*.400 BC the scheme was fully developed and applied to female as well as male figures.

Recognizably contrapposto figures on the classical model begin to reappear in the art of Nicola *Pisano and form a stream of consistent development in Renaissance sculpture from *Donatello's *S. Mark* (Florence, Or San Michele) onward. *Michelangelo's *David* (Florence, Accademia) took the basic principle of balanced and opposing masses to a new pitch of virtuosity and complexity, and a good deal of Italian sculpture of the later 16th century, such as *Giambologna's *Apollo* (Florence, Palazzo Vecchio) was preoccupied by the pursuit of ever-more elaborate and extreme contrapposto compositions. AJL

CONVERSATION PIECE, a term used to describe paintings which contain a group of full-length portrait figures of family or friends, at leisure, usually within a domestic setting or a landscape before a country house. They are small in scale and informal in manner and the term is specific to the 18th century when they had a considerable vogue from the 1720s. In England they are commonly associated with the charming, slightly stilted, provincial group portraits of Arthur Devis, best represented in his home town of Preston (Harris AG). However fine examples, painted with far greater skill and panache, were produced by his contemporary *Hayman (*Jonathan Tyers with his Family*, 1740; London, NPG) and the younger artists, *Gainsborough, *Zoffany, whose *Tribuna of the Uffizi* (1772–8; London, Royal Coll.) transcends the genre, and *Wheatley. The format was derived from continental sources including *Watteau, through the French émigré painters Philip Mercier and *Gravelot, and expatriate Flemish painters. Probably the best-known continental exponent of the conversation piece is the Venetian Pietro *Longhi. DER

D'Oench, G., *The Conversation Piece: Arthur Devis and his Contemporaries* (1980).

COOPER BROTHERS. British portrait *miniaturists. **Samuel** (1608?–72), arguably, was the greatest native-born British painter of the 17th century; **Alexander** (1609–*c*.1658), though a lesser artist, had a successful career on the Continent, where Samuel's work was also admired. Both brothers were pupils in London of their uncle John *Hoskins, the principal portrait miniaturist to Charles I. Samuel (hereafter referred to as 'Cooper') made his name with a portrait of van *Dyck's mistress *Margaret Lemon* (*c*.1635; Paris, Fondation Custodia, Inst. Néerlandais), which shows his characteristics already fully developed: animation, stylishness, breadth of form, richness of colour, and a strength of modelling in light and shade previously unknown in miniature painting. Many of these qualities were adapted from van Dyck's portraits on the scale of life, but, by concentrating on the expression in the eyes and mouth, Cooper drew the observer into an apparently intimate relationship with the sitter, abolishing the sense of distance inherent in life-sized portraiture.

Although starting in royalist circles, Cooper had no hesitation in looking for, or difficulty in finding, sitters among the parliamentarians during the Civil War and Commonwealth, and his most famous single portrait is his characterful sketch, which he retained in the studio for making copies, of *Oliver Cromwell* (1650; priv. coll.). Then, within ten days of the Restoration, Cooper was painting *Charles II* (1660; later versions at Goodwood House, W. Sussex, and elsewhere); he also portrayed several of the King's mistresses in his most seductive style, as well as, in a more dignified manner, many of the leading intellectuals and politicians.

By comparison, Alexander Cooper's work appears timid and conventional, though he was a good colourist. Problems of attribution remain. By the early 1630s he was in The Hague working for the exiled King and Queen of Bohemia (Charles I's sister), and in 1642 he was in Amsterdam. In 1647, he was appointed portrait miniaturist to Queen Christina of Sweden (from 1654 to Charles X) in Stockholm, where he apparently died in or about 1660. MK

Murdoch, J., et al., *The English Miniature* (1981).

COPAL VARNISH. See RESIN.

COPENHAGEN, NY CARLSBERG GLYPTOTHEK. In 1879, the brewer Carl Jacobsen purchased the *Rayet Head* (530–520 BC), an Archaic head connected stylistically with a series of works from the *Athenian Acropolis. Thus began a lifelong passion for Antiquity that culminated in the foundation first of a small museum at his home in 1882 and the opening of the present museum in 1906. The greatest period of acquisitions dates to 1887–97. In 1902, Jacobsen founded the Ny Carlsberg Foundation; prior to that date, the objects in the collection were purchased with his private funds. Although the majority of the collection was acquired between 1879 and the death of Jacobsen in 1914, additional objects have been added to the collection since.

The art of Egypt, Greece, Rome, and Etruria is represented, with a strong bias towards sculpture. The focus of the collection is the more than 350 portraits of the Roman period (see ROMAN ART, ANCIENT: SCULPTURE) that range chronologically from the late Republic period to Constantine (1st century BC–4th century AD). The portraits include imperial as well as private portraiture, often illustrating the relationship between the two. Famous figures of Roman politicians are also included, such as the sensitive portrait of the Roman general *Pompey the Great* (beginning of the 1st century AD), which was copied after the bronze original in his theatre at Rome, at the foot of which Julius Caesar is said to have been murdered. Other important statues include the *Small Niobids* (440–430 BC), three figures from a *Classical temple pediment, and the portrait-statue of the Athenian orator *Demosthenes* (1st century AD copy of a 3rd century BC original). The collection also includes *Greek vases, *Archaic, and Classical grave stelae, *Roman sarcophagi, as well as more utilitarian objects such as Roman marble tables and *oscilla*. L-AT

COPLEY, JOHN SINGLETON (1738–1815). Generally considered the greatest 18th-century American painter. He was born in Boston, the son of a tobacconist. On his father's death his mother married the engraver Peter Pelham (c.1695–1751) and thus Copley grew up in an artistic milieu. Although essentially self-taught when he began his career as a portrait painter in 1753, aged 15, Copley surely knew the work of his stepfather's friends John *Smibert and Robert Feke and he also learnt from his competitor, the English portraitist Joseph Blackburn (active in America 1753–64) whom he soon surpassed. By the late 1750s Copley's American style was fully established; portraits like the spectacular *Thaddeus Burr* (1758–60; St Louis, Art Mus.), elegantly if conventionally posed, in a startlingly blue waistcoat, reveal his characteristic directness, strong tonal contrasts, and the realism preferred by his mercantile clientele. Realism dictated the need for accurate representation of textiles and furnishings exemplified in his portrait of the wealthy *Mrs Ezekiel Goldthwait* (1770–1; Boston, Mus. of Fine Arts) seated, plumply, in lace and satin at a richly polished table, her hand above a bowl of luscious fruit. Copley prospered but, conscious of his provincialism and wishing to compete with European artists, sent *Boy with a Flying Squirrel* (1765; Boston, Mus. of Fine Arts) for exhibition in London at the Society of Artists in 1766. Praised by *Reynolds and *West, Copley was elected to the Incorporated Society and continued to send exhibits until he moved to London in 1775, a move precipitated by the Boston Tea Party (1774) and growing revolutionary tension.

In England his style changed, becoming smoother and more decorative and losing much of the vigour and originality of his American work. However London offered the opportunity for more ambitious paintings, which Copley seized in 1778 with his picture of *Brooke Watson and the Shark* (Washington, NG). Like his countryman West, whose *Death of Wolfe* (1771) may have inspired him, Copley flew in the face of the conventions of *history painting by using a recent incident, sensational rather than moral, contemporary dress, and specific location, the harbour of Havana. The painting made his name and was succeeded by the hugely popular *Death of the Earl of Chatham* (1779), and the dynamic *Death of Major Peirson* (1783; both London, Tate). The former caused antagonism with the RA (see under LONDON), to which he had just been elected, when exhibited privately in competition with the Academy's annual exhibition. His later works are uninspired and with the turn of the century he grew unfashionable, dying, after a long illness, lonely and debt-ridden. DER

Prown, J., *John Singleton Copley*, 2 vols. (1966).

COPPER. See SUPPORTS.

COPPERPAINT. See METALPAINT.

COPPO DI MARCOVALDO (active c.1250–76). Italian painter. Coppo, a Florentine citizen, was captured by the Sienese at the battle of Montaperti (1260). In 1261 he signed the *Madonna del Bordone* (Siena, S. Maria dei Servi). He painted frescoes in Pistoia Cathedral in 1265 and 1269, and a number of panels for which he and his son Salerno were contracted in 1274. These are all lost, except for a *Crucifix* (Pistoia Cathedral sacristy), usually attributed to Salerno. The imposing (2.2 m/7¼ ft × 1.25 m/4 ft) *Madonna del Bordone* is one of the most important monuments of the renovation of Italian painting in response to *Byzantine models, incorporating a new sense of pictorial depth, continuous modelling, convincing anatomical structure beneath the Byzantine convention for drapery (Chrysography), and active figure relationships. The principal faces of the Siena panel were repainted c.1300 in *Duccio's style, but another attributable *Madonna and Child* (c.1265–70; Orvieto, S. Maria dei Servi) is largely unaltered. Also attributed to Coppo is a powerful *Crucifix* in San Gimignano (c.1250–60; Pin.) which combines recent Italian sources with direct reworkings of 12th-century Byzantine formats in the Passion scenes of the apron. JR

White, J., *Art and Architecture in Italy 1250–1400* (1987).

COQUES, GONZALES (1614/18–84). Flemish genre and portrait painter. After an apprenticeship with Pieter *Brueghel II and later David Rijckaert II, he probably lived in England before joining the Antwerp painters' guild in 1640/1. Nicknamed 'Little van *Dyck' because of his elegant small-scale compositions, Coques was a favoured portraitist among patricians and aristocrats in the Southern Netherlands, as well as in England, Holland, and Germany. He was patronized by the Dutch house of Orange, and his work was admired by successive governors-general of the southern Netherlands. He is best known for group portraits in which the sitters are depicted going about their daily activities in their houses or gardens (*Family Portrait in a Landscape*, c.1647; Brussels, Mus. Royaux). KLB

Sutton, P. C., *The Age of Rubens*, exhib. cat. 1993 (Boston, Mus. of Fine Arts; Toledo, Oh., Mus.).

CORINTH, LOVIS (1858–1925). German painter, born in east Prussia. Corinth studied art in Königsberg before enrolling at the Munich Academy in 1880. His early paintings are naturalistic in style, showing the influence of *Hals and *Rubens. In 1884, however, he moved to Antwerp, and from there to Paris, where he worked at the Académie Julian 1885–7, and frequented *Symbolist circles. He settled in Munich in 1891, and was a founder member of the *Sezession, exhibiting pictures in which Symbolist and *Impressionist influences are clearly visible. In 1901 he moved to Berlin, and opened a school which provided a vital introduction to *modernism for many young painters. Crippled by a stroke in 1911, Corinth's style changed substantially as he fought his way back to painting—it became far more violent and expressionistic; cruder in colours and in line, but powerfully emotive, often concerned with religious themes, as in *Ecce Homo*

(1925; Munich, Neue Pin.), or with landscape under extreme conditions of light and weather. He became chairman, and later president, of the Berlin Sezession (formed in 1899). There is a Corinth Museum at his birthplace in Tapiau. JH

Osten, S. von Der, *Lovis Corinth* (1959).

CORNEILLE DE LYON (*c.*1500–75). Dutch portrait painter from The Hague, also known as Corneille de la Haye. His known sitters range from courtiers to the bourgeoisie of Lyon, and he had a large studio. He lived in Lyon by 1534 and was soon working for the Valois court, becoming painter and *valet de chambre* of Henri II in 1551. Many people made collections of portraits in 16th-century France, and Corneille introduced a more realistic style than that of the quintessentially French *Clouets: his works are small, restricted to head and shoulders, the sitter often looking directly at the viewer, the background green or blue. His contemporary Brantôme, who recorded the lives of illustrious men and women of the court, says that Catherine de Médicis was painted by him in Lyons. Good examples of his work are the very Netherlandish-looking *Pierre Aymeric* (1534; Paris, Louvre), and *Béatrix Pachecho d'Escalona* (Versailles) from the 17th-century collection of Roger de Gaignères, by whom Corneille's work was later rediscovered. LL

Zerner, H., *L'Art de la Renaissance en France* (1996).

CORNELISZ. VAN HAARLEM, CORNELIS (1562–1638). Dutch painter and and draughtsman, who ranks with Hendrik *Goltzius and Karel van *Mander as one of the leading representatives of *Mannerism in Haarlem at the end of the 16th century. Cornelisz. probably trained under Pieter Pietersz. in Haarlem and later with Gillis Coignet in Antwerp, although his work is more indebted to *Spranger. After his return to Haarlem *c.*1580, his first official commission was for an influential group portrait of the *Militia Banquet of the Haarlem Civic Guard* (1583; Haarlem, Frans Hals Mus.). Shortly afterwards he met Goltzius and van Mander and they formed the 'Haarlem Academy'. Another prestigious commission came from the city of Haarlem between 1590 and 1593 for four paintings for the Prinsenhof. One of these, *Adam and Eve* (1592; Amsterdam, Rijksmus.), is characteristic. Stylish figures, elongated and twisted, in a range of different gestures and postures, are set into a dark landscape background. Cornelisz. designed prints which enhanced his reputation. His drawings are rare. His red chalk sketches were eventually inherited by his illegitimate grandson Cornelis *Bega, also a painter. CFW

McGee, J. L., *Cornelis Corneliszoon van Haarlem, Patrons, Friends and Dutch Humanists* (1991).

CORNELISZ. VAN OOSTSANEN, JACOB, also called Jacob Cornelisz. van Amsterdam (*c.*1472×7–1533). North Netherlandish painter and designer of woodcuts. He is the first important artist working in Amsterdam, then an up-and-coming provincial town. His early work is indebted to the Haarlem painter *Geertgen tot Sint Jins, but he later came under the influence of *Dürer, especially in his woodcuts (he may have gone to Antwerp to meet Dürer during the latter's Netherlandish journey 1520–1). His paintings, which are crowded with elaborately costumed figures and lavish decorative details, are related to those of the *Antwerp Mannerists (*Crucifixion*, *c.*1510; Amsterdam, Rijksmus.). A unique example of his portraiture is his *Self-Portrait* of 1530 (Toledo, Oh., Mus.). In what is perhaps the earliest known self-portrait of an artist standing before an easel with brush in hand as an independent work (and not as S. Luke painting the Madonna), the painting has special significance for the status of the artist in the *Renaissance. Jacob ran a productive workshop with pupils, among them Jan van *Scorel and his son Dirck Jacobsz. KLB

Filedt Kok, J. P., et al. (eds.), *Kunst voor de beeldenstorm*, exhib. cat. 1986 (Amsterdam, Rijksmus.).

CORNELIUS, PETER VON (1783–1867). German painter. Cornelius trained at the Düsseldorf Academy, travelling to Italy in 1811. He joined the *Nazarenes in Rome, becoming their leader after *Pforr's death, and was responsible for extending their ideals and works into public commissions. He also illustrated two major works: Goethe's *Faust* (1816) and *The Nibelungenlied* (1812–17). Influenced by *Schlegel, Cornelius thought allegory the only expressive art, seeking to synthesize Greek classicism (see GREEK ART, ANCIENT) and Christianity in monumental figurative painting. In 1819 he left Rome, returning to *Munich, where he became head of the Munich Academy (1825). An excellent teacher and administrator, the revival of fresco painting in Germany and Europe generally owes much to his influence; to his Glyptothek murals (Munich, 1819–26), and massive *Last Judgement* in the Ludwigskirche (1836–9). Visiting England in 1841, he advised on the Houses of Parliament frescoes. His last commissioned murals were for the projected Campo Santo in Berlin. Cornelius's works, essentially linear in the tradition of *Dürer, avoid painterly composition or colour. Eclectic in his sources, contemptuous of realism, often over-intellectual and theatrical in approach, his grandeur of conception and powerful images nevertheless amply justify the high regard in which he was held. JH

Andrews, K., *The Nazarenes* (1964).

CORNELL, JOSEPH (1903–72). American artist, a celebrated exponent of assemblage. Cornell, who received no formal training in art, initially took inspiration from the *Surrealists, many of whom he met at the Julien Levy Gallery (opened 1931) in his native New York. While he experimented with *collage and film, it is for his boxes and constructions that he is best remembered. Assembled from prints, photographs, and *objets trouvés, they were influenced by the Surrealist device of juxtaposing usually unrelated objects to startle the imagination into creative interpretation. The shy and religious Cornell was unconcerned with the carnal preoccupations of many of his Surrealist acquaintances, instead creating an idiosyncratic realm evocative of childhood, fantasy, and nostalgia. *The Hotel Eden* (1945; Ottawa, NG Canada) is typically enigmatic, a doll's-house world in miniature, composed within the formal constraints of its box. A taste for Victoriana characterizes his work of the early 1940s, while later pieces exhibit a move towards greater abstraction. Reluctant even to sell his work, Cornell was relatively unknown at the time of his death, but his reputation has appreciated considerably since. AA

McShire, K. (ed.), *Joseph Cornell* (1980).

COROT, JEAN-BAPTISTE-CAMILLE (1796–1875). French 19th-century painter best known for his landscapes. Corot received a classical education in Rouen before embarking upon an apprenticeship in the family's textile trade. A family inheritance allowed him to devote himself entirely to painting.

Corot studied first with Achille-Etna Michallon and with Jean-Victor Bertin, both of whom had studied under the leading historical landscape painter Pierre-Henri de *Valenciennes. This classical artistic grounding led Corot to travel to Italy in 1825. He visited the countryside surrounding Rome and produced *plein air* studies of sites of natural beauty and classical Antiquity. Fresh, starkly lit sketches like *The Roman Campagna* (London, NG), one of the most popular aspects of Corot's œuvre, were produced as private note-taking for developing studio compositions, such as *Homer and the Shepherds* (St Lô, Mus. des Beaux-Arts). They reflect debates which lay at the heart of 19th-century *landscape painting which sought to reconcile classical inspiration and idealization with closely observed rendering of the effects of light and climate. His early works gave way in later life to a diffuse, tonal light and handling typified by *Souvenir de Mortefontaine* (Paris, Louvre).

Having made his debut at the *Paris Salon of 1827, Corot continued to exhibit there regularly. Many of these paintings were purchased by the state for provincial museums and by important collectors like Emperor Napoleon III. Corot was made a Knight of the Legion of Honour in 1846, an Officer in 1867, and a Knight of the Order of S. Michael at the Munich International Exposition in 1869.

Corot's œuvre shows great dexterity in a variety of styles and genres. His principal medium was oil, but he also worked in *cliché-verre* (see GLASS PRINTS) and etching. He also made decorative ensembles for churches, in Ville d'Avray and Rosny-sur-Seine, and for private residences, both for his family in Ville d'Avray, and for artist friends including Charles *Daubigny, Alexandre-Gabriel Descamps (1803–60), and the collector Prince Demidoff. His figure subjects, including *Rococo studio fantasies, private portraits, nudes, and literary and religious compositions, have recently attracted acclaim.

Corot was profoundly influential both upon his contemporaries and friends Daubigny, Théodore *Rousseau, and Jean-François *Millet and a younger generation including Gustave *Courbet and Berthe *Morisot. Corot is an essential link between the artistic preoccupations of the 18th and 19th centuries. CIRO'M

Corot, exhib. cat. 1996 (New York, Met. Mus.).

CORREGGIO (Antonio Allegri) (?1489–1534).

Emilian painter celebrated for his illusionistic frescoes in the domes of two churches in Parma. Although relatively little known during his lifetime, Correggio's reputation and influence steadily grew after his death.

He was born in Correggio, a small agricultural town in the Po valley. There he probably received a rudimentary training from his uncle, but his main artistic inspiration was undoubtedly Andrea *Mantegna who worked in nearby Mantua. As the latter died when Correggio was 16 it is even possible that he taught him. Two very damaged fresco roundels of the *Holy Family* and the *Deposition* formerly in S. Andrea, Mantua (c.1510; Mantua, Curia Vescovile) may well be by Correggio, and show him working in an austere style close to that of late Mantegna. His influence is also apparent in other early works, notably the *Mystic Marriage of S. Catherine* (Washington, NG), but Correggio was also inspired by the *sfumato* effects and dreamy introspection of *Leonardo da Vinci as well as by the intense colouring of the local Bolognese School. The soft lighting, as well as the pointing gesture of the Baptist, in Correggio's more sophisticated *Mystic Marriage of S. Catherine* (Detroit, Inst. of Arts) attest to the influence of Leonardo during the first half of

the second decade. Perhaps the most successful of his early productions are a series of devotional works of the Madonna and Child, sometimes accompanied by the infant Baptist, a fine example of which is in the Art Institute of Chicago. Correggio's first documented work, the *Virgin of S. Francis* (1514–15; Dresden, Gemäldegal.), painted for the church of S. Francesco in Correggio, immediately recalls in its conservative composition the work of Bolognese *Peruginesque painters like Lorenzo *Costa, but the sense of airy spaciousness and the lucid structural clarity are evidence of the artist's far greater sophistication. Correggio was at this early date an uneven artist, unable, for example, to sustain the lively characterization and movement of the figures in the *Adoration of the Kings* (Milan, Brera) in the disappointingly wooden *Four Saints* (New York, Met. Mus.).

In about 1519 he moved to Parma, where he received a commission to decorate the ceiling of a room in the Benedictine convent of S. Paolo. At about this time Correggio travelled to Rome where he must have studied classical works and the paintings of *Raphael and *Michelangelo. The impact of this trip is apparent in the impressive illusionistic (see under ILLUSIONISM) effect of the nude putti visible through ovals in the fictive arbour covering the umbrella vault, and the references to Antique coins in the grisaille scenes in the ovals at the base of the ceiling. His next commission was for the fresco decorations in S. Giovanni Evangelista, where he began by painting the dome (c.1520–22) with the *Vision of S. John the Evangelist*. In this, the saint, cut off by the base of the dome, gazes upwards at the figure of Christ bathed in golden light, while below him are near-naked apostles on clouds. This heroic vision is contrasted with the vigorous theological debate of the twinned figures in the pendentives, who are observed by mischievous-looking putti. In the original scheme the dome would have been complemented by the fresco of the *Coronation of the Virgin* (1522–4) in the nearby apse, but this effect was ruined when it was dismantled (the central section is preserved in the Parma Galleria, and a copy is *in situ*) to allow the church to be extended eastwards.

In 1522 Correggio was commissioned to decorate the much larger octagonal dome, as well as the apse and choir vault, of Parma Cathedral. In the event only the dome fresco of the *Assumption of the Virgin* and the pendentives below with the patron saints of the city were painted (both finished by 1530). The illusionistic effects with steeply foreshortened figures seeming to float above the viewer inspired *Barocci, and later numerous *Baroque artists. Of these Annibale *Carracci was perhaps Correggio's greatest interpreter; evident both in the playful illusionism of the Farnese ceiling, and in his atmospheric chalk

studies which closely resemble those by his great Emilian predecessor.

In Correggio's mature paintings his gift for illusionistic effects enhances the dramatic narrative—such as the blinding light which emanates from the Christ child in the nocturnal *Adoration of the Shepherds* also known as the *Notte* (c.1530; Dresden, Gemäldegal.). In religious works such as the *Virgin of S. George* (c.1530; Dresden, Gemäldegal.), Correggio anticipates Baroque art in the way in which he seeks through the gestures and expression of his figures to encourage the viewer to become an active participant in the devotion. Correggio's illusionistic and painterly gifts, not least his sensuous appreciation of female flesh, also found expression in a number of erotic mythological works, most brilliantly in *The Abduction of Ganymede* and its pendant, *Io* (c.1532; both Vienna, Kunsthist. Mus.). HCh

Gould, C., *The Paintings of Correggio* (1976).
Popham, A. E., *Correggio's Drawings* (1957).

CORTESE, CRISTOFORO (c.1400–before 1445).

Italian illuminator who dominated manuscript illumination in Venice in the first half of the 15th century. He was the son of Marco, a painter and illuminator, and was himself described as 'miniator' in a register compiled between 1367 and 1399 (Venice, Mus. Correr, MS IV, 118). His only signed work is the choir-book initial with the *Death of S. Francis* (Paris, Mus. Marmottan, no. 68) on which all other attributions depend, including woodcuts and tapestry designs. He undertook many commissions for the *scuole* or lay confraternities of Venice, for example the opening folio of a rule-book with the *Virgin of Mercy* and confraternity members (c.1422: Paris, Mus. Marmottan, no. 78). Cristoforo combined a compact, solid figure style with free, calligraphic handling; borders and initial staves are made up of lush acanthus leaves and fantastic birds, their form defined by frondy strokes of white or whiskery black. He also contributed to the decoration of many choir books in Venice and the Veneto; some of his finest work being in a gradual commissioned for S. Mattia a Murano (Milan, Bib. Nazionale Braidense, MS AB XVII. 28). KS

Hindman, S., Levi d'Ancona, M., Palladino, P., and Saffiotti, M. F., *Illuminations in the Robert Lehman Collection* (1998).

CORTESE, GUGLIELMO. See COURTOIS BROTHERS.

CORTONA, PIETRO DA (Pietro Berrettini) (1596–1669).

Italian painter and architect, an early exponent of the full Roman *Baroque style. He was born at Cortona and was trained under Andrea Commodi (1560–1638). He began as a painter in Rome with four large pictures for the

Sacchetti family (1624–51; Rome, Capitoline Mus.), where classical designs are fused with Venetian colour and, in the *Rape of the Sabines*, with a harmonious landscape. He was also employed to decorate the chapel of the Sacchetti villa at Castel Fusano, near Ostia, with exceptionally natural, cool, and freely painted landscapes with scenes from the life of Christ (c.1625–9). He was patronized by the powerful Barberini family, and received papal commissions to paint both *frescoes in S. Bibiana, Rome (1624–6), in a style that seeks to recapture the spirit of the ancient world, and also the altarpiece of the *Trinity* in the Cappella del Sacramento of S. Peter's (1628–32). Cardinal Francesco Barberini, nephew of Pope Urban VIII, then commissioned the huge ceiling fresco in their family palace, the *Allegory of Divine Providence*. The artist began the latter c.1632, but interrupted the work in 1637 to go to Florence and paint two frescoes of *The Golden Age* and *The Silver Age* commissioned by the Grand Duke of Tuscany for the Sala della Stufa in the Pitti Palace. He returned to finish the Barberini ceiling in 1639. This, his most famous painting, is a triumph of illusionism, for the centre of the ceiling appears open to the sky and the figures seen from below (*di sotto in sù*) appear to come down into the room as well as to soar out of it. Cardinal Mazarin must have realized the potential value of such a painted apotheosis when he invited the artist to Paris. The offer was, however, declined and he returned to Florence in 1641 to finish his decorations in the Pitti Palace, painting the *Age of Bronze* and the *Age of Iron*. He also started work (1641–3 and 1645–7) on a new commission there for seven ceilings (completed by his pupil Ciro Ferri). These allegories of Virtues and Planets have elaborate stucco accompaniments uniting the painted ceilings with the framework of the rooms.

From 1647 until his death Pietro da Cortona worked in Rome, and with the help of numerous pupils executed many more illusionist frescoes and easel pictures. The chief frescoes are those in the Chiesa Nuova where he decorated the dome with the *Trinity in Glory* (1647–51); and the *Divine Providence* and a series of scenes from Virgil's *Aeneid*, alluding to the Pamphili family's descent from Aeneas, commissioned by the new pope, Innocent X, for the Pamphili Palace, Piazza Navona (1651–4). HB

Lo Bianco, A. (ed.), *Pietro da Cortona*, exhib. cat. 1997 (Rome, Palazzo Venezia).

COSMATI WORK, the name given to a technique, developed in Rome and central Italy c.1100–c.1300, that involved inlaying coloured and gold glass and marble tesserae in richly decorative patterns into a marble or stone background. This brilliant incrustation, sometimes used in conjunction with porphyry, was applied to ciboria, bishops'

thrones, paschal candlesticks, pulpits, tombs, cloister colonnettes, campanili, and huge areas of flooring. The term derives from the inscriptions left on their works by a succession of family workshops, a number of whom signed their work with some variation on the name Cosmas: Magister Cosmas, Cosmas civis Romanus, Johannes filius Magistri Cosmati, etc. There was a strong dynastic element in the composition of these workshop teams. The concept of geometrically interwoven patterns inlaid on floors originated in Antiquity and was developed in Byzantium and South Italy before being extended in central Italy to its application on other forms by the Cosmati workers.

Although there are a number of dated and datable examples of Cosmati work it has not been possible to establish any evident stylistic development over the period in which this richly decorative art form flourished. The fame of these Roman marble workers, with their uniquely characteristic art, was nevertheless sufficient for them to be invited in 1268 to work in Westminster Abbey, London, on the monuments to Edward the Confessor and the family of Henry III, where their work can still be seen. PH

Glass, D. F., *Studies on Cosmatesque Pavements* (1980).
Hutton, E., *The Cosmati: The Roman Marble Workers of the XIIth and XIIIth Centuries* (1950).

COSSA, FRANCESCO DEL (c.1435–76/7). Italian painter who worked in Ferrara, his birthplace, and in Bologna where he appears to have settled after 1470. He is associated with Cosimo *Tura and Ercole de' *Roberti, who worked in the same area and on some of the same commissions. Like them, he was influenced by Andrea *Mantegna and *Piero della Francesca, employing expressive line and strongly contoured sculptural forms. He designed stained glass and marquetry and, as the son of a mason, he may have worked in stone.

Cossa's frescoes of *The Months* (1469) in the Palazzo Schifanoia, Ferrara, are sophisticated secular decorations, depicting mythological divinities, signs of the zodiac, and illusionistic scenes of court and city life. They are executed in glowing colour and with fine detail which points to the influence of Florentine art.

The complex Griffoni altarpiece for S. Petronio, Bologna (1473; central panel London, NG), and *Virgin and Child with Saints* (1474; Bologna, Pin. Nazionale) suggest a shift towards a more sombre, monumental style and hardness of form. MS

Scasellati-Ricardi, V., *Cossa* (1965).

COSTA, LORENZO (c.1460–1535). North Italian painter whose work spans the gulf between the hard style of the 15th-century Ferrarese School and the softer, more

poetic manner of *Giorgione. Trained in the studio of Ercole de' *Roberti in Ferrara, he moved to Bologna in the early 1480s where his interest in classical sources attracted the patronage of the ruling Bentivoglio family. The large *Madonna and Child Enthroned with Saints* for the Rossi Chapel (Bologna, S. Petronio) and *The Concert* (London, NG), both 1492, are typical examples of his emerging skill and the increased range of his art. In 1504 he was commissioned to paint an *Allegory* (Paris, Louvre) for Isabella d'Este's *studiolo* at *Mantua and after the fall of the Bentivoglio in 1506 he succeeded *Mantegna as court painter at Mantua. As well as court decorations he completed *The Reign of Comus*, left unfinished by Mantegna, and undertook many altarpieces and portraits such as the *Woman with a Lap Dog* (Hampton Court, Royal Coll.). He seems also to have been in demand beyond Italy; *Venus* (1518; Budapest, Szépművészéti Mus.) was probably painted for François I of France. PSt

COTMAN, JOHN SELL (1782–1842). English landscape and watercolour painter, together with *Crome the most important representative of the *Norwich School. Son of a well-to-do Norwich merchant, he went to London in 1798 to become an artist and was employed first by Rudolf Ackermann, proprietor of the Depository of Arts in the Strand, and later by Dr Munro. In 1800 he was in Wales and became a member of the circle of artists around the collector Sir George Beaumont, where he met Thomas *Girtin. In 1803, and again in 1804 and 1805, he visited Yorkshire and received the hospitality and friendship of the Cholmeley family of Brandsby Hall. In 1806 he settled in Norwich, where he opened a school for drawing and design and became vice-president of the Norwich Society of Artists founded by Crome, and in Yarmouth, where he became drawing master to the family of the banker and antiquarian Dawson Turner. In 1834 he was appointed professor of drawing at King's College, London, through the good offices of Lady Palgrave, Dawson Turner's daughter. Throughout his life Cotman was subject to periods of melancholia and despondency.

In his earlier *watercolour landscapes Cotman already displayed a strong sense of classical design which, as some have thought, looked forward to *Cézanne. He used large flat washes to build up form in clearly defined planes and austerely decorative patterns. In his later years he tried to catch the public fancy by large and gaudily melodramatic watercolours, in which he used an impasto obtained with rice paste. From c.1810 he devoted himself also to etching as a mode of expression for the genuine love of architectural antiquities which formed a bond with his patron Dawson Turner. Between 1816 and 1818 he brought out two books on the

architectural antiquities of Norfolk, followed by the *Sepulchral Brasses in Norfolk and Suffolk* in 1819. He spent the summers of 1817, 1818, and 1820 making sketches in Normandy, from which he did plates for Dawson Turner's *Architectural Antiquities of Normandy* (1822) and *Tour in Normandy* (1820). Although Cotman was never as fully at home with etching as with watercolour or monochrome drawings, his *Liber studiorum* (1838) with its 48 soft-ground plates ensures him a place of importance in the history of British etching. It has been said of him that 'at his best he stands up high and grey and serene among the world's great architectural etchers, including architectural landscape'. His work suffered a period of relative oblivion until near the end of the 19th century, after which interest in the formal aspect of landscape led to a new appreciation of the structural strength of his treatment. HO

COUNTERPROOF, a way of obtaining a reverse image of a print by passing a still damp impression through the press with another sheet of paper, to which the ink is transferred. All prints reverse the direction of the design on the original plate or other matrix, so that is a useful way for the artist to see a print in the same direction that it appears on the plate. Counterproofs were also printed as works of art in their own right by such artists as *Hollar, *Ribera, and *Rembrandt, the last named printing many counterproofs of landscapes, and of certain subjects which he deemed to have lost some balance in the printed reversal of their design. A similar technique may be employed with *chalk drawings which have been damped, enabling an artist to obtain an alternative pose. It was used by *Watteau and by a number of 17th-century Dutch artists, and the result is known as an *offset. RGo

COURBET, GUSTAVE (1819–77). French painter. Courbet was born in Ornans, near the Swiss border, the son of a wealthy farmer. Although he later denied it, he appears to have trained in Besançon and Paris. His lifelong scorn for academic practice seems to have extended to a disregard for technique, which had a disastrous effect on many of his paintings. Vain and opinionated, Courbet reacted badly to criticism and eschewed the Paris Salon, and the possibility of rejection, preferring to show his work in the provinces and abroad during the 1840s. Only after the state purchased his *Dinner at Ornans* (Lille, Mus. des Beaux-Arts) in 1849, thereby exempting his work from the selection committee, did he choose to show at the Salon. His debut was uncompromising; he exhibited three major paintings at the Salon of 1850, the huge *Burial at Ornans* (Paris, Mus. d'Orsay), *The Peasants at Flagey* (Besançon,

Mus. d'Art), and *The Stonebreakers* (destr.), which were defiantly *realistic and unidealized views of everyday rural life and thus considered both uncouth and socialistic. Courbet was unrepentant about his chosen style, rejecting both *classicism and *Romanticism and declaring that he could only paint what he could see; furthermore as an ardent republican and anticleric he embraced his socialist sobriquet. In 1853 he met Alfred Bruyas, who was to become his most important patron, and immortalized him in the life-size *Bonjour, Monsieur Courbet* (1854; Montpellier, Mus. Fabre). Two years later, considering himself slighted, he withdrew his paintings from the Exposition Universelle in Paris and showed them in the grounds, under the title *Le Réalisme*, thus establishing a precedent which led to the *Impressionist exhibitions. His exhibition included *The Painter in his Studio* (1855; Paris, Mus. d'Orsay), which he claimed, somewhat obscurely, as his artistic manifesto. It includes a standing model whose physicality is typical of his sensuous weighty nudes, sometimes, like *La Source* (Paris, Louvre), set outdoors and occasionally and less successfully, as in the explicitly lesbian *Sleepers* (1866; Paris, Petit Palais), in the boudoir. In 1871 Courbet joined the Commune and was imprisoned after its suppression for his role in the destruction of the Vendôme Column. Two years later he was retried and ordered to pay for its restoration. Facing bankruptcy he fled to Switzerland, where he concentrated on mountain landscapes, employing studio assistants whose work reflected badly on his later reputation. A difficult and independent figure whose work is of extremely variable quality, Courbet can nonetheless be seen as the founder of modern realism and his impact on subsequent artists was immense. DER

de Forges, M., Toussaint, H., et al., *Gustave Courbet*, exhib. cat. 1978 (Paris, Grand Palais; London, RA).

COURTOIS (Cortese) BROTHERS. French painters. **Jacques** (1621–76) was a painter of *battle scenes. Born in the Franche-Comté—hence his nickname 'Le Bourguignon' (or in Italian 'Il Borgognone')—he spent his entire life from the age of 15 in Italy. He trained in Bologna, Florence, and Siena, and was settled in Rome by 1640, where he probably knew the battle painter Michelangelo *Cerquozzi and the Flemish genre painter Pieter van *Laer. Jacques's battle scenes have a *Baroque sense of drama, a deftness of touch, and an evocative atmosphere that made him much in demand in his lifetime and ensured that subsequently vast numbers of inferior pictures have been erroneously attributed to him. During the 1650s he travelled throughout northern Italy fulfilling commissions. In 1657 he joined the Jesuit order, but continued to paint, adding

pictures with religious themes to his repertoire. His brother **Guillaume** (1628–79) was a well-known exponent of religious painting in Rome. MJ

Holt, E. L., 'The Jesuit Battle Painter Jacques Courtois (le Bourguignon)', *Apollo* (Mar. 1969).
Salvagnini, F. F., *I pittori Borgognoni Cortese (Courtois)* (1936).
Waterhouse, E., *Roman Baroque Painting* (1976).

COUSIN, FATHER AND SON. French painters. **Jean the elder** is recorded as active in Sens from 1526 and Paris from 1538. He died around 1560. He was evidently a successful painter and designer of stained glass. The reclining female nude *Eva Prima Pandora* in the Louvre is attributed to him, and dated to before 1538. It shows the influence of *Rosso and the School of *Fontainebleau in the elegant distortions of the figure's anatomy, but its cavelike setting and mysterious landscape background suggest a first-hand acquaintance with the work of *Leonardo. Two windows at Sens Cathedral are traditionally attributed to him, as is a set of tapestries of the life of S. Mammès. Attributions to his son **Jean the younger** (*c*.1522–*c*.1594) are also uncertain, though like his father he must have enjoyed a high reputation. His *Livre de Fortune* (1568) contains designs for emblems in the manner of Rosso, and his *Last Judgement* in the Louvre is an example of the Florentine *Mannerist influence that pervaded French painting at the end of the 16th century. MJ

Blunt, A., *Art and Architecture in France, 1500–1700* (rev. edn., 1988).

COUSTOU FAMILY. French sculptors of whom the most important were the brothers **Nicolas** (1658–1733) and **Guillaume I** (1677–1746). They were trained by their uncle *Coysevox and later in Rome, where Guillaume worked with *Legros. From both experiences they absorbed a vigorous and up-to-date *Baroque style nuanced with both grace and, in their many portraits, a pungent naturalism. They worked for the Crown on the chapel at Versailles and on the Invalides in Paris, as well as at the Château de Marly. In the informal atmosphere of Marly they provided garden sculpture that is both decorative and dynamic—witness the pair of interacting running figures made in 1713 of *Apollo* (by Nicolas) and *Daphne* (by Guillaume), both now in the Louvre. Although such works by Nicolas as the allegorical group *The Seine and the Marne* (1712; Paris, Tuileries Gardens) are among the most impressive of their kind, it was Guillaume who was the outstanding sculptor of the early part of the reign of Louis XV. His so-called *Marly Horsetamers* (1745; Paris, originals in the Louvre, replicas Place de la Concorde) are among the most widely reproduced statues

of all time. Guillaume I's son **Guillaume II** (1716–77) was also a sculptor, working in a more restrained, classicizing style. His masterpiece is the tomb for Louis XV's eldest son the Dauphin in Sens Cathedral. MJ

Levey, M., *Painting and Sculpture in France 1700–1789* (2nd edn., 1994).

Souchal, F., *French Sculptors of the 17th and 18th Centuries: The Reign of Louis XIV*, vol. 1 (1977).

COUTURE, THOMAS (1815–79). French painter. Born in Senlis, Couture trained under *Gros 1830–8 and *Delaroche in 1838/9. Talented and ambitious, his failure to win the *Prix de Rome left him with a lifelong animosity to the École des Beaux-Arts, Paris. His early works were anecdotal genre but in 1847 he triumphed at the Salon with the orgiastic but moralizing *Romans of the Decadence* (Paris, Mus. d'Orsay) which was purchased by the state despite suggestions that it was an allegory of the current government. In the same year he opened an atelier where he proved an innovative and influential teacher; *Manet, *Puvis de Chavannes, and *Feuerbach were amongst his pupils. Couture never repeated the success of *Romans* and despite commissions from Napoleon III (1808–73) and mural schemes including that for S. Eustache, Paris (1856), despaired of further public recognition. He returned to Senlis in 1859 and painted portraits and decorative paintings, based on the *commedia dell'arte*, for private patrons. His smaller works are freely handled with sharp tonal contrasts and an expressive use of colour and brushwork. DER

Boime, A. *Thomas Couture and the Eclectic Vision* (1979).

COXCIE, MICHIEL (1499–1592). Flemish painter, designer of stained glass, tapestries, and prints. According to van *Mander, he was trained in the studio of Bernaert van *Orley at Brussels. From c.1530–9 he was in Rome; in 1539 he was inscribed as a member of the painters' guild in his home town Malines. He later also lived in Brussels, Antwerp, and Ghent. Coxcie is the first northern artist who painted frescoes while in Italy, absorbing Italian *Renaissance forms more thoroughly than any other northerner before *Rubens. He also made designs for engravings of the *Story of Cupid and Psyche*, based on *Raphael's frescoes in the Farnesina. Raphael was Coxcie's primary inspiration, and he himself was dubbed in his own day the 'Flemish Raphael'. Though his style remained derivative and eclectic, he was important in transmitting Italian ideas to the north (*The Death of Abel*, c.1538/9; Madrid, Prado). He was highly appreciated by Rubens, who owned

and copied his works. KLB

Handelingen van de Koninklijke Kring voor Oudheidkunde, Letteren en Kunst van Mechelen, 96, 1992 (Malines, 1993; entire issue).

COYPEL FAMILY. French dynasty of painters, of whom **Noël** (1628–1707) was the head. He worked in the grand Charles *Le Brun style, creating large-scale decorations such as the ceiling of the Grande Chambre in the Parlement de Bretagne at Rennes (1656–62) and later working at *Versailles. In 1672 he was appointed director of the French Academy in Rome, where he brought up his son **Antoine** (1661–1722). Antoine was influenced by the work of the *Carracci and *Poussin, but also by *Correggio and the Venetian colourists. He returned to Paris in 1676 and worked in an eclectic manner that expressed the desire of his generation to move away from the constraints of the French academic style. He became a friend of the pro-colour theorist Roger de *Piles, and during the 1690s came out as a strong admirer of *Rubens in the colour versus drawing controversy (see *DISEGNO E COLORE*). Antoine was fortunate in being taken up by the Duke of Orléans, who in 1702 gave him the opportunity to paint the ceiling of the gallery of the Palais Royal with a scene from the *Aeneid, The Assembly of the Gods*. Although destroyed, this vast work is known from an oil sketch (Angers, Mus. des Beaux-Arts). It employed the full panoply of *Baroque illusionism and drama to open the vault to the infinite sky. The inspiration for this striking display, which went further than anything that would have been sanctioned by Le Brun, was Rubens. Such an extravagant scheme was attractive to the Duke of Orléans because it was in opposition to the style favoured by Louis XIV. It is thus significant of a shift in official taste that Antoine Coypel was commissioned in 1708 to paint the vault of the new royal chapel at Versailles. This time he produced an even bolder Italianate scheme inspired by Pietro da *Cortona. These two ceilings, skilfully designed and executed rather than original, represent the high tide of the Baroque in France. Antoine's son **Charles-Antoine** (1696–1751) was a much-employed decorative painter who was also a very active and efficient director of the Académie Royale (see under PARIS). MJ

Garnier, N., *Antoine Coypel* (1989).
Jamieson, I., *Charles-Antoine Coypel* (1930).
Schnapper, A., 'Noël Coypel et le grand décor peint des années 1660', *Antologia di belle arti* (1977), 1.

COYSEVOX, ANTOINE (1640–1720). The most able French sculptor of the later part of the reign of Louis XIV. He introduced a dynamic *Baroque style that superseded the grand classical manner of C. *Le Brun and *Girardon. Coysevox trained in Paris, but

spent the early part of his independent career in his native Lyon. By the 1670s he was making a superb series of portrait *busts of members of the court, including those of *Le Brun* (1676; London, Wallace Coll.) and *Colbert* (Château de Lignières). Thereafter his career was dominated by work for royal buildings, in particular Versailles, where he provided a bust of the King (1681) for the Escalier des Ambassadeurs and a dramatic stucco relief of *The Triumph of Louis XIV* (1681–3) for the Salon de la Guerre, as well as many statues and vases for the park. Coysevox later worked on the decoration of the Invalides, Paris, and made a bronze equestrian statue of the King for Rennes (1686–93), melted down during the French Revolution. His tomb of Cardinal Mazarin (1689–93), in the chapel of the Institut de France in Paris, is one of the best of its period. Coysevox's late works, such as the charming marble statue of *The Duchesse de Bourgogne as Diana* (1710) in the Louvre, anticipate the *Rococo. The *Coustou brothers were his nephews and trained with him. MJ

Keller-Dorian, G., *Antoine Coysevox* (1920).
Souchal, F., *French Sculptors of the 17th and 18th Centuries: The Reign of Louis XIV*, vol. 1 (1977).

COZENS, FATHER AND SON. English draughtsmen. **Alexander** (1717–86), the son of a master shipbuilder, was born in Russia and educated in England. He studied art in Rome 1746–8. He exhibited landscape oils in the 1760s and 1770s but these are lost and he is remembered now for his brown wash and varnished monochrome drawings and for his theoretical publications. In *A New Method of Assisting the Invention in Drawing Original Compositions of Landscape* (1786) he aimed to stimulate the intellect and the visual imagination by the use of ink blots to be developed into different types of invented landscapes. He had wealthy pupils and patrons, including William Beckford (1760–1844), and taught drawing first at Christ's Hospital, 1759–64, and later at Eton College.

John Robert (1752–97), his son, was initially inspired by his father, and became an influential topographical *watercolourist. He evolved a highly poetic style of landscape using soft harmonious tones with radiant light effects created from carefully graded transparent washes. His luminous Alpine and Italian scenes are his finest works and were influential on the young *Girtin and *Turner and on *Constable, who also copied from Alexander's publications. Cozens travelled to Italy in 1776 via the Swiss Alps aided by his patron Richard Payne *Knight. He stayed until 1779 and was in Italy again in 1782–3 with William Beckford. Both patrons came to own many works by Cozens, who had other important patrons in Bath and London. He made replicas and variants,

some very large, of his most successful landscapes. *Lake Albano and Castel Gandolfo* (Manchester, Whitworth AG) exists in at least ten versions. In the 1790s a mental illness affected him and he was tended by Dr Monro at an establishment in Smithfield. MP

Wilton, A., *The Art of Alexander and John Robert Cozens*, exhib. cat. 1980. (New Haven, Yale Center for British Art).

CRANACH, LUCAS, ELDER AND YOUNGER. German painters and designers of *woodcuts, active at the court of the electors of Saxony at Wittenberg. **Lucas the elder** (1472–1553), whose family name was Maler ('painter'), took his name from his birthplace, Kronach, near Bamberg, where he was probably trained by his father Hans. Around 1500 he was in Vienna. Cranach's early works are examples of the *Danube School style, in which he employed landscape and landscape details as major formal and expressive elements (*Rest on the Flight into Egypt*, 1504; Berlin, Gemäldegal. *Dr Johannes Cuspinian* and *Anna Cuspinian*, c.1502; Winterthur, Oskar Reinhart Coll.). In 1505 he went to Wittenberg to the court of Frederick the Wise, Elector of Saxony, the protector of Luther. Cranach has been called the chief artist of the Reformation. He illustrated Luther's Bible translations, designed Lutheran altars, and several times painted the reformer's portrait. Luther was godfather to Cranach's daughter Anna, and the artist himself was named godfather of Luther's first son.

In Wittenberg, Cranach developed a highly ornamental style better suited to the demands of court painter. He and his workshop produced innumerable portraits in many copies and variants of the electors, which avoided a more personal approach in favour of a style readily reproducible by many hands under the master's supervision. He seems to have been the first to introduce a new *portrait type, the full-length life-size figure against a monochromatic ground (*Duke Henry the Pious of Saxony* and *Duchess Catherine*, 1514; Dresden, Gemäldegal.). In these works, the bodies are elongated, the silhouette of the elaborate costumes stressed; only the heads are realistically modelled in light and shade.

In addition to portraits, Cranach and his workshop specialized in small cabinet pictures depicting the female nude in the guise of classical deities or Old Testament heroines (e.g. *Judgement of Paris*, 1530; Karlsruhe, Kunsthalle; *Venus*, 1532; Frankfurt, Städelsches Kunstinst.; *Bathsheba*, 1526; Berlin, Gemäldegal.). Despite their ostensibly Antique origins, these figures are late Gothic in their proportions, and their beauty is decorative rather than formed on a canon of idealized proportions. Unlike Dürer, who incessantly studied the secret harmony of human proportions,

Cranach intended to appeal to the erotic fantasies of his patrons. Large compositions of a third subject produced in Cranach's workshop reflect another preoccupation of the court: hunting (examples in Vienna, Kunsthist. Mus., and Madrid, Prado).

Simultaneously, Cranach continued to produce altarpieces and devotional images reflecting Lutheran theology. His last work was the *Allegory of Redemption* (1553–5; Weimar, Stadtkirche), which was finished by his son **Lucas the younger** (1515–86), who continued the tradition of his father's workshop. In the central panel the artist is depicted at the foot of the cross, flanked by John the Baptist and Luther, the blood of Christ spurting directly onto his forehead—no priestly intercessor between him and Redemption. KLB

Koepplin, D., and Falk, T., *Lukas Cranach*, exhib. cat. 1974 (Basle, Kunstmus.).

CRAQUELURE is the network of cracks on a painting. Patterns of cracking may affect the whole surface or specific colour areas. This is particularly the case when the cracking (sometimes called premature or drying craquelure) is the result of defective drying of the paints, caused by incorrect proportions of oil and pigment, inappropriate paint layer structures, or pigments such as bitumen which impede the drying of oils. The edges of drying cracks are generally rounded and contraction of the paint film can lead to the formation of wide channels. Sharp-edged cracks (sometimes called age cracks) develop with time. The organic materials in grounds, gilding, paint films, and varnishes become embrittled with age and can no longer flex to accommodate movement in the support. The nature of the *support will affect the craquelure: that of a canvas painting differs from a work on panel. Different wood species can generate a distinctive craquelure. It is also influenced by the composition of the *ground and paint layers. Egg tempera, for instance, will not crack in the same way as oil. JD

CRAWFORD, THOMAS (1813–57). American sculptor. Probably born in New York, by 1832 Crawford was working as a marble carver, producing decorative mantelpieces and busts, whilst copying Antique casts in the National Academy of Design in the evenings. In 1835 he left America for Rome where he worked, briefly, in the studio of *Thorvaldsen, the leading *Neoclassical sculptor. He soon established himself as a carver of portrait busts but had higher ambitions, fulfilled in 1839 when he completed the plaster of *Orpheus* (Boston, Mus. of Fine Arts), his first large ideal work. A marble version of this over-life-size figure was exhibited

in Boston in 1844 and its discreet nudity and classical associations proved an instant success. In 1850 he won the competition for a bronze equestrian statue of *Washington* for Richmond, Va., which led to commissions from the government including *The Progress of Civilization* (1854) for the pediment of the Capitol in Washington. His domestic work was less austere than his official commissions and his sculptures of children are touched by sentimentality. His extremely successful career was cut short by cancer. DER

Gale, R. L., *Thomas Crawford, American Sculptor* (1964).

CRAYER, CASPAR (Gaspar) DE (1584–1669). Flemish painter and draughtsman. His work went through a number of stylistic phases, but de Crayer was particularly influenced by the early work of his contemporary *Rubens. He became one of the earliest disseminators of Rubens's style and, after the latter's death in 1640, one of the leading painters of the southern Netherlands. De Crayer spent the greater part of his career in *Brussels, becoming court painter to the Cardinal-Infante Ferdinand in 1635. His oil sketch *Triumph of Scipio Africanus* (1635; London, Courtauld Inst. Gal.), one of the decorations for the triumphal entry into Ghent of the Cardinal-Infante Ferdinand, reveals de Crayer's debt to Rubens in its exuberant monumentality and compositional structure. Internationally acknowledged, Crayer was commissioned to work on the Dutch palace at Huis ten Bosch. He was in demand principally for his large-scale religious works, such as *The Madonna Offering the Rosary to S. Dominic* (Brussels, Mus. Royaux), which were in accordance with Counter-Reformation ideas. An important patron was the Archbishop of Malines, Jacob Boonen, for whom he painted many altarpieces, including those for Afflighem Abbey. CFW

Vliege, H., *Gaspar de Crayer: sa vie et ses œuvres* (2 vols., 1972).

CRAYON. The word is derived from the French *craie* meaning chalk. Modern crayons in the form of sticks are made of colours combined with waxy, oily, or greasy binders or with combinations of water-soluble and fatty binders. During the 17th and 18th centuries the word was used as descriptive of drawings made in both *chalks and *pastels and in a general way seems to have implied merely the employment of colour. By the early 19th century the modern essentially greasy crayon encased in wood began to be developed and several recipes for making crayons were proposed. Of special interest were those of Aloys Senefelder, who needed crayons in his new invention of *lithography and he mentioned such materials as tallow, wax, spermaceti (a white wax

obtained from the sperm whale), shellac, and soap. PHJG

CRESPI, DANIELE (c.1598–1630). Italian painter. During his short career in Milan, cut short by the plague, Daniele Crespi established a new monumental style of religious painting that broke away from the exaggerated *Mannerism of such artists as Giovanni Battista *Crespi and Giulio Cesare *Procaccini. His technique was more painstaking than theirs, based on the use of preparatory chalk drawings in the Emilian tradition, although there is evidence of him also producing autonomous oil sketches in a *fa presto* manner. His early formative influences included Guglielmo Caccia, Il Moncalvo (1568–1625), with whom he worked at S. Vittore al Corpo, Milan (c.1617). His independent work at S. Protasio ad Monachos, Milan (1623), now at S. Giovanni Battista, Busto Arsizio, shows an unaffected naturalism that he skilfully maintained when faced with the more demanding task of producing designs for the awkwardly tall but narrow organ shutters in S. Maria della Passione, Milan, which represent the *Raising of the Cross* and *Christ Taken down from the Cross* (when closed) and *Christ Washing the Feet of the Disciples* (when open). It was for the same church that he painted, in a starkly realistic style, the celebrated image of *S. Carlo Borromeo Fasting* (*in situ*). Attention is focused on the bread, water, and book that lie on the table in the extreme foreground, close to the picture plane, with the remainder of the room steeply foreshortened. There is none of the heightened realism associated with the Caravaggesque artists, no emphasis on dramatic lighting or sensual tactile detail, but simply an impression of monastic silence and austerity, comparable with the early work of *Zurbarán. Daniele Crespi also enjoyed considerable success as a decorator at the Certosa di Garegnano (1629) and at the Certosa di Pavia (1630). He was admired as a portrait painter although most of his subjects were relatively unexciting, austere scholarly types. Within a very brief career Daniele Crespi had successfully purged Lombard painting of its self-regarding excesses, but he left no followers to build on his achievement. HB

Neilson, N., *Daniele Crespi* (1996).

CRESPI, GIOVANNI BATTISTA (Cerano) (1567/8–1632). Italian painter who played a leading role in the regeneration of artistic activity in Milan during the period when Cardinal Federico Borromeo was archbishop (1595–1631). His training included a visit to Rome, where he studied *Cavaliere d'Arpino's work at S. Prassede, and absorbed the formulas of late *Mannerist design. He was established as an artist at Milan by the late 1590s and in 1602 was commissioned to paint four large tempera paintings on canvas with scenes from the life of Carlo Borromeo for display in Milan Cathedral as part of the campaign to have the late Archbishop canonized. By 1603 he was working at S. Maria presso S. Celso, designing and painting the stuccoes and frescoing the vaults of four chapels, as well as painting an altarpiece of the *Martyrdom of S. Catherine of Alexandria* (1609). In 1610, as part of the celebration of S. Carlo's canonization, he completed six more pictures for the cathedral, representing the saint's miracles. However, his capacity for dramatic bravura found a more successful outlet in the *S. Ambrose Baptizing S. Augustine* (1618; Milan, S. Marco), where the over-life-size figures in the foreground add a further disturbing dimension to the exaggerated foreshortening of the design. Cerano's work also appealed to a distinctive group of private collectors in Milan, some of whom seem to have taken pleasure in commissioning pictures involving more than one artist. He was almost certainly the moving force behind the *Martyrdom of S. Ruffina and S. Seconda* (Milan, Brera), which also involved G. C. *Procaccini and *Morazzone. From 1621–3 Cerano was head of Federico Borromeo's newly founded Accademia Ambrosiana (see under MILAN). His own studio assistant was Melchiorre Gherardini (1607–68), who coarsened his manner. HB

Cannon-Brookes, P., *Lombard Paintings c.1595–1630: The Age of Federico Borromeo*, exhib. cat. 1974 (Birmingham, Mus. and AG).

Rosci, M., *Mostra del Cerano*, exhib. cat. 1964 (Novara, Mus. Civico).

CRESPI, GIUSEPPE MARIA (Lo Spagnuolo) (1665–1747). Italian painter and draughtsman. He was born at Bologna and represents the end of an artistic tradition founded on the *Carracci academy of drawing. His work has been characterized by Waterhouse as 'the last flash of genius in a dying school' and a 'deliberate reaction to all that was solemn and academic in the Bolognese tradition'. His early frescoes in the Palazzo Pepoli, Bologna, representing *The Triumph of Hercules*, are remarkable for their informal iconography and a rustic charm in the characterization of the figures that eclipses the portentous frescoes by his master Domenico Canuti (1625–84) in the adjoining *salone*. A few years later, in his *Massacre of the Innocents* of 1706 (Florence, Uffizi), commissioned as a present for Prince Ferdinand of Tuscany, Crespi again tackles a theme much favoured by classical artists such as Guido *Reni, but interprets it with an inimitable fusion of understated realism and poetic fantasy, as a dramatic nocturnal encounter enacted beneath a rustic bridge. Above all in his *Seven Sacraments* (Dresden, Gemäldegal.), painted for Cardinal Ottoboni in 1712, he takes up a theme already treated with the utmost gravity by *Poussin in a strictly historical context; and interprets it instead in a contemporary idiom, showing ordinary people, including his own friends, directly involved in these solemn religious rituals. He leaves us with an inescapable sense of the banality, vanity, and humour of their everyday life.

Crespi's capacity to break down the formality of the classical tradition was advanced by his astonishing range of subject matter, and his predilection for the depiction not only of low-life *genre scenes in the manner of the *Bamboccianti, such as the *Fair at Poggio a Caiano* (1709; Florence, Uffizi), but also more low-key genre such as the *Courtyard scene* (Bologna, Pin. Nazionale) and *The Flea* (Pisa, Mus. Nazionale). He further applied himself to a variety of still-life subjects, including game birds, plants, and books, as well as a remarkable sequence of informal portraits, including the elegant *Lute-Player* (Boston, Mus. of Fine Arts) in a manner that anticipates *Piazzetta and the jolly *Postman* (Karlsruhe, Kunsthalle) in a more robust Netherlandish manner.

Crespi had been encouraged to pursue his predilection for genre by Prince Ferdinand and when toward the end of his life, and after his wife's death, he became reclusive and pious, and tried to concentrate again on religious work, he had lost his touch. His *Annunciation* (1723) for the cathedral at Saranza (La Spezia), led to a spate of further commissions—the *Crucifixion* (Milan, Brera), the *Dream of S. Joseph* (Bologna, Conservatorio del Baraccano)—which fuse an outmoded classical language with mawkish Counter-Reformation sentiment. Considered in the context of the great classicizing works of the Carracci and their immediate followers, the figures in Crespi's late altarpieces seem like misshapen pygmies in a city renowned for perfectly proportioned giants. Giuseppe Maria's style was continued, not entirely successfully, by his sons Luigi and Antonio; and his posthumous reputation has been seriously compromised by the proliferation of studio versions and copies, masquerading as autograph original work. HB

Emiliani, A., and Rave, A., *Giuseppe Maria Crespi*, exhib. cat. 1990 (Bologna, Pin. Nazionale).
Waterhouse, E., *Italian Baroque Painting* (2nd edn., 1969).

CRISTOFANO, FRANCISCO DI. See FRANCIABIGIO.

CRIVELLI, CARLO (c.1430–94). Italian painter. Crivelli's career was largely spent outside his native Venice (where he was imprisoned for abduction in 1457): in Dalmatia until 1468 and then the Marches of Italy, where he pursued a successful and prolific career from his base in Ascoli Piceno. Crivelli's style, from the early *Madonna of the*

Passion (s.d. 1460; Verona, Castelvecchio) to the Fabriano *Coronation of the Virgin* (s.d. 1493; Milan, Brera), is consistent in its adherence to the linearity and sharp detail of Paduan painting. Crivelli's densely worked and exquisitely ornamental panels rarely reflect developments elsewhere in Italy after 1450: the Florentine *sacra conversazione* replacing the older polyptych format only late in his career (e.g. the *Madonna della Rondine* of 1490; London, NG). He is, nonetheless, a great artist, expressive and inventive, with a rich vein of fantasy and a superlative sense of design. His powers are represented at their most engaging by the 1486 Ascoli Piceno *Annunciation*, one of a large collection of his works in London (NG).
JR

Zampetti, P., *Carlo Crivelli* (1986).

CRIVELLI, TADDEO (active 1451–79). Italian illuminator who epitomizes the courtly Ferrarese style of the 15th century. His earliest documented work was for Domenico Malatesta Novello, Lord of Cesena, but he is best known for the manuscripts he illuminated for Borso d'Este, Duke of Ferrara, above all the magnificent Bible (Modena, Bib. Estense, MSS lat. 422–3) that was completed in 1461. Crivelli's involved, agitated, and richly coloured compositions show the influence of Cosimo *Tura. His characters are expressive, the settings often include Renaissance architecture, and his borders contain a profusion of animals, birds, heraldic motifs, and portrait busts among the customary scrolling tendrils with leaves and flowers. He continued as one of the leading illuminators in Ferrara, working for the court and other noble patrons until his move to Bologna in 1473. Once there Crivelli's major commissions were from ecclesiastical patrons, in particular S. Petronio and the Benedictine monastery of S. Procolo, for whom he illuminated choir books. The characteristics of his style, nonetheless, remained essentially the same. His involvement from 1473 in the decoration and in 1476, possibly, in the publication of maps is documented.
KS

The Painted Page: Italian Renaissance Book Illumination 1450–1550, exhib. cat. 1994/5 (London, RA; New York, Pierpont Morgan Lib.).

CROCE, BENEDETTO (1866–1952). Italian philosopher and politician. He exerted a profound influence on Italian cultural life in the earlier 20th century, standing as a liberal government minister, founding and editing *La critica*, and writing on economics, literature, and history. Among the many concerns which stem from his philosophy of the spirit, he made a significant impact on thinking about art with his book *Estetica* (Aesthetic, 1902). This argues that art consists entirely of intuition; that it does not reside in physical objects. It is intuition (or 'expression') that

creates images, whether or not they find outward embodiment. Such intuition is a primary activity of the spirit, manifesting our categorical freedom, and cannot be subordinated to other mental domains. Later writings by Croce refine the argument, distinguishing lyrical intuition from cosmic intuition. Croce's stance, which compares with the emphasis on self-determined 'vision' made by contemporary artists like *Gauguin, would be adapted by the English philosopher R. G. Collingwood in *Outlines of a Philosophy of Art* (1924); though its anti-materialist aspect has inevitably been sharply criticized.
DC/JB

Moss, M., *Benedetto Croce Reconsidered* (1987).

CROME, JOHN (1768–1821). English landscape painter, who was born, worked, and died in Norwich. Crome was of humble origin and was first apprenticed to a coach and sign painter. He was befriended by Thomas Harvey of Catton, an amateur painter and collector, in whose collection he studied works by *Gainsborough and the Dutch masters, *Hobbema in particular. He was also influenced by Richard *Wilson and must have seen landscapes by *Rembrandt. He established himself locally as a landscape painter, was a founder member of the Norwich Society of Artists in 1803, and exhibited intermittently in London at the Royal Academy and the British Institution. He earned a part of his livelihood as a drawing master. His only journey abroad was to Paris in 1814 to see the exhibition of the pictures which had been seized by Napoleon.

Crome painted a number of small pictures of woodland clearings and mills or houses by the riverside, which are Dutch in conception though not in execution. With *Cotman, he was the major artist of the *Norwich School and his reputation stands high in the history of English landscape painting. The most important of his larger works are *Slate Quarries* (London, Tate), *Moonrise on the Marshes of the Yare* (London, NG), *Mousehold Heath* (London, Tate), and *The Poringland Oak* (London, NG). Of these the first two are thought to belong to the decade 1800–10, the last two to 1810–20. They are marked by a broad handling of the paint, a bold realization of space, and keen appreciation of local characteristics. His work is honest sometimes to the point of clumsiness. Crome, together with Wilson, represents the transition from the 18th-century *picturesque tradition to the *Romantic conception of *landscape. He rarely painted in the open air but composed his oils from watercolours and drawings made on the spot and from prints and etchings, of which he made a collection. His larger compositions lack the architectural quality of classical construction and have been accused of woolliness in realization; but they are often saved

by a unity of mood which anticipates the Romantics (*Yarmouth Jetty*, Norwich, Castle Mus.). He himself said in a letter to his disciple James Stark: 'do not distress us with accidental trifles in nature but keep the masses large and in good and beautiful lines, and give the sky, which plays so important a part in all landscape, so supreme a one in our low level lines of distance, the prominence it deserves, and in the coming years the posterity you paint for shall admire your work.'

As an etcher Crome's accomplishment was modest and during his life he never published his plates: they were published by his widow and eldest son John Bernay (1794–1842), thirteen years after his death. He is sometimes referred to as 'Old Crome' to distinguish him from this son, who painted in his manner but with inferior talent.
HO

CROSS, HENRI-EDMOND (1856–1910). French *Neo-Impressionist painter of landscapes and figure subjects. His real name was Delacroix, but he changed it to avoid comparisons with his illustrious namesake. Born in Douai, he arrived in Paris in 1881 and worked in the *Impressionist style for the next ten years; from 1884 he exhibited at the Salon des Indépendants (see under PARIS). In 1891 he moved to Le Lavandou on the Mediterranean coast and adopted *Seurat's Pointillist technique, which he used for essentially decorative purposes. He had pronounced anarchist sympathies and many of his paintings depict idyllic, utopian outdoor scenes; in his large decorative work *L'Air du soir* (1894; Paris, Mus. d'Orsay) dreamlike figures, set in a landscape of flattened, decorative planes, suggest an ideal harmony and tranquillity. Together with the work of *Signac these paintings had a brief but strong influence on the work of *Matisse, who visited the two painters in the south of France in 1904.
AJL

Compin, I., *H.-E. Cross* (1964).

CRUIKSHANK, GEORGE (1792–1878). English *caricaturist. Cruikshank was taught by his father Isaac (1756?–1811?), who worked in the manner of *Gillray. A precocious talent, he had established himself by 1810 when he published his caricature of the arrest of *Sir Francis Burdett*. Until the 1820s he concentrated on political satires, taking such topical figures as Napoleon, Joanna Southcott, and the Prince Regent for his targets. After 1820 he was in great demand as an illustrator whose enormous output, in both etching and engraving, included *Grimm's Popular Tales* (1824–6) and novels by Ainsworth and Thackeray. He illustrated both *Sketches by Boz* (1836–7) and *Oliver Twist* (1837) and his work may be compared to that of Dickens in its multiplicity of characters, restless action, and love of the grotesque. In

middle age he embraced the cause of abstinence, producing two influential propagandist woodcuts *The Bottle* (1847) and *The Drunkard's Children* (1848), and returned to the subject with a huge allegorical painting, *The Worship of Bacchus* (1860–2; London, Tate). His work lacks the elegance and subtlety of Gillray but seethes with typically Victorian energy. DER

George, M. D., *Hogarth to Cruikshank* (1967).

CUBISM. The term refers, when understood narrowly, to the set of interests and formal innovations originated by Georges *Braque and Pablo *Picasso c.1907–11 and developed later by Juan *Gris and Fernand *Léger. More broadly, it covers a range of distinct variants of this approach employed by associated artists based in Paris in the 1910s and early 1920s. Its ideas and methods proved enormously influential on many different schools of 20th-century art. The name originated as a gibe, appearing in a review by the critic Louis Vauxcelles which referred to simplifications of form into geometric shapes in Braque's pictures of c.1908.

Formalist interpretations of Cubism view its essential significance as lying in a revolutionary approach to the depiction of space, volume, and mass. The naturalism of three-dimensional, illusionistic perspective was overthrown in favour of an emphasis on the material quality of the flat picture plane and the medium. Early Cubism used multiple viewpoints to depict three dimensions; this is perhaps visible first in Picasso's proto-Cubist *Les Demoiselles d'Avignon* of 1907 (New York, MoMa). Forms in space were also rendered through a continuous pattern of flat planes; most famously, and again perhaps first, in Braque's *Houses at L'Estaque* (1908; Berne, Kunstmus.). The development of these innovations later led to the early years of the style being termed its 'analytic' phase.

In 1912 Braque and Picasso began to introduce *collage and *papier collé: this lent a clearer, if schematic, system of reference into a style which had become increasingly abstract. The materiality of the picture plane was further underlined by the introduction of the new procedures, which allowed the exploration of new effects of depth from the overlapping of collaged planes. This phase was later termed 'synthetic', suggesting the free invention of emblematic signs for the objects depicted. However, it should be recognized that both these labels, 'analytic' and 'synthetic', were merely later critical terms, never used by the artists at the time, and in many respects they distort appreciation of the work by imposing rigid distinctions of approach. The term 'analytic' Cubism perhaps suggests more of an emphasis on visual

perception and realism than was really present: Cubism is a conceptual realism, the outcome of intellectualized vision rather than the spontaneous eye of the *Impressionists. This is certainly suggested by the muted, narrow chromatic range of the early 'analytic' work, although this was also a reaction against the sensuous, atmospheric suggestiveness of the Impressionists and the decorative colour of the *Fauves.

The Cubist milieu was by no means close-knit, the artists moving in different if overlapping social circles. However, two groups might be distinguished, defined by those who had the financial support and protection of the German dealer Daniel-Henry Kahnweiler (Picasso, Braque, Gris, and Léger) and those that did not and relied on the non-academic Salons for their publicity. In fact the first organized group show of Cubism, held at the Salon des Indépendants (see under PARIS) in 1911, featured only Léger, Robert *Delaunay, *Le Fauconnier, *Metzinger, and *Gleizes. Of these, it was Gleizes and Metzinger who published the first major theoretical text on the movement in 1912, entitled *Du Cubisme*. Later, a wider circle become associated with this group, among them Francis *Picabia, Marcel *Duchamp, Jacques *Villon, Raymond Duchamp-Villon, Jacques *Lipchitz, and Henri *Laurens. From this milieu sprang the *Section d'Or group in late 1912 and the 'Orphic' Cubists (Duchamp, Delaunay, Picabia, and Leger) grouped together by Guillaume *Apollinaire.

The foremost influences on the development of Cubism, certainly in its initial stages, were *Cézanne's late work and also, undoubtedly, non-western or 'primitive' sculpture. However, a wide range of other influences came to bear on the movement, cutting across the many critical categories that have been devised for it on formal bases. Input came from disparate philosophical, literary, and scientific sources: the philosopher Henri Bergson's ideas about time were certainly important to many and Robert Delaunay developed his own version of these ideas in his theory of 'simultaneity'. Theories of *proportion were important, particularly to those who exhibited as the Section d'Or; and Apollinaire inflected the work of the *Orphists with mystical, *Symbolist notions. Less distinctly, but no less strongly, the whole atmosphere of Paris in the period, in all its fast-moving, cosmopolitan modernity, came to bear on the work.

Cubism's richest period of innovation lay in the years before the First World War called many of its practitioners to the front, yet it remained important well into the 1920s, feeding into the post-war period's conservative interest in *classicism. Beyond this, the movement's formal innovations and ideas exerted enormous influence outside France,

especially in Russia and America. MF

Cooper, D., et al., *The Essential Cubism, 1907–1920: Braque, Picasso and their Friends*, exhib. cat. 1983 (London, Tate).

Golding, J., *Cubism: A History and an Analysis, 1907–1914* (1959).

Green, C., *Cubism and its Enemies: Modern Movements and Reaction in French Art, 1916–1928* (1987).

CURRIER & IVES PRINTS, popular lithographs published in New York by Nathaniel Currier (1813–88) from 1835 and in partnership with James Ives (1824–95) after 1857. Currier's success began with his print of the burning of the *SS Lexington* in 1840 and he soon became the leading publisher of popular prints in America. Their subjects covered all aspects of contemporary American life, lithographed in black and white and hand coloured by a production line of women. They were little regarded when published but have since become highly collectable. There is a large collection in New York (City Mus.). DER

Reilly, B., *Currier and Ives: A Catalogue Raisonné* (1984).

CURRY, JOHN STEUART (1897–1946). American painter. He was born on a farm near Dunavant, Kan., and never forgot his midwestern roots. After studying at the Kansas City Art Institute, 1916, and the Art Institute of Chicago, 1916–18, he worked as an illustrator for pulp magazines from 1919 to 1926, then spent a year in Europe before settling in New York. He believed that art should grow out of everyday life and be motivated by affection, and his subjects were taken from the midwest he loved. Two of his most famous works are *Baptism in Kansas* (1928; New York, Whitney Mus.) and *Hogs Killing a Rattlesnake* (1930; Chicago, Art Inst.); they show his anecdotal, rather melodramatic style (he often depicted the violence of nature)—sometimes weak in draughtsmanship, but always vigorous and sincere. In the 1930s Curry was recognized—along with Thomas Hart *Benton and Grant *Wood—as one of the leading exponents of *Regionalism, and he was given commissions for several large murals; the best known—generally regarded as his masterpieces, even though the scheme was never finished—are in the State Capitol in Topeka, Kan. (1938–40), where the subjects include the activities of John Brown, the famous campaigner against slavery. In 1936 Curry was appointed artist in residence by the College of Agriculture at the University of Wisconsin, one of the first such posts to be created in the country. He held the position for the rest of his life. IC

CUYP FAMILY. Dutch painters of Dordrecht. **Jacob Gerritsz.** (1594–1651/2), a pupil of Abraham *Bloemaert in Utrecht, was

a versatile history and genre painter. His portraits of children are particularly fine. **Benjamin Gerritsz**. (1612–52), the half-brother of Jacob, was a history and genre painter in *Rembrandt's circle. **Aelbert** (1620–91), who was born and died in Dordrecht, was the most famous of the three. He was the son and pupil of Jacob. Aelbert Cuyp specialized as a landscape painter and his earliest works from 1639 show the influence of Jan van *Goyen. Around 1642 he seems to have made an extensive sketching tour throughout Holland which may have brought him into contact with various Italianate landscape painters based in Utrecht, such as Jan *Both. His style changed significantly at this time and his compositions became more expansive, infused with a warm golden morning or evening light. The landscape around Dordrecht was a constant theme, often with the Grote Kerk as a focal point in the distance. Another journey made in 1651/2 along the Rhine inspired some of his outstanding later works, such as *Landscape with a Rider and Peasants* (London, NG). CFW

Sutton, P., *Masters of 17th Century Dutch Landscape Painting*, exhib. cat. 1987 (Amsterdam, Boston, Philadelphia).

CYCLADIC ART. This term, used to describe the art and culture of the Bronze Age Cyclades, describes the circle (*kuklos*) formed by these central Aegean islands around the sacred island of *Delos. In the early Cycladic period (*c*.3300–2000 BC) handmade clay vases are decorated using burnishing, incised patterns, and linear painted designs. The clay 'frying pans' are circular vessels with low walls and a short handle; incised decoration covers the outer surface and walls and includes rayed sun motifs, the earliest drawings of Aegean ships surrounded by spirals, and schematic representations of the female pubic area. The full significance of the symbolism eludes us but it may refer to ritual preoccupations with the female form and the sun. Stone vases (bowls, collared jars, and pyxides) were carved, using bronze tools and abrasives, from chlorite schist and marble. The marble of Paros and Naxos provided the medium for stylized human figurines, ranging from *c*.35 cm (14 in) to monumental sculptures over a metre (3 ft) high. As with later Greek sculpture the dazzling purity of form is partially a modern illusion: tantalizing traces of paint indicate lost details of facial features and tresses of hair. Predominantly female, the canonical or folded-arm figurines are poised on pointed toes, right arm folded below left across the body, head tipped upwards. More ambitious compositions include a male flautist and a seated harper. During the Middle and Late Bronze Age (*c*.2300–1100 BC) Cycladic arts

come under the influence of *Minoan, and later *Mycenaean culture, although some islands (Melos, Thera) maintain lively local pottery traditions. Excavations at the town of Akrotiri on Thera, buried in a massive volcanic eruption (*c*.1550 BC), have revealed Theran artistic traditions, notably in architecture and frescoes. Although closely related to Minoan frescoes in technique and overall style, the Thera frescoes are distinctive in their use of a plain white background and in conventions such as blue paint to indicate shaved human heads. Theran artists painted both on a large scale and in miniature style, the latter exemplified by the *Ship* fresco from the West House. Themes include females gathering crocuses to offer to a goddess (building Xeste 3), and images from the natural world, such as monkeys, or swallows and lilies in a rocky landscape. CEM

Doumas, C., *The Wall-Paintings of Thera* (1992).
Renfrew, C., *The Cycladic Spirit* (1991).

CYPRIOT ART, the prehistoric culture of Cyprus, which combines a Cypriot identity with openness to external influences. Chalcolithic (*c*.3800–2300 BC) stone figures take a cruciform shape from the outstretched arms or from a second figure at right angles to the first. Red Polished ware vases and sculptures of the early–middle Bronze Age (*c*.2300–1600 BC) have dark red surfaces often enlivened with incised details. Extravagantly shaped vases with moulded animal or human attachments were made as tomb offerings. Ironically, art made for the dead offers glimpses of ancient life, e.g. scenes of ploughing, grinding corn, rituals involving bulls and snakes. Cypriot individuality remains strong during the late Bronze Age (*c*.1600–1200 BC) with rounded bowls in White Slip ware, and juglets, tankards, and figurines in dark grey Base Ring ware. Now, too, Cyprus enters the international world of eastern Mediterranean trade. The Enkomi Silver Bowl (Nicosia, Cyprus Mus.)—its 'milk bowl' shape Cypriot, but the inlaid bulls' heads Mycenaean in inspiration—epitomizes the flow of ideas seen also in ivory- and faience-work. That an island rich in copper ores should produce skilled bronzesmiths is no surprise; their achievements include solid-cast statuettes, such as the *Enkomi Horned God* (Nicosia, Cyprus Mus.), and bronze four-sided stands with figured decoration. The Bronze Age ends with the collapse of palatial Mediterranean societies and their arts, and Aegean peoples sought refuge in Cyprus, thus beginning the Hellenization of the island. Cypriot culture, however, continued to thrive during the 12th–11th centuries BC, as shown by the Kourion Sceptre: a golden shaft surmounted by a sphere on

which are perched a pair of birds, all executed in skilful cloisonné enamelling (Nicosia, Cyprus Mus.). CEM

Coldstream, J. N., *The Originality of Ancient Cypriot Art* (1986).
Tatton-Brown, V., *Ancient Cyprus* (1997).

CYRIAC OF ANCONA (1391–1455). Italian merchant and amateur classicist who played a vital role in the *Renaissance discovery of Antiquity (see ANTIQUE). Between 1412 and 1449 he travelled throughout the ancient world observing, studying, and, most importantly, documenting the works of art he encountered. His notebooks provide invaluable information on ancient monuments subsequently destroyed or damaged, such as his drawings of the temple of Artemis at Didyma in Turkey before its desolation by an earthquake, and the west front of the *Parthenon (1436–7; Berlin, Staatsbib., Cod. Berolinensis Hamiltonianus 254, fo. 85r) with its frieze intact. His achievements were celebrated within his lifetime and many copies of his manuscripts survive. His contemporary admirers included Felice Feliciano and Andrea *Mantegna. Cyriac's detailed notes and drawings, together with his interests in collecting, made him a role model for later antiquarians. KC

Momigliano, A., 'Ancient History and the Antiquarian', *Journal of the Warburg and Courtauld Institutes*, 13 (1950).
Weiss, R., *The Renaissance Discovery of Classical Antiquity* (1969).

CZECH ART. Strictly, the term should refer to art and sculpture produced after 1918, when the independent Republic of Czechoslovakia was founded. However, the arts in the 19th century already manifest particular Czech characteristics in the choice of subjects drawn from Slavic history and legend, which parallels a similar nationalistic awareness in politics and literature. This is best seen in the work of Josef Myslbek, the late 19th-century sculptor admired by *Rodin, for example the Wenceslas Monument (1888–1923; Prague), or in the paintings of Antonín Mánes and his son Josef Mánes. Paris replaced Vienna and Munich as the artistic centre which attracted those Czech artists who travelled abroad. These were painters such as Karel Purkyně, a Courbet-inspired portraitist, Viktor Barvitius, a painter of urban life, and Soběslav Pinkas, a landscape and genre painter. However, in the mid-19th century, only Jaroslav Čermák acquired an international reputation, spending years not only in Paris but also in Dalmatia. His work is indebted to French artists such as *Delacroix, but his subject matter is Czech or Dalmatian, as in *Dalmatian Wedding* (1875–7; Prague, Národní Gal.). The national spirit discernible in painting and sculpture reaches an

apogee in the decoration of a number of important architectural projects in Prague, including the National Theatre and Obecní Dům (Municipal House). The central figures in this vibrant 'National Theatre Generation' were the sculptor Ladislav Šaloun and the artists Mikoláš Aleš, Frantisek Ženíšek, and Alfons Mucha. Šaloun's most important work, the John Huss Monument (1900–15; Prague), illustrates his forceful and individual blend of *Art Nouveau elongation with a vigorous working of his material. Aleš is known for his sweeping scenes from Czech history, for example Hussite Camp (1878; Prague, Národní Gal.), whilst Ženíšek's large cycles for Obecńi Dům (Life, Poetry and Death, 1911; Love Song, Battle Song, and Burial Song, 1914) are inspired by Czech legends. At the end of the 19th century, Slovakia, although part of the new Czech Republic, was closer to Hungary in artistic matters. Slovakian artists, such as Josef Czayczik and Peter Michel Bohún, remained in their native region, whereas two fine painters, Baron Ladislav Medňansky and Dominik Skutechý, came to be appropriated as Hungarian artists.

The importance of Czech artists of the early 20th century has only recently begun to be recognized. One of the pioneer abstract painters of European significance was Frantisek *Kupka. From 1895 Kupka lived mainly in France and, by 1912, was producing purely abstract works, such as Amorpha: Fugue in Two Colours (Prague, Národní Gal.). Prague immediately before the First World War was a major centre of European avant-garde, with a number of highly influential exhibitions organized by the secessionist Association of Artists (founded 1887). For example, an exhibition held in 1905 of the Norwegian Edvard *Munch led to the formation in 1907 of The Eight (Osma), the first group of avant-garde Czech artists. Four years later members of this group founded the Association of Plastic Arts, composed of artists who embraced *Cubism, including Bohumil Kubišta, Josef *Čapek, Emil *Filla, Antonin Procházka, and Václav Spála. The outstanding sculptor of the early 20th century was Otto Gutfreund who, by 1914, was allied closely with Analytical Cubism, as in Cubist Bust (1913–14; Prague, Národní Gal.); moving later to Synthetic Cubism, which he subsequently abandoned for a style known as Objective Realism; for example Industry (1923; Prague, Národní Gal.).

The founding of the new Republic in 1918 saw a period of renewal and vitality in the arts. Czechoslovakia's geographical position in the centre of Europe made it a meeting point for the main 20th-century art movements ranging from *Constructivism to the *Bauhaus. In 1920 a new avant-garde group was formed called the Devětsil, a name of mysterious derivation. Led by Karl Teige, a collage artist, poet, and theorist, members of the group rejected notions of high art in favour of an enthusiasm for popular culture, reflected in the consciously naive art of Jan Zrzavý (Church in Camaret, 1927; Prague, Národní Gal.) and František Tichý (Magician, 1934; Prague, Národní Gal.). The work of sculptors of this period, such as Zeděk Pešánek, shows influences from Russian Constructivism, as in his One Hundred Years of Electricity series (1935–6; Prague, Národní Gal.). *Constructivism was also an important influence upon a number of pioneering photographers, such as Jaroslav Rössler, Jaromir Funke, František Drtikol, and Josef Sudek. However, the movement which had a lasting significance for Czech painters and sculptors, just before and during the Second World War, was *Surrealism. Artists included Ladislav Zívr, Zdenek Rykr, Jindřich Štyrský, Kamil Lhoták, and the woman artist Marie Čermínová, known as Toyen. The work of other artists, such as Alen Diviš and Vaclav Boštik, fuses a dark foreboding and alienation with Surrealist imagery, inspired by the years of war and occupation; for example Alen Diviš's Hallucination (1941; Prague, Národní Gal.).

During the years of Communism after 1948 artistic developments were not particularly memorable. CFW

DADA, an artistic movement of anarchic revolt against bourgeois society, occasioned by the horrors of the First World War. Dada emerged in neutral Zurich in 1916 when a group of expatriate artists and writers, including *Arp, *Tzara, and Richard Huelsenbeck (1892–1974), began gathering at the Cabaret Voltaire, founded by the German writer Hugo Ball (1886–1927). Sickened by the butchery of war and disgusted at the supposedly rational society that had produced it, they sought to confound the principles of logic, reason, authority, and tradition and thus subvert smug bourgeois values. The movement went to extremes in its use of buffoonery and provocative behaviour to shock and disrupt public complacency. The apogee of Dada expression was the gratuitous act, exemplified by the selection of the name Dada, according to many accounts obtained by inserting a penknife at random into the pages of a dictionary (*dada* is French for hobby-horse). Initially Dada did not involve a specific style or aesthetic, although *collage and montage (which defied values then espoused by academies of art) and the nonsense poem later became favourite techniques. Dada owed much to *Futurism, but replaced Futurist optimism with facetious nihilism.

Concurrent with events in Zurich, Marcel *Duchamp, Francis *Picabia, and *Man Ray in New York spontaneously devised their own anti-rational programme with aims remarkably similar to those of Dada, and all three later became Dada initiates. Berlin Dada, instigated by Huelsenbeck who arrived there in 1917, was more violent than its Swiss counterpart, and characterized by a strong political dimension which spawned the vicious photomontages and acid satire of George *Grosz, *Hausmann, and John *Heartfield. Dada spread briefly to Cologne (1919–20) where activity centred around Max *Ernst, who was joined by Arp, while in Hanover Kurt *Schwitters, to whom Huelsenbeck had

taken an acute aversion and excluded from Berlin Dada, tirelessly devoted himself to Dada ideals.

Dada finally reached Paris in 1919 with the arrival there of Tzara and Picabia, doing their best to incite cultural pandemonium. Dada in Paris was more literary than in other cities, attracting among others André *Breton, and after a period of brilliancy burned itself out in quarrels and disputes, out of which arose *Surrealism in 1924. Despite its nihilism, Dada was trail-blazing in its questioning and debunking of accepted norms and traditions, and without it many subsequent artistic developments would have been impossible. Its legacy directly persists in *Pop art (sometimes referred to as Neo-Dada) and in much recent installation work. AA

Foster, S. (ed.), *Crisis and the Arts: The History of Dada* (1996).
Richter, H., *Dada: Art and Anti-Art* (1965).

DADD, RICHARD (1817–86). English painter. Dadd entered the RA Schools, London, in 1837 and exhibited literary and historical subjects at the British Institution in 1839. By 1841, when *Titania Sleeping* (priv. coll.) was shown at the RA, he had found his métier as a painter of fairy subjects. In 1842 he accompanied Sir Thomas Phillips on a Middle Eastern tour during which he first evinced signs of insanity. On his return he continued to paint but in August 1843 he murdered his father. He fled to France but was arrested, extradited, and committed to Bethlem Hospital in 1844, transferring to Broadmoor in 1864. The regimes at both hospitals were surprisingly enlightened and Dadd was encouraged to paint. Much of his work was based on Eastern themes (*Flight out of Egypt*, 1849–50; London, Tate) or, like *The Fairy Feller's Master-Stroke* (1855–64; London, Tate), fairy subjects. *Sketches to Illustrate the Passions*, of which 30 survive (*Idleness*, 1853; London, V&A), may

have been undertaken as therapy. Dadd's work, after his illness, contains a personal iconography painted in intense, hallucinatory detail with a miniaturist's skill. DER

Allderidge, P., *Richard Dadd* (1974).

DADDI, BERNARDO (active *c*.1312–48). Italian painter. Bernardo Daddi was a younger Florentine contemporary of *Giotto who ran a successful workshop specializing, mostly, in small altarpieces and portable tabernacles. The frescoes attributed to him in the Pulci-Berardi chapel in S. Croce reveal a certain unease with large-scale narrative, but on a smaller scale Daddi's absorption of Giotto's monumentalism on his own terms is impressive. The Bigallo Triptych (1333; Florence, Mus. del Bigallo), with a central *Enthroned Madonna*, and the *Nativity* and *Crucifixion* in the wings, strikes a balance between the reflection of Giotto's *Ognissanti Madonna* (Florence, Uffizi) in the central panel and a vein of poetic intimacy in the narratives and the *Saints* and *Prophets* flanking the *Madonna*. The compound of the monumental and the miniature which characterizes this and other small panels extends to larger altarpieces like the 1347 *Madonna* in Or San Michele and the two polyptychs of Daddi's later years (1344; Florence, S. Maria Novella; 1348; London, Courtauld Inst. Gal.). JR

Offner, R., *A Corpus of Florentine Painting* (1930–), 3.3.

DAEDALUS, or Daidalos, mythical craftsman, inventor, and architect. According to Homer he made a *choros* (perhaps a dancing floor) for Ariadne at Knossos. Other ancient authors credit him with numerous and often magical creations, notably the model cow with which Pasiphaë satisfied her lust for the Cretan bull; the labyrinth that King Minos commissioned for that union's offspring, the Minotaur; and the waxen wings by which he and his son Icarus left Crete. (Icarus, famously, neglected his father's instructions, flew too close to the sun, melted the wax, and plummeted into the sea.) Daedalus escaped to Sicily, or to Athens according to Athenians, who adopted him as an ancestor and added early, local adventures to his exploits. He is depicted in the visual arts as early as the 7th century BC on an Etruscan Bucchero jug (Cervetere Mus.), winged and inscribed TAITALE, and appears on 6th-century Greek ceramics (Athens, Acropolis Mus.; Bonn, Akademisches Kunstmus.; Kiel, Antikensammlung; New York, Met. Mus.; Paris, Louvre) and ivories (London, BM). Ancient authors attributed to him various early works of art in Greek sanctuaries and they also considered him the first to represent human figures in motion and with eyes open. KDSL

Morris, S. P., *Daidalos and the Origins of Greek Art* (1992).
Simon, E., 'Early Images of Daidalos in Flight', in S. P. Morris and J. B. Carter (eds.), *The Ages of Homer* (1995).

DAHL, JOHAN CHRISTIAN (1788–1857). Norwegian painter. Dahl travelled in Italy before settling in Dresden in 1823 where he taught, as a professor at the Dresden Academy, from 1824. A friend of *Friedrich, whose *Romanticism he shared, his work was greatly admired by *Goethe. His landscape paintings combine natural observation and imaginative composition and often include dramatic effects of light and perspective, as in *Birch Tree in Storm* (1849; Bergen, Billedgal.) which exemplifies the Pathetic Fallacy, the attribution of human emotions to nature. His Norwegian subjects, which increasingly expressed a nationalistic spirit, earned him his contemporary reputation as the discoverer of Norwegian landscape. JH

Johannesen, O., *J. C. Dahl* (1965).

DAHL, MICHAEL (1659–1743). Swedish-born portrait painter. Dahl came to London in 1682, for three years, and returned permanently in 1689 having visited France and Italy in 1685. Initially in competition with *Kneller, whose work his own resembles, he prospered after Kneller's death in 1723 and developed the largest practice in England. Comparison between Dahl's portrait of *Joseph Addison* (1719) and Kneller's painting of the same sitter (pre-1717; both London, NPG) shows that while he lacks Kneller's bravura he surpasses him in characterization. An early religious painting *The Magdalene* (*c*.1695) is at York (AG). DER

Nisser, W., *Michael Dahl* (1927).

DALÍ, SALVADOR (1904–89). Spanish artist, a leading exponent of *Surrealism. A Catalan by birth, Dalí received an academic training in Madrid (1922–6), although some of his early work is in fact *Cubist in style. After moving to Paris in 1929, he joined the Surrealists, who were immediately influenced by his meticulously executed dreamlike paintings, which he himself described as the 'hand-coloured photographs' of his delirium. He also collaborated with Luis Buñuel (1900–83) on the films *Un chien andalou* (1929) and *L'Âge d'or* (1930). During the 1930s his principal innovation was the development of 'paranoia-criticism', which he defined as a form of 'irrational understanding based on the interpretive-critical association of delirious phenomena'. This was inspired by the systematic quality of certain kinds of neurosis, in which a complex series of illogical associations can be made on the basis of a single obsessive belief. In pictorial terms this led to bizarre juxtapositions of rationally unconnected objects, and to multiple images, where a single form could be interpreted as representing more than one subject. Despite their initial approval, the Surrealists repudiated Dalí in the late 1930s, on account of his right-wing views and increasing commercial success. After spending eight years in the USA, Dalí returned in 1948 to Europe, where he continued to produce spectacular fantasy paintings. Dalí was also a prolific writer: as well as producing a novel *Hidden Faces* (1944), he vividly described his artistic goals in such works as *The Conquest of the Irrational* (1935) and *The Secret Life of Salvador Dalí* (1942). CJM

Ades, D., *Dalí* (1988).

DALMASIO AND LIPPO DI DALMASIO SCANNABECCHI. Probably the most successful family of painters in 14th-century Bologna. **Dalmasio**'s (active 1342–73) work is undocumented, but he is credited with a succession of *Giottesque panel paintings and frescoes, particularly close to *Maso di Banco, in Bologna, Pistoia, and S. Maria Novella, Florence. The earliest work attributed to him, and the most native in style, is the Triptych for S. Vitale (1333; Paris, Louvre). Dalmasio married the sister of *Simone dei Crocefissi (1350); their son **Lippo di Dalmasio** (*c*.1352/9–*c*.1410), became the most prolific artist of the 1390s, painting a series of *Madonnas of Humility* including an early example in S. Domenico, Pistoia, and others in S. Maria della Misericordia, Bologna (1397; London, NG). Two polyptychs by him survive (Bologna, Pii Inst.), and a frescoed one in S. Maria dei Servi. Lippo held major notarial and judicial offices at the end of his life, but the survival of numerous signed Madonnas gave him mythic status during the Counter-Reformation as the epitome of the devout artist. RG

Gibbs, R., 'Two Families of Painters', *Burlington Magazine*, 121 (1979).

DALMAU, LLUÍS (active 1428–61). Dalmau travelled to Castile from his native Valencia by order of Alfonso V, king of Aragon. The King, much enamoured of the Netherlandish style in painting, sent Dalmau to Flanders in 1431 to perfect his technique. Five years later Dalmau reappeared in Valencia, then arrived in Barcelona sometime between 1438 and 1443, the year in which the councillors of Barcelona commissioned him to paint an altarpiece for the Casa del Consell. The resulting *Virgin of the Councillors* (1445; Barcelona, Mus. Nacional d'Art de Catalunya), Dalmau's masterpiece, reveals his affinity for the style of Jan van *Eyck, a painter much admired by Alfonso V. After 1452 Dalmau received fewer commissions and was paid less for them, perhaps because he was unable to

modernize the Eyckian style that had made him successful. SS-P

Padros, M. R., et al., *Cathalonia: arte gótico en los siglos XIV–XV*, exhib. cat. 1997 (Madrid, Prado).

DALOU, AIMÉ-JULES (1838–1902). French sculptor. He had a conventional classical training at the École des Beaux-Arts (see under PARIS) but first won acclaim with his naturalistic *Embroiderer* (Paris, Petit Palais), which he exhibited at the 1870 *Paris Salon. His left-wing republican views led to his involvement with *Courbet in the Paris Commune. As a result he spent the years 1871–9 in exile in London. There his descriptive naturalism and narrative format were admired by English collectors and artists, while through his teaching at the South Kensington School of Art he influenced the young artists who later formed the *New Sculpture movement. Dalou returned to Paris to execute his colossal bronze group *The Triumph of the Republic* (1879–99) for the Place de la Nation. This work combines Neo-Baroque scale and exuberance with naturalistic rendering of its heroic working-class figures. Elsewhere in Paris he executed monuments to *Delacroix (unveiled 1890; Luxembourg Gardens) and to the murdered liberal journalist Victor Noir (1890; Père-Lachaise cemetery), the latter one of the most moving tomb sculptures (see FUNERARY MONUMENT) of the 19th century. In later life Dalou produced many models for a never-realized Monument to Workers. These and other works may be seen in the Musée du Petit Palais in Paris. MJ

Hunisak, J., *The Sculptor Jules Dalou: Studies in his Style and Imagery* (1977).
Janson, H. W., *Nineteenth-Century Sculpture* (1985).

DAMMAR. See RESIN.

DANBY, FRANCIS (1793–1861). Irish-born English painter. Danby trained at a Dublin drawing school before coming to London in 1813. By 1814 he had settled in Bristol as a landscape painter and was soon prominent among the city's artists. His paintings are topographically accurate but distinctly pastoral and, as in *Children by a Brook* (c.1821; London, Tate), frequently contain children; the oils are characterized by vivid colour and an almost enamel-like finish. Realizing that such modest subjects would be unlikely to make his reputation Danby exhibited the sinister *Upas Tree* (London, V&A) for his London debut in 1820 and moved there in 1824. In 1825 when Sir Thomas *Lawrence purchased *Sunset at Sea after a Storm* (Bristol, AG) his future seemed assured. He exhibited apocalyptic works throughout the 1820s, accusing his competitor John Martin of plagiarism in 1826. However, despite receiving £1,000 for *The Opening of the Sixth Seal* (Dublin, NG Ireland) in 1828,

Danby, whose affairs were chaotic, fled to Paris the following year to avoid financial ruin. He remained abroad until 1839, finally settling in Exmouth in 1847. DER

Greenacre, F., *Francis Danby*, exhib. cat. 1988 (London, Tate).

DANCE, NATHANIEL (1735–1811). English painter. A son of the architect George Dance, he trained under Francis *Hayman before leaving for Rome in 1754, determined to be a *history painter whilst supporting himself by portraiture. *The Death of Virginia* (1765; lost) was probably the first classical subject painted by a British artist; and on returning to London in 1765 he quickly established a reputation. *Timon of Athens* (1767; London, Royal Coll.) was purchased by George III but on Benjamin *West's appointment as Royal Historical Painter in 1772, Dance turned increasingly to portrait painting. In the mid-1770s he received an inheritance and in 1783 increased his fortune by marriage. From now on he virtually ceased painting and resigned from the Royal Academy (see under LONDON), of which he was a founder member, in 1790 when he was elected to Parliament. Apart from the occasional landscape, exhibited as by 'A gentleman', his output after 1800, when he became a baronet, was confined to the caricature. His career epitomizes the dichotomy between artist and gentleman, the hierarchy of rank being directly inverse to that of subject matter. DER

Goodreau, D., *Nathaniel Dance*, exhib. cat. 1977 (London, Kenwood House).

DANIELE RICCIARELLI DA VOLTERRA (1509–66). Italian painter and sculptor of the *Mannerist period. He was born in Volterra and was trained there by *Sodoma. He moved to Rome c.1536, where his first commissioned work was a frescoed frieze in the Palazzo Massimi depicting a story of Fabius Maximus—firmly composed scenes with finely drawn and disposed nudes. He was in close personal touch with *Michelangelo but was too individual and too intelligent to join the crowd of followers who aped the master. His finest surviving work is the one remnant of his fresco decorations in the Cappella Orsini in SS Trinità dei Monti: the *Deposition*, a powerful and moving representation, based compositionally on *Rosso Fiorentino's famous painting of the same subject in Volterra. This was one of the most admired works of its generation in Rome.

Daniele wavered for many years between painting and sculpture, completing little of either. His sculpture includes, however, the famous bronze bust of Michelangelo (best examples in the Case Buonarroti, Florence,

and the Louvre, Paris), made shortly after the latter's death. HO

DANIELL FAMILY. English painters. Thomas (1749–1840) exhibited topographical views and flower pieces at the Royal Academy (see under LONDON) between 1774 and 1784, having trained as a coach painter and studied in the RA Schools. In 1785 he went to India with his 15-year-old nephew William (1769–1837). In Calcutta in 1788 they drew, engraved, and published a set of city views. For the next two years they travelled widely in northern India, visiting Delhi, Lucknow, and the Himalayas. Back in Calcutta their accumulated work was disposed of by lottery to fund a tour to southern India. Another lottery in Madras was followed by a western tour of India to Bombay. Their magnum opus, the six folio volumes of *Oriental Scenery*, with 144 coloured *aquatints, was published by them between 1795 and 1808, after their return to England in 1794. Both artists became RAs, Thomas in 1799 and William in 1822, and they exhibited many oils based on their vast numbers of Indian sketches. Architects and designers in search of the exotic and evocative turned to the Daniells' published views of India for inspiration, thus spreading their influence widely in popular and academic circles. MP

Sutton, T., *The Daniells* (1954).

DANISH ART. See SCANDINAVIAN ART.

DANTE ALIGHIERI (1265–1321). Italian writer. Dante was the greatest of medieval poets and his vernacular *Divine Comedy*, written after 1302 when he was in exile from Florence and charting the journey through the three realms of the afterlife, the greatest of all medieval poems. Specific mentions of art are few, though highly significant, like the reference to the fame of the rising stars *Giotto and Franco Bolognese eclipsing that of *Cimabue and Oderisi (*Purgatorio* 11), or the vivid description of the relief carvings on the cornice of Pride (*Purgatorio* 10). An exceptionally acute visual sense pervades his verse and has provoked a continuous and powerful artistic response since the time of the earliest illustrated manuscripts of the *Comedy*. This takes different forms, from the direct illustrations of the text by *Botticelli and Gustave *Doré to highly personal adaptations of its imagery like those of *Rossetti. Since the *Renaissance, for which the entire multi-layered texture of the *Comedy*, drawing on the full wealth of scholastic philosophy and medieval history, was of central importance, artistic interest has tended to focus on the dramatic and picturesque qualities of the *Inferno* and romanticized interpretations of Dante's life. JR

DANTI (Dante), VINCENZO (1530–76). Italian architect, writer, and one of the most significant sculptors of Florentine *Mannerism. He was born in Perugia, but by 1557 he was in Florence, where he carved his marble masterpiece *Honour Triumphant over Falsehood* (1561; Florence, Bargello). This group, influenced by the artistic ideals of *Michelangelo, *Bandinelli, and *Cellini, displays a complex arrangement of compressed anatomical forms, a variety of carved textures, and a remarkable sense of inner tension. Following the success of *Honour*, he worked for the Medici in the 1560s and was involved in preparations for Michelangelo's funeral in 1564. He completed his masterpiece in bronze, the *Decollation of the Baptist*, for Florence Baptistery in 1571; this work, a confident excercise in Mannerist sculpture, is characterized by the purity of its volumes, clearly defined contours, and weightless forms. In 1573 he was back in Perugia, where he was appointed city architect and professor at the newly founded Accademia del Disegno. He published *Il primo libro del trattato delle perfette proporzioni*, which was dedicated to Grand Duke Cosimo, in 1567.　　FB

Summers, D., *The Sculpture of Vincenzo Danti* (1979).

DANUBE SCHOOL. Not a school or movement in the usual sense, the term is applied to a group of Austrian and German artists who early in the 16th century became fascinated by the scenery along the Danube. They employed *landscape, specifically dense forests and high hills, as an expressive component of their art. The best-known exponents of the school are Albrecht *Altdorfer, Jörg *Breu the elder, Lucas *Cranach the elder, and Wolf *Huber. Though most of their paintings include a narrative subject, we also find, for the first time, pure painted landscape (Altdorfer, *Danube Landscape*, c.1522–5; Munich, Alte Pin.). But even in the compositions with figures, it is nature, not man, which dominates. In their overwhelming commitment to nature, the Danube painters anticipated German *Romanticism of the 19th century.　　KLB

Die Kunst der Donauschule, exhib. cat. 1965 (Linz, Stift S. Florian und Schlossmus.).

DARET, JACQUES (c.1400×5–c.1468). Netherlandish painter, active in Tournai and Arras. He was registered as an apprentice of Robert *Campin in 1428, alongside Rogier van der *Weyden, and as a master of the painters' guild in 1431.

Daret designed a range of items for the abbey of S. Vaast in Arras and, between 1433 and 1435, he painted the wings of the abbey's prestigious carved altarpiece of *The Virgin*. Four panels survive, the *Visitation* and *Adoration of the Magi* (Berlin, Gemäldegal), *Presentation in the Temple* (Paris, Petit Palais), and *Nativity* (Madrid, Thyssen Mus.). These are characterized by large, static figures set against attractive, miniature-like landscapes (as in the *Visitation*), and cheerful, sometimes unusual facial types (e.g. the midwife in the *Nativity*).

Daret's panels display a debt to the works of the *Master of Flémalle, thereby supporting the latter's identification with Robert Campin. The *Presentation*, for instance, includes architecture and figures similar to those in Flémalle's *Marriage of the Virgin* (Madrid, Prado). The small *Virgin and Child in an Interior* (London, NG) once attributed to Campin is now thought to be a possible work by Daret. In his day he was an eminent member of Arras and Tournai's flourishing art industry. He is last recorded in Bruges in 1468 as one of the highest-paid artists working on the decorations for the wedding of Charles the Bold.　　MS

Châtelet, A., *Robert Campin: le maître de Flémalle: la fascination du quotidien* (1996).
Dijkstra, J., 'Jacques Daret', in R. van Schoute and B. de Patoul (eds.), *Les Primitifs flamands et leur temps* (1994).

DAUBIGNY, CHARLES-FRANÇOIS (1817–78). French landscape painter. He introduced a new kind of naturalistic *landscape, of rivers, beaches, and canals, which are distinguished by their simple compositions and clarity of atmospheric effect. Introduced to painting by his father Edmé-François, a painter of classical landscapes, in 1838 he joined the studio of *Delaroche, and exhibited at the *Paris Salons from 1848. In 1870–1 he visited Holland and England. His pictures show the valleys of the rivers Seine, Marne, and Oise in the Île de France. A pioneer of *plein air painting, he completed many of his smaller pictures on the spot. He observed the effects of light on water from a studio boat, which formed the subject of his etching *The Artist in his Floating Studio* (1861). His *River Scene with Ducks* (1859; London, NG) is a characteristic scene, low key, unassuming, the water delicately patterned with coloured reflections, and in the middle distance the artist's boat. He was admired by *Boudin and *Jongkind, and was an important influence on early *Impressionism.　　HL

Hellebranth, R., *Charles-François Daubigny* (1976).

DAUCHER FAMILY. Augsburg sculptors. **Adolf the elder** (c.1460–1523/4) was a joiner and possibly also a sculptor. After working in Ulm he moved to Augsburg, where he collaborated with Gregor *Erhart and Hans *Holbein the elder on the high altar (destr.) for the Cistercian monastery at Kaisheim (c.1498–1502). These three artists worked together again on the Frühmessaltar (destr.) in the Moritzkirche, Augsburg. Adolf the elder's children included **Adolf the younger** (c.1485–1557), who carved the choir stalls and pulpit (1550–1) in the minster in Schwäbisch-Gmünd, and **Hans** (c.1485–1538), the most famous of the family. He probably trained with his father, but from 1500 he resided with his uncle and main teacher Gregor Erhart. He may have travelled to Venice and northern Italy prior to 1514 when he became a master in Augsburg. From 1516 at the latest until 1522 he lived in his father's house and it is likely that the two shared a common workshop. In 1519–22 they collaborated on the high altar in the Annenkirche, Annaberg. In 1536 Hans moved to Stuttgart, where he entered the service of Ulrich, Duke of Württemberg. Most of his works are small limestone reliefs destined for collectors which combine late German Gothic trends with Italian architectural motifs (*Judgement of Paris*, 1522; Vienna, Kunsthist. Mus.).　　KLB

Smith, J. Chipps, *German Sculpture of the Later Renaissance* (1994).

DAUMIER, HONORÉ (1808–79). French *caricaturist, *lithographer, painter, and sculptor, who brought a new violence to the political cartoon, and, deeply committed to the realist demand for contemporaneity, captured many aspects of city life. In 1830 he began to contribute cartoons to the journal *Caricature*; in 1832 he was briefly imprisoned for depicting Louis-Philippe as Rabelais's *Gargantua*. His *lithographs of this time include the anti-heroic *La Rue Transnonain* (1834). On the suppression of political satire in 1835 he began to work for *Le Charivari* and turned to satire of social life, with such series as *Les Baigneuses* and *Les Bons Bourgeois*. At the time of the 1848 Revolution he returned to political satire, and created those greatest of political types, Robert Macaire and Ratapoil. After 1848 he also painted, choosing themes such as strolling players, laundresses, refugees, drab travellers in *The Third Class Carriage* (c.1856; New York, Met. Mus.), which, executed in subdued colours, document a bleak urban existence. His sculptures are mainly roughly modelled caricature heads in painted terracotta.　　HL

Adhémar, J., *Honoré Daumier* (1954).

DAVID, GERARD (c.1460–1523). Netherlandish painter, active in Bruges from 1484 where he was the main painter after the death of *Memling. Born in Oudewater in the north, he would have been familiar with Haarlem artists, and early works like his *Nativity* (New York, Met. Mus.) show their influence in the sturdy, homely figures and attention to landscape details.

His mature works combine features of his Bruges predecessors, van *Eyck's fascination with the detail of the visible world and Memling's refinement, with some compositional elements from Hugo van der *Goes. His figures are, however, solid and grave and, as in the *Virgin among Virgins* (Rouen, Mus. des Beaux-Arts), rhythmically arranged in clearly defined space. The *Virgin and Child with Saints and Donor* (London, NG) recalls van Eyck's *van der Paele Madonna*, meticulously detailed and brilliantly coloured, while its low viewpoint and anatomically observed figure group is more credible than Memling's idealized formality.

Although some late works show evidence of the collaboration of David's assistant Ambrosius *Benson, others, like the *Adoration of the Magi* (London, NG), feature attractive *sfumato* effects and subtle colouring. Drawings attributed to David display an even more sophisticated understanding of *Renaissance developments. David was much imitated, and his works copied and exported to Spain and Italy. MS

Ainsworth, M. W., 'Gerard David', in R. van Schoute and B. de Patoul (eds.), *Les Primitifs flamands et leurs temps* (1994).

Ainsworth, M. W., *Gerard David, Purity of Vision in an Age of Transition* (1998).

DAVID, JACQUES-LOUIS (1748–1825). French painter who was the leading artist of the *Neoclassical movement. He was the son of upwardly mobile Parisian bourgeois parents. When he was 9 his father was killed in a duel. The theme of loss and the search for a father figure are apparent in David's art and his career. On the advice of *Boucher, a distant relation, David went to train in the studio of *Vien, then at the forefront of the classicizing reaction to the *Rococo style of the Louis XV period. David's early paintings show a progression through the styles of Boucher, *Doyen, *Fragonard, and Vien in search of a mode of his own. In 1774 he won the coveted *Prix de Rome with the classical composition *The Illness of Antiochus* (Paris, École des Beaux-Arts). But this was his fourth attempt and his suspicion of a plot to deny him the prize that he believed to be his due made him intensely hostile to the powerful Académie Royale (see under PARIS).

David spent the years 1775–80 in Rome at the French Academy where Vien was newly appointed director. This was a period of intense psychological stress as he struggled to absorb a wide range of artistic influences, to develop a style of his own that would fulfil his ambition to be recognized as the leading modern painter in France, and to deal with what he felt to be the oppressive and authoritarian regime of the Academy. Classical sculpture and the different strands of painting represented by the work of *Raphael, the *Carracci, *Caravaggio, and *Poussin all influenced him at this time. The outstanding painting of this period is the *Baroque *S. Roch Interceding for the Plague-Stricken* (Marseille, Mus. des Beaux-Arts). But David must already have been planning the picture which won him election to the Académie Royale, and which when exhibited at the *Paris Salon of 1781 instantly secured him recognition as the most innovative painter in France. *Belisarius Receiving Alms* (Lille, Mus. des Beaux-Arts) is a subject from Roman history painted with all the gravitas of Poussin. Its uncompromisingly moral theme and its return to the Grand Manner of the 17th century not only made the art of Boucher look frivolous and escapist but also showed up the fashionable insubstantiality of Vien's brand of *Neoclassicism.

During the 1780s David achieved a series of brilliant *history pictures that are the high-water mark of Neoclassical painting. They have classical subjects of great moral seriousness and an austerity of style in which colour is subordinated to line and both to a rigorous clarity in the presentation of the picture's theme. *The Oath of the Horatii* (1784; Paris, Louvre), *The Death of Socrates* (1787; New York, Met. Mus.), and *Brutus and his Dead Sons* (1789; Paris, Louvre) gave expression to the new cult of the sterner civic virtues of stoical self-sacrifice, devotion to duty, honesty, and austerity which the later 18th century thought to find in ancient Rome. Rarely has the predominant philosophical and political spirit of an age been so perfectly and convincingly embodied in art. With these pictures David gained international recognition as the leader of the French school, and his studio became the training ground for painters from across Europe. Among his pupils were *Gérard, *Gros, *Girodet, and *Ingres. David's portraits at this time to some degree also reflect the preoccupations of his history paintings as he struggled to release the fashionable image from its Rococo past. His double *portrait of the aristocratic scientist and farmer-general Lavoisier and his wife at work among their laboratory equipment (1788; New York, Met. Mus.) is the culmination of this pre-revolutionary phase and is perhaps the quintessential portrait of the Enlightenment.

During the French Revolution David was a committed and increasingly radical republican, his fate entwined with the powerful personality of Robespierre. He became a deputy and voted for the death of Louis XVI. His seat on the Committee of Public Instruction not only gave him the leading role in designing and organizing the great revolutionary festivals and public funerals, but also allowed him to revenge himself on the Académie Royale by abolishing it. He made a series of increasingly extreme speeches in the Convention, made largely incomprehensible to his listeners by the benign mouth tumour that is apparent in his self-portraits, and was implicated in the excesses of the Terror. Despite his political activities David continued to paint. Many of his portraits from this period appear unfinished, and his scheme to commemorate the historic vow of the deputies of the Third Estate in a great painting of *The Oath of the Tennis Court* (1789) was overtaken by the pace of events and never got beyond preparatory sketches (Versailles; Cambridge, Mass., Fogg Art Mus.). His three paintings of republican martyrs, however, raised commemorative portraiture into the domain of universal tragedy. In particular that of *The Dead Marat in his Bath* (1793; Brussels, Mus. Royaux) was later praised by *Baudelaire as a secular *pietà* for the modern age.

With the fall of Robespierre and David's imprisonment (1794–5) his political career was at an end. Released on the plea of his wife, who had divorced him because of the extremism of his political views, he began work on *The Intervention of the Sabine Women* (1799; Paris, Louvre). At all levels a painting of reconciliation, it is also generally taken to represent the furthest point in the development of David's Neoclassicism. Despite its nude figures based on Greek statues, its frieze-like composition, and archaeological exactitude, it lacks the compelling vigour of his neo-Poussinist history paintings of the 1780s. Already others, including a group of David's own pupils known as 'les primitifs' as well as *Flaxman and *Carstens, were taking Neoclassicism to ever more 'purified' extremes. The real renewal in David's art came through his portraits and more particularly his modern history paintings. Among portraits of this period are the touchingly fresh and natural *Mme Sériziat and her Daughter* (1795; Paris, Louvre) and the subtle and intriguing *Mme Récamier* (begun 1800; Paris, Louvre). Under the consulate and empire of Bonaparte David was official painter, retaining much of the power and prestige he had enjoyed under the protection of Robespierre, though increasingly annoying the Emperor with his very high fees. In 1801 he painted the *equestrian portrait of *Napoleon Crossing the St Bernard Pass* (Château de Malmaison), depicting him 'calm on a fiery steed' (in fact Napoleon crossed the Alps into Italy on a mule). The huge *Coronation of Napoleon* (1807; Paris, Louvre) and *The Distribution of the Eagle Standards* (1810; Versailles) are among the best of the propaganda pictures designed to elevate the ceremonial events of the empire. The cold local colours and spare compositions of the heroic classical paintings gave way to crowded pageantry and rich colouring that are closely related to *Romantic painting.

David's classical subjects meanwhile tended evermore towards a ponderous archaeologism which sat uncomfortably with a growing realism. *Leonidas at Thermopylae*

(Paris, Louvre), painted in 1814 in the dying days of the Napoleonic adventure and appropriately defiant in subject, is an odd and unsatisfactory picture. This tendency was apparently exacerbated when David chose exile in Brussels after the Hundred Days rather than make his peace with the restored Bourbons. *Mars Disarmed by Venus* (Brussels, Mus. Royaux) was painted in 1824, and is thus contemporary with *Delacroix's Romantic masterpiece *The Massacres at Scio* (Paris, Louvre). It has frequently been seen as the decadent work of an exhausted artist without a style of old age such as *Rembrandt or Poussin had. In assessing David's late work critics have preferred to lay emphasis on the unflattering realism and psychological penetration of his portraits, among them the striking *Three Ladies of Ghent* (Paris, Louvre). Nevertheless, with the general reassessment of official painting in 19th-century France it is clear that David's late classical paintings inspired the neo-Hellenism of the mid-century, though whether this makes them any more admirable is open to doubt. The school that David founded continued to dominate painting in France well into the 19th century and was the benchmark against which such avant-garde artists as Delacroix, *Courbet, and *Manet defined their radicalism, though they reserved a degree of admiration for the work of David himself. MJ

Brookner, A., *Jacques-Louis David* (1980).
Johnson, D., *Jacques-Louis David: Art in Metamorphosis* (1993).
Lee, S., *David* (1999).
Schnapper, A., and Sérullaz, A., *Jacques-Louis David*, exhib. cat. 1989 (Paris, Louvre; and Versailles).

DAVID, PIERRE-JEAN (called David d'Angers) (1788–1856). The foremost French sculptor of the *Romantic movement. Born in Angers, he went to Paris in 1807 where he worked in the studio of Philippe-Laurent Roland and attracted the attention of the powerful Jacques-Louis *David. In 1811 he won the *Prix de Rome and spent the years to 1815 in Italy, where he was influenced by the neo-Greek style of *Thorvaldsen and had an unhappy affair with a daughter of the aristocratic Odescalchi family. In 1816 David was in London to see the newly displayed Elgin Marbles. Back in Paris he received official commissions for sculpture at the Louvre (1824) and the Arc de Triomphe du Carrousel (1827). He also began a series of commemorative public statues in bronze and marble that are to be seen in towns throughout France. David d'Angers is best known for two works: the set of more than 500 bronze medallion portraits of eminent contemporaries and the pedimental sculpture of the Pantheon, Paris, representing great French patriots (begun 1830). Despite their vastly different scale, both these works embody David's vigorous, dramatic, and naturalistic style together with his republican and meritocratic political principles. The latter led to his exile by Napoleon III in 1851–2, when he travelled to Greece to see his monument to Marco Botzaris, a martyr of the Greek War of Independence. David's published journals are filled with his homespun wisdom. The collection of his works founded in Angers in 1839 and now housed in the Abbaye Toussaint gives a comprehensive overview of his very prolific output. MJ

Bruel, A., *Les Carnets de David d'Angers* (1958).
Jouin, H., *David d'Angers* (1878).
Pingeot, A. (ed.), *La Sculpture française au XIXe siècle*, exhib. cat. 1986 (Paris, Grand Palais).

DAVIES, ARTHUR BOWEN (1862–1928). American painter. Born in Utica, NY, Davies studied at the Art Institute of Chicago and in New York. In 1893 he visited Europe where he admired the *Pre-Raphaelites, *Whistler, and *Puvis de Chavannes. Influenced by French *Symbolism, he developed a conservative and Romantic style, painting Arcadian landscapes populated by ethereal nude women and mythic animals, close in spirit to *Böcklin. Despite his recherché subject matter, *Unicorns* (1906; New York, Met. Mus.) being typical, Davies exhibited with the predominately realist *Eight in 1908 and in 1911 was the principal organizer of the *Armory Show for, despite his own work, he was an enthusiastic admirer of European *modernism. Much of the Armory Show's success was due to Davies's diplomacy, wide knowledge, influential connections, and catholic interests, although his own taste was reflected in the inclusion of 32 works by *Redon. Inspired by his own exhibition Davies dabbled with *Cubism in 1912–13 but *Intermezzo* (c.1913; New York, Graham Gal. in 1967) reveals only a superficial grasp of the style and by 1920 he had reverted to his familiar decorative manner. DER

Arthur Bowen Davies, exhib. cat. 1962 (Utica, NY, Munson-Williams-Proctor Inst.).

DAVIS, STUART (1892–1964). American painter. Born in Philadelphia, Davis moved to New York to study under Robert *Henri and was heavily influenced by the Ashcan School. In 1913 he was overwhelmed by the European *modernism exhibited at the *Armory Show and his style entered an eclectic, derivative phase, influenced by *Gauguin, *Matisse, and van *Gogh. In the 1920s he became interested in *Léger and synthetic *Cubism and his work evolved more formal clarity, a planar austerity, and acute abstraction: *Percolator* (1927; New York, Met. Mus.) He worked for the *Federal Art Project in the 1930s, but rejected the dogmatism of *social realism and vigorously defended a position which saw the modernist style as closely tied to society. During this period he came to be seen as America's premier modernist. His clear, ordered, and objective style led to his marginalization after *Abstract Expressionism rose to the fore, but his early interest in packaging, advertising, and signs gave him a new currency with the rise of *Pop in the 1960s. MF

Hills, S., *Stuart Davis* (1996).

DEARE, JOHN (1759–98). English sculptor. After training in London at the RA Schools he won a grant to study in Rome for three years, remaining there from 1785 for the rest of his short life. He worked in a severe *Neoclassical style, specializing in marble low reliefs with a linear quality reminiscent of the drawings and engravings of *Flaxman and *Fuseli. His relief *The Judgement of Jupiter* (1786; Los Angeles, County Mus.) has been described as one of the outstanding pieces of English Neoclassical sculpture. Deare is said to have died as the result of sleeping on a block of marble to gain inspiration. MJ

Gunnis, R., *Dictionary of British Sculptors 1660–1851* (rev. edn., 1968).
Smith, J. T., *Nollekens and his Times* (1828).

DEATH MASKS AND LIFE MASKS. These are made by applying to the face a soft material such as wax, plaster, or, in modern times, agar, a vegetable gelatine. This gradually hardens and when removed serves as a mould from which a cast can be taken in plaster, wax, or any other suitable medium. When a life mask is taken breathing tubes or straws must be inserted in the nostrils. The experience is uncomfortable and may even be hazardous; it is reported that Washington was nearly suffocated. Moreover, plaster generates heat as it dries. It is not always possible to distinguish life masks from death masks, because both kinds necessarily give an effect of lifelessness and alterations to the mould are sometimes made by hand, especially when it is desired to represent the eyes open.

When and why the first masks were made is uncertain. They were known to the ancient Egyptians as early as 2400 BC. They certainly played an important role in Etruscan and Roman ancestor worship and family cults. Wax masks were worn by Roman actors in funeral processions and were kept in a special shrine in Roman houses. We know little about their use in the Middle Ages but they certainly existed in 15th-century Florence. The church of SS Annunziata had a famous collection of them and although most are lost, the haunting death mask of Lorenzo il Magnifico has fortunately been preserved. Since then it has been quite a common practice to take death masks of the illustrious. The wax images of Queen Elizabeth I and other

sovereigns in the Westminster Abbey collection are all based on death masks. Napoleon's and *Goethe's features are known to us through masks, as are those of Keats, whose mask was taken during life by B. R. *Haydon. A curious variant is the plaster cast taken from the hands of musicians, artists, writers, and even statesmen. HO/MJ

DECADENCE is the idea that the cultural, political or moral achievement of a society is falling short of greater achievements in the past. The Decadents were a group of writers and artists in France in the second half of the 19th century.

The idea that current standards and achievement are falling short of an earlier heroic and golden age was widespread in Antiquity, though the word decadence did not appear until after the 15th century. The thought that civilizations (characteristically the Roman Empire) are subject to an inevitable life cycle of growth and decay was commonplace by the 18th century. Both these ideas were opposed by the belief in Progress which began in the 18th century and rapidly developed into a crude confidence in increasing productivity and materialistic bourgeois prosperity as the 19th century got under way.

In France the key figure in exploring the post-Romantic sensibility, in repudiation of the idea of Progress, was *Baudelaire, who was explicitly described as decadent by *Gautier in his preface to the 1868 edition of Les Fleurs du mal. The cult of the dandy, the pursuit of exquisite refinement for its own sake, and the fascination with outlandish sensation—especially languorous eroticism—were all part of Baudelaire's serious moral vision, and they remained constant themes of the Decadent movement when it became more or less overtly established, particularly by the journal Le Décadent (1886), and by Paul Bourget's Essais de psychologie contemporaine (1880–3).

The definitive literary statement of the Decadent position was in Huysmans's novel A rebours (1884), whose hero, des Esseintes, is a completely alienated nobleman whose admiration for Baudelaire is frequently emphasized. Des Esseintes's favourite painters are Odilon *Redon and Gustave *Moreau, and the book contains a long and steamy passage in which des Esseintes contemplates a Moreau watercolour of Salome with a vision of the head of John the Baptist. Moreau's paintings of this theme are, indeed, the classic images of the Decadent movement, and they bring out the extent to which it was permeated by hatred of women and the equation of sex and death. Hostility to women, verging on the pornographic, was a main feature of the work of *Rops, who was admired by

Huysmans for having celebrated the spirituality of lust. Indeed, the widespread pathological feelings about women in the 1880s and 1890s led to the proliferation of a veritable menagerie of man-threatening sphinxes, mermaids, medusas, vampires, snake-women, etc. by artists such as von *Stuck, *Burne-Jones, *Munch, *Khnopff, and *Toorop.

In France the Decadent movement was soon absorbed by *Symbolism but in England the world of Huysmans continued to exert a powerful fascination. Oscar *Wilde (who was furiously attacked for the 'decadence' of his personal life) wrote his own version of the Salome legend (in French) and The Picture of Dorian Gray is manifestly under the direct influence of A rebours. Wilde's Salome was illustrated by Aubrey *Beardsley, but his rigorous and ironic graphic art is a long way from Moreau's hothouse visions. AJL

Dijkstra, B., Idols of Perversity (1986).
Gilman, R., Decadence (1979).

DECALCOMANIA, a technique for producing pictures by transferring an image from one surface to another. It is thought to have been invented by the Spanish *Surrealist, Oscar *Dominguez, in Paris in about 1935, although the term had been applied in the 19th century to a similar idea used in ceramic design (the word comes from the French décalquer: to transfer+manie: mania, and in the 1860s there was indeed a craze for transferring pictures to glass, porcelain, etc.). In Domínguez's method, splashes of colour were laid with a broad brush on a sheet of paper. This was then covered with another sheet and rubbed gently so that the wet pigment flowed haphazardly from one surface to the other, typically producing effects resembling fantastic grottoes or jungles or underwater growths. The point of the process, which had the blessing of *Breton, was that the picture was made without any preconceived idea of its subject or form (sans objet préconçu). Several other Surrealists adopted it, most notably Max *Ernst, who sometimes began a picture by decalcomania and finished it by conventional means. See also AUTOMATISM. IC

DECAMPS, ALEXANDRE-GABRIEL (1803–60). French painter. Decamps was born in Paris and studied under minor artists 1816–20. He first showed at the Salon in 1827 and in the following year travelled in Asia Minor and North Africa, returning with sketches which he worked up in paintings like Turkish Patrol (c.1830; London, Wallace Coll.) and returned to throughout his career. These paintings, often small, are characterized by dry brush strokes, a warm earthy palette, and dramatic shadows. A notably eclectic painter, Decamps showed a number

of humorous *singeries in the 1830s, including The Monkey Painter (c.1833; Paris, Louvre) and Monkey Musicians (1839; Barnsley, Cooper AG), which combine close observation with sentimental anthropomorphism. In 1835 he visited Italy and on his return to France worked on a number of biblical subjects, setting his incidents in realistic Near Eastern landscapes, a useful legacy of his early travels. Decamps was prosperous, prolific, and greatly admired by his contemporaries. In 1855 he was one of three painters accorded a retrospective at the Exposition Universelle, Paris, the others being *Ingres and *Delacroix. DER

DE CHIRICO, GIORGIO (1888–1978). Originator of *Metaphysical painting. Born in Greece of Sicilian parents, he was trained in Athens, Florence, and Munich. In Germany he was particularly influenced by the paintings of *Böcklin, and the philosophy of Schopenhauer and Nietzsche. It was not until after his return to Italy in 1910 that he began to develop the unique imagery for which he is celebrated. On moving to Paris in 1911, he met the circle of *Picasso and *Apollinaire, who greatly admired his work. The paintings of this period are dominated by eerie cityscapes with unexpected perspectives, and a disconcerting combination of classical architecture, smoking chimneys, and other seemingly unrelated objects, ranging from ancient statues to mannequins and rubber gloves. De Chirico was attempting to reveal the reality behind everyday experience by ridding ordinary things of their usual associations and setting them in new and mysterious relations. He spent most of the First World War in Ferrara, producing some of his most enigmatic, dreamlike images, such as The Melancholy of Leavetaking (1916–17; London, Tate), and greatly influencing the work of *Carrà. In the post-war period he was lionized first by the *Valori plastici group in Rome, and then by the *Surrealists in Paris. During the 1920s his work was dominated by a kind of surreal classicism, as in the remarkable series depicting groups of gladiators in claustrophobic interiors. From the 1930s, however, his work lost much of its imaginative intensity, while preserving its technical virtuosity, based on a prolonged study of the great Italian masters. CJM

Giorgio de Chirico, exhib. cat. 1966 (New York, MoMa).

DÉCOLLAGE (French: unsticking), the opposite of collage. The term was coined by Raymond Hains (1926–) and Jacques de La Villeglé (1926–) in the early 1950s, to describe their technique of tearing down *posters to reveal the surface of the earlier posters beneath. HO

DECONSTRUCTION, a procedure of *poststructuralism, often used as a label for this trend in thinking. It is a method of textual analysis that works to establish the instability of textual meanings and, concomitantly, to show that there are no authoritative interpretations of texts. The method was founded by Jacques Derrida (1930–), who used it to mount a radically sceptical critique of the assumption, supposedly prevalent in Western culture, that meanings are fixed and determinate. In particular, deconstruction opposed *structuralist claims that discourse has underlying structures that furnish and support its meanings. In place of such a view, it invited both critic and reader to operate imaginatively, engaging in 'active interpretation' of a text regarded as a free-floating network of words. Puns and wordplay abounded in deconstruction and were used by its exponents to illustrate the drifting indeterminacies and transformations of meanings they take to be characteristic of discourse.

Derrida's own approach to the visual arts was circumspect: his *The Truth in Painting* (1978) deconstructs what *Cézanne wrote, rather than what he painted. Nonetheless his critical practice not only influenced much academic writing on art during the 1980s and 1990s, but also provided a model for *Conceptual artists like the 'Pictures' group in 1980s America. DC

Brunette, P., and Wills, D. (eds.), *Deconstruction and the Visual Arts* (1994).

DECORUM. The Latin word *decorum*, the equivalent of the Greek *prepon* or *harmotton*, expressed one of the most pervasive aesthetic concepts of late classical Antiquity, particularly in Roman poetics and theories of rhetoric. The notion combined the two requirements that the various elements of a work of art shall be congruent with each other and that there shall be congruence or 'appropriateness' between the work of art and those aspects of external reality which are reflected in it.

In the *Hippias major* *Plato exposed a paradox in the identification of beauty (*kalon*) with appropriateness or what is 'becoming' (the Greek word *prepon* carried both connotations). In general, however, he condemned incongruity of style, melody, or rhythm and demanded appropriateness of expression to subject and occasion. Suitability of style to subject and purpose was a primary requirement with *Aristotle and Isocrates. Aristotle's requirement (*Poetics*) that the qualities of characters in dramatic art should be appropriate to their class and situation became the basis in *Renaissance and *Neoclassical literary theory of the demand that characters should be 'true to type'. In *Cicero, *Horace,

and later Roman critics the principle of decorum became paramount. Cicero quotes with approval the actor Roscius that 'a sense of fitness, of what is becoming, is the main thing in art, and yet the only thing which could not be taught by art' (*De oratore* 1. 132). Although Horace does not use the word 'decorum' in his *Ars poetica*, the idea is a dominant principle throughout and he held that propriety or fitness was to be observed in a work as a whole and in its several parts; it applied to the form, the expression, and the characterization; it determined the choice of subject, the metre, the particular style or tone; while it also forbade the mixing of incongruous elements, the mingling of genres, the creation of characters that lacked verisimilitude, the improper use of the *deus ex machina*, and the like. In medieval theory the word *conveniens* was often used to express the same idea. During the Renaissance and still more in Neoclassical literary theory the demands of decorum were often applied so as to bolster a rigid and unimaginative insistence on the segregation of literary types with strict rules for each.

Although it was elaborated primarily in the field of literary theory, the idea of decorum also influenced theories of art and assumed considerable importance in the teachings of the 17th-century *academies. There it was essentially a social idea of what was 'fitting', for example, to a nobleman or a peasant, and a breach of decorum in a painting was thought by academic critics to endanger its status as art. While *Raphael and *Poussin appeared models of decorum, it was the main charge against naturalists such as *Caravaggio or *Rembrandt that they disregarded this rule by introducing low types into noble stories and neglected the conventions of costume, gesture, and setting which had come to be considered appropriate. The idea of decorum had its strongest hold on the traditions of portraiture of nobles and worthies. HO

Atkins, J. W. H., *Literary Criticism in Antiquity* (1934).

DÉCOUPAGE (French: cutting out), the technique of cutting shapes from paper and applying them to a surface to create an image. The finest examples of the technique are *Matisse's late gouaches découpées which include *L'Escargot* (1953; London, Tate). HO

DEGAS, HILAIRE-GERMAIN-EDGAR (1834–1917). French painter. Trained at the École des Beaux-Arts, *Paris, and by Louis Lamothe, a pupil of *Ingres, Degas had a thorough academic education as an artist, reinforced by the copies of old master works that he made during a period of study in Italy (1856–9) and in the Louvre. His first independent works were *history paintings.

Some of these revealed the impact of Ingres's linear style, as in *Sémiramis construisant Babylone* (c.1861; Paris, Mus. d'Orsay), but others, such as *La Fille de Jephté* (c.1860; Northampton, Mass., Smith College Mus. of Art), were evidently indebted to *Delacroix's dynamic compositions and use of colour. For the remainder of his career, Degas was to devote himself to the problem of reconciling line with colour, traditionally regarded as opposites in academic theory.

Alongside these ambitious projects, Degas painted many portraits, mainly of family or friends, and, early in the 1860s, he began also to paint modern life genre scenes—initially of racecourses, and then, later in the decade, of theatre and ballet scenes. In many of these, he made a novel and ambitious combination of *portraiture with *genre painting, by showing recognizable figures in their habitual surroundings of work or leisure, for instance the members of the orchestra in *L'Orchestre de l'Opéra* (c.1870; Paris, Mus. d'Orsay), or his friends the Valpinçon family in a carriage at a racecourse in *Aux courses en province* (1869; Boston, Mus. of Fine Arts). During the 1870s he developed this idea further, notably in *Portraits dans un bureau (Nouvelle-Orléans)* (1873; Pau, Mus. des Beaux-Arts), an elaborate interior of a cotton office, painted during a visit to his uncle's family in New Orleans. At the same time, he was becoming increasingly preoccupied with ballet subjects. Normally the dancers are shown rehearsing or at rest; sometimes the dancers are under the instruction of a recognizable male ballet master, but many pictures focus on the dancers alone, presented as anonymous members of the *corps de ballet*, harmoniously grouped as they practise a movement, or resting, stretching, or scratching themselves between exercises.

In his modern life subjects, Degas developed distinctive compositional techniques, viewing the scenes from unexpected angles and framing his compositions in unconventional ways, often cutting off figures and other forms at the margins of the picture. These devices owed something to the example of Japanese colour prints, but they were also grounded in close observation of the world around him; they were his means of suggesting the distinctive character of the visual experience of the modern world, the glimpses and passing images encountered in the city. Although their effect is informal and at first sight casual, these compositions were elaborately worked out in sequences of preparatory studies, both drawn and painted, and variations on the same figures recur, in different groupings, in many canvases. As Degas himself insisted, 'No art is less spontaneous than mine.'

Although this self-conscious artifice distinguishes his art from that of the *Impressionist landscape painters and their concern

with painting out of doors, Degas regularly exhibited in the Impressionist group exhibitions between 1874 and 1886. He had exhibited a few works at the *Paris Salon during the 1860s, but the relatively small paintings that he produced after 1870 would have stood little chance of attracting notice on the crowded walls of the Salon. Moreover, his concern with images of the modern world allied him closely with many other members of the Impressionist group during the 1870s.

From around 1880 onwards, he came to focus more closely on the figures in his compositions, playing down the settings and environments in which they are placed; at the same time, the interchange between his figures became less legible, as he focused more on the purely visual effects of interlocking forms and colours. Ballet dancers remained a central theme in his art, but he also produced a long sequence of images of the female nude; rejecting the conventional poses of the academic nude, he viewed the figure, he said, as 'a human creature preoccupied with herself . . . it is as if you looked through a keyhole'.

Throughout his career, Degas experimented with a great variety of techniques, and, from around 1880 onwards, increasingly explored the possibilities of pastel, although he continued to work in oil until the end of his career. In a sense, pastel allowed him finally to reconcile drawing with colour, by enabling him to draw in colour; the surfaces of his later pastels are built up by sequences of bold graphic marks, worked up into richly harmonized colour compositions. He also experimented with reproductive media, notably the *monotype, and from the late 1870s onwards he made a sequence of wax sculptures, of dancers, bathing women, and horses; the most celebrated of these, *Petite Danseuse de quatorze ans* (original wax Upperville, Va., Coll. of Mr and Mrs Paul Mellon; bronze casts in many museums), was exhibited at the 1881 Impressionist group exhibition dressed in a real tutu.

Failing eyesight in his last years restricted Degas's production and may have contributed to the broadening of his technique, but this had little impact on the overall development of his career; this was closely paralleled by other members of the Impressionist group such as *Monet and *Renoir, in its gradual shift from the explicit modernity of his scenes of the 1870s to the richer and more simplified colour effects of his later work.

JHo

DEINEKA, ALEKSANDR (1899–1969). Soviet painter and graphic artist. Deineka served with the Red Army and studied at Kharkov Art School 1915–17 and Vkhutemas (Higher Artistic and Technical Studios) 1921–5. In 1925 he was a founder member of OSt (Society of Easel Painters) which, not disdaining a figurative approach, sought to reconcile politically motivated modern subjects with contemporary styles. Early work such as *The Defence of Petrograd* (1927; Moscow, Tretyakov Gal.) presaged Deineka's flair for monumental propaganda combined with innovative formal aspects which adapted avant-garde tendencies to a more proletarian accessibility. Criticized during the 1930s for excessive formalism he adapted somewhat to achieve a more prosaic realism but retained a distinctive and dynamic personal style: *Air Ace Shot Down* (1943; St Petersburg, Russian State Mus.), showing the literal and symbolic fall of a Nazi pilot, remains one of the strangest and most idiosyncratic of Soviet images. He was a respected and honoured painter, becoming a People's Artist of the USSR in 1963, but avoided portraying Party officialdom. Favoured subjects were industrialization, collectivization, and stalwart images of healthy athleticism: *Freedom* (1944; St Petersburg, Russian State Mus.). A gifted graphic artist, he also designed architectural decorations for the Moscow metro.

DJ

Sysoev, V., *Aleksandr Deineka* (2 vols., 1989).

DE KOONING, WILLEM (1904–97). Dutch-born American painter. De Kooning was born in Rotterdam. He left school at 12 and was apprenticed to a house painter but attended evening classes until 1925 when he emigrated, illegally, to America. He worked as a decorator in New York for ten years while continuing to paint and established friendships with the painters Stuart *Davis and Arshile *Gorky. Through the latter, with whom he shared a studio in the late 1930s, he developed an interest in *Surrealism whose influence, together with that of *Picasso, may be seen in his paintings of the late 1930s and early 1940s. His first solo show, at the Charles Egan Gallery, New York, in 1948, established his reputation as an abstract painter but it was not until 1953, when he exhibited his first series of *Women*, that he came to fame. These pictures, of which *Woman I* (1950–2; New York, MoMA) is typical, are characterized by fragmented images, in which the figure and abstract background struggle for supremacy, painted with great gusto and, in common with *Abstract Expressionism, with equal emphasis given to the technique and the image. Their obvious figurative element seemed as shocking to his fellow artists, committed to abstraction, as the violence of the images seemed to the public. De Kooning, the only American artist of his generation to take the human figure as his central theme, continued to explore the subject throughout his career. From the late 1950s he painted landscapes on the coastline of the Hamptons to which he moved in 1963. Like the figurative paintings they are primarily abstract, catching the essence rather than the appearance of reality.

DER

Yard, S., *Willem de Kooning* (1995).

DELACROIX, FERDINAND-VICTOR-EUGÈNE (1798–1863). French painter. Although often described as the leader of the French *Romantic movement, Delacroix himself repudiated the label, and in the final reckoning his genius was too wide ranging and his attachment to the tradition of the old masters too strong for him to be so confined.

His elderly father Charles Delacroix had been foreign minister under the Directory, and it was rumoured that his much younger wife was the mistress of the statesman Talleyrand, who was thus Eugène's natural parent. Delacroix received an upper-class education at the Lycée Impériale in Paris, and for the first few years of his adult life enjoyed a private income, before the family fortunes were ruined by lawsuits over property. At the end of 1815 he entered the studio of the *Neoclassicist Pierre-Narcisse *Guérin, a pupil of *David. He followed the usual course of academic study, copying the *Antique and *Raphael. This is reflected in the conventional and immature style of his first two commissioned works, both altarpieces for provincial churches. But he drew greater inspiration from studying the old masters in the Louvre, in particular such colourists as *Rubens and *Veronese. While with Guérin Delacroix met *Bonington and *Géricault. The former introduced him to English art and to watercolour technique. The latter dazzled him not only with his unconventional paintings (Delacroix posed for one of the dying figures in *The Raft of the Medusa*), but also with his dandified dress and dashing lifestyle.

At the 1822 *Paris Salon Delacroix exhibited his first major painting in the Romantic vein. *Dante and Virgil in the Infernal Regions* (Paris, Louvre) was praised by *Gros and by the future prime minister Thiers, then a liberal art critic. It was harshly attacked by conservative supporters of the school of *David, but nevertheless bought for the state. In his next important painting *The Massacres at Scio* (1824; Paris, Louvre) Delacroix took a topical contemporary subject, albeit an exotic one, from the Greek War of Independence. He also partially abandoned the conventional tonal modelling and sombre palette of *Dante and Virgil* and began to replace them with broadly applied areas of strong colour: it is said that he repainted parts of the canvas after seeing *Constable's *The Haywain* on show in a Paris dealer's shop before it went on display at the Salon.

Delacroix's enthusiasm for English painting took him to London in 1825, where he admired the work of *Gainsborough,

*Lawrence, *Wilkie, and *Etty. The English influence is apparent in such works as the jewel-like historical scene *The Execution of Doge Marino Faliero* (1827; London, Wallace Coll.), which was inspired by Bonington, and in the full-length portrait of *Baron Schwiter* (1826; London, NG), in the manner of Lawrence. This first and most Romantic phase of Delacroix's career culminated in the vast and sanguinary *The Death of Sardanapalus* (1827; Paris, Louvre), the 'extremism' of which earned him a rebuke from the minister for fine arts, and *Liberty Leading the People* (1831; Paris, Louvre), which has since become one of the icons of French republicanism.

In 1832 Delacroix visited Morocco in the entourage of the Comte de Mornay. Among the Arabs and Jews of North Africa he thought he had discovered the living grace and dignity of Antiquity, far from the dust of the academy and the inhibitions of modern Europe. Not only did Delacroix store up in his sketchbooks a fund of exotic subjects to last throughout his life (*Women of Algiers in their Harem*, 1834; Paris, Louvre; *The Jewish Wedding*, 1841; Paris, Louvre), but under the effect of the African light his style and technique underwent a change. In place of luminous glazes and contrasted values he began to use a personal technique of vibrating adjacent tones and *Divisionist techniques. Breaking almost completely with the methods of both the Davidian School (as exemplified in the polished canvases of his arch-rival *Ingres) and his Romantic contemporaries, he gave his surfaces a worked and impasted quality that put the brushwork to expressive use instead of concealing it. He made colour enter into the construction of the picture to an unprecedented extent. His fresh mastery of colour was studied and admired by artists as different as *Renoir and *Seurat, and his understanding of the symbolic and evocative power of colour inspired van *Gogh. He is often regarded as the greatest colourist among all French painters.

After his travels of 1832 Delacroix continued to paint very large pictures for public exhibition, among the best of them *The Crusaders Taking Constantinople* (1841; Paris, Louvre). He also went on with the small cabinet paintings on literary, devotional, and semi-erotic themes that he sold to the art trade and private collectors. And his series of *lithographs illustrating *Faust* (1828) was succeeded by a *Hamlet* suite (1843). But much of his energy for the rest of his career was taken up with monumental mural schemes for public buildings. Among them his decorations in Paris for the libraries of the Palais Bourbon (1838–47) and the Palais du Luxembourg (1841–6) are without doubt the best of their kind painted in the 19th century. Their ambition and achievement have been compared with the murals of his heroes among the old masters—Rubens, *Tintoretto, and Veronese. His late murals in S. Sulpice, Paris—*Jacob Wrestling with the Angel* and *Heliodorus Expelled from the Temple* (1853–61)—are among the maturest expressions of his decorative richness of colour and grandiose sense of structure. They are also a reminder that without being an orthodox religious artist Delacroix painted throughout his career devotional pictures infused with a genuine power to move the onlooker. *Baudelaire said of him that he was the only artist who 'in our faithless generation conceived religious pictures' and van Gogh wrote: 'Only Rembrandt and Delacroix could paint the face of Christ.'

By the time of the 1855 Exposition Universelle in Paris Delacroix's reputation at the pinnacle of French art had been secure for more than a decade. A room was devoted by the state to a retrospective of his work, as it was to that of Ingres. Nevertheless, some shadow of the establishment hostility he had encountered early in his career is apparent from the fact that it was only in 1857 that he was elected to the Institut de France, on his eighth application, a situation he records with ironic detachment in his *Journals*. These are among the most compelling autobiographical writings ever. Begun in 1822, discontinued between 1824 and 1847, but then written regularly until a few weeks before his death, they give us the thoughts of one of the most passionate and cultivated men of the 19th century on art, literature, society, politics, sex, and the human condition.

Delacroix was in many respects a *Romantic by temperament and in his choice of subjects from poets such as Shakespeare, Goethe, Dante, and Byron, or from the modern Orient. He shared with his Romantic contemporaries a hostility to the academicism of David's followers, their conventional choice of classical subject matter and arid technique. Yet he denied he was a revolutionary, hated the posturing of the generation of 1830, and constantly looked to the tradition of the old masters. His *Baroque energy of conception was always tempered with a classical appreciation of simplicity and grandeur. As a man of strong intellectual powers, many of his most powerful effects were carefully thought through. With his impeccable good manners and elegant dress he was as much at home in the political and cultural drawing rooms of his day as he was in the studio. Baudelaire, on whose deportment and aesthetic ideas Delacroix had a profound effect, perhaps summed up the contradictions better than anyone when he described him as 'a volcano hidden in a bunch of violets'. MJ

Johnson, L., *The Paintings of Eugène Delacroix: A Critical Catalogue* (6 vols., 1981–9).

Rossi Bortolatto, L., *L'opera pittorica completa di Delacroix* (1972).

Trapp, F. A., *The Attainment of Delacroix* (1972).

The Journal of Eugène Delacroix, ed. H. Wellington (3rd edn., 1995).

DELAROCHE, PAUL (1797–1856). French painter. Although late in his career he achieved some renown as a painter of religious scenes and portraits, Delaroche's greatest successes came as a *history painter. Born into the generation that saw in the rivalry between *Delacroix and *Ingres the stylistic conflict between *Romanticism and Davidian *classicism, Delaroche chose the middle path. Using the subjects from medieval and 16th- and 17th-century history that appealed to the Romantics, his carefully researched costumes, accessories, and settings, as well as the clear contours and highly finished surfaces of his pictures, allied him to the followers of *David. He scored his first notable success at the 1828 Salon with *The Death of Elizabeth I* (Paris, Louvre). This began a series of scenes from French and English history, of which the most acclaimed in its day, and the most lastingly famous, is *The Execution of Lady Jane Grey* (1834; London, NG). This vast work has the mesmerizing qualities of a *tableau vivant*. Delaroche's *Artists of All the Ages*, which decorates the hemicycle at the École des Beaux-Arts in Paris, occupied him from 1837 until 1841. Its recreation of the appearance of more than 70 painters, sculptors, and architects from Antiquity to the 18th century is a fine statement of mainstream 19th-century academic taste, both it its selection of the 'elect' and in its meticulous execution. MJ

Bann, S., *Paul Delaroche: History Painted* (1997).
Delaborde, H., *Œuvre de Paul Delaroche* (1858).
Ziff, N. D., *Paul Delaroche: A Study in French Nineteenth-Century History Painting* (1977).

DELAUNAY, HUSBAND AND WIFE. Painters. **Robert** (1885–1941) was a student of theatre design in Paris before taking up painting c.1904. His experiments with the intrinsic qualities of colour, begun c.1906, place him among the earliest of abstract artists. Stimulated by *Pointillist techniques, Robert Delaunay became interested in how large areas of colour interacted, and especially in the sense of movement induced by the shimmering effects of simultaneous contrasts. Although he denied working scientifically, his paintings are based on a subtle combination of his knowledge of colour theory and upon instinct. In 1912, at the Salon des Indépendants (see under PARIS), he exhibited a major work *City of Paris* (1910–12; Paris, Centre Georges Pompidou), an allegorical painting incorporating fragmented views of Paris. *Apollinaire considered it the most important picture in the exhibition for the way in which Delaunay had partly applied *Cubist principles, but given priority to colour over form, a significant Cubist development which Apollinaire named *Orphism (see also SECTION D'OR). He developed this in a

series entitled *Windows* (1912–14), which was first exhibited in Germany, where it had considerable impact on the *Blaue Reiter group. Even more radical in 1913 was the series *Circular Forms*, which, although still expressive of subject, were almost purely concerned with colour movement. The years 1910–13 were Delaunay's most significant; thereafter, he wavered between abstraction and representation, sometimes reverting to earlier themes and styles as in his *Rythym* paintings of the 1930s. The coloured reliefs made with his wife, for the Paris International Exhibition, 1937, represented one of their largest commissions. **Sonia** (née Terk) (1885–1979) was born in the Ukraine but from 1905 lived mostly in Paris as a painter and designer. Through *Fauvism, she became interested in the powerful effect of brilliant colour contrasts, which, it is thought, may have significantly influenced Robert Delaunay, whom she married in 1910. She played an important part in developing Orphism and applied its colour principles to various activities like textile, ceramic, and theatrical costume design. She lived with her husband in Spain and Portugal 1914–21. Following Robert's death, she worked with *Arp and Sophie Taeuber, and with Alberto Magnelli (1888–1971), and from 1940 produced some of her finest colour experiments. There were retrospective exhibitions of her work in Paris (1967) and Lisbon (1972), and when, in 1964, her large gift of works by Robert and herself to the Musée National d'Art Moderne, Paris, was shown at the Louvre, she became the first woman to exhibit there in her lifetime.

YJ

Robert Delaunay, exhib. cat. 1976 (Paris, Mus. Orangerie).
Sonia Delaunay: A Retrospective, exhib. cat. 1980 (Buffalo, Albright-Knox Gal.).

DELFT SCHOOL. See DUTCH ART.

DELOS. Considered the centre of the Cyclades in Antiquity, Delos became the principal cult centre of Ionian Greeks from the 8th century BC. The birthplace of Artemis and Apollo, its importance as a locus of cult resulted in alternating periods of building/dedication and purification by removal of burials to nearby Rheneia. Control passed to Athens in the 5th century BC; a century and a half interlude of independence ended in 166 BC when Rome handed control to Athens anew. Affluence associated with its function as a trade centre resulted in devastating sacks (88 and 69 BC), from which the island never recovered.

In the *Archaic and *Classical periods, the mass of material from the site takes the form of dedications to the gods of the sanctuary. The *Nicander Kore* (640–630 BC; Athens, Nat. Arch. Mus.), the earliest preserved marble statue from Greece, was a dedication in the

Archaic sanctuary of Artemis; an inscription on the side of the statue records the dedication and Nicander's lineage. A colossal fragmentary Apollo from the sanctuary of Apollo dates to the next century (580–570 BC; Delos Mus.).

In the *Hellenistic period, the small population of Delians (c.3,000–4,000) orchestrated an important centre of trade and commerce, with Italian bankers and merchants predominating. Some of our best evidence for Hellenistic domestic decoration comes from Delos. Mosaics included copies of well-known originals (e.g. the *Doves* of Sosius). Wall painting prefigured first-style *Pompeian wall painting, with moulded stucco and plaster painted in imitation of coloured marbles. Statuary within the house was largely restricted to small-scale pieces, although a life-size marble copy of the *Diadoumenus* of *Polyclitus was found in the house of the same name (Athens, Nat. Arch. Mus.). Marble portrait statues, with body types modelled on Greek prototypes, are well represented. Most interesting are a group in 'veristic' style (see ROMAN ART, ANCIENT: SCULPTURE), found in the Agora of the Italians and at least one house associated with an Italian trader (Delos Mus.), fuelling scholarly dispute over the origins of this style.

L-AT

Bruneau, P., and Ducat, J., *Guide de Délos* (1983).
Stewart, A., *Attika: Studies in Athenian Sculpture of the Hellenistic Age* (1979).

DELPHI became one of the major international sanctuaries of the Greek world, based on the oracular cult of Apollo (together with a lesser one of Athena). Set on the lower slopes of Mt. Parnasus at the copious water source of Castalia, the sanctuary's origins probably lie in the 10th century BC. By the 7th century the oracle was already attracting non-Greek potentates. In the 6th, the Pythian games were established as a Panhellenic festival. The size of Apollo's sanctuary expanded, to become a walled area of c.125×180 m (410×590 ft). Control of the sanctuary was disputed on several occasions, demonstrating its symbolic worth to the Greek cities. It could be said to have had a long decline from the 3rd century BC, as the oracle's popularity waned and many other games were established.

The site is architecturally important for buildings of the Archaic and Classical periods, and it bulks large in our corpus of Archaic architectural sculpture, for the most part of imported stone. Cities built their own 'treasuries', small temples architecturally speaking, with lavish adornment. We have much of the frieze of the treasury of the Siphnians of c.525, as well as one of the caryatid figures supporting the porch; other buildings so decorated are extremely scrappily preserved. The author of the 2nd century AD, *Pausanias, described what he still saw,

including details of famous paintings of c.460 BC by Polygnotus of Thasos in a 'rest-house', now merely foundations; his account is fundamental in the study of Classical Greek painting (see GREEK ART, ANCIENT). He also saw many statues, very few of which survive, including what was for long our only early Classical life-size bronze, the *Charioteer*; its full group has to be reconstructed with the help of a single block of the base. Similar painstaking work has helped recreate the forest of such dedications that once existed, including some giant works of the 6th and 5th centuries BC.

AWJ

Boardman, J., *Greek Sculpture: The Archaic Period* (1978).
Bommelaer, J.-F., and Laroche, D., *Guide de Delphes: le site* (1991).
Guide de Delphes: le musée (1991).

DELVAUX, PAUL (1897–1994). Belgian painter, associated with *Surrealism. Although his early work was in an *Expressionist or *Neo-Impressionist style, from the mid-1930s his work was heavily influenced by the dreamlike images of *Magritte and *de Chirico. Many of his paintings depict idealized women, nude or clothed, in front of an incongruous architectural background. The hallucinatory quality of the scene is enhanced by the precise, almost photographic technique. Despite his lack of interest in revolutionary politics, he was acknowledged by the Surrealists as one of the leading exponents of their movement. In the post-war period, as well as continuing to paint in oil, he created a number of murals (e.g. in the Casino at Ostend, 1952). His long career culminated in 1982 with the opening of a museum of his work at S. Idesbald.

CJM

Rombout, M., *Paul Delvaux* (1991).

DEMUTH, CHARLES (1883–1935). American painter. Demuth studied at the Pennsylvania Academy of Fine Arts, Philadelphia. In 1907–8 he was in Europe and spent 1912–14 in Paris. Although aware of contemporary European movements Demuth's early work is traditional. He illustrated fiction, including Poe, from 1915 and painted vaudeville and circus subjects in watercolour: *Acrobats* (1919; New York, MoMA). In 1917 he holidayed in Bermuda with the *Cubist, Marsden Hartley (1877–1943), and over the next decade developed a precisionist style and iconography. He took industry and architecture as his subjects and, encouraged by *Duchamp, embraced technology. *Machinery* (1920; New York, Met. Mus.) is typically precisionist, spare, elegant, and objective. Industrial buildings with their essentially geometric shapes responded well to simplification into cubes, planes, and cylinders and the *Futurist 'lines of force' which Demuth incorporated into works like *My*

Egypt (1927; New York, Whitney Mus.), a delicate symmetrical study of grain elevators. In the late 1920s he created 'poster portraits' synthesizing words, numbers, and objects associated with the subject. *I saw the figure five in gold* (1928; New York, Met. Mus.), an evocation of the poet William Carlos Williams, is the best known. DER

Farnham, E., *Charles Demuth* (1971).

DENDROCHRONOLOGY. The fundamental principle of dendrochronology is that each year trees grow by the addition of a concentric ring between the bark and the sapwood, which can be measured by comparison with trees grown in a similar locality and climatic condition.

To provide the chronological framework, or the master curve, as it is sometimes called, one must begin with living trees. Their ring patterns are compared with those of felled trees or with the wood from buildings whose ring patterns overlap the living tree. The testing of works of art in or on wood can only be carried out if there is a master chronology for the type of wood used, and if at least 100 rings exist in the sample to be tested. The existence of the bark also allows a precise dating to the year of felling. Since wood is seasoned before use, the time between felling and working must be added in order to arrive at a probable dating for the object. AB

Kuniholm, Peter I., 'Dendrochronology', *American Journal of Archaeology*, 99 (1995).

DENIS, MAURICE (1870–1943). French painter and writer on art theory. He was a founder member of the *Nabis in 1888 and in 1890 he published his 'Definition of Neo-Traditionism', opposing contemporary illusionistic naturalism and arguing that *Gauguin (along with *Puvis de Chavannes and *Anquetin) represented the true, decorative, tradition of painting. This contains the famous formula 'remember that a picture—before being a war-horse or a nude or a genre scene—is primarily a flat surface covered with colours arranged in a certain order'. His early work (*Avril 1892*; Otterlo, Kröller-Müller) is characterized by large areas of non-naturalistic colour and a cultivated air of mystery, and he was also influenced by Japanese prints. However, by 1899, following visits to Italy, he was advocating and painting in a monumental classicizing style, as in *Bathers* (1899; Paris, Petit Palais). He was a fervent, reactionary, anti-Dreyfusard Catholic, and the religious dimension of his work became increasingly dominant. In 1910 he founded the Ateliers d'Art Sacré, dedicated to the revival of Christian art. His articles were collected in *Théories* (1912) and *Nouvelles Théories* (1922). AJL

Bouillon, J. P., *Maurice Denis* (1993).

DE NITTIS, GIUSEPPE (1846–84). Italian painter, whose naturalistic *plein air* style can be compared with French *Impressionism. Born in Barletta, in 1860 he moved to Naples, where he soon achieved considerable fame. His subdued, unidealized landscapes, characterized by subtle light effects, were profoundly influential on the *Macchiaioli in Florence. In 1868 he decided to move to Paris, where at first he produced historical genre scenes. However, he also continued to practise landscape painting, adopting a bright palette similar to that of the Impressionists, while his unconventional, asymmetrical compositions were influenced by both photography and Japanese prints. De Nittis was also celebrated for his animated scenes of urban life, both in Paris and London, which he regularly visited. Despite their innovations, de Nittis's oil paintings were perhaps less adventurous than those of the Impressionists. However, his pastels, such as the triptych *Races at Auteuil* (1881; Rome, Gal. Nazionale d'Arte Moderna), are among the boldest and most luminous examples of this genre. CJM

Dini, P., and Marini, G. L., *Giuseppe de Nittis: la vita, i documenti, le opere dipinte* (2 vols., 1990).

DENNISTOUN, JAMES (1803–55). Scottish antiquarian of Jacobite sympathies, and best known as author of a seminal book *Memoirs of the Dukes of Urbino* (1851). Dennistoun's decision to write a book on the dukes of Urbino and Federigo da Montefeltro's patronage of the Umbrian artists who had preceded *Raphael of Urbino was inspired by his encounters c.1838 with the German *Nazarene circle in Rome, particularly *Overbeck; and by J. D. Passavant's *Rafael von Urbino*, a monograph which combined Nazarene aesthetic sensibility with an academic reliance on original documentation and objective *connoisseurship. *Eastlake, reviewing Passavant in the *Quarterly Review* (June 1840), had observed that 'we find treated here with the attention it deserves for the first time . . . the importance of Urbino both in a political and social point of view at the period when Raphael began his career'; and this prompted Dennistoun to attempt a book on the princely house of Urbino which would blend 'into one continuous narrative the incidents of war and politics, the development of letters and arts, with their influence on civilisation and national character'. This involved a substantial excursus into the development of Umbrian art before the time of Raphael in which Dennistoun reflects the further influence of *Rio's *De la poésie chrétienne* and his concept of the *école mystique*. Dennistoun endorses the ideal of Christian art and suggests that 'in the mountains of Umbria that mystic school long maintained its chief seat; because there its types sank deepest into the

popular mind; and because it reached its culminating point of perfection and glory in Raffaelle of Urbino'. He goes on to trace an artistic chain of influence from Oderisio da Gubbio (d. 1299) to Giovanni *Santi and *Raphael via Benedetto Bonfigli, *Perugino, and others. He also embraces artists originating from outside the duchy, but who were invited to work at Urbino by Federigo da Montefeltro who built the ducal palace, especially *Gentile da Fabriano and *Piero della Francesca whose commissions included the *Flagellation* (Urbino, Palazzo Ducale), the S. Bernardino altar (Milan, Brera) and the double portrait of *Battista Sforza* and *Federico da Montefeltro* (Florence, Uffizi). Although Dennistoun's concept of an Umbrian school of painting that could draw strength from patronage in Urbino was flawed, his book played its part in propagating a taste for early Italian art in Britain. And while he regarded later artistic patronage in Urbino, under the della Rovere dukes, as a period of decline that embraced artists from *Titian to *Barocci, his friend and Scottish contemporary Sir William *Stirling, in an influential review (*Fraser's Magazine*, June 1855), singled out the last duke of Urbino, Francesco Maria II, as the most admirable of all. 'He had fought at Lepanto a greater battle than had fallen within the military experience of Duke Federigo; he was as good a scholar as Guidobaldo I; and in his stud and forests, his palaces, villas, theatres, his galleries, his libraries, and his patronage of arts and learning, emulated the tastes, enriched the collections and surpassed the magnificence of all his predecessors.'

Dennistoun's other major work concerned the Jacobite circle in 18th-century Rome: *Memoirs of Sir Robert Strange and Andrew Lumisden* (1855) based on archival material inherited from his wife's great-uncle.

His collection, mainly of early Italian art, was sold at Christie's, London, in June 1855. His most important acquisition, the illuminated Ghislieri Book of Hours (c.1492–1505), had been disposed of privately some years earlier and is now in the British Library, London. HB

Brigstocke, H., in *Connoisseur* (Oct., Dec. 1973; Aug. 1978).
Dennistoun, J., *Memoirs of the Dukes of Urbino: Illustrating the Arms, Arts and Literature of Italy from 1440 to 1630* (new edn., ed. E. Hutton, 1908).

DERAIN, ANDRÉ (1880–1954). French painter. Born near Paris, Derain first studied engineering before becoming a painter. By 1905 he was exhibiting alongside his friends *Matisse and *Vlaminck at the seminal *Fauvist Salon of that year. *Boats in Collioure* (1905; Stuttgart, Staatsgal.) is characteristic of his Fauvist work in its separate marks of pure colour. However, his passion for the compositions of *Cézanne and the

tonality and subjects of France's old masters led him away from the movement; he also remained isolated from the *Cubists, despite being close to *Picasso and *Braque and sharing their enthusiasm for primitive sculpture. Derain's growing commitment to figurative painting, historical styles, and classical subjects made him a prominent representative of the conservative 'call to order' in the 1920s and he was critically acclaimed for the 'Frenchness' of his work. Classical and religious preoccupations continued to dominate his monumental late work. MF

Lee, J., *Derain* (1990).

DERUET, CLAUDE (c.1588–1660). Court painter to the Duke of Lorraine at *Nancy, Deruet ran a busy workshop, producing theatrical designs, religious works, mythological pictures, portraits, and many small pictures on copper, ivory, panel, canvas, and glass. After training with *Bellange, he spent about ten years in Italy, where he painted an *Assumption* in a small chapel in the Villa Borghese, Rome, returning to Nancy by 1619. Most of his output has been lost, but his series of four paintings *The Amazons* (Strasbourg, Mus. des Beaux-Arts) are influenced by the prints of *Tempesta. Spirited, elegant, rich in learned detail, and set in artificial landscapes, they are characteristic of his courtly, late *Mannerist art. He was more active in Paris from the 1640s, and his most celebrated works are *The Four Elements* (1641–2; Orléans, Mus. des Beaux-Arts) painted for Cardinal Richelieu. HL

Century of Splendour, exhib. cat. 1993 (Montreal, Mus. of Fine Arts).

DESCO DA PARTO, used in medieval and early *Renaissance times as a tray to bring mothers who had given birth gifts, sweets, and refreshments. These generally round or twelve-sided trays were decorated on front and back with a variety of subjects such as scenes of a mother with her newborn in bed, familial arms, and subjects from Greek and Roman mythology. An early trecento example is in the Metropolitan Museum, New York. MLS

Carli, C. de, *Desco da parto* (1998).

DESHAYS, JEAN-BAPTISTE (1729–65). French painter. In his short lifetime he became the most celebrated painter of large-scale religious and mythological scenes in mid-18th-century France, hailed by *Diderot as 'the first painter of the nation'. He trained with *Boucher (who became his father-in-law) and with Carle van *Loo before going to the French Academy in Rome. During his time there (1754–58) he was greatly influenced by the 'Grand Manner' of *Raphael and the Bolognese painters of the 17th century. Such altarpieces as *The Flagellation of S.

Andrew (Rouen, Mus. des Beaux-Arts), shown at the 1761 Salon, are magnificent within the terms of their genre even if not very appealing to modern taste. They exerted a considerable influence on *David's early history paintings. Deshays also occasionally painted pastoral scenes in the manner of the Genoese painter *Castiglione. MJ

Sandoz, M., *Jean-Baptiste Deshays* (1977).

DESIDERIO DA SETTIGNANO (1429×32–64). Florentine sculptor, who enjoyed considerable fame during his lifetime, but whose complete œuvre is now difficult to establish clearly. From *Donatello he appears to have learned the low-relief technique which characterizes some of his most luminous works, such as the *S. Jerome before a Crucifix* (c.1450–60; Washington, NG) and the *Panchiatichi Madonna* (c.1461–4; Florence, Bargello). One of his most important documented works is the Marsuppini tomb in S. Croce (after 1453–60), which, though dependent in conception on Bernardo *Rossellino's Bruni tomb in the same church, employs less austere, exquisitely carved decorative detail. His tabernacle of the Sacrament for S. Lorenzo (1461) established a prototype for tabernacle design with its illusionistic space, its attendant candle-bearing angels and putti, and the Christ child over the pediment. AB

Cardellini, I., *Desiderio da Settignano* (1962).
Pope-Hennessy, J., *Italian Renaissance Sculpture* (4th edn., 1996).

DESIGN (Italian *disegno*). In Italian when a systematic terminology of art was being worked out *disegno* had a wider and a narrower connotation, as has 'design' today, although the emphasis has shifted. Its primary sense was drawing, as, for example, when the *Renaissance theorist Franceso Lancillotti in his *Trattato di pittura* (1509) distinguished *disegno, colorito, compositione,* and *inventione* as the four elements of painting. So too *Cennini made *disegno* and colouring (*il colorire*) the bases of painting and *Vasari set design over against invention as the father and mother of all the arts. In its wider meaning *disegno* came to imply the creative idea in the mind of the artist (as this was often thought to be bodied forth in the preliminary drawing). Thus *Baldinucci defines it as a visible demonstration by means of lines of those things which man has first conceived in his mind and pictured in the imagination, and which the practised hand can make appear.

A certain mystique attached to the word as a result of analogies often drawn between the creative activity of the artist and the creation of the world by the deity or by a Platonic (see PLATO) demiurge in accordance with Ideas or prototypes. In this context of ideas it was the power to design which was

held to distinguish the artist from the craftsman. In the late 16th and 17th centuries Platonists such as *Lomazzo, F. *Zuccaro, and *Bellori tended to identify *disegno* with the idea. In his *L'idea de' pittori, scultori e architetti* (1607) Zuccaro distinguished what he called *disegno interno* or 'idea' from *disegno esterno*, the execution of the idea in paint, stone, wood, or other material. The Aristotelians by contrast taught that understanding of the scheme of things comes empirically by noticing what particular individuals have in common and therefore insisted that 'design' must be based on a careful observation of nature—what de *Piles in his *Cours de peinture par principes* (1708) calls 'la circonscription des objets'.

In modern usage design in its widest sense denotes the planning of any artefact whether for use or for show, and is often used in relation to certain branches of industrial production. In relation to the fine arts design is no longer used primarily of drawing but in a sense closer to what was formerly meant by composition. Courses in basic design came into vogue in the art schools around the middle of the 20th century with instruction in the elements of artistic expression and the objective principles of their combination and manipulation. Design is therefore a concept very close to the principle of construction in any work of art. HO

DESPORTES, ALEXANDRE-FRANÇOIS (1661–1740). French painter of animals. He studied in Paris with a pupil of *Snyders, and though he spent the years 1695–6 at the court of Poland as a portrait painter, for most of his career he continued the Flemish realist tradition of hunting scenes and dead game. He worked first for Louis XIV and was later appointed portrait painter to the royal hunt by Louis XV. Something of the aura of success that surrounded his career can be judged from his magnificent *Self-Portrait as a Huntsman* (Paris, Louvre), painted in 1699. He was almost unique in his time for painting a series of *plein air* landscape studies of the countryside around Paris to be used as material for the backgrounds to his more formal pictures. Some of these may be seen in the museum at the Manufacture Nationale at Sèvres, while some of his best sporting pictures are in the Musée de la Chasse, Paris. MJ

Faré, M., and Faré, F., *La Vie silencieuse en France: la nature morte au XVIIIe siècle* (1976).
L'Atelier de Desportes à la manufacture de Sèvres, exhib. cat. 1982 (Paris, Louvre).

DEUTSCH (or Alleman), NIKLAUS MANUEL, THE ELDER (1484?–1530). Swiss painter, draughtsman, designer, writer,

179

and politician. His early pen and wash designs indicate that he may have received his artistic training in a glass painter's workshop, although it is thought that he was self-taught as a painter. His paintings show that he was familiar with the work of Hans Fries and the woodcuts of *Dürer and his early drawings reveal the influence of Hans *Burgkmair, Hans *Baldung, and Urs *Graf. Works produced in the 1510s include paintings, drawings, frescoes, monumental wall paintings, and designs for metalcuts, woodcuts, stained glass, and sculpture. His 90 or so extant drawings cover the period 1507–29. A recurrent theme is the power of women, allegorized in his *Five Female Nudes* (c.1510; Basle, Kunstmus.), eroticized in his *Unequal Lovers* (c.1510; Basle, Kunstmus.), and characterized through suggestive ideogrammatic elements in *Allegory on Man's Morality* (c.1513; Basle, Kupferstichkabinett). The woodcuts called *Wise and Foolish Virgins* (1518) are his only known signed prints. His known paintings date from 1513 to 1520. His largest work was a life-size *Dance of Death* painted on the outside walls of the Franziskanerkirche in Berne. It comprised 41 pairs of figures set against an arcaded background (destr. 1660, but known from gouache copies by Albrecht Kauw, 1649; Berne, Kunstmus.). Deutsch also enjoyed a successful political career, which from 1520 reduced his artistic output, and he played a major role in bringing the Reformation to Berne in 1528. OI

Niklaus Manuel Deutsch: Maler, Dichter, Staatsmann, exhib. cat. 1979 (Berne, Kunstmus.).

DEVIS FAMILY. British painters. The most important was the eldest, **Arthur** (1712–87), who was the leading mid-18th-century painter of fashionable *conversation pieces. Dating from c.1740 onwards, these differ from *Hogarth's (the chief pioneer of the genre) in being neater, simpler, sharper in outline, and lighter in tone. After c.1748, Devis preferred to place his sitters out of doors, often with the family's country house in the background. His paintings typically have an unpretentious, seemingly artless air, redolent of provincial life, which is at variance with the trend towards metropolitan sophistication characteristic of much British painting in the period. When exhibiting in London, he showed at the unassuming Free Society, of which he became president in 1768, not at the grander Society of Artists or the RA. There are good examples of his work at the Yale Center for British Art.

Anthony Devis (1729–1816), half-brother to Arthur, was a topographical landscapist. **Thomas Anthony** (1757–1810), a minor portrait painter, and **Arthur William** (1762–1822) were Arthur's sons. The latter studied at the RA Schools and began, like his father, with conversation pieces. In the 1780s and 1790s he travelled to China and India. He also painted a few history pictures. MK

D'Oench, E., *The Conversation Piece: Arthur Devis and his Contemporaries*, exhib. cat. 1980 (New Haven, Yale Center for British Art).

DEVOTIONAL IMAGE (commonly referred to in German as an *Andachtsbild*), a type of religious image particularly popular in the late Middle Ages, usually small in scale. Their function was to aid private piety by evoking empathy with the holy people depicted. They come in the form of panel paintings, sculpture, miniatures, woodcuts, engravings as well as on jewellery such as the Man of Sorrows pendant (c.1400; Munich, Schatzkammer). Some of the most popular subjects were the Pietà, Salvator Mundi, the Man of Sorrows, the Madonna of Mercy, the Madonna of Sorrows and the Virgin and Child, the *Arma Christi*, and the Five Wounds of Christ, which were depicted in close-up and often removed from the narrative context to heighten the experience for the worshipper. Whilst the fashion for private worship certainly increased the popularity of devotional images, their association with indulgences added to their cult. Pope Sixtus IV (d. 1484), for example, granted 11,000 years' indulgence for a particular prayer to be said before an image of the Virgin and the Sun. This combination of devotional image and text is wonderfully represented on the back wall of Petrus *Christus' *Portrait of a Young Man* (London, NG), where a devotional image of Jesus and an abbreviated version of the prayer 'Salve sancte facies' hangs. KC

Ringbom, S., *Icon to Narrative: The Rise of the Dramatic Close-up in Fifteenth Century Devotional Painting* (1965).
van Os, H., *The Art of Devotion in the Late Middle Ages in Europe: 1300–1500*, exhib. cat. 1994 (Amsterdam, Rijksmus.).

DIAZ DE LA PEÑA, NARCISSE-VIRGILE (1807–76). French painter. From 1835 he regularly painted in the forest of Fontainebleau and was a leader of the *Barbizon landscape school, close to Théodore *Rousseau but increasingly attempting dramatic light effects by heavy impasto and free brushwork, as in *Forest Scene* (1867; St Louis, Art Mus.). Some landscapes are livened up with anecdotal gypsy staffage, and he maintained a miscellaneous output of pieces designed to respond to popular taste—oriental, mythological, and historical genre scenes, nudes, flower paintings, and *fêtes galantes*. AJL

Adams, S., *The Barbizon School and the Origins of Impressionism* (1994).

DICKINSON, EDWIN (1891–1978). American painter. Dickinson, born at Seneca Falls, NY, studied in New York (1910–13) and in Provincetown (1912–14) with the inspirational Charles Webster Hawthorne, who had studied under *Chase. He made painting trips to Europe in 1919–20, 1937–8, 1952, and 1959–60. From 1921 to 1937 he lived mainly in Provincetown, working in isolation, but in 1944 moved to New York practising as artist and teacher. Dickinson was basically a Romantic naturalist in the 19th-century tradition, best seen in his small *plein air* landscapes. His more ambitious works, each worked on obsessively over several years yet still, according to the artist, unfinished, are mystical, sometimes disquieting, explorations of his private fantasies, akin to aspects of *Surrealism. Some of these paintings, such as the theatrical *Fossil Hunters* (1926–8; New York, Whitney Mus.) and *Composition with Still Life* (1934–7; New York, MoMa), contain superimposed imagery which adds to their dreamlike complexity. Although widely exhibited, Dickinson remained a true original, untouched by developments in contemporary American art and wielding no influence on younger painters. DER

Kuh, K., *The Artist's Voice* (1962).

DIDEROT, DENIS (1713–84). French philosopher and critic, best known as one of the founders of the *Encyclopédie* (1751–76), the great monument to Enlightenment thought. His views on the theory of art and criticism, which in some ways anticipated the rise of *Romanticism, are chiefly contained in *Paradoxe sur le comédien* (1830), the article 'Beau' (1752) in the second volume of the *Encyclopédie*, his *Essai sur la peinture* (1765), on which *Goethe wrote a commentary, and his famous *Salons*, critical commentaries on the nine exhibitions of the Académie Royale (see under PARIS) between 1759 and 1781, which are widely regarded as the foundation of modern art criticism. Diderot was influenced by English 18th-century aestheticians, particularly Lord *Shaftesbury, whom he translated. Against the intellectualist bias of *Neoclassical theory he maintained that our ideas of beauty arise from practical everyday experience of beautiful things, based on a *sentiment* for the 'conformity of the imagination with the object'. He regarded *taste* as a faculty acquired through repeated experience of apprehending the true or the good through immediate impression which renders it beautiful. He opposed constraints imposed by such a priori rules as those set forth by Boileau or the tyranny of the ancients and defended the right of genius to create beauty by the idealization of nature. His views on the relation between poetry and painting provided a basis for the *Laokoon* of *Lessing. Although much of Diderot's more abstract thinking about art was available to his contemporaries, his Salon criticism was privately circulated as part of Grimm's *Correspondance*

littéraire to subscribers who included Frederick the Great and Empress Catherine of Russia, leaving Diderot free to express his views without constraint. Driven in part by his desire to see painting once again deal with moral subjects, whether heroic or domestic, and above all by his conviction that painting must move the emotions of the viewer, he was led to deplore what he regarded as the 'immoralities' of *Boucher and to put a high value on the sentimental dramas of *Greuze. Perhaps the easiest of his evaluations for modern taste to agree with is his admiration for the *still lifes of *Chardin, who was probably responsible for teaching him about the techniques of art. Since his readers were far from Paris, Diderot used his formidable literary skills to describe and evoke the works of art that he discussed. Some of his set pieces can conjure a more vivid image in the mind's eye than the surviving works of art themselves. HO/MJ

Diderot, D., *Œuvres esthétiques*, ed. P. Vernière (1968).
Diderot, D., *Salons*, ed. J. Seznec and J. Adhémar (3 vols., 2nd edn., 1975–83).
Diderot on Art, ed. and trans. J. Goodman (2 vols., 1995).
Furbank, P. N., *Diderot: A Critical Biography* (1992).
Sahut, M.-C., and Volle, N. (eds.), *Diderot et l'art de Boucher à David*, exhib. cat. 1984 (Paris, Hôtel de la Monnaie).

DINE, JIM (1935–). American painter, printmaker, experimental artist, and poet, born in Cincinnati, Ohio. Both his father and his grandfather were storekeepers whose stock included painting materials. He studied at the University of Cincinnati, the School of the Museum of Fine Arts, Boston, and Ohio University, Athens, where he graduated in 1957. In 1959 he moved to New York and quickly became one of the pioneers of *happenings and then—in the early 1960s—one of the most prominent figures in American *Pop art (he also made an impact in England, where he lived 1967–71). His Pop canvases were vigorously handled in a manner recalling *Abstract Expressionism, but he often attached real objects to them—generally everyday items such as clothes and household appliances (including a kitchen sink). Characteristically the objects were Dine's personal possessions and his work often has a strong autobiographical flavour. In addition to such *assemblages, he also made free-standing works and Environments, but since his return to the USA in 1971 he has concentrated more on conventional two-dimensional work, especially drawings (he has written and illustrated several books of poetry) and prints. His style, too, has become more traditionally figurative, under the influence of *Kitaj. He has made *lithographs and *screen prints, but his favourite printmaking medium is *etching. Dine prefers not to draw directly on the plate; he instead makes meticulous preparatory drawings that are transferred photographically or by tracing. IC

DIORAMA, a form of public entertainment in which large-scale illusionistic paintings were displayed with dramatic changes of scene and effects of light and atmosphere. Its inventor around 1820 was the French landscape painter Louis Daguerre (1787–1851), later a pioneer of *photography and originator of the daguerreotype. The scenes were painted in opaque and transparent colours on translucent cloth and were illuminated from behind by a system of shutters and coloured filters which let in daylight. The audience sat in darkness and the whole spectacle was an ancestor of the cinema. Daguerre's Diorama was first shown in Paris in 1822 in a specially constructed building. The following year he opened a Diorama in London's Regent's Park in a still surviving building with a façade by John Nash. *Constable visited the London show and commented in a letter to a friend, 'I was at the private view of the "Diorama"; it is in part a transparency; the spectator is in a dark chamber, and it is very pleasing and has great illusion. It is without the pale of art, because its object is deception . . . The place was filled with foreigners, and I seemed to be in a cage of magpies' (C. R. Leslie, *Memoirs of the Life of John Constable R.A.*, 1845). (See also PANORAMA.) HO

Gernsheim, H., and Gernsheim, A., *L.-J.-M. Daguerre: The History of the Diorama and the Daguerreotype* (1968).

DIPTYCH, term for a type of polyptych, consisting of two hinged panels. Diptychs varied in size and were made from a wide range of materials, including ivory, bone, metal, enamel, or painted wooden panels. Their hinged design meant that they could be closed when not in use, and easily transported. They were most often used as portable altarpieces, although small ivory or enamel diptychs could be used for private devotional purposes. Perhaps the most famous example is the Wilton Diptych, probably made for the private devotions of King Richard II (*c*.1395–9; London, NG). TJH

DIPYLON PAINTER (active *c*.760–735 BC). Athenian vase painter working during the first stage of the late Geometric style and named after the small cemetery near the later Dipylon Gate in *Athens, for which he made vast monumental vessels marking the graves of his aristocratic patrons: amphorae for women, pedestalled craters for men. The central register is always occupied by a *prothesis*—the wake of the deceased, lying on a bier and attended by mourners; on the craters, accompanied also by warriors and chariot teams, with battle scenes in other registers. Subsidiary zones are filled by key meanders among other rectilinear motifs; there may also be friezes of goats and deer, derived from Levantine sources. This artist, the earliest recognizable personality in Greek vase painting, rendered his figures in simple silhouette and with conceptual vision: viewpoints vary so that every limb is visible, and the function of each figure is clearly seen—mourners tearing hair, warriors advancing with weapons and armour, charioteers holding reins. Light filling ornaments occupy the background, softening the contrast between figures in bold silhouette and the hatched geometric ornament in other registers. JNC

Coldstream, J. N., *Greek Geometric Pottery* (1968).

DIRECT CARVING, the practice of producing sculpture (particularly stone sculpture) by cutting directly into the material, as opposed to having it reproduced from a plaster model using mechanical aids and assistants. Although this might seem a purely technical matter, in the 20th century it became associated with aesthetic, ethical, and even political issues, particularly in Britain (where it was related to the idea of truth to materials) and in France.

During the 19th century it was customary for sculpture to be exhibited in plaster; it was much more expensive and time-consuming to produce bronze casts or marble carvings, so these were usually made only when firmly commissioned. A device called a *pointing machine enabled the sculptor to make an exact replica or enlargement of the plaster model by taking a series of measured points on it and transferring them to the copy. It was common for both bronzes and marbles to be produced from the same model and for smaller versions to be made for the domestic market. This situation reflected economic realities (a sculptor would want to maximize earnings from a work in which much time and effort had been invested), but it also indicated a priority of idea and subject over material—the sculptor's artistry being located in the concept and form, rather than in the handicraft. A successful sculptor could thus become the administrator of a large studio producing numerous, almost identical versions of popular works (*Rodin employed many assistants, including artists of the calibre of *Bourdelle, Charles Despiau (1874–1946), and François Pompon (1855–1933), and he rarely touched hammer and chisel himself, only occasionally adding final touches to his works in marble). This kind of procedure had been attacked by John *Ruskin in his *Aratra Pentelici: Six Lectures on the Elements of Sculpture* (1872), where he denounced the 'modern system of

modelling the work in *clay, getting it into form by machinery, and by the hands of subordinates'. Ruskin argued that the sculptor of such works thinks in clay and not in marble and that 'neither he nor the public recognize the touch of the chisel as expressive of personal feeling and that nothing is looked for except mechanical polish'. In embryonic form he was stating two fundamental tenets of the philosophy of direct carving as it later developed: that stone, as opposed to plaster, has particular qualities of its own; and that there is a special relationship between the hand of the artist and the material he uses.

In spite of Ruskin's influence and the force of his arguments, it was not until the early years of the 20th century—when his authority as a critic and prophet was waning—that his ideas on direct carving were put into practice by sculptors in Britain. Among the most important pioneers were Jacob *Epstein, Eric *Gill, and Henri *Gaudier-Brzeska, who collectively illustrate some of the range of issues involved in the practice. For Epstein, the activity of carving was linked to his interest in sculpture from outside the Graeco-Roman tradition, such as that of Assyria and Africa, and it reflected his contact in Paris with *Brancusi and *Modigliani, who had similar interests. For Gill, a return to carving was a return to a medieval practice, through which he hoped to overcome the iniquitous effect of industrialism in dividing the work of the thinker and maker. For Gaudier-Brzeska, carving was equated with a struggle that was both manual and creative, an aspect of a 'virile' art that contrasted with the 'feminine' modelling which had dominated the previous generation of *New Sculptors; he wrote that in the sculpture he admired 'every inch of the surface is won at the point of a chisel'. The difficult economic conditions in which Gaudier-Brzeska lived also had an influence on his working methods, for he was dependent on found or even stolen fragments of stone in odd shapes that would suggest forms and subjects.

After the First World War a number of British sculptors, including Barbara *Hepworth and Henry *Moore, practised direct carving as a dogma, while others, such as Frank *Dobson, worked as both carvers and modellers. Whereas academic sculptors favoured white marble because of the smooth and detailed finish it made possible, these direct carvers used a wider variety of stone, which they exploited for its range of texture and colour. However, direct carving was not associated exclusively with avant-garde artists; it was advocated, for example, by the conservative critic Kineton Parkes (1865–1938) in articles in *Architectural Review* and in his book *The Art of Carved Sculpture* (2 vols., 1931).

In France there was a similar development, whereby direct carving (*taille directe* in French) moved from being chiefly an avant-garde concern before 1914 to wider acceptance in the 1920s. Brancusi and *Derain made direct carvings as early as 1907, and they were almost certainly preceded by the more traditional Joseph Bernard (1866–1931). The issue of precedence is complicated by the existence of an artisanal tradition of stonecarving in provincial France; one of the major exponents of *taille directe*, André Abbal (1876–1953), came from a family of stonecarvers working near Moissac in the south of the country.

The death of Rodin in 1917 had important consequences for public awareness of the issues involved in direct carving, for until then it had not been widely appreciated how much the most famous sculptor of the day had relied on assistants (*praticiens*) in the physical production of his work. In 1919 there was a scandal when a number of fakes of his work were revealed, leading to legal action, and the press coverage included accounts by some of Rodin's *praticiens* of the extent of their involvement. The critic Louis Vauxcelles (1870–1943) took advantage of the situation to attack the 'lie of modelling'—the mechanical transcription of one material into another. The scandal encouraged the acceptance of direct carving, which became such a vogue that by 1922 even the *praticien* Charles Jonchery (1873–1937), who had been implicated in the Rodin scandal, was exhibiting work described as *taille directe*.

Another factor in the growth of direct carving in France was the way in which it was stimulated by nationalist rhetoric in the wake of the First World War. For example, in his book *Modelleurs et tailleurs de pierre, nos traditions* (1921), the sculptor Joachim Costa (1888–1971) linked direct carving with medieval French cathedrals; these had suffered so much damage in the war that some patriots accused the Germans of a deliberate campaign against them. Another consequence of the war was the demand for memorials, and several of the leading exponents of this type of sculpture were direct carvers, among them André Abbal (1876–1953), Paul Dardé (1890–1963), and Raoul Lamourdedieu (1877–1953).

Patriotic support for direct carving also came from the journal *La Douce France* (originally called *La Belle France*), published from 1919 to 1924. Its ideology went beyond conventional nationalism to propose a pure Celtic French identity associated with the north of France, in opposition to the south, in which the heritage had been corrupted by compromise with Latin invasion. (This is especially bizarre in view of the actual geographical origins of some of the carvers.) 'La Douce France' was also the name of a group of sculptors, founded in 1913, which held six exhibitions between 1922 and 1931. These featured carving alongside the equally medieval arts of fresco and tapestry, but the group's most permanent monument is a pergola made for the Paris Exposition des Arts Décoratifs (see ART DECO) in 1925. It was originally intended that the pergola should be placed in a prime site in the garden behind Notre-Dame Cathedral in Paris, but it has ended up in a park in Étampes, about 50 km (30 miles) south of the capital. In this work the idea of Celtic identity is expressed in the choice of subjects from Arthurian legend, and patriotism is underlined by the use of stone from the battlefield at Verdun. However, the fact that the Russian-born *Zadkine was among the ten sculptors who worked on the pergola (others were Costa and Lamourdedieu) suggests that La Douce France may have been more dogmatically nationalist in theory than in practice.

In the period between the two world wars, direct carving was taken up in other countries; but since the Second World War the carving versus modelling debate has been rendered largely obsolete by the prevalence of newer techniques that make both procedures seem conservative. JG-S

DISCOURSE ANALYSIS, a critical method exemplified by the work of Michel *Foucault and Jean-François Lyotard (1924–). It examines the ways in which particular kinds of discourse or social practice, such as those of art, or criticism or morality, arise in a society: how their values are formulated and their influences operate. Foucault's 'archaeologies' are investigations through which he sought to provide 'a history of the present', rejecting the rigidities of *structuralist analyses and instead suggesting that there is no pattern or underlying coherence in history, and that a flux of discontinuity and difference is the norm. In similar vein, Lyotard dismissed grand theories and authoritarian discourse, propounding instead the idea of the 'little narrative', the discourse of individuals which, he maintained, has no need of the justification or authority of 'grand narratives' such as *Marxism or Christianity. Art writers have been in varying ways responsive to this subversive approach. Its broader presuppositions relate to those of art in the era of *postmodernism. DC

Lyotard, J.-F. *The Postmodern Condition: A Report on Knowledge* (1979).

DISEGNO E COLORE, a debate born in 16th-century Italy, which flourished over the next two centuries at least. Its subject was whether a painting should be judged by its *disegno* (see DESIGN), defined as both the formal power of drawing, and the imaginative idea, or by its *colore*, or *colour, and the greater mimetic power of a free and painterly technique. Central Italian writers, led by *Vasari, favoured *disegno* and idolized *Michelangelo; Venetians, most eloquently Lodovico Dolce, praised *colore* and the

naturalism of *Titian. Seventeenth-century classicists saw the *Carracci as uniting *disegno* and *colore*, and contrasted their art with the unlearned *Caravaggio's dependence on colour alone. In late 17th-century France the Academy spilt into opposing factions, the Poussinistes, who praised the intellectual qualities of the mature *Poussin, and the Rubénistes, led by Roger de *Piles, who championed the naturalism and sensuality of Titian and *Rubens. Echoes of the controversy lingered on in the rivalry between *Ingres and *Delacroix, and perhaps even in that between *Picasso and *Matisse.　　HL

DIVISIONISM. See NEO-IMPRESSIONISM.

DIX, OTTO (1891–1969). German painter and printmaker. Dix was born at Untermhaus, Thuringia, and was apprenticed to an interior decorator (1905–9) before studying at the Dresden School of Arts and Crafts 1909–14. At Dresden he absorbed the work of the *Expressionists and was particularly influenced by van *Gogh. From 1914 to 1918 he served in the First World War; initially enthusiastic, he was soon sickened by the horror and violence which he recorded in dramatic oil paintings, full of movement and violence, which incorporated the techniques of *Futurism. After the war he studied at the Academies of Dresden (1918–22) and Düsseldorf (1922–5) gradually moving from *Dadaism towards the greater realism exemplified by the *Neue Sachlichkeit, although his work can hardly be described as objective. He remained deeply scarred by his wartime experiences and disillusioned by post-war society; *Der Krieg* (The War), a series of 50 etchings, published in 1924, has a *Goyaesque intensity and his paintings of crippled war veterans, like *Die Skatspieler* (1920; Berlin, Neue Nationalgal.), have a crude and compelling immediacy. Prostitutes, another recurrent theme in the 1920s, are used almost allegorically as a symbol of a decadent corrupt society and, usually obese or emaciated, are cruelly shocking moralities. From 1927 Dix taught at the Dresden Academy and also established a reputation for his idiosyncratic unflattering portraits; but in 1933 he was dismissed by the Nazis and in 1934 forbidden to exhibit. After the Second World War, in which he was briefly conscripted, he lived in Hemmenhofen, on the Bodensee, where he was inspired by the Alpine landscape to turn to German Renaissance masters, like *Dürer and *Altdorfer, as prototypes for mannered allegorical and spiritual paintings which, despite their ambition, remain essentially vapid.　　DER

Hartley, K., *Otto Dix*, exhib. cat. 1991 (London, Tate).

DOBELL, SIR WILLIAM (1899–1970). Australian painter. Dobell trained as an architect before studying in Sydney (1924–9) and the Slade School, London (1929–31). His *Sickertian London pictures, painted after a year in Holland, are gently satirical, for instance *Mrs South Kensington* (1937; Sydney, AG NSW). Returning to Australia in 1939 he achieved notoriety in 1943 when his prizewinning *Joshua Smith* (destr.) was the subject of a court case in which it was described as a caricature. His portraits, in which such diverse influences as *Soutine and *Parmigianino appear, are highly mannered, like the elongated *Dame Mary Gilmore* (1957; Sydney, AG NSW).　　DER

Smith, B., *The Antipodean Manifesto* (1976).

DOBSON, FRANK (1886–1963). English sculptor. In 1920 he exhibited with Wyndham *Lewis's short-lived *avant-garde coalition Group X (1919–20). Briefly influenced by *Vorticism he created the backdrop for Edith Sitwell's *Façade* (1922) and a streamlined, polished bust of her brother Osbert (1923; London, Tate). By 1926 he was critically acclaimed but within a decade his reputation was eclipsed by younger sculptors. His nude and semi-draped female figures are related to *Maillol and to *Picasso's classical work of 1919–25. His small late *terracottas share the monumentality of his larger sculptures.　　DER

True and Pure Sculpture: Frank Dobson, 1886–1963, exhib. cat. 1981 (Cambridge, Kettle's Yard).

DOBSON, WILLIAM (1611–46). English portraitist. His father was employed by Sir Francis Bacon in decorative and building works at Gorhambury and Verulam House (Herts.). Dobson trained with William Peake (c.1580–1639) and subsequently with Francis Cleyn (c.1580–7), the Rostock-born chief designer of the Mortlake tapestry works. He is presumed, perhaps via Cleyn, to have had access to Charles I's art collection (see LONDON, ROYAL COLLECTION), rich in Venetian paintings, especially those by *Titian, whose influence is discernible in his work. While Dobson's colour and texture are inspired by Venetian art, his earthy yet poetical feeling for character may be considered typically English. Dobson's earliest known works are of the late 1630s: a *Self-Portrait* (priv. coll.) and its pendant *Portrait of the Artist's Wife Judith* (London, Tate). Considering van *Dyck's importance during the 1630s, Dobson's work is surprisingly free of his influence. Most of his 60 or so known paintings, mainly half-length portraits, date from 1642–6 after he had moved with Charles I's Civil War court to Oxford. The thick impasto of the early works gives way later to a mere skim of paint—

probably reflecting a wartime scarcity of materials. His finest portraits are those of *Endymion Porter* (c.1643–5; London, Tate) and the swagger *John, 1st Baron Byron* (c.1643; Manchester, Tabley House Coll.). After Oxford fell to Parliament in June 1646, Dobson returned to London, and died there in October.　　KH

William Dobson 1611–1646, exhib. cat. 1983 (London, NPG).

DOESBURG, THEO VAN (1883–1931). Dutch artist and theorist (born Christian Küpper), founder of De *Stijl. Self-taught, the maverick van Doesburg initially detested the *avant-garde and pursued naturalism. In response to the ideas of *Apollinaire and *Kandinsky, however, his outlook altered, and by 1915 he was fully converted to abstraction. As much a theorist and critic as practitioner, he became acquainted with many avant-garde Dutch artists over the following years, including *Mondrian, culminating in the founding of De Stijl in 1917. As editor of the periodical of the same name until 1928, van Doesburg was the linchpin of the group, and almost its sole representative after 1924. *De Stijl* included nearly as many architects as artists, reflecting van Doesburg's concern with the integration of art and architecture. He taught for a short period at the *Bauhaus, and collaborated on numerous architectural projects. His paintings share the rectilinearity of Mondrian's as in *Counter-Composition V* (1924; Amsterdam, Stedelijk Mus.), although he later advocated a theory of Elementarism which he considered a correction of Mondrian's *Neo-plasticism. His attempt to re-establish *De Stijl* in 1931 was forestalled by his untimely death.　　AA

Baljeu, J., *Theo van Doesburg* (1974).

DOLCE, LODOVICO (1508–68). Italian editor, proof-reader, and compiler. He worked for the successful Venetian publisher Giolito. He translated and adapted classical texts, prepared editions and commentaries on vernacular poetry (Dante, Petrarch, and Ariosto), and composed his own plays and poetry, as well as one dialogue on painting entitled *L'Aretino*.

Its main interlocutor, the writer Pietro Aretino, who represents Venetian art, endeavours to demonstrate to a Florentine grammarian, Piero Fabrini, the superiority of *Raphael over *Michelangelo in the three main parts of painting (*invenzione* (see INVENTION), *disegno* (see DESIGN), and *colore* (see COLOUR)). After an enumeration of the leading painters of the cinquecento the dialogue concludes with a long praise of *Titian.

L'Aretino was the first art treatise to oppose and attack *Vasari's exaltation of Florentine art. Dolce criticizes the alleged indecency of Michelangelo's *Last Judgement* (Vatican) and unfavourably compares the obscurity of its

allegories and style with the language of Dante. By contrast he hails Raphael and Titian as models whose achievements reflect those of Petrarch and Ariosto. In spite of the low esteem in which scholarship has held Dolce, his dialogue stands out as one of the most representative art treatises of the 16th century. FQ

Dolce. L., *L'Aretino*, ed. P. Barrocchi (1962; English trans. in M. Roskill, *Dolce's 'Aretino' and Venetian Art Theory of the Cinquecento*, 1968).

DOLCI, CARLO (1616–87). Italian painter who was born in Florence and worked there throughout his life. He received his early training from Jacopo Vignali (1592–1664) and gave early notice of his talent with a life-size *Portrait of Fra Ainolfo dei Bardi* (1632; Florence, Pitti). He developed a meticulous, highly polished style well suited to portraiture and to the simple deeply devotional paintings which appealed to various members of the Medici family. Cardinal Leopoldo de' Medici commissioned the *Adoration of the Magi* (probably the version now at Blenheim Palace, Oxon.). During the 1640s, Dolci painted the *Virgin of the Lilies* (1642; Montpellier, Mus. Fabre), *S. Andrew Adoring the Cross before Martyrdom* (1643; Birmingham, Mus. and AG), and, on a much larger scale, *Christ in the House of the Pharisee* (1649; Corsham Court, Wilts.). According to *Baldinucci, his biographer, Dolci was also a still-life painter, but the only surviving picture of this kind is a *Vase of Flowers* painted for Giovanni Carlo de' Medici (Florence, Uffizi). The artist was much admired by British visitors to Florence and painted portraits of Sir John Finch, the British resident, and of Sir Thomas Baines, who studied medicine at Padua (1665–70; Cambridge, Fitzwilliam). The 5th Earl of Exeter, who was welcomed into the circle of the Grand Duke Cosimo III de' Medici during his Italian tours of 1679–81 and 1683–4, and may have been affected by the religious bigotry of the Grand Duchess Vittoria, acquired seven paintings by Dolci and was later given an eighth by Dolci's Florentine patron Andrea del Rosso. The best of these is *Christ Consecrating the Elements* (Burghley House, Lincs.). Another version was acquired by Sir Paul Methuen (1672–1757) of Corsham, Wilts. (*in situ*). HB

McCorquodale, C., *Painting in Florence 1600–1700*, exhib. cat. 1979 (London, RA).

DOMENICHINO (Domenico Zampieri) (1581–1641). Italian painter, who, after *Raphael, was the most influential exponent of the classical style in Rome. He had been born in Bologna, where he was a pupil of Denys *Calvaert and joined the Carracci Accademia degli Incamminati in 1595, the year that Annibale *Carracci left for Rome. In 1602 Domenichino in his turn moved to Rome, following in the footsteps of other academy pupils, including Guido *Reni and *Albani. Annibale employed him there to paint scenes from Ovid in the Palazzetto Farnese c.1603–4; and also invited him to participate in decorating the walls of the Galleria in the Palazzo Farnese c.1604–5. Domenichino's contribution included the *Perseus and Andromeda*, the *Virgin with a Unicorn*, and at least two of the four cardinal virtues, *Charity* and *Justice*. However he quickly gave notice of his own independent spirit in his rigorous critical analysis of Annibale's late style, expressed through painting his own corrected versions of the *Adoration of the Shepherds* (Edinburgh, NG Scotland) and the *Pietà* (lost), in which the expressive naturalism of Annibale (his lost *Adoration*; ex-Paris, Orléans Coll; the etching of the *Adoration of the Shepherds*, c.1606; the *Three Marys*; London, NG) is smoothed away and replaced with a more refined *classicism, with clearly articulated and sculptural figures, and a more abstract concern with clarity of design. Domenichino found a sympathetic home at Rome with the theorist Giovanni Battista *Agucchi, and at his suggestion painted a *Liberation of S. Peter from Prison* (1604; lost, ex-Potsdam, Sanssouci). Annibale Carracci was also a friend of Agucchi, and there is still uncertainty as to whether he or Domenichino painted the intimate and informal portrait now at York (AG). On Annibale's recommendation Domenichino was commissioned c.1608 by Cardinal Odoardo Farnese to decorate the Cappella dei SS Fondatori at the abbey of Grottaferrata; and by Cardinal Scipione Borghese to paint the *Flagellation of S. Andrew* in the Oratorio di S. Andrea at S. Gregorio Magno (1609). Here above all Domenichino demonstrates his commitment to clearly articulated narrative and dramatic expression within a carefully constructed perspectival space, framed by architecture, in which the figures articulate their emotions through gesture. It is a style that was inspired by Raphael's tapestry cartoons of the *Acts of the Apostles* (London, V&A) and by Annibale's most Raphaelesque paintings such as the *Domine, Quo Vadis?* (London, NG). The concentrated precision of Domenichino's manner is underlined by comparison with Guido Reni's fresco of *S. Andrew Led to Martyrdom* (1609), situated on the wall opposite, which is conceived in a far more lucid and relaxed classical style as a procession of figures moving across the picture surface against a landscape background. In his *Last Communion of S. Jerome* (1614; Vatican Mus.) Domenichino turns his critical eye towards Agostino *Carracci's picture of the same relatively unusual subject matter (1590s; Bologna, Pin. Nazionale), which he had studied on a brief visit to Bologna in 1612. Domenichino transforms Agostino's intimate and almost anecdotal interpretation into a picture of monumental solemnity and dramatic focus, and emphasizes the central role of the priest and the significance of the sacrament he administers.

By 1615 Domenichino had completed the frescoes on the life of S. Cecilia for the church of S. Luigi dei Francesi, which reveal his close study of Raphael's *Fire in the Borgo* (Vatican, Stanze); and shortly afterwards painted *Diana Hunting with Nymphs at Play* (1618; Rome, Borghese Gal.), where he recreates the romantic spirit of *Titian's Ludovisi *Bacchanals* (Madrid, Prado), in the cooler forms of Roman classicism. In 1618 Domenichino went north to Fano to paint a series of frescoes on the *Life of the Virgin* in the cathedral, and for the next three years was otherwise mainly employed at Bologna. Here he painted a sequence of major altarpieces in which he appears to be re-examining the north Italian tradition of painting from *Titian to Ludovico *Carracci: they include the *Madonna of the Rosary* (1617–25), the *Martyrdom of S. Agnes* (1619–22), and the *Martyrdom of S. Peter Martyr* (1619–25) (all Bologna, Pin. Nazionale).

On the election of Pope Gregory XV in 1621, Domenichino returned to Rome. His most important commission was for the apse and the pendentives beneath the cupola in S. Andrea della Valle; the dome was commissioned from his great rival, the *Baroque painter *Lanfranco. Domenichino's extensive drawings (Windsor Castle, Royal Lib.) show a variety of experiments for the pendentives, based on *Correggio and *Michelangelo. In 1631 he was invited to Naples to decorate the Cappella del Tesoro di S. Gennaro in the cathedral. By the time of his death there he had completed three lunettes of the life of S. Gennaro (1631–7) and four altarpieces.

No account of Domenichino's career would be complete without reference to his activity as a painter of portraits and landscapes. Most of his work in portraiture, ranging from the early *Portrait of a Young Man* (1603; Darmstadt, Landesmus.) to the *Portrait of Pope Gregory XV and Cardinal Ludovico Ludovisi* (1621–3; Béziers, Mus. des Beaux-Arts), is relatively severe and formal. As a landscape painter his capacity to conceive strongly structured views, which transcend anecdotal genre or poetic pastoral fantasy and induce a mood of contemplative introspection in a manner that would influence both *Claude and *Poussin in the 1640s, is evident from the background of such compositions as the *Last Communion of S. Jerome* (Vatican) or the *Calling of S. Peter and S. Andrew* in the apse of S. Andrea della Valle. It is further developed in pictures such as the *Hercules and Achelous* and the *Hercules and Cacus* (c.1622–3; Paris, Louvre), which have a heroic grandeur and evoke a

nostalgic sense of the ancient world. However the involvement of G. B. Viola (1576–1622) as a collaborator on some of Domenichino's decorative projects, including the *Scenes from the Life of Apollo* painted for a garden pavilion at the Villa Aldobrandini, Frascati (1616–18; *in situ* and London, NG) has led to controversy surrounding the traditional attribution to Domenichino of such oil paintings as the *Landscape with S. John Baptizing* (Cambridge, Fitzwilliam) and a desire by some scholars to advance the alternative claims of Viola as the principal landscape painter in Domenichino's circle. Notwithstanding the problems of connoisseurship surrounding his landscapes and indeed the portrait of Agucchi described above, Domenichino's supreme achievement unquestionably was to lay the foundations of an uncompromisingly classical style that would not only profoundly influence Poussin but would remain at the heart of the classical tradition until the time of *Ingres. His vision was based on drawing, in both chalk and pen and ink, an obsessive and analytical interest in individual forms, and their orchestration into lucid demonstrations of visual harmony.
HB

Brigstocke, H., 'Domenichino Copies after Annibale Carracci', *Burlington Magazine*, 115 (1973).

Brigstocke, H., and Spear, R., 'The Ratta Sibyl: Replication in Domenichino's Studio', *Ars artibus et historiae*, 34/17 (1996).

Domenichino, exhib. cat. 1996 (Rome, Palazzo Venezia).

Pope-Hennessy, J., *The Drawings of Domenichino . . . at Windsor Castle* (1948).

Spear, R., *Domenichino* (1982).

DOMENICO VENEZIANO (active *c*.1410–61). Italian painter. Among the founders of *Renaissance painting he is the most elusive. His name suggests he was born in Venice, but he was active mainly in Florence. As his considerable contemporary reputation was based on fresco decorations, now lost, his importance is deduced from a few surviving works and his influence on *Piero della Francesca. He probably trained in Florence, and links with *Masolino are indicated by the emphatic perspective and foreshortening in his earliest extant work, the Carnesecchi Tabernacle (early 1430s; London, NG). Piero assisted Domenico in 1439 on a celebrated fresco cycle (lost) in S. Egidio, Florence, and his later treatment of landscape recalls Domenico's contemporary *Adoration of the Magi* (Berlin, Gemäldegal.). Domenico's major surviving work is the *S. Lucy* altarpiece (mid-1440s; main panel, Florence, Uffizi), a *sacra conversazione* painted for S. Lucia dei Magnoli in Florence. The coherent perspective of its architectural setting, the subtle chalky colours, and, above all, Domenico's exquisite handling of light make it one of the most important paintings of the early Renaissance in Florence.
LH

Wohl, H., *The Paintings of Domenico Venziano* (1980).

DOMINGUEZ, OSCAR (1906–1958). Spanish artist. Dominguez's first solo exhibition was in his birthplace Tenerife in 1933 where his *Daliesque style labelled him a *Surrealist, even though he did not meet the group until a year later when he settled in Paris. From 1934 to 1940 he was an active member of *Breton's group and in 1935 he curated the International Surrealist Exhibition in Tenerife. Dominguez's talent lay in his ability to create or experiment with new ideas and techniques. His most applauded contribution to Surrealist 'pictorial automatism' was the *decalcomania*, the suggestion of images through chance-generated ink patterns. Dominguez constructed a number of extraordinary poetic objects such as *Never*, exhibited in the 1938 International Surrealist Exhibition. Also highly original was his short 'cosmic period' 1938–9, in which he painted volcanic-type structures and strange vegetation growing among lunar, wind-blown landscapes. However, apart from these, he never fully exploited his potential. After 1940 he stopped developing his own style, preferring instead to paint pastiches of *de Chirico and *Picasso. He committed suicide at the age of 51.
CC

Zaya, A., *Oscar Dominguez* (1992).

DOMINICI, BERNARDO DE (1683–1759). Neapolitan art historian. The son of a minor painter, he was himself an undistinguished painter of *Bamboccianti pictures and landscapes. His main work was the *Vite de' pittori, scultori ed architetti napolitani*, published in three volumes 1742–5. In the manner of *Vasari, the *Vite* sought to establish an ancestry and structured progression in Neapolitan art, culminating in de Dominici's hero *Solimena. De Dominici was soon vilified for inaccuracy, the fabrication of documentary sources, and the invention or perpetuation of tall stories such as the preposterous notion of a 'Company of Death' of revolutionary artists led by Aniello Falcone (1607–56) at the time of Masaniello's revolt. In recent years the Vasarian conventions governing his work have been better understood. His subtle illumination of the artistic purposes of the artists close to his own time, his deeply felt response to their art, and his information about the contemporary art world are now seen as making him the indispensable source for the period, though his factual unreliability remains manifest.
AJL

Colton, J., *A Taste for Angels: Neapolitan Painting in North America, 1650–1750*, exhib. cat. 1987 (New Haven, Yale University AG).

DONATELLO (Donato di Niccolò) (1386–1466). Italian sculptor considered one of the most original and comprehensive geniuses of that remarkable group of sculptors, architects, and painters who created an artistic revolution in Florence during the first quarter of the 15th century. *Vasari recognized Donatello's stature, claiming that he had equalled the sculptors of *Antiquity. Certainly he possessed an imaginative understanding of classical sculpture, probably acquired during a number of visits to Rome in 1413–15 and again around 1432. In his enthusiasm for the Antique he was the counterpart of the early Florentine humanists such as Poggio Bracciolini, with whom he is known to have been in touch, and of the architect *Brunelleschi, a close friend and possible collaborator. Though Donatello was to introduce major expressive and technical changes to the possibilities of marble and bronze sculpture, his early training was in the traditional setting of *Ghiberti's workshop, where he would have learned goldsmiths' skills. His revolutionary conception of sculpture is first exemplified in the great series of standing and seated figures for the niches of Or San Michele and for the façades of Florence Cathedral and the campanile. This began with the seated *S. John the Evangelist* (1408–15; Florence, Mus. dell'Opera del Duomo) for the cathedral, in which the imperious solemnity of the saint is accentuated by the elongation of the figure's upper body. In his *S. Mark* (1411–13; Florence, Or San Michele) the figure's drapery still adheres to a *Gothic swaying line, while the celebrated *S. George* (*c*.1414; Florence, Bargello) for another niche at Or San Michele is conceived as a chivalric hero. The so-called *Zuccone* ('baldpate') for the campanile (completed in 1436) is his most uncompromisingly unidealized prophet, whose sinewy vitality and particularized character indicates first-hand observation, and is comparable in its fidelity to the actual construction of the human body with Antique Roman senator figures. One of the most specifically classical of Donatello's works is the bronze *David* (Florence, Bargello), which originally stood in the courtyard of the Medici Palace, and probably belongs to the decade following his second visit to Rome. Yet the tombs for Baldassare Coscia (Pope John XXIII) in the Florence Baptistery (*c*.1424), and Cardinal Brancaccio in Naples (*c*.1427; S. Angelo a Nilo), carved in collaboration with *Michelozzo, also incorporate many Antique features. A tangible testament to his goldsmith's training is the highly finished gilt-bronze *S. Louis of Toulouse* (*c*.1418–22; Florence, Or San Michele). He was in Padua 1443–53, and during this time he began to react against classical principles, though his *equestrian statue of *Gattamelata* (1447–53; Padua, Piazza del Santo) represents an exception, for it stands in the square in

front of the Santo in emulation of the Antique *Marcus Aurelius* on the Capitol in Rome. His chief undertaking in Padua was a new high altar for the Santo, and its seven bronze statues and 22 reliefs were originally arranged beneath a *baldacchino as a *sacra conversazione*. In the four large reliefs on the altar illustrating S. Anthony's miracles he exploited further the device of the central *perspective system that was probably developed by Brunelleschi, as well as developing dynamic and complex compositions in which the action often overlaps the limits of the relief. In his earlier marble reliefs, such as the *S. George and the Dragon* (1417; Florence, Or San Michele), he arranged his forms parallel to the surface and developed a distinctive low-relief style, commonly called *rilievo schiacciato*. Contours and depth are literally suggested and he shows an awareness of the possibilities of aerial perspective far in advance of his time. This is particularly noticeable in the *Ascension with Christ Giving the Keys to S. Peter* (1420s; London, V&A), in which dramatic effect and spatial complexity are achieved by such means. A striking later illustration of this is the bronze reliefs which he designed towards the end of his life for the two pulpits in S. Lorenzo, Florence (c.1465, completed by assistants). His exploitation of the expressive possibilities of distortion for dramatic emphasis is also apparent in the bronze *Lamentation* relief (London, V&A), and in three full-length statues representing *S. John the Baptist* (1438; Venice, Frari), *Judith and Holofernes* (Florence, Palazzo Vecchio), and *S. Mary Magdalene* (c.1456–60; Florence, Mus. dell'Opera del Duomo), the first and last in wood and the second in bronze. The expressive quality of these late works, so astonishingly original in style and so deeply moving in spirit, is matched by Donatello's capacity for tenderness, for instance in the moving *Cavalcanti Annunciation* (1430s; Florence, S. Croce), or in the numerous marble and stucco Madonna and Child reliefs (such as the *Verona Madonna*) which became the prototype for the next generation of sculptors.

HO/AB

Janson, H. W., *The Sculpture of Donatello* (2 vols., 1957).
Poeschke, J., *Donatello and his World: Sculpture of the Italian Renaissance* (1993).

DONGEN, KEES VAN (1877–1968). Painter of the School of *Paris. Van Dongen was born in Rotterdam where he studied painting before settling in Paris in 1899. His first years there were difficult; he had to support himself for a time as a circus wrestler and lived in poverty in the Bateau-Lavoir in Montmartre. In 1905 he showed at the Salon d'Automne (see under PARIS) among the painters soon to be known as the *Fauves and continued to work in their schematized and intensely coloured style. *The Red Dancer*

(1907–8; St Petersburg, Hermitage) is characteristic, with its bold handling of colour and eroticized form; *Spring* (1907–8; St Petersburg, Hermitage) demonstrates his urge toward a more decorative, abstract style. By 1910 he was successful, staging exhibitions throughout Europe and America, but became noted primarily as a society painter. After the Second World War he continued to portray the stars of the day, including Brigitte Bardot and Maurice Chevalier.

MF

Chaumeil, L., *Van Dongen* (1967).

DONNER, GEORG RAPHAEL (1693–1741). Austrian sculptor who worked in Salzburg, Bratislava, and Vienna. He began in a late *Baroque manner, exemplified by the decoration of the staircase in the Mirabell Palace, Salzburg (1725), and the Elemosynarius chapel, Bratislava Cathedral (1730–2). He later became a pioneer in the movement towards *classicism, thus exerting an important influence in central Europe, particularly through the fountain in the Neuer Markt in Vienna (1739), which assembles nymphs and river gods in a manner reminiscent of 16th-century Italian classical sculpture.

HO/MJ

Blauensteiner, K., *Georg Raphael Donner* (1944).
Georg Raphael Donner, exhib. cat. 1993 (Vienna, Belvedere).

DORÉ, GUSTAVE (1832–83). A prolific artist and celebrated member of Parisian society, whose ambitions to be accepted as a painter and sculptor of grandiose works remained unfulfilled, but who became the most popular French designer of wood-engraved book illustration of the mid-19th century. His exuberant illustrations to Rabelais (1854) established his fame, and his works include illustrations of Dante's *Inferno* (1861), of Munchausen (1862), and of the Bible (1866), where Old Testament grandeur is created by vast, mountainous scenes, with lurid skies. He became increasingly popular in England in the 1860s, and in 1869 the Doré Gallery opened in New Bond Street with a permanent exhibition of his work. His masterpiece is the set of engravings *London: A Pilgrimage* (1872), which juxtaposes scenes of aristocratic leisure with panoramic and brutal depictions of Dickensian slums, whose symbolic intensity captured the attention of van *Gogh.

HL

Richardson, J., *Gustave Doré* (1980).

DOSSAL (Latin *dorsal*: back), a textile hanging placed behind the altar of a Christian church. This was normally suspended from the ceiling or attached to the back wall, and like a retable or reredos acted as a backdrop for the clergy celebrating Mass. Examples dating from around the 12th century onwards were normally woven with figures of saints; for instance an embroidered

silk fragment, thought to be an altar dossal, from Lower Saxony depicting SS Bartholomew and Paul standing within arcades (c.1150–60, London, V&A).

TJH

DOSSI BROTHERS. Court painters at Ferrara. **Dosso Dossi** (Giovanni di Niccolo di Luteri or de Lutero) (1486/87–1542) was a highly original artist, who responded to the mood of *Giorgione, and to the brilliant colour of *Titian, and created a lyrically romantic style distinguished by sultry, glowing effects of light and an interest in exotic landscape. He also had a penchant for wit and fantasy; his subjects are often idiosyncratic, and iconographical puzzles remain. Dosso was probably born at Mirandola, near Ferrara and Mantua, and in 1514 he entered the service of the Este family in Ferrara, where he and his brother **Battista** (c.1477–1548), whose independent works are weak, carried out the many varied tasks of the court artist, painting frescoes and mythological canvases, devotional works and portraits, and designing for the theatre and festivals. He also painted many altarpieces for other patrons.

He is first recorded at Mantua in 1512, which seems to tie in with *Vasari's observation that he was trained under Lorenzo *Costa, the Mantua court painter. However, nothing definite is known about his early years, and documents discovered in 1995 prove that his collaboration with *Garofalo on a major altarpiece in Ferrara took place a decade or more earlier than had previously been supposed. This altarpiece, the Costabili Polyptych (Ferrara, Pin. Nazionale), now known to date from 1513–14, is already a mature work and shows him painting in a profoundly Venetian idiom owing most to Giorgione but with a knowledge of Titian. It also reflects enough of *Raphael to make it probable that Dosso had by then been to Rome.

The *Three Ages of Man* (c.1514–15; New York, Met. Mus.) shows Dosso using the pastoral imagery of Giorgione and Titian and creating flickering foliage that seems to engulf the figures. The *Melissa* (c.1515–16; Rome, Borghese Gal.) unites a new formal grandeur with bold effects of colour and light; it is the perfect visual equivalent of the courtly poetry of Ariosto from which its probable subject is taken. Dosso visited Venice frequently in these years, he journeyed to Florence in 1517, and in 1519 he accompanied Titian to Mantua on an expedition to inspect Isabella d'Este's art collection.

During the 1520s and 1530s Dosso's figures increasingly show the influence of Raphael and *Michelangelo as in the *S. Sebastian* altarpiece (c.1521; Modena Cathedral). Much of his decorative work in Ferrara has perished, but two surviving canvases with scenes from Virgil's *Aeneid* (c.1522; Birmingham, Barber

Inst.; Ottawa, NG Canada), painted as a frieze for the Camerino d'Alabastro in the Este Castle, are distinguished by their deep and glowing landscapes. In 1529–30 the brothers decorated the Villa Imperiale at Pesaro for the Duke of Urbino. Here, in the brilliantly inventive Camera delle Cariatidi, leafy caryatids frame a deep and illusionistic landscape that surrounds the entire room. There followed, in 1531–2, the decoration of the Castello del Buonconsiglio at Trent, commissioned by Cardinal Bishop Bernardo Clesio. Dosso's late works, such as the satirical allegory *Stregoneria* (1541–2; Florence, Uffizi), show a new and vigorous realism. Battista frequently collaborated in Dosso's later work and inherited his workshop. HL

Humfrey, P., et al., *Dosso Dossi, Court Painter in Renaissance Ferrara*, exhib. cat. 1998 (Ferrara, Gal. d'Arte Moderna e Contemporanea).

DOTTED MANNER. See MANIÈRE CRIBLÉE.

DOU, GERRIT (1613–75). Dutch *genre painter of Leiden of foremost importance among the painters known as the Leiden *fijnschilders* (fine painters), of which Frans van *Mieris the elder and younger are later representatives. Dou had a large studio, and was prosperous and highly respected by contemporaries; numbering Queen Christina of Sweden and Charles II of England among his patrons. He was *Rembrandt's first pupil from 1628 until Rembrandt left for Amsterdam three years later. In his use of chiaroscuro and the subject matter of *tronies* (uncommissioned character studies), Dou remained indebted to Rembrandt, although he swiftly developed a style of his own, painting on a small scale, with a surface of almost enamelled smoothness. His interior scenes usually contain single or a small number of figures, framed by a stone niche or curtain and surrounded by elaborate still lifes of vegetables, books, or musical instruments. *The Young Mother* (1658; The Hague, Mauritshuis) and *The Doctor* (1653; Vienna, Kunsthist. Mus.) are characteristic of Dou's main areas of specialization which were imitated far into the 19th century. CFW

Sutton, P., *Masters of 17th Century Dutch Genre Painting*, exhib. cat. 1984 (Philadelphia, Berlin, London).

DOURIS (505–470 BC). Athenian vase painter. Douris specialized in painting drinking cups and was one of four leading cup painters of late Archaic and early Classical periods in Athens. He was prolific—his signature is known on more than 50 vases— and inspired many pupils and imitators. His most original work belongs to a transitional period immediately preceding the vast output of his middle period, for example, the *Sacrifice of Iphigenia* in Palermo (Mus. Nazionale), or the voting scene on a cup showing the dispute over the arms of Achilles (Vienna, Kunsthist. Mus.). His middle-period masterpiece, on the interior of a cup (Paris, Louvre), is classic in spirit and shows Eos lifting the body of her dead son Memnon. Frequency of signatures and other inscriptions, clear development of style, and sequential use of evolving ornament allow a more precise ordering of the some 250 vases attributed to Douris than for most other Attic vase painters. DB-O

Buitron-Oliver, D., *Douris: A Master-Painter of Athenian Red-Figure Vases* (1995).

DOVE, ARTHUR (1880–1946). American artist. Dove was born in New York and studied at Cornell. He lived in Paris between 1908 and 1909, where he absorbed the influence of avant-garde abstraction before returning to the USA. After leaving Cornell he worked as an illustrator, but despite growing success it was only in the 1930s that he gave up this work. Alfred Stieglitz, the New York dealer, gave him his first exhibition at the 291 Gallery, which was the first public showing of *abstract art by an American. In the late 1920s Dove lived on a houseboat and made *collages of found objects which showed the influence of *Cubism and *Dada, such as *Goin' Fishin'* (1925; Washington, Phillips Coll.). During the same period he developed an interest in Eastern religions and theosophy, and finding *Kandinsky's work sympathetic, he developed a loose, painterly style and calligraphic line to render abstract natural forms, as in *The Park* (1927; Washington, Phillips Coll.). In the 1930s his work began to reflect an interest in *Surrealism, but towards the end of the decade he abandoned biomorphic abstraction for a more geometric style. MF

Cohn, S., *Arthur Dove: Nature as Symbol* (1985).

DOWNMAN, JOHN (c.1750–1824). English portrait painter. Downman appears to have been a pupil of *West, whose undated portrait he painted (London, NPG), before enrolling in the newly founded RA Schools (see under LONDON) in 1769. From 1773 he travelled to Italy with Joseph *Wright, remaining there until 1775, drawing landscape, under Wright's tutelage, and studying the *Antique. He may have intended to become a *history painter but later attempts attracted derision. *Edward IV Visiting the Duchess of Bedford* (1797; London, RA, untraced) proved that 'attempts at sublimity are above his powers' according to the *Morning Post*. A small oil of *Jason and Medea* (Wolverhampton, AG) confirms this contemporary criticism. By 1777 he had found his *métier* and was painting small portraits in Cambridge. His mature style had evolved by 1780 when he painted members of the *Hertford Family* (1781; London, Wallace Coll.). From now on most of his pictures show single sitters, shoulder-length, in profile or three-quarter face, like the elegant *Sarah Siddons* (1787; London, NPG), in pencil and charcoal tinted with watercolour. Although criticized as flattering this formula proved extremely popular with his clients. DER

Munro, J., *John Downman, 1750–1824: Landscape, Figure Studies and Portraits of 'Distinguished Persons'*, exhib. cat. 1996 (Cambridge, Fitzwilliam).

DOYEN, GABRIEL-FRANÇOIS (1726–1806). French painter. He studied with Carle van *Loo and in 1752 went to the French Academy in Rome where he fell under the spell of *Raphael and the Bolognese painters of the 17th century. After his return to Paris he exhibited a series of enormous canvases of scenes from classical literature which enjoyed great critical acclaim; some, such as *Venus Wounded by Diomedes* (1761; St Petersburg, Hermitage), subsequently being bought by Empress Catherine of Russia. To a public more used to the light-hearted *Rococo mythologies of *Boucher, Doyen's work seemed to announce a new and more serious kind of painting, albeit one enriched, unlike that of his *Neoclassical successors, with Venetian-inspired colour and brushwork. Doyen's masterpiece is the frenetic, proto-Romantic *Le Miracle des Ardents* (Paris, S. Roch) of 1767. During the early years of the Revolution he was involved in the foundation of the French national museum in the Louvre (see under PARIS), but in 1792 he went to Russia as professor at the St Petersburg Academy. MJ

Sandoz, M., *Gabriel-François Doyen* (1975).

DRAPERY PAINTER, a specialist responsible for the costumes in portraits. From at least the early 17th century the demands made on the time of fashionable portrait painters obliged them to rely on specialist assistants or subcontractors for the more mechanical parts of their productions, such as clothes and other draperies, landscape backgrounds, fruit and flowers, and in some cases even hands. Van *Dyck certainly used studio assistants to block in the costumes of his sitters from his drawings, though usually adding the finishing touches himself. *Lely's studio had a highly organized division of labour, while in France it is clear that *Rigaud, for instance, used such a system, since the heads of some of his full-length portraits are painted on separate pieces of canvas pasted onto the rest of the picture. By the early 18th century in England the practice was widespread, if also widely criticized by purists such as *Hogarth. Specialist drapery painters, chief among them the Fleming Joseph van Aken (c.1699–1749), had their own London studios, to which not

only provincial painters but also well-known artists such as Allan *Ramsay, Thomas *Hudson, and Joseph *Wright of Derby sent their unfinished pictures, often choosing from a standard repertoire of poses and costumes. By the mid-19th century the practice had virtually died out, even a portraitist as prolific as *Winterhalter painting the costumes in the original versions of his compositions.　MJ

DRAWING. *See opposite.*

DRAWING BOOKS, term for books usually designed to teach the beginner how to construct a plausible image of the human figure, of animals, trees, etc., by providing examples to be copied and simple diagrams to be memorized. There are many specialized books on how to draw hands, eyes, birds, flowers, or sailing boats, and whole encyclopedias providing a drawing course. These books, which are far removed from the preoccupations of contemporary artists, have a venerable ancestry. *Villard de Honnecourt included similar diagrams of simplified figures in his pattern book of the 13th century and we can infer that many similar series existed in medieval workshops. The first printed book of this kind is by Heinrich *Vogtherr of Strasbourg (1538) containing pages of heads, hands, feet, and ornaments without, however, any diagrammatic analysis of the shapes. This was provided by Erhard Schön (1538) and several other south German artists, such as Hans Sebald *Beham, whose work was published posthumously in 1565 and Heinrich Lautensack (1564) as well as by Jean *Cousin in France (1593), all of whom stressed the need for schemata of *proportion in the construction of figures.

The spread of this genre to Italy may be connected with the Academy of the *Carracci and with Odoardo Fialetti (1608), *Guercino (1619), and others providing examples. In the Netherlands Pieter de *Jode (1629) and Crispijn van de Passe (1643) collected and enriched this visual vocabulary, the growing demand also eliciting copies of drawings from the masters such as A. *Bloemaert's *Drawing Book*, which was probably put together by his heirs.

In the 18th century innovations such as Charles *Le Brun's studies of *expression were embodied in these encyclopedias, which also paid increasing attention to *picturesque landscape motifs. This special field, so attractive to the amateur, soon produced a genre of its own, of which the most famous and the most original is the one by Alexander *Cozens (1786) teaching the transformation of blots into *Claude-like scenery.

The sketching amateur was catered for in the 19th century by treatises of John Burnet (1784–1868) and James D. Harding (1798–1863), as well as by many more elementary drawing books.　HO

DRESDEN: PATRONAGE AND COLLECTING. Dresden's artistic significance rests on the collections of the electors of Saxony who had their seat there. They owe their present form mainly to the two electors who also ruled as kings of Poland; Friedrich August I, 'Augustus the Strong' (ruled as Elector 1694–1733 and as King August II of Poland 1697–1733), and Friedrich August II (ruled also as King August III of Poland 1733–63). Apart from the high quality of the collections, their reordering and display by Augustus the Strong was an important step in the evolution of specialist museums and art galleries.

Seat of the dukes of Saxony since 1485, Dresden became capital of the electorate following the battle of Mühlburg in 1547 when Charles V conferred the electorship on Duke Moritz (ruled 1541/7–53). The requirement for more lavish entertaining necessitated the extension of the Residenz Palace and the establishment of electoral collections. With Moritz's humanistically educated brother, the Elector August (ruled 1553–86), one of the most important collectors of the *Renaissance took up the reins of government. August's library and collection of parade weaponry (Armoury) were already renowned among his contemporaries. But his greatest claim to fame was the establishing in 1560 in the Dresden palace of the *Kunstkammer, one of the first exhibition rooms north of the Alps. Its orientation was both artistic and scientific, and this remained characteristic of the electoral collections during their constant enlargement under August's successors, from Christian I (ruled 1586–91) to Johann Georg IV (ruled 1691–4).

After his acquisition of the Polish crown (1697), and his concomitant conversion to the Catholic faith, the ambitious, art-loving Elector-King Augustus the Strong methodically set about building Baroque Dresden as a royal seat of European stature, and as part of the same political statement he became increasingly preoccupied with what were now the royal collections. August succeeded in engaging outstanding artists from all fields for his court. His ambition was however not only to increase the collection by means of commissions and acquisitions of a high standard, but also to reorder it. In the course of this reorganization, particular collections were separated out of the much enlarged *Kunstkammer* and developed into independent entities. The purchase of *Giorgione's *Sleeping Venus* in 1699 marks the beginning of a definite acquisition policy for paintings; these were displayed in 1707 in the palace's Redoutensaal (ballroom), which was fitted out as a picture gallery. The Dutch (subsequently Japanese) Palais housed August's

collection of china from the Far East as well as that produced in the Meissen factory founded in 1710. His jewellery and most prized pieces together with earlier works from the *Kunstkammer* were arranged in the Green Vault (Grünes Gewölbe), which was fitted out as a treasure chamber and museum from 1723 onwards in what had been the palace's strongroom. In 1728 August founded the Palais Royal des Sciences in Dresden's Zwinger Palace with exhibition rooms for natural history specimens, scientific instruments for mathematics and physics, and copperplate engravings as well as for the older collections from the *Kunstkammer*, library, and anatomy room. In the same year he acquired Gottfried Wagner's collection of drawings in Leipzig and the Chigi and Albani collections of antiquities in Rome. In 1730 the sculpture collection found a home in the Palais in the Great Garden, and the Salon for Mathematics and Physics was established in the Zwinger. In addition to the drawing up of inventories of the collections, Augustus also promoted their publication and opened them to the public.

Friedrich August II resolutely continued his father's work, but not in all its aspects. By concentrating on high-quality acquisitions for the picture gallery, the engravings collection, and the library, he furthered those arts which were to develop most markedly in the bourgeois age. In 1746, after the spectacular purchase of 100 paintings from the Duke of Modena's collection, he opened his new picture gallery in the former stable building. From 1738 the prime minister Count von Brühl (1700–63) was responsible for the overall management of the royal collections. His own collections, for which Brühl built the first separate gallery building in 1742–4, were on a par with those of Friedrich August. The art connoisseur Carl Heinrich von Heineken (1706–91) undertook the purchases for both the Elector-King and the Count, and also saw to the publication of reproductive engravings from both galleries. The Venetian collector and critic Francesco *Algarotti (1712–64) also acted as an adviser. The paintings and drawings bought by Catherine II of Russia from Brühl's estate are today among the treasured possessions of the Hermitage. Dresden's artistic life, which had long been in the thrall of the court, became more bourgeois in orientation at the end of the 18th century. The Academy of Art co-founded in 1764 by Christian Ludwig von Hagedorn (1712–80) made a decisive contribution to this development. The patronage of the arts in Dresden in the Romantic period was in the hands of private art collectors, including Johann Gottlob von Quandt (1787–1859) and Berhard von Lindenau (1779–1854), but also King Friedrich August II of Saxony (ruled

continued on page 190

· DRAWING ·

DRAWING is the act of making a mark by pulling a medium across a surface. It is the oldest and most widespread art form since it is the mode of (non-performance) artistic expression that requires the least preparation and the simplest materials. Cave paintings (or rather, drawings) are the earliest examples of fine art of which we have a substantial corpus, and their reductive vocabulary—the outline and the profile—recurs throughout human visual expression.

A drawn line, of finite width, is usually the representation of the infinitesimally narrow boundary between surfaces, tones, or colours, and is thus abstract to some degree. Nonetheless our continual exposure to such representations at every level of schematization allows us to interpret instantly drawings of a remarkable range of complexities: an Egyptian pictogram, a figurated Greek vase, a Chinese scroll painting, and a *Matisse line drawing are all equally, immediately legible without the need to learn a visual-cultural language. Further, some drawings we react to instinctively: a baby will smile at a 'face' comprised merely of two circles and a line; fledglings cower below the silhouette of a hawk.

This sensitization to linear structure is central to our visual perceptions, and in the *Renaissance drawing became fundamental to the creative processes of the visual arts, both practically and theoretically (the Italian *disegno*, 'design' as well as 'drawing', is applied to all aspects of representation, including the three-dimensional). Prior to the Renaissance the principal design tool had been the pattern book, a collection of careful drawings of heads, figures, animals, and so on. Artists could combine these standard images into a composition as required (with appropriate improvisation), allowing the workshop assistant to know what to paint, in the required style, and the patron to know what to expect. But during the 15th century developing humanistic attitudes among patrons increasingly esteemed the creative contribution of the individual artist, and the emphasis of contracts shifted from those skills necessary to construct the artefact, to those necessary to devise the composition.

The *pattern book tradition thus gradually gave way to a method whereby the elements of a composition were devised for one specific commission, and this required more preparatory work in the form of drawings. The supply of *paper rapidly increased during the 15th century and its cost dropped; whether this was a consequence of artists drawing more, or merely a coincidence, paper soon became the favoured support for drawing, supplanting both parchment (expensive) and wooden tablets coated with a renewable preparation (ephemeral).

The free sketch allowed an artist to evolve an image in an individual and semi-automatic way, each new line a largely instinctive response to the patterns already present on the paper. But despite this personalization of the planning of a composition, the artefact itself continued to be a complex physical product. Assistants remained essential for all large-scale projects, and the working drawing became the medium for controlling and harmonizing the members of the studio. This regulation of the creative process through drawings can be seen developing in the larger workshops of the later 15th century (such as that of *Ghirlandaio), though the very poor survival rate of drawings from this period makes generalization hazardous, especially outside Italy.

Around 1500 the range of drawing seems to have expanded dramatically. This was partly due to technical advances, in particular the exploitation of natural *chalks, simple to use and versatile in character, which rapidly displaced the labour-intensive and exacting *metalpoint. More profoundly, two highly influential individuals, Albrecht *Dürer in Germany and *Leonardo da Vinci in Italy, realized the potential of drawing for all aspects of visual research. Hammering out a composition in a tangle of lines; studying the nude model or the fall of drapery; recording the finest details of animals and plants; codifying human proportion or anatomy, military fortification, or the movement of water; capturing a personal impression of a landscape or the memory of a dream; producing a drawing to be appreciated as an independent work of art: almost all the modes of draughtsmanship of subsequent centuries were prefigured in their works.

Both artists were gregarious, generous, and itinerant. Personal contact and the dispersal of their drawings (and, crucially, Dürer's prints, which captured the vitality and range of his drawings) disseminated their innovations throughout Europe. Leonardo's years in Florence after 1500 revolutionized the artistic scene there, and his example was fundamental to the development of his two great successors, *Michelangelo and *Raphael.

Raphael's pragmatic use of drawings allowed him to cope with a deluge of work in his later career and direct a large and changing band of assistants. A distillation of current practices yet also endlessly innovative, his workshop methods were reduced by later generations to a formula: compositional sketches to determine the general form of the work; the elaboration of individual figures, usually from the model; and their subsequent integration and enlargement to the scale of the finished work. This essentially mechanical task could be delegated to assistants, an increasingly prevalent practice in *Baroque art as the scale of major commissions increased and expectations of meticulous finish declined.

This systematization of the creative process through drawing was central to the methods of the formal *academies of art. These were established as the guild system declined in importance and the status of the painter rose inexorably from craftsman to liberal artist. Beginning

with the explicitly named Accademia del Disegno in Florence in 1563, and reaching their apogee under *Le Brun in Paris in the late 17th century, the academies aimed to provide (in parallel with the practical workshop apprenticeship to a master) an intellectually based education, almost always based on drawing.

The simplicity of drawing allows the pupil to concentrate on form alone, without being distracted by the physical demands of the medium, and therefore has consistently been the basis of art training. It teaches discipline and control, being a faithful record of the movements of the hand, and an initial emphasis on copying from other works of art inculcates an approved style in the young artist. In the academies students usually drew first from casts of Antique sculpture or of the human body, progressing to drawing from the posed model (in time these life drawings were themselves called 'academies'), before being permitted to work on independent compositions.

This teaching method remained virtually unchanged (however outdated) in the academies until well into the 20th century, although few artists of any note ever adhered strictly to an orderly progression of working drawings for their own compositions. It is true that those artists closer to a classical ideal were generally more productive and methodical draughtsmen, such as *Domenichino, *Maratti, and *Ingres, but some artists with very strong elements of *disegno* in their work (*Caravaggio is the prime example) relied little on drawing. In the Low Countries, artists' drawing habits rarely conformed to the academic ideal. *Rembrandt drew incessantly, and made the activity the foundation of his pupils' tuition, yet relatively few of his sheets were in direct preparation for paintings; *Rubens's drawings were usually preparatory studies, but, like Raphael, he was continually adapting his methods to answer specific needs.

From the late 15th century onwards highly finished drawings had been produced sporadically for collectors as objects of virtu, such as the chalk portrait heads of northern Italy, Michelangelo's presentation drawings of the 1530s, or *Goltzius's 'pen works' around 1600. More significant was the growth in the collecting of preparatory drawings, by those who were not artists themselves, as pure manifestations of artistic inspiration—a product of the increasing concern with the creatively intellectual content of a work of art, and the use of drawing as the

vehicle for this creativity. It is apparent (though little documented) that many types of studio drawings in the 16th century were produced with an eye on the collectors' market or recycled from the studio, such as *Barocci's pastel heads. The growth of a broad collecting class in the Netherlands during the 17th century led to the large-scale production of explicitly independent, marketable drawings of many types, especially landscapes and genre scenes, often with the addition of watercolour to the usual preparatory materials.

The 18th century saw the entrenchment of many of the trends of the previous 200 years, with the *academies dominating most major art centres. The production of drawings for sale was a significant part of many artists' work, especially in Venice (*Piazzetta, *Tiepolo, *Canaletto); in England, *watercolour emerged as an autonomous activity midway between drawing and painting, and pastel portraits enjoyed a great vogue across Europe. But the tensions between the conservatism of academic routines and the practices of the avant-garde were becoming insuperable, and in the 19th century there was a marked fragmentation of graphic purpose among the artistic community—the aims and methods of *Turner, *Delacroix, *Ingres, and *Menzel, for instance, were fundamentally different.

Drawing was to become increasingly free of its role as a preparatory activity, a process that reached its conclusion in the 20th century. The subservience of drawing to the more traditional finished media (oil on canvas, sculpture, architecture, and so on) has disappeared, and the final blow to its essential design role since the Renaissance has now come with the development of Computer-Aided Design programs, which have replaced manual drawing for all large-scale projects. The versatility of drawing has made it a vital aspect of the work of nearly all experimental artists, most notably *Picasso, and a much higher proportion of works executed for sale (excluding prints) are made on paper. The growth of the exhibition industry, a decline in classical and religious education, and the individualism of the latter half of the 20th century have led to an appreciation among the general public of drawing as a prime expression of creative genius. MC

Meder, J., *The Mastery of Drawing*, trans. and rev. W. Ames (1978).
Monnier, G., and Rose, B., *History of an Art: Drawing* (1979).
Rawson, P., *Drawing* (2nd edn., 1987).
Sciolla, G. C. (ed.), *Drawing* (1991–3).

1830/6–54), who assembled a first-class collection of graphic art. From 1791 the *Romantic painter Caspar David *Friedrich was an important presence in Dresden, and from the 1820s the city was one of the main centres of the *Nazarene movement.

Artists benefited from more broadly based sponsorship with the foundation in 1828 of the Sächsischer Kunstverein. Towards the end of the 19th century a private art market was established in Dresden. The painter Gotthardt Kuehl (1850–1915) reformed the exhibition scene from 1897 onwards and introduced the *Impressionists to Dresden.

In 1905 the modernist group Die *Brücke was founded in Dresden, though it had at least as much influence in Berlin as in Dresden itself. In 1911 the key founder members *Kirchner, *Heckel, and *Schmidt-Rottluff moved to Berlin and the group was formally dissolved there two years later.

One of the most important collections of modern art was that of Ida Bienert (1870–1966), whose promotion of the 1926 International Art Exhibition had a decisive influence. The destruction of Dresden in the Second World War caused a considerable hiatus in cultural life. A large proportion of the art treasures rescued by the Soviet army and taken to Russia did not return until 1956/8. From 1946 the GDR's main art exhibitions were mounted in Dresden, and from 1950 exhibition and acquisition policy was largely under state control. CS

Haskell, F., *Patrons and Painters* (1963).
Kaufmann, T. da C., *Court, Cloister and City* (1995).

DRESDEN, GEMÄLDEGALERIE. There are two painting collections of major importance: the Gemäldegalerie Alte Meister (Old Master Gallery) and the Gemäldegalerie Neue Meister (Gallery of New Masters). The former is housed in the Semper Gallery, which forms part of the Zwinger museum complex and the latter is at present in the Albertinum. The Albertinum also houses the Skulpturensammlung (Sculpture Collection). The origins of these collections lie in the collecting zeal of the electors of Saxony (see DRESDEN).

The collection of paintings remained in the converted stables of the Judenhof until 1855, when it was installed in the Semper Gallery, newly built for the purpose. The strength of the collection lies in its Italian paintings of the 16th and 17th century and Dutch and Flemish pictures of the 17th century, and it was Friedrich August II (ruled 1733–63), together with his prime minister, Count Brühl, who shaped the collection as it is today. The paintings acquired from the Duke of Modena in 1745 included *Holbein's *Sieur de Morette* and *Titian's *Lady in White* and four pictures by *Correggio, while *Raphael's *Sistine Madonna* was added in 1754. In 1747 Bernardo *Bellotto was invited to paint 25 views of Dresden. Little was then added until the 19th century, when the work of early Italian Renaissance artists such as *Mantegna, *Botticelli, and *Antonello da Messina entered the collection.

The Skulpturensammlung in the Albertinum was founded by Augustus the Strong with a collection of Antique sculptures, from which the collection grew to include sculpture of all periods. Later, in 1782, a collection of *plaster casts was added from the estate of the *Neoclassical painter Anton Raphael *Mengs. A number of modern sculptures by artists such as Ernst *Barlach were lost during the Nazis' campaign against 'degenerate art'.

The Gemäldegalerie Neue Meister collection was built up, not by Saxon rulers, but by a retired minister of state, Bernhard August von Lindenau (1779–1854), with works by German Romantic artists such as Caspar David *Friedrich and Ludwig Richter. In 1882 Karl Woermann became director of the gallery and announced his intention to make the collection more representative of 19th-century contemporary art. Woermann and his successor, Hans Posse, added works by German artists such as *Menzel, *Böcklin, and *Liebermann, as well as French painters, including *Courbet, *Manet, *Monet, and *Gauguin. A number of important *Expressionist paintings, such as by Otto *Dix, Emil *Nolde, and Karl *Schmidt-Rottluff, reflect 20th-century developments, as do social realist paintings, including the work of Hans Grundig, acquired during the Communist period. CFW

DROUAIS, FRANÇOIS-HUBERT (1727–75). French painter. He was the son of the portrait painter Hubert Drouais (1699–1767), who with *Boucher trained him. He succeeded Jean-Marc *Nattier as the most fashionable portrait painter at Louis XV's court. Most at home with images of young women and children, he popularized the conceit of depicting aristocratic children in rustic guise. A good example of this genre is *The Children of the Duc de Choiseul as Savoyards* (1759; New York, Frick Coll.). Drouais was, nevertheless, capable of less superficial work and his magnum opus is his full-length of the elderly *Mme de Pompadour* working at her embroidery (1763; London, NG). Drouais's son Jean-Germain Drouais (1763–88) was a history painter and the favourite pupil of David until his suicide. MJ

Gabillot, G., 'Les Trois Drouais', *Gazette des beaux-arts*, 34 (1905); 35 (1906).

DRYING OILS. See MEDIUM.

DRYPOINT, a method of scoring lines into a copper plate by drawing directly onto its surface with an etching needle. No acid or varnish is used, and the technique requires great force and skill. As the needle scores the plate a little ridge of copper is ploughed up on each side of the line. This prints with a dense black, slightly clotted effect, known as *burr. The burr very quickly wears out, and as a consequence only a few good impressions can be printed. The technique has frequently been used to augment regular etched line.

It was first used by the *Master of the Housebook, who employed no other method, and his work probably inspired the handful of drypoints by *Dürer, who possibly abandoned its use because of its limited commercial application. In the 17th century it was much employed by its greatest master, *Rembrandt, who used it on its own in such plates as the *Three Crosses*, and as a device to work up areas of his etched plates. It was also used in Italy by Salvator *Rosa and *Castiglione as a means of enlivening their plates. It was little used in the 18th century but it was probably the influence of Rembrandt that saw its reappearance in the 19th century when it was used by *Whistler, *Rodin, and many others. It has always been favoured for its effect of spontaneity, and has been used in the 20th century by artists as varied as *Beckmann and *Picasso. RGo

DUBOIS, AMBROISE (1542/3–1614/15). Flemish painter of the Second School of *Fontainebleau, who links this school with the French *Baroque. He was first recorded at nearby Avon in 1595. Much of his work has survived at Fontainebleau, and, like *Dubreuil, he would have had a large studio. The strongest influence on his style comes from *Primaticcio and *Nicolò dell'Abbate in the Galerie d'Ulysse (destr.). Fragments of his decoration for the Galerie de Diane (constructed 1600, destr. 1810) have been incorporated into the Galerie des Assiettes. Dubreuil was painter to Marie de Médicis in 1606. For her he decorated the Queen's Cabinet (destr.) with episodes of the story of *Tancred and Clorinda* from Tasso's *Gerusalemme liberata*, the first book Marie read in French. Some pictures are still at Fontainebleau, some in the Louvre. The Oval Chamber, now the Salon Louis XIII, contains most of the episodes of the complicated and lengthy romance of *Theagenes and Chariclea* from the *Aethiopica* of Heliodorus. Dubois tells the story with clarity and simplicity, exploring effects of chiaroscuro, his figures solidly three-dimensional. LL

DUBREUIL, TOUSSAINT (c.1561–1602). French painter, a leading figure of the Second School of *Fontainebleau. His hand is only known from drawings in a style derived from *Primaticcio. He and presumably a considerable studio produced *cartoons for tapestries, including the *Histoire de Diane*, paintings for Henri III and Henri IV at Fontainebleau, the Tuileries, and the Louvre, little of which survives. Van *Mander says that he often used Flemings to paint for him, adding only a few touches himself. This would explain the variety of hands and northern *Mannerist qualities in the few pictures identifiable from the 78 he provided c.1600 for the Château-Neuf of St Germain-en-Laye. They illustrate episodes from Ronsard's *Franciade*, published 1572, a reworking of the *Aeneid* to celebrate the descent claimed by the French kings from the Trojans. Mannerist forms are treated with a broad brush stroke and bright, decorative colour, as in *Hyante and Climène at their Morning Toilet* (Paris, Louvre). Vouet was influenced by these qualities. LL

Cordellier, D., 'Dubreuil, peintre de la Franciade de Ronsard au Château-Neuf de St Germain-en-Laye', *Revue du Louvre* (1985).

DU BRŒUCQ, JACQUES (c.1505×10–1584). Flemish sculptor who had first-hand knowledge of Italian *Renaissance forms which he introduced to the Southern Netherlands. He also worked as an architect for Mary of Hungary and the Emperor Charles V. He was in Italy 1530/5, and seems to have looked carefully at works by *Raphael, *Michaelangelo, and *Sansovino. Back in the Netherlands, he worked principally in Mons, where his major commission was the *rood-screen (1535/49) for the Cathedral of S. Waudru. The screen was innovatory in its use of classical architectural forms, their realization in black marble and white alabaster, and in the profusion of Italianate figure

sculpture and reliefs. Much was destroyed at the French Revolution, but surviving alabaster figures of the *Cardinal and Theological Virtues* (Mons, S. Waudru) have a classical calm and weight, with typically fleshy features. *Giambologna worked with du Brœucq c.1544/50.

LL

DUBUFFET, JEAN (1901–85). French painter, sculptor, and writer. Dubuffet's involvement with art was sporadic, until the early 1940s when he abandoned his wine business to devote himself to painting. His first exhibitions, featuring canvases rendered in an aggressively infantile style, were greeted with uproar and derision. In a 1947 publication he expounded his theory that anyone could create art, and that the output of professionally trained artists was often worthless in comparison to the raw emotional spontaneity of work by children and imbeciles. He also began a collection of *Art Brut, consisting largely of works by psychiatric patients. Financially independent with no need to exhibit, Dubuffet operated entirely alone in the spirit of an amateur. His enormous and varied output included scenes drawn from Parisian street life (*Man with a Hod*, 1956; London, Tate) and from the mid-1960s on a series of large sculptures in vinyl-painted expanded polystyrene (employed for rapidity of execution). As the public became more blasé towards his assaults on conventional notions of artistic skill and craftsmanship, so later works displayed a certain complacency and repetitiveness.

AA

Chambres pour Dubuffet, exhib. cat. 1995 (Vence, Fondation Émile Hugues).

DUCCIO DI BUONINSEGNA (active c.1278, d. 1318/19). Sienese painter. Duccio's career as the foremost painter in Siena from the 1280s until his death can be traced through a number of contracts and one major signed masterpiece. After commissions for various minor painted works which have not survived, in 1285 his first major contract was for a *Madonna* for S. Maria Novella in Florence. His career reached a climax in 1308 with the contract for a huge altarpiece which was to replace an older one on the high altar of Siena Cathedral. This complex assemblage of panels centred round the *Virgin in Majesty*, or *Maestà*, and was completed in 1311. Most of the panels are now displayed in the Museo del Duomo there; among those absent are some now in London (NG), New York (Frick and Rockefeller Colls.), and Washington (NG). This is Duccio's only surviving work which is both documented and signed, and his œuvre has had to be established by reference to it. The other major painting associated with Duccio is the so-called *Rucellai Madonna* (Florence, Uffizi) which although

ascribed by *Vasari to *Cimabue is now usually accepted as Duccio's S. Maria Novella picture contracted in 1285 and described above. Other pictures attributed to Duccio include the exquisite, gemlike panel known as *The Madonna of the Franciscans* (Siena, Pin.). He appears never to have worked in fresco.

It is difficult to exaggerate the splendour, originality, and importance for Sienese and Tuscan art of Duccio's *Maestà*. In form it is double-sided; the front is dominated by an image of the enthroned Virgin and Child, attended by ranks of saints and angels, four of the former being patronal saints of Siena. This treatment of a unified compositional space stands between the hieratic and separately framed images of the late medieval altarpiece and the developed *sacra conversazione* of the 15th century. The back of the *Maestà* incorporated a uniquely extensive programme of 26 scenes from the Passion and life of Christ after the Resurrection, and this too broke new ground in its complexity and extent.

Duccio's style at its culmination in the *Maestà* represents a supremely original synthesis of earlier iconography (in some cases of *Byzantine origin) and a Tuscan understanding of form and volume. With this is blended an unerring understanding of the decorative possibilities of colour and line, and of how the context or setting of a narrative episode can be used to assist or emphasize the meaning and dramatic significance of the action. In addition to his grasp of large-scale aesthetic effect Duccio also displays a finely tuned perception of human qualities in his painting: the excited actions of the tree-climbing children in *Christ's Entry into Jerusalem* on the back of the *Maestà*; and the child wriggling to give a blessing to the diminutive, kneeling friars in the *Madonna of the Franciscans*.

The calmly lucid and supremely decorative qualities of Duccio's art conceal a socially difficult and even anarchic personal character. The records of Siena contain numerous references to fines levied on the artist for a variety of antisocial offences, including refusal to swear an oath of allegiance to a city official, as well as for debt.

PH

Stubblebine, J. H., *Duccio di Buoninsegna and his School* (2 vols., 1979).

White, J., *Duccio. Tuscan Art and the Late Medieval Workshop* (1979).

DUCHAMP, MARCEL (1887–1968). French artist, widely acknowledged as one of the most important and influential avant-garde theorists of the first half of the 20th century. The youngest brother of Raymond *Duchamp-Villon and Jacques *Villon, Duchamp studied painting for a year at the Académie Julian in Paris, but subsequently failed the entrance examination for the École

des Beaux-Arts. In his early work he experimented with a variety of styles. The year 1911 marked his *Cubist period (see also SECTION D'OR), which, following the influence of *Futurism, culminated in the creation of *Nude Descending a Staircase* (1912; Philadelphia Mus.). This work, after rejection by the Salon des Indépendants (see under PARIS), became a *succès de scandale* at the 1913 *Armory Show. By now Duchamp was on the verge of entirely forgoing conventional painting. He pre-empted *Dadaism with his inclination towards the anti-rational, and deliberate contradiction of convention. His promulgation of an art devoted to the idea, which eschewed craftsmanship and any concern with aesthetics, led to the origination of the ready-made. The first was *Bicycle Wheel* (1913; original lost), later followed by the notorious *Fountain* (1917; original lost), a urinal unmodified bar the addition of the date and the signature R. Mutt. In 1915 Duchamp began an extended sojourn in New York, and started his major work *The Bride Stripped Bare by her Bachelors, Even*, or *The Large Glass* (1915–23; Philadelphia, Mus. of Art), a mixed-media piece of arcane, mechanical imagery. Initiation to Dadaism during a stay in Paris was followed by celebrated iconoclasm such as *LHOOQ* (1919; priv. coll.)— a reproduction of the *Mona Lisa* adorned with beard, moustache, and obscene inscription—and the birth of a female alter ego, Rose (later Rrose) Sélavy. With *Man Ray and Katherine Dreier (1877–1952) Duchamp founded the Société Anonyme (1920), and was a central figure in the short-lived New York Dada movement. After declaring *The Large Glass* 'finally unfinished' in 1923, he abandoned art for chess, which had become an obsession, and which he played at world-class level. His involvement with art continued, however, as he was instrumental in the organization of numerous publications and exhibitions, including the 1938 Exposition Internationale du Surréalisme, at the Salon des Beaux-Arts, Paris. During the 1950s he adopted US citizenship, and was venerated as a grand old man of the pre-war avant-garde. It was posthumously revealed that he had spent the final 20 years of his life working in utter secrecy on a large assemblage, *Étant donnés* (1946–66; Philadelphia Mus.). The shock-wave of his legacy reverberates to this day.

AA

Moure, G., *Marcel Duchamp* (1988).

Paz, O., *Marcel Duchamp: Appearance Stripped Bare* (1978).

DUCHAMP-VILLON, RAYMOND (1876–1918). French sculptor, born in Damville, near Rouen, the brother of Marcel and Suzanne *Duchamp and of Jacques *Villon (he adopted the name Duchamp-Villon in about 1900). After illness forced him to give up his medical studies at the University of Paris in 1898 he took up sculpture, at

which he was self-taught. For the next dozen years or so he experimented with various styles until in about 1910 he became involved with *Cubism. Several other Cubists used to meet in the studios of Duchamp-Villon and Jacques Villon and from these meetings the *Section d'Or group emerged. In 1914 Duchamp-Villon enlisted in the army as an auxiliary doctor, and he contracted typhoid fever in 1916; he spent his last two years as an invalid before he died in a military hospital in Cannes. His death cut short a career of great promise; his major work, *The Horse* (1914, of which there are casts in the Tate Gallery, London, MoMa, New York, and elsewhere) was one of the most dynamic expressions of physical power and movement by any strictly Cubist artist.

DUFY, RAOUL (1877–1953). French painter and designer. Dufy began painting in an *Impressionist manner, influenced by van *Gogh and *Boudin. Discovering *Fauvism at the Salon des Indépendants (see under PARIS) in 1905, his style absorbed the movement's exuberant colours and loose handling in such work as *Posters at Trouville* (1906; Paris, Centre Georges Pompidou). However, the influence of *Cézanne later led him to a stronger compositional structure and more subdued use of colour. In the 1920s he developed his mature, distinctive style: decorative and calligraphic, colour is applied independently of line to create a lively, dynamic effect. MF

Werner, A., *Raoul Dufy* (1985).

DUGHET, GASPARD (Gaspard Poussin) (1615–75). French painter, draughtsman, and printmaker, born in Rome, where he made an important contribution to the development of classical *landscape painting. He was the brother-in-law and pupil of Nicolas *Poussin, and often known by his name. Most scholars accept a group of lyrical and naturalistic landscape paintings, formerly attributed to the Silver Birch Master, as Dughet's earliest works. His frescoes of scenes from the lives of Elijah and Elisha (1647–51; Rome, S. Martino ai Monti) introduced a new grandeur to landscape, and thereafter Dughet was much in demand with the Roman aristocracy, for whom he painted decorative fresco cycles and easel paintings. His landscapes celebrate the wild beauty of the Roman Campagna. Their clarity of structure often suggests Poussin, but in such works as *View of Tivoli* (c.1659; Oxford, Ashmolean) the land is craggier, and the patterns of light more fluid; a vaguely classical herdsman evokes the countryside of *Horace and Virgil. In a further series of majestic, windswept scenes Dughet developed the theme of the storm. He was immensely influential in

the 18th century, particularly in England.
 HL

Boisclair, M. N., *Gaspard Dughet: sa vie et son œuvre (1615–1675)* (1986).

DUJARDIN, KAREL (1626–before 1678). Dutch painter and etcher. Although active as a portrait and history painter, he is best known for his Italianate landscapes. Their similarity to the works of Nicolaes *Berchem has led to the suggestion that Dujardin was his pupil, though no evidence exists to support this. Typical of his landscape paintings is *Farm Animals in the Shade of a Tree* (1656; London, NG). Dujardin is known to have spent the last years of his life in Italy, though the style and subjects of his paintings and landscape etchings suggest that he had also spent time there much earlier in his career. MJ

Nederlandse 17e eeuwse Italianisrende landschapschilders, exhib. cat. 1965 (Utrecht, Centraal Mus.).

DUPLESSIS, JOSEPH-SIFFRED (1725–1802). French portrait painter. Born in Carpentras, he went to Rome in 1745. There he studied under *Subleyras, whose skills at rendering both character and clothing in portraits he absorbed. After difficult beginnings in Paris his career was launched by the opportunity to paint the first official portrait of Louis XVI in 1775 (Versailles). From then on he was much in demand in the fashionable world. In the years leading up to the French Revolution he painted many of his foremost contemporaries, including *Benjamin Franklin* (numerous versions) and the composer *Willibald Gluck* (1775; Vienna, Kunsthist. Mus.). At their best his portraits are lively and insightful in characterization and display an attractive sense of colour harmony. MJ

Belleudy, J., *J.-S. Duplessis, peintre du Roi* (1913).
Sahut, M.-C., and Volle, N. (eds.), *Diderot et l'art de Boucher à David*, exhib. cat. 1984 (Paris, Hôtel de la Monnaie).

DUQUE CORNEJO, PEDRO (1678–1757). Spanish sculptor. He was the last major representative of the *Baroque sculptural tradition in Spain. His dynamic, richly polychromed and gilt works in both stone and wood are to be found in the churches of his native Seville, in Granada, Cordoba, and Madrid. His most characteristic works are the elaborate carved retables that he made for Granada Cathedral (1716) and S. Luis de los Franceses in Seville (1731). He was also responsible in the last years of his life for the polished mahogany choir stalls in Cordoba Cathedral. MJ

Martín, González, J. J., *Escultura baroca en Espana, 1600–1770* (1983).

DUQUESNOY, FRANÇOIS (1597–1643). A Fleming by birth, he settled in Rome and became one of the most sought-after sculptors of the 17th century. He trained in Brussels with his father, Jérôme Duquesnoy the elder (c.1570–1641). In 1618 he went to Rome where he at first supported himself by restoring *Antique sculptures, among them the famous *Rondanini Faun* (London, V&A). He became close friends with Nicolas *Poussin and like him was much influenced by *Titian and by Antique sarcophagi. The result was a series of works featuring children, including the marble relief *A Bacchanal of Children* (1626; Rome, Doria Pamphili Gal.), casts of which were standard equipment in artists' studios well into the 19th century. His principal monumental works, both of which display his restrained and graceful classicizing style in contrast to the dynamic *Baroque of his contemporary *Bernini, are statues of *S. Susanna* (1627–33) in S. Maria di Loreto and *S. Andrew* (1627–39) in S. Peter's, Rome. The latter is companion to Bernini's much more emphatic *S. Longinus*. Duquesnoy also produced small-scale bronzes and portrait busts (e.g. *Cardinal Maurice of Savoy*, 1635; Turin, Sabauda Gal.) in which he aimed for a dignified timelessness. In 1643 he left for France at the summons of Louis XIII, but died en route at Livorno. His brother Jérôme Duquesnoy the younger (1602–54) had a career as a sculptor in Spain and Portugal before returning to Flanders where he was responsible for the magnificent tomb of Antoine Trieste, Bishop of Ghent (1651–4) in S. Bavo, Ghent. His career was cut short when he was tried and executed for sodomy. MJ

Hadermann-Misguich, L., *Les du Quesnoy* (1970).
Nava Cellini, A., *Francesco Duquesnoy* (1966).

DURAMEAU, LOUIS-JACQUES (1733–96). French painter. He was mainly active as a history painter, earning the praise of *Diderot, and with such pictures as *The Continence of Bayard* (1777; Grenoble, Mus. des Beaux-Arts) being among the first to add scenes from French national history to the traditional repertoire of classical and biblical themes. By the 1780s, however, his work had come to seem old-fashioned by comparison with that of *David and other *Neoclassicists. Durameau's most lastingly attractive pictures are his portraits, his genre scenes in the manner of Hubert *Robert, and the ceiling representing *Apollo Crowning Illustrious Men of the Arts* that he painted in tempera for the opera house at the Château de Versailles.
 MJ

Sandoz, M., *Louis-Jacques Durameau* (1980).

DURAND, ASHER BROWN (1796–1886). American landscape painter. Born in Jefferson Village, NJ, he was apprenticed to the engraver (see LINE ENGRAVING) Peter

Maverick 1812–17, established his reputation with his print of *Trumbull's *Declaration of Independence* in 1820, and ran successful businesses until 1831. In the 1830s he abandoned engraving for landscape painting, encouraged by the example and friendship of Thomas *Cole the leader of the *Hudson River School. In 1840–1 Durand visited Europe where he was influenced by 17th-century Dutch painters, clearly seen in works like *The Babbling Brook* (1851; Boston, Mus. of Fine Arts). Durand, like Cole, tempered naturalism with *Claudean idealism and shared his belief that landscape manifested divinity. However, following Cole's death in 1848, which Durand memorialized in *Kindred Spirits* (1849; New York, Public Lib.), he painted a series of *Studies from Nature, en plein air*, which realistically recorded both landscape and weather, a typical example being *Rocks and Trees* (c.1855; New York, Historical Society), a major development in American landscape painting. As president of the National Academy of Design (see under NEW YORK) (1845–61) Durand was an important figure whose *Letters on Landscape Painting* (1855) were highly influential. DER

Asher B. Durand, exhib. cat. 1983 (New York, Hudson River Mus.).

DURANTY, EDMOND (1833–80). French naturalist writer, chiefly known now as an early champion of the *Impressionists and a close friend of *Degas. In 1856 he edited the short-lived review *Réalisme*; there followed, in 1876, around the time of the Impressionists' second exhibition, a 38-page pamphlet entitled *La Nouvelle Peinture*. This was a powerful plea for artists to turn away from traditional subjects, and depict the aspects of modern urban life which had attracted naturalist writers. Duranty explored the origins of the new painting, and analysed the Impressionist interest in the vibration of light and heat. But above all he desired that painting should characterize the modern individual, in his home, in his professional or social life, or in the street; it should create a new immediacy through unusual viewpoints and cropped images. In his novel *Le Peintre Louis Martin* (1881), *Manet, *Courbet, Degas, and other painters figured. Duranty was himself painted by Degas (1879; Glasgow, Burrell). HL

Moffett, C. S., *The New Painting: Impressionism 1874–86*, exhib. cat. 1986 (San Francisco, Fine Arts Mus.) (contains a translation of *La Nouvelle Peinture*).

DÜRER, ALBRECHT (1471–1528). German painter, draughtsman, printmaker in both relief and intaglio, and theoretician; the first artist in northern Europe who transformed the arts from the product of the essentially medieval workshop to a conscious expression of artistic genius. He sought to learn the general laws underlying Italian *Renaissance art—the laws of optics and the 'rules' of ideal beauty and harmony—and he succeeded in synthesizing these laws (*Kunst* in Dürer's terminology) with his own northern heritage with its interest in the particular and emphasis on practical skill (*Brauch*). Through his *woodcuts and engravings (see LINE ENGRAVING), most of them published by himself, he became an international figure, supplying iconographic models to artists throughout Europe and setting new standards of technical mastery.

Dürer was born in Nuremberg, second son of Albrecht Dürer the elder, a goldsmith from Hungary, who had trained in the Netherlands, and godson of Anton Koberger, one of Germany's foremost printers and publishers. Until the age of 5 he lived in a house behind that of the rich patrician and humanist Willibald Pirckheimer, and at 15 he was apprenticed to the leading painter and book illustrator in Nuremberg, Michael *Wolgemut. These four men exercised a powerful influence on Dürer and determined to some degree his artistic career. The father must have taught him the rudiments of drawing, particularly with silverpoint, as is borne out by the 13-year-old boy's *self-portrait (1484; Vienna, Albertina). From Wolgemut Dürer learned the painter's trade and the technique of woodcut. Through Koberger he had access to the world of books and learning, and Pirckheimer directed these interests towards Italy and the new humanism.

After completing his apprenticeship Dürer set out in 1490 on the customary journeyman years. He was supposed to go to Colmar to work under Martin *Schongauer; when he arrived early in 1492, Schongauer had been dead for nearly a year and his three brothers recommended that he go to Basle, one of the great centres of European book production. The designs in many of the illustrated books published there 1492–4 have been attributed to Dürer, including those in the 1494 edition of Sebastian Brant's *Narrenschiff*. The one certain attribution to Dürer is the frontispiece for the *Letters of S. Jerome*, published in 1492. By 1494 Dürer was in Strasbourg, another publishing centre, before returning to Nuremberg the same year. It was probably in Strasbourg that he produced the first and most charming of his painted self-portraits (1493; Paris, Louvre).

Back in Nuremberg a marriage had been arranged for Dürer by his father. A drawing of Agnes Frey, Dürer's wife, inscribed 'mein angnes' suggests affection (Vienna, Albertina), though indications are that the marriage, which remained childless, was unhappy. Dürer left his wife almost immediately on his first trip to Venice (summer 1494–spring 1495), one of the earliest northern European artists to experience the Italian Renaissance on its native soil. The main evidence for the trip consists of drawings and watercolours of Alpine views and Venetian costume studies.

After his return from Italy Dürer settled down in Nuremberg. There followed a decade of extraordinary productivity, during which he carried out numerous paintings—the *Self-Portrait* of 1500 (Munich, Alte Pin.) and the *Adoration of the Magi* (1504); (Florence, Uffizi), originally commissioned for the Schlosskirche in Wittenberg, being the most important early works. He began to print and publish his own woodcuts and engravings, including the *Apocalypse* (1498), the *Large Woodcut Passion* (1510), and the *Life of the Virgin* (1510), and continued to draw and paint in watercolours for his own pleasure and instruction (e.g. the *Hare*, the *Blue Roller*, and the *Great Piece of Turf*, all Vienna, Albertina). At the same time he occupied himself with the Renaissance problems of *perspective, of absolute beauty, of *proportion and harmony. He sought instruction from Jacopo de' *Barbari, an Italian artist who was visiting Nuremberg at the time, and he read Vitruvius. The engravings of *Adam and Eve* and the *Nativity*, both of 1504, are the first fruits of these investigations.

Dürer's prints of these years established his international reputation so that on his second trip to Italy, 1505–7, he was no longer an unknown young northerner but the most celebrated German artist of his age. Upon his arrival in Venice he secured the commission for an altarpiece in the church of the German community, S. Bartolommeo. The theme of the large panel is the *Feast of the Rosegarlands* (now Prague, Národní Gal.), which celebrates the brotherhood of all Christians in their devotion to the rosary. Dürer elaborated the act of distributing the rosary by presenting it as a type of *sacra conversazione*, an Italian subject that features the Madonna and Child enthroned, flanked by saints and donors arranged in a frieze composition. According to his own testimony, the painting was much admired by fellow artists and the aristocratic community in Venice. In its enriched sense of colour, the S. Bartolommeo altarpiece paid tribute to Venetian art, particularly to Giovanni *Bellini, whom Dürer met personally and of whom he wrote that he was 'very old but still the best painter of them all' (letter to Pirckheimer, 7 Feb. 1506).

Dürer relished the social position accorded to artists in Italy when he stated in a letter (dated 13? Oct. 1506) to Pirckheimer: 'How shall I long for the sun in the cold; here I am a gentleman, at home I am a parasite.' Back in Nuremberg, he tried to attain a similarly elevated position. He bought a large house, wrote verse, studied languages and mathematics, and began to draft an elaborate treatise on the theory of art. He succeeded in

bringing out three books on geometry, on fortifications, and on the theory of human proportions, this last appearing posthumously. At the same time, he received commissions for altarpieces, not only from his home town (*Adoration of the Trinity*, 1511; Vienna, Kunsthist. Mus.), but from as far afield as Frankfurt, where Jakob Heller commissioned the *Assumption of the Virgin* for the Dominican church there (1509). The central panel by Dürer was destroyed in 1729 (copy by Jobst Harrich; Frankfurt, Historisches Mus.) but over 20 preparatory sketches for the composition survive, among them the famous *Praying Hands* (Vienna, Albertina).

From about 1511 Dürer also turned with increased energy to his graphic works, experimenting with tonal effects more than he had before the Venetian journey. He produced three 'master engravings' in 1513 and 1514 which are exceptionally large in size, meticulous in technique, and unprecedented in the representation, by linear means alone, of texture, lustre, and light: *Knight, Death, and the Devil*, *S. Jerome in his Study*, and *Melancolia I*. At this time he also designed two more Passion series: the *Small Woodcut Passion* (1511) and the *Engraved Passion* (1513).

After 1512 Dürer's most important patron was the Emperor Maximilian I. For him he designed an enormous *Triumphal Arch* and *Procession*, all on paper and executed in woodcut by members of Dürer's workshop and others. These curious substitutes for true Renaissance pageantry may seem to us rather more intriguing than satisfactory. Dürer is more himself in the marginal drawings for the Emperor's Prayer Book (to which Lucas *Cranach the elder, *Altdorfer, and *Burgkmair also contributed). Works of this kind, which mark the so-called 'decorative' phase of the master's œuvre (he also designed armour and silverware), end with the death of Maximilian in 1519 and his own conversion to Lutheranism *c.*1520.

Dürer's religious beliefs did not however prevent him from travelling to Aachen to attend the coronation of Maximilian's successor, the ultra-Catholic Emperor Charles V, and to secure the renewal of his pension granted him by Maximilian. This was the occasion of Dürer's year-long trip to the Netherlands (1520–1), this time accompanied by his wife. The journey, his last, was as much the artist's triumphal tour as a sightseeing and sketching expedition (*Silverpoint Sketchbook*, dispersed among several museums) and a sales and shopping trip (Agnes Dürer was in charge of selling her husband's prints at fairs). In Ghent, his enthusiasm for the great altarpiece by Hubert and Jan van *Eyck was matched by his interest in the lions kept at the zoo, which he drew in his sketchbook (Berlin, Kupferstichkabinett). He also was attracted by the unusual objects sent to Charles V from Mexico, gifts given to Cortés

by the Mexican Emperor Montezuma, which were on display in Brussels while Dürer was there: 'All the days of my life I have seen nothing that rejoiced my heart so much as these things, for I saw amongst them wonderful works of art, and I marvelled at the subtle *Ingenia* of men in foreign lands. Indeed I cannot express all that I thought there' (Netherlandish Diary, 26 Aug.–3 Sept. 1520).

After his return from the Netherlands, already weakened by a malarial fever contracted there, Dürer was busy with painting portraits and with small-scale engravings, many of them portraits in profile. His last important paintings were the monumental panels with the *Four Apostles*. They were donated by the artist to the city of Nuremberg (now Munich, Alte Pin.), which eighteen months earlier had adopted Lutheranism as its official religion. Referred to in Dürer's letter of dedication 'a remembrance in respect for your wisdom', they are inscribed with texts which are meant to castigate both papists and the more radical Protestants falsifying—in Dürer's view—Luther's teachings (such radical views were expressed by the *Beham brothers and Georg *Pencz).

When Dürer died in 1528, though he was widely known as a painter, his real fame rested on his graphic work which was used in the north and the south. He who may be said to have brought the Italian Renaissance to northern Europe, in turn influenced Italy through his prints. He supplied artists with motifs very much as pattern books had. His originality of invention—encouraged by the medium which required no commission—led to new and unusual iconographic forms, especially in secular subjects. Beyond that, he had elevated the print to a great expressive medium, unsurpassed until *Rembrandt. KLB

Anzelewski, F., *Dürer: His Art and Life* (1982).
Hutchison, J. Campbell, *Albrecht Dürer* (1990).

DURET, THÉODORE (1838–1927). French critic and collector. Born into a wealthy family in Charente, Théodore Duret, Count de Brie, became a major champion of the *Impressionists. He was also a traveller, art dealer, and collector who amassed two substantial collections of contemporary art. Despite his aristocratic background Duret was a keen republican who fled to London on the fall of the Commune in 1871 and visited America and the Far East before returning to France in 1873. His first book, *Les Peintres impressionistes*, accompanied the fourth Impressionist exhibition, held in Paris in 1878, and together with his collected reviews, *Critique d'avant garde* (1885), brought many artists into fashion. Among them were his friends *Whistler and *Manet whose portraits of Duret (respectively 1883; New York, Met.

Mus.; 1868; Paris, Petit Palais) record their esteem; in 1889 he contributed 1,000 francs towards the purchase of Manet's *Olympia* for the Louvre. Like Whistler, he was an enthusiast for Japanese art and his essay *L'Art japonais* (1884) influenced van *Gogh. Forced to sell his first collection after business losses, his second encompassed the *Post-Impressionists. JH

Denvir, B. (ed.), *The Impressionists at First Hand* (1987).

DUTCH ART, painting and graphic art produced from the early 15th century to the present day in the seven Dutch northern provinces of the Netherlands. These seven provinces were Holland, Zeeland, Utrecht, Gelderland, Overijssel, Friesland, and Groeningen.

Until the 17th century this area was agricultural with no cities of economic or cultural importance. These northern provinces, originally part of a larger Netherlands, were a loose collection of territories controlled by the dukes of Burgundy until 1477. The Netherlands were then inherited by Mary, Charles the Bold's daughter, who married Archduke Maximilian of Austria, later Holy Roman Emperor, and thus the Netherlands became part of the Habsburg Empire.

When the Habsburg Empire was divided, on the abdication of Charles V in 1555, the Netherlands became, both politically and economically, a valuable possession of the Spanish Crown. After many years of revolt during the 16th century, the Dutch freed themselves from Spanish rule and, in 1609, the Twelve Year Truce led to the seven northern provinces separating from the Southern Netherlands and becoming an independent political entity, known either as the United Provinces, the Dutch Republic, or, more popularly, Holland, which was the largest and most powerful of the provinces. The struggle had been due partly to religious differences and the impact of Protestantism in the area.

In the 15th century one of the earliest identifiable Dutch painters was Albert van *Ouwater. He was probably the teacher of *Geertgen tot Sint Jins, who also worked in Haarlem. An early awareness of Flemish art was shown by both artists, in that their works are realistic, strong in colour, and have masterly landscape backgrounds. Dutch artists tended to move to the wealthier centres of Bruges and *Antwerp in the Southern Netherlands, one being Gerard *David, who moved to Bruges at the end of the 15th century. A certain confusion arises with artists living in cities on the border between the two parts of the Netherlands as to whether they form part of Dutch or Flemish art. One such is David's contemporary, Hieronymus *Bosch, who appears to have resisted the temptation to move away from his native

's Hertogenbosch, which only became part of the Dutch Republic in the 17th century. Bosch's work shows an individual and novel approach to religious subject matter. His paintings, such as the *Garden of Earthly Delights* and the *Haywain* (Madrid, Prado), illustrate the sins that were important to his contemporaries as well as their consequences, in explicit scenes of hell. The moralizing character of Bosch's many-figured scenes were to make a lasting impact on the work of his successors, both Dutch and Flemish, throughout the 16th century, in particular on the work of Pieter *Bruegel.

In the 16th century influences from Renaissance Italy permeated Dutch art. Dutch artists were drawn to Antwerp in the Southern Netherlands, the leading European port and an important centre of economic and artistic activity. Amongst these artists were Jan *Mostaert, who incorporated Renaissance motifs in his altarpieces and portraits, yet retained Dutch characteristics of meticulous detail and objectivity. Cornelis *Engelbrechtsz. painted in the style of the so-called *'Antwerp Mannerists' with crowded compositions of elongated and twisting figures.

*Lucas van Leyden, Engelbrechtsz.'s pupil, was the dominant Dutch artist of the early 16th century. He was outstanding as a graphic artist, as can be seen in his engravings (see LINE ENGRAVING) such as *Ecce Homo* (1510), which mark him out as an inventive and influential figure in the new technique of printmaking. Even before meeting *Dürer in 1521, Lucas's prints show the impact of the German artist and, through the prints of Marcantonio *Raimondi, the work of *Raphael. Lucas's prints and paintings reveal a new approach to subject matter, exploring themes of everyday life in such paintings as *The Chess Players* (c.1524; Berlin, Gemäldegal.), which anticipate developments in the 17th century. Jan van *Scorel was the first Dutch painter to travel extensively in Italy. His pupil Anthonis *Mor van Dashorst became a court portrait painter with an international reputation throughout the Habsburg Empire, second only to the Venetian painter *Titian. Maerten van *Heemskerck, who was also a pupil of Scorel, emerged as the leading painter of religious subjects in a highly charged *Mannerist style.

By the end of the 16th century a strong, last phase of Mannerism dominated painting in Haarlem. Karel van *Mander, *Cornelisz. van Haarlem, and Hendrik *Goltzius were the first northern artists to form a group known as the Haarlem Academy in 1583. Karel van Mander is remembered more as a writer than a painter and, in 1604, published his influential *Het schilderboeck*. In Utrecht too, Mannerism dominated the work of painters such as Abraham *Bloemaert and Joachim *Wtewael.

Still life began to emerge as an independent subject during the 16th century. Pieter *Aertsen painted inventive still-life and genre scenes, usually large in scale, such as *Kitchen Scene with Christ in the House of Martha and Mary* (1553; Rotterdam, Boymans-van Beuningen Mus.). He ran a successful workshop and his work had a lasting impact upon future artists, not only through his nephew and pupil the Fleming Joachim *Bueckelaer, but also through prints after his works. These prints were disseminated widely, probably influencing early Seville paintings by *Velázquez.

The 17th century is often known, and rightly so, as the Golden Age of Dutch art. A large number of excellent artists emerged with outstanding talents who tackled new areas of subject matter. Although these novel subjects had their foundation in the 16th century, it was only in the 17th century that portraiture, landscape, still life, and genre became subjects in their own right, in place of religious art which, though tolerated, was discouraged in the increasingly Protestant climate of the Dutch Republic.

In the 17th century the outstanding artists were *Rembrandt, Frans *Hals, and *Vermeer. Yet a host of other painters, such as Pieter de *Hooch, Jacob van *Ruisdael, and Carel *Fabritius, would still have raised Dutch painting to a level equal with that of anywhere else in Europe. A combination of political, economic, and social factors at the beginning of the 17th century contributed to a situation in which the arts could flourish. Dutch energies had been built up by the many years spent fighting the Spanish and this had led to a nationalistic pride in their cities, landscape, and institutions such as militia companies and guilds. The recent blockade by the Dutch of the Flemish port of Antwerp had led to the decline of that city and the rise of the port of *Amsterdam in its place. Dutch ships explored new trade routes and brought back a great variety of commodities such as shells, fine carpets, and tulips which were avidly collected and became an important source of inspiration for still-life painters.

Dutch merchants became the new patrons of art, replacing the Church and nobility. The market determining the development of artistic production in the Dutch Republic differed from elsewhere in Europe. Merchants commissioned works either as individuals or as a group, as may be seen in the large number of portraits recording these successful people. Dutch artists were also different from their European contemporaries in that they specialized to a far greater extent in the new subjects of landscape, still life, and marine painting. They did not rely on commissions, but aimed to find a ready market for their work at fairs, and through dealers and auctions. The English diarists John Evelyn and Peter Mundy, who travelled to Holland in the 1640s, both remarked on these methods of art sales. Prices for paintings tended to be low and were more easily affordable by a wider section of the population than elsewhere in Europe.

*History painting, including religious, mythological, and classical subjects, did not disappear and many painters initially aspired to be history painters. In the early 17th century Utrecht and Haarlem emerged as important artistic centres, and particularly in Utrecht there was a resurgence in the commissioning of altarpieces for secret Catholic churches. Three young artists, Hendrick ter *Brugghen, Gerrit van *Honthorst, and Dirck van *Baburen, travelled to Rome from Utrecht which, being the seat of the Catholic archbishopric, had maintained strong links with the papal city. On their return the young painters introduced the work of the Italian artist *Caravaggio, to the north. These 'Utrecht *Caravaggisti' influenced not only Dutch painters, such as Rembrandt, but also French painters, such as Georges de *La Tour.

Throughout his career Rembrandt often turned to the Bible and appears to have found a market for small-scale religious subjects, such as the *Tobit and Anna* (1626; Amsterdam, Rijksmus.), which would probably have appealed to new Protestant sects, such as the Mennonites, or a painting such as *Belshazzar's Feast* (c.1639; London, NG) to a growing circle of Jewish patrons.

*Portraiture had flourished in the 16th century, as the Dutch became wealthy and wanted a permanent memorial to their success. By the second decade of the 17th century painters such as Cornelis *Ketel and Michiel van *Mierevelt were meeting the overwhelming demand for such work. Their portraits, showing solemn men and women dressed in simple but sumptuous black clothes, reflected the sober, hard-working values of the newly emerging Protestant nation. A down-to-earth realism, lack of flattery, and an emphasis upon likeness and character are characteristics of Dutch portraiture at that time. In Amsterdam the dominant portrait painter was Thomas de *Keyser, who injected a new informality and liveliness; probably influencing Rembrandt's early Amsterdam portraits, such as the *Anatomy Lesson of Dr Tulp* (1632; The Hague, Mauritshuis) or the outstanding *The Mennonite Preacher Cornelis Claesz. Anslo and his Wife* (1641; Berlin, Gemäldegal.). Rembrandt never ceased to paint portraits. In his later work dramatic contrasts of light and dark and a calm static quality are pre-eminent, his weighty figures emerging from mysterious shadows, as in *Agatha Bas* (1641; London, Royal Coll.). His technique became more experimental, with smooth detailed strokes being replaced by areas of strongly impasted paint, suggesting a profound inner spirituality. These characteristics may be seen in the pendant pair of portraits *Margaretha de Geer*

and *Jacobus Trip* (1661/2; London, NG). However, by the middle of the century, taste in Amsterdam was shifting towards the elegant, more descriptive technique of artists such as Bartholomeus van der *Helst, due in part to the influence of the Flemish painter Anthony van *Dyck, and fashions emerging from France.

In Haarlem, Rembrandt's slightly older contemporary was Frans Hals. His nine surviving group portraits (Haarlem, Frans Hals Mus.; Amsterdam, Rijksmus.), influenced by the development of the militia portrait by Cornelisz. van Haarlem, broke new ground. They show his ability to portray figures which appear to exist easily in their own space. Each figure has a highly individual likeness and personality, distinct yet equal in importance to its neighbour. During the first part of Hals's career the militia companies continued to play a vital role in the defence of each city. In Hals's portrait *The Militia Company of S. George* (Haarlem, Frans Hals Mus.), officers are seated around a laden table and his extraordinary technique evokes a moment of life in which the spectator seems also to be caught up.

In 1648 the Peace of Münster brought to an end the Dutch and Spanish struggles and the militia companies were disbanded. Frans Hals's later group portraits were more sombre in their composition and use of colour, but his technique became increasingly spontaneous, with broader strokes of the brush being used to explore character. Hals's parents had emigrated from Antwerp and his style may be indebted to contemporary Flemish artists such as Rubens. In the 19th century Hals's late group portraits, such as the *Regentesses* (1664; Haarlem, Frans Hals Mus.), impressed the painters *Manet and van *Gogh. Hals had an influence on genre painters such as Judith *Leyster, Jan Miense *Molenaer, who may have been his pupils, and also the Flemish painter Adriaen *Brouwer.

*Landscape became a major subject for Dutch painters in the 17th century. The foundations for its importance had been laid in the 16th century and new developments came from the Southern Netherlands at the end of that century. Flemish immigrants, such as Gillis van *Coninxloo and David *Vinckboons, were responsible for bringing these ideas northwards. Coninxloo came to Amsterdam in 1595 and painted forest scenes which influenced his Dutch pupils, Esaias van de *Velde and Hercules *Seghers, to take up an increasingly realistic approach. They both joined the Haarlem guild in 1612 and Haarlem became an important centre for new developments in landscape painting. Esaias van de Velde's *Winter Landscape* (1632; London, NG) indicates the direction of future developments, with its freer technique, low

horizon, increasing tonalism, and an observation of cloud and sky effects. Van de Velde's pupil in Haarlem, Jan van *Goyen, together with Salomon van *Ruysdael, represent developments during the mid-17th century. They both specialized in scenes of rivers and estuaries, in which the landscape is depicted with greater monochromatic tonalism and a lower horizon. Hercules Seghers, in both his etchings and paintings, was influenced by the Flemish panoramic tradition in his use of dramatic and imaginary sweeping landscape vistas. Rembrandt admired Seghers's work and was influenced by him in landscape paintings, such as the *Baptism of the Eunuch* (1638; Hanover, Niedersächsische Landesgal.). Numerous drawings and prints indicate a ready market and the pride of Dutch patrons and artists in their landscape. Rembrandt adopted a more realistic approach to landscape in his innovative etchings and drawings, such as *Jan Six's Bridge* (etching), where the flatness and breeziness of the Dutch landscape is strikingly accurate. Both trends were combined by Rembrandt's pupil Philips *Koninck, in panoramas of a typically Dutch dune landscape.

A new grandeur and monumentality characterize the work of later 17th-century landscape painters, such as Jacob van Ruisdael and his pupil Meindert *Hobbema. Ruisdael was influenced by his uncle Salomon van Ruysdael and others of the previous generation in his use of tone and atmosphere. His monumental structures and bold contrasts, particularly in his depiction of trees, created a moody grandeur, sometimes described as heroic. The *Mill at Wijk* (c.1670; Amsterdam, Rijksmus.) is characteristic of his profound knowledge of nature and his ability to extract its powerful essence. Ruisdael's unusual dramatic waterfall and forest scenes were influenced by Allart *Everdingen's drawings made on his visit to Scandinavia. Hobbema transformed Ruisdael's solemn landscapes into sunnier wooded vistas, more limited in composition. However Hobbema's *The Avenue, Middelharnis* (1689; London, NG) is both outstanding and daring. Other artists travelled further afield for inspiration, notably Nicolaes *Berchem, the *Both brothers, Jan and Andries, Karel *Dujardin, and the prolific Philips *Wouverman, who all found in the sunlit Italian countryside an inspiration for their work. Another painter, Aelbert *Cuyp, infused the Dutch countryside with a warm Mediterranean light, although he never visited Italy.

Church interiors, townscapes, and *marine painting were separate specializations. Pieter Jansz. *Saenredam was the first Dutch artist to paint recognizable buildings and his great whitewashed interiors of the newly Protestant churches of Haarlem and Utrecht are almost abstract studies of solids, voids, and

light effects. Other painters, such as Gerrit Adriaensz. *Berckheyde and Emanuel de *Witte, continued this specialization until the end of the century. Townscape painting was one of the last specializations to develop and Jan van der *Heyden became its main exponent. In his work, buildings appear drenched in a sunlight which plays over the meticulously painted brickwork.

Marine painting developed separately, but paralleled landscape painting in a gradual development towards tonalism and the observation of wind and weather in the work of Jan *Porcellis and Simon de *Vlieger, to the later calm, monumental seascapes of Jan van de *Cappelle and the van de Veldes.

*Genre subject matter, with its origins in 16th-century Flemish painting, became popular early in the 17th century. At first merry company and guardroom scenes were popular, developed by Haarlem painters such as Willem *Buytewech and Dirck *Hals, brother of Frans, and then by the Amsterdam painters Willem *Duyster and Pieter Codde. Two pupils of Frans Hals, Adriaen Brouwer and Adriaen van *Ostade, specialized in lively low-life scenes. In Leiden, Gerrit *Dou, Rembrandt's first pupil, developed a meticulous, elegant, and brightly coloured technique, which brought him outstanding success and financial rewards. His many pupils, such as the van *Mieris family and Eglon van der Neer, continued to make Leiden a renowned centre of *fijnschilders* until the 18th century.

Subject matter became more varied towards the middle of the century. Interior scenes with figures making music, writing or reading letters, looking after children, or undertaking various trades are some of the subjects by innumerable painters of high quality, such as Gabriel *Metsu, Gerard ter *Borch, or Pieter de *Hooch. Some of these scenes may have been intended to have a moralizing impact on contemporary audiences. Details within the picture, such as monkeys, shells, or birds, may have a secondary symbolic meaning. Contemporary prints, popular literature, and particularly emblem books can be of assistance to a 20th-century audience in understanding likely 17th-century interpretations. Jan *Steen was a prolific and inventive painter of a wide range of genre subjects in the mid-century.

Delft developed somewhat later in the 17th century and painters there specialized in townscapes and church interiors, but genre, generally single-figure compositions by Vermeer, are greatly admired by late 20th-century audiences. *The Kitchen Maid* (c.1658; Amsterdam, Rijksmus.) is typical of the way in which, through small liquid drops of paint, Vermeer explored the fall of light upon objects in a simple, airy interior.

*Still life, although considered elsewhere in Europe as the least important of subjects, was highly esteemed in the Dutch Republic. This can be explained by the Dutch love of their familiar surroundings, the cultivation of their gardens encouraged by the importation of new plants, such as the tulip, and the advances in botanical science and optics, which transformed the observation of plants and objects. It is thought that certain still-life paintings, known as *vanitas or *memento mori*, in which details of skulls, watches, and extinguished candles are prominently displayed, were intended as reminders of the transitory nature of life. For a Protestant audience, these were acceptable alternatives to banned religious art. As in other subject areas, Flemish immigrants, such as Ambrosius *Bosschaert, introduced *flower painting to the Dutch Republic. His exquisite arrangements of jewel-like flowers in vases upon a ledge were continued by his three sons and his brother-in-law Balthasar van der *Ast. Paintings of fruit or objects were a different specialization and painters from Haarlem, such as Pieter *Claesz. and Willem Claesz. *Heda, developed the 'breakfast piece' towards the middle of the century. As in the work of their contemporaries in landscape and genre, their palette became tonal and the relationship of objects and the sensitive rendering of reflections in glass and silver became an end in itself. Towards the end of the 17th century tonalism gave way once again to glowing colour, particularly in still lifes, known as *pronken*, with their sumptuous display of more precious objects and expensive food. Artists such as Willem *Kalf or Jan Davidsz. de *Heem were important exponents. Other artists specialized more particularly in the painting of fish, such as Abraham van Beyeren, of birds, such as Melchior d' *Hondecoeter, or of hunting trophy still lifes, such as Jan Weenix.

After 1700 and the splendours of the aptly named 'Golden Age', there was a gradual decline in the quality of Dutch art. The styles and ideas of the previous century were imitated by many artists of lesser quality. French influences, as in the work of Adriaen van der Werff, already present in the 17th century, permeated Dutch art, especially after the Revocation of the Edict of Nantes in 1685, when many French skilled workers found a tranquil Protestant haven in the Dutch Republic. Two 18th-century painters of individuality were Cornelis *Troost, who also worked as a pastellist, and Wybrand Hendricks. Some of the high quality of 17th-century still-life painting was carried on into the 18th century by Rachel *Ruysch, whose delicate, pastel flower studies against dark backgrounds have an almost ethereal quality. The flower pieces of Jan van *Huysum are more monumental and explode with asymmetrical profusion and rococo colour, while

Jacob de *Wit's illusionistic grisaille paintings imitating sculptural reliefs were popular as interior decoration.

In the early 19th century Dutch art closely followed the styles and ideas of art elsewhere in Europe. A revival of history painting was influenced by French *Neoclassical painters. Important for the future was the revival of landscape painting. This was partly inspired by a reawakening of interest in 17th-century landscape and partly by realistic trends from France, as exemplified in the work of the *Koekkoek family. Painters known as the *Hague School dominate the later 19th century, of whom artists such as Jozef *Israels, the *Maris brothers, Anton Mauve, and Hendrik Willem *Mesdag concentrated on an essentially Dutch landscape and simple genre scenes, bringing a new integrity to their subject matter. There are strong echoes in their work of the slightly earlier French *Barbizon School artists.

However the influence of Dutch painters on later 19th-century French painting can be seen in the work of two Dutch artists, Johan Barthold *Jongkind and his outstanding compatriot Vincent van *Gogh. Jongkind settled on the north coast of France and, together with the French painter *Boudin, was a major influence on the young *Monet. Van Gogh belongs not so much to a history of Dutch art, but to French developments after his departure for Paris in 1886. His early Dutch works, such as the *Potato Eaters* (1885; Amsterdam, Van Gogh Mus.), show a debt to the Hague School, combined with powerful expressive qualities, which are the hallmark of his later paintings. Other Dutch painters, such as Johan *Thorn Prikker and Jan *Toorop, were influenced by the late 19th-century French *Symbolist movement.

During the 20th century Dutch artists introduced various styles of European art, such as *Fauvist characteristics in the work of Jan *Sluyters, who joined artists of the 'Bergen Group' experimenting with *Abstract Expressionism. Piet *Mondrian was the foremost Dutch artist of the 20th century. The calm and ordered structures of his abstract compositions recall certain elements of his Dutch predecessors, echoing latent abstract values and a certain timeless serenity observed in Vermeer's quiet domestic scenes, Jacob van Ruisdael's monumental landscapes, or Saenredam's empty church interiors. CFW

Haak, B., *The Golden Age: Dutch Painters of the Seventeenth Century* (1984).

Israels, J., *The Dutch Republic: Its Rise, Greatness and Fall* (1995).

Schama, S., *The Embarrassment of Riches* (1987).

Westermann, M., *The Art of the Dutch Republic* (1996).

DUTCH ART AS OBJECTS OF PATRONAGE AND COLLECTING. *See opposite.*

DUTCH ITALIANATES, a group of 17th-century Dutch artists who painted the Italian landscape. The first generation, dominated by *Poelenburch and *Breenbergh, worked together in Rome c.1617–30; they painted small scenes of shepherds and Roman ruins in the Campagna. Most distinguished of the second generation were *Both, *Asselijn, and *Berchem. Their styles are grander, more individual, and, as in Both's *Rocky Italian Landscape* (London, NG), rugged mountains and a golden light suggest the pleasures of southern travel. The bustle of Mediterranean harbours, with exotic figures and classical ruins, fascinated Johannes Lingelbach and Jan Baptist Weenix. HL

Duparc, F. L., and Graif, L. L., *Italian Recollections: Dutch Painters of the Golden Age*, exhib. cat. 1990 (Montreal, Mus. of Fine Arts).

DUVET, JEAN (c.1485–c.1570). The most original *line engraver of 16th-century France, who began as a goldsmith and was master of the Dijon guild 1509. Born in Dijon, he worked much at Langres, designing decorations for royal entries, medals, and fortifications. None of his metalwork survives, but it included the reliquary for the head of S. Mammès (1524) for Langres Cathedral and a bowl damascened with moresques for François I (1529). His engravings show clear borrowings from *Dürer, *Raimondi, and *Mantegna, cut with richly varied lines and oddly juxtaposed perspectives. The dense, mysterious, intensely personal images are far removed from the art of *Fontainebleau, and are best studied in his *Apocalypse* illustrations (1561), a subject of particular relevance in this time of religious conflict. He is sometimes called the Master of the Unicorn from his series of engravings illustrating this medieval story, reminiscent stylistically of Jean *Cousin the elder. He may be the Jean Duvet recorded in Geneva, but this is not certain. LL

Eisler, C., *The Master of the Unicorn: The Life and Work of Jean Duvet* (1979).

Zerner, H., *L'Art de la Renaissance en France* (1996).

DUYSTER, WILLEM CORNELISZ. (1599–1635). Dutch genre painter. Although often described as a pupil of his contemporary Pieter Codde, this seems unlikely given their closeness in age. Duyster's œuvre is not extensive and though he produced some atmospheric portraits (e.g. *Portrait of a Man*, 1629; Amsterdam, Rijksmus.) he is best known for his small-scale interiors with groups of soldiers drinking, singing, or gaming. A number of them include remarkable and attractive effects of firelight and candlelight, and all show his talent for painting both psychological relationships and the texture of stuffs. A representative nocturnal

continued on page 200

· DUTCH ART AS OBJECTS OF PATRONAGE AND COLLECTING ·

AFTER 1579, when the Dutch provinces seceded from the Southern Netherlands, the economy of the Dutch Republic grew rapidly. The unprecedented political and economic situation fundamentally restructured the patronage, collecting, and making of art.

The Republic was governed by the partnership of the States General (upper middle-class delegates of the provinces) and the Stadholder, their military appointee, whose office was invariably held by a prince of Orange-Nassau. While the princes of Orange could not establish courts of imperial or royal calibre, Frederick Henry, the third Stadholder (ruled 1625–47), and his wife Amalia van Solms upgraded courtly culture in The Hague by collecting the works of local painters, sculptors, and weavers and by patronizing young painters such as Gerrit van *Honthorst, *Rembrandt, and Jan *Lievens. After Frederick Henry's death, Amalia commissioned Dutch *classicizing painters to produce an allegorical ensemble in his memory, installed in the Oranjezaal of her palace the Huis ten Bosch (1647–52). Although it was the grandest commission of Dutch painting in the 17th century, the mausoleum's centrepiece is *The Triumph of Frederick Henry* by the Flemish artist *Jordaens. The relative lack of court patronage was partially compensated by public commissions from the strong towns. The most significant municipal project, the Baroque decoration of the new town hall of Amsterdam (1650–65), was entrusted to the Flemish sculptor Artus *Quellinus I and the Dutch painter Govaert *Flinck. After Flinck's death, Jordaens, Rembrandt, and others completed the pictorial programme, which celebrates Amsterdam's pre-eminence in Roman historical narratives.

Jordaens's Calvinist denomination may have helped him secure Dutch commissions, for the Republic's dominant religion was Reformed. Because of Calvinist proscription of the use of images in worship, patronage for Catholic altarpieces and private devotional objects virtually dried up. Calvinist theologians did allow paintings for private educational, decorative, and commemorative ends, and, combined with the favourable economy, this latitude encouraged the development and widespread collecting of biblical narratives from the Old Testament or Christ's parables, contemplative *still life, *marine painting, and, most profusely, *landscape and *portraiture. While John Evelyn surely exaggerated his claim that even plain farmers invested thousands in landscape and genre paintings (1641), the Dutch market for art made on speculation was Europe's most vibrant. The production of Dutch paintings in the 17th century is estimated at *c.* six million.

The 'open' Dutch art market functioned in myriad ways, from direct contacts between artists and customers to remote transactions arranged by dealers, from auctions organized by painters to hawking at fair booths. The most ambitious and innovative painters had lucrative contacts with portrait sitters and collectors. Soon after 1585, when the Dutch artistic community was strengthened by the arrival of Protestant refugees from Antwerp, prominent Dutch officials and merchants began to collect art in an international manner, on the model of the aristocratic collectors of Europe's monarchies. Hendrik *Goltzius and Joachim *Wtewael found well-informed collectors for pictures in a sophisticated *Mannerist idiom. Rembrandt painted for an elite of merchants, preachers, intellectuals, and professionals, but appears to have maintained an independent stance, to the point of outright defiance to Don Antonio Ruffo of Sicily, who in 1661 returned a painting with the request that he correct it. The 'fine' painters Gerrit *Dou and Frans van *Mieris were paid annual fees by patrons, merely for the first choice of the paintings they made. *Vermeer apparently enjoyed similar status with a collector who bought the majority of his rare pictures. Occasionally shared religion determined patronage. The Remonstrant painter Jacob Victors (1620–c.1676) virtually limited himself to Old Testament narratives for collectors of the same persuasion, and the Catholic artists Jan *Steen and Quirijn van Brekelenkam (1620/5–68/9) were sought out by a prominent Catholic collector. Most 17th-century artists, however, catered to a more anonymous, diverse public. While many inventories from the major cities *Amsterdam, Leiden, and Haarlem contain over 100 pictures and objects of art, most are modest and contain few attributions, suggesting that for their owners works of art mattered primarily for their subjects or functions.

Throughout the 17th century, Dutch works of art were collected by connoisseurs abroad. The Emperor Rudolf II (see PRAGUE) patronized the landscape, still-life, and genre painter Roelandt *Savery and collected Dutch drawings. Adriaen de *Vries cast elegant bronzes for him and for the courts of Copenhagen, *Munich, and *Vienna. Paulus van *Vianen made refined silver objects in Prague and Munich, and his son Christiaan (c.1600–c.1667) became silversmith to Charles I. Although Charles I (see LONDON) privileged the Venetian tradition in painting, he acquired early works of *Rembrandt and Lievens. His interest in Dutch art was promoted by the States General, who in 1636 sent him several Dutch pictures. Charles II was a less avid collector, but upon the Restoration in 1660 the States General wooed him with a 'Dutch Gift' including paintings by Dou and Pieter *Saenredam. During his reign, the Dutch-born woodcarver Grinling *Gibbons, who was trained in Quellinus's entourage, introduced his spectacular still-life carvings. The latest Dutch architecture, garden design, and decorative arts came to England with

William III and Mary after 1689. In the same period, the courts of Munich and Düsseldorf assembled rich collections of Dutch painting, ranging from Adriaen *Brouwer's peasant pictures to the smooth paintings of Adriaen van der Werff, who became court artist to the Elector Palatine.

Dutch artists loudly lamented the contraction in patronage and collecting in the 18th century. As the Republic lost its global trade dominance, the Dutch art market participated in the economic decline. Eighteenth-century Dutch collectors favoured 'old masters', in particular highly finished genre, still-life, and hunting scenes. Substantial collections of Dutch drawings and prints were formed by Valerius Röver and Cornelis Ploos van Amstel in Holland and by Pierre Crozat and Pierre Mariette in *Paris. Although art critics in France derided the low character of Dutch art, French collecting of Dutch *genre and landscape was greatly stimulated later in the century by dealers such as J.-B.-P. Lebrun. Catherine the Great (see ST PETERSBURG) simultaneously founded the Russian collections of Dutch art by acquiring private collections throughout Europe.

During the French Revolution, Dutch painting assumed a prominent place in the national museum at the Louvre (see under PARIS), which incorporated much of the Stadholder's collection. The repatriation of Dutch art in 1815 occasioned vigorous support for the national art gallery that had been founded in 1800. Although the 19th-century history of the *Amsterdam Rijksmuseum was fitful, by 1900 the institution had become the primary repository for Dutch art acquired from private sources, a function it now shares with more specialized museums founded in the 19th and 20th centuries.

In the 19th century the English art market became the primary supplier of Dutch pictures, fuelled by bankers such as the Barings, who acquired entire continental collections. Private collectors and curators of the European national galleries bought prime Dutch stock in London. Sir Robert Peel's fine collection of Dutch pictures entered the National Gallery (see under LONDON) in 1871. After the Civil War, American collectors and municipal museums energized the market. Stimulated by perceived affinities between the American Republic and its Dutch predecessor and by admiration for Dutch business acumen, American entrepreneurs such as Henry Clay Frick and Benjamin Altman invested heavily in Dutch old masters (see the Frick Collection and Metropolitan Museum under NEW YORK). The United States simultaneously became a deep market for contemporary Dutch landscapes and genre scenes in updated 17th-century modes, supplied by artists of the *Hague School and its *Barbizon-style colonies.

American collectors and museums remained the most prominent buyers of Dutch old masters during the 20th century. Collecting policy in Holland concentrated on recovering art previously sold abroad or looted during the Second World War and on preventing the departure of more works; it also diversified its attention to decorative arts. Works of prominent modern Dutch artists such as *Mondrian, the Expressionist Karel *Appel, and the postmodernist Jan Dibbets (1941–) are found in distinguished public and private collections, especially in the United States and Germany. MW

Gerson, H., Ausbreitung und Nachwirkung der holländischen Malerei des 17. Jahrhunderts (2nd edn., 1983).

Great Dutch Paintings from America, exhib. cat. 1990–1 (The Hague, Mauritshuis; San Francisco, Fine Arts Mus.).

Haskell, F., Rediscoveries in Art (1976).

Montias, J. M., 'Socio-economic Aspects of Netherlandish Art from the Fifteenth to the Seventeenth Century', Art Bulletin, 72 (1990).

scene is Soldiers beside a Fireplace (1632; Philadelphia Mus.). MJ

Sutton, P., et al., Masters of 17th-Century Dutch Genre Painting, exhib. cat. 1984 (London, RA).

DVOŘÁK, MAX (1874–1921). Austro-Czech art historian. Following Alois *Riegl's death in 1905, Dvořák became associate professor of art history at Vienna University, and was appointed full professor there four years later. While his earlier studies were still indebted to the formalism of Riegl (e.g. Das Rätsel der Kunst der Brüder van Eyck, 1903), Dvořák subsequently developed a method which saw art history as part of a broader history of ideas (Kunstgeschichte als Geistesgeschichte), an approach which owed much to the notion of Geistesgeschichte (intellectual history) put forward by the philosopher Wilhelm Dilthey. For Dvořák, art was not so much a deviation from, but rather an independent embodiment of, a particular Weltanschauung, and represented an analogy to other phenomena of human existence, such as language or religion. Key studies applying this concept to various art historical periods include Idealismus und Naturalismus in der gotischen Skulptur und Malerei (1918) and Über Greco und den Manierismus (1928). As head of the conservation of state monuments Dvořák edited the Österreichische Kunsttopographie (founded 1907); he also acted as art historical adviser for a number of restoration projects, such as the Palace of Diocletian in Split, and the Wawel in Cracow. AT

Österreichische Zeitschrift für Kunst und Denkmalpflege, 27/3 (1974).

DYCE, WILLIAM (1806–64). Scottish-born painter. Dyce was a graduate of Aberdeen University when he attended the RA schools (see under LONDON). He completed his education with visits to Italy, in 1825 and 1827–30, where he studied the old masters, particularly *Raphael. In Rome he met the *Nazarenes whose influence can be seen in his deliberately archaic Virgin and Child (c.1838; Nottingham, Castle Mus.). However, in the 1830s, working in Edinburgh, most of his work was conventional portraiture (Sir Galbraith Cole, c.1834; London, NPG). In 1836 he was summoned to London to work for the Government School of Design and became director in 1840. In 1844, after researching continental fresco technique, he was commissioned to paint The Baptism of S. Ethelbert (1847; London, House of Lords) for the Palace of Westminster and continued to work there until his death. Dyce, who shared many of the principles of the *Pre-Raphaelite Brotherhood, secured *Ruskin's interest on their behalf in 1851 and his paintings of the late 1850s, Titian's First Essay in Colour (1856/7; Aberdeen, AG) and the startlingly illusionistic Pegwell Bay (1859–60; London, Tate), were influenced by them. DER

Pointon, M., William Dyce (1979).

DYCK, SIR ANTHONY VAN (1599–1641). Flemish painter who was not only one of the pre-eminent European artists of the

17th century, but also through his portraits exerted an influence on English painting still felt at the beginning of the 20th century. He was born in Antwerp, then the principle mercantile and cultural centre of the Spanish Netherlands. He trained with Hendrik van *Balen, but such was his precocious talent that he was an independent artist c.1615/16 and a master in the guild of S. Luke (see ANTWERP) in 1618. The main influence on him was, inevitably, *Rubens, whose chief assistant he was while still in his teens. This was the period of militant Catholicism in the Southern Netherlands as the Spanish viceroys sought to reimpose their authority after the loss of the Protestant northern provinces. Rubens was much in demand to supply new Counter-Reformation altarpieces. Van Dyck's hand is apparent in a number of them, including the famous *Coup de Lance* (Antwerp, Koninklijk Mus. voor Schone Kunsten), and the robust influence of Rubens is clear in such early works by Van Dyck as *The Carrying of the Cross* (1617–20; Antwerp, S. Pauluskerk). Although van Dyck was to become a very accomplished painter of subject pictures in the Grand Manner, his principal gift to posterity is his *portraiture. His originality—manifested in a delicacy of touch and an easy grace of composition—first emerged in this genre around 1620–1. Among the finest of his portraits from this time is the pair of the painter *Frans Snyders* and his wife *Margaretha de Vos* in the Frick Collection, New York.

In 1620 van Dyck went to London, where he spent a few months in the service of James I. He was briefly in Antwerp again before setting off to Italy in 1621. This most influential journey in his life lasted for six years. He travelled extensively, visiting Rome, Florence, Bologna, Venice, Mantua, and Palermo, but returning frequently to his base in *Genoa, where Rubens had also worked fifteen years earlier. Although the Roman *Baroque style was now fully formed and the city bursting with artists of the greatest distinction, among them Pietro da *Cortona, *Domenichino, *Guercino, and *Bernini, it was in particular to Venice and the work of the artists of the previous century—*Titian, *Veronese, and *Tintoretto—that van Dyck was drawn. His Italian Sketchbook (London, BM) is full of drawings of the pictures he most admired and those of Titian predominate. The culminating subject picture of these years is the altarpiece *The Virgin of the Rosary* (begun 1624; Palermo, Congregazione del Rosario). Nevertheless, it is portraits that are the main achievement of van Dyck's Italian years. Influenced by the grandeur combined with easy grace of Titian's full-length portraits he developed in a series of paintings of the merchant-nobles of Genoa the full repertoire

of pose, gesture, and *mise-en-scène* that he later used for his portraits of Charles I of England and his court. In such paintings as the equestrian portrait of *Anton Giulio Brignole Sale* (Genoa, Palazzo Rosso), the group of *The Lomellini Family* (Edinburgh, NG Scotland), or the single figure of the *Marchesa Doria* (Paris, Louvre) van Dyck created the pattern of the fashionable portrait that was to remain in vogue until the time of John Singer *Sargent. What is remarkable is that he could make them at the same time the correlative of a hierarchical society's vision of social authority, an occasion for a sensitive and intelligent exploration of individual character, and works of art of the greatest beauty.

Van Dyck returned to Antwerp in 1628 as an accomplished courtier-artist. These were busy years with commissions for major religious pictures as well as portraits. In contrast to Rubens it was contemplative subjects that best suited his more introspective talents, as evidenced by *The Crucifixion* (Lille, Mus. des Beaux-Arts) and *The Holy Family* (Munich, Alte Pin.). He also renewed his contacts with the English court, with the result that in 1632 he was appointed portrait painter to Charles I. The art-loving Charles, who had long sought to have a painter of international stature in *London, granted van Dyck unheard of privileges, including a pension of £200 and a knighthood.

It is van Dyck's portraits of the members of the cultured and shortly to be doomed Caroline court that have been responsible for the best and the worst aspects of his reputation. In his sophisticated portraits of the royal family and their associates he far exceeded anything that his rivals Cornelius *Johnson and Daniel *Mytens could provide, holding up a flattering mirror that reflected back the vision of cultured, aristocratic ease that his sitters wished to see. The figures represented in such autograph works as *Charles I out Hunting* (Paris, Louvre), *The Pembroke Family* (Wilton House, Wilts.), or *Anne Killigrew* (Parham Park, Sussex) with their sylvan settings, fine costumes, and nice adjustments of silken curtains and fragments of classical statuary or architecture, are imperishably glamorous and beautifully painted in a much higher and more vivacious key of colour than the rich but sombre Genoese portraits. But in England van Dyck was also the victim of the compelling success of his formulas. The proliferation of inferior studio versions, later copies, and poor pastiches hopefully attributed to him has detracted from his stature.

Among van Dyck's other activities in England was the design of all and the etching of a handful of the *Iconographie*, a series of prints of princes, scholars, and artists, and the planning of a series of tapestries representing the

history of the Order of the Garter to decorate the Banqueting House at Whitehall. He was a master draughtsman in chalk and pen and wash. More surprisingly, he painted a handful of informal landscape *watercolours (e.g. Chatsworth House, Derbys.; Birmingham, Barber Inst.) of a kind not seen again until the later 18th century.

There is some evidence that by the late 1630s van Dyck was looking for new employment in Europe as he sensed the imminent breakdown of court life in England. After Rubens's death in 1640 he was in Antwerp and Brussels, and in the following year, though very ill, he was in Paris hoping to gain the commission to decorate the Grande Galerie of the Louvre. Such a monumental task would perhaps have suited his talents better than those of *Poussin who was given the job, but not a great deal more. He returned disappointed to London, where he died shortly afterwards, a year before the outbreak of the Civil War that destroyed the court culture he had done so much to define.

MJ

Brown, C., *Van Dyck* (1982).
Brown, C., and Vlieghe, H. (eds.), *Van Dyck, 1599–1641*, exhib. cat. 1999 (London, RA).
Larsen, E., *The Paintings of Van Dyck* (1988).
Millar, O., *Van Dyck in England*, exhib. cat. 1982 (London, NPG).
Wheelock, A. K. (ed.), *Anthony van Dyck*, exhib. cat. 1990 (Washington, NG).

DYING GAUL, Roman marble statue (Rome, Capitoline Mus.) of a fallen warrior straining to support himself as blood gushes from a wound in his side. Traditionally thought to reproduce part of a bronze group erected at *Pergamum c.220 BC to commemorate Attalid victories, it appears to recreate dramatically the carnage of battle and to extol the victors by highlighting their opponents' powerful physiques and defiant spirit in the face of death. The carefully detailed nude body, bushy hair, and metal torque identify the Gaul and manifest fascination with foreigners. A curved horn suggests the original authorship of the Attalid court sculptor *Epigonus, whose *Trumpeter* *Pliny mentions. Recorded in the Ludovisi Collection, Rome, in 1623, the marble was apparently recovered from the site of the Gardens of Sallust. It was greatly admired, erroneously said to have been restored by *Michelangelo, and copied for European kings and the French Academy in the 17th century, English gardens in the 18th, and in miniature ornaments and paperweights in the 19th.

MBe

Pollitt, J. J., *Art in the Hellenistic Age* (1986).

EAKINS, THOMAS (1844–1916). American painter. Eakins was born in Philadelphia where he entered the Pennsylvania Academy of Fine Arts in 1862. In 1866 he studied under *Gérôme at the École des Beaux-Arts in *Paris, developing a sombre realism influenced by his master and by *Couture. A Spanish visit, studying *Velázquez and *Ribera, reinforced his natural inclination to closely observed, serious art. Returning to Philadelphia in 1870, he painted geometrically composed sculling and sailing scenes and unsentimental family portraits, like *Baby at Play* (1876; Washington, NG). In 1875 he painted the controversial *Rembrandtesque *Gross Clinic* (Philadelphia, Jefferson Medical College), a frank portrayal of an operation which still has the power to shock. He began a successful career as a teacher at the Pennsylvania Academy in 1876, becoming director in 1882. However, his use of a naked male model in mixed classes caused his dismissal in 1886. His interest in anatomy led to experiments with photography, used for paintings like *The Swimming Hole* (1882; Fort Worth, Art Center). Between 1900 and 1910 he painted many small portraits of great psychological intensity, concentrating on the vulnerability and humanity of his subjects. DER

Wilmerding, J. (ed.), *Thomas Eakins*, exhib. cat. 1993 (London, NPG).

EARDLEY, JOAN (1921–63). British painter, born in Sussex but considered Scottish (her mother was Scottish and she lived in Scotland from 1940). She studied at Goldsmiths' School of Art, London, 1938–9 (leaving because of the outbreak of war), Glasgow School of Art, 1940–3, and, after working for three years as a joiner's labourer, at the summer school at Hospitalfield House, Arbroath, 1947. Her teacher there was James Cowie (1886–1956); he perhaps helped to shape her preference for subjects drawn from everyday experience, but her approach was more earthy and sensuous than his. In 1948–9 she travelled abroad, mainly in Italy, on a scholarship awarded by the Royal Scottish Academy. After her return she divided her time between Glasgow (where she painted *Kitchen Sink type subjects) and the fishing village of Catterline, about 30 km (20 miles) south of Aberdeen on the north-east coast. She discovered this fairly remote spot in 1950 and became increasingly devoted to it, acquiring a house and studio there. Her favourite subjects in her later years were the village and the sea, especially in stormy weather (she is said to have set off from her Glasgow home as soon as she heard reports of gales). The freely painted, often bleak and desolate works that resulted are among the most powerful and individual landscapes in 20th-century British art. After her early death from breast cancer her ashes were scattered on the beach at Catterline. Her work is well represented in the Scottish National Gallery of Modern Art, Edinburgh. IC

EARL, RALPH (1751–1801). American painter. Earl, born in Connecticut, is first recorded in 1775 making sketches of revolutionary battles, for engraving. He is better known as a portrait painter. *Roger Sherman* (c.1775–7; New Haven, Yale University AG), in a stiff provincial style in subdued brown tones, is his only known portrait before his stay in England (1778–85). In *Admiral Kempenfelt* (1783; London, NPG) he comes nearest to swagger, although the figure remains wooden. On his return to America he resumed his wilful simplicity which, during the mid-20th century, appealed to many Americans as being essentially independent and nationalistic. DER

Kornhauser, E., et al., *Ralph Earl: The Face of the Young Republic*, exhib. cat. 1991 (Washington, NPG).

EARLY CHRISTIAN ART. *See opposite.*

· EARLY CHRISTIAN ART ·

EARLY Christian art is the term given to the Christian art, particularly in the Mediterranean, of the centuries after the death of Christ up until the 5th or 6th centuries. In the eastern Mediterranean, this leads directly to *Byzantine art; in northern Europe, this period tends to be characterized as the *migration period.

The term is problematic for another reason: by labelling art of this period 'Christian', it plays down the fact that the 4th–6th centuries were a period of assimilation. Until the conversion of the Emperor Constantine in 313, Christianity was a persecuted religion, essentially because of the inability of its devotees to compromise their belief in one God with Roman polytheism. The refusal of Christians to sacrifice to the official deities of the Roman state led to them being perceived as traitors to that state and scapegoats for all disasters, though the level of persecution varied from emperor to emperor. Once Christianity became the official religion of the Roman Empire, all this changed. However, apart from the Bible and commentaries on the Bible, Christianity had little literature of its own, and still less art. Classical culture dominated the empire. So throughout the early Christian period, Christians were faced with the dilemma of what to do with this pagan culture, both art and literature; should they reject it completely or absorb it?

Artists and patrons alike had been brought up in the traditions of pagan art, so it was within the styles and conventions of such art that Christian art and *iconography developed. Such art is not distinct in form but in content, yet much of that content is borrowed directly or adapted from *Roman art. Even the very earliest remaining art from the persecution days contains pagan motifs. During this period, Christian art was very much a secret art, above all in the catacombs below Rome. While burial in underground galleries carved out of soft rock was not restricted to Roman Christians alone, it is with them that the catacombs are most commonly associated. From the 3rd century on, Roman Christians in particular buried their dead in subterranean tombs composed of networks of corridors and rooms, ranging from the small, single-family to the large multi-storeyed with hundreds of tombs and administered by the Church (the catacomb of Callixtus, for example). These tombs were marked with carved or painted inscriptions identifying the occupant and images expressing Christian hopes of salvation. The images and motifs were often adaptations from traditional Roman wall painting: both the Good Shepherd and Orpheus the musician symbolized Christ and both were borrowed from pastoral scenes; scenes of feasting had a place in pagan and Christian beliefs about the after-life. Symbolism was common: the peacock with its incorruptible flesh represented immortality and the fish indicated Christ (the Greek word for fish, *icthus*, is made up

of the initial letters of the phrase 'Jesus Christ Son of God Saviour' in Greek). Simplified versions of Old Testament scenes were used to foreshadow salvation—Jonah and the whale suggesting the burial and rebirth of Christ, Daniel in the lions' den indicating salvation. Such images were not designed to be explicit. Their meaning was apparent to the believer, but for the non-initiate, they seemed merely traditional pastoral or animal representations. Later, as Christians gained in confidence, more overt scenes of the miracles of Christ and then the Virgin and Child appeared.

The earliest surviving Christian paintings from above the ground come from the house church meeting place at Dura Europos in eastern Syria, dated to c.240. This house church, probably typical of many others throughout the empire, was an ordinary house whose rooms surrounding a courtyard were designated for Christian activities from baptism to celebration of the Eucharist. One room was decorated with individual narrative scenes from the Old and New Testaments.

In 313 Constantine the Great made Christianity the official religion of the Roman Empire. Apart from the brief reign of Julian (361–3), persecution of Christians by pagans ceased; with its official status, Christian art developed in a public context. Catacombs continued to be used, becoming more elaborate, but churches were now built and used officially. These took the form of basilicas, rectangular boxes, with two or more aisles and an apse at the east end, modelled on Roman meeting halls and offering space for large assemblies. These churches were decorated with *mosaic and paint, the apse in particular a favoured area. Both narrative and symbolic images were employed, as at S. Maria Maggiore in Rome (432–40) and in the churches of Ravenna in the 5th and 6th centuries. Official Christian building went some way to offsetting the decline of civic building in late Antique cities, especially Rome, where churches such as S. Maria Antiqua in the 6th and S. Agnese in the 7th centuries continued to be built and decorated even after the barbarian conquests.

Classical art remained problematic throughout the period. Two main courses of action were followed by Christians. Pagan art might be destroyed. This was the fate of much classical statuary, often perceived as housing demons, and of many pagan temples, including the temple of Artemis at Ephesus, one of the *Seven Wonders of the world. Alternatively, pagan art might be converted to Christian purposes. In the city of *Aphrodisias, the temple of Aphrodite was converted into a Christian church; in *Athens, the Parthenon was rededicated as a church of the Virgin Mary. The floor mosaic of the church at Aquilea originally belonged in some official building. It portrays pastoral scenes such as the labours of the months, wildlife, and putti (little winged cupids, a popular Roman motif) fishing. On the conversion of the building, these

scenes were left largely unchanged but given a Christian significance by the insertion of a plaque commemorating the bishop and scenes of Jonah and the whale added in with the fishing putti.

That Christian art tended to adapt pagan traditions to suit its messages was in part governed by the fact that the majority of artists producing it were, initially, almost certainly pagan. The silver casket forming part of the Esquiline Treasure from Rome (Projecta's Casket, 4th century; now London, BM) is purely pagan in its iconography and decoration, yet an inscription along the lid identifies it as Christian. It is possible that caskets like this were customized for their owners. Similarly with sarcophagi. Both pagan and Christian sarcophagi from this period have very similar motifs and probably came from the same workshops, again customized for the buyer. One of the most elaborate sarcophagi is that of Junius Bassus, prefect of Rome, who died in AD 359 (Rome, Grotte Vaticane); the front is carved with a variety of Old and New Testament scenes, but classical putti harvest vines along the sides, and its elaborate three-dimensional carving is essentially classical in style.

Some forms of imagery did not change. Imperial imagery continued to employ the traditional Roman vocabulary. The Arch of Constantine (see TRIUMPHAL ARCHES) in Rome commemorating Constantine's victories over his pagan enemies has nothing Christian on it and is indeed a composite of earlier Roman monuments and flatter, harsher 4th-century imagery; the scenes on the base of the obelisk of the Emperor Theodosius I in Constantinople (390–1) depict a couple of Chi-Rho (the first two letters of Christ's name, X and P in Greek, were used as a monogram) standards in the background of the imperial court, but offer no other indication that this monument commemorates a devoutly Christian emperor. Classical personifications such as Nike (victory) and Tyche (fortune) continued to appear on coins, ivory consular diptychs, and all other forms of official art. Such personifications frequently appeared in Christian iconography; scenes of the Baptism of Christ generally included a representation of the river Jordan, as is the case in both the Orthodox and the Arian baptisteries in Ravenna.

Many of the traditional forms of Roman art continued. Mosaics, ivories, manuscripts continued to be produced, but emphasis moved towards a Christian content. Bibles and Gospel books began to predominate over classical authors. These Christian books were sometimes lavishly produced on expensive purple-dyed parchment, written in gold or silver ink, and with copious illustrations, for example the Vienna Genesis (Vienna, Österreichische Nationalbib., Cod. theol. gr. 31). Ivories with Christian scenes superseded pagan representations, and as Christian art became increasingly more expensive and luxurious, this was a clear sign that Christianity had a significant hold on the upper levels of society.

The other issue was the fundamental question about the place of images in Christian worship, a debate which formed the basis of arguments for and against art in Byzantium. Those in favour of images believed that they served as a means of both recognizing and communicating with the holy. Those against argued that the wrong sort of image was blasphemous and broke the Second Commandment against graven images. Praying to an image was regarded as idolatrous. It was the sort of thing pagans did to idols and therefore had no place in Christian worship. Moreover, it was argued that painting was inglorious, dead, and speechless but the saints and Christ were glorious, alive, and could speak, so the image could not possibly look like the person and certainly was not the person. Nevertheless, the quantity of images produced continued to increase throughout the early Christian period and increasing numbers of stories bore witness to their miraculous powers. Above all, this period saw the development of the *icon, which perhaps had its roots in late Roman mummy portraits.

Art historians have attempted to distinguish Christian and pagan art in stylistic terms: Christian art is seen as stylized, flatter, cruder, and two-dimensional; pagan art continues to use *classical forms. However, this distinction does not work. Objects such as the sarcophagus of Junius Bassus or Projecta's Casket are as classical in style as anything Roman; conversely, imperial imagery in the 3rd century—the porphyry tetrarchs now outside S. Mark's in Venice are a good example—is as stylized as anything Christian. Rather than a simple division, this change in style reflects a change in artistic practice empire-wide, related to changing perceptions about the function of art.

LJ

Brown, P., *The World of Late Antiquity* (1991).
Kitzinger, E., *Byzantine Art in the Making* (1977).
Lowden, J., *Early Christian and Byzantine Art* (1997).
Milburn, R., *Early Christian Art and Architecture* (1988).

EARLY NETHERLANDISH, term used to describe art produced in the Southern Netherlands during the 15th and early 16th centuries. Artists from this period, since the 19th century also known as Flemish primitives, are seen as the inventors and perfectors of oil painting. Apart from the technical innovations which these painters introduced, they also succeeded in breathing a realism and warmth into their paintings which still gives their works the directness of photographs even today. It is precisely this quality that led scholars to suggest that artists intended everyday objects in their paintings to bear hidden meaning ('disguised symbolism'). Flemish painting enjoyed international renown in this period, and its success was due largely to the active patronage of the ducal house (from Philip the Bold to Margaret of Burgundy) emulated by the aristocracy, clergy, rich bourgeoisie, and foreign tradesmen. The study of early Netherlandish painting techniques is seen by many as a means of solving problems of attribution. *Campin, van *Eyck, van der *Weyden, and *Memling are important contributors to the Netherlandish School.

MFC

EARTHWORKS. See LAND ART.

EASTER SEPULCHRE, a temporary structure set up in a church on or near the altar to represent the tomb of Christ for the symbolic enactment of the Entombment and Resurrection. A cross, or sometimes the

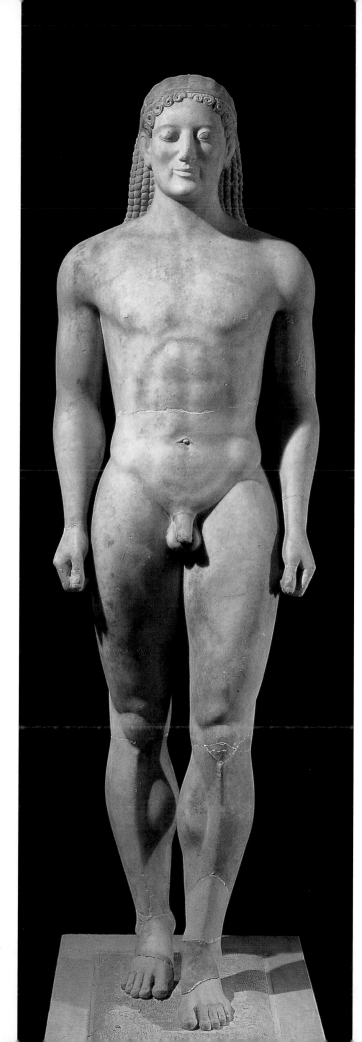

Kouros, from Finikia (Attica) (*c.*540 BC), marble, 1.94 m
(76½ in) high, Athens, National Museum.

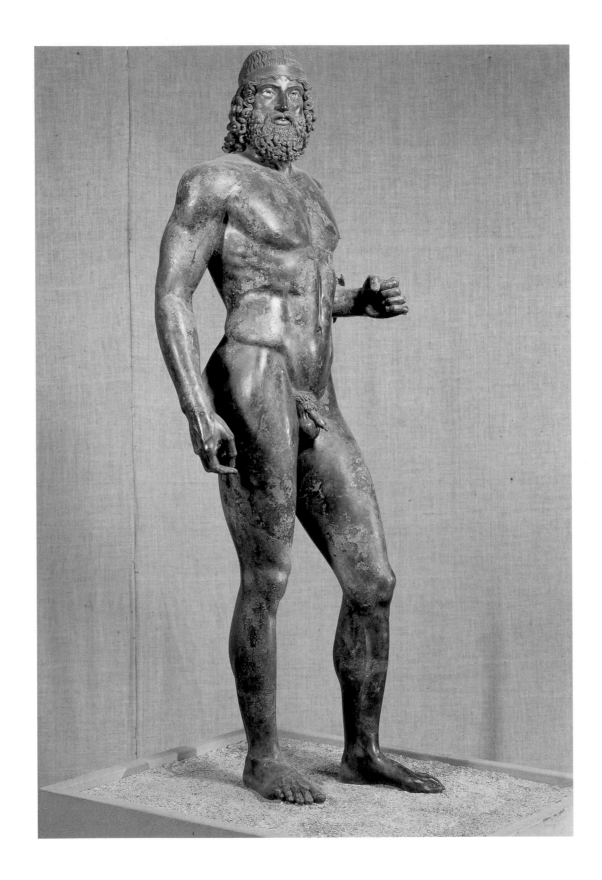

Riace Warrior A (c.450 BC), bronze with bone, glass paste, silver, and copper inlay, 1.98 m (78 in) high, Reggio di Calabria, Museo Nazionale.

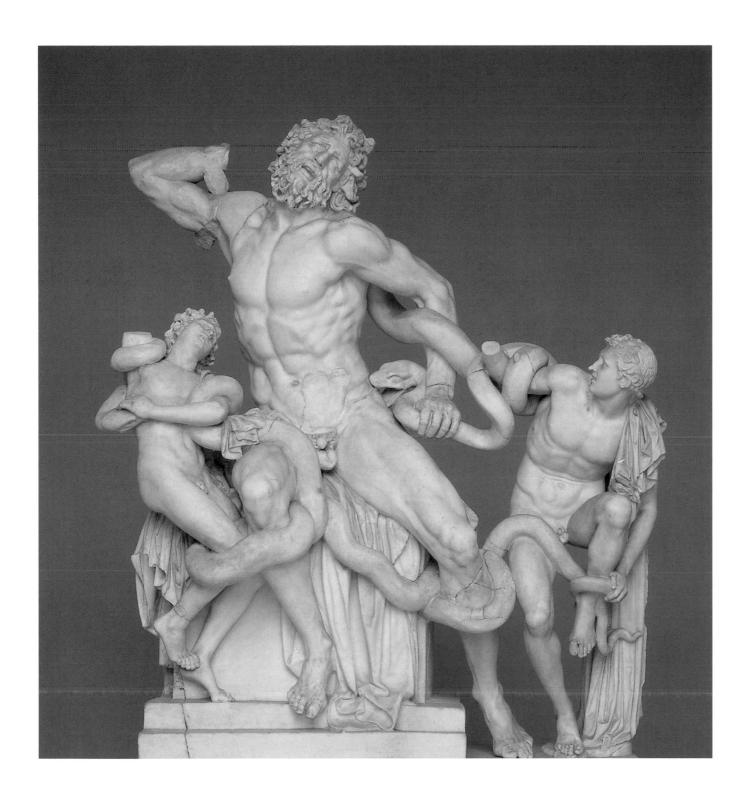

Hagesander, Polydorus, and Athenodorus, *Laocoön and his Two Sons* (c. late 1st century BC), marble, 2.42 m (95½ in) high, Vatican, Museo Pio Clementino.

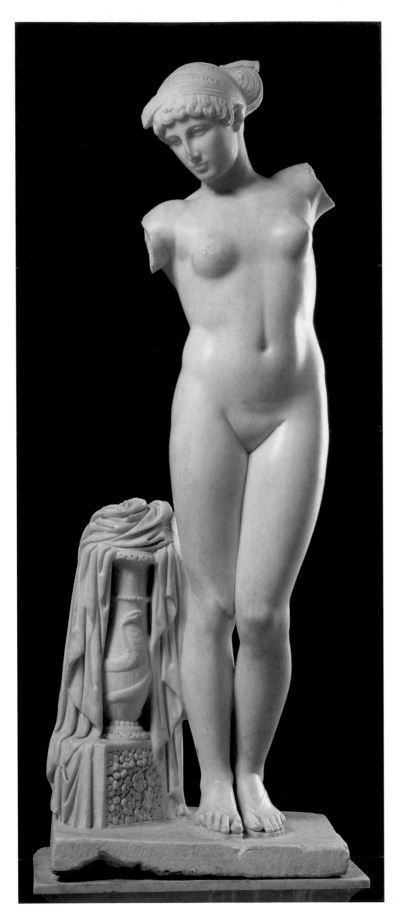

Aphrodite (The Esquiline Venus) (2nd century AD),
marble, 1.55 m (61 in) high, Rome, Museo dei Con-
servatori.

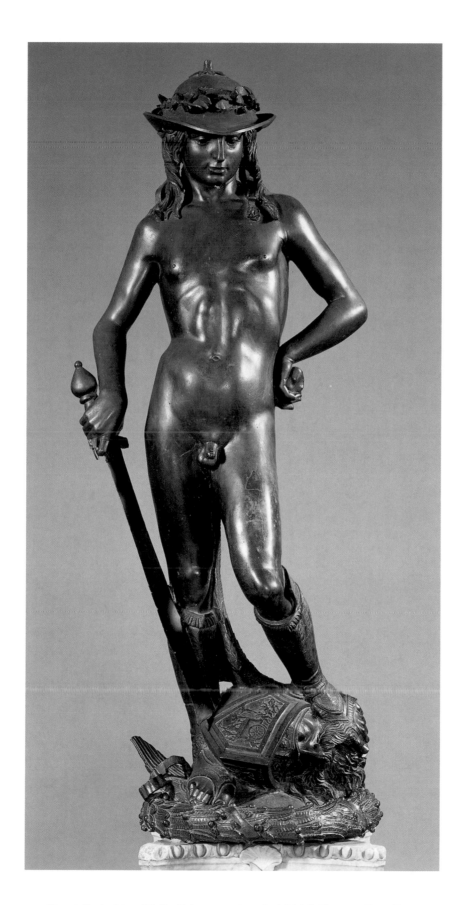

Donatello (1386–1466), *David*, bronze, 1.85 m (73 in) high Florence, Bargello.

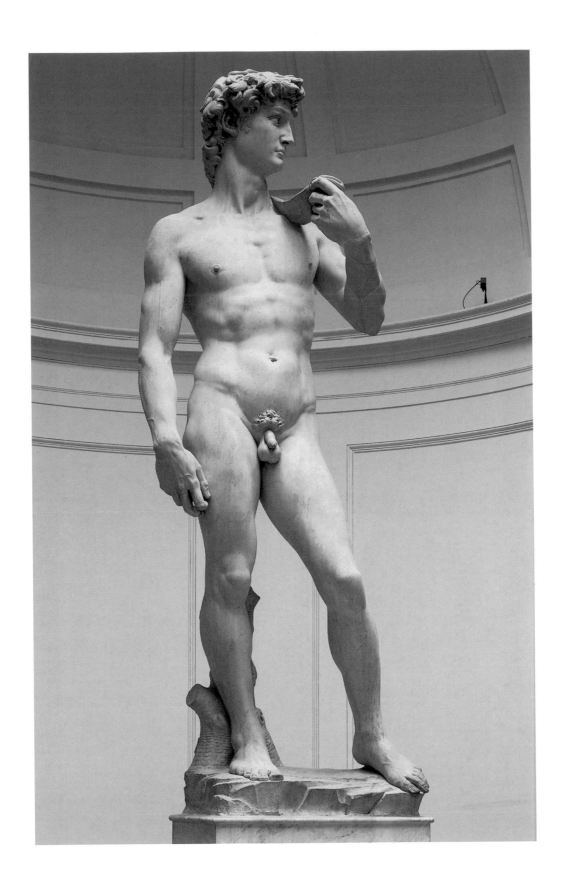

Michelangelo, *David* (1501–4), marble, 4.34 m (14 ft 4 in), Florence, Accademia.

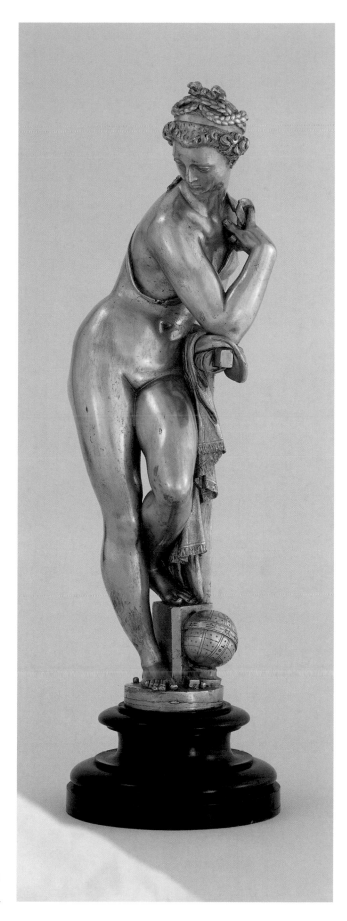

Giambologna (1529–1608), *Astronomy*, gilt bronze, 39 cm
(15⅜ in) high, Vienna, Kunsthistorisches Museum.

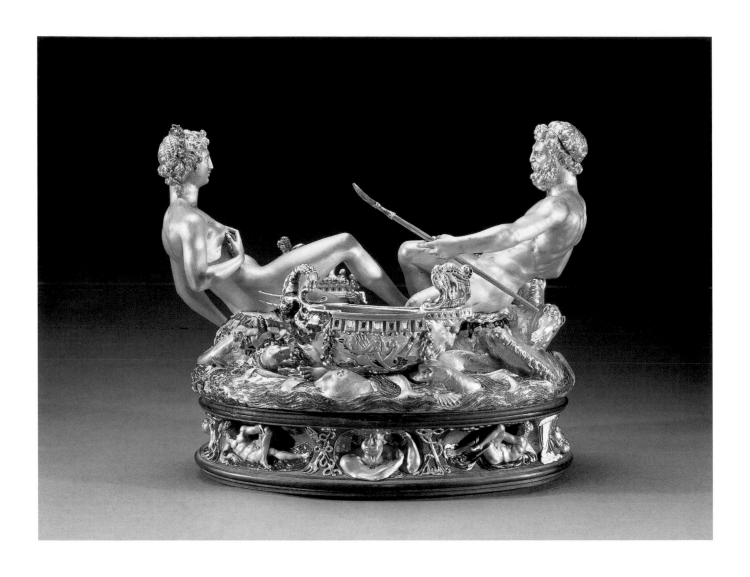

Benvenuto Cellini (1500–71), salt–cellar with Neptune and Ceres, gold and enamel, 26 × 33.5 cm (10¼ × 13¼ in), Vienna, Kunsthistorisches Museum.

Host, was placed in the sepulchre from Good Friday to Easter Sunday. The ritual was described in the 10th-century *Regularis concordia*. In the late Middle Ages testators sometimes requested a tomb beside the altar that could be used for the Easter Sepulchre.

The permanent stone structures ornamented with fine decorative and figure sculpture that were set up in eastern England in the 14th century (e.g. Heckington, Lincs.; Hawton, Notts.) belong to a separate, but related, tradition of the Tomb of Christ, associated with the Feast of Corpus Christi, instituted in 1318. Sacrament houses, to honour the body of Christ, are also associated with this. NC

Rubin, M., *Corpus Christi: The Eucharist in Late Medieval Culture* (1991).

EASTLAKE, SIR CHARLES LOCK (1793–1865). English artist, museum director, and art historian. A pupil of Benjamin Robert *Haydon, he first established his reputation as a history painter; and he combined this with landscapes, anecdotal brigand subjects, biblical scenes, and romantic evocations of Mediterranean life. He was elected RA in 1830 and president of the RA in 1850. His art historical interests were inspired by travel in Italy, Germany, and the Netherlands; he lived mainly in Italy 1816–30. In Rome he met the German *Nazarenes and became familiar with the writings of German art historians, particularly von *Rumohr, who was breaking new ground in his study of early Italian art. His interest in the history of technique and his sympathy for the revival of fresco painting by the Nazarenes led to his appointment, in 1841, at the suggestion of Sir Robert Peel, as secretary of the Fine Arts Commission, responsible for supervising the decoration, in fresco, of the walls of the new Palace of Westminster. In 1842 he edited an English edition of Franz Kugler's *Handbook of the History of Painting from the Age of Constantine the Great to the Present Time*; and in 1847 he further enhanced his scholarly reputation with the first volume of his *Materials for a History of Oil Painting*. In 1855 he was appointed director of the National Gallery (see under LONDON) (he had already served as keeper from 1843), with the express purpose of acquiring pictures on the Continent, especially in northern Italy, which was still under Austro-Hungarian rule. Working with Otto Mündler (1811–70), a Bavarian expert who was employed as the gallery's travelling agent, Eastlake acquired 59 pictures in Italy between 1855 and 1857, including works by *Mantegna, *Perugino, *Romanino, and *Veronese. In Florence he bought a substantial group of paintings from the Lombardi-Baldi Collection; among these were early works selected with a view to forming a historically representative collection. In London in 1861 he bought the *Baptism of Christ* by *Piero della Francesca, then still a little-appreciated artist about whom he had written perceptively in the *Quarterly Review* in 1840 (reprinted in his *Contributions to the Literature of the Fine Arts* 1848). As an art historian Eastlake was at the forefront of changing taste and new approaches to the study of early Italian and north European painting. Yet he failed to produce a definitive book on the subject to match the writings of *Lindsay, *Ruskin, *Dennistoun, J. A. Crowe, and G. B. Cavalcaselle. His most tangible legacy, unquestionably, was the acquisition policy over which he presided as director of the National Gallery. HB

Robertson, D., *Sir Charles Eastlake and the Victorian Art World* (1978).

ÉCHOPPE, a type of large *etching needle, with the point cut off diagonally. It was mainly used in 17th-century France by *Callot and *Bosse as a means of simulating the swelling lines produced by the burin in *line engraving. RGo

ECKERSBERG, CHRISTOFFER WILHELM (1783–1853). Danish painter. Eckersberg was born in the province of Jutland and briefly apprenticed to a minor painter before studying at the Kunstakademie, Copenhagen (1803–10), where he received a conventional *Neoclassical training. In 1809 he received the Danish Prix de Rome which financed a stay in Paris, where he became a pupil of *David (1811–13), on his journey to Italy. In Rome (1813–16) he was introduced to classical Antiquity (see ANTIQUE) by *Thorvaldsen whose portrait, naturalistic but with classical attributes, he painted in 1814 (Copenhagen, Koningen Kunstakademie). In 1816 he returned to Copenhagen to a successful career as a leading painter and influential teacher, becoming a professor at the Akademie in 1818; *Købke was amongst his pupils. Although he continued to paint portraits he excelled at maritime subjects, painting with great precision learnt from his archaeological studies in Rome. His finely detailed ships sail below luminous skies in compositions of great clarity. Like *Turner, with whom he shares no one attribute, he made several North Sea voyages between 1833–9 to experience and observe the changing conditions. DER

Danish Painting: The Golden Age, exhib. cat. 1984 (London, NG).

ECLECTIC, term in criticism for a person or style which conflates features borrowed from various sources. Such a style often arises from the overt or tacit doctrine that the excellences of great masters can be selected or combined in one work of art. In criticism the doctrine is traceable to the ancient teachers of rhetoric and was actually applied by *Lucian to sculpture and painting. After *Vasari had praised *Raphael for his skill in selecting the best from the art of his predecessors, writers of the 16th and 17th centuries liked to use the same formula in their eulogies of other artists. Thus it was said that *Tintoretto had set himself to combine the colour of *Titian with the drawing of *Michelangelo. In the 18th century 'eclectics' became a label for the *Carracci family and their followers, and by the 19th century was used to suggest the cold application of a systematic theory. More recently this view has been challenged, and the concept of eclecticism has provoked heated debate on the relationship of *Renaissance art to theory. HL

Mahon, D., *Studies in Seicento Art and Theory* (1947).

ÉCOLE DE PARIS (School of Paris), a term that was originally applied to a number of artists of non-French origin, predominantly Jewish in background, who in the years immediately after the First World War lived in Paris and painted in figurative styles that might loosely be called poetic *Expressionism, forming the most distinctive strand in French painting between *Cubism and *Surrealism. *Chagall (a Russian), Tsugouharu Foujita (a Japanese), Moïse Kisling (a Pole), *Modigliani (an Italian), Jules Pascin (a Bulgarian), and *Soutine (a Lithuanian) are among the most famous artists embraced by the term. However, the meaning of the term was soon broadened (particularly outside France) to include all foreign artists who had settled in Paris since the beginning of the century (the Dutchman van *Dongen and the Spaniard *Picasso, for example), and then it expanded still further to cover virtually all progressive art in the 20th century that had its focus in Paris. In the broadest sense, the term reflects the intense concentration of artistic activity, supported by critics and dealers, that made the city the world centre of innovative art up to the Second World War.

In 1951 an exhibition devoted to the École de Paris, covering the period 1900 to 1950, was held at the New Burlington Galleries, London. In his introduction to the catalogue Frank McEwen wrote that Paris then had 130 galleries (as opposed to a maximum of 30 in any other capital city), in which were shown the work of some 609,000 artists, one-third of them foreigners; there were 20 large Salons exhibiting annually an average of 1,000 painters each, mostly semi-professionals. IC

ÉCORCHÉ FIGURE (French: flayed), a model of a figure with the skin removed, displaying the major muscles, and produced in several media. First developed during the 16th century, these served as models for *anatomical studies in artists' workshops and

academies. Later, the human écorché was joined by écorché models of animals, among the finest being those of the horse by *Stubbs. HO/AB

Amerson, L. P., Jr., *The Problem of the Écorché: A Catalogue Raisonné of Models and Statuettes from the Sixteenth Century and Later Periods* (1975).

EDELFELT, ALBERT (1854–1905). Finnish painter and illustrator. Edelfelt, the son of a Swedish aristocrat, studied at the University of Helsinki from 1871, determined to become a history painter. In 1874 he moved to Paris where he was a pupil of *Gérôme at the École des Beaux-Arts 1874–7. He now established a pattern of spending summers in Finland and wintering in Paris. In the late 1870s he was painting historical subjects but was inspired by his friend *Bastien-Lepage to paint rural scenes, based upon *plein air* sketches, in a realist technique. Success followed the exhibition of *A Child's Funeral* in the salon of 1879 (Helsinki, Ateneumin). From 1883 he painted summer scenes of Finnish peasant life which, towards the end of the decade, show *Impressionist influence tempered by Bastien-Lepage's naturalism. Increasing interference from Russia in the face of nationalistic tendencies is reflected in the growing patriotism of his later subjects, particularly book illustrations. Edelfelt painted portraits throughout his career, including that of the great French chemist *Louis Pasteur* (1822–95), shown in his laboratory (1885; Paris, Mus. d'Orsay), which are notable for their psychological insight. DER

Hintze, B., *Albert Edelfelt* (3 vols., 1942–4).

EDINBURGH, NATIONAL GALLERY OF SCOTLAND. The National Gallery opened in 1859 in a Neoclassical building designed by William Playfair (1790–1857) which was shared with the Royal Scottish Academy (RSA) until 1912; the foundation stone had been laid by Prince Albert in 1850. The urgent need for the gallery building had arisen out of a quarrel between the Royal Institution, an association of noblemen and gentlemen, founded in 1819 to arrange exhibitions of old master paintings from their own collections, and the Scottish Academy, founded in 1826, which shared the Royal Institution's building but suspected it of misdirecting receipts from exhibitions of modern art to form its own permanent collection of old masters. In 1830–1 the Scottish artist Andrew Wilson had bought for the Royal Institution 38 'ancient pictures' including three impressive van *Dycks, from collections in Genoa and Florence. They were intended for the instruction of artists, but the artists were not impressed. As the 1831 catalogue explained: 'The nature of the collection at present aimed at is principally directed more towards that class of the genuine works of the great masters which are more especially of an instructive character to artists, than such as are usually selected with a view to the adornment of a gallery, as a public spectacle—pictures to be relied upon as safe models upon which the student may advantageously form his taste and correct his practice, although those may prove less attractive to the cursory observer, or be less calculated to dazzle by the brilliancy of subject and effect.' These pictures, together with works from the Erskine of Torrie bequest to Edinburgh University including J. *Ruisdael's *The Banks of a River* (1649), in due course would form the nucleus of the National Gallery collection which was displayed in the western half of the new building. The gallery's curator was to be chosen from among the Academicians; this procedure, which continued until 1904, in practice made the gallery ancillary to the RSA. By the time the gallery opened its doors a number of important gifts had already been received, including *Tiepolo's *Finding of Moses* and ter *Brugghen's *Beheading of S. John*. These were followed in 1861 by the bequest of Lady Murray of Henderland, comprising the collections of Allan *Ramsay and his son General John Ramsay: 380 drawings both by Ramsay and by Italian masters including *Batoni; Ramsay's portrait of his second wife; and outstanding French paintings from the General's collection including *Watteau's *Fêtes vénitiennes* and *Greuze's *Girl with a Dead Canary*.

Since the gallery had no purchase funds there was no debate about an acquisitions policy or the concept of a historically representative collection, along the lines of that assembled at the National Gallery in London. However when in 1903 the gallery did finally secure an annual purchase grant of £1,000 per year efforts were soon made to acquire works dating from before 1500, starting (in 1908) with *Vitale da Bologna's *Adoration of the Kings*, followed by a 15th-century Spanish *S. Michael* and a 15th-century Ferrarese *Madonna and Child*. Another area of expansion was French Impressionism and Post-Impressionism. *Gauguin's *Vision of the Sermon* was bought in 1925 followed by *Degas's *Diego Martelli* in 1932. This aspect of the collection was finally consolidated by the 1960 gift and 1965 bequest of Sir Alexander Maitland, which comprised 21 works by *Monet, Degas, Gauguin, and other French artists.

The long-term loan in 1946 of part of the Duke of Sutherland's collection, including works by *Raphael and *Titian and *Poussin's *Seven Sacraments* which had all been acquired from the Orléans Collection in 1798, totally changed the profile of the gallery and encouraged the serious art historical study of the collection. This was initiated by Sir Ellis Waterhouse, director 1949–52. Increased purchase grants from 1952 reinforced these developments and made possible a series of outstanding acquisitions including *Verrocchio's *Ruskin Madonna*, Gerard *David's *Three Legends of S. Nicholas*, Quentin *Massys's *Portrait of a Notary*, El *Greco's *Saviour of the World*, the early *Velázquez *Old Woman Cooking Eggs*, *Elsheimer's *Stoning of S. Stephen*, and *Il contento*, *Claude's *Landscape with Apollo and the Muses*, *Saenredam's *Interior of S. Bavo's Church, Haarlem*.

Some pictures from the National Gallery were transferred in 1889 to the new National Portrait Gallery in Queen Street. Twentieth-century paintings were transferred in 1960 to the new Scottish National Gallery of Modern Art. HB

Thompson, C., Brigstocke, H., et al., *Pictures for Scotland* (1972).

ECKHOUT, GERBRAND VAN DEN (1621–74). Dutch painter, draughtsman, and etcher, who lived and worked in his native town of Amsterdam. Eeckhout painted mainly history paintings, but also landscapes, portraits, and genre scenes. He was trained by *Rembrandt, probably between 1635 and 1640/1; *Houbraken, the 18th-century biographer, noted that Eeckhout was one of Rembrandt's best friends. Rembrandt's influence remained powerful; both Eeckhout's *Isaac Blessing Jacob* (1642; New York, Met. Mus.) and his *The Tribute Money* (1674; Lille, Mus. des Beaux-Arts) are indebted to the warm colours and crowded compositions of Rembrandt's art in the 1640s. His genre scenes, such as *The Music Lesson* (1655; Copenhagen, Statens Mus. for Kunst), are close to the elegant works of *Terborch. HL

Manuth, V., in *Rembrandt: The Master and his Workshop*, exhib. cat. 1991 (London, NG).

EGAS, CUEMAN (active 1452–95). Most important sculptor in Toledo in the second half of the 15th century, sometimes called Egas de Bruselas. His brother was the architect Hanequín de Bruselas and his sons Antón Egas and Enrique Egas became architects like their uncle. Egas worked with Hanequín on the latter's building projects and collaborated with Juan Alemán and Francisco de las Cuevas on the carving of the Puerta de los Leones of Toledo Cathedral (begun 1452). The choir stalls that Egas carved for Cuenca Cathedral (1454; now Belmonte, Colegiata) show his fine hand with the Netherlandish style and his wonderful eye for decoration. He was also noted for his sculptured *tombs, including that of Gonzalo de Illescas (1458; Guadalupe, Hieronymite monastery) and a particularly innovative one for Alonso de Velasco and his wife, with the couple shown kneeling in prayer while pages lounge casually in a doorway behind them. Egas collaborated with Juan *Guas on several important projects including the sculpture for S. Juan de los Reyes, Toledo (begun c.1476)

and for the *trascoro* of Toledo Cathedral (1483–93).　　　　　　　　　　　　　　　　SS-P

Proske, B. G., *Castilian Sculpture: Gothic to Renaissance* (1951).

E GELL, PAUL (1691–1752). The most important sculptor active in the Rhineland principalities of Germany in the *Rococo period. His work as part of Balthasar *Permoser's team decorating the Zwinger in Dresden before 1720 was the formative influence on his elegant and expressive sculpture in stone, wood, and stucco. Although much of his fine decorative work in Mannheim and Hildesheim was destroyed in the Second World War, fragments of his masterpiece, the carved and giltwood altar for S. Sebastian in Mannheim (1739–41), survive in the Bode Museum, Berlin. His style, combining German late *Gothic, Italian *Baroque, and French Rococo influences, was a perfect vehicle for expressing 18th-century Catholic piety.　　　　　　　　　　　　　　　　MJ

Lankheit, K., *Der kurpfälzische Hofbildhauer Paul Egell, 1691–1752* (1988).

E GG, AUGUSTUS (1816–63). English painter. Egg attended the RA Schools (see under LONDON) 1834–6 and two years after leaving exhibited *A Spanish Girl* (1838; lost) at the Annual Exhibition. He was, however, critical of the Academy and with his friends *Frith and *Dadd a member of 'The Clique', the first of the 19th-century anti-academic groups which culminated with the *Pre-Raphaelite Brotherhood. *A Scene from The Winter's Tale* (1845; London, Guildhall), painted with lively clarity, is typical of his literary subjects. His early rebellion against academic tyranny may explain his championing of the Pre-Raphaelites. He obtained a purchaser for Holman *Hunt's *Rienzi* in 1849 and commissioned *Claudio and Isabella* from him in 1850. The relationship proved to be mutually beneficial, for Egg's finest and most notorious painting, the triptych *Past and Present* (1858; London, Tate), owes a clear debt in both style and subject (infidelity) to Hunt's *The Awakening Conscience* (1854). *The Travelling Companions* (1862; Birmingham, Mus. and AG) an equally 'modern' if less controversial subject, set in a railway carriage, is a fine example of Egg's closely observed mature style.　　　　　　　　　　　　　　　　DER

Trebble, R., *Great Victorian Pictures*, exhib. cat. 1978 (Arts Council touring exhib.).

E IDOPHUSIKON. The invention of the painter Philippe de *Loutherbourg, an experienced stage designer, the Eidophusikon was a miniature theatre, without actors, which relied on sophisticated special effects for its appeal. It opened on 26 February 1781, in a luxurious room in his house in Lisle Street, London, which seated over 100 spectators who each paid five shillings. The dimensions of the area in which the spectacle was performed were approximately 2 m (6 ft) wide by 1 m (3 ft) high by 3 m (10 ft) deep. Contemporary descriptions record the accurate simulation of natural phenomena and stirring events achieved by lights, gauzes, coloured glass, and smoke. An elaborate system of rods and pulleys provided the means for the movement of figures, ships, and vehicles. Performances were accompanied by a harpsichord and there were musical interludes between the scene changes. The Eidophusikon attracted a fashionable and artistic audience including *Gainsborough, who was inspired to create his own 'shadow box', and *Reynolds, who exhorted his pupils to attend. Loutherbourg operated the theatre for several seasons before selling it to Chapman, his assistant, who took it on a provincial tour.　　　　　　　　　　　　　　　　DER

Joppien, R., *De Loutherbourg*, exhib. cat. 1973 (London, Kenwood House).

E IGHT, THE, a group of eight American artists, formed by the realist painter Robert *Henri in 1907 in opposition to the conservatism of the National Academy. Although all figurative artists, their styles differed considerably and they were only united in supporting progressive trends in painting and subverting the dominance of the Academy. Their one exhibition, held in New York, in 1908, was influential in establishing the American school of non-academic realism and led, indirectly, to the *Armory Show (1913) and the foundation of the Society of Independent Artists (1917).　　　　HO

Homer, W., *Robert Henri* (1969).

E KPHRASIS, a Greek rhetorical term for a kind of description. In modern criticism the term *ekphrasis* is often used to mean a 'description of a work of art' and applied to a variety of poetic and prose treatments of the arts ranging from the Homeric 'Shield of Achilles' to John Keats's 'Ode to a Grecian Urn' or the descriptions of paintings within *Vasari's *Lives of the Artists*. But although some ancient *ekphraseis*, like those of the *Philostrati or *Callistratus, did describe paintings or sculptures, the term had a far broader meaning in Antiquity. It was described as a vivid speech which appealed to the imagination, making the listener seem to see the subject matter. *Ekphraseis* of battles, for example, were used in historiography while the rhetorical *encomia* of the later Roman Empire often contained *ekphraseis* of the people, places, and monuments they celebrated. Since the authors of an *ekphrasis* sought to rival the impact of the visual arts it is not surprising that from the Roman period onwards they often chose to describe works of art, often as free-standing compositions. In this they were following a long established literary tradition reaching back to the Homeric 'Shield of Achilles'. But the practice of composing *ekphraseis* of sculptures, paintings, and many other subjects as rhetorical exercises in Roman and Byzantine schools also encouraged this development.

Late Antique and Byzantine writers continued to make use of *ekphrasis*, both as free-standing works and as passages of larger works, often describing monuments or graphic arts. Paul the Silentiary's lengthy verse *ekphrasis* of Hagia Sophia was composed to celebrate Justinian's repairs to the building in the 6th century. After the defeat of Iconoclasm in the 9th century the Patriarch Photius marked the restoration of images to the same building with a sermon which included an *ekphrasis* of a depiction of the Virgin and Child. Byzantine *ekphraseis*, whether of art, architecture, or other subjects, tend like their classical predecessors to neglect the details of the subject's appearance and to evoke instead the visual and emotional impact of the sight upon the viewer, making these *ekphraseis* valuable sources for the role of art in society as well as for the appearance of these monuments.

With the Western rediscovery of Greek literature in the *Renaissance, artists and patrons saw the potential of ancient *ekphraseis* of works of art, like the Philostratean *Imagines*. *Alberti's translation of *Lucian's *Calumny* in his treatise *On Painting* inspired many artists to attempt a reconstruction of the painting. It is not necessary to see the influence of ancient *ekphraseis* on every Renaissance description of a work of art but Philostratus in particular may well have inspired writers like Giambattista Marino and *Bellori.　　RW

Land, N. E., *The Viewer as Poet: The Renaissance Response to Art* (1994).
Maguire, H., *Art and Eloquence in Byzantium* (1981).
Rosand, D., '*Ekphrasis* and the Generation of Images', *Arion*, 3 (1991).
Webb, R., '*Ekphrasis* Ancient and Modern: The Invention of a Genre', *Word and Image*, 14 (1998).

E LECTROTYPES, known as galvanotypes in continental western Europe. A copy made in copper or nickel of an existing relief-printing block made by electrolytically plating a mould. First a negative of the original woodblock is made by pressing it into wax, soft lead, plaster, or a synthetic resin. This matrix is covered with silver or graphite, allowing a copper or nickel layer to form when the matrix is placed in a galvanic bath. Once the wax has been removed the electrotype can be strengthened with lead and by setting it onto a wooden support. The copy is a precise and extremely durable replica of the original. Electrotypes have many advantages, especially for commercial printing: they allow the original form from which they

were made to be preserved unblemished and a great number of prints can be made from one plate—up to 150,000. By using several plates made from one original simultaneously, speed of production can be increased. The plates can also be adapted for use in a rotary press. In the mid-19th century electrotypes were made of plants or leaves creating unusual intaglio prints and the colour electrotype was developed by Albert Fischer.

MFC

ELSHEIMER, ADAM (1578–1610). German painter who was born in Frankfurt but was mainly active in Italy. By the time he had reached Rome in April 1600 he had travelled in Bavaria and absorbed the influence of *Altdorfer. He visited Venice c.1598 where he was associated with the Munich artist *Rottenhammer and apparently studied the works of *Bassano and *Tintoretto. His interest in vividly observed and intensely lit landscape, combining Flemish and Italian influences, is already apparent in his *Baptism of Christ* (c.1598–1600; London, NG) and the *Flood* (Frankfurt, Städelsches Kunstinst.). They are painted in a precise miniaturist technique on a copper support which provided a smooth surface for his meticulous brushwork and he continued to work in this manner for the rest of his life.

In Rome he shared a house with the engraver Hendrick Goudt who made prints of some of his pictures and for a time supported him financially. He also mixed in learned humanist circles. His activities are not well documented and the chronology of his Roman work from 1600 until his premature death in 1610 is not secure. Early pictures probably include the *Preparation for the Martyrdom of S. Lawrence* (London, NG), the *Stoning of S. Stephen* (Edinburgh, NG Scotland), and the *Finding and Exaltation of the True Cross* (Frankfurt, Städelsches Kunstinst.), all of which are distinguished by a remarkable attention to detail and an eye for anecdotal realism. Yet in its complexity a scene such as the *Finding and Exaltation of the True Cross* with its crowded design and ambiguous spatial setting is comparable to Tintoretto at his boldest. Elsheimer's biographer *Sandrart considered *Il contento* (Edinburgh, NG Scotland) to be his masterpiece; it has a more contrived and theatrical quality, with a strong sense of lateral movement, also apparent in the preparatory drawing (Paris, Louvre).

Elsheimer was particularly fascinated by the potential of nocturnal scenes. The candlelit *Mocking of Ceres* (Madrid, Prado) and the moonlit *Flight into Egypt* (1609; Munich, Alte Pin.), with a remarkable rendering of the starry sky at night, which was still in the studio at his death, haunted the next generation of northern artists who came to work in Rome. His work was also greatly admired by *Rubens, *Rembrandt, *Tassi, *Saraceni, and *Claude.

HB

Andrews, K., *Adam Elsheimer* (1977).

EMBLEMS AND EMBLEM LITERATURE (Greek *emblema*: inlaid work or mosaic). The use of emblems in art and literature arose during the 15th century through the rediscovery of classical epigrams and Egyptian hieroglyphs and became particularly popular during the 16th and 17th centuries when, helped by the advent of printing, they were collected and published in books and reached a wide public. An emblem consists of three parts; a short, sometimes classical motto or proverb (*inscriptio*), a pictorial image (*pictura*), and an epigram (*subscriptio*), which last explains to the reader the symbolic meaning to be derived from the combination of motto and image. For example, the motto *Festina lente* ('Make haste slowly') appears with the image of a dolphin and an anchor and an epigram explains that maturity is achieved by a combination of the speed and energy of the dolphin and the steadiness and gravity of the anchor.

Classical texts provided the sources from which the earliest emblem books of the Renaissance were derived. The main examples were the rediscovered *Hieroglyphica* (1419; printed 1505) by the late classical Horapollo (active early 5th century BC) and a collection of classical epigrams made by Maximus Planudes in the 13th century, and published as the *Anthologia Graeca* (1494). Other sources included the Bible. The earliest and most influential emblem book is the *Emblematum liber* (1531) by Andrea Alciati, which is the main source for later authors. Emblem books such as *Sinnepoppen* by Roemer Visscher (1614) or those by the influential and prolific Jacob *Cats became especially popular with the 17th-century Protestant audiences in the Dutch Republic. These often provided an inspiration for the moralizing content in the work of Dutch genre painters.

Emblems, known as imprese, were used as personal devices. For example the Emperor Charles V combined the device of the Pillars of Hercules with the motto *Plus ultra*. Imprese specific to the sitter were used by Renaissance artists, such as that of the cannon in *Titian's portrait of *Alfonso d'Este* (New York, Met. Mus.); or to draw a general symbolic meaning such as chastity in the case of the ermine in *Leonardo da Vinci's *Cecilia Gallerani* (Cracow, Czartoryski Gal.) and most frequently on the reverse of portrait medals. Emblems, for example those of the Montefeltro family in the Palazzo Ducale, Urbino, were also widely used in interior decoration. Designers of festivals and triumphs made use of them, as did *Rubens for example, in his *Pompa introitus Ferdinandi* (1635).

The use of emblems saw a revival in 19th-century Britain, both for theological reasons engendered by Christian revival movements and as a means of artistic expression, in the work of book illustrators and *Pre-Raphaelite painters.

CFW

ENAMEL. In its original sense enamel is glass or vitreous paste fused to a prepared surface, usually of metal, by means of intense heat. The word probably derives from the Old French *esmail* or *esmal* first used in the 13th century.

Though easily fractured, like glass, enamel is extremely durable and gives great brilliance of colour, especially when used in its translucent form against a ground of precious metal. Many of the greatest examples of medieval and Renaissance goldsmiths' works owed their beauty to their enamelled enrichment. During this period such objects were regarded and valued as highly as any art form; they were commissioned by the most discerning noble and ecclesiastical patrons, and were designed by the greatest artists of the day. *Pucelle, two of the de *Limburg brothers, Antonio *Pollaiuolo, and *Holbein are among those documented as training as goldsmiths or as designing metalwork.

There are five main types of enamelling: cloisonné, *champlevé*, *basse-taille* or translucent, *émail-en-ronde-bosse* or encrusted, and painted. Satisfactory English equivalents for the French terms do not exist.

In cloisonné enamelling cells, or cloisons, are built up on a thin sheet of metal by attaching metal wire or fine strips of metal fixed edgewise. These cells are filled with finely powdered glass paste, which is then fused to the metal in a furnace. As the enamel shrinks on melting and cools with a concave surface, more has to be poured in and the process repeated. Finally the surface is levelled and the whole is smoothed and polished. Neither the place nor the period when cloisonné enamelling originated is known with certainty. The earliest known enamels are articles of jewellery from Mycenaean Greece in cobalt-blue and green enamel from around the 13th century BC. The finest piece is a gold sceptre with a spherical knob surmounted by two hawks (Nicosia, Cyprus Mus.). A very small amount of blue and white enamelling appears on Greek gold jewellery from the 6th to the 3rd century BC.

Cloisonné enamelling first appears as a major art in Europe in the Byzantine Empire, the earliest examples dating from the 6th century. Although much was destroyed during the Iconoclastic disputes of the 8th century, the conclusion of these disputes in 842 was followed by a great revival that lasted into the 11th century. *Byzantine enamels are of great magnificence. Gold was used for both the ground and the framework of the cells, giving added brilliance to the enamel

colours. Two forms of cloisonné enamel were employed. In the earlier the whole surface of the gold plaque to be enamelled was covered with enamel (Beresford-Hope Cross; London, V&A); in the other process part of the surface of the plaque was recessed and in the field thus created the cells built up. When the process was completed the enamelled surface was polished level with the surrounding gold border. The greatest monuments of Byzantine enamelling in western Europe are the Reliquary of the Holy Cross (Limburg Cathedral treasury) and the Pala d'Oro, the golden altar front of S. Mark's, Venice (976, present setting 1342–5), which contains 83 enamelled panels of Byzantine origin.

Cloisonné enamelling was soon copied in western Europe, where it was probably introduced by Greek goldsmiths, and it played an important part in the goldsmith's art of the *Carolingian and *Ottonian eras, when it was used as an alternative to or in combination with precious stones. The earliest examples are probably Italian but the most ambitious cloisonné enamelled work of the early Middle Ages, the altar frontal of S. Ambrogio, Milan (the Paliotto), signed and dated Wolvinius in the year 835, is the work of a German artist. In the Ottonian period workshops seem to have existed in the German monasteries, in particular at Trier, Essen, Regensburg and Reichenau; but knowledge of the technique spread as far as England (the Alfred Jewel, 9th century; Oxford, Ashmolean). Even once the technique of champlevé enamel was predominant the use of cloisonné continued and was employed in many of the major goldsmiths' works of the Romanesque period.

In champlevé the design to be enamelled is cut out of the thickness of the metal ground and glass powder is placed in the resulting cavities. After firing the enamelled surface is smoothed level with the metal and polished. While the Romans made little, if any, use of enamel, the process was certainly employed by many of the peoples they conquered. Amongst the latter were the Britons, who had achieved great skill before the Roman conquest (Battersea Reach Shield; London, BM), and numerous domestic objects decorated with champlevé enamel dating from the Roman period have been excavated in England. Provincial Roman and the subsequent Celtic enamels were produced on a bronze base. The incursions of invading peoples drove the Celtic enamellers westwards to Ireland, where the art of champlevé enamelling enjoyed a late flowering.

Towards the end of the 11th century champlevé enamelling on copper appeared in various countries and it continued to be produced on an increasingly commercial scale, although still as a fine craft, until the beginning of the 14th century.

The champlevé technique had the advantage over cloisonné that a greater degree of freedom of design was possible. Though figure subjects were rendered in cloisonné, their treatment had been extremely formalized. Instead of gold a copper ground was now used, an inexpensive material that made possible the production of pieces of monumental proportions. As the copper ground discoloured when the enamel was fired, it was necessary to use opaque colours. These, while lacking the brilliance of translucent colours, did not fuse so easily with one another, and it was therefore possible to combine several colours within one cavity, giving an effect of shading and colour gradation. The surrounding metal surfaces were sometimes engraved or gilded. Champlevé enamels were produced in three main regions: the towns on the Rhine and the Meuse, the French city of Limoges, and in Spain. The fact that Abbot Suger of S. Denis brought enamellers from Lorraine to work on a large cross in honour of his patron saint, consecrated in 1147, indicates that the northern enamels were widely known at an early date. *Mosan enamels were of very high quality, and the figures carved in the copper plate display a superb sense of line. The names of several Mosan goldsmith-enamellers are known. Godefroid de Clair of Huy on the Meuse is generally regarded as the author of the finest early examples, his greatest work being the Heribert shrine at Cologne. *Nicholas of Verdun working around the end of the 12th and the beginning of the 13th century is outstanding among the later artists.

While Mosan enamelling was gradually crowded out by other techniques of goldsmiths' ornament without, however, suffering any marked decline in quality, the history of Limoges enamel shows a steady decline as mass-production methods were adopted to deal with the great demand from all over western Europe. In the Limoges enamels from the first half of the 12th century the enamel was confined to roundels, but by the second half of the century exquisitely drawn figures in coloured enamels against a vermiculated ground were produced, the most splendid example being the sepulchral monument of Geoffrey Plantagenet (d. 1151) (Le Mans, Mus. Tessé). In the 13th century the practice was reversed: instead of the figures being coloured against a gilt ground, the ground was cut away and enamelled and the figures merely engraved and gilded. Though some Limoges enamels may have been produced in monastic workshops, in particular those of the abbeys of S. Martial and Grandmont, the scale and variety of production were such as to predicate large-scale manufacture in several workshops. In the 13th century, as had also been the case in the Mosan shops, figures were rendered in relief, but at Limoges these were hammered into moulds instead of being worked up by hand. Limoges did not produce great spectacular pieces such as the shrines made by Mosan goldsmiths and enamellers, but manufactured smaller pieces which were within the reach of parish churches. Production continued throughout the 13th century and the most imposing example in England, the enamelled effigy of William de Valence in Westminster Abbey, dates from the first decade of the 14th century.

While *Romanesque goldsmiths had worked with opaque enamels, their successors found the brilliance of translucent enamels better suited to match the delicate architectural structure of *Gothic goldsmiths' work. Silver or, rarely, gold was used instead of copper. A further refinement was achieved by the Gothic enamellers in that they sculpted their designs in the thickness of the plaque, so that when enamelled the highest parts of the relief were pale in colour while the lower parts showed darker, thus providing graduated effects of light and shade. The technique, called basse-taille, probably originated in Italy towards the close of the 13th century and the earliest examples are Italian. But in the 14th century it quickly spread over western Europe and was freely used in the decoration of chalices, crosses, diptychs, and other objects of religious use as well as for domestic plate and jewellery. The earliest surviving example is the chalice of Pope Nicholas IV (1288–92: Assisi, Tesoro Mus. Basilica S. Francesco) signed by the Sienese goldsmith Guccio di Mannaia.

An important school of goldsmith-enamellers grew up in Paris but it is no longer generally accepted that the small enamelled plaques which are found mounted on ecclesiastical and domestic vessels made elsewhere were all exported from France. The finest surviving example of this class of goldsmith's work so widely documented in 14th-century French inventories is the Royal Gold Cup intended for the King of France and then given to a king of England (1380–90; London, BM). The art of basse-taille enamelling spread so widely that it is impossible to separate with any certainty the productions of different schools. A group of small diptychs have been identified as English and to the same group may be added the gold triptych formerly belonging to Mary Queen of Scots (Stonyhurst College). Enamelling of exceptionally fine quality was achieved by the 14th-century goldsmiths of Stockholm, to whom a series of richly enamelled chalices and patens in Swedish churches are attributed. The Basle Münsterschatz contains many 14th-century enamelled pieces and allows us to recognize Basle as another centre of the art.

The technique of encrusted enamel (émail-en-ronde-bosse) developed in the 14th century but the earliest examples to survive date

from the beginning of the 15th century. During this period translucent enamel could only be used on more or less flat surfaces; but opaque colours could be painted and securely fused on to a slightly roughened surface. In this technique the fully three-dimensional figures cast from gold were first covered with white enamel and then colour was applied, particularly to drapery and trimmings. Most of the many-figured devotional works or reliquaries of this type to survive are the work of Paris goldsmiths, and constitute some of the most sumptuous examples of the goldsmith's craft in existence. The most spectacular and famous example is the group known as the Goldenes Rössl (1403–4: Altötting, SS Philipp and Jacob, Schatzkammer), which shows the figure of Charles VI of France, to whom it was presented, kneeling before the Virgin and Child, accompanied by his page and with his squire at a lower level holding the King's horse. This same type of encrusted enamel is also found on jewellery.

Painted enamel proper was also introduced during the 15th century. In this technique repeated firings were necessary as the colours fused at different temperatures. The object decorated had also to be enamelled on both sides. Gold, silver, or copper could be used as a ground and the process was less exacting altogether than that of translucent enamel. Painted enamels appeared about the middle of the century in Italy, France, and the Netherlands. Particularly attractive were the enamelled drinking vessels produced by Netherlandish goldsmiths for the Burgundian court (the Monkey Cup; New York, Met. Mus.). These, usually executed in grisaille, display a sophistication of taste typical of late Gothic art. They were the work of a few individual masters; but at Limoges an important workshop was already in existence by the third quarter of the 16th century. The early technique of these Limoges masters was not far removed from that of the translucent enamels, since over a ground enamelled brown the contours of the design were drawn in black enamel and the figures then filled in with translucent colours.

In grisaille of the kind also called *camaïeu*, instead of using a carved ground, the enamel was applied with a spatula to a flat ground on which was traced a design. In this style white enamel paste was superimposed on a ground of black or dark blue enamel paste and then the outlines of the design were carved down with the spatula to the level of the dark ground in the manner of cameo carving. In grisaille the whole surface was covered with a layer of enamel, not subdivided into cells, and it thus paved the way for true painted enamels, in which coloured designs in enamel were painted on to a smooth white enamel ground which had been previously fired onto a metal plaque. Unlike earlier techniques of enamelling this style has more affinity with the art of the miniature painter than with the goldsmith's craft. The work was generally confined to miniature portraiture and the decoration of watches etc. HO/KS

Campbell, M., *An Introduction to Medieval Enamels* (1983).

Snowman, K., *A Thousand Years of Enamel*, exhib. cat. 1971 (London, Wartski).

ENCARNADO, Spanish term for the flesh tones of a carved wooden figure, as distinguished from the gilded and painted garments. Spanish *polychromed figures were carved by sculptors, then finished by gilders (*doradores*), painters who specialized in creating the effects of brocades and other fabrics (*estofadores*), and by *encarnadores*. SS-P

ENGELBRECHTSZ., CORNELIS (1460×5–1527). North Netherlandish painter active in Leiden. His principal works are two triptychs executed for the Augustinian convent of Marienpoel in Oestgeest, near Leiden (*Lamentation*, c.1508; *Crucifixion*, c.1517–22; both Leiden, Stedelijk Mus.). The style is related to that of the *Antwerp Mannerists, though there is no evidence that Cornelis had received his training in Antwerp. In the *Crucifixion* the surface is crowded with animated figures dressed in fanciful costumes; the expressions display overly rhetorical gestures of grief or brutality, bordering on caricature. But his technique is extremely refined and the colours are warm with areas of bright hues. All three of Cornelis's sons became painters: Pieter Cornelisz. Kunst (c.1484–1560/1), Cornelis Cornelisz. Kunst (1493–1544), and Lucas Cornelisz. de Cock (1495–1552). According to van *Mander, he was the teacher of *Lucas van Leyden, though there is little in his art that relates to Lucas's early works. KLB

Gibson, W. S., *The Paintings of Cornelis Engelbrechtsz.* (1977).

ENGLISH ART (1) *Painting*; (2) *Sculpture*

1. PAINTING

The history of English art before the 18th century is essentially that of a provincial style, constantly looking abroad for inspiration and influence and only notable for the shrewd importation of foreign artists. The lack of evidence of a flourishing national school has been seen as the result of two centuries of iconoclasm beginning with the suppression of the monasteries in the 1530s and ending with the restoration of the monarchy in 1660. Certainly the proscription of religious art effectively divorced the development of English painting from that of the Continent but the few remaining examples of pre-Reformation painting and sculpture suggest that it was derivative and dependent on European prototypes. The rare masterpiece that has survived, like the exquisite Wilton Diptych (c.1390–1410; London, NG), may well have been executed by a foreigner and, a century later, the employment of the Italian *Torrigiano to execute the tombs of Henry VII and Queen Elizabeth (1512; London, Westminster Abbey) suggests a dearth of equally skilled native talent. After the cessation of religious art, *portraiture was paramount (and was to remain so until the 19th century). Here too foreign artists predominated. Henry VIII employed the German painter *Holbein to create his image and immortalize his court in a series of brilliant paintings and drawings and the majority of royal and courtly portraits during the reign of the Tudors are attributed to European painters. Holbein's individual genius had little influence on his successors; his perceptive naturalism was followed by the hierarchic mannerism that characterizes portraits of Elizabeth I, like the Ditchley Portrait by *Gheeraerts (c.1592; London, NPG), which, with its emphasis on decorative costume, established a pattern followed by such native painters as William *Larkin. The outstanding exception to this general rule is found in the practice of *miniature painting which, from the 1580s until the 1660s, from *Hilliard to Samuel *Cooper, provided works of the finest quality, independent of continental practitioners. Charles I, the second Stuart monarch, was a knowledgeable and enthusiastic connoisseur who amassed an impressive collection of old master and contemporary paintings and patronized the Flemish painters *Rubens, whose Banqueting Hall ceiling was installed in 1635/6, and van *Dyck, arguably the greatest portrait painter of his time. Van Dyck's fluid, elegant, and magisterial portraits left as timeless, if more flattering, a record of the cavalier court as that which Holbein achieved for Henry VIII but unlike the earlier painter his influence was immense, stretching from his immediate Protectorate follower William *Dobson, through *Gainsborough and *Lawrence to the 20th century.

From the accession of Charles II in 1660 until almost the end of George I's reign in 1727 English portrait painting was dominated by the Dutch-born Peter *Lely and his successor as court painter, in 1689, the German Godfrey *Kneller, who shared the post with John *Riley until the latter's death. Lely's elegance is derived from van Dyck, Kneller was more robust and Baroque; both used studio assistants and produced large numbers of inferior formulaic works which established a common pattern for their imitators. Riley's low-keyed and unflattering style was adopted by his pupil *Richardson but, significantly, Kneller's only serious rival was the Swedish painter Michael *Dahl.

The royal and aristocratic patrons who favoured Lely and Kneller also employed continental artists to decorate their newly built palaces and mansions. The Italian painters Antonio *Verrio, *Pellegrini, Sebastiano and Marco *Ricci, and Jacopo *Amigoni worked in England between 1671 and 1739 and with the French artist *Laguerre had a virtual monopoly on decorative painting until 1716 when Sir James *Thornhill, the only significant English practitioner of the international *Baroque style, won the competition for the decoration of the dome of S. Paul's Cathedral, London, defeating Pellegrini and Sebastiano Ricci in the process. A far greater Italian painter, the Venetian *Canaletto, encouraged by the patronage of English *Grand Tourists, worked in England 1746–55 during which time he transformed English view painting. This had previously been the province of Dutch and Flemish painters like Jan *Siberechts, working in England from 1674, and Peter Tillemans (1684–1734), who arrived in 1704, and their English followers. The alternative 'ideal' landscape tradition, deriving for the most part from *Claude, became increasingly popular after 1660 but had few skilled English practitioners before Richard *Wilson in the 18th century. Both John Wootton and *Lambert painted decorative landscapes inspired by Gaspard *Dughet but the former's claim to fame rests more on his pioneering sporting paintings.

Self-conscious independence from foreign influences is first seen in the works of Thornhill's son-in-law William *Hogarth, perceived within his lifetime and subsequently as the 'Father' of English painting, who chauvinistically fought for the recognition of a national school. Beginning as a lowly engraver Hogarth established himself as a painter of theatre and conversation pieces before, in 1730, creating the original genre of the 'modern moral subject' which made his reputation. In the late 1730s he became a self-appointed spokesman for English painters, decrying the aristocratic taste for foreign and old master pictures. His contempt for contemporary French art was expressed in the series *Marriage à la Mode* (c.1753; London, NG) in which he adopted French mannerisms to depict the excesses of fashionable life. His mastery of the idiom stems from his close association with the St Martin's Lane Academy, a descendant of Kneller's Academy of 1711, which he re-established in 1734, where his fellow teachers included the French engraver Hubert *Gravelot. Another tutor, Francis *Hayman, was also an accomplished painter in the *Rococo style and, like Hogarth, an active propagandist for professional training and public exhibitions. A founder of the Society of Artists in 1760, he became one of the first members of the Royal Academy (see both under LONDON) in 1768. The Academy, under the patronage of George III, transformed the status and opportunities of English painters, providing a sound education on continental principles and a public showcase which remained pre-eminent until the late 19th century. The first president, the esteemed portrait painter Joshua *Reynolds, provided, in his *Discourses* (1769–90), a manifesto for the successful artist which included an aspiration towards elevated subjects, high art, and an 'ideal' style achieved through the study of nature and classical Greek and Renaissance Italian art; from now on a stay in Italy was *de rigueur*. Study in Rome was not new—John Michael *Wright stayed there 1642–56—but had only recently become commonplace. Reynolds was in Rome 1749–52 when fellow expatriates included the landscape painter Richard Wilson and Thomas *Patch, one of several English artists, like the sculptor Joseph *Nollekens and the painter Gavin *Hamilton, patronized by visiting English Grand Tourists. Rome remained the favoured training ground for English painters until overtaken by Paris in the mid-19th century; *Poynter was to study at both, in Rome in 1853 and in Paris 1856–9. Gainsborough, Reynolds's only serious (and arguably superior) rival as a portrait painter, never visited Italy, taking Dutch 17th-century painters as his models for early landscapes and van Dyck for his portraits, which also reveal restrained Rococo elegance.

*History painting, promoted but scarcely practised by Reynolds, was to prove unpopular with English patrons. Gavin Hamilton had a successful career in Rome, supported by his entrepreneurial activities, but primarily for Italian customers. James *Barry, whose stay in Rome (1765–71) was financed by Edmund *Burke, achieved prominence with his admired, but unprofitable, *Progress of Human Culture* for the Society of Arts in London (1777–84; *in situ*) but his later career was spent in poverty and two later practitioners of the Grand Manner, *Bird and *Haydon, were ruined by their high-minded ambitions. The only English artists to win success with heroic *Neoclassical subjects were *Romney, like Reynolds primarily a portrait painter, and the sculptor John *Flaxman, in Italy 1787–94, whose international reputation was made by the wide distribution of engravings of his skilful but insipid linear drawings. The fanciful and sublime works of *Fuseli and *Blake, pivotal in the change from the ideal *Neoclassic to *Romantic intensity, had only a limited appeal.

The English still preferred paintings of themselves and their animals which, from the 1760s, provided a living for the greatest of English animal painters, the modest genius George *Stubbs, whose integrity and unsentimentality became unpopular towards the end of his career when 18th-century sense was overtaken by 19th-century sensibility.

Some of Stubbs's honest realism and the spirit of scientific enquiry which inspired his anatomical drawings may be seen in the work of his contemporary Joseph *Wright, one of the very few 18th-century artists to establish a reputation whilst working outside London. Wright however also essayed *sublime subjects, both modern and historical. At the turn of the century English art was dominated by three painters, *Lawrence, *Turner, and *Constable, although the latter was largely neglected by his contemporaries. Lawrence's sparkling bravura portraits, which culminated in his series of the leaders of the European anti-Napoleonic alliance, commissioned by the Prince Regent in 1815, captured the sophistication and worldliness of Regency society. Turner and Constable, in their different ways, combined observation and Romanticism to produce highly original works which were to inspire a younger generation of English and European painters. Both were deeply concerned with atmospheric effects, scientific and psychological, and thus owed a debt to the English *watercolour tradition, the imaginary blot-landscapes of Alexander *Cozens and the meticulous painting notes of Francis *Towne. Watercolour, a fragile and fluid medium, was ideally suited to capture the climatic changes of this essentially misty and watery country. Turner and his follower Clarkson Stanfield (1793–1867) were the last great English *marine painters, a popular genre in a maritime nation, long dominated by Dutch influence.

The 19th century saw major demographic, economic, industrial, and political changes which revolutionized patronage and subject matter. By the mid-century aristocratic patrons were outnumbered by the new middle classes, self-made industrialists, financiers, and engineers who, for the most part, favoured literary and historical genre paintings and unexceptional landscapes, the latter either English or continental, tours abroad being no longer the prerogative of the scholar or gentleman. Queen Victoria, a strangely bourgeois monarch, popularized animal painting, both realistic and sentimental, by her patronage of *Landseer and, after 1853, misty Scottish landscapes through her annual stay at Balmoral. The Westminster Hall Competitions (1843–6) for scenes from English history accurately reflected the patriotic *Zeitgeist* which affected all levels of society, anxious, in these changing times, to find common ground. *Dyce, *Maclise, and innumerable inferiors catered to the demand for history while, from 1854, with *Life at the Seaside* (London, Royal Coll.), *Frith set standards of contemporary realism which satisfied the most down-to-earth connoisseur. The short-lived *Pre-Raphaelite Brotherhood, founded in 1848, briefly combined the two genres, with historical, religious, and literary themes and their 'modern subject' pictures

both painted with photographic realism. One of the many groups to oppose the RA, although by far the best known, the principal members had parted company by 1853; *Rossetti to become a precursor of *Symbolism, *Hunt a religious obsessive, and *Millais a president of the Royal Academy and a baronet, 'Typically English, in the best sense', according to a posthumous profile by Alfred Lys Baldry (1899), 'a good shot, a keen fisherman, and a fearless horseman'. Although still powerful the Academy's role was diminished by the rise of picture dealers, like Agnew and Gambart, and flourishing provincial academies and was to decline further in the 20th century. The unprecedented economic and political power of Britain in the mid-19th century, which drove the search for a national identity, made it necessary to define a British School of painting. The Exposition Universelle of 1855, held in Paris, provided an opportunity; for the French critics, who received the English pictures favourably, claimed that the identifying characteristic of English art lay in its very diversity. This paradoxical theory, which extolled the 'freedom' of the English artist, typified by Hogarth, was current until the early years of the 20th century when English painters were still seen as champions of the liberty of modern art, an idea crushed by Clive *Bell and Roger *Fry who successfully marginalized the later followers of the Pre-Raphaelite tradition.

In the mid-1860s a move towards classical subjects, combining archaeological exactitude with legitimized nudity, emerged in the works of *Leighton, *Alma-Tadema, and Poynter and influenced such diverse painters as *Watts, Albert *Moore, *Burne-Jones, and John *Waterhouse. Watts and Burne-Jones are now seen as precursors of Symbolism and, certainly, the latter's androgynous and palely loitering maidens elicited admiration from younger continental painters. At the other extreme a brief burst of sentimental social realism, seen in the work of artists associated with the *Graphic* magazine, *Herkomer, *Fildes, and Frank Holl, was highly popular in the mid-1870s. A strong French influence emerged in the 1860s and many younger artists studied in France, a practice which prevailed until the First World War, despite the foundation of the Slade School of Art in 1871 and the growing liberalization of British art education. George du Maurier's *Trilby* (1894) is a fictitious but detailed account of his own student days, at Charles Gleyre's atelier in the 1850s. *Whistler, the greatest of the French-influenced painters, had also studied at Gleyre's, in 1855, but counted *Courbet and *Manet among his friends and, being American by birth and having spent his childhood in Russia, was a truly cosmopolitan figure. Together with the architect E. W. Godwin (1833–86), the painter Albert Moore, and the

writer Oscar Wilde, he pioneered the Aesthetic movement, 'art for art's sake' in England (see AESTHETICISM). He exhibited at the first exhibition of the avant-garde Grosvenor Gallery in 1877, when his *Nocturne—The Falling Rocket* (Detroit, Inst. of Arts) attracted the wrath of *Ruskin; the subsequent court case which he effectively lost may be seen as one of the first of many clashes between the traditional and the modern in the history of English art.

French *realism and *plein air* painting inspired the work of Stanhope Forbes (1857–1947) and the Newlyn School painters 1885–95 and in 1886 Aesthetes, realists, and Symbolists grouped together under the aegis of the New English Art Club (see under LONDON), an exhibiting society formed in direct opposition to the conservative Royal Academy. Sir George Clausen, *Steer, and Sargent were among the first members but from 1889 the NEAC was dominated by Whistler's pupil Walter *Sickert, the most outstanding painter of his generation, a one-man link between the French avant-garde and English progressive painting. Sickert's personal impressionistic style, his urban subjects, and, above all, his quiet dark tonality were influential until the 1960s and the spread of his ideas from the NEAC via the Camden Town Group (1911–13) and the London Group (1913–) to the Euston Road School (1937–9) painters William Coldstream (1908–87) and Lawrence Gowing (1918–91), who were both respected teachers, can be clearly seen (see all three groups under LONDON). From the time of the controversial *Post-Impressionist exhibitions of 1910 and 1911, organized by Roger Fry, English modernist painters, with the exception of the odd eccentric like *Spencer, were international in their outlook. *Cézanne, on whom Fry wrote a monograph (1927), was probably the single greatest influence until the 1960s when artists turned to America for inspiration. *Cubism and *Surrealism had few followers although the latter included Paul *Nash and *Burra, *Futurism fathered the *Vorticist painters led by Wyndham *Lewis, while *Mondrian and *Constructivism were adopted in the 1930s by *Nicholson and *Hepworth and, two decades later, by Victor *Pasmore and Kenneth (1905–84) and Mary (1907–69) Martin. Few English artists, however, achieved the intensity and integrity of their European models; an aura of gentility and English modesty, of 'good taste', often pervades their work, a rare and undervalued exception being the *Fauve-inspired Matthew *Smith. The mid-1950s saw the emergence of *Pop art, pioneered by Richard *Hamilton and Eduardo *Paolozzi, and American-inspired abstraction. Subsequent noteworthy developments include *Conceptual and *Land art and an increasing exploitation of technical advances, particularly *video. The establishment of the Turner Prize

for young artists in the 1960s and the adoption of a pro-active avant-garde position by the Tate Gallery has caused considerable controversy and suspicion, for the English taste for portraits and horses has not entirely disappeared and despite hyperbolic promotion, few English patrons, with the exception of Charles Saatchi (1943–), buy avant-garde English art.

2. SCULPTURE

Pre-Reformation English sculpture, much of which has survived, tended to follow continental styles. After the Norman Conquest French influence prevailed but was soon naturalized, leading to specifically English features, most notably the use of tiered figures on cathedral façades as at Wells (mid-13th century), which originally boasted 176 sculptures, and, later, Exeter. Like the carved tombs which became popular in the 13th century they were usually *polychrome. Roof bosses, like sedilia and gargoyles, were often given humorous or grotesque decoration although foliate carving was also common. From the late 13th century figures and draperies grew more graceful and flowing, as seen in the large number of *alabasters, popular from c.1325 for tombs and altarpieces, which were widely exported. The alabaster workshops were severely disrupted by the iconoclasm following the Reformation and by the reign of Elizabeth they had been superseded by the Southwark workshops of Protestant immigrants, who introduced Flemish Renaissance forms to English monumental sculpture. The emergence of sculptors, rather than masons, is seen in the 16th century with the arrival of Pietro *Torrigiano whose tombs of Henry VII and his Queen (1512–18; London, Westminster Abbey) introduced Renaissance realism into English sculpture. A similar naturalism and individuality is seen in the work of Epiphanius *Evesham and the Amsterdam-trained Nicholas *Stone a century later. A growing interest in *Antique classical sculpture is epitomised by the collection of Thomas Howard, 2nd Earl of Arundel (1585–1646) (see OXFORD, ASHMOLEAN MUSEUM). From the reign of Charles I, who employed the Florentine Francesco Fanelli (active 1609–after 1662), to the death of *Roubiliac in 1762, English sculpture, like painting, was dominated by foreign artists. The French sculptor Hubert *Le Sueur popularized the portrait bust with his bronze of *Charles I* (c.1635; London, NPG) and in the absence of religious patronage, busts and tombs were the prevailing sculptural types. The Great Fire of London (1666) offered considerable opportunities for artists including the virtuoso carver Grinling *Gibbons, who worked on the interior of S. Paul's Cathedral, and Caius Cibber (1630–1700) who designed the Monument (1673–5; London) in an Italian *Baroque style. Cibber, like John

Nost (d. 1729) also cast a number of garden sculptures, a genre which, whether classical or *Rococo, was fashionable well into the 18th century. From 1700 to 1775 the three principal sculptors were the Dutchman *Scheemakers, a classicist, the Fleming *Rysbrack, whose Baroque style was tempered towards the classical by his association with William Kent and Lord Burlington, and the French Roubiliac, a master of the Rococo style and the most successful sculptor of his generation with seven major works in Westminster Abbey alone. During the second half of the 18th century native artists predominated. Thomas *Banks, John *Deare, *Nollekens, and *Flaxman, all of whom trained in Rome, were all classically inspired and worked during the period of change from the Rococo to the *Neoclassical. The development of *Coade stone by Eleanor Coade (active 1769–1821) provided an inexpensive medium for mass-produced sculptures exploited by John *Bacon whose extensive studio also produced low-relief designs for Flaxman's patron Josiah Wedgwood. The Neoclassical tradition continued well into the 19th century in the work of Sir Richard Westmacott (1775–1856), a student of *Canova, and Thomas *Banks, best known for his archaeologically correct *Tinted Venus* (1851–6; Liverpool, Walker AG). An alternative naturalistic style was adopted by Sir Francis *Chantrey, whose belief in the primacy of Nature inspired his sensitive portrait busts. The undemonstrative realism of Thomas Woolner (1825–92) and Alexander Munro (1825–71), both associated with the Pre-Raphaelites, was challenged in the last quarter of the century by the rise of the *New Sculpture, a movement characterized by sinuosity of outline, great detail, and, later, the use of mixed media and symbolic subjects. Paramount in the movement was Sir Alfred *Gilbert, a protégé of Leighton, whose own *Athlete Struggling with a Python* (1874–7; London, Leighton House) has much in common with the New Sculpture. Gilbert's best-known work, *Eros* (1886–93; London, Piccadilly Circus), is among the first cast aluminium statues. Sir George Frampton's polychrome *Mysteriarch* (1892; Liverpool, Walker AG) typifies the *Symbolist strand of the New Sculpture. During the 20th century two World Wars provided the melancholy opportunity for large numbers of memorial monuments; among the most distinguished are those by Charles Sargeant *Jagger, himself a holder of the MC, including *Artillery* (London, Hyde Park Corner). After c.1905 international modernism dominated English sculpture, pioneers being *Epstein, influenced by both *Rodin and *primitivism, the *Cubist-inspired *Gaudier-Brzeska, Eric *Gill, and Frank *Dobson, whose later work became increasingly classical. *Surrealism informs the earlier work of Henry *Moore and F. E.

McWilliam (1909–) and *Constructivism, encouraged by Naum *Gabo's stay in England (1936–46), was adopted by *Hepworth. Technical advances encouraged experimentation with new techniques and materials. Sir Anthony *Caro introduced welded steel sculpture in 1960, soft materials were used by Barry Flanagan (1941–) and detritus by Tony Cragg (1949–). The use of mixed media and installations which characterizes much recent British art has made painting and sculpture largely indistinguishable. DER

Boase, T. S. R., *English Art, 1800–1870* (1959).
Compton, S. (ed.), *British Art in the 20th Century* (1986).
Esdaile, K., *English Church Monuments, 1510–1840* (1946).
Farr, D., *English Art, 1870–1940* (1978).
Irwin, D., *English Neoclassical Art* (1966).
Read, B., *Victorian Sculpture* (1982).
Sunderland, J., *Painting in Britain, 1525–1975* (1976).
Waterhouse, E., *Painting in Britain, 1530–1790* (1978).
Whinney, M., and Millar, O., *English Art, 1625–1714* (1957).
Whinney, M., *Sculpture in Britain 1530–1830* (rev. edn., 1988).

ENGLISH ART AS OBJECTS OF PATRONAGE AND COLLECTING. *See overleaf.*

ENGRAVING. See LINE ENGRAVING.

ENSOR, JAMES (1860–1949). Belgian painter and printmaker. A complete original, whose finest work was done in one decade, Ensor was an inspiration to German *Expressionist painters, claimed as a precursor by the *Surrealists, and still exerts a significant influence. He was born in Ostend, the son of an English father and Belgian mother, and, apart from studying at the Brussels Academy (1877–9), remained there. His early work, bourgeois interiors, still life, and landscape, is painted in sombre colours in a thick impasto for which he used a palette knife. After his paintings were rejected by the Brussels Salon in 1883, Ensor was a founder member of the avant-garde group Les *Vingt. During the late 1880s he began to introduce grotesque and macabre elements into his works and created the familiar cast of skeletons and masked and carnival figures for which he is best known. At the same time he lightened his palette whilst retaining his robust painterly technique. Ensor employed his characters to create ironic allegories which incorporated social and religious criticism. The finest of these, *The Entry of Christ into Brussels* (1888; Los Angeles, Getty Mus.), a satire on contemporary hypocrisy, proved so shocking that he was expelled from Les Vingt and became increasingly misanthropic. However he continued to paint in the same vein, repeating favourite themes, often enigmatic like *Intrigue* (1890) and *Two Skeletons Fighting over a Dead Man* (1891; both Antwerp,

Koninklijk Mus. voor Schone Kunsten). Reclusive and little known he nonetheless fascinated younger, largely German, painters and was visited by *Nolde. Wider recognition came following exhibitions in Brussels (1920) and the Jeu de Paume, Paris (1927), and he was created a baron in 1929. DER

Tricot, X., *James Ensor: Catalogue Raisonné* (2 vols., 1993).

ENVIRONMENTAL ART, term used to describe a type of art which was characterized by its manipulation of controlled spaces—such as galleries and warehouses—into which the spectator was immersed and involved in a variety of sensory stimulations—visual, auditory, kinetic, tactile, and sometimes olfactory. Allan Kaprow (1928–) has been credited with the initiation of such art in the 1960s, although comparable experiments with gallery space took place in *Dada and *Surrealist exhibitions of the 1920s and 1930s. Environments were usually planned to force the spectator to engage with them in as many ways as possible, causing them to become 'happenings', a form also pioneered by Kaprow. Leading exponents included Edward *Kienholz (1927–93), Claes *Oldenburg, and Meret Oppenheim (1913–85). Environmental art has sometimes been confused with *Land art, although the latter was concerned with the site-specific location of works within the natural environment, whereas the former intended the work itself to constitute an environment. Both however unite in their rejection of the conventional methods of exhibiting art in galleries. OPa

Henri, A., *Environments and Happenings* (1974).
Kaprow, A., *Assemblages, Environments, Happenings* (1966).

EPIGONUS (active late 3rd century BC). Hellenistic sculptor active in *Pergamum, known from eight signed statue bases on the Acropolis and from literary *testimonia*. *Pliny (*Natural History* 34. 84) names an otherwise unknown Isigonus as one of several artists who created victory monuments for Eumenes and Attalus' battles against the Gauls. Most scholars, probably correctly, assume that this is a textual corruption. Pliny (34. 88) also mentions Epigonus as sculptor of an entire range of iconographic types; praise is reserved for his *Trumpeter* and *Weeping Child Caressing its Murdered Mother*. The *Trumpeter* has been identified as one of the figures of the Pergamene Larger Gaul group, dedicated to celebrate the victory of Attalus I; the *Dying Gaul* (Rome, Capitoline Mus.) has been recognized as a Roman copy of the original. An inscribed long base erected in the sanctuary at Pergamum in 226–223 BC reads: 'works of Epigonus'. The *Trumpeter* and the remainder

continued on page 215

· ENGLISH ART AS OBJECTS OF PATRONAGE AND COLLECTING ·

AS in every other western European country, the principal patron of art in Britain throughout the Middle Ages was the Church, through the monasteries and cathedrals where the art itself, which comprised everything from illuminated books to sculpture and wall paintings, was produced. More than in later periods, the centres of patronage, and hence of artistic production, were dispersed across the country, at ecclesiastical foundations such as Winchester, Durham, and St Albans, rather than being concentrated in London. Beginning in the 10th century, however, the monasteries, besides producing illuminated books for their own liturgical needs, increasingly supplied them on commission to royalty, members of the nobility, and, by the 15th century, some country gentry and city merchants (all these patrons whatever their rank were almost as often women as men). In addition, some illuminated books and embroidered ecclesiastical vestments, the latter known as *opus anglicanum*, were exported abroad. One royal patron, Henry III (1216–72), should also be singled out for his patronage of Westminster Abbey.

With the coming of the Reformation all this changed. The monasteries were dissolved, bringing production there to an end, and the middle decades of the 16th century witnessed a Calvinist-inspired, state-sponsored campaign of destruction, to be repeated in the following century by the Puritans, aimed at eliminating religious imagery from cathedrals and churches. Meanwhile, the Crown failed to give a lead in promoting secular art, other than portraiture and ephemeral decorations needed for festivities, although during the Tudor period the royal palaces and a good many private houses seem to have contained minor works of art of various kinds, including painted hangings and small alabaster reliefs, some with religious or mythological subjects, a few portraits—which might as often represent a current or previous monarch as the owner of the house—and, in the case of the grandest houses, tapestries. Much of this comparatively humble work, which also included decorative painting and carving on the panelling, may well have been done by native craftsmen, whose interests were jealously guarded by the appropriate branches of the painter-stainers' company, or guild.

The more ambitious portrait painters, by contrast, whether native or foreign born, tended not to belong to the guild, and from the late 16th century onwards it was to these painters that the world of high-class art patronage was opened up. The inventory of Lord Lumley (1590) is often taken as representative in this respect, or at least as a portent of the future. Although this collection included some subject pictures it was predominantly made up of portraits, comprising members of the Lumley and other noble families and important figures from history and contemporary politics; in other words, it was an assembly of likenesses of persons with whom the owner wished to be associated, and this, or an interest in history, or simple family pride, was often, down to the 18th century, the motive for forming a portrait collection. Other patrons, less interested in art, remained content with portraits of themselves, their wives, and (especially, it seems, in the provinces) their families. The counterpart of the English and Scottish passion for painted portraits was an almost equal obsession with sculpted effigies on tombs.

During the 17th century, any patron of consequence preferred to have himself or herself portrayed by one of the many foreign-born artists, mostly of Flemish or Dutch origin, who were settled in London, rather than employ an Englishmen; only English portrait miniaturists were, rightly, in demand, and it was only in the exceptional circumstances of the Civil War and Commonwealth that English-born portraitists working on the scale of life came to the fore. The great collections of religious and historical paintings formed by Charles I and a few of his associates were also totally dominated by the work of continental artists, living and dead; these collections were all dispersed by 1660 but collecting began again in a small way after the Restoration, and in a few cases English pictures were now included. During the 18th and early 19th centuries, the heyday of the British aristocracy, the country house, and the *Grand Tour, the collecting of classical antiquities and foreign old master paintings was resumed on a grand scale.

The second quarter of the 18th century, however, saw a change in the fortunes of native British artists. For the first time they were able to obtain commissions for royal and aristocratic portraits, a field which, a generation later, they captured for good. Sporting painting, which began at about the same time, was also a British artists' monopoly. William *Hogarth complained loudly at the failure of the collectors of old masters to commission subject pictures from living British painters, though his own engravings were popular with the wider public at home and with artists abroad. In the 1740s, two public spaces in London, the Foundling Hospital and Vauxhall Pleasure Gardens, successfully displayed new British history paintings, religious pictures, and landscapes, thereby preparing the ground for the success of art *exhibitions when these started in the 1760s. However, the Royal Academy (see under LONDON), through its exhibitions, did more for the patronage of portraiture than for the art form it officially encouraged above all others, large-scale history painting. Meanwhile, two significant British art exports in the period should be noted: the informal style of landscape garden (although

this is outside the scope of the present article), and reproductive prints.

Around 1800, a few aristocratic landowners and Whig politicians decided, from a sense of patriotic duty, to switch from collecting foreign old master paintings to supporting contemporary British art. This particularly benefited landscapists and genre painters, and also sculptors. The taste of these collectors was somewhat conservative but it set a pattern for the whole 19th century. In the 1830s, the prices of British pictures began to rise significantly. At the same time, rich middle-class merchants and industrialists, whose tastes ran almost exclusively to modern British pictures, took over from the aristocracy as the nation's art collectors; the museums and galleries in the industrial cities of England and Scotland, and ultimately the Tate Gallery, are their memorial. High Victorian painters such as John *Millais and Frederick *Leighton became rich and famous and, in a different field, religious art was readmitted to Anglican churches. Soon after 1900, however, the market for contemporary British painting and sculpture collapsed, not to be revived again until after the Second World War.

Small numbers of British paintings were acquired in France and Germany, particularly Hamburg, in the 19th century, and in the years either side of 1900 there was a snobbish interest all over western Europe and America in British 18th-century Grand Manner portraits. Only in America, however, did this interest continue until the Second World War; afterwards it was replaced by Paul Mellon's love of British 18th- and early 19th-century sporting painting, landscapes, and outdoor genre scenes (see NEW HAVEN, YALE CENTER FOR BRITISH ART). The works of some 20th-century British artists, above all Henry *Moore, have also been acquired abroad in the past 50 years. MK

of the group, which includes the *Barbarian Chieftain and his Wife* (Rome, Mus. Naz. Romano), is extraordinary for the humanity and dignity ascribed to the defeated enemy.
 L-AT

Pollitt, J. J., *Art in the Hellenistic Age* (1986).
Smith, R. R. R., *Hellenistic Sculpture* (1991).

EPSTEIN, SIR JACOB (1880–1959). American-born English sculptor. Born in New York, of Russian-Jewish parents, Epstein studied in Paris (1902–5), where his lifelong interest in ancient and 'primitive' sculpture was inspired by visits to the Louvre. In 1905 he came to London, becoming a British citizen in 1907. His first major commission, for eighteen figures for the façade of the British Medical Association in the Strand (1907–8), resulted in a violent controversy (the first of many) owing to their nudity and expressionistic deformity. In 1910 he worked on the symbolic monumental sculpture for Oscar Wilde's tomb in Père-Lachaise, Paris, deliberately emphasizing the figure's genitalia which were later covered, briefly, by a bronze fig leaf. In 1912 he met *Picasso, *Brancusi, and *Modigliani and this may have influenced his work towards a more geometrical approach. He was a founder member of the *London Group in 1913 and a flirtation with *Vorticism in 1914 resulted in his best-known *modernist work, the bronze *Rock Drill* (1915; London, Tate), a successful fusion of man and machine. Epstein's work may be usefully divided into modelling and carving; modelled pieces were executed in a fluid impressionistic style whereas the carvings retained his early 'primitive' influences. The latter, deliberately expressionistic, often aroused public antagonism and ridicule; *Genesis* (1930), a massive and grossly pregnant woman, was displayed for a time in a Blackpool sideshow. With hindsight, the carved works show far greater originality than his admittedly lively portrait *busts of the contemporary great and good including *Joseph Conrad* (1924), *G. B. Shaw* (1934), and *T. S. Eliot* (1951; all London, NPG). Epstein also painted vigorous and colourful watercolours of flowers, nudes, and landscapes. A major figure in the development of modern British sculpture, he was knighted in 1957. JH

Buckle, R., *Jacob Epstein, Sculptor* (1963).

EQUESTRIAN STATUE. The equestrian monument has presented the sculptor with a formidable problem. It involves the balance of a vertical element on a large horizontal mass which in turn rests on very slender supports; and this problem leads to another, that of combining the two forms into a structural unity. Furthermore, nearly all equestrian statues are portraits—portraits of a special kind, because the character of the rider may be suggested by that of his mount. The horse at rest evokes a sense of authority, the rearing horse implies the man of action. Most of the statues may in fact be classified by the pose of the horse as belonging to one of these two types.

Free-standing equestrian statues were made in Antiquity, but we know the Greek works only through literature and very few examples now remain of the Roman (see ROMAN ART, ANCIENT): two marble ones from the forum of *Pompeii are in the museum of Naples. Of the many equestrian bronzes to be found in Rome in late Antiquity, the only one now surviving is that of *Marcus Aurelius* (2nd century AD; Rome, Capitoline Mus.) which, formerly at the Lateran, was moved in 1538 to the Capitol, where a replica now stands. It was preserved throughout the Middle Ages because it was believed to represent the first Christian emperor, Constantine. Aurelius rides without stirrups, checking the trotting pace of his steed with one hand while the other is outstretched in a gesture of command. The group has a measured forward movement and great dignity.

The Middle Ages abandoned the idea of the personal monument. The stone statue of *Otto I* or *Otto II* (mid-13th century; Magdeburg) is a symbol of justice. Similarly the equestrian statues and reliefs of S. Martin and S. George must be understood as representations of virtues. The most famous and impressive of these Christian horsemen, the *Bamberg Rider* (c.1235; Bamberg Cathedral), presumably has some meaning of this kind, which has been interpreted in various ways.

As a funerary monument the equestrian statue reappears with the *Cangrande della Scala* (1329; Verona), a stocky and slightly comic figure of a knight rigidly encased in armour. The masses of cloth which cover the horse act as a support for its legs and thus solve one of the technical problems particularly associated with a statue in stone or marble. The Renaissance often used equestrian monuments to commemorate the dead. *Uccello's *Sir John Hawkwood* (1436) and *Castagno's *Niccolò da Tolentino* (1456), both in Florence Cathedral, are paintings in grisaille imitating sculpture. The Venetians at the end of the century liked to place gilded wooden riders on the tombs of nobles (Bergamo, Cappella Colleoni).

The first free-standing equestrian bronze since classical Antiquity was created by *Donatello. This is the *Gattamelata* (c.1446; Padua). While working at Padua Donatello was within range of Venice, where he would have seen the four bronze horses over the porch of S. Mark's, Hellenistic (or Roman) works brought there from Constantinople in

1204. It is clear that he also knew the *Marcus Aurelius*. *Verrocchio's *Colleone* (1485–8; Venice) has more drama and tension, achieved by a system of crossing diagonals: the *condottiere* checks the horse's forward movement, rising slightly in his stirrups as though to give a command to his troops.

When *Leonardo designed the Sforza and Trivulzio monuments he experimented with the traditional type but also developed an entirely new one, the prancing horse. His ideas are known to us only through drawings and various small 16th-century bronzes. While the horse in *Giambologna's famous *Cosimo de Medici* (1587–94; Florence, Piazza della Signoria) lifts a front and a hind hoof, it was not until the 17th century that sculptors tackled the severe technical problems which the prancing composition involved in large. Pietro *Tacca's statue of *Philip IV* on a rearing horse (1634–40; Madrid, Plaza de Oriente) is derived from a painting by *Rubens of the same monarch. *Bernini's terracotta sketch for *Louis XIV* (c.1667; Rome, Borghese Gal.) mounted the young King on a massive rearing horse, but when the sketch was executed in marble for *Versailles, the belly of the horse supported on rocks, it met with such disapproval that it had to be transformed into a *Marcus Curtius* and relegated to a distant corner of the gardens. French academic taste preferred the older formula of imperial dignity, and this was adopted by *Girardon in his statue of 1699, which, though destroyed in the Revolution, is known through a wax model. Bernini's ideas were taken up by *Falconet, and developed in a masterly way in his spirited bronze monument to Peter the Great (1766–78; St Petersburg). The horse rears up on a stone pedestal shaped like a cliff—a dramatic composition which must have inspired *David's painting of *Napoleon Crossing the St Bernard Pass* (1800; Versailles).

The 19th century with its love of monuments cluttered the streets and squares of European capitals with equestrian statues which too often lacked artistic merit; the 20th century erected few. Well-known examples of somewhat varying merit include: *Marko Kraljević* by Ivan *Meštroviíc; *The Valkyrie* (Copenhagen) by Stephan Sinding; *Kaiser Wilhelm I* (Berlin) by Reinhold Begas; *Physical Energy* (London, Kensington Gardens; and Cape Town) by G. F. *Watts; *Sigurd* (London, Tate) by Gilbert Bayes; *General Sherman* (New York) by Augustus *Saint-Gaudens; *Jeanne d'Arc* (Paris) by Emmanuel Fremiet; and groups *The Union Monument* (Bratislava) by Ladislav Šaloun and *Wrestlers* (Brussels) by J. de Lalaing. The equestrian statue has led to no new conquest of sculptural form in the modern period, but has sometimes provided occasion for the tour de force, as for example: C. J. Bonnesen's *Life and Death* (Copenhagen),

Sir Thomas Brock's *A Moment of Peril* (London, Tate), Gilbert Bayes's *The Fountain of the Valkyries* (Auckland), Frederick MacMonnies's *Pioneer Monument* (Denver, Colo.). *Marini has found inspiration in Etruscan and Geometric Greek art for many figures of horse and rider which are arresting images of generalized forms but not equestrian portraits. The history of the equestrian monument seems to be near its end, since great men of the future are unlikely to be commemorated on horseback.

The *casting of these very large bronzes was always done by the *cire perdue* process, except in the 19th century when the sand method was often preferred. All the stages of the work had to be carried out in the same place, because the apparatus was too big to be moved. The wax was burnt out of the mould, rather than melted out, because the mould could not be inverted; and when the metal was to be poured in the mould was enclosed in an iron cage instead of being packed into a sandpit. Ideally the whole monument would be cast in one piece, but often it was found convenient to cast certain parts separately, and attach them afterwards with 'Roman joints'. The casting of so large a work required exceptional skill, a fact which was recognized. The statue of the *Great Elector* in Berlin (1696–1700), one of the most powerful Baroque treatments of the theme of horse and rider, gained less credit for its creator, Andreas *Schlüter, than for the bronze founder, Jacobi, who was presented with a golden chain and had his portrait engraved at the state's expense. The idea that the casting of an equestrian statue was a greater achievement than its invention persisted until the 19th century, when the pouring in of the metal could still be a ceremonial occasion attended by the court, who watched from a dais. Sometimes the operation miscarried. When Falconet's *Peter the Great* was cast, the figure of the rider and the upper parts of the horse were found not to have been reproduced. Falconet made a new wax model of the missing parts and with great ingenuity contrived to cast it into one piece with the part which had been reproduced at the first attempt.

In order to avoid the risk and expense of casting in bronze a method was devised in the 18th century of making these large statues of beaten copper. A model was first carved out of oak, and over each part of it in turn a thin sheet of copper was laid, which, being relatively soft, could be hammered until it took the form of the carving, as in repoussé work. Finally the copper plates were assembled and mounted on a framework. *Schadow's famous horses on the Brandenburg Gate in Berlin (1791) were made in this way, and so were many of the horses on the

elaborate fountains of the 19th century.

HO/MJ

Glorious Horsemen: Equestrian Art in Europe 1500–1800, exhib. cat. 1985 (Springfield, Mass. Mus. of Fine Arts, and Louisville, KY., Speed Art Mus.). Friis, H., *Rytterstatuens historie*, 1: *Europa* (1933).

ERHART, FATHER AND SON. South German sculptors. **Michel** (active 1469–1522) was the leading late *Gothic sculptor of Ulm. In 1474 he worked with Jörg *Syrlin the elder on figures (destr.) for the high altar of the Munster and he may have participated in the carving of the surviving choir stalls there. The major extant attribution to him is the sculpture of the high altarpiece of the Klosterkirche at Blaubeuren (c.1493–4), on which Michel may have collaborated with his son **Gregor** (active 1494–1540). This is one of the greatest of late Gothic retables, combining life-size *polychromed figures of the Apocalyptic Virgin and four Saints with painted wing reliefs of the *Nativity* and *Adoration of the Magi* and paintings of the *Passion* and *Life of S. John the Baptist* by a team of mainly Ulmish painters. The sculptural style subjects the monumental and compacted formats of Hans *Multscher. to the more animated and florid style of Nicolaus *Gerhaerts and is characterized by great refinement of carving, pose, and expression.

JR

Baxandall, M., *The Limewood Sculptors of Renaissance Germany* (1980).

ERNST, MAX (1891–1976). German painter, a prominent member of the *Surrealist movement. He taught himself to paint while studying philosophy at the University of Bonn, and in 1913 exhibited at the first German Salon d'Automne. His experience of the First World War disillusioned him with conventional cultural and moral values. Consequently in 1919 he founded a *Dada group in Cologne, together with Theodor Baargeld (d. 1927), founder of the Communist periodical *Der Ventilator*, and *Arp, whom he had first met in 1914. He soon came into contact with Tristan *Tzara and André *Breton in Paris, where he settled in 1922, allying himself with Surrealism. Apart from wartime exile in the USA during and immediately after the Second World War, Ernst lived in Paris for the rest of his life.

Ernst used a variety of technical means to create fantastic, often nightmarish images, which made frequent references to childhood experiences that were also vividly described in his writings. His interest in Freudian psychoanalysis is apparent in such works as the oil painting *Pietà, or Revolution by Night* (1923; London, Tate), while his interest in *automatism led him to develop the techniques of *frottage and grattage. He also produced brilliant, disquieting *collages, often using images from popular engravings, and

in the late 1930s started to use *decalcomania in his painting. Despite his departure from the Surrealist movement in 1938, he continued for the rest of his career to produce works of extraordinary imagination and originality.　　　　　　　　　　　　　　　CJM

Spies, W., et al., *Max Ernst: Catalogue of Works* (4 vols., 1969–79).

ERRARD, CHARLES (1606–89). French painter and architect. He spent many of his early years in Rome drawing from the Antique and working in *Poussin's studio, and later returned to be first director of the French Academy in Rome (1666). His work in Paris (at the Palais-Royal, Louvre, Tuileries, and Fontainebleau) was mainly decorative.　　　　　　　　　　　　　　　　　　　HB

ESCHER, M. C. (Maurits Cornelis) (1898–1972). Dutch printmaker known, since c.1944, for mainly black and white *Surrealist woodcuts based on visual ambiguity. He drew with mathematical precision and thus confounds expectations; his perspective looks correct but is spatially impossible with contradictory viewpoints, shared vanishing points, and anomalies like never-ending circular staircases (*Ascending and Descending*, 1960). Equally disconcerting are prints like *Metamorphosis III* (1967–8), where images are almost imperceptibly transformed. The Escher Foundation (The Hague, Gemeentemus.) holds examples of virtually every Escher print.　　　　　　　　　　　　　　　　YJ

Bool, F. H., *M. C. Escher: His Life and Complete Graphic Work* (1982).

ESCORIAL. The royal Hieronymite monastery dedicated to S. Laurence, founded and built between 1563 and 1584 by Philip II of Spain (1527–98) at El Escorial outside Madrid, is the most remarkable ensemble of architecture and art of the later *Renaissance. The Escorial was the monument of the Spanish Habsburg dynasty—the mausoleum of Philip's parents, the Emperor Charles V (1500–58) and Empress Isabella—and of the Counter-Reformation Catholic orthodoxy to which their authority was inextricably bound, and it addressed European culture in both ideological and artistic terms. Its scale and complexity rivalled the most ambitious projects by bringing together a monastery, a college and seminary, a royal library, a royal palace, and a hospital into a single complex focused upon the huge basilica of S. Laurence at the centre. The Escorial's vast collections—from the splendid library of books and manuscripts to its paintings and relics—were assembled under Philip's supervision. The Escorial was Philip's most cherished artistic project; and after 40 years of tireless effort and expense, he lived to see it completed.

The decoration of the Escorial was carefully co-ordinated with the architecture to create a unified artistic effect. The sober statue of S. Laurence on the main façade and the six statues of Old Testament kings on the façade of the basilica (carved by Juan Bautista Monegro in the 1580s) prepare the way for a splendid display of saints and kings inside the basilica. In 1576 the paintings, predominantly of standing pairs of saints, for the 44 secondary altars of the basilica were commissioned from Juan *Fernández de Navarrete, 'El Mudo' (c.1538–79), a gifted Spanish painter working in a sober version of Venetian style, but Navarrete died suddenly and Philip had to look elsewhere. His choices fell on Spanish painters—Alonso *Sánchez Coello, Luis de Carvajal, and Diego de Urbina—and also on Italians. In 1580 Philip also commissioned one of the altarpieces from the greatest artist after *Titian to come his way: El *Greco, whose *Martyrdom of S. Maurice and the Theban Legion* (1580–3; Escorial) he rejected for the basilica, although he kept it in the monastery.

Philip was difficult to please, but there was a compelling aesthetic reason to restrict individual artistic expression at the Escorial. Decoration needed to be in keeping with the sober, relatively unornamented classicism of the building if it was to bring the triumphant unity of the project to full expression. Although a great lover of painting, Philip made his choices for the painted decoration of the Escorial in relation to the architecture and the sculpture, trying to commission as few artists as possible in order to preserve a homogeneous effect. This ideal and its successful achievement are most visible in the sanctuary of the basilica. Nowhere else in Renaissance art do architecture, painting, and sculpture come together in a composition of such unified splendour in which every detail appears as a necessary part of the whole. Here the decoration culminates in richly coloured marbles, gold, and painting in a setting where the *Rex Sacerdos* may be glimpsed in prayer before Almighty God. The retable altarpiece was designed by Juan de Herrera (c.1530–97). Its over-life-size gilded bronze statues of saints, Christ, and the Virgin were made in Milan between 1579 and 1590 by Leone *Leoni and his son Pompeo *Leoni, with assistance from the Flemish sculptor Adrian de *Vries. The huge jewelled tabernacle above the altar was executed by Jacopo da Trezzo and his shop in Madrid. On either side of the sanctuary are Pompeo Leoni's magnificent cenotaphs of the family of Charles V (Epistle side) and Philip II (Gospel side). Five over-life-size gilded statues of the imperial family kneel in prayer in adoration of the Eucharist on the altarpiece. Philip's own family group, represented by five similar statues on a matching stage above his bedroom, was not quite ready when Philip

died in 1598. Full-sized gilded plaster copies of the statues occupied the stage until 1600 when Leoni's finished bronzes were set in place.

In the early days, when this program of decoration was still taking shape, Philip hoped to have Titian execute the paintings for the main altarpiece and his *Martyrdom of S. Laurence* (still in its original place in the temporary church in the monastery) arrived from Venice in 1567. It did not fit the new designs, however, and over the next several years Philip's quest for an artist led him to *Tintoretto and *Veronese, then to Fernández de *Navarrete, to whom he gave the commission in 1579. When Navarrete died, Luca *Cambiaso was recruited from Genoa and worked at the Escorial from 1583 until 1585 when he frescoed the monastic choir. When he died, Federico *Zuccaro came from Rome and stayed at the Escorial between 1585 and 1588 where he painted the reliquary altarpieces and a number of paintings for the main altarpiece, only five of which the King finally used. Finally the architect and painter Pellegrino *Tibaldi arrived from Milan. Between 1588 and 1593 he successfully completed the altarpiece with three paintings, including the *Martyrdom of S. Laurence*, and the rest of the decoration—the cycle of frescoes in the royal library and the frescoes in the main cloister and its staircase.

The history of the decoration of the Escorial is a record of Philip's sometimes reluctant accommodation to circumstances beyond his control. It is also a remarkable chronicle of his artistic experiments and daring choices. His late decision to have Leoni's cenotaph figures made from bronze rather than marble and his even later order to gild the hands and faces of these statues, which were originally supposed to be painted, were all crucial to the final effect of the sanctuary.

Later rulers modified the Escorial somewhat. Philip IV completed the Royal Pantheon, a chapel containing the bodies of Spanish kings, in the 17th century. There have been some losses to its collections through fire and pillage, but the Escorial remains the most complete and impressive monument of the later Renaissance.　　CWZ

Fernando Checa, C., *Felipe II: mecenas de las artes* (1992).

Mulcahy, R., *The Decoration of the Royal Basilica of El Escorial* (1994).

Navascués Palacio, P., *El Real Monasterio de S. Lorenzo de El Escorial* (includes English trans.) (1994).

Zerner, C. W., *Juan de Herrera, Architect to Philip II of Spain* (1993).

ESQUIVEL, ANTONIO MARÍA (1806–57). Spanish academic painter principally known for portraits, religious, and genre paintings executed in a loose style often associated with the school of Seville, and in an

imitation of *Murillo. He was an active participant of the Liceo Artístico y Literario, one of the key intellectual organizations of Romantic-era Madrid, as well as the Liceo in Seville. He painted numerous portraits of members of these societies as well as people from more bourgeois circles; among the most famous is the group portrait of *A Reading by Zorilla in the Studio of Esquivel*, also called *Reunion of Contemporary Poets* (1846; Madrid, Buen Retiro). OEV

Guerrero Lovillo, J., *Antonio María Esquivel* (1957).

ESTOFADO, Spanish term for a *polychromy technique used to embellish the garments of carved figures in imitation of patterns and textures of textiles (*estofas*). Paint is applied over gilding and then engraved or scratched away to reveal the gold beneath.
SS-P

ETCHING, an intaglio method of printmaking in which lines are etched into copper by the immersion of the plate in corrosive acid. The polished sheet of copper is covered on both sides with dark varnish, or alternatively with melted wax on the working surface, which is then smoked to render it dark. The artist draws directly onto the surface with the sharp point of a steel etching needle, exposing the naked copper with each line that is made. When the work is finished, or sufficiently advanced, the plate is immersed in a bath containing a solution of nitric acid, of a strength determined by the etcher. As the acid eats into the exposed lines bubbles form, which the etcher disperses with a feather. The length of immersion is determined by the strength of line desired; a few minutes for a shallow line, longer for a deep line. The plate is then removed, and the wax or varnish removed by a solvent. The plate is printed in the same way as an engraving, although often with more variations of wiping to create different tones. Ink is spread all over the plate, and then a rag is used to remove it from the smooth surface of the plate, so that it remains lodged only in the etched lines. It is then printed in a roller press, where the ink is forced from the lines onto the paper.

If the etcher wishes to add to his work the plate is revarnished and more work added. Such successive changes are known as the different states of a print. The basic principles of etching are quickly mastered, and this has always made it a congenial discipline for a painter or draughtsman. It encourages spontaneity, and a landscape artist can carry a grounded plate in his pocket and work directly from nature. However, the complete mastery of the niceties of biting and hand-wiping the plate requires great mastery.

Etching was pioneered in the Augsburg workshop of Daniel Hopfer (c.1470–1536) who was probably etching iron plates for printing as early as 1500. At this period there were close links between etching plates for printing and etching decoration into armour. *Dürer etched a few plates, and his *Man of Sorrows* of 1515 is probably the first dated etching. Many German artists produced etchings, often on a small scale, and their example led to the introduction of etching in the Netherlands and Italy. It was a technique well suited to the lyrical draughtsmanship of *Parmigianino and *Schiavone whose plates show a free, sketchy technique.

It was in the 17th century that etching reached its maturity, notably in Holland, where the work of *Rembrandt in all its variety represents the summit of the art. In France *Callot and *Bosse had practised a more regularized technique, while the rapidity of the technique was best exploited in the enormous œuvre of *Hollar. A free and lively draughtsmanlike manner of etching was practised by many Italian artists, including *Testa and *Reni.

Throughout the 18th century etching was widely practised, frequently by amateurs, and it was also increasingly used as the foundation for the large reproductive engravings of the period. G. B. *Tiepolo made small etchings of fantastical subjects that glitter with sunlight, and in Rome G. B. *Piranesi made large etchings with a technique of wonderful breadth and freedom, best seen in the nightmarish plates of the *Carceri*. The century was ushered out by the etching and *aquatint of *Goya's *Los caprichos* (1799), which possibly owe something to the bold etchings of the English *caricature tradition.

By the 19th century etching had become an industry, its production augmented by the introduction of the steel plate, which allowed lines to be laid even closer together without breaking down, and encouraged large editions. It was practised with most enthusiasm in England and France where collectors abounded. By the 1860s and 1870s publishers encouraged limited editions of artists' etchings, signed in pencil. Samuel *Palmer's highly wrought etchings of Romantic landscape are in contrast to the abbreviated marks of *Whistler whose work had a prestige second only to Rembrandt, but more robust work was done in France by *Degas. In many cases however the art was degraded by trick printing and mechanical work.

Etching in the first part of the 20th century enjoyed cult status until the Depression of the 1930s, when the booming collector's market collapsed. Many specialist etchers had provided countless landscapes and portraits for a market now including the United States, which also produced many talented etchers, such as Edward *Hopper. Only in the 1960s did the art regain its popularity, with many artists using complex techniques of colour printing. As with almost all other printmaking techniques, the presiding genius was *Picasso, whose talents had early been recognized by such publishers as Vollard, and who made etchings of great vitality almost until his death. RGo

Hind, A., *A Short History of Engraving and Etching* (1908).

ETRUSCAN ART. *See opposite.*

ETTY, WILLIAM (1787–1849). Etty was the only English painter to specialize in nude subjects. He entered the RA Schools (see under LONDON) in 1807 and continued to frequent the life classes for his entire career. He was among the last generation of artists to be inspired by the teachings of *Reynolds and resolved to be a history painter. Study with *Lawrence and a prolonged stay in Italy (1822–3) determined his mature style which, in rich colour and lively brushwork, is deeply influenced by *Titian, *Veronese, and *Rubens. In 1821 he exhibited *Cleopatra's Arrival* (Port Sunlight, Lady Lever Gal.), an elaborate composition of naked women, golden boats, and glistening water; elements he repeated in *Youth at the Prow and Pleasure at the Helm* (1832; London, Tate). The latter was criticized for indecency, a familiar complaint about his work which climaxed in 1834 with strident attacks on *Venus and her Satellites* (version, York, AG). However, from 1841 Etty, who benefited from the expansion of bourgeois patronage, was wealthy and respected. In 1848, he retired to his native city of York, where the largest collection of his work may be seen. DER

Farr, D., *William Etty* (1958).

EUPHRONIUS (last two decades of the 6th century BC). Athenian vase painter. Euphronius and his group of Pioneers were the first to take full advantage of the technical possibilities of red-figure vase painting style. In their desire accurately to depict the human body, they relied on observation of figures in action and on knowledge derived from anatomical dissections. Inscriptions on vases record the Pioneers' awareness that progress in painting was measured in terms of realistic depiction of the human body; the inscriptions also reveal a competitiveness in seeking to achieve this goal. The large vases of Euphronius' mature period gave full scope to innovations in foreshortening and suggestion of receding space: for example, a calyx-crater with Hercules wrestling the giant Antaeus to the ground (Paris, Louvre), or a calyx-crater with Sleep and Death removing the body of Sarpedon from the battlefield at Troy (New York, Met. Mus.). DB-O

Euphronios peintre à Athènes au V siècle avant J.-C., exhib. cat. 1990 (Paris, Louvre).

· ETRUSCAN ART ·

1. Introduction

LOCATED in Etruria (bounded by the Arno and Tiber rivers and the Apennines) with outposts in the Po valley and Campania, the Etruscan civilization flourished through the 1st millennium BC until it merged with that of the Roman Empire in the 1st century BC. Etruscan art is known primarily from cemeteries and sanctuaries which have yielded a wealth of paintings, sculpture, pottery, and minor arts. Major centres of production were Caere (Cerveteri), Tarquinia, Vulci, Veii (Veio), Vetulonia, Volterra, Chiusi, and Orvieto; a prominent feature is regional differences in media and forms.

In the 10th–late 8th centuries BC production was dominated by pottery and metalwork in a local tradition with cultural links within Italy and with central and eastern Europe, with abundant geometric decoration. In the 8th century trading contacts with Aegean and Levantine groups introduced new artefacts, materials, techniques, and foreign craftsmen. The Orientalizing period (late 8th–early 6th centuries BC) is marked by an influx into Etruria of east Mediterranean goods, techniques, and iconography—the human figure, real and fantastic beasts (especially the lion), and vegetal and geometric motifs including the lotus and palmette. Wall painting and statuary began, and representational art became a major element.

The Archaic period (c.early 6th century–480 BC) saw a great flowering of Etruscan art with the production of fine tomb paintings, funerary sculptures, and architectural terracottas. There are also the earliest remains of substantial buildings (e.g. the Portonaccio temple, Veio, c.500 BC). From the Archaic period onwards much Etruscan art shared in the contemporary art styles of the Greek world. Eastern craftsmen continued to arrive in Etruria, especially after the Persians conquered the Ionian Greeks (western Turkey) in the mid-6th century. The Classical period (c.480–300 BC) saw conflict with the Greeks in the Tyrhennian sea which led to a period of economic decline, especially for the southern Etruscan cities. Contact with Greece was later revived via the Adriatic and Etruscan trading stations in the Po valley. Additions to the artistic repertoire include large-scale hollow-cast bronzes, Etruscan red-figure vase painting, and elaborate stone sarcophagi. By the early part of the Hellenistic period (c.300–1st century BC) all the Etruscan city-states had become subject-allies of the Roman Republic, and Etruscan culture became increasingly Romanized. Although the Mediterranean was increasingly dominated by the Romans and their developing artistic culture, many local artistic and social traditions were maintained in the Etruscan cities such as the production of stone and terracotta sarcophagi and ash urns.

2. Painting

ETRURIA has yielded the largest group of surviving wall paintings in the ancient world, outside Egypt, *Pompeii, and *Herculaneum. They date between the 7th and 2nd centuries BC, and decorated the walls of a small percentage (only c.2% at Tarquinia) of the elite rock-cut chamber tombs which are such a feature of Etruscan culture. Of the c.280 painted tombs so far found in Etruria, almost 80% occur at Tarquinia. Initially, pigment was applied directly to the smoothed rock face, but lime plaster was soon introduced. The main elements of the composition were sketched or incised into the plaster freehand or via templates, while details and some minor elements were painted freehand. The earliest tomb paintings come from Veio and Cerveteri, for example the Tomba Campana (late 7th–early 6th centuries BC; Monte Michele, Veio) has an elaborate scene on one wall in the Orientalizing style, with figures and polychrome real and fantastic creatures arranged in two registers, and an element of narrative.

To the Archaic period belong the greatest number of tomb paintings, and also developments in composition, subject matter, and technique. The rock-cut form of the chambers and painted details refer to architectural features such as columns and doors. The tomb paintings generally cover a whole chamber, and the subject matter apparently refers to aristocratic activities: the commonest scene is of the banquet, with elegantly dressed couples reclining on couches, attended by naked servants and entertained by dancers and musicians (the Tomb of the Lionesses, c.520 BC; Monterozzi, Tarquinia). There are also scenes of hunting (Tomb of Hunting and Fishing, c.510 BC; Monterozzi) and games, perhaps funerary (Tomb of the Augurs, c.520 BC; Monterozzi). Also of Archaic date are rare groups of large polychrome terracotta slabs, such as the five *Boccanera* slabs (London, BM) from Cerveteri, c.560–550 BC, representing the *Judgement of Paris*.

Fewer tomb paintings belong to the subsequent periods. Sub-Archaic (c.490–440 BC) paintings, such as the Tomb of the Triclinium (c.470 BC; Monterozzi), differ from the Archaic examples only in details of dress and coiffure, and reflect some of the developments in the rendering of the human body seen in contemporary vase painting. 'Classical' painting (c.440–330 BC) is marked by the

introduction of references to the otherworld. In addition to the usual banquet scene, the Tomb of the Blue Demons (c.420 BC; Tarquinia, Monterozzi; found 1985) also features a cortège, including musicians and dancers, leading to the underworld, and a scene of the dead arriving in Hades after crossing the Styx, accompanied by Charun and various demons: one has blue skin and holds two bearded snakes. The Tomba François (c.350 BC; Ponte Rotto, Vulci) has a central T-shaped chamber painted with scenes from Greek myth (including the sacrifice of the Trojan prisoners) and Etruscan history or myth.

In the Hellenistic period painted tombs become even rarer, and often include inscriptions giving family details, while the underworld theme continues. Painting technique develops from blocks of colour with dark outlines and drawn details to include shading with multiple brush strokes in various tones, exemplified in the handling of the contorted muscular body of the winged demon from the Tomb of the Typhon (later 3rd to mid-2nd century BC; Monterozzi, Tarquinia).

3. Sculpture

ETRUSCAN sculpture is primarily funerary and religious: decorated sarcophagi and ash urns in terracotta and various local stones (tufa, limestone, sandstone, alabaster), votives in bronze and terracotta, and architectural terracottas.

Early Iron Age sculpture consists of rare small-scale figures in bronze or clay often attached to vessels. It is only in the Orientalizing period that sculpture of any size appears, apparently under the influence of Greek and Near Eastern craftsmen. From the mid–later 7th century, stone and terracotta figures occur in tombs. They represent tomb guardians or ancestors, such as the five painted terracotta figures in the Tomb of the Five Chairs (c.625–600 BC; Cerveteri), or replacement bodies for the dead as in the terracotta and bronze canopic cremation urns of Chiusi.

The Archaic period saw a great flourishing of large-scale sculpture in stone and terracotta. Much Archaic Etruscan sculpture shared in the contemporary Ionian Greek style which was spreading throughout the Mediterranean world. The use of stone in a funerary context continues with the production of tomb guardians, including centaur and lion figures from the 6th century onwards, at sites such as Chiusi and Vulci, and from the later Archaic period at Chiusi there are gravestones, ash urns, and sarcophagi finely carved in local stone with low-relief scenes of Etruscan funerary rituals, games and banquets. Painted terracotta was used for sarcophagi and ash urns in the form of a funeral or banqueting couch. A finely modelled example from Cerveteri (Sarcophagus of the Married Couple, c.525–500 BC; Rome, Villa Giulia Mus.) depicts a man and woman reclining together. Also of this date are the over-life-size terracotta figures of Apollo, Hercules, Hermes, and a female with baby which stood on the roof-ridge of the Portonaccio temple at Veio. On a smaller scale are votive bronzes in various figure types (including athletes and gods), animals, and anatomical subjects.

By the Classical period some temples have pedimental decoration in painted terracotta; subjects vary from the *Seven against Thebes* scene from Pyrgi (c.510–485 BC; Rome, Villa Giulia Mus.) with intertwined overlapping figures in high relief with heads in the round, to winged horses (Ara della Regina, Tarquinia, Mus. Arch.). Some large-scale hollow-cast votive bronzes survive, such as the *Chimaera of Arezzo* (c.375–350 BC; Florence, Mus. Arch.).

Architectural terracottas and large bronzes continue into the Hellenistic period, alongside a flourishing production of sarcophagi and ash urns with reclining figures on the lids. The urn front, in high relief, generally depicts complex scenes of violence (from Greek myth and Etruscan history and myth). There are series of mass-produced, inexpensive, mould-made, brightly painted terracotta ash urns from north Etruria, and at the other end of the market are high-quality, individually commissioned ash urns carved in local stone (notably alabaster at Volterra), often with hints of portraiture. From c.350 BC there is a series of elongated bronze figures, such as the *Evening Shadow* (2nd century BC; Volterra, Mus. Etrusco Guarnacci), which continues an early Italic tradition of abstracted boardlike votives.

4. Pottery

VILLANOVAN pottery was hand-made in *impasto* (unpurified clay) and often decorated with incised and impressed geometric patterns. The distinctive Etruscan ware, Bucchero, was developed at Cerveteri c.675 BC. It is fired black throughout, is burnished to a metallic sheen, and the elegant forms largely derive from contemporary metalwork. Other centres soon produced this fine Bucchero, and later a heavier version developed, often with rich plastic decoration (c.575–500). Bucchero was traded across the Mediterranean and into Europe. From the 8th century there was a series of pottery styles drawing on contemporary Greek production: Italo-Geometric (8th–7th centuries BC), Etrusco-Corinthian (c.630–540 BC), black-figure (c.550–480 BC), and red-figure (c. end 5th–early 3rd century BC). Black glaze ware was widely produced in Etruria from the mid-4th century BC after the importation of Attic pottery had ceased. Moulds were often used and the forms again imitate metal vessels.

5. Metalwork

ETRURIA has extensive metal deposits and from the Bronze Age there developed a great tradition of bronzeworking producing a wide range of utensils, furnishings, and jewellery. Etruscan bronzes were prized in Antiquity, and it is easy to see why from the examples found in tombs and sanctuaries. These include lamps, candelabra, incense burners,

round caskets (*cistae*), mirrors, banqueting and wine-drinking equipment, many elaborately decorated with cast and chased figures and patterns. Candelabra and incense burners first occurred in the 6th century BC and production reached its height in the Classical period. Mirrors are produced from c.500 BC and bear a wide range of finely engraved scenes from Greek and Etruscan myth and daily life. Elaborate jewellery in gold, silver, and semi-precious stones was produced from the Orientalizing period and employed masterly Eastern techniques of filigree and granulation.

JTo

Brendel, O., *Etruscan Art* (new edn. with revised bibliography 1995).
Macnamara, E., *The Etruscans* (1990).
Spivey, N., *Etruscan Art* (1997).

EUSTON ROAD SCHOOL. See under LONDON.

EVENEPOEL, HENRI (1872–99). Belgian painter. Evenepoel was born in Nice, his mother died in his infancy, and he was raised by his father. From 1889 to 1890 he studied at the Académie des Beaux-Arts in Brussels and from 1892 at the École des Beaux-Arts in Paris where he was a pupil of *Moreau and a fellow student of *Rouault and *Matisse. He made his debut at the *Paris Salon in 1894 with a portrait of his cousin, *Mme D.* (Antwerp, Koninklijk Mus. voor Schone Kunsten), who was also his lover and bore his child. He exhibited four portraits at the Salon in the next year and continued to show there annually until his death. His portraits, which are mainly of family and friends, are sensitive and direct and owe a debt to *Manet and *Whistler. He spent the winter of 1898–9 in Algiers, recording life and scenery with a brighter palette in response to the North African light. On his return to Paris he painted a number of Impressionistic street scenes and interiors before his untimely death from typhoid.

DER

Roberts-Jones, P., et al., *Henri Evenepoel* (1994).

EVERDINGEN FAMILY. Dutch painters and draughtsmen. **Caesar** (1616/17–78) and his younger brother **Allart** (1621–75) were the sons of a notary of Alkmaar. Caesar was a history and portrait painter, living in Alkmaar for most of his career, except for the years 1648–57 when he lived with his brother in Haarlem. His history paintings, such as *Jupiter and Callisto* (1655; Stockholm, Nationalmus.) represent a classical revival, particularly associated with Haarlem, and are characterized by simple, powerfully lit compositions. In 1648 Caesar was given important commissions for the Oranjezaal of the Huis ten Bosch.

Allart was a prolific landscape painter and draughtsman. In 1644 he travelled to Scandinavia, a journey which had lasting consequences. He may have been the pupil of Roelandt *Savery in Utrecht and Pieter de *Molyn. His work certainly shows the impact of both artists. His dramatic Scandinavian landscapes, inspired by the many sketches he brought back, introduced scenery, hitherto unknown to Dutch landscape painters.

Such works as *Scandinavian Waterfall with Water Mill* (1650; Munich, Alte Pin.) with its fir trees, craggy rocks, and tumbling waters, influenced Allart's contemporaries such as Jacob van *Ruisdael.

CFW

Blankert, A., *Gods, Saints, Heroes*, exhib. cat. 1980 (Washington, NG; Detroit, Amsterdam).
Davies, A. I., *Allart van Everdingen* (1978).

EVERGOOD, PHILIP (1901–73). American painter. Born in New York, but educated at Eton, Cambridge, and the Slade in England, Evergood finally returned to settle in New York in 1931, having lived in Paris and travelled throughout Italy. His style has been loosely described as expressionistic, surrealistic, naive, and primitive, but was also strongly influenced by the urban realism of John *Sloan. Throughout the 1930s he worked for the *Federal Art Project, producing his most militant, politically inclined work. *American Tragedy* (priv. coll.) is typical of this period, based on a bloody battle between strikers and police at a Chicago steel mill in 1937. In the late 1940s his interest in social satire receded and a freer, more visionary style came to the fore, often figuring the nude. *The Jester* (New York, Whitney Mus.) demonstrates his even more detached style of the 1950s, fantastic and faintly satirical, sensuous and symbolic. He left New York in 1947 following a burglary and murder at his house, eventually retiring to Connecticut in 1952. He had a retrospective at the Whitney Museum of American Art in 1960.

MF

Taylor, K., *Philip Evergood* (1987).

EVESHAM, EPIPHANIUS (1570–after 1633). English sculptor. The first native-born sculptor of distinction in a period dominated by foreign artists, he was the fourteenth son of a Herefordshire squire and trained in one of the many sculpture yards at Southwark. From 1601 to about 1614 he was working in Paris, and though no work from this time has been traced his later English tomb sculpture bears some of the imprint of the sophisticated style of French *Mannerism. Surviving works include the tombs of Lord Rich (after 1619; Felstead, Essex) and Lord Teynham (1632; Lynsted, Kent), both of which exhibit qualities of design, execution, and characterization of the figures superior to the mass-produced work of the Flemish-run workshops of the time.

MJ

Esdaile, K., ' "A Most Exquisite Artist": The Work of Epiphanius Evesham', *Country Life*, 169 (1981).

EWORTH, HANS (active 1540–74). Flemish painter, active in England as a portraitist. He has been identified as the monogrammist 'HE', by whom about 40 works are known. In 1540, 'Jan Eeuwots' became a freeman of the artists' guild in Antwerp, but was expelled from that city for heresy in 1544. Eworth was recorded in London from 1549, the date on the first known work signed by 'HE', *A Turk on Horseback* (priv. coll.). In 1550, Eworth painted the allegorical portrait of *Sir John Luttrell* (London, Courtauld Inst. Gal.) which is highly *Mannerist in content and handling. Extant portraits of Queen Mary I suggest that Eworth was her official portraitist, though documentary evidence is lacking. Of his religious and mythological subjects, only the *Allegory of the Wise and Foolish Virgins* (1570; Copenhagen, Statens Mus. for Kunst) survives, though the allegorical *Elizabeth I and the Three Goddesses* (1569; Hampton Court, Royal Coll.) may also be by his hand. Eworth was influenced by the compositions of Hans *Holbein II. His finest portraits are strongly expressive of personality, but also include meticulous depictions of rich fabrics and jewellery, for example *Unknown Lady* (1565–8; London, Tate). Eworth is last recorded in 1573–4, designing sets and costumes for Elizabeth I's court entertainments.

KH

Hans Eworth, exhib. cat. 1965 (London, NPG).
Hearn, K., *Dynasties*, exhib. cat. 1995 (London, Tate).

EXEKIAS (6th century BC). Athenian potter and painter. Exekias signed black-figure Attic vases of the third quarter of the 6th century BC as both potter and painter. As potter, he was skilled and innovative, experimenting with new shapes (perhaps inventing the calyx-crater) and unusual techniques such as a coral-red wash to enhance colour. As painter, he was a master draughtsman, who excelled in marrying decoration to shape. His subject matter was unusual and he devised compositions in which every element conveyed not only the story, but also mood or emotion.

Approximately 35 vases by Exekias are

known, among them masterpieces such as an amphora showing Ajax and Achilles playing dice at Troy (Vatican Mus.), a drinking cup with an unusual picture of Dionysus with dolphin/pirates (Munich, Antikensammlung), an amphora with Achilles slaying the Amazon Queen Penthesilea (London, BM), and an amphora showing Ajax preparing to commit suicide (Boulogne, Mus. Communal).

DB-O

Beazley, J. D., *The Development of Attic Black-Figure* (rev. edn., 1986).

EXHIBITIONS. Art exhibitions began as a result of the formation of *academies in Europe towards the end of the 18th century. Although most of the academies confined their activities to teaching and to the provision of models for artists to study a few began to offer members and friends a chance to show their recent work in public. In France the Académie Royale paved the way with regular exhibitions held at the Salon Carré in the Louvre, hence the name of the annual exhibition in Paris, and when the charter for the Royal Academy in *London was drafted it required the members to hold an annual exhibition open 'to all artists of distinguished merit'. The first Summer Exhibition was held in 1769 and the event still continues today.

In their heyday in the 19th century exhibitions like the Salon and the Summer Show were events of great social and artistic importance. Huge crowds came to see them. It is estimated there were a million visitors to the Salon and on some Sundays in the 1860s, a free day, 50,000 people would shuffle through the galleries of the Palais d'Industrie on the Champs-Élysées after the exhibition had moved there from the Louvre. The new location was intended to remove the chronic overcrowding of pictures and sculpture which forced the organizers to hang paintings with frames touching and in rows up to the ceiling. The same problems occurred in London and elsewhere in Europe. The more successful these annual exhibitions became the more works were submitted and the more artists fought to have their works accepted and placed in prominent positions. The circus-like atmosphere did not appeal to some high-minded artists. *Ingres disliked the Salon and resented the criticism his carefully crafted portraits and history paintings received. For a number of years he even boycotted the event. Still, most people recognized that the Salon was an important forum for discussion about the arts and it was here that the battles between the *Neoclassicists and *Romantics were fought, where Ingres and his followers took on *Delacroix and his, where the *Ideal, *Realism, and the merits of *Barbizon paintings were analysed and discussed. Similarly, in London, it was at the Royal Academy's Summer Exhibition that *Turner and *Constable showed some of

their most famous paintings and where the *Pre-Raphaelites first gained *Ruskin's support. Apart from the critical attention given to exhibitions like the Salon, in much greater depth than is the case today, these annual events also offered prizes, state commissions, and a chance to find buyers among the new wealthy collectors created by the Industrial Revolution. The system encouraged artists to produce a Salon-type picture of large proportions which would pass the jury and please the crowds. The trouble was the jury largely consisted of artists with a vested interest in maintaining the status quo. The result was continual friction between the accepted and the refused, between the old ways of doing things and the new, and it was this friction which explains the avant-garde tradition which has been a characteristic feature of art from the mid-19th century to the present day.

In Paris, a city used to revolt and revolution, the cries of the rejected were particularly vehement and in 1848, the year of revolution in Europe, the jury was abolished and all artists were accepted. The exhibition was a mess and the experiment was not repeated. In 1863 Napoleon III went over the head of his arts minister Count de Nieuwerkerke and ordered an alternative exhibition for the work refused by the Salon. It was at the Salon des Refusés, as it was called, that *Manet showed his controversial *Déjeuner sur l'herbe* (Paris, Musée d'Orsay).

For artists like Manet, who craved public recognition, the Refusés provided only a temporary answer to the difficulty of exhibiting his work. He soon began to look for alternative methods. First he showed his work with a dealer and later, following Courbet's example, when excluded from the big international exhibition held near the Pont d'Alma in 1867, he built his own pavilion to house 50 of his paintings. His struggles with officialdom were watched by a group of younger artists that used to visit his studio in the Batignolles quarter (the subject of a famous painting by Henri *Fantin-Latour), and by the beginning of the 1870s the group began to hatch plans for an independent exhibition to be run and paid for by the artists themselves. In 1874 the group, which gave themselves the deliberately bland title of Société Anonyme des Artistes, Peintres, Sculpteurs, et Graveurs, held an exhibition of their work in the studio of the photographer Félix Nadar. The group which included *Monet, *Renoir, *Bazille, *Degas, and *Pissarro, but not Manet who still had his eye on the Salon, were dubbed by a mainly critical press as '*Impressionists' and the name stuck. In different forms and locations the exhibition was repeated for a further seven occasions, the last exhibition taking place in 1886 in which *Seurat showed his large painting *La

Grande Jatte*. By then most of the original protagonists had gone their separate ways and the Salon itself was divided and no longer held in much esteem. In addition a new Salon had opened, the Salon des Indépendants, founded by a group which included Seurat, *Signac, and *Redon, and open to all artists without exclusion. In the early days it became the main showplace for the work of the *Pointillists and *Symbolists, but by its nature it was a ragged and confusing affair and in 1903 a new exhibition forum was opened, the Salon d'Automne, which attempted to steer a middle way between the anarchic *indépendants* and the reactionary Salon National. It was at this venue in 1905 that *Matisse and the *Fauve movement began to be noticed by a wider public and it was here in 1910 that *Cubism moved from the studios of Montmartre to the centre of Parisian cultural life. By 1910 the changes which had taken place in Paris had spread like ripples on a pond to other art centres in Europe—to London, Berlin, Munich, Vienna, Moscow, and Milan—and a wave of Secessionist movements and exhibitions took place. In 1905 a group of artists who called themselves Die *Brucke (The Bridge) staged an exhibition in a factory showroom in the suburbs of Dresden, which marked the beginning of German *Expressionism. A rival group of avant-garde artists in Munich called Die *Blaue Reiter (The Blue Rider), and headed by Wassily *Kandinsky, held their first exhibition in 1911. In London in 1910, the critic and painter Roger *Try suggested an exhibition of recent French art to fill the gap in the exhibition programme of the Grafton Gallery. The exhibition was called *Manet and the Post-Impressionists* and in hidebound London it caused a furore. In New York in 1913, a similar storm was created by an exhibition organized by a group of artists and critics and held at an *Armory, or drill hall. The exhibition included *Duchamp's *Nude Descending a Staircase* (Philadelphia, Mus.) and marked the beginning of public acceptance of modern art in America.

By the beginning of the 20th century the nature of exhibitions had changed from being annual surveys of recent work by living artists into events aimed at changing tastes and perceptions. The age of the curator had started and the age of art exhibitions as a form of political or cultural exercise in propaganda had begun. Artists in Germany, Russia, and Italy developed posters, catalogues, and other events to publicize their exhibitions. In the 1920s and 1930s the *Surrealists turned exhibitions into stage events and dramatic confrontations between the artists taking part and the public invited to attend. In Germany the state itself used art exhibitions to convey a political message, either in support of a heroic nationalist art which they wished the public to see or to

denigrate art which they thought was unhealthy. It was in these circumstances that the Exhibition of Degenerate Art was staged in Munich in 1937.

It is hard to say when exhibitions of old masters started. To judge from paintings by David *Teniers, *Watteau, and others, art dealers would invite patrons to visit their galleries where a hodgepodge of old masters would be on view. In 1806, the British Institution, founded in the previous year, mounted an exhibition of old masters for the benefit of artists to study and copy and in 1813 they held an exhibition of works by Sir Joshua *Reynolds, which was the first commemorative exhibition to take place in Britain. The various World Fairs held in Europe and America from 1851 onwards often contained displays of old masters. In 1857 the German art historian G. F. Waagen organized a massive *Art Treasures* exhibition of old masters from British private collections which was housed in a temporary structure in Manchester and which was seen by an estimated audience of 1,300,000. It was perhaps this exhibition which launched the curated blockbuster show which is still with us today.

In the period between the two World Wars, under the presidency of Sir William Llewellyn, the Royal Academy in *London organized a series of mammoth loan exhibitions devoted to Dutch, French, and Persian art, but the most famous was the Italian art exhibition of 1930 which contained an astonishing display of masterpieces which would never be allowed to travel today. There were 78 loans from the Uffizi Gallery in *Florence including *The Birth of Venus* by *Botticelli and 21 from the Academia in *Venice including the *Tempesta* by *Giorgione; 600,000 visitors came to see the exhibition.

See also Académie Royale, Salon, Salon d'Automne, Salon des Indépendants, and Salon de Refusés all under PARIS. ID

Altshuler, B., *The Avant-Garde in Exhibition: New Art in the 20th Century* (1994).

Dunlop, I., *The Shock of the New* (1972).

Hutchison, S., *The History of the Royal Academy 1768–1968* (1968).

Lethève, J., *Daily Life of French Artists in the Nineteenth Century* (1968, 1972).

EXISTENTIALISM, a philosophy of personal existence. It examines the human experience of being in the world and seeks to describe, in the most general philosophical terms, what it is like to be a human being. Its most influential exponents were Martin Heidegger (1889–1976) and Jean-Paul *Sartre. The foundational tenet of existentialism is that 'existence precedes essence'. According to Sartre, a human being first exists, 'encounters himself in the world', and defines himself afterwards. This choosing of oneself is unavoidable: we are, Sartre says, condemned to be free, and are wholly responsible for our

choices. This stance proved highly influential in intellectual and artistic circles in the 20 years following the Second World War, starting in Paris. Its adaptability as an analysis allowed critics to argue for an existentialist dimension in the work of contemporary artists such as *Giacometti, Francis *Bacon, *Wols, and Jackson *Pollock. DC

Macquarrie, J., *Existentialism* (1972).

EXPRESSION AND GESTURE. The communication of emotional states through the depiction of facial expression and gesture was long considered an essential component of painting. According to *Leonardo: 'The good painter has two principal things to paint, that is man and the intention of his mind. The first is easy, the second difficult, because it has to be represented by gestures and movements of the parts of the body' (*Treatise on Painting*, ed. A. P. McMahon, 1956). A generation earlier the Renaissance theorist *Alberti in his *Della pittura* (1436) laid equal stress on this branch of painting. For Alberti painting's ability to move the beholder was an essential part of its claim to be an equal of poetry, a liberal, rather than a mechanical, art. This ability derived from its capacity to depict the emotions: 'A "historia" will move spectators when the men painted in the picture outwardly demonstrate their own feelings as clearly as possible ... we mourn with the mourners, laugh with those who laugh and grieve with the grief stricken' (*Della pittura*, trans. Grayson, 1972). But as Alberti admitted from evident bitter experience practice could not always match theory: 'Who, unless he has tried, would believe it was such a difficult thing, when you want to represent laughing faces, to avoid them appearing tearful rather than happy' (ibid.). For both Alberti and Leonardo the solution to this problem lay in the careful observation and copying of the natural world. Leonardo suggested the artist should take his sketchbook into the street to observe people surreptitiously in their natural actions and more contentiously advocated a particular study of the gestures and expressions of the deaf and dumb—a confusion of expressive gesture with a conventional sign language.

Although Alberti and Leonardo were the first Renaissance theorists to write on the problems of gesture and expression, they were scarcely the first artists to explore the possibilities of the expressive face and body. The 15th-century sculptors of the cathedrals of Strasbourg, Bamberg, Magdeburg, and Naumburg, for example, demonstrated a particular penchant for heightened expression. Medieval devotional images exploited the expressive faces and gestures of Christ and companions during his Passion and 15th-century developments saw an increasing emphasis on the emotional reactions of

the witnesses to the Passion and other events of Christ's life. These were often shown close up, half- or shoulder-length, inviting the empathy of the spectator. In the Netherlands the paintings of Rogier van der *Weyden and his followers reveal a study of expression every bit as profound as that advocated by the Italian theorists.

It was the importance given to expression by Alberti and Leonardo that inevitably influenced later academic theorists. *Lomazzo devoted most of a book of his *Trattato dell'arte de la pittura* (1584) to 'the movements which may be produced in the body by the different emotions of the soul'. Here he attempted a classification of about 100 human emotions giving accounts of their expression, both corporal and facial, together with descriptions of imaginary pictures in which such expressions might feature.

In the 17th century the desire to master the representation of expression and expressive gesture was deep and widespread—as witnessed by the works and surviving opinions of *Domenichino, the *Carracci, and *Poussin. *Rembrandt's only surviving utterance on his artistic aims, in his letter to Constantijn *Huygens of 1639, speaks of his desire to capture 'the greatest and most natural emotion'. Some of his self-portrait studies pulling a variety of faces reflect a practice, described by his pupil Samuel von *Hoogstraten, of acting out and recording different emotional states in front of a mirror.

It was the problems inherent in expressing emotions through facial expression, rather than gesture, that received most attention in the 17th century and beyond as, for example, in Charles *Le Brun's lecture on the subject delivered to the French Académie in 1688 and published as *Conférence sur l'expression générale et particulière*. Le Brun attempted to describe the expression of the passions not from empirical observation but from scientific principles, basing his theory on René Descartes's analysis of the workings of the soul upon the human body. For Descartes and Le Brun facial expressions were caused by the flow of animal spirits around the circulatory and nervous systems from their source in the soul situated, so Descartes claimed, in the pineal gland behind the forehead. Le Brun explained all expressions in relation to the flow of animal spirits. He believed particular passions would result in specific facial movements which he attempted to describe and codify.

Le Brun's lecture went through 63 separate editions but the full complexity and ambition of his theories had less influence on the arts than the illustrations of expressive heads that accompanied the text. *Hogarth referred to it as 'the common drawing book ... for the use of learners' (*The Analysis of Beauty*, ed. J. Burke, 1955), and its use as a pattern book

throughout the 18th century can be demonstrated by many examples. Le Brun's figure of anger for example can be seen reflected in the figure of the irate father in *Greuze's The Father's Curse (1777; Paris, Louvre). Despite its influence Le Brun's lecture was attacked as too prescriptive and formulaic. In 1708 in his Cours de peinture par principes Roger de *Piles, anticipating much later criticism, claimed the very notion of providing rules for the depiction of expressions 'would be depriving the art of that excellent variety of expression; which has no other principle than diversity of imaginations, the number of which is infinite and productions as new as the thoughts of man are various' (The Principles of Painting, trans. 'a Painter', 1743). In 1759 with similar motives the Count de Caylus instituted the Prix Caylus, a prize at the French Académie for an expressive head taken from a model rather than derived from rules or a pattern book. Criticism of another sort was levelled at the 17th-century purveyors of heightened expression by *Neoclassical theorists such as *Winckelmann who saw expression as a threat to the ideal of beauty.

The first attempt to examine expression with reference to the anatomical structure of the face and the action of facial muscles was made by James Parsons in his Human Physiognomy Explain'd (1746), in which he criticized Le Brun for his ignorance of anatomy. The anatomical study of expressions continued in the 19th century most notably in the work of the French Dr Duchenne de Boulogne whose Mécanisme de la physionomie humaine was published in 1862. Duchenne lectured on expression at the École des Beaux-Arts, *Paris, which still houses his remarkable photographs of experiments involving the attaching of electrodes to the selected facial muscles of a thankfully insensate man.

A different approach was inaugurated by the physiologist Sir Charles Bell who in his The Anatomy and Philosophy of Expression as Connected with the Fine Arts (1806) speculated on the origin of expressions. He was the first to suggest that some expressions might be practical in origin while others might derive from involuntary changes in the respiratory organs. These ideas were to be developed much further by Charles Darwin in his The Expression of the Emotions in Man and Animals (1872), who argued for an evolutionary origin of expression.

More recent studies have concentrated on how expressions are perceived and recognized. Expressions are movements and experiments with photographs have shown that still images of expressions cannot provide reliable evidence as to the emotion being expressed except in extreme forms of a very limited range of basic emotions. In other words the correct recording of an expression does not guarantee that the viewer will be able to recognize which emotion is being expressed. Running counter to the difficulty of interpreting still images of facial expressions is the propensity of the beholder to do so even to the extent of supplying information not provided by an image—for example reading emotion into a hidden or neutral expression—or the tendency towards projecting human expressions onto animals or inanimate objects—seeing basset-hounds as sad and worried. The reading of an expression can also depend upon its context, as demonstrated in the 1920s by the Soviet film-maker Kuleshov, who discovered that the neutral expression of a matinée idol was interpreted in different ways when intercut with images of a child playing with a doll, a peasant eating soup, and a dead old woman. Similarly a neutral face seen next to an expressive one will appear to express an emotion opposed to that of its neighbour. The artists who were earliest in recognizing and exploiting the role of the spectator in the interpretation of expression were *caricaturists, for example the Swiss inventor of the comic strip Rodolphe Töpffer who in his short Essai de physiognomie of 1845 formulated what Ernst Gombrich has termed 'Töpffer's law'; that every face however badly or feebly drawn will, by the simple fact of its being drawn, have some perfectly defined expression. Psychologists have confirmed our tendency to physiognomic perception; that is our natural predisposition to read expressions into even inanimate objects provided that they supply what has been called the 'minimum clue' that allows us to interpret an object as a face. ASt

Barasch, M., Giotto and the Language of Gesture (1987).
Montagu, J., The Expression of the Passions: The Origin and Influence of Charles Le Brun's Conférence sur l'expression générale et particulière (1994) (contains very good bibliography).
Schmitt, J.-C., La Raison des gestes dans l'Occident médiéval (1990).

EXPRESSIONISM, term used to describe a movement in painting, sculpture, and the graphic arts which flourished c.1905–20, gaining its most productive foothold in Germany until its suppression by the Nazis after 1933. The Expressionists are characterized by a deliberate rejection of the ideals of *naturalism and *Impressionism, which had dominated art in the later 19th century with their emphasis on the reproduction of observed reality.

Although much debate has surrounded the origins of the term Expressionism itself, it was given public currency by the German gallery owner and publisher Herwart Walden, who used it in a generalized sense to characterize all the modern art opposed to Impressionism. In 1911 the term could be used to describe the *Fauve artists with their strident expressiveness of colour and the *Cubists with their analysis of form; indeed the movement itself can be argued to have its origins in France, developing almost simultaneously, however, in other European countries as well.

One line in the development of Expressionism can be traced from the work of Paul *Gauguin and Vincent van *Gogh, with Gauguin's bold and decorative use of colour and van Gogh's great expressiveness of mark and gesture, through the work of Edvard *Munch with his symbolic-melancholic images of angst, and that of James *Ensor, with his imagery of masks. Van Gogh was perhaps the most influential forerunner. Both in his letters, where he wrote of his need 'to express . . . man's terrible passions', in his use of line and colour, and in the bold fervency with which he directed his mark-making, he acted as a linchpin between the art movements of the 19th and the 20th centuries.

The break with Impressionism that Gauguin's art represents was perhaps more conscious than that of van Gogh. Gauguin, influenced by an aesthetic attitude comparable to that of the Symbolist poets, reacted forcefully against the representation of observed reality emphasized by the Impressionists and the scientific preoccupations of the *Neo-Impressionists, embodied in the painting of *Seurat and *Signac. Gauguin transformed the role of colour in painting, releasing it from its dependence on the data of perception, to attain a decorative and emotional autonomy. He juxtaposed areas of bold, flat colour, whose striking decorative effect was heightened by powerful outlines, producing rhythms reminiscent of both Japanese prints and *stained-glass technique. Gauguin described his method as 'symbolic', implying an art in which the forms and patterns echoed and evoked mental images, ideas, and moods. His voyage to the South Pacific provided a model for later Expressionist artists, including Emil *Nolde and Max *Pechstein.

While van Gogh and Gauguin were in their individual ways attempting to establish a new order in painting of emotion and symbol over fact and sign, and to liberate colour and line from their adherence to observed reality, Edvard Munch, working after contact with their work in France, took back with him to Norway a desire to capture and express the complex emotional landscapes of mankind, employing violently jarring, acidic colours and linear distortions to conjure highly idiosyncratic and unsettling evocations of anxiety, fear, love, and hatred. He is now considered, by virtue of his heightened psychological sensitivity and reopening of a consciousness in painting of the darker, more primal aspects of mankind, to be a major influence on the development of Expressionism in Germany after 1905. Like Munch, Ensor in Belgium was preoccupied with man as a social, psychological, and sexual animal.

Ensor employed notions of carnival and the mask motif to represent the rich baseness and corruption of modern man. His use of the paradoxically expressive mask and his vehemence of style and subject matter had a powerful and lasting effect on the emergent Expressionism in Germany.

In 1905, the year the Fauves in France were recognized as an autonomous group, the first German Expressionist group, Die *Brücke, was founded in Dresden by Ernst Ludwig *Kirchner, Karl *Schmidt-Rottluff, and Erich *Heckel, holding its first exhibition the following year. Whereas the Fauve artists with their leader Henri *Matisse were still essentially concerned with harmony of composition and the autonomy of lucent colours (and in these respects carried forward the legacy of Gauguin), Die Brücke showed the strongest empathy of spirit in their paintings and their highly influential use of the *woodcut technique with van Gogh and Munch. With their great violence of impact, dissonant combination of colours, and deliberate rejection of the balance of design, the Brücke artists established the qualities that distinguished German Expressionism from its French counterpart in the Fauves.

During their Dresden years the Brücke artists displayed a particular interest in the self-expression of the individual in nature. This reflected the growing popularity of naturist cults and the increasing currency of aspirations for a return to an agrarian way of life in Germany. The independent Expressionist artist Paula *Modersohn-Becker took this philosophy to heart by living in a community of artists at Worpswede, where she painted the local peasant life with an earthy and expressive German primitivism. Emil Nolde, one of the most powerful Expressionists in his depiction of external geographical and internal psychological landscapes, although allied briefly with the Brücke group, spent much of his life in the vast open expanses of his native north Germany.

While the Brücke artists headed after 1910 to the metropolis of Berlin and towards a renewed emphasis on man in an urban environment, another group of German Expressionists was establishing itself in Munich. Der *Blaue Reiter, founded in 1911 by the Russian artist Wassily *Kandinsky with Franz *Marc and others, was a more theoretically programmatic group than Die Brücke, disseminating its aims and ideas both in the *Blaue Reiter Almanac* (1912) and through Kandinsky's own writings on art, such as *Concerning the Spiritual in Art* (1911). These artists were primarily concerned with a focus on the spiritual and an empathetic identification with the animal kingdom and developed, particularly in the painting of August *Macke, Franz Marc, and Kandinsky, both a

keen interest in colour theory and an increasing tendency towards a non-objective idiom.

The First World War acted as a caesura in the development of the Expressionist movement in Germany. Both main focal points of organized Expressionism, the Brücke and the Blaue Reiter, were disbanded by the outbreak of war. Although the Brücke artists all survived the conflict, the Blaue Reiter's Marc and Macke were both killed in action. After 1918, art in Germany began to evolve towards a new focus on social commentary and critique. The three leading exponents of what is often termed the second generation of German Expressionists, George *Grosz, Otto *Dix, and Max *Beckmann, turned towards an often brutal and visceral depiction of the depravity and social chaos that they felt lay at the heart of Weimar Germany. With a renewed emphasis on a representational idiom and with a sense of their duty to depict society's ills (a duty at odds with the abstraction towards which Expressionism had tended shortly before the war), this second generation became known as *Neue Sachlichkeit (New Objectivity) artists.

Although the survivors of the first Expressionist generation continued to paint after the war, the impact and freshness of their approach had lost much of its power by 1920. The Neue Sachlichkeit artists exchanged Expressionism's focus on the symbolic and emotional, and on the individual and the psychological, for a hard realism and a commentary on German society as a whole that was to continue until its suppression by the propaganda art of the Nazis.

Although Expressionism has been lent added definition as a movement by the foreshortening effects of art history, which can tend to obscure the very diverse characters of its individual practitioners, it is certain that the movement had a highly significant impact on the development of Western art. *Abstract Expressionism from the late 1940s in America and Neo-Expressionism from the late 1970s in Germany are just two of the movements which can trace their roots back to the artists who found this loud, clear voice and new, vital means of expression in the first two decades of the 20th century.

RRAM

Parsons, T., and Gale, I., *Post-Impressionism: The Rise of Modern Art 1880–1920* (1992).

E X-VOTO (Latin: by reason of a vow), an object offered to a saint in return for aid and protection. Ex-votos are commonly placed at a significant site, either where relics of a particular holy person lie, or where a miracle has occurred or vision appeared. These gifts can be in the form of paintings, clothes, strips of cloth, wreaths, sculpture, or

jewellery. The will of Margaret of York, Duchess of Burgundy (d. 1504), for example, requested that her marriage coronet be placed on the statue of the *Virgin and Child* in Aachen Cathedral, where it remains. This ex-voto to the Virgin was thought to ensure that the Madonna would act as intercessor on Margaret's behalf on the Day of Judgement. During the 14th century a type of votive image was developed where the person appealing for help is depicted in prayer whilst offering the gift to saints, the Virgin, or even God himself. These images are particularly interesting as they form some of the earliest *portraits painted, for instance Enrico Scrovegni presenting the Arena chapel to the Virgin (Padua, Arena chapel).

KC

Kriss-Rettenbeck, L., *Ex-voto: Zeichen, Bild und Abbild im christlichen Votivbrauchtum* (1972).

E YCK, BARTHÉLEMY D' (van Eyck) (active *c*.1440–*c*.1469). Netherlandish painter, illuminator, and designer, active in France. Documented in Aix-en-Provence in 1444 with the painter Enguerrand *Quarton, by 1447 he was painter and *valet de chambre* to René, Duke of Anjou, with whom he was associated throughout his subsequent career. The relationship between patron and artist seems to have been particularly close since Barthélemy is documented accompanying René on his travels and even working next to the apartments of the Duke. If he is identified with the 'Barthélemy the painter' working for the Duke of Burgundy in 1440 at Dijon, where René had been kept captive, this would explain the origins of the relationship. Since his stepfather, a draper, certainly accompanied René to Naples in 1438, the possibility exists that Barthélemy's work was known there also.

No documented works by Barthélemy survive, but circumstantial evidence allows his œuvre to be reconstructed. The famous *Annunciation* (*c*.1442–5; Aix-en-Provence, S. Marie-Madeleine), commissioned by the draper Pierre Corpici (a colleague of Barthélemy's stepfather) for Aix Cathedral, was painted when he is known to have been in Aix. Its Netherlandish character, its stylistic connections with the work of the Neapolitan painter Colantonio (reputed to have been trained during René's time in Naples), its debt to the sculpture of *Sluter at Dijon, and the remains of an inscription, all favour him as its painter. This artist has been identified as one of two illuminators of a book of hours (New York, Pierpont Morgan Lib.), the other being Quarton. Many of the mature manuscripts illuminated by this artist, such as the celebrated *Livre du cueur d'amour esprit* and the delightful *Théséide* (*c*.1460–70; both Vienna, Österreichische Nationalbib., Cod. 2597), are

associated with René, making a very tight case for his identification with Barthélemy. Stylistically, such works derive from Netherlandish painters like *Campin, but their astonishing draughtsmanship, colouring, and exceptional vision connect them with *Fouquet, whom Barthélemy probably knew. Pélerin's early 16th-century perspectival treatise celebrates both painters, clear evidence that Barthélemy was considered one of the most distinguished painters to have worked in France. TT

Avril, F., and Reynaud, N., *Les Manuscrits à peintures en France 1440–1520*, exhib. cat. 1993 (Paris, Bib. Nat.).

Reynaud, N., 'Barthélemy d'Eyck avant 1450', *Revue de l'art*, 84 (1989).

Sterling, C., *Enguerrand Quarton* (1985).

EYCK, VAN. Netherlandish painters; brothers, possibly born in Maascik, near Liège, who worked mainly in Bruges and Ghent respectively. **Jan** (c.1395–1441) is regarded as one of the most important painters of the period, who developed a style of symbolic realism that depended upon the refinement of his oil technique; this was recognized as so remarkable that for centuries, from *Vasari onwards, he was mistakenly credited with the invention of painting in oil. As a court painter with an international reputation, and diplomatic envoy, he reflects the status which could be achieved by the talented and intellectual artist. **Hubert** (d. 1426) is a more shadowy figure, whose works are not firmly identified and whose participation in paintings generally given to Jan has been much debated.

Jan van Eyck is first documented in The Hague in 1422, working for John of Bavaria, ruler of Holland. He became court painter and probably worked there until John's death in 1425.

By 1425 Jan had moved to Bruges, where he became court painter and *valet de chambre* to Philip the Good, thereby beginning a long association with the Duke. From this date he travelled frequently, visiting Spain and Portugal, and perhaps the Holy Land and Italy, and spent periods of time in Lille and Arras. A marriage was being negotiated, between Philip the Good and the Portuguese Infanta, whose portrait van Eyck painted, satisfactorily it seems since they were married in Bruges in 1430.

Those who accept the miniatures in the Turin–Milan Hours as by Jan also attribute works that resemble them in their intricate panoramic landscapes and focused narrative to him, including a diptych depicting the *Crucifixion* and *Last Judgement* (New York, Met. Mus.).

While settled in Bruges, Jan was occupied until 1432 with the great retable of the *Adoration of the Lamb*, also known as the Ghent altarpiece (Ghent, S. Bavo). It consists of 20 panels (one a replica of one stolen in 1934), which form a coherent programme illustrating the prophecy and Incarnation of Christ, redemption, and the final triumph. This learned scheme follows the wishes of the donors, Jodocus Vijd and his wife, whose endowment provided for a daily Mass, and who are depicted kneeling in prayer on the outer wings. The altarpiece is inscribed with a verse which says that it was begun by Hubert 'than whom no greater was found' and completed by Jan 'his brother, second in art'. If true, this indicates that the overall design of the work may have been Hubert's, and that some areas of at least the lower paint layers were executed by the time of his death in 1426. The verse includes a chronogram of the year of dedication as 1432. Although it is difficult to distinguish the contribution of each brother, diversities in scale and style, as well as examination of underdrawing, have led critics to apportion areas. The lower inside panels show the *Adoration of the Lamb*, a subject taken from the Book of Revelation, in a panoramic landscape with groups of small, varied, figures. In contrast, other panels contain larger-scale figures in convincingly constructed settings. The four outer panels of the *Annunciation*, in particular, create a spacious, if low-ceilinged, and warmly lit room whose windows overlook a busy Flemish town; underdrawings of Gothic arches suggest a change, perhaps by Jan, to the original design. The figures of Adam and Eve, on the inner wings, are remarkably real, illusionistically lit from below, and roundly modelled. Overall, with the exception of the portraits of the donors, the outer panels suggest grisaille or sculpture, while the inner panels display rich effects of colour and texture, with jewelled crowns and gold embroidery minutely observed and sparkling

No other paintings can be definitely associated with Hubert van Eyck, although he is known to have designed an altarpiece for the magistrates of Ghent, and it has been thought possible that he began the *Three Marys at the Tomb* (Rotterdam, Boymans-van Beuningen Mus.), which bears a resemblance to what are regarded as the earlier panels of the Ghent altarpiece.

Jan, however, produced several signed and dated works in and after 1432. These include portraits, donor altarpieces, and small devotional images. His service for Philip the Good secured him an annual pension but it did not prevent him from taking commissions from other patrons. Nor was he restricted to painting pictures; in 1436 he gilded and painted

statues and tabernacles for Bruges Town Hall.

The *Virgin and Child with Chancellor Rolin* (Paris, Louvre) was commissioned by Nicolas Rolin, a prominent figure at the Burgundian court, for his funerary chapel in Autun. It is one of a group of Jan van Eyck's mature works which feature a donor, sometimes accompanied by saints, kneeling in prayer and contemplation before the Virgin. The location is either a church or, as in this case, a palatial loggia overlooking a distant panorama. The main figures are large and richly clad, surrounded by objects and surfaces which are painted with illusionistic precision, and glitter with reflected light.

Some smaller, private works are softer and more atmospheric in their technique. The triptych of the *Virgin and Child with S. Michael and S. Catherine* (1437; Dresden, Gemäldegal. (Alte Meister)) reduces the splendour of large church panels to a miniature world, and the *Virgin and Child in a Church* (Berlin, Gemäldegal.) is remarkable for its light, which streams through the windows of a Gothic church, falling in pools upon the floor, its purity echoing that of the Virgin herself.

The symbolism of the visible world is a feature seen in several of Jan's works. *The Arnolfini Portrait* (1434; London, NG), a full-length, double portrait of Giovanni(?) Arnolfini and his wife, is one of several works painted for the community of Italian merchants in Bruges. The significance of the inscription on the wall of the room which records that Jan 'was here' and his apparent inclusion as one of the two men reflected in the convex mirror have been extensively discussed. Whether a real event is being documented is not clear, but the realism of the setting, with prosperous and richly dressed figures in a comfortably furnished room, is undeniable. This assembly of material objects has been scrutinized for allegorical references.

Jan's half-length portraits typically show the sitter in a confined space set against a plain background and, where they survive, in illusionistic painted and inscribed frames. The *Portrait of a Man* leaning on a parapet carved with the inscription 'Léal Souvenir' (1432), and the *Portrait of a Man* ('Self-Portrait?') (1433; both London, NG), are remarkable both for their distinct personalities and for the detail of their depiction. The desire to reproduce every feature visible in life may have impelled Jan to research the properties of the oil medium, which enabled him to build up layers of fine brush strokes and light-reflecting glazes. A fully developed and annotated preparatory drawing for the portrait of Cardinal Albergati (drawing, Dresden, Kupferstich Kabinett; painting, Vienna, Kunsthist. Mus.) illustrates the precision of

his observations and method. Patterns from his workshop continued to be used for some time after his death.

Jan's technical ability, artistic invention, and intellect were universally recognized, by writers and artists in Italy as well as the Netherlands. Petrus *Christus took over as the leading Bruges artist, reproducing much of Jan's style, and while it can be argued that Rogier van der *Weyden's formal and emotional influence was perhaps greater, Jan established the characteristic Flemish technique. Later artists such as *David, *Massys, and *Gossaert perpetuated his fusion of the material and the spiritual.

MS

Campbell, L., *The Fifteenth Century Netherlandish Schools*, 1998 (London, NG).

Dhanens, E., *Hubert en Jan van Eyck* (1980).

Smeyers, M., 'Jan van Eyck, "Pictor Doctus" ', *Onze Alma Mater* (1991).

Sterling, C., 'Jan van Eyck', *Revue de l'art* (1976).

FABRITIUS BROTHERS. Dutch painters. **Carel** (1622–54) was a highly original and technically very accomplished painter. He was baptized in Midden-Beemster, but trained in *Rembrandt's studio in Amsterdam at the same time as *Hoogstraten in the early 1640s. Fabritius became a member of the artists' guild in Delft in 1652 and was succeeded in this position by *Vermeer, whose work he may have influenced. Few works by him survive, but they explore a wide variety of subjects—portraits, genre, and architectural scenes, such as the *View of Delft* (London, NG) with its complex illusionistic perspective. He also produced charming virtuosic studies like *The Goldfinch* (The Hague, Mauritshuis). The artist was killed by injuries resulting from the explosion of the Delft powder magazine. His younger brother **Barent** (1624–73) also fell under the spell of Rembrandt, although was probably not one of his pupils, and worked in a broader manner, with dramatic contrasts of light and dark. He seems to have worked in Delft and extensively in Leiden and produced history paintings and genre scenes. CB

Brown, C., *Carel Fabritius: Complete Edition with a Catalogue Raisonné* (1981).

FALCONET, ÉTIENNE-MAURICE (1716–91). French sculptor and writer. He was one of a brilliant generation who trained under *Lemoyne. He entered the Académie Royale, *Paris, in 1744 on presenting his group *Milo of Crotona* (marble version of 1754; Paris, Louvre), an elegant reworking of *Puget's famous piece. In 1757 Falconet completed for Mme de Pompadour the marble version (Paris, Louvre) of his statue *L'Amour menaçant*, one of the quintessential works of 18th-century French art, which depicts Cupid as a svelte and knowing pre-pubescent boy. A similar *Rococo character pervades the models for porcelain that he designed while director of sculpture at the Sèvres factory 1755–66, as well as the statuettes of female bathers so much associated with his name. In 1766, at the suggestion of *Diderot, he was called to St Petersburg by Catherine II to undertake the bronze *equestrian monument to Peter the Great. Nothing in Falconet's previous work prepares for the grand proto-Romantic originality of the statue, which, with great technical mastery, depicts the founder of modern Russia calm on a rearing horse. The pedestal, which is without the usual allegorical accoutrements, seems roughly hewn from the living rock overlooking the river Neva. The statue was taken as a model by *David for his portrait of *Napoleon at the St Bernard* (Malmaison, Mus. Nat.) and inspired Pushkin's poem *The Bronze Horseman*. The Czar's head was modelled by Falconet's pupil and daughter-in-law Marie-Anne Collot (1748–1821), who also made the telling portrait of the sculptor now in the museum at Nancy. Falconet was a pugnacious auto-didact who corresponded with Diderot and defended the superiority of modern art over that of the ancients in many essays and pamphlets, most notably *Réflexions sur la sculpture* (1761), which was admired by the young *Goethe. MJ

Réau, L., *Étienne-Maurice Falconet* (1922).

Weinshenker, A. B., *Falconet: His Writings and his Friend Diderot* (1966).

FANCELLI, DOMENICO DI SANDRO (*c.*1469–1519). Italian sculptor. He was born in Settignano near Florence, first training as a hardstone cutter. He is known principally for introducing Italian *Renaissance styles into Spain. He carved a number of *tombs in Carrara and Genoa, only travelling to Spain for their installation. His series of tombs for the Mendoza family, including the tomb of Diego Hurtado de Mendoza, Archbishop of Seville (*c.*1508; Seville Cathedral), preceded the tomb of Prince Juan (1513; S. Thomas, Ávila) and the tombs of Ferdinand and Isabella (1506–21; Granada, Chapel Royal). Fancelli's works are characterized by a static

design and dry carving, though he was clearly aware of Andrea *Sansovino's tomb sculpture in Rome. AB

Lenaghan, P., *Domenico Fancelli and Spanish Sculpture* (1993).

FANCY PICTURE, a term applied specifically to a type of late 18th-century English painting which includes works by *Reynolds (*Cupid as Link-Boy*, 1774; Buffalo, Albright-Knox Gal.) and *Gainsborough (*Haymaker and Sleeping Girl*, c.1785; Boston, Mus. of Fine Arts). Reynolds's subjects are usually children, or sprites, inspired in part by Renaissance putti, while those of Gainsborough concentrate on idealized rustic life and owe a debt to the charming urchins of *Murillo. However they are both products of the artist's 'fancy', or imagination, and have no didactic or moral purpose. They were usually uncommissioned but proved to be highly popular with aristocratic patrons for, unlike portraits, they could be hung successfully among old master paintings. Reynolds himself greatly admired Gainsborough's work in this vein and purchased *The Girl with Pigs* (1782; Castle Howard, Yorks.). The term rapidly acquired a more general usage and is sometimes used to describe any non-specific unrealistic genre scene by English 18th-century artists. It is incorrect, however, to use the phrase to indicate the purely decorative or ornamental qualities of a painting. DER

FANTIN-LATOUR, IGNACE HENRI JEAN THÉODORE (1836–1904). French painter. Fantin was born in Grenoble, the son of a portrait painter, and trained, briefly, in Paris. He first specialized in *flower paintings and portraiture but despite his essentially traditional style Fantin was close to the modernist painters *Degas, *Whistler (who introduced his work to England in 1859), and *Manet, and recorded these friendships in detailed and academic group portraits including *Homage to Delacroix* (1864; Paris, Mus. d'Orsay) and *Homage to Manet* (1870; Paris, Louvre). His flower pieces, which he continued to paint throughout his career, were much admired, particularly in England. In 1861 a production of Richard Wagner's (1813–83) *Tannhauser* inspired him to begin a series of paintings and lithographs on musical themes which culminated in the 1880s with his illustrations to Adolphe Jullien's *Richard Wagner* (1886). These highly Romantic and lyrical allegorical figure subjects, far removed from his popular still lifes, were highly praised by *Symbolist critics but confused his more conservative admirers. Later figurative works like the poetic, but equally Symbolist, *Night* (1897; Paris, Louvre) received general acclaim. DER

Druick, D., and Hoog, M., *Fantin-Latour*, exhib. cat. 1983 (Ottawa, NG Canada).

FARINGTON, JOSEPH (1747–1821). English painter and diarist. Farington, who came from a prosperous Lancashire family, entered the RA Schools (see under LONDON) in 1768 and also studied under Richard *Wilson, whom he probably assisted by painting replicas. Although he continued to paint oils he is better known for lively topographical pen and wash drawings, executed during sketching tours in England, Scotland, and France, examples of which may be found in the British Museum and V&A in London. From 1773 to 1776, assisted by his brother George, he copied old master paintings at Houghton for Robert Walpole, Earl of Orford, before their sale. He then lived in Keswick, until 1780, drawing *picturesque views which were published, in 1789 and 1816, as *Views of the English Lakes*. He settled in London in 1781, became an RA in 1785 and immersed himself in Academy politics where, although he never held high office, his influence was all-pervasive. From 1793 until his death Farington kept a diary (MS, Windsor Castle, Royal Lib.; 1st published 1922) which provides the fullest account of the English art world during this period. DER

The Diary of Joseph Farington, ed. K. Garlick, A. Macintyre, and K. Cave (1978–84).

Ruddick, W., *Joseph Farington*, exhib. cat. 1977 (Bolton, AS).

FARNESE BULL (late 2nd–early 1st century BC; Naples, Mus. Arch. Naz.), one of a series of colossal sculptural groups after Hellenistic works (e.g.: *Laocoön, Sperlonga *Polyphemus Group*). *Pliny (*Natural History* 36. 37) noted the technical erudition of the late 2nd- or 1st-century BC sculptors Apollonius and Tauriscus of Rhodes. The myth portrayed is the punishment of Dirce by Amphion and Zetus, the sons of Antiope and Zeus. To avenge their mother's maltreatment, they tied the offending woman to a wild bull. The base is decorated with further scenes of struggle, man against beasts and beasts against beasts. Said to have been first displayed in Rhodes, it was then one of the centrepieces of the collection of Asinius Pollio in Rome. Found in the south-east palaestra or exercise court of the Baths of Caracalla in Rome in 1545, it was heavily restored and fitted out as a fountain by the Farnese. In 1788 it was transported to Naples (now Mus. Arch. Naz.). L-AT

Haskell, F., and Penny, N., *Taste and the Antique* (1981).

FARNESE HERCULES (3rd century AD; Naples, Mus. Arch. Naz.), colossal marble copy of a bronze original attributed to the Greek sculptor *Lysippus, also known as the 'leaning Hercules'. The hero is represented resting after the completion of his labours. He leans on his club, embellished with the skin of the Nemean lion; the apples of immortality are in his right hand behind his back. The portrait-like head of Hercules became the archetype for all later representations of the hero. Found in the cold room (*frigidarium*) of the Baths of Caracalla in Rome in 1545, it seems to have been made specifically for the baths and thus dates to AD 200–20. This copy is inscribed on the rock by the copyist: 'Glycon the Athenian made it.' Another copy in Florence (Pitti) is inscribed instead: 'of Lysippus'; the use of the genitive case perhaps indicates its derivation from the original. Interestingly, the Naples copy, despite its overblown musculature, is considered closer to the Lysippan original. L-AT

Stewart, A., *Greek Sculpture* (1990).

FATTORI, GIOVANNI (1825–1908). Italian painter, a leading member of the *Macchiaioli. Having trained in Florence under Giuseppe Bezzuoli, in the 1850s Fattori became associated with the most innovative Florentine artists of the day, in particular Nino Costa (1826–1903), whom he first met in 1859. Under Costa's influence, he began to apply paint in large spots (Italian 'macchie'), which accentuated the chiaroscuro in the work. As well as painting landscapes, Fattori also represented key events in the Risorgimento, as in *The Italian Camp during the Battle of Magenta* (completed 1862) and *The Battle of Custoza* (completed 1880; both Florence, Pitti): Fattori had himself participated in the revolutions of 1848–9. In the 1880s he began to concentrate on graphic work, especially etchings of the melancholy Maremma landscape in southern Tuscany, and of the peasant life in the area. Although Fattori visited Paris in 1875, his later work is largely unaffected by contemporary developments in French art. CJM

Biancardi, L., and della Chiesa, B., *L'opera completa di Fattori* (1970).

FAUVISM. 'Fauve' is a term that covers a style in French painting practised by a loose association of artists from c.1898 to c.1908 and characterized by violent, anti-naturalistic use of strong colour, often applied unmixed straight from the tube. The artists were labelled *les fauves*, meaning 'wild beasts', by the critic Louis Vauxcelles in 1905; while the movement lacked any coherent theoretical position, the name aptly described the violence of their shared reaction to the prevailing styles of *Impressionist and academic painting. Vauxcelles was describing an exhibition, in a room at the 1905 Salon d'Automne (see under PARIS), that brought together the work of three separate sets of artists: the pupils of Gustave *Moreau (Henri *Matisse, Albert *Marquet, Georges *Rouault,

Henri-Charles Manguin, and Charles Camoin); Maurice *Vlaminck and André *Derain from Chatou; Émile-Othon *Friesz, Georges *Braque, and Raoul *Dufy from Le Havre; and the Dutchman Kees van *Dongen. They came together over shared interests and influences: *Gauguin influenced the style's decorative, symbolic bias and its use of broad areas of flat colour; and the work of van Gogh lent elements of expression and facture evident in Vlaminck's use of curving, broken lines and small dots of colour in his *Landscape at Chatou* (1906; Amsterdam, Stedelijk Mus.). Matisse's *Luxe, calme et volupté* (1904-5; Paris, Mus. d'Orsay) also shows the important influence of *Neo-Impressionist technique in its isolated marks. The beginnings of the style can be seen as early as 1898. Certainly Marquet claimed to have been painting in the style alongside Matisse at that time: his nude of 1898, subsequently known as the *Fauve Nude* (Bordeaux, Mus. des Beaux-Arts), exhibits the style's primacy of colour. The climax of the group's activity came in 1905-6. In the summer of 1905 Matisse and Derain stayed at Collioure in the sun-drenched French Mediterranean; the location was crucial in developing the style, which Matisse saw as fitting to describe the rustic scenery and simple, uninhibited lives of the town's inhabitants. By 1908, following their exhibitions together in Paris at the Salon d'Automne of 1905 and the Salon des Indépendants in 1906, the group began to lose coherence and the artists took separate directions. The enormous influence of the *Cézanne retrospective of 1907 did much to change the climate of interest, as artists, among them Derain, sought to impose more structure on their work and a clearer articulation of space and volume. However, the Fauve style has been enormously influential; its expressive colour, spontaneous handling, and decorative tendencies are all qualities that have been mirrored by the work of much later *Abstract Expressionists. MF

Herbert, J. D., *Fauve Painting: Making of Cultural Politics* (1992).

Oppler, E. C., *Fauvism Reexamined* (1976).

FEDERAL ART PROJECT, a project instituted by the United States government between 1935 and 1943 with the dual purpose of assisting artists and providing public works of art. Under the supervision of Holger Cahill the scheme employed artists on a monthly salary and on its termination over 3,500 artists had produced over 16,000 works including 1,200 murals, few of which now survive. The work was essentially populist but included abstract works (Arshile *Gorky, *Study for Aviation*, 1936; New York, MoMa). Many artists, including George Biddle (1885-1973: *Study for Sweatshop*, c.1935; Baltimore, Maryland Inst.), used the opportunity to

comment on prevailing social conditions. Although the Project resulted in few works of outstanding quality it radically changed the public's perception of art as being elitist and integrated art into everyday life. The majority of the *Abstract Expressionists of the late 1940s and 1950s, including *Pollock, *de Kooning, and *Rothko, had been employed on the scheme, and the emphasis on large public works had a significant effect on the scale of subsequent American painting which affected not only the next generation but also the *Pop painters of the 1960s.
DER

O'Connor, F., *Federal Art Patronage, 1933-43* (1966).

FEI, PAOLO DI GIOVANNI (c.1344-1411). Sienese painter. Paolo was one of the leading Sienese painters of his time, holding several prestigious civic offices. He may have been trained in the circle of *Bartolo di Fredi, and his work, not unusually for this period, is largely based on free variations on established Sienese formats of the early trecento. His altarpiece of the *Birth of the Virgin and Four Saints* (Siena, Pin.) subjects Pietro *Lorenzetti's version of the same scene (1344; Siena, Mus. dell'Opera del Duomo) to a process of decorative embellishment which dissipates most of the concentration and spatial invention of his source. In 1398 Paolo painted a triptych of the *Presentation of the Virgin in the Temple* (now Washington, NG) for Siena Cathedral which similarly depends on Ambrogio *Lorenzetti's *Presentation* altarpiece (1342; Florence, Uffizi), adding attractive genre elements and blunting both the force and the logic of Ambrogio's deep pictorial space. JR

Mallory, M., *The Sienese Painter Paolo di Giovanni Fei* (1976).

FEININGER, LYONEL (1871-1956). American-German painter. Born in New York, Feininger travelled to Germany in 1887 to study music. However, drawing lessons at the Kunstgewerbeschule, Hamburg, and the Berlin Akademie led him to become a cartoonist and until 1909 he contributed work to German and American magazines. In 1911 he exhibited at the Salon des Indépendants, *Paris, and became aware of *Orphism, early *Cubism, and *Futurism, each of which played a part in the development of his personal style of angular lines and transparent intersecting planes. From 1912 he was associated with progressive German painters, although never a true *Expressionist. In 1919 Feininger was invited by Walter Gropius (1883-1969) to teach at the newly founded *Bauhaus and designed the woodcut *The Cathedral of Socialism* (1919; New York, MoMa) for the prospectus. He taught until 1933 when the Bauhaus was terminated by the Nazis. His own work was declared degenerate and in 1937, his career destroyed, he moved to

America and success. He added skyscrapers to his repertoire of sailing ships and Gothic cathedrals, for instance *Gelmeroda VIII* (1920-1; New York, Whitney Mus.), and celebrated the Manhattan skyline in a series of paintings from 1940 to 1944. DER

Hess, H., *Lyonel Feininger* (1961).

FÉLIBIEN DES AVAUX, ANDRÉ (1619-95). French administrator, art historian, and critic. A period in Rome (1647-9) as secretary to the French ambassador introduced him not only to the works of art of the ancient and recent past, but also to living painters, most notably *Poussin, one of whose greatest champions he became. On his return to France Félibien was appointed to influential positions in the secretariat of both the Académie Royale d'Architecture and the Académie Royale de Peinture et de Sculpture (see under PARIS). He rapidly became the most active writer on art of his time, deeply committed to the project of establishing the pre-eminence of the French School. Among his works are the *Description sommaire du château de Versailles* (1674), extolling the wonders of Louis XIV's great palace, and *Conférences de l'Académie Royale de Peinture et de Sculpture* (1668), a collection of lectures given at the Académie as part of the effort to give French art a theoretical underpinning. Félibien's most famous and lasting work, however, is the *Entretiens sur les vies et les ouvrages des plus excellens peintres anciens et modernes* (10 vols., 1666-88), a history of European art from Antiquity to his own times. This book is the foundation of both French art historical writing and French art criticism. The eighth *Entretien*, an appreciation of Poussin, is the definitive 17th-century statement of the supremacy of *classicism in the visual arts and thus a crucial contribution to French academicism.
MJ

Tessèydre, B., 'Félibien et Roger de Piles: historiens de la peinture française avant Poussin', *Information de l'histoire de l'art*, 6/3 (1961).

Thuillier, J., 'Pour André Félibien', *XVIIe siècle*, 158 (1983).

FEMINISM (1) *Feminist practice in art*; (2) *Feminist theory*; (3) *Feminist art history*

1. FEMINIST PRACTICE IN ART
Women have made art that deals with their status in society, and with the range of economic, social, and psychological forms of oppression this may entail: such art, having political aspects, may be called feminist. It has developed over the later 20th century from the early, and important, notion that 'the personal is political' towards a view which sees art as a means of exposing the myths of a patriarchal society, in particular the social construction of femininity.

The Women's Movement (initially called

Women's Liberation), which began in America in the late 1960s, encouraged women to protest against discrimination within the art world, particularly the ludicrously small percentage of women included in major museum shows. The most important single event, however, was the setting up in 1971 of the first Feminist Art Program by Judy Chicago (1939–) and Miriam Schapiro (1923–) at the California Institute of the Arts. Their exhibition *Womanhouse* involved the transformation of seventeen rooms of an old house 'to concretise the fantasies and oppressions of women's experience' (Lippard), and included a bridal staircase and a menstruation bathroom. It was important not only because the project was essentially collective but also because it challenged the stereotype that domesticity was inimical to art. Much of early feminist art practice was thus to do with celebrating femaleness as something positive and creative and by implication different from the careerist ambitions of mainstream male artists. The result was that separatism—a conscious decision to isolate themselves from male-dominated culture and only mount exhibitions for their own audiences—became a chosen policy for many feminists.

Performance has been an important area, partly because it is a relatively new and thus undefined area and, as Judy Chicago explained in an interview in 1970, 'performance can be fuelled by rage in a way that painting and sculpture can't' (Rosen and Brawer). In *Ablutions*, an influential piece performed in California in 1972 by Suzanne Lacey (1945–), Judy Chicago, and others, women bathed themselves in broken eggs, blood, and clay to a tape of first-hand accounts of rape. Much early material was autobiographical and involved investigations into hitherto neglected aspects of women's lives. As women's confidence increased, however, they began to move into a more public arena, for example in *Three Weeks in May*, which was staged in Los Angeles in 1977 by Suzanne Lacey to protest against violence towards women, and which received widespread media coverage.

The single most important work of art was Mary Kelly's (1941–) *Post Partum Document* (1976–80), in which she chronicled the first four and a half years of her son's life. In six sections totalling 165 parts, she documented not only the process of individuation by which her son took his place in the world as a gendered subject but also deconstructed the stages which marked the constitution of her identity as a mother. Drawing on the work of Jacques *Lacan and Michel *Foucault, she used found objects as well as fragments of texts to show that motherhood is a social and psychological process as opposed to a simple biological category. At the same time she was bringing together the historically separated roles of mother and artist, and uniting the public and the private, the domestic and the professional.

After a falling off of activity in the 1980s, there has been a resurgence of activist art in the 1990s, especially in America. Probably the most notable of a host of new organizations are the 'Guerrilla Girls'. As well as their public events, in which members remain anonymous because of their gorilla head masks, they have also flyposted a large number of strikingly designed posters in cities both in America and Europe. These posters draw attention to issues of discrimination against women in all kinds of areas, underlying the fact that there are numerous battles still to be fought. FC

Chadwick, W., *Women, Art and Society* (1990).
Lippard, L. R., *From the Centre: Feminist Essays on Women's Art* (1976).
Rosen, R., and Brawer, C. (eds.), *Making their Mark: Women Artists Move into the Mainstream 1970–85* (1989).

2. FEMINIST THEORY

One of the most influential figures for feminist theory in the later 20th century was Julia Kristeva (1941–), working as both a literary and cultural theorist and a practising psychoanalyst. Much of her work was concerned with the development of the theory of the subject as a subject in process. Because of the complex constitution of the subject, she rejected the simple category of woman, as entailing an essentialism that denied potentialities for change.

On the other hand the work of Luce Irigaray (1932–) has been seen as a celebration of femininity. She was trained as a linguist and an analyst under Jacques *Lacan and her early work explored the language of those suffering from dementia. Her later work was concerned with investigating the possibilities of female experience deemed to be outside conventional modes of expression and with finding a voice for women which was as yet non-existent in phallocentric culture. As she said in an interview in 1977, 'in the face of language, constructed and maintained by men only, I raise the question of the specificity of a feminine language: of a language which would be adequate for the body, sex and imagination (imaginary) of the woman' (Tickner). This notion of an *écriture féminine*, a form of writing marked by the pulsions of a female sexual body, has also been explored by Hélène Cixous (1937–), who believes that 'by writing her self, woman will return to that body which has been more than confiscated from her' (quoted in Morag Shiach, *Hélène Cixous: A Politics of Writing*, 1991).

The writings of the French feminists have been especially important to the American artist Nancy Spero (1926–), who has stated that in her work she is attempting *la peinture féminine*. In her scrolls, fragments of words are combined with fragments of images, so that the idea of a single reading or truth is scorned. Other ideas from their writings can be seen as being reflected in the work of the American artist Kiki Smith (1954–) For example her *Mother*, with the streams of (paper) liquid issuing from her breasts, provides a visual correlative to a poetic notion of Cixous, of women writing their bodies 'with white ink' (their mother's milk).

One of the chief aims of feminism has been to expose the systems of power which prohibit representations challenging the status quo. For this reason feminism has been welcomed by some theoreticians of the *postmodern; yet many feminists have been wary of this response, fearing that in this new spirit of pluralism they will in effect be marginalized as one among many alternative voices. In the 1980s the *photographs of herself by Cindy Sherman (1954–) contested the power of representation, in that they worked to expose the ways in which contemporary culture created images of women for public consumption. In a similar way the early texts of Jenny Holzer (1950–) were truly postmodern in that it was impossible to recognize a single 'voice' speaking, although it is notable that they became more personal as her power increased. And Barbara Kruger (1945–) made use of her training in advertising to make works which combined found images and texts in such a way that the relationship between the two was problematic and up to the viewer to deconstruct.

In the 1990s black women artists were especially prominent. Sonia Boyce (1962–), Lubaina Humid (1954–), and Sutapa Biswas (1962–) all made work which sought to reappropriate their cultural heritage in a variety of ways. Also important has been the reopening of debates about pornography, with women claiming the right to renegotiate the territory on their own terms. In general there was a greater freedom of expression, with the result that an artist such as Sarah Lucas (1962–), who did not operate within a theoretical framework, could make outrageous but amusing works, which parodied conventional notions of sexuality.
 FC

Foster, H. (ed.), *Postmodern Culture* (1983).
Tickner, L., and Bird, J., in *Nancy Spero*, exhib. cat. 1987 (London, Inst. of Contemporary Arts).
Wright, E. (ed.), *Feminism and Psychoanalysis: A Critical Dictionary* (1992).

3. FEMINIST ART HISTORY

Feminist art historians, initially concerned with tracing the roles of women in art, moved between the 1970s and the 1990s to exploring more generally issues of gender—that is to say the different behaviour regarded as proper to the masculine and the feminine—as these relate to the making and interpretation of art and architecture. Feminist critiques have entailed revision of the tradition stemming from the *Lives* of Giorgio

*Vasari, in which the history of painting, sculpture, and architecture from the 14th century onwards is presented in terms of Great Masters, who are grouped in regional schools and stylistic periods, and who are celebrated for solving a succession of artistic problems and thereby attracting hosts of followers.

Feminist art historians joined writers who called for a *new art history which would go beyond the study of influential careers to investigate the full circumstances in which paintings, sculptures, and buildings were produced, the various ways in which artists were trained and did business, the changing institutions and interests of patronage, the manner in which images and buildings were used and the ways they were interpreted by viewers, and the production of history writing and criticism themselves. The study of women who had practised as artists (even if they had been insufficiently influential to fit the 'Great Masters' model) could be regarded as unexceptionable within such an inclusive and broadly based redefinition of art history. Equally this was a model which invited research into such fields as the ways in which women had been represented, and the roles of women as viewers, critics, historians, and commissioners of art.

In addition, feminist art historians questioned definitions of art confined to the 'fine' or 'high' arts of painting, sculpture, and architecture, which were part of Vasari's legacy. Since the foundation of the earliest academies in the 16th century these art forms had been institutionally separated from other branches of the visual arts thenceforth designated as 'minor' arts, 'decorative' arts, or crafts—such as weaving, bookbinding, goldsmithing, woodcarving, embroidery, and pottery. These narrow definitions were seen as demoting art forms such as textile design which women had been able to practise and whose histories needed to be included in a fuller account of human making.

The new art history invited a wide variety of academic disciplines to contribute to the investigation of the social history of art. These new directions in turn changed the scope of the investigation itself. Feminist art historians began by considering the socio-economic facts which had barred women from making or buying art as men did (the law, educational and professional opportunity, the family). They also traced the beliefs concerning the nature of women which supposedly justified unequal treatment. To understand the tenacity and pervasiveness of such beliefs, feminist scholars drew from such fields as anthropology, the philosophy of language, and theories of psychoanalysis. These lines of investigation entailed an examination of concepts of gender difference at every stage in the making and reception of art, from the notion of genius as masculine

and of artistic development stemming from the innovations of Great Masters to the critical polarities used to evaluate a work of art.

Rather than regarding the term 'woman' as a biological given, researchers treated it as a linguistic label which represented the dominant views of proper 'feminine' behaviour at any time and which served the crucial role of defining and sustaining by contrast the notion of the 'masculine'. Gender differences were seen as maintained by dualist patterns of social behaviour, so that for example the feminine could be termed private and dependent in scope while the masculine was considered public and independent. Accordingly male artists and historians had been deemed able to take objective views of society or humanity while women were capable only of a partial and relative viewpoint. According to feminist theory, this mode of categorizing was repeated in various bodies of knowledge and patterns of behaviour—that is discourses (see DISCOURSE ANALYSIS)—such as those of medicine, ethics, theology. Notions of gender difference could be seen as constantly in question. For instance, the existence of inventive females threatened to collapse the divide. According to feminist theorists, such a threat to the concept of gender difference and the supposed inferiority of the feminine is continually rebuffed by masculine control over linguistic structures and the institutions which validate what counts as knowledge. Thus the inventive female is represented as 'the exception'. While the role of language has been identified as primary in creating and recreating concepts of gender difference, theorists have also studied the powerful part played by images, artefacts, and buildings, and the people who are allowed to make them, in questioning or reinforcing notions of gender difference.

On the basis of feminist investigations, concepts of gender difference may therefore be seen as having an importance equal to, and intersecting with, key concepts such as those of class, religion, and beliefs about race, when it comes to analysing the workings and effects of the institutions which have produced and evaluated art. CEK

Peterson, T. G., and Matthew, P., 'The Feminist Critique of Art and Art History', *Art Bulletin*, 69 (1987).
Pollock, G., 'The Politics of Theory: Generations and Geographies in Feminist Theory and the Histories of Art Histories', in G. Pollock (ed.), *Generations and Geographies in the Visual Arts: Feminist Readings* (1996).
Rees, A., and Borzello, F. (eds.), *The New Art History* (1986).

FÉNÉON, FÉLIX (1861–1944). French art critic and journalist, inventor of the term *Neo-Impressionism. In the 1880s he successfully combined a War Ministry job with radical art criticism; his analytical article *Les Impressionistes en 1886* served as an apologia

for *Seurat's scientific overhaul of *Impressionism via Divisionist theory (see NEO-IMPRESSIONISM). He was tried for anarchist involvement in 1894. Subsequently, working as editor and art dealer representing Bernheim-Jeune, Fénéon maintained less controversial links with contemporary artists. BT

Halperin, J. U., *Félix Fénéon, Aesthete and Anarchist in Fin-de-Siècle Paris* (1988).

FERGUSSON, JOHN DUNCAN (1874–1961). Scottish painter and sculptor. Born in Leith, Fergusson abandoned his medical studies in order to become a painter. He trained briefly at the Académie Colarossi, Paris, in 1898, but had no other formal training. His early work shows echoes of *Manet and *Whistler but during a prolonged stay in France (1905–14) he was profoundly and permanently influenced by *Fauvism, adopting a bright palette for his paintings like *In the Sunlight* (1907; Aberdeen, AG). He was also influenced by the Ballets Russes, which came to Paris in 1909, a time when the female nude dominated his work; the dynamic and sensuous rhythms of dance may be seen in *Les Eus* (1911; Glasgow, AG). Returning to London in 1914, Fergusson worked as a *war artist producing a series of paintings of Portsmouth docks. After the war he divided his time between London, Scotland, and France and in addition to his paintings experimented with carved and cast sculpture. In the late 1920s Fergusson was loosely associated with his friends F. C. B. Cadell (1883–1937), Leslie Hunter (1879–1931), and S. J. Peploe (1871–1935) in an informal group, the Scottish Colourists, united in their use of vibrant colour, and in 1940 he was president of the New Scottish Group of painters, an offshoot of the New Art Club. The University of Stirling holds an important group of his works. JH

Morris, M., *The Art of J. D. Fergusson* (1974).

FERNANDES, VASCO (c.1475–1541). The leading north Portuguese painter of his time. He was known as O Grão Vasco, Vasco the Great, and is documented from 1501 at Viseu. Attributed to him are panels in the retable of the Cathedral of Viseu now in the city museum (which is named after him); whereas his panels for the high altarpiece of Lamego Cathedral (1506–9; Lamego Mus.) are documented. Some of his designs were inspired by German and Italian engravings. He is perhaps best known for a monumental *S. Peter Enthroned* (c.1535; Viseu Mus.). JBB

FERNÁNDEZ, ALEJO (c.1475–1543). Spanish painter whose father was probably from northern Europe; the artist took his mother's surname. Fernández's earliest

works include *The Last Supper* (c.1505; Saragossa, El Pilar). Although the classical architectural setting and the use of linear perspective suggest that Fernández was familiar with Italian painting, it is more likely that his inspiration was the work of Flemish painters who had already incorporated Italianate elements into their own style. Fernández moved from Cordoba to Seville in 1508 to work for the cathedral chapter; he remained there until his death, active as the foremost painter of the city. When Charles V married Isabella of Portugal in Seville in 1527, Fernández had charge of the decoration of the city, including the construction of huge triumphal arches in the classical manner. Assisted by a large workshop, he painted gilded statuary, and worked as a miniaturist. Perhaps his most original work is the *Virgin of the Navigators* (c.1530–40; Seville, Alcázar), a rare early reflection of Spain's conquest of the Americas and the important role of Seville in the trade with the Indies. SS-P

Angulo Iñiguez, D., *Alejo Fernández* (1946).

FERNÁNDEZ (or Hernández), GREGORIO (c.1576–1636). Spanish sculptor, active in Valladolid from c.1605. Fernández carved groups of figures that were carried in processions by religious confraternities (as in Valladolid, Mus. Nacional de Escultura Religiosa) as well as a number of versions of devotional images such as Christ at the Column and the dead Christ lying on a bier (as in Madrid, El Paular). His sculptures, more naturalistic in form and less ornately polychromed than those by his *Mannerist predecessors Alonso *Berruguete and Juan de *Juni, were painted and gilded and placed in architectural frameworks by members of his workshop. Fernández's realistic figures set the standard for Castilian sculpture during his lifetime and after. SS-P

Martín González, J. J., *El escultor Gregorio Fernández* (1980).

FERRARI, GAUDENZIO (1475/80–1546). Italian painter and sculptor, born at Valduggia in Piedmont, who worked in Lombardy, eastern Piedmont, and Milan. His early work was strongly influenced by *Leonardo and *Bramantino, and also by *Perugino's work at the Certosa di Pavia. But in a fresco cycle of *Christ's Passion* (1513; Varallo, S. Maria delle Grazie) he developed a more highly charged style, indebted to north European late *Gothic art. From 1517 he worked as painter, sculptor, and perhaps architect at the *Sacro Monte of Varallo, where he created violent scenes, powerful in gesture and expression. In the chapel of the Crucifix painted terracotta statues of extreme realism enact a passionate drama before a painted background, and the effect is force-

fully illusionistic. A more sophisticated form of illusionism is found in his *Assumption* for the dome of S. Maria dei Miracoli, Saronno (1534–6), where tiers of music-making angels encircle the ascending Virgin. From 1539 Gaudenzio worked in Milan where, as in the *Martyrdom of S. Catherine* (Milan, Brera), his art became more rhetorical, and he experimented with elaborately contrasting poses of heavily muscled figures. HL

Viale, V., *Gaudenzio Ferrari* (1969).

FERRATA, ERCOLE (1610–86). Italian sculptor. After training in Genoa and a period in Naples he arrived in Rome in 1646, where he worked as a trusted assistant to both *Bernini and *Algardi. From the mid-1650s Ferrata was involved in most major Roman sculptural projects and established a flourishing workshop. In it were trained many of the most prominent sculptors of the late *Baroque period, including *Caffa, *Foggini, and *Rusconi. Ferrata's best-known mature work is the flamboyantly Baroque statue of *S. Agnes on the Pyre* (begun 1660), part of his scheme for the decoration of S. Agnese in Agone. His later work is more temperate in style, depending more on the example of Algardi than Bernini. MJ

Montagu, J., *Alessandro Algardi* (1985).
Montagu, J., *Roman Baroque Sculpture: The Industry of Art* (1989).
Wittkower, R., *Gian Lorenzo Bernini* (rev. edn., 1961).

FERRUCCI FAMILY. Sculptors and stonecutters from Fiesole, near Florence, who were active throughout the 15th and 16th centuries. **Francesco di Simone** (1437–1493) was active in Florence, Bologna, and Prato, and though a technically proficient sculptor, his style was eclectic and formulaic. Probably trained in the family workshop, he may have worked with *Verrocchio in the 1470s. His most important independent commission was the monument for Alessandro Tartagni (c.1477–80; Bologna, S. Domenico), while his tabernacles for S. Maria di Monteluce near Perugia (1483), and for Ostiglia, near Mantua (1486), illustrate his familiarity with *Desiderio da Settignano's works. Drawings for altars and tabernacles (London, V&A and elsewhere) were probably prototypes for use in his workshop. **Andrea** (1465–1526), a relative of Francesco di Simone, was active as a carver of altars for the Cathedral of Pistoia (1497–9) and for Fiesole (1488–92/3). His altarpiece for S. Girolamo (1490s; London, V&A) is his principal achievement, incorporating all the decorative and figural characteristics of the Ferrucci workshop style. **Francesco di Giovanni (del Tadda)** (1497–1585) was the most significant member of the family in the later 16th century, principally for his development of the lost art of *porphyry cutting.

As court sculptor to Cosimo I de' Medici he carved porphyry portrait reliefs, the porphyry basin for Verrocchio's *Putto with a Fish* (1555; Florence, Palazzo Vecchio), and between 1570 and 1581 he carved the colossal figure of *Justice* surmounting an Antique granite column on the Piazza S. Trinita in Florence, to mixed critical reception. AB

Pope-Hennessy, J., *Catalogue of the Italian Sculpture in the Victoria and Albert Museum* (3 vols., 1964).

FÊTE CHAMPÊTRE (fête galante), a genre of painting which shows elegant figures meeting in the romantic setting of parkland or woodland, their dreams of love often heightened by music. The theme may be rooted in the Gardens of Love of courtly medieval art, and in the early 16th-century Venetian pastoral of the *Concert champêtre* (Paris, Louvre). It was immensely popular in French painting in the early years of the 18th century, as part of a reaction against the severe grandeur of 17th-century French *classicism, in favour of the warmer, more open, and sensuous appeal of Venetian and Flemish art. The most famous painter of *fêtes champêtres* was *Watteau, who was received into the Académie in 1717 for his *Pilgrimage on the Island of Cythera* (Paris, Louvre) described as 'un tableau qui représentait une fête galante'. The restraint and unexpressed melancholy of Watteau's pictures is lacking from the listless, and more coyly erotic, works of *Lancret and *Pater, and the genre died a quiet death in the early 1740s. *Boucher's pastorals and *Fragonard's landscape and figure sketches are only very loosely linked to the original conception. HL

FETTI, DOMENICO (1588/9–1623). Italian painter, born in Rome, where he was taught by his father and studied with Andrea Commodi (1560–1638). He appears to have been influenced by *Elsheimer and *Saraceni and the *Bamboccianti painters. Cardinal Ferdinand Gonzaga provided patronage and on his accession as 6th Duke of Mantua invited Fetti to come to Mantua in 1614. Here he painted numerous religious works, both at the Palazzo Ducale and elsewhere, in a Venetian manner strongly influenced by *Tintoretto and *Veronese, whose work he had obviously studied closely. His *Miracle of Loaves and Fishes* (Mantua, Palazzo Ducale) is a particularly impressive example of his capacity to handle a complex design on an enormous scale without loss of lively brushwork. It was during this period that he painted the more intimate cycle of Parables (1618–21) on which his reputation now largely depends (eight at Dresden, Gemäldegal.) and of which many secondary versions were circulated. They show the biblical scenes, often with engaging humour, as genre, frequently set against

lively landscape backgrounds in the Venetian manner. Further evidence of his imaginative skill as a landscape painter is provided by the *Flight from Sodom* (Sandon Hall, Staffs.). Fetti was also much in demand as a portrait painter, working in the warm direct manner of Tintoretto and Leandro *Bassano: among these are the *Portrait of the Actor Francesco Andreini* (St Petersburg, Hermitage); the *Portrait of Vincenzo Avogadro*, rector of the Mantuan church of S. Gervasio and S. Protasio, which was bought by Consul Smith (London, Royal Coll.); and the *Portrait of a Musician* (Los Angeles, Getty Mus.). In 1622 Fetti was obliged to make an abrupt departure from Mantua after a violent quarrel at a football match and settled in Venice under the patronage of Giorgio Contarini dagli Scrigni; he died there the following year. HB

Safarik, E., *Fetti* (1990).

FEUCHTMAYER, JOSEPH ANTON (1696–1770). A member of an extensive dynasty of artists and craftsmen, he was among the most original sculptors of the *Rococo period in southern Germany. While his decorative stuccowork is an extravagant extension of French Régence models, his figure sculptures, with their elaborate contrapposto and wildly flowing draperies, are an eccentric but expressive amalgam of Italian late *Baroque and Swabian late *Gothic influences. He worked for much of his life at the monastery of Salem, but his best surviving work can be seen in the interior of the pilgrimage church of Neubirnau, near Konstanz (1748–50). MJ

Boeck, W., *Der Bildhauer, Altarbauer und Stukkator Joseph Anton Feuchtmayer* (1981).
Bushart, B., *Der Genius Joseph Anton Feuchtmayers* (1980).

FEUERBACH, ANSELM (1829–80). German painter. Born in Speyer, the son of an archaeology professor, he grew up in a serious, scholarly atmosphere which influenced his work. After a thorough academic training in Düsseldorf and Antwerp, under Baron Wappers, he studied in *Couture's studio in Paris (1852–3), which freed his style from received academic mannerisms. Spurning both the purely decorative and the wholly naturalistic, Feuerbach wished to found a noble, didactic, and moral school of painting, taking his subjects from Greek Antiquity (see ANTIQUE) and his style from the Italian High *Renaissance, particularly *Raphael. Pursuing his aims he moved to Rome in 1855 and remained in Italy apart from an unsuccessful period as professor of history painting at the Viennese Academy (1873–6). *Plato's Feast* (1869; Karlsruhe, Kunsthalle) is typical of his grand moralistic paintings, a conflict between libido and intellect, which despite its noble intentions remains essentially lifeless. His

portraits of his mistress Nanna Risi, whom he also painted as *Iphigenia* (1862; Darmstadt, Hessisches Landesmus.), are now considered to be his finest work. A vainglorious man, he died in Venice having failed to receive the recognition he believed his due. DER

FIAMMINGO, DIONISIO. See CALVAERT, DENYS.

FIBONACCI SERIES, a system of expanding relationships connected with the *Golden Section. Leonardo of Pisa, called Fibonacci (1175–1230), discovered that if a ladder of whole numbers is constructed so that each number on the right is the sum of the pair on the preceding rung, the arithmetical ratio between the two numbers on the same rung rapidly approaches the Golden Section. Thus, for practical purposes, the Golden Section may be approximated by such mathematical ratios as 5 : 8, or 13 : 21. However, arithmetic teaches us that beginning with any two numbers whatsoever, we are led by successive summations towards pairs of numbers whose ratios to one another converge to the Golden Section. For example, instead of 1, 2, 3, 5, 8, 13 start with 2, 7, 9, 16, 25, 41. HO

FICINO, MARSIGLIO (1433–99). Florentine philosopher, commentator, and translator. Ficino produced the first Latin edition of *Plato's complete works. Although he never displayed any special interest in art, his commentary on Plato's *Symposium*, published in both Latin and the vernacular, noticeably influenced European conceptions of aesthetics and artistic creation.

Ficino's ideas on the Egyptian sources of Platonic and Mosaic philosophy prompted interest in hieroglyphics and symbolic images from the *Renaissance onwards. His conception of beauty as an incorporeal reflection of God, perceived only by sight and hearing, laid the foundation for 16th-century doctrines of Platonic love. In turn, this influenced the view, common in the contemporary artistic literature, that the works of the best artists express a grace which cannot be measured.

Ficino's commentaries and translations also revived the belief that poets wrote under the impulse of divine inspiration. This view was sporadically applied to artists in the 16th century. Although later discussions described it as a physiological rather than divine phenomenon, *furor divinus* played an important role in the genesis of the modern idea of genius. FQ

Chastel, A., *Marsile Ficin et l'art* (1975).

FILARETE, properly Antonio di Pietro Averlino (c.1400–c.1469). Florentine sculptor and architect reported by *Vasari to

have studied under *Ghiberti although there is little indication of this in his work. His bronze doors commissioned by Pope Eugenius IV for the old S. Peter's in Rome (1433–45) show a muddled knowlege of contemporary Florentine relief sculpture but they are remarkable in their juxtaposition of classical and early Christian elements. Forced to leave Rome in 1448 he worked in northern Italy before taking up a position as an architect in Milan. His main building project was an uncompleted hospital but while there he wrote his treatise *Il trattato di architettura* (1460–4). This devotes 21 books to architecture and three to painting and drawing in the form of a dialogue between the theorist and his princely patron, Francesco Sforza. It includes a vision of a new city, Sforzinda, to be planned and decorated in the new *Renaissance style which is the first symmetrical town planning scheme in modern times. Slightly eccentric in its combination of practicality and fantasy, the treatise was widely read in the 15th and 16th centuries. PSt

Spencer, J. R., *Filarete, Treatise on Architecture* (1965).

FILDES, SIR LUKE (1843–1927). English illustrator and painter. Born in Liverpool, Fildes studied at South Kensington before entering the RA Schools (see under LONDON) in 1866. In the same year he began drawing for wood engravings, including the illustrations for Dickens's *Edwin Drood* in 1870. In 1874 he achieved overnight fame when *Applicants for Admission to a Casual Ward* (Egham, Royal Holloway College) was exhibited at the RA. This exercise in sentimental reportage, which had previously appeared as a wood engraving in the *Graphic*, briefly established Fildes as the leading *social realist painter in England. In the same year he first visited Venice, which resulted in over a decade of Venetian genre generally featuring attractive young women. These were immensely popular but by 1889, when he painted *An Al-fresco Toilette* (Port Sunlight, Lady Lever Gal.), critics were finding them over-pretty. The resourceful painter responded by painting *The Doctor* (1891; London, Tate) which had enormous appeal, particularly to the medical profession, who recognized his grave, responsible, but caring physician as excellent propaganda for their trade. For the remainder of his lucrative career Fildes specialized in society and state portraits. DER

Fildes, L. V., *Luke Fildes* (1968).

FILIPPO NAPOLETANO (Filippo Liagno, or d'Angeli) (c.1587×91–1629). Italian painter of landscapes, battle scenes, marines, and still lifes, important in the development of naturalistic *landscape in the early 17th century. The son of a painter, born in Rome or Naples, he spent his youth in Naples. In Rome from c.1614, he was in Florence

at the Medici court 1617–21, and then again in Rome. He was influenced by the landscape style of *Elsheimer and *Tassi, and in Florence responded to *Poelenburch, *Breenbergh, and *Callot. Early sources tell us that he painted landscape from nature, and was one of the first to paint the falls at Tivoli. A group of small landscapes in Florence, among them *Country Dance* (1618; Florence, Uffizi) and the *Mill* (Florence, Pitti), convey the charm of country life; they capture effects of bright sunlight, and their detailed naturalism is close to that of north European landscape artists. Filippo, like his patron Cardinal del Monte, was fascinated by natural history and owned a museum of 'curiosities'; he dedicated a series of prints of *Skeletons of Animals* (1620–1) to the papal doctor, Johannes Faber. HL

Chiavini, M., *Artisti alla corte granducale*, exhib. cat. 1969 (Florence, Pitti).

FILLA, EMIL (1882–1953). Sculptor and painter born in Chropyne, Czechoslovakia. He studied at the Prague Academy 1903–6 and his early work was *Expressionist in manner. He was a member of the Czech group The Eight (Osma), whose aim was to give a new direction to Czechoslovak art. In 1911, under the influence of *Picasso and *Braque, he remodelled his style according to *Cubist principles and became one of the most important exponents of Cubism in Czechoslovakia. From 1911 to 1914 he was active in the Manes group. He spent the First World War in the Netherlands. During the 1930s he produced large paintings based on folk legends and illustrating the struggles of oppressed masses. In 1936, Filla wrote a book about art, *Kunst und Wirklichkeit: Erwägungen eines Malers*. In the Second World War he was imprisoned in the concentration camp at Buchenwald. After the war he taught at the School of Industrial Art in Prague and painted a series of enormous landscapes.
OPa

Matajcek, A., *Emil Filla* (1938).

FINELLI, GIULIANO (1601/2–53). Italian *Baroque sculptor, a virtuoso marble carver, and a key figure in the development of Neapolitan Baroque sculpture. Born in Carrara, he trained in Naples, but in 1622 came to Rome where he worked with Pietro and later Gianlorenzo *Bernini. He created such spectacular effects as the windswept hair of Bernini's *Apollo and Daphne* (Rome, Borghese Gal.). His tomb of Cardinal Giulio Antonio Sartorio (1633–4; Rome, S. John Lateran) develops the idea, created by Bernini, of showing the deceased turned in everlasting adoration towards the altar. But Bernini failed to advance him, and in 1638 he settled in Naples. Here he produced a series of thirteen bronze statues of saints (1637–48) for the

chapel of the Tesoro in the cathedral; he was active as a tomb and portrait sculptor, creating, as in his *Carlo Andrea Caracciolo, Marchese di Torrecuso* (1643; Naples, S. Giovanni a Carbonara) highly realistic and slightly stolid images. In 1650 he returned to Rome. HL

Causa, R., and Spinosa, N. (eds.), *Civiltà del seicento a Napoli*, exhib. cat. 1985 (Naples, Capodimonte).

FINI, LÉONOR (1908–96). Argentinian/Italian painter. Fini was born in Buenos Aires but raised in Trieste. She had little formal education but travelled widely in Europe where her somewhat dramatic taste led to an interest in Italian *Mannerism, German *Romanticism, *Pre-Raphaelitism, and the *Decadents. Largely self-taught but precocious, she was painting commissioned portraits in her late teens. In 1936 she moved to Paris where she associated with the *Surrealists although, finding André *Breton overbearing, she was never an official member of the group. She experimented with *automatist drawings and dreamlike fantasy paintings which owe something to *Dalí, like her most ambitious work, *The End of the World* (1944; priv. coll.), in which a disturbingly fashionable young beauty floats, bust high, in a fetid sea surrounded by the skulls of fantastic creatures. The chic-ness of much of Fini's work largely negates any emotional power and even her most extreme fantasies seem highly controlled. Not surprisingly she was a successful illustrator for fashionable magazines and designed a bottle, in the shape of a naked female torso, for a Schiaparelli perfume. DER

Léonor Fini, exhib. cat. 1983 (Ferrara, Gal. d'Arte Moderna).

FINIGUERRA, MASO (1426–64). Florentine goldsmith, niellist, and designer of intarsia panels, who was much admired by *Vasari and *Cellini. He excelled in the articulate grouping of large numbers of small figures, as in the *niello pax of the *Coronation of the Virgin* (Florence, Bargello), which, like all his work, is close in style to Filippo *Lippi. His name is often linked with that of the younger artist *Pollaiuolo, as both collaborator and rival. Paper impressions were taken from his nielli, but he never seems to have made *line engravings. Nonetheless he exerted enormous influence on early Florentine and Ferrarese engraving, and Vasari considered him to be the founding father of Italian printmaking. A large number of drawings survive but their attribution has been much debated.
RGo

FINLAY, IAN HAMILTON (1925–). Scottish artist-poet, born in Nassau, Bahamas, of Scottish parents. He studied briefly at Glasgow School of Art, but originally attracted attention as a poet. In 1963 he began

making Concrete poetry, in which the physical appearance of the poem—its shape and typography—is regarded as part of its meaning. From this he developed the idea of using artists and craftspeople—stonecarvers, potters, calligraphers, even specialists in neon lighting—to translate his poems into other media. In 1967, with his wife Sue, he moved to Stonypath, a remote farmhouse in the Pentland Hills of 'Strathclyde, the Infernal Region' (Finlay's words), and they created a garden in which many of his poem objects are displayed: 'it is a garden full of surprises and contrasts, and manages to entertain as well as to stimulate thought. Visual puns and other jokes abound: for instance, a headstone next to a birch tree has the slogan "Bring back the birch"; a real clump of grass resembling an Albrecht *Dürer watercolour has Dürer's monogram placed next to it; a tortoise carries the words "Panzer Division" engraved in gothic lettering on its shell; and birds land on a bird tray in the form of an aircraft carrier.' (Michael Jacobs and Paul Stirton, *The Mitchell Beazley Traveller's Guides to Art: Britain & Ireland*, 1984). The garden has attracted considerable publicity, not only because of its artistic interest, but also because of Finlay's long-term fight against Strathclyde Council, which has attempted to tax a garden 'temple' as a commercial art gallery.
IC

FINNISH ART. See SCANDINAVIAN ART.

FIXATIVES are used to protect drawings in certain fragile media such as *charcoal, when they have been applied to a surface. However, fixatives can also affect both these media and the paper by changing the colour or causing darkening. They may also alter the vivacity of the draughtsmanship by flattening or softening the marks. Fixatives used during the 16th century and later were made of adhesive binders from such natural sources as dilute white of egg, dilute skimmed milk, fig juice, and rice water, as well as various gums. Fixatives today are largely produced from synthetic resins in solvents and are usually applied in the form of a spray. In the past it was more usual to spread the fixative quickly over the drawing with a thick brush. PHJG

FLANDRIN, HIPPOLYTE (1809–64). French painter. One of three painter sons of an amateur portraitist in Lyons, the others being Auguste (1801–42) and Paul (1811–1902), he was taught *lithography by his elder brother and sold his prints, of mainly military subjects, as a teenager. Both he and Paul received their early training in Lyons at the École des Beaux-Arts (1826–9) before walking to Paris where they entered *Ingres's studio. In 1832 Hippolyte won the *Prix de Rome

with the *Neoclassical *Theseus Recognized by his Father* (Paris, École des Beaux-Arts). In Rome 1833–8 he developed an interest in religious subjects and carried out his first commission, *S. Clare Healing the Blind* (1836–7; Nantes Cathedral). On his return to Paris he painted murals of the *Life of S. John* for S. Severin, a sober Neoclassical work completed in 1841, and henceforward had more work than he could undertake. In the following year he began his greatest mural scheme for S. Germain-des-Prés, dramatic and *Raphaelesque biblical scenes completed by Paul after Hippolyte's death. He was appointed professor at the École des Beaux-Arts in 1857 and in 1863 returned to Rome. DER

Hippolyte, Auguste et Paul Flandrin: une fraternité picturale au XIXe siècle, exhib. cat. 1984 (Paris, Luxembourg).

FLAXMAN, JOHN (1755–1826). British *Neoclassical sculptor, designer, and illustrator, the son of a plaster-cast maker, who joined the RA Schools (see under LONDON) when he was 15. From 1775 to 1787 he produced designs of singular purity and elegance, several based on Greek vase paintings (see, GREEK ART, ANCIENT), for example, the *Apotheosis of Homer* (1778), for the pottery manufacturer Josiah Wedgwood. Meanwhile, he gradually built up a practice as a sculptor. To this end, he lived from 1787 to 1794 in Rome, studying both the *Antique and Italian medieval art, which greatly attracted him. While there, he was commissioned by the eccentric 4th Earl of Bristol and Bishop of Derry (the 'Earl-Bishop') to sculpt an over-life-size marble group of the *Fury of Athamas* (begun 1790; Ickworth, Suffolk). More fruitfully, he also received commissions from visiting English patrons for series of drawings illustrating Dante's *Divine Comedy*, Homer's *Iliad* and *Odyssey*, and the *Works of Aeschylus*. His purpose in these was to achieve an effect of primitive directness and simplicity, qualities which were enhanced (though also in a sense coarsened) in the engravings made after them by Tommaso Piroli, who turned Flaxman's already linear drawings into pure outline. Published from 1793 onwards, these engraved series became well known and influential throughout Europe.

From his return to England in 1794 until his death, Flaxman was overwhelmed with sculptural commissions. He was elected ARA in 1797 and RA in 1800. In 1810, he became the first professor of sculpture at the RA and gave a number of lectures combining the history of the art with practical advice. Apart from one other large 'poetic' group, *S. Michael Overcoming Satan* (1819–26; Petworth House, West Sussex), the majority of his works were now tomb sculptures (see FUNERARY MONUMENT), such as the imposing free-standing monuments to Lord Mansfield (1795–1801; Westminster Abbey) and Lord Nelson (1809;

S. Paul's Cathedral). However, his most characteristic work appears in simpler and smaller sculptures executed in relief which, though seldom Christian in imagery, are strongly Christian in sentiment. In these, Flaxman's great gift for linear design is given full play: see, for example, his beautiful monument to Agnes Cromwell (1798–1800; Chichester Cathedral). The same qualities are apparent in the plaster models he left in his studio, the bulk of which are now in University College, London. MK

Irwin, D., *John Flaxman, 1755–1826: Sculptor, Illustrator, Designer* (1979).

FLEGEL, GEORG (1566–1638). German still-life painter born in Olmütz (Olomouc), Moravia, who moved first to Vienna, later to Frankfurt. In Vienna he became the assistant of Lucas van *Valckenborch I, with whom he went to Frankfurt. He collaborated with Valckenborch on his pictures of the *Seasons* (e.g. *Meat and Fish Market (Winter)*, Montreal, Mus. of Fine Arts) and his portraits, painting in fruit, table utensils, and flowers as still-life set pieces. Between c.1600 and 1627/30 Flegel produced 110 watercolours depicting flowers, fruit, and animals, and one *Self-Portrait* (Berlin, Kupferstichkabinett; 31 destr. 1943–4). From 1611 he painted pictures of tables set for meals (e.g. *Meal with Bunch of Flowers*, 1630; Stuttgart, Staatsgal.). His still lifes are depicted with precise accuracy, sometimes displaying an artistic use of lighting effects, but generally lacking the ornamentation of contemporary Dutch and Flemish presentations. KLB

Antonawa, I., et al. (eds.), *Das Stilleben und sein Gegenstand*, exhib. cat. 1983 (Dresden, Albertinum).

FLEMISH ART, painting, graphic art, and sculpture produced in an area similar in size to that of modern Belgium and Luxembourg, formerly known as the Southern Netherlands. Flemish art assumed a major role in the history of European art during the 15th, 16th, and 17th centuries. The largest county in the Southern Netherlands was Flanders and the term Flanders may be used to refer to the whole of the Southern Netherlands, just as Holland has often given its name to the whole of the Northern Netherlands.

Flemish art should describe art produced only in the county of Flanders, but the term is used to describe work carried out over a wider region, including neighbouring Brabant, Hainaut, Picardy, and Artois, the last two now part of France. Although small, in the Middle Ages these areas lay between the powerful kingdoms of England, France, and the Holy Roman Empire and were densely populated and economically prosperous, because of their advantageous geographical location close to the sea. Through an excellent

system of waterways linking them to the sea and a close trading relationship with England, the Flemish cities of Bruges and Ghent became economically prosperous centres of the wool trade in the 15th century. Wool produced from English sheep was woven by Flemish weavers and then sold at fairs and exported to other European cities.

Little survives of Flemish art before the 14th century. The earliest examples are fragmentary and of unknown origin. In Tournai Cathedral there are wall paintings which survive from the early 13th century and in the Onze Lieve Vrouwkerk (church of Our Lady), Bruges, there are a number of painted tombs dating from the 13th and 14th centuries. They depict the Madonna and Child, saints, and angels painted in a strong, black outline style, with the details of drapery and facial features shaded in yellow and red earth colours. There are further wall paintings in Bijloke Abbey, Ghent, dating from about 1350, which show a strong French Gothic influence in the elegant drapery patterns and naturalistic details.

Towards the end of the 14th century the names of Flemish artists are increasingly documented working at the courts of France and Burgundy. One of the earliest was Jan *Baudolf, also known as Jean de Bruges, active from about 1368 to 1381. In 1368 he became court painter to Charles V and designed the *Angers Apocalyse* tapestry series (c.1375; Angers, Tapestry Mus.). Such artistic ties became even stronger as a result of the marriage between Philip the Bold, first Duke of Burgundy, and Margaret, the daughter and heiress of Louis de Mâle, Count of Flanders, since, in 1384, Philip inherited the county of Flanders from his father-in-law. Philip the Bold became a notable patron of Flemish artists, commissioning them particularly for the decoration of his monastic foundation of the Charterhouse of Champmol, near Dijon, one of the foremost projects of the late Middle Ages. Except for some fragments of sculpture and a few carved and painted altarpieces, nothing remains of this magnificent enterprise. The main sculptor was Claus *Sluter, whose surviving works such as the *Well of Moses* (*in situ*) or the tomb of Philip the Bold (Dijon, Mus. des Beaux-Arts) show a new dynamic realism in the powerful figures with their weighty draperies. Another artist involved in the decoration of the Charterhouse of Champmol was Melchior *Broederlam. Only two large painted wings of a carved triptych (Dijon, Mus. des Beaux-Arts) survive, of which the central carved and gilded panels are by Jacques de *Baerze, who was a Flemish woodcarver from Termonde, near Ghent. The wings by Broederlam are examples of what has now become known as the *International Gothic style, in which typical Flemish attention to naturalistic detail is combined with Italian architectural forms

reminiscent of Sienese painting and the weighty figure forms of Florentine painters such as *Giotto. Flemish artists became known at this time as manuscript illuminators. John, Duke of Berry, younger brother of Philip the Bold, was an enthusiastic book collector and attracted Flemish artists to his court. *Jacquemart de Hesdin became his court painter in 1402 and, in 1409, was replaced by the three brothers *Limburg, who produced for the Duke the illuminations of the Très Riches Heures (Chantilly, Mus. Condé). The calendar pages, in particular, show an extraordinary understanding of landscape with cast shadows, reflections, and a feeling for atmosphere and weather conditions.

During the 15th century Flemish artists of outstanding ability proliferated. One of the first artists to develop both large- and small-scale religious altarpieces and the new subject of portraiture was Robert *Campin, active in Tournai at the beginning of the century, who probably taught Rogier van der *Weyden. Many art historians accept him as being synonymous with the unknown *Master of Flémalle. Examples of his work are the Merode altarpiece (c.1425; New York, Met. Mus. Cloisters) and a pair of portraits of A Man and A Woman (London, NG). The powerful physicality of his figures, probably influenced by the sculpture of Sluter, demonstrate a new concern for realism. The figures, set within typical Flemish 15th-century interiors, are often dressed in contemporary clothes.

The Ghent altarpiece (1432; Ghent Cathedral), one of the most ambitious and complex altarpieces of northern European art, was created by Campin's contemporaries, the brothers Hubert and Jan van *Eyck. An inscription on the triptych, now thought to be original, describes Jodocus Vijd as the patron and Hubert as the brother who began the altarpiece, which was then finished by Jan. The influence of Sluter and Campin can clearly be seen on the closed front panels in the solid figures and sculptural draperies, but the glowing colours, the intensely realized depiction of jewels, and the golden light of the landscape of the inner panels represent a supremely novel contribution. After three years' service with the Count of Holland, Jan van Eyck was appointed court painter to Philip the Good, Duke of Burgundy, in 1425 and undertook a number of diplomatic missions for him, travelling to Portugal, probably via England, to bring back the Infanta Isabella as Philip's bride. Jan also worked for other leading patrons attached to the Burgundian court, including Nicolas Rolin, for whom he painted the Virgin and Child (Paris, Louvre). In the subtle definition of the textures of fabrics and jewels, together with the suggestive atmospheric space in the vast but detailed panoramic background, the altarpiece reveals Jan van Eyck's mastery of the new technique of oil

painting. Jan's successors such as Petrus *Christus and Dieric *Bouts were influenced by his technical skill and powers of invention. Such developments not only brought Jan van Eyck international renown, as shown in the writings of Italian authors such as Bonifacio Fazio and *Vasari, but also raised a general awareness of Flemish artists among Italian artists and patrons during the last half of the 15th century.

By the mid-15th century van Eyck's position in Bruges was filled by Petrus Christus and other cities, such as Louvain where the Bouts family were the main painters, became important artistic centres. Another leading artist was Rogier van der Weyden. It is generally accepted that he was Campin's pupil and in 1435 was appointed official painter to the city of Brussels. The dramatic power of Rogier's work, as in the Deposition (Madrid, Prado), was achieved through his use of strong line and the portrayal of expressive emotions on the faces of his large, serious figures. Rogier shows a considerable restraint in his use of colour and his landscape background details are kept to a minimum, as in the Last Judgement (Beaune, Hôtel-Dieu).

Petrus Christus and Dieric Bouts were influenced by both Jan van Eyck and Rogier van der Weyden. Petrus Christus may have been responsible for completing a number of unfinished works by Jan van Eyck. His S. Eligius and Two Lovers (1446; New York, Met. Mus.) shows a debt to van Eyck in the gleaming details of the goldsmith's shop and the convex mirror, which reflects the viewer's space outside the painting, as in van Eyck's earlier Arnolfini Portrait (1434; London, NG). On the other hand, another of Christus' works, a Deposition (Brussels, Mus. Royaux) is, in its sculptural and linear form, reminiscent of van Weyden's work. In his portrait painting, Christus avoids the dark background of earlier pioneer portrait painters such as Campin, van Eyck, and van der Weyden and introduces window settings and finely detailed interiors, as in the portrait of Edward Grymstone (1446; London, NG).

Dieric Bouts, of Dutch origin from Haarlem, became the leading painter in the important university city of Louvain (Leuven). The wide diversity of patronage enjoyed by Flemish artists is exemplified by a number of his more important commissions such as the altarpiece of The Holy Sacrament (Louvain, S. Pierre) commissioned by the confraternity of the Holy Sacrament and the Justice of the Emperor Otto panels (Brussels, Mus. Royaux) painted for the courts of justice in Louvain Town Hall. Most Flemish painting which has survived is on wooden panel, but many altarpieces were painted on linen and have not survived in such numbers. Bouts's Entombment (London, NG) is a fine and rare example of this delicate medium.

The remainder of the 15th century is dominated by Hans *Memling and Gerard *David in Bruges, and Hugo van der *Goes in Ghent. Memling's peaceful, balanced altarpieces, such as the triptych (London, NG) commissioned by the English court official Sir John Donne, proved very influential and were sought after by both public and private patrons. An Italian merchant, Angelo Tani, commissioned a Last Judgement (Gdánsk, National Mus.). Intended for Italy, the altarpiece was part of booty taken by pirates. Another Italian patron, the Medici agent Tommaso Portinari, commissioned the Adoration of the Shepherds (Florence, Uffizi) by Hugo van der Goes. Soon after it was painted it was sent to Italy and contributed in the late 15th century towards the increasing impact of Flemish art on Italian Renaissance painters, such as Domenico *Ghirlandaio and *Piero della Francesca.

In the 16th century *Antwerp, on the river Scheldt, became the major port, superseding Bruges and Ghent whose canals had begun to silt up and were no longer capable of accommodating the larger ships needed for trade with the New World. It became a city of outstanding economic importance, as well as a centre of cartography, printing, and art. Antwerp's printing presses spread the new ideas of humanist scholars such as Erasmus, and printmaking became an influential art form of mass communication. At the same time a greater variety of subject matter such as landscape, genre, and still life appeared in painting and Flemish artists became more aware of ideas from Renaissance Italy. The work of Quentin *Massys in Antwerp at the beginning of the 16th century epitomizes these characteristics. His large triptychs such as his S. Anne altarpiece (Brussels, Mus. Royaux) for the confraternity of the archers' guild of Louvain, with its monumental figures and classicizing architecture, may reveal Massys's knowledge of the work of Italian artists such as *Leonardo da Vinci. Massys contributed to the development of *genre painting, for example in the Moneylender and his Wife (Paris, Louvre). This development made an important impact on his contemporaries such Joos van *Cleve, Jan Sanders van *Hemessen, and *Marinus van Reymerswaele. The Tax Gatherers (London, NG) by van Reymerswaele is typical of a continuing demand throughout the 16th century for such work.

Jan *Gossaert was credited by the Netherlandish writer Karel van *Mander in his influential Het schilderboeck, published in 1604, as the first painter to introduce from Italy to the Netherlands the painting of nude figures and mythological subjects. In 1508–9, whilst *Michelangelo and *Raphael were working for Pope Julius II in the Vatican, Gossaert visited Rome and Florence, where he made drawings of Antique sculpture. On returning

to the Netherlands his compositions of Italianate nude figures, with somewhat exaggerated musculature, such as *Venus and Cupid* (1521; Brussels, Mus. Royaux), reveal the impact of his visit. Prints made after his work influenced his successors such as his pupil Jan van *Scorel and Lambert *Lombard, who taught the 'Italian manner' to the next generation of artists. Amongst these were Willem *Key, Hendrik *Goltzius, Maerten van *Heemskerck, and Frans *Floris. Floris visited Rome in 1541 and his *Fall of the Rebel Angels* (1554; Antwerp, Koninklijk Mus. voor Schone Kunsten) is indebted to Michelangelo's *Last Judgement* (Vatican, Sistine chapel) which Floris saw there.

By the 16th century Brussels had become an important centre of tapestry production and, in 1516, Raphael's cartoons were sent there to the workshop of Pieter *Coecke van Aelst to be woven into tapestries. A number of Flemish artists saw them, among them Bernaert van *Orley, who was employed as court painter by Margaret of Austria, the Regent of the Netherlands, and her successor Mary of Hungary. However, after 1530, his main occupation seems to have been the designing of tapestries and stained-glass windows, such as the transept windows of S. Gudule, Brussels.

A highly individual, vigorous *Mannerist style developed in Flanders towards the end of the 16th century. This may be seen in the work of Hendrick de Clerck and Bartholomäus *Spranger. Spranger was one of a number of Flemish artists, including the painters Jan *Brueghel and Roelandt *Savery and the goldsmith and draughtsman Paulus van *Vianen, who were invited to the Emperor Rudolf II's court in *Prague.

Flemish *portraiture was dominated during the 16th century by the *Pourbus family. Frans Pourbus the younger was one of the leading court portrait painters of Europe. He worked first at the court in Brussels and subsequently, 1600–9, he was employed by Duke Vincenzo Gonzaga I in *Mantua. In 1609 Marie de Médicis summoned him to Paris, where he became her court portrait painter up to the time of his death. A meticulous handling of jewellery and sumptuous fabrics, as in Pourbus' *Archduchess Éléonore* (1604; Vienna, Kunsthist. Mus.), are typical Flemish characteristics sought after by courtly sitters.

*Landscape painting emerged as an independent subject during the 16th century. Joachim *Patinir and his followers, such as Cornelis *Massys and Herri met de *Bles, are early exponents of pure landscape. Landscape backgrounds had always been an important ingredient of the work of earlier Flemish painters such as Jan van Eyck and Hugo van der Goes, but Patinir's work such as *Flight into Egypt* (Antwerp, Koninklijk Mus.

voor Schone Kunsten) shows a new relationship between the figures and the surrounding natural world. Patinir may have been influenced by the panoramic vistas painted by his contemporaries Quentin Massys and the Dutch painter Hieronymus *Bosch. Throughout the 16th century, painters were influenced by Patinir's *Weltlandschaften* (world landscapes). His compositions of vast imaginary vistas of rocky mountains, woods, and pastures with their bird's-eye viewpoint and three-tier colour system gave a new direction which influenced the rest of the century.

*Landscape and *genre were developed further as independent subjects in the work of Pieter Bruegel the elder and his two sons, Pieter Bruegel the younger and Jan the elder. Pieter Bruegel's place and date of birth are uncertain, but he joined the Antwerp guild in 1551/2, leaving for Italy soon after but returning again to Antwerp in 1555. His early work seems to have been as a printmaker, first for the Antwerp printer Hieronymus Cock. His compositions, such as the *Seven Deadly Sins*, were at first strongly influenced by Hieronymus *Bosch, whose work was enjoying a fashionable revival. The Alpine landscape through which Bruegel passed on his travels remained a constant inspiration and contributed to a remarkable and influential series of landscape prints inspired by his pen and ink drawings such as *Alpine Landscape* (Paris, Louvre). His concern with space and atmosphere were to make a lasting impact on his contemporaries, both Flemish and Dutch, including his own son Jan Brueghel, Joost de *Momper, and even *Rubens. Upon his marriage to the daughter of his teacher Pieter Coecke van Aelst and his subsequent move to Brussels, Bruegel turned to painting for the remainder of his short career. Compositions of many small figures engaged in all manner of activities such as *Netherlandish Proverbs* (Berlin, Gemäldegal.) give way to fewer larger figures painted in simple blocks of colour in which red and green predominate, such as *Village Wedding* or *Village Holiday* (both Vienna, Kunsthist. Mus.). Among Bruegel's patrons were some of the leading scholars and humanists, for example the cartographer Ortelius, or the wealthy connoisseur Nicolaas Jonghelinck, whose taste for landscape Bruegel satisfied with the series of the *Seasons* (1566; New York, Met. Mus.; Vienna, Kunsthist. Mus.; Nelahozeves, Lobkowicz Coll.). Genre and *still life were also developed by Bruegel's contemporaries, the Dutch-born Pieter *Aertsen and Joachim *Bueckelaer, whose workshop in Antwerp produced influential large-scale compositions sometimes of pure still life such as Aertsen's *Butcher's Shop* (1551; Uppsala, University Art Coll.), or more usually combined with monumental genre figures such as Bueckelaer's *Market Woman with Fruit and Vegetables*

(1554; Kassel, Staatliche Kunstsammlungen). Through prints these compositions influenced Spanish painters such as *Velázquez or the Italian painters Vincenzo *Campi, *Passarotti, and Annibale *Carracci.

During the last quarter of the 16th century there is a decline in Flemish art brought on by the political unrest between the northern and southern parts of the Netherlands. Much religious art was destroyed in the ensuing iconoclasm and many Flemish artists left the Southern Netherlands for Rome, central Europe, or the Dutch Republic to find a more conducive environment for their work. Landscape painters such as Gillis van *Coninxloo, who arrived in Amsterdam in 1595, or the *Bril brothers who went to Rome, carried with them new ideas of landscape painting, whilst Ambrosius *Bosschaert introduced Flemish ideas of still life to the Dutch Republic. By 1609 and the much needed respite provided by the Twelve Year Truce, Flemish art once again enjoyed a revival and the first half of the 17th century is dominated by the careers of three artists, Pieter Paul Rubens, Anthony van *Dyck, and Jacob *Jordaens. Religious art in particular was much in demand under the influence of the Counter-Reformation. It was injected with a new vigour by renewed influences from Italy through the work of Rubens who, after eight years in Italy, returned to Antwerp in 1608 with an already established reputation. Two of his early works, *The Raising of the Cross*, painted for S. Walburga, but now in the Cathedral, and *The Deposition* (Antwerp Cathedral), were important public commissions and established his position as the leading exponent of the *Baroque in Europe. Although he remained in Antwerp as court painter to the Spanish rulers of the Southern Netherlands, Rubens's visits on their behalf as diplomat to foreign courts enhanced his reputation as an artist and gained him commissions from the foremost patrons of his day. For the English King Charles I (see LONDON), Rubens provided canvases for the newly completed Banqueting House (London, Whitehall) and for the French Queen Marie de Médicis (see PARIS), an extensive series celebrating her career (Paris, Louvre). Many Flemish painters were involved in Rubens's workshop, either as specialists in landscape or still life, such as Lucas van *Uden and Jan *Brueghel, or as assistants such as the young van Dyck, who carried out the major part of the 39 ceiling paintings and altarpiece for the Jesuit Church, Antwerp (destr.; existing only in oil sketches by Rubens in various collections). Rubens's artistic abilities were also outstanding in the fields of portraiture and landscape. His early portraits for the Genoese nobility, such as *Brigida Spinola Doria* (Washington, NG), established a type of full-length portrait, to be followed so

successfully by van Dyck in his many portraits in *Genoa and in London. Rubens's enthusiasm for the traditional Flemish subject of landscape was reawakened by the purchase of a country house, immortalized in *Landscape with Château de Steen* (London, NG).

Although van Dyck was influenced by Rubens he stands out in his own right, particularly in the field of portraiture. His early portraits, such as *Elena Grimaldi* (Washington, NG) combined elegance and grandeur with livelier and sensitive feeling for character. His portraits, such as the *Children of Charles I* (London, Royal Coll.), not only contributed to his success at the English court, but also provided a permanent image of the Stuarts which survives until today. They contributed to the future of portrait painting in Britain and had a lasting influence on British painters such as *Gainsborough and *Reynolds in the following century.

Jacob Jordaens painted religious and mythological works as well as portraits. Much admired are his exuberant genre scenes, for example *As the Old Sing, so the Young Twitter* (1638; Antwerp, Koninklijk Mus. voor Schone Kunsten) which often illustrate Flemish proverbs.

Adriaen *Brouwer was a technically brilliant painter who introduced new small-scale low-life subjects such as *A Boor Asleep* (London, Wallace Coll.). These were to be of influence on contemporary Dutch 17th-century genre painters, such as Adriaen van *Ostade.

The range and variety of still life during the 17th century was considerably enlarged by painters such as Clara *Peeters, Frans *Snyders, and Jan Davidsz. de *Heem.

As far as the 18th, 19th, and 20th centuries are concerned few later Flemish artists seem to have reached the stature of their predecessors. *Romanticism in the 19th century is exemplified by the history paintings of Gustave Wappers and by the macabre subject matter of Antoine *Wiertz, whose studio remains untouched in Brussels. *Impressionist influences from France can be seen in the work of Alfred *Stevens and Henri *Evenepoel. Flemish artists whose work has had a lasting international importance are James *Ensor, René *Magritte, and Paul *Delvaux. Ensor's colourful but sinister scenes, such as *Christ's Entry into Brussels* (1888; Los Angeles, Getty Mus.), anticipate *Expressionism and René Magritte and Paul Delvaux are the leading Flemish exponents of *Surrealism in the 20th century. CFW

FLEMISH ART AS OBJECTS OF PATRONAGE AND COLLECTING. From the second half of the 14th century Flemish art enjoyed a continuous tradition of patronage by the Burgundian and French courts. One of the greatest opportunities for such patronage came with the construction of the Carthusian monastery of Champmol, near Dijon, by Duke Philip the Bold, first Duke of *Burgundy. Jan *Malouel and Melchior *Broederlam both contributed painted altarpieces and Jacques de *Baerze carved two large retables (Dijon, Mus. des Beaux-Arts), one of which has two painted wings by Broederlam, his only surviving work. The French patron John, Duke of Berry employed not only the *Limburg brothers, who painted for him the *Très Riches Heures* (Chantilly, Mus. Condé), but also André *Beauneveu, who was both illuminator and sculptor.

During the 15th century under Philip the Good, third Duke of Burgundy, patronage of Flemish artists intensified. Philip's love of splendour and ceremonial led him to commission tapestries, jewels, and illuminated manuscripts, as well as to appoint Jan van *Eyck as his court painter in the trusted position of *valet de chambre*. Nothing survives which was painted by van Eyck for the Duke, but other works by him indicate that wealthy middle-class and ecclesiastic patrons followed the lead of the Burgundian Duke. Jan van der Paele, a canon of the cathedral of S. Donatian, Bruges, commissioned a *Virgin and Child* altarpiece from van Eyck (Bruges, Groeningemus.) and a merchant and town councillor of Ghent, Jodocus Vijd, commissioned the altarpiece of *The Mystic Lamb* (1432; Ghent Cathedral) from the van Eycks for his family chapel.

Along with others of Philip the Good's courtiers, the chancellor Nicolas Rolin commissioned not only Jan van Eyck, by whom he is depicted kneeling in front of the Virgin (*Rolin Madonna*; Paris, Louvre), but also other contemporary artists such as Rogier van der *Weyden, who provided the altarpiece of the *Last Judgement* for the Hôtel-Dieu at Beaune, which Rolin and his wife endowed.

In the later 15th century there were a growing number of wealthy merchant patrons from both inside and outside Flanders. Communal patronage by guilds, confraternities, or civic authorities was increasingly significant. For example, the guild of cross-bowmen of Louvain commissioned the *Deposition* by Rogier van der Weyden for S. Pierre, Louvain while the confraternity of the Holy Sacrament chose Dieric *Bouts to paint a *Last Supper* for the same church. The city authorities asked van der Weyden to paint *Justice* scenes (now destr.) for the Brussels Town Hall. Their example was followed when Dieric Bouts was commissioned to paint scenes of *The Justice of the Emperor Otto* for the new Louvain Town Hall. Gerard *David's *Justice of Cambyses* scenes (Bruges, Groeningemus.) for the town hall of Bruges survive. Amongst foreign patrons visiting or living in Flanders, the Italian Tommaso Portinari commissioned Hugo van der *Goes to paint the *Adoration of the Shepherds* (Florence, Uffizi) and Angelo de Jacopo Tani, the Medici agent in Bruges, commissioned Hans *Memling to paint the *Last Judgement* (Gdánsk, National Mus.). When Sir John Donne visited Bruges in the 1470s on behalf of the English King Edward IV he ordered a private devotional triptych (London, NG).

*Diptychs were popular commissions of private patrons of all kinds and a speciality of Flemish artists. Martin van Nicuwenhove commissioned one from Memling (Bruges, Memlingmus.) and the interesting double portrait of the humanists Erasmus and Pieter Gillis by Quentin *Massys was painted for their English friend Thomas More in 1514.

Flemish artists became renowned in the 16th century for the development of the new subjects of *landscape, *genre, and *still life. Such paintings were collected by a growing number of local connoisseurs such as Nicolaas Jonghelinck, for whom Pieter *Bruegel painted the *Seasons* (New York, Met. Mus.; Vienna, Kunsthist. Mus.; Nelahozeves, Lobkowicz Coll.). Pieter *Aertsen and Joachim *Bueckelaer produced large-scale genre and still-life compositions which were collected by the Farnese family in Italy and, through prints, their compositions reached Spain. Small delicate landscapes and flower pieces by many late 16th-century Flemish painters were widely collected for cabinets and the work of Jan *Brueghel was greatly prized for example by Cardinal Federico Borromeo (now Milan, Ambrosiana).

During the late 16th century political unrest in the Netherlands resulted in the emigration of Flemish painters. The brothers Matthijs and Paul *Bril went to Rome and were employed on fresco cycles (Vatican, Torre dei Venti). Others, such as Pieter Stevens and the *Valckenborch family of painters, fled to the Protestant refuge of Frankenthal where they were protected by the Elector Palatine. Gillis van *Coninxloo and Ambrosius *Bosschaert were amongst Flemish artists who emigrated to the Dutch Republic and introduced new subjects of landscape and still life to an expanding middle-class market.

The major patrons of the 16th and 17th centuries were the Habsburgs, who ruled the Netherlands from 1477 when the Emperor Maximilian I married Mary, the heiress of Charles the Bold of Burgundy. Bernaert van *Orley and Jan Cornelisz. *Vermeyen became painters at the court of Margaret of Austria at Malines and through her Charles V and Philip II commissioned Flemish portrait painters like Anthonis *Mor and tapestry designers such as the Pannemaker family. During the governorship of Archduke Ernest, himself an enthusiastic patron, the painters Joris *Hoefnagel and Roelandt *Savery and the sculptor Adriaen de *Vries were among those invited to the court of Ernest's brother, the Emperor Rudolf at *Prague.

The patronage and collecting of Flemish

art received renewed impetus after the Counter-Reformation. On his return from Italy in 1608 *Rubens became court painter to the Spanish archdukes. A host of other patrons collected Rubens's works, including Charles I of England, Philip IV of Spain, and the wealthy Nicolas Rockox. Commissions from Anthony van *Dyck and Jacob *Jordaens were also enthusiastically sought. Van Dyck became court painter to Charles I and spent his later years in England, while Jordaens worked in the Dutch Republic on decorations for the Huis ten Bosch near The Hague and the town hall in Amsterdam.

During the 18th century, although the Austrian Habsburg regents continued to commission works, much of the vigour and innovation of Flemish art had dwindled. Political upheavals towards the end of the century contributed further to the decline.

From the 19th century onwards, with the emergence of an independent Belgian state, patronage was taken over by state institutions and the wealthy middle classes. Octave Maus was an important patron who promoted avant-garde artists and furthered the careers of the Symbolists, James *Ensor, and Fernand *Khnopff, or the Neo-Impressionist Théo van *Rysselberghe.

Enthusiasm for the collecting of so-called Flemish primitives of the 15th century began to revive during the early part of the 19th century, although in England some 18th-century collectors, such as Horace Walpole, had already begun to collect Flemish artists as a reflection of their interest in the 'Gothick'. Edward Solly, an English timber merchant, living in Berlin during the Napoleonic Wars, amassed a fortune and a remarkable collection of paintings, including some outstanding Flemish works (see under BERLIN). Among the many collectors who visited the Musée Napoléon in Paris, which contained plundered Flemish paintings, were the brothers Sulpiz and Melchior Boisserée, who, on their return to Cologne, built up a collection of early Flemish and German pictures (now Munich, Alte Pin.) which excited the attention of *Goethe and other European connoisseurs. The German merchant Karl or Charles Aders, as he became on his arrival in London, inspired by his friends the Boisserée, also built up an outstanding collection which helped to raise the awareness of the British public to Flemish art.

CFW

FLINCK, GOVAERT (1615–60). Dutch painter. Born in Cleves, Flinck settled in Amsterdam in 1631–2 and worked there for the remainder of his life. He studied with *Rembrandt in the mid-1630s, and redeployed his style for the next decade, enjoying extensive patronage as a portraitist and painter of historical subjects. From the early 1640s, however, Flinck's work took a new turn as he became increasingly influenced by the elegant manner of Bartholomeus van der *Helst and van *Dyck. The artist worked for the Amsterdam burgomasters, John Maurice of Nassau, and the Elector of Brandenburg. In 1659, as a measure of the esteem in which he was held Flinck was commissioned to paint a cycle of twelve large history paintings for the new town hall in Amsterdam illustrating *The Revolt of the Batavians*. He was to be paid 1,000 guilders for each of them, and he provisionally plotted four in watercolours, but three months later he died and the project was divided between *Lievens, *Jordaens, and Rembrandt.

CB

von Moltke, J. W., *Govaert Flinck 1615–60* (1965).

FLORENCE: PATRONAGE AND COLLECTING. *See opposite.*

FLORENCE, BARGELLO (Museo Nazionale del Bargello), the most important museum of Renaissance sculpture in Italy. The massive Palazzo del Bargello was begun in 1255 and was the seat of the Podestà from 1261. In 1574 it became the headquarters of the Bargello (the chief of police) and subsequently parts of the interior were converted into prison cells. A programme to restore the building was begun in 1857 and two years later, after the collapse of the grand duchy of Tuscany, one of the first acts of the provisional government was to establish a new museum in it for post-Antique works of art other than painting.

The kernel of the new museum was the grand ducal collection of sculpture, much of which had previously been kept in the Uffizi. Many of these pieces, from the time of *Donatello onwards, had originally been executed for the Medici, and the collection remains strongly oriented towards the work of Tuscan artists and those, such as *Giambologna, who had worked under Medici court patronage. As it now stands, the collection includes major works by every significant sculptor working in Florence in the 15th and 16th centuries. One way in which the collection has been, and continues to be, expanded is by the removal into museums of sculptures previously outside public buildings; the Donatello *S. George* (1416), for example, was taken from Or San Michele into the Bargello in this way in 1891.

The museum's collection of *medals, which is probably the best in Italy, is based on the Medici collection, begun by Lorenzo il Magnifico. The important collection of minor arts (goldwork, ivories, majolica, etc.), benefited greatly from the bequest of the Carrand Collection in 1888.

AJL

FLORENCE, PALAZZO PITTI, the official residence of the grand dukes of Tuscany. It contains one of the most splendid of all collections of 16th- and 17th-century paintings. The old masters are exhibited in the Galleria Palatina. In addition, the Galleria d'Arte Moderna is an important gallery of more recent Italian painting.

Cosimo I moved his household from the Palazzo Vecchio to the Pitti Palace in 1550, and the palace was subsequently extended in various building campaigns. The collection of paintings in the palace was begun by Cosimo II around 1620. Particularly notable additions were the collections of Cardinal Leopoldo de' Medici (1617–75), who had a special interest in northern painting, and that of the passionate collector Grand Prince Ferdinando (1663–1713), who amassed 16th- and 17th-century masterpieces of many schools, including several altarpieces. The Lorraine-Habsburg dynasty of grand dukes gave particular attention to restoring the collection after the losses of the Napoleonic Wars. In 1828 Leopold II opened several rooms to the public as a picture gallery, though the palace continued to be used as a residence by the grand dukes, and subsequently by the kings of Italy, until it was presented to the state in 1919.

Although the Pitti Collection began as a private one while the Uffizi had a public image from the first, the history of the two collections overlaps, since both of them benefited from settlements such as the acquisition of the della Rovere Collection, and many paintings have been moved between the two collections. The atmosphere of the two galleries could not, however, be more different. Whereas the paintings in the Uffizi are hung at eye level in a consistent historical order, those in the Pitti cover the entire walls and are displayed in an essentially decorative way. The display is especially impressive in the state rooms on the first floor, which were decorated (1637–65) with stupendous stucchi and frescoes by Pietro da *Cortona and Ciro *Ferri. Originally, however, the walls of these rooms were covered with tapestries rather than paintings.

Although the gallery contains several magnificent paintings by *Rubens, a marvellous van *Dyck portrait, and an important group of works by Jan *Brueghel, *Bril, and *Poelenburch, the core of the collection consists of Italian painting of the 16th and 17th centuries, including famous groups of paintings by *Raphael and *Titian. *Andrea del Sarto is particularly well represented and, in accordance with the decision made when the Uffizi was reorganized in 1919, the Pitti holds the best of all collections of later Florentine artists such as *Cigoli, Carlo *Dolci, and Cristofano Allori. There is also an important group of paintings by Salvator *Rosa, who spent many years in Florence, and several Medici portraits by *Pourbus and *Suttermans.

The Galleria d'Arte Moderna was founded

continued on page 243

· FLORENCE: PATRONAGE AND COLLECTING ·

THE traditional patronage of Church and guild which dominated the Middle Ages was supplemented in the early *Renaissance by a new class of private patron, the beneficiaries of Florence's trading wealth following the acquisition of the ports of Pisa and Livorno. At the same time a new generation of individual artists grew up alongside the craftsmen of the old collective medieval system.

Among the first generation of private collectors and connoisseurs were Niccolò da Uzzano (d. 1433), who commissioned works from *Donatello and *Bicci di Lorenzo; Palla Strozzi (b. 1372), who commissioned *Gentile da Fabriano's *Epiphany* altarpiece (1423; Florence, Uffizi); Cosimo de' Medici, who came into his inheritance in 1429 but concentrated on books and antiquities as well as vast building projects; Giovanni Rucellai (1403–81), who owned works by *Castagno, *Uccello, *Domenico Veneziano, Antonio *Pollaiuolo, *Verrocchio, and *Desiderio da Settignano; and Giovanni Martelli (b. 1408), patron of Donatello.

Lorenzo il Magnifico (1449–92) headed the next generation. Patron of Verrocchio, *Perugino, and *Ghirlandaio and an eclectic collector of Flemish paintings, gems, and cameos, he set up in 1491, under Bertoldo's direction, a training centre for such young artists as *Lorenzo di Credi, *Granacci, Giuliano Bugiardini, and *Michelangelo. His kinsman Pier Francesco (d. 1503) owned *Botticelli's *Primavera* and *Pallas and the Centaur* (both Florence, Uffizi) and *Signorelli's *Pan* (destr.). The Medici circle included Francesco Sassetti and Giovanni Tornabuoni for whom Domenico Ghirlandaio painted fresco cycles in S. Trinita (1483–6) and S. Maria Novella (1485–90) respectively; and Tommaso Portinari, Florentine agent in Bruges, who commissioned in 1476 the altarpiece from Hugo van der *Goes (Florence, Uffizi) and through whom the Medici probably acquired several of their Flemish paintings.

Such patrician collecting was paralleled by the rise of a market system where the new upper middle-class customers could buy 'ready-made' works as part of their 'domiciliary culture'. The demand for Virgins, Crucifixions, and Baptists, for *cassoni and *deschi da parto, was sufficiently great for workshops to be able to produce them without a particular customer in mind. Such merchants as Bartolommeo Serragli specialized in supplying such needs and he is known to have employed Donatello, Filippo *Lippi, and Desiderio da Settignano as well as providing illuminated manuscripts and terracotta Madonnas; while the bookseller Vespasiano da Bisticci arranged for Iluminators such as *Attavante degli Attavanti to work for the Duke of *Urbino and for Matthias Corvinus of Hungary; the same artist was commissioned by another Florentine merchant, Chimenti di Cipriano di Sernighi, to illuminate an eight-volume Bible for Prince Manuel of Portugal (1494–7; Lisbon, Arquivos Nacionais).

*Vasari mentions the dealer Giovanni Battista della Palla who ordered or acquired objects for the French King including a fountain by Tribolo for the park at *Fontainebleau, and who was already buying from private owners as well as acquiring paintings from Ridolfo Ghirlandaio, *Andrea del Sarto, and Fra *Bartolommeo.

On the occasion of the marriage of Pierfrancesco Borgherini to Margherita Acciaioli in 1515, the bridegroom's father commissioned the decoration of the bridal chamber with paintings on the Old Testament theme of Joseph by *Pontormo (London, NG), Andrea del Sarto (Florence, Pitti), and Granacci (Florence, Uffizi and Palazzo Davanzati).

The Grand Duke Cosimo I (1519–74) became president of the newly instituted Accademia del Disegno in 1563; with a membership of about 70 painters, sculptors, and architects it was the first academy of art to be established in Europe. For him *Vasari painted the ceiling of the Sala dei Cinquecento (1560–5). The Grand Duke Francesco (1541–87) made large additions to the Uffizi (see under FLORENCE) and created the Tribuna. In 1570 he commissioned Vasari to supervise the decoration of the *studiolo* in the Palazzo Vecchio (1570–2) by *Bronzino, *Maso da San Friano, and *Santi di Tito with sculpture by *Giambologna and *Ammanati.

Later patronage in Florence included the decoration of the Camera degli Argenti in the Palazzo Pitti for the marriage of Ferdinand II and Vittoria della Rovere in 1637; the frescoes on the ceilings of the principal rooms on the *piano nobile* of the Palazzo Pitti by Pietro da *Cortona (started 1641, finished by Ciro Ferri by 1665); Luca *Giordano's decoration of the gallery of the Palazzo Riccardi (1682–5); the sculptural decoration of the chapel dedicated to S. Andrea Corsini in S. Maria del Carmine by *Foggini (after 1675); the cupola frescoed by Luca Giordano (1682); and Sebastiano *Ricci's frescoes for the Palazzo Marucelli (1706–7).

With the rising importance of Naples, Bologna, Rome, and Genoa as centres of the art trade in the 17th century Florence sank into comparative obscurity. A notable exception was the Neapolitan dealer/collector family del Rosso who settled in Florence and who owned several paintings by Carlo *Dolci (one of which, sold to the 5th Earl of Exeter, is still at Burghley House, Lincs.) as well as by Luca Giordano, Mattia *Preti, *Solimena, Ciro Ferri, and Giovanni Bilivert.

Such obscurity was about to change with the rise of the *Grand Tour. *Zoffany's painting of the *Tribuna* commissioned in 1772 (London, Royal Coll.) is evocative of the new breed of visitors desperately trying to absorb the scale of the treasures in the Uffizi. Zoffany was adviser to the 3rd Earl Cowper (1738–89), who lived in Florence from 1760, over the purchase of a notable collection including two *Raphael Madonnas (Washington, NG), Pontormo's Borgherini *Stories of Joseph* (London, NG), and a tondo by

Fra Bartolommeo (Los Angeles, Getty Mus.). Cowper also commissioned works from contemporary artists working in Florence such as *Mengs, *Zuccarelli, and *Hackert.

From 1740 Sir Horace Mann was British resident in Florence, dying there in 1786, and was the first contact for British visitors such as Frederick Hervey, the Earl-Bishop (1730–1803), who collected the works of *Cimabue, *Giotto, *Guido da Siena, Marco da Siena and all that old pedantry of painting which seemed to show the progress of art at its resurrection' and who acquired from the Riccardi family *Simone Martini's *Christ Discovered by his Parents in the Temple* (Liverpool, Walker AG); and the 2nd Earl of Ashburnham (1724–1812), who started the important collection which largely remained at Ashburnham Place until its break-up in 1953.

Expelled from Rome in 1755 Thomas *Patch settled in Florence and was befriended by Mann. He earned a living as dealer/middleman to Grand Tour visitors for whom he also painted topographical views and wickedly witty caricatures. From him we have a description of Ignazio Enrico Hugford (1703–78), an Anglo-Italian painter, copyist, forger, collector, and editor of the sixth edition of Vasari, 'well known for his judgement and practice in paintings as well as the large collection of Pictures which he is possessed of'. Among these were Filippino Lippi's *S. Augustine*, the Starnina *Thebaid*, and the *Memling *Madonna and Child* (all Florence, Uffizi). It seems probable that the collection of wax models bought by the South Kensington Museum (now London, V&A) from the Gherardini family in 1854 was formed by Hugford.

Other British collectors included the Revd John Sanford (1777–1855), living at the Casino Torrigiani 1832–7. Many of his pictures were sold in 1839 and 1899 but some 40 of them remain at Corsham Court, Wilts.; and John Udney, British consul at Livorno, whose collection was sold by his brother at Christie's in 1804, where the 207 lots are described as coming partly from the Gerini, Salviati, Pucci, and Chigi-Taddei collections.

French collectors included Alexis-François Artaud de Montor (1772–1849), who spent the years 1801–7 in Rome and Florence and who subsequently published his *Considérations sur l'état de la peinture dans trois siècles qui ont précédé Raphaël* (1808), where, in a footnote, he implies that his collection of some 100 14th–16th-century paintings had been acquired in part from Hugford; the painter François-Xavier Fabre (1766–1837), who left his collection to his native *Montpellier; E. Joly de Bammeville, buying in the 1840s, whose sale at Christie's in 1854 included Filippo Lippi's *Vision of S. Bernard* (London, NG) and *Duccio's *Crucifixion* (Manchester, AG); and the elusive 'M. Dubois' who bought the Botticelli Tondo (London, NG) and the Fra *Angelico/Fra Filippo Lippi Tondo (Washington, NG) at the Guiccardini sale in 1810. Jean-Baptiste Wicar (1754–1818) left a superb collection of drawings to Lille together with Donatello's *Feast of Herod*. He also owned Michelangelo's Tondo from Casa Mattei (London, RA) and it is tempting to think that both pieces were included in four crates of sculpture which he arranged to send from Livorno to Rome. From the Buonarroti heirs he acquired 100 Michelangelo drawings, subsequently bought from him by Sir Thomas *Lawrence in Rome.

A further group of Michelangelo drawings was bought from the Buonarroti heirs by the British Museum (see under LONDON) in 1859 on the advice of Sir Charles *Eastlake. Director of the National Gallery, London, 1855–65, Eastlake was a frequent visitor to Florence and made detailed notes on dealers and collections. The purchase by the gallery in 1865 of Pollaiuolo's *S. Sebastian* and the Raffaellino del Garbo tondo of the *Madonna and Saints*, both from the Palazzo Pucci, as well as the Filippino altarpiece from the Palazzo Rucellai, resulted from one of these visits. In 1853 he had visited the shop of Ludwig Metzger whose father Johann had acted for Crown Prince Ludwig of Bavaria (pictures now in *Munich, Alte Pin.) and bought for himself the *Annunciation* by Filippino *Lippi from the Palazzo Riccardi; the companion panel was sold to Alexander Barker (d. c.1874) and, at the same time, Barker bought Botticelli's *Venus and Mars* and *Piero della Francesca's *Nativity* (all London, NG); from the Palazzo Pucci he bought four panels of the story of *Nastagio degli Onesti* by Botticelli (Madrid, Prado; Florence, priv. coll.). It seems likely that Metzger acted for Wilhelm von Bode who joined the *Berlin Museum in 1872 and who acquired outstanding pictures for the museum from Florentine collections 1873–83.

The Hon. William Fox-Strangways, later 4th Earl of Ilchester (1795–1865), bought many pictures when secretary to the Legation in Florence 1825–8, bequeathing them to Oxford, Christ Church (1828/34), and the Ashmolean (1850). His kinsman the 4th Lord Holland (1802–59) was appointed British minister in Tuscany in 1840 and, with 'Count' Richard Cotterell (d. c.1870), was involved in the sale of the collection of the Duke of Lucca in London 1840–1. Encouraged by Holland, William Blundell Spence (1815–1900) took up art dealing in Florence. In 1853 he was asked to express his opinion to the trustees of the London National Gallery on the importance of the collection formed by the dealer Francesco Lombardi (for whom Metzger was an executor) and the restorer Ugo Baldi which was housed in Piazza Pitti. It was finally bought by the gallery in 1857 and included works by Botticelli, Uccello, and *Orcagna, all from Florentine collections.

By 1856 Spence claimed to have amassed 1,000 paintings and was attracting leading buyers such as Lord *Lindsay (1812–80) who lived for many years at the Villa Palmieri at Fiesole; Thomas *Gambier-Parry (1816–88), the bulk of whose collection was bequeathed to London University in 1966 (London, Courtauld Inst. Gal.); the Lords Lothian, Wimborne, Windsor, and Southesk; and J. C. Robinson (1824–1913), buying extensively for the South Kensington Museum (see under LONDON, VICTORIA AND ALBERT MUS.). He was less successful with William Boxall, director of the National Gallery, *London, 1866–74, whose inability to buy a series of masterpieces offered to him in Florence proved calamitous.

Robinson also bought at various dates sixteen pieces of

sculpture for South Kensington from the Florentine dealer Tito Gagliardi, another of whose clients was Anatoli Nikolaevich Demidoff (1812–70), who settled in Florence in 1836 and obtained the Tuscan title of Principe di S. Donato. He bought *Crivelli's Ascoli altarpiece (London, NG) at the Rinuccini sale in Florence in 1852, where another buyer was the Savoyard Baron Hector Garriod (1803–83), who lived in Florence from 1830 and was agent/adviser to the Grand Duke of Hesse-Darmstadt, to the house of Savoy, to the King of Holland, as well as to Demidoff, godfather of his daughter. He left a collection of 244 pictures to his native Chambéry. Garriod's advice was also appreciated by the American James Jackson Jarves (1818–88), who arrived in Florence in 1852 and whose collection of 'primitives' was ultimately acquired by Yale in 1871.

The departure of the Garriod and Jarves collections marked the last notable lootings of art from Florence. Attitudes were changing and already in 1865 a committee had been formed to promote the idea of a National Museum of Sculpture based at the Bargello, already set up as a Museum of Local History in 1859. The Lyonnais Louis-Hilaire Carrand (1821–99) gave his paintings and applied arts to the new museum in 1888. This was followed by the Russmann collection of arms and armour in 1899 and the Franchetti textiles in 1906. In the same year the Italo-Scottish ex-soldier Frederick Stibbert (b. 1838) left his astonishing collection of some 20,000 items and his vast villa to the city. It was only when the cataloguing of the collection was recently completed that its importance as a 'teaching instrument' was realized. In 1916 Herbert Horne (b. 1864) bequeathed the Palazzo Corsi and its contents as a museum and in 1928 Charles Loeser left his collection of old masters and sculpture to the Palazzo Vecchio. Among the dealers Elio Volpe left pictures and furnishings for the Palazzo Davanzati, Stefano Bardini left his house and a large collection to the Comune in 1922, and the Neapolitan Salvatore Romano left his collection of sculpture to the Cenacolo di S. Spirito in 1946. Bernard *Berenson's villa, library, and collection were bequeathed as a foundation in 1959, followed by a similar bequest by Roberto Longhi in 1970. Harold Acton's Villa La Pietra and its contents were left as a centre under the care of New York University in 1996. After protracted negotiations the collection formed by the dealer Alessandro Contini-Bonacossi have found a definitive home in the Uffizi.

WMO

Brigstocke, H., *William Buchanan and the 19th Century Art Trade* (1982).

Burke, P., *The Italian Renaissance* (1987).

Fleming, J., 'Art Dealing and the Risorgimento', *Burlington Magazine* (1973).

Hale, J. R., *Florence and the Medici* (1977).

Haskell, F., *Rediscoveries in Art* (1976).

Levey, M., *Florence: A Portrait* (1996).

Previtali, G., *La fortuna dei primitivi* (1964).

Wackernagel, M., *The World of the Florentine Renaissance Artist* (1981).

in 1860 and rearranged in basically its present form in 1918. It is, in effect, a gallery of 19th-century Italian art, including a large number of academic history paintings and, more notably, a fine collection of work by the *Macchiaioli group of mid-19th-century Tuscan realist artists. The attempt to build up a representative collection of 20th-century Italian art has had only limited success.

AJL

Gregori, M., *Paintings in the Uffizi and Pitti Galleries* (1994).

FLORENCE, UFFIZI (Galleria degli Uffizi), the most comprehensive and famous collection of Florentine *Renaissance painting in the world. The collection, housed in the administrative palace that *Vasari built for Grand Duke Cosimo I between the Palazzo Vecchio and the Arno, also includes many important works from other schools and some celebrated *Antique statues.

The first Medici treasures were dispersed during the banishments of the family and were only partially recovered under Cosimo I (ruled 1532–74). Francesco I (ruled 1574–87) decided in 1581 to move the main collections into the east gallery on the upper floor of the Uffizi Palace, and in 1584 he had the Tribuna constructed by Bernardo *Buontalenti in that gallery. This severely magnificent top-lit octagonal room was decorated according to a complex cosmological programme glorifying the Grand Duke's rule and using the arts as part of that glorification. In it was displayed the cream of the collection, including paintings by *Raphael, *Andrea del Sarto, and *Pontormo. In 1677 Cosimo III (ruled 1670–1723) began to transfer some of the Medici collection of Antique statues from Rome to Florence and a group of celebrated statues including the *Medici Venus was soon set up in the Tribuna. Several generations of connoisseurs regarded the *Venus*, in particular, as a supreme masterpiece, and the Tribuna became the most famous room in Europe. The Medici had been among the first rulers to allow public access to their collection, and throughout the 18th century the Uffizi was a compulsory stop on the *Grand Tour. It was, however, the Antique marbles rather than the paintings that made it so.

Meanwhile, the picture collection continued to grow by purchase, bequests, and marriage settlements. In 1631 Vittoria della Rovere, who was to marry Ferdinand II three years later, inherited much of the artistic patrimony of the dukes of *Urbino and about 60 splendid paintings, including several famous *Titians, were brought to Florence. Cosimo III extended the collection into the west wing of the Uffizi and added 17th-century Dutch paintings to the collection. In 1675 he inherited the collection of his uncle Cardinal Leopoldo, including the nucleus of the Uffizi's collections of drawings and of self-portraits. (The latter collection is now kept in the corridor, built for Cosimo I by Vasari, which runs from the Uffizi to the Pitti Palace.)

In 1737 the Medici were succeeded by the Lorraine-Habsburg dynasty of grand dukes, who were enlightened rulers who took their custodianship of the Florentine artistic patrimony very seriously. Under Pietro Leopoldo (ruled 1765–90) the state collection of paintings began to be systematized on didactic principles, with the advice of the art historian Abbot Luigi Lanzi. The Uffizi assumed a clearer role as the public exposition of the Grand Duke's treasures, and works were for the first time grouped according to schools and trends. Works were brought in from villas and other grand ducal property and Italian 'primitive' (i.e. pre-16th-century) paintings began to enter the collection, especially from suppressed religious foundations. A deliberate effort was also made to expand the collection of non-Florentine painting.

Napoleon respected the public nature of the Uffizi, taking only the *Medici Venus* to Paris and commissioning *Canova's *Venere italica*

(now in the Pitti) to replace it. Following their restoration in 1815 the grand dukes continued with the broad policy established in the 18th century, though without Pietro Leopoldo's energy and flair. A crucial change came after the unification of Italy in 1859, when much sculpture and other material was transferred to the Bargello (see under FLORENCE) and Archaeological museums and the Uffizi was left to concentrate on painting.

After the First World War the Uffizi became a national gallery and the other Florentine galleries were drawn on to support it in its role of presenting an art historical survey. The display was systematized in 1919 in broadly chronological order so as to project a Vasarian view of the development of painting from the time of *Cimabue to the 18th century. At this point the gallery assumed its modern form, with its unmatched initial sequence of rooms. These culminate in the extraordinary group of masterpieces by *Botticelli, mostly brought into the collection during the 19th century, and Hugo van der *Goes's Portinari Triptych, which had always been in Florence but which only entered the collection in 1919.

In 1999 the gallery was in the process of an expansion plan to exploit the space in the lower floors of the palace which had been occupied by the Archivio di Stato from 1852 to 1989.　　　　　　　　　　　AJL

Berti, L., *The Uffizi* (1971).

FLORIS (de Vriendt) FAMILY. Flemish artists active in Antwerp. The most important members were the brothers **Cornelis** (c.1513/14–75) and **Frans** (1519/20–70). They went to Italy c.1540 (Cornelis is documented in Rome in 1538) and returned to Antwerp with a desire to emulate the Italian *Renaissance manner.

Cornelis Floris was a sculptor and architect. In addition to church furnishings and tombs, he specialized in the design of ornamental motifs, which he popularized in a series of engravings, 1548–77. Paradoxically, his sculpted monuments do not display an abundance of decoration but distinguish themselves by their austere and classicizing forms. His shop concentrated on the working of black and red marble, with alabaster for the figures (*Tabernacle*, 1550–2; Zoutleeuw, S. Leonarduskerk). Cornelis's principal achievement in architecture is Antwerp Town Hall, 1560–4.

Frans Floris was one of the leading *'Romanists' in Antwerp and the most influential history painter of his generation. According to Karel van *Mander, he had over 100 pupils. An eclectic artist, Frans combined Netherlandish realism with Italianate forms and ideals. He painted religious and mythological themes as well as portraits (*Portrait of*

an Old Woman, 1558; Caen Mus.). Having studied with the Italianate painter Lambert *Lombard, 1538–40, he went to Rome c.1541, where he much admired *Michelangelo's *Last Judgement* (*Fall of the Rebel Angels*, 1554; Antwerp, Koninklijk Mus. voor Schone Kunsten). He was also influenced by *Giulio Romano and *Tintoretto, and by ancient sculpture.

　　　　　　　　　　　KLB

Huysmans, A., et al., *Cornelis Floris* (1996).
van de Velde, C., *Frans Floris* (1975).

FLÖTNER, PETER (1485×96–1546). German sculptor, medallist, cabinetmaker, and designer, active in Nuremberg. He may have been trained in the workshop of Hans *Daucher in Augsburg, and may have visited Italy before settling in Nuremberg in 1522, leaving for Italy once more before 1530. Flötner's work is astonishing for its variety: he designed epitaphs, organs, fountains, furniture, and decorative objects that are extraordinary for their adaptation of Italian *Renaissance forms. Perhaps his most important work is the design and model for the Apollo Fountain of 1532, cast by Pankraz Labenwolf, for the courtyard of the Herrenschisshaus in Nuremberg (now Stadtmus. Fembohaus). Apollo, based on an engraving by Jacopo de' *Barbari, is surrounded by putti riding sea creatures. He also carved the wall panelling, the doorways and the chimney piece in the Hirschvogelsaal in Nuremberg (1534; destr. 1945). Flötner's use of classical architectural orders and grotesque ornament, as well as such features as Georg *Pencz's *illusionistic ceiling paintings for the same room, testify to the extent to which Italian Renaissance innovations had been assimilated in Nuremberg.　　　KLB

Smith, J. Chipps, *German Sculpture of the Later Renaissance* (1994).

FLOWER PAINTING. *Pliny the elder wrote that Pausias, a follower of *Apelles, painted a garland to impress his sweetheart Glycera. Most flower painting in the ancient world, however, probably took the form of decorative mural schemes, and free-standing painting of flowers did not appear as a significant genre in its own right until the second half of the 16th century, when it emerged along with other genres such as landscape and still life. Until then flower painting had been embedded in the context of religious works and in the specialist context of herbals. *Bellori states that *Caravaggio was the first to make independent flower paintings, in the 1590s, but the movement must have been further advanced in the north. The Westphalian painter Ludger *tom Ring the younger probably made flower pieces that were free of extraneous associations in the 1560s and, in the Netherlands, Joris *Hoefnagel seems to have done them before 1589. By

1603, when Roelandt *Savery dated a flower piece in oils, the genre appears well established, and production of flower pieces rapidly gathered momentum, especially in the Netherlands.

Many kinds of flowers have well-recognized specific emblematic meanings; flowers also carry the general connotation of fragility and transience, and it was also customary to regard them as the loveliest of God's gifts. Cardinal Federico Borromeo doubtless thought of the flower paintings that he gathered in the Ambrosiana (see under MILAN) primarily as aids to contemplation of these themes, and he wrote touchingly about them in *Pro suis studiis* (1628). 'I have enjoyed having various vases in the room and varying them . . . according to my pleasure. Then when winter encumbers . . . everything with ice, I have enjoyed . . . artificial flowers . . . expressed in painting . . . and in those flowers I wanted to see a variety of colours, not fleeting, as in nature, but stable and enduring' (P. M. Jones, *Federico Borromeo and the Ambrosiana*, 1993).

Some 17th-century Dutch flower pieces include elements that make it manifest that they were intended to touch symbolic and emblematic resonances, but it is not at all clear that these spiritual themes were generally uppermost in the minds of painters or purchasers. Just as probably, most purchasers were simply seeking luxury objects that enabled them to enjoy, all the year round, the sensation of looking at cultivated flowers that were new arrivals in Europe and were themselves luxury items and enormously expensive. Indeed, in the 1630s a single bulb of a particularly prized variety of tulip cost far more than even a top-quality flower painting.

Cardinal Borromeo's flower pieces were done for him by the Flemish painter Jan *Brueghel whose work had much in common with the contemporary first wave of Dutch flower painters in the early 17th century. Their compositions were symmetrical and bathed in an even light; only perfect examples of cultivars in full bloom were included, and individual blooms were painted with scrupulous accuracy. The compositions were, however, constructs of the imagination; blooms were included regardless of their flowering season, and in any event nobody would have prejudiced such valuable property as a rare tulip bulb by using the plant simply as a cut flower.

The key figure whose style dominated the second half of the 17th century in the Netherlands was Jan Davidsz. de *Heem, who spent most of his working life in Catholic Antwerp and only returned to his native Utrecht in the years 1669–72. De Heem admitted common flowers and a good deal of foliage into his compositions, which were usually illuminated in a dramatic and unnatural way

against a sombre background. He had phenomenal powers of draughtsmanship and tonal control, and established the spatial relationship of the elements of his compositions with rigorous and magisterial precision.

During the same period more decorative styles of flower painting developed in France, Spain, and Italy (especially Rome and Naples). Their focus was not so much on virtuoso displays of illusionism as on creating an overwhelming Baroque impression of colour and abundance. The numerous flower pieces for *Versailles by Jean-Baptiste *Monnoyer and the painted mirrors by *Maratti and Mario Nuzzi ('Mario dei Fiori', 1603–73) in the Galleria Colonna, Rome, are good examples.

The Dutch tradition was brought to a close by Jan van *Huysum, who moved decisively away from the earlier dark backgrounds and concern to present an illusion of space. In his late style the backgrounds are light, the register of colour is greatly heightened, and the emphasis is on the decorative design of swirling *Rococo arabesques of flowers and foliage.

By the mid-17th century flower painting had become so specialized that the main practitioners did little or no other kinds of work. Although art theorists regarded it as the lowest of the genres, the leading flower painters were famous people and their work commanded extremely high prices. It was considered an especially suitable type of painting for women and several women are known to have been successful, including Rachel *Ruysch, who was the leading Dutch flower painter in the early 18th century, along with van Huysum. In England Mary *Moser was, at the age of 24, a founder member of the Royal Academy in 1768.

Since the early 19th century flower painting has reflected the wider preoccupations that painters have had, on the one hand, with realism and the management of colour and, on the other hand, with *Symbolism. The most famous 19th-century flower specialist, *Fantin-Latour, painted flowers from his garden with a painstaking realism that made his work very popular in Victorian England. The tradition of exact botanical illustration also remained vigorous throughout the period, with a supreme exponent such as Pierre-Joseph Redouté (1759–1840) operating at the interface between science and fine art.

Many of the *Impressionists—especially *Monet and *Renoir—made flower pieces in which the individual blooms are characteristically dissolved in colour, and *Manet's last paintings are simple flower pieces of vibrant spontaneity. However, in *Gauguin's and van *Gogh's flower pieces—and, later, in those of *Nolde—the emphasis is not on description, and the subjects are clearly intended to bear an importance beyond the merely rational.

Flowers had a special role in the Symbolist repertoire: the sense of colour having a magical property is exemplified in the late paintings and pastels of flowers by *Redon, who wrote of flowers as having their existence at the conjunction of image and memory. HO/AJL

Mitchell, P., *European Flower Painters* (1973).
Taylor, P., *Dutch Flower Painting 1600–1720* (1995).

FLUXUS, a loosely organized international group of avant-garde artists set up in Germany in 1962 and flourishing until the early 1970s. There was no common stylistic identity among the members; one of their manifestos stated that its aim was to 'purge the world of bourgeois sickness . . . of dead art . . . to promote a revolutionary flood and tide in art, to promote living art, anti-art'. Reviving the spirit of *Dada, Fluxus was fervently opposed to artistic tradition and to everything that savoured of professionalism in the arts. Its activities were mainly concerned with *happenings (usually called *Aktionen* in Germany), street art, and so on. Fluxus festivals were held in various European cities (including Amsterdam, Copenhagen, Düsseldorf, London, and Paris), and also in New York, which became the centre of the movement's activities. The most famous artist involved with Fluxus was Joseph *Beuys. Other participants included leading avant-garde artists from various countries, among them the Frenchman Robert Filliou (1926–87), the American Dick Higgins (1938–), the Japanese-born American Yoko Ono (1933–), and the German Wolf Vostell (1932–). The movement's chief co-ordinator and editor of its many publications was the Lithuanian-born American George Maciunas (1931–78), who coined its name—Latin for 'flowing', suggesting a state of continuous change. IC

FOCILLON, HENRI (1881–1943). French art historian. He held a succession of distinguished academic posts in Lyon and Paris, but spent his last years in the USA. The range of his studies was exceedingly wide: he wrote on *Piranesi, Katsushika Hokusai, *Rembrandt, classical inscriptions in Africa, and 19th-century French painting, besides medieval art, the subject of a major study. His underlying concern with the analysis of style development, rather than with iconography, was expressed theoretically in *La Vie des formes* (1934), which built on the thinking of Heinrich *Wölfflin and Alois *Riegl. JB

Focillon, H., *The Life of Forms* (rev. Eng. trans., 1989).
Focillon, H., *The Art of the West in the Middle Ages* (rev. Eng. trans., 1986).

FOGGINI, GIOVANNI BATTISTA (1652–1725). Italian sculptor. Born in Florence, he trained in Rome with Ercole *Ferrata before

returning in 1676 to become the leading late *Baroque sculptor in Tuscany. His marble reliefs of scenes from the life of S. Andrea Corsini (completed 1691) in S. Maria del Carmine, Florence, and his many busts of members of the Medici court, such as that of *Cardinal Leopoldo de' Medici* (1697; Florence, Uffizi), are typical of his highly pictorial style. Nevertheless, he is perhaps best remembered for his highly inventive small figural bronzes, which were often conceived in pairs (e.g. *The Rape of Orithyia by Boreas* and *The Rape of Proserpine by Pluto*; versions, Rome, Barberini Gal.). These display a remarkable range of vigorous contrapposto effects. Foggini was also active as a designer of furniture and hardstone objects for the Medici grand dukes, many of his drawings for which survive. MJ

Florentine Baroque Bronzes, exhib. cat. 1975 (Toronto, Royal Ontario Mus.).
The Twilight of the Medici: Late Baroque Art in Florence, 1670–1743, exhib. cat. 1974 (Detroit, Inst. of Arts; Florence, Pitti).

FOLK ART. A term used to describe objects and applied decoration derived from community tradition and executed by people without formal training, either for daily use or associated with a particular tradition, occasion, or ceremony. Typical products include woodcarving, weaving, decorative painting, basketry, and earthenware, but it ranges in sophistication from the subtlety of American quilts to the cheerful brash flower painting of English canal-ware. True folk art is little subject to fashion and changing taste. Its methods are handed down from generation to generation and traditional patterns and designs persist with little alteration. However its resistance to change, despite changes in society, exposes it to the danger of irrelevance. Once central to a particular culture it has become increasingly marginalized, produced for tourists and thus inevitably debased or artificially maintained as a leisure occupation practised by enthusiasts. The perpetuation of unadulterated folk art largely depends upon the continuation of a peasant population, shared religious belief, or other relatively settled social structure. The term has always been used by commentators rather than practitioners and is generally confined to European and colonial communities. DER

FONT (Latin *fons*: source, spring), term in Christian architecture for a receptacle for holy water in church, used for the sacrament of baptism. In the early Christian period baptism took the form of immersion in a bath and was carried out in a baptistery, which formed a separate building near to the church. By the 9th century this ritual had given way to simple affusion, which could be conducted inside a church using a font, which was normally positioned in the west

end of the nave, or in an adjoining chapel, although in Italy baptisteries continued to be built up to the end of the Middle Ages and these also contained fonts. Early fonts could be either square or circular in form, and were usually fitted with a flat lid. Most fonts were made of stone, although other materials such as marble, lead, copper, and bronze were also used. They were often decorated in relief with scenes, the most popular being the Baptism of Christ (e.g. the bronze circular font designed by Rainer of Huy, in the church of S. Barthélemy, Liège, c.1107–18). From the 13th century octagonal fonts became fashionable, and were often elaborately decorated in the *Gothic style, with large superstructures or canopies. Little changed in font design until the 17th century when variously coloured and richly carved marble fonts reflected the grandeur of *Baroque churches; an example being the spectacular font at S. Peter's in Rome, comprising an Antique porphyry sarcophagus cover, used in the 10th century for Otto II's tomb, with elaborate gilt-metal mounts by the architect Carlo Fontana (1638–1714). TJH

FONTAINEBLEAU, SCHOOLS OF. The interior decoration of the Château de Fontainebleau was the most brilliant expression of the ambition harboured by François I to emulate the great humanist princes of Italy and to glorify the prestige of the French Crown by bringing about a national revival of the arts under the aegis of lavish court patronage. Lacking an indigenous tradition of mural painting adequate to his grandiose conceptions, he inevitably brought in Italian masters to lead the work, which was carried out from the arrival of *Rosso Fiorentino in 1530 until the deaths of Francesco *Primaticcio and *Nicolò dell'Abbate in the 1570s. This group of artists and their Italian, French, and Flemish assistants who created the distinctive variant of *Mannerism found at the château is known as the First School of Fontainebleau. After the hiatus caused by the Wars of Religion in the 1580s Henri IV, the first Bourbon king of France, deliberately sponsored a revival of the artistic style of his Valois predecessors as a symbol of dynastic continuity. This phase and the mainly French artists associated with it are known as the Second School of Fontainebleau. Thus the elegant, refined, sensual, and highly idiosyncratic style invented by Rosso and Primaticcio held sway in French court circles for nearly a century, until Simon *Vouet introduced the ample classicism of the early *Baroque on his return from Rome in the late 1620s.

At Fontainebleau the Galerie François Premier, usually attributed to Rosso, and the Galerie d'Ulysse, designed by Primaticcio, the former intact though much restored, the latter destroyed in the 18th century but known through drawings and prints, were the two most magnificent examples of the new style. Both decors employed the characteristic combination of fresco paintings set in elaborate high-relief stucco frames above a high, plain dado. It is a matter of debate as to which artist was responsible for this innovation. Primaticcio had used similar combinations of paintings and stucco when assisting *Giulio Romano at the Palazzo del Te in Mantua, but the effect had been much more classical. Unique to Fontainebleau is the bare lower wall and the overwhelming abundance, high relief, and elongated proportions of the sculpted figures, fruit garlands, and strapwork above, which have no direct parallel in 16th-century Italy. It seems likely, therefore, that the development of the style was a collaborative effort blending Italian *Renaissance prototypes with a response to the courtly tradition of late medieval French art.

The paintings, mainly of mythological themes, often with a distinctly erotic tinge, share the same stylistic character as the stucco work, though Primaticcio's designs for paintings (he rarely executed them himself, preferring to delegate to Niccolò and others) are more classicizing than Rosso's. The drawings of both masters enjoyed wide circulation in the form of etchings by Pierre Milan and René Boyvin. It was these that ensured the dissemination of the style and its use in everything from easel paintings (see NICOLÒ DELL'ABBATE; COUSIN, FATHER AND SON; CARON, ANTOINE) and tomb sculpture (see BONTEMPS, PIERRE; GOUJON, JEAN) to decorative objects, having in the latter category far more influence than the relatively inaccessible objects produced by *Cellini in Paris for François I.

Although the most brilliant phase of the Fontainebleau style ended with the death of Primaticcio the achievement of such artists of the second phase as Caron, Ambroise *Dubois, Toussaint *Dubreuil, and Martin *Fréminet was not negligible. Among the most characteristic surviving examples of the Second School of Fontainebleau are Freminet's decorations in the Chapelle de la Trinité at Fontainebleau and the anonymous nude double portrait of *Gabrielle d'Estrées and the Duchesse de Villars in their Bath* (Paris, Louvre). HO/MJ

Béguin, S., *L'École de Fontainebleau* (1960).
Béguin. S. (ed.), *L'École de Fontainebleau*, exhib. cat. 1972 (Paris, Grand Palais).
Lévêque, J.-J., *L'École de Fontainebleau* (1984).
Zerner, H., *L'École de Fontainebleau: Gravures* (1969).

FONTANA, ANNIBALE (1540–87). Italian sculptor. He began his career as a medallist and hardstone engraver, but after 1570 he turned to large-scale sculpture in marble, seemingly working exclusively for the church of S. Maria presso S. Celso in his adoptive Milan. For the exterior of the church he produced a number of statues of prophets (1575–6), and three large reliefs from the life of Christ (1580–5) for the façade. He also produced statues for the interior, including an *Assumption of the Virgin* (1583–6). In contrast to the prevailing *Mannerist aesthetic of his time, Fontana's work is marked by its adherence to the classicizing and somewhat academic canons of the Florentine followers of *Michelangelo. MJ

Pope-Hennessy, J., *Italian Renaissance Sculpture* (4th edn., 1996).

FONTANA, FATHER AND DAUGHTER. Prospero (1512–97) was among the first Bolognese artists to be influenced by the *Mannerist style of *Vasari, with whom he worked, rather than the local version of *Parmigianino. After a brief period at *Fontainebleau with *Primaticcio around 1560, he used Vasarian Mannerism with more conviction, as in the *Disputation of S. Catherine* (Bologna, Madonna del Baraccano). However, works from the 1570s, such as *S. Alessio Distributing Alms* (Bologna, S. Giacomo Maggiore), show a return to naturalism, reflecting the didactic emphasis of the Council of Trent.

Lavinia (1552–1614) was the first woman artist to undertake large-scale commissions in addition to portraits (and eleven children). Trained by her father, she was an established portrait painter in Bologna by 1577, blending north Italian naturalism with Mannerist elegance in such works as *Senator Orsini* (Bordeaux, Mus. des Beaux-Arts) and the *Gozzadini Family* (1584; Bologna, Pin. Nazionale). Of her religious pictures, the best known is the *Noli me tangere* (1581; Florence, Uffizi), in which the muted light and autumnal colours suggest the influence of *Correggio. Major altarpieces include the *Holy Family* (1589; Escorial) and the *Vision of S. Hyacinth*, for S. Sabina in Rome, where she lived from 1603. LH

The Age of Correggio and the Carracci, exhib. cat. 1986 (Washington, NG; New York, Met. Mus.; Bologna, Pin. Nazionale).
Cantaro, M. T., *Lavinia Fontana bolognese* (1989).

FONTANA, LUCIO (1899–1968). Italian artist. Born in Argentina, he moved as a child to Milan, where he was trained at the Accademia di Brera. Although he started as a figurative sculptor, influenced by Arturo *Martini, during the 1930s he also began to develop a form of expressive abstraction partly inspired by the automatism of the *Surrealists. He spent the Second World War in Argentina, returning in 1947 to Milan, where he expounded his ideas on 'Spazialismo', rejecting the traditional illusionism of the two-dimensional canvas by incorporating real space into his sculpture. One common device was to cut long slashes into a canvas, while other sculptures were created

by puncturing a surface with irregularly shaped holes. The significance of these works was sometimes enriched by giving them expressive titles, as in *Spatial Concept-Expectations* (1959; Paris, Mus. d'Art Moderne), in which the incisions seem to reveal a mysterious, limitless space that is in fact simply a dark surface behind the canvas. Fontana also produced remarkable installations using neon light, which were highly influential on younger artists. CJM

Crispolti, E., *Lucio Fontana: catalogue raisonné des peintures, sculptures etc.* (1970).

FOPPA, VINCENZO (1427×30–1515×16). Italian painter. The most significant painter in Lombardy before *Leonardo da Vinci, he played a key role in the early *Renaissance there. Born in Bagnolo, he probably trained in Padua with *Mantegna's master Francesco *Squarcione, and in his earliest signed work, a *Crucifixion* (1456; Bergamo, Gal. Accademia Carrara), the use of a classical setting and coherent perspective is comparable to Mantegna and Jacopo *Bellini. From 1458 he was associated with the Sforza dukes of Milan, where he painted frescoes in the Medici Bank (*Boy Reading Cicero*; London, Wallace Coll.) and in the Portinari chapel in S. Eustorgio. His command of large-scale perspective in the Portinari cycle marks a turning point in Lombard art. In the mid-1470s he worked for Galeazzo Maria Sforza in Pavia and began decorating the Averoldi chapel in S. Maria del Carmine, Brescia. Depictions of S. Sebastian (e.g. Milan, Brera and Castello Sforzesco) from the 1480s demonstrate his mastery of the nude. His last works include a charming *Epiphany* (London, NG) set in a classical ruin. Foppa's austere but appealing style influenced numerous pupils. LH

Matalon, S., *Vincenzo Foppa* (1965).

FORAIN, JEAN-LOUIS (1852–1931). French painter, illustrator, and caricaturist, who worked in Paris. He studied at the École des Beaux-Arts and as a young man was particularly interested in *Rembrandt and *Goya. He started his career as a caricaturist on Paris journals such as *La Vie parisienne*, and, a friend and follower of *Degas, exhibited in four of the *Impressionist exhibitions. His early urban scenes, of dancers, brothels, and women in domestic settings, reflect the influence of Degas and *Manet, although, as in *Behind the Scenes* (c.1880; Washington, NG), Forain's sexual innuendoes are coarser, his social humour more robust. In his later years he was closer in style to *Daumier, and he worked in a restricted and usually subdued palette, focusing, as in *Counsel and Accused* (1908; London, Tate), on the cruelties of the legal system and on social and political problems. HL

Browse, L., *Forain* (1978).

FORD, RICHARD (1796–1858). English writer, collector, and amateur artist. His principal publication was the *Handbook for Travellers in Spain*, first published in 1845, which enjoyed immediate success, with its irony, wit, and *joie de vivre*, as well as descriptions of churches, monuments, and works of art, including a detailed account of pictures in the Prado, Madrid. He had spent three years in Spain with his family 1830–3, based at Seville during the winter, where he became a friend of the British consul, Julian Benjamin Williams, a noted picture collector and *marchand-amateur*; and then lodging at the Alhambra, Granada, during the hot summer months. He would travel around on horseback, in Spanish dress, and made some 500 drawings as a record of out-of-the-way sites. Sometimes he was joined by Sir William Eden Bt. of Windlestone (Co. Durham), another amateur artist and collector, to whom he dedicated the *Handbook*. The first of his three most extended tours, in the southern provinces, took place in the spring of 1831: he left Seville for Madrid passing through La Mancha and returning via Talavera, Mérida, and Badajoz. In the autumn of the same year he went from Granada to Valencia and Barcelona and then returned via Saragossa. The next spring he went to the north, visiting Ciudad Rodrigo, Salamanca, Santiago, Oviedo, León, Valladolid, Burgos, Vitoria, and Bilbao. On his return from Spain Ford settled at Heavitree, near Exeter, and redesigned the gardens in Spanish style. In 1836 he disposed of the pictures he had acquired in Spain, including *Murillo's *Two Franciscans* (Ottawa, NG Canada) and *Zurbarán's *Martyrdom of S. Serapion* (Hartford, Conn., Wadsworth Atheneum), but retained a magnificent Murillo drawing *Christ on the Cross* (London, Brinsley Ford Coll.) which he had been given by Julian Williams. He then began work on the *Handbook*. During this period he corresponded regularly with Sir William *Stirling, who would later publish *Annals of the Artists of Spain* (1848). They even contemplated a journey to Spain together in 1849, until Ford's wife became ill which forced him to withdraw. As Ford wrote (19 Feb. 1849), 'It would be curious to see two men travelling together with Ford's Handbook and Stirling's Annals for their sole guide through the land of 'no se sale y no se puede'. Ford was less influential than Stirling as a scholar and art historian, but his popular *Handbook* played a decisive role in stimulating the British discovery of Spain and of Spanish art in the aftermath of the Peninsular War. HB

Brigstocke, H., 'El descubrimiento del arte español en Gran Bretagnà', in *En torno a Velázquez*, exhib. cat. 1999–2000 (Oviedo, Mus. de Bellas Artes de Asturias).
Ford, R., *Handbook to Spain*, ed. Ian Robertson (3 vols., 1966).
The Ford Collection, Walpole Society 60 (1998).

FORMALISM, term used for interpretations of art in which aesthetic values are considered to be autonomous. A formalist reading of a painting attributes absolute internal coherence to its formal and chromatic components, enabling critical judgement of the work to be detached from any consideration of wider social influences. Formalism was the dominant critical mode in *modernist accounts of 20th-century art, reflecting the self-referential qualities of abstraction. Critics whose understanding of such art could be termed formalist include Roger *Fry and Clement *Greenberg. Formalism was assailed from the 1960s by such factors as the emergence of *Conceptual art and *Environmental art. OPa

FORMENT, DAMIÁN (c.1470–1540). Spanish *Renaissance sculptor active in Aragon. Born in Valencia to a family of sculptors, he began his career in his family's shop. Some scholars have hypothesized that Forment studied in Italy as a youth, but no record of such a trip survives and his style may be explicable without it. In 1509, he left Valencia for Saragossa where he contracted the retable of El Pilar Saragossa (completed 1512; *in situ*). From the outset, he demonstrated a preference for rounded figures with deep-cut folds and emphatic gestures; although some of the youthful figures have an idealized quality that evokes classical examples, his compositions and architectural settings remain firmly within the *Gothic tradition. The success of the retable at El Pilar led to further commissions; including those for the Huesca Cathedral (1520) and S. María de Poblet (1527). Here, however, he began to incorporate *plateresque decoration in the architecture without altering his figure style significantly. His last major work is the retable for S. Domingo de la Calzada (1537) which reflects the influence of *Berruguete's retable for S. Benito, Valladolid (1526). PL

La escultura del Renacimiento en Aragón, exhib. cat. 1993 (Saragossa, Mus. e Inst. de Humanidades 'Camón Aznar').
Souto Silva, A. I., 'Nuevas aportaciones documentales sobre el origen de Damián Forment', *Boletín del Museo e Instituto Camón Aznar*, 51 (1993).

FORTUNY Y MARSAL, MARIANO JOSÉ BERNARDO (1838–74). One of the most successful Spanish painters and printmakers of the 19th century. Fortuny achieved

a wealth and status enjoyed by few Spanish artists since Spain's Golden Age. He spent much of his life working outside Spain, especially in Rome, Paris, and Morocco. His fame was built largely on small Rococo revival subjects of costumed, leisured aristocrats, painted in a style dubbed 'preciocismo' for its gemlike finish of small, bright-toned strokes. He was also known for North African genre and orientalist themes, many of which were inspired by his trip to Morocco where, commissioned by the Diputació de Barcelona, he also completed large-scale paintings of the 1860 Spanish–Moroccan War. OEV

González López, C., *Mariano Fortuny Marsal* (2 vols., 1982).

FOUCAULT, MICHEL (1926–84). French philosopher. From the late 1960s onwards his challenging enquiries into the relations between knowledge and social control were highly influential throughout the Western academic world. Systematically suspicious about the power motives underlying all forms of institution, he was equally sceptical as to the supposed autonomy of any individual subject who might resist them. Foucault's researches delved into fresh terrains, such as the histories of madness and of sexuality, and threw up a new terminology to describe his own activity: an 'archaeology' of developing social practices, or a '*discourse analysis'. Writers such as John Tagg and Jonathan Crary have applied this type of methodology to the history of visual culture. Foucault himself began his first book *Les Mots et les choses* (The Order of Things), published in 1966, with a bravura essay in art criticism, analysing *Velázquez's Las meninas* (1656) as an exploration of the paradoxes inherent in representation. This account, attacked by some art historians, led to a friendly correspondence with René *Magritte, whose painting is saluted in a later essay. JB

Foucault, M., *The Order of Things* (Eng. trans., 1967).
Foucault, M., *This is Not a Pipe* (Eng. trans., 1983).
Owens, C., 'Representation, Appropriation, Power', in *Beyond Recognition* (1984).

FOUNTAIN, a jet or spring of water around which an architectural or sculptural structure has been built. It is either freestanding or built into a wall. Historically fountains have served many functions: the practical, supplying the populace with water; the religious, celebrating the glory of creation; the political, to signify power and territory; the pleasurable as well as the purely decorative. These rarely exist in isolation and the function of fountains is usually quite eclectic. The evolution of fountains has developed according to innovation in hydraulic technology, whilst changes in architecture and sculpture have impacted on their aesthetic nature. Of the estimated 1,000 fountains which existed in the ancient world, very few survive. They comprised simple shaft and basin designs through to monumental fountain houses as documented on Greek vase paintings (see GREEK ART, ANCIENT). Ancient Rome (see ROMAN ART, ANCIENT) was the city of fountains; the construction of aqueducts in the 1st century BC saw over 500 public fountains built with some 700 basins. The gardens of Hadrian's Villa at *Tivoli with its little canals leading into grottoes and pools with jets (AD 18–34) were built to celebrate Hadrian's victories and power. During the Middle Ages fountains were closely associated with the Church; often they were consecrated and became public baptismal *fonts. The spring of the fountain came to symbolize the River of Life in the Garden of Eden, as beautifully presented in the *Très Riches Heures* (1411–16; Chantilly, Mus. Condé, MS 65, fo. 25ᵛ). This religious symbolism manifested itself quite literally in decorative schemes such as Nicola *Pisano's Fontane Maggiore (1277–8; Perugia, Piazza Quattro Novembre) featuring sculptures of prophets, saints, months of the year, and scenes from Genesis. Many public fountains in the 16th century became political statements signifying the wealth of and improvements to the city under the current regime whether a free commune, like Pisano's Perugia, or Bologna under Pius IV, who commissioned *Giambologna's *Neptune* (1563; Bologna, Piazza Nettuno). Concurrently, 16th-century monarchs were building fountains in their palace gardens for the same reason as Hadrian 1,400 years earlier. François I's grandiose scheme for a 16-m (50-ft) Fountain of Mars designed by Benvenuto *Cellini in Fontainebleau, whilst never realized, shows the extent of this vogue. Historically, as well as artistically, one of the most important periods for urban fountain construction was the 17th and early 18th century at Rome, when several massive structures appear under the patronage of a succession of popes. The most famous of these are Nicola Salvi's Trevi Fountain (1732–60; Piazza dei Trevi) for Clement XII which combines architecture, sculpture, and water display; Bernini's Triton Fountain (1642–3; Piazza Barberini), commissioned by Urban VIII, and his Four Rivers Fountain (1648–51; Piazza Navona) for Innocent X. In 17th-century France the most monumental fountains were built not in urban areas, rather they graced the gardens of palaces, becoming an intrinsic part of landscape design as seen in François de Francine's *Bassin du char d'Apollon* featuring Jean Tuby's gilded sculpture *Apollo in his Chariot* for François I at Versailles (1668–70; Versailles). In the 19th and 20th century fountains were mostly constructed to enhance the urban environment or were incorporated into plazas of corporate buildings such as Dan Kiley's Fountain Place (1986; Dallas, First Interstate Bank Tower Plaza) with its centre fountain of over 160 jets. KC

Baur, A., *Brunnen: Quellen das Leben und der Freude* (1989).
Kapossy, D., *Brunnenfiguren der hellenistischen und römischen Zeit* (1969).
Miller, N., *French Renaissance Fountains* (1977).
Moore, C. W., *Water and Architecture* (1994).

FOUQUET, JEAN (c.1420–81). French painter. Fouquet, the leading French painter of the 15th century, was born and mostly worked in Tours, though perhaps trained in Paris. According to *Filarete he was in Italy in the 1440s, where he painted a lost portrait of Pope Eugenius IV (d. 1447) and his nephews. Much has been made of this Italian journey, the influence of which can be detected in the use of perspective and assimilation of classical architecture in his subsequent works, and in the volumetric clarity of his figure grouping. The cool monumentalism of his style may reflect the influence of Fra *Angelico and others, but his handling of light and pictorial space, and above all his *drawing, are highly personal. After his return from Italy (c.1447–8) Fouquet began working for the French court, eventually becoming 'Peintre du Roy' in 1475. The *Portrait of King Charles VII* (c.1445–50; Paris, Louvre), the Melun Diptych (c.1450), painted for the Treasurer Étienne Chevalier, and the *Portrait of Guillaume Jouvenel des Ursins*, Chancellor of France (c.1455–60; Paris, Louvre) reveal Fouquet's carefully selective approach to Italian models. The left wing of the Melun Diptych (Berlin, Gemäldegal.) sets the presentation of the donor in a clearly Italianate courtyard. The faces of Chevalier and of the Virgin of the right wing (Antwerp, Koninklijk Mus. voor Schone Kunsten), a presumed portrait of Charles VII's mistress Agnes Sorel, have the clarity of Italian painting, subjected to a process of abstraction effected by a superb control of line. The final effect is not un-Italian, and it is also quite distinct from the forensic realism of Netherlandish painting. A tiny (6.8 cm/2½ in) gold and enamel circular *Self-Portrait* (Paris, Louvre) once formed part of the Melun Diptych's frame. For Étienne Chevalier Fouquet produced a now dismembered Book of Hours (c.1452–60), of which 47 individually mounted miniatures survive (the majority in Chantilly, Mus. Condé) to give the most complete view of Fouquet's synthesis of northern and Italian ideas. Most remarkable is the empirical and experimental approach to pictorial space, which Fouquet approaches with an optical intelligence of a kind unparalleled until *Leonardo's deconstruction of linear *perspective later in the century. The Chevalier Hours' development of relatively large-scale, semi-autonomous, manuscript illustrations is taken further in Fouquet's work for

the *Grands Chroniques de France* (1458; Paris, Bib. Nat., MS fr. 6465) and the *Antiquités judaïques* of Josephus (c.1470; Paris, Bib. Nat. MS fr. 247). The Josephus narratives (each 21×18 cm/8×7 in) are monumental and completely painterly images, often set in landscapes of great depth and spatial continuity. A large panel of the *Pietà* discovered in the parish church of Nouans-les-Fontaines in 1931 is generally accepted as Fouquet's work. JR

Schaefer, C., *Jean Fouquet* (1994).

FRAGONARD, JEAN-HONORÉ (1732–1806). The last great painter of the French *Rococo. Despite early successes in the Grand Manner he chose instead to paint on a smaller scale and in a highly personal and poetic idiom, which moved during his career from recollections of *Watteau and *Boucher to prefigurations of *Romanticism. Between 1746 and 1752 he trained first with *Chardin and then with Boucher, before winning the *Prix de Rome. In 1756 he went to Rome and it was Italian artists such as *Barocci, Pietro da *Cortona, *Solimena, and *Tiepolo who made the greatest impression on him. Falling in with the landscape painter Hubert *Robert and the dilettante Abbé de Saint-Non (see GRAND TOUR) he also discovered the beauties of the Roman Campagna and above all the splendours of the gardens of the Villa d'Este at *Tivoli. These he depicted in a superb series of chalk drawings (examples in the Mus. des Beaux-Arts, Besançon). Fragonard's romantic vision of an ebullient, resurgent, and benign nature breaking out of the bounds made for it by man recurs throughout his work, most notably perhaps in his famous painting *The Fête at Saint-Cloud* (c.1775; Paris, Banque de France), which completely refreshed the theme of the *fête galante* established 60 years earlier by *Watteau. In 1761 Fragonard returned to Paris, where he exhibited at the Salon to universal praise the large history painting *Corésus and Callirhoé* (Paris, Louvre). An official career seemed assured, but he preferred to follow his own inclinations and to paint landscapes, gallant genre scenes, and fantasy portraits for a sympathetic coterie of wealthy private clients. The latent eroticism of his subjects found a perfect counterpart in his virtuosic brushwork. Whether in portraits, such as that of *Diderot* (1769; Paris, Louvre), in *fêtes galantes*, such as *The Swing* (1769; London, Wallace Coll.), or in out-and-out erotica, such as *The Useless Resistance* (Stockholm, Nationalmus.), the prime impression is one of barely contained, joyful energy. The masterpiece of Fragonard's career is the series of four large canvases called *The Progress of Love* (1771–3; New York, Frick Coll.), which he painted to decorate Mme du Barry's house at Louveciennes. These were

never installed, since the royal mistress rejected them in favour of inferior but chic *Neoclassical substitutes by *Vien. Fragonard continued to paint, undismayed, for his old clients, experimenting with landscapes in the Dutch style influenced by *Berchem and *Cuyp, with genre scenes with carefully finished enamel-like surfaces that recall *Boilly, and with romantic allegorical subjects anticipating *Prud'hon. But the rejection of his Rococo fantasy for Louveciennes in favour of Vien's Neoclassicism was an intimation of the ruin of his career during the Revolution. His style and subjects came to seem wildly inappropriate and his patrons melted away. Although thanks to *David's protection he held some posts in the new artistic administration and continued to paint, his career never recovered and he died virtually forgotten. MJ

Cuzin, J.-P., *Fragonard: Life and Work* (1988).
Fragonard, exhib. cat. 1987–8 (Paris, Grand Palais; New York, Met. Mus.).
Wildenstein, G., *Fragonard* (1976).

FRAMES are intended to protect, delimit, display, and enhance the pictures they contain—and may also be decorative objects in their own right. They help to focus attention on the painted image, to lead the observer into its world, and to bind it harmoniously to the interior where it hangs. Architecture and the fine and decorative arts meet within the picture frame: its design and execution have involved famous artists and architects, sculptors, carvers, and silversmiths, cabinetmakers, ebony workers, and gilders.

Geometric margins were used for vase and tomb paintings from the second millennium BC; architectural borders were applied to wall carvings and later to classical mosaics. By the early Middle Ages, these had become protective ornamental frames—for ivory bas-reliefs, metalwork altars, and, from the 12th century, wooden *altarpieces. These ancestors of modern movable frames were at first of one piece—'engaged'—with the picture, which was painted on a lowered surface carved from the wooden panel. In Italy the resulting raised perimeter acquired architectural mouldings (*Simone Martini, *The Holy Family*, 1342; Liverpool, Walker AG); whereas in Germany it was treated like the flat border of an *illuminated manuscript (German School, Cologne Diptych, c.1320–30; Berlin, Gemäldegal.).

These early rectangular frames began to alter in shape; from the 13th century large Italian altarpieces imitated the cross-section of a basilica church with its gabled top (*Cimabue, *Virgin and Child*; Paris, Louvre), and were then elaborated into *polyptychs based on the elevation of a *Gothic cathedral (*Taddeo di Bartolo, *Virgin and Child*, 1411; Volterra,

Pin. Comunale). 'Aisles', 'crypt', and 'clerestory' contained paintings of sacred figures, whilst the 'nave' held the principal image—Crucifixion, Nativity, etc. The frame acquired the architectural elements of its churchlike structure: columns, cornices, arches and traceries, buttresses, ornate roundels like rose windows. In Italy the silhouette was fretted with finials, gables, and crockets, whilst in Spain and the northern countries an outer rectangular or curve-topped frame protected these fragilities (Stefan *Lochner, *Adoration of the Magi*, c.1440–5; Cologne Cathedral).

The altarpiece thus represented the spiritual Church, humbling and inspiring the worshipper. Quantities of *gilding reinforced the idea of celestial splendour—and helped to illuminate the paintings. The craftsmen who created such visions worked as an equal team (Simone the carver, Gabrieli the gilder, *Spinello Aretino the painter, all signed the Monteoliveto altar, 1384–5; Florence, Accademia); more money might be expended on the giltwood structure than on the painted images.

During the *Renaissance the altarpiece metamorphosed to a single image, in an architectural frame based on a classical temple. This now functioned as a window opening onto an illusory space intended to appear as continuous with that of the 'real' world (Giovanni *Bellini, Frari Triptych, frame by Jacopo da Faenza, 1488; Venice, Frari). Such frames were influenced by funerary *monuments and might be designed by architects and sculptors (Benedetto and Giuliano da *Maiano in Italy, *Herrera in Spain). Because they were now movable, rather than part of the overall structure, their design began to pass from the carver to the painter; so that drawings for frames exist by *Carpaccio, *Lippi, *Dürer, etc.

From the 15th century secular paintings were produced in increasing quantities. Like the earliest altarpieces they were rectangular, their frames deriving from those 'engaged' raised borders and from the entablatures of classical architectural altarpieces. The result was the Italian *cassetta* (little box) frame: a decorative frieze between narrow mouldings, recognizably modern in form. International travel, trading links, and political groupings ensured that this basic structure diffused through Europe, acquiring or losing elements on the way—differences of material, technique, profile, ornament, and finish; whilst the frame itself might be employed in various ways.

The *cassetta* could be decorated with carving, moulded *pastiglia* or stucco ornament, overall or parcel gilding, paint, woodstain and polish, sgraffito (motifs scratched through paint to the gilding beneath), or *trompe l'œil* devices such as marbling.

Depending on its cross-section, the frame could act as a decoratively flattening border

or a perspectival funnel, enhancing the pictorial illusion of space; whilst carved, gilded ornament was used to articulate light around the image. The design and finish of the frame was often determined by its intended surroundings and the status of the subject matter. Ornament was either classical and architectural, or foliate. Finish could be gilded, painted, or polished wood.

In the Netherlands, Belgium, Britain, and France the *cassetta* was generally plainer both in structure and finish. These northern frames are often black with parcel gilding; their mouldings echo the panelled walls where they hung, and they might be made by the joiners who produced that panelling (British School, *George Talbot*, 1580; Hardwick Hall, Derbys.). They fit the more austerely clad portraits of the northern Renaissance, and anticipate Protestant taste. Other examples of this type are the *trompe l'œil* stone finishes which mimic church plaques (Jan van *Eyck, *Margaret van Eyck*, 1439; Bruges, Groeningemus.). Later, more decorative designs appeared, often based on the ubiquitous classical motif of scrolling foliage (Louis XIII frame carved with roses and acanthus, *Raphael, *Baldassare Castiglione*, c.1514–15; Paris, Louvre).

Apart from foliate designs, and the architectural ornament of some German frames, Renaissance patterns diffused relatively slowly through northern Europe and Spain. *Mannerist and *Baroque frame designs achieved more rapid currency, partly because their energetic ornamental rhythms and theatrical use of light and colour were ideally suited to the propagandizing art of the great secular European courts, which replaced much church patronage in the 16th and 17th centuries.

They were closely related both to the art they enclosed, and to the surrounding architecture. In Italy the use of exaggerated geometrical ornament (swooping diagonals and strong volutes) mimicked the foreshortened, spiralling forms of Mannerist compositions—especially in the characteristic 'Sansovino' frame, which derives from exuberant stuccowork in the Doge's palace, Venice (Paris *Bordone, *Knight in Armour*, c.1540–5; Raleigh, North Carolina Mus. of Art). Spanish 'Herrera' frames also employ emphatic geometrical motifs—gemstones and knulled shapes. However, Dutch, British, and late Italian Mannerist frames are based on exaggerated organic forms: the Auricular style, in which wood is forced to imitate the liquid cartilaginous and marine shapes of early 17th-century silverwork (Cornelius van Ceulen, *Jasper Schade*, 1654; Enschede, Rijksmus. Twenthe; van *Dyck, *Countess of Southampton as 'Fortuna'*, c.1638; Cambridge, Fitzwilliam).

Baroque frames are similarly dynamic, using reverse (bolection) profiles which push the picture out from the wall surface, and prominent corner (and often centre) ornaments. The bolection profile imitates the opposing curves of a Baroque architectural façade, whilst helping to project the painting against a correspondingly opulent interior. Corner ornaments (cartouches) also help to isolate and highlight the image; the imaginary lines which join these cartouches across the picture surface were often exploited by the artist to emphasize compositional elements. Spanish 17th-century frames are particularly notable for their sculptural cartouches and coloured panels (*Velázquez, *Don Pedro de Barberana*, 1631–3; Fort Worth, Kimbell Mus.). Like Italian Baroque frames they also employ continuous leaf mouldings. These derive from classical laurel garlands, transformed, from the mid-17th century in Italy, Britain, and France, into boldly carved surrounds for door frames, stucco ceilings, etc. Such leaf 'toruses' form the dominant motif for the French Louis XIII frame, carved into twisting, broken ropes of foliage, flowers, and berries, which suit the vigorous forms of Baroque painting (E *Le Sueur, *Young Man with a Sword*, c.1640; Hartford, Conn., Wadsworth Atheneum).

The 17th and 18th centuries saw a golden age of frame-making develop in France. Louis XIII and XIV Baroque designs, Régence, and Louis XV *Rococo, all display virtuoso performances in carving sophisticated patterns, recutting minute details in the covering gesso, and orchestrating light through the use of matt and burnished gold leaf (contemporary Louis XIV frame, Frans *Hals, *Joseph Coymans*, 1644; Hartford, Conn., Wadsworth Atheneum; original French Rococo frame, *Liotard, *Jean-Louis Buisson-Boissier*, 1764; Houston, Mus. Fine Arts). Ornament was inspired by the work of skilled designers—*Le Brun and *Bérain in the 17th century, François Roumier and Nicolas Pineau in the 18th—and during the 18th century frame-makers began to sign their work again.

French patterns were enormously influential elsewhere in Europe, designers such as the Huguenot Daniel Marot recreating Louis XIV styles in Britain and the Netherlands. Rococo designs were also widely diffused, but developed distinctive national characteristics in Italy, Germany, Scandinavia, and Britain—each of which achieved their own apotheosis of design in the so-called trophy frame. This was a ceremonial setting of sculptural bravura, carved with representations of objects symbolic of the sitter's status (original British Rococo trophy frame, *Hudson, *The Hon. John Byng*, c.1756; priv. coll.; original German Rococo trophy frame, studio of Antoine Pesne, *Friedrich Wilhelm I*, 1748; Stockholm, Drottningholm Palace).

The French Baroque patterns emulated in the Netherlands were natural successors to the gilded Auricular frames of the 1650s–1690s. Both might be found in Dutch interiors, hung amongst the archetypal 17th-century ebonized frames. These latter 'cabinetmaker's frames' harmonize with contemporary dark Netherlandish furniture; they are suited to the pale walls or panelling and the diffuse light of northern Europe, and to the Protestant mercantile bourgeoisie of Holland who bought them. They became symbolic of the rejection of Spanish rule in the Netherlands, and its association with Catholicism, courtly patrons, and uniformly gilded settings.

However, they too might signify status and wealth: these apparently plain, dark frames frequently being made from offcuts of exotic woods or tortoiseshell brought back from the Dutch colonies (Jan Mytens, *Margaretha Riccen*, 1658; Antwerp, Mus. Mayer van der Bergh). They could also be ornamented with 'ripple' patterns, cut laboriously by mechanical jigs and polished to give a flicker of movement and light around the picture; very elaborate ripple and wave frames were made in central Europe (Willem Drost, *Self-Portrait*, c.1652; Cologne, Wallraf-Richartz-Mus.), Spain, and Italy.

Other styles coexisting with the French Baroque frame include the British Palladian frame, and the Roman 'Salvator Rosa' or '*Maratti'. Both represent the endurance of linear designs and classical architectural ornament alongside the curvilinear, organic patterns diffused from France. The typical Palladian or 'Kent' frame (after the architect William Kent) has square outset ('eared') corners, and is designed for an integrated interior scheme, where windows, doors, and chimney pieces share the same architectural structures and ornament (Kent, designs for saloon, Houghton Hall, Norfolk, 1725; London, priv. coll.; frame from set carved by Gerrard Howard, 1733, for *Kneller, 41 portraits of the Kit-Cat Club, c.1697–1717; London, NPG).

The Roman frame also provided a strong alternative to Rococo designs. Known as a 'Salvator Rosa' from its application to Rosa's pictures, it has a Baroque profile of opposed concave and convex forms, providing a bold linear structure—with central light-reflecting hollow—which was used (from c.1680s) for economical mass-framing in the great Roman *palazzi*. This plain form could be transformed with runs of ornament to increasingly luxurious patterns (Rosa, *Allegory of Study*, c.1649; Sarasota, Fla., Ringling Mus.). It was popularized in Britain through its acquisition on the *Grand Tour, and native versions called the 'Carlo Maratti' were produced (British 'Maratti' trophy frame, attributed to Chippendale, for *Reynolds, *George, Prince of Wales*, 1784; priv. coll.).

The enduring taste for classical forms exemplified in these frames fed the late 18th-century *Neoclassical style. In France,

reaction against the asymmetric filigree of late Rococo produced *goût grec cassetta*-like frames with architectural frets and interlaced ornament, suited to the Neoclassical interior. However, since Rococo furniture with its curving, comfortable lines continued in popularity, the frames might be softened by swags of carved leaves and rounded crests or 'frontons', helping to bind furnishings to architecture.

Later Neoclassical designs (Directoire and Empire) spread throughout Europe under Napoleon's rule—the first international frame styles, unmodified by national interpretations. But the Napoleonic Wars were also responsible for fundamental changes in the production of picture frames. Countries impoverished by war could not afford luxury goods or support their producers; the number of carvers in London fell from 600 in the late 18th century to 70 by 1813. The Industrial Revolution simultaneously provided, in the middle classes, a newly enriched market hungry for prints, cheap paintings, and mass-produced frames. Instead of hand-carved, water-gilded settings, the few remaining carvers turned out reverse wooden moulds for the pressed composition ornament decorating so many 19th-century frames. Innovative design was replaced by revived historical styles.

Versions of these moulded historicizing frames are still produced today, but reaction against them began, mainly amongst artists, as early as the 1830s. In the 1860s the first wave of 'artists' frames' was catalysed by the work of *Rossetti and Ford Madox *Brown, who designed geometric frames gilded directly onto the wood (Rossetti, *Lucrezia Borgia*, 1860–1; London, Tate). These were followed by *Whistler's reeded frames with painted ornament; the *Impressionists' white or coloured borders (*Degas, *After the Bath*; Paris, Mus. d'Orsay); the hammered metal frames of *Klimt and Holman *Hunt; *Pointillist borders (*Seurat, *Young Woman Powdering Herself*, 1888–90; London, Courtauld Inst. Gal.) and contemporary variants of altarpiece frames (Ernest Laurent, *Sicile*, 1897; Lille, Mus. des Beaux-Arts). They were designed to provide alternatives to traditional ornament, to enhance pictorial colour without recourse to gold leaf, to create decoratively flattening borders, or to evoke a suggestive symbolism.

In the 20th century artists' frames continue to diverge from mass-produced borders. Where they have not been minimalized—or discarded—they are used for dislocating, ironic effect, or to undercut the apparent flatness of the image (*Braque, *The Musician*, 1917–18; Basle, Öffentliche Kunstsammlung). *Magritte and *Dalí used off-the-peg mouldings to fragment and define their work: standard mouldings distorted into male and female silhouettes determine the subject of Dalí's *Couple with their Heads Full of Clouds* (1936;

Rotterdam, Boymans-van Beuningen Mus.). Howard Hodgkin overpaints conventional frames, subsuming them into his work; while *video artists such as Gary Hill use the contour of the screen to delimit and separate. For much fine art the frame has been altogether abandoned; yet the consciousness of its long history allows it to be remade or used in other fields—in advertisements and shop-window displays—for symbolic and suggestive effect. PM/LR

Fuchs, S. E., *Der Bilderrahmen* (1985).
Grimm, C., *Alte Bilderrahmen* (1978; trans. as *The Book of Picture Frames*, 1981).
In Perfect Harmony: Picture+Frame 1850–1920, exhib. cat. 1995 (Amsterdam, Van Gogh Mus.).
Mitchell, P., and Roberts, L., *A History of European Picture Frames* (1996).
Mitchell, P., and Roberts, L., *Frameworks: Form, Function and Ornament in European Portrait Frames* (1996).
The Art of the Edge: European Frames, 1300–1900, exhib. cat. 1986 (Chicago, Art Inst.).

FRAMPTON, SIR GEORGE (1860–1928). English sculptor. Born in London, Frampton trained at the RA Schools (see under LONDON) and in Paris. He is associated with the *New Sculpture movement of the late 19th century, working with exotic materials in a decorative style influenced by *Art Nouveau and frequently, as in *Mysteriarch* (1892; Liverpool, Walker AG), with a symbolic content. With success his work became more academic and he was responsible for a number of public monuments including *Peter Pan* (1911; London, Kensington Gardens). His son Meredith (1894–1984) was a highly original portrait painter. DER

Read, B., *Victorian Sculpture* (1982).

FRANCAVILLA, PIERO. See FRANCQUE-VILLE, PIERRE.

FRANCESCO D'ANTONIO DEL CHIERICO (1433–84). Italian illuminator (see ILLUMINATED MANUSCRIPTS) and goldsmith. One of the foremost Florentine illuminators of his day, he was employed by successive members of the Medici and, through the bookseller Vespasiano da Bisticci, leading patrons throughout Europe including Ferdinand I, King of Naples, and Matthias Corvinus, King of Hungary. Francesco's lively figure style and pale and delicate palette can be recognized in books of all types and sizes from devotional and liturgical books to copies of contemporary poetry and classical works. The white-vine borders that decorate many of the classical texts he illuminated included, alongside birds, beasts, and somewhat heavy-thighed putti, medallions with bust-length figures that attest to his skill as a portraitist: for example the copy of Pliny the

elder's *Natural History* made for Piero de' Medici (*c*.1458: Florence, Bib. Laurenziana, MS 82, 3). Although he was documented as a goldsmith from 1452 no surviving work is known. KS

The Painted Page: Italian Renaissance Book Illumination 1450–1550, exhib. cat. 1994/5 (London, RA; New York, Pierpont Morgan Lib.).

FRANCESCO DI GIORGIO (1459–1501). Italian painter, sculptor, architect, and engineer, born in Siena. Before *Leonardo, whom he probably knew, di Giorgio came closest to the ideals of the *Renaissance artist. Accomplished in all the arts, he first trained with *Vecchietta. His early works include *cassone paintings and religious works in the refined tradition of Sienese painting. Eventually he assimilated stylistic traditions from Florence, noticeable in the plastic modelling of the figures in his monumental *Coronation of the Virgin* (1472–4; Siena, Pin.). As fortifications engineer in the employ of Duke Federigo da Montefeltro from about 1475, he may also have been involved in the design of the ducal palace at Urbino. A number of sculptures, including the *Deposition* (1474–7; Venice, S. Maria del Carmine) and the stucco *Discord* (London, V&A), whose forceful and classical compositions contrast markedly with his painting style, probably date from his time in Urbino. Concurrently active as an architect, his church of S. Maria del Calcinaio in Cortona (1485) is a landmark in Renaissance church planning, incorporating his theories on proportion and clarity of design. AB

Weller, A. S., *Francesco di Giorgio* (1943).

FRANCIA (Francesco Raibolini) (*c*.1450–1517). Italian goldsmith of Bologna who turned to painting about 1485, achieving considerable success with local patrons. The pattern of his early work is unclear since his frescoes in the Bentivoglio Palace in Bologna were destroyed when the family fell in 1506 but he is generally thought to have been influenced by *Cossa and the Ferrarese School. His portrait of the humanist *Bartolomeo Bianchini* (London, NG), an early work in oils, shows some knowlege of Flemish art. He entered into a partnership with *Costa after the latter came to Bologna in the 1480s and modified the harshness of the Ferrarese manner by a delicate and poetic if somewhat monotonous elegance which set the tone for the Bolognese School of painting. After Costa left Bologna for Mantua Francia's style showed further softening under the influence of *Perugino (*Scenes from the Life of S. Cecilia*, 1504–6; Bologna, S. Giacomo Maggiore). His late work achieved great popularity in northern Italy and is often regarded as the

starting point for *Mannerist painting at Bologna. PSt

FRANCIABIGIO, (Francisco di Cristofano Bigio) (1482–1525). Italian painter born most likely in Florence, where he died. The pupil of Mariotto *Albertinelli, he assimilated the more superficial qualities of *Raphael and especially of *Andrea del Sarto, with whom he collaborated while working in Florence in the Chiostro dello Scalzo and the cloisters of SS Annunziata. He painted a fresco in the atrium (1513) representing the *Sposalizio*, the betrothal of Mary and Joseph. Unfortunately, this was partly destroyed by the artist himself who became furious over the removal of the screen covering the painting and, seizing a hammer, proceeded to almost strike out the heads of the Virgin and some of the other figures. Neither Franciabigio nor any other craftsmen could be persuaded to repair the damage. He undertook several commissions for the Medici. He was a minor but genuine talent, most successful in his portraits of young men: for example those in Detroit (Inst. of Arts), Florence (1514; Uffizi), and Paris (Louvre). AM

Heil, W., 'A Portrait by Franciabigio', *Bulletin of the Detroit Institute of Arts*, 10 (1928–9).

FRANCKE, MASTER (active *c*.1424–36). German painter who worked in Hamburg, where in 1424 he painted a huge altarpiece for the company of merchants who traded with England, the so-called 'Englandfahrer Altar', originally placed in their chapel in the Johanniskirche (remnants in Hamburg, Kunsthalle). When closed, the double-winged altarpiece displayed four scenes from the life of S. Thomas Becket, the patron saint of the company, above four scenes from the life of the Virgin (e.g. *Nativity*; Hamburg, Kunsthalle). Opened, the altarpiece showed scenes from the Passion of Christ. Francke was a leader of the northern German version of *International Gothic. He had close links with French book illumination (he may have worked in Paris for some time) and the paintings of the Rhineland, especially those of *Conrad van Soest, though it is not known where he received his training. KLB

Grohn, H. W., et al. (eds.), *Meister Francke und die Kunst um 1400*, exhib. cat. 1969 (Hamburg, Kunsthalle).

FRANCKEN FAMILY. Five generations of Flemish artists. Here some of the members of two generations are discussed. **Hieronymus I** (*c*.1540–1610), **Frans I** (1542–1616), and **Ambrosius I** (*c*.1544–1618) were brothers. After an apprenticeship with Frans *Floris, Frans and Ambrosius became important painters of altarpieces in Antwerp, essentially working in the style of their teacher (Frans I, *Christ among the Doctors*, 1587;

Ambrosius I, *Miracle of the Loaves and Fishes*, 1598; both Antwerp Cathedral). Hieronymus's career took place in France where he was painter to the King, returning occasionally to Antwerp to execute ecclesiastical commissions. He specialized also in pictures of masquerades (*Venetian Carnival*, 1565; Aachen, Suermondt-Ludwig Mus.) and ballroom scenes. **Frans II** (1581–1642) was the son of Frans I; he is now the best-known member of the family. He produced some altarpieces, but his main speciality was in small cabinet pictures with historical, mythological, or allegorical themes as well as genre and fantastical scenes, such as the witches' sabbath. He was one of the first artists to use the interior of a picture gallery as a subject, giving faithful miniature reproductions of the works in the collection (*Interior of Burgomaster Nicholas Rockox's House*, *c*.1630/5; Munich, Alte Pin.). KLB

Härting, U., *Frans Francken der Jüngere (1581–1642)* (1989).

FRANCO DEI RUSSI (active 1453–82). Italian illuminator. Although born in Mantua, he was first documented in Ferrara where he was named with Taddeo *Crivelli in the contract for the illumination of the opulent Bible being made for the Duke, Borso d'Este (completed 1461: Modena, Bib. Estense, MS V.G. 12, lat. 422–3). Franco's work can be recognized in Leviticus and Matthew. In the early 1460s he moved to Padua where he undertook a large number of commissions, including frontispieces for a copy of the first Bible printed in Italian (1471), one of which he signed 'franchi' (Wolfenbüttel, Herzog August Bib., Bibelsammlung 2° 151, vol. 1). He is unusual among illuminators in having signed several of his works. By this date he used a cooler palette with the gentle tonal graduation that he combined with crisply defined forms. He is believed to be the 'master francho of Ferrara' recorded as a member of the Duke of *Urbino's household in a list of 1482 and miniatures in the Dante made for the Duke are sometimes attributed to him (Vatican, Bib. Apostolica, MS Urb. lat. 365). KS

The Painted Page: Italian Renaissance Book Illumination 1450–1550, exhib. cat. 1994/5 (London, RA; New York, Pierpont Morgan Lib.).

FRANÇOIS, MAÎTRE (active 1460–80). The leading illuminator (see ILLUMINATED MANUSCRIPTS) in Paris in the third quarter of the 15th century. François is the documented painter of a two-volume French translation of S. Augustine's *City of God* (*c*.1469–73, Paris, Bib. Nat., MSS fr. 18–19). In addition to many books of hours, for example the Wharncliffe Hours (Melbourne, NG Victoria, MS Felton 1), he is known for his complex, densely populated compositions in classical, secular, and

theological texts, often of large format and in several volumes. His style depends on that of the Master of Jean Rolin (active 1445–65) and was continued by the Master of Jacques de Besançon, also known as the chief associate of Maître François (active *c*.1480–95), whose works were once seen as part of François's own output. KC

Avril, F., and Reynaud, N. (eds.), *Les Manuscrits à peintures en France, 1440–1520*, exhib. cat. 1993 (Paris, Bib. Nat.).

FRANCQUEVILLE, PIERRE (or Francheville or Piero Francavilla) (1548–1615). French sculptor. Born in Cambrai, he became one of *Giambologna's most important followers. He worked briefly in Paris before moving to the archducal court in Innsbruck (1565–71). Sent to study under Giambologna in Florence, he remained there, somewhat overshadowed by his master, whom he assisted at the Grimaldi chapel in Genoa (1579–90). Nonetheless, his considerable compositional and carving skills are demonstrated in the attractive group of marble figures carved for Abate Antonio Bracci's villa garden at Rovezzano (1574–91; London, Royal Coll. and V&A; Hartford, Conn., Wadsworth Atheneum), and the colossal statues of *Jupiter* and *Janus* (1585; Genoa, Gal. Palazzo Bianco), and the graceful, attenuated *Jason* (*c*.1589; Florence, Palazzo Ricasoli-Goldoni). Less successful is his series of stiff grand ducal statues in Pisa and Arezzo (1594–5) after Giambologna's models. Summoned to Paris in 1604 by Henri IV to complete the equestrian monument of the monarch for the Pont Neuf (now destroyed), he remained there until his death. AB

Francqueville, R., *Pierre de Francqueville, sculpteur des Médicis et du roi Henri IV (1548–1615)* (1968).

FRANKENTHAL SCHOOL, a group of 16th-century landscape artists, mainly of forest scenes, who lived in Frankenthal in the Palatinate. In 1562 the Elector Palatine, Friedrich III, established the village as a place of asylum for Protestant refugees. The term 'school' suggests a formal colony of artists but it is more likely to have been a small and shifting number of painters who soon passed on to other, more profitable centres of patronage. The most influential was Gillis van *Coninxloo but others were Pieter Schoubroeck and Antoine Mirou. CFW

Sutton, P., *The Age of Rubens*, exhib. cat. 1993 (Boston, Mus. of Fine Arts).

FRÉART DE CHAMBRAY, ROLAND (1606–76). French administrator and writer. He was the elder brother of Paul Fréart de Chantelou. Both spent time in Italy studying art and architecture in the 1630s before joining the French royal arts administration, the Bâtiments du Roi. In 1639 Fréart de

Chambray travelled with his brother to bring *Poussin back to Paris from Rome. He published translations of Palladio's *Quattro libri dell'architettura* and *Leonardo's treatise on painting (both 1651). His original writings include *Parallèle de l'architecture antique et moderne* (1650), which asserts the superiority of Greek and Roman art to that of modern times. *Idée de la perfection de la peinture* (1662), with its emphasis on the primacy of drawing over colour, and Poussin as its hero, became the key manifesto of the pro-*disegno* lobby in the Académie Royale, *Paris, its counterpart on the pro-*colore* side of the debate being Roger de *Piles's *Dialogue sur les coloris* (1673), with its defence of the Venetian masters and *Rubens. MJ

Chardon, H., *Les Frères Fréart de Chantelou* (1867).

FREESTONE, any good-quality, fine-grained sandstone or limestone suitable for carving or building. AB

FRÉMINET, MARTIN (1567–1619). French painter, one of the leading artists of the Second School of *Fontainebleau. He spent the early part of his career in Italy, where he admired the work of *Michelangelo and was much influenced by such *Mannerists as the Cavaliere d'*Arpino, as can be seen in his altarpiece *The Adoration of the Shepherds* (1602–3; Gap, Mus. Départementale). He was recalled to France in 1602 by Henri IV to take part in the restoration of the Château de Fontainebleau. There his principal work was the ceiling of the Chapelle de la Trinité, an ambitious painting with architecture and figures seen in dramatic foreshortening. Completed in 1614, it is one of his few surviving works.

MJ

Béguin, S., *L'École de Fontainebleau*, exhib. cat. 1972 (Paris, Grand Palais).

FRENCH, DANIEL CHESTER (1850–1931). American sculptor. French, who was born in Exeter, NH, was largely self-taught but studied in the 1870s under the sculptors William *Rimmer and Thomas Ball (1819–1911). In 1873, before his brief training, he won a competition to commemorate the battle of Concord with *The Minute Man* (1874; Concord, Mass.), a life-size bronze figure with a pose adapted from the *Apollo Belvedere* in the Vatican. After two years in Italy (1874–6) he worked in Washington and Boston as a portrait and monumental sculptor with considerable success. A visit to Paris in 1886–7 introduced him to contemporary French sculpture which freed his own work from its constraining academicism. On his return he settled in New York, opened a studio, and was soon, with *Saint-Gaudens, one of the foremost American sculptors. Major commissions included the bronze doors for Boston Public Library (1904) and his best-known work, the over-life-size (6 m/19 ft high) marble *Abraham Lincoln* (1919) for the Lincoln Memorial in Washington, which gained the status of a national icon. DER

Daniel Chester French, exhib. cat. 1976 (New York, Met. Mus.).

FRENCH ART. The French tradition is one of the most enduringly brilliant in the history of Western art, and France is home to some of the most important artistic monuments and collections in Europe. At the cross-roads between the idealizing tendencies of Italy and the realist impulses of the Low Countries, France has benefited from both. Artists French by birth or adoption have been responsible for some of the most notable achievements in the Western canon. The *Gothic style was first developed in France. The French cathedrals and abbeys, with their architecture, sculpture, glass, reliquaries, and plate, together with the manuscripts illuminated for clerical and secular patrons, are among the most complete expressions of high medieval art. In the 16th century artists and craftsmen working for François I at the Château de *Fontainebleau created a distinctive French *Renaissance style that spread throughout northern Europe, while in the first decades of the 17th century *Poussin and *Claude achieved international renown. Under Louis XIV, whose new palace at *Versailles became a model for princely grandeur everywhere, France was the first country to develop the Italian idea of the *academy into an official system of education for artists with a supporting structure of state patronage and regular public exhibitions. It was this more than anything that sustained the claim of *Paris in the 18th century to be an art centre second only to Rome. French art, artefacts, artists, and craftsmen were exported to the remotest corners of the Continent where fashion and sophistication were valued by the rich and powerful. During the 19th century Paris became the art capital of the world, and the most significant developments in modern art were generated in France up until the First World War. It was only with the emigration of European artists to the United States on the eve of the Second World War that the centre of gravity of the art world finally shifted to New York. France remains, nevertheless, one of the most important world centres for the study of old art and for the creation of new.

The first evidence of artistic activity in the geographical area we now call France is at Lascaux, where the most famous example in Europe of palaeolithic cave painting survives, dating from around 15,000 BC. In Provence remains of Celtic wall painting and stone sculpture indicate a flourishing artistic culture before the arrival of the Romans, who themselves left notable classical monuments throughout southern Gaul, which were later to provide inspiration to French artists. A fresh artistic impulse did not begin after the end of the Roman Empire until the establishment of the Christian kingdom of the Franks in the region to the west of the Rhine in the 5th and 6th centuries AD. For many centuries thereafter most painting and sculpture was devotional.

The arts prospered particularly under the Emperor Charlemagne at the end of the 8th century. In the western part of his empire mosaics and stuccowork survive at Germigny-des-Prés and wall paintings at Auxerre, while manuscript illumination (see under ILLUMINATED MANUSCRIPTS) reached new levels of sophistication firstly in his capital at Aachen (Aix-la-Chapelle), then at other centres, notably Reims and Tours. The most famous surviving *Carolingian manuscript, the so-called Utrecht Psalter (Utrecht, University Lib.), was illuminated in 816–34 at the monastery of Hautvilliers near Reims.

With the foundation of the Capetian dynasty at the end of the 10th century it begins to be possible to speak of a French kingdom, though not necessarily of a French art. During the following two centuries the monumental *Romanesque style was developed under the patronage of wealthy religious foundations, with many distinctive regional variants reflecting local tastes, needs, and materials. Thus, manuscripts produced in *Burgundy under the influence of the abbey at Cluny are typified by a rich, dark palette and figure style derived from the Italo-Byzantine tradition, while those from Touraine in the west, for long periods under English control, have features derived from the Anglo-Saxon tradition. In sculpture the new style was first developed in northern France. Later, around 1100, the first of the great carved church portals were constructed in the south and west. Important examples, with densely packed and schematic tympanum reliefs supported above stone figures of hieratic dignity, survive at Conques, Cluny, and Vézelay. The relief of the *Last Judgement* at Autun is remarkable for being signed, by one *Gislebertus.

From the mid-12th century the Île de France became the focus of the newly centralized government of the French monarchy, with Paris as its administrative and cultural capital. The impetus to enlarge and embellish the important churches of the region, combined with ever more daring solutions to the engineering problems of vaulting large spaces in stone, led to the evolution of the Gothic style, with its pointed arches and enormous windows. This was the first international style to have its origins in France. New carved portals were made, first for S. Denis Abbey, then at Chartres and elsewhere. The soaring interior spaces of the new

churches had their counterpart in elegantly designed and purposefully placed sculptures. A trend towards a clear narrative iconography culminated in the 13th century in the carvings of the façade of Amiens Cathedral, which was called by *Ruskin a 'bible in stone'. The painted glass of the S. Chapelle in Paris, built in 1243–8, is the most spectacular example of the impetus given to this art form by the structural innovations of the Gothic church builders.

Later Gothic art in France was characterized by a tendency towards sumptuous elegance, encouraged by the development of an art market geared to the sophisticated tastes and conspicuous consumption of the royal family and upper nobility. Book production moved from the scriptoria of monasteries to become part of a highly organized commercial trade in Paris. Small-scale sculptures in ivory or precious metals, particularly in the form of *reliquaries, shared with monumental sculpture a new grace of posture and elegance of gesture. Similar concerns are apparent in manuscript painting of the 14th century, a period from which we begin to know the names of the artists responsible. Jean *Pucelle's Book of Hours illuminated for Jeanne d'Évreux, wife of Charles IV, in the late 1320s, is an example of this courtly style sometimes known as *International Gothic.

Although Paris was the hub of fashionable art production in France in the late Middle Ages, there were other innovative centres also. In Avignon, a papal city, Italian painters, including *Simone Martini, were employed in the 1340s to decorate the Palais des Papes with works in the latest central Italian style. Dijon, the capital of the dukes of Burgundy, attracted talented Netherlandish artists, and it was there at the turn of the 15th century that the International Gothic style reached its apogee in the manuscript illuminations of the *Limburg brothers. Their Très Riches Heures (1411–16; Chantilly, Mus. Condé) is one of the most sumptuous manuscripts ever made. Even the humblest scenes from the Gospel are presented with the chivalric pomp of a court pageant and a hitherto unparalleled technical sophistication. While surviving panel paintings from this period are rare, they also display something of this same lavish style. By contrast, the most significant late medieval sculptor, Claus *Sluter (also Flemish by birth), worked in a vigorous and naturalistic manner exemplified in his carvings for the Charterhouse at Champmol, near Dijon.

Artistic patronage and production took time to recover from the trauma of the French defeat at Agincourt in 1415. The work of two of the most distinctive panel painters of the second half of the 15th century, Enguerrand *Quarton and the Master of Moulins (see HEY, JEAN), still belongs to the late Gothic tradition. That of the royal painter Jean *Fouquet combines this with classical references and a use of perspective learned on a visit to Rome in the 1440s. But by the last decades of the century the extraordinary prestige of Italian Renaissance culture and the territorial adventurism of the French kings led to the wholesale admiration of Italian style in the visual arts.

At first the new Renaissance vocabulary was introduced to France through imported works made by Italian artists and craftsmen. Louis XII ordered a classical funerary monument from Girolamo Viscardi of Genoa in 1502 and François I bought or commissioned works by *Raphael, *Titian, *Leonardo, and others. Leonardo himself was persuaded to settle at Amboise, where he died, *Andrea del Sarto was briefly in the King's service in 1518–19, and *Cellini made a longer stay in the 1540s. Although native-born artists, chief among them the sculptor Michel *Colombe, did work in the new idiom, rich 16th-century patrons at first preferred Italians. It is clear, however, that the style of decoration created by the Florentine *Rosso, the Bolognese *Primaticcio, and their associates for the royal Château de *Fontainebleau from the late 1520s, was much more than a provincial variant of Italian *Mannerism. The sophisticated and inventive style of the School of Fontainebleau was not the only strand in French art of the period—portraiture in the hands of the Flemish-born *Clouet family and of *Corneille de Lyon was also of high quality—but it was the outstanding achievement of the French Renaissance in the visual arts.

The Fontainebleau style was the predominant one in France into the early 17th century, and through the medium of prints was spread through much of northern Europe. But with a few noteworthy exceptions, such as the work of the sculptor Germain *Pilon, little that was new or inventive was produced by French artists of the last quarter of the 16th century, a period disturbed by religious disputes and civil war. An artistic revival in *Nancy, capital of the duchy of Lorraine, particularly associated with the etcher Jacques *Callot, was the last flowering of mystical and religious Mannerism. When, with the end of the wars of religion, France under Henri IV and Louis XIII embarked on a period of reconstruction, artists and patrons turned to the *Baroque art of *Rubens and contemporary Roman painters and sculptors.

The presence in Paris of Rubens's series of paintings The Life of Marie de Médicis (completed 1625; Paris, Louvre) did not have its full impact on French art until the last decades of the 17th century. While Flemish-born artists, chief among them Philippe de *Champaigne, did dominate portraiture and also still life, the training in Rome of talented and ambitious young history painters such as Claude *Vignon and Simon *Vouet quickly made the art of Guido *Reni, Pietro da *Cortona, and *Domenichino the model for metropolitan art from the 1630s. *Caravaggism, with which the same artists had flirted in Rome, quickly became a provincial phenomenon, exemplified above all by one of the most original painters of the 17th century, Georges de *La Tour in Lorraine.

Two of the most outstanding French painters of the period chose to make their careers in Rome, where they found the artistic and intellectual culture, and the physical environment more attractive than in Paris. Both benefited from their proximity to the remains of *Antique art and that of the High Renaissance. *Claude Lorrain made landscape painting into a genre worthy of the interest of the most discerning collector, and established parameters for classical landscape that were deemed valid for two centuries. Poussin, though he worked for the most part on modestly sized easel paintings with sometimes abstruse mythological and religious themes, became the single most admired artist in the French tradition—a touchstone for both the academics and the avant-garde. In the 1660s, when Louis XIV's minister Colbert called on Charles *Le Brun to reorganize the Académie Royale (see under PARIS) as an instrument for state control of the arts, it was the example of Poussin's painting that was placed at the heart of the new body of academic theory, not that of his own teacher Vouet, though the latter had dominated painting in Paris.

The characteristic artistic activity of the reign of Louis XIV was a kind of high-grade teamwork in royal service. The Château de Versailles was rebuilt with a lavishness unparalleled even at Fontainebleau. The painters and sculptors who worked under the direction of Le Brun evolved a style inspired by the dramatic Roman Baroque of Pietro da Cortona and *Bernini but consciously modified into a more dignified and richly classical idiom deemed to be more characteristically French. That the style of Versailles, soon adopted throughout France and by the end of the century a standard for Europe, was consciously evolved as a political and aesthetic gesture of self-definition is underlined by the unhappy outcome of Bernini's visit to France when his designs for completing the Louvre were rejected. Sculpture, which had been the province of foreign artists such as *Giambologna and Pierre *Francqueville in the early decades of the century, reached a high point in the last decades in the work of François *Girardon and Antoine *Coysevox, who were the perfect exponents of the grand manner.

Artistic life continued away from the centre—the painter Nicolas *Mignard in Avignon and the sculptor Pierre *Puget in Toulon were both significant figures—but it became difficult for monumental sculptors

and history painters to work in a nonconformist manner. The Académie Royale placed increasing emphasis on the intellectual principles of *classicism. The assertion that art should conform to rules that can be rationally deduced and taught, with the consequent elevation of the role of draughtsmanship and denigration of colour, eventually led to a revolt among the academicians. The orthodox representatives of Poussinisme, led by the writer *Félibien, triumphed, at least temporarily, over the revolutionary advocates of Rubénisme, whose spokesman was Roger de *Piles. Yet while the tenets of classicism ossified into academicism, younger painters including *La Fosse and Antoine *Coypel were inspired by the example of Rubens to experiment with new effects of rich colour and illusionistic perspective.

The academic view of art—which privileged large-scale works with serious themes treated in a serious way over the 'lesser' genres, such as portraiture, landscape, and still life—continued to dominate institutional thinking throughout the 18th century in France. But the economically disastrous effects of the wars at the end of Louis XIV's reign meant that the Crown could no longer afford to be a patron on such a lavish scale. The call for works with religious and historical themes continued, nevertheless, and there were able practitioners in the first half of the century, such as the painters *Jouvenet, *Natoire, and *Subleyras, and the sculptors Nicolas and Guillaume *Coustou. But the fact that the Crown felt obliged to institute occasional competitions for the encouragement of *history painting clearly demonstrates the shift in demand that had occurred.

The youthfulness of Louis XV and the move of the court to Paris put a new emphasis on the less formal and self-consciously grandiose social life led by the younger members of the metropolitan aristocracy. Fashionable Parisian taste, with its emphasis on civility, elegance, and comfort, now set the tone for the court. With the remodelling of the town houses of the rich in the emergent *Rococo style, artists were called upon to provide decorative canvases shaped to fit panelling, as well as small-scale paintings and sculptures with light-hearted subject matter for the connoisseur and collector. The arcadian *fêtes galantes* (see FÊTE CHAMPÊTRE) of *Watteau, for which the Académie Royale had to invent a new category in its hierarchy of genres, reflect something of the self-image of society at the time and were widely imitated by less able artists.

The most successful artist of the mid-century was *Boucher. His stylish and decorative mythological paintings, tapestry cartoons, and designs for porcelain provided the setting for the lives of the rich and fashionable. His svelte, erotically charged, and amiable works found their counterparts in the marble bathers of *Falconet and the early terracotta groups of *Clodion. But the complexity of this period, about which it is difficult to make generalizations, is demonstrated by the work of his contemporaries *Chardin and *Bouchardon. The former raised the lowly genre of *still-life painting to new heights of seriousness, and the latter created sculptures of austere monumentality. All three had patrons in common. Portraiture evolved from the ostentatious formality of *Rigaud and *Largillierre to the relaxed charm of the pastels of Maurice-Quentin de *La Tour and the sculptured busts of *Pigalle, reflecting not only the easier manners of the time but also Enlightenment theories of individualism. *Landscape painting underwent a revival too. But although conforming to the general principles of the classical landscape established by *Claude Lorrain, two new tendencies were detectable. In the paintings of Hubert *Robert and *Fragonard there is a proto-Romantic pleasure in ruins and decay, while the famous series of French seaports commissioned from Claude Joseph *Vernet by Louis XVI demonstrates a characteristic Enlightenment concern to display the achievements of responsible government.

By the 1760s a turn away from the subject matter and style of the Rococo was apparent. Critics such as La Font de Saint-Yenne and *Diderot began to label the work of many of their contemporaries shallow, frivolous, and licentious. They called instead for a morally serious art, which would teach responsible behaviour by example. The loves of the gods were to be banished in favour of stoic episodes from classical history or scenes of rustic virtue. Such a mood, fully in tune with other manifestations of Enlightenment thinking, was reinforced by the new emphasis on Nature as a guide to human behaviour. Sadly, the ponderous Carle van *Loo, best-established history painter of the time, provided no example of a style in which to express the new sentiments and the new subject matter. Artists turned instead to the work of Poussin and also to the newly uncarthed wall paintings of *Herculaneum and *Pompeii. *Greuze was inspired by Poussin's compositions to paint some of the first *Neoclassical pictures in France; *Vien was more interested in transposing ancient wall paintings into a chic classicizing version of the Rococo that his patrons liked.

Where Rococo was a French invention, exported across fashionable Europe, Neoclassicism was an international phenomenon. But while its epicentre was Rome, it achieved its most complete expression in painting in the work of the French artist *David, in a group of history paintings on Antique Roman themes commissioned by the government of Louis XVI in the 1780s. The ambition, if not the *éclat*, of such pictures as David's *Oath of the Horatii* (1784; Paris, Louvre) was mirrored in the series of monumental statues of great Frenchmen commissioned from the most eminent sculptors of the day, among them *Caffiéri, *Pajou, and *Houdon.

The French Revolution brought an abrupt halt to most forms of artistic activity. Many artists closely associated with royal or aristocratic patrons went into exile or saw their careers collapse. Even David, who rapidly became the politically most powerful artist in France, was obliged to live mainly off portrait commissions. Among the many institutions swept away was the Académie Royale, though it was not long before its powerful functions as a regulator of artistic education and an exhibiting society were taken up by a new body, the École des Beaux-Arts (see under PARIS). This was to prove itself in the course of the following century even more conservative than its predecessor.

By the first decade of the 19th century the combined prestige of David's teaching studio and the collections of art brought by Napoleon from across conquered Europe to the Louvre had completed the process begun by the patronage of Louis XIV. Paris had replaced Rome as the centre of the art world, a position the city was to hold until the Second World War. The rich diversity of French art in the 19th century may be explained by the dynamism of Paris as an artistic capital that attracted artists and patrons from all over Europe and North America. Opportunities to train, to exhibit, and to make contact with an increasingly sophisticated and well-structured art market were well in advance of any other European city.

While Neoclassicism and David's teaching remained the academic yardsticks well into the century, the influence of literary *Romanticism, nationalism, and the great Napoleonic adventure turned many artists into other channels. David himself and his pupil *Gros were among the first to turn back to Rubens and other artists of the Baroque for principles to guide them in huge canvases of Napoleonic pomp or the field of battle. Although scenes from ancient history and mythology were still depicted, notably by David's most original pupil, *Ingres, there was a new interest spreading with the Romantic movement from England and Germany, in taking subjects from Shakespeare, Goethe, Byron, Scott, and the spurious poet Ossian, as well as from modern French writers. Scenes from French medieval history, in the *troubadour style, became fashionable also. Later, after the Restoration, subjects from the history of the *ancien régime* were almost as frequent in state commissions as big devotional pictures to replace those lost in the Revolution.

When painters of the Romantic generation, most famously *Géricault and *Delacroix, were attacked in the 1820s by

conservative critics, it was for their novel subject matter and hectic finish rather than their rejection of Neoclassical style. Delacroix was employed continuously by the state on major decorative commissions in the middle decades of the century. Ingres, the chief guardian of the flame of Neoclassicism, and *Delaroche, a successful representative of the large number of artists who did not take a strong stance on matters stylistic, were not nearly so busily employed. While the legacy of Neoclassical sculpture remained strong in the many French followers of Napoleon's favourite *Canova, Romanticism found varied outlets ranging from the impassioned, pro-republican monuments of *David d'Angers to the wild beast fights of *Barye.

Genre scenes and landscape played an important role in the 19th century. With portraits they were popular with middle-class buyers. Historical genre was gradually eclipsed by scenes from a semi-imaginary Orient, a reflection of the colonialism of the mid-century. Painters as diverse as Ingres, Delacroix, and Horace *Vernet painted such scenes. By the 1840s Théodore *Rousseau, *Daubigny, and other painters of the *Barbizon School were popularizing naturalistic scenes of the landscape around Paris, loosely inspired by the art of 17th-century Holland. Rejection of classical landscape formulas accelerated as life became more urbanized and the native landscape consequently more prized.

Two opposite trends—*realism and *Symbolism—are discernible in French art from the middle of the 19th century. Both reflected the growing industrial and urban culture of the time, with its Positivist philosophy and middle-class pragmatism. *Courbet was not the only painter to renounce the imaginative worlds of both classicism and Romanticism in favour of a robust treatment of the here-and-now. *Daumier and *Millet also did so. But the scale of his treatment of such everyday events as a country funeral was unprecedented. He was attacked for giving A Burial at Ornans (1849; Paris, Mus. d'Orsay) all the importance of a history painting. Courbet's realism was closely allied to the republican and democratic principles of the 1848 Revolution, which gave conservative critics an additional reason for disliking him. Manet's realism was of a different kind. Where Courbet adopted the persona of the noisy democrat, and took his themes mainly from his rural roots, Manet was the gentleman flâneur personified and his paintings portray the leisure activities of Parisian life. And where Courbet's technique and palette remained that of the old masters, Manet was an innovator, experimenting with compositional devices and applications of colour inspired by photography and Japanese prints.

Such experiments were carried considerably further by a loosely knit group of younger painters. *Monet, *Renoir, *Pissarro, *Degas, Berthe *Morisot, and the American Mary *Cassatt were given the derisive name *Impressionists by a journalist. Though these artists exhibited together in the 1870s and 1880s because they were excluded from the official Salon, their broadly similar aims manifested themselves in very different ways. They were united, however, in their desire to paint subjects from modern life, and to discard the techniques and palette of the art schools in favour of painting directly from the motif, often out of doors, to try to capture the immediacy of their visual impressions.

Sculpture lent itself less easily to modern life subject matter, but *Carpeaux, among others, caused considerable scandal by introducing a vigorous and veristic treatment of the human body into public works, most notably in the group La Danse (1868) for the Paris Opera. Degas made small clay studies of human and animal figures, unique in their flouting of traditional conventions, but unknown until his death. It was *Rodin, however, who finally destroyed the conventions of sculpture with his Gates of Hell (begun 1880; version Paris, Mus. Rodin).

Despite modern perceptions, realism and Impressionism were never part of the mainstream. The artists involved found it difficult to exhibit at the Salon or to get government commissions. Names that would have been instantly recognizable to fashionable 19th-century exhibition visitors, such as *Gérôme, Léon Bonnat, *Meissonnier, *Bouguereau, and *Bastien-Lepage, are only now re-emerging after nearly a century of neglect to provide a historical context for the avant-garde. Unlike the Impressionists, *Symbolist painters, including Gustave *Moreau, *Puvis de Chavannes and Odilon *Redon, received a welcome from the establishment. Moreau became an influential teacher at the École des Beaux-Arts, and Puvis was widely regarded as the foremost mural painter of his time. Their beautiful and strange visions of an inner dream world were the last manifestations of Romanticism, appealing to a public looking for escapism and a renewal of spirituality at the fin de siècle.

Both Symbolism and, ironically, Impressionism had the effect of releasing the next, so-called *Post-Impressionist, generation from the constraints of mimesis, the predominant aim of art since the *Renaissance. With Pointillism *Seurat and *Signac took the Impressionist experimentation with colour to its logical conclusion. *Cézanne, perhaps the most important late 19th-century painter as far as the development of *modernism is concerned, wanted to create a monumental modern style in which the illusion of depth was replaced by an interlocking and inevitable grid of forms and colours on the surface of the canvas. Whilst scorning the methods and subjects of the academy, he revered both the compositions of Poussin and the stony, harshly lit landscape of his native Provence, aiming, in his own words to 'do Poussin over again from Nature'. *Gauguin and the Dutchman van *Gogh, both regarded as little more than madmen by their contemporaries, explored the expressive possibilities of pure colour and rejected the conventions of Western art in favour of a primitivism invested with highly personal symbolic associations.

The monolithic conservatism of the French academic system and a series of scandals surrounding the exclusion of the works of more experimental artists from Manet on, had led by the end of the 19th century to the reform of the École des Beaux-Arts and the foundation of several liberal exhibiting societies, chief among them the Société des Artistes Indépendants. The term *Ecole de Paris (School of Paris) is applied to the loosely knit groups of experimental artists, not all of them French by birth, based in the city in the early decades of the 20th century. The innovations of the Impressionists and the portentous subjects of the Symbolists had themselves become fashionable orthodoxy by the time *Matisse and *Derain made their sensational colourist debut in 1905, an event that earned them the sobriquet 'les Fauves' (the wild beasts). Where the *Fauves were influenced by aspects of the art of van Gogh and Gauguin, and belonged to the Romantic tendency in French art, the radical, anti-mimetic *Cubist experiments of *Braque and *Picasso in the years leading up to the First World War allied them through Cézanne to the classical, rationalist tradition. This intense period of creativity and experimentation was brought to a halt by the First World War. The immediate aftermath of the war was marked by a nostalgic return by many artists to the springs of Mediterranean culture. Paris also became home to modernist artists displaced from elsewhere in Europe, among them *Chagall and *Modigliani, as well as the practitioners of abstraction (see ABSTRACT ART), *Mondrian and, after 1933, *Kandinsky. The dominant avant-garde aesthetic of the inter-war period in France was, however, *Surrealism, the principal protagonists of which were *Miró, *Dalí, *Ernst, *Magritte, and the poet André *Breton. But the art of the Surrealists should be put into the context of *Art Deco painting and sculpture, the much more widely dispersed, commercial, and fashionable face of modernism in the period of the entre deux guerres.

The fall of France in 1940 and the subsequent German occupation of Paris again brought most artistic activity to a halt. The emigration of many European artists to the United States contributed to the decline of

Paris as the pre-eminent art centre of the Western world, though in the post-war period France remained home to many distinguished artists. Such groups or movements as *Art Informel, *Art Brut, *Nouveau Réalisme and Groupe de Recherche d'Art Visuel, as well as the works of such artists as Bernard Buffet (1928–), Balthus (1908–), *Dubuffet, *Klein, *Tinguely, and *Vasarely testify to the variety of artistic activity in post-war France, though they have tended to be overshadowed by the achievements of those living in New York and, latterly, London. MJ

Blunt, A., Art and Architecture in France, 1500–1700 (rev. edn., 1988).

Conisbee, P., Painting in Eighteenth-Century France (1981).

Dodwell, C. R., Painting in Europe, 800–1200 (1971).

Grodecki, L., and Brisac, C., Gothic Stained Glass, 1200–1300 (1985).

Hamel, C. de, A History of Illuminated Manuscripts (1995).

Janson, H. W., Nineteenth-Century Sculpture (1985).

Levey, M., Painting and Sculpture in France, 1700–1789 (1993).

Lynton, N., The Story of Modern Art (1989).

Mérot, A., French Painting in the Seventeenth Century (1995).

Muller, T., Sculpture in the Netherlands, Germany, France and Spain, 1400–1500 (1966).

Novotny, F., Painting and Sculpture in Europe, 1780–1880 (1985).

Rosenberg, P. (ed.), French Seventeenth-Century Paintings from American Collections, exhib. cat. 1982 (New York, Met. Mus.).

Rosenblum, R., Transformations in Late Eighteenth-Century Art (1967).

Rosenblum, R., and Janson, H. W., Art of the Nineteenth Century (1984).

Sauerländer, W., Gothic Sculpture in France, 1140–1270 (1972).

Souchal, F., French Sculptors of the 17th and 18th Centuries: The Reign of Louis XIV (4 vols., 1977–93).

FRENCH ART AS OBJECTS OF PATRONAGE AND COLLECTING. See overleaf.

FRERE BROTHERS. French painters. **Charles Théodore** (Frere Bey) (1814–88) was born in Paris and studied under Leon Cogniet (1794–1880) and Charles Roqueplan (1800–55). He began by painting French rustic interiors and landscapes but following a stay in Algeria in 1837, the year in which the French took Constantine, specialized in Eastern subjects, showing his first orientalist painting at the Salon of 1839. Frere made a longer Middle Eastern journey in 1851 and accompanied the Empress Eugénie to the Near East in 1869. His undramatic but exotic landscapes, townscapes, and interiors, carefully delineated and full of detail, like the Café de Galata, Constantinople (c.1880; Barnsley, Cooper AG), were immensely popular and won him the patronage of Louis-Philippe, the King of Württemberg, and admirers throughout Europe and the United States.

His brother, the popular and successful realist genre painter **Édouard** (1819–86), who specialized in rustic youthful scenes like In Front of the School (1881; Sheffield, AG), was highly praised by *Ruskin, particularly for his portrayal of young country beauties. DER

Montrosier, E., Artistes modernes II (1896).

FRESCO. See WALL PAINTING.

FREUD, LUCIAN (1922–). German-born British painter and draughtsman. He was born in Berlin, son of an architect, Ernst Freud, and grandson of Sigmund Freud. In 1932 he settled in England with his parents, and he acquired British nationality in 1939. His earliest love was drawing and he began to work full-time as an artist after being invalided out of the Merchant Navy in 1942 (his formal training was brief but included an important period in 1939 studying with Cedric Morris, who encouraged his pupils to let feelings prevail over objective observation). From 1948 to 1958 he taught at the Slade School, London. He first exhibited his work in 1944 and first made a major public impression in 1951 when his Interior at Paddington (Liverpool, Walker AG) won a prize at the Festival of Britain; it shows the sharply focused detail, pallid colouring, and obsessive, slightly bizarre atmosphere characteristic of his work at this time. Because of the meticulous finish of such paintings, Freud has sometimes been described as a 'realist' (or rather absurdly as a *Super-realist), but the subjectivity and intensity of his work has always set him apart from the sober tradition characteristic of most British figurative art since the Second World War. From the late 1950s he painted with much broader handling and richer colouring, without losing any of his intensity of vision. His work includes still lifes, interiors, and urban scenes, but his specialities are portraits and nudes, often observed in arresting close-up, with the flesh painting given an extraordinary quality of palpability (The Painter's Mother, 1982; London, Tate). He prefers to paint people he knows well, one of his favourite recent subjects being the Australian *Performance artist Leigh Bowery (1961–94), who was a friend from the mid-1980s: 'If you don't know them, it can only be like a travel book.'

Freud's work has been shown in numerous one-man and group shows and he has steadily built up a formidable reputation as one of the most powerful contemporary figure painters. In 1993 Peter *Blake wrote that since the death of Francis *Bacon the previous year, Freud was 'certainly the best living British painter', and by this time he was also well known abroad (a major retrospective exhibition of his work in 1987–8 was seen in Paris and Washington as well as London). IC

FREUD, SIGMUND (1856–1939). Austrian psychologist. As the thinker who coined such concepts as 'the ego and the id', 'the Oedipus complex', and 'psychoanalysis', his influence on 20th-century culture was incalculable. His psychology, developed in tandem with clinical practice in Vienna, attempted a theory of the mind in terms of organizing energies or 'drives'. The principal of these he named the 'libido', the sexual urge that sought fulfilment and which if repressed would yet emerge in the form of dreams, jokes, or for that matter artistic creations. Freud's venture into art criticism, accounting for *Leonardo's Virgin and Child with S. Anne along such lines, does not state his case to best advantage, being based on faulty data. His ideas however proved immensely stimulating to the art world. The *Surrealists explicitly sought to release the unconscious in visual art from 1924 onwards: *Dalí drew an admiring portrait sketch in 1938, though Freud, more attuned to classical art, did not reciprocate the enthusiasm. In criticism from the 1920s Freud's impact—often mediated through interpreters like Melanie Klein (see STOKES, ADRIAN) or Jacques *Lacan—has been far-reaching. JB

Spector, J., The Aesthetics of Freud (1972).

FRICK COLLECTION. See NEW YORK.

FRIEDLAENDER, MAX JACOB (1867–1958) German art historian, one of a pioneering generation born in the 1860s, and central to the historiography of art history. Born in Berlin (in a house barely 200 yards from the Altes Museum), he studied art history in Munich, Leipzig, and Florence, with, from the start, a strong inclination towards *connoisseurship. He succeeded Wilhelm von Bode as director of the Gemäldegalerie in *Berlin and made important acquisitions, particularly in early Netherlandish painting. This was his subject, and he used the skills of the connoisseur to clarify its history, a study which culminated in his great work Die Altniederländische Malerei (14 vols., 1924–37). His methods were similar to those which *Berenson was applying to Italian painting. He was a prolific writer, and his works include a monograph on Max *Liebermann, fundamental essays on landscape and genre painting, and speculations on the problems of connoisseurship—such as intuition and the first impression, documentary evidence and inventories, dealers and agents, originals, copies, and forgeries. In 1934 he retired to Holland. HL

FRIEDRICH, CASPAR DAVID (1774–1840). The most important German landscape painter of the *Romantic movement.

continued on page 261
257

· FRENCH ART AS OBJECTS OF PATRONAGE AND COLLECTING ·

TO a large degree the early history of patronage in France after the collapse of the Roman Empire is the history of the building, rebuilding, decorating, and furnishing of important ecclesiatical buildings—the abbeys and cathedrals, and their associated libraries and treasuries. The first significant post-Roman patron in western Europe was Charlemagne at the end of the 8th century. A considerable amount of the art that he commissioned was made in France, in particular the illuminated manuscripts produced at Reims and Tours. Although the Emperor set an example of royal patronage to his successors, the weakness of the first French monarchs meant that the most ambitious and wealthy early medieval patrons were the abbots of the great monastic foundations. It was the growth of the power of the orders, chief among them the Benedictines of Cluny, that drove the development of the *Romanesque style. Monastic patronage culminated in the activities of Abbot *Suger at the royal abbey of S. Denis in the early 12th century, where he oversaw a completely integrated scheme of architecture, sculpture, stained glass, and plate.

The new prosperity of the cities made the metropolitan bishops significant figures in art patronage in the 13th and 14th centuries. Already at the end of the 11th century Bishop Odo of Bayeux had commissioned the most famous surviving piece of medieval needlework, the Bayeux Tapestry, to decorate his cathedral and commemorate the conquest of England by his half-brother William I. As the increasingly powerful French monarchy came to regard Paris and the Île de France as the focus of its activities in the mid-12th century, there was an impetus to enlarge and embellish its urban churches. Chartres, Laon, Bourges, Notre-Dame in Paris, and later Reims, Rouen, and other cathedrals were rebuilt and adorned by their bishops with the wealth of royal and private donors, and funds derived from relics and pilgrims. The high quality of French Gothic manuscripts, plate, and enamels, such as those from Limoges, meant that such portable works of art found their way to churches and princely households throughout Europe. These works were often exported as diplomatic gifts, but increasingly as purchases ordered by foreign patrons, sometimes through agents such as the 'Merchant of Prato' (Francesco di Marco Datini), a Tuscan merchant settled in Avignon.

By the 14th century the most active patrons were beginning to be secular individuals, mainly those from the royal and ducal houses, such as Jeanne d'Évreux, wife of Charles IV, who ordered a particularly sumptuous book of hours from Jean *Pucelle in the 1320s, or Charles V, who at the end of the 14th century formed a library of manuscripts at his palace of the Louvre. This was perhaps the first significant art 'collection' in France. The acquisition of objets de luxe for show as much as use reached a high point in late medieval France with the activities in the early 15th century of John, Duke of Berry, uncle of Charles VI, who was the main patron of the *Limburg brothers, and of his brother Philip, Duke of Burgundy, patron of Claus *Sluter. Such lavish patronage set the pattern for other great nobles, but increasingly also for a new breed of rich merchants, bankers, and administrators, of whom the best known is Jacques Cœur, a powerful functionary at the court of Charles VII. His home in Bourges is the most important surviving example in France of a 15th-century town house. Closely connected with the rise of the bourgeois secular patron was the beginning of an art market organized towards the production of finished and semi-finished works that would await a purchaser rather than being made on a bespoke basis. This can be seen clearly in the late medieval book trade, when production moved definitively out of the monastic scriptoria and into the highly organized craft districts of Paris.

The 16th and 17th centuries were the period par excellence of royal patronage and collecting, with fashionable taste defined by that of the court. François I, who modelled himself on the great *Renaissance rulers of Italy, was an outstanding arbiter of the arts. But while local talents were employed on the great works at his Château de *Fontainebleau, the prime roles went to imported Italians, just as the royal collection was swollen by works by *Leonardo, *Raphael, *Titian, and by *plaster casts after Antique sculptures. The only significant exception to this rule was in the field of portraiture, where Jean and François *Clouet and *Corneille de Lyon found favour.

While the style of the School of Fontainebleau was exported throughout northern Europe into the early decades of the 17th century, mainly through the medium of prints, there was as yet little call for the export of French artists. At home, court taste continued to prefer the work of well-known foreign painters and sculptors—mainly Italians, but also Flemings such as *Pourbus and *Rubens—until *Vouet and his generation returned from training in Rome in the 1620s. Simpler tastes were, however, satisfied by the output of the humble French and Flemish artists who sold their wares on the Pont Notre-Dame in Paris, or by those who worked in the provinces.

After the destruction of the Wars of Religion both ecclesiastical and secular buildings were restored or rebuilt in the first half of the 17th century, providing much work for sculptors and painters. The missionary orders, in particular the Oratorians and the Jesuits, were particularly active patrons. Royal patronage was exercised during the minority of Louis XIII first by his mother Marie de Médicis, who gave Rubens his most magnificent commission in France, and later by Cardinal Richelieu, whose Palais

Cardinal in Paris rivalled the royal palaces in its splendour. Richelieu, like his successor as first minister Cardinal Mazarin, assembled an art collection on a heroic scale. Antique statues were accompanied by works of the Italian High Renaissance and canvases by such French contemporaries as Philippe de *Champaigne and *Poussin. Rich collectors were able to take advantage of the break-up of some of the foremost Italian princely collections, chief among them that of the Gonzaga dukes of *Mantua, and then of the sale of that of Charles I of England. (See LONDON, ROYAL COLLECTION).

The gentleman collector of modest means first became a force about this time. With a scholarly interest in the art of Antiquity and the Renaissance, and a connoisseur's interest in modern painting, the Roman civil servant Cassiano dal Pozzo, the Lyonnais Pointel, and the Parisian functionary Chantelou were among the most constant of Poussin's patrons and friends. The most famous amateur of this kind was Claude-Nicolas Fabri de Peiresc, an official of the parliament of Provence and a friend of Rubens, whose collection contained not just paintings and sculpture, but antiquities and natural curiosities. Increasingly, such educated art lovers were also involved in the theoretical and critical debates of the day.

The patronage of Louis XIV is legendary, as is his use of the Bâtiments du Roi—the department of the royal household concerned with the administration of royal commissions—and the Académie Royale to organize artists in the service of his statecraft. He was also a voracious collector, mainly of works by Italian artists of the High Renaissance and Baroque periods, and of Antique sculpture, but also of works by Dutch and Flemish painters and by the more highly regarded French artists of the recent past. The King's vision as a patron was shaped first by the activities of his ambitious Superintendent of Finances Nicolas Fouquet, builder of Vaux-le-Vicomte, and then by his artistic adviser, the painter *Le Brun. His contribution as a collector was defined by his wish to make the royal collection the most splendid in Europe. Thus the collections of Richelieu, Mazarin, Fouquet, and the banker Everard Jabach—the most assiduous buyer at the sale of Charles I's pictures—were successively swallowed up by gift, confiscation, and other means (Richelieu's heir lost his collection to the King in a tennis match).

While Poussin and *Claude were the first French artists to achieve international renown (being patronized by such foreign grandees as Pope Urban VIII and Philip IV of Spain) and thus to see their works profitably traded among collectors, it was the success of Louis XIV's political policies that made French art in demand across Europe. Even as royal commissions dwindled at the beginning of the 18th century, the powerful and fashionable across Europe were eager to employ French artists, competing with the aristocrats, bankers, and tax farmers who were the main patrons of art in the age of Louis XV. Foreign monarchs active in the French art market included Queen Louisa Ulrika of Sweden, whose agent in Paris, Count Tessin, himself assembled a beguiling collection of contemporary French art (Stockholm, Nationalmus.), Frederick the Great of Prussia, and Catherine the Great of Russia. The Bourbon connection ensured that Spain and Portugal came under French artistic influence, with French painters and sculptors employed to redecorate the royal residences, while many Protestant artists and craftsmen fled to London after the Revocation of the Edict of Nantes. The presence of the prestigious Académie de France in Rome meant that many Roman collectors and others passing through the city had the chance to see the works of younger French artists, while for English noblemen the *Grand Tour often began with a stay in Paris where they might sit to a fashionable portraitist. The English also developed a taste for the classical landscapes of Claude and *Dughet, many such pictures entering aristocratic collections in the course of the century as reminders of an Arcadian past, and the perfect complement to the Palladian country house. Later in the century Russian collectors including Grand Duke Paul found similar reminiscences in the ruin pictures of Hubert *Robert: today the Hermitage Museum in *St Petersburg has the richest collection in the world of his work.

Despite the depleted royal purse, public commissions were not entirely absent in the early 18th century. The Bâtiments du Roi sponsored a competition to promote *history painting. The corporation of Paris ordered a number of important monuments, among them *Bouchardon's fountain in the Rue de Grenelle, as did the local authorities in provincial cities. The Paris goldsmiths' guild continued its annual tradition of commissioning an altarpiece for Notre-Dame. Nevertheless, by the time that the Crown began once again to be a significant patron, royal taste tended to follow that of fashionable Paris—a trend that is particularly clear in the luxurious commissions of Louis XV's mistress Mme de Pompadour, whose brother the Marquis de Marigny was an able and well-educated head of the Bâtiments du Roi.

The most important developments in the 18th-century French art world were the growth of the art market and of public exhibitions. From 1737 the occasional *exhibitions of members' works organized by the Académie Royale became a regular feature. Unlike the street-market atmosphere of the open exhibition held in the Place Dauphine, the Académie Royale's Salon at the Louvre was an event where artists and their public could meet in a dignified and fashionable setting. By mid-century the Salon had given birth to another phenomenon—published art criticism in which authors, among them the *philosophe* *Diderot, aimed to interpret and evaluate the offerings of the artists. The rise of the exhibition was also accompanied by the rise of public auctions and of the specialist art dealer. The print dealer and drawings collector Pierre-Jean Mariette wrote the catalogue for the 1741 sale of *Crozat's collection—the first occasion that sound principles of connoisseurship had been applied to such a publication. Others followed him, including Edmé Gersaint, the picture dealer for whom *Watteau painted a shop sign (Berlin, Schloss Charlottenburg), a semi-fictional

representation of a picture dealer's premises. By the time of the revolution of 1789 many dealers had begun to specialize in particular kinds of pictures. This reflected not only new areas of interest among collectors—Jean-Baptiste Lebrun (husband of Élisabeth *Vigée-Lebrun), for instance, specializing in Dutch and Flemish pictures—but also an increasingly scientific approach to the study of the history of art, an outlook which found its fullest expression in the public art museums of the 19th century with their scrupulous distinctions between schools and periods.

Royal patronage in the final decades of the *ancien régime* was divided between the exquisitely self-indulgent—the whimsy of Marie-Antoinette and her circle—and the gravely responsible. It is often forgotten that the stoic history paintings of *David and the series of statues of great men of France were commissioned by Count d'Angiviller, reforming director of the Bâtiments du Roi, as part of a programme to encourage art that would educate public morals. In addition, d'Angiviller inaugurated plans to turn the Louvre into a public museum based on the royal collection. This was also the period in which a number of rich collectors for the first time formed collections of French art, while the print trade developed sophisticated new techniques in response to the wish of the professional classes to own affordable reproductions of paintings by French artists.

The careers of many artists never fully recovered from the loss of their aristocratic patrons during the Revolution. Commissions from the revolutionary government for records of contemporary events or decorations for its elaborately staged festivals, or small roles as advisers and curators to the committees that oversaw the confiscation of the property of émigrés and the establishment of a network of public museums, helped some. Others—most famously Mme Vigée-Lebrun—chose to exploit the prestige of French art abroad and travelled from capital to capital in Europe. Many of the great private collections were sold, mainly to British dealers and collectors. The auction in London of the Orléans pictures not only brought some of the most famous Italian High Renaissance and Baroque works into British collections, but reinforced the taste for 17th-century French painting. Among the masterpieces introduced by this route was Poussin's series of *The Seven Sacraments* (Duke of Sutherland Collection, on loan Edinburgh, NG Scotland). Other collections were seized by the state and now form the nucleus of the French provincial museums. In the public domain there was much wanton destruction of paintings and sculptures with royal or religious associations. A handful of antiquaries and government officials made heroic efforts to save what they could from what educated opinion had begun to regard as the national cultural heritage. Foremost among them was Alexandre Lenoir who founded the Musée des Monuments Français with fragments of medieval and Renaissance architecture and sculpture.

Napoleon consciously followed the example of Louis XIV in his self-aggrandizing use of art. Where his extensive patronage was motivated by political concerns, that of his extensive family was largely a matter of self-indulgence. As a collector, Napoleon was even more ruthless than his great predecessor, looting works of art and archaeological artefacts from across conquered Europe. The Musée Napoléon which added these spoils to the old royal collection was hugely influential on French artists, connoisseurs, and historians. The whole imperial adventure introduced not only new styles and themes to French artists but also opened up new fields of collecting as masterpieces of early Italian art were brought to Paris and as French generals brought booty home from Spain (see ITALIAN ART AS OBJECTS OF PATRONAGE AND COLLECTING: FRANCE; SPANISH ART AS OBJECTS OF PATRONAGE AND COLLECTING: FRANCE).

Although most of the looted works of art were returned after the fall of Napoleon, the machine of state patronage worked ever faster. The institution of the Beaux-Arts functioned much as had the Académie Royale, administering government commissions and controlling the Salon. After the iconoclasm of the Revolution there were many altarpieces and public monuments to be replaced, as well as scenes from *ancien régime* history to take the place of the Napoleonic decors in public buildings. State-sponsored works remained the mainstay of many painters until the end of the Second Empire. Such schemes as the Galerie des Batailles, commissioned by Louis-Philippe for Versailles, or the ceiling decorations for the Senate, commissioned by Napoleon III, were expensive and prestigious undertakings. There were still ambitious private commissions too, such as the decoration of the château de Dampierre for the Duke of Luynes. And there were discerning collectors of modern art who dealt directly with artists, such as Alfred Bruyas, a patron of *Delacroix and *Courbet. But during the 19th century the trend was towards speculative production for a well-to-do middle-class market requiring works of art on a domestic scale, with the art exhibition, the newspaper art critic, and, increasingly, the art dealer mediating between artist and patron. Although sculptors were reliant on public patronage for far longer than painters—the governments of the Third Republic were particularly active in commissioning public monuments—the wide availability of small-scale plaster and bronze casts reflected the shift to a bourgeois, domestic consumption of art objects.

Some artists, Courbet, being the notable example, were extremely adept at self-promotion and very carefully adapted their subject matter to conform to saleable categories. Others depended more on the guidance of dealers. Adolphe Goupil was one of the most financially successful of the Second Empire, promoting the work of mainstream painters such as *Gérôme and *Bouguereau to clients throughout Europe, and later in North America, while the increasing commercial success of the *Impressionists from the 1880s was largely due to the activities of Paul Durand-Ruel, who like Goupil realized the financial potential of the emerging market for art in the United

States. Among his clients were Bertha Palmer and Louisina Havermeyer, both of whom acquired significant groups of Impressionist pictures.

In the 1850s, after a long period of disfavour, the *Rococo art of the 18th century began to come back slowly into favour. By the 1860s nostalgia for the art of the *ancien régime* was firmly established through the writings of the Goncourt brothers and the collecting activities of Dr Louis La Caze, who donated his paintings by Watteau, *Boucher, and *Fragonard to the Louvre. The Marquess of Hertford, an Englishman resident in Paris, formed an outstanding collection of 17th- and 18th-century French painting, sculpture, furniture, and porcelain now known, after his illegitimate son Sir Richard Wallace, as the Wallace Collection. By the end of the 19th century such works had moved from the dusty shops of the *brocanteurs* described in Balzac's *Le Cousin Pons* to that of the smart dealers of the Faubourg S. Honoré. The American railway baron Henry Clay Frick and the banker J. P. Morgan both had significant, and expensively acquired, 18th-century French art in their wide-ranging and distinguished collections of European old masters. In the 20th century French art and decoration of the 18th century has remained with Impressionist pictures and the work of the early masters of *modernism such as *Picasso and *Matisse firmly a part of the taste of international millionaire collectors. The American oil millionaire J. Paul Getty, the Dodge motor family of Detroit, and the Greek shipping magnate Stavros Niarchos have all formed notable collections that have included a sizeable representation of French art of the 18th century. Impressionist and *Post-Impressionist paintings have become an international currency for super-rich investors, with Japanese department store owners and Australian entrepreneurs brought to the brink of bankruptcy by imprudent speculation. By contrast, French art of the 17th century and earlier is the domain of the scholarly private collector and the public museum.

State patronage played little part in the story of avant-garde art in the first half of the 20th century. In their early years *Braque, Matisse, Picasso, and others were supported either by private patrons who bought directly from them, such as Gertrude Stein and her brothers, or by enthusiastic dealers who were prepared to take risks. Durand-Ruel invested the money he was making from Impressionist art in the new avant-garde, while Daniel-Henry Kahnweiler was the main channel through which *Cubist paintings reached collectors as far afield as New York and Moscow. It was only after the Second World War, when such artists were established as the grand old men of international modernism, that they received any substantial government-sponsored commissions through the initiative of the Ministère des Affaires Culturelles, established for General de Gaulle by André Malraux. As the result in particular of the policies of President Georges Pompidou in the 1970s France has probably the most highly organized and well-funded system of arts administration in the world. Nevertheless, while this has borne fruit conspicuously in the conservation of historic monuments and in the development of old museums and the foundation of new ones, it is unclear that it has had any beneficial effect on the creation of art.

See also Académie Royale under PARIS, Wallace Collection under LONDON, and Frick Collection under NEW YORK.

MJ

Béguin, S., and Cox Rearick, J., *La Collection de François Ier*, exhib. cat. 1972 (Paris, Louvre).

Bonnaffé, E., *Dictionnaire des amateurs français au XVIIe siècle* (1884).

Crow, T., *Painters and Public Life in Eighteenth-Century Paris* (1985).

Haskell, F., *Rediscoveries in Art* (1967).

Marrinan, M., *Painting Politics for Louis-Philippe: Art and Ideology in Orleanist France* (1988).

Mousnier, R., and Mesnard, J., *L'Âge d'or du mécenat, 1598–1661* (1985).

Pomian, K., *Collectionneurs, amateurs et curieux, Paris, Venise, XVIe–XVIIIe siècle* (1987).

His intense, poetic depictions of northern scenery have become a byword for a melancholic, spiritually inspired attitude to nature. His manner of painting is meticulous. His compositions are often deliberately formal and contrived to produce a striking effect. Yet the individual forms in his pictures were usually based on painstaking direct study and observation. He was also a master at creating poignant effects of light and atmosphere.

Friedrich was born in Greifswald, a small Pomeranian harbour town on the Baltic. He came from a craft background, his father being a ships' chandler and soap boiler. An unfortunate accident in his youth—in which a brother was drowned—seems to have encouraged his disposition towards melancholy. However, it must be remembered that the melancholy contemplation of nature was a fashion of the period, much inspired in Germany by the influence of such English

nature poets as Young and Gray. In 1794 Friedrich went to study at the Copenhagen Academy. In 1798 he settled in *Dresden, remaining there for the rest of his life. Dresden was already famous for its great art collection. It was also the centre of the important circle of writers and critics, including the *Schlegel brothers, Ludwig Tieck, and Novalis, who spearheaded the German Romantic movement. Like his fellow Pomeranian the painter Philipp Otto *Runge, Friedrich was deeply influenced by the ideas of this movement and came to look upon landscape painting as a vehicle for spiritual revelation. This led him to produce his first great work *The Cross in the Mountains* (1808; Dresden, Gemäldegal.), in which he painted a view of a cross glinting in the setting sun on the summit of a fir-topped mountain as an altarpiece. Both the radical design and the seeming blasphemy of the work provoked a dramatic outburst and scandal that made his name.

This was confirmed when two even more radical works, *The Monk by the Sea* (1809; Berlin, Nationalgal.) and *The Abbey in the Oakwoods* (1810; Berlin, Nationalgal.), were shown to acclaim in Berlin. They were bought by the Prussian Crown Prince. The popularity of Friedrich's work at this time was partly related to the emerging nationalist movement that had been stimulated by Napoleon's invasion of Germany in 1806. After the defeat of Napoleon in 1815 Friedrich's work became less popular. His symbolic approach to landscape began to seem stilted and strange to a younger generation more interested in naturalism. Furthermore, his radical political views appear to have hindered official recognition. Although made a member of the Dresden Academy in 1816, he was never given a teaching post there.

Yet Friedrich's art continued to develop and change and he produced some of his most charming and poignant works during

this period. Influenced by the growing tendency towards naturalism he made some charming small fresh studies such as the *Woman at the Window* (1820; Berlin, Nationalgal.), which showed his wife looking out of his studio window. The figure viewed from the back looking at a scene is a highly characteristic motif in Friedrich's work. As he became more isolated, his pictures took on a more poignant mood, as in his highly original *Large Enclosure near Dresden* (1832; Dresden, Gemäldegal.), which is arguably his greatest work. Friedrich suffered much from ill health in later life and after a stroke in 1835 he could no longer produce oil paintings. He died in obscurity. Since the end of the 19th century, however, his reputation has revived, and he has had an immense influence on artists of the *Symbolist, *Expressionist, and *Surrealist movements, as well as being recognized by historians as one of the key artists of the period in which he lived. WV

Borsch-Supan H., and Jähnig, K. W., *Caspar David Friedrich* (1976).
Koerner, J. L., *Caspar David Friedrich and the Subject of Landscape Painting* (1990).
Vaughan, W., *German Romantic Painting* (2nd edn., 1994).

FRIESZ, ÉMILE-OTHON (1879–1949). French painter. A native of Le Havre, Friesz painted in an *Impressionistic manner despite an academic training in Paris. He became close to *Matisse in 1905 and painting in the *Fauve style he exhibited alongside him in 1905. However, his preference for the strong pictorial structure and monumentality of *Cézanne led him away from Fauvism. Travels in Italy in 1909 stimulated the Arcadian themes he painted 1908–14, which confirmed his reputation as a leading modernist drawing on the French classical tradition. MF

Gauthier, M., *Othon Friesz* (1957).

FRINK, DAME ELIZABETH (1930–93). English sculptor. Frink studied at Guildford School of Art (1947–9) and Chelsea (1949–53) and achieved immediate success when the Tate (see under LONDON) purchased her fiercely expressive *Bird* from her first exhibition in 1952. The male nude, simplified and increasingly heroic and monumental, dominates her work together with huge bronze heads, redolent of Easter Island sculptures, some of which, the sinister *Goggle Heads* of the 1960s, were inspired by the Algerian War. Birds, horses, and dogs are also recurrent subjects, often anatomically distorted for emotional expression. Similar themes appear in her highly regarded illustrations. Frink received many public commissions and inter-

national recognition; she was created DBE in 1982. JH

Robertson, B., et al., *Elizabeth Frink: Catalogue Raisonné* (1984).

FRITH, WILLIAM POWELL (1819–1909). English painter. Frith, who studied at the RA Schools (see under LONDON), began his career painting literary subjects and continued in a similar vein until 1900. However, his reputation rests on his huge panoramas of modern life conceived in 1837, and executed, for the most part, in the 1850s and 1860s. The first of these, *Ramsgate Sands* (London, Royal Coll.), caused a sensation at the RA in 1854 and was purchased by Queen Victoria. He followed this success with *Derby Day* (1858; London, Tate), which had to be protected by a railing when shown at the Academy, and *The Railway Station* (1862; Egham, Royal Holloway College). The latter, commissioned by the dealer Louis Flatow for 4,500 guineas, attracted over 21,000 visitors when exhibited for seven weeks in Flatow's gallery. All three paintings, which *Ruskin perceptively described as Dickensian, are packed with incident and individual portraits. Closely observed and meticulously recorded details appealed to the Victorians and serve today as a valuable social record. Unlike the *Pre-Raphaelites, whose 'modern' subjects of the 1850s criticized society, Frith avoided controversy and was considered banal by many younger artists. DER

Frith, W. P., *My Autobiography and Reminiscences* (1887).

FROMENT, NICOLAS (active c.1460, d. 1483/4). French painter, probably from Picardy. A triptych of the *Raising of Lazarus* (Florence, Uffizi) dated 1461 is his earliest known work, though his participation in the cartoons of a (now fragmentary) set of tapestries executed for the Bishop of Beauvais in 1460 has been conjectured. The triptych, commissioned by an Italian prelate who visited the Netherlands in 1459–62, is executed in a powerful, though awkward style, deriving from painters like Dieric *Bouts. Documented in Uzès (Languedoc) in 1465, Froment had by then probably settled in Provence where he was based for the remainder of his career. His success is evident from a series of commissions (mostly recorded in Avignon, where he owned several properties) for altarpieces, designs for stained glass, livery, heraldry, and shields, and props for processional entries. His most distinguished patron was René, Duke of Anjou, for whom c.1475 he executed the impressive triptych of the *Burning Bush* (now Aix-en-Provence Cathedral). Although still Netherlandish in approach, this altarpiece shows some elements, notably in the expansive landscape, which suggest knowledge of

contemporary Florentine painting. TT

Laclotte, M., and Thiébaut, D., *L'École d'Avignon* (1983).

FROMENTIN, EUGÈNE (1820–76). French painter and writer who by 1847 was exhibiting in the *Paris Salon. His preference for oriental themes was decisively shaped by three visits to Algeria, made between 1846 and 1853. Many of his pictures, mostly small-format, show hunting and wildlife scenes and episodes from the life of the Algerian nomads, set in the luminous landscape of northern Africa. His Romantic exoticism was the target of criticism from the naturalists such as *Duranty. Fromentin's literary œuvre includes a review of the Salon of 1845, two travel books, a lyrical novel (*Dominique*, 1862), and, most importantly, *Les Maîtres d'autrefois* (1876), studies of Flemish and Dutch painting written after a visit to the Low Countries. As a painter, Fromentin was particularly interested in the sensual and technical aspects of Netherlandish painting. His book also contains an analysis of the effect of Dutch landscapes on French painters such as *Claude and Théodore *Rousseau. AT

Thomson, J., and Wright, B., *La Vie et l'œuvre d'Eugène Fromentin* (1987).

FRONTAL, term in Christian church architecture for a panel or screen placed directly in front of or attached to the altar, sometimes called an antependium. They were made in a variety of materials, including painted wood, ivory, bronze and other metals, enamel, or embroidered textiles. The most lavish, however, were made of gold, for example that given to Basle Cathedral by the Emperor Henry II c.1022–4 (now Paris, Mus. Cluny). The exposed position of these precious frontals meant that they were sometimes moved on top of the altar for safety, thus becoming *retables (for example that dating from 1195–1205 at Cividale in Friuli). The imagery of frontals varied, but the most common subject was Christ in Majesty surrounded by scenes from the New Testament (e.g. the gold altar frontal at S. Ambrogio, Milan, c.850, or the so-called Pala d'Oro, c.1020, given by Henry II to the palace chapel, Aachen). TJH

FROTTAGE (French: rubbing), a technique of creating an image by placing a piece of paper over some rough surface such as grained wood or sacking and rubbing the paper with a crayon or pencil until it acquires an impression of the surface quality of the substance beneath. The resulting image is usually taken as a stimulus to the imagination, forming the point of departure for a picture expressing subconscious imagery. The technique was invented in 1925 by Max *Ernst, who described how he was inspired

by some floorboards, 'the grain of which had been accentuated by a thousand scrubbings . . . I made from the boards a series of drawings by placing on them, at random, sheets of paper which I began to rub with black-lead. In gazing attentively at the drawings thus obtained . . . I was surprised by the sudden intensification of my visionary powers and by the hallucinatory succession of contradictory images superimposed, one upon the other, with the persistence and rapidity peculiar to amorous memories. My curiosity awakened and astonished, I began to examine indiscriminately, using the same means, all sorts of materials found in my visual field: leaves and their veins, the frayed edges of a bit of sackcloth, the brush strokes of a "modern" painting, a thread unwound from a spool, etc.' Many other *Surrealists adopted the technique. See also AUTOMATISM. IC

FRUEAUF, RUELAND, ELDER AND YOUNGER. Austrian painters, active in Salzburg and Passau. **Rueland the elder** (c.1440×50?–1507) was the leading painter of altarpieces in Salzburg and Passau from 1470. In 1484 Salzburg city council appointed him as an adviser to Michael *Pacher in executing the altar of the parish church (now Franciscan church Unsere Liebe Frau). After initially working in a manner derived from Rogier van der *Weyden, he changed to a more monumental style, influenced by Michael Pacher (*Man of Sorrows*, c.1495; Salzburg, Mus. Carolino Augusteum). To his son **Rueland the younger** (c.1465×70?–after 1545) are attributed the wings of an altar of S. Leopold (1505; Klosterneuburg) in which he shows himself to be a forerunner of the so-called *Danube School. In the *Boar Hunt*, the boar and three huntsmen and their hounds are surrounded by springtime woods with fertile hills and ploughed fields. This is probably the first spring scene in German painting to have been truly observed from nature.
 KLB

FRY, ROGER (1866–1934). English critic and painter. After graduating in natural sciences at Cambridge Fry studied art history and painting in Paris and Italy. He became art critic of the *Athenaeum* (1901) and was a founder of the *Burlington Magazine* in 1903, the year in which he also held his first exhibition. From 1905 to 1910 he was curator of paintings at the Metropolitan Museum, *New York. His discovery of *Cézanne in 1906 was a revelation and converted him from being a student of Italian old masters to a champion of the *avant-garde. His ground-breaking *Post-Impressionist exhibitions at the Grafton Galleries, London, in 1910 and 1912 effectively introduced modernism to England although his own paintings, despite his use of a Post-Impressionist palette, are essentially cautious and conservative. His paintings and critical writings simultaneously developed his beliefs in formal relationships, plastic rhythm, and expressive colour to create a reality of essences irrespective of appearance or subject. His critical writings, collected in *Vision and Design* (1920) and *Transformations* (1926), were widely influential and ranged over the whole history of art, from the Aztecs to Cézanne. Fry was also a gifted teacher and lecturer and was appointed Slade professor at Cambridge in 1933. His interest in practical design, as theorist and craftsman, was manifested in his creation of the Omega Workshops in 1913 with the intention of producing unpretentious domestic ware and furnishings. He was assisted in this by other members of the *Bloomsbury Group, particularly Vanessa *Bell and Duncan *Grant. JH

Green, C. (ed.), *Art Made Modern: Roger Fry's Vision of Art*, exhib. cat. 1999 (London, Courtauld Inst. Gal.).

Spalding, F., *Roger Fry: Art and Life* (1980).

FUCHS, ERNST (1930–). Austrian painter and graphic artist, born in Vienna. He studied at the Vienna Academy under Albert von Gütersloh, 1946–50, and is the best-known member of the school of Fantastic Realism made up mainly of Gütersloh's pupils. His subjects are drawn from religion and magic, treated in an outlandish and vividly detailed manner—often his imagery is close to that of horror comics. He is a prolific etcher as well as a painter. Fuchs has an international reputation and in 1993 had a major exhibition at the Russian State Museum, St Petersburg.

FÜHRICH, JOSEPH VON (1800–76). Austrian painter. Born in Kratzau, Bohemia, he was trained by his father Wenzel, a painter and mason. He first exhibited at the Prague Academy in 1819, showing two historical paintings to considerable success. His illustrations to J. L. Tieck's *Leben und Tod der Heiligen Genoveva* (1824–5) won him the patronage of the Austrian statesman Prince Metternich (1773–1859), who arranged for him to study in Italy. His early work was influenced by *Dürer but his style and philosophy were formed by his contact with the *Nazarenes in Rome (1827–9), where he assisted *Overbeck and his fellow Austrian Joseph *Koch with the frescoes in the Tasso room of the Casino Massimo. In 1834 he obtained a post at the Vienna Kunstschule, becoming professor of historical composition in 1840. He specialized in religious painting, in the *Raphaelesque Nazarene tradition, including the enormous fresco cycle of the *Stations of the Cross* (1844–6) in S. Johann Nepomuk, Vienna. In his later years his line engravings of biblical subjects, which were highly popular, earned him the nickname of 'der Theologe mit dem Stifte' (the theologian with the pencil). DER

Dreger, M., *Joseph Führich* (1912).

FUNCTIONALISM, a concept used in Antiquity and revived in the 18th century to define one of the qualities appertaining to beauty. In the *Memorials of Socrates* by his pupil Xenophon (c.435–354 BC), Socrates argues that human bodies and artefacts are considered beautiful and good with reference to the objects for which they are serviceable: a theory which he refutes in the *Symposium* (also attributed to Xenophon) by arguing that an ugly man could thus be more beautiful than a handsome one because his protuberant eyes could see more and simian nostrils smell more. *Aristotle, in his *Topica* (102^a6 and 135^a13), discusses the definitions of beauty as 'the fitting' and 'the efficient for a good purpose', with reference to *Plato's *Hippias Major* (293^a6–294^c10). Both these definitions have reappeared in modern times in connection with architecture and applied art.

Functionalism reappeared as a theory for discussion in the writings of 18th-century aestheticians and philosophers. Edmund *Burke questioned its relevance in his *Philosophical Enquiry into the Origin of our Ideas of the Sublime and Beautiful* (1757) when he wrote, 'It is said that the idea of a part's being well adapted to answer its end, is one cause of beauty, or indeed beauty itself . . . In framing this theory, I am apprehensive that experience is not sufficiently consulted.' Denis *Diderot, however, subscribed to the idea in his *Essai sur la peinture* (1765), in which he defined a beautiful man as one best endowed by nature to defend himself and propagate the species. *Hogarth took a middle course in his *Analysis of Beauty* (1753) by distinguishing beauty that pleases the senses and beauty that is functional, although the two are not mutually exclusive.

After the 18th century the concept was largely reserved for architecture and applied art. In the case of the latter the famous if not hackneyed dictum of William Morris (1834–96): 'Have nothing in your homes that you do not believe to be beautiful or know to be useful' distinguishes between perceived beauty and utility. Functionalism as an aesthetic creed was not preached until the 20th century. Here it was usually confined to architecture and design, championed by *Le Corbusier and some of the *Bauhaus teachers. However, total adoption of the theory was criticized by Herbert *Read in *Art and Industry* (1934) when he declared, 'That functional efficiency and beauty do often coincide may be admitted . . . The mistake is to assume that the functional efficiency is the cause of the beauty; because functional,

therefore beautiful. That is not the true logic of the case.'

There is no doubt that the quality of functional efficiency and the suitability of part to purpose can form an aesthetic experience analogous to the appreciation of intellectual beauty in a philosophical or mathematical theorem. But visual beauty does not necessarily follow from it. A good watch, for example, needs to be efficient but need not be visually beautiful. DER

FUNERARY MONUMENT. The commemoration of the dead and the celebration in sculptural and architectural form of their real or supposed attributes has been a consistent aspect of the Western cultural tradition in both pagan and Christian times. In some cases this has involved the artistic conception or decoration of the vessel containing the remains of the dead (sarcophagus, coffin, or cinerary urn) or the place of burial (grave or tomb). But in many cases there is no direct link between the site of the person's physical remains and the site of their monument.

Admired by the Greeks as one of the *Seven Wonders of the ancient world, the *Mausoleum at Halicarnassus in Asia Minor was perhaps the most famous tomb of Antiquity and gave its name to the whole genre of magnificent memorial tombs. Erected for the Carian dynast Mausolus (c.350 BC), it was built by Greek architects and sculptors in a monumental style that had no precedent in metropolitan Greece, where the simple stela, or memorial stone, was the usual form in classical times. The sarcophagus, or sculptured stone coffin, which has a long history of use by the Romans and early Christians, also originated in Asia Minor. A fine series of sarcophagi dating from the middle of the 5th to the late 4th century BC was found at Sidon (Istanbul Mus.). The most magnificent of these, the so-called Alexander Sarcophagus, has continuous friezes of battle and hunting scenes. The sarcophagus became the usual form of burial again in the 2nd century AD when inhumation began to to replace the earlier Roman custom of cremation. The discovery of many hundreds of sarcophagi with elaborately carved reliefs had a powerful impact on the development of the visual imagery of the *Renaissance.

The *Etruscans used the sarcophagus with a characteristic feature of the effigy of the deceased reclining on the lid. This feature too has a long and complex history in Christian mortuary art. While the figure represented recumbent as in death was frequently used on medieval tombs, the figure propped on an elbow as in life was frequently adopted by Renaissance and Baroque artists. The Romans (see ROMAN ART, ANCIENT) took over and adapted Etruscan forms, but whereas the typical Etruscan tomb was excavated in the ground, Roman ones, such as those along the Via Appia, were frequently small architectural compilations above ground level. There occur also stelae with portrait *busts in high relief or standing figures, while small sepulchral altars, decorated with rams' or bulls' heads and festoons of laurel, survive in large numbers and later became part of the visual repertoire of the Renaissance.

Considerably more of the repertory of commemorative architecture and sculpture was elaborated by the Romans. These include the great circular mausolea of Augustus and Hadrian in Rome, the latter now the Castel S. Angelo, as well as the monumental sculptured free-standing columns erected over the chambers containing the ashes of the Emperors Trajan and Marcus Aurelius. They also took from Egypt the pyramid form, the best-known Roman variant being the Pyramid of Cestius, Rome, a form that re-entered the vocabulary of Western funerary sculpture with *Neoclassicism.

The earliest Christian burials were in catacombs, but with the official recognition of Christianity in the 4th century the sarcophagus form of burial became current with Christian figural subjects in place of pagan. The Mausoleum of Theodoric the Goth (c.525), a massive circular building of stone once surrounded by a colonnade, is remarkable evidence of the persistence of classical ideas after the fall of Rome. The early Middle Ages did not produce important tombs or funerary monuments. It was only in the late *Romanesque period, when burials began to take place inside churches, that the tomb regained importance. Two types prevailed— the incised or carved slab laid in the floor, and some form of sarcophagus, either freestanding or set against a wall. Where there was an effigy, a recumbent figure showing the deceased dead or sleeping was most common. By the end of the 15th century elaborately carved and painted stone canopies were used above the tombs of the wealthy and powerful, while small figures of mourners ('weepers') were carved into or set around the sarcophagus. This theme reached its climax in the dramatic work of Claus *Sluter at Dijon (c.1404–11), from which developed a rare type with the effigy supported on a bier-like slab resting on the shoulders of weepers or figures of virtues. In the late 14th century portraiture began to appear, while in the 15th century there was a fashion for the use of the 'gisant', a macabre skeleton sometimes depicted with the flesh rotting on the bones, which was placed within arcades with the slab and effigy above. The material used for medieval tombs was usually stone, though there are surviving examples of *alabaster or metal figures, while incised brass was used for figures on floor slabs in England and Germany.

Early Renaissance tombs in Italy followed patterns that were familiar from Italian medieval art. Inside churches wall tombs within an architectural niche were preferred to free-standing ones and the recumbent effigy often rested on a draped bier with the sarcophagus below. Such features as the two figures drawing back curtains above the effigy, first used by *Arnolfo di Cambio in the 13th century, continued to find favour. Gradually, the discovery of Roman tomb sculpture brought Antique motifs into play. Jacopo della *Quercia's tomb of Illaria del Carretto (c.1406) in Lucca Cathedral was among the first to revive the sarcophagus with putti and garlands, while later in the 15th century *Verrocchio broke new ground with his Medici tomb (Florence, S. Lorenzo), which has no effigy and no Christian symbolism.

The first major innovation was that of Antonio *Pollaiuolo, who in his tomb of Innocent VIII (1492; Rome, S. Peter's) represented the Pope both seated as in life and lying peacefully in death. It was this humanistic interpretation of the funerary monument that generally prevailed over the next two centuries. The emphasis, both north and south of the Alps, was on the living person, sometimes shown in portrait, even if often idealized, with a consequent decline in the importance of Christian symbolism and the depiction of the ravages of death and decay. French royal tombs from Louis XII (c.1515; S. Denis) onwards have kneeling figures on an arcaded base, which encloses a recumbent effigy, and allegorical figures standing or seated at the corners. The reclining figure supported on one elbow appeared in France and Spain, and by the end of the 16th century in England also. Bust monuments, set in a roundel, provided a less expensive way to demonstrate the interest in personality typical of the period. In Rome and Venice tombs reached new levels of elaboration with architectural and sculptural components rising through several tiers against church walls, but the most innovative funerary monuments of the 16th century were *Michelangelo's Medici tombs (1521–34) in S. Lorenzo, Florence, with their seated portrait statues in Antique dress and their reclining and essentially pagan nude allegorical figures.

The Baroque age brought many innovations as the sculptural elements of the tomb were gradually released from the confines of their architectural setting in order to dramatize the Counter-Reformation's emphasis on death as struggle and release. *Bernini's tomb of Alexander VII (1671; Rome, S. Peter's) shows Death emerging from his prison to strike at the kneeling Pope absorbed in prayer. Bernini also brought the more modest bust and half-length portrait figures in wall niches to new heights of pathos which were widely imitated in Catholic northern Europe, especially Flanders. Combinations of

patinated and gilded bronze and coloured marbles and semi-precious stones were added to the white marble of the previous generation to add richness to the theatre of death. Permanent memorials took on something of the theatricality and emotionalism of the elaborate funeral rituals of the period. The culminating expression of the Italian *Baroque was, perhaps, the sepulchral chapel of the Cornaro family in S. Maria della Vittoria, Rome, where Bernini set likenesses of living members of the family in balconies watching the *Ecstasy of S. Teresa*, and no sarcophagus was shown.

The 18th century continued many of these Baroque themes, albeit in less demonstrative form. The tombs of Languet de Gergy in Paris (S. Sulpice) by Michel-Ange *Slodtz and of Lady Elizabeth Nightingale in London (Westminster Abbey) by *Roubiliac both use variations of the personification of Death invented by Bernini for his Alexander VII monument. But the trend as the century wore on was to naturalize the dramatic elements of the large-scale monument and to replace Counter-Reformation religious sentiment with a rationalized appreciation of the virtues of the patriotic and heroic individual. The finest example of such a funerary monument is that for the Maréchal de Saxe (1753–76) by *Pigalle in Strasbourg, which has its counterpart in the series of monuments to British military and naval heroes erected in S. Paul's Cathedral at the end of the 18th century and the beginning of the 19th. The second half of the 18th century is, however, much more remarkable for its small-scale, private funerary monuments in which sculptors employed considerable ingenuity in combining bust or medallion portraits of the deceased with mourning allegorical figures, broken columns, cinerary urns, and other tactful symbols of death and loss.

The static nature of *Neoclassical composition lent itself best to such modest memorials, which began to be produced to standardized formulas adapted from compositions by well-known sculptors such as *Flaxman. There were, nevertheless, some striking and original Neoclassical tombs. That by *Canova for the Archduchess Maria Christina of Austria (1798–1805) in the Augustinerkirche, Vienna, with a statue of the deceased entering the dark doorway of a pyramidal sepulchre, is outstanding in its quiet pathos. The 19th century with its programmes of new church building and the development of the suburban cemeteries was essentially the age of the mass production of funerary monuments, which could take their stylistic cue from any number of historical examples, though explicitly religious symbolism underwent a revival in popularity. Even specially commissioned monuments usually rehearsed one or more well-known themes from the tradition. Nevertheless, Lorenzo Bartolini (1777–1850) in Italy, *Dalou in France, *Gilbert in England, and *Saint-Gaudens in the United States all produced one or more funerary monuments of real distinction and originality. In the 20th century only a handful of war memorials, the mass funerary monuments to the fallen in two World Wars, rose above the mediocrity in which the funerary monument is expiring. But Edwin Lutyens's Cenotaph in Whitehall, London, and his memorial arch at Thriepval, northern France, are more properly to be considered architectural than sculptural monuments. HO/MJ

Janson, H. W., *Nineteenth-Century Sculpture* (1985).
Panofsky, E., *Tomb Sculpture: Its Changing Aspects from Ancient Egypt to Bernini* (1964).

FUSELI, HENRY (Johann Heinrich Fussli) (1741–1825). Swiss-born painter and writer. Fuseli was born in Zurich into the intellectual household of his father, a successful portrait painter. As a student he was introduced, by the historian and literary scholar J. J. Bodmer (1698–1782), to classical literature, Dante, Shakespeare, Milton, and the *Nibelungenlied*, which were to provide subjects for his paintings. His friends included Johann Lavater (1741–1801), whose study of physiognomy, which he was to illustrate (1781–6), was a further influence on his work. He was ordained in 1761 but abandoned religion after meeting J.-J. *Rousseau in 1766. In 1764 he arrived in London to report on literary developments, stayed to publish his translation of *Winckelmann's *Painting and Sculpture of the Greeks* (1765), and three years later, encouraged by *Reynolds, determined to become a painter. There followed eight years of intensive study and practice in Rome (1770–8). He rejected Winckelmann's theory of the ideal, which favoured calm and blandness, preferring the *terribilita* of *Michelangelo. Inspired by the Sistine chapel frescoes he adopted a mannered linear style, and painted heroic subjects in dramatic compositions in timeless settings, often simply monochrome, with a limited palette. Considering Rousseau, with whom he quarrelled, as utopian, he hypothesized an art which was morally neutral and elitist. Reports of his success in Rome, where he dominated an international group of *Neoclassical artists, preceded his return to London, in 1780, and he was welcomed by intellectuals, artists, and patrons. *The Nightmare* (1781; Detroit, Inst. of Art), exhibited in 1782, an archetypal image of horror, ensured his fame as an imaginative and original painter. In 1786 he became involved in *Boydell's projected *Shakespeare Gallery* which he worked on until it opened in 1789. Elected RA (see under LONDON) in 1790, he rose rapidly through the Academic hierarchy, twice serving as professor of painting (1799–1805; 1810) and becoming keeper in 1804. His lectures, published in 1801, largely follow Reynolds but incorporate *Burke's views on terror. In 1790 he began an ambitious project to paint a *Milton Gallery* and completed 47 pictures, exhibited in 1799 to public indifference and the praise of his peers. His later years were uneventful but he was a much respected, if eccentric, teacher.

Fuseli's work is unique in English painting for its compositional drama, psychological intensity, and implicit eroticism. Almost all his works, whether heroic like *The Vision of the Deluge* (1796–1800; Winterthur, Kunstmus.) or poetic, *Titania and Bottom* (1780–90; London, Tate), contain undertones of cruelty and sexual subjugation which may partly explain Victorian neglect and 20th-century rediscovery. DER

Schiff, G., *J. H. Fussli* (1973).

FUTURISM, a movement, founded in 1909 by the poet Filippo *Marinetti, which extended to politics, literature, architecture, the theatre, music, dance, and even cooking, as well as the fine arts. Apart from Marinetti, the major figures were the five painters Umberto *Boccioni (who was also a distinguished sculptor), Giacomo *Balla, Gino *Severini, Luigi Russolo (1885–1947), and Carlo *Carrà. The Futurists reacted against traditional Italian culture, calling for the destruction of museums and libraries, and celebrated the dynamism and excitement of contemporary life. They were particularly fascinated by technological developments, ranging from artificial illumination to railways and modern weaponry.

Although Marinetti lived in Milan, he first publicized his aims in a 'Manifesto of Futurism' printed in the Parisian newspaper *Le Figaro* on 20 February 1909, in which he declared that 'the essential elements of our poetry will be courage, audacity and revolt'. While the initial manifesto largely ignored the visual arts, it was followed in 1910 by the similarly aggressive 'Manifesto of Futurist Painters'. However, this rather vague document is less illuminating than the 'Technical Manifesto of Futurist Painting', published later in the same year, which developed the concept of a 'universal dynamism' uniting objects apparently separated by time and space. The Futurists were profoundly affected by physical phenomena such as the persistence of the image on the retina or the discovery of X-rays, which encouraged them to represent reality as a flux of constantly changing, interpenetrating forms. As the Manifesto put it, 'to paint a human figure you must not paint it;

you must render the whole of its surrounding atmosphere'.

For all the revolutionary intentions expressed by the Technical Manifesto, the Futurists failed initially to develop a correspondingly original style. At first their work was heavily influenced by *Neo-Impressionism, which Severini and Boccioni had learnt in Rome from Balla some years previously. However, Severini, who lived in Paris, also knew the work of the French *Cubists, whose fragmented compositions of intersecting planes were highly influential on the Futurists' subsequent work. In 1912 a Futurist exhibition (accompanied by yet another manifesto), was held at the Galerie Bernheim-Jeune in Paris. Severini's contribution included the *Pan-pan à Monico* (1910–12; destr.; copy made 1959; Paris, Mus. National d'Art Moderne), in which movement was suggested by simultaneously representing successive aspects of forms in motion. Still more remarkable were Boccioni's paintings of *States of Mind* (1911: New York, Met. Mus.), which expressed the various emotions experienced as a train leaves a station, through a brilliant use of colours and pictorial forms, including dynamic 'lines of force', a common Futurist device.

Marinetti propounded his ideas on international speaking visits. In St Petersburg, he stimulated Kasimir *Malevich and Natalia *Goncharova into developing a Russian version of Futurism known as 'Rayonism', and in London he inspired the work of the *Vorticists and Christopher *Nevinson. The French artists Marcel *Duchamp and Robert *Delaunay also developed in their own ways the Italians' ideas about the representation of movement. Futurism even affected the *Dadaists' activities, particularly their noisy, often offensive methods of self-publicization.

In Italy the development of Futurism was drastically curtailed by the First World War, in which Boccioni died. However, although most of the surviving Futurists subsequently painted in a classicist style, Balla was associated during the inter-war period with a group of younger artists who continued to explore Futurist themes. These included Enrico Prampolini (1894–1956) and Gerardo Dottori (1888–1977), who were notable exponents of 'Aeropittura', painting concerned with the experience of flight. However, despite the efforts of Marinetti, who had been an early supporter of Mussolini, Futurism received little support from the Fascist regime, and became an increasingly marginal element in the art of the period. CJM

Appolonio, U. (ed.), *Futurist Manifestos* (1973).
Tisdall, C., and Bozzola, A., *Futurism* (1977).

FYT, JAN (1611–61). Flemish painter of monumental still lifes and hunting pieces, active in Antwerp. After an apprenticeship with the obscure painter Hans van den Berch in 1621/2, Fyt entered the studio of Frans *Snyders. In 1629/30 he became a master in the guild of S. Luke, but continued to work for Snyders until 1631. He was in Paris in 1633–4, and sometime later in Italy. He returned to Antwerp in 1641, where, apart from a brief visit to the Northern Netherlands in 1642, he apparently remained for the rest of his career, though a second visit to Italy in the 1650s cannot be completely ruled out. A prolific painter chiefly of dead game still lifes (*Feathered Game, Mushrooms, and Vegetables*; Brussels, Mus. Royaux) and hunting pieces, Fyt also painted a few flower and fruit still lifes. He occasionally collaborated with other artists, such as Erasmus *Quellinus II, Thomas Willeboirts *Bosschaert, Pieter Thijs, and possibly Jacob *Jordaens. KLB

Sutton, P. C., *The Age of Rubens*, exhib. cat. 1993 (Boston, Mus. of Fine Arts; Toledo, Oh., Mus.).

GABO, NAUM (born Naum Pevsner) (1890–1977). Russian-born sculptor, the most influential exponent of *Constructivism. Gabo studied sciences in Munich (1910–14), then moved to Norway, where, encouraged by his elder brother Antoine *Pevsner, he produced his first constructions. The evocation of space and volume became his lifelong concern, clearly evident in the interlocking planes of his first piece *Constructed Head No. 1* (1915; priv. coll.). Lured by the promise of the Revolution, the brothers returned to Russia in 1917 where they participated in what became known as Constructivism. The *Realistic Manifesto* (1920) outlined Gabo's concepts of art, one of which—that 'art has its absolute, independent value'—ran contrary to the Bolsheviks' doctrine of utility, prompting Gabo's departure for Berlin in 1922. While there he produced designs for Diaghilev's ballet *La Chatte* (1926–7) and lectured at the *Bauhaus (1928). Nazism drove him first to Paris (1932) where he joined *Abstraction-Création, and then to Britain (1936). Post-war he emigrated to the USA. His last three decades were marked by prestigious awards, retrospectives, and numerous public commissions: *Torsion* (1970; London, S. Thomas' Hospital). AA

Naum Gabo, exhib. cat. 1987 (London, Hayward).

GADDI, FATHER AND SON. Italian painters. According to Cennino *Cennini (Agnolo's pupil), **Taddeo Gaddi** (active *c*.1320–66) was *Giotto's godson and for 24 years his disciple. Between them the Gaddi, father and son, span virtually the entire history of Florentine trecento painting. Taddeo's *Castelfiorentino Madonna* (*c*.1320–5; Castelfiorentino, S. Francesco) is a faithful, if rather brusque, imitation of Giotto's *Ognissanti Madonna*, and was probably done while Taddeo was still with Giotto. The same may be true of his frescoes of the *Life of the Virgin* in the Baroncelli chapel in S. Croce (*c*.1328). On several

fronts these represent a bold development of Giotto's pictorial language. An illusionism always strictly controlled in Giotto's work is here overt: in the fictive vault drums containing figures of the *Virtues*; in the spiral columns framing the east wall narratives, and in the *trompe l'œil* cupboards and niches at dado level. Taddeo's use of light extends Giotto's at both descriptive and emotive levels: this may be seen in the *Annunciation to the Shepherds*, a remarkable pictorial nocturne. Architectural settings, too, are developed, as in the *Presentation of the Virgin*, whose small figure climbs an immense and complex staircase to a sharply foreshortened temple whose ancestry lies in the obliquely placed architecture of Giotto's Peruzzi chapel frescoes in the same church. The organization of large-scale narrative is busier than Giotto's, less selective, and dominated by narrative and genre detail. Taddeo's later work, particularly after Giotto's death in 1337, and perhaps to some extent because of it, presents a gradual retreat from the adventurousness of the Baroncelli frescoes. His status is suggested by his obtaining the commission to paint the altarpiece for S. Giovanni Fuorcivitas in Pistoia (1353): he was chosen from a 1347 shortlist of the most admired painters then alive. This, and the small *Maestà* of 1355 (Florence, Uffizi), are still based on the *Ognissanti Madonna*, but now substitute for Giotto's monumental clarity a concern with decorative surfaces and two-dimensional pattern-making.

Taddeo's son **Agnolo's** (active 1369–96) work illustrates the complexity of late trecento painting in Florence. For Cennini, Agnolo was a living link with the heroic age of Giotto. To some extent he did indeed restore Giottesque values: in his Washington Polyptych *Madonna and Child with Angels and Four Saints*, (*c*.1390; Washington, NG), where the spatial setting of the throne is carefully delineated. Elsewhere, as in his frescoes of the *Legend of the True Cross* in the choir of S. Croce, Florence (*c*.1380), the pictorial language of

Giotto and early Taddeo is refined and prettified: the emphasis now on the picturesque detail and the elegant gesture, the style anticipating that of *Lorenzo Monaco.　　JR

Cole, B., *Agnolo Gaddi* (1977).

Ladis, P., *Taddeo Gaddi* (1982).

GAGGINI **(Gagini) FAMILY.** Italian sculptors. This vastly ramified family active in Genoa and Sicily from the 15th to the 17th century produced three artists of interest. **Domenico** (c.1430–92) may have trained in Florence. His work for Genoa Cathedral, which includes the façade reliefs for the chapel of S. Giovanni Battista, shows the influence of *Donatello. Around 1460 he settled in Sicily where he established a busy workshop that was vastly expanded by his son **Antonello** (1478–1536). He supplied the ambitious Renaissance sculptural decoration of the chancel of Palermo Cathedral. Their Genoese relation **Pace Gaggini** (active 1493–1521) is best known for the supply of sculpture to patrons in France and Spain, helping to introduce the *Renaissance style to those countries.　　MJ

Cervetto, L. A., *I Gaggini da Bissone* (1903).

Kruft, H.-W., *Domenico Gagini und seine Werkstatt* (1972).

Kruft, H.-W., *Antonello Gagini und seine Söhne* (1980).

GAILDE, **JEAN** (active c.1493–d. c.1519). French mason and sculptor who ran an important workshop at Troyes. His triple-arched *rood-screen (1508–17) in the church of S. Madeleine, Troyes, is elaborately carved and pierced in soft white stone in flamboyant *Gothic style, which flourished in this area well into the 16th century. Such *Renaissance detail as appears is hardly noticeable. This is one of the great rood-screens to survive in France, along with those of Albi, late 15th century, and S. Étienne-du-Mont, Paris, of 1530–40. Gailde is buried beneath his masterpiece, fearlessly awaiting the end of the world, according to his epitaph.　　LL

GAINSBOROUGH, **THOMAS** (1727–88). British painter of portraits, landscapes, and fancy pictures, born at Sudbury, Suffolk. He went to London in or about 1740, where he trained with the French draughtsman and engraver Hubert *Gravelot and probably with Francis *Hayman; he also no doubt frequented the St Martin's Lane Academy, then in its heyday under the leadership of *Hogarth. Still too young, however, to obtain other than menial jobs in London, he returned in 1748, aged 19, to Sudbury, moving to the county town of Ipswich in 1752. His patrons were the local squires and merchants, whose portraits he painted on the scale of life either half-length or head and shoulders, or, alternatively, 'in little' but whole-length, alone or with their wives, in landscapes: the finest is *Mr and Mrs Andrews* (c.1748–50; London, NG). He also secured some commissions for pure landscapes. His style at this time was a blend of the English, the French, and the Dutch, inclined towards the *Rococo and somewhat understated, but infused with a vitality which is purely Gainsborough. Although he was to translate this style into far bolder and more impressive terms later, it remained the key to his approach as an artist for the rest of his life. It represented a decisively different stylistic direction from that taken by the majority of his contemporaries in the 1750s, above all *Reynolds, who chose to follow the path of Italy and the classical *Grand Manner; it was symptomatic that Gainsborough never travelled abroad.

In 1759, in search of more plentiful and more fashionable patronage, he moved to Bath. All his portraits were now life sized and frequently full-length. To gain the necessary skills of breadth of handling, richness of colour, and mastery of scale, he studied the portraits by van *Dyck in nearby country houses (though his drawing of the human figure always remained slightly uncertain). To this period belong many of his most ravishing portraits, such as *Mary, Countess Howe* (c.1764; London, Kenwood House), who, dressed in pink, steps lightly towards the spectator through a cloudy, picturesque landscape. A flickering pattern of light and shade cast over the whole composition, highlighting the sitter, distinguishes Gainsborough's portraits of his Bath period. His landscapes, now given added breadth by the influence of *Rubens, show similar characteristics and exhale an air of enchantment. Both his portraits and landscapes were sent to London for exhibition, first at the Society of Artists and then at the RA, of which Gainsborough became a founder member in 1768.

In 1774, he settled permanently in London, continuing intermittently to exhibit at the RA but aggrieved that his pictures were often shown in a bad light. His portraits became grander, and sometimes wilder, culminating in full-lengths of the King, Queen, and three eldest princesses, and a set of ovals of the monarchs and their thirteen children (all 1782; London, Royal Coll.). It is one of several contradictions of Gainsborough's character that, while he preferred to paint landscapes, which he nevertheless found difficulty in selling, and despised his aristocratic sitters, whom he thought good only for their money, he was a very successful portrait painter and chose to live, not in the artists' quarter of Soho, but in the West End close to St James's Palace. In his last decade, he experimented with several new types of picture and media, most famously his 'fancy pictures'. These were paintings of peasants, often children, in landscapes, which were regarded as touchingly simple and affecting by the sophisticated public of the day but which have been interpreted recently as unwitting *exposés* of the harshness of life in the countryside.

Gainsborough was an original: wholly English in spirit yet more admired abroad today than any other British artist except perhaps *Turner.　　MK

Barrell, J., *The Dark Side of the Landscape: The Rural Poor in English Painting, 1730–1840* (1980).

Hayes, J., *Gainsborough: Paintings and Drawings* (1975).

Hayes, J., *The Landscape Paintings of Thomas Gainsborough* (1982).

GALLE **FAMILY.** Engravers and publishers of Dutch origin who settled in Antwerp. The print workshop and publishing house founded by Philipp Galle was one of the most important centres for engraving (see LINE ENGRAVING) in Antwerp from the late 16th to the early 17th century. The business was continued by his sons Theodoor and Cornelis Galle, who are chiefly known as reproductive engravers after compositions by *Rubens and as engravers of title-pages and book illustrations.

Philipp (1537–1612) left Haarlem for Antwerp, where he entered the workshop of Hieronymus Cock. Shortly after 1557 he started his own publishing and print business. His engraved œuvre includes works after his own designs, but he is primarily known for his prints after other artists, including Maerten van *Heemskerck, Frans *Floris, Pieter *Bruegel the elder (*Death of the Virgin*, 1574), Marten de *Vos, and a number of Italian artists. **Theodoor** (1571–1633) and his younger brother **Cornelis** (1576–1650) continued in their father's tradition. After a joint trip to Rome in 1596, they returned to Antwerp to enter the family business. Both were engaged as reproductive engravers, but after their father's death, Theodoor was mainly active as publisher and print dealer, while Cornelis continued to execute prints, among them after the works of Rubens (*Judith Beheading Holofernes*, c.1610).　　KLB

Mai, E., and Vlieghe, H. (eds.), *Von Bruegel bis Rubens*, exhib. cat. 1992 (Cologne, Wallraf-Richartz-Mus.).

GALLEGO, **FERNANDO** (active 1466–d. 1507). Spanish painter of altarpieces working in Castile during the second half of the 15th century. Gallego's first known commission was for the altarpiece of S. Ildefonso in the Cathedral of Plasencia. In 1473 he received a commission for six altarpieces in the Cathedral of Coria (all now lost). During 1478–90 Gallego and his studio were working

on both the main altarpiece for S. Lorenzo in Toro and the enormous one for the Cathedral of Ciudad Rodrigo (26 extant panels; Tuscon, University of Arizona Mus. of Art, Kress Coll.). He is last documented in 1507 working on fresco decorations in the chapel of the University of Salamanca. Gallego's style depends on the Netherlandish and German artists active during the 1450s and 1460s, particularly the prints of Martin *Schongauer. Gallego's Hispanicized version of northern style, with its marked realism and rigid, angular treatment of both anatomy and drapery, was carried all over Spain by his pupils and imitators. SS-P

Eisler, C., *Complete Catalogue of the Samuel H. Kress Collection: European Paintings Excluding Italian* (1977).

GALLEN-KALLELA, AKSELI (1865–1931). Finnish painter and designer. Gallen-Kallela was born in Pori and studied at art school in Helsinki and in the studio of Adolf von Becker (1831–1909). In 1884 he moved to Paris, where he attended the Académie Julian, returning to Finland in 1890. From the beginning of his career Gallen-Kallela showed a great interest in the great Finnish saga of the *Kalevala* from which he took the subject for his Aino Triptych (1889; Helsinki, Bank of Finland). Much of his stylistic development, from French *realism through *Symbolism to a personal linear *Expressionism, was inspired by his search for a style he considered appropriate to his chosen subject. *Lemminkainen's Mother* (1897; Helsinki, Ateneumin), with heavily outlined figures and decorative surface pattern, shows a debt to the *Nabis. In 1894–5 he designed and built a studio in the Finnish countryside inspired by traditional Karelian architecture, where he both painted and designed stained glass, fabrics, and jewellery. Murals, including one for the Finnish National Museum (1928) in Helsinki, and further illustrations to the *Kalevala* consolidated his position as the pioneer of Finnish nationalist *Romanticism. DER

Martin, T., and Siven, D., *Akseli Gallen-Kallela* (1985).

GALLERIES, INDIVIDUAL. See under town name.

GALLERY, a long narrow room, often on an upper floor, intended for exercise and recreation. In the 16th century it was increasingly used for the display of works of art, and the term widened out to mean a space where art is displayed, and hence art gallery (see under MUSEUM). But this article focuses on the *Renaissance idea of a gallery, within a noble residence, and intended as a display of wealth and magnificence.

The gallery originated in the open colonnaded loggias of Antiquity and was first developed in France. The earliest surviving example is the Galerie François I at *Fontainebleau (c.1533–40), richly decorated with paintings and stuccoes, which established a pattern for many French châteaux and English country houses, where the 'long gallery' was a popular feature. In 1547 Henry VIII had nineteen pictures in his Long Gallery at Hampton Court, and by the end of the century many English noblemen displayed family portraits in their galleries, as symbols of rank and magnificence. In Italy the concept was taken up by Francophile Italians, perhaps first at the Roman Palazzo Capodiferro-Spada (1559). Then, with Francesco I de' Medici (ruled 1574–87), a new era opened. Around 1574 he began to display the Medici collection of paintings and sculptures in the two galleries of the Uffizi (see under FLORENCE), and commissioned the lavishly decorated octagonal Tribuna at its centre to display his most precious works. These displays soon became celebrated as exemplars of enlightened princely patronage and magnificence. In 1591 Francesco Bocchi, in his *Bellezze della città di Firenze*, described the Uffizi as a 'Magnificent and regal palace, so full of statues, noble paintings, and precious furnishings . . . today in truth one of the most celebrated marvels of the world'; Galileo, responding to this new fashion, compared the poetry of Tasso to an old fashioned *studietto*, with petrified crabs, spiders in amber, an odd sketch by *Parmigianino, etc, but that of Ariosto to a princely gallery, with ancient sculptures, history paintings, and rare crystals and jewels. The fashion spread rapidly. In *Mantua Duke Vincenzo I Gonzaga's Galleria della Mostra (1595–1612) displayed both Antique sculpture and painting, while Duke Vespasiano of Sabbioneta built there a Galleria degli Antichi (1583–90) nearly 100m (330 ft) long. Such galleries were emulated in northern Europe and in Spain, where the most significant example, the vast Antiquarium (1569) at *Munich, was designed by the Mantuan Jacopo Strada.

Scamozzi, in *L'idea dell'architttura universale* (1615), commented on the popularity of galleries in Rome and Genoa, adding that they were fitting only for great lords and celebrated people. In this period, as connoisseurs and virtuosi honed their new skills, they dreamed of possessing galleries of rare and splendid collections to enhance their status and to enjoy the pleasures of *conversazioni*. *Marino's *Galeria*, a collection of madrigals and epigrams about works of art, perhaps suggests the displays of wit in which courtiers delighted as they strolled together through the gallery, while *Mancini advised collectors on how to hang their pictures. The picture gallery should be 'in some convenient spot where the light and air are good; where it is brushed by the north winds and shielded from the winds from the south' (R. Enggass and J. Brown (eds.), *Italy and Spain 1600–1750: Sources and Documents* (1992)). The pleasure was often heightened by windows looking out over the gardens enriched with ancient sculptures.

Throughout this period, and until the 19th century, the principle of display was symmetry, and pictures were hung frame to frame in tiers, most often against a red background. At Rome, the gallery at the Palazzo Pamphili, unusually long and enriched by the splendid frescoes of Pietro da *Cortona, was a setting for lavish entertainment. And courtiers might also enjoy the pleasures of aestheic debate, as at the Galleria Farnese, where Annibale *Carracci's decoration created an illusionistic picture gallery above an anthology of ancient sculptures, and played on the idea of the *paragone between painting and sculpture. Asdrubale Mattei took up the cause of naturalism, and commissioned a group of *Caravaggesque paintings for his gallery in the Palazzo Mattei.

North European travellers were awed by the Roman galleries, and Richard Burton, in the *Anatomy of Melancholy*, wrote of 'those well furnished cloisters and Galleries of the Roman Cardinal, so richly stored with all modern pictures, old Statues and Antiquities—' (M. Girouard, *Life in the English Country House*, 1978) and Italy created the pattern for north and central European and Spanish galleries. *Mytens's portraits of the Earl and Countess of Arundel (1618; Arundel Castle) set his sitters in the sculpture and painting galleries at Arundel House, the first of their kind in England. Absolutist France responded to the grandest 17th-century galleries of Rome and Florence, with their rich use of stucco, fresco, and mirrors, and at *Versailles the sumptuous Galerie des Glaces (1678–84), lined with unprecedentedly large mirrors, proclaimed the power of the King. Its vast space is preceded by a more intimate cabinet, a contrast recommended in Louis Savot's *L'Architecture française des bastimens particuliers* (1624). The Seigneur de la Vrillière (1599–61) displayed his modern taste by commissioning a series of contemporary Italian works for his new gallery at the Hôtel de la Vrillière, Paris (begun 1635).

In the 18th century the passion for collecting Graeco-Roman marbles and casts of ancient sculptures led to the development of a new kind of sculpture gallery. In the German courts and in England many painting and sculpture galleries were created, often to display the treasures of returning *Grand Tourists. The sculpture galleries were fittingly Roman in style, and, as at Adam's Newby Hall in Yorkshire and Ince Blundell Hall (1810) in Lancashire, suggested the influence of the Pantheon. But a desire to instruct became increasingly important, and towards the end of the century the Renaissance idea

of a gallery began to be replaced by the public *museum.　　　　　　HL

Prinz, W., Die Entstehung der Galerie in Frankreich und Italien (1970).

GALLI-BIBIENA FAMILY. See BIBIENA FAMILY.

GAMBIER-PARRY, THOMAS (1816–88). English painter and collector who lived at Highnam Court (Glos.). He was an active member of the Cambridge Camden Society, founded to promote the restoration of old churches and encourage the building of new ones on sound ecclesiological principles, and himself initiated the erection of the parish church of the Holy Innocents at Highnam (1849–51) by his friend Henry Woodyer (1816–96), which he then decorated with his own medieval-style wall paintings (1866–8). Gambier-Parry played a major role in the 19th-century revival of mural painting and invented a technique called Spirit Fresco which was suitable for the English climate. It substituted a concoction of organic media for the irreversible chemical process of carbonation in buon fresco, which required rigorous planning and offered a more limited palette and which had already proved a failure in the decoration of the Palace of Westminster. Gambier-Parry's system of wall painting ('Wallpainting versus English Climate') was first published in the Ecclesiologist (June 1862) and he himself applied it not only at Highnam but also at Gloucester Cathedral, Ely Cathedral, and Tewkesbury Abbey. He also made an important collection of early Italian art; paintings, sculpture, majolica, ivories, glass, and enamels. Most of these acquisitions were made, during travel to Italy, from dealers such as W. B. Spence in Florence. The collection was bequeathed to the Courtauld Institute Gallery, London.　　HB

Farr, D., Manning, T., et al., Thomas Gambier-Parry as Artist and Collector, exhib. cat. 1993 (London, Courtauld Inst. Gal.).
Gambier-Parry, T., Spirit Fresco Painting (1880).

GANDOLFI BROTHERS. Italian painters and draughtsmen. **Ubaldo** (1728–81) and his younger brother **Gaetano** (1734–1802) played a major role in transforming the academic tradition of late *Baroque painting in Bologna into a more energetic, graceful, and fanciful style inspired by Venetians such as Sebastiano *Ricci and G. B. *Tiepolo. Ubaldo studied painting at the Accademia Clementina, Bologna, first under Felice Torelli (1667–1748) and then under Ercole Graziani (1688–1765). Gaetano worked at the Accademia Clementina under Ercole Lelli (1702–66). Both were virtuoso draughtsmen and a large corpus of their drawings has survived. In 1760, under the patronage of a Bolognese merchant, Antonio Buratti, Gaetano (and possibly Ubaldo as well) went to Venice. The impact of Venetian decorative painting is apparent from Ubaldo's fresco of The Resurrection of Christ (Bologna, S. Luca; bozzetto Bologna, Pin. Nazionale) and Gaetano's Liberation of S. Peter (Stuttgart, Staatsgal.). It was at this time that the style of the two artists converged and the problem of distinguishing their respective hands sometimes arises.

During the 1770s Ubaldo painted mythological paintings, with much naked flesh, for the apartments of the Senatori Gonfalonieri in the Palazzo Pubblico, Bologna (Perseus and Andromeda, Diana and Endymion); also altarpieces for Bolognese churches; and smaller, devotional works including four half-length oval pictures of saints (Bologna, Palazzo Comunale). He died while at work on a fresco at S. Vitale, Ravenna.

Gaetano developed in a different direction, adopting a more severe *Neoclassical manner. The beginning of this process is apparent in his Death of Socrates (s.d. 1782; priv. coll.). It received further impetus from his visits to Paris and London in 1787, reflected in his large painting of the Inauguration of the Foundling Hospital by the Beato Bernagalli (c.1788; Pisa Cathedral). And the development continued until his death, with such pictures as the Communion of the Apostles and the Martyrdom of S. Lawrence (1795; Budrio, S. Lorenzo).　　HB

Riccomini, E. (ed.), L'Arte dell' settecento emiliano, exhib. cat. 1979 (Bologna, Palazzo del Podestà e di Re Enzo).

GARGIUOLO, DOMENICO. See MICCO SPADARO.

GARGOYLE (Latin gargulio: throat), a waterspout projecting from the eaves or buttresses of a building to throw water clear of the masonry. In a simpler form they existed in ancient Egyptian, Greek, and Roman buildings, but they are particularly characteristic of *Gothic and Gothic Revival styles; they also feature in Chinese architecture.

In medieval architecture, the earliest surviving gargoyle is a *Romanesque example at Autun Cathedral, c.1120. By the 13th century they appeared all over Europe, developed into their final form of elongated, grotesque figures, animal, human, or composite. Occasionally they take other forms, such as the boat at Selby Abbey (Yorks.), c.1330. The most famous gargoyles, however, are the series of gigantic mythical creatures at Notre-Dame, Paris, partly restored but mostly created in the 19th century, under the inspiration of the Romantic movement. The subject matter of gargoyles and their position at the edges of buildings provide useful material for students of marginalia in art.　　NC

Camille, M., Image on the Edge (1992).
Sheridan, R., and Ross, A., Gargoyles and Grotesques (1975).
Viollet-le-Duc, E. E., Dictionnaire raisonné de l'architecture française du XIe au XVIe siècle (1854–68).

GAROFALO (Benvenuto Tisi) (1481–1559). Italian painter from Ferrara who probably trained under Boccaccio Boccaccino of Cremona. He was also influenced in his formative years by Lorenzo *Costa and *Giorgione. His commissions at Ferrara included work at the Palazzo di Schifanoia and frescoes on the ceiling of the Aula Costabiliana in the Palazzo di Ludovico il Moro. Following a visit to Rome (according to *Vasari) his style increasingly became dominated by the influence of *Raphael, evident in his Nativity (1513; Ferrara, Pin. Nazionale) and his Madonna of the Clouds with S. Jerome and S. Francis and Two Members of the Suxena Family (commissioned for the church of S. Spirito, Ferrara, now Ferrara, Pin. Nazionale). Garofalo went on to produce altarpieces for most of the principal churches of Ferrara. He also made an ambitiously conceived fresco of The Old and New Testament (1523; Ferrara, Pin. Nazionale) for the refectory of S. Andrea, Ferrara.　　HB

GAUDIER-BRZESKA, HENRI (1891–1915). French-born English sculptor. Gaudier was born near Orléans and was an art student in Paris in 1910 when he met the Polish-born Sophie Brzeska with whom he settled in London, as brother and sister, in 1911. Despite a lack of formal training he gradually obtained commissions and introductions through the patronage of the critic Haldane MacFall, Frank Harris, and Roger *Fry and by 1912 had met *Epstein, who encouraged him towards direct carving, and Wyndham *Lewis and was sufficiently established by 1913 to become a founder member of the *London Group. His widely diverse style emerged in part from frequent visits to the Louvre (see under PARIS) and the British Museum (see under LONDON) where he made a close study of 'primitive art', which particularly influenced his small carved animal sculptures, Bird Swallowing a Fish (c.1913–14; London, Tate) being typical. His ambitious heroic bronze bust of Horace Brodsky (1913; London, Tate), on the other hand, shows an awareness of *Rodin tempered by *Vorticist stylistic idioms. He was also a prolific and fluent draughtsman whose many drawings of wild animals are well represented in the Tate, London. Enlisting in the French army in late 1914 he was killed in action in June 1915. Despite his early death his precocious talent has sustained his reputation as an innovative

figure in 20th-century British art.　　　JH

Cole, R., *Burning to Speak: The Life and Art of Henri Gaudier-Brzeska* (1978).

GAUGUIN, PAUL (1848–1903). French painter, sculptor, and printmaker; born in Paris, died in self-imposed exile in the South Seas. He spent his childhood in Lima where his mother had distant relatives, joined the merchant marine in 1865, and from 1872 worked successfully in Paris as a stockbroker. Introduced to art by his guardian Gustave Arosa, he became a spare-time painter and sculptor. In 1876 he had a landscape accepted by the Salon (see under PARIS). Encouraged by *Pissarro, he also began to make a collection of *Impressionist pictures, notably key examples by *Cézanne. Invited to exhibit in the fourth Impressionist exhibition of 1879, Gauguin participated regularly thereafter. His *Study of a Nude: Suzanne Sewing* (1880; Copenhagen, Ny Carlsberg Glyptothek) was acclaimed by J.-K. *Huysmans in his review of the sixth exhibition. In 1883 he gave up his employment to become a full-time artist. He adopted a peripatetic existence, moving to Rouen, then to Copenhagen. Failing to market his own pictures, he began to sell his collection. He left his family in Copenhagen and returned to Paris; then after exhibiting unsuccessfully at the last Impressionist exhibition in 1886, he made a first visit to *Pont-Aven in Brittany. In 1887–8 he went to Panama and Martinique, in 1888 returned to Brittany, before his brief, ill-fated stay in Arles with van *Gogh.

Hostile to the scientific preoccupations of the *Neo-Impressionists, Gauguin turned to exotic and primitive stimuli and in 1888, influenced by Émile *Bernard, adopted the synthetic manner, seen in *Vision after the Sermon; Jacob Wrestling with the Angel* (1888; Edinburgh, NG Scotland). This allowed him to free colour from its representational function and emphasize instead its decorative or emotional effect. The exhibition of the new Synthetist works at the Café Volpini in 1889 helped to establish Gauguin as the pivot of a group of artists who were attracted by his picturesque personality and new ideas in aesthetics. Adept at self-promotion, he publicized his project to find an idealized 'primitive' paradise freed from the economic and social constraints of western European life. He set sail for Tahiti in 1891, having been hailed leader of the *Symbolists.

In many ways the archetypal colonial adventurer, Gauguin endeavoured to 'go native'. Although disappointed by the paucity of indigenous Tahitian artefacts, removed or destroyed by Europeans, he drew inspiration from the arts of other ancient or primitive peoples (Javanese carvings, pre-Columbian Peruvian pottery, etc.); his painting became more profound, his colours more resonant, his drawing more grandly simplified. In 1893

he returned to Europe and exhibited his work at Durand-Ruel's gallery, Paris, to moderate critical acclaim. He prepared *woodcuts to illustrate his book *Noa Noa*, a romanticized *récit* of his stay in Tahiti, again deploying crude, primitivizing techniques. Disillusioned by failure to sell his work, he returned to Tahiti in 1895.

At the end of 1897 he painted his great picture *D'où venons-nous? Que sommes-nous? Où allons-nous?* (Boston, Mus. of Fine Arts) before attempting suicide. In September 1901, having begun to receive a regular stipend from the French dealer Vollard in return for pictures, he moved to the Marquesas islands where he died in 1903. An exhibition to mark his death was held at *Paris in the first Salon d'Automne of 1903, while the major retrospective there in 1906 laid the basis of his future reputation.　　　BT

Gauguin, exhib. cat. 1988–9 (Washington, NG; Chicago, Art Inst.; Paris, Grand Palais).

GAULLI, GIOVANNI BATTISTA (Il Baciccio, Baciccia) (1639–1709). Italian painter and draughtsman whose illusionistic style of fresco painting marks the high point of Roman *Baroque art. He was born in Genoa but had moved to Rome by 1658. His earliest commission there, an altarpiece in the church of S. Rocco, reveals his Genoese background, with its distinctive warmth of colour, and he retained this exuberant quality until quite late in his career. His first major challenge as a decorator was the commission (1666) to paint the pendentives of S. Agnese a Piazza Navona with figures of the Christian virtues, a task he completed in 1672. On *Bernini's advice, he first went to Parma (c.1669) to study *Correggio. Gaulli successfully combines the feminine charm of Correggio's manner with a vigour and expressive power he had absorbed from Bernini. The success of this work led to the commission from the Jesuits to transform Vignola's barrel-vaulted Gesù into a late Baroque church, with an illusionistic fresco depicting *The Adoration of the Name of Jesus* (1678–9). Gaulli breaks free from the limitations of a framed image, which the form of the vault might have indicated, and adds not only stucco figures but also projecting flaps of stucco which were then covered with painted figures. These *trompe l'œil* effects, combined with the freedom and energy of Gaulli's style, create an illusion (see ILLUSIONISM) for the spectator of witnessing a celestial vision. It represents the culmination of a stylistic development that had begun with Pietro da *Cortona's ceiling at the Palazzo Barberini.

Gaulli's oil paintings never quite match his achievement at the Gesù. In 1676 he painted the *Death of S. Francis Xavier* for S. Andrea al Quirinale and in 1698 painted the *Birth of S. John the Baptist* for S. Maria in Campitelli. While the former has in full measure the

realistic and theatrical manner associated with the high Baroque, the later work marks a development in Gaulli's work from the mid-1680s, toward a calmer synthesis of classical and Baroque principles. This tendency is confirmed in his last major decorative project, completed in 1707, the vault fresco of *Christ in Glory Receiving Franciscan Saints* for SS Apostoli, Rome, where the figures are rigorously contained within the framed space, the colour is toned down, and the general effect is of a classical design.

Gaulli's efforts to find a point of stylistic balance between classical and Baroque was realized more successfully in smaller-scale works for private clients, including the 5th Earl of Exeter, a remarkable British tourist who bought four such pictures, either when he was in Rome c.1684 or, more probably, on a later visit in 1699. They are the *Christ in the House of Simon the Pharisee* (Burghley House, Lincs.) and its pendant *The Three Marys at the Tomb* (now Cambridge, Fitzwilliam); and *Venus Dissuading Adonis from the Chase* (Burghley House, Lincs.) and its pendant *The Death of Adonis* (Oberlin, Oh., Allen Memorial Art Mus.).

Gaulli was also in demand for portraits, and according to his biographer L. Pascoli (*Vite de' pittori*, 1730) he painted all seven popes from Alexander VII to Clement IX (1667–9; Rome, Barberini Gal.). He twice painted Bernini (1673; Rome, Palazzo Barberini; and in another pose, Edinburgh, NG of Scotland); and made a flatteringly romantic *Self-Portrait* (c.1668; Florence, Uffizi).

He was a prolific and conscientious draughtsman, and prepared his major fresco decorations with lively *bozzetti (a Genoese speciality) and careful chalk drawings of which more than 300 are preserved now at Düsseldorf (Kunstmus.).　　　HB

Engass, R., *The Paintings of Baciccio* (1964).

Graf, D., *Kunstmuseum Düsseldorf: die Handzeichnungen von Guglielmo Cortese und Giovanni Battista Gaulli* (1976).

GAURICUS, POMPONIUS (early 1480s–1528×30). Humanist scholar from southern Italy (he took his name from Gauro, the village near Salerno where he was born). He moved in literary and artistic circles in Padua from 1501–2 to after 1505, and there wrote *De sculptura*, a treatise on bronze sculpture, and an important source for 15th-century sculpture in northern Italy. The treatise is written as a *Ciceronian dialogue, set in Gauricus' own studio, where he worked as a dilettante sculptor; it is rooted in ancient writings by *Pausanias, *Philostratus, and *Pliny. It has important chapters on *proportion and *perspective, and stresses the value of learning and literary culture to the sculptor. Gauricus knew Tullio *Lombardo, Andrea *Riccio, and Severo da *Ravenna, and his treatise ends with a eulogy to the latter. He idolized

*Donatello, and makes surprisingly early comments on Andrea *Sansovino, Giovanni Francesco Rustici, and *Michelangelo, 'etiam pictor'. From 1512 Gauricus lived in Naples.

HL

Gauricus, P., *De sculptura* (1504; French trans. ed. A. Chastel and R. Klein 1969).

GAUTIER, THÉOPHILE (1811–72). French poet, writer, and art critic. Gautier was the foremost exponent of *l'art pour l'art*, for which his preface to *Mademoiselle de Maupin* (1836) remains the most eloquent manifesto. Yet the Salon criticism of this 'pagan' devotee of Beauty (published regularly for 30 years in *La Presse* and *Le Moniteur universel*) lacks the theoretical subtlety and the polemical audacity of *Baudelaire's. His contemporaries saw him as a 'doux critique', and indeed his approach is based on the amiable principle of evaluating a work of art by its own standards. In practice his aestheticism was an accommodating doctrine which permitted him to maintain eclectic tastes, and he displayed almost equal enthusiasm for artists as diverse as *Ingres, *Delacroix and Paul Chenavard (see, for example, *Les Beaux-Arts en Europe*, 1855). In fact, Gautier's principal talent as a critic lay in his unsurpassed mastery of descriptive prose, which allowed him to recreate works of art in the medium of literature.

PC

Snell, R., *Théophile Gautier: A Romantic Critic of the Visual Arts* (1982).
Spencer, M. C., *The Art Criticism of Théophile Gautier* (1969).

GAVARNI, PAUL, pseudonym of Guillaume-Sulpice Chevalier (1804–66). French caricaturist who, as a satirist of French bourgeois life, has few equals. He worked initially as an industrial draughtsman but from 1828 he earned his living in Paris with drawings of costumes for dressmakers and the theatre. From 1837, when he began to contribute to *Le Charivari*, he specialized in the humorous drawings of social manners for which he is famous (*Fourberies de femmes en matière de sentiment*, 1837–41; *Le Carnaval*, 1846). He visited England from 1847 to 1851, where he studied the life of the poor and, in a series of plates, *Gavarni in London* (1849), graphically contrasted it with that of the rich. From this moment the benign irony of the earlier works gave way to a more trenchant satire with political implications, embodied in the character of Thomas Vireloque (*Les Propos de Thomas Vireloque*, 1851–3). His work moves from caricature to a comedy of manners, and depicts with profound cynicism the miseries of the 1840s.

HL

GEERTGEN TOT SINT JINS (active *c*.1475–95). North Netherlandish painter who may have been a pupil of Albert van *Ouwater in Haarlem. His name, little Gerard of S. John, refers to the order of S. John in whose monastery in Haarlem he lived and for whom he painted an altarpiece. Two panels from this survive (Vienna, Kunsthist. Mus.), a *Lamentation*, which includes figures inspired by works by South Netherlands artists, and a scene of the *Burning of S. John's Bones*, which features one of the earliest group portraits.

These works are the basis for attributing other works to Geertgen. All are characterized by his distinctively naive figures, doll-like and melancholy. In the *Nativity at Night* (London, NG), the childish Virgin, the pretty angels, and the soft eyes of the animals emerge from the darkness lit by the rays from the Christ child. The miniaturist technique used in this, and other, very small panels has inspired suggestions that he may also have illustrated books. In *S. John in the Desert* (Berlin, Gemäldegal.) the introspective saint, chin on hand, is placed in a complex luxuriant landscape, whose details of plants and flowers prefigure the work of *Dürer.

In spite of a short career, Geertgen was influential in the development of Dutch landscape, and had followers including Jan *Mostaert.

MS

Châtelet, A., *Early Dutch Painting* (1981).
Mander, Carel van, *The lives of the Illustrious Netherlandish and German Painters*, ed. H. Miedema (1994).

GEFFROY, GUSTAVE (1855–1926). French journalist, novelist, and art critic, director of the Gobelins tapestry works from 1908. A disciple of *Zola's naturalism, in his regular column for Georges Clémenceau's paper *La Justice* Geffroy attacked academicism and passionately defended such independent artists as *Monet and *Rodin. He collaborated with *Toulouse-Lautrec and was portrayed by *Cézanne (1895–6; Paris, Mus. d'Orsay). His series of published articles, *La Vie artistique* (8 vols., 1892–1903), consistently advocated values of sincerity and humanism.

BT

Culler Paradise, J., *Gustave Geffroy and the Criticism of Painting* (1982).

GELDER, AERT DE (1645–1727). Born in Dordrecht, a Dutch painter of considerable skill. He became a pupil of Samuel van *Hoogstraten and then in the 1660s worked in the studio of the ageing *Rembrandt in Amsterdam for at least two years. He developed a free but controlled style, with extensive use of the end of the brush, richly loaded with paint, which was particularly effectively employed for religious narratives, and carried Rembrandt's late manner loyally on into the 18th century. A notable example of such work is his *Jacob's Dream* (Dulwich, Gal.), a proto-Romantic, almost mystical image, with very bold contrasts of light and dark, which was considered up until the late 19th century to be an important work by Rembrandt himself. It was partially inspired, as were a number of his compositions, by Rembrandt etchings. After his sojourn in Amsterdam, de Gelder returned to Dordrecht where he remained for the rest of his life. It is thought that he provided material for *Houbraken's important early biography of Rembrandt which was published in 1718.

CB

Lilenfeld, K., *Arent de Gelder* (1914).

GEMS. Precious stones, when cut, engraved, and polished, have been used for the purposes of adornment for over 7,000 years. Three qualities are largely responsible for their enduring popularity; first the beauty and vibrant colour of the stones themselves, secondly the skill and delicacy of their workmanship, and thirdly superstitious beliefs in their magical properties. The hardest stones, such as diamonds, rubies, emeralds, and sapphires, are normally cut and polished and mounted as jewellery. Other stones, including varieties of silica, ranging from transparent rock crystal, through amethyst, chalcedony, sard, cornelian, and the jaspers, to the onyxes, were more often engraved to form intaglios, where the design is cut into the stone, or cameos, where the design is in relief. In the case of the latter the artist often uses the stone's colouring to differentiate the design from the ground, and with skill exquisite colour effects can be achieved with this method. The most common use for intaglios was as seals, while cameos were more suitable for brooches and other types of jewellery.

The earliest known gems are cylinder seals made in Babylon about 4000 BC. The practice spread throughout the Middle East where gems were normally pierced and either set in rings or suspended from the body as amulets. The most common Egyptian amulet was the scarab, made in the form of a sacred beetle, and this design continued to be used in early Greek and Etruscan work. The Minoans produced gems of a different style, with designs of warriors, gods, and naturalistic animals. Scenes from daily life, as well as heroic legends, became increasingly popular in Greek (and Persian) gem engraving from the later 5th and 4th centuries BC. Some of the finest engraving dates from the Hellenistic period, and this coincides with the widespread appearance of the cameo. The most famous engraver of this period was Pyrgoteles, who is said to have portrayed Alexander the Great on cameos, although no such works have survived.

In Italy the Etruscans imported gems, and probably engravers, from Greece. During the Roman Republic (see ROMAN ART, ANCIENT), the Hellenistic cameo style was very popular. Perhaps the most famous example of such

work from the period is the Tazza Farnese, which was possibly commissioned by Cleopatra, carved from sardonyx and depicting an allegory of Egypt's fertility under the protection of Isis, Horus, and Osiris-Sarapis (1st century BC; Naples, Mus. Arch. Naz.). This high level of artistic achievement continued into the imperial period, and one of the finest examples of large sardonyx cameos is the Gemma Augusta (AD 14–37; Vienna, Kunsthist. Mus.). Gem workers did not only produce cameos and intaglios, for bowls, cups, and other vessels carved from gems were often richly decorated in relief and greatly treasured. Busts and statuettes were also carved from precious stones.

The fascination with gems continued into the Middle Ages. While the *Carolingian period produced some exceptional examples of engraved crystal (e.g. the so-called Lothar Rock Crystal, c.850–69; London, BM), most engraved gemstones were reused from Antiquity, appearing in a variety of contexts. Cameos and intaglios were often mounted as rings, worn as amulets or brooches, and sometimes even mounted on elaborate Gospel book covers or reliquaries. A magnificent chalice, incorporating a Hellenistic sardonyx fluted cup, was mounted in silver gilt by Abbot Suger for his abbey at S. Denis, c.1140 (Washington, NG). Although *Antique engraved gems were highly sought after and very expensive throughout the Middle Ages, the craftsmen of the period showed an obvious delight in the colour and luminosity of uncut gemstones, known as cabochons. Such gems could be woven into important clothing, on belts and girdles, mounted as jewellery, or just collected for their own sake. Numerous lapidaries survive from the Middle Ages identifying gemstones and describing their magical properties, the earliest and most famous by Marbode of Rennes (c.1090). When expensive gemstones were unavailable, medieval craftsmen gained similar effects by using glass and coloured pastes, which were mounted as if they were gems.

The great period for collecting Antique gems was during the *Renaissance, and the most notable connoisseurs were Lorenzo de' Medici (d. 1492) and Pope Paul II (d. 1471). Antique cameos and intaglios were also a source of inspiration for numerous artists and engravers of the period, such as Domenico Campagni (active 1570s), who attempted to emulate their virtuosity. Intricate landscapes populated with numerous figures challenged an artist's technical and compositional skill. A fine example is the intaglio known as *'Michelangelo's Ring', depicting the Education of Bacchus (second half 16th century; Paris, Bib. Nat.). Milan was one of the principal centres for gem engraving and the artists trained there worked all over Europe, such as Jacopo da Trezzo (c.1514–89), who travelled to Spain, Gian Giacomo Caraglio

(c.1500–65), who worked in Poland, members of the Miseroni family, who served Rudolf II of Austria, and Matteo del Nassaro (1515–47/8), who, among others, founded a flourishing school in France.

Gem engraving continued to reach new heights of virtuosity in the 17th and 18th centuries, with Johann Lorenz *Natter and Jacques Guay (1711–93, a protégé of Mme de Pompadour) among the best engravers of their day. There was also a keen antiquarian interest in antique gems. Such interest is not hard to understand when we remember that these small durable objects provide some of the best preserved examples of classical art. It was also recognized that since classical engravers often copied contemporary statues and paintings, the gems represent the best evidence for the appearance of vanished masterpieces. Forgeries proliferated during this period; however, there were also many gifted artists producing classically inspired work during the later 18th and 19th centuries, including Johann Pichler (d. 1799) in Italy, Benedetto Pistrucci (d. 1855), Edward Burch (d. c.1840), and William Brown (d. 1877) in England. The art of the cameo also influenced artists in other fields, such as Josiah Wedgwood. Since the turn of the 20th century the art of gem engraving has been largely confined to the cutting and polishing of gems for jewellery. TJH/HO

Boardman, J., Greek Gems and Finger Rings (1971).
Gebhart, H., Gemmen und Kameen (1925).
Lightbown, R. W., Medieval European Jewellery (1992).
Weiss, R., The Renaissance Discovery of Classical Antiquity (1969).

GENERALIĆ, IVAN (1914–92). Yugoslav naive painter, born in Hlebine, Croatia. In 1930, after meeting the painter Krsto Hegedušic (1901–75) and members of the Zemlja group from Zagreb, he formed the *Hlebine group of peasant painters. He first exhibited with the Zemlja group in 1931, and his first one-man show was in the Salon Ulrich, Zagreb, in 1938. He painted in watercolour, oil on canvas, and oil behind glass, a technique for which he became renowned. Common themes for his paintings are scenes from village life, festivals, landscapes, still lifes, figures, and portraits. While some of his pictures are straightforwardly idyllic representations of peasant activities, in others there are elements of grotesque fantasy reminiscent of *Brueghel and *Bosch, while still others create *Surrealist impressions of incongruity, such as The Fish (1963; priv. coll.), in which an enormous hooked fish is suspended in the air above a landscape containing an angler with his rod dangling into the village stream. His works are also characterized by the recurrent use of particular images—such as roosters—which appears to

invest them with a mysterious, symbolic significance. OPa

GENOA: PATRONAGE, AND COLLECTING. Liguria has always been frontier territory. Genoa is close to France but is also the gateway to Lombardy; it faces the Mediterranean, and so has close links with Spain as well as the most important ports of the Italian peninsula. This means that the city has had a constant opportunity from the Middle Ages until modern times to compare itself with other centres of culture. The Genoese ruling classes' business and trading activities determined that the city had particularly close links with Flanders from the 15th century until the end of the 17th century. Genoa was always a clearing house for works of art, which accumulated over the centuries in private residences. The most important commercial ventures and artistic commissions can be attributed to individual families, rather than to the city itself. The wealth of the Genoese families was based largely on shipbuilding and trade. In 1097 the Genoese fleet was put into service in the First Crusade; and a brilliant colonial policy enabled the families involved (Cattaneo, Giustiniani) to gain vital commercial control of the Genoese overseas territories. The trade in alum, for instance, controlled initially by the Giustiniani family (14th and 15th centuries) and subsequently by the Pallavicino family, was a huge source of income.

The Genoese talent for commerce was put to use in military expeditions (led by members of the Doria and Spinola families), and, from the 16th century onwards, also in financial ventures. This was mainly due to strengthened relations with Spain following the political reforms of Andrea Doria. Although the Genoese also lent money to France, Russia, and England, it was the loans made to Charles V, Philip II, and Philip III of Spain which made them rich. This new activity saw the emergence of 'new nobles' (Brignole-Sale, Balbi, the Ivrea family), and the city now attracted the most important merchant bankers in Europe. In repayment for loans, enormous quantities of precious metals poured into the coffers of the Genoese. Some of these profits were converted into grandiose buildings, villas, and palaces in the 16th and 17th centuries (including Strada Nuova in the mid-16th century). It fell to the aristocracy of the 17th century to decorate with furnishings and works of art the sumptuous dwellings built by the previous generations.

From the 15th century onwards, many works of foreign artists (for example the Flemings Jan *Provost, Gerard *David, and Joos van *Cleve, and the Lombards Vincenzo *Foppa and Carlo Braccesco (active 1478–1501) and the French Provençal artist Louis Bréa (active 1475–1522)) found their way to Genoa.

The renewal of the local artistic culture in the 16th century is due to the initiative of Andrea Doria, who, in 1528, called to work on his villa in Fassolo an artist of the school of Raphael, Perino del *Vaga. Genoese artists felt the need to bring themselves up to date, and the journeys of Luca *Cambiaso—to Rome and Spain—contributed to the birth of a true local school of painting. Although this school benefited from a free exchange with other centres of culture, it now had its own character which was to be consolidated in the 17th century. Genoese workshops began to specialize in fresco decoration, to satisfy the demand for decoration of the façades and the interiors of splendid recently built palaces, which already held large quantities of paintings and tapestries, mainly imported from Flanders. In the first decade of the 17th century the arrival in Genoa of *Rubens, court artist and ambassador of the Gonzagas, who were in debt to the Genoese banker Nicolò Pallavicino, started an unprecedented artistic flowering in Genoa which earned the city the nickname 'Superba'. The arrival of van *Dyck in 1621 was probably due to relations with the Genoese family of Cattaneo who had settled in Flanders for business reasons. The Genoese aristocracy (Doria, Spinola, Lomellini, Cattaneo, Pallavicino, Balbi, and Durazzo) commissioned splendid portraits from this great master, which are perhaps the most grandiose works of art produced in Genoa in any century of its history. The fashion for collecting at this time encouraged other Flemish artists to come to Genoa, and to introduce a wider range of subject matter, including still life, landscape, and genre painting. Meanwhile, masterpieces of religious art were placed in the city's churches: A Rubens's *Circumcision*, Guido *Reni's *Assumption of the Virgin*, and *Vouet's *Crucifixion*, all in the Gesù, *Barocci's *Crucifixion* in the cathedral, and Giulio Cesare *Procaccini's *Last Supper* at the church of the Annunziata. The old collecting tradition of the Genoese families—who had mostly favoured the masters of the Venetian Renaissance—was brought up to date thanks to the personal contribution of Marcantonio and Gio. Carlo Doria, who turned to some of the most lively contemporary artists (including *Caravaggio, G. C. Procaccini, Vouet, O. *Gentileschi). Generations of local painters now had to measure their own achievements against these yardsticks, and on the basis of this multiplicity of stimuli there flourished a glorious local school of Genoese painting. Artists such as Giovanni Battista *Paggi, Bernardo *Strozzi, Gioacchino Assereto (1600–49), Valerio *Castello, Domenico Piola (1627–1703), Gregorio de Ferrari (1647–1726), Bartolomeo Guidobono (1654–1709), and Alessandro *Magnasco produced a flow of easel paintings and *Baroque fresco cycles which

continued until the early 18th century. AO

Poleggi, E., *La pittura a Genova e in Liguria* (2 vols., 1987).

GENOA, ACCADEMIA LIGUSTICA DI BELLE ARTI, founded in 1751 by a group of Genoese nobles and intellectuals, determined to bring the Enlightenment to the conservative Genoese art establishment. The Accademia was closely identified with the *Neoclassical movement under Carlo Giuseppe Ratti's long directorship (1775–95). Ratti was a friend of *Winckelmann and *Mengs, who was made an honorary academician in 1770 and whose powerful *Self-Portrait* is in the Museo dell'Accademia, which mainly contains Genoese paintings, including *Strozzi's masterpiece *S. Augustine Washing Christ's Feet* (c.1620–5). AJL

Briganti, G. (ed), *La pittura in Italia: il settecento* (1989).

GENOA, PALAZZO BIANCO AND PALAZZO ROSSO, splendid former palaces of the Brignole Sale family, containing rich collections of painting. The Palazzo Rosso was built for the Brignole Sale in 1671–7, when the Genoese aristocracy were still at the height of their power and wealth. Between 1686 and 1692 the rooms of the second floor were frescoed by Gregorio de Ferrari (1647–1726) and other Genoese painters in a spirit of overwhelming exuberant magnificence. The Palazzo Bianco was remodelled for the family in 1716 on the basis of a 16th-century Grimaldi palace. The Palazzo Rosso and its contents were given to the city of Genoa in 1874 by the Duchess of Galliera, who in 1889 bequeathed the Palazzo Bianco to the city for use as a picture gallery. Following damage in the Second World War both collections were reorganized according to a didactic programme. The Palazzo Bianco opened in its present form in 1950, and the Palazzo Rosso in 1961.

The Palazzo Bianco holds a distinguished collection of Genoese painting, together with a large section of the Dutch and Flemish painting that had such a strong influence on the art of Genoa. The paintings in the Palazzo Rosso consist of the old Brignole Collection, filled out with some other works so as to tell a fuller art historical story. Like that of the Palazzo Bianco, the collection is strong on Genoese painters (especially *Strozzi) and it includes a notable group of Genoese aristocratic portraits by van *Dyck. AJL

GENRE (French: kind, variety) is art that takes everyday life as its subject matter. This limited use of the word only became established in the 19th century and it followed the broader, and still current, use of the term to include all the specialized categories (genres) of art, such as landscape and still life,

that established an independent identity at around the end of the 16th century.

*Aristotle mentions a low-life painter, Pauson, but no free-standing classical Greek painting has survived. From the 6th century, however, Greek vase painting (see GREEK ART, ANCIENT) included a wide range of motifs from everyday life, including banquets, dancing, lovemaking, sporting events, workshop scenes, agricultural labour, and episodes from the theatre. During the *Hellenistic period, with its increased emphasis on realism, genre subjects proliferated in types such as the numerous surviving 'Tanagra' terracotta statuettes that show women in a range of social activity. Full-size statues were also made that presented such figures as decrepit old women and fishermen in a ruthlessly realistic manner that made sophisticated play between the impressive medium and the low-life subject matter.

The most informative and influential classical text on genre painting is *Pliny the elder's (*Natural History* 35) description of the Greek painter Piraicus, of unknown date, whose mastery of his art was such that 'but few rank above him, yet by his choice he perhaps marred his own success, for . . . he painted barbers' shops, cobblers' stalls, asses, eatables and similar subjects, earning for himself the name of painter of odds and ends (*rhyparographos*)'. Pliny records that Piraicus could sell these humble scenes for more than his competitors could get for their large pieces, and this unease at the commercial success of the least theoretically deserving form of art was to resurface practically unchanged in the 17th century.

Within the religious and political imperatives of medieval art there was also a steady stream of direct and lively observation from life. Themes such as the labours of the months provided material for genre scenes in manuscript illustrations and church carvings throughout the period, and vignettes of domestic and street life figured as subsidiary elements in religious paintings. Interest in these aspects of reality was always more pronounced in northern Europe than in Italy, and it became markedly more important in Netherlandish art at the beginning of the 15th century, in the work of painters such as *Campin and van *Eyck. Within Italy, interest in genre seems to have been strongest in the north, where there was a tradition of secular mural painting in castles, as in the courtly *International Gothic scenes of the months (1407; Trent, Castello del Buonconsiglio) and the boldly realistic frescoes of workshops and commercial scenes (1488–95; Issogne, Castello Challant).

During the 16th century genre developed in northern Europe with a strong bias towards *Hieronymus Bosch's emphasis on didactic moralizing and satire, in which

licentiousness and indulgence were characterized by exaggerated and repulsive deformity. In the second half of the century, Pieter *Aertsen and his pupil Joachim *Bueckelaer founded a school of broadly handled monumental low-life genre that celebrated a world of exuberant piles of food and sturdy serving-women whose poses owe something to *Michelangelo. Pieter *Bruegel's vision is psychologically far deeper. His peasants' boorishness may have been intended as a satire on human folly, but they are simultaneously heroic figures, eternally bound to the cycles of nature.

Genre took a different course in northern Italy where, in the wake of *Giorgione, painters such as Giovanni Cariani and *Savoldo developed a type of idyllic and elegiac genre piece that echoed the mood of contemporary Arcadian poetry. Later in the century, bawdy low-life scenes showing Aertsen's influence were developed by Vincenzo *Campi in Cremona and Bartolommeo *Passarotti in Bologna, and the latter led directly to Annibale *Carracci's genre pieces such as the *Butcher's Shop* (c.1583; Oxford, Christ Church). *Caravaggio's early genre pieces explored a new dimension of direct presence. Only two of them—the *Card-Sharpers* (1594–5; Fort Worth, Kimbell Mus.) and the *Gypsy Fortune-Teller* (1593–4; Rome, Capitoline Mus.)—are half-lengths that depict contemporary figures in a dramatic encounter, but this type rapidly gained an enormous following throughout Europe.

Genre painting achieved its richest flowering in the 17th century, and it is paradoxical that this was simultaneously the period when academic theory became rigidly set against it as a low form of art in comparison with the nobility of history painting. The idea of the hierarchy of the genres, based on their subject matter, had been current in classical Antiquity. It was revived in Italy, notably by Giulio *Mancini, but it was finally elaborated into a complex set of schematic dogmas in France, especially by the architect and theorist André *Félibien in the 1660s and 1680s. This theoretical deprecation of genre in France and Italy reflected societies in which a predominantly idealizing artistic tradition was at the service of patronage from the Catholic Church and the nobility. While genre paintings were produced in those countries, and could command high prices, the category never assumed the importance in France and Italy that it did in the Protestant Dutch Republic, where the prosperous new bourgeois clientele had an insatiable appetite for genre that represented the life of the confident new society that had been established there. Even in the Dutch Republic, however, there was little theoretical defence of the minor genres, and when *Houbraken compiled his sourcebook on 17th-century Dutch painters (published 1718–21) he adopted a rigidly conventional classicizing line. We can only guess what the great Dutch genre painters really thought they were doing.

From the late 1620s the picturesque cabinet pictures of Roman street life by the northern painters known as *Bamboccianti became extremely popular with Italian collectors. Genre painting in Naples, under Spanish government and artistic influence, was harsher and more uncomfortable, as in *Ribera's enigmatic *Boy with a Club Foot* (1642; Paris, Louvre). In Spain itself, *Velázquez's early tavern or kitchen scenes are saturated with a quasi-religious gravity of treatment, while *Murillo's later scenes of beggar children are sentimental confections. In France, Georges de *La Tour's highly idiosyncratic tenebrist art and Louis *Le Nain's immobile groups of melancholy peasants stand out against the most formalized grand art patronage system of any country.

The vast 17th-century Dutch picture industry was managed by dealers, and local centres specialized in particular sub-varieties. One strand in the mass of genre was a tamed and unthreatening variant of the peasant scene, derived from the savage Flemish painter *Brouwer and ultimately going back to Bruegel. Most Dutch genre, however, depicted the life of the better-off, often in scenes of household life, but also in markets, barrack rooms, taverns, inns, and brothels. Alongside the delight in realistic depiction there is often a strong element of didactic moralizing, especially about the evils of drink and sexual licence. This perhaps reached its peak in the work of Jan *Steen, who developed the theme of the unruly house and whose work rams home its message with a mind-numbing battery of sexual symbols such as oysters, broken eggshells, and smokers' fingers thrust obscenely into the bowls of their pipes. Ter *Borch's art is more refined and psychologically enigmatic, to the extent that *Goethe famously misinterpreted a brothel scene as a girl in a respectable household being admonished by her father. In the 1650s and 1660s Delft established its leadership in a form of quiet domestic genre that was at least partly a celebration of the increasing prosperity and comfortable lifestyle of the times. The best work of the Delft painters de *Hooch and, even more, *Vermeer goes far beyond this, however. These painters treated light and space with extreme subtlety and control, so that the balance of these elements, and the figures' counterpoint with their well-ordered surroundings, become the true subject of the painting.

The nearest 18th-century heir to the Delft masters was perhaps *Chardin, whose reticent scenes of frugal petit bourgeois life similarly imply through the values of the painting itself a message about the dignity of a well-ordered life. His champion *Diderot later transferred his admiration to *Greuze, who introduced a new type of elaborate anecdotal genre that wallowed in the contemporary cult of sensibility. In England, *Hogarth also wanted to represent contemporary life in a way that rivalled history painting, but he took genre in a completely different direction. His 'modern moral subjects' are dramatic anecdotes that are packed with contemporary detail and which lash the evils of society with every possible satirical device. The Amsterdam painter *Troost also painted comic social episodes, but his genial art makes no attempt at Hogarth's cutting edge.

The conventional classical tradition continued most strongly in Italy. The chiaroscuro low-life scenes of the major Bolognese painter G. M. *Crespi represent one very unusual rebellion against it. The Venetian painter *Longhi, on the other hand, painted nothing but small pictures depicting the daily life of the Venetian aristocracy, and their rigid insipidity reflects the claustrophobic quality of the society they represent.

By the mid-19th century the idea of *history painting as the pre-eminent category no longer carried conviction, and *realism had become a dominant theory both in literature and the visual arts. A classic 'realist' painting such as *Courbet's *Burial at Ornans* (1849–50; Paris, Louvre) shows, however, that the pictorial means for projecting the new aesthetic did not lie readily to hand. Courbet is still using something like the language of history painting to signal the importance that he wants to attach to the ordinary people and events that he depicts. In 19th-century England, the great outpouring of representations of contemporary life was, for the most part, stuck in a relentless literary anecdotalism coupled with trite pictorial values.

The decisive breakthrough came in the 1860s and 1870s with *Manet and the *Impressionists, who discovered a new repertoire of daily urban life and bourgeois leisure as their main subject matter, and worked out a modern aesthetic vocabulary for representing it. They were concerned to capture the movement, speed, and ephemeral quality of modern life, and their optical experiments and apparently random compositions are all part of that programme. To the next generation, this detached, snapshot quality came to seem spiritually meagre, but *Seurat's great explorations of colour still take Parisian lower middle-class life for their subject, while *Toulouse-Lautrec used many of the Impressionists' techniques to construct his unique feverish world.

After 1900 the everyday life tradition continued with painters like *Bonnard and *Vuillard in France, the *Ashcan School in America, and the Camden Town Group in *London. Perhaps the most successful of all

painters in capturing the dislocation of modern life was the American Edward *Hopper. However, the battle between low and high art had been settled by the 'art for art's sake' doctrine of the late 19th century. As representational and abstract types of art have since proliferated it has become increasingly unrealistic to categorize art according to its subject matter. AJL

Langdon, H., *Everyday Life Painting* (1979).

Sutton, P. C., *Masters of Seventeenth Century Dutch Genre Painting*, exhib. cat. 1984 (Philadelphia Mus.).

GENTILE DA FABRIANO (c.1385–1427). Italian painter from the Marches region who worked on important civic projects and for powerful patrons in a number of cities. He represents the elaborate, courtly late *Gothic style which dominated Europe around 1400 and which combined naturalistic detail with ornamental refinement.

Assessment of Gentile's achievement is restricted due to the loss of documented work. This includes a prestigious fresco cycle, depicting a naval battle, executed for the main assembly hall in the Doge's palace, Venice (c.1409–14); the decoration of a chapel in the town hall, Brescia, for Pandolfo Malatesta (1414–19); and frescoes for Pope Martin V in S. John Lateran, Rome (1425–7). These commissions indicate the range and status of the patronage he received, while his contemporary reputation is demonstrated by Bartolomeo Fazio's account of 1456, in which he praises Gentile's technical versatility, his wide range of subject matter, and the dramatic and realistic qualities in his work which prompt the spectator to share the emotions of his painted figures. He cites the fear and horror induced by a painting of a storm at sea.

Gentile's early work seems to depend upon Lombard illumination and the languorous, rhythmic style of painters and illuminators such as Michelino de Besozzo, who was in Venice at the same time. The Valle Romita altarpiece (1410–12; Milan, Brera), with its central panel a heavenly vision of the Coronation of the Virgin, balances abstract decorative elements, including a tooled and burnished gold background, with natural objects—foliage, flowers, and textures faithfully rendered and modelled by light and shade.

Between 1420 and 1425 he worked in Florence and was commissioned by Palla Strozzi to paint the *Adoration of the Magi* for the sacristy of S. Trinita (1423; Florence, Uffizi; one predella panel Paris, Louvre). This altarpiece can be seen as a seminal example of the International style of the late Middle Ages, sumptuous in its colour and decoration, teeming with activity and realistic detail,

and, therefore, at odds with the more sober investigations of space and form associated with *Masaccio and *Donatello. Nevertheless, in the main panel Gentile introduced a number of details suggesting depth and foreshortening, while the predella panels feature convincing depictions of landscape and urban settings and an innovative observation of the behaviour of light. Assimilation of Florentine developments is also evident in the monumentality of the Quaratesi Polyptych (1425; central panel London, NG). Moreover, Gentile shared with the artists of Florence an interest in the classical past, as seen in the drawings in the Roman sketchbook which originated in his workshop.

MS

Christiansen, K., *Gentile da Fabriano*, (1982).

GENTILESCHI, FATHER AND DAUGHTER. Italian painters. **Orazio** (1563–1639), who was born in Pisa, the son of a Florentine goldsmith, and **Artemesia** (1593–1652/3), who was born in Rome, were among the most gifted followers of *Caravaggio and they both established an international reputation. Orazio had moved to Rome c.1576–8 and initially worked on large-scale decorative projects under Giovanni Guerra (1544–1618) and Cesare Nebbia (1536–1614). It was not until the early years of the new century that he established a more personal idiom, inspired by admiration for the meticulous work of Adam *Elsheimer, who was in Rome 1600–10, and by the naturalism and dramatic use of light and shade of Caravaggio's early style. The influence of the former is apparent in the *S. Christopher* (Berlin, Gemäldegal.), while the Caravaggesque element is felt in such striking pictures as *David Slaying Goliath* (Dublin, NG Ireland) and *David Contemplating the Dead Goliath* (Berlin, Gemäldegal.). Orazio's imaginative response to Caravaggio reaches its climax with the *Lute-Player* (Washington, NG), *Judith* (Hartford, Conn., Wadsworth Atheneum), and the *Stigmatization of S. Francis* (Rome, S. Silvestro in Capite), all of which probably date from the second decade of the century. Gentileschi did not attempt to emulate Caravaggio's later, darker, and more robust style, but drew from his early work a realism and immediacy that remains tender in spirit and graceful in form. In 1621 Gentileschi accepted an invitation from Giovanni Antonio Sauli to work for him in Genoa. A *Lot and his Daughters* (Madrid, Thyssen Mus.) is probably the version of this design that he painted for Sauli. Another version was painted for the Duke of Savoy c.1622, for whom he also painted the *Annunciation* (Turin, Sabauda Gal.) and a further version was sent c.1624 to Marie de Médicis for whom he subsequently worked in Paris in

1626. Finally in the autumn of 1626 Orazio moved to *London, where he became court painter to Charles I and where he stayed for the remainder of his life. His *Finding of Moses* (priv. coll.) of c.1630–3 reflects the growing refinement that characterizes Orazio's style after he had left Rome, with an emphasis on the surface texture of draperies, strong bright colouring, and an almost Pre-Raphaelite attention to rocks, stones, foliage, and accessories. His most important work in England was the ceiling for the Great Hall in the Queen's House, Greenwich, representing the *Allegory of Peace and the Arts under the English Crown* (1638–9; now London, Marlborough House).

Artemesia has become a legendary figure, much celebrated by the feminist movement, and not without reason since her achievements were unprecedented for a woman in 17th-century Italy. Her notoriety is further enshrined in her rape at the hands of Agostino *Tassi, who had collaborated with her father on the decoration of the Casino delle Muse (Rome, Pallavicini Gal.) in 1611–12 and had been employed to teach her perspective. The ensuing trial in 1612 was a very public affair and the incident has often been regarded as the root source of Artemesia's preoccupation with painting pictures of heroic women in violent action. Artemesia's Caravaggesque style and technique had been learned in Rome directly from her father. Her earliest signed and dated work is a *Susanna and the Elders* (1610; Pommersfelden, Schloss Weissenstein), which in its capacity to reconcile naturalistic detail with graceful forms is close to Orazio's manner. A little later, however, in her *Judith and Holofernes* (Florence, Uffizi) of c.1613–14, which she presented to Cosimo II de' Medici, she demonstrates a capacity to reinterpret the designs not only of her father but also of Caravaggio into far more brutal, indeed gruesome, visual images. Having announced her arrival in Florence with the *Judith*, she went on to join the Accademia del Disegno, and was commissioned to paint an allegorical scene for the Galleria of the Casa Buonarroti (1615–17). She was back in Rome in 1620, and in Genoa in 1621. By 1622, when she painted another signed and dated *Susanna and the Elders* (Burghley House, Lincs.), her style had become far more relaxed and sensual; the picture has an atmospheric landscape background reminiscent of *Guercino. This classicizing tendency continued after Artemesia had moved to Naples in 1630, reflected for instance in the *Birth of S. John the Baptist* (Madrid, Prado). The later part of her career, which included a three-year visit to London to join her ailing father in 1638, appears to have been less rewarding and successful. Her *Self-Portrait as an Allegory of Painting* (London,

Royal Coll.) is a striking image, perhaps dating from c.1630, remarkable for its naturalism and modesty. HB

Bissell, Ward, *Orazio Gentileschi and the Public Tradition in Caravaggesque Painting* (1981).
Conti, R., and Papi, G., *Artemisia*, exhib. cat. 1991 (Florence, Casa Buonarroti).
Finaldi, G. (ed.), *Orazio Gentileschi at the Court of King Charles I*, exhib. cat. 1999 (London, NG).
Garrard, M., *Artemisia Gentileschi* (1989).

GEOMETRIC GREEK ART, term describing Greek pottery c.900–700 BC, decorated mainly with abstract rectilinear motifs. Invented in Attica, the style spread to other Greek areas with much regional variation, passing through early, middle, and late phases. Characteristic shapes include the amphora (two-handled storage jar), oinochoe (wine jug), scyphus (two-handled drinking vessel), pyxis (lidded box), and crater (mixing bowl). Geometric pottery occurs in settlements, sanctuaries, and cemeteries. Special care was devoted to making pottery designed for burials: thence come the finest and most elaborately decorated vessels, sometimes much larger than what is required in daily life. Some Attic artists of the late (c.760–700 BC) phase (e.g. the *Dipylon Painter) introduced extended figured scenes, especially funerals and battles, on vast craters and amphorae serving as monuments marking aristocratic graves. Hence arose the earliest consistent figured style in *Greek vase painting, in which human beings and animals are rendered conceptually and in plain silhouette. JNC

Coldstream, J. N., *Greek Geometric Pottery* (1968).

GÉRARD, FRANÇOIS-PASCAL-SIMON, BARON (1770–1837). French painter. Gérard, who was half-Italian, was born in Rome but moved to Paris aged 12 and was a pupil in *David's studio at 16. A favoured student, he avoided military service through David's influence. His reputation was made by two paintings, the *Portrait of Isabey and his Daughter* (1795; Paris, Louvre), a tender but unsentimental image of the fashionable miniaturist and his small child, and the precious and coyly erotic *Cupid and Psyche* (1798; Paris, Louvre). By 1800 he was the most fashionable portrait painter of his day, not averse to flattery as can be seen by comparing his pretty *Mme Récamier* (1805; Paris, Louvre) with her austere portrait by David painted five years earlier (Paris, Louvre). He thrived under Napoleon but equally happily accepted the patronage of Louis XVIII, after the restoration of 1814, becoming painter to the King and accepting a barony. His political insincerity was a factor in the bitter rivalry which arose with both David and *Gros. All his work, including his historical paintings, like *The Battle of Austerlitz* (Versailles), depends on the example of David, but is often superficial. DER

Friedlander, W., *David to Delacroix* (1952).

GERHAERTS, NICOLAUS (Nikolaus Gerhaert van Leyden) (active 1462–73) Netherlandish sculptor. Gerhaerts's career is sparsely documented and for only a fraction of its presumed length. His few surviving works mark him as the most original northern sculptor since Claus *Sluter. His style, transmitted in part via the engravings of the *Master E.S. and Martin *Schongauer, was decisive for the development of the final phase of late *Gothic art in and around Germany. Recorded in Trier in 1462, in Strasbourg 1463–7, in Baden-Baden and Constance, he ended his days working on the tomb of the Emperor Friedrich III in Vienna. His Strasbourg years are represented by the epitaph of Canon Conrad von Busang (1464; Strasbourg Cathedral) and a number of smaller figures. The epitaph sets half-length figures of the canon and the Virgin, linked by an active Christ child, within a Gothic tabernacle. The quasi-theatrical naturalism of the ensemble is enhanced by the lively poses and the activated drapery. An overt illusionism characterized the group of a *Sibyl and Prophet*, only fragments of which survive (Strasbourg, Mus. de l'Œuvre de Notre-Dame), formerly leaning out from a fictive window overlooking the entrance of the Neue Kanzlei. Gerhaerts's revolutionary new figure style is exemplified by the small sandstone bust of a man, perhaps a self-portrait, once in the cathedral (Strasbourg, Mus. de l'Œuvre de Notre-Dame). The profound psychological concentration of this figure, its introspective naturalism, are expressed by a design conceived fully in the round. The internal torsion, compounded by the spiralling disposition of the arms, reveals a sculptural imagination of a kind rarely matched anywhere in Europe during the 15th century. JR

Muller, T., *Sculpture in the Netherlands, Germany, France and Spain, 1400 to 1500* (1966).

GERHARD, HUBERT (c.1545–before 1621). Dutch sculptor who worked in Germany and Austria. He may have trained in Florence in the circle of *Giambologna, by whose *Mannerist style he was heavily influenced. Working for a number of major patrons, including the Fuggers in Augsburg, Wilhelm V of Bavaria in Munich, and Archduke Maximilian III in Innsbruck, Hubert is best known for his works in bronze. These include the group of *S. Michael and Lucifer* (cast 1588) on the façade of the Michaelskirche, Munich, and the elaborate Augustus Fountain (1589–94) in Augsburg. It was through these and similar works that the sophisticated style of Italian Mannerism was introduced to southern Germany and the Tyrol. MJ

Welt in Umbruch: Augsburg zwischen Renaissance und Barock, exhib. cat. 1980 (Augsburg, Maximilianmus.).

GÉRICAULT, THÉODORE (1791–1824). French painter of outstanding originality, who is usually regarded as one of the founders of the French *Romantic School. He was born at Rouen but came to Paris as a boy and after studying for two years with the sporting artist Carle *Vernet entered the studio of the academic painter Pierre-Narcisse *Guérin, where *Delacroix also studied. At the same time he made copies of the old masters in the Louvre and developed a passion for the art of *Rubens. From his youth Géricault was particularly interested in horses and racing, and he developed a brilliant and rapid execution capturing vividly the sense of movement. His picture *The Charging Chasseur* (1812; Paris, Louvre) won a gold medal at the Salon and its vigorous and realistic treatment was regarded by the younger artists as a repudiation of the conventions of the *Neoclassical school of *David.

Géricault spent the years 1816–18 in Florence and Rome, and there became an enthusiastic admirer of *Michelangelo. He worked on a series of studies and oil sketches for a never-completed monumental painting of the annual Roman riderless horse race, a device by which he thought to reconcile the demands of heroic painting and contemporaneity. On his return to Paris the picture for which he is most famous, *The Raft of the Medusa* (1819; Paris, Louvre), caused a furore because of its realistic treatment of its macabre (but true) subject matter, its implicit criticism of the royalist government whose policies had led to the shipwreck and its grisly aftermath, and its repudiation of the flawless heroism of the *Neoclassicists. Exhibited also in England, the picture had a *succès de scandale* and Géricault spent the years 1820–2 in England, where he painted jockeys and horse races (e.g. *Derby at Epsom*; Paris, Louvre, painted without spectators and with the racecourse romantically depicted as a blasted heath). He conceived an admiration for the paintings of *Constable and *Bonington and was one of the first to introduce English painting to the notice of French artists. According to Delacroix, the dandified Géricault was also among the first to introduce the taste for English tailoring to Restoration France.

In the eleven years of his tempestuous career as an artist Géricault displayed a meteoric and many-sided genius which never matured into a unified or settled bent. His series of portraits of the insane, painted around 1822 (Paris, Louvre; Lyon, Mus. des Beaux-

Arts, and elsewhere), are among the first sympathetic portrayals of madness, but his lovingly arranged still lifes of the severed heads and limbs of criminals in the morgue (c.1819; Stockholm, Nationalmus.) strike a shockingly voyeuristic note. The high-mindedness of *The Raft of the Medusa* is counterbalanced by highly erotic drawings and plaster models. Towards the end of his life Géricault was simultaneously exploring the expressive possibilities of landscape in such works as *The Lime Kiln* (c.1822–3; Paris, Louvre) and searching for a new heroic historical theme for a major Salon picture. His predilection for *Baroque exuberance in composition, his fascination with the macabre, his interest in modern subject matter, and his realism point towards many of the key developments in 19th-century French painting and made him a seminal figure for those who followed. He died from spinal injuries sustained in a fall from a horse. On receiving the news Delacroix, who had posed for one of the figures in *The Raft of the Medusa*, noted in his journal, 'What a different fate his great bodily strength and his warmth and imagination seemed to promise.' The recent discovery of a correspondence that reveals that Géricault had an adulterous and incestuous affair with the young wife of his uncle has led to speculation that at least some of the storminess of his art can be attributed to the guilt he suffered as a consequence. HO/MJ

Bazin, G., *Théodore Géricault: étude critique, documents et catalogue raisonné* (6 vols., 1987–94).
Eitner, L., *Géricault: His Life and Work* (1982).
Laveissière, S., Chenique, B., and Michel, R., *Géricault*, exhib. cat. 1991–2 (Paris, Grand Palais).

GERINI, NICCOLÒ DI PIETRO (active 1368; d. before 1416). Florentine painter who had a long and productive career in various Tuscan centres. He frequently collaborated with others and was involved in important civic commissions. He joined the Arte dei Medici e Speziali in 1368 and worked with Jacopo di Cione, brother of Andrea di *Cione, in the early 1370s and in 1383, in which year he worked on a fresco of the *Annunciation* in Volterra (Palazzo dei Priori). The central scene is attributed to Gerini, and, despite its ruinous state, the composition displays refined, motionless figures. In 1386 he worked on the façade of the Bigallo, Florence, with Ambrogio di Baldese; the surviving fresco reveals a lively composition enriched by elegant costumes, gesticulating figures, and closely observed architectural detail. Gerini's narrative style, characterized by a certain objectivity, is best displayed in a fresco cycle in Prato (c.1395; S. Francesco). From around 1395 he tempered the late *Gothic elements of his style with a renewed interest in *Giotto; this resulted in more rigidly constructed compositions with fewer

concessions to descriptive detail. FB

Boskovits, M., *Pittura fiorentina alla vigilia del Rinascimento* (1975).

GERM. See PRE-RAPHAELITE MOVEMENT.

GERMAN ART. The extent to which one can speak of the 'Germanness' of German art is a question that has exercised both artists and historians from at least the 16th century, when a discrete idea of cultural identity, created in rivalry to that of Italy, emerged in the writings of German humanists. Since then, at certain periods, particularly in the 19th and early 20th centuries, artists have responded to a collective notion of cultural identity based around the idea of nation. Yet for a geographical area and chronological span of such immense sweep, incorporating such diverse peoples and cultural traditions, and which until 1871 was a patchwork of hundreds of small independent principalities, it is probably more accurate to speak of 'Art in Germany' rather than 'German Art' as such. 'Germany' may be defined as the territory bounded loosely in the east by the Oder, by the Rhine in the west, by the Alps in the south, and by the Baltic in the north.

The Roman occupation of the western and southern parts of the Germanic territories marks the beginnings of a discernible artistic culture. The architectural remains and the archaeological evidence of both local and imported Roman art in the ancient settlements of Trier and Cologne bear witness to a flourishing artistic activity. From the 4th century onwards, the Roman Empire gradually gave way to the influx of tribes from the north and the east, who brought with them works of art that were small-scale and portable and found their best expression in finely wrought pieces of personal jewellery of filigree metalwork and cloisonné enamel, worked into complex geometric patterns. The so-called *migration period gradually came to an end as the old Roman dominions were settled by the *Merovingian kings. During this period a strong Mediterranean influence combined with the indigenous decorative elements of style. It was only in the 9th century, however, when Charlemagne (see under CAROLINGIAN) imposed strong political authority over a large geographical area, that a renewal of monumental art came about. Charlemagne made the cultivation of art part of his political programme, consciously reviving classical forms to reflect his own imperial ambitions and modelling his art on an idea of Rome that drew on late Roman (see ROMAN ART, ANCIENT) and *Byzantine art. He imported Byzantine ivory workers, goldsmiths, and manuscript illuminators to the workshops at his imperial seat in

Aachen. The flourishing of manuscript illumination owed much to the personal interest of the Emperor and the importance he placed on literacy and learning.

The artistic vitality of Charlemagne's rule waned under his successors. A new 'renaissance' of the arts flourished only under the *Ottonians (c.955–late 11th century). The style which emerged combined the classical heritage of Charlemagne with a renewed Byzantine influence, particularly following the marriage of Otto II to the Byzantine princess Theophanu (c.956–91). The building of basilicas as in Mainz, Worms, and Speyer ushered in the *Romanesque style. Monasteries, such as that at Hildesheim on the island of Reichenau, assumed a new importance as centres of patronage. Manuscript illumination acquired a heightened spiritual content and refinement of abstract shape and colour, evident for instance in the Bamberg Apocalypse (Bamberg, Stadtbib.); some of the earliest murals to survive are also to be found at Reichenau (before AD 1000; S. Georg, cycle of *The Miracles of Christ*). The great medieval monasteries oversaw the development of small-scale sculpture in ivory, wood, stone, and metalwork, in the form of Crucifixes, reliquaries, and (rarely surviving) narrative series, such as the great bronze doors of Hildesheim Cathedral.

The *Gothic style, originating in France, established itself in Germany chiefly in the media of architecture, stained glass, and sculpture in the course of the 13th century. The French influence, most apparent in early examples such as Cologne Cathedral, gradually gave way to more distinctively local variations, as in the cathredrals of Ulm and Freiburg. The same is true of sculpture, which acquired a new role in adorning the grand cathedral portals. The life-size statues of the 'twelve founders' in the west chancel of Naumburg Cathedral are among the most famous examples of mid-13th-century art; yet the realism and drama they exhibit are exceptional in the period, matched perhaps only by the famous *Bamberger Reiter*. More immediately influential was the lighter and graceful manner found amongst the sculptural group of *Vices and Virtues* of the west portal of Strasbourg Cathedral.

After the establishment of the imperial court under the Emperor Charles IV in *Prague in the 14th century, the city became an important centre for the arts. The *Parler family, engaged from 1356 onwards in the rebuilding of S. Vitus' Cathedral, inspired a school of *Bohemian art which brought together strands of Burgundian, Italian, and French styles. This is typified by the so-called 'Beautiful Madonnas' (*Schöne Madonnen*), carved and richly polychromed sculptures of the Virgin, conforming to an elongated and sinuous S—curve, elaborated with graceful drapery folds and crowned by a small head

of doll-like, idealized beauty. By the first part of the 15th century, the courtly or 'soft' style (*weiche Stil*), to which this type belonged, had spread widely throughout Germany. Its influence can be seen as far north as Hamburg in, for instance, the Grabow altarpiece of Master *Bertram of 1379–83 (Hamburg, Kunsthalle).

During the 15th century, German art may be said to have consisted of a number of local variations of imported styles, drawn mainly from the Netherlands. In this period the winged *altarpiece began to replace fresco painting, bringing together the separate media of sculpture and painting within an elaborate and monumental architectural frame. The influence of *Flemish art, both technical and stylistic, is discernible in painters such as *Conrad von Soest in Westphalia, and in Cologne the *Master of S. Veronica and Stefan *Lochner. Each combined to different degrees the international courtly style with the realism of Jan van *Eyck and Robert *Campin. In Basle, Konrad *Witz introduced a more literal form of realism to the south. The widespread influence of Rogier van der *Weyden later in the century was assisted by the new medium of engraving, brought to a high point of artistic expression in the prints of the Alsatian artist Martin *Schongauer.

In the course of the century, an increasingly widespread form of mystical piety provoked a taste for small devotional works of intimate character, determined by habits of private meditation and greatly assisted by the development of the print medium. In the Bavarian south, this affective piety manifested itself in an extreme form of violent and subjective realism developed around the image of the suffering Christ and the Passion story.

As regards sculpture, the traditional cathedral or minster workshops slowly gave way to secular-run and larger-scale organizations. The tradition of the *Schöne Madonna* persisted in many parts, but, as with painting, an increasingly realist, Netherlandish type was introduced into the upper Rhine by such artists as Nicolaus *Gerhaerts, who worked in Trier and Strasbourg. In the hands of Tilman *Riemenschneider of Würzburg and Veit *Stoss of Nuremberg, a distinctively German 'florid style' reached its apogee in the early 16th century.

It is usual to characterize as the 'German Renaissance' the work of a spectacularly talented generation of painters who were born in the 1470s and came to maturity in the first decades of the 16th century. Collectively, they brought the craft of painting to new levels of accomplishment, extended its range of subject matter, and raised its status among the sister arts. Yet although individually their works all respond on certain levels to the stimulus of humanism and a limited knowledge of Italian art, it is difficult to discern any unity in their art.

Albrecht *Dürer was the most important in terms of lasting influence. His combination of extraordinary manual skill and powerful artistic and intellectual vision brought a new realism to the depiction of the natural world and to portraiture, informed by the intellectual spirit of the Nuremberg *humanist circle. Conscious from his earliest youth of his own natural gifts, he laboured to raise the status of painting from that of a craft to a liberal art, imbuing his work with powerful intellectual and religious meanings. His position is brilliantly summarized in the great self-portrait of 1500 (Munich, Alte Pin.). Through his treatises on *perspective and human *proportion, he gave the first theoretical foundation for German art; through engravings such as *The Fall of Man*, the *S. Jerome*, or the *Knight, Death and the Devil*, he gave it practical expression. The enormous influence of his *woodcuts and engravings (see LINE ENGRAVING) turned the print into a significant and distinctively German art form. Dürer was one of the few German artists to visit Italy. The Augsburg painters Hans *Burgkmair the elder and Jörg *Breu the elder are also known to have travelled at least to Venice. Yet the foremost influence upon them as for other German artists was not so much direct experience as that of Italian prints. These were the vehicles by which both classical themes and style were introduced into the north.

The young Albrecht *Altdorfer in Regensburg copied the prints of *Mantegna, yet the classical is only an incidental element in his mature work. His famous *Battle of Issus* (1530; Munich, Alte Pin.), in which the battling armies of Alexander the Great and Darius are dwarfed by the immense panoramic landscape backdrop, expresses a relationship between man and nature that is fundamentally un-Italianate. Altdorfer's interest in the landscape of mood and drama was shared by a number of artists who have been linked under the name the *Danube School, though they worked in an area extending well beyond the Danube basin. Among these artists, Wolf *Huber was important in pioneering *landscape as an independent genre.

*Grünewald was also a master of naturalism. He placed a piercing realism at the service of the divine, bringing, in his great Isenheim altarpiece (Colmar, Unterlinden Mus.), the tradition of affective religious imagery to its apogee at the very moment of its demise. The complex iconographic programme, spread over three series of folding panels, expresses a medieval monastic vision of Providence and human redemption.

With the onset of the Reformation, painting and monumental sculpture suffered a serious setback. In Protestant areas the demand for altarpieces and monumental religious art, the mainstay of the artists' trade, vanished overnight; even in those areas which remained Catholic, the patronage of public religious schemes dropped significantly. While a Lutheran art developed, in which tenets of belief were stated in simple, ideogrammatic form, artists looked increasingly to the secular sphere for employment. The workshop of Lucas *Cranach and his son exemplified this position, producing images of sober, Protestant probity on the one hand, and large numbers of profane and erotic works on the other. The religious situation in Basle forced Hans *Holbein the elder, perhaps the most gifted painter of his generation, to find work at the artistically backward court of Henry VIII in England (see LONDON) and to channel his protean talents into the single field of portraiture.

From the 1530s onwards, creative energies flowed into small-scale cabinet pieces and the decorative arts. It was the craftsmen and *Kleinmeister* who developed a tradition of classicism in the north. The intellectual tradition initiated by Dürer was carried on by the virtuoso goldsmith Wenzel Jamnitzer, who combined stunning manual skill with a firm theoretical grasp of perspective, geometry, classical architectural theory, and literature. A similar sophistication and self-consciously intellectual approach characterized the cabinetmakers of Augsburg, who by the end of the century had developed the *Kunstschrank* ('Art-cabinet') into one of the most sophisticated forms of contemporary art.

By 1600, German art had fully absorbed the example of Italy and had become internationalist in scope and ambition, encouraged by the patronage of the great central European courts, such as the Wittelsbachs in *Munich and the Habsburgs in *Vienna, *Innsbruck, and *Prague. While these fostered artistic interchange by attracting Italian and Flemish artists, many German artists travelled abroad. The two most prominent painters of this period, Adam *Elsheimer and Johann *Liss, both spent much of their careers outside Germany.

The destruction and economic dislocation brought about by the Thirty Years War (1618–48) was catastrophic in its effects upon the arts, ensuring the disruption of consistent artistic patronage until the mid-century and in effect polarizing the arts into geographic areas. In the Catholic south and Austria the *Baroque developed into an exuberant decorative style. In the ceilings of countless monasteries, village churches, and palaces is manifest the desire to emulate the splendour and scale of *Bernini's and Borromini's grand designs in Rome and of the *Versailles of Louis XIV. This was the age of the *Gesamtkunstwerk* ('total work of art'), in which architecture, painting, sculpture, and stuccowork

were combined in overwhelming super-abundance, brilliantly exemplified in a religious context by the *Asam brothers' interior of the abbey at Weltenburg (completed 1755), and in the secular, by Balthasar Neumann's splendid Kaisersaal (throne-room) and staircase in the archiepiscopal palace at Würzburg, dazzlingly complemented by the frescoes of G. B. *Tiepolo (1753). In the north, the Zwinger Palace in Dresden, built by Matthäus Daniel Pöppelmann and decorated with the sculptures of Balthasar *Permoser, demonstrates a playful and exaggerated form of Bernini's rhetorical style. This sculptural tradition was extended and lightened in the small-scale porcelain genre pieces of Johann Joachim Kändler and Franz Anton Bustelli, who, working at the factories of Meissen and Nymphenburg respectively, employed the surface brilliance and natural fluidity of this new medium to create perhaps the most developed form of 18th-century *Rococo art.

In 1755, *Winckelmann published his *Gedanken über die Nachahmung der griechischen Werke in der Malerei und Bildhauerkunst*, which gave theoretical foundation to an emerging *Neoclassical movement that was to spread all over Europe. The painter *Mengs was regarded as the leading exponent of this style in painting, although most of his career was spent in Italy and Spain. *Academies, which sprung up in many major cities such as Stuttgart (founded 1761) or Dresden, encouraged a form of *history painting along the lines of *David, under such figures as Philipp Friedrich von Hetsch and Adam Friedrich Oeser. The sculptor *Schadow brought the ideals of *Canova to Germany.

The 1780s saw the emergence of the *Sturm und Drang* movement, which attempted to overturn the ethos of the German Enlightenment. This was the first of a series of revolutionary periods which have punctuated the continuity of German culture in the course of the last two centuries. It served to effect a reaction among artists away from a prevailing academic classicism into a kind of art that was subjective and personal. In 1809, a group of Viennese painters, chief among them *Overbeck and *Pforr, formed a so-called Lukasbund (see NAZARENES), modelled on the idea of the medieval guild, and took up residence in an abandoned monastery outside Rome. Deeply pious, yet disillusioned by the existing forms of religious art, they sought a spiritually pure form of expression, taking as their model the art of Dürer and of *Raphael, and developing a lighter palette and more 'primitive' figure style. Their work may be seen in the larger European context of the growing Gothic Revival, the reaction against the classical taste, and the wider *Romantic movement (see MUNICH).

In Dresden and Hamburg, Caspar David *Friedrich and *Runge sought a similar spiritual renewal through the agency of Nature. Friedrich's landscapes express the immanence of the divine in a nature that is both majestic and mysterious. Typically, references to an ancient and simple Christian piety—a wayside Crucifix, a ruined Gothic church—are set within landscapes both bleak and mysterious and charged by a symbolism of form derived from older religious art. Runge, by contrast developed both an obsessional realism, as in his portrait group *The Hülsenbeck Children* (1805; Hamburg, Kunsthalle), and a form of allegory, expressed in a heightened neo-Raphaelesque style. The Romanticized landscape spawned a whole generation of followers and variants of which those of Karl *Blechen achieved a particular prominence in the 1830s.

As in France and England, the nationalistic impulse of the Romantic movement manifested itself most notably in a form of history painting, devoted to stirring patriotic themes, exemplified by the works of Alfred *Rethel and the Düsseldorf School. At the other pole of popular taste, a form of 'petty bourgois' genre and portraiture grew out of the *Biedermeier taste. In the face of this, the tradition of classical idealism was maintained by Anselm *Feuerbach, Hans von *Marées, and, in sculpture, by A. von *Hildebrand. The most gifted painter to emerge from the Biedermeier milieu in the 1830s was the Berlin artist Adolph von *Menzel. In a manner that paralleled the *realist painters of France, he developed a form of history painting based on the acute observation of the everyday. Later, in Munich and Berlin, Max *Liebermann injected the influence of *Courbet and the *Barbizon School into the German landscape tradition by painting monumental and sympathetic images of the labouring poor. From the 1880s, he painted the German middle classes at their leisure, adapting to the German spa-towns the *flâneurism* of contemporary Parisian art in a technique influenced by *Impressionism.

Only in the 1890s did a strong reaction to the historicist traditions of the academies emerge under the umbrella of *Jugendstil*, the German *Art Nouveau. In Munich, the Sezession movement was formed in 1892, by, amongst others, Max *Slevogt, Hugo Habermann, and Franz von *Stuck.

This was superseded in the first two decades of the 20th century by forms of art that may be defined by the term *Expressionism. The term embraces the attempt of a number of artists to break radically with the values of the past and to find a new and unprecedented way of experiencing the world. In 1905, a group of Dresden artists, among them *Kirchner, *Heckel, and *Schmidt-Rottluff, formed Die *Brücke (The Bridge). They developed an art made up of violent contrasts of colour, which, breaking through the perceptual world of objects, expressed a vision ruled by instinct, feeling, and affect. In Munich a parallel, but more lyrical and less socially engaged, form of Expressionism arose among a group of painters known as Der *Blaue Reiter (The Blue Rider), which included Franz *Marc, August *Macke, and *Kandinsky. Marc used horses or deer as metaphors of spiritual purity, in implied criticism of the modern world of technological 'progress'. Kandinsky, similarly striving for a regeneration of spiritual values, attempted to find an art of pure 'inwardness', in which colours and lines could communicate psychological and emotional meanings directly and without the mediation of subject matter. In this way, the first purely *abstract paintings came into being.

These two currents—the violent reworking of the world and the embracing of abstraction—were to form the most distinct ways forward in German 20th-century art. In the immediate aftermath of the First World War, these dual tendencies may be seen in the anti-art of the *Dada movement and the formalist idealism of the *Bauhaus. The post-war years produced a mood of existential disgust, expressed through an idiom of self-consciously ugly realism. This is typified as much by the savage social satires of George *Grosz or the mordant dramas of Max *Beckmann, as by the overt social concern of Kathe *Kollwitz's or Ludwig Meidner's (1884–1966) images of poverty and deprivation. The artists of the so-called *Neue Sachlichkeit (New Objectivity), such as Otto *Dix and Christian Schad, painted stylishly deadpan works reflecting the vital artistic ferment and bohemian fringes of the Weimar Republic.

The rise of National Socialism brought this vibrant era to an abrupt close. Within five years, German culture was effectively extinguished and artists and their works made the object of official abuse. This was symbolized by the 1937 Munich exhibition of 'Degenerate Art'. Many artists fled abroad, while others stayed to work secretly on 'unpainted paintings', as Emil *Nolde termed his clandestine works. Their work was replaced by an anodyne 'heroic' romanticism, placed exclusively at the service of the state.

The post-war division of Germany into East and West led to a polarization of artistic development. In the East, as early as 1946–7, the move towards social realism greatly hindered any re-emergence of individualism. In the West, the main impetus for artists of the late 1940s and 1950s came from outside Germany, especially the American *Abstract Expressionist movement; and variants of *COBRA, Art Informel, and geometric abstraction took hold.

Only in the 1960s was there a return to themes and preoccupations that reflected upon a specifically German tradition. Artists

such as Markus Lüpertz (1941–), Georg *Baselitz, and Anselm *Kiefer, keenly aware of the Nazis' legacy of cultural deprivation, were the first to investigate specific—and often painful—themes of German identity and history. This was accompanied by a return to expressionist techniques: the 'heftige Malerei' of Rainer Fetting (1949–) and the work of the so-called 'Neue Wilde' seemed self-consciously to pay homage to the German tradition of the first part of the century. The Romantic ideal of recreating the self and society was resurrected in Joseph *Beuys's 'expanded concept of art', by which, in 'Aktionen' or performances, he sought to embrace every aspect of life—economic, social, political, ecological—in an attempt to make life itself a continuous creative act.

The momentous political events of the late 1980s, culminating in the fall of the Communist regime and the reunification of the two Germanies, has prompted many artists once again to face issues of national and artistic identity. In the pared-down hieroglyphic language of A. R. Penck (1939–), or in the allegorical *Café Deutschland* series of Jörg Immendorf (1945–), one may discern kinds of art which, in their expressive language, love of symbolism, and interest in the mythic and the allegorical, continue to build upon an awareness of, and identification with, well-defined German artistic traditions. AMo

Bartrum, G., *German Renaissance Prints 1490–1550* (1995).

Baxandall, M., *The Limewood Sculptors of Renaissance Germany* (1980).

Benesch, O., *German and Austrian Art of the 15th and 16th Centuries* (1972).

Budde, R., *Deutsche römische Skulptur, 1050–1250* (1979).

Bushart, B., *Deutsche Malerei des 17 und 18. Jahrhunderts* (2 vols., 1967).

Dodwell, C. R., *Painting in Europe, 800–1200* (1971).

Joachimedes, C. M., Rosenthal, N., and Schmied, W. (eds.), *German Art in the 20th Century: Painting and Sculpture, 1905–1985* (1986).

Lindemann, G., *History of German Art* (1972).

Novotny, F., *Painting and Sculpture in Europe, 1780–1880* (rev. edn., 1978).

Schmidt, G., *Gotische Bildwerke und ihre Meister* (2 vols., 1992).

Smith, J. C., *German Sculpture of the Later Renaissance: Art in an Age of Uncertainty* (1994).

Vaughan, W., *German Romantic Painting* (1980).

GERMAN ART AS OBJECTS OF PATRONAGE AND COLLECTING (1) *Until 1871; (2) 1871 Onwards*

1. UNTIL 1871

The heartland of the Holy Roman Empire comprised the German-speaking territories corresponding to modern Germany and Austria, plus Alsace and Silesia. Its periphery included Switzerland, the Low Countries, Lorraine, the Franche-Comté, and Bohemia. German settlers were also established along the Baltic coast towards Russia, in neighbouring Poland and Hungary, and down the Danube to Transylvania. From the time of Charlemagne until the First World War, the cultural life of these lands was conditioned by the tension between a resilient, but constantly changing, imperial idea and a political system in which actual power was exercised on a regional or civic level.

Following the division of the Carolingian Empire in 843, the Ottonian rulers united their German kingship with the imperial crown. However, the collapse of the Hohenstauffen dynasty in 1250 frustrated the rise of a unified kingdom. Medieval emperors were itinerant, and their principal residence varied according to their territorial base, including Aachen, *Prague, Buda, *Innsbruck, and *Vienna, and even Palermo. In 1356 the Golden Bull of the Emperor Charles IV emphasized the empire's 'variety of customs, ways of life and language' and acknowledged that the seven imperial electors (the archbishops of Mainz, Cologne, and Trier, the elector palatine of the Rhine, the king of Bohemia, the margrave of Brandenburg, and the elector of Saxony) were its 'solid foundations and immovable pillars'.

The Habsburgs were effectively hereditary emperors from 1438, but their direct rule was limited at first to Austria, and subsequently Bohemia and Hungary. In 1701 Brandenburg-Prussia became a kingdom. A century later, Bavaria, Württemberg, and Saxony also achieved independence and the last Holy Roman Emperor renounced the crown to become Emperor of Austria. The Austro-Hungarian dual monarchy was established in 1867, and four years later Prussia became the nucleus of a united German state, with its capital in Berlin.

Charlemagne (see CAROLINGIAN) embellished Aachen with antiquities, and the classicism of his court workshops reveals the influence of Italian and Byzantine art. The *Ottonian emperors reaffirmed this tradition through works such as the Cross of Lothair II, made around 1000, which utilizes an antique cameo as its centrepiece. The ambitious and powerful Henry the Lion, Duke of Saxony and Bavaria (c.1129–95), advertised his imperial heritage through the sumptuous decoration of his Gospel Book and the colossal bronze lion which he erected in his city of Brunswick. Frederick II (1194–1250) emphasized continuity with ancient Rome by striking gold coins styling him as 'Caesar Augustus'.

The principal artists' workshops of early medieval Germany were located in the archbishoprics of Cologne, Trier, Mainz, and Salzburg, cathedrals such as Bamberg and Regensburg, and monasteries, especially Echternach, near Trier, and Reichenau, on Lake Constance. The fame of the Reichenau scriptorium earned the abbey privileges from Pope Gregory V (996–9). Senior churchmen frequently belonged to the higher nobility; Otto I's brother Bruno was Archbishop of Cologne, his son Wilhelm was Archbishop of Mainz, and his granddaughter Matilda became an abbess at Essen. Clerics were often magnificent patrons. S. Bernward, Bishop of Hildesheim (993–1022), founded a major scriptorium, established his city as the principal German centre for bronze casting, and reputedly practised himself as a miniaturist and metalworker.

For much of the 13th century, the Emperor was absent from Germany, locked in the conflict with the papacy which terminated with the interregnum of 1250–72. Between 1230 and 1250 spectacular *Gothic sculptural groups were added to the cathedrals of Strasbourg, Bamberg, Magdeburg, Naumburg, and Meissen. These have an expressive force and a naturalism which surpasses their French models. The elegant, doll-like figures in the Codex Manesse at Heidelberg, painted in the Zurich region around 1300–15, celebrate the courtly culture of the *Minnesänger* and the decentralized 'Age of the Princes' which followed the election of Rudolf of Habsburg as emperor in 1273. A similar daintiness animates the statues added around 1300–22 to Strasbourg Cathedral, the minster at Freiburg im Breisgau, and Cologne Cathedral.

In 1308 Henry of Luxembourg was elected emperor; a title to which he added that of King of Bohemia and Moravia in 1311. Under his grandson Charles, elected emperor in 1347, and Charles's sons Wenceslaus (ruled 1378–1400) and Sigismund (ruled 1410–37), the centre of the empire migrated to *Prague and later Buda. Their culture was heterogeneous, closely linked to the courtly 'International Style'. Charles IV engaged Peter *Parler to rebuild Prague Cathedral from 1344 and commissioned the statue of *S. George and the Dragon*, perhaps the first monumental equestrian bronze since Antiquity, in 1373. He designated Aachen Cathedral as the location for German coronations and endowed it with magnificent reliquaries. Frankfurt retained its historic role as the location for imperial elections, while *Nuremberg received custody of the imperial regalia. Bohemia was eclipsed by the outbreak of the Hussite Wars in 1419, and *Vienna emerged as the principal court in the empire; a status confirmed by the election of Duke Albrecht of Austria as emperor in 1438.

By the later 14th century, civic authorities and associations were leading patrons. In 1383 Master *Bertram of Minden completed the enormous high altarpiece in S. Petri in Hamburg. From this Hanseatic centre, knowledge of his weighty style spread as far as Lund in Sweden and Westminster. In 1424, the Hamburg merchants trading with England commissioned the *Englandfahrer altar*

with scenes from the life of S. Thomas Becket (Hamburg, Kunsthalle) from Master *Francke. Town halls became a focus of civic pride. Stefan *Lochner's great *Adoration of the Magi with the Patron Saints of Cologne* tryptych of 1440/5 was commissioned for the chapel of Cologne Town Hall. From the mid-15th century, a vogue arose for large carved altarpieces with painted wings. Some were commissioned by cathedrals and abbeys, such as Michael *Pacher's *S. Wolfgang* altarpiece, ordered by the Abbot of Mondsee in 1471. Most were made for town councils or parish authorities, as was Tilman *Riemenschneider's Münnerstadt altarpiece, commissioned in 1490. A south German sculptor carved reliefs in the choir stalls of the Venetian church of the Frari, dated 1468, and the grandest of all the limewood altarpieces was made by Veit *Stoss in 1477–89 for S. Mary's in Cracow.

During the lifetime of Albrecht *Dürer, 1471–1528, the cities of Renaissance Germany were at the height of their prosperity and independence. Many enjoyed the services of great artists; at Nuremberg, Dürer, Veit Stoss, and the bronze founder Peter *Vischer ran workshops, while Augsburg was the home of the painters Hans *Holbein the elder and younger, Hans *Burgkmair, and the sculptor Gregor *Erhart. Other distinguished figures worked in smaller places, such as Martin *Schongauer in Colmar, and Albrecht *Altdorfer at Regensburg. All supplied a clientele which extended far beyond their place of residence, and some travelled as far as Venice and London to execute commissions.

During the 1440s and 1450s, the introduction of engraving and the invention of printing opened new vistas for artists and patrons. The engravings of the *Master E.S. and Schongauer were distributed internationally, and German printers established presses throughout Europe. Hartman Schedel's *World Chronicle*, published at Nuremberg in 1493, was a de luxe publication with 645 separate *woodcuts. Dürer published his illustrated *Apocalypse* in 1498 and a decade later complained: 'I shall stick to my engraving, and if I had done so before I should today have been a richer man by 1000 florins' (J. Campbell Hutchinson, *Albrecht Dürer: A Biography*, 1990). The printer-publishers constituted a new class of entrepreneurs, and patrons of the new media ranged from monasteries and indulgence sellers to humanist scholars and the Emperor Maximilian.

By 1530 the distinction between Italian (*Welsch*) and traditional German (*Deutsch*) styles was commonplace. Giving 'the Italians very high praise for their naked figures and especially for their perspective' (W. M. Conway, *The Literary Remains of Albrecht Dürer*, 1889), Dürer prepared artistic treatises for his compatriots, believing that 'they will in time allow no other nation to take the prize before

them'. The culture of humanism was embraced by princes such as Frederick the Wise, Elector of Saxony, and fostered the development of classicizing genres, including the mythological paintings of Lucas *Cranach, the small bronzes of Peter Vischer, and the medals of Hans Schwarz.

The Reformation marked a watershed in German patronage. In the Protestant regions, which included most major cities, large-scale religious commissions ceased. The reformers and their Catholic opponents exploited printed illustration in a 'pamphlet war' conducted through the press. As religious sculpture languished, sculptors explored new outlets for the expression of corporate pride, such as the Italianate civic fountains erected in Mainz, Augsburg, and Nuremberg from the 1520s. The colossal cenotaph of the Emperor Maximilian, gradually completed between 1502 and 1584, inspired elaborate tombs, including the mausoleum of the Fuggers of Augsburg, built in 1509–18, and the shrine to Moritz of Saxony, erected at Freiberg in 1559–63.

From 1573 Archduke Ferdinand II rebuilt his castle at Ambras near *Innsbruck to house his collections of natural history specimens, sculpture and applied art, scientific instruments, and miraculous objects. Thereafter, the *Kunstkammer, or 'cabinet of curiosities', became a characteristic feature of German courts: by 1587 the catalogue of the *Dresden collection ran to 317 double pages. Rudolf II, elected emperor in 1576, was celebrated as 'the greatest art patron of the modern world'. He amassed a huge collection at Prague Castle, and engaged Flemish and Italianate German painters, including Josef *Heinz and Hans von *Aachen. Adriaen de *Vries furnished his court with bronzes, and exported sculpture to Liechtenstein, Schaumburg-Lippe, Brunswick-Wolfenbüttel, and Saxony.

Nearly 40 years after his death, Dürer's reputation was such that a humanist claimed he combined the abilities for which *Praxiteles, *Lysippus, *Apelles, and others were esteemed, providing an example which no subsequent achievement would ever match. Between 1585 and 1603, Rudolf II assembled the greatest single collection of Dürer's works, including four major altarpieces and spectacular drawings, watercolours, and prints. His taste was shared by Maximilian I, Elector of Bavaria (ruled 1597–1651), who acquired many of the paintings by Dürer now in *Munich. Such collecting fostered the so-called 'Dürer-Renaissance' of the late 16th and early 17th centuries, when numerous copies and variants in Dürer's style were produced by artists including Hans Hoffmann (c.1545×50–1591/2), Jan *Wierix, and Hendrik *Goltzius.

Adam *Elsheimer was the last German painter of European rank for over a century.

The Thirty Years War (1618–48) witnessed the sacking of numerous cultural centres, including Heidelberg, Magdeburg, and Prague. Throughout the Empire, the pre-eminence of Flemish and Dutch painters was unchallenged. *Rubens received major commissions from Duke Wolfgang Wilhelm of the Palatinate-Neuburg from 1614 and Jan *Lievens worked for the Elector Friedrich Wilhelm of Brandenburg in 1654–5. The Habsburg Archduke Leopold Wilhelm commissioned an altarpiece from 'the German Vasari' Joachim von *Sandrart in 1648, but he employed *Teniers as his court painter and curator of the superb collection of Flemish and Venetian paintings which he assembled in the Netherlands in 1646–56.

Following the defeat of the Turks in 1683, Vienna rapidly assumed the character of a Baroque capital. The Austrian field marshal Prince Eugène of Savoy was praised as the 'supreme lover of the fine arts', but preferred Italian artists. After the coronation of Friedrich I as king of Prussia in 1701, *Berlin emerged as a major cultural centre, the home of numerous immigrant French Huguenot artists and artisans. August II, Elector of Saxony (ruled 1694–1733) and King of Poland (1697–1702 and 1719–33), established *Dresden as the artistic capital of Germany. He reorganized the treasury, the celebrated Grünes Gewölbe (Green Vault), founded the picture gallery and print room, and purchased classical antiquities. August assembled unrivalled collections of porcelain, and patronized Johann Friederich Boettger, who founded the Meissen factory in 1710. The vogue for the new ware spread, and porcelain factories soon appeared throughout Germany. August III (1733–63) enriched the Dresden collections with spectacular Italian paintings (see under ITALIAN ART AS OBJECTS OF PATRONAGE AND COLLECTING). Thirty years after his first visit to Dresden in 1768, *Goethe recalled the 'new prospect . . . that has had its effect on my whole life' which beckoned in this 'splendid hierarchy of art' (J. Gage (ed.), *Goethe on Art*, 1980).

German artists had found employment in England since the time of Hans Holbein. This tradition was continued through the 17th century by Peter *Lely and J. B. Closterman, and in 1768 the founding members of the Royal Academy included Johann *Zoffany and Angelica *Kauffmann. During the later 18th century, Germans became leaders in the artistic community in Rome; Anton Raphael *Mengs and his brother-in-law Anton von *Maron held senior positions in the Accademia di S. Luca (see under ROME). Mengs became court painter to Charles III of Spain and *Hackert was employed by the King of Naples. Such painters enjoyed celebrity as practitioners of an international Neoclassicism, presided over by *Winckelmann. Goethe had championed German Gothic

against French and Italian *classicism in 1772, and Napoleon's defeat of Austria and Prussia in 1805–6 created an introspective mood favourable to the exploration of explicitly German values.

From 1804 the dissolution of the *Cologne monasteries allowed the merchants Sulpiz and Melchior Boisserée to form a spectacular collection of early northern paintings, which they sold to Ludwig I of Bavaria (see MUNICH). The huge collection of primitives assembled by Edward Solly, including works by Altdorfer, Cranach, and Holbein, was purchased by the Prussian government in 1821. A similar taste was cultivated by J. D. Passavant in Frankfurt from 1817. This new enthusiasm for the German past also informed the brooding landscapes of Caspar David *Friedrich, which were purchased by the Grand Duke of Weimar and the Prussian monarchy. The 'pious simplicity' of the early Renaissance was imitated more literally by Friedrich *Overbeck, the founder of the *Nazarene brotherhood in Rome, who was patronized by Ludwig I of Bavaria and admitted to the Berlin Academy in 1845.

The classicism associated with the Berlin court sculptor Johann Gottfried *Schadow was gradually succeeded by a passionate realism exemplified by *Blechen, whose paintings were collected by bankers and dealers, as well as the King of Prussia. This consensus between the upper bourgeois and the nobility, analogous with the political alliance which provided the foundation for the unification of Germany under Bismarck, is clearly visible in the work of Adolphe von *Menzel. He achieved fame with history paintings of Frederick the Great and official commissions such as the *Coronation of Wilhelm I in Königsberg*, and was praised by *Degas as 'the greatest living master'. The 'Deutsch-Römer' painters Arnold *Böcklin and Hans von *Marées favoured poetic, mythological subjects and were patronized by the Munich collector, Count Adolf Friedrich von Schack. However, while the art critic Julius Meier-Graefe condemned Böcklin in 1905 for demonstrating 'all the sins committed by the Germans against the logic of art', he enthroned Marées beside *Cézanne as a founder of modern painting. At the end of the 20th century, both are revered as forerunners of European *Symbolism and representatives of the *'Romantic Spirit' which continues to haunt German art. MLE

2. 1871 ONWARDS

After the Franco-Prussian War, German museums increasingly collected contemporary art. The work of Arnold *Böcklin and Wilhelm *Leibl was sought by the Hamburg Kunsthalle director Alfred Lichtwark; artists from the *Sezessions were collected by Wilhelm Bode, who went from directing the *Berlin museums to create a contemporary collection for *Munich's Neue Pinakothek. The growing number of private collectors included Eduard Arnold, who supported Adolphe von *Menzel and Max *Liebermann and founded the Villa Massimo in Rome, an academy for German artists. American collectors also supported the Sezessions.

Between 1871 and 1914, this prospering art market encouraged the foundation of auction houses, academies, and design schools. Patronage came from royalty—Wilhelm II supported the Darmstadt artists' colony—from individuals such as Bernhard Köhler, who encouraged the *Blaue Reiter, and from industries such as the Bahlsen biscuit company. Notable galleries included Der Sturm in Berlin, showing the Blaue Reiter, and Richter & Gutbier in Dresden, showing Die *Brücke. The Cassirer gallery in Berlin, supporting German Impressionists, was the first in Germany to take artists under contract.

If royal patronage ended with the Weimar Republic, state, private, and industrial support continued. Josef Haubrich supported *Expressionism, eventually donating his collection to *Cologne's Wallraf-Richartz-Museum. *Dada was mainly supported by Wieland Herzfelde and his Malik-Verlag. The Mannheim Kunsthalle director Gustav Friedrich Hartlaub staged the first exhibition of *Neue Sachlichkeit, a movement also fostered by Paul Westheim's *Kunstblatt* magazine.

State patronage predominated during the Third Reich, under ideological dictates: a 'national' art comprising contemporary genre scenes and heroic landscapes was exclusively approved, while suspicion of 'cosmopolitan' influence behind most of the movements mentioned above led to the closure of galleries, the confiscation of collections, and the knock-down selling-off of such 'degenerate art' (*Entartete Kunst*) in Switzerland (for instance at the Galerie Fischer sale in Lucerne, 1939). Many German artists made their way to Paris, London, or New York. Nazi Germany was also excluded from the international art market by its foreign exchange controls, high customs duties, and travel restrictions.

After the Second World War, patronage and collecting followed differing patterns in West and East Germany. The West maintained a system of state, industrial, and private patronage. The first of these was decentralized insofar as each state of the Federal Republic determined its own cultural affairs. Initially, museums concentrated on collecting the art the Nazis had deemed degenerate. Industry meanwhile supported young German artists through foundations like the Kulturkreis im Bundesverband der Deutschen Industrie (from 1951) and the Jürgen-Ponto-Stiftung (from 1977). Some companies, such as BMW and BASF, had their own cultural budgets. Banks entered into patronage: for instance, the Bayerische Hypotheken- und Wechselbank created the Hypo-Kunsthalle in Munich, which has staged touring exhibitions of modern art since 1982. Leading private collectors included Peter Ludwig, buying both old masters and contemporary German and international work; Bernhard Sprengel, whose 20th-century collection is displayed in a museum now bearing his name in Hanover; Ottomar and Greta Domnick with their museum in Nürtingen showing work by Arnulf *Rainer and Hans *Hartung; Prince Franz of Bavaria, buying post-1960 art; and Erich Marx, a patron of Joseph *Beuys.

In the East, meanwhile, state patronage was inherent to government policy, but extended only to socialist artists. Private galleries and art unions stayed active in the 1950s but were gradually closed. Individuals involved with the state system might however also collect; these included Lothar Lang, a major patron of East German art, and Georg Brühl, who also bought *Jugendstil* work. Reunification in 1990 led to an extension of the West German system into the East.

The work of German artists was until the later 20th century less exported than that of France or Italy. The National Gallery in London added outstanding acquisitions to its old master collections in the 1980s and 1990s, and work from 1900 to the Nazi era found American buyers from the 1970s, two major holdings being the Rifkind Collection in Los Angeles and the Fishman Collection in Milwaukee. From the early 1980s, however, contemporary German art achieved an unprecedented international prestige, with the work of Beuys, Gerhard Richter, Anselm *Kiefer, Sigmar Polke, Georg *Baselitz, and many others reaching a global market. JV

GÉRÔME, JEAN-LÉON (1824–1904). French painter and sculptor, a specialist in highly detailed and archaeologically precise scenes of daily life from ancient Greece and Rome, in oriental subjects, and in historical tableaux set in the Baroque era. A pupil of *Delaroche, and of Charles Gleyre, from 1855 he travelled regularly in Turkey, Egypt, and Asia Minor. His Egyptian genre scenes won him the admiration of *Gautier, and *The Prisoner* (1861; Nantes, Mus. des Beaux-Arts) became one of the most famous 19th-century pictures. His *Death of Caesar* (1859; Baltimore, Walters AG) carefully recreates the past, suggesting, with a cool and polished surface, Rome's marmoreal splendour, while *L'Éminence grise* (1874; Boston, Mus. of Fine Arts), set in the world of Cardinal Richelieu, is a Baroque costume drama, painted in a delicate range of powdery blues and salmon pinks. In 1870 Gérôme was in London, where he began a series of oriental bath scenes. He made his

debut as a sculptor in 1878, with a bronze group, the *Gladiators* (Paris, Mus. d'Orsay).

HL

Ackerman, G. M., *The Life and Work of Jean-Léon Gérôme* (1986).

GERSTL, RICHARD (1883–1908). Austrian painter, born in Vienna. He later studied at the Academy there. His early painting was in the style of the Vienna *Sezession and the Austrian *Jugendstil*, and was influenced to some degree by the paintings and murals of Gustav *Klimt, which were characterized by their decorative linearity. Traces of such influences soon vanished, however, and by 1905 he had developed a distinctive *Expressionist style, whose main characteristic was the use of extremely thick oil paint which stood out from the canvas. The subjects of his portraits often appear to have distorted faces, which relates them to the works of contemporaries such as James *Ensor and Edvard *Munch. Such distortions, combined with his heavily impasted brushwork, appear to grant a high degree of psychological intensity to Gerstl's portraits, the most famous of which are two groups of the family of the composer Arnold Schoenberg. He committed suicide before allowing his style to mature fully; his paintings, which anticipated those of Expressionists such as Oskar *Kokoschka, remained virtually unknown until the 1930s.

OPa

GERTLER, MARK (1891–1939). English painter. The son of poor immigrants, Gertler was an outstanding pupil at the Slade School, London, 1908–12. His early paintings, taken from his family (*The Artist's Mother*, 1913; London, Tate) and Jewish life showed great promise and his talent and physical attractiveness won him the patronage of fashionable intellectual circles. His finest work, the menacing *Roundabout* (1916; London, Ben Uri Gal.), is highly original. After 1917 he became unduly influenced by *Post-Impressionism and from the early 1920s depression caused further personal and artistic decline which led to suicide.

DER

Woodeson, J., *Gertler* (1972).

GESSNER, SALOMON (1730–88). Swiss writer, etcher, and painter. The son of a bookseller, he early attempted to paint landscapes that reflected his love of nature and his dislike of the conventions of Baroque landscape painting. These efforts failed due to his lack of training and he turned instead to book illustration. He etched numerous vignettes for editions of classic and modern writers published by the family firm, including translations of Shakespeare and Swift. His own prose work *Der Tod Abels* (1758) expressed his criticism of the artificialities of 18th-century society and this point of view also underlies his later illustrations to his own collected works. His gouache landscapes (e.g. *Arcadian Music*, 1781; Zurich, Kunsthaus) painted from the later 1770s combine pastoral settings derived from *Claude and *Poussin with figures in Antique dress to create an atmosphere of *Romantic idealism more reminiscent of the writings of Rousseau than of his 17th-century classicist heroes. Gessner's proto-Romantic views on landscape are recorded in his *Briefe über die Landschaftsmalerei*, published in his collected works (1770–2).

MJ

Bircher, M., Weber, B., and Waldkirch, B. von, *Salomon Gessner* (1982).

GESSO. See GROUND.

GESTALT (German: configuration), adopted as the term for a school of psychology associated with the names of Wertheimer, Kohler, and Koffka, which came to prominence in the first half of the 20th century. Its basic principle that the ultimate elements of experience are structures and organizations which cannot be broken down into 'atomic' components was not entirely new or original but was supported with more systematic experimental research than hitherto. Five subsidiary principles constitute the special features of the Gestalt School: (i) the 'figure/ground' principle maintains that every perceptive experience is a pattern discriminated against a background; (ii) the principle of 'differentiation' which maintains a relation between patterns of stimuli and the formation of structures in perception; (iii) the principle of closure which maintains that incomplete stimuli patterns tend to be distorted in perception into completed structures; (iv) the principle of 'good gestalt' which maintains that one perceptual structure will tend to supersede another based on the same stimulus pattern; (v) the principle of 'isomorphism' which asserts a structural correspondence between physiological or brain processes and what is perceived.

Gestalt psychology has devoted more attention than other schools of psychology to the artistic aspect of experience, illustrating its own theories from artistic phenomena and applying itself to elucidate the facts of artistic appreciation. Its perceptual configurations have been thought to have a special relevance to the emergence of formal artistic qualities which cannot be reduced to a measurable aggregate of more elementary constituents. The work of such writers as Rudolph Arnheim (1904–) initiated a new line of approach to problems of artistic appreciation.

The Gestalt psychologists also launched an attack on the older theory of empathy and maintained that the so-called 'aesthetic' or 'emotional' qualities, such as cheerfulness, elegance, solemnity, grace, are directly perceived in the objects of perception and are not projected upon them. This theory gave rise to the concept of 'tertiary' qualities which are supposed to permeate and suffuse all experience but particularly the experience of art objects and are regarded as of central importance to artistic appreciation. It was maintained that 'emotional' qualities, although described in the language of subjective mood, are directly perceived in the object and not reflected upon it from subjectively experienced emotion. Sometimes the principle of isomorphism has been called upon at this point and it has been alleged that there is a structural correspondence between perceived artistic configurations and the basic patterns of human feeling and emotion.

HO

GESTURE. See EXPRESSION AND GESTURE.

GHEERAERTS, MARCUS, ELDER AND YOUNGER (c.1525–before 1591). **Marcus the elder** was an etcher, engraver, and painter. He was born and trained in Bruges, from whence he was banished in 1568 for his religious beliefs, moving to Protestant London with his small son Marcus. His only signed solo painting, a portrait of *Elizabeth I* (priv. coll.), presumably survives from this period, although he later returned to Flanders. He is principally known as an etcher and engraver, for instance of the illustrations to the 1567 edition of Aesop's *Fables De warachtige fabulen der dieren*.

Marcus, the younger (1561/2–1636) was a British portrait painter. Born in Bruges, he trained with the Flemish-born Lucas de Heere (1534–84) in London, and was subsequently linked by marriage with the painter John de Critz the elder (c.1551/2–1642) and the miniaturist Isaac *Oliver. Eight works signed by Gheeraerts survive and a further score or so have been attributed to him on the basis of their common form of inscription. His earliest portraits date from 1592, and during the 1590s, under the patronage of Elizabeth I's Master of the Armoury, Sir Henry Lee, Gheeraerts seems to have been the leading court portraitist. His most celebrated work is the immense 'Ditchley' image of the Queen standing on a map of England (c.1592; London, NPG). His early iconic style changed with the new century to a softer, more sensitive mode, the flesh modelled in light blue-grey tones. He was among the earliest English painters of full-length portraits, and continued as court artist to James I's Queen, Anne of Denmark, until the arrival of the Netherlandish Paul van Somer (1576–1621) in about 1616. His later sitters were academics

and members of the gentry, and his last known portraits are dated 1629.　　KH

Hearn, K. (ed.), *Dynasties*, exhib. cat. 1995 (London, Tate).

Hodnett, E., *Marcus Gheeraerts the Elder of Bruges* (1971).

Waterhouse, E. K., *Painting in Britain 1530–1790* (5th edn., 1994).

GHERARDO DI GIOVANNI DI MINIATO (1445–97) and **MONTE DI GIOVANNI DI MINIATO** (1448–1532/3). Italian illuminators and painters. These sons of a sculptor worked together, until 1476 with a third brother Bartolomeo, on producing manuscripts for the leading ecclesiastical and secular patrons of Florence. Their frequent collaboration, as in the manuscripts or printed books they illuminated for Matthias Corvinus, King of Hungary, makes their individual work difficult to distinguish; for example in the large Bible now in Florence (Bib. Laurenziana, MS Plut. 15. 17). Both artists were familiar with contemporary art, and the influence of both Netherlandish and Florentine painting is evident in some of their ambitious compositions. Their rich and complex frontispieces often included depictions of reality, whether portraits of people or buildings; for example in the Didymus Alexandrinus *De spiritu sancto* made for Matthias Corvinus (New York, Pierpont Morgan Lib., MS M. 496) the King, his Queen, and other members of their family and household are shown in the architectural surround of the author portrait, which itself has a view of Florence in the background. Gherardo and Monte are often credited with devising an *all'antica* border type incorporating grotesques, classical ornament, and cameos or mythological scenes copied from classical gems; quotations from gems in the collection of Lorenzo de' Medici are made in the illumination of the printed copy of Pliny's *Natural History* (1476) illuminated for Filippo Strozzi between 1479 and 1483 (Oxford, Bodleian Lib., Arch. G. b. 6).　　KS

The Painted Page: Italian Renaissance Book Illumination 1450–1550, exhib. cat. 1994/5 (London, RA; New York, Pierpont Morgan Lib.).

GHERARDUCCI, DON SILVESTRO DEI (1339–99). Italian illuminator and painter. A Camaldolese brother, he was recorded at S. Maria degli Angeli, Florence, where he was subprior by 1389 and became prior in 1397. The monastery's scriptorium was the most important in Florence and, in his life of *Lorenzo Monaco, *Vasari singled out Don Silvestro for the excellence of his illumination. Vasari cited series of choir books containing his work not only in the Florentine house (Florence, Bib. Laurenziana, Cod. Cor. 2, 6, 9, 19) but also in the Camaldolese monasteries of Murano. Both series were mutilated during the Napoleonic period, and leaves or cuttings from them are dispersed among various collections in Europe and America. The Gradual completed for S. Maria degli Angeli (text completed 1370; Cod. Cor. 2) is of the highest quality; the refined execution and elegance of his figures are combined with a wealth of delicate surface decoration including punched gold, *Cosmati strips, mordant gold patterns and tendrils, and sprays of flowers. More than 50 leaves and cuttings have been identified as coming from the Murano choir books, which must have been illuminated between 1392 and 1399 (New York, Pierpont Morgan Lib., MS M. 653). The invention and richness of these books made a sufficient impression on Cristoforo *Cortese and *Belbello da Pavia for them to emulate and develop his compositions when they worked on further choir books for Murano.

Various panel paintings related in style to the work of the *Cione brothers have been attributed to Don Silvestro by some scholars, for example the *Crucifixion* in the Lehman Collections (New York, Met. Mus.).　　KS

Kanter, L., *Painting and Illumination in Early Renaissance Florence 1300–1450* (1994).

GHEYN, JACQUES DE, II (1565–1629). Dutch draughtsman, engraver, and painter whose father and son, by the same name, were also artists, though of less renown. Born in Antwerp, Jacques II studied in Haarlem with Hendrik *Goltzius, with whom he stayed for five years. By 1590–1 he was in Amsterdam making engravings after his own and other artists' designs. From 1596 to 1601/2 he lived in Leiden. Here he befriended some of the leading humanists (among them the famous law scholar Hugo de Groot) and scientists of the time, which may have resulted in his careful renderings of insects and other creatures. By 1603 de Gheyn had moved to The Hague, where he was employed at the court of Prince Maurice of Orange and, after the latter's death, of his brother Frederick Henry. He began to paint only *c*.1600, mainly *vanitas* still lifes and flower pictures. De Gheyn is primarily known for his drawings of domestic subjects, which are considered the finest before *Rembrandt (*Mother and Child Studying a Drawing Book*; Berlin, Kupferstichkabinett).　　KLB

Luyten, G., et al. (eds.), *Dawn of the Golden Age*, exhib. cat. 1994 (Amsterdam, Rijksmus.).

GHEZZI, PIER LEONE (1674–1755). A significant Roman painter, now remembered for his mild *caricature drawings of papal courtiers and *Grand Tourists, which were influential in England through Arthur Pond's engravings. He was also an antiquarian draughtsman, theatrical designer, and musician. He was given a rigorous academic training by his father, also a painter, and after winning the Accademia di S. Luca (see under ROME) competition in 1695 he became an instant success as a *history painter. In 1708 he was appointed to the important position of painter to the Camera Apostolica by Clement XI. While adept in the classical manner of *Maratti, he developed a livelier narrative style, full of touches of acute observation and with a documentary concern for authenticity. He also painted several informal decorative schemes, including a set of landscape views in the gallery of the papal palace at Castelgandolfo in 1747.

His numerous portraits are painted with dramatic spontaneity until the mid-1720s; thereafter he moved towards a calmer style in the French manner, with more emphasis on the details of clothing and accessories.　　AJL

Briganti, G. (ed.), *La pittura in Italia: il settecento* (1989).

GHIBERTI, LORENZO (1378–1455). Italian sculptor of the Florentine School. He was trained as a goldsmith, then worked as a painter. In 1401 his relief of the *Sacrifice of Isaac* (Florence, Bargello) was successful in the competition, against *Brunelleschi and della *Quercia, for the commission offered by the merchant guild to make a pair of bronze doors for the baptistery of Florence. The work on these took 23 years. In about 1426 he was asked to make a second pair of doors for the same building, which occupied him until 1452. These two commissions lay at the centre of the civic and religious life of Florence and their fulfilment necessitated the formation of a large workshop in which most Florentine artists of the period received at least part of their training. Ghiberti also served on the committee in charge of the architectural works of Florence Cathedral (an episode of which *Vasari has preserved the highly biased account circulating among Brunelleschi's followers). In monumental statuary his work completing three important statues for Or San Michele in Florence oscillates between an essentially *International Gothic style in the *S. John the Baptist* (1413–14) and a classicizing gravity in the *S. Matthew* (1419–22); he then reverts to a more linear Gothic style for the *S. Stephen* (1425–9), perhaps in order to conform to the wishes of his patrons, the wool guild.

Despite the prominent place which Ghiberti occupied in the classical revival, his style was deeply rooted in the tradition of Gothic craftsmanship, noticeable for instance in the shrine of S. Zenobius (1432–42; Florence, Bargello) whose design adheres to medieval reliquary patterns. Moreover, not only was his first pair of baptistery doors closely modelled on Andrea *Pisano's earlier doors, but the 20 episodes from the life of Christ and its eight saints again reflect the

International Gothic style with their emphasis on graceful lines, lyrical sentiment, and minute attention to landscape detail. While these traits survive in Ghiberti's second pair of doors, they are here subordinated to the new principles of the *Renaissance. The doors are divided into ten large panels in which episodes from the Old Testament are represented on carefully constructed stages. In the mastery of composition within a spatial framework they must rank among the most advanced works of their time; most were planned and laid out by 1437 although only completed by 1452. Some such as The Visit of the Queen of Sheba point forward to *Botticelli's frescoes in the Sistine chapel, at the Vatican. They also incorporate many details derived from classical art (see ANTIQUE) and architecture, such as the figure of Noah in the Drunkenness of Noah, which is inspired by Roman river gods, or the circular building in the Joseph panel, based on a Roman temple. The fame of these doors always stood high, and according to Vasari it was *Michelangelo who judged them worthy of the Gates of Paradise. They were also publicized in an engraving in the 18th century by Thomas *Patch, who brought plaster casts of them to England. When the originals were taken down for safety during the Second World War the original gilding was discovered under centuries of dirt, and their cleaning not only revealed many subtleties, but almost changed their character, for we can now see them again as the last manifestation of the medieval tradition of goldsmiths' work.

In addition to his sculptural work Ghiberti designed stained-glass windows. He was also a writer; and left a large incomplete manuscript under the title Commentarii, which, apart from a survey of ancient art based on *Pliny and notes on the science of optics, contains valuable records of Italian painters and sculptors of the trecento as well as his own autobiography, perhaps the first ever written by an artist. The same interest in the new *humanist ideals that is reflected in Ghiberti's writings may also have prompted him to acquire classical sculptures, including the so-called Bed of Polyclitus, one of the first Greek sculptures (see GREEK ART, ANCIENT) to be associated with a Florentine collection.

HO/AB

Krautheimer, R., and Krautheimer-Hess, T., Lorenzo Ghiberti (2 vols., rev. 3rd edn., 1982).

GHIRLANDAIO, DOMENICO BIGORDI (c.1448–94). Italian painter, mosaicist, and possibly goldsmith who headed one of Florence's most successful workshops, assisted by his two younger brothers. His extensive fresco cycles display compositional and narrative complexity and combine historical themes with contemporary detail. Unlike the more avant-garde *Botticelli, he

consolidated and popularized the style of earlier artists including *Verrocchio, Fra Filippo *Lippi, and even *Masaccio.

Early frescoes such as the Madonna of Mercy with the Vespucci Family (1473; Florence, Ognissanti), display this eclectic character, while the two scenes from the life of S. Fina (1475; S. Gimignano, Collegiata) illustrate Ghirlandaio's skills in composition and in vivid characterization.

In 1480 he painted a fresco of the Last Supper for the refectory of the church of the Ognissanti, setting the sacred event in an airy loggia whose architecture and perspective continue that of the real building and whose furnishings, the utensils, even the flowers and trees in the garden, suggest a familiar Florentine scene. In addition, the varied reactions of the apostles, and their grouping, anticipate *Leonardo da Vinci's celebrated interpretation in Milan.

In the following year Ghirlandaio went to Rome to paint frescoes for the Sistine chapel, notably Christ Calling the Apostles, which is inhabited by portraits of contemporary Florentines. This feature, and his talent for portraying the life of the day in his religious works, commended him to middle-class patrons, from whom he secured his major Florentine commissions—the decoration of the Sassetti chapel, S. Trinita (1482–5), and the Tornabuoni chapel, S. Maria Novella (1486–90). In both he employed massive, Roman-inspired architectural settings, and views through windows of familiar landscape. The scenes from the life of the Virgin (S. Maria Novella) seem to show the story taking place in the home of a wealthy Florentine; the figures wear contemporary dress and have the features of his patrons.

Numerous studies and sketches such as that for the Birth of the Virgin (London, BM), and his evident use of cartoons, buon fresco, and regular giornate indicate Ghirlandaio's sound technical methods. Similar command can be seen in his altarpieces. The Adoration of the Shepherds (Sassetti chapel) is characteristic of his well-organized yet detailed compositions, its intense naturalism, particularly in the physiognomy of the shepherds, and the expansive landscape pointing to the influence of Flemish painters.

Some examples of his realism are ruthlessly unidealized, as in the Old Man and his Grandson (Paris, Louvre), a tender portrait which reveals the artist's perception of the importance of nature. This attribute may hint at the developments of the next generation, particularly that of his apprentice *Michelangelo.

MS

Micheletti, E., Domenico Ghirlandaio (1990).

GHISLANDI, GIUSEPPE (Galgario, Fra) (1655–1743). Italian painter from Bergamo. He started life as a friar of the order

of Minims in Venice, 1675–88. He then trained as an artist in the studio of Sebastiano Bombelli (1635–1719) in Venice c.1689–1702. After this he settled at Bergamo, living in the Convento del Galgario from which he derived his name. He specialized in portraiture, mostly of provincial society, sometimes painting in a relaxed and realistic style, but at others characterizing his subject with sardonic detachment, as is the case with the Gentleman with a Tricorn Hat (Milan, Poldi Pezzoli Mus.). He also painted fanciful heads as character studies and this genre was in demand from a wide range of patrons and collectors, including Prince Eugène of Savoy and Marshal Johann Matthias von der Schulenberg, of whom he also painted a portrait (Bertelli and Danios no. 9; see below). His Self-Portrait (1732) is in the Accademia Carrara, Bergamo.

HB

Bertelli, C., and Danios, A., Fra Galgario: 14 dipinti da collezioni private, exhib. cat. 1995 (Milan, Gal. Carlo Orsi).

Testori, G., Fra Galgario (1970).

GIACOMETTI, ALBERTO (1901–66). Artist of the *École de Paris. After studying art in his native Switzerland and then in Italy, Giacometti settled in Paris in 1922 where he began working in a *Cubist and primitivizing manner. In the early 1930s he became involved with the *Surrealist group, producing disturbing sculptures and uncanny objects, typified by the uneasy eroticism of Suspended Ball (1930–1; Zurich, Giacometti Foundation). From 1935 he began to return to realism, incessantly drawing from life. By the time he returned from Switzerland, where he had sheltered from the war, he had evolved a style which finely articulates some of the phenomenological thought of the emerging *existentialist movement in Paris; he quickly became involved with the period's central figures, associating with Jean-Paul *Sartre and Samuel Beckett among others. In paintings, drawings, and sculptures, his attenuated figures seem oppressed by a thick palpable space. The Artist's Mother in her Room (1951; Paris, Centre Georges Pompidou) shows his overriding concern with the problems of the representation of objects and distance.

MF

Sylvester, D., Looking at Giacometti (1994).

GIAMBOLOGNA (Giovanni Bologna or Jean de Boulogne) (1529–1608). Born in Douai in French Flanders, he became one of the most successful and prolific *Mannerist sculptors in Florence. He trained under Jacques *du Brœucq before travelling to Rome around 1550 to study *Antique art. On his way home in 1552 he stopped in Florence, where he was commissioned by the collector Bernardo Vecchietti. Over the next five years Giambologna produced his first independent sculptural works and architecture for this

patron. Through Vecchietti he entered the service of the Medici family in the early 1560s submitting, unsuccessfully, a model for the competition for the Neptune Fountain for the Piazza della Signoria. His ideas for this project may be reflected in the bronze Fountain of Neptune in Bologna (1563–6) that established his reputation. The two-figure marble group *Samson and the Philistine* (c.1560–2; London, V&A), originally placed in the garden of Francesco de' Medici's Casino di S. Marco, Florence, shows the complexity and sophistication that is characteristic of Giambologna's compositions as well as the influence of *Michelangelo's designs. He made several other figures for fountains in Medici villas, including the colossal figure of *Apennine* for Pratolino (1580). Although the Medici were his principal patrons, and in spite of their reluctance, Giambologna also undertook non-Medicean commissions. The completion of a series of important marble and bronze sculptural works, for example the decoration of the Grimaldi chapel (1580–90) in Genoa, and the Salviati chapel in S. Marco, Florence (1581–7), were made possible by the large and well-ordered workshop where the sculptor collaborated with highly skilled assistants, including Piero *Francavilla, Pietro *Tacca, and Antonio *Susini. Towards the end of his career his efforts were concentrated on the casting of two monumental bronze *equestrian statues of the Medici, *Cosimo I* (1587–93; Florence, Piazza della Signoria) and *Ferdinand I* (1601–8; Florence, Piazza SS Annunziata); these depend on the Antique *Marcus Aurelius* from the Campidoglio in Rome (Rome, Capitoline Mus.). Further equestrian monuments of *Henri IV of France* (destr.) and *Philip III of Spain* were completed by assistants. In addition to his large-scale works his highly collectable bronze statuettes and groups spread his designs around Europe, even if their authorship is sometimes in doubt. The *Flying Mercury* (1563; Florence, Bargello) has endured as an image of speed and grace to this day. Giambologna's most successful and popular composition is the *Rape of a Sabine* (1581–2; Florence, Loggia dei Lanzi); the spiralling contour of the three-figure composition was to have an important impact on *Bernini.　AB

Avery, C., *Giambologna: The Complete Sculpture* (1987).
Avery, C., and Radcliffe, A. (eds.), *Giambologna, Sculptor to the Medici, 1529–1608*, exhib. cat. 1978 (Edinburgh, Mus. of Scotland).

GIAMBONO, MICHELE (c.1400–62). Venetian painter who was one of the greatest exponents of the full-blown late *Gothic style in 15th-century Venice. Despite coming into contact with the art of *Donatello in Padua and Andrea del *Castagno in Venice, he expressed little interest in early 15th-century Florentine innovations in space and form. On the basis of his shimmering panel of *S. Michael* (c.1440?; Settignano, I Tatti) Giambono's style is characterized by rich surface textures and colour, remarkable attention to detail, and an extremely spirited and rhythmic sense of line. His highly developed late Gothic manner, especially his delight in natural detail, developed in the Venetian milieu under the influence of *Jacobello, *Gentile da Fabriano, and *Pisanello. Giambono is particularly indebted to Gentile for the design of his facial types and for the mellow and radiant skin textures of his figures. He designed a series of mosaics depicting the *Life of the Virgin* in the Mascoli chapel (Venice, S. Marco) in the 1440s. His *S. Chrysogonus* (Venice, S. Trovaso) is probably later in date (1450s).　FB

GIANI, FELICE (1758–1823). Italian painter. He is best known as a decorative painter in the *Neoclassical style. After training with *Batoni at the Accademia di S. Luca in *Rome he went on to design decorations for Catherine II of Russia (1788) and to contribute to schemes at the Tuileries Palace in Paris for Napoleon (c.1800–9). His most important work was fresco decoration in the Palazzo Milzetti at Faenza. Giani was also a fine draughtsman in a style reminiscent of *Fuseli.　MJ

Acquaviva, S., and Vitali, M., *Felice Giani* (1979).
Servolini, L., 'Un romantico in anticipo: il focoso pittore Felice Giani', *L'arte* (1952–3).

GIAQUINTO, CORRADO (1703–66). Italian painter. He was born at Molfetta and received his early training there before moving in 1721 to Naples, where he worked in the studio of Nicola Maria Rossi (1690?–1758), a pupil of *Solimena. Giaquinto's early style reflects the influence both of Solimena and *Giordano, but after he had moved to Rome in 1727 he modified his manner in response to the more delicate *Rococo manner of Sebastiano *Conca. In 1733 he was commissioned to decorate the nave and cupola of the French church of S. Nicola dei Lorensi, Rome, and this was followed by employment at the Savoy court in Turin. His work at Turin included *Apollo and Daphne* and *The Death of Adonis* for the Villa della Regina (1733; *in situ*); *Rest on the Flight to Egypt* and *Death of S. Joseph* and a vault fresco of *S. Joseph in Glory* (c.1735; S. Teresa); and a series of six pictures on the life of Aeneas (now Rome, Palazzo Quirinale). In 1740 he was elected to the Accademia di S. Luca, Rome, and during the first half of the 1740s he undertook major decorative assignments at S. Giovanni Calabita and at S. Croce in Gerusalemme, Rome. His response at this time to the classicizing tradition of *Maratti is reflected in the *Baptism of Christ* (1750; Rome, S. Maria dell'Orto).

His international reputation was reflected in the commission in 1748 from Ferdinand VI of Spain to decorate the church of S. Trinità degli Spagnoli, Rome (including the altarpiece *The Holy Trinity Freeing a Captive Slave*, 1750). This in its turn led to the invitation to go to Madrid, where he was appointed First Painter to King Ferdinand as well as director of the Academia de S. Fernando (see under MADRID). He was responsible for the entire decorative project at the Palacio Real and enjoyed considerable power. His own frescoes include the vaults, choir, presbytery, and cupola of the royal chapel (1758–9); the vault of the grand staircase where he painted *Spain Rendering Homage to Religion and the Catholic Church*; the vault of the Hall of Columns where he painted the *Birth of the Sun* and the *Triumph of Bacchus* (1762); and the vault of the Hall of Halberdiers (1762). His progress was then halted by illness and he returned to Naples, where he remained until his death. Here he completed a series of altarpieces on the life of Mary for the royal church of S. Luigi di Palazzo (1764–5); these works are now widely dispersed. Giaquinto was a master of the freely executed but carefully controlled oil sketch, often painted in relatively light and luminous pastel tones; these were much imitated by his Spanish and Italian followers.

HB

Corrado Giaquinto, capolavore dalle corti in Europa, exhib. cat. 1993 (Bari, Castello Svevo; Rome, Palazzo Venezia).

GIBBONS, GRINLING (1648–1721). Sculptor born in Rotterdam and perhaps trained in the *Quellinus family workshop. By 1671 he was working in London and is best known for his naturalistic woodcarvings of swags of fruit and flowers, small animals, and cherubs' heads. Their virtuoso quality is unsurpassed in England and his fame is such that almost all good 17th-century woodcarving has at one time or another been attributed to him. He was recommended by the painter *Lely and others to Charles II and Christopher Wren. As a result, fine examples of his woodcarving may be seen at Windsor Castle, Hampton Court, and in the choir stalls of S. Paul's Cathedral. He was also active as a monumental sculptor, though his work in marble and bronze is very varied in the quality of its design and execution and it is not clear how much personal responsibility he had for this aspect of the output of his workshop. His large marble tombs, such as that for *Sir Cloudesley Shovell* (c.1707; London, Westminster Abbey), are often clumsy, but the best bronze statues, among them *James II* (1686; London, Trafalgar Square), are of finer quality, and may well have been designed by his partner

Artus Quellinus (1653–86). HO/MJ

Beard, G., *The Work of Grinling Gibbons* (1989).
Esterly, D., *Grinling Gibbons and the Art of Carving*, exhib. cat. 1998 (London, V&A).
Green, D., *Grinling Gibbons: His Work as Carver and Statuary* (1964).

GIBSON, JOHN (1790–1866). English *Neoclassical sculptor who became the most successful member of the Anglo-Roman School. He was largely self-taught until in 1817 he travelled to Italy where he settled in Rome. There he studied with both *Canova and *Thorvaldsen, the leading masters of Neoclassical sculpture. Gibson quickly built up a thriving practice with commissions from British patrons. His most famous, or perhaps notorious, work, the *Tinted Venus* (1851–6; Liverpool, Walker AG), is a nude marble figure with painted details and a waxed surface. This very cautious attempt to recreate the polychromy of Greek sculpture was considered indecent when the statue was shown at the 1862 London International Exhibition. Gibson was an opponent of naturalism and modern dress subjects, declaring, 'the human figure concealed under a frock-coat and trousers is not a fit subject for sculpture', remaining true to the idealizing principles of Neoclassicism to the end of his life. MJ

Matthews, T., *The Biography of John Gibson, RA, Sculptor* (1911).
Read, B., *Victorian Sculpture* (1982).

GILBERT, SIR ALFRED (1854–1934). He was the most influential artist in the New Sculpture movement, which in the last decades of the 19th century strove to release British sculpture from the dead weight of *classicism. Gilbert first came into contact with anticlassical tendencies as a student at the École des Beaux-Arts in Paris. From 1878 until his return to London in 1884 he lived in Italy, where he came under the spell of the great *Renaissance bronzes of *Donatello, *Verrocchio, and *Cellini, as well as the ampler and more demonstrative sculpture of the *Baroque. His new and individualistic style, closely related to contemporary developments in European *Symbolist art, first manifested itself in the lithe, nude statuette *Perseus Arming* (1882; London, V&A), with which he also reintroduced the technique of lost-wax *casting to Britain. Gilbert's memorial at Piccadilly Circus to Lord *Shaftesbury, topped by the flying figure of *Eros* (begun 1886, and the first use of aluminium for a statue), is probably the most famous sculpture in London. More impressively monumental is the seated statue of *Queen Victoria* in Winchester (commissioned 1888), which has been compared with *Bernini's *Urban VIII* in S. Peter's, Rome. The full range of Gilbert's stylistic originality—a heady but homogeneous combination of *Pre-Raphaelite, neo-

Florentine, Baroque, and *Art Nouveau influences—as well as his rich and colourful use of materials—including bronze, ivory, aluminium, marble, and brass—can be seen to fullest advantage in his masterpiece, the tomb of the Duke of Clarence (1892–9) in the Albert memorial chapel at Windsor Castle. In 1901 the sculptor declared himself bankrupt and moved to Bruges, not returning to London until 1926, when he completed the last details of the Clarence tomb and executed a memorial to Queen Alexandra at Marlborough Gate, London (completed 1932). MJ

Dorment, R., *Alfred Gilbert* (1985).
Dorment, R., *Alfred Gilbert: Sculptor and Goldsmith*, exhib. cat. 1986 (London, RA).

GILBERT AND GEORGE (Gilbert Proesch, 1943– , and George Passmore, 1942–). British artists (Gilbert is Italian born) who met whilst studying at St Martin's School of Art in London in 1967 and since 1968 have lived and worked together as self-styled 'living sculptures': 'Being living sculptures is our life blood, our destiny, our romance, our disaster, our light and life.' They initially attracted attention as *Performance artists, their most famous work in this vein being *Underneath the Arches* (1969), in which—dressed in their characteristic neat suits and with their hands and faces painted gold—they mimed mechanically to the 1930s music hall song of the title. Although they gave up such 'living sculpture performances' in 1977, they still see themselves as living sculptures, considering their whole lifestyle a work of art. Since the early 1970s their work has consisted mainly of photo-pieces—large and garish arrangements of photographs, usually in black and white and fiery red, and often violent or homoerotic in content, with scatological titles. The images are often drawn from the street life of the East End of London in which they live.

Gilbert and George have become the most famous British avant-garde artists of their generation. Their work has been shown worldwide and in 1986 they won the Turner Prize. Critical opinion on them is sharply divided, however: to some they are geniuses, to others tedious poseurs. For example, in the first issue of *Modern Painters* in 1988, a letter from the Anthony d'Offay Gallery, London, which has shown several exhibitions of their work, stated: 'One of the things we most admire about Gilbert and George is their positive attitude and their understanding of present time. They are great contemporary artists because they see the present for what it is.' In the same issue of the journal, however, the philosopher and critic Roger Scruton wrote: 'they are masters of hype, and can find for any painting, however boring, some suitable paragraphs of art-school lingo with which to market it . . . With brazen effrontery

they lay claim to every possible moral and artistic virtue . . . Their sole skill is in having made self-advertisement profitable, in having sold as creative masterpieces works which have no aesthetic quality at all.'

GILDING. *See opposite.*

GILL, ERIC (1882–1940). English sculptor and engraver. Gill was apprenticed to an architect but studied stonecarving and lettering at the Central School of Art, London. His first sculpture was commissioned in 1910, when he had already gained a reputation for letter cutting. He converted to Roman Catholicism in 1913 following which much of his work, like *The Stations of the Cross* (1914–18; London, Westminster Cathedral), has a religious theme. In 1918 he set up a semi-religious community at Ditchling, Sussex, dedicated to promoting the integrity of the craftsman and the community role of the artist; some of his ideas, such as his insistence on truth to materials and his idealistic view of the designer-maker, owe a debt to William Morris. Apart from his sculpture, simplified and linear, for which he received several public commissions, Gill is best known for his contributions to the printed book. In 1924 he joined Robert Gibbings (1889–1958) at the Golden Cockerel Press, where he provided both typefaces and elegant woodcut illustrations; he also designed typefaces for the Monotype Corporation including the modernist Gill-sans. Gill's highly personal religion combined devout Catholicism with aspects of Indian culture including a fascination with sexuality which he believed to be important to artistic creation. Revelations of his sexual activities, including consensual incest, which appeared in 1989 have ensured his continuing notoriety. JH

MacCarthy, F., *Eric Gill* (1989).

GILLRAY, JAMES (1756–1815). Gillray is undoubtedly the greatest British political *caricaturist, a genre which he pioneered. He was apprenticed to an engraver before entering the RA Schools (see under LONDON) in 1778 where he was taught by Francesco Bartolozzi. In the same year his first political satire, *Grace before Meat* (London, BM), was published and by 1784 he was recognized as England's leading caricaturist whilst also practising as an engraver. His originality lay in exaggerating the features of his subjects rather than identifying them by attributes. Many of his finest plates, including *A Voluptuary under the Horrors of Digestion* (1792; London, BM), satirized the Prince of Wales, who nonetheless purchased all his prints between 1803 and 1810. He was also active, after 1789, in anti-French propaganda, publishing the horrific *Zenith of French Glory* (London, BM) in

continued on page 291

· GILDING ·

1. Painting

GILDING on paintings involves the use of a metal, usually, but not invariably, gold, applied, either as foil or in a powdered form, to imitate gold or to represent golden objects. On Western paintings the various gilding techniques were widely employed until about the mid-16th century. Thereafter they are more commonly found on sculpture, carved furniture, and frames.

Most of the gold on medieval and Renaissance paintings was used in the form of gold leaf, made by beating gold coins (which were supposed to be of pure 24-carat gold) to thin sheets which were cut into squares which were stacked, interleaved with parchment or paper. The stacks were then hammered until the gold had spread sufficiently to make a thin foil or leaf. In most early Italian paintings, and many northern European works as well, the gold leaf was applied by the technique of water gilding. Since this was carried out before painting, the areas to be gilded had to be designated, the contours often marked by an incised line. The gesso or chalk ground was prepared with an application of bole, a clay usually pigmented with iron oxides and therefore of a red-brown colour, in which case it is often called Armenian bole. Less commonly, a yellow or dark brown bole or a green earth might be used. The bole is bound in the same size (animal-skin glue) used for the *ground. Its purpose is to provide a smooth, almost slippery, surface for later burnishing, but the red and yellow boles also enrich the colour of the gilding. Gold leaf is so thin that when laid on white it can appear cold and slightly green. In water gilding the squares of leaf are laid on a padded leather gilders' cushion, cut to size if necessary and picked up with a gilders' tip. The modern gilders' tip is a brush made from long hairs set between two pieces of card, but earlier gold leaf was slightly thicker and so could be handled using a piece of card or parchment. The area of bole to be gilded is brushed with water (sometimes with added size or egg white) to reactivate the glue in the bole (hence the term water gilding) and the leaf laid over it. The leaf is patted down with a soft wad but when first applied it still appears crumpled and matt. To achieve the reflective gleam of solid gold which is the aim of water gilding it needs to be burnished by rubbing the surface with a burnisher, usually a hard polished stone such as haematite or agate mounted in a wooden handle. In the case of old paintings, damage, especially abrasion, and the formation with age of fine cracks in the ground and bole layers mean that much of the intended effect of burnished water gilding is lost.

In northern European paintings matt, unburnished gilding is also found and contracts may specify which areas are to be burnished and which are to be matt. For matt gilding the gold leaf is laid over an oil-based adhesive, essentially oil paint consisting of a drying oil and pigment, commonly yellow and red earths to imitate the colour of gold. This has to dry to the right degree of tackiness before the leaf can be laid. Throughout Europe this technique of oil-mordant gilding is also used in the final decoration of painted areas (see below) and for areas of gilding in wall paintings. Gold leaf is too delicate to be laid directly on the relatively rough surface of plaster and so the gold leaf is backed with thicker and more robust tin foil using an oil mordant as the adhesive.

White metals such as tin and, more particularly, silver may occur on paintings for decorative effects and to represent white metal objects such as swords and armour, but they were also used as cheaper substitutes for costly gold leaf when they were coated with transparent oil and resin glazes coloured with yellow dyestuffs such as saffron. Alternatively savings could be made by hammering gold together with silver leaf to produce half-gold (in old English *party (ie)-gold*, in German *Zwischgold*, in Italian *oro di metà*). Originally these substitutes could be remarkably convincing (and guilds frequently regulate against their use unless permitted in the contract) but, with time, damage to the glazes and especially tarnishing of the silver mean that the effects are now lost.

Areas of gilding were frequently enlivened with forms of indented decoration which sparkle and catch the light, particularly flickering flames of candles. Haloes, for example, could be distinguished against a gilded background. With burnished water gilding this tooling of the surface was carried out after gilding. The ground and bole will compress sufficiently to allow lines to be incised into them using a metal stylus—both freehand and ruled, or inscribed with dividers for the arcs and circles of haloes—and for designs to be stippled by pressing with a rounded metal point. The burnished gold should be sufficiently bonded so that it will not tear. In Italy in the early 14th century artists began to employ elaborate forms of punched decoration. Designs were engraved into the ends of punches, usually made of metal, but wood was adequate if they were to be used for larger cruder motifs in wall paintings. The punch was held perpendicular to the surface to be decorated and tapped sharply with a hammer, imprinting the design into the gilded surface. Since each engraved punch is distinctive, it has been possible to track the transfer of some of these tools from workshop to workshop in the course of the 14th century. Gilding around the punched motif might be made to sparkle by stippling or graining: on larger areas time could be saved by using a rosette, a composite punch with several rounded points on a single head or by rolling a small wheel with the points radiating from the rim. Tooling of northern European paintings is generally less elaborate

and is usually confined to incising and stippling, partly perhaps because chalk grounds tend to be harder than gesso and are therefore less easy to punch.

Gilding may also be ornamented by various types of relief decoration. The simplest form is that most commonly found on 14th- and 15th-century Italian paintings and usually called *pastiglia*. Before gilding, a raised pattern is built up on the gesso ground by dribbling lines of liquid gesso from a brush. Sometimes glass beads, substituting for precious stones, were set into the pastiglia. Conversely, in many German and Austrian paintings an exceptionally thick ground is laid and the pattern then carved into the ground, achieving an effect of relief but in fact leaving the painted areas proud of the gilded surface. From the 13th to the 15th centuries, and especially in northern Europe, relief patterns were also achieved by making casts from carved wooden moulds and gluing them to the area to be gilded. This form of decoration is often characterized by a chequerboard arrangement of the small square casts. In German and some early Netherlandish paintings—but more commonly sculptures—moulds were also used in the execution of applied relief brocade to represent cloth-of-gold textiles. The design, usually including the ridges of the diagonal threads of the textile, was carved into a very shallow mould which was then lined with tin foil and filled, usually with a slightly flexible composition. The unmoulded cast was then stuck to the area to be decorated, its thinness and flexibility allowing it to be bent to accommodate the curved surface of a sculpture where necessary. Finally, the tin foil (now uppermost) was mordant-gilded in the usual way and the cut velvet parts of the textile pattern painted on.

Several decorative effects are produced by superimposing paint layers over gilding although the adhesion of paint to gilding is not always good—indeed Cennino *Cennini made it clear that for tempera paintings gilding should not extend too far into areas reserved for painting and that any excess should either be scraped off or covered over with a paint containing lead white, a pigment which generally adheres well. In tempera painting the most spectacular technique to combine gilding and paint is that of sgraffito, most often used to depict cloth of gold. The whole area to be treated was gilded and burnished and then painted over with the principal colour of the textile, the pigment bound in egg tempera. The pattern was then transferred, sometimes by *pouncing, and any secondary colours added. When the tempera paint was dry, but before it became too hard, it was scratched and scraped away (sgraffito is Italian for 'scratched') from the areas of the design which were to be gold. The exposed gold could then be stippled or grained to suggest the shimmer of the threads of the textile. In an oil medium the translucency of certain pigments, notably the red and yellow lakes and the verdigris and 'copper resinate' greens, meant that they could be used as glazes to decorate areas of gold and silver leaf to produce rich and jewel-like effects. These oil glazes occur not only on northern European paintings but also on early Italian works which

are otherwise painted in tempera. Unfortunately they seldom survive in anything approaching their original condition.

Once painting was complete, draperies and forms could be further embellished with gilding. Until the 16th century this was most commonly by mordant gilding in which the lines of decoration, for example the embroidered hem of a drapery, were painted with the chosen mordant. At the appropriate moment, while the mordant was still tacky, scraps of gold leaf were laid over the area of decoration, the gold adhering to the lines of mordant but not to the dry paint beneath. Composition of mordants varied. In 14th-century Italian paintings they usually consisted of oil and resin with assorted pigments, selected both to colour the mordant and to control its consistency and drying time. Oil mordants from early in the century tend to produce distinctly raised lines. Later they became flatter and by the 15th century artists were making more use of quick-drying mordants with little bulk, based on materials such as egg yolk or white, glue, or fermented garlic juice. At about the same time, powdered gold leaf painted on in an aqueous binder, usually size, glair (egg white), or gum, and known as 'shell gold' because of the practice of keeping the paint in a mussel or similar shell, also came into increasing use. More delicate effects can be achieved than with mordant gilding and 'shell gold' is therefore particularly well suited to manuscript painting. Also more common in manuscripts, but occasionally found on panel paintings, are powdered silver and also mosaic gold, not in fact gold but a synthetically produced tin sulphide. Its particles have a dull metallic lustre, far less brilliant than that of gold.

'Shell gold' is expensive and in the 19th century imitation gold-bronze powders based on various alloys of copper, zinc, and tin were introduced. The colour varied with the alloys. From the 18th century the gold leaf used in sculpture, furniture, and frames had been available tinged with a variety of shades, from yellow, orange, and red through to blue and green, as a result of the introduction of other metals to the gold. Cheap substitutes for gold leaf such as brass were also common. These substitute materials were often used by those few 19th-century artists who included gilding in their paintings. JD

2. Sculpture

OIL, water or mordant, and fire gilding are all methods of applying gold to sculpture, and have been in use since the pre-Dynastic Egyptian period. In ancient *Greek sculpture gold leaf might have been included in *chryselephantine sculpture, as well as applied over an entire figure. In classical Rome (see ROMAN ART, ANCIENT) it continued to be used to cover or enhance figures of marble or bronze, for example *Marcus Aurelius* and *Hercules*

(Rome, Capitoline Mus.) were entirely gilt. Gold leaf was also applied over Roman terracotta or plaster figures.

In medieval and *Renaissance sculpture the use of all three methods of gilding is noted. Water gilding allows the object to be burnished to achieve a polished, shining surface. A gesso layer, mixed with size, is applied to the surface of the sculpture and allowed to set hard. After polishing to achieve a smooth skin, a reddish or pink bole is applied and this is polished again. The leaf gold is then applied onto the slightly moistened bole and finally burnished, using a hardstone shaped like a dog's tooth (usually agate). This allows traces of the bole to show through and adds to its reflective power. A linseed mordant is the common medium used for oil gilding, and this can also be coloured. The mordant is painted on and, when at the tacky stage, the leaf is applied. It cannot be burnished as in water gilding, since the fixing agent adheres too well, though the pigment enhances its colour.

German and Austrian *polychrome sculpture of the 15th and 16th centuries, particularly large carved and painted *altarpieces, frequently combine pigmented sculpture with water and mordant gilding, such as in the spectacular Boppard altarpiece (c.1500–25; London, V&A). The punching and decoration of the gilded surfaces of clothing and in haloes add to the sumptuous and brilliant effect of these altarpieces in dark churches only illuminated by flickering candles, such as Michael *Pacher's S. Wolfgang altarpiece (1471–81; S. Wolfgang in Salzkammargut, St Wolfgang). The use of decorated gilding over imitation brocades and textiles is also seen in 17th- and 18th-century Spanish polychrome sculpture, when the gilding might also be overpainted with transparent glazes to change the chromatic value of the surfaces.

Fire gilding (or its other names, mercury, amalgam, or parcel gilding, or ormolu) refers to the property of mercury to form an amalgam with gold through firing, and was used as a gilding technique for copper and silver. Despite its known hazardous side effects, it was widely used as early as the medieval period, and was described in *Theophilus' De diversis artibus (c.1110–40). Its bond with the receiving surface is greater than with water or oil gilding, and the methods were in use until the 19th century when more efficient and inexpensive methods, such as electrogilding, took over. In an early method of mercury gilding the metal to which it was to be applied needed to be scrupulously cleaned and the surface scratched to form a key for the amalgam. The mercury was applied by vigorously brushing it onto the surface of the metal. Sheets of gold laid over this surface were burnished to drive off the mercury, leaving the surface gilded (a method referred to by *Pliny). An alternative method is that of 'quicking' (a method frequently used in the 18th century), in which the clean metal is dipped in mercuric nitrate, thus precipitating the mercury onto the surface of the metal. An amalgam of gold and mercury is prepared by mixing gold filings (also called or moulu, hence the term ormolu) into a boiling mercury solution. This is applied to the metal by brushing and then being warmed, thus driving off the mercury, as well as by continuous brushing. Its matt surface could be further polished and worked.

This form of gilding might be applied to a bronze sculpture, either all over the figure, such as on the effigy of Richard Beauchamp, Earl of Warwick (1442–62; Warwick, S. Mary's), or on certain details, such as on *Donatello's relief of The Virgin and Child with Four Angels (1456; London, V&A). Spectacular examples of fire gilding are *Ghiberti's second set of doors, the so-called Gates of Paradise (1425–52; Florence Baptistery), or 18th-century French ormolu sculpted ornaments applied to furniture and objects, such as a porphyry Covered vase (c.1764; London, Wallace Coll.). HO/AB

Theophilus, De diversis artibus, ed. C. R. Dodwell (1961); reissued as Theophilus, The Various Arts (1986).
The Treatises of Benvenuto Cellini on Goldsmithing and Sculpture, trans. C. R. Ashbee (1967).

1793. His work in the political interest of his patron George Canning won him an annual pension of £200 in 1797. In 1803 Gillray created a prototype caricature of Napoleon which was widely copied by his competitors. He was insane for the last five years of his life. DER

Hill, D., Mr Gillray, the Caricaturist (1965).

GILPIN, SAWREY (1733–1807). English animal painter. Gilpin came to London in 1749 and was pupil and assistant to the marine painter Samuel Scott (1702–72) until 1758 when he was commissioned to paint horses by the Duke of Cumberland. Outshone as an animal portraitist by *Stubbs, Gilpin sought to ennoble the animal painter's role by using heroic and literary sources as in The Election of Darius (c.1772; York, AG). His success may be measured by his presidency of the Society of Artists in 1774 and his election as RA (see both under LONDON) in 1797. DER

Taylor, B., Animal Painting in England (1955).

GIMIGNANI, GIACINTO (1606–81). Italian painter and etcher. He was born in Pistoia and received his early training in Rome from Pietro da *Cortona c.1632. He was patronized by the Barberini and his earliest known work is a fresco of The Rest on the Flight to Egypt (1632) in the chapel of the Palazzo Barberini. He developed an individual classicizing style influenced by *Sacchi, under whose direction he produced the fresco of the Vision of S. Constantine in the baptistery of S. John Lateran (c.1640; in situ). He was also responsive to the more austere and precisely conceived work of *Domenichino and N. *Poussin, evident in his fresco of The Martyrdom of S. Marius and S. Martha (1641; Rome, S. Carlo ai Catinari) and his painting of the Adoration of the Magi (s.d. 1642; Burghley House, Lincs.), painted as a companion piece to the Raising of Lazarus by his father-in-law Alessandro Turchi (1578–1649), who also influenced him at this time. This Poussinesque quality may explain his popularity with French patrons, notably François Annibal d'Estrées who commissioned Rinaldo and Armida (1640; Bouxwiller Mus.). During the 1650s, Gimignani was also in Florence and Lucca; and at Pistoia he painted 25 history and biblical paintings for the Palazzo Rospigliosi (1652; in situ). HB

Brejon de Lavergnée, A., and Volle, N., Seicento: le siècle de Caravage dans les collections françaises, exhib. cat. 1988 (Paris, Grand Palais).

Fischer-Pace, U., 'Les œuvres de Giacinto Gimignani dans les collections publiques françaises', Revue du Louvre, 5/6 (1978).

GIORDANO, LUCA (1634–1705). Italian painter from Naples who acquired an international reputation within his own lifetime and was employed at Florence, Venice, and Madrid. He specialized in fresco decorations for which he would prepare numerous *modelli (and ricordi after the event), and large-scale canvases, including both religious altarpieces and secular mythologies for private collectors. In his early years he was influenced by the rugged realism of artists such as *Ribera, whose celebrated paintings of philosophers he sometimes imitated; *Preti; and *Rubens, whose work was admired and collected by Giordano's first great supporter, the merchant Gaspar Roomer. His style as a decorator reflects his study of Pietro da *Cortona, following a visit to Rome c.1652. In 1665 he visited Florence and Venice. During the 1670s he worked in many important Neapolitan churches, including S. Gregorio Armeno (c.1678–9). In 1682 he returned to Florence where he decorated the Corsini family chapel in the Carmine church, and stayed with the del Rosso family, who collected his works. It was probably during this period that he painted the monumental Death of Seneca and Rape of Europa that were acquired in 1683 by the 5th Earl of Exeter for Burghley House, (Lincs.; in situ). He was also commissioned to decorate the library and gallery of the Palazzo Medici-Riccardi, Florence, for which he began to prepare modelli (Three Fates, Manchester, AG) before rushing back to Naples to paint a vast fresco of Christ Driving the Merchants from the Temple in the church of the Gerolamini (1684). He returned to Florence the following year to complete the work at the Palazzo Medici-Riccardi. In 1692 he was invited by King Charles II of Spain to come to Madrid and was appointed court painter in 1694. He decorated the vault of the Imperial Staircase at the Escorial (1692–4), worked at the monastery at Guadalupe (1696), and decorated the ceiling of the Buen Retiro, Madrid, with the Foundation of the Order of the Golden Fleece (1697). He also painted a remarkable Homage to Velázquez (London, NG), probably inspired by Las meninas which he would have seen in the royal collection.

In 1702, following the death of the King, he left Spain and returned to Naples, where he found further work at the church of the Gerolamini; and he decorated the dome of the Cappella del Tesoro at the Certosa di S. Martino (1704) in a lighter illusionistic style that anticipates the *Rococo. Although Giordano employed many assistants, none was able to match his achievements in Naples. His influence was probably greatest in Venice, where artists such as Sebastiano *Ricci appreciated his dramatic use of space and chiaroscuro, and where the tradition of decorative painting still had a long way to run. HB

Ferrari, O., and Scavizzi, G., Luca Giordano (1996).
Ferrari, O., in C. Whitfield and J. Martineau (eds.), Painting in Naples from Caravaggio to Giordano, exhib. cat. 1982 (London, RA).

GIORGIONE (Zorzi da Castelfranco) (1477/8–1510). Venetian painter, who initiated the High *Renaissance style in northern Italian art. He left his birthplace Castelfranco at an early age to study with Giovanni *Bellini in Venice, where he painted one of his earliest commissions, the Castelfranco altarpiece (Castelfranco Cathedral), which he sent home to his patron, Tuzio Costanzo, a Cypriot condottiere, c.1498. According to *Vasari and other biographers Giorgione had a genial personality, and a handsome presence with fashionable hair worn to his shoulders. Confirmation of his biographers' testimony may be found in his own Self-Portrait as David (Brunswick, Herzog-Anton-Ulrich Mus.), the first allegorical portrait of an artist in Venetian art.

From his earliest works Giorgione was remarkably innovative. He introduced pastoral *landscape into the backgrounds of most of his paintings, beginning with the panels of the Judgement of Solomon and the Trial of Moses (Florence, Uffizi), c.1496, where religious and classical scenes take place against a Veneto landscape, irrespective of the source for the subject. These very early works together with the slightly later Allendale group, that is the Allendale Adoration of the Shepherds (Washington, NG) and the Benson Holy Family (Washington, NG), demonstrate a novel approach to the construction of figures in a landscape. As original as his approach to landscape was Giorgione's new allegorical conception of portraiture, and his representations of women in such portraits as the Portrait of a Woman, Called Laura (Vienna, 1506; Kunsthist. Mus.). In his painting on a small door of Judith (St Petersburg, Hermitage), he introduced the subject of the Jewish heroine of the Apocrypha to Venetian painting, while in his Sleeping Venus in a Landscape (c.1507, and reworked by *Titian in 1510; Dresden, Gemäldegal.) he created the first erotic sleeping nude in Venice, to celebrate a marriage theme that was to become constantly repeated in paintings by Titian and other artists. Within a brief lifespan of some 30 years Giorgione, though of humble birth, managed to find favour with a number of patrician patrons in Venice, who commissioned modish small cabinet pictures of secular subject matter, such as the Tempesta (Venice, Accademia) and the Three Philosophers (Vienna, Kunsthist. Mus.). These easel paintings are described for the first time in the notebook of a patrician collector Marcantonio Michiel, who recorded them several decades after Giorgione's death. Within the history of art

these two works have inspired more iconographical readings than any other Renaissance painting.

Contemporary documentation of his works is slight, which has led to considerable controversy. There is an inscription on the reverse of the Portrait of Laura which dates the portrait to 1 June 1506. Vasari describes a stylistic change in Giorgione's work about 1507, at a time when he was commissioned to paint a canvas for the Audience Hall in the Palazzo Ducale, destroyed in the fire of 1577, and the subject of which is unrecorded. In 1508 he is known to have received the prestigious commission for a series of frescoes of large flaming red nudes on the façade overlooking the Canal Grande of the German Customs House in Venice, the Fondaco dei Tedeschi, located near the Rialto bridge, which were among the most prominent and discussed works in Venetian art. Only one of these frescoes of fiery female figures survives, a monumental female nude (Venice, Gal. Franchetti alla Ca' d'Oro); while another possible fragment from the building of a Cupid Tapping Apples is at Saltwood Castle (priv. coll.). Vasari states that Giorgione saw some things by *Leonardo da Vinci's hand that were very soft, dark, and shadowy; this Leonardesque style pleased Giorgione so much, that while he was alive he pursued it. Giorgione's indebtedness to Leonardo's drawings is manifest in terms of precisely derived motifs, but also in conceptual and theoretic issues relating to portraiture and the *paragone, the debate concerning the competition between painting and sculpture to demonstrate the superiority of one medium over another. From Vasari we also know that Giorgione dispensed with preparatory drawing on paper and worked out his compositions on canvas as he went along, in a way which was later followed by his pupil Titian. Vasari's testimony is confirmed by the absence of drawings on paper, and by infra-red photography which reveals underdrawing, executed with the tip of a brush in the Allendale Adoration and Benson Holy Family. Other paintings which have been shown to have curious underdrawings are the Terris Portrait, c.1500 (San Diego, Mus. of Art), and the Three Ages of Man (Florence, Pitti).

The most explicit text we have regarding Giorgione's inventions is the Dialogue on Painting by a Venetian theorist Paolo *Pino, published in 1548, where he defines Giorgione's style of painting as being one of poetic brevity. He contrasts it with the cluttered historical style of artists of the generation of Giovanni Bellini and *Carpaccio. The stylistic idea of brevity relates to how subjects are invented and depicted without too much detail, thereby creating many problems for *iconographers; how subjects are represented with a novel technique, for he had a spare chalky way of applying paint to the

canvas, which resulted in innumerable problems for conservators in later centuries. Giorgione's commitment to theory is manifest in conceptual issues relating to portraiture and the *paragone*, the debate concerning the competition between painting and sculpture, in his case to demonstrate the superiority of painting by the most poetic and refined means possible. JA

Anderson, J., *Giorgione: The Painter of 'Poetic Brevity'* (1997).

GIOTTO DI BONDONE (c.1267–1337). Italian painter. Ever since Dante's allusion to his Florentine contemporary's ascendant fame in the *Divine Comedy* (*Purgatorio* 11. 94), Giotto's status as the seminal figure in the revival of the visual arts in Italy has remained virtually unchallenged. Trecento humanists like *Petrarch and *Boccaccio initiated a process by which the explanation of Giotto's superiority became integral to the development of the vocabulary and discipline of art history itself. Petrarch's insistence on Giotto's possession of *ingenium*, that his work, 'which the ignorant cannot understand, but which stuns the masters of this art' exhibits qualities of intellectual distinction hitherto not associated with the 'mechanical' art of painting, was instrumental in the acceptance of the visual arts as the equivalent of the ancient liberal arts and the identification of Giotto as the founding father of *Renaissance painting. His status and its significance for his successors was acknowledged by the artists of the High Renaissance: explicitly in *Leonardo's notebooks and implicitly in *Michelangelo's early drawings after Giotto and *Masaccio. This settled tradition, further supported by Florentine patriotic historiography, and which received definitive statement in *Vasari's *Vite* (2nd edn. 1568), has tended to blur the traceable outlines of Giotto's career and artistic character. The old story of his 'discovery' by *Cimabue is unconvincing, at least in isolation; more likely is wider formative exposure to the art of late duecento Rome; to *Cavallini and the Isaac *Master, as well as to Giotto's compatriot *Arnolfo di Cambio. Giotto's place in the history of Western art is more complex than the received tradition allows. His work involves no systematic rejection of the adventurous styles of northern *Gothic and recent *Byzantine art, nor did it rise, meteor-like, from an artistic Dark Age. Most component features of his style have identifiable precedents. His supreme and lasting significance rests instead on the quality and integration of his synthesis of existing models and the vigour with which he developed them.

The nature of Giotto's early style is inextricably bound up with the long-standing and problematic attribution to him of the *Legend of S. Francis* fresco cycle in the upper church of S. Francesco in Assisi (see ASSISI, BASILICA OF S. FRANCESCO; MASTER OF THE S. FRANCIS LEGEND; MASTER OF S. CECILIA). While the likely chronological window for the S. Francis cycle (probably mid-1290s; by 1307 at the latest) might allow for Giotto's participation prior to his work in Padua, there are difficulties involved in reconciling the encyclopedic naturalism of the Assisi frescoes with the style of the frescoes in the Arena chapel in Padua, painted between 1305 and 1313, whose qualities of narrative concentration and pictorial control form the basis of Giotto's subsequent reputation. More persuasive is the widespread attribution of a *Crucifix* of c.1290–1300 (Florence, S. Maria Novella) which exhibits overt *classicizing tendencies in the terminal *S. John* and a more or less wholesale modernization of duecento formulas for the representation of the dead Christ. This apart, the earliest work which can be attributed to Giotto with anything like certainty is the decoration of the Arena chapel in Padua, for which there is an uncontested attributional history dating back to Riccobaldo Ferrarese's *Compilatio* of 1313.

The Arena chapel, built among the ruins of the Roman amphitheatre, was originally attached to the now demolished palace of its builder, Enrico Scrovegni. The plain brick structure, barrel-vaulted and lit by six lancet windows in the south wall, is otherwise largely devoid of architectural embellishment; the interior, with the exception of the small choir, entirely given over to Giotto's frescoes. Three tiers of narratives run round the chapel, from top to bottom, illustrating the *Life of the Virgin*, the *Life and Ministry of Christ*, and the *Passion*. A *Last Judgement* fills the entrance wall and the dado level has grisaille figures of the *Virtues and Vices* set in a fictive marbled framework. Flanking the choir arch are a pair of *trompe l'œil* 'chapels', examples of the kind of advanced pictorial *illusionism which underpins much of the trecento praise of Giotto's work. Giotto's intellectually rigorous and selective *naturalism informs the frescoes at every level, from the carefully controlled illusionism of the whole cycle: spatial settings and directional lighting conforming to an overall order; to the handling of individual scenes like the *Mocking of Christ*, in which the compositional clarity and spatial control meet the demands of the narrative at every point. The complete absence of superfluous detail allows the unexaggerated gestures of the participants to register with full dramatic force. The space is legible and coherent, the forms within it tactile, weighty, and active. The figure of Pilate draws, appropriately enough, on *Antique sources, and the clear individuation of the seven tormentors of Christ testifies to unprecedented powers of psychological realism. Giotto's grasp of the third dimension has its immediate precedents, but nowhere in duecento Rome or Assisi had so powerful and controlled a synthesis been achieved.

Giotto's career is sparsely documented, but the overall profile is reasonably clear from 1301, when he is noted as living in the parish of S. Maria Novella in Florence, in which city he is recorded sporadically until 1326. Between 1328 and 1333 he served as court painter to King Robert 'The Wise' of Naples. In 1334 he was appointed *capomaestro* of Florence Cathedral, whose campanile incorporates designs which are probably his. A great deal of Giotto's work from the post-Paduan years is lost, including all his Neapolitan frescoes. A substantial body of frescoes in the lower church at Assisi has been overlooked in many accounts of his work on the basis of anachronistic modern divisions between supposed autograph work and the products of assistants. The frescoes of the Magdalen chapel at Assisi show an expansion of a number of Paduan compositions, and the right transept vault frescoes of the *Presentation in the Temple* and *Christ among the Doctors*, which may be dated to the second decade of the century, establish a standard of spatial representation which denotes a rapid development from the Arena frescoes and which was only occasionally matched (Pietro and Ambrogio *Lorenzetti in Siena; *Altichiero and Giusto de' *Menabuoi in Padua) until the quattrocento. In Florence itself Giotto's maturity is represented by the large *Madonna* of c.1310–15 for the church of Ognissanti (Florence, Uffizi); by the *Coronation* altarpiece in the Baroncelli chapel of S. Croce; and by the frescoes of the adjacent Bardi (c.1315–20) and Peruzzi (c.1320) chapels. The *Ognissanti Madonna* reinvents the vertical *Maestà* format of *Cimabue's *S. Trinita Madonna* and *Duccio's *Rucellai Madonna* of 1285 (both Florence, Uffizi) in terms of the monumental clarity and tactile power of the Arena frescoes. The Bardi and Peruzzi frescoes, six per chapel and laid out on an expansive scale, develop in quite different ways some of the many compositional and spatial formats first mooted in Padua. The Bardi frescoes of the *Life of S. Francis* represent the zenith of Giotto's organizational powers: large-scale figure compositions in expansive settings. The Peruzzi chapel narratives of the *Lives of SS John the Baptist and Evangelist* were painted substantially on dry plaster (*a secco*), which, allowing as it does more flexible painting conditions, may reflect their greater visual complexity. The Peruzzi chapel *Raising of Drusiana*, with its great receding background wall, powerfully articulating the foreground narrative, but establishing ambitious and persuasive relationships of scale and distance hitherto never attempted, and with the unprecedented

grandeur of its figures, is a highpoint of Renaissance painting. JR

Basile, G., *Giotto: The Arena Chapel Frescoes* (1993).
Cole, B., *Giotto and Florentine Painting* (1976).
d'Arcais, F., *Giotto* (1996).
Previtali, G., *Giotto e la sua bottega* (1974).

GIOVANNI BOLOGNA. See GIAMBOLOGNA.

GIOVANNI DA MILANO (Giovanni da Como) (active *c*.1346–69). Italian painter responsible for several major altarpieces in Florence during the 1360s. His most important work is the Ognissanti Polyptych (*c*.1363; dispersed, several panels in Florence, Uffizi), a large altarpiece with six pairs of saints flanking the Virgin and Child, which was commissioned to replace *Giotto's *Ognissanti Madonna*. It has been suggested that a more stylized, hieratic manner dominated Florentine painting in the years after the Black Death of 1348, yet Giovanni's work retains a simplicity and massiveness associated with the school of Giotto and a refined linear sense, possibly derived from *Simone Martini. These features are well illustrated in *Christ of the Apocalypse*, a panel from a dismembered polyptych of *c*.1365, now in the National Gallery, London. PSt

GIOVANNI DA SAN GIOVANNI (Giovanni Manozzi) (1592–1636). Italian painter. He was the most distinguished fresco painter working at Florence in the 17th century. His essential provincialism as an illustrator of religious subject matter for Tuscan churches is redeemed by his capacity to portray scenes of country life and lyrical pastoral landscapes. This is visible in his scenes from the life of the Virgin (1621) in the chapel of the Palazzo Mainoni-Guiccardini at Vico di Val d'Elsa and his *Holy Family Arriving at an Inn*, originally painted for the chapel of the convent at la Crocetta, Florence (*c*.1621; now Florence, Accademia). Shortly after completing these commissions he went to Rome where he received influential patronage from Cardinal Bentivoglio. He painted a number of unusual burlesque subjects for private patrons, including the *Marriage Contract* (Rome, Barberini Gal.) and the *Parish Priest Arlott Mainardi Playing a Joke on some Huntsmen* (Kedleston, Derbys.), which reflects his interest in the Bamboccianti artists. Reputedly commissioned but rejected by Cardinal Barberini, it was given to Giovanni Francesco Grazini who on the artist's return to Florence in 1628 had engaged him to decorate the courtyard of the Villa del Pozzino at Castello with rustic scenes from Apuleius' *Metamorphoses, or The Golden Ass*. By 1635 he was working at the Palazzo Pitti on frescoes celebrating the wedding of the Grand Duke Ferdinand II but died before the project was completed. HB

Mannini, M., and d'Afflitto, C., *Giovanni da San Giovanni*, exhib. cat. 1978 (Sesto Fiorentino, Vico d'Elsa).

GIOVANNI DA UDINE (1487–1564). Italian painter, decorative artist, and architect. Born at Udine, he entered *Raphael's workshop in Rome and was put in charge of the two chief decorative undertakings of the Raphael School, the Vatican Loggias (1517–19) and the Villa Madama (1520). Inspired by archaeological discoveries in Rome such as the ancient grotesques in the Baths of Titus, he evolved a light and graceful decorative style in stucco and fresco. Later he returned to Udine, where he worked both as decorator and architect, in 1552 being made responsible for all public architectural undertakings there. His decorative style, propagated throughout Italy by the activity of his colleagues, was imitated all over Europe by 18th-century *Neoclassical designers. HB

GIOVANNI DI BALDUCCIO (active 1317–49). Italian sculptor. Giovanni's origins lie in Pisa, where he is recorded in 1317 working in the Opera del Duomo. From here he travelled throughout Tuscany and beyond, but his historical importance rests on the work he did after *c*.1334 in Lombardy, where he introduced the new sculptural language of the *Pisani and their followers. His major Lombard work is the elaborate tomb of S. Peter Martyr (1335; Milan, S. Eustorgio), based, as the Milanese Dominicans explicitly required, on the shrine of S. Dominic by Nicola Pisano's workshop (*c*.1265; Bologna, S. Domenico). The sarcophagus, with eight reliefs separated by standing *Saints*, is raised above eight caryatid figures representing *Virtues*. Its sloping lid is flanked by eight more figures and topped with a three-bay tabernacle containing a seated *Virgin and Child* with *SS Dominic and Peter Martyr*. The qualitative gulf between the best work, like the refined and beautifully poised *Virtues*, combining the expressive mobility of Giovanni Pisano with the gravity of *Arnolfo di Cambio, and the sections carved by Giovanni's local assistants reinforces the supremacy of the Pisan sculptural tradition in this period. JR

Pope-Hennessy, J., *Italian Gothic Sculpture* (4th edn., 1996).

GIOVANNI DI PAOLO (*c*.1399–1482). Sienese painter and illuminator, close in style to *Sassetta. His lyrical figure style and archaic yet charming settings contribute to an effect of spiritual elevation.

He is documented as illustrating a book of hours in 1417, and by the 1420s was painting altarpieces which are within the Sienese tradition of *Simone Martini and *Taddeo di Bartolo. They display sinuous, sometimes agitated, line and decoration, with little concern for Florentine spatial developments. Predella panels (New York, Met. Mus.) are in fact close to the late Gothic delicacy and detail of *Gentile da Fabriano.

Later works, such as scenes from the life of S. John (London, NG), show, increasingly the influence of Sassetta in their use of smoother line. Two of these panels derive from reliefs for the Siena Baptistery font by *Ghiberti and *Donatello and while Giovanni was interested in their illusionistic spatial settings, he was primarily concerned with decorative effects. In a panel depicting *S. John in the Desert* logical proportion and perspective are disregarded and colour is limited, unrealistically, to red and green.

In *The Last Judgement* (1463; Siena, Pin.) Sienese and Gothic elements are combined with Renaissance features inspired by Fra *Angelico, producing a gorgeous and elegant vision of Paradise. MS

Christiansen, K., Kanter, L. B., and Stuhlke, C. B., *Painting in Renaissance Siena, 1420–1500*, exhib. cat. 1988–9 (New York, Met. Mus.).

GIOVIO, PAOLO (1483–1552). Italian historian, biographer, professional courtier, man of letters, and witty conversationalist. Giovio was a colourful *Renaissance personality, who, after working as a doctor in his native Como, played a busy role in the *humanistic milieux of Rome (1512–51) and Florence. His most influential achievement was his museum of portraits of famous men, open to the public, for which he built a villa near Como (1537–40; destr.) on a site associated with *Pliny. It included portraits of men of letters, dead and living; artists and wits; popes, kings, and generals; he composed written lives, or elogia, to accompany the portraits. Giovio's *Museum* was part of the Renaissance cult of glory, and became the prototype for many later portrait collections of famous men. He enjoyed the company of artists, such as *Pontormo and *Bronzino; he supervised *Vasari's frescoes of the life of Paul III (Rome, Cancelleria) and encouraged Vasari to record the lives of artists. His *Dialogo dell'imprese*, created for courtiers, became a popular and basic work on chivalric devices. HL

Zimmermann, T. C. P., *Paolo Giovio* (1995).

GIRALDI, GUGLIELMO (active 1445–89). Italian illuminator. He was documented in Ferrara from 1445 to 1477 where he was one of the favourite illuminators of Borso d'Este and worked on books not only for the Duke's own use but for the Certosa and the cathedral. Some of his finest work from this period is the sequence of paintings in the lower margins of the *Aeneid* in the Virgil made for Leonardo Sanudo, the Venetian

representative at Borso's court (1458; Paris, Bib. Nat., MS lat. 7939A). They already show the mastery in rendering space and the narrative invention that find their most remarkable expression in Giraldi's miniatures in the *Divine Comedy* (c.1480: Vatican, Bib. Apostolica, MS Urb. lat. 365) illuminated for Federigo da Montefeltro, Duke of Urbino. Giraldi was recorded working in the Duke's library in 1480.

Although the influence of the Ferrarese painters Cosimo *Tura and Francesco del *Cossa is sometimes detected in his work, his is a distinctive style with carefully spaced figures often clothed in rhythmic, vertical drapery folds; the figures and setting suffused with a warm light. KS

The Painted Page: Italian Renaissance Book Illumination 1450–1550, exhib. cat. 1994/5 (London, RA; New York, Pierpont Morgan Lib.).

G IRARDON, FRANÇOIS (1628–1715). French sculptor. He studied in Rome at the expense of Louis XIV's Chancellor Séguier and from about 1650 worked in the Paris studio of the *Anguier. His talents and his early association with Charles *Le Brun, future First Painter to the King, led to his rapid rise to pre-eminence. He worked with Le Brun at the Château de Vaux-le-Vicomte, where the opulent *classicism that found its finest expression at *Versailles was first developed. From the 1660s Girardon contributed major works to the gardens and palace at Versailles, among them the marble group *Apollo Tended by the Nymphs*, inspired by Hellenistic prototypes, as well as spectacular fountains. Although the Apollo group is often thought of as the most purely classical work of French 17th-century sculpture, Girardon's style was remarkably flexible. *The Rape of Persephone*, also at Versailles, is a controlled answer to *Bernini's similar group, while his tomb of Cardinal Richelieu in the chapel of the Sorbonne, Paris, combines Baroque theatre with a gravity that makes it the finest French funerary monument of its time. Girardon's later works, such as the magnificent equestrian statue of *Louis XIV* (1685–92; destr.) for what is now the Place Vendôme in Paris, continue the trend towards a more dynamic concept of sculpture that was most fully exploited by his younger rival *Coysevox. Girardon was also a notable collector of sculpture. MJ

Francastel, F., *Girardon* (1928).
Souchal, F., *French Sculptors of the 17th and 18th Centuries: The Reign of Louis XIV*, vol. 2 (1981).

G IRODET DE ROUCY, ANNE-LOUIS (called Girodet-Trioson) (1767–1824). French painter. He studied with *David and won the *Prix de Rome in 1789. He was in Italy from 1790 to 1795, visiting Naples and Venice as well as Rome. While in Rome he painted *The Sleep of Endymion* (1792; Paris,

Louvre), a work in which the robust *Neoclassicism of his master is given a romantic and dreamlike quality by his elongated treatment of the nude figure of Endymion and the silvery moonlight effect that bathes it. On Girodet's return to Paris he was regarded as one of the brightest hopes of the French School. Yet while employing the technique of David he continued to move into eerie and sometimes hallucinatory realms with such paintings as *Ossian Welcoming the Ghosts of Fallen Officers of the Empire* (commissioned by Napoleon for Malmaison in 1801) and *The Entombment of Atala* (1808; Paris, Louvre). The latter was a subject taken from Chateaubriand, of whom Girodet painted a brooding portrait (St Malo, Mus. des Beaux-Arts). Thus despite being, after David's exile in 1815, one of the leaders of the Neoclassical school he was much admired by the painters of the *Romantic generation, who as well as his publicly exhibited paintings knew his work through his book illustrations to Anacreon, Virgil, and Racine. MJ

Bernier, G., *Anne-Louis Girodet, Prix de Rome 1789* (1975).
Girodet, exhib. cat. 1967 (Montargis, Mus. Girodet).
Rosenberg, P., *De David à Delacroix: la peinture française de 1774 à 1830*, exhib. cat. 1974 (Paris, Grand Palais).

G IROLAMO DA CARPI (Girolamo Sellari) (1501–c.1556). Italian painter and architect. He was trained as a painter at Ferrara in *Garofalo's workshop. From 1525 he worked extensively in Bologna, developing a style in which his Ferrarese origins are overlaid with the strong influence of *Raphael's Roman workshop. *Parmigianino's influence is also obvious, both in his uneasily tense portraits and in his religious commissions, of which the *Adoration of the Magi* (1532; Bologna, S. Martino) is characteristic.

From 1530 he was often at Ferrara, and was an architect for the Palazzo Naselli-Crispi. In 1537 he returned there permanently to work for the ruling house of Este, usually in collaboration with other established painters such as Garofalo and Battista 'Dossi. In 1549 he was with Cardinal Ippolito II d'Este in Rome where he made many architectural and antiquarian drawings. In 1550 he worked on the modification of the Belvedere at the Vatican for Pope Julius III. By 1553 he was back in Ferrara and working on the rebuilding of the Este castle. AJL

Briganti, G. (ed.), *La pittura in Italia: il cinquecento* (1987).

G IROLAMO DA CREMONA (active 1451–83). Italian illuminator and painter. He was one of the most significant illuminators of northern Italy. His training and early career were in Padua but throughout his life

he travelled to centres in northern and central Italy taking part in some of the most ambitious projects of book illustration. He was called to Ferrara to work on the Bible of Borso d'Este (completed 1461; Modena, Bib. Estense MS VG 2–13, lat. 422–3): in Siena he worked alongside *Liberale da Verona on the choirbooks for the cathedral (1470–4; Siena, Bib. Piccolomini): he illuminated luxury copies of works printed in Venice, for example the Aristotle of 1483 (New York, Pierpont Morgan Lib., ChL907).

Throughout his mature career his figure style and crisp description of forms and details seem influenced by *Mantegna, who in 1461 had recommended Girolamo to Barbara, Marchioness of Mantua; his border style and page design was always lush and included jewels, goldsmith's work, and rich optical effects. In his Venetian frontispieces, the most remarkable and inventive of his late works, he combined these in *trompe l'œil* layouts treating areas of the page as though at different depths and different levels of reality. KS

The Painted Page: Italian Renaissance Book Illumination 1450–1550, exhib. cat. 1994/5 (London, RA; New York, Pierpont Morgan Lib.).

G IROLAMO DAI LIBRI (1474/5–1555?). Italian illuminator and painter. He was the son of the Veronese illuminator Francesco dai Libri and documents suggest that he lived his entire life in Verona. According to *Vasari, Girolamo was already renowned at the age of 16, and a large body of work, including panel paintings as well as manuscripts, has been attributed to him. Some of the miniatures believed to be early works, for example the Antiphonary for SS Nazarius and Celsus (1492: London, V&A, MS AM 4929–1866), are relatively subdued but his finest works could be characterized as showing serene and accomplished compositions within initials constructed from involved and fantastic forms. For example the cutting of an initial 'B' containing *King David* (London, V&A, E. 1168–921) has initial staves of blue shading to green composed of scaly dragons, tails entwined, trying to consume a crested triton. Many of Girolamo's manuscript commissions survive only as isolated cuttings removed from choirbooks. KS

The Painted Page: Italian Renaissance Book Illumination 1450–1550, exhib. cat. 1994/5 (London, RA; New York, Pierpont Morgan Lib.).

G IRTIN, THOMAS (1775–1802). English landscape painter in watercolour. Girtin's early style was influenced by his teacher, the topographical watercolourist Edward Dayes (1763–1804). It developed after contact with Dr Thomas Monro of Adelphi Terrace, London, who employed him (and *Turner) to copy drawings by J. R. *Cozens. Girtin was an

original member of the Sketching Club, founded in May 1799; it was a group of professional and amateur artists which met weekly in London to illustrate poetic passages with landscape compositions. From 1794 he exhibited regularly at the RA, his watercolours based on numerous pencil studies made on tours of the north of England, Scotland, the west of England, north Wales, and Yorkshire. A trip to Paris (Nov. 1801–May 1802) resulted in many impressive studies, 20 being etched by Girtin for *Picturesque Views in Paris* (1803). His *Eidometropolis*, a large circular panorama of London painted on canvas from watercolour studies, was exhibited late in 1802. Girtin's mature style introduced a new force into watercolour painting, enhancing its status and giving it a more competitive edge with oil painting. His dramatic use of light and shade, broadly massed forms, and naturalistic weather effects influenced a new generation, including John Varley (1778–1842) and J. S. *Cotman, after his untimely death in November 1802, aged 27.　　　　　　　　　　MP

Girtin, T., and Loshak, D., *The Art of Thomas Girtin* (1954).

GISANT (French: recumbent), a tomb effigy dating from the 14th century onwards, when effigies were carved in high relief, with great attention to naturalistic detail. The figure's hands were in prayer; a second figure, kneeling in prayer (the orant), could be placed on the tester.　　　　NC

GISLEBERTUS (active *c.*1125–35). Sculptor responsible for the west and north portals and around 60 capitals in the Cathedral of S. Lazare at Autun. His status is implied by the prominent inscription immediately beneath Christ on the west tympanum: 'Gislebertus hoc fecit'. Trained in the Burgundian style of Cluny and Vézelay, where he may have worked, he developed a dramatic and expressive manner which was to inspire other Burgundian sculptors and, through its tender humanity, contribute towards the development of *Gothic. The west tympanum depicts the *Last Judgement*, dominated by a massive figure of Christ separating the chosen from the damned. The visionary character of the work is emphasized by extreme contrasts in the size of the figures around Christ. In the outer zones of the arch are the seasons, labours of the months, and signs of the zodiac.

The lintel of the now fragmentary north doorway showed the *Temptation* and *Fall*. The surviving figure of Eve (Autun, Mus. Rolin) demonstrates the exceptional and inventive talents of Gislebertus, for she is shown as a large-scale reclining nude, without parallel in medieval art. The capitals from portals and

nave are carved as linked narrative sequences of Bible scenes, further evidence of Gislebertus' innovative combination of plastic and decorative values.　　　　CMH

Grivot, G., and Zarnecki, G., *Gislebertus, Sculptor of Autun* (1961).

GIULIO ROMANO (Giulio Pippi) (*c.*1499–1546). *Mannerist painter who worked in Rome and Mantua. Born in Rome, he entered *Raphael's shop as a teenager. A precocious talent, he played an increasing part in the execution of Raphael's decorative projects, such as the Stanza dell'Incendio (*c.*1516–17), the Psyche Loggia in the Farnesina (1518), and the Vatican Loggia (finished 1519). Giulio's early style, both in paint and chalk, is extremely close to that of Raphael. And in a number of small-scale commissions executed towards the end of Raphael's life, such as the *Madonna della Perla* and the *Madonna della Quercia* (both Madrid, Prado), it is difficult to determine if they are collaborative works, or wholly by Giulio.

Following Raphael's death, Giulio and the shadowy Giovanni Francesco *Penni took control of his studio and all its commissions. The most prestigious of these was the Sala di Costantino, the largest of all the Vatican Stanze, named after the four large frescoes depicting scenes from the life of the Emperor Constantine. The Emperor's vision of the cross, and the splendidly animated scene of his victory at the Milvian bridge, were painted mainly by Giulio based on Raphael drawings. The compositions of the remaining frescoes, the *Donation* and *Baptism of Constantine* (1523–4), lack the coherence of those initiated by Raphael. During this period Giulio also painted independent works, like the *Holy Family with Saints* (Rome, S. Maria del Anima), which are close in style to Raphael's late *Leonardesque manner.

In 1524 Giulio left Rome for Mantua where he was to serve as the court painter and architect to the Gonzaga family for the rest of his life. His most important work there was the design and decoration of the Palazzo del Te (1526–35). His work there is typical of the new Mannerist style, both for the overall decorative conception that unites architecture, painting, and stucco (an idea taken up by his pupil *Primaticcio in *Fontainebleau); and the exaggerated theatricality of the effects—most famously in the Sala dei Giganti, where the illusion (see ILLUSIONISM) of falling masonry threatens to crush both the giants and the spectator alike. Giulio relied mainly on assistants to execute the enormous fresco decorations in the Palazzo del Te and the Palazzo Ducale, and they rarely possess the verve of his preparatory drawings. His imaginative brilliance is most apparent in his inventive and often witty designs for

furniture and metalwork.　　　　HCh

Giulio Romano, exhib. cat. 1989 (Mantua, Palazzo Te and Palazzo Ducale).
Hartt, F., *Giulio Romano* (1958).

GIUNTA (DI CAPITINO) DA PISA (or Giunta Pisano) (active 1236–54). The most important identifiable Italian large-scale painter before *Cimabue, given his absolute mastery of Byzantine *icon-painting technique. In 1239 his son Leopardo, a priest, was in Rome, indicating that Giunta was born *c.*1180–90. His certain œuvre is confined to three signed Crucifixes, the earliest related to one formerly dated 1236 in the basilica of S. Francesco, Assisi (Assisi, S. Maria degli Angeli). Giunta painted a similar but more mature work for the shrine of the Dominican founder (Bologna, S. Domenico), both works being notable for a remarkably assured cursive brushwork very different from the tight linearity of Lucchese and Florentine duecento artists. Only the Christ of the third Crucifix (Pisa, S. Raniero from S. Anna) is autograph, but all three are remarkable for their subtle chiaroscuro modelling. Altarpieces of *S. Francis* in Assisi, the Vatican, and Pisa have been attributed to Giunta without general agreement, but his influence on many Crucifixes painted in Umbria and Bologna is self-evident.　　　　RG

Campini, G, *Giunta Pisano Capitini e le croci dipinte romaniche* (1966).
Garrison, E., *Italian Romanesque Panel Painting* (1949).
Tartuferi, A., *Giunta Pisano* (1991).

GIUSTI, ALESSANDRO (1715–99). Italian sculptor active in Portugal. He was called to Portugal around 1744 to supervise the assembly of the chapel of S. John the Baptist in S. Roque, Lisbon, a work ordered from Luigi Vanvitelli and Nicola Salvi in Rome. His principal work for the Portuguese crown was the replacement of the painted altarpieces at the Palace-Convent of Mafra with marble reliefs. Begun in 1750, the sequence of reliefs was nearing completion when Giusti went blind in 1791. The school that he established at Mafra produced the sculptors who dominated the art in Portugal well into the 19th century.　　　　MJ

Carvalho, A. de, *A escultura de Mafra* (1950).

GIUSTO BETTI, GIOVANNI DI. See JUSTE, JEAN.

GLACKENS, WILLIAM (1870–1958). American draughtsman and painter. After training at the Pennsylvania Academy Glackens worked as a reporter-illustrator on his home town paper the *Philadelphia Press*. In 1891 he met the charismatic Robert *Henri

who encouraged him and his fellow illustrator John *Sloan to paint scenes from everyday life. Glackens followed Henri to New York in 1904 and became associated with the New York realists, The *Eight, and the *Armory Show (1913). During a stay in *Paris in 1895 Glackens had been deeply influenced by French *Impressionism, clearly demonstrated in his homage to *Manet, *Chez Mouquin* (1905; Chicago, Art Inst.) with its echoes of *A Bar at the Folies-Bergère*. Like the Impressionists, and unlike his fellow *realists, he painted cheerful bourgeois pastimes, such as the elegant promenade of *The Drive, Central Park* (1905; Cleveland, Mus. of Art). By 1910, when he painted *Nude with Apple* (New York, Brooklyn Mus.), *Renoir's influence and palette predominated. From 1912 Glackens, who had continued to work as an illustrator, was employed by the millionaire collector Albert Barnes (1872–1951), for whom he purchased paintings, including works by *Cézanne and van *Gogh, in Europe. DER

Gerdts, W. H., *William Glackens* (1996).

GLASS. See SUPPORTS.

GLASS PRINTS (or *clichés-verre*) are made by exposing sensitized photographic paper to the sun beneath a glass plate on which the artist's design has been drawn. The glass is covered with an opaque ground, and the design is drawn on it with a fine point, leaving the glass transparent where the lines are to appear. The result is close to etching, but lacking relief. Its very limited history is mainly confined to France in the 1850s, when it was practised by *Daubigny, *Millet, Théodore *Rousseau, and most notably, *Corot.

A different technique of glass prints, sometimes called glass transfer pictures, was evolved in 18th-century Britain. A print was glued to a sheet of glass, the paper carefully rubbed away, and the back of the print adhering to the glass was coloured on the back. These were framed as decorative prints, and were usually cheap portraits or trivial genre subjects. RGo

GLAZE, a transparent, or more precisely translucent, paint which allows the colour of any underlying layer to play a part in the final effect. Glazes can be made only from certain pigments which, because of their optical properties, form a translucent paint film when combined with drying oils and resins. The most important glaze pigments in earlier techniques are the red and yellow lakes, the verdigris and 'copper resinate' greens, and some organic brown colours. Various modern equivalents are now available. When used in media such as egg tempera these pigments are insufficiently transparent to make true glazes. Paints made

with opaque pigments, for example lead white, can be applied thinly so as not to obscure underlying colours, but in this case the translucency is a function of the thinness of the layer and not the optical properties of the pigment, and so it should properly be called a scumble. However, the term glaze is often used inaccurately to mean any translucent paint layer, regardless of its colour and composition. JD

GLEIZES, ALBERT (1881–1953). French painter and writer. He began painting in an *Impressionist manner but by 1909 was associating with Henri *Le Fauconnier and Jean *Metzinger with whom he would later found the *Cubist *'Section d'Or' group. Under their influence his work gained more emphatic structure and volume, and by 1911, when he exhibited with the Cubists at the *Paris Salon des Indépendants, his style had become increasingly abstract and fragmentary: *The Man on the Balcony* (1912; Philadelphia Mus.). This development continued towards the end of the decade and gained a more dynamic quality, based on an interest in circular movement, as in *The Lorraine Pitcher* (1915; priv. coll.). While in America, where he stayed between 1915 and 1919, he experienced a religious conversion, and a new interest in religious thought entered his theoretical writings. Throughout his life Gleizes was invested with great proselytizing spirit and a strong belief in the importance of art in society; his writings include the important theoretical text *Du Cubisme*, on which he collaborated with Metzinger (1912). MF

Alibert, P., *Albert Gleizes: naissance et avenir du Cubisme* (1982).

GLOCKENDEN FAMILY. German illuminators and printsellers active in Nuremberg at the end of the 15th and the beginning of the 16th century. **Georg I** (active 1484–1514), son of Albrecht Glockenden I, was a painter, printer, and woodblock cutter. Although his illuminated books were praised, he is now best known for his print publishing and the *Erdapfel* (1491–2; Nuremberg, Germanisches Nationalmus.), the oldest extant terrestrial globe, which he painted with his wife. One of his two sons, **Albrecht II** (active 1506?–45), assumed control of his father's workshop on the latter's death, reissued his father's *Von der Kunst Perspectiva* in 1540, and published woodcuts by other Nurembergers. His illuminations for the Prayer Book of Hans Imhoff (1522; Nuremberg, Stadtbib., MS Cent. V Append. 76) are particularly noted. His brother **Nikolaus** (active 1515–34) became the leading illuminator in Nuremberg after the death of Jakob Elsner in 1517. Many of his works are signed; like his brother's, his works show the influence of Simon *Bening. Nikolaus's most significant

patron was Cardinal Albrecht von Brandenburg for whom he illuminated several manuscripts including the Missale Hallense (1524; Aschaffenburg, Hofbib., MS 10). And although he drew upon the compositions of artists such as *Dürer, *Schongauer, and *Burgkmair, his technical accomplishment in figure drawing, the use of colour, and decorative, architectural settings show him to be an independent and original artist. OI

Hutchison, J. C., *Early German Artists*, vol. 8 (6/1) of the *Illustrated Bartsch*, ed. W. L. Strauss (1980).
Strauss, W. L., *Sixteenth-Century German Artists*, vol. 11 (7/2) of the *Illustrated Bartsch*, ed. W. L. Strauss (1981).

GLOVER, JOHN (1767–1849). English landscape painter. Glover was a drawing master in Lichfield from 1794 and an exhibitor at the RA from 1795. He exhibited with the newly established Society of Painters in Watercolours from 1805 to 1817 and was involved in its change of constitution, to include oils as well as watercolours. He amassed a substantial fortune from his highly priced pictures, derived from his many sketching trips in this country and, from 1814, on the Continent. He used technical tricks, adopted from William Payne (*c*.1760–after 1830), such as a split-brush to depict foliage. He held several critically acclaimed one-man exhibitions in the 1820s which included paintings by *Claude, *Poussin, and *Wilson placed in self-conscious rivalry with his own. In 1824 he helped establish the Society of British Artists and exhibited there from 1824 to 1829. He then set off for Tasmania where he spent 20 years farming sheep and painting the scenery and inhabitants. Over 50 of his Tasmanian watercolours were on show in London in 1835. His modern reputation has not matched that which he achieved in his lifetime when he was placed among the foremost landscape painters. MP

GODESCALC (active 781–3). *Carolingian scribe named in the dedicatory poem of the Gospel Book (Paris, Bib. Nat., MS nouv. acq. lat. 1203) commissioned by Charlemagne and his wife Hildegard. The work was produced between 781 and 783 and written in gold and silver on purple-dyed parchment. Whereas the text is written in uncial, and the incipits in capitals, the dedication verses are thought to be the earliest example of Carolingian (or caroline) minuscule—the new, simple, and easily legible script that was an element of Charlemagne's planned reform of education, grammar, and liturgy. Towards the end of the 15th century this script was adopted by the first Italian printers for their typeface; it was called 'Roman', and is perhaps the most apparent and enduring achievement of *Carolingian civilization. OI

GOES, HUGO VAN DER (c.1440–82). South Netherlandish painter who represents a change in the realism and spirituality expressed in Flemish art, while synthesizing the influence of the artists of the previous generation.

It is thought that Hugo was born in Ghent, although he may have trained elsewhere. Similarities suggest that he may have been a pupil of Dieric *Bouts in Louvain. He was enrolled as a master in the Ghent guild of painters in 1467, under the sponsorship of Joos van Wassenhove, and in 1468 he went to Bruges to work on decorations for the wedding of Charles the Bold and Margaret of York. In subsequent years he had similar civic and ducal commissions in Ghent. In 1474–5 he was appointed dean of the painters' guild, and in 1480 he was asked to evaluate the *Justice* panels in Louvain, left unfinished on the death of Bouts.

Little evidence survives on which to base a chronology of Hugo's works, although a small diptych (Vienna, Kunsthist. Mus.) may be an early work. It depicts, unusually, the *Fall of Man* and the *Deposition*, the latter reminiscent of Rogier van der *Weyden in its physical expressions of grief.

The only surviving authenticated painting is the Portinari altarpiece (c.1473–8; Florence, Uffizi), a massive triptych commissioned by the Florentine merchant Tommaso Portinari for S. Maria Nuova, Florence. The central panel shows the *Adoration of the Shepherds*, a scene witnessed by the patron's family and saints on the wings. The entire composition is unified by an extensive, wintry landscape containing distant narrative details. In contrast, the main figures are substantial and remarkably lifelike, the rustic shepherds as individualized as any portraits. The focus of this realistic scene is an intensely spiritual act of adoration of the naked Christ child, who lies upon the ground in a pool of light, surrounded by praying figures and a still life which symbolically alludes to his sacrifice.

Hugo's unique fusion of realism and visionary drama may derive from his own religious and mental state. By 1478 he had become a lay brother at the monastery of the Roode Kloster, near Brussels, and subsequently suffered from mental illness and delusions of damnation. The *Death of the Virgin* (Bruges, Groeningemus.), with its bleak setting and cold colours, is stark and melancholy. It might reflect the artist's own anguish towards the end of his life, sharing the grief of the apostles, who gaze out at us from the painting.

Other large-scale works are innovative and sophisticated. The *Monforte Adoration of the Magi* (Berlin, Gemäldegal.) is remarkable for its perspectival recession as well as for its contrasts of light, splendid colour, and rich textures, while the *Nativity* (Berlin, Gemäldegal.) features two prophets drawing back curtains to display the holy vision. Hugo's realism extends to individual portraits, as in that of Edward Bonkil, on one of the *Trinity* panels (Edinburgh, NG Scotland, on loan from Royal Coll.).

An original and much copied artist, Hugo's influence is illustrated by Domenico *Ghirlandaio's inclusion, in his *Adoration* (1485; Florence, S. Trinita), of a group of shepherds as earthy as those in the Portinari altarpiece.

MS

Dhanens, E., *Hugo van der Goes* (1998).
Thompson, C., and Campbell, L., *Hugo van der Goes and the Trinity Panels in Edinburgh* (1974).

GOETHE, JOHANN WOLFGANG (1749–1832). The major poet of the German Romantic movement. Throughout his life he devoted much time to the study of painting and his writings on art were very influential in the upsurge of Romantic ideas in Germany. His appreciation of the development of the traditions emanating from Classical Greek art and the *Renaissance revival of classical values led him to develop his exaltation of the concept of genius, of central significance for the development of European *Romanticism. In contrast to the speculative character of post-Kantian German Idealism, Goethe set his chief emphasis on intuition (*Anschauung*) in regard to the apprehension of beauty.

His first publication, *Von deutscher Baukunst* (1772), was inspired by a youthful enthusiasm for the Gothic cathedral at Strasbourg. He was one of the first in Germany to appreciate the robust strength of the 'primitive' *Gothic, while it was customary to rely on the stereotyped criteria of *Neoclassicism. Identifying art with 'nature', Goethe held that great art must simulate and carry on the blind creative force in nature. He also advocated the typically Romanticist view that art should concentrate on what is individually 'characteristic' rather than on generic type.

He went to Italy in 1786 and in Rome came into contact with the German circle of *Winckelmann, *Mengs, *Maron, and Angelica *Kauffmann and was influenced by their Neoclassical interests. The German artist *Tischbein painted a celebrated portrait of him (1786–7; Frankfurt, Städelsches Kunstinst.). In his diary Goethe records: 'I am to be portrayed life-size, as a traveller, wrapped in a white cloak, sitting on a fallen obelisk in the open air, looking over the ruins of the Campagna of Rome.' This Arcadian image of Goethe musing on the classical world reflects the change in his taste that occurred in Rome. In Naples, in 1787, he met *Hackert (whose biography he wrote in 1811) and was absorbed into the circle of Sir William *Hamilton. He then visited Sicily with the artist C. H. Kniep and on his return to the mainland surrendered to the beauties of the Doric Greek temples at Paestum, which had already been etched by *Piranesi (1778). He described his conversion to a classical concept of beauty in his *Italienische Reise* (1816–17). It is reflected in articles contributed to *Die Propyläen*, which he edited (1798–1800) with the Swiss Heinrich Meyer (1760–1832), and in *Über Kunst und Altertum* (1816–32). He defended the classical ideal of beauty in *Winckelmann und sein Jahrhundert* (1805) but the First Part of *Faust*, published in 1808, was accepted by his generation as the triumph of Romantic art. Goethe also wrote a book on the theory of *colour, *Zur Farbenlehre*, in which he purported to refute the *Optics* of Newton, bringing him into disrepute with nineteenth-century Positivist thought, but considered consistent with modern studies on perception. He wrote a commentary on *Diderot's *Essay on Painting* and in 1818 he published an essay on the paintings described by *Philostratus.

HB/HO

Goethe, J. W. (trans. Auden, W. H., and Mayer, E.), *Italian Journey* (1786–8), 1970.

GOGH, VINCENT WILLEM VAN (1853–90). Dutch *Post-Impressionist painter whose work involved an original synthesis of the *realism of his native school with the experimental brush and colour techniques he adopted in France. Born in northern Brabant, the son of a Protestant pastor, van Gogh's early career involved spells working as an art dealer and teacher in The Hague and London, and as a lay preacher in Belgium, prior to becoming an artist in 1880. With his father's disapproval he embraced the life of the bohemian. During the ten years of his painting career when he sold virtually nothing and endured poverty he was supported financially by his younger brother Theo. His prodigious output of work resulted in over 800 paintings and about 850 drawings.

In 1881 van Gogh settled in The Hague where he pursued a programme of self-education, studying contemporary manuals and reproductions (engravings collected from English and French illustrated journals) and receiving advice from his cousin Anton Mauve, one of the leading members of the *Hague School of realists. In keeping with his humanitarian outlook, nurtured by reading novelists such as Dickens, George Eliot, and *Zola, van Gogh resolved to become a painter of peasants in emulation of *Millet. From 1883 to 1885 he studied the rural life of Drenthe and Nuenen, his father's new parish. The culminating work of this period was *The Potato Eaters* (1885; Amsterdam, van Gogh Mus.). He wrote that he intended 'to instil by this painting the idea that the people it depicts at their meal have dug the earth with the hands they are dipping into the dish.... I really would not wish everyone to admire it or think it beautiful straightaway.'

After a few months in Antwerp, in February 1886 van Gogh went to Paris to join his brother Theo, working for the art dealing firm Goupil & Co. He enrolled in Cormon's studio. His painting technique underwent a rapid metamorphosis, influenced in turn by *Delacroix, *Monticelli, the *Impressionists, the Divisionists (see NEO-IMPRESSIONISM), and Japanese printmakers. He introduced bright and broken colour and explored more modern urban themes. During 1887 he organized two exhibitions in informal café settings, one of Japanese prints, another of his own work together with that of avant-garde contemporaries *Bernard, *Toulouse-Lautrec, and *Anquetin; this was the first public display of the *Cloisonnist style.

In February 1888 van Gogh settled at Arles, the beginning of a highly productive period. Although isolated he remained in close touch with fellow artists in Paris and Brittany, sharing their interest in the symbolic and expressive values of colours and dreaming of founding an artists' co-operative, the Studio of the South. He briefly adopted Cloisonnism, applying colour more boldly and flatly, as in *Night Café* (1888; New Haven, Yale University AG), of which he wrote: 'I have tried to express with red and green the terrible passions of human nature.' In October 1888 he was joined by *Gauguin, but although they exchanged many ideas, their collaboration ended, famously, in a quarrel when van Gogh attacked himself with a razor, a crisis commemorated in his *Self-Portrait with Bandaged Ear* (1889; London, Courtauld Inst. Gal.). Suffering recurrent nervous crises with hallucinations and depression, in May 1889 van Gogh voluntarily entered a nearby asylum at St Rémy. He continued working between bouts of illness, producing many important paintings in the course of this year, including *Wheatfield with Cypresses* (1889; London, NG), *Starry Night* (1889; New York, MoMa), and beautiful pen and ink drawings. In May 1890 Vincent returned north to Auvers-sur-Oise, lodging with the patron and connoisseur Dr Paul Gachet. After a short renewal of activity, in July 1890 he died from the results of a self-inflicted bullet wound.

Van Gogh's voluminous correspondence with his brother Theo and fellow artists is an abundant source of information about his own aesthetic aims and his relationship with the wider artistic debates of the period. BT

Hulsker, J., *The New Complete Van Gogh: Paintings, Drawings, Sketches: Revised and Enlarged Edition of the Catalogue Raisonné of the Works of Vincent Van Gogh* (1996).

van Gogh, V., *The Complete Letters* (3 vols., 1958).

GOLDEN SECTION, the name given in the 19th century to the proportion derived from the division of a line into what Euclid called 'extreme and mean ratio' and defined in bk. 6, prop. 3 of the *Elements* as follows: 'A straight line is said to have been cut in extreme and mean ratio when, as the whole line is to the greater segment, so is the greater to the less.' This ratio occurs several times in the theory of regular polygons and polyhedra. It is the only ratio (i.e. quantitative relation between two magnitudes) that is also a proportion (similarity between ratios). A proportion requires at least three terms, but in the Golden Section the third term is the sum of the first and second. Consequently it is more economical in terms than any other proportion. It can be expressed algebraically as $a/b = b\ (a+b)$, or arithmetically as $\frac{1}{2}\ (\sqrt{5}\pm1)$, or numerically as a progression 0.618, 1.618, 4.236 … Geometrically it may be constructed by various methods all of which involve making a geometrical equivalent of the numbers $\frac{1}{2}\ (\sqrt{5}\pm1)$ by means of a diagonal of a rectangle composed of two squares. From the diagonal of a rectangle of 1×2 add or subtract one and place the remainder against the longer side of the rectangle.

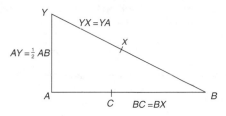

Fig. 2 AC:CB::CB:AB and AB = AC + CB

It is traditionally held that *Plato began the study of 'The Section' as a subject in itself. The construction of the pentagon by means of the isosceles triangle having each of its base angles double the vertical angle (72°, 72°, 36°) was due to the Pythagoreans (Euclid, bk. 4, prop. 10). In this triangle the base forms a Golden Section with the longer sides. The triple interwoven triangle, the pentagram, which makes multiple 'Sections', was used by the Pythagoreans as a symbol of recognition between members of the brotherhood and was called by them Health.

From the beginning of the 15th century great interest was taken in the regular solids. Luca Pacioli (c.1445–c.1514), a Franciscan, the most famous mathematician of his day, who was a close friend of *Leonardo and of *Piero della Francesca and knew *Alberti, wrote a book on the Golden Section called *Divina proportione* (1509). Pacioli's book was in accordance with the tendencies of the time and credits this 'divine proportion' with various mystical properties and exceptional beauties both in science and in art. There are three parts of the book. In the first the author gives various theorems relating to this proportion, with reference to Euclid, finding a noble adjective for each property, as if he were carried away by so much harmony and wished to distinguish the individual themes. Like many other learned men of the Middle Ages and *Renaissance, Pacioli was anxious to harmonize the knowledge of pagan Antiquity with the Christian faith, and in the chapter in which he justifies his choice of title he explains that this ratio cannot be expressed by a number and being beyond definition is in this respect like God, 'occult and secret'; further, this three-in-one proportion is symbolic of the Holy Trinity. But the most worthy property of the Divine Proportion is that without it no regular pentagon can be made, 'nor the noblest of all the regular bodies called the Dodecahedron, which the divine Plato attributed in the Fifth Essence, namely the Heavens'. Here Pacioli follows Plato who, in his dialogue *Timaeus*, associated the tetrahedron, octahedron, cube, icosahedron with the four elements, fire, air, earth, water (in this order), while in the remaining regular solid he sees in some sense the figure of the universe as a whole.

In the *Divina proportione* Pacioli believes he can detect an aesthetic principle which is found in architectural forms, in the human body, and even in the capital letters of the Latin alphabet. The third part of the book is an Italian translation of the treatise on the regular bodies, *De quinque corporibus regularibus*, by his compatriot Piero della Francesca, with only a few alterations and without acknowledgement (a work of which Piero speaks in the dedicatory letter to Duke Guidobaldo of Urbino as having been composed in his extreme old age 'in order that his wits might not go torpid with disuse'). This part deals with polygons and polyhedra and plane figures, deriving mainly from Euclid.

The greatest ornament of *Divina proportione* is the 60 drawings of regular and semiregular bodies made by Leonardo, as Pacioli himself states, 'which it would not be possible to make better in perspective drawing even if *Apelles, *Myron and Polycletus [see POLYCLITUS] and others were to return among us, made and shaped by that ineffable left hand, most fitted for all the mathematical disciplines, of the prince among mortals of today, that first of Florentines, our Leonardo da Vinci, in that happy time when we were together in the most admirable city of Milan, working for the same patron [Ludovico il Moro].'

It is often claimed that the Golden Section is aesthetically superior to all other proportions and if it is admitted that what pleases the eye is unity in variety, it may be said that this proportion fulfils the condition better than any other. The claims have been supported by an immense quantity of data, collected both from nature and from the arts. Statistical experiments are said to have shown that people involuntarily give preference to proportions that approximate to the Golden Section. But this weakens the case for maintaining that when such forms are found

in a work of art they have been put there intentionally. In fact, the Golden Section is likely to turn up fairly frequently in any design derived from the square and developed by applying a pair of compasses.

La *Section d'Or was the collective name used by a group of *Cubist painters who exhibited together in Paris in 1912. They, however, were not referring to Euclid's 'extreme and mean ratio', but to the ratio between the side of a square and its diagonal (the 'root-2 rectangle'). See also FIBONACCI SERIES. HO

Cook, T. A., *The Curves of Life* (1914).
Ghyra, M., *A Practical Handbook of Geometrical Composition and Designs* (1952).
Pascioli, L., *De divina proportione* (1509; English trans. ed. G. Masott Biggiogero and F. Riva, 1956).

GOLTZIUS, HENDRIK (1558–1617). Engraver and painter of the Haarlem School whose work epitomizes the extravagant designs and virtuoso execution of Dutch *Mannerism. Encouraged by Karel van *Mander he engraved numerous works by *Spranger, but after a visit to Rome in 1590, his work acquired a more classicizing tendency and he worked increasingly from his own designs, as well as producing prints that were sophisticated imitations of *Dürer and *Lucas van Leyden, such as the *Life of the Virgin* (1593–4). The variety and dazzling execution of his engravings has scarcely been surpassed, and he also made very original *chiaroscuro woodcuts. He was a superb draughtsman, equally at home with tiny silverpoint portraits or with vast highly finished pen drawings, such as *The Three Graces* (London, BM) which have all the bombast of a public performance. In about 1600 he turned to painting, largely abandoning printmaking, executing large hotly coloured works of mainly mythological themes, *Vertumnus and Pomona* (Cambridge, Fitzwilliam) being a particularly good example, but his real genius was for graphic work, and he inspired numerous other Dutch engravers. RGO

Strauss, Walter (ed.), *Hendrik Goltzius: The Complete Engravings and Woodcuts* (1977).

GONÇALVES, NUNO (active 1450–71). Portuguese artist documented in 1450 as court painter to King Afonso V (ruled 1438–81). He was categorized by Francisco de *Holanda (in *Da pintura antigua*, 1548), as one of the great painters or 'eagles' of European art. The *S. Vincent* altarpiece painted by him in Lisbon Cathedral was particularly praised; and six large panels now in the Lisbon Museum have been identified as the *S. Vincent* masterpiece to which Holanda referred. The panels, dated c.1460–75, portray the court and the various ranks of society (at the time when the Portuguese were on the threshold of their great maritime adventures) praying in the presence of a youthful saint usually identified as S. Vincent, patron saint of Lisbon. The style is dry but powerfully realistic, and the colours carefully thought out. There are affinities with the contemporary work of Dieric *Bouts and with Burgundian art, especially tapestries. JBB

dos Santos, R., *Nuno Gonçalves* (1955).

GONCHAROVA, NATALIA (1881–1962). Russian artist and designer. Goncharova trained at the Moscow School of Painting, Sculpture, and Architecture (1897–1903). After 1906, she combined the influences of *Gauguin, *Cézanne, and *Matisse with Russian crafts and lubok prints, and became a leader of the Russian Neo-primitivist movement, with Mikhail Larionov (1881–1964) and *Burlyuk. Her contribution to the international culture of modern art started with *Futurist graphics and Cubo-Futurism as in *Electric Lamp* (c.1912; Paris, Mus. National d'Art Moderne). She showed with the *Blaue Reiter (Munich, 1912), Roger *Fry's second Post-Impressionist exhibition (London, 1912), and Sturm Galleries (Berlin, 1912, 1913) and she had large solo shows in Moscow (1910, 1913) and Leningrad (1914). With Larionov, Goncharova moved to Paris in 1915, designing decor and costumes for Diaghilev's Ballets Russes until 1929. At the Moscow Institute of Artistic Culture in 1921, Goncharova, with Alexandra Exter (1882–1949), Liubov *Popova, and Varvara *Stepanova rejected easel art, and she became the first professional female designer of textiles and clothing for an industrial mass market. To the end of her life, she continued to paint, design (including theatre design), and exhibit. GS

Chamot, M., *Goncharova* (1972).

GONCOURT BROTHERS. French men of letters, aesthetes, art collectors, and historians. **Edmond** (1822–96) and **Jules** (1830–70) **de Goncourt** began their literary career, which remained a close collaboration until the death from syphilis at the age of 40 of Jules, with a review of the Paris Salon of 1852. They then turned to fiction as their main form of expression, publishing a series of now underrated realist novels which had a formative influence on Zola. Although they continued to write about contemporary art (including a book on their friend *Gavarni in 1868) and also published on Utamaro (1891) and other masters of the Japanese woodcut, their main contribution to the literature of art is the series of essays eventually collected under the title of *L'Art du dixhuitième siècle*. In these studies, which are a persuasive mixture of aesthetic evocation and historical research, they pioneered the revival in the taste for French *Rococo art. The essays, some of which amount to substantial monographs with extensive notes and documentation, were first published in various periodicals. Between 1856 and 1875 they were republished in twelve parts with etched illustrations by Edmond. The most important of them are those on *Watteau, *Boucher, *Chardin, Maurice-Quentin de *La Tour, *Greuze, and *Fragonard. Although the Goncourt were by no means the only mid-19th-century critics to rediscover the art of the 18th century and though their collection, mainly drawings and pastels, was relatively modest, their finely wrought and deeply Romantic view of the Rococo period continued to influence all subsequent commentators for the next 100 years. To some degree, perhaps, their aesthetic attachment to the 18th century can be seen as an antidote to the extensive research into the seamier side of 19th-century urban life which they undertook for their novels. The six main essays have been translated into English as *French XVIII Century Painters* (1948), and despite the more robust views held by modern art historians remain not only a substantial achievement of research, but in their poetic insights and acute discriminations the most appealing port of entry to French art of the 18th century. The nine volumes of the Goncourt *Journal* (which may be sampled in English in *Pages from the Goncourt Journal*, 1978) contain many not always flattering references to contemporary artists including *Manet, *Degas, and *Rodin. MJ

Brookner, A., *The Genius of the Future: Studies in French Art Criticism* (1971).
Simches, S. O., *Le Romantisme et le goût esthétique du XVIIIe siècle* (1964).

GONZALEZ, EVA (1849–1883). French painter. Gonzalez enjoyed a sophisticated literary and artistic upbringing in Paris, where she began her art training with Charles Chaplin. Throughout her life, she maintained a painting style of middle tones and light figures against a dark background. *The Little Soldier* (Villeneuve-sur-Lot, Mus. des Beaux-Arts), one of two paintings and a pastel portrait in this style, was shown at her first *Paris Salon in 1870. This same Salon also displayed a portrait of her, *Eva Gonzalez* (London, NG), by Édouard *Manet, whom she had met in the previous year and whose pupil she became for a while. They remained close colleagues and personal friends. Regular Salon submissions (except for a single rejection in 1873), followed by favourable reviews, ensured commissions from a loyal French, as well as English and Belgian, clientele. She was a friend of the *Impressionist artists and shared their everyday subject matter but, though invited, never exhibited with them. With Manet, she believed that the only route to success was through the official Salon (see under PARIS). GS

Garb, Tamar, *Women Impressionists* (1986).

GONZÁLEZ, JULIO (1876–1942). Spanish sculptor. González learnt to work in metals from his father, a sculptor and metalworker; after studying in Barcelona he moved to Paris in 1900. Here, he supported himself by making decorative metalwork; it was not until the 1930s that he flourished as a fine artist, a period that was heralded by collaborations with *Picasso between 1928 and 1931. Following this he worked in a *Cubist manner, executing a number of simplified, abstract heads: *Head of a Woman II* (1930; Antibes, Hans Hartung Coll.). In the early 1930s his work became more linear, pictorial, and dynamic in such pieces as *Maternité* (1934; London, Tate). He is most famous for *Montserrat* (1937; Amsterdam, Stedelijk Mus.), his realist depiction of a Catalan peasant woman, made for the Spanish pavilion of the Exposition Universelle in Paris in 1937. The emotion invested in the piece is typical of his later work. MF

Withers, J., *Julio González: Sculpture in Iron* (1978).

GORKY, ARSHILE (1904–48). American painter, born in Turkish Armenia. His family emigrated to America in 1920; he studied at the New Rhode Island School of Design and at the Grand Central School of Art, New York. His early work is influenced by *Picasso: *The Artist and his Mother* (1926–9; New York, Whitney Mus.). After working on the *Federal Art Project in the 1930s he became increasingly interested in *Surrealism, encouraged by *Matta, whom he met in 1941, and *Breton in 1943. An influential member of the *Abstract Expressionists, his mature work is characterized by an acidic use of colour, biomorphic imagery, and calligraphic line: *The Liver is a Coxcomb* (1944; Buffalo, Albright-Knox Gal.). In 1946 a series of tragedies struck him, starting with a fire in his studio which destroyed much of his work; he developed cancer; and was involved in a serious car crash. He hanged himself in 1948. After his death his reputation flourished and he is now recognized as a pivotal figure in American art. RJP

Lader, M., *Arshile Gorky* (1985).

GOSSAERT, JAN, also called Mabuse (c.1478–1532). South Netherlandish painter, the earliest of the so-called *'Romanists'. His Latinized name suggests that he was born in Maubeuge in the province of Hainaut (now in France). He was the first Fleming to travel to Rome in order to record ancient works of art (*View of the Colosseum*, 1508; Berlin, Kupferstichkabinett). It is not known where he trained; Bruges and Antwerp have been suggested. He became a master in Antwerp in 1503. After 1507 Gossaert's name disappears from the Antwerp archives. By then he seems to have been engaged by Philip of Burgundy, an illegitimate son of Philip the

Good, though this is not certain. What is certain is that he accompanied Philip on his mission to the Vatican in 1508–9. After his return, Gossaert may have settled in Zeeland before he was commissioned, together with Jacopo de' *Barbari, to decorate Philip of Burgundy's castle of Suytburg (now Souburg, Walcheren Island), which Philip intended to make into a *Renaissance centre in the north.

Gossaert's early style is closely based on early Netherlandish examples, particularly those of Jan van *Eyck, whose compositions and technique he copied (*Madonna in a Church*; Rome, Doria Pamphili Gal.). The *Adoration of the Magi* (c.1510–12; London, NG) refers back to Gerard *David and Hugo van der *Goes, but its mastery of *perspective and grandeur also testify to Italian influence. In the *Virgin and Child with SS Catherine and Barbara*, the so-called 'Malvagna Triptych' (c.1512; Palermo, Gal. Regionale Sicilia) Gossaert combined Flemish elements, such as the late Gothic architectural setting and landscape with music-making putti; *S. Luke Drawing the Virgin* (1513–14; Vienna, Kunsthist. Mus.) shows the late Gothic Virgin surrounded by a profusion of drapery folds seated in a classicizing architectural setting. In 1515 Gossaert began a series of mythological paintings at the castle of Suytburg. This led him to explore methods of painting the nude (*Neptune and Amphitrite*, 1516; Berlin, Gemäldegal.). Curiously, rather than turning to the drawings he had made in Rome, he utilized models by Dürer, Marcantonio *Raimondi, and the German sculptor Conrad *Meit, whom he met both in Malines and Suytburg. In addition to his altarpieces and mythological paintings, Gossaert remains well known for his *portraits, which are among the finest examples of Renaissance portraiture in northern Europe. His sitters were members of the Burgundian court, their associates and friends, among them Jean Carondelet, Chancellor of Flanders, the young Eleanor of Austria, and the children of the deposed king of Denmark, Christian II. KLB

Pauwels, H., et al., *Jan Gossaert, dit Mabuse*, exhib. cat. 1965 (Rotterdam, Boymans van Beuningen Mus.).

GOTHIC. *See overleaf.*

GOTTLIEB, ADOLPH (1903–74). American painter and sculptor. Born in New York, where he studied at the Art Students' League, he visited Europe in 1921. He was one of the founding members of the Expressionist group 'The Ten' in 1935. In 1936 he started work for the *Federal Art Project and came under the influence of the *Surrealists, Freudian psychology, and the idea of the unconscious as a source of artistic material. These together with myth and symbol were

interests he shared with *Rothko and *Pollock, colleagues in the *Abstract Expressionist group. He liked to work in series, one of which, *Pictographs*, he worked on 1941–52, an example being *Masquerade* (1945; New York, Adolph and Esther Gottlieb Foundation). His mature work is non-figurative; often two contrasting forms, a disc and flat emblem, as in *Red and Blue No. 2* (1966; New York, priv. coll.), part of the *Burst* series, on which he was still working at his death. RJP

Adolph Gottlieb: A Retrospective, exhib. cat. 1981 (Washington, Corcoran Gal.).

GOUACHE. This term seems to have been first used in France in the 18th century to define a way of painting in colours rendered opaque by mixing them with whites or chalks in a medium of honey and gum. The word first appears in English in 1882 and came to be employed to describe a drawing made in this manner. Today it is used somewhat loosely of any drawing executed entirely in *bodycolour. PHJG

GOUJON, JEAN (c.1510–c.1568). French sculptor whose classical style is quintessentially French, distant and refined. He is first known in 1541, when he provided two classical columns for the church of S. Maclou, Rouen. He may be associated with the design of the *tomb of Louis de Brézé, husband of Diane de Poitiers, in Rouen Cathedral. In 1544 he was in Paris, working on Pierre Lescot's *rood-screen in S. Germain-l'Auxerrois. The screen was demolished in the 18th century, but Goujon's stone panels are in the Louvre, and epitomize his style. The *Lamentation* panel includes figures derived from *Parmigianino and *Rosso, and the *Evangelists* are close to *Raimondi. The degree of relief is subtly modulated to suggest volume and slight recession, contours are precisely cut against the plain ground, and drapery patterns are essentially linear.

He worked closely with Lescot at the Louvre, outside on the Cour Carrée (1547/9) and inside on the Salle des Caryatides. Goujon's four caryatids, begun in 1550 after a model by Lescot, are his most monumental work, astonishingly Greek (Roman copies of the Erechtheion caryatids from *Athens existed then in Rome). Goujon and Lescot probably collaborated at the Hôtel Carnavalet, and on the Fontaine des Innocents, both in Paris. The latter was a loggia for viewing the entry of Henri II into Paris (1549), providing minimal water; it has been radically altered since. Goujon's nymphs, closely integrated into the architecture, remain *in situ*, but the panels of *Nereids and Tritons* are now in the Louvre. They are closest in style to *Cellini's *Nymph of Fontainebleau*, and are characterized by *Mannerist elegance and proportions.

continued on page 307

· GOTHIC ·

1. Introduction

GOTHIC is a term denoting styles in the art and architecture of the West from about the mid-12th century to the 15th (Italy) or mid-16th (elsewhere). It was first used by *Vasari to describe pre-Renaissance architecture, following humanist writers who had associated architecture before *Brunelleschi with *gente barbara* or Germans. From the 18th century, when antiquaries distinguished a *Romanesque style, Gothic was restricted to the centuries between Romanesque and the *Renaissance.

The first Gothic building is widely held to be S. Denis abbey church near Paris, begun 1137. Gothic art can be associated with architecture in the literal sense, as much of it is physically attached to buildings, and architectural motifs in miniature were used as settings for figures and narrative in such media as monumental and manuscript paintings, textiles, metalwork, and ivory carvings. Yet, although the beginning of Gothic art has been pegged to the rebuilding of S. Denis, the character of the sculpture and stained glass in that church was thoroughly Romanesque; Romanesque styles persisted in all the arts for at least a generation in Paris and the Meuse region, and considerably longer elsewhere. Other historiographic traditions that affect attitudes to Gothic art include the primacy of France in inventing and developing Gothic, which means that the arts of other regions tend to be discussed as provincial offshoots of French styles; the cyclical view, prevalent in 19th-century scholarship, that Gothic rose to perfection in the mid-13th century and declined steadily thereafter to a decadent late phase; and the Renaissance humanist view that saw Gothic as anticlassical. The latter is especially misleading, as medieval artists believed that they were working in a continuous tradition. These approaches, still current, obscure the great variety of Gothic art over both time and place, and, more significantly, take no account of its function.

Medieval art was not created for art's sake. Patrons were not, as they are today, interested primarily in art, but in the object. While by the later Middle Ages some works, especially books and secular metalwork, were produced for sale on the open market, most were created as individual commissions for a specific location. The purpose of art was defined and fairly narrow. It was used for secular display and, overwhelmingly, in the service of the Christian Church. Its focus was not the celebration of Man, but the relation of Man to God.

High art, with which this article is concerned, primarily served one aspect of people's lives: the search for forgiveness of sin in this world and redemption and salvation in the next. An *altarpiece or *reliquary, for example, was given to a church as a sign of largesse and in hope of spiritual return in the form of salvation. The church building provided the link between earth and heaven, saints and martyrs the intercession between man and God. Monumental art—architectural sculpture, *stained glass, *wall painting—gave visual expression to the Christian faith in narrative, didactic, or symbolic representations, which also appeared on carved and painted altarpieces. Much of the activity of metalworkers, ivory- and woodcarvers was given over to such church furnishings as liturgical vessels, reliquaries, votive figures, and statues of the Virgin and saints. *Illuminated manuscripts comprised service books, prayer books, bibles, and works of meditation. There was also demand for secular works in all these media: histories and romances could be illustrated in wall painting, manuscripts, and carved ivory mirror-backs and boxes; jewels were set in finger rings; cups and buckles were ornamented with enamels; but secular subjects often had a strongly moralizing content, and objects for daily use were often decorated with religious themes.

Although styles changed over the years, artistic innovation and originality were not sought. The aim was to affirm the Christian tradition by building and maintaining continuous links with its historic beginnings. The modern notion of the creative individual had little place in the collaborative world of medieval art production. As most medieval buildings and works of art required the contribution of workers in several different media, individual attribution is difficult, and too much emphasis on this can be unhelpful. The perceived anonymity of medieval craftsmen in modern times is also, however, the result of their low status: their names survive in contracts or records of payment, but rarely on works of art. The practice of signing works was commoner in Italy than elsewhere, but a signature could often represent the workshop rather than the named person.

Owing to destruction through decay, neglect, religious ideology, and war, the hierarchy of medieval art has become distorted. Contemporaries valued the works that have survived best—buildings, sculpture, and wall painting—below precious metals, *enamels, and illuminated manuscripts (which were associated metaphorically with the Word of God). Insofar as it is possible to elucidate medieval aesthetic preferences, it is clear that expensive materials and glittering surfaces were most highly prized, perhaps also because of the equation of light with the holy and transcendent. But such works are now comparatively rare or inaccessible. Some reflection of their status does, however, survive in buildings and altarpieces, where stone and wood were carved, painted, and gilded

to imitate as far as possible the effects of precious metal and enamel.

2. c.1140–c.1220

THE beginnings of Gothic art appeared in the Île de France and the Meuse region. It is identified by a gradual move away from the abstract representations that characterize Romanesque towards greater naturalism and idealization. The elaborate figured programmes of church portals, with their column statues and carved tympana, are the most prominent manifestation; but the larger windows of great churches provided new opportunities for stained glass. *Iconography in both windows and portals—the earliest at S. Denis and Chartres—was more coherently organized, and new themes were devised: the *Coronation of the Virgin* on the west tympanum of Senlis Cathedral became the definitive image of the subject.

The development of later 12th- and early 13th-century styles—often known as Transitional—was influenced by contemporary *Byzantine art, coming into western Europe on such portable objects as *diptychs and boxes. Although overt Byzantine influence is seen in relatively few works—the Winchester Psalter (London, BL, MS Cotton Nero C. iv); portable altars (Siegburg, Treasury)—covertly it was subsumed into figure styles with oval faces and softly linear draperies drawn across the body to define the limbs beneath. The liveliness of figures is, however, not Byzantine but a reinterpretation of Romanesque expressions of spirituality into more three-dimensional forms. The small, seated figures of patriarchs and prophets in the main portals at Mantes Cathedral, although enclosed by the architectural framework of the archivolt, are treated as much in depth as if they were cast in metal for the foot of an altar cross (e.g. St Omer, Mus. de la Ville).

Soft, classicizing styles were adopted in England by the late 12th century (Psalter; Paris, Bib. Nat., MS lat. 8846; Westminster Psalter; London, BL, MS Royal 2 A. XXII). In continental Europe the 'trough' style of drapery associated with the workshop of *Nicholas of Verdun (enamel panels; Klosterneuburg Abbey), appeared also in such manuscripts as the Ingeborg Psalter (Chantilly, Mus. Condé, MS 9/1695). Romanesque persisted longer in Germany, Spain, and the Italian peninsula; in the former, changed figure styles accompanied the new architecture, with carved portals (Santiago de Compostela) and large windows. French influence was never strong in Italy, but there Gothic forms found favour on small objects and tombs more readily than on buildings.

3. 1220–1320

SEVERAL developments in 13th-century religion and society brought about changes in imagery and presentation. The new mendicant orders of Franciscans and Dominicans encouraged individual piety and with it the beginnings of affective religion—the empathetic experience of Christ's Passion through private meditation and prayer. Large numbers of books for private use, such as psalters and books of hours, were produced. By 1300 individual patrons had built prominent, canopied *tombs, with effigies and small weeper figures. There was a new focus on the Eucharistic significance of the altar and the cult of the cross. Cults of the Virgin, saints, and relics grew with their importance as intercessors.

Before the middle of the century the carved portal was popular in Spain (León Cathedral) and Germany (Bamberg Cathedral) as well as France. The impact of the sculpture's message was enhanced by vivid colour, which survives at Lausanne Cathedral. The portal statues, now freed from columns, could appear to interact (Reims Cathedral), and tympana were carved in several horizontal bands, increasing the scope for narrative. Equally significant, however, was the development of monumental figure sculpture inside churches. The rood—Christ on the cross flanked by the Virgin and S. John—placed above a screen at the entrance to the choir, was now an established feature. Spanish churches (Las Huelgas Abbey) had free-standing Deposition groups, carved in wood. Such themes invited meditation on the Passion and redemption. Large stone figures, set against piers or in relief on walls, illustrated the history and sanctity of the building (past benefactors at Naumburg Cathedral; miracles of S. Edward the Confessor at Westminster Abbey) or its relics (apostle witnesses of the True Cross, Paris, S. Chapelle).

Shrines and relics became more prominent. *Reliquaries could be kept on altars, screens, or beams. The main shrine—often a reliquary casket over 1 m/3 ft long—could be elevated on a high stone base behind the high altar, visible to the officiating priest and accessible to pilgrims. Tombs of ecclesiastics (Obazine Abbey, Hereford Cathedral) were made deliberately shrinelike, with relief carving or a pinnacled canopy. The presence of relics in every altar profoundly affected church designs, which increasingly reflected and symbolized the building's sacred contents. Just as reliquaries began to resemble miniature churches, with gables, spires, and buttresses (shrine of S. Gertrude, Nivelles), architectural sculpture became more metallic in appearance, and adopted the microarchitecture of reliquaries. By 1300 the arch and gable motif was ubiquitous on wall arcading, tombs, shrine bases, ivories, and liturgical furnishings, the largest and most prominent of which were painted altarpieces (Westminster Abbey).

During the 13th century, crucifixes and images of saints and the Virgin, which had long been hung in churches or carried in procession, were located permanently on the altars with which they were associated. Often combining an image and narrative scenes (*Coppo di Marcovaldo, Crucifix; San Gimignano, Pin. Civica), they could also show a monumental figure of the Virgin in Majesty (*Maestà*) with the Christ child and angels (e.g. by *Guido da Siena; Siena, Pin.). Such works are especially characteristic of Italy, but, owing to her special role, the Virgin was

depicted in all media, both free-standing (painted wood, Leau, S. Léonard) and on altar frontals, particularly in Scandinavia.

Figure styles were common to all media. The great change, the influence of which lasted to the end of the Middle Ages, occurred in the 1230s, when linear, troughed drapery styles gave way to the 'broad fold' style of heavy, smooth folds falling straight to the floor. It was developed first, unusually, in stone sculpture, probably in Paris. The same, familiar characters were constantly depicted. Small metal, ivory, wax, or wooden figures of saints were offered at altars and shines either in anticipation or ex-voto; they also surrounded the congregation in *stained glass. There the saturated colours and patterned armatures of the early 13th century gave way to a lighter palette and the 'band' window, in which coloured, figured panels alternate with patterns of grisaille (Tours Cathedral). By 1300 glaziers were forced to organize their designs to fit complex patterns of window tracery.

The medallion patterns of iron armatures were one influence on the design of manuscript pages, where complicated theological statements had to be illustrated with the condensed immediacy of modern cartoons, as in the *Bible moralisée*, a commentary on the biblical text. Miniatures could be full-page, sometimes with elaborate architectural frames (S. Louis Psalter; Paris, Bib. Nat. MS lat. 10525) or interspersed in the text, as in the Apocalypse manuscripts produced in France and England. The initial letter continued to be an important decorative focus, and the *bas-de-page* illustration was evolved: a small scene, often a grotesque image, that formed a commentary on the main contents of the page, as in some early 14th-century psalters assciated with patrons in East Anglia.

Monsters and *grotesques, often derived from late Antique imagery, were prominent also on misericords and decorative sculpture. 'Babewyns' and hybrids represented sin and licence, offering an outlet for subversive comment and humour. But such abnormal creatures helped medieval people to define their ideas of the normal and acceptable, and their presence at the heart of established religion might equally serve to reinforce the Church's authority and dominance.

The corollary of grotesque extremes was naturalism. The interest in naturalism in the later 13th century was expressed within limits. There was a brief phase of naturalistic foliage sculpture, notably at Reims, Naumburg, and Southwell, with identifiable plants and fruits. Naturalistic animals were carved on misericords in the early 14th century (Winchester Cathedral), and individualized facial features appeared on the small human heads that decorated keystones and arch mouldings. Naturalism allowed emotion to be expressed through facial expression rather than, as before, in pose or drapery. This is particularly clear in German art (e.g. fragments of *pulpitum* screen; Mainz Cathedral). But the expressions of tomb effigies, saints, and the Virgin were mostly refined and idealized. They were intended to reveal the state of the soul rather than physical likeness. Although the earliest 'portraits'

date from this time (Naumburg Cathedral), they were of long-dead benefactors; the origins of medieval portraiture seem to lie in dynastic cults rather than representations of contemporaries.

Naturalism was one aspect of the wider artifice that expressed the known and unknown world through enhanced, idealized reality. Thus, most figures were still shown in timeless, enveloping, sub-Antique drapery, but it would be painted or studded with mock jewels in imitation of contemporary fabrics. Naturalism may, however, reflect the Franciscan celebration of God's creation. Early experiments in depicting believable spatial settings were made in the frescoes of S. Francesco at Assisi, and in *Giotto's paintings in the Arena chapel, Padua, which date from 1305–13. It was around this time, too, that sculptors began to carve some monumental statues almost fully in the round: although they were not released from an architectural setting, such works as Giovanni *Pisano's figures for Siena Cathedral and the saints at Notre-Dame, Écouis, Normandy, are designed to be seen from several viewpoints.

4. 1320–1400

MANY of the developments in 13th-century Gothic art set the pattern for the rest of the Middle Ages. Private devotion and preparation for death were the greatest stimuli to patronage as *chantry chapels, founded for prayers for the dead, proliferated together with tombs and books for prayer and meditation. Increased documentary evidence for this period gives more information about both patrons and craftsmen. The religious orders, especially the mendicants, and the secular churches were prominent patrons, as were the leading individual laymen and ecclesiastics; but lower ranks in society could now afford to buy commemorative brasses and such portable objects as books, plate, and boxes and mirrors of metal or ivory. Royalty and related aristocrats can now be seen as collectors: John, Duke of Berry (d. 1416) collected books and jewels. The significant development, however, was in civic patronage, that of the newly emerging guilds and fraternities, which paid for new town churches, developed ceremonies around Corpus Christi and other feasts, and commissioned works for their town halls, of which *Simone Martini's (disputed) *Guidoriccio da Fogliano* (Siena, Palazzo Pubblico) is an outstanding example.

For much of the 14th century the main figure style was based on a slender, swaying pose that was developed in France around 1300. Voluminous drapery was swathed loosely across the body, falling with reversed folds (allowing subtle colour changes) to the floor. This style is found across Europe to a greater or lesser degree, combined with the influence of Italian spatial recession, which was also stronger or weaker in different regions, very influential in Spain, especially Catalonia, less so in England.

The spread of styles owed as much to the movement of

craftsmen as the taste of patrons. Far more artists are known by name (Master *Bertram of Hamburg, the *Parler family in Bohemia and the empire, numerous Italians). The names of some craftsmen now represent a workshop style, for example Jean *Pucelle, a name associated with manuscripts painted for the French royal family in the first half of the century. More significant than named individuals, however, was mobility: Simone Martini went from Siena to the papal court at Avignon; Claus *Sluter from the Netherlands to Burgundy; *Jean de Liège to England. More than ever was European art united by a common stock of motifs, which also integrated designs within individual works. Secular and religious motifs crossed barriers: with the increasing prevalence of heraldry, backgrounds to pictures were often powdered with heraldic designs; and micro-architecture adorned not only reliquaries but table fountains (Cleveland, Mus. of Art).

Integrated design is seen particularly in settings for imagery. Micro-architecture and foliage twisted to arch shapes—including the new ogee or S-curve—framed most figures, whether sculpted, embroidered, or painted. Micro-architecture defined the church interior, on walls, in stained glass—where tall figures were posed under towering architectural canopies—on altarpieces and furnishings such as thrones, sedilia, and choir stalls. In Italy, wall paintings were framed by fictive *Cosmati mosaic or twisted columns. The implied illusionism was deliberate. Late medieval art is often illusionistic, both in materials—with stone painted to imitate metalwork—and iconographically: carved figures lean out of windows or over balconies (Mühlhausen, S. Maria), painted scenes are set in deeply recessed, naturalistic space (e.g. by the *Lorenzetti).

Developing earlier tendencies, works of art shared not only motifs but materials. A panel painting might have a background of stamped, gilded gesso and enamels and precious stones in its frame. Carved figures were painted, and often wore metal attachments, such as crowns, belts, or swords. Metalwork was routinely enamelled; ivories often partly gilded and painted. As most works required the attention of more than one craftsman, production was inevitably concentrated, either in big cities such as London or near the main residences of great patrons—Paris for the French kings and queens, Prague for Emperor Charles IV, Cracow for Kazimierz III, Arras for Mahaut, Countess of Artois. But what stimulated the mix of universal and local styles was the cross-influence between those artists who travelled great distances and those who did not, and between the great centres and small, local workshops.

New or developed techniques and media served and perhaps produced a taste for sumptuous materials and surfaces. Oil painting, practised in England and Scandinavia by at least the 13th century, continued its development in northern Europe, notably in S. Stephen's chapel, Palace of Westminster, where wall paintings were combined with sculpture and metalwork to produce an interior rich in illusionistic fantasy. *Alabaster was newly fashionable for effigies and statuettes. Two *enamelling techniques provided ever greater lustre and preciousness: the jewel-like glow of translucent enamel (the late 14th-century Royal Gold Cup, London, BM); the pearly richness of enamel en ronde bosse (Göldenes Rössel; Altötting, treasury).

Altar furnishings included the monstrance, which, following the cult of the Sacrament, displayed the host in an elaborate gilded setting that shared the attenuated, spiky architectural qualities of reliquaries (Aachen Cathedral treasury). Similar attenuation appears in manuscript illuminations, where long tendrils of spiky trefoil foliage spread across the page, interspersed with lively figures, naturalistic and hybrid creatures, or small scenes (the Bohun Psalter; Vienna, Österreichische Nationalbib., Cod. 1826*). Decoration was enhanced by patterns of linear pen-work added by the scribes. Some psalters and books of hours are tiny—for example, the Hours of Jeanne d'Évreux (New York, Met. Mus. Cloisters)—and ownership or patronage was often indicated by heraldic shields incorporated into initials or border decoration.

Wall paintings were produced in great numbers, with extensive narrative or symbolic schemes (Florence, S. Maria Novella, chapter house). Panel paintings could be a single image—owned by even the smallest church, with some privately owned panels documented—or vast, multi-sectioned polyptychs, with figures of saints individually framed, the frames topped by gables and pinnacles (Jacopo di Cione, S. Pier Maggiore altarpiece; London, NG). Subject matter emphasized salvation not only in traditional ways but also through more directly secular messages, such as the Triumph of Death (Pisa, Camposanto). Tomb designs included the transi, or rotting corpse, that reminded the living to pray for the dead. How far this overt preoccupation with death was provoked by the visitation of the Black Death in the late 1340s is questionable. It more likely reflects greater individual wealth and the increasing control that the laity exercised over ecclesiastical spaces.

5. After 1400

BY the end of the 14th century, Gothic styles were extraordinarily diverse. The art of the years around 1400 is traditionally known as *International Gothic, as the more elegant figure styles have been equated with a 'court' style common to such aristocratic centres as Paris, Milan, Dijon, Bourges, and Prague. There was evidently much exchange, of artists, gifts of books and other works, of sons and daughters in marriage, all of which contributed to awareness of what was going on elsewhere. But aristocratic patronage was no more dominant, nor were the results more uniform, than they had been before. As aristocratic courts proliferated, so did their need for display. There was simply more demand for craftsmen. But there was also more patronage in such non-aristocratic, civic centres as Bruges, Ghent, and London. The enormous numbers of craftsmen working in these and other

towns in the early 15th century cannot be explained by aristocratic demands alone.

The term 'International Gothic' has meaning only in the sense that artists travelled extensively, setting up foreign colonies in all the main centres of production. The styles that they produced ranged from the swaying, smiling figures of the 'Beautiful Madonnas' in Bohemia and the empire, the intense naturalism of Claus Sluter's figures, the soft grace of the Boucicaut *Master's manuscript miniatures to the *classicizing style of *Donatello and his circle in Florence. Since the work of the Pisani in the 13th century, classicizing and Gothic styles had been equally popular in Tuscany, and Gothic at its most decoratively beguiling continued in 15th-century Florence with such painters as *Gentile da Fabriano.

Fifteenth-century Gothic art, often presented as morbid, introspective, and in decline, was in fact the opposite—lively, confident, and inventive. It reflects the prosperity of cities across Europe, particularly in Italy and the south Netherlands, and the wealth of the great rulers. Among the genres to become established north and south of the Alps was portrait painting. Developed techniques included *woodcuts and engraving (see LINE ENGRAVING), encouraged by the much wider availability of *paper. Through these, new subject matter and models were widely disseminated, with diffusion into book illumination and sculpture. Engravings by Martin *Schongauer and *Master E.S. were particularly influential. The medium of oil paint, already in use for several centuries, was given new subtlety by Netherlandish experiments with layers of translucent *glazes.

Salvation was still the main preoccupation. A town church such as S. Lorenz, Nuremberg, could be fitted out with shrine tabernacles and other furnishings by individual citizens, as offerings for their personal salvation. Thematically it was treated in any number of ways. Under the influence of mystical writings and communities of lay and religious contemplatives there was an evident need for imagery suitable for meditation, and such depictions of Paradise as the van *Eycks' Adoration of the Lamb altarpiece in Ghent Cathedral. Hierarchies and litanies were emphasized: the nine orders of the angels, the Joys and Sorrows of the Virgin. Ranks of figures, perhaps kings or saints, were carved or painted on screens: particular saints, often those dramatically martyred, such as Catherine and Margaret, appeared over and over again. The head of John the Baptist, profusely bleeding, was carved in relief on alabasters, for private contemplation. But the theatricality and drama inherent to medieval church art was also manifest, in large-scale figure sculptures enacting scenes of the Passion (the Entombment of Christ at Tonnerre): the drama was enhanced and reality reinforced by showing the biblical figures in 15th-century dress.

In the 15th century the tension between naturalism and artifice, used to underpin the distinction between the material and spiritual worlds, was if anything intensified. Naturalistic detail abounded, not only in costume, but in carefully recorded domestic details in, for example, the calendar pages of the Très Riches Heures of the Duke of Berry (Chantilly, Mus. Condé, MS 65), or scenes from the New Testament (Dieric *Bouts, Last Supper; Louvain, S. Pierre). Animals and plants powder the backgrounds to such tapestries as the Lady and the Unicorn series (New York, Met. Mus.); *Pisanello distributed studies of animals drawn from life randomly through his painted background. Yet naturalistic representation was also more integrated. Although artificial *perspective as devised in Italy was not yet used in northern Europe, South Netherlandish painters introduced depth beyond the picture surface by creating spatial recession for both interiors and exteriors—landscape, which had been indicated symbolically by a stylized tree or hill, was now shown in full and careful detail, though still a background feature rather than a subject in its own right.

Naturalism was explored especially in the depiction of people, both formally and informally. The stiff, schematic rendering of figures such as those in Buda Castle or on the pulpitum screen of York Minster was by no means universal. Portraits, still made for dynastic statements or private rather than public display, became popular in Italy and the Netherlands, where Jan van Eyck, Petrus *Christus and Hans *Memling, among others, extended the possibilities of pose and setting, and above all minutely recorded details of feature and expression. More light-heartedly, the sculptor and architect Anton Pilgram (c.1450–1515) carved his self-portrait on an organ case in the Stefansdom in Vienna. Small figures cast in bronze or carved in stone or wood (masons and musicians on the buttresses of 's-Hertogenbosch Cathedral; choir stalls of Ulm Cathedral), were equally naturalistic. Just as portrait painters depicted faces in their different planes, sculptors explored more actively the three-dimensional possibilities of the carved figure. Some sculptors bulked out the silhouette with elaborate drapery, but figures by Nicolaus *Gerhaerts and his followers occupy space through the turn of their bodies, enhancing the reality of the figure and inviting interaction with the viewer.

Naturalism could, however, conflict with the demands of the setting, as in the stained glass at Fairford church, where the stone mullions cut across compositions designed as a unity. Between the extremes of naturalism and overt artifice there are transitional pieces that combine both modes. Such modes were used to convey the conjunction of earth and heaven, as in paintings of the Virgin and Child in domestic interiors, or altarpieces featuring donors in the same space as their patron saints (Hugo van der *Goes, Portinari altarpiece; Florence, Uffizi), where figures from another world are shown in all the realistic detail of this one. The works in which these implications were handled perhaps most successfully were the great carved winged altarpieces of Germany and the Tyrol.

In Tilman *Riemenschneider's altar of the Virgin in Creglingen, south Germany, scenes of the life of the Virgin are set in elaborate frames of spiky, filigree late Gothic tracery, in which foliate forms twist and weave through three dimensions. Typically for the late 15th century, the wooden

figures are both naturalistic and emotionally intense, drawing in the spectator's empathetic response while the wholly artificial framework sets the images apart from the space in which the altarpiece is set. The foliage acts as both barrier and transition, and it was by such means that the boundaries of art and realism were set, so that, however naturalistic the figures were, no one was deceived into thinking them real. This was emphasized by the decoration: the figures could be painted in *polychrome, but increasingly often had only a tinted glaze or were varnished and partly gilded.

The taste for figures in exotic settings was widespread, and they appeared on all kinds of objects, including screens (Albi Cathedral), tombs and retables (Charterhouse of Miraflores, Burgos). By the late 15th century and into the 16th foliate and architectural decoration had become dense and stiff, often entwined elaborately with heraldic symbols, rebuses, and mottoes. Spectacular and dramatic setpieces include the *S. George and the Dragon* group (Stockholm, Storkyrka), a free-standing ensemble 6 m (20 ft) high, created from antlers and hair as well as wood. Yet, where money and patronage allowed, the ideal work was the complete memorial ensemble of church building and tomb, as at Margaret of Austria's early 16th-century church at Brou, where the tracery of windows and parapets is echoed in the *pulpitum* screen and the tombs. Margaret's shrinelike tomb canopy is almost hidden under carved foliage and tracery, with openwork rebuses, initials and ropework. Traditional statuettes of saints stand under vaulted, traceried canopies.

At this time some of the most lively Gothic art was being produced in Spain, where German and Netherlandish influence had spread deeply; innovation continued in Portugal, with the *Manueline style based on marine forms. But in the north Italian influence was becoming stronger. The putti standing at the feet of Margaret of Austria's effigy show how Antique *iconography, subject matter, and figure styles were beginning to encroach. The tabernacled canopy over the tomb of S. Sebaldus in Nuremberg is a mixture of Gothic and *classicizing details. At first, artists used the latter indiscriminately alongside traditional motifs; but by the end of the 16th century that had changed. NC

Focillon, H., *Art of the West*, 2: *Gothic* (1963).
Henderson, G., *Gothic* (1967).
Legner, A. (ed.), *Rhin-Meuse: art et civilisation 800–1400*, exhib. cat. 1972 (Cologne, Kunsthalle; Brussels, Mus. Royaux).
Martindale, A., *Gothic Art* (1967).

In 1547 he contributed some plates and text for the first French edition of Vitruvius. It is not known whether he had already visited Italy, but by 1563–4 he was in Bologna, escaping religious persecution, and died there. His interpretation of classical form is paralleled by the contemporary French writer Joachim du Bellay's enrichment of the French language through the study of Greek and Latin. Goujon has remained central to French classicism and has influenced *Girardon, *Clodion, *Ingres, and the glassmaker René Lalique. LL

du Colombier, P., *Jean Goujon* (1949).
Zerner, H., *L'Art de la Renaissance* (1996).

GOWER, GEORGE (d. 1596). English portraitist and decorative painter. Of a Yorkshire gentry family, his date of birth and the nature of his training are unknown. His earliest extant works are the documented *Sir Thomas Kytson* and *Elizabeth Cornwallis, Lady Kytson*, painted in London (1573; London, Tate). His *Self-Portrait* (1579; priv. coll.) also survives and these three works have been used as a basis for attributing further portraits to him. His unshadowed, typically English style nevertheless conveys a strong sense of character. Appointed Serjeant Painter to Queen Elizabeth I, he received royal payments for heraldic and decorative painting from 1581 to 1596, though none of his applied work is now known. In 1584 a patent was drafted granting him a monopoly of all painted and engraved portraits of Elizabeth (except for the miniatures, allocated to Nicholas *Hilliard). Although no certain portraits by him of the Queen survive, he merited a grant of property from her in 1589. He lived in the London parish of S. Clement Danes from 1585 until his death in August 1596. KH

Gapper, C., ' "Trompe l'Œil" Architectural Painting on Plaster in the Royal Works 1582–9', *Traditional Paint News*, 1/2 (1996).
Hearn, K. (ed.), *Dynasties*, exhib. cat. 1995 (London, Tate).

GOYA Y LUCIENTES, FRANCISCO JOSÉ (1746–1828). Spanish painter. Born in the town of Fuendetodos (Aragon), the young Francisco Goya y Lucientes trained in the studio of José Luzán Martínez in the Aragonese capital of Saragossa. An early biography states that he studied with Luzán for four years, probably until 1763, when the artist entered a competition of the Academia de S. Fernando (*Madrid). He was unsuccessful both in this competition, and in a second attempt of 1766.

By 1771, Goya was in Italy, where he again competed at the Academy in Parma. His painting of the assigned subject, *Hannibal, en route across the Alps, stopping to survey the Italian prospect*, has recently come to light (Cudillero, Fundación Selgas-Fegalde). Although he did not win first prize, which went to the Italian Paolo Borroni, Goya received six votes. He submitted the painting from Rome, where he lodged with the Polish artist Taddeus Kuntz, in an apartment on the Strada Felice (today, Via Sistina). By October 1771, Goya had returned to Saragossa, where he won the commission to paint the vault of the small choir of the basilica of S. María del Pilar. By 1774, he had gained sufficient renown as a painter of religious images to win the commission for a mural cycle illustrating the life of the Virgin for the Charterhouse of Aula Dei.

In 1773, Goya married Josefa Bayeu, sister of the court painter Francisco *Bayeu. Through Bayeu's influence, Goya gained a position painting cartoons for tapestries to be woven by the Royal Tapestry Factory of S. Bárbara in Madrid, where he arrived in early 1775. His first group of cartoons was a collaborative effort with a second brother-in-law, Ramón Bayeu, under the supervision of Francisco Bayeu. Beginning in 1776, Goya was allowed to paint cartoons that he qualified as being 'of my invention'. Given licence to formulate his subject matter, Goya turned to scenes of contemporary life, many of which featured stock types common in prints and theatre of his day. From 1777 to 1778, Goya also executed his first series of *etchings, reproducing paintings by *Velázquez that hung in the royal collection.

In 1780, Goya was elected a member of the Academia de S. Fernando; five years later he would become adjunct director of painting in the same institution. This decade brought a change in Goya's fortunes, as war with England and budgetary problems led to the temporary closing of the Royal Tapestry Factory in 1780. Goya sought other commissions, one

of which brought about his return to Saragossa and to the basilica of S. Maria del Pilar. His assignment, to fresco a dome depicting Mary, Queen of Martyrs, was again supervised by Francisco Bayeu. A dispute over the decency of Goya's images led to a falling out between the brothers-in-law, and by 1781 a bitter Goya had returned to Madrid.

Shortly after his return, Goya received a commission for the altarpiece of *S. Bernardine of Siena*, to be painted for the royally patronized convent church of S. Francisco el Grande in Madrid. This commission marks a turning point. During the coming decade, Goya garnered prestigious commissions for portraits and religious paintings from aristocratic patrons including Don Luis de Borbón (the brother of King Charles III), the Count of Altamira, and, finally, the Duke and Duchess of Osuna who would become important patrons through the 1790s. The portrait of the *Family of the Duke and Duchess of Osuna* (1788; Madrid, Prado) illustrates Goya's move toward a greater naturalism in his portraiture, as well as the introduction of a tonal background, inspired by Velázquez.

In 1786, Goya was given the salaried position of *pintor del rey* (painter to the king), which made him again responsible for painting tapestry *cartoons for the now reopened royal factory. In 1788, King Charles III died, to be succeeded by his son Charles IV and his queen María Luisa of Parma. The new monarchs had long been patrons of Goya's tapestry cartoons, which might explain the artist's appointment as court painter in April 1789. The artist immediately turned to painting portraits of the new monarchs. When asked to paint another series of tapestry cartoons in 1790, he initially refused, taking on the commission only after official pressure was brought to bear.

In October 1792, Goya was one of several professors to present to the Academia de S. Fernando recommendations for revising the curriculum: his report criticizes the trivialization of his art through petty competitions, prizes, and mechanical lessons of geometry and perspective. His suggestions had little impact, as later that year Goya was struck with an illness that would leave him deaf. During his convalescence, he turned to executing uncommissioned, small-scale cabinet paintings, depicting original subjects. By January 1794, he submitted to the Academy a series of these, which included the *Courtyard with Lunatics* (1794; Dallas, Meadows Mus.). From this point on, Goya would paint a number of uncommissioned works that were sought out by patrons and collectors.

During the mid-1790s, Goya also began drawing subjects derived from life, caricatures, and fantastic figures. These drawings, executed until the end of his life, comprise eight albums, designated with the letters A–H. At the same time, his thoughts turned again toward printmaking, and by 1797 he was developing a series of satirical etchings published in February 1799 and today known as *Los caprichos*. The earliest of Goya's works to be known outside Spain, these etchings fostered his reputation as a critic of the *ancien régime*; in fact, their ambiguity makes it impossible to determine specific targets. Eight months after publishing them, Goya was granted the highest position for an artist at court: First Court Painter.

In addition to the inventive uncommissioned works of the 1790s, Goya continued to paint portraits of Madrid's elite and undertake religious commissions, the most important of which was a fresco cycle for the interior of the church of S. Antonio el Grande in Madrid (1798). The following year, he began a series of portraits of the monarchs that culminated in 1800 with a commission to paint the *Family of Charles IV* (Madrid, Prado). The reputation of the portrait as a satiric springs from its naturalistic depiction of these rulers, but in fact the patrons themselves had approved sketches for the work.

From 1800 to 1808, Goya also executed several works for the royal favourite Manuel Godoy, including the *Clothed Maja*, a pendant to the *Naked Maja*, which was already listed in an inventory of Godoy's collection by 1800 (both Madrid, Prado). After the Napoleonic invasion of 1808, Joseph Bonaparte assumed the Spanish throne and Goya painted some works for his supporters (including the *Allegory of the City of Madrid*, 1810; Madrid, Mus. Municipal). An inventory of 1812, taken upon the death of the artist's wife, documents his uncommissioned production, including a series of twelve still-life paintings, now dispersed. In 1810, he began the series of etchings known today as the *Disasters of War*, published posthumously in 1863. These etchings, many of which may have been inspired by newspaper accounts, record the atrocities of the war and the famine in Madrid. The series also includes satirical etchings that criticize the conservative restoration regime of Ferdinand VII.

In March 1814, two months before the scheduled return of the restored monarch to Madrid, Goya proposed to the interim government paintings to commemorate the heroism of the Spanish patriots. Probably completed that same year, the early history of *The Second of May* and *The Third of May 1808* (Madrid, Prado) is unknown.

Many of Goya's works after 1814 are uncommissioned and therefore difficult to date. The *Tauromaquia*, a series of 33 etchings depicting the history of the bullfight in Spain, was announced for sale in 1816: nothing is known of their early reception or dissemination. Goya continued to paint portraits of the King, although these were commissioned by corporations or municipal governments; the King himself preferred the more classical style of the recently appointed court painter Vicente *López.

Goya continued to paint large-scale scenes of *genre subjects, including *The Forge* (New York, Frick Coll.). This tendency to large-scale figural scenes with often enigmatic subjects culminates with a series, known as the 'Black' paintings, executed in oil directly upon the plaster walls of the *quinta del sordo* (house of the deaf man). Thus named for a previous owner, the house once sat on the outskirts of Madrid and was purchased by Goya in 1819. These scenes, which combine fantasy, ritual, and myth, were transferred from the walls of the *quinta* to canvas in the 1870s. After being exhibited at the Exposition Universelle in Paris (1878) they were sold to the Museo del Prado, where they are seen today.

For reasons not known, following the liberal triennial of 1820–3, Goya went into hiding. Still a court painter, he obtained permission to travel to France by stating that he was going to 'take the waters' in Plombières. In fact, after a stop in Bordeaux where he met the exiled Spanish writer Leandro Fernández de Moratín, Goya continued to Paris in summer 1824. By the autumn, he had returned to Bordeaux, where he took up residence with Leocadia Weiss and her daughter (and a future painter) Rosario. In Bordeaux, Goya painted portraits of acquaintances, drew, and perfected his command of the medium of lithography. In 1825, four bullfight scenes, known as the *Bulls of Bordeaux*, were published by the lithographic establishment of Gaulon. While in Bordeaux, Goya experimented with a new technique of painting miniatures on ivory, creating with broad strokes scenes of popular characters and faces that had appeared in his earlier works.

In 1826, he returned briefly to Madrid to request his retirement as court painter; in view of his long service and advanced age, he would retain his full salary. He then returned to Bordeaux, where he died on 16 April 1828. JT

Gassier, P., and Wilson, J., *The Life and Complete Work of Francisco Goya* (1971).
Harris, T., *Goya: Engravings and Lithographs* (1963).
Sayre, E., *The Changing Image: Prints by Francisco Goya*, exhib. cat. 1974, (Boston, Mus. of Fine Arts).
Tomlinson, J., *Francisco Goya y Lucientes 1746–1828* (1994).

GOYEN, JAN VAN (1596–1656). Born in Leiden, van Goyen was a prolific and influential Dutch painter of landscapes, dune and river scenes. He was trained by various masters in Leiden and is recorded as having spent a year at the age of 19 in France. Van Goyen was one of the earliest of Dutch artists to bring a sense of actuality and naturalism to landscape painting. His pictures are largely based on brown or grey schemes illuminated with vivid touches of colour, and

are notable for their very subtle gradations of tone. The horizons in them are often low and the skies cloudy and animated. As similar motifs recur in a number of his paintings, they must have been based on a repertoire of drawn studies made during his travels. Topographical details in them include aspects of Dordrecht, Nijmegen, and other centres. He died in The Hague and had a number of pupils, including Jan Coelenbier (active 1632–71). CB

Beck, H. U., *Jan van Goyen 1596–1656: ein Oeuvre-verzeichnis* (2 vols., 1972).

GOZZOLI, BENOZZO (Benozzo di Lese) (1420/2–97). Italian painter of the Florentine School who is perhaps best known for his fresco prodution. Apprenticed as a goldsmith, Gozzoli worked in his early years both with *Ghiberti on the baptistery doors, Florence, and with Fra *Angelico in Rome and Orvieto.

In 1459, Piero de' Medici commissioned Gozzoli to decorate the private chapel of the Palazzo Medici, Florence. Patron and artist, sharing a taste for pageantry, rich colours, and Burgundian tapestries, conspired to produce the most glittering fresco paintings of the century, recalling and perhaps rivalling, *Gentile da Fabriano's altarpiece of the *Adoration of the Magi* of 1423 (Florence, Uffizi). Gozzoli took the same subject but distributed the processions of the Three Kings over three of the walls of the chapel, making each procession converge on the central point beneath the star represented in the coffering of the ceiling and in front of the altar.

Gozzoli's other major work was a fresco cycle with scenes from the Old Testament, now badly damaged, in the Camposanto at Pisa, begun in 1467. He also painted altarpieces, one of which, dated 1461, is in the National Gallery, London. HO/MLS

GRADUAL. See CHOIR BOOK.

GRAF, URS (c.1485–1527/9). Swiss goldsmith, designer for stained glass, printmaker, and draughtsman, best known for his lively pen and ink drawings, of which about 100—more than half of the extant total—are in the Basle print room. Graf seems to have been an adventurous and, on occasion, violent man: he was frequently in trouble with the authorities in Basle on a variety of charges, including attempted homicide, consorting with prostitutes, and wife-beating. Between 1510 and 1521–2 he was enlisted as a mercenary soldier in foreign campaigns in Italy and France. His prints and drawings chronicle the bloody and lustful life of soldiers of fortune and their camp followers (*Bust Portrait of a Prostitute*, 1518; Basle, Kupferstichkabinett); his genre scenes of Basle street life hint at parody and caricature. Unusually

for this period of German art, it appears that many of Graf's drawings were executed as independent works. Although stylistically conservative, his subject matter and his experiments with *woodcut techniques (*Standard Bearer*, 1514; white-line woodcut) make Graf an original and highly imaginative artist. KLB

Andersson, C., *Dirnen – Krieger – Narren* (1978).

GRAFFITI ART. Graffiti may be seen as a defacing or destructive activity, but it may also be said to derive from the primordial desire for mark-making which is reflected—although camouflaged by various degrees of sophistication—in all art. Two important qualities of graffiti—transgression and self-referentiality—have also characterized much 20th-century art. Graffiti has appeared in many artists' works, including those of Antoni *Tàpies and David *Hockney. A famous example is Marcel *Duchamp's addition of a moustache to the *Mona Lisa*. Although they are considered the most prominent and recent exponents of graffiti art, neither the work of Jean-Michel Basquiat (1960–88) nor that of Keith Haring (1958–90) relates very closely to actual, contemporary graffiti, which is usually a form of signature, either a stylized monogram ('tag') or a larger, more elaborate and colourful design ('wildstyle'). The Museum of American Graffiti opened in New York in 1989. OPa

GRAFFITO (or Sgraffito) (Italian: scratched), a drawing or ornament scratched on a wall; or more specifically, the technique of producing a design by scratching through a layer of paint or other material to reveal a ground of a different colour. In a medieval panel painting, for instance, the ornamental parts would be covered with gold leaf, burnished, and painted, and a design would then be scratched through the paint. In *wall painting too the technique was in use in the Middle Ages, and on many façades of *Renaissance palaces; in these cases the layers were both of plaster, differently coloured. The technique still survives, but nowadays less linear and more pictorial effects are sought by cutting away the plaster overlayer from whole areas and graduating the amount removed in order to produce middle tones. In graffito pottery the design was produced by scratching though the overglaze.

The predilection in certain 20th-century aesthetic movements for an appearance of accidental and undesigned decoration combined with a heightened interest in surface texture for its own sake has sometimes directed attention to the effects of random markings and scratchings on walls and other surfaces. These have been photographed and reproduced. Some non-figurative painters have tried to develop this into special kinds

of textural effects which formed the predominant motif of their painting. HO

GRANACCI, FRANCESCO (1469–1543). Minor Florentine painter. He trained in Domenico *Ghirlandaio's workshop, where he became a friend of his fellow student *Michelangelo. In 1508 Michelangelo called him and other Florentine painters to Rome to assist with the ceiling of the Sistine chapel, though in the event Michelangelo soon decided to dispense with their services. In about 1515 he was one of the team of artists who made small paintings for the bridal chamber of Pier Francesco Borgherini, for which he contributed two panels including *Joseph Presenting his Father and Brothers to Pharaoh* (Florence, Uffizi).

Granacci generally painted in an unexciting, old-fashioned way that slowly developed into a placid version of Fra *Bartolommeo's monumental late style; *Vasari describes him as an easygoing character for whom art was a pastime. In some predella panels and smaller works, however, he displayed a livelier talent, and he enjoyed a reputation as a designer of masques and ephemeral decorations. AJL

Briganti, G. (ed.), *La pittura in Italia: il cinquecento* (1987).

GRAND MANNER, a term used to describe the elevated style of *history painting (usually on a large scale) advocated by *academies of art in the 17th and 18th centuries, most famously in *Reynolds's Third and Fourth *Discourses* (1770, 1771). Having established classical precedents for the concept of ideal beauty, Reynolds asserts that the *gusto grande* of the Italians, the *beau idéal* of the French, and the *great style*, *genius*, and *taste* among the English are but different appellations of the same thing. He attributes this excellence to the Roman (in which he subsumed French 17th-century academicians), Florentine, and Bolognese schools but denies it to the Venetians since 'There are two distinct styles … the grand, and the splendid or ornamental', a distinction which emphasizes the element of sobriety which is intrinsic in the Grand Manner. 'Intellectual dignity' is the term Reynolds uses, and it is important to note that his advocacy of the Grand Manner is intended to elevate the position of the artist to beyond that of a 'mere mechanick'.

The concept is derived from classical handbooks of rhetoric and was first applied to painting in 17th-century Italy. *Bellori, in his life of *Domenichino (1672), quotes a passage from the *Trattato della pittura* by G. B. *Agucchi attributing *lo stile grande* to *Michelangelo. To achieve the Grand Manner, the subject should be grandiose, the treatment generalized, the concept intellectual, and the style unmannered. For Reynolds the Grand

Manner requires subordination of the particular and emphasis on the generic ideal: 'the whole beauty and grandeur of the art consists … in being able to get above all singular forms, local customs, particularities, and details of every kind.' Thus costume and setting should be timeless which, in practice, invariably meant a generalized Antiquity. Vulgar or trivial subjects are to be avoided in favour of elevated, heroic themes with universal moral dimensions. Thus there arose a hierarchy of subjects, with *history at the apex and *still life and rustic *genre at the base, which led, in particular, to the denigration of much Dutch and Flemish painting.

Success in the Grand Manner was rewarded by Academic advancement which, in turn, ensured commercial success. The style was therefore aspired to by such diverse artists as the animal painters *Stubbs and *Ward and the genre artists *Bird and *Haydon with deleterious and, in the latter's case, tragic results. DER

Reynolds, Sir J., *Discourses on Art*, ed. R. Wark (1975).

GRAND TOUR. *See opposite.*

GRANET, FRANÇOIS-MARIUS (1775–1849). French painter. Granet was born and trained in Aix before serving as a draughtsman in the siege of Toulon in 1793. In 1796 he went to Paris, studied briefly under *David, and made his debut at the Salon (see under PARIS) with *Little Cloister of the Feuillants* (1799; untraced), thus beginning a career as a painter of ecclesiastical interiors. From 1802 to 1824 he worked in Rome painting archaeological monuments and church interiors, peopling the latter with incidents from literature or history. In 1814 he exhibited *The Choir of the Capuchin Church in Rome* (New York, Met. Mus.), repeated at the Salon of 1819 (Cardiff, National Mus. Wales) and, such was its popularity, a further fifteen times. His church interiors owe much to Dutch 17th-century painters but are characterized by dramatic chiaroscuro and melancholy Romanticism. He also took subjects from the lives of famous artists and, as curator of Versailles from 1833, contemporary history. By the 1840s his work was unfashionable and in 1847 he returned to Aix where he painted landscape sketches, a lifelong practice. On his death the Aix Museum was named after him. DER

GRANT, DUNCAN (1885–1978). British painter, decorator, and designer, born into an ancient Scottish family at Rothiemurchus, Inverness (although both his grandmothers were English). His father was an army officer stationed in Burma, and Grant spent most of his early childhood there. He studied at Westminster School of Art, 1902–5, at the Académie de la Palette, Paris, 1906–7, and for six months at the Slade School, 1907. Through the writer Lytton Strachey (his cousin) he became a member of the *Bloomsbury Group, and he was also familiar with avant-garde circles in Paris (he met *Matisse in 1909 and *Picasso soon afterwards). Up to about 1910 his work—which included landscapes, portraits, and still lifes—was fairly sober in form and restrained in colour, but he then underwent a rapid development to become one of the most advanced of British artists in his response to modern French painting (he exhibited at Roger *Fry's second *Post-Impressionist exhibition, London, 1912). From about 1913 he was also influenced by African sculpture, and he was one of the first British artists to produce completely abstract art; in 1914 he made an Abstract Kinetic Collage Painting, which was meant to be unrolled to the accompaniment of music by J. S. Bach (this is now in the Tate Gallery, London, which has had a film made demonstrating the painting being unrolled in the desired fashion). However, this extreme avant-garde phase was fairly-short-lived and he soon reverted to a figurative style. In 1913 he began working for the *Omega Workshops, and having discovered a taste and talent for interior decoration, he sought similar commissions when the Workshops closed in 1919. In this field he worked much in collaboration with Vanessa *Bell, with whom he lived from 1916 (although Grant was basically homosexual, he enjoyed a long and happy relationship with Bell, who bore him a daughter in 1918).

Grant was at the height of his popularity and esteem in the 1920s and 1930s. He had several decorative commissions for private houses, and he was also active as a designer of stage decor, textiles, and pottery. Gradually he became something of an establishment figure, but his work still retained the power to shock conservative eyes, as when his murals for the new Cunard liner *Queen Mary* (1935) were rejected by the company. His largest commission (executed with Vanessa *Bell and her son Quentin) was a series of wall paintings in Berwick church, Sussex, 1942–3, commissioned by George Bell, Bishop of Chichester. After the war, Grant's work went totally out of fashion and he had difficulty selling his pictures. However, he lived long enough to see a great revival of interest in the Bloomsbury Group, which brought a renewed appreciation of his own work. He continued painting until a few days before his death at the age of 93. Sir John Rothenstein considers that as an artist he had 'a tasteful intelligence' but 'an insufficiency of passion'. IC

GRAPHITE is a crystalline allotropic form of carbon and is the essential ingredient in the manufacture of *pencils. It is also called 'plumbago' and 'black lead'. The latter is an especially confusing term since there is no lead in graphite, and hence it is strictly incorrect to talk of a 'lead' pencil. This is a misnomer which has arisen from the shortening of 'black lead'. Graphite seems to have been first used for underdrawing in the 16th century as a substitute for *leadpoint. PHJG

GRASSER, ERASMUS (active 1474–1518). German sculptor. The leading late *Gothic sculptor of Munich, where he is first recorded in 1474, later holding office in both guild and city council. He ran an active workshop, producing both stone and wood sculpture, and also practised as an engineer, which calling may have engaged him personally rather more than sculpture in his later years. His best-known sculptures, the limewood *Morris Dancers* from the old Munich Rathaus (1480; Munich, Stadtmus.), take the mobility and complex poses of late Gothic sculpture almost to the point of caricature. This mobility also characterizes the signed red marble memorial to Ulrich Aresinger (1482; Munich, Petrikirche), and the intensity of facial expression is echoed in those of the slender figures of *S. John* and the *Virgin* from a dismembered *Crucifixion* group (Munich, Bayerisches Nationalmus.). JR

Liebmann, M. J., *Deutsche Plastik 1350–1550* (1982).

GRASSET, EUGÈNE (1841–1917). French illustrator and designer of Swiss birth. Grasset was born in Lausanne and studied architecture before arriving in Paris in 1871. He was soon established as a graphic designer and illustrator and in 1881 a commission to design furnishings for the new Chat Noir cabaret in Montmartre brought him into contact with the avant-garde artists Théophile-Alexandre Steinlen (1859–1923) and *Toulouse-Lautrec. Like them he designed posters in an 'aesthetic' style (see AESTHETICISM) with *Art Nouveau elements, tendrils and sunflowers. Japanese woodcuts were another influence which predominate in his uncharacteristically powerful lithographs of *La Vitrioleuse* (1894) and *La Morphinomane* (1897). His book illustration and design is best seen in the *Histoire des quatre fils Aymon* (1883), a collaboration with the printer Charles Gillot, a masterpiece of Art Nouveau in which text and illustration are fully integrated. By the 1890s Grasset was designing for most media including stained glass for Tiffany which, with its heavy leaded outlines, influenced his graphic work. He was also an influential teacher and published his theories and practice in *La Plante et ses applications ornementales* (2 vols., 1897–1900) and *Méthodes de composition ornementales* (1905). DER

Plantin, Y., *Eugene Grasset* (1980).

· GRAND TOUR ·

THE Grand Tour has been defined as a journey made by the classically educated male members of the north European ruling or aristocratic class to complete their classical education, by visiting the sites associated with classical literature. It would appear that the term was first used by Richard Lassels, an English Roman Catholic priest, who published *The Voyage of Italy* in 1670 and suggested that nobody could understand Livy or Caesar if they had not done the Grand Tour of France and the Giro of Italy. Here he reflects a reverence toward the classical world that had already been voiced since the early years of the 17th century by English writers such as Fynes Moryson (1617) and George Sandys (1615), and had also been given tangible expression in the Italian visit made by Thomas Howard, 2nd Earl of Arundel, in 1613–14. Travelling with the architect Inigo Jones, Arundel had excavated for antiquities in Rome, studied the principles of ancient architecture, and enthused over the classical buildings of Palladio in Venice and Vicenza, which had just been described in some detail by Thomas Coryate in his *Crudities*, published in 1611, a work otherwise renowned for its account of Venetian courtesans.

By the 1630s, Rome and Naples had become the focal points of the Grand Tour. Accounts of the Phlegraean Fields, the coastal landscape around Naples strongly associated with the mythology of the ancient world, published by Sandys, Fynes Moryson, Gilbert Burnet (1686), and the Scottish botanist Sir Andrew Balfour (1700) all added to the popularity of this area, and by 1705 we find the essayist Joseph Addison, in his *Remarks on Several Parts of Italy*, conjuring up an image of British travellers reciting the works of Cicero, Virgil, Horace, and Martial, and reliving in their minds the great journeys of Odysseus and Aeneas. However, as Horace Walpole later remarked, Addison 'travelled through the poets and not through Italy; for all his ideas are borrowed from descriptions and not from reality'.

An even more imaginative and poetic approach to the ruins of Antiquity preserved in Italy came from the French writers, artists, and travellers. The French response was codified as early as the 16th century by the poet Joachim du Bellay (*Les Antiquitez de Rome* and *Les Regrets*), the essayist Guez de Balzac (1594–1634), followed in 1632 by Jean-Jacques Bouchard, friend of the Roman antiquarian Cassiano dal Pozzo. Above all it was embodied in the Arcadian spirit of paintings by *Claude, which convey both the grandeur and simplicity, the beauty and the desolation of the Italian classical landscape; and in the recreation of the Antique world achieved by Nicolas *Poussin in almost all his work, his history paintings, his *poesie*, and his landscapes.

The Grand Tour also brought the visitor face to face with the splendour of the *Renaissance and the exuberance of the *Baroque. Although 17th-century English writers, particularly John Raymond (*Il Mercurio Italico*, 1648) and Lassels, cover this ground, it is not until the 18th century that we find travel writers who exhibit any serious preoccupation with the *connoisseurship of pictures: Jonathan *Richardson (1722), John Breval (1725), Robert Samber (1722), and perhaps above all the French author and engraver Charles-Nicolas *Cochin the younger (1758), who had accompanied the future Marquis de Marigny on his tour of Italy in 1749–51. With these perceptive writers the overwhelming impression is of a preoccupation with the art of the past rather than with the work of contemporary or recently deceased late Baroque artists from *Gaulli to *Tiepolo; the only notable exception is in their estimation of *Bernini, whose sculpture was widely admired. As Francis Haskell has observed, 'the distinguishing and paradoxical feature of the golden age of the Tour . . . is that the more it became institutionalised, the narrower it became in scope'. Visitors after about 1720 'came primarily to admire the past and scorn the present— except when they could make use of living talents in order to satisfy tastes and prejudices which they had already brought with them from home' (in *Grand Tour*, exhib. cat. 1996; London, Tate).

Although there were exceptions—notably the 5th Earl of Exeter, who made three extensive Italian tours in 1679– 81, 1683–4, and 1699–1700, and accumulated a vast collection of contemporary Baroque paintings, ranging from intensely devotional images to highly erotic mythologies—most tourists were content to commission portraits of themselves by both Italian and visiting foreign artists, as well as view paintings of sites they had visited and enjoyed. Thus in the mid-17th century we find Salvator *Rosa painting an ambitious allegorical portrait of *Sir James Altham*, while Stanzione painted Altham's cousin *Jerome Bankes* (both Kingston Lacy, Somerset), during their visit to Naples. *Maratti, in Rome, was commissioned to paint *Wentworth Dillon, 4th Earl of Roscommon*, as well as *The 2nd Earl of Sunderland* (both Althorp, Northants), c.1664; and in 1677 he painted *Sir Thomas Isham* (Lamport Hall, Northants). In the 18th century British tourists gravitated to Bartolomeo Nazari (1699–1758) and *Carriera in Venice; the English artist *Zoffany in Florence (above all his conversation piece *The Tribuna of the Uffizi*, commissioned by Queen Charlotte in 1772 (London, Royal Coll.), showing the British resident Sir Horace Mann with the collector Lord Cowper and Thomas *Patch, the caricaturist); while in Rome the most favoured portrait artists were *Trevisani, *Batoni, who painted around 200 English visitors alone, Angelica *Kauffmann, and the Scottish painters Gavin *Hamilton and Nathaniel *Dance. German tourists also turned to Batoni, as well as their own countrymen *Mengs and *Maron, who in 1768 painted the great classical archaeologist and writer *Winckelmann (Weimar, Kunstsammlungen). However arguably the most

famous of all German Grand Tour portraits is *Tischbein's Neoclassical image of *Goethe in the Campagna (Frankfurt, Städelsches Kunstinst.), dating from 1787, an arcadian image with the poet musing on the beauties of a lost classical world. The French, both the patrons and the visiting artists, appear to have been much less interested in portraiture while travelling in Italy, although *Subleyras painted Frederick Christian, Elector of Saxony (Dresden, Gemäldegal.) in 1739; and Thomas Blanchet enjoyed some success with British patrons, including Henry Willoughby of Birdsall (priv. coll.).

The market among Grand Tourists for landscapes and *capricci was also shared between Italian artists and a steady stream of foreign practitioners, especially the French and English. In Venice, *Canaletto was preferred by the English; *Guardi, with his more imaginative vision and *Rococo manner, appealed to the French; and *Bellotto enjoyed success with the Germans. In Rome *Panini's capricci and *Piranesi's fantastic vedute were widely collected by the British and emulated by French painters including Hubert *Robert and *Clérisseau. British artists, including *Wilson, Jonathan Skelton, *Towne and *Cozens, following in the footsteps of *Claude and Gaspard *Dughet to Tivoli and the Campagna, also found support. However it was the French artist *Fragonard, sketching at Tivoli during the summer of 1760, with his patron the Abbé de Saint-Non, and also the Swiss artist Louis Ducros (1748–1810), working at Tivoli on a series of twelve large watercolours for Sir Richard Colt Hoare (Stourhead, Wilts.) c.1786–93, who most effectively extended the Arcadian spirit of Claude and Dughet into works of picturesque *Romanticism.

Although some Grand Tourists, especially the grandest, travelled with their own entourage, including a tutor or bear leader, most relied heavily for help with sightseeing and buying souvenirs on the two leading British antiquarians resident in Rome, James Byres and Thomas Jenkins. The scope for acquiring old master paintings was still restricted—it was the Napoleonic Wars which triggered that market—although Byres achieved one notable coup when he bought Poussin's Seven Sacraments (Belvoir Castle, Rutland) from the Boccapaduli family, Rome, in 1785 on the understanding that he would say nothing, replace them with copies, and continue to bring tourists to admire them. Jenkins dominated the market for the sale and restoration of antiquities and played a formative role in the creation of many of the sculpture galleries at English country houses, such as Marbury Hall (Ches.), and collections at London, above all that of Charles Townley, at Park Street, Westminster, as recorded in the celebrated conversation piece by *Zoffany (Burnley, Townley Hall Gal.).

By the second half of the 18th century the focus of the Grand Tour was changing, with a new interest in the excavations in the neighbourhood of Naples at *Herculaneum (from 1731) and *Pompeii (from 1764). Charles Cochin was quick to publish an unfavourable account of the frescoes at Herculaneum in 1756. The Doric temples at Paestum were also receiving scholarly attention from the

1750s. More intrepid travellers increasingly extended their tour to Sicily, following the lead of George Berkeley who in 1717 had shown a pioneering interest in the island's Greek remains and Doric temples. One of the earliest published accounts, by John Dryden, son of the poet, dates from a tour made as early as 1700–1, although it was not published until 1776 as A Voyage to Sicily and Malta. This was intended as a companion to Patrick Brydone's A Tour through Sicily and Malta (1773), which took the form of a series of letters to William Beckford, dating from a tour made in 1770. Brydone gives descriptions of Vesuvius, Stromboli, Lipari, the ancient theatre at Taormina, Syracuse, the temples at Agrigentum, as well as a discussion of the differences between Virgil and Horace in their respective descriptions of the island and the myths and legends associated with it. An even more comprehensive account was provided by Henry Swinburne's Travels in the Two Sicilies (1783–5), based on a tour made in 1777–80. However the most influential publication was by the Abbé de Saint-Non. His Voyage pittoresque ou description des royaumes de Naples et de Sicilie (1781–6) was illustrated with drawings by a group of artists that included Claude-Louis Chatelet, working under Dominique Vivant-Denon.

Other artists engaged in recording excavations and temples in southern Italy included Antonio Joli (c.1700–77), who made some of the earliest records of Paestum for John, Lord Brudenell, at the time of his visit to Naples in 1756–8 (Bowhill, Selkirk); Piranesi, who published in 1778 a series of some fifteen drawings and eighteen etchings of the temples which helped transform attitudes from narrow archaeological interest to a more emotional empathy with their primitive and expressive form; and *Hackert (the German-born artist much favoured by the Bourbon King Ferdinand IV), who together with Charles Gore accompanied the antiquarian Richard Payne *Knight, on a tour of Sicily in 1777. Hackert later painted for Lord Berwick The Ruins of Pompeii, and a pendant of Lake Avernus (Attingham Park, Shropshire); these date from 1799 just before the French occupation of Naples.

The central attraction of any visit to Naples was the circle of Sir William Hamilton at the British embassy. He too had visited Sicily in 1769, accompanied by Lord Fortrose. Connoisseur and scholar, he had developed a particular interest in *Etruscan vases and other classical antiquities—his vase collection was published by Baron d'Hancarville—and an equally serious interest in volcanology and geology—his Observations on the Volcanoes of the Two Sicilies (the Campi Phlegraei) with illustrations by Pietro Fabris (active 1756–79) was published in 1776–9. In Naples he provided a social centre for musical assemblies and for his second wife Emma to perform her Attitudes, posing as a succession of figures from Antiquity. Their home was also a refuge for Goethe, who visited Naples in 1787, and for Admiral Nelson after he had defeated the French at Aboukir Bay in 1798.

The wars brought to an abrupt end the aristocratic tradition of the Grand Tour that had lasted for 200 years. When travel resumed early in the next century the cult of

the *Antique had given way to the collecting of and professional speculation in old master paintings of the 16th and 17th centuries. These opportunistic entrepreneurs were followed by a wave of more academic travellers, who rediscovered early Christian art, a topic which 17th- and 18th-century travel writers and almost all aristocratic Grand Tourists had studiously ignored. HB

Chaney, E., *The Evolution of the Grand Tour* (1998).

Chard, C., and Langdon, H. (ed.), *Transports, Travel, Pleasure, and Imaginative Geography 1600–1830* (1996).
Ingamells, J. (ed.), *A Dictionary of British and Irish Travellers in Italy 1701–1800*, compiled from the Brinsley Ford Archive (1997).
Pine-Coffin, R. S., *Bibliography of British and American Travel in Italy to 1860* (1974).
Wilton, A., and Bignamini, I. (ed.), *Grand Tour: The Lure of Italy in the Eighteenth Century*, exhib. cat. 1966 (London, Tate).

GRASSI, DE. Three members of this Italian family were recorded at work on the Cathedral of Milan at the end of the 14th century. **Giovannino** (active 1380s–98) was a draughtsman, painter, and architect who first provided designs and painted pictures and then, from 1391, was given more far-reaching responsibilities in the rebuilding of the Cathedral of Milan. Although his designs are likely to be behind much of the present cathedral (for example the columns with sculpted capitals in the nave), little of his documented work survives; his reputation instead is based on the inscription naming him as draughtsman in a sketchbook in Bergamo (c.1390; Bib. Civica A. Mai, MS delta vii 14). Some of the late 14th-century drawings in this book link it with the earliest illuminations in the Psalter-Hours begun for Giangaleazzo Visconti (Florence, Bib. Nazionale, MS Banco Rari 397 and MS Landau Finaly 22), which is consequently attributed to Giovannino, and has led to his being regarded as one of the most inventive of all Italian illuminators. Both Giovannino's brother **Porrino** (active 1395–9) and his son **Salomone** (active 1397–1400) worked as painters and illuminators for the cathedral. The latter illuminated the manuscript called *Beroldus* (1397–8; Milan, Castello Sforzesco, Bib. Trivulziana, MS lat. 2262) and on the basis of the similarity in style it is likely that he was responsible for the second campaign of decoration in the Hours-Psalter left unfinished by his father. From 1398 to 1400 he was on the salaried staff of the cathedral and was elected 'designatore'. KS

GRAVELOT, HUBERT-FRANÇOIS BOURGUIGNON (1699–1773). French painter, engraver, and illustrator. Gravelot's importance depends upon his influence on English painting. He studied in Paris, under *Boucher, and had an established reputation as an illustrator when he arrived in London in 1732. His delicate, elegant drawings, in a *Rococo tradition derived from *Watteau, were highly influential on his English contemporaries including *Hogarth, *Highmore, and *Hayman. According to *Vertue, Gravelot, who was highly critical of English draughtsmanship, established a drawing school in James Street, Covent Garden, but his main contacts were made through the St Martin's Lane Academy, re-established by Hogarth in 1734. Here Gravelot taught drawing, having *Gainsborough as a pupil in 1789, and collaborated with Hayman, a fellow teacher, on the designs for Vauxhall Gardens. He was in great demand as a designer and engraver, illustrating Gay's *Fables* (1738), Shakespeare (1740), and, with Hayman, Richardson's *Pamela* (1742). He returned to Paris in 1746 but continued to work for English clients. His few paintings, of which *Le Lecteur* (1750s; York, AG) is typical, are small and intimate, intended for engraving. DER

Briand, Y., 'Hubert Gravelot etc.', *Gazette des beaux-arts*, 55 (1960).
Snodin, M. (ed.), *Rococo Art and Design in Hogarth's England*, exhib. cat. 1984 (London, V&A).

GRAVER. See BURIN.

GRECO, EL (1541–1614). Born Domenikos Theotokopoulos in Candia, Crete, El Greco may be regarded as one of Spain's foremost painters. He reached artistic maturity in Toledo, and his career and style are bound to the patronage and spiritual environment he found in the Spanish city.

He was formed in the tradition of Byzantine art current in Crete, where he was a master painter in 1566, but by 1568 he is recorded in Venice, where he underwent a second artistic education that transformed him into a painter of the Venetian School. The pictures of this period, small tempera paintings on panel (*Annunciation*; Madrid, Prado), show his progressive assimilation of contemporary Venetian painting. In 1570 El Greco went to Rome, and the few paintings done there incorporate artistic models from central Italian 16th-century painting.

Dissatisfied with his career in Rome, El Greco went to Spain in 1576. He is first documented in Toledo in 1577, at work on the *Disrobing of Christ*, a large canvas for the sacristy of its cathedral. Its rich colour and daring brushwork are Venetian in origin, but the composition's density, spatial compression, and vertical axis reflect the concerns of central Italian *Mannerist art. The project that had taken him to Toledo was a commission for three altarpieces for S. Domingo el Antiguo (1577–9). Some of the most distinctive features of his style—lack of space between figures, purplish red and acid olive-green draperies that obscure the underlying bodies—can already be seen in the central pictures for the high altar, the *Assumption of the Virgin* (Chicago, Art Inst.) and the *Holy Trinity* (Madrid, Prado).

A much-hoped-for commission from Philip II came in 1580: the *Martyrdom of S. Maurice and the Theban Legion* for one of the principal altars of the church of El *Escorial (Nuevos Mus.). The King, however, did not like the picture, and had it replaced by the work of another artist. After this failure at court, El Greco settled in Toledo for the remainder of his life.

El Greco's most famous work is the *Burial of the Count of Orgaz* (1586–8) in the church of S. Tomé in Toledo, painted in memory of a 14th-century benefactor of S. Tomé and of the Augustinians of S. Esteban. It depicts the lowering of the Count's body into his tomb by S. Augustine and S. Stephen, and his soul's ascension to the Heavenly Glory. In the earthly zone, which includes a gallery of portraits of Toledan gentlemen, the figures are only mildly attenuated and their garments are painted with the best Venetian illusionistic technique. The Glory, on the other hand, makes clear that El Greco had already developed an anti-naturalistic style for figures and space.

The multi-picture altarpiece for the College of Nuestra Señora de la Encarnación in Madrid (1597–1600) is one of El Greco's most important commissions outside Toledo. In these pictures, the attenuation of the figures, the compression of their volumes on the picture plane, the brilliant, cold light playing over the yellowish greens, purplish reds, and leaden blues of the draperies, and the abstract handling of forms throughout—flesh, cloth, clouds, all share identical surface textures and consistency—enhance the expressive intensity and supernatural character of the scenes. The anti-naturalism that informed his painting in Toledo from the start is carried to its limits in the late *Assumption of the Virgin* (c.1607–13; Toledo, Mus. de S. Cruz), where the image attains a degree of abstraction that decidedly disconnects it from

313

earthly reality. In his last works, the artist also takes the Venetian technique of painterly freedom to its ultimate consequences.

The *View of Toledo* (c.1600; New York, Met. Mus.), El Greco's only landscape, is formally consistent with his religious pictures. Its transcendental aura is a result of his compositional methods, which create a formidable tension between the patterns on the picture plane and the volumes implicit in the view, and of his characteristic cataclysmic skies and eerie light. The *View* is not a realistic panorama, but displays instead the city's most notable monuments in a single image that highlights its past and present grandeur.

El Greco's many portraits show him as a consummate portraitist. Perhaps the earliest, in which format, composition, and iconography reflect Venetian models, is *Giulio Clovio* (Naples, Capodimonte), painted in Rome c.1570–2. His most important one, for its size and superb artistry, is the *Portrait of a Cardinal* (c.1600; New York, Met. Mus.), probably the great patron of the arts Bernardo de Sandoval y Rojas, who was made cardinal and Archbishop of Toledo in 1599. The portrait's format, a full-length, life-size seated figure, is rare at this date.

El Greco's writings on painting and architecture were never published and the manuscripts are lost, but some of his ideas are known through his marginal notes on his copies of *Vasari's Lives of the Painters* and Vitruvius' *Ten Books on Architecture*. They reflect Mannerist art theory in the importance given to grace and virtuosity, but he also places great emphasis on colour, regarding as ideal a synthesis of Venetian *colore* and Florentine-Roman *disegno* (see DISEGNO-COLORE). NAM

Brown, J., et al., *El Greco of Toledo* (1982).
Davies, D., *El Greco* (1976).
Wethey, H. E., *El Greco and his School* (1962).

GREEK ART, ANCIENT (1) Introduction; (2) Inscriptions; (3) Painting; (4) Vase-painting; (5) Sculpture; (6) Mosaics; (7) Patronage and collecting

1. INTRODUCTION

Declaring it a great error, Paul *Gauguin acknowledged the essential fact that Greek art has served as both the cornerstone and yardstick of Western visual culture. This authority, and Gauguin's complaint, is largely the result of the high value placed upon realism—which Greek artists conscientiously explored and eventually mastered—by the Romans (who adopted and disseminated Greek styles and motifs throughout their empire) and by successor civilizations. However, to focus merely on identifying incremental stages in the relatively rapid stylistic evolution towards naturalism in the depiction of the human body—always the chief concern of Greek craftsmen in diverse media (stone sculpture and painted pottery are only the best preserved)—reduces Greek art to a linear progression, as if photographic realism had always been its paramount objective. To be sure, styles as well as techniques did change considerably from the abstract, Geometric figures of the 8th century BC; to the adaptations and innovations of the Orientalizing phase (7th century BC); the formal, patterned images of the Archaic period (6th century BC); the moving, thinking, balanced beings of the Classical, so-called 'Golden Age' (5th and 4th centuries BC); and the eclectic, often ultra-realistic depictions of the *Hellenistic period (3rd–1st centuries BC). The impulse to describe the world, however, was always tempered by the need to communicate essentials effectively, and thus naturalism was in constant tension with idealization. Despite their creativity—whether in modifying Egyptian and Near Eastern forms, or inventing the Doric and Ionic orders of architecture—Greek artists worked in established genres. (Thus, for example, the reliance on schemata evident in Archaic *kouroi and korai, and the longevity of the architectural orders.) Most of the objects we consider works of art were functional. From pots to temples, friezes to finger rings, moreover, Greek art was essentially narrative, conveying stories of gods, heroes, and humans. Such expositions were normative, providing models of behaviour, proper and improper; and whether to be viewed in a sanctuary or cemetery, during a symposium or a battle, images served primarily as vehicles for personal piety, social assertion, and political propaganda. KDSL

2. INSCRIPTIONS

For modern scholars inscriptions are a prime source of information; they appear on many art objects from the early days of Greek alphabetic writing, c.700 BC. Makers' names are frequent but so too names of commissioners and of recipients, often deities. On pottery and occasionally sculpture, gems, and coins, names identify the characters portrayed, becoming an integral part of the artefact; figures on pots can be given words issuing from the mouth, or funerary statues can speak to the passer-by. Artefacts too often 'speak'—'Exekias made me'—and we recall that all reading in the ancient world was aloud. On vases of c.550–400 BC less relevant remarks are also found, notably praise of youths, 'kalos' names, originally perhaps commissioned by wealthy admirers-about-town, though in time becoming a cliché. Such writing on objects was frequent, though rarer in the plastic arts after c.475 BC. Dedications to the gods and epitaphs, rarely more mundane texts, were often in verse. Pattern of use is very uneven and clearly depended much on the producer and his local background; there is little to suggest that the names were added primarily to assist the viewer. Styles of writing vary, though a general chronological trend from large to neat lettering is clear; name labels begin as near to the head of the figure as possible extending into any available space, a habit that weakens only in the 5th century under the influence of more monumental script, when many artists now write in straight lines, neatly ordered. A variety of alphabets were in use in the Greek world until then and letter forms can be a good guide to the origin of artefacts or artists when other indications are lacking. Our knowledge of individual vase painters comes solely from their painted signatures and a few specific dedications. Sculptors of the Archaic period are known mainly from signatures, which also supplement information from ancient authors for *Classical and *Hellenistic artists. AWJ

Immerwahr, H., *Attic Script* (1990).
Jeffery, L. H., *The Local Scripts of Archaic Greece* (2nd edn., 1990).
Marcadé, J., *Recueil des signatures de sculpteurs grecs* (1953–).

3. PAINTING

Painting, on panels or walls, was a major form of ancient Greek art, especially in the 5th and 4th centuries BC. Almost nothing survives from this period, and we rely largely on ancient writers, notably *Pliny (*Natural History* 35) and *Pausanias. We read detailed descriptions of lost paintings, biographies, and anecdotes about painters and their social status, and information on technique. Painting was the subject of philosophical and moral debate (e.g. *Plato) and of rhetorical description (e.g. *Quintilian).

In the *Archaic period (7th–6th centuries BC), the sources are least reliable, but more paintings survive. From the beginning, painting was a public rather than private art, used primarily on temples. Pliny says painting originated at Corinth or nearby Sicyon. In the 7th century BC, the neighbouring temples at Corinth and Isthmia had painted decoration, the former simple bands of colour, the latter preserving patterns and a horse on stucco panels on the exterior walls. The colours used are white, yellow, orange, purple, blue, and black. The style is comparable to that of mid-7th-century Corinthian vase paintings, on some of which the artist has employed a brown wash on human figures to represent flesh tones. Terracotta panels on the temple façade at Thermon in Calydon (c.630; Athens, Nat. Arch. Mus.) are decorated with mythological scenes in Corinthian style.

Elsewhere in the Greek world, painters absorbed local styles: Greek and Persian elements mingle on tomb paintings at Elmali in Lycia (c.525–475 BC), and a stone plaque from Persepolis (c.500 BC); south Italian tomb

paintings, notably at Paestum (c.480 BC), are in Greek style.

From the late 6th century, vases show three-quarter views, an important development in painting attributed to Cimon of Cleonae. Together with detailed descriptions, vases (see below) provide our best impression of lost early *Classical panel paintings (c.480–450 BC). They were multi-figure compositions, with figures at different levels to convey depth. *Perspective was developed about the same time, apparently in a theatrical context, notably by *Agatharchus.

For technique, we again rely on literary sources. The paintings in the Painted Stoa in *Athens (c.475–450 BC) were on wooden panels; a late 4th-century traveller notes their removal. At *Delphi, indications exist of a frame to hang such panels. The only surviving paintings on wood are small plaques (the largest c.15×30 cm/6×12 in) from Pitsa in the Corinthia (c.540–500 BC; Athens, Nat. Arch. Mus.). The wood has been whitened, the neutral background facilitating a broad range of colours, including blue. Classical wooden panels were whitened before painting, using a 'four-colour' scheme consisting of red, yellow, black (perhaps including blue), and white. Pliny details colours used, their origins, and painters' preferences. Paint was applied by brush, although the encaustic technique (mixing paint with heated wax) was used at least from the time of *Polygnotus.

The most famous paintings were in buildings such as the Painted Stoa at Athens and the Leche (Club-House) of the Cnidians at Delphi (c.458–447 BC). Themes employed are historical (the battle of Marathon) and heroic (Troy, Greeks battling Amazons); later paintings include *Theseus, Democracy and the People*, painted in the Stoa of Zeus at Athens by Euphranor in the 4th century. These preoccupations differ markedly from those of vase painters, reflecting the public nature of the art. The Painted Stoa in Athens, built under Cimon c.475–450 BC, was originally named after a relative of his, and the themes used in the public art of his day, and that of Pericles, glorified Athens. The painters, such as Polygnotus, Micon, and Panaenus, became famous, and we read about them, their contributions to the development of painting, and the moral tone of their art.

The last decade of the 5th century and the first of the 4th saw the next peak of Greek painting: Pliny says Apollodorus 'opened the gates of painting', balancing light and shade. *Zeuxis followed, renowned for shade and mass, then Parrhasius, renowned for contour. Euphranor (active 364), famed as sculptor and painter, said that Parrhasius' *Theseus* appeared to have been fed on roses, while his own was fed on meat. Xenophon (*Memorabilia* 3. 10. 1–5) has Parrhasius debate painting styles with Socrates. The most prominent

painter of all was *Apelles, who alone was allowed to paint Alexander the Great. Contemporary are the most extensive and spectacular surviving paintings, on the tombs of *Vergina in northern Greece. Contemporary paintings from the same area include those from tombs at Aineia, which employ at least six colours, and Lefkadia, which use shading. Slightly later are tomb paintings from Kazanlak (Bulgaria), which use outline and shading, but limited colour; they are true fresco, with a binding medium.

The *Hellenistic period is of less interest to our sources, and the style of its paintings must be inferred from Roman *mosaics apparently copying paintings. KWA

Bruno, V. J., *Form and Colour in Greek Painting* (1977).
Pollitt, J. J., *The Art of Greece* (rev. edn., 1990).
Robertson, C. M., *A History of Greek Art* (1975).

4. VASE PAINTING

In the so-called Dark Ages between the fall of the Mycenae and the revival of economic life in mainland Greece, c.1200–900 BC, the potter's craft remained essential to daily life. Continuity with the Bronze Age is clear in the repertory of shapes, even though decoration was minimal during this period of poverty and limited artistic expression. The development of tighter shapes and richer, more defined decoration throughout the proto-Geometric and early Geometric periods, the 10th and 9th centuries BC, sets the stage for the blossoming of the ripe *Geometric style in the 8th century. This first step in what would be a continuous development in pottery production lasting 500 years was named for the abstract, linear patterns dominating Geometric vases. Ornamental patterns, arranged according to principles of symmetry and proportion, opened up to provide progressively larger areas to be filled with human and animal figures which, like the ornament, were rendered with geometric forms.

In the 8th century BC potters and painters mastering the technically complex method of forming, decorating, and firing pottery produced precisely proportioned monumental vases. In the apparent absence of sculpture, pottery production, widely practised in many centres of the Greek world and with subject matter varying from place to place, was the only monumental art form. In Athens vase painters focused on the human figure which appeared in funeral and mourning scenes and in chariot processions and battles, reminders of heroic life. Such scenes reflected the function of these large vases as grave markers. One of the best Athenian painters, the *Dipylon Painter, invested his scenes with narrative clarity by employing several perspective viewpoints. Some scholars have linked the introduction of narratives with oral epics current in the 8th century. Scenes of shipwrecks and battles

have been identified as mythological stories but they lack specificity to prove the connection.

In the later 8th century, travel and trade exposed the Greeks to neighbouring cultures, mainly in the Near East, which has led scholars to call the 7th century the Orientalizing period. It was a period of innovation and experimentation with new decorative techniques. In vase painting, a new repertory of curvilinear floral and animal motifs enriched without overwhelming the native Greek tradition which continued the Geometric focus on proportion, symmetry, and articulation of parts. In late Geometric, black silhouetted figures had already been lightened by rendering such areas as faces and female garments in outline not filled with black glaze. In the 7th century, outline drawing for entire figures flourished in Athens (proto-Attic or black and white style), and elsewhere. Polychromy appeared briefly in Corinth and the Argolid, probably influenced by larger panel paintings such as the painted terracotta metopes from Thermon (Athens, Nat. Arch. Mus.) These techniques were short-lived because in the vase medium outline figures are poorly distinguishable from surrounding ornament.

Black-figure retained the clarity of the Geometric silhouette but artists provided additional inner detail by engraving the black glaze with a sharp tool. It has been suggested that this technique, first seen in Corinth, evolved from Near Eastern metalwork. Added colours like red and white for highlights and other details provided further contrast. Animal friezes remained popular, enlivened with species introduced from the east such as lions, cocks, and hens, as well as imaginary creatures, such as sphinxes, sirens, griffins, and chimeras. The animal style reigned supreme in Corinthian black-figure, but in Athens the human figure remained paramount. The narrative tendencies of the ripe Geometric now took on true mythological content combining heroic stories of the Mycenaean past with heroes of Near Eastern derivation. Inscriptions sometimes identified the protagonists, and occasionally provided artists' signatures.

In the 6th century, Athenian black-figure supplanted Corinthian and became the dominant ware with workshops exporting painted ceramics throughout the Mediterranean and beyond. Signatures of potters and painters, rare earlier, now appear with increasing frequency. Sophilus, the earliest Attic painter to sign his name, continued the Corinthian-style animal friezes in the first half of the 6th century but also painted innovative narrative scenes: spectators watching the funeral games of Patroclus is the best known (Athens, Nat. Arch. Mus.). Miniature painting, favoured for drinking cups known as Little Master cups, was also used for the

0.6-m/2-ft tall volute crater known as the François Vase, signed by Cleitias and Ergotimus (Florence, Mus. Arch.). The artists organized the field into horizontal zones with a dozen mythological subjects featuring overlapping figures and architectural settings.

Toward the mid-6th century, Exekias, the finest black-figure artist, signed vases as potter and painter. He painted elegant shapes with attention to detail, and in figure scenes he has an unsurpassed ability to convey the essence of a story through imaginative use of composition, pose, and unusual choice of moment. The other great mid-century black-figure painter is known as the Amasis Painter because of his collaboration with the potter Amasis. A master of balanced composition and detail, the Amasis Painter experimented with outline drawing which may have influenced the development of red-figure.

Vase production in Athens was motivated by practical and popular demand, the vases intended for use in daily life and therefore decorated with subjects of current interest to potential buyers, myths as well as scenes of daily life, though the dividing line between the two was never firm. In Greek art generally, as in literature and theatre, myths were used as metaphors for historical or contemporary events: the battle of the Amazons could signify the Greek victory over the Persians. Certain heroes come to represent political interests: Theseus, hero of Athenian democracy. Vases provide a unique window onto the concerns of Archaic and Classical Athens.

A momentous change in convention occured about 530–520 BC. Vase painters reversed the black-figure scheme so that the figures were reserved in the red clay against the black ground. Scholars have attributed this change to the potters Andocides and Nicosthenes and the painters who collaborated with them, as well as the painter Psiax. The impetus for the change from black-figure to red-figure is debated, with explanations ranging from technical experimentation in the pottery workshops, to external influences from textile manufacture, metalwork, or monumental sculpture.

The first generation of red-figure painters merely reversed the black-figure style without taking advantage of the possibilities of the new technique. This was left to their successors dubbed the Pioneers (520–500 BC). Led by *Euphronius, they were the first to use diluted glaze for colouristic effect, contrasting it with the sharper, denser relief glaze line. They experimented with representing the human figure in complex, three-dimensional poses drawing on knowledge of anatomy, with a predilection for mythological subjects often focusing on Hercules and stories from the Trojan cycle. The leading late Archaic painters (500–480 BC), such as the Cleophrades Painter, the Berlin Painter, Onesimus and *Douris, continued and expanded the experiments of the Pioneers, using dilute glaze to create texture and shading, perfecting a realistic representation of the human body in action, including the accurate rendering of a profile eye (Sosias Painter, Berlin, Altes Mus.). In this period vase painting was at its best, the strong, simple forms of the figures and ornament admirably suited to the curving surface of the vase.

In the early Classical period (480–450 BC), the influence of monumental wall painting changed the picture, but since no masterpieces by the major painters such as *Polygnotus or Parrhasius has survived, our best visual evidence for their appearance is vase painting, especially that on white ground vases. The white ground technique had been used since the late 6th century especially for the lecythus, an oil jug used as a grave offering, generally decorated with scenes reflecting death, burial, and tomb cult. Toward the mid-5th century the Achilles Painter and the Phiale Painter among others both took this technique further, producing some of the earliest master drawing of the West, exploiting the painterly possibilities of dilute glaze and added colours for line, texture, and shading. The influence of large-scale painting is also apparent in the use of different ground lines for figures indicating depth (Niobid Painter; Paris, Louvre), and in a preference for scenes of figures standing quietly with a subdued, monumental quality. Mythological subjects continue, especially scenes of gods pursuing mortals. Everyday life is reflected in scenes focusing on activities of women.

In the second half of the 5th century the Eretria Painter and the Meidias Painter employ a more ornate style of decoration, crowded compositions, and subjects full of metaphor and allusion. Filled with detail, these vases are far from the elegantly austere vases from early in the century. The curved surface and restricted field of the vase was less well suited to reflections of monumental compositions and ornate approaches, both of which strained the limits of the medium.

By the late 5th century, the ornate style dominated pottery decoration. Late 5th- and 4th-century Attic wares found a market to the east in Black Sea cities. Vases excavated in the Crimea near the Kerch provide examples of this late Attic 'Kerch' style characterized by attention to detail and increased use of colour, relief, and gilding.

In the same period the craft took on new life in the Greek colonies to the west, in south Italy, where potters and painters seem to have emigrated from Athens by the third quarter of the 5th century. Red-figure appears first in Lucania (a pottery workshop has been excavated at Metaponto), then in Apulia, probably in Taranto. In the 4th century other schools developed in Campania, Paestum, and Sicily. The earliest south Italian vase painters reflect eclectic Attic sources of inspiration, both ornate and plain. During the 4th century, production of monumental vases flooded with figures carried the ornate style to an extreme. South Italian vase painters adapted Athenian iconographic schemes to their own interests, primary among which was the theatre. Theatrical scene painting inspired south Italian vase painters to focus on architectural *perspective (attempted already in the early 5th century), but south Italian vase painters tackled the problem with renewed vigour and effective though never completely accurate results. The south Italian schools represent the last flourishing of figural Greek vase painting. DB-O

Boardman, J., Athenian Black Figure Vases (1974).
Boardman, J., Athenian Red Figure Vases: The Archaic Period (1975).
Boardman, J., Athenian Red Figure Vases: The Classical Period (1989).
Rasmussen, T., and Spivey, N. (eds.), Looking at Greek Vases (1991).
Sparkes, B. A., Greek Pottery: An Introduction (1991).
Trendall, A. D., Red Figure Vases of South Italy and Sicily (1989).
Williams, D., Greek Vases (1985).

5. SCULPTURE

By about 900 BC, small-scale votive offerings in the form of bronze figurines were being cast in large numbers in the Greek world for deposit in the major sanctuaries. *Olympia has yielded the largest numbers of these early offerings. Because of their abstract simplicity, the style is named *Geometric. Images representing birds, animals, and humans bear a close resemblance to contemporary figures in Greek vase-painting. A man usually consists of a round head with a prominent chin which may be interpreted as a beard, triangular torso, prominent genitals, sticklike limbs, and perhaps a helmet, a shield, and a sword; a woman has a head augmented with straight hair, a triangular torso, sticklike arms, and a long cylindrical skirt. Groups tend to be a mare, a cow, or a doe with her young. By the 8th century BC, there are images of artisans and musicians, and chariot groups, fighting animals, a man with a centaur, and a man fighting a lion, perhaps an early representation of a mythological event, such as Hercules and the Nemean lion.

Olympia, an active sanctuary during the Geometric period, has also yielded a number of failed *castings from the nearby workshops where the dedications were produced. The statuettes were cast solid by the lost-wax process: wax was cut, rolled, pinched, and tooled; the wax body parts were stuck together; the resulting model was invested with a clay mould; the mould was baked to burn out the wax; and bronze was poured

into the mould to replace the wax. The base was usually cast along with the figurine. During the 7th century BC, generic standing men became more specific representations of ram- or calf-bearers, of youths, and of striding attacking gods, types which continued to be made through the *Archaic period.

Although bronze statuettes were produced long before large-scale bronzes were cast, *sphyrelaton* was an early technique used to make some larger images. According to the 2nd-century AD traveller *Pausanias (3. 17. 6), the process involved hammering sheets of metal into the shape of a figure and riveting them together over a solid core. Only a few such images survive—the best known are a male (height 0.8 m/2 ft 5 in) and a pair of much smaller females (height 0.4 m/1 ft 4 in) from a small sanctuary at Dreros in Crete (Crete, Heraklion Mus.). Stiffly frontal cylindrical standing figures, they are usually dated to the late 8th century or the early 7th century BC.

The Orientalizing period of the 7th century BC was a period during which the Greeks imported metal objects, textiles, ivories, and ideas from Phoenicia, Syria, Phrygia, and Urartu. The styles and subjects of their own works were affected, and six or more exotic griffins' heads with inlaid eyes are added to the shoulders of bronze cauldrons that served as dedications, some of the cauldrons standing more than 3 m (10 ft) tall.

The Greeks also traded with Egypt, where they saw large-scale statuary in stone and in bronze. Egypt had a long-established sculptural tradition of blocklike, frontal figures with carefully formulated proportions. By the middle of the 7th century, the Greeks had brought home these 'new' ideas, as well as the knowledge of large-scale bronze-casting and *stonecarving methods. The sculptures that were produced in 7th-century Greece are derived from the Egyptian tradition, both stylistically and technically, but they are adapted to fit the needs of Greek religious dedications.

The style associated with the 7th century is called 'Daedalic', after the legendary artist/craftsman *Daedalus. A typical example is the standing marble *kore* (young woman) dedicated by Nicander on the island of Delos (Athens, Nat. Arch. Mus.). Stiffly frontal, she has neat triangular sections of hair arranged symmetrically on either side of a triangular face, broad shoulders, a triangular torso, a tight but nonetheless unrevealing belted tunic, hands attached to the sides, and feet emerging from beneath an upward-curving hem. From the side, the figure's shortcomings become clear: she is unnaturalistically erect, and thin and planklike in contour. Two similarly formulaic women were carved in the later 7th century BC as reliefs on the underside of a limestone lintel-block at Prinias in Crete, and two three-dimensional

women are seated atop either end of the same lintel (Crete, Heraklion Mus.; height of seated women c.0.82 m/2 ft 8 in).

The limestone temple of Artemis on Corfu (c.590–580 BC), constructed at the beginning of the Archaic period in Greece, is the earliest Greek temple known to have been built entirely of stone with stone pedimental sculptures (Corfu Mus.). The problem of how to fit figures into the triangular space was addressed by varying the scale: tiny figures of dead giants lie with their heads in the corners of the west pediment; then come two larger pairs consisting of gods attacking giants; then two giant spotted panthers, couchant; and, in the centre, a monstrous Medusa (height 2.85 m/9 ft 9 in) overlaps the peak of the pediment, her huge face and bulging torso frontal, her arms and legs in profile. Her vigorous position, with one knee down and one up, coupled with the wings on her ankles, is illustrative of flight; her huge eyes and lolling tongue are apotropaic. The Gorgon is flanked by her diminutive children Chrysaor and Pegasus, born at the moment of her death; used here, like the giants in the corners of the pediments, to evoke a story.

Archaic bronze statuettes have been found in particularly large numbers in Olympia, *Athens, *Delphi, Dodona, and Samos. Traditionally, they have been grouped according to the theory that there were various regional centres of production, in Attica, Aegina, Corinth, Sicyon, Argos, Sparta, Arcadia, Magna Graecia, and east Greece. These identifications are generally based upon style, not upon find-spots. Some of the most sophisticated Archaic bronze statuettes have been found at the Heraion (sanctuary of Hera) on Samos, and they were probably made in the immediate vicinity of that site. These bronzes support the evidence of the ancient literary *testimonia* which ascribe legendary skills and achievements in casting techniques to the Samian bronzeworkers Rhoicus and Theodorus (see Pausanias 8. 14. 8; 9. 41. 1; 10. 38. 6). The Samians were among the most active of the Greek traders with Egypt. A three-times-life-size marble *kouros* from the Heraion, dating to the early Archaic period, c.580/70 BC, attests to the impact of that contact (Samos, Arch. Mus.).

Hundreds of images of korai and kouroi (young men), some in bronze but most of them painted stone, were erected to serve as votive offerings or as grave markers. The colossal *Sounion Kouros* (Athens, Nat. Arch. Mus.) is a good example of the early Archaic style. Nude, blocklike, and frontal, he stands over 3 m (10ft) in height, one leg extended ahead of the other, but both feet rest flat on the ground, and neither hips nor shoulders are affected by his stance. His hands are clenched against his thighs, though on later kouroi the arms may be extended forwards

from the elbows. Anatomical details are sharply articulated, but they are governed by the principle of surface design. A large cubic head is decorated with elaborate linear detail, including rows of stylized curls, volute-like ears, and huge bulging eyes. The shoulder blades, epigastric arch, and kneecaps serve as decorative surface design on an otherwise massive figure which retains the characteristics of the four-sided block of marble from which the image was carved.

The 6th-century kore wears a long dress, long hair, and always has her feet together, but as the Archaic period progresses, her garments, symmetrically placed long locks of hair, and jewellery become more elaborate. There is much evidence of gilded and brightly painted decorative details. By the last quarter of the 6th century, the Doric peplos, a heavy woollen, smoothly hanging belted garment, was replaced by the lightweight frilly Ionian chiton, with its greater possibilities for the addition of cascading hems, of ornament, and of elaborate surface patterns. Throughout the century, the 'Archaic smile', the mouth with upturned corners, delicately creased, is the constant formula used on all statues, male and female alike.

The Siphnian Treasury at Delphi, closely dated to between 530 and 520 BC was originally rather like a brightly painted and showy jewel-box (Delphi Mus.). The islanders' expensive, carefully sited, and heavily sculpted dedication, made in the Ionic style, had two caryatids (female supporting figures), painted and embellished with bronze, instead of columns on the façade, and relief sculptures in both pediment and friezes. In the pediment, Hercules tries to wrest the Delphic tripod from Apollo; in the frieze, complex interlocking figures with their names inscribed represent scenes from the Trojan War, seated gods, and a battle between gods and giants. The carved metopes on the Athenian Treasury, also at Delphi (c.490–480 BC; Delphi Mus.), focus on the labours of Theseus and of Hercules, and on the battle between Greeks and Amazons. The trophies erected outside the simple Doric treasury completed the monument to victory over the Persians at the battle of Marathon.

Repetition is no more unusual in Greek sculpture than it is in Greek vase painting. An early 6th-century Tanagran grave stela for Dermys and Cittylus (Athens, Nat. Arch. Mus.; height of youths 1.47 m/4ft 10 in), made of limestone carved in high relief, shows two standing males in poses that are mirror images of one another. Two massive kouroi dedicated at Delphi c.580 BC, traditionally but probably incorrectly identified as Cleobis and Biton of Argos, are practically identical (Delphi Mus.; height of each 1.97 m/6 ft 6 in). Three Samian korai lined up on a statue-base as part of a family dedication are essentially

identical in pose and in appearance.

Lost-wax casting is a reproductive process, and the Greeks used it to make large-scale bronzes from the Archaic period onwards. This method was well suited to sculpture that was stylistically repetitive, limited to standing, striding, or seated figures that served exclusively religious functions. In other words, although bronze has a far greater tensile strength than does stone, its flexibility was not exploited, for large-scale bronze statues of the 6th century did not deviate from the strict formulas dictated by Archaic stylistic convention. Thus two small bronze horsemen from Samos were cast from the same original model (Samos, Arch. Mus.), as were two bronze kouroi (Samos, Arch. Mus.; and Berlin, Altes Mus.), the only real difference between the latter being that the left leg of one of them was inscribed by the dedicator, Smicrus.

To cast a bronze statue, the Greeks took piece-moulds from a basic model, and lined them with wax to make a thin-walled wax working model, which was normally produced in sections and then pieced together. After adjusting the wax limbs and modelling and carving the surface details, the artist/technician dismantled the working model. The piece-moulds could be reused to form additional wax working models when more than one bronze was to be cast from the same basic model. The individual sections of the statue were invested separately in clay moulds, and baked—to dry the clay and melt out the wax. Next, molten bronze was carried from the nearby furnace, poured into funnels, and thus channelled into the moulds to cast the statue sections. These could be joined mechanically or metallurgically. For instance, the *Delphi Charioteer*'s head, arms, and torso were socketed in place, whereas his lower legs and feet appear to have been hard-soldered to a plate hidden by the hem of the columnar skirt (478 or 474 BC; Delphi Mus.; height 1.8 m/6 ft) Finishing touches included inset silver teeth, a silver meander in the fillet binding his head, and lifelike stone eyes encased in copper lashes.

Workshops for the production of statues and of statuettes certainly existed near many of the sanctuaries in which the images were dedicated, though small bronzes could also have been carried into a sanctuary from an entirely different locale. The use of duplicative processes further complicates the question of regional styles, since this type of production meant that moulds taken from one basic model could have been transported elsewhere for creating waxes and then casting them in bronze.

According to ancient literary sources, the tradition of erecting statues of victors in athletic contests began in the 3rd quarter of the 6th century. Pausanias makes it clear that such statues were not votive offerings, but that they were 'given to the victors in the games' (5. 21. 1). The earliest such statues were made of wood, but bronze soon came to be preferred, no doubt because of the freedom of movement this lightweight medium afforded. A new impetus towards naturalism in sculpture had begun well before the end of the 6th century. The standing frontal male statue is reduced to life size, becomes slightly asymmetrical, and is more naturalistic. The early 5th-century marble *Kritios Boy* (Athens, Acropolis Mus.; present height 1.17 m/3 ft 10 in) is a fine example of this trend towards naturalism. His head turns a little to his right, his hips and shoulders shift because he is actually standing on one leg and relaxing the other one. His spine curves, his flesh appears soft and youthful, the Archaic smile is gone, and the eyes were once inlaid to lend realism to the boy's gaze. In bronze too, the illusion of realism was increased by inlaid eyes with copper lashes, copper lips and nipples, silver teeth, and silver fingernails. There is also evidence that the surfaces of some bronzes made during the *Classical period were painted or patinated.

Our few preserved large bronze statues make a striking contrast to the many extant statuettes, whose complex movements and marked torsion make them strongly three-dimensional. Differences between the types represented in statuettes and in large-scale bronzes are probably due more to independent stylistic traditions than to differences in methods of production. The early Classical bronze *Artemision God* (Athens, Nat. Arch. Mus.) is a convincingly naturalistic exception to this rule. He takes a big step and draws back his arm to hurl a weapon, twisting slightly at the waist, left arm forward to balance himself. And yet his essentially two-dimensional silhouette is not far removed from the stiffly striding attacker of the Archaic period, with a frontal torso and arms and legs in profile. *Myron's famous early Classical bronze discus-thrower does not survive, but the literary sources give a clear sense of a young man 'who bends down . . . turning toward the hand that holds the discus, and slightly bending the other knee, as if to straighten up with the throw' (Lucian, *Philopseudes* 18). In addition, there are a number of ancient reproductions of the statue, including two erected by the Roman Emperor Hadrian at his country villa in Tivoli (Vatican Mus.; London, BM).

Although athletes might be represented engaged in sport, the more common 5th-century type was that of standing bronze athletes, heroes, or generals developed from the Archaic kouros. Statuettes probably reflect large-scale images of the same types. The emphasis that scholars have placed upon regional centres of production during the Archaic period is replaced by a tendency to associate Classical statues with the names of particular artists who are known from the ancient literary *testimonia*. The over-life-size *Riace Bronzes, for instance, have been given at least eight attributions—to Onatas, Myron, *Phidias, or the 'school' of Phidias, *Polyclitus, or a 'follower' of Polyclitus, Attica, or south Italy. Whoever made them, the statues are rare survivals of the Classical style, for most ancient bronzes were eventually melted down so that the metal could be re-used, often for weapons and ammunition.

The *Riace Bronzes, their heads turned, muscles flexed, and feet bearing unequal weight, exemplify the naturalistic yet perfected Classical style (Reggio Calabria, Mus. Nazionale). A single basic model was apparently used for both of these nude statues (height 1.97 and 1.98 m/6 ft 6 in), and their overall similarities are unmistakable, but each version was individualized in the wax before being cast, resulting in significant differences, particularly in the faces, beards, and hair. They were meant to be seen as individuals, though both images have idealized bodies, and both were once helmeted and equipped with shield and spear.

In the 1st century AD, *Pliny estimated that a major city or sanctuary might contain about 3,000 statues. On the strength of surviving statue-bases, we can assume that the standing nude male was the most common type of image. Commemorative statues of athletes, as of military heroes and political leaders, were to be seen in every city and wherever competitions were held in Greece: some in action, others simply standing, naked as in competition, one hand raised to the victor's wreath, or holding a strigil or a palm-branch.

Three different groups of marble pedimental figures were carved for the temple of the nymph Aphaia on the island of Aegina near Athens (Munich, Glyptothek). They include a range of styles produced during a 20-year period (500–480 BC), at the time when Greece was under constant threat of takeover by the Persian Empire. The fully three-dimensional figures in these elaborate battle scenes are carved to one scale, with the exception of the colossal images of Athena overseeing the battle from the centre of each pediment. Indeed, the many positions that can be used for a battle scene are well suited to the triangular confines of a pediment. Two fallen warriors illustrate the differences between the earlier and later styles. The earlier one reaches almost jauntily for the dagger stuck between his ribs, his face adorned with an Archaic smile; while the later one is clearly dying, his head bent, his sagging body supported only by the wrist still fixed in its shield-strap. The extensive use of added bronze features on these figures recall references in the ancient literary sources to a famous bronze alloy that was produced on this island.

Pliny relates that the Athenians introduced a new custom when in the late 6th century BC they set up two statues commemorating real people, and did so at public expense (*Natural History* 34. 17). The bronze *Tyrant-Slayers* stood in the Agora at Athens until they were carried off by the Persians in the course of destroying the city in 480 BC. Just three years later, the Athenians set up another pair of striding attacking *Tyrant-Slayers*. Finally, Alexander the Great (336–323 BC) or one of his successors reclaimed the original pair, and set them beside the others in the city centre (ancient marble copies in Naples, Mus. Arch. Naz.).

The rise of the Classical style is usually dated to 480 BC, when the Persians were decisively repulsed from Greece, ten years after their first devastating invasion of the Greek mainland. Reflections of the Greek victories over the barbarians may be seen in the choice of mythological subjects—Greeks defeating non-Greeks—that continued to be used for architectural sculpture during the 5th century. Well-groomed handsome Greek youths fight wild-haired ageing centaurs in the early Classical marble sculptures from the west pediment of the temple of Zeus at Olympia (*c*.460 BC; Olympia Mus.). Relationships between bodies and drapery are explored, complicated groups of figures are portrayed in exaggerated actions, and individuals reveal a modicum of emotional response to physical predicaments. In stark contrast to this frenzied activity, the quiet figures in the east pediment are preparing for the chariot race between Pelops and Oenomäus, whose fatal outcome would have been known by every visitor to Olympia. After the race, Pelops was to become the eponymous ruler of southern Greece, the Peloponnese.

Phidias designed far more idealized sculptures to adorn the *Parthenon in Athens, whose building accounts, inscribed in stone, date the project between 448 and 432 BC. By their vast numbers, and by the range of subjects illustrated, these sculptures make a public statement about the glory of the city. They are used today to exemplify the high Classical style. The 92 metopes around the outside of the building represent conflicts between Greeks and Trojans, Amazons, and centaurs, and between the Greek gods and the giants (447–442 BC; London, BM). Above the metopes, the marble figures in the pediments, carved fully in the round, illustrate the birth of Athena, the city's eponymous goddess (on the east), and the competition between Athena and Poseidon over the city of Athens (on the west) (438–432 BC; London, BM). These massive figures are youthful and idealized, their significance described without emotion, but in terms of extraordinarily expressive drapery and of perfected anatomy. Within the colonnade, the idealized figures of the frieze around the temple's *cella*

represent a non-mythological event, one that was familiar to all Athenians—they move in ranks around the building in the Panathenaic procession to honor Athena's birthday, the head of the procession halting before a relaxed assemblage of seated Olympian deities (442–438 BC; London, BM).

The colossal chryselephantine (gold and ivory) statue of *Athena Parthenos* (the virgin) that stood within the temple, known today only from ancient descriptions and small-scale reproductions, exemplified the majesty, sublimity, and dignity of Phidias's work (Dionysius of Halicarnassus, *Isocrates* 3). In fact, chryselephantine, the richest and most desired material for cult statues, was a speciality of Phidias, as were colossal statues and cult images. His most famous work in this medium was a huge statue of *Zeus* for the temple of Zeus at Olympia, which was greatly admired, and came to be hailed as one of the *Seven Wonders of the ancient world. Both Phidias and Polyclitus of Argos, the best-known artists of their day, worked in chryselephantine, bronze, and marble. And, as with the building accounts for the Parthenon, records for the production of Phidias's colossal bronze *Athena* for the Athenian Acropolis (Athens, Epigraphical Mus.) indicate that a successful artist was not solely responsible for the creative idea behind a statue, but also hired the staff and supervisors for the completion of the project. Indeed, in ancient Greece, one word—*techné*—was used to mean art, craft, and skill.

Polyclitus, a contemporary of both Myron and Phidias, was the most celebrated sculptor of his time. His speciality was athletic statuary, and he was extensively praised for his bronze statue of the *Doryphorus* (Spear-Bearer), which, like his treatise on that work, he called the *Canon*, whence comes the modern use of that word. Pliny says that Polyclitus was a rival of Myron, both in his choice of Delian bronze over Aeginetan bronze and in the style of statuary which he produced (for two of the numerous Roman marble copies, see Naples, Mus. Arch. Naz., and Minneapolis, Inst. of Arts). Indeed, Polyclitus worked primarily in bronze, and he was said to have perfected the skill of sculpture (Pliny, *Natural History* 34. 55). Of particular interest to scholars has been his concern with *symmetria*, as explained in his treatise and exemplified in the *Doryphorus*. Though both the book and the statue are lost, *symmetria* apparently refers to the precise mathematical proportions of the parts of a statue to one another. The proportions developed by Polyclitus were considered so correct that other artists copied them endlessly, in the hope that they too would achieve perfection in their work. There are many ancient reproductions of the *Doryphorus*, in the form of full statues and of

busts, in marble and in bronze, not to mention the many athletic statues and portrait statues which emulated that famous work. The difficulties inherent in modern attempts to evaluate an original from a reproduction are evident when one considers that the 'copy' is often in another form or another medium than the original. For example, a bronze head cast atop a herm and found in a Roman villa is unmistakably that of the *Doryphorus*, but it is inscribed 'Apollonius, the son of Archius, the Athenian, made this' (Naples, Mus. Arch. Naz.).

Praxiteles and *Lysippus are the two names that dominate accounts of 4th-century sculpture. The closest we can come to the lost works of Praxiteles is through the approximately 60 surviving versions of his famous *Aphrodite of Cnidus, said to have been the first statue of a nude woman ever made, and to have been modelled after Praxiteles' lover Phryne. The painted marble statue of Aphrodite was, according to Pliny, one of two that Praxiteles carved, the other being draped, following tradition. The people of Cos chose the draped image, but the Cnidians purchased the nude, which became far more famous (Natural History 36. 20). The large-scale reproductions show a plump but less-than-feminine naked woman half-heartedly covering her genital area with one hand, while the other lets slip her discarded garment, which cascades over a *hydria* (water-jar) standing at her side (e.g. Vatican Mus.). The statues of Erotes, of Apollo slaying a lizard, of satyrs, and others that have been ascribed to Praxiteles on the strength of the literary testimonia are all problematic, as is the Hermes with the baby Dionysus (Olympia Mus.), which was once widely thought to be an original work by the artist, but which is far more likely to be a creation of Hellenistic or Roman date.

Lysippus was the court portraitist for Alexander the Great, and his famous portrait of the ruler, though based upon the tradition of heroic standing figures, is a distinctive type. The emphasis that Lysippus is said to have placed upon the turn of Alexander's head, on the gaze, and on the sense of power, with one hand outstretched, the other raised to hold a spear, were common characteristics of honorary statues produced during the Hellenistic and Roman periods.

For much of the 4th century, the production of bronze statuary was dominated by the Sicyonian workshop of Lysippus and his family. Lysippus produced not only portraits of Alexander and his friends, but also works like an *Apoxyomenus* (athlete scraping himself with a strigil: one Roman marble version in Athens, Nat. Arch. Mus.), a drunken girl playing a flute, a couple of hunting groups, various chariot groups, a portrait of Socrates, and a satyr. There is no question that his style was very influential, and he was also a prolific

artist. Literary references to his having worked directly from nature, thus improving the art of portraiture, are probably derived from streamlined production processes that were developed in the family foundry, which would have both improved likenesses and speeded production, to meet the growing demand for his popular bronzes.

The Mausoleum at Halicarnassus (modern Bodrum) was the name given the tomb of Mausolus, the Persian governor of Caria (d. 353 BC). The huge rectangular building, crowned by a colossal four-horse chariot holding portrait statues of Mausolus and his wife (height c.3 m/10 ft; London, BM), was one of the Seven Wonders of the ancient world. The sculpted friezes adorning the building or its podium were carved by some of the great artists of the 4th century— Scopas, Bryaxis, Timotheus, and Leochares. Authorship cannot now be assigned with any certainty to surviving frieze-blocks, but the subjects depicted did not depart from established traditions, and included a centauromachy, an Amazonomachy, and a chariot race. (Many of the surviving sculptures are now in London, BM.)

Alexander's rule (d. 323 BC) marks the end of the Classical period. The *Hellenistic period lasted until Octavian's defeat of Antony at Actium in 31 BC. The Classical stylistic tradition continued, as did the need for public monuments and religious dedications. The Attalid dynasty at *Pergamum in Mysia (Asia Minor) commemorated decisive victories over the barbarians (the Gauls) in the 170s and 160s BC by building an altar to Zeus on their acropolis which was decorated with a frieze illustrating the battle between the gods and the giants. Carved in high and dramatic relief, the frieze is a virtuoso example of the so-called 'Hellenistic baroque' style (Berlin, Pergamum Mus.). The dramatic action, the emotional expressions, the striking chiaroscuro of the deeply carved details, the explosion of figures beyond the boundaries of the frieze, and the multiple textures of wings, scales, drapery, and flesh, make these reliefs a tour de force, fascinating for their unexpected and exhaustive details. But the subject and the groupings of figures are not entirely innovative: they are also a conscious recollection of the 5th-century Parthenon in Athens, with its pointed references to the Greeks' rout of the barbarians (the Persians) in 480 BC. Here too, Athena was the protector of the city. Pergamum, like Athens, was a cultural capital, and its library was second only to the great library in Alexandria: the *Gigantomachy* is encyclopedic and all players are included, their names inscribed for those who might be uncertain of the iconography.

At the same time, new types of statues and new styles were introduced to satisfy the rapidly growing market for statuary among private owners. Those who had seen Lysippus' portraits of Alexander wanted their own portraits cast. As the market grew, people came to want statues for their homes and gardens. There were statues for everyone, for every context. Popular figure types could be modified to suit a particular need or desire, but images that were one of a kind were also available. A buyer could choose a theme for a particular context, or buy an Archaizing kouros, a reproduction of the famous Aphrodite of Cnidus, or a more contemporary image of Aphrodite adjusting a golden necklace.

Certain popular types, like the sleeping Eros, had such wide appeal that variants were produced in bronze, marble, and terracotta, in all sizes, and were sold all over the Mediterranean, Europe, Egypt, and Asia Minor. Deities that were represented were not necessarily devotional, and new ones were introduced to accommodate new interests. Aphrodite at her toilet was widely sold, as were satyrs, nymphs, Hermaphrodites, Hypnus, Pan, the Eastern boy-god Attis, and the Egyptians Isis and Horus/Harpocrates. The ordinary, the exotic, and the grotesque gained in popularity: foreigners, comic actors, and street people. There were bronze images of famous philosophers, and of people dancing, crouching, wrestling, and sleeping, including the young, old, malnourished, and deformed. In bronze, decorative details were emphasized, patination and painting were common, and features such as eyes, teeth, lips, nipples, fillets, and drapery ornaments were very often inlaid in copper, silver, and niello.

Major Hellenistic centres of production included Egypt, Asia Minor, and Syria, in addition to Greece proper. Rome became a major market, and some Greek craftsmen established workshops in Italy. Such a widespread koine grew up that difficulties in establishing chronology and in recognizing regional differences among works produced in the Hellenistic/early Roman period are legion. Stylistic dating is impossible, for Hellenistic works may be adaptations of Classical or Archaic works or genres. Two shipwrecks dating to the early 1st century BC give a good sense of the trade at that time. Both went down along the route between Greece to Italy, and both were found by sponge fishermen. A ship found off the island of Anticythera was carrying assorted marble and bronze sculptures, ranging in date from the 4th century BC to about 100 BC. The marbles include a Hercules of the relatively common 'Farnese' type (see FARNESE HERCULES), the first example of which has been ascribed by scholars to Lysippus, and two statues of Aphrodite, two of Hermes, and a Zeus, an Apollo, Achilles, Odysseus, an oil-pourer, horses, seated men, a helmeted man, youths, and dancers, perhaps all of them from popular production lines (finds are in Athens, Nat. Arch. Mus.). The second ship, discovered off the coast of modern Tunisia, contained a vast cargo of luxury items. There were marble craters (mixing bowls) and candelabra, statuary, busts, reliefs, column capitals and bases, and 60 to 70 marble column shafts. The bronzes included statuary and furnishings— a statue of a winged Eros, a head of Dionysus on a herm (rectangular shaft), and large statuettes of Eros playing a lyre, of three dancing dwarfs, a satyr, an actor, Hermes, and a dog. There were hanging lamps, in the form of hermaphroditic figures, a number of vessels, a mirror, and the bronze legs and fittings for more than 20 dining couches (finds are in Tunis, Mus. National du Bardo). The cargoes of these two ships illustrate the range of marketable types and styles of images that were being produced in workshops throughout the Mediterranean during the late Hellenistic period. CCM

Boardman, J., *Greek Sculpture: The Archaic Period* (1978).
Boardman, J., *Greek Sculpture: The Classical Period* (1985).
Mattusch, C., *Greek Bronze Statuary* (1988).
Mattusch, C., *Classical Bronzes* (1996).
Palagia, O., and Pollitt, J. J. (eds.), *Personal Styles in Greek Sculpture* (1996).
Pollitt, J. J., *Art in the Hellenistic Age* (1986).
Ridgway, B. S., *Fourth-Century Styles in Greek Sculpture* (1997).
Ridgway, B. S., *Roman Copies of Greek Sculpture* (1984).

6. MOSAICS

The practice of decorating floors with coloured stones apparently originated in the ancient Near East. Pebbles were cemented in geometric patterns at 8th-century BC Gordion. No early Greek mosaics survive, but artfully arranged river pebbles (white, grey, bluish black, reddish brown) adorned the dining rooms of rich, late 5th-/early 4th-century BC houses in Greece (notably Corinth, Sicyon, Eretria, and Olynthus), Asia Minor, and Sicily: patterned borders frame rectangular and circular panels, some containing images of animals and mythological scenes. Smaller pebbles outline larger ones, and the light on dark scheme recalls contemporary red-figure vase painting (though the stimulus of lost textiles should not be discounted).

Pebbles continued to decorate elite late 4th-/early 3rd-century buildings: best preserved are floor mosaics from Macedonia (Pella and Vergina), Illyria, and Rhodes, but fragments survive from Athens, Olympia, and elsewhere. These mosaics exploit sophisticated painterly effects of foreshortening, shading, and highlighting, thus modelling figures and objects three-dimensionally. A wider range of colour is also evident, and some pebbles were cut in the centre for the application of paint (red

and green), providing a polychromatic palette. Narrow strips of lead and terracotta were also occasionally inserted amidst the stones to render inner markings and contours of figures. Examples of these techniques can be seen at Pella, where *Dionysus on a Panther, Lion Hunt, Abduction of Helen,* and *Stag Hunt* are generally considered to reflect the appearance of lost wall paintings. The last, signed by Gnosis, is bordered by an elaborate floral scroll of a type often attributed to the painter Pausias (Pliny, *Natural History* 35. 125).

Artificially squared tesserae (Greek *abakiskoi*: small slabs) of stone, terracotta, faience, and glass appear to be developments of the 3rd century BC. The precise geographical origin of tesserae—a refinement on stone chippings and the transitional use of some specially cut stone elements (*opus sectile*)—is unclear, but the technique soon became predominant. The sumptuous galley of the Sicilian ruler Hieron II (270–216 BC) contained the entire story of the *Iliad* in miniature mosaics, and such work was always associated with luxury. While most mosaics appear to have been laid directly on site, small fine *emblemata*, high-quality inset panels of images or ornamental motifs—some consisting of minute, worm-like tesserae as small as 1 mm/$\frac{1}{25}$ in per side (*opus vermiculatum*)—might be pre-assembled in trays of stone or terracotta.

*Delos offers a fine *in situ* 'collection' of Hellenistic tessellated mosaics, and other, apparently earlier, examples have been excavated at Alexandria, Morgantina, and *Pergamum, the last of which ancient literary sources report was a centre of production: the creations of Sosus were highly praised for their illusionism (Pliny, *Natural History* 36. 184) and were apparently imitated at Rome: *Doves* (Rome, Capitoline Mus.) and *Unswept Floor* (Vatican Mus.). Many of the 2nd and 1st century mosaics buried by Vesuvius (Naples, Mus. Arch. Naz.) also seem to emulate earlier Greek works and/or are the creations of Greek mosaicists. KDSL

Ginouvès, R. (ed.), *Macedonia* (1994).
Pollitt, J. J., *Art in the Hellenistic Age* (1986).
Robertson, C. M., *A History of Greek Art* (1975).

7. PATRONAGE AND COLLECTING

The ancient Greeks had no separate category of 'art' as non-functional aesthetic creations produced and collected for their own sake before the Hellenistic period. Most Greek objects considered works of art today were dedications to the gods or offerings to the dead. Even jewellery and painted pottery, which had aesthetic and more practical uses, were also employed in these contexts. Thus sanctuaries and cemeteries constituted the principal collections of *Archaic and *Classical Greek art. No contracts for private offerings survive to elucidate the relationship between artists and patrons in this period, but inscriptions on or accompanying surviving monuments often reveal motivations for dedication, frequently as tithes or thanks for some success; victory in war also provided the impetus as well as the means for making offerings. Inscriptions naming artists demonstrate that private patrons employed itinerant as well as local craftsmen, and installations excavated at sanctuaries indicate that workshops were established on site to cater to pilgrimage traffic. While expensive items, like statues of Olympic victors, must have been specially commissioned, lesser objects, particularly painted pottery, but also many votive and funerary reliefs of the 4th century and thereafter (to judge by their generic compositions and often middling quality), were made for the market, although some were certainly produced to order. Information as to the nature of commissions is equally patchy regarding most state projects of the Archaic and early Classical periods (even when we have the names of artists or contractors, as in the case of some Panathenaic prize amphorae; or Herodotus' account of the Athenian Alcmaeonids surpassing the terms of their contract to reconstruct the temple of Apollo at *Delphi in the late 6th century BC; or the projects *Polygnotus and *Phidias created for the Athenians under Cimon and Pericles, respectively). Inscribed building accounts from the late 5th century and thereafter, especially at Epidaurus reveal considerably more about the construction of temples and other major monuments: jobs might be advertised by travelling heralds, and contracts awarded after competitive bidding or the submission of models; skilled craftsmen were paid a daily, monthly, or annual wage, or piece rates for individual elements or larger portions, the latter entrusted to workshops that might be led by a single individual who could also resort to subcontractors; local guarantors were sometimes employed to insure the state against default, and fines could be levied for substandard work or delays. Coinage was also commissioned by the state, and its production overseen by magistrates, though signatures of die engravers indicate that they might work for more than one polity, as, of course, did artisans in other media.

In all cases, whether designed to please the gods, commemorate the dead, or adorn the body, home, or city-state, Archaic and Classical Greek art was produced to serve specific purposes. Greek works of art, moreover, were also inevitably intended to project the status of the dedicator/patron, whether individual or collective, as well as the artist, as the content and frequency of signatures make clear. The Greeks placed little stock in anonymous gestures.

In the *Hellenistic and *Roman periods, with changes in the nature of society and a growing awareness of historical styles of art (conditioned in part by the advent of art historical and related literatures and the pre-eminence of individual artists), production for the market increased as did private collecting. Cities erected honorific statues to curry favour from powerful individuals, and writers describe relationships between artists and patrons, though few are contemporary with the individuals involved. Alexander the Great reputedly preferred the sculptor *Lysippus, the painter *Apelles, and the gem carver Pergoteles; Demetrius Poliorcetes treated the painter Protogenes with particular favour; and the Pergamene kings, who dedicated buildings and sculptural groups at Athens, Delos, and Delphi as well as at home, employed Epigonus and the Athenians Niceratus and Phyromachus among others. Greek 'old masters' were collected enthusiastically: Pliny the elder (*Natural History* 35) reports the exorbitant sums paid for the works of Apelles, Pausias, and others. These paintings (not one of which survives) were acquired by Greek and Roman rulers. Statues too were carried to Rome in great numbers, particularly as a result of the conquest of Sicily and southern Italy in the late 3rd and 2nd centuries BC, but also from the Greek mainland, islands, and Asia Minor: they were exhibited as booty, dedicated in temples, and displayed in programmatic ensembles. While much of this collecting was public spirited (though certainly not disinterested), the Emperor Tiberius is said to have been so enamoured of Lysippus' *Apoxyomenus* (a marble copy survives Vatican Mus.) that he had the statue installed in his bedroom until popular complaint forced its return, and sources hostile to Nero accuse him of plundering works of art from Greece for his personal satisfaction. Few bronze statues brought to *Rome survive, but some Greek marbles have been recovered from secondary contexts there. 'Antique' Greek metal vessels and luxury goods were also avidly collected by Romans: 'Corinthian bronzes' (composed of a special alloy) fetched particularly high sums, and ancient forgeries were produced to meet demand. The popularity of Greek works of art in Rome is especially evident in copies of notable works, and these, like many Greek-style adaptations in retrospective styles, were often produced by ethnic Greek craftsmen, the most renowned being *Pasiteles, who was granted Roman citizenship, and the Rhodian sculptors (see HAGESANDER, ATHENADORUS, AND POLYDORUS) of the *Laocoön (Vatican Mus.). KDSL

Burford, A., *The Greek Temple-Builders at Epidauros* (1967).
Burford, A., *Craftsmen in Greek and Roman Society* (1972).
Jex-Blake, K., and Sellers, E., *The Elder Pliny's Chapters on the History of Art* (1896).
Pollitt, J. J., *Art in the Hellenistic Age* (1986).

Ridgway, B. S., *Roman Copies of Greek Sculpture* (1984).
Sparkes, B., *Greek Pottery* (1991).
Stewart, A., *Greek Sculpture* (1990).

GREENBERG, CLEMENT (1909–94). American critic. He was a central figure in the American art world between the 1940s and the 1960s. His criticism developed out of youthful Trotskyite sympathies: 'Avant-garde and Kitsch' (1939) argued that advanced art was needed to sustain a cultural space for opposition to capitalism. A further strikingly written essay for the *Partisan Review*, 'Towards a Newer Laocoön' (1940), proposed that what each art advanced towards was a concentration on its own formal nature. In Greenberg's development of this doctrine in criticism for the *Nation* (1942–9), painting was historically progressing towards an assertion of its own flatness. The leading edge of this development, formerly occurring in the studios of Paris, was now to be found in those of New York (see ABSTRACT EXPRESSIONISM)—notably in the work of Greenberg's friend Jackson *Pollock. Greenberg moved on during the 1950s to promote other painters compatible with, or subscribing to, his prescriptions for 'modernism': he adopted the label of *Post-Painterly Abstraction for his approved avant-garde of the 1960s. Greenberg's authoritative status, backed by his forceful historical vision, became a frequent butt for derision from the 1970s onwards, not least for its American nationalism. JB

Greenberg, C., *Collected Essays and Criticism* (1986–93).

GREENOUGH, HORATIO (1805–52). American *Neoclassical sculptor. He graduated from Harvard before going to Italy where he studied sculpture with *Thorvaldsen. His lifelong ambition was to create an American sculptural style that combined a realism judged to be appropriate to the young democracy with the ideal models of European classical art. After a brief return to his native Boston he spent much of the rest of his life in Florence, regularly sending home works carved from his models in the marble quarries of Carrara. He made portrait busts and ideal works on themes from such authors as Milton and Byron. He is chiefly remembered, however, for his monumental marble statue of *George Washington* (1832–41; Washington, National Mus. of American History) commissioned by Congress. This landmark in the evolution of American public sculpture combines a pose inspired by a reconstruction of *Phidias's *Zeus Olympia* (see OLYMPIA) with a realistic portrait head derived from *Houdon's famous bust of Washington. The resulting synthesis is not entirely happy, but the image has nevertheless become a popular one. In later life Greenough elaborated a theory of functional form that inspired architects including Louis Sullivan and Frank Lloyd Wright. MJ

Greenough, H., *Form and Function*, ed. H. A. Small (1947).
Wright, N., *Horatio Greenough: The First American Sculptor* (1963).

GREUZE, JEAN-BAPTISTE (1725–1805). French painter, a pioneer of sentimental *genre subjects. He infused his genre scenes with a moral and social import, capitalizing on the appeal of the rustic virtues and Rousseauesque (see ROUSSEAU, JEAN-JACQUES) sentiment. His work was praised as 'morality in paint' by *Diderot, who reserved less elevated appreciation for the artist's coquettish wife. Such paintings as *The Village Bride* (1761; Paris, Louvre), *The Well-Loved Mother* (1769; Madrid, Laborde Coll.), and *The Prodigal Son* (1771; Paris, Louvre), with their friezelike compositions, sober colouring, and homely morals, were contrasted favourably by advanced critics with the voluptuous mythologies of *Boucher. Despite the public success of such pictures, Greuze's career received a check in 1769, when he presented as his reception piece to the Académie Royale (*Paris) the classical *history painting *Caracalla Rebuked by Septimius Severus* (Paris, Louvre). Fully expecting to be elected as a history painter (the highest category), he was only awarded the lowly status of genre painter. His somewhat inept and pretentious picture was the subject of ridicule when it was shown at the *Paris Salon. Greuze did not exhibit again at the Salon until after the Revolution, preferring to show in his studio. Despite its faults, *Caracalla and Septimius Severus* has an important place in the evolution of *Neoclassicism in France towards its apotheosis in *David and his school. The moral genre scenes are fine paintings despite their sobriety and became widely known through engravings. Greuze also painted a series of fancy pictures of pubescent girls. With their titillating subjects and suggestive titles, such as *Young Girl Weeping over her Dead Bird* (1765; Edinburgh, NG Scotland), they were widely admired by 19th- and early 20th-century collectors and helped to keep Greuze's reputation alive. Less well known are his superb portraits, among which those of the collector *Claude-Henri Watelet* (1765; Paris, Louvre) and of the engraver *Johann-Georg Wille* (1763; Paris, Mus. Jacquemart-André) are fine examples. HO/MJ

Bookner, A., *Greuze: The Rise and Fall of an Eighteenth-Century Phenomenon* (1972).
Munhall, E., *Jean-Baptiste Greuze*, exhib. cat. 1976 (Hartford, Conn., Wadsworth Atheneum).

GRIEN, HANS BALDUNG. See BALDUNG, HANS.

GRIMMER, FATHER AND SON. Flemish landscape and genre painters. **Jacob** (1525/6–before 1590) became a master in the Antwerp painters' guild in 1547. He was one of the first Netherlandish landscape painters to make a break with the tradition of the panoramic mountain landscape (see PATINIR). Instead he represented the flat Flemish countryside dominated by villages and farmhouses which he recorded in drawings (1573; Hamburg, Kunsthalle). Later drawings show a more intimate view of landscape, foreshadowing the type of forest scenery that was to be developed by artists of the next generation, for example those of the *Frankenthal School. **Abel** (after 1570–before 1619) was trained by his father before joining the Antwerp guild in 1592. He specialized in small panels of country scenes, which often form part of a series of the four seasons or the months of the year (*The Four Seasons: Spring, Summer, Autumn, Winter*, 1607; Antwerp, Koninklijk Mus. voor Schone Kunsten). Some of his compositions are based on designs by Pieter *Bruegel the elder or Hans *Bol. KLB

Bertier de Sauvigny, R. de, *Jacob et Abel Grimmer* (1991).

GRIMSHAW, ATKINSON (1836–93). English painter. Born in Leeds, where he spent most of his working life, Grimshaw is best known for his nocturnes but began his career as a landscape painter. *A Woodland Valley* (1862; Barnsley, Cooper AG) reveals the influence of *Ruskin, closely observed and painted in clear fresh tones, typical of his early work. From c.1875 he painted some literary and genre subjects but by the 1880s specialized in scenes painted at night. These are primarily townscapes, city streets, and docksides, lit by the moon and the artificial lights of street lamps, windows, and hansom cabs, frequently reflected by puddles and damp cobbles. They are highly detailed and combine topographical accuracy (he often used photography as an aid) with considerable atmosphere. Despite their rather melancholy aspect they were extremely popular with his northern patrons and his sons Arthur (1868–1913) and Louis (1870–1943?) ran a virtual cottage industry producing imitations. Although sometimes formulaic, his finest works, like the evocative *Liverpool Quay by Moonlight* (1887; London, Tate), have a poetic quality which transcends photographic realism (see PHOTO-REALISM). DER

Robertson, A., *Atkinson Grimshaw* (1988).

GRIS, JUAN (1887–1927). Spanish-born painter of the *École de Paris. After studying maths, physics, and engineering Gris briefly studied art. He worked as an illustrator both before and after his move to Paris in 1906 where he met *Picasso; through him he found a studio and also met the

writers *Apollinaire, and André Salmon; *Braque and Max Jacob. He began to paint seriously in 1910 and, resisting the extreme fragmentations of form characteristic of Picasso and Braque's work, he retained more clarity in the description of the objects in his still lifes which were rendered on the framework of an emphatic compositional grid. *Still Life with Flowers* (1912; New York, MoMa) demonstrates his use of subdued colour at this time and his careful analysis of fragmented light and shadow. His compositional and mathematical interests led him to exhibit with the *Cubist *Section d'Or at their Salon in 1912. In 1913 and 1914 he began to experiment with *collage techniques which also facilitated the introduction of lettering into the compositional play: *The Pedestal Table* (1914; Philadelphia Mus.) is a good example of this.

MF

Juan Gris, exhib. cat. 1992 (London, Whitechapel Gall.).

GRISAILLE, monochrome painting in grey or greyish colour. *Renaissance artists used it for effects of modelling and often imitated sculpture with it. *Giotto's series of *Virtues and Vices* in the Arena chapel, Padua, suggests grey stone, and in the van *Eycks' *Adoration of the Lamb* (Ghent, S. Bavo) the two S. Johns are like statues. In Florence Cathedral the equestrian figures of the English *condottiere* John Hawksmoor by *Uccello and of Niccolò da Tolentino by *Castagno both simulate sculptured monuments. *Mantegna used grisaille to convey the austere character of the Romans with masterly effect. *Rubens sometimes used monochrome techniques in sketching compositions for engravers. Illuminators of manuscripts used grisaille, especially for subsidiary decoration, but in their hands it became less dependent on sculpture. Jean *Le Tavernier made a speciality of it. Grisaille has also been effectively used in *stained-glass painting. Grisaille enamelware obtains a design in light and shade by painting over an opaque white background in one colour.

HO

GROS, ANTOINE-JEAN (1771–1835). French painter. A child prodigy, at age 14 he became a pupil of *David. Disappointed by his failure to win the coveted *Prix de Rome he left Paris for Genoa in 1793, where he was impressed by the works of *Rubens and van *Dyck. A meeting in Genoa with the future Empress Josephine led to an introduction in Milan to the victorious General Bonaparte, conqueror of Italy. Gros's first masterpiece was his dramatic portrait of *Bonaparte Crossing the Bridge at Arcola* (1796; Versailles). Thereafter he received many official commissions to paint the epic events of the Napoleonic era. *The Battle of Nazareth* (1801; Nantes, Mus. des Beaux-Arts), *The Victims of the

Plague at Jaffa (1804; Paris, Louvre), and *The Battle of Eylau* (1808; Paris, Louvre) are works of Tolstoyan dimensions, full of drama, vigour, pathos, and colour. But despite his official successes under the Empire and the Restoration (he was created a baron by Charles X), and the admiration his paintings inspired among the *Romantic generation of *Géricault and *Delacroix, Gros remained guiltily in thrall to David and the *Neoclassical ideal. From exile after 1815 David urged his former pupil to paint 'real *history paintings', meaning Neoclassical ones. Gros's last picture, *Hercules and Diomedes*, a tribute to David, was very badly received by the critics. In a fit of depression he drowned himself in the Seine.

MJ

Gros, ses amis et ses élèves, exhib. cat. 1936 (Paris, Petit Palais).

Tripier-Lefranc, J., *Histoire de la vie et de la mort du Baron Gros* (1880).

GROSZ, GEORGE (1893–1959). German draughtsman and painter. Born in Berlin, Grosz spent his childhood in a cavalry barracks. He studied at the Dresden Academy (1909–12) and the Berlin Kunstgewerbeschule (1912–14) before volunteering for the army. Discharged as unfit in 1915, he was conscripted in 1917 and, mistakenly, sentenced to execution in 1918; from now on the German army was one of the principal targets of his savage and telling satires. Grosz and his fellow student John *Heartfield (both Anglicized their names in 1917) had collaborated on *Dada *collages and journals during the war and in 1920 he was a leading figure in the first international Dada exhibition in Berlin. In the same year he published *Gott mit uns*, ten photolithographs of his spare and almost naive line drawings, a bitter attack on the German military for which he was arrested and fined. Undeterred he issued the satirical collection *The Face of the Ruling Class* in 1921. Further court appearances followed in 1923 and 1928. In his drawings and paintings, which assimilated elements from *Cubism, *Futurism, and, particularly, *de Chirico's *Pittura metafisica*, Grosz established archetypal images of post-war German militarists and profiteers, exemplified by *The Pillars of Society* (1926; New York, MoMa) in which priest, soldier, businessman, editor, and aristocrat are mercilessly *caricatured. As a Communist, atheist, and satirist Grosz was a natural target for the National Socialists but left for America in 1932. His American years were artistically disappointing and in 1959 he returned to Berlin, only to die in an accident.

DER

Flavell, M., *George Grosz: A Biography* (1988).

GROTESQUE (French, from the Italian *grotta*). The word originated as a descriptive term for the fanciful mural decorations with mixed animal and human forms and

floral ornament, inspired by the rediscovery of the Roman interiors of the *Domus Aurea* of Nero excavated *c.*1500 (see ROMAN ART, ANCIENT). Such decoration quickly became popular throughout Europe and was adopted into many contemporary schemes. One of the earliest examples of grotesque ornament can be found in a frieze in Carlo *Crivelli's *Annunciation* (1486; London, NG). Extravagant use was made of it in 1502 with Bernardino *Pinturicchio's decoration of the ceiling vaults of the cathedral library, Siena, and Luca *Signorelli's decorations for Orvieto Cathedral in 1499–1504, as well as *Raphael's decoration of the Vatican Loggias (1518–19) which contains over 200 strips bursting with grotesque ornament. One of the most important examples was *Rosso Fiorentino's decoration of François I's new chateau at *Fontainebleau (1530–40; *in situ*), which incorporated high-relief stuccowork. Throughout the 16th century this manner of ornament remained extremely fashionable, and its use continued in Germany and the Netherlands in the following century. The excavations of *Pompeii and *Herculaneum in 1752 and their subsequent publication brought about a revival of the taste. Marie-Antoinette's Petits Apartements in Versailles and Fointainebleau were decorated respectively in 1783 and 1786 by Jules-Hughes and Jean-Simon Rousseau using a new more elegant and refined interpretation. Whilst in England, Robert Adam featured grotesque ornament in his Etruscan Dressing Room at Osterley Park House, (Middx.) in 1775. When applied to other fields of art the word came to mean what is intrinsically strange, incongruous with ordinary experience, contrary to natural order. *Ruskin's treatment of the grotesque had the effect of establishing it as a respectable artistic genre and in *Modern Painters* (1843–60) he wrote: 'A fine grotesque is the expression, in a moment, by a series of symbols thrown together in bold and fearless connection, of truths which it would have taken a long time to express in any verbal way.' By the late 19th and early 20th century the grotesque was not highly valued and a standard analysis of the concept was given by George Santayana in the *Sense of Beauty* (1896), where he defines it as 'the suggestive monstrous'.

KC

Chastel, A., *La Grotesque* (1988).

GROUND. *See overleaf.*

GROUP OF SEVEN, Toronto-based Canadian landscape painters who began working together *c.*1912 and established a group in 1920. They used a palette of pure, intense colours to capture the clear light and

continued on page 325

· GROUND ·

GROUND is the term describing the layer, or layers, applied to the support as a preparation for painting. Until the 20th century, rough unprepared wood and raw canvas have not been considered suitable painting surfaces for most media, with the exception of glue size (or distemper) painting on fabric supports. For this technique the canvas was usually prepared with no more than a preliminary coating of glue size. An application of glue size is more commonly just the first stage in the building up of a ground, whether on canvas or on panel, its purpose being to seal the wood or textile fibres and to improve the adhesion of the subsequent layers.

In early panel paintings the ground consisted of an inert white filler bound with an animal-skin glue or size. In Italy the filler was almost always based on gypsum (mineral calcium sulphate). The Italian word for gypsum is *gesso*. The term is often used to describe all such white grounds, but in northern Europe the filler generally was chalk (natural calcium carbonate). In Spain either chalk or gypsum were used and in Alpine regions it might be locally occurring dolomite (calcium magnesium carbonate). The powdered white filler was mixed with warm glue and brushed on in several layers. Cennino *Cennini (writing c.1400), gives a detailed description of the application of grounds for early Italian panel paintings. The first layer was of coarse *gesso grosso* (roasted gypsum), followed by several layers of finer *gesso sottile*, gypsum slaked by prolonged soaking in water. Whether based on chalk or gesso, the aim was to apply sufficient layers to fill the woodgrain and other imperfections. When dry and hard the ground was scraped and abraded to a smooth flat surface, especially important if there were to be areas of *gilding. In the case of 16th-century panels, when gilding was less common, grounds are noticeably thinner and less evenly finished; on earlier panels in Italy the gesso ground was often a great deal thicker than the paint layers on top, particularly in egg tempera paintings. If canvases were to be painted in egg- or oil-based media until well into the 16th century they were usually prepared in a similar way, but the ground had to remain relatively thin to avoid cracking and flaking of the brittle gesso from the flexible support. For example, the canvas paintings of *Botticelli, *Bellini, and *Titian were prepared in this way.

In tempera techniques the paint can be applied directly to a gesso or chalk ground; but for colours bound in oil, these grounds are too absorbent, soaking up the oil and leaving the paint underbound and matt. Therefore it was customary first to seal the ground. Sealing layers might consist of no more than an application of glue size or of an unpigmented layer of drying oil. Lead white was often added to the oil, increasing the rate at which it dried while retaining the luminosity of the white ground. However, brilliant white grounds can be difficult to cover when painting thinly and with translucent colours, and 15th-century Netherlandish artists sometimes added small amounts of coloured pigments to the lead white, usually no more than enough to tint the priming and to take the edge off the whiteness. The Flemish word for such a layer (used by Karel van *Mander in 1604) is *primuersel* and in Italian it is *imprimi(a)tura*. The English equivalent is priming, but unfortunately the term is often utilized for any preparatory layer or ground, and sometimes for a local underpainting. Here it is employed in the limited sense of a layer applied to the whole surface of the ground to modify it before the process of painting.

In the early 16th century primings tended to become more strongly coloured, especially in northern Italy where artists such as *Correggio, *Parmigianino, and Dosso *Dossi seem to have been among the first to work on relatively dark red-brown and grey or greyish brown surfaces. They offered the possibility of a more rapid and freer execution of the painting, being easier to cover, especially when using darker and more translucent colours. Furthermore any area of preparation exposed by gaps and breaks in the brushwork or at junctions between colour areas will recede and not be as apparent as when painting on a white surface. By the middle of the century the priming layers on canvas paintings had often become thicker and more substantial than the underlying gesso grounds. Eventually the gesso was omitted, completing the evolution of the coloured ground. Nevertheless many 16th-century artists continued to work mainly on light-coloured preparations, among them *Titian—often believed, in the past, to have favoured red-brown grounds.

By the 17th century, for canvas painting, a variety of grounding methods had developed and it was unusual to paint on to a white or light-coloured surface. Two widespread types of canvas ground application were in use, and for many painters and their workshops, both varieties of ground might be found in their paintings. Relatively dark-toned grounds consisting of a range of types of earth pigment, usually of brown, red-brown, orange, and brownish yellow combined with other mineral materials, principally chalk (calcium carbonate) and silica (quartz), and containing also small quantities of lead-white drier, were commonplace in *Baroque painting in Italy, Spain, and to some extent in northern Europe. The tonality of these brown grounds, the colour of which was often exploited in the composition of a painting, either by leaving parts exposed to stand for middle tone values, or by modification of the dark underlayer with *glazes and scumbles, varied considerably from warm mid-yellow and red-brown colours to cold, dark chocolate-coloured surfaces, sometimes incorporating black pigment to darken the tone further. Clear examples can be seen in the works of painters practising in Rome such as *Caravaggio,

*Poussin, *Reni, Salvator *Rosa, and others, as well as in 17th-century Neapolitan and Bolognese paintings on canvas; *Guercino provides examples from the latter school. In Spain, *Zurbarán and *Velázquez used brown grounds in certain of their paintings, while in northern Europe the technique is perhaps most associated with *Rembrandt and the large circle of his followers.

From the 1640s, Rembrandt employed a specialized development of a single-layered brown ground in certain works on canvas, and increasingly in the later part of his career, in which a high proportion of fairly coarse mineral silica (quartz) was incorporated in the priming in addition to earths and some lead white and which gave the surface of the ground layer a significant texture or 'tooth'. These so-called 'quartz' grounds have not been identified in the work of other painters and may be restricted to Rembrandt and his circle; the coarse texture of this type of ground and its dark colour was conducive to painting in the 'rough manner'. It can be argued that grounding methods for Dutch 17th-century paintings are more varied than at any time and place before or since. There appear to have been local methods in use, in addition to the standard dark grounds and a so-called double ground type which is described below. Thus, individual and distinctive varieties of canvas grounds seem to have been employed in Haarlem, Dordrecht, Delft, and so on.

A common alternative method to dark grounds for canvas paintings was employed in the work of many 17th-century painters, including Rembrandt. This involved what is known in modern terminology as a 'double ground', the most widespread, indeed standard, form of which consisted of a lower layer of a strongly coloured red or red-brown earth pigment in a drying oil and over this a second priming of oil paint usually of a light or mid-grey colour or of pale fawn. The upper ground, like the lower, would be present under the composition as a whole and presented the painter with a smooth cool grey or a faintly warm light brown or greyish brown working surface. No entirely satisfactory explanation for the origin of this type of ground in the 17th century has been advanced, but it was very frequently used, occurring in paintings from the Low Countries, England, France, and Spain. It was a less standard practice in Italy, but not unknown. One possibility for its popularity is that ochres, which are widely available inexpensive pigments with good drying properties in oil, were used to first fill the weave of a canvas so as to provide a fairly smooth stable surface for the application of the second grey or light brown priming. The second layer usually contains a good deal of lead white

often tinted with fairly coarse wood charcoal or small quantities of other black pigments with a variety of earths. Historically, double grounds seem to coincide with the establishment of professional canvas primers as artists' suppliers, but the method was evidently used by workshop assistants as well. Paintings with double grounds with an ochreous lower layer and a grey or light brown upper ground are known for ter *Brugghen, Rembrandt, *Lievens, van *Dyck, Velázquez, Poussin, *Claude, *LeNain, *La Hyre, and others.

Grounds for panel paintings on oak in the Low Countries in the 17th century were less varied in constitution and usually consisted of a chalk and glue lower ground, with a second thin translucent oil-based priming containing lead white, some black pigment, and umber. The streaky grey *imprimiture* of *Rubens's oil sketches and panel paintings are of this type; so too are Rembrandt's panels from the 1630s and 1640s. In the latter case they were usually standard commercial products of the panel maker.

The tendency was for grounds to become progressively lighter in tone in the 18th and 19th centuries, although the traditional double ground method for canvases made up of lower ochreous layers and a light grey or brown upper grounds survived in 18th-century painting, for example in *Canaletto and *Tiepolo's work, and has been found for a number of French 18th-century paintings. Many British school pictures of the 18th century are on white or off-white oil grounds, usually composed of lead white mixed with a proportion of chalk and sometimes very lightly tinted with small quantities of red ochre, golden ochre, lampblack, umber, and other cheap stable pigments. Ready-grounded stretched canvases with primings of this general type became widespread as commercial products in the 19th century, particularly in France. The canvases were available in a range of standard formats with white grounds or just off-white colours of very pale grey, fawn, pink, cream, and even pale greens and lavender colours. By the mid-19th century, from about 1860, barium sulphate was added as an inert white filler to lead white primings, and zinc white (zinc oxide) was also sometimes employed, as well as other white inerts such as mineral talc, kaolin, gypsum, and chalk with and without lead white. In the 20th century, ready-grounded canvases are invariably white and often contain zinc white, titanium white, barium sulphate ('blanc fixe'), or 'lithopone' (a manufactured mixture of barium sulphate and zinc sulphide), with linseed oil or synthetic binders. Many 20th-century painters have worked on un-primed canvas.

AR

rugged forms of areas like the Canadian Shield region around the Great Lakes in Ontario and also painted in the Rocky Mountains, the Arctic, and the Laurentian Hills of Quebec. They worked initially in an *Impressionist style but c.1915 adopted bolder and more stylized Post-Impressionist techniques, employing larger, flatter areas of unmodelled colour.

Strongly nationalist, their goal was to create art that would help give Canadians a sense of their unique identity. The original members were Frank Carmichael (1890–1945), Lawren *Harris, A. Y. *Jackson, Frank

Johnston (1888–1949), Arthur Lismer (1885–1969), J. E. H. MacDonald (1873–1932), and Frederick Varley (1881–1969). A. J. Casson (1898–1992) replaced Johnston in 1926. Later members were Edwin Holgate (1892–1977) and LeMoine FitzGerald (1890–1956). They disbanded in 1931 to join the larger Canadian

Group of Painters. KM

Mellen, P., *The Group of Seven* (1970).

GRÜNEWALD, MATTHIAS (*c*.1475×80–1528). German painter, draughtsman, hydraulic engineer, and architect whose real name was Mathis Gothart Neithart (Nithart or Neithardt). He acquired the name Grünewald from his 17th-century biographer Joachim von *Sandrart (*Teutsche Academie*, 1675), but the origin of this name remains obscure. Grünewald was probably born in Würzburg. Nothing is known about his early career, although some authors have seen connections with the work of Hans *Holbein the elder, which could have been established in Augsburg or Frankfurt, where Holbein painted the high altar for the Dominican church in 1500–1. From *c*.1511 Grünewald worked for the Archbishop of Mainz Uriel von Gemmingen (who however resided in the archepiscopal palace at Aschaffenburg), and his successor Albrecht von Brandenburg, for whom he also designed waterworks and fountains. He lost the patronage of the Archbishop when he participated in the Peasant Rebellion of 1525. In 1526 he moved to Frankfurt (Main) and the following year to Halle where he died.

Grünewald is best known today for the complex folding polyptych called the Isenheim altarpiece, completed 1515 for the hospital order of S. Anthony at Isenheim (now Colmar, Mus. d'Unterlinden). The altarpiece (*c*.1500–15) consists of a sculpted shrine attributed to Niclas *Hagnover and nine painted panels for the triple wings. When closed, the polyptych displayed the *Crucifixion* and the two patron saints, Anthony and Sebastian, painted as living sculptures standing on consoles; the first set of wings revealed the *Annunciation*, *Incarnation* (*Angel Concert* and *Madonna and Child in a Garden*), and *Resurrection of Christ*; the second set of wings opened to the sculpted figures of S. Anthony, enthroned between SS Augustine and Jerome, flanked on either side by the painted scenes of the *Temptation of S. Anthony* and the *Meeting of S. Anthony and the Hermit Paul* in the desert. The altarpiece's original location would seem to account in some measure for the gruesome iconography, which stresses the physical wounds of Christ in the *Crucifixion* and *Lamentation* (on the predella), the sickly, diseased demon in the *Temptation of S. Anthony* (the Antonites administered, among others, to victims of ergotism, a devastating skin disease commonly known as S. Anthony's fire), and the inclusion of S. Sebastian, one of the 'plague saints', in addition to the prominent presence of S. Anthony, the patron saint of the order. But the expressive power of the altarpiece results less from its imagery than from its pictorial treatment which relies on distorted proportions and strong colouristic effects thrown into bright relief by a dark background for symbolic and emotional ends.

Grünewald was the greatest 16th-century German artist after *Dürer. Like Dürer, he was an outstanding draughtsman, but he used drawing only as a preliminary to painting. His true medium is pictorial, not graphic: he was a painter and colourist par excellence. More importantly, while Dürer strove to reconcile Italian idealization with northern European naturalism, Grünewald stressed exaggeration and distortion inherent in the latter. His subject matter was more limited than that of other German artists of his day. All surviving paintings have religious themes, especially those expressing extreme religious emotions. In addition to the *Crucifixion* on the Isenheim altar, there are three other panels of the same subject (Basle, Washington, and Karlsruhe). The lyricism of the *Madonna and Child in a Garden* on the Isenheim altar is again reflected in a painting of the same subject in the parish church of Stuppach, near Würzburg (1519, probably part of the *Virgin of the Snow* altarpiece, now dismantled). There are also representations of individual saints, including those on the wings of the Heller altarpiece (Frankfurt, Städelsches Kunstinst.; Karlsruhe, Kunsthalle), for which Dürer painted the central panel (*Assumption and Coronation of the Virgin*, 1508–9, destr. 1729; known from a copy). KLB

GUARDI FAMILY. Italian painters. **Domenico** (1678–1716) founded the family *bottega* or workshop of *veduta* painting in Venice and the business was carried on by his two sons, **Giovanni Antonio** (Gianantonio) (1699–1760), one of the founders of the Venetian Academy, and **Francesco** (1712–93). Recent researches have radically altered our conception of Francesco Guardi's early development and training. Previously known as a painter of views and commemorative pictures of state visits, it is now certain that he only began to specialize in this genre towards 1760 after a long period of association with his brother Giovanni Antonio, a painter of large altarpieces, including the *Death of S. Joseph* (Berlin, Gemäldegal.) and probably the *Vision of S. Giovanni di Matha* (Pasiano di Pordenone, parish church). Francesco worked under Gianantonio in the family studio, and their individual contributions to joint works during the period 1730–60 are not determined. There are a few signed drawings from this period. Most of the paintings concerned are altarpieces with large figures and very little landscape: an exception is the *Stories of Tobias* painted for the organ loft in the church of the Angelo Raffaele in Venice, where figures and landscape are of equal importance. Current opinion favours Gianantonio as the creator of the Tobias series, although in style they anticipate the *Rococo vitality of Francesco's work.

Francesco became the most famous of the family, largely because of his success as a view painter. Where *Canaletto aimed at firm structure in his paintings Guardi preferred the effects of a vibrant atmosphere on buildings and water. His handling of paint derives from *Magnasco, whose sharp angular touch he adopted and transformed into Rococo fantasy. Guardi's many beautiful drawings have an unmistakable style. In general his pictures are small (some measure half the size of a postcard), but at Waddesdon (Bucks.) there are two colossal views measuring 3 m× 4 m (9×14 ft). His *capricci, dating from the latter part of his life, are more purely imaginative than Canaletto's. They represent an international trend towards greater fantasy, seen also in the late landscapes of *Gainsborough and the exotic fairy-tale romances and plays of the period. Francesco Guardi never achieved Canaletto's social, academic, or financial success. John Strange, the English resident, commissioned works from him, and in 1782 Peter Edwards gave him a cautiously worded commission to paint four views of the ceremonial visit to Venice of Pius VI (one at Oxford, Ashmolean). HB

Problemi Guardeschi: atti del convegno di studi promosso dalla mostra dei Guardi: Venezia (1965).

GUARIENTO (active 1338; d. 1370). Italian painter. Guariento di Arpo was the leading painter of mid-trecento Padua. His style combines a *Giottesque solidity of form, a highly developed use of pictorial space characteristic of Paduan painting, and more overtly lyrical and decorative aspects. His major Paduan commission was for the decoration (*c*.1350–5) of the ruling Carrara family's palace chapel. This comprised partly extant Old Testament frescoes (Padua, Sala dell'Accademia) and a multi-panelled ceiling decoration of the *Angelic Orders* (Padua, Mus. Civico). The *Angel* panels reveal Guariento's style at its most elegant; highly inventive in the many variations on a basic idea. The frescoes show his racy handling of narrative and his pungent characterization. In 1366 Guariento was in Venice where he painted the gigantic fresco of *Paradise* in the Sala del Maggior Consiglio of the Doge's palace, damaged by fire in 1577 and rediscovered under *Tintoretto's replacement in 1903. The synthesis of courtly elegance, pictorial ambition, and dramatic invention, visible in the surviving fragments even now, may account for the Venetian Republic's preference for Guariento over any Venetian painter for this prestigious commission. JR

d'Arcais, F. F., *Guariento* (1980).

GUAS, JUAN (active 1453–d. 1496). Architect and sculptor of French origin, active in Spain from his first appearance in Toledo working on the sculpture of the main portal of the cathedral (Puerta de los Leones). Guas soon became most active as an architect, serving as Master of Works of the Cathedral of Segovia between 1473 and 1491 and working on churches and monasteries in Valladolid, Ávila, Toledo, Guadalupe, and elsewhere. Between 1479 and 1480 he worked for Ferdinand and Isabella on the building and sculptural decoration of the royal monastery of S. Juan de los Reyes in Toledo, a notable example of the Isabelline style (see PLATERESQUE). Guas also worked for the Spanish aristocracy, designing the Palacio del Infantado in Guadalajara for the powerful Mendoza family. SS-P

GUERCINO (Gian-Francesco Barbieri) (1591–1666). Italian painter of the Bolognese School. He was called Guercino on account of his squint. Born at Cento, he started his career as a provincial painter working under the influence of Bolognese and Ferrarese artists, but soon gained the patronage of the papal legate at Ferrara and the Archbishop of Bologna. His earliest and best manner, with its lively and capricious lighting and characteristic north Italian naturalism, owes a good deal to Ludovico *Caracci. An example is *S. William Receiving the Monastic Habit* (1620) in the Pinacoteca at Bologna. In 1621, on the election of the Bolognese Pope Gregory XV, Guercino was summoned to Rome, where he painted the celebrated ceiling fresco of *Aurora* at the Villa Ludovisi and an altarpiece for S. Peter's, *The Burial and Reception into Heaven of S. Petronilla* (Rome, Capitoline Mus.). The preference of his Roman patrons for the classical manner of Annibale *Carracci and *Domenichino led to a gradual change of style, which continued after his return to Cento in 1623 on the death of the Pope. There he remained until 1642, when he succeeded Guido *Reni as the leading painter in Bologna. His manner became increasingly classical, losing much of the liveliness and movement of the early works whilst approaching nearer to the lighter, more delicate, and less naturalistic style of Reni. Guercino was a brilliant draughtsman, the finest collection of his drawings being in the Royal Library at Windsor. HB

Mahon, D., and Turner, N., *The Drawings of Guercino in the Collection of Her Majesty the Queen at Windsor Castle* (1989).
Mahon, D., *Guercino: Master Painter of the Baroque*, exhib. cat. 1992 (Washington, NG).

GUÉRIN, PIERRE-NARCISSE (1774–1833). French *Neoclassical painter. He trained with Nicolas-Guy Brenet and later

Jean-Baptiste *Regnault, winning the *Prix de Rome in 1797. Lack of state funds prevented him being sent to Italy and by the time he did go in 1803 he was already one of the best-known painters in the generation after *David. Success was ensured by his *Return of Marcus Sextus* (Paris, Louvre), shown at the 1799 Salon. Its subject, which deals with the tragedy of the émigré, struck a chord with the French public in the aftermath of the Revolution, as did its style, echoing David's with a more theatrical pathos. Guérin continued to paint in a histrionic version of the prevailing academic style, choosing themes from classical Antiquity, often as interpreted by the great French dramatists, as in *Phaedra and Hippolytus* (1802; Paris, Louvre), inspired by Racine's *Phèdre*. Much of his later career was taken up with teaching. The future *Romantics *Géricault, *Delacroix, and Ary *Scheffer all passed through his Paris studio, and in 1822–8 Guérin was director of the French Academy in Rome. MJ

Delécluze, E., *Louis David: son école et son temps* (1855).
Lacambre, J., *The Age of Neo-classicism*, exhib. cat. 1972 (London, RA).

GUGLIELMO DELLA PORTA (active 1534). Italian sculptor born in Porlezza in north Italy. Before moving to Rome in 1537 he contributed to the most important Genoese sculptural commission of the period, the monument to Giuliano Ciybo (Genoa Cathedral), and was probably familiar with *Perino del Vaga's work at the Palazzo Doria. In Rome he succeeded *Sebastiano del Piombo at the Papal Mint (1547). His effigy for the tomb of Francesco de Solis (c.1545) was reused for Luis de Torre's tomb in the cathedral in Malaga, and the reclining figure illustrates a familiarity with Andrea *Sansovino's Sforza tomb in S. Maria del Popolo. He specialized in the restoration of *Antique sculpture, most spectacularly with the *Farnese Hercules (Naples, Mus. Arch. Naz.), and in casting series of bronze busts and figures after the Antique for the Farnese family (c.1575). His project for Paul III's tomb was never fully realized, though some sculpted figures and other fragments still survive in S. Peter's and in the Palazzo Farnese in Rome. The rich polychrome marble *Bust of Paul III* (after 1546; Naples, Capodimonte) demonstrates his skill in carving and characterization. His series of bronze reliefs of Ovid's *Metamorphoses* and *Story of Orpheus* were highly influential for northern European sculptors in Rome. AB

Vitali, C. (ed.), *Der Glanz der Farnese*, exhib. cat. 1995 (Munich, Haus der Kunst).

GUIDO DA SIENA (active later 14th century). Sienese painter identified from the signature on the large *Madonna* from S. Domenico (Siena, Palazzo Pubblico), whose date

1221 is not that of its execution. It is probable that it had two wings with the life of Christ in 24 scenes; scattered fragments survive (Siena, Pin.; Princeton, University Art Mus.; Altenburg, Staatliche Lindenau-Mus.; Utrecht Catharijneconvent). The faces of Mary and Christ were repainted by a follower of *Duccio; those of Christ and the angels in the separate *cimasa* identify Guido's style. Guido's narratives compress *Byzantine *iconography and space into two dimensions. His clear drawing and draperies, long rectangular faces, and calm, rather sentimental gestures appear to derive from the S. Bernardino Master (*Madonna* dated 1262; Siena, Pin.), a major artist more familiar with Byzantine or north Italian sources. Guido appears to have been the most productive painter in Siena in the later duecento, establishing the principal types of Madonna (Hodegetria) and altar dossals with half-length figures under a common gable (Siena, Pin.) and his style dominated Sienese painting up to Duccio.
RG

Stubblebine, J. A., *Guido da Siena* (1964).
van Os, H., *Sienese Altarpieces*, vol. 1 (1984).

GUILDS AND CONFRATERNITIES, associations of craftsmen or merchants specific to a particular town or region. From the 13th to the 16th centuries they became an intrinsic part of artistic production as well as city life. Controlling quality and the quantity of artisans and output, guilds held great social, economic, and political power. The establishment of guilds encouraged a highly specialized division of labour, the production of textiles, for example, required cloth merchants, dyers, spinners, weavers, and tailors, each with their own guild. The popularity of guilds can be witnessed in Nuremberg, where in 1400 the city council listed 141 separate craft guilds. Competition often existed between similar guilds from different cities. In 1426, for example, the powerful librarians' guild in Bruges banned the sale of imported illuminated miniatures. Bruges was an affluent centre at the time and its guild enjoyed the patronage of the great bibliophiles the dukes of Burgundy. This restriction forced many illuminators who had resided elsewhere to take up citizenship in Bruges, effectively shifting the main centre of manuscript production in the Low Countries to Flanders. Not all guilds comprised craftsmen; many were religious confraternities, who met for Mass and also carried out charitable deeds. In the 15th century in *Venice there were over 200 active confraternities or *scuole*, many of which were also great patrons of the arts. The Scuole Grande di S. Rocco commissioned *Tintoretto to provide a vast cycle of paintings to decorate the entire interior of their building. At the beginning of the 15th century in Florence the exterior of

Or San Michele was a source of local competition between the guilds, each attempting to outclass the others with the quality of their commission and the reputation of the artist employed. Luther's criticism of confraternities led to their decline in Protestant regions. Those that survived were suppressed in the 19th century with the Industrial Revolution, which so radically changed methods of production. KC

Clune, G., *The Medieval Guild System* (1943).
Mackenney, R., *Tradesmen and Traders: The World of the Guilds in Venice and Europe c.1250–c.1650* (1987).
Mackenney, R., and Humphrey, P., 'The Venetian Trade Guilds as Patrons of Art in the Renaissance', *Burlington Magazine*, 128 (1987).

GÜNTHER, IGNAZ (1725–75). With *Egell and *Donner one of the foremost sculptors of the *Rococo period in Germany. After training in the Munich workshop of Johann Baptist Straub and briefly in Mannheim with Egell he settled in Munich. From there he worked mainly for religious foundations in southern Germany. His sculptures are nearly all in wood with elaborate naturalistic *polychromy (executed by others). Among his best works are the flamboyant high altar of SS Marinus and Anianus at Rott am Inn (1759–62) and an *Annunciation* in SS Peter and Paul, Weyarn (1764). MJ

Volk, P., *Ignaz Günther* (1991).

GUSTON, PHILIP (1913–80). American painter. Born in Montreal, he moved to Los Angeles in 1919 where in 1930 he studied at the Otis Art Institute with Jackson *Pollock. Guston moved to New York in 1935, working 1936–40 in the mural division of the *Federal Art Project and 1938–42 on commissions for the Treasury Department's Section of Fine Arts. In 1945 he was awarded first prize at the Carnegie Institute, Pittsburg. His early paintings, inspired by a visit to Mexico in 1934, were influenced by the Mexican Muralists, for example *Bombardment* (1937–8; New York, Estate Philip Guston). Then in 1948 as a leading member of the *Abstract Expressionist group in New York, he began a series of abstract paintings that became increasingly fluid, painterly, and *'Turneresque', for example *Painting* (1952; New York, MoMa). This phase was followed by the return to a figurative style with some resemblance to the work of Jean *Dubuffet; political, strong, and childlike in its simplicity, often very large in scale, as in *Ancient Wall* (1976; Washington, Hirshorn Mus.). RJP

Storr, R., *Philip Guston* (1986).

GUTFREUND, OTTO (1889–1927). Czech sculptor, born in Dvur Kralove. He was trained at the Prague School of Decorative Arts and worked with the sculptor *Bourdelle in Paris, 1909–10. While there, he became interested in early experiments in *Cubist painting, and was among the first to apply the principles of Cubism to sculpture. When he returned to Prague in 1911 he became associated with a small group of avant-garde artists who were variously attempting a fusion of Cubism with *Expressionism. An example of his work from this time is *Cubist Bust* (1912–13; London, Tate). He spent the First World War in France and after his return to Prague in 1919 developed a more popular and naturalistic style based on folk art. OPa

GUTTUSO, RENATO (1912–87). Italian painter, one of the leading figurative artists of his day. During the 1930s he reacted against the classicizing art supported by the Fascists, eventually joining the Expressionistic Corrente group in 1940. His experiences with the Resistance movement led him to produce a series of drawings about wartime atrocities (1944; Rome, Gal. Nazionale d'Arte Moderna), which were published in 1945 under the title *Gott mit uns*. His most celebrated works, however, are the large-scale *Flight from Etna* (1940) and *The Crucifixion* (1941; both Rome, Gal. Nazionale d'Arte Moderna), whose shocking treatment of a conventional subject attracted criticism from the Church. Such paintings reveal a variety of influences, ranging from those of *Picasso's *Guernica* to *Caravaggio and *Rosso Fiorentino. A committed Communist, Guttuso continued during the post-war period to produce intelligible, emotive images that were consistent with the artistic values of the Party. CJM

Guttuso, exhib. cat. 1996 (London, Whitechapel AG).

GUYS, CONSTANTIN (1805–92). French illustrator. He was a soldier as a young man and travelled widely. He seems to have been self-taught as a draughtsman, though it is not clear at what date he turned to illustration as a profession. By 1848 he was working for the *Illustrated London News* and in 1854 he covered the Crimean War as the paper's special correspondent. He is best remembered, however, for his pictorial record of Paris life under the Second Empire. His witty and lively drawings reinforced by thin washes of tone or colour depict all facets from the imperial court to the demi-monde. His talent was admired by *Daumier and *Manet, and he was imortalized in *Baudelaire's essay *The Painter of Modern Life*. HO/MJ

Baudelaire, C., *The Painter of Modern Life and Other Essays*, trans. J. Mayne (2nd edn., 1995).
Geffroy, G., *Constantin Guys, l'historien du Second Empire* (1920).

GYPSUM. See GROUND.

HACKERT, JAKOB PHILIPP (1737–1807). German painter who trained in Berlin and travelled in Sweden and France before arriving in Rome in 1768. Two years later he moved to Naples where he spent most of the rest of his life. In 1777 he and his pupil, the amateur Charles Gore (1729–1807), accompanied the connoisseur Richard Payne *Knight on a tour of Sicily, recording archaeological remains in drawings (London, BM). Hackert, a sociable man, gained the friendship of Ferdinand IV of Naples (1751–1825) and Queen Maria Carolina and was appointed court painter in 1786. Although his royal duties included portraiture, as in *Harvest Time at Carditello: Ferdinand IV and his Family in Peasant Costume* (Naples, Mus. Nazionale di S. Martino), he is best known as a sensitive landscape and topographical painter in the *Claudean tradition. His prolific views of famous sites found a ready market among foreigners on the *Grand Tour. He frequently collaborated with his brother, the painter Johann Hackert (1744–73). *Goethe, whom he met in 1787 and who wrote his biography in 1811, recognized Hackert's important role in the encouragement of art in Naples. His work is well represented at Attingham Park, Shropshire: most notably *The Ruins of Pompeii* (1799) and *Lake Avernus* (1800). DER

HAGESANDER, ATHENADORUS, AND POLYDORUS (1st century BC/AD). Ancient Rhodian sculptors known from both the literary sources and preserved signatures. Pliny names them as the sculptors of the *Laocoön in the Palace of Titus in Rome. Their signatures are preserved on the boat of Odysseus in the Scylla group of the colossal sculpture groups at *Sperlonga. Active between 50 BC and AD 25, there is no consensus on whether the signatures there are of the same men or their descendants of the same name. L-AT

Stewart, A., *Greek Sculpture: An Exploration* (1990).

HAGGADAH (pl. Haggadot; Hebrew: telling the story). The Jewish home liturgy of the *Seder* (ritual meal) celebrated at the feast of the Passover, telling the story of the Exodus. The earliest extant text is a fragment datable to the 8th/9th century. The Haggadah is the only Hebrew text with a tradition of illustration, either with decoration set within the text or in the margins, or more elaborately with full-page illuminations. The earliest were in small format, but later were larger. The decorations have a regional style, with the most famous of the Ashkenazi tradition being the 'Sarajevo' Haggadah (Spanish, 14th century), and of the Sephardi the 'Darmstadt' (German, 15th century). The earliest known printed Haggadah with illustrations was printed at Constantinople in 1515 (two pages extant), followed by that of Soloman Ha-Kohen at Prague in 1526. Of more recent editions the most renowned are those with illustrations by Ben Shahn (1898–1969) and Jacob Steinhart (1887–1968). PCo

Yerushalmi, Y. H., *Haggadah and History* (1975).

HAGNOVER (or Hagenower), NICLAS (active 1493; d. before 1538). German woodcarver active in Strasbourg. He is known principally for the (undocumented) figures for the shrine of the Isenheim altar, the wings of which were painted by *Grünewald (c.1500–15; Colmar Mus.). To a certain extent he continued the style of Nicolaus *Gerhaerts, but the faces of his figures are more individualized and strongly marked. He was probably the father of Friedrich Hagenauer, a Strasbourg-trained sculptor, who became one of the greatest portrait medallists in the first half of the 16th century. KLB

Baxandall, M., *The Limewood Sculptors of Renaissance Germany* (1980).

HAGUE, THE, MAURITSHUIS. Also known as the Koninklijk Kabinet van Schilderijen (Royal Cabinet of Paintings), the Mauritshuis is named after Johann Maurits (John Maurice), Count van Nassau Siegen (1604–79), great-nephew of William of Orange. After a successful career as a soldier, Johan Maurits returned to The Hague in 1844 and moved into the newly built Mauritshuis. After various vicissitudes, including a fire, the Mauritshuis was purchased by the Dutch state to accommodate the Royal Cabinet of Paintings and Curiosities and the gallery opened in 1817 to 'anyone who is well dressed and not accompanied by children'. The core of the collection consists of some 120 paintings, formerly in the collection of Prince William V, returned to The Hague after confiscation by the French in 1795. After the Napoleonic occupation, Prince William's son, King William I, continued to play an active role in acquiring paintings for the museum. *Rembrandt's Anatomy Lesson of Dr Tulp, Johannes *Vermeer's View of Delft, and Jacob van *Ruisdael's View of Haarlem came to the gallery in this way. From 1832 onwards no further purchases were made until in 1874 the collection expanded again with the purchase of the Steengracht Collection. Twenty-five pictures were also bequeathed by Abraham Bredius, a former director of the gallery. The collection is mainly composed of 17th-century Dutch paintings of exceptional quality, together with a few outstanding works by *Holbein, Rogier van der *Weyden, and *Rubens. The Schilderijengalerij Prins Willem V (The Prince William V Gallery of Paintings) was reopened in 1977. The collection is housed nearby in a former inn, purchased in 1771 by Prince Willem V to house his collection. The paintings are hung as they would have been in the 18th century, closely packed together and one above the other, reaching to the height of the wall. This is of great interest, even though the paintings may not be of as high a quality as those in the Mauritshuis. CFW

HAGUE SCHOOL, the term applied to a group of Dutch painters who lived and worked in The Hague between 1860 and 1900. Their intention was to make realistic pictures of the landscape and seascape, architecture, and everyday life of the area and its people in undramatic but evocative paintings like Anton Mauve's A Morning Ride along the Beach (Amsterdam, Rijksmus.) and Jacob *Maris's Arrival of the Boats (1884; Amsterdam, Rijksmus.). In some ways this was a romantic revival of a Dutch 17th-century tradition and this nostalgic strain, particularly in the early years, distinguishes them from their French counterparts, the *Barbizon painters. Like many Dutch artists they were particularly sensitive in recording light and atmospheric effects. Leading members

included Hendrik Johannes Weissenbruch (1824–1903), *Israels, Mauve, the Maris brothers, and *Mesdag. Their work, together with that of contemporary French artists, was an important influence on English painters of the *Newlyn School (1885–95), who shared many of their preoccupations. They are well represented in The Hague Municipal Museum and the Rijksmuseum, Amsterdam.
 DER

Colmjon, G., The Hague School: The Renewal of Dutch Painting since the Middle of the Nineteenth Century (1951).

HALL, PETER ADOLF (1739–93). Swedish miniaturist. He abandoned medical studies to become a painter of miniature portraits, receiving in 1766 a bursary from the Swedish Crown to study in Paris. He developed a novel method of stippling gouache onto an ivory support to produce an almost Impressionistic liveliness. This, combined with the success of his 1768 portrait of The Dauphin and his Brother the Comte d'Artois (ex-Pierpont Morgan Coll.), brought him fashionable patrons and he enjoyed a lucrative career until the French Revolution ruined his trade. Hall also occasionally painted portraits in oils or pastels on the scale of life. There are examples of his work in the Nationalmuseum, Stockholm, and the Wallace Collection, London. MJ

Löfgren, J. Z., The Miniatures of Peter Adolf Hall (1976).

HALS FAMILY. Dutch painters originally from the Southern Netherlands, of whom the best known are **Frans** (1581×5–1666) and his brother **Dirck** (1591–1656). The latter specialized in small-scale genre subjects. They were the sons of a clothworker who settled in Haarlem sometime after 1585. Haarlem was an important commercial and artistic centre in the newly emerging Dutch Republic and Frans Hals became one of the leading painters, specializing in portraits which are outstanding for their lifelike qualities, spontaneous poses, and an innovatory technique of loose, sparkling brushwork. Mystery surrounds Hals's early training. Although he is listed in Karel van *Mander's Het schilderboeck (1618) as a pupil, van Mander appears to have had little influence on Hals's early works. In 1610 Hals married and became a master of the Haarlem painters' guild. No drawings can be ascribed to Hals and his earliest dated painting is Jacobus Zaffirus (1611; Haarlem, Frans Hals Mus.). This half-length portrait shows all the characteristics of Hals's mature style. The head is brightly lit, against a cool grey background. Impasted paint, particularly that applied to Zaffirus' forehead, helps to give a convincingly three-dimensional quality. The brushwork varies from broad sweeps of the brush for fur and fabric to short strokes for beard and skin.

Hals continued to develop these features in lively commissioned portraits, such as The Laughing Cavalier (1624; London, Wallace Coll.) and Pieter van den Broecke (London, Kenwood House), in which the sitters are caught in a spontaneous, fleeting expression and in which hands and elbows seem to burst through the picture plane towards the spectator. In these early portraits drama is created through the contrast of the sober but rich clothes of these wealthy sitters with the light-flooded blond backgrounds.

Hals, together with *Rembrandt, became the greatest exponent of the group portrait. Of the nine group portraits to survive, six are of militia companies painted in the first half of Hals's career. The remaining three depict the regents of philanthropic institutions in Haarlem and date to the latter half of Hals's career. The first militia portrait, The Banquet of the Officers of the S. George Civic Guard Company (1616; Haarlem, Frans Hals Mus.), in which Hals himself served in 1612, is loosely based upon an earlier composition by *Cornelisz. van Haarlem (1599; Haarlem, Frans Hals Mus.), but in Hals's work the composition is transformed through the grouping of his figures in a series of sweeping and dramatic diagonals, arranged in a space flooded by light. This technique is further developed in the next two militia group portraits of the Haarlem S. George and S. Adrian Civic Guard Companies (both 1627; Haarlem, Frans Hals Mus.).

In 1616, Hals went to Antwerp, where he may have visited *Rubens's studio. Possible influences from Rubens and other Flemish painters may partly explain Hals's highly individual technique which is so unlike that of his Dutch contemporaries. The Portrait of a Married Couple (1622; Amsterdam, Rijksmus.) resembles Rubens's Self-Portrait with Isabella Brant (1610; Munich, Alte Pin.), which Hals may well have seen. 1616 was also the year of the earliest documented claims on Hals by his creditors, suggesting that he was also active as a dealer. Half-length figure compositions survive from the earlier part of Hals's career, which do not appear to have been commissioned but nevertheless have a lively veracity, as for example Boy with a Skull (London, NG) or La Bohémienne (Paris, Louvre). The subjects may have been influenced by Dutch *Caravaggesque painters such as *Honthorst and ter *Brugghen.

The two Haarlem militia company group portraits (1633 and 1639; Haarlem, Frans Hals Mus.) mark the beginnings of a transition in Hals's work. Earlier light-filled banquet scenes have given way to a more sombre arrangement of officers standing in a tranquil horizontal line. In 1633 Hals was commissioned to paint the Amsterdam Crossbow Civic Guard Company (1637; Amsterdam, Rijksmus.). As is typical of Amsterdam militia portraits, the officers are represented full-length. After a preliminary visit, Hals refused to return to

Amsterdam and the composition was left unfinished, being completed by the Amsterdam painter Pieter Codde (1599–1678). The restraint already evident in Hals's work continued throughout the remainder of his career. Backgrounds become darker and colours more tonal. However, Hals's technique is even more spontaneous, with textures and character suggested rather than described. Examples include an outstanding pair of portraits *Stephanus Geraerdts* (Antwerp, Koninklijk Mus. voor Schone Kunsten) and *Isabella Coymans* (priv. coll.). A decline in the number of commissions coincided with an increase in Hals's domestic problems in his later years. Nevertheless, in 1662 the Haarlem authorities granted Hals a yearly pension and he also received a prestigious commission for two penetrating group portraits *The Regents of the Old Men's Almshouses* and the pendant of the *Regentesses* (both Haarlem, Frans Hals Mus.). These reveal that even in old age Hals was making an extraordinary artistic contribution, which only began to be fully appreciated in the 19th century. Five of Hals's sons became artists. Probable pupils include Judith *Leyster, Jan Miense *Molenaer, and Adriaen *Brouwer. CFW

Slive, S., *Frans Hals*, exhib. cat. 1989–90 (Washington, London, Haarlem).

HAMEN Y LEON, JUAN VAN DER (1596–1631), Spanish still-life painter. His father was a courtier who had emigrated from Brussels to Madrid. Both father and son were members of the Flemish royal guard of archers, which was a significant position in the Spanish court, and van der Hamen was patronized both by the court itself and by all sorts of affluent collectors in Madrid. He achieved great fame in his lifetime and was praised by many contemporary writers, including Lope de Vega and Góngora. Although he produced portraits, religious, and other figure paintings, he was famous above all for his *still lifes, and he made a number of innovations in this genre including, in particular, the arrangement of objects on a series of stepped ledges, as in *Still Life with Sweets and Pottery* (1627; Washington, NG). He was a master of the illusionistic depiction of surfaces and materials and in his best painting there is a powerful tension between the intellectual rigour of his spatial analysis and the sensuous treatment of pottery, glass, basketwork, sweetmeats, and fruit. AJL

Jordan, W. B., and Cherry, P., *Spanish Still Life from Velazquez to Goya*, exhib. cat. 1995 (London, NG).

HAMILTON, GAVIN (1723–98). Scottish painter and dealer. Hamilton, educated at Glasgow University, arrived in Rome, where he was to remain for most of his life, in 1748. He studied portraiture but, influenced by the architects James Stuart (1713–88) and Nicholas Revett (1720–1804), became an archaeologist and *history painter. His work, which was admired by *Winckelmann, was intended to emulate the heroic subjects and universal moral truths of Greek art. Much is now lost but known through the engravings which ensured him wide contemporary influence. *Achilles Lamenting the Death of Patroclus* (1763; Edinburgh, NG Scotland) and *Hector Taking Leave of Andromache* (1760s; Glasgow, Hunterian), which owe a compositional debt to *Poussin, are typical Homeric subjects. The deliberate generality of his history paintings is fortunately absent in his few portraits. *The 8th Duke of Hamilton with Dr John Moore and Ensign Moore* (1777; Lothian, Lennoxlove) reveals him as a worthy rival to *Batoni. Hamilton was also a dealer in old masters and antiquities whose coups included *Leonardo's *Virgin of the Rocks* (London, NG) and the Warwick Vase (Glasgow, Burrell). DER

Stainton, L., *British Artists in Rome*, exhib. cat. 1975 (London, Kenwood House).

HAMILTON, RICHARD (1922–). British painter, printmaker, teacher, exhibition organizer, and writer, one of the leading pioneers of *Pop art. He was born in London and after leaving school at 14 worked in advertising and commercial art whilst attending evening classes in painting. He then studied at the Royal Academy, *London, in 1938–40 and 1946 (interrupted by war service as an engineering draughtsman) and at the Slade School, 1948–51. In 1952 he became a member of the *Independent Group and in 1956, with other members, he helped to organize the exhibition *This is Tomorrow* at the Whitechapel Art Gallery. Hamilton's photomontage *Just What Is it that Makes Today's Homes so Different, so Appealing?* (1956; Tübingen, Kunsthalle) was displayed blown up to life size at the entrance to the exhibition; a satire on consumerism and suburbia, it is made up of advertising images (including a lollipop bearing the word 'Pop') and is sometimes considered to be the first Pop art work. 'Ever since then, his paintings and prints have engaged with countless aspects of popular culture and styling, as well as investigating the borderline between hand-made and mechanically made imagery' (Gray Watson in Susan Compton (ed.), *British Art in the 20th Century*, exhib. cat., Royal Academy, London, 1987). Hamilton's work has influenced *Blake and *Hockney amongst others, and he has played a significant role as an organizer of exhibitions (notably 'The Almost Complete Works of Marcel *Duchamp' at the Tate Gallery, London, in 1966, for which he made a reconstruction of Duchamp's *The Bride Stripped Bare by her Bachelors, Even*, now in the Tate's collection). He has also had a distinguished career as a teacher, notably at King's College,

Newcastle upon Tyne (later Newcastle University), 1953–66. An anthology of his writings, *Collected Words*, appeared in 1982. IC

HAMMERSHOI, VILHELM (1864–1916). Danish painter. Hammershoi was born and trained in Copenhagen, the subject of much of his work. He painted both portraits and landscapes but is best known for his quiet interior scenes, like *Interior* (1899; London, Tate). These are painted in muted colours in which grey predominates and have a surface resemblance to paintings by *Vermeer, often containing a single seated or standing figure but on occasion empty of both figures and furniture. They were usually painted in the rooms of his own homes, simply but tastefully decorated and containing antique furniture of the First Empire period (1804–14). His portraits include a remarkable group of five artist friends (1901; Stockholm, Thielska Gal.), spare and dark and illuminated by candlelight, in which each sitter appears self-absorbed and indifferent to his fellows. His landscapes are equally melancholy, often painted under grey cloudy skies. The individuality of his work was the cause of controversial rejections from several of the annual exhibitions of the Copenhagen Academy which led to the foundation of the Independent Exhibition in 1891. DER

Vad, P., *Vilhelm Hammershoi and Danish Art at the Turn of the Century* (1992).

HANEQUÍN DE BRUSELAS. See EGAS, CUEMAN.

HANNEMAN, ADRIAEN (c.1604–71). Dutch portrait painter. After an early training with Anthonie van Ravesteyn (1580/88–1669) in The Hague, Hanneman moved in 1626 to London, where he married and may have worked as an assistant to van *Dyck, who also settled there in 1632. Hanneman worked mainly as a portrait painter and, after his return to The Hague in 1638, his clientele included English royalists exiled to the Netherlands during the later 1640s. Hanneman's portraits of *Constantijn Huygens and his Children* (1640; The Hague, Mauritshuis) or *Henry, Duke of Gloucester* (1653; Washington, NG) show a continuing debt to van Dyck in the confident poses, elegant dress, and glossy paintwork of the sitters. In 1664 Hanneman was commissioned to paint two allegories, *Justice* (The Hague, Oude Stadhuis) and *Peace* (The Hague, Binnenhof). Hanneman became the first dean of Pictura, an association set up in 1656 by artists who had dissociated themselves from the painters' guild in The Hague. Despite his obvious respectable social standing and financial success, Hanneman seems to have suffered various financial setbacks in

later life, for reasons which remain unclear.

CFW

Millar, O., *The Age of Charles I: Painting in England 1620–49*, exhib. cat. 1972 (London, Tate).

ter Kuile, O., *Adriaen Hanneman: een haags portret-schilder* (1976).

HANSON, DUANE (1925–96). American sculptor. Hanson was born in Alexandria, Minn., and studied at several institutions, as both undergraduate and postgraduate, 1943–51. In 1953 he moved to Germany where he taught in Munich and later Bremerhaven and made sculptures in a variety of styles and media. He returned to America in 1960, as *Pop art was emerging, and, influenced by the full-size plaster-cast figures of George *Segal, developed his own distinctive style. Like Segal, Hanson used life casts as the basis for his fibreglass and resin figures but also applied lifelike colour, dressed them in real clothing, and provided them with real accessories. He took his subjects, like *Tourists* (1970; Edinburgh, NG of Modern Art), from the lower middle classes, specializing in the banal and slightly depressing. Although they had no satiric intent they were designed as a commentary on the emptiness of lives dominated by consumerism. Hanson's figures are more realistic, like waxworks, than those of his contemporary Pop artists and he is more properly associated with the *Photo-realists who emerged in the early 1970s.

DER

Varnedoe, K., *Duane Hanson* (1985).

HAPPENING. See PERFORMANCE ART.

HARNETT, WILLIAM MICHAEL (1848–92). American painter. Harnett, an Irish immigrant, spent his childhood in Philadelphia. From *c*.1865 he worked as a silver engraver, attending art classes in the evenings. He followed the same pattern in New York 1869–75 and was a professional still-life painter by 1876 when he returned to Philadelphia. From 1880 to 1886 he was in Europe, spending the years 1881–5 in Munich. *After the Hunt* (1885; San Francisco, California Palace of the Legion of Honour), a splendid *trompe l'œil* in his mature style, portrays distinctly Germanic objects among the other elements composed into a virtually classical trophy. He returned to New York, where he was to remain, in 1886 and won popular renown for his brilliant *illusionism. He excelled in simulation of textures and depiction of gravity but was more than a mere imitator of appearances, for his compositions are highly sophisticated and he was also anxious to include a narrative element in his work. *The Faithfull Colt* (1890; Hartford, Conn., Wadsworth Atheneum), in which a rusty gun hangs on a nail against a splintered door, is as much a romantic evocation as an optical deception.

DER

Frankenstein, A., *After the Hunt* (1953).

HARRIS, LAWREN S. (1885–1970). Canadian painter, born in Brantford, Ontario. After studying in Berlin (1904–7) he returned to Toronto and, with artists including A. Y. *Jackson and Tom *Thomson, set up a communal studio in 1914 and went on sketching trips to the rugged wilderness of northern Ontario. His early paintings show influences of *Post-Impressionism and contemporary Scandinavian art.

In 1920 Harris was a founder of the *Group of Seven and was considered its most intellectual spokesman and most eloquent theoretician. He became a theosophist and, in the austere, elemental Lake Superior landscape, found images that visually embodied his quest for a union of the earthly and material with the spiritual. In paintings like *Clouds, Lake Superior* (1929; Winnipeg, AG) he reduced his composition to a few smooth forms bathed in a cool, bluish silver light. Painting trips to the Rocky Mountains and the Arctic in the 1920s and 1930s reinforced his mystical beliefs. Harris lived in the USA from 1934, moving permanently to Vancouver, where he painted abstractions (see ABSTRACT ART), in 1940.

KM

Larisey, P., *Light for a Cold Land: Lawren Harris's Work and Life—an Interpretation* (1993).

HARTFORD, WADSWORTH ATHENEUM. In 1841 Daniel Wadsworth, a local patron of the arts, first proposed establishing an art museum for the city of Hartford, Connecticut. The funds were raised by subscription, and on land donated by his father on Main Street, the original neo-Gothic Atheneum was built in 1843 and opened in the summer of 1844. It is the oldest public art museum in America still functioning.

The museum's first collections were the holdings of the bankrupt American Academy of Fine Arts and the bequest of Daniel Wadsworth's American paintings in 1848. Later, following her death in 1905, the estate of Elizabeth Colt brought a new building and additional American works. The result was that by the beginning of this century the Atheneum had remarkable holdings of American masters, including *Cole, *Church, and *Trumbull. However, it was not a flourishing institution and to save it, the Revd Francis Goodwin turned to his cousin J. Pierpont Morgan, who ultimately not only gave funds, but also built a new building in memory of his father. J. P. Morgan died in 1913, but to honour his connection with Hartford his own son in 1917 donated more than 1,000 objects of ancient and European art to the Atheneum.

A decade later the museum arrived at a true turning point. A bequest of over $1 million from the banker Frank Sumner for the acquisition of 'choice paintings' allowed the Atheneum's new director. A Everett Austin, Jr., known as Chick, the means to build a significant collection of European art. Austin was in the forefront of enthusiasts rediscovering the *Baroque and thus the Atheneum acquired notable paintings by *Giordano, *Strozzi, *Murillo, *Poussin, and *Claude, and in 1943 the first authentic *Caravaggio to come to America, *The Ecstasy of S. Francis*. Often his taste was prescient as in the case of *Le Nain and *Sweerts. Austin was equally acclaimed for his willingness to explore the new. He presented the first American museum exhibitions of both *Surrealism and *Picasso, and as his limited budget allowed, he also took the risk of purchasing still controversial modern works. These included, in addition to the first *Dalí, *Mondrian, *Calder, and *Cornell to enter any American museum, works by *de Chirico, Picasso, *Miró, *Ernst, and *Tanguy. Austin's love of Surrealism led him to recognize the original quality of the then neglected American *trompe l'œil masters, and he acquired examples by both *Harnett and John Peto. A major coup was the purchase in 1933 of the entire Serge Lifar collection of Ballets Russes material. This consisted of not just costumes and set designs, but major paintings and drawings by all of Diaghilev's collaborators, Picasso, de Chirico, *Rouault, and *Bakst.

Austin's successor as director 1946–66 was a more traditional but equally brilliant connoisseur, Charles Cunningham. Building on the Baroque foundation were the extraordinary *Zurbarán *S. Serapion*, *Gentileschi's *Judith*, *Rosa's *Ricciardi as the Muse of Poetry*, and *Ribera's *Sense of Taste*. Two great examples of Dutch painting were *Hals's *Portrait of Joseph Coymans* and *Berchem's *Moor Presenting a Parrot to a Lady*. Most unusual was his taste for English painting: *Wright of Derby's macabre *Old Man and Death* and William Holman *Hunt's extraordinary *Lady of Shalott*, and a large Stanley *Spencer. Through gifts and acquisitions the museum was able to embrace more fully the 19th century with works by *Géricault, *Delacroix, and *Ingres, and from the later part of the century *Monet, *Degas, van *Gogh, and, most popular of all, *Renoir's depiction of Monet painting in his garden at Argenteuil.

In more recent years the Atheneum has become known for its expanded 20th-century holdings. On the European side acquisitions have included examples by Picasso, Matisse, *Kirchner, and *Munch and on the American, *O'Keeffe, *Hartley, *Pollock, *de Kooning, *Rauschenberg, *Warhol; and several wall paintings by Hartford's own Sol *Lewitt.

EZ

Gaddis, E. R., et. al., *'The Spirit of Genius': Art at the Wadsworth Atheneum* (1992).

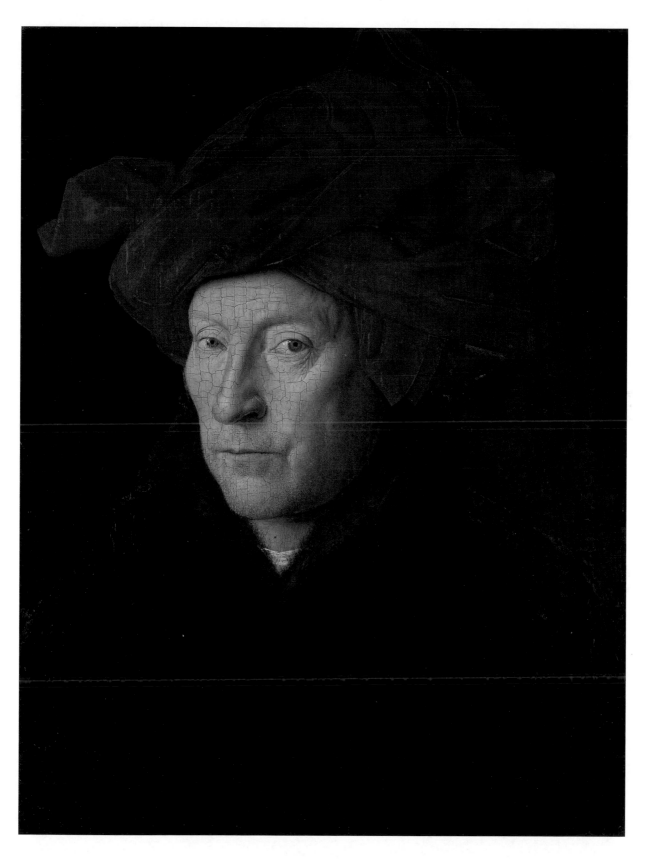

Jan van Eyck (*c*.1395–1441), *A Man in a Turban*, oil on wood, 33.3 × 25.8cm (13 × 10in), London, National Gallery.

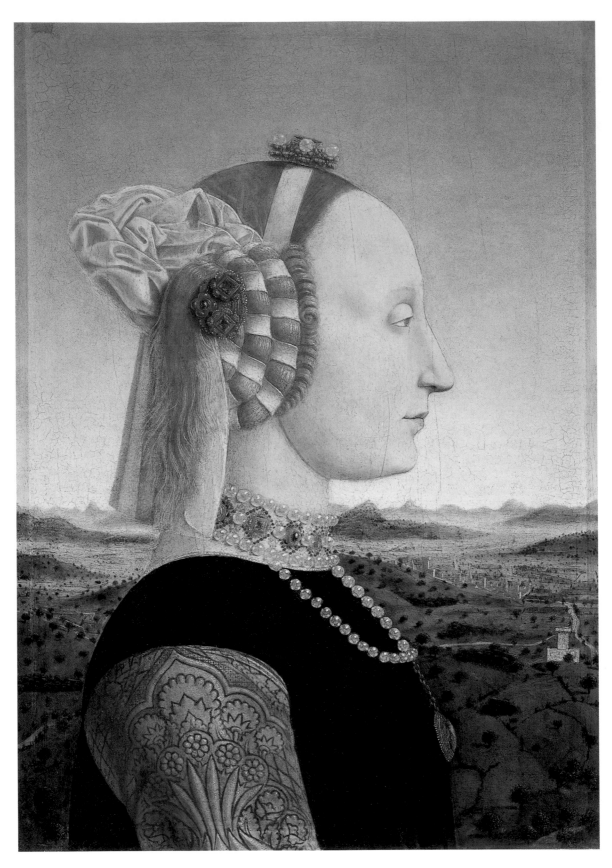

Piero della Francesca (c.1415–92), *Battista Sforza*, Duchess of Urbino and *Federico da Montefeltro*, Duke of Urbino, oil and tempera on panel, 47×33 cm (18½×13 in), Florence, Uffizi.

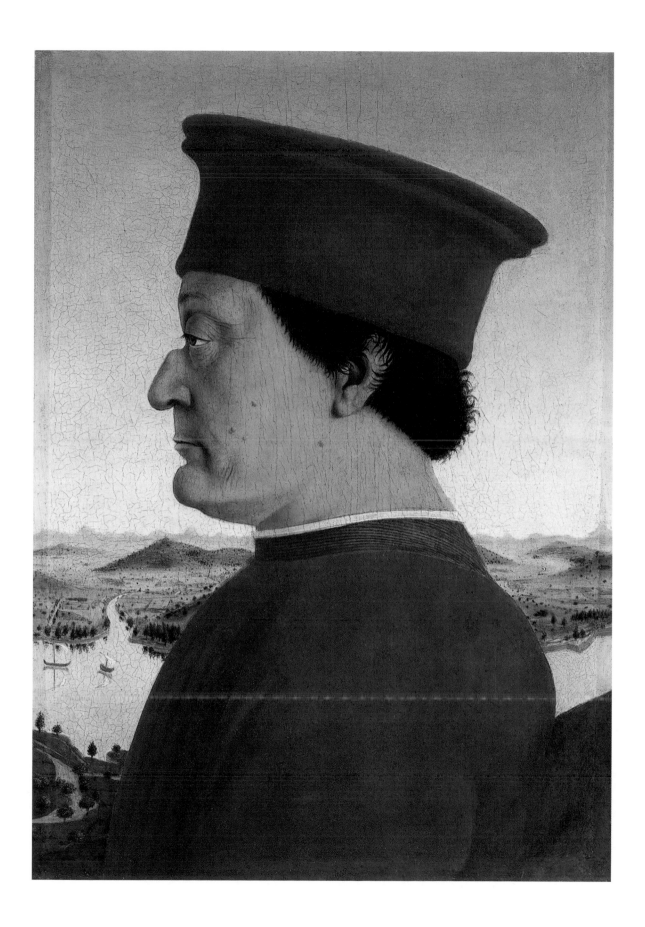

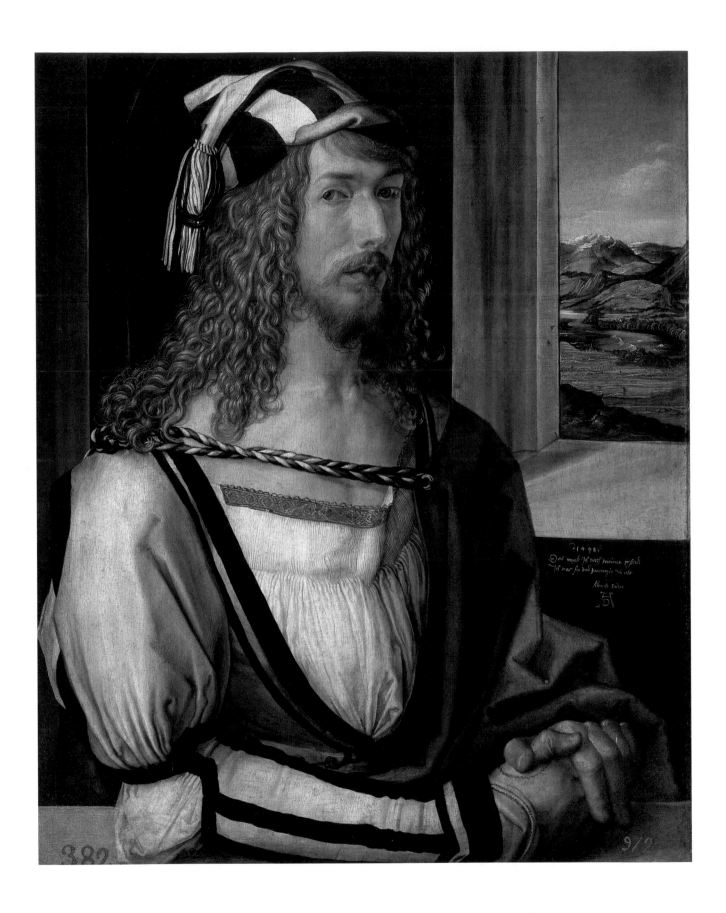

Albrecht Dürer, *Self-Portrait* (1498), oil on wood, 52 × 41 cm (20½ × 16 in), Madrid, Prado.

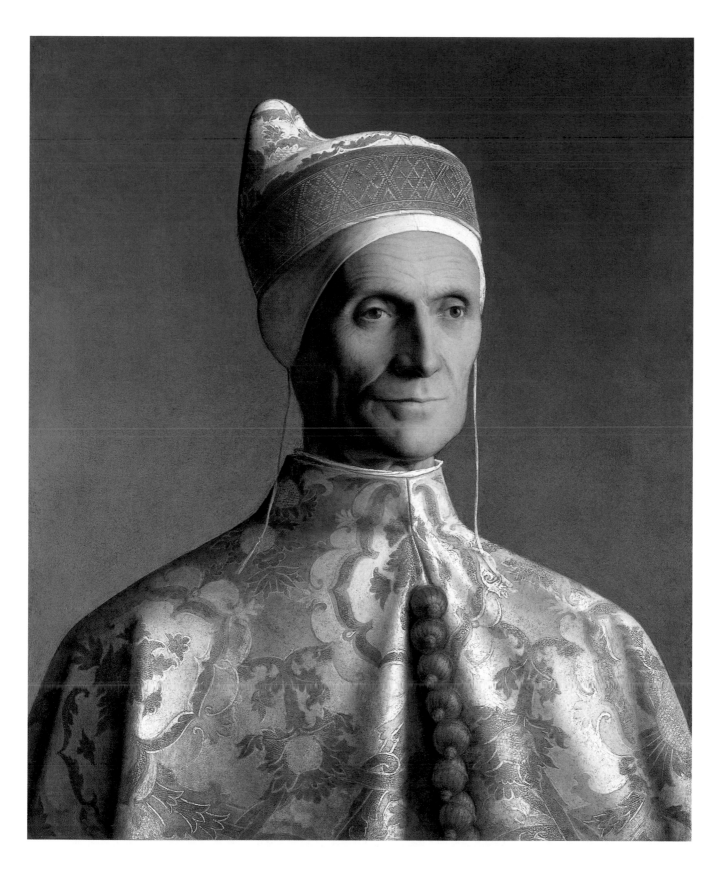

Giovanni Bellini (d. 1516), *Doge Leonardo Loredan*, oil on wood, 61.6×45.1 cm (24¼×17¾ in), London, National Gallery.

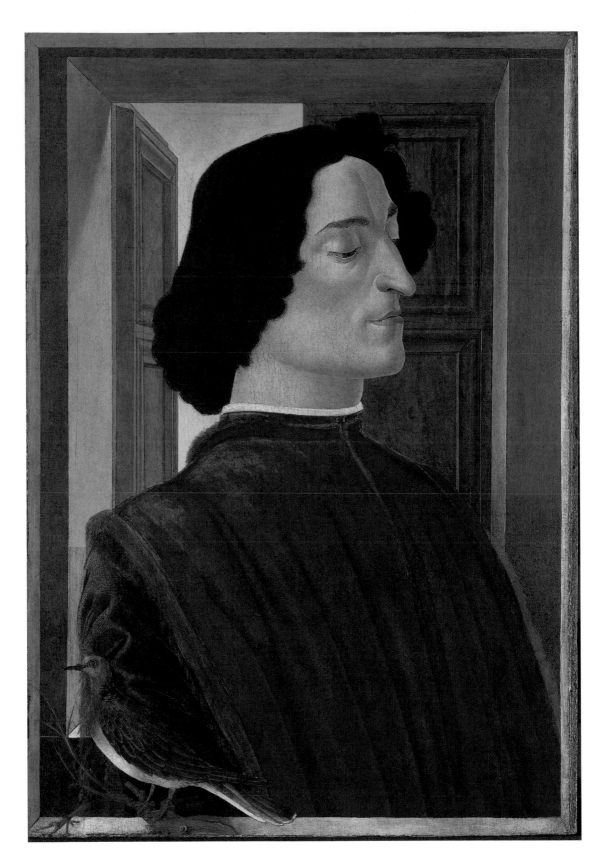

Sandro Botticelli (1445–1510), *Giuliano de' Medici*, tempera on panel, 75.6 × 52.6 cm (29¾ × 20⅝ in), Washington, National Gallery of Art, Samuel H. Kress Collection.

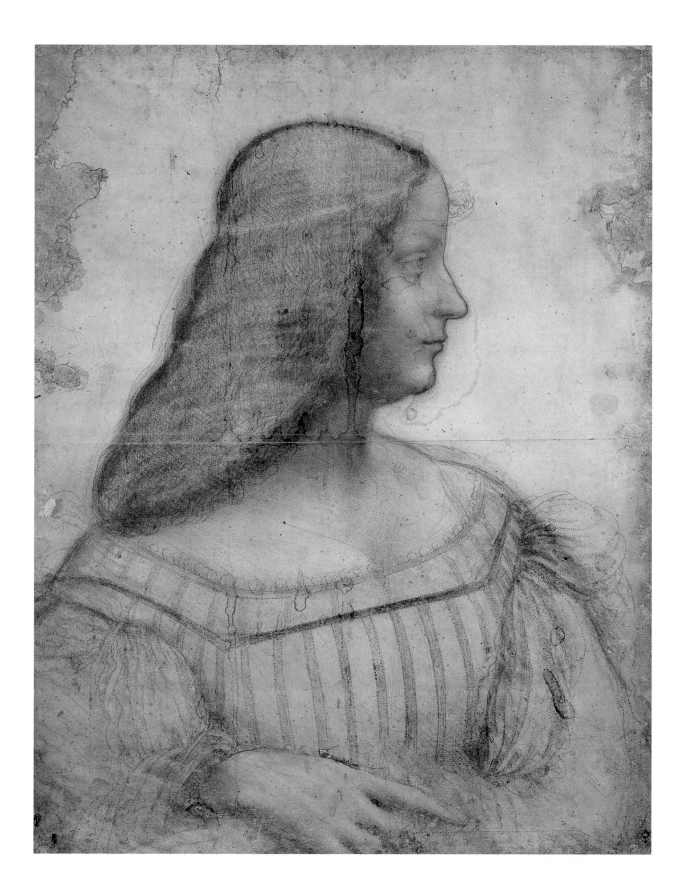

Leonardo da Vinci, *Isabella d'Este* (1499), black and red chalk, 63×46 cm (24⅞×18⅛ in), Paris, Louvre.

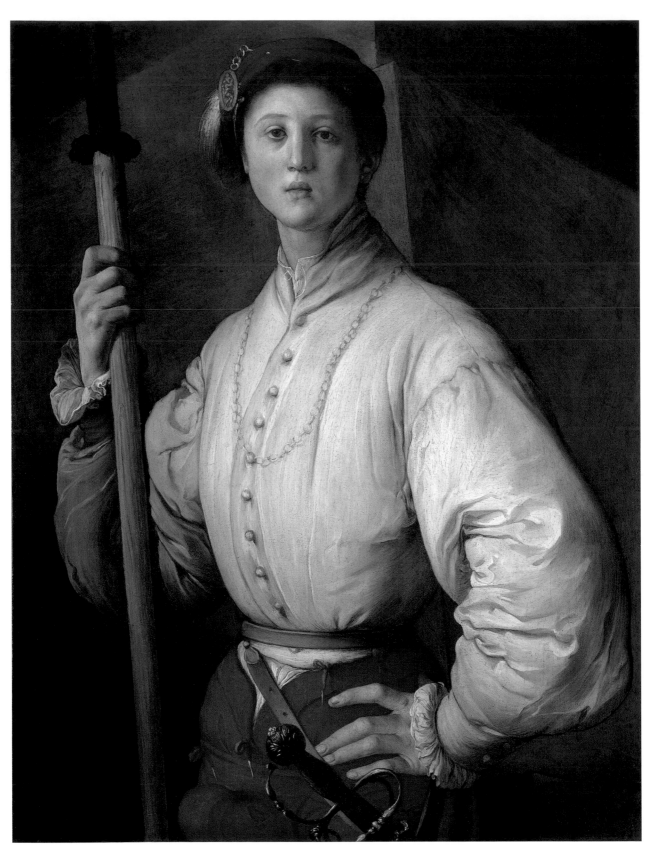

Jacopo da Pontormo (1494–1556), *Portrait of a Halberdier*, oil (or oil and tempera) on panel transferred to canvas, 92×72 cm (36¼×28⅜ in), Los Angeles, J. Paul Getty Museum.

HARTLEY, MARSDEN (1877–1943). Born Edmund Hartley in Maine, New England, he won a scholarship to study in New York where he would base himself for much of his life, in between long trips to Europe. He began painting in a *Post-Impressionist manner, with dark, brooding landscapes, for instance *Storm Clouds, Maine* (1906–7; Minneapolis, Walker Art Center). In 1909 he met Alfred Stieglitz in New York, who introduced him to more contemporary work, and Hartley began to paint still lifes influenced by *Picasso and *Cézanne; this subject would continue to preoccupy him throughout his career. In Paris he discovered *Kandinsky, to whose spiritualism he was receptive, and in 1912 he began to paint 'intuitive abstractions'. In Germany 1913–15 he developed a more symbolic language: *Portrait of a German Officer* (1914; New York, Met. Mus.) is his most famous work, a still life of military regalia subtly eroticized by its very allegorical nature, it has become iconic as an example of the coded language of homosexual culture employed in the fine arts. MF

Robertson, B., *Marsden Hartley* (1995).

HARTUNG, HANS (1904–89). German-born artist of the *École de Paris. Alongside astronomy and psychology, Hartung developed an interest in *'Expressionism', and in 1922 completed a series of untitled, abstract watercolours (Antibes, Foundation Hans Hartung). He was born in Leipzig, and studied at Dresden and Munich, where he met *Kandinsky. He moved to Paris in 1926 and became one of the most successful artists of the École de Paris, evolving a calligraphic, linear style. This he employed both in his paintings (generally simply numbered rather than titled) and later in wire sculptures. MF

Descargues, P., *Hartung* (1977).

HASSAM, CHILDE (1859–1935). American painter. He was born near and studied in Boston, Mass. His early works include moody, atmospheric street scenes, recalling the *Luminist tradition in American painting, and for the remainder of his career he found inspiration in city life. In 1886 he made his second visit to Europe during which he studied for some time at the Académie Julian in Paris. Hassam was immediately struck by recent developments in French painting and was strongly influenced by *Impressionist technique and palette, particularly in the work of *Monet, *Pissarro, and *Sisley. In a painting of 1887, *Rainy Day, Rue Bonaparte* (New York, priv. coll.), he retains his familiar subject matter but paints with heightened colour and broken brush strokes; his composition, however, remains conventional and he never achieved the informality of the French painters. Returning to New York in 1889 he exhibited with like-minded artists, most of whom had trained in Paris, as The Ten American Painters from 1895. Their exhibitions were intended to promote a distinct American Impressionism and to wean American patrons from European art. Hassam's painting is lively, bright, and exhilarating but remains essentially conservative. DER

Hiesinger, U., *Childe Hassam: American Impressionist* (1994).

HAUSER, ARNOLD (1892–1978). Hungarian art historian. After studying at Budapest, Paris, and Berlin, Hauser founded his own film company in 1930. In 1938 he emigrated to England and between 1951 and 1957 taught art history at Leeds University. As a Marxist theorist he argued that the production of art was socially determined and that works of art were used by society to come to terms with the chaotic nature of things. His chief works are *The Social History of Art* (1951) and *The Philosophy of Art History* (1959). AT

HAUSMANN, RAOUL (1886–1971). Austrian-born artist and *Dadaist. Trained in Berlin, Hausmann became a leading figure in Berlin Dada after its debut in 1917. As well as contributing to the *outré* antics of the group, he edited the revue *Der Dada* (1919–20), and produced copious collages and photomontages. From 1927 on he devoted himself to *photography, producing images of often unsettling beauty: *Alt-Berlin* (1931; Rochechouart, Mus. Départemental). After a period in Ibiza he fled to France during the war. Post-war he participated in numerous photography exhibitions and Dada retrospectives. AA

Raoul Hausmann, exhib. cat. 1994 (S. Étienne, Mus. d'Art Moderne).

HAYDON, BENJAMIN ROBERT (1786–1846). English painter. Born in Plymouth, son of a bookseller, Haydon studied at the RA, *London. Early influenced by *Reynolds's concept of the *Grand Manner and the example of *Fuseli, he saw painting as a high-minded activity. He became influential in matters of taste with his remarks on the Elgin Marbles, which he drew and studied in 1808. Later, in the 1830s, he lectured widely on art education. He published some lectures in 1844 but became best known not for his art, but for his diary, posthumously published. He knew Wordsworth, Keats, Shelley, and *Hazlitt. He enjoyed noble and even royal patronage but was often in debt, taking years to produce his large, unwieldy *history paintings. His *Judgment of Solomon* (1814; Plymouth, Mus. and AG) took two years whilst *Christ's Entry into Jerusalem* (1820; Cincinnati, S. Mary's Seminary) took six years. His self-promotional tendencies often antagonized the art establishment, which spurned him. His lifelong purpose to educate and improve public taste failed and he committed suicide in 1846. If his paintings now seem uneven his finely observed drawings from life are frequently exceptional. Edwin *Landseer was among his pupils. MP

Pope, W. T. (ed.), *Haydon's Diaries* (1960–3).

HAYEZ, FRANCESCO (1791–1882). Italian painter. Born in Venice, Hayez was apprenticed to a restorer before studying painting. In 1809, with the patronage of *Canova and *Cicognara, he won a scholarship to study in Rome where he met the *Nazarenes and *Ingres. The latter was a major influence on his style despite his subsequent reputation as a *Romantic painter, which owes more to his subject matter than his technique, which remained essentially linear rather than painterly. In 1817, with Cicognara's help, he was commissioned to paint decorative frescoes in the Vatican which were paid for by Canova. Hayez moved to Milan in 1822 and taught at the Brera, becoming an influential professor in 1850 and director in 1860. A brilliant portraitist, he painted many of his most eminent contemporaries including Cavour and Rossini and rivalled Ingres in his paintings of fashionable women. His romantic historical subject paintings, of which the most famous is *The Kiss* (1859; Milan, Brera), show a knowledge of the work of *Delacroix and *Delaroche although he does not appear to have visited France. Hayez was a pivotal figure in the transition from *Neoclassicism to Romanticism in Italian painting. DER

Gozzoli, M., and Mazzocca, F., *Hayez*, exhib. cat. 1983 (Milan, Palazzo Reale).

HAYMAN, FRANCIS (1708?–76). English painter, probably born in Exeter. After training as a decorative artist he worked successfully at Drury Lane, London, as a scene painter. In the 1740s he painted portraits and domestic *conversation pieces for a new audience of middle-class patrons, among them actors and writers. *Samuel Richardson and his Family* (priv. coll.). At Vauxhall Gardens Hayman painted innovative scenes from Shakespeare as well as French-influenced scenes of contemporary life, children playing, and rural entertainments. His own theatrical experience and the advice of Garrick strengthened his depiction of gesture and action, seen in his many book illustrations to Shakespeare, Milton, Smollett, and Richardson among others. With *Hogarth and others he contributed to the decoration of the Foundling Hospital (*Finding of Moses*, 1746). He was a founder member of the St Martin's Lane Academy, *London, and an advocate of a public art academy to promote *history painting. From 1760 to 1768 he exhibited at the Society of Artists and from 1769 to 1772 at the new Royal Academy of which he was also

333

a founder member (see both under LONDON). In 1770 with his health failing he became the Academy's librarian. MP

Allen, B., *Francis Hayman* (1987).

HAZLITT, WILLIAM (1778–1830). English writer and painter. Hazlitt probably trained under his brother John (1767–1837) but abandoned portraiture in 1804 after painting *Charles Lamb* (London, NPG). From 1812 he made a living as a prolific writer on literature (for which he is best known), politics, and art. His art criticism arose from seeing in London, when a painter, the Orléans Collection, in 1799, and his subsequent tour of great English collections. His heroes were *Titian, *Raphael, *Correggio, *Poussin, and *Rubens and the quality he most admired was 'gusto', the power and passion that only great art attained. His volatile friendships with Wordsworth and Coleridge coloured his sensibility and he brought to criticism the Romantic qualities of empathy and imagination. His unconvincing attempt at an artistic theory, contained in his essay *The Fine Arts* in the seventh edition of the *Encyclopaedia Britannica* (1824), is, primarily, an attack on *Reynolds, based solely on naturalism. Hazlitt was a difficult and feckless individual whom many contemporary painters considered spiteful but his enthusiastic evocation of great paintings, for a lay readership, ensures his importance as a pioneer of journalistic art criticism. DER

Jones, S., *Hazlitt* (1989).

HEAPHY, CHARLES (c.1820–81). English-born painter mainly active in New Zealand. Born in London, the second son of Thomas Heaphy (1775–1835), a portrait and watercolour painter, Heaphy studied at the RA Schools (see under LONDON). In 1839 he was appointed artist and draughtsman to the New Zealand Company. For the next three years he travelled throughout the country, which was largely an unexplored wilderness as the first permanent European settlement was only established in 1840. The paintings and drawings he made, which are now in the Alexander Turnbull Library, Wellington, form a unique record of early colonial New Zealand. His book *Residence in New Zealand*, designed to encourage settlers, was published in 1842. His career as a surveyor prospered and he became, successively, surveyor of Auckland in 1858 and chief surveyor of New Zealand in 1864. He distinguished himself during the third Maori War and was awarded the Victoria Cross in 1867, the year in which he began a political career as a member of the House of Representatives. His elder brother Thomas Jr. (1813–73) was a portrait and subject painter and his sisters Mary Anne Musgrave and Elizabeth Murphy were miniature painters. DER

HEARNE, THOMAS (1744–1817). English *topographical draughtsman. He toured widely with the connoisseur and collector Sir George Beaumont (1753–1827): to Norfolk and Suffolk (1771) and to the north of England and Scotland (1777 and 1778). In 1771 he went to the Leeward Islands with the new Governor who commissioned 20 large views, ten being of Antigua. These Hearne painted from his many on-the-spot sketches when he returned home. In 1778 he began publishing *The Antiquities of Great Britain*, pioneering a new accuracy and quality in antiquarian depictions. Volume 1, with 52 plates, was published in 1786; volume 2, with 32 plates, in 1806. The younger generation of artists, including *Turner and *Girtin, were initially influenced by Hearne's watercolours which they saw in the collection of Dr Monro. Careful drawing, subtle subdued colours, and fine textural touches characterize Hearne's works, which are among the most successful 18th-century examples of topographical and antiquarian subjects. MP

Hardie, M., *Watercolour Painting in Britain*, vol. 1 (1966).

HEARTFIELD, JOHN (1891–1968). German artist, a celebrated exponent and pioneer of *photomontage. Born Helmut Herzfeld, he trained as a graphic artist. Like his close friend George *Grosz, whom he met in 1915, Heartfield Anglicized his name in protest at German nationalism during the First World War. The two became founding members of the Berlin *Dada group, and experimented with photomontage. Heartfield developed the technique with his brother and lifelong artistic partner Wieland Herzfelde. His approach is encapsulated in the slogan 'Use photography as a weapon', which crowned the entrance to the Heartfield room at the 1929 *Film und Foto* exhibition in Stuttgart. A committed Communist, Heartfield worked for political ends, viciously lampooning opponents of the left. His most famous compositions date from the 1930s, and were produced for the left-wing periodical *Arbeiter-Illustrierte Zeitung*—for example *Der Sinn von Genf* (The Meaning of Geneva) (1932; Berlin, Akademie der Künste), a brutally simple image conveying a complex message, typical of his best output. Nazism (a favourite target) eventually drove him to exile in London, but he moved to the GDR in 1950, where he remained until his death. AA

Evans, D., *John Heartfield AIZ/IV 1930–38* (1992).

HECKEL, ERICH (1883–1970). German artist and founder member of Die *Brücke. He met *Schmidt-Rottluff at school in Chemnitz and *Kirchner while studying architecture in Dresden, founding Die Brücke with them in 1905.

Heckel's work from his Dresden period is characterized by a tendency towards an elongation of the figure and a sensation of withdrawal and *Weltschmerz* in the subject matter, an almost prophetic fear and spiritual constriction. His early subjects were predominantly circus performers, and the painting *Clown and Doll* (1912; priv. coll.) epitomizes his pre-war œuvre.

Following his move to Berlin in 1911 with Die Brücke, Heckel came into contact with a number of the *Blaue Reiter artists, including *Marc and *Macke. They had seen the work of *Delaunay in Paris and Heckel's style developed under Delaunay's influence towards a new dynamism and lyricism in the years immediately preceding the First World War, although the earlier sense of doubt and desolation was still evident. After the war, Heckel returned to Berlin and his art during the 1920s became more decorative in tone, his pre-war *Expressionism giving way to a new focus on nature and landscape and a style increasingly influenced by the emerging New Objectivity. RRAM

Henze, A., *Erich Heckel: Leben und Werk* (1983).

HEDA, WILLEM CLAESZ. (1590–1680). Dutch painter of *still life. Heda's training is uncertain but he is first mentioned in the register of the painters' guild in Haarlem in 1631. He and Pieter *Claesz. are the most important representatives of the monochromatic *ontbijt* (breakfast piece). It is sometimes difficult to make a distinction between their works although Heda's choice of object is more aristocratic than that of Claesz. and his work tends to be somewhat smoother and more detailed. Oysters, game pies, elaborate silver, and glass feature prominently and the objects are usually arranged in a strong diagonal composition unified by means of an atmospheric grey-green or light beige tonality as in *Still Life* (1634; Madrid, Thyssen Mus.). Gradually, by the later 1630s, more objects of an increasingly sumptuous type fill the composition. These features together with a controlled disorder characterize *Breakfast Still Life with Blackberry Pie* (1645; Dresden, Staatliche Kunstsammlungen). Heda's still lifes were much in demand and *Rubens owned two of his works. CFW

Haak, B., *The Golden Age: Dutch Painting in the 17th Century* (1984).

HEEM, DE. Dutch *still-life and *flower painters, father and son, mainly active in Flanders. **Jan Davidsz.** (1606–83/4) was born in Utrecht and his earliest still lifes are very close to those of Balthasar van der *Ast. In 1626 he moved to Leiden, where he painted *vanitas* subjects and increasingly adopted the monochrome palette of Haarlem still-life painters. He moved to Antwerp in 1635 and soon became famous for large-scale

banquet pieces that combined the lavish Flemish tradition with the precision of his Dutch training. Around 1650 he turned increasingly to flower painting, in which he established a sombre and magisterially controlled manner (*Vase of Flowers*; Washington, NG) that was to dominate Dutch flower painting until the time of van *Huysum. He was back in Utrecht 1669–72 but then returned to Antwerp. He had many followers both in Holland and Flanders, and Abraham Mignon (1640–79), Maria van Oosterwyck (1630–93), and Elias van den Broek (c.1650–1708) all worked in his studio. His son **Cornelis** (1631–95) was a close follower and collaborator. AJL

Taylor, P., *Dutch Flower Painting 1600–1720* (1995).

HEEMSKERCK, MAERTEN VAN (1498–1574). Dutch painter, draughtsman, and designer of prints, born in the village of Heemskerck, near Haarlem. He was an immensely productive, inventive, and erudite artist, one of the second-generation *Romanists. After studying in Haarlem and Delft, he entered the workshop of Jan van *Scorel, who had recently returned from Italy and in 1527–30 was seeking respite in Haarlem from political turmoil in Utrecht. According to van *Mander, Heemskerck was eager to absorb Scorel's Italianate manner even before his own trip to Rome, 1532–6. His early paintings include portraits and the famous *S. Luke Painting the Virgin*, which he dedicated to the Haarlem painters' guild (Haarlem, Frans Hals Mus.). In Rome he was profoundly affected by the work of contemporary artists and by examples of ancient statuary which he recorded in sketchbooks, along with city views, ruins, landscapes, and architectural fragments (Berlin, Kupferstichkabinett). After his return to Haarlem, he painted mythological scenes, altarpieces, and portraits (*Self-Portrait with a View of the Colosseum*, 1553; Cambridge, Fitzwilliam). Important commissions which he received from other cities suggest the extent of his reputation. Engravings after his paintings and his many drawings were a great influence on northern artists. KLB

Fildet Kok, J. P., et al. (eds.), *Kunst voor de beeldenstorm*, exhib. cat. 1986 (Amsterdam, Rijksmus.).

HEGEL, GEORG WILHELM FRIEDRICH (1770–1831). German philosopher. He called his philosophy 'Absolute Idealism', holding that Mind or Spirit (*Geist*) is the ultimate reality and that only Absolute Mind, which he equated with God, is entirely real. He maintained that history demonstrates a continuous progression towards greater self-consciousness of Mind. Art had a major place in Hegel's account of history, as a mode through which Mind comes to know itself. In a course of lectures (1828) he outlined three stages of its development. The 'symbolic' art

of early cultures grappled with physical material simplistically; 'classical' art, principally that of Greece, achieved an equivalence of matter and thought that remained a lasting norm of beauty; whereas in 'romantic' art—meaning all post-classical work—Mind took precedence over its material embodiment, a tendency that might eventually lead to the end of art. The characteristic forms developed by each phase were, respectively, architecture, sculpture, and painting. Hegel's innovatory historical system, contentious but enlivened by his sensitivity to particular works, had a deep influence on subsequent conceptualization of the field (see ART HISTORY AND ITS METHODS). DC/JB

Hegel, G. W. F., *Introductory Lectures on Aesthetics* (1993).

HEIDELBERG SCHOOL, a group of Australian painters led by Tom Roberts (1856–1931) who established a camp in a deserted house at Eaglemont, Heidelberg, Victoria, in 1888. Roberts, who studied in London, was introduced to the periphery of *Impressionism in Spain in 1883. On his return to Melbourne in 1885 he enthusiastically adopted *plein air* painting and with his fellow painters Frederick McCubbin (1855–1917) and Arthur Streeton (1867–1943) painted his native landscape at a camp at Box Hill during the summers of 1886–7. In 1888 they moved to Eaglemont where they were joined by Charles *Conder. The work they produced, immediate, fresh, and unlike any previous Australian painting, was exhibited in the 9×5 Impression Exhibition, shown in a Melbourne saleroom in 1889. These small pictures, painted for the most part on cigar-box lids, achieved considerable local notoriety and, although Roberts, Streeton, and Conder returned to Europe to pursue their careers, the exhibition established the foundation for subsequent, consciously Australian, *landscape painting. DER

HEINZ, JOSEF (1564–1609). Swiss painter of Italian descent who travelled to Rome in 1584 where he studied classical artefacts, as well as contemporary artists such as *Raphael and *Michelangelo. In 1587 he visited Florence and Venice. Rudolf II summoned Heinz to *Prague in 1591 as 'portraitist and court painter'. He returned to Italy, where he bought works of art for the Emperor and made drawings of the antiquities. Court commissions for the Emperor Rudolf consisted mainly of mythological subjects in a late *Mannerist style and meticulously detailed portraits of the Habsburgs such as the stylish *Archduchess Konstanze* (Williamstown, Mass., Art Inst.). CFW

Kaufmann, T. DaCosta, *The School of Prague* (1988).

HELLENISTIC ART (336–31 BC). The beginning of the Hellenistic age is defined as the rise to power of Alexander the Great. The period ends with the fall of the final Hellenistic dynast, Cleopatra VII, and the foundation of the Roman Empire. Following the death of Alexander in 323 BC, the empire divided into separate kingdoms: Antigonides in Macedonia, Seleucids in Syria, Ptolemies in Egypt; a smaller kingdom was founded by the Attalids in *Pergamum. Massive building programmes resulted, which filled the royal capitals, sanctuaries, and new cities of these kingdoms with works of art for public and private display. Victory monuments, monumental altars, and porticoed squares competed with royal palaces in the richness of their artistic display. Funerary art became a major means of self-representation with the proliferation of massive tombs bedecked with sculpture following the model of the *Mausoleum at Halicarnassus. Painting focused on monumental battles (*Alexander* mosaic; Naples, Mus. Arch. Naz.), hunt scenes (Vergina), and marriage megalographies (Boscoreale; New York, Met. Mus.). Hellenistic dynasts commissioned portraits on coins and in bronze and marble. Overall, there is an increase in honorific statues with mortal women portrayed more than in earlier periods. The characterization of age, emotion, and set types predominates with Dionysiac and genre figures (fishermen, peasants, drunken women) most common. Style seems to be intimately tied to theme with an entire range applied according to the subject portrayed. L-AT

Charbonneaux, J., Martin, R., and Villard, F., *Hellenistic Art* (1973).
Onions, J., *Art and Thought in the Hellenistic Age* (1979).
Pollitt, J. J., *Art in the Hellenistic Age* (1986).

HELST, BARTHOLOMEUS VAN DER (1613–70). Dutch painter, who replaced *Rembrandt as the most famous portrait painter in Amsterdam c.1640–70. Born in Haarlem, he moved to Amsterdam apparently c.1637 where he was probably a pupil of Nicolaes Eliasz., and responded briefly to the naturalism of Rembrandt. But his mature style, most brilliantly displayed in the vast *Celebration of the Peace of Munster, 1648* (1648; Amsterdam, Rijksmus.), opposes that of Rembrandt; the work is brightly coloured, highly finished, and evenly lit; each figure is distinct and solidly modelled. He was immensely successful as a group portraitist, and most of his contemporaries believed that he surpassed Rembrandt and *Hals; as late as 1781 *Reynolds wrote of this work: 'This is, perhaps, the first picture of portraits in the world' (*Journey to Flanders and Holland* 1781). He later responded to the elegance of Flemish portrait painting, in particular to that of van *Dyck; his marriage portrait of *Abraham del*

Court and his Wife (1654; Rotterdam, Boymans-van Beuningen Mus.) is a sumptuous display of rich fabrics, ceremonious gesture, and subtly flattering symbolism.　　　HL

Gelder, J. J. de, *Bartholomeus van der Helst* (1921).

HEMESSEN, VAN. Antwerp painters, father and daughter. **Jan Sanders** (active 1519–56) became a master sometime before 1524, after an extended trip to Italy. He also visited *Fontainebleau in the mid-1530s. Like his contemporary Marinus van *Reymerswaele, Hemessen specialized in compositions with large, half-length figures in scenes which expose human vanities and follies, such as greed and loose living. His figures are muscular and strongly three-dimensional, placed close to the picture plane. One of his most influential paintings is the *Prodigal Son* (1536; Brussels, Mus. Royaux) in which the errant son sits at a richly decked table consorting with prostitutes. This was to become a popular theme down through the 17th century (for example, *Rembrandt's famous *Self-portrait with Saskia* in Dresden). Hemessen had considerable influence on Pieter *Aertsen and Joachim *Bueckelaer, who developed his compositional innovations and moralizing genre scenes.

His daughter **Catharina** (1528–after 1587) was a pupil of his. Of her small œuvre (eight portraits and two religious pictures) two portraits deserve special mention: *Self-Portrait* (1548; Basle, Kunstmus.) and *Young Woman Playing the Virginal* (1548; Cologne, Wallraf-Richartz-Mus.). In 1554 Catharina married Chrétien de Morien, an organist at Antwerp Cathedral. The couple were admired by Mary of Hungary, and in 1556 left for Spain in Mary's entourage. No paintings by Catharina have survived dated after 1552; her artistic career seems to have come to an end after her marriage.　　　KLB

Wallen, B., *Jan van Hemessen* (1985).

HENRI, ROBERT (1865–1929). American painter. Henri was born in Cincinnati and studied in Philadelphia. From 1888 to 1891 he received an academic training in Paris where he was untouched by *Impressionism but admired *Hals and *Manet, primarily for their lively and economic brush strokes which he later adopted. In 1891 he returned to Philadelphia and became the focus of a group of newspaper illustrators, *Glackens, *Sloan, *Luks, and Everett Shinn (1876–1953), whom he enthused with the idea of a popular American art devoted to everyday subjects. In 1898, in Europe, he was impressed by *Goya, whose influence is seen in his portrait *The Masquerade Dress* (1911; New York, Met. Mus.). By 1904 the Philadelphia group was reunited in New York, painting urban scenes in a free, unpolished manner. Serving on the jury of the National Academy

in 1907, Henri was incensed by the exclusion of his friends and resigned, organizing an independent exhibition, The *Eight, in 1908. Whereas The Eight exhibition had only a qualified success, his second independent show, in 1910, proved hugely popular. Henri's importance lies less in his paintings than in his leading role in establishing a popular democratic American art.　　　DER

Homer, W., *Robert Henri* (1969).

HEPWORTH, DAME BARBARA (1903–75). English sculptor. Born in Wakefield, Yorkshire, Hepworth studied at Leeds School of Art, where Henry *Moore was a fellow student, and the Royal College, London. A stay in Italy (1924–6) was followed by her first London exhibition. During the 1930s Hepworth and her husband Ben *Nicholson were active in the abstract groups the 7 & 5 Society and Unit One. Her work is essentially biomorphic in appearance, with smooth sensual finishes. In *Pierced Form* (1931; destr.) she first used the device of a hole, which was to become a characteristic, another common motif being strings or wires stretched across the concave hollows of her pieces. In 1939 she moved to St Ives, Cornwall. Hepworth made some representational works, usually of female subjects, throughout her career, and sensitive drawings, like that of the surgeon Norman Capener, *Trio* (1948; Exeter Mus.) but they are less respected than her abstracts. By the mid-1950s she had an international reputation and received many commissions. She died in a fire at her St Ives studio which is now a museum.　　　GS

Bowness, A., *Barbara Hepworth: Complete Sculpture* (1971).

HERCULANEUM, ancient Roman city, destroyed by the eruption on Vesuvius in AD 79. Unlike the neighbouring city of *Pompeii, which was buried in volcanic ash, a 16–20-m (50–65-ft) layer of slime composed of ash and water interred Herculaneum, preserving in its wake organic material such as wooden furniture, wooden panelling, and papyri. The depth of the volcanic mud saved it from ancient pillaging and thus masses of bronze and marble statuary and various luxury goods of the city survive (most finds now in Naples, Mus. Arch. Naz.). The earliest discoveries date from 1709, when the theatre was found by well-diggers; systematic excavations began almost 30 years later under the Bourbons. The character of the volcanic matter and the position of the modern town above have rendered excavation difficult. To date only about a quarter of the city has been uncovered (5 ha/12 acres); the city's major public buildings have yet to emerge.

Herculaneum seems to have been a municipal city with less trade activity than Pompeii. The houses are smaller than those at

Pompeii but decorated with greater refinement. A series of impressive town villas set on top of the city walls with views toward the sea were fitted out with pavilions, dining rooms, and covered porticoes; contemporary wall paintings provide insight into their original aspect. Their decoration imitates their larger-scale models, suburban aristocratic villas, with sculpture and other decorations reduced to fit the smaller dimensions of these Herculaneum town villas. Wooden heads representing the owner's ancestor are preserved also from one shrine dedicated to these images.

Outside the city, no need for compromise was necessary, as demonstrated by the sprawling Villa of the Papyri with its more than 27-m (88-ft) sea-front terraces. Discovered in the mid-18th century, this villa is undergoing new excavations. More than 80 bronze and marble statues (1st century BC) have been found. Copies after Archaic and Classical statuary as well as portrait busts, herms, and statues of Greek poets, orators, and philosophers are joined by images of Hellenistic dynasts, testifying to the eclectic taste of the patron. Attempts to assign a programmatic unity to its iconography and decoration have been largely unsuccessful. Some idea of the original feel of the villa can be experienced at the J. Paul Getty Museum in Los Angeles.

The finds' influence on 18th-century taste was promulgated by *Le antichità di Ercolano esposte*, the lavish publication of the antiquities of Herculaneum and Pompeii produced by the Accademia Ercolanese 1757–92.　　　L-AT

Deiss, J. J., *Herculaneum, Italy's Buried Treasure* (1985).

HERING, LOY (c.1485–1554). German sculptor. Trained in the workshop of the Augsburg sculptor Hans Beierlein, he later moved to Eichstätt (between 1512 and 1515) where, in addition to running a large and successful workshop, he held high civic positions. Hering specialized in epitaphs and tombs, carved from the local fine-grained limestone. In 1512 he was engaged to create a monument to S. Willibald for the cathedral (*in situ*). The over-life-size seated statue of the saint, the first bishop of Eichstätt, is one of the finest sculptures in 16th-century Germany. Like Hans *Daucher in Augsburg, Hering also made small-scale reliefs of secular subjects for collectors (*Rhea Silvia*, 1532–5; London, V&A).　　　KLB

Smith, J. Chipps, *German Sculpture of the Later Renaissance* (1994).

HERKOMER, SIR HUBERT VON (1849–1914). Bavarian-born English painter. Herkomer arrived in England as a child in 1856 and studied at the South Kensington Schools, London, before beginning a career

as an illustrator. In February 1871 his engraving *Sunday at Chelsea Hospital* was published in the *Graphic* and, following his contemporary *Fildes, Herkomer used it as the basis for a painting, *The Last Muster* (1875; Port Sunlight, Lady Lever Gal.), which made his reputation. This picture, which shows a dying Chelsea Pensioner attending chapel, became one of the most exhibited paintings of the century and won him a medal of honour when shown in Paris in 1878. Like Fildes, he was seen as a *social realist and did indeed paint one further famous picture, *On Strike* (1891; London, RA), in this vein. However his worldly success came from the portraiture of Establishment figures which are usually competent but undistinguished, an honourable exception being his sensitive watercolour of John *Ruskin (1879; London, NPG). A larger than life figure, Herkomer ran a successful academy at Lululand, his house in Bushey, from 1883 to 1904, composed operas, and designed film sets. DER

A Passion for Work: Sir Hubert von Herkomer, 1849–1914, exhib. cat. 1982 (Watford Mus.).

HERLIN, FRIEDRICH (c.1425×30–1500). German painter and contractor of altarpieces active in Nördlingen (Swabia), who was the principal follower of Netherlandish ideas in south-west Germany. His earliest surviving work, two wings from an altarpiece with scenes from the life of the Virgin, is dated 1459 (Munich, Bayerische Nationalmus.; Nördlingen, Städtisches Mus.). In 1466 he was in Rothenburg ob der Tauber painting the altarpiece for the high altar of the Jakobskirche. Herlin's most mature work is the so-called *Family* altarpiece (1488; Nördlingen, Städtisches Mus.). On the left S. Luke presents the kneeling donor (sometimes identified as the artist himself) and four sons; at the right S. Margaret presents the donor's wife and five daughters to the enthroned Virgin who holds the Christ child in a pose derived from *Memling. Sharper modelling, harsh lighting, and the loss of the fluidity and gradation of tones give a sense of flattened space and an aura of provincialism to Herlin's emulation of Flemish style. KLB

HERMENEUTICS, term adopted from ancient Greek culture. It is the art and methodology of interpreting texts, speech, actions, and similar cultural manifestations. In theology it is the interpretation, afresh for each generation, of the spiritual truths of the Scriptures. Since the early 20th century hermeneutics has been developed from the impetus of Wilhelm Dilthey's (1833–1911) account of *Verstehen*, a special form of understanding that works to comprehend something in the context of its cultural milieu and its individual origins. The term 'hermeneutic circle' describes a network of determining relationships that have no fixed starting point and that obtain, in the case of a picture, for example, between the elements of painting such as pigment and brush strokes, the painter's whole œuvre, and one of her works. Hermeneutic interpretation investigates such a complex, presupposing that some kind of common human nature and shared capacities make its findings communicable and intelligible. Its main thrust is to establish appropriate methods for the study of cultural life and to liberate that study from the domination of orthodox science. DC

Ricœur, P., *Hermeneutics and the Human Sciences*, trans. J. B. Thompson (1981).

HERMITAGE MUSEUM. See ST PETERSBURG: PATRONAGE AND COLLECTING.

HERNÁNDEZ, GREGORIO. See FERNÁNDEZ, GREGORIO.

HEROIC, one of the terms taken over by art criticism from the terminology of poetry (e.g. the 'heroic epic'). It denoted everything that is elevated and noble, and was used in particular with reference to a style of *landscape painting in the 17th and 18th centuries. De *Piles, in his *Cours de peinture par principes* (1708), distinguished between the heroic and the pastoral, or rural, mode. For him the heroic landscape, which was most perfectly represented by *Poussin, shows nature idealized, and embellished by magnificent architecture, such as temples and pyramids. In the 20th century the term ideal landscape is more commonly used. The term was also used to indicate a size of statuary between life size and colossal. HL

HERRERA, FRANCISCO DA, ELDER AND YOUNGER. Spanish painters, **Francisco the elder** (c.1589×91–1654×7) was born in Seville. His early pictures (1614–27) reflect the compositional patterns of Italian *Mannerism, but he developed more naturalistic figure types and spatial construction in the series on the life of S. Bonaventura, painted in 1628 for the church of the College of S. Bonaventura. The chiaroscuro and loose brushwork of his painting in the 1630s opened the way for the dramatic handling of light and painterly technique of the following generation of Sevillian painters. His work of the 1640s has a more idealizing style and softer emotional tone (*S. Joseph and the Christ Child*; Budapest, Szépmürészeti Mus.). In 1650, Herrera moved to Madrid, where he died. His last dated work is of 1648.

His son **Francisco the Younger** (1627–85), born in Seville, was his father's pupil. He was in Italy sometime between 1647 and 1653. His first datable work, painted in Madrid, is the *Triumph of S. Hermenegild* (1654; Madrid, Prado), where Herrera forsakes realism for idealized figures in lively, elegant poses, and a kinetic composition. The brilliant light, painterliness, and *di *sotto in sù* are inspired by Venetian art. In 1655 Herrera moved to Seville, where he painted the *Triumph of the Holy Sacrament* (1656) for the chapel of that brotherhood in the cathedral. Its dazzling chiaroscuro and painterly bravura surpass his earlier performances. Back in Madrid in 1660, he executed important frescoes and worked on architectural projects, which have not survived. He was named painter to the king in 1672, and royal architect in 1677. NAM

Brown, J., *The Golden Age of Painting in Spain* (1991).
Mallory, N. A., *El Greco to Murillo: Spanish Painting in the Golden Age, 1556–1700* (1990).

HERRING, J(OHN) F(REDERICK), SR. (1795–1865). English sporting painter. Herring began his career as a coach painter but studied briefly under Abraham Cooper (1786–1868). He achieved prosperity with his portraits of racehorses, which were often engraved. Despite ambitions to be a narrative painter, *Roundheads at an Arundel Church* (1847–51; Burnley, AG), and his appointment as animal painter to the Duchess of Kent, Herring was never elected RA. His rural scenes, like *The Timber Wagon* (1843; Wolverhampton, AG), were imitated by his son J. F. Herring Jr. (d. 1907) to the confusion of collectors. DER

Beckett, O., *J. F. Herring* (1981).

HESSE, EVA (1936–70). German-born American sculptor. Her family fled the Nazis, settling in New York in 1939, and she became a US citizen in 1945. She studied at various art schools in New York, then at Yale University under Josef *Albers, graduating in 1959. She did not take up sculpture until 1964, so her career lasted only six years, before her early death from a brain tumour. However, in that time she gained a high reputation as an exponent of 'Eccentric Abstraction' (the title of an exhibition in which her work was included, organized by her friend the art critic Lucy Lippard, at the Fischbach Gallery, New York, in 1966. Hesse is sometimes described as a *Minimalist, but her work was too restlessly experimental to fit neatly into any category. It often shared with Minimal art the use of repeated units and severely limited colour, but she made inventive use of materials (including fibreglass, wood, wire, various fabrics, and rubber tubing), and her work is far from the emotional reserve associated with Minimalism; her forms are often organic and sexually suggestive. IC

HESSELIUS, GUSTAVUS (1682–1755). Swedish artist working in America. Hesselius's life is obscure before he settled in Philadelphia in 1712 to work as an itinerant

portrait painter in a market virtually free from competition. He made one or more painting tours through Delaware, Maryland, and Virginia between 1715–30 and a further trip c.1740 executing commissions. His early surviving portraits, like *Mrs Henry Darnall III* (1722; Baltimore, Maryland Historical Society), in a stock pose in a feigned oval, are competent cosmopolitan works in a derivative international *Baroque style. However, by c.1740 his work is less refined and more realistic as seen in the striking and unflattering portrait of his wife, *Mrs Gustavus Hesselius* (Philadelphia, Historical Society of Pennsylvania), in a stiff but informal pose. Hesselius, as a jobbing painter, also turned his hand to a mythology, the distantly *Rubensesque *Bacchus and Ariadne* (c.1720; Detroit, Inst. of Arts), an altarpiece of *The Last Supper*, and portraits of the Delaware chieftains *Tishcohan* and *Lapowinsa* (Philadelphia, Historical Society of Pennsylvania) commissioned by John Penn. His son John (1728–78) was also a professional and prolific portrait painter. DER

Baigell, M., *A History of American Painting* (1971).

HEY (or Hay), JEAN (active c.1475–c.1505). Master of Moulins, Netherlandish painter, active in France. An inscription on the reverse of a *Christ with Crown of Thorns* (1494; Brussels, Mus. Royaux) identifies the artist as 'the famous painter' Jean Hey and the patron as Jean Cueillette, secretary to the King. A poem by Jean Lemaire de Belges (1504) describes Hey as one of the greatest of living painters. Both Cueillette and Lemaire were associated with the family of the Duke of Bourbon, confirming Hey's identification with the painter of a series of remarkable works featuring members of the Bourbon family, evidently executed by their court painter. Hey's most impressive work is a large altarpiece (c.1498; Moulins Cathedral) showing the Virgin and Child surrounded by angels, with portraits of the Duke of Bourbon and his wife and daughter on the wings. As in many of his paintings, aspects of this altarpiece's composition suggest Hey's formation in the workshop of the Netherlandish painter Hugo van der *Goes. The end of his career may have been spent in Paris. TT

Sterling, C., 'Jean Hey, le Maître de Moulins', *Revue de l'art*, 1–2 (1968).

HEYDEN, JAN VAN DER (1637–1712). Accomplished Dutch painter who particularly excelled at depicting cityscapes. Van der Heyden was born in Gorinchem, but lived in Amsterdam from about 1650 until his death, and many of his most important works depict aspects of that city. According to the biographer *Houbraken he was the pupil of a glass painter. Van der Heyden portrayed the architecture of Amsterdam, and various

towns in Holland, Flanders, and the Rhineland, with an astounding attention to details of colour and texture, but did not let his concern for verisimilitude distract from the calm grandeur of his compositions. As well as producing topographically (see TOPOGRAPHICAL ART) accurate pictures, he also painted *capricci, and occasionally some landscapes and still lifes. There are fine examples of his work in the National Gallery, London, and the Wallace Collection. His skills and interests extended, however, far beyond painting, as he executed engravings (see LINE ENGRAVINGS) and was concerned with civic amenities in Amsterdam—ranging from organizing street lighting to overseeing improvements in the work of the fire brigade (reputedly he invented the fire hose). CB

de Vries, L., *Jan van der Heyden* (1984).

HICKS, EDWARD (1780–1849). American folk painter. Hicks, who was born in Pennsylvania, was a devout and active Quaker who devoted much of his painting to the advancement of religion. His best known work *The Peaceable Kingdom* was inspired by the theme of William Penn's (1644–1718) tract *The Holy Experiment* and illustrates Isaiah 11: 6–9, 'the wolf also shall dwell with the lamb', etc. Hicks painted over 60 versions of this painting (one example New York, Met. Mus.) which shows a small child amidst resting wild beasts with incidents from Penn's life in the background. Hicks was not an untaught *primitive; the naivety of his style belongs to an established tradition for he was apprenticed to a coach painter and later painted signs for inns and shops. His paintings of Quaker farmsteads, of which *The Residence of David Twining, 1787* (c.1846; Williamsburg, Va., Rockefeller Folk Art Coll.) is a particularly fine example, are as much allegories of a peaceful and ordered earthly kingdom as representations of actuality. DER

HIEPES, TOMÁS (1610–74). Valencian painter of still lifes. In documents and earliest (1642) signed paintings, his surname appears 'Yepes'; from 1649 it was Latinized to Hiepes. As a painter of still life, and thus considerably below the esteem in which history painters and even portraitists were held in the 17th century, Hiepes was little noted by his contemporaries. A rare mention appears in 1655 when Valencia celebrated the second centenary of the canonization of S. Vincent Ferrer; the decoration of the convent of S. Domingo included highly praised paintings of fruit by Hiepes. His clients included the artisans and wealthy farmers of the Valencian region; his subjects run the gamut of themes found in 17th-century still-life painting: the sweets and dried fruits typical of the sophisticated compositions of Juan van der

*Hamen; the flowers and fowl painted by Flemish masters; kitchen scenes reminiscent of the Florentine Jacopo da Empoli (1551–1640); and still-life compositions in landscape settings. SS-P

Jordan, W., and Cherry, P., *Spanish Still Life from Velázquez to Goya*, exhib. cat. 1995 (London, NG).
Pérez Sánchez, A., *Thomas Yepes*, exhib. cat. 1995 (Valencia, Centre Cultural Bancaixa).

HIGHMORE, JOSEPH (1692–1780). English painter. Articled to an attorney, Highmore gave up law for portrait painting, studying with *Kneller 1713–15. At the St Martin's Lane Academy, *London, in the 1720s he encountered continental fashions and later journeyed to the Low Countries in 1732 to study the works of *Rubens and van *Dyck. In 1734 he studied both public and private collections in Paris. As a *history painter he is represented at the Foundling Hospital, London, with *Hagar and Ishmael* (1739) but his uncomplicated and direct observation was better suited to middle-class portraiture and *conversation pieces, of which he painted many in the 1740s. His simply read narrative style is exemplified in his 1744 series of twelve subjects from Samuel Richardson's *Pamela* (1740) which were engraved in 1745 and published to much acclaim. In the early 1760s he dispensed with his studio and retired to Canterbury and wrote articles on art which he contributed to the *Gentleman's Magazine* (1766 and 1768). In 1754 he had written a book on the paintings by Rubens in the Banqueting House in Whitehall. MP

Joseph Highmore, exhib. cat. 1963 (London, Kenwood House).

HILDEBRAND, ADOLPH VON (1847–1921). German sculptor. Born in Marburg, Hildebrand studied in Nuremberg and, in 1866, under the Munich sculptor Kasper Zumbusch whom he accompanied to Italy in 1867. In Rome he met the philosopher Konrad Fiedler and the painter Hans von *Marées. Hildebrand returned to Italy in 1872 and remained there for much of his career. He assisted Marées with the frescoes at the Naples Aquarium (begun 1873), designing the frieze and executing busts of the scientists *Darwin* and *von Baer* (Naples, Aquarium). The influence of Marées's paintings of naked Neapolitan fishermen on Hildebrand's sculpture may be seen in *The Net Carrier* (1886; Munich, Neue Pin.) which also owes a debt to *Michelangelo. In his time he was considered a leading exponent of sculpture in the classical tradition, opposed to the *realist tendencies which soon prevailed, his finest work being the allegorical equestrian groups of the Wittelsbach Fountain in Munich (1891–5; partly destr.) which brought him further public commissions. His treatise *Das Problem der Form*

in den bildenden Kunst (1893), influenced by Fiedler, with its credo of 'pure form', was influential in promoting a move against surface naturalism in sculpture.　　　DER

Haas, A., *Adolph von Hildebrand: das plastiche Portrait* (1984).

HILL, CARL FREDRIK (1849–1911). Swedish landscape painter, who went to Paris in 1873 and, inspired by *Corot and the *Barbizon School, evolved a personal manner of landscape using intense colour ranges. In 1876 he was struck by an incurable mental illness. This was long considered as a great loss to art, but today Hill's reputation rests no less on the thousands of drawings and pastels which he produced during his years of insanity. These reveal a keenness in design and imagination and a subtlety of colour to which the word insane no longer seems applicable.　　　HO

HILLIARD, NICHOLAS (c.1547–1619). English portrait miniaturist. Hilliard trained as a goldsmith, although miniatures which he painted as a teenager also survive. His earliest known *miniature of Elizabeth I is dated 1572 (London, NPG) but he also apparently made large-scale paintings, possibly including the 'Pelican' and 'Phoenix' portraits of the Queen (c.1574; Liverpool, Walker AG; c.1575–6; London, NPG on loan to Tate). Hilliard was in France 1576–8. Some of his finest miniatures post-date his return, such as the *Man Clasping a Hand from a Cloud* (1588; London, V&A). His unshadowed, linear technique endowed his miniatures with exceptional clarity and elegance. In 1584 he was commissioned to design Elizabeth's Second Great Seal, and may have attempted to gain the monopoly for her portrait in miniature. During the 1590s, Hilliard painted innovatory miniature full-length portraits of courtiers in allegorical settings, such as the *3rd Earl of Cumberland* (c.1590; London, National Maritime Mus.). After Elizabeth's death in 1603, James I retained Hilliard as both his official miniaturist and medallist, Hilliard employed various assistants, including his son Laurence. His manuscript *The Arte of Limning* combines technical advice with his philosophy of the ennobling nature of miniature painting.　　　KH

Edmond, M., *Hilliard and Oliver* (1983).
Murdoch, J., *17th Century Miniatures: In the Collection of the Victoria and Albert Museum* (1997).

HILLIER, TRISTRAM (1905–85). British painter of landscape, still life, and occasional religious subjects, born in Peking, where his father was manager of the Hong Kong and Shanghai Bank. After two years studying at Cambridge University (which he described as 'a waste of time'), he was apprenticed to a London firm of chartered accountants, but he quickly abandoned this career to study at the Slade School under Henry Tonks, 1926–7. He then went to Paris, where he studied at the Académie Colarossi under André Lhote (1885–1962), and until 1940 he lived mainly in the south of France, with visits to Spain, which he 'came to love' above all other countries'. Early in his career Hillier was influenced by a variety of modern idioms, and his work (which included abstracts) showed little individuality. In the mid-1930s, however, he evolved a distinctive style to which he remained faithful for most of his life; he painted with great sharpness of definition and smoothness of finish, creating scenes of stillness and calm that evoke an air of *Surrealist strangeness and otherworldliness through the juxtaposition of incongruous objects and the use of unreal perspectives. One of the earliest examples in which he showed this personal voice is *La Route des Alpes* (1937; London, Tate), which like many of his paintings is executed in tempera. He came to regard himself as 'the slave of my own style', but in some of his later work he used freer brushwork or applied paint with a palette knife. In 1954 he published an autobiography, *Leda and the Goose*.　　　IC

HILTON, ROGER (1911–75). British painter of German extraction, born in Northwood (Middx.). His father (a cousin of the great scholar Aby *Warburg) was a doctor who changed his surname (Hildesheim) because of anti-German feeling during the First World War. His mother, Louisa Holdsworth Sampson, had trained as a painter at the Slade School. Hilton also studied at the Slade, 1929–31 and 1935–6, and during the 1930s he lived in Paris for a total of about two and a half years, spending part of this time at the Académie Ranson, where he was taught by Roger Bissière (1886–1964). In 1939 he joined the army, and he was prisoner of war from 1942 to 1945 after being captured in a commando raid on Dieppe. After the war he taught for several years. In 1950 he began painting abstracts; initially he was influenced by developments in Paris (which he revisited regularly), but after meeting the Dutch painter Constant (1920–) in 1953 and visiting Amsterdam with him, he was inspired more by *Mondrian: 'Hilton simplified his painting, limiting his palette to the primaries, black and white, and a few earth colours; some works suggest landscape or the human female figure but some are among the most uncompromisingly abstract paintings of their time executed in Britain' (*DNB*). From 1955 he reintroduced a sense of a shallow pictorial space, and from 1956, when he began making visits to *St Ives, there are suggestions of beaches, boats, rocks, and water in his work. In 1961 he returned to overt figuration with a series of exuberant, joky female nudes. These dismayed some of his admirers, who regarded him as a standard-bearer for abstraction, but they are now among his most popular works (*Oi yoi yoi*, 1963; London, Tate). In 1965 he moved from London to St Just in Cornwall and lived there for the rest of his life. For the last few years of his life he was bedridden with a muscular disease, but his ill health was belied in the series of colourful, goodhumoured gouaches he did in this period.　　　IC

HIRSCHVOGEL, AUGUSTIN (c.1503–53). German etcher, cartographer, and mathematician from Nuremberg. Trained as a glass painter in his father's workshop, he turned to etching after Nuremberg accepted the Reformation (1525), since the production of monumental stained-glass commissions was much reduced. From 1536 to 1543 he was in Ljubljana, though the purpose of this visit is unknown, and in 1544 he moved to Vienna, where he was mainly engaged as a cartographer, mathematician, and etcher. He developed the modern trigonometric system of surveying. His use of triangulation in maps of Vienna, made after the Turkish siege of 1543 for the future defence of the city, and completed in 1547, received wide acclaim. Hirschvogel's reputation as a creative artist lies in his 35 landscape etchings in the manner of the *Danube School (*Castle Yard*, 1546).　　　KLB

Talbot, C., and Shestack, A. (eds.), *Prints and Drawings of the Danube School*, exhib. cat. 1969 (New Haven, Yale University AG).

HISTORICISM, a term often used in art historical writing to describe the new interest in past styles that characterizes much late 18th- and early 19th-century art, when archaeology and historical research had made a wide range of styles newly available, and *Neoclassicism had begun to pall. Artists often chose moments from the past that held a moral for the present or seemed to celebrate a national history, as in the popular deathbed scenes of geniuses and heroes, such as François Ménageot's *Death of Leonardo da Vinci* (1781; Amboise, Mus. de l'Hôtel de Ville). They painted Graeco-Roman, medieval, Renaissance, and oriental scenes, with an emphasis on the painstaking recreation of a real historical moment, through exhaustively researched details of costume, weapons, architectural setting, and portrait heads. Historical events, such as *Bonington's *Henri III and the English Ambassadors* (London, Wallace Coll.), became anecdotes, with the feel of historical costume pieces.　　　HL

Rosenblum, R., *Transformations in Late Eighteenth Century Art* (1967).

HISTORY PAINTING. *See opposite.*

HITCHENS, IVON (1893–1979). English painter of still lifes, nudes, flower pieces, and landscapes. The son of a painter, he exhibited with the 7 & 5 Society 1920–35, and was elected to the *London Group in 1931 and to the Society of Mural Painters in 1937. Hitchens's earlier work shows the influence of *Cézanne, *Braque and *Matisse: *Balcony View, Iping Church* (1943; London, Courtauld Inst. Gal.). With maturity it became unique in vision, technique, and format. Bomb damage in 1940 to his Hampstead studio caused him to move permanently to the 2.5 ha/6 acres of Lavington Common (West Sussex) woodland he had acquired the year before, which, with its pool and surrounding downs, became the centre of his activity: *Boathouse, Early Morning* (1956; Cambridge, Fitzwilliam). There he worked directly from nature on horizontal, double-square (or longer) canvases, registering minute shifts in weather or season without description or figurative detail. He gave form to his sensations with wide, calligraphic strokes of vibrant colour, painting the landscapes upon which his reputation rests. Hitchens also created large murals at Cecil Sharp House, London (1950–4), and the University of Sussex (1960–2). JL

Bowness, A. (ed.), *Ivon Hitchens* (1973).
Heron, P., *Ivon Hitchens* (1955).

HLEBINE SCHOOL, a term applied to Yugoslav (Croatian) naive painters (see under PRIMITIVE) working in or around the village of Hlebine, near the Hungarian border, from about 1930. The school developed from the encouragement given by Krsto Hegedušić (1901–75) to the young Ivan *Generalić, whom he met in 1930. Generalić in turn encouraged his friends Franjo Mraz (1910–81) (likewise a native of Hlebine) and Mirko Virius (1889–1943; who came from the nearby village of Djelekovac) and these three, sometimes known as the 'Hlebine Trio', formed the nucleus of the group. Hegedušić encouraged them to paint scenes of social protest in line with his own left-wing political views, but after the Second World War Hlebine painters concentrated more on idyllic depictions of country life (the post-war phase is sometimes characterized as 'second Hlebine School'). Generalić continued to be the dominant figure, and the younger artists included his son Josip. In the 1950s the school became well known internationally, shown at leading exhibitions such as the São Paulo Bienal in 1955. IC

HOBBEMA, MEINDERT (1638–1700). Dutch landscape painter. Recorded as in the care of an Amsterdam orphanage in 1653, Hobbema two years later entered the studio there of Jacob van *Ruisdael. Early works are river scenes strongly influenced by Salomon van *Ruysdael and Cornelis *Vroom: *River Scene* (1658; Detroit, Inst. of Arts). During the 1660s his work shows the increasing impact of Jacob van Ruisdael's grander landscape vision, although Hobbema's works are always sunnier and less brooding. Many of these works are woodland scenes and often feature houses, watermills, and sandy roads, as in *Wooded Landscape with Water Mill* (Chicago, Art Inst.). In 1668 Hobbema married and took up a post as a wine gauger for the municipality of Amsterdam. As a result of these responsibilities, Hobbema's activity as a painter was much reduced. However, freed from financial restraints, he became more experimental in his late works, which are broader in technique, full of sweeping grandeur, created sometimes by the isolation of one monumental element in the landscape, as in *Avenue of Middelharnis* (1689; London, NG). CFW

Sutton, P., *Masters of 17th Century Dutch Landscape Painting*, exhib. cat. 1987 (Amsterdam, Boston, Philadelphia).

HOCKNEY, DAVID (1937–). British painter, draughtsman, printmaker, photographer, and designer, active mainly in the USA. After a brilliant career as a student, Hockney had achieved international success by the time he was in his mid-20s, and he has since consolidated his position as by far the best-known and most critically acclaimed British artist of his generation.

Hockney was born in Bradford (Yorks.) into a working-class family, and studied at Bradford School of Art, 1953–7. His early work—including portraits and views of his surroundings—was in the tradition of the Euston Road School (see under LONDON). After two years working in hospitals in lieu of National Service (he was a conscientious objector), he went to the Royal College of Art, London, in 1959 and graduated with the gold medal for his year in 1962. His fellow students included Derek Boshier (1937–2000), Allen Jones (1937–2000), R. B. *Kitaj, and Peter Phillips (1939–2000), and with them Hockney was regarded as one of the leaders of British *Pop art after the Young Contemporaries exhibition in 1961. Hockney himself disliked the label 'Pop', but his work of this time makes many references to popular culture (notably in the use of graffiti-like lettering) and is often joky in mood.

In 1963 he had his first one-man show at the gallery of the London dealer John Kasmin (1934–), and his first retrospective came as early as 1970, at the Whitechapel Art Gallery, London (it subsequently toured to Hanover, Rotterdam, and Belgrade). By this time he was painting in a weightier, more traditionally representational manner, in which he did a series of large double portraits of friends, including the well-known *Mr and Mrs Clark and Percy* (1970–1; London, Tate). These portraits are notable for their airy feeling of space and light and the subtle flattening and simplification of forms, as well as for the sense of stylish living they capture. Hockney often paints the people and places he knows best and he has memorably celebrated his romance with Los Angeles (he first visited the city in 1963 and settled there permanently in 1976), particularly in his many paintings featuring swimming pools (*A Bigger Splash*, 1967; London, Tate). R. B. Kitaj has written of these works: 'It is a rare event in our modern art when a sense of place is achieved at the level of very fine painting. *Sickert's Camden Town comes to mind, and above all *Hopper's America, in which I grew up. Hockney's California is one of the only recent exemplars.'

Another contemporary of Hockney's, Tom Phillips, has written that 'his seemingly effortless draughtsmanship is the envy of fellow artists', and he has indeed been as outstanding as a graphic artist as he has as a painter. His work in this field includes etched illustrations to Cavafy's *Poems* (1967) and *Six Fairy Tales of the Brothers Grimm* (1969), as well as many individual prints, often on homoerotic themes. In the 1970s he came to the fore also as a stage designer, notably with his set and costume designs for Stravinsky's *The Rake's Progress* and Mozart's *The Magic Flute*, produced at Glyndebourne in 1975 and 1978 respectively. In the 1980s he experimented a good deal with photography, producing, for example, photographic collages and—since 1986—prints created on a photocopier. Painting has continued to be his central activity, however. His works of the 1990s include a series entitled *Very New Paintings*, begun in 1992, in which he depicted Californian scenery in almost abstract terms. The loose handling of such works has disappointed some critics who admired the clarity of his earlier paintings. Hockney is a perceptive commentator on art and has published two substantial books on his own work: *David Hockney by David Hockney* (1976) and *That's the Way I See It* (1993). IC

HODGES, WILLIAM (1744–97). English landscape painter. Hodges was a pupil of *Wilson, whose style he imitated. In 1772–5 he was draughtsman on Captain Cook's second expedition, making drawings in the South Pacific islands which he worked up as paintings on his return (London, National Maritime Mus.). From 1779 to 1784 he worked in India for Warren Hastings (1732–1818), once again making sketches, published, as aquatints, in *Travels in India* (1793). Finished pictures, like *The Fortress of Chunar Gur* (1785–6; Wolverhampton, AG), painted for Hastings, combine topographical accuracy with the *picturesque. In 1790 he visited St Petersburg. DER

· HISTORY PAINTING ·

HISTORY painting is a form of narrative painting depicting several figures enacting a scene normally drawn from classical history or mythology, or from the Bible. Its special position from the early Renaissance to the 19th century stemmed directly from the generally dominant aesthetic doctrine that the highest aim of painting was to discover and represent perfect forms of the human passions and intellect.

*Alberti's seminal *De pictura* (1435) described *istoria* as 'the most important part of a painter's work' and touched on all the issues that were to dominate the theoretical discourse. Thus, an *istoria* should only depict the few essential characters; the (preferably life-size) figures should demonstrate their feelings clearly, though with grace and modesty, and with postures appropriate to the action. The figure drawing should be anatomically expert, combining a selection of beautiful features to create a faultless whole, and contrasting human types should be depicted. Variety and abundance were desiderata and restrained components of animals, buildings, landscape, etc. should therefore be included.

Alberti mentions only one post-classical work of art— *Giotto's *Navicella* mosaic (Rome, S. Peter's; destr.)—but he cites many classical literary sources describing vanished works. His appeal to classical authority and insistence on the vast knowledge required to paint an *istoria* constantly recur in later commentaries. All this underlines that much of the lasting agenda of classical art theory (see CLASSICISM) was to establish painting among the acknowledged liberal arts. The *academies that were established from the late 16th century were naturally dedicated to this project to take painting away from its craft associations and to present it as a learned vocation—analogous to poetry and subject to essentially the same theory that was applied to literature.

By definition, the distinction between history painting and other kinds of painting could not be fully evident until the emergence of the various genres (*portraits, *landscapes, *still life, etc.) around the early 17th century. From then the dominance of history painting was taken as read in every commentary that appeared. Even in the naturalizing environment of the Netherlands (where *Lastman and *Rembrandt aimed to be history painters) the theorists simply repeated the classical clichés.

*Caravaggio's claim simply to imitate nature was a short-lived rebellion against classical authority, but even amongst those who did agree on general theory there was argument on modes and styles. In 1634–8 the Accademia di S. Luca (see under ROME) disputed whether illustrations of historical themes should depict few or many figures. The reductionists, following *Sacchi, argued for the simplicity of tragedy; their rivals, led by Pietro da *Cortona, argued for the magnificent expansiveness of epic. By the 1670s, when the arch-classicist theoretician *Bellori was secretary to the Accademia, the purists had won the argument and *Raphael, in such works as *Christ on the Road to Calvary* (c.1517; Madrid, Prado), was universally recognized as the supreme modern master of history painting. *Poussin, who assisted Bellori, was the most cerebrally controlled of all painters who sought to express narrative and moral content within this tradition. His own written comments (culled from ancient and modern sources) emphasize that the *Grand Manner required noble subjects, a concentration on essentials, and a clearly intelligible projection of the various emotions implicit in the action. In one comment he says that painting is 'an idea of incorporeal things, even though it shows bodies'.

These ideas were inflexibly codified and prescribed by the Académie Royale de Peinture et de Sculpture in *Paris under *Le Brun. In particular, the various genres were formally ranked into a fixed hierarchy, with history painting occupying the summit and with academy membership tied to a particular category. Style was also prescribed, with the ancients, Raphael and his Roman followers, and Poussin ranked in that inexorable order of excellence, while the Venetian, Dutch, and Flemish schools were explicitly discounted.

Between Alberti and the French Academy, therefore, the broader idea of the *istoria* had become narrowed down to mean one highly prescribed type of painting. Furthermore, this type had become effectively tied to the classical/Raphaelesque Grand Manner as its necessary style.

After Le Brun's time the supremacy of the ancients and of Raphael both came under challenge but throughout the first half of the 18th century the French Academy was attempting to nurture traditional history painting, while the work that was actually being commissioned tended strongly towards the hedonistic and the *Rococo. The Academy's history painters still steeped themselves in the classics, in search of recherché subjects, but they were an isolated elite. The severely archaizing *Neoclassical style was deliberately conceived in the 1750s and 1760s as a reaction to Rococo licence and *David's successes in this style, such as *Belisarius* (1781; Lille, Mus. des Beaux-Arts) and *The Oath of the Horatii* (1785; Paris, Louvre) mark the last occasion when unambiguous history painting of the traditional kind was at the forefront of European art.

In his *Discourses* (1769–90) to the new Royal Academy in London *Reynolds preached the familiar classical art theory, constantly emphasizing the history painter's concern with general ideas rather than particular description, exhorting the students not to stray from the conventional Grand Manner, and justifying the restriction of subjects to classical and scriptural texts on the grounds that these were 'familiar and interesting to all Europe'. His hope was that the Academy's training would give rise to a British

school of public art, understood by a public trained to appreciate the generalized depiction of central forms. These hopes were to be disappointed, though *Barry, *West, and *Haydon were among the painters whose own performance was cruelly unable to live up to the bombastic fervour of their claims for English history painting.

Reynolds himself was not a history painter but he infused his society portraits with a vague aura of classical authority derived from the Grand Manner. In an analogous way *Greuze composed his bourgeois anecdotes in classical formats, and in his *Death of Wolfe* (1770; Ottawa, NG Canada) West packaged a modern-dress battle piece as a classical tableau. However, the propaganda by David and *Gros for the cult of Napoleon represents the most technically assured and emotionally charged attempt to enlist the authority of history painting in the depiction of contemporary events. Gros's *Napoleon Visiting the Plague Hospital at Jaffa* (1804; Paris, Louvre) is an exceptional example.

During the 19th century most countries developed a voracious appetite for paintings of historical events, running the gamut from fancy-dress confections to work with more serious aims. Simultaneously, distinctions between the genres became blurred and classical art theory became just one among several competing doctrines. The circumstances that had supported the traditional idea of history painting thus effectively disappeared. Scholars disagree about the extent to which 19th-century historical painting can be said to discharge the functions previously associated with academic history painting, but it becomes progressively more difficult to apply the term meaningfully to work later than the Napoleonic period. AJL

HODLER, FERDINAND (1853–1918). Swiss painter, born in Bern. Hodler's family was decimated by tuberculosis, casting a shadow over the rest of his life and career. He worked as a sign painter, then painted landscapes for the tourist market, before entering the École des Beaux-Arts at Geneva (1872). He visited Madrid (1878–9), Paris (1891), and Italy (1905), although Geneva remained his principal base. By 1885 Hodler was intimate with the *Symbolists, and his style changed radically; in 1890 his large picture *Night* (Berne, Kunstmus.) was highly acclaimed in Paris, establishing his reputation among the leading Symbolist painters of the day. He exhibited with the *Rosicrucians during 1891–2, developing his theories of 'Parallelism'—the expressive and symbolic power of repetitive, near-symmetrical patterns of lines, forms, and colours giving coherence to simplified, monumental figures and landscapes, seen in *The Disillusioned* (1892; Munich Neue Pin.); From 1894 to 1899 he taught in Fribourg, and undertook major mural commissions in Geneva (1896) and Zurich (1897–1900): monumental paintings based on Swiss history and landscape. In 1903 he joined the Munich *Sezession. A forerunner of Expressionism, his work was influential throughout Europe; he was awarded a gold medal at the Paris Exposition Universelle in 1900, and the Legion of Honour in 1913. JH

Hirsch, S., *Ferdinand Hodler* (1982).

HOEFNAGEL, JORIS (Georg) (1542–1600). Flemish miniaturist, watercolourist, and engraver, renowned for his *topographical panoramic scenes, and for his major works of nature illumination. In 1570, after travelling widely, he was in his native Antwerp, where he is said to have trained with Hans *Bol. In 1576 he travelled in Germany and Italy with the cartographer Abraham Ortelius, and made many panoramic views for the latter's famous atlas, the *Theatrum orbis terrarum*, in some of which he and Ortelius themselves appear, sketching or surveying the scene; in the 1580s he was involved in Braun and Hogenberg's atlas of the world's cities, the *Civitates orbis terrarum*, organizing its publication, and producing many original views. From 1578 Hoefnagel was active in Munich, Frankfurt, and Vienna, and in 1590 he entered the service of Rudolf II. His most celebrated work of illumination is the *Four Elements* (Washington, NG), four volumes of illustrations of living creatures, accompanied by emblematic inscriptions, and rendered with sharp and fresh detail. Hoefnagel also made independent flower pieces, such as a tiny watercolour on parchment (1594; Oxford, Ashmolean) and his miniatures of flowers, insects, fruits, and shells became widely influential through engravings made by his son Jacob Hoefnagel (1575–c.1630) in 1592. AJL

HOFMANN, HANS (1880–1966). German-American teacher and painter, born in Weissenberg, Bavaria. In 1932 he emigrated, settling in New York and teaching at the Art Students' League, but soon leaving to open the Hans Hofmann School of Fine Arts. His teaching was influential, particularly on the *Abstract Expressionists, through his knowledge of 'pictorial mechanics' and his wide knowledge of the European avant-garde. His painting is very variable. Initially it was representational in an Expressionist style: *Table with Teakettle, Green Vase, Red Flowers* (1936; Berkeley, University AG); but it became increasingly abstract after 1940. RJP

Goodman, C., *Hans Hofmann* (1986).

HOGARTH, WILLIAM (1697–1764). British painter and engraver, who played a crucial part in establishing a native school of painting free from continental domination. He did this by identifying himself with those forces in early 18th-century British culture which were forging a new, more prosperous nation. These forces can be summed up as London-based, rabidly mercantile, individualistic, politically liberal, irreverent, xenophobic, not overshadowed by a powerful church or court, and rather coarse. Hogarth was the son of an unsuccessful Latin scholar and coffee-house proprietor who spent time in prison for debt. The artist was apprenticed to a silver-plate engraver and by 1720 was in business on his own. In the same year, he studied life drawing at an academy in St Martin's Lane, London, and in 1721–4 published prints satirizing the financial scandals of the day and attacking the contemporary taste for Italian architecture and music. In 1728 he executed his first significant oil painting, *The Beggar's Opera* (several versions, of which the best, 1731, is in London, Tate), which illustrated the climactic scene from John Gay's popular opera based on English folk tunes. In the early 1730s, he took up the new genre of the *conversation piece and from c.1740 began painting portraits on the scale of life, to earn money and to hold his own with his fellow artists.

Contemporary drama and novels provided Hogarth with analogies for the composition of his 'modern moral subjects' (his own phrase). These were series devised in six or eight scenes unfolding in each case a cautionary tale of vanity, corruption, and betrayal leading to decline and death. Strikingly inventive and filled with vivid characterizations and a wealth of detail, they were instantly popular, in their engraved form, and they remain Hogarth's most famous works. The first was *A Harlot's Progress*

(1731; paintings lost; engraved 1732), followed by *A Rake's Progress* (1733–4; London, Soane Mus.; engraved 1735). Then came the more 'upmarket' *Marriage à la Mode* (1743; London, NG; engraved 1745), for which Hogarth employed a more refined style of painting and hired specialist French engravers. Afterwards he adopted a more directly didactic approach, used engraving only, and aimed for a lower-class audience. He did this in *Industry and Idleness* (1747), *Beer Street* and *Gin Lane* (1751), and the *Four Stages of Cruelty* (1751). Finally, in 1754–5, he reverted to the satirical mode and to painting in the four scenes of *The Election* (London, Soane Mus.).

Another, different expression of Hogarth's wish for the improvement of society was his interest in hospitals. In 1736–7, he painted, without fee, the staircase walls of St Bartholomew's Hospital, close to where he had been born, with appropriate biblical scenes in a high *Baroque style. He was also a keen supporter of the Foundling Hospital, inaugurated in 1739 by Captain Thomas Coram. For this institution, he portrayed Coram seated full-length, in the *Grand Manner (1740), contributed two other paintings of his own, and persuaded other artists to present pictures—with the result that the hospital both benefited from the sale of admission tickets and became a showcase for contemporary British painting. (All the paintings still hang in the administration block of the Foundling Hospital, London, although the hospital itself no longer exists). As this venture shows, Hogarth was far from being only a popular recorder of the seamier side of London life. He was deeply concerned about the prospects for the artistic profession in Britain, which he felt was held back by lack of patronage, other than for portraiture, and he was an original if somewhat muddled thinker about the problems of high art. In 1735, he had founded a second academy in St Martin's Lane and ran it for 20 years as a centre of lively discussion as well as professional practice, much of the former being reflected in his treatise *The Analysis of Beauty* (1753).

MK

Paulson, R., *Hogarth* (3 vols., 1991–3).

HOLANDA, FRANCISCO DE (1517/18–84). Portuguese writer on art, artist, and architect. He claimed to be an autodidact in both art and letters. Brought up at court, he was sent by the King to Italy in 1537 'to make drawings of fortresses and other notable things there'. These drawings, collected in an album (*As antigualhas*; Escorial, Lib.), provide a mine of information on ancient and Renaissance art and architecture. At Rome he met leading humanists and artists including *Michelangelo; but at Venice he was ignored by *Titian and *Sansovino. Returning to Portugal in 1541, he began, in 1545, an illustrated world history (*De aetatibus mundi imagines*; Madrid, Bib. Nacional) with striking images of the Creation inspired by astronomical diagrams. In 1548 he completed a treatise on art, *Da pintura antigua* (first fully published, serially, 1890–2), expounding principles he had learned in Italy. The second part of the treatise (sometimes called 'the Roman dialogues') purports to record conversations in which Michelangelo and others re-express the same ideas; while a theory of portraiture of similar Neoplatonic complexion is promulgated in a companion treatise *Do tirar pelo natural* (1549; first published 1868).

JBB

Bury, J. B., 'Francisco de Holanda', *Portuguese Studies*, 1 (1985–6).

HOLBEIN FAMILY. Two generations of German artists, which included **Hans the elder** (c.1465–1534), his brother **Sigmund** (c.1470–1540), and his sons **Ambrosius** (c.1493/4–c.1519) and **Hans the younger** (1497/8–1543). The family originated in Augsburg, the most cosmopolitan German city of the *Renaissance and a dissemination point of Italian Renaissance ideas. Through his mother Anna Mair Hans the elder was related to important artists working in or near Augsburg. These included his uncles Hans Mair (probably identical with the painter Mair von Landshut) and Michel *Erhart, and his cousins Gregor Erhart, Paulus Erhart, and Hans *Daucher, all of whom were sculptors.

Hans Holbein the elder was one of the foremost artists of his generation, whose work was influenced by the art of the Netherlands, which he may have visited several times. From c.1515 he tried to assimilate, less successfully, Italian influences in his work. His most important commissions were executed 1499–c.1510: the so-called basilica paintings representing S. Maria Maggiore (1499) and S. Paolo fuori le mura (c.1504) made for the convent of S. Catherine, Augsburg (now Augsburg, Schaezlerpalais); the high altar for the Dominican church, Frankfurt (1501; Basle, Kunstmus.; Hamburg, Kunsthalle; Frankfurt, Städelsches Kunstinst.); and the high altar for Kaisheim (1502; Munich, Alte Pin.). In addition, he painted several portraits, a series of Madonnas, and the *Fountain of Life* (1519; Lisbon, Mus. Nacional de Arte Antiga), which incorporates Renaissance ornaments. In 1516 Holbein went to Isenheim in Alsace, where he may have worked for the monastery of S. Anthony, where *Grünewald had just completed his famous high altar. Today, Hans the elder is best known for his superb silverpoint portrait drawings only rivalled and eventually surpassed by those of his son Hans the younger (*The Artist's Sons*, 1511; Berlin, Kupferstichkabinett).

Hans Holbein the elder was the head of a busy workshop in Augsburg and the teacher of both his sons. Among his assistants were his brother Sigmund (from the mid-1490s until 1516) and Leonhard Beck, whose collaboration started later and seems to have come to an end by 1503.

Hans Holbein the younger arrived in Basle as a journeyman in 1515 and found his first employment, together with his brother Ambrosius, working for the circle of humanists and their publishers. The brothers collaborated on a sign board for the teacher Oswald Myconius, each painting a side, and Hans drew marginal illustrations in a copy of Erasmus' *Praise of Folly* owned by Myconius (Basle, Kunstmus.). Later he painted three portraits of Erasmus, using the formula of the scholar in his study first devised by Quentin *Massys (1523; Basle, Kunstmus.; Paris, Louvre; Longford Castle, Wilts.). Hans's main commission in 1516 was the double portrait of the mayor Jacob Meyer and his wife (Basle, Kunstmus.). Meyer became an important patron (*Virgin with the Family of Burgomaster Meyer*, c.1526–30; Darmstadt, Hessisches Landesmus.).

Between 1517 and the summer of 1519 Hans assisted his father in the mural decoration, both inside and outside, of the new town house in Lucerne of Jacob von Hertenstein, a rich merchant of that city (destr.). A journey to Italy at this time seems very possible though it is not documented; many works from the 1520s owe a debt to Italian models, notably to *Mantegna and *Leonardo: frescoes for interiors and façades of houses in Basle, now largely destroyed (1521–2; Basle, Great Council Chamber, Town Hall; Basle, façade 'Haus zum Tanz', design Berlin, Kupferstichkabinett); religious works, including the famous *Dead Christ* (1521–2; Basle, Kunstmus.), and portraits (*Magdalena Offenburg as Laïs of Corinth*, 1526; Basle, Kunstmus.). Holbein looked simultaneously to both German and Netherlandish art, especially to *Baldung and Quentin Massys.

In the autumn of 1519 Holbein was admitted to the painters' guild in Basle, becoming a citizen in the following year. Against a background of social and religious strife he went to France in 1524, apparently in the hope of royal patronage. On the journey he met the brothers Trechsel in Lyon, who were later to publish the woodcuts of the *Dance of Death* (1538), on which Holbein worked c.1523–6. These woodcuts are his most popular graphic work, though he had previously designed a great number of book illustrations. Recommended by Erasmus to Sir Thomas More, Holbein travelled to England in 1526 via Antwerp, where he met Quentin Massys. In England he lived in More's house in Chelsea (then outside the walls of London). During this stay, which lasted until 1528, he painted a number of portraits, notably the single portrait of More (1527; New York, Frick Coll.) and the *Group Portrait of More and his Family*, the first known non-devotional group

portrait in northern Europe, now surviving only in an old copy (London, NPG) and a drawing that had been sent by More to Erasmus (Basle, Kupferstichkabinett).

Holbein was back in Basle in 1528, but the increasing restrictions on religious commissions enforced by the Reformed Church compelled him to return to England in 1532, leaving his wife and children behind, but not before painting them in one of his greatest and most moving portraits (Basle, Kunstmus.). By 1532 Holbein's old patron Thomas More had fallen into disgrace and the artist found his patrons among the German merchants of the Steelyard, the settlement of the Hanseatic League in London. His portrait of *George Gisze* (1532; Berlin, Gemäldegal.) reintroduces the format and iconography of a work by Jan van *Eyck. Gisze is surrounded by objects denoting his wealth and intellectual interests. This category of portrait is developed further in the full-length life-size double portrait of *The Ambassadors* (1533; London, NG) in which, however, a strong *vanitas* motif is introduced in the form of a large skull, shown in anamorphic perspective. Later portraits employed a simpler format, setting the figure against a neutral background, often a cool blue. For the German merchants Holbein also painted decorations in grisaille illustrating the *Triumphs of Riches* and *Triumphs of Poverty* (lost) for their Banqueting Hall, and designed a triumphal arch, Parnassus, for the coronation of Anne Boleyn in 1533.

By 1536 Holbein had entered the service of Henry VIII, having already portrayed many members of the court. In addition to easel portraits of the King (Madrid, Thyssen Mus.), and of his wives (e.g. Jane Seymour) and prospective brides, of which the most accomplished is the full-length portrait of *Christina of Denmark* (1538; London, NG), Holbein was responsible for the mural decorations glorifying the Tudor dynasty in the Privy Chamber of Whitehall Palace (destr. 1698; part of the cartoon London, NPG), and designed jewellery, table decoration, silver plate, arms, etc. He also painted *miniature portraits. Drawings survive for many of his painted portraits, starting with those of Burgomaster Meyer and his wife, and including an extensive record of the court of Henry VIII (Windsor Castle, Royal Coll.). Apart from the portrait drawings, there are compositional sketches for large paintings, studies of details, such as the *Hands of Erasmus* (Paris, Louvre), of animals, and of costume.

Hans Holbein the younger's elder brother Ambrosius probably left their father's workshop in 1511/12. After painting decorative murals at Stein am Rhein, he joined his brother in Basle in 1515, where he specialized in book illustration. He left excellent portrait drawings which have been partly confused with his brother's early works. The brother's

paternal uncle Sigmund Holbein spent many years in the Augsburg workshop, but died in Berne. His work has proved difficult to define within the artistic milieu of Hans Holbein the elder's workshop. KLB

Bätschmann, O., and Griener, P., *Hans Holbein* (1997).
Busholt, B., et al., *Die Malerfamilie Holbein in Basle*, exhib. cat. 1960 (Basle, Kunstmus.).

HOLGUIN, MELCHOR PÉREZ DE (*c*.1665–*c*.1730). The foremost representative of the late *Baroque tradition in the Spanish Empire, working in Potosí, Bolivia, the largest and most prosperous city in South America. His powerful and sumptuous paintings depict either religious subjects (e.g. *S. Matthew*, 1724; Potosí, Casa Moneda) or festivities connected with the viceregal administration (e.g. *The Entry into Potosí of the Viceroy Diego Morcillo*, 1716; Madrid, Mus. América). MJ

Mesa, J. de, and Gisbert, T., *Holguin y la pintura virreinal en Bolivia* (1977).

HOLLAR, WENCESLAUS (1607–77). Born in Prague, his style was formed in Germany, and he became an immensely diverse and productive *etcher and *topographical draughtsman. In 1636 at Cologne he met the great collector the Earl of Arundel, who brought him to England to join his household. He etched copies of works in Arundel's collection, views of London, and fashionably clad women, but his most original etchings, the still lifes of *Fur Muffs* were mostly done in Antwerp from 1644 to 1652, when he also etched his highly original set of *Shells*. On his return to England, bereft of patronage, he worked mainly for the booksellers, and his illustrations to Dugdale's *History of S. Paul's Cathedral* (1658) are the only record of the old cathedral before its destruction in the Great Fire of 1666. The fire thwarted his ambition to produce a huge bird's-eye view of London, of which only a beautiful specimen sheet (London, BM) remains. His work, even on a tiny scale, is observant and delicate, and mirrors the intellectual curiosity of his milieu in London. RGo

Pennington, R., *A Descriptive Catalogue of the Etched Work of Wenceslaus Hollar* (1982).

HOLOGRAPHIC ART. A hologram is a type of photograph of an object that produces the illusion of its three-dimensionality through the diffractional effects that arise when a laser beam meets light from the object on the photographic plate. Holograms were invented in 1948 by the Hungarian physicist Dennis Gabor (1900–79), and their use in art can be traced to the mid-1960s. Holographic art flourished in the 1970s, and was often used in the construction of environments and installations

by artists such as Margaret Benyon (1940–) and Dieter Jung (1941–). Insofar as they rely on movements of the viewer to be properly perceived, holograms are a form of *kinetic art; they also relate closely to other contemporary art forms—like laser art and *computer art—in which the technological processes required to create images are of equal importance to the images themselves. However, holographic art can be distinguished from these other forms by its dependence on light, which is both its subject and generative principle. In their apparent dematerialization of solid objects, and creation of areas of uncertain space, holograms have been interpreted as a form of *postmodernist art. OPa

Popper, F., *Art of the Electronic Age* (1993).

HOLST, THEODOR VON (1810–44). English artist. Born in London, to Russian émigrés, Holst studied under *Fuseli from 1820 and at the RA Schools (see under LONDON) from 1824. He so absorbed his master's style that his early drawings have often been confused with Fuseli's. His precocious talent led to patronage from *Lawrence including erotic drawings for George IV. In 1827 he first exhibited at the RA with a subject from Goethe's *Faust* (lost) and, pursuing his interest in German Romantic themes, both literary and artistic, visited *Retzsch in Dresden in 1829. Fuseli's influence was now modified by that of the *Nazarenes; Germanic illustrations to *Frankenstein* (1831) and Dante followed. After Victoria's accession in 1837 Holst, sensing a change in taste, painted less dramatic subjects including *The Bride* (1842; priv. coll.), which may have inspired *Rossetti, a great admirer, to begin his single female figure subjects. DER

Browne, M., *The Romantic Art of Theodor von Holst* (1994).

HOLZER, JOHANN EVANGELIST (1709–40). German painter. He learnt his trade in Augsburg with Johann Georg *Bergmüller. The greater part of his output consisted of large, *illusionistic fresco decorations in the south German *Rococo style. They included façade decorations as well as ceilings for both secular and ecclesiastical buildings. His most ambitious work, now lost, was the series of frescoes in Balthasar Neumann's abbey church at Münsterschwarzach (1737–40). His best surviving work is the cupola in S. Anton, Partenkirchen (1736). Holzer died young of typhoid. MJ

Mick, E. W., *Johann Evangelist Holzer, 1709–1740* (1984).

HOME, HENRY, LORD KAMES (1696–1782). Scottish judge and philosopher. Born at Kames, Berwickshire, he was called to the bar in 1723 and raised to the judiciary

in 1752. He was a prolific writer on legal and philosophical subjects. *Elements of Criticism* (1762), his best-known work, is one of the most elaborate and systematic treatises on aesthetics ever written and ranks along with Archibald Alison's (1757–1839) *Essays on the Nature and Principles of Taste* (1790) as one of the principal works of 18th-century aesthetic theory in English. It remained influential until superseded by Germanic philosophy in the 19th century. DER

Wilmerding, J., *Winslow Homer* (1972).

H OMER, WINSLOW (1836–1910). American painter. Raised in Cambridge, Mass., Homer trained as a *lithographer in Boston. In 1859 he moved to New York where he achieved a reputation for his Civil War reportage in *Harper's Weekly*. In 1867, in Paris, he saw Japanese prints which had a lasting influence. His painting style in both oil and watercolour, realistic, broadly composed, with strong contrasts, developed from his illustrations and his ability to capture the essential. Early works, like *Long Branch, New Jersey* (1869; Boston, Mus. of Fine Arts), have a holiday atmosphere, exemplified in *Breezing Up* (1876; Washington, NG) a carefree scene of sailing boys. In the late 1870s his palette and themes became darker as hunting expeditions brought him closer to nature. After two years in the English fishing village of Tynemouth he settled in the coastal community of Prout's Neck, Maine, and from henceforward the sea, and its dangers, dominated his work. *The Gulf Stream* (1899; New York, Met. Mus.), in which a mariner awaits certain death, is the darkest of these variations on human vulnerability. In his last decade his work became increasingly *Expressionist and idiosyncratic. DER

Wilmerding, J., *Winslow Homer* (1972).

H ONDECOETER, D'. Three generations of Netherlandish painters. **Gillis** was a Flemish landscape painter who moved to Holland and died in Amsterdam in 1638. **Gysbert** (1604–55), his son, painted landscapes and still lifes. **Melchior** (1636–95), the best known, was the pupil of his father Gysbert and his uncle Jan Baptist Weenix, and was active in Utrecht, The Hague, and Amsterdam. His specialization, in which his work is unmistakable, was in extremely accurate, large-scale paintings of birds. Often the birds are in violent action, as in *Fight between a Rooster and a Turkey* (1668; Kassel, Staatliche Kunstsammlungen) but other compositions are simply fine specimens in a poultry yard, or of exotic creatures such as pelicans. He also painted decorative murals in which birds featured against landscape and topographical backgrounds. In addition to his speciality of live birds, Melchior also did a significant number of game pieces in which the booty and hunting accoutrements are usually displayed against a landscape background. AJL

Haak, B., *The Golden Age: Dutch Painters of the 17th Century* (1984).

H ONORÉ, MASTER (active by 1288, d. 1300×17?). French illuminator, from Amiens. The earliest mention of Honoré occurs in an inscription added to a manuscript of Gratian's *Decretals* (Tours, Bib. Municipale), indicating that it had been purchased in 1288 from a Parisian illuminator, reasonably identified with the Honoré documented in 1292 paying the highest tax of any illuminator active in Paris in this year. Although this year may not have been typical, it seems likely that this Honoré, who probably headed a flourishing workshop, owed such success to recognition of artistic pre-eminence. Indeed accounts in 1296 reveal payments to him for unspecified books for the King, one of which may have been the so-called Breviary of Philip the Fair (Paris, Bib. Nat.). The elegance of the figures and the smooth modelling of their draperies, with its distinctive highlighting, distinguish this and other near-contemporary manuscripts in the same style, such as a *Somme le roy* (London, BL), as the finest of their time. The Gratian documented by Honoré is arguably from the same workshop at an earlier stage in its development. TT

Millar, E. G., *The Parisian Miniaturist Honoré* (1959).

H ONTHORST, GERRIT VAN (1592–1656). Dutch painter, one of the most important of a group of artists known as the Utrecht Caravaggisti. Also nicknamed 'Gherardo della Notte' because of his reputation as a painter of dramatic night scenes, Honthorst came from a large Catholic family in Utrecht, where he received his training with Abraham *Bloemaert. In about 1610 he left for Italy where he lived in the palace of a patron of *Caravaggio, Vincenzo Giustiniani, for whom he painted *Christ before the High Priest* (London, NG). Here, unlike Caravaggio, whose work was a powerful influence, Honthorst's use of a lighted candle as the source of light gives a greater warmth of colour and a more suffused light. By 1620, Honthorst had returned to Utrecht and his work which shows great variety includes *The Dentist* (1622; Dresden, Gemäldegal.) and *Granida and Daifilo* (Utrecht, Centraal Mus.). By 1628, when Honthorst travelled to England, his Caravaggesque manner had given way to an elegant, sometimes uninspiring, portrait style. The remainder of Honthorst's successful career was spent in Utrecht and The Hague as a painter of court portraits and of decorative schemes for Danish royal palaces and, in 1649, the Dutch palace of Huis ten Bosch. CFW

Judson, J. R., *Gerrit van Honthorst: A Discussion of his Position in Dutch Art* (1959).

H OOCH, PIETER DE (1629–85). One of the greatest of all Dutch *genre painters, de Hooch specialized in indoor, courtyard, and garden scenes. His works are invariably imbued with a sense of calm and serenity, and often when at their best quietly convey a feeling for domestic virtue. De Hooch was born in Rotterdam, the son of a mason. According to the biographer *Houbraken he may have been trained in Haarlem by Nicolaes *Berchem, and he is certainly subsequently recorded both back in Rotterdam and in Delft and Amsterdam. He is primarily associated with Delft, where he is documented from 1652, and where his younger contemporary *Vermeer, who may well have influenced him, worked. Critics often suggest that his greatest works date from before his move to Amsterdam (c.1667), and are characterized by spatial clarity, and ingenious, subtle variations of texture, hue, and tone. This approach was probably informed by contact with the works of Carel *Fabritius and Nicolaes *Maes. His later pictures by contrast are often more ornate in composition and coarser in execution. CB

Sutton, P., *Pieter de Hooch* (1980).

H OOGSTRATEN, SAMUEL VAN (1627–78). Dutch painter, draughtsman, engraver, theorist, and prominent citizen of Dordrecht. A pupil of his father, in 1641 he entered *Rembrandt's studio in Amsterdam. Early works such as *Self-Portrait* (1645; Vaduz, Liechtenstein Coll.) reveal a debt to Rembrandt in the warm colours and free handling of paint. Returning to Dordrecht, he then left for Vienna in 1651 where he was employed by the Emperor Ferdinand III, visiting Rome the following year. By 1654 he had returned to Dordrecht. He remained there until 1661, when he left for London, where he was much in demand as a portrait painter. Van Hoogstraten seems also to have specialized in perspectives of interiors, sometimes in the form of peepshow boxes. The only surviving example is *Peepshow with Views of an Interior of a Dutch House* (London, NG), which, when viewed through a hole, appears to create a complete interior. Well known by contemporaries for his poetry and prose, his influential book *Inleyding tot de hooge schoole der schilderkunst*, 1678 (Introduction to the High School of the Art of Painting) contains a rare contemporary appraisal of Rembrandt's work. CFW

Brown, C., et al., *Samuel van Hoogstraten: Perspective and Painting*, Technical Bulletin 11 (1987).
Brusati, C., *Artifice and Illusion: The Art and Writing of Samuel van Hoogstraten* (1995).

HOPPER, EDWARD (1882–1967). American painter. America's foremost 20th-century realist, Hopper was born in New York, where he studied commercial illustration and then painting under Robert *Henri among others. During 1906–10 he made three long trips to Paris and was heavily influenced by *Impressionism. Though Hopper made his first picture sale at the New York *Armory Show of 1913 he only gave up work as an illustrator in 1924. *Soir bleu* (1914; New York, Whitney Mus.), while clearly showing the influence of *Degas, demonstrates the mood of introspection that would later dominate his style of painting. However, John *Sloan's work led him away from European models to more urban, American subjects. *House by a Railroad* (1925; New York, MoMa) marks the beginning of his mature style: it is thoroughly characteristic in its striking composition, taking up an unconventional viewpoint, and in its evocation of a melancholic mood; the subject is also representative of Hopper's interest in vernacular architecture. He led a famously reserved private life and his paintings of human interaction often depict disenchantment and loneliness. MF

Levin, G., *Edward Hopper: An Intimate Biography* (1995).

HOPPNER, JOHN (1758–1810). British portrait painter, the son of Bavarian immigrants employed at the court of George III. After an upbringing in royal circles, he studied at the RA, *London, first exhibiting there in 1780, and in 1785 painted portraits of the three youngest princesses, which are among his most attractive works (London, Royal Coll.). Early in the following decade, however, the King dropped him and he was taken up instead by the Prince of Wales. In 1795, he was elected RA. During the remainder of his life, Hoppner painted most of the prominent figures of the day, including *Nelson* (begun 1801; London, Royal Coll.) and *William Pitt* (1806; London, NPG). As an artist, he took over the broad brushwork of the mature *Reynolds but followed the fashion of the 1790s and early 1800s for more restrained compositions and simplicity in dress; clothes were now often restricted in colour to black for men and white for women, which was not to Hoppner's advantage, as he was potentially a fine colourist. MK

HORACE (65–6 BC). Roman poet. In his poem on the *Art of Poetry*, Horace draws analogies between poetry and the visual arts. He uses the words 'ut pictura poesis' (poetry is like painting) to introduce his point that, like paintings, poems vary in quality and in the type of attention they demand from an audience. Taken out of their original context, Horace's words have come to be used to express a variety of ideas about the relationship between poetry and painting. RW

Trimpi, W., 'The Meaning of Horace's *ut pictura poesis*', *Journal of the Warburg and Courtauld Institutes*, 36 (1973).

HORENBOUT FAMILY. Flemish painters, illuminators (see ILLUMINATED MANUSCRIPTS), and miniaturists active in Flanders and England. **Gerard** (1465?–1541) was a painter, designer, and cartographer who was admitted into the Ghent guild of painters and illuminators in 1487. Despite his illustrious appointments to the courts of Margaret of Austria, Regent of the Netherlands, in 1515 and Henry VIII in 1528, his only surviving documented work is the contribution he made to the Hours of Bona Sforza (1519–21; London, BL, Add. MS 34294). All other attributions depend upon his identification with the Master of James IV of Scotland, one of the dominant figures of 16th-century Flemish illumination whose finest work includes the calendar of the Grimani Breviary (Venice, Bib. Nazionale Marciana, MS lat. XI 67 (7531)) and the Spinola Hours (Los Angeles, Getty Mus., MS Ludwig IX). **Lucas** (1490×5?–1544), Gerard's son, was a miniature painter. He trained in his father's workshop in Ghent and became a successful miniaturist at the court of Henry VIII, where he was court painter from 1531 until his death. Lucas is credited with introducing the art of portrait *miniatures to England and his *Henry VIII* (1525–6; Cambridge, Fitzwilliam) is the earliest surviving English example of this genre. Lucas, also taught a fellow court artist, Hans *Holbein, the technique of limning. **Susanna** (active 1520–50), Gerard's daughter, was an illuminator. She, too, trained in her father's workshop. Her work is unknown although *Dürer mentioned her in his diaries and was so impressed with her that, whilst visiting the Netherlands in 1521, he purchased a miniature by her. She was in the employment of Henry VIII from the mid-1520s as a painter and lady-in-waiting. KC

Campbell, L., and Foister, S., 'Gerard, Lucas and Susanna Horenbout', *Burlington Magazine*, 128 (1986).
Evans, M., *The Sforza Hours* (1992).

HOSKINS, JOHN (c.1590–1664/5). English *miniature painter. Hoskins was probably the leading English miniaturist between 1625 and 1640 and was closely associated with the Stuart court. He seems to have begun his career as a portrait painter but by c.1620 was painting miniatures, possibly sensing an opportunity following the death of *Hilliard, whose influence may be seen in his early works, in 1619. In the 1630s he developed a technique of stippling in polychrome which allowed him to copy, with great tonal accuracy, full-size portraits. His

many copies after van *Dyck were particularly popular but he also painted originals of *Charles I* (London, Royal Coll.), *Queen Henrietta Maria* (c.1632; Amsterdam, Rijksmus.; Chatsworth, Derbys.) and courtiers including *Sir Kenelm Digby* and the *4th Baron North* (London, NPG). In 1640 he was appointed limner to the King but by then his work was eclipsed by that of his nephew and pupil Samuel *Cooper. His work is well represented in the V&A, London. DER

Foskett, D., *British Portrait Miniatures* (1963).

HOUBRAKEN, FATHER AND SON. Dutch artists. **Arnold** (1660–1719) was a painter who is now mainly remembered for his biographies of Dutch painters: *De Groote schouburgh der nederlantsche konstschilders en schilderesen* (3 vols., 1718–21), which was conceived as a sequel to van *Mander's *Schilderboeck* of 1604. In spite of errors, interesting but apocryphal anecdotes, and gaps that now appear curious—*Vermeer is not mentioned—this work remains the most important sourcebook on 17th-century Dutch artists. Houbraken himself was a strong *classicist and he used the *Groote schouburgh* to promote a classicizing agenda. His son **Jacobus** (1698–1780) was a leading portrait engraver. He engraved plates after his father's designs for the *Groote schouburgh* and after Thomas Birch's *Heads of Illustrious Persons of Great Britain* (1743–51). HO/AJL

Hofstede de Groot, C., *Arnold Houbraken und seine 'Groote schouburgh'* (1893).

HOUDON, JEAN-ANTOINE (1741–1828). The finest French portrait sculptor of the last quarter of the 18th century. He was a pupil of *Lemoyne and Michel-Ange *Slodtz and won the *Prix de Rome in 1761. From 1764 to 1768 he was in Rome and much influenced by *Antique sculpture. His life-size écorché figure, the result of his anatomical studies in Rome, was soon widely used in artists' studios, while his contemplative statue of *S. Bruno* (Rome, S. Maria degli Angeli) is a classicizing riposte to Slodtz's more animated and *Baroque statue in S. Peter's. Throughout his career Houdon continued to make statues on mythological and allegorical themes. These include the svelte *Diana the Huntress* (1780; Lisbon, Gulbenkian Foundation) and the sexy *La Frileuse* (1783; Montpellier, Mus. Fabre), which represents winter as a naked, shivering girl. He also made funerary *monuments in *Neoclassical style. But his true *métier* was as a portraitist of international reputation. He achieved great fame with his statue of *Voltaire* (1781; Paris, Comédie-Française), seated and draped in classical garments. His statue of *Washington* (1788; Richmond, Va., Capitol), the result of a trip to America in 1785, depicts the sitter at his own request in modern dress, the only classical reference being to the

ploughshare of Cincinnatus. Nevertheless, it is in his portrait *busts that Houdon made his outstanding contribution to the history of sculpture. Lively, characterful, and technically brilliant whether in plaster, terracotta, marble, or bronze, these add up to a gallery of some of the greatest personalities of the time. Among them are *Diderot* (1771), *Voltaire* (1778), *Rousseau* (1778), and *Jefferson* (1789), captured in images of such authority and disseminated from Houdon's studio in so many versions and copies that they have become posterity's enduring vision of them. During the Revolution Houdon produced striking portraits of *Mirabeau* and *Barnave*, and later he made a severe herm bust of *Napoleon* (1806). The hieratic nature of the style of the latter, however, deprived Houdon of the device by which his earlier busts became such speaking likenesses—the use of a characteristic expression or gesture to capture personality.

MJ

Arnason, H., *The Sculptures of Houdon* (1975).
Réau, L., *Houdon, sa vie, son œuvre* (1964).

HUBER, WOLF (c.1480×5–1553). Austrian-born painter, draughtsman, designer of woodcuts, and architect, the youngest of the major exponents of the *Danube School style (see also Albrecht *Altdorfer, Jörg *Breu, and Lucas *Cranach the elder). Born in Feldkirch in Austria, he set out on his journeyman years c.1505, drawing the picturesque scenery on his way to Innsbruck and Salzburg (*Mondsee*, 1510; Nuremberg, Germanisches Nationalmus.). By 1515 he had become court painter and architect to the Bishop at Passau, where he remained, with occasional visits to Austria, for the rest of his life. He painted altarpieces and portraits (*Jacob Ziegler*, 1544–9; Vienna, Kunsthist. Mus.). His most important contribution, however, are the pen and ink drawings of landscapes which he elevated to independent works of art. In their poetic interpretation of the Danube valley they foreshadow 17th-century Dutch landscapes, such as those by Hercules *Seghers.

KLB

Winzinger, F., *Wolf Huber* (1979).

HUDSON, THOMAS (1701–79). English painter who studied under Jonathan *Richardson and married his daughter. By 1735 he was established as a fashionable portrait painter. Within ten years he had the largest flow of commissions in London, and he retained this position until he retired from professional practice c.1755. *Reynolds was one of his pupils. Hudson was an accomplished but unoriginal painter, whose portraits followed a stereotyped pattern. He employed Joseph van Aken (1699?–1749), and later van Aken's younger brother, as drapery painters.

HB

HUDSON RIVER SCHOOL, a term retrospectively applied to a group of American landscape painters, working c.1825–75, many of whose works were inspired by the landscape of the Catskill Mountains and the Hudson river. The precursor was Thomas Doughty (1793–1856) and the most influential was Thomas *Cole, whose follower Asher *Durand and pupil Frederick *Church shared some of his religious enthusiasm. All believed, to some degree, that God's presence was revealed by his creation and no more so than in the dramatic grandeur of the virgin American landscape. They also shared, and benefited from, the nationalistic feeling that the individuality of their country was best symbolized by its natural wonders. Their paintings, worked up from sketches made on the spot and completed in their studios, were essentially idealistic and *Romantic with a compositional debt to *Claude. Although rendered with detailed realism the particular was always subordinate to the general effect of transcendent beauty or *sublimity. After Cole's death in 1848 Durand painted several realistic, *plein air*, *Studies from Nature* but continued to idealize the landscape in his finished pictures.

DER

Novak, B., *American Painting in the Nineteenth Century* (1969).

HUE. See COLOUR.

HUERTA, JUAN DE LA (active 1431–62). Spanish-born sculptor, documented at the Carmelite convent of Chalon-sur-Saône in 1443, commissioned by Philip the Good, Duke of Burgundy, to complete the tombs of John the Fearless and Margaret of Bavaria which had been begun by Claus de *Werve for the Charterhouse of Champmol. Juan de la Huerta worked on the double alabaster tomb as well as on other commissions in Dijon until 1456.

SS-P

HUGHES, ARTHUR (1832–1915). English painter. Hughes was born in London and studied under Alfred *Stevens before entering the RA Schools (see under LONDON) in 1847. In 1850 he met *Hunt, *Rossetti, and *Brown and became an enthusiastic disciple of *Pre-Raphaelitism, showing *Ophelia* (Manchester, AG) at the Academy in 1852. In 1856 he painted a triptych of *The Eve of S. Agnes* (London, Tate), a subject previously painted by Hunt (c.1848; London, Guildhall) and in the same year exhibited his masterpiece *April Love* (London, Tate). This sensitive picture of young lovers, which reveals his sophisticated sense of colour and composition, was much admired by *Ruskin and was purchased by William Morris (1834–96). The subject is clearly influenced by *Millais as is *The Woodman's Child* (1860; London, Tate), for although technically gifted Hughes was unoriginal in

his ideas. In 1857 Hughes was recruited by Rossetti to decorate the Oxford Union which resulted in a brief flirtation with Arthurian subjects, but his finest work was done and in his later years he was mainly occupied by book illustrations, which he executed from 1855.

DER

Roberts, L., *Arthur Hughes: His Life and Works. A Catalogue Raisonné* (1997).

HUGUET, JAUME (c.1412–92). Born in Tarragona, Spain, a painter of the Catalan *Gothic style trained in Barcelona. Huguet's earliest documented work, the main altarpiece for S. Antonio Abad in Barcelona, was commissioned in 1454 (destr. 1909); the altarpiece of the monastery of Ripoll was painted in 1455 (fragments in Vic, Mus. Episcopal); and the altarpiece of SS Abdón y Senén, in the church of S. Pere de Terrassa, was completed in 1460. Huguet then painted four altarpieces for the Barcelona guilds, including one dedicated to *S. Michael Archangel* in the church of S. María del Pi (now Barcelona, Mus. Nacional d'Art de Catalunya). A royal commission for an altarpiece for the palace in Barcelona was completed 1464–5. The enormous altarpiece undertaken for the monastery of S. Agustí (1463–86) was completed with considerable help from his workshop. Huguet's style combines Gothic traditions (compressed space and generous use of gilding) with a certain Flemish realism in the depiction of the figures, distinguished by a lively and expressive narrative style.

SS-P

Cathalonia: arte gótico en los siglos XIV–XV, exhib. cat. 1997 (Madrid, Prado).

HUMANISM, ambiguous term covering both a 19th-century moral movement and *Renaissance classical learning. Later humanism might be described as a secular version of Christian ethics, redirected to 'human' and social goals; Renaissance humanism had no such ethical dimension and involved no inherent antithesis to Christianity, but signals a secular interest in *Antique, specifically pagan, literature, history, and philosophy (the 'sciences' as well as the 'humanities'), and with it a good command of decent Latin (sometimes also Greek and Hebrew) and a more critical approach to tradition and traditional institutions. Humanism is often opposed to medieval scholasticism and macaronic language. *Petrarch was an influential early mover, with followers particularly at first in Florence and then, from the 15th century onwards, throughout Italy; in the 16th century, throughout Europe. The term 'humanist' was not used at all commonly in the Renaissance and humanists were not a single class—there were humanist princes, prelates, patricians, and merchants and there were humanist courtiers, poets, or

other kinds of dependants—until by the mid-16th century humanism was ubiquitous among the literate. So-called 'civic' humanism was one early 15th-century aspect of the current, typified by Florentine civil servant humanists such as Leonardo Bruni, but Renaissance courts found them useful, too, and the curia of Pope Leo X (1513–21) in particular was remarkable for its brilliant humanists. Another dimension of humanism was educational reform, or simply its secular institution, led by Guarino da Verona (1374–1460). Yet another was the impetus given to philosophy by return to and rediscovery of original texts by *Aristotle and *Plato; this followed on the wider teaching of Greek—at first by Byzantine émigrés—and led to a brief wave of *Neoplatonism. The Bible and religious texts were studied in similar spirit, enabling received authority to be challenged: one early achievement of humanism was the challenge by Lorenzo Valla (1407–1457) to the 'Donation of Constantine', an 8th-century document supposedly substantiating a gift of temporal powers in Italy by the 4th-century Emperor to the Pope; it was also a factor in the Reformation. The humanist study of literature led not only to the use of a more elegant Latin, but also to the codification of a vernacular language for literature (first in Italy in the 16th century). The study, collation, and imitation of classical texts had its effect, too, on art: by analogy with literature, classical art became a paradigm of excellence, giving rise eventually to *classicism, and classical subject matter became widely used in secular contexts, whether in the form of historical or mythologial 'examples' or moralized stories, or in the form of allegories, using the gods as personifications of abstract qualities. Thanks also to humanists, art criticism became more articulate in the Renaissance, and the remarkable humanist and architect Leon Battista *Alberti combined theory with practice. PHo

Baxandall, M., *Giotto and the Orators* (1971).
Kristeller, P. O., *Renaissance Thought and the Arts* (1965).
Trinkaus, C., *In our Image and Likeness* (1970).
Weiss, R., *The Spread of Italian Humanism* (1964).

HUNGARIAN ART. Any historical discussion of Hungarian art necessarily extends beyond the present borders of the country and includes both Slovakia and Transylvania. The pagan Hungarians of the Finno-Ugrian language group arrived in the Carpathian basin in AD 895. Their previous contact with Siberian, Turkic, Mongolian, and Persian peoples resulted in an artistic style best exemplified by the 10th-century silver artefacts ornamented with interlace, foliage, and palmette motifs. After settlement and conversion to Christianity, in 1000 the first Hungarian king—S. Stephen—was crowned with a crown sent by Pope Silvester II.

The earliest survivals of *Romanesque art in Hungary are linked to the patronage of S. Stephen and his wife Gizella; a particularly fine example is the *casula* with their portraits that was later converted into a coronation robe (Budapest, National Historical Mus.). The type of palmette patterns that decorate surviving 11th-century architectural elements (Budapest, NG Hungary) are a specifically Hungarian stylistic feature. By the second half of the 12th century a mature Romanesque style prevailed over the entire country; the finest survivals are the reliefs of biblical scenes decorating the crypt of Pécs Cathedral that show Italian and French influence. Béla III appears to have been the first ruler to recruit French artists. The Porta Speciosa of S. Adalbert's Cathedral in Esztergom, which is encrusted with marble inlays, was made by northern French masters familiar with *Byzantine models, and the decoration of the sarcophagus of Queen Gertrudis (1220s; Pilisszentkereszt) is related to contemporary sculpture of Paris and Chartres. The close connection with the art of southern Germany and northern Italy is most obvious in paintings such as the frescoes in the crypt of Feldebrö church and the ink drawings of the Pray Codex (early 13th century; Budapest, Szèchènyi National Lib.). The filigree decoration prevalent in Hungarian goldsmiths' work such as the handle and mount of the coronation sceptre (Budapest, National Historical Mus.) was Byzantine in origin. The Benedictine abbey at Ják shows close contact with Bamberg.

In the 14th century the court of the Anjou kings of Hungary—Charles Robert (ruled 1308–42) and, especially, Louis I, the Great (ruled 1342–82)—was one of the central European centres of *Gothic art. Two richly illuminated codices of this period, the Anjou *Legendarium* (Vatican, Bib. Apostolica and New York, Pierpont Morgan Lib., other leaves dispersed) and the *Pictorial Chronicle* (Budapest, Szèchènyi National Lib.), best demonstrate the internationalism of the Anjou court and the influence of the Italian trecento that can also be seen in contemporary fresco paintings.

The only extant work of the sculptors Martinus and Georgius de Colosvar is the bronze *S. George Slaying the Dragon* (c.1373–4; Prague Castle), remarkable for being the earliest large free-standing equestrian statue since Antiquity. Panel paintings and carved altarpieces survive from the second half of the 14th century and the devotional images of the Virgin donated by members of the house of Anjou to Mariazell, Częstochowa, and Aachen combine Italian panel painting with ornate Hungarian metalwork frames. The international character of Hungarian art during the reign of Sigismund of Luxembourg (ruled 1387–1437) is best characterized by the statues that used to decorate his Buda Castle. The group found in 1974 (Budapest, Castle Mus.), has links with the work of *Beauneveu while other pieces show the influence of the Master of Großlobming. The first outstanding altarpiece was painted by Thomas de Colosvar in Garamszentbenedek (1427; Esztergom, Christian Mus.).

The reign of Matthias Corvinus (1458–90), culturally and economically a highpoint in the history of Hungary, witnessed the first appearance of the Renaissance north of the Alps. Italian, Dalmatian, and Hungarian masters worked in the royal stonecarving workshops and there is documentary evidence for bronze statues for the palace court at Buda. The scientific and artistic importance of Matthias's library, the Biblioteca Corvina, was acknowledged by his contemporaries; manuscripts were illuminated for him in Italy and Italian illuminators also travelled to Buda to work for him. It is in late *Gothic altarpieces from this period that the earliest influence of Flemish art is apparent. Altarpieces made in the late 15th and early 16th centuries, a time of constant Ottoman menace and later conquest, only survive from upper Hungary and Transylvania: the altarpiece by *Master M.S. from Selmecbánya, S. Jacob's high altar from Löcse, and the altarpiece of *The Virgin* from Csikmenaság.

The Hungarian Renaissance extended further during the reign of Matthias's Jagiellonian successors, even to other central European centres such as Prague and Cracow, and flourished in parallel with the emergence of the *Baroque until the end of the 17th century. The altarpiece made for the Jesuits in Nagyszombat (c.1640) is perhaps the greatest work of the Hungarian Baroque. Other prominent artists of the late 17th and 18th centuries were the portrait painter Ádám Mányoki (1673–1757) and the painter of still lifes Jakab Bogdány (1660–1724), who lived in London from 1690 to his death and also worked for the royal court. The Austrian sculptor Georg Raphael *Donner lived in Pozsony, the coronation city during that period, and he embellished the high altar of S. Martin's church with huge lead statues. Many other renowned Austrian artists worked in Hungary during the 18th century including Anton *Maulbertsch (the fresco in Sümeg church is one of his finest works), Johann Lucas Kracker of Vienna who settled in Eger as painter to the episcopal see, and, the most prolific. István Dorfmaister of Sopron (1731–97), who decorated innumerable churches and castles in Transdanubia. Johann Anton Krauss was an outstanding *Rococo sculptor and the goldsmith János Szilassy was highly appreciated for his monstrances and chalices adorned with coloured enamel.

*Neoclassicism, the dominant style of the early 19th century in both painting and sculpture, can first be detected in the portraits of János Donát (1744–1830) at almost the same time as the first signs of *Romanticism appear in the landscapes of Károly Kisfaludy (1788–1830). The *Biedermeier period of the mid-century produced portraits, conversation pieces, mythologies, and landscapes by Miklós Barabás (1810–98), József Borsos (1821–83), Károly Markó (1791–1860), and Károly Brocky (1807–55). History painting was represented by Victor Madarász (1830–1917), Bertalan Székely (1835–1911), Mihály Zichy (1827–1906), and Mór Than (1828–99) in the 1860s and 1870s. The new trends of the latter half of the century are evident in Géza Mészöly's (1844–87) *plein air* painting. Pál Szinyei Merse (1845–1920) was an outstanding early representative of *Impressionism. Romanticism and realism merged in Mihály Munkácsy's (1844–1900) works showing the life of the poor. László Paál's (1846–79) landscapes were a late flowering of the *Barbizon School.

The sculptor István Ferenczy (1792–1856), influenced by *Canova, set out to revive national sculpture: *Shepherdess* (1820–2; Budapest, NG Hungary). Miklós Izsó (1831–75) worked in a Romantic idiom to depict scenes of rural life. The outstanding representatives of the eclecticism of memorial sculpture at the end of the century were Alajos Strobl (1856–1926), György Zala (1858–1937), and János Fadrusz (1858–1903). Béni Ferenczy (1890–1967) was one of the most outstanding sculptors of the century.

Modern Hungarian painting was launched by the Nagybánya School, which grew out of Simon Hollósy's (1857–1918) private school in Munich and settled in Nagybánya, Transylvania, in 1896. They continued Szinyei's initiative, although the artist most markedly determining the school's style—Károly Ferenczy (1862–1917)—moved away from *plein air* work to painting in a Sezessionist manner. The influence of the Vienna *Sezession combined with that of the *Pre-Raphaelites also dominated the work, both in painting and the decorative arts, of another colony of artists in Gödöllő. The Sezession was a formative influence on the style of József Rippl-Rónai (1861–1927), a noted member of the Nabis in France for ten years. The first avant-garde group in Hungary was The *Eight (also known as 'The Seekers'), influenced by French *Cubism and *Fauvism, as well as German Expressionism. Others continued their initiatives taking up features of *Expressionism and *Constructivism. During the 1930s a new Neoclassicism arose with the School of Rome. The 'separate world' of József Egry (1883–1951), whose main theme was the light of Lake Balaton, can be interpreted as a variant of late Expressionism. In the inter-war period the painter István Szönyi (1894–1960), an outstanding representative of *Post-Impressionism, was a marked influence on the post-war generation. GyT

Kampis, A., *The History of Art in Hungary* (1966).

HUNT, WILLIAM HENRY (1790–1864). English painter. A Londoner, Hunt was noted for watercolour figures and still lifes executed exclusively from nature. Apprenticeship with John Varley (1778–1842) and election to the Old Water-Colour Society led to commercial success throughout an otherwise uneventful life. Early subjects include topographic views, rustic characters, and domestic interiors. His anecdotal scenes featuring comic urchins were considered vulgar by critics but appealed to wealthy industrialists. In maturity, Hunt became identified with studio arrangements of fruit, flowers, moss, and nests—the latter earning him the sobriquet of 'Bird's Nest Hunt'. For this original and much-imitated genre, he developed a method of stippling translucent watercolour over opaque pigment creating subtle colour effects, as in *Primroses and Bird's Nest* (London, Tate). Hunt's technique was described by John *Ruskin in *Elements of Drawing* (1854), which in turn influenced the French *Pointillists. Despite Ruskin's passionate advocacy, Hunt's work became unfashionable after his death, only to be reappreciated in recent years. Many British municipal galleries have examples of his work, with notable collections in London (BM and V&A). TJ

Witt, J., *William Henry Hunt (1790–1864)* (1982).

HUNT, WILLIAM HOLMAN (1827–1910). British painter. He studied at the RA Schools (see under LONDON) where he met *Millais and *Rossetti with whom he founded the anti-academic *Pre-Raphaelite Brotherhood in 1848. He was undoubtedly the movement's theorist and remained true to its principles of close observation and moral subjects for his entire career. His early paintings have literary sources but *The Hireling Shepherd* (1851; Manchester, AG) with its strong moral message presages his future development. In 1851 he began *The Light of the World* (1851–3; Oxford, Keble College) and from 1854 religious enthusiasm prompted several visits to the Middle East to paint biblical subjects in their correct locations. *The Scapegoat* (1854; Port Sunlight, Lady Lever Gal.), during the painting of which several goats met their fate, was the result of the first of these. At his best Hunt's meticulous attention to detail and use of vivid colour are admirable but all too often both his imagery and his technique are heavy-handed. He was a naturally proud and belligerent man and his memoir *Pre-Raphaelitism and the Pre-Raphaelite Brotherhood* (1905) is in large part an attack on Rossetti. DER

Bennet, M., *William Holman Hunt*, exhib. cat. 1969 (Liverpool, Walker AG).

HUTCHESON, FRANCIS (1694–1746). Scottish philosopher who, with Lord *Shaftesbury, pioneered the application of John Locke's empirical philosophy to *aesthetic issues (Locke himself having shown little interest in beauty or the arts). His major work, *An Inquiry into the Original of our Ideas of Beauty and Virtue* (1725), is the first systematic study of this area in English, founding aesthetic (and moral) judgement on the notion of a special kind of perception. For Hutcheson, just as our sense of sight enables us to see colours directly, so do we possess an analogous 'inner' sense enabling us to perceive less tangible values—be they ethical or aesthetic. To stimulate this 'inner' sense aesthetically, an object must possess the right kind of ratio between 'uniformity and variety', signalled by the pleasurable arousal of an idea of beauty. Beauty, although a property of the object, also depends for its existence on our subjective engagement. This attempt to harmonize objective and subjective elements of aesthetic experience set a pattern for later British aesthetic thought. NMcA

HUYGENS, CONSTANTIJN (1596–1687). Dutch writer, patron, and court official, who served Frederick Henry, Stadholder of the Netherlands, as a diplomat in Venice and London. Huygens not only spoke six languages but was also a musician, composer, and poet who translated the poems of John Donne into Dutch. He was taught drawing by Hendrick Hondius. It is as a patron that he is best remembered, employing Jacob van Campen and Pieter Post to design his house in The Hague (destr.) as well as his country retreat at Hofwijk. They were later used by Count John Maurice of Nassau to build the Mauritshuis (see under HAGUE). Huygens also advised the Stadholder's widow Amalia van Solms on the iconographic programme and choice of artists for the decoration of Huis ten Bosch. His writings, especially an autobiography begun in 1629, give important information, for example the record made of his visit to the Leiden studio which the young *Rembrandt and *Lievens shared and whom he praised greatly. It is likely that Huygens was responsible for obtaining from Frederick Henry the commission for the Passion cycle which Rembrandt painted for him during the 1630s. CFW

Eyffinger, A. (ed.), *Huygens herdacht* (Hygens Commemorated), exhib. cat. 1987 (The Hague).

HUYSMANS, JORIS-KARL (1848–1907). French novelist and art critic. In his early career he wrote naturalist novels, which chart working-class life in suburban Paris, and suggest parallels with modern painters. In 1883 he published *L'Art moderne*, a

collection of reviews of the Salon and the Salon des Indépendants (see both under PARIS), and in these he sought the ideal painter of modern life. He praised *Degas, celebrating, in 1881, the 'terrible realism' of his statuette, *La petite danseuse*; he admired the drab Paris of *Forain and Jean-François Raffaëlli; he showed an early enthusiasm for *Gauguin, appreciating the provocative realism of his *Nude Woman Sewing* (1881; Copenhagen, Ny Carlsberg Glyptothek). But in 1884, with the publication of *A rebours* (Against Nature), Huysmans withdrew from naturalism. Its hero, the aristocratic des Esseintes, retired from modernity to create an artificial world of the most exquisite and precious sensations and images. The novel, which was revered by Decadent and *Symbolist artists and writers, celebrates, in highly wrought prose, the dreamlike paintings of *Moreau, *Redon, and *Bresdin. Thereafter Huysmans, a Roman Catholic convert, wrote mainly on religious art, admiring above all Fra *Angelico, *Grünewald, and Flemish painters.　HL

Brookner, A., *The Genius of the Future* (1971).

HUYSUM, VAN. Dutch *flower painters, father and sons. **Justus** (1659–1716) founded the family flower-painting business in Amsterdam, and taught his sons Jan, Justus II, Jacob, and Michiel. **Jan** (1682–1749) was by far the most talented of the family; he set up shop by himself in Amsterdam and worked solitarily, as he feared other painters (including his brothers) learning his working methods. He seems to have been an awkward and rather paranoid character. Starting from the prevailing sombre manner of de *Heem, of which he was a master, he steadily moved away from the concern to represent a persuasive illusion of three-dimensionality towards a *Rococo emphasis on decorative design. In his fully developed work (*Flowers in a Terracotta Vase*, 1736 and 1737; London, NG) swirling arabesques of flowers and foliage are placed against light backgrounds, often containing landscapes. He had a European reputation and his work commanded huge prices. In addition to flower pieces he did a few Arcadian landscapes. His meticulous craftsmanship deteriorated in his last years, perhaps because of failing eyesight.　AJL

Taylor, P., *Dutch Flower Painting 1600–1720* (1995).

IBBETSON, JULIUS CAESAR (1759–1817). English landscape painter. Ibbetson, who owed his name to a Caesarian birth, began as a scene painter in Hull. In 1777 he went to London and exhibited at the RA (see under LONDON) from 1785. He visited Java in 1788 but, after 1799, spent most of his life in Yorkshire. Like his friend *Morland, Ibbetson painted small populated rustic landscapes, *Evening Landscape* (1799; York, AG), and was described by *West as 'the *Berchem of England'. He also etched and painted watercolours and in 1803 published *Accidence or Gamut of Painters in Oil and Watercolour.* DER

Clay, R. M., *Ibbetson* (1948).

ICELANDIC ART. See SCANDINAVIAN ART.

ICON. The word derives from the Greek *eikōn*, meaning simply 'image'. In its broadest sense, an icon is a representation of a sacred person or event, produced in any media and to any scale, from the monumental to the portable. In its narrower sense, icon is most often used of devotional wooden panel paintings, above all those produced in Byzantium and the Orthodox Church.

Painted wooden panels are one of the most distinctive forms of *Byzantine art, a form which continues to be produced today wherever there are Orthodox believers. The earliest surviving examples date to the 6th and 7th centuries, though a great many were probably destroyed during the period of Iconoclasm. The monastery of S. Catherine, Sinai, offers the major comprehensive collection of surviving Byzantine icons. Painted on wooden rectangles, either in encaustic (pigment suspended in wax) or tempera (pigment suspended in egg yolk), the form and the medium of the icon have remained constant to the present. Icons might also be made from a variety of media. Miniature mosaic icons, images in metal, ivory, and steatite, at different scales and levels of skill

all survive. The decoration of icons with a silver covering for all areas except face and hands developed in the later and post-Byzantine period.

Content has also changed little. Icons depict portraits of Christ, the Virgin, prophets and saints (never, in Byzantine art, God the Father, though post-Byzantine and Russian icons may show him), New and Old Testament scenes, and lives and deaths of the saints. The earliest icons tended to show single figures or groups of figures, facing outwards to communicate with the believer. They seem to have served a personal, devotional function, offering the individual believer a direct line of communication and mediation with the holy. After Iconoclasm, icons were also used within churches as a part of liturgical rites and processions, often displayed as appropriate on the iconostasis. As a result, increasing numbers of icons show scenes from the life of Christ, the lives of saints, and, from the 11th century onwards, emotive images based on hymns and prayers. After the fall of the Byzantine Empire in 1453, icons continued to be produced in centres of Orthodoxy, notably Venetian Crete, Russia, and Mt. Athos in Greece. Greek and Russian Orthodoxy retain the icon as an intrinsic focus for the believer, who will kiss it, caress it, and pray to it in the same ways and expecting the same results as the Byzantines seem to have done.

The artists of most icons are anonymous and little is known about them. Some were monks, others laymen. A handful of late Byzantine icons are signed but it is not until the post-Byzantine period, particularly in Crete and Russia, that much evidence for artists such as Angelos Akotantos, Domenikos Theotokopoulos (El *Greco), and Andrei *Rublev exists. The *Painter's Manual*, written by the monk Dionysius in the 18th century, offers a guide to how icons were painted—the ways in which colours were made and applied and the personal characteristics of each subject—

and although many of the techniques do relate to Byzantine images, we cannot be certain that the same practice applied.

Although Christianity inherited a hostile attitude towards images, from very early on, Christian places of worship were decorated with images regarded as holy. The icon held a special place as it was regarded as offering individuals direct contact with the divine. In response to fears about the breaking of the Second Commandment, it was believed that worship was offered not to the icon but to its prototype: the believer did not pray to the icon but to the person depicted on it. Consequently, one of the key points in the use of the icon for worship was the belief that it was a true and accurate portrayal of the holy person. Many stories about the miraculous powers of icons tell how the believer recognized the saint because that saint looked like their picture on the icon. The class of image known as *acheiropoieta*, 'not made with hands', established the true and accurate portrayals of Christ, the Virgin, and the long-dead saints. The earliest images of Christ, such as the Mandylion of Edessa, were miraculously created to record a likeness through non-human agency. As for the Virgin, her likeness, it is believed, was recorded from life by S. Luke. It is because of this necessary stress on identity that icons maintain a high level of uniformity across time and place.

Icons had tremendous power for the true believer. They acted as a channel for divine force and could heal, save, and punish. The major wonder-working icons could save cities as the icon of the Virgin rescued Constantinople in the 7th century. The icon of the Virgin of Vladimir (Moscow, Tretyakov Gal.) acts in a similar way as a *palladium* of the Russian Church and state. LJ

Barasch, M., *Icon: Studies in the History of an Idea* (1992).

Belting, H., *Likeness and Presence* (1994).

Cormack, R. S., *Painting the Soul: Icons, Death Masks and Shrouds* (1997).

Weitzmann, K., *The Icon* (1978).

ICONOCLASM means image breaking and, as such, is a term applied to any period where the destruction of images has taken place, as for example, the Puritan movement in 17th-century England. However, in the 7th and 8th centuries, the ideology and world view of the entire Byzantine Empire was disrupted by the period of Iconoclasm, when the dispute as to whether images had any part in worship became of paramount concern throughout every level of society (see under BYZANTINE ART). Iconoclasm was the culmination of the rumblings about the validity of Christian images which had been present from before Constantine the Great; in its aftermath, the place of the image was secured in Orthodox worship and has remained unchallenged ever since. Much

of the debate was focused around the issue of whether it was possible to represent the divine through a material medium—can the holy be shown in paint?

In 726, Emperor Leo III ordered an image of Christ which was placed above the main entrance to the Great Palace of the Byzantine emperors to be removed. Extensive destruction of religious images in all media followed, with Leo's son and successor Constantine an even more enthusiastic iconoclast than his father. Throughout the empire, images were removed and replaced with the cross. In the church of the Dormition in Nicaea (destr. 1922), the gold background of the apse mosaic bears witness to the cross that was there, replaced after Iconoclasm with the *Virgin and Child*. In Hagia Eirene in Istanbul, the mosaic cross in the apse still remains. In 787, the second Church Council of Nicaea, summoned by the Empress Eirene, restored the place of *icons in church worship. After her downfall, a further period of Iconoclasm ensued until 843 when a further Council of the Church finally had the worship of images restored as an official part of Orthodox worship, where they remain to the present. The first major public image to be restored was the apse mosaic of the *Virgin and Child* in Hagia Sophia, dedicated in 867. More overtly, the Khludov Psalter (Moscow, State Russian Lib., MS 129D) visually compared the Iconoclasts to the persecutors of Christ.

The reasons for Iconoclasm are unclear. The 8th century was a period of crisis for the empire, assaulted externally and devastated internally by a series of natural disasters. This was seen as a sign of divine anger for, the Iconoclasts believed, the sin of image worship or idolatry, which broke the Second Commandment. The Iconoclasts asserted that religious images were both blasphemous and impossible. An image of Christ does the impossible in the sense that it pins down the divine aspect of Christ, which cannot be portrayed by human means and through material things. Correct Orthodox belief says that Christ has one indivisible nature, human and divine, godhead and humanity fused and inseparable, that the incarnate Christ was fully human and fully divine at one and the same time. Since the divine cannot be portrayed, Christ cannot be portrayed and images of him are blasphemous, because they cannot portray his divinity. Once the image of Christ is condemned, all other holy images fall into the same category.

Such arguments were based on a belief that an image represented the person of the model. The Iconophiles (icon lovers) held this same fundamental position. However, they argued that the honour given to the image was conveyed to the prototype, that is the person represented. Christian worship, in contrast to pagan idolatry, was acceptable to

God because it honoured the person concerned, not the image. The believer did not worship the picture but the person pictured, revering the message not the medium. The image merely acted as a reminder of the person in question. As for the portrayal of Christ's divinity, the Iconophiles argued that since no man has seen God, so no man can describe God. On the other hand, quite a lot of people had seen Christ and therefore it was possible to describe him. Christ is God in human form, and because he had human form, he could be portrayed. Indeed, for him to have been fully incarnate, it must be possible to portray him.

Although all that survive are Iconophile writings about the dispute, incorporating and probably misrepresenting Iconoclast beliefs, a picture of Byzantine attitudes to images is clearly revealed. Clearly both sides had the same attitude to pictures: pictures showed the person of the model and were truthful and accurate. Iconoclasm tackled the need to portray ideas of shattering immensity—the incarnation of God—and to prove the truth of the Christian message. It established that only what exists and what has really happened can be portrayed. Thus, picturing the Christ child and the Virgin proved the Incarnation really happened. A picture of a saint proved that that saint really existed and could be called on for help. Byzantine writings on art underline this point. In this way, the ideology of the Byzantine Empire, Christianity, was maintained and art upheld what were perceived as universal truths. LJ

Bryer, A. A. M., and Herrin, J. (eds.), *Iconoclasm* (1977).

Cormack, R. S., *Writing in Gold* (1985).

ICONOGRAPHY (Greek *eikōn*: image; *graphia*: writing). The term initially referred to a discipline auxiliary to archaeology, which identified, among other things, portraits on antique coins. From the 19th century onwards, however, the meaning of iconography was extended to cover the entire descriptive and classificatory investigation of subject matter in the arts. Since all art bears a theme or a motif, iconography is potentially applicable to works from any given period, and thus forms one of the most fundamental branches of research in the history of art. A straightforward use of iconographical analysis might for instance be the identification of a saint through his or her attributes, but equally much more complex programmes such as the elaborate allegories of a *Baroque ceiling fresco can be decoded. Apart from classifying themes, motifs, attributes, allegories, and symbols, iconography also traces their historical development, focusing for example on the perpetuation of certain visual traditions and the resulting standardization of image formulas.

Iconography is usually divided into religious and secular, although many interactions are possible: medieval ruler iconography for example influenced the development of representations of Christ as judge or king in bibles or Gothic portals (or vice versa). The image formula 'enthroned figure with attributes, possibly a crown, and surrounding, probably kneeling persons' is transferred here from the theme of secular kingship to that of *Christus Rex*. To describe this phenomenon of transposition, Jan Białostocki has introduced the expression 'iconographic gravity' (1966). 'Iconographic gravity' is especially ubiquitous within certain global or overarching themes (*Rahmenthemen*) which concern fundamental aspects of human existence and experience, such as heroism, sacrifice, motherhood, or, as in the above case, rulership. Iconographical literature can be traced back to the 16th and 17th centuries (e.g. Giorgio *Vasari, *Ragionamenti*, 1588; Antonio Bosio, *Roma sotterranea*, 1632). One of the first systematic studies which classified works of art according to subject matter is the vast *Recueil d'antiquités égyptiennes, étrusques, grecques, romaines et gauloises* (1752–67), written by the art collector and antiquarian the Count de *Caylus. Iconography as a scientific discipline was primarily established through the investigation of Christian themes and motifs. An important impetus was provided here by the so-called French iconographic school, which itself owed much to a new *Romantic religiosity, as evinced by Chateaubriand's *Le Génie du christianisme* (1802). A key figure of this school was Adolphe-Napoléon Didron (1806–86), whose *Iconographie chrétienne: histoire de Dieu* (1843) represents one of the first attempts to provide a comprehensive synopsis of Christian iconography. In Germany, the beginnings of scientific iconography are associated with Anton Springer (1825–91), in particular with his *Ikonographische Studien* (1860).

Iconographical research reached its first apogee in the years around 1900 with the studies of Émile *Mâle in France, Karl Künstle in Germany, and Vladimir Pokrovsky and Nikodim Kondakov in Russia. Although generally considered useful, the results were criticized by some (e.g. Alois *Riegl) for their marked positivism. Other criticisms anticipate those directed against *iconology about half a century later: iconography, it was argued, failed to grasp the very nature of art and reduced the work of art to the status of a mere historical or cultural document.

While for some art historians the development of iconography became increasingly linked to that of iconology, especially after Erwin *Panofsky had clearly differentiated between a work's theme and content, the meticulous and empirical approach pioneered around the turn of the century continued to be popular with others,

culminating in such colossal lexicographic projects as the *Dictionnaire d'archéologie chrétienne et de liturgie* (1907–53), by Fernand Cabrol and Henri Leclercq, Louis Réau's *Iconographie de l'art chrétien* (1955–9), and the *Lexikon der christlichen Ikonographie* (1968–76), edited by Engelbert Kirschbaum and Wolfgang Braunfels. Closely connected with the trend to make iconographic knowledge accessible to scholars in encyclopedic form was the development of card indexes and classification systems. The Index of Christian Art, begun in 1917 by Charles Rufus Morey at Princeton University, for example contains a vast quantity of iconographically indexed material relating to Christian medieval art before 1400. Other specialized archives, which also cover various aspects of secular iconography, include the Index of German Baroque Art at the Zentralinstitut für Kunstgeschichte in Munich, and the Index for Political Iconography in Hamburg.

Among the many methods to describe and classify iconography, *Iconclass* is certainly the most comprehensive and successful. Developed by Henry van de Waal (1910–72) at the University of Leiden, the system is widely used for filing and retrieval purposes in various image collections and documentation centres, and is also increasingly applied to computer-generated databases. It consists of a series of hierarchically arranged alphanumeric codes, which correspond to an English text description of themes and motifs. The notation for 'Christ's Entombment' (73D76) is thus composed as follows: 7 = Bible; 73 = New Testament; 73D = Passion of Christ; 73D7 = from Christ's Deposition to his Entombment; 73D76 = Christ's Entombment. Theoretically *Iconclass* provides the most objective tool to describe any iconographical constellation and must rank as one of the most important achievements of iconographical research in the 20th century.

AT

Białostocki, J., *Stil und Ikonographie: Studien zur Kunstwissenschaft* (2nd edn., 1981).
Kaemmerling, E., *Bildende Kunst als Zeichensystem*, 1: *Ikonographie und Ikonologie* (6th edn., 1994).
Straten, R. van, *Einführung in die Ikonographia* (1989).

ICONOLOGY (Greek *eikōn*: image; *logos*: word). Although sometimes used interchangeably with iconography, iconology can be distinguished from the former by its more wide-ranging approach. While iconography is a descriptive and classificatory discipline, iconology is an interpretative method, which aims to contextualize works of art culturally and explore their possible meanings. In its traditional sense, the term referred to compendia of iconographical patterns (allegories, symbols, personifications) used by artists' workshops, and art lovers. Among the most important of these handbooks was Cesare

Ripa's *Iconologia* (1593), which was translated into numerous languages.

In its modern sense, the expression 'iconological' was first used by Aby *Warburg in his lecture (1912) on the frescoes of the Palazzo Schifanoia in Ferrara. For him, iconology was closely connected to his call for a general socio-cultural science, which would in time assimilate and supersede art history. The first scholar, however, to differentiate properly between the iconographical and iconological method was the Dutch art historian G. J. Hoogewerff (1884–1963): 'After the systematic examination of the development of themes has been accomplished [by iconography], iconology then poses the question of their interpretation [and] seeks to understand the symbolic, dogmatic, or mystical sense (even if hidden) in figural forms' (1931). Despite their pioneering studies both Warburg and Hoogewerff omitted to provide a proper scientific basis for iconology. It was Erwin *Panofsky who developed the systematic foundations for the iconological discipline. His methodological principles were first set out in the introduction to *Herkules am Scheidewege* (1930), and presented in a more mature form in *Studies in Iconology* (1939). Minor changes were once again made in *Meaning in the Visual Arts* (1955). Panofsky's approach was shaped significantly by his contact with Warburg, and also by the philosophy of the Neo-Kantian Ernst Cassirer (1874–1945), in particular by his study *Philosophie der symbolischen Formen* (1923–9). A third important force behind Panofsky's methodological outlook was *Dvořák's notion of *Kunstgeschichte als Geistesgeschichte*.

Drawing on a model provided by the Austrian sociologist Karl Mannheim, Panofsky advances a tripartite method of interpretation that aims to penetrate into the various strata of meaning of a work of art, with each step representing a deeper level of enquiry. For each level of analysis Panofsky lists the necessary equipment for the interpreter, and formulates corrective principles of interpretation which account for the historical context of the work.

The *pre-iconographical* description concerns the *primary or natural subject matter*, involving the identification of factual subjects (human beings, animals, objects) and expressional subjects (such as a sorrowful gesture or attitude). In order to arrive at a correct result the interpreter must have practical experience (familiarity with objects and events) and should have a balancing knowledge of the history of style ('insight into the manner in which, under varying historical conditions, objects and events were expressed by forms').

The second level of Panofsky's model, the *iconographical analysis*, examines the *secondary or conventional subject matter*, and involves the linking of artistic motifs or their combinations with themes or concepts, and thus

identifies images, stories, and allegories. Their recognition requires a knowledge of literary sources ('familiarity with specific themes and concepts'), the corrective principle here being an acquaintance with the history of types ('insight into the manner in which, under varying historical conditions, specific themes or concepts were expressed by objects and events').

Whilst iconography determines and classifies images, the third stage in Panofsky's procedure, the *iconological interpretation*, is concerned with interpreting the *intrinsic meaning or content*. On this last level of interpretation the work of art is considered as a manifestation of fundamental principles in a culture, a period, or a philosophical attitude. Following Cassirer, Panofsky regards artistic motifs, images, and allegories as 'symbolic forms', as symbolic equivalents of reality constructed by the intellect. At this level the researcher must apply 'synthetic intuition', a mental faculty which is conditioned by personal psychology and *Weltanschauung* ('familiarity with the essential tendencies of the human mind'). The essential corrective is a knowledge of the 'history of cultural symptoms or "symbols" in general' ('insight into the manner in which, under varying historical conditions, essential tendencies of the human mind were expressed by specific themes and concepts').

In contrast to iconography, the iconological method proceeds from synthesis rather than analysis. The benefits arising from this interdisciplinary approach are summarized by Panofsky as follows: 'It is in the search for intrinsic meaning or content that the various humanistic disciplines meet on a common plane instead of serving as handmaidens to each other.'

Panofsky's method exerted a fundamental influence on the development of art history, especially in the Anglo-Saxon world. This was partly due to his own emigration, but also to the general exodus of German and German-trained art historians to England and America in the 1930s and 1940s. Although iconology had traditionally been applied to the representational arts, painting and sculpture (e.g. the studies by Charles de Tolnay on *Michelangelo or Wolfgang Stechow on *Rembrandt), the method was also used by architectural historians, in particular by Richard Krautheimer and Günther Bandmann. By viewing, for example, copies of the Aachen palatine chapel not as mere stylistic or typological successors to their model, but as manifestations of particular sets of ideas and values, iconological scholarship has opened new horizons in the history of architecture.

However, there was also opposition to Panofsky's method. Whilst Marxist art historians have argued against the reluctance of iconologists to consider the social function of art, for example as the conveyor of certain ideologies (Mikhail Libman), other art historians have criticized the exaggerated role which philosophy, especially Neoplatonism, has been allotted in iconological scholarship (Horst Bredekamp). The most significant critique was launched by the school of art historical hermeneutics, with Oskar Bätschmann as its principal exponent. Representing, in a sense, a modernized version of classical formal analysis, the school aims to move away from the sometimes nebulous notion of 'meaning' elicited by iconologists in order to concentrate on a meaning that primarily resides in the 'pictorial level' (*Bildtext, Bildlichkeit*) of the work of art itself. AT

Hoogerwerff, G.-J., 'L'Iconologie et son importance pour l'étude systématique de l'art chrétien', *Rivista d'archeologia cristiana*, 8 (1931).

ICONOSTASIS, the name given to the screen separating the nave from the sanctuary in a Byzantine or Orthodox church. Strictly speaking, iconostasis applies to a post-Byzantine screen, whilst *templon* is the term used in a Byzantine church. It began as a low barrier between nave and sanctuary in the mid-5th century, developing throughout the Byzantine period in height and width into a very large columnar structure of marble or wood obscuring most of the altar. From perhaps the 11th century onwards, the screen was hung with *icons between the columns; these could be changed to depict scenes commemorating the particular feast or saint's day. Very large icons of Christ, the Virgin, and the patron saint of the church, often mosaic or fresco with elaborate frames, were placed on the piers separating the parts of the *templon*. An elongated panel with the Deësis (Christ between the Virgin and S. John the Baptist) and the feasts of the Church often ran along the top of the epistyle. LJ

Epstein, A. W., 'The Middle Byzantine Sanctuary Barrier: Templon or Iconostasis?', *Journal of the British Archaeological Association*, 134 (1981).

IDEA, which in Ancient Greek initially meant the outward appearance of things perceived by the sense of sight, designated, from the *Renaissance onwards, the image conceived in the mind of the artist. Its various shades of meaning reflect its evolution as a Platonic concept growing in an Aristotelian soil under a Christian sky.

In art, Idea applied more to theory than to practice and served to emphasize the intellectual character of painting. The doctrine emerged in 15th-century Italy, underwent its most important developments from the mid-16th century onwards, and blossomed in the company of concepts such as imitation and *disegno*.

The term entered philosophy through *Plato who presented Ideas as the models of the perceptible world which the human soul contemplated before entering the body. To understand is to remember: a beautiful person, a good judge, or an equilateral triangle may trigger reminiscences of Ideas such as beauty, justice, equality. However, Plato's distrust of sensory perception led him to reject the visual arts. Since they reproduce the appearance of the sensible world, which is only an imperfect copy of the Idea, they are even further removed from the truth.

With Christianity Platonic Ideas became the notions in God's mind which preceded and guided divine creation. Nevertheless, from the Middle Ages onwards, the philosophy of *Aristotle, Plato's best pupil, dominated the field of faculty psychology. Aristotelian philosophy dismissed the doctrine of Ideas on the grounds that the soul can only know through the senses and stated that there is nothing in the intellect which was not previously in the senses. Nevertheless the Platonic doctrine of Ideas survived throughout 16th-century art and love literature but mostly as a rhetorical evocation of beauty rather than as a philosophical account of the formation and expression of mental images.

Thus while theologians explained divine creation through the example of the image in the artist's mind, Renaissance art theorists defined this image through Aristotelian faculty psychology. Accordingly, the elaboration of an artistic Idea consisted in a discerning synthesis of the data brought to the intellect by the senses. The frequently retold anecdote of the ancient painter *Zeuxis selecting the best parts of five beautiful girls to devise a picture of Helen of Troy exemplified this process.

The formation of artistic Ideas involved not only imagination, which provided an inner sense of sight, but also the extensive exercise of higher rational faculties ordering and composing the inner images in terms of *proportion and *anatomy. Thus 17th-century *classicists, such as *Bellori (1672) in Italy or *Fréart de Chambray (1662) and *Félibien (1669) in France, could debase *naturalism as a mechanical copy of the visible and hail the art of *Raphael and *Poussin as intellectual recreations of a perfected world.

By then Idea designated the characteristic beauty of images composed through synthetic imitation. This shift between the image in the mind of the artist and the Ideal he follows and expresses opened the way to the 18th-century notion of Ideal. Its various treatments and uses in the works of *Batteux, *Diderot, *Reynolds, and especially *Winckelmann and *Kant constitute variations on a doctrine of aesthetics established in the 17th century. Thus the doctrine of Ideas and Ideal survived until the 19th century as a focal

point in controversies opposing the advocates of realism to the partisans of *Classicism.　　　　　　　　　　　　　　　　FQ

Fattori, M., and Bianchi, M. L. (eds.), *Idea* (Proceedings of a Symposium) (1990).
Panofsky, E., *Idea: A Concept in Art Theory* (1968).

IDEOPLASTIC, a term originated by Max Verworn in *Zur Psychologie der primitiven Kunst* (1917) to mean a form of representation which derives from what the draughtsman thinks and knows about the subject rather than from direct observation or from a memory image. Applied primarily to the abstract and schematic drawings of children and some primitive peoples, the term suggests that children and primitives draw what they know rather than what they directly see, in the sense of drawing from intellectual concepts rather than from visual memory images. This intellectualist theory has been controverted by exponents of *gestalt psychology and notably by Rudolf Arnheim, who argues that the simplified schemata of children and primitives are not progressive abstractions from the observation of a number of instances but represent global general features and structural characteristics which are inherent to primary perception, the differentiation of individual cases being secondary.　　　　　　　　　　　　　　　　HO

Arnheim, R., 'Perceptual Abstraction and Art', repr. in *Toward a Psychology of Art* (1966).

ILLUMINATED MANUSCRIPTS. *See overleaf.*

ILLUSIONISM, the attempt in the visual arts to give the illusion that what is represented is substantially present. The use of shading to give volume to objects in painting, for instance, is illusionistic insofar as it makes them seem more substantial; this is the sense for which the art historian Franz Wickhoff coined the term in 1895. Painting statues to make them more lifelike could likewise be called illusionistic. Many 20th-century writers went on from this to characterize critically as illusionism any attempt to reproduce appearances in painting.

In art historical usage, however, illusionism specifically refers to painting dedicated to blurring the distinction between substantial and represented objects. One main problem faces a painter wishing to do this: the fact that when a viewer moves, the planes of a painted object or scene will not change their relation as they would were the object or scene three-dimensional. Effective illusions thus require some constraint, either on what is shown or on how it is seen. In the former case, the painter only shows objects that seem to jut or recede shallowly from the picture plane, so that the viewer expects little change in the aspect: this is the range of

effects known as *trompe l'œil*. In the latter case, the painted scene is meant to be seen, either through a narrow opening, as in a peepshow, or at a distance where the relation of the planes would change relatively slowly in three dimensions. Typically, such painting might be placed on a theatre backdrop, or across a large hall or church nave, or on a high ceiling. In such settings the transition into illusion may be eased by repeating or developing the surrounding architecture in painted perspectival recessions. This practice, a specialism among Italian painters from the 16th to the 18th century, is known as *quadratura*.

A taste for illusionism seems to have been cultivated in Greece (see GREEK ART, ANCIENT) and Italy (see ROMAN ART, ANCIENT) from the 5th century BC, when theatrical scene painting was introduced to Athens by *Agatharcus, till at least the 3rd century AD, when *Philostratus the younger wrote lyrically about painting's power to deceive the eye. First-century murals from *Pompeii extensively employ painted architecture and picture framing and *trompe l'œil* still life. There is little evidence however of a continuous illusionistic tradition from the late classical era to the turn of the 14th century.

*Giotto's innovations at this time in modelling and painted architecture set an example of illusionism, followed in the proliferation of Italian paintings done as windows or as recesses in the following century, and developed with the new tool of *perspective in *Masaccio's fresco of the *Trinity* (1427; Florence, S. Maria Novella). Simulated architecture pervades Italian frescowork from this time on, just as *trompe l'œil* effects pervade 15th-century panel painting from both Italy and Flanders. The range of illusionism was significantly expanded when *Mantegna introduced a painted opening to the sky in the ceiling of the Camera degli Sposi (1474; Mantua, Palazzo Ducale). This new possibility was soon adapted to ecclesiastical contexts, and in the hands of painters such as *Correggio at Parma Cathedral (1520–2) the illusionistic painted dome became a staple of church decoration. In 16th-century secular decoration the tradition could be exploited for teasing, paradoxical effects, as in the collapsing architecture of *Giulio Romano's Sala dei Giganti (1532–4; Mantua, Palazzo del Te). An outstanding example is *Veronese's work at the Villa Barbaro, Maser (1561).

Beyond these teasing effects, illusionistic techniques also offered a way to envelope the viewer in a totally directed experience of overwhelming import. This is how they were employed in the northern Italian *Sacri Monti from c.1510, and how they would be employed by *Baroque painters working to respond to the painting-like effects of *Bernini's sculpture—for instance Giovanni

Battista *Gaulli's work on the ceiling of the Gesù, Rome (1676–9). Gaulli had trained in Genoa, which, like Bologna, was a centre of expertise in *quadratura*, exporting specialists on decorative commissions across Europe. Another Genoese, Andrea *Pozzo, the creator of the most ambitious sustained exercise in the genre, on the ceiling of S. Ignazio, Rome (1688–94), took the art to Vienna. The German-speaking lands were the one area outside Italy where the tradition took root independently, in the *Gesamtkunstwerken* of the *Asam brothers or the frescoes of Johann Georg *Bergmuller.

Venetian painters of the early 18th century were the last great exporters of Italian illusionism; most notably Giambattista *Tiepolo, whose painting on the ceiling of the Kaisersaal (1750–3; Würzburg, Residenz) was the example for the Austrian illusionistic painter Franz Anton *Maulbertsch. Tiepolo however lived to see the whole ethos of illusionism, with its relish for teasing simulations, decisively repudiated by *Neoclassical and *Romantic painting and criticism. While the repertory of illusionistic effects remains a part of painting, the ambition behind them has never regained artistic centrality. Arguably illusionism was a taste diverted into the *diorama, and thence ultimately into the cinema.　　　　　　　　　　　　　　　　JB

d'Otrange Mastal, M. L., *Illusion in Art* (1975).
Freedberg, D., *The Power of Images* (1989).

ILLUSTRATORE, L' (active c.1330–43×8). This is the Italian art historian Roberto Longhi's nickname for an anonymous artist dominating Bolognese illumination between the activities of the 1328 Master and *Niccolò da Bologna. He was originally dubbed the Pseudo-Niccolò, but the inclusion in this term of work by younger artists such as the 1346 Master has led to its abandonment. The most likely identification for him is with Tomaso di Galvano, son of a Bolognese scribe and brother of another illuminator: Tomaso established his family in Padua as well. He introduced or developed rich acanthus foliage into manuscript decoration and developed the expressive range of the 1328 Master's work. His blocks of figure groupings are inspired by *Giotto's art, as are the faces of his massive figures, sometimes urgently upturned, but their rounded shoulders and snub noses underline the dramatization of gesture in contrast to Giotto's restraint. The *Liber Sextus* and *Constitutiones Clementis V* (Padua, Bib. Capitolare, A24/25) for Nichas of Esztergom (the latter dated 1343) are the most celebrated of his large production, devoted mainly to legal texts.　　　　　　　　　　　　　　　　RG

de Veer-Langenzaal, J., 'A Cutting by the Illustratore', *J. Paul Getty Museum Journal* (1992).

· ILLUMINATED MANUSCRIPTS ·

ILLUMINATED manuscripts are handwritten books or rolls with painted decoration and illustration. The use of the term 'illuminate' to describe the painting of books derives from medieval usage; Dante (1265–1321) refers to 'quell'arte Ch'alluminar chiamata è in Parisi' (*Purgatorio*, 11. 80–1). Sire de Joinville's (*c*.1224–1317) description of the scribe 'qui a fait son livre l'enlumine d'or et d'azur' suggests that the use of the verb may have been stimulated by the fact that the pages appeared literally to be 'lit up' by the burnished gold that was so frequently employed in book decoration from the 13th century onwards. Although some have thought the term 'illuminated' to be strictly applicable only to those manuscripts where the painting is enhanced by the use of gold or silver, it is now more widely used of any manuscript with decoration more elaborate than simple coloured initials (see MANUSCRIPT ILLUMINATION).

Sometime around the 4th century AD the relative advantages of the parchment codex over the papyrus scroll achieved widespread recognition in western Europe and became the predominant form used for the recording and transmission of texts. One consequence of this shift was the provision of a flat, stable, and enduring surface that could carry more elaborate illustration than was possible on the fibrous, absorbent—and, when the scroll was consulted, shifting—surface of papyrus. The increased importance of the written word, especially in association with the rise and spread of Christianity, led to a gradual proliferation in the production of illuminated books that reached a peak in the 14th and 15th centuries. As a class, more manuscripts survive than any other medieval artefact, and the painted images protected within the pages of these books far outnumber the extant works of art in any other medium. The painted embellishment or illustration of texts continued to be a desired component of formally produced books well into the 16th century, and for some decades after the invention of printing with movable type the grandest copies of an edition would be those printed on vellum and furnished with illuminated decoration and illustration, such as the 20 copies from Jensen's edition of the Italian translation of *Pliny the elder's Natural History* (1476) (e.g. Holkham Hall, Norfolk, ML C52 BN1985). An exceptional continuation has been the tradition of illuminating individually produced commemorative documents, such as those confirming titles, arms, or the award of degrees, for example the *carta executoria de hidalguia* produced in such numbers in the 16th–18th centuries for the Spanish nobility.

Inevitably, over the course of the millennium or so that illuminated manuscripts were produced in western Europe both the texts reproduced and illustrated and the means of their production changed; there might even be a wide variation in practice within a single centre according to the markets served or civic regulation. As the principal medium for cultural transmission the manuscripts that were made reflected the interests and concerns of the dominant groups in the societies that produced them.

The copying of texts was already regarded as an essential in the early Church; S. Jerome (*c*.342–420) included the copying of books among monastic duties, and Cassiodorus (*c*.485–*c*.580) founded two monasteries where he encouraged both secular and religious learning, thus establishing the monastic tradition of scholarship responsible for the preservation of so much classical as well as theological writing. The Bible known as the Codex Amiatinus that was made in Northumberland for presentation to the Pope (*c*.700–16: Florence, Bib. Laurenziana, MS Am. I) has a miniature showing a prophet writing a manuscript while seated in front of a large cupboard containing writing implements and a Bible in nine volumes: it is believed that the illustration, like the text itself, was copied from Cassiodorus' own large, single-volume Bible. Its presence as a frontispiece is an implicit statement of the importance that the recorded and written word had to Christian doctrine. Biblical manuscripts, Gospels and psalters, were the most elaborately illuminated products of *Insular, *Carolingian, *Ottonian, and *Anglo-Saxon art. Whether they were to serve the purposes of missionaries, monks, or emperors these manuscripts were mostly produced in the scriptoria or cloisters of abbeys and monasteries. Around 1100 this situation began to change because the proliferation of new texts during the *Romanesque period and the expansion of demand gave rise to the collaboration of secular scribes and illuminators on monastic production. It seems particularly that the best illuminators were no longer necessarily trained in the monasteries that patronized them. The rise of the universities and the growing desire from the laity for the ownership of books led to an ever-increasing importance for the secular book trade, and there is abundant evidence from the 13th century of the sophisticated organization of the trades of the book in the university cities of Paris and Bologna. The most obvious, and numerous, monuments to the efficiency of the Paris book trade are the 13th-century pocket bibles that were produced in huge numbers, and with a layout and appearance that is still emulated in bibles printed today. From this point on, whether employed at a piecework rate or as a privileged member of a noble household, it was professional, and usually secular, artists who illuminated the ever-broadening range of texts desired by religious and civic institutions and individual members of bourgeois and court society. During the *Gothic period the trades associated with producing a manuscript seem often to have been located within a particular district of a city—on the left bank in Paris and around Fleet Street in London—and the co-ordination of their tasks seems often to have been undertaken by a bookseller or stationer. There had clearly always been a market for second-hand manuscripts and during the 15th century it appears that the trade was sufficiently well

developed for standard *books of hours at least to have been produced speculatively.

With the spread and increase in the production of printed books and their availability to wider ownership, the expectation and requirements of an illustrated book changed; this combined with technical expediency to result in integrated mechanical production of both text and illustration and decoration. Since the middle of the 16th century it has only been in isolated and eccentric cases that the hand-produced illustration of texts has been a focus of artistic attention. The most notable exception to this was the self-conscious resurgence of interest in illuminated manuscripts by members and followers of the Arts and Crafts movement, above all William Morris, in the late 19th and early 20th centuries.

The approach to decorating a page or illustrating a text varied widely; the page may be treated straightforwardly like any more monumental support and simply carry a rectangular painting, but the most inventive artists have recognized and exploited both the freedom of the blank leaf and the restrictions of a page of text. In the Passion cycle in the *Très Riches Heures* of John, Duke of Berry (c.1416: Chantilly, Mus. Condé) the de *Limburgs alter the shape of the miniature from scene to scene, extending the picture-field in an unparalleled fashion in order to highlight the narrative. An equally innovative response was often shown in the more constrained context of the decoration of a page of text, especially by some illuminators in Flanders and the Veneto in the decades around 1500, who seemed to delight in playing illusionistic games as though denying the existence and limits of the parchment surface. They treated the lines of text as if they were written on a screen erected in front of the events and the world that they depicted in the margins beyond. In some instances, when the illustrations predominated and their integration into the text required it, a specific page layout might be devised, as for example for *bibles moralisées*, but this was exceptional. More commonly the illumination of a page drew upon a repertoire of illustrative and decorative elements that were variously provided or combined according to the type of text, the prevailing style, and, most importantly, the level of expenditure of the patron.

The most standard elements were the miniatures and historiated initials that contained scenes or figures illustrating or complementing the text; other illuminated initials, borders, and line-endings served a more decorative purpose and—even when they included figures, whether grotesques placed in margins or dragons entwined in initials—not necessarily related to the significance of the text. As well as having an instructive and decorative purpose the illumination had another more mundane and practical role: the different hierarchy of decoration, the varying size or type of initial used to open a book, a chapter, or a verse, made it easy for readers to find their way around a manuscript. Furthermore the images could identify a text for someone whose reading skills were not great: reaching a miniature of the *Annunciation to the Virgin* in a book of hours, one could be certain that the beginning of the office of the Virgin had been found. KS

Alexander, J. J. G., *Medieval Illuminators and their Methods of Work* (1992).

Backhouse, J. M., *The Illuminated Manuscript* (1979).

Hamel, C. de, *A History of Illuminated Manuscripts* (1986).

Pächt, O., *Book Illumination in the Middle Ages* (1986).

IMAGINERÍA, Spanish term for painted or sculpted images of sacred characters, usually applied to polychromed wood sculpture, produced in Spain since the Middle Ages. Among the most distinguished artists to work in this medium were Alonso *Berruguete and Juan de *Juni in the 16th century, and Gregorio *Fernández, Juan Martínez *Montañés, and Alonso *Cano in the 17th.

NAM

Gómez-Moreno, M. E., *Breve historia de la escultura española* (1951).

IMPASTO, painters' term for the application of oil paint in thick solid masses. HB

IMPERIALI, (Francesco Fernandi) (1679–1740). Italian painter, born in Milan and active at Rome from c.1705. His early work consisted of animal paintings reminiscent of the Genoese painter *Scorza and the Bolognese G. M. *Crespi. However, around 1720 he fell under the influence of *Maratti and adopted a more elevated style, focused on *history painting. He was commissioned by Owen MacSwinny to paint the *Allegorical Tomb of George I* (priv. coll.), one of a series of capricci by Italian painters (see PITTONI, GIAMBATTISTA; RICCI FAMILY) of English heroes. His style was also strongly coloured by his study of *Poussin's Roman commissions; this is immediately apparent in his *Martyrdom of S. Eustace* (1720s, Rome, S. Eustachio) and two paintings of the *Martyrdom and Beheading of S. Valentine and S. Hilary* at Viterbo Cathedral. In subsequent work, however, Imperiali's Poussinesque severity gives way to a more relaxed *Rococo manner, and he painted a number of pastoral scenes in which mythological figures are shown in Arcadian landscapes. Although an independent artistic figure in Rome, sometimes out of favour at the Accademia di S. Luca (see under ROME), Imperiali was influential as a teacher. *Batoni was one of his pupils, and like his protégé Imperiali enjoyed the patronage of British visitors to the city. HB

Waterhouse, E., 'Francesco Fernandi detto Imperiali', in *Arte lombarda*, vol. 3 (1958).

IMPRESA (Italian: badge), a personal badge consisting of an image and a motto, which together form a whole, although the relationship between the two can be enigmatic. They are highly personalized; although sometimes they were inherited they were more often unique to an individual. Unlike coats-of-arms which were granted and recorded family lineage, the impresa was self-invented and revealed something of the owner's self-image; for example William Burne's provocative impresa of a hawk snatching its prey featuring the motto *faus amie seit honnie* (a false friend, but honest). Imprese became extremely fashionable in Europe in the 16th and 17th centuries and were used in ceremonies such as coronations, marriages, baptisms, funerals, official entries into cities, and tournaments. They appeared on shields, vases, tea services, and were incorporated into paintings and architecture on tiles and bricks. Mary Queen of Scots owned a collection of embroidered imprese. On medals, however, they found greatest popularity. One of the largest collections of imprese belonged to Elizabeth I, which was

built up over 30 years and housed on the walls of a gallery of Whitehall Palace, London. KC

Goodall, J., 'All Earliest Imprese: A Study of Some Medieval Seals and Devices', *Antiqua J.*, 72 (1993). Strong, R., *Splendour at Court: Renaissance Spectacle and Illusion* (1973).

IMPRESSIONISM. *See opposite.*

IMPRESSIONS. See PRINTS.

IMPRIMATURA. See GROUND.

INDEPENDENT GROUP, a small and informal discussion group that met intermittently between 1952 and 1955 at the Institute of Contemporary Arts, London. The members, who represented a wide cross-section of the visual arts, included the critic Lawrence Alloway (1926–90), Richard *Hamilton, Eduardo *Paolozzi, the architectural and design historian Reyner Banham (1922–88), and several architects. The issues they discussed included advertising and mass culture, and the first phase of British *Pop art grew out of the group. After it had ceased to exist, some of the members were involved in mounting the *This is Tomorrow* exhibition (1956) at the Whitechapel Art Gallery, London. IC

INGLÉS, JORGE (active *c*.1454–85). Painter, perhaps of English origin, active in Spain. Both his style and his technique of painting in oils on panel suggest that Inglés's artistic training took place in the Netherlands. In 1455 Iñigo López de Mendoza, Marquis of Santillana, added a codicil to his will ordering that an altarpiece by Jorge Inglés be placed on the high altar of the church of the hospital of S. Salvador in Buitrago, the Marquis's ancestral home. Some of the panels survive—the four *Fathers of the Church* from the predella and the portraits of the patron and his wife (Madrid, Marquis of Santillana's Coll.). Inglés also worked for the Marquis as an illuminator of manuscripts (i.e. S. Augustine's *De vite beata*; Madrid, Bib. Nacional). An altarpiece painted by Inglés for the Hieronymite monastery of La Mejorada at Olmedo has as its main panel a representation of *S. Jerome in his Study* (Valladolid: Mus. Nacional de Escultura Religiosa) accompanied by tiny figures of monks and a lion calmly enjoying its lunch. The painting exemplifies Inglés's ambiguous use of perspective and charming anecdotal details. SS-P

INGRES, JEAN-AUGUSTE-DOMINIQUE (1780–1867). French painter. A curious and contradictory figure, yet one of the greatest French painters of the 19th century, Ingres has often been described as the prime representative of the dead hand of academicism.

Although in later life he was loaded with official honours and his appearance and lifestyle were quintessentially bourgeois, his art was attacked by conservative critics until he was well into middle age. And despite his lifelong devotion to the *Antique and to *Raphael, he was, as much as his *Romantic rival *Delacroix, in rebellion against the academic norms imposed by the school of *David, though continuing to admire the personal achievement of his master. Compared with Delacroix he was a man of limited intellectual range who treated relatively conventional subjects, but he was always in the curious position of wishing to be an establishment painter with a highly idiosyncratic and emotionally charged style. Ingres frequently stated that 'drawing is the probity of art', yet in purely academic terms his drawing is often deliberately defective and exaggerated. But as other great draughtsmen have recognized, *Degas and *Picasso among them, the force and strangeness of Ingres's art lie in his subtle and often unnaturalistic orchestration of contour, so that outline rather than volume is the organizing principal of his paintings, and in his efforts to produce a painted surface of such smoothness that almost no trace of human intervention remains. It is a tribute to the power of his art and to his authority as a teacher that without stylistic concession he eventually became the most generally admired French painter of his day.

Ingres was trained first by his father, a sculptor in Montauban, then at the Toulouse Academy, before entering the Paris studio of David in 1797. While in Toulouse he had supported his studies by playing the violin in the opera orchestra. The instrument remained his favourite leisure activity, hence the phrase a 'violon d'Ingres' to mean a hobby achieved to near professional standard. In 1801 he won the coveted *Prix de Rome with the Neoclassical *The Envoys of Agamemnon at the Tent of Achilles* (Paris, École des Beaux-Arts). His trip to Rome was delayed until 1806 because of the state of government finances. In the interim he received two public commissions for portraits of Napoleon, as well as undertaking private portrait commissions. Of the latter, those of the Rivière family (Paris, Louvre) already demonstrate the subjection of anatomy and drapery to the achievement of sensuous linear pattern and the enamel-like colouring that became the hallmark of his mature portraits. Of the former, *Bonaparte as First Consul* (1804; Liège, Mus. des Beaux-Arts) is a relatively conventional exercise in the manner of *Gérard. But *Napoleon on the Imperial Throne* (1806; Paris, Mus. de l'Armée), with its hieratic reminiscences of Antique gems and the paintings of van *Eyck, is a strikingly original work which was condemned by the critics as bizarre and revolutionary.

From 1806 to 1820 Ingres lived in Rome, for the first four years as a *pensionnnaire* at the French Academy in the Villa Medici. Although much influenced by Antiquity and the High *Renaissance masters, Ingres continued to evolve a very personal and purified style, in part also inspired by the outline engravings of *Flaxman and the Italian and Flemish 'primitives'. Conventional modelling by chiaroscuro was replaced by an ever-increasing emphasis on clear linear patternings, with discrete patches of local colour emphasizing the surface of the canvas or panel. The first, and one of the most famous, of his many paintings of the female nude— the *Valpinçon Bather* (1808; Paris, Louvre), so called after a one-time owner—was executed at this time. In 1811 Ingres sent for exhibition in Paris the enormous *Jupiter and Thetis* (Aix-en-Provence, Mus. Granet), which was savaged by the critics for its 'archaic' style. Nevertheless Ingres received important state commissions, including two decorative paintings for Napoleon's palace in Rome. Another of the great nudes was painted in 1814: the *Grande Odalisque* (Louvre), a reclining figure, the sensual elongations of whose back and legs hark back to the mannered style of the School of *Fontainebleau.

In 1814, with the fall of Napoleon, the French colony in Rome, which had been the principal source of Ingres's income, mainly with portrait commissions, melted away. He sustained himself with a steady output of superb and inexpensive pencil portraits. He also turned to small cabinet paintings with Renaissance and medieval themes such as *The Death of Leonardo da Vinci* and *Paolo and Francesca*. These were designed to exploit the fashionable Romantic taste for the troubadour style. At the suggestion of the sculptor Lorenzo Bartolini he moved to Florence in 1820 and there set to work on an altarpiece commissioned for Montauban Cathedral. Exhibited at the 1824 Paris Salon, the Raphaelesque *Vow of Louis XIII* was the first of Ingres's paintings to win near universal acclaim. He returned to Paris in triumph, where he was awarded the Cross of the Legion of Honour by Charles X and subsequently made a member of the Académie des Beaux-Arts. His success as an official painter, respected teacher, and society portrait painter seemed assured.

Ingres spent much of the next decade working on two major public commissions, *The Apotheosis of Homer*, a ceiling painting for the Louvre (installed 1827), and *The Martyrdom of S. Symphorian*, for Autun Cathedral (exhibited 1834). He also continued to paint nudes and portraits. However, always sensitive to criticism, he was deeply hurt by the muted response to *S. Symphorian*, which he regarded as one of the major religious pictures of its

continued on page 360

· IMPRESSIONISM ·

IMPRESSIONISM was never a school or movement with a clearly defined programme, rather it refers to a disparate group of painters who banded together in Paris in the 1870s and 1880s for the purpose of mounting independent exhibitions of their work. The name 'Impressionism' was coined by the critic Louis Leroy in response to their work at the first exhibition in 1874; the artists themselves did not adopt it officially until 1877. The label is often used in an indiscriminate way to refer either to those painters who showed avant-garde tendencies in their work or to those who wished simply to exhibit outside the state-sponsored Salon system which dominated Parisian artistic life in the 18th and 19th centuries. There was little real alternative available at that time for painters and sculptors to generate sales and to make a reputation, and the jury selecting the works for inclusion at the Salon (see under PARIS) tended to perpetuate an academic, often conservative, approach to painting, with a clearly defined hierarchy of subject matter in which the large-scale, heroic compositions based on a close study of the human form, and with a slick technique, took precedence. Édouard *Manet is often associated with the Impressionists but he never exhibited with them, preferring instead to court critical success at the Salon, and Pierre-Auguste *Renoir, who worked in an Impressionist idiom in the 1860s and 1870s, continued to submit works to the Salon for most of his working life. Similarly, Paul *Cézanne, Paul *Gauguin, and Georges *Seurat, who are now associated with *Post-Impressionism, exhibited with the Impressionists at the start of their careers.

To attempt a definition based on an Impressionist style is similarly problematic. The informality of brushwork, bright colour, and tendency to work in the open air often associated with Impressionism cannot be applied to all of those regarded as Impressionists: Edgar *Degas preferred to work from the model in the studio and his crisp linear technique betrays his admiration for academic principles. Moreover, *plein air* painting was not an innovation made by the Impressionist painters, but rather had been recommended in academic theory and practice from the late 18th century as fundamental to the study of nature and the basis of landscape painting. Jean-Baptiste-Camille *Corot's *The Roman Campagna with Claudian Aqueduct* (c.1826–8; London, NG), for example, resembles an Impressionist landscape of 50 years later: it has been painted rapidly on the spot on a light-coloured canvas which is visible in several places; the clouds have violet touches and there is an absence of human form to lend narrative detail. The informality and spontaneity of the composition suggests an Impressionist work, but in fact Corot's approach was standard practice for a preparatory sketch, intended as a reference tool for the landscape painter who would refer to it in the studio in order to recreate atmospheric effects in a larger, much more finished composition which could then be submitted to the Salon.

The series of paintings that Claude *Monet and Renoir produced in the summer of 1869 at La Grenouillère on the river Seine are often regarded as the beginnings of a mature Impressionist style. These scenes of leisure in a fashionable suburban setting were typical of much of the work of the 1860s and 1870s and demonstrate a continuation of the *realist commitment to modern life subject matter; but it was especially the works' technique that has been regarded as radical. Monet's *Bathers at La Grenouillère* (1869; London, NG) combines a spontaneity of execution with a commitment to close study of the way in which the *colours of objects are modified by the effects of light. The ability to work *en plein air* had only recently become much easier with the invention of collapsible metal paint tubes and the development of lighter, portable painting equipment. The growth in interest in landscape painting owed as much to these technical innovations as to any desire for a break with the past. At the time, Monet wrote to Frédéric *Bazille: 'I have a dream, a picture of the bathing place at La Grenouillère, for which I have made a few poor sketches, but it is only a dream. Renoir, who has spent two months here, also wants to paint the same picture' (Monet to Bazille, 25 Sept. 1869). This suggests that Monet himself regarded these paintings as preparatory sketches, from which a finished work could be produced in the studio. As such, he was following conventional academic practice.

Although the idea of an independent exhibition had been proposed as early as 1867, a number of factors delayed the first group show. The Franco-Prussian War and the Commune of 1870–1 were especially disruptive and the recession of 1873 meant that the future Impressionist painters lost the support of the dealer Paul Durand-Ruel (1831–1922) who had dealt mainly in *Barbizon landscapes in the 1860s. Their first show was held in the studio of the photographer Nadar on the Boulevard des Capucines from 15 April to 15 May 1874, and was described as the Société Anonyme des Artistes, Peintres, Sculpteurs, et Graveurs. That is, despite Camille *Pissarro's recommendation that they organize themselves co-operatively, the artists formed a joint stock company, demonstrating that they regarded the exhibition as a business venture. Their charter, for which Pissarro was largely responsible, allowed membership to anyone on payment of an annual fee of 60 francs, and had three main aims: exhibitions of work; the promotion of sales; and the publication of a journal devoted to the arts (*L'Impressionniste*, edited by Georges Rivière, appeared in 1877 only). Apart from Eugène *Boudin, Cézanne, Degas, Jean-Baptiste Guillaumin, Monet, Berthe *Morisot, Pissarro, Renoir, and Alfred *Sisley, most of the 30 exhibitors included in the catalogue are now largely forgotten. The event was well covered in the press, with a number of major articles devoted to the

show, and several critics supportive of the principle of an independent exhibition. Reaction to the work itself was mixed, and the exhibition was a financial failure. Nevertheless there were a further seven exhibitions: in 1876, 1877, 1879, 1880, 1881, 1882, and 1886.

By the 1880s, however, a number of the painters were dissatisfied with the institutional framework of the show: Renoir exhibited *Portrait of Mme Charpentier and her Children* (1878; New York, Met. Mus.), a large group portrait of his wealthy patrons, at the Salon of 1878 and Monet exhibited at the Salon of 1880. The 1882 exhibition was organized mainly at the instigation of Durand-Ruel who was eager to convey that the Impressionists formed a coherent group in an effort to encourage sales of their work. By the 1880s, most of the painters had refined the informality of their earlier approach and had in many cases begun working on larger, more finished compositions in the studio. Renoir's *Bathers* (1887; Philadelphia Mus.) demonstrates his interest in a more traditional way of composing his paintings, heavily reliant on drawing. Monet's commitment to landscape painting developed into his interest in the series paintings of the 1890s.

By the time of the final exhibition in 1886, at which Seurat exhibited his major Divisionist statement, *La Grande Jatte* (1884; Chicago, Art Inst.), the Salon had begun to lose its monopoly, while alternative exhibiting forums and an increase in dealers and private collectors had all meant that artists could sell their work more easily without compromising on technique and subject matter. As early as 1878, in *Les Peintres impressionnistes* (1878) Théodore Duret included Georges de Bellio (1828–94), Georges Charpentier (1846–1905), Jean-Baptiste Faure (1830–1914), and Victor Chocquet (1821–91) among the most important collectors of Impressionist work. (See also NEO-IMPRESSIONISM). LSt

Bomford, D., Kirby, J., Leighton, J., and Roy, A., *Art in the Making: Impressionism*, exhib. cat. 1990 (London, NG).

Herbert, R. L., *Impressionism: Art, Leisure and Parisian Society* (1988).

House, J., *Landscapes of France: Impressionism and its Rivals*, exhib. cat. 1995 (London, Hayward).

Moffett, C. S. (ed.), *The New Painting: Impressionism 1874–1886* (1986).

Rewald, J., *The History of Impressionism* (4th edn. (rev.), 1980).

Shiff, R., *Cézanne and the End of Impressionism* (1984).

Smith, P., *Impressionism* (1995).

time, and asked to be appointed as director of the French Academy in Rome in succession to Horace *Vernet. His reforming directorship lasted until 1841. During this period he painted only three works of significance—*Odalisque with Slave* (1839; Cambridge, Mass., Fogg Art Mus.), an orientalizing reprise of his favourite theme; *The Virgin with the Host* (1841; Moscow, Pushkin Mus.), another homage to Raphael; and *Antiochus and Stratonice* (1840; Chantilly, Mus. Condé), a classical fantasy of almost miniaturist perfection.

On his return to Paris, much of Ingres's energy was taken up with a scheme to decorate the Château de Dampierre for the Duke of Luynes with two murals depicting *The Age of Gold* and *The Age of Iron*. He did not finish the scheme, despite working on it from 1843 to 1848. In 1853 he received a commission from Napoleon III to decorate the ceiling of the Salon de l'Empereur in the Paris Hôtel de Ville with a painting of *The Apotheosis of Napoleon I* (destr. 1871). It depicted a naked Bonaparte crowned by Victory rising heavenwards in an Antique quadriga. At the 1855 Paris Universal Exhibition Ingres's artistic career was crowned with a retrospective exhibition, and in 1862 his establishment status institutionalized with his appointment to the Senate.

Ingres's paintings of female nudes continued through this period to culminate in *The Turkish Bath*, on which he seems to have worked from about 1852 until 1863, when he was 83. Some critics have seen in these sensual and voyeuristically conceived nudes the only full expression of Ingres's artistic imagination. But the lasting achievement of his

later career must surely be the series of portraits that he painted after his return to Paris. These works epitomize a whole class of 19th-century French society, with its sense of security and well-being based on immense wealth. In such paintings of women as *La Comtesse d'Haussonville* (1845; New York, Frick Coll.), *Baronne James de Rothschild* (1848; priv. coll.), and, supremely, *Mme Moitessier* (1856; London, NG), Ingres succeeded in combining an almost perfect musicality of contour (often in contradiction of anatomical and spatial realities), with a sumptuousness of decorative colouring in which costume merges into upholstery, and a dissolution of the individual into the type, that place them among the great examples of the portrait as social icon and the sitter as aesthetic object. Perhaps only *Bronzino has done this better. MJ

Rosenblum, R., *Ingres* (1967).

Ternois, D., *Ingres* (1980).

Tinterow, G., and Conisbee, P. (eds.), *Portraits by Ingres: Images of an Epoch*, exhib. cat. 1999 (New York, Met. Mus.; London, NG).

Wildenstein, G., *Ingres* (1954).

INKS. Iron-gall ink which was traditionally used for writing before and during the Renaissance period was also employed in drawing. It was derived from a suspension of iron salts in gallic acid taken from the nut-galls (oak apples) of oak trees, growths caused by disease. Although almost black when first applied, iron-gall ink turns brown over time which explains the characteristic appearance of so many old master drawings. It is also acidic which means that it can bring about fracturing or holes in paper. An artist

whose drawings are frequently affected in this way is *Guercino. Carbon ink was used in Antiquity by the Chinese and the Egyptians but was not much used for drawing in Europe until the 16th century. Particles of carbon were obtained from the soot of burning oils, resins, resinous woods, or the charcoal from wood. These particles were ground to a powder and mixed with a binder. Unlike iron-gall ink carbon ink does not fade or turn brown.

Indian or Chinese ink is essentially lamp-black (carbon ink) which is mixed with gum and resin and hardened by baking. The resin gives the line a sheen and the ink is waterproof. This kind of ink is much favoured by cartoonists and illustrators because its sharpness of definition makes it suitable for reproduction by photography. Bistre is a brown ink produced by the extraction of soluble tars from wood soot. Water was used to dissolve the dark brown greasy soot and the solution was filtered to remove the insoluble sediment. The ink colour was intensified by evaporating or boiling part of the water in the solution. Bistre was a popular drawing medium during the 17th and 18th centuries.

Sepia is an ink which ranges from black to yellowish brown and is derived from the ink-bag of the cuttle-fish. At the end of the 18th century it gained in popularity as a drawing medium because a reliable method of chemical extraction was discovered which produced a concentrated ink from the natural sepia. PHJG

INNES, JAMES DICKSON (1887–1914). Welsh painter. Innes studied at the Slade School and was influenced by Philip Wilson

*Steer towards an *Impressionist appreciation of light and colour. A member of the New English Art Club, he later joined the rival Camden Town Group (see both under LONDON). Painting in the south of France he developed a use of hot, bright colour applied in small dabs which became characteristic; his work relates to the *Cloisonnist techniques of *Gauguin and the *Pont-Aven School; *South of France; Bozouls, near Rodez* (1908; London, Tate) is typical.

From 1910 the isolated Welsh landscape obsessed him, especially Arenig Fawr mountain, which he painted under various conditions of light and weather, as in *Arenig Mountain* (1910; Swansea, AG). He generally worked on a small scale, with hectic energy and very fast. His landscapes combine feeling for subtle atmospheric effects with an instinct for decorative pattern; his brilliant colour recalls *Matisse and *Derain. Ravaged by tuberculosis he still pursued a frenetic and promiscuous lifestyle, often in company with Augustus *John and Derwent Lees (1885–1931). In 1913 he painted in the Pyrenees, before travelling to Morocco hoping to recover his failing strength. He died shortly after his return to England. JH

Hoole, J., *James Dickson Innes* (1977).

INNESS, GEORGE (1825–94). American landscape painter. Born in Newburgh, NY, Inness was largely self-taught and his early works, like the panoramic *Sun Shower* (1847; Santa Barbara, Calif., Mus. of Art), are influenced by the *Hudson River painters, particularly Asher *Durand. In 1847 he visited England and Italy and, after 1850, paid frequent visits to France where he studied the paintings of *Corot and learnt much from *Diaz, Théodore *Rousseau, and other *Barbizon painters. By the mid-1850s he had abandoned Hudson River Romanticism to concentrate on the essence of landscape, limiting the physical scope of his pictures for greater intensity and blurring the outlines of his forms in the manner of Corot. A deeply religious man, he believed that the purpose of art was to refine man's spiritual nature. His paintings became increasingly subjective and poetic and at times he rapturously identified himself with natural objects. In his mature works he ignored atmospheric light, preferring to paint in broad areas of bright contrasting colour. His late work, like the dramatic *Afterglow* (1893; Chicago, Art Inst.), is intensely personal and spiritually symbolic. DER

Cikovsky, N., *George Inness* (1971).

INNSBRUCK: PATRONAGE AND COLLECTING. Innsbruck, occupying a strategically important position on the road to Italy through the Brenner Pass, is the capital of the Tyrol region of Austria. From the 1490s it was the seat of the regional Habsburg administration, intermittently used by the imperial court itself though becoming something of a provincial satellite to the court at *Vienna.

The city was closely identified with Emperor Maximilian I (ruled 1493–1519), even though his peripatetic court spent more time in Augsburg, Vienna, and Linz. The Goldenes Dachl (1500), a *Gothic double loggia with sculpture by the Swabian Niklas Türing, may have been intended as a symbolic statement of the Emperor's presence. The sculpture (originals now transferred to the Tiroler Landesmus. Ferdinandeum) includes portraits of Maximilian with his first and second wives, Mary of Burgundy and Bianca Maria Sforza.

The monument of Maximilian in the Hofkirche is the most significant piece of Habsburg patronage in the city and represented the main local art project over many years. Design was begun under Maximilian's instructions in about 1502, though the final figure was not cast until 1583. As originally conceived, the ensemble would have included a Burgundian-inspired funeral procession of 40 over-life-size bronze figures of ancestors and forerunners, together with well over 100 smaller figures of Roman emperors and Habsburg family saints. In the event the project was left incomplete, with only 28 of the large figures and with the remaining staffage scaled down accordingly. Some of the figures, including one designed by *Dürer, were cast by masters in Nuremberg, Landshut, and Augsburg, but most of the work was done at Innsbruck, where Maximilian appointed Gilg Sesselschreiber to supervise the foundry in 1508. The project's focus on legitimizing Habsburg imperial status, its overwhelmingly extravagant scale, and its strange blend of humanistic classicizing elements with a love of medieval romance and chivalry are all very characteristic of the fascinating character and fervent art patronage of Maximilian.

The final phase of work on the Maximilian monument was carried out between 1562 and 1583 by the Flemish sculptor Alexander Colin (c.1526–1612) under Archduke Ferdinand II (1529–95), Regent of the Tyrol, who presided over a glittering intellectual centre at Innsbruck. From 1565 he established a *Kunstkammer, a huge collection of portraits and a collection of the armour of famous men in Schloss Ambras. He was an important figure in the history of collecting, systematically arranging the contents of the Kunstkammer in cabinets according to their materials, and organizing a detailed catalogue of the armour.

The last major Habsburg enterprise at Innsbruck was the rebuilding of the Hofburg under Maria Theresa (ruled 1740–65). The ceiling of the main state room, the Riesensaal, was later frescoed (1776) by Franz Anton *Maulbertsch with a *Triumph of the House of Habsburg Lorraine*. AJL

Osten, G. von der, and Vey, H., *Painting and Sculpture in Germany and the Netherlands, 1500–1600* (1969).

INSCRIPTIONS, GREEK AND ROMAN. See GREEK ART; ROMAN ART.

INSTALLATION ART, a term which arose in the early 1970s to describe works of art constructed in galleries and other places—such as warehouses and museums—for specific exhibitions. The term has been applied to a diverse range of phenomena, and has been used synonymously with other terms such as *assemblage and *Environmental art. Installation art does relate to these other forms in that they all reject concentration on one object in favour of a consideration of the relationships between various elements. However, an installation may perhaps be distinguished from these other types of art by the extent to which it is bound up with the concept of 'site-specificity', relating it to *Land art (which has been interpreted as a branch of Installation art). Unlike Land art, though, installations are generally concerned with the occupation of internal spaces.

The relationships between exhibition space and work of art are in fact so closely connected in much Installation art that the distinction between the two is deliberately annulled. An example is *Vault* (1992; London, Mus. Installation) by Chris Jennings (1949–). Constructed so as to rely on its site, the piece was composed of metal rods creating a series of arcs which were supposed to define the space around them. In other works, the same objects are rearranged according to site. Antony Gormley (1950–) created several different versions of *Field*, one having clay figures arranged in a radiating pattern (1989; Sydney, AG NSW), another involving the occupation by more than 35,000 such figures of an entire gallery (1991; New York, Salvatore Ala Gal.).

In the 1980s and 1990s, installations were increasingly constructed to express the points of view of specific social groups; they have been an important element of *feminist art—as in the installations of Jenny Holzer (1950–) and Barbara Bloom (1951–)—and gay art—as in those of Robert Gober (1954–). In 1990 the Museum of Installation was opened in London, the first place dedicated to site-specific work. Subsequent exhibitions of Installation art have included *Four Rooms* at the Serpentine Gallery, London, in 1993. For this, four artists—Nat Goodden (1947–), Mona Hatoum (1952–), Vong Phaophanit (1961–), and Gladstone Thompson (1959–)—were commissioned to create installations in

each of the gallery's rooms. Other notable exponents of Installation art include Rebecca Horn (1944–), Jean *Tinguely, and Edward *Kienholz (1927–94). The works of these artists can, however, also be interpreted as Environments. OPa

Oliveira, N. de, *Installation Art* (1994).

INSTITUTIONAL THEORY OF ART, a philosophical attempt to resolve the dilemma posed by works like Andy *Warhol's 1960s *Brillo Boxes* or Marcel *Duchamp's 1920s 'ready-mades': how is it that such everyday objects can be transfigured into works of art while remaining perceptually identical with their non-artistic appearances? What makes them 'art' for followers of this theory is not the presence of visible aesthetic qualities but rather 'something the eye cannot descry—an art world' (Danto), constituted of artists, critics, art lovers, gallery owners, and the like. The 'institutionalist' view that the art world calls the tune when it comes to defining contemporary 'art' was elaborated by George Dickie in the 1970s into a general theory of art which seemed invitingly liberating at the time because of its ability to accommodate any future *avant-garde. Yet insofar as the art world's decisions cannot be challenged by appeal to any independent criteria such as *aesthetic ones, the institutionalist position has been attacked by philosophers including Tilghman and Wollheim for its ultimate arbitrariness. NMcA

Danto, A., 'The Artworld', *Journal of Philosophy* (1964).
Dickie, G., *Art and the Aesthetic* (1974).
Tilghman, B. R., *But is it Art?* (1984).
Wollheim, R., *Painting as an Art* (1987).

INSULAR, descriptive term applied to the art of the British Isles in the early medieval period, used both for the wider period between the 5th and 11th centuries, from the departure of the Romans to the beginnings of the *Romanesque style, and for the more specific phase from the 6th to 9th centuries, between the conversion to Christianity and the Viking settlements. The term was first devised in 1901 in a palaeographical context, in an attempt to distinguish between the features of early continental manuscript writing, and those common to Irish, English, and Welsh scribes, and so characteristic of the British Isles. The meaning was then extended to cover the decoration of these manuscripts, and then to other media of the period with shared or similar ornamental characteristics, particularly religious and secular metalwork and jewellery, and stone sculpture.

Several other terms have been devised for this distinctive cultural era, based variously on nationality, chronology, or subject matter, which illustrate the problems of providing a consistent and acceptable definition.

'Hiberno-Saxon' and 'Celto-Saxon' imply the artistic interaction between the native Celtic population and that of the incoming Anglo-Saxons; Hiberno-Saxon is too restrictive since it implies only the Irish, or 'Hibernian', contribution, and ignores that of North Britain. 'Early Christian' includes the third essential component, the influence of the arts of Mediterranean Christianity. But, together with the inaccurate 'Dark Age', and the rather general 'early medieval' there is no specific reference to the British Isles, since these terms are also applicable to other areas of Europe. 'Insular' prevents a contentious attribution to England, Scotland, or Ireland, given that it is normally impossible to define correctly the place of origin of a portable decorated object at this time, but suggests the generally accepted definition as belonging stylistically to the early medieval common cultural area of Britain and Ireland.

This cultural area saw the fusion and interaction of four separate art styles, with the catalyst being the advent of Christianity and the requirements of the Church. The decoration of 7th- and 8th-century manuscripts such as the Book of Durrow and the Book of Kells (Dublin, Trinity College Lib., MS A. IV. 5 and MS A. I. 6), liturgical metalwork such as the Ardagh Chalice (Dublin, National Mus. Ireland), and the crosses of Iona combine interlacing animals, as used by Anglo-Saxon jewellers, with the scroll designs of Celtic metalwork; and there are also motifs copied from imported Mediterranean items like Italian Gospel books, and animals taken from the art of the Picts, of north-eastern Scotland, whose stone sculpture both absorbed and contributed to the development of Insular art. CMH

Spearman, M., and Higgit, J. (eds.), *The Age of Migrating Ideas: Early Medieval Art in Northern Britain and Ireland* (1993).

INTAGLIO METHODS OF ENGRAVING. See PRINTS.

INTAGLIOS. See GEMS.

INTENSITY. See COLOUR.

INTERIÁN DE AYALA, JUAN (1656–1730). Theologian, philosopher, and author of several treatises and sermons. Ayala was born in Madrid and studied at Alcalá de Henares, where he entered the Mercedarian order in 1672. Later, he studied philosophy in Huete and theology at the University of Salamanca, where he became rector of the Colegio de la Vera Cruz. In 1714, he was appointed a member of the newly founded Royal Spanish Academy in Madrid, participating in the compilation of the *Diccionario de autoridades* published under the patronage of Philip V.

He is best known for his treatise *El pintor christiano y erudito*, written as a guide for painters and sculptors in the creation of religious images. Drawing on his erudition and great knowledge of the Bible, he strove to combat the ignorance of both artists and patrons, waging war on idolatrous exaggeration and misinterpretation. His treatise was published in 1730 in Latin and translated in 1782 into Spanish at the order of the Count of Floridablanca, first minister to the King, with a view to attracting a wider readership in response to growing concern about the need for 'correctness' in religious painting. Along with the works of *Pacheco and *Palomino, his treatise was an important component of contemporary artists' personal libraries. XB

INTERLACE, two-dimensional pattern which imitates the effect of three-dimensional strands passing over and under one another, as in plaiting, basketry, or weaving. Interlace can vary from simple two-strand twists used as linear borders to three- or four-strand bands which can form roundels, knotwork, or squares, or fill entire panels. With no one source of origin, its distribution has been almost worldwide in the applied arts, but it was of particular significance in early Christian art. Adapted from its role as border ornament on late Roman mosaic pavements, it was developed both in Byzantine sculpture and in the early medieval art of the British Isles. Skilled craftsmen applied ultimately Celtic or Germanic techniques of linear design to the creation of complex interlace patterns, which sometimes incorporate attenuated animal forms as well as ribbon bands: such designs are the most characteristic ornament of the crosses, Gospel books, and liturgical metalwork of the period, for example the Lindisfarne Gospels (c.698; London, BL, Cotton MS Nero D. IV). Despite its non-figural nature, there can be no doubt that interlace contributed to Christian symbolism, as a form of sacred geometry. CMH

Bain, G., *Celtic Art: The Methods of Construction* (repr. 1977).

INTERNATIONAL GOTHIC. Term in art history and criticism, denoting a late form of Gothic art, sometimes called the international style. It was first coined by Louis Courajod in 1892, in reference to a style of painting common throughout western Europe from c.1370 to c.1425. The wide-ranging application of the term to other art forms such as *mosaics, *tapestries, *enamels, *ivories, embroideries, *stained glass, and *manuscript illumination, together with a lack of precision in stylistic analysis, means that the term has only a limited usefulness.

The characteristics of International Gothic have been variously described as a stylized

elegance of form, refinement, prettiness, restrained vitality, decorative fantasy, and sumptuous colour. Others have identified an interest in nature in the form of plants and landscape, and a penchant for secular themes from aristocratic life. It is often claimed that this somewhat disparate and intangible style represented a fusion between Italian naturalism, Flemish realism, and French courtly art. It has been argued that courtly patrons helped to spread the style from northern France in the late 14th century through Flanders, Lombardy, Burgundy, the Rhineland, and as far east as Prague, as well as to England in the north and Spain to the south. However, it is highly debatable whether the art of these diverse areas in this period can be categorized by a single style.

Certain international traits can, nevertheless, be identified in the period. The influence of Italian artists on French art of the 14th century is well attested. The papal schisms of this period, and the withdrawal of the popes from Rome to Avignon, led to the building and decoration of the Palais des Papes in the second half of the century, carried out mainly by Italian craftsmen and painters under *Matteo Giovannetti. *Simone Martini was patronized by the French court, and in 1339/40 he was summoned to Avignon to lead a painters' workshop. This link with Sienese painting, with its emphasis on Byzantine models, influenced native French artists and was an important factor in spreading the achievements of *Duccio. The French illuminator Jean *Pucelle was one such artist influenced by Italian/Byzantine styles, and who may even have travelled to Italy himself. His workshop dominated manuscript painting in Paris during the first half of the 14th century.

Pucelle is sometimes regarded as one of the earliest exponents of International Gothic, with his eclectic and highly successful fusion of greater corporeal naturalism with traditional iconography on ornate decorative backgrounds. The importance of *Paris as an artistic centre, particularly in the book trade, meant that many foreign artists gravitated towards the French capital, attracted by the wealth of patrons. The *Limburg brothers were just such artists, moving from their native Guelders to Paris in 1399. They executed some of the finest illuminations of the period, for John, Duke of Berry, including the Très Riches Heures (c.1412–16; Chantilly, Mus. Condé), which is frequently cited as the greatest work of the International Gothic style.

Other artists normally associated with this style are Jan *Baudolf, the Boucicaut *Master, and the Bedford *Master. The latter are named after their patrons, Jean de Boucicaut, Marshal of France (d. 1421), and John, Duke of Bedford, Henry V's brother and Regent of England during the minority of Henry VI. If the disparate group of artists associated with International Gothic have anything in common it is the patronage of a small, intimately connected group of aristocratic patrons such as these men. Others in the group included King Charles V of France, his two brothers John, Duke of Berry, and Philip the Bold, Duke of Burgundy, King Wenceslaus of Bohemia, and King Martin of Aragon. These kings and princes shared many family ties and a love of courtly display that culminated in liberal patronage of the arts and it is in this, rather than any single style, that any unity in the arts lies in the period between c.1375 and c.1425. TJH

INVENTION (Italian invenzione; Latin inventio), a term that embraces the artist's ability to find or to conceive a powerful subject, and the general planning of the composition. It originated as one of the stock elements of rhetoric in classical Antiquity, as set forth by *Quintilian (Institutio oratoria 3.3), and was transferred to the visual arts in the *Renaissance. The Venetians *Pino and *Dolce divided painting into three parts, invenzione, disegno, and colorito (see DISEGNO E COLORE), and Italian critics urged the painter to study poetry and history, the stimulus to fine invention. Artists began to claim the right to suggest their own subject matter, unshackled by scholars or patrons. When Isabella d'Este (1474–1539) attempted to prescribe a subject for Giovanni *Bellini, Pietro Bembo (1470–1547) reminded her that great artists prefer to work to their own invention. Invention did not necessarily imply novel subjects, but rather, as *Poussin commented, singular and new treatments of traditional themes. In the 18th century it began to suggest the artist's power to arouse wonder by subjects of the greatest beauty and perfection. HO

IRISH ART begins with abstract decoration on Bronze Age gravestones, as at Newgrange, Co. Meath. Expressive linear pattern, natural observation, and a pervasive vein of fantasy form the roots of a distinctive tradition too often considered outside its national context.

Initially the Church dominated Celtic society; illuminated sacred texts are among the glories of Irish art. The Book of Durrow (Dublin, Trinity College) and the Lindisfarne Gospels (London, BM), both 7th century, combine imagination, decoration, and realism, perfected in the 8th-century Book of Kells (Dublin, Trinity College), and in carved wayside crosses and ornamented metalwork. Ninth-century Viking raids ended this period, although the interwoven motifs of the Cross of Cong Abbey (c.1123; Dublin, National Mus. Ireland) recall past achievements. From the 12th century Norman examples dominated arts and crafts; not until the 15th century did Irish art regain its originality.

Painting flourished through the 16th and 17th centuries. Landscape developed from military woodcuts to a distinct genre, while James Gandy (1619–89) and Thomas Pooley (1646–1723) gave portraiture the directness and sympathy which became characteristic. English artists took the 'Irish Tour', contributing to the new enrichment of Irish culture—Charles Jervas (1675–1739) was the most influential. Dublin's portraitists prospered, notably Thomas Frye (1710–62) and James Latham (1696–1747); the Dublin Society, founded in 1731 and granted royal recognition from 1820, initiated various schemes promoting the arts. John Butts (d. 1765), painting landscapes around Cork, influenced George *Barret and James *Barry, the first Irish artists to gain international recognition, while the philosopher, statesman, and connoisseur Edmund *Burke shaped European aesthetics with his writings.

Through the 19th century many artists migrated to more dynamic centres, particularly London. Barret's landscapes were acclaimed; Daniel *Maclise became one of England's most noted history painters; while Martin Archer Shee (1769–1850) achieved presidency of the Royal Academy (see under LONDON). Barry was less successful—over-ambition marred his imaginative flair, while his notorious temper made him the only artist ever expelled from the Academy. Francis *Danby achieved fame with biblical spectaculars and lyrical landscapes, while William *Mulready's subject pictures, including The Last in (1835; London, Tate.), helped establish the Victorian taste for narrative genre.

In 1880s Belgium the Antwerp School artists, led by Walter Frederick Osborne (1859–1903) and Joseph Kavanagh (1856–1918), worked under *Symbolist influence, bringing evocative mystery to Irish settings. Several later painted in Brittany, including Dermod O'Brien (1865–1945), president of the Royal Hibernian Academy, the most significant foundation in a stormy history of institutions, which, from 1823, provided a relatively stable centre for artistic activity into the current century.

Not all artists left Ireland. Landscape thrived, James Malton (d. 1803), George Petrie (1790–1866), and William Davis (1812–73) being the most distinguished practitioners. James Arthur O'Connor (1792–1841), another Irish peripatetic, influenced Dublin and London with atmospheric landscapes, while Nathaniel Hone the younger (1831–1917) developed the lessons of *Barbizon in Pastures at Malahide (Dublin, NG Ireland). Roderic O'Conor (1861–1940) worked with *Gauguin at Pont-Aven, sending home distinctive *Post-Impressionist paintings.

Twentieth-century Irish artists were distinguished for diversity. William *Orpen's accomplished portraiture won popularity in pre-war London; Belfast-born John Lavery (1856–1941) influenced the Glasgow School. Sarah Purser (1849–1943) applied the psychological acuity of *Degas and *Manet to Dublin's inhabitants, while John B. *Yeats produced outstanding portraits, notably his sons, the poet William and painter Jack.

Jack B. *Yeats captured the essences of Irish life: his sensitive watercolours and ruggedly expressive oil paintings, sparsely populated with mysterious figures, convey the obstinacy, sensitivity, poverty, and strangeness to which *The Two Travellers* (1942; London, Tate) gives universal power. He stands alone, deliberately isolated, and refusing pupils; a maverick genius.

A new generation explored *Impressionism and Post-Impressionism. Paul Henry (1877–1958) and James Craig (1877–1944) studied light in Connemara, while George Russell ('AE', 1867–1935) transformed peasant communities into scenes from a mythical fairyland. W. J. Leech (1881–1968) experimented with *Pointillism, but his strength lies in enigmatic, implied narrative, as does that of Sean Keating (1889–1977), Patrick Tuohy (1894–1930), and Charles Lamb (1893–1964), who painted an enduring rural Ireland with simple directness overlying lyricism, recalling the writings of Yeats and Synge.

Mainie Jellett (1896–1943) and Evie Hone (1894–1955) developed Parisian experiences of *Cubism in a local context: Jellett's *Deposition* (Dublin, Gal. of Modern Art) is a powerful example of semi-abstract religious art. Another Irish original, Louis Le Brocquy (1916–), expressed themes of Irish dispossession and isolation through formal dissolution. Conscious national pride has developed an art universalizing Ireland's ancient and continuing problems, exemplified through figures and landscape by Gerard Dillon (1916–71), Colin Middleton (1910–83), Daniel O'Neill (1920–74), and Norah McGuiness (1901–80). William Scott (1913–89) became central to London abstract painting, while Derek Hill's (1916–) wild seascapes provide a rare example of an Englishman working in Ireland. Inspired by his work, James Dixon (1887–1970) captured Irish coastal life with evocative primitivism.

Irish sculpture has a long history, developing authoritatively through the 19th century and up to the present. F. E. McWilliam (1909–92) made his mark in London and Paris; at home Andrew O'Connor's (1874–1941) *Daniel O'Connell* (1931; Dublin, National Bank) was highly influential, while the religious abstracts of Oisin Kelly (1915–81) recall medieval glories. Hilary Heron (1923–77), Gerda Fromel (1931–), and recently Dorothy Cross (1956–)

continue metamorphic, religious, and abstract traditions with a distinctively *feminist slant.
JH

Arnold, B., *A Concise History of Irish Art* (1969).
Dillon, M., and Chadwick, N., *The Celtic Realms* (1967).
Fallon, B., *Irish Art 1830–1990* (1994).
McConkey, K., *A Free Spirit: Irish Art 1860–1960* (1990).
Snoddy, T., *Dictionary of 20th Century Irish Artists* (1996).
Strickland, W. G., *A Dictionary of Irish Artists* (new edn., 1968).

ISABEY, FATHER AND SON. French painters. **Jean-Baptiste** (1767–1855) was a French portrait and miniature painter. Born in Nancy, he trained under Jacques-Louis *David and achieved success as a painter of leading figures of the French Revolution which culminated with his appointment as court painter to Napoleon (1769–1821) and, after 1814, the Bourbons. His son **Eugène-Gabriel** (1803–86), born in Paris, was a historical and marine painter whose successful career lasted from his debut in the Salon of 1824 until his death. He painted modern and medieval history in a romantic decorative style derived from *Delacroix and his colour was praised by *Baudelaire in his 1845 Salon review. He is, however, better known for his sea pieces. In 1830 he sailed to Algiers with the French navy as a marine painter and, later, painted many works on the Normandy coast. His scenes of the everyday life of fisherfolk ally him to the *Barbizon School but his innate *Romanticism is seen in his pictures of storms and shipwrecks, like *Boat in a Storm* (c.1850; York, AG), painted with great panache and a characteristic use of impasto.
DER

Miquel, P., *Eugene Isabey* (1980).

ISENBRANDT, ADRIAEN. See YSENBRANDT, ADRIAEN.

ISRAELS, JOZEF (1824–1911). Dutch painter. He studied in Amsterdam and in Paris under *Delaroche who influenced the historical pieces Israels painted on returning to Holland in 1847. His work underwent a dramatic change in 1855 when he began to paint the everyday life of poor fisherfolk in Zandvoort, realistic and sombre but not without nostalgic sentimentality. He settled in The Hague in the 1870s becoming a leading figure in the *Hague School. His peasant studies influenced van *Gogh. His son Isaac (1865–1934) was a Dutch *Impressionist painter; both are represented in Amsterdam and The Hague.
DER

Eisler, M., *Josef Israels* (1924).

ISTORIA (or *historia, storia*) (Italian: history or story), a term introduced in 15th-century Italy to describe the then newly ambitious narrative subjects, drawn from Christian or classical literature, and believed to represent the painter's highest achievement. As an art historical term it has no precise equivalent in English. It was defined in books 2 and 3 of *Alberti's treatise *On Painting* (written 1435). For Alberti an *istoria* must convey an elevated story through beauty, expression, and the movements of the body; it must give pleasure through a rich variety of colours, and of figures, animals, and buildings. One figure should relate, through gesture or glance, directly to the spectator. Alberti's examples are drawn from ancient art, except for *Giotto's *Navicella* mosaic (Rome, S. Peter's; lost), which he praised for its variety of expression. Literary men can inspire the artist, and Alberti cites *Lucian's description of the *Calumny of Apelles*, a celebrated ancient painting which *Renaissance artists, most famously *Botticelli (Florence, Uffizi), were inspired to recreate. In later centuries its meaning became less precise, and academic theorists used the term history painting to denote morally weighty human narratives.
HL

Alberti, L. B., *On Painting* (1991).

ITALIAN ART (1) *Introduction*; (2) *The 13th and 14th centuries*; (3) *The 15th century*; (4) *The 16th century*; (5) *The 17th and 18th centuries*; (6) *The 19th and 20th centuries*

1. INTRODUCTION
Italy became a single nation in the 19th century, when the nationalistic movement (Risorgimento) achieved its aim of political unification under the house of Savoy. Before that, and since the decentralization that followed the ending of the Roman Empire in the 5th century, it had been a mass of separate regions, with no national identity. After about 1200 there evolved a variety of political entities. There were the city states of northern and central Italy; the marine republic of Venice; the papal court of Rome; princely courts ruled over by local families, and, in the south, the kingdom of Naples and Sicily, ruled by the Angevins and Aragonese. The French, Spanish, and Austrians fought over Italy from the late 15th century, and by the late 18th century the country was subject to the Spanish Bourbons and Austrian Habsburgs. Napoleon invaded in 1796, and, after the Congress of Vienna (1814–15), the Risorgimento flourished. This history has encouraged the growth of local schools of art, and the *campanilismo* of individual cities and regions has been important in Italian art; yet it has also been enriched by a wealth of cultural exchanges, both within the peninsula and from other European countries.

2. THE 13TH AND 14TH CENTURIES

In the second half of the 13th century artists began to create a fresh new naturalism, and it is perhaps from this moment that we can speak of 'Italian' art. In the early century *Byzantine influence was strong, for after the capture of Constantinople (1204) some of the Greek workshops were brought to Italy. In Rome this influence blended with that of *early Christian and ancient art. *Torriti and *Cavallini introduced a new note of Antique grandeur into the decoration of Roman basilicas. In the Tuscan city-states artists in Pisa, the *Berlinghieri family in Lucca, and *Coppo di Marcovaldo and *Cimabue in Florence painted great crosses and Madonnas which reflect Byzantine styles, culminating in a series of vast gabled *Maestàs* produced in Florence and Siena around the turn of the century. The painted *altarpiece, initially of a horizontal rectangular format, appeared in the mid-13th century. A new realism and emotional power were introduced by the sculptors Nicola and Giovanni *Pisano from the 1260s. Nicola revived the naturalism of ancient art, while Giovanni also responded to French *Gothic, and on the façade of Siena Cathedral his sculpture seems to burst out of its architectural frame. The carved *pulpit, the sculptural *tomb and the *equestrian monument were important forms.

The 14th century opened with the Florentine *Giotto's fresco cycle *The Lives of the Virgin and Christ* (1305–8: Padua, Arena chapel). Giotto created a new interest in naturalism and three-dimensional space. His settings are stark, yet spatially convincing, and his figures, weighty and yet simplified, convey human feeling with new power. Giotto also worked in Naples and Florence, and in the early years of the 14th century many mural narrative cycles were produced, often by his followers, and often, as in the upper church at Assisi, showing the life of S. Francis. Franciscan spirituality itself encouraged an emphasis on narrative, for it valued the visible world, and new popular texts, such as *The Golden Legend* (before 1264) and the *Meditations on the Life of Christ* (c.1270), laid fresh emphasis on lively human stories.

At Siena *Duccio's *Maestà* (Siena, Mus. dell'Opera del Duomo) added bright narrative to Byzantine splendour. After 1320 large Sienese workshops collaborated on the creation of vast *polyptychs, where the lavish use of burnished gold creates awe, and many artists, above all *Simone Martini, were dazzlingly skilful in creating rich fabrics, executed in sgraffito, and elaborately tooled haloes. Giotto's naturalism influenced Pietro and Ambrogio *Lorenzetti, who were innovatory in their treatment of space and emotionally expressive form. But the 1350s saw a return to a more conservative, hieratic style, and Tuscan art was dominated by the Florentine workshop of the di *Cione family, whose altarpieces are characterized by severe figures amid sumptuous draperies and ornamental frames.

3. THE 15TH CENTURY

*Renaissance ideas began to spread from the late 14th century. Renaissance, or rebirth, meant a revival of classical learning and a renewed interest in the visible world and in the power of man. In painting and sculpture it inspired a greater naturalism, indebted to ancient art. Artists were stimulated by *Pliny's descriptions of painted grapes so magically real that the birds pecked at them. Illusionistic skills came to be admired more than costly materials, and collectors began to value an individual artist's style. A more liberal attitude to art developed, encouraged by the first treatises, such as *Alberti's *On Painting* (1435). Through the invention of single vanishing-point *perspective, the study of anatomy and the analysis of *proportion, and the study of light and shade, the Renaissance artist created a new reality. There was a constant interchange of ideas between sculptors, painters, and architects.

Florence was the main centre of *humanism and of the new art, and sculptors took the lead. Monumental *bronze-casting projects were concentrated there, such as *Ghiberti's second and third pair of baptistery doors, on which he worked for 50 years at the head of a large studio. Sculptors vied with the achievements of classical Antiquity; *Donatello's bronze *David* (Florence, Bargello) recreated the free-standing, life-size nude, while his *Gattamelata* (Padua) recalled the *equestrian monuments of classical Rome (see ROME, ANCIENT ART). The portrait *bust, the portrait *medal, and the classicizing tomb (e.g. Bernardo *Rossellino's *Leonardo Bruni*, c.1445–50; Florence, S. Croce), all ancient themes, became popular. Donatello also introduced a new kind of pictorial relief, suggesting atmospheric space through very low relief (*rilievo schiacciato*).

In painting the *International Gothic, an aristocratic, decorative art, which developed from Simone Martini and Lombard and Franco-Netherlandish stylistic sources, continued well into the century, and there is a delight in sumptuous golds and patterns in the art of *Gentile da Fabriano and many later painters.

A new kind of painting began with *Masaccio in the 1420s. He used the new perspective to create a convincing illusionistic space, unified by directed light; his solid figures, influenced by the Antique, convey a rare gravity of feeling. Later generations (Fra *Angelico, Fra Filippo *Lippi, *Pollaiuolo, *Uccello) united his discoveries with an interest in colour, in landscape, in atmospheric perspective, and in the figure, especially the male nude, in movement. Demand grew for mythological pictures to decorate *palazzi* and villas, such as *Botticelli's *Birth of Venus* and *Primavera* (Florence, Uffizi). Small devotional images, *deschi da parto*, and marriage chests were created for domestic settings. *Portraits, initially in profile, but later in three-quarter or full face, were a popular new form, inspired by a new interest in man's individuality.

In Siena artists responded to the Florentine preoccupation with space, yet retained a traditional interest in rich decoration. In Umbria *Piero della Francesca combined a subtle luminosity with consummate geometrical skill. *Mantegna revived the illusionism of ancient art for the humanist court of *Mantua, while Ferrarese painters (*Tura, *Cossa, Ercole de' *Roberti) specialized in fantastic ornament. In the kingdom of Naples art celebrated royal power. A team of sculptors created a marble triumphal arch in honour of Alfonso of Aragon, while monumental, multi-tiered tombs inspired awe and reverence for royal virtue. Several courts, most famously the court of Urbino, had *studioli*, decorated by paintings of Muses and a display of perspective skill in intarsia.

The *medium of most 15th-century painting was egg tempera, and colours and light tend to be bright and clear, and edges hard. But the works of Netherlandish painters in oil were known in several Italian cities, and gradually Italian painters began to work in oil, predominantly in Venice. Strong links with Byzantium and the East had inspired a richly decorative Venetian style, but Giovanni *Bellini, who began to paint in oil, moved from a sharp linearity to a warm atmospheric art. A new kind of small easel painting, of pastoral and literary themes, was introduced by *Giorgione, who achieved a rare unity between figure and landscape, form and light.

4. THE 16TH CENTURY

In the early years of the 16th century, traditionally labelled the High *Renaissance, the concept of the creative genius was born, above all in the lives and works of *Leonardo da Vinci, *Raphael, and *Michelangelo. Leonardo likened the artist's creativity to that of God, and the artist was celebrated for *invenzione* (see INVENTION), or imaginative power. Sculptors and painters became supremely confident, and 15th-century scientific naturalism yielded to an idealizing art, characterized by a new softness of colour and atmosphere, by grace, ease, and harmony, and by a new grandeur and psychological complexity.

The High Renaissance style was initiated by Leonardo, who developed a profoundly influential *sfumato* modelling through light and shade; he created grand and balanced compositions that gave new emphasis to a dramatic language of gesture and *expression. Raphael and Michelangelo developed

his compositional complexity, particularly in the pyramidal groups of Raphael's Madonnas, and in the *tondo. The centre moved from Florence to Rome, where the *Domus Aurea* of Nero, and many classical Roman sculptures (see ROME, ANCIENT ART), were rediscovered. Artists now emulated and surpassed these ancient works, and, in the first two decades of the century, Michelangelo and Raphael created a style that spread through Italy, hastened by the new importance of *drawings and engravings. Michelangelo's Sistine ceiling (Vatican) and colossal *David* (Florence, Accademia) are displays of the heroic power and awesomeness of the male nude, while Raphael's frescoes in the Stanza della Segnatura (Vatican) epitomize High Renaissance symmetry and balance. The sources of *Mannerism, a style distinguished by a display of virtuoso skill and a formally sophisticated treatment of the figure and of space, lie in the late Roman works of these artists. Mannerist painters—*Pontormo, *Rosso, *Giulio Romano, *Parmigianino—developed, in different ways, high-keyed *cangiante* colours and elongated or excessively muscular figures set in irrational space. The Mannerist portrait was icily formal, or esoteric and darkly brooding. In sculpture Medici Florence was central, and Mannerist sculptors—*Cellini, *Ammanati, *Giambologna—created graceful and intricately detailed works. The *figura serpentinata*, and spiralling groups of figures, became the showcase of the sculptor's mastery of design.

From mid-century Venice competed with Rome as Italy's artistic centre. Venetian art was more painterly than the sculptural art of central Italy, and artists used light and colour more dramatically; *Titian, *Tintoretto, and *Veronese developed the expressive power and illusionism of oil painting. Writers became passionately partisan, some praising Venetian *colore*, and others Florentine *disegno* (see DISEGNO E COLORE). Venetian painters were important to the development of landscape painting, creating idyllic pastoral scenes, and studying the dramatic effects of dusky light on the waters of the lagoon, or the play of dark foliage against sunset skies. The theme of the female nude, and the erotic mythology, or *poesia*, are special contributions of Venetian art; as is the illusionistic ceiling painting on canvas, set into compartmentalized frames. In Lombardy art was more soberly naturalistic, and *Moretto introduced the full-length portrait, a type ennobled by Titian and Veronese. Beyond the Venetian border Dosso *Dossi at Ferrara developed a romantic style of painting, and *Correggio at Parma a daring illusionism.

Throughout the 16th century the political and religious worlds were in chaos. In 1517 the Reformation began, and in 1527 Rome was sacked by the troops of Emperor Charles V. The Catholic Church responded to the threat of Protestantism with the Council of Trent (1545–63), and towards the end of the 16th century there was a demand for a direct and clear religious art, that rejected the abstruseness of Mannerism and limited the use of the nude. The Catholic Reformation encouraged new religious themes, particularly devotional images of the Virgin, scenes of martyrdom, and paintings of saints, especially in ecstasy.

5. THE 17TH AND 18TH CENTURIES

In the years around the turn of the century painters in Rome and central Italy began to move away from the cold, sculptural style of the 16th century, and to renew an interest in nature and in the glowing colour of Venice. To their contemporaries the works of Annibale *Carracci and *Caravaggio seemed to restore the lost splendour of Roman painting. The Bolognese Carracci united a passionate study of nature with an interest in both ancient art and in the Renaissance, creating figures both warm and palpable and yet ideally beautiful. Annibale Carracci's decoration of the Farnese Gallery in Rome, preceded by very many studies from life and compositional drawings, was immensely influential. Sixteenth-century aesthetic treatises stressed that art should be rooted in nature, and yet idealized, and the naturalism of the Lombard Caravaggio was intensely provocative; he painted directly onto the canvas, without preparatory drawings, and used aggressively common models in his religious works. Bold contrasts of light and dark introduced a new violence and theatrical drama. The illusionistic power of Caravaggio's art enthralled younger artists, and many became his followers.

In the 1620s, as the Protestant threat waned, and the Catholic Church became increasingly triumphalist, sculptors and painters developed the *Baroque style in Rome, now the artistic centre of Europe. This is a splendid style, which makes a strong appeal to the spectator. Artists developed illusionistic techniques, conveyed passion through a wider range of gesture and expression, and treated movement and space in new, dynamic ways, breaking down the barrier between the painted and real worlds. Sculptors created a wealth of portrait busts, *fountains and garden sculpture, and life-size marble statues, often of ecstatic or dying saints, and grandiose tombs for Roman churches. *Bernini, a virtuoso in the management of richly coloured materials, light, and setting, transformed every sculptural form and mastered every effect of movement; he created a series of influential works which fuse the three arts of painting, sculpture, and architecture. *Lanfranco's frescoed dome the *Assumption of the Virgin* (Rome, S. Andrea della Valle), which incorporates the real light admitted by the lantern, was seminal to Baroque illusionism, while Pietro da *Cortona's vast fresco *The Triumph of Divine Providence* (Rome, Barberini Gal.) initiated the overwhelming power of the high Baroque.

Throughout this period classicizing artists resisted this exuberance. They preferred paintings that consisted of few figures and were clearly composed and easily read, with severe, relief-like compositions. Annibale's late Roman style inspired his pupils, *Domenichino and *Reni, who developed classicizing styles, rooted both in the Antique and in Raphael, early in the century. In the 1630s *classicism became increasingly influential, in the art of *Sacchi, and with a French artist, *Poussin, as its greatest exponent in Rome. Ideal *landscape painting was another form of classicism, introduced by Annibale; it depended on drawing from nature, yet selecting and idealizing natural forms to suggest an ancient world more harmonious and more beautiful than the real world.

Other centres made significant contributions to the Baroque. Florentine painters created languorous, sensual works for the Medici court, while Bologna became the centre of *quadratura* painting, and in the Borromeo era Milanese painters, above all G. B. *Crespi and G. C. *Procaccini, created a darkly passionate religious art. In the *Sacri Monti* of Lombardy sculptors and painters together produced realistically detailed *tableaux vivants* of religious subjects which startle the spectator with their shocking emotional power. But the liveliest regional schools were those of Genoa and Naples. Genoa was a centre of decorative fresco painting, and at the same time its artists, including above all B. *Strozzi, receptive to the presence of Flemish painters, introduced a new kind of rustic genre. Naples was dominated by Caravaggio, who had worked there, and his presence transformed Neapolitan art. The Spanish *Ribera and native painters (*Caracciolo, *Stanzione, *Preti) developed his *chiaroscuro, his harsh realism, and his violent themes.

In the second half of the century artists began to move towards the lighter rhythms and all-over flickering patterns that characterize the late Baroque. In the late 17th and early 18th centuries the vaults of many Roman churches, and palace ceilings, were decorated by such artists as *Gaulli, *Pozzo, Giovanni Coli (1636–81), and Filippo Gherardi (1643–1704), with sumptuous illusionistic frescoes. The marble relief and sculptural altarpiece, heralded by Algardi's *Encounter of Leo the Great and Attila* (1646–53; Rome, S. Peter's), and increasingly painterly in treatment, became a characteristic form of late 17th and early 18th sculpture in Rome, Florence, and Venice. *Stucco was a popular medium, handled with brilliant *Rococo grace by *Serpotta in Sicily. In the final years of the 17th century, however, Roman art was dominated

by the classicism of *Maratti, whose calm and simple forms inspired a greater classicism in Roman sculpture and culminated in the *Neoclassicism of *Mengs.

As Roman patronage declined, Naples, and increasingly Venice, became the centres of late Baroque and Rococo art. Decorative painters, above all *Giordano and Sebastiano *Ricci, created a dazzling decorative style, swiftly executed, with light and airy colours, and softer rhythms, indebted to Cortona and to 16th-century Venetian art. Baroque merges into Rococo, and many leading artists travelled widely. Neapolitan painters worked at *Turin, where their art was touched with a French Rococo charm. And in the 18th century Venetian art, so dull in the 17th century, rose to new splendour. The sombre dark altarpieces of *Piazzetta are the last great exemplars of Counter-Reformation religious art, while *Tiepolo painted luminous and high-keyed frescoes of religious and mythological subjects.

In Naples and northern Italy there was also an interest in realistic *genre, ranging from G. M. *Crespi's vivid, unassuming motifs, to *Ceruti's sordid array of beggars and cripples, *Traversi's ironic scenes of middle-class life, and *Longhi's pictures of Venetian life. Naples was also a centre of still-life painting, of kitchen scenes with fish, and of increasingly profuse flowers and fruit. This was the era of the *Grand Tour, and artists in Rome, Venice, and Naples developed new forms of art—view paintings (see VEDUTA), *capricci, the Grand Tour portrait—to satisfy the tastes of tourists. Rome became a museum of antiquities, and foreign visitors bought capricci of Roman ruins by *Panini, and etchings by *Piranesi, while *Batoni painted them elegantly posed before ancient monuments. In Venice they sat to Rosalba *Carriera, and the dignity and order of Venice were painted by *Canaletto, while *Guardi caught its poetry and atmosphere. The Venetian *Canova moved to Rome in 1781, where his tomb of Pope Clement XIV (1783–7; Rome, SS Apostoli), its simplicity so suggestive of Greek art, introduced Neoclassicism.

6. THE 19TH AND 20TH CENTURIES

Throughout the 19th and 20th centuries Italian artists struggled with the vast weight of a great yet sometimes crippling tradition. Artists turned away from academicism, and in the early 19th century artists of the Scuola di Posillipo, responding to English traveller artists, painted lyrical and romantic Neapolitan landscapes, while in 1856, in Florence, a group of painters called the *Macchiaioli was formed; its members painted *plein air sketches, influenced by *Barbizon realism, in macchie (patches) of colour. They also painted portraits and bourgeois interiors. In the 1860s and 1870s Milan became the centre of the Scapigliatura (dishevelled), a literary and

artistic movement whose members chose a bohemian way of life, and whose more *Impressionist brush stroke influenced Divisionism, a less scientific variant of French Neo-Impressionism. This originated in Lombardy and Piedmont (1891–1907), with *Segantini its best-known practitioner. In sculpture Medardo *Rosso reacted against academicism by modern subjects and by breaking open his forms and studying light on roughened surfaces.

The break with the past became more confident and rowdy in 1909 when the poet *Marinetti founded *Futurism, a movement which made a major contribution to 20th-century art. Marinetti sought freedom from the past, preaching the destruction of museums and academies, and glorifying, in a series of exuberant manifestos, the modern world, machinery, speed, violence. Artists responded, and, in urban and industrial subjects, sought new forms to suggest an ideal of speed, showing movement by successive aspects of forms in motion or by 'lines of force', and developing from *Cubism a dynamic fragmentation of form. *Boccioni's Unique Forms of Continuity in Space (1913; New York, MoMa), with its emphasis on action and dissolving forms, is a seminal Futurist work.

But with the First World War Futurist optimism faded, and *Metaphysical painting, founded by *Carrà and *de Chirico in 1917, is pervaded by a deep sense of loss; these artists painted dreamlike empty squares, inhabited by disturbing mannequins and classical statues, redolent of a lost past. In the post-war period Italian artists participated in the 'call to order' that took many forms in European art, and was given critical support by the Roman journal *Valori plastici (1918–22). It was manifest in a new classicism, in simple geometric forms and structure, and in traditional subjects (landscape, the nude, peasant life) and techniques; *Morandi's still lifes explore order and harmony. In Italy it was often intensely patriotic, and many artists looked back to earlier Italian art, to the trecento and Renaissance, and above all to Giotto and Piero della Francesca, whose influence pervades Felice *Casorati's haunting Silvana Cenni (1922; Turin, priv. coll.) painted in tempera and epitomizing this moment in Italian art. Others, such as the sculptor Arturo *Martini, and Massimo *Campigli, created a more archaizing style, drawing inspiration from ancient myth and *Etruscan art. In 1922 the Novecento Italiano was founded, which promoted the revival of classical and Renaissance traditions; some of its artists were associated with Fascism, and in the 1930s large-scale murals and sculptures supporting Fascist ideals were created. A second generation of Futurists, the 'Aeropittura', painted man's conquest of space.

After the Second World War artists responded to its terrors in varying ways, as in

the red-stained sackcloth collages of *Burri, so evocative of blood, or in *Manzù's doors for S. Peter's in Rome (1964) with their depiction of cruelty and violence. An anti-Fascist group, Corrente, had been founded in Milan in 1938, and after the war *Picasso's Guernica (Madrid, Reina Sofia) exerted a powerful influence on artists of the Fronte Nuovo delle Arti (1947–8) whose work, as in *Guttuso's disturbing and aggressive social realist pictures, had a strong political content. In the 1960s American styles dominated the art world, and Italian art reflected international contemporary movements—Arte Povera, *kinetic art, happenings (in 1961 Manzoni signed people as Manzoni works of art), and *Super-realist (Pistoletto). But the *Postmodernism of the 1980s encouraged a return to Italian traditions; Carlo Maria Mariani (1931–) linked past and present by the exploration of classical myths and forms; Francesco Clemente (1952–) and Sandro Chia (1946–) restored a painterly art, with an expressive style that often used dream symbolism and archetypal Mediterranean myths.

HL

ITALIAN ART AS OBJECTS OF PATRONAGE AND COLLECTING. See overleaf.

ITTEN, JOHANNES (1888–1967). Swiss painter, theorist, and educationalist. Initially trained as a schoolteacher, Itten subsequently resolved to become a painter and studied in Stuttgart 1913–16. He then moved to Vienna where he opened an art school and met the architect, Walter Gropius (1883–1969), who invited him to teach at the newly founded *Bauhaus in 1919. Itten ran the progressive and highly influential preliminary course, in which development of the inner self was emphasized. As a painter he was much interested in *colour theory—Die Begegnung (1916; Zurich, Kunsthaus). Zealous pursuit of Mazdaism made him enemies, and discordance with Gropius prompted his resignation in 1922. He founded his own school in Berlin (1926, closed 1934) and in 1932 became director of a school of textile art in Krefeld. Sacked by the German authorities, he returned to Switzerland in 1938 and until 1953 ran the Zurich Arts and Crafts Museum and School. He also set up and directed (1952–6) the Rietburg Museum of Non-European Art. Later years were spent revising and publishing theories of art and education; his influence persists in many design courses today.

AA

Rotzler, W. (ed.), Johannes Itten: Werke und Schriften (1978).

IVANOV, ALEKSANDR (1806–58). Russian painter. He studied at the Imperial Academy 1817–28, where his father Andrey

continued on page 380

· ITALIAN ART AS OBJECTS OF PATRONAGE AND COLLECTING ·

1. Italy

A belief in the supremacy of Italian art dominated European taste until the 20th century, and Italians, in whose society the pictorial arts play a vast role, have primarily patronized Italian artists, and collected Italian art. The religious world demanded an unparalleled wealth of frescoes and altarpieces, mosaics and tombs, and complex networks of patronage were involved. Princely rulers, small states, and republics all saw the power of art to exalt their lineage or authority, while individuals used the splendour of a rich art collection to display wealth and status, or to create domestic joy and pleasure. Until the creation of the nation state (1861) Italy had no cultural unity, and local pride and patriotism, and the spirit of competition, played a large role in patronage and collecting, for celebrated artists became symbols of the glorious history of city or state. The Italian tradition of patronage and collecting is distinguished by its wide and cultured sympathies; it has been relatively free of a desire to restrict or regiment the artist.

In the Middle Ages churches and monasteries were active patrons of didactic and devotional art, and from the 8th to the 12th centuries the Benedictines were dominant. From c.1200–1400 the mendicant orders, funded by merchants and bankers, became the focus of patronage, commissioning vast altarpieces, and, particularly in Franciscan churches, narrative fresco cycles. Celebrated Florentine and Sienese artists worked at S. Francesco in *Assisi, and Sienese artists produced altarpieces for Florentine churches, where the members of a choral confraternity commissioned *Duccio's *Rucellai Madonna* (Florence, Uffizi). After 1320 private altars and chapels proliferated, such as those built by the Bardi and Peruzzi families in S. Croce, Florence, which were frescoed by *Giotto. With the rise of the city-state the government became a powerful patron, and the communes vied with one another in the grandeur of their commissions. In early 14th-century *Florence the guilds were significant patrons, while in Siena the government of the Nine honoured Sienese artists, celebrating Duccio's great *Maestà* (Siena, Mus. dell'Opera del Duomo) as an image of Siena's identity. *Simone Martini and Ambrogio *Lorenzetti's

decoration of the new town hall sang the virtues of good government, and these 14th-century works came increasingly to represent the splendour of Siena and its art. A civic pride is conveyed by the monumental sculptures and sculptural decoration which enrich the cathedrals of Milan, Florence, Bologna, and Siena, and the Florentine Or San Michele became an arena where the guilds competed in ever grander commissions.

With the *Renaissance the emphasis moved towards the individual, and Florence was dominated by the Medici desire to convey its lustre through art, while other rich merchant families—the Strozzi, the Sassetti—displayed their wealth through sumptuously decorated chapels. The kingdom of *Naples and the duchy of *Milan, and the smaller courts of *Mantua, *Urbino, and Ferrara saw the power of art to convey their aspirations, and a new courtly patronage developed. At Ferrara the emphasis was on local artists, and the aim to foster a sense of tradition and identity through native painters, while at *Naples Alfonso of Aragon was attracted by the fame of *Pisanello, a much travelled artist who created chivalric images for many courts. Tuscan sculptors were also prominent in Naples, and Antonio *Rossellino and Benedetto da *Maiano executed works for the church of Monteoliveto. At the same time, stimulated by *humanism, and by *Pliny's descriptions of Roman collectors, a new tradition of collecting pictures began. Fifteenth-century Florentines felt that they were living in a great epoch, and that Florentine artists were unparalleled. Their interest shifted from devotion to art, and Giovanni Rucellai's (1403–81) daybook conveyed pride in the fame of the Florentine artists, among them *Uccello and *Lippi, represented in his palace. Small-scale works for the home, celebrating marriages and births, such as *cassoni*, *deschi da parto*, and painted beds, became fashionable. Patronage and collecting became less easy to distinguish. Isabella d'Este, and Alfonso I d'Este, rather than employing court artists at *Mantua, commissioned works from the most excellent Italian painters to decorate their small rooms, the *studiolo* and *camerino*, but Isabella controlled her artists rigorously. With the Renaissance passion for Antiquity (see ANTIQUE) artists who could imitate an Antique style became popular. The Estes and Gonzagas commissioned many small *all'antica* bronzes, while *Michelangelo's *Bacchus* (1496; Florence, Bargello) entered the antiquarian and humanist collection of Jacopo Galli.

The 16th century saw *Rome renew its traditions of patronage, with the papal court as the dominant centre; Julius II used the genius of Michelangelo and of Raphael to extol the power of the Church and its doctrines. In *Venice the Venetian government and the confraternities, particularly the wealthy *scuole grandi*, were the most significant

patrons, and their commissions to Venetian artists created a Venetian stylistic tradition. Through the 16th century the fashion for art collections grew, both at the courts, and among individuals. A belief in the supremacy of Italian art was fostered by Vasari's *Vite* (1550), while his notion of progress and decline encouraged the creation of a canon, establishing the Italian works of the early 16th century as of unsurpassable perfection. The intellectual status of the artist rose, and Vasari formed the first collection of Italian drawings, developing an awareness of their value as an expression of artistic creativity. Vasari also described the prints of Marcantonio *Raimondi as appealing to art lovers as well as to artists, and dealers specializing in prints appeared; Annibale *Carracci, in his prints of Bolognese tradesmen, included a seller of prints hawking his goods in the streets.

Sixteenth-century collections were formed to create splendour and to express taste, and most valued were contemporary works, and, increasingly, the great masterpieces of Vasari's golden age, the early 16th century. The many secular easel paintings in the collections of 16th-century Venetian connoisseurs were described by Marcantonio Michiel, and the *Giorgiones in the collections of Gabriel Vendramin and Cardinal Domenico Grimani were treasured as the masterpieces of Venetian art. Portraits of the collector, such as *Lotto's *Andrea Odoni* (London, Royal Coll.) were fashionable. Throughout this period the confraternal movement grew in prominence, and in such centres as Cremona, along with schools and charitable institutions, were the most significant patrons of altar paintings and frescoes from local artists.

In 17th-century Rome the popes, the wealthy papal nephews, and the new religious orders dominated patronage, and, under Urban VIII and Alexander VI, *Bernini transformed Rome. The papal nephews and the cardinals were intensely competitive in their decoration of churches, palaces, and country villas, and the religious orders often entrusted the decoration of chapels in their new churches to them. Rome was increasingly an artistic capital, where national rivalries played a powerful role. There were few Roman artists, and popes and private individuals tended to favour their compatriots, so that there was a constant turnover of artists attracted to Rome. *Guercino came to Rome when the Bolognese Gregory XV became pope in 1621; the Florentine Sacchetti family were keen patrons of the Tuscan Pietro da *Cortona. At the same time the passion for collecting grew, and many nobles displayed their sumptuous collections in long *galleries, which superseded the *studioli* of Renaissance collectors. Outside Rome one of the most magnificent was the long gallery of Duke Vincenzo I Gonzaga, at Mantua, finished in 1612, which displayed his collection of Caravaggesque and Venetian painting, built up on the advice of *Rubens. The characteristic 17th-century collection was wide and eclectic. The Genoese banker Vincenzo Giustiniani had both classical Bolognese paintings and Caravaggesque works, great Venetian masterpieces, and many

Genoese pictures. Others were more focused; Asdrubale Mattei, an enthusiast for modern naturalism, had a remarkable gallery of Caravaggesque works; Cardinal Federico Borromeo (see MILAN, AMBROSIANA) built up a collection intended both to teach religious truths, and to provide excellent examples of the great traditions of Italian art, with an emphasis on Lombardy, for contemporary Milanese painters. Bourgeois collectors began to play a part, and *Mancini's treatise *Considerazioni sulla pittura*, addressed to the gentleman amateur, advised virtuosi on how to form a collection of paintings. Newly rich lawyers and bankers, socially on the rise, sought the patronage of chapels in Roman churches, where sometimes, as in the case of Caravaggio's *Death of the Virgin* (Paris, Louvre), rejected by the church for which it was painted, their taste proved too modern for the clergy. The complex and learned Cassiano dal Pozzo, most famous as a patron of *Poussin, also inspired Italian artists through his vast museum of drawings after the Antique. In Naples there were no such collectors, skilled in aesthetic debate, and the religious institutions were the main source of patronage. Caravaggio arrived there in 1606, where his fame immediately attracted wealthy patrons, while later Neapolitan patrons rejected local talent, favouring artists celebrated in Rome, such as the *Cavaliere d'Arpino, *Domenichino, and *Lanfranco. A link between Naples and *Genoa was forged by Marcantonio Doria, who commissioned works from Caravaggio and *Caracciolo, and stimulated the collecting of Caravaggesque works in Genoa.

In the late 17th and 18th centuries official patronage in Rome declined, and here, as elsewhere in Italy, foreigners came to play an important role. But other cities were gaining a new vitality, and new ideas were influencing collectors, as the hedonistic spirit of earlier centuries yielded to a more scholarly approach to collecting, and to a desire to evaluate different styles of art. At *Turin the court attracted artists from all over Italy—*Conca, *Trevisani, *Solimena, *Ricci, and Francesco de Mura—and encouraged the creation of a new *Rococo style, while the Savoy collections were enhanced by central Italian works. In Florence there was a new interest in Venetian art, while in Venice the Church and the religious orders remained wealthy patrons of art, but they were deeply conservative, and privileged the most traditionally Baroque artists. Yet Venice's artistic vitality was revived by a group of distinguished cosmopolitan connoisseurs, among them *Algarotti and *Zanetti. Algarotti planned a gallery for August of Saxony intended to illustrate the entire history of painting, and he promoted a dazzlingly wide range of modern Italian painters, from many centres, who represented different styles. These new ideas led to the rediscovery of early Italian painting. Local historians, most notably Carlo Lodoli (1690–1761) in Venice, inspired by local pride and learning, rather than aesthetic pleasure, played a major role in this movement, which continued until the end of the century when Giacomo Carrara made public his collection of 15th- and 16th-century pictures from Lombardy

and the Veneto, to which he later attached a school of painting.

Towards 1800 the great traditions of aristocratic patronage were declining, and the collections dispersing. The newly founded Italian nation state at first encouraged nationalistic commissions. In 1859 the grand duchy of Tuscany had collapsed, and the provisional government of Bettino Ricasoli in Florence hastened to establish the Bargello as a national museum of sculpture; in 1859 Giovanni Fattori won a contest organized by this government for a painting on the subject of the recent battles of the second war of independence. In these years the *Macchiaioli, who were attempting to revitalize Italian art, were supported and inspired by the writer Diego Martelli at Castiglioncello. The later 19th and early 20th centuries saw the growth of increasingly eclectic collections, for example those of Gian Giacomo Poldi Pezzoli in Milan, and Stefano Bardi in Florence; a new interest in creating rich displays of paintings and sculptures in period rooms developed. There was a growing emphasis on early Italian painting and on the 15th century, an interest now rooted in aesthetic appreciation, and encouraged by *Purism. In the 20th century Italian collectors took less interest in contemporary Italian art, although the Neapolitan Alberto della Ragione donated his collection of Italian art from the inter-war years to Florence in 1970. And Italian cities continue to take an intense pride in their local painters, collecting their works in modern museums, such as the Museo *Morandi in Bologna, and the Musei Civici d'Arte Moderna at Ferrara, which shows many works by the Ferrarese Giovanni *Boldini. HL

Alsop, J., *The Rare Art Traditions* (1982).
Haskell, F., *Patrons and Painters* (1965).

2. France

THE first systematic attempt to bring Italian art to France dates from the reign of François I (ruled 1515–47). It followed a period of artistic stagnation and isolation, following military defeat by the English at Agincourt (1415). Nevertheless the artist Jean *Fouquet from Touraine had visited Italy in the 1440s. And Louis XII (ruled 1498–1515), who had overrun Lombardy and become Duke of Milan in 1499, had acquired several panel paintings by Lombard artists, including one signed by Ambrogio de *Predis; he was also in intimate contact with *Leonardo da Vinci. However it was during the reign of François I in c.1515/16 that Leonardo was persuaded to settle at Amboise in Touraine with an appointment as painter and engineer to the King. They may have met first at Bologna when the King went to see Pope Leo X in 1515. François appears to have appreciated the entire range of Leonardo's abilities, including his obsessive preoccupation with making drawings of storms and deluges (Windsor Castle, Royal Collection) and his designs for a royal palace at Romorantin in Italian

Renaissance style, which was never built. The paintings by Leonardo now in the Louvre, including the *Mona Lisa*, the *Leda*, the *S. John the Baptist*, and the *Virgin and Child with S. Anne*, may have been taken to France by the artist and some at least may have been completed there. *Andrea del Sarto was also in Touraine from 1518 to 1519.

The most influential initiative by François I was to bring to *Fontainebleau *Rosso Fiorentino (from Florence), Francesco *Primaticcio (from Bologna), and *Nicolò dell'Abate (from Modena). The extreme *Mannerist style associated with all these artists, especially the linear elegance and refinement of Primaticcio, became the established taste of the French court until the 1570s. It was widely disseminated through reproductive prints and was also taken up and further developed by French artists, including Ambroise *Dubois and Toussaint *Dubreuil.

François I also collected Italian paintings by established Renaissance masters, including *Raphael (*La Belle Jardinière*), *Giulio Romano (*Joan of Aragon*), *Sebastiano del Piombo (*Visitation*), and *Savoldo (*Self-Portrait*), all now in the Louvre. He possessed sculptures, now lost, by *Cellini (*Jupiter*) and *Michelangelo (*Hercules*); also *Tribolo's *Goddess of Nature* (Fontainebleau); and numerous casts after the Antique. More precious objets d'art included Cellini's saltcellar (Vienna, Kunsthist. Mus.) and Valerio Belli's (c.1468–1546) casket (Florence, Pitti).

French art and patronage sank back into incipient provincialism during the long wars of religion that continued from 1562 to 1598. The patronage of Italian art then rapidly gathered fresh momentum during the reigns of Louis XIII (ruled 1610–43) and Louis XIV (ruled 1643–1715); while many talented French artists, most notably *Vouet, went to work in Rome early in the century before returning to France to participate in the artistic regeneration of Paris, with an appealing if undemanding classical *Baroque style inspired by Italian prototypes.

The principal French followers of *Caravaggio and *Manfredi in Rome, notably *Tournier and *Valentin, made no impact in the French capital after their return to Paris. On the other hand Marie de Médicis, who lived at the Palais du Luxembourg, received as a gift from her nephew Ferdinando Gonzaga in 1624 a series of paintings by *Baglione of *Apollo and the Muses* (Arras, Mus. des Beaux-Arts). She also invited Orazio *Gentileschi for a brief stay in Paris (1624–6) and commissioned *La Félicité publique triomphant des dangers* (Paris, Louvre). At about the same time Roger du Plessis de Liancourt, Duke of La Roche-Guyon, whose Paris *hôtel* was adjacent to the Palais du Luxembourg, acquired Gentileschi's *Diana as a Huntress* (Nantes, Mus. des Beaux-Arts). He also owned Caravaggio's *Portrait of Alof de Wignacourt* (Paris, Louvre).

The expansion of the royal collections, and the taste for Italian painting in the *Grand Manner, at the opposite extreme to Caravaggism, owed much to the inspired initiatives of the King's first ministers, Cardinal Richelieu (1624–42), Cardinal Mazarin (1643–61), and Jean-Baptiste Colbert (1661–85). It was an opportune moment, due to the dispersal of major collections elsewhere, particularly the

collection of King Charles I in London and the Gonzaga collections in Mantua. Moreover these royal ministers, especially Richelieu and Mazarin, were also collectors in their own right. Richelieu acquired paintings by *Mantegna, *Perugino, and *Costa (all now Paris, Louvre), originally painted for the *studiolo* of Isabella d'Este at *Mantua, and in 1635 commissioned *Poussin to complete the scheme with three *Bacchanals* (now London, NG, and Kansas City, Mo., Nelson Atkins Mus.). Mazarin, who had formed his taste in Rome during the pontificate of Urban VIII, helped arrange for *Bernini to make a bust of Cardinal Richelieu (1640–1; Paris, Louvre). He bought Antique sculpture; acquired notable old master paintings by Raphael (*Portrait of Baldassare Castiglione*), *Titian (*Pardo Venus*, ex-coll. Charles I), and *Correggio (*Mystic Marriage of S. Catherine*, a gift from Cardinal Antonio Barberini), all now in the Louvre; and patronized French artists who had worked in Italy, including Poussin. Above all he supported contemporary Italian artists and twice brought Pietro da *Cortona's pupil Giovanni Francesco Romanelli (1610–62) to Paris. In 1645–7 Romanelli was employed to fresco the ceiling of the gallery at the Palais Mazarin with mythological scenes (now the Galerie Mazarine at the Bibliothèque Nationale). Then, on his second extended visit, from 1655 to 1657 he worked with *Le Sueur on decorations for Anne of Austria's *appartements* at the Louvre. His work there included a ceiling painting of the *Glorification of France* (Lille, Mus. des Beaux-Arts), the *Finding of Moses* (Compiègne, Mus. du Château), and other scenes from the life of Moses (Paris, Louvre). All these paintings, with luminous colours and elegant Hellenistic figures, display a lyrical and decorative classicism.

A little earlier another scheme, conceived by François Annibal d'Estrées while he was a special diplomatic envoy to Rome in 1639, brought Italian and French artists into even closer confrontation. He invited Giacinto *Gimignani to join Charles *Errard, Pierre *Mignard, and François *Perrier to paint a sequence of pictures illustrating Tasso's *Gerusalemme liberata* (now Bouxwiller Mus. and Reims, Mus. des Beaux-Arts). Gimignani's graceful interpretation of the *Meeting of Rinaldo and Armida* makes an interesting contrast to the more meditative, almost Poussinesque, classicism of Mignard's *Godefroy de Bouillon* and the *Testa-like approach to expressive and dramatic narrative in Errard's *Rinaldo Taking his Leave from Armida*.

Even more ambitious was the gallery of pictures commissioned by Phélypeaux de la Vrillière for his Parisian *hôtel*, designed by François Mansart (1598–1666) and now the Banque de France. Over a period of some 30 years he commissioned a series of paintings representing heroic deeds from ancient history by Guido *Reni, *Guercino, Alessandro Turchi, *Maratti, Pietro da Cortona, and Poussin. If Reni's *Abduction of Helen* (1628–31; Paris, Louvre) and Maratti's *Sacchi-like *Emperor Augustus* (1655–7; Lille, Mus. des Beaux-Arts) come closest to the French classical ideal, with their emphasis on surface design and grandly modelled figures, Pietro da Cortona's three pictures, *Caesar and Cleopatra* (1637; Lyon, Mus. des Beaux-Arts), *Romulus and Remus* (1643; Paris, Louvre), and the *Augustus and the Tiburtine Sibyl* (c.1660; Nancy, Mus. des Beaux-Arts), with their breathtakingly vigorous brushwork and sensuous rendering of both human forms and the world of nature in the background, offered a challenge to the somewhat restrictive limits of French academic taste. The collection also contained valuable old masters, ranging from Raphael's *Vièrge au diadème bleu* (Paris, Louvre) to the proto-Baroque late Titian *Perseus and Andromeda* (London, Wallace Coll.).

On the death of Mazarin in 1661, his agent Jean-Baptiste Colbert became the King's principal adviser. Under his influence many of the private collections formed in France earlier in the century were now acquired for the royal collection. In addition to the pictures from Richelieu and Mazarin, Louis XIV bought the collection formed by the banker Everard Jabach, who possessed many pictures from King Charles I's collection and other prestigious sources: Titian's *Entombment* and *Fête champêtre*; pictures by Annibale *Carracci and Guido Reni; and over 5,000 old master drawings (all now Paris, Louvre).

During the 18th century French collecting of Italian art was dominated by Philippe II, Duke of Orléans, who became French regent on the death of Louis XIV in 1715. He was advised by the French painter Antoine *Coypel, and was also assisted by the banker Pierre Crozat (himself a major collector of drawings which were then sold in a celebrated sale in 1741), who in 1721 acquired on his behalf most of Queen Christina of Sweden's pictures, many originating from the Gonzaga collections. The collection of 123 paintings included ten pictures by Correggio; Raphael's *Madonna del passeggio*, and Titian's *Three Ages of Man* (both Duke of Sutherland Coll.; on loan Edinburgh, NG Scotland). At the death of Philippe II in 1723 the Orléans Collection amounted to 485 pictures by all the leading Renaissance and 17th-century Italian artists, as well as Poussin's second series of *Sacraments* (Duke of Sutherland Coll.; on loan Edinburgh, NG Scotland) and equally fine Dutch and Flemish works.

The provenance of some of these pictures suggests the extraordinary depth of French collecting at this time and the relative speed with which celebrated pictures changed hands, indicating an active market which still has not been fully researched. For instance Raphael's *Holy Family with the Palm Tree* (Edinburgh, NG Scotland), which had reached France by 1656, when it was engraved, then passed through the hands of Henri Hurault, Count de Cheverny, the Marchioness d'Aumont, the Abbé de La Noue, Antoine Tambonneau, and M. de Vannolles, who sold it to the Duke of Orléans in 1724. Raphael's *Bridgewater Madonna* (Edinburgh, NG Scotland) was in the collection of the Marquis de Seignelay (1651–90), the jeweller Laurent Le Tessier de Montarsy, and the jeweller André Rondé, who sold it to the Orléans family. The entire collection was sold by Louis Philippe-Joseph (Philippe-Égalité) in 1791 to a Brussels banker; and was subsequently dispersed in London, one of the most significant turning points in the history of British taste and collecting.

The political and social upheavals associated with the French Revolution and the Napoleonic Wars in Italy paradoxically stimulated fresh interest in preserving the artistic heritage both of France and Italy. At home Alexandre *Lenoir, a French painter, attempted to preserve French medieval art at the Musée des Monuments Français, founded in 1793. While abroad, French officials resident in Rome began to collect early Italian gold-ground paintings and created a new taste for primitive Christian art. François Cacault, ambassador in Rome 1800–3, left his collection to the museum at Nantes. Artaud de Montor, another French diplomat, who was in Rome from 1804 to 1807 (and again 1814–16 and 1818–30), published an influential and well-illustrated catalogue of his collection of early Italian art in 1808. Dominique Vivant-Denon, who was requisitioning art all over Europe on a massive scale for the Musée Napoleon in Paris, of which he was director, went out of his way to acquire a small collection of Italian primitives, including a picture by *Cimabue, that had become available due to the suppression of the monasteries in Italy in 1811 (see PARIS, LOUVRE). Cardinal Fesch (1763–1839) was another French official to take advantage of his position as a relation of Napoleon to acquire pictures on a wholesale scale in Rome during the wars (1796–8), and again when he succeeded Cacault as French ambassador (1803–6), and then again when he retired to Rome in 1815, as an exile, having quarrelled with the Emperor. His collection, which eventually amounted to 16,000 works and included *Giotto's *Dormition of the Virgin* and the celebrated *Last Judgement* attributed to Fra *Angelico (both Berlin, Gemäldegal.), was displayed at the Palazzo Falconieri, Rome. After his death most of the early Italian pictures went to his birthplace, Ajaccio (Corsica), for a newly created museum there (1852); and more than 3,000 further pictures were sold by auction in Rome between 1843 and 1845, including early Italian works, some of which were eagerly acquired by pioneer English collectors and dealers (see below, 4. Great Britain).

Indeed in the final analysis the British gained more than the French from the upheavals in Italy. Inspired by the dispersal of the Orléans Collection in the London salerooms, it was above all British speculators and their agents, rather than French dealers such as J. B. P. Lebrun (1748–1813), who took best advantage of the troubles in Italy to acquire not only Italian primitives but also masterpieces of Renaissance and Baroque art to which no Grand Tourist travelling in the 18th century would ever have aspired. HB

Bréjon de Lavergnée, A., and Volle, N., *Seicento: le siècle de Caravage dans les collections françaises*, exhib. cat. 1989 (Paris, Grand Palais).

Buchanan, W., *Memoirs of Painting with a Chronological History of the Importation of Pictures by the Great Masters into England since the French Revolution* (1824).

Haskell, F., *Rediscoveries in Art: Some Aspects of Taste, Fashion and Collecting in England and France* (1976).

3. Spain

ITALIAN painting was admired in Spain from the 15th century onwards, as demonstrated by the invitation extended in 1472 by Cardinal Rodrigo Borgia, later Pope Alexander VI, to two Italian artists, Paolo da San Leocadio and Francesco Pagano, to decorate a chapel in the cathedral in Valencia. From the 16th century until the late 18th century, kings, courtiers, ecclesiastical patrons, and private collectors imported a considerable body of Italian paintings into Spain. Close political and trading links between the two nations helped to promote the flow. Spanish viceroys governed the kingdom of Naples and Sicily and the duchy of Milan, including for a significant period the states of Genoa, Mantua, and Tuscany, while trading between the Mediterranean ports of Genoa, Naples, Barcelona, and Valencia assisted in the transfer of ideas and artefacts.

Among the earliest direct imports of Italian paintings into Spain were four works by *Sebastiano del Piombo brought to Valencia in 1521 by Jeronimo Vich y Volterra, Spain's ambassador to the Holy See. The first Spanish monarch to show a significant interest in Italian painting was the Habsburg Emperor Charles I of Spain, who had been introduced by Duke Federico Gonzaga to *Titian while in northern Italy in the late 1520s. Over the following years, he commissioned several portraits and religious paintings from Titian, including the famous portrait of him on horseback, now in the Prado (1548). Charles's son Philip II continued this patronage, ordering portraits and religious and mythological paintings from Titian, including the six celebrated *poesie* pictures now to be found at museums such as the Prado, Madrid, National Gallery of Scotland, Edinburgh, National Gallery, London, the Wallace Collection, and the Isabella Stewart Gardner Museum in Boston. In the 1580s, on completion of the building works at El *Escorial, Philip invited prestigious Italian painters to decorate the interior, including Luca *Cambiaso, Federico *Zuccaro, and Pellegrino *Tibaldi.

Some of these Italian painters stayed on in Spain, working for monastic and ecclesiastical patrons. Among them were the Florentine painters Bartolomeo Carducci (see CARDUCHO BROTHERS) and his younger brother Vicente, who painted a series of 32 scenes from the life of S. Bruno for the Charterhouse of El Paular between 1626 and 1632. Itinerant Italian artists also came to Spain in search of commissions, following in the footsteps of El *Greco, who arrived in Spain from Rome in 1577. They included the Roman painter Orazio *Borgianni, who came to Spain in 1598 and stayed for several years. His surviving works in Spain include several altarpieces painted in Rome in 1613–14 for the convent of Portacoeli in Valladolid.

In 1610, a returning viceroy of Naples, Alonso Pimentel y Herrera, came home with *Caravaggio's *Crucifixion of S. Andrew* (Cleveland Museum of Art) for his collection in Valladolid. In Valencia, meanwhile, painters such as Francisco *Ribalta developed an indigenous tradition drawing

on Caravaggesque influences, including a copy of Caravaggio's *Crucifixion of S. Peter* acquired by the Archbishop of Valencia, Juan de Ribera, in around 1610.

In the course of the 17th century, Philip IV enriched the royal collection with Italian paintings, many of them bought through the agency of his viceroys in Naples, such as the count of Monterrey and the Marquis de Carpio, or at sales such as the 1649 dispersal by the Commonwealth of the English royal collection amassed by Charles I (see under LONDON). One of the most important works bought for the Spanish King in London by his ambassador to the court of St James, Alonso de Cardenas, at the 1649 sale of the English royal collection was *Tintoretto's *Christ Washing the Feet of his Disciples* (Madrid, Prado Mus.). Monterrey was instrumental in commissioning paintings, now all in the Prado museum, by *Domenichino, Giovanni *Lanfranco (various scenes from Roman history), Artemisia *Gentileschi, and Massimo *Stanzione, to decorate the newly built palace of the Buen Retiro.

In 1648, Philip sent *Velázquez, his First Court Painter, to Italy to buy paintings and sculptures and contact fresco painters such as the Bolognese Agostino Mitelli and Angelo Michele Colonna, who came to Madrid in 1652 to decorate the ceilings of the royal palace. Works brought back by Velázquez included *Veronese's *Venus and Adonis* (1580; Madrid, Prado Mus.). In 1661, Philip bought *Raphael's famous *Christ on the Road to Calvary*, now in the Prado, from a Sicilian monastery. In 1692, Charles II invited Luca *Giordano to paint in fresco the ceilings of the Escorial and the Buen Retiro. During an eight-year stay in Spain, Giordano carried out a number of commissions, including a cycle depicting the life of the Virgin at the Hieronymite monastery of Guadalupe. Spanish aristocratic connoisseurs, such as the Marquis of Leganes, also formed notable collections of Italian paintings.

With the arrival of the Bourbon dynasty in the 18th century, French artistic tastes dominated the court. However, the Italian second wife of Philip V, Isabella Farnese, collected Italian paintings and engaged Andrea Procaccini as court painter. In 1724, Procaccini acquired for Philip V most of Carlo *Maratti's collection of late 17th-century Roman paintings, including works by Maratti himself. In 1735, the Italian architect Juvarra, who had been summoned to Madrid to rebuild the royal palace, contracted Italian artists such as Francesco *Solimena, Andrea Casali, Francesco *Imperiali, Sebastiano *Conca, and Agostino *Masucci to paint scenes from the life of Alexander the Great for the throne room at the Palace of La Granja, near Segovia.

Under Ferdinand VI, Jacopo *Amigoni was employed to paint portraits and design cartoons for tapestries to decorate the newly rebuilt royal palace. On Amigoni's death in 1752, the King summoned the Neapolitan frescoist Corrado *Giaquinto to Madrid to decorate the royal chapel and two grand staircases. In 1763, Charles III invited the Venetian painter Giambattista *Tiepolo to paint the throne room and other important ceremonial rooms. With Tiepolo came his two sons Giandomenico and

Lorenzo, who won acclaim for their pastels of contemporary Spanish life. Charles IV decorated his *casitas* with Italian pictures, notably by Clemente Ruta, from Parma. XB

4. Great Britain

THOMAS Howard, 2nd Earl of Arundel (1585–1646), who visited Venice and Vicenza, Rome and Naples with the architect Inigo Jones (1573–1652) in 1613, was described by Horace *Walpole as the 'father of virtù in England'. He was the first great English collector to impart a taste for Italian art to his countrymen, and in particular at the sophisticated and cultivated court of King Charles I in London. His friendship in Rome with the Marquis Vincenzo Giustiniani stimulated his taste for studying and collecting *Antique sculpture and his interest in contemporary Roman painting, including the *Caravaggisti. And shortly after his return to Britain he also acquired an important group of Venetian paintings, by *Tintoretto and other *Renaissance masters, originally obtained in Italy by Sir Dudley Carleton (1573–1632), the British ambassador in Venice, for James I's disgraced favourite Robert Carr, Earl of Somerset. Further paintings and drawings were bought in Italy for Arundel by the scholarly agent the Revd. William Petty, including some 500 drawings by *Michelangelo from a collection in Naples, and pictures by *Titian, for instance the *Mocking of Christ* (Munich, Alte Pin.), and *Schiavone, including the *Adoration of the Shepherds* (Vienna, Kunsthist. Mus.). Petty also tried to protect Arundel's interests in the tense negotiations for the collection of Bartolommeo della Nave in Venice, one of the finest in the city; but was eventually outmanœuvred by the British ambassador, Basil Feilding, acting for his brother the Duke of Hamilton. On the other hand he won a battle with the same rivals to acquire *Raphael's *S. Margaret* (Vienna, Kunsthist. Mus.) from the collection of Procurator Priuli.

Arundel's scholarly approach to collecting is well reflected in his acquisition of an album of *Leonardo da Vinci drawings now in the Royal Collection at Windsor, and a large group of drawings by *Parmigianino which have been widely dispersed. This cerebral quality distinguishes his interest in Italian art from that of others at court, including King Charles himself, and George Villiers, Duke of Buckingham (1592–1628), although they were strongly influenced by him. Buckingham is reported to have said he was 'not so fond of antiquity to court a deformed or misshapen stone' and ignored classical Sculpture in favour of colourful Venetian paintings. In 1621 the diplomat Sir Balthazar Gerbier bought for him in Italy the Titian *Ecce Homo* (Vienna, Kunsthist. Mus.); and three years later sent him from France a Tintoretto *Danaë* (Lyon, Mus. des Beaux-Arts) and Titian's *Portrait of Georges d'Armagnac and his Secretary* (Alnwick Castle, Northumberland). Buckingham also patronized living artists: in 1621 Gerbier had bought for him two paintings by *Manfredi; and he acquired Orazio *Gentileschi's *Penitent Magdalen* and a *Rest on*

the *Flight into Egypt* (both Vienna, Kunsthist. Mus.), probably painted shortly before the artist arrived in England from *Paris. Gentileschi, however, had a low opinion of Gerbier's connoisseurship and famously they fought in the Strand on 9 January 1629. This incident followed Buckingham's death the previous year. He left a collection of 330 pictures, recorded in a 1635 inventory, and including around 80 Venetian Renaissance works.

Meanwhile, the Prince of Wales, later Charles I, had visited Spain with Buckingham in 1623, with a view to negotiating marriage with the Spanish Infanta. He would have seen the incomparable collection of Venetian paintings in the Spanish royal collection and on his departure from Madrid Philip IV presented him with Titian's *Pardo Venus* (Paris, Louvre). He also returned with *Giambologna's *Samson and the Philistine* (now London, V.&A.), which he gave to Buckingham. Had the marriage negotiations not collapsed he would also have received Titian's late *poesie* of *Diana and Actaeon* and *Diana and Callisto* (Duke of Sutherland loan; Edinburgh, NG Scotland). On the other hand he was able to buy Raphael's tapestry cartoons of the *Acts of the Apostles* (London, V. & A.). Having succeeded to the throne in 1625, Charles, encouraged by Buckingham, went on to negotiate successfully through the agency of Nicolas Lanier (1588–1666), the English court musician and art dealer, and Daniel Nys, a Venetian dealer, for the collection of Ferdinando Gonzaga, 6th Duke of *Mantua. In the process Marie de Médicis and Cardinal Richelieu (see above, 2. France) were outmanœuvred; and at the enormous cost of £18,000 Charles had, at a stroke, in 1629 acquired a collection worthy of comparison with the royal collection in Spain. There were numerous Renaissance works: *Mantegna's series of nine large canvases of the *Triumphs of Caesar* (Hampton Court, Royal Coll.) and several pictures by Titian, including the *Entombment* (Paris, Louvre) and the twelve *Roman Emperors* (destr.); *Correggio's *Venus and Cupid* (Paris, Louvre), *Caravaggio's *Death of the Virgin* (Paris, Louvre), Guido *Reni's four *Labours of Hercules* (Paris, Louvre), and several paintings by Domenico *Fetti which introduced a contemporary aspect to the Royal Collection. This was reinforced by the arrival in London in 1626 of Orazio Gentileschi, who would stay for the remainder of his life and would decorate the Queen's House at Greenwich. Finally a large painting by Guido Reni of *Bacchus and Ariadne* (destr.) was commissioned for the ceiling of the Queen's bedroom at Greenwich through Cardinal Francesco Barberini and the papal legate at Bologna, Cardinal Sacchetti. It was completed by 1640 but never delivered to England, although the exiled Queen Henrietta Maria may have received it later in France. The Civil War and the Commonwealth led to the cruel loss of the collections of Arundel, Buckingham, Hamilton, and King Charles, and cut off the supply of Italian art to Britain. For a period of some 20 years London had been one of the most sophisticated centres of patronage and collecting in Europe, especially for the enjoyment and appreciation of Italian art. And although on his accession in 1660 Charles II, who had been brought up

with memories of Whitehall and Hampton Court at their most splendid, attempted to inject a new sense of energy and purpose into the artistic life of the court, it was a very secondary affair involving such mediocre artists as Benedetto Gennari (1663–1713) and Antonio *Verrio. Verrio painted many walls and ceilings at the royal palaces up to 1688, and again at Hampton Court after 1699. Gennari's commissions oscillated between erotic mythologies for the King and religious pictures for the Queen, Catherine of Braganza, who had created a Roman Catholic chapel at Whitehall. Another Italian artist who came to the attention of the court was the Florentine Carlo *Dolci. Sir John Finch, the English resident at Florence, who had his own portrait painted by Dolci (Cambridge, Fitzwilliam), commissioned for Catherine of Braganza a *Penitent Magdalene* (1670; London, Royal Coll.) and for the King a *Salome* (London, Royal Coll.).

During this period the court painter Sir Peter *Lely made the first collection of old master drawings systematically stamped with a collector's mark. Many may have come from the dispersed collections of Arundel and Lanier, since there is no evidence of his buying from abroad. He was the first in a distinguished line of painter-collectors that also included the *Richardsons, Thomas *Hudson, *Reynolds, and *Lawrence. Aristocratic collectors who made their mark in this specialist area of connoisseurship include John, Lord Somers (1651–1716), who bought the drawings of the Roman collector Padre Sebastiano Resta (1635–1714), and William Cavendish, 2nd Duke of Devonshire (d. 1729), who built up the collection still at Chatsworth (Derbys.).

Outside the court one of the most interesting collectors was Sir Thomas Isham of Lamport Hall, (Northants), from a family of staunch royalists, who was in Italy for an unusually extended tour from 1677 to 1679 and bought paintings by *Maratti, Giacinto Brandi (1621–91), Ludovico Gimignani (1647–97), Filippo Lauri (1623–94), and Salvator *Rosa. His agent was a Sr. Talbot, a priest at the Vatican; and he appears to have had contact with Cardinal Barberini, who was contemplating the gift of a picture to the Duchess of York, Mary of Modena, in 1677. Of even greater importance are the activities of John Cecil, 5th Earl of Exeter (1648–1700), of Burghley House (Lincs.) who made three extended tours of Italy, apparently with the principal objective of acquiring contemporary late Italian *Baroque paintings on a breathtaking scale and with indiscriminate enthusiasm. He had succeeded to the earldom in 1678 and embarked on an ambitious programme for refurbishing his Elizabethan ancestral home. As hereditary Lord High Almoner at the court he must have absorbed the royal taste for Verrio, Gennari, and Dolci. On his first Italian tour (1679–81) he ordered an autograph copy (Burghley House) of Dolci's *Adoration of the Magi*, which he had seen in the collection of the Grand Duke Cosimo III at Florence (now at Blenheim Palace, Oxon.). And on his return home, in 1682, he commissioned three pictures by Gennari. He went to Italy again in 1683–4 and bought paintings by an astonishing range of

contemporary artists working in Florence, Rome, Naples, Venice, and Genoa. They included Dolci again (he eventually owned nine works by him), *Giordano, *Recco, Maratti, Brandi, Giacinto Calandrucci (1646–1707), *Seiter (1647–1705), Pietro Liberi (1605–87), Antonio Zanchi (1631–1722), Johann Carl Loth (1639–98), and a group of Genoese painters (the inventory reads like the chapter headings of Soprani's *Vite de' pittori Genovese* (1674)). In 1688, after the Revolution, he offered refuge and work at Burghley House to Verrio, who duly painted the Heaven Room and the Hell Staircase. On the accession of William of Orange, which Exeter consistently opposed in all parliamentary divisions, he refused to take the oath of allegiance and never sat in the House of Lords after 13 February 1689. Instead, defiantly, he and his wife made another Grand Tour in 1699–1700 to celebrate the Pope's jubilee in Rome, notwithstanding vigorous attempts by King William to discourage him. During this trip he apparently met the exiled King James II at Fontainebleau; and was much fêted in Rome by the French Cardinal Bouillon (1663–1715), himself a notable picture lover whose portrait was painted by *Gaulli (Versailles). And he continued to buy the latest examples of Italian Baroque painting: works by Gaulli, *Chiari, and *Trevisani, including autograph replicas of the paintings the artist had only just completed (1696) for S. Silvestro. He also bought an *Andromeda and the Sea Monster* (New York, Met. Mus.) by Pierre *Monnot, the French sculptor, resident in Rome; and also commissioned a bust portrait of himself (Burghley House) and a funerary monument for his wife and himself, destined for the church of S. Martin at Stamford, which portrays them together dressed in Roman attire, flanked by figures of Victory and the Arts.

During the early years of the 18th century British taste for Italian late Baroque and early *Rococo art is associated largely with Whig aristocrats, Protestant and anti-French, who were anxious to establish their power and prestige and turned consciously to republican Venice rather than papal Rome in their choice of artists to decorate their new country houses designed by architects such as Sir John Vanbrugh (1664–1726). In 1707 Charles Montagu, 4th Earl and later 1st Duke of Manchester, had visited Venice as Queen Anne's special ambassador—his arrival is recorded in a magnificent painting by *Carlevaris (Birmingham Mus. and AG)—and he persuaded *Pellegrini and Marco *Ricci to return home with him. Pellegrini, after working at the Haymarket Theatre, London, as a stage designer, was employed at Castle Howard (North Yorks.) by Charles, 3rd Earl of Carlisle, and filled the dome with a dramatic *Fall of Phaeton* (1709; destr.). The following year, he was at Lord Manchester's seat, Kimbolton Castle (Cambs.), where he left his most important decorative scheme in Britain, executed with a spaciousness of design, a shimmering radiance of colour, and subtle silvery effects that anticipate *Tiepolo. Marco Ricci was also involved at the Haymarket Theatre, and then in 1709–10 was paid for over-doors, overmantels, and a series of wild Romantic landscape paintings for Castle Howard. For the same collection he also made a topographical view of the Mall in St James's Park which anticipates by more than 40 years *Canaletto's similar pictures of London. However by 1710 Ricci had left England 'upon some disgust with *Pellegrini', only to return two years later with his uncle Sebastiano *Ricci, with the avowed intention of putting Pellegrini out of business as a history painter. The Ricci may even have nurtured hopes of securing the commission to decorate the dome of S. Paul's. Although that commission eluded him, Sebastiano was successfully employed c.1713–14 at Bulstrode by the Duke of Portland, the son of William of Orange's great favourite, the Dutch William Bentinck; the decorations were destroyed in the 19th century. He was also employed by Lord Burlington c.1714, for three large canvases of *Diana, Galatea,* and *Bacchus and Ariadne* (London, Burlington House (RA)). Another enterprising patron of Italian artists was Owen MacSwinny (1676–1754), opera manager at the Haymarket Theatre, who was a friend of Consul Joseph Smith (c.1674–1770) in Venice, and commissioned a series of paintings of imaginary monuments to recent English heroes, reflecting his Whig sympathies. Among the artists involved were the Ricci, Canaletto, *Pittoni, and *Piazzetta.

The last of the Venetian decorators to try his luck in Britain was Jacopo *Amigoni, who arrived in 1729 and was employed by Benjamin Styles of Moor Park (Herts.) to paint stories of Jupiter and Io to be set in the Neo-Palladian plasterwork. The discovery of Palladio by Richard Boyle, 3rd Earl of Burlington (1694–1753), during his Grand Tour of Italy in 1719 and the Whig intellectual Lord *Shaftesbury's intemperate outbursts against all Baroque architecture from *Bernini to Francesco Borromini, Wren to Vanbrugh, ensured that in future there would be little need or space for illusionistic Baroque painting to decorate the new Palladian style country houses. Unfortunately G. B. *Tiepolo came to maturity as an artist at precisely this moment and was ignored. Consequently the only major Tiepolo painting to enter Britain during his lifetime was the *Finding of Moses* (Edinburgh, NG Scotland), which was bought in Venice for Lord Bute in 1769 in the mistaken belief that it was by *Veronese. Only in the mid-19th century, with the eccentric scholar and romantic novelist Edward Cheney (1803–84), did a substantial collection of Tiepolo oil sketches and drawings find its way to Britain although it was dispersed after his death.

For most of the 18th century British Grand Tourists and collectors would concentrate largely on portraiture, Italian view painting, and architectural capricci. For portraits they turned to Rosalba *Carriera in Venice, *Solimena in Naples, *Batoni in Rome, although the Jacobites favoured *Trevisani. For view painting or capricci Canaletto in Venice, *Panini in Rome, and the etchings of *Piranesi were the most favoured. And when the Wars of the Austrian Succession interrupted the tourist trade Canaletto was persuaded to visit England in 1740. Of the old masters, Salvator Rosa, together with French painters who worked in Rome including *Poussin, *Claude, and Gaspard *Dughet, appealed to those concerned with landscape

gardening as well as those seeking vicariously to experience the Arcadian associations of the Italian Campagna.

The most influential British collector living in Italy during this period was Consul Smith, whose collection of paintings and drawings by Canaletto and the Ricci was sold in 1762 to King George III and remains in the Royal Collection. Although during the Grand Tour period there were British artists and ciceroni, including the antiquarian James Byres (1734–1817) and Gavin *Hamilton, who earned a living in Rome and elsewhere from dealing with their countrymen in old master paintings and antiquities, the supply was severely restricted. A major influx of Italian Renaissance and 17th-century paintings did not occur until after the disruptions caused in Italy by the Napoleonic Wars when Scottish dealers, notably James Irvine (1759?–1831), acting in Rome and *Genoa for William Buchanan (1777–1864), and Andrew Wilson (1780–1848), who was also in Genoa, led a speculative boom, vividly described in Buchanan's own *Memoirs of Painting* (1824) and his private correspondence (see below).

The fundamental turning point in British taste and British collecting of Italian old masters followed the importation from France of the Orléans Collection (see above, France), which included an overwhelming quantity of major works by Raphael and Titian as well as examples of all the leading early 17th-century artists such as Annibale *Carracci, *Domenichino, and Guido Reni. The pictures were exhibited in London in 1798, having been acquired by a syndicate of three noblemen, the 3rd Duke of Bridgewater (1736–1803), his nephew Earl Gower, and the 5th Earl of Carlisle, who together kept the lion's share and disposed of the rest. The impact on the public is vividly captured by William Hazlitt (*On the Pleasures of Painting* (1820) in *Works*, vol. 8): 'My first initiation into the mysteries of the art was at the Orleans Gallery: it was there that I formed my taste, such as it is: so that I am irreclaimably of the old school in painting. I was staggered when I saw the works there collected and looked at them with wondering and with longing eyes. A mist passed away from my sight: the scales fell off. . . . We had heard of the names of Titian, Raphael, Guido, Domenichino, the Carracci—but to see them face to face, to be in the same room with their deathless productions, was like breaking some mighty spell—was almost an effect of necromancy.' It was in the slipstream of this burst of enthusiasm and connoisseurship among the British aristocrats, bankers, and merchant princes that Buchanan masterminded the London market that led to the formation of collections—John Julius Angerstein (1735–1823); Sir George Beaumont (1753–1827); the Revd William Holwell Carr (1758–1830)—that would later form the backbone of the new National Gallery (see under LONDON).

Paradoxically, before the National Gallery had opened its doors, a reaction had already begun against the academic qualities of Italian painting in the Grand Manner (or rather the academic manner in which it was perceived) and in favour of a more inclusive historical interest in early pre-Renaissance Italian art. Many of the original initiatives in this direction came from the French colony resident in Rome at the end of the 18th century. In particular the antiquarian *Séroux d'Agincourt who was in Rome from 1787 began a survey that continued for 20 years of engraved copies of Antique and medieval art, tracing those elements within medieval art that linked classical Antiquity to the revival of classical values in the High Renaissance. They were probably designed to illustrate Edward Gibbon's *Decline and Fall*, yet they also served to draw attention to the residual impact of Palaeo-Christian art, Byzantine mosaics, and the expressive work of some 14th- and 15th-century Florentine artists. Among the British artists who helped with the illustration of his volumes was William Young Ottley (1771–1836), who had travelled in Umbria and Tuscany before settling in Rome to work for d'Agincourt in 1799. Ottley came to admire the early Italian works, in a Neoclassical context, and began to collect on his own account. Many of his pictures were said to have been 'taken from churches during the occupation by the French soldiery, and but for Mr. Ottley's intervention, might have been destroyed' (J. S. Sartain, *Reminiscences of a Very Old Man*, 1899). They included *Botticelli's *Nativity* (London, NG), *Gentile da Fabriano's *Madonna* (London, Royal Coll.) and *Pesellino's *Trinity* (London, NG). Other British collectors in Rome who pursued a similar path included Colin Morison (1732–1810), the Scottish antiquary, and Bishop Frederick Augustus Hervey (1730–1803), Earl of Bristol. Morison's collection was confiscated by the French and most of Hervey's early pictures disappeared after being shipped from Leghorn to Naples in 1798, although some of his primitives found their way to Christie's, London, in 1802. On the other hand the Liverpool scholar William Roscoe (1753–1831), who in 1796 published his *History of Lorenzo de' Medici*, had managed by 1816 to make a collection of early Italian art, including *Simone Martini's *Christ in the Temple* and an Ercole de' *Roberti *Pietà* (Liverpool, Walker AG), from the British trade, without ever setting foot abroad. A further buying opportunity occurred in Rome in 1843–5 with the dispersal of the collection of Cardinal Fesch; it attracted many discerning British buyers including the influential London dealer Samuel Woodburn (d. 1860), William Coningham, MP for Brighton, and the Revd Walter Davenport-Bromley of Capesthorne, near Manchester.

By the 1850s, thanks to pioneering books by such writers as Lord *Lindsay, Anna *Jameson, and James *Dennistoun the collecting of early Italian art in British circles had become a fashionable pastime, and *Florence now began to overtake Rome as the principal centre for British buyers. It had already been the scene of some informed collecting of primitives since the era of Sir Horace Mann (1706–86), the British resident whose circle included the artist Thomas *Patch, the Italian Ignazio Hugford (1703–78), and the Earl of Ashburnham (1724–1812). There was further activity at the time when William Fox-Strangways (1795–1865) was secretary to the British Legation in Florence (1825–8); his collection is now divided between the Ashmolean Museum, Oxford, and Christ Church, Oxford.

And the Revd John Sanford (1777–1855) of Nynehead (Som.), who lived at the Casino Torrigiani, Florence, also made a systematic collection, part of which was sold in London in 1839. The new wave of more fashionable collecting of early Italian art from after *c*.1856 was largely due to the inspiring presence in Florence of William Spence (1815–1900), a sociable English dealer whose clients included Robert Holford (1808–92) of Dorchester House, London; Thomas *Gambier Parry, who built the parish church at Highnam (Glos.) and decorated it in Italian medieval style; Lord Lindsay; Lord Wimbourne; and Lord Southesk. Hard on the heels of this romantic embrace of the Middle Ages came the more art historical approach and objective connoisseurship of Sir Charles *Eastlake, who, with the help of Otto Mündler (1811–70), his travelling agent from 1855 to 1858, was buying in Italy for the National Gallery, and was responsible for the exceptional strength and depth of the holdings there.

In the face of this new orientation Italian art of the 17th century was virtually ignored for 100 years, and often despised: in 1946 many of the Bridgewater House pictures dating from this period were sold in London at knockdown prices, whereas the Italian Renaissance paintings (and even pictures by Poussin) were eagerly received on loan at the National Gallery of Scotland. The 17th-century classical and Baroque Italian masters were only returned to critical favour later in the 20th century, due to the advocacy and informed collecting of scholarly connoisseurs such as Sir Denis Mahon, most of whose pictures, principally by Bolognese and Roman masters, are now on deposit at the National Gallery, London. HB

Brigstocke, H., *William Buchanan and the 19th-Century Art Trade: 100 Letters to his Agents in London and Italy* (1982).

Brigstocke, H., and Somerville, J., *Italian Paintings from Burghley House*, exhib. cat. 1995 (Pittsburgh, Frick Art Mus. and other locations).

Buchanan, W., *Memoirs of Painting with a Chronological History of the Importation of Pictures by Great Masters into England* (1824).

Croft-Murray, E., *Decorative Painting in England 1537–1837*, 2 vols. (1962, 1970).

Haskell, F., *Rediscoveries in Art: Some Aspects of Taste, Fashion and Collecting in England and France* (1976).

Howarth, D., *Lord Arundel and his Circle* (1985).

Levey, M., *The Later Italian Pictures in the Collection of Her Majesty the Queen* (1991).

Pears, I., *The Discovery of Painting: The Growth of Interest in the Arts in England 1680–1768* (1988).

Waterhouse, E. K., *Italian Art and Britain*, exhib. cat. 1960 (London, RA).

5. Germany and central Europe

ONE of the earliest major Italian works of art exported to Germany was the equestrian statue, believed to portray Constantine, but probably of Theodoric, which Charlemagne brought from Ravenna and erected before his palace in Aachen—a conscious reference to the statue of *Marcus Aurelius* then outside the Lateran basilica in Rome. Through the Middle Ages, Italian and Byzantine works of art were confused with classical antiquities, and all three were endowed with prestige through association with the Roman Empire and early Christianity. Although increasingly German in outlook, the Holy Roman Empire never wholly lost its international aspirations, and emperors until Charles V visited Italy to obtain confirmation of their authority through a papal coronation. In the earlier 13th century, the seat of empire was briefly transferred to Italy—when the Emperor Frederick II ruled from his maternal domains in Sicily. Bohemia was part of the empire, and the imperial idea was pervasive in the neighbouring kingdoms of Poland and Hungary, whose monarchs strove to assert their authority against a powerful nobility.

The Emperor Charles IV visited Italy twice and commissioned triptychs from *Tomaso da Modena in around 1360 for his palace at Karlštejn near *Prague. Charles of Anjou, a cadet of the Neapolitan Angevins, became king of *Hungary in 1308. Hungarian court culture was distinctly Italianate, and the mid-14th-century frescoes in the castle chapel at Esztergom are clearly by an Italian painter. Throughout central Europe, the innovations of the trecento masters were rapidly assimilated and adapted to local use.

During the early 15th century the Italians Branda Castiglione, Giovanni da Buondelmonte, and Andrea Scolari were bishops of the Hungarian diocese of Veszprém, Kaolocsa, and Nagyvárad. All employed Italian artists, of whom the best known is the Florentine painter *Masolino, on the decoration of their residences. Sigismund of Luxembourg, who was both King of Hungary and Emperor, attracted leading Italian humanists to his court at Buda. Their presence encouraged adoption of the new learning by scholars such as János Vitéz, the tutor of Matthias Corvinus, who was elected king of Hungary in 1458.

At the Hungarian court, the culture of humanism was fortified by Matthias's marriage in 1476 to Beatrix of Aragon, the daughter of Ferrante, King of Naples. Matthias acquired sculptures and metalwork by *Verrocchio, Benedetto da *Maiano, Giovanni da Dalmata, Gian Cristoforo Romano, and Il Caradosso. His Biblioteca Corviniana, which included manuscripts *illuminated by *Francesco del Chierico, *Attavante degli Attavanti, and *Gherardo and Monte di Giovanni, was the first great humanist library outside Italy. *Humanism was fostered in Poland from the 1470s and *Renaissance art was introduced to Cracow by the sculptor Franciscus Florentinus around 1500.

Following the marriage of the Emperor Maximilian I to Maria Bianca Sforza in 1494, Milanese works of art, such as an exquisite volume of sonnets decorated by Giovanni Pietro *Birago (now in Wolfenbüttel), reached south Germany and Austria. Ambrogio de *Predis, a follower of *Leonardo da Vinci, entered the Emperor's service as a portrait painter and coin designer. In 1500 he was joined by the Venetian painter and printmaker Jacopo de'

*Barbari, who subsequently worked for Frederick the Wise of Saxony and Joachim I of Brandenburg, before moving to the Low Countries. Between 1500 and 1530, Renaissance style and subject matter was embraced by artists throughout the empire.

Antiquarian enthusiasm for coins and medals was firmly established in Germany by 1553, the year in which the expatriate Mantuan dealer Jacopo Strada published his influential account of the numismatic collection of Hans Jakob Fugger, the great Augsburg banker. From 1566 Strada was instrumental in the acquisition of *Antique marbles by Albrecht V of Bavaria, and played a major role in the creation of the Antiquarium at the *Munich Residenz—the first building in northern Europe designed for the display of classical sculpture.

As Charles V preferred to reside in Spain, his patronage of *Titian and the sculptor Leone *Leoni is tangential to the cultural history of central Europe. However, the Emperor was responsible for Titian's visits to Augsburg, in 1548 and in 1550–1, when the Venetian master undertook commissions from nobles attending the imperial Diet. Charles's nephew, the Emperor Maximilian II, employed the Milanese 'prince of illusionists and most acrobatic of painters' Giuseppe *Arcimboldo at Vienna, but failed to dislodge the sculptor *Giambologna from the employ of the Grand Duke of Tuscany. From Florence, Giambologna produced numerous bronzes for Maximilan. His son Rudolf II, elected emperor in 1576, was celebrated as 'the greatest art patron of the modern world'. His enormous art collections, kept in Prague Castle, included *Correggio's Jupiter and Io and Rape of Ganymede, and *Parmigianino's Self-Portrait in a Convex Mirror (now Vienna, Kunsthist. Mus.).

In 1605 Rudolf acquired the extensive collection of Renaissance bronze statuettes assembled by his uncle Archduke Ferdinand II, which he augmented with works by Giambologna and his student Adriaen de *Vries. Cabinets of coins, medals, and bronze statuettes became a characteristic feature of German princely collections. One of the earliest bronzes to enter the *Kunstkammer of the electors of Saxony in *Dresden, in around 1585, was *Filarete's miniature Marcus Aurelius made in 1465 for Piero de' Medici. About a third of the small bronzes assembled by the 17th-century dukes of Brunswick-Wolfenbüttel are of Italian origin.

Maximilian I, Elector of Bavaria (ruled 1597–1651) (see also under MUNICH), was a patron of *Rubens, and an enthusiastic collector of the works of *Dürer, but he owned only one significant Italian painting—a *Raphael Madonna, now lost. When, in 1614, after protracted negotiations, he failed to acquire a painting by *Michelangelo, he grumbled that 'some people praise Michelangelo even more than Dürer'. In 1630 Maximilian refused to negotiate over a *Correggio and a *Titian because he considered their valuations excessive. Twenty years later, the Habsburg Archduke Leopold Wilhelm utilized his position as Governor of the Spanish Netherlands to acquire spectacular Venetian paintings, many from the dispersed collection of Charles I of England. Inherited by the Emperor Leopold I, these remain the core of *Vienna's great holdings of Venetian art. They include *Antonello's S. Cassiano altarpiece, *Bellini's Young Lady at her Toilet, *Giorgione's Laura and Three Philosophers, sixteen paintings by Titian, and major groups of work by *Bassano, *Palma Vecchio, *Tintoretto, and *Veronese. When Maximilian II of Bavaria was Governor of the Netherlands in 1691–1701, he also acquired notable Italian pictures for his palace at Schleissheim, such as Titian's Charles V and seven works by Veronese.

Johann Wilhelm, Elector Palatine, married the daughter of Cosimo III of Tuscany in 1691. Her dowry brought Raphael's Canigiani Holy Family and *Andrea del Sarto's Holy Family to Düsseldorf. The Elector acquired numerous works of art in Spain, after his sister's marriage to King Charles II, including 21 pictures by Luca *Giordano. Johann so liked Carlo Cignani's Assumption of the Virgin, commissioned by him for the Jesuits of Neuburg to replace an altarpiece which he had expropriated, that he kept it too. During the opening decades of the 18th century the Austrian field marshal Prince Eugène of Savoy was perhaps the greatest patron in Europe. He employed numerous Italian artists, including Carlo *Carlone, *Solimena and G. M. *Crespi, to decorate his palaces in Vienna. Another soldier, Marshal Schulenburg, retired to Venice, and was a great patron of Venetian artists, especially *Pittoni, *Piazzetta, and Gian Antonio *Guardi. He also acquired old master paintings, including works by Raphael, Correggio, and Giorgione.

August II, the Strong, Elector of Saxony and King of Poland, established *Dresden as the artistic capital of Germany. In 1728 he purchased in Rome the Chigi collection of classical marbles, and other antiquities from Cardinal Albani. His son August III acquired the first sculptures excavated at *Herculaneum in 1736, from the collection of Prince Eugène. He is better known for making, a decade later, the greatest single acquisition of Italian pictures of the 18th century; 100 of the finest paintings in the collection of the Duke of Modena. This included Andrea del Sarto's Sacrifice of Isaac, three paintings by Titian, five by Dosso *Dossi, four by Correggio, three by Veronese, seven by the *Carracci, and major works by Parmigianino, Guido *Reni, and *Guercino. This coup was exceeded in the public imagination by his purchase, from Piacenza in 1754, of Raphael's Sistine Madonna, which rapidly became one of the most famous paintings in Europe.

August III also obtained numerous pictures from Venice, including groups of paintings by Palma Vecchio, Veronese, Bassano, and *Canaletto. The last mentioned may have prompted his employment of Bernardo *Bellotto. Between 1747 and 1767 Bellotto portrayed Dresden in a series of panoramic canvases which established its reputation as the finest Baroque city in the north. He subsequently immortalized Vienna for the Empress Maria Theresa, and Warsaw for King Stanisłaus August. In 1750–3 another Venetian, Giambattista *Tiepolo, executed the greatest Italian decorative cycle in Germany, the frescoes

of the *Four Continents* in the Residenz of the Prince-Bishop of Würzburg.

From the 1750s, *Winckelmann, Angelica *Kauffmann, *Mengs, and Anton von *Maron became leaders of the artistic community in Rome, as described in *Goethe's letters of 1786–8. They played a leading role in the growth of *Neoclassicism, which was espoused by nobles on the *Grand Tour, such as Prince Karl Wilhelm of Brunswick and Duchess Anna Amalia of Weimar. However, there is little evidence of a flood of works of art from Italy to Germany, comparable to that which occurred in Britain between the end of the Seven Years War and Napoleon's invasion of Italy.

Prince Ludwig of Bavaria (see MUNICH) 'was overcome with awe' when he saw *Canova's *Hebe* in Venice in 1804. He began a campaign to obtain Italian masterpieces with a supposed Raphael *Self-Portrait*, purchased in Rome in 1808. From Italy, Ludwig acquired *Botticelli's *Lamentation*, *Perugino's *Vision of S. Bernard*, four panels by Fra *Angelico, and significant pictures by Raphael, *Ghirlandaio, Filippo *Lippi, and *Beccafumi. In 1812 he purchased the recently discovered Archaic pedimental figures from Aegina, which *Thorvaldsen restored prior to their display in the *Munich Glyptothek. Ludwig assembled a distinguished collection of classical marbles, including antiquities which Goethe had admired. Legislation made the export of major works increasingly difficult, and negotiations could take years: nineteen in the case of Raphael's *Tempi Madonna*, bought in 1829. Ludwig failed in his bid to acquire the Esquiline *Discobolus* and his purchase of the *Barberini Faun* was only permitted after the intervention of his sister, the Empress of Austria. The Prince took advantage of the political turmoil of 1815 to purchase paintings by *Cima and *Francia from the collection of the Empress Josephine, and Titian's *Virgin and Child in an Evening Landscape*, formerly in the *Escorial, from General Sébastiani. Noticing that Italian paintings were readily available in *London, he bought Raphael's *Madonna della Tenda* from the collection of Sir Thomas Baring in 1818. After ascending the throne, King Ludwig transformed the appearance of Munich with Italianate buildings, including the Alte Pinakothek (see under MUNICH), which opened its doors to the public in 1836.

Frederick the Great had acquired some fashionable 17th-century paintings by artists such as Guido Reni and Carlo *Maratti for his gallery at Potsdam during the 1760s, but the Prussian royal collection included few Italian paintings until after the Napoleonic Wars. In 1815 Friedrich Wilhelm III purchased in Paris the Giustiniani Collection, which included *Amor Victorious* and four other paintings by *Caravaggio, three portraits by *Lotto, and works by Ghirlandaio, Palma Vecchio, Veronese, and Annibale Carracci, and presented it to the public. The character of the Prussian collection was transformed in 1821 by the purchase of over 1,000, primarily Italian, paintings from the collection of Edward Solly, an English merchant in Berlin. Solly was one of the first *connoisseurs of Italian primitives, and his collection included Filippo Lippi's

Virgin Adoring the Child, *Castagno's *Assumption*, *Mantegna's *Presentation of Christ*, and fine works by Pietro *Lorenzetti, *Lorenzo Monaco, Fra Angelico, Antonello, Giovanni and Jacopo *Bellini, *Tura, *Pollaiuolo, Botticelli, Cima, *Carpaccio, and the young Raphael. This taste for primitives was also apparent at the Städelsches Kunstinstitut in Frankfurt, founded in 1817 and advised by J. D. Passavant, a member of the *Nazarene circle in Rome and an admirer of the historian of the Medici and collector of early panel paintings William Roscoe. One of the Städel's first acquisitions was a Verrocchio, followed in 1828–33 by paintings by Fra Angelico, *Crivelli, Perugino, Bellini, and Cima.

With Gustav Waagen as its director, the *Berlin collection including the Giustiniani and Solly Collections went on public display in the Altes Museum in 1830 (see BERLIN, GEMÄLDEGALERIE). One of the first professional curators, Waagen sought to make its holdings more comprehensive, by purchasing High *Renaissance works including Raphael's *Madonna Terranuova* and Titian's *Young Woman with a Bowl of Fruit*. Shortly after the unification of Germany, Wilhelm von Bode joined the museum, of which he became director in 1905. He established its great collection of Italian Renaissance sculpture, and added major paintings by Giotto, *Simone Martini, *Masaccio, Giorgione, and Titian. By Bode's retirement in 1920, the German Empire had collapsed and Italian art no longer represented the acknowledged summit of artistic excellence. Hitler's purchase of the *Discobolus* for the Munich Glyptothek in 1938 was not so much the acquisition of an artistic masterpiece as a political gesture, tainted by racial fantasies.

It should be stressed that most of the above collectors of Italian art assembled considerably more extensive holdings of German, Netherlandish, or French paintings. This applies to the Emperors Maximilian I and Rudolf II, as much as to the monarchs Frederick the Great and Ludwig of Bavaria, or the curators Passavant and Bode. Personal connections with Italy, or the art dealers of the Low Countries and London, were a significant factor—as with Charles V and Archduke Leopold Wilhelm, or Johann Wilhelm of the Palatinate and Marshal Schulenburg. August III of Saxony was unusual in his particular enthusiasm for Italian paintings, and he also acquired major northern pictures. Overall, the spectre of empire and a profound respect for *Classicism invested Italian art with a depth of significance which seems to have limited its purely hedonistic enjoyment in Germany. MLE

6. USA

THE fashion for collecting early Italian painting that gathered momentum in Great Britain during the third quarter of the 19th century quickly spread to the USA. The pioneers in this development were James Jackson Jarves (1818–88) and Thomas Jefferson Bryan (1802–70). Bryan, who was born at Philadelphia and had access to substantial family

funds, spent more than 20 years in Europe from c.1828 until the early 1850s. Here he formed a substantial and wide-ranging collection; but, above all, it contained at least thirteen early Italian works from the collection of the French diplomat, Artaud de Montor (1772–1849) which had been formed in Rome 1804–7 (see above, 2. France), exhibited at Paris by 1811, lavishly catalogued, and eventually sold in 1851. Bryan's acquisitions included a *Crucifixion* then attributed to *Botticelli, but now attributed to *Giovanni da Milano; a *desco da parto* of the *Triumph of Fame* with the arms of Lorenzo de' Medici, then attributed to *Giotto and now attributed to Giovanni di ser Giovanni, called Lo Scheggia (1406–86); a pair of panels of the *Virgin and Child* and *The Last Judgement*, then attributed to *Piero di Cosimo and now attributed to the Master of San Martino alla Palma (active Florence c.1310–35); and a *Madonna and Child* then attributed to *Guido da Siena and now attributed to Nardo di Cione who probably worked in the shop of his more famous brother Andrea di *Cione. As these radically altered attributions make plain, Bryan was in the market before the era of methodical *connoisseurship of early Italian art. The focus of his interest is reflected in his decision, following his return home, to exhibit his collection in New York from 1852 to 1859 as The Bryan Gallery of Christian Art. In 1864 he presented it to the New York Historical Society, where it remained until disposal by auction (Sotheby's, New York, 12 January 1995). Jarves on the other hand formed a more art-historical collection to illustrate the progress of Italian art, albeit with somewhat optimistic attributions (it was sold to Yale University in 1871). He also published a book on the subject, *Art Studies* (1861), that was written from both a moralistic and historical viewpoint. However, it was Bernard *Berenson (1865–1959), renowned as a connoisseur trained in the tradition of the Italian Giovanni *Morelli, whom he knew in Italy, who gave rich American collectors the confidence to invest substantial sums of money in the creation of collections of early Italian and Renaissance art, many of which are still preserved in a museum context. It was largely under Berenson's influence that Isabella Stewart Gardner filled her Italianate villa on the Fenway at *Boston with Italian masterpieces, ranging from Giotto and *Simone Martini to *Raphael and *Titian's *Rape of Europa*. Berenson also advised the New York collector Carl W. Hamilton (1886–1967), whose perceptive taste and zeal for the spiritual associations of early Italian art were not always matched by his financial resources. He acquired *Piero della Francesca's *Crucifixion* (New York, Frick Coll.), *Mantegna's *Judith and Holofernes* (Washington, NG), and Giovanni *Bellini's *Feast of the Gods* (Washington, NG), as well

as *Domenico Veneziano's *S. John in the Desert* (Washington, NG), a gift from Mary Berenson. Berenson was also actively involved in Joseph Widener's (1872–1943) acquisition of Andrea del *Castagno's *David and Goliath* shield-painting (Washington, NG), from the English dealer Arthur Sulley. And he advised John G. Johnson (1841–1917), who made a more historical collection, now at the *Philadelphia Museum; Henry Walters (1848–1931), whose collection is now at Baltimore; and Robert Lehman (1892–1969), whose collections are now at the Metropolitan Museum, *New York. He also advised Samuel H. Kress (1863–1955), the last of the great collectors of Italian early Renaissance art, much of which went to the National Gallery, *Washington DC. Notable acquisitions made on Berenson's advice included Giotto's *Madonna* (Washington, NG) and a tondo of the *Adoration of the Magi* (Washington, NG) attributed to Fra *Angelico and Filippo *Lippi. Berenson was closely associated with the British New York dealer Joseph Duveen (1869–1939), who had the financial resources to take advantage of the buyer's market in Great Britain and Europe, and whose clients included Benjamin Altman, Henry Clay Frick, J. Pierpont Morgan, and Andrew W. Mellon (see under NEW YORK, METROPOLITAN MUSEUM, and FRICK COLLECTION; and under WASHINGTON, NATIONAL GALLERY). And although Berenson's position as a scholarly connoisseur may have been compromised by the financially rewarding nature of this association, there can be no argument that these two men changed the status of America as a centre of collecting, as radically as William Buchanan and the advisory artists on his payroll changed the London scene during the speculative boom there in the early years of the 19th century (see above, 4. Great Britain).

In the second half of the 20th century American museums, many formed around the private collections described here, were among the first to participate in the revival of interest in Italian 17th-century art that had been sidelined as too academic while the primitives were in fashion. Much of the recent scholarly attention devoted to such artists as Annibale *Carracci, *Domenichino, Guido *Reni, Andrea *Sacchi, *Caravaggio, *Cavallino, G. B. *Castiglione, and *Testa has originated in the USA and has informed the astute collecting of such museums as the Metropolitan, New York, the *Cleveland Museum of Art, and the J. P. Getty Museum, *Los Angeles. HB

Brown, D. A., *Berenson and the Connoisseurship of Italian Painting*, exhib. handbook 1979 (Washington, NG of Art).
Haskell, F. 'The Benjamin Altman Bequest' in *Past and Present in Art and Taste. Selected Essays* (1987).

taught. From 1831 to 1857 he lived in Italy. Deeply religious, he lived an ascetic life, shunning worldly contacts to devote over 20 years to one enormous canvas, *Christ Appearing to the People* (1837–57; Moscow, Tretyakov Gal.). Influenced by the academicism of *Raphael and *Poussin, his approach was

nevertheless realistic, observing from life rather than precept. The painting partook of Ivanov's mysticism, symbolizing man's moral transformation and spiritual enlightenment, but also his practical view of art as an influence for the betterment of mankind, an outlook shared by the *Nazarene *Over-

beck, with whom he was acquainted. Studies for the work, including exceptionally fine portraits recording the unidealized ethnographic peculiarities of each sitter, and vibrant *plein air* landscapes, are now highly prized. Ivanov's observation of the reflection of colour on surrounding objects and the

stylistic experimentation of his later water-colours, particularly *The Biblical Sketches* of the 1850s, show him to be a thoughtful innovator. DJ

Barooshian, V., *The Art of Liberation: Alexander A. Ivanov* (1987).

IVORIES. Ivory has been worked since ancient times, when it was considered a luxury material with gold and precious stones, and appears as such in the poetic imagery of the *Odyssey* and the Song of Songs. Triumphal monuments of Egypt, Assyria, and Rome show tusks being brought as tribute by captives. By peaceful means, too, Egyptians obtained them from African sources (and Tutankhamun's tomb included ivory), while Assyrians bargained with Phoenicians for supplies from India. *Chryselephantine statues produced during the ancient Greek period, such as *Phidias' statues of Zeus at Olympia and Athena at Athens, used ivory together with gold over a wood carcass. Romans used ivory for pyxes and on furniture and for the consular diptychs which later came to represent models for the design of religious ivory reliefs.

Besides its physical charm ivory still retains something of the aura of mystery and legend which surrounded it during the medieval period. For centuries it was associated with the rarely seen elephant and the only slightly more fabulous unicorn whose horn was said to neutralize poison contained in a cup made from it. In the Far East Marco Polo learned that the unicorn was identified with the rhinoceros, but in Europe the source of the long horn with corkscrew grain was the narwhal of the Arctic Ocean. Even morse (walrus) ivory was rare enough in the 9th century to make King Alfred listen to the Norwegian explorer who had seen these 'horse whales' off the coast of Russia.

Early Christian ivories, such as the Brescia Casket (Brescia, Mus. Civico Cristiano) and the Berlin Pyxis (Berlin, Staatliche Mus.) derive from Syrian classical carvings, though their subjects are Christian. The proximity of Constantine's new capital on the Bosporus undoubtedly stimulated production in these centres, and confirmed the importance of ivory in the symbolic art of the empire and Church. The chair and sceptre of secular power had their counterparts in the episcopal throne and pastoral staff, which were also frequently of ivory, and the most famous carving of its period is the throne of Bishop Maximian (546–56) in Ravenna, decorated with scenes from the lives of the Virgin and Christ with the story of Joseph. Ivory carving declined during the *Iconoclastic controversy of the 8th and 9th centuries, but began to flourish again under the Macedonian dynasty and magnificent triptychs and caskets were produced during the 10th and 11th centuries. Triptychs probably developed out

of the diptych form, and were probably used for private devotion, since the image, usually of the Virgin and Child, is carved in the inner surface, and protected by the wings when closed. An elaborate example is the Harbanville Triptych (Paris, Louvre), which is carved both on the interior and exterior sides of the wings. Though some caskets have religious iconography, usually they have classical imagery, as on the Veroli Casket (London, V&A). Often the decorative framing motifs include rosettes or heads in roundels.

Under Charlemagne and his successors, caskets and liturgical combs and fans were produced in emulation of early Christian and *Byzantine examples. The main production was in book covers, which vary in style from hieratic stiffness in the covers of the Lorsch Gospels (Vatican and London, V&A) to lively narrative in those of the Psalter of Charles the Bald (Paris, Bib. Nat.).

These divergent tendencies reappear in *Ottonian and *Anglo-Saxon art of the 10th and 11th centuries. On the one hand the hieratic style of the Ottonian ivories was strengthened by contact with Byzantium, though the most typical examples, such as *Christ Raising the Widow's Son* (London, BM), and other plaques from the same altar frontal have an intensity quite different from the detached calm of the Byzantine work. Some Anglo-Saxon ivories, such as the Alcester Tau (London, BM), reflect the agitated and linear fantasy of the 'Winchester' style of manuscript illumination.

Though the elephant itself was little known in Europe during the medieval period, an elephant from Jerusalem was given as a present to Henry III in 1255 and housed in the Tower of London, where it became the object of much curiosity. There it was painted by the English monk Matthew *Paris (d. 1259) in his *Chronica majora*. Recent research has shown that from as early as the 10th century and particularly during the Middle Ages ivory (together with gold and other precious materials) was exported in great amounts to Europe from the African continent. Much came through trade routes from East Africa, above all through Swahili traders, who obtained the tusks from the African interior and exported these to Europe and to the East. Ivory carvings produced during this period may have played a part in the revival of stone sculpture in France at the end of the 11th century, judging by the close parallels between *Romanesque ivories and the carved capitals and porches of churches. A tau in Florence (Bargello), with scenes from the story of Dives and Lazarus, echoes a favourite theme of churches in the Languedoc in France, and the standing apostles on a plaque in Berlin (Berlin, Staatliche Mus.) are strikingly paralleled on the lintel of the south door of S. Sernin in Toulouse. In England,

however the ivories are more often linked with manuscript styles, as the king from the *Adoration of the Magi* (Dorchester, Dorset County Mus.) which is related to the Shaftesbury Psalter (London, BM).

A transitional phase between the *Romanesque and the *Gothic is suggested by the later 12th-century English crozier (London, V&A) on which episodes from the infancy of Christ and the life of S. Nicholas are represented. Over 50 years separate these from French ivories of the 13th century, whose style emerged fully formed, as if without evolution, and again has close relationships with monumental sculpture. The change is marked by the sudden appearance of free-standing statuettes after *c*.1240. Among the finest are the *Coronation of the Virgin* (Paris, Louvre), which relates closely to cathedral sculpture, and a *Deposition* (Paris, Louvre), one of the most expressive works of the period. Around this period saw the revival of the diptych and triptych, especially designed to be portable and for use in personal devotion. Unlike their Byzantine predecessors, many of these, such as the Soissons Diptych (London, V&A), are carved with crowded rows of figures in an architectural framework, set one above the other and forming continuous narratives similar to the elaborate biblical cycles of contemporary manuscript illustration. This new taste in the anecdotal rather than the dogmatic corresponded to a change in patronage. Like the manuscripts, ivories were increasingly commissioned and executed by laymen, and secular objects decorated with scenes from romance and courtly love, such as combs, caskets (*La Chatelaine de Vergy*; New York, Met. Mus.), and mirror cases (*The Elopement from the Castle of Love*, Liverpool Mus.; or *Couple Playing Chess*, Cleveland, Mus. of Art), were produced in the same workshops. For the first time the names of craftsmen are recorded, and although the French style dominated the whole of Europe, a *Virgin and Child* in Pisa Cathedral can be identified with one carved by Giovanni *Pisano in 1299. A documented large altarpiece made by the workshop of Baldassare degli Embriachi in around 1400 for the Certosa of Pavia is the key to a large group of works from the same workshop, such as altarpieces and caskets, which are distinguished by their use of carved strips of bone instead of ivory. An English group of carvers has been identified through a triptych (London, BM) made for Bishop Grandisson of Exeter (1327–69).

After the 14th century ivory carving as an art steadily declined, despite revivals in the 17th and 18th centuries. The Baroque tankards, statuettes, and reliefs of German and Flemish carvers such as Georg Petel (*c*.1590–1634), Gerard van Opstal (*c*.1597–1668), and Lukas Faydherbe (1617–97) are often three-

dimensional recreations of *Rubens's compositions or other print sources. The ivories of Balthasar *Permoser are reduced versions of his monumental sculpture, and the consummately elegant portrait ivories of Jean Cavalier (active 1680–1707) and David Le Marchand (1674–1726) come close to medallic art. With the elaborate standing cups and ornaments produced on the lathe by German craftsmen, and by aristocratic amateurs of the 17th century, art descended to mere skill.

HO/AB

Barnet, P. (ed.), *Images in Ivory: Precious Objects of the Gothic Age*, exhib. cat. 1997 (Detroit, Inst. of Arts).
Penny, N., *The Materials of Sculpture* (1993).

JACKSON, ALEXANDER YOUNG (1882–1974). Canadian painter. Born in Montreal, he studied there and then at the Académie Julian in Paris (1907). On a second trip to Europe (1911–13) he further familiarized himself with *Impressionist and *Post-Impressionist styles. In 1913 he moved to Toronto. There he met Lawren *Harris, Tom *Thomson, and others and accompanied them on sketching trips to northern Ontario. *Terre sauvage* (1913; Ottawa, NG Canada) is one of his first paintings depicting the rocky, forested terrain of the northland. In 1920 he became one of the founders of the *Group of Seven.

Jackson was the most fervent nationalist of the group, writing and lecturing about the importance of an art that would give Canadians a sense of their identity. He painted widely in Canada, especially in Quebec, and made sketching trips to the Arctic and Northwest Territories. His paintings often feature undulating horizons of rows of low hills, curves of muddy roads and snowdrifts, and patterns made by ploughed farmland. In 1958 he wrote his autobiography, *A Painter's Country.* KM

Firestone, O. J., *The Other A. Y. Jackson: A Memoir* (1979).

JACOBELLO DEL FIORE (active 1400; d. 1439). Italian painter. Jacobello was one of the leading painters of early quattrocento Venice, where he received a substantial state salary. His career can be divided into two sections, between which he encountered the work of *International Gothic artists working in Venice. Jacobello's early work makes little advance on the kind of painting practised in Venice since the mid-trecento. After the period during which the Sala del Maggior Consiglio of the Doge's palace was decorated by *Gentile, *Pisanello, et al. (Jacobello's own participation is conjectural) his work comes more into line with developments on mainland Italy. The triptych of *Justice Enthroned with the Archangels Michael and Gabriel* that Jacobello painted for the office of the Magistrato del Proprio (1421; Venice, Accademia) is representative of his maturity, richly decorated with gilding and *pastiglia*, the draperies and banderoles extravagantly curvaceous, the modelling highly refined. JR

JACOMART, MASTER. See BAÇO, JAIME.

JACQUEMART DE HESDIN (active by 1384, d. after 1413). Franco-Netherlandish painter, active in France. In 1384 he received payment for work undertaken in Bourges for the Duke of Berry, subsequently receiving a regular salary. While working at Poitiers in 1398, he and others were accused of stealing colours and designs from another painter employed by the Duke. Ducal inventories mention two books of hours by him and his assistants. The later of these is the *Grandes Heures* (completed 1409; Paris, Bib. Nat., MS lat. 919). Unfortunately, the large pictures for which Jacquemart was responsible have been extracted from this manuscript, though one has reasonably been identified with a *Road to Calvary* (Paris, Louvre). Assuming this is by him, it seems unlikely that Jacquemart was a trained illuminator, his pictorial interests stemming more from Tuscan fresco painting than French illumination. This seems consistent with the identification of the earlier entry with the Brussels Hours (before 1402?; Brussels, Bib. Royale, MSS 11060–1), in which the full-page miniatures make extensive use of expansive *landscapes and high viewpoints, features uncharacteristic of earlier French illumination. TT

Pélegrin, G. (ed.), *Les Fastes du Gothique: le siècle de Charles V*, exhib. cat. 1981 (Paris, Grand Palais).

JAGGER, CHARLES SARGEANT (1885–1934). British sculptor, best known for his war memorials. He was born at Kilnhurst (Yorks.), the son of a colliery manager, and at the age of 14 he was apprenticed as a metal

383

engraver with the Sheffield firm of Mappin & Webb. In 1907 he won a scholarship to the Royal College of Art, London, where he studied from 1908 to 1911. His early work, such as *Torfrida* (c.1911; Rotherham, Clifton Park Mus.) shows the impact of the *New Sculpture in its medievalism and concentration on surface qualities. At the end of his student period he won a travelling scholarship that enabled him to spend several months in Rome and Venice. In 1913 he was placed second to Gilbert Ledward (1888–1960) in competition for the Rome Scholarship and the following year he won the award. However, the First World War intervened before he could take it up. He enlisted in the army, fought at Gallipoli and in France, was wounded three times, and won the Military Cross. His experience of trench warfare is reflected in his huge bronze relief *No Man's Land* (1919–20; London, Tate). He began making sketches for this in 1918 when he was recovering from a severe wound, and the finished work was commissioned by the British School of Rome in lieu of the scholarship he had relinquished. It is one of the grimmest images inspired by the war, showing a solitary lookout taking cover behind corpses strewn across barbed wire.

Some of this realism survived in his memorials, the first of which was the Hoylake and West Kirby Memorial (Lancs.) (1919–20); it contrasts a powerfully characterized infantryman—dishevelled but resolute—with an allegorical figure of Humanity. Jagger's most famous work is the Royal Artillery Memorial (1921–5; London, Hyde Park Corner), the most prominent feature of which is a huge stone howitzer (fulfilling the wishes of the regiment that the monument should be clearly identifiable as its own). Below this, life-size bronze statues of an officer, a driver, a shell-carrier, and—a bold decision—a dead soldier are combined with stone reliefs depicting war as painful labour in a style reflecting Jagger's admiration for Assyrian art. This was a vision far removed from the symbolic or idealized approach of most contemporary war memorials and the work caused considerable controversy, partly because the howitzer was in stone rather than the more natural-seeming bronze (Jagger said that he did not want a dark object against the skyline).

Jagger remained a leading sculptor after the demand for war memorials was over, his major commissions including stone figures at Imperial Chemical House, London (1928). He came to be regarded as a conservative figure, although some of his late work clearly shows the influence of *Art Deco. In 1933, a year before his sudden death from a heart attack, he published an instructional book *Modelling and Sculpture in the Making*; this was still in print in the 1950s and remains a valuable account of studio practice in the early part of the 20th century. JG-S

JAMESON, ANNA BROWNELL (née Murphy) (1794–1860). English writer. Her interest in art was awakened by a visit to Germany c.1834 when she met Wilhelm Schlegel and Ottilie von Goethe. Her reputation was established by a pioneering series of popular articles on early Italian art for the *Penny Magazine*, republished as *Memoirs of the Early Italian Painters* (1845). This was followed by two guidebooks or catalogues: *A Handbook to the Public Galleries of Art in and near London* (1842); and *Companion to the Most Celebrated Private Galleries of Art in London* (1844). In a thoughtful introduction to the former she defines and distinguishes various art forms, styles, and techniques, and then goes on to discuss the philosophy of art, critical reception, and *connoisseurship. By far her most important contribution was the four-volume work on Christian *iconography and symbolism in art, comprising *The Poetry of Sacred and Legendary Art* (2 vols., 1848); *Legends of the Monastic Orders* (1850); *Legends of the Madonna* (1852). Like Lord *Lindsay, who had preceded her with an extended section on Christian mythology, in his *Sketches of the History of Christian Art* (1847), Anna Jameson was conscious of religious art as a poetic reflection of the legendary literature of previous ages which interacted with historical fact and religious doctrine. However, her general approach was far less speculative than Lindsay's; and in relation to sacred subject matter was far more object oriented. She emphasizes the importance of historical and physical context in the process of interpreting a work of art, elucidating the subject matter and identifying the protagonists. Her books played a major part in popularizing the early Italian painters, and in promoting an aesthetic, as opposed to a religious, view of their work. HB

Jameson, A., *Diary of an Ennuyée* (1826).
MacPherson, G., *Memoirs of the Life of Anna Jameson* (1878).

JANSSENS, ABRAHAM (1575–1632). Flemish painter of religious and mythological works. After an early training in Antwerp with the art dealer and painter Jan Snellinck I, Janssens is recorded as being in Rome between 1598 and 1601. *Diana and Callisto* (1601; Budapest, Szépművészeti Mus.) may have been painted in Rome, but it is also typical of the Mannerist style popular in the Southern Netherlands (see ANTWERP MANNERISM). After Janssens's return to Antwerp in 1602 his close reliance on *Raphael is clear, as seen in *Olympus* (Munich, Alte Pin.) which combines Janssens's study of the *Antique and of *Michelangelo, not only in Italy but also through prints which he could have seen in Antwerp. After 1608, Janssens's reputation suffered through comparison with *Rubens, although both painters were commissioned in 1609 to decorate the State Room of the town hall in Antwerp with Rubens's *Adoration of the Shepherds* (Madrid, Prado) and Janssens's *Scaldis and Antwerpia* (Antwerp, Koninklijk Mus. voor Schone Kunsten). Janssens's compositions are characterized by a blend of realism and classicism, usually with two or three sculptural and sharply lit figures at the extreme forefront of the picture plane. Colours are clear and bold and the technique is smooth and glossy. His pupils included Theodoor *Rombouts and Gerard *Seghers. CFW

Sutton, P., *The Age of Rubens*, exhib. cat. 1993 (Boston, Mus. of Fine Arts).

JAPANESERY (japonaiserie), a term coined in 1885 to describe Western art influenced by Japanese examples. Following the recommencement of trade with Japan in 1853, after a gap of two centuries, Japanese art was eagerly collected in the West. By the 1880s the cult of Japan had reached epidemic proportions and was caricatured in satirical magazines. Japanese influence was first seen in decorative art but was soon apparent in paintings. In some cases, like *Manet's *La Japonaise* (1876; Boston, Mus. of Fine Arts), the influence was superficial but more profound effects, particularly asymmetrical composition, may be seen in works by *Toulouse-Lautrec, *Degas, and *Whistler. DER

JAWLENSKY, ALEXIS VON (1864–1941). Russian-born painter and printmaker. Jawlensky first studied art under *Repin while stationed in St Petersburg as a military cadet. From 1896 he travelled, forging a lasting friendship with *Kandinsky while in Munich, and developing his own Expressionistic style, using broad patches of colour and heavy black outlines: *Landscape, Oberstdorf* (1912; Emden, Kunsthalle). While in Switzerland during the war he began his series of *Variations*, increasingly abstract landscapes which reflect his growing interest in theosophy and mysticism. His approach became more geometric in his series of *Heads*, paintings merging the tradition of Russian *icons with the principles of abstraction. In 1924 he formed the Blue Four, along with *Klee, Kandinsky, and *Feininger, aimed at spreading their ideas abroad with lectures and exhibitions, but his determination to stay in Germany led to his increasing isolation when the others had emigrated. In 1929, suffering from crippling arthritis, Jawlensky began to paint smaller pictures, for example the *Meditations* series, but by 1937 he was forced to cease work altogether. MF

Jawlensky, A., Jawlensky, M., and Pieroni-Jawlensky, L., *Catalogue Raisonné of the Oil Paintings, 1890–1914* (1991).

JEAN DE BRUGES. See BAUDOLF, JAN.

JEAN DE CAMBRAI (active 1375–1438). South Netherlandish sculptor who worked chiefly for John, Duke of Berry. He began in 1386–7 as a craftsman receiving a monthly salary, was promoted to *valet de chambre* in 1397, and by 1401–2 had achieved the status of *imagier*. Little of the work he completed for the Duke survives. The alabaster effigy of John, Duke of Berry, made for his tomb (Bourges, S. Chapelle) was not finished when Jean died and Étienne Bobillet and Paul Mosselman completed it; this adds to the difficulty in distinguishing Jean de Cambrai's hand, although it is thought that the five weepers from the tomb (Bourges, Mus. Berry; St Petersburg, Hermitage) are by him, as is the monumental white marble *Virgin and Child* presented by John, Duke of Berry to the Celestine monastery of Marcoussis (now parish church). KC

Erlande-Brandenburg, A., 'Jean de Cambrai, sculpteur de Jean de France, Duc de Berry', *Monuments Piot*, 63 (1980).

Legner, A. (ed.), *Die Parler und der schöne Stil, 1350–1400: europäische Kunst unter den Luxemburgern*, exhib. cat. 1978 (Cologne, Schnütgen-Mus.).

JEAN DE HUY (active between 1311 and 1329). Tomb sculptor who was one of the earliest 14th-century Netherlandish sculptors to be documented as a resident of Paris. He mostly worked in alabaster and marble. He carried out much work for Mahaut, Countess of Artois, including the tomb of her husband, Otto IV, Count of Burgundy (1312; fragments in Vesoul, Cousin priv. coll.) and the tomb of the Countess's son Robert d'Artois (1317–20; Paris, S. Denis). The tomb of Philippe d'Artois, the brother of Mahaut, has also been attributed to him. He worked for Louis, Count of Clermont, on the tomb of his sister Marguerite de Bourbon. Apart from tombs, he is known to have made a *Virgin and Child* for the nuns of Gosnay and one for the Dominican church at Poligny. KC

Schmidt, G., 'Drei Pariser Marmorbildhauer des 14. Jahrhunderts. I. Jean Pépin de Huy. Stand der Forschung und offene Fragen', *Wiener Jahrbuch*, 24 (1971).

JEAN (HENNEQUIN) DE LIÈGE (active c.1360–81). Southern Netherlandish sculptor active in France, who mostly worked on tombs and funerary monuments. He invented a particular tomb format whereby the deceased was guaranteed eternal mourning by the sculpted weepers that surrounded the sarcophagus. This form became extremely popular throughout Europe and was used particularly effectively by Claus *Sluter. Jean de Liège worked on the tomb for the infant daughters of the future Charles V (bust of Bonne, c.1460; Antwerp, Mus. Mayer van den Bergh). Among other work undertaken for the King were, in 1365, the sculptures of *Charles V* and his wife *Joanna of Bourbon* for the great staircase of the Palais du Louvre, which was destroyed in 1624 (sometimes identified as two figures in Paris, Louvre) and various other tombs for himself and members of his family. In 1336 he was called to London by Philippa of Hainaut, Queen of Edward III, to make her a tomb to go into the chapel of Edward the Confessor in Westminster Abbey. The realistic portrayal of the Queen, a departure from the idealized type of effigy, reveals much about Liège's interests in naturalism. Of the 32 weepers around the sides of the tomb only one survives. This sculptor should not be confused with Jean de Liège, a Franco-Flemish sculptor active c.1381–1403, who worked for Philip the Bold on the chapter house of Champmol-lès-Dijon. KC

Schmidt, G., 'Beiträge zu Stil und Oeuvre des Jean de Liège', *Metropolitan Museum Journal*, 4 (1971).

Stone, L., *Sculpture in Britain: The Middle Ages* (1955).

JEAN D'ORLÉANS (1361–c.1420). French painter. Documents certify that he was a prolific painter who served as *huissier de salle* and *valet de chambre* to the French Kings John II, Charles V, and Charles VI until c.1407, as well as working for John, Duke of Berry, and Philip the Bold, Duke of Burgundy. Despite the detailed accounts which survive of his activities, which included painting an audience hall in the Louvre, evaluating paintings, colouring a crib for Philip the Bold's first son (1371) and a statue for Charles V for his funerary chapel, executing triptychs and quadritychs and restoring wall paintings, no documented works have been recognized. He has been identified as the *Master of the Parement de Narbonne but this is entirely conjectural. KC

Henwood, P., 'Jean d'Orléans peintre des rois Jean II, Charles V et Charles VI: 1361–1407', *Gazette des beaux-arts*, 45 (1980).

JEANNERET, CHARLES-ÉDOUARD. See LE CORBUSIER.

JEHAN DE PARIS. See PERRÉAL, JEAN.

JEHAN, DREUX (active 1448–d. c.1468). Franco-Flemish scribe, illuminator, book restorer, and designer. Between 1448 and 1456 he worked exclusively for Philip the Good, Duke of Burgundy, illuminating, binding, and restoring manuscripts and was appointed *valet de chambre* in 1449. In 1451 Philip commissioned him to renovate the *Grandes Heures* of Philip the Bold (Cambridge, Fitzwilliam, MS 3-1954; Brussels, Bib. Royale, MSS 11035–7). After eight years in the Duke's service he distanced himself from court and set up an independent workshop. Although resident in Brussels for most of his career, he also paid for citizenship in Bruges, probably to avoid restrictions on the import of manuscripts into that city. Jehan is thought to be identifiable with the Master of the Girart de Roussillon (Vienna, Österreichische Nationalbib., Cod. 2549) illuminated for Philip the Good. KC

Arnould, A., and Massing, J. M. (eds.), *Splendours of Flanders*, exhib. cat. 1992 (Cambridge, Fitzwilliam).

JEWISH ART. The Jewish attitude to art was long thought to have been conditioned by the stern prohibition on 'graven images' found in the Second Commandment (Exodus 20: 4), but there are indications that this was interpreted leniently even in biblical times. Bezaleel decorated the tabernacle with winged creatures called cherubim, and in the First Temple in Jerusalem (c.950 BC) there were sculpted images of lions, oxen, and cherubim. Though there were undoubtedly times when figuration was avoided, this was usually as much for political and social reasons as for religious ones. For example the great revolt against the Romans of AD 66 led to demonstrations and ordinances against Roman imagery. The discovery of mosaics on synagogue floors depicting biblical scenes such as *The Sacrifice of Isaac* (Israel, Beth Alpha) further challenged the notion of Jewish art as being non-figurative, as did that of the 3rd-century synagogue of Dura Europos with its frescoes of biblical narrative (now in Damascus, National Mus.), which show stylistic influences of both Roman and Greek traditions. This susceptibility to influences of 'host' cultures is evident in many other aspects of Jewish art, such as in illuminated manuscripts which, as the only artistic field in which medieval Jews were permitted to practise, held particular importance. The most favoured manuscripts include the Passover *Haggadah and the Megillah or Scroll of Esther. Styles were once more closely related to geographical areas; in Islamic lands, where art was non-figurative, Jewish manuscripts concentrated on decoration using stylized patterns and micrography (where the script is employed as a decorative element), whereas in Christian countries, they showed similarities to Latin psalters and breviaries. In Islamic lands, Jews excelled as silversmiths, but since, with the exception of Poland, Jews were not allowed to become members of the appropriate guilds in Christian lands, they commissioned others to produce ceremonial metalwork. Written sources provide evidence of wall paintings in synagogues from medieval times, and the wooden synagogues of eastern Europe were richly decorated. Most were destroyed during the Second World War, but the wooden synagogue of Horb has been reconstructed (Jerusalem, Israel Mus.). Whilst from the 17th century there are examples of portraits and miniatures of Jews, even of orthodox rabbis,

by Jewish amateurs, it was only with the advent of the Jewish enlightenment or *Haskalah* in the late 18th century that artists of the Jewish faith were able to enter schools of art. Many nevertheless chose to convert to Christianity, including Ismael Mengs, artist father of the better-known Anton Raphael *Mengs, Philipp *Veit, and Eduard Bendemann (1811–89). Whilst *Zoffany is rumoured to have been Jewish, the first unequivocally Jewish artist to succeed was Moritz Oppenheim (1800–82) whose depictions of bourgeois Jewish life were both an attempt to dispel the prejudice and ignorance surrounding Judaism, and a nostalgic evocation of a fast disappearing world. Similar scenes were painted by the Austrian Isidor Kaufmann (1853–1921), the Pole Maurycy Gottlieb (1856–79) and the British Solomon Alexander Hart (1806–81). None, however, achieved the fame of the Impressionist Camille *Pissarro, who chose almost complete assimilation and did not paint any Jewish subjects. Similarly *Liebermann in Germany and the Dutchman Jozef *Israels achieved artistic success with only rare references to their Jewish heritage. The early 20th century saw a flood of Jewish artists arriving in Paris. Most came from eastern Europe where it was almost impossible for a Jew to study art, though there were exceptions such as the Italian *Modigliani. The best known include *Soutine and Jules Pascin. Whilst a few, most noticeably *Chagall and Mané-Katz (1894–1962), painted scenes of Jewish life from the *shtetls* of Russia and Poland, the majority instead turned to the prevalent avant-garde styles. The number of Jewish artists living in Paris led to the notion of an *École juive* as a subdivision of the *École de Paris. The most important attempt to create a national Jewish art form took place in Russia immediately following the 1917 revolution, where artists such as Issachar Ryback (1897–1935), El *Lissitzky, and Chagall turned to sources of Jewish folk art for inspiration, combining these with *Cubism and *Constructivism to produce Jewish scenes, designs for the Yiddish theatre, and illustrations for religious texts. In Britain a number of artists from east European immigrant families became artists, among them *Bomberg, *Gertler, and Alfred Wolmark (1877–1961), who all portrayed overtly Jewish subject matter early in their careers. There are similar cases in the USA, such as *Weber and Ben *Shahn, who developed an interest in Hebrew calligraphy late in his career. Abstract Expressionists *Rothko, *Newman, and *Gottlieb were all Jewish; Newman not only expressed an interest in Jewish mysticism and the Kabbalah, but also designed a synagogue (unexecuted). Perhaps because sculpture is the art form most closely identified with idolatry, there have been fewer Jewish sculptors of renown. The first was Mark Antokolsky (1843–1902), who was followed by

*Epstein, *Lipchitz, and *Segal, all of whom depicted Jewish scenes at some point in their lives. Although Israel only achieved independence in 1948, the Bezalel School of Arts and Crafts was established in Jerusalem as early as 1906. In the 1920s, artists such as Reuven Rubin (1893–1974) painted works celebrating the renewed fertility of the land. Later, the Canaanite movement became interested in the early history of Semitic peoples. Tragically, the Holocaust has come to be regarded as specifically Jewish subject matter. Over 30,000 works of art by the victims in a variety of media exist, and a number of contemporary artists including survivors have explored the subject, such as Samuel Bak (1933–), R. B. *Kitaj, and Christian Boltanski (1944–). AJW

Roth C. (ed.), *Jewish Art: An Illustrated History* (1971).

JODE, DE. Family of engravers and print publishers in Antwerp during the 16th and 17th centuries. The most important members were **Pieter I** (1570–1634) and his son **Pieter II** (1604–after 1674). Pieter I was the son of Gérard de Jode (1509×17–91), an engraver, map-maker, and publisher. Around 1595 he travelled to Rome, later to Holland, where he worked with Hendrik *Goltzius, and to France. In 1599/1600 he was admitted into the *Antwerp guild of S. Luke; in 1602 he married Suzanne Verhulst, a sister-in-law of Jan *Brueghel the elder, who himself married Pieter de Jode's sister Isabella. Pieter's early engravings, which include three after Bartholomäus *Spranger, are strongly influenced by Goltzius. After his return to Antwerp, his work was mainly focused on book illustrations. However, he continued to execute *reproductive prints after the works of Sebastian *Vrancx, Otto van *Veen, *Rubens (*Christ Giving the Keys to S. Peter*) and van *Dyck. Pieter de Jode II was trained by his father before becoming a master in 1628/9. In 1631–2 he was in Paris together with his father. There is considerable confusion between the engravings of Pieter the elder and the younger. In his later works, after van Dyck and Rubens, Pieter II developed a more painterly style (*The Visitation*, after Rubens, 1632–4). KLB

JOEST, JAN (c.1460–1519). Netherlandish painter whose origins remain uncertain but who may have been born in Haarlem. Later he is documented in Kalkar (1505–9) and Haarlem (1510), where he died. The shutters of the high altar of the parish church of S. Nikolai in Kalkar (1505/6 and 1508/9; *in situ*) are his principal achievement. The 20 panels with scenes from the life of Christ show the influence of earlier 15th-century Flemish painting (*Memling, Gerard *David, Hugo van der *Goes) as well as contemporary prints (*Schongauer, van *Meckenem,

*Dürer). Stylistic analysis supported by some documentary evidence suggests that Joest is also the painter of an altarpiece for Palencia Cathedral, commissioned in 1505 by Juan de Fonseca, Bishop of Palencia. Seven panels show the *Sorrows of the Virgin* while a larger eighth panel depicts the donor adoring a grieving Virgin supported by S. John. Jan Joest was the teacher of Bartholomäus *Bruyn and Joos van *Cleve. KLB

Wolff-Thomsen, U., *Jan Joest von Kalkar* (1997).

JOHAN, PEDRO (1398–after 1458). Catalan Gothic sculptor influenced by the 14th-century manner of Jaume Cascalls. Johan carved the altarpiece of the Cathedral of Tarragona (1426) in alabaster enhanced with gilding. He had begun the altarpiece for the Cathedral of Saragossa when he was called to work in Naples by King Alfonso V of Aragon in 1447. SS-P

JOHANNES VON VALKENBURG (Valke), (active 1299). German scribe and illuminator. He was a Franciscan friar who probably came from Valkenburg (French Fauquemont, now in Limburg, the Netherlands) who wrote, noted, and illuminated two Franciscan graduals probably for his own house (both signed and dated 1299: Cologne, Erzbischöfliches Diözesan- und Dombib., MS 1B; Bonn, Universitätbib., MS, 384). They are the first of a number of large *choir books produced in the first half of the 14th century by workshops in Cologne whose style he influenced but from which his work remains distinct. Both works are of considerable accomplishment. Groups of small elegant figures against patterned backgrounds, all painted in enamel-like colouring, are typical of his style. He was influenced by contemporary *Mosan manuscripts and Cologne stained-glass painting. OI

Oliver, J., 'The Mosan Origins of Johannes von Valke', *Wallraf-Richartz-Jahrbuch*, 40 (1978).

JOHN, BROTHER AND SISTER. British painters. **Augustus** (1878–1961), the son of a Welsh solicitor, trained at the Slade School, London (1894–8), where he was a precociously talented student. He rapidly gained a reputation as a brilliant draughtsman, a romantic bohemian, and a handsome Don Juan. His major early paintings, *Lyric Fantasy* (c.1911) and *Galway* (c.1916; both London, Tate), are Arcadian visions of Romany gypsies, for whom he felt a strong affinity, influenced by *Puvis de Chavannes, whose work he knew well from frequent visits to France. After the war he pursued a successful career as a portrait painter, but his work is remarkably uneven, being perceptive and lively when he found his sitter sympathetic, for instance *Dylan Thomas* (1936; Cardiff, National Mus. Wales) and perfunctory when painting

bores. Fêted by the media as the last of the bohemians, John's artistic reputation declined after 1930. **Gwen** (1876–1939), unlike her younger brother, avoided publicity; her reputation, however, grew as his waned. She trained at the Slade and at *Whistler's Parisian Academy, 1898–1900, where she developed a refined, fluid technique which her *Self-Portrait* (c.1900; London, Tate) typifies. In 1903 she returned to France permanently. Her single-minded devotion to painting and the frugality of her life are both exemplified by *The Artist's Room in Paris* (1907–9; Sheffield, AG) painted with the hesitant individual strokes which characterize her mature work. She supplemented her meagre income by modelling for *Rodin, with whom she had a passionate affair, from 1906. In 1913 she converted to Roman Catholicism and many of her later paintings show the nuns and schoolchildren of Meudon, the suburban village to which she moved in 1914. DER

Chitty, S., *Gwen John* (1981).
Holroyd, M., *Augustus John* (1974–5).

JOHNS, JASPER (1930–). American painter, sculptor, and printmaker. His career has been closely associated with that of Robert *Rauschenberg, and they are considered to have been largely responsible for the move away from *Abstract Expressionism to *Pop art and *Minimal art that characterized American art in the late 1950s. Johns was born in Augusta, Ga., and studied at the University of Southern Carolina before dropping out and moving to New York in 1949. After two terms at a commercial art college, he worked at various jobs and did military service before meeting Rauschenberg in 1954. They were close friends until 1962, when they broke up with some bitterness (for a time they were lovers, sharing a triangular relationship with a woman). Soon after meeting they formed a partnership to design window displays for upmarket stores, the money they earned allowing them to pursue their artistic experiments. In 1955, inspired by a dream, Johns painted a picture of an American flag—a faithful flat copy of the real thing, except that the brushwork was heavily textured: 'One night I dreamt I painted a large American flag, and the next morning I went out and bought the materials to begin it.' It was the first of many, and much of his subsequent work has been done in the form of series of paintings representing such commonplace two-dimensional objects—for example *Targets* and *Numbers*. His sculptures have most characteristically been of equally banal subjects such as beer-cans or brushes in a coffee tin. Such works—at one and the same time laboriously realistic and patently artificial—are seen by his admirers as brilliant explorations of the relationship between art and reality; to others, they are as uninteresting as the objects depicted. Johns has said that he is not concerned with their symbolism, but simply wants to look at familiar objects with fresh vision.

In 1958 Johns had his first one-man show—at Leo Castelli's gallery in New York—and it was a huge success; the Museum of Modern Art, New York, bought four works and only two remained unsold. After this he rapidly became one of the most famous (and most wealthy) of living artists. As early as 1961 he bought a house on Edisto Island, off the coast of South Carolina, to escape some of the pressures of celebrity (it was destroyed by fire in 1968). In the 1970s many of his paintings were characterized by a cross-hatching motif, and in the 1980s he often introduced autobiographical elements, as for example in *Racing Thoughts* (1983; New York, Whitney Mus.), a collage that depicts various elements from his bathroom and other personal references. Much of his later work has been in the form of his prints; he took up *lithography in 1960. His other work has included designs for the Merce Cunningham Dance Company, of which he was appointed artistic adviser in 1967. IC

JOHNSON, CORNELIUS (or Cornelis Janssens van Ceulen) (1593–1661). Portraitist, born in London to Flemish parents. He was probably trained in the Netherlands, but was back working in England from about 1618. Exceptionally prolific, he was the first painter in Britain consistently to sign and date his works. The earliest are in head-and-shoulders format, often in an oval *trompe l'œil* opening, such as that of *Susanna Temple* (1620; London, Tate). His extremely sensitive and individual portraits are based upon a sound technique. Johnson also worked at three-quarter-length and occasionally full-length, as well as painting portrait miniatures in oil on copper. In 1643 he left Commonwealth England for the Netherlands, where he continued his career in various cities including Amsterdam, Middelburg, and Utrecht. The delicacy of his post-van-*Dyckian Dutch phase is exemplified by the portrait of an *Unknown Lady* (1654; London, NG). KH

Waterhouse, E. K., *Painting in Britain 1530–1790* (5th edn., 1994).

JOHNSON, EASTMAN (1824–1906). American painter. Born in Maine, Johnson was apprenticed to a Boston lithographer and became known for his almost photographic pencil and crayon portraits of literary and political figures. In 1849, in common with several other mid-19th-century American artists, he entered the Düsseldorf Academy where he acquired the academically desirable smooth European finish. He remained in Europe until 1855 studying in The Hague, where he admired *Rembrandt, and Paris. Fame arrived with the exhibition of 'a scene of negro life in the South', familiarly known as the *Old Kentucky Home* (1859; New York, Historical Society). Painted only two years before the outbreak of the Civil War it portrays a sympathetic but sentimentally sanitized scene of poor but happy blacks under Southern paternalism. Elected to the National Academy of Design (see under NEW YORK) in 1860, Johnson continued to paint popular genre but, ever eclectic, produced some far looser and immediate landscape and figure paintings in the 1870s which reveal an awareness of the *Barbizon School. Later in his career he abandoned the increasingly unfashionable genre scenes for effective Rembrandtesque portraits with a superficial similarity to the work of *Eakins. DER

Hills, P., *Eastman Johnson* (1972).

JOHNSON, GERARD (or Garet Janssen) (d. 1611). Dutch-born sculptor and mason. Johnson was among those Protestant refugees who fled the Low Countries during religious conflicts and arrived in London c.1567. He established workshops in Southwark and soon developed a large and thriving practice carving tombs, chimney pieces, and fountain basins. Johnson, and his fellow Dutch émigré sculptors, introduced canopied tombs, deeply carved, with portrait figures and heraldic devices, urns, and strapwork, usually in *alabaster which was then coloured and gilded. Typical examples are the tombs of the 2nd Earl of Southampton (1592; Titchfield, Hants) and the 3rd Earl of Rutland (1591; Bottesford, Leics.); his son Nicholas is credited with the tomb of the 4th Earl (1611). Another son, Bernard (active 1610–30), is said to have been the principal mason for Audley End (1603–16; Saffron Walden, Essex), the grandest of Jacobean country houses, and Northumberland House, London (demolished). Gerard the younger sculpted the pedestrian memorial portrait bust of *Shakespeare* (1616; Stratford upon Avon). DER

Kemp, B., *English Church Monuments* (1980).

JONES, THOMAS (1742–1803). Welsh painter. Jones studied under his fellow Welshman *Wilson 1763–5. He attended the RA Schools (see under LONDON) in 1769, but was already a practising painter in the manner of his master. He exhibited landscapes of Welsh and Italian scenes, of little originality, at both the Society of Artists and the RA. He was in Italy (1776–83), in Rome and later Naples, and wrote a journal (Walpole Society, 32, 1946–8) which provides an illuminating record. On his return he spent much of his

time in Wales. Jones would have been justifiably forgotten as a painter had it not been for the discovery, in the 1960s, of a group of oil sketches which had remained in his family. These are small paintings of observed landscape, both Italian and Welsh, painted in the open air for his own instruction or amusement. The subjects, of which *Buildings in Naples* (1782; Cardiff, National Mus. Wales) and *A Wall in Naples* (1782; London, NG) are typical, are unremarkable but are painted, in a limited but subtle palette, with great directness and achieve an almost abstract beauty.
 DER

Edwards, R., *Thomas Jones*, exhib. cat. 1970 (London, Marble Hill House; Cardiff, National Mus. Wales).

JONGKIND, JOHAN BARTHOLD (1819–91). Dutch painter and etcher. Jongkind studied in The Hague under the Romantic painter Andreas Schelfhout (1787–1870). In 1846 he moved to Paris and from then onwards associated with French modernist painters. He worked and exhibited with the *Barbizon School painters and during the 1860s was an important precursor of *Impressionism. His marine pictures and views of ports and waterways, like *River Scene with Barges* (n.d.; Sheffield, AG), which brilliantly capture the effects of air and atmosphere, influenced *Boudin, whom he first met in 1862, and *Monet, whose work of the 1890s he anticipated, by painting two views of Notre-Dame under different atmospheric conditions, in 1864. Unlike most of the Barbizon and Impressionist artists he painted his oils in his studio, basing them on the spontaneous drawings and watercolours he made *en plein air*. His lively and immediate etchings, examples of which may be seen in London (BM and V&A), were praised by *Baudelaire. Like his countryman van *Gogh, Jongkind suffered serious psychological problems which, in his case, led to alcoholism, a life of squalor, and eventual madness. DER

Hennus, M., *Johann Barthold Jongkind* (1945).

JOOS VAN WASSENHOVE (active c.1460–c.1475). Southern Netherlandish painter. He is first mentioned in 1460 as a matriculate of the Antwerp painters' guild and he was a master in Ghent from 1464. His only recorded commission was for painting 40 escutcheons for the cathedral church of S. Bavo in 1467, the same year as he sponsored Hugo van der *Goes's application to the Ghent painters' guild. In 1469, his final appearance in the archives of the guild, he acted as sponsor for Sanders *Bening. A document of 1475 records his recent departure for Rome with a loan advanced by Hugo van der Goes. It is generally believed that Joos should be identified with the Flemish painter known as *Justus of Ghent. OI

Evans, M., ' "Uno maestro solenne": Joos van Wassenhove in Italy', *Ned. Kunsthist., Jb.*, 44 (1993). Friedlander, M. J., *Die altniederlandische Malerei* (1933; English trans. as *Early Netherlandish Painting*, 1974).

JORDAENS, JACOB (1593–1678). Flemish painter, tapestry designer, and draughtsman, active in Antwerp, where he took primary place after *Rubens's death in 1640. He was the pupil and later son-in-law of Adam van Noort (1562–1641), who was also a teacher of Rubens. He was admitted as a master 'waterschilder' (tempera painter) to the guild in 1615, which qualified him to paint cartoons for tapestries. His early works show the influence of van *Dyck and Rubens as well as *Caravaggio, though he himself never went to Italy. Although he continued to borrow motifs from Rubens, Jordaens's work 1620–35 is marked by greater realism, a tendency to crowd the surface of his compositions, and a preference for the burlesque, even in religious and mythological themes (*S. Peter Finding the Tribute Money in the Fish's Mouth*, also called 'The Ferry at Antwerp', c.1623; Copenhagen, Statens Mus. for Kunst). Primarily a *history painter, he also painted illustrations of Flemish proverbs (*As the Old Sing so the Young Twitter*, examples in Antwerp, Koninklijk Mus. voor Schone Kunsten; Valenciennes Mus.; Ottawa, NG Canada) and boisterous depictions of Flemish festivals (*The King Drinks*, examples in Paris, Louvre; Kassel, Staatliche Kunstsammlungen; Brussels, Mus. Royaux; Vienna, Kunsthist. Mus.), as well as portraits. Between 1635 and 1640, when Rubens was ill with gout, and after his death in 1640, Jordaens was called upon to work from Rubens's sketches on the decorations for the triumphal entry of the Cardinal-Infante Ferdinand into Antwerp (1635), and on the cycle of paintings for Philip IV's hunting lodge, the Torre de la Parada near Madrid (1637–8). In 1639/40 Charles I commissioned him to decorate the Queen's chambers at Greenwich (now lost), a commission originally given to Rubens. In 1649 Jordaens contributed to the decorations of the Oranjezaal at the Huis ten Bosch in The Hague with two immense paintings of the *Triumph of Frederick Henry* and the *Triumph of Time* (both *in situ*), and in 1661 he was asked to paint three large lunettes for the new Amsterdam Town Hall. At the end of his life Jordaens converted to Protestantism, but continued to accept commissions to decorate Catholic churches. KLB

d'Hulst, R.-A., *Jacob Jordaens* (1982).

JORN, ASGER (Asger Oluf Jørgensen) (1914–73). Danish artist, born in west Jutland. He went to Paris in 1936 and studied with *Léger and *Le Corbusier. At the Exposition Universelle in Paris in 1937, he helped paint part of Leger's huge canvas for the Grand Palais de la Découverte, called *Le Transport des Forces*. In the Second World War he edited an anti-Nazi magazine in Denmark. In 1948 he founded the *COBRA group in Brussels. During this time his paintings related very closely to *Art Informel, being brightly coloured abstracts executed with violently expressive brushwork. In 1951–2 he was in hospital in Silkeborg for seventeen months with tuberculosis, when he began to work in ceramics, and produced two large paintings on hardboard called *On the Silent Myth* (Silkeborg, Public Lib.). In 1953 he moved to Switzerland, where he was active in the international Situationist movement (1957–61). In the 1960s his pictures were increasingly exhibited abroad. His later work represented a desire to invalidate distinctions between *abstract art and *kitsch, and became increasingly unorthodox and horrific in its imagery. OPa

Atkins, G., *Asger Jorn* (1964).

JOURNEYMAN (French *journée*: day), artist or craftsman who was fully trained in his chosen profession, but who was not qualified as a master of his guild. For this reason he was not authorized to work for himself, and worked for a master by the day. The years spent as a journeyman gave the young artists or craftsmen a chance to observe masters working in various regions and styles. A journeyman wishing to become a master had to submit a *masterpiece, often of a prescribed character, and pay a substantial sum to the appropriate guild. Guilds tried to protect master craftsmen, their dominant members, from journeymen wanting mastership or higher wages, by setting high standards and guild dues for masterpiece tests, limiting workshop sizes, and discouraging day-work and craftsmen from other towns. The journeyman was often itinerant, not always regularly employed, and belonged to the second lowest caste in the social structure of cities. However, journeymen seem to have prospered at large annual fairs held in the Netherlands over which guilds had no control. MFC

JOUVENET, JEAN (1644–1717). French painter. He joined the studio of *Le Brun in 1661 and took part in the decoration of *Versailles, working in an academic manner derived from Le Brun and *La Hyre. His true talent lay, however, in religious painting. Like many of his near contemporaries, including *La Fosse and Antoine *Coypel, he later developed an eclectic style, blending classicizing, Baroque, and realist elements in an

attempt to create a more modern and dynamic art than that demanded by the principles of the Academy. Although the size and subjects of his works, such as the four huge canvases of *The Miracles of Christ* (1706; Paris, Louvre), do not appeal to modern taste, he was a painter of considerable distinction and deserves to be thought of as more than a transitional figure between the 17th century and the 18th. His most attractive work is a *Descent from the Cross* (1697; Paris, Louvre), a poignant and richly coloured work inspired by *Rubens. MJ

Schnapper, A., *Jean Jouvenet et la peinture d'histoire à Paris* (1974).

JUAN DE FLANDES (active 1496–d. 1519). Flemish painter known by the name given him in Spain, where he worked for 23 years. First recorded on the payroll of Queen Isabella in 1496, he worked with the Estonian painter Michel Sittow on some of the 47 small panels for the portable altarpiece known as the Polyptych of Isabella the Catholic; one panel by Juan de Flandes represents the *Temptation of Christ* (c.1500; Washington, NG) in a delicately painted landscape that recedes from brown to green to blue tones in the Flemish manner. Juan de Flandes remained in Castile after Isabella's death. The last decade of his life was spent working on the large paintings for the main altarpiece of the Cathedral of Palencia and for the church of S. Lázaro there (four panels now in Madrid, Prado). The precise technique applied by Juan de Flandes to the small panels of Isabella's altarpiece suggest that he was trained as a miniaturist in the Ghent–Bruges School. However, he rose capably to the demands of a large scale at Palencia, creating narrative compositions of great clarity and restrained emotion, exemplified in his *Christ Carrying the Cross* (1509–18; Palencia Cathedral). SS-P

Vandevivère, I., *Juan de Flandes* (1986).

JUAN DE JUANES. See MAÇIP, FATHER AND SON.

JUDD, DONALD (1928–94). American artist. Born in Missouri, Judd studied philosophy and, much later, art history at Columbia in New York. Between 1959 and 1965 Judd worked as art critic for *Arts Magazine*. During the 1950s he was also active as an artist, and experimented with painting in a number of styles before abandoning it in 1961–2; instead he began making wall reliefs and simple free-standing constructions, which established him as one of the foremost *Minimalists. The wall reliefs, which he had machine made after 1963, and which he termed 'specific objects', basically fall into two series: 'stacks' of vertically arranged boxes, and 'progressions', horizontal bars cut at various intervals; all have the rigid, monumental clarity. His more recent work, dealing with the environment and relating to architecture and furniture, is less austere. In 1973 he moved away from the art scene in Soho, New York, to Marfa, a small town in Texas, where he set up a studio. MF

Donald Judd, exhib. cat. 1988 (New York, Whitney Mus.).
Donald Judd: Complete Writings 1959–1975 (1975).

JUEL, JENS (1745–1802). Danish painter of portraits and intimate family groups. He studied first in Hamburg (1760–5), where he came under the influence of Dutch 17th-century art, then at the Royal Danish Academy, Copenhagen (1765–71). His early portraits follow the fashionable French pattern of *Perronneau and *Tocqué. They launched him on a successful career that enabled him to travel to Rome via Paris and Geneva. In Rome he came into contact with *Batoni's more classicizing portraits. On his return to Copenhagen in 1780 he was made painter to the Danish court and later became director of the Royal Academy. His later portraits, such as *Mother and Son* (c.1795; Copenhagen, Ny Carlsberg Glyptothek) exhibit the informal naturalism of the *Neoclassical style. MJ

Monrad, K., *Danish Painting: The Golden Age*, exhib. cat. 1984 (London, NG).
Poulsen, E., *Jens Juel: malerie og pasteller* (2 vols., 1961).

JUGENDSTIL. See ART NOUVEAU.

JULIEN, JEAN-ANTOINE (1736–99). Swiss painter active in France and Italy. He earned his living as an itinerant portrait painter before arriving in Paris in 1756 to seek his fortune. Not finding it there, he decided to go to Italy to perfect his style as a history painter. In Rome he met the French chief minister of the duchy of Parma, who appointed him court painter. In return for his stipend Julien had to deliver annually a painting to the Duke of Parma. Despite the fact that he henceforth styled himself 'Julien de Parme' he never visited the duchy. Typical of his output on almost exclusively mythological themes are *Thetis Bringing Armour to Achilles* (1766; Florence, Pitti) and *Diana and Endymion* (1779; Madrid, Prado). Idiosyncratically *classicizing in style they demonstrate the strong influence of *Domenichino on Julien's painting. From 1771 he was again in Paris, where this time he enjoyed the protection of a number of powerful patrons, but remained outside the Académie Royale (see under PARIS) and never achieved the recognition that he felt was his due. The publication in 1984 of 50 of his letters dating between 1768 and 1781 throws interesting light on the art world of his time. MJ

L'arte a Parma dai Farnese ai Borboni, exhib. cat. 1979 (Parma, Gal. Nazionale).
Rosenberg, P. (ed.), 'Une correspondance de Julien de Parme (1736–1799)', *Archives de l'art français*, 26 (1984).

JUNI, JUAN DE (c.1507–77). Sculptor, probably of Burgundian origin, active in Spain after 1533. Trained in France, he also travelled to Italy before coming to Spain. He worked at Salamanca and León where he carved several tombs and the upper choir stalls of the monastery of S. Marcos. By 1543 he had settled in Valladolid where he would undertake several important projects. A prolific sculptor of religious subjects, he worked in both wood and terracotta. Whether in reliefs or figures carved in the round, he achieved dramatic expression of emotion through the intense faces, emphatic gestures, and cascading draperies of his figures. The huge retable which he executed 1545–61 for S. María la Antigua, Valladolid (now in the cathedral), is a *Mannerist composition of elaborate ingenuity. His most famous works are the versions of the *Entombment* in Valladolid (1541–4; Mus. Nacional de Escultura Religiosa) and Segovia (1565–71; Cathedral) which capture the intensity of the moment with striking immediacy. PL

González, M., and José, J., *Juan de Juni: vida y obra* (1974).

JUNK SCULPTURE, a type of *assemblage created by the piecing together of worthless materials—such as scrap metal and household rubbish—which form the detritus of urban society. It emerged as a distinct critical category in the USA in the 1950s, when Lawrence Alloway (1926–) used the term 'junk art' to describe the 'combines' of Robert *Rauschenberg. The applications of the term subsequently broadened to cover works made from smashed cars, broken machine parts, and used timber, by artists such as John Chamberlain (1927–), Robert Mallary (1917–); Richard Stankiewicz (1922–83), and Mark Di Suvero (1933–). *Surrealist *objet trouvé *collages, and those of artists such as Kurt *Schwitters, have been cited as precedents for these works. By consisting of previously discarded objects, Junk sculpture represented a literal rejection of the aesthetic value placed, in more traditional modes of art production, on the use of fine materials; it can also be interpreted as constituting a metaphorical rejection of the commercial value placed on art by collectors and dealers. In Europe, notable exponents of Junk sculp-

ture included Antoni *Tàpies and Alberto Burri (1915–95). OPa

JUSTE, JEAN (Giovanni di Giusto Betti)

(1485–1549). Florentine sculptor working at Tours, naturalized 1513. One of the first generation of Italians to use *Renaissance form and ornament in France. He worked with his elder brother Antoine on the tomb of Thomas James, Bishop of Dol (1507; Dol Cathedral), and Antoine is known to have participated in the prestigious work at Gaillon for Cardinal Georges d'Amboise from 1508. The tomb of Louis XII and Anne of Brittany (1516–31; Paris, S. Denis) is Jean's most famous work. It is designed like a rectangular arcaded catafalque, with small seated prophets within the arcades and rather large cardinal virtues on the corners of the base, around which Louis XII's military exploits are recorded in relief. The tomb of Giangaleazzo Visconti at Pavia is an understandable source, as the King's grandmother was a Visconti. The gisants, and priants above, may be by Guillaume *Regnault. Jean Juste's son and nephew also worked on the tomb. LL

JUSTUS OF GHENT (or Giusto da Guanto)

(active 1473–c.1482). Southern Netherlandish painter who worked in Italy for Federigo da Montefeltro, Duke of *Urbino. He painted a large altarpiece, the *Communion of the Apostles* (1473–4; Urbino, Gal. Nazionale), for the confraternity of the Corpus Domini, and he is reasonably assumed to be identical with the unnamed 'eminent master', skilled in oil painting, that Federigo da Montefeltro was reported to have summoned from Flanders, and whose work for the Duke included a series of philosophers, poets, and doctors of the Church for the Duke's *studiolo*; these are the 28 panels known as the *Famous Men* (1476: Paris, Louvre; Urbino, Gal. Nazionale). Other paintings for Federigo that are attributed to Justus are the two surviving panels *Rhetoric* and *Music* from a set of the *Liberal Arts* (c.1480; London, NG) and *Federigo listening to a Discourse* (Hampton Court, Royal Coll.). The triptych of the *Crucifixion* (1460s; Ghent, S. Bavo) has been identified as a work executed by Justus before he left for Urbino. The transition in style from the *Crucifixion* to the *Liberal Arts* demonstrates an extraordinary evolution effected in response to a change in culture and to the demands and stimulus of a princely patron. The Italian works seem likely also to be affected by the intervention of assistants; in order to carry out the ambitious projects commanded by Federigo, Justus must have run a workshop, and it is evident that the *Famous Men* were not finished by the Ghent artist. Some scholars believe that the Spanish painter Pedro *Berruguete worked on them.

It is generally believed that Justus of Ghent was the documented Ghent artist *Joos van Wassenhove who left Ghent for 'Rome' some time before 1475; such an identification is not without problems. KS

Campbell, L., *National Gallery Catalogues: The Fifteenth Century Netherlandish Schools* (1988).

KAHLO, FRIDA (1907–54). Mexican painter. An accident at the age of 18 left Kahlo crippled and she began to paint during her convalescence. Kahlo is known as much for her persona as for her paintings; she has become a symbol of 'Mexicanness' as well as an icon of 20th-century *feminism. The bulk of Kahlo's work is autobiographical, self-portraits that depict her physical and psychological pain, anguish, and fantasies: *The Two Fridas* (1939; Mexico City, Mus. de Arte Moderno). The principal means of expression in her work is by representations of her body, painted as either wounded or fragmented, as in *The Broken Column* (1944; Mexico City, Dolores Olmedo Foundation), or interconnecting with nature. Through her body she illustrates her main preoccupations: sexuality, eroticism, death, and childbirth. Kahlo was inspired by Mexican popular culture and folklore. This, together with her Communist sympathies, was shared with her husband Diego *Rivera, with whom she had a troublesome yet passionate relationship. Due to its focus on her interior world, André *Breton qualified Kahlo's work as innately *Surrealist, although she firmly rejected the label. CC

Herrera, H., *Frida: A Biography of Frida Kahlo* (1989).

KALF, WILLEM (1619–93). Dutch painter who is primarily remembered for his meticulous and often complex *still lifes, although he explored other genres. Kalf was born in Rotterdam, and probably trained with Hendrik *Pot in Haarlem. He is documented in Paris in 1641, and possibly arrived there a couple of years earlier; by 1646 he had returned to Rotterdam, and in 1651 he married in Hoorn. His wife was Cornelia Pluvier, a glass-engraver, poet, and musician. The couple moved to Amsterdam, and Kalf, who soon became known as one of the leading painters in the city, remained there until his death. He painted some interior scenes in the first half of the 1640s, but then specialized in still lifes, and particularly built a reputation for the most ornate category of such pictures, known as *pronkstilleven*, which often included luxurious imported objects, such a Venetian glass, oriental rugs, or Chinese porcelain, as well as exotic foods. His compositions are invariably formally complex and convey a sense of the monumental, although retaining within them detailed and precisely ordered juxtapositions of rich colours. CB

Grisebach, L., *Willem Kalf* (1974).

KANDINSKY, WASSILY (1866–1944). Russian-born painter, teacher, writer, and theorist, considered one of the most important pioneers of abstraction. At the age of 30 Kandinsky abandoned a promising legal career in Moscow to study painting in Munich. In 1901 he co-founded the avant-garde artists' association Phalanx, in whose school he also taught until 1903. During the next five years he travelled widely around Europe and North Africa. His early Russian fairy-tale style, influenced by *Jugendstil* (see ART NOUVEAU), was superseded from 1908 by his first truly abstracted works, culminating in his series of *Compositions*, *Improvisations*, and *Impressions* (1910–13): *Study for Composition IV* (1910; London, Tate). Kandinsky believed that art should express the spiritual, and had slowly come to realize that, for him, representation of objects was 'disturbing' to this aim. One incident he cited as instrumental in this discovery was his surprise one evening, on entering his studio, at seeing a painting he did not recognize which seemed to glow 'with an inner radiance'—in fact one of his own figurative works lying on its side. Highly sensitive to *colour, he sought to produce painting that would react on the eye as music does on the ear (see SYNAESTHESIA). From 1911 to 1914 he was prominent in the *Blaue Reiter, editing its almanac with Franz *Marc. Kandinsky's theories of art, rooted in

theosophy and mysticism, were published in *Über das Geistige in der Kunst* (On the Spiritual in Art, 1911), which became extremely influential (throughout his life he wrote voluminously). The year 1913 saw the breakthrough to total, non-objective abstraction; where previous paintings employed forms derived from observation of nature, subsequent canvases owed nothing to the world of objects: *Black Lines* (1913; New York, Guggenheim). The outbreak of war compelled Kandinsky to return to Russia in 1914. After the Revolution he held various distinguished academic posts under the new regime but, out of tune with Bolshevik utilitarianism, he returned to Germany in 1921. The following year he took up the architect Walter Gropius's (1883–1969) invitation to teach at the *Bauhaus, remaining loyal to the school until the bitter end. The Bauhaus years witnessed a new interest in geometry in his work, as well as the publication in 1926 of another important theoretical text, *Punkt und Linie zu Fläche* (Point, Line, and Surface). World events provoked emigration once again in 1933, this time to a suburb of Paris, where he remained until death. Often cited (contentiously) as the first to create an abstract work (see ABSTRACT ART), Kandinsky's influence, through his tireless devotion to his painting, teaching, and writing, was enormous. AA

Barnett, V. E., *Kandinsky at the Guggenheim* (1985).
Overy, P., *Kandinsky: The Language of the Eye* (1969).

KANT, IMMANUEL (1724–1804). German philosopher. Thoroughly revising previous systems and erecting new terminologies, his 'critical philosophy' marks a turning point in Western thought. One of his major critical analyses, the *Critique of Judgement* (1790), has a singular place in the history of *aesthetics. Earlier 18th-century writers, such as Edmund *Burke, had treated both responses to nature and art as the province of aesthetic thought; Kant, who was indifferent to painting and music, went against subsequent trends in laying his emphasis on nature. Aesthetic judgements, he contended, rest on disinterested perceptual experiences, where we find ourselves contemplatively responding to the formal appearances of things with delight or aversion. Our feelings on this level are distinct from everyday pleasure where 'everyone has their own tastes', and from perceptions of objects made in the course of practical activity; instead, they allow the presence of the object to show forth, no longer obscured by our preconceptions. The 'free beauty' at which such contemplation aims is primarily exemplified in compact natural forms like sea-shells; Kant contrasts it with our delight at the sublime in nature, exemplified by the vastness of the starry sky. Analogously, art might either be 'neat and elegant' in character, or else reach

for the sublime in the productions of the dynamic, rule-breaking genius. Art, however, possessed only 'dependent beauty', admixing conceptual elements with the forms of objects.

Kant's analysis of the experience of beauty has retained a place in aesthetic discussions, and the example of his critical method has inspired various theorists of art such as *Picasso's interpreter Daniel-Henry Kahnweiler (1884–1976) and Clement *Greenberg.

NMcA

KANTOR, TADEUSZ (1915–90). Polish painter and experimental artist. He was born at Wielopole near Cracow and trained at the Cracow Academy. His work was highly varied and he was regarded as one of the main pioneers and exponents of avant-garde art in Poland after the Second World War. Following a *Surrealist period that lasted until the mid-1950s he passed through a *Tachiste phase and during the 1960s painted in a more personal idiom, depicting vaguely suggested objects against a monochromatic background. At this time, too, he experimented with *Pop art. Kantor also worked as a theatre director (during the Second World War he ran an underground experimental theatre, which was revived in the 1950s). Both in his theatrical productions and in his paintings he introduced the factor of chance and he organized Poland's first happenings. In the 1970s he experimented with *Conceptual art. IC

KAUFFER, E. MCKNIGHT (1890–1954). American designer and painter, active mainly in England. After studying in San Francisco, Chicago, and Paris, he settled in London in 1914. He was a member of Group X and of the Cumberland Market Group, but he virtually abandoned easel painting in 1921 and is best known for brilliant and witty poster designs, notably for the London Transport Board and the Great Western Railway; he created posters for London Underground from 1915 to 1940, under the patronage of its commercial manager Frank Pick (1878–1941), who was the mastermind behind the modern image that the company created in the inter-war years through employing some of the best artistic talent of the day. McKnight Kauffer was also a successful textile designer and book illustrator. In 1940 he returned to the USA and settled in New York. His work in America included posters (for government agencies during the Second World War and afterwards for American Airlines) and also book jackets and illustrations.

KAUFFMANN, ANGELICA (1741–1807). Swiss-born painter. She was born in Chur, the daughter of a painter, Joseph Johann Kauffmann (1707–82), who encouraged

her studies. In 1763 she went to Rome where she painted *Winckelmann (1764; Zurich, Kunsthaus), an accomplished and popular work (there are five versions) which established her reputation. In 1766 she came to London, possibly on the advice of *West, whose portrait she drew in 1763 (London, NPG). She was much admired; *Dance, who met her in Rome, was besotted, and there were false rumours of a liaison with *Reynolds, who championed her work. A founder member of the RA (see under LONDON) in 1768, for which she painted the decorative allegory *Painting* (c.1780; London, RA), her best-known works are small decorative *Neoclassical scenes, from mythology, history, and literature, which were widely disseminated through engravings. In 1781 she married Antonio Zucchi (1728–95), with whom she had collaborated on decorative schemes for Adam, and returned with him to Rome where she continued to paint. Although frequently criticized as insipid her work is far from mediocre. DER

Roworth, W., *Angelica Kauffmann: A Continental Artist in Georgian London* (1992).

KAULBACH, WILHELM VON (1804–74). German painter. Kaulbach was born in Arolsen and was trained by his father before studying under the *Nazarene painter *Cornelius at the Kunstakademie in Düsseldorf (1822–6). Kaulbach assisted Cornelius with his extensive works in Munich for Ludwig I of Bavaria and in 1837 was appointed court painter. His idealized historical painting *The Destruction of Jerusalem* (1836–46; Munich, Neue Pin.), intended for a Russian princess, was recommissioned by Ludwig in 1841. This monumental work, already of gigantic proportions, was enlarged further at the King's request and necessitated the building of a new gallery, the Neue Pinakothek (see under MUNICH), to house it. Kaulbach also provided exterior frescoes for the building (destr. 1945) commemorating Ludwig's liberality as a patron. A second version of *Jerusalem* (1847–65; destr.) was commissioned by Friedrich Wilhelm IV of Prussia as part of the ambitious scheme for the staircase of the Neues Museum, Berlin, which recorded a nationalistic history of human progress in 39 large oil murals. From 1849 Kaulbach was director of the Munich Academy of Painting and the founder of an artistic dynasty, for his son Hermann (1846–1909), nephew Friedrich (1822–1903), and the latter's son Friedrich August (1850–1920) were also painters. DER

KENSETT, JOHN FREDERICK (1816–72). American landscape painter. Born in Cheshire, Conn., Kensett trained as an engraver and worked for his father and uncle c.1828–c.1840. Presumably he also painted for

in 1840 he sailed to England with Asher *Durand and spent the next seven years studying and painting in England, France, Switzerland, and Italy. Early works, like *English Landscape* (c.1843–5; New York, Brooklyn Mus.), are painterly and vigorous but when he returned to America a *Claudean calm pervaded his work, brush strokes were eliminated, tonal changes were virtually imperceptible, and, like earlier members of the *Hudson River School, he imposed a Romantic sensibility on the vast American wilderness. His acute observation of light effects, refined from nature, in works like the misty *Lake George* (1869; New York, Met. Mus.), associate him with *Luminism. Towards the end of his life the format of his work became increasingly horizontal, often of extensive coastal views like the *Coast Scene with Figures* (1869; Hartford, Conn., Wadsworth Atheneum), a *Friedrich-like essay in Romanticism. Kensett played an active role in public life and was a founder trustee of the Metropolitan Museum, *New York, in 1870. DER

Howat, J. K., *John Frederick Kensett* (1968).

KERSTING, GEORG FRIEDRICH (1785–1847). German painter. Kersting was born in Gustrow and studied at the Copenhagen Academy under Jens *Juel 1805–8 before settling in Dresden. He became a close friend of *Friedrich, who had also studied at Copenhagen, and accompanied him on a prolonged hike through the Riesengebirge in 1810. He painted Friedrich at work in several versions, as in the spare, realistic, and sympathetic *Caspar David Friedrich in his Studio* (c.1811; Hamburg, Kunsthalle). Unlike Friedrich, Kersting eschewed *Romanticism and painted small, almost quietist, *Neoclassical portrait figures, usually set in domestic surroundings, a genre he virtually invented. Typical is the charming *Embroidress* (1812; Weimar, Kunstsammlungen), bought by the Grand Duke Karl August of Weimar on the recommendation of *Goethe. Until 1818, when he was appointed director of painters at the Meissen porcelain factory, Kersting was a successful drawing master whose pupils included the Polish Princess Sapieha in Warsaw in 1816–18. His work for Meissen included the supervision of the decoration of the dinner service presented by Friedrich August of Saxony to the Duke of Wellington (c.1820; London, Apsley House). DER

Gartner, H., *Georg Friedrich Kersting: Leben und Werke* (1988).

KESSEL, JAN VAN (1626–1679). Flemish painter of still life, flowers, and exotica, active in Antwerp where he became a guild member in 1645. He was the grandson of Jan *Brueghel and shared his grandfather's liking for painting exotic wildlife in small format on copper or panel (set of 40 paintings representing *The Four Quarters of the Globe*; Madrid, Prado). He also made larger still-life paintings, including dead game pieces in the manner of *Snyders and flower garlands and bouquets under the strong influence of Daniel *Seghers. His most individual works, however, are small paintings of collections of insects and shells. These quasi-scientific paintings, many of which are on copper, are painted with extraordinary exactness and vivid colours, and they make a powerfully obsessive impact. They appealed to the Habsburg rulers of Flanders and there is a large collection of them in the Prado, Madrid. AJL

Laureyssens, W., in *Bruegel: une dynastie de peintres*, exhib. cat. 1980 (Brussels, Palais des Beaux-Arts).

KETEL, CORNELIS (1548–1616). Dutch portrait and history painter. After training with his uncle Cornelis Jacobsz. Ketel (d. c.1568) in Gouda and with Anthonie Blocklandt in Delft, he went to Fontainebleau and Paris (1566), but was forced to return to Gouda for political reasons. In 1573 he again left the Netherlands, this time for London, where he was active as a portraitist, and in 1581 he settled in Amsterdam for the remainder of his life. Van *Mander praised Ketel's painted allegories, none of which has survived. He is now best known for his portraits which show him to be an accomplished and innovative painter. He established in the Northern Netherlands the full-length group and single portrait; *The Company of Captain Dirck Jacobsz. Rosecrans* (1588; Amsterdam, Rijksmus.) is in its immediacy and topicality the immediate precursor to the great 17th-century Dutch group portrait. Around 1600, because of gout or some other illness, Ketel painted pictures using his fingers and toes instead of brushes. He was also a poet, active in rhetoricians' circles. KLB

Luijten, G., et al. (eds.), *Dawn of the Golden Age*, exhib. cat. 1994 (Amsterdam, Rijksmus.).

KETTLE, TILLY (1734–86). English portrait painter. After studying at Shipley's and St Martin's Lane Academy, London, Kettle worked in Oxford and the Midlands in a competent style derived from *Reynolds, which may be seen in *Robert Sewell* (c.1762; York, AG). From 1768 to 1776 he worked in India painting the native nobility, with whom he was popular, and East India Company nabobs like the swagger *Charles and John Sealy* (1773; London, Courtauld Inst. Gal.) and the thoughtful *Warren Hastings* (c.1775; London, NPG). Unsuccessful when back in England, he returned to India dying, en route, in Aleppo. DER

Archer, M., *India and British Portraits* (1979).

KETUBBAH (plural *ketubbot*; Hebrew: writing), the Jewish marriage contract, originating from the Talmud to provide material protection for the wife. Often with border illustrations, the earliest surviving examples from Europe are on vellum, whilst those from Islamic countries are on paper. They were most popular amongst the Sephardim, and, following the expulsion of the Jews from Spain, the tradition of illustrated *ketubbot* spread to other countries. Italian examples on vellum are the most noteworthy for their varied decoration during the 17th to 19th centuries (e.g. *ketubbah* from Venice, 1649; Los Angeles, Hebrew Union College Skirball Mus.). During the 20th century the tradition of the manuscript *ketubbah* was revived in the United States of America. PCo

Davidovitch, D., *The Ketuba: Jewish Marriage Contracts through the Ages* (1968).

KEY FAMILY. Flemish painters originally from Breda. **Willem** (c.1515/6–68) may have received some training in the workshop of Pieter *Coecke van Aelst in Antwerp before studying with Lambert *Lombard in Liège, along with Frans *Floris. He became a master in the *Antwerp guild of S. Luke in 1542. He had a particular talent for portraiture, though lacked the bravura of his contemporary Anthonis *Mor. Among the prominent personalities to have their portraits painted by him were Cardinal Granvelle and the Duke of Alba (untraced). Rubens owned at least two portraits by Key, one of which, a supposed *Self-Portrait*, he copied (Berlin, Gemäldegal.; Rubens's copy is in Munich). **Adriaen Thomasz.** (c.1544–after 1589), often identified as a nephew of Willem Key, was probably a more distant relative, but was almost certainly his pupil. He became a member of the Antwerp guild in 1568. His portraits are remarkable for their cool objectivity, as observed in his several versions of the portrait of *William the Silent* (e.g. c.1579; Amsterdam, Rijksmus.). KLB

KEYSER, DE. Dutch family of artists, architects, and sculptors. **Hendrick** (1565–1621) became the leading architect and sculptor in Amsterdam in the late 16th century. He left his mark on the city at the time when it was expanding rapidly and his architectural projects, for example the Westerkerk (Amsterdam, 1620 onwards), are a transition between the fantastical, decorative designs of Renaissance and Mannerist architects, such as Vredeman de Vries, and the 17th-century classicism of Jacob van Campen. Much of Hendrick de Keyser's sculpture is related to his architectural projects. However, in 1614 the States General commissioned him to design the funerary monument for William the Silent in the Nieuwe Kerk, Delft. Under a canopy of white

marble, William's white marble effigy lies surrounded by four allegorical figures in bronze which symbolize the virtues. At the head of the effigy is the seated bronze figure of the Prince of Orange, balanced at the other end by a bronze figure of Fame. The design appears to have been influenced by French sculptors such as Germain *Pilon. Two of his sons, **Pieter** (1595–1676) and **Willem** (1603–after 1674), were sculptors. Willem worked in London in the studio of Nicholas *Stone. Hendrick's third son was **Thomas** (1596/7–1667). After training with his father (1616–18), he worked as municipal architect to the city of Amsterdam from 1662 until his death, but he is best known as a portrait painter. How he trained as a painter is mysterious. His work is imaginative and wide-ranging but his most individual contribution can be seen in small-scale, full-length portraits set in contemporary interiors, such as the outstanding *Constantijn Huygens and his Clerk* (1627; London, NG). Huygens is portrayed being handed a note by his clerk and various objects, including globes and a musical instrument, indicate his wide interests. Thomas was also an early exponent of group portraiture, for example the *Militia Company of Captain Allaert Cloeck* (1632; Amsterdam, Rijksmus.). During the 1640s he traded in stone and marble and his output as a painter declined somewhat. Nevertheless important commissions date from his later career such as an important history painting for the Stadhuis in Amsterdam, *Ulysses Beseeching Nausicaa* (still *in situ*; Amsterdam, Royal Palace). An unusual equestrian portrait of two unknown men, *Two Riders* (1661; Dresden, Gemäldegal.), is an interesting late work. Although small in scale, there is a feeling of space with the two riders placed against an extensive landscape and airy sky. CFW

Rosenberg, J., Slive, S., and ter Kuile, E. H., *Dutch Art and Architecture 1600–1800* (1997).

KHNOPFF, FERNAND (1858–1921). The leading Belgian *Symbolist painter. He was born in Bruges to a wealthy family which moved to Brussels in 1865. In 1875 he abandoned legal studies to train at the Académie Royale des Beaux-Arts and was greatly influenced by several visits to Paris (1877–80) during which he saw work by *Moreau and *Burne-Jones at the Exposition Universelle in 1878. His first Symbolist paintings, *After Flaubert* (Brussels, priv. coll.) and the atmospheric *Listening to Schumann* (Brussels, Mus. Royaux des Beaux-Arts) both date from 1883, the year in which he became a founder of the avant-garde international group Les *Vingt. He painted many female portraits in the 1880s, realistic and formal but imbued with self-assurance verging on imperiousness. In later works his female heads are frequently truncated at the brow or side adding to their

mystery. Erotic and perverse themes dominate his work of the 1890s, women looking into mirrors, female-headed panthers, and *Medusa*, a subject he also executed in sculpture *c.*1900. By the 1890s, when he regularly visited England, his reputation was international but declined with the advent of modernism after 1914. DER

Delevoy, R., et al., *Fernand Khnopff: Catalogue de l'œuvre* (1987).

KIEFER, ANSELM (1945–). German painter, born in Donaueschingen. He originally studied law and his intermittent training as a painter included periods of study with Horst Antes (1968) and Joseph *Beuys. Early in his career he was a *Conceptual artist (his work included a series of photographs of himself giving the Nazi salute), but he turned to painting and has come to be regarded as a leading exponent of Neo-Expressionism. His characteristic works are large, heavily worked canvases, often incorporating material such as straw (he has also sometimes mixed blood with his paint). His subjects frequently refer to German history or Nordic mythology and show an attempt to come to terms with his country's recent past.

KIENHOLZ, ED (1927–94). American sculptor. Born in Fairfield, Wash., Kienholz had little formal training. He moved to Los Angeles in 1953 and in 1954 made his first wooden *assemblages, deliberately drab, which he exhibited at the short-lived Now Gallery (1956–7) and the avant-garde Ferus Gallery of which he was a founder. A leader of the Californian Funk (offensive) artists, Kienholz created his first tableau, *Roxy's*, in 1962. Based upon a famous bordello and set in 1943, *Roxy's* combined *Dada and *Pop elements and a debt to 'B' movies to create a disturbing and extreme image of urban degeneration. As the life-size installations were expensive to create Kienholz produced *Concept Tableaux* from 1965, bronze plaques bearing the title, accompanied by a written description; for a further fee the purchaser could have the project completed. *The State Hospital* (1964–6; Stockholm, Moderna Mus.), a harrowing scene based on his experiences working in a mental hospital in 1948, was one of the few to be realized. Deliberately shocking, though with a moralistic purpose, his retrospective at the Los Angeles County Museum in 1966 caused outrage. From 1973 he spent periods in Berlin producing work which satirized Nazism. In 1981 he acknowledged joint authorship with his wife Nancy (1943–) with whom he had collaborated since 1972. DER

Kienholz, exhib. cat. 1989 (Düsseldorf, Kunsthalle).

KINETIC ART. The main purpose of this form of art is to create movement, or the illusion of movement. The term 'kinetic' was first used in relation to fine art by the *Constructivist artists Naum *Gabo and Antoine *Pevsner in their *Realistic Manifesto* of 1920. It was not until the 1950s, however, that it became established as a recognized addition to critical classification, at a time when artists like Bruno Munari (1907–), Pol Bury (1922–), and Jean *Tinguely were constructing objects primarily designed to express movement.

The forms taken by kinetic art are, unsurprisingly, very diverse, given that the nature of the art is non-material. They include the optical illusions imparted by the paintings of *Vasarely and Bridget *Riley, the fluorescent strip-lighting in works by Dan Flavin (1933–96), and *mobiles by Alexander *Calder. Conceptual and formal precedents for these works can be found in a similarly wide range of art, from the presupposition of movement in a *Cubist painting, to the inoperative mechanization of a *Duchamp *'ready-made'. OPa

Brett, G., *Kinetic Art* (1968).
Popper, F., *Origins and Development of Kinetic Art* (1968).

KIRCHNER, ERNST LUDWIG (1880–1938). German artist. Leader of Die *Brücke from 1905 to 1913. Kirchner studied architecture in Dresden from 1901 and painting in Munich between 1903 and 1904. Returning to Dresden that year, he met *Heckel and *Schmidt-Rottluff and founded Die Brücke with them in 1905. Kirchner's early influences from the Western art tradition were the *Neo-Impressionists, and later the *Fauves. The pared-down quality of expression demonstrated most clearly in his woodcuts and graphic works was informed by *Munch and late Gothic woodcuts. The greatest influence on his emerging *Expressionist vocabulary was perhaps exerted, however, by the African and Oceanic art which he saw in the ethnological collections of Dresden and Berlin. Kirchner was able to harness these influences to his own artistic vision and produce some of the most significant works in the German Expressionist canon.

Kirchner's work from the Dresden period focused chiefly on man in nature and images of studio life. He sought to distil his subject matter into what he termed 'primordial' signs; the bold, pared-down vocabulary of line and form evident in such works as *Self-Portrait with Model* (1910; Hamburg, Kunsthalle). In 1911, Kirchner moved to Berlin and his work showed an increasing shift away from the symbolic to the psychological, with images evoking the tensions and dynamism of modern life in the city dominating his

œuvre with a vibrant coloration and freshness of mood.

Kirchner volunteered when war broke out in 1914, but suffered a nervous breakdown and moved in 1917 to a sanatorium in Switzerland. His painting soon resumed with an energy reminiscent of his Brücke period, and he gradually moved towards a calmer, more abstract idiom (influenced from the mid-1920s by *Cubism) of landscapes and studies of peasant life in Switzerland, where he was to live until his suicide in 1938.　　RRAM

Grisebach, L., *Ernst Ludwig Kirchner* (1996).

KITAJ, RON B. (1932–). American painter and graphic artist, active mainly in England, where he has been one of the most prominent figures of the *Pop art movement. He was born in Cleveland, Oh., and studied at the Cooper Union, New York, 1950–1, and the Academy in Vienna, 1951–2. After working as a merchant seaman and serving in the US Army in Germany he came to England on a GI scholarship, studying at the Ruskin School, Oxford, 1958–9, and the Royal College of Art, London, 1959–61. His wide cultural horizons gave him an influential position among his contemporaries at the RCA (they included David *Hockney and Allen Jones (1937–)), particularly in holding up his own preference for figuration in opposition to the prevailing abstraction. (He has continued to be seen as a champion of figurative art, stressing the importance of drawing and painting from the life, and in 1976 he organized an Arts Council exhibition of figurative art entitled *The Human Clay*.) Unlike the majority of Pop artists, Kitaj has had relatively little interest in the culture of the mass media and has evolved a multi-evocative pictorial language, deriving from a wide variety of visual and literary sources—indeed he has declared that he is not a Pop artist. Typically his work uses broad areas of flat colour within a strong linear framework, creating an effect somewhat akin to comic strips.

After a visit to Paris in 1975 Kitaj was inspired by the example of *Degas to take up pastel, which he has used for much of his subsequent work. Late 19th-century French art has been a major source of inspiration, as has a preoccupation with his Jewish identity, and he has said: 'I took it into my cosmopolitan head that I should attempt to do *Cézanne and Degas and Kafka over again, after Auschwitz.' In 1994 a retrospective exhibition of his work at the Tate Gallery, London, received strongly negative reviews; his wife, the American artist Sandra Fisher (1947–94), died of a brain haemorrhage only months later, and Kitaj caused much controversy by blaming this on his critics: 'They tried to kill me and they got her instead.'　　IC

KITCHEN SINK SCHOOL, a title given to a group of English *social realist painters working in the mid-1950s. It was originally used, as a derogatory term, to describe John Osborne's drama *Look Back in Anger* (1956) before being applied to paintings. The four leading figures were John Bratby (1928–92), Derrick Greaves (1927–), Edward Middleditch (1923–), and Jack Smith (1928–), all of whom studied at the Royal College of Art, London. They shared a bold painterly technique, particularly Bratby, who worked in thick *impasto (but, unlike the others, with bright, strident colours), and an interest in drab domestic subjects. The latter trait, exemplified by Bratby's *Still Life with Fish Frier* (1955; priv. coll.), earned them their sobriquet. They were never a close-knit group. Bratby, who achieved great success, winning a Guggenheim award in 1956 and 1958, retained his early style until his death, albeit in an increasingly formulaic way, but became unfashionable in the 1960s with the dominance of *Pop art. Greaves, Middleditch, and Smith all turned to abstraction (see ABSTRACT ART) in the 1960s and the latter has since vehemently rejected the term Kitchen Sink.　　DER

KITSCH, a term of denigration of uncertain but probably Germanic origin. It is applied to creations whose artistic content is considered false, pretentious, or vulgarized, lacking in profundity and designed expressly to please, generally for commercial ends. Where, supposedly, 'real' art is autonomous and embodies some irreducible, intrinsic meaning, kitsch merely plays to the crowd, supplying 'instant beauty' and/or make-believe to the purchaser. As such it embraces everything from garden gnomes to the castle of Neuschwanstein. The emergence of kitsch—a concept unknown before the 19th century—is inextricably linked with that of industrialism, which engendered expansion of the middle classes, consumerism, and development of methods of mechanical reproduction. The demand for kitsch has been explained as originating from a desire to ape the taste of the ruling classes and/or to fill leisure time with facile amusement. Genuine art can become kitschified through incessant reproduction, as posters, tea-towels, etc. Kitsch lends itself strongly to irony and camp, and has thus appealed to the avant-garde, but even the image of avant-gardism has been appropriated and commercially exploited by kitsch.　　AA

Calinescu, M., *Five Faces of Modernity* (1987).

KLEE, PAUL (1879–1940). Swiss painter. Klee was born in Munchenbuchsee, near Berne. The son of a music teacher, he became an accomplished violinist and music had a constant if tangential influence on his mature paintings. He trained at the Munich

Academy (1898–1901) under Franz von *Stuck, whose *Jugendstil* influence may be seen in his early graphic works, like the etching *Young Woman in a Tree* (1902) with its *fin de siècle* perversity. From 1901 to 1902 he travelled in Italy and in 1905 visited Paris with the painter Louis Moilliet (1880–1962). In 1906 he settled in Munich and married the pianist Lily Stumpf whose earnings allowed him financial independence. By 1911 he was connected with the *Blaue Reiter and exhibited with them in 1912, the year of his second visit to Paris, where he first saw the work of *Picasso and Henri *Rousseau and was influenced by the colour theories of Robert *Delaunay. A visit to Tunisia, with Moillet and August *Macke, in 1914 had a profound and permanent effect on Klee's use of colour which had been largely confined to black and white. Works like *The Niesen* (1915; Berne, priv. coll.) in which he portrays an Alpine landscape in Tunisian colours, in a formalized style with debts to *Cubism and Delaunay, reveal the total yet personal adoption of *modernism which characterizes his mature work. After the war, in which he served 1916–18, a large exhibition in Munich (1919) established his reputation and led to an invitation from Walter Gropius to teach at the *Bauhaus in Weimar. During his Bauhaus years (1921–31) Klee was an influential teacher and formulated an artistic philosophy expressed in his lecture *On Modern Art* (1924), published in English in 1948. His approach is essentially mystical; the artist is the medium through which experience and imagination are transformed into art, a different but equally valid reality. An interest in the art of children and the insane influenced his own work, but when accused of childishness in his spidery almost automatist drawings, Klee replied, in *On Modern Art*, 'I do not wish to represent the man as he is but only as he might be.' Despite his versatility of style, through figuration to abstraction, his work is nonetheless instantly recognizable, vivacious, sometimes almost whimsical, as in *The Twittering Machine* (1922; New York, MoMa), yet sophisticated in colour and composition. From 1931 to 1933 he taught at the Düsseldorf Academy before being dismissed by the Nazis. He then moved to Berne where he continued to work until his death. A large collection of his work is held by the Klee Foundation in the Kunstmuseum, Berne.　　DER

Guse, E.-G. (ed.), *Paul Klee: Dialogue with Nature* (1991).

KLEIN, YVES (1928–62). French artist. Born in Nice, Klein, whose parents were also artists, had no formal art training, but had begun to paint seriously by 1946 and quickly formulated theories about *colour and the monochrome (a canvas filled entirely with one, usually strident, intense colour). His theories were informed by a

mixture of esoteric interests which gave philosophical weight to his central preoccupations: immateriality and the void; and the experience of transcendental freedom through the 'absoluteness' of colour. In 1955 he submitted the monochrome *Expression of the World of the Colour Lead Orange* (priv. coll.) to an annual salon showing abstract art in Paris. It was rejected, and by this gesture Klein showed up the bankruptcy of the reigning style, reintroducing the *Duchampian spirit to a new generation of artists. In 1956 he developed his trademark ultramarine blue, named IKB (International Klein Blue). He used this on monochromatic paintings, sculptures, and on his *Anthropometries* (1960), which he made by pressing naked, paint-covered women onto canvases. He was interested in natural elements, and employed air, fire, and water in his later work.　　MF

Stich, S., *Yves Klein* (1995).

KLIMT, GUSTAV (1862–1918). Austrian painter. Klimt trained at the School of Applied Art in Vienna and began his career as a decorative painter in the tradition of *Makart, whose decoration in the Kunsthistorisches Museum, Vienna, he completed. He was, however, drawn to avant-garde art and influenced by *Impressionism, *Symbolism, and *Art Nouveau. In 1897, dissatisfied with the conservatism of the Viennese Artists' Association, he founded the *Sezession and became its first president, leaving, after a quarrel, in 1905. His Symbolist-inspired mural paintings for Vienna University (1900–3; destr. 1945) were criticized as indecent and thereafter he concentrated on private commissions. His portraits of women, in which the features are naturalistic and the dress and background elaborately and perversely decorative, like that of *Adele Bloch-Bauer* (Vienna, Kunstmus.), were highly popular. His decorative allegorical works, frequently of femmes fatales, like *Salome* (1909; Venice, Gal. d'Arte Moderna), take the contrast between realistic likeness and bejewelled, almost abstract, setting even further. His linear style, strong colours, and emphatic sensuality link him to the succeeding generation of *Expressionists, particularly *Kokoschka and *Schiele.　　JH

Whitford, F., *Artists in Context: Gustav Klimt* (1993).

KLINE, FRANZ (1910–62). American painter. Born in Wilkes-Barre, Pa., he studied painting at Boston University 1931–5, visited Europe, and attended Heatherley's Art School, London, in 1937. Kline had a passion for drawing and a deep interest in the old masters, in particular *Rembrandt, *Goya, *Manet, and *Whistler. He returned from Europe to New York in 1939 and worked on both abstract and figurative paintings, for instance *Palmerton, Pa.* (1941; Washington, National Mus. of American Art), and murals until 1949, when he saw some of his small brush drawings enlarged by projector. This sparked the work for which he is best known, large abstract black on white forms, freely worked and painted with enormous brush strokes: *Mahoning* (1956; New York, Whitney Mus.). A significant and very popular member of the *Abstract Expressionist group, he won a major prize with his one-man show at the XXX Biennale, Venice, in 1960. In 1961 he became ill, ceased painting, and died of heart disease in 1962.　　RJP

Gaugh, H., *Franz Kline: The Vital Gesture* (1985).

KLINGER, MAX (1857–1920). German painter and sculptor. Born in Leipzig, Klinger studied at Karlsruhe and Berlin until 1883. He spent the next decade in Paris (1883–6), Berlin (1886–8), and Rome (1888–93) before settling in Leipzig in 1893. His style incorporates strong *Art Nouveau elements into conventional classical academicism and he is usually included among the *Jugendstil* artists. His work is technically complex and of considerable invention, full of symbolism and fantasy. As a sculptor he experimented with *polychromy, in the manner of Greek *chryselephantine statues, culminating in his monumental sculpture of *Beethoven* (1899–1902; Leipzig, Mus. der Bildenden Kunst) in white and coloured marbles, bronze, alabaster, and ivory, which formed the centrepiece of the 14th exhibition of the Vienna Sezession. As a painter he is best known for the vast *Judgement of Paris* (1885–7; Vienna, Kunsthist. Mus.) in which the frame forms part of the whole. His most original work is to be found in his fantastic *etchings which anticipate *Surrealism. The most remarkable are those in the series *Adventures of a Glove* (1881), a grotesque exploration of fetishism which antedates *Freud.　　DER

Varnedoe, K., *Graphic Works of Max Klinger* (1977).

KLUCIS (Klutsis), GUSTAV (1895–c.1944). Latvian painter, sculptor, graphic artist, theatre and poster designer, active in Russia. An influential exponent of *Constructivism he studied variously in Latvia 1911–15 and Petrograd 1915–17 before joining the pro-Bolshevik Latvian Rifle Regiment, where he sketched Lenin. He designed street decorations and posters for the 1918 May Day celebrations and studied at Svomas (Free Art Studios), Moscow, 1918–21, where he experimented with constructions of mixed media amalgamating the geometry of *Suprematism and the Constructivist concern for volume. An early follower of *Malevich he exhibited in several key avant-garde exhibitions in Russia and abroad. From 1922 his stylistically radical work was put to utilitarian ends, including the design of speakers' tribunes and latterly agitprop photomontage and graphic design. The poster *1st May: Day of International Proletarian Solidarity* (1930) epitomizes Klucis's innovative use of simple but dynamic forms, bold imagery, and asymmetrical typography, for which he is now best known. He taught at Vkhutemas (Higher Artistic and Technical Studios) 1924–30. A victim of the cultural purges, he was arrested and reputedly died in a labour camp, but possibly was executed.　　DJ

Lodder, C., *Russian Constructivism* (1983).
Oginskaya, L., *Gustav Klutsis* (1981).

KNAVE OF DIAMONDS, *avant-garde grouping of Russian painters active in Moscow 1910–17, the name derived from the diamond-shaped designs on convicts' uniforms signifying the artist's role as revolutionary and social outsider. Influenced by Russian Neo-primitivism and contemporary Western trends including *Cézanne, German *Expressionism, *Cubism, and the *Fauves, the group's subjects, taken from everyday or low life, were characterized by severe, often brutal simplification of form. The movement included at various times *Goncharova, Mikhail Larionov (1881–1964), *Malevich, the *Burlyuk brothers, *Kandinsky, and *Chagall. Foreign exhibitors included *Matisse, *Léger, *Braque, and *Picasso.　　DJ

Bowlt, J., *Russian Art of the Avant Garde: Theory and Criticism 1902–1934* (1988).

KNELLER, SIR GODFREY (1646–1723). German-born painter working in England. Kneller, originally Kniller, was born in Lübeck and trained in Amsterdam by *Bol before studying in Italy from 1672. He arrived in London c.1676 and soon obtained royal patronage. His career flourished after *Lely's death in 1680, and on the death of *Riley, with whom he was joint Principal Painter to the Crown, in 1691, his domination of English portrait painting was unchallenged. His notorious vanity was flattered by a knighthood (1692) and baronetcy (1715). Kneller's best work is robust and painterly and shows a strong grasp of character. His 42 paintings of the *Kit-Cat Club* (1702–17; London, NPG), including his swagger *Self-Portrait*, are probably his finest work. These small half-lengths of Whig grandees, in each of which (with the exception of his own) only one of the sitter's hands is visible, measure 91.4×71.1 cm (36×28 in), a size subsequently referred to as a Kit-Cat. However, like Lely, he could only complete his commissions by using assistants

and many of his lesser paintings are mechanical and formulaic. DER

Stewart, J., *Kneller*, exhib. cat. 1971 (London, NPG).

KNIGHT, RICHARD PAYNE (1751–1824). English connoisseur and collector. Knight, who was financially independent from boyhood, travelled in France, Italy, and Switzerland in 1772 and 1776 before making an archaelogical expedition to Sicily in 1777. On his return he occupied Downton Castle (Herefordshire), a pioneering Gothic house built to his own design, and spent the next decade creating a picturesque park inspired by *Claude. In 1794 he published *The Landscape* which proposed greater *Romanticism in garden design in opposition to the ideas of 'Capability' Brown (1715–83). He followed this with an *Analytical Inquiry into the Principles of Taste* (1805), a successful and acerbic attack on *Burke, which argued that taste is the result of personal experience. Knight, who began collecting antiquities in 1785, wrote the scholarly *Worship of Priapus* (1786), considered obscene by his critics, and collaborated with Charles Townley (1737–1805) on *Specimens of Antient Sculpture* (1809 and 1835), the first serious study of the *Antique written in English. His reputation as an arbiter of taste suffered after an ill-considered attack on the quality of the Elgin Marbles in 1816. DER

Clarke, M., and Penny, N., *The Arrogant Connoisseur*, exhib. cat. 1982 (Manchester, Whitworth).

KOBELL FAMILY. German painters active in Mannheim and Munich in the 18th and 19th centuries. The best known are **Ferdinand Kobell** (1740–99) and his son **Wilhem von Kobell** (1766–1853). Both were landscape painters, the father working in a manner heavily influenced by *Cuyp and *Claude (e.g. *Rocky Landscape with Herdsmen at a Brook*, 1772–3; Mannheim, Städtisches Reiss-Mus.), the son in a more naturalistic vein drawing inspiration from contemporary English work (e.g. *Hunting Party at Tegernsee*, 1824; Winterthur, Oskar Reinhart Coll.). MJ

Biedermann, M., *Ferdinand Kobell: das malerische und zeichnerische Werk* (1973).

Wichmann, S., *Wilhelm von Kobell* (3 vols., 1970–3).

KØBKE, CHRISTEN (1810–48). Danish painter. Købke was born in Copenhagen and entered the Kunstakademi aged 11. He was taught by *Eckersberg from whom he continued to learn after leaving the Academy in 1832. His paintings of the Citadel of Copenhagen, which he knew intimately, like *The North Gate of the Citadel* (1834; Copenhagen, Ny Carlsberg Glyptothek), are characterized by intense clarity of style and informality of subject and a mastery of atmospheric effects learned from Eckersberg. In 1834 he moved to the country which he recorded in calm, uneventful, yet timeless works. These, like his many paintings of the royal castle of Frederiksborg, despite their apparent simplicity, are highly sophisticated compositions. Sometimes touched with the Romantic melancholy of *Friedrich, whom he visited in Dresden in 1838 en route for Italy, they more often reveal an individual vision which delights in recording the appearance of objects under changing light, for example *One of the Turrets at Frederiksborg Castle* (1834–5; Copenhagen, Kunstindustrimus.), a fascinating and seemingly photographic roofscape. His early portraits, usually of family or friends, like the painter *P. H. Gemzoe* (1833; Copenhagen, Statens Mus. for Kunst), are direct and informal, becoming more monumentally simple after 1835. Købke was never particularly successful and was virtually ignored after his death until rediscovered in the late 19th century. DER

Schwartz, S., *Cristen Købke* (1992).

KOCH, JOSEPH ANTON (1768–1839). Austrian painter. Born in Obergibeln in the Tyrol, Koch studied at the Hohe Karlsschule in Stuttgart 1785–91 after which he spent much of the next three years sketching in the Alps. From 1795 he worked mainly in Rome, financed by an English patron, Dr George Nott, where he was influenced by the *Neoclassical style of his friends Asmus *Carstens and *Thorvaldsens. In his history and subject paintings Koch took the works of Ossian and Dante for his inspiration and used subjects from the latter's *Inferno* for his frescoes in the Casino Massimo, Rome (1825–8), on which he worked with the *Nazarenes. Despite his Neoclassical credentials Koch's innate *Romanticism can be seen in his landscapes although compositionally they remain in the Italianate tradition established by *Poussin. In works like the highly detailed *Schmadribach Falls*, of which he painted two versions (1811; Leipzig, Mus. der Bildenden Kunst; 1822; Munich, Neue Pin.), he achieved a combination of dramatic sky, vast mountain, foaming water, and impenetrable forest which exemplified the Romantic *sublimity he found in nature. DER

Holst, C. van, *Joseph Anton Koch: Ansichten der Natur* (1989).

KOEKKOEK, BAREND CORNELIS (1803–62). Dutch landscape painter. Koekkoek was born in Middelburg and studied at the *Amsterdam Academy and under his father Johannes Hermanus Koekkoek (1778–1851), a painter of seascapes. He based his style on Dutch 17th-century masters like *Hobbema, van *Goyen, and *Wijnants and painted traditional Dutch subjects like *Winter Landscape* (c.1838; Amsterdam, Rijksmus.), which, in common with most of his work, contains figures. He also painted more *picturesque paintings which appealed to contemporary Romantic sensibilities, for he frequently travelled to the more rugged areas of Belgium and Germany to paint forests and mountains, as in the *Forest Landscape* (1848; Amsterdam, Rijksmus.). His highly detailed pictures often contain dramatic skies and, like many Dutch painters, he excelled at the light effects of dawns and sunsets. A prolific and successful painter, he established an art school in Cleves, where he lived in his later years. His younger brother Hermanus (1815–82) was a marine painter: *Ships at Sea* (1852; Sheffield, AG); and his nephew Willem (1839–95) painted townscapes in the 17th-century Dutch manner. DER

Gorissen, F., *B. C. Koekkoek, 1803–1862* (1962).

KOKOSCHKA, OSKAR (1886–1980). Austrian painter. Kokoschka was born in Pochlarn and studied at the *Vienna School of Arts and Crafts. He was associated with the *Sezession under *Klimt's presidency and a contributor to the Wiener Werkstätte through which he met the architect Adolf Loos (1870–1933), whom he painted in 1909 (Berlin, Neue Nationalgal.). His early portraits, freely painted and designed to show the sitter's inner self, were, like his allegorical play *Murderer, Hope of Women* (1909), intended to shock. In 1909 he moved to Berlin where he became a prolific illustrator for *Der Sturm* and painted figure subjects in a variety of styles united by an *Expressionist intensity. The culmination of his pre-war work was the almost visionary *Tempest* (1914; Basle, Kunstmus.), painted in swirling blues, inspired by a love affair. He was badly wounded in 1915 but recovered to teach at the Dresden Academy (1919–24). Vehemently anti-Nazi, Kokoschka moved to Prague in 1934 and England in 1938, becoming naturalized in 1947. He continued to paint landscapes, townscapes (*Jerusalem*, 1929–30; Detroit, Inst. of Arts), and portraits in an unchanging but distinctive personal Expressionist style. DER

Winkler, J., and Erling, K., *Oskar Kokoschka: die Gemälde* (1995).

KOLLWITZ, KATHE (1867–1945). German graphic artist and sculptor. Born in Königsberg into a nonconformist, socialist family, Kollwitz trained at the female art schools in Munich and Berlin. In 1898, at the Berlin Free Art Exhibition (1893–1936), she came to prominence with her print cycle *The Weavers' Revolt* (1893–7), inspired by Hauptmann's play about social injustice, deprivation, and rebellion. She always championed the oppressed, especially poor, urban women, and was subsequently regarded with suspicion by the National Socialists. She was a great

admirer of *Dürer, *Rembrandt, and *Daumier, and, apart from her controversial subject matter, her expressive style in woodcut, lithography, and etching remained figurative and conservative. One of her many public distinctions came in 1919 when she became the first woman elected to the Prussian Academy of Art, and she was also head of graphics there (1928–33). She was a strong pacifist, especially after her son's death in action in 1914. Her commissioned sculpture of grieving parents, using her own and her husband's features, was installed at the entrance to Roggevelt military cemetery, Belgium, in 1933.　　　　　　　　　　　　　GS

Prelinger, E., *Kathe Kollwitz* (1992).

KONENKOV, SERGEI (1874–1971). Russian sculptor. Despite an academic training Konenkov travelled and exhibited widely and was conversant with contemporary European developments, including the work of *Rodin and *Gauguin. After 1917 he taught in various state studios and was politically active, participating in Lenin's Plan for Monumental Propaganda 1918 with a wooden sculpture, *Stepan Razin*, and a memorial plaque *To the Fallen in the Struggle for Peace and the Fraternity of Nations* (both St Petersburg, Russian State Mus.). He remained loyal, however, to dynamic and expressionistic interpretations of Russian myth and folklore, in his preferred medium of wood. In 1923 he emigrated to the USA but returned to Russia at Stalin's invitation, in 1945 to sculpt monumental statues and portrait busts of the political and cultural elite, including Lenin. A much decorated 'People's Artist' and Stalin Prize winner, Konenkov adapted his personal stylistic exuberance to the demands of *Socialist Realism whilst continuing with private projects of a mystical and fantastic nature, born of a long-standing interest in ancient civilizations, astrology, and pagan-occult practices. His last work, *Cosmos* (1950–68; Moscow, Konenkov Mus.), is an arcane fusion of cryptic and magical symbolism.　　　　　　　　　　　　　DJ

Bychkov, Yu. (ed.), *S. Konenkov: Reminiscences, Articles, Letters* (1984).

KONINCK FAMILY. Now primarily known as an important Dutch landscape painter, in the 17th century **Philips** (1619–88) was also renowned as an artist who produced portraits and genre pictures. He was born in Amsterdam and initially trained as a pupil of his elder brother Jacob in Rotterdam. By the early 1650s he had returned to Amsterdam where he remained for the rest of his life. The biographer *Houbraken describes him as a pupil of *Rembrandt; this has not been corroborated but some of his works do illustrate affinities with the paintings and etchings of Rembrandt. His landscapes usually show, from an imaginary vantage point, vast panoramas of the flat Dutch countryside, enlivened with towns and water features, beneath restless skies, and convey a powerful sense of space.

His older cousin **Salomon** (1609–56) was also a painter; a pupil of Claes Moeyaert, he worked in the style created by Rembrandt in the 1630s, on smaller pictures of hermits, old men, and philosophers, and larger historical compositions, often with exotic costumes and bold contrasts of light and shadow.　　CB

Gerson, H., *Philips Koninck* (repr. 1980).

KOUROS/KORE (plural: kouroi/korai), generic terms for Archaic Greek statues of nude male youths and clothed maidens, respectively. Both types first appear in marble in monumental form in the Cyclades in the 7th century BC (e.g. Delos Mus.). The males, clearly adapted from Egyptian prototypes, stand with left foot advanced and hands at their sides. The early statues have long hair, and some wear belts, perhaps on the model of Homeric heroes. The type spread quickly, examples clustering in cemeteries and sanctuaries, for they were polysemic, serving as funerary markers, votive offerings, and depictions of divinities: diverse functions were signalled by context as well as by added attributes and/or inscriptions. Although similar to one another in stance, regional preferences as to the ideal body type can be discerned, as can a general chronological development towards more naturalistic representation of anatomical details, which appears to have ultimately led to the demise of the type c.500 BC, when the statues appear to be struggling to break free from a restrictive formula. Korai served the same variety of functions as their male counterparts, but while the kouroi provided sculptors with a ground for experimentation in rendering the nude human body, the draped female figures allowed for an ever-increasing elaboration of folded and patterned garments (peplos, chiton, himation, epiblema), which were combined according to regional and chronological fashions, as well as an exploration of their relationship with the underlying female forms. As much of the paint that originally adorned the korai has been lost, many appear considerably plainer today than in Antiquity, although traces of colour have been preserved on some statues, notably those recovered from the Athenian Acropolis (Athens, Acropolis Mus.). Both kouroi and korai were also produced in other materials (e.g. bronze, terracotta, wood, and ivory), and at a variety of scales from miniature to colossal, but approximately life-size marble figures appear to have been the most popular throughout the 6th century BC. The wide distribution of these types throughout the Greek world (perhaps as many as 20,000 once existed) is indicative of both a unified aristocratic culture and competitive emulation, for these statues were made for prominent display and projected elite values of strength, beauty, and wealth, which naturally differed for males and females.　　　　　　　　　KDSL

Richter, G. M. A., *Korai* (1968).
Richter, G. M. A., *Kouroi* (1970).
Stewart, A., *Greek Sculpture* (1990).

KRAFT, ADAM (active 1490–c.1509). German sculptor. Kraft was the leading late *Gothic stone sculptor of Nuremberg. His origins are undocumented, though he may have been trained in Strasbourg. His mature career was spent exclusively in Nuremberg and is represented by several major commissions for its patrician families. The sandstone Schreyer-Landauer Epitaph of 1490–2 fills an exterior bay of the Sebalduskirche with a set of Passion scenes in exceptionally high relief. Two conversing witnesses to the *Crucifixion* apparently represent the patron, Sebald Schreyer, and the artist. Another self-portrait, crouched in working clothes and holding a mallet, supports the base of Kraft's best-known work, the Lorenzkirche Sacrament House of 1493–6, an 18-m (60-ft) multi-figured tabernacle of extraordinary complexity, its topmost finial elegantly bending to follow the curve of the choir vaults. Between 1506 and 1508 Kraft carved seven reliefs of the *Stations of the Cross* for the road to the Johannisfriedhof cemetery. Their combination of pungent naturalism, dramatic pathos, and a genuinely monumental sense of form are characteristic of Kraft's work as a whole.　　JR

Muller, T., *Sculpture in the Netherlands, Germany, France and Spain, 1400 to 1500* (1966).

KRASNER, LEE (1908–84). American painter. Born Brooklyn, New York, she studied at the Art Students' League and then with Hans *Hofmann, where she first came to know Jackson *Pollock, with whom she exhibited in 1941, and whom she married in 1945. She supported, encouraged, and managed him at the expense of her own work, which was often ignored or slighted, but after Pollock's death she developed a body of work of high quality, much of it using *collage, which gained recognition: *Diptych* (1977–8; New York, Robert Miller Gal.). Her will established the Pollock-Krasner Foundation to aid artists in need.　　　　　　　　　RJP

Rose, B., *Lee Krasner: A Retrospective* (1985).

KRIEGHOFF, CORNELIUS (1815–72). Canadian painter. He was born in Amsterdam but grew up in Bavaria. In 1836 he

emigrated to the United States, where he served as a mercenary soldier. He married a French-Canadian and by the 1840s was living in and near Montreal, where he began to paint small studies of the local *habitants* (French-Canadian rural folk). These became popular with the buying public, and he expanded the theme into large-scale genre paintings illustrating their activities and customs, often in a winter setting. In 1853 Krieghoff moved to Quebec City, where his paintings found a ready market, especially among British soldiers stationed there. After the mid-1860s his productivity lessened, and he moved to Chicago, where he died in 1872.

A prolific artist, Krieghoff's lively, anecdotal, and often gently satirical scenes were principally influenced by 17th-century Dutch painting. *Merrymaking* (1860; Fredericton, Beaverbrook AG), his best-known work, depicts the chaotic morning departure of revellers outside an inn after an all-night celebration. KM

Harper, J. Russell, *Krieghoff* (1979).

KRØHG, CHRISTIAN (1852–1925). Norwegian painter and writer. Krøhg was born near Christiania (Oslo), where he studied law 1869–73 while attending drawing classes in the evenings. He trained under Karl Gussow (1843–1907) at the Karlsruhe Kunstschule and the Berlin Akademie until 1879. Living in great poverty, he was attracted to the realist theories of *Zola and chose to paint the reality of urban and rural poverty, painting the gritty *Net Menders* (1879; Oslo, NG Norway) in the artist's colony at Skagen. In 1881 he visited Paris and under French influence his palette grew richer and warmer although his subjects remained the same. In 1886 he wrote a novel, *Albertine*, on the subject of prostitution, from which he took subjects for paintings which, like the book (which was banned), scandalized Oslo society. From 1890 he combined his careers as painter and writer, undertaking journalism and criticism. After seven years teaching at the Académie Colarossi in Paris he became director of the Oslo Kunstakademi in 1909. In later life, for pleasure, he painted many self-portraits and nudes. DER

Christian Krøhg, exhib. cat. 1987 (Oslo, NG Norway).

KRØYER, P(EDER) S(EVERIN) (1851–1909). Danish painter and sculptor. Krøyer, who was born in Stavanger, trained at the Copenhagen Akademi (1864–70) and first exhibited in 1871. In the mid-1870s he joined the artists' colony in the fishing village of Hornbaek where he drew studies of

everyday life. In 1877 he moved to Paris where he trained under the gifted teacher Léon Bonnat (1833–1922) and developed a more fluid painterly style. He continued to paint rustic scenes, working in Brittany in 1879 and in Italy 1879–81. His pictures were increasingly realistic, showing the influence of *Bastien-Lepage, like the *Italian Village Hatters* (1880; Copenhagen, Hirschspaungske), which was a medal winner at the Paris *Salon of 1881, the year in which he returned to Denmark. From now on he divided his time between his studio at the coastal village of Skagen and Copenhagen, where he taught 1882–1904. Friendship with *Krøhg *c.*1883 introduced him to *Impressionism and his later work, much of which includes his wife Marie whom he married in 1889, shows a greater interest in atmosphere and the use of brighter colours. DER

P. S. Krøyer: Tradition and Modernity. exhib. cat. 1992 (Århus, Kunstmus.).

KRUYDER, HERMAN (1881–1935). Dutch painter, born in Lage Vuursche. In about 1900 he learned techniques of painting at the School of Arts and Crafts in Haarlem. He later worked as a glass painter in Delft. In 1910 he returned to Haarlem and decided to become a painter, arriving at a distinctive artistic style by 1916. From then he lived in various villages around Haarlem and painted scenes and objects relating to rustic life. One of the main characteristics of his work is that human beings and animals are rendered disproportionately small in relation to their rustic settings, causing them to look like toys. They usually possess large, staring eyes. The clumsily stylized shapes of these figures are made even more incongruous by their extremely meticulous and precise colouring, which reflected Kruyder's skill as a glass painter. Indeed, the general appearance of his works is reminiscent of the painting on Dutch folk pottery. His style seems to represent a point halfway between naive art and *Expressionism. OPa

KUBIN, ALFRED (1877–1959). Austrian graphic artist. Born in Leitmeritz, Bohemia, Kubin was raised in Salzburg. In 1898 he entered a Munich art school and by 1903 had held his first exhibition and published a volume of drawings. From the first his work was macabre and fantastic, influenced by *Goya's *Caprichos*, the drawings of *Beardsley, the eroticism of *Rops, and the symbolism of *Redon. Psychologically troubled, he attempted suicide in 1896 and had a breakdown in 1903; his work reflects his neuroses and his obsession with sexuality and death;

his *Dance of Death* was published in 1918. The intensity and satire of his work allied him to the *Expressionists, he joined Der *Blaue Reiter in 1911 and exhibited in Der *Sturm exhibition of 1913, and his bizarre images also influenced the *Surrealists. Kubin, who wrote a Kafkaesque novel *Die andere Seite* in 1909, was a prolific book illustrator, choosing his subjects from the horrific and despairing, Nerval, Poe, and Dostoevsky. However he was both popular and influential, becoming professor of the Prussian Akademie der Kunste in 1937 and exhibiting at the Albertina, Vienna, in the same year. DER

Hoberg, A. (ed.), *Alfred Kubin (1877–1959)* (1990).

KULMBACH, HANS (SÜSS) VON (*c.*1482–1522). German painter and designer of stained glass, who took his name from his town of birth in upper Franconia. He arrived in Nuremberg *c.*1504–5 and became a citizen and independent master in 1511. He was apprenticed to Jacopo de' *Barbari, who worked in Germany for several years from 1500. He also was in *Dürer's workshop, possibly as an assistant. Kulmbach's chief altarpieces were mainly painted for Nuremberg and Cracow (Poland) which he may have visited. His works show a strong dependence on Dürer but distinguish themselves from those of his master in their clear and luminous colours (*Virgin and Child with Saints*, the so-called Tucher altarpiece, 1513; Nuremberg, Sebalduskirche). Many of Kulmbach's designs for glass paintings survive, including a number for windows still *in situ* in the Sebalduskirche. Next to *Baldung, Kulmbach was Dürer's most important pupil, and next to Dürer himself, Nuremberg's most noteworthy painter in the first two decades of the 16th century. KLB

Löcher, K., *Germanisches Nationalmuseum Nürnberg: die Gemälde des 16. Jahrhunderts* (1997).

KUNSTKAMMER (German: art chamber). While the medieval princes had mainly collected relics of saints, those of the 16th century and later assembled collections of pictures, small bronzes and marbles, and rare and precious objects, which art historians describe by the term *Kunstkammer* or *Wunderkammer*. Such collections aimed to embrace all reality; they juxtaposed the natural and artificial, and included works of art and scientific instruments, Greek or Roman antiquities, exotic objects from Africa or the New World, and bizarre or marvellous products of nature. They were established by Italian princes, and Francesco I de' Medici's *studiolo* in the Palazzo Vecchio, Florence, was

celebrated, but in the later 16th century many princely and bourgeois collections were created in Germany and central Europe. Famous *Kunstkammers* included those of Rudolf II at Prague, of Peter I at St Petersburg, and of Archduke Ferdinand II at Schloss Ambras (which displayed *Cellini's Salt Cellar; Vienna, Kunsthist. Mus.). In the 17th century, especially at Antwerp, they became the subject of paintings, and Jan *Brueghel's *Allegory of Sight* (Madrid, Prado) conveys their rarefied and precious atmosphere. HL

Impey, O., and MacGregor, A. (eds.), *The Origin of Museums* (1985).

KUPKA, FRANTIŠEK (1871–1957). Czech-born painter of the *École de Paris. After studying in Jaromer in eastern Bohemia, Prague, and Vienna, Kupka settled in Paris in 1895, supporting himself as an illustrator. Initially he worked in a *Symbolist manner, as in *Ballad-Joys* (1901–2; Prague, Národní Gal.), but his interest in *colour theory and his studies of movement led him towards abstraction. *Piano Keys—Lake* (1909; Prague, Národní Gal.) combines naturalistic depiction of water with abstract strips of colour which relate to his ideas about musical composition. This work is indicative of Kupka's distance from the dominant Parisian mode of abstraction, *Cubism, and his conceptual approach to art. He soon developed an uncompromising geometrical abstraction based on strong compositional grids: vertical strips, diagonal grids, and concentric or spiralling circles, for instance *Disks of Newton, Study for Fugue in Two Colours* (1911–12; Paris, Centre Georges Pompidou). His later work has a more subdued colour, reduced elements, and a more static effect, *Purist in tone. MF

Frantisek Kupka: 1871–1957, exhib. cat. 1989 (Paris, Mus. d'Art Moderne).

LABILLE-GUIARD, ADELAÏDE (1749–1803). French portrait painter. She trained under François-Élie Vincent (1708–90) and was received as a member of the Académie Royale (see under PARIS) in 1783, on the same day as her rival Élisabeth *Vigée-Lebrun. She worked in a sober, dignified, naturalistic manner in both pastels and oils. She was favoured by the more conservative members of the aristocracy and royal family, and became official painter to Mesdames, the sisters of Louis XVI—her impressive full-length portrait of *Mme Adelaïde* (1787; Versailles) is one of the better court portraits of its period.
MJ

Passez, M.-A., *Adelaïde Labille-Guiard* (1973).

LACAN, JACQUES (1901–81). French theorist. His interpretations of Freud's ideas, refracted through the linguistics of Ferdinand de Saussure and a diverse array of scholarly and artistic references, gained a growing audience from the 1960s, as structuralism and *poststructuralism were disseminated internationally. His intellectual formation, however, lay in the *Surrealist circles of 1930s Paris. Lacan wrote of the linguistic formation of human subjects and of objects of thought out of a pre-linguistic context that lacked any essence or centre. He also stressed the role of the gaze (*le regard*) in fixing images both of the other and of the self (initially, in the infant's encounter with its reflection in 'the mirror phase'). The potential disjunctures between this 'imaginary' mode of experience and the 'symbolic' mode of language are explored in his discussion of *Holbein's *Ambassadors* (London, NG). Lacan's intense, densely expressed interest in pictures was matched by the art world's interest in his thought during the 1980s and 1990s, when his terminologies had a prominent

presence in art writing.
JB

Lacan, J., *The Four Fundamental Concepts of Psychoanalysis* (1977).

LACHAISE, GASTON (1882–1935). French sculptor, born in Paris. He trained at the École Bernard Palissy, 1895, and then at the Académie des Beaux-Arts, 1898–1904. He emigrated to America in 1906, becoming one of the pioneers of modern sculpture there by helping to reintroduce the method of *direct carving. In Boston, he worked for René Lalique and Henry Hudson Kitson. In 1912, he moved to New York, where he became assistant to Paul Manship (1885–1966). His style matured in the following years and he had his first one-man show at the Bourgeois Gallery, New York, in 1918. Although he did a number of portrait busts, including one of the poet E. E. Cummings, and a coloured plaster of the painter John *Marin, he is known mainly for his massive and voluptuous female nudes, whose sense of overt femininity has been compared to that in *Renoir's paintings. The best-known example is *Standing Woman* (1912–27; New York, Whitney Mus.). He also executed commissions for sculpture on the Electricity Building, Chicago, and the Rockefeller Center, New York.
OPa

Kramer, H., *The Sculpture of Gaston Lachaise* (1967).

LAER, PIETER VAN (Il Bamboccio) (1599–1642?). Dutch painter and printmaker. He was mainly active in Rome, where he arrived *c*.1625–8 and became the leader of the *Schildersbent, a bacchanalian fraternity of Netherlandish artists living in the city. He specialized in painting scenes of everyday life, with soldiers, travellers, brigands, and herdsmen, but often set, perhaps as a form of poetic paradox, against the ruins of ancient Rome (*The Blacksmith in a Grotto*, 1635;

Schwerin, Staat-Mus.) This new type of low-life genre painting became known as *bambocciata*, apparently an allusion to van Laer's physique rather than his art. His followers among the Dutch artists were known as the *Bamboccianti. This conscious rejection of the traditional artists' hierarchies and the concept of noble subject matter offended theoretical Italian writers such as *Passeri and *Malvasia; but it found a ready following both among the Roman aristocratic collectors and the second generation of Dutch Italianate artists working in Rome, including *Berchem, *Asselijn and *Dujardin. After returning to Amsterdam in 1637, van Laer left Haarlem five years later to go back to Rome but apparently never arrived. HB

Briganti, G., Trezzani, L., Laureati, L., *The Bamboccicianti: The Painters of Everyday Life in 17th Century Rome* (1985).

LA FOSSE, CHARLES DE (1636–1716).
French painter. He trained in Paris under *Le Brun but spent the years 1658–63 in Italy, where he absorbed the up-to-the-minute *Baroque decorative style of Pietro da *Cortona and was also influenced by the softness of *Correggio and the colour of the Venetians. He returned to France with an eclectic but attractive style evident in his reception piece for the Académie Royale, *The Rape of Proserpine* (*Paris, École des Beaux-Arts). During the 1670s he worked as an assistant to Le Brun at the Tuileries and Versailles, his own tendency towards the flamboyant being kept in check by the need to conform to his master's style. In the 1680s, encouraged by the pro-colour theorist Roger de *Piles, La Fosse turned to *Rubens for inspiration. His *Presentation of the Virgin* (1682; Toulouse, Mus. des Augustins) is probably the most Baroque picture painted in France up to that time. La Fosse was able to display his flair for large-scale decoration in 1689–92, when he worked at Montagu House in London (destr.). Like near contemporaries such as Antoine *Coypel and Jean *Jouvenet, La Fosse was searching for a way forward from the by then ossified decorum of the *classicizing style advocated by Le Brun and the Academy. In later works such as *Bacchus and Ariadne* (c.1699; Dijon, Mus. des Beaux-Arts) and in the illusionistic decoration of the dome of the Invalides (begun 1692) La Fosse proved himself to have a more assured and lighter touch than his colleagues. Though it is hard for modern taste to love his work, he should certainly be seen as more than just a transitional figure between the age of Le Brun and the age of *Boucher. MJ

Stuffmann, M., 'Charles de La Fosse et sa position dans la peinture française à la fin du XVIIe siècle', *Gazette des beaux-arts*, 2 (1964).

LAGRENÉE FAMILY. French painters.
Louis (called Lagrenée the elder) (1724–1805) had one of the most successful official careers of any history painter in 18th-century France. After training with Carle van *Loo he spent a year (1754) at the French Academy in Rome, before returning to employment in Paris, by the Crown, the Church, and wealthy private clients. In 1760–2 he was in Russia as first painter at the St Petersburg Academy, and in 1781–5 he was director of the French Academy in Rome. Such *grandes machines* as *Allegory on the Death of the Dauphin* (1767; Fontainebleau), with their reminiscences of the 17th-century Bolognese masters, were received enthusiastically. But by the 1780s with the advent of *David's brand of *Neoclassicism they had come to seem laborious and old-fashioned. Louis's brother **Jean-Jacques** (called Lagrenée the younger) (1739–1821) was his pupil and worked in a similar manner. MJ

Sandoz, M., 'Louis-Jean-François Lagrenée, peintre d'histoire', *Bulletin de la Société de l'Histoire de l'Art Français* (1961).

Sandoz, M., 'Jean-Jacques Lagrenée, peintre d'histoire', *Bulletin de la Société de l'Histoire de l'Art Français* (1962).

LAGUERRE, LOUIS (1663–1721). French
decorative painter active in England. He was the son of the keeper of Louis XIV's menagerie. After a brief period in the studio of Charles *Le Brun he settled in England where he worked with Antonio *Verrio at Windsor Castle before becoming his main rival. A number of important *Baroque decorative schemes by Laguerre, combining figures with illusionistic architecture, survive in English stately homes. They include those at Chatsworth (Derbys.) (1689–97), Burghley House (Lincs.) (1698), and Blenheim Palace (Oxon.) (c.1720). The passage of time and the restorer's brush have done much to take the bloom from Laguerre's work. The discovery in 1984 of scenes from the story of Dido and Aeneas in the staircase hall at Frogmore House, Windsor, unseen since they were covered over in 1760, has done much to show the quality of his work as it must have appeared originally. In Laguerre's later years anti-French feeling during the War of the Spanish Succession led to his ousting from several important commissions, notably that for painting the cupola of S. Paul's Cathedral, where he was replaced by James *Thornhill. MJ

Croft-Murray, E., *Decorative Painting in England, 1557–1837*, vol. 1 (1962).

Smith, N., 'Frogmore House before James Wyatt', *Antiquaries Journal*, 65/2 (1985).

LA HYRE, LAURENT DE (1606–56). French
painter, draughtsman, and printmaker. He was the son of Étienne de La Hyre, a painter from whom he received his early

training. He also studied at the Château de *Fontainebleau and 1622–5 in the studio of Georges Lallemant (c.1580–1636). These Mannerist influences are evident in his brilliantly conceived set of four etchings on mythological themes which date from early in his career, c.1626; the *Venus and Adonis* and *Apollo and Coronis* in particular show striking parallels with the early work of N. *Poussin, who had also trained under Lallemant in Paris before going to Italy. La Hyre's early paintings include an *Agony in the Garden* (Le Mans, Mus. Tessé) conceived as a nocturne like Poussin's small painting on copper for the Barberini (priv. coll.); a *Martyrdom of S. Bartholomew* (c.1627; Mâcon, Cathédrale S. Vincent) which echoes *Caravaggio in its brutal realism; and the *Nicholas V at the Tomb of S. Francis of Assisi* (1630; Paris, Louvre), another nocturnal scene lit by candlelight and of intense dramatic concentration which was painted for the Capuchins in the Marais. It is extraordinary to reflect that La Hyre apparently never visited Italy or experienced at first hand the work of Caravaggio and his followers.

La Hyre's mature style is more explicit and cerebral: *S. Peter Curing the Sick with his Shadow* (1635; Paris, Notre-Dame) is notable for its theoretical demonstration of perspective within an architectural setting; whereas his *Conversion of S. Paul* (1637; Paris, Notre-Dame) is more dramatic, oscillating between the exaggerations of late Mannerism in the contorted forms of the foreground figures, and a proto-Baroque sense of movement and physical energy. A didactic and archaeological spirit governs the *Cornelia Refusing Ptolemy's Crown* (1646; Budapest, Szépművészeti Mus.), set against an austerely formal background of classical architecture. La Hyre was much in demand as a decorator. He painted a series of half-length female allegorical figures representing the liberal arts for the Parisian *hôtel* of Gédéon Tallement (1613–88); they are all striking images and include *Music* (?1649; New York, Met. Mus.) and *Grammar* (1650; London, NG).

Many of La Hyre's most visionary and individual paintings were pastoral landscapes, in a distinctly Italianate style, such as the *Landscape with Flute-Player* (1647; Montpellier, Mus. Fabre), *Landscape with Swineherd* (1648; Montreal, Mus. of Fine Arts); *Landscape with Justice and Peace* (1654; Cleveland, Mus. of Art). He also made a suite of six romantic landscape etchings, which are probably contemporary with his prints (1639) of the *Holy Family and Angels with the Cross*, and the *Virgin and Angels Presenting the Cross to the Infant Christ* which echoes a recently completed etching on the same theme by Pietro *Testa.

La Hyre's final years are notable for several important religious commissions: the *Descent from the Cross* painted for the Capuchins of Rouen in 1655 (now Rouen, Mus. des Beaux-

Arts) and two exceptionally austere compositions for the Charterhouse of Grenoble, the *Disciples at Emmaus* and *Noli me tangere* (1656; Grenoble, Mus. des Beaux-Arts), which already seem to prepare the ground for the *Neoclassical period, a time when his work would be much revered. HB

Rosenberg, P., and Thuillier, J., *Laurent de La Hyre*, exhib. cat. 1989 (Grenoble, Mus. des Beaux-Arts).

LAIRESSE, GÉRARD DE (1640–1711). Painter and art theorist from Liège. Lairesse trained first with his father then, from 1655, with Bertholet Flémal (Flémalle) after which he began a successful career in Liège. His early work (*The Baptism of S. Augustine*; Mainz, Landesmus.) is influenced by Flemal, but also shows the impact of *Poussin in the idealized figures, clear bright light, and staged settings. In 1664 a scandal involving a broken marriage contract forced Lairesse to move to 's-Hertogenbosch and then Utrecht, finally settling in Amsterdam. In Amsterdam French taste was already influencing every aspect of Dutch society and his complex mythological works such as *Benefits of the Peace of Breda* (1667; The Hague, Gemeentemus.) soon attracted the attention of a wealthy clientele. He also introduced a new kind of allegorical *trompe l'œil* decoration for patrician houses seen in the grisaille canvases *The Four Ages of Man* (1682; Orléans, Mus. des Beaux-Arts). In 1690 blindness cut short his brilliant career and Lairesse spent the remaining ten years of his life giving successful art lectures, which his sons published in 1701 as *Grondlegginge der teekenkunst* (Principles of Design), and in 1707 as *Het groot schilderboek* (Great Book of Painters). This last book is still invaluable as a source of information on late 17th-century Dutch art. CFW

Roy, A., *Gérard de Lairesse 1640–1711* (1992).

LAM, WIFREDO (1902–87). Cuban painter. The son of a Chinese father and an Afro-European mother, Lam's multicultural heritage is reflected in his work. After studying in Havana and Madrid he went to Paris in 1938 where he met *Picasso and joined the *Surrealists. The European modernist interest in African art and culture prompted him to examine his own roots; after his return to Cuba in 1941, paintings such as *The Jungle* (1943; New York, MoMa) skilfully began to fuse black iconography with imagery from the Cuban *Santería* religion, using European avant-garde techniques. CC

Fouchet, M. P., *Wilfredo Lam* (1984).

LAMBERTI, FATHER AND SON. Niccolò di Pietro (c.1370–1451) and **Pietro di Niccolò** (c.1393–1435) were both sculptors of Florentine origin, but mainly active in Venice. Niccolò di Pietro worked on the Porta della Mandorla for Florence Cathedral and is next recorded in connection with a figure of *S. Mark* in 1415 (Florence, Mus. dell'Opera del Duomo). From 1416 he was in Venice, where he played an important part in the sculpture for the facade of S. Mark's. His son Pietro di Niccolò was active at Or San Michele in Florence in 1410, but then appears to have accompanied his father to Venice. His main monument in Venice (in collaboration with Giovanni di Martino from Fiesole) was the tomb of Doge Tommaso Mocenigo (1423; Venice, SS Giovanni e Paolo). Subsequently he worked on the tomb of Raffaelle Fulgioso in the Santo in Padua (1429–30), and in Verona. Modern scholars are divided over whether he was responsible for the relief of the *Judgment of Solomon* (c.1424–58) on the Doge's palace in Venice. HO/AB

Pope-Hennessy, J., *Italian Gothic Sculpture* (4th edn., 1996).

Wolters, W., *La scultura Veneziana Gotica (1300/1460)* (1976).

LAMI, EUGÈNE (1800–90). French painter. Lami was born in Paris and trained under Horace *Vernet from 1815 and *Gros, 1817–20. He began as a lithographer of military subjects publishing prints of the *Spanish Cavalry* (1819) and, with Vernet, *French Army Uniforms, 1791–1814* (1821–4). In 1824 he established his reputation with *Battle at Puerto da Miravete* (1823; Versailles) and in 1830 was commissioned by Louis-Philippe to paint a series of panoramic battles for the Château de Versailles (1830–8; *in situ*). On Louis's marriage in 1837 Lami's role changed to that of chronicler of court life, with scenes like *The Arrival of Queen Victoria at Tréport* (1843; Versailles), at which he excelled, having a miniaturist's eye for detail. From 1848 to 1852 he was in England, in the exiled court of Louis-Philippe, painting lively and charming watercolours of English society, several of which are in the Royal Collection at Windsor. On returning to France he continued to paint decorative figurative watercolours and was active in the foundation of the Société des Aquarellistes in 1879. DER

Lesmoisne, P.-A., *L'œuvre de Eugène Lami* (1914).

LANCRET, NICOLAS (1690–1743). French painter. Like *Watteau he was a pupil of Claude Gillot (1673–1722). He had a considerable success in imitating Watteau's *fêtes galantes* and his pictures were bought by discerning collectors of Watteau's art such as Jean de Jullienne as well as by members of the court. Less monotonous than his Watteauesque fantasies are his scenes of modish contemporary life, of which *A Family in a Garden* (1742; London, NG) is a charming example. MJ

Holmes, M. Tavener, *Nicolas Lancret, 1690–1743*, exhib. cat. 1991 (New York, Frick Coll.).

LAND ART. Also known as 'Earthworks'. It uses natural materials such as earth, rocks, and soil in the construction of (usually very large) works of art. It emerged in the 1960s. Although it has been considered as a reaction against the industrially controlled designs of *Minimal art, Land art relates quite closely to it in terms of formal simplicity, and was, more importantly, a reaction against the limitations imposed on art objects by their exhibition in galleries. In this respect, the scale of much Land art constituted a rejection of a perceived commodification of art; *Spiral Jetty* (1970) by Robert *Smithson and *Mile Long Drawing* (1971) by Walter De Maria (1935–) were impossible to exhibit as conventional art objects. Smithson's work was a (now submerged) rock road which stretched 460 m (1,500 ft) into the Great Salt Lake, Utah; De Maria's was a pair of parallel white lines traced in the Nevada desert. Their indivisibility from the natural environment attempted to create a purer form of encounter with art than that offered by conventional exhibition spaces. Smithson wrote that galleries caused art to become 'neutralised, ineffective, abstracted, safe and politically lobotomised' ('Cultural Confinement', *Artforum*, Oct. 1972).

Ancient structures such as pyramids and standing stones have been considered as precedents for Land art. These objects, however, may have been constructed for functions that would not now be considered artistic, and were defined sharply against the natural environment in which they were located. Works of Land art such as the underground mazes of Alice Aycock (1946–) performed no specific function, and were intended to cause the environment itself to become a work of art, rather than the location for one. In its use of external, uncontrolled spaces, and of unrefined materials, Land art draws attention to questions of creative control, and the extent to which it is possible to establish a distinction between artificial and natural structures. It is also inherently concerned with the effects of time on manipulated forms; the expectation that a work would be submerged or disintegrate relates pieces such as *Spiral Jetty* to *Process art.

In questioning the methods by which art was normally exhibited, Land art was disruptive to *modernist critical practices; it has, consequently, been seen as a branch of *Conceptual art. The comparison is derived from incidental, rather than theoretical similarities; many Land art projects were so big that they had to remain at the planning stage, by implication becoming examples of Conceptual art. The use of photographic records for both types of art also appears to unite them. Whereas Conceptual art advocated a dematerialization of the art object, however, Land art was specifically concerned with the dematerialization of the gallery. OPa

LANDI (DEL POGGIO), NEROCCIO DE' (1447–1500). Sienese painter and sculptor. Born into a noble family, Neroccio was one of the most able artists of late 15th-century Siena. He probably completed his initial training under Il *Vecchietta, whose style is particularly noticeable in Neroccio's early work in painting and sculpture. Among his earliest documented commissions are a panel and a terracotta *S. Jerome* for the Compagnia di S. Girolamo (1467–8; lost). In 1468 he formed a partnership, which was dissolved in 1475, with *Francesco di Giorgio Martini. Contact with Francesco di Giorgio almost certainly influenced Neroccio's style which, on the basis of the signed and dated (1476) altarpiece of the *Virgin and Child with Saints* (Siena, Pin.), appears to be characterized by delicate figure types, smoothly painted textures, and a pastel palette. In the 1480s he was involved in a variety of commissions, including a design for an intarsia pavement (1483) and the execution of the monument to Bishop Piccolomini (1485), both in Siena Cathedral. This last work displays a confident handling of *all'antica* motifs.

FB

Bellosi, L. (ed.), *Francesco di Giorgio e il Rinascimento a Siena 1450–1500* (1993).

LANDSCAPE PAINTING. The prime concern of landscape painting is the depiction of natural scenery. Like the other independent genres that appeared in the 16th century it was practised in the classical world and vanished with its collapse. As with the other genres, the practice of landscape painting began to re-emerge in a fragmentary and cumulative fashion during the later medieval period, and classical texts about it were cited in the (rather sparse) theoretical writing on the subject from the early *Renaissance onwards. Among the themes that preoccupied scholars in the 20th century were the relationship of landscape painting to wider attitudes towards nature, and the extent—if any—to which the concept of landscape must necessarily have had to have been enunciated before the fully developed speciality could appear. Current scholarship is concerned with a range of other issues, notably the socio-economic motivation for the patronage of different kinds of landscape.

Little is known about *Hellenistic landscape painting, but the *Idylls* of Theocritus (c.308–240 BC) established the literary pastoral, in which herdsmen and their rustic lovers inhabit a remote and perpetually beautiful countryside. That theme was developed in the 1st-century Roman world in the *Eclogues* of Virgil (70–19 BC), who went on to produce a more robust and earthbound image of the countryside in his *Georgics*, which celebrate the Roman virtues of order and good husbandry. Both the pastoral vision and that of the *Georgics* were to be influential in various later perceptions of landscape.

It is clear from several literary references that cultured Romans had a deep love of the countryside, and consciously appreciated it as a place for peace, retirement, and contemplation. From at least the middle of the 1st century BC this was reflected in the decoration of villas with illusionistic landscapes which typically appeared to exist beyond painted architectural settings (SEE ROMAN ART, ANCIENT). In a famous passage *Pliny the elder (*Natural History* 35) writes of an Augustan painter, Studius, whom he describes as having introduced 'the most attractive fashion of painting walls with pictures of country houses and porticos and landscape gardens, groves, woods, hills, fishponds, canals, rivers, coasts, and whatever anybody could desire'. Pliny's description goes on to make it clear that Studius' style of painting included a great variety of genre scenes, but we know from the examples that have survived from the 1st century that a number of different landscape styles existed, and that they showed a convincing command of *aerial perspective. They include idyllic pastorals with little emphasis on genre, mythological scenes, and rooms surrounded by illusionistic painted gardens, full of flowers and fruit and enlivened by birds. Landscape painting continued to be common through the 2nd century AD, probably with a tendency towards the introduction of increasingly complex architectural fantasies in the scenery.

With the Christianization of the Roman Empire, the depiction of landscape very soon shrank to the *Byzantine system of symbolical notation, and through the Middle Ages the beauty of nature remained something that religious patrons regarded with suspicion. During the 14th century, however, English and French manuscript illuminations (usually of the labours of the months) show an increasingly fresh and vivid interest in country activities. In Italy, Ambrogio *Lorenzetti's large fresco *The Effects of Good Government* (1338; Siena, Palazzo Pubblico) stands out as an extraordinary achievement, creating a recognizable evocation of the local countryside and populating it with aristocrats on an outing and with husbandmen performing their tasks in the spirit of the *Georgics*. This attempt to depict and celebrate a complete society within its physical setting had no immediate successors, but by the beginning of the 15th century an elegant *International Gothic mode had become established to represent courtly life, incorporating landscape elements as in the *Limburg brothers' *Très Riches Heures du Duc de Berry* (1411–16; Chantilly, Mus. Condé), which includes accurate topographical records of the Duke's castles.

From the beginnings of the *Renaissance period Flemish painters were famous for their ability to capture the detail and irregularity of natural scenery. The great paradisal landscape in the van *Eycks' Ghent altarpiece (c.1425–32; Ghent Cathedral) already shows impressive command of the recession of a distant view, and in innumerable lesser northern works the backgrounds teemed with details from nature that exploited the new descriptive possibilities of oil paint. Even the most effective landscape passages in early Renaissance Italian painting, such as Fra *Angelico's *Visitation* in the predella of *The Annunciation* (c.1430; Cortona, Mus. Diocesana) appeared generalized in comparison. By the last quarter of the 15th century Italian painters such as *Piero della Francesca and *Pollaiuolo were producing markedly more illusionistic landscape backgrounds to portraits and religious works, *Ghirlandaio's backgrounds openly acknowledged their Flemish ancestry, and *Perugino and his followers had developed a system of charming landscape backdrops perfectly in tune with the conventional sweetness of the religious characters depicted. Also in this period *Leonardo da Vinci made intense exploratory landscape drawings and Alberti echoed the classical writer Vitruvius in recommending the decoration of palaces and villas with landscapes, though no work of that kind had yet been done since Antiquity. Fifteenth-century painting perhaps came closest to independent landscape in Venice, where Giovanni *Bellini achieved a new order of coherent space, light, and meaning in late works such as *The Madonna of the Meadow* (c.1500–5; London, NG.).

It is conventionally reckoned that the decisive shift of emphasis to landscape becoming the dominant motif took place early in the 16th century in Antwerp, the Danube area, and north Italy, notably Venice. In Antwerp *Patinir devised the 'world landscape' formula of a sweeping panorama seen from a high viewpoint, enlivened with fantastic rocks and much incidental detail, passing from a brown foreground through green middle distance to a deep blue and often mountainous background. Large numbers of this type, and of prints derived from it, were exported to Italy throughout the century. Ultimately, Pieter *Bruegel's paintings and prints were the weightiest works deriving from the idiom. In the Danube area *Altdorfer and *Cranach were noted for weirdly romantic forest scenes. Altdorfer also did more straight descriptive work; his startlingly modern-looking *Landscape with a Footbridge* (c.1520; London, NG) is the earliest known pure landscape in oil. In Venice *Giorgione

invented a type of languorous, enigmatic mood picture for which the ground had been prepared by the publication in Venice in 1502 of *Sannazaro's pastoral *Arcadia*. This type was widely disseminated in prints by Domenico *Campagnola and others, and it was the starting point for *Titian's treatment of landscape, for which he became renowned.

The encaustic mural paintings of scenes from the life of the Magdalene and of S. Catherine of Siena (Rome, S. Silvestro al Quirinale) that *Polidoro da Caravaggio made around 1525 appear to show a deep understanding of Antique landscape. They long remained an isolated achievement, though they were certainly influential in the following century.

By the end of the 16th century pure landscape was popular in Italy through prints, decorative fresco schemes, and small cabinet pictures, in all of which Flemish artists were prominent. It was not, however, taken seriously as a genre that could compare with the importance of history painting. In Rome at the very beginning of the new century, however, Annibale *Carracci's lunette *Landscape with the Flight into Egypt* (1604; Rome, Doria Pamphili Gal.) established a new kind of massively architectonic idealized landscape that clearly aspired to convey human feelings with the utmost gravity. This type of landscape was immediately taken up by *Domenichino and then brought to its fullest development by *Poussin, who saturated it with references to the moral authority of the classical world. A different idealized response to Antiquity was developed by another Frenchman working in Rome, *Claude Lorrain, who was the first absolutely front-rank artist to specialize exclusively in landscape. Claude's paintings, which often include recollections of the Campagna and of Roman buildings, are superbly crafted luxury objects. In their carefully balanced compositions a dreamlike sense of the past is united with phenomenally accurate observation of the effects of light, based on assiduous *plein air* studies. Contemporary with Poussin and Claude in Italy were Gaspard *Dughet, who specialized in a less rarefied representation of the landscape around Rome, and Salvator *Rosa, who developed a highly personal vision of austerely melancholy wilderness scenes. Writing in 1708 the French theorist Roger de *Piles asserted that the two basic categories of landscape were the heroic, exemplified by Poussin, and the pastoral or rural, to which Claude belongs, but most of the classicizing theorists of the 17th and 18th centuries ignored landscape altogether.

*Rubens's grand landscapes, mostly done late in his career for his own pleasure, show his characteristic fusion of Flemish exuberance and deeply felt Italian *classicism. While these celebrations of abundance, fertility, and social order are formed within the Flemish landscape tradition they are also saturated with the feeling of Titian's poetry.

In the liberated, Protestant, Dutch provinces, however, a completely new naturalistic landscape art flourished from the 1620s. In formal terms the new style broke from the high viewpoint of the northern 'world picture', and this may have owed something to the experiments of Dutch painters who had travelled to Rome. More broadly, the huge market that developed in realistically painted Dutch country scenes must have reflected the confidence and pride that the new class of prosperous bourgeois patrons felt about their country, and also a special concern for the literal description of the world that is a notable feature of that period of Dutch culture and is shown in such activities as botanical illustration and map-making. By the mid-1620s painters such as Jan van *Goyen and Salomon van *Ruysdael had established the so-called tonal phase of Dutch landscape, in which colours were muted almost to a monochrome and subject matter was usually limited to the most placid motifs. In the succeeding classic phase colouring was richer, subjects more dramatic and compositions more structured; Jacob van *Ruisdael in particular achieved a mood of brooding elemental power that turned to a more decorative grace in the hands of his main follower *Hobbema.

During the 18th century in France an elegant style of *Rococo *pastoral developed from *Watteau's Venetian vision, tinged with haunting sadness at the passing of time, to the stagey artifice of *Boucher and *Fragonard. A strong new influence in both France and England, however, was the vision of Italy, fed by the burgeoning *Grand Tour. A busy trade developed in topographical reminders of Italy, and in England Richard *Wilson cultivated the speciality of depicting English and Welsh scenes in a strongly Claudean style that played to his clients' perception of themselves as belonging to the highest unbroken tradition of culture. This was the period when seriously rich people in England, many of whom owned real Claudes and Dughets, were implying an even stronger statement of ownership by having their own parkland rearranged so as to resemble those models.

In 1756 Edmund *Burke published his theory of the aesthetics of the *sublime and the beautiful and a taste soon developed in England for 'sublime' rocky crags, storms, volcanoes and similar violent motifs. The less threatening category of the *picturesque achieved an even greater following, and connoisseurship of picturesque views became a routine part of the attainments expected of a well-bred person. The greatest English *watercolourists, however, produced strikingly limpid studies of nature.

The *Romantic movement represented a watershed in sensibility about nature, which took on some of the significance previously associated with religion. While *Turner was a complex and eclectic artist, much of his work is suffused with a Romantic sense of nature's sublime power and wonder. There is something of the same sense, too, in 19th-century American painters' awe at the vastness of the landscapes that were being penetrated for the first time. *Constable's quieter, Wordsworthian, art was rooted in the Dutch tradition, but he brought to bear an obsessive observation of the transient effects of light on his scenes of solid East Anglian rural life.

As the 19th century progressed landscape became established as probably the most dominant mode of painting (though it is important to remember that many of the large Salon and Academy landscapes of the period may now look emotionally cold and bombastic). In France the trend to landscape was accompanied by increasing emphasis on painting *en plein air*. *Corot had used this technique in his fresh Italian views in the 1820s and it was widely adopted by the *Barbizon group, who paid tribute to nature in simple French rural scenes of forest and heath in a vaguely Dutch manner. The *Impressionists on the other hand, for whom painting *en plein air* was almost an article of faith, took a much more cheerful view of the countryside, which (with the exception of Pissarro) they tended to see through the eyes of optimistic bourgeois enjoying themselves.

In reaction to the Impressionists' overwhelming success in capturing the superficial appearances and ephemerality of visual impressions, landscape was used in many different ways by artists concerned in search of deeper meanings. *Cézanne devoted himself to an agonizing search for the means to express the depth of his response to structures and correspondences in nature. Van *Gogh expressed psychological turmoil through expressionist contrasts of violent colour. *Seurat attempted an art of static permanence through the Divisionist (see NEO-IMPRESSIONISM) theory of colour and unparalleled calculation of composition. Many painters joined colonies, such as *Pont-Aven, Skagen, and *Newlyn, where the motivation of cheap living was allied with the feeling that nature was somehow more real in primitive rural communities. The dominant Pont-Aven painter, *Gauguin, left Europe altogether to find a new vision in Tahiti.

Landscape remained an important theme for at least the first half of the 20th century. The Arcadian vision of sun-drenched Mediterranean countryside was probably the dominant motif for the *Fauve group, including *Matisse, and the *Nabi painter *Bonnard continued to paint the theme throughout his life. While *Braque and *Picasso did not continue with landscape after

their earliest *Cubist experiments, the creation of an abstract spiritual landscape metaphor was at the heart of *Kandinsky's work. The Die *Brücke group used harsh simplified landscapes to express their sense of freedom.

In this century of psychoanalytical awareness several artists have also used the conventions of representational landscape to develop a landscape of the subconscious, invariably threatening or alienating. *De Chirico's Arte Metafisica was succeeded by the *Surrealist deserts of *Dali's and *Tanguy's dream landscapes and by the suffocating Germanic forests of Max *Ernst.

In England a Romantic sense of identification with the English countryside persisted in the work of John *Nash. After the 1939–45 war Graham *Sutherland and Ivon *Hitchens continued in that vein, though in less directly representational idioms. By the end of the century this traditional mood of English artists seemed to have been displaced away from painting, and to flourish in the form of *Land art. AJL

Clark, K., *Landscape into Art* (1949).

Turner, A. R., *The Vision of Landscape in Renaissance Italy* (1966).

LANDSEER, SIR EDWIN (1802–1873). English painter of animals, often with anthropomorphic qualities, particularly monkeys (*The Monkey who had seen the World*; London, Guildhall) and dogs, such as *Old Shepherd's Chief Mourner* (London, V&A). Following a visit to the Highlands of Scotland in 1824 he added pictures of deer and deer-hunting to his regular repertoire and for many years visited Scotland every autumn. He was patronized by Queen Victoria and his pictures of the royal family in Scotland are in the Royal Collection. Other celebrated works include the *Monarch of the Glen* (c.1851; London, John Dewar & Sons Ltd.). He also designed the four bronze lions around Nelson's column in Trafalgar Square and was active as a book illustrator. HB

Ormond, R., *Sir Edwin Landseer*, exhib. cat. 1982 (Philadelphia Mus.; London, Tate).

LANFRANCO, GIOVANNI (1582–1647). Italian painter and draughtsman from Parma, notable principally as a decorator who played a major formative role in the development of the *Baroque style in Rome and Naples. He was trained initially by Agostino *Carracci in Parma and after Agostino's death in 1602, and at the instigation of the Duke of Parma, gravitated to the circle of Annibale *Carracci in Rome. However, his early *Adoration of the Shepherds* (Alnwick Castle, Northumb.), probably painted c.1606–7, while obviously indebted to prototypes by *Correggio and Annibale Carracci, is equally remarkable for its stylistic independence,

most particularly in the dramatic and effective use of chiaroscuro. After much activity in northern Italy, especially Piacenza, as well as in Rome, he made his mark with frescoes for the Sala Regia in the Palazzo del Quirinale, Rome (1616–17). This was followed by a commission (1624–5) to decorate the Cappella del Sacramento in S. Paolo fuori le mura, Rome, with eight vast canvases of scenes relating to the Eucharist (now Dublin, NG Ireland; Los Angeles, Getty Mus.; Marseilles, Mus. des Beaux-Arts; Poitiers, Mus. des Beaux-Arts). His most famous work was the dome fresco of the *Assumption of the Virgin* for S. Andrea delle Valle, the first of its kind in Baroque Rome (1625–7), and it reflects his study of Correggio's dome in S. Giovanni Evangelista, Parma, and his capacity to add fresh vigour to this illusionistic tradition. The success of this high Baroque landmark led to the prestigious commission to paint a vast fresco of *S. Peter Walking on the Water* for S. Peter's (1627–8, destr.). His reputation was underlined in 1631 by his election as principal of the Accademia di S. Luca, *Rome; yet he was overshadowed in Rome by Pietro da *Cortona and *Bernini and in 1634 he chose to move to Naples, where he stayed until 1646. Here he undertook numerous important commissions: the cupola of the Gesù Nuovo (1634–6); the nave, vault, and other work besides at the Certosa di S. Martino (1637–9); extensive work throughout the Theatine church of SS Apostoli; and the cupola of the Cappella del Tesoro of the cathedral (1643) which profoundly influenced the next generation of Neapolitan painters, such as *Preti, *Giordano, and *Solimena. However, his last important work was undertaken back in Rome where he completed the apse fresco, in S. Carlo ai Catinari, representing *S. Carlo Borromeo in Glory with the Three Theological Virtues* (1647). HB

Schleier, E., *Disegni di Giovanni Lanfranco* (1983).

LAOCOÖN, ancient marble sculptural group (Vatican Mus.) depicting the Trojan priest Laocoön with his sons, writhing in physical agony and emotional anguish, as they are attacked by serpents, sent as punishment either by Athena for warning against the wooden horse (Virgil), or by Apollo for breaking vows of celibacy (Hyginus). Probably carved after a mid-Hellenistic bronze original in the later 1st century BC by the Rhodian sculptors *Hagesander, Polydorus, and Athenadorus, who specialized in virtuoso marble reproductions of *Hellenistic mythological scenes, the statue was admired by *Pliny in Titus' palace. It was rediscovered in 1506 on the Esquiline, acquired by Pope Julius II for the Belvedere, and soon echoed in the works of *Michelangelo and *Raphael, cast in plaster and bronze by *Sansovino, *Bandinelli, and *Primaticcio (from whose moulds a bronze was fashioned

for François I at Fontainebleau), and emulated by *Bernini, *Titian, El *Greco, and *Rubens. Engravings and literary encomia further disseminated its fame. *Winckelmann (1755) extolled its 'noble simplicity and quiet grandeur', characteristic, in his teleology, of Classical Greek art, and *Lessing made it a subject of an eponymous essay (1766). MBe

Haskell, F., and Penny, N., *Taste and the Antique* (1981).

Pollitt, J. J., *Art in the Hellenistic Age* (1986).

LARGILLIERRE, NICOLAS DE (1656–1746). He shares with *Rigaud the honour of being the best French *portrait painter of the early 18th century. After training in Antwerp and then with *Lely in London, he returned to Paris in 1682. He quickly established a fashionable practice among the rich merchant and banking classes who loved the aristocratic ease and opulence of a style derived from *Titian and van *Dyck. Largillierre's rich colouring, the fluid textures of his paint, his abilities to describe expensive fabrics, and the Arcadian poetry of his landscape settings are more in evidence in his portraits than penetration into character. This is probably how his clients wished it. Such pictures as *Portrait of a Family* (Paris, Louvre) and the famous *La Belle Strasbourgeoise* (1703; Strasbourg, Mus. des Beaux-Arts) prove that in hands as talented as Largillierre's this is a compelling formula. There is ample evidence, however, that he could engage with the personality of a sitter if he found them interesting. His ravishing portrait of the young English recusant nun *Elizabeth Throckmorton* (c.1729; Washington, NG) is a case in point. MJ

Rosenfeld, M. N., *Largillierre and the Eighteenth-Century Portrait* (1982).

LARKIN, WILLIAM (c.1580–d. 1619). English portrait painter. Larkin is first recorded in 1606, on becoming a freeman of the London painter-stainers' company. According to Edward, 1st Baron Herbert of Cherbury's (1583–1648) autobiography, Larkin painted him in 1609–10, and head-and-shoulders companion portraits of Herbert and his friend Sir Thomas Lucy in classical dress, painted on copper, survive at Charlecote Park (War.). In 1618, Lady Anne Clifford, Countess of Dorset, referred to her portrait by 'Larkinge' (now lost) in her diary. This connection, and visual comparison with the Charlecote paintings, has led to the fairly recent attribution to William Larkin of full-length portraits of the 2nd and 3rd earls of Dorset (London, Ranger's House). Their distinctive strong lighting, polished treatment of flesh, metallic satin curtains, and a minute

attention to the details of rich fabrics, jewellery, and oriental carpets are found in further spectacular full-length portraits formerly in the Suffolk Collection, now also at Ranger's House. Larkin died in London in the spring of 1619. KH

Millar, O., review of Strong, *Icons, Burlington Magazine*, 39 (1997).
Strong, R., *Icons of Splendour: The Portraits of William Larkin* (1995).

LAROON, MARCELLUS, ELDER AND YOUNGER. Marcellus the elder (1653–1702),

also known as Marcel Lauron, was trained by his father, a French painter working in Holland. He came to London, probably in his early twenties, and worked as a studio assistant to *Kneller. He is best known for his engravings of *The Cryes of the City of London* (London, Geffrye Mus.), elegantly composed but realistically observed. His second son **Marcellus** (1679–1772) was probably trained by his father, and visited France and Italy in 1697–8. In 1707 he joined the footguards and was a captain by 1712, when he subscribed to Kneller's Academy. He retired from the army in 1732 and devoted himself to the arts of music, drama, and painting. His best-known works are *conversation pieces, which owe a debt to the theatre, derived from French *fêtes galantes*. *The Rencontre* (c.1740–5; York, AG), reveals his characteristic and eccentric technique of painting clearly defined outlines, which he coloured with a thin, virtually monochrome, wash. *Vertue, who described them as 'large drawings', although they were painted in oil, criticized their lack of colour. DER

Raines, R., *Marcellus Laroon* (1967).

LASTMAN, PIETER (1583–1633). Lastman

was the leading *history painter in Amsterdam when *Rembrandt was establishing his reputation in the city, and the younger painter trained as his pupil for six months in 1625. Rembrandt soon moved away from the manner of his master, but the fact that Lastman had specialized as a history painter probably influenced Rembrandt's decision to explore religious and mythological subjects. Lastman had visited Italy (1604–7), where he had clearly been impressed by the works of *Elsheimer and *Caravaggio, and he developed a rhetorical style of painting, characterized by the use of rich colour, and emphatic gestures and forceful expressions, which was based upon their pictures. A fine example of such work is his *Crucifixion* in the Rembrandthuis, Amsterdam. Such paintings were much admired in Amsterdam, where he enjoyed considerable success, being lavishly praised in contemporary poetry by

Rodenburgh and Vondel. Lastman also established an international reputation, being commissioned to paint a series of pictures for the Frederiksborg Palace by King Christian IV of Denmark. CB

Tümpel, A., *The Pre-Rembrandtists*, exhib. cat. 1974 (Sacramento, Calif., Crocker Art Mus.).

LATE ANTIQUE ART, the art of the later

Roman period. Debate continues over the precise chronological boundaries of the late Antique period. Its beginning can be read in historical terms as the rise of the Severan emperors (ruled AD 193–235) or placed earlier to coincide with the economic and military unrest that characterized the reigns of the later Antonines, Marcus Aurelius and Commodus (ruled AD 161–92). An older view saw the origins of the late Roman period in the so-called 'crisis of the 3rd century' as military leaders vied for power over the 50 years that spanned the period between the death of Severus Alexander (AD 235) and the establishment of the Tetrarchy in AD 384. Its conclusion is more clearly articulated by historical events, either the sack of Rome in AD 410 or the fall of the last Western emperor in AD 476.

The Arch of Constantine (see TRIUMPHAL ARCHES) (AD 315) is often seen as the embodiment of late Antique style, complete with its reuse of *spolia* from earlier imperial monuments. The Constantinian elements express the new emphasis on social hierarchy, frontality, and symmetry to the exclusion of naturalism that constituted the creation of a 'non-classical' style. L-AT

Bianchi Bandinelli, R., *Rome, the Late Empire* (1971).
Elsner, J., *Imperial Rome and Christian Triumph* (1998).
L'Orange, H. P., *Art Forms and Civic Life in the Late Roman Empire* (1965).
Weitzmann, K., *The Age of Spirituality* (1979).

LATHEM, LIEVEN VAN (active 1454–

d. before 1493?). Flemish illuminator active in Ghent and Antwerp. He completed work for three generations of Burgundian dukes. Between 1457 and 1459 he was in the employment of Philip the Good; for Charles the Bold, Philip's son, he illuminated the *Petites Heures* (1469; Larrivière, Charnacé, priv. coll.) and for Mary of Burgundy, Philip's granddaughter, he painted a large part of the Hours of Mary of Burgundy (c.1466; Vienna, Österreichische Nationalbib., Cod. 1857). His skills were not confined to manuscript illumination; he was also actively involved with the preparations for two colossal celebrations for Philip the Good; the assembly of the Golden Fleece and the marriage of Charles the Bold to Margaret of York in 1468. His style can be recognized by its intense palette with dominant blues and reds, a delight in the use

of aerial perspective, and the beautiful grotesque figures in the borders. KC

Dogaer, G., *Flemish Miniature Painting in the 15th and 16th Centuries* (1987).
Schryver, A. de, 'Lathem van Lieven, een onbekende grootmeester van de Vlaamse miniatuurschilderkunst', *Handelingen van het XXe Vlaams Filologencongres* (1957).

LATIN KINGDOM OF JERUSALEM. In

1099, Jerusalem fell to the Crusaders; the first king of the new Latin kingdom was crowned in the city on Christmas Day 1100. The ruler of the kingdom of Jerusalem claimed sovereignty and leadership over the other Crusader states in the Holy Land. By 1187, the Greek Christians in the city, repelled by Latin arrogance and intolerance, helped Saladin to regain Jerusalem. The kingdom was never re-established here, making its new base at Acre, where it held out until 1291.

Though defensive architecture was a first priority throughout the crusading period (Krak des Chevaliers perhaps the best-known castle), the presence of Crusader states in the Holy Land set the stage for vigorous artistic activity especially in the holy places of Jerusalem, Bethlehem, and Nazareth. Crusader art was sponsored mainly by the resident Latins but produced by artists from Western, Byzantine, and indigenous traditions. In Jerusalem, the church of the Holy Sepulchre was rebuilt into its present *Gothicized form, and the Gothic church of S. Anne constructed. Bethlehem and Nazareth, where further churches were built, became centres of painting and sculpture respectively. Centres for illuminated manuscripts flourished in Jerusalem, where Queen Melisende's Psalter (London, BL, MS Egerton 1139) was produced, and later in Acre. Crusader icons, showing a mingling of Western and Byzantine styles and scenes, were another typical production of the kingdom, for example the triptych with scenes from the life of the Virgin at S. Catherine's Monastery, Sinai. LJ

Folda, J. (ed.), *Crusader Art in the 12th Century* (1982).
Hazard, H. (ed.), *The Art and Architecture of the Crusader States* (1977).

LA TOUR, GEORGES DE (1593–1652).

French painter from Lorraine, who was born at Vic-sur-Seille and settled at Lunéville, shortly after his marriage in 1617. He was by far the greatest but also the most enigmatic of the French realist painters who responded, directly or indirectly, to the influence of *Caravaggio, both in his use of humble figures in his religious works and *genre scenes, and in his dramatic *chiaroscuro. Only about 35 pictures can be securely attributed to him and an insufficiency of dated works has frustrated all attempts to establish a clear chronology or even to trace the origins of his style and the basis of

his stylistic development. There is not even agreement as to whether he visited Rome, arguably at some point between 1610 and 1616, and studied Caravaggio at first hand, or whether his Caravaggesque manner was acquired instead from contemporary French artists in the circle of Jean Leclerc (*c*.1587–1633) and Jacques *Bellange, as well as from Dutch imitators of Caravaggio, possibly following a visit to the Netherlands.

La Tour's work divides naturally into two categories: day scenes such as *The Cheat* (Fort Worth, Kimbell Mus.), in which the artist offers a far more expressive, extravagant, and self-conscious view of human life than Caravaggio, often theatrical and flamboyant, the protagonists dressed in ostentatious costumes and communicating by means of sidelong glances and knowing gestures; and night scenes almost invariably illuminated by candlelight, in which La Tour renounces the nervous, lively handling associated with his more descriptive daylight pictures, reduces and generalizes individual forms to their greatest possible simplicity, and arrests all violence and distracting movement. The two styles may well have been developed concurrently. The earliest daylight pictures include *The Old Man* and *The Old Woman* (San Francisco, Fine Arts Mus.), *Old Peasant Couple Eating* (Berlin, Gemäldegal.); a series of *Apostles*, that were donated to Albi Cathedral in 1694 (dispersed after 1795; two now Albi, Toulouse-Lautrec Mus., others at Norfolk, Va., Chrysler Mus.; and Tokyo, Ishizuka Coll.); and the *Musician's Brawl* (Los Angeles, Getty Mus.). The earliest of the nocturnal pictures is almost certainly the *Payment of Taxes* (Lvov Mus.). This has been dated as early as 1616 and interpreted as a reflection of the direct influence of Bellange. Alternatively it might date from some years later and be regarded as evidence of La Tour's contact with the art of Caravaggio and the *Manfredi circle in Rome. La Tour's later candlelit pictures show a much more emphatic chiaroscuro: *The Penitent Magdalen* (Paris, Louvre), the *S. Joseph as a Carpenter* (Paris, Louvre), and the *S. Peter* (1645; Cleveland, Mus. of Art). Here the almost exaggerated use of artificial light is far closer to the style of the northern followers of Caravaggio, such as *Honthorst, than to Caravaggio himself who never painted a candlelit scene. Equally, the theatricality and artifice of such works as the *Job and his Wife* (Épinal, Mus. Départemental des Vosges) and the *Woman with a Flea* (Nancy, Mus. Historique) suggest northern prototypes such as ter *Brugghen.

Towards the end of his life La Tour appears to have aspired toward a more complex and stylized abstraction and a simplification of form that marks a decisive development from the more colourful descriptive detail and theatrical artifice that characterizes his early style. These new qualities are evident in his *S. John the Baptist in the Desert* (Conseil Général de la Moselle) which stands apart as the only nocturne without a visible source of artificial light, and the *S. Sebastian Tended by S. Irene* (Paris, Louvre), from which all anecdotal extraneous detail has been eliminated. As A. Blunt has observed of the *S. Sebastian*: 'The forms are generalised to their greatest simplicity and all violence, all movement even, are eliminated, so that the picture takes on the quality of stillness and silence rarely to be found in the visual arts. In this calm, detailed interpretation of Caravaggesque naturalism La Tour comes close to the classicism of *Poussin and to the nobility of the finest compositions of Champaigne.' Thus La Tour reconciles the two most extreme polarities of Roman painting in the first half of the 17th century. HB

Blunt, A., *Art and Architecture in France, 1500–1700* (rev. edn., 1988).
Conisbee, P., *Georges de La Tour and his World*, exhib. cat. 1997 (Washington, NG).
Cuzin, J. P., and Rosenberg, P., *Georges de La Tour*, exhib. cat. 1997–8 (Paris, Grand Palais).
Thuillier, J., *Georges de La Tour* (1993).

LA TOUR, MAURICE-QUENTIN DE (1704–88). French pastellist. He was one of the most accomplished portraitists in a century and a country that set the highest standards. His vivid and forceful characterizations were matched by his unsurpassed technical virtuosity and his eccentric personality. In 1727 he settled in Paris where he began to exploit the rage for pastel portraits inaugurated by the visit of Rosalba *Carriera from Italy. By the 1740s he was making portraits of Louis XV's court, culminating in a full-length of *Mme de Pompadour* (Paris, Louvre), exhibited to justified acclaim at the 1755 Salon. La Tour's outstanding achievement is the series of bust-length portraits of the writers, actors, and intellectuals of his day, among them the actresses Mlle Clairon and Mme Favart, and the *philosophes* Voltaire, d'Alembert, and Rousseau, some of which may be seen in the Louvre. Artistic curiosity and a strong dash of vanity led him to draw a remarkable series of self-portraits, unrivalled in the history of French art. Although La Tour's reaching after effect in his finished works can sometimes seem a little vulgar in comparison with the more sober pastels of his main rival *Perronneau, it is difficult not to warm to his less finished and more intimate portrait studies, such as that of *Mlle Fel*, which form part of the extensive collection of his art in the museum at his native S. Quentin. MJ

Besnard, A., and Wildenstein, G., *La Tour: catalogue raisonné* (1928).
Bury, A., *Maurice-Quentin de La Tour* (1971).

LATTEN, a base yellow metal, similar to, or the same as, brass, often hammered into sheets. The tomb of Richard Beauchamp, Earl of Warwick (1442–62; Warwick, S. Mary's), is probably in latten. Its use appears to be confined to northern European sculpture and liturgical objects. AB

LAURANA, FRANCESCO (active *c*.1430s–1502?). Sculptor born in Vrana, near Zara in Dalmatia, then under Venetian dominion. He is first recorded in 1453 as working on the triumphal arch of Alfonso I at the Castelnuovo in Naples. His subsequent career was divided between France and southern Italy, and before 1466 he was in France executing medals for René d'Anjou. Later, between 1479 and 1481, he worked on a relief of *Christ Carrying the Cross* now in S. Didier, Avignon, and on the S. Lazare chapel monument for the Old Cathedral in Marseilles. In Sicily his most significant commission was for the Mastroantonio chapel in Palermo, in collaboration with the Lombard Pietro de Bonitate (1468). At this period he also specialized in *polychromed Madonna and Child groups, such as one in the Museo Regionale in Messina (1470), and traces of polychromy are also evident on his series of masklike marble female portraits of members of the Neapolitan and Milanese royal families (examples in New York, Frick Coll.; Paris, Louvre; Palermo, Mus. Nazionale). AB

Kruft, H.-W., *Francesco Laurana: ein Bildhauer der Frührenaissance* (1995).

LAURATI, PIETRO. See LORENZETTI BROTHERS.

LAURENCIN, MARIE (1885–1956). French painter. Born in Paris, Laurencin was largely self-taught apart from evening classes. In 1907 she met the influential critic and poet *Apollinaire, with whom she lived until 1914, and was thus introduced to *Picasso and the *Cubists, exhibiting with them in 1907 and 1909–13. Her painting *Group of Artists* (1908; Baltimore, Mus. of Art), which was purchased by Gertrude Stein, includes herself, Picasso, Fernande Olivier, and Apollinaire. In fact, despite Apollinaire's chivalrous assertions to the contrary, her work has nothing in common with Cubism. She painted delicate pastels in sugary tones, of mythological creatures, dancers, and actresses, in a deliberately 'feminine' idiom, believing that male and female art was intrinsically different, a view that was increasingly challenged. Her place in *modernism relies more on her role as Apollinaire's muse than on her own work. GS

Gere, C., *Marie Laurencin* (1977).

LAURENS, HENRI (1885–1954). French artist. Born in Paris, Laurens was apprenticed to an ornamental sculptor at an early age and studied academic drawing in the evenings. He settled in Montmartre in 1905.

In 1911 he met *Braque, and between 1914 and 1915 he produced the *Constructions* series, polychromed wood and plaster sculptures with an emphatic frontality, which investigated juxtapositions of volume. These works were shown in a series of solo shows at Leonice Rosenberg's gallery in Paris before 1920. He also produced *papiers collés until 1918 and then *polychromed stone and terracotta reliefs. His free-standing figures of the early 1920s show the influence of *Matisse, which led to more naturalistic, curved forms. He met *Maillol in 1925 and this undoubtedly consolidated his turn toward *classicism, evident in *Reclining Woman with Drapery* (1927; Paris, Centre Georges Pompidou). In the early 1930s his work became more organic, the biomorphic forms gradually developing a *Surrealist tone. MF

Hoffman, W., *Henri Laurens* (1970).

LAWRENCE, SIR THOMAS (1769–1830). English portrait painter. Lawrence was born in Bristol but spent his childhood in Devizes, at a coaching inn run by his educated but feckless father. The inn had a fashionable clientele, staying overnight on their way to Bath, and Lawrence, an infant prodigy, was soon employed in drawing their likenesses in profile. By 1780, when the family moved to Bath, his crayon and watercolour portraits provided a major part of their income. By 1787 Lawrence was in London where he was admitted to the RA Schools (see under LONDON), already totally proficient and painting in oils. Next year he wrote to his mother: 'excepting Sir Joshua (*Reynolds), for the painting of a head, I would risk my reputation with any painter in London.' In 1789 he was commanded to paint Queen Charlotte (London, NG), which, together with his portrait of the actress *Eliza Farren* (1789; New York, Met. Mus.), established his reputation. His early paintings have an informality and lightness of touch peculiar to the artist and were praised for their likeness and the execution of drapery which, unlike Reynolds, he painted himself. He consolidated but did not greatly alter his style for the rest of his career, although after 1800 his work reflects the prevailing Romantic sensibility. In 1797 he attempted a work in the *Grand Manner, *Satan Summoning his Legions* (London, RA), which, despite being a critical failure, provided the template for his dramatic and successful *Kemble as Coriolanus* (1789; London, Guildhall). On the death of *Hoppner, whom he rightly considered an inferior painter, in 1810, he was recognized as the finest portrait painter in England and patronized by the Prince Regent, whom he immortalized in velvet and silver satin in 1818 (Dublin, NG Ireland). In 1815 he was knighted as a preliminary to the royal commission to paint the leaders of the allied victory over Napoleon (Windsor Castle, Royal Coll.), a series which culminates with the masterly *Pope Pius VII* (1819).

His apparent facility, for which he was later criticized, was painstakingly achieved. His late paintings of children, like the *Calmady Sisters* (1824; New York, Met. Mus.), are romantically sentimental, but his adult portraits are psychologically penetrating. He caught the hauteur of *Payne *Knight* (1794; Manchester, Whitworth AG) without sacrificing his obvious intelligence, and the shrewdness of the bankers, *Barings* (1807; priv. coll.), without neglecting their humanity. The latter advised him on his massive financial difficulties, debts of over £20,000 in 1807. His collection of old master drawings, arguably the finest ever created, was reputed to have cost him over £60,000. DER

Garlick, K., *Sir Thomas Lawrence* (1987).

LEADPOINT, a variety of *metalpoint which made use of lead or an alloy of lead and tin. It was frequently employed in the 15th and 16th centuries as an underdrawing for a sheet intended to be completed in pen and ink, black chalk, or some other medium. Although the point was hard and left a clear indentation in the paper it only left a faint mark. It had the advantage of portability and unlike metalpoint was usually used on papers on which no ground had been laid. PHJG

LEAD SCULPTURE. Lead is a heavy, bluish grey, lustrous metal, which is extremely malleable, ductile, and so soft that it can easily be scratched with a knife. It is a cheaper metal than bronze and its very ease of shaping constitutes its greatest hazard for the sculptor. Great skill is necessary to keep a leaden statue from being a dull and amorphous mass, and a lead figure usually requires an internal armature for support. Lead may be worked directly, by being hammered or beaten into shape, or indirectly, melted and cast as with bronze, or it may be cast in the rough and then finished by hammering. It was used by the Greeks (see GREEK ART, ANCIENT) for small statuettes and reliefs (6th-century Spartan figures), and by the Romans (see ROMAN ART, ANCIENT) for garden ornaments and vases. Since then its uses include the English baptismal fonts of the 12th century (for instance, at S. Mary, Frampton-on-Severn, Glos.), which were produced in great numbers in central workshops of lead-mining districts (Derbys. and the Mendips). During the 16th century it was the preferred, because easily available, material for German plaquettes and reliefs. During the 17th century it was increasingly used for large-scale garden sculpture, particularly at *Versailles, in the form of vases, and fountain figures. In England copies of *Giambologna's *Samson and the Philistine* and his *Mercury* appear to have been particularly popular choices during the 18th century, as were versions of several classical prototypes. Though some are of rather poor quality as individual works, they provided pleasing ornamental adjuncts in their landscape settings. John Cheere (1709–87), at his workshop at Hyde Park Corner, specialized in such garden sculpture, offering lead versions of mythological subjects, characters from the *commedia dell'arte*, and pastoral figures. Cheere's sculptures were often painted 'with an intention to resemble nature', or in imitation of stone. It has probably never been used more skilfully than by Georg Raphael *Donner in his figures from the New Market Fountain in Vienna (1739, now Vienna, Belvedere, Österreichische Gal.). These possess the easy flow of molten lead and yet are given enough sharp edges, accents, and turns of direction to seem lively, animated, and resilient forms. The expressive potential of lead, which is easily worked in the cold, was fully exploited in the series of caricature heads by Franz Xaver *Messerschmidt (examples in Vienna, Belvedere, Österreichische Gal.). Lead was used decoratively in George Gilbert Scott's Albert Memorial (1863–76; London, Kensington Gardens). During the 20th century, partly on account of its toxic qualities, it was more rarely used in sculpture. HO/AB

Jekyll, G., *Garden Ornament* (2nd edn., 1984).
Weaver, L., *English Leadwork: Its Art and History* (1909).

LE BRUN, CHARLES (1619–90). French painter, designer, and theorist, best remembered as the leading artist of Louis XIV's *Versailles. He trained at Paris in the studio of Simon *Vouet before going to Rome in 1642 in the company of *Poussin, who had admired his early work *Hercules and Diomedes* (c.1640; Nottingham, Castle Mus.). Le Brun was converted to Poussin's theories of art, which he was later instrumental in making the chief basis of academic doctrine. Nevertheless, it was Vouet's mastery of large decorative schemes, his command of a big and prosperous studio, and his royal and noble patrons that provided the model for Le Brun's career as designer, manager, and courtier. On his return to Paris in 1646 Le Brun found his true bent in large and flamboyant decorative paintings, the most important of this period being the *Baroque illusionistic ceiling for the gallery of the Hôtel Lambert, Paris. In 1658 he began work for the finance minister Nicolas Fouquet at the Château de Vaux-le-Vicomte, where his role expanded from that of painter of walls and ceilings to managing and providing designs for the sculptor François *Girardon, the gardener Le Nôtre, Nicolas Fouquet's tapestry works at Maincy (near Vaux), and a host of lesser artists and craftsmen. It was thus at

Vaux that the opulent style that reached its apogee at Versailles was first created. From 1661 Le Brun became established in the employ of Louis XIV and his chief minister Colbert as the chief impulse behind the grandiose decorative schemes at Versailles, and as Colbert's right-hand man in implementing his policy of imposing unified standards of taste and enforcing a strong centralized control over artistic production. He was raised to the nobility in 1662 and named *premier peintre du roi*. In 1663 he was made director of the reorganized Gobelins factory and supplied designs for the artists and craftsmen who were there employed in making furniture and decorations for the royal palaces. At the same time he was made director of the reformed Académie Royale (see under PARIS), and turned it into a channel for imposing a codified system of orthodoxy in matters of art, though not without opposition from some leading painters such as Pierre Mignard, who chose to stay outside the institution. Le Brun's lectures came to be accepted as providing the official standards of artistic correctness and, formulated on the basis of the *classicism of Poussin, gave authority to the view that every aspect of artistic creation can be reduced to teachable rule and precept. In the controversy over the relative importance of colour and drawing (see *DISEGNO E COLORE*) he gave his verdict in favour of the latter. In 1668 he delivered a series of lectures entitled *Méthode pour apprendre à dessiner les passions*, in which he attempted to provide artists with an accurate and appropriate language of facial expression for communicating the human passions.

Despite the classicism of his theories, Le Brun's own talents lay in the direction of magnificent large-scale decorative effects. His activities were many and his influence pervasive. Among the most outstanding works for Louis XIV were the Galerie d'Apollon at the Louvre (1661), the famous Galerie des Glaces at Versailles (1679–84), and the Escalier des Ambassadeurs (1671–8, destr. 1752). His importance in the history of French art is twofold: his contributions to the magnificence of the Louis XIV style and his influence in laying the basis of academicism. HO/MJ

Charles Le Brun, exhib. cat. 1963 (Versailles).
Le Brun à Versailles, exhib. cat. 1985 (Paris, Louvre).
Montagu, J., *The Expression of the Passions* (1994).

LECK, BART VAN DER (1876–1958). Dutch painter and designer, born in Utrecht. After working for eight years in stained-glass studios, he studied painting in Amsterdam, 1900–4. His early work was influenced by *Art Nouveau and *Impressionism, but from about 1910 he developed a more personal style characterized by simplified and stylized forms: his work remained representational, but he eliminated perspective and reduced his figures (which included labourers, soldiers, and women going to market) to sharply delineated geometrical forms in primary colours. In 1916 he met *Mondrian and in 1917 was one of the founders of De *Stijl. At this time his work was purely abstract, featuring geometrically disposed bars and rectangles in a style close to Mondrian and van *Doesburg. However, he found the dogmatism of the movement uncongenial and left it in 1918, reverting to geometrically simplified figural subjects. In the 1920s he became interested in textile design and during the 1930s and 1940s he extended his range to ceramics and interior decoration, experimenting with the effects of colour on the sense of space. His work can best be seen at the Rijksmuseum Kröller-Müller, Otterlo. IC

LE CORBUSIER (Charles-Édouard Jeanneret) (1887–1965). Swiss-born architect, painter, designer, and writer who settled in Paris in 1917 and became a French citizen in 1930. Although chiefly celebrated as one of the greatest and most influential architects of the 20th century, Le Corbusier also has a small niche in the history of modern painting as co-founder (with *Ozenfant) of *Purism in 1918. Up to 1929 he painted only still life, but from that time he occasionally introduced the human figure into his compositions. He retained the Purist dislike of ornament for its own sake, but his work became more dynamic, imaginative, and lyrical, though still restrained by his horror of any form of excess. He adopted the pseudonym Le Corbusier in 1920, but continued to sign his paintings 'Jeanneret'; the pseudonym derives from the name of one of his grandparents and is also a pun on his facial resemblance to a raven (French *corbeau*). Apart from architecture and paintings, his enormous output included drawings, book illustrations, lithographs, tapestry designs, furniture, and numerous books, pamphlets, and articles. IC

LECTERN (Latin *lectio*: to read), term in Christian church architecture for a reading stand. In the early Middle Ages they were originally arranged in pairs, known as ambos, situated on the north and south sides of the choir. With the disappearance of ambos in the later Middle Ages a movable lectern, often positioned in the centre of the choir, came to be used on its own for daily readings of the Bible. They were most commonly made of wood and took the form of a plain slanted bookrest on a pierced structure or turned shaft, although metal lecterns, mainly in bronze, brass, and copper, were also popular and have generally survived better. The lectern developed in the 15th century into its most distinctive form with the bookrest modelled as an eagle with outstretched wings, and many examples of this type of lectern survive in use to this day throughout western Europe. An alternative type of wooden lectern with the pedestal mounted on a finely carved cupboard made its first appearance in Italy during the 15th century, and was subsequently widely adopted in Germany during the Baroque period. TJH

LE FAUCONNIER, HENRI (1881–1946). French painter, mainly of figure subjects, including nudes and allegories. He was born at Hesdin, Pas-de-Calais, the son of a doctor, and in 1900 he began studying law at the University of Paris. However, he soon gave this up for art and had his main training at the Académie Julian. From about 1910 he was influenced by *Cubism and he took part in the first organized group show of Cubist artists, at the Salon des Indépendants, *Paris, in 1911. In about 1914 his style began to become more *Expressionist, but he still retained structural features derived from Cubism. He spent the First World War in the Netherlands, where he laid the basis of a European reputation and exercised considerable influence on the development of Expressionism in the country (his work is better represented in Dutch collections than it is in French). After returning to Paris in 1920 he gradually abandoned Expressionism for a more restrained style. He never again enjoyed his former level of fame and in his final years he became a recluse. He is not now generally highly regarded as a painter, but he played an important role in spreading the mannerisms of Cubism. An example of the wide exposure his work had is that his painting *Abundance* (1911; The Hague, Gemeentemus.) was reproduced in the *Blaue Reiter Almanac* in 1912 and in the same year was shown in the *Knave of Diamonds exhibition in Moscow (in 1911 it had been shown at the Salon des Indépendants in Paris). IC

LEGA, SILVESTRO (1826–95). Italian painter, a leading member of the *Macchiaioli. After training in the 1840s at the Accademia di Belle Arti in Florence, he was associated with the movement known as Purismo, inspired by 15th-century Florentine art. In the early 1860s, however, he began to fall under the influence of the *Macchiaioli, often painting scenes from the Risorgimento and naturalistic landscapes, rendered with patches of bright colour. Many of his finest paintings date from this decade, when he was a regular visitor to the Batelli family, whose household he often represented. Partly as a result of his poor eyesight, his brushwork became more impressionistic in his later years, as exemplified by *Haystacks in*

the Sun (c.1890; Piacenza, Gal. d'Arte Moderna Ricci Oddi). CJM

Matteucci, G., *Lega: l'opera completa*, (2 vols., 1987).

LÉGER, FERNAND (1881–1955). French painter and designer, born at Argentan in Normandy of peasant farming stock. In 1897–9 he was apprenticed to an architect in Caen, then in 1900 settled in Paris, where he supported himself as an architectural draughtsman (and for a while as a photographic retoucher) whilst studying art at the Académie Julian and elsewhere. His early paintings were *Impressionist in style, but in 1907 he was overwhelmed by the exhibition of *Cézanne's work at the Salon d'Automne, *Paris, and in the following year he came into contact with several leading avant-garde artists. Robert *Delaunay was among his friends and he met and admired Henri *Rousseau. He was briefly influenced by *Fauvism, but in 1909 he turned to *Cubism. Although he is regarded as one of the major figures of the movement (see SECTION D'OR), he always stood somewhat apart from its central course; he disjointed forms but did not fragment them in the manner of *Braque and *Picasso, preferring bold tubular shapes (he was for a time known as a 'tubist'), as in his first major work, *Nudes in a Forest* (1909–10; Otterlo, Kröller-Müller). He also used much brighter colour than Braque and Picasso. In 1912 he had his first one-man exhibition, at the dealer Kahnweiler's gallery, and he was beginning to prosper when the First World War interrupted his career. By this time his work had come close to complete abstraction.

Léger enlisted in the army and served as a sapper in the front line, then as a stretcher-bearer. The war was 'a complete revelation to me as a man and a painter'. It enlarged his outlook by bringing him into contact with people from different social classes and walks of life and also by underlining his feeling for the beauty of machinery: 'During those four war years I was abruptly thrust into a reality which was both blinding and new. When I left Paris my style was thoroughly abstract . . . Suddenly, and without any break, I found myself on a level with the whole of the French people; my new companions in the Engineer Corps were miners, navvies, workers in wood. Among them I discovered the French people. At the same time I was dazzled by the breech of a 74-millimetre gun which was standing uncovered in the sunshine: the magic of light on white metal. This was enough to make me forget the abstract art of 1912–13 . . . Once I had got my teeth into that sort of reality I never let go of objects again.' After being gassed, he spent more than a year in hospital and was discharged in 1917. In that year he painted *Soldiers Playing at Cards* (Otterlo,

Kröller-Müller), which he regarded as 'the first picture in which I deliberately took my subject from our own epoch'. During the next few years, Léger's work showed a fascination with machine-like forms, and even his human figures were depicted as almost robot-like beings (*The City*, 1919; Philadelphia Mus.). In 1920 he met *Le Corbusier and *Ozenfant, who shared his interest in a machine aesthetic, and in the mid-1920s his work became flatter and more stylized, in line with their *Purist style. He used bold, poster-like contrasts of form and colour, with strong black outlines and extensive areas of flat, uniform colour. In the inter-war years he expanded his range beyond easel painting with murals (sometimes completely abstract) and designs for the theatre and cinema (in 1923–4 he conceived, produced, and directed the film *Le Ballet mécanique*, with photography by *Man Ray; it has no plot and shows everyday objects in rhythmic motion). He was also busy teaching at his own school founded with Ozenfant in 1924 as the Académie de l'Art Moderne (Ozenfant left in 1929 but it continued as the Académie de l'Art Contemporain until 1939). He also travelled extensively, making three visits to the USA in the 1930s. The contacts that he made during these visits stood him in good stead when he lived in America during the Second World War, teaching at Yale University and at Mills College, Calif.

Léger's work of the war years included pictures of acrobats, cyclists, and musicians, and after his return to France in 1945 he concentrated on the human figure rather than the machine. He joined the French Communist Party soon after his return (he had been sympathetic to it long before this) and favoured proletarian subjects that he hoped would be accessible to the working class. Some of these pictures were very big (notably *The Great Parade*, 1954; New York, Guggenheim), and in his later career he also worked a good deal on large decorative commissions, notably stained-glass windows and tapestries for the church at Audincourt (1951) and a glass mosaic for the University of Caracas (1954). In 1949 he began making ceramic sculptures. Many honours came to him late in life, including the Grand Prix at the 1955 São Paulo Bienal. Shortly before his death he bought a large house at Biot, a village between Cannes and Nice, and his widow built a museum of his work here, opened in 1960.

In the catalogue of the exhibition *Léger and Purist Paris* (Tate Gallery, London, 1970), John Golding wrote of Léger: 'No other major twentieth-century artist was to react to, and to reflect, such a wide range of artistic currents and movements. Fauvism, Cubism, *Futurism, Purism, *Neo-Plasticism, *Surrealism, *Neoclassicism, *social realism, his art experienced them all. And yet he was to remain supremely independent as an artistic

personality. Never at any time in his career could he be described as a follower; the very vigour and strength of his character would in themselves have rendered such a position inconceivable. But his originality lay basically in his ability to adapt the ideas and to a certain extent the visual discoveries of others to his own ends.' IC

LEGROS, PIERRE (1666–1719). French sculptor. The son of a sculptor active at the park at Versailles, he went to Rome in 1690 and stayed for the rest of his life, becoming the finest sculptor in the generation after *Bernini. Many of his works were made for the Jesuits, beginning with the dramatic marble group *Religion Casting down Heresy* (1695–9) and the life-size silver statue of *S. Ignatius Ascending to Heaven* (1697–8), both for the Gesù. Legros's style stands somewhere between the *Baroque flamboyance of Bernini and the more restrained mode of *Algardi, nuancing both with an outstanding delicacy of technique and an ability to convey the mystical inwardness of late 17th-century Catholicism. He was as adept at reliefs as sculpture in the round—his marble bas-relief of *The Apotheosis of S. Luigi Gonzaga* (1698–9), also in the Gesù, being his best—and his lively terracotta sketch models were highly prized by contemporary collectors. His most famous work is the multi-coloured marble statue of the boy saint *Stanislas Kotska on his Deathbed* (1702–3) in S. Andrea al Quirinale, which ranks with Bernini's *Ecstasy of S. Teresa* as a piece of religious theatre of the greatest brilliance. MJ

Enggass, R., *Early Eighteenth-Century Sculpture in Rome* (1976).

LEHMBRUCK, WILHELM (1881–1919). German sculptor. Lehmbruck was born at Meidensich, near Duisburg, and trained at the Düsseldorf Academy (1901–7), visiting Italy in 1905 on the proceeds of prize money. He lived in Paris 1910–14 and was influenced by the Expressionistic naturalism of *Rodin. From this and his friendship with the *modernists *Modigliani and *Brancusi he developed a personal style first revealed in the *Kneeling Woman* of 1911 (New York, MoMa) which was hailed as a triumph of *Expressionism when shown in Cologne in 1912. This figure, gaunt and awkward, shows the elongation which became his characteristic mannerism. On the outbreak of the First World War he returned to Germany and worked for a time in a military hospital. His *Dying Warrior*, a proposed war memorial, aroused popular hostility when exhibited in 1916 and he moved to Zurich where he modelled the *Young Man Seated* (1918; Duisburg, Kunstmus.) a despairing angular youth. In 1919 he returned to Berlin where he committed suicide, thought to be the result of his

wartime experiences. Like his contemporary *Barlach his work has an underlying Gothic strain. DER

Hofmann, W., *Wilhelm Lehmbruck: Life and Work* (1969).

LEIBL, WILHELM (1844–1900). German painter. Leibl was born in Cologne and studied in both Cologne and Munich. In 1869 his portrait of *Frau Gedon* (Munich, Neue Pin.) was exhibited in Munich where it was singled out for praise by Gustave *Courbet, who invited him to Paris. His visit was terminated by the Franco-Prussian War (1870) but Courbet's realism had a decisive effect on Leibl's art and on his return to Germany he soon abandoned Munich for the Bavarian countryside, where he painted the local peasantry in a sombre realistic style which he summed up as 'solidity'. For a brief period in the late 1870s he attempted to emulate *Holbein, adopting a painstaking, miniaturist technique which produced a smooth enamel-like surface. His masterpiece, *Three Women in a Church* (1878–82; Hamburg, Kunsthalle), haunting and Gothic, dates from this period. For his later works he adopted a more fluid and painterly technique which never achieved the same intensity. Despite being the acknowledged leader of contemporary German realism Leibl had a greater reputation in France where he regularly exhibited at the *Paris Salon. DER

LEIGHTON, FREDERIC, LORD (1830–96). English painter and sculptor. Leighton was born in England but from 1840 until 1853 his family lived abroad and his youth was peripatetic until he established himself in Rome in 1854. By then he was soundly trained in continental academic practice and had a wide acquaintance among contemporary painters. Thus, when he made his debut at the RA (see under LONDON) with *Cimabue's Madonna* (London, Royal Coll.) in 1855, he was already an accomplished and cosmopolitan artist. This vast picture, carefully researched, clearly defined, and brightly coloured, was purchased by Queen Victoria and Leighton's English reputation was assured. After three years in Paris he settled in London in 1859, building a magnificent one-bedroomed mansion in Holland Park. From the 1860s he specialized in classical subjects with the occasional fine portrait like that of *Sir Richard Burton* (1875; London, NPG). His late work was largely Aesthetic culminating in the highly mannered, luminous *Flaming June* (c.1895; Puerto Rico, Ponce Mus.). From 1878, when he became president of the RA, he was much honoured. His character remains elusive, neither greatly admired nor disliked, the head prefect of late Victorian art. DER

Newall, C., et al., *Leighton*, exhib. cat. 1996 (London, RA).

LEINBERGER, HANS (1480×5–after 1531). South German woodcarver and sculptor active in Landshut. Not much is known about him before 1513 when he was at work on his major commission, the high altar of the former collegiate church of S. Castulus in Moosburg (*in situ*): *The Virgin and Child with S. Castulus* [whose relics had lain in Moosburg since the 8th century] *and Emperor S. Henry II*. The figures, enveloped in deeply cut drapery folds creating stark contrasts of light and shade, display the pathos and expressiveness of German late *Gothic art. Along with *Riemenschneider and Veit *Stoss, Leinberger is one of the last of the great German sculptors working in the florid style. KLB

Baxandall, M., *The Limewood Sculptors of Renaissance Germany* (1980).

LELY, SIR PETER (1618–80). Dutch-born painter who dominated English portraiture from 1650 until his death. Born Pieter van der Faes, at Soest, Westphalia, he trained under Pieter de Grebber (c.1600–c.1653) at Haarlem. He arrived in London c.1643 and flourished under the Commonwealth, painting history and subject pieces including the frankly erotic Italianate *Nymphs by a Fountain* (c.1650–5; Dulwich, Gal.). He soon turned to portraiture, filling the gap left by the death of van *Dyck, whose style influenced *The Children of Charles I* (1646–7; Petworth, Sussex). In 1660, at the Restoration, he became principal painter to Charles II, whose courtiers and mistresses he painted, with *Baroque swagger, in decorative flattering portraits. *The Windsor Beauties*, painted for the Duchess of York (1662–8; Hampton Court, Royal Coll.), handsomely *déshabillé* and languorous, successfully capture the hedonistic climate of the court. The series of admirals, the twelve *Flagmen* (1666–7; London, National Maritime Mus.), commissioned by her husband, reveal greater individuality in character and pose. His prolific output was maintained by employing many assistants and using templates for the poses with only the head being painted from life. DER

Millar, O., *Sir Peter Lely*, exhib. cat. 1979 (London, NPG).

LE MOITURIER, ANTOINE (c.1425–after 1495). French sculptor from Avignon. His style owes much to his uncle Jacques *Morel, with whom he most likely trained. He is best known for his work (1463–9) on the alabaster and black marble tomb of John the Fearless, Duke of Burgundy, and Margaret of Bavaria, which had been begun by Juan de la *Huerta (Dijon, Mus. des Beaux-Arts), although this has been substantially damaged and restored; it is believed that the nine weepers at the head of the procession are by his hand. Before Le Moiturier moved to Dijon, Canon Jacques Oboli had commissioned an altarpiece for S. Pierre in Avignon from him. Only two angels from this massive work survive (c.1463–5; Avignon, Mus. du Petit Palais). Stylistic similarities with the tomb of Philippe Pot, Seneschal of Burgundy, from the abbey of Cîteaux (1477; Paris, Louvre) support the argument that this is also a work by Le Moiturier. KC

Antoine Le Moiturier: le dernier des grands imagiers des ducs de Bourgogne, exhib. cat. 1973 (Dijon, Mus. des Beaux-Arts).

LEMOYNE, FRANÇOIS (1688–1737). The last major French painter to be influenced by the heroic style of *Le Brun. Lemoyne was taught by his stepfather the portraitist Robert Tournières (1667–1752) and by the decorative and religious painter Louis Galloche (1670–1761), who inculcated a respect for *Raphael, *Rubens, *Correggio, and *Veronese. Later, in the 1720s, Lemoyne spent time in Italy, but earlier was able to see Italian art in the private collections of Paris. His best-known work is the ceiling painted in 1736 for the Salon d'Hercule at *Versailles depicting the apotheosis of the hero. Embodying the dynamism of composition and the high key of colour associated with Rubénisme it nevertheless belongs to the tradition of monumental mural painting begun at Versailles by Le Brun. The ceiling brought Lemoyne fame and the coveted title of Premier Peintre du Roi. Perhaps more to modern taste are such easel paintings as *The Bather* (1724; St Petersburg, Hermitage), which with its reminiscences of Veronese and *Parmigianino also looks forward to the sensual art of *Boucher, who, with *Natoire and other distinguished painters of the next generation, was Lemoyne's pupil. MJ

Bordeaux, J.-L., *François Lemoyne and his Generation* (1984).

LEMOYNE, JEAN-BAPISTE (1704–78). French sculptor. The son and nephew of sculptors, Lemoyne trained in *Paris, becoming a member of the Académie Royale in 1738, and eventually succeeding François *Boucher as its director. Like many of his contemporaries, he contributed to the decoration of the gardens at Versailles and supplied works for the churches of Paris, notably a marble group of *The Baptism of Christ* for S. Roch. His most prestigious commissions were for a series of statues of Louis XV. The grandest of these was a bronze equestrian monument in Bordeaux (1731–43), which was melted down during the French Revolution.

Lemoyne's most attractive works are his portrait busts, which are among the most technically able and vividly characterized of the 18th century. Among them are those of the scientist *Réaumur* (Paris, Louvre), the actress *Mlle Clairon* (Paris, Comédie-Française), and the writer *Crébillon* (Dijon, Mus. des Beaux-Arts). Lemoyne trained some of the best sculptors of the next generation, including *Falconet, *Pajou, *Pigalle, and *Houdon.

MJ

Réau, L., *Les Lemoyne* (1927).

LE NAIN BROTHERS.

French painters. **Antoine** (*c*.1600–48), **Louis** (*c*.1600–48), and **Mathieu** (*c*.1607–77) were born at Laon but had all moved to Paris by 1629. Mathieu was made painter to the city of Paris in 1633, and all three brothers were foundation members of the Académie Royale (see under PARIS). Their work belongs to a type of naturalistic *genre which had no previous tradition in French painting and was exceptional at the time. The treatment of the poor was a matter of serious discussion, especially among the clergy of S. Sulpice, the parish in which the three artists lived, and this may account for the early popularity of their work. The art of the Le Nain brothers quickly went out of fashion and was largely forgotten until the latter half of the 18th century, when peasant scenes were again in demand under the influence of J.-J. *Rousseau.

The signatures on Le Nain paintings being without initials, historians have tentatively divided the works into three groups on stylistic grounds, although there is a tradition that the brothers collaborated in many cases. The first group, traditionally attributed to Antoine, consists of almost expressionless figures. Awkward in scale and executed in brilliant colours, they are mostly painted on copper. The group includes *Woman and Five Children* (London, NG), which, characteristically, is lacking in any narrative or anecdotal interest. The second and by far the most powerful group consists of larger-scale peasant scenes painted in silvery grey-green colours; it is attributed to Louis. *The Forge* (Paris, Louvre) and *Resting Cavalier* (London, V&A) have a classical monumentality learned perhaps from the Dutch and possibly connected with the naturalistic tradition of Spanish painting of the same period. The emotionless figures calmly confront the spectator, but in a realistic manner without the disengaged abstraction associated with the previous group. In the third group, attributed to Mathieu, are placed pictures which are more complex in design and where the figures have more animated facial expressions. These are chiefly religious and history paintings, including the *Adoration of the Shepherds* (London, NG) and *The Supper at Emmaus* (Paris, Louvre).

The Le Nain brothers were also successful as portrait painters, but the identification of their work is problematical.

HB

Cuzin, J. P., 'A Hypothesis Concerning the Le Nain Brothers', *Burlington Magazine*, 120 (1978).
Rosenberg, P., *Tout l'œuvre peint des Le Nain* (1993).
Thuillier, J., *Les Frères Le Nain*, exhib. cat. 1978 (Paris, Grand Palais).

LENOIR, ALEXANDRE-MARIE

(1761–1839). French archaeologist and curator. Lenoir, who was born in Paris, began his career as an art student but following the revolutionary nationalization of the Church in 1789 obtained an official post at Les Petits Augustins. In 1791 this former monastery was utilized as a depository for works of art confiscated from ecclesiastical and aristocratic collections, many of which had been vandalized or partly destroyed, and Lenoir was employed to create inventories. In the same year it was decreed that the artefacts should be sold or melted down with only unsold sculptures being retained, a decision that Lenoir successfully hampered, saving, among other irreplaceable works, *Michelangelo's *Slaves* (Paris, Louvre). Following the abolition of Christianity in 1793 he salvaged a large collection of monumental sculpture which opened to the public as the Musée des Antiquités et Monuments Français in 1796. The collection grew dramatically and Lenoir was criticized by the archaeologist Quatremere de Quincy (1755–1849) for acquiring works which were no longer threatened. After the Restoration of 1815 the works were dispersed. Whatever his motives—arguably an 'obsessive and all embracing passion to preserve under his own authority every surviving vestige of the past at a time when the past was being annihilated as efficiently as possible' (Haskell)—Lenoir was individually responsible for the successful preservation of many important works of art.

DER

Haskell, F., *Rediscoveries in Art* (1976).

LE NOIR, JEAN

(active 1331–75). French illuminator. In 1331 he was in service to Yolande of Flanders, Duchess of Bar, and later to the King. As reward for their services, Jean and his daughter Bourgot, also an illuminator, were given a house in Paris in 1358 by the King's son, the future Charles V, for whom they also worked after he ascended the throne in 1364. During the early 1370s Jean and Bourgot worked at Bourges for the Duke of Berry, who also held them in high esteem. The survival of three books made for the same sequence of patrons for whom Jean worked, featuring illumination evidently all by the same artist, has made it possible tentatively to reconstruct his œuvre. Assuming this identification is correct, Jean was the leading illuminator (see ILLUMINATED MANUSCRIPTS) working in Paris following *Pucelle, whose style and compositions he clearly emulated. Indeed his strength lies not in innovation, but in his refinement and extention of earlier decorative formulas, at their most eye-catching in the Passion cycle from the *Petites Heures* (*c*.1375; Paris, Bib. Nat., MS lat. 18014).

TT

Avril, F., *Manuscript Painting at the Court of France* (1978).

LEONARDO DA VINCI

(1452–1519). Italian painter. (1) *Introduction*; (2) *Early work and life*; (3) *Milan 1482–1499*; (4) *Florence and elsewhere 1500–1519*

1. INTRODUCTION

Leonardo was the most variously accomplished artist of the Italian *Renaissance. His paintings are few, but they inhabit a context provided by numerous *drawings and the copious observations of Leonardo's notebooks, from which his artistic goals and preoccupations can be extrapolated to an extent beyond that of any other Renaissance artist. In his own letter of *c*.1482 to Ludovico Sforza, Leonardo places painting last amongst a formidable list of his capabilities in the fields of engineering and other sciences. The letter was written with a view to future employment, and its apparent downgrading of art should not be taken at face value, or at any rate misinterpreted. It is, in fact, precisely the extent to which Leonardo viewed ostensibly discrete disciplines as related facets of a wider process of enquiry which underpins his lasting status as the epitome of 'Renaissance Man'. The underside of this breadth of interest is reflected in Leonardo's own question of himself—'tell me if anything was ever done'—and *Michelangelo's gibe, as reported by *Vasari, at Leonardo's inability to finish his work.

2. EARLY WORK AND LIFE

Leonardo was born at Anchiano, near the Tuscan hill town of Vinci, the illegitimate son of Ser Piero da Vinci, a Florentine notary, and Caterina, a peasant. Little is known of his upbringing, the subject of historical conjecture by Vasari and others and highly speculative interpretation by writers of the Romantic period and, more interestingly, Sigmund Freud. At some stage in the later 1460s Ser Piero brought Leonardo to Florence, where he joined the workshop of Andrea del *Verrocchio. In 1472 Leonardo was enrolled in the painters' company of S. Luke, though he remained in Verrocchio's shop until 1476. Several works from this period survive, though only a pen and ink landscape drawing of 1473 (Florence, Uffizi) is both inscribed (not signed) and dated. A tradition dating back to Albertini's *Memoriale* of 1510, and repeated by Vasari, that Leonardo painted the left-hand

angel in Verrocchio's *Baptism of Christ* (Florence, Uffizi) is supported by the visual evidence. Leonardo must also have painted the atmospheric landscape behind the angels, with which the only contemporary analogies are the 1473 drawing and the equivalent passages of the Monte Oliveto *Annunciation* (Florence, Uffizi) and the *Portrait of Ginevra de' Benci* (Washington, NG). The exact sequence of these works between c.1472/3 and 1476 is problematic, and the post-Vasarian tradition that the *Baptism* angel was Leonardo's first painting—which Vasari does not explicitly say—may need revision. Of the painted *landscapes that of the *Annunciation* seems the least advanced, only partly translating into paint the tremulous, quasi-impressionistic qualities of the drawing. In this respect the *Baptism* landscape looks the most mature of all. The kneeling angel, too, is a more ambitious and internally complex design than the static Verrocchiesque figures of the *Annunciation* and more fluid than the *Ginevra de' Benci*. Ginevra's marriage, possibly the occasion of her portrait, took place in 1474. The painting has been cut down, with the loss of her hands, known from a preparatory drawing, closely following those of Leonardo's overt source for the whole design, Verrocchio's marble *Bust of a Lady* (Florence, Bargello). The *Annunciation* is an uneasy combination of elements drawn from Verrocchio's repertoire, like the Virgin's desk and the over-zealous receding lines of her house, with more adventurous aspects like the landscape. The sense that this is an assembly of disparate and not always well-matched parts is amplified by the clumsiness of the spatial relationship between the Virgin and her immediate surroundings. This may be Leonardo's earliest securely attributable painting. The general picture of this group is of increasingly rapid development away from the dry linearity of the Verrocchio shop style.

Aspects of Verrocchio's influence survived this process, and other features of his work, like the integration of large contrasting forms in the bronze *Christ and S. Thomas* (completed 1483; Florence, Or San Michele), underpin Leonardo's work from the mid-1470s to 1481, which saw him establish a standard of pictorial organization unprecedented in Florentine art and which laid the foundations for the High Renaissance. The new style is first announced in the *Benois Madonna* (St Petersburg, Hermitage) and a number of associated drawings. The dramatic novelty of the *Benois Madonna* can be appreciated if it is compared with any Madonna by Verrocchio or *Botticelli, or with Leonardo's own *Madonna with a Vase of Flowers* (Munich, Alte Pin.). Integration of the two figures is coherent and complete: complex in design, but planned so carefully that the effect is finally one of 'natural' simplicity, embodying, as no artist of *Alberti's

time had consistently done, that writer's insistence that strain and exaggeration should never mark even the most involved of figure groupings. The painting also reflects for the first time Leonardo's own insistence that painters have a primary duty to invent compositions which truthfully reflected the inherent qualities of the subject rather than repeat traditional formats. The means of achieving this can be seen in two studies for a *Madonna and Child with a Cat*, recto and verso of the same sheet (London, BM), in which a new style of free improvisatory sketching allows newly organic figure groups to emerge from a maelstrom of scribbled lines.

The unfinished *Adoration of the Magi* (Florence, Uffizi), commissioned in 1481 for the monastery of S. Donato a Scopeto, extends this new compositional aesthetic to large-scale narrative painting. Several preparatory studies show the development of the composition away from the standard Florentine *Adoration* type to the organic cohesion and taut drama of the final design. The background, to which the elaborate *perspective scheme worked out in one of the studies (Florence, Uffizi) is relegated, full of rearing horses and inchoate ghostly figures, speaks of a natural order far stranger than that of the *International Gothic models to which other Florentine painters still looked. This combination of expanded dramatic eloquence and a quasi-architectural massing of the component parts of a composition into a unified whole makes the *Adoration*, which never got beyond the stage of monochrome underpainting, a turning point in Western art, something recognized by the generations of Florentine artists who studied it long after its abandonment by Leonardo.

3. MILAN 1482–1499

The immediate reasons for Leonardo's move to Milan are unclear, though it may have hinged on some perception that his expanding range of interests would be better received at the Sforza court than in Medici Florence. His first major Milanese commission was from the confraternity of the Immaculate Conception for an altarpiece in S. Francesco Grande. The history of the two versions of the *Virgin of the Rocks* (Paris, Louvre; London, NG) associated with this commission is problematic. It is clear, though, that the London version is much the later of the two, and that the Louvre painting is probably the one begun in response to the 1483 contract, but sold elsewhere by Leonardo and his associates Ambrogio and Evangelista de *Predis. The *iconography is unusual, with the inclusion of the infant S. John the Baptist, the Archangel Uriel, and a rocky setting of fantastic type. The pyramidal central group of the kneeling Virgin, the holy children, and Uriel, is pointedly articulated by gestures and glances, something toned

down in the later version. Most remarkable in this, the first surviving large-scale work of Leonardo's maturity to have been completed, is the warm tonal blend which unifies the composition, with suppressed local colour and a wonderfully modulated chiaroscuro. This may reflect the intensive optical studies recorded in the notebooks which Leonardo kept from his arrival in Milan, where a collection of some 4,000 pages, gathered together as the Codice Atlantico, still remains (Milan, Ambrosiana).

Several portraits from this period survive, of which the finest are the unfinished *Portrait of a Musician* (Milan, Ambrosiana) and the *Lady with an Ermine* (c.1485; Cracow, Czartoryski Gal.). The latter, which is generally accepted as the likeness of Ludovico Sforza's mistress Cecilia Gallerani, draws on Leonardo's new vocabulary of organic composition and tonal control. The quick glance of both the sitter and her pet ermine (*galée* in Greek), as if towards someone entering the room, furnishes the required narrative basis for the spiral around which the composition rotates. The formal design thus reflects the causal chain which determines it, both in terms of exterior events and the interior movement of the sitter's soul: 'the hands and arms in all their actions must display the intention of the mind that moves them ... A good painter has two objects to paint, man and the intention of his soul.'

Two major commissions close this period. Both epitomize the exasperating nature of Leonardo's more ambitious projects. The first, for a colossal bronze *equestrian statue of Ludovico Sforza's father Francesco, had been mooted before Leonardo's arrival; his 1482 letter includes an offer to tackle it. Leonardo initially accepted from Antonio del *Pollaiuolo's earlier design the challenging motif of a rearing horse, explored in his own sketches from c.1485. By the time he made the full-size (= thrice life-size) clay model of the horse, completed by the turn of 1492/3, he had adopted a walking pose closer to that of *Donatello's *Gattamelata* (1447–53; Padua, Piazza del Santo). Though the model was widely admired, matters proceeded no further, and the great 'earthen horse' was used for target practice by the French troops invading Milan in 1499.

The second commission was for the *Last Supper* of 1495–7, painted on the end wall of the refectory of the Dominican convent of S. Maria delle Grazie, a house with which Ludovico Sforza had particularly close connections. Leonardo eschewed traditional fresco technique in favour of an experimental recipe of his own, with the result that the painting has long been in a ruinous state (see WALL PAINTING). The composition, though, is legible, and there are many fine preparatory drawings. The design employs the same criteria of movement, individual posture, and

overall composition as reflections of psychological movement, as the *Lady with an Ermine*. The choice of the dramatic moment when Christ announces his imminent betrayal allowed Leonardo to structure his design round a shock-wave, travelling out from the motionless Jesus and through the disciples, each carefully individuated, but each too a component part of a larger pattern of turbulence. Judas is identified by psychological means alone, no longer physically isolated, as in the standard Renaissance format for this scene. The complete dominance of the composition by the figures, themselves projected on so heroic a scale, was a major influence on the course of High Renaissance art.

4. FLORENCE AND ELSEWHERE 1500–1519

The history of the major commission of Leonardo's second Florentine period continues the pattern set in Milan. In October 1503 he began preparations for a large mural painting of the *Battle of Anghiari* in the Sala del Gran Consiglio of the Palazzo Vecchio. This was to be one of a pair of murals depicting great Florentine victories, the other being the *Battle of Cascina* by Michelangelo. In 1505 the cartoon was made and painting begun. Once again, Leonardo employed a medium of his own choice which revealed its defects almost from the beginning. Even so, a substantial part of the painting was executed, and was carefully preserved after Leonardo's departure from Florence in 1506 until the 1560s, when Vasari overpainted it. The *cartoon, too, is lost, but its qualities are preserved in *Rubens's drawing (made via an intermediary source) of the central section, the *Fight for the Standard* (Paris, Louvre). It confirms the evidence of Leonardo's preparatory drawings that his depiction of war, that 'most bestial madness', grew out of an initial idea for a kind of compositional vortex, reflecting the violent external eddies of battle and the internal animal passion of the combatants. The extreme contortion of the left-hand horseman in Rubens's version might seem proto-*Mannerist, but the pose is as much a rational representation of internal and external forces bearing on the subject as that of the *Lady with an Ermine*, grounded in the study of natural forces.

Several variants exist of another composition with which Leonardo was occupied in this period, the *Virgin and Child with S. Anne*. The two major versions are a large cartoon (London, NG) and a painting (Paris, Louvre). Both indicate the application to this expanded *Madonna* group of Leonardo's mature powers of organization. This level of large-scale integration of contrasts distinguishes the later version of the *Madonna of the Rocks* (London, NG), on which Leonardo probably worked on his return to Milan in May 1506, from the Paris version. The London painting, for which final payment was made in 1508, may have been begun by Leonardo before his departure from Milan in 1499, as a replacement for the picture previously sold. Only parts are clearly autograph, but the greater unity and monumental figure grouping of Leonardo's maturity are evident. Other innovative compositions date from this period: the *Madonna and Child with a Yarnwinder*, which exists in the form of an at least partly autograph painting (priv. coll.), and *Leda and the Swan*, known only from copies. Dating Leonardo's most famous picture, the *Mona Lisa* (Paris, Louvre), is difficult. He may have worked on it over a period of some years, perhaps as late as 1514. The picture is cut down, with the loss of much of the balcony on which the subject sits, this format fulfilling Leonardo's insistence that a figure placed against the exterior, but viewed by an artist situated inside the room, gave the greatest opportunities for the desired illusion of relief (*rilievo*). Even in its darkened condition the painting reveals an extraordinary refinement of modelling and tonal modulation, product both of Leonardo's obsessive studies of optics and visual perception, and his increasing insistence, against the whole tenor of the Florentine tradition, that linear means were inadmissible for painters who approached their subjects, as he did, in the spirit of natural science. Mona Lisa's facial features are defined, not by graphic outlines, but by pure tonal variation, the edges treated not as boundaries but as receding planes and interfaces with the adjacent atmosphere. The smoky outlines—*sfumato—were adopted by countless painters with no interest in Leonardo's profoundly considered basis for them. The landscape background similarly epitomizes Leonardo's preference for atmospheric recession over traditional linear perspective, which he came to regard as optically unreliable.

Long before Leonardo's death at Amboise, in France, where he had lived under the protection of King François I since 1516, his work had become integral to the creation of the High Renaissance style. It is profoundly ironic that he, who so vehemently denounced the habit of imitating other painters rather than studying nature, 'the mistress of all masters', should have become the most persistently influential of all Renaissance artists. Few of his contemporaries or immediate successors paid much heed to his exalted understanding of what he called the 'science of painting . . . the grandchild of nature and . . . related to God', and it is only in the last century or so that the entirety of Leonardo's work has received full attention. The extent to which it all coheres is still a matter for debate. There is, though, very little in his writings that sheds no useful light on his paintings, and the extent to which they, in turn, reflect the vast reaches of his questioning imagination is a major factor in their enduring claims to attention. JR

Clark, K., *Leonardo da Vinci* (1939).
Kemp, M., *Leonardo da Vinci: The Marvellous Works of Nature and Man* (1981).
Richter, J. P. (ed.), *The Literary Works of Leonardo da Vinci* (3rd edn., 1970).

LEONI, FATHER AND SON. Italian sculptors. **Leone** (1509–90) was, with his son **Pompeo** (*c*.1533–1608), the most important sculptor in the service of Charles V (d. 1558) and Philip II of Spain (d. 1598). Leone was trained as a goldsmith and *medallist, perhaps in Venice or Padua, and engaged as an engraver at the papal mint in Rome from 1538–40 and master of the imperial mint in Milan 1542–5 and 1550–89. His medals included portraits of Andrea Doria (who had saved him from the galleys) and members of the imperial court. Most of his monumental sculpture was cast or carved in Milan but exported to Brussels and Spain, the most astonishing example being the *Charles V Restraining Fury* (1549–55; Madrid, Prado) with its removable armour. His bronze tomb of Gian Giacomo de' Medici (1560–2; Milan Cathedral) may depend on a design by *Michelangelo. The 'prisoners' on the façade of his own Casa degli Omenoni in Milan display his inventive architectural mind.

Pompeo collaborated with his father on the magnificent set of 27 bronze figures for the high altar (*c*.1582) and flanking memorial groups (1598) in the Capilla Mayor of the *Escorial, as well as independently undertaking others for the imperial court in Spain. AB

Plon, E., *Leone Leoni, Sculpteur de Charles-Quint et Pompeo Leoni, Sculpteur de Philippe II* (1887).
Pope-Hennessy, J., *Italian High Renaissance and Baroque Sculpture* (4th edn., 1996).

LÉPICIÉ, NICOLAS-BERNARD (1735–84). French painter. He was the son of the engraver François-Bernard Lépicié (1698–1755), who made many of the best prints after *Chardin. Most of Nicolas Bernard's effort was devoted to the painting of enormous *history pictures of uplifting moral content and little imagination, such as the sombre and obscure *The Piety of Fabius Dorsus* of 1781 (Chartres, Mus. des Beaux-Arts). He did, however, also paint some of the most appealing small-scale genre pictures of the later 18th century. The best known is probably the mildly erotic *Le Lever de Fanchon* (1773; S. Omer, Mus. Hôtel-Sandelin), which shows a dishevelled young housemaid dressing in her untidy attic bedroom. MJ

Gaston-Dreyfus, P., *Catalogue raisonné de l'œuvre peint et dessiné de Nicolas-Bernard Lépicié* (1923).
Sahut, M.-C., and Volle, N. (eds.), *Diderot et l'art de Boucher à David*, exhib. cat. 1984 (Paris, Hôtel de la Monnaie).

LESE, BENOZZO DI See GOZZOLI, BENOZZO DI.

LESSING, GOTTHOLD EPHRAIM (1729–81). German dramatist and critic. Although primarily remembered for his plays (e.g. *Nathan der Weise*, 1779) Lessing also had a keen interest in the visual arts. In 1774, whilst working as a librarian in Wolfenbüttel, north Germany, he discovered and subsequently wrote about the famous 12th-century treatise on painting, *De diversis artibus*. His main contribution to contemporary art theory was the essay *Laokoon oder über die Grenzen der Malerei und Poesie* (1766), in which he attacks the *Neoclassical conception of Antique beauty and *Winckelmann's ideal of the tragic hero. Lessing attempts here to find principles by which to differentiate between painting or sculpture, and poetry, that is the spatial and the temporal arts. Whereas Winckelmann had assigned the notion of ideal grandeur to all of Antiquity, Lessing restricts it to the visual arts alone. Central to his argument is the artist's ability to select the 'fruitful' moment, which would simultaneously preserve physical beauty and encapsulate references to past and future action. For Lessing the *Laocoön* group represents a particularly masterly choice of moment, as it delights the eye but also stimulates the imagination. AT

LE SUEUR, EUSTACHE (1616–55). French painter and draughtsman. A pupil of *Vouet, he developed a classical style that enabled him to establish a dominant position as a painter of mythological and religious paintings in France and earned him his reputation as the French Raphael. Born in Paris, he began his career in the studio of Vouet, where he remained *c.*1632–42. Already by the late 1630s, he was able to demonstrate his own stylistic independence in such pictures as *Sea Gods Paying Homage to Love* (*c.*1636–8; Los Angeles, Getty Mus.), which is painted in a far more fluid and sensual manner than that of his mentor, while his talent for portraiture is brilliantly displayed in *Gathering of Friends* (*c.*1640; Paris, Louvre). One of his first major commissions as an independent artist was the series of 22 paintings on the life of S. Bruno for the small cloister of the Charterhouse, Paris (1645; Paris, Louvre). In their dependence on *Raphael and *Poussin they are more schematic and austere in style than Vouet's work and are all the more remarkable when one recalls that Le Sueur had never visited Rome. The ultimate achievement of his Raphaelesque manner is the *S. Paul at Ephesus*, painted for Notre-Dame de Paris (1649), although this is matched on a smaller scale by the *Holy Family* (1651; Norfolk, Va., Chrysler Mus.). Le Sueur's later work displays a more rigid classicism, already evident in the monumental *Martyrdom of S. Lawrence* (1650–1; Buccleuch Coll., Boughton, Northants.) and the *Annunciation* (1652; Paris, Louvre). A major decorative commission followed, at the Hôtel Lambert, Paris, where he painted a series of Muses and a complex decorative ceiling of *Phaethon Asking Apollo's Permission to Drive the Chariot of the Sun* (1652; all Paris, Louvre). In his later years he continued to receive major religious commissions, for instance the *Adoration of the Shepherds* (1653) for the Oratorians at La Rochelle (now Mus. des Beaux-Arts), but the sheer volume of his output has perhaps undermined modern appreciation of his individuality and of the purity of his classical vision. HB

Merot, A., *Eustache Le Sueur* (1987).

LE SUEUR, HUBERT (*c.*1590–after 1658). Sculptor born and trained in Paris, later becoming court sculptor to Charles I (d. 1649). His early equestrian statuettes of *Henri IV* and *Louis XIII* (*c.*1615–20; both London, V&A) show that he was familiar with Piero Francavilla's (see FRANCQUEVILLE, PIERRE) work in Paris. He came to Britain in 1625, concentrating on dull but accurate portrait busts of King Charles I in marble (1631; London, V&A) and bronze (one at Stourhead, Wilts.). His most important royal commission was the bronze equestrian statue of Charles I, at the head of Whitehall (1633). He provided the King with bronze casts after the most renowned Antique statues in Rome (*c.*1631; Windsor Castle, Royal Coll.), and busts of *Philosophers* (1637; Hampton Court, Royal Coll.). His considerable bronze-*casting and marble-carving skills are well illustrated by the tomb of the Duke and Duchess of Buckingham (after 1634; London, Westminster Abbey) in which the mixed media combine in a sumptuous ensemble reminiscent of the French royal mausoleum at S. Denis. Knowledge of Florentine fountain designs (probably through prints) can be seen in his Diana Fountain (1636–9; London, Bushey Park), originally for the courtyard of Somerset House. AB

Avery, C. A., 'Hubert Le Sueur, the "Unworthy Praxiteles", of King Charles I', in *Studies in European Sculpture*, vol. 2 (1988).

LE TAVERNIER, JEAN (active 1434–60). South Netherlandish illuminator active in Tournai and Oudenaarde. The most notable feature of his output was his widespread and accomplished use of grisaille. His work for Philip the Good, Duke of Burgundy, included the illumination of chronicles such as the *Cronicques et conquests de Charlemaine* (1458; Brussels, Bib. Royale, MSS 9066–8), with a frontispiece scene of a bustling town with Philip receiving the manuscript in the background. Perhaps his finest work, also for Philip, was in a book of hours (The Hague, Koninklijk Bib., MS 76.F.2) that contains 165 grisaille miniatures. His miniatures show the influence of contemporary panel painting; they have generously proportioned interiors comfortably accommodating his somewhat stiff figures and showing an attention to domestic detail. His exterior scenes are peopled with many busy figures. KC

Dogaer, G., *Flemish Miniature Painting in the 15th and 16th Centuries* (1987).

LEU, HANS (*c.*1490–1531). Swiss painter and draughtsman from Zurich. He was the son of Hans Leu the elder (*c.*1460–before 1507) and probably trained by him. During his journeyman years he entered the workshop of *Dürer in Nuremberg, *c.*1510, and subsequently very probably of Hans *Baldung in Freiburg. He was evidently back in Zurich by 1514. The impact of the Reformation, which put a halt to church commissions, forced Leu to ally himself to the Catholic party. He died in the battle at Gubel, near Zurich. Leu's strength lies in his landscape sketches whose style was influenced by the *Danube School drawings. Both the technique (pen on coloured paper, highlighted in white) and the representation of natural forms are reminiscent of *Altdorfer (*Landscape with Water Castle*; Nuremberg, Germanisches Nationalmus.). KLB

Mielke, H., *Albrecht Altdorfer*, exhib. cat. 1988 (Berlin, Kupferstichkabinett).

LEUTZE, EMANUEL (1816–68). German-American painter. Leutze, who was born near Württemberg, emigrated with his family in 1825 and settled in Philadelphia where, from 1834, he was taught by John Rubens Smith (1775–1849). Two years later he received his first portrait commissions and continued portraiture until 1841 when, with financial assistance, he travelled to Europe, enrolling at the Royal Art Academy, Düsseldorf, as a history painter. Despite successes Leutze resented the rigid academicism of the Academy and left in 1843 to travel in Germany and Italy. In 1845 he returned to Düsseldorf where he embraced liberal political beliefs which inspired many of his historical subjects. He entertained visiting American painters and remained involved in American affairs, beginning, in 1849, his most famous work, *Washington Crossing the Delaware* (1851; New York, Met. Mus.). He exhibited this vast and dramatic picture in New York and Washington in 1851 to great popular acclaim. From 1852 he worked in Düsseldorf, returning to America in 1859. His successful career encompassed history paintings, including the mural *Westward Ho* (1862) for the Capitol in

Washington, and portraits of Unionist leaders of the Civil War including Lincoln and General Grant. DER

Emanuel Leutze 1816–1868, exhib. cat. 1975 (Washington, Smithsonian).

LEWIS, JOHN FREDERICK (1805–76). English painter. Lewis was taught by his father F. C. Lewis (1779–1856). His engraved *Studies of Wild Animals* (1824) brought him commissions from George IV and he seemed set on a successful career as an animal painter. However, in 1832 he visited Spain where he abandoned animals for Spanish subjects and oil paints for watercolours. His Spanish pictures, painted in meticulous detail using a minute stippling technique, were much admired but these too were relinquished in the early 1840s when, for obscure reasons, he travelled to Egypt, via Italy and Greece, arriving in Cairo in 1842. For the next eight years he ceased to exhibit and lived the life of a nabob in Cairo. In 1850 he sent *The Hhareem* to the Old Water Colour Society (original lost, version 1850; London, V&A). This exotic and jewel-like picture caused a sensation and for the rest of his life, after his return to London in 1851, he painted Eastern subjects in both oil and watercolour. His paintings were eulogized by *Ruskin and admired by the *Pre-Raphaelites, whose own techniques he anticipated. DER

Lewis, M., *John Frederick Lewis* (1978).

LEWIS, PERCY WYNDHAM (1882–1957). Canadian-born English painter and writer. Lewis studied art at the Slade School in London (1898–1901), where his draughtsmanship was much admired, and spent the next seven years in Europe, often with Augustus *John in Paris. Most of his early work is lost. On his return to England his work displayed elements of *Cubism and *Futurism and in 1912 he was included in Roger *Fry's second *Post-Impressionist exhibition. He worked briefly in Fry's *Omega Workshops (1913) before founding the Rebel Art Centre (1914) the focus of his self-styled *Vorticist movement. *Workshop* (1914; London, Tate) is a typical Vorticist picture, semi-abstract and angular and obsessed by the energy and impersonality of the machine. Together with Ezra Pound and *Gaudier-Brzeska he founded the Vorticist journal *Blast* (1914) which he also edited. Working as an official Canadian war artist in both World Wars, Lewis developed Vorticism along more humanistic lines although his compositions remained jagged and his linearity exaggerated. An admired portraitist, in both drawing and painting, his subjects include *Edith Sitwell* (1923–35; London, Tate). His combative and egocentric nature, evident in his prolific writings and his *Self-Portrait as a Tyro* (1920;

Hull, University), ensured that his membership of artistic groupings, like Group X (1919), was short-lived. Later in his career, influenced by *de Chirico, his work became increasingly mythological. In 1953 blindness ended his painting and he devoted himself to writing. His novels, which include *The Apes of God* (1930) and *Malign Fiesta* (1955), are renowned for their vehement satire. JH

Farrington, J., *Wyndham Lewis* (1980).

LEWITT, SOL (1928–). American sculptor, graphic artist, writer, and *Conceptual artist. He was born in Hartford, Conn., and studied at Syracuse University, NY, where he graduated in fine art in 1949. After serving in the US Army in Japan and Korea, 1951–2, he settled in New York, where he worked as a graphic designer and also painted. His career did not take off until the early 1960s, when he turned to sculpture and became one of the leading exponents of *Minimal art. His 'structures', as he prefers to call them, characteristically involve permutations of simple basic elements, sometimes arranged in box- or table-like constructions. He is also an exponent of Conceptual art; in 1968, for example, he fabricated a metal cube and buried it in the ground at Visser House at Bergeyk in the Netherlands, documenting photographically the object's disappearance (this has also been considered an example of *Land art). LeWitt has also written numerous articles on Conceptual art. His other work includes prints in various techniques. IC

LEYSTER, JUDITH (1609–60). Dutch painter of genre scenes and portraits. In 1633 she became the first woman to join the Haarlem painters' guild. Her monogram includes a star, a play on 'Ley/ster' (lode star). She probably begun her career under the Haarlem portrait painter Frans Pietersz. de Grebber, with whom she is praised in 1627/8, in a poem about Haarlem by Samuel Ampzing. Leyster seems quickly to have acquired a successful reputation, probably working in Frans *Hals's workshop in the late 1620s, where she copied his half-length figures such as *The Lute-Player* (Paris, Louvre). The impact of the Utrecht *Caravaggisti also can be seen in night scenes such as *The Serenade* (1629; Amsterdam, Rijksmus.). Here Leyster's broad handling of paint owes more to Hals, although the upward glance and low viewpoint is particularly characteristic of Leyster. Most of her surviving paintings date from 1626 to 1636 when she married Jan Miense *Molenaer and moved to Amsterdam. She is at her best in small lamplit scenes such as *The Proposition* (1631; The Hague, Mauritshuis), where she anticipates later artists such as de

*Hooch in the timeless tranquillity of the domestic scene. CFW

Hofrichter, F. F., *Judith Leyster: A Woman Painter in Holland's Golden Age* (1989).

LIBERAL ARTS, classical term for those areas of learning suitable for study by free men (*artes liberales*), as opposed to crafts practised by slaves (*artes vulgures*). *Aristotle made the distinction in *Politics* 8.2, although the fragmentary nature of this section makes it impossible to decide which arts he had in mind. Subsequent authorities have tended to disagree over which arts are to be classed as liberal. Marcus Terentius Varro (116–27 BC) provides us with a fairly standard list of nine liberal arts; grammar, logic, rhetoric, geometry, arithmetic, astronomy, music, medicine, and architecture. In the 2nd century AD, Galen gives an alternative list in *Protrepticus*, tentatively including painting and sculpture, although these arts were not normally considered as liberal in Antiquity. Music, on the other hand, was included for its mathematical sense of proportion and harmony and not for its value in performance.

Late Roman authors bequeathed the notion of liberal arts to the Middle Ages. In the early 5th century Martianus Capella gives a list of seven in his allegorical tale *The Marriage of Philology and Mercury*; grammar, dialectic, rhetoric, geometry, arithmetic, astronomy, and music. The philosopher Boethius (480–524) devised a curriculum which divided the liberal arts into two parts; the first stage being the *trivium* (grammar, rhetoric, and logic), the second known as the *quadrivium* (arithmetic, astronomy, geometry, and music). Although first propounded in pagan times learned monks, such as Cassiodorus in *Institutions of Divine and Human Readings* (*c.*562), described the liberal arts as necessary for true comprehension of the Scriptures. Emphasis on the *trivium* and *quadrivium* was further strengthened at the court of Charlemagne (768–814), and the Emperor himself is known to have followed this course of study, helped by some of the leading scholars of the day such as Alcuin.

The emergence of cathedral schools during the 11th century perpetuated the study of these disciplines, and by the 12th century distinct centres of learning had been established in northern Europe, notably around Paris and in Oxford. These centres developed into universities in the 13th century, where the Liberal Arts formed a complete faculty, along with the higher faculties of theology, canon law, and medicine. Arts students studied the *trivium*, parts of the *quadrivium*, and an increasingly large amount of Aristotle. Although the arts faculties were originally considered subservient to the higher faculties, they nevertheless came to dominate the universities, not only because they formed by far the largest group of students and teachers

in the university, but also because, as Cassiodorus had pointed out, a good grounding in the liberal arts was considered fundamental for further study in the higher faculties. Although the length of study varied between institutions it normally took a student about six years to become a Master of Arts and a further two or three years of teaching were normally required before embarking on further studies in, for example, the theology faculty, which could take another ten years. The terminology of Bachelors and Masters of Arts etc. has persisted in universities to this day.

The theoretical distinction between liberal and vulgar arts was maintained throughout the Middle Ages. S. Thomas Aquinas (d. 1274) states that while some arts are praiseworthy because they are useful for a particular end, others are more highly regarded and are honourable as they are useful in themselves. Painting and sculpture were not included among these honourable arts as they were regarded primarily as practical skills and artists found it difficult to shake off the associations with manual labour.

It was this low opinion of the status of the artist and the visual arts in general that led *Leonardo to put an alternative case for including painting and, to a lesser extent, sculpture among the liberal arts, in his *Trattato della pittura*. Leonardo emphasized the intellectual and rational basis for art, particularly with regard to arithmetic and geometry, which underpinned the artist's use of *perspective. Other artists, such as *Alberti, had also stressed the learned basis for the visual arts, but Leonardo was the most outspoken advocate for including painting and sculpture among the liberal arts, and he argued that they should be treated as equal to poetry and rhetoric (already regarded as liberal).

The arguments for elevating painting and sculpture were ultimately successful, and by the 16th century it was normal for both to be included in lists of the liberal arts, appearing for example, in such a list written by Castiglione in *The Book of the Courtier* bk. 1. In the 17th century, however, soon after the visual arts received recognition as liberal, they came to be seen as differing significantly from the likes of grammar, logic, astronomy, geometry, arithmetic, and rhetoric, in their aesthetic dimension, and thus a new term was coined, the 'fine arts' or *les beaux arts*, incorporating painting, sculpture, architecture, and poetry. Music, previously only studied as a theoretical art, was often included among this new group, which was thus also known as the 'five arts'. This new distinction clearly linked the term 'art' with the notion of beauty and *aesthetics, connotations that it had not previously had, and this meaning has survived to this day, often contrasted with the empirical enquiry associated with the sciences.

The liberal arts were frequently given visual representation from the Middle Ages onwards. They form part of the sculpture of the right bay of the Royal West Porch of Chartres Cathedral (1145–55), each art personified by its greatest exponent (for example rhetoric is represented by *Cicero, geometry by Pythagoras, logic by Aristotle, and so on). Other examples can be found in the 14th-century designs of *Giotto for the Campanile at Florence (1334–87) and the murals of *Andrea da Firenze in the Spanish chapel of S. Maria Novella in Florence. These representations were elaborated by later artists, and in *Pinturicchio's frescoes for the Appartamento Borgia (c.1490; Vatican) we find the seven enthroned arts surrounded by numerous followers. Such large-scale representations of the arts influenced many later painters including *Raphael in his frescoes for the Stanza della Segnatura (Vatican). TJH

LIBERALE DA VERONA (1445–1527×9). Italian illuminator and painter. He was one of the most remarkable and inventive artists of his day. Although he was born into an artists' family in Verona, much of his early career was spent in Siena. In 1467 he is recorded there among the artists working on the new choir books for the cathedral (Siena, Bib. Piccolomini) that are one of the most impressive sets of manuscripts ever to have been made. The leaves that Liberale illuminated are among the most spectacular, perhaps none more so than the famous image of the North Wind as a blue male nude with ballooning, billowing hair racing over a seaborne barque (before 1470: Cod. 20. 5, fo. 36v). His contact on this project with *Girolamo da Cremona was influential on both artists. He continued to work in Siena until 1476 when he returned to Verona where he established himself as one of the city's major painters. One work, of lasting influence and showing all his verve and inventiveness, was the designs for the woodcuts to illustrate an edition of *Aesop* (Verona, 1479). He is also known to have worked in Rovato (1481) and Venice (1487) painting frescoes and altarpieces. He returned to Verona and his large-scale works there included the *Adoration of the Magi* (Verona Cathedral). He was extremely influential upon other Veronese artists but, although he continued to receive numerous commissions throughout his final decades, his late works lack the consistent dynamism and invention that characterized his earlier output. KS

LIBRE ESTHÉTIQUE. See under VINGT, LES.

LICHTENSTEIN, ROY (1923–97). American painter. Lichtenstein was born in New York and trained from 1940–9 at Ohio State University, interrupted by military service (1943–6). His early work embraced *Cubist and geometrical and *Abstract Expressionist elements but in the early 1960s, teaching at Rutgers University, Lichtenstein painted his first comic strip works (see POP ART). Shown at the Leo Castelli Gallery in 1962, they were an instant success and Lichtenstein moved to New York in 1963 and ceased teaching in 1964. The comic strip paintings, of which *Whaam!* (1963; London, Tate) is an outstanding example, took popular commercial images, refined them, enlarged them, and imitated their method of reproduction by including the Ben Day dots with which newspaper images were printed. This technique emphasized the clichés of popular imagery whilst also endowing them with iconic status. Having elevated the comic to fine art Lichtenstein used the same technique to reduce high art to the level of a comic by adapting details from paintings by *Picasso and other masters and rendering both techniques and styles, as in *Purist Painting with Bottles* (1975; Wolverhampton, AG), in elegant and humorous pastiche. DER

Waldman, D., *Roy Lichtenstein* (1993).

LIEBERMANN, MAX (1847–1935). German painter and graphic artist whose importance to German art lay in his susceptibility to foreign influences. Although his work has more affinities with that of *Courbet, *Millet, and the *Barbizon School than that of *Manet and *Renoir, by 1878 he was regarded as Germany's leading *Impressionist painter. In 1899 he founded the Berlin *Sezession and became its president. However, he was increasingly alienated by developments in art, and a decade later his work was regarded as representative of the old-fashioned traditionalism against which *Nolde, Die *Brücke, and other German *Expressionists were in revolt. OPa

Stuttmann, F., *Max Liebermann* (1961).

LIÉDET, LOYSET (1420?–d. 1479). Franco-Flemish illuminator. Documents survive recording numerous commissions, predominantly for illustrating secular texts, for Philip the Good and Charles the Bold, dukes of Burgundy. His early career was spent in Hesdin where he was paid by Philip the Good for illuminating 55 'histoires' in Jean Mansel's *Histoires romaines abrégées* (1454–60; Paris, Bib. Arsenal, MSS 5087–8). His early work shows the influence of Simon *Marmion. By 1468 he had moved to Bruges where he appears to have led a productive workshop. He mainly illustrated romances, treatises, and courtly codices, such as the *Chroniques de Hainaut* (Brussels, Bib. Royale, 9244). Although he sometimes worked in grisaille his miniatures were usually highly coloured, peopled by long-limbed gawky figures, and surrounded by a simple gold frame. KC

LIEFERINXE, JOSSE (active *c*.1493–*c*.1505). Netherlandish painter, active in Provence. Known as the 'Picard painter', Lieferinxe is recorded in 1493 working on a *Madonna of Mercy* for the Hôpital S. Lazare in Marseilles, the first of a series of documented altarpieces commissioned from him (mostly lost) by various patrons in Marseilles and Aix-en-Provence. He was then working for the painter Philippon Mauroux, but he became independent shortly afterwards, entering into partnership by 1497 with Bernardino Simondi, who a year later bequeathed Lieferinxe his sketchbook of drawings. Seven panels illustrating scenes from the life of S. Sebastian (one in Philadelphia Mus.) have been identified as coming from an altarpiece commissioned from this partnership before Simondi's death, though completed by Lieferinxe afterwards. Their style suggests a training in the Northern Netherlands and exposure to a range of southern French influences. Knowledge of works by *Mantegna at Padua also seems likely. The same mixture of elements, though achieved with greater poise, is evident in fragments of a life of the Virgin (one Paris, Louvre) which have been attributed to Lieferinxe *c*.1500. TT

Laclotte, M., and Thiébaut, D., *L'École d'Avignon* (1983).

LIEVENS, JAN (1607–74). Talented and precocious Dutch history painter, whose early career ran in parallel with that of his more famous contemporary *Rembrandt. Like Rembrandt Lievens was born in Leiden and studied in Amsterdam with Pieter *Lastman. Back in Leiden he shared a studio and closely collaborated with Rembrandt (*c*.1625–31); their works at this time can be so close that it is difficult to distinguish between them. Lievens is later thought to have travelled widely, visiting England (*c*.1632–4) and Antwerp (*c*.1635–43). His later works move away from the precision of his earlier pictures towards a broader manner, in part inspired by contact with the paintings of *Rubens and van *Dyck which he had seen at the court in London. From the mid-1640s Lievens was back in the Netherlands, working in Amsterdam and The Hague. In 1661 he was commissioned to contribute to the decoration of the new town hall in Amsterdam. Lievens made a number of etchings and woodcuts. CB

Schneider, H., *Jan Lievens, sein Leben und seine Werken*, rev. R. E. O. Ekkart (2nd edn., 1973).

LIFE MASKS. See DEATH MASKS AND LIFE MASKS.

LIGORIO, PIRRO (*c*.1513–83). Italian architect, painter, and antiquarian born in Naples. He was an encyclopedic antiquarian (and some suspect occasional forger), who drew heavily on medallic and archaeological material for his reconstructions, as illustrated in his surviving manuscripts, for instance *Delle antichità di Roma* (1553) and a map of ancient Rome (1561). In his most important architectural projects, the Villa d'Este (*c*.1560) at Tivoli for Cardinal Ippolito d'Este and Pius IV's Casino in the Vatican Gardens (*c*.1558), he employed the whole repertoire of Antique sources. In 1565 he was dismissed from his post at S. Peter's for having altered Michelangelo's designs, and moved to Ferrara, where he died. HO/AB

Gaston, R. W. (ed.), *Pirro Ligorio, Artist and Antiquarian* (1988).

Mandowsky, E., and Mitchell, C., *Pirro Ligorio's 'Roman Antiquities'* (1963).

LIMBURG (or Limbourg), DE (active *c*.1400–16). Three Netherlandish illuminators, brothers from Nijmegen, active in France. The extent of their activity is unclear, though there is evidence to suggest it included painting and metalwork. Part of their training may have taken place in Paris and Dijon, where their uncle *Malouel was court painter. They are best known for two manuscripts illuminated for the Duke of Berry: the *Belles Heures* (*c*.1405–8; New York, Met. Mus.); and the celebrated *Très Riches Heures* (*c*.1408–16?; Chantilly, Mus. Condé), which, though incomplete at the time that the brothers died (of the plague in 1416), was always highly valued, holding a fascination for later artists until the mid-16th century. Two of the brothers, **Pol** and **Jean**, also began a *Bible moralisée* (1402–4; Paris, Bib. Nat.), probably modelled on a mid-14th-century manuscript, for Philip the Bold, Duke of Burgundy. Work on this ended at the Duke's death, and the brothers seem to have entered Berry's service soon afterwards. They created an unprecedented relationship with their patron, exchanging gifts of precious stones, all three becoming wealthy and receiving the title *valet de chambre*. Pol seems to have gained particular admiration from Berry, receiving a house in Bourges said to be appropriate for residence by a member of the royal family.

The Limburgs broke the mould of earlier French illumination, built on the elegant, fussy principles of *Pucelle, and introduced into their miniatures monumental qualities drawn from large-scale painting and even sculpture. Their breaking of conventions is already apparent in the *Bible moralisée*, which far from following its model introduces such devices as illusionistic frames, *landscape settings, and *aerial perspective. In the books of hours the creative personalities of the brothers become increasingly distinctive: one brother (Pol?) was interested in portraiture (both people and buildings) and other visual aspects of courtly life, such as spectacular costumes; another (Jean?), employing Italian sources and an understanding of the sculpture of *Sluter, specialized in creating scenes involving a developed sense of pictorial space, often emphasizing the less fortunate in society; the third (**Herman?**) drew on the innovations of his brothers, compensating for lack of originality by including superfluous figures.

The Limburgs' most admired miniatures have always been the calendar scenes in the *Très Riches Heures*, among the most striking of later medieval images, breaking traditional iconographic and devotional conventions, and replacing them with a complete view of the world and its seasons, which inspired subsequent generations of artists. TT

Cazelles, R., and Rathofer, J., *Illuminations of Heaven and Hell* (1988).

Meiss, M., *The Limbourgs and their Contemporaries* (1972).

LIMEWOOD or linden wood (Latin *tilia*), was the most common wood used between the 16th and 18th centuries for sculpture in southern Germany, predominantly between the Rhine and Main rivers in Franconia, and during the 18th century in southern Germany. Lime trees are a hardwood tree, and limewood's particular structural character lends itself well to carving, allowing tools to be used both along the grain and to some extent axially. Despite its relative cost, it was considered suitable for the drier climate of the south. During the late 15th and early 16th centuries limewood was the preferred material for the genre of the winged altarpiece, and some of the most important examples of limewood sculpture are in this category. Veit *Stoss's high altarpiece for S. Mary's, Cracow (1477–89), typifies the most magnificent of these, with its central panel of figures in the round, flanked by relief scenes on the wings, all its surfaces flickering with rich *polychromy and *gilding.

German limewood sculpture was usually polychromed; even the supposedly monochrome sculptures of *Riemenschneider, such as the altarpiece of the *Last Supper* (1499–1505; Rothenburg, Jakobskirche), had tinted glazes applied to their surface. Limewood may split with age and with the irregular expansion from moisture within the cells of the wood, and as a means of avoiding great distortions the heartwood is removed from the log, since it shrinks at a different rate from the outer sapwood, and the reverse of a sculpture is hollowed out.

In the 18th century Ignaz *Günther and Johann Baptist Straub's (1704–84) exuberant limewood carvings, sometimes only painted white and gilded, represented the distinctly German *Baroque development of this sculptural style. AB

Baxandall, M., *The Limewood Sculptors of Renaissance Germany* (2nd edn., 1990).

LIMNER, an English corruption of an 'illuminator' of manuscripts. From the 16th century the term was used for painters of miniature portraits, who combined the technique and approach of the Flemish manuscript illuminator with that of the portrait painter in oils in the style of *Holbein. The limner was never solely a miniaturist, but worked in other formats and media too. The miniature portraits of members of the royal family set in ivory boxes painted by Lucas *Horenbout, a contemporary of Holbein at the court of Henry VIII, were the first of their kind. In France, Jean *Clouet is known to have produced similar objects. According to Karel van *Mander it was Horenbout who taught Holbein the art that was to occupy an important role in Britain for nearly a century. In the hands of Nicholas *Hilliard, author of the practical treatise *The Arte of Limning* (c.1598–1603), and Isaac *Oliver limning became a popular genre first in court circles and later to a wider audience. The subject matter of miniatures was extended greatly in the 18th century. The term became obsolete in the 19th century. MFC

LINDNER, RICHARD (1901–78). German-born painter who became an American citizen in 1948. He was born in Hamburg, into a bourgeois Jewish family, and grew up in Nuremberg, where he studied piano at the Conservatory. He then moved to Munich, where he studied at the Academy and became art director of a publishing firm. In 1933 he fled Germany because of the rise of Nazism (he left the day after Hitler became Chancellor) and settled in Paris, then moved to New York in 1941. At first he worked very successfully as an illustrator for magazines such as *Harper's Bazaar* and *Vogue* and he did not begin to paint seriously until the early 1950s. He had his first one-man exhibition at the Betty Parsons gallery, New York, in 1954. His most characteristic works take their imagery from New York life, often with overtly erotic symbolism, and are painted with harsh colours and hard outlines. The effects he created owed something to *Expressionist exaggeration, *Surrealist fantasy, and *Cubist manipulations of form, but his style is vivid and distinctive and anticipates aspects of *Pop art. Some of his later work does in fact use the kind of garish poster-like imagery favoured by many Pop artists (*Rock-Rock,* 1967; Dallas, Mus. of Art). IC

LINDSAY, ALEXANDER WILLIAM, 25TH EARL OF CRAWFORD (1812–80). Art historical writer, picture collector, and bibliophile. His *Sketches of the History of Christian Art* (1847) was the first serious survey of early Italian painting and sculpture in English. He was inspired by *Rio's *De la poésie chrétienne* (1836) which he read while travelling from Rome to Assisi; the book belonged to the French sculptress, Félicie de Fauveau, who also played a crucial part in introducing Lindsay to the École Mystique, especially the Benozzo *Gozzoli frescoes in San Gimignano. Like Rio, Lindsay brought a strong moral and philosophical bias to his study of art; but he also took a scholarly interest in medieval *iconography, symbolism, and legends of the saints which distinguished his book from the French writer's more subjective sentimental approach. Lindsay anticipates Mrs *Jameson in his recognition that medieval religious art was a reflection of the legendary literature of previous ages. He was well acquainted with popular Romance literature of the Middle Ages and recognized the origin of some Christian beliefs in ancient pre-Christian Eastern cultures. He relied especially on the *Catalogus sanctorum* of Petrus de Natalibus, a Venetian compilation of the lives of the saints, originating from the late 14th century and published in 1493, which he carried around with him on his travels. Lindsay showed particular art historical insight in his appreciation of the seminal importance of *Byzantine art in the revival of Christian art in the West; whereas Rio's sectarian bias against the schismatic Byzantium blinded him in this respect. However Lindsay shared with his mentor empathy with the pure religious spirit of 14th and 15th century artists, including N. *Pisano, *Giotto, *Duccio, *Orcagna, and Fra *Angelico, although as a Protestant, anxious to disassociate himself from the Puseyites and the Oxford movement, he could not follow their Catholic faith, nor as a critic could he bring himself to overlook, entirely, their technical limitations. Equally he was unwilling to renounce all classical art because it was pagan. To resolve this internal conflict he devised a determinist historical and philosophical system, published as *Progression by Antagonism* (1846), by which man advances toward the truth by a dialectical process, involving sense, intellect, and spirit. The architecture of Egypt expresses 'the ideal of Sense or matter'; the Sculpture of Greece is 'the voice of Intellect and Thought, communing with itself in solitude, feeding on beauty and yearning after Truth', while 'the Painting of Christendom (and we must remember that the glories of Christendom in the full extent of the term are yet to come)— is that of an immortal Spirit, conversing with its God'. Lindsay's thesis was clearly inspired, directly and indirectly, by earlier German writers, including Schiller, Friedrich Wilhelm von Schelling, A. W. Schlegel, and his brother Friedrich von *Schlegel, who all saw the artist as a prophet and art as truth revealed through the unconscious medium of the artist. Lindsay went on to express his hope for a second regeneration of Christian art in England—he had been deeply impressed by the work of the German *Nazarenes in Munich, especially Hieronymus Hess—and pointedly dedicated the *Sketches* to his cousin Coutts, an independent artist and the founder of the Grosvenor Gallery, London, with whom he had travelled extensively in Italy in 1841–2. HB

Brigstocke, H., 'Lord Lindsay and the Sketches of the History of Christian Art', *Bulletin of the John Rylands University Library Manchester*, 64/1 (autumn 1981).

Lightbown, R. W., 'The Inspiration of Christian Art', in S. Macready and F. H. Thompson (eds.), *Influences on Victorian Art and Architecture* (1985).

LINE ENGRAVING, the art of incising lines into a metal plate, usually copper, by the use of a burin. It is an intaglio process, the lines engraved into the plate being inked and printed under high pressure in a roller press. Unlike *etching it is a highly formalized technique, requiring a notoriously long and arduous training, and *Hogarth stated ruefully that excellence was 'scarcely ever attaind but by men of a quiet turn of mind'.

The engraver works in an ambidextrous manner, holding the burin in the palm of the right hand while the plate, resting on a leather pad, is controlled by his left hand. The reflections of bright light on the glistening copper are diminished by the use of a screen. The burin is pressed down and into the metal, throwing up a sliver of copper ahead of the incised line which is later cleared away by a burnishing tool. By manipulating the plate with his left hand in harmony with the motions of the burin, the engraver can facilitate the direction of the lines, as well as steadying the plate.

Engraving is fundamentally a linear method, but the engraver can obtain modulations of tone and contrast by the use of elaborate cross-hatching, and by a variety of short flicks and dashes. He can also augment or partially construct the work by the use of etching, a practice that was common in the 18th century.

Engraving is often described as a slow and laborious process, and its practitioners as drudges, but this is misleading. Many great engravers worked at great speed and with dazzling panache, their burins slicing through the copper with swelling and diminishing lines, culminating in the sharp pointed end to the line characteristic of the technique. It is the province of the virtuoso, delighting in display, as well as the servant of the dogged craftsman. Its commercial potential has always been enormous, since deeply engraved lines will allow large numbers of prints to be produced.

Engraving was developed in the first half of the 15th century, where its roots in Germany and Italy are to be found in the workshops of goldsmiths and other craftsmen in metal. On the upper Rhine both the *Master

of the Playing Cards and the *Master E. S. were also goldsmiths, and in Nuremberg *Dürer was the son of a goldsmith. Martin *Schongauer was the first great German engraver, and gave the art great impetus. In Italy the art also had its roots in the work of goldsmiths, and with the decorative metalwork of *niello artists. Florentine engraving was intially characterized by a fine linear manner, and later expanded by the development of the so-called 'broad manner' which used broad lines of parallel shading. The greatest achievements in early Italian printmaking were *Pollaiuolo's only plate, the great *Battle of the Ten Nudes*, executed with virile contours supplemented by delicate modelling with parallel lines. The figures are arranged as a sculptural frieze of violent poses, and the plate serves almost as a treatise on anatomy. The only other great Italian artist to essay the technique was *Mantegna, whose few large plates of religious and pagan subjects are perhaps the greatest of all Italian prints.

In the High *Renaissance the art flowered, and did much to circulate imagery between different countries. The great engravers of the north, Dürer and *Lucas van Leyden, raised the art to new levels, and were celebrated and imitated in Italy. Marcantonio *Raimondi was the pre-eminent Italian engraver of the High Renaissance. He engraved his own designs, but is best known for his engraved copies, particularly from works by *Raphael, and this reproductive role underpins much of the subsequent history of engraving.

At the end of the 16th century a school of *Mannerist engravers in Haarlem, inspired by *Goltzius, developed techniques of great and conspicuous virtuosity, making use of swelling lines and optically dazzling patterns of burin work. Thenceforward etching became the preferred technique of painters, and, with the exception of portrait engravers such as Robert *Nanteuil in France, most engravers worked after the drawings and paintings of others. *Rubens employed a whole school of engravers to produce hundreds of carefully supervised prints from his designs. Many plates passed from one generation of print publishers to another, and continued to yield impressions for many decades.

In the 18th century the reproductive role of engraving became even more pronounced, and the supposedly secondary status of engravers was marked by their exclusion from the ranks of the Royal Academy (see under LONDON). Many engravers in France and Britain, the major homes of engraving, began to use etching for the preliminary stages of their work, imparting a greater freedom of technique. Many engravers at this time complained of the rivalry of easier techniques, such as *mezzotint and *stipple engraving,

and argued for the moral superiority of their more demanding technique. William *Blake's engravings at the end of his career are the apotheosis of engraving as a creative linear technique.

After 1815 engraving was revolutionized by the development of the steel plate, which yielded many more impressions than copper, and allowed the engraver to place lines even closer together. *Turner supervised the production of hundreds of densely worked plates from his work, and throughout the 19th century engravers produced increasingly detailed prints which could be printed in their thousands, and find their way into even modest households. The works of such painters as *Landseer thus became familiar to a vast and international audience. The work of publishers and dealers in regulating this huge trade was important, and much expanded by Ernest Gambart who acted for Holman *Hunt amongst others, obtaining huge sums for the painters by the sale of the copyright of their pictures. Yet comparatively few prints from these vast editions survive in good condition, since machine-made 19th-century paper was usually very poor. By the end of the century however, engraving had been ousted by *photography, and in the 20th century it was practised mainly in a revivalist mode, although a few artists, such as Stanley William Hayter, engraved in a free and innovatory manner. RGo

Hind, A., *A Short History of Engraving and Etching* (3rd edn., 1923).

LINOCUT, a relief method of printmaking, identical in principle to *woodcut, but using the softer and more pliable material of linoleum. Woodcutting tools are used to gouge out lines and areas, but the smoothness of the surface also allows the incision of lines with the fineness of wood engraving. The technique is particularly suited to *colour printing by the use of superimposed blocks.

The simplicity and cheapness of this ordinary household material has often recommended it to painters, as well as for use in schools. In the 1950s in England it was used to good effect by Claude Flight (1881–1955) and his school in prints of a midly *Futurist nature. Its greatest exponents were *Matisse and *Picasso, the former achieving grand but simple effects of white line, while Picasso cut large and flamboyant prints, often using brown or vivid combinations of colour. DER

LINSEED OIL. See MEDIUM.

LIOTARD, JEAN-ÉTIENNE (1702–89). Swiss pastel painter. He spent his early career in Paris, where pastel portraits had been made fashionable by Rosalba *Carriera.

From 1736 he embarked on a long period of travel that took him to Constantinople, as well as to Rome, Vienna, London, and Holland. His eccentric manner and long beard acquired in Turkey made him a curiosity in Europe, but his virtuoso talents meant he was much in demand. Although his portraits have none of the verve of characterization and execution of his contemporary Maurice-Quentin de *La Tour, his genre subjects are outstanding. Among them are *Woman in Turkish Costume with her Servant* (1742–3; Geneva, Mus. d'Art et d'Histoire) and his masterpiece of illusionism, *Maid Carrying Chocolate* (before 1745; Dresden, Gemäldegal.). MJ

Fosca, F., *Liotard* (1956).
Loche, R., and Roethlisberger, M., *L'opera completa di Liotard* (1978).

LIPCHITZ, JACQUES (1891–1973). Russian-born sculptor of the *École de Paris. He came to Paris in 1909 and trained at the École des Beaux-Arts and the Académie Julian. His early work is well characterized by the naturalistic, classical figure *Pregnant Woman* (1912; London, Tate). His increasing acquaintance with the Parisian *avant-garde in these years eventually led him to *Cubism in 1915; *Sculpture* (1915; London, Tate) is typical of the totemic and architectonic abstraction of his Cubist work. He met Juan *Gris in 1916 and, possibly in response, his subjects became clearer, the forms less austere, as in *Seated Man with Clarinet* (1919–20; Paris, Mus. National d'Art Moderne). From the mid-1920s Lipchitz became increasingly interested in problems of space and transparency, his sculpture becoming linear, pictorial 'drawings in space': *Acrobat on a Horse* (1927; priv. coll.). His work in the 1930s drew increasingly on mythological and sexual themes, influenced by the prevailing mood created by *Surrealism, his forms retaining the simplifications of Cubism, but with a lyrical, organic tone. In 1940 he emigrated to New York, returning briefly to France in 1946–7. MF

Hammacher, A. M., *Jacques Lipchitz* (1960).

LIPPI, FILIPPINO (c.1457–1504). Florentine painter and draughtsman, highly regarded in his own day. Initially trained by his father Filippo *Lippi, from c.1472 he was apprenticed to *Botticelli, whose influence is apparent in the elegant figures and ethereal atmosphere of early works such as the *Virgin and Child with S. John* and *Adoration of the Kings* (both London, NG). These are enriched by Filippino's characterisically detailed landscapes and varied human activity, features which he developed in a number of *cassone panels, and which might owe something to the presence in Florence of the Portinari altarpiece by Hugo van der *Goes.

Other devotional paintings, such as the *Vision of S. Bernard* (Florence, Badia) and *Virgin

and Child with SS Jerome and Dominic (London, NG), both c.1485–7, add to their poetic lyricism an increasing solidity and concern for anatomical detail, as in S. Jerome's musculature in the London picture. This culminated in late works which are even more volumetric and monumental (the Marriage of S. Catherine, 1501; Bologna, S. Domenico).

Filippino received important commissions for frescoes in Rome (Caraffa chapel, S. Maria sopra Minerva) and Florence (Strozzi chapel, S. Maria Novella). These are distinguished by dramatic, sometimes exaggerated, effects and dynamic relationships between figures and architecture. The Raising of Drusiana (1502; Strozzi chapel) also demonstrates this, as well as the use of ornate classicizing detail. The breadth and energy of the fresco compositions may be due to Filippino's speed of execution, suggested by the size of the giornate. His technical skill and vigour is evident in many brilliant sketches and studies, for instance S. Martin and the Beggar (1494; Florence, Uffizi), and this may have prompted Lorenzo de' Medici to describe him as 'superior to *Apelles'. MS

Berti, L., and Baldini, U., Filippino Lippi (1957).
Sale, R., Filippino Lippi's Strozzi Chapel in Santa Maria Novella (1979).

LIPPI, FRA FILIPPO (c.1406–69). Florentine painter and father of Filippino *Lippi. He was a Carmelite monk, although not entirely suited to this calling, judging by his frequent court appearances and his abduction of Lucrezia Buti, a novice from the Augustinian convent in Prato. His early works naturally owe much to *Masaccio, who was working at Florence in the Brancacci chapel of the Carmine when Filippo resided there. His own fresco of the Reform of the Carmelite Rule (c.1432) for the cloister displays similar spatial and architectural clarity and monumental figure style, although less severe in spirit than Masaccio's. This realism was reinforced by the influence of Florentine sculptors. The Annunciation (1430s; Florence, S. Lorenzo) combines single-point *perspective, creating depth and symmetry, with expressive and vital figures similar to those in *Donatello's Annunciation tabernacle in S. Croce.

After c.1440 Fra *Angelico's influence is apparent in Filippo's use of brilliant colours and elongated figures. His increasing preoccupation with the decorative effects of line, fluttering, transparent draperies, textures, and incidental detail can be seen in the lunette of the Annunciation (1450s; London, NG) or the Adoration of the Christ Child (1453; Florence, Uffizi), both featuring idyllic landscape settings. His characteristic expressiveness and appealing figure style is particularly effective in his half-length Madonnas, for instance his Uffizi Madonna and Child, from the 1460s.

Frescoes in the cathedrals of Spoleto and Prato (1450s and 1460s), largely painted a secco (see WALL PAINTING), are distinguished not only by stunning linear design and spatial settings, but also by meticulous detail usually reserved for panel paintings. Filippo's distinctive, linear and decorative manner may have influenced *Botticelli. MS

Ruda, J., Fra Filippo Lippi (1993).

LIPPO VANNI (active 1344–73). Vanni was a highly successful Sienese painter in the period after the Black Death, first to be cited in the 1356 list of Sienese painters. He was a member of the Consiglio Maggiore of the city in 1363 and 1370, offices which probably related to the commission for the fresco of the Battle of Val di Chiana (Siena, Palazzo Pubblico, signed, probably datable 1373–4). The Battle is notable for its grisaille technique and vivid narrative detail. His early work includes numerous manuscript illuminations such as the *choir books of the Spedale della Scala (1344–5; Siena, Museo dell'Opera del Duomo). The strong reflections of the figure style, thoughtful compositions, and spatial clarity of the *Lorenzetti, evident in his frescoed altarpiece (Siena, S. Francesco, ex-Martinozzi chapel) and the chancel frescoes of S. Leonardo al Lago, distinguish Lippo Vanni's art from much other Sienese painting of the period. RG

Chelazzi Dini, G. (ed.), Il gotico a Siena (1979).
van Os, H., Sienese Altarpieces, vol. 2 (1990).

LISS, JOHANN (c.1597–1631). German painter, active mainly in Venice and Rome. He was born in Holstein and for some years he worked in the Netherlands. According to *Sandrart, who knew him, and who described his frenzied working methods, he was in Amsterdam and worked in the manner of *Goltzius (J. von Sandrart, Academie der Bau-, Bild- und Mahlerey-Kunst, 1675). After passing through Paris he was in Venice by 1621, and then moved to Rome. He was back in Venice by 1628 when he probably painted his only official commission The Inspiration of S. Jerome (Venice, S. Nicolò di Tolentino), a strongly painterly work that was notably advanced for the time and place. He died of the plague in Verona.

Sandrart acknowledged Liss's debt to *Fetti in Venice, and many other influences can be seen in his few works, including those of the *Caravaggisti and *Rubens. He was, however, amongst the most original and poetic painters of his time, as in the Fall of Phaeton (London, Denis Mahon Coll.), and he painted with consummate technical assurance. AJL

Gregori, M., and Schleier, E. (eds.), La pittura in Italia: il seicento (1988).

LISSITZKY, EL(IEZER MARKOWICH) (1890–1941). Russian abstract painter, designer, graphic artist, teacher, and theorist, and among the most influential Russian artists in the West. *Chagall appointed him professor of architecture and graphic art at Vitebsk (1919), where *Malevich encouraged him to work abstractly. His earliest and perhaps most important *abstract paintings were Prouns (1919–24), for instance Proun 12E (Cambridge, Mass. Busch-Reisinger Mus.), an uncompromisingly geometric series which he considered halfway between painting and architecture. More obviously related to the spirit of the new Russia was his famous abstract propaganda poster Beat the Whites with the Red Wedge (1919–20; Eindhoven, Stedelijk van Abbemus.). Lissitzky taught briefly in Moscow and came under *Constructivist influence. He left Russia in 1921, for political reasons, and lived in *Berlin where, besides helping to arrange the first major exhibition of Russian abstract art in the West (1921), his Constructivist writings influenced the *Bauhaus, and groups like De *Stijl and *Dada. Whilst in Germany, he pioneered modern typography with The Story of Two Squares (1922), an interest he pursued after his return to Russia in 1925 when he also developed photomontage. YJ

Lissitzky-Küppers, S. H., El Lissitzy: Life, Letters and Texts (1980).

LITHOGRAPHY, a technique of surface printing from stone or prepared plate. In its simplest form the design is freely drawn with greasy crayon or ink on the smooth surface of a slab of special limestone, called the lithographic stone. The technique is based on the fundamental antipathy of grease and water. The artist draws directly on the stone which is then prepared by the printer with chemical material that will fix the design to the stone. Water is applied, and is repelled by the greasy lines, but absorbed by the untouched areas of the stone. A roller is used to apply ink to the surface, which adheres to the drawn lines, but is repelled by the rest of the damp surface. A sheet of paper is placed on the stone, which is then passed through the lithographic press, thus transferring the design, in reverse, to the sheet of paper. In principle very large numbers may be printed of similar quality.

The technique was invented in 1798 by Aloys Senefelder (1771–1834; see CRAYON), a Bavarian playwright experimenting with methods of duplicating his plays. He took out patents for his invention in various countries, but the technique was first seriously applied for artistic purpose in England, with the publication by Phillip André in 1803 of Specimens of Polyautography containing pen lithographs by Benjamin *West, James *Barry, and other British artists. These were reissued in 1806–7 by G. J. Vollweiler with additional prints, and it appears that he was also courting the potentially lucrative amateur market. However, the technique

failed to make much headway until the close of the Napoleonic Wars, and the establishment of a lithographic press in London by the great printer Charles Hullmandel (1789–1850). In 1824 he published his treatise *The Art of Drawing on Stone*, and in 1821 he published the superb lithographs of *Various Subjects Drawn from Life on Stone* by Theodore *Géricault, and in 1824 James *Ward's Romantic *Celebrated Horses*.

In Britain lithography developed primarily as a medium for topography, and many sets of picturesque views were published, although the most ambitious project was published in France: Baron Taylor's nineteen volumes of *Voyages pittoresques et romantiques dans l'ancienne France* (1820–78). Whereas in England lithography was harnessed to the watercolour tradition, in France it was more closely related to the richer tones of oil painting, and painters such as *Isabey and *Delacroix were also very important lithographers, but the most productive and vigorous of lithographers was the caricaturist Honoré *Daumier. In the country of its invention, Germany, a number of important lithographs were made by *Romantic artists such as Ferdinand Olivier (1785–1841) and K. F. Schinkel (1781–1841), who employed a more precise linear manner than English or French artists. However, perhaps the most brilliant and virtuoso of all early lithographs are the *Bulls of Bordeaux* by *Goya, a set of four large prints issued in Bordeaux in 1825, which have a freedom of execution only rivalled in later years by *Manet.

Colour printing was a logical progression for the medium, and great stimulus was provided by a set of colour lithographs by Thomas Shotter *Boys, the *Picturesque Architecture in Paris, Ghent, Antwerp, etc.* (1839), in which he used four or five separate stones to print his carefully blended colour harmonies. Colour printing had enormous commercial potential through the development of chromolithography, and a large part of the history of lithography is in its commercial application, often bright and garish, to *posters and advertisements.

The greatest triumphs of lithography in the second part of the 19th century are mainly French. *Manet and *Degas were both brilliant and experimental lithographers, while a curious, dense linear manner was practised by *Bresdin. The most productive and influential French lithographer was *Toulouse-Lautrec, whose posters and freely drawn lithographs reflected the influence of Japanese prints, embraced the possibilities of the medium with joyous abandon, and greatly influenced succeeding generations of artists and designers. At this period *Bonnard and *Vuillard used colour lithography to great effect, contrasting highly textured areas on a fabric or wall with bold flat areas, while

*Redon used the inherent richness of the medium to conjure up mysterious and Romantic subjects. In England the most engaging lithographer was *Whistler, who used delicate lines and tints in his *Nocturnes* of the Thames.

In the 20th century a close collaboration between artists and master printers was a notable feature, particularly in Paris, where *Picasso's printers at the atelier of Fernand Mourlot recounted with awe the artist's unprecedented assaults on the stones prepared for him. Every print was almost a reinvention of the art. He frequently made numerous changes as he progressed, preserved in the succeeding states of the print. The great *Two Nude Women* (1945–6) goes through no fewer than sixteen states, forming a veritable commentary on the tradition of the female nude in art. In more recent times much vital work has been done in advanced workshops in America, notably the fluent and innovative work of Jasper *Johns with its piquant combinations of seemingly improvised lines, tones, and figurative references, and, in more traditional mode, the large figure subjects of *Hockney. RGo

Man, F. H., *Artists' Lithographs: A World History from Senefelder to the Present Day.* (1970).

LITTLE MASTERS. The English term is a misleading translation of the German *Kleinmeister* mentioned by Joachim von *Sandrart in 1679. It refers to various northern European artists who produced small-scale works, almost always engravings, during the first half of the 16th century. Usually the term is applied to Hans Sebald *Beham, his brother Barthel *Beham, and Georg *Pencz, known also as the Nuremberg Little Masters or the 'three godless painters' as they were all evicted from Nuremberg in 1525 for their radical involvement during the Peasants' Revolt. All were influenced by their contemporary, *Dürer. Others may be included such as Master I.B., Jakob Binck, and Heinrich *Aldegrever or Allaert Claesz. and Dirck Vellert from the Netherlands. The size of these delicately detailed prints may vary from that of a postage stamp to a postcard. They show a wide range of biblical and mythological subjects but are especially interesting for a new development towards secular themes. Their popularity grew and anticipated the late 16th-century demand for miniature objects and the enthusiasm for the *Kunstkammer. CFW

Goddard, S. H., *The World in Miniature: Engravings by the German Little Masters*, exhib. cat. 1988 (Lawrence, Kan., Lawrence University).

LOCHNER, STEFAN (active 1440?–51). German painter born at Meersburg on Lake Constance who worked in Cologne from 1442 till his death. The paintings that have been

associated with his name make up the major work of the Cologne School, although the basis for this association between the documented artist and the surviving body of work has been questioned.

The central paintings of the group are two altarpieces, the *Dombild* or triptych of the *Patron Saints of Cologne*, originally painted for the town hall of that city (Cologne Cathedral), and the *Last Judgement* (Cologne, Wallraf-Richartz-Mus.). The decorative qualities of these works—the punched gold backgrounds and rich, glowing colours, the sweet elegance of the figures, and the naturalistic treatment of plants and brocades—show the influence of earlier Cologne painting and the Westphalian *Conrad von Soest. Other works that can be associated with the *Dombild* can be dated to 1453 and 1454 while Lochner died in 1451. AM

Wolfson, M. 'Hat Dürer das Dombild gesehen? Ein Beitrag zur Lochner Forschung', *Zeitschrift für Kunstgeschichte*, 49 (1986).

LOMAZZO, GIOVAN PAOLO (1538–1600). Italian painter, poet, and art theorist, whose writings remain a major source for the art life of Milan in the later 16th century. He was a voracious intellectual; his eccentric personality is conveyed by his *Self-Portrait* (1568; Milan, Brera) where he presents himself as the abbot of an academy devoted to Bacchus, crowned with laurel, ivy, and vine, and a Bacchic thyrsus against his shoulder. After travelling widely he established himself in Milan, where he frescoed the Foppa chapel in S. Marco (c.1570), but this promising career was cut short by his blindness (1571). He then concentrated on art theory, and his two major works were *Trattato dell'arte de la pittura* (1584) and *Idea del tempio della pittura* (1590). The *Trattato* is a compendium of *Mannerist theory, most interesting for the emphasis it places on light and on psychological expression, where he revived themes explored by *Leonardo. Lomazzo was drawn to *Neoplatonism, and the *Idea* makes use of a complicated system of astrological symbolism and the symbolism of numbers. HL

Lomazzo, G. P., *Scritti sulle arti*, ed. R. Ciardi (1973–4).

LOMBARD, LAMBERT (1505–66). Flemish painter, draughtsman, engraver, architect, and humanist. Apprenticed in Antwerp to Jan or Arnold de Beer, although he seems mainly to have been influenced by the Romanists Jan *Gossaert and Jan van *Scorel. By 1532 he is mentioned as court painter to Erard de la Marck, Prince-Bishop of Liège. In 1537 Lombard made a visit to Italy in the retinue of Cardinal Reginald Pole where he

studied *Antique sculpture and contemporary *Renaissance works, meeting Francesco *Salviati and Baccio *Bandinelli. Returning to Liège in 1538/9, he founded the earliest known *academy in the Netherlands and his studio attracted many pupils and followers including Frans *Floris, Hubert Goltzius, and Willem *Key. Another follower, Domenicus Lampsonius, wrote a biography, published in 1565, in which Lombard's admiration for Antiquity and contemporary Italian artists is described. Despite a high reputation in his own time, most of Lombard's paintings have disappeared. Nearly 500 drawings survive. They include drapery studies, sketches of Roman and medieval sculpture, and drawings inspired by French, German, and Italian engravings of the 15th and 16th centuries.

CFW

Hand, J. O., et al., *The Age of Brueghel*, exhib. cat. 1987 (Washington, NG).

LOMBARDO FAMILY. Three of this family of Italian sculptors and architects, **Pietro** (c.1435–1515) and his sons **Tullio** (c.1455–1532) and **Antonio** (c.1458–1516), were the leading Venetian sculptors of their day. Pietro probably spent time in Florence, and his knowledge of Florentine tomb sculpture is reflected in his tomb of Doge Pietro Mocenigo (1476–81; Venice, SS Giovanni e Paolo), executed in collaboration with his sons. Its largely secular *iconography reflects a shift in dogal imagery. The tomb's success led to Pietro's design for S. Maria dei Miracoli, Venice (1481–9), whose decoration has been compared to a 'jewel casket'.

Tullio's marble-carving skills were employed in a drily classical relief style, which in the *Coronation of the Virgin* (1500–1502; Venice, S. Giovanni Crisostomo) threatens to deaden the novelty of his composition. His equally severe reliefs in the chapel of S. Antonio in the Santo in Padua (1501–25) accompany a single one by his brother Antonio; the latter's shows a more humane classicism. In Tullio's tomb for Doge Andrea Vendramin (1490s; Venice, SS Giovanni e Paolo) the complexity of earlier multi-tiered tombs is rationalized into a triumphal arch with bier, attendant warriors, and virtues. The *Adam* (New York, Met. Mus.) from the monument is a superb *all'antica* figure.

Antonio was active both as a bronze and marble sculptor, for instance in the Zen chapel (1503–6; Venice, S. Mark's), and on exquisite marble reliefs for Alfonso I d'Este's Camerino d'Albastro in Ferrara (1506–16; St Petersburg, Hermitage).

Antonio's sons Aurelio (1501–63), Girolamo (c.1505/10–c.1584/9), and Ludovico (c.1507/8–c.1575) were also bronze casters and marble sculptors active mainly in Loreto, Recanati, and Rome, and were responsible for establishing a flourishing bronze-*casting tradition in the Marches.

HO/AB

Hope, C., and Martineau, J. (eds.), *The Genius of Venice 1500–1600*, exhib. cat. 1983 (London, RA).

LONDON: PATRONAGE AND COLLECTING (1) *From Tudor times to the 19th century;* (2) *The 20th century*

1. FROM TUDOR TIMES TO THE 19TH CENTURY

Positioned on the Thames where it was possible to establish a major port and to bridge the river, London has been the place where central authority over Britain was exercised since Roman times, but it was not until the 17th century that London reached international eminence in the field of art. Unlike many Italian cities, London's artistic life was not due to the patronage of a single family, but evolved as a result of its status as the capital city of a prosperous and successful nation.

Little record exists of London's artistic life in its first thousand years. S. Paul's Cathedral was established in the City of London in 604 by S. Æthelbert, King of Kent. Westminster Abbey, founded by Edward the Confessor, was consecrated in 1065: the 11th-century Bayeux Tapestry records its image. The Tower of London was begun by William the Conqueror soon after 1066.

*Portraiture developed in Tudor times. Hans *Holbein the younger (1497/8–1543) first visited London in 1526–8, with a letter of introduction from Erasmus to Sir Thomas More, for whom he painted the lost More family group portrait. By 1532, Holbein was once more in London, remaining until his death: he painted a matchless series of portraits of members of the court and, in 1537, the lost fresco of the Tudor family in the Privy Chamber of Whitehall Palace, known through the 17th-century copy by Remigius van Leemput. Henry VIII also brought to London the Italian sculptor Pietro *Torrigiano, who worked at Westminster Abbey and made portraits in *terracotta.

The sophisticated taste of King Charles I (1600–49) and his court (see LONDON, ROYAL COLLECTION), their enthusiasm for *Antique and *Renaissance works of art, and their interest in contemporary works of art lifted patronage and collecting in London to new heights, which could stand comparison with continental European cities. Contemporary collectors included the earls of Arundel and Somerset and the Duke of Buckingham. Arundel assembled at Arundel House not only his collection of marbles, but also a superb collection of pictures in which he showed a special liking for northern paintings, and a particular interest in Holbein. Arundel patronized François Dieussart, Francesco Fanelli, and Wenceslaus *Hollar. Somerset collected Venetian pictures with the help of Sir Dudley Carleton, ambassador to Venice, and Antique marbles and heads. Buckingham was an even more enthusiastic collector of 16th-century Venetian paintings, and also acquired *Samson and the Philistines* by *Giambologna.

Charles, who visited Madrid in 1623, returning to London with outstanding works by *Titian and *Correggio, succeeded to the throne in 1625. In 1627 he bought the entire Gonzaga cabinet of paintings and antiquities from *Mantua. He was an active patron of contemporary artists, attracting *Rubens and van *Dyck to London: by 1635, Rubens had completed nine huge panels for the ceiling of the Banqueting House at Whitehall, a most significant commission in which Rubens displayed his powers as an artist for the early Stuarts as he had done for the Medici, Gonzaga, Bourbons and Habsburgs. Charles I owned fine pictures by contemporary Italian painters, including the *Carracci, Domenico *Fetti, Guido *Reni, *Caravaggio, and Orazio *Gentileschi who came to London. He also owned works by *Bernini and *Rembrandt. The onset of the Civil War led to the loss from London, for sale in Holland, of the Arundel and Buckingham collections, but the dispersal under the Commonwealth of King Charles's collection of pictures, miniatures, statues, bronzes, and medals ranks as one of the greatest sales of works of art of all time.

London was to recover from this artistic depletion. The city was almost entirely rebuilt after the Great Fire of London, and the greater part of the West End originated in the 18th century. Young men who had made their *Grand Tour returned from France, Switzerland, and above all Italy with vast quantities of paintings, sculpture, prints, drawings, and other works of art. Thomas Martyn's book *The English Connoisseur* of 1766 records the substantial London picture collections of the Duke of Devonshire (Devonshire House), John Barnard (Berkeley Square), Paul Methuen (Grosvenor Street), Charles Jennens (Red Lion Street, Holborn), and Sir Gregory Page (Wricklemarsh, Blackheath).

Artistic activity in London flourished in the 18th century. Successful British artists were attracted to London to live and work there: *Reynolds and *Hogarth in Leicester Fields, *Gainsborough in Pall Mall and *Romney in Cavendish Square. Some continental artists visited London, responding to the demand for pictures: among them were *Pellegrini, *Amigoni, and above all *Canaletto. The Society of Dilettanti was founded in 1732 by a group of men who had visited Italy on the Grand Tour, and promoted an interest in the arts. The Society made a serious attempt to found an Academy of Arts in London similar to those existing in *Rome, Bologna, and other cities: negotiations took place in 1755 between the Dilettanti and a

group of artists headed by *Hayman, but broke down on the issue of control. The Royal Academy was eventually founded in 1768 with Reynolds as its first president: as well as holding exhibitions, the Academy conducted art schools.

In the years following the French Revolution and into the 19th century, an apparently inexhaustible flow of works of art reached London, making this period one of the most favourable in the history of both art dealing and collecting. Among the collections which were dispersed in London were those of Calonne, Fagel, and Vitturi, but the greatest collection sold was that of the Duke of Orléans, dispersed chiefly to aristocratic collectors in London in the 1790s. One of the principal buyers of the Italian section of the Orléans pictures was the Duke of Bridgewater, whose collection remained at Bridgewater House near St James's Park until shortly before the Second World War.

By the mid-19th century, the idea of a major London house being partly a picture gallery was well established. Bridgewater House was rebuilt in the 1850s. Grosvenor House was successively altered and extended between 1807 and 1842 by Porden, Salvin, and Cundy. In 1821, the collection contained 143 major paintings. Other significant 19th-century collections in this tradition include those at Apsley House (Duke of Wellington), Dorchester House (Robert Stayner Holford), and those belonging to members of the Baring, Hope, and Rothschild families.

However, by the 19th century collecting was not confined to the aristocracy. The collecting of old masters was given continuous stimulus by the arrival in London of pictures from the Continent, but the emerging Victorian middle class, with fortunes built on industrial success, combined collecting with patronage of contemporary British artists. Notable among such collectors were Elhanan Bicknell, James Morrison, John Sheepshanks, and Sir Henry Tate.

The London art market first became organized in the early 18th century. Auctions originated in Holland and reached London in 1676. By the 1770s, auctions were held regularly by Christopher Cock and Abraham Langford in their houses in Covent Garden. Sotheby's was founded in 1733 by Samuel Baker, originally for selling books: Christie's, established in 1766, has a longer history of selling paintings. The leading London picture dealers of the first half of the 19th century were William Buchanan of Oxenden Street; C. J. Nieuwenhuys of 29a Pall Mall; the brothers Allen & Samuel Woodburn of 112 St Martin's Lane; and John Smith and his two sons of 137 New Bond Street. The Woodburn brothers had a leading role in forming the unrivalled collections of drawings formed by Sir Thomas *Lawrence. Buchanan published his memoirs in 1824, conveying much of the

excitement of dealing and collecting at that time.

The National Gallery (see under LONDON) was founded in 1824: although this was late by the standards of many continental cities, its establishment exemplifies the role of London as the centre of patronage, collecting, and the art market in the United Kingdom.

CALS-M

Martyn, T., The English Connoisseur (1766).
Millar, O., The Queen's Pictures (1977).
Piper, D., Artists' London (1982).

2. LATE 19TH AND 20TH CENTURY
The turn of the century saw a significant change in the London art market as the role of dealers developed and commercial galleries multiplied. Whereas the 19th-century dealer, like Thomas Agnew (1794–1871) and his sons William (1825–1910) and Thomas (1827–83) or the Belgian, Ernest Gambart, had purchased contemporary artists' works for resale at a profit, often making more on the lucrative reproduction rights than on the sale of the picture, the 20th-century dealer actively promoted the artists' works by holding one-man and mixed exhibitions and retaining a percentage of the returns on paintings sold. Simultaneously the role of the RA annual exhibition as a market place for contemporary art diminished with the rise of alternative exhibition societies, like the New English Art Club (1886–1910) and the Allied Artists Association (1908–10). The establishment of the Tate Gallery in 1897 provided the first national museum with a remit to purchase works by contemporary British artists and the growth of provincial public galleries offered further opportunities for artists to make sales. The more avant-garde of the newer dealers, particularly Alex Reid (1854–1928), the Leicester Galleries, the Carfax Gallery, and the Grafton Gallery, promoted the work of French *Impressionist and *Post-Impressionist painters before the First World War, and the latter hosted Roger *Fry's notorious Post-Impressionist exhibitions in 1910 and 1912. Few English patrons collected this seemingly avant-garde art although notable exceptions included Sir Hugh Lane (1875–1915), Maynard Keynes (1883–1946), and Fry himself. Outstanding among later and richer collectors of French late 19th- and early 20th-century paintings were the sisters Gwendoline and Margaret Davies, who purchased from 1912 and bequeathed their collection to the National Museum of Wales (see under CARDIFF) in 1951, and Samuel Courtauld who purchased over 40 major works 1924–9, given to the Courtauld Institute in 1932; all purchased works in London and Paris. Major collectors of English contemporary art included the educationalist Sir Michael Sadler (1861–1943) and Sir Edward Marsh (1872–1953) who acted as a purchaser

for the Contemporary Art Society, an organization founded in 1910, by Roger Fry among others, to promote the purchase of work by living English artists. Sadler was also able to build a representative collection of historic English watercolours often purchased from the same dealers who sold him contemporary works, for few galleries were wholly specialized.

The agricultural depression of the 1890s, the devaluation of land, and, later, punitive death duties depleted many aristocratic fortunes and a steady stream of masterpieces appeared in the London salerooms, mainly destined for export. At the same time American collectors and museums were purchasing 18th-century British paintings, often through the dealer Joseph Duveen (1869–1939), who made amends with magnificent philanthropic donations to London museums including the British Museum and the Tate Gallery. During the two World Wars fortunate artists were briefly supported by government patronage through the war artists scheme, negotiated during the latter by Sir Kenneth *Clark, the director of the National Gallery, himself a discerning collector. Inertia reigned during the inter-war years, a period which saw a nadir in the reputations of many 19th-century painters, but the influx of refugees in the late 1930s saw a renaissance in commercial London galleries as continental scholars and dealers established themselves in the city. The Arts Council of Great Britain, created in 1946, was to become an influential patron for contemporary artists through both purchases for its own collection and exhibitions.

However, despite the rare enlightened collector, like Ted Power and Hans Juda, few modern British artists had reliable patrons until the 1960s when *Pop art, with its vibrant, easily accessible imagery, attracted a new buying public. The narrative and decorative elements in Pop art and the related *Psychedelic art of the late 1960s led to a reappraisal of Victorian painting, which attracted buyers like the multi-millionaire Lord Lloyd-Webber (1948–) and record prices. The Young Contemporary exhibitions of the 1960s and the Contemporary Art Fairs of the 1980s and 1990s catered to the demand by new collectors for works by younger, less expensive artists. More recently, although the majority of British avant-garde art is exported, the much hyped Brit art of the 1990s, purchased on a dramatic scale by the collector Charles Saatchi (1943–), has made collecting fashionable.

See British Museum, Courtauld Institute, New English Art Club, Royal Academy, and Tate Gallery under LONDON. DER

LONDON, BRITISH MUSEUM. The museum was founded by Act of Parliament in 1753 when the government purchased the

large and varied collections of the physician, naturalist, and antiquarian Sir Hans Sloane (1660–1753), which included books, works of art, and natural history. The collections were soon augmented by the acquisition of Sir William Hamilton's classical vases and antiquities (1772), the Townley Marbles (1805), the Phrygian Marbles (1815) and the notorious Elgin Marbles (see PARTHENON SCULPTURES) (1816). Egyptian antiquities, including the Rosetta Stone, were spoils of the Napoleonic Wars at the turn of the century. The collections of printed books and manuscripts were greatly enhanced by the magnificent library of George III (1823) and the Grenville bequest of rare books and manuscripts (1847). By the mid-19th century the museum's collections were among the most extensive and valuable in Europe. Archaeological digs, colonial surveys, and military and civil expeditions provided large collections of archaeology, natural history, and anthropology, the latter two being the foundations of the Natural History Museum, which separated in 1881, and the Museum of Mankind, an out-station established in the 1960s. Prints and Drawings, which became a department of the museum in 1808, having previously been subsumed in the general collections, began with over 2,000 works from the Sloane Collection, which included an album of *Dürer's drawings. In 1824 the bequest of the connoisseur Richard Payne *Knight of over 1,000 drawings included works by *Rembrandt and *Rubens and 273 drawings by *Claude. It is now one of the largest and most comprehensive collections in the world, containing more than two million items. The British Museum Library, initially an integral part of the institution, was reconstituted as the British Library in 1973 and moved to a new building, by Colin St John Wilson, at King's Cross, in 1998. The museum was first housed in Montagu House, Bloomsbury, and occupied its present building in Great Russell Street, designed by Sir Robert Smirke (1781–1867), in 1829. The great circular reading room, constructed in the central quadrangle, was designed by the librarian, Sir Anthony Panizzi (1797–1879), and completed in 1857.
DER

LONDON, CAMDEN TOWN GROUP. The Camden Town Group developed from the Fitzroy Street Group, a loose association of artists formed by Walter *Sickert after his return from France in 1905, with the intention of bringing modern painting to the attention of the general public. Of the eight original members the most important, after Sickert himself, were Harold Gilman (1876–1919), Charles Ginner (1878–1952), Spencer Gore (1878–1914), and Lucien *Pissarro; they were also supported by the critic Frank Rutter.

By 1911 the gathering had reformed itself into the more solidly based and dynamic Camden Town Group. Gore became the president, although Sickert's influence remained dominant. New members included Robert Bevan (1865–1925), James Dickson *Innes, and Wyndham *Lewis. Breaking away from the increasingly conservative New English Art Club, they held three exhibitions in 1911 and 1912. Taut economy of design, and subject matter drawn from the working class, urban environment around them characterized the group's work. They inherited the *Impressionists' concern with coloured shadows and broad brushwork, but were also excited by the work of the *Post-Impressionists, especially *Gauguin's emphasis on the decorative and emotional potential of intense, semi-abstract colour, and van *Gogh's commitment to the poetry of the everyday world. In October 1913 a number of members exhibited as English Intimistes in the Post-Impressionist and *Futurist art exhibition at the Doré Galleries, London. Shortly afterwards the London Group was formed, combining the Camden Town painters with Wyndham Lewis and his circle of *Vorticists. Always a collection of strongly individual painters, stylistically and in character, the Camden Town Group itself finally broke up when Gilman replaced Gore as president after the latter's early death in 1914, and Sickert resigned. Gilman and Ginner also held a separate Neo-realist exhibition in 1914.
JH

Baron, W., *The Camden Town Painters* (1979).

LONDON, COURTAULD INSTITUTE AND GALLERY. The first specialized centre for the study of art history in England, the institute, a department of the University of London, was endowed in 1931 by the millionaire industrialist and art collector Samuel Courtauld (1876–1947) who, a year later, presented it with most of his superb collection of French *Impressionist and *Post-Impressionist paintings including such masterpieces as *Manet's *Bar at the Folies-Bergère* and van *Gogh's *Self-Portrait with Bandaged Ear*. Courtauld, a discerning and pioneering collector, had previously given £50,000 to the Tate Gallery in 1923 for the purchase of French 19th-century paintings. The institute's co-founders, Lord Lee of Fareham (1868–1947) and Sir Robert Witt (1872–1952), left collections to the Courtauld and the latter also presented his enormous photo reference library. Other important bequests include those of the painter and critic Roger *Fry, the early gold-ground Italian paintings, sculpture, and applied art collected by Thomas *Gambier-Parry, bequeathed by his great-grandson in 1966, and, more recently, in 1978, that of the Anglo-Austrian art collector Count Antoine Seilern (1901–78), which includes a superlative group of works by *Rubens. Until 1989, when both moved to Somerset House, the institute and its collection were physically separated; the former was based in Courtauld's London house, 20 Portman Square, designed by Robert Adam, while the latter had had a number of temporary homes. Their new proximity fulfils Samuel Courtauld's intention that students should work in intimate contact with original works of art. DER

LONDON, DULWICH PICTURE GALLERY. The collection originated with the bequest of Edward Alleyn (1566–1626) to Dulwich College, his own charitable foundation, in 1626 and grew in 1686 with the bequest of William Cartwright (1606–86) of mainly British paintings. The gallery's fortunes changed in 1810 when the painter Sir Francis Bourgeois (1756–1811) presented his own collection and, more importantly, that of his friend, the art dealer Noel Desenfans (1745–1807). Desenfans, a strong believer in a National Gallery, had assembled a major group of old master paintings for the King of Poland, which were left on his hands on the dissolution of Poland in 1795. These formed the nucleus of his collection, which included works by *Rembrandt, *Rubens, *Poussin, and *Claude, and which he bequeathed to Bourgeois on condition that the latter left them to a suitable institution for public display. Later gifts include 46 pictures given by Charles Fairfax Murray (1849–1919), of mainly English works including a *Gainsborough and two *Hogarths. Dulwich Picture Gallery, which for many years was intimately associated with Dulwich College, is now administered by independent trustees.

The gallery, by Sir John Soane (1753–1837), was designed in 1811 and built, with financial assistance from Mrs Desenfans, by early 1813 at a cost of £9,778. The building housed not only pictures but also a mausoleum for the three benefactors, Bourgeois and Mr and Mrs Desenfans, and a range of almshouses. Expansion into the almshouses took place in the 19th century and new rooms were added in the early 20th century; an ambitious extension was completed in 2000. DER

LONDON, EUSTON ROAD SCHOOL, a term coined by Clive *Bell to describe the School of Drawing and Painting in London, opened in October 1937 in Fitzroy Street, which moved to 314/316 Euston Road in February 1938. The school, in which teachers and students worked together, was founded by William Coldstream (1908–87), Victor *Pasmore, and Claude Rogers (1907–79) with the declared aim of an objective approach to realism, inspired by *Cézanne. Close observation was supported by scientific analysis, particularly by Coldstream who established a rigorous system of proportional measurement. In this way the School opposed the largely formulaic realism of London's Royal

Academicians to provide a serious alternative to abstraction. The school closed in 1939 but its post-war influence was considerable, for Coldstream became head of one of London's chief art schools, the Slade, in 1949, to be succeeded in 1975 by Lawrence Gowing (1918–91) who had studied at Euston Road. After the closure of the school the term Euston Road was used generically to describe a British taste for quiet, austere pictures, painted with apparent hesitancy in a subdued palette. DER

Laughton, B., The Euston Road School (1985).

LONDON, NATIONAL GALLERY,

founded in 1824, when Parliament voted £60,000 for the purchase and exhibition of 38 paintings from the collection of the late John Julius Angerstein at his house at 100 Pall Mall. They included *Raphael's Portrait of Pope Julius II, *Sebastiano del Piombo's Resurrection of Lazarus, and five works by *Claude, including the ex-Bouillon Collection The Mill and Embarcation of the Queen of Sheba. A year earlier another prominent collector, Sir George Beaumont, motivated by a desire to protect his pictures from ruination at the hands of restorers, had offered to give his collection to the nation provided that a home was provided for them. His gift of sixteen pictures, including works by *Rembrandt, *Rubens, Claude's Hagar and the Angel and *Canaletto's Stonemason's Yard, was received in 1856. Another early benefactor was the Revd Holwell Carr, whose bequest in 1831 included *Tintoretto's S. George and the Dragon, *Barocci's Madonna del Gatto, and *Domenichino's S. George and the Dragon. Early purchases by the gallery reflected the same taste for established *Renaissance and *Baroque old masters in the Grand Manner: *Titian's Bacchus and Ariadne; *Correggio's Ecce Homo and Mercury Instructing Cupid before Venus; Annibale *Caracci's Domine, quo vadis?, and *Poussin's Bacchanal before a Herm. By the time the gallery had been rehoused in a new building, designed by William Wilkins and erected in Trafalgar Square, which opened in 1838, Sir Robert Peel was propounding the idea of a National Gallery as a social force, a bond between rich and poor, as well as a stimulus for the improvement of industrial design. At the Government's Committee on Arts and . . . Manufactures, Gustav Waagen, director of the Berlin gallery which had just opened in 1830, advocated the concept of historicism in determining the acquisition policy and display of a public museum; and Edward Solly, an English merchant and pioneer collector of early Italian art, whose collection had been acquired by Berlin, gave evidence along the same lines.

By 1843 the National Gallery collection had grown from 38 to 194 pictures. The artist Charles *Eastlake was appointed keeper, to work under a committee of sixteen trustees. Yet throughout the early 1840s the gallery remained virtually paralysed as a buying institution while the debate on an acquisitions policy continued. Should it, in the interests of historical comparison, represent the progression of art from the earliest times onwards, or should it confine itself to the Grand Manner, to those works which contemporary artists were still encouraged to copy and emulate (the Royal Academy shared the Trafalgar Square site until 1869). Thus while the Revd Davenport Bromley, a pioneer collector of early Italian art, bought 40 paintings at the Cardinal Fesch sale in Rome in 1845, the National Gallery failed to secure anything. On the other hand the private purchase in 1846 of Philip IV Hunting Wild Boar, overoptimistically attributed to *Velázquez, for £2,200, provoked howls of protest. A year later, frustrated by public criticism of the gallery's uncertain purchasing policy and its cleaning and restoration techniques, Eastlake resigned. The timing was unfortunate, for in the years that immediately followed the London auction rooms were flooded with affordable masterpieces of Italian Renaissance art from collections formed earlier in the century by William Young Ottley, Thomas Blayds, and above all William Coningham, MP for Brighton, who had put together a magnificent collection in Rome and elsewhere with the help of the dealer Samuel Woodburn. Rudderless, the trustees appeared unable to seize the initiative and even rejected pictures offered directly including *Bellini's Ecstasy of S. Francis (New York, Frick Coll.). The most significant exception was the purchase at the Louis-Philippe sale in 1853 of *Zurbarán's S. Francis, although the opportunity to buy exceptional works by El *Greco and other Spanish artists was missed. It was not until 1895 that the gallery acquired its first El Greco, a gift from J. C. Robinson, former superintendent of the V&A.

In 1855, following a select committee to investigate the affairs of the gallery, Eastlake was appointed the first director with a clear brief to establish a historical collection and to buy aggressively from continental collections, especially in northern Italy, working with Otto Mündler, a German expert, as his European travelling agent. During the next two years alone, Eastlake bought 59 pictures including works by *Mantegna, *Perugino, *Romanino, and *Veronese's Family of Darius before Alexander. In Florence he acquired *Pollaiuolo's S. Sebastian from Marquis Pucci and a substantial group of paintings from the Lombardi Baldi Collection, notably *Uccello's Battle of S. Romano, together with more primitive works by Margarito of Arezzo and *Duccio 'selected solely for their historical importance', as he recorded in his official report. However, even with an agent on the spot in Italy, the gallery still missed many opportunities. For instance at the Manfrini Collection, Venice, which he visited five times, Mündler failed to recognize the importance of *Giorgione's Tempesta (Venice, Accademia) and *Verrocchio's Ruskin Madonna, which was rescued by Charles Fairfax Murray acting for John Ruskin (now Edinburgh, NG of Scotland). And although Mündler was aware of the importance of *Piero della Francesca's art, it was nevertheless two English experts, J. C. Robinson and William Spence, who managed to procure the Baptism of Christ from Sansepolcro in 1859 and the English collector Alexander Barker who persuaded the Cavaliere Frescobaldi in Florence to part with the Nativity, although Eastlake wanted it. Ironically both pictures quickly returned to the London market and were then effortlessly acquired by the gallery. Whatever the merits of the gallery's preoccupation with buying abroad, Mündler's role quickly attracted criticism: he had made expensive mistakes, his high-profile buying role was said to be provoking price inflation, and Lord Elcho believed it was more appropriate for the director himself to undertake the visits to foreign collections. Following a hostile motion in Parliament Mündler was sacked.

Although Eastlake continued to nurture his Italian contacts—he bought the Bellini S. Jerome in his Study from the Manfrini Collection and *Moroni's The Tailor from a collection in Bergamo—he also looked to other centres. Rather daringly, in 1860, as part of a package of 46 pictures, he bought *Bronzino's Allegory of Venus, Cupid, and Time from the Edmond Beaucousin Collection, Paris, together with early Flemish pictures including Rogier van der *Weyden's Magdalene Reading. In London he bought Bellini's Agony in the Garden and *Pesellino's Trinity from the Davenport Bromley sale in 1863 but ignored the sale in 1860 of Samuel Woodburn's *Masaccio Virgin and Child (now NG).

Eastlake died in Pisa in 1865 and his widow presented the gallery with *Pisanello's Madonna and Child with S. George and Anthony Abbot and the Assassination of S. Peter Martyr, ascribed to J. Bellini.

It was under Eastlake's successor, Sir William Boxall, that the gallery was able to develop its representation of Dutch paintings through the acquisition of Sir Robert Peel's collection, in 1871, 20 years after his death. This was augmented by the bequest of Wynn Ellis, an MP and silk trader, in 1876, during the directorship of Sir Frederic Burton; and by the bequest of George Salting in 1910.

British painting was included from the time of the gallery's foundation; Angerstein's collection had included *Hogarth's Marriage à la Mode series. However, following the creation of the Tate Gallery in 1897, the majority of British pictures, including the Turner bequest of 1851, have been transferred from the

National Gallery to the Tate, although outstanding examples remain in the National Gallery, and other paintings, for instance *Whistlejacket* by *Stubbs, have been purchased.

Recent developments include the new Sainsbury wing, designed by Robert Venturi, and opened in 1992, for the display together, in a chronological sequence, of Italian and Netherlandish paintings before 1510; a vibrant and greatly expanded education department; and the receipt of the art historian Sir Denis Mahon's collection, which has strengthened the gallery's representation of Italian 17th-century classical and Baroque paintings. Mahon's collection endorses the taste for the Grand Manner which governed the gallery's original founders but then fell out of fashion for the next 100 years. It would appear now that the gallery has not deviated significantly from its original intent. HB

Brigstocke, H., in *Burlington Magazine*, 131 (Sept. 1989).

Fredericksen, B., and Dowd, C. (ed.), *The Travel Diary of Otto Mündler* (1988).

Martin, G., 'The Founding of the National Gallery' (Parts 1–8), *Connoisseur* (Apr.–Nov. 1974).

Robertson, D., *Sir Charles Eastlake and the Victorian Art World* (1978).

LONDON, NATIONAL PORTRAIT GALLERY. Founded in 1856 at the instigation of the 5th Earl Stanhope (1805–75) as a collection of portraits of eminent British men and women, it was first housed at 29 Great George Street, moving to its current building, adjacent to the National Gallery, in 1896. The collection includes paintings, drawings, miniatures, sculpture, and photography, chosen for the fame of the sitters rather than the skill of the portraitist and thus of very variable quality, ranging from masterpieces to the frankly amateur. However, owing to the importance of *portraiture in the history of British painting, the majority of major native painters are represented. There is also a vast reference archive of prints and photographs which are not displayed. In recent years, in a search for contemporary relevance, the NPG has adopted a controversial policy of commissioning portraits of living sitters.

Taking the NPG as an example, the Scottish National Portrait Gallery was established in Edinburgh in 1882 (opened 1889) and the National Portrait Gallery of America, in Washington, in 1962. DER

LONDON, NEW ENGLISH ART CLUB. Founded in 1886, the NEAC intended to offer exhibiting opportunities to artists alienated by the conservatism and restrictive selection procedures of the Royal Academy. It also promoted French *Impressionism, especially *Bastien-Lepage and the *Plein-Airistes. Many of the leading members, including Sir George Clausen (1852–1944), Herbert La Thangue (1859–1929), Frederick Brown (1851–1941), Wilson *Steer, and *Sargent had trained in Paris, and all were keen to establish greater naturalism in painting. Also involved were artists from the Cornish *Newlyn School, including Henry Scott Tuke (1858–1929) and Stanhope Forbes (1857–1948), and a Scottish contingent, led by Sir John Lavery (1856–1941) and Sir James Guthrie (1859–1930). *Sickert became a member in 1888.

The NEAC did not remain united, splitting into factions with different ideas about modernism and the significance of French developments. By 1889 the original groups had drifted apart; the club was dominated by Sickert and his associates, interested in *Monet and *Degas, rather than the realists. They held an exhibition of *London Impressionists* in December; *Sickert and Steer being the main exhibitors. Brown became a professor at the Slade School in 1892, and, with Henry Tonks (1862–1937) and Steer, made the club a forum for his pupils. The French connection was maintained by William Rothenstein (1872–1945), Charles *Conder, and Roger *Fry, all notable exhibitors.

In fact British Impressionism quickly became popular, allowing painters free choice of NEAC or Academy. During the 1890s the club represented the British *avant-garde, holding regular exhibitions 1887–1904, but by 1910 this initiative had passed to the Camden Town Group and the London Group (see both under LONDON); this, combined with the Academy's relaxation, diminished its importance. However its role in introducing British artists to continental innovations, and as an outlet for the work of progressive young artists at the turn of the century, cannot be overestimated. JH

Thornton, A., *Fifty Years of the New English Art Club* (1935).

LONDON, ROYAL ACADEMY OF ARTS. The RA was founded in 1768 under the patronage of George III, who had been approached by Benjamin *West and Sir William Chambers (1723–96), for his support. Membership comprised 40 Academicians (increased to 50 in 1972) and, after 1769, 20 Associates, increased to 30 in 1876. The founders' intentions were to raise the status of their profession by providing a thorough academic training, the free exhibition of works chosen by a jury of Academicians, and the promotion of a national school of art. Teaching, based on continental prototypes, was carried out in the Antique and Life Schools by professors of anatomy, architecture, painting, and perspective and geometry (a professorship of sculpture was added in 1810), drawn from the Academicians, and the annual presidential lectures, the most outstanding of which were the *Discourses* delivered by the first president, Sir Joshua *Reynolds. Inspirational examples of earlier art, including *Michelangelo's Taddei Tondo (c.1505; London, RA), bequeathed by Sir George Beaumont in 1820, and *Leonardo's cartoon for *The Virgin and Child with S. Anne and the Infant S. John* (London, NG), were acquired, but the majority of the collection comprises the 'diploma' works presented by each new Academician. From its foundation the RA, which had an effective stranglehold on training, taste, and patronage, was riven by petty jealousies and intrigues; *Barry was expelled in 1799 for reviling the RA and a sustained attack by *Haydon from 1812 led to a parliamentary committee in 1836 to examine criticism of the institution. In 1848 the mediocrity of both the RA and its Schools was the ostensible reason for the foundation of the *Pre-Raphaelite Brotherhood. Further broadsides led to the establishment of a royal commission in 1863 which, among other recommendations, suggested a move to larger premises. In the late 19th and early 20th centuries the RA's perceived conservatism marginalized its institutional role and by 1949, when Alfred Munnings, the president, launched his infamous anti-modernist attack on *Picasso, the RA had reached an artistic nadir. Its finances too were suffering: an annual profit of c.£3,000 in the 1860s had become a deficit of over £2,000 by 1915 and yearly income depended largely on the success of the temporary winter loan *exhibitions, established in 1870. By 1960 the RA's money problems were only solved by the controversial sale of the Leonardo cartoon to the National Gallery. In recent years the RA has established a Friends organization, a Trust Fund, and a strong commercial arm in order to survive. At the same time successful attempts to entice a younger audience and elect younger RAs have disarmed many critics whilst alienating some of its traditional audience. The RA was first housed in Pall Mall, transferred to Somerset House in 1780, shared Wilkins's Trafalgar Square building with the National Gallery (1837–68), and finally moved to its present premises, Burlington House, Piccadilly, in 1869. The House had been remodelled for the 3rd Earl of Burlington by Colin Campbell (d. 1729) in 1717. Recent alterations include Sir Norman Foster's ingenious extension to house the Sackler Gallery. The bronze statue of Sir Joshua Reynolds, which stands in the quadrangle before the façade, was sculpted by Alfred Drury RA (1856–1944) in 1931. DER

Hutchinson, S., *The History of the Royal Academy 1768–1986* (1986).

LONDON, ROYAL COLLECTION. The Royal Collection consists of the works of art held by the Queen as sovereign in trust

for her successors and the nation. It is a vast assemblage of works of art of all kinds and a solitary survivor among the great European royal collections, most of which now form part of national museums. The collection has not been assembled using art historical criteria, and so is a reflection of the personal tastes of individual monarchs and their closest advisers and relations. Whilst works of art have been added to the collection continuously since the Tudor era, the three monarchs who had a particular interest in art and added most significantly to the collection were Charles I, George IV, and Queen Victoria (with the help of her consort Prince Albert). Important groups of paintings were also added by Henry, Prince of Wales, and Frederick, Prince of Wales, in the 17th and 18th centuries respectively.

Early inventories show that the Tudor palaces were furnished with numerous portraits, many of which are no longer in the collection, but some of the most important paintings can still be identified, such as the anonymous *Portrait of Elizabeth I when Princess*. However, the collection was enlarged significantly during the early 17th century on the Stuart accession.

Charles I's enthusiasm for collecting began before his accession in 1625 but his singular achievement as a collector was to obtain over 1,000 pictures in a period of about fifteen years. A notable coup was the purchase of the Gonzaga Collection in Mantua in 1627–8. His preference was for 16th-century Venetian painting, and *Titian in particular, but he also acquired works by contemporary Italian artists and attracted several important foreign artists to his court, including *Rubens and van *Dyck. Many of Charles I's paintings were sold to foreign collectors after his execution in 1649, and can still be identified in many of the major museums of the world. Of the works amassed by Charles I remaining in the Royal Collection, the series of *Cartoons* by *Raphael, on loan to the V&A since 1865, and the nine canvases by Andrea *Mantegna comprising the *Triumphs of Caesar* are the most significant. Charles I also obtained early works by *Rembrandt (for example the *Portrait of the Artist's Mother*) but on the whole he was not so interested in northern European painting.

Many important paintings by such artists as Godfrey *Kneller, Johann *Zoffany, and Thomas *Gainsborough were added to the Royal Collection during the 17th and 18th centuries on the basis of commission. The purchase by George III in 1762 of the collection formed by Consul Smith introduced a whole range of near contemporary Venetian painting into the collection, particularly a group of nearly 50 paintings by *Canaletto, as well as works by Marco *Ricci and Francesco *Zuccarelli. However, it was George IV who was the most lavish collector

and enthusiastic patron in the history of the collection. He purchased the work of leading English artists of the recent past such as Joshua *Reynolds and Thomas Gainsborough, as well as commissioning contemporary artists including David *Wilkie and *Turner, and his collection included many sporting pictures, particularly those by George *Stubbs. Of great distinction also are the series of portraits by Sir Thomas *Lawrence depicting those who had played a part in the defeat of Napoleon, subsequently installed in the Waterloo Chamber at Windsor Castle.

George IV also purchased a remarkable group of Dutch 17th-century paintings, reflecting contemporary taste amongst leading British and French collectors, including works by Aelbert *Cuyp, Jan *Steen, and Rembrandt. He also purchased pictures closely associated with Charles I such as van Dyck's *Triple Portrait of Charles I*, and Rubens's *S. George and the Dragon*. Although his well-known appreciation of French art is exemplified more by the decorative arts, the acquisition of works by *Claude and *Vigée-Lebrun illustrates George IV's taste for this school in painting.

Queen Victoria's additions to the collection include ceremonial pictures, family portraits, and animal paintings that she commissioned on a regular basis. The chief portraitists were F. X. *Winterhalter and H. von Angeli. For animal paintings reliance was placed on Edwin *Landseer. Queen Victoria was encouraged in her artistic pursuits by Prince Albert, who had a special interest in the Italian and northern Renaissance. Most of the early Italian paintings in the collection were acquired at his prompting. Also he obtained the Öttingen-Wallerstein Collection which included early Netherlandish and German paintings of note. Many of Queen Victoria and Prince Albert's paintings were hung at Osborne House on the Isle of Wight during their lifetime.

A large proportion of the paintings from the Royal Collection can be seen in the royal residences open to the public throughout the year—the State Apartments at Windsor Castle; the Palace of Holyroodhouse, Edinburgh; Kensington Palace; and Hampton Court Palace. In addition, many other royal residences are open to the public for a part of the year, displaying further significant works from the collection. KB

Lloyd, C., *The Royal Collection* (1999).
Millar, O., *The Queen's Pictures* (1977).

LONDON, ST MARTIN'S LANE ACADEMY. This institution, which, unlike continental academies, was unhierarchic, was founded in 1711 as the Kneller Academy of Painting and Drawing, in Great Queen Street, under *Kneller's governorship. It provided the unique opportunity to draw from the life

and attracted established painters who each paid an annual subscription of a guinea. In 1716 *Thornhill replaced Kneller but was ousted in 1720 by Louis Chéron (1660–1725) and John Vanderbank (1694–1739) who moved the school to premises in St Martin's Lane where, after a few years, it ceased to function. In 1734 it was revived by *Hogarth, who had worked at the previous academy under Vanderbank and was also Thornhill's son-in-law, in a nearby building in Peter Court, St Martin's Lane. The principal teachers were *Gravelot, until 1745 when he returned to France, Hogarth himself, *Hayman and the sculptor *Roubiliac. French influences on Hogarth and Hayman and the employment of expatriate French artists resulted in the Academy being the centre of the *Rococo style in English art. It remained active until the foundation of the Royal Academy (see under LONDON) in 1768. DER

LONDON, SOANE MUSEUM (Sir John Soane's Museum). The museum, which houses the eclectic collection of the architect Sir John Soane (1753–1837), was established by Act of Parliament in 1833. The collections, of casts, models, sculpture, marbles, and other antiquities, often of a funerary nature, are displayed to Soane's design in a series of rooms, including a Gothick Monk's Parlour, naturally lit with considerable ingenuity; the overall effect is one of great and charming eccentricity. Soane became a serious collector after 1790 when a legacy from his wife's uncle gave him financial independence; his purchases were displayed at Pitshanger Manor, Ealing, which he designed in 1800, and were moved to the present building in Lincoln's Inn Fields when Pitshanger was sold in 1812. Lack of space necessitated highly original solutions to the problems of displaying his treasures, and the paintings, which include *Hogarth's series of *The Rake's Progress* (c.1733) and *An Election* (c.1754), are partly hung on hinged walls, which open to reveal a second layer of pictures. His own drawings form the nucleus of an important collection of architectural drawings.

Soane purchased 12 Lincoln's Inn Fields in 1792 and had rebuilt it by 1794 adding a rear extension on ground behind No. 13 in 1808. In 1812 he exchanged houses with his neighbour and thus acquired No. 13, a larger building, which he demolished and redeveloped with a distinctive façade comprising a three-storey loggia of Portland stone, with balconies and Coade stone caryatids. The interior successfully combines classical and Gothic details to create an individual and original whole. Work continued on the house from 1816, the most important change being the addition of a further storey and Picture Room in 1825 when he also set four 14th-century corbels from Westminster Hall into

the façade and purchased No. 14, the adjoining house to the east.　　　　DER

LONDON, SOCIETY OF ARTISTS. The Society of Artists arose from proposals to establish an academy and annual exhibition of contemporary British art during the 1750s. Unable to obtain royal or parliamentary support the majority of leading painters, led by those associated with the Foundling Hospital, decided to organize an exhibition themselves in the rooms of the Society of Arts in 1760. Disagreements with the Council of the Society of Arts, particularly over admission fees and the hanging of works, resulted in the principal painters, including *Reynolds, finding an alternative venue, in Spring Gardens, Charing Cross, in 1761. However the Society of Arts continued to hold annual exhibitions and those artists who remained with them, the majority of whom were lesser painters, formed themselves into the Free Society of Artists in 1762. The Spring Gardens faction, led by *Hayman, now adopted the title Society of Artists and were incorporated as such, by royal charter, in 1765. Despite the foundation of the Royal Academy in 1768, which arose in part from friction in the Society which led to the expulsion of Hayman and *West, the Society of Artists survived until 1791.　　　　DER

LONDON, TATE GALLERY, the national collection of British art and art from *c*.1870 to the present day. The gallery, which opened at Millbank in 1897, is named after Sir Henry Tate (1819–99), the sugar magnate and philanthropist, who offered his collection, of mainly contemporary pictures, to the nation in 1890, provided that the government could find a suitable site. Although Tate had envisaged the gallery as an independent institution to house British paintings it was established as subordinate to the National Gallery and until 1910, when the *Turner bequest was transferred from the National, was limited to modern works. Expansion of the Tate's role came in 1915 when the Curzon Committee recommended that the gallery should house British art, including historic works, and that a Gallery of Modern Foreign Art should also be established under the Tate's aegis; the contemporaneous Lane bequest of 37 modern pictures, predominantly French, was particularly fortuitous. The collection of *Impressionist and *Post-Impressionist works was further encouraged by the Courtauld Fund of 1923. Complete independence from the National Gallery came in 1954 although transfers of paintings still take place and, by convention, each is represented by a trustee on the other's governing board.

Whereas the historic British collection, which includes outstanding works by *Blake and Turner, is uncontroversial, the growth and content of the modern collection has been criticized by both the avant-garde, who, until recently, considered it too cautious, and the conservative who think it unacceptably fashionable; the purchase of Carl André's (1935–) *Equivalent VIII* (1966), which comprised a rectangle of 120 bricks, in 1976, caused outrage among the latter. In recent years the gallery has adopted an unapologetic pro-active approach to contemporary art, epitomized by the establishment of the annual Turner Prize, for young British artists.

The gallery is situated by the Thames, at Millbank, in a classical building designed by Sidney Smith (1858–1913). The transfer of the Turner bequest in 1910 necessitated an extension which was paid for by the art dealer Joseph Duveen (1869–1939) whose son, the 2nd Lord Duveen, financed further building in 1926 and 1937. A major expansion took place in 1979 and in 1987 a new gallery, to display the Turner bequest, named after a major benefactor, Sir Charles Clore (1904–79), was constructed alongside the original building. In 1988 the Tate established a major out-station at Liverpool and a small subsidiary gallery at St Ives opened in 1993.

On 23 March 2000 the Tate Gallery at Millbank was relaunched as Tate Britain in an ambitious programme of expansion and development. The opening on 12 May 2000 of Tate Modern at Bankside has allowed the Millbank building to revert to the original intention of its founder, Sir Henry Tate, as the national gallery of British Art. Tate Modern, at the transformed Bankside Power Station, is dedicated to the display of the Tate's collection of international twentieth-century art. The Bankside building is a remarkable combination of the old and the new. The original power station, designed by Sir Giles Gilbert Scott, architect of Liverpool Anglican Cathedral and also the designer of the red telephone box, has been converted by the Swiss architectural firm, Herzog and de Meuron, following an international competition. The most visible change to the building is a glass structure running the length of the roof, which adds two floors and provides natural light for the upper galleries.　　　　DER

Spalding, F., *The Tate: A History* (1998).

LONDON, VICTORIA AND ALBERT MUSEUM. The genesis of the V&A arose from concern about the state of British art and design as applied to commercial manufacture in the 1850s. The brainchild of Prince Albert, it developed from the Great Exhibition of 1851, the profits from which were used to purchase and develop a site in South Kensington as museums and educational institutions. The Museum of Ornamental Art (as it was originally named) at Marlborough House reopened on the present site in 1857 to exhibit items of applied art, mostly purchased for the Great Exhibition, for the emulation and instruction of designers, students, and manufacturers, under the directorship of Sir Henry Cole. His interests in the applied arts and ornament were complemented by those of his keeper (later arts referee), J. C. Robinson, whose primary interest was figure sculpture. It was Robinson who was responsible for the great expansion of the collections from 1852 to 1867, especially in the fields of Italian *Renaissance and Spanish *Baroque sculpture, although at the outset the creation of a national collection of sculpture was not on the agenda. His first acquisitions, dating from 1853–4, comprise two bronze papal busts ascribed to *Algardi and *Bernini and a marble relief by the Milanese artist Agostino Bambaia (*c*.1483–1548); yet, as he records, other relievos were rejected, 'the formation of a methodic sculpture collection not being then contemplated'. In 1854 the acquisition of the Gherardini collections of wax and terracotta sketches, from Florence, including several by *Giambologna, nudged the museum decisively towards the idea of forming a historical collection. This was confirmed in 1861 with the purchase of the combined Gigli–Campana Collections from Rome, which enabled the museum to show a representative nucleus of Italian sculpture, with works by *Arnolfo di Cambio, *Donatello, Luca della *Robbia, *Verrocchio, and Jacopo *Sansovino. In 1862 Robinson published a seminal scholarly catalogue in which he discusses the concept of sculpture both as a fine art and as a decorative art of ornamental carving, and continues with an eloquent justification of his and the museum's acquisition policy. 'Finally it may be observed that it is the intimate connection of medieval and Renaissance sculpture with the decorative arts in general, which clearly indicates the Museum as the proper repository for this class of the National acquisitions; consequently the present Collection should be regarded as part of a methodic series, following the antique sculptures of the British Museum, to be eventually continued down to our own time.'

In 1863 Robinson turned his attention to Spain and Portugal and made three extended visits there in 1863–4, 1865, and 1866. His acquisitions were mainly in the field of Spanish metalwork, in particular a silver gilt pax of *c*.1525, now attributed to the goldsmith Juan de Orna, but which he attributed to Antonio d'Arfe; and Spanish Baroque sculpture (earlier examples were hard to come by), including polychromed woodcarvings ascribed to Alonso *Cano, Alejandro Carnicero (1693–1756), Luisa Roldán (1650–1704), José Risueño (1655–1732), and Alonso *Berruguete. In 1867 he was ignominiously removed from his post, possibly for buying in Spain on his own account and for other art dealing activities,

but also due to internal tensions within the museum. Yet even today the strength of the museum's sculpture collection derives primarily from the significant nucleus of Italian and Spanish objects acquired by Robinson.

Although still primarily concerned with applied art and sculpture, the museum's eclectic holdings have also come to include the national collections of *miniatures and *watercolours and an outstanding collection of works by *Constable, reflecting a more general concern, in the later 19th century, with British culture. The educational beginnings of the V&A continued to be reflected in its subsequent development until the mid-1970s when the Circulation Department, which had sent out small didactic exhibitions to regional museums, fell victim to financial restraints. The museum still houses the National Art Library.

The present building, by Sir Aston Webb (1849–1930), was begun in 1899 and renamed the Victoria and Albert Museum when Victoria laid the foundation stone on 17 May. The completed building was opened by King Edward VII on 26 June 1909. A dramatic and unconventional extension, designed by Daniel Libeskind, is currently (2000) under consideration. HB

Baker, M., 'Spain and South Kensington. John Charles Robinson and the Collecting of Spanish Sculpture in the 1860's', V&A Album, 3 (1984).
Physick, J., The Victoria and Albert Museum: The History of its Building (1982).
Pope-Hennessy, J., Catalogue of Italian Sculpture in the Victoria and Albert Museum (1964).
Robinson, J. C., Italian Sculpture of the Middle Ages and Period of the Revival of Art (1862).
Trusted, M., Spanish Sculpture: Catalogue of the Post-Medieval Spanish Sculpture . . . in the Victoria and Albert Museum (1966).

LONDON, WALLACE COLLECTION, a national museum holding the collection of the Seymour-Conway family, earls and later marquesses of Hertford, bequeathed to the nation in 1897 by the widow of Sir Richard Wallace (1819–90), the illegitimate son of the 4th Marquess. It is housed in Hertford House, Manchester Square, the former London residence of the family. The collection reflects the taste of Richard, the 4th Marquess (1800–70), and his son Sir Richard, who both spent much of their lives in Paris. The Marquess, who had inherited a number of works including family portraits, several *Canalettos, and *Titian's Perseus and Andromeda, purchased by his father, bought most of the superb 18th-century French furniture, applied art, and paintings, unrivalled in English collections, and a large collection of works by *Bonington. The French paintings, mostly small cabinet pictures, include important works by *Watteau, *Boucher, and *Fragonard. Sir Richard added much Renaissance decorative art and a magnificent collection of

arms and armour. Although primarily distinguished for French art, the collection, which cannot be added to, also includes rich holdings of 17th-century Dutch and Flemish paintings, among which *Hals's Laughing Cavalier (certainly the collection's best-known work) and *Rubens's Landscape with a Rainbow are outstanding. Under the terms of the bequest the works must be shown together, thus precluding loans from the collection.
 DER

Hughes, P., The Founders of the Wallace Collection (1981).
Ingamells, J. (ed.), The Hertford Mawson Letters: The 4th Marquess of Hertford to his agent Samuel Mawson (1981).
Mallett, D., The Greatest Collector: Lord Hertford and the Founding of the Wallace Collection (1979).

LONDON GROUP, an English exhibiting society formed in 1913. It was an amalgamation of Camden Town Group members and those influenced by the avant-garde continental movements, *Cubism and *Futurism. Among the founder members were *Bomberg, Harold Gilman (1876–1919), *Nevinson, Paul and John *Nash, the sculptors *Epstein and *Gill, and the *Vorticists Wyndham *Lewis, *Wadsworth, and *Gaudier-Brzeska. The first exhibition was held in Brighton in 1913 and revealed the group's great breadth of styles. The first London exhibition came in 1914, the works for which were selected by members chosen by rote. Two exhibitions were held annually thereafter until 1939 when they became annual. After Vorticist membership waned during the First World War the *Bloomsbury painters *Fry, Duncan *Grant, and Clive *Bell came to constitute the most influential faction within the London Group. Their *Post-Impressionist legacy was seen in the work of London Group members, *Gertler and Matthew *Smith, in the 1920s. But the group was no longer considered progressive in Britain by 1930 and after exhibitions of significant sculpture by John Skeaping (1901–80), *Moore, and *Hepworth in the 1930s, its momentum declined. MT

London Group, exhlb. cat. 1964 (London, Tate).

LONG, RICHARD (1945–). British avant-garde artist whose work brings together sculpture, *Conceptual art, and *Land art. Born in Bristol, he studied there at the West of England College of Art, 1962–5, and then at St Martin's School of Art, London, 1966–8. Since 1967 his artistic activity has been based on long solitary walks that he makes through landscapes, initially in Britain, and from 1969 also abroad, often in remote or inhospitable terrain. Sometimes he collects objects such as stones and twigs on these walks and brings them into a gallery, where he arranges them into designs, usually circles or other fairly simple geometrical

shapes (Circle of Sticks, 1973; Slate Circle, 1979; both London, Tate). He also creates such works in their original settings, and documents his walks with photographs, texts (which refer to the things he passes and more recently to his state of mind), and maps.

Long is the leading British exponent of *Land art; he was awarded the Turner Prize and in 1991 a major Arts Council exhibition of his work entitled Walking in Circles was held at the Hayward Gallery, London.

LONGHI, FATHER AND SON. Italian painters. Pietro (1700×2–1785) was the son of a Venetian silversmith, Alessandro Falca. He turned to painting and probably studied under G. M. *Crespi at Bologna. From c.1732 onwards he lived at Venice, and although he carried out some fresco commissions—the Fall of the Giants—at the Palazzo Sagredo (1734) he is known principally for his small *genre scenes and *conversation pieces of contemporary life. The Concert (1741; Venice, Accademia) shows an interior view of Venetian noble life; and subsequent pictures, such as The Rhinoceros (Venice, Ca' Rezzonico) and The Fortune-Teller (London, NG), reflect the same society in a mildly satirical spirit. The lives of more ordinary people are reflected in the anecdotal series of Seven Sacraments (Venice, Gal. Querini-Stampalia); these recall G. M. Crespi's celebrated series on the same theme (Dresden, Gemäldegal.), although the comparison exposes Longhi's limitations. Equally, while his much-loved Shooting in the Lagoon (Venice, Gal. Querini-Stampalia) has the naive charm often found in sporting art, it fails entirely to capture the atmosphere of the Venetian lagoon. In a society dominated by allegorical and historical painting, his scenes of contemporary life were regarded as a novelty. He was a friend of the playwright Carlo Goldoni. Alessandro (1733–1813), son of Pietro, was apprenticed to Giuseppe Nogari (1699–1766) and specialized as a portrait painter. His portraits show that he had inherited his father's sense of irony. He was patronized by the Pisani family and he was the official portrait painter to the Venetian academy. His Compendia delle vite de' pittori veneziani istorici (1762) was illustrated with portraits which he engraved himself. HB

Levey, M., Painting in Eighteenth-Century Venice, rev. edn., 1980).
Pignatti, T., Pietro Longhi (English edn., 1969).

LOO, VAN. French family of painters of Flemish origin. This extensive dynasty produced three artists of stature in the 18th century. Jean-Baptiste (1684–1745) trained as a *history painter, working in Rome, Turin, and Genoa as well as Paris. From 1737 to 1742 he was in London, working as a society portrait painter at a time when there was little

home-grown competition. He trained his younger brother **Carle** (1705–65), who achieved a remarkable reputation as France's foremost history painter at mid-century. He worked on many of the same decorative schemes as his contemporary François *Boucher, whose *Rococo style he counterbalanced with his own drier and more academic mode. Such large and portentous canvases as *Mlle Clairon as Medea* (1759; Potsdam, Sanssouci) were, happily, relieved by small-scale genre scenes including *La Lecture espagnole* (1761; St Petersburg, Hermitage), which was painted for Mme Geoffrin. Although his work will never again enjoy its 18th-century esteem, Carle was responsible for training some of the most influential painters of the next generation, among them *Deshays, *Doyen, Louis *Lagrenée, and *Fragonard. Jean-Baptiste's son **Louis Michel** (1707–71) was a portraitist, and in purely painterly terms perhaps the best artist in the family. His lively and engaging portrait of *Diderot* (1767; Paris, Louvre), caught in the act of writing, is a good example of his sophisticated work. MJ

Sahut, M.-C., *Carle van Loo, premier peintre du roi*, exhib. cat. 1977 (Nice, Mus. Chéret).

Sahut, M.-C., and Volle, N. (eds.), *Diderot et l'art de Boucher à David*, exhib. cat. 1984 (Paris, Hôtel de la Monnaie).

LOPES, GREGORIO (active from 1513– d. 1550). Son-in-law of the court painter Jorge *Afonso and himself a court painter from 1522. In 1524 he was made a knight of Santiago. His work, some executed with collaborators, is well represented in the Lisbon and Évora Museums. No other painter conveys a better idea of the sumptuousness of Portuguese life at that time. Portuguese art historians have argued that Lopes's *Martyrdom of S. Sebastian* (1536/8; Lisbon, Mus. Nacional de Arte Antiga) introduced *Mannerism into Portugal, but without addressing the fundamental question whether Lopes knew the classical rules and broke them deliberately or whether his solecisms were simply the results of ignorance. JBB

A pintura maneiriata em Portugal, exhib. cat. 1995 (Lisbon, Centro Cultural de Belém).

LÓPEZ PORTAÑA, VICENTE (1772–1850). Spanish painter whose eclectic style and long life have caused him to be characterized as a 'transitional' painter bridging the *Neoclassical age of Kings Charles III and Charles IV, and the reigns of Ferdinand VII and his daughter Queen Isabella II. López became director general of the Academia de S. Fernando (see under MADRID), in 1822 and was one of the pre-eminent court painters; his portraits, such as *The Family of Charles IV* (1802; Madrid, Buen Retiro), were at times preferred to those of his contemporary Francisco de *Goya, who has since come to overshadow

him historically. López also executed numerous religious and mythological deocrative paintings such as the frescoes within Madrid's royal palace. OEV

Agullo y Cobo, M. (ed.), *Vicente López*, exhib. cat. 1989 (Madrid, Mus. Municipal).

LORENZETTI (or Laurati) BROTHERS. Italian painters. The Lorenzetti brothers, of whom **Pietro** (active *c.*1306–45) is assumed to be the elder, developed the *Ducciesque language of early trecento Sienese painting to an extraordinary degree. Their work, together with *Simone Martini's, made Siena one of the most significant centres of European painting before the Black Death of 1348, in which both brothers may have died. Pietro's frescoed altarpiece of the *Madonna and Child and Saints* in the chapel of S. Giovanni Battista in the lower church of S. Francesco in Assisi is close to Duccio. The *Passion* frescoes with which he covered the adjacent transept vaults, perhaps as early as 1315, are already much more adventurous, showing, in the *Last Supper*, for instance, a mixture of closely observed genre detail with an unprecedented use of light. The drama of the *Deposition*, perhaps painted rather later, is articulated in a complex, active, figure group reflecting the style of Giovanni *Pisano. Giovanni's influence is found, too, in the *Madonna* of Pietro's first dated altarpiece, for the Pieve in Arezzo (1320), which also boasts an *Annunciation* on the central pinnacle remarkable for Pietro's blurring of the distinctions between the pictorial space and the frame. This aspect of Pietro's pictorial intelligence finds its most consistent expression in his 1342 S. Savino altarpiece for Siena Cathedral. The main panel of the *Birth of the Virgin* uses triptych form with great freedom, treating the dividing pilasters of the frame as though part of the room in which the Virgin lies. To the left the space recedes into a depth clearly and rigorously projected.

Ambrogio Lorenzetti (active *c.*1317–48) was arguably the most original and exploratory painter of the trecento: 'learned', as *Ghiberti called him. He had early contact with Florentine painting, reflected in the monumentalism of his *Vico l'Abate Madonna* (1319; Florence, Mus. Arcivescovile). Four *Miracles of S. Nicholas of Bari* (*c.*1330; Florence, Uffizi), part of a dismembered altarpiece, subject architectural settings and a seascape ultimately derived from Duccio to a radical development. This reinvention of established formats consistently characterizes Ambrogio's work in Siena after *c.*1330. Smaller panels like the *Madonna del Latte* (1330s; Siena, Palazzo Arcivescovile), or the more ambitious *Maestà* panels in Massa Marittima (*c.*1335; Mus. Arch.) and Siena (*c.*1340; Pin.), all display inventive powers seen at their fullest in the frescoes of the Sala dei Nove in the Palazzo Pubblico in Siena (1338–

9). These comprise *Allegories of Good and Bad Government* and illustrations of the *Effects of Good and Bad Government on Town and Country*. The *Effects of Good Government on the City and Country* juxtaposes a detailed view of Siena with a sweeping landscape unprecedented in post-Antique painting. Two late altarpieces sum up Ambrogio's development of pictorial space: the *Presentation* (1342; Florence, Uffizi), and the *Annunciation* (1344; Siena, Pin.). The former, painted for the Cathedral, like Pietro's S. Savino altarpiece (see above), is remarkable for its spatial depth; the latter for its use of one-point *perspective in the recession of the floor tiles. JR

Cole, B., *Sienese Painting from its Origins to the Fifteenth Century* (1980).

Rowley, G., *Ambrogio Lorenzetti* (1968).

LORENZO DI CREDI (*c.*1457–1536). Florentine painter whose work, though limited in range and imagination, was highly praised by *Vasari for its technical proficiency. Lorenzo was a colleague of *Leonardo and *Perugino in the studio of *Verrocchio during the 1470s and it was the combination of these influences which formed his mature style. On Verrocchio's death in 1488 Lorenzo became master of the studio, concentrating on devotional pictures and portraits. His altarpieces, mostly *sacre conversazioni*, are relatively static and traditional in design. In the 1490s, however, he fell under the sway of Savonarola which may explain the heightened religiosity of such pictures as *The Adoration of the Shepherds* (Florence, Uffizi). Lorenzo's early portrait style has not been clearly defined and is confused by doubtful attributions but his later work, such as the *Portrait of a Young Woman* (New York, Met. Mus.), shows the continuing influence of Leonardo. Lorenzo's portrait *drawings were much admired during his lifetime and a number have survived. PSt

LORENZO MONACO (1370x5–1422 or later). Italian painter born Piero di Giovanni, perhaps in Siena, who appears to have worked exclusively in Florence. In 1391 he took vows at the Camaldolese monastery of S. Maria degli Angeli, renowned for its illuminators, where he illustrated several manuscripts, including choir books now in the Laurentian Library. While retaining close links with the monastery and painting altarpieces for Camaldolese churches, he established a large workshop outside the convent in *c.*1396.

In his large-scale works, including the only known frescoes, in the Bartolini chapel, S. Trinita, his style retains characteristics of the illuminator, albeit within a broader treatment of light and space. The swinging line of his draperies and the use of luminous reds,

blues, and golds resulted in compositions, such as the *Coronation of the Virgin* (1415; London, NG), that were brilliantly decorative rather than realistic in effect. A small, early *Virgin and Child Enthroned* (Cambridge, Fitzwilliam) suggests the Florentine origins of this style by its similarity in composition, human form, and expression to *Giotto's *Ognissanti Madonna* (Florence, Uffizi). The *Gothic delicacy of the angels' wings, however, points towards the elegant, courtly character of his *Coronation of the Virgin* (1414; Florence, Uffizi) with its swaying ranks of saints.

The unfinished polyptych of the *Deposition* (Florence, Mus. S. Marco), was taken over by Fra *Angelico, an artist who linked Lorenzo's graceful spirituality to the new realism of *Masaccio.　　　　　　　MS

Eisenberg, M., *Lorenzo Monaco* (1989).

LORENZO VENEZIANO (active 1356–79?). Italian painter. Lorenzo was the leading late trecento Venetian painter. Unlike the older (and probably unrelated) *Paolo Veneziano he worked extensively outside Venice, and his art drew on a wider range of sources. His professional relationship with Paolo is unclear. Early work, like the Lion *Annunciation* polyptych (s.d. 1357; Venice, Accademia), uses figure types derived from Paolo but clothed in Gothic draperies and articulated with a distinctive vivacity of expression. A greater fluidity of drawing and a more refined and continuous modelling of surfaces underpin the enhanced naturalism and emotional intimacy of other works of this period, such as the *Mystic Marriage of S. Catherine* (1359; Venice, Accademia). In later work, like another *Annunciation* polyptych (s.d. 1371; Venice, Accademia), Lorenzo combines the linear decoration of the early panels with a more compact and plastic figure style. The predella narratives are typically exuberant. The new solidity, together with a developing interest in complex architectural settings evident in a signed and dated *Madonna* of 1372 (Paris, Louvre), Lorenzo's last dated work, may reflect the impact of contemporary Paduan painting.　　JR

Pallucchini, R., *La pittura Veneziana del trecento* (1964).

LORRAIN, CLAUDE. See CLAUDE LORRAIN.

LOS ANGELES, J. PAUL GETTY MUSEUM. The museum is on two sites: architect Richard Meier's minimalist home for the European collections which was opened at Brentwood in 1997, and the reconstruction of the Roman Villa dei Papiri in Malibu which will reopen in 2002 and house the antiquities collections. From 1954 until 1974, when the Villa was opened, the collections were displayed in J. Paul Getty's ranch house, which still exists behind the Villa. The content of the collections reflected Getty's interests and comprised Greek and Roman antiquities, oriental carpets, and French 18th-century furniture together with a small eclectic gathering of paintings. Throughout his life Getty continued to collect, mainly for his own residences, until he decided to build the Villa, the impending opening of which precipitated a burst of important painting acquisitions under the then curator Burton Fredericksen. In 1982 Getty's lavish endowment to the museum came into effect and funds were channelled into four new areas: European sculpture, manuscripts, photography, and drawings, as well as into some of Getty's established interests. The collections now at Brentwood are western European dating from c.1200 to 1900, with the exception of the photography collection which also includes American works, and continues up to the present day.

The European sculpture collection, formed since 1982, is mainly *Mannerist and *Baroque and is rich in decorative ensembles. It starts with a wonderful *Antico bronze bust. Other highlights include a rare *Giambologna marble, important bronzes by Johann Gregor van der Schardt (?1530/1–after 1581), and de *Vries, an exquisite *Houdon bust, and some impressive French 19th-century terracottas including *Chinard.

The illuminated manuscript collection was founded in 1983 by the purchase of 144 manuscripts from the Peter Ludwig collection, and is especially strong in Flemish 15th-century illuminated books. There are some fine medieval manuscripts as well as illuminations by *Fouquet, *Marmion, and *Hoefnagel.

The drawings department was founded in 1981 with the acquisition of a *Rembrandt drawing, followed by a choice group of sheets from Chatsworth (Derbys.). It is now a small but impressive trophy collection representing most of the famous names from the late 15th century up till 1900—*Leonardo, *Michelangelo, *Raphael start the collection of some 400 drawings which ends with *Delacroix, a *Degas sketchbook and a *Cézanne watercolour.

Following Getty's death in 1976 his Eastern carpets were deaccessioned, and his world-class French furniture holding has been little changed since the reorganization of 1982. The antiquities collection has continued to grow—the *Lansdowne Hercules* acquired in 1955 has been joined by an interesting group of bronzes, vases, gems, and, most recently, the Flieschman Collection.

Of all the areas of the collections, the paintings have grown most rapidly with the assistance of funds from Getty's estate. There are now four Rembrandts giving unusual depth to one of the founder's favourite artists. The Rembrandt School is also well represented together with many other Dutch 17th-century artists including *Hals, *Dou, ter *Borch, and van de *Cappelle. In the Italian Renaissance, *Simone Martini, Bernardo *Daddi, *Gentile da Fabriano, *Massacio, *Mantegna, Fra *Bartolommeo, *Correggio, Dosso *Dossi, and *Pontormo have been acquired. French painters include Georges de *La Tour, *Poussin, *Greuze, and *Fragonard, as well as 18th-century French pastels (Maurice-Quentin de *La Tour) to complement the earlier purchase of work by the Swiss artist *Liotard. Good *Géricaults, late *Davids, and a *Corot lead to the collection of late 19th-century paintings including van *Gogh's *Irises*, four Cézannes, and three *Monets. This choice holding of French paintings is still small by American standards but is complemented by surprises like the *Ensor.

In general the collection is to be singled out for the state of the paintings—an exceptionally large number are unlined and otherwise well preserved—as much as for the fame of the examples. The museum did not have first pick, but has been selective about what was acquired and has taken much care to present them in optimum natural lighting conditions. The J. Paul Getty Museum is still the most richly endowed institution collecting western European art and its holdings can only be expected to grow in depth and quality.　　　　DJa

Jaffé, D., *Summary Catalogue of European Paintings in the J. Paul Getty Museum* (1997).
Walsh, J., and Gribbon, D., *The J. Paul Getty Museum and its Collections* (1997).

LOST WAX. See CASTING.

LOTTO, LORENZO (c.1480–1556). Italian painter. He was born in Venice but in the course of his career travelled widely in the Venetian provinces and the Marches where he could obtain well-paid commissions for altarpieces. He worked occasionally in fresco, at Trescore and Bergamo. He also painted devotional pictures—mainly *sacre conversazioni*—for private use; and he was an accomplished portrait painter. His early signed works at Asolo, dated 1506, and in S. Cristina al Tavorone (Treviso) show the stylistic influence of Alvise *Vivarini and above all Giovanni *Bellini. A polyptych executed for the church of S. Domenico in Recanati (now in the Pinacoteca) in 1508 marks the end of his traditional 15th-century style. From now on he would more often paint on canvas rather than a wooden panel. Lotto's work next shows the influence of *Raphael whose art he could have seen when he visited Rome in 1509. This is evident in his *Entombment* at Jesi dated 1512. Thereafter he evolved a highly individual and expressive style and its progress can be followed through his numerous signed and dated altarpieces in Bergamo, Venice, and several

of the cities in the Marches including Ancona, Jesi, and Loreto. Lotto's individuality and intensity is also apparent in his portraiture which is often enigmatic and elusive in mood and symbolism: for instance the portrait of a married couple (St Petersburg, Hermitage); the portrait of the collector Andrea Odoni (London, Royal Coll.) clutching his Crucifix but surrounded by the material culture of the classical world; and the portrait of a lady as Lucretia (London, NG). The paradoxes inherent in Lotto's distinctive style may well reflect a conjunction of particular personal circumstances. He was melancholic by temperament and highly religious; he spent the last two years of his life as an oblate at the Santa Casa of Loreto. Yet he was intellectually progressive and had well-connected patrons, including Bernardo de' Rossi, Bishop of Treviso, of whom he painted a striking portrait in 1505 (Naples, Capodimonte), and Conte Alessandro Martinego Colleoni in Bergamo, for whom he painted the exceptionally large high altar for S. Stefano (now Bergamo, S. Bartolommeo) which was completed in 1516. Lotto's relatively isolated and peripatetic existence—especially during the last 25 years of his life—combined with his complex personality may account for the impression left by his work of a talented, sometimes visionary but ultimately provincial master. While well regarded by his contemporaries he did not exert major influence or attract artistic followers. His high standing today stems from his rediscovery by *Berenson in 1895. HB

Berenson, B., *Lorenzo Lotto* (1895).
Brown, D., et al., *Lorenzo Lotto: Rediscovered Master of the Renaissance*, exhib. cat. 1997 (Washington, NG).
Humfrey, P., *Lorenzo Lotto* (1997).

LOUIS, MORRIS (1912–62). American painter. Born in Baltimore, he studied at the Maryland Institute of Fine and Applied Arts 1929–33. He worked on the *Federal Art Project, living in New York 1936–40, and attended the workshops of the Mexican painter David *Siqueiros. In 1948 he moved to Washington as instructor at the Washington Workshop Center where he remained until 1952. Louis was one of the group of American artists, called 'Post-Painterly Abstractionists' by Clement *Greenberg, who emerged after the *Abstract Expressionists. In 1952, inspired by a studio visit to Helen Frankenthaler, his work became wholly abstract and he changed his painting technique. Like *Pollock he poured paint onto canvas but to completely different effect. Louis's paints were thin, colourful acrylics which when poured on unprimed cotton canvas acted like a dye, forming a single surface with the canvas: *Gamma Delta* (1959–60; New York, Whitney Mus.). In 1960 he started a series of large paintings named *Unfurleds*, and had

completed 120 before the summer of 1961. RJP

Elderfield, J., *Morris Louis* (1970).

LOUTHERBOURG, PHILIPPE JACQUES DE (1740–1812). French-born painter. Loutherbourg, the son of a miniature painter, trained in Paris from 1755 under J.-B. van *Loo. His first *Paris Salon exhibit, in 1763, was praised by Diderot and by 1766 he was an academician. He came to England in 1771 and was employed by David Garrick as a designer at Drury Lane 1772–6. Loutherbourg's sensational sets were an immediate success and he was retained until 1781, in which year he became an RA and established his own miniature theatre, the *Eidophusikon. During the 1780s he painted dramatic *picturesque landscapes until an involvement with the charlatan Cagliostro (1714–95) 1786–8 led to financial disaster. From 1789 to 1800 he painted religious works including *The Opening of the 2nd Seal* (1798; London, Tate), for Thomas Macklin's *Holy Bible* (1800). In 1793 he collaborated with *Gillray on *The Battle of Valenciennes* and *Lord Howe's Victory* (1794; London, National Maritime Mus.) which led to further patriotic subjects. His two volumes of *Picturesque Scenery* (1801 and 1805) included *Romantic views of industrial sites (*Coalbrookdale*, 1801; London, Science Mus.). Loutherbourg was an accomplished painter of great versatility. DER

Joppien, R., *Loutherbourg*, exhib. cat. 1973 (London, Kenwood House).

LOWRY, L(AURENCE) S(TEPHEN) (1887–1976). English painter. Born in Manchester, he studied intermittently at art schools in Manchester and Salford 1905–25 before making his home at the latter. His works, painted in parallel to a career as a clerk, record the industrial north in a faux-naive style with flat buildings and stylized black figures against whitish backgrounds. At his best (*The Bandstand*; *Peel Park*, 1931; York, AG) he captured daily life with some charm but often, particularly in later years, he was simply painting to a formula. His work is extremely popular. DER

Leber, M., and Sandling, J., *L. S. Lowry* (1987).

LUCAS VAN LEYDEN (c.1494–1533). Dutch painter, draughtsman, and printmaker, one of the most innovative northern artists of the 16th century. He was a pioneer of genre painting, and developed new approaches to spatial (including landscape) and narrative construction. Initially influenced by *Dürer (whom he met in Antwerp in 1521) and by direct contact with Italian prints, he in turn exercised great influence. In the 17th century *Rembrandt was to be inspired by his engraving of the *Ecce Homo*, 1510.

A youthful prodigy, Lucas studied first with his father, the Leiden painter Hugo Jacobsz., before entering the workshop of Cornelis *Engelbrechtsz. He seems to have worked independently as early as 1508, the year of his first dated work, the accomplished and thematically highly unusual engraving of *Mahomet and the Monk Sergius*. Lucas's interest in perspective and Italianate architecture is witnessed in the already mentioned *Ecce Homo*. The earliest genre scene dates from about the same year (c.1510; *Chess Players*; Berlin, Gemäldegal.), followed by the *Card-Players*, (c.1514; Wilton House, Wilts.). These paintings of half-length figures grouped around a gaming board or table were probably meant to convey moral messages. Of obvious moral content is such a work as the triptych with the *Worship of the Golden Calf* (c.1525; Amsterdam, Rijksmus.), where the main theme is not so much that of Moses guiding the Israelites as the consequences of lascivious living. The activities of the Israelites are rendered as everyday events: children play, lovers embrace, old men gossip, and all enjoy food and drink. These goings-on are placed within a broadly constructed landscape of rolling hills and distant mountains. The painting is a good example of Lucas's considerable narrative skill, which combines anecdotal details with logically constructed space and clearly arranged forms and figures. KLB

Smith, E. Lawton, *The Paintings of Lucas van Leyden* (1992).

LUCIAN OF SAMOSATA (2nd century AD). Greek rhetorician and satirist. Lucian frequently included discussions or descriptions of real and imaginary works of art and architecture in his essays. In *The Hall*, he describes the magnificent room in which the piece was delivered; *Zeuxis* describes the artist's painting of a centaur family; and his *Herodotus* includes a description of a painting of the marriage of Roxana and Alexander the Great. Elsewhere Lucian uses descriptions of allegorical paintings to illustrate his points. The most famous of these is the depiction of *Calumny* which he ascribes to *Apelles and which was reconstructed by several *Renaissance artists, including *Botticelli. RW

Massing, J. M., *Du texte à l'image: la Calomnie d'Apelle et son iconographie* (1990).

LUINI, BERNARDINO (1485?–1532?). Lombard painter who was one of the leading artistic personalities of the Milanese *Renaissance. *Vasari mentioned he was a follower of *Leonardo, whose cartoon of the *Virgin and Child with SS Anne and John* (London, NG) Luini owned and copied (Milan, Ambrosiana). His work was highly prized by 19th-century art collectors for the formal refinement of his graceful style and his clever use of classical forms. Among his earliest works are the

Maggianico Polyptych (after 1510; Maggianico, parish church) and a fresco of the *Madonna and Child with Angels* in the abbey of Chiaravalle, near Milan (1512; *in situ*). Both indicate that he had assimilated much from contemporary Lombard painting. The period 1520–5 is particularly rich in securely dated commissions in fresco, and one of his finest achievements is the *Life of the Virgin* in S. Maria dei Miracoli, Saronno (1525); this work combines heroic architectural forms with noble figure types and naturalistic landscape. FB

LUKASBRÜDER (Lukasbund). See NAZARENES.

LUKS, GEORGE (1867–1933). American painter and draughtsman. Born in Williamsport, Pa., Luks trained at the Pennsylvania Academy of Fine Arts before studying in Europe, mainly in Düsseldorf and Paris. In the 1890s he was in Philadelphia, working as a reporter-illustrator, a member of the group who frequented Robert *Henri's studio formulating a democratic, popular art. The most flamboyant of the Henri circle, Luks claimed kinship with the miners who were his first subjects and later, in New York, chose to work in the most deprived areas. Fittingly, for a man who sometimes adopted the alter ego of 'Lusty' Luks, an ex-pugilist, his best-known painting is *The Wrestlers* (1905; Boston, Mus. of Fine Arts), a dramatic and immediate scene which reveals his acknowledged debt to *Hals. His penchant for striking contrasts and bravura brush strokes also appears in *The Old Duchess*, of the same year (New York, Met. Mus.), in which *Manet's influence may be seen. His enthusiasm and gusto made him neglect technique to the detriment of his paintings. Luks showed with The *Eight in 1908 and exhibited in the *Armory Show in 1913. DER

Cary, E., *George Luks* (1931).

LUMINISM, a word coined by the American art historian John Baur in 1954 to describe a style of 19th-century American landscape painting characterized by a realistic but heightened treatment of atmospheric light. The pioneer of the style was George Harvey (1800–78), whose watercolour *Atmospheric Landscapes of North America* dates from the mid- to late 1830s, but it is generally agreed to have flourished 1850–75. Leading exponents include Sanford Gifford (1823–80), Fitz Hugh Lane (1804 65), and Martin Johnson Heade (1819–1904), but there is no evidence that they shared any theoretical basis for their work. Luminist works achieve an almost supernatural stillness and timelessness accomplished both tonally and by the supression of individual brush strokes. Their luminosity depends largely on compositional devices, huge skies, and expanses of water in a panoramic format. The style has been claimed as distinctly and exclusively American, endowed with transcendental spirituality and with a provenance stretching back to *Copley, but similar atmospheric treatments may be seen in European painting including the work of C. D. *Friedrich and his followers and the Dane *Christen, Købke. DER

American Light: The Luminist Movement 1850–1875, exhib. cat. 1980 (Washington, NG).

LUMINOSITY. See COLOUR.

LUSTRE. See COLOUR.

LUTI, BENEDETTO (1666–1724). Florentine painter who trained under Anton Domenico Gabbiani (1652–1726) before moving to Rome in 1690 and working there under the protection of the Grand Duke of Tuscany. His earliest work is *God Cursing Cain* (1692; Kedleston Hall, Derbys.). He worked for many of the leading families in Rome and was involved in the decoration of the Palazzo de Carolis where he made a ceiling painting, an *Allegory of Diana*. He was profoundly influenced by the Roman classical tradition; this is reflected in his *Investiture of S. Ranieri* (1712; Pisa Cathedral), and *S. Carlo Borromeo Administering Extreme Unction to Victims of the Plague* (1713; Schleissheim, Neue Schloss). He was equally successful as a portrait painter, both oil paintings and pastel drawings. And from as early as 1703 he was making charmingly coloured chalk figure drawings in the style of *Correggio that were widely collected in the 18th century. A pastel *Self-Portrait* (Paris, Louvre) dating from *c.*1720–2 was made for the Roman dilettante Nicola Pio's collection of artists' portraits; it too exploits the subtlety inherent in the medium. Luti was influential as a teacher; his pupils included William Kent, Carle van *Loo, and *Panini and he influenced *Batoni. He was also respected as a connoisseur of old masters, a collector of drawings, and a dealer and agent. HB

Bowron, E. P., 'Benedetto Luti's Pastels and Coloured Chalk Drawings', *Apollo*, CXI (1980).
Waterhouse, E., *Roman Baroque Painting* (1976).

LYSIPPUS OF SICYON (4th century BC). Prolific Greek sculptor in bronze, renowned as a favourite of Alexander the Great. Many of his works were transferred to Rome, and ancient authors record his (i.e. his workshop's) prodigious output in various genres: portraits of athletes and public figures, heroes, gods, action groups, and animals. No originals survive, apart from inscribed bases (e.g. Corinth, Arch. Mus.), but many statues have been identified, often over-optimistically, in Roman versions in diverse media. Most reliable are the *Kairos* (Turin, Mus. Arch.), *Eros* (Rome, Capitoline Mus.), *Apoxyomenus* (Athlete Cleaning Himself; Vatican Mus.), *Alexander* (Paris, Louvre), and *Farnese Hercules* (Naples; Mus. Arch. Naz.). The preserved visual evidence and copious written tradition indicate experimentation in motion, space, proportion, naturalism, and scale. *Pliny (*Natural History* 34. 65) praised Lysippus' scrupulous attention to detail and reports that he made the heads of his figures smaller and their bodies taller and leaner than did previous sculptors, giving them the appearance of greater height. Lysippus' brother Lysitratus is said to have been the first to take plaster moulds from live models for use in bronze casting. KDSL

Moreno, P., *Lysippo: l'arte e la fortuna* (1995).
Pollitt, J. J., *Art in the Hellenistic Age* (1986).
Ridgway, B. S., *Fourth-Century Styles in Greek Sculpture* (1997).
Stewart, A., *Greek Sculpture* (1990).

MABUSE. See GOSSAERT, JAN.

MACCHIAIOLI, Italian artistic group, active during the second half of the 19th century. The leading members were Telemaco *Signorini, Giovanni *Fattori, and Silvestro *Lega, although important contributions were also made by such artists as Vicenzo Cabianca (1827–1902), Serafino de Tivoli (1826–92), Vito d'Ancona (1825–84), Cristiano Banti (1824–1904), Odoardo Borrani (1834–1905), Giuseppe Abbati (1836–68), and Raffaello Sernesi (1838–66). The Macchiaoli derived their name from the word *macchia*, meaning a spot or blotch, which was used in 1861 by a hostile critic to describe their technique of juxtaposing broad patches of colour, with abrupt transitions from dark to light. Although their *plein air* methods anticipated *Impressionism, they used a more conventional palette and faithfully applied the rules of *perspective.

The group was formed during the 1850s in the meetings of progressive artists held at the Caffè Michelangiolo in Florence. As well as opposing the influence of the city's art academy, the artists were also united by a sympathy for the cause of Italian unification. Their political loyalties are clearly demonstrated by such works as Giovanni Fattori's *Italian Camp during the Battle of Magenta* (completed 1862; Florence, Pitti). However, much of the Macchiaioli's best work consisted of a poetic response to everyday life, as in Silvestro Lega's *Singing of the Ballad* (1867; Florence, Pitti).

The Macchiaioli's nationalism did not prevent them from appreciating contemporary French *realism, partly under the encouragement of Nino Costa (1826–1903), who arrived in Florence in 1859. Individual Macchiaioli also made visits to Paris, where they were able to study the *Barbizon School, as well as the work of *Manet and *Degas, who himself visited Florence in 1856. In the 1870s the Macchiaioli's champion Diego Martelli specifically compared them to the Impressionists, while recognizing the differences between them. In general the Italians used colour and tone to create a far more conventional illusion of pictorial space. Moreover, their vigorous brushwork invites comparisons with the work of earlier artists, such as *Titian, placing them firmly within the tradition of Italian painting. CJM

Broude, N., *The Macchiaioli: Italian Painters of the Nineteenth Century* (1987).

MACDONALD SISTERS. Scottish illustrators and designers. **Margaret** (1865–1933) and **Frances** (1874–1921) were born at Newcastle under Lyme, England, and both studied, together, at Glasgow School of Art, in the early 1890s, where, with their fellow students C. R. *Mackintosh and Herbert MacNair (active 1889–1944), whom they were to marry in 1900 and 1899 respectively, they were known as The Four. They initially worked together, producing posters, illustrations, and applied art which, after 1893, influenced by *Toorop, became decidedly *Art Nouveau in style, characterized by elongation, sinuous curves, and bold outlines, and *Symbolist in content. Despite unpopularity in Great Britain (the sisters' interest in the macabre and fantastic earned them the nickname of the Spook School) they achieved considerable continental success, being praised at the Vienna *Sezession of 1900, where their work influenced *Klimt, and the Turin International Exhibition of 1902. The sisters' early work is indistinguishable but after c.1910 Frances's work became more *Expressionist, Margaret's more decorative, although *La Morte parfumée* (1921; priv. coll.),

possibly a memorial to Frances, and still indebted to Toorop, is intense and melancholy.
DER

Helland, J., *The Studios of Frances and Margaret Macdonald* (1996).

MACDONALD-WRIGHT, STANTON (1890–1973). American painter, designer, experimental artist, teacher, administrator, and writer, remembered chiefly as a pioneer of abstract art. He was born in Charlottesville, Va, moved to California as a child, and entered the Art Students' League of Los Angeles in 1905. In 1907 he moved to Paris, where he studied briefly at the Académie Colarossi, the Académie Julian, and the École des Beaux-Arts. He met Morgan *Russell in 1911 and together they evolved *Synchromism—a style of painting based on the abstract use of colour. They first exhibited their works in this style in 1913 and claimed that they, rather than Robert *Delaunay and *Kupka (whose work of the time was very similar), were the originators of a new type of abstract art. In 1914–16 Macdonald-Wright lived in London, where he helped his brother, the critic Willard Huntingdon Wright, with his book *Modern Painting: Its Tendency and Meaning* (1916). He returned to the USA in 1916, living first in New York, and then from 1919 in California. By this time he had abandoned Synchromism for a more traditional representational style. From 1922 to 1930 he was director of the Art Students' League of Los Angeles, and from 1935 to 1942 he worked for the *Federal Art Project, in which capacity he invented a material called Petrachrome for the decoration of walls. He was also involved in other types of experimental work, including colour processes for motion pictures (he was interested in the theatre as well as cinema, writing satires and designing sets for the Santa Monica Theater Guild). In 1937 he visited Japan, and from 1942 to 1952 he taught oriental and modern art at the University of California at Los Angeles. After a second visit to Japan in 1952–3 he gave up teaching and devoted himself full-time to painting, working in a suave, colourful, abstract style that was at times close to his early Synchromism. Some of his best work was done in this late stage of his career. From 1958 he spent part of every year in a Zen monastery in Japan.
IC

MACHADO DE CASTRO, JOAQUÍM (1731–1822). Portuguese sculptor and author. He learned from his father, a versatile sculptor and organist, at Coimbra, then from José de *Almeida in Lisbon, and at Mafra from Alessandro *Giusti, whose assistant he became (1756–70). In 1771 his model won the competition for a colossal bronze *equestrian statue, nearly three times life size, of *King Joseph I* to be erected in the Praça do Comercio (Terreiro do Paço) at Lisbon, celebrating the rebuilding of the city after the earthquake of 1755. Machado de Castro's instructions were to follow an academic project dating back to 1760; but he contrived to lighten and enliven every part of the design. The head of the King was not taken from life because Joseph was too ill to give sittings, but the horse is the closely observed portrait of a fine Spanish stallion named Gentil belonging to the Marquis of Marialva (William Beckford's friend). The monument was completed in 1775 and Machado de Castro made a knight of the Order of Christ. More than 37 tonnes of bronze were used in the *casting, which was a remarkable technical feat. Machado de Castro was responsible for a great deal of religious sculpture in stone, terracotta, and wood, notably at the basilica of the Estrela (built 1779–90); also allegorical figures for the royal palaces, as well as monumental tombs, and *presepios*. He published a number of poems, in addition to essays on the theory and practice of sculpture. The national museum of sculpture in his native town of Coimbra, which is named after him, was established in 1912.
JBB

MACHUCA, PEDRO (d. 1550). Spanish architect and painter, who showed a full understanding of the Italian cinquecento. The son of Castilian gentry, he travelled to Italy where he absorbed the art of the High *Renaissance; during this trip, he painted the *Madonna del suffragio* (1517; Madrid, Prado) which reflects the influence of the artists he met in Florence and Rome. He returned to Spain 1519/20 in the company of Jacopo Torni l'Indaco, and the two undertook an altar for the royal chapel in Granada. His panels there as well as other works painted in Spain, such as the *Descent from the Cross* (1547; Madrid, Prado), show a style unchanged from his earlier Italian works. Machuca's major contribution to Spanish art, however, lies in his architectural designs for the royal palace of Charles V in Granada, in the grounds of the Alhambra. Projected in 1526, the palace was left unfinished at his death, and the final work was only completed in 1967–70. Machuca's elevations and groundplan—a circular courtyard enclosed in a square building—evoke the work of *Francesco di Giorgio, *Peruzzi, and designs for the Villa Madama (by Antonio da Sangallo and *Raphael).
PL

Rosenthal, Earl E., *The Palace of Charles V in Granada* (1985).

MAÇIP, FATHER AND SON. Spanish painters. **Vicente** (c.1475–1550) was the founder of an artistic dynasty in Valencia continued by his son, known as **Juan de Juanes** (c.1510–79). Maçip's paintings were influenced by Valencia's close ties with Italy, though tempered by lingering vestiges of the Flemish style. He used prints after *Raphael for compositional models and was later inspired by four paintings by *Sebastiano del Piombo which were in Valencia from 1521; the latter's example is followed by Maçip in the *Lamentation* he painted for the high altarpiece of the Cathedral of Segorbe (completed by 1530; *in situ*). Juan de Juanes's paintings, delicately drawn and finished with brilliant, enamel-like colour, were immensely popular and often copied. His conservative (sometimes bland) Romanist style, as seen in *The Last Supper* (c.1560; Madrid, Prado), evinces a cautious Counter-Reformation spirituality that was continued by his followers in Valencia until well into the 17th century.
SS-P

Albi, J., *Joan de Joanes y su círculo artístico* (3 vols., 1979).

MACKE, AUGUST (1887–1914). German painter and member of the *Blaue Reiter group. He studied under *Corinth in *Berlin and visited Paris in 1907 and 1908. In 1910 he saw the work of *Matisse in Munich and met Franz *Marc there, joining the Blaue Reiter in 1911.

Assimilating a range of styles, from *Impressionism and *Fauvism to *Cubism and the work of Robert *Delaunay he had encountered in Paris, Macke during his short life as a painter showed a great feeling for colour combined with a strong sense of lyricism and semi-abstract form. Although he was killed at the Front in 1914 when his uniqueness of voice was only just beginning to crystallize, nature in the city environment and fashionable women in the metropolis, *Promenade* (1913; Munich, Städtische Gal.), are two of the themes that predominate in his work.

Some of Macke's most mature works came out of his trip to Tunis with Paul *Klee in 1914 shortly before he was killed. These watercolours and oils show Macke's rich combination of colour and geometrical patterning with figurative and abstracted, symbolic forms that hold their power to this day.
RRAM

Bitter, R. von, *August Macke* (1995).

MACKINTOSH, CHARLES RENNIE (1868–1928). Scottish architect and designer. Although best known as an architect Mackintosh was a gifted graphic and watercolour artist. In the early 1890s he attended classes at Glasgow School of Art and together with his fellow students Herbert MacNair and Margaret and Frances *Macdonald, whom they were to marry, formed The Four. The group produced applied art, illustrations, posters, and watercolours in a style, derived from continental *Art Nouveau, which was sufficiently individual to become known as the Glasgow Style. Their work,

437

which is sometimes virtually indistinguishable, is characterized by formalized flower heads, Celtic pattern, vertical emphasis, and parallel organic upright forms, clearly seen in Mackintosh's posters for *The Scottish Musical Review* (1896; Glasgow University). An exhibition in London in 1896 was poorly received but continental acclaim followed in the early 1900s. In 1914 Mackintosh virtually abandoned architecture and moved to Walberswick where he commenced painting elegant linear flower studies. He lived in Chelsea (1916–23) and 1923–7 in the French Pyrenees, where he painted watercolour landscapes which, as in *Fetges* (c.1927; London, Tate), retain mannerisms acquired from both Art Nouveau and architectural drawing. DER

Billcliffe, R., *Mackintosh Watercolours* (1978).

MACLISE, DANIEL (1806–70). Irish-born painter. Maclise was born in Cork and attended the School of Art before practising as a portrait draughtsman. A drawing of *Sir Walter Scott* (1825; London, BM) made his reputation. He arrived in London in 1827 to attend the RA Schools (see under LONDON) where his progress was meteoric. He continued to draw portraits and in 1830 began a series of caricatures for *Fraser's Magazine*. He painted his friend *Dickens* in 1839 (London, NPG) and illustrated *The Chimes* (1844). His real ambition, however, lay in subject paintings. *The Choice of Hercules* (1831; priv. coll.) won the gold medal for history painting, and *Merry Christmas in the Baron's Hall* (1838; Dublin, NG Ireland) established his popularity. From the 1840s, when a strong Germanic influence appeared in his work, he specialized in early English history and was thus a natural choice as a contributor to the Westminster Hall frescoes. *The Spirit of Chivalry* and *Spirit of Justice*, executed 1846–9, led to his greatest work, the frescoes of *Wellington and Blücher* and the *Death of Nelson* (1858–65; London, House of Lords). DER

Ormond, R. (ed.), *Daniel Maclise*, exhib. cat. 1972 (London, NPG).

MADERNO, STEFANO (1575–1636). He was perhaps the most interesting Italian sculptor in the generation before Gianlorenzo *Bernini, and contributed to the creation of the early *Baroque style in sculpture. He worked almost exclusively in Rome, where his best-known work is the recumbent statue of the martyred *S. Cecilia* (1600; Rome, S. Cecilia in Trastevere) carved to mark the spot where remains identified as hers had been discovered in 1599. Though naturalistic and classicizing in style, the drama with which the marble corpse is imbued anticipates many of the effects later used by Bernini, and indeed the statue was the

inspiration for the latter's *Blessed Ludovica Albertoni* (1671–4) in S. Francesco a Ripa. In addition to a series of monumental works that include innovative reliefs for the tomb of Paul V (1613–15) in S. Maria Maggiore, Maderno produced a number of small bronzes and terracottas loosely derived from the *Antique. Always sought after by collectors, they include a series of terracottas on the theme of *The Labours of Hercules* (early 1620s; Venice, Ca' d'Oro). MJ

Nava Cellini, A., *Stefano Maderno* (1966).

MADRAZO, DE. An extensive family of painters, architects, lithographers, and critics; among the most powerful and influential of Spanish academicians of the 19th century. The *Neoclassical painter **José de Madrazo y Agudo** (1781–1859), who studied under *David and is best known for works such as *The Death of Viriatus* (c.1815; Madrid, Buen Retiro), began a nepotistic tradition within *Madrid's Academia de S. Fernando that was often criticized for being derivative of French styles, and one continued by his son **Federico de Madrazo y Küntz** (1815–94) (who studied under *Ingres). José played a leading role in establishing (1825) the first *lithographic press in Spain, later the Real Calcografía. Federico is best known for finely polished portraits of the nouveaux riches and of the high aristocracy, among the most famous of which is his *Condesa de Vilches* (1853; Madrid, Buen Retiro). He served as First Court Painter, director of the Prado Museum and the Academia de S. Fernando, and was professor at the Escuela Superior de Pintura, Escultura y Grabado (Madrid). Further, he was collaborator and artistic director of two of the era's most important artistic magazines, *El artista* (1835–6) and *El Renacimiento* (1847). OEV

Díez, J. L. (ed.), *Federico de Madrazo*, exhib. cat. 1994 (Madrid, Prado).

Ealo de Sa, M., *José de Madrazo, primer pintor neoclásico de España* (1981).

González López, C., *Federico Madrazo y Küntz* (1981).

Vega, J. (ed.), *Origen de la litografía en España*, exhib. cat. 1990 (Madrid, Fábrica Nacional de Moneda y Timbre).

MADRID: PATRONAGE AND COLLECTING. Madrid's importance as a centre of art, patronage, and collecting has been dictated by its position as Spain's capital. The royal court was established in the previously insignificant town by Philip II (ruled 1556–98) in 1561. Philip's first court portraitist was Anthonis *Mor, who established an understated Habsburg formula that was continued by Alonso *Sánchez Coello and by the Cremonese portraitist Sofonisba *Anguissola. Otherwise, Philip's collection was biased towards Flemish art (especially Hieronymus *Bosch) and Venetian painting (by *Titian above all). Titian

had effectively been court painter to Philip's father Emperor Charles V, and he supplied Philip with about 30 further paintings including the great mythological *poesie*.

Philip's major project was the dynastic mausoleum of the *Escorial, which he attempted to decorate with a maniacal commitment to Counter-Reformation orthodoxy. While Spanish painters received several altarpiece commissions there, Philip was eager to recruit Italians, and he eventually obtained Luca *Cambiaso, Federico *Zuccaro, and Pellegrino *Tibaldi.

Under the weak Philip III (ruled 1598–1621) the favourite Duke of Lerma rapidly identified himself as a major collector so that, when the Duke of Mantua sent *Rubens with gifts to Philip in 1608, he also included a group of paintings for Lerma. The taste that Lerma encouraged among his circle, however, was for the 'reformed' school of contemporary Florentine painting, which Ferdinand I of Tuscany was only too glad to supply and which had a strong influence on religious painting in Madrid.

Philip IV (ruled 1621–65) began by relying for 20 years on his favourite the Count-Duke of Olivares, who encouraged him to spend lavishly on the arts and whose kinsmen both built up their own collections and supplied paintings to the King. A major project was the Buen Retiro Palace, which provided work for a host of painters. These included *Velázquez, whom Olivares had brought to Madrid in 1623, and who was soon appointed as a royal painter and recognized as a talent quite out of the ordinary.

In 1628–9 Rubens returned to Madrid on a diplomatic mission and was given rooms in the royal palace. The King visited him most days and showered him with commissions when he returned to Antwerp. Velázquez rose up the hierarchy of courtiers to become curator of the royal collections. Philip took full advantage of such contacts, becoming probably the greatest royal connoisseur who has ever lived, and keeping a close watch on buying opportunities throughout Europe. When Rubens died in 1640 Philip secured the cream of his collection.

The King's passion for painting became a dominant feature of the reign. Spanish ambassadors were used to search out acquisitions; the court was seized with collecting fever; and gifts of paintings by the great names of the Italian cinquecento or by Rubens were the standard way to obtain royal favour. Probably the most important collector was Luis de Haro, Marquis of El Carpio, Olivares's nephew and his successor as chief minister. He arranged for the Spanish ambassador in London to buy much of Charles I's collection at the Commonwealth sale, and while he gave many of the finest works to Philip he also kept many for his own vast collection.

While works by Velázquez, *Ribera, and the Spanish still-life painters were accepted in the royal and noble collections, Spanish painters were generally restricted to portraiture, decoration, and religious work (where they were often subject to very conservative church patrons). In particular, the noble collectors round the court looked to Italy and Flanders for landscapes, genre pieces, and mythologies. This distinction existed for the whole period of Habsburg rule and it partly reflected the fact that Flanders, Milan, and Naples were under Spanish sovereignty throughout the period.

Although Spain's political power continued to slump during Philip IV's reign, his picture collection at the time of his death was certainly the finest in Europe. For a short period Madrid must also have seen more paintings being bought and sold than any other European city. Some painters owned their own shops for direct sales to the public, and others (including Velázquez) did a bit of dealing on the side. No specialist cadre of picture dealers emerged, however.

It is ironic that while Charles II (ruled 1665–1700), the last Habsburg ruler, pathetically presided over a further decline in Spain's power, he brought Luca *Giordano to Madrid to paint, amongst much else, a great ceiling fresco of *The Triumph of the Spanish Habsburgs* (1692–4) in the Escorial.

The Bourbon dynasty that ruled from 1700 sought to encourage national performance in the arts as in other spheres. The Real Academia de Bellas Artes de S. Fernando was established in 1744/52 on the model of the French Academy, to lift Spanish painters from their previous artisan status, and paintings by earlier Spanish painters such as *Murillo began to enter the royal collection at this time. Major royal commissions, however, still tended to go abroad in the traditional way. Jacopo *Amigoni was made court painter in 1747, to be followed in the next two decades by Corrado *Giaquinto and Anton Raphael *Mengs, both of whom frescoed ceilings in the new royal palace and were also directors of the academy. *Tiepolo, too, made some great ceilings in the palace, though his work could hardly have been more different from Mengs's *Neoclassicism that had become the official style and his final altarpieces were soon replaced by Mengs.

*Goya was appointed in 1774 by Mengs to design cartoons in the royal tapestry works. He became First Royal Painter and although his work developed in passionate, *Romantic, and apparently revolutionary ways during and after the Napoleonic Wars he enjoyed royal favour until his death.

During the 19th century Madrid's experience was similar to that of many Italian cities. On the one hand, tentative steps towards an industrialized society created a bourgeois clientele for conservative home-produced landscapes, genre paintings, and portraits. On the other hand, earlier Spanish painting became fashionable and an external market developed to exploit the value of the paintings locked up in churches and in the great noble collections that were now breaking up. Since most of the collections were sent to auction in *Paris or *London, however, this had little effect on the art market within Madrid.

Since the 1830s Madrid's importance as an art centre has rested not so much on production, patronage, and collecting, as on the existence of the Prado Museum, which became the repository of the phenomenal royal collection. In the 1980s the Centro de Arte Reina Sofía was established to exhibit *Picasso's *Guernica* and other modernist work, and in 1992 most of the Thyssen-Bornemisza Collection was put on permanent show in a palace near the Prado. AJL

Brown, J., *Painting in Spain, 1500–1700* (1998).

MADRID, ACADEMIA DE S. FERNANDO. The Academy's museum is located in a mansion occupied by the Academia de S. Fernando since 1774 (at that time the building was renovated according to Neoclassical principles). Its collection proceeds from various origins. First come the works of art produced by the academicians since the Academy was founded in 1752. Secondly there are some important paintings selected from among those confiscated when the Jesuits were expelled from Spain in 1767. After the Peninsular War (1808–14), the Academy kept a selection of the paintings seized by the French, notably major works from the collection of Godoy (Charles IV's favourite). The Academy profited very little from the consequences of the suppression of the convents in 1835–7: the Museo Nacional de la Trinidad deprived the Academy of the paintings it had helped to gather. On the other hand, the Academy received a bequest of several major works by *Goya in 1839. Later on, its collection increased gradually, particularly by means of donations. For a long time reserved for the use of academicians, public access to these collections dates from 1817.

No better place can be found to understand the evolution of 18th- and 19th-century Spanish painting, when the Academia de S. Fernando was at its height, including the academicians and court painters Francisco *Bayeu, Vicente *López, and Federico de *Madrazo. The variety of the collections, however, also enables the visitor to admire works by *Bellini, *Correggio, *Tiepolo, *Rubens, and *Fragonard. As for the Spanish school, this museum boasts paintings by most of the Spanish masters: *Pereda, *Murillo, *Ribera, *Cano, El *Greco, Madrazo, *Sorolla, and above all *Morales, *Zurbarán, and Goya.

The museum owns, furthermore, an important collection of Italian and Spanish drawings. Most of the Italian drawings acquired in 1775 had originally come from Carlo *Maratti's collection and had been kept by his student Andrea Procaccini, who had been court painter to the Spanish Bourbon Philip V. Apart from drawings by Maratti and his studio the collection includes studies by *Domenichino and *Sacchi. The holding of Spanish drawings is largely made up of those presented for competitions by Spanish academicians. PG

MADRID, PRADO. It was the first public museum opened in Spain, founded in 1819 by Ferdinand VII, after the attempts of Joseph Bonaparte and the Academia de S. Fernando had failed. Built up exclusively from the royal collections and administratively dependent on the royal household, it became a national museum in 1868, and was enriched shortly afterwards by the addition of the collections of the defunct Museo Nacional de la Trinidad (1858–72) created in Madrid following the suppression of the convents (1835–7). From that time, the collections slowly increased through purchases and bequests. In 1971, the 19th-century paintings of the Museo de Arte Contemporáneo (founded in 1894) were allocated to the Prado.

The Prado collections provide an exact measure of the history of royal patronage in Spain, which was especially distinguished during the Habsburg age (1516–1700), when numerous paintings by Venetian masters including *Titian, *Tintoretto, and *Veronese were commissioned or acquired. Philip II had also broadened his horizons and demonstrated a notable interest in Flemish painting (Rogier van der *Weyden, *Master of Flémalle, Hieronymus *Bosch, Joachim *Patinir).

In the 17th century, thanks in particular to Philip IV's patronage, the royal collections had continued to grow. In addition to major works by the Spanish painters of the Golden Age, *Murillo, *Zurbarán, *Ribera, and *Velázquez (the latter a court painter), cycles of paintings were commissioned from artists such as *Rubens, *Stanzione, and *Lanfranco through agents and viceroys posted in London and Naples. Paintings such as *Mantegna's *Death of the Virgin* were acquired from Charles I's collection during the Commonwealth sales in 1649–51 (see LONDON). Under the Bourbons, Philip V and his second wife Isabella Farnese formed an important collection of paintings. She brought over Italian paintings and developed an obsession with Murillo's religious paintings while the court was in Seville 1729–33. Through his court painter, Philip acquired in 1724 the collection of the Roman painter Carlo *Maratti, which contained notable works by *Domenichino,

Guido *Reni, and Maratti himself. In addition, a significant group of classical sculptures were acquired from Queen Christina of Sweden. French portraitists such as Louis-Michel van *Loo, Jean Ranc, and Michel-Ange Houasse (1680–1730) employed at court left significant portraits of the royal family. Later Charles IV commissioned landscapes from Claude-Joseph *Vernet to decorate his *casitas* (small country houses).

The very remarkable collection of *Goya's works, as well as those of El *Greco, were acquired for the most part during the 19th and 20th centuries. Goya tapestries were discovered in the vaults of the royal palace in 1868 and entered soon after.

Located in the building conceived by Juan de Villanueva in 1785 in order to accommodate an academy of arts and science, the Prado museum annexed the Casón del Buen Retiro in 1980. A new extension will soon enable the museum to display most of the numerous works in reserve until now. PG

MADRID, THYSSEN MUSEUM. Founded in 1992 as a result of the loan agreement signed in 1988 between the Spanish Crown and Baron Hans Heinrich Thyssen-Bornemisza, the museum is located in the Villahermosa Palace, an 18th-century building facing the Prado museum. Completely renovated—except for the façades—in 1992 for its new purpose, it displays a comprehensive selection of the best works of this private collection, previously in Villa Favorita, Lugano. In 1993, the Spanish state purchased the 775 paintings of the Permanent collection. Heinrich Thyssen (1875–1947), who became Baron Thyssen-Bornemisza on his marriage to the daughter of a Hungarian aristocrat, was head of a vast economic empire based on banking, and began purchasing works of art in the 1920s. Interested first in early German masters, he then turned his attention to the Flemish and Dutch schools, and, finally, the Italian, Spanish, and French. He had little interest in 19th- and 20th-century painting. His son Hans Heinrich (1921–) initially remained faithful to his father's taste: he continued to enlarge the collection of old masters, but in the 1960s he started to build up a remarkable collection of modern painting. Very rich in German *Expressionism and 20th-century American painting, the collection provides the visitor with a wide panorama of western European artistic movements and of the Russian avant-garde. PG

MAELLA, MARIANO SALVADOR (1739–1819). One of the most successful artists employed at the court of Charles III and Charles IV. Having won several competitions at the Royal Academy of S. Fernando (see under MADRID) during the 1750s, he was sent to Rome in 1758 with a special royal pension to copy after the *Antique and study Roman painting. He displayed particular talent as a draughtsman, using late Roman *Baroque compositions and a loose and vibrant technique reminiscent of drawings by *Giordano. On his return to Madrid in 1764, he was engaged as an assistant to the court painter, Anton Raphael *Mengs, to decorate the ceilings of the recently rebuilt royal palace. In 1774, he was named court painter and given commissions for ceilings in various royal residences, notably the Pardo Palace outside Madrid. As court painter, Maella was required to paint portraits of the King and his family, altarpieces for the royal chapels, and designs for tapestry cartoons. His drawings and *bozzetti* show a quick-spirited brush and warm colours, conditioned by Mengs's cold and Neoclassical finish in vogue at the time. Maella fell from favour after the Napoleonic War, when the restored Ferdinand VII suspected him of having worked for Joseph Bonaparte. XB

Morales y Marin, J. L, *Maella* (1997).

MAES, NICOLAES (1634–93). A fine painter of biblical and genre scenes as well as portraits. Maes was born in Dordrecht, but entered *Rembrandt's studio in Amsterdam in about 1648–50. He seems to have returned to Dordrecht (1653–73), and then resettled in Amsterdam. He is also described as having travelled to Antwerp in the mid-1660s in order to see paintings by *Rubens and van *Dyck. While there he visited the studios of artists such as *Jordaens. Maes's early works, such as *The Dismissal of Hagar* (New York, Met. Mus.) of 1653 and *Christ Blessing the Children* (London, NG) of the same period, were deeply influenced by Rembrandt's broad style of the 1640s. But his later *genre paintings are far more independent in spirit, meticulous, and move away from an emphasis on dark and reddish schemes, towards a cooler approach. They often treat gently didactic themes such as *The Idle Servant*. From 1660 on Maes specialized in portraiture, often producing very small works, which proved extremely popular. CB

Valentier, W. R., *Nicolaes Maes* (1924).

MAESTÀ, or Virgin in Majesty, an image showing the Madonna and Child enthroned, often accompanied by angels and saints. With the increasing emphasis upon the role of the mother of Christ, such altarpieces were particularly popular in 13th- and 14th-century Italy. The earliest examples, such as *Coppo di Marcovaldo's *Madonna del Bordone* (1261; Siena, S. Maria dei Servi), closely followed *Byzantine tradition. The most renowned *Maestà* was the huge, double-sided panel painted by *Duccio for the high altar of Siena Cathedral (1311; Siena, Mus. dell'Opera del Duomo). MLS

MAGIC REALISM, in visual art, a term coined in 1925 by the German critic Franz Roh to classify aspects of Neue Sachlichkeit painting in which a quasi-photographic precision led at once to a sense of heightened clarity and of dreamlike strangeness. Roh also considered some non-German painters to be magical realists, such as Joan *Miró and *Picasso, and the application of the term has subsequently broadened to include any painting in which elements of weirdness or unreality are created by a punctilious method of depiction that seems polarized against every form of abstraction. Magic realism thus defines the styles of some *Surrealist paintings, such as those of Salvador *Dalí and René *Magritte, in which optical illusions and impossible objects are rendered with disconcerting naturalism. In the works of Tristram Hillier (1905–83), deserted landscapes are painted with such extreme precision that they acquire a hallucinatory quality and are suffused with a mysterious sense of 'presence'. The term was brought into wider use in 1943 by the exhibition *American Realists and Magic Realists*, held at MoMa New York, and curated by Alfred Barr. OPa

MAGNASCO, ALESSANDRO (1667–1749). One of the most eccentric, brilliant, and original artists working in Milan in the *Baroque era. He was born in Genoa and may have received his early training there from Domenico Piola (1627–1703). His vibrant, animated designs, with small contorted hyperactive figures may have been inspired by the spirit and technique of oil sketches by earlier artists active in Genoa such as *Castiglione, Valerio *Castello, and his own short-lived father, Stefano Magnasco (c.1635–c.1670/3). However, it was in Milan that he achieved his artistic identity; he settled there from c.1680 until 1703, when he moved temporarily to Florence to work for Ferdinand de' Medici (until 1709). He was inspired not only by Lombard painters, such as *Morazzone and *Cairo, but also by Sebastiano *Ricci, who was in Milan 1694–6 and collaborated with the elusive landscape painter Antonio Francesco Peruzzini (1646/7–1724), who also specialized in painting architecture. Collaboration with Peruzzini, S. Ricci, and his nephew Marco appears to have been fundamental to Magnasco's own artistic practice and may also reflect the esoteric tastes of sophisticated collectors, is well documented in old inventories of Milanese and Florentine collections. However, Magnasco was certainly capable of producing his own landscape backgrounds, which show a degree of abstraction and fantasy that was

alien to Peruzzini and Marco Ricci, as seen for instance in the *Baptism of Christ* and *Christ Saving S. Peter from the Sea* (Washington, NG). Left to his own devices Magnasco was an artist of vision and imagination, a cruel sardonic satirist of the contemporary world with a particular eye for claustrophobic or reclusive environments—the religious life with nuns or monks, Jews or Quakers; prison life; or life at court. It is a world in disequilibrium, affected by physical and psychological displacement, troubled by storms and tempests, and excited by religious visions, frenzied sexual orgies, torture, and punishment (e.g. *Embarkation of the Galley Slaves in Genoa Harbour*; Bordeaux, Mus. des Beaux-Arts). In artistic terms he looks back to *Callot, Salvator *Rosa, and G. M. *Crespi, and looks nervously ahead to *Goya. HB

Brigstocke, H., *Alessandro Magnasco*, exhib. review, *Burlington Magazine*, 138 (Oct. 1996).

Castellotti, M. B., et al., *Alessandro Magnasco*, exhib. cat. 1997 (Milan, Palazzo Reale).

MAGRITTE, RENÉ (1898–1967). Belgian *Surrealist painter. Magritte's family moved to France in 1910; two years later his mother drowned herself. At 17 he painted his first pictures, influenced by his enthusiasm for detective films and the bizarre paintings of James *Ensor. He studied at the Brussels Academy from 1916, associating with the Belgian avant-garde—poets and painters—and admiring the *Futurists and the Italian metaphysical painter Giorgio *de Chirico. After completing his military service, and experimenting with abstraction, he painted *The Menaced Assassin* (New York, MoMA) in 1926—the first of his 'snapshots of the impossible', in which he exploited the dislocation between image and reality.

Magritte moved to Paris in 1927, becoming closely involved with the newly formed Surrealist group, led by André *Breton, including Salvador *Dalí, the poet Paul Éluard, and the film-maker Luis Buñuel. He returned to Brussels in 1930 after a quarrel with Breton, and remained there for the rest of his life, visiting England briefly in 1937, and moving to Carcassonne during the Nazi occupation of Belgium.

In the latter part of his career, Magritte's international reputation gained him many public commissions: large frescoes including *The Enchanted Domain* (1952; Knokke-le-Zoute) and *Les Barricades mystérieuses* (1961) for the Brussels Palais des Congrès. His work became especially popular in America, which he visited several times. His disturbing, evocative images, thinly painted with meticulous attention to naturalistic detail, explore the poetic reality behind the appearances of objects by setting them in bizarre juxtapositions. His titles deliberately relate obliquely, if at all, to the apparent situations, thus adding an enigmatic intellectual

element, frequently witty, to the imaginative paradoxes he creates. JH

Sylvester, D., *Magritte* (1992).

MAHLSTICK. See STUDIO EQUIPMENT (PAINTING).

MAIANO, DA. Italian sculptors, father and son. **Benedetto** (1442–97) was a Florentine who with *Verrocchio was the principal sculptor of the later 15th century. He probably trained initially as an intarsia worker, and for most of his career collaborated with his brother, the architect Giuliano da Maiano (1432–90). At an early stage he may have assisted Antonio *Rossellino, and learned his marble-cutting skills from him, especially noticeable in the masterly portraits of *Pietro Mellini* (1474; Florence, Bargello) and *Filippo Strozzi* (1475; Paris, Louvre). His early works include the shrine of S. Savino in Faenza Cathedral (1468–71) and an altar of S. Fina in the Collegiata at San Gimignano (c.1475). His masterpiece is the marble pulpit commissioned by Mellini for S. Croce in Florence (1472–85), whose panels depicting scenes from the life of S. Francis are organized with clarity within decorative architectural frames. During the 1480s he completed work begun by Rossellino for Naples, for instance the *Annunciation* altar for S. Anna dei Lombardi, Naples, which had a defining impact on local sculptors. With his brother Giuliano he was involved in the design of the Palazzo Strozzi, Florence, and worked on Filippo Strozzi's tomb in S. Maria Novella (unfinished in 1491). His marble *S. John the Baptist* (1480–1; Florence, Palazzo Vecchio) complements Verrocchio's bronze version of the subject.

Giovanni (1486–c.1542), Benedetto's son, trained in Florence with his father, but by about 1520 he was in England as an associate of Pietro *Torrigiano who had been commissioned by Henry VIII to make tombs in Westminster Abbey (see LONDON) for his father Henry VII and for himself and his first wife Catherine of Aragon. Maiano, known in England as John de la Mayn, worked for Henry and for Cardinal Wolsey. Although the screen of King's College Chapel, Cambridge, has been attributed to him, his only documented surviving work is a set of eight terracotta roundels of Roman emperors set into the exterior of Hampton Court. These are among the first examples of Italian Renaissance sculpture in England. AB/MJ

Auerbach, E., *Tudor Artists* (1954).

Darr, A., 'New Documents for Pietro Torrigiani and other Early Cinquecento Sculptors Active in Italy and England', in M. Cämmerer (ed.), *Kunst der Cinquecento in der Toskana* (1992).

Pope-Hennessy, J., *Italian Renaissance Sculpture* (4th edn., 1996).

MAILLOL, ARISTIDE (1861–1944). French sculptor, painter, graphic artist, and tapestry designer. He was born in Banyuls-sur-Mer, in the south-east of France, near the Spanish border, and moved to Paris in 1881 to study painting (he entered the École des Beaux-Arts in 1885). His early career, however, was spent mainly as a tapestry designer, and he opened a tapestry studio in Banyuls in 1893. He first made sculpture in 1895, but it was only in 1900 that he decided to devote himself to it after serious eye strain made him give up tapestry. In 1902 he had his first one-man exhibition (at the Galerie Vollard in Paris), which drew praise from *Rodin; in 1905 came his first conspicuous success as the Salon d'Automne, *Paris; and after about 1910 he was internationally famous and received a constant stream of commissions. With only a few exceptions, he restricted himself to the female nude, expressing his whole philosophy of form through this medium. Commissioned in 1905 to make a monument to the 19th-century revolutionary Louis-August Blanqui, he was asked by the committee what form he proposed to give it and replied, 'Eh! une femme nue.' More than any other artist before him he brought to conscious realization the concept of sculpture in the round as an independent art form stripped of literary associations and architectural context, and in this sense he forms a transition between Rodin and the following generation of modernist sculptors. This was acknowledged in his lifetime. In 1929 Christian Zervos wrote in *Cahiers d'art*: 'With other premises and a very different effect, Maillol was a precursor of today's *Constructivism. All his figures create an impression of massive structure, of a search for beautiful volume.' Maillol himself said, 'My point of departure is always a geometrical figure', and that although 'there is something to be learned from Rodin . . . I feel I must return to more stable and self-contained forms. Stripped of all psychological details, forms yield themselves up more readily to the sculptor's intentions.' He rejected Rodin's emotionalism and animated surfaces; instead, Maillol's weighty figures, often shown in repose, are solemn and broadly modelled, with simple poses and gestures. Although it was forward-looking in many ways, Maillol's work also consciously continued the classical tradition of Greece and Rome (he visited Greece in 1908); at the same time it has a quality of healthy sensuousness (his peasant wife sometimes modelled for him).

Maillol settled at Marly-le-Roi on the outskirts of Paris in 1903 but usually spent his winters in the south. In 1939 he returned to his birthplace. He took up painting again at this time, but apart from his sculpture the most important works of his maturity are his book illustrations, which helped to revive

the art of the book in the 1920s and 1930s. His finest achievements in this field are the *woodcut illustrations (which he cut himself) for an edition of Virgil's *Eclogues* (begun 1912 but not published until 1926), which show superb economy of line. He also made *lithographic illustrations. A museum dedicated to Maillol opened in Paris in 1995, and there are examples of his work in many important collections of modern art. IC

MAINARDI, BASTIANO (Sebastiano) (1466–1513?). Tuscan painter. Mainardi was, as *Vasari first suggested, closely connected to Domenico *Ghirlandaio and the Ghirlandaio family throughout his life. As well as marrying the Ghirlandaio brothers' half-sister, Mainardi was probably trained by Domenico in the 1470s and was later employed by the Ghirlandaio studio in Pisa in 1492 and 1494. He is, however, first documented in 1484 in San Gimignano, where in the church of S. Agostino he executed a fresco of *S. Geminianus Blessing Three Noblemen* (1487). This early work, characterized by the calm poses of the figures, the plasticity of the forms, and incisive drawing, is heavily dependent on the style of Ghirlandaio. From a more mature phase is the *Madonna and Child with Saints* (1507; Indianapolis Mus.), which displays more softly painted forms and gentler lighting effects. However, Mainardi's Ghirlandaiesque inheritance is still apparent in the overall balance of the composition, the careful and clear order of the blocklike figures in space, and the quiet serenity of the poses, gestures, and facial expressions. FB

Fahy, E., *Some Followers of Domenico Ghirlandaio* (1976).

MAINO, JUAN BAUTISTA (1578–1641). Painter born in Spain of a Milanese father and Portuguese mother. Maino's artistic style was formed during a sojourn in Italy where he evidently knew Annibale *Carracci and Guido *Reni. Back in Spain by 1608, Maino then moved to Toledo to paint the main altarpiece at the Dominican friary of S. Pedro Mártir. The large *Adoration of the Shepherds* and *Adoration of the Magi* (1612–13; Madrid, Prado) painted for that altarpiece show Maino's understanding of *Caravaggio's early Roman style. The realistic (though exotic) figures and their genuinely human response to the miraculous are rendered with carefully arranged *chiaroscuro and brilliant colour. Maino joined the Dominican order in 1613. In 1614, appointed drawing master of the future Philip IV, he moved to the court in Madrid. From then on, he seldom painted. However, Maino's contribution to the series of *battle paintings for the Buen Retiro Palace in Madrid demonstrates that his command of painting was undiminished.

Indeed Maino's *Recapture of Bahía* (1634–5; Madrid, Prado) is nearly the equal of *Velázquez's *Surrender of Breda* (1634–5; Madrid, Prado) in its compositional originality. SS-P

Brown, J., *The Golden Age of Painting in Spain* (1991).

MAITANI, LORENZO (active 1290–1330). Sienese architect and probably sculptor, who worked mainly in Orvieto, where he supervised the construction of the cathedral from 1310 until his death. He was also responsible for other civic structures there and was consulted on the construction of Siena Cathedral and on acquaducts in Perugia. The terms of his Orvieto contract reflect his celebrity as an architect, which is justified by his remedial work on the cathedral transept, apse, and roof.

Maitani is credited with the design of the façade and supervision of all aspects of the construction and decoration of the lower half; a preliminary drawing (Orvieto, Mus. dell'Opera del Duomo) is ascribed to him. His contribution to the sculptural decoration is largely conjectural. He is thought to be responsible for the bronze Evangelist symbols, the bronze and marble group of the *Virgin and Child with Angels*, and some of the marble reliefs which flank the doors. These feature slender, linear figures which may be influenced by French *Gothic sculpture, similarly the vine tendrils which divide the reliefs. While Giovanni *Pisano's Siena Cathedral façade may have provided an inspiration for Maitani's design, his style of execution as a sculptor is more independent in character.

MS

Pope-Hennessy, J., *Italian Gothic Sculpture* (4th edn., 1996).

MAKART, HANS (1840–84). Austrian painter. He was born in Salzburg and studied at the Munich Akademie where he was taught and influenced by the historical painter Karl von Piloty (1826–86). After visiting Paris, London, and Rome (1862–3) Makart returned to Munich where he made his reputation with two large decorative triptychs, *Modern Cupids* (Vienna, Zentsparkasse) and *The Plague in Florence* (Schweinfurt, Sammlung Schafer), which he exhibited in 1868. In the following year he was summoned to Vienna by the Emperor Franz Josef where he worked for a decade on massive, florid, and theatrical paintings and decorations for the court and other patrons. A winter in Cairo (1875–6) led him to add oriental subjects, for instance *Cleopatra's Nile Journey* (1875; Stuttgart, Staatsgal.), to his mythological and historical repertoire. Similarly a visit to the Netherlands in 1876 was the inspiration for his monumental but bathetic *Charles V's Entry into Antwerp* (1877–8, Hamburg, Kunsthalle), a riotous extravaganza of brightly coloured figures which was shown

to popular acclamation at the Paris Exposition Universelle in 1878. Makart's later years, which he devoted to the Nibelung myth, were dogged by illness and his reputation diminished rapidly after his death. DER

Frodl, G., *Hans Makart* (1974).

MÂLE, ÉMILE (1862–1954). French art historian who pioneered the study of religious *iconography. Mâle was made a full professor of art history at the Sorbonne in 1912, and in 1925 appointed director of the École Française d'Archéologie in Rome. In 1927 he became a member of the Académie Française. He achieved wide popular acclaim with *L'Art religieux du XIIIe siècle en France* (1898). The book considers the religious *iconography of the 13th century in its intellectual context. Mâle thus draws analogies between medieval compendia of knowledge, written by authors such as Vincent of Beauvais, and the imagery of the French *Gothic cathedral, which is interpreted here as a monumental visual encyclopedia. In his later years Mâle chose to examine religious art from the 12th to the 18th centuries along similar lines (e.g. *L'Art religieux après le Concile de Trente*, 1932). His polemical book *L'Art allemand et l'art français du moyen âge* (1917) dismisses German medieval art as derivative, but must be seen in the context of the general outcry caused by the destruction of French monuments by German troops during the First World War. AT

MALEVICH, KASIMIR (1878–1935). Russian painter, designer, and founder of *Suprematism. After studying at various art schools in Russia, he began as a painter of mainly *Post-Impressionist landscapes, and peasant subjects. In 1910, he contributed to the first Knave of Diamonds exhibition in Moscow, at the invitation of the avant-garde artist Mikhail Larionov. He visited Paris briefly in 1912, and began to combine *Cubist and *Futurist elements in paintings like *The Knife Grinder* (1912; New Haven, Yale University AG), but experimented 1913–15 with a *Surrealist and 'nonsense realist style' as in *An Englishman in Moscow* (1914; Amsterdam, Stedelijk Mus.) which, as a form of protest against logicality, presaged the anarchical work of the *Dadaists. Belonging to a wide circle of Futurists which included poets and writers, he designed the scenery and costumes for Kruchenykh's outrageously modern Futurist opera *Victory over the Sun* (1913), painting one of the backdrops with a black and white square. Although he maintained this was the start of Suprematism, it is generally agreed that an exhibition at the 0.10 Gallery in Petrograd marked its launch in 1915, when, together with his paintings of coloured geometric shapes against white

grounds, he showed *Black Square*, his first Suprematist painting. In the same year he published his ideas in *From Cubism to Suprematism: The New Painterly Realism*, the first of many such expositions. His now famous *White on White* paintings (1918) represented the ultimate Suprematist statements. He could go no further, and diverted his energies to teaching, first in Moscow, and then in Vitebsk (1919) where, with the aim of designing revolutionary posters, he founded UNOVIS (Affirmation of New Art), which numbered *Lissitzky among its members. Here also, he developed a series of architectural drawings into plaster sculptures called *Architectonics*. He moved to Leningrad in 1922 where, besides teaching, he designed ceramics according to Suprematist principles. He accompanied an exhibition of his work to Warsaw and Berlin in 1927, and visited Dessau to oversee the *Bauhaus publication of *The Non-objective World* (1926), which, written mostly in 1919–20, described his teaching theories. Through this, and through Lissitzky and *Moholy-Nagy at the Bauhaus, and the *De Stijl* artists, his ideas significantly influenced the course of art, design, and architecture throughout Europe. Now recognized as a major artist, he died in neglect in Leningrad but was fittingly buried in a coffin of his own Suprematist design. His work is well represented in the Stedelijk Museum, Amsterdam. YJ

Demosfenova, G. (ed.), *Malevich, Artist and Theoretician* (1990).
Kasimir Malevich, 1878–1935, exhib. cat. 1990–1 (Washington, NG).

MALLARMÉ, STÉPHANE (1842–98). French poet and critic, champion of the *Impressionists and figurehead of the *Symbolists. An inspiration to younger writers who elected him the 'Prince of Poets' in 1896, Mallarmé also earned the respect and friendship of the innovative painters of his generation. *Manet, who painted his portrait (1876; Paris, Mus. d'Orsay) and illustrated his verse, was the main subject of the poet's long essay on Impressionism published that year in English. Obliged to teach English for a living, he also compiled a short-lived fashion magazine *La Dernière Mode*. His poetic output (including *Hérodiade* and *L'Après-midi d'un faune*, 1876) was rarefied and highly wrought; his ideas were nevertheless seminal, notably his belief in the poet's duty to remain enigmatic and suggestive rather than to tie down with concrete description. From 1880 on Mallarmé's Tuesday soirées provided a focal point for the diverse members of the Symbolist movement and his circle of artistic friends included *Monet, *Degas, *Redon, *Gauguin, Berthe *Morisot, *Whistler, and the *Nabis. BT

Millan, G., *The Throw of the Dice: The Life of Stéphane Mallarmé* (1994).

MALOUEL (or Maelwael), JEAN (active by 1382, d. 1415). Netherlandish painter from Nijmegen, active in France. The son of a heraldic painter, Malouel was working in Paris by 1396 for Queen Isabeau on textile designs, subsequently entering the service of the dukes of Burgundy at Dijon, where he based the remainder of his career. Like his predecessor Jean de *Beaumetz, he received the title *valet de chambre*. In 1398 he completed an *Apostles with S. Anthony* and also began five large altarpieces, all for the Charterhouse of Champmol, the Duke's monastic foundation at Dijon. Only one of these has been identified, the *Martyrdom of S. Denis* (Paris, Louvre), though problems in interpreting the documentation have led some scholars to consider it the work of his successor Henri *Bellechose. A beautiful round *Pietà* (Paris, Louvre), full of pathos, is reasonably attributed to Malouel before 1404, indicating his familiarity with Tuscan painting and his influence on his nephews, the *Limburg brothers. He was extraordinarily esteemed, being paid more highly than either Beaumetz or Claus *Sluter, whose sculpture at Dijon he painted. TT

Châtelet, A., *Early Dutch Painting* (1981).

MALVASIA, COUNT CARLO CESARE (1616–93). Aristocratic Bolognese art historian, connoisseur, and collector, who possessed some practical skill as a painter; his *Felsina Pittrice: vite de' pittori bolognesi* (1678) is an important source for knowledge of the great period of the Bolognese school. Fiercely nationalistic, he tirelessly promoted Bologna, constantly attacking *Vasari's belief in the artistic supremacy of Florence. *Felsina Pittrice* traces the course of Bolognese art from the primitives, through the era of the *Carracci (Malvasia preferred Lodovico, who had stayed in Bologna, to Annibale, who had deserted for Rome), and culminates with his contemporaries Guido *Reni and *Domenichino. The lives are written in an idiomatic language, and, full of intimate, sometimes malicious detail, they bring their subjects to bright life through lively anecdote and gossip. Most remarkable is the life of Reni, with its strange blend of adulation for the angelic beauty of Guido and his paintings, and vivid stories about his gambling, his hatred of women, and his superstitious fears. Malvasia's guide to the paintings of Bologna (1686) was one of the first of its kind. HL

Malvasia, C. C., *Felsina Pittrice: vite de' pittori bolognesi*, ed. G. Zanotti (2 vols., 1841).

MANCINI, GIULIO (1558–1630). Italian biographer and writer on art, who initiated a new kind of treatise, influential in 17th-century Europe, which was aimed at the noble amateur, or *connoisseur, rather than the practitioner. He came to Rome from his native Siena in 1592, where he became physician to Pope Urban VIII, and cultivated the friendship of many painters. His *Considerazioni*, written in 1619, contains biographies, and information for the collector on such questions as how to buy and make judgements on works of art, how to hang a collection, how to distinguish a copy from an original, or how to determine a work's date or origin. His *Viaggio per Roma*, written in 1623–4 (published 1923), was a new type of guidebook, with an emphasis on works of art. Mancini wrote on *Poussin, and produced the first biographies of *Caravaggio and Annibale *Carracci. An ebullient personality, he was an atheist and adulterer, and made clever use of his official position to further his activities as art dealer. HL

Mancini, G., *Considerazioni sulla pittura*, ed. A. Marucchi and L. Salerno (1956).

MANDER, KAREL VAN (1548–1606). Poet, writer, painter, and draughtsman. He was born in Flanders but travelled and worked in many cities including Rome, Basle, and Vienna, before settling in Holland. He moved to Haarlem and worked there from 1583 to 1603, and in Amsterdam from 1604 until his death. He is chiefly known for his *Schilderboeck*, a handbook for artists first published in 1604. The second edition (1618) includes an anonymous biography of van Mander. The *Schilderboeck* is a source of great art historical importance, above all for the section devoted to the lives of Netherlandish and German artists from the time of Hubert and Jan van *Eyck; this was the earliest systematic account of northern European artists and it has led to van Mander being regarded as the 'Dutch Vasari'. Like *Vasari, van Mander was a practising artist. His artistic output was entirely in line with the theoretical ideas he propounded in other sections of the *Schilderboeck*; they are dominated by mythological and moral, allegorical subject matter. Drawings and engravings after his designs survive in considerable numbers; his earliest drawings show the influence of *Spranger, whom he had befriended in Rome. His paintings show the enduring influence of his Flemish formation. Van Mander was said to have founded an academy at Haarlem with *Cornelisz. van Haarlem and Hendrik *Goltzius. OI

Greve, H. E., *De bronnen van Carel van Mander* (The Sources of Karel van Mander) (1903).
Mander, Carel van, *The Lives of the Illustrious Netherlandish and German Painters*, ed. H. Miedema (1994).
Miedema, H., *Karel van Mander: Het bio-bibliografisch materiaal* (1972).

MANDORLA (Italian: almond), also called aureole or *vesica piscis*. An almond-shaped outline or series of lines surrounding the body of a person endowed

with divine light, usually Christ or the Virgin in scenes of theophany such as the Transfiguration and the Ascension—for example the panel by *Barnaba da Modena (Rome, Capitoline Mus.)—or iconic presentations such as the *Virgin and Child Enthroned* by *Margarito of Arezzo (London, NG). The mandorla was used to denote the supernatural and non-material status of the portrayed figure from early Christian art until the 15th century.

MLS

MANET, ÉDOUARD (1832–83). French painter. The son of a wealthy and high-ranking Parisian civil servant who worked in the Department of Justice, Manet was destined for the law, but studied painting, despite parental opposition, training under Thomas *Couture 1850–6. Equally important for his stylistic development was his study of old master painters in France, Germany, Austria, and Italy, particularly *Hals, *Ribera, and, above all, *Velázquez, whom he was later to describe as 'the painter of painters'. From these masters Manet evolved a style characterized by bold brushwork, absence of half-tones, chiaroscuro, and a generous use of black. Enthusiasm for Spain, which he was not to visit until 1865, inspired a number of Spanish subjects in the early 1860s including bullfights, *A Spanish Guitar Player* (priv. coll.) which was respectfully received at the salon of 1861, and the *Goya-inspired etchings of *Les Gitanos* and *Lola de Valence* (both 1862), taken from Spanish gypsies and performers visiting Paris. In 1863 Manet won unwelcome notoriety when *Le Déjeuner sur l'herbe* was rejected by the Salon and shown in the Salon des Refusés to a shocked and hostile reception (see both salons under PARIS). This picture, in which a group of clothed men and two naked women share a picnic on a river bank, was based on *Renaissance paintings, the subject derived from the *fêtes champêtres* of *Giorgione and *Titian and the composition from the right-hand group in *Raphael's lost *Judgement of Paris* known through Marcantonio *Raimondi's engraving. What shocked was not the nudity *per se*, *Ingres's *Bain turc* (Paris, Louvre) had been shown at the Salon in the previous year, but the contemporary nature of the scene and its nonchalant portrayal, with none of the suggestions of history, allegory, or exoticism which served to make nudity acceptable. With the possible exception of some of his Spanish subjects, Manet always took modern life as his subject, by inclination and by following the precept of his friend *Baudelaire, whose portrait he etched in 1865, and thus anticipated the *Impressionists. *La Musique aux Tuileries* (London, NG), shown earlier in 1863, which was criticized for its free handling, inconsequential subject, and lack of classical composition, is the prototype for the Impressionist street scene exemplified by *Renoir's *Moulin de la Galette* (1876; Paris, Louvre). Despite the vilification of *Le Déjeuner*, Manet returned to the theme of the nude with *Olympia* (Paris, Mus. d'Orsay), shown at the Salon to general abuse in 1865. Based on Titian's erotic *Venus of Urbino* (1583; Florence, Uffizi), Manet's courtesan, attended by her black maid, stares imperiously towards the viewer, challenging in her un-idealized nakedness. Despite support from his friends Baudelaire and Émile *Zola *Olympia* was generally attacked on moral and artistic grounds and Manet never painted a nude again. Between 1867 and 1869 Manet tackled yet another controversial modern subject, *The Execution of Maximilian* (1867–8; Boston, Mus. of Fine Arts; 1868; London, NG; 1869; Mannheim, Kunsthalle), inspired by the death of the puppet Emperor Maximilian of Mexico, abandoned to his fate by Napoleon III in 1867. The painting, which was politically suspect, is a manifestation of Manet's republicanism, and owes a significant debt to Goya's *Execution of the Third of May* (1808; Madrid, Prado). By the late 1860s Manet had won the admiration and friendship of the younger Impressionist painters and under the influence of Berthe *Morisot, whom he met in 1868 and who later became his sister-in-law, and Claude *Monet, painted *en plein air* and adopted a lighter palette and broken brush stroke in some of his paintings, like *Argenteuil* (1874; Tournai, Mus. des Beaux-Arts), a summery boating scene painted near the village in which Monet lived 1871–6. Despite his reputation for modernity and immorality Manet, true to his class, was essentially conservative and wished for conventional artistic success; he therefore distanced himself from the Impressionists, who were perceived as dangerously avant-garde, and did not exhibit in the Impressionist exhibition in 1874, preferring to show at the Salon. In the late 1870s tiredness, caused by a debilitating illness, led him to concentrate on pastels but his last great oil painting, *A Bar at the Folies-Bergère* (1882; London, Courtauld Inst. Gal.), is a brilliant piece of bravura painting and a synthesis of his own idiosyncratic style and the bright modernity of Impressionism.

Manet never achieved the conventional success he sought and despite his appointment as a Chevalier of the Legion of Honour in 1882 died a disappointed man. Although associated with the Impressionists, he was never part of a movement but a highly individual artist with a pragmatic approach to style and technique who, like his friend *Degas, significantly also upper class, brought an objective and unsentimental eye to his subjects. His pictures, however, are by no means straightforward depictions of nature but informed by his knowledge of past masters, a legacy of his academic training. His freedom from literary, anecdotal, and moralistic associations and his artistic independence confirm his reputation, recognized by Roger *Fry in his *Post-Impressionist exhibition of 1910–11, as one of the founding fathers of modern art.

DER

Cachin, F., and Moffett, C. (eds.), *Manet 1832–1883*, exhib. cat. 1983 (Paris, Grand Palais).

MANFREDI, BARTOLOMEO (1582–1622). Italian painter, born at Ostiano, near Mantua, who moved to Rome c.1605 and became *Caravaggio's first and most imaginative follower. His predilection for picaresque scenes of gamblers, soldiers, musicians, and fortune-tellers, and his refreshing capacity to secularize religious subject matter, distinguish him from his mentor whose principal works were seriously religious in spirit, notwithstanding their shockingly naturalistic style. Manfredi's distinctive half-length genre scenes, usually of horizontal format, the figures closely grouped in an enclosed space against a neutral dark background, quickly caught the imagination of French and Netherlandish artists living in Rome c.1615–22, especially *Valentin, *Baburen, and *Tournier, and created an international fashion, later described by the German writer *Sandrart as the *Manfrediana methodus*.

Manfredi had trained in Rome under Cristoforo *Roncalli and his early *Cupid Punished by Mars* (Chicago, Art Inst.) with its foreshortened figures and elegantly twisted forms reflects this late *Mannerist influence, although it is profoundly Caravaggesque with its violent and sado-masochistic dramatic action, accentuated through strong *chiaroscuro. In his religious paintings such as *Christ Driving the Merchants from the Temple* (Libourne, Mus. des Beaux-Arts), *Christ among the Doctors* (Florence, Uffizi), and the *Denial of S. Peter* (Brunswick, Herzog-Anton-Ulrich Mus.). Manfredi draws inspiration from the humble figure types and secular setting of Caravaggio's *Calling of S. Matthew* (Rome; S. Luigi dei Francesi) yet deliberately ignores its dramatic understatement and mood of spiritual concentration in favour of a more anecdotal and naturalistic approach. Indeed such pictures are essentially no different from the many genre scenes now attributed to Manfredi, including the *Reunion of Drinkers* (on loan to Los Angeles, County Mus.), *The Concert* (Florence, Uffizi), and *The Fortune-Teller* (Detroit, Inst. of Arts).

Although there is a prima facie case for supposing these religious and genre pictures to be by Manfredi, none is documented and some, for instance the *Denial of S. Peter*, have also been attributed to Manfredi's French associate Tournier. Conversely, two pictures which had been attributed to Manfredi since 1624, just after his death, *Man with a Glass* and *Man with a Bottle* (Modena, Gal. Estense), are now usually thought to be copies after Manfredi by Tournier although they are very

close in style and quality to the pictures described above. Inevitably Manfredi's individual artistic personality has been obscured as a result of his enormous popularity and consequent copying and pastiche. Yet for a brief period after 1615 there appears to have been an open and fruitful exchange of ideas and motifs between the group of talented artists in Manfredi's immediate circle who together succeeded in isolating one aspect of Caravaggio's art and then refashioned it into a steady stream of popular images. HB

Gregori, M., et al., *Dopo Caravaggio: Bartolomeo Manfredi e la Manfrediana methodus*, exhib. cat. 1988 (Cremona, Mus. Civico).

Nicolson, B., *Caravaggism in Europe* (2nd edn., 1990).

MANIÈRE CRIBLÉE (French: sieved manner) (or dotted manner).

A relief printmaking technique most common in France and Germany in the second half of the 15th century. A metal plate was engraved with the outline of the subject and the remaining dark areas were worked with punches of various sizes to produce a textured decoration or sievelike shading. The effect was to produce a tonal dotted surface. The printing process was the same as for *woodcuts, and the appearance of the final print is very similar to an impression taken from a woodcut. A copper plate worked in manière criblée could also be used to make paste prints: a criblée plate was impressed upon a sheet of paper covered with a tinted paste leaving an embossed impression, parts of which were then hand coloured or gilded. Alternatively the plate might be inked first and then impressed on the treated paper. Either way it resulted in a print akin to embossed leatherwork in appearance. OI

MANNERISM. *See overleaf.*

MAN RAY (1890–1976).

American photographer, painter, sculptor, filmmaker, and draughtsman. Born Emmanuel Radnitsky in New York, Man Ray's career was ordained by two events: the 1913 *Armory Show, and his 1915 introduction to the French artist Marcel *Duchamp. Duchamp became a lifelong friend, and together they participated in New York *Dada and the Société Anonyme. Drawn to Europe, Man Ray emigrated to Paris in 1921. It was here, mixing with first the Paris Dadaists, and then the *Surrealists, that he produced his most celebrated work. Although never formally attached to these movements, he was arguably the greatest, and most prolific, practitioner of *photography in a Dada/Surrealist vein. Primarily studio-bound, his photographs are inventive and often witty (e.g. *Le Violon d'Ingres*, 1924), and include *rayographs* (prints made without a camera). His nihilistic temperament is well expressed in his object *Cadeau* (1921; destr.). Ironically the multifarious Man Ray yearned for greatness as a painter—posterity has not accorded him this distinction. After eleven years' banishment in Hollywood, occasioned by the war, he returned to Paris in 1951, and continued working until his death. AA

Foresta, M. (ed.), *Perpetual Motif: The Art of Man Ray* (1988).

MANTEGAZZA BROTHERS.

Italian sculptors. **Cristoforo** (active 1464; d. 1481?) and **Antonio** (active 1472; d. 1495?) were among the most talented sculptors working in Milan in the late 15th century. Cristoforo is first documented in 1464 in Pavia, where he worked on the nave and cloisters of the Certosa; by 1472 Antonio was also active in the Certosa. In 1473 the Duke of Milan consulted them over an artistic matter and in the same year the brothers were commissioned to work on the façade of the church of the Certosa. Sharply cut, flattened drapery forms and figure types characterize the work most frequently attributed to them. The latest research on the Mantegazzi has focused on attributing surviving work to each of them, and on defining the nature of each of their individual styles. Morscheck proposed that Cristoforo worked in a soft, gentle manner, as in the *Madonna* keystone in the Certosa, and that Antonio worked in the more angular style of the *Lamentation* (London, V&A). FB

Morsheck, C. R., *Relief Sculpture for the Façade of the Certosa di Pavia, 1473–1499* (1978).

MANTEGNA, ANDREA (1431–1506).

Recognized as the leading painter in Italy by the time of his death, Andrea was born near Padua and trained in this university city, then from 1460 spent the rest of his life as painter to the Gonzaga court in *Mantua. A prodigy, he set up as an independent painter at the age of 17, after settlement with the master to whom he had been apprenticed, Francesco *Squarcione. For all Squarcione's contacts with Ciriaco d'Ancona and like-minded antiquarians, the dominant influence on Mantegna's art was *Donatello, at work in Padua 1443–53, whose repertoire of pose and expression, sophisticated perspective and still rather erratic use of the *Antique he rapidly translated into his own highly consistent idiom. His frescoes in the Ovetari chapel in the Eremitani in Padua, begun in 1448, largely destroyed in 1944, demonstrate his accomplished assimilation of Donatello, probably also some contact with the Bellini workshop (he married Nicolasia Bellini in 1453), and, already, his trademark calligraphic drapery style, which looked more convincingly classicist than any contemporary's. His altarpiece for S. Zeno, Verona (1457–59) is an accomplished *Renaissance *sacra conversazione not only unifying the old triptych form into a single space and lightfall but unifying that space with the frame in a common fictive/carved classical architecture.

At Mantua he proved himself a superb portraitist (*Cardinal Mezzarota*; Washington, NG; looking more Julian than Caesar himself), though rather too incisive according to one courtier. With miniaturist meticulousness he painted a series of curved panels illustrating the life of the Virgin for the ducal chapel (c.1459–64; Florence, Uffizi, and Madrid, Prado: the last famous for its view of the lake of Mantua). On a larger scale he undertook the (today) celebrated frescoes of the Camera degli Sposi in the ducal palace, originally known simply as 'the painted room' (completed 1474); the nine enormous canvases of *The Triumph of Caesar* (1486 onwards; Hampton Court, Royal Coll.), his most celebrated work in his own day; and not least a few important altarpieces such as the *Madonna of Victory* (1496; Paris, Louvre). The Camera degli Sposi, though far from unique in its subject matter—essentially it commemorates the Gonzaga family and their connections, including, for instance, the King of Denmark—is remarkable for the inventive skill with which its dynastic head-count has been animated—for instance by the device of the delivery of a letter to the courtly group—in an illusionistic architecture converting the whole room into a perspective theatre (see further under ILLUSIONISM). Particularly the oculus illusionistically cut into the centre of the ceiling, from which figures appear to look down and a pot threatens to topple, stands at the head of a tradition of unified fictive architecture continued initially by *Melozzo da Forlì, later by *Correggio and many others. Other scenes open out into Mantegna's typical landscapes—rocky mountains scarified by striations and pockmarked with classical ruins. The context and date of the *Triumphs* have been difficult to establish, and the canvases themselves have suffered, but they may still be regarded as the finest, grandest recreation of a purely classical subject achieved in the Renaissance period. The *Madonna of Victory* shows Mantegna enhancing his colours—otherwise his style changes very little—and participating in the pan-Italian development of the ecclesiastical *sacra conversazione*. The frescoes Mantegna painted in the Belvedere for Pope Innocent VIII on a visit to Rome (1488–90) have been lost.

Mantegna's smaller-scale, more 'private' art is equally important. Soon after his arrival at Mantua he turned to engraving (see

continued on page 447

· MANNERISM ·

MANNERISM is the name given to an art style of 16th- and early 17th-century Europe. It is usually defined by contrast with the High *Renaissance on the one hand and the Baroque on the other. It has been identified not only in the visual arts, but also in literature and music. However there has been considerable disagreement about the exact meaning and application of the term. The word mannerism (*manierismo*) was used for the first time by Luigi Lanzi in his *Storia pittorica della Italia* (1792) to describe the decadence of Italian painting after the achievements of masters such as *Raphael, *Michelangelo, *Titian, and *Correggio. In Lanzi's view this 'mannerism' began at different times in different places: in Florence about 1540 among those who, without understanding, imitated Michelangelo, while in Venice it developed later in the century among those who followed Titian, *Veronese, and *Tintoretto. This was the meaning the term had through the 19th century.

*Bellori in *Le vite de' pittori* (1672) had identified a decline in the 16th century, when art was corrupted with 'maniera'. He explained 'maniera' as a reliance on the artists' own imaginations and on technical facility: they failed to imitate nature. In his view the decline began after the death of Raphael (1520), taking firm hold around the middle of the century. *Malvasia, in his *Felsina Pittrice* (1673), also saw a decline, attributing it to a search for novelty which resulted in weak drawing, washed out colour, and a style that was hasty and affected (*manieroso*). He was more specific than Bellori, who had named only the *Cavaliere d'Arpino, as to who the protagonists were: they were artists active from about 1530 to 1600, including Francesco *Salviati, *Vasari, the *Zuccari, Tommaso Laureti, *Calvaert, and Prospero *Fontana.

In France, *Fréart de Chambray in his *Perfection de la peinture* (1662) scornfully called 'maniéristes' those who, like the Cavaliere d'Arpino, had facility and superficial brilliance but no understanding of the true principles of art. Bellori, Malvasia, and Fréart de Chambray thought that 'maniera' was a deviation from the classical tradition that ran from *Antiquity through Raphael (see further under CLASSICISM). In their opinion the *Carracci, *Domenichino, and *Poussin restored correctness.

In the early 20th century, against a background of thinking that rejected the universalist aesthetic of the classical tradition and saw period styles as the key to true historical understanding, Mannerism came to be re-evaluated. W. Friedlaender (1925) used the term to describe developments in 16th-century Italian painting that he saw as antithetical to the High Renaissance. Instead of interpreting them as a decline, he saw them as evidence of a new artistic feeling. For him the High Renaissance was a high classic style that involved definite rules, conforming to the Antique and also laying claim to nature. Mannerism began around 1520 as an anticlassical style. The key figures were *Rosso Fiorentino and Jacopo da *Pontormo, who created spiritualized forms, and *Parmigianino, who was concerned with grace and elegance. All three of them rejected the normative in favour of unnaturally elongated figures and of compositions lacking in symmetry or logical spatial structure. Friedlaender distinguished a second phase of Mannerism, beginning around 1550, when the forms that had been pioneered by the anticlassical revolutionaries came to be domesticated and used routinely in a mannered way ('mannered Mannerism'). He argued that the style came to an end around 1590, when artists like the Carracci and *Caravaggio emerged as anti-mannerists.

Friedlaender was reticent about providing explanations for the changes he observed. *Dvořák (1921) identified in the elongated forms and unreal spatial structures of El *Greco, *Tintoretto, and the late Michelangelo a spiritual inwardness which was quite distinct from the confident materialism of the Renaissance. This for him constituted Mannerism; it was a European rather than simply an Italian phenomenon. He interpreted it as a response to a crisis that had religious, political, and intellectual dimensions, when old certainties disappeared after the Renaissance and the Protestant Reformation. Benesch (1945) developed Friedlaender's and Dvořák's idea that there was a *Gothic quality in Mannerism and argued that in north Europe the style took root because it fitted the supposedly transcendental and expressionistic mentality of those peoples. At an important exhibition devoted to European Mannerism at Amsterdam in 1955, it was presented as a style of the unreal, an art of anxiety, in which grace was allied to the bizarre and the extravagant. The emphasis of the exhibits was on the aristocratic and courtly aspects of the style: with the Medici in *Florence, the French kings at *Fontainebleau, the Emperor Rudolf II in *Prague.

The diversity of visual forms that had come to be included under the label Mannerism attracted scepticism, and belief in style as a symptom of essential cultural characteristics was questioned. Around 1960 Smyth and Shearman advanced important new theories, both claiming to base them on interpretations of the word 'maniera' as used in a positive sense in the 16th century itself. Smyth thought the term applied best to the work of mainly central Italian painters in the period 1530 to 1580: *Salviati, *Vasari, and *Bronzino were, for him, the key figures. He argued that they created a set of conventions, derived primarily from a study of Roman relief sculpture (see ROMAN ART, ANCIENT), which could then be inventively varied; their intention was to create an idealizing and 'antiquizing' art. The conventions he emphasized involved the flattening of three-dimensional forms onto the surface.

Shearman associated Mannerism with a graceful and

accomplished art that emerged in Rome, around 1520, among the pupils and followers of Raphael. *Giulio Romano, *Perino del Vaga, *Polidoro da Caravaggio, Parmigianino, and the mature Rosso Fiorentino were the protagonists. The movement of artists, especially after the Sack of Rome in 1527, and the medium of *prints, spread their ideas through Europe. Shearman developed Weise's insight (1952) that the word 'maniera' derived from the medieval French language of manners, and referred to a stylish effortlessness of comportment. He proposed that it became an aesthetic ideal in the 16th century, and that the art that possessed 'maniera' was an art of refined elegance and self-conscious artistry. As characteristic products he indicated the abstracted complexity of paintings by Salviati and Bronzino, the exquisite virtuosity of the sculpture of *Cellini and *Giambologna, and *Buontalenti's inventive stage sets. A hallmark of the style was the 'figura serpentinata', a pose in which the human body was twisted into a complex rising spiral, achieved without visible strain.

Both Smyth and Shearman argued for a continuity between the 'maniera' artists and their High Renaissance predecessors. Smyth identified his Mannerist conventions in certain works by *Leonardo and Raphael, while Shearman found a dominating preoccupation with grace and accomplishment in certain works by Raphael and Michelangelo. Mannerism was not a break with the past but the isolation and development of certain qualities already present in the earlier period. Neither scholar claimed that what they identified as Mannerism amounted to the style of the period. For Shearman, painters such as Pontormo, Tintoretto, or El Greco were not Mannerists at all, because they were primarily concerned with expressive vitality. Outside Italy he thought that only very sophisticated artists, who understood the rules of classical art and played with them, could be included: such as *Oliver in England, *Goujon and *Pilon in France, and de *Vries, *Gerhard, and *Goltzius in the Low Countries and Germany.

The relationship between Mannerism and the Counter-Reformation has exercised scholars. The view of Mannerism developed by Dvořák, with its stress on the spiritual and the transcendental, was used by Nikolaus Pevsner (1925) to argue that it was the style of the Counter-Reformation. Shearman, by contrast, in viewing Mannerism as a stylish style, saw it as basically antipathetic to the serious educational purposes of resurgent Catholicism. In Shearman's view Mannerism was in decline in the field of religious art soon after the end of the Council of Trent in 1563.

Recently there has been little new discussion of Mannerism. This is in part to be explained by a loss of confidence in the value of style labels in general. But there is a more specific reason too. Underlying all the diversity of 20th-century interpretation of Mannerism was a notion of a normative, 'classic' High Renaissance, in relation to which it could be defined. Increasingly that notion is being questioned. MB

Acts of the Twentieth International Congress of the History of Art, 2: Studies in Western Art: The Renaissance and Mannerism (1963).

Benesch, O., The Art of the Renaissance in Northern Europe (1945).

Conseil d'Europe, Le Triomphe du Maniérisme européen, exhib. cat. 1955 (Amsterdam, Rijksmus.).

Dvořák, M., 'On El Greco and Mannerism', trans. J. Hardy, in M. Dvořák, The History of Art as the History of Ideas (1984; German original 1921).

Friedlaender, W., Mannerism and Anti-Mannerism in Italian Painting (1957; German original 1925).

Pevsner, N., 'The Counter Reformation and Mannerism', in Studies in Art, Architecture and Design, 1: From Mannerism to Romanticism, (1968; German original 1925).

Shearman, J., Mannerism (1967).

Smyth, C. H., Mannerism and Maniera (2nd edn., 1992).

Weise, G., 'La doppia origine del concetto di manierismo', in Studi Vasariani (1952).

LINE ENGRAVING), producing or having produced (the issue is by no means clear) the first ever prints of a quality equal to that of the finest painting. By their means he was able successfully to propagate both his style and the imagery of the 'inventions' for which he was admired by *humanists. *Dürer, not to mention many lesser Italian artists, was dependent on them for his understanding of the fashion he found so prevalent in Venice in 1506 for the antigisch. Since Mantegna was known so well as an inventor, it is likely that he himself devised the allegories he painted for Francesco Gonzaga's wife Isabella d'Este's studiolo in the ducal palace (now Paris, Louvre), while on other artists of comparable reputation, such as *Perugino or Giovanni *Bellini, Isabella sought to impose her subject matter in detail. Mantegna also had a leading role in the development of half-length devotional 'icons' isolating individual events of the Gospel for meditative devotion.

PHo

Lightbown, R. W., Mantegna (1986).

Martineau, J. (ed.), Andrea Mantegna, exhib. cat. 1992 (London, RA; New York, Met. Mus.).

MANTUA: PATRONAGE AND COLLECTING. Mantua's reputation as city of art is almost entirely owing to the patronage of the Gonzaga family (rulers from 1328 to 1708) and to their employment of artists imported from elsewhere. One cannot speak therefore of the indigenous character of 'Mantuan art' and few artists of significance were born there; an exception was the goldsmith and bronze caster Pier Jacopo Alari Bonacolsi known as *'Antico' (active by 1479) but Mantuan-born painters were only of secondary importance, such as Lorenzo Leonbruno (1477–1537), Rinaldo Mantovano (active c.1528–64), or Ippolito Andreasi (1548–1608). However Mantua's distinction as the birthplace of Virgil and as the setting of the *humanist school of Vittorino da Feltre from c.1420 to 1446, its accessibility by river and proximity to larger cultural centres (Bologna, Ferrara, Milan, Padua, Venice, Verona) and above all, the disposition and financial resources of its rulers and some of their courtiers, helped to make it a notable location for *Renaissance art, even though much of it (particularly in outlying Gonzaga country palaces such as Marmirolo, Goito, Gonzaga) has been destroyed. *Pisanello was there for at least part of the period c.1422–39, though a later date is widely favoured for his unfinished Arthurian tournament scenes, the very damaged frescoes uncovered in the 1960s in the ducal palace. His bronze *medals with portraits in relief commemorating members of the Gonzaga family and Vittorino are also

dated to *c*.1446–8; this neo-Antique commemorative art form was much favoured by subsequent Gonzaga rulers (e.g. medals by Melioli, Sperandio, *Leoni). Leon Battista *Alberti was another visitor; in the early 1460s his advice was sought and to some extent followed by Marquis Ludovico Gonzaga for the designs of the churches of S. Andrea in the centre of the city and S. Sebastiano on its periphery. Meanwhile Ludovico had enticed Andrea *Mantegna from Padua to become Mantuan court painter (1460–1506). His principal works, the narrative frescoes of the Camera Dipinta (Camera degli Sposi) in the ducal palace and the *Triumphs of Caesar* for the one-time palace of S. Sebastiano (now Hampton Court, Royal Coll.), immediately became showpieces used to impress outside visitors. Mantegna's inspiration from Antiquity (see ANTIQUE), his output of prints and devotional paintings and his connection with the Venetian art world (he married Giovanni *Bellini's sister) helped to assure his fame which, partly because of the coincidence of his surname, is so much associated with Mantua. His large votive altarpiece the *Madonna of Victory*, commemorating Francesco II Gonzaga's supposed victory over the French at Fornovo in 1495, was one of the trophies taken in 1797 to France, where it remains (Paris, Louvre). Francesco's wife Isabella d'Este (living in Mantua from 1490 to 1539) was a celebrated connoisseur and collector of ancient gems and vases, marble busts, etc., which she displayed together with the exquisite bronze statuettes of Antico, her *Sleeping Cupid* by the young *Michelangelo, and allegorical paintings by Mantegna, *Perugino, and *Costa (Paris, Louvre) in her *studiolo* and *grotta*, though much of what she amassed must have been kept in other apartments including her large set of majolica plates with mythological scenes (*c*.1525). Their son Federico (marquis 1519, duke 1530–40) was also a well-informed patron, employing *Giulio Romano (in Mantua 1524–44) to design and decorate his suburban palace of the Te (with portraits of horses and huge illusionistic mythologies), new apartments in the ducal palace (Appartamento di Troia, 1536–8), and to advise on buildings and urban improvement. However, *Titian was the painter Federico most admired, obtaining from him over 30 works, including his own portrait (Madrid, Prado), religious paintings, and the series of eleven Roman emperors. After Federico's death (1540) the tradition of munificent Gonzaga patronage continued for almost a century; Flemish tapestries with narrative scenes, mythological and religious paintings, and portraits continued to be commissioned by Cardinal Ercole Gonzaga, Duke Guglielmo, and Duke Vincenzo I Gonzaga. Vincenzo was another voracious collector and brought *Rubens to Mantua from *c*.1600 to 1608, thanks to whom

he acquired *Caravaggio's scandalous *Death of the Virgin* (Paris, Louvre) and decorations on a huge scale for the new Jesuit church of S. Trinità: two scriptural scenes (now in Antwerp and Nancy), and *The Adoration of the Trinity* with portraits of many members, living and dead, of the Gonzaga family (cut up and dispersed, but the greater part in the ducal palace, Mantua). Vincenzo's taste for northern painters was also shown in the employment of Frans *Pourbus the younger, who painted many Mantuan portraits, but Ferdinando, Vincenzo's second son (Duke 1612–26), a former cardinal with first-hand knowledge of leading Italian artists, commissioned works from, among others, Domenico *Fetti, *Guercino, and Guido *Reni. Although Ferdinando had yet another palace-villa, the Favorita, built near Mantua, financial difficulties led to much of the Gonzaga Collection being sold between 1625 and 1630 to King Charles I of England (see LONDON); important items were subsequently sold on to Cardinal Richelieu and other collectors. Relatively little remains in Mantua, though the ducal palace and Palazzo del Te with their famous mural and ceiling decorations are preserved. DSC

MANUEL, NIKLAUS. See DEUTSCH, NIKLAUS MANUEL.

MANUELINE, Portuguese style of architectural decoration named after Manuel I (1495–1521), with whose reign it roughly coincided. The style combines a late *Gothic decorative vocabulary with *mudéjar* and *plateresque elements from Spain and others of Italian *Renaissance derivation. The best-known Manueline monument is the chapter house of the early 16th-century convent of Christ at Tomar, where the windows are surrounded by stone tree trunks, coral, artichokes, and the characteristic twisted rope motif. Elsewhere, the sculptors carved nautical motifs reflecting Portuguese navigational exploits, exotic flora and fauna, and African angels. SS-P

MANUSCRIPT (Latin: written by hand), a scroll, tablet, codex, or any object which is designed to be portable and upon which there is handwritten script, whatever the support or writing material. Before the invention and mass production of paper, parchment was the main material used for manuscripts in Europe due to its strength, durability, and quality of surface. In the early Christian period, the copying of liturgical texts by monks was encouraged by the church fathers such as Jerome (*c*.342–420). This practice led to the monasteries being the centres for production until the 12th century. From then on the role of monasteries in book

production was superseded by that of secular urban workshops. Centres of manuscript production had also been established around courts such as the late 9th-century court of Charlemagne in Aachen and the 15th-century court of the dukes of Burgundy in Bruges. Medieval university towns such as Bologna, Paris, and Oxford also developed as major centres of production. This change in the manner of production was part of the wider cultural change in the spread of education, literacy, and wealth. By the 15th century the production of manuscripts was no longer restricted to individual commissions for particular patrons, but saw much more speculative production of works offered for sale at fairs and markets, as well as through booksellers and stationers. Highly prized de luxe models continued to be commissioned by the aristocracy and members of the bourgeoisie. Initially the invention of printing with movable type in the mid-15th century had little impact upon the manuscript industry, but within a century the manuscript had lost its supremacy.

See also ILLUMINATED MANUSCRIPT and MANUSCRIPT ILLUMINATION. KC

Alexander, J. J., *Medieval Illuminators and their Methods of Work* (1992).

Hamel, C. de, *A History of Illuminated Manuscripts* (1995).

MANUSCRIPT ILLUMINATION. Except for the trimming and binding of the completed leaves the illumination was the last of the series of crafts whose practice was necessary to produce an illuminated manuscript. Whoever may have overseen the production by co-ordinating the work of the different craftsmen involved, the extent of the painted decoration and the role that the illuminator would play was already partly determined by the scribe's copying of the text. The position of the text area on the page, the spaces left for miniatures or initials—whether of one, two, or more lines' height—restricted any decision to be made when the folios were handed on for illumination. Occasionally it is obvious that an illuminator has deviated from the scheme envisaged by the scribe, for example by inserting additional blank folios to carry extra miniatures, but usually the integrated appearance and practicality of the manuscript require the illumination to follow the scribe's prescription. The decorative scheme would not only make the completed codex more aesthetically satisfying but would enable the user to find his or her way around the text. When the folios reached the illuminator it was common, in addition to the implied intention on position and size, for there to be some specific instruction to the illuminator on the type of decoration or illustration required; this seems often to have been at least partly carried on the folios themselves. At the

simplest level, whereas the scribe will usually have completed the rubrics in red ink, the larger or more highly decorated initials to be painted or drawn by an illuminator will only have been written as small, fine guide letters. More complicated instructions that might be conveyed to illuminators on the pages they received ranged from letters or spots of pigment to indicate the colour or gold to be used, to written instructions on subject matter in the field of the miniature, or schematic drawings in the margin. Examples survive of all of these, although the intention must have been for them to be obscured by painting or trimmed away in the completed manuscript.

From surviving unfinished manuscripts it seems to have been the case, by the 14th century at least, that rather than working through the manuscript bringing each page to completion before moving on to the next, it was customary to follow the sequence of tasks across an entire section of the, as yet unbound, folios: all would be drawn, then the elements to be gilded would have a chalk or gesso ground applied, all of these would then have gold leaf applied and burnished, then the decorative elements were painted—often before the figural elements—and finally, where appropriate, a crisp defining ink outline might be given to some of the forms. This had various practical advantages. It was clearly more efficient and cost-effective to mix up, and then use up, a larger quantity of pigment than would be needed in one small miniature, and to continue with one process and tool rather than constantly to switch from brush to pen to burnisher. Furthermore, in a craft where there seems to have been a hierarchy of tasks and skills, and where collaboration was common, there could be a division of labour so that the most skilled draughtsman or painter could restrict himself to drawing or painting the figural elements while an assistant painted border or backgrounds, applied bole or gold leaf. One artist could work on one task on one section of leaves while another craftsman was simultaneously at work on another. It is clear from manuscripts like the *Tres Riches Heures* (Chantilly, Mus. Condé, MS 6), where some of the miniatures left unfinished by the de *Limburgs were completed decades later by Jean *Colombe following the earlier drawing, that even renowned artists had no resistance to painting the designs of gifted predecessors. The value placed upon patterns and the circulation and reuse of particular designs or motifs testify that there was no reluctance on the part of medieval craftsmen to take advantage of the achievements of others. One consequence of this potential intermingling of contribution can be the difficulty, if not invalidity, of art historical attempts to attribute authorship to an individual artist.

Across the thousand years or so that illumination was a major art form there were substantive variations in taste, technique, and the materials used. Drawings might be made with a *stylus, *graphite (or 'plummet'), or silverpoint (see METALPOINT); they were usually strengthened or finalized in ink. Generally the pigments used were the same as those employed in painting on a more monumental scale but with the additional possibility, since the work would be protected within the pages of a closed book, of using more fugitive or fragile materials that in another medium would be too susceptible to damage by light or atmosphere. The tinted drawings where illustrations were only coloured with light thin washes, for example in English apocalypses from the 13th century, were a particular exploitation of the special possibilities of the form. Whatever pigments were selected or manufactured for use, the binding medium with which they were incorporated was either glair, the beaten white of egg allowed to settle to a clear liquid, or a solution of gum. The paint was applied with a fine brush—often of squirrel hair—or a quill. On occasions illuminators were categorized as 'illuminator with the pen' or 'illuminator with the brush'; the former usually executed the flourished initials that from the 13th century were such a common subsidiary decoration. The quill would also have been used to apply the ink outlines that gave the final definition to forms, whether the contours of features and drapery or the gilded elements of borders.

Once the completed manuscript was bound between rigid covers clasped firmly shut it was well protected. It is only with the exposure of the illumination to light, damp, and atmospheric gases that it loses its radiance and intensity. The organic pigments fade, vermilion blackens. Lead white and red lead—the minium so common in manuscript decoration that it gave its name, 'miniare', to the whole activity and later by association to a word meaning small—if exposed to traces of hydrogen sulphide turn black. Blackened lead white can be treated by oxidizing but oxygen will tarnish any silver. Copper-based pigments, especially verdigris, can become destructive, carbon inks can flake, and iron-gall inks become corrosive. The parchment folios may be eaten by worms or nibbled by rodents, but parchment is particularly susceptible to change in humidity, the leaves 'cockling' as they shrink unevenly. Ideally, except when they are being consulted, manuscripts should be kept securely closed at a relative humidity of between 55 and 60% and at an ideal temperature of around 19°C.

KS

Alexander, J. J. G., *Medieval Illuminators and their Methods of Work* (1992).

M ANZONI, PIERO (1933–63). Italian artist. A disciple of Lucio *Fontana, he was a pioneer of *Conceptual art and strongly influenced Arte Povera (see MINIMAL ART). Manzoni's most characteristic works included *Achromes*, partly influenced by the monochrome paintings of *Klein, such as one produced in 1958 (Turin, Mus. Civico) which consists of a canvas covered only with white kaolin. For him everything could be a work of art simply through 'being', without any representative or expressive qualities. He also extended this potential for artistic status to people in his *Magic Base* (1961; Venice, Attilio Codognato Coll.), which converted anyone who stood on it into a work of art. His desire to subvert traditional artistic concepts culminated in the canning of his own excrement, which he then presented to the public as *Artist's Shit* (1961; Zurich, Woog-Institut). CJM

Piero Manzoni, exhib. cat. 1971 (Rome, Gal. Nazionale d'Arte Moderna).

M ANZÙ, GIACOMO (1908–91). Italian sculptor. Initially influenced by the work of Aristide *Maillol, Manzù remained throughout his career a figurative sculptor, using traditional media, especially bronze. His work shows a strong appreciation of the formal beauty inherent in both the human figure and everyday objects, as can be seen in *Girl in a Chair* (1948; Turin, Gal. Civico d'Arte Moderna). His strongly religious upbringing led him to represent Christian themes, even after he moved towards Marxism in later life. In *Christ with General* (c.1947; Rome, Gal. Nazionale d'Arte Moderna) he used the Crucifixion to symbolize the suffering of his own times. Manzù was also an influential teacher and a gifted graphic artist. CJM

Rewald, J., *Giacomo Manzù* (1967).

M AQUETTE (French: model), a small preliminary model for a work of sculpture. The word implies something in the nature of a rough sketch, not so fully worked out as a *bozzetto. Henry *Moore used maquettes extensively in his work, especially in his latter years, as a means of working out a design or composition on a small scale in clay or plaster, for scaling up to full size by assistants before being cast or carved. AB

M ARATTI (Maratta), CARLO (1625–1713). Italian painter and draughtsman, the last major artist working in the classical tradition. He moved to Rome from his birthplace, Camerano, in c.1636 and was trained there by *Sacchi under whose eye he developed a mastery of drawing and a critical awareness of current debates at the Accademia di S. Luca (see under ROME) between the respective proponents of *DISEGNO E COLORE.

449

He returned to classical principles (see CLASSICISM) of composing his designs with few figures and a pale, even-toned palette that focuses attention on the plastically conceived figures. A *Tobias and the Angel* (priv. coll.) shows the extent of Maratti's debt to Sacchi; its classical orthodoxy in no way diminishes its lyrical and tender qualities. One of Maratti's first independent conceptions is the *Adoration of the Shepherds* (1650; S. Giuseppe dei Falegnami, Rome). This was followed by a prestigious commission from Louis Phélypeaux de la Vrillière in Paris for a *Peace of Augustus* (Lille, Mus. des Beaux-Arts) which was to hang alongside paintings by *Poussin, *Reni, and Pietro da *Cortona. In 1656 he executed a fresco of the *Adoration of the Shepherds* at the Palazzo Quirinale, Rome, and painted a *Visitation* (Rome, S. Maria della Pace) that is more Baroque in spirit, with many figures in movement, reflecting the influence of *Bernini. In 1664 he became principal of the Accademia di S. Luca; and in the same year his admiring biographer, *Bellori, lectured there on 'L'idea del pittore', an influential text that was subsequently published as the preface to his *Vite* (1672), where he expounded his classicist theory of art. In 1674 Maratti was commissioned by Pope Clement X to provide a fresco of *The Triumph of Clemency*, to a programme devised by Bellori, for the Palazzo Altieri. It is conceived strictly according to classical requirements, with the clearly defined individual figures and the carefully articulated design kept firmly under control within the ceiling's framework—the very antithesis of *Gaulli's contemporary decoration on the vault of the Gesù church. A similar spirit of stylistic rivalry may be detected in Maratti's *Death of S. Francis Xavier* (1676; Rome, Gesù), which is conceived as a *history painting in the tradition of Annibale *Carracci, in marked contrast to Gaulli's interpretation of the subject at S. Andrea Quirinale (1676). The culmination of Maratti's classicizing approach is the *Apollo and Daphne* (1681; Brussels, Mus. Royaux) commissioned by King Louis XIV of France. Bellori, who wrote a pamphlet eulogizing it, saw it as a perfect illustration of the doctrine of *Ut pictura poesis* and went on to analyse its language of expression. The figure of Daphne, inspired by the antique *Medici Venus* (Florence, Uffizi) expressed the *affetti*, while Apollo, inspired by the *Apollo Belvedere* (Vatican Mus.), embodied the idea of beauty.

Maratti was also successful as a portrait painter. These range from the understated *Andrea Sacchi* (c.1655; Madrid, Prado) to the celebrated image of *Pope Clement IX* (1669; Vatican Mus.). He was much in demand from British tourists and painted portraits of Thomas Isham (Lamport Hall, Northants), Charles Fox (Earl of Ilchester coll.) and John Herbert, Master of the Bench of the Inner Temple, London (*in situ*). His idealized *Self-*

Portrait is at Brussels (c.1695; Mus. Royaux); and a further grandiose image of the artist, surrounded by Graces, and painting the Marquis Nicolò Pallavicini who is being crowned with laurel (1706), is now at Stourhead (Wilts.).

Following the death of Bernini, Maratti's workshop became the most powerful in Rome, and work increasingly was delegated to assistants including *Chiari and *Masucci. Maratti was absorbed with numerous administrative duties and became director of the antiquities of Rome. He also advised collectors and himself owned Poussin's *Triumph of David* (Madrid, Prado). HB

Bellori, G. P., *Vita di Guido Reni, Andrea Sacchi e Carlo Maratti* (1695), ed. M. Piacenti (1942).
Mena, M., 'Carlo Maratti e Raffaello', in *Atti del IV Corso Internazionale di Alta Cultura, Accad. N. Lincei. Roma* (1990).
Schaar, E., and Sutherland Harris, A., *Die Handzeichnungen von Andrea Sacchi und Carlo Maratta: Katalog der Kunstmuseums Düsseldorf* (1967).

MARC, FRANZ (1880–1916). German painter and founder member of the *Blaue Reiter best known for his depictions of the animal kingdom. Having entered the Munich Academy in 1900, Marc travelled to Paris in 1903 where he was influenced by the *Fauves and their use of *colour. The turning point came in 1909 in his contact with the work of *Kandinsky, meeting him for the first time in 1910 when he also befriended *Macke.

Marc said that he did not want to paint the animal as we see it, but as the animal feels its own existence; his symbolic use of colours evoking certain moods was linked with this aim, and echoed the philosophy of his fellow Blaue Reiter artists. His Expressionist voice crystallized in the years leading up to the First World War, with his paintings becoming increasingly explosive and visionary. *Tierschicksale* (Animal Destinies) (1913; Basle, Kunstmus.) is an apocalyptic vision prefiguring the impending destruction. Between 1912 and the war, Marc produced a series of *watercolours that rank among his most powerfully lyrical works. Shortly before the war Marc came under the influence of *Cubism, and demonstrated an increasing shift towards *abstraction. He fell near Verdun in March 1916. RRAM

Rosenthal, M., *Franz Marc* (1989).

MARÉES, HANS VON (1837–87). German painter. Marées studied in Berlin (1853–5) before working in Munich. He first visited Italy, his spiritual and later physical home, in 1864, to copy old masters for Count von Schack. In 1869 he travelled in France, Holland, and Spain with the philosopher Konrad Fiedler. After military service (1870–1) he returned to Italy in 1873 and lived there

for the rest of his life. His work is largely devoted to idealized human figures in pastoral settings, climaxing with his two versions of *The Golden Age* (1879–80 and 1880–3; both Munich, Neue Pin.). He is best known for his ambitious frescoes in the Aquarium at Naples (*in situ*) commissioned by Anton Dohrn in 1873, on which he was assisted by his pupil the sculptor Adolph von *Hildebrand. Painted in a style similar to that of the foremost French fresco artist *Puvis de Chavannes, these murals celebrate an idealized version of the lives of Neapolitan fishermen. Like his contemporaries, his countryman Anselm *Feuerbach and the Swiss painter Arnold *Böcklin, he had a Romantic vision of an Arcadian Italy and remained untouched by the growth of *realism. DER

MARGARITO OF AREZZO (active c.1250–c.1290). Italian painter. Margarito was a seemingly successful and prolific painter of the later duecento. His modern fame rests on an unusually large number of signed works and on the tendentious use of his work by critics of *Renaissance art from *Vasari (who calls him 'Margaritone') onwards as a foil to the brilliant innovations of his Italian successors. Though the only known document mentioning Margarito places him in Arezzo in 1262, he may have been trained in Florence. His altarpiece of the *Madonna and Child with Saints* for S. Margherita in Arezzo (London, NG) shows a characteristic taste for two-dimensional symmetry and finely crafted linear decoration. A full-length image of *S. Francis* (c.1275; Arezzo, Pin.), one of at least eight attributed to Margarito, marks an engaging advance on earlier, rather remote, Italian portrayals of the saint. The sense in which the drapery partly reveals the underlying stance may reflect Margarito's exposure to the more forceful art of *Coppo di Marcovaldo, an influence also seen on an altarpiece of c.1285 for S. Maria delle Vertighi in Monte S. Savino. JR

Garrison, E. B., *Italian Romanesque Panel Painting: An Illustrated Index* (1949).

MARIESCHI, MICHELE (1710–43). Venetian view painter (see VEDUTA) and engraver. The son of an engraver, he is said by his 17th-century biographer to have worked in Germany, perhaps c.1729. In the first part of his career he is documented as a scene painter and seems also to have specialized in *capricci that are characterized by sultry colours and thick impasto; his *Stairwell in a Renaissance Palace* (c.1740; Stockholm, Nationalmus.) is one of a group of works which reflect Venetian stage designs and look forward to *Piranesi. In the late 1730s, under the influence of *Canaletto, he produced a number of views of Venice. His œuvre remains controversial, but his masterpiece, *The Grand Canal at*

the Entrance to Cannaregio (1741–2; Potsdam, Sanssouci), which was bought by *Algarotti for Frederick the Great, reveals a nervous, lively handling that anticipates *Guardi. In 1741–2 he published 21 etchings of views of Venice, under the title Magnificentiores selectioresque Venetiarum prospectus, whose steep perspectives create a sense of theatre and fantasy. AJL

Toledano, R., Michele Marieschi (1995).

MARIN, JOHN (1870–1953). American artist. He studied first at the Pennsylvania Academy and then at the Art Students' League in New York. He travelled in Europe between 1905 and 1909, where he developed a *Whistlerian style of painting in muted colours, and also made etchings and watercolours. Upon his return to New York he joined the circle around Alfred Stieglitz's 291 Gallery. Here he developed his personal style, mixing a turbulent Expressionism with a strong pictorial structure and dynamic movement derived from *Cubism and *Futurism. He now began to depict iconic scenes of New York, redolent of the city's modernity, such as Brooklyn Bridge (c.1912; New York, Met. Mus.). He was also drawn to the landscape and seascape around Maine which he depicted with a looser, gestural, Fauvist style, as in The Sea, Cape Split, Maine (1939; Washington, Phillips Coll.). During the 1920s he was important as a leading American modernist.
 MF

John Marin, exhib. cat. 1987 (New York, Parrish Art Mus.).

MARINE PAINTING is the painting of sea subjects with particular attention to ships and shipping. It is distinguished from *landscape painting (with which it overlaps) by its main objective of conveying information about shipping in its natural environment. A product of the naval and commercial preoccupations of the great maritime nations, it flourished most notably in the Dutch Republic of the 17th century. Specialist marine painting, the main patrons of which were naval officers, shipowners, and shipmasters, made exacting demands on the artist; he had to unite accurate ship portraiture with the rendering of water, light, and atmosphere; often he had to depict a precise moment in a complex naval engagement. In addition to the world of public commissions and acknowledged artists there developed, from the mid-18th century, a thriving trade in ship portraits that were commissioned by shipowners from 'pierhead artists' in many ports, including Copenhagen, Marseilles, Naples, and in Malta, as well as the major ports in the United Kingdom and USA. The painterly quality of this popular art was often limited, but the artists were expected to understand the complexities of sails and rigging, and to depict it accurately.

Throughout the 16th century separate strands of artistic activity, which were to be brought together in fully developed marine painting, proceeded in the Netherlands. In the second decade *Patinir established a formula for the painting of calm seas, while interest in depicting stormy seas came later. Accurate ship portraiture, which may be traced back to the seals of maritime cities in the 12th century, was developed by graphic artists, among them Pieter *Bruegel the elder. From mid-century the panoramic seascape, with scenes of shipping set against city profiles, became popular. Two remarkable paintings, the Portuguese Carracks (c.1520–30; London, National Maritime Mus.) and Henry VIII Leaving Dover Harbour (c.1520–30; Hampton Court, Royal Coll.) united these interests in atmosphere and accurate description and anticipated the ambitions of the 17th century.

When marine painting finally emerged as a distinct genre, in the 17th-century Dutch Republic, the initial focus was on large, publicly commissioned history paintings commemorating naval engagements against the Spanish and important political and commercial events. It was initiated by *Vroom, who made his name with the design (1592) of a set of tapestries (destr.) commemorating the Armada, and thereafter specialized in large, precisely detailed, and extremely expensive historical commissions. From the 1620s a huge market developed for smaller marine paintings, by such artists as *Porcellis, de *Vlieger, van de *Cappelle, and van de *Velde the younger, in which the interest lies in the broader depiction of atmospheric effects and the behaviour of the sea in various conditions. These artists created several distinct categories of marine paintings, among them calms, beach scenes, storms, and 'parade' pictures, the latter designed to show a variety of types of vessel and usually enlivened by some fictive ceremonial action, such as the arrival of a dignitary.

The Anglo-Dutch Wars (1652–74) revived interest in publicly commissioned historical painting, and both Willem van de Velde and his son built up a highly successful practice in depicting the battles against the English for Dutch patrons. In 1674 however they were both appointed as painters to Charles II, and given the use of a studio in the Queen's House, Greenwich, where they employed a number of assistants including Isaac Sailmaker (1633–1721), Jacob Knyff (1638–1681), and Peter Monamy (1681–1749); all of whom later worked independently. The market leaders in marine painting had moved to London.

The van de Velde influence dominated English marine painting in the 18th century. Samuel Scott (c.1702–72) and Charles *Brooking were among the best painters in the genre, but the official marine painter to George III was Dominic Serres (1722–93). In France Claude-Joseph *Vernet was commissioned to paint a series of the French ports for Louis XV; he developed the *Romantic potential of storms and shipwrecks, a theme developed in England by the influential French artist de *Loutherbourg, who emphasized the frailty of man before the violence of nature. The Revolutionary and Napoleonic Wars generated a good deal of traditional marine painting, by such artists as Nicholas Pocock (1740–1821), and coastal views, storms, and sea battles were immensely popular in the early 19th century. The early marine paintings of *Turner were in conscious and evident emulation of Dutch painters such as van de Cappelle and van de Velde the younger, but Turner's more dramatic vision inspired the next generation of marine artists, and he superseded van de Velde as their model. His influence is apparent in the work of many marine artists, such as Edward William Cooke (1811–80), and Clarkson Stanfield (1793–1867), who continued to flourish in England throughout the 19th century. Their art is less documentary than the work of 18th-century painters, and their picturesque harbours more Romantic in mood. The royal appointment of a specialist Marine Painter in Ordinary lasted as late as 1912, though the artistic quality of the product had certainly declined by then. HO/AJL

Keyes, G. S., Mirror of Empire: Dutch Marine Art of the Seventeenth Century, exhib. cat. 1990 (Minneapolis, Inst. of Arts).
Russell, M., Visions of the Sea (1983).

MARINETTI, FILIPPO TOMMASO (1876–1944). Italian poet, who in 1909 published the first manifesto of *Futurism in Le Figaro. He created an aesthetic glorifying the dynamism of modern technology, brilliantly summarized in the assertion that 'a speeding automobile . . . is more beautiful than the Victory of Samothrace' ('Manifeste du Futurisme', Le Figaro, 20 Feb. 1909). Initially influenced by French *Symbolism, he evolved a highly individual poetic style characterized by a free association of words and ideas, with a complete abandonment of conventional syntax, grammar, and punctuation. His arrangements of 'words in freedom' had a highly pictorial quality, as can be seen in his novel Zang Tumb Tuum (1914), and influenced the use of writing in paintings by other Futurist artists. Marinetti was also an energetic political activist: he enthusiastically supported Italian intervention in both World Wars, and was a fervent admirer of Mussolini. However, during the Fascist period Futurism received little patronage, and Marinetti died an embittered, isolated figure. CJM

Lista, G., Marinetti (1976).

MARINI, MARINO (1901–80). Italian sculptor. Born in Pistoia, he received an academic training in Florence. From the late 1920s his work was influenced by the 'Etruscan' style of Arturo *Martini whom he succeeded in 1929 as teacher of sculpture at the Scuola d'Arte della Villa Reale in Monza. He was also associated with the Novecento movement during this period, contributing to its exhibitions both in Italy and abroad. During the 1930s he began to produce his celebrated series of *Horsemen*, which were initially characterized by serene, harmonious compositions. However, from the 1940s a disquieting quality enters his work, exemplified by the *Horseman* of 1947 (London, Tate). His later work includes sculptures and paintings that make highly abstracted references to organic forms. CJM

Marino Marini, exhib. cat. 1989–90 (Milan, Palazzo Reale and Mus. Marino Marini).

MARINO, GIAMBATTISTA (1569–1625). Italian poet, collector, and art theorist. His poems are distinguished by their metaphorical extravagance, and he believed that the aim of art is the marvellous. Born in Naples, Marino lived as courtier-poet in Rome (1600–5), Turin, and Paris (1615–23). His major theoretical work is *Painting, or the Holy Shroud* (1614) which includes a discussion of the *paragone and many anecdotes. *La Galeria* (1619), inspired by *Philostratus, is a collection of madrigals and sonnets to works of art, which privilege the theme of an art that rivals or conquers Nature herself. Best known are poems to *Caravaggio's *Medusa* (Florence, Uffizi) (Marino knew Caravaggio, who painted his portrait) and to works by Guido *Reni, which emphasize Reni's fascination with horror and beauty. A longer poem to the Magdalene inspired many voluptuous paintings. In Paris Marino discovered *Poussin and commissioned from him a series of drawings of Ovidian subject matter (1622–3; Windsor Castle, Royal Coll.). On his return to Italy Marino dreamed of building up a gallery in Naples, but died too soon. HL

Marino, G. B., *La Galeria*, ed. Marizio Pieri (1979).

MARINUS VAN REYMERSWAELE (c.1490×5–after 1567). Netherlandish painter whose identity and biography have not been decisively established by documentary evidence. Reymerswaele, or Roymerswaele, is a village in Zeeland. The name Marinus appears as a signature on a group of pictures portraying half-length figures of *S. Jerome, Two Tax Gatherers* (e.g. London, NG), and a *Banker* (or Money-Changer) *and his Wife*. These images are repeated in many variants. Marinus' grotesque, caricature-like figures, surrounded by the objects of their occupations, are meant to depict different types of human folly, such as greed and avarice. Even the scholarly S. Jerome, with his spidery fingers and fanatical gaze, looks like a prophet of doom rather than the personification of the contemplative life (e.g. 1521; Madrid, Prado). The Bible before him is opened to an illumination of the Last Judgement. Marinus' compositions were much imitated, for example by Jan Sanders van *Hemessen. KLB

Snyder, J., *Northern Renaissance Art* (1985).

MARIS FAMILY. Three Dutch brothers, born in The Hague, who painted in the second half of the 19th century. The eldest, **Jacob** (1837–99), became a leading figure in the *Hague School. He studied at the academies in The Hague and Amsterdam before working in Paris, where he was influenced by the landscapes of *Corot and the *Barbizon School. His subjects were usually Dutch landscapes and undramatic scenes of everyday life, like *A Bleaching Yard* (1870; Amsterdam, Rijksmus.), typical of the Hague School artists. His manner has affinities with *Impressionism but he seldom painted directly from nature. His brother **Matthias** (1839–1917) received the same training but, more romantically inclined, was influenced by contemporary German painters like *Schwind, and, after 1877 when he settled in London, *Pre-Raphaelite subjects. His paintings, like *Fairy Tale* (Amsterdam, Rijksmus.), are visionary and poetic. **Willem** (1844–1910) was taught by his brothers and influenced by the work of Anton Mauve (1838–88). He became a leading Dutch Impressionist and exhorted his pupils to paint *en plein air*. *Cows at a Watercourse* (Amsterdam, Rijksmus.) is typical of his work which is almost entirely confined to landscapes of meadows and cattle. DER

De Raad, J., and van Zadelhoff, T., *Maris: een Kunstenaars-familie*, exhib. cat. 1991 (Laren, Singer Mus.).

MARMION, SIMON (1424–89). Illuminator and painter from a family of artists in Amiens. He was established in Valenciennes by 1458 and became the most celebrated illuminator of his day. Until the identification of two surviving leaves from a documented work, the Breviary of Charles the Bold, Duke of Burgundy (New York, Met. Mus., Lehman Coll.), Marmion's œuvre was assembled around the painted wings of the altarpiece of *S. Bertin* (1455–9; Berlin, Gemäldegal.; London, NG) and the *Grandes Chroniques de France* (c.1455; St Petersburg, Russian National Lib., Erm. Fr. 88), both commissioned by Guillaume Fillastre, Abbot of S. Bertin. The attributed œuvre was made up of manuscripts of exceptional quality painted with great delicacy using a subtle palette combining pastel shades with browns and greys, for example the Huth Hours (London, BL, Add. MS 38126): the varied subject matter of the illumination demonstrates compositional ambition and invention, for example the *Visions of Tondal* for Margaret of York (Los Angeles, Getty Mus.). The Lehman Collection leaves support the earlier attributions. KC

Kren, T. (ed.), *Margaret of York, Simon Marmion and the 'Visions of Tondal'* (1992).
Kren, T. (ed.), *Renaissance Painting in Manuscripts: Treasures from the British Library*, exhib. cat. 1983–4 (Los Angeles, Getty Mus.; New York, Pierpont Morgan Lib.; London, BL).

MARMITTA, FRANCESCO (active c.1500). Italian illuminator, painter, and gem engraver from Parma. His style appears to derive from Ercole de' *Roberti and shows affinities with that of Lorenzo *Costa, during his Bolognese period. Although Franciscus Maria Grapaldus, writing in the 1506 edition of *De partibus aedium*, refers to Marmitta as a painter of altarpieces, his only firmly authenticated work is the illumination of a manuscript of Petrarch in the library at Kassel (Landesbib. MS Poet. 4°–6) Other miniatures have been attributed to him on the basis of stylistic comparison: they include a missal at Turin (1498–1501; Mus. Civico) executed for Cardinal Domenico della Rovere (d. 1501), and a book of hours from the Durazzo Collection (Genoa, Bib. Berio). Drawings attributed to Marmitta include a *Crucifixion* (Paris, Louvre) and an *Entombment* (London, BM). Two paintings, somewhat different from each other in style, are attributed to him. A small panel of the *Scourging of Christ* with its distinctive slender and elongated figures (Edinburgh, NG Scotland) might be a relatively early work when the artist was influenced by Ercole de' Roberti. An altarpiece of the *Virgin and Child with S. Benedict and S. Quentin* (Paris, Louvre) may be later in date; the figures are conceived more boldly and the artist has employed effects of light and shade to enhance their physical presence. HB

Brown, D., 'Maineri and Marmitta as Devotional Artists', *Prospettiva* (1988–9).
Pouncey, P., 'Drawings by Francesco Marmitta', *Proporzioni*, 3 (1950).

MARON, ANTON VON (1733–1808). Austrian *Neoclassical painter who spent most of his life in Italy. From 1756 until 1761 he was the pupil and assistant of *Mengs in Rome. His own independent decorative works, such as the ceiling of the casino at the Villa Borghese (1784), reflect this experience, with their classical subjects treated without any attempt at *Baroque illusionism but as if they were a series of easel paintings displayed horizontally. Maron is best known, however, for his portraits of *Grand Tourists, which have many affinities with those by *Batoni. They usually depict the subject standing at ease against a distant view of Rome and with their character and interests

underlined by an appropriate piece of *Antique sculpture (e.g. *Sir Archibald Menzies*; Cambridge, Mass., Busch-Reisinger Mus.). Maron's portrait of his friend the antiquary *Johann Joachim *Winckelmann* (1768; Weimar, Schlossmus.) is a fine example of his less formal and more penetrating private portraits.
MJ

Röttgen, S., '"Antonius de Maron faciebat Romae": intorno all'opera di Anton von Maron a Roma', in *Artisti austriaci a Roma* (1972).

MARQUET, PIERRE-ALBERT (1875–1947). French painter, born at Bordeaux. He went to Paris in 1890 where he studied at the École des Beaux-Arts under Gustave *Moreau. Here he became a close friend of *Matisse and collaborated with him on decorations for the Exposition Universelle. He quickly developed a loose handling and applied colour in broad areas; an early nude from this period later became known as the *Fauve Nude* (1898; Bordeaux, Mus. des Beaux-Arts), anticipating the style in its technique and the primacy given to colour. He exhibited alongside the *Fauves at the Salon d'Automne of 1905 but subsequently abandoned the style and turned to more naturalistic landscapes in the tradition of *Corot: *Pine Tree at Algiers* (1932; Bordeaux, Mus. des Beaux-Arts). He became noted for his many views of the banks of the Seine, for instance *Quai Bourbon* (1908; Bordeaux, Mus. des Beaux-Arts), and for the landscapes he executed during his travels.

See École des Beaux-Arts and Salon de Refusés under PARIS.
MF

Guerman, M., *Albert Marquet: The Paradox of Time* (1995).

MARTIAL, Marcus Valerius Martialis (AD 38×41–101×4). Latin poet active in the Flavian period in Rome. His series of epigrams for attachment to gifts for the festival of Saturnalia are a fount of information on paintings and statues. Both he and his rival Statius describe a dinner party hosted by the connoisseur Novius Vindex at which the centrepiece was a bronze statuette of the *Hercules Epitrapezios* purported to be by the sculptor *Lysippus (9. 43, 9. 44). Martial includes a reference to the inscription on the base: 'of Lysippus'.
L-AT

Sullivan, J. P., *Martial: The Unexpected Classic* (1991).

MARTIN, ELIAS (c.1739–1818). Swedish landscape painter and engraver. Martin was born in Stockholm and trained in his father's carpentry shop and with the painter Friedrich Schultz (1709–69). He first worked at the Finnish naval base of Sveaborg as a decorative painter and teacher and made many accurate topographical studies of the coast and fortress in addition to fanciful landscapes based on engravings. In 1766 he was taught by J. *Vernet in Paris and in 1768 settled in London becoming one of the first Associates of the Royal Academy (see under LONDON) in 1771. Influenced by the *Romanticism of *Wilson and English *watercolourists, Martin abandoned pen and wash for pure colour and had some success as a painter of country houses including *Pope's Villa at Twickenham* (1773; Stockholm, Nationalmus.), and as a *caricaturist. He returned to Sweden in 1780 and received many commissions to paint noble houses and estates in the new Romantic style. Much admired, he became a professor at the Royal Academy, Stockholm, in 1785. He revisited England 1788–91 after which his landscapes became increasingly dramatic and *sublime. His brother Johan Fredric (1755–1816) was an engraver.
DER

Hoppe, R., *Malaren Elias Martin* (1933).

MARTIN, JOHN (1789–1854). English painter and engraver. Martin was born near Newcastle where, after an apprenticeship to a coach painter, he studied under an expatriate Italian, Boniface Musso, with whom he moved to London in 1806. After working as a china painter he exhibited a landscape at the RA, *London, in 1811 followed, in 1812, by *Sadak in Search of the Waters of Oblivion*, the first of the dramatic biblical scenes which made his reputation. The huge popular success of *Joshua Commanding the Sun to Stand Still* (London, United Grand Lodge) in 1816 led to his appointment as historical painter to Princess Charlotte. He continued in apocalyptic vein for the rest of his career, culminating in three gigantic paintings *The Last Days* (1851–3; London, Tate). His income was enhanced by the publication of *mezzotints, which he engraved himself, after his paintings and as independent ventures, including *Paradise Lost* (1825–7). Although accused of popularism there is evidence to show that, under the influence of millenarianism, Martin may have seen his work as an allegory of contemporary civilization. His reputation, which had declined dramatically, revived in the 1960s.
DER

Feaver, W., *John Martin* (1975).

MARTINI, ARTURO (1889–1947). Italian sculptor and painter, born at Treviso, where he served apprenticeships as a goldsmith and in a ceramics factory before turning to sculpture in 1906. He moved to Venice in 1908 and in 1909 went to Munich to study under *Hildebrand. In 1912 and 1914 he visited Paris and after the First World War (during which he worked in an armaments factory and gained a knowledge of casting) he worked mainly in Rome, Venice, and Milan (he taught at the Villa Reale Art School at Monza, near Milan, in the 1920s). Some of his early work was extremely adventurous, notably the bizarrely *Expressionist *Prostitute* (1909–13; Venice, Ca' Pesaro) in coloured terracotta, but in 1921 he became associated with the journal *Valori plastici* and, in line with its views calling for a return to the Renaissance tradition, his work took on a classical simplicity. It is also possible to detect the influence of Hildebrand in his generalized forms. However, his work was far from being mere revivalism or pastiche. There is often an air of *Surrealist strangeness in his sculptures, especially his rather ghostly terracotta figures, and he reflected the troubles through which he lived. Martini began to paint in the late 1930s, and in 1945, suffering an artistic crisis, he published a pamphlet announcing the death of sculpture, *La scultura: lingua morta*.
IC

MARTORELL, BERNAT (active 1427–d. 1452). One of the great painters of *Gothic altarpieces in the Catalan region of Spain. Martorell's style during the 1430s synthesized aspects of Netherlandish painting without sacrificing the artistic traditions of the Catalan region or ignoring the novelty of Italian art then being felt in Spain. Martorell's name appears frequently in documents of the time, but few works surely by his hand have been identified. An altarpiece of *S. George*, its panels now divided between the Chicago Art Institute and the Louvre, Paris, once ascribed to 'the Master of S. George' is now attributed to Martorell. Documented works include the altarpiece for the parish church of Púbol (1437; Gerona, Mus. d'Art) and works for S. María del Mar, Barcelona (c.1447–9) which were practically destroyed during the Spanish Civil War (1936). Martorell's figures are distinctive; intricately drawn and delicately modelled, they wear pensive, even dreamy, expressions. Toward the end of his life, Martorell had many pupils and a busy workshop that continued in operation after his death.
SS-P

Cathalonia: arte gótico en los siglos XIV–XV, exhib. cat. 1997 (Madrid, Prado).

MARVILLE, JEAN DE (active 1366–89). Southern Netherlandish sculptor who worked in Lille, Rouen, and *Burgundy. In 1369 he was paid with *Jean de Liège for work in the chapel of Charles V in Rouen Cathedral and by 1372 he had caught the attention of Philip the Bold, Duke of Burgundy, who appointed him court sculptor. He worked on sculptural projects in many of the Duke's residences employing over 20 assistants, including the young Claus *Sluter, who later succeeded him. Sluter's modification of his designs at the Charterhouse of Champmol make the isolation of his contribution difficult but he was probably responsible for the overall design of the tomb for Philip the Bold and carved the arcade to house the

453

weepers (Dijon, Mus. des Beaux-Arts). KC

Morand, K., *Claus Sluter* (1991).

Roggen, D., 'Hennequin de Marville en zijn atelier te Dijon', *Gentsche bijdragen tot de Kunstgeschiedenis*, 1 (1934).

MARXISM. If in politics the term may be used as a demarcation of allegiance, in cultural matters it extends less precisely to forms of thought that acknowledge and build in some way on the writings of Karl Marx (1818–83). Marx's socio-political theory upturned the idealist vision of history outlined by *Hegel, positing a world in which matter, rather than mind, comes to consciousness of itself. Materially constituted humanity, seen in terms of its needs, its labour, and its production, moves forward historically through forms of economic relation like capitalism which alienate it from itself (not least by throwing up ideological superstructures such as religion) towards a future identity of needs and production, communism, which it is the role of the working classes to bring about through revolution.

Marx's vision is insistently comprehensive, relating all matters by implication to its political agenda; yet his remarks on aesthetic matters are few and inexplicit, leaving a kind of lacuna in his system. One conclusion drawn from his work is that art, as a form of production entirely determined by ideological concerns, must either take on a politicized role within the revolution or be consigned to the now disposable bourgeois order it overthrows. This thinking formed a personal agenda for countless 20th-century artists, being spoken for in diverse manners and contexts by Alexander *Rodchenko in the 1920s, David *Siqueiros in the 1930s, *Picasso in the 1940s, and John Berger (1926–) in the 1960s. Yet during the same period, Communist regimes found it an eminently convenient justification for the repression of art.

Against this many thinkers, encouraged by Marx's own deference towards high cultural achievement, have proposed accounts of art that, while recognizing its ideological serviceability, also recognize a 'relative autonomy' in the aesthetic sphere. It can be argued that patterns of production in the art world tend to relate only indirectly to the political and economic realities on which it ultimately depends, and that to reach for a 'base-superstructure' model at every point of interpretation fails to provide the adequate total account at which Marxist materialist description should aim. Thinking along these lines, promoted by the criticism of György Lukács (1885–1971), Antonio Gramsci (1891–1937), and Theodor *Adorno, has proved highly productive for art studies, from those of Meyer *Schapiro to those of T. J. Clark, through whom it has fed into the field of *new art history. JB

MARZAL DE SAX, ANDRÉS (active 1394–1410). Painter of German origin who established a busy workshop in Valencia. Several large altarpieces were painted in collaboration with the Valencian artist Pere Nicolau. Marzal de Sax was paid in 1400 for an altarpiece of *S. Thomas*, the central panel of which survives in Valencia Cathedral. A vast battle scene commemorating the victory of Pedro I at Albocacer, near Huesca, has been convincingly attributed to Marzal de Sax (London, V&A). The painting, originally part of an altarpiece dedicated to S. George, demonstrates the artist's command of complex composition as well as the expressive originality of his tall, graceful figures. SS-P

MASACCIO (Tommaso Giovanni di Mone) (1401–28). Italian painter born in San Giovanni Val d'Arno, about 50 km (30 miles) from Florence, where he lived from at least 1422 until going to Rome in 1428. Within a short time of his death there, his reputation as an innovator and representative of the new Florentine style of realism was initiated. *Alberti, the Florentine *humanist Cristoforo Landino, and *Leonardo da Vinci contributed to this perception, while *Vasari identified Masaccio's links with his older contemporaries *Brunelleschi and *Donatello. Masaccio seems to have adopted from them his mathematically constructed compositions, which convincingly evoke three-dimensional space on a flat surface, classicizing architectural settings, and the depiction of convincing human figures conveying identifiable emotional or spiritual reactions.

This observation of the human condition within nature reflects the humanist values evolving during the period, and relates to the painting tradition of *Giotto, an earlier Florentine, rather than to the contemporary more decorative and elegant styles of *Lorenzo Monaco or *Gentile da Fabriano. Masaccio's reputation is remarkable considering his short life and career; only one of his works, the Pisa Polyptych (dispersed: panels in Pisa, Mus. Nazionale; Berlin, Staatliche Mus.; London, NG) is documented. Two others, the S. Ambrogio altarpiece (Florence, Uffizi) and the frescoes in the Brancacci chapel (Florence, S. Maria del Carmine) were executed in collaboration with *Masolino, an older and more conservative artist, who was perhaps more influenced by Masaccio than an influence on him. A fourth work, the fresco of the *Trinity* with the Virgin, S. John, and two supplicants (1425; S. Maria Novella), illustrates clearly Masaccio's debt to Brunelleschi. The painted architecture is an ambiguous structure, suggesting church, mausoleum, and triumphal arch, and demonstrates not only the *Antique features

which Brunelleschi was introducing to Florence, but also, in the dramatic foreshortening of the vault, his theories on *perspective. The resulting spatial illusion (see ILLUSIONISM) is reinforced by the figures, which are life size, have volume, and are painted as if seen from below to accommodate the spectator's point of view. Donatello, in sculpture, made similar allowances in the design of figures such as *S. John* for the exterior of Florence Cathedral.

In his fresco depicting the *Tribute Money* in the Brancacci chapel (1423–8), Masaccio used single-point perspective to focus attention on the head of Christ, and to create an extensive exterior setting in which to place the various parts of the narrative. His large brush strokes, heavily laden with paint, show with what assurance and speed the artist worked, setting dark against light tones to establish the solidity of his forms. In addition to deploying these technical means of manipulating the viewer's perception of space and time, Masaccio introduced a mood of emotional intensity into scenes such as the *Expulsion of Adam and Eve* where Adam covers his eyes in shame while Eve raises an anguished face to heaven.

Masaccio's smaller-scale paintings also display a similar monumental and austere realism and narrative clarity. The central panel of the Pisa Polyptych (1426; London, NG) shows the Virgin, massive and heavily robed in rich lapis lazuli blue, gazing down towards the viewer, the foreshortening of the classical throne reinforced by the diagonal pose of the lute-playing angels. MS

Berti, L., *Masaccio* (1988).

Joannides, P., *Masaccio and Masolino: A Complete Catalogue* (1993).

MASEREEL, FRANS (1889–1972). Belgian printmaker. Born in Blankenberge into a wealthy famly, Masereel studied briefly at the Ghent Academy before settling in Paris where he published his first volume of woodcuts in 1914. On the outbreak of war he moved to Switzerland and lived in Geneva where he contributed anti-war illustrations to the newspaper *La Feuille*, using a brush and black ink which made his drawings resemble woodcuts. He was a co-founder, with the poet René Arcos, of Les Éditions du Sablier which published works by contemporary writers in fine editions illustrated with his own prints and continued to produce albums of his work like *Le Soleil* (1919). He later developed anti-capitalist themes and flirted with communism, visiting the Soviet Union and China, although he never became a party member. He painted with indifferent success but is remembered solely for his semi-Expressionist woodcuts and illustrations, invariably in dramatic

black and white, which influenced contemporary Belgian printmakers. DER

Avermaete, R., *Frans Masereel* (English trans., 1977).

MASKS. See DEATH MASKS AND LIFE MASKS.

MASO DA SAN FRIANO (Tommaso Manzuoli) (1531–71). Florentine painter who was one of the leading figures in the *Andrea del Sarto and *Pontormo revival. He probably received his early training from the Florentine painter Pier Francesco Foschi, whose influence can be seen in Maso's earliest known work, the *Portrait of Two Architects* (1556; Rome, Palazzo Venezia). By 1560 Maso's reputation was such that he won two important commissions for altarpieces: the de' Pesci chapel in S. Pier Maggiore, Florence (1560; Cambridge, Trinity Hall), and another for the Convento della Trinità in Cortona. In both the grandeur of the compositions, and the monumental gravity of the figures, are derived from del Sarto. The earlier master's influence continued in Maso's later works, such as the *Adoration of the Shepherds* (c.1566–7; Florence, SS Apostoli). He was also inspired by the intense colouring and highly wrought drama of Pontormo's work, as is evident from his two paintings (c.1570–1) in the *studiolo* of Francesco I in the Palazzo Vecchio, Florence: the *Diamond Mine*, whose attenuated figures and intricate composition recall Pontormo's *Story of Joseph* paintings, and the *Fall of Icarus*. HCh

MASO DI BANCO (active c.1335–47). Italian painter, perhaps the greatest of *Giotto's immediate followers. For early commentators like Filippo Villani and Lorenzo *Ghiberti, who left a list of his works, he was a seminal figure, a judgement with which recent scholarship has increasingly agreed. A small number of attributable panels survive, but Maso's masterpiece is the fresco cycle of the *Life of S. Sylvester* in the Bardi di Vernio chapel in S. Croce, Florence (c.1335–40). Maso's searching development of the pictorial language of Giotto's adjacent Bardi and Peruzzi chapel frescoes can be seen in the use of space: the frontal and oblique architectural settings combined to persuasive, clarifying, and highly evocative effect (e.g. the ruined Roman Forum in *S. Sylvester and the Dragon*). Minute deviations from strict rectilinearity convincingly suggest the optical reality of lateral recession. Figures are monumental, contained within powerfully simplified outlines, and painted in broad luminous planes of dense, rather cool, colour. The frescoes were extensively repainted in the 1930s, but as a similar technique characterizes Maso's S. Spirito altarpiece (Florence, S. Spirito), the repaint may still reflect those qualities of monumental concentration on essentials which may be what Ghiberti

praised as 'abbreviation'. JR

Offner, R., 'Four Panels, a Fresco and a Problem', *Burlington Magazine*, 54 (1929).

MASOLINO DA PANICALE (c.1383–1435?). Italian painter whose reputation is based on the collaboration with *Masaccio at the Brancacci chapel in S. Maria del Carmine, Florence, in 1424–5 although the work produced there was contrary to the main preoccupations of his art. Masolino may have been trained in the studios of *Ghiberti or *Starnina, but it was the *International Gothic of *Gentile da Fabriano which exerted the strongest influence on his style. The difference between Masaccio's austere, sculptural manner and Masolino's more decorative tendency is apparent in the *Virgin and Child with S. Anne* (1424–5; Florence, Uffizi) which the two artists undertook for S. Ambrogio in Florence. This contrast is even more marked in the Brancacci chapel frescoes. Masaccio's *Tribute Money* relies on massing of heavy figures in a coherent space while Masolino's *S. Peter Raising a Cripple and the Raising of Tabitha* appears to dwell on details, despite the open urban setting created by the perspective. That Masolino was drawn more to detail and decoration is confirmed by later independent works, including the frescoes of the *Life of the Virgin and of S. John the Baptist* at Castiglione Olona in Lombardy. PSt

Joannides, P., *Masaccio and Masolino: A Complete Catalogue* (1993).

MASSON, ANDRÉ (1896–1987). French painter, printmaker, sculptor, stage designer, and writer, one of the major figures of *Surrealism. He was born at Balagne and at the age of 8 moved with his family to Brussels, where he studied art part-time whilst working as a pattern drawer in an embroidery studio. In 1912 he moved to Paris, where he studied at the École des Beaux-Arts (see under PARIS) until the outbreak of the First World War, when he joined the army. During the war he was seriously wounded and deeply scarred emotionally. His pessimism was accompanied by a profound and troubled curiosity about the nature and destiny of man and an obscure belief in the mysterious unity of the universe; he devoted the whole of his artistic activity to penetrating and expressing this belief.

After the war Masson lived in the south of France until 1922, when he returned to Paris. Initially he was influenced by *Cubism, but in 1924 he joined the Surrealist movement and remained a member until 1929, when he left in protest against *Breton's authoritarian leadership. His work belonged to the spontaneous, expressive, semi-abstract variety of Surrealism, and included experiments with *automatism, chance effects, and unusual

materials (he sometimes incorporated sand in his paintings). Themes of metamorphosis, violence, psychic pain, and eroticism dominated his work. In 1936 he lived in Spain until the Civil War drove him back to France and in 1941–5 he took refuge from the Second World War in the USA. There his work formed a link between Surrealism and *Abstract Expressionism. It included a series of large canvases reflecting the carnage he had lived through, among them *There is No Finished World* (1942; Baltimore, Mus. of Art), which features disintegrating monsters symbolizing (in his own words) 'the preciousness of human life and the fate of its enterprises, always threatened, destroyed, and recommenced'. In 1945 Masson returned to France and two years later settled at Aix-en-Provence, where he concentrated on landscape painting, achieving something of the spiritual rapport with nature associated with Chinese painting. Apart from paintings his work included designs for the theatre, book illustrations, and several sculptures. He also wrote a good deal on art, including the two-volume book *Métamorphose de l'artiste* (1956). IC

MASSYS (also Matsys, Metsys), FATHER AND SONS. Antwerp painters, of whom the father, **Quentin** (c.1465/6–1530), was the most important. Born in Louvain, nothing is known of his training. He is first mentioned as a painter in 1491, when he entered the guild of S. Luke in Antwerp. He was an eclectic artist who borrowed freely from the Italians, notably *Leonardo, but also from *Dürer and earlier Netherlandish masters.

Massys's most important works are two great triptychs, the *S. Anne* altarpiece (1507–9; Brussels, Mus. Royanx) and the *S. John* altarpiece (1508; Antwerp, Koninklijk Mus. voor Schone Kunsten). The *S. Anne* altarpiece clearly demonstrates Massys's eclectic style: the iconography is northern (the clan of Anna, mother of the Virgin Mary) as is the structure, but the group is set against an Italianate loggia, and the soft modelling of the flesh parts in the essentially Gothic figure types betrays knowledge of Leonardo's *sfumato*. The vast mountainous landscape is painted in *aerial perspective. By using three zones of basic colour—brown, green, blue—Massys anticipated the three-colour landscapes of Joost de *Momper and later 16th-century artists. The *S. John* altarpiece depicts as its centre the *Lamentation*, which is in many ways a reworking of Rogier van der *Weyden's *Descent from the Cross* (Madrid, Prado). At the same time it shows yet another feature derived from Leonardo: Massys's ability to juxtapose elegance and the grotesque. This is especially prominent in the *Martyrdom of John the Evangelist* on the right wing, where the evil

of the tormentors is portrayed in their grimacing faces, coarse bodies, and spastic movements.

Massys's preoccupation with *caricature and the grotesque can also be seen in his portraits which, yet again, combine Italian influences with northern portrait tradition. The *Grotesque Old Woman*, the so-called 'Ugly Duchess' (c.1513; London, NG), is based on a drawing by Leonardo (Windsor Castle, Royal Coll.), while the famous likenesses of *Erasmus* and *Petrus Aegidius*, painted for Sir Thomas More in 1517 (Rome, Barberini Gall.; Longford Castle, Wilts., Radnor Coll., respectively) are conceived in the northern scholar-portrait formulas.

Interest in the grotesque may have motivated Massys to turn his attention to satirical or moralizing genre subjects. The best-known such work is the *Unequal Lovers* (c.1515; Washington, NG), in which a young prostitute caresses a lecherous old man while she passes on his purse to a fool. The exact source for the iconography is not certain, but the subject is closely related to the satirical writings of Erasmus with whom Massys was associated. *Unequal Lovers* is an important example of the emerging prominence of secular, moralizing subjects, which were taken up later in the works of painters like *Marinus van Reymerswaele and the artists's own sons Jan and Cornelis. After studying with their father, both became members of the Antwerp guild of S. Luke in 1531. **Jan** (c.1509–73), more so than his brother, worked in the style of his father. Like Cornelis, he seems to have left Antwerp immediately after becoming a master. It has been suggested on stylistic grounds that he worked at *Fontainebleau, but this is disputed. He was in Italy around 1549, but was back in Antwerp before December 1555. Jan painted religious subjects and satirical genre scenes already painted by his father. However, he is best known for his treatment of the female nude, in Old Testament, allegorical, and mythological subjects (*Flora*, 1559; Hamburg, Kunsthalle). **Cornelis's** (c.1510–c.1557) importance today lies primarily in his sketches of landscapes, which are among the earliest surviving landscape drawings in the Netherlands (*Mountainous Landscape with a Castle*, 1541; Berlin, Kupferstichkabinett). KLB

Silver, L., *The Paintings of Quinten Massys* (1984).
Pieter Bruegel d. Ä. als Zeichner, exhib. cat. 1975 (Berlin, Kupferstichkabinett).
Buijnsters-Smets, L., *Jan Massys* (1995).

M ASTER of . . . or in German *Notname*. Invented nickname or name of convenience given by art historians to an artistic personality identifiable only through a coherent body of work, and not securely associable with any evidence from sources or documents. Entries on such artists are here arranged alphabetically as a group under the overall heading Master. Documented artists known only by their first name, for example Maître François, are entered according to their given names. KS

MASTER OF THE AIX ANNUNCIATION. See EYCK, BARTHÉLEMY D'.

M ASTER OF ALKMAAR (active 1475–1515). Netherlandish painter named after the polyptych of the *Seven Acts of Mercy* (1504; Amsterdam, Rijksmus.) painted for the confraternity of the Holy Ghost in Alkmaar. The acts of mercy are shown as contemporary scenes peopled by somewhat stiff figures in spacious settings, strongly lit, and with deep shadows. His portraits include *Jan van Egmond* and *Magdalena van Waerdenberg* (c.1504; New York, Met. Mus.). The Master was most likely Cornelis Buys the elder, the brother of Jacob *Cornelisz. van Oostsanen and teacher of Jan van *Scorel, who was active in Alkmaar 1490–1524. KC

Friedländer, J. J., *Early Netherlandish Painting*, vols. 5 and 12 (1967–76).

MASTER OF THE AMSTERDAM CABINET. See MASTER OF THE HOUSEBOOK.

M ASTER OF THE BAMBINO VISPO (active early 1400s). Invented name of an Italian painter now convincingly equated with Gherardo *Starnina. In 1904 the Master's hand was identified in a group of anonymous works, including a *Virgin of Humility* (Philadelphia Mus.), in which the painter had designed a lively Christ child (*bambino vispo*) with an animated expression. It was wrongly assumed that the *anonimo* had emerged from the circle of *Lorenzo Monaco and was active in the 1420s. Elements of the Master's vigorously Gothicizing style (such as his sensitivity for ornament and decoration, his enveloping and spirited drapery forms, his strongly characterized figures, and his expressive use of calligraphic line) display quite obvious affinities with Valencian late *Gothic painting, and the style and provenance of his *Last Judgement* (Munich, Alte Pin.; formerly in Majorca) led some to conclude that he was the Spanish painter Miguel Alcañiz. However, with the discovery of fresco fragments by Starnina in Florence and Empoli, striking points of contact between the work of the Master and Starnina were noticed. FB

van Waadenoijen, J., *Starnina e il gotico internazionale a Firenze* (1983).

M ASTER, BEDFORD (active 1405–65). An illuminator active in Paris named after manuscripts bearing the coat-of-arms and mottoes of John of Lancaster, Duke of Bedford, English Regent in France from 1422 to 1435, including the Bedford Hours (London, BL, Add. MS 18850) and the Salisbury Breviary (begun c.1424; Paris, Bib. Nat., MS lat. 17294). The Master's style is characterized by a painterly quality and complex compositions containing narrative cycles, sometimes as a series of scenes accommodated within elegant architectural structures. The Bedford style was continued by a workshop that drew upon a preserved stock of designs that may reappear in several manuscripts. Their market was firmly rooted in Paris. Many of the manuscripts were in production for substantial periods; work continued on the Salisbury Breviary, for example, for some 40 years. KC

Backhouse, J., *The Bedford Hours* (1990).
Reynolds, C., and Stratford, J., 'Le Manuscrit dit "Le pontifical de Poitiers"', *Revue de l'art*, 84 (1989).

M ASTER OF THE BOQUETEAUX (Master of the Bible of Jean de Sy) (active c.1350–80). French illuminator, whose name derives from the little copses of trees (*boqueteaux*), often rooted in exaggerated hillocks, which characterize many landscape settings in Parisian illumination c.1350–80. The name is misleading since he was certainly not alone in using this motif, and probably did not devise it. The designation Master of the Bible of Jean de Sy is therefore sometimes preferred to indicate more precisely a characteristic production from his (often routine and prolific) output, and not simply a loose reference to a general feature, potentially pointing to a considerable number of artists, perhaps forming a workshop. This Bible (begun c.1355; Paris, Bib. Nat., MS fr. 15397), which was named after the author instructed to translate it, shows the artist's skill in depicting lively figures, though his draughtsmanship and feeling for nature are at their most developed in two miniatures from a volume of Machaut's poetry (c.1377; Paris, Bib. Nat., MS fr. 1584). Though probably associated with the painter Jan *Baudolf, he cannot be identified with him. TT

Sterling, C., *La Peinture médiévale à Paris*, vol. 1 (1987).

M ASTER, BOUCICAUT (active 1390–1430). An illuminator mainly active in Paris who greatly influenced manuscript illumination in France in the 15th century. He is named after a book of hours (after 1401; Paris, Mus. Jacquemart-André, MS 2) which was made for Jean II le Meingre, Maréchal de Boucicaut. The Boucicaut Master's greatest achievements were in the depiction of perspective and light, especially in landscape settings such as the background of the *Flight into Egypt* in the Boucicaut Hours, where the extensive, undulating scene culminates in one of the earliest representations of a sunrise. A large group of manuscripts have been attributed to him based on their similarities with this Book of Hours, these include books for such important patrons as Charles VI of

France; John, Duke of Berry; Louis, Duke of Guyenne, and the Visconti of Milan. The variations in handling within the group have been accounted for by suggestions that the Master had an influential and productive workshop. KC

Meiss, M., *French Painting in the Time of Jean de Berry: The Boucicaut Master* (1968).

MASTER OF THE BRUNSWICK DIPTYCH (active 1480–1510). Northern Netherlandish painter named after a diptych with the *Virgin and Child with S. Anne* and *Carthusian Monk Presented by S. Barbara* (c.1490; Brunswick, Herzog-Anton-Ulrich Mus.). Much of his work was formerly regarded as being the early work of *Geertgen tot Sint Jins. More recently the contribution of the two artists has been distinguished. The Master of the Brunswick Diptych uses a lighter palette, his drapery is more convincingly rendered, and his backgrounds are quite sparse. It has been suggested that the Master was the teacher of Jan *Mostaert. The early 16th-century artist and writer van *Mander stated in 1604 in his *Schilderboeck* that Mostaert was the student of Jacob van Haarlem. It may be the Master of the Brunswick Diptych that should be identified as Jacob van Haarlem. KC

Châtelet, A., *Early Dutch Painting* (1981).
Middeleeuwse kunst der noordelijke Nederlanden, exhib. cat. 1958 (Amsterdam, Rijksmus.).

MASTER OF THE BRUNSWICK MONOGRAM (active c.1520–40). Flemish artist named after a painting in the Herzog-Anton-Ulrich Museum in Brunswick of *The Parable of the Great Supper* (Luke 14). There is no agreement on how the monogram should be read. A dozen or so small pictures have been attributed to the same hand; about half depict religious subjects in the open air, and most of the others scenes in brothels. The artist's observation of nature, his fine drawing, and ability to integrate figures into a landscape make him an important forerunner of Pieter *Bruegel the elder. Attempts have been made to identify him with Jan Sanders van *Hemessen and Jan van Amstel (c.1500–c.1540). HO

MASTER OF CATHERINE OF CLEVES (active c.1435–c.1460). Northern Netherlandish manuscript illuminator named after an extensively illuminated book of hours which includes the portrait and coat-of-arms of Catherine of Cleves, Duchess of Gelders (New York, Pierpont Morgan Lib., M. 917, M. 945). Although the influence of contemporary panel painters is evident in a few compositions, as well as in the detailed observation and description of reality, the most remarkable feature of the manuscript is the rich, anecdotal representation of daily life, whether in the borders or the sacred scenes, for example those showing the domestic life of the Holy Family. The illuminator's narrative invention was matched by the variety of his border decoration; this included *trompe l'œil* borders made up of mussels, feathers, and coins. His work has been identified in around fourteen other manuscripts, several of them localizable to Utrecht. KC

Plummer, J. (ed.), *The Golden Age of Manuscript Painting*, exhib. cat. 1990 (Utrecht, Rijksmus. het Catherijneconvent; New York, Pierpont Morgan Lib.).

MASTER OF CHAOURCE, also known as the Master of S. Martha (active 1510–30). French sculptor. He worked in Champagne, near Troyes. He was named by E. Devaux, after the *Entombment* (c.1515; Chaource, S. Jean-Baptiste), which was commissioned by the Captain of Chaource, Nicolas de Moustier. His alternative name, the Master of S. Martha, derived from a statue of *S. Martha* (c.1515; Troyes, La Madeleine). In both these pieces the mannered elegance of the traditional Gothic form is combined with a livelier naturalism of expression and movement. It has been suggested that he may be Nicholas Halins, the French sculptor active between 1502 and 1541. KC

Devaux, E., *Le Maître de Caource* (1956).
Vie Champagne, 309 (1981) (issue dedicated to Troyes sculpture).

MASTER OF CHARLES V (active 1505–33). Flemish illuminator named after a book of hours made for Emperor Charles V (c.1517; Vienna, Österreichische Nationalbib., Cod. 1856). This manuscript features distinctive borders emulating carved picture frames incorporating elaborate architectural details. Similar borders can be found in the work of the panel painter Bernaert van *Orley. He was one of the earliest Netherlandish illuminators to show the influence of the Italian *Renaissance and he is often described as a 'Romanist'. It is uncertain exactly where he was based but he was most likely employed at the Habsburg court. He remains to be identified. KC

Dogaer, G., *Flemish Miniature Painting in the 15th and 16th Centuries* (1987).
von Liechtenstein, H. K., *Das Gebetbuch Karls V* (1976).

MASTER, COËTIVY (active 1450–80). French illuminator, painter, and designer of tapestries and stained glass. He was named after a manuscript belonging to Olivier de Coëtivy and Marie de Valois (Vienna, Österreichische Nationalbib., MS 1929). He delighted in the representation of dramatic scenes, especially battles, as well as atmospheric landscapes, the use of brilliant colours, and individual facial expression as evidenced in the panel of the *Raising of Lazarus with Donors* (c.1455–60; Paris, Louvre). Apart from illuminating *books of hours, he painted secular texts including a French translation of Dante's *Divine Comedy* for Charles of France (Paris, Bib. Nat., MS ital. 72) and designed tapestries depicting the *Story of the Trojan Wars*, the 'petits patrons' for which survive (Paris, Louvre). Attempts have been made to identify him with documented artists, most recently and plausibly as Colin d'Amiens. What is certain is that the Coëtivy Master was the foremost illuminator in Paris of his day. KC

Avril, F., and Reynaud, N., *Les Manuscrits à peintures en France 1440–1520* (1993).

MASTER OF THE DEATH OF THE VIRGIN. See CLEVE, JOOS VAN.

MASTER OF THE DRESDEN PRAYER BOOK (active 1460–1520). Netherlandish illuminator and engraver. He was named after a book of hours in Dresden and Paris (c.1470; Dresden, Sächsische Landesbib., MS A311; two detached miniatures in Paris, Louvre, inv. no. 20694, 20694bis) with an unusual sequence of twelve full-page calendar miniatures. Approximately 40 manuscripts have been attributed to his workshop but in addition he specialized in providing the calendar cycles in books of hours painted by other illuminators. He appears to have delighted in depicting changing light, landscape, and atmosphere, as seen in the calendar of the *Voustre Demeure* Hours (Madrid, Bib. Nacional, MS Vit. 25–5). Although often active in Bruges, he seems also to have worked in Valenciennes where he collaborated with Simon *Marmion. One of his most important commissions was the Breviary of Isabella the Catholic, Queen of Spain (1480s; London, BL, Add. MS 18851) for which he painted most of the miniatures. His style is characterized by his use of bright colours and stocky figures with large heads, a delight in narrative detail, and the loose, rather painterly handling. The engravings in an edition of Boccaccio's *De la ruine des nobles hommes et femmes* published in Bruges in 1476 have also been attributed to him. KC

Brinkmann, B., *Die flämische Buchmalerei am Ende des Burgunderreichs: der Meister des Dresdener Gebetbuchs und die Miniaturisten seiner Zeit* (1997).

MASTER OF THE ÉCHEVINAGE DE ROUEN (or Master of the Geneva Latini) (active c.1455–85). French illuminator. He headed a successful workshop in Rouen, producing decorated books (secular and devotional) principally for the city aldermen, though serving patrons from as far as Tours and Bourges. After the English were expelled from Normandy (1450), a demand for French material connected with the history and law

of the duchy provided the artist with the basis of his career. An early example is a manuscript of *La Bouquechardière* by the Norman chronicler Jean de Courcy (c.1457–61; Paris, Bib. Nat., MS fr. 2685), a text the artist illuminated on at least two further occasions. Though no innovator, he had a gift for pictorializing complicated narratives and allegories of literary origin, often set in deep landscapes, in a style derived from illuminators associated with the Bedford *Master workshop, such as the Master of the Munich Golden Legend. Formerly named after a manuscript of Brunetto Latini's *Le Trésor* (c.1470; Geneva, Bib. Publique et Universitaire, MS fr. 160), he was once mistakenly identified with the scribe Jacobus ten Eyken.

TT

Avril, F., and Reynaud, N., *Les Manuscrits à peintures en France 1440–1520*, exhib. cat. 1993 (Paris, Bib. Nat.).

MASTER OF THE EMBROIDERED FOLIAGE (active 1495–1500?). Painter active in Flanders named after the distinctive foliage in his work which gives the impression of being embroidered. Such ornamental details were frequent inclusions in his work. His œuvre reveals an intense interest in landscape, so much so that it has been suggested that he was chiefly a landscape painter and was so employed by other artists. His work is heavily indebted to his predecessors Hugo van der *Goes and Rogier van der *Weyden, and many of the Master's paintings of the Virgin depend on compositions by van der Weyden such as the *Virgin and Child* (1510–20; Philadelphia Mus.) or *Virgin and Child with Angels* (Lille, Mus. des Beaux-Arts).

KC

Callataÿ, E. de, 'Étude sur le maître au feuillage en broderie', *Musées Royaux des Beaux-Arts Belgique Bulletin*, 21 (1972).
Friedländer, M. J., *Early Netherlandish Painting*, vols. 4 and 14 (1967–76).

MASTER E.S. (active c.1450–67). German, or possibly Swiss, engraver (see LINE ENGRAVING) and goldsmith and the first engraver to sign his plates with a monogram. More than 300 of his engravings are known, many in unique impressions, and it is probable that many have been lost entirely. He is notable for his desire and ability to create strongly plastic forms by a combination of linear strength with cross-hatching and systematic flicks of the burin to model figures and drapery. In this he was a pioneer, but he combined such work with the decorative surface work created by the use of goldsmith's punches, and it is likely that some of his prints were in fact intended as models for goldsmiths. His work encompasses both courtly and devotional subjects, and is seen at its most lively in his late prints of 23 fantastical letters, forming a complete alphabet (only complete set in the print room at Munich). His work was an important influence on the engravings of Martin *Schongauer, particularly the control of his engraved modelling.

RGo

Bevers, H., *Meister E.S.* (1987).

MASTER OF FLÉMALLE (active, c.1420–40). See also CAMPIN, ROBERT. Southern Netherlandish painter. One of the founders of the naturalistic style developed during the 15th century in the Netherlands, although debate over his identity and œuvre has sometimes distracted attention from his achievements. He is named after three panels from a lost work, mistakenly supposed to have come from an unidentified 'abbey of Flémalle' near Liège. These panels, a *Virgin and Child*, a *S. Veronica*, and a grisaille of the *Trinity*, are in Frankfurt am Main (Städelsches Kunstinst.). Because of the similarities between these and other paintings by the Master with works by Jacques *Daret and Rogier van der *Weyden, the Master of Flémalle is widely identified with Robert Campin, in whose Tournai workshop Daret and, probably, Rogier trained. This link is reinforced by similarities with surviving fragments from a mural, the *Annunciation* (Tournai), which can be argued to be a documented work of Campin.

The Frankfurt panels combine strong line and tones with sumptuous detail, realistic figures and settings, and a gravity of expression culminating in the sombre dignity of the Trinity. A fragment depicting the *Crucified Thief* (also in Frankfurt) from a lost *Deposition* is similarly expressive. The dramatic contours and sculptural modelling of the corpse's flesh are harshly real against a gold background, while the onlookers' bejewelled and patterned costumes provide textural contrasts. This painting may be earlier than the Flémalle panels, while the exquisite Seilern Triptych (London, Courtauld Inst. Gal.), is thought to be the Master's earliest surviving work.

Other accepted paintings display features typical of the artist's maturity. Notable is the deep landscape of the *Nativity* (Dijon, Mus. des Beaux-Arts), and the ornate architectural setting and exotic details of the *Marriage of the Virgin* (Madrid, Prado). Another form of realism is evident in two portraits of a man and a woman (London, NG) which are strongly modelled and lit, sculptural, and psychologically incisive. They may be technically less refined than van *Eyck's *Portrait of a Man* (Self-Portrait?) (London, NG) but are equally arresting.

Of the disputed paintings, The Merode Triptych of the *Annunciation* (New York, Met. Mus. Cloisters), is thought by some to be the work of an associate. Although finely, even charmingly, detailed its overall design is inconsistent. Other paintings showing a similar relationship to the Master of Flémalle without his technical mastery are the *Virgin and Child before a Firescreen* (London, NG), and the Werl Panels (Madrid, Prado); many lesser works indicate the influence of the Flémalle style. The most important stylistic relationship is with Rogier van der Weyden, whose works display similar sculptural definition and emotional expression, as well as quoting some compositional devices. Such similarities led to a suggestion, now rejected, that the Flémalle œuvre were early works by Rogier, but they do support the link between the identities of Flémalle and Robert Campin.

MS

Campbell, L., 'Robert Campin, the Master of Flemalle and the Master of Merode', *Burlington Magazine*, 116 (1974).
Châtelet, A., *Robert Campin: le maître de Flémalle: la fascination du quotidien* (1996).
Foister, S., and Nash, S. (eds.), *Robert Campin: New Directions in Scholarship*, proceedings of symposium, 1996 (London, NG).

MASTER OF 1466. See MASTER E.S.

MASTER OF FRANKFURT (active 1480–1520). A Flemish painter named after the two most significant works in his œuvre, an altarpiece of the *Holy Kinship* (c.1503; Frankfurt, Historisches Mus.) and a *Crucifixion* (Frankfurt, Städelsches Kunstinst.), both which were commissioned by patrons from Frankfurt, the first for the Dominicans and the later for Claus Humbracht. Ironically, though, the Master of Frankfurt is unlikely to have actually worked in the city itself; it is more likely that he had a studio in Antwerp as evident in the *Portrait of Artist and his Wife* (1496; Antwerp, Koninklijk Mus. voor Schone Kunsten) in which the arms of the Antwerp guild of S. Luke are included. He is known for mass-producing the classics of 15th-century Netherlandish panel paintings after Rogier van der *Weyden and Hugo van der *Goes for the open market. It has been suggested that the Master of Frankfurt is, in fact, Hendrik van Wueluwe, a celebrated artist from Antwerp with a large workshop employing seven apprentices.

KC

Friedländer, M. J., *Early Netherlandish Painting*, vol. 7 (1967–76).
Goddard, S., 'Brocade Patterns in the Shop of the Master of Frankfurt: An Accessory to Stylistic Analysis', *Art Bulletin*, 67 (1985).

MASTER OF THE GENEVA LATINI. See MASTER OF THE ÉCHEVINAGE DE ROUEN.

MASTER OF HOHENFURTH. See MASTER OF VYŠŠÍ BROD.

MASTER OF THE HOLY BLOOD (active c.1530). A Flemish painter often referred to by his French name Maître du Saint-Sang. He was named after the Bruges brotherhood of the Holy Blood for whom he painted a triptych of the *Lamentation* (c.1530; Bruges, Mus. Heilige Bloed). As the majority of the work attributed to him does not contain donor portraits of coat-of-arms, it has been surmised that the Master was largely painting speculatively for an open market, most probably selling his work at the famous Bruges *pandt* market which flourished in the first half of the 16th century. As his œuvre shows the influence of painters from Antwerp, such as *Massys, as well as Bruges, such as Gerard *David, it is hypothesized that the Master spent his youth and maybe apprenticeship in Antwerp and only later moved to Bruges. Of the 30 works attributed to him, the discrepancies in technique and quality indicate that his œuvre should be reassessed. KC

Anonieme vlaamse primitieven: Zuidnederlandse meesters met noodnamen van de 15de en het begin van de 16de eeuw, exhib. cat. 1969 (Bruges, Groeningemus.).
Friedländer, M. J., *Early Netherlandish Painting*, vol. 9 (1967–76).

MASTER OF HOOGSTRAETEN (active c.1505). Netherlandish painter active in Antwerp. He was named after the town of Hoogstraeten, where panels each depicting one of the Sorrows of the Virgin (c.1505; Antwerp, Koninklijk Mus. voor Schone Kunsten) hung in the church of S. Katharina until the beginning of the 19th century. The identity of the Master is not known, although attempts have been made to link him with the Passchier van der Mersch, a Fleming who was one of Hans *Memling's students. Yet, it has also been suggested that, as his work shows a clear Dutch influence, the Master was in fact from the Northern Netherlands. KC

Châtelet, A., *Early Dutch Painting* (1981).
Friedländer, M. J., *Early Netherlandish Painting*, vol. 7 (1967–76).

MASTER OF THE HOUSEBOOK, also called Master of the Amsterdam Cabinet (active late 15th century). German painter and drypoint engraver, who owes his names first to a book of drawings by him and his followers at Castle Wolfegg (south Germany), and then to the unrivalled collection of his prints in the print room of the Rijksmuseum, Amsterdam. His origins and history are mysterious, but he probably worked in the upper and middle Rhineland. The only painting universally accepted as his is the courtly *Young Lovers* (Gotha Mus.), but a number of religious pictures and stained-glass windows are close in style. Ninety-one prints are attributed to the Master, from which only 124 impressions are known, many being unique. They are of great enchantment, combining late *Gothic absorption in courtly and chivalric imagery with a truth and ease of draughtsmanship which looks forward to the High *Renaissance.

About half of these are religious subjects, but he was equally at home with little plates of peasants, a *Young Woman with Radishes in her Escutcheon* (Dresden, Kupferstichkabinett), or a *Dog Scratching Itself* (Amsterdam, Rijksmus.). A preoccupation with the fragility of life is apparent in many plates, notably the *Young Man and Death*, which is one of his finest works. He exerted considerable influence, notably on *Dürer, but no artist could quite match the ease of his hand, nor the gentle playfulness of his imagery. RGo

Filedt Kok, J. P., *Livelier than Life: The Master of the Amsterdam Cabinet or the Housebook Master* (1985).

MASTER, IPPOLITA (active 1459–70). Italian illuminator. He mainly worked for the ducal court in Milan and was named after the manuscripts made in 1465 as a wedding gift for Ippolita, daughter of Francesco Sforza and Bianca Maria Visconti, including a copy of Domenico Cavalca's *Vite di santi padre* (Paris, Bib. Nat., MS ital. 1712). Earlier the Master had illuminated manuscripts for the instruction of Francesco's son and heir Galeazzo Maria; one of the more flippant and charming of these works is a copy of one of the earliest dancing manuals known, Guglielmo da Pesaro's *De practica seu arte tripudii* (1463: Paris, Bib. Nat., MS ital. 973). His highly stylized and decorative compositions are particularly indebted to the *Master of the Vitae Imperatorum. With his succession to the dukedom, Galezzo Maria continued his father's patronage of the illuminator. KS

MASTER, ISAAC (active c.1290–1300). Italian painter. The Isaac Master is so named after two of his frescoes in the upper church of the basilica of S. Francesco, *Assisi. This great *anonimo*'s work is confined to the upper walls of the first two bays from the façade and the vault of the first bay. Chronologically these frescoes follow the frescoes of the first and second vault bays from the crossing, and precede the *Legend of S. Francis* (see MASTER OF THE S. FRANCIS LEGEND; MASTER OF S. CECILIA). They may be most persuasively dated to the mid-1290s. The frescoes comprise the *Doctors of the Church* in the vault, a *Pentecost* on the interior façade, and a *Lamentation* and Old Testament scenes on the nave walls. The scenes of *Isaac and Esau* and *Isaac and Jacob* reveal a precocious and cogent projection of pictorial space, and a powerfully concentrated grasp of narrative. The weighty, classicizing forms of the principals, sheathed in finely pleated drapery, are projected with a painterly freedom unprecedented in the duecento. These qualities have sometimes led to an identification of the Master with the young *Giotto. This is unconvincing *per se*, but indicates the immense significance of the Isaac Master's role in the transformation of Italian art towards 1300. JR

Mather, F. J., *The Isaac Master* (1932).

MASTER OF LATIN 757, or the Lancelot Master (active c.1380–95). Italian illuminator who worked in Milan for members of the Visconti court. He is named after the large Book of Hours/Missal (Paris, Bib. Nat., MS lat. 757) made for Bertrando de' Rossi, counsellor to the Lords of Milan, Bernabò (d. 1386), and then his nephew Giangaleazzo (Duke of Milan from 1395). Both in the type of text that the Master illustrated—including books of hours, astrological treatises, health handbooks, and Arthurian romances (e.g. the so-called *Lancelot du Lac*, Paris, Bib. Nat., MS fr. 373, that gave him his alternative name)—and in his miniatures he perfectly reflected the taste and environment of his patrons. His was essentially a courtly and decorative style using a bright clear palette to depict rather doll-like figures, often wearing contemporary fashionable dress and sometimes set among recognizable Milanese buildings: the *Nativity* in another book of hours (Modena, Bib. Estense, MS lat. 862) shows the birth of Christ as taking place outside the walls of Milan. His style was fundamental to that of *Tomasino da Vimercate—both worked on a copy of Dante's *Divine Comedy* now in Florence (Florence, Bib. Nazionale, MS Banco Rari 39)—and was the basis for the strand of amiable and charming illumination that retained its popularity among patrons at the court of Milan into the third quarter of the 15th century. KS

MASTER OF THE LEGEND OF S. BARBARA (active 1470–1500). A Flemish painter and draughtsman named after a triptych showing the *Legend of S. Barbara* (c.1475; Bruges, Mus. Heilige Bloed; Brussels, Mus. d'Art Ancien). As there are relatively few surviving drawings from this period, the existence of some preparatory drawings for this altarpiece (Paris, Louvre; New York, Met. Mus.) has contributed to the Master's significance. He collaborated with many other painters including the *Master of the View of S. Gudule, the Master of the Legend of S. Catherine, and the Master of the Martyrdom of SS Crispin and Crispinian, all residents of Bruges, suggesting that the Master of the Legend of S. Barbara was likely also to have worked there. His paintings often contain a complete narrative cycle within one panel, using spatial unity to create an overall harmonious and integrated effect. Other works include the *Resurrection of Lazarus* (Melbourne, NG Victoria) and the *Battle of Henry II against*

459

the Pagans (Münster, Stadtmus.). KC

Friedländer, M. J., *Early Netherlandish Painting*, vols. 4 and 14 (1967–76).

Janssens de Bisthoven, A. (ed.), *Primitifs flamands ano-nymes: Maître aux noms d'emprunt des Pays-Bas méridio-naux du XVe et du début du XVIe siècle*, exhib. cat. 1969 (Bruges, Groeningemus.).

MASTER OF LIESBORN (active 1460–90). German painter, possibly active in Cologne, named after the Benedictine monastery of Liesborn for which he painted a massive altarpiece after 1465 depicting the *Crucifixion* surrounded by the *Annunciation*, *Adoration of the Shepherds*, *Adoration of the Magi*, and the *Presentation in the Temple*. In 1804 the altarpiece, which had in the previous century been dismantled, was sold off as fourteen separate parts and they are now dispersed among several private and public collections. Eight of the fragments are in the National Gallery, London, whilst others are in the Westfälisches Landesmuseum and the Westfälisches Kunstverein in Münster. KC

Brandl, R., 'The Liesborn Altar-piece: A New Reconstruction', *Burlington Magazine*, 85 (1993).

Der Kalvarienberg des Meisters von Liesborn, exhib. cat. 1988 (Münster, Stadtmus.).

MASTER OF THE LIFE OF THE VIRGIN (active 1460–80). German painter named after an altarpiece bequeathed to S. Ursula in Cologne by Johann von Hirtz, comprising eight panels that depict the *Life of the Virgin* (c.1465; London, NG; Munich, Alte Pin.). His œuvre consists of many religious paintings fusing Netherlandish, German, and Italian elements, as well as displaying a delight in expression and individuality. Mindful of this, it is not surprising that the Master of the Life of the Virgin was also a sought-after portraitist, often commissioned to paint 'professional' portraits such as the *Portrait of an Architect* (1470; Munich, Alte Pin.) and the *Portrait of a Scholar* (1480; Karlsruhe, Kunsthalle). The Master's recognized œuvre has been substantially reduced recently by distributing some works to the Master of the Lyversberg Passion, the Master of the Legend of S. George, and the Master of the Bonn Diptych. KC

Förster, O. H., 'Der Linzer Altar und die Frühwerke des Meisters des Marienlebens', *Wallraf-Richartz-Jahrbuch*, 3–4 (1926–7).

Zehnder, F. G., *Katalog der Altkölner Malerei*, vol. 11 of *Katalog des Wallraf-Richartz-Museums* (1990).

MASTER OF MARY OF BURGUNDY (c.1469–c.1483). A Flemish manuscript illuminator named after some of the miniatures in the Hours of Mary of Burgundy (c.1477; Vienna, Österreichische Nationalbib., Cod. 1857). He forged a style of illumination which was preoccupied with *illusionism. In his most famous creation, the frontispiece of Mary's Hours, the conventionally shaped miniature is presented as a scene visible through an open window in front of which Mary of Burgundy sits reading her prayer book. The Master was an early exponent of *trompe l'œil borders, showing flowers, jewels, insects, and the like as though they had been strewn upon the coloured or golden surface of the page, thus giving the effect that they are part of the reader's world, whilst the main miniatures are pushed into the distance, as if viewed through a window. In five borders in the *Voustre Demeure* Hours (c.1481; Madrid, Bib. Nacional, MS Vit. 25–5) he reversed this relationship and the lines of text are shown as though suspended or tied in front of a distant scene or narrative. Both his remarkable innovations in layout and his compositions were widely influential in the final decades of the century. His identification as the documented illuminator Sanders *Bening has been suggested but the apparent span of his activity does not correspond with the documented span of Sanders's life. KC

Alexander, J. J. G., *The Master of Mary of Burgundy: A Book of Hours for Engelbert of Nassau* (1970).

Inglis, E., *The Hours of Mary of Burgundy* (1995).

MASTER OF THE MODENA HOURS. See TOMASINO DA VIMERCATE.

MASTER OF MOULINS. See HEY, JEAN.

MASTER, M.S. (active in the decades around 1500) The most outstanding of the late *Gothic artists of Hungary. He is named from the monogram, accompanied by the date 1506, on a *Resurrection* in the Christian Museum, Esztergom. This painting, the *Agony in the Garden*, *Christ Carrying the Cross*, and the *Crucifixion* (all Esztergom, Christian Mus.), were outer panels of a winged altarpiece from Selmecbánya. Traces of reliefs with figures of saints against a gold background survive on the reverses of the *Carrying of the Cross* and the *Crucifixion*. It is likely that the *Visitation* in the Hungarian National Gallery (Budapest) was part of the same altarpiece, which was probably made for the high altar of the former church of the Virgin Mary in Selmecbánya. The rich burghers of this important mining town in northern Hungary were in close contact with the royal court in Buda.

Other works attributable to the painter include a *Nativity* (Hontzentantal, parish church) and an *Adoration of the Magi* (Lille, Mus. des Beaux-Arts). His style shows similarities with the Danube School—the Lille panel was once attributed to Jörg *Breu—and his debt to the engravings of *Schongauer and *Mantegna is evident in features of composition and motif, but the dramatic expressiveness of his Passion scenes is entirely individual and cannot be directly related to other known workshops. GyT

MASTER OF THE PAREMENT DE NARBONNE (active c.1375–85?). Painter named after the *Parement de Narbonne* (Paris, Louvre), an enormous and very delicate drawing executed in black on plain silk, depicting episodes concerning the death of Christ, set in an illusionistic frame. Its origin is unknown, but since it features representations of Charles V of France and his Queen it may have been a royal commission, probably made before the Queen's death in 1377, and in all likelihood (if appearances are any guide) c.1375. Hangings apparently in a similar technique feature in contemporary inventories; these suggest that the *Parement* was made to be suspended above (or perhaps in front of) an altar during Lent. The artist was working in the tradition of *Pucelle, though his figures are more substantial, and his treatment of space suggests familiarity with Italian painting. He was probably one of the artists employed by Charles V, possibly *Jean d'Orléans. Miniatures in the *Très Belles Heures* of the Duke of Berry (c.1380 or later; Paris, Bib. Nat., MS nouv. acq. lat. 3093) have reasonably been attributed to the same artist. TT

Sterling, C., *La Peinture médiévale à Paris*, vol. 1 (1987).

MASTER OF THE PLAYING CARDS (active mid-15th century). German engraver, probably from the upper Rhineland, who engraved a set of 60 playing cards notable for their sensitive depiction of fashionably clad figures, animals, and flowers. He had considerable powers of observation allied to a delicate use of sloping engraved lines. RGo

MASTER OF THE PRAYER BOOKS OF C.1500 (active 1500). A Flemish illuminator, named after a group of books of hours datable to around 1500 that appear to have been speculative productions made for sale on the open market. Ironically his most accomplished work illustrates secular texts, the best known being the greatest illuminated copy of the allegory of chivalric love, the *Roman de la Rose* (c.1490–1500; London, BL, MS Harley 4425), which was probably commissioned by Engelbert of Nassau, courtier of Charles the Bold. His other remarkable and ambitious secular work is the illumination of two full-page miniatures added to a Virgil (Norfolk, Holkham Hall, MS 311). Unlike many of his contemporaries, he does not show much interest in landscape, rather concentrating on figures and their elaborate dress. His calendar illuminations show the influence of the *Master of the Dresden Prayer Book. KC

Kren, T. (ed.), *Renaissance Painting in Manuscripts: Treasures from the British Library*, exhib. cat. 1983–4 (Los Angeles, Getty Mus.; New York, Pierpont Morgan Lib.; London, BL).

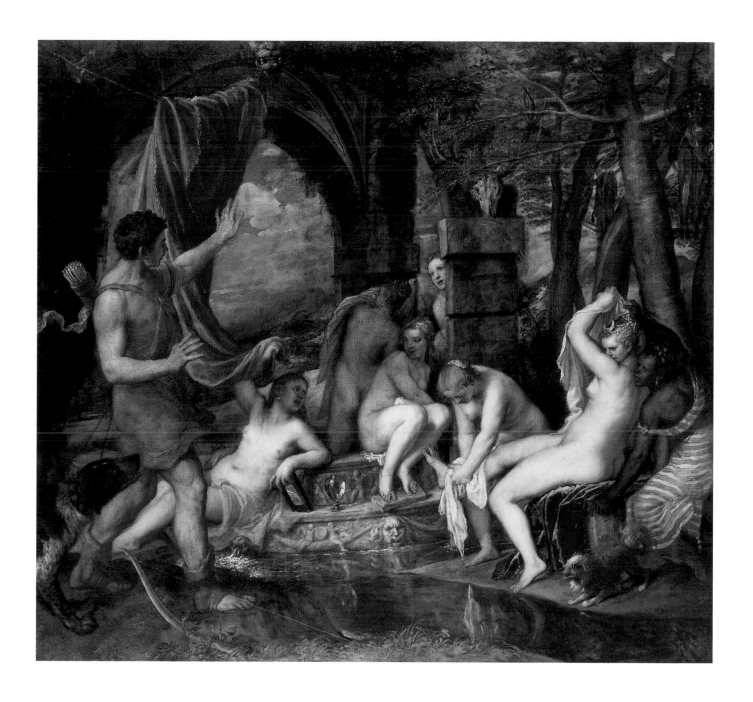

Titian, *Diana and Actaeon* (1559), oil on canvas, 184.5 × 202.4 cm (73 × 79¾ in), Edinburgh, National Gallery of Scotland.

OVERLEAF RIGHT: Edgar Degas (1834–1917), *Nude combing her hair*, pastel on paper, 61.3 × 46 cm (24⅛ × 18⅛ in), New York, Metropolitan Museum of Art.

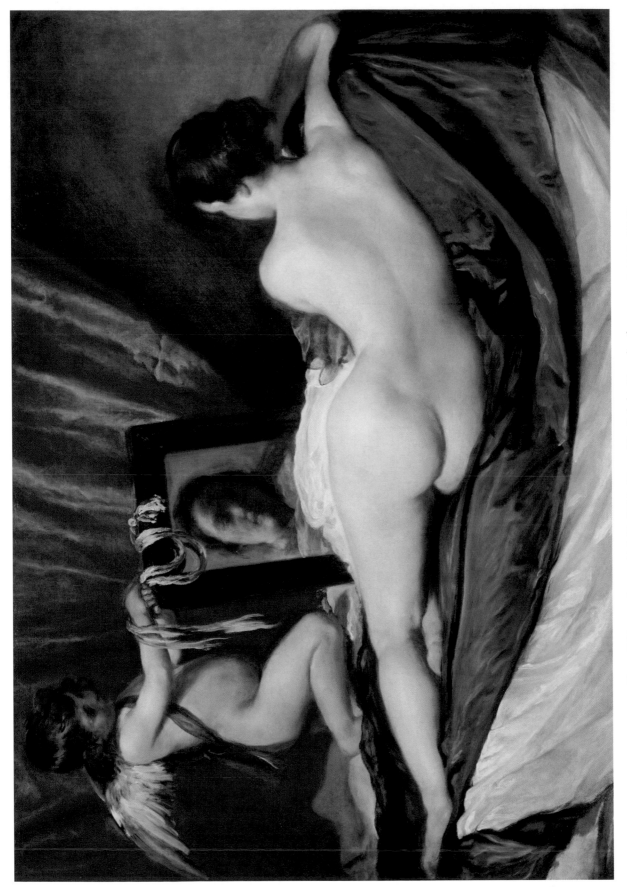

Diego Velázquez (1599–1660), *The Toilet of Venus* (The Rokeby Venus), oil on canvas, 122.5×177 cm (48¼×69¾in), London, National Gallery.

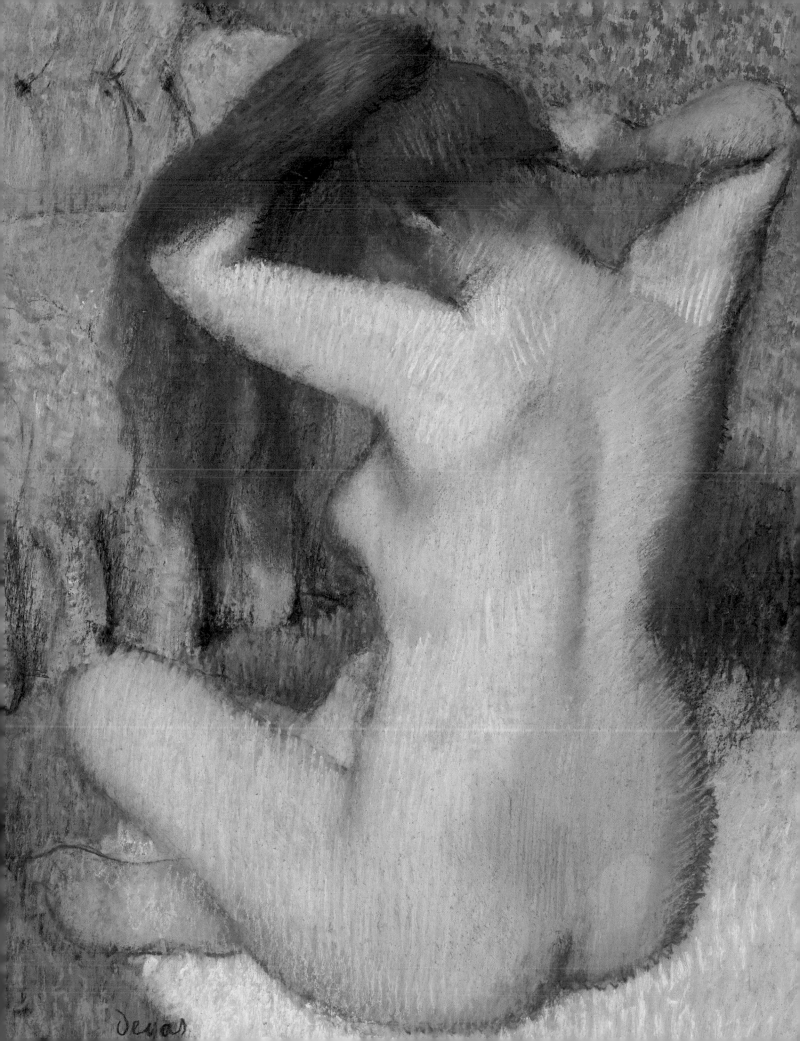

Degas

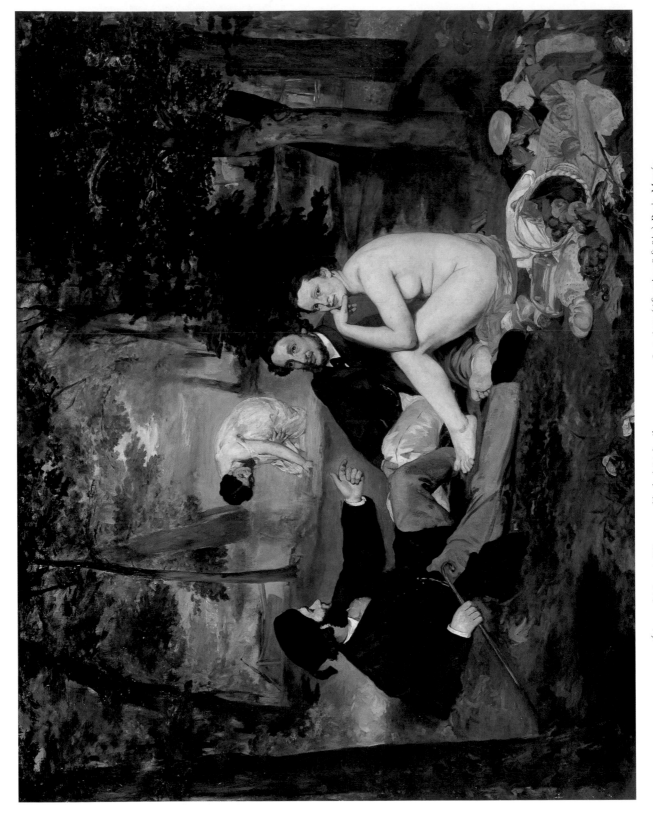

Édouard Manet, *Déjeuner sur l'herbe* (1863), oil on canvas, 2.08×2.64m (6ft 10in×8 ft 8in), Paris, Musée d'Orsay.

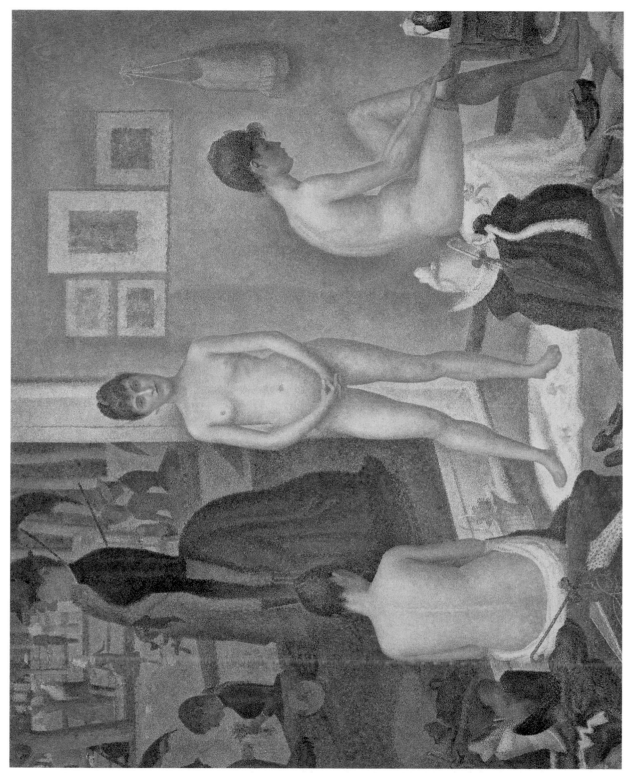

Georges Seurat, *Les Poseuses* (1887–8), oil on canvas, 200 × 250 cm (78¾ × 98¾ in), Merion, Pennsylvania, Barnes Foundation.

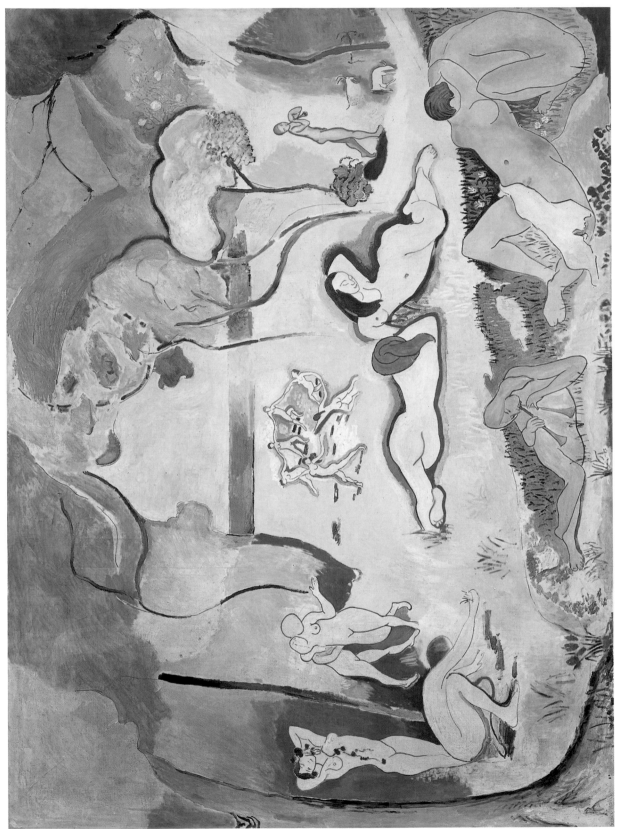

Henri Matisse, *The Happiness of Life* (1905–6), oil on canvas, 1.75 × 2.41 m (69 × 94⅞ in), Merion, Pennsylvania, Barnes Foundation.

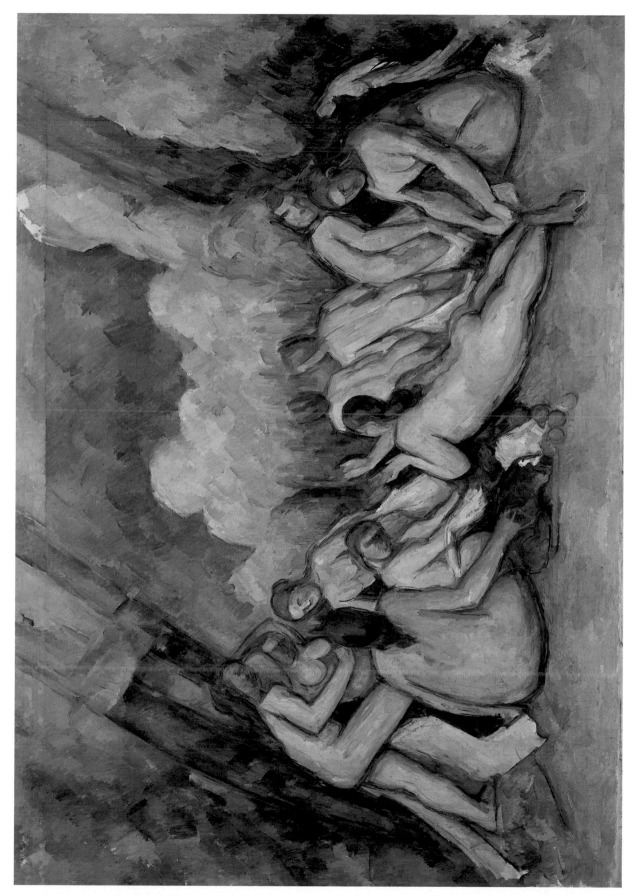

Paul Cézanne, *Les Grandes Baigneuses* (1900–6), oil on canvas, 127.2 × 196.1 cm (50 × 77 ¼ in), London, National Gallery.

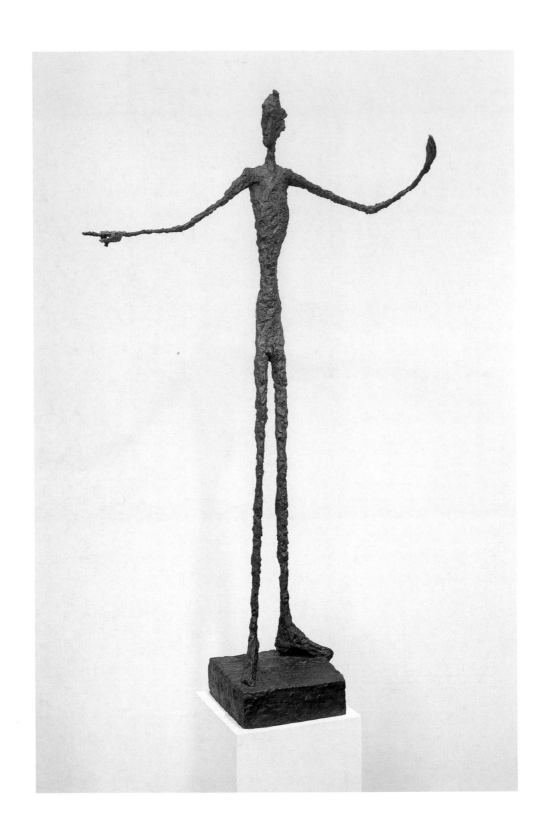

Alberto Giacometti, *Man Pointing* (1947), bronze, 179 × 103.4 × 41.5 cm (70 1/2 × 40 3/4 × 16 3/8 in), New York, MoMa.

MASTER OF RENÉ OF ANJOU. See EYCK, BARTHÉLEMY D'.

MASTER, ROHAN (active 1410–40). French illuminator active in Champagne, Paris, and Anjou. He is named after the *Grandes Heures de Rohan* (Paris, Bib. Nat., MS lat. 9471), a book of hours containing the coat-of-arms of the Rohan family, although it is possible that these were later additions and that the manuscript was, in fact, commissioned by someone at the Angevin court, possibly Yolande of Aragon, wife of Louis II, Duke of Anjou. His is a distinctive, non-naturalistic style often with an expressive or dramatic quality: the palette is restricted and strong red and blue dominate—perspective is distorted and figures or gestures can be exaggerated for emotional effect. Up to 40 manuscripts have been attributed to the Rohan Master and his workshop, but few approach the quality of execution and taut design of the Rohan Hours. KC

Avril, F., and Reynaud, N. (eds.), *Les Manuscrits à peintures en France, 1440–1520*, exhib. cat. 1992–3 (Paris, Bib. Nat.).

MASTER OF THE S. BARTHOLOMEW ALTARPIECE (active c.1470–c.1510). German or Netherlandish painter. This painter's origins were probably Netherlandish: his earliest dated work, a book of hours for Sophia von Bylant (1475; Cologne, Wallraf-Richartz-Mus.), has a saints' calendar peculiar to the diocese of Utrecht. The bulk of his career was spent in Cologne, where he painted the altarpiece for the church of S. Columba, after which he is named (1503; Munich, Alte Pin.). Netherlandish training is suggested by the plasticity of his figures and the clear pictorial space in which they are set; and by the fictive Gothic tabernacle in which he places them, for instance a large *Deposition* (c.1510; Paris, Louvre), painted as if a box retable of inverted T-shape, like Rogier van der *Weyden's Escorial altarpiece. Rogier's emotionalism is reflected in the Master's heightened naturalism, his emphasis on tear-stained features. At the opposite expressive pole are the standing figures of *SS Peter and Dorothy* from a dismembered altarpiece (c.1505–10; London, NG). Their mutual awareness is handled with sympathy and humour, and the complex postures and drapery of late German, or 'florid', Gothic are put to surprisingly delicate expressive use. JR

Late Gothic Art from Cologne, exhib. cat. 1977 (London, NG).

MASTER OF S. CECILIA (active c.1290–1307). Italian painter. This painter is named after the dedicatee's altarpiece from the church of S. Cecilia in Florence (before 1304; Florence, Uffizi). Other panels can be attributed to him, but it is on the strength of the four frescoes he contributed to the *Legend of S. Francis* in the upper church of S. Francesco in Assisi that his reputation as one of the most distinctive contemporaries of *Giotto rests. These, the last of the cycle to be painted, combine a fluent technique with a compositional clarity and tonal warmth unmatched in the earlier frescoes. The elongated figures echo those of the S. Cecilia altarpiece narratives, as does the range of delicate and spacious architectural settings. At Assisi the artist also displays a remarkable interest in the appearance of specific buildings, like the temple of Minerva at Assisi in the *Homage of a Simple Man of Assisi*. Though probably Florentine, the Master was clearly acquainted with recent Roman painting: the soft, monumental drapery of the central figure of the S. Cecilia altarpiece has clear affinities with *Cavallini's frescoes in S. Cecilia in Trastevere, Rome. JR

Smart, A., *The Assisi Problem and the Art of Giotto* (1971).

MASTER, S. FRANCIS (Maestro di S. Francesco) (active c.1250–75). A prolific artist supposedly influenced in his designs but not in his essentially linear technique (and 'ashy flesh tints', Garrison) by *Giunta da Pisa. Named from a panel of S. Francis (Assisi, S. Maria degli Angeli) he is better known for the frescoes in the lower church the basilica of S. Francesco *Assisi, including the earliest substantial cycle devoted to the saint, drawing on both the *Vita secunda* and *Legenda maior* (c.1260–5). Major Crucifixes by the artist survive in London (NG), Paris (Louvre), and Perugia (dated 1272, Gal. Nazionale), none particularly close in design to Giunta's. He is a fine late Romanesque painter open to more modern influences, particularly those emanating from *Byzantium, perhaps via Franciscan illuminated manuscripts. Surviving panels by him include parts of a *Passion* polyptych, recalling his frescoes in S. Francesco, Assisi. RG

Bomford, D., Dunkerton, J., Gordon, D., and Roy, A., *Art in the Making: Italian Painting before 1400* (1989).
Garrison, E., *Italian Romanesque Panel Painting* (1949).

MASTER OF THE S. FRANCIS LEGEND. This term refers to the second major fresco cycle illustrating S. Francis's life, to be found on the dado section of the nave of the upper church of the basilica of S. Francesco, *Assisi and datable c.1295–1300. *Vasari first attributed this cycle to *Giotto, probably through a misunderstanding of *Ghiberti, whose reference to the 'lower part of the church' probably meant the lower church, where Giotto's workshops painted much of the transept and western chapels. Most Italian historians have followed Vasari's attribution, while most non-Italian historians have denied it. But there are several distinct masters responsible for this cycle, together with numerous assistants, even if there is a strong continuity between their workshops. Some scholars (A. Prevital and L. Bellosi) have attributed the whole cycle to Giotto or to Pietro *Cavallini (Zanardi). Though such attributions to single artists are unpersuasive, the attribution to Cavallini at least reflects the unmistakably Roman style of most of the *Legend of S. Francis*. This is best considered as the work of two or possibly three masters working in sequence, and of the Florentine *Master of S. Cecilia who completed the cycle with Scenes I and XXVI–XXVIII. RG

Belting, H., *Die Oberkirche von San Francesco in Assisi* (1977).
Smart, A., *The Assisi Problem and the Art of Giotto* (1971).

MASTER OF S. GILES (active c.1490–1510). Painter of French or Netherlandish origin, active in Paris. He is named after two panel paintings depicting scenes concerning S. Giles, the reverses of which are painted in grisaille and show figures in niches (London, NG). Two further panels of similar character and format, once also painted on the reverses, show scenes identified as pertaining to S. Rémi (Washington, NG). These panels may have formed parts of an altarpiece, which on the evidence of costume may have been painted c.1500. The scenes feature portraits of buildings in Paris and neighbouring towns, suggesting that the artist was based in this vicinity and that the commission for the altarpiece came from a Parisian church, possibly S. Leu-S. Gilles, a theory which would explain several themes of royal significance in the *iconography. The artist's distinctive style, characterized by attention to naturalistic detail, is evident in several further works attributable to him, and suggests a formative period of training in the Netherlands. However, his viewpoints, colouristic preferences, and topographical portraiture connect him closely with traditions in France. TT

Sterling, C., *La Peinture médiévale à Paris*, vol. 2 (1990).

MASTER OF THE S. LUCY LEGEND (active last quarter of the 15th century). Flemish follower and probably pupil of *Memling, active in Bruges, named after the altarpiece of the *Legend of S. Lucy*, (1480; Bruges, S. Jacques). Friedländer characterized his style as showing 'an understanding of architecture, intimate observation of the plant world, and a pleasing decorative sense'. A general influence from Hugo van der *Goes is noted by scholars, for example in *The Virgin of the Rose Garden* (1475/80; Detroit, Inst.

of Arts) and *The Virgin among Virgins* (Brussels, Mus. Royaux). AM

Friedländer, M. J., *Early Netherlandish Painting* (1967–76).
Roberts, A., 'The Lucy Master and Hugo van der Goes', *Koninklijk Museum voor Schone Kunsten Jaarboek* (1987).

MASTER OF S. MARTHA. See MASTER OF CHAOURCE.

MASTER OF THE S. URSULA LEGEND. Two anonymous Masters have been given this name and to complicate matters further they were contemporaries active in northern Europe. The first, a Flemish painter active in Bruges 1470–1500, was identified and named by Max Friedländer after a polyptych which depicts among other scenes a comprehensive cycle of the *Legend of S. Ursula* (before 1482; Bruges, Groeningemus.). That much of his œuvre had been previously attributed to Rogier van der *Weyden, Hans *Memling, and Hugo van der *Goes shows the significance of their influence on the Master's style. The other Master of the S. Ursula Legend was a German painter active in Cologne 1480–1510. He is also named after an extensive cycle of paintings of the *Legend of S. Ursula*, comprising nineteen panels (1492–6; Bonn, Rheinisches Landesmus.; Cologne, Wallraf-Richartz-Mus.; Cologne, Erzbischöfisches Diözesan-Mus.; London. V&A; Paris, Louvre). A superb colourist, his work is of exceptionally high quality. For many years it was attributed to the Master of S. Severin. KC

Flemish Master:
Friedländer, M. J., *Early Netherlandish Painting*, vol. 6 (1967–76).
Pauwels, H., 'Maître de la Légende de Sainte Ursule', in A. Janssens de Bisthoven (ed.), *Primitifs flamands anonymes: Maître aux noms d'emprunt des Pays-Bas méridionaux du XVe et du début du XVIe siècle*, exhib. cat. 1969 (Bruges, Groeningemus.).

German Master:
Kauffmann, C. M., *The Legend of Saint Ursula* (1964).
Strange, A., *Die deutschen Tafelbilder vor Dürer: kritisches Verzeichnis*, vol. 1 (1967).

MASTER OF S. VERONICA (active 1395–1425). Eminent German artist who established a new style of painting known as 'the School of Cologne', which flourished until *c*.1440 and the arrival of Stefan *Lochner. He is named after his most celebrated work *S. Veronica with the Sudarium* (*c*.1415; Munich, Alte Pin.). Despite his importance any attempts to ascertain the identity of this anonymous painter have failed. In the past he has been associated with the documented artists Herman of Cologne and Herman Wynrich von Wesel, neither of which has been fully accepted. Similarities in style as well as technique show links between the Master and

*Conrad von Soest, one of the most important late medieval German painters, not only leading to suggestions that he may have been an apprentice in von Soest's workshop, but also resulting in many paintings of the Master's being attributed to von Soest, such as the *Trinity* (1400–5; Cologne; Wallraf-Richartz-Mus.). Mindful of this it is important to note that the Master's style is softer in form and more muted in colour than that of von Soest. KC

Vor Stefan Lochner: die Kölner Malerei von 1300–1430, exhib. cat. 1974 (Cologne, Wallraf-Richartz-Mus.).
Zehnder, F. G., *Der Meister der heiligen Veronika* (1981).

MASTER OF SEGOVIA. See BENSON, AMBROSIUS.

MASTER OF THE SMALL LANDSCAPES (active mid-16th century). Anonymous Flemish draughtsman who takes his name from two series of landscape prints published in 1559 and 1561 by Hieronymus *Cock. Although the etchings have been attributed to Jan or Lucas Duetecum, the identity of their designer remains unknown (a most plausible nomination has been the little-known Joos van Liere; active 1546, d. 1583). He was, after Pieter *Bruegel the elder, the most original Netherlandish landscapist of the mid-16th century. All his designs represent straightforward views of the Flemish countryside, with houses, farms, fields, and roads (*Village behind Trees*; Cambridge, Fitzwilliam). KLB

Hand, J. O., et al. (eds.), *The Age of Bruegel*, exhib. cat. 1986 (Washington, NG).

MASTER OF THE TŘEBOŇ ALTARPIECE (active last quarter of the 14th century). Bohemian painter. The altarpiece from which this unknown master takes his name was painted for the church of S. Giles in the Augustinian priory at Třeboň. The three suviving panels (now Prague, Národní Gal.) show scenes from the Passion, with saints on the outer side. Such was the impact of the artist's style, with its slender figures swathed in elaborate draperies, luminous colours, and visionary use of light, that he must have been based in Prague; the few remaining panels attributed to his workshop seem to have been commissioned for provincial centres closely connected with the court. Nothing is known about him; he was clearly familiar with Franco-Flemish painting, but his main debt is to the earlier court school in Bohemia, at Karlštejn and in the chapels of the cathedral in Prague. His influence lasted well into the 15th century, and can be seen in manuscript illumination as

well as monumental painting, and in sculpture, notably in the so-called 'Beautiful Madonnas'. AS

Kutal, A., *Gothic Art in Bohemia and Moravia* (1971).

MASTER OF THE VIEW OF S. GUDULE (active 1470–90). Flemish painter active in Brussels. He is named after the panel of the *Pastoral Sermon* (before 1480; Paris, Louvre) which includes the incomplete Cathedral of S. Gudule, Brussels, in the background. His fascination with the architecture of Brussels is evident throughout his work, such as the *Portrait of a Young Man Holding a Heart-Shaped Book* (London, NG) which features a view of Notre-Dame-du-Sablon, Brussels. Even though Jan van *Eyck and Rogier van der *Weyden strongly influenced several of the Master's earlier works, he added his own sense of dramatic tension and expressionism. He probably collaborated with the *Master of the Legend of S. Barbara on the altarpiece the *Legend of S. Géry* (The Hague, Mauritshuis; Dublin, NG Ireland). KC

Friedländer, M. J., *Early Netherlandish Painting*, vols. 4 and 14 (1967–76).
Janssens de Bisthoven, A. (ed.), *Primitifs flamands anonymes: Maître aux noms d'emprunt des Pays-Bas méridionaux du XVe et du début du XVIe siècle*, exhib. cat. 1969 (Bruges, Groeningemus.).

MASTER OF THE VIRGO INTER VIRGINES (active 1483–98). Northern Netherlandish painter who designed *woodcuts which were published in Delft between 1483 and 1498 by Jacob van der Meer, Christiaan Snellaert, and Eckert van Hombruch. His name derives from an altarpiece depicting the Virgin Mary surrounded by the virgin martyrs Catherine, Cecilia, Ursula, and Barbara (Amsterdam, Rijksmus.). The devout character of his religious paintings made him a popular artist and much of his production was made on commission for foreign patrons as suggested not only by the present locations of his work throughout Europe, but also by their provenance. Highly emotive figures depicted on occasion in extraordinary states of distress, such as the *Crucifixion* and *Massacre of the Innocents* (Florence, Uffizi), place him as an important predecessor of the Dutch School. It has been suggested that the Master of the Virgo inter Virgines is the painter Dirc Jansz., one of the few artists appearing in records in Delft. KC

Boon, K. G., 'De Meester van de Virgo inter Virgines', *Oud-Delft*, 2 (1963).
Châtelet, A., *Early Dutch Painting* (1981).

MASTER OF THE VITAE IMPERATORUM (active 1430–*c*.1453). Italian illuminator named after an Italian translation of Suetonius (1430; Paris, Bib. Nat., MS ital. 131) made for Filippo Maria Visconti, Duke of

Milan, for whom he undertook many commissions. He may have trained with *Tomasino da Vimercate to whose style his own seems closely related, although his figures are shown with a more controlled animation and a more descriptive modelling. His illumination is polished and controlled but shows a greater concern with pattern, decorative effect, and narrative force than with any serious naturalism. The peak of his invention and expressive range is seen in the miniatures he painted for the Duke's copy of Dante's *Inferno* (c.1438; Paris, Bib. Nat., MS ital. 2017 and Imola, Bib. Comunale, MS 32).

He was patronized by other citizens of Milan than the Visconti court and many manuscripts have been attributed to him. He was once thought to be identical with the Olivetan of Milan who inscribed an initial 'C' with the *Communion of the Apostles* (1439; Venice, Fondazione Cini, no. 2099). This initial and other related work is now attributed to a second artist referred to as the Olivetan Master.

One of his latest works is the copy of Filelfo's *Satires* (Valencia, Bib. General de la Universidad, MS 398) completed by the author in 1448 and sent to Alfonso V of Aragon in 1453. KS

The Painted Page: Italian Renaissance Book Illumination 1450–1550, exhib. cat. 1994/5 (London, RA; New York, Pierpont Morgan Lib.).

M ASTER OF VYŠŠÍ BROD (active mid-14th century). Bohemian painter, known only from an altarpiece painted for the Cistercian monastery at Vyšší Brod (Hohenfurth) in southern Bohemia (Prague, Národní Gal.). The nine panels show the childhood and Passion of Christ. They were probably executed before 1347, as the donor, shown kneeling with the Rožmberk arms in a corner of the *Nativity* panel, has been identified as Petr I of Rožmberk, who died in that year. As with most large-scale works of the period, there is an obvious division of labour amongst the panels, but the bright colouring, understanding of *perspective, and dramatic tension all point to the workshop's first-hand knowledge of contemporary Italian painting. Karl IV of Bohemia and his courtiers travelled widely in Italy during the 1330s and 1340s, and must have brought both manuscript and panel paintings back to Bohemia. The anonymous master responsible for the Vyšší Brod altarpiece combined elements of the new Italian work with existing Bohemian traditions to produce the court style of the third quarter of the century. AS

Kutal, A., *Gothic Art in Bohemia and Moravia* (1971).

M ASTER OF WAVRIN (active 1450–75). Illuminator active in Lille who mostly illuminated chivalric romances such as the *Roman de Florimont* (Paris, Bib. Nat., MS fr. 12566) and historic cycles such as the *Histoire d'Oliviers de Castille* (Ghent, Bibliotheek, Rijksuniversiteit, MS 470). He is named after Jean de Wavrin, Lord of Forestel (d. c.1475), whose coat-of-arms appears in several manuscripts by this anonymous master. The Master of Wavrin worked on paper with pen and ink drawing heightened with coloured wash. His rather summary technique produced idiosyncratic but lively and engaging scenes. There are many similarities between his work and that of the Master of the Champion des Dames (Grenoble, Bib. Municipale, MS 875). KC

Avril, F., and Reynaud, N. (eds.), *Les Manuscrits à peintures en France 1440–1520*, exhib. cat. 1992–3 (Paris, Bib. Nat.).

MASTER OF WITTINGAU. See MASTER OF THE TŘEBOŇ ALTARPIECE.

M ASTERPIECE (or *chef d'œuvre*). An obligatory test-piece and virtuoso accomplishment by which, from the medieval period onwards, a craftsman demonstrated that he had mastered his craft, on approval gaining membership of his guild. This achievement marked the end of a period of training as an apprentice and often also as a journeyman. Protectionist guilds required up to three masterpieces. Thus the diploma pieces of the Royal Academy might be said to be masterpieces. In the 19th century the term acquired a new meaning following the contradiction between the standards of industrial and art production. Nowadays, in the words of Walter Cahn (*Masterpieces*, 1979), when a work of art impresses us as the highest embodiment of skill, profundity, or expressive power, we call it a masterpiece. 'Where formerly the evidence was thought to be plain enough to see or hear, testimony has to be given and proof to be found. . . . dealing with masterpieces has remained almost entirely a naming activity.' One of the earliest citations of 'masterpiece' in English is contained in the announcement of the death of Duncan in Shakespeare's *Macbeth*: 'Confusion now hath made his masterpiece.' MFC

MASTIC. See RESIN.

M ASUCCI, AGOSTINO (1690–1768). Italian painter, born in Rome. He was apprenticed first to Andrea Procaccini (1671–1734) and later to *Maratti. With the death of *Chiari in 1727 he became the last major figure surviving from the Maratti School and played an important role in perpetuating the style. He enjoyed much patronage from the Rospigliosi family and worked on the decoration of the audience chamber in the Palazzo Rospigliosi-Pallavicini, Rome, where he completed a large canvas of *Hercules Received on Olympus*. Another influential patron was King João V of Portugal for whom Masucci painted several religious subjects, including three for the chapel of S. John in S. Roch, Lisbon (1747). He was most influential as a portrait painter and painted several of the Rospigliosi family, including Cardinal Banchieri (1728; priv. coll.). However, his reputation suffered a setback after his portrait of *Pope Benedict XIV* (1743; Rome, Accademia di S. Luca) was compared unfavourably with a portrait of the Pope by *Subleyras (1740; Chantilly, Mus. Condé). He was well supported by the British and painted striking portraits of *James Ogilvie, Lord Deskford* (Cullen House, Banff), and *John, 4th Earl of Hyndford* (Skirling House, Lan.). He also recorded the marriage of James Francis Edward Stuart to Maria Clementina Sobieska (Edinburgh, Scottish NPG). His pupils included *Batoni and the Scotsman Gavin *Hamilton. HB

Clarke, A., 'Agostino Masucci: A Conclusion and a Reformation of the Roman Baroque', in *Essays in the History of Art Presented to Rudolph Wittkower*, vol. 1 (1967).

M ATEO DE COMPOSTELA (active 1168?–1217). Spanish architect and sculptor. He was Master of the Works of the Cathedral of Santiago de Compostela and his name appears in an inscription on the lintels of the Pórtico de la Gloria (installed 1188). Although he has traditionally been thought of as a sculptor, the inscription records his direction of the building work and it is possible that he contributed rather than executed the designs for the sculptural decoration of the cathedral. Mateo has been tentatively identified in various documents from the period 1189 to 1217. OI

M ATHIEU, GEORGES (1921–). French painter, born in Boulogne. After studying philosophy and law, he began to paint in 1942. In 1947 he settled in Paris and in the 1950s gained an international reputation as one of the leading exponents of expressive abstraction. He regards himself as a traditional history painter working in an abstract style. His fame has depended partly on a flair for publicity that has led to him being described as 'the Salvador *Dalí of *Art Informel'. He works rapidly, often on a large scale, with sweeping impulsive gestures, sometimes squeezing paint straight from the tube onto the canvas. Matthieu has written several books expounding the theories behind his work.

M ATISSE, HENRI (1869–1954). French painter. He and *Picasso are generally regarded as the two greatest artists of the 20th century. Matisse, noble and serious by nature, demonstrated an almost ruthless dedication to work and progressive development. Born at Le Cateau in northern France,

he was originally a student of law at Paris but enrolled at the Académie Julian in 1891 (under *Bouguereau) and the École des Beaux-Arts (under Gustave *Moreau) in 1892, staying there until 1896. Fellow students were Henri Manguin (1874–1949), *Marquet, and *Rouault. He was elected associate of the Société Nationale in 1896 after selling a painting to the nation from among the four he exhibited at the Salon du Champ de Mars, Paris. Influenced in tone and colour by *Chardin and *Corot, he now experienced the *Impressionists and visited London (on *Pissarro's advice) to look at *Turner, leading him to adopt a brighter palette and make *colour experiments which freed colour from association or description. Paul *Signac bought his *Luxe, calme et volupté* (Paris, Mus. d'Orsay) from the 1905 Salon des Indépendants. At the Salon d'Automne of that year, he and his friends Marquet, Manguin, *Derain, and *Vlaminck made a sensational impact and were thereafter called *Fauves. Michael, Leo, and Gertrude Stein began to collect his work, Leo buying *Le Bonheur de vivre* (Merion, Pa., Barnes Foundation) from the 1906 Indépendants.

The quest for integrity of form when applying colour at its most intense led to the abandonment of conventional spatial devices, yet, while achieving great expressive power, he turned away from *Expressionism, seeking 'balance, purity and moderation'. His stated aim, to bring comfort and express joy, was realized in pure colour and increasingly abstract compositions, a powerful mode of decorative painting. In sculpture, printmaking, illustration, and drawing, he invented and demonstrated new, influential forms. *La Danse* and *La Musique* (1909–10; St Petersburg, Hermitage) were carried out for S. I. Shchukin, a Moscow merchant, who, like his compatriot I. A. Morosov, became an important patron. (In 1923 nearly 50 of Matisse's works from their collections were exhibited in Moscow.) He participated in the 1913 New York *Armory Show and showed his Moroccan paintings and sculptures in Paris; his reputation was growing. From 1916 he began to winter in Nice and after 1922 divided his year between that city and Paris. For Diaghilev in 1920 he designed *Le Chant du rossignol*. For the Barnes Foundation he created the great murals *La Danse* between 1931 and 1933. Odalisques, models-in-interiors, fruit, plants, and flowers were chosen subjects throughout the 1930s and in 1938 he produced the first gouache découpée (see PAPIERS COLLÉS). During the Second World War he moved to Bordeaux and St Jean-de-Luz before settling in Nice. Two operations for serious illnesses were needed in 1941; illness became intrusive and he discovered ways of working in bed.

A retrospective of his work was held at Paris in the Salon d'Automne of 1945 and 1947 saw him created Commander of the Legion of Honour. He published his *Jazz* and began to design the wall paintings and stained glass for the Rosary chapel at Vence (realized 1949–51) and big gouaches découpées, thus, at 80, producing the last great flowering of his art, the collaged decorations, for instance *The Snail* (1952–3; London, Tate).

See École des Beaux-Arts, Salon d'Automne, Salon des Indépendants, and Salon du Champs de Mars under PARIS. JL

Elderfield, J., *Matisse*, exhib. cat. 1993 (New York, MoMa).

Gowing, L., *Matisse*, exhib. cat. 1968 (London, Hayward).

MATSYS, FATHER AND SONS. See MASSYS, FATHER AND SONS.

MATTA ECHAURREN, ROBERTO SEBASTIÁN (1911–). Chilean painter. Matta studied architecture in Santiago, worked for *Le Corbusier in Paris 1935–7, then joined the *Surrealists. Using the automatist technique, he developed an abstract biomorphic style, greatly influencing the *Abstract Expressionists. Inspired by Latin American nature, his oneiric, volcanic landscapes reflect the artist's psyche struggling within a warring cosmos. His later paintings evoke the horrors of war: apocalyptic architectural spaces with pre-Columbian and science fiction-like creatures, as in *A Grave Situation* (1946; Chicago, Mus. of Contemporary Art). CC

Fletcher, V., *Crosscurrents of Modernism: Four Latin American Pioneers* (1992).

MATTEIS, PAOLO DE (1662–1728). Italian painter who was born at Salerno and trained at Naples under *Giordano. His art represents a calculated movement away from the dramatic bravura of Giordano's *Baroque style towards a more delicate and also a more classicizing manner influenced by *Maratti and the Roman classical Baroque tradition initiated by Annibale *Carracci. Before 1683 De Matteis had moved to Rome and his earliest known work, the *Allegory of Divine Wisdom Crowning Painting as the Sovereign of the Arts* (Los Angeles, Getty Mus.), probably dates from this period, and reflects his stylistic synthesis of classical and Baroque impulses. In Rome he attracted the attention of the Spanish ambassador, the Marquis of El Carpio, who was appointed viceroy of Naples in 1683. De Matteis followed him there and received numerous commissions from Spanish patrons. Such was the artist's success and growing international reputation that he was invited to Paris in 1705–14, on the initiative of Victor-Marie, Count d'Estrées. And following the Wars of the Spanish Succession (1701–14) he was patronized by the new Austrian governors of Naples. However de Matteis's most fruitful engagement was with the English Whig intellectual Lord Shaftesbury, who commissioned him to paint *Hercules at the Crossroads between Vice and Virtue* (1711; Oxford, Ashmolean) in a rigorous classical style and following a careful programme. Lord Shaftesbury was violently opposed to Baroque art and architecture and wrote to the artist advising him to reject any sensual or painterly effects: 'the merely natural must pay homage to the historical or moral . . . nothing is more fatal, either to painting, architecture or the other arts, than this false relish, which is governed by what immediately strikes the sense, than by what consequentially and by reflection pleases the mind and satisfies the thought and reason' (*A Notion of the Historical Draught or Tablature of the Judgement of Hercules*, 1713). Or, as he wrote more provocatively in his *Characteristiks of Men, Manners, Opinions and Times* (1711; 1714 edn., vol. 2): 'the beautifying not the beautified is really beautiful.' This remarkable commission clearly appealed to de Matteis, who painted several other works at this time with literary themes or emblematic allusions, notably the *Self-Portrait in the Act of Painting, an Allegory of the Peace of Utrecht and the Peace of Rastadt* (c.1714; fragment Naples, Capodimonte). Yet he continued to decorate the churches of Naples with both frescoes and oil paintings in a delicate, almost *Rococo manner. HB

Haskell, F., *Patrons and Painters: A Study in the Relations between Italian Art and Society in the Age of the Baroque* (1963).

MATTEO GIOVANETTI (b. 1295×1300, active 1322–68/9). The outstanding painter (*pictor pape*) at the papal court at Avignon after the death of *Simone Martini, to whose art his own clearly owed much. A native of the papal city of Viterbo, he may be a cleric of S. Luca recorded 1322–8, and prior of S. Martino, Viterbo, 1336. Frescoes of the *Crucifixion* and saints in S. Maria Nuova, Viterbo, show or reflect his early style. In 1343 Matteo was working on the hunting scenes of the Garderobe Chamber, papal palace, Avignon. He painted for the palace the chapels of S. Martial, 1344/5 (of political importance for the Avignon papacy), S. Michel (lost) (payments 1346), S. Jean, 1347/8, and the Audience Chamber in 1352; also the chapel of Innocent VI in the Certosa at Villeneuve-lez-Avignon in 1355, before going to Rome where he was painting at the Vatican 1367/8; his absence from documents of 1369 might suggest retirement or death. His works are peopled with elegant and varied characters in richly flowing Gothic draperies, with generally pallid complexions and intense 'portrait-like' faces daintily modelled (a trait that remained typical of Viterbo's art), and are set in extensive landscapes with remarkably precise architectural settings inspired by *Giotto or

the *Lorenzetti. His fertile eclecticism might reflect his taking up painting after an ecclesiastical rather than a professional upbringing, and was crucial for the diffusion of Italian painting techniques in mid-14th-century France. RG

Castelnuovo, E., Un pittore italiano alla corte di Avignone (Matteo Giovanetti e la pittura in Provenza nel secolo XIV) (2nd edn., 1991).
Faldi, I., Pittori viterbesi di cinque secoli (1970).

MAULBERTSCH, FRANZ ANTON (1724–96). Austrian painter. He was one of the most highly esteemed fresco painters in the Habsburg territories of central Europe in the late Baroque period. The vigour of his compositions and the freshness of his colour have been compared favourably with the art of Giambattista *Tiepolo. Perhaps the most impressive of his frescoes is the ceiling painting of The Glorification of Bishop Leopold Eck (1759) in the episcopal palace at Kroměříž, Moravia, which displays his mastery of *illusionism. In his later decorative work something of this exuberance was lost as Maulbertsch tried to adapt to the more rigorous tenets of the newly fashionable *Neoclassical style, as in the ceiling for Györ Cathedral, Hungary (1781). More attractive are the small-scale works from his last decade. These include genre paintings such as The Peep-Show Man (1785; Nuremberg, Germanisches Nationalmus.) as well as accomplished etchings in a *Rembrandtesque manner. MJ

Franz Anton Maulbertsch und sein Kreis in Ungarn, exhib. cat. 1984 (Budapest, Szépmüvészeti Mus.).
Garas, K., Franz Anton Maulbertsch: Leben und Werk (1974).

MAUSOLEUM AT HALICARNASSUS (modern Bodrum, Turkey), the gigantic tomb of the local dynast, Mausolus, satrap of Caria. Considered one of the *Seven Wonders of the ancient world, it provides the modern term for any stately sepulchre. Although ancient literary traditions (e.g. Pliny, Natural History 36. 30–1; Vitruvius, De architectura 7 praef. 12–13) are not wholly reliable, the building was apparently 43 m (140 ft) tall, consisting of a high rectangular podium supporting an Ionic colonnade surmounted by a pyramid of 24 steps crowned by a quadriga bearing a statue of Mausolus. Construction began c.367 BC and was completed only after the death of Mausolus in 353, and that of his wife Artemisia in 351. Its architect Pytheus of Priene composed a treatise about the building with the sculptor Satyrus; Scopas, Bryaxis, Leochares, *Praxiteles, and Timotheus are also reported to have carved its profuse sculptural decoration. Damaged by earthquakes, its remains were dismantled in 1494 by the Knights Hospitallers and reused to construct the Castle of S. Peter. The site was excavated in the 19th and 20th centuries, and much of its marble statuary was brought to London (BM). KDSL

Jeppesson, K., et al., The Maussolleion at Halikarnasos (1981–91).
Waywell, G. B., 'The Mausoleum at Halicarnassus', in P. Clayton and M. Price (eds.), The Seven Wonders of the Ancient World (1988).

MAYAKOVSKY, VLADIMIR (1893–1930). Russian poet, playwright, and artist, a leading exponent of Russian *Futurism, who engaged in provocative modes of dress, behaviour, and artistic performance. Primarily a writer and poet, his visual productions were enormously inventive, frequently characterized by an energetic and primitive cartoon style derived from peasant art forms and modernist experimentation, using bright colours and humorous text to tendentious effect. He was active for the Soviet government agency Narkompros (People's Commissariat for Enlightenment) 1919–20, producing large stencilled posters for ROSTA (Russian Telegraph Agency) extolling Soviet policy in simple eye-catching designs. From 1921 he was leader of LEF (Left Front of the Arts) overseeing a move from fine art to utilitarian design and propaganda, a project carried out under Lenin's New Economic Policy. He committed suicide in 1930. A bold and complexly diverse talent, Mayakovsky believed sincerely in the popular and revolutionary facets of his work. His funeral, itself a piece of Futurist street theatre, was attended by over 150,000. DJ

Elliot, D. (ed.), Mayakovsky: Twenty Years of Work (1982).

MAYER, (Marie Françoise) CONSTANCE (1775–1821). French painter. Born in Paris, the daughter of a customs officer, Mayer began painting as an amateur but studied under J.-B. *Greuze, whose influence was pervasive, and briefly under *David in 1801. She specialized in portraits and *genre but revealed ambitions to be a *history painter in her self-assertive yet filial Self-Portrait with Artist's Father: He Points to a Bust of Raphael, Inviting Her to Take This Celebrated Painter as a Model (1801; Hartford, Conn., Wadsworth Atheneum). In 1802 she became a pupil of *Prud'hon and, following his wife's breakdown in 1803, his housekeeper and collaborator. Their joint works, exhibited either under her name or his, depending on who finished the painting, have caused subsequent confusion. The Sleep of Venus and Cupid, Disturbed by Zephyrs (1806; London, Wallace Coll.), for example, was commissioned from her and exhibited as by her in 1806, but acquired by Wallace as by Prud'hon. Her later genre paintings are sentimental, in the manner of Greuze, but increasingly melancholy. Despite official recognition she committed suicide in 1821. DER

MAZO, JUAN BAUTISTA MARTÍNEZ DEL (1610×15–67). Spanish painter and son-in-law of *Velázquez. Little is known of Mazo prior to his marriage to Velázquez's daughter in 1633. At that point, he became the artist's chief assistant and began a career at court ·that culminated with his appointment to succeed Velázquez as painter to the King in 1661. Although his duties primarily involved repeating compositions by Velázquez or copying works in the royal collections, his versions were of such quality that contemporary observers frequently professed to be unable to distinguish them from the originals. Difficulties arise assessing Mazo's artistic personality, because few original works can be attributed to him. Those that can, however, such as the painting of his family (Vienna, Kunsthist. Mus.) or his portrait of Queen Mariana (London, NG), reveal a great debt to his father-in-law. Mazo was also one of the few Spanish painters of landscape, such as the View of Saragossa (Madrid, Prado), and these works combine a sureness of composition with a delicate painterly touch. PL

Mallory, N. A., El Greco to Murillo: Spanish Painting in the Golden Age, 1550–1700 (1990).

MAZZONI, GUIDO (c.1450–1518). Italian sculptor. He was born in Modena, where he is first recorded as active on decorations for the entrance of Eleonora of Aragon. His terracotta Nativity and Lamentation groups were produced in some numbers, and can be found in several churches in and near Modena (1475; Busseto, S. Francesco), Venice (S. Antonio in Castello), and Crema (S. Lorenzo). By 1489 he was in Naples, where his most renowned Lamentation group (1492) was produced for the church of S. Anna dei Lombardi, and includes the portraits of Alfonso, Duke of Calabria, and King Ferrante in the guise of mourning figures. He was later in the service of Charles VIII (d. 1498) in France, whose tomb for S. Denis he executed in 1498 (destr. 1789). Dividing his time between France and Modena, he also executed an equestrian monument of Louis XII (d. 1515) at Blois (c.1507). In 1509 he made a sketch for the tomb of Henry VII, (d. 1509) later realized by *Torrigiano. Like *Niccolò dell'Arca, his skill lay in the use of life-size *polychrome terracotta figures arranged as a sort of sculptural Passion Play. AB

Lugli, A., Guido Mazzoni e la rinascita della terracotta nel quattrocento (1990).

MAZZUOLI BROTHERS. Giuseppe (1644–1725) and **Giovanni Antonio** (after 1644–after 1706) were Italian sculptors of the late Baroque period. Giuseppe was taught to sculpt by his younger brother, who remained in their adoptive Siena when he

went to Rome to work under Ercole *Ferrata. Giuseppe collaborated also with *Bernini and contributed independently to such major Roman sculptural commissions as that for S. John Lateran, for which he provided the monumental statue of *S. Philip* (c.1703–12). Giovanni Antonio was the pre-eminent sculptor in Siena in the late 17th century, a typical work being the stucco relief of *The Assumption* (c.1700) in the cathedral. Compared, however, with the fluent metropolitan style of his elder brother his work remained old-fashioned and provincial. MJ

Nava Cellini, A., *La scultura del seicento* (1982).

MECKENEM, **ISRAHEL VAN** (c.1445–1503). He was the most prolific German engraver (see LINE ENGRAVING) of the 15th century, a small number of original inventions seasoning the mass of his work, which consists largely of copies from other engravers, such as the *Master E.S. and the young *Dürer. He was active initially at Bocholt on the lower Rhine where he also finished his career, but he travelled in south Germany and probably in Flanders. His early style is harsh, angular, and *Gothic, but his mature work is sophisticated and gracefully engraved. His genre scenes are of great distinction, featuring musicians, dancers, and courtly couples, being valuable records of the fashions and furnishings of the period. His masterpiece is the *Self-Portrait with his Wife*, a rare print which is not only the first engraved self-portrait, but the first engraved portrait of an identifiable sitter. RGo

Koreny, F., *Israhel van Meckenem*, Hollstein series (1986).

MEDALS. *See opposite.*

MEDICI **VENUS,** Hellenistic/Roman marble statue (Florence, Uffizi), adapted from *Praxiteles' *Aphrodite* of Cnidus, depicting the nude goddess covering her pudenda and left breast. Erotes riding a dolphin support her left leg, alluding to her sea birth. The plinth bears the name of the Athenian artist Cleomenes, son of Apollodorus. First attested in the Villa Medici in Rome in 1638, the statue was transferred to its present location in 1688. Greatly admired in the 18th and 19th centuries, it was widely praised and repeatedly copied in marble, bronze, and lead to adorn royal residences and English gardens. The type, also extant in other versions, such as the *Capitoline Venus* (Rome, Capitoline Mus.), was already popular in the 15th century, appearing in *Masaccio's *Expulsion* in the Brancacci chapel (Florence, S. Maria del Carmine) and *Botticelli's *Birth of Venus* (Florence, Uffizi). MBe

Haskell, F., and Penny, N., *Taste and the Antique* (1981).
Havelock, C. M., *The Aphrodite of Knidos and her Successors* (1995).

MEDIUM, the binding agent and vehicle, initially fluid, used for the application of particles of pigment to a surface in painting. Prior to the rise of modern synthetic chemistry, natural product (mainly animal and vegetable) paint binding media were confined chiefly to certain seed oils (drying oils), egg tempera, animal (or fish) glue distemper (based on proteins, which solidify by loss of water), gums, natural resins, and waxes. Modern paint media are based for the most part on synthetic alkyds (possibly oil-modified) and acrylics. Linseed oil was mentioned frequently in manuscripts on oil painting technique; it dried the best, but yellowed most and came to be used with the darker pigments or those which tend to inhibit the drying process. Poppyseed oil had the poorest drying characteristics, but yellowed least and its use was relatively common in works from the 18th century onwards; it was popular amongst the French *Impressionists. Walnut oil's properties were intermediate between those of poppyseed and linseed oils.

Egg tempera paints dried quickly, were matt, and had low transparency. Passages had to be worked quickly. Its low refractive index, compared with that of the pigments, cause the scattering of considerable amounts of incident (white) light, resulting in less saturated colours. Drying oil medium with a higher refractive index produces correspondingly greater colour saturation and increased transparency. Drying time is extended, resulting in the ability to rework passages as required and allowing the development of 'wet-in-wet' techniques. Oil media tend to yellow more than egg tempera; drying may be inhibited and cold-flow paint-film defects may result, particularly where black and brown pigments—derived by the burning of organic materials (charcoals, bistres, soots) or geologically modified materials (asphaltum or bitumen)—are concerned.

In northern Europe, documentary evidence supported by a growing body of experimental evidence has indicated a long tradition of oil painting. Thus analytical examinations of the paint media of 15th- and 14th-century Norwegian altar frontals and works such as the 13th-century Westminster retable revealed a thorough understanding of the properties of drying oils as well as pigments. This tradition is continued in a variety of 15th-century works by Netherlandish painters like Robert *Campin, Rogier van der *Weyden, and Jan van *Eyck. In a recent analytical survey of paint medium used by early Netherlandish and German School painters,

it was found that linseed oil was most commonly used, whilst in the 15th- and 16th-century early Netherlandish Schools, walnut oil was sometimes used for whites, blues, and other pale and cool colours.

Limited use of egg tempera paint was found, being confined to some 15th-century early Netherlandish workshops of the Campin group, van der Weyden, and *Bouts. Its use as an underpaint appeared again, in a very limited form, in later Netherlandish School painters. Its preferential use, as opposed to that of drying oil, in certain passages of pale flesh-coloured and white paint in Gerard *David's *The Virgin and Child with Saints and Donor* (London, NG), would seem to underline a sophisticated understanding of the optical, as well as the working properties, of the different media.

Heat-bodied oil (usually linseed), a drying oil pre-polymerized by the action of heat, is particularly suited to overcome the poorly drying pigments mentioned above, as well as red lake pigments. The addition of traces of lead, manganese, copper, and later cobalt salts—known as 'driers'—will also help. Heat-bodying will also effect some enhancement in transparency of the medium and lower the tendency for specular scatter at the pigment/medium interface, augmenting the degree of colour saturation attainable. Apart from its improved drying properties, heat pre-polymerized oil dries to form a smooth, level film, free from brushmarks. Rich red and green glaze paints, more usually the former, in both early Netherlandish and German School paintings were often found to contain a little resin, usually pine tree resin, in addition to heat-bodied oil. The Strasbourg Manuscript suggests that, for each colour, three drops of varnish (in this context, invariably a drying oil/resin varnish) should be added to the pigment, ground with oil. An example is the trace of pine resin found in the green dress of Arnolfini's wife in Jan van Eyck's *Arnolfini Portrait* (London, NG).

There is some body of analytical evidence to suggest the interplay of egg tempera and oil technique in early Italian works was more complex. Broadly speaking an egg tempera technique figured prominently in 14th-century works from Siena and Florence (including artists such as *Duccio, *Ugolino, Nardo di Cione—see under CIONE, ANDREA DI) and early 15th-century works (including works by *Lorenzo Monaco, *Masaccio, and *Sassetta). Later in that century, one may also find further examples, mainly from north Italian artists, including Giovanni *Bellini, *Cossa, *Zoppo, and Ercole de' *Roberti. Some works, even quite early, exhibit the use of egg tempera in some paints and the use of oil with certain other pigments. An example is the *Crucifix* attributed to the *Master of S. Francis (London, NG), active in Umbria in the

continued on page 469

· MEDALS ·

IN 15th-century Italy the study of ancient Greek and Roman coins in tandem with surviving texts from Antiquity became a commonplace of *humanist scholarship. It was quickly realized that the preservation of an emperor's name and (putative) appearance, and hence his fame, depended on the durable medium of his coins, struck in gold, silver, or bronze. It is not therefore surprising that the hereditary rulers of northern Italy chose to emulate ancient example, and from the mid- to late 1430s a rash of medals was cast commemorating the virtues of figures like Leonello d'Este, Marquis of Ferrara, and Sigismondo Malatesta, lord of Rimini, as well as the scholars and artists in their employ. And it was from ancient Roman coins that medals took their basic form: two-sided round metal objects, with an image in relief on either side, both usually accompanied by an inscription in Latin. The front (or obverse) has the portrait of the medal's subject, generally in profile, and identified by the legend. The reverse, often in slightly lower relief than the obverse, so that the medal will sit flat, bears an image which elaborates the portrait to express an aspect of the subject's character: an allegory of courage or sagacity; a personification of Faith or Peace; the depiction of an ancient god or hero, whose biography was to be associated with the subject's; a small narrative; or even a second portrait, of wife or child, or a repeated image of the subject performing a particular role. It is certain that the considerable skills of the painter *Pisanello were instrumental in ensuring the medal's immediate popularity in courtly circles, and he is often called the medal's inventor. Certainly many of the ingredients of the medal described above were already in place in his earliest experiments in the genre. His first piece is traditionally (though not necessarily accurately) said to be his portrait medal of the penultimate Byzantine emperor, John VIII Palaeologus (London, V&A), a work which depends for its large scale and method of manufacture—casting—on two late 13th-century Franco-Burgundian medals of Constantine and Heraclius, a pair of forgeries thought to be authentically Antique until the 17th century. The fact that both ancient coins and modern medals were called *medaglie* throughout the 15th and 16th centuries is a clear reflection of the fact that they were perceived as equivalent; that the commemorative medal was less a *Renaissance invention than a revival.

The popularity of the portrait medal spread from the courts to embrace the increasingly confident bourgeois elites of Florence and Bologna, and in the 16th century the medal was taken up elsewhere in Europe, welcomed initially by the scholarly community. Whereas in Italy making medals was generally the secondary activity of a sculptor, painter, or goldsmith, in Germany, and particularly in Nuremberg and Augsburg, the medal became sufficiently successful to provide the sole living for artists like Hans Schwarz (c.1492–after 1521) and Matthes Gebel (active 1523–74). Apart from the medal's intellectual appeal, its increasing popularity also depended on the migration of highly skilled Italian medallists: Giovanni Candida (c.1445/50–c.1498/9) and Benvenuto *Cellini to France, and the Lombard sculptors Leone *Leoni, Jacopo da Trezzo (c.1514–89), and Antonio Abondio (1538–91) to Habsburg courts in Brussels, Madrid, Vienna, and Prague. In each country, local artistic traditions ensured variations in the medal's appearance. In Germany, for example, carved wood and stone models were used to cast medals rather than wax, and silver was a much more popular medium in northern Europe than in Italy.

In the first years of the 16th century, the screw-press was invented, probably by *Bramante for the striking of papal bulls. This new technology was quickly adapted for the making of medals, which therefore became, through their size and manufacture, closer intellectually to their ancient prototypes. The introduction of an easy way of striking medals was to have two effects. First, they could be made in much larger numbers (editions of quattrocento cast medals were often tiny) and thus circulated more widely to become objects of propaganda. Secondly medallists needed access to presses. It is not then surprising that the medal became increasingly an instrument of the state. Commissions from private individuals continued to be cast, until the early 18th century (when Cosimo III de' Medici, Grand Duke of Tuscany, encouraged Massimiliano Soldani (1656–1740) to revive the method as a deliberate reminder of 15th- and 16th-century Medici commissions) but the trend in medal-making was towards centralized production by state mints.

The propagandist potential was first exploited on a grand scale by the Valois kings of France, by Cosimo I de' Medici, and by the popes, who by the second half of the 16th century were striking medals annually commemorating, for the widest possible audience, an important event in the papal year. The imagery on such pieces was carefully controlled by a whole range of mint officials. In France the sculptor Germain *Pilon was the first Contrôleur Général des Effigies, designing the royal portraits for medals as well as coins and jettons. In England approval of John Croker's (1670–1741) designs for the medals of Queen Anne was granted by Sir Isaac Newton, Master of the Mint.

Although these pieces were struck for topical ends, their creators must have been very aware that they could and would later be grouped to make series, as were those of Queen Anne, for instance. Increasingly, from the 16th century onwards, ancient coins were ordered into coherent series, to narrate, for example, the lives of the emperors, and they came to be published

in this way. Such systems of classification might of course be applied to groups of medals produced randomly over a long period of time, as they were, for instance, by John Evelyn in his *Discourse on Medals*, a medallic history of England (1697). However, at the end of the 17th century, Louis XIV of France was to set a potent example by commissioning a biographical series, struck in two sizes, and eventually accompanied by an explanatory volume. From the start of the 18th century other kinds of historical series were struck: of the rulers of a particular country, of its celebrated inhabitants, writers, scientists, warriors, and so on, or even, like the 1741–4 series by Jacques Antoine Dassier (1715–80?), which included Alexander Pope and Robert Walpole, of famous contemporaries.

Both the introduction of new technology and increasing state control saw to it that medal-making became an increasingly collaborative activity. Die engraving was a specialized art, highly prized. Engravers, however, were not always skilled designers. And in their turn, designers usually lacked the requisite capacity to invent inscriptions, or to decide where appropriate on the events to be commemorated. Thus the Petite Académie des Inscriptions, that group of scholarly worthies, was created precisely to determine the subject matter and mottoes of Louis XIV's *Histoire métallique*, ideas which were then realized by two artists, Sébastien Leclerc (1637–1714) and Antoine *Coypel, whose drawings were in their turn translated into dies by a whole team of engravers. The primacy of the engraver in this process is indicated by the fact that before the 19th century the designer of a medal is rarely acknowledged in its signature. Collaborations were sometimes occasioned by a desire to improve the artistic standards of medals. Pope Alexander VII, who took an unusually keen interest in papal medal production, employed Gianlorenzo *Bernini to design his *annuali*. When Vivant-Denon (1747–1825) oversaw the manufacture of the medallic history of Napoleon Bonaparte, he was sufficiently aware of the different individual skills of both designers and engravers that he was able to make sophisticated choices in assigning particular subjects to particular artists.

As die engraving became an ever more specialized activity, practioners were highly sought after, and countries where native skills were lacking would look abroad for talent. Moreover, medal-making increasingly became the preserve of long-lasting artistic dynasties, families whose activities usually extended to the engraving of dies for coins, as well as of seal matrices, and who would pass down their techniques through family networks. In Rome, for example, during the 17th century, three generations of the Mola family were employed by the papal mint. This dynasty was succeeded by another, the Hamerani, who had a more or less total monopoly on medal-making in Rome until the early 19th century. In Britain, a family of German immigrants, the Wyons, raised themselves from humble beginnings, engraving tokens in Birmingham, to fill most of the most important state engraving posts in the first half of the 19th century. William Wyon (1795–1851), in particular, was a great exponent of the *Neoclassical style for the medal, the result of his profound admiration for the work of the sculptor John *Flaxman and of his patrons' deliberate adoption of the visual vocabulary pioneered by Napoleon's medallic history. Members of the Wyon family were still to be found making medals in the 1930s.

Although medals were made throughout the 15th, 16th, and 17th centuries to celebrate the achievements and qualities of the individual portrayed on them, it was only later that the concept was extended to mark the achievement of others by the awarding of a medal associated with a particular activity. It is known that awards for military service were first made, in Britain, during the Civil War and, after the Restoration, during Charles II's conflict with the Dutch. In the mid-18th century awards were made for more peaceful accomplishments by institutions like the Society for the Promotion of Arts and Manufacture and the Royal Academy, London. Such commissions were to become a lucrative money-spinner for die engravers in the 19th century.

By the end of the 19th century struck medals had become so institutionalized, their designs so dull and repetitive, over-reliant on a jaded Neoclassical tradition, and even their engraving uninspired, that the artistic backlash which then occurred is not surprising. In Britain the French sculptor Alphonse Legros (1837–1911), his pupils at the Slade School of Art, and the practitioners of the so-called *New Sculpture led a return to the making of large, cast medals. These sculptors found inspiration in medals by Pisanello, now valued more as works of art, than as images of the personages commemorated by them. Stress was laid on what the critic Edmund Gosse (1849–1928) called 'the individualities of the model' and 'the odd phenomena of surface'. The fact that the sculptural element of the medal had become paramount is shown by the fact that some of these medals have invented portraits of fictional Renaissance subjects. Thus the art medal was born.

That is not to say that many countries ceased to use medals in fairly large numbers as a means of state propaganda (or, at least, not until after the Second World War). It is also true that large business concerns used medallic methods of self-promotion. The *Art Deco style was very successfully adopted for such ends in France and Belgium. But medallists produced more and more uncommissioned, deliberately unofficial works, such as the many viciously satirical medals made in Germany during and immediately after the Great War. At the same time the market for medals was in decline. The emphasis on sculpture had perhaps become self-defeating, given that collectors had always placed more emphasis on the historical significance of the medal. Once medals ceased to be thought of as

educational tools, and were forced to compete in the art market, practical aspects, such as the difficulty of their display, seem to have deterred collectors. There have been notable exceptions to this rule. Artists in the Soviet bloc found the medal a powerful means of expression and dissent, and companies in Portugal and the Netherlands continue to encourage innovative design (to the extent that Pisanello, were he alive today, might find it difficult to recognize many of these pieces as medals at all).

LS

1270s–1280s. Flesh paint contained egg tempera alone as medium, whilst a dark green glaze (confirmed as 'copper resinate') was bound in drying oil. In the later 15th century, Domenico *Ghirlandaio's *Virgin and Child* painted between about 1480 and 1490 (London, NG) is principally in egg tempera, but the azurite paint of the Virgin's mantle was identified as containing walnut oil. Other Italian works of the mid-15th century exhibit the use of egg tempera as a quick-drying and relatively opaque medium for underpainting, combined with the use of pigments in an oil medium as glazing paints. Evidence also exists for the use of egg tempera medium, as an emulsion by the incorporation of some drying oil and other combinations becoming popular among Florentine painters of the generation after Filippo *Lippi and *Pesellino. As we move on into the 16th century in Italy, so oil technique, mainly based on walnut oil, supplants egg tempera and the use of linseed oil becomes progressively more common.

RWh

MEGILLAH (plural Megillat; Hebrew: scroll), the name for the separate scroll containing the Book of Esther, read in the synagogue during the feast of Purim, commemorating the deliverance of the Jews from Babylon. Synagogue Megillat were unornamented, but those for private use were often lavishly illuminated and preserved in silver, and occasionally gold, cases, especially in Italy and the Netherlands during the 16th to 18th centuries, while decorated examples from Islamic countries tend to date from the 19th century. Decoration between the columns of the text varied from country to country, with floral scrolls, geometric motifs, and allegorical scenes all being popular. Megillat with engraved decorations appeared in the 18th century probably after Shalom Italia (c.1619–c.1655) with the columns of text surrounded by decoration, for example the Megillah from Italy, mid-18th century (Paris, Mus. Cluny).

PCo

MEISSONIER, JEAN-LOUIS-ERNEST (1815–91). French painter. Meissonier was born in Lyon and trained under Leon Cogniet. He specialized in military and genre subjects and came to fame for his paintings of the Napoleonic campaigns. His work, which is frequently small scale, is distinguished by attention to historical accuracy and almost miniaturist detail with a high gloss finish. His style derives, consciously, from Dutch and Flemish 17th-century cabinet pictures; his subjects included card-players and drinkers in addition to soldiers and he was described by *Baudelaire as a 'Fleming' in 1845. Both his style and subject matter appealed to contemporary taste, including that of Sir Richard Wallace who bought sixteen paintings (London, Wallace Coll.), and he was the first artist to receive the Grand Cross of the Legion of Honour. Although much of his work is meretricious, on occasion, as with the *Rue de la Martellerie* (1848; Paris, Mus. d'Orsay), recording atrocities of the revolutionary events of 1848, he achieves emotional depth. Self-consciously artistic, his vanity and pomposity are clearly revealed in his *Self-Portrait* (1889; Paris, Mus. d'Orsay).

DER

Ernest Meissonier, exhib. cat. 1993 (Lyon, Mus. des Beaux-Arts).

MEIT, CONRAD (1480s?–1550/1). German sculptor from Worms, active mostly in Brabant and France. After spending some time in the workshop of Lucas *Cranach the elder, probably 1505–11, he left Germany permanently, first to work for Philip of Burgundy, patron of Jan *Gossaert, at Middelburg, and 1514–30 as court sculptor to the Regent Margaret of Austria at Malines. In 1534 he moved to Antwerp, where he joined the guild of S. Luke two years later. Meit's major work is the marble and alabaster mausoleum for Margaret of Austria at Brou, near Bourg-en-Bresse (1526–32), but his importance lay in small, highly finished statuettes, executed in metal, boxwood, or fine stone, which blend supreme sensuousness with *Düreresque proportions (*Judith*, bronze; Cologne, Kunstgewerbemus.). In these figures, sculpture exists for its own sake in a manner unprecedented in the north, with no relation to or support by architecture.

KLB

von der Osten, G., and Vey, H., *Painting and Sculpture in Germany and the Netherlands* (1969).

MELÉNDEZ, LUIS (1716–80). Spanish painter. Meléndez trained as a young artist in the studio of his father Francisco Antonio. As a student in the newly formed Academia de S. Fernando, *Madrid, the 30-year-old Meléndez would paint a self-portrait in which he displays a study of an academic nude (Paris, Louvre). His promising career was cut short when his irascible father printed and distributed a denunciation of the Academy's founding commitee, leading to the expulsion of both father and son. Meléndez assisted his father 1751–4 in painting miniatures for three choirbooks, commissioned by Ferdinand VI to replace those destroyed in the 1734 fire at the Alcázar. In 1760, Meléndez finally turned to *still-life subjects, on which his reputation now rests. Eleven years later, he showed these to the future Charles IV. Although the future King acquired 44 paintings, Meléndez's attempt to gain steady royal patronage failed.

JT

Kasl, R., and Stratton, S., *Painting in Spain in the Age of Enlightenment: Goya and his Contemporaries*, exhib. cat. 1997 (Indianapolis, Mus.).

Tomlinson, J., 'The Provenance and Patronage of Luis Meléndez's Aranjuez Still Lifes', *Burlington Magazine*, 132 (1990).

Tufts, E., *Luis Meléndez: Eighteenth Century Master of Spanish Still Life, with a Catalogue Raisonné* (1985).

MELOZZO DA FORLÌ (1438–94). Italian painter whose work shows strong interest in *perspective and foreshortening, possibly due to early contact with *Piero della Francesca in *Urbino. This aspect is present in his first major fresco in Rome, *Sixtus IV Founding the Vatican Library* (c.1476–7; Rome, Vatican), in which the Pope and his nephews are depicted within a monumental receding arcade. His most important and influential work was the fresco cycle in the apse of SS Apostoli in Rome, commissioned by Giuliano della Rovere, later Pope Julius II. Only fragments of this scheme survive but the details of *Christ Blessing* (1479–80), now in the Palazzo Quirinale, indicate a very bold design of steeply foreshortened figures that anticipates many of the effects of the High *Renaissance and the *Baroque. Melozzo's late frescoes in S. Biagio in Forlì (destr.) maintained his innovative design but suffered from the weak execution of his workshop following his death. He exerted some influence over the next generation of painters in north Italy; it has been suggested that his pupil Giovanni *Santi transmitted Melozzo's interest in form and perspective to his son

*Raphael. Melozzo is also thought to have dabbled in architecture, designing the oratory of S. Sebastiano in Forlì. PSt

Clark, N., *Melozzo da Forlì* (1990).

MEMLING, HANS (1430×40–94). South Netherlandish painter, born in Seligenstadt, Germany, but active in Bruges. He continued the realistic style originated by the earlier generation, van *Eyck, the *Master of Flémalle, and Rogier van der *Weyden; *Vasari claimed that he was a pupil of Rogier in Brussels. He was registered as a citizen of Bruges in 1465 and, although not recorded in the painters' guild, he became the most eminent painter in the city, and had a prolific output, executing works for the wealthy bourgeoisie, merchants, clerics and the aristocracy. His clients included foreigners, especially Italians with mercantile or diplomatic links with Bruges.

In the many works which survive, little stylistic change can be discerned, but those thought to be the earliest suggest the influence of Rogier. Memling's *Last Judgement* triptych (Gdańsk, National Mus.) has points of comparison with Rogier's *Last Judgement* (Beaune, Hôtel-Dieu) both in composition as well as in figure types. Memling's personal style is expressed in his spacious landscape and in the gentleness and grace of his figures, a sweetness which may derive from German painting.

These features contribute to the serenity which characterizes the artist's mature works. The Donne Triptych (c.1479; London, NG) depicts the Virgin and Child with saints and donor family, harmoniously arranged in an airy, brightly lit loggia which spans all three panels. The figures are uniformly elegant, their gestures minimal, and their expressions spiritual. Behind them stretches an ideal landscape, whose tranquillity belies the reality of Bruges's political and economic disorder. Decorative details and textures are perfectly executed in jewel-like colours, and Memling's awareness of Italian art is suggested by the marbled columns and spatial construction. Several of his later works include *Renaissance ornament, such as putti and swags.

The timeless quality of the religious images is also apparent in his portraits. *A Young Man at Prayer* (London, NG) is dreamily abstracted, his physiognomy rather than his personality described, while portraits like that of Martin van Nieuwenhove (Bruges, S. John's Hospital) are individualized largely by the inclusion of identifying emblems and devices. This idealized realism contributed to Memling's being highly prized as a portraitist in his own day and also led to the sentimental and mystical interpretation of his art that caused its popularity in the 19th century.

A rare painted reliquary, the Shrine of S. Ursula (Bruges, Memlingmus.), is in the form of a Gothic chapel, gilded and decorated, its long sides painted with six narrative scenes of the life and martyrdom of the saint. Its minute and anecdotal detail, and accurate depictions of identifiable locations, are proof of Memling's skill as a narrator. His crystal-clear vision of the world is in the tradition of van Eyck's Bruges, complemented by additional influences. Gerard *David and *Juan de Flandes continued this development.
MS

van Schoute, R., Verongsbaete, H., and Smeyers, M. (eds.), *Memling Studies*, proceedings of the international colloquium (Louvain, 1997).
Vos, D. de, *Hans Memling: The Complete Works* (1994).
Vos, D. de (ed.), *Hans Memling*, exhib. cat. 1994 (Bruges, Groeningemus.).

MEMMI, LIPPO (active 1317–c.1350). Italian painter. Memmo di Filippuccio (active 1288–1324) was the first significant painter of this Sienese family. Between 1303 and 1317 he worked in San Gimignano, where a number of attributable paintings survive. His sons Tederigho and Lippo were both painters, the latter closely associated with *Simone Martini, his sister Giovanna's husband. Lippo's signed *Maestà* fresco of 1317 (San Gimignano, Palazzo del Popolo) is a virtual replica of Simone's 1315 *Maestà* (Siena, Palazzo Pubblico). Other paintings by Lippo, like the signed *Madonna dei Servi* (Siena, S. Maria dei Servi), reveal a dependence on Simone shared by a number of his less technically skilled contemporaries. In this light it is hard to determine at all precisely Lippo's contribution to the 1333 *Annunciation* altarpiece for Siena Cathedral (Florence, Uffizi), which he co-signed with Simone. JR

Bagnoli, A., and Bellori, L. (eds.), *Simone Martini e 'chompagni'*, exhib. cat. 1985 (Siena, Pin.).

MENA, PEDRO DE (1628–88). Spanish sculptor active in Granada and Malaga. Born in Granada to a family of sculptors, he studied first with his father Alonso de Mena (d. 1646) and later, in 1652, he collaborated with Alonso *Cano, supplying sculptures after his models. In 1658, Mena moved to Malaga to carve the choir stalls of that city's cathedral, and he would remain there for the rest of his life with the exception of a trip to Madrid (c.1662?). Although his stay there was short, it spread his fame throughout Spain, because he made important connections at court and was named sculptor to Toledo Cathedral. He rarely carved entire ensembles, and his primary importance consists as a creator of single figure types that were widely emulated. In particular, his statues of the *Grieving Virgin* (Madrid, Academia de S. Fernando), *Penitent Magdalene* (Madrid, Prado), and *S. Francis* (Toledo Cathedral) are notable for their elegant expression of intense religious emotions. Proud of his work, he signed more of his pieces than any other contemporary Spanish sculptor.
PL

Anderson, J., *Pedro de Mena: Seventeenth-Century Spanish Sculptor* (1998).
Martín González, J. J., *Escultura barroca en España 1600–1770* (1983).
Orueta y Duarte, R. de, *La vida y obra de Pedro de Mena y Medrano*, ed. Domingo Sánchez-Mesa (1988).
Pedro de Mena y Castilla, exhib. cat. 1989 (Valladolid, Mus. Nacional de Escultura Religiosa).

MENABUOI, GIUSTO DE' (active c.1349–90). Italian painter. Giusto di Giovanni de' Menabuoi was a Florentine whose career was based in Lombardy and in Padua, where he died. A Milanese triptych of the *Coronation of the Virgin* (s.d. 1367; London, NG) mingles the influence of *Giotto with the iconographic formats of Bernardo *Daddi and the smoky modelling of *Giovanni da Milano. From c.1370 Giusto was in Padua where he painted two frescoes of the *Madonna* in the Arena chapel choir and a damaged cycle of the *Liberal Arts, Philosophers, and Virtues* in the church of the Eremitani. Around 1375 he began his major surviving work, the frescoes of the baptistery. This encyclopedic decoration is remarkable for its rich chromatic range and the most adventurous demonstration of pictorial space in the trecento. The projection of the complex and varied architectural structures in which Giusto sets his teeming narratives reveals a remarkable *illusionistic capability, a speciality of Paduan painting after 1350. This quality informs Giusto's later frescoes (c.1382) in the Belludi chapel of the Santo, Padua, to an even greater degree. JR

Bettini, S., *Le pitture di Giusto de' Menabuoi nel battistero del Duomo di Padova* (1960).

MENGS, ANTON RAPHAEL (1728–79). German painter and writer active in Italy and Spain. As one of the pioneers of *Neoclassicism Mengs has suffered from the comparison of his somewhat exploratory style with the more confident achievement of such successors as *David. It is hard to defend his history paintings from the commonly levelled charges of insipidity and eclecticism. Yet he occupies an important position in the history of 18th-century art and his reputation deserves to stand higher than it does.

Mengs spent much of his career in Italy, where he was first taken in 1740–4 by his father, the Dresden court painter Ismael

Mengs (1688–1764). On his return to Dresden he occupied himself with portraits, a genre in which he excelled throughout his career (his self-portrait of 1773–4 in the Uffizi, Florence, is particularly fine). In 1750 a commission for an *Ascension* for the Hofkirche provided an excuse for a research trip to Italy to study the works of *Raphael and *Correggio. The two formative events of this journey were his meeting in Rome in 1755 with the antiquary Johann Joachim *Winckelmann (of whom he painted a notable portrait in 1761; New York, Met. Mus.) and the commission in 1759 from Cardinal Albani to paint a ceiling fresco of *Parnassus with Apollo and the Muses* for his villa on the outskirts of the city. This work, which benefited from Mengs's contact in Naples with Antique paintings excavated at *Herculaneum, was a consciously reformist one inspired by the *classicizing ideals of Winckelmann. The *illusionism and dynamic composition characteristic of Roman *Baroque ceilings was entirely rejected in favour of a stable grouping of individual figures in a shallow setting. All was designed to emphasize not that the room opens onto mythic but contiguous realms, but that the scene is a painted representation. Neither the insipid colouring nor the androgynous figures help to give the fresco presence, but it remains a seminal work in the development of Neoclassicism. Mengs never again attempted this degree of purism in his large-scale decorative works, though he did continue to explore this path in some of his easel paintings, such as *The Meeting of Octavian and Cleopatra* (1760–1; Stourhead, Wilts.). In those frescoes that he executed for the Palacio Real in Madrid, where he and *Tiepolo were invited to work by Charles III in 1761, he was obliged to respond to the more conservative expectations of the Spanish court. For *The Triumph of Aurora* (1762–5) and *The Apotheosis of Hercules* (1762–9 and 1775) Mengs drew inspiration from the *Carracci and the more classicizing painters of the early Baroque. Although the results are undoubtedly impressive, the contrast with the exuberance of Tiepolo's neighbouring decorations is piquant.

The latter part of Mengs's career was overshadowed by ill health brought on by overwork. He left Madrid for Rome in 1769 and did not return until 1774, by which time his powers were seriously weakened. Two years later he returned to Italy for good, leaving unfinished his ceiling for the court theatre at Aranjuez. His earlier involvement in attempts to reform the Academia de S. Fernando in *Madrid had led him to write two theoretical texts, continuing an activity begun in the 1760s with his handbook for painters—*Gedanken über die Schönheit und über den Geschmack in der Malery* (Thoughts on Beauty and Taste in Painting) (1762)—which he pursued also in retirement. MJ

Pelzel, T., *Anton Raphael Mengs and Neo-classicism* (1979).

Röttgen, S., 'Winckelmann, Mengs und die deutsche Kunst', in *Johann Joachim Winckelmann, 1717–1768* (1986).

MENZEL, ADOLPHE VON (1815–1905). German painter and illustrator. Menzel was trained in Berlin and in 1832, on his father's death, took over his family's *lithography business. Surprisingly the illustrations which made his reputation were not lithographs but 400 designs for *woodcuts for Franz Kugler's *Geschichte Friedrichs des Grossen* (1840–2). These illustrations established a popular image of the founder of Prussia which Menzel exploited in several oil paintings including *Frederick at Dinner with his Friends* (1850; destr. 1945) and their nationalistic overtones made him a natural choice to record the exploits of Wilhelm I (1797–1888) when he succeeded to the Prussian throne in 1861. Menzel's reputation today rests not on these official works but on a series of personal, informal sketches and paintings, like *The Artist's Sister with a Candle* (1847; Munich, Neue Pin.), which were unexhibited in his lifetime. Possibly inspired in part by *Constable, whose work he had seen in Berlin in 1839, these fresh and lively works, painted for his own pleasure, anticipate *Impressionism. Paradoxically he disliked contemporary developments in French painting, considering them 'unfinished', and much preferred the glossy historical romances of his friend *Meissonier. DER

Keisch, C. (ed.), *Adolph Menzel* (1996).

MERIAN, MATTHÄUS (1593–1650). Engraver and publisher of Swiss origin who settled in Frankfurt (1624). He is primarily known for his topographical prints of European towns, though only a few are based on his own drawings (*View of Basle*, 1620–4; Berlin, Kupferstichkabinett). Much of his vast output came from the hands of assistants, among them Wenceslaus *Hollar. His daughter Maria Sibylla Merian (1647–1717) was an artist who settled in Holland and visited Surinam. She is best known for her drawings of insects and butterflies, which are as remarkable for their scientific accuracy as for their delicate beauty. KLB

Matthaeus Merian des Aelteren, exhib. cat. 1993 (Frankfurt, Mus. für Kunsthandwerk).

MERLEAU-PONTY, MAURICE (1908–61). French philosopher. Working in contact with Jean-Paul *Sartre and Jacques *Lacan, he developed Edmund Husserl's ideas about attempts to specify the nature of conscious experience. His *Phenomenology of Perception* (1945) based all human knowledge on the body's 'primordial encounters' with the world. Their pre-linguistic nature could be realized and re-enacted in the activity of painting, which thus took on a momentous existential role in Merleau-Ponty's philosophy. His essay 'The Doubt of Cézanne', interpreting *Cézanne's work as revealing these primordial apprehensions, has resultantly maintained a sympathetic audience among painters. JB

The Merleau-Ponty Aesthetics Reader, ed. G. A. Johnson (1993).

MEROVINGIAN, term describing the art of the Franks, named after Merovech, the founder of the ruling dynasty. These Germanic peoples settled within the former Roman Empire (modern France, Belgium, and Germany) between the 5th and 8th centuries. Frankish craftsmen blended the styles and techniques of pagan Germanic metalwork with early Christian art as a deliberate adoption of Roman culture. Most evidence comes from ornaments and weapons excavated from cemeteries and from prestigious royal burials, such as those in Cologne Cathedral and S. Denis, Paris. These reveal the development of a recognizably Frankish style characterized by gold and garnet jewellery, Roman techniques (chip carving and filigree) applied to Germanic brooch types, the use of Roman coins as ornaments (e.g. necklace of Roman coins found in the grave of a princess buried before the mid-6th century in a chapel beneath Cologne Cathedral; Cologne, Römanisches-Germanisches-Mus.), and the depictions of pagan interlacing animals and classical figures. Christianity required the production of stone sculpture, for grave slabs and architectural ornament, where biblical or Mediterranean imagery, such as vine-scrolls or griffins, was combined with Germanic geometric or animal patterns (e.g. the 7th-century steps to the Hypogée des Dunes at Poitiers with entwined snakes shown in symbolic combination with fish and vine-scrolls). Similarly, the first manuscripts are decorated with brightly coloured animals copied from metalwork, evidence again of the skilled fusion of models (e.g. mid-8th-century Sacramentary of Gelasianum; Vatican, Bib. Apostolica, MS Vat. Reg. lat. 316). CMH

Hubert, J., Porcher, J., and Volbach, W., *Europe in the Dark Ages* (1969).

MERYON, CHARLES (1821–68). French *etcher. Meryon was born in Paris, the illegitimate son of an English doctor and a French dancer; his early career was spent as a French naval officer. His considerable reputation rests on a series of views of Paris which he began to etch and publish from *c*.1850. All are executed with great refinement of drawing and strong chiaroscuro reminiscent of

*Piranesi, but whereas some are straightforward views of city buildings, like *The Clock Tower* (1852; London, V&A), many have macabre overtones. *The Morgue* (1854; London, V&A), which seems initially to be an objective portrayal of a Parisian institution, shows, on closer examination, an idle prurient crowd watching the arrival of a naked cadaver under the supervision of a gendarme. It may have been this morbid element which so appealed to *Baudelaire who described him, aptly, as 'a strange but stalwart man' ('Salon of 1859', *Revue française*). Some etchings contain elements of fantasy which are symptomatic of Meryon's own disturbed mental state; probably schizophrenic, he spent his last two years in an asylum, convinced that he was God. DER

Schneiderman, R., *Charles Meryon: The Catalogue Raisonné of the Prints* (1990).

MERZ. See SCHWITTERS, KURT.

MESDAG, HENDRIK WILLEM (1831–1915). Dutch painter and collector. Mesdag was born in Groningen into a family of bankers. He joined the family business but studied in his leisure time under the Groningen painters C. B. Buys and J. H. Egenberger. In 1866 he abandoned banking and moved to Brussels for three years where he was taught by the historical artist *Alma-Tadema and the landscape painter Willem Roelofs (1822–97). In 1869 he moved to The Hague, where he made his home, and was soon established as a leading *Hague School artist. He specialized in marine and coastal views and the everyday life of the local people and his undemanding work proved highly popular. He is best known for his enormous panorama of the picturesque fishing village of *Scheveningen*, of 1881, c.120 m (390 ft) in circumference, which is housed in a custom-built gallery in The Hague. The Mesdag Museum, in the same city, contains his collection of paintings which includes outstanding works by painters of the *Barbizon School and his fellow Hague School artists. DER

MESENS, E. L. T. (1903–71). Belgian poet and artist. Mesens was a man of many talents—poet, collector, dealer, curator, and artist—all of which were dedicated to promoting Surrealist ideals. A key figure in Belgian and English *Surrealism, Mesens began as a musician, then turned to poetry in 1923. He met *Magritte in 1919, and, becoming intimate friends, they collaborated on the last issue of *Picabia's magazine *391*, then published their own short-lived but successful *Dada-inspired magazines *Œsophage* and *Marie*. Mesens organized numerous Surrealist exhibitions such as *Minotaure* (Brussels,

1934), *Surrealism Today* (London, 1940), and *Surrealist Diversity* (London, 1945). In 1938 he moved to London, edited the Surrealist-oriented *London Bulletin* and founded the London Gallery, a centre for Surrealist activity. Having experimented with drawing, *photography, and *collage since the 1920s, he dedicated himself completely to the latter in 1954. Particularly inspired by *Man Ray and *Ernst, his collages make use of a variety of materials and techniques. They are a curious combination of Dada humour and poetic sensitivity, and are executed in a free yet meticulous manner. CC

Vovelle, J., *Le Surréalisme en Belgique* (1972).

MESSERSCHMIDT, FRANZ XAVER (1736–83). German sculptor educated at the Vienna Academy and active there. He is best known for the compelling series of 69 physiognomic heads begun in 1770 which demonstrate the expressions associated with various states of mind. They all depict a similar middle-aged and bald man, and seem to have been based on his own features caught in a mirror. Messerschmidt is said to have made them as therapy for his own increasingly disturbed mental state. With titles such as *The Anxious Man* and *The Serious Man* they demonstrate carried to its extreme the naturalistic aspect of *Neoclassicism derived from Roman republican portrait busts. There is a set of the *Charakterkopfe* in the Österreichische Galerie, Vienna. MJ

Kris, E., 'Die Charakterkopfe des Franz Xaver Messerschmidt', *Jahrbuch der Kunsthistorischen Sammlungen in Wien*, 6 (1932).
Potzl-Malikova, M., *Franz Xaver Messerschmidt* (1982).

MEŠTROVIĆ, IVAN (1883–1962). Yugoslavian-born sculptor. He studied sculpture at the Academy in Vienna, 1900–4, and exhibited with the Vienna *Sezession from 1902, showing 50 pieces in the 1909 exhibition. In 1907–8 he was in Paris, where he met *Rodin and *Bourdelle. He spent the First World War in Rome, Geneva, Paris, and London, where a large exhibition of his works was held at the V&A. In 1919 he returned to Yugoslavia, where he received many public commissions and strengthened his fame internationally as a monumental sculptor. He worked in bronze and marble, almost always on a colossal scale, using a variety of classical styles invested with a few trappings of modernity. In 1933 a large show of his work toured Prague, Munich, Vienna, and Berlin. In 1934 he produced sculptures for an enormous mausoleum outside Belgrade in commemoration of the Unknown Soldier. During the Second World War he received several commissions from the Vatican. After living in Switzerland from 1943 to 1946 he went to America, where he became professor

of sculpture at Syracuse University and, from 1955, professor of sculpture at the University of Notre Dame, Indiana. OPa

Schmeckebier, L., *Ivan Meštrović* (1959).

METAL CUT, a method of relief printing, similar in principle to *woodcut, but using a soft metal such as pewter. The artist uses tools such as a burin to gouge out those lines and areas which are to remain white, while those areas left in high relief accept the printing ink. The principle is found in *manière criblée prints of the 15th century, but its most vital and inventive exponent was *Blake, who in such prints as *The Man Sweeping the Interpreter's Parlour* (c.1821) used *etching as well as engraving (see LINE ENGRAVING) to establish his lines.

In the 20th century engravers such as the Mexican artist *Posada have used type metal as a printing base, the effects being very similar to wood engraving. RGo

METALPOINT, a short metal rod, sharpened to a fine point at one end, that was one of the principal and most refined drawing tools of the *Renaissance. The rod can be made from lead, copper, silver, or gold, but silver was the material most prized, producing especially subtle shades of grey line.

It may only be used on paper prepared with a ground of Chinese white pigment, or Chinese white mixed with a watercolour pigment such as pink, to give a coloured ground. The metalpoint reacts chemically with the Chinese white to produce a delicate grey line, but the medium poses great difficulties since the lines, once made, cannot be erased. It therefore demands great certainty of decision on the draughtsman's part. The technique appeared in medieval Italy, and was used to most beautiful effect in Renaissance Italy by such artists as *Leonardo and *Botticelli. It was also popular with 15th-century Netherlandish artists, and pictures by Rogier van der *Weyden and *Gossaert show its use in paintings of *S. Luke Drawing the Virgin* (Paris, Louvre; Prague, Národní Gal.). A celebrated German example is the youthful *Dürer's *Self-Portrait* of 1484 (Vienna, Albertina). In many Renaissance drawings it is evident that artists took an epicurean delight in the luxuriant effects created, especially in variations of coloured grounds.

The technique survived only intermittently after the 16th century when it was largely replaced by the more convenient graphite, and *Rembrandt's engagement portrait of *Saskia* (Berlin, Gemäldegal.) is almost consciously antiquarian in his choice of the medium. It was occasionally revived thereafter, for instance by French miniature painters in the 18th century, and it was at its

last gasp when used by the French artist Alphonse Legros (1837–1911) for some outstanding portrait drawings in the late 19th century.

RGo

METAPHYSICAL PAINTING. The label 'la pittura metafisica' was applied to an Italian movement active around the period of the First World War. Its origins lie in the enigmatic, poetic works created by *de Chirico 1911–15, while he was in Paris. The paintings were characterized by dreamlike perspectival settings, containing a range of apparently unrelated objects, faceless mannequins, ancient statues, and isolated human figures. De Chirico further developed this style in Italy during the First World War, suggesting different layers of meaning by, for example, including pictures within pictures, as in *Metaphysical Interior with Large Factory* (1916–17; Stuttgart, Staatsgal.). It was during this period, while being treated at a military hospital in Ferrara, that de Chirico met the former *Futurist Carlo *Carrà, who soon began to produce similar works, although he was more interested in purely formal qualities of line and colour.

The other major figure to be influenced by de Chirico was Giorgio *Morandi, whose *still lifes of 1918–19 were said by de Chirico to have 'sanctified' Metaphysical painting. In the immediate post-war period the magazine *Valori plastici* (1918–21) continued to publish examples of their 'Metaphysical' painting, together with related works by Filippo de Pisis (1896–1956) and de Chirico's brother Alberto Savinio (1891–1952). The movement's historical importance lies in the influence that it exerted on the *Surrealists, who expressed particular admiration for de Chirico.

CJM

Calvesi, M., and Coen, E. (eds.), *La Metafisica: museo documentario* (1981).

METSU, GABRIEL (1629–69). Metsu was a sophisticated painter of *genre scenes. He was born in Leiden, and according to the biographer *Houbraken was a pupil of Gerrit *Dou. He was one of the founder members of the painters' guild in the city in 1648. By 1657 Metsu had settled in Amsterdam where he remained until the end of his life. He notably concentrated on intimate domestic subjects; his earliest dated painting is *A Young Woman Spooling Thread* of 1643 (St Petersburg, Hermitage), and perhaps his most celebrated is the *Mother and Sick Child* of about 1660 (Amsterdam, Rijksmus.). In such works there is a sense of quietude and a delicate compositional and colour balance. Metsu also painted a few religious themes, portraits, and game pieces. Although he forged an original contribution to the development of genre painting in particular, he was influenced by a number of contemporaries, ranging from *Rembrandt and ter *Borch to *Steen and *Vermeer.

CB

Robinson, F. W., *Gabriel Metsu (1629–1668): A Study of his Place in Dutch Genre Painting of the Golden Age* (1974).

METSYS, FATHER AND SONS. See MASSYS, FATHER AND SONS.

METZINGER, JEAN (1883–1956). French painter (mainly of still life, landscapes, and figure compositions) and writer on art. He was born in Nantes, where he studied at the Académie des Beaux-Arts, and moved to Paris after three of his paintings sold well at the Salon des Indépendants (see under PARIS) in 1903. After passing through *Neo-Impressionist and *Fauvist phases, he became one of the earliest devotees of *Cubism and a central figure of the *Section d'Or group. He was undistinguished as a painter and is remembered mainly as the co-author with *Gleizes of the book *Du Cubisme* (1912), the first book to be published on the movement. In the year in which the book appeared, Metzinger painted a portrait of Gleizes (Providence, Mus. of Art, Rhode Island School of Design). In the 1920s he turned from Cubism to a more naturalistic style, but from about 1940 he made a partial return to his earlier manner.

IC

MEXICAN ART. Mexico was conquered in 1521 and remained under Spanish dominion for three centuries. The imposition of a European aesthetic tradition upon the existing pre-Hispanic culture created an art peculiar to New Spain. Far from being a pale imitation of European art, Mexican colonial art is a complex and interesting assimilation and reinterpretation of European, especially Spanish, aesthetics. The evangelizing mission of the Spanish conquerors gave most colonial art a religious nature. Indigenous craftsmen elaborated upon engravings imported by religious orders, painting frescoes, carving church façades, and making feather mosaic ornaments for the clergy. However, the shortage of imported models as well as the frequent misinterpretations of an alien iconography often led to them resorting to the more familiar pre-Hispanic iconography, which created subtle new models.

The first group of European artists arrived in New Spain at the end of the 16th century; *Mannerist painters and sculptors who brought with them the ideals of the *Renaissance. Henceforth New Spain was introduced to successive European artistic currents—Renaissance, *Baroque, *Neoclassicism—either by European immigrants or by Creoles trained in Europe. The Academy of S. Carlos, founded in 1785, disseminated these techniques to generations of Mexican artists. Even though aesthetic values remained predominantly European during the colonial period (fostered particularly by the Academy), there were attempts to depict themes in tune with the Mexican reality, its land and people. The growing Creole class towards the end of the 17th century prompted an interest in Mexican historical, and especially pre-Colombian, subjects, a trend that gathered force and reached a peak in the late 19th century.

Mexican Independence was won in 1821, yet apart from portraits of its heroes, it took most of the 19th century before Independence was reflected in the country's art. In the meantime Mexican art was open to diverse influences. Propelled by the European Enlightenment and inspired by their visits to Mexico during the 1830s, European traveller-reporter artists recorded their scientific observations on Mexican history, geography, botany, and archaeological sights in beautifully executed engravings and lithographs. The German Johann Moritz Rugendas (1802–58), the Englishman Daniel Thomas Egerton (1800–42), and the Frenchman Jean Baptiste Louis Gros (1793–1878), among others, stimulated local artists to continue recording their country's iconography. The landscape genre also flourished during the 19th century, represented principally by José Maria Velasco (1840–1912), who depicted panoramic Mexican landscapes in a naturalistic manner. At the turn of the century, a very different genre emerged, the Mexican political caricature. Porfirio Diaz's conservative government (1876–1911) gave birth to numerous satirical papers. The most famous engraver was José Guadalupe Posada, who had a profound influence on 20th-century Mexican art in its search for a national iconography with, in particular, the *Taller de arte gráfica popular*, founded in 1937.

During 1890–1911, a group of artists called the *modernistas* began studying the current trends of Paris and Munich—*Symbolism, *Impressionism, *naturalism, *Art Nouveau, and oriental art. The sculptor Jesus F. Contreras (1866–1902) and the painters Julio Ruelas (1870–1907) and Roberto Montenegro (1866–1968), among others, attempted to internationalize Mexican art while preserving a Mexican identity. This effort was cut short by the nationalism spurred by the 1910 Revolution and its brainchild, Muralism.

The Muralist movement emerged from Obregón's post-revolutionary attempt to increase the level of literacy in Mexico. The Education Minister José Vasconcelos commissioned artists to paint monumental didactic murals depicting Mexico's history on the walls of government buildings. This programme gave birth to Mexico's most famous artistic movement, which had such a powerful hold on the country's artistic sensibility that for the first half of the 20th century it is

difficult to extricate Mexican art from Muralism. Nevertheless, despite the energetic, positive thrust of this Mexican renaissance, for many artists, its uncompromising social and political ideals became claustrophobic.

The first to break with the Muralist aesthetic in the 1940s was Rufino Tamayo, who explored Mexican identity in a more subtle manner. Rather than depicting its history and politics, he focused on the inner 'essence' of Mexico. He also forged connections with the international art scene, despite disapproval from the Mexican mainstream. Other artists who diverged from Muralism were Frida *Kahlo, Maria Izquierdo (1902–55), Antonio Ruiz (1897–1964), Carlos Mérida (1891–1984), and Agustín Lazo (1898–1971), who in their own particular way depicted the colour, humour, myth, and fantasy of daily life in Mexico. The artistic panorama during the 1940s was also enriched by European *Surrealists who migrated to Mexico during the diaspora: Luis Buñuel (1900–83), Remedios Varo (1908–63), Leonora Carrington (1917–), Wolfgang Paalen (1905–59), Alice Rahon (1916–87), and Kati Horna (1912–) all made a lasting impression on Mexico's cultural and artistic heritage.

Furthering the search for greater artistic freedom, a generation of young artists in the mid-1950s decided to break through the 'cactus curtain' erected by the Muralists. Known as the 'rupture' artists, their work assimilated the recent currents in world art—*Dada, Surrealism, *Pop art, *Minimal, and *Conceptual art—without losing sight of their cultural identity. Their rejection of state patronage instigated the first private gallery network in Mexico. The group comprised a number of artists who, without having a single style, were united by their rebellion against the institutionalized aesthetic ideology of the Muralists. Juan Soriano (1920–), José Luis Cuevas (1934–), Lilia Carrillo (1929–74), Fernando García-Ponce (1933–87), Alberto Gironella (1920–), Pedro Coronel (1922–85), the Oaxacan engraver Francisco Toledo (1940–), and the abstract artists Vicente Rojo (1932–) and Manuel Felguérez (1928–), among others, made and still make up the Mexican vanguard. The rupture movement heralded a change in Mexican aesthetic expression and is largely responsible for the varied and cosmopolitan direction in which Mexican art has developed today. CC

Mexico: Splendors of Thirty Centuries, exhib. cat. 1990 (New York, Met. Mus.).

M**EZZOTINT,** a method of engraving in tone, used from the middle of the 17th century until the end of the 19th century, largely for the reproduction of paintings. A plate is first worked all over with a tool with a serrated edge, called a *rocker. If printed at this stage the plate would produce a sheet of solid black. The image is formed by scraping away the roughened surface where the lights are required, using a scraper. The plate is covered with ink, and then wiped with rags. The roughened areas of the plate will print as a solid black, but the smoothed areas will hold less ink, or none at all, and print in different degrees of light. A mezzotint is thus unique in being worked from dark to light. Engraved or etched lines can be added, as can punched dots or flecks; this is known as mixed method mezzotint.

It was the invention of Ludwig von Siegen, whose first dated mezzotint was published in 1642, but it was carried to much greater refinement by Prince Rupert, the nephew of Charles I, and his large plate of the *Large Executioner* is the method's first masterpiece. Wallerant *Vaillant was another pioneer, and his work, like that of Prince Rupert, no doubt was intended to match the strong *chiaroscuro effects used in much contemporary painting, and was also notable for his numerous original subject prints. It is unfortunate that the willingness of early mezzotinters to make original subject prints was not matched by their successors.

Prince Rupert's example did much to forward the art in England, where it prospered throughout the 18th century. Valentine Green, John Raphael Smith, and many others scraped large plates after the portraits of *Reynolds, *Romney, and the subject pictures of *Wright of Derby. It is essentially a black and white medium, but ambitious and ultimately unsuccessful attempts were made to adapt it to complex colour printing by J. C. Le Blon (1667–1741) and others. A mezzotint plate produced fewer impressions than a *line engraving, but the engravers bewailed its invention, as being an easier and more facile process. Original works were few, a noticeable exception being the large portraits and fanciful heads by Thomas Frye.

The method continued to prosper in the 19th century, when larger editions could be pulled due to the introduction of the steel plate. Most important are the landscapes by David Lucas (1802–81) after *Constable, and some small highly *Romantic landscapes by *Turner known as the *Little Liber*. More histrionic subjects were scraped by *Martin.

From about 1870 until 1929 there was an extraordinary craze in Britain and America for the collecting of old mezzotints in rare states, and they became some of the most expensive works of art on the market. This market collapsed after the Wall Street Crash of 1929, and the art was dormant until recent years when it enjoyed a modest revival, rather strangely in Japan, and more notably in the large Photo-realist townscapes of the American artist Craig McPherson (1948–). RGo

Wax, C., *The Mezzotint* (1990).

M**ICCO SPADARO (Domenico Gargiuolo)** (1609–75?). Italian painter and draughtsman, mainly of genre, religious, and mythological scenes, who made a distinctive contribution to an emerging school of naturalistic Neapolitan *landscape. He took his name, 'Mick the Knife', from his father, who made swords (*spade*). He trained with Aniello Falcone, and in his early years sketched in the open air with Salvator *Rosa. His early frescoes, painted for the Certosa di S. Martino, Naples (1638 and 1642–7), include wild and dramatic landscapes. He contributed spirited figures, whose source lies in *Callot, to the architectural scenes of *Cerquozzi, and painted many lyrical biblical scenes and crowded martyrdoms. His late works include some remarkable pictures which present events in recent Neapolitan history as genre, amongst them the eruption of Vesuvius and the plague of 1656. The *Execution of Don Giuseppe Carafa* (c.1647; Naples, Mus. Nazionale di S. Martino) shows, in a realistic Neapolitan setting, the violent scenes of torture and decapitation which occurred during the revolt of Masaniello. HL

Sestieri, G., and Dupra, B., *Domenico Gargiulo detto Micco Spadaro* (1994).

M**ICHAUX, HENRI** (1899–1984). Belgian painter and poet. Born in Namur, Michaux had a Catholic education and remained deeply religious. He began painting in 1926 after moving to Paris. Between 1937 and 1940 he evolved a personal style, which he named Phantomisme, painting gouaches on black grounds, using *automatism. Around 1950 his style changed dramatically, becoming increasingly frantic, abstract but evoking apocalyptic visions. In 1955 Michaux experimented with the hallucinogenic drug mescalin and produced all-over drawings superficially resembling *Pollock and Cy *Twombly, like *Untitled Chinese Ink Drawing* (1961; London, Tate). During the 1960s figurative allusions appeared in his work. DER

Leonhard, K., *Henri Michaux* (1967).

M**ICHELANGELO BUONARROTI** (1475–1564). Italian sculptor, painter, architect, and poet, one of the greatest figures of the *Renaissance and, in his later years, one of the forces that shaped *Mannerism. He was born on 6 March 1475 at Caprese, near Sansepolcro, where his father was *podestà*. Michelangelo's father was a member of the minor Florentine nobility and throughout his life Michelangelo was touchy on the subject; it may have been pride of birth that caused the opposition to his apprenticeship as a painter and Michelangelo's own insistence in later life on the status of painting and sculpture among the liberal arts. Certainly his own career was one of the prime causes of the far-reaching change in

public esteem and social rating of the visual arts. He was formally apprenticed to Domenico *Ghirlandaio for a term of three years on 1 April 1488 and from him he must have learnt the elements of fresco technique, since the Ghirlandaio workshop was then engaged on the great fresco cycle in the choir of S. Maria Novella, Florence. He could not have learnt very much else, however, since he seems to have transferred very quickly to the school set up in the Medici gardens and run by *Bertoldo di Giovanni. More important than either master was what he learned from the drawings he made of figures in the frescoes of his true masters, *Giotto and *Masaccio. His work in the Medici gardens soon brought him to the notice of Lorenzo the Magnificent himself and one of Michelangelo's earliest works, the *Centaurs* relief (Florence, Bargello) may have been made for Lorenzo and left unfinished because of his death on 8 April 1492. After the death of Lorenzo the political situation in Florence deteriorated, first with Savanarola's oppressive theocracy and then with his judicial murder (1498). In October 1494 Michelangelo left Florence for Bologna, where he carved two small figures and an angel for the tomb of S. Dominic. On 25 June 1496 he was in Rome, where he remained for the next five years and where he carved the two statues which established his fame—the Bacchus (Florence, Bargello) and the Pietà (Rome, S. Peter's). The latter, his only signed work, was commissioned in 1497 (the contract is dated 27 August 1498) and completed about the turn of the century. It is completely finished and highly polished and is in fact the consummation of all that the Florentine sculptors of the 15th century had sought to achieve—a tragically expressive and yet beautiful and harmonious solution to the problem of representing a full-grown man lying dead on the lap of a woman. There are no marks of suffering—as were common in northern representations of the period—and the Virgin herself is young and beautiful. There is a story that objection was taken to the fact that the Virgin seemed too young to be the mother of the dead Christ, and Michelangelo countered this by observing that sin was what caused people to age and therefore the Immaculate Virgin would not show her age as ordinary people would. The story is told by Michelangelo's pupil and biographer Condivi and is therefore presumably true in essentials. No other living artist except *Leonardo da Vinci would have thought out the implications of his subject and linked the desire to achieve the utmost physical beauty and the maximum technical virtuosity with so considered an interpretation of the Christian mystery. Still in his twenties, Michelangelo returned to Florence in 1501 to consolidate the reputation he had made in Rome. He remained there until the spring of

1505, the major work of the period being the *David* (1501–4; Florence, Accademia), which has become a symbol of Florence and Florentine art. The nude youth of gigantic size (approx. 6 m/18 ft high) expresses in concrete visual form the self-confidence of the new Republic. It is really a relief although actually carved in the round. It displays complete mastery of human anatomy, and it is taut with imminent action and latent energy.

Other works of this productive period (up to c.1507) include the *Madonna* (Bruges, Notre-Dame), and the *Apostles* intended for Florence Cathedral (contract of 24 April 1503), of which only the *S. Matthew* (Florence, Accademia) was even begun. He probably also carved the Taddei Tondo (London, RA) and painted the Doni Tondo (Florence, Uffizi), which is distinguished by both the clarity of its design and its high-key colours, during these years. Immediately after the *David* was completed (Mar. 1504) Michelangelo received a commission from the Signoria of Florence to paint a huge battle piece (see BATTLE PAINTING) for the new Council Chamber in the Palazzo Vecchio, a commission which he shared with the older Leonardo. This painting was never completed, but Michelangelo began work on the full-size *cartoon in the winter of 1504, and the fragment known as the *Bathers* (i.e. a group from the *Battle of Cascina* as a whole) was, while it existed, a model for all the young artists in Florence, including *Raphael, and was one of the prime causes of *Mannerist preoccupation with the nude figure in violent action. There is a copy of the *Bathers* (Holkham Hall, Norfolk) and an engraving, as well as some *drawings by Michelangelo himself (e.g. London, BM). These drawings allow us to reconstruct the project with some accuracy and they are also important in that Michelangelo's intentions can be seen in them. He is one of the first great artists whose drawings have survived in sufficient quantity for us to be able to follow the stages of creation, and his draughtsmanship acquired seminal status for those who upheld *disegno* as the fundamental basis of all art. Somewhat later he made a number of highly finished drawings for *presentation to friends (examples survive Royal Coll.; Oxford, Ashmolean; London, BM; and elsewhere) which were the first drawings to be regarded as major works of art in their own right.

The *Battle of Cascina* was never painted and in the spring of 1505 Pope Julius II summoned Michelangelo to Rome to make him a tomb for S. Peter's. The 'Tragedy of the Tomb' (as Condivi described it) was about to begin. Julius II was one of the greatest of patrons, but his ardent temperament was too like that of Michelangelo himself and they soon quarrelled. On 17 April 1506 Michelangelo went back secretly to Florence and for some time held out against the Pope's demands for his

return until the Florentine government itself put pressure on him. In November he went to Bologna and there he made a colossal bronze of the Pope in his role of conqueror of the Bolognese. They destroyed it in 1511. In the spring of 1508 he was again in Rome, working for Julius II once more, this time on the frescoes of the Sistine chapel, and the grandiose project for the papal tomb seems to have been temporarily shelved: in fact the original design, which provided for more than 40 large figures, was never begun and the greater part of what was actually carried out—the *Moses* (in situ) and two *Slaves* (both now Paris, Louvre)—was in accordance with a second contract (1513) made with the heirs of the Pope. After the death of Julius, Michelangelo had no peace from his successors and other great personages, all of whom tried to make him break his contractual obligations to Julius's heirs, who naturally resented such conduct. Further contracts, each reducing the amount of work to be carried out by Michelangelo himself, were signed in 1516, 1532, and the fifth and final one on 20 August 1542. Under the terms of this a much reduced and mutilated version of the original titanic idea was set up in S. Pietro in Vincoli in 1545. Only the *Moses* retains his superhuman grandeur, and from the point of view of style may best be compared with the *Prophets* of the Sistine chapel frescoes.

The vast fresco cycle which covers the whole of the vault and part of the upper walls of the Sistine chapel was painted almost entirely by Michelangelo's own hand in a very short time, and in some ways it is the most complete work of his early maturity that has come down to us (a small part of the cycle on the altar wall was destroyed to make way for Michelangelo's own *Last Judgement*).

Work began in the spring of 1508 and the first half, painted in reverse of the narrative sequence from the *Drunkeness of Noah* and the *Prophet Zechariah* up to and including the fifth bay of the vault (*Creation of Eve*), was completed in September 1510. Then followed a long break, while fresh scaffolding was prepared, the first half being officially unveiled on 15 August 1511. After this work on the second half proceeded rapidly and the whole was unveiled on 31 October 1512. The ceiling of the Sistine chapel is a shallow barrel vault, approximately 35 m (118 ft) by 14 m (46 ft), with the windows cutting into the vault so as to produce a series of alternating lunettes and spandrels. The central field is almost flat and is defined by a painted cornice which is cut laterally by five pairs of ribs, which in turn define five small and four large rectangles containing scenes from the Old Testament. In the second phase the figures are larger in scale and more powerfully modelled, often pressing against the architectural framework with dramatic foreshortening,

and creating a sense of spatial disequilibrium. The small scene over the altar represents the *Primal Act of Creation*; the last, also small, over the entrance used by the laity, represents the *Drunkenness of Noah*, i.e. the sinful state of man. Each of the smaller fields has at each corner a nude youth (the *Ignudi*), whose exact significance is uncertain: most probably they have been thought to represent the Neoplatonic ideal of humanity, an interpretation which explains their position near the sacred scenes and above the figures of the *Prophets* and *Sibyls*, who foretold the coming of the Messiah but were nevertheless human and therefore subject to Original Sin. The *Prophets* and *Sibyls* occupy the triangular shapes between the windows and are seen, together with their thrones, in normal perspective: by contrast, the *Ignudi* are not subject to the laws of foreshortening. At each of the corners of the ceiling there is a double spandrel and these are occupied by *The Brazen Serpent*, *The Crucifixion of Haman*, *Judith and Holofernes*, and *David and Goliath*, i.e. four scenes of salvation. Finally, the spaces above and beside the windows are filled with representations of the purely human *Ancestors of Christ*. They occupy the lowest and darkest part of the vault furthest from the histories in the central part, which is apparently open to the sky.

From the moment of its completion the Sistine ceiling has always been regarded as one of the supreme masterpieces of pictorial art, and Michelangelo at the age of 37 was not only recognized as the greatest artist of his day but was also regarded as having raised the status of the arts to a point where he could be referred to as 'il divino Michelangelo'. He himself began by regarding the whole undertaking as an unwanted task to be got over as soon as possible with the help of assistants. But he could not find any to measure up to his standards and the ceiling, which grew under his hands, was almost entirely painted by him (see also under WALL PAINTING). To some extent he came to regard it as a substitute for the Julius monument, but as soon as the ceiling was finished he returned to the carving of figures for the tomb. The stylistic affinity between the *Moses* and the *Prophets*, the *Slaves* and the *Ignudi*, is very evident.

The problem of designing the architectural parts of the Julius monument led Michelangelo to consider the art of architecture, and in December 1516 he was commissioned by the new Pope, Leo X, to design a façade for the Medici parish church in Florence, S. Lorenzo, which had been left unfinished by *Brunelleschi. In fact the project came to nothing and wasted a good deal of Michelangelo's time, but it led to two other works for S. Lorenzo: the Medici chapel, or New Sacristy, planned as a counterpart to Brunelleschi's Old Sacristy, and the Biblioteca Laurenziana.

The Medici chapel was intended to be a union of architecture and sculpture (like the projected S. Lorenzo façade), with the view from the altar leading to the climax of the whole composition in the figures of the *Madonna and Child* (unfinished) and with the Active and Contemplative Life symbolized by figures on the wall-tombs of Giuliano and Lorenzo de' Medici. The figures of the Medici are set above the reclining figures symbolizing *Day and Night* (for *Vita activa*) and *Dawn and Evening* (for *Vita contemplativa*). One of the reasons why the chapel was unfinished is that when the Medici were expelled from Florence in 1527, Michelangelo declared himself a republican and took an active part in the defence of the city. After the capitulation in 1530 he was pardoned and set once more to work on the glorification of the Medici until in 1534 he settled in Rome and worked for the papacy for the 30 years that still remained to him.

He was at once commissioned to paint the *Last Judgement* in the Sistine chapel and began the actual painting in 1536. It was unveiled on 31 October 1541, 29 years to the day after the unveiling of the Sistine ceiling but a whole world away from it in feeling and meaning. Contemporaries admired the *Last Judgement* for its vivid high-key and strongly contrasting colours, recently unveiled by cleaning which removed centuries of accumulated surface dirt; and for the impressive representation of figures in motion. In the intervening period the world of Michelangelo's youth had collapsed in the horror of the Sack of Rome and its confident humanism had been found insufficient in the face of the rise of Protestantism and the new, militant austerity of the Counter-Reformation. It is significant that Michelangelo knew S. Ignatius Loyola, the founder of the Society of Jesus, and all his last works reflect his intense preoccupation with religion. Apart from the apocalyptic *Last Judgement* itself, the works of his old age are the *Conversion of S. Paul* and the *Crucifixion of S. Peter* (1542–50), frescoes in the Cappella Paolina commissioned by the same Pope, Paul III, who had commissioned the *Last Judgement*. There is also a series of drawings of the Crucifixion and carvings of the dead Christ, one of which (now in Florence Cathedral) was intended for his own tomb and contains a self-portrait as Nicodemus. And most important of all, the greatest commission in Christendom, was the completion of New S. Peter's, which remained almost as Donato Bramante (1440–1514) had left it. Michelangelo began work on it in 1546 when he was 71, and when he died on 18 February 1564 the basilica was so far advanced that completion was possible within the next half-century, although the church as we know it retains hardly any traces of his own work except in the apse. It was at this time that Michelangelo wrote some of his finest poetry, as

pessimistic in feeling as his drawings, paintings, and sculpture. HO/HB

Condivi, A., *Vita di Michelangelo Buonarroti* (1553); trans. A. S. Wohl, *The Life of Michelangelo* (1976).
Hartt, F., *The Paintings of Michelangelo* (1968).
Hartt, F., *Michelangelo: The Complete Sculpture* (1969).
Hirst, M., *Michelangelo and his Drawings* (1988).
Symonds, J. A., *The Life of Michelangelo* (1892).
Tolnay, C. de, *Michelangelo* (5 vols., 1943–60).
Weinberger, M., *Michelangelo the Sculptor* (1967).

MICHELINO DA BESOZZO (active 1388–after 1450). Italian illuminator, painter, designer, and glass painter. He was regarded by contemporaries, and for a further century in Milan, as one of the greatest artists of his day. He seems likely to be the 'Michelino pictore' recorded at work in the Pavian monastery of S. Piero in ciel d'oro in 1388, and he was still in Pavia in 1404 when the committee in charge of the rebuilding of Milan Cathedral decided to call upon him as the greatest in the arts of painting and design. It is known that Michelino was in Venice in 1410 but from 1418 all references place him in Milan where he undertook many commissions for the cathedral, several in connection with stained glass. All that survives of this documented work is six trefoils with prophets (1425; Milan Cathedral), and the corpus of attributions to Michelino depends on the signed panel *The Mystic Marriage of S. Catherine* (Siena, Pin.). The distinctive stylistic features—jewel-like colour, simplified, curved contours, and idiosyncratic facial types—combined with an exquisite technique remained constant throughout his career. The Prayer Book in New York (Pierpont Morgan Lib., MS M. 944) is the supreme example of his delicacy of handling and sophisticated design. Here the facing leaves of an illuminated opening present a unified scheme, with the borders repeating a stylized but recognizable flowering plant, a single type for each opening, and the flowerheads of this plant reappearing to pattern the gold grounds of the miniatures. The animals included in the miniatures of this manuscript, and the portrait busts in the *Funeral Eulogy and Genealogy of Giangaleazzo Visconti* (1403; Paris, Bib. Nat., MS lat. 5888) give some idea of Michelino's skill in two of the areas for which he was highly praised but, otherwise, the extant œuvre reflects little of the wide subject matter and range of techniques which sources reveal were produced during his long, influential, and successful career.

KS

MICHELOZZO (1396–1472). Florentine sculptor and architect who was in partnership with *Ghiberti from *c*.1420 on the first baptistery doors and on the *S. Matthew* (Florence, Or San Michele). Setting up studio with *Donatello before 1427, he worked on the classicizing niche for Donatello's *S. Louis*

(1423; Florence, Or San Michele), and collaborated on the tombs of Pope John XXIII (1424; Florence Baptistery) and Cardinal Brancacci (1426–8; Naples, S. Angelo a Nilo), and on the exterior pulpit at Prato (1428–33). Later he worked with Luca della *Robbia on the bronze doors for the cathedral sacristy (1445–7, 1463–4). Independently he undertook the now dismantled severely classical tomb of Bartolommeo Aragazzi (1427–38; Montepulciano Cathedral; two *Angels*, London, V&A). Other sculptural works include three terracotta figures of the *Madonna and Child, S. John the Baptist*, and *S. Augustine* (after 1437; Montepulciano, S. Agostino), and a silver *S. John the Baptist* (1452; Florence, Mus. dell'Opera del Duomo). He was a favoured Medici architect, behind important and innovative building projects in Florence and succeeding *Brunelleschi as supervisor of the cathedral (1446–52). His works in Venice (1433–4), Milan (1462; S. Eustorgio, Portinari chapel), and Ragusa (1462–4) helped to spread the new style.

HO/AB

Lightbown, R., *Donatello and Michelozzo* (1980).

M IEL, JAN (1599–1664). Flemish *genre painter. He lived in Rome between 1636 and 1658 (when he left for Turin) and joined the *Schildersbent, a Roman confraternity of northern artists, when he was given the nickname 'Bieco' ('threatening look'). Genre scenes by a fellow countryman, Pieter van *Laer (known as Il Bamboccio), were a formative influence. By the 1640s Miel's subject matter became more varied with scenes from town and country life, sometimes collaborating with Michelangelo *Cerquozzi. Miel's spirited and confident *Carnival in the Piazza Colonna* (Hartford, Conn., Wadsworth Atheneum) is typical of his maturity.

CFW

Sutton, P., *Masters of 17th Century Dutch Landscape Painting*, exhib. cat. 1987 (Amsterdam, Boston, Philadelphia).

M IELICH, HANS (1516–73). German painter, court artist to Duke Albrecht V of Bavaria in *Munich. Trained by his father Wolfgang Mielich, Hans moved to Regensburg *c*.1536; his earliest paintings are dependent on that city's leading painter, Albrecht *Altdorfer. By 1539–40, Mielich was in Munich. Shortly afterwards he visited Italy, to return to Munich in 1543, taking on his appointment at court a few years later. His portraits of Albrecht of Bavaria and members of his court are highly elaborate and mannered (*Ladislaus von Fraunberg, Count of Haag*, 1557; Vaduz, Liechtenstein Coll.). Mielich's chief work and last major painting was the high altar for the cathedral at Ingolstadt, commissioned by Albrecht V in conjunction with the centennial of the University of Ingolstadt (completed 1572). Containing more than 80 paintings by Mielich and his workshop, the altar's *iconographic programme, devised with the help of the university's theologians, depicts Christ as teacher, helper, and redeemer, and scenes from the life of the Virgin. It is the first great Counter-Reformation altarpiece in Germany.

KLB

Hand, J. O., *German Paintings of the Fifteenth through Seventeenth Centuries*, exhib. cat. 1993 (Washington, NG).

M IEREVELT, MICHIEL VAN (1567–1641). Dutch portrait painter. The son of a Delft goldsmith, Mierevelt trained under Anthonie Blocklandt in Utrecht, returning to Delft in 1589 where he embarked on the career of a successful portrait painter, becoming official painter to the Stadholder's court. He was much sought after for his very competent, detailed manner and his ability to capture a likeness without flattery. He ran a large workshop. Replicas were made by studio assistants of his most successful works and kept in stock for possible sale. Mierevelt is said to have made about 10,000 portraits, but little over 100 survive of what was probably a total of about a 1,000. The regular flow of his work only begins in 1607 when the Delft authorities commissioned him to paint a portrait of *Prince Maurice* (Amsterdam, Rijksmus.). His position at court was superseded by Gerrit van *Honthorst from 1637. He influenced other portrait painters, including Jan van Ravesteyn and Paulus *Moreelse. Prints of his work further increased his influence.

CFW

Luijten, G., et al. (eds.), *Dawn of the Golden Age: Northern Netherlandish Art 1580–1626*, exhib. cat. 1993 (Amsterdam, Rijksmus.).

M IERIS, VAN. Dutch family of artists in Leiden. The earlier generation consisted of three brothers, Frans, Dirck, and Jan, who were goldsmiths. However more important was Jan's son **Frans** (1535–1681). He developed a highly successful practice painting small-scale interior scenes with elegantly dressed figures, such as *Young Woman Standing before a Mirror* (Munich, Alte Pin.). The formative influence upon his style and subject matter was Gerrit *Dou, the leading painter of Leiden, with whom van Mieris had served an apprenticeship. Dou referred to him as the 'prince of his pupils' and they represent what is known as the Leiden School of *fijnschilders* (fine painters) because of their meticulous technique. Two of Frans's sons became painters, **Jan** (1660–90) and **Willem** (1662–1747). Few works survive by Jan but Willem continued in the manner of his father although his work is over-detailed, having a hard brittle quality. Such shortcomings also tend to occur in the work of Willem's son **Frans II** (1689–1763), who otherwise carried on in the tradition of his father and grandfather.

CFW

Naumann, Otto, *Frans von Mieris* (1981).
Sutton, P. (ed.), *Masters of 17th Century Dutch Genre Painting*, exhib. cat. 1984 (Philadelphia, Berlin, London).

M IGNARD BROTHERS. French painters born at Troyes. **Nicolas** (1606–68) and **Pierre** (1612–95) both passed through the studio of Simon *Vouet and achieved considerable success as portrait painters. Pierre, the more celebrated brother, succeeded *Le Brun at the Académie (see under PARIS) and was made First Painter by the King in 1690. He was one of the principal supporters on the side of de *Piles and the *'Rubénistes' in their battle against the *classicism of the 'Poussinistes'. His own historical and religious paintings, however, did not exemplify his theories but fitted into the scheme of academic classicism in the tradition of *Domenichino and *Poussin. His portraiture alone shows some originality and in contrast to Philippe de *Champaigne he introduced a style of court portrait which came to be associated with his name, based partly on Venetian artists such as Girolamo Forabosco (1605–79). He also revived allegorical and mythological portraiture.

HO

M IGRATION PERIOD ART, the art produced by the various Germanic peoples who overran the declining Roman Empire from the 4th century AD. The constant movement of barbarian tribes was nothing new (being described, for example, by Julius Caesar in the 1st century BC) but there were increased pressures from the north, of Angles, Saxons, Franks, and Lombards, and from the south-east of the Gothic tribes, including Visigoths, Ostrogoths, and Vandals, who had earlier migrated to south Russia and were now forced back westwards by the invading Huns from Mongolia. These migrations combined with the Roman Empire's internal process of decay to contribute to its fall. But the invaders also ensured that classical art survived, through their deliberate attempts to emulate Roman political structures and culture (see ROMAN ART, ANCIENT), involving the copying and adapting of styles, motifs, and techniques. Conversely, their adoption of Christianity meant that designs of pagan origin contributed to the arts of the new religion. So the art of the period reflects a true fusion between classical and barbarian taste.

Much of the surviving evidence comes from decoration applied to portable equipment (which has been recovered as a result of archaeological excavations) as grave goods or treasure hoards. Possessions were designed for display indicating personal rank, status, or tribal affiliation; they include glittering jewellery, elaborate battle gear, and

horse trappings, made richer by being embedded with semi-precious stones. The characteristic gold and garnet cloisons provide evidence of the taste for polychromy and richly textured surfaces. The decorative motifs include recognizable birds and fish, or indeterminate interlacing animal forms, of symbolic as well as ornamental value, for instance sea-horse-shaped fibula, gold cloisonné, garnet, and filigree, from the Alemannic cemetery, Deisslingen, Germany, late 6th-century (Stuttgart, Württembergischer Kunstverein).

Of the migrating peoples, the Angles and Saxons settled in south and east Britain, applying many of their jewellery designs and distinctive animal patterns to the ornament of Christian manuscripts and metalwork. The Franks occupied Gaul, developing into the powerful *Merovingian Empire, whose art synthesized a wide range of influences, Gallo-Roman, *Byzantine, and even Coptic. The Ostrogoths occupied Italy, making Ravenna their capital; King Theodoric attempted to combine Byzantine and barbarian style, by regarding himself as a Roman emperor. Their richly decorated jewellery retained its oriental quality, exemplified in the Cesena Treasure (Nuremberg, Germanisches Nationalmus.), with the typical eagle brooch of the Gothic tribes, and other garnet cloisons decorating crosses. The Visigoths moved from Italy to Spain, and their rich native jewellery traditions were again fused with Roman and Byzantine design, to express a particularly devout form of Christianity, creating a distinctive stone sculpture. The Vandals occupied North Africa, successfully assimilating late Roman art.

By the 9th century AD, late Roman had been transformed into early medieval art through the new European kingdoms, whose stability brought to an end the migration period.　　　　　　　　CMH

Hubert, J., Porcher, J., and Volbach, W. F., *Europe in the Dark Ages* (1969).
Laszlo, G., *The Art of the Migration Period* (1974).

MILAN: PATRONAGE AND COLLECTING.

Unlike many Italian cities, Milan does not have a consistent school of painting because its history has been often interrupted. The Latin name Mediolanum (middle of the land) indicates its central position and consequent involvement in international events.

Little painting remains from the 14th-century reign of the first lords, the Visconti, and that which survives is generally described as *International Gothic. With the arrival of the Sforza in the mid-15th century, Milan began to develop a *Renaissance style, at times directly imported from Tuscany. Of especial note is the Portinari chapel, commissioned by a Florentine banker and frescoed

by Vincenzo *Foppa (1462–8; Milan, S. Eustorgio). The most famous Florentine in Milan was, of course, *Leonardo da Vinci; his *Last Supper*, a ducal commission, still exists in a damaged state (c.1495–7; Milan, S. Maria delle Grazie). Other examples of the Lombard Renaissance are the chapels along the left-hand nave of S. Pietro in Gessati; the most important, dedicated to S. Ambrose, was frescoed by Bernardo Zenale and Bernardino Butinone (1490–3) on the commission of the Milanese senator Ambrogio Griffi.

The fall of the Sforza in 1499 changed not only the history of Milan, but that of the Italian penisula. In 1535 the city passed under Spanish rule. Private patronage was not lacking, and the sculptor *Leoni formed an important collection including drawings by Leonardo and casts of *Antique sculpture (the latter: Milan, Ambrosiana). Other important patrons included Count Pirro Visconti, with his villa and collections at Lainate. But the most important persons in late 16th- and early 17th-century Milan were the Borromeo archbishops, first S. Carlo (1538–84) and then his cousin Federico (1564–1631). The churches of the city, with their altarpieces by such local artists as G. B. *Crespi, G. C. *Procaccini, and Daniele *Crespi, still show the direct and indirect importance of their patronage and their religious work. S. Carlo championed a severe style of painting while Federico founded the Ambrosiana and donated his own collection to that institution in 1618. Didactic in aim, it includes important Venetian pictures, early 16th-century Lombard works, and a major *Raphael cartoon. Another 17th-century collection still largely intact is that formed by Archbishop Cesare Monti who bequeathed it to the Arcivescovado at his death in 1650. Monti's collection is richer in Lombard works than Borromeo's and also includes Venetian and Emilian paintings. These two collections must stand for the many formed by the Milanese nobility during the *Baroque era, collections not necessarily as distinguished, and now long dispersed.

In 1706, Milan passed under Austrian dominance, and by 1786 àll local institutions had been absorbed by Viennese reforms. From the point of view of Milanese patronage, the pattern of building and collecting by the nobility, often on a surprisingly international scale, continued. Particularly noteworthy is the Venetian Giambattista *Tiepolo's fresco (1740) commissioned by Antonio Giorgio Clerici for his palace. With the Enlightenment, in which Milan played an important role, the situation changed dramatically. First under Maria Theresa of Austria and her son Josef II, then under Napoleon, who entered Milan in 1796, religious orders were suppressed, and their altarpieces formed the nucleus of the Brera Gallery. The old rule of primogeniture was abandoned,

leading indirectly to the breaking up of collections as all heirs shared equally in an estate. This flood of material led to the formation of new collections; those of Austrian and Napoleonic officials such as Carlo Firmian, Giacomo Melzi d'Eril, and Eugène Beauharnais are only a few, and pictures from such sources are now found throughout the world.

In 1859, however, Milan was free of foreign rule and part of the nascent kingdom of Italy. The second half of the 19th century saw the city take an active part in the development of an international market (laws were less restrictive than now) with Lombards such as Giovanni *Morelli (his collection; Bergamo, Gal. Accademia Carrara) and his cousin Gustavo Frizzoni among the leading *connoisseurs. New private collections were formed; that of Gian Giacomo Poldi Pezzoli has been open to the public since 1879. The civic museums were created toward the end of the century and are principally displayed in the Castello Sforzesco and the Villa Reale. And at the beginning of this century, Milan was the home of the last Italian artistic movement of international importance: *Futurism. Badly damaged during the Second World War, Milan quickly regained its importance; commercial galleries such as II Milione and Galleria Blu played central roles in the development of contemporary painting and collecting, both on the national and international levels.　　　　　　　NWN

MILAN, AMBROSIANA.

This institution, founded by Cardinal Federico Borromeo, now consists of the Biblioteca Ambrosiana (founded 1607) and the Pinacoteca Ambrosiana (founded 1618); it is housed in the Palazzo dell'Ambrosiana, begun in the 17th century under the direction of Lelio Buzzi.

The cardinal dedicated the collection to the city of Milan, intending to fulfil Tridentine demands to instruct and move the public through a clear and direct religious art. He also wished to provide artists with examples of excellence, and originally the Pinacoteca was associated with the Accademia del Disegno (active from c.1613) where Milanese artists trained. His collection included many religious works, by *Titian, *Raphael, and the followers of *Leonardo; still lifes and landscapes by Flemish artists, exalting the richness and variety of God's creation; copies of Paolo Giovio's portrait collection; and many prints, drawings, and casts of Antique sculptures. The nucleus of the gallery is the cardinal's collection—arranged as it is described in his printed catalogue, *Musaeum* (1625), with *Caravaggio's *Basket of Fruit* hanging alone, since the cardinal lamented that he could not find another of similar beauty and excellence. There are many later additions, however, including Sebastiano Resta's collection

of drawings, and part of Manfredo Settala's famous encyclopedic museum, which had been an essential stop for *Grand Tourists in Milan. HL

Jones, P. M., *Federico Borromeo and the Ambrosiana: Art Patronage and Reform in Seventeenth Century Milan* (1993).

MILAN, BRERA GALLERY (Pinacoteca di Brera) one of the major Italian picture galleries, containing the most significant collection of Lombard painting anywhere.

The Palazzo di Brera was originally a college of the Jesuit order, which had taken over the site from the Umiliati in 1572 at the instigation of S. Carlo Borromeo. The main palace was built to the designs of Francesco Maria Ricchino in 1651–86. In 1776 the Empress Maria Theresa established a number of learned institutions in the college, including an Academy of Fine Arts. Although the Academy formed a small study collection, not much attention was given to the collection of paintings until Napoleon's occupation of north Italy, when the religious orders were dissolved and a flow of confiscated religious paintings began arriving at the Brera. The Viceroy of the kingdom of Italy, Hortense de Eugène de Beauharnais, took a close interest and in 1806 Napoleon ordered that the National Museum in Milan should be the most important in the kingdom of Italy. In order to make room for the expanding collection the adjoining church was destroyed and the new galleries are said to have been opened to mark Napoleon's birthday in 1809.

Throughout most of the 19th century the Brera collection remained part of the Academy (which still occupies part of the palace) and it was not open to the public except by special appointment. In 1892 the gallery was split from the Academy and was established as a national art gallery in its own right. Owing to lack of storage space the 19th-century managers of the Academy unsystematically disposed of some paintings, while others entered the collection through bequests and purchases. Nevertheless, the nature of the collection was set by the circumstances of its foundation, and the Brera remains memorable for its sequences of sombre north Italian altarpieces, with an emphasis on the regional schools of Lombardy. The original accumulation of paintings extended to the whole of the Napoleonic kingdom of Italy, however, and there are major works (e.g. by *Tintoretto, *Savoldo, and *Barocci) from the Veneto and the Papal States.

One notable direction in which the gallery's range has been expanded is towards 19th- and 20th-century Italian painting. The collection now includes important *Macchiaioli works, including the *Pergola* (1868) by Silvestro *Lega, and the 20th-century section was greatly strengthened by the donation of the Jesi Collection in 1976. AJL

Coppa, S., *La pittura lombarda del seicento e del settecento nella Pinacoteca di Brera* (1989).

MILLAIS, SIR JOHN EVERETT (1829–96). British painter. Millais, an artist of precocious talent, entered the RA Schools (see under LONDON) aged 11. In 1848 he was a founder of the *Pre-Raphaelite Brotherhood with Holman *Hunt and *Rossetti and instinctively grasped the theories of painting so painstakingly formulated by Hunt. His drawings are superb and the precise visual and psychological observation of *Lorenzo and Isabella* (1849; Liverpool, Walker AG) encapsulates all that is best in Pre-Raphaelite paintings. In 1850 *Christ in the House of his Parents* (London, Tate) was attacked as blasphemous but his reputation was saved by the intervention of *Ruskin who adopted him as his protégé. In 1853, while painting his portrait in Scotland, Millais fell in love with Ruskin's wife Effie, the victim of an unconsummated marriage, whom he wed in 1855. From the time of his marriage Millais abandoned Pre-Raphaelite technique for a broader, more painterly, style and Pre-Raphaelite seriousness for vapid sentimentality, epitomized by *The Boyhood of Raleigh* (1870; London, Tate), which pleased his Victorian audience and ensured worldly success. He was created a baronet in 1855 and elected president of the RA in 1896. DER

Donovan, C., and Bushnell, J., *John Everett Millais, 1829–1896*, exhib. cat. 1996 (Southampton, AG).

MILLET, JEAN-FRANÇOIS (also called Francisque) (1642–79). French painter of classical landscapes. He was born in Antwerp of a French father and had settled in Paris by 1659. Although he travelled in Flanders, Holland, and England, he never went to Italy, despite the fact that he was one of the most accomplished practitioners of Italianate landscape painting in the generation after *Poussin and *Claude. Although Millet's works lack the intellectual underpinning of Poussin's or the painterly refinement of Claude's, they are always heroic in conception and in some cases, such as the *Landscape with a Flash of Lightning* (London, NG), can strike a genuinely epic note. Both his son and his grandson carried on his style into the 18th century, also using the name Francisque. MJ

Claude to Corot: The Development of Landscape Painting in France, exhib. cat. 1990 (New York, Colnaghi).

MILLET, JEAN-FRANÇOIS (1814–75). French painter. Millet was born at Grouchy, near Gréville, Normandy, of peasant stock, and spent his early years as a farm-worker alongside his father. In 1832 he went to Cherbourg to study painting under Langlois, a pupil of *Gros, and in 1837 moved to Paris where he trained under the history painter Paul *Delaroche. His early works were anecdotal genre, history, and portraits but he met with little success. In 1848 he exhibited the first of his peasant subjects *The Winnower* (London, NG) and in 1849 moved to Barbizon, near the forest of Fontainebleau, with his wife and children. Inspired by his own childhood experiences, the daily life of the local peasantry, which he shared, and influenced by Honoré *Daumier's unsentimentalized paintings of the poor, Millet now began to specialize in the scenes of rustic life on which his reputation rests. *The Sower* (1850; Paris, Louvre), which owes a considerable debt to Daumier, revealed his ability to elevate the mundane to the heroic and the specific to the general. Major works of the 1850s include *The Gleaners* (1857; Paris, Louvre), in which the bending figures are set against a flat and muddy landscape, and *The Angelus* (1859; Paris, Louvre), the painting which both made and broke his reputation. Although not widely known until the 1860s, *The Angelus* was to become one of the most widely reproduced of all 19th-century paintings; a study of noble peasant piety, it had a wide appeal to the comfortable bourgeois public and ameliorated Millet's reputation for socialism. It is, however, undoubtedly sentimental if not positively sanctimonious, a criticism made by *Baudelaire in reviewing another painting of 1859, *The Cowgirl* (Bourg-en-Bresse, Mus. de l'Ain), and was largely responsible for the eclipse of his career after his death when Victorian sentiment was derided. Although Millet's work was much admired by fellow artists for nobility of subject, composition, and colour, public acclaim came late, in 1867 when nine of his major paintings were shown in the Paris Exposition Universelle, and much of his career was spent in extreme poverty. Towards the end of his life, encouraged by his friend the *Barbizon painter Théodore *Rousseau, he painted a number of pure landscapes. His reputation has been reassessed in recent years but is still controversial. He undoubtably influenced European *realism and his drawings, spare and monumental, were important to van *Gogh, but he is still accused of romanticizing the grinding harshness of rural poverty which, ironically, for much of his life he shared. DER

Murphy, A., *Jean-François Millet* (1984).

MINIATURE. 1. A term used to describe a representational image in an illuminated manuscript that is independent of any other decorative element, although it may be framed by a border and may occupy

only part of the page. It is particularly distinguished from historiated initials—the opening letters of text that contain appropriate scenes or figures integrated within the staves and field of the initial. KS

2. The term 'miniature' is also used to describe small paintings, particularly portraits such as those by *Hilliard and others, named 'limnings' or 'pictures in little' by the Elizabethans. They were painted on vellum (occasionally on ivory or card), mounted, and often could be worn like lockets or cameos. The portrait miniature seems to be a development of two older traditions: the medieval illumination of manuscripts and the *Renaissance portrait *medal, which was itself a revival of a classical form. The earliest detached miniatures appear in France towards the end of the 15th century, but the real breeding ground was probably the Netherlands, and it was perhaps a family of Flemish artists who established the art in England—the *Horenbouts, who were working there when *Holbein arrived in 1526 and one of whom is said to have instructed him in the technique. Perhaps less than a dozen of Holbein's miniatures now survive, but they rank among the greatest ever painted. Yet they show exactly the same quality and the same analytical artistry as his oil paintings; his *Anne of Cleves* (London, V&A) is but a portable concentration of his larger portrait of the same sitter, both deriving from an initial drawing. At this time the miniature was simply a painting done small; for practical purposes one was personal, the other household, furniture. Toward the end of the 16th century, the miniature began to be worn fairly commonly as an ornament of dress and the standard shape changed from round to oval, to the shape of a locket, while the frames were often highly wrought with jewels of great value. The miniature acquired an aesthetic of its own, an intimacy and delicacy of charm not derived from or possible for the full-size oil portrait. In this mode the Elizabethans produced the best of their visual art in the work of Nicholas *Hilliard. His was not a naturalistic art; he sublimated decorative adornments into masterpieces of the imagination. But he probably needed a rarefied climate, as provided by the late Elizabethan court, to stimulate him. His pupil Isaac *Oliver worked in a more naturalistic manner, for a different type of client. In the 17th century, while the artist's social position improved steadily, the standing of *portraiture did not. Serious painters aspired to historical or religious themes and by the end of the century portrait painters were known as 'face painters'. The miniature, regarded as something even slighter, a toy branch of face painting, was generally ignored. This decline in the prestige of the miniature was reflected in the

work of the generations immediately following Hilliard and Oliver. Their techniques were ably but uninventively continued by their sons, Laurence Hilliard and Peter Oliver, and by John *Hoskins, but with one exception they no longer led the way. Full-size portraits of the Elizabethan era seem to be but inflated miniatures; after van *Dyck the situation was reversed; the full-size portrait won a standing that it never lost and the miniature became dependent on it. The exception was Samuel *Cooper, society painter of the Commonwealth and Restoration. Even he was known as 'the van Dyck in little', and indeed he effected no startling technical or formal revolution. His triumph was based on subtle observation allied to a superb technique. After Cooper the decline was resumed. Thomas Flatman (1635–88) stemmed it briefly, painting miniatures of some individuality, melancholy in temperament but coarser in feeling and skill than Cooper's. The rest aped the life-size painters with very considerable dexterity into the most tedious stylization. Nicholas Dixon (active 1660–5) and Peter Cross (d. 1724) were the best of them, with the immigrants at the beginning of the 18th century, the Lens family, C. Richter, and the enamellist C. Boit. A revival began about 1750, the age of the English equivalent of the *Rococo, of the bijou, of Horace Walpole (perhaps the greatest English collector of miniatures). The large sweeping rhythms of *Baroque were broken up and men looked again for the detailed, the minute. After 1700 artists began to work with thinner colour on ivory instead of vellum, achieving far greater brilliance. Allied with this came a freshness of vision, first noticeable perhaps in the work of Nathaniel Hone (1718–1784). And then in the portrayals of the late 18th-century miniaturists flowered an incomparable, pretty elegance, which probably conveys the atmosphere of the 18th-century drawing room and boudoir better than any other witness. Richard Cosway (1742–1821) with his bold mannerisms drove this elegance almost to abstraction, and after him miniaturists fell back on the full-size oil painting for their model. Andrew Robertson (1777–1845) based his style squarely on *Raeburn's, painting solidly as if in oils. And so at the beginning of the 19th century the art of miniature entered upon its final decline. Sir William Ross (1794–1860), the last of the great men, is typical; his large miniatures, rectangular, often over a foot high, are in fact pictures in small. Miniatures ceased to be personal jewels and became part of a toy picture gallery. From c.1850 *photography began to sweep the country, and almost overnight the miniature was obsolete. Its *raison d'être* had always been the demand for intimate, esoteric portable likenesses; the photograph

offered these more cheaply, more accurately, and the miniature died. HO

Reynolds, G., *The English Miniature* (2nd edn., 1988).

MINIMAL ART, term used to describe a trend which emerged in the 1950s, mainly in America. Like *Conceptual art, to which it has been compared, Minimal art is a difficult term to define precisely, since it has had a wide variety of applications. Unlike Conceptual art, it has specific formal characteristics—geometric, monochromatic shapes—and a recurrent concern with effacing all signs of artistic personality and effort from the work itself. At the end of the 1960s, however, the label encompassed a great diversity of styles, including certain aspects of *Pop art such as works by Andy *Warhol, Tom Wesselmann (1931–), and Claes *Oldenburg; Funk art by Edward *Kienholz; and kinetic works by *Chryssa, Julio Le Parc (1928–), and members of the Düsseldorf *Zero group.

The paintings with which the term is associated are united in their repudiation of the expressive qualities of *Abstract Expressionism. Post-Painterly Abstraction has been considered a subsection of Minimal art. In their implicit rejection of internal relations among parts of a composition, minimalist paintings are characterized by flat colour, either entirely monochromatic like those of Yves *Klein or arranged in geometrically contrasting blocks for instance Ellsworth Kelly (1923–). To deny the possibility of its 'expressive' interpretation, gestural facture was also abolished, either by the impersonal application of enamel paint with house painter's tools, practised by Frank *Stella, or by the staining of unprimed canvas, as in the work of Morris Louis (1912–62) and Helen Frankenthaler (1928–).

Despite having their origins in painting, many of the concepts subsequently associated with the term have been perceived predominantly within the works of sculptors, such as the Primary Structures of Robert Morris (1931–), and the Serial sculptures of Carl André (1935–). A work such as *Lever* (1966, various locations) by André arguably takes a concentration on form to its furthest degree. Prefabricated industrial materials (bricks) have been placed in a straight line: a pure embodiment of ordered, simple form is thus achieved, in which ambiguity has been negated by the effacing of artistic personality and signs of creative effort.

In that its origins lie in a rejection of *Abstract Expressionism, and in that its exponents believed that a work of art should be entirely conceived in the mind before its execution, Minimalism can be related to Conceptual art. However, attitudes to form taken by these two types of art are irreconcilable; by comparison with the dematerialization of

the art object advocated by Conceptual artists, the exclusive concentration by Minimalists on shape and colour seems relatively conventional. OPa

Battcock, G. (ed.), *Minimal Art: A Critical Anthology* (1968).

MINNE, GEORG (1866–1941). Belgian sculptor, painter, and graphic artist, born at Ghent, the son of an architect. He initially studied architecture at the Ghent Academy, then transferred to painting and sculpture. In 1886 he met the *Symbolist poet Maurice Maeterlinck and began to illustrate Symbolist books, including Maeterlinck's *Serres chaudes* (1889), in a pseudo-medieval manner. Then, turning his attention increasingly to sculpture, he became one of the most successful artists in expressing Symbolist ideas in bronze and marble. His favourite theme was the kneeling adolescent. Minne's work has links with *Expressionism, and it was influential on Expressionist sculptors such as *Lehmbruck, who admired Minne's *Fountain of the Kneeling Youths* (1898–1906), commissioned for the Hagen Museum and now in the Folkwang Museum, Essen. From 1898 Minne lived at Laethem-St Martin, with the exception of the years of the First World War, when he took refuge in Wales. In about 1908 he began to turn away from his Symbolist outlook, which no longer seemed viable. Thinking that he had lost touch with nature, he studied anatomy and turned to a more realistic and socially oriented style in the manner of his countryman Constantin Meunier. From the 1920s, by which time he was internationally famous, he did little more than rework earlier motifs, carving in a monumental, blocklike manner. However, in some of his representations of the mother and child from the late 1920s there is a note of sensuality in an œuvre that was otherwise deliberately ascetic.

MINOAN ART. *See overleaf.*

MINO DA FIESOLE (*c.*1430–84). Italian sculptor of the Florentine school who also worked in Rome. He is renowned principally for the incisiveness and skill of his male portraits, which include the unrelentingly realistic *Niccolò Strozzi* (1454; Berlin, Gemäldegal.) and the lively *Diotisalvi Neroni* (1464; Paris, Louvre). During an early period in Rome he worked on a ciborium (1461–3) and on an altar to S. Jerome in S. Maria Maggiore (destr.; reliefs in Mus. di Palazzo Venezia). He was important in Rome for having introduced Florentine tomb styles, and worked in collaboration with Giovanni Dalmata on the large tomb of Paul II (1474–7; Rome, S. Peter's). His linear and archaic relief style, seen for instance in his tomb of Count Hugo of Tuscany (1469–81; Florence, Badia), contrasts with the naturalism of his portraiture. His probable use of drawings was expedient for a large workshop. HO/AB

Pope-Hennessy, J., *Italian Renaissance Sculpture* (4th edn., 1996).

MINTON, JOHN (1917–57). British painter, graphic artist, and designer, born at Great Shelford (Cambs.). After studying in London at St John's Wood School of Art, 1936–8, he spent a year in Paris, where he shared a studio with Michael *Ayrton (with whom he later collaborated on designs for John Gielgud's production of *Macbeth* at the Piccadilly Theatre, London, in 1942). Among the artists whose work he saw in Paris, he was particularly influenced by the brooding sadness of Eugene Berman (1899–1972) and Pavel Tchelitchew (1898–1957). In 1941–3 he served in the Pioneer Corps, and after being released on medical grounds he had a studio in London at 77 Bedford Gardens (the house in which Robert Colquhoun (1914–62), Robert MacBryde (1913–66), and Jankel Adler (1895–1949) lived), 1943–6. From 1946 to 1952 he lived with Keith Vaughan (1912–77). Minton was a leading exponent of *Neo-Romanticism and an influential figure through his teaching at Camberwell School of Art (1943–7), the Central School of Arts and Crafts (1947–8), and the Royal College of Art (1948–56). He was extremely energetic, travelling widely and producing a large body of work as a painter (of portraits, landscapes, and figure compositions), book illustrator, and designer. After about 1950, however, his work went increasingly out of fashion. He made an effort to keep up with the times with subjects such as *The Death of James Dean* (1957; London, Tate), but stylistically he changed little. Minton was renowned for his charm and generosity, but he was also melancholic and troubled by self-doubt. He committed suicide with an overdose of drugs.

MIRÓ, JOAN (1893–1983). Spanish painter. Miró was born and studied in Barcelona, where he met *Picasso. From 1914 he practised as a painter; his early works, painted in strong hot colours, show some *Cubist influence. In 1920 he moved to Paris and in 1925 took part in the First Surrealist Exhibition in the Galerie Pierre, Paris. However, whilst recognized as a distinguished member of the *Surrealist group and sharing their interest in the unconscious, Miró retained his independence and his style remained distinctive. He ignored the hostility between Surrealism and *abstraction, exploiting the tensions between them in delicate, tautly poised compositions which expressed the energies of life through rhythmically organized amoeboid forms, sometimes humorous, sometimes alarming, and always original and suggestive; much of his later work became increasingly abstract. He returned to Spain, in 1940, and began making ceramics which resulted in a number of public commissions, most notably *Mur du soleil* and *Mur de la lune*, for the Paris UNESCO building (1956). From 1966 he also worked in bronze. The Foundation Joan Miró, overlooking Barcelona, was opened in 1975 as a memorial museum and arts centre. JH

Lanchner, C., *Joan Miró* (1993).

MISERICORD (Latin *misericordia*: pity, sympathy), term in Christian church architecture for a shelflike structure or bracket, positioned on the underside of the folding seats in the choir. They were designed for the participants in the Mass to lean on and rest during the long service, whilst still giving the appearance of standing. They first appeared in the 12th century; however, most surviving examples date from between the 13th and 15th centuries. Misericords were carved in wood and at their best represent some of the most accomplished and inventive sculpture of the Middle Ages. They frequently depicted profane imagery, often taken from the *bestiaries, labours of the months, and even popular folk tales (the misericords of Worcester Cathedral are carved with such tales as the clever peasant girl). Other notable examples can be seen at the cathedrals of Ely and Wells in England, Bamberg in Germany, and Barcelona in Spain. TJH

MOBILE, a term invented in 1932 by Marcel *Duchamp to describe hand- and motor-operated kinetic sculptures created by Alexander *Calder. It was soon also applied to another type of sculpture pioneered by Calder, consisting of flat metal parts suspended on wires, the ensemble delicately balanced to move with currents of air. It is this latter variety which is now generally implied by the word mobile, variants of which have become popular as items of interior decoration, especially for children's bedrooms. Other artists have subsequently experimented with mobiles, notably Lynn Chadwick. AA

Marter, J. M., *Alexander Calder* (1991).

MOCHI, FRANCESCO (1580–1654). Italian Baroque sculptor who trained in Rome. In his *Annunciation* group for Orvieto Cathedral (*c.*1603–9) and in his twin, bronze, *equestrian statues of the Farnese dukes of Parma dominating the Piazza Cavalli at Piacenza (commissioned 1612), Mochi invented much of the drama and energizing of space

continued on page 483

· MINOAN ART ·

MINOAN art is the art and culture of Bronze Age Crete (*c.*3000–1050 BC). The name refers to the legendary King Minos of Crete and was coined by Sir Arthur Evans, who began the recovery of the lost world of the Minoans through his excavations (from AD 1900) at the 'Palace of Minos' at Knossos in north-central Crete. The Minoan period can be subdivided into phases according to the successive styles of pottery, with approximate absolute dates calculated on the basis of contacts with Egypt:

Early Minoan (EM) I–III, *c.*3000–2000 BC

Middle Minoan (MM) I–III, *c.*2000–1600 BC

Late Minoan (LM) I–III, *c.*1600–1050 BC

An alternative system takes the development of a palace-based society as its starting point: Prepalatial (EM I–MM I); First Palaces (MM I–II); Second Palaces (MM III–LM I); Postpalatial (LM II–III).

The Prepalatial period shows clear evidence of regional differences in material culture: for example, the circular 'tholos' tombs of southern Crete, and the rectangular 'house tombs' of eastern Crete. Prepalatial pottery is hand made and exhibits a considerable range of decorative techniques. Painted decoration—red to black on a light ground—favours linear, abstract designs. The surfaces of chalices in Pyrgos ware (EM I) are pattern burnished to produce a faceted effect, while the irregular red and black mottled surface of Vasiliki ware (EM II) is achieved through firing. Jugs and other pouring vessels, such as the teapot-shaped jars with elongated spouts, first appear in EM. The skilled manufacture of stone vases from this time may owe something to contacts with Egypt. The Minoans favoured coloured and variegated stones for jars and bowls, as well as blue-green chlorite for incised designs and even relief sculpture, such as a lid handle in the form of an outstretched dog (EM II, from Mochlos; Crete, Heraklion Mus.). Stone and imported ivory were also used to produce engraved seals which could be impressed onto a clay sealing to secure and identify property. The shapes are highly varied—cylinders, prisms, animals—and the designs range from abstract patterns to figured images of people and animals.

The construction of the first palaces (*c.*1900 BC) at Knossos, Mallia, and Phaistos marks the emergence of a stratified society which supported specialized craft skills in the service of the palace elite. In this context fine wheel-made pottery appears. Named Kamares ware (after the sacred Kamares cave on Mt. Ida where it was first found) this wheel-made pottery is notable for its technical skill—some vases are so fine and delicate they are termed 'eggshell' ware—and for its sophisticated decoration. Polychrome designs in white and crimson red (and sometimes orange and purple) are applied to a dark background. Spirals and floral designs seem to flow organically with the vase shapes in a unity of form and decoration. Plastic decoration, moulded clay flowers or even relief impressions from real sea-shells, was also used. Small clay figures, human and animal, were modelled and placed as offerings on mountain peak sanctuaries. Faience, an early form of coloured glass with a long history in Egypt, was used to make beads, inlay plaques and the well-known *Snake Goddesses* from Knossos (Crete, Heraklion Mus.); these figures, delicately coloured in creamy white, orange, brown, and black, wear Minoan palatial dress with the bodice fitted tightly under their bared breasts; both brandish or display snakes and two snakes are sinuously entwined around the body of the slightly larger figure (height 34.2 cm/13⅖ in). The jeweller's skills in gold are exemplified by the Aegina Treasure (London, BM) and the bee pendant from Mallia (Crete, Heraklion Mus.); the latter illustrates the assured use of both filigree and granulation, that is, the art of attaching fine gold wires and granules to the surface of the gold.

The Minoans responded to the earthquake destruction of their first palaces (*c.*1700 BC) by building the second palaces (MM III–LM I). Pottery is now decorated with dark painted designs on a pale background, a striking change from the light-on-dark designs of the preceding Kamares ware. Hallmarks of the period (LM I) are floral designs and Marine Style; for the latter the painters made maximum use of the artistic possibilities, making octopus tentacles twist and curve in harmony with the vase. Potters also shaped by hand the huge 'Ali Baba' jars decorated with relief and impressed designs which lined the storage rooms of the palaces. Hard stones such as obsidian and rock crystal were added to the repertoire of the stone-vase maker. An exquisite rock crystal rhyton (ritual pouring vessel) from the palace of Zakro in eastern Crete has an arching handle of stone beads threaded together with bronze wire (Crete, Heraklion Mus.). Softer bluish to greenish black steatite or serpentine was the preferred material for carving, as in the case of a sensitively sculpted bull's head rhyton embellished with eyes of jasper and crystal and with shell inlay around the nostrils (Crete, Heraklion Mus.). A number of steatite vases bear elaborate figured scenes carved in relief: e.g. the Harvester Vase with a crowd of neatly overlapping figures, and the Boxer Rhyton which brings together a series of scenes of boxing, wrestling, and bull leaping (Crete, Heraklion Mus.). Small sculptures of the human form are shaped from clay, cast in bronze, and carved in ivory. A male figure from Palaikastro stands nearly 50 cm (20 in) high: the ivory body is fitted together with dowels, details such as veins and fingernails are faithfully modelled, and remains of gold leaf recall the later Greek practice of combining gold and ivory in chryselephantine statues. Miniaturist skills find their fullest expression in sealstones; retorted, recumbent, and heraldic animals artfully occupy the restricted fields

of the lentoid and amygdaloid (almond-shaped) forms carved on a wide range of colourful, semi-precious stones including jasper, sardonyx, and carnelian. Gold seal-rings are a feature of the 15th century BC, and their engraved oval bezels are notable for showing rituals—such as dance or tree pulling—designed to summon a divine epiphany. Metalworkers provided a wide range of artefacts from vessels and votive offerings to tools and weapons. Larger bronze vessels were made in sections and riveted together, and repoussé designs decorate fine bronze and silver jugs and cups. The pictorial art of fresco or wall painting is a phenomenon of the Second Palace period both on Crete and in the Cyclades, though plain red and geometric plaster patterns are known much earlier. On Crete the special status of Knossos is underlined by its extensive fresco programme, for it is the only palace with pictorial frescoes. Frescoes are also known from Cretan villa sites (e.g. Ayia Triadha, Tylissos), and evidence for Minoan artists working overseas is provided by the site of Avaris (Tel ed-Dab'a) in the Egyptian Nile Delta. The use of lime plaster distinguishes Aegean frescoes technically from their Egyptian counterparts, and the colour palette centres around white, red, yellow, blue, and black. The fragmentary *Saffron Gatherer* fresco from Knossos (Crete, Heraklion Mus.) is considered to be one of the earliest surviving frescoes due to its use of a dark red background (a scheme shared with contemporary MM III vase painting). The sympathetic depiction of the natural world—here blue monkeys gathering saffron crocuses in a rocky landscape, elsewhere diving dolphins or a cat stalking a bird—is a strong element in Minoan art. Minoan frescoes can be classified in three groups: large scale, miniature, and relief. The *Procession* fresco from Knossos (Crete, Heraklion Mus.) depicts large male and female figures (characterized respectively by the Aegean convention of red-brown and white skin tones) who frame a central female figure, probably a goddess. The famous sport of Minoan bull leaping appears on a series of panels at a smaller scale (the *Toreador* fresco; Crete, Heraklion Mus.); the bull leapers have the slender, 'wasp-waists' and delicate curls and flowing hairlocks so typical of the depiction of the human form in Minoan art. Miniature frescoes use a shorthand impressionistic style to create lively crowds of spectators in the *Sacred Grove* fresco from Knossos (Crete, Heraklion Mus.). Large-scale relief frescoes use plaster relief to create a modelled impression; fragments are known from a number of Cretan sites but the best-preserved examples come from Knossos. These include the *Priest King* or *Lily Prince* (Crete, Heraklion Mus.) which may have adorned a passage leading south from the central court. The Minoan visitor arriving at the North Entrance passage was greeted by the bull grappling reliefs (Crete, Heraklion Mus.). The excavator, Sir Arthur Evans, suggested that this powerful bull image was still visible in post-Minoan times, and perhaps contributed to the myth of the Minotaur, just as its lair, the labyrinth, might be rooted in the complex layout of the Minoan palace with its apparent disregard for symmetry, yet with pleasing spatial rhythms quite different from those inherited from Graeco-Roman traditions.

The end of the Second Palace period is marked by the destruction of all the palaces except for Knossos which probably came under Mycenaean rule at this time. The ensuing Postpalatial period lacks the spectacular art forms of the earlier periods but is more strongly regional in material culture with recognizably local styles of pottery. During LM III pottery designs become increasingly stylized and the motifs confined within zones or panels. Painted terracotta *larnakes* (sarcophagi) include some with pictorial imagery—hunting, chariots, ships—which may be symbolically associated with ideas of death and the afterlife. The unique Ayia Triadha Sarcophagus (Crete, Heraklion Mus.), painted in fresco technique on limestone, shows a stunning kaleidoscope of Minoan symbols and ritual—libation, bull sacrifice, offerings, all accompanied by musicians—apparently in honour of a dead man. Notable is the rare use of green in addition to the usual fresco palette. Minoan deities are represented by a new tradition of large terracotta female figures arranged on benches in shrines. Termed 'goddesses-with-upraised-arms' from their distinctive gesture, they have wheel-thrown bodies and their tiaras are adorned with a range of symbols. One figure from Gazi in central Crete has a tiara surmounted by poppyheads, the capsules vertically slit to indicate the extraction of juice for opium (Crete, Heraklion Mus.). Other tiaras carry familiar images—horns of consecration, birds, snakes—which the Minoans had used to symbolize their relationship with the sacred world throughout the Bronze Age. CEM

Hood, S., *The Arts in Prehistoric Greece* (1994).

that animate Italian *Baroque sculpture. From this promising beginning he later found himself overtaken by *Bernini and *Algardi. Although still considered one of the leading sculptors in Rome when he was awarded the commission for the colossal figure of S. Veronica (1629–39) for the crossing of S. Peter's, his agitated interpretation of the theme was not well received. He had few later commissions of importance, and as his style became increasingly mannered even fewer were accepted on completion. Despite these failures, which left him deeply embittered, modern critics have found his highly idiosyncratic late style intriguing and given him full credit as an innovative pioneer of the Baroque. MJ

Gregori, M., et al., *Francesco Mochi, 1580–1654* (1981).

MODEL. The term is commonly used in connection with painting and sculpture of a figure, generally a human figure, posed for the artist to copy. Drawing from the life, which usually means from the nude, is taken for granted as an element in the curriculum of any art school, a fundamental part of the painter's as well as the sculptor's training. The tradition of drawing from the nude goes back to the *Renaissance but probably not before. In Classical Greece the nude male was an everyday sight in the gymnasia and was regularly featured in sculpture (see GREEK ART, ANCIENT). The nude female form, except possibly in Sparta, accorded less with social convention. In the *Memorabilia* (3. 11) Xenophon speaks of a woman of easy virtue and outstanding beauty who, when painters went to her to take her portrait, 'showed as

much of her person as she could with propriety'. The story of the *Aphrodite of Cnidus (c.350 BC) designed by *Praxiteles from the nude model of Phryne made its impact in Antiquity precisely because it was something out of the usual. In medieval art the figures were, with certain permissible exceptions, normally clothed and modesty could sometimes cause even Adam and Eve to be depicted in long robes. Through most of the Middle Ages nudity was not distinguished from nakedness and it was not until the new naturalism of the 13th century that work from the living model can be conjectured, as for example in the Adam and Eve of van *Eyck's Adoration of the Lamb (Ghent, S. Bavo), the nudes in *Masaccio's frescoes for the Brancacci chapel in S. Maria del Carmine, Florence, and later Hugo van der *Goes's painting The Fall of Man (Vienna, Kunsthist. Mus.).

The earliest practice drawings from the nude model which have survived are by *Pisanello. Their delicate outlines represent a woman in various natural poses, and are so faintly shaded as to suggest that a veil was hung between the draughtsman and his model. Fifteenth-century figure studies were more often of men, not only because they were less likely to incur the disapproval of the Church, but also because it was generally felt that the male form was the nobler and the female one lacking in proportion. The duty of posing fell naturally to the apprentices in the workshop, and there are several drawings from *Pollaiuolo's circle representing youths, clothed or naked, standing with long staves in their hands in attitudes suggesting an attendant saint. Even a study for a female character would often be taken from a male model. The monastic painter of course could not do otherwise, unless he used a lay figure (an articulated model).

In his search for ideal proportions of the human figure *Dürer related his mathematical system to a type taken from Antique sculpture, but many of his drawings were certainly taken from the life. Drawing from the nude had its opponents even in Renaissance times. *Vasari has a story that Fra *Bartolommeo burnt his drawings after hearing an impassioned sermon by Savonarola, but changed his mind after seeing *Michelangelo's works in Rome, and when this backsliding aroused complaint, justified it by producing an execrable painting of S. Sebastian. The models chosen were generally tall and slender. *Leonardo recommended that they should have long limbs and not too much development of muscle. *Signorelli and Michelangelo, however, chose to stress the strength and sinew of the male body, and this was the tradition that the *Carracci took up and handed on to posterity.

The first drawings of what are obviously professional models belong to the latter part of the 15th century. In the following century Italian painters took to forming groups which met to draw a hired model—a custom which van *Mander noticed on his visit to Italy and introduced to Holland in 1583. To this time belong the beginnings of the 'life class' as a part of the painter's education. When Federico *Zuccaro, in the 1570s, was trying to reform the Accademia del Disegno in Florence he suggested a room for life drawing, and though his advice was not taken at the time, by the end of the century the life class had become a feature of such *Academies as then existed, whether public or private. A male model was constantly available at the school of life drawing established by the Carracci at Bologna and female models were posing for 17th-century artists in Rome. Yet few academies introduced nude female models before the second half of the 18th century. The French Académie Royale (see under PARIS), founded in 1648, employed a full-time male model, made the life class the culmination of its educational course, and acquired a monopoly by inducing Louis XIV to prohibit all life drawing elsewhere. The student prepared for it by drawing from *plaster casts of the Antique. The class occupied four hours each day and it was a duty of the professors to 'set' the pose. There was less formality in the Netherlands and 17th-century artists drew and painted from the nude. A drawing representing *Rembrandt's studio in 1650 shows a female model on a dais and several pupils drawing her, while the master looks critically at the work of one; the whole scene is exactly like a life class of today except that the pupils are working with pen and ink. In fact Rembrandt's close adherence to the model with all its imperfections was a stock accusation advanced by academic critics. In 18th-century England life classes organized by artists jointly preceded the foundation of the Royal Academy (see under LONDON), where the model was posed by a professor usually in imitation of conventional types. It was in an attempt to avoid the unnatural posturings of such academy figures that in the late 19th century *Rodin made his models move freely around the studio.

The retreat from naturalism in the 20th century has made the life class problematical, though it is still part of the curriculum in most art schools. There have been few 20th-century artists who have not recognized the value of life drawing, in the schools or elsewhere, as a discipline and as a means of acquiring a repertory and a mastery of forms.

HO/HB

MODEL BOOK. See PATTERN BOOK.

MODELLO (Italian: model), a drawing, painting, or sculptural model of a composition, made for a patron either in the hope of gaining a commission, or to give a visual idea of the commission already placed. Such presentation drawings or clay models were sometimes made for a competition, and frequently the modello might be a more elaborate and accurate representation of the final work than a more spontaneous compositional sketch or *bozzetto. In 15th- and 16th-century Italian fresco painting squared drawings served as the preparatory stage for transfer into the full-size fresco, perhaps with a further intermediary *cartoon; such drawings are noted in *Raphael's workshop practice, and *Vasari discusses them in his theoretical writings on art. Sculpted modelli also served as guides for assistants within the workshop, as models after which they could study problems of anatomy and drapery. In addition, as in painting, small clay or wax modelli allowed the sculptor to create a scaled-down visual image of the full-size sculpture, a practice probably known to ancient Greek sculptors, and revived during the *Renaissance. Examples of this include *Verrocchio's terracotta model for the Forteguerri monument (London, V&A), or *Giambologna's numerous wax and terracotta models for sculptures in Florence (examples in London, V&A). These might be made simply by moulding wax in a rapid and spontaneous composition (such as *Michelangelo's wax model for a Slave in the V&A, London), or more elaborately on a wooden or metal armature, as recommended by *Cellini in his two Trattati. This could then be worked up into a yet larger, full-scale model in plaster. *Bernini appears to have preferred working with clay modelli, some of which survive for his statues of angels for the Ponte S. Angelo, or for the model for the Cathedra Petri (Detroit, Inst. of Arts), and they are highly prized in their own right. Modelli produced by *Degas or *Rodin mark a return after the somewhat rigid academic models of the earlier 19th century to a more spontaneous visualization of a composition. *Rubens's small oil sketches for the Marie de Médicis cycle of large paintings (Paris, Louvre) show how completely a great painter could use modelli to present his intentions as regards composition and colour scheme, and today these also have an intrinsic value and attraction.

HO/AB

Katz, L. (ed.), Fingerprints of the Artist: European Terracotta Sculpture from the Arthur M. Sackler Collection, exhib. cat. 1984 (Washington, NG; New York, Met. Mus.; Cambridge, Mass., Fogg Art Mus.).
Lambert, S., Drawing: Technique and Purpose, exhib. cat. 1981 (London, V&A).

MODERNISM. The term has been used to denote an ethos shared by many 19th- and 20th-century works of art and

often considered to dominate the culture of this era. How best to describe such an ethos in visual art has been the subject of ongoing debate among critics, especially since Clement *Greenberg proposed definitions for it in essays such as 'Modernist Painting' (1960). In the broader world, 'modernism' and 'modern art' have long been epithets used to characterize various innovatory styles, or else the ethos of artistic innovation in general.

Various factors from this broader context contribute to the meanings of 'modernism'. The French Revolution, the Industrial Revolution, and the new thinking of *Kant and the Romantics may be seen as ushering in the 'modern' era of culture. *Baudelaire's 'The Painter of Modern Life' (1859) proposed a new relation between the artist, a detached consciousness, and the urban artifice of such a 'modern' reality. The essay seems to foreshadow the subsequent painting of *Manet, a crucial component in all histories of modernism; arguably, it also influenced *Picasso in 1907 when he painted *Les Demoiselles d'Avignon*, another fixture of the modernist canon.

These examples, and the work of *Cézanne that historically stands between them, share a refusal to comply with received methods of representation. This refusal may be seen as asserting critical opposition to the surrounding culture of capitalism, or equally as a concentration on the formal essence of the art being practised: Greenberg argued in turn for both contentions, tracing modernist developments forward to the American painters of his own day. The self-defeating tendency of the avant-garde to become institutionalized, however, and the anti-formalist character of much later 20th-century art have both suggested to many critics that modernism as an ethos belongs to an era that effectively ended in the 1960s. (See also POSTMODERNISM.) JB

Clark, T. J., *Farewell to an Idea* (1999).
Varnedoe, K., *A Fine Disregard* (1990).

MODERSOHN-BECKER, PAULA (1876–1907). German painter. Born in Dresden, Paula Becker trained at the St John's Wood Academy (London) and the School for Women Artists in Berlin. In 1897 she first visited the artists' colony at Worpswede, then settled there, marrying the landscape painter Otto Modersohn (1865–1943). But she became disillusioned with Worpswede naturalism, and therefore spent four extended periods in Paris in 1900, 1903, 1905, and 1906 where she was influenced by van *Gogh, *Gauguin, and *Cézanne, and by Egyptian and Japanese art. In most of her 259 completed paintings she used flattened, monumental shapes and strong, clear colour for a range of subjects which included peasant women, adolescent girls, motherhood, and old age, as well as still-life studies and several self-portraits.

Notable examples include her enigmatic *Self-Portrait with Camelia* (1907; Essen, Folkwang Mus.), and an unsentimental, yet naturally sensual, *Mother and Child* (1907; Bremen, Roselius Coll.). Later *Expressionist artists were indebted to her work, sadly cut short by a heart attack soon after the birth of her daughter. GS

Paula Modersohn-Becker, exhib. cat. 1997 (Munich, Lenbachhaus).

MODIGLIANI, AMADEO (1884–1920). Italian-born painter of the School of Paris. Modigliani settled in Montmartre in 1906 and began producing paintings influenced by the tonality and mood of *Picasso's Blue Period, and the pictorial structure of late *Cézanne. In 1909 he met *Brancusi and began to concentrate on sculpture; the thin features and primitive references in his series of stone heads of 1909–14 clearly reflect Brancusi's influence which also extended to Modigliani's commitment to direct carving, for example *The Head* (1911; London, Tate). He abandoned sculpture in 1914, but the distinctive mannerisms of this work, the long necks and attenuated features, continued in his later painted portraits. While his linear technique can often make the figures appear stiff, his portrait *Chaim Soutine Seated at a Table* (1916–17; Washington, NG) demonstrates his capacity for individual characterization. Modigliani is also renowned for the series of languorous nudes, some of which he exhibited in 1918, in Paris, in a show which was closed over allegations of obscenity: *Reclining Nude—Le Grand Nu* (c.1919; New York, MoMA). He died aged only 35 of tubercular meningitis. MF

Schmalenbach, W., *Modigliani* (1990).

MOHOLY-NAGY, LÁSZLÓ (1895–1946). Hungarian-born artist, educator, author, and designer. Moholy-Nagy initially studied law, but took up drawing and painting during service in the First World War. He arrived in Berlin in 1920, where he was influenced by *Dadaism, *Suprematism, and particularly *Constructivism. In 1923, at the invitation of the architect Walter Gropius (1883–1969), he joined the *Bauhaus as head of the metal workshop. He later took over the preliminary course and was responsible for the series of *Bauhausbücher* (Bauhaus Books). Moholy-Nagy experimented in many media, including *photography, *photomontage, film, and theatre, and was especially interested in the effects and uses of light. He resigned from the Bauhaus in 1928 and pursued commercial work in Berlin, including stage design. His magnum opus, which synthesized his ideas, was the *Light-Space Modulator* (1922–30; Cambridge, Mass., Busch-Reisinger Mus.), a *kinetic sculpture for creating light displays. A two-year sojourn in

London ended in 1937 when, at Gropius's suggestion, he left to head the New Bauhaus in Chicago. After its failure he founded his own school in 1939, which later became the Institute of Design. Teaching was central to his ethos, and his influence was considerable. AA

Passuth, K., *Moholy-Nagy* (1985).

MOILLON, LOUISE (1610–96). French painter active in Paris. She was the daughter of a Protestant painter and art dealer living in Paris, but after his death in 1619 was trained by the minor still-life painter François Garnier. By the age of 20 she had already begun to specialize in still life. Her most typical works consist of a basket of fruits displayed on a sharply sloping table top, sometimes with homely vegetables alongside. An example from 1630 is in the Art Institute, Chicago. A few pictures survive that also incorporate figures: *The Fruit and Vegetable Seller* in the Louvre, Paris, is an example. Moillon's style has an archaic simplicity that is immensely appealing and contrasts with the flamboyant abundance of contemporary Flemish and Dutch still life. She seems to have painted little after her marriage in 1640. Her Protestantism led to persecution after the Revocation of the Edict of Nantes (1685) and she died in obscurity. MJ

Faré, M., *Le Grand Siècle de la nature morte en France* (1974).

MOLA, PIER FRANCESCO (1612–66). Italian painter and draughtsman. He was born at Coldrerio, near Lugano, but settled in Rome in 1616. He travelled widely in northern Italy, especially c.1633–40 and again 1641–7, absorbing influences everywhere from which to nourish his remarkably eclectic style. He was a brilliant draughtsman, with a painterly technique involving much use of wash; and was an extremely witty *caricaturist with a ribald sense of humour. His best paintings are relatively small-scale scenes, drawn from ancient mythology and the Bible, with romantic landscapes in the neo-Venetian style associated with *Poussin. Mola was a friend of *Testa, another artist who worked best on a small scale, and drew a portrait of him in 1637 (Montpellier, Mus. Fabre). His most famous picture is perhaps the *Barbary Pirate* (s.d. 1650; Paris, Louvre), which has a colourful naturalism reminiscent of *Serodine. Of Mola's more public commission the most important was a fresco of *Joseph and his Brothers* for the Palazzo del Quirinale, Rome (1656–7). The figures are positioned in the carefully constructed foreground space, against an idealized landscape, in a classical manner that suggests the influence of *Raphael's tapestry designs of

the *Acts of the Apostles* (London, V&A). A preparatory drawing (London, BM), with its emphatic use of the brush and warm wash to establish forms through light and shade, might also suggest he had studied Poussin drawings for the *Seven Sacraments* (1644–8; Edinburgh NG Scotland). In marked contrast the *Vision of S. Bruno*, painted for the Chigi family (c.1662–3; Los Angeles, Getty Mus.), is a powerful *Baroque image with a cool white-robed figure that recalls the monks in *Sacchi's *Vision of S. Romuald* (1631; Vatican Mus.), offset against a wild warm-toned landscape. Although Mola was a secondary figure on the Roman artistic scene, he was a highly talented artist, untroubled by academic theory but with a fertile visual imagination, especially in his graphic work. HB

Kahn-Rossi, M. (ed.), *Pier Francesco Mola*, exhib. cat. 1989 (Lugano, Mus. Cantonale).
Sutherland Harris, A., in *Master Drawings*, 30/2 (1992).

MOLENAER, JAN MIENSE (c.1610–68). Dutch painter and draughtsman. A colourful personality, Molenaer developed a career in Haarlem as a painter of genre, portraits, and allegories. Nothing is known of his training but a major influence on his work was Frans *Hals with whom his work is sometimes confused. In 1636 he married Judith *Leyster and they moved to Amsterdam after Molenaer's property had been confiscated to pay debts. The humorous *Two Boys and a Girl Making Music* (1629; London, NG) is a characteristic early work. The children, dressed in colourful clothes, chuckle mischievously in a golden, light-flooded space. It is freely painted although Molenaer's technique varies considerably depending upon the subject matter. One of his allegories is the impressive *Woman at her Toilet* (1633; Toledo, Oh., Mus.). From the 1640s, Molenaer specialized in low-life scenes, influenced by Adriaen van *Ostade, such as *Peasants Carousing* (1662; Boston, Mus. of Fine Arts). Molenaer seems always to have experienced financial difficulties, although property in Haarlem and Amsterdam and a large collection of 16th- and 17th-century paintings are listed in his will. CFW

Sutton, P., *Masters of 17th Century Dutch Genre Painting*, exhib. cat. 1984 (Philadelphia, Berlin, London).

MOLVIG, JON (1923–70). Australian painter. Molvig was born in Newcastle, New South Wales, and after serving in the Second World War studied at East Sydney Technical College and during trips to Europe 1945–52. In 1955 he moved to Brisbane where he taught painting until he became ill in 1967. Molvig's pictures 1955–9 are painted in a linear *Expressionist style verging on abstraction, which has much in common with American painters like *de Kooning, as seen in the vigorously painted *Primordia* (1956–7; Sydney, priv. coll.). In 1958 he made an expedition to central Australia where he was deeply impressed by Aboriginal art, which influenced his later paintings, particularly the *Pale Nudes* of 1964 and his *Tree of Life* series (1968–9). His work was included in several international exhibitions of Australian painting including Canada and New Zealand (1959) and London and Ottawa in 1962. DER

Churcher, B., *Molvig: The Lost Antipodean* (1984).

MOLYN, PIETER DE (1595–1661). Dutch landscape painter, a prolific draughtsman and etcher. Son of Flemish parents and born in London, Molyn became a master in the Haarlem guild in 1616. He was one of a number of Dutch artists including Esaias van de *Velde, Jan van *Goyen, and Salomon van *Ruysdael in the late 1620s who began to make small, monochromatic landscapes of local Dutch country scenes which are generally agreed to mark the beginning of the age of realistic painting in the Northern Netherlands. It is not known if these three painters worked together, if they arrived at similar solutions independently, or if one of them began experiments with tonal painting and others followed his lead. *Dune Landscape with Trees and Wagon* (1626; Brunswick, Herzog-Anton-Ulrich Mus.) is startling in its novelty and shows Molyn's new approach in the lower horizon, freer palette, and the subtle tonal colouring suggestive of air and atmosphere. His later paintings do not match the breadth and subtlety developed subsequently by van Goyen and Ruysdael. A series of four etched landscapes with genre figures bear the date 1626. CFW

Brown, C., et al., *Dutch Landscape: The Early Years*, exhib. cat. 1986 (London, NG).

MOMPER, JOOST (Josse) DE (1564–1635). The most important of a family of Flemish painters. He became a master in the Antwerp painters' guild in 1581. In the same year he probably went to Italy; he was back in Antwerp in 1590. Joost was a prolific landscape painter whose work is important in the transition between the constructed *landscapes of the 16th century and the naturalistic landscapes of the 17th. Early paintings are, typically, panoramic views related to works by Pieter *Bruegel I, but he also painted town and village views in the manner of Jan *Brueghel I, in which the forms are more realistic. He often collaborated with the figure painters Jan Brueghel I (*A Market and Bleaching Fields*, c.1621/2; Madrid, Prado), Hendrik van *Balen, Frans *Francken II, David *Teniers II, Tobias Verhaeght, and Sebastian *Vrancx. He had many followers and imitators, of whom his nephew Frans de Momper (1603–60) was the most important. KLB

Ertz, K., *Josse de Momper der Jüngere* (1986).

MONDRIAN, PIET (Pieter Cornelis Mondriaan) (1872–1944). Dutch *abstract painter and founder of *Neoplasticism. Led by deeply held spiritual beliefs, Mondrian experimented with *Impressionism, *Fauvism, *Divisionism, and *Cubism, in his search for the means to express a perfect universal harmony. A former student at Amsterdam Academy, his early paintings in the Dutch naturalistic tradition, for instance *Mill at Evening* (1905; The Hague, Gemeentemus.), show the simplicity of colour and composition which underscores all his later work. Inspired by *Toorop, and perhaps by his own theosophical beliefs, Mondrian's paintings of 1907–10 were *Symbolist in character, with bright primary colours chosen for their spiritual content. Living in Paris 1912–14, he developed the analytical linear style of his 'Tree' paintings (*Arbre*, 1913; London, Tate), which owe much to Cubist thinking. He remained in Holland during the First World War and by 1917 had totally rejected nature from his pictures for rectangles of white, grey, and primary colours, within lines of black or grey, which, he argued, had their own intrinsic values and relationships: *Compositions* (1914–17). Ultimately (c.1920), by using strict geometry, he eliminated the spatial dimension from his paintings and achieved the harmony he sought. It is for these uncompromising Neoplasticist paintings, as he called them, that Mondrian is best known, for instance *Composition with Red, Yellow and Blue* (1937–42; London, Tate). He lived in Paris 1919–38, where he based several paintings on the rhythms and square formation of the then popular foxtrot, and joined the *Abstraction-Création group, before moving to London, and finally settling in New York in 1940. New York's lively impact is evident in one of his most famous paintings *Broadway Boogie-Woogie* (1942–3; New York, MoMA), which, with its rhythmically broken lines, reflects his interest in the syncopated tempos of jazz and dance. Mondrian was a prolific writer who, together with van *Doesburg, founded the journal *De *Stijl* (1917) to spread ideas of how to achieve environmental harmony, leaving when other members introduced diagonals into their work. Other publications include his exposition *Le Néo-plasticisme* (1920), and an important essay *Jazz and Neo-plasticism* (1927). His collected writings *Piet Mondrian: Plastic Art and Pure Plastic Art* were published posthumously (1987). Besides greatly influencing the *New York School, and artists like Ben *Nicholson

and Max *Bill, his impact was felt throughout 1930s modern design and architecture. YJ

Joosten, J., and Welsh, R., *Piet Mondrian: A Catalogue Raisonné* (1996).

MONE (or Monet) JEAN (or Jan, Jehan) (c.1485×90–1549?). Sculptor from Louvain active in the Southern Netherlands. His earliest known works are the four stone statues for the portal of Aix-en-Provence Cathedral (1512 and 1513; destr. 1794). He was influenced by the classicizing sculpture of Jean Guiramand. It is presumed that he spent time in Italy, after which he moved to Barcelona where he worked as an assistant to Bartolomé *Ordóñez on the decoration in the choir of the Cathedral of S. Eulalia from 1517 to 1519. Following his appointment in 1522 to the court of Charles V Mone's success was assured, and from 1524 he signed himself 'Artiste de l'Empereur'. His best extant work, an alabaster altarpiece at Notre-Dame-de-Hal, reveals the depth of Mone's debt to 15th-century Italian traditions. His work is generally executed in a graceful and delicate style, with freely flowing forms and considerable sensitivity in the handling of subject matter and material. He was among the first Italianizing artists in the Netherlands, and probably among the most successful of his contemporaries in his ability to bring together and understand *Renaissance forms. OI

MONET, CLAUDE (1840–1926). French *landscape painter who exhibited at the *Impressionist exhibitions. He was introduced to painting out of doors by Eugène *Boudin whom he met in Le Havre in 1856–7. In 1859 he went to Paris where he studied at the Académie Suisse and, after two years' military service in Algiers, joined the studio of Charles Gleyre (1808–74), where he met Pierre-Auguste *Renoir, Alfred *Sisley, and Frédéric *Bazille. By 1864 he was working *en *plein air* in Barbizon, a favourite location for landscape painters since the 1840s. Two of his seascapes of the Seine estuary met with some critical success at the Salon of 1865 and for the rest of the 1860s he had a number of works accepted at the Salon (see under PARIS). In the summer of 1869 with Renoir he painted views of the bathing resort at La Grenouillère on the river Seine which because of their loose handling, informal compositions, commitment to *plein-airisme*, and the study of the way in which the colours of objects are affected by their environment, are often regarded as the earliest examples of the Impressionist idiom. Yet *La Grenouillère* (1869; New York, Met. Mus.) was probably never intended as a finished painting, but was closer to the sketches that landscape painters produced in the open air.

In 1874 Monet participated in what became known as the first Impressionist exhibition, and his painting *Impression: Sunrise* (1872; Paris, Mus. Marmottan), a loosely painted sketch of an industrial seascape, was mocked by the critic Louis Leroy in *Le Charivari* and the name was subsequently given to the exhibiting group itself. He exhibited at the Impressionist exhibitions of 1876, 1877, 1879, and 1882. In 1880 he had a work accepted at the Salon, but thereafter depended on dealers' shows to exhibit his work to a wider public. In the 1860s Monet had specialized in scenes of modern life but with his move to Argenteuil in 1871, and to Vétheuil in 1878, he began gradually to distance himself from representing urban or suburban landscapes, favouring those scenes in which references to the contemporary were notably absent. Although the dozen canvases of the *Gare St Lazare* in Paris, which were begun in 1877, dealt with an important aspect of modern life, the works were shorn of any social comment with which a *realist painter might have invested them, and were instead vehicles for the study of changing effects of light and atmosphere. The *Arrival of the Normandy Train at the Gare St Lazare* (1877; Chicago, Art Inst.) which was shown at the third Impressionist exhibition, displays a refinement of the *plein air* aesthetic with the dissolving forms broken up by the smoke.

In 1883, Monet moved to Giverny and from the 1890s he enjoyed considerable wealth which allowed him to construct a garden where he painted some of his most ambitious paintings, including over 250 versions of the *Waterlilies*. In the 1890s, Monet produced a number of paintings done in series. The first series, of the Creuse valley, was shown at a joint exhibition with *Rodin at Georges Petit's gallery in Paris in 1889 and this was followed by poplars, grainstacks, and views of Rouen Cathedral. Although each work was intended to capture a very specific atmospheric effect and time of day, taken as a whole the group had the effect of universality and timelessness and any references to the contemporary world were carefully suppressed. Nowhere was this deliberate withdrawal into a perfectly constructed rural utopia more apparent than in the *Waterlilies* decorative cycle (now in the Orangerie des Tuileries in Paris) which preoccupied Monet during the First World War and was technically unfinished at the time of his death in 1926. LSt

House, J., *Monet: Nature into Art* (1986).
Monet in the '90s: The Series Paintings, exhib. cat. 1989 (Boston, Mus. of Fine Arts).
Spate, V., *The Colour of Time: Claude Monet* (1992).
Tucker, P. H., *Monet at Argenteuil* (1982).

Wildenstein, D., *Claude Monet: biographie et catalogue raisonné* (5 vols., 1974–8).

MONNOT, PIERRE-ÉTIENNE (1657–1733). French sculptor who spent most of his career in Rome, where he was among the foremost artists of the late *Baroque. Although his earlier works have the elaborate draperies and agitated silhouettes typical of the followers of *Bernini, his masterpiece—a monumental marble figure of *S. Peter* (1708–13) in the nave of S. John Lateran—has the calmer rhythms and noble presence associated with the sculpture of François *Duquesnoy. For much of his life Monnot worked on the complex sculptural decoration of the Marmorbad at Kassel, a domed pleasure pavilion for which he supplied twelve life-size groups and eight reliefs with themes from Ovid. Another work exported from Rome—the tomb of the 5th Earl and Countess of Exeter (completed 1704; Stamford, Lincs., S. Martin) with its reclining effigies of the deceased propped up, Etruscan fashion, on one elbow—was very influential on English funerary *monuments of the 18th century. MJ

Enggass, R., *Early Eighteenth-Century Sculpture in Rome* (1976).

MONNOYER, JEAN-BAPTISTE (1636–99). Flemish painter and engraver, who after studying in Antwerp achieved a considerable reputation as a decorator in France and England. As assistant to *Le Brun he supplied designs of *grotesques for tapestries executed at Beauvais and painted flower pieces for Le Brun's decorations of the Galerie d'Apollon at the Louvre and elsewhere. He came to England in 1690 with the Duke of Montagu and contributed to the decorations at Montagu House, Hampton Court, Windsor, and Kensington Palace. HO

MONOTYPE, a method of working directly onto a copper plate or other surface such as glass or card. Printing ink is used, applied by brushes, fingers, or rags, and since no etching or engraving takes place only one or two impressions may be printed. G. B. *Castiglione and Anthonis Sallaert (c.1590–1658) made monotypes in the 17th century, and at the end of the 18th century some large colour prints were made by William *Blake. The most prolific artist in monotype was *Degas, who produced colour landscapes as well as a remarkable series of brothel scenes. In the 20th century its greatest exponent has been Jasper *Johns. The technique can often be recognized by a curious mottled texture of the ink, where it has been partially dragged from the surface of the plate in the printing. A monotype, particularly one drawn on glass, can be printed without a

press by simple manual procedure, by pressing paper against the inked surface. RGo

Reed, S. W., and Shapiro, B., *The Painterly Print: Monotypes from the Seventeenth to the Twentieth Century*, exhib. cat., 1980 (New York, Met. Mus.).

MONRO, DR THOMAS (1759–1833). English patron. Monro, who was physician to George III, ran an informal private *academy, at his house in Adelphi Terrace, London, to encourage young artists. *Turner, *Girtin, and *Cotman were among the many who benefited from copying English drawings in Monro's collection, which included works by J. R. *Cozens whom he had cared for at the Bethlem Hospital. He was a keen, if indifferent, amateur draughtsman influenced by his hero *Gainsborough, and is represented in the V&A, London. DER

Dr Thomas Monro and the Monro Acadamy, exhib. cat. 1976 (London, V&A).

MONTAGNA, BARTOLOMEO (1449?–1523). Italian painter. He was the most important artist in Vicenza at the close of the 15th and start of the 16th centuries; his son Benedetto Montagna worked as a painter and engraver well into the cinquecento. As the fresco fragment of the *Virgin and Child* (1481?; London, NG) attests, Bartolomeo's early work is influenced by Giovanni *Bellini and *Antonello da Messina, reflected in his rounded forms and crisp contours. In 1487 he executed an altarpiece of the *Virgin and Child with Saints* (Bergamo, Gal. Accademia Carrara), which, in line with his other mature works, is characterized by an interest in spatial complexity and a skilful manipulation of colour and light. In his later years he does not appear to have been interested in adapting or softening his style to emulate contemporary developments in Venice and he continued to paint crisply defined forms and complex architectural settings. In 1509–14 he resided in Padua, where he painted the fresco *The Exhumation of S. Anthony* (1512; Scuola S. Antonio). FB

Barbieri, F., *I pittori di Vicenza, 1480–1521* (1981).

MONTAÑES, JUAN MARTÍNEZ (1568–1649). The leading sculptor of the Sevillian School in Spain. His *polychrome sculptures continued the tradition of the 16th century but their heightened realism and more direct appeal savour of the *Baroque (cf. Gregorio *Fernández in Castile). His first important work was the reredos of S. Isidore at Santiponce, near Seville (begun in 1609), in which he had the collaboration of *Pacheco as his polychromist. Among his several versions of *The Immaculate Conception* that in Seville Cathedral combines a classical serenity and simplicity of pose with direct and naturalistic treatment. In 1636 he was called to Madrid to undertake his only recorded secular

work, a portrait head of Philip IV to serve as model for the *equestrian statue of the King executed by Pietro *Tacca in Florence. He directed a flourishing workshop at Seville and exported statues and reredoes to Peru. He exercised an important influence on his younger contemporaries, including *Zurbarán, *Velázquez, and *Cano. HO/MJ

Gilman Proske, B., *Juan Martínez Montañez: Sevillian Sculptor* (1967).

Hernández Díaz, J., *Juan Martínez Montañez 1568–1649* (1987).

MONTE DI GIOVANNI DI MINIATO. See GHERARDO DI GIOVANNI DI MINIATO.

MONTICELLI, ADOLPHE (1824–86). French painter of landscape, still life, *fêtes galantes*, genre, and portraits, who worked in Paris and in his native Marseilles. His early works are highly finished, but in 1855–6, in Paris, he responded to the Romantic art of *Delacroix; he also painted with *Diaz, whose influence is strong in such works as *Forest Scene* (c.1856; Dublin, Gal. of Modern Art) and in his growing interest in fantasy and *Rococo themes. Monticelli was a restless, experimental artist, whose style became increasingly abstract; his late landscapes, mainly on small wooden panels, are distinguished by richly textured surfaces, vibrant colour, and thick impasto. Among his many fantasy pictures are themes from *Faust* and the *Decameron*, and oriental and North African scenes; others are Renaissance costume pieces, suggestive of *Veronese. Such works as *Fountain in a Park* (London, NG) look back to *Watteau, and are part of a revived 19th-century interest in the Rococo, conveying nostalgia for a more graceful age. Monticelli was a friend of *Cézanne, and was revered by van *Gogh. HL

Garibaldi, C., and Garibaldi, M., *Monticelli* (1991).

MONTPELLIER, MUSÉE FABRE, a major French regional art gallery, with a character largely dictated by three Montpellier personalities. The painter François-Xavier Fabre (1766–1837), was trained at the Montpellier Society of Arts and sent to study in Paris with local support. He went to Rome in 1787, but moved to Florence in 1794 in the turbulence of the French Revolution. He became a successful portrait painter and dealer, and in 1824 he inherited the estate of his friend the Countess of Albany, the widow of the Young Pretender and muse of the great poet Alfieri. The following year he offered his collection to the Montpellier town council, and in 1826 he was received in triumph, having been brought from Livorno by a French warship. He oversaw the creation of the museum from an old mansion, became its first director, and was made a baron in 1828. His fine collection was oriented towards 16th-

and 17th-century Italian old masters, Dutch Italianate landscapes, and 18th-century French painting. In 1836 it was complemented by A. L. J. P. Valedau's bequest of top-quality 17th-century Dutch landscapes and genre pieces. Valedau had made his money profiteering from the Revolutionary Wars.

The second figure was the strange, melancholic local art enthusiast and collector Alfred Bruyas, the friend of many of the important French painters whose work he collected. Bruyas is depicted paying homage to *Courbet in *La Rencontre* (or *Bonjour Monsieur Courbet*) which Courbet painted during a visit to Montpellier in 1854, and this is probably the best-known painting in the collection that Bruyas left to the museum in 1876. The collection included several other important Courbets and a fine group of works by *Delacroix.

The last important personality for the museum was the early *Impressionist painter Frédéric *Bazille, who came from a prominent local family and was killed in the Franco-Prussian War. Several of his works have been presented to the museum by his family at various times, so that it now has the best collection of his work.

Fabre pursued an active acquisition policy during his time as director, and the Montpellier council have maintained the tradition in a notably enlightened way. AJL

Cabanne, P., *Nouveau Guide des musées de France* (1997).

MOORE, ALBERT (1841–93). English painter. Moore, the son of a mural and decorative painter, entered the RA Schools (see under LONDON) in 1858 and studied, briefly, in France in 1859 and Rome 1862–3. His early works, often on religious themes, were influenced by the *Pre-Raphaelites and in the 1860s he produced some stained-glass designs for William Morris's Company. However, little of Pre-Raphaelitism remains in his mature style which was fully formed by 1865. Moore's work derives from a synthesis of Greek sculpture and Japanese art which results in obviously classical female figures in poses of considerable refinement as in *A Venus* (1869; York, AG). He met *Whistler in 1865; each admired the other's work and had in common an interest in 'subjectless' pictures which resulted, in Moore's case, in titles like *Blossoms* (1881; London, Tate) which deliberately avoid any suggestion of narrative content. His figures, nude or draped, single or in groups, in a shallow picture plane, have no purpose other than to please the senses and thus typify *Aestheticism, art for art's sake. His work was unduly neglected for much of the 20th century. DER

Green, R., *Albert Moore and his Contemporaries*, exhib. cat. 1972 (Newcastle upon Tyne, Laing AG).

MOORE, HENRY (1898–1986). English sculptor and draughtsman. The son of a Yorkshire coalmining engineer, Moore studied at Leeds School of Art in 1919, after war service in France. In 1921 he won a scholarship to the Royal College, London, where, in addition to his studies, he spent much time in the British Museum. An enthusiastic *modernist, Moore kept in touch with European developments and admired the work of the British sculptors *Epstein, *Gaudier-Brzeska, and *Gill. From 1925 to 1931 he taught at the Royal College during which time, in 1928, he received his first commission, a relief for the London Underground Headquarters which proved controversial because of its *'primitivism'. His work of this period, like the *Reclining Figure* (1929; Leeds, AG) shows the influence of Epstein and 'primitive' Mayan art. During the 1930s Moore was associated with the Hampstead artists, particularly *Nicholson and *Hepworth whom he joined in the 7&5 Society in 1930 and Unit One in 1933, and moved to Chelsea School of Art (1932–9) which he found more progressive than the Royal College. The abstract biomorphic carvings of this period, including *Family* (1935; Henry Moore Foundation) and *Square Form* (1936; Norwich, Sainsbury Centre), are among his most innovative works and, in common with Hepworth, he also explored the potential of the pierced form, a stylistic device which was to bring him notoriety, in the 1930s. In 1940, through the diplomacy of Kenneth *Clark, Moore was commissioned as a *war artist and his drawings of sleepers in the Underground during the Blitz are among the most moving records of the Home Front. During the 1940s he established an international reputation which was confirmed by the award of the International Sculpture Prize at the Venice Biennale of 1948. During the 1950s monumental reclining female figures, of varying degrees of abstraction, dominated his work, culminating in the *Reclining Figure* carved for the UNESCO building, Paris, in 1957. He also produced increasing numbers of modelled and cast figures and through the 1960s experimented with sculptures in several parts, creating tension between the individual elements, as in *Double Figure* (London, outside Westminster Cathedral). Moore's output, from the 1960s until his death, was enormous and entailed the employment of many studio assistants; public and corporate commissions were matched by the sale of small maquettes, in limited editions, to satisfy individual collectors and inevitably the work is of uneven quality. There is, however, no doubt of his stature in 20th-century sculpture. Determinedly humanist, even at his most abstract, his forms evolved to chart human awareness and anxieties in a changing world. Vitality was the quality in sculpture that for him defined success or failure, a force unrelated to traditional concepts of beauty, revealed through the energy contained within the work. JH

Berthoud, R., *Henry Moore* (1987).

MORA, JOSÉ DE (1642–1724). Spanish Baroque sculptor, heavily influenced by Alonso *Cano during his stay in Granada. His *polychromed figures, such as the kneeling *Mater Dolorosa* of 1671 in S. Ana, Granada, display the realism and pathos demanded by popular devotion in 17th-century Spain. Mora spent the 1670s in Madrid as court sculptor to Charles II, before returning to the family workshop in Granada. During this time the melancholy realism of his work increased with the use of such materials as real hair and glass beads for tears. MJ

Gallego Burín, A., *José de Mora* (1925).
Martín González, J. J., *Escultura barroca en España 1600–1700* (1986).

MORALES, LUIS DE (c.1520–86). Spanish painter, active in Extremadura. A poorly documented life has invited various hypotheses about the artistic training of 'el divino Morales', as his contemporaries dubbed this master of Counter-Reformation spirituality. The figures in Morales's devotional paintings of *The Holy Family* (1562–9; New York, Hispanic Society of America) or the *Pietà* (c.1560–70; Madrid, Academia de S. Fernando) are clearly Flemish in origin, as is the enamel-like finish achieved by several layers of glaze. However, the *sfumato* modelling indicates familiarity, as well, with Italian painting. Morales lived and worked in the small and unremarkable city of Badajoz near Portugal, but he must have had contact with the important artistic centre at Seville. Morales's deeply expressive images suited the religious tenor of Spain, especially during the decades of the 1550s and 1560s; this, joined to his noted speed of execution, brought him many commissions for important foundations such as the Cathedral of Badajoz and the Dominican priory at Évora (Portugal), as well as for the parish churches of Extremadura. SS-P

Bäcksbacka, I., *Luis de Morales* (1962).

MORANDI, GIORGIO (1890–1964). Italian painter and etcher. He was born in Bologna, where he lived all his life. He remained aloof from the experiments of early 20th-century art, except for a brief period c.1918–19, when he practised a form of *Metaphysical painting. Although he produced some landscapes, most of his works were *still lifes, devoid of any symbolic content. They are characterized by subtle combinations of colour within a narrow tonal range, as in *Still Life* (1921; Cologne, Ludwig Mus.). Despite their relative conservatism, Morandi's paintings won great respect both in Italy and abroad for their poetic quality and refined composition. CJM

Vitali, L., *Morandi: catalogo generale* (2 vols., 1977).

MORAZZONE, IL (Pier Francesco Mazzucchelli) (1573–1625/6). Italian painter, born at Morazzone (Lombardy). He was one of the group of painters (which also included G. B. *Crespi and G. C. *Procaccini) associated with the artistic revival in Lombardy in the years when Cardinal Federico Borromeo was archbishop of Milan (1595–1631). He was trained in Rome, probably under Ventura Salimbeni (1568–1613) and *Cavaliere d'Arpino, and received an independent commission to paint frescoes of the *Visitation* and the *Adoration of the Magi* for S. Silvestro in Capite (in situ). These attractive early efforts suggest he had also studied the work of Taddeo *Zuccaro and *Barocci. By 1598 Morazzone was back in Lombardy, working at Varese on frescoes for the vault of the chapel of the Rosary in S. Vittore. By 1605 he had moved on to the *Sacro Monte* at Varallo where he frescoed one of the chapels with the *Road to Calvary*. This was followed by an *Ecce Homo* (1609–10) for a chapel where he collaborated with the sculptor Giovanni d'Enrico (c.1560–1646), whose terracotta figures are fully integrated with the *illusionistic space created by the frescoes. Morazzone also completed similar work in the chapel of the Flagellation at the *Sacro Monte* of Varese (1609). In 1611 we find him at Como, working on frescoes in the Sagrestia dei Mansionari in the cathedral. He was back at Varallo 1614–17 working in the chapel of the Condemnation.

Morazzone was at his best when painting in fresco in a style that draws on the dramatic realism of Gaudenzio *Ferrari and the vigorous, if somewhat over explicit, artistic tradition of rural Lombardy. However he was also in demand for altarpieces and religious narrative paintings: among these the most notable are the *Adoration of the Magi* in S. Antonio Abate, Milan (1611–12); and a series of scenes from the life of the Virgin at S. Maria Nascente, Arona (1617–18), where he makes dramatic use of chiaroscuro, for theatrical rather than naturalistic effect.

He was a truly visionary painter, and his ultimate achievement was the decoration of the Cappella della Buona Morte at S. Gaudenzio Novara (1620), both with illusionistic frescoes of angels on the ceiling and a vast canvas of the *Last Judgement* on the side wall. Francesco *Cairo was the only artist who attempted to emulate Morazzone's heightened sense of drama and religious emotion,

but he lacked his mentor's vitality and inimitable imagination. HB

Gregori, M., *Il Morazzone*, exhib. cat. 1962 (Varese).

MOREAU, GUSTAVE (1826–98). One of the fathers of French *Symbolism. He forged an eclectic, erudite, yet highly personal style of history painting inspired above all by the suggestive colourism of *Delacroix and the ornate allegories of 15th-century Italy. He was a Neo-Romantic painter-poet whose highest ambition was to express literary, philosophical themes by pictorial means. His enigmatic *Orpheus* (1865; Paris, Mus. d'Orsay), which entered the Musée du Luxembourg in 1866, became an object of pilgrimage for Symbolist writers, fascinated by its strange oneiric mystery. In his novel *A rebours* (1884) J.-K. *Huysmans created the enduring myth of Moreau as a kind of high priest in the Decadent cult of the femme fatale. In 1891 he began a career as an inspired professor at the École des Beaux-Arts, *Paris, numbering *Marquet, *Matisse, and *Rouault among his pupils. Towards the end of his life he created his own museum, the Moreau Museum in Paris. PC

Cooke, P., 'Gustave Moreau from *Song of Songs* (1853) to *Orpheus* (1866)', *Apollo* (Sept. 1998).
Kaplan, J. D., *The Art of Gustave Moreau* (1982).
Lacambre, G., *Gustave Moreau: Between Epic and Dream* (1999).
Mathieu, P.-L., *Gustave Moreau* (1977).

MOREAU, JEAN-MICHEL (1741–1814). Often called 'Moreau le jeune' to distinguish him from his older brother the landscape painter Louis-Gabriel Moreau (1740–1805), he was one of the most accomplished printmakers and draughtsmen of late 18th-century France. In the early part of his career, after a brief period as a drawing master at the St Petersburg Academy, he was a successful reproductive engraver after *Boucher, *Greuze, and other popular painters. He also contributed illustrations to Diderot and d'Alembert's *Encyclopédie*. His most enduring and appealing works, however, are the drawings and prints that he made of the fashionable manners and morals of the *ancien régime*. These range from his wash drawings of royal festivities at Versailles, such as those celebrating the marriage of the future Louis XVI to Marie-Antoinette in 1770 (Paris, Louvre), to his elegant and witty illustrations for the famous *Monument du costume physique et morale* (published 1777 and 1783; e.g. Paris, Bib. Nat.). He continued to put his skills to good use in the Revolution, though his more classicizing later style is rather thin and dry, and lived to enjoy briefly his reappointment to his old post of Dessinateur et Graveur du Cabinet du Roi at the Restoration. MJ

Moreau, A., *Les Moreau* (1893).
Normand, C., *Moreau le Jeune* (1909).

MOREELSE, PAULUS (1571–1638). Dutch painter. He came from a prosperous family in Utrecht, where he returned before 1596 from a visit to Italy. He was active in the establishment of Utrecht University, and became a town councillor. His political contacts resulted in many commissions for portraits, which are mostly rather stiff productions in the manner of his master van *Mierevelt. In the 1620s his repertoire broadened to include the mythologized portrait (*Sofia Hedwig, Duchess of Brunswick-Wolfenbüttel, with her Children, as Caritas*, 1621; Apeldoorn, Mus. Het Loo). At the same time he developed a genre of Arcadian fancy scenes—shepherds and shepherdesses, with the blonde shepherdesses often displaying deep décolletage—that became very popular. His Italianate history and religious paintings (*Beheading of John the Baptist*, 1618; Lisbon, Mus. Nacional de Arte Antiga) look old-fashioned and tentative in comparison with the assured *Caravaggism of his pupil van *Baburen. AJL

MOREL, JACQUES (active *c.*1418, d. 1459). French sculptor and son of sculptor Pierre Morel, who worked for the papal court in Avignon. Jacques was incredibly prolific and his documented commissions include working in Lyons for Cardinal Amédée de Saluces, in 1422 on a silver altarpiece for the Avignon Cathedral, in 1433 in Béziers on the church of S. Aphrodise, in 1448 in Rodez on the decoration of the southern portal of the cathedral, and in Angers on the tomb of King René of Anjou. Many of these works have been destroyed. His only surviving documented work is the tomb of Charles I, Duke of Bourbon, and Anne of Burgundy (1448–53; Souvigny, Chapelle Neuve de S. Pierre). This shows his assimilation of the dramatic qualities that Claus *Sluter had introduced to sculpture; it was most likely this that led to his winning the commission for the Bourbon tomb: the contract specified that it should be based on Sluter's renowned tomb for Philip the Bold, Duke of Burgundy (Dijon, Mus. des Beaux-Arts). KC

Robin, F., *La Cour d'Anjou-Provence: la vie artistique sous le règne de René* (1985).
Troescher, G., *Die burgundische Plastik des ausgehenden Mittelalters und ihre Wirkungen auf die europäische Kunst* (1940).

MORELLI, GIOVANNI (1816–91). Italian politician, connoisseur, and scientist, who wrote a revolutionary book that made *connoisseurship the central concern of art history for a century. Although Morelli was by birth an Italian, he was by parentage and education Swiss, and by intellectual development German, having studied science at the universities of Munich and Erlangen 1833–8. In the 1850s he developed his scientific method of attribution, a method inspired by the comparative methodologies of the natural sciences. His method consisted of analysing a hierarchy of details, some anatomical, such as the characteristic hands, eyes, and ears used by Renaissance artists, and others, such as the habitual elements of colouring, folds of drapery, and landscape motifs. By means of his method Morelli had an enviable ability to make the right attributions, both to assign pictures to great names (such as *Giorgione's *Sleeping Venus in a Landscape* (Dresden, Gemäldegal.)), and also to take away impossible attributions from famous artists (such as the elimination of the *Reading Magdalene* from *Correggio's œuvre (Dresden, Gemäldegal.). From the 1870s, in a series of articles and books, published under the pseudonym Ivan Lermolieff, Morelli successfully revised the attributions of thousands of Italian Renaissance paintings in private and public collections in Italy and abroad. These articles were translated into English as *Italian Painters: Critical Studies of their Works* (1892–3). Morelli's invention of connoisseurship was a diagnostic instrument to identify and preserve the national patrimony of Italy against the aggressive collecting policies of national galleries abroad such as *London and *Berlin. As a politician (1859–72 elected representative for Bergamo in the Camera dei Deputati, 1874–91 Italian senator) he was responsible for devising legislation to prevent the export of works of art from Italy, for creating new museums with novel installations, and for the establishment of restoration on sound principles in Italy. Morelli's politics in the Risorgimento helped define the *Renaissance for posterity. JA

Anderson, J., *Collecting, Connoisseurship and the Art Market in Risorgimento Italy: Giovanni Morelli's Letters to his Cousin (1866–1872)*, Memorie del Instituto Veneto di scienze, lettere ed arti (1997).
Anderson, J., 'National Museums, the Art Market and Old Master Paintings', in P. Ganz (ed.), *Kunst und Kunsttheorie 1400–1900*, Wölfenbütteler Forschungen IIL (1991).

MORETTO DA BRESCIA (Alessandro Bonvicino) (*c.*1492×5–1554). The foremost Brescian painter of the 16th century, creating grave and powerful religious works for the churches of many Lombard towns, and influential portraits. He was trained in the tradition of *Foppa, but was early influenced by *Titian, and in his mature period responded to central Italian art; his best works unite humble figures, and a Lombard realism of surface and texture, with Roman grandeur and rhetoric. In 1521–4 he collaborated with *Romanino in the decoration of the Cappella del Sacramento in S. Giovanni Evangelista, Brescia. Many of his works were commissioned by the religious confraternities in Brescia, and Moretto was a devout

painter, whose art movingly conveys the re-awakened religious fervour characteristic of these years; his *Apparition of the Virgin to the Deaf Mute Filippo Viotti* (1533–4; Paitone, sanctuary) is a strikingly naturalistic treatment of a visionary subject. His late works, such as *Christ and the Angel* (1540s; Brescia, Pin. civica Tosio e Martinengo), in pale greys and browns, are increasingly stark. His *Portrait of a Gentleman* (1526; London, NG), relaxed and direct, is the earliest surviving Italian full-length portrait, a theme developed by Titian and by Moretto's pupil *Moroni. HL

dell' Acqua, G. A., *Alessandro Bonvicino, il Moretto*, exhib. cat. 1988 (Brescia, Monastero S. Giulia).

M ORINCK, HANS (c.1555–1616). Dutch sculptor active in Germany who is first documented in 1578 working at Peterhausen Abbey near Konstanz. His earliest works show the influence of other sculptors active in the area, the Heiligenberg Master and Master Michael, the monogrammist MVDV. Morinck adopted the former's restrained interpretation of Cornelis *Floris's architectural decorations, and from the latter the technique for carving in shallow relief and the preference for Netherlandish prints as a source of compositional design. Much of his work during the 1580s was executed in wood, including his earliest important commission, the *Coronation of the Virgin* for the altar of the abbey church of S. Blasien (1586; untraced). Later works were often executed in stone, including the tomb of Helene von Raitenau (1595; SS Petrus and Paulus, Örsingen), with dramatic, packed compositions in high relief. His finest works include the *Trinity* (c.1600; Kahlsruhe, Landesmus.), the *Crucifixion* (1606; Oberstadion), and his most noted work, the *Entombment* (1609–10; Konstanz, S. Stephan). Morinck achieved considerable success and his work is of a quality comparable to the best of his contemporaries in Germany. OI

M ORISOT, BERTHE (1841–95). French *Impressionist painter. Her father was a senior civil servant, and she remained a respected member of the well-to-do Parisian *haute bourgeoisie*. She was an informal pupil of *Corot, and exhibited work under his influence in the 1864 *Paris Salon. In the late 1860s she became friendly with *Manet (whose brother Eugène she married in 1874) and with *Degas. She was a committed member of the Impressionist group and exhibited at all the Impressionist exhibitions except the fourth. Morisot's gender and social class excluded her from training at an art school, from participation in the life of the cafés, and from much social contact and observation. Many of her paintings represent scenes of charming bourgeois domesticity featuring

members of her family, especially her daughter. Such themes were considered appropriate for women painters; Morisot must certainly have found them convenient and perhaps congenial. Her flickering, sketchy brushwork is often very successful in capturing the effect of a fleeting moment in *plein air pieces, as in *Woman and Child in the Garden at Bougival* (Cardiff, National Mus. Wales). AJL

Adler, K., and Garb, T., *Berthe Morisot* (1987).

M ORLAND, GEORGE (1763–1804). English painter. He was trained by his father Henry (c.1719–97), who was reputed to have exploited his son's precocious talents, and from the late 1770s showed accomplished genre scenes at the Society of Artists and the RA (see both under LONDON). Larger works of rustic genre and dramatic coastal scenes, often painted on the Isle of Wight, for instance *The Coming Storm* (1789; Wolverhampton, AG), followed. These gained widespread popularity through prints and japanned trays. His notorious dissipation undermined his early promise and he produced many inferior copies of his work to stave off poverty. DER

Thomas, D., *George Morland*, exhib. cat. 1954 (Arts Council touring exhibition).

MORO, ANTONIO. See MOR VAN DASHORST, ANTHONIS.

M ORONE, DOMENICO (1442?–after 1518). Veronese painter, considered to be the most important of his native city in the early *Renaissance. His reputation endured into the 16th century through his own activity and that of his son Francesco Morone. Among Domenico's earliest surviving recorded works is a *Madonna and Child* (Berlin, Gemäldegal.) signed and dated in 1483. *Mantegna's influence is evident in this piece, and Domenico almost certainly came into contact with a Mantegnesque style through the art of Francesco Benaglio, considered to be Domenico's teacher. In 1494 he executed a large-scale battle scene of the *Expulsion of the Bonacolsi* (Mantua, Palazzo Ducale), which reveals an animated and well-designed narrative influenced by Venetian sources and enriched with keenly observed details of Mantua. Throughout the 1490s Domenico led a large workshop which was involved in many great commissions including the fresco cycle for the library of S. Bernardino, Verona (1503); in this work he blended his own powers of observation with Mantegnesque spatial effects and decorative motifs. FB

Marinelli, S., in M. Lucco (ed.), *La pittura nel Veneto: il quattrocento* (1990).

M ORONI, GIOVANNI BATTISTA (1520×4–78). Italian painter, the most distinguished portraitist working in 16th-century Bergamo and its neighbouring towns, whose works are characterized by an unusual directness and warm naturalism. Born in Albino, in the foothills of the Alps, he was from c.1532 a pupil of *Moretto in Brescia. Later he worked at Trent and Bergamo, and 1561–78 largely at Albino. His early portraits, mainly of Brescian and Bergamese noblemen, are full-length and life size, and, as in the *Knight of the Wounded Foot* (late 1550s; London, NG), often embody emblems, classical ruins, and inscriptions, which evoke the cult of chivalry and Spanish manners then fashionable. His late portraits are sombre in colour, and the sitters look directly at the spectator, creating, as in the *Tailor* (c.1570; London, NG), a sense of vivid immediacy. His profoundly conservative religious works include altarpieces and devotional works, and Moroni conformed to Counter-Reformation demands for simplicity and clarity. Such works as *Crucifixion with S. John the Baptist, S. Sebastian, and a Donor* (Bergamo, S. Alessandro della Croce) unite portraits and religious figures. The secular figures seem to invite the spectator to contemplate the sacred theme, and may reflect Counter-Reformation meditative techniques. HL

Gregori, M., *Moroni* (1975).

M ORPHOLOGY, the science of form. The history of morphology and its influence on art is as complex as the disciplines to which the term has been applied. It is associated historically with zoology, where it was first developed into a separate branch of enquiry with works such as Abraham Trembley's *Mémoires, pour servir à l'histoire d'un genre de polypes d'eau douce* (1744), and is the branch of biology interested in the nature of anatomy in plants and animals, in particular the homologies, structures, and metamorphoses which govern or influence form.

It is *Goethe who is credited with the invention of the science but the most fundamental figure in its application to, and analysis of, art was the Italian writer, collector, and art historian Giovanni *Morelli. He appropriated Goethe's term 'morphology' and used it for his scientific method of *connoisseurship based on the study of external forms in painting. One of the many influential adherents to this method was Bernard *Berenson. OI

M ORSE, SAMUEL (1791–1872). American artist and inventor. Morse was born in Charlestown, Mass., and after graduating from Yale (1810), accompanied *Allston to London to study under *West. Morse had ambitions to be a *history painter, claiming, 'I cannot be happy unless I am pursuing the

intellectual branch of the art.' From c.1812 to 1815 he was preoccupied by the subject of the death of Hercules, winning the Society of Arts' gold medal, in 1812, for a statuette and exhibiting an enormous, dramatic, but bathetic oil, *The Dying Hercules* (New Haven, Yale University AG), at the RA in 1815. In the same year he returned to America and, finding no market for histories, reluctantly turned to portraiture. In 1826 he helped to found the National Academy of Design (see under NEW YORK), becoming the first president, and, coincidentally, painted one of his finer portraits, *Lafayette* (New York, Brooklyn Mus.), a brooding full-length of the French politician, beside busts of Roman statesmen, against a portentous sky. In 1829–32 and 1838 he was in Europe but, between the two visits, abandoned painting for science, inventing the magnetic telegraph on which his fame rests.

DER

Larkin, O., *Samuel Morse and American Democratic Art* (1954).

MOR VAN DASHORST, ANTHONIS, also called Antonio Moro (1516×20–1575/6). Dutch portrait painter. He was the pupil of Jan van *Scorel in Utrecht and had visited Italy before 1547 when he was registered in the Antwerp guild. His subsequent work reveals a knowledge of *Titian's portraiture. By September 1549 he was working for Cardinal Granvelle, Bishop of Arras, and beginning a career in the Habsburg court. This involved visits to Spain, Portugal, and England where, in December 1554, he was appointed painter to Philip of Spain, apparently as a reward for his painting of *Mary Tudor* (1554; Madrid, Prado). In 1559 he followed Philip to Spain but abruptly returned to the Netherlands, probably in 1561. He remained in contact with the Habsburg court, even after the outbreak of revolt and iconoclasm in 1566, but also painted the mercantile and humanist elites of Antwerp and Utrecht, and a few religious and classical subjects. His portraiture is distinguished by its reconciliation of intense illusionism with creative use of established conventions to produce acute social and psychological characterizations.

JW

Friedlander, M., *Early Netherlandish Painting*, vol. 13 (2nd English edn., 1975).

MORTIMER, JOHN HAMILTON (1741–79). English painter and etcher. Mortimer, who was apprenticed to the portrait painter Thomas *Hudson c.1757, supplemented his training by attending the St Martin's Lane Academy, London, and studying with the historical painter Robert Edge Pyne (1730–88). He painted competent portraits close to those of his great friend *Wright of Derby and conversation pieces in the manner of *Zoffany but found his true *métier* after

1764 when he won the Society of Artists' prize for *history painting with *S. Paul Preaching to the Britons* (High Wycombe, Guildhall). After 1770 his work shows the acknowledged influence of Salvator *Rosa whose subjects he copied in drawings and etchings and adapted for his own paintings of romantic banditti: *Bandit Taking up his Post* (Detroit, Inst. of Arts). He was an accomplished etcher whose *Shakespearean Heads* (1775–6; London, BM) were admired by his contemporaries and his drawings greatly influenced Thomas *Rowlandson who owned a large collection. Mortimer was closely associated with the Society of Artists, becoming vice-president in 1773, but was finally wooed over to the RA in 1778.

See Royal Academy, St Martin's Lane Academy, and Society of Artists under LONDON.

DER

Nicholson, B., *John Hamilton Mortimer*, exhib. cat. 1968 (London, Kenwood House).

MOSAIC is the creation of images and designs from small blocks of coloured glass, stone, and other suitable materials fixed in a plaster bed. It was developed extensively by the Romans (see ROMAN ART, ANCIENT) in pavements and by the *Byzantines as wall and vault decoration, particularly in churches. Mosaic has been occasionally used as exterior decoration on the façades of medieval churches and modern architecture; it has also been used as a furniture inlay and to create small-scale portable pictures. One of the most remarkable forms of mosaic production is Byzantine miniature mosaic icons, where tesserae of no more than 1 mm (¹⁄₂₅ in) square were set in wax or resin on wood to create detailed images. However, it is as a monumental, interior medium that it is most effective.

A form of mosaic was made by the Sumerians, who ornamented their buildings with cones of coloured terracotta; the Egyptians used a simple form of glass mosaic on some interior walls; and small cubes of gold and precious stones, which may have been used for miniature mosaics, have been discovered from *Minoan Crete. Natural pebble mosaic floors are found throughout the east Mediterranean from the neolithic period; 8th- or 7th-century BC examples from Asia Minor display simple geometric patterns. From perhaps the 5th century BC, pictorial scenes of mythology and daily life are found in Greece, notably at Pella and Olynthus in Macedonia; light colours are used for figures and dark for backgrounds. From the 3rd century, deliberately cut and shaped stone pieces, or tesserae, begin to appear and then to dominate mosaics. Tesserae were normally of stone, though terracotta and glass might also be used. The stone was usually local, though desirable rocks might be transported some distance. With the development of artificial

tesserae came increasing care in mosaic construction. Foundations were a crucial area, great care being taken to lay these correctly, solidly, and accurately. Guide lines for the mosaic were ruled or painted on the top layer of the foundations and tesserae then laid on a thin bed of mortar spread over these. By the 1st century, a durable, waterproof cement foundation for mosaic had been invented, facilitating its use. Mosaic was thus made suitable for paving courtyards and bathhouses as well as private rooms. Three ways of setting the mosaic were practised. Floor mosaics might be laid directly into the bedding mortar; they might be bedded in sand and then glued to strong paper or cloth and set in the mortar, the backing then removed; or they might be assembled in reverse, each piece glued face down to the backing, to create an image the reverse of that showing on the backing paper. These last two methods allowed mosaics to be prefabricated, with all the advantages that entailed. On the other hand, breaks in borders and interrupted panels apparent in some floor mosaics bear witness to the drawbacks of these techniques.

Early Roman floor mosaics tended to have plain black figures and designs on white backgrounds. Increasingly elaborate and intricate mosaics, known as *emblema*, were used as centrepieces for floors of otherwise simple design. Made with minute tesserae—the work was referred to as *opus vermiculatum*, or worm-work—these were probably prefabricated for export and setting into locally made floors, a practice which continued late into the Roman period. Subjects varied widely—scenes from nature, mythology, daily life, the theatre, and even historical scenes, as with the very large *Alexander* mosaic from *Pompeii, depicting the defeat of Darius at the battle of Issus and based on a Greek wall painting. Multicoloured mosaics of a uniform pictorial design, as in the series from Antioch, are a slightly later development, superseding the *emblema* by the 2nd century AD. Often the subject was designed to fit the room; athletes are pictured in the palaestra of the Baths of Caracalla in Rome. Large scenes were popular, as in the hunting mosaic from the villa of Piazza Armerina in Sicily, dated to the 4th century, and the scenes of daily life and hunting from the Great Palace floor mosaics at Constantinople (?6th century).

The Romans also made wall mosaics. Until the mid-1st century AD, these were used almost exclusively in fountains and nymphaea, or grottoes, which acted as cool retreats and so had a place in almost every villa. Shell, pumice, stucco, and marble formed the basic materials, but gradually glass was incorporated also. No large-scale compositions have survived, but mosaics of

coloured glass are found in doorways, pillars, and niches at, for example, *Herculaneum and Pompeii and in Nero's *Domus Aurea* in Rome. They are similar in design and texture to floor mosaics, though the shift from floor to wall enabled a wider range of less durable materials to be introduced, above all glass.

Once Christianity became the official religion of the Roman Empire, mosaics were no longer used only on floors. It was felt more respectful to depict holy personages on walls and ceilings, away from trampling feet. It was the Byzantines who used wall mosaic to its greatest potential. For the Byzantines, mosaic was the material par excellence of art, its use a claim to skill, artistry, and prestige. It was the most elaborate and expensive form of mural decoration used, and it survives today, above all, in churches. Initially mosaics were restricted to areas such as domes and apses and often, as at S. Maria Maggiore in Rome, produced on too small a scale to be visible from the body of the church. Gradually, however, they began to dominate the interior of buildings; in the 4th century Mausoleum of Galla Placidia in Ravenna, spectacular blue mosaics cover the entire roof and vault space. The later 5th–6th-century churches of S. Apollinare Nuovo and S. Apollinare in Classe in Ravenna and S. Demetrius in Thessaloniki show how a basilica church could be successfully decorated with mosaics. At S. Vitale, Ravenna, with its paired images of the Emperor Justinian and Empress Theodora with their attendant courts, and in the Rotunda in Thessaloniki, mosaic is used to great effect in domed, centrally planned churches. In both cases, mosaic is used as a fluid medium, knitting to the architecture and following and emphasizing the lines of each of these very different buildings; images are life size and decoration fills the entire space. The 6th-century rebuilding of Hagia Sophia, Istanbul, established a new model; marble panels rose up to the level of the springings of the vaults and gold mosaic filled everywhere above. By the late 8th century, mosaic images of holy figures were a common feature in churches, replaced in *Iconoclasm with crosses, as at Hagia Eirene in Istanbul, animals, and floral ornament. After Iconoclasm, mosaic was used extensively in churches, pulling together a unified scheme of decoration in which the church served as heaven on earth. Sacred images were arranged in a hierarchical fashion, Christ and the Virgin in dome and apse, scenes from the life of Christ at the next level, and saints below. Cycles of the life of Christ and the life of the Virgin became increasingly detailed and holy figures proliferated. The Greek churches of Hosios Loukas, Nea Moni, and Daphni, dating to the 10th and 11th centuries, retain the fullest surviving Byzantine examples of this sort of scheme. The delicate,

brighter mosaics of the 13th/14th-century Kariye Camii (the church of Christ in Chora) in Istanbul show how the art continued to the fall of the empire. Mosaic was also used in secular contexts, generally imperial, as with the imperial portraits in Hagia Sophia and, Byzantine authors inform us, in the Great Palace of the Byzantine emperors.

The West, after the breakdown of the Roman Empire, rapidly lost the skill of mosaic-making and became dependent on Greek artists and models. A 9th-century series of mosaics was produced in Rome, and Charlemagne had mosaics constructed for his palace chapel at Aachen. Tesserae and artisans were constantly exported from the empire. In the 8th century, they went to decorate Pope John VII's oratory in Rome and to the Great Mosque in Damascus and the Dome of the Rock in Jerusalem; in the 11th century to S. Sophia in Kiev; and in the 12th century to Sicily and the Norman churches in Cefalù, Palermo, and Monreale; and to Bethlehem. Byzantine mosaicists also worked at S. Mark's, Venice, and the island churches of Torcello and Murano in this same period. In Venice, the art became firmly established; local artists provided most of the work for the 13th- and 14th-century mosaics in S. Mark's.

Mosaic was a vastly expensive medium, involving huge amounts of glass tesserae—it is calculated that 2.5 million gold tesserae were needed for the apse of Hagia Sophia alone. Consequently, only the wealthiest—the emperor and the highest ecclesiastical or lay nobility—could afford such commissions. In this way, mosaic represented the ultimate artistic status symbol of the Middle Ages. For those states that did not possess the necessary skills, the import of artists and materials from Byzantium was both a gesture of their own status and an acknowledgement of Byzantine cultural superiority.

Glass tesserae were standard in wall mosaics from about the time of the Roman Emperor Tiberius (AD 14–37), though stone, brick, shell, and other such materials were also employed. Roman and Byzantine mosaic glass is essentially of the type known as soda-lime glass. The colours of such glass depend on the impurities present in the basic mixture of sand and lime and the different metallic oxides deliberately added to produce specific colours. Copper oxide, for example, might be added to produce deep and pale blues and deep greens, depending on the quantity added. Roman and Byzantine chemical knowledge was not always equal to removing the impurities in raw materials. The range of coloration in glass often indicates the uncertain outcome of the attempt to produce a fixed hue—tesserae have a wide range of shades, which may well be unintentional. Even where old, proven recipes were used, wildly differing results could be obtained

depending on the materials and proportions employed and the temperature of the furnace.

Though the method of colouring glass tesserae is identical to that of colouring glassware, the means of production of the glass itself are different. Mosaic glass seems to have been made in a variety of ways. The muff technique involved molten glass being blown and then shaped on a marvering slab (the flat slab on which molten glass is rolled). It was then reheated, formed into cylindrical shapes, cut lengthways, and opened up into sheets of glass. In the annealing chamber, these were heated very slowly and allowed to flatten under their own weight, with the aid of a smoothing block. These sheets were of varying thickness and unconfined by moulds at the edges—a rounded edge on one side of a tessera indicates that it came from the side of a plate. The glass was then cut into the required shapes and sizes in a way similar to scoring and cutting toffee. Alternatively, glass could be drawn into tubes, cut lengthways and laid out; or it could be cast as thin cakes which were then subdivided. The evidence from the 14th-century cathedral at Orvieto provides indications of the tools used in mosaic-making, ranging from hammers, anvils, and a variety of cutting tools to blowpipes, shears, and ladles on the glass-making side.

The sizes of the tesserae depend on the thickness of the plate and also where the pieces were to be used in the mosaic. The largest, used in backgrounds and large areas of colour, might be as much as 1.5 cm (½ in); the smallest, used for details such as faces, could be no more than 4 or 5 mm (³⁄₁₆ in). Different surfaces could be obtained for varying visual effects: the fractured side of a tessera is the most lustrous and the top and bottom both appear different. Tesserae of the darkest values are most glossy, and free from air holes, which become larger and more numerous the lighter the piece. Tesserae of mixed colour could be obtained by using several metals in the making of the glass plates. Metallic tesserae were made by overlaying a plate of transparent (usually, in fact, pale green) glass perhaps 6 mm (¼ in) thick with the gold or silver leaf, and then coating this with a thin (1 mm/less than ¹⁄₁₆ in) layer of clear glass. This was then heated until the elements fused. Where this fusion did not occur, layers have since been lost. A variety of effects can be achieved through the use of gold tesserae. They create an amber effect when set on their sides, as can be seen at the Kariye Camii, Istanbul. Also at the Kariye, molten glass for the manufacture of gold tesserae was apparently poured on a surface covered with a red substance. This has given the undersurface of these tesserae a red

colour and pebbled texture. When set in reverse, they can be mistaken for red tesserae. Silver tesserae were also mixed in with gold to vary the overall background effect, or used to great effect in their own right in figural details. Where colours were hard to make or obtain, uncoloured tesserae were overpainted: red glass was particularly difficult and often, as in the narthex panel in Hagia Sophia, red paint was applied.

Because lack of analysis and excavation makes it unclear whether tesserae were made on site or imported, it has been proposed that instead of manufacturing glass, the Byzantines imported all their needs from the Arab world, combining this with a continual reuse of tesserae. However, as Byzantine craftsmen were imported for the construction of the Great Mosque in Damascus and the Dome of the Rock, Jerusalem, and since tesserae went with them there, and later to Kiev, there seems little reason to suppose that the Byzantines lacked the skill to make their own materials. Moreover, the practicalities of putting up a mosaic and the quantities of tesserae involved suggest that the Byzantines needed to provide their own tesserae, preferably on site. Research on the composition of tesserae suggests an extensive localization of glass-making. Tesserae from Shikmona in Israel (5th century), Hosios Lukas (Greece) (10th century), and from S. Mark's, Venice (11th to 13th century), have been tied tightly to each site on the grounds of their composition, suggesting if not necessarily a local industry for each, then at least a single, separate source for each group. However, it may be that more than one source was needed to provide the full range of colours available. At Orvieto, documentary evidence about the mosaics of 1321–c.1390 shows that much glass was made on site or locally, but that some was imported, notably from the glass-making centre of Venice. Some colourants were also brought in, and special reference is made to blue, as is the case elsewhere in Italy for painters and other craftworkers. What colours were available for a particular mosaic depended on what was available and the only way that this could be controlled and organized in any practical sense would be in its manufacture on site. The mosaicist's ability to obtain colours, and the availability of certain types of glass, determines the appearance of the mosaic. The evidence from Nea Moni (Greece) and the Kariye Camii suggests that a fairly narrow range of shades may have been preferred; documents from Orvieto record that buyers in Venice were instructed to buy three to five shades of each colour.

The Orvieto evidence suggests the existence of mosaic workshops, but for Byzantium, little evidence of actual working practices exists. Until the late 1950s, it was believed that mosaics were made in sections in a workshop, tesserae being attached to cartoons, and then transferred to the wall. However, such a method is inherently impractical. It is now generally accepted that artists (quite probably the mosaicists themselves) painted preliminary drawings straight onto the plaster of the walls and then set the tesserae directly. Mosaic setting beds consist of two or three layers of mortar. The first, a coarse, strong cement, was applied directly to the masonry and roughened to receive the second, finer layer. The top layer, a form of plaster, was the finest, and smoothed to receive the cubes. This layer was occasionally reinforced with iron clamps. Unlike with true fresco, large areas of wall could be plastered at once as the drying does not seem to have been particularly rapid. However, we have no real knowledge of how rapidly mosaicists could work. Two kinds of preliminary sketches seem to exist: those painted onto the masonry itself or on early layers of plaster, and those painted directly onto the setting beds. These acted as guides for the mosaicist, though they were not always followed. At the Kariye Camii, the plaster beneath the mosaics seems to have been painted in considerable detail, including shading. It is suggested that this acted as a detailed guide to the mosaicists in the delineation not only of form and drapery folds, but also in the indication of colours and the values of these colours. It also concealed the white interstices of the tesserae.

Normal procedure in laying out a mosaic seems to have been to set the outlines of the figure first and then to fill in the surrounding areas. However in later mosaics work was begun from the top with the gold background, which was laid down as far as the figures, which were then inserted. This can be seen, for example, in the 9th-century apse mosaic of Hagia Sophia, where concentric gold lines come down from the crown of the apse to the head of the Virgin and then resume around her. In the late Antique period, the illusion of three-dimensional form was created by the juxtaposition of tesserae of contrasting colour values, which merged into a recognizable shape only when seen from a distance. In mosaics in Rome in the late 6th and early 7th centuries, each form is clearly defined with dark outlines, tightly set with tesserae of a single colour, resulting in a flat unified surface. This is apparent, for example, in the churches of S. Agnese and S. Lorenzo fuori le mura and in the oratory of Pope John VII at S. Peter's. Dark lines are used to indicate basic form: contours, facial features, drapery folds; colour is used within this framework to create a glittering effect.

Glass was preferred because of its light-catching properties; the effect of glass tesserae in a mosaic is to create brilliance and richness through the changing effect of the refraction of light. The insertion of single tesserae produced a non-uniform surface picking up light through the angling and aligning of tesserae for the creation of particular optical effects. Other substances might be employed if they provided the colour more easily and cheaply, depending on the resources available, or to create different colouristic effects. Stone, especially marble, terracotta, and shells might be used to this end. They were also more stable sources of colour. For floor mosaics, stone remained the dominant material. Before the 4th century, there appears to have been little use of gold tesserae.

Mosaics present a major challenge to the artist. Coloured glass is not a flexible medium. The mosaicist is forced to model and build a picture using only small blocks of pure colour. Colours cannot be mixed; to change colour, the artist can only pick up the next set of coloured cubes. Blending is virtually impossible. Strips of pure colour have to be laid down next to each other; consequently, in photographs, mosaics often look crude, two-dimensional, unmodelled. Ugly, jarring colours, greens and oranges especially, are juxtaposed in creating textures, faces, and details. The trick Byzantine mosaicists employed to overcome this problem was that of distance. Mosaics were designed to be seen from a distance and at an angle: those in Nea Moni, Greece, are perhaps 10 m (30 ft) above ground; the Virgin in the apse of Hagia Sophia, Istanbul, is some 30 m (100 ft) up. Very simply, mosaic art is a monumental art. What looks clumsy, artificial, flat, and coarse from close to or head on springs into focus from afar. The techniques and skills of Byzantine mosaicists lay in manipulating optical artifices to get the best out of their medium and to turn the apparently intractable nature of pure colour into a flexible, fluid medium, even to the extent of creating three-dimensional effects if so desired. The mosaicist's work was in two spatial dimensions, creating from close up a work designed only to be seen from far away.

It is the lack of flexibility in the use of colour which forms the key element in understanding the artistic construction of a mosaic. Within a mosaic, colour must be used in blocks defined and bound by contours, the lines around each colour plane. Modelling and form are revealed through colour changes. As mosaic does not allow for subtle modelling, the representation of faces presented particular problems in the use of colour. Here, optical tricks were combined most effectively with the advantage of distance. The most common of these devices were the so-called 'chequerboard' and 'neo-impressionistic' techniques. The chequerboard effect alternates light and dark cubes with no attempt at continuity, in a bid to achieve a rapid transition from light to dark:

the viewer's eye automatically fills in the intervening shades. Given the impossibility of more subtle modelling, this technique avoids the problem of striping or of large expanses of one colour. It is particularly effective in the modelling of faces. The second device, 'neo-impressionism', seems to have been an attempt to mix optically tones that could not have been gained through the use of individually coloured cubes. It works on the optical phenomenon employed in *Pointillism but known in Antiquity, that the light reflected from two adjoining patches of colour will mix on the retina and form a third. In the face of the Virgin in the 13th-century *Deesis* panel in Hagia Sophia, Istanbul, the heavy blues of an apparent 'five o'clock' shadow seen in close-up disappear from a distance, creating an effect of soft, natural shading. Highlighting, another method employed on both faces and garments, was also used to great effect in modelling. Other tricks to manipulate colour included creating the illusion of space through darkening colour to represent increasing depth or through increasing the saturation of the horizontal and vertical planes. In S. Maria Maggiore in Rome, the reverse, the lightening of tone towards the rear of the picture, also serves to produce a feeling of depth.

Mosaic is subservient to the shape of the building and thus affected by a variety of factors: the different inclinations of surfaces, the degree of reflectance of surfaces in white light, the changes in external illumination reaching the surfaces. Consequently, light striking the mosaic acts as a dynamic force, a force which has to be carefully and deliberately employed by the mosaicist to create the desired effect. The light-reflectant quality of mosaic is emphasized through the distribution of light, in contrast with the more uniform illumination of paintings. Each tessera, each cube of glass, is itself a mirror, reflecting light back. To exploit this asset to the full, the Byzantines combined geodesy, the art of measuring volume and surface, with optics to work on a careful planning and placing of mosaics. They experimented with devices for the reflection and refraction of light: mosaics were placed in carefully constructed squinches and pendentifs, in curved apses, in domes; even on flat surfaces, curved setting beds were employed. The deliberate use of an uneven surface allows for the greater play of light.

Concern with the manipulation of external light to create visual effects can be seen very clearly in the setting of gold mosaic backgrounds. The solid background of the Byzantine mosaic forms the most obvious colour mass, against which the figures in a scene are set. This gold background is clearly not conceived of as a solid, static sheet but as the site

for creating light effects, scattering light, creating glitter. In the late 9th-century narthex panel of Hagia Sophia in Istanbul, above the great west door, the background is not laid as a solid mass but as alternating rows of tesserae and plaster bed. The tesserae are angled so that for the viewer below, and this panel can only be seen from below, the background appears solid. The apse mosaic of the *Virgin and Child* in the same church, dated to the early 9th century, is illuminated from below. Here, gold and silver tesserae are used in the background to create movement. Different colours are frequently used to provide variation in an otherwise monochrome surface. Gold tesserae can be set in reverse, plain glass used to create a translucent effect, yellows and greens mixed in with gold. The mosaic is curved to obtain different angles of reflectance of light. The gold and silver tesserae of the background have their surfaces angled forward, whilst those of the border are set vertically. All of these devices serve to vary the light effect of the gold background. In the 13th-century *Deesis* mosaic, again in Hagia Sophia, Istanbul, the background gold tesserae are laid in a ripple trefoil pattern. This background serves to diffuse the light and alters as the light itself changes and moves, creating a shimmering effect.

In Byzantine art, light tends to be projected from in front of and above the picture. This real light is then represented in pictorial terms. In the *Deesis* panel from Hagia Sophia, Istanbul, where real light comes from windows to the viewer's left and above, the direction of this light is represented pictorially: a shadow line runs across Christ's neck, from the right-hand side of his jaw, the shadow cast by a real jaw in real light from this direction. Light within a picture is represented predominantly through highlighting, in both white and gold. In the case of mosaics, sharp contrasts between dark and light are necessary to avoid creating a silhouetted effect. Increasingly, highlighting becomes stylized; rather than conforming to body shapes, it has a patterning effect. This seems partly a result of using and directing real light through the internal highlights. Real light can also be used to play a part in the scene itself. In the representation of the *Annunciation* at Daphni, light is collected in the niche between the Virgin and the Archangel. They stand either side of a pool of light, which can be read as iconographically significant.

Since light is such an intrinsic element of mosaic, dirt presents a particular problem. Soot and grime serve to diminish its effectiveness, destroy details, and distort appearances. It was believed that a technique known as 'reverse highlighting' had been employed in the mosaics of Hosios Loukas, until cleaning revealed that this was actually the effect of centuries of accumulated dirt.

The Byzantines conceived their art, above

all, their mosaic art, as painting with light. It was the glittering, sparkling effect of mosaic that was most admired, seen as light created by space as well as by colour. The 6th-century Byzantine historian Procopius wrote of Hagia Sophia in Constantinople: 'it was singularly full of light and sunshine; you would declare that the place was not lighted by the sun from without, but that the rays are produced within itself, such an abundance of light is poured into this church'. Mosaic is a medium above all designed to interact with external light. The Byzantines conceived of it as a sheathing for the walls, a skin lying over the masonry; as such, light brought it to life.

Since the Byzantine period, such a conception of mosaic and its potential tends to have been overlooked. The West, other than in Italy, above all the glassworkers of Venice, failed to acquire the skills of mosaic-making and relatively few were produced. After the fall of Constantinople in 1453, many of the skills were lost. The mosaics of S. Mark's in Venice, originally created by Byzantine and Byzantine-trained workers, were remodelled continuously from the 15th century on by artists as varied as *Titian and *Tintoretto. Italian painters, perhaps because of its durability and links with ancient art, never completely lost interest in mosaic. *Giotto, for one, worked on mosaics in Rome. The *Ghirlandaio brothers were responsible for several pictures in mosaic, including the *Annunciation* over the north door of Florence Cathedral, though their scheme for lining the whole of the interior of the dome with mosaic was never realized. In Rome, the Chigi chapel in S. Maria del Popolo was decorated with a mosaic of the *Creation* based on a *Raphael cartoon. However, the most striking feature of these later mosaics is how indistinct and one-dimensional they are in contrast to medieval mosaics, particularly when viewed from a distance. Later artists ignored the specific nature of mosaic, regarding medieval work as old-fashioned, and tried to treat it as if it were paint, aiming to create subtle shaded effects. Continuous effort was made to increase the number of shades available and paint was often overlaid on the finished mosaic to soften the transition from one tone to another and to increase the plastic effect. Efforts, especially at the Vatican School of Mosaic, founded in the 18th century, were made to reproduce the styles of contemporary painters in mosaic. This reduced the visual effectiveness of mosaic. It works best as monumental art on an undulating surface and designed to be seen at a distance. It thus shares few of the technical devices of painting: using mosaic to imitate painting is a waste of time and effort.

Since the 18th century, Italian mosaicists have produced work across Europe and America, usually of low quality. Using ready-made cartoons produced by local artists and

executing the work in studios rather than on site, the results are flat, turgid, and depressing, as with the mosaics designed by *Watts and *Stevens for S. Paul's Cathedral, London. Westminster Cathedral, based on a Byzantine model, appropriately enough contains mosaics, but these too fail to use the medium to its potential. Modern artists have used mosaic as a medium, but have tended to employ it as a form of large-scale collage, using glass, ceramic, and other material on, in many cases, a flat surface, rather than using its light-bearing qualities to any real effect. Eduardo *Paolozzi's mosaics in the Tottenham Court Tube Station in London are one such example, where mosaic has become a form of tiling. LJ

Demus, O., *Byzantine Mosaic Decoration* (1948).

Demus, O., *The Mosaics of San Marco in Venice* (1984).

Harding, C., 'The Production of Medieval Mosaics: The Orvieto Evidence', *Dumbarton Oaks Papers*, 43 (1989).

James, L., *Light and Colour in Byzantine Art* (1996).

Strong, D., and Brown, D. (eds.), *Roman Crafts* (1976).

MOSAN, literally, 'of the Meuse', standing for the geographical area of modern-day France, Belgium, and Holland through which the river Meuse flows. Today, 'Mosan' is taken to mean art of the second quarter to the end of the 12th century produced in the medieval diocese of Liège, which also included parts of modern Germany. Related objects were also produced in the adjoining archdiocese of Cologne, one of the most important commercial and religious centres of the age. It was a prosperous area, rich in minerals and a centre for cloth manufacture. The Mosan workshops were notable for their ivories, superlative *champlevé* *enamel, often with sophisticated typological iconography, and cast and embossed metalwork. Surviving pieces are almost exclusively ecclesiastical, often in the form of elements from larger objects such as altarpieces, shrines (e.g. the gable end of the shrine of S. Oda, *c.*1170; London, BM), reliquaries, book covers, and Crucifixes, some of which are associated with major patrons of the period, including Abbot *Suger of S. Denis and Abbot Wilibald of Stavelot. PS

Lasko, P., *Ars sacra 800–1200* (2nd edn., 1994).

Stratford, N., *Catalogue of Medieval Enamels in the British Museum, 2: Northern Romanesque Enamel* (1993).

MOSCOW: PATRONAGE AND COLLECTING. From the 14th to the early 18th century when the capital was removed to St Petersburg, Moscow was the most important artistic centre in Russia. *Icon painting, manuscript illumination, church wall painting, and a variety of decorative arts—goldsmithing, niello and enamelwork, ceramic and glassware—thrived under the hegemonic patronage of Church and court. Icon painting culminated in the early 15th-century work of Andrei *Rublev and *Theophanes the Greek, proliferating to regional towns and influencing local schools in the late 15th century under the leadership of Dionisy. During the 16th century the best artists and craftsmen worked on Moscow's many palaces and major restoration work following the Kremlin fire of 1547. From the mid-1640s there was large-scale decoration of the Kremlin cathedrals and numerous churches, with the Kremlin Armoury acting as an early state art school housing icon-painting workshops. Moscow's decline as the centre of art production and patronage accompanied Peter the Great's transfer of the state capital, though the secularization of the arts was felt in Moscow as icon painting incorporated some of the naturalizing tendencies and optical illusionism of Western art, and portraiture began to thrive. The establishment of the Academy of Arts in St Petersburg in 1757 heralded a wholesale adoption in court circles of Western influences—chiefly the *Baroque and *Neoclassical—though the independence of Moscow was retained by the Stroganov School of Art founded in 1825, and in 1833 by the Moscow Arts Society, which was transformed in 1866 into the Moscow School of Painting, Sculpture, and Architecture. This institution retained a more democratic spirit and an early receptivity towards the emerging realist school, some of its graduates, most notably Vasily Perov, forming the core of the *Peredvizhniki. The rising importance of urban mercantile patronage in the second half of the 19th century, notably Pavel Tretyakov, again placed Moscow at the forefront of artistic life. Other important merchant patrons including Tretyakov's brother Sergei specialized in the collection of Western art, which was soon taken to more radical ends by S. I. Shchukin and A. I. Morozov whose celebrated collections of *Impressionist and *Post-Impressionist art were later incorporated into the *Moscow Pushkin Fine Art Museum. The coalescence of Russian national art and elements of western *Art Nouveau was fostered from the 1870s to the 1890s at the *Abramtsevo artistic colony on the outskirts of Moscow, taking its major influence from the city's indigenous art and architecture. The dominance of the Peredvizhniki in Muscovite culture was challenged by the Union of Russian Artists in 1903 which was followed by a rapid pluralization of cultural activity. Of note were the formation of the *Blue Rose group of Symbolists in 1907, the Cézannist Knave of Diamonds in 1910, and the *Futurist *Donkey's Tail* exhibition of 1912 which included Mikhail Larionov (1881–1964) and *Goncharova. After 1917 Moscow again became the state capital and the fulcrum for much experimental cultural activity including Svomas, the system of national studios for free art which formed the basis for Vkhutemas (Higher Artistic and Technical Studios). Collections were largely nationalized and patronage resided with the state. Lenin's Plan for Monumental Propaganda in 1918, the widespread use of agitprop (particularly revolutionary festivals), large-scale poster production, and the enormous All-Russian Agricultural and Industrial Exhibition of 1923 were characteristic of a vigorous campaign to bring art to the masses. The 1920s saw the establishment in Moscow of some of the most influential artistic groups, chiefly AKhRR (Association of Artists of Revolutionary Russia) and OSt (The Society of Easel Painters) as well as the factory-based productionist tendencies of Proletkult (Proletarian Culturo-educational Organization), from which emerged Eisenstein's innovations in cinema, and various strands of *Constructivism in art and architecture. After 1932 the disbandment of all artistic groupings saw the establishment of single unions for each of the arts, of which the Moscow Artists' Union was dominant in the visual arts. Under its chairman Alexander Gerasimov the union became an influential player in the formation and promulgation of *Socialist Realism assisted by the Committee on Arts, formed in 1936, and after the Second World War the Academy of Arts of the USSR. The state hold on Moscow's artistic life remained consistently firm though it was challenged in the 1970s and early 1980s by a younger generation of avant-garde activity, notably the *Exhibition of the 23* and the *Seventeen Youth Exhibition*. With the collapse of communism Moscow has again become the centre for a vibrant and bewilderingly diverse range of cultural phenomena of a largely experimental nature and debatable quality, perhaps unified solely in its celebration of artistic licence. DJ

Moscow: Treasures and Traditions, exhib. cat. 1990 (Washington, Smithsonian).

MOSCOW, PUSHKIN FINE ART MUSEUM, in scope and size one of the richest and diverse collections of its kind. Built between 1898 and 1912 to a design by R. Klein and paid for by public subscription, the refined, grey classical building with its hexastyle portico surmounted by a frieze of the Olympic Games was opened in 1912, as the Alexander III Fine Art Museum. The basis of the collection was plaster casts of the best classical, medieval, and Renaissance sculptures to which were soon added an important collection of Egyptian antiquities assembled by the Egyptologist V. Golenishchev. The picture gallery was opened in 1924, consisting in large part of works 'liberated' from pre-revolutionary private collections. However the notable collections of S. I. Shchukin and A. I. Morozov, which provided the museum with its superb body of French *Impressionist and *Post-Impressionist art,

including notable works by *Manet, *Monet, *Degas, *Cézanne, *Gauguin, van *Gogh, and *Matisse, were originally part of the Museum of New Western Art and these were only transferred to the Pushkin Museum in 1948. The museum now houses a vast collection of western European art representing virtually all of the traditional and modern schools and masters from ancient Greece to *Picasso. DJ

Antonova, I., *Pushkin Museum of Fine Arts, Painting* (1988).

MOSCOW, TRETYAKOV GALLERY.
Founded by the Moscow textile magnate Pavel Tretyakov (1832–98), the present gallery, designed in a Neo-Slavic style by Viktor Vasnetsov in 1902, grew from a collection started in 1856, opened to the public in 1874, and presented to the city of Moscow in 1892, together with the Western art collection of Tretyakov's brother Sergei—in total exceeding 1,800 items. Pavel Tretyakov initially collected western European and 17th-century Dutch art but switched his allegiance to indigenous art in the 1860s to establish the basis of the largest collection of Russian art. Though associated chiefly with the 19th-century realist school, the *Peredvizhniki, whose chief patron he became, Tretyakov was a diverse collector with tastes ranging from early *icons to the early modernist works of artists like Isaak Levitan, Valentin Serov, and Mikhail Vrubel. He appreciated also academic art of the 18th and early 19th centuries embodied in the works of Orest Kiprensky, *Bryullov, and A. A. *Ivanov. Without doubt the pre-eminent repository of national art, the Tretyakov houses unrivalled collections of Russian icons, most notably Andrei *Rublev's *Old Testament Trinity* (early 15th century), works by the best Peredvizhniks (*Repin, Ivan Kramskoy, Vasily Perov), a unique collection of national portraits (Tolstoy, Dostoevsky, Mussorgsky, etc.), and fine examples of Russian *Art Nouveau and *Symbolism. Nationalized in 1918 as the State Tretyakov Gallery it underwent extensive renovation and reorganization from 1985, its collection of some 100,000 pieces reopening a decade later greatly reconfigured to include the radical experiments of the previously derided Russian avant-garde (*Malevich, *Rodchenko, *Stepanova), a separate display of icons in the adjacent church of S. Nicholas, and an affiliated venue for Soviet realism in the Central House of the Artist at the north end of Gorky Park. DJ

Nikonova, I. I. (ed.), *The State Tretyakov Gallery: Its History and Collections* (1989).

MOSER, FATHER AND DAUGHTER.
George Michael (1706–83) was Swiss born and trained in Geneva as a chaser and engraver. He arrived in London c.1726 and was soon established as a virtuoso designer of gold and enamel boxes and a skilled draughtsman. In the latter capacity he taught at the St Martin's Lane Academy and was drawing master to the royal family. He was a founder member of the RA, *London, becoming its first keeper in 1768.

His daughter **Mary** (Mrs Hugh Lloyd; 1744–1819), who was probably trained by her father, was also a founder member of the RA, in 1768, and exhibited there 1769–1802, transferring her allegiance from the Society of Artists where she had shown flower paintings from 1760. She suffered from short-sightedness but her still lifes, in the manner of J.-B. *Monnoyer, are highly finished and accurate. In the late 1770s she attempted a number of *history paintings but her only surviving works are *flower pieces, the most spectacular being the elaborate panels with which she decorated a room at Frogmore House for Queen Charlotte (c.1795; Windsor Castle, Frogmore). DER

Zweig, M., 'Mary Moser', *Connoisseur Yearbook* (1956).

MOSER, LUKAS (active 1402?–34). German painter. He may be identified with the painter Lucas recorded in Ulm in 1402, and between 1409 and 1434, when he designed windows for the cathedral. Only one work by Moser is known, the *S. Mary Magdalene* altarpiece (s.d. 1431) in the church at Tiefenbronn, near Pforzheim. This, inscribed with an extravagantly pessimistic lament, marks him as one of the most significant painters of 15th-century Germany. Moser's style combines a detailed naturalism derived from Netherlandish art with remnants of older formats. Though the harbour wall in the *Arrival at Marseille* and the distant landscape of the *Sea Journey* are transcribed with forensic realism, the sea surface in the *Journey* is presented as a stylized, netlike pattern. The spatial linking of the four main scenes of the Tiefenbronn altarpiece is Netherlandish, as is the use of light and the plastic weight of the figures. Moser's pictorial space is less controlled than that of the artist with whom he has most affinities, Konrad *Witz, but Moser was a generation older. JK

Ullman, E., *Geschichte der deutschen Kunst 1350–1470* (1981).

MOSES, GRANDMA (Anna Mary Robertson) (1860–1961). American primitive painter. Anna Robertson was born in Washington County, NY, and in 1887 married Thomas Moses with whom she farmed until his death in 1927. She began painting in the mid-1930s when arthritis prevented her sewing. Her work was discovered in 1938 by a New York collector, Louis Caldor, on whose recommendation three of her paintings were included in the exhibition *Contemporary Unknown American Painters* (1939; New York, MoMa). There followed a one-woman show in New York in 1940 when the sobriquet Grandma was first used, in a review in the *New York Herald Tribune*. From now on her success was phenomenal and by the 1940s she was a household name, widely reproduced on greeting cards. Entirely self-taught, she painted remembered rural scenes, which appealed to popular nostalgia, brightly coloured and with primitive figures. She painted over 1,000 works, including those painted on ceramic tiles in the 1950s, working on several at once, beginning with the sky and ending with the figures. She is well represented in American galleries, particularly at Bennington Museum, Vermont. DER

Kallir, O., *Grandma Moses* (1973).

MOSTAERT, JAN (c.1472/3–1555/6). Painter from Haarlem. Active in his native city, he also served intermittently at the court of the Regent of the Netherlands, Margaret of Austria, in Brussels and Malines (probably before 1519–after 1521). His work combines elements from the older Haarlem painter *Geertgen tot Sint Jins with the more modern Southern Netherlandish art of *Gossaert and, in his landscape backgrounds, of *Patinir. He is best known for his devotional panels and his portraits. In the *Portrait of Abel van den Coulster* (c.1500–10; Brussels, Mus. Royaux) the aristocratic, thin-faced nobleman stands before a palace. In the adjacent courtyard is a subsidiary scene of the *Vision of Augustus*. Mostaert showed an interest in the lands of the Americas, no doubt inspired by reports of the Spanish explorations, which must have reached him through his contacts with the court of Margaret of Austria, the aunt of Charles V. His *West Indies Landscape*, with many nude people, a fantastic cliff, and exotic houses and huts is however purely imaginative (Haarlem, Frans Hals Mus.). KLB

Snyder, J., *Northern Renaissance Art* (1985).

MOTHERWELL, ROBERT (1915–91). American painter, printmaker, writer, and editor, born in Washington. He studied art at the Otis Art Institute, Los Angeles, and Stanford University (where he changed to philosophy), with further studies at Harvard in 1937, and Columbia 1940–1. In 1941 he made contact with the *Surrealists in New York and travelled to Mexico with *Matta. In 1948 he co-founded the Subjects of the Artist School in New York with *Baziotes, *Newman, *Rothko, and *Still. A leading art theorist, Motherwell taught at *Black Mountain College, NC, in the 1940s and at Hunter College, NY, 1951–9; he also edited the series Documents of Modern Art, to which he contributed *The Dada Painters and Poets* (1951). Motherwell was the youngest but most

cosmopolitan and widely read of the painters described as *Abstract Expressionists. His paintings are often very large, simple strong shapes, reminiscent superficially of *Kline, but, unlike Kline, with a strong political and literary content: *Elegy to the Spanish Republic XXXIV* (1953–4; Buffalo, Albright-Knox Gal.). RJP

Arnason, H., *Robert Motherwell* (1982).

MOZARABIC, art and architecture of Christians (the 'Mozarabs') living under Moorish rule in Spain. Mozarabic art, which persisted into the 11th century, offers features of both the lingering Visigothic and the dominant Hispano-Moorish styles. The church of S. Miguel de Escalada near León, with its characteristic horseshoe arches, is the principal surviving example of the style in architecture. In the minor arts, the outstanding examples of the work of Mozarab artisans are found in manuscript illumination, notably the commentaries of Beatus of Liébana, including the *Commentary on the Apocalypse* (c.950; New York, Pierpont Morgan Lib.). There was some interaction between this Hispano-Arabic art and artistic currents elsewhere in Europe. Under Alfonso VI of León and Castile (1065–1109) the schools of learning at Toledo attracted scholars from all over Europe, including England and Scotland. Through this point of contact, Mozarabic art transmitted Moorish features to the European *Romanesque. SS-P

MUCHA, ALPHONSE (1860–1939). Czech painter, sculptor, graphic artist, and designer, who became, throughout Europe and America, one of the most celebrated artists of *Art Nouveau. After working in Vienna and Munich, he moved to Paris in 1887, where he mixed with the *Nabis and the *Symbolists. In the 1890s he produced the posters for which he is best known. Many were made for the actress Sarah Bernhardt, and in such posters as *Gismonda* (1895) and *La Dame aux camélias* (1896) he introduced a new poster format, elongated and narrow, and pale, clear colours; his style is characterized by subtle patterns of undulating lines and decorative motifs drawn from *Byzantine and *Celtic art. In the early 20th century he spent some time teaching design in various American cities. Mucha was an ardent Czech nationalist, and in a cycle of vast paintings glorified the history of the Slav people (1911–26). In 1911 he completed a series of murals in Prague Town Hall, and he designed the banknotes for the new Czech Republic. HL

Alphonse Mucha, exhib. cat. 1993 (London, Barbican AG).

MUDÉJAR, a style of architecture and decorative art reflecting the presence of the Moors in Spain and Portugal. *Mudéjar* refers to the work of Muslim craftsmen working for Christian patrons and to the continuance of the style by Christian artisans after the expulsion of the Moors from the Iberian peninsula. The style was remarkably long-lived, from the 12th into the 17th centuries, and continuing in Spanish and Portuguese colonial arts through the 18th century. The characteristic decorative vocabulary, including both angular geometric forms and graceful foliate abstractions (called arabesques), graces architectural landmarks such as the 14th-century Alcázar in Seville, where it is applied to ceramic tiles (*azulejos*), stucco (*yesería*), and elaborate wooden ceilings (*techos artesonados*). *Mudéjar* motifs were extremely well adapted to the minor arts and fine examples of the style can be found in bookbinding, textiles, ceramics, ivory, furniture, inlays of wood (*taraceas*) and metal (as in the famous damascene work produced in Toledo). SS-P

MÜLLER, OTTO (1874–1930). German painter. Müller was born in Liebau, Silesia, and studied *lithography before training at the Dresden Academy (1896–8). He remained in Dresden until 1908 when he moved to Berlin but no paintings of this period survive. Once in Berlin Müller met *Kirchner and joined Die *Brücke. Müller, who had already developed his lifelong theme of the harmony of man and nature, was an apt recruit, for the Brücke artists, who had recently begun painting *en plein air*, were also exploring Arcadian themes at this period, particularly nudes in landscapes, Müller's most characteristic subject. Under Kirchner's influence Müller's nudes became more angular but otherwise his style, which has echoes of *Gauguin in his use of pure colour, and *Lehmbruck, whose elongated forms are clearly evident in the *Large Bathers* (1910–14; Bielefeld, Städtisches Kunsthaus), remained largely unchanged for the rest of his life. His spare compositions, painted in a limited range of flat, somewhat harsh, distemper colours, as in *Bathers in a Thicket of Reeds* (c.1922; Berlin, Nationalgal.), achieve his stated intention of simplicity. From 1919 he taught at the Breslau Academy. DER

Buchheim, L.-G., *Otto Müller, Leben und Werk* (1963).

MULREADY, WILLIAM (1786–1863). Irish-born painter. Mulready, born in Co. Clare, arrived in London as a child c.1792. He entered the RA Schools (see under LONDON) aged 14 and exhibited by 1803. Like his brother-in-law John Varley (1778–1842) and his friend John Linnell (1792–1882) he began as a landscape artist, painting Dutch-inspired views of London's rural outskirts: *The Forge* (c.1811; Cambridge, Fitzwilliam). Between 1809 and 1812 his pictures became more populated, and by 1815, with *The Fight Interrupted* (1815–6; London, V&A), they had developed into genre. The majority of his subject paintings concern childhood, frequently with a moral purpose. His work has an individuality which denied him popular appeal but he was fortunate in his patrons and earned a growing income from the early 1810s. John Sheepshanks (1787–1863), whose portrait he painted (1832–4; London, V&A), was a particularly avid collector. From the mid-1820s Mulready often used a white ground and painted with a stipple technique which anticipated the *Pre-Raphaelites. In 1839 he designed the first pre-paid envelope but its allegory of England and Empire invited parody and it was unsuccessful. DER

Pointon, M., *Mulready*, exhib. cat. 1986 (London, V&A).

MULTIPLES. This term was specifically applied to a type of art which emerged in the mid-1960s. Multiples were small sculptures or collections of objects whose production, although comparable to the limited edition of prints and books, was theoretically unlimited and, as such, intended to attack the concept of originality in art, and also to reject the status accorded to the ownership of individual works of art. Multiples embodied a process of industrial mass production entirely inappropriate to formalist interpretations of the meaning and function of art, and it could be argued that this constituted a variation on the theoretical rejection of art objects themselves, for which contemporary movements such as *Conceptual art and *Performance art were renowned. In terms of their method of production, multiples have also been interpreted as the furthest logical point of *Pop art. A typical example of a multiple is *False Food Selections* (1966) by Claes *Oldenburg, which was a wooden chest containing sheets of notes by the *Fluxus artist George Maciunas (1931–78), and pieces of plastic and rubber food. Other leading exponents include Alexander *Calder, Jim *Dine, Tom Wesselmann (1931–) and Andy *Warhol. OPa

MULTSCHER, HANS (c.1400–67). German stone and limewood sculptor who had a large workshop in Ulm that produced the most important altarpieces of its period in southern Germany. It seems that he had direct experience of the Burgundian sculpture of Claus *Sluter's followers. In 1433 he signed a retable altarpiece for Ulm Minster (stripped of its carved figures in the *iconoclasm of 1531); in 1456–9 he worked for and, some of the time, at Sterzing (now Vipiteno, Italy) on a retable for the parish church. This was dismantled, but many fragments have been identified (Sterzing, Pfarrkirche and Multscher Mus.; Munich, Bayerisches

Nationalmus.; Innsbruck, Ferdinandeum; Basle, priv. coll.). Multscher's workshop also produced paintings which were integral to the carved altarpieces, but it is not certain whether he himself was a practising painter (e.g. wings of the Wurzach altarpiece, 1437; Berlin, Gemäldegal.). KLB

Baxandall, M., *The Limewood Sculptors of Renaissance Germany* (1980).
Reinhart, B., and Roth, M. (eds.), *Hans Maultscher*, exhib. cat. 1957 (Ulm Mus.).

MUNCH, EDVARD (1863–1944). Norwegian painter and graphic artist, arguably the greatest of Norwegian painters and a major influence on *Expressionist painting. Munch was born in Loten and studied in Oslo; his early work was conventionally naturalistic, and, by 1884, he belonged to the avant-garde bohemian circle of the *realist painter Christian *Krøhg. In 1885 he visited Paris where he was particularly impressed by *Manet. He made further prolonged stays there 1889–92, being influenced by the *Symbolists, van *Gogh, and, above all, *Gauguin and establishing his familiar nervous linear style. In 1892 he exhibited over 50 works at the Berlin Kunstlerverein (Artists' Union); the exhibition caused a scandal and was closed after a week, the repercussions leading to the formation of the Berlin *Sezession in 1899. He spent much of the next decade in Berlin developing his recurrent morbid themes of sexual awareness (*Puberty*, 1894–5; Oslo, NG Norway), illness (*The Sick Child*, 1896; Oslo, NG Norway), jealousy (*Jealousy*, 1896–7; Bergen, Billedgal.) and madness (*The Shriek*, 1893; Oslo, NG Norway). These intense and disturbing works reflected not only Symbolist obsessions but, more importantly, the neuroses which stemmed from his own traumatic childhood, plagued by the deaths of his mother and sister and his father's near insanity. These works formed part of his ambitious scheme *The Frieze of Life*, intended as a symbolic distillation of his own experiences. In 1908 he suffered a complete nervous breakdown and returned permanently to Norway, deliberately abandoning his disturbing themes to retain his sanity. His work became more extrovert, his palette brighter, and his subjects more optimistic, although after 1916 Munch became increasingly reclusive and his work regained some of its earlier intensity. MT

Edvard Munch, exhib. cat. 1992 (London, NG).

MUNICH: PATRONAGE AND COLLECTING. *See overleaf.*

MUNICH, ALTE PINAKOTHEK, NEUE PINAKOTHEK, AND GLYPTOTHEK. Decisive steps towards a public gallery to house the collection of pictures formed by the Wittelsbach rulers of Bavaria were taken in the reign of King Ludwig I (ruled 1825–48), when the foundation stone of the Alte Pinakothek was laid in April 1826. The building, designed in the Italian Renaissance revival style by the court architect Leo von Klenze, opened in 1836 with more than 1,000 works. The collection reflects the wide-ranging taste and collecting zeal of the Wittelsbachs, from the time of Duke Wilhelm IV (ruled 1528–40).

King Ludwig I was guided by artistic and historical considerations and, to fill gaps in the collection, purchased pictures by Italian artists such as *Giotto and *Raphael as well as the Boisseréen brothers' pioneering collection of early northern art (see COLOGNE). He also acquired a considerable number of contemporary German works by *Overbeck, *Waldmüller, and *Schwind, which form the nucleus of the Neue Pinakothek, now housed nearby in a building (1975–81) by Alexander von Branca. In the 19th century French and more German works were added such as *Manet's *Breakfast in the Studio* and van *Gogh's *View of Arles*.

The Staatliche Antikensammlung und Glyptothek is a Neoclassical building (1816–30) commissioned from Leo von Klenze by Crown Prince Ludwig for his *Antique, *Renaissance, and contemporary sculpture collection. It is now exclusively devoted to ancient *Greek and *Roman sculpture and illustrates developments from the 6th century BC to the 1st century AD. The collection was first formed from outstanding sculptures, such as the *Barberini Faun, recently excavated in Rome in 1811 and acquired there for Crown Prince Ludwig by his agent Martin von Wagner. CFW

MURILLO, BARTOLOMÉ ESTEBAN (1617–82). Spanish painter, born and active in Seville. He was apprenticed to Juan del Castillo c.1633–8, but his works between 1639 and 1646 were also influenced by *Roelas, *Herrera the elder, and *Zurbarán. His own style and personal pictorial technique emerges in a cycle of large canvases started in 1645 for a cloister in the convent of S. Francisco (*Angel Kitchen*, 1646, Paris, Louvre). The *Flight into Egypt* (c.1648; Detroit, Inst. of Arts) and the *Holy Family with the Bird* (c.1650; Madrid, Prado) illustrate the naturalism of Murillo's early religious paintings and his tender approach to the subjects. Murillo's paintings of the Virgin and Child popularized this image, infrequent in Spain before 1650, but his most often repeated subject was the Immaculate Conception. His first important version is the monumental canvas for the Franciscan church in Seville (c.1650/2; Mus. Provincial), in which he eliminated most of the Marian symbols usually scattered throughout sky and landscape.

In 1656, Murillo painted the *Vision of S. Anthony of Padua* for the baptismal chapel of the cathedral, a dramatic, *Baroque work, perhaps influenced by *Herrera the younger's work. In 1658, he travelled to the court, where he was exposed to contemporary Spanish, Flemish, and Italian painting. The *Birth of the Virgin* for Seville Cathedral (1660; Paris, Louvre) shows a further change in his style and handling of light. The decade following his wife's death in 1663 was Murillo's most prolific; some of his largest commissions were completed between 1664 and 1672, among them four lunettes for S. María la Blanca, Seville (1665), 21 canvases for the Capuchins of Seville (1665–9), and six for the Hospital de la Caridad (1667–72). In these works the compositions are more spacious and airy, and his chiaroscuro more transparent; Murillo also explores daring light effects. The ever more refined and vaporous works of his last years (*Martyrdom of S. Andrew*; Madrid, Prado; *Two Trinities*; London, NG) show no decline in either expressive force or technical brilliance.

Murillo's *genre pictures are a small but important facet of his work. The starkly naturalistic *Boy Killing Fleas* (c.1646–50; Paris, Louvre) is Murillo's first known essay in pure genre. Most of his genre scenes were painted c.1670–5, and have as principal actors poor children engaged in various activities, with emphasis on the anecdotal content. In contrast with the objectivity of his earlier genre pictures, his late ones (*The Little Fruit Vendors*, *Boys Playing Dice*; Munich, Alte Pin.) present a poetic and light-hearted vision of childhood.

Portraits play a minor role within Murillo's œuvre. Most are full-length likenesses in architectural settings (*Don Andrés de Andrade y la Col*; New York, Met. Mus.; *Don Justino de Neve*; London, NG), or busts within an oval stone frame (*Self-Portrait*; London, NG; *Nicolás Omazur*; Madrid, Prado). The stiff bearing and impassive countenances of the full-length images endow them with a severe formality.

While working on a large altarpiece for the church of S. Catalina in Cadiz, Murillo fell from his scaffolding. He died a few months later, probably as an outcome of his fall. His work was highly esteemed in France and England until the late 19th century. NAM

Angulo, D., et al., *Bartolomé Esteban Murillo 1617–1682* (1982).
Brown, J., *The Golden Age of Painting in Spain* (1991).
Mallory, N. A., *El Greco to Murillo: Spanish Painting in the Golden Age: 1556–1700* (1990).

MURPHY, GERALD (1888–1964). American painter. Murphy was born into a wealthy Irish-American family in Boston, graduated at Yale, and went on to work in the family business for a number of years. He then studied landscape architecture at Harvard. Finally, in Paris with his family in 1921, Murphy discovered modern art and at the age of 33 decided to become a painter. Working as a stage painter for the Ballets

continued on page 501

· MUNICH: PATRONAGE AND COLLECTING ·

MUNICH, the capital of Bavaria, was until 1918 the seat of the ruling Wittelsbach dynasty who vied with the Habsburgs as patrons and collectors of art. One of the first significant Wittelsbach art projects was in 1528 when Duke Wilhelm IV (ruled 1508–50) called in several well-known German painters from outside Munich, including Jörg *Breu and Hans *Burgkmair, to help his court artists with a series of sixteen paintings of scenes from Antiquity, in which the heroes were presented as spiritual forerunners of the Wittelsbachs. The most impressive of these is the celebrated *Battle of Issus* (see BATTLE PAINTING) (1529; Munich, Alte Pin.) by *Altdorfer.

Duke Albrecht V (ruled 1550–79) was a magnificent collector of books, coins, and goldwork, acquiring the collections of Hans Fugger and building the Antiquarium at the Munich Residenz to display his antiquities. The Antiquarium, which was one of the largest secular halls north of the Alps, was conceived by the Mantuan art adviser Jacopo Strada and was consciously modelled on the display areas of the Gonzaga.

Duke Wilhelm V (ruled 1579–98) identified the Wittelsbachs as the leaders of the Counter-Reformation in Germany by his sponsoship of the Jesuits and his construction for them from 1583 of the Michaelskirche in Munich. Wilhelm used the façade of this major church for a political programme of sculpture, including figures of himself and the two most recent dukes as protectors of the faith and a group of *S. Michael Overcoming Lucifer*, symbolizing the Catholic Church defeating Protestant heresy. These sculptures were by Hubert *Gerhard, who was typical of the Italianate Netherlandish artists who were favoured at Wilhelm's court. Perhaps the most distinguished painter active in Munich in this period was Hans von *Aachen, who was one of several artists to move on from Munich to the court of Rudolf II at Prague.

Duke and Elector Maximilian I (ruled 1597–1651) was the leader of the Catholic League in the Thirty Years War, which led to the devastation of much of Bavaria and the occupation of Munich by the Swedes for two years from 1632. Like his father Wilhelm V he was a fervent supporter of the Jesuits but until he was overwhelmed by military preoccupations he was also a fervent collector of the work of contemporary Dutch and Flemish artists such as Jan *Brueghel the elder, *Rubens, and *Elsheimer. He also had a special penchant for earlier German masters, especially *Dürer, of whose work he owned some 20 examples including the Paumgartner altarpiece (1498) and the *Four Apostles* (1526) which are now among the most celebrated paintings in the Alte Pinakothek in Munich. As a patron, Maximilian's energy was mainly directed to the sumptious expansion of the Munich Residenz under the sculptor and architect Hans Krumpper, who had been apprenticed to Hubert Gerhard by Wilhelm V.

As Bavaria recovered from the Thirty Years War official patronage went through a period when Italian artists were much in favour under the rule of Ferdinand Maria (ruled 1651–79), who was married to a princess of Savoy. The long-term trend of the absolutist court was, however, towards the incorporation of the latest French influences into hugely costly displays relying equally on architecture, painting, sculpture, and ornament. For almost a century from 1663 the expansion and decoration of the Schloss Nymphenburg complex was a project of key importance for the Wittelsbach court. From 1691 to 1701 Maximilian II Emanuel (ruled 1679–1704 and 1715–26) was Governor of the Spanish Netherlands, where he was a great collector of paintings (Rubens, van *Dyck) as well as all kinds of other artwork.

Although French and Italian artists remained in vogue at court, native German architects, decorative painters and sculptors soon established themselves as leading practitioners of the Bavarian *Baroque and *Rococo (see ZIMMERMAN BROTHERS). None was more celebrated than the *Asam brothers who made many church interiors throughout Bavaria and who were responsible for an unique example of private patronage in the Munich church of S. Johann Nepomuk (1729–46). This small church was built next to the dwelling of Egid Quirin Asam, who paid for the entire project, and the interior's moulding of architectural form and decoration into an emotional religious statement is one of the supreme achievements of northern Baroque art.

The princely collections at Munich were swollen when the Munich line of the Wittelsbach dynasty died out in 1777 and Karl Theodor (ruled 1777–99) of the Palatinate branch succeeded to the Bavarian title and brought with him the collections from Düsseldorf and Mannheim. In 1799 the title passed to the collateral Zweibrücken branch who similarly brought their collections to Munich. In 1803 the suppression of the monasteries brought a further 1,500 pictures.

In 1806 Napoleon raised Bavaria to the status of a kingdom, and in 1826 King Ludwig I (ruled 1825–48) founded the Alte Pinakothek, which was one of the first and most influential examples in the great 19th-century educational movement of public museums. He was also instrumental in bringing the *Nazarene painter *Cornelius back to his homeland to decorate the Glyptothek, the building that was to house his collection of Antique sculpture, and the newly built Ludwigskirche. In a parallel gesture of enlightened government, the Munich Academy of Fine Arts was encouraged, so that it became the acknowledged leading instructional institution in central Europe in the second half of the century, and attracted a considerable influx of foreign artists into Munich. This was a prosperous time for Bavaria and there developed a flourishing art market, concentrating on conventional, unchallenging

bourgeois genre pieces. From 1863 international shows were organized by the main artists' society, the Künstlergenossenschaft.

In 1892 the first *Sezession movement in Germany was established in Munich. This may have been partly due to the inherent tensions between a predominantly conservative local clientele, the presence of many foreign artists, and the existence of well-developed international contacts and commercial links. As the Sezession was perceived as itself becoming ossified, it was supplanted by a succession of new modernizing groupings, including the Neue Künstlervereinigung München (1909) which contained the Munich painter Franz *Marc as well as the Russians *Kandinsky and *Jawlensky. These went on to become leading members of the *Blaue Reiter (1911–14), which was the most important modernist movement in Germany along with the Dresden-based Die *Brücke. Because of the integrated national and international art market at this time, the Blaue Reiter were able to look beyond Munich for their clientele, relying especially on the Berlin editor and art dealer Herwarth Walden. The Berlin industrialist Bernhard Koehler was also an enthusiastic patron.

After the First World War Munich sank back into its traditional conservative art values with little to match the avant-garde activity in Berlin, though Christian Schad (1894–1982) was a notable member of the *Neue Sachlichkeit group. Politically, the city was the heartland of the Nazi movement and in 1937 it was the site of the notorious polemically complementary exhibitions of 'degenerate' (i.e. modernist) art and of scrupulously naturalistic works extolling the power of the Nazi government. In the second half of the 20th century the city has become once again a vigorous and prosperous commercial centre with an art market to match its broader economic importance.

AJL

Kaufmann, T. DaC., *Court, Cloister and City* (1995).

Russes, he met *Braque, *Picasso, and *Léger, who was a major influence, encouraging Murphy's shared enthusiasm for mass-produced objects, advertising, and design. Such ordinary objects characterize his pictures made between 1924 and 1929, such as *Razor* (1924; Dallas, Mus. of Art), rendered in a clear, reductive, and geometric abstraction. Murphy kept a renowned summer house in Antibes, which was regularly visited by Léger, Picasso, and famous expatriate Americans including Hemingway and F. Scott Fitzgerald. His brief artistic career ended in 1929 when his son developed tuberculosis and the family returned to America in 1932.

MF

The Paintings of Gerald Murphy, exhib. cat. 1974 (New York, MoMa).

MUSÉE DES ANTIQUITÉS ET MONUMENTS FRANÇAIS. See LENOIR, ALEXANDRE-MARIE.

MUSEUM OF ... See under city name.

MUSEUMS. The word museum is derived from the ancient Greek *mouseion*, originally a temple of the Muses and later, as in the literary academy at Alexandria, founded by Ptolemy II in the 3rd century BC, a learned institution. The origin of the picture gallery may be traced to the Pinacoteca, a part of the Propylaea of the Acropolis in Athens where pictures by *Polygnotus were displayed in the mid-5th century BC. The modern concept of museums and galleries dates from the *Renaissance, the first example being the display of *Antique sculptures on the Belvedere court, designed for Pope Julius II (reigned 1503–13) by Bramante, for the benefit of artists (see ROME, VATICAN MUSEUM). However the first official Vatican Museum, the Capitoline (see under ROME), was founded by Pope Clement XII (ruled 1730–40) in 1734. Early museums were the province of aristocrats and antiquaries and developed from the *Kunstkammer or cabinet of curiosities in which works of art rubbed shoulders with natural curiosities. All were privately owned and could only be seen by the privileged few, scholars or social equals, although, gradually, collections were also acquired by colleges and societies, one of the first being the Pinacoteca Ambrosiana, *Milan, founded by Cardinal Federico Borromeo in 1618 as a study collection for the Accademia delle Belle Arti. Early catalogues served connoisseurs and noble visitors whilst also publicizing the taste and wealth of the owner. The *Galleria Giustiniana* (1631), describing the Antique sculptures of Marquis Vincenzo Giustiani, was the first to include illustrations. The *Musaeum Tradescantianum* (1656) described the 'Closett of Rarities' collected by the horticulturist John Tradescant (1608–32) which formed the basis for the collections of the Ashmolean Museum, *Oxford, when presented by the antiquarian Elias Ashmole in 1683. During the 18th century, although still limited, access to collections increased; the Empress Maria Theresa allowed admission to some of the Austrian royal collection in the 1740s, and the royal collection in *Dresden opened in 1768, followed by the Albertina, *Vienna (1776) and the fabulous Medici collections in the Uffizi (see under FLORENCE), bequeathed to the Tuscan state by the Grand Duchess Anna Maria, last of the Medici, in 1789. In 1753 the British Museum (see under LONDON), the first national museum of its kind, opened in Montagu House, Bloomsbury, following the purchase of the vast and varied collection of the royal physician Sir Hans Sloane (1660–1753) which had been displayed in his private museum in Chelsea since 1712. Private commercial museums and galleries also appeared. Sir Ashton Lever's collection of over 28,000 objects, including specimens from Captain Cook's Antipodean expeditions, was displayed at Leicester House, London, from 1774 to 1806, admission 2s. 6d., and Boydell's Shakespeare Gallery in Pall Mall opened from 1789 to 1805, although both failed to retain public interest and the exhibits and paintings were auctioned. A similar venture in America, the painter Charles Willson Peale's gallery and museum, which contained both his own paintings and a substantial collection of fossils, opened in Philadelphia in 1782, and was probably the first American museum. Democratization of collections multiplied towards the end of the century following the French Revolution. The Louvre (see under PARIS) opened as the first national public art gallery in 1793, although limited access had been granted since 1681. Under Napoleon Bonaparte the collections of the Brera in *Milan and the Accademia in *Venice, which had both benefited from the suppression of the religious orders (1796–9), became public in 1807 and in the following year Louis Bonaparte (1778–1846), King of Holland (1806–10), decreed that the Dutch royal collections should be nationalized; the Rijksmuseum, in *Amsterdam, finally opened in 1817. Mindful of Napoleon's example, a combination of self-interest and noblesse oblige swept through the remaining European courts. The Prado (see under MADRID) opened in 1818, the Mauritshuis in 1820, some access to the British royal collections began in the late 1830s,

and the Hermitage (see under ST PETERSBURG), containing the splendid collections of Catherine the Great (1790–96), was opened to the public by Tsar Nicholas I in 1852. In 1824, after much lobbying by artists and connoisseurs, including the dealer Noel Desenfans whose own collection was by now displayed at Dulwich Picture Gallery (see under LONDON) (1813), the first public art gallery in England, the National Gallery, *London, was founded. One of the few state art galleries which did not subsume a royal collection, the nucleus of its holdings was purchased from the executors of John Julius Angerstein (1735–1823). In 1850 Scotland followed suit with a National Gallery designed by William Playfair (1790–1857) alongside his earlier Royal Institution (1822–6) on the Mound in *Edinburgh. Many collections, however, still remained in private hands and although visitors were usually allowed they were often strictly vetted. In 1806 the Marquess of Stafford's collection at Cleveland House, London, was open on Wednesday afternoons between May and July to people known to the Marquess or his family or on personal recommendation; artists had to provide a reference from a Royal Academician. The Ellesmere Collection at Bridgewater House was commendably accessible and remained open to the public until the Second World War. Country seats could also be inspected when the owner was absent but many tourists resented the fees extorted by the servants. On occasion private collectors became public benefactors. In 1783 the physician Dr William Hunter (1718–83) bequeathed his diverse scientific and artistic collections to Glasgow University. The 7th Viscount Fitzwilliam left his works of art to *Cambridge University in 1816, with money for a building, and Sir John Soane bequeathed his house and collections to the nation in 1837. The last great bequest of a private collection in England was that of the Wallace Collection (see under LONDON) in 1900.

In the 19th century museum architecture became increasingly sophisticated. The new Hermitage (1852) was designed by Leo von Klenze (1784–1864), also responsible for the Glyptothek (1816–30), a museum of antiques, and the Alte Pinakothek (1836) in *Munich, and German architects dominated the market for appropriate buildings to house princely and state collections. Classical styles were usually preferred because of their associations with Antiquity, although important exceptions include the Ruskinian Natural History Museum in Oxford, designed by Benjamin Woodward (1815–61) in 1857. Gradually, typical floor plans emerged. Whereas private galleries were usually restricted to one room, admittedly sometimes enormous, like Lord Ellesmere's at Bridgewater House, London, designed by Sir Charles Barry (1795–1860) in 1847, public institutions favoured the enfilade, a series of linked rooms, exemplified by Klenze's Alte Pinakothek. This plan, as Mrs Anna Jameson pointed out in her *Handbook to the Public Galleries of Art in and near London* (1842), enabled paintings of different periods or schools to be displayed discretely and chronologically, a practice pioneered by Dr Gustav Waagen, the first director of the Royal Picture Gallery in *Berlin. The single enfilade soon developed into adjoining rooms arranged around a central core or staircase which allowed easier perambulation, as in Karl Friedrich Schinkel's (1781–1841) Altes Museum, Berlin (1822–8), a practice that has continued into the 20th century, the Barber Institute, Birmingham (1930s) being a prime example. The great majority of the purpose-built museums were top lit, often diffused by a lay-light, to reduce reflections. Artificial lighting became common after the 1850s; initially rooms were lit by gas jets, an obvious fire hazard resisted by the Trustees of the National Gallery, which was replaced by the far safer electric lighting in the 1880s. In the later 20th century scientific and technical advances have resulted in extremely sophisticated lighting systems which protect exhibits from the harmful effects of both artificial and natural light. Where a building served as both museum and gallery, as at Wolverhampton (1884), the ground floor, containing the museum, was fenestrated and the first floor was windowless. The second half of the 19th century saw an increased emphasis on the educational role of the museum. The Museum of Ornamental Art at South Kensington, later the Victoria and Albert Museum (see under LONDON), opened in 1852, financed by the profits of the Great Exhibition, to encourage 'the improvement of public taste in design'; John Ruskin's Museum of the Guild of S. George (1889) at Sheffield was intended to educate the artisan; and as late as 1914 the London County Council opened the Geffrye Museum in Hoxton for the benefit of apprentices in the local furniture industry. As art was also believed to be morally uplifting wealthy philanthropists, and artists including *Watts and *Leighton, financed the South London Art Gallery (1889) and the Whitechapel Gallery (1901) in deprived areas of London. Several museums and galleries, including Exeter (1865) and York (1879), also housed schools of art. The rapid growth of municipal museums in England was made possible by the Museums Acts of 1845 and 1850 which allowed funding from local taxation but most, as their names testify, depended on private benefactors for their foundation. A similar situation prevailed in Europe, the most remarkable example being the gift of the Tretyakov Museum (1902) to *Moscow by the brothers Pavel (1832–98) and Sergei Tretyakov, and was most notable in America where galleries and museums proliferated from the 1870s, when the Museum of Fine Arts, *Boston (1870), the Metropolitan Museum, *New York (1870), and the Art Institute of *Chicago (1879) were founded. Vast numbers of European works of art and Antiquities, including historic buildings, were bought by rich Americans and subsequently entered public collections, usually by gift. Henry Clay Frick (see under NEW YORK) left his house and collection to New York in 1919 and Isabella Stewart Gardner (see under BOSTON) was equally munificent to Boston in 1924. The National Gallery in *Washington (1937) received fabulous gifts from the multimillionaires Andrew Mellon (1855–1937) and Samuel Kress (1863–1955) and the Museum of Modern Art, *New York (MoMa), was privately funded from its foundation in 1929. The majority of American museums are still dependent on private benefactors, including the wealthiest museum in the world, the Getty Museum in *Los Angeles (1954, 1974) founded by the oil tycoon J. Paul Getty (1892–1976).

Following the example of Frank Lloyd Wright's (1869–1959) remarkable, spiral Guggenheim Museum, New York (completed 1959), several recent museum buildings, including I. M. Pei's (1917–) Louvre pyramid, Richard Rogers's (1933–) and Renzo Piano's Pompidou Centre, Frank Gehry's Guggenheim Museum, Bilbao, and Daniel Libeskind's proposed extension to the V&A, aspire towards being works of art themselves.

DER

Waterfield, G. (ed.), *Palaces of Art*, exhib. cat. 1992 (Dulwich, Gal.).

MUYBRIDGE, EADWEARD (1830–1904). British-born pioneer of chronophotography. Muybridge emigrated to America where he became a landscape *photographer of some renown. He achieved worldwide fame with his first experiments in chronophotography (1872), which proved beyond doubt that a horse in motion does at times simultaneously remove all four feet from the ground. Muybridge went on to produce thousands of studies of animals and humans in motion, and the results, which he energetically publicized, revolutionized perceptions of movement and its representation. The Muybridge Collection is housed at the Stanford University Museum of Art.

AA

Coe, B., *Muybridge and the Chronophotographers* (1992).

MUZIANO, GIROLAMO (1532–92) A Brescian artist, who trained in Padua and Venice, and worked in Rome from 1549; he was a link between northern and central Italy, and in the 1570s and 1580s dominated religious art in Rome. Initially Muziano won fame with his *landscapes, but he studied

hard to become a figure painter, shaving his head to avoid the temptations of love. He made his debut with the *Raising of Lazarus* (1555; Vatican, Mus.), with heavy, *Michelangelesque figures, followed by a series of grave altarpieces for Rome and Orvieto which satisfied Counter-Reformation piety. Muziano ran a big studio, and supervised the decoration of the Galleria Geografica in the Vatican Palace. But he was perhaps most significant as the popularizer of wild landscapes of retreat, where saints meditate in rocky gorges or in gloomy forests, and seven of his landscapes with penitent saints were influentially engraved by Cornelis Cort (1573–5).

HL

Turner, A., *The Vision of Landscape in Renaissance Italy* (1966).

MYCENAEAN ART. The term Mycenaean refers to the art and civilization of mainland Greece and its spheres of influence during the late Bronze Age (also known as the late Helladic period). The civilization is named after the key site of Mycenae in the north-east Peloponnese, first excavated by Heinrich Schliemann in 1876 following on from his excavations at Troy. At both sites he was searching for the physical remains of the society evoked in the Homeric epic of the *Iliad*, the golden Mycenae of Agamemnon and Priam's windy Troy, and though the historical reality of the Trojan War remains a topic of lively debate, Schliemann can be credited with discovering the lost Bronze Age world of Greece. Archaeologists subdivide the Mycenaean period into phases using changes in pottery styles and correlations with Egyptian absolute dates, with the following major phases:

Late Helladic I–II, *c.*1550–1400 BC
Late Helladic III, *c.*1400–1050 BC

This timespan encompasses the rise of elite warrior groups, the establishment of a centralized bureaucratic society based around the Mycenaean citadels or palaces, and the dramatic and violent collapse of this complex society towards the end of the 12th century BC. Mycenaean art represents an amalgam of mainland Helladic traditions with the influences and skills of *Minoan palatial society, and it is therefore relevant to review briefly the character of the earlier early–middle Helladic (EH–MH, *c.*3000–1550 BC) periods. EH pottery is hand made with burnished surfaces. By the beginning of MH new pottery traditions had emerged: Matt Painted ware with linear painted designs, and, most importantly, Minyan Ware, the sharply articulated shapes of which reflect a new technology—the introduction of the potter's wheel. The cool elegance of the shapes, such as stemmed goblets, is matched by the smooth silvery-grey burnished surfaces, and a less common variant, yellow Minyan, from which the lustrous pale surfaces of later Mycenaean pottery are derived.

The introduction of Mycenaean pottery defines the beginning of the late Bronze Age and it exemplifies the growing influence of Minoan Crete on the arts and crafts of the mainland since both shapes (e.g. cups, rhyta) and decorative designs (e.g. spirals, floral motifs) are Minoan in origin. The emergence of elite groups with access to luxury materials and to skilled artists finds expression in the richly furnished Shaft Graves of Mycenae (*c.*1600–1500 BC), the spectacular contents of which are displayed in Athens (Nat. Arch. Mus.), and it is here too that the complex blending of Minoan and native Helladic artistic traditions can be clearly observed. The graves themselves are marked by limestone stelae, some with simple relief carvings such as chariots and hunting lions. These show little sign of Cretan influence and represent new local traditions with images of aggression and combat appropriate to the ideology of a warrior elite, whose martial credentials are indicated by the fine collection of weaponry—swords, daggers, spears—in the burials. The short daggers with inlaid decoration along both sides of the blade are technically and artistically remarkable. Scenes of human and animal pursuit are exquisitely inlaid in precious metals onto a niello background; thus a scene of wild cats hunting duck (adapted from Egyptian imagery) has golden cats and a winding river stocked with silvery fish. The origin of this elaborate technique of 'painting in metal' remains uncertain but may have reached the Aegean from Syria.

Gold and silver plate is also plentiful in the graves; there are, for example, five gold and twelve silver cups in grave V. Many of the shapes are Minoan in origin, though the highly varied workmanship is suggestive of local craftsmen as well as Minoan imports. Other metal vessels of note include the silver Siege Rhyton decorated in repoussé with an vigorous battle scene taking place under the gaze of the inhabitants of a besieged town and a gold stemmed cup with birds perched on the top of the handles, romantically named Cup of Nestor for its passing resemblance to the splendid vessel owned by wise King Nestor in Homer's *Iliad* (11. 632–5). The Shaft Grave burials were provided with golden paraphernalia produced especially for the grave: funerary masks (including the Mask of Agamemnon), diadems, and relief cut-outs, the latter reproducing Minoan motifs such as griffins, tripartite shrines, octopuses. The flood of Minoan forms and imagery makes it difficult to be sure whether individual artefacts are the creation of Minoan or Mycenaean artists and whether they were made in Crete or to commission on the mainland. Some gold seal-rings, for example, show typically Minoan ritual scenes, while others with scenes of battle and man–lion combat seem rather to have Mycenaean tastes in mind.

By *c.*1450 BC episodes of destruction in the Minoan palaces and the rise to prominence of the Mycenaeans in the Aegean seem to have resulted in Crete being drawn into the Mycenaean sphere of influence. Developments in Mycenaean pottery (LH II–III) clearly illustrate both the consummate skills of the potter and the preference for structured or tectonic decoration with stylized motifs—just recognizable as the descendants of earlier floral and marine motifs—neatly confined within encircling bands and lines meticulously painted on the wheel. Typical shapes include a range of drinking vessels, stemmed cups (*kylikes*), and mugs of more generous capacity, while stirrup jars (named for the stirrup shape of the handle) and alabastra were mass produced as transport containers for oils and perfumes which were traded throughout the Mediterranean. The hands of individual painters are recognizable in more complex pictorial scenes painted on large craters with rows of stately chariots, bulls, or plump water-birds. LH III clay *larnakes* (sarcophagi) with pictorial decoration are known only from Tanagra in Boeotia (Thebes Mus.); they are unique both as artistic images and as social documents. Their iconography includes scenes of sphinxes, mourning women, and in one case a poignant scene of figures lowering a tiny body into a *larnax* drawn in X-ray, outline technique. Terracotta figurines, decorated in the same range of stylized motifs as pottery and therefore probably produced in the same workshops, range from small pieces—human, animal, even little model chariots and furniture—to more imposing human and animal figures thrown on the wheel. Amongst the most striking are a series of figures from Mycenae with dark painted forbidding expressions (Nauplion Mus.); the largest is 70 cm (27⅜ in) in height and holds aloft a hammer-axe. It is unclear whether they represent deities or votaries.

The art of wall painting was adopted through contact with Crete; and Mycenaean frescoes are known from major centres such as Mycenae, Tiryns, Thebes, and Pylos. Some themes are adopted from the Minoan repertoire—ladies in gaily coloured flounced skirts, acrobatic bull leapers—though they tend to be more stiffly drawn and lack the grace and spontaneity so characteristic of Minoan art. Familiar from the artistic repertoire of the Shaft Grave phase are themes of warfare and of hunting which appropriately graced the Mycenaean megaron at the heart of the Mycenaean palace or citadel. The *Tiryns Boar-Hunt* fresco, though fragmentary, preserves a fierce-tusked boar trapped in a marshy thicket by the hunters who are ac-

companied by chariots driven by women (identifiable by the conventional white skin) and by long-legged hunting dogs with extraordinary pink and blue dappled coats (Athens, Nat. Arch. Mus.). Painted floors were also popular in Mycenaean palaces; at Pylos in Messenia the floor was divided into rectangular blocks of geometric and stylized marine designs while the focal point of the floor was the great central hearth with frescoed flame patterns around its edges. Frescoes also decorate the Cult Centre at Mycenae and images such as a female attired in a helmet made from overlapping slices of boar's tusk and another grasping sheaves of grain (Nauplion Mus.) make it tempting to speculate on possible links with later Greek divinities such as Athena, warrior protectress of the city, and Demeter, goddess of agriculture.

Luxury arts, such as goldwork, gem cutting, and ivory carving flourished in palace workshops. The excellence of Mycenaean skills in ivory carving is widely recognized. A circular box lined with strips of tin (c.1400 BC; Athens, Nat. Arch. Mus.) was carved from a section of elephant tusk and the relief decoration shows a scene of griffins swooping down onto a herd of deer who twist and struggle to escape the sharp beaks and talons of their attackers (Athens, Agora Mus.). Fragments of inlays for furniture, mirror handles, and even a lyre (from Menidi in Attica; Athens, Nat. Arch. Mus.) demonstrate the widespread use of ivory as inlays and appliqués. Ivory carving in the round is well represented by a group of two embracing women and a child from Mycenae (height 6.3 cm/2½ in; Athens, Nat. Arch. Mus.); the artist has carved an intricate shawl around the backs of both women which further emphasizes the unity of the composition. Monumental sculpture, so characteristic of later Greek art, is rare, but the great entrance at

Mycenae boasts the famous Lion Gate, a sculpted limestone relief designed to cover the relieving triangle over the massive conglomerate lintel. The relief depicts a pair of lions (their missing heads were probably made from a different, more valuable material); standing with their forepaws on altars with incurved sides, they flank a central column. The significance of this unique sculpture is uncertain but a heraldic device of the ruling elite or an aniconic symbol of a protecting deity are possibilities.

With the collapse of the palatial system towards the end of the 12th century BC the trappings of civilization all but disappeared—monumental tombs, palaces, luxury arts. Local styles begin to emerge with a general decline in quality. There are pockets of artistic expression such as the elaborately decorated 'Close style' vases and pictorial images of warriors and chariots, the artistic voice of the troubled, unstable times. Through the Dark Ages it is the humble yet essential craft of the potter, meeting basic needs, which allows the archaeologist and art historian to trace a continuous thread to the early development of Greek art. CEM

Hood, S., The Arts of Prehistoric Greece (1994).

MYRON (active c.470–440 BC). Greek sculptor from Eleutherai (bordering Boeotia and Attica). Ancient sources praise the deceptive realism of his work in bronze, especially statues of athletes and a *Heifer* at Athens, which were celebrated in numerous epigrams. Like *Polyclitus, he appears to have been much concerned with issues of composition and motion (*rhythmos*) and of proportion (*symmetria*), yet, according to *Pliny (*Natural History* 34. 58), 'though he was very attentive to his figures' bodies, he does not seem to have expressed the feelings of the mind' and his work displayed certain

archaisms. No originals by him survive, but his *Athena and Marsyas* is preserved in Roman marble copies (Frankfurt, Liebieghaus; Vatican Mus.) as is his better-known *Discobolus* (Discus-Thrower; Rome, Mus. Naz. Romano; London, BM), which though described fully by *Lucian and *Quintillian was not recognized until the discovery of a complete version in 1781, after which it was universally admired and frequently replicated. KDSL

Haskell, F., and Penny, N., *Taste and the Antique* (1981).
Robertson, C. M., *A History of Greek Art* (1975).
Stewart, A., *Greek Sculpture* (1990).

MYTENS, DANIEL (c.1590–1647). Dutch portraitist. He probably trained with *Mierevelt at The Hague but by 1618 was in London painting the Earl and Countess of Arundel. With Paul van Somer (c.1576–1622) and Abraham van Blijenberch (active 1617–22), Mytens introduced a more three-dimensional naturalism to the English tradition of full-length *portraiture. He depicted *James I* (1621; London, NPG) and from 1623 onwards, repeatedly, his son who acceded as Charles I in 1625 (e.g. 1623; Hampton Court, Royal Coll.). The number of full-lengths of Charles I, including replicas, suggest that Mytens, who was appointed royal 'picture drawer' in 1625, had workshop assistance. He made visits back to the Netherlands in 1626 and 1630, perhaps to study the newest developments in his field. Mytens was the leading English court portraitist until the arrival of van *Dyck in 1632. His two finest, and most penetrating, portraits are of the same sitter: *James Hamilton, Later 1st Duke of Hamilton* (1623; London, Tate; 1629; Edinburgh, Scottish NPG). In 1634 he returned permanently to The Hague, where he subsequently practised mainly as an art dealer. KH

Waterhouse, E. K., *Painting in Britain 1530–1790* (5th edn., 1994).

NABIS, a group of painters formed in 1892 by members of the Académie Julian, Paris, who were converted by Paul *Sérusier to *Gauguin's expressive use of colour and rhythmic pattern. The group included *Denis, *Bonnard, *Vuillard, K. X. Roussel, the sculptor George Lacombe, and Paul Ransom. The name Nabis derived from the Hebrew word for prophets, and was related to their interest in Eastern religions, and to their attitude to the new Gauguin style as a kind of religious illumination. The first Nabis exhibition was held in 1892 in the gallery of the Parisian dealer Le Barc de Bouteville, but the group drifted apart after 1899. They were united by their reaction against *Impressionism and academic training, and sought new inspiration in 15th-century Florentine art and in Japanese prints. Their work, which includes paintings, prints, posters, book illustration, and theatre design, is characterized by a decorative or emotional use of flat colour patterns and linear distortion. They disliked middle-class values, but the most accomplished Nabis works are Bonnard's and Vuillard's depictions of bourgeois Paris. HL

Julliet, C., *Nabis 1888–1900*, exhib. cat. 1993 (Paris, Grand Palais).

NADELMAN, ELIE (1882–1946). Polish-born American sculptor. Nadelman was born in Warsaw where he also studied. In 1903 he moved to *Paris where he was initially influenced by *Rodin and the *Antique before turning towards abstraction (see AB-STRACT ART), referring to his work of 1904–14 as 'Researches in Volumes and Accords of Forms' and attempting by calculation to produce ideal abstract beauty. His *Abstract Head*, shown at the Galerie Drouet in 1909, anticipates *Brancusi, and he later became obsessed by the belief that his ideas had been stolen by the *Cubists. His work was included in the controversial *Armory Show in New York in 1913 and in 1914, with the patronage of the art-loving cosmetics magnate Helena Rubinstein, he emigrated to New York. Nadelman continued to work in a Cubist idiom as seen in *Standing Bull* and *Wounded Bull* (both 1915; New York, MoMa) but, influenced by the beau monde, became more fashionable, encompassing sleek and female heads in marble to grace Rubinstein's beauty salons, sophisticated portrait busts, and witty painted figures in both wood and smooth terracotta. Much of his work was accidentally destroyed in 1935 and he ceased to exhibit. DER

Kirstein, L., *Elie Nadelman* (1973).

NAHL, JOHANN AUGUST (1710–81). German sculptor and decorator. A key figure in the development of the *Rococo style in Germany, he trained in Paris and Rome before being summoned to Berlin in 1741 by Frederick the Great. There he contributed to the elaborate stucco decor of Schloss Charlottenburg and at nearby Potsdam that of Schloss Sanssouci. It was only after fleeing to Switzerland in 1746 to escape the working conditions imposed by the soldier-king that he embarked on large-scale sculpture, including the graceful tomb of Maria Magdalena Langhans (1751–2) in the church at Hindelbank near Berne. Thereafter he worked as a sculptor and decorator for the Landgrave of Kassel, his last monumental work being a statue of *Landgrave Friedrich II* (erected 1785) for the Friedrichsplatz, Kassel. MJ

Bleibaum, F., *Johan August Nahl* (1933).

NAIVE ART. See PRIMITIVE.

NANCY, city in eastern France (Meurthe-et-Moselle) which was until 1766 capital of the independent duchy of Lorraine. Although nominally owing allegiance to the empire, since the Renaissance Lorraine and

its capital have looked to Italy and France for their cultural inspiration. Little of artistic interest survives in Nancy from before the 16th century, though for 100 years previously the court had been an important patron of illuminated manuscripts and elaborate festivities. Nancy's most important Renaissance sculptor was Florent Drouin (*c*.1540–1612), figures for whose tomb of Cardinal de Vaudémont survive in the church of the Cordeliers. Court patronage reached its zenith under Duke Charles III (ruled 1559–1608) and Duke Henri II (ruled 1608–24). Something of their love of lavish spectacle and ceremony can be recaptured in the drawings and prints collected in the Musée Historique Lorrain in Nancy. It is also reflected in the extravagant *Mannerism of the group of distinguished painters and printmakers who worked in the city in the early 17th century. Among them were Jacques *Bellange, Jean Leclerc, Claude *Deruet, and Jacques *Callot, who are well represented in the Musée Historique. *Claude Lorrain worked briefly in the city as assistant to Deruet in 1625–6, before returning permanently to his adopted Rome. Lorraine's most famous native painter Georges de *La Tour worked almost exclusively at Lunéville, about 30 km (18 miles) from the capital. However, Nancy is home to two important works—*Woman with a Flea* and *The Discovery of the Body of S. Alexis* (both Mus. Historique). During the 1630s Lorraine was caught up in the tragedy of the Thirty Years War and plague and occupation by French troops brought artistic life in Nancy to a virtual standstill. Nevertheless the period is remarkable for one major work of art, Callot's series of etchings the *Grandes Misères de la guerre*, which reflect the upheavals of the time. The 18th century was the period when Nancy assumed its present form as one of the most elegant and gracious small cities in Europe. But the patronage of Duke Leopold (ruled 1697–1729) and of Grand Duke Stanislaus Leczinski (ruled 1736–66), former King of Poland and father-in-law to Louis XV of France, was mainly architectural and decorative, culminating in one of the most attractive ensembles of architecture and sculpture of the 18th century—the Place Stanislas with its Hôtel de Ville by Emmanuel Héré (1705–63), its fountains and statues by Barthélemy Guibal (1699–1757), and its superb iron grilles by the native metalworker Jean Lamour (d. 1771). Also noteworthy is the moving monument to Stanislas's wife Catherina Opalinska by Nicolas-Sébastien *Adam (1749; Notre-Dame de Bon Secours). On the death of Stanislas Lorraine was incorporated into France and Nancy ceased to be an artistic centre of importance, though the sculptor *Clodion, born in the city, lived there in 1793–8 to escape the Terror. At the end of the century Nancy enjoyed a renaissance as a centre of the decorative arts with the glassmakers

Emile Gallé (1846–1904) and August Daum (1853–1909) among the best known of the so-called École de Nancy. Among the works in the interesting Musée des Beaux-Arts is the spirited historical canvas *The Death of Charles le Téméraire at Nancy* by *Delacroix (1831) which had been commissioned by Charles X for the museum. MJ

'La Vie artistique', in H. Collin (ed.), *Encyclopédie illustrée de la Lorraine* (1987).

Taveneaux, R. (ed.), *Histoire de Nancy* (1978).

NANNI DI BANCO (*c*.1380×5–1421). Italian sculptor, born in Florence. He trained under his father Antonio di Banco, and during his career was involved in commissions for the city's most important sculptural projects at the cathedral and at Or San Michele. Though Nanni's work can justifiably be associated with a new classical style emerging in Florence, his relationship to the *Antique was equivocal. His *Isaiah* (1408; Florence, Duomo) and the *S. Luke* (1413; Florence, Mus. dell'Opera del Duomo) display his awareness and receptivity to classical sculpture. Yet the four figures in his most *classicizing work, the *Quattro santi coronati* (*c*.1415; Florence, Or San Michele), though modelled on Roman senator figures, nevertheless have an awkward stiffness of demeanour. In its oval design, inscribed on a triangle, his Porta della Mandorla (1414–21; Florence Cathedral) marks a return to a more *Gothic linear grace. HO/AB

Wundran, M., *Donatello and Nanni di Banco* (1969).

NANTEUIL, ROBERT (1623–78). French portrait engraver and pastellist. His early drawing style was influenced by the dignified and austere realism of Philippe de *Champaigne. Translated into the medium of *line engraving with the highest level of technical skill Nanteuil's style set the standard for portrait prints in France well into the 18th century. His sequence of life-size, head-and-shoulders portraits of his contemporaries reads as a gallery of the most distinguished personalities of the age of Louis XIV, including the King himself, Cardinal Mazarin, and Jean-Baptiste Colbert. Examples may be seen in many print rooms including those of the Bibliothèque Nationale, Paris, and the British Museum, London. The Louvre has a number of his accomplished pastel portraits. MJ

Petitjean, C., and Wickert, C., *Catalogue de l'œuvre gravé de Robert Nanteuil* (1925).

NAPLES: PATRONAGE AND COLLECTING. As a centre of art, Naples has played a major role in Italy since the end of the 13th century. The Angevins (1266–1414) recruited important artists to renew the capital of the kingdom. *Giotto and *Simone

Martini worked for the court and the religious orders principally the Franciscans: Giotto, Naples, Castel Nuovo, Cappella di S. Barbara, frescoes; Naples, S. Chiara, choir, frescoes, both destr.; Simone Martini, *S. Ludovic of Tolosa Crowning his Brother Roberto*, Naples, Capodimonte. These new tendencies were followed by Neapolitan artists such as Roberto d'Oderisio (Naples, S. Maria dell'Incoronata, frescoes, 1352–4). During the 14th century the political changes gave a new order to the arts. After the Aragonese conquest of the kingdom (1442), Alfonso I of Aragon commissioned the Arco di Trionfo at Castel Nuovo (after 1443); Guillermo *Sagrera, Francesco *Laurana, and other masters together worked on this classical relief, commemorating the entrance of Alfonso into Naples. Under Aragon's domain Naples became a prominent art centre in *Renaissance Italy, and again the royal courts were the most important patrons. Colantonio del Fiore established a Neapolitan Renaissance school of painting, whose best pupil was *Antonello da Messina. Works by *Pisanello and others were commissioned or bought by the Aragonese sovereigns. *Donatello and *Michelozzo sent to Naples a marble relief for the burial monument of Cardinal Brancacci (1426–8; Naples, S. Angelo a Nilo), strengthening the Tuscan artistic influence in the city, demonstrated also by Antonio *Rossellino and Benedetto da *Maiano sculptures in the church of Monteoliveto. During the last decades of the 15th century the two Spanish sculptors Diego de *Siloe and Bartolomé *Ordóñez created a new Neapolitan style, continued in the early 16th century by the main local master Giovanni Marigliano da Nola. Almost all the Renaissance sculpture of Naples was commissioned for churches; the main patrons were the Carafa, the Caracciolo, and later the Pignatelli, all among the most important families of the kingdom, who became established in the capital after the arrival of Alfonso. The most important public 16th-century commission, the burial monument of the Viceroy, Don Pedro de Toledo and his wife (*c*.1570; Naples, S. Giacomo degli Spagnoli), symbolizes the new Spanish power over the kingdom. In painting there were important commissions including the *Madonna del Pesce* by *Raphael (Madrid, Prado), commissioned *c*.1514 by Giovan Battista del Duco for his family chapel in S. Domenico Maggiore, Naples. Recruited to Naples by the prior general of the Olivetan order, Gianmatteo d'Aversa, Giorgio *Vasari frescoed the so-called Refettorio of the monastery of Monteoliveto and produced several pictures on panel for the same room (1544). This pictorial cycle is an example of mature *Mannerism and reconfirms the Florentine connections of the Olivetan order in Naples. During the second half of the century the

Counter-Reformation religious orders became the main art patrons in Naples. Two-thirds of the new building activity was instigated by the monasteries. A generation of artists including Belisario Corenzio (active 1590–1646), Gerolamo Imparato (active 1571–1607), Fabrizio Santafede (active 1576–1623), and Giovan Bernardino Azzolino (c.1572–1645), imposed a style influenced by foreign artists in the city such as Marco da Siena (c.1525–c.1587) and Dirck Hendricksz. (Teodoro d'Errico; d. 1618). The Benedictines of SS Severino e Sossio were among the main patrons of Marco Pino da Siena, while the Armenian nuns of S. Gregorio Armeno commissioned from Dirck Hendricksz. the grand ceiling of the nave, depicting *Stories of S. Gregorio Armeno, S. John the Baptist, S. Benedict and the Virgin* (c.1580–2). In the first two decades of the 17th century the Neapolitan artistic scene was radically transformed by the two sojourns of *Caravaggio (1606–7 and 1609–10). Caravaggio left a considerable number of altarpieces in Naples (*The Seven Acts of Mercy*, 1607; Pio Monte della Misericordia; *Flagellation of Christ*, 1606–7; S. Domenico Maggiore), and influenced all the Neapolitan painters of his time, especially Giovanni Battista *Caracciolo. Caravaggio's patrons were noblemen including Marcantonio Doria (who commissioned from *Genoa in 1610 the *Martyrdom of S. Ursula*; Naples, Banca Commerciale Italiana); and businessmen such as Nicolò Radulovich from Ragusa, resident in Brindisi.

Once again Naples was a crossing point for foreign artists: Guido *Reni, *Domenichino (Cappella del Tesoro di S. Gennaro, frescoes and paintings), Giovanni *Lanfranco (frescoes in the church of the Charterhouse of S. Martino; frescoes in the nave ceiling and pediments of the church of SS Apostoli; in the dome of the Cappella del Tesoro di S. Gennaro), Simon *Vouet (*Circumcision of Christ*; S. Angelo a Segno; *Madonna and S. Bruno*; S. Martino); Nicolas *Poussin (the *Adoration of the Golden Calf*, destr.), Charles Mellin (paintings for S. Maria Donnaregina Nuova and for Montecassino), Pietro da *Cortona (*Death of S. Alessio* in the Gerolamini). In 1612 Jusepe de *Ribera moved from Rome to Naples, where he stayed until his death. Ribera gave a realistic quality to Neapolitan painting in both public and private works (*Prophets* and *Deposition of Christ* in the nave of S. Martino; *Triumph of Silenus*; Capodimonte; *Venus and Adonis*; Rome, Gal. Corsini). There was also a flourishing local school of painters: Massimo *Stanzione built up an important school, whose main exponents were Francesco Guarino, Pacecco de Rosa, Agostino Beltrano, and Bernardo *Cavallino. These artists, together with Aniello Falcone and *Micco Spadaro, took important commissions both from religious and private patrons, above all decorating with frescoes and paintings churches of the religious orders: Gesù

Nuovo, S. Martino, S. Paolo Maggiore, and the Gerolamini. They also played a key role in providing a group of paintings (now Madrid, Prado) depicting stories of Roman emperors commissioned by the Count-Duke of Olivares for the Casón del Buen Retiro in Madrid (around 1633–7), and which arrived in Spain through the Count of Monterrey, Viceroy of Naples. The Count-Duke of Olivares's commission for the Buen Retiro pictures shows the international reputation achieved by the Neapolitans. In the same years a group of private patrons and collectors in Naples, in particular Gaspar Roomer and Ferdinand Vandeneynden, developed a more modern and outward-looking taste in painting. Roomer had a very varied taste: he collected works by Dutch masters together with local painters such as Andrea *Vaccaro, Massimo Stanzione, and Luca *Giordano, and around 1640 he commissioned from Peter Paul *Rubens the *Feast of Herod* (now Edinburgh, NG Scotland), thereby introducing to Naples a neo-Venetian style of great influence for the evolution of the local Baroque.

Pietro Bernini (1562–1629) took the lion's share of sculpture commissions between the end of the 16th century and the beginning of the 17th (sculptures for the Charterhouse of S. Martino; two *Allegories* for the niches in the façade of the church of the Monte di Pietà). After Pietro's departure for Rome with his son Gianlorenzo *Bernini, Cosimo Fanzago became the leader in sculpture and architectural decoration (sculptures in the cloister and interior of the church of S. Martino; projects for S. Maria degli Angeli alle Croci, S. Teresa a Chiaia). And two assistants from Gianlorenzo Bernini's studio came to work in Naples: Giuliano *Finelli (c.1630) and Andrea Bolgi (c.1650). They became the two principal portrait specialists of the first half of the 17th century (Finelli: kneeling portrait of *Cesare Firrao*, c.1640; Naples, S. Paolo Maggiore; bust of *Carlo Andrea Caracciolo, Marquis of Torrecuso*, c.1643; Naples, S. Giovanni a Carbonara; Bolgi: four portraits of exponents of the de Caro-Cacace family, 1653; Naples, S. Lorenzo Maggiore). Both Bolgi and Finelli had already participated in Filippo Borromini's Altare Filomarino in SS Apostoli (Naples, 1642–7), which had been commissioned by Cardinal Ascanio Filomarino, the most Roman-oriented patron in Naples. Filomarino, who had connections with the Barberini family in Rome, also acquired works by *Valentin, Vouet, and Reni.

Baroque painting is represented in Naples by Luca Giordano and Francesco *Solimena. In Naples Giordano's principal patron was probably Don Guzmán de Haro, the Marquis of El Carpio, Viceroy of Naples 1683–7. It is also interesting to see how Gordano benefited from the free art market linked to almost all parts of Italy that was developed in Naples by art dealers such as Carlo della

Torre who sold important works by Giordano to Venetian Jewish traders such as Vincenzo Samuelli and Simon Giogali, who also acted as agent for the Elector of Bavaria. Although Solimena never moved from Naples, he became a prominent international figure, sending his works to Vienna, England, France, and many Italian cities. In Naples his principal patrons were religious orders such as the Theatines (S. Paolo Maggiore, frescoes in the sacristy, 1689–90) and the Jesuits (church of the Gesù Nuovo, frescoes in the rear façade, 1725). Many aristocrats commissioned from Solimena portraits and works depicting classical stories in an Arcadian style: full-figure portrait of *Diego Pignatelli d'Aragona*, c.1730; Rome, priv. coll. *Dido and Aeneas*; Naples, Mus. Nazionale di S. Martino, commissioned c.1740 by the family Spinelli di Tarsia.

Giordano's and Solimena's reputation survived the changes of political power in the 18th century: the Austrian domination (1707–1734) and the Bourbon dynasty (1734–99). Solimena's followers received almost all the commissions for the decorations in the royal palace of Caserta, in the royal palace at Naples, and the various 'Siti Reali' (Carditello, Persano, Fusaro); Francesco de Mura (1696–1782), Giuseppe Bonito (1707–89), Filippo Falciatore (active 1728–68), Fedele Fischetti (1732–92), and Pietro Bardellino (1728–1819) worked under the rule of Charles III and his son Ferdinand IV. Domenico Antonio Vaccaro (1678–1745), a son of the sculptor Lorenzo Vaccaro, was a follower of Solimena who worked brilliantly as painter, sculptor, and architect for many religious orders in Naples (particularly at S. Martino, and at the church of the Concezione a Montecalvario).

From the second half of the 18th century onwards Naples was deeply affected by the stream of European travellers on the *Grand Tour. A typical instance of Grand Tour patronage is the commission from John Montagu, Lord Brudenell, to Antonio Joli (c.1700–77) for more than 30 views of Naples and the kingdom (c.1756–8). *Goethe, the most famous Grand Tour traveller at the end of the 18th century, visited the south of Italy accompanied by his friend Johann Heinrich *Tischbein, who portrayed the German poet in the famous work *Goethe in the Roman Campagna* (Frankfurt, Städelsches Kunstinst.) and provided a visual equivalent of Goethe's *Italienische Reise* with a great number of sketches, views, and landscapes. An immense contribution to the knowledge and the diffusion of the taste for the *Antique was made by Sir William Hamilton (1730–1803), who lived in Naples until 1799. Enriched by the discoveries in *Pompeii and *Herculaneum, Hamilton's collection of antiquities was a crucial influence in fostering a taste for *Neoclassical art at the Bourbon court.

In the 19th century the decadence of the

religious orders and of the Bourbons gradually reduced the status of the arts in Naples. Antonio *Pitloo, Giacinto Gigante, and others continued a local style of view painting principally produced for foreign travellers. Such work was frequently handled by low-level dealers or bought directly by foreign collectors. The Scuola di Resina was an anti-academic local movement, parallel to French *Impressionism, which developed in the context of a local market dominated by small dealers. During the 20th century, Naples has lost the prestige of earlier times. RL

NAPLES, CAPODIMONTE (il Museo e le Gallerie Nazionali di Capodimonte), a major Italian gallery, holding many paintings from the Farnese Collections in Rome, Parma, and Piacenza. Charles Bourbon had already inherited the Farnese patrimony when in 1734 he became the first Bourbon king of Naples and decided to move the Farnese Collections to that city. The palace of Capodimonte, designed for the paintings, was begun in 1738; many paintings were displayed in it from 1759. Following the Napoleonic interregnum the Farnese paintings were incorporated in the Royal Bourbon Museum and were exhibited in a former university building, together with the great Farnese collection of Antique sculpture from Rome, the finds from *Pompeii and *Herculaneum, and other local collections. This agglomeration reflected contemporary gigantism in European national museums. For many years the Capodimonte Palace was used as a royal residence, incorporating public galleries for modern painting, armour, and the minor arts. It was established as a museum in its present form in 1957.

In addition to the Farnese pictures the Capodimonte collection includes various later acquisitions, especially Neapolitan secular and religious paintings brought together in the period from 1790 to 1821. The Farnese paintings themselves are mainly of the 16th and 17th centuries. They include the famous papal portraits and the *Danaë* done by *Titian for the Farnese in the 1540s and also many important works by Emilian painters (e.g. *Correggio, *Parmigianino, Bartolomeo *Schedoni, the *Carracci). AJL

Museo e Gallerie Nazionali di Capodimonte, *La collezione Farnese* (1995).

NAPLES, MUSEO ARCHEOLOGICO NAZIONALE. Founded as the Real Museo Borbonico (Royal Bourbon Museum) in 1777, the collection is composed of a combination of private collections and finds from 18th–20th–century excavations in Naples and its environs. The Farnese Collection was relocated here from Rome in 1788. The colossal *Farnese Bull* and *Farnese Hercules,* found in 1545 on Farnese property at the Baths of Caracalla in Rome, are particularly spectacular examples. Perhaps the most impressive and best-known material comes from the buried cities of *Pompeii, *Herculaneum, and Stabiae, discovered in the mid-18th century. Following the vogue of the day, segments of painted walls and inset panel paintings were removed from the walls of houses and public buildings. These and other excavation finds, from the banal—keys and workman's tools—to the sublime—more than 80 bronze and marble statues from the grandiose Villa of the Papyri—were all stripped from their context with little formal recording. They found their way first to the Museo Ercolanese in Portici, then were transferred here between 1805 and 1822. They provide the most complete documentation for Roman art of the republican to the early imperial period, with a *terminus ante quem* of AD 79. The possibility of reconstructing finds from single houses, villas, and temples sites (such as that from the temple of Isis) testifies to a *koine* (a standard set of finds), often best revealed by variation therefrom. Thus, the Villa of the Papyri is extraordinary for its portraits of Hellenistic dynasts whereas the temple of Isis focuses on Egyptian and Egyptianizing iconography. Other groups, such as the massive silver dining service from the House of the Menander, Pompeii, testify to individual wealth. Other important material comes from the finds at Cumae and Baiae, as well as from private collections of Greek vases from Etruria. L-AT

Museo Archeologico Nazionale di Napoli, vols. 1–2 (1989).

NASH BROTHERS. English painters. **Paul** (1889–1946), born in London, trained at Chelsea Polytechnic (1907–8) and the Slade School (1910–12), where a chance remark from the distinguished Academician Sir William Blake Richmond (1842–1921) led him towards landscape painting. Perceiving the 'reality of another aspect of the accepted world, [a] mystery of clarity at once elusive and positive' (*Outline,* see below), he set himself the task of revealing the spirit behind the familiar world. The beginning of a successful career, helped by Roger *Fry among others, was interrupted by the First World War in which he served firstly as a soldier and latterly as a *war artist. His war paintings, which brilliantly express the destruction and disillusion of the participants, as in *We are Making a New World* (1918; London, Tate), established his reputation when shown at the Leicester Gallery in 1918. During the 1920s and 1930s he was drawn to *Surrealism and his landscapes became increasingly symbolic, like the desolate *Winter Sea* (1925–37; York, AG), although he continued to see himself within the lyrical tradition of *Turner and *Blake. Fascinated by the Metaphysical paintings of *de Chirico, seen in 1928, he adopted distortions of *perspective and scale to create mysterious affinities, as shown in *Landscape from a Dream* (1938; London, Tate). During the same period an interest in *objets trouvés, which he both displayed and photographed, influenced works like *Landscape of the Megaliths* (1937; Buffalo, Albright-Knox Gal.). During the Second World War, attached to the Air Ministry, Nash produced many memorable images, including the haunting *Totes Meer* (1940; London, Tate), which extended his explorations of the personality of inanimate objects from natural wood and stone to machinery. Concurrently he was painting a final group of landscapes in which the mysteries of existence are symbolically celebrated through the metamorphic union of sunflower and sun at the ancient festivals of the Solstice, the climax of his perception of the interpenetration of past and present, reality and vision: *Eclipse of the Sunflower* (1945; London, V&A) is a typical example. A vital link between the English landscape tradition and the modern movement, Nash remains one of the great interpreters of the spirit of landscape through his unique blend of memory, observation, and imagination. He was also a penetrating critic whose writings, *Outline: An Autobiography and Other Writings,* were published posthumously in 1949. His brother **John** (1893–1977) worked as a painter and wood engraver, producing finely detailed botanical illustrations for the Golden Cockerell Press. He received no formal training but his landscapes, especially in watercolour, have a delicate balance of observation and formality which effectively captures the essence of the English countryside. *The Cornfield* (1918; London, Tate) and *Park Scene, Great Glenham* (c.1943; Liverpool, Walker AG) are typical examples. JH

Causey, A., *Paul Nash* (1980).
Rothenstein, J., *John Nash* (1983).

NASONI, NICCOLÒ (1691–1773). Tuscan painter and designer of sculpture, though more famous as an architect. He introduced a highly ornate late *Baroque style into north Portugal where he was active from 1725, executing decorative schemes which by the mid-century were becoming stylistically close to the *Rococo. He was born near Florence, but early moved to Siena where he studied under Giuseppe Nasini (1657–1736) whose style (which his pupil absorbed) owed much to *Buontalenti and Pietro da *Cortona. From Siena Nasoni emigrated via Rome to Malta where he is documented in 1724 and 1725, painting *trompe l'œil decorations at Valetta in the residence of the grand master and in other palaces. By November 1725 he was at Oporto where he painted the chancel (*capela-mor*), aisles,

and sacristy of the cathedral with convincingly illusionist frescoes, of great elaboration, theatricality, and inventiveness (1726–34); and then the nave aisles and chancel vaults of Lamego Cathedral (1734–8). In the best Baroque tradition Nasoni was also a prolific designer of architectural ornament, dramatic retables, and sculpture in stone, wood (*talha*), and metal, including statues and fountains. JBB

Smith, R. C., *Nicolau Nasoni* (1966).

NATOIRE, CHARLES-JOSEPH (1700–70). French painter. He was a pupil of *Lemoyne and won the *Prix de Rome in 1721. The years 1723–8 were spent in Italy where he was influenced by the work of *Raphael and Pietro da *Cortona. Natoire returned to a successful official career in Paris, executing decorative schemes and tapestry cartoons for the Crown. His most remarkable decoration was for the chapel of the Enfants-Trouvés (the Paris Foundling Hospital) with an imaginative sham-ruined ceiling (completed 1751, but now known only through engravings). His best-known surviving paintings are his amorous mythologies set into the panelling of the Hôtel de Soubise, Paris (1737). They seem weak, however, in comparison with the neighbouring canvases by *Boucher, his fellow pupil from Lemoyne's studio. In 1751 Natoire was appointed director of the French Academy in Rome. This effectively was the end of his career as an active painter and he never returned to France. Towards the end of his life, however, he quite unexpectedly began to draw and paint the landscape of the Roman Campagna (e.g. the drawing *View of S. Gregorio, Rome*, 1765; Edinburgh, NG Scotland). *Fragonard and Hubert *Robert were pupils at the Rome Academy during Natoire's directorship. MJ

Julia, I., *Charles-Joseph Natoire*, exhib. cat. 1977 (Rome, Académie de France; Nîmes, Mus. des Beaux-Arts).

Mantz, P., *Boucher, Lemoyne et Nattier* (n.d.).

NATTER, JOHANN LORENZ (1705–63). German *medallist and gem engraver. After training as a goldsmith he led a peripatetic existence moving from capital to capital. In Florence, encouraged by the antiquary Philipp von Stosch, he developed a classical style based on Antique carved gems. This early manifestation of *Neoclassicism found particular favour in Augustan England, where Natter made a handsome medal with a bust portrait *all'antica* of *Sir Robert Walpole* (1741; London, BM). In the next decade he travelled extensively and adapted his style to conform with the prevailing taste for *Rococo design. His most constant patron was William IV, Stadholder of the Netherlands, who commissioned many gems and medals from him. In 1754 he published a treatise on the methods used for gem engraving in Antiquity. MJ

Nau, E., *Lorenz Natter* (1966).

NATTIER, JEAN-MARC (1685–1766). French painter. Although he trained as a *history painter he soon changed to the more lucrative field of society portraits. His delicately coloured, well-mannered images, often showing the sitter in allegorical semi-disguise, have become synonymous with the court culture of the age of Louis XV. He excelled at depicting women, and such works as *The Duchesse d'Orléans as Hebe* (1744; Stockholm, Nationalmus.) are the epitome of *Rococo portraiture. Nattier's reputation was consolidated in the late 1740s by his series of portraits of Louis XV's wife and daughters. That of the neglected *Queen Maria Leczinska* (1748; Versailles) is a tour de force, miraculously combining opulence with piety. MJ

Huard, G., 'Nattier', in L. Dimier (ed.), *Les Peintres français du XVIIIe siècle*, vol. 2 (1930).

NATURALISM. *See overleaf.*

NAVARRETE, JUAN FERNÁNDEZ DE (1526–79). Spanish painter, nicknamed El Mudo (deaf mute). Part of his artistic training took place in Italy, and his style shows a blend of Florentine and Venetian inspiration. Upon his return to Madrid in 1568, Philip II named him court painter and set him to work for the new monastery of El *Escorial. Between 1569 and 1571, Navarrete finished four large canvases, of which the most impressive is the *Decapitation of S. James* (1571). Although influenced by *Tintoretto's art in colour and composition, the expressive naturalism of the saint's face is a personal feature that enhances the scene's emotive content. Four more pictures followed in 1571–5, among them a night *Nativity*, also related to contemporary Venetian painting in its *chiaroscuro and rich luminary effects. In 1576, Navarrete started a series of altarpieces for the basilica. By the time he died, he had completed eight paired representations of the apostles and the Evangelists, monumental and powerfully characterized figures. In both style and technique, Navarrete stands out as the most progressive and accomplished of the Spanish painters working in the Escorial. NAM

Brown, J., *The Golden Age of Painting in Spain* (1991).
Mallory, N. A., *El Greco to Murillo: Spanish Painting in the Golden Age: 1556–1700* (1990).

NAY, ERNST WILHELM (1902–68). German painter. Nay was born in Berlin and studied in his home city at the Berlin Academy (1925–8) under the individualistic painter Carl Hofer (1878–1955). In 1928 he went to Paris, where he was influenced by *Picasso, and spent 1930–1 in Rome. In 1936 he was invited to Norway by *Munch where he painted fjords and landscapes with Expressionist intensity in bright, Fauve-like colours. He continued to paint during his military service in France (1942–4) and, after the war, his style developed from *Expressionism to increasing abstraction (see ABSTRACT ART). In 1951 he settled in Cologne and joined the Zen Group of painters which included Hann Trier (1915–), Emil Schumacher (1912–), and Bernard Schultze (1915–) who practised automatic calligraphy to express the spirit of Zen Buddhism, much as *Tobey had done in America. Nay's calligraphic linear style developed towards a form of *Tachisme, with a greater emphasis on colour, in the mid-1950s. His reputation is largely confined to Germany where he had retrospective exhibitions at Düsseldorf (1959) and Essen (1962). DER

Haftmann, W., *Ernst Wilhelm Nay* (1960).

NAZARENES, the nickname, originally satirical, of a group of 19th-century German painters who set out to purify art by reviving the spirit and style of early religious painting. In 1809 Franz *Pforr and Friedrich *Overbeck founded the guild of S. Luke (Lukasbund) in Vienna, in protest against the restrictions of academic training. With Johann Kottinger (1788–1828), and (Georg) Ludwig Vogel (1788–1879) they moved to Rome, and in 1810 settled in the abandoned monastery of S. Isidoro, outside the city.

The Brotherhood were inspired by the writings of the German *Romantics, particularly August and Friedrich von *Schlegel, Johann Tieck, and Wilhelm Wackenroder. Adopting the lifestyle of a religious order, their time was spent communally, divided between painting and prayer. Their sources were eclectic but consistent: they admired *Dürer and the *Gothic painters, the masters of the Italian quattrocento, and the early work of *Raphael, believing that only the naive piety of primitivism could purge the excesses of later art.

Other artists joined the Brethren, notably Peter *Cornelius, Ferdinand Olivier (1785–1841), and Julius *Schnorr von Carolsfeld. Despite their avowed withdrawal from the world, they soon gained patrons; during the 1820s their works were fashionable with the growing tourist population. Their studios became the centre of Roman revivalist art, and the archaism of their style was admired by many foreign artists, including *Ingres, Ford Madox *Brown, and William *Dyce, whose influence inspired the English *Pre-Raphaelites.

One of the group's aims was to revive monumental fresco painting, executed communally following medieval and *Renaissance tradition. They completed two major commissions: at the Casa Bartholdi (1816–17;

509

· NATURALISM ·

THE term 'naturalism' was first used in connection with the visual arts in 1672 by the theoretician *Bellori, to characterize the work of *Caravaggio and his followers, who had focused on the details of nature, irrespective of whether they were beautiful or ugly. Only in the 19th century did it assume a central importance in art criticism. Late in the 19th century, and in much subsequent art historical writing, it acquired a more precise meaning, referring to works that claimed to record the external world with scientific accuracy. This was largely derived from the theoretical writings of the novelist Émile *Zola, who claimed that his literary 'naturalism' was analogous to scientific method, revealing the necessary laws of cause and effect in human action.

However, the use of 'naturalism' cannot legitimately be restricted in this way. Earlier in the 19th century, it was often used as a loose synonym for *'realism', to characterize paintings of everyday subjects, treated in a way that rejected academic conventions. In 1863, the critic Castagnary insisted that it should be applied to current tendencies in French painting, but he did not see it as distinct from 'realism'; rather, he argued that 'naturalism' was a more appropriate term for the whole range of art, including that of *Courbet, that was generally called 'realist' in the critical writing of the period.

Moreover, any claims of 'naturalism' to scientific accuracy are misleading. Any representation, whether verbal or visual, involves value-laden choices, both in the selection of the material and in the ways in which it is presented. In a painting such as Jean-François Raffaëlli's The Absinthe Drinkers (c.1881; priv. coll.), just as in Zola's novel L'Assommoir (1876), the effects of alcohol are evoked by a combination of rhetorical devices—in Raffaëlli's painting, by the physiognomies, poses, and gestures of the figures, and by the details of their setting, which are all carefully selected to heighten the effect of their dependency on absinthe.

The issue of 'naturalism' in late 19th-century painting is further complicated by the fact that many painters at the time used *photographs as an aid in working up their compositions, in part to save time and the cost of models, and in part in order to give their paintings a heightened sense of actuality. Photography was generally viewed in the 19th century as a mechanical, and hence in a sense scientific, means of reproduction; only gradually did it acquire the status of a creative 'fine art'. However, the painters used photographs as a part of a complex act of picture-making, and the photographs themselves were carefully posed and composed; their use cannot be taken as evidence of an objective or scientific viewpoint.

Beyond this, the term 'naturalism' and the adjective 'naturalistic' are often loosely used in relation to art of many periods, from prehistoric art and classical Antiquity to the present day, in order to characterize works that appear to depend on direct observation of the external world, in contrast to others that are more stylized or idealized or dependent on stereotypes. While such distinctions may be valuable, three issues must always be borne in mind: such observation, and the idea of 'nature' itself, may stand for very different values in different historical contexts; any artistic representation, however 'naturalistic' it may look at first sight, involves processes of selection and arrangement of the objects represented; and, finally, any representation in an artistic medium involves a comprehensive act of transposition, from the sensory experience of the object itself into the particular physical characteristics of the chosen medium—be it line drawing, oil paint, clay modelling, or even a photograph.

JHo

now in Berlin, Staatliche Mus.), and for the Marquis Massimo, (1817) at his Casino near the Lateran. By the time this work was finished in 1829, however, the brotherhood had dispersed: Cornelius left Rome for *Munich in 1819 and Schnorr joined him there in 1827. Only Overbeck remained in Rome, his studio providing a meeting place for young artists who spread Nazarene ideals through Europe.

Among the first to express the revived enthusiasm for early art which dominated the 19th century, the sincerity of the Nazarenes ensured that their ideas continued to be influential long after their community ceased to exist. Their artistic merit is less certain: their compositions are often uncomfortably crowded, their figures awkward, and they were never entirely at ease with colour. Caught between their genuine religious beliefs, and the desire to revive art, necessitating public recognition of their works, their early commitments inevitably loosened, and individual talents asserted themselves. Their best works are landscape and portrait drawings which combine simplicity with genuine feeling for the divinity in the natural world.

JH

Andrews, K., The Nazarenes: A Brotherhood of German Painters in Rome (1964).

NEEL, ALICE (1900–84). American painter. Born and raised in Pennsylvania, Neel studied at the Philadelphia School of Design for Women (1921–5) before moving to Havana, with her husband, the Cuban artist Carlos Enríquez, where she exhibited in avant-garde exhibitions. In 1927 they returned to New York where, abandoned by Enriquez, she joined the Public Works of Art Project (see FEDERAL ART PROJECT) in 1933 and also painted several controversial portraits, like that of the poet Kenneth Fearing (1935; New York, MoMa), stylistically related to the German *Neue Sachlichkeit painters. During the 1940s and 1950s Neel lived in hardship in Spanish Harlem, painting her neighbours but also retaining links with left-wing intellectuals and associating, in the late 1950s, with the writers of the Beat Generation. Her fortunes changed in the early 1960s when, supported financially by a woman friend, she had several successful exhibitions and began to paint portraits of artistic celebrities, including the intellectual Henry Geldzahler, the composer Aaron Copland, and Andy *Warhol. The most notable are unsparing nude full-lengths, including her Nude Self-Portrait (1980; Washington, NPG), which strip

her sitters of all pretension and reveal their vulnerability. DER

Hills, P., *Alice Neel* (1985).

NEER, VAN DER. Father and son, Dutch painters. According to *Houbraken, **Aert** (1604–77) began as a steward to a local family at Gorinchem, but from the mid-1630s he made his career as a painter in Amsterdam. In 1659 he set up as an innkeeper, but he was declared bankrupt in 1662 and presumably relied on painting for the rest of his life. His early work was closely related to that of the Camphuysen brothers Rafael (1597/8–1657) and Jochem (1601/2–1659) with whom he was friendly at Gorinchem, but his mature paintings consistently display the most sensitive mastery of atmospheric and light effects. He specialized in moonlit and winter scenes, usually including a sheet of water and sometimes also involving the light of a fire, and he also painted sunsets and views at dawn or twilight. The *Landscape in Moonlight* (The Hague, Mauritshuis) is typical. He was a master of subtle modulations of colour and conveyed the impression of light and air by slight changes in the value of his warm browns, pinks, delicate greys, and whites. His son **Eglon** (1634–1703) had an extremely successful career painting genre scenes in the style of ter *Borch and *Metsu. HL

Bachmann, F., *Die Landschaften des Aert van der Neer* (1966).

NEGRETTI, GIACOMO. See PALMA FAMILY.

NEOCLASSICISM was the predominant artistic style in Europe and North America between about 1750 and 1830. There has been more than one classical revival since the end of the culture of the ancient Greeks (see GREEK ART, ANCIENT) and Romans (see ROMAN ART, ANCIENT), most notably that of the *Renaissance of the 15th and 16th centuries. What is distinctive about the classical revival of the later 18th century was its emphasis on archaeological exactitude, the result of the period's unprecedented level of knowledge of the art and architecture of the ancient world. The scientific study of surviving artefacts begun by scholars such as Dom Bernard de Montfaucon and the Count de *Caylus, the systematic excavation of the Roman cities of *Herculaneum and *Pompeii (1738–56), and the exploration and recording of the monuments of the Greek islands and mainland was accompanied by the publication of large-format illustrated books, which considerably expanded the repertoire of models available to artists. To this was added a body of critical theory elaborated in particular by the German scholar *Winckelmann. In his *Reflections on the Imitation of the Painting and Sculpture of the Greeks* (1755) and *History of Ancient Art* (1764), Winckelmann attempted for the first time to give a history of the development of ancient art based on an understanding of its particular aesthetic features, principal among which were deemed to be calm simplicity and noble grandeur.

Rome, with its dense concentration of ancient buildings and sculpture, was the inevitable epicentre of any classical revival. A reaction to the art of the late *Baroque was already apparent in the 1730s among some students of the French Academy in Rome, most notably the sculptor Edmé *Bouchardon. In the following two decades some of the pioneering themes of the Neoclassical revival in architecture were rehearsed by students of the French Academy in the floats they designed for the annual pageant of the Chinea. But it was only in the 1750s in the circle of artists gathered in Rome around Winckelmann and the influential German painter *Mengs that the movement began to gather momentum. Mengs's own most famous work, the *Parnassus* ceiling (1761) in the Villa Albani, shows his limitations, contriving to be both pretentious and insipid. It is perhaps rather to the contemporary paintings on themes from classical literature and history painted in Rome by the British artist Gavin *Hamilton and the American Benjamin *West that one should look for the beginnings of the heroic phase of Neoclassical painting.

Where architects and sculptors could look towards specific classical precedents for their work, painters were able to draw little inspiration from surviving fragments of ancient painting. The Frenchman *Vien used an engraving of a wall painting from Herculaneum as the basis for his mildy erotic *Cupid Seller* of 1763 (Fontainebleau). But artists looking for a means to represent the more heroic and morally uplifting themes that were urged upon them by critics such as *Diderot, in reaction to what was increasingly perceived as the frivolous and unedifying subject matter of *Rococo art, were obliged to turn to the example of *Raphael and, above all, *Poussin for inspiration. In France in particular, Neoclassicism was associated with a desire to return to the dignity and grandeur of the art of the 17th century. Both the aesthetic and the moral aspects of Neoclassicism found their most compelling expression in the works of *David. Combining the Stoic themes and austere compositions of Poussin with a renewed study of ancient sculpture, in particular relief sculpture, such paintings of the 1780s by David as *The Oath of the Horatii* (Paris, Louvre) and *The Death of Socrates* (New York, Met. Mus.) represent the high-water mark of Neoclassical painting.

Sculpture played a central role in Neoclassical theory. This was reflected in a newly classicizing approach to contemporary work. Low-relief sculpture enjoyed a revival, and the portrait *bust was increasingly based on those of the Roman republican period, with sitters depicted wearing their own hair close cropped and with naked shoulders. By the beginning of the 19th century the austerely frontal Greek herm form was also in use. *Houdon in France, *Chantrey in England, and *Schadow in Germany were pre-eminent as portraitists. Above all, there was an increase in the production of gallery sculpture—works, usually with classical themes, created for public display in their own right rather than for decoration of a building or garden. The late 18th century produced two artists who achieved international reputations for this category of work. The Italian *Canova, the favourite sculptor of Napoleon, remained faithful throughout his career to the ideal of ancient sculpture as interpreted through the suave Roman copies of Greek originals known to the Renaissance and extolled by Winckelmann. *Thorvaldsen, a Dane, chose to base his later works on the more primitive and 'purer' sculptural art of Greece, as it became better known in the first decades of the 19th century.

The debate between the respective merits of Roman and Greek art was a heated one, already begun in the 1760s and 1770s with the publication of measured drawings of the ancient buildings of Greece, and as more enterprising *Grand Tourists began to visit the Greek Doric temples at Paestum, near Naples (see also GOETHE; PIRANESI). This debate was not a matter of mere stylistic preference but a profoundly serious one about the nature and merits of two different classical civilizations. Fuel was added by the arrival in London and Munich early in the 19th century of sculpture from the *Parthenon and from Aegina. Some connoisseurs, such as the Englishman Richard Payne *Knight, refused to accept that this work from the 5th century BC could have any artistic merit, though many artists were startled and stimulated by its strength and simplicity. The situation was further complicated by the archaeological researches in Egypt of scholars attached to the conquering armies of Napoleon. At the end of the 18th century the etcher and polemicist Piranesi stoutly defended the superiority of Roman classicism, while the English sculptor and designer *Flaxman produced a series of highly influential illustrations to Homer and Aeschylus, which, inspired by Greek vase paintings in the collection of Sir William Hamilton (see NAPLES), eschewed all effects of modelling in favour of pure line. These radically simplified designs, which drew praise from David and inspired painters as diverse in their aims as *Blake and *Ingres, underline the fact that Neoclassicism was never a monolithic or static style. What had begun as a rejection of the artificialities and extravagances of late

Baroque and Rococo art in favour of a style inspired by *Hellenistic sculpture and the paintings of Poussin ended for some artists with a quest for purity that conflated the virtues of Archaic Greek art with those of the Flemish and Italian 'primitives'. Whilst painters and sculptors were enjoined by critics to adopt didactic themes from the ancient world, some of the most successful works of the period are those, such as West's *Death of General Wolfe* (1770; Ottawa, NG Canada) and David's *Death of Marat* (1793; Brussels, Mus. Royaux), that take contemporary events as their subject. And it is worth remarking that Neoclassicism appealed as much to the absolutist government of Louis XVI as to the republican founders of the United States. MJ

Honour, H., *Neoclassicism* (1968).
Irwin, D., *Neoclassicism* (1997).
The Age of Neoclassicism, exhib. cat. 1972 (London, RA and V&A).

NEO-IMPRESSIONISM. This name was first given by the critic Félix Fénéon to a movement originated by the artist *Seurat which was both a scientific development of certain *Impressionist techniques and also a classical revival in reaction from the empirical realism of the Impressionists. The first Neo-Impressionist picture was Seurat's *Baignade* (London, NG), which he exhibited in May 1884, with Le Groupe des Indépendants. Seurat, who was then 25, there met *Signac, who was to become the chief mouthpiece for his theories, and together they formed a new group, the Société des Artistes Indépendants. At the first exhibition of the Société in December 1884 (see PARIS, SALON DES INDÉPENDANTS) Seurat exhibited a sketch for his next picture, *La Grande Jatte* (Chicago, Art Inst.) and in the same year Fénéon, then 22, founded the *Revue indépendante* to help the new movement. In 1885, Signac introduced *Pissarro, who was for a time won over to Seurat's methods. Other adherents were Henri-Edmond *Cross, Albert Dubois-Pillet (1846–90), Maximilien Luce (1858–1941), and Théo van *Rysselberghe. The movement had a passing influence on the important individualistic artists van *Gogh, *Toulouse-Lautrec, and *Gauguin.

The technical basis of Neo-Impressionism was Divisionism or the use of pure *colours, without mixture of pigments, in small areas so that intermediate colours would be created by optical painting in the eye of the observer. This method achieves a maximum of luminosity with saturation of colour since admixture is by the additive rather than by the subtractive principle. The method was by no means new. It had been practised to some extent by *Watteau, by *Delacroix (whose work Seurat studied), by *Turner, and others. Among the Impressionists it had been introduced by *Renoir and elevated into a deliberate doctrine by *Monet, who was familiar with the colour theories of Hermann von Helmholtz and *Chevreul. It was in relation to Renoir and *Monet that the word *Pointillism was first used, since they applied pure pigments in small dots rather on the principle of modern colour printing processes. Seurat and the Neo-Impressionists preferred the word 'divisionism' to describe their more scientific development of the technique. Signac defined Divisionism as a method of securing the utmost luminosity, colour, and harmony by (a) the use of all the colours of the spectrum and all degrees of those colours without any mixing, (b), the separation of local colours from the colour of the light, reflections, etc., (c) the balance of these factors and the establishment of these relations in accordance with laws of contrast in tone and radiation, and (d) the use of a technique of dots of a size determined by the size of the picture.

Seurat made Renoir's rainbow palette a more scientific instrument of technique, restricting himself more consistently to spectrum colours and juxtaposing them according to principles he had worked out not only from the study of Delacroix and other precursors but from scientific optical theory. The main source of this aspect of Neo-Impressionist theory was *Grammaire des arts du dessin* (1867) by the eminent critic and art historian Charles Blanc; this contained an analysis of Delacroix's views about colour and a résumé of the theories of colour admixture in Michel-Eugène Chevreul's *De la loi du contraste simultané des couleurs* (1839). They also knew *Modern Chromatics: Students' Text-Book of Color* (1879) by Ogden N. Rood, a physicist and amateur artist, and the views of the Swiss David Sutter, who wrote and taught on *aesthetics at the École des Beaux-Arts, *Paris, in strong reaction from the *Romantic reliance on feeling and instinct and whose *L'Esthétique générale et appliquée* (1865) was summarized in a series of six articles published in the periodical *L'Art* (1881) under the title *Phénomènes de la vision*.

After 1886 Seurat, and through him the group, were influenced by the views of the young scientist and aesthetician Charles Henry, who had published an elaborate theory of art in *La Revue contemporaine* (August 1885, under the title 'Introduction à une esthétique scientifique'). Between 1887 and 1891 Seurat was working out the possibilities of reducing to scientific principles the expressive or emotional qualities of colours and lines, thus linking up with a long established theory of the academies. The belief that specific arrangements of pictorial elements can induce definite states of emotion and mood had been expressed by *Poussin in a letter to his patron Fréart de Chantelou (24 Nov. 1647) and had become an accepted doctrine of the Académie (see under PARIS), popularized by Charles *Le Brun and André *Félibien.

This later doctrine was consistent with the *classicism which Seurat brought back with his first Neo-Impressionist painting and from which he never receded. Besides systematizing Impressionist techniques the Neo-Impressionists introduced a spirit which went directly counter to the empirical *realism of the Impressionists and to their ideal of an exact reproduction of casual and uninterpreted experience. They reintroduced the idea that a picture is to be deliberately planned and composed for an extended and foreseen effect scientifically calculated. It is for this reason that Seurat, along with *Cézanne, stands as the great renovator at the headstream of modern painting. HO

NEO-PLASTICISM, a translation from the Dutch *nieuwe-beelding*, used by Piet *Mondrian to describe the artistic theory which lay behind wholly geometrical work when he abandoned his abstractions from nature after 1914. His theory, which derived in part from the writings of the popular Dutch philosopher M. J. H. Schoenmaekers, was published in *Néo-plasticisme* (1920) and further developed in *Plastic Art and Pure Plastic Art* (1937). He claimed that, to attain harmonic perfection, art should be freed from any representation of nature and be created from wholly abstract, geometrical elements. Thus he restricted the elements of design to the straight line and the rectangle, in horizontal and vertical positions only. Similarly, to avoid associations with naturally observed colours, he restricted his palette to the primaries, blue, red, and yellow, together with white, black, and grey. His intention was to achieve the expression of universal harmony by avoiding individualism and particularity. The theory was adopted by Mondrian's disciples, particularly van *Doesburg, whom he first met in 1915, and propounded in *De Stijl*, the journal they founded with Bart van der *Leck in 1917. DER

NEOPLATONISM, the revival or reuse of ideas deriving from the Greek philosopher *Plato, or adherence to his metaphysics. Christianity being a form of Neoplatonism, it has a long history in the West, and pervades all kinds of Western thought, not simply its philosophical tradition. Usually in rather degraded form, it has also influenced ideas about art. Plato himself criticized artists for imitating 'appearance' rather than (invisible) reality, so his own art theory was not often cited, although late 19th-century versions of this Platonic notion may have helped *Gauguin, for instance, justify departing from *naturalism. Another Platonic idea (expounded above all in his *Symposium*) is that love may progress from a carnal to a spiritual object; this idea became current in the late 15th century, when there

was a spurt of interest in Plato, thanks partly to the influence of the translation with commentary of Plato's *Symposium* by Marsiglio *Ficino (1484). A Neoplatonic theory of love has been put forward as the key to the allegory of *Botticelli's *Primavera* (Florence, Uffizi) and other works. However, painting would not have occurred to Ficino, Pico della Mirandola, or other Neoplatonists themselves as a suitable vehicle for their ideas, and a direct connection specifically of their ideas to the subject matter of art cannot be proven, though in the middle years of the 20th century it was a popular line of interpretation. Thirdly, it was a *Renaissance and later figure of speech that the artist was assumed to create his art object ultimately from a mental 'idea' (or even from a 'form' deemed to be in potential residence in the material with which a sculptor would work), and here, too, Renaissance and later theories of artistic creation can also be regarded as Neoplatonic, although they were only indirectly dependent on Plato's ideas and not exclusively so.

PHo

Robb, N., *Neoplatonism of the Italian Renaissance* (1935).

Wind, E., *Pagan Mysteries in the Renaissance* (1958).

NEO-ROMANTICISM, a school of landscape painting which developed in England during the 1930s, first defined by the critic Raymond Mortimer in the *New Statesman*, 1942. Never more than loosely affiliated, its painters took inspiration from the early 19th-century landscapists: from Samuel *Palmer and his circle at Shoreham, and from *Turner. They were also influenced by French post-*Cubist developments during the 1930s. The beginnings of the movement were dominated by Graham *Sutherland and Paul *Nash, and, to an extent, by John *Piper. Their conception of the anthropomorphic potential of natural landscapes and the objects within them had a powerful influence on the younger generation of artists who became popular in the early 1940s, developing a style of agonized and sinister landscape very different from their early exemplars. Michael *Ayrton, John *Minton, and John Craxton (1922–) were the most expressive and innovative of the painters involved; others who shared the concerns of the movement for a time included Keith Vaughan (1912–77) and the Scottish artists Robert Colquhoun (1914–62) and Robert MacBryde (1913–66).

Neo-Romanticism was an art of shadows, brittle and linear, concerned with mysterious atmosphere and enigmatic situations rather than painterly use of colour and form—Ayrton's *Temptation of S. Anthony* (1945; London Tate), and Minton's *Recollections of Wales* (1944; London, British Council), are typical examples. Frequently theatrical and melodramatic, it captured the tensions of wartime Britain, thriving in enforced isolation. However, it fell rapidly out of favour, even with its exponents, from the late 1940s, under the renewed influence of European painting, and subsequently of American abstraction. More recently it has undergone a revival, major exhibitions at the Fischer Fine Art Gallery (1983) and the Barbican Centre (1987), London, revealing its relevance to present-day anxieties concerning man's place within the environment.

JH

A Paradise Lost: The Neo-Romantic Imagination in Britain 1935–55, exhib. cat. 1987 (London, Barbican AG).

NERI DI BICCI (1417/19–1491/3). Italian painter, born and died in Florence. He was a pupil of his father *Bicci di Lorenzo and the grandson of Lorenzo di Bicci. Influenced by *Domenico Veneziano and Fra Filippo *Lippi, Neri later had his own studio, which produced among others Cosimo *Rosselli and Francesco *Botticini. A number of works in his style exist, although few are signed. Between the years of 1453 and 1475, Neri kept a diary of all his commissions and the details of his activity (*Le Ricordanze 10 Mar. 1453–24 Apr. 1475*). One of the most opulent altarpieces recorded in his diary is *Tobias and Three Archangels* (Detroit, Inst. of Arts), commissioned for the church of S. Spirito, Florence, on 7 May 1471. In its decoration, it displays ingenious combinations of paint, gold, and gold leaf.

AM

NETSCHER, CASPAR (1639–84). Genre painter and portraitist, who was born in Heidelberg, the son of a sculptor. He spent most of his life in the Netherlands, having studied with ter *Borch in Deventer, from whom he inherited a predilection for depicting richly dressed figures—invariably women wearing meticulously defined white satin. His genre paintings also have stylistic affinities with the work of *Metsu and Frans van *Mieris the elder. Netscher set out for Rome in the late 1650s, but only got as far as Bordeaux. He then settled in The Hague, where he specialized in small, elegant half-length portraits for the court circles in the city, which draw inspiration from the work of van *Dyck. King Charles II invited Netscher to England in about 1668; however, he seems to have remained in the Netherlands where he depicted a number of English and other foreign sitters. Occasionally Netscher also painted religious and classical subjects. His son Constantijn Netscher (1668–1723) continued working in his father's manner.

CB

MacLaren, N., *National Gallery Catalogues: The Dutch School*, rev. C. Brown (1991).

NEUE SACHLICHKEIT (German: new objectivity), a movement in German painting between 1919 and 1933, the period of the Weimar Republic, characterized by the repudiation of *Expressionism in favour of a an insistent realism. The term was coined in 1923 by Gustav Hartlaub, director of the Munich Kunsthalle, in connection with an exhibition, eventually held in 1925, of work by 'artists who have retained or regained their fidelity to positive, tangible reality'. The movement, which was stylistically diverse, had no theoretical basis or manifesto and from the beginning was seen to have 'left' and 'right' wings. It encompassed the veristic social criticism of *Grosz and *Dix, the elegant portrayal of 1920s decadence by Christian Schad (1894–1982), and the prosaic industrial scenes of Carl Grossberg (1894–1940); all, however, were concerned with representation of the contemporary world. The movement dissolved in 1933 under pressure from the Nazis and several of the leading artists were declared 'degenerate'.

DER

Schmied, W., *Neue Sachlichkeit and German Realism of the Twenties*, exhib. cat. 1979 (London, Arts Council).

NEVELSON, LOUISE (1900–88). Russian-born American artist. Nevelson emigrated to the USA in 1905 and lived in New York from 1920, studying at the Art Students' League (1929–30) and under Hans *Hofmann in Munich (1930–2). She began to make *Constructivist sculpture in 1932 and towards the end of the 1950s created the 'sculptured walls' for which she is most famous. These wooden constructions comprise a number of stacked compartments each of which contains further wooden elements, usually architectural, like chair legs, balusters, and mouldings. Many are very large, like *An American Tribute to the British People* (1960–5; London, Tate), which measures 27×4 m (88×13 ft), and are painted in monotone; early works are uniformly black but later she also used white or gold. From the late 1960s she worked in a greater variety of materials, including lucite, as in *Transparent Sculpture V* (1967–8; New York, Whitney Mus.), and, for the outdoor works for which she received many commissions, steel, an example being *Transparent Horizon* (1975; Cambridge, Mass., Massachusetts Inst. of Technology). Her work, which has affinities with Constructivism, *Surrealism, and *Pop art, can be profoundly impressive.

DER

Glimcher, A., *Louise Nevelson* (1972).

NEVINSON, CHRISTOPHER RICHARD WYNNE (1889–1946). English painter and printmaker. Nevinson studied at the Slade School, London (1908–12), and in Paris, where he shared a studio with *Modigliani, and experimented with *Cubism. His early works concentrate on urban subjects and he was strongly influenced by the Italian

*Futurists; he entertained their leader, *Marinetti, in London in 1913 and in 1914 joined with him in the manifesto *Vital English Art*. A founder member of the *London Group, he refused to join the *Vorticists, although he was closely linked with Wyndham *Lewis at the Rebel Art Centre, and his prints establish a new Vorticist idiom in that medium.

Nevinson was among the first official war artists, holding a highly successful exhibition of war paintings at the Leicester Gallery, London, in 1916. Paintings such as *A Burst Shell* (1915; London, Tate) and *Troops Resting* (1916; London, Imperial War Mus.) show the fractured structure and dynamic energy typical of Futurism. From 1919 he increasingly spent time in Paris and New York; his style became less radical, although he continued to paint subjects from modern life as well as landscapes and flower pieces. Elected to the New English Art Club, *London, in 1920, he became an ARA in 1939.　　　JH

Sitwell, O., *C. R. W. Nevinson* (1925).

NEW ART HISTORY, collective term for a variety of approaches which from the early 1970s onwards have been brought to bear on the discipline of art history. To emphasize the pluralistic nature of this development some scholars prefer to speak of 'new art histories'. The trend stems from a critique of art history as practised and taught during the 1950s and 1960s, with its orthodox, positivistic methods of *connoisseurship, stylistic and *iconographical analysis, and its concern with categories such as 'quality' and 'genius'.

In contrast to 'traditional' art history, which views the production of art as a largely private and secret event confined to the artist's studio and taking place at the margins of society, new art history places the work of art at the nexus of social power structures and tries to analyse its role in articulating and constructing the needs and identities of certain groups and classes. To meet these objectives, scholars have imported a variety of methodologies first developed in the neighbouring fields of linguistics (e.g. *structuralism, *semiotics), psychology, social science, and history (e.g. the French *Annales* school). As a result, a high level of theory (with a corresponding new terminology) has found its way into art historical discourse since the 1970s. Due to the work of a number of *Marxist and radical *feminist scholars certain aspects of new art history have also become overtly political.

One of the earliest calls for a change in direction had been T. J. Clark's 'The Conditions of Artistic Creation' (*Times Literary Supplement*, 1974). According to Clark 'the dreary professional literature' of post-war art history lost sight of the 'important, unavoidable questions' which the previous generation of art historians, influenced by *Hegel—in particular Alois *Riegl, Max *Dvořák and Erwin *Panofsky—had still tried to address. For Clark the future of the discipline lay in an all-embracing social history of art centred on the ideologies underpinning art production. 'Ideologies' are defined here as 'those bodies of beliefs, images, values and techniques of representation by which social classes, in conflict with each other, attempt to "naturalize" their particular histories'.

Concerned not so much with class, but with gender, practitioners of feminist art history have attempted to assess the role of art, and sometimes even that of art history, in the social construction of sexual difference. Whilst at the outset feminist scholarship still sought to retrieve the names and works of neglected women artists through monographs and catalogues raisonnés (methods which also lay within the boundaries of 'traditional' art history), it then began to challenge the categories and values of the discipline itself. In the words of one prominent feminist critic, Griselda Pollock, art history is a 'masculine discourse' and a form of 'patriarchal culture', which 'contributes actively to the production and perpetuation of gender hierarchies' (*Vision and Difference: Femininity, Feminism and the Histories of Art*, 1988).

Semiotics, too, can be applied to the study of art and its relation to structures of power. More than being simply an object which offers itself to the perception of the innocent eye, a work of art is a socially generated sign. To 'read' a painting or a sculpture correctly requires, as Norman Bryson puts it, 'an ability that presupposes competence within social—that is, socially constructed—codes of recognition' (Introduction to *Calligram: Essays in New Art History from France*, 1988).

The term 'new art history' is mainly used to characterize scholarship in Great Britain, but there are comparable developments in other countries, too. In Germany, for example, the so-called Ulmer Verein promotes a critical engagement with the art historical discipline and its methods. Founded in 1968 in the wake of the student revolt, this association of scholars has organized a variety of conferences on art and its social context, and publishes an important periodical, the *Kritische Berichte*.　　　AT

Rees, A. L., and Borzello, F. (eds.), *The New Art History* (1986).

NEW ENGLISH ART CLUB. See under LONDON.

NEW HAVEN, YALE CENTER FOR BRITISH ART. The centre opened in April 1977. The building and the collections, together with an endowment to sustain its operations, were entirely the gift of Paul Mellon (1907–99) to Yale University, from which he had graduated in 1929. The building was designed by Louis I. Kahn and, although completed posthumously, it closely followed his original plans. The design of the centre with its naturally lit galleries, and its rich and restrained palette drawn from the materials of the building itself, establish it as a landmark of modern architecture.

The centre's collection extends from Tudor times to the present day and encompasses paintings, sculpture, drawings, watercolours, prints, rare books, and manuscripts. It is the largest and most comprehensive collection of British art ever assembled outside the United Kingdom. It was personally acquired by Paul Mellon, and reflects his distinctive taste in British art. Mellon had a particular interest in George *Stubbs and the sporting art of the 18th and early 19th centuries. He preferred the small, informal portrait, the conversation piece, landscape, and genre painting to full-length portraits in 18th-century British art. Similarly he was attracted to the sketch or the study which led to the comprehensive collection of 18th- and 19th-century watercolours and drawings and the impressive group of oil paintings and studies by J. M. W. *Turner and John *Constable.

Although the first oil painting Mellon acquired was George Stubbs's *Pumpkin with a Stable Lad*, the first British artist he acquired systematically during the 1940s and 1950s was William *Blake, especially the illuminated books. The bulk of the collection now at Yale was acquired by Mellon from 1959 onwards.

The centre mounts exhibitions of British art on a regular basis, ranging widely in theme, period, and media. The exhibitions and the scholarly and educational form part of the centre's mission to widen and deepen the knowledge of British art in the United States.　　　PMcC

NEWLYN SCHOOL. The Newlyn School was established at the Cornish fishing village of Newlyn around 1885 by a group of artists inspired by the *plein air naturalism of *Bastien-Lepage and the painters of *Barbizon. Most of the original members had trained in Paris; several had also visited the colony at *Pont-Aven. They made no formal announcement of aims or intentions, existing as a community rather than an institution. Stanhope Forbes (1857–1947) was the nominal leader, with his wife Elizabeth (1859–1912), also a painter; other leading members included Henry Scott Tuke (1858–1929), Frank Bramley (1857–1915), and later the Knights, Laura (1877–1970) and Harold (1874–1961), and the Procters, Dod (1891–1972) and Ernest (1886–1935).

The Newlyn artists specialized in scenes of daily life, painted out of doors with a distinctive square brush technique: Forbes's *Fish Sale on a Cornish Beach* (1884; Plymouth, AG)

and Bramley's *A Hopeless Dawn* (1888; London, Tate) are typical. They deliberately immersed themselves in Newlyn as an independent and picturesque community, living closely with the local people, but remained outsiders looking in, with one eye on the RA, *London as the logical exhibition centre for their large and ambitious compositions. Their scenes have the appearance of spontaneity, but were often carefully posed, using friends and local models. The group was also concerned with rendering effects of light and atmosphere, as in Tuke's *August Blue* (1893–4; London, Tate), and Dod Procter's *Morning* (1927; London, Tate).

Forbes and his wife established an art school in Newlyn in 1900, but the pioneering edge of the movement was by this time blunted, and the group was superseded by other Cornish colonies, notably those at Lamorna, Zennor, and *St Ives. Still, for ten years the group was an important force within the British art scene, producing some striking pictures, and vitally important in the establishment of a distinctively British *Impressionism. JH

Fox, C., and Greenacre, F., *Artists of the Newlyn School* (1979).

NEWMAN, BARNETT (1905–70). American painter, printmaker, and sculptor. Born in New York, he studied at the Art Students' League (1922–6) and at the City College, New York (1926–7). He refused to work on the *Federal Art Project (he was a lifelong anarchist), and later destroyed all his work of the 1930s on the grounds that the styles of that period were played out. In 1939/40 he stopped painting and when he started again reconstructed his approach. In 1948 he helped to found the Subjects of the Artist School with *Baziotes, *Motherwell, *Rothko, and *Still, and was a core member of the *Abstract Expressionist group. He strongly believed in modernity and progress, and was enormously ambitious for *abstract art, convinced it could carry the weight of profound metaphysical ideas. The work for which he is best known is often of gigantic size, simplified to flat vertical divisions: *First Station* (1958; Washington, NG). In 1966 the *14+1 Stations of the Cross* were shown at the Solomon R. Guggenheim Museum in New York, and his stature was widely recognized although some authorities still question whether these enormous austere canvases convey the weight of meaning Newman attached to them. RJP

Rosenberg, H., *Barnett Newman* (1978).

NEW SCULPTURE. Alfred *Gilbert is the best-known figure in this inventive movement in British art in the last decades of the 19th century. Turning their backs on the perceived elitism and dullness of mainstream Victorian sculpture and taking their lead from such sculptural mavericks of the previous generation as Alfred *Stevens and Lord *Leighton, a loosely knit group of younger sculptors that included Gilbert, William Hamo Thornycroft (1850–1925), and George *Frampton blended influences from *Renaissance and *Baroque sculpture into an individualistic and evocative style that was closely related to developments in contemporary European *Symbolist art. For their private work these sculptors preferred subjects of mysterious and psychologically inward-looking character, executed often in richly contrasting materials and in a style that blended naturalism with the sinuous, organic forms of *Art Nouveau. In such public works as Thornycroft's monument to W. E. Gladstone (1905; London, Strand) and Gilbert's to Lord Shaftesbury (1886–93; London, Piccadilly Circus) they introduced a new and high level of artistic distinction to metropolitan monumental sculpture. Their achievement was, however, quickly overshadowed by the development of European *modernism after 1900 and the true originality of their contribution to sculpture in Britain forgotten. MJ

Beattie, S., *The New Sculpture* (1983).

NEW YORK: PATRONAGE AND COLLECTING. 'I should be hardly believed . . . were I to relate the utter ignorance respecting pictures to be found among persons of the first standing in society.' So Frances Trollope wrote of New York City in her *Domestic Manners of the Americans* in the 1830s. The city was indeed a backwater compared to her native *London, but as the nation's emerging commercial capital, New York was poised to overtake *Boston and Philadelphia as its cultural centre. Support for art was viewed as a patriotic, even moral, duty by those who sought to define the cultural identity of the young republic. Edward and Robert Livingston founded the New York Academy of Arts in 1802 to promote the 'polite arts' in America. Old masters were shown alongside contemporary Americans at the suggestion of John *Trumbull, who became the Academy's president when it was reformed as the American Academy of the Fine Arts in 1817. Desiring an institution dedicated to contemporary art, younger artists including Samuel F. B. *Morse formed the rival National Academy of Design in 1826. The American Academy closed in 1842, but the National Academy shaped the city's art scene for nearly a century. Among its patrons, Luman Reed (1785–1836) was admired for his support of living artists and for regularly opening his collection for public viewing.

The art market grew during the 20 years preceding the Civil War, then boomed as investors sought art as a hedge against inflation. Local artists were encouraged by the American Art Union, founded in 1839 to buy paintings for distribution by lottery. The Düsseldorf Gallery and the International Art Union opened in 1849 as the city's first galleries dedicated to contemporary European art. Decried as immoral, French art found favour among millionaires like A. T. Stewart, August Belmont, and William H. Vanderbilt. American artists remained their own dealers, including the founders of the 10th Street Studio, which opened in 1857 as combined studios and galleries. Collectors however also began to look toward Europe's past: Thomas Jefferson Bryan (1802–70) and James Jackson Jarves (1818–87) spent decades abroad acquiring old masters they hoped might become the basis for a national gallery in New York. Bryan exhibited his collection in the city in 1852, and Jarves followed suit in the 1860s, but neither attracted support equal to his ambitions.

With the founding of the Metropolitan Museum of Art in 1870, New York had a repository for major collections, and between 1890 and the Great Depression the city's robber barons assembled collections of European art destined for its galleries. The specialization of their collections reflected the influence of expert dealers like Sir Joseph Duveen (1869–1939), supplier to Benjamin Altman, Henry Goldman, Michael Freidsam, Jules S. Bache, and, most notably, Henry Clay Frick (1849–1919). Though J. Pierpont Morgan (1837–1913) consulted with Duveen, the English expert and dealer, Robert Langton Douglas (1864–1951), and others, his vast collections were formed by his own judgement and voracious acquisitiveness.

The city's artists also followed continental trends and chafed against their dependence on the National Academy. Sharing little but an interest in French painting, William Merritt *Chase, John La Farge, and others formed the Society of American Artists in 1877. *Impressionism was embraced by The Ten, who exhibited annually at the Durand-Ruel and Montross galleries from 1898 until 1918. When the National Academy refused to include several painters in its 1907 exhibition, Robert *Henri encouraged Arthur B. Davies to organize an exhibition of the rejected artists at the Macbeth Gallery, thus launching The *Eight and the Ashcan School. Henri's circle joined with artists influenced by Leo and Gertrude Stein to form the Association of American Painters and Sculptors, charged with promoting European art developments in the USA. On its behalf, Davies and Walter Kuhn organized the *Armory Show of 1913, introducing a broad US audience to European *modernism. The stage for this revelation had been set by Alfred Steiglitz (1864–1946), whose Photo-Secession Galleries

at 291 Fifth Avenue had promoted modernism since 1905.

The Armory Show and the exorbitant prices of old masters led many collectors to modernism and American art. John Quinn, Walter Arensberg, and Katherine Dreier supported contemporary modern art, but earlier periods were more popular with many collectors. The Impressionists and *Post-Impressionists collected by Henry and Louisine Havemeyer, Adolph and Sam Lewisohn, and Robert Lehman were destined for the Metropolitan Museum, which had become the world's wealthiest museum by the 1920s. However, its conservatism led patrons of modern art to look for alternatives. While John D. Rockefeller Jr.'s donations to the museum included the nation's finest collection of medieval art, his wife Abby Aldrich Rockefeller joined with Lillie P. Bliss and Mary Quinn Sullivan in 1929 to found the Museum of Modern Art (MoMa) naming Alfred H. Barr Jr. (1902–81) as its first director. Gertrude Vanderbilt Whitney (1875–1942) founded the museum that bears her name in 1931 after the Metropolitan refused to accept her collection of American moderns. Solomon R. Guggenheim (1861–1949) collected on the advice of Hilla Rebay and opened the Museum of Non-objective Art in 1936; the museum would later be renamed after its founder.

*Social realism, the Harlem renaissance, and American scene painting were described as national modern movements, but all efforts to define an indigenous avant-garde became less relevant with the arrival of European artists during the Second World War. With the Paris art world in disarray, New York was the new capital of contemporary art. Galleries proliferated around 57th Street, several proving to be influential trendsetters. *Surrealism was exhibited by Julien Levy and Peggy Guggenheim (1898–1979), whose Art of This Century gallery launched the career of Jackson *Pollock in 1943. Informed by the critical support of Clement *Greenberg, the *New York School was exhibited at the galleries of Samuel Kootz, Betty Parsons, Sidney Janis, Martha Jackson, and Charles Egan. *Pop art was later featured in the Upper East Side galleries of Janis, Leo Castelli (1907–99), Richard Bellamy, and Ronald Feldman. Encouraged by the city's lively trade, the London-based auctioneer, Sotheby's, opened a New York office in 1954; its rival Christie's would follow in 1977. The galleries and regular auctions allowed the city's collectors to acquire a more catholic array of art, ranging from the Impressionists of John Jay Whitney to the African art of Paul and Ruth Tishman to the contemporary American art of Roy Neuberger. MoMa's rapid rise to prominence was aided by collectors of modern art including James Thrall Soby, Nelson Rockefeller, and Philip Johnson.

By the late 1960s, New York's art scene was becoming larger and more diverse. Artists were engaged in such varied practices as *Minimalism, Earthworks (see LAND ART), *Photo-realism, *Conceptual art, *Performance art, and *feminist art. From 1969, these new directions were exhibited in SoHo, a former industrial area converted into a neighbourhood of studio lofts, galleries, and artists' collectives that became the city's most dynamic art centre. During the economic boom of the 1980s, SoHo gallerists such as Tony Shafrazi and Mary Boone (1950–) promoted cogent styles that were resisted by the funkier short-lived East Village scene. By the mid-1990s, commercial galleries had largely abandoned SoHo for another industrial area, Chelsea, while an alternative scene emerged in Williamsburg, Brooklyn. With some 500 galleries, New York was home to the world's most influential artists, collectors, critics, art schools, and publishers. After only a half-century as the centre of the international art world, the city had put aside its concern with defining nationality through culture. New York now claimed the world as its purview.
 GT

NEW YORK, FRICK COLLECTION.
Henry Clay Frick of Pittsburg, who had made a considerable fortune in coal, steel, and railroads, began collecting art in the 1870s. His earliest purchases were of the then popular school of *Barbizon. However, by the time he built his French-style mansion designed by Thomas Hastings on New York's Fifth Avenue in 1913–14, he had, with the assistance of the dealer, Joseph Duveen and Roger *Fry, become one of America's most discriminating collectors of old master paintings and sculpture. On his death in 1919, Frick bequeathed his home and its contents as a public gallery (like the Wallace Collection, *London) to be known as the Frick Collection. He also provided an endowment to maintain and expand the collection at the trustee's discretion. It was, however, only after the death of Mrs Frick in 1931 that the house with the addition of painting galleries designed by John Russell Pope was formally opened to the public.

Frick's first foray into the Italian and Spanish Renaissance came in 1905 when he acquired *Titian's Portrait of Pietro Aretino and El *Greco's S. Jerome. Ten years later he added another Titian, Man in a Red Cap, Giovanni *Bellini's S. Francis in Ecstasy, and *Bronzino's Portrait of Ludovico Capponi. Two allegories by *Veronese had been purchased in 1912. In a few short years Frick, with his eclectic approach, accumulated masterpieces of the various other European schools of painting. A French Pietà with Donor of the 15th century was purchased in 1907, but the most impressive early northern works are the two *Holbeins, especially the Portrait of Sir Thomas More. However, Frick generally gravitated towards more grandiose works from the 17th century, notably *Rembrandt's late Self-Portrait of 1658 and the famous but much debated Polish Rider, as well as great portraits by *Hals and van *Dyck and three genre subjects by *Vermeer. Large-scale landscapes ranged from Dutch examples by *Ruisdael, *Cuyp, and *Hobbema to English pictures by *Constable, including Salisbury Cathedral, and several *Turners. Frick likewise admired English portraiture and his collection included fine examples by *Gainsborough and *Romney.

Frick's delight in 18th-century French paintings and furnishings is reflected in the *Boucher series of The Arts and Sciences and The Four Seasons, and, most significant by far, the room of *Fragonard paintings devoted to the Progress of Love that were commissioned and then rejected by Mme du Barry. Two later artists favoured by Frick were *Goya, represented by two portraits and the genre subject The Forge, and *Whistler with four portraits and a seascape. Of the few 19th-century works acquired in his later years by Frick, the most important are *Manet's Bullfight and *Degas's The Rehearsal. With the assistance of Duveen, Frick formed a notable collection of Italian sculpture—bronzes by among others *Pollaiuolo, *Vecchietta, and *Riccio, and a rare marble Bust of a Lady by *Laurana. Frick also made a small, but choice, collection of prints and drawings by such masters as *Pisanello, *Rubens, Rembrandt, Goya, and *Ingres. In the years following Frick's death significant additions to the collection have been made in the area of early Italian painting with masterworks by *Duccio, *Domenico Veneziano, and *Piero della Francesca. The French School has grown the most with from the 17th century a *La Tour and a *Claude; and of the 18th century a *Greuze, *Chardin, and an early *Watteau, as well as *Houdon's terracotta Diana. EZ

Davidson, B., Paintings in the Frick Collection (2 vols., 1968).
Pope-Hennessy, J., and Radcliffe, A., Sculpture in the Frick Collection (1970).
Ryskamp, C., et al., Paintings from the Frick Collection (1990).

NEW YORK, METROPOLITAN MUSEUM OF ART.
The Metropolitan Museum was founded in 1870 and had several temporary locations before the building at 82nd Street between Central Park and Fifth Avenue designed by Calvert Vaux was opened in 1880. Many additions have been made over the years with the major ones designed by McKim, Mead, and White in 1909 and later ones planned by Roche, Dinkeloo, and Associates to house the American wing and Sackler galleries. The Greek and Roman Department was one of the earliest owing to the purchase of a trove of ancient sculptures in 1873 from the collection of Luigi Palma di Cesnola, the American consul in Cyprus,

who also became the first director of the museum. Today the collection ranges from *Cycladic statuettes (*Seated Harp-Player*), through the *Archaic period (standing kouros), to the *Hellenistic period (*Old Market Woman*). Greek vases include the Euphronius Crater. The *Etruscan collection includes a bronze chariot of the late 6th century BC. Ancient *Roman art is represented by numerous marble portraits and sarcophagi, and fresco paintings from Boscoreale, near Pompeii.

The collection of European paintings is one of the greatest in the world and has grown thanks to wise purchases and generous gifts from a long series of distinguished donors. In 1887 Catherine Lorillard Wolfe bequeathed over 140 European 19th-century paintings. The following year the museum's president, Henry Marquand, bought it 37 paintings that included noted examples by *Rembrandt, van *Dyck, *Vermeer, and *Hals. The next year Erwin Davis gave two *Manets. From 1904 to his death in 1913, J. P. Morgan was president and, with funds from the recently established Rogers Fund, the curators, Roger *Fry and then Bryson Burroughs, began making major acquisitions of works ranging from *Giotto, *Carpaccio, and *Veronese to *Brueghel and *Rubens on to *Ingres and *Renoir. The Benjamin Altman bequest of 1913 added yet more Dutch 17th-century masters as well as *Botticelli and *Dürer, and William K. Vanderbilt's 1920 bequest brought English portraits. Not only old masters, such as El *Greco and *Bronzino, but also the greatest accumulation of French 19th-century works came to the museum with the benefaction of Mrs Henry O. Havemeyer in 1929. This begins with Ingres's *Portrait of J. A. Moltedo*, continues with many notable *Corots, *Courbets, and *Daumiers, and culminates in the many Havemeyer *Impressionists, now integrated into the handsomely reinstalled André Meyer Galleries. A few of the highlights are Manet's *Boating* and his *Dead Christ*, *Degas's *Woman with Chrysanthemums* and bronze *La Petite Danseuse*, Renoir's *By the Seashore*, *Monet's *La Grenouillère*, and *Cézanne's *Mont S. Victoire*. The next major bequest was Julius Bache's collection, which in 1944 added works by Rembrandt, *Velázquez, and *Goya's *Manuel Osorio*. Two years later Gertrude Stein left the Museum her portrait by *Picasso. Bequests by Samuel A. Lewisohn in 1951 and Adelaide Milton de Groot in 1967 brought great *Post-Impressionist masterpieces. For Robert Lehman's 1969 bequest a special wing was built to house early Italian and Flemish panels by *Sassetta, *Giovanni di Paolo, and Petrus *Christus; and further paintings by El Greco, Rembrandt, Ingres, and Corot. Major purchases made during these decades included *Caravaggio's *Musicians* (1952), Rembrandt's *Aristotle Contemplating the Bust of Homer* (1961), Monet's *Terrace at St Adresse* (1967), and Veláz-

quez's *Juan de Pareja* (1971). Since the 1950s the greatest ongoing series of gifts have been from Mr and Mrs Charles Wrightsman including works by *Lotto, *La Tour, *Guercino, Rubens, *David, and *Delacroix. Another couple who have enriched the holdings of the late 19th and early 20th centuries are Walter and Leonore Annenberg. Among their outright and 'anticipated gifts' are works by Monet, Renoir, *Gauguin, Picasso, and *Braque.

The Department of European Drawings began in 1880 with a gift of over 600 drawings purchased by Cornelius Vanderbilt from James Jackson Jarves. This has been expanded to encompass sheets by *Leonardo, *Michelangelo, Ingres, and Degas. The Havemeyer bequest in 1929 added drawings by Rembrandt and Daumier. In 1949 Georgia *O'Keeffe donated the Alfred Stieglitz Collection, which included 20th-century masters. Stieglitz himself in 1928 presented the museum with its first photographs. These became a component of the now enormous Print Department that had originated with gifts of *Whistlers from H. B. Dick in 1916 and Dürers from Junius Spencer Morgan in 1919. Another great bequest of old master prints came from Felix Warburg in 1941.

The museum, as befits an institution that had several distinguished painters among its founders, has a very great collection of American painting and sculpture housed in its own wing. Many of the 19th-century's iconic images such as *Leutze's *Washington Crossing the Delaware*, *Bierstadt's *Rocky Mountains* *Cole's *Oxbow*, *Church's *Heart of the Andes*, and *Homer's *Northeaster* were all acquired by 1910. Added later were *Sargent's infamous *Mme X*, *Bingham's *Fur Traders*, Martin Heade's (1819–1904) *The Coming Storm*, and John White Alexander's (1856–1915) *Repose*. Mrs Havemeyer's 1929 bequest included several examples by her friend Mary *Cassatt. The Alfred Stieglitz Collection received in 1949 brought the mid-century masters *Demuth, O'Keeffe, *Dove, and *Hartley. The Department of 20th Century Art was established only in 1967, but grew rapidly. The 1998 bequest of the Gelman Collection from Mexico has added key works by *Matisse and *Dali. Of the post-war American holdings, the most famous is probably Jackson *Pollock's *Autumn Rhythms* of 1950, but there are also characteristic works by all the chief painters—*Gorky, *Rothko, *de Kooning, *Louis, and *Motherwell. The department's largest work is the French *Art Deco mural from the luxury liner *The Normandie*.　EZ

Baetjer, K., *European Paintings in the Metropolitan Museum of Art: A Summary Catalogue* (1995).

Beeson, N., and Salinger, M., *Guide to the Metropolitan Museum of Art* (1972).

Frelinghuysen, A. C., et al., *Splendid Legacy: The Havemeyer Collection* (1993).

Tomkins, C., *Merchants and Masterpieces* (1970).

NEW YORK, MUSEUM OF MODERN ART (MoMa). The museum first opened in 1929 with an exhibition of the little-known *Post-Impressionists. It was established through the efforts of three women, Lillie P. Bliss, daughter of a textile manufacturer, who made the initial bequest of 235 works; Mary Quinn Sullivan, a former art teacher; and Abby Aldrich Rockefeller. They invited A. Conger Goodyear, the former head of the Albright Art Gallery and an enthusiast for contemporary art, to form a committee to establish a museum which would represent European and American art from the end of the 19th century onwards. Alfred H. Barr was appointed its first director. Through his extensive knowledge and European travels, Barr was concerned that the collection should cover not only painting and sculpture, but all the arts of modern life, including *photography, video, and film.

A permanent marble and glass building, one of the early examples of the International Style, by Philip Goodwin and Edward Durrell Stone, opened in 1939 and further wings were added in 1964 and 1984, including the remodelling of the original sculpture garden. Although originally committed to the display of modern art, the strength of the collection lies in the historical span from the Post-Impressionists of the 1890s to *Pop art and *abstraction of the 1960s.　CFW

NEW YORK SCHOOL, a term used to designate a loose affiliation of artists who came together as an avant garde in New York in the late 1940s. This first generation of the school included Jackson *Pollock, Mark *Rothko, Barnett *Newman, Adolph *Gottlieb, Willem *de Kooning, Robert *Motherwell, Clifford *Still, Arshile *Gorky, Franz *Kline, and Philip *Guston, who are commonly labelled the *Abstract Expressionists, as well as the independently minded Ad *Reinhardt. Some Abstract Expressionists employed a violently gestural facture, such as de Kooning and Pollock, but the manner of the painters who came to prominence in the mid—1950s, such as Sam Francis (1923–94), was less aggressive, giving rise to the epithet 'Abstract Impressionists'. A further generation of artists promoted by the prominent critics Clement *Greenberg and Harold Rosenberg were added to 'the school' at the beginning of the 1960s, including Frank *Stella; but the label is not commonly taken to include the *Pop generation of Andy *Warhol, who achieved public prominence from 1962.　MF

Sandler, I., *The New York School* (1978).

NEW ZEALAND ART. The native tradition of Maori art developed for centuries in isolation, but the modern state of New Zealand and its art dates from 1840, when British colonizers settled there. Pre-colonial depictions of the topography of New Zealand by Europeans are rare, existing because of isolated visits to the country. Examples are the large oil paintings by William *Hodges, draughtsman with Captain Cook's second expedition in 1772; and the watercolours and sketches of Augustus Earle (1793–1838). For 50 years after 1840, there were no professional artists in New Zealand, although many works exist by amateurs, which reflect a specific range of concerns that were closely paralleled by colonial art in Australia. The exclusive subject of such art was landscape. In the nature both of their depiction, and of certain details within them, however, these works often betray their creators' uncertainty of their function either as purely aesthetic views or as anthropological studies. Notable amongst early colonial amateur artists are John Alexander Gilfillan (1793–1863) and Charles *Heaphy, both of whose works show domestic and other scenes of the Maori community within the New Zealand landscape. An example is Heaphy's *Interior of a Native Village* (c.1850), which survives only in lithographic reproduction. The problems faced by the colonialist in depicting views of a new country were tackled differently by other amateur artists, such as John Gully (1819–88), Charles Barraud (1822–97), James Richmond (1822–98), and William Hodgkins (1833–98), all of whom aimed to render the New Zealand landscape in terms of the English *Romantic idiom. Having achieved this, Gully became known as the 'New Zealand *Turner'. Barraud was a founder and member of the New Zealand Academy of Fine Arts, and Hodgkins organized the building of a gallery in Dunedin. Such acts made it possible for professional artists to begin to exist. The first of these were not born in New Zealand but arrived in the early 1890s. They include: Petrus van der Velden (1834–1913) who painted genre pieces in the Dutch manner; and James Nairn (1859–1904), who worked in a semi-Impressionist style. Although traditional watercolour landscapes continued to be produced, for example by Alfred Wilson Walsh (1859–1916), the arrival of European artists caused a marked diversification of styles and forms in New Zealand art by the end of the century. Many native artists also attempted to establish careers in Europe, including Alfred Henry O'Keeffe (1858–1941) and C. F. Goldie (1870–1947), both of whom studied in Paris at the Académie Julian; and Margaret Stoddart (1865–1934), who exhibited at the RA, London. However, these artists all achieved greater success in their own country. The first New Zealand artist to gain an international reputation was Frances Hodgkins (1869–1947). She divided her time between New Zealand and England, and her colourful abstract paintings have come to be associated more with British *modernism than with that of her native country. Thus, although modern art was widely practised in New Zealand in the early 20th century, its creators had to contend with an awareness of its essentially colonial nature, as well as with a sense that their work was inferior to that being produced in Europe. After 1940, however, the country began to gain its own artistic impetus; artists such as T. A. McCormack (1883–1965), John Weeks (1888–1965), M. T. Woollaston (1910–), and Colin McCahon (1919–) all drew on the landscape tradition variously to create a sense of national identity. In 1963 the Queen Elizabeth II Arts Council was established, ensuring a measure of state patronage for the visual arts. In the 1960s and 1970s, while landscape painting continued to be prominent, for example the *Surrealist landscapes of Rita Angus (1908–70) and Michael Illingworth (1932–88), it was increasingly influenced by Maori art forms and legends, which were used in different ways by artists such as Gordon Walters (1919–), Dennis Knight Turner (1924–), Cliff Whiting (1936–), and Richard Killeen (1946–) to express a sense of cultural identity peculiar to New Zealand. Walters and Knight Turner emulated in their paintings the curvilinear ornamentation of Maori woodcarving, whereas Killeen drew on ancient legends and folklore, as in *Dreamtime* (1980; Dunedin, NG). OPa

Thomson, K., *Art Galleries and Museums of New Zealand* (1981).

NICCOLÒ DELL'ARCA (Niccolò da Ragusa, Nichollo de Bari, Nicolò di Puglia) (active 1462–94). Italian sculptor who took his name from the shrine (*arca*) of S. Dominic in the church of S. Domenico in Bologna. For this shrine, begun by Nicola *Pisano and later worked on by *Michelangelo, he carved most of the small free-standing figures of Evangelists and other saints c.1469–73. Though little is known of his activity before his arrival in Bologna in 1462, when he was described as a 'magister figurarum de terra', these sculptures show the influence of *Desiderio da Settignano and Antonio *Rossellino, and of Burgundian sculpture. He may have worked on the Castelnuovo arch in Naples (1450s) and in Ragusa. His *Lamentation* group (early 1460s or c.1485–90; Bologna, S. Maria della Vita) is remarkable for its emotional force and technical brilliance, and is arranged as a *tableau vivant* of seven free-standing, formerly polychromed, terracotta figures in attitudes of extreme grief. His terracotta *Madonna di Piazza* (1478; Bologna, Palazzo Comunale) shows the influence of *Verrocchio. AB

Gnudi, C., *Niccolò dell' Arca* (1942).

NICCOLÒ DI GIACOMO DA BOLOGNA (active 1349–1403/4). The best documented Italian illuminator of the trecento, dominating Bolognese and north Italian illumination from 1350 to 1400. His work develops that of L'*Illustratore in its figure types, the use of modelled acanthus foliage for letters and marginal decoration, and rich foliate backgrounds, but with a wider range of characterization and more precise modelling of figures and features than the earlier artist. His work develops in parallel with his friend *Simone dei Crocefissi. He illuminated the sumptuous but tiny *Kremsmünster Hours* (1349; Kremsmünster, Stiftsgal., Clm. 4) and developed dramatic representations of Giovanni d'Andrea teaching, of the Mass, and of the arts and sciences, for a new generation of legal texts (1353; Vatican, Bib. Apostolica, MSS lat. 1456, lat. 2534). His mature style, more coarsely but boldly modelled, is well displayed in full-page spreads of New Testament scenes in the Munich Missal (Staatsbib., Cod. lat. 10072, 1374) and many choirbooks in Bologna, while the massive figures of his late style are well displayed in a set of civic bank records of 1394–5 (Bologna, Archivio di Stato). RG

Cassee, E., *The Missal of Cardinal Bertrand de Deux* (1980).

NICHOLAS OF VERDUN (active 1181–1205). Goldsmith and metalworker from Lorraine known from two signed and dated works, the former pulpit from Klosterneuburg Abbey (1181) and the shrine of the Virgin in Tournai Cathedral (1205). Both show the classicizing elements and moves towards naturalism that are regarded as characteristic features of the *transitional style between *Romanesque and *Gothic. The 45 original plaques from the pulpit, remodelled into a winged altarpiece in 1331, are the largest and most important example of medieval *champlevé *enamel; they comprise an extensive *typological scheme. Stylistic analysis has resulted in the contribution of several artists being discerned in both the enamels of the pulpit and the repoussé figures of the Shrine of the Virgin. The magnificent *reliquary made for the remains of the Three Magi (c.1198: Cologne Cathedral) was probably made under Nicholas's direction by the same team as worked at Klosterneuburg. KS

Buschhausen, H., 'The Klosterneuberg Altar of Nicholas of Verdun: Art, Theology and Politics', *Journal of the Warburg and Courtauld Institutes*, 37 (1974).

NICHOLSON FAMILY. English painters. **Sir William Nicholson** (1872–1949) was a painter and engraver. He studied in

Paris, admiring *Manet and *Velázquez. From 1893 to 1899 he and his brother-in-law James *Pryde, designed posters as 'The Beggarstaff Brothers'. Thereafter he made his reputation as a painter of elegant still life, landscape, and portraits, combining sensitivity to tone and formal pattern with acute observation of reality. A founder member of the National Portrait Society in 1911, he was knighted in 1936.

Ben Nicholson OM (1894–1982), his son, studied briefly at the Slade School, London (1910–11), then travelled on the Continent (1912–18). During the 1920s he painted landscapes and still life in a consciously naive manner, influenced by Alfred Wallis (1855–1942). He joined the 7&5 Society in 1924, and became its president in 1926, shifting the focus of the group towards abstraction; he also joined Paul *Nash's Unit One in 1933. Nicholson first encountered *Cubism in Paris in 1921; in 1932 he and his second wife, the sculptor Barbara *Hepworth, made direct contact with *Picasso, *Brancusi, and *Arp, joining the avant-garde group *Abstraction-Création. Nicholson's work became increasingly abstract, developing from Cubist-based compositions such as *Au Chat Botté* (1932; Manchester, AG) to the geometric reliefs for which he is best known: white circles and squares starkly incised into board. In 1937 he co-edited the international *Constructivist review *Circle* with Naum *Gabo; he was also close to *Mondrian.

Nicholson spent the war in *St Ives, Cornwall, the centre of an artists' community. His work became more figurative, based on the town and harbour, but after the war returned to an abstract style, integrating landscape elements into geometric designs. His reputation grew rapidly: he held a number of retrospective exhibitions, at the Venice Biennale in 1954, and the Tate Gallery in 1955 and 1968. From 1958 he lived in Switzerland, with his third wife the photographer Felicitas Vogler. He completed a group of monumental reliefs, working colour into carved board with characteristic energy and dexterity, as in *Feb. 1960 (Ice-off-Blue)* (London, Tate).

Internationally acknowledged as among the leading painters of his generation, Nicholson believed in the potential of abstract art to recreate physical and metaphysical dimensions of human experience. Writing in *Circle* that 'realism must be abandoned in the search for reality', his paintings and reliefs work to establish a universal aesthetic language.

Winifred Nicholson (née Dacre) (1893–1981) married Ben Nicholson in 1920. A notable painter in her own right, her experiments with light, rhythm, and abstract form influenced her husband. They continued a lifelong artistic correspondence. Winifred's later works explore prismatic colour effects;

she also painted landscapes and flower pictures (*Glimpse upon Waking*, 1976; London, Tate) where luminous colour creates space and form. JH

Browse, L., *William Nicholson* (1956).
Lewison, J., *Ben Nicholson* (1991).
Nicholson, W., *Unknown Colour: Paintings, Letters, Writings by Winifred Nicholson* (1987).

NICOLÒ DELL'ABBATE (c.1512–71). Italian painter who spent much of his life in France and exerted an influence on French landscape painting. He was trained in the tradition of his birthplace, Modena, but he developed his mature style in Bologna (1548–52) under the influence of *Correggio and *Parmigianino. There he decorated palaces, combining painted stucco with figure compositions and landscapes (Palazzo Pozzi), and painted some portraits of the *Pontormo type. He was invited to France in 1552, probably at the suggestion of *Primaticcio, under whom he worked at *Fontainebleau. Most of his work in the palace itself has been lost. But his latest paintings, executed independently for Charles IX, included some landscapes with mythologies (*Landscape with the Death of Euridice*; London, NG) through which Nicolò became the direct precursor of *Claude and *Poussin and one of the sources of the long-lived tradition of French classical landscape. HO/MJ

Béguin, S., *L'École de Fontainebleau*, exhib. cat. 1972 (Paris, Grand Palais).
Mostra di Nicolò dell'Abate, exhib. cat. 1969 (Bologna, Palazzo Archiginnasio).

NIELLO PRINTS. Niello plates are objects such as knife handles where the engraved designs are filled in with a black composition of metal alloys, giving them an independent decorative function. A niello print is an impression taken from such an object, many of the examples known being printed at a later date. The art flourished exclusively in Italy in the second half of the 15th century, where a number of artists, notably Maso *Finiguerra, made elaborate plates intended specifically for printing. The method had some influence on orthodox line engraving, notably on *Pollaiuolo's *Battle of the Ten Nudes*, where the figures stand out in relief against a dark background. Niello prints received a great deal of critical attention in the late 18th century when a number of very sophisticated fakes deceived connoisseurs. RGo

Hind, A., *Nielli in the British Museum* (1936).

NIKE OF SAMOTHRACE (2nd century BC; Paris, Louvre), monumental (2.45 m/8 ft high) Greek marble statue of the winged goddess of victory alighting on a ship's prow. Discovered on the island of Samothrace in the north-east Aegean in 1863,

the headless, armless figure now stands atop the Escalier Daru of the Louvre; fragments of the right hand were recovered in 1950. Apparently originally set in the upper basin of a two-level fountain overlooking the Sanctuary of the Great Gods, the figure is remarkable for the rippling textures and chiaroscural effects of its deeply cut, wind-blown drapery, which, despite a naturalistic appearance, is simultaneously dense and transparent, revealing the anatomical details of the female form underneath. The exuberance of the carving, attributed to Rhodian sculptors, and the dramatic, illusionistic setting are characteristic of the *Hellenistic baroque. The monument's date is uncertain, but its dedication has been associated with the battle of Magnesia (189 BC). KDSL

Pollitt, J. J., *Art in the Hellenistic Age* (1986).

NOGUCHI, ISAMU (1904–88). American sculptor and designer, born in Los Angeles to a Japanese father and an American mother. He spent his childhood in Japan and returned to the USA in 1918, briefly studying under Gutzon Borglum. In 1927 he travelled to Paris and worked as assistant to *Brancusi, whose organic abstraction and attitudes to natural materials clearly influenced Noguchi's biomorphic forms of the 1940s. The influence of *Arp and *Miró is also evident in his famous *Kouros* (1945; New York, Met. Mus.). Noguchi maintained an emphatically social conception of sculpture's role and throughout his life his sculpture related to the design and creation of sculpted environments. In 1933 he submitted a model of a *Play Mountain* to the New York City Parks Department. Though this was rejected, as were many of his subsequent designs for playgrounds, he saw the execution of a number of his gardens: IBM Headquarters, Armonk, New York, 1964. Throughout his career he also produced 20 set designs for the choreographer Martha Graham. MF

Altshuler, B., *Isamu Noguchi* (1994).

NOLAN, SIR SIDNEY (1917–92). Australian painter. Nolan was born in Melbourne and studied there by attending evening classes. He held his first solo exhibition, of abstract work, in 1940. From 1941 to 1945 he served in the army and, whilst stationed in the Wimmera district of Victoria, painted bright rudimentary landscapes which first revealed his unique ability to capture the peculiar aridity of the Australian landscape. After demobilization he visited sites associated with the bushranger Ned Kelly, an Australian folk-hero, whom he commemorated with the series of childlike figurative paintings for which he is best known. He followed these, c.1947, with a series of escaped convicts, like the chilling *Convict in Swamp* (Adelaide, AG South Australia),

painted with his characteristic use of overlaid thin washes of colour. Later Australian subjects included the explorers Burke and Wills and the severe drought of 1952. From 1954, with an international reputation, he often worked in London and expanded his subjects to include a series based on the legend of Leda and the Swan. DER

Lynn, E., *Sidney Nolan: Myth and Imagery* (1967).

NOLAND, KENNETH (1924–). American abstract painter and sculptor, born in Asheville, NC. After serving in the US Air Force during the Second World War he studied at *Black Mountain College, 1946–8, and then under *Zadkine in Paris, 1948–9. In 1949 he moved to Washington, where he became a close friend of Morris *Louis. On a visit to New York in 1953 they were greatly impressed by the work of Helen Frankenthaler (1928–) and they began experimenting with the kind of pouring and staining techniques she pioneered. They became the leading figures of the group of *colour field painters known as the Washington Color Painters, but from the late 1950s Noland began to use centralized circular images. At first these were fuzzy, but they became much more precisely articulated until by 1960 he was producing crisp, target-like images featuring concentric circles of strongly contrasting colours on a square canvas. During the 1960s he developed other sharply delineated formats that won him a reputation as one of the leading exponents of Hard Edge painting. The 'targets' lasted until 1962 (*Gift*, 1961–2; London, Tate), and were followed by a chevron motif (1962–4), which developed into diamond-shaped pictures (1964–7), sometimes of very large format. From 1967 he used horizontal stripes running across a long rectangular canvas. At about the same time he began making sculpture, influenced by his friend Anthony *Caro. Noland lived in New York from 1961 to 1963, then in South Shaftesbury, Vt., until 1979, when he settled in South Salem, NY. IC

NOLDE, EMIL (1867–1956). German painter. Nolde trained in furniture design, teaching craft 1892–8. Thereafter he painted independently, visiting Paris, Copenhagen, and Berlin before settling on Alsen Island in 1903; here he worked from nature, spending winters in Berlin. From 1906 to 1907 he joined the Expressionist group Die *Brücke. He also began working in *woodcut, *lithography, and *etching, creating a body of powerful graphic work. From 1913 to 1914 he visited Russia, China, Japan, and the South Seas and was impressed by the expressive conviction of native art and religion. His own religious sense was strong; from 1909 he painted New Testament scenes where agitated brushwork and impasted layers and blotches of violent colour convey the emotional intensity of religious experience. He also painted fiercely evocative landscapes, and surprisingly delicate watercolours. Many of his paintings were confiscated by the Nazis and in 1941 he was forbidden to paint or exhibit, working in isolation at his farm at Seebull until 1946. He had a retrospective exhibition in Hanover in 1948, and won the Venice Biennale Prize for graphics in 1952. There is a museum of his work at Seebull. JH

Selz, P., *Emil Nolde* (1963).

NOLLEKENS, JOSEPH (1737–1823). English sculptor. He trained with Peter *Scheemakers but in 1760 left for a ten-year stint in Rome. There he laid the foundations of a huge fortune working as a copyist and restorer of Antique statues for the *Grand Tourist market. He also made a number of portrait *busts, including those of *David Garrick* (Althorp, Northants) and *Lawrence Sterne* (1766; London, NPG). This was a genre in which he excelled for the rest of his career, creating a remarkable gallery of his contemporaries, ranging from the politicians *Charles James Fox* (1791; Holkham Hall, Norfolk) and *William Pitt* (1807; Windsor Castle, Royal Coll.) to the musicologist *Dr Burney* and the collector *Charles Townley* (both 1802; London, BM). In these works he successfully combined a fashionably *Neoclassical format with pungent characterization. Less successful were his ideal sculptures such as the group *Venus Chiding Cupid* (1778; Lincoln, Usher AG), which can seem both pretentious and flaccid. Nollekens also had a thriving practice supplying *funerary monuments of all sizes. Although the workmanship of these is sometimes slipshod and the designs repetitive towards the end of his career, the best are professional in concept and high quality in execution, combining gentle drama with a not too severe classicism, as in that to Sir Thomas and Lady Salusbury (1777; Offley, Herts.). Nollekens and his wife were well-known figures in the London artistic circles of their time, both of them being notorious skinflints, though he left a fortune of £200,000. HO/MJ

Smith, J. T., *Nollekens and his Times* (1828).
Whinney, M., *Sculpture in Britain 1530–1830* (rev. edn., 1988).

NONELL I MONTURIOL, ISIDRE (1873–1911). Spanish (Catalan) artist. Nonell was born in Barcelona, where he studied at the Escola de Belles Arts (1893–5) although he had first exhibited in 1891. With a group of like-minded students, the Colla del Safra, he painted realistic rustic landscapes and farmyards on the outskirts of Barcelona. In 1896, with members of the group, he visited the remote Boi valley in the Pyrenees, where he drew many studies of the disabled and thus found his *métier* as a painter of the disadvantaged. In 1897 he moved to Paris with the painter Ricard Canals (1876–1931) where he exhibited with both the *Impressionists and *Symbolists and also held a controversial show at the newly founded artists' café Els Quatre Gats, in Barcelona, of invalided soldiers returning from defeat in Cuba in 1898. His work became increasingly *Expressionist, with harsh outlines, and his unromantic paintings of gypsies, shown in the Sala Pares, Barcelona, in 1902, influenced *Picasso's Blue Period. After 1907 his palette and subjects both lightened and his work, which now included still lifes, became popular with a wider audience. DER

Fontbona, F., *Nonell* (1987).

NORGATE, EDWARD (1580×9–1650). English *miniature painter and calligrapher. Norgate's importance lies in his authorship of *Miniatura; or, the Art of Limning* (c.1646; Oxford, Bodleian Lib.), a technical manual. Evidence in this manuscript suggests that he may have been trained by *Hilliard, whose working practice he describes. In 1611, probably through the influence of his stepfather, the Bishop of Ely, he entered the employment of James I. He served the King in a variety of capacities including those of organ-tuner, calligrapher, and courier and after James's death in 1625 remained in the royal household. Norgate was also a protégé of Thomas Howard, 2nd Earl of Arundel (1586–1646), and familiarity with the royal pictures and those of Howard, the two finest collections in England, developed his powers of connoisseurship. In 1639 he was involved in commissioning Jacob *Jordaens to decorate the Queen's Cabinet at Greenwich. He was dismissed from court after the King's execution in 1648. Despite his contemporary fame virtually none of his works survive apart from a miniature of his wife, *Judith Norgate* (1617; London, V&A). DER

Norgate, E., *Miniatura: or, the Art of Limning*, ed. M. Hardie (1919).

NORWEGIAN ART. See SCANDINAVIAN ART.

NORWICH SCHOOL, the name applied to a group of *landscape painters working in Norwich in the early 19th century associated with the Norwich Society founded by John *Crome in 1803 with the grandiloquent intention of 'an Enquiry into the Rise, Progress and present state of Painting, Architecture and Sculpture, with a view to point out the Best Methods of Study to attain the Greater Perfection in these Arts'. The society, whose members included both professional

and amateur painters, held annual exhibitions in the city 1805–25 and 1828–33. After Crome's death the presidency was held by John Sell *Cotman until his departure for London in 1834. The Norwich School was the first self-sustaining provincial artistic community and its survival is partly explained by the relative isolation and insularity of the Norfolk gentry and merchants who provided patronage both by purchasing paintings and by employing the artists as drawing masters for their wives and daughters. A fashionable taste for antiquarian subjects also induced several members to take up printmaking. The two major figures, Crome and Cotman, share no similarity of style, the former being essentially Dutch influenced and bosky and preferring to work in oils, the latter more topographical and elegantly lucid, with watercolour as his chosen medium. They are united only by fellowship and a predilection, partly for reasons of saleability, for local landscape and architecture. At his best, as in *Scene on the River at Norwich* (c.1818; New Haven, Yale Center for British Art), Crome combines honesty of vision and subtlety of touch to produce a convincing rural idyll but his minor works are sometimes crudely handled and have suffered from deterioration (he was also much copied and forged and attribution is often difficult). Of the two Crome was the more influential on his fellow members, particularly on his pupils James Stark (1794–1859) and George Vincent (1796–1832) and his son John Bernay Crome (1794–1842), in whose hands his father's often robust style frequently degenerates into clumsiness. Cotman's sons Miles Edmund (1810–58) and John Joseph (1814–78) were also landscape painters and drawing masters. Miles, the more successful, exaggerated the decorative qualities of his father's style to the point of mannerism. It would be over-simplistic, however, to divide the painters into followers of Crome on the one hand and Cotman on the other and all shared, no matter their stylistic differences, an interest in outdoor sketching and *naturalism. Other leading members included Robert Ladbrooke (1769–1842), his son John Berney Ladbrooke (1803–79), a pupil of Crome, and John Thirtle (1777–1839). The Norwich School is well represented in the Castle Museum, Norwich. DER

Hemingway, A., *The Norwich School of Painters* (1979).

NOTKE, BERNT (c.1440–1509). German sculptor and painter, who was one of the most important 15th-century artists in northern Germany, and instrumental in the development of the Lübeck School and the introduction of modern sculptural styles in Denmark and Sweden. He combined his early training as a painter with that of a sculptor, for instance in his first important commission of the *Triumphal Cross* in Lübeck

Cathedral (1470–7) and in the decorative, winged Heiliggeist altarpiece in Reval (1482–3; Heiliggeistkirche; now Tallinn, Estonia). His masterpiece is the *S. George and the Dragon* (1489; Stockholm, Storkyrka), commissioned by Sten Sture to commemorate the defeat of the Danes at Brunkeberg in 1471. The two-part group is a decorative pageant of polychromy, gilding, and jewels, and represents the most important sculptural work in Sweden at this date. Notke's Swedish career extended also to a position as Master of the Mint. His legacy can be seen in the work of his assistants in many Swedish provincial churches. AB

Eimer, G., *Bernt Notke: das Wirken eines niederdeutschen Künstlers im Ostseeraum* (1985).

NOUVEAU RÉALISME, a term coined by the French critic Pierre Restany in 1960 (in a manifesto of this name) to characterize the work of a group of artists who incorporated real objects (often junk items) in their work to make ironic comments on modern life. The Nouveau Réalisme movement was part of the vogue for *assemblage and had affinities with *Junk sculpture and *Pop art. Restany also recognized a debt to *Dada—hence the title of an exhibition he held at his Galerie J in Paris in 1961, *40° au-dessus de Dada* (40 Degrees above Dada). In the following year another representative exhibition, entitled *New Realists*, took place at the Sidney Janis gallery in New York. Yves *Klein was closely associated with Restany in the foundation of Nouveau Réalisme, and among the other leading artists involved were Arman (1928–), César (1921–), and *Tinguely (all three exhibited at both the Paris and New York shows mentioned above). IC

NOVEMBERGRUPPE, a group of radical left-wing German artists in Berlin, led by Max *Pechstein and the stage designer Cesar Klein (1876–1954), who, in a spirit of post-war optimism, named themselves after the revolution of November 1918 which led to the establishment of the Weimar Republic. Their manifesto of January 1919, addressed to all '*Cubist, *Futurist and *Expressionist artists', called for the 'closest integration between art and the people'. In the same year they established the Arbeitsrat für Kunst (Workers' Council for Art) which demanded involvement in town planning and architecture, reformation of museums and art education, exhibition spaces, and freedom from censorship. Despite some governmental patronage, particularly posters, and a number of exhibitions, this idealistic movement, which was mirrored in several other German cities, failed to appeal to the proletariat and dissolved around 1924 as public opinion moved to the right. Its main legacy is to be found in

the educational theories of the *Bauhaus.

The Novembergruppe should not be confused with the November Group, an association of modernist nationalist Finnish artists established in Helsinki in 1917, from which emerged a distinctive style of Finnish Expressionism. DER

NUREMBERG: PATRONAGE AND COLLECTING. During the late Middle Ages and Renaissance Nuremberg reigned as one of Europe's foremost artistic centres. Founded in the 11th century on the Pegnitz river in northern Franconia (Germany), Nuremberg deftly exploited its position along major trade routes and its status as an imperial free city. Having banned guilds, Nuremberg's patrician government exerted tight control over artistic production. Trades such as goldsmithing and metalwork, considered vital to the city's economy, were organized under the closely regulated 'sworn crafts' while the 'free arts', including painting and printmaking, were only loosely monitored. For the latter this meant a much freer movement of artists and ideas than in most towns.

Nuremberg supported an exceptionally dynamic community of metalworkers ranging from renowned armourers, such as Valentin Siebenbürger and Kunz Lochner, to bronze and brass casters to goldsmiths. Peter *Vischer the elder and his sons (Hermann, Peter, and Hans) created brass tombs, epitaphs, fountains, and small collectable statues for patrons throughout central Europe. Their monumental Shrine of S. Sebaldus (completed in 1519), in the church of S. Sebaldus, honors Nuremberg's patron saint. The sons pioneered new types of sculpture and incorporated contemporary Italian design elements. Pankraz and Georg Labenwolf followed by Benedikt Wurzelbauer continued the foundry tradition into the late 16th and early 17th centuries. Georg Labenwolf cast the Neptune Fountain (mid-1570s–1583) for the King of Denmark's castle at Kronborg and his nephew Wurzelbauer made the intricate Fountain of the Virtues (1583–89) in Nuremberg. The city's rich pool of metalworkers explains why Nuremberg became a leading producer of portrait medals as sculptors Hans Schwarz (1492–after 1521), Matthes Gebel (c.1500–74), Joachim Deschler (c.1500–c.1571), and Valentin Maler (1540–1603), among others, made hundreds of attractive likenesses for clients across the empire.

Nuremberg's goldsmiths enjoyed exceptional renown. In 1514 the city sustained 129 gold- and silversmiths who devised both utilitarian and luxury wares. The Schlüsselfelder Ship (c.1500), a great wine vessel shaped like a merchant boat now in the Germanisches Nationalmuseum (Nuremberg),

epitomizes the refinement of both the local masters and their patrons. Wenzel Jamnitzer, Germany's greatest goldsmith, produced jeweled chests, table fountains, and life castings after insects, reptiles, and plants for noble and patrician collectors. His Merkel Table Decoration (1549), today in Amsterdam (Rijksmus.), was originally commissioned as a gift by Nuremberg's council but then kept as a supreme example of the virtuosity of their artists. Hans Jamnitzer, Jonas Silber, Hans Petzoldt, and Christoph Jamnitzer, among others, perpetuated Nuremberg's fame well into the next century.

The city's sculptors also enjoyed great distinction, especially between 1490 and 1540. Local artists, most notably Veit *Stoss and Adam *Kraft, made religious art for regional churches. Among their masterpieces in the local church of S. Lorenz are Stoss's *Annunciation of the Rosary* (1517–18), which hangs from the vault and Kraft's 18.7-m (60-ft) tall Sacrament House (1493–6) with its life-size self-portrait. By contrast, Peter Flötner (1485×96–1546) specialized in small sculptures, prints, and designs often intended for use by other artists or by his collaborators

such as goldsmith Melchior Baier. He skilfully integrated modern Italian and German artistic ideas in works such as his famed Apollo Fountain (1532), which originally stood in the garden of a local shooting yard.

Nuremberg reached its creative zenith during the lifetime of Albrecht *Dürer. Anton Koberger, Dürer's godfather, established the city as one of Europe's first great publishing centres. He printed the *Nuremberg Chronicle* (1493), illustrated by Michael *Wolgemut, Dürer's master, and Hans *Pleydenwurff, and assisted Dürer in the production of his *Apocalypse* (1498). Through the dissemination of his woodcuts and engravings, Dürer's compositions and ideas greatly influenced artists across Europe. Whether directly through his workshop or indirectly, he shaped a generation of painters and printmakers in Nuremberg including Hans von *Kulmbach, Hans *Baldung, Hans *Schäufelein, Hans Springinklee (c.1495–after 1522), Erhard Schön (c.1491–1542), Barthel and Sebald *Beham, and Georg *Pencz. These masters also specialized in the creation of broadsheets, woodcuts coupled with texts that comment upon contemporary religious controversies and social

attitudes. The Reformation, weakening economic conditions, and the Margrave War (1552) eroded Nuremberg's artistic primacy. Nevertheless, it continued to support such talented printmakers as Hanns Lautensack (c.1520–64×66), Virgil *Solis, and Jost *Amman as well as painters Nicolas Neufchatel (active 1539–73), Hans Hoffmann (c.1545×50–91/2), Lorenz Strauch (1559–c.1630), and Paul Juvenel the elder (1579–1643). Joachim von *Sandrart, the renowned painter, worked here from 1673 and helped found the earliest art academy in Germany. He wrote the *Teutsche Academie* (German Academy, 1675–9), a critical theoretical treatise and biography of artists.

By the mid-17th century Nuremberg lost its importance. It was rediscovered in the early 19th century by the Romantics, who celebrated Nuremberg's cultural heritage, its rich stock of late Gothic buildings and fortifications, and the accomplishments of Dürer and his contemporaries.　　　　JCS

Gothic and Renaissance Art in Nuremberg, 1300–1550, exhib. cat. 1986 (New York, Met. Mus.).
Smith, J. C., *German Sculpture of the Later Renaissance* (1994).
Smith, J. C., *Nuremberg: A Renaissance City, 1500–1618* (1983).

OBJET TROUVÉ (French: found object), a term originated by the *Surrealists to describe a natural or man-made object displayed as a work of art. The essence of the objet trouvé is that the finder-artist recognizes such a find as an aesthetic object and by choosing it elevates it to artistic status. In this it differs from a *'ready-made' as the latter is selected using no aesthetic criteria and is manufactured, for instance *Duchamp's *Fountain*, which was a mass-produced ceramic urinal. DER

OCHTERVELT, JACOB (1634–82). Dutch painter of Rotterdam who specialized in aristocratic genre scenes. Little is known of his training, although Ochtervelt may have been a pupil of Nicolaes *Berchem, a Dutch Italianate painter, in Haarlem. Certainly his early work shows the general impact of the Dutch Italianate painters. By 1655 when Ochtervelt returned to Rotterdam he concentrated on elegant interior scenes in which figures dressed in shimmering silks appear silhouetted against plain walls in a strong expressive light, as in *The Music Lesson*, (1671; Chicago, Art Inst.). The dazzling lemon yellow of the dress and the angular positions of the figures are characteristic of his work. By 1674 Ochtervelt had moved to Amsterdam, where he prospered. In the same year he painted *The Regents of the Amsterdam Leper Hospital*, one of his twelve known portraits. Ochtervelt's later work shows the impact of *Vermeer and Gerard ter *Borch, although with his later scenes, often set in doorways or entrance halls, such as *Street Musicians in the Doorway* (1665; St Louis, Art Mus.), Ochtervelt makes an individual contribution. CFW

Kuretsky, S. D., *The Paintings of Jacob Ochtervelt* (1979).

O'CONOR, RODERIC (1860–1940). Irish painter. He was born in Milton, Co. Roscommon, and was educated in England at Ampleforth. There followed a long artistic training in Dublin (1879–83), Antwerp (1883–4), and in Paris under Carolus-Duran (1838–1917). In 1888 he exhibited a portrait in the Paris Salon but in the following year abandoned academicism for modernity by showing at the Salon des Indépendants where he continued to exhibit until 1908 (see both salons under PARIS). His early work was influenced by *Monet but in 1891, following *Gauguin's example, he moved to Brittany and adopted the bolder colours and flatter planes of the *Pont-Aven artists. From 1892 to 1895 his work, as in *Yellow Landscape, Pont-Aven* (1892; London, Tate), shows a debt to van *Gogh, a fellow exhibitor at the annual shows organized by the avant-garde Belgian artists Les *Vingt (1883–93). His later Brittany paintings, like *The Wave* (1898; York, AG), whilst retaining thick impasto and vigorous brushwork, revert to *Impressionist prototypes. In 1904 he returned to Paris where he continued to paint in increasing obscurity. A sombre *Self-Portrait* (c.1910; York, AG) shows him in bourgeois top hat and overcoat. DER

Benington, J., *Roderic O'Conor* (1992).

OFFSETS of drawings, generally in red chalk, were produced by damping and pressing a drawing onto another piece of dampened paper. The impression made appeared in reverse and was invariably fainter and less crisp than the original which itself might be similarly affected. Offsetting was one of the methods used by engravers to reverse a design in the direction in which it was to be engraved on a copper plate (see COUNTERPROOF).

In 18th-century France offsetting was also used by artists such as *Watteau in order to increase the number of original drawings available for collectors. The process meant that the artist was saved the trouble of making an entirely new copy of a popular drawing although it was also a common practice to rework offsets. PHJG

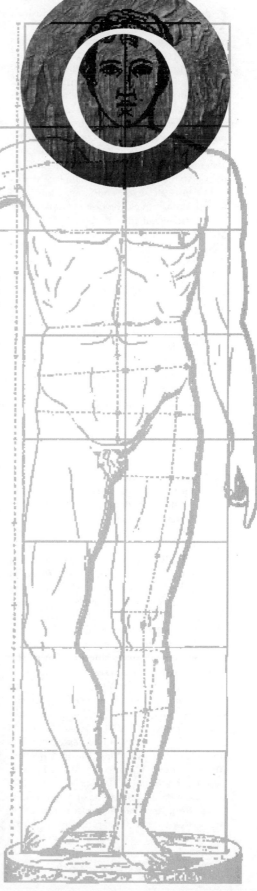

O'GORMAN, JUAN (1905–82). Mexican painter and architect. O'Gorman was one of the principal expounders of functionalist architecture in Mexico. In 1935 he turned to painting, executing murals such as *The History of Michoacán* (1941) at the Gertrudis Bocanegra Library in Pátzcuaro, Michoacán, and *El retablo de la independencia* (1960–1) at Chapultepec Castle in Mexico City. Although most of his subject matter, social criticism and the history of Mexico, is in keeping with the first generation of Mexican Muralists, O'Gorman's style is highly original. His works weave intricate detail and fantasy into epic historical narratives, the best example being the controversial murals commissioned for Mexico City airport in 1936 (destr.) on the theme of aviation, which he treated in a fantastic and mythical way, with details reminiscent of *Bosch and other 16th-century Dutch and Flemish painters. He also painted landscapes and portraits. His most acclaimed work is the mosaic covering the library at University City—4,000 square m (43,000 square ft) illustrating the history of Mexico from pre-Columbian to modern times, assembled with tiny multicoloured stones gathered from all around the country. CC

Luna Arroyo, A., *Juan O'Gorman* (1973).

O'KEEFFE, GEORGIA (1887–1986). American painter. O'Keeffe was born in Sun Prairie, Wis., and studied at the Chicago Art Institute (1905–6) and the Art Students' League, New York (1907–8). She taught between 1912 and 1916, when she had her first exhibition at the 291 Gallery, New York, owned by Alfred Stieglitz, whom she married in 1924. O'Keeffe is generally considered as among the first American abstract painters (see ABSTRACT ART) although she always worked from nature. Her stylistic variety is united by emphasis on the abstract elements to be found in natural and built objects and environments. During the mid-1920s she painted vastly enlarged features of plants, as in *Black Iris* (1926; New York, Met. Mus.), with sexual connotations; in the early 1930s she abstracted elements of buildings, like *White Canadian Barn 2* (1932; New York, Met. Mus.) and she later, in works like *Ram's Skull with Brown Leaves* (1936; New Mexico, Roswell Mus.), painted the objects realistically, suspended before a plain background. She avoided urban subjects, taking her inspiration from the harsh landscape of New Mexico where she wintered from the 1930s and lived, after Stieglitz's death, from 1946. DER

Dijkstra, B., *Georgia O'Keefe and the Eros of Place* (1998).

OLDENBURG, CLAES (1929–). Swedish-born sculptor and graphic artist who became an American citizen in 1953, a leading figure of *Pop art. He was born in Stockholm, the son of a consular official. His father's diplomatic duties took the family to New York in 1929–33 and Oslo in 1933–6 before they settled in Chicago in 1936. Oldenburg studied art and literature at Yale University, 1946–50, then returned to Chicago, where he took courses at the Art Institute whilst earning his living with part-time jobs as a reporter and illustrator. In 1956 he settled in New York, where he came into contact with a group of young artists including Jim *Dine, Allan Kaprow (1927–), and George *Segal, who were in revolt against *Abstract Expressionism, and from *c*.1958 he was involved in numerous happenings. Creating the props and costumes for these helped to turn his interest from painting to three-dimensional work—*environments as well as sculpture. His inspiration was drawn largely from New York's street life—shop windows, advertisements, graffiti, and so on—and in 1961 he opened The Store, at which he sold painted plaster replicas of domestic objects. This led to the work with which his name is most closely associated— giant sculptures of foodstuffs, typically made of canvas stuffed with foam rubber (*Dual Hamburger*, 1962; New York, MoMA), and 'soft sculptures' of normally hard objects such as typewriters and washbasins, typically made of shiny vinyl. With these he was hailed as one of the leaders of American Pop art. Subsequently Oldenburg has also become well known for projects for colossal monuments—for example, *Lipsticks in Piccadilly Circus* (1966; London, Tate), consisting of a magazine cutting of an array of lipsticks pasted onto a picture postcard. The first of these projects to be realized was a giant lipstick erected at Yale University in 1969. Since 1976, in collaboration with his second wife, the Dutch writer Coosje van Bruggen, Oldenburg has concentrated almost exclusively on such large-scale projects, for example the 20-m-high (65-ft) *Match Cover* erected in Barcelona in 1992. IC

OLIVER, ISAAC (*c*.1565–1617). *Miniature painter working in Britain. Brought to England by his French goldsmith father in about 1568, his first known miniature is dated 1587. Oliver trained with Nicholas *Hilliard, although his early portrait miniatures show Netherlandish influence, and unlike Hilliard he modelled his sitters' faces with deep shadows, using a characteristic stippled technique, for instance in his *Self-Portrait* (*c*.1590; London, NPG). In the mid-1590s Oliver visited Italy and his style subsequently became lighter and softer. From 1596 he was patronized by Elizabeth I's favourite the Earl of Essex, of whom a number of miniatures survive (e.g. *c*.1596; London, NPG). Among Oliver's finest works is the larger miniature full-length group *The Browne Brothers* (1598; Burghley House), whose composition derives from a French engraving. In 1605, Oliver became official miniaturist to James I's consort Anne of Denmark and later to their son Prince Henry, portrayed in a fine, rectangular miniature of *c*.1612 (London, Royal Coll.). Oliver, who apparently always considered himself a Frenchman, only took on English naturalization in 1606. He also produced subject miniatures such as the *Allegorical Scene* blending genre and landscape to depict differing forms of love (*c*.1590–5; Copenhagen, Statens Mus. for Kunst) and various drawings showing Italian influence: *Charity* (*c*.1596–1617; London, Tate). KH

Edmond M., *Hilliard and Oliver* (1983).
Murdoch J., *17th Century Miniatures: In the Collection of the Victoria and Albert Museum* (1997).

OLYMPIA, the most renowned of Greek sanctuaries, is situated at the confluence of the Alpheus river and Cladeus stream in the north-west Peloponnese, with the flood plain affording good open areas for athletic and equestrian events. The first Olympic festival is said to have taken place in 776 BC, though votive materials date back earlier; a recent find demonstrates that the Games were still being held in AD 387. Throughout its history Olympia attracted wealthy dedicators from the whole Greek world and beyond. The athletic core of the festivals is reflected in such offerings; the victor's statue was omnipresent. The huge seated cult statue of *Zeus* by *Phidias certainly attracted more ancient notice than the rest, though sharing the same oblivion; much of the bronze, ivory, and even stone statuary now exists in splendid scraps (eyes, hands, hair), though close reading can link some to the invaluable ancient description written in the 2nd century AD by *Pausanias, to whom a great deal of our knowledge is indebted. Many leading classical sculptors plied their trade and refined their techniques with commissions available from victors, or their proud townsfolk; plausibly both *Myron's *Discobolus* (e.g. Rome, Mus. Naz. Romano) and *Polyclitus' *Doryphorus* (Spear-Bearer; Vatican Mus.) may have been such pieces. Pausanias notes that the temple of Hera housed venerable statues, many of wood and ivory, but including a Hermes carrying the baby Dionysus in marble by Praxiteles. A piece found near where Pausanias saw it is possibly the original statue of *c*.350 BC, despite some technical arguments to the contrary (Olympia Mus.). Earlier, *c*.425, is a marble *Nike* (Victory), a remarkable feat of marble carving when once intact with wings and billowing drapery, made by Paionius,

according to the text on the high pillar support, to celebrate a military victory—another frequent cause to thank Zeus. Phidias' cult statue is known from minimal echoes, notably a couple of Hadrianic bronze coins—3 cm (1 in) as against the reported height of some 13.5 m. (44 ft). Built up of wood, ivory sheet, gold foil, and perhaps glass, the only remnants are some of the residual material left in the workshop beside the temple, constructed c.440 BC, to the very size of its *cella*, where Phidias also left one of his clay drinking mugs, with his name inscribed underneath. AWJ

Ashmole, B., and Yalouris, N., *The Sculptures of the Temple of Zeus at Olympia* (1967).

Boardman, J., *Greek Sculpture: The Classical Period* (1985).

Drees, L., *Olympia: Gods, Artists and Athletes* (1968).

OMEGA WORKSHOPS, decorative arts company founded by Roger *Fry in London in 1913 with the twin aims of improving the standard of design in Britain and providing work for the young avant-garde artists in his circle. The headquarters were at 33 Fitzroy Square in Bloomsbury, a handsome Robert Adam house that is now part of the London Foot Hospital; there were two showrooms on the ground floor and two large workshops on the first floor. In a prospectus, Fry wrote that the Workshops would undertake 'almost all kinds of decorative design, more particularly those in which the artist can engage without specialized training in craftsmanship'. A press view was held on 8 July 1913, and the works on show included tables and chairs, fabrics, bedspreads, screens, and designs for murals. Several commissions came from aristocratic patrons, including Lady Ottoline Morrell. Fry disliked the smooth finish of machine products, and Omega works characteristically have the irregularities of hand craftsmanship, although the furniture it sold was originally bought ready made and then painted on the premises, and its linens were expertly printed in France. The favourite Omega motifs included flowers, nudes, and abstract patterns, and colour was often very bright; *Cubism and *Fauvism were strong influences.

Apart from Fry himself, the designers most closely associated with Omega were Vanessa *Bell and Duncan *Grant, and several other distinguished artists worked for the enterprise, including Paul *Nash and William *Roberts. However, all the work was sold anonymously. Artists were paid a regular wage (the financing came from Fry himself and from subscribers including George Bernard Shaw), and this steady income could be of great importance.

The First World War had a disastrous effect on Omega's sales (Fry in any case had little business aptitude) and in June 1919 the Workshops' remaining stock was sold off; the company was officially liquidated in 1920. The best idea of Omega furnishings in a contemporary setting can be gained at Charleston, the country home of Bell and Grant at Firle in Sussex. There are also good examples in London at the Courtauld Institute Gallery and the V&A.

OP ART, a journalist's rhyming label, in the era of Pop art, for 'optical' art that relies entirely upon the sensations created by visual processes. It was an international form of geometric abstract painting and sculpture which assumed importance as a style in the 1960s, evolving from the work of artists like Josef *Albers and Victor *Vasarely, who became one of its leading exponents. Adopting theories from the psychology of perception, the Op artists manipulated colour, line, and shape to induce vibrant effects of shifting, flickering, and even dazzling surfaces, sometimes so startlingly that the work appears to throb with energy and movement. The geometric images, whether very simple or extraordinarily complex, and the colours are meticulously worked out in advance of painting to ensure a precise result. Thereafter, since technical rather than artistic skills were required, the painting was sometimes undertaken by studio assistants. The term Op art was first used anonymously in *Time* magazine (23 Oct. 1964), and a major exhibition, *The Responsive Eye*, followed in 1965 (New York, MoMa). Op art, particularly the work of the British painter Bridget *Riley, was plagiarized by 1960s and 1970s fashion and popular graphics. YJ

Lancaster, J., *Introducing Op-Art* (1973).

OPIE, JOHN (1761–1807). English painter. Opie, 'the Cornish Wonder', was discovered by the writer John Wolcot (1738–1819), who launched him in London, as a prodigy, in 1781. Instant success followed and by 1805 he was professor of painting at the RA (see under LONDON). He was an able portraitist, capable, as in *Mary Godwin* (c.1797; London, NPG), of more than simple likeness. Opie had ambitions to be a *history painter and Boydell commissioned several works including *The Death of Rizzio* (1787; destr.), which was much admired. After his death Opie's great fame soon declined. DER

Peter, M., *John Opie*, exhib. cat. 1962 (Arts Council touring exhibition).

OPPENHEIM, MERET (1913–85). Swiss artist. Oppenheim studied in Basle and Paris, met *Arp and *Giacometti, and exhibited with the *Surrealists in Paris, New York, Copenhagen, and London. Known for her beauty, she posed for *Man Ray's camera several times. Despite this, she never fully adhered to Surrealism. She is most famous for her objects, particularly *Cup, Saucer and Spoon in Fur* (1936; New York, MoMa), but she also executed drawings, sculptures, oil paintings, and *collages. From the 1970s onwards she became involved in *feminist discussion and with the role of women in art. CC

Curiger, B., *Meret Oppenheim* (1989).

OPUS SECTILE is the term used, initially by the Romans, to describe marble inlay, both on floors and walls, where the stone is cut into pieces following the lines of the picture or pattern. Marble, mother of pearl, and glass were the most frequently used materials. They were cut into plates no thicker than 5 cm (2 in), polished on one side, and then cut to size according to design. The pieces might be fixed in a plate of stone, shaped to receive the parts, or assembled face down and then affixed to a setting bed. In contrast to *mosaic where pieces are cut to a uniform size and their grouping provides the pattern, in *opus sectile*, pieces are much larger and more fragile, and consequently more precious, and it is their shape which provides the form of the composition.

Opus sectile seems to have originated in Egypt and Asia Minor before its Roman popularity. Examples survive from *Pompeii, *Herculaneum, and Rome, but the richest surviving group comes from the 4th-century AD Roman basilica of the consul Junius Bassus, where designs include an elaborate chariot scene. The technique was popular in the Christian Church from at least the 5th century, as Italian churches such as S. Sabina (Rome), S. Ambrogio (Milan), and S. Vitale (Ravenna) reveal. In Hagia Sophia in Istanbul, rinceau patterns and elaborate figured wall designs, such as the jewelled cross and dolphins above the west door, dominate. After the 6th century, *opus sectile* on walls was far rarer, though examples remain at Daphni in Greece (11th century) and the 13th-century Kariye Camii in Istanbul. Painted imitations were a cheap and easy version of this complex and expensive art form. An 11th-century *opus sectile* icon of S. Euphemia was found at the Lips monastery in Istanbul.

Opus sectile was more common on floors, where it was usually laid in rectangular panels of simple geometric designs in coloured marbles, often comprising large-scale curvilinear designs, parts of which are filled with intricately laid small pieces and even figures. Such floors appear in later *Byzantine churches, such as the Pantokrator Monastery in Istanbul, Hagia Sophia in Trebizond, and the recently destroyed floor of the former Chrysokephalos church in the same city.

Greek artisans brought the skill back to medieval Italy, working with the *Cosmati in 12th-century Rome, in Sicily in the great Norman churches, and at S. Mark's, Venice, and the neighbouring islands of Torcello and

Murano. By the 13th century, Tuscan artists were creating black and white figured pavements, as *Beccafumi did for Siena Cathedral.

LJ

ORCAGNA. See CIONE, ANDREA DI.

ORCHARDSON, SIR WILLIAM QUILLER (1832–1910). Scottish painter. Orchardson was born in Edinburgh where he studied at the Trustees Academy under the enlightened mastership of Robert Scott Lauder (1803–69). His early subjects were taken from Scottish history (*Wishart's Last Exaltation*, 1853; St Andrews University) but he was also a gifted portrait painter. The charming *Mrs John Pettie* (1865; Manchester, AG) was painted as a wedding present for his fellow student Pettie (1839–93), whom he accompanied to London in 1862. Orchardson continued to paint Scottish pictures, including subjects from Scott, until 1877 when he abandoned them for the scenes of psychological drama, set in Regency or contemporary times, for which he is best known. His *Mariage de convenance* (1884; Glasgow, AG) and its companion *After!* (1886; Aberdeen, AG), which deal with a mismatch and its consequence, were greatly praised when exhibited at the Royal Academy (see under LONDON) for their moral seriousness. His use of space as a compositional device to denote emotional isolation became as much a characteristic of his work as the flickering brush strokes, broken colour, and sombre palette he habitually employed.

DER

Hardie, W., *Sir William Quiller Orchardson*, exhib. cat. 1972 (Scottish Arts Council touring exhibition).

ORDÓÑEZ, BARTOLOMÉ (1485–1520). Spanish sculptor who was one of those principally responsible for introducing High *Renaissance forms to the Iberian peninsula. He trained in Italy, possibly with Domenico *Fancelli, some of whose Spanish commissions he took over on his death. By 1515 he had a flourishing workshop in Barcelona but two years later he was back in Italy working in Naples (then a Spanish possession) with Diego de *Siloe on the reredos of the Caracciolo chapel in S. Giovanni a Carbonara. He was in Spain again in 1519, when he decorated the choir stalls in Barcelona Cathedral with reliefs in Renaissance style and took over two of Fancelli's commissions—the tombs of Queen Joanna and Philip I (Granada, Capilla Real) and of Cardinal Jiménez de Cisneros (Alcalá de Henares, S. Ildefonso). Both exhibit Ordóñez's free interpretation of the early style of *Michelangelo and seem to have been largely completed by him and his team of Italian craftsmen in the quarries at Carrara before his early death.

MJ

Gomez Moreno, M. E., *Bartolomé Ordóñez* (1956).

ORLEY, BERNAERT VAN (c.1488–1541). Brussels painter and designer of tapestries and stained glass who was the chief court artist, first to the Regent of the Netherlands, Margaret of Austria, 1518, then to her successor, Mary of Hungary, 1532. He was one of the greatest exponents of Romanism, though it seems unlikely that he visited Italy. Instead, he knew Italian engravings and the cartoons by *Raphael, which he studied from 1517 as supervisor of the tapestries woven from them in Brussels. Van Orley's most famous work is the altarpiece of the *Ordeals of Job* (1521; Brussels, Mus. Royaux), which shows the parable of *Lazarus and the Rich Man* on the outside wings. The events are rendered in a highly dramatic manner which assimilates Italianate architectural and figural motifs, e.g. the *Rich Man in Hell* (right outer wing) was inspired by the pose of Raphael's figure of Ananias in the *Acts of the Apostles* tapestry cartoons. From 1525 van Orley became increasingly involved in designs for tapestry and stained glass. Pieter *Coecke van Aelst, Michiel *Coxcie, and Jan *Vermeyen were among his pupils.

KLB

Ainsworth, M. W., and Christiansen, K. (eds.), *From Van Eyck to Bruegel*, exhib. cat. 1998 (New York, Met. Mus.).

OROZCO, JOSÉ CLEMENTE (1883–1949). Mexican painter. One of the 'Three Great' Mexican Muralists of the 1940s. He studied at the Academy of S. Carlos in Mexico City 1906–14, and then worked as a satirical cartoonist for radical newspapers such as *La vanguardia* and *El ahuizote* during the Mexican Revolution. Among his early works is a well-known series of watercolours entitled *Mexico in Revolution*. During the 1920s he took part in Vasconcelos's educational programme, painting his famous murals at the National Preparatory School 1923–6, most of which were subsequently destroyed by students reacting against the blatant and violent way Orozco treated religious and social themes. His murals aimed to convert the illiterate and heterogeneous masses to a realization of the miseries and futilities of war. His style differs from that of *Siqueiros and *Rivera in being highly expressionistic. Orozco's theme extends much further than the Muralist focus on the national revolutionary struggle, encompassing universal social conflict and suffering. Also, unlike the others he disliked propagandistic art, stating that 'My one theme is Humanity; my one tendency is EMOTION TO A MAXIMUM.' His style is severe, almost violent, with fierce swirling brush strokes and sombre colours sliced through with red and white gashes, as seen in *Combat* (mid-1920s; Mexico City, Mus. de Arte Carrillo Gil) and *The Trench* (1926–7; Mexico City, National Preparatory School). His work often contains Christian imagery, sometimes subtle, at others more blatant. From 1927–34 he worked extensively in the USA, painting murals at Pomona College, Clairmont, Calif., and at Dartmouth College, Hanover, NH. He also painted murals at the Palacio de Bellas Artes, the History Museum, the University, and the Government Palace in Mexico City.

CC

Orozco!, exhib. cat. 1980 (Oxford, Mus. of Modern Art).

ORPEN, SIR WILLIAM (1878–1931). Irish-born painter. Orpen studied at Dublin School of Art and the Slade School, London (1895–9), where he was a contemporary of Augustus *John. Like John, whose *Whistlerian portrait he painted c.1900 (London, NPG), Orpen's career was one of youthful brilliance followed by successful mediocrity. *The Mirror* (1900; London, Tate) exhibits his technical virtuosity, gained through unremitting study, and his early interior conversation pieces culminate with *Hommage à Manet* (1909; Manchester, AG) a sympathetically observed group of friends gathered at Hugh Lane's tea-table. His chalk portrait of *Augustine Birrell* (London, NPG), of the same year, demonstrates his remarkable draughtsmanship and the impressionistic *Jury of the New English Art Club*, also 1909 (London, NPG), reveals his quirky humour. But by 1910 Orpen had established a portrait practice which was to become the most successful and remunerative of his age. From now on, with the rare exception of ill-conceived allegories like *The Unknown British Soldier* (1923; London, Imperial War Mus.), he painted the Establishment with skill, industry, and superficiality and was rewarded with great wealth and a knighthood (1918) for his work as a *war artist.

DER

Arnold, B., *Orpen* (1981).

ORPHISM, a term coined by Guillaume *Apollinaire to describe the art of Robert *Delaunay exhibited at the *Section d'Or, Paris, in 1912. It was conceived by him as an offshoot of *Cubism in which a more lyrical use of colour was evident than in the relatively austere works of *Picasso, *Braque, and *Gris. The word *orphique* had previously been used by the *Symbolists, and in reviving it Apollinaire gave it a poetically charged significance, which also implied an interest in the analogy between pure colour abstraction and music; this was a main preoccupation with František *Kupka, another artist associated with the term. Others included Sonia *Delaunay-Terk, Francis *Picabia, Marcel *Duchamp, and Fernand *Léger. In *Les Peintres cubistes* (1913), Apollinaire described Orphism as non-representational colour abstraction in which new structures were created entirely from the artist's imagination, without

reference to the 'visual sphere'. In 1912 Delaunay had begun his series of abstract *Simultaneous Discs* and *Circular Rhythms*, showing interpenetrating and revolving areas of pure colour which constituted colour structures in their own right. Although it was short-lived, Orphism was the first movement devoted explicitly to non-representational colour abstraction. OPa

Spate, V., *Orphism* (1980).

ORRENTE, PEDRO (1580–1645). Spanish painter, born in Murcia and apprenticed in Toledo, where he resided in 1600. Some time between 1604 and 1612 he was in Venice, presumably working with Leandro *Bassano. His activity from 1612 to 1632 was divided between Toledo, Murcia, and Valencia. He is recorded in Valencia in 1638, and remained there until his death. Orrente's pictures are seldom signed; confirmed dates are scarce and limited to the years 1615–19.

His most characteristic works are those in which the art of the Bassano family's influence is strongest: subjects from the Old or New Testament where people and animals, often small in scale, appear in rustic settings (*Laban Comes to Jacob at the Well*; Madrid, Prado). The Venetian component of Orrente's style is also strong in the altarpieces painted in Toledo, such as the *Adoration of the Shepherds* (cathedral sacristy), but they also display the vigorous realism characteristic of early *Baroque painting in Spain. The physical types and landscape of the *Martyrdom of S. Sebastian*, for Valencia Cathedral (*c*.1615–18) show the blend of Castilian realism and Venetian style typical of his work. NAM

Brown, J., *The Golden Age of Painting in Spain* (1991).
Mallory, N. A., *El Greco to Murillo: Spanish Painting in the Golden Age: 1556–1700* (1990).

OS, VAN. Dutch family of painters active during the late 18th and 19th centuries. **Jan** (1744–1808), the founder of this dynasty, was born in Middelharnis and studied under Aert Schouman (1710–92) before establishing himself in The Hague. He painted some sea pieces early in his career but later specialized in highly detailed illusionistic *still lifes of flowers and fruit, dead birds, and insects, as in *Still Life of Flowers, Fruit and Dead Birds* (1799; Amsterdam, Rijksmus.), in the manner of Jan van *Huysum with whom his works were sometimes later confused. His daughter **Maria Margrita** (1780–1862) and son **Georgius Jacopus Johannes** (1782–1861) worked in the same vein as their father. Georgius settled in France in 1826 and worked as a decorative painter for the Sèvres porcelain factory. Another son, **Pieter Gerhardus** (1776–1839), painted cattle scenes and a few military subjects like *The Bombardment of Naarden* (1814; Amsterdam, Rijksmus.), a siege

in which he actually participated as a soldier. All three children were taught by their father. Pieter's son **Pieter Frederik** (1802–92), who worked in Haarlem, continued the family tradition and was the teacher of Anton Mauve (1838–88). DER

OSONA, FATHER AND SON. Rodrigo (*c*.1440–1518) and his son **Francisco** (*c*.1465–*c*.1514) were painters in Valencia, then a major Mediterranean centre, comparable to Genoa or Marseilles, which generated a wealth of artistic production. Rodrigo worked for Cardinal Rodrigo de Borgia (future Pope Alexander VI), the Cathedral of Valencia, and important parish churches. He worked with Bartolomé *Bermejo on an altarpiece dedicated to the Virgin of Montserrat (*c*.1481–5: Acqui Terme Cathedral). His early style, so like that of his contemporary Hugo van der *Goes, suggests he may have spent time in Flanders. Though he probably never travelled to Italy, Rodrigo saw works by the Italian painters brought to Valencia to paint frescoes in the cathedral (1472–6). However, Italianate reflections in the art of the Osonas remained limited and superficial, as in the use of classical ornament in architectural settings. Francisco, formed in his father's shop, was submerged in his style. His *Adoration of the Magi* (*c*.1505: London, V&A) is modestly inscribed by 'the son of Master Rodrigo'. SS-P

El mundo de los Osona ca.1460–1540, exhib. cat. 1995 (Valencia, Mus. de Bellas Artes de S. Pío V).

OSTADE, ADRIAEN VAN (1610–84). A Dutch painter and printmaker who worked all his life in Haarlem. Ostade explored most subjects, although he is chiefly remembered for his charming and sometimes boisterous *genre scenes. According to the biographer *Houbraken he was a pupil of Frans *Hals at the same time as Adriaen *Brouwer. By 1634 he had entered the artists' guild in Haarlem, and he eventually became its dean in 1662. His second wife was a devout Catholic and it is possible that Ostade converted to Catholicism. His earlier genre scenes concentrate on peasants merrymaking or brawling in houses, taverns, or barns. He also made a small number of biblical paintings and a few portraits. But his later works are more colourful and restrained in terms of content. Ostade made numerous watercolour drawings, and over 50 etchings. His pupils included his brother Isaak (1621–49), Cornelis Dusart, and Cornelis *Bega; and many contemporary imitations of his popular creations were made. CB

Schnackenburg, B., *Adriaen van Ostade, Isack van Ostade: Zeichnungen und Aquarelle*, (2 vols., 1981).

OSTIA. Founded in the 4th century BC and inhabited for more than 900 years, Ostia divulges a precious view of everyday life in the ancient Roman world. The port of Rome, Ostia served as an important military and commercial centre that housed more than 50,000 inhabitants at its height. Unlike *Pompeii and *Herculaneum, destroyed in a single night under the falling ash and embers of the eruption of Vesuvius, the city of Ostia gradually fell into ruin as the Tiber silted up and the site became dangerously malarial. Apartment complexes and luxurious villas testify to the domestic lives of the inhabitants. The theatre and numerous bath complexes represent the life of leisure while the Piazzale delle Corporazioni, with its mosaic floors that identify the trade connected with each 'office', hints at the commercial focus of the city. The cosmopolitan population is reflected by the wide range of temples and dedications to both Roman gods and foreign cults.

The wealth and ethnic diversity of the city is reflected in the material remains. More than 1,000 statues, reliefs, and sarcophagi survive on the site, despite its systematic plundering at the hands of Gavin *Hamilton and others in the 18th century to supply the collections of English and other European aristocracy with marble statuary. The masses of material provide important insights into the setting and reception of sculpture in the ancient world.

Unlike Pompeii and Herculaneum, copies after Greek originals are common in both public and private spaces. For example, more than 60 Venus statues, from public buildings and private houses, testify to both the importance of the goddess and the range of functions that her images fulfilled. Funerary/honorific statuary of imperial and private individuals provide important evidence for the overlapping between gods and men, with both the living and dead portrayed as gods. Iconographically and stylistically the Ostian material reveals close connections with art of Rome itself. For example, the motif of Victories killing bulls from a frieze in the Forum of Trajan reappears in a contemporary frieze at Ostia.

Surviving wall painting is of lesser interest and quality. Shop signs and playful twists on traditional themes, such as the wall painting of the seven sages, with their advice on intestinal functions, are to be contrasted with the sumptuous decoration of later public and private buildings with coloured marble revetment and mosaics. For example, the 4th-century House of Cupid and Psyche contains several rooms with marble revetment and *opus sectile mosaic pavements; a grand colonnaded nymphaeum (decorative fountain) completes the luxurious picture. L-AT

Meiggs, R., *Roman Ostia* (2nd edn., 1973).
Pavolini, C., *Ostia* (1983).

OTTERLO, RIJKSMUSEUM KRÖL-LER-MÜLLER, founded by the shipping heiress Hélène Kröller-Müller (1869–1939) in 1921 to house her private collection of modern art, one of the largest and finest in Holland. She began to collect in 1907 following a meeting with the painter and critic H. P. Bremmer (1871–1956), who remained her adviser. Her intention was didactic and charitable; she wished to show the development of modern painting within an art historical context and to this end she purchased not only works painted between the 1870s and the 1920s but also some ancient art, old masters, and oriental art for comparative purposes. Her first major purchase was three works by van *Gogh and she eventually owned 272 paintings and 256 drawings by the artist which remain one of the glories of the collection. The *realists, *Symbolists, *Cubists, and *Surrealists are also well represented; and she collected Piet *Mondrian, although she avoided wholly abstract works. The museum opened on its present site in 1938 with Hélène Kröller-Müller as the first director; further acquisitions have been added to the collection including a sculpture garden.

From 1920 the Kröller-Müllers were the principal patrons of the architect Henry van de Velde (1863–1957) who designed several buildings for their vast estate Hoge Veluwe, near Otterlo, including a museum (1920–6) to house the collection which, for financial reasons, was never built. In 1935 van de Velde was commissioned to design another museum for the site which was built by the Dutch government in return for the bequest of the estate and collection. The building, in a severe international modern style, was opened in 1938 and there have been later additions. DER

OTTONIAN ART. *See opposite.*

OUDRY, JEAN-BAPTISTE (1686–1755). French painter, a pupil and admirer of *Largillierre. Like his older rival François *Desportes, he established his name as a painter of still lifes and animals. Like Desportes also, he achieved considerable technical brilliance and was interested in landscape for its own sake (e.g. the drawing *The Park at Arcueil*; Paris, Louvre, Cabinet des Dessins). He was official designer to both the Beauvais and Gobelins tapestry factories (appointed 1726 and 1736), and his series of canvases of *The Hunts of Louis XV* (Fontainebleau) were painted as tapestry cartoons. His interpretation of the Flemish animal painting tradition of *Snyders is more purely decorative than that of Desportes, as is well exemplified in *The Dead Wolf* (1721; London, Wallace Coll.). His sense of colour and tone could be very subtle as in the exquisite and much-reproduced *The White Duck* (1753; priv. coll.), with its variations on white, from paper and feathers to silver and stone. There is a particularly choice collection of Oudry's paintings in the Nationalmuseum, Stockholm, which was assembled by Count Tessin, Swedish ambassador to the court of Louis XV. It includes a portrait of Tessin's favourite pet dachshund, *Pehr* (1740). HO/MJ

Lauts, J., *Jean-Baptiste Oudry* (1967).
Locquin, J., *Catalogue raisonné de l'œuvre de Jean-Baptiste Oudry* (repr. 1968).
Opperman, H., *J.-B. Oudry*, exhib. cat. 1983 (Paris, Grand Palais; Fort Worth, Kimbell Mus.).

OUTSIDER ART, a term used to describe the art made by people not conventionally associated with art production, such as psychiatric patients, children, and prisoners. It is synonymous with Art Brut—'raw art'—a term coined by Jean *Dubuffet, who, in 1964, began to collect works he considered to be free from cultural norms and fashions or traditions in art. In 1948 he had founded the Compagnie de l'Art Brut with André *Breton, in the first edition of whose periodical Dubuffet defined the term as 'works executed by people free from artistic culture, for whom mimesis plays little or no part, so that their creators draw up everything from their own depths and not from the stereotypes of classical art or of modish art. We have here a "chemically pure" artistic operation' (*L'Art brut*, 1, 1964).

Although it is not possible to describe a 'style' of outsider art, there are, particularly among the paintings and drawings of psychiatric patients, certain formal similarities. For example, picture surfaces are often entirely covered with meticulous detail (such as patterns and writing) which creates works whose diagrammatic, cartographical compositions suggest an urge either to understand something, or to be understood. These characteristics are strikingly displayed in the art of the schizophrenic prisoner Adolf Wölfli (1864–1930). OPa

Beyond Reason, Art and Psychosis, exhib. cat. 1996 (London, Hayward).
Cardinal, R., *Outsider Art* (1972).
Thevoz, M., *Art brut* (1976).

OUWATER, ALBERT VAN (active c.1440–65). North Netherlandish painter, notable for his landscapes, identified by Karel van *Mander in 1604 as a leading Haarlem artist, and the master of *Geertgen tot Sint Jins.

No contemporary documentation of Ouwater's work exists. His only undisputed work is a *Raising of Lazarus* (Berlin, Gemäldegal.). Unusually, Lazarus is naked and the miracle takes place in an interior, the chancel of a Romanesque church. This remarkably spacious setting recalls that of Jan van *Eyck's *Van der Paele Virgin and Child* (Bruges, Groeningemus.). The meticulous detail can also be related to the influence of the art of the South Netherlands, but again Ouwater's individuality is suggested by the freshness and diversity of his observations, as in the spectators peeping through the ambulatory door. His palette is more subdued than that of southern contemporaries and the picture is evenly rather than brilliantly lit.

Possibly a version of a lost picture by Ouwater is a *Mission of the Apostles* (on loan Aschaffenburg, Stiftskirche), which illustrates his concern for convincing spatial settings, featuring a panoramic background that may relate to the landscape praised by van Mander in an untraced 'Roman altar' in S. Bavo, Haarlem. MS

Châtelet, A., *Early Dutch Painting* (1981).
Mander, Carel van, *The Lives of the Illustrious Netherlandish and German Painters*, ed. H. Miedema (1994).

OUWATER, FATHER AND SON. Dutch painters. **Isaak**, also known as Jacob, **Ouwater the elder** (d. 1775) painted landscapes and still lifes. His son **Isaak** (1748–93) specialized in townscapes in the manner of van der *Heyden. The younger Ouwater spent most of his life in Amsterdam, but he made on-the-spot sketches for views of several Dutch towns including Haarlem, The Hague, Edam, Utrecht, and Delft. His meticulous work is topographically accurate, and his scenes are usually bathed in sunlight. What most distinguishes his work from van der Heyden's, however, is the prominent staffage of 18th-century citizens, often including groups resembling miniature conversation pieces. One of Ouwater's best-known, but least typical, paintings is the *Bookshop and Lottery Agency of Jan de Groot in Kalverstraat, Amsterdam, 1779* (1779; Amsterdam, Rijksmus.). This records the sale of lottery tickets on 25 October 1779, exciting all sorts of lively reactions among the crowd on the pavement, in contrast to the flat grid pattern of windows and 17th-century brickwork that takes up most of the painting. AJL

The Age of Elegance, exhib. cat. 1995 (Amsterdam, Rijksmus.).

OVERBECK, FRIEDRICH (1789–1869). German painter. Overbeck studied at the Vienna Academy (1808). Rapidly disillusioned by the rigid regime, he founded the Lukasbund (see NAZARENES), with *Pforr, dedicated to reviving the spirituality of the German and Italian primitives. The group moved to Rome c.1810. Idolizing both *Raphael and *Dürer, Overbeck worked to integrate the styles of north and south, a desire symbolized in *Italy and Germany* (1811–28; Munich, Neue Pin.). The most religious of the Nazarenes, he converted to Catholicism in 1813, after Pforr's death. His contribution to the

continued on page 530

· OTTONIAN ART ·

OTTONIAN art is the distinctive national style which emerged in Germany after the collapse of the Carolingian Empire, and lasted from the mid-10th to the mid-11th century, when it was gradually superseded by but also crucially contributed towards the pan-European *Romanesque. It is named after the powerful dynasty of the Saxon Emperors Otto I, II, and III, who, like their great predecessor, used art to reinforce power. Otto I (ruled 936–73) sought to revive the political and cultural ideals of Charlemagne's empire; initially much Ottonian art was therefore no more than a deliberate revival of *Carolingian sources. But at the same time, there was a renewed interest in *early Christian art, resulting from direct contacts with Rome. Contemporary *Byzantine art also exerted a strong influence, because of the strategic alliance which had been made between the two imperial courts: Theophanu, wife of Otto II (ruled 973–83), was a Byzantine princess, so not only were Byzantine imports available as models but Byzantine craftsmen worked for the Ottonian court. Ecclesiastical patronage was as important as imperial: one highly significant figure was Bernward, Bishop of Hildesheim, whose own design skills contributed to, and whose workshop certainly produced, the remarkable bronzes now installed in the cathedral, including great doors (1015) with vividly told biblical scenes in high relief, and a massive column based on imperial Roman models but depicting the life of Christ. He was also responsible for commissioning many other smaller bronze works. Other evidence of goldsmiths' skills comes from pieces like the beaten gold plate altar frontal of Henri II, c.1019 (Paris, Mus. Cluny).

However, Ottonian sculptors were no longer satisfied just with recreating exquisite but generally small-scale Carolingian metalwork and ivories, although important regional workshops linked to scriptoria continued to flourish. There was also concern to explore the quite different potentials of wood and stone through developing qualities of monumentality, severity, and emotional impact—all to become fundamental elements of Romanesque art. Wooden sculpture was inextricably linked with the goldsmith's art, since carved figures in the round were intended to be encased in metalwork, inlaid with gems, or painted with gold and other vivid colours (although such embellishments now rarely survive), but the features of increasing size, greater expression, and three-dimensionality are all new. Christ Crucified is no longer represented in the form of a small portable image of ivory or gold, but is now portrayed as a life-size figure intended to stand by the altar. The powerful *Gero Crucifix* of c.970 (Cologne Cathedral), made of painted oak, and more than life size, is the earliest surviving example. Another new subject, three-dimensional and free standing, combining the techniques of jeweller and woodcarver, was the Virgin and Child; the late 10th-century *Madonna* (Essen Cathedral treasury) has an outer casing of gold, enamel, filigree, and jewels over a wooden core. Wood was also used for relief carving, as in the New Testament scenes on the mid-11th-century doors of S. Maria im Kapitol (Cologne).

Stone sculpture, through its combination of simplicity and scale, is again innovative. Although sculptors would have been familiar with classical works, there was no attempt to produce three-dimensional figures in stone: relief panels and friezes in limestone or sandstone, together with stucco, were preferred. There were several regional schools, that of Cologne being particularly distinguished. Elaborately sculptured tombs, such as those in Gernrode Abbey church and Werden Abbey, combined Christian iconography with the layout and techniques of Roman sarcophagi. The sandstone sarcophagus commissioned by Bernward (Hildesheim, S. Michael) is a direct copy of an early Christian type, while Otto II was buried in a genuinely Antique one. Architectural carving was restrained, with simple geometric or foliate capital and column designs derived from contemporary Byzantine or north Italian sources.

Despite distinctive regional schools, Ottonian manuscript illumination is unified by emphasis on the human figure, invariably imbued with expressionistic qualities and the use of often exaggerated gestures to underline the pictorial content. There is concern with symmetry and abstract patterns, together with the simplification or elimination of background detail. The most influential Carolingian source was the solemn *Ada School rather than the more delicate school of Utrecht. Carolingian iconography is extended to incorporate a wider range of Gospel narratives, including illustrations of Christ's miracles and other dramatically expressive cycles. Among the various scriptoria, that of Trier was supported by the patronage of Bishop Egbert, and may be the source of much of the so-called 'Reichenau' School of illumination, which produced masterpieces such as the late 10th-century Gospel Book of Otto III (Munich, Staatsbib.). Cologne was another important centre, blending Reichenau with Byzantine elements, where the ascendance of colour over line gives a distinctive character to the illustrations. The Byzantine element, always present in Ottonian art, was particularly strong in the Regensburg School, which laid emphasis on decorative detail. Fresco painting, expressive and dramatic, is seen in narrative cycles responsive to the function of the surrounding architecture, another Romanesque trait. CMH

Hollander, H., *Early Medieval* (1990).
Kitzinger, E., *Early Medieval Art* (1983).
Lasko, P., *Ars sacra 800–1200* (1972).

Casa Bartholdi frescoes (now Berlin, National-algal.), *Joseph Being sold by his Brothers* (1816–17), is impressive; strictly quattrocento in style, his reticent colour emphasizes the linear design. He remained in Rome after his associates departed, pursuing religious art with growing fervour. Called by A. W. N. Pugin 'the Prince of Catholic painters', his studio in Rome became the centre of European revivalist painting. He had distinguished patrons—the Prince Consort bought his cartoon *The Triumph of Religion in the Arts* (1830–40; London, Royal Coll.)—and his influence extended throughout Europe, especially in England, despite the restricted religiosity of his subjects, and increasing sentimentality. His best later works are portraits, which combine clarity of line and modelling with sensitivity to the sitter. JH

Howitt, M., *Friedrich Overbeck* (2 vols., 1971).

OVERDOOR, the framed decoration in fresco, canvas painting, or stucco relief of the area above an interior door, which forms an integral part of the doorcase.
 CFW

OXFORD, ASHMOLEAN MUSEUM. The fine and applied art museum of the University of Oxford, the Ashmolean originated in the cabinet of curiosities formed by the horticulturist and traveller John Tradescant (1608–62), given in 1659 to the virtuoso Elias Ashmole (1617–92) who presented it to the university in 1675. The present collections are large and varied. The museum is particularly rich in ancient art, including material from the excavations of Sir Arthur Evans (1851–1941) at Knossos, and classical carvings and sculpture from the Selden bequest of 1645 and the 17th-century collection of Thomas Howard, 2nd Earl of Arundel (1586–1646), acquired in 1667. Early Italian Renaissance painting is well represented, including *Uccello's *A Hunt in the Forest*, given in 1850 by William Fox-Strangways, who formed his pioneering collection whilst on diplomatic service in Italy. A fine group of Dutch still lifes were acquired through the Ward bequest (1940), and the bequest of the widow of the university printer Thomas Combe (1797–1872) in 1893 is the nucleus of an interesting group of *Pre-Raphaelite paintings and drawings. The outstanding holding of old master drawings originated with the purchase, by public subscription, of drawings by *Raphael and *Michelangelo, from the celebrated collection of Sir Thomas *Lawrence, in 1846.

The first building to house the collection, designed by the mason Thomas Wood (1643/4–95), was opened in 1683, the first public museum in England. The present building in Beaumont Street, designed by C. R. Cockerell (1788–1863), was opened in 1845 and enlarged by the C. D. E. Fortnum extension in 1894. In 1899 the designation Ashmolean Museum was transferred to the present building and the original museum of Thomas Wood, which now houses the Museum of the History of Science, became known as the Old Ashmolean Building. Further sensitive expansion, preserving the original façade, was carried out in the 1980s and 1990s. DER

OZENFANT, AMÉDÉE (1886–1966). French painter, born in St Quentin, Aisne. After studying drawing he settled in Paris in 1906 and studied painting. While never a member of the *Cubist group, he was very interested in the style and after 1915 began to articulate his dissatisfactions with its directions in his review *L'Élan* (1915–17). This led him to develop the theory of *Purism along with the architect and painter *Le Corbusier, with whom he wrote *Après le Cubisme* in 1918. Together, from 1920 to 1925, they articulated these ideas in their journal *L'Esprit nouveau*, putting themselves at the forefront of the period's conservative 'call to order'. *Nature morte: le pot blanc* (1925; Paris, Centre Georges Pompidou) is typical of his Purist work in its restrained, sombre palette and flat, mechanical, geometric forms. From the late 1920s he executed a number of large figurative murals completing the vast *Les Quatre Races* in the Musée National d'Art Moderne in Paris in 1928. Throughout his life Ozenfant was also involved in teaching, setting up academies in Paris, London, and New York.
 MF

Amédée Ozenfant, exhib. cat. 1985 (St Quentin, Mus. Lecuyer).

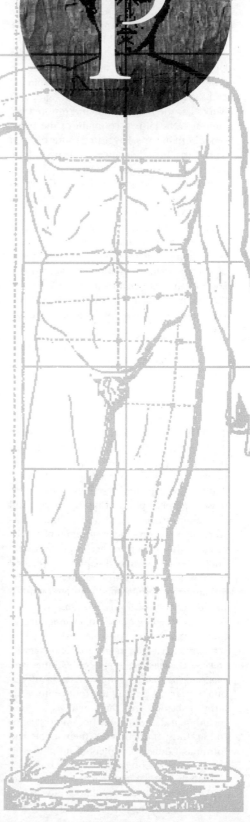

PACHECO, FRANCISCO (1564–1644). Pacheco's significance in the history of Spanish art rests primarily on his authorship of the *Arte de la pintura*, published posthumously (1649), a rich source of knowledge of the practice and theory of art in Spain in the early *Baroque period. He also was *Velázquez's master.

Born in Sanlúcar de Barrameda, he trained in Seville and briefly in Ghent. Most important for his artistic future was his residence in the house of a homonymous uncle, canon of the Cathedral of Seville, poet, and classical scholar. In the canon's intellectual circles Pacheco acquired knowledge that was seldom part of a 17th-century painter's education. Through his frequent association with the Jesuits, and as censor of sacred paintings for the Inquisition, he also gained special familiarity with theological matters. This *humanistic and theological culture served as the base for his writings on art.

Pacheco's pictures no longer follow the canons of *Mannerism, but neither do they embrace the naturalism that dominated Spanish painting in the first third of the 17th century. His types are conventional and inexpressive, and his forms hard and stilted. The *Christ on the Cross* (1614; Granada, Fundación Rodríguez Acosta) and the *Immaculate Conception with Miguel Cid* in the Cathedral of Seville (c.1621), subjects whose iconography he explicates in detail in his treatise, are typical of his work. NAM

Brown, J., *The Golden Age of Painting in Spain* (1991).
Mallory, N. A., *El Greco to Murillo: Spanish Painting in the Golden Age: 1556–1700* (1990).

PACHER, MICHAEL (active 1462–98). German or Austrian painter and sculptor (or perhaps only designer of sculpture produced in his workshop) based in Bruneck in the Tyrol (Brunico, Italy). He designed and was responsible for complex wood, stone, and painted structures for *altarpieces on a magnitude unprecedented in northern European art. His sculpture is northern in style, combining *Multscher's manner with the new grand figure types of Nicolaus *Gerhaerts. Pacher's painting, however, demonstrates first-hand knowledge of Paduan art, especially the work of *Mantegna. His most complete extant work is the high altar for the parish church in S. Wolfgang, Austria (1471–81; *in situ*). It consists of a carved shrine in limewood, polychromed and gilded, with the *Coronation of the Virgin with SS Wolfgang and Benedict*, and two sets of painted wings with scenes from the life of S. Wolfgang (closed), as well as an extensive cycle of scenes of the lives of Christ and the Virgin (opened). KLB

Baxandall, M., *The Limewood Sculptors of Renaissance Germany* (1980).

PAGGI, GIOVANNI BATTISTA (1554–1627). Italian painter and theorist. He was born at Genoa, the son of a nobleman, but established his artistic reputation at the Medici court in Florence, after being banished from his home town for killing a client. His work in Florence included a fresco of *S. Catherine Converting Two Criminals* (1582; Florence, S. Maria Novella) and an opulent *Salome* (1599; ex-Locko Park, Derbys.), as well as numerous altarpieces in Tuscan churches at Lucca, Pisa, and Pistoia. He returned to Genoa in 1599 and undertook numerous commissions for the Doria including the *Stoning of S. Stephen* (1604; Genoa, S. Ambrogio). A *Rinaldo and Armida* (priv. coll.; exhibited Genoa, 1992) suggests he was responsive to the work of Lombard *Mannerist artists associated with Gian Carlo Doria, particularly G. C. *Procaccini. He in his turn was a formative influence on the next generation of Genoese artists, including Domenico Fiasella (1589–1669) and G. B. *Castiglione. HB

Gavazza, E., and Terminello, G., *Genova nell'età Barocca*, exhib. cat. 1992 (Genoa, Palazzo Spinola and Palazzo Reale).

PAJOU, AUGUSTIN (1730–1809). French sculptor. He trained in Paris with Jean-Baptiste *Lemoyne and then spent four years at the French Academy in Rome. On his return to *Paris he became a member of the Académie Royale, presenting the marble group *Pluto and Cerberus* (Paris, Louvre). Among his many royal commissions is the graceful gilt wood relief decoration in the Opera House at *Versailles, completed in time for the wedding of Marie-Antoinette and the future Louis XVI in 1770. Pajou also worked at the Palais-Royal and restored the famous 16th-century Fountain of the Innocents, both in Paris. His seated statue of *Pascal* (1781; Paris, Inst. de France) is the best of the series of posthumous portraits of great Frenchmen commissioned by the Crown as its contribution to the Enlightenment. Pajou is best known, however, for his portrait *busts in marble and terracotta, which give a lively and humane picture of pre-revolutionary society. Among them are those of the royal mistress *Mme du Barry* (Paris, Louvre), the painter *Mme *Vigée-Le Brun*, and the naturalist *Buffon* (Paris, Louvre). From 1777 Pajou was Keeper of the King's Antiquities.
MJ

Draper, J. D., and Scherf, G., *Augustin Pajou: Royal Sculptor*, exhib. cat. 1998 (New York, Met. Mus.).

Stein, H., *Augustin Pajou* (1912).

PALAEOGRAPHY is the study of 'ancient writing' (Greek *palaiographia*), encompassing scripts and their adjuncts, such as punctuation and abbreviations. Although Antique and medieval scribes had a well-developed perception of types of script and their appropriate uses, the Italian *humanists were the first consciously to attempt to distinguish styles of writing according to culture and date. The formal discipline developed from the 17th century around attempts by the Bollandists and the Benedictines to establish the authenticity of grants. Working principles were advanced by Mabillon, *De re diplomatica* (1681), and were further developed by scholars such as Tassin and Toustain, *Nouveau Traité de diplomatique* (1750–65), Montfaucon, *Palaeographia Graeca* (1708), and Maffei of Verona (1675–1755). During the 19th century the term 'palaeography' assumed its current meaning and 'diplomatic' became restricted to the study of documents, their scripts and formulas. Codicology emerged at this time as the study of the physical structure of books. Twentieth-century approaches to palaeography included the philologically based methods of Ludwig Traube of Munich and

the technical and aesthetic perceptions of E. A. Lowe.
MPB

Boyle, L., *Medieval Latin Palaeography: A Bibliographical Introduction* (1984).

PALEOTTI, GABRIELE (1522–97). Italian cardinal and writer on art. His treatise on painting, *Discorso intorno alle immagini sacre e profane* (1582), was the most comprehensive and influential Italian attempt to explain the decisions of the Council of Trent concerning sacred art. In 1566, after attending the Council, he returned as bishop to Bologna, and his work on the treatise was part of a vigorous programme of reform. To him sacred art was the 'bible of the illiterate' and should be accessible to all; he railed against the *Mannerist delight in difficult poses and complex allegories, demanding instead a naturalistic art that should be clear, direct, and moving. In biblical pictures the artist should avoid novelty and strive for historical accuracy; portraits should be unadorned and shun glorification. Paleotti was associated with the naturalist Ulisse Aldrovandi, and believed that the painter's rendering of nature should be based on scientific observation. The increased severity in the styles of Bartolomeo Cesi (1556–1629) and Prospero *Fontana, and the tenderness and clarity of Ludovico *Carracci's early works, have been associated with his thought.
HL

Prodi, P., *Il Cardinale Gabriele Paleotti* (1959–67).

PALETTE. See STUDIO EQUIPMENT (PAINTING).

PALETTE KNIFE. See STUDIO EQUIPMENT (PAINTING).

PALMA (Negretti) FAMILY. Italian painters active in Venice from the early 16th century to the early 17th century. **Jacopo Palma (il) Vecchio** (the elder) (1479/80?–1528) was born at Serina (Bergamo) but is first recorded as an artist in Venice. He may have trained under Andrea Previtali (c.1480–1528), a follower of G. *Bellini, but Jacopo Palma's style is less hieratic and formal and moves towards a more physical and sensual High *Renaissance conception of the human figure. Although he painted altarpieces for Venetian churches—notably the *S. Barbara Polyptych* for S. Maria Formosa (1522–4) and the *Adoration of the Magi* for S. Elena (1525–6; now Milan, Brera)—his main clientele was among private collectors. For them he specialized in wide-format *sacre conversazioni* in which the Virgin and saints inhabit a pastoral landscape; and half-length figures of attractive idealized women, with erotic implications, for instance the *Flora* (London, NG). He was also an accomplished portrait painter—his *Self-Portrait in a Fur Coat* (1516–18; Munich, Alte Pin.) was praised by *Vasari. Vasari also admired his *S. Mark Saving Venice*

from the Ship of Demons (Venice, Scuola Grande di S. Marco) which was still incomplete when the artist died suddenly in 1528.

Giacomo Palma il Giovane (the younger) (c.1548–1628) was the great-nephew of Palma Vecchio. He was taken up by Guidobaldo II della Rovere, Duke of Urbino, and lived in Pesaro and then from 1567 in Rome, where he remained for several years before returning to Venice. His first major public commission there, following a fire at the Doge's palace in 1577, was for three canvases for the ceiling of the Sala del Maggior Consiglio, including *Venice Crowned by Victory*. His style combines Mannerist formulas inspired by his years in Rome with a breadth of handling in the tradition of late *Titian and *Tintoretto. Increasingly in his later years he worked for the Church, developing a dramatically effective Counter-Reformation style; for instance the scenes of *Purgatory* on the ceiling of the Ateneo Veneto (c.1600).
HB

Hope, C., and Martineau, J. (ed.), *The Genius of Venice*, exhib. cat. 1983 (London, RA).

Mason Rinaldi, S., *Palma il Giovane: Opera completa* (1994).

Rylands, P., *Palma il Vecchio opera completa* (1988).

PALMER, ERASTUS DOW (1817–1904). American sculptor. Born in Syracuse, NY, Palmer began his career as a carpenter and decorative moulding carver before taking up portrait cameo carving c.1846. In 1849 he settled in Albany, NY, sculpting portrait busts and religious bas-reliefs in a style which tempered *Neoclassical idealism with growing realism. An exhibition in New York in 1856 established his reputation and three years later he completed his most celebrated work *The White Captive* (1859; New York, Met. Mus.). This enormously popular sculpture, inspired by the example of Hiram *Powers's *Greek Slave* of 1843 (New Haven, Yale University AG), shows a young naked girl, captured by native Americans but sustained by her Christian faith. This heady combination of sentiment, sensationalism, religion, and eroticism was an immediate success with the American public. Smoothly carved in white marble, the head of the girl was posed for by his daughter. After the mid-1860s he produced several lively bronze portrait busts. Palmer's artistic theory is contained in his essay *Philosophy of the Ideal* (1856), a *Ruskinian belief that art should be based upon but not imitative of Nature.
DER

Webster, J. C., *Erastus D. Palmer* (1983).

PALMER, SAMUEL (1805–81). English landscape painter. About 1824, through John Linnell, Palmer met William *Blake whose influence was profound and long-lasting. Recollections of Blake's *Virgil* wood

engravings (1821) and his *Book of Job* copper engravings (1825) appear in Palmer's striking visionary landscapes from the mid- to late 1820s. Imbued with his knowledge of the Bible, Milton, Virgil, and Bunyan and set in the Kent countryside around Shoreham, where he mainly lived 1826–35, they contain huge full or crescent moons, dense, luxuriant vegetation, and no hint of the modern world: *The Valley Thick with Corn* (1825; Oxford, Ashmolean). Palmer used pen and ink and varnished brown wash, and also watercolour. More prosaic, florid landscapes followed in the 1830s, particularly during and after his honeymoon trip to Italy (1837–9). He exhibited at the Society of Painters in watercolours, and in 1850 joined the Etching Club. His later years (from 1862 he lived in Redhill) were spent on landscapes inspired by Milton and Virgil, regaining some of his visionary insights, especially in his few but brilliant etchings, an inspiration to British Neo-Romantic artists in the 1920s and 1930s. MP

Grigson, G., *Palmer* (1947).

PALOMINO DE CASTRO Y VELASCO, ACISCLO ANTONIO (1655–1726). Well-born Spanish painter and author. He was educated by the Dominicans in Cordoba, took holy orders, and then abandoned that calling for his vocation as an artist. In 1687 Palomino presented himself at the court in Madrid as proficient in both 'las Artes y la Teología'. There he befriended the court painters Juan Carreño de Miranda and Claudio *Coello and he met Luca *Giordano, the Neapolitan painter commissioned to create fresco decorations in the royal palaces. Palomino's most notable works are fresco decorations in the high *Baroque style; he was one of the few Spanish painters then active in that medium. Extant examples are found in the church of S. Esteban in Salamanca (1705) and in the Carthusian charterhouse in Granada (1711–12). However, Palomino is now best known for his book *Museo pictórico y escala óptica* (vol. 1, 1715; vol. 2, 1724). The second volume included a third part entitled *Parnaso español pintoresco laureado*, a collection of biographies of Spanish painters. It is an important source for the history of Spanish painting and sculpture from the 15th to the 17th centuries. SS-P

Gaya Nuño, J. J., *Vida de Acisclo Antonio Palomino* (2nd edn., 1981).

PANEL. See SUPPORTS.

PANINI (Pannini), GIOVANNI PAOLO (Gianpaolo) (1691–1765). Italian painter, born in Piacenza and trained under the stage designers at Bologna, possibly with one of the Galli-*Bibiena family. He settled in Rome in 1711, where he was for a time the pupil of Benedetto *Luti. In 1719–25 he decorated the Villa Patrizi and did several further fresco commissions for cardinals and for Pope Innocent XIII at the Palazzo Quirinale. He also specialized in paintings of public festivities and events of historical importance: the birth of the Dauphin in 1729 (Paris, Louvre) and the visit to Rome of the Bourbon monarch in 1745 (*Visit of Charles III to S. Peter's*; Naples, Capodimonte). He is best known nowadays for his pictures inspired by Roman monuments and ruins. Some are careful and accurate topographical views (*vedute reale*) such as the Piazza S. Maria Maggiore and the Piazzal del Quirinale painted for Pope Benedict XIV (1742; Rome, Coffee House in grounds of Palazzo del Quirinale); others (*vedute ideale*) often juxtapose and regroup real monuments or classical sculptures in imaginary settings, and sometimes peopled by anachronistic figures of soldiers and biblical characters. These capricci had great influence in their day and started a vogue, although in their calm and carefully organized design they had nothing of the romantic turbulence and sheer extravagance of Piranesi. One of the most impressive series of capricci by Panini is at Castle Howard (North Yorks.), commissioned by the 4th Earl of Carlisle in 1738–9 and delivered c.1740. The pictures reflect the essence of English 18th-century taste for Antiquity and picturesque ruins. Panini's connections with French collectors were equally close and included Cardinal Polignac, French ambassador to the Holy See. He was a member of the French Academy in Rome from 1732 and taught optics and *perspective there. HB

PANOFSKY, ERWIN (1892–1968). German and American art historian. Panofsky taught history of art at the universities of Hamburg and New York, and from 1935 was professor at the Institute of Advanced Studies, Princeton. At Hamburg, under the influence of Aby *Warburg and the philosopher Ernst Cassirer, he began to develop his *iconological approach, first set out in works such as *Hercules am Scheidewege* (1930) and his study on *Dürer's *Melancolia*, written jointly with Fritz Saxl (1926). The method was only given its ultimate form in his much later essay collection *Meaning in the Visual Arts* (1955). Panofsky here suggests inquiring into the meaning of art by means of a three-step model, involving the pre-iconographical description, the *iconographical analysis, and the iconological interpretation, the latter revealing the 'intrinsic meaning' of the work of art in the culture within which it was produced. Whilst attempts to contextualize works of art culturally can be traced back to *Winckelmann and *Rumohr, Panofsky was the first to provide a theoretical basis for this approach. His other important studies include *Early Netherlandish Painting* (1953), which combines iconographic and stylistic analysis, and *Renaissance and Renascences in Western Art* (1960), a synthesis of his conception of art history in western Europe. AT

Holly, M. A., *Panofsky and the Foundations of Art History* (1984).

PANORAMA, a picture, usually of a landscape, townscape, or battle, either painted around the inside surface of a large cylinder in which the viewer stands (cyclorama), or made to pass before the viewer by means of rollers. It was the invention of Robert Barker (1739–1806), a Scottish artist, who patented the device in 1787. The first example, a view of Barker's home town Edinburgh, was shown in Scotland and London in 1789 to great acclaim. It was much admired by *Reynolds, who had originally doubted its practicality, and *West who allowed Barker to quote his praise in publicity material. Around 1792 a special exhibition hall was built in Leicester Fields and opened with a panorama of the *Grand Fleet at Spithead* under the supervision of Barker's son Henry (1774–1856). In 1799 the *Battle of the Nile* attracted compliments from Lord Nelson. Henry Barker continued to paint and display panoramas until 1822 and the practice attracted a number of other artists, most notably *Girtin, who exhibited his *Eidometropolis*, a vast panorama of London, in 1802. DER

Whitley, W. T., *Artists and their Friends in England* (1928).

PANTOJA DE LA CRUZ, JUAN (1549×53–1608). *Sánchez Coello's pupil and successor as Spanish court painter. His earliest portraits are datable c.1590/3, and follow his master's models without attaining their pictorial quality (*Infante Don Felipe in Armour*; Vienna, Kunsthist. Mus.); his style becomes still harder with time. In Pantoja's courtly portraits, the dominance of pattern and detail, the stylization of his models' features, and their impassive expressions result in a flattening of the image; his subjects are defined primarily by their rich costumes and formal poses. In portraits of sitters of less rank he worked with a softer technique and greater physical and psychological realism. In his last eight years of life, Pantoja painted dozens of portraits of the royal family and relevant personalities in Philip III's court.

Pantoja also executed some religious pictures (*Birth of the Virgin*, 1603; Madrid, Prado). These works, in which chiaroscuro plays an important role, relate to Venetian and Lombard painting of the late 16th century. Our knowledge of Pantoja's life goes back only to 1585; he might well have been in northern

Italy earlier on. NAM

Brown, J., *The Golden Age of Painting in Spain* (1991).
Mallory, N. A., *El Greco to Murillo; Spanish Painting in the Golden Age: 1556–1700* (1990).

PAOLO VENEZIANO (active 1333–58). Italian painter. Paolo da Venezia, as he styled himself on a 1333 altarpiece of the *Dormition of the Virgin* (Vicenza, Pin.), was the foremost painter of trecento Venice. If he held no formal position as painter to the Republic he still secured many of the major state commissions. The Vicenza altarpiece combines the influence of recent *Byzantine art in the central narrative with that of *Giotto in the flanking saints. In 1345 Paolo and his sons signed the cover of the Pala d'Oro S. Mark's, Venice. The narratives combine great splendour with a lively naturalism. The development of Paolo's style can be traced through a series of panels of the *Madonna and Child* and several larger altarpieces. Of these the S. Chiara *Coronation* altarpiece (1340s?; Venice, Accademia) is perhaps the most sumptuous. A firm sense of pictorial space and a modelling of forms again reflecting Giotto do nothing to diminish the chromatic and decorative brilliance of Paolo's art. This wide-ranging synthesis informs Paolo's last work, another *Coronation of the Virgin*, signed with his son Giovanni (1358; New York, Frick Coll.). JR

Muraro, M., *Paolo da Venezia* (1970).

PAOLOZZI, SIR EDUARDO (1924–). British sculptor, printmaker, and designer, born in Edinburgh of Italian parentage. He studied at Edinburgh College of Art, 1943, and the Slade School, 1944–7. While still a student he had his first one-man exhibition as a sculptor, at the Mayor Gallery, London, in 1947. In the same year he began making witty *collages using cuttings from American magazines, advertising prospectuses, and technological journals: *I Was a Rich Man's Plaything* (1947; London, Tate). Paolozzi regarded these collages as 'ready-made metaphors' representing the popular dreams of the masses, and they have been seen as forerunners of *Pop art (he eventually amassed a large collection of 20th-century pulp literature, art, and artefacts, which he presented to the University of St Andrews). In 1947–50 he lived in Paris, where he was influenced by the legacy of *Dada and *Surrealism, and in the early 1950s he was a member of the *Independent Group, the nursery of British Pop art.

From the 1950s Paolozzi has worked primarily as an abstract or semi-abstract sculptor, often on a large scale. His work of the 1950s was characteristically heavy and bulky, often incorporating industrial components, showing his interest in technology as well as popular culture. In the 1960s his work became more colourful, including large totem-like figures made up from casts of pieces of machinery and often brightly painted. In the 1970s he made solemn machine-like forms and also boxlike low reliefs, both large and small, in wood or bronze, sometimes made to hang on the wall, compartmented and filled with small items. The compartmented reliefs were sharply and precisely cut and had some resemblance to the work of Louise *Nevelson. His more recent work has included several large public commissions, for example mosaic decorations for Tottenham Court Road underground station in London (commissioned 1979, installed 1983–5) and *The Wealth of Nations* (installed 1993), a huge bronze sculpture commissioned by the Royal Bank of Scotland for a new building at South Gyle on the edge of Edinburgh. It represents a great, fallen giant struggling not as the *Laocoön with living serpents, but with the modern, abstract, mechanized shapes of the world of technology. Paolozzi has taught at various art schools and universities in Britain, Europe, and the USA. He was knighted in 1989 and has been awarded many other honours. In November 1998 he gave some of the content of his studio to the Gallery of Modern Art (Dean Gallery), Edinburgh.

Macmillan, D., *Scottish Art in the 20th Century* (1994).

PAPER is macerated and hydrated cellulose fibre, derived from plant material, held in suspension in water and formed by one of three different methods: into individual sheets either by hand or on a cylinder mould machine (invented by John Dickinson in 1809), or formed as a continuous web on a Fourdrinier machine (developed by Bryan Donkin in 1804 from an original invention by Nicholas Louis Robert in 1798). Paper is made either laid or wove, regardless of the method of manufacture. Laid paper is formed on a surface made from thin parallel wires held together every inch or so by chain wires whilst wove paper is formed on a woven wire cloth.

Originally invented in China *c*.100 AD, the manufacture and use of paper spread westwards via Samarkand (AD 751), Baghdad (793), and Cairo (900) before arriving in Europe through Spain (1036). In Britain the first paper usage dates from the 14th century but it was not until *c*.1495, long after its establishment in Italy (1270), France (1348), and Germany (1390), that the first paper mill in England was established.

For most of its history paper has been designed for three specific uses: writing and printing (both usually made as white or off-white papers), and, the largest area of production, wrapping papers (generally blues, browns, and drabs). Only since the mid-18th century have papers designed for particular artistic practices been developed. Before that date artists' colourmen stocked ranges of white and coloured papers, often sold as 'drawing' papers, but originally designed for other uses. Local and regional variations in raw material supply and papermaking practice led to rich varieties of papers that were nominally the same colour. Preparation of the pulp, rather than the formation of the paper, by hand or by machine, is the major influence on the life and durability of the sheet. Most of the earliest papers survive very well because they were made from intrinsically pure materials: rags derived from linen and cotton, old hemp ropes, and sailcloth.

Paper was traditionally made in a range of sizes based on local measurements that varied slightly from country to country: the most common artists' papers sizes were: Foolscap (16½×13½ in), Crown (19×15 in), Demy (20×15½ in), Large Post (21×16½ in), Royal (24×19 in), Super Royal (27½×19½ in), Imperial (30×22 in), Colombier (34½×23½ in), Atlas (34×26 in), and Antiquarian (53×31 in). Some of these sizes are still available in handmade and mould-made papers but for most purposes paper is now made in International Standard A sizes, based on A0 with an area of 1 square metre (9 square ft), A1 being half A0, A2 being half A1, etc.

The traditional handmade surfaces of sheets were described as: Rough, produced by the weave of the wet press felt; Not, the same surface but further smoothed by pressing the sheets again against each other; and Hot Pressed, glazed by means of metal plates, although heat was rarely used. Later refinements included calendered surfaces produced by passing sheets through rollers.

The first developments in the long process that led to the design of specific papers for *watercolour, crayon, *lithography, and *etching began in the late 17th century with the invention of the hollander beater designed to produce more pulp more quickly. Papermakers realized that the beater also allowed them to blend and develop different potentials in the fibres in ways that had not been possible before.

The first of these new artists' papers were designed for copperplate engraving (see PRINTS), followed by *'drawing' papers designed for use with watercolour. An important impetus for these developments was the demand, from users, for papers without the texture of the laid and chain lines. James Whatman's (1702–59) invention of wove paper (initially designed for printing papers) where the paper mould was covered with a woven wire cloth was admirably suited for watercolour and drawing papers: the mould drained more slowly, allowing the papermaker to consolidate the sheet better during formation, producing a stronger, more stable, and smoother sheet.

The advent of the paper machine in 1804, which produced a greater volume of paper at higher speeds, concentrated surviving hand-made paper production on the new grades of artists' papers and accelerated the demand for alternative supplies of raw materials. Softwood fibres derived from pine began to be used, straw and esparto grass papers were developed, but they had various disadvantages over rag: the shorter fibre length and complex chemistry involved in their preparation led to weaker, softer, and much less durable sheets. Changes in sizing, from animal gelatine to rosin and starches, also led to lower-grade papers.

Artists have always been idiosyncratic in their use of paper, choosing to work on whatever paper satisfied and challenged their vision, regardless of the use it was actually designed for. This has often led to the use of low-grade papers which deteriorate very quickly, setting considerable conservation problems for the individuals and institutions which own the works. It was common practice for much of the last 1,000 years for artists to prepare their papers before working on them, often resizing them, washing them with coloured grounds, etc., or buying ready-prepared papers from the colourmen. The paper trade has always been international: papers were imported and exported all over Europe. In 18th-century Britain it was generally considered that the best printing papers came from either the Auvergne or Genoa and the best drawing papers from Holland. Small amounts of Islamic and oriental papers can also be found in use by Western artists.

Handmade paper production survives because the small scale of operation and the direct involvement of the maker at every stage of the process ensures that highly specific papers of fine quality can be made that both satisfy and challenge the demands made upon them by users. However, the raw materials used have changed: rag-based papers really disappear with the advent of man-made fibres after the Second World War. Most of the artists' papers made since then have used cotton linters, the short fibre waste from the ginning operation. Some handmade hemp-based papers are now being made specifically for artists. Since the middle of the 20th century most artists' watercolour and printmaking papers have been made on cylinder mould machines. Many of the great makers of the past, Whatman (UK), Canson Montgolfier (France), and Fabriano (Italy), are still in operation producing ranges of very fine papers for all areas of artistic practice. PAHB

Bower, P., *Turner's Papers* (1990).
Hunter, D., *Papermaking* (1978).
Krill, J., *English Artists Paper* (1987).

PAPIERS COLLÉS (French: glued paper), a term used to describe both the application of paper or papers to a canvas or similar ground and the incorporation of pieces of paper into a composition. Thus, in the former sense it may be applied to *Matisse's late gouaches découpées of the early 1950s (*L'Escargot*, 1953; London, Tate) and in the latter to *Picasso's and *Braque's assimilation of newspapers and tickets into their oil paintings of 1911–14 (Picasso, *Violin*, 1912; Paris, Mus. Picasso). DER

PARAGONE (Italian: comparison), a debate on the superiority of painting or sculpture, most popular in the *Renaissance courts of the 16th century. Defenders of sculpture praised its permanence, grandeur, and multiple viewpoints; to these the partisans of painting opposed painting's greater difficulty, and the painter's greater skill in handling light and shade, *colour, and *perspective. A vivid discussion of the *paragone* opens *Leonardo da Vinci's *Trattato della pittura*, where he sets the sculptor, dirty and sweaty, against the well-dressed, lute-playing painter. In 1547 *Varchi held an inquiry into the topic in Florence, and *Bronzino, *Cellini, and *Michelangelo were among those who responded to him. In Lombardy and Venice painting tended to dominate, and *Giorgione is said to have painted a *S. George*, reflected in a pool, and in two mirrors, to demonstrate that painting can show an entire figure at one glance. Around 1600 the debate became less important, but Galileo wrote on it in 1612, and it remains one of the themes of Annibale *Carracci's decoration of the Farnese Gallery, Rome. HL

Klein, R., and Zerner, H., *Italian Art 1500–1600: Sources and Documents* (1966).

PARCHMENT, animal skins, cow, goat, sheep, or less frequently, pig and other animals, prepared for writing, painting, illumination, and occasionally for printing. It was an ideal support for illumination and provided a very receptive and durable surface for writing. Because of this durability it continued to be used for authoritative documents and luxury books after the widespread availability of paper. Depending on the animal used, the final product varied in colour, weight, and size. Often referred to as vellum, which etymologically means calfskin, parchment results from soaking the skins in lime and water, scraping, and drying them while stretched.

The use of animal skin as writing material is mentioned by Herodotus (5. 58). *Pliny (*Natural History* 13.2) claims that parchment was discovered by Eumenes II (197–159 BC) of *Pergamum, after the Ptolemies had banned the export of papryus from Egypt in an attempt to prevent the growth of the Pergamene library; the word derives from the Latin *pergamena*, 'of Pergamum'. Parchment became widely used from the 4th century AD and was much more suitable for use in a codex than papyrus. AM

PARET Y ALCÁZAR, LUIS (1746–99). Spanish painter. Luis Paret y Alcázar studied at the Academia de S. Fernando, *Madrid, and in Rome, where from 1763 to 1766 he was supported by Don Luis de Borbón, brother of Charles III. In 1775, he was appointed court painter to Don Luis, for whom he painted several of his best-known *genre scenes, including *The Boutique* (Madrid, Mus. Lázaro Galdiano). Accused of assisting Don Luis in his clandestine love affairs, Paret was exiled to Puerto Rico in 1775, but pardoned and allowed to return to Spain four years later. Not permitted to return to the capital, he settled in Bilbao. In 1780 he became a member of the Academia de S. Fernando, painting *Diogenes* (Madrid, Academia de S. Fernando) as a reception piece. Six years later, he received a royal commission for a series of Spanish ports, inspired by the scenes which Louis XV had commissioned from Claude-Joseph *Vernet. In 1787, Paret was permitted to return to Madrid. During the last decade of his life, he was increasingly occupied by duties within the Academy. JT

Delgado, O., *Luis Paret y Alcázar: pintor español* (1957).
Luis Paret y Alcázar, exhib. cat. 1991 (Bilbao, Mus. de Bellas Artes de Bilbao).

PARIS, MATTHEW (d. 1259). English illuminator. He was a monk at the Benedictine abbey of S. Albans from 1217, and became its official chronicler. He wrote and also illustrated a number of books (mainly chronicles and lives of saints), and in the *Historia Anglorum* (London, BL, MS Roy. 14.C.vii) included a picture of himself kneeling before the enthroned Virgin and Child, and the inscription 'Frater Mathias Parisiensis'. The last entry in his own hand is dated 1259, and another hand has added a picture of the monk on his deathbed, with the comment 'hic obit matheus parisiensis'. The use of tinted outline drawings is one of the main characteristics of books produced by his scriptorium at S. Albans, where he appears to have had two principal assistants. Although not documented as a monumental painter, Matthew's figure style is reflected not only in wall paintings in the chapel of the Holy Sepulchre in Winchester, but also in a number of panel paintings in Norway, where he was sent on a mission to King Haakon in 1248. AS

Lewis, S., *The Illustrations of the Chronicles of Matthew Paris* (1987).

PARIS: PATRONAGE AND COLLECTING.
See opposite.

PARIS, ACADÉMIE ROYALE DE PEINTURE ET DE SCULPTURE.

The French Royal Academy was founded in Paris in 1648 by a group of artists including Charles *Le Brun who wished to break away from the craft-based corporation of S. Luc and establish the status of painting and sculpture as intellectually rather than manually based activities. In 1663 the Académie Royale was refounded under the protection of Louis XIV's minister Jean-Baptiste Colbert, for whom it was primarily an instrument of his centralizing statecraft. Until its dissolution in 1793 during the Revolution the Académie Royale was responsible for codifying the rules of art (see LE BRUN, CHARLES; PILES, ROGER DE), for the intellectual aspects of artistic education and for the Salon, the most prestigious location for public exhibition of art in France. As part of its educational activities it ran the *Prix de Rome, a competition for young artists which led to the award of state bursaries to study at its dependent institution, the Académie de France in Rome. Such was the power of the Académie Royale that few artists in later 17th- and 18th-century France could hope to pursue successful careers outside its structures. In 1795 its functions were taken over by the new École des Beaux-Arts (see under PARIS).

MJ

Alaux, J.-P., *L'Académie de France à Rome* (1933).
Crow, T. E., *Painters and Public Life in Eighteenth-Century Paris* (1985).
Vitet, L., *L'Académie Royale de Peinture et de Sculpture: étude historique* (1861).

PARIS, CENTRE NATIONAL D'ART ET DE CULTURE GEORGES POMPIDOU, also known as the Beaubourg Centre.

It houses the Musée National d'Art Moderne, the public reference library, a design centre, and an institute for contemporary music. The Musée was founded in 1947 around a nucleus of 20th-century works transferred from the Jeu de Paume and the Luxembourg museums. From 1961 it occupied a wing of the Palais Tokyo, adjacent to the Musée d'Art Moderne du Ville de Paris. The emphasis was on French art, including paintings by *Matisse, *Delaunay, and *Léger, but the collection was initially of variable quality with several significant art movements poorly represented if at all. This has been rectified over the years through generous gifts, like Mme *Kandinsky's bequest of her husband's pictures, and shrewd accessions and the museum now holds one of the finest collections of 20th-century art in the world. The centre also functions as a showcase for all the creative arts, and there is an ambitious programme of temporary exhibitions.

The centre, named after Georges Pompidou (1911–74), President of the French Republic 1967–74, was built on the Plateau Beaubourg, a derelict area in Les Halles. It is ostentatiously modern, particularly in contrast to the historic buildings which surround it. Built between 1971 and 1977 to the designs of Renzo Piano (1937–) and Richard Rogers (1933–), the service ducts and escalators are placed on the exterior of the building and brightly colour-coded to reveal their functions; thus the interior is singularly adaptable, having no fixed internal walls. The building is now a major tourist attraction, visited by more people than the Eiffel Tower. However, it has been criticized as unsuitable for displaying paintings and, more damagingly, for the durability of the exterior which has weathered badly.

DER

PARIS, ÉCOLE NATIONALE SUPÉRIEURE DES BEAUX-ARTS.

The chief of the official art schools of France. The origins of the École des Beaux-Arts go back to 1648, the date of the foundation of the Académie Royale de Peinture et de Sculpture, but it was not established as a separate institution until 1795, during the administrative reforms of the French Revolution. It controlled the path to traditional success with its awards and state commissions, and teaching remained conservative until after the Second World War. Entry was difficult—among the artists who failed the examinations were *Rodin and *Vuillard—and students often preferred the private academies. However, even some of the most progressive artists obtained a sound technical grounding there. The École, which is housed in a complex of early 19th-century buildings in Paris, has a large and varied collection of works of art. Many of them are primarily of historical interest (including a vast number of copies and portraits of teachers), but the collection of drawings is of high quality. The École also often hosts temporary exhibitions.

See Académie Royale under PARIS.

IC

PARIS, LOUVRE.

The building of the Louvre in its present form was begun in 1546 by François I, who also founded the royal collections, acquiring works by *Leonardo, *Raphael, and *Titian. Louis XIV was both the most enthusiastic developer of the site and the most heroic art collector (buying in 1661 much of the Mazarin Collection that contained many paintings owned by Charles I of England), and under him the collection was briefly moved into the Louvre. When *Versailles was established, however, the collection was dispersed.

In the half-century before the Revolution there had been inconclusive discussion about using the Louvre for displaying the royal pictures. A selection of—mostly Italian—masterpieces was put on show in the Palais du Luxembourg. In 1784 Hubert *Robert was put in charge of setting up a 'muséum' in the Louvre but the project stalled.

In 1792 the monarchy fell. Roland, the Minister of the Interior, immediately decided to press on with installing the national museum in the Louvre, and it opened as the Muséum (later Musée) Central des Arts precisely one year later. Over 100 paintings were brought from *Versailles, to join the ones from the Luxembourg, and there were several altarpieces from the huge accumulation of nationalized church property. (Additionally, the state had taken over the property left behind by émigrés and also the collection of the Académie Royale de Peinture et de Sculpture.)

The policy of expert official looting that went on throughout the Revolutionary and Napoleonic Wars began at the outset, with the French occupation of Belgium in 1794, when Belgium was immediately picked clean of all its most celebrated works—at that time mostly paintings by *Rubens and van *Dyck. While, therefore, Napoleon did not invent the looting policy, he continued to implement it with passionate enthusiasm during his Italian campaign beginning in 1796. His motive was certainly not aesthetic—he preferred to walk resolutely past works of art in museums and was completely at a loss if he was forced to slow down and look at one. Beyond populist triumphalism, what took place seems to have been a political statement that the centre of the civilized world was moving from Rome to Paris, just as it had moved from Athens to Rome. That also lay behind the emphasis that was placed on conservation and on education. In 1800 over 800 pictures, including several confiscated Italian masterpieces, were distributed to French provincial museums.

By 1802 the Louvre's Grande Galerie (then 30% longer than now) contained a high proportion of the most celebrated 16th- and 17th-century paintings from north and central Italy, Belgium, and Munich, as well as the masterpieces of the French royal collection. In other rooms the display of Antique sculpture included, amongst much else from Rome, all the most famous pieces from the Belvedere sculpture court in the Vatican (see under ROME). In that year Dominique Vivant-Denon became director of the museum, which was renamed Musée Napoléon the following year.

Vivant-Denon was a ruthless but inspired director, years ahead of his time in his view of art history and commitment to build a fully representative collection. After the battle of Jena in 1806 he swept through the princely collections of north Germany and selected more than 1,000, mainly Dutch and German, paintings to go to Paris. In 1811 the

continued on page 539

· PARIS: PATRONAGE AND COLLECTING ·

PARIS is now regarded as one of the foremost art centres in the West, but this status was hard won. Records of artistic activity in its first millennium are scarce. There are traces of wall paintings from the Gallo-Roman period, and Fortunatus expressed admiration for the early basilican cathedral in 566, but we know little about non-architectural production during the Merovingian period, although by the 7th century there was a goldsmiths' quarter.

The city first emerged as a significant artistic centre under the early Capetians (Hugh Capet crowned 987). In the 11th century, the scriptorium at S. Germain-des-Prés produced innovative work. Abbot *Suger's tenure at the abbey of S. Denis (1122–51), north of the city, brought breakthroughs in the development of the early *Gothic style, notably in the new choir of the abbey church (dedicated 1144). In 1194, Philippe Auguste designated Paris his capital; Notre-Dame rose 1162–c.1230, a period during which the city's university gained greatly in prestige. The reign of Louis IX (1226–70) saw the advent of 'courtly', or Rayonnant, Gothic. Celebrated throughout Europe, this pre-eminently Parisian style encompassed not only architecture and monumental sculpture but many movable goods, notably ivory carvings, metalwork, and manuscript illumination. The growing demand for such work probably explains the appearance of the *Livre des métiers* of Étienne Boileau (1268), a codification of extant civic regulations governing Parisian artistic practice. The influx of prosperous intellectuals and administrators created a new market for illuminated books, secular and sacred, which prompted the development of production networks outside the city's monastic houses (*bibles moralisées*, 1220–50; Psalter of S. Louis; Master *Honoré, active 1285–1300; Jean *Pucelle, active 1319–34).

The Hundred Years War (1337–1453) was disruptive but had a less sustained impact on this production than has sometimes been claimed. In the early 15th century, Christine de Pisan deemed Parisian manuscript illuminators of her day 'the best in the world'. Many of these artists were of northern origin but were cognizant of Italian models; clearly, the war did not preclude their being drawn to the city by its creative energy and professional opportunities (Boucicaut *Master, Bedford *Master, the *Limburg brothers, first documented in Paris in 1399; *Jacquemart de Hesdin).

François I's decision to spend most of his time 'in and around his good town of Paris' after 1528 was a watershed event in the city's artistic history. François summoned prestigious Italian artists to work for him, notably at *Fontainebleau, which became a royal showplace (*Rosso Fiorentino, arrived 1530; Francesco *Primaticcio, arrived 1532; Benvenuto *Cellini, in Paris 1537 and 1540). In the city itself, Domenico da Cortona designed a new Hôtel de Ville

(begun 1532). Pierre Lescot was engaged to rebuild the Louvre (1546) and two indigenous artists who had assimilated the lessons of Fontainebleau, Jean *Cousin the elder (c.1490–c.1560) and Jean *Goujon (active 1540–62), were commissioned to design Henri II's elaborate entry into the city (1549). *Nicolò dell'Abbate, who arrived in 1552, worked at Fontainebleau (Galerie d'Ulysse; destr.) as well as for Parisian patrons (chapel of the Hôtel de Guise; destr.).

The Wars of Religion (1562–98) seriously curtailed large-scale production. Henri IV (ruled 1598–1609) reinvigorated royal patronage but focused on building; Marie de Médicis (regent 1609–30) commissioned *Rubens to paint the great cycle of paintings glorifying her (1622–5; Paris, Louvre), but, while she brought Orazio *Gentileschi to Paris (c.1623–4), he did not long remain, and she offered little encouragement to native artists.

In 1681 Louis XIV officially transferred the seat of government to *Versailles, which he had begun to enlarge in the preceding decade. Much of the work for its interiors, notably the furniture, tapestries, and carpets, were made in Parisian royal manufactories (Gobelins, est. 1663; Savonnerie, est. 1664). In the 1690s the seeds of the *Rococo were sown at Versailles and Meudon, but these interiors were the work of Paris-based artists (notably the ornamentalist Jean *Bérain and cabinetmaker André-Charles Boulle). The most luxuriant phase of this idiom, which affected all manner of artefacts, from tapestries to porcelain to luxury furniture, took shape within the city c.1720–50 (Claude III Audran (1658–1734), Juste-Aurèle Meissonnier (1695–1750), Nicolas Pineau (1684–1754)).

Art collecting, as distinct from patronage and the assemblage of polyglot curiosity cabinets, attained significant proportions rather suddenly, through the efforts of a cohort of wealthy individuals dubbed (by Antoine Schnapper) the generation of 1630 (Charles II, Marshal-Duke of Créquy; Roger du Plessis, Duke of Liancourt; Louis II Phélypeau de La Vrillière; Louis Cauchon, known as Hesselin; and others); the royal ministers Richelieu and Mazarin assembled superb collections of both French and foreign work, but the French monarchy did not itself collect on a grand scale until 1662–85, when Louis XIV began to make aggressive acquisitions, most crucially from the banker, Everhard Jabach (1618–95). The royal collection continued to grow under Louis XV and Louis XVI, notably in the field of northern painting (1777–86). Complaints about the inaccessibility of this dazzling assemblage led to establishment of the Musée du Luxembourg (1757–79), but a sea change came in 1793, when the royal holdings were declared national property and placed on display in the Louvre. Between 1799 and 1814, when the collection was augmented by artistic booty seized in the wake of Napoleon's military victories, the Louvre was the greatest museum of Western art in history. Many—though by no

means all—of these works were returned after 1815, considerably depleting the city's artistic treasure.

There was a comparable loss when the great painting collection assembled by the Regent, Philippe II Duc d'Orléans (1674–1723), between 1703 and 1724 was dispersed after the Revolution. Rich in canvases by the great Venetians and 17th-century Bolognese masters, it was auctioned in London in 1793, 1798, and 1800; a mere 40 of its almost 500 canvases were seized by the young republic for its new museum after the execution of Philippe-Égalité in 1793, the balance having already left the country. But for most of the 18th century this visual feast was on display in the Palais-Royal; indeed, its relative accessibility was cited as a positive counter-example by the critic Lafont de Saint-Yenne in 1747 when he criticized the Crown for keeping its art treasures behind closed doors.

Although preceded by occasional, individually organized for-profit displays, notably those mounted by *David (1799), *Courbet (1855, 1867), and *Manet (1867), the seven exhibitions sponsored by the independent *Impressionist group (1874–86) were symptomatic of a significant decentralization of the Parisian art world under the Third Republic (1870–1940). This development was the result of a protracted evolutionary process. Until the 18th century, the most important venues for the public display of paintings were churches, which made ecclesiastical patronage especially important for contemporary artists, but this began to change in 1737, with establishment of the regular Salon. A prestige forum for public exhibition, assessment, and critical commentary, initially it was limited to academicians but in 1791 was opened to all comers. In response to declining attendance and artists' complaints about quality control, jury selection was instituted in 1800. The state relinquished responsibility for the Salon to the Société des Artistes Français in 1881, but large artist-controlled exhibitions long continued to function in analogous ways (Salon de la Nationale, est. 1890; Salon d'Automne, est. 1903).

Paris lagged behind Amsterdam, Rotterdam, and The Hague in developing a market for old master paintings. In the 17th century there were virtually no professional art dealers in Paris; most works were trafficked by artists or acquired at the occasional auction, and a few connoisseur-collectors dominated the field (Pierre Crozat (1664–1740), artistic adviser to the Regent; Pierre-Jean Mariette (1694–1774), a renowned connoisseur of drawings). In the second quarter of the 18th century, dealers known as marchands-merciers, who sold both paintings and luxury artefacts (Edmé-François Gersaint), pioneered modern merchandizing techniques, but only c.1755 did a true professional class of picture dealers begin to emerge, in parallel with a significant expansion of the Paris art market and an increasing focus on the 'science' of attribution (Pierre Rémy, Alexandre-Joseph Paillet, Jean-Baptiste-Pierre Lebrun). By the 1830s such businesses were a settled fixture, but the profession became more dependably lucrative—though still commercially volatile—only in the 1850s, when paintings began to function as objects of financial speculation for a broader circle of collector-investors (Hôtel Drouot, still the city's pre-eminent auction house, opened near the Bourse in 1853). The modern dealer-critic system fell into place in the period 1870–1900, when operators like Georges Petit and Paul Durand-Ruel acquired both 'blue-chip' established contemporary masters and 'futures' in the form of emerging artists, which they promoted with the aid of critics. Ambroise Vollard continued the latter trend with his marketing of *Cézanne's 'difficulty' from 1895, when he mounted a large exhibition capitalizing on the notoriety accruing to the artist's intractable style as a result of the Gustave *Caillebotte bequest of the previous year, when the French government refused to accept many of the offered Impressionist canvases. Vollard also represented *Picasso early in his career, but it was Daniel-Henry Kahnweiler who became *Cubism's commercial godfather, developing canny marketing strategies in the years after 1907 that made this initially unpalatable style seem increasingly collectable.

The three institutions that long dominated the city's art world—the Academy, the École des Beaux-Arts, and the Salon—greatly affected the dynamics of both patronage and collecting, but their relation to both activities was complex: 'official' preferences counted for much in the establishment of normative models, but there were mavericks even among 17th-century artists and amateurs, and the patronage of Louis XIV himself was more stylistically eclectic than is often admitted, especially toward the end of his reign. In the 19th-century Parisian market, a rebellious artistic persona often functioned as a career-booster: the standard trajectory, pioneered by J.-L. *David and consolidated by *Delacroix, the *Barbizon School, Courbet, and Manet, became one of contested innovation followed by acceptance among cognoscenti and then general consecration. Despite increasing decentralization, the Salon retained its prestige well into 1880s; its juried selections served as a necessary foil for high-profile artistic unorthodoxy, but they were also a crucial testing ground of viewer response—and political viability. For the brave new world of freedom from stable affiliation with Church and/or state entailed both new opportunities and new uncertainties. As controversial artists won public support and market share, government patronage often followed, but not always. J.-L. David and *Gros produced major works glorifying Napoleon; Delacroix was entrusted with important canvases and decorative schemes by the government of Louis-Philippe, but neither Courbet nor Manet was given the public commissions he coveted. After 1851, the growing prestige of adversarial artistic practices collided head-on with the political realities of official patronage; as a result, public commissions tended to go to artists whose artistic personalities were unexceptionable rather than prickly.

The continuing pre-eminence of large-scale painting in the first half of the 19th century was partly the result of official commissions. In addition to such projects as ceilings for the Musée Charles X in the Louvre and paintings

for Louis-Philippe's Museum of French History at Versailles, sacred works can legitimately be included under this rubric, for the Church, whose revenue-producing properties had been confiscated by the state early in the Revolution, was short of funds, and the government retained responsibility for maintaining church buildings. Between 1815 and 1848, its officials commissioned some 2,000 large canvases for Parisian churches.

Despite the massive scale of this patronage, another state initiative was perhaps more important: the establishment in 1818 of a museum for contemporary French painting in the Palais du Luxembourg (moved to its orangery in 1886). The state purchased works at every Salon for this collection, which offered Parisians a permanent, if conservative, overview of recent production. It was here, for example, that the Caillebotte bequest of Impressionist painting was first installed (see below). This venue was briefly augmented by the Galerie Espagnol in the Louvre, a display of Spanish painting that opened in January 1838 (see SPANISH ART, PATRONAGE AND COLLECTING). Its collection—of uneven quality but with a core of masterpieces by *Goya, *Murillo, *Ribera, and *Zurbarán—had been acquired in Spain over eighteen months by Baron Isidore-Justin Taylor, using monies provided for the purpose by Louis-Philippe. In 1848, however, the abdicating French King claimed the collection as his personal property, and the young Second Republic obliged, sending it after him to England, whence it was dispersed.

The history of Parisian private collecting in the last three centuries is complex and under-studied, but a few general observations can be hazarded. Northern cabinet pictures were favoured by many mid-18th-century non-princely Parisian collectors (Augustin Blondel de Gagny, 1695–1776), but such preferences were rarely exclusive. The collection of contemporary French art on a significant scale was pioneered by Ange-Laurent de La Live de July in the 1750s and 1760s, but this tendency became pervasive only in the 19th century, when modern painting began to acquire social cachet among upwardly mobile members of the middle class. Beginning with the *Romantic generation of 1830, however, the ideological rift between 'advanced' and 'retrograde' taste had a marked influence on Parisian patterns of collecting. The noisy controversy in 1894–5 over the proposed Gustave *Caillebotte bequest of his Impressionist collection to the French government was a watershed event; although some superb canvases were rejected, many were accepted and installed in the Musée du Luxembourg along with Manet's controversial Olympia, presented to the state in 1890 thanks to a subscription campaign organized by Monet. The Impressionists found early Parisian collector-champions in the likes of the famous baritone Jean-Baptiste Faure and the retired customs official Victor Chocquet (whose first loves had been, respectively, the Barbizon School and Delacroix), but the work of these artists was long frowned upon by established Parisian wealth, which preferred the more highly finished and conventional representational modes now collectively known as Salon painting. A few moneyed Americans proved more adventurous, for example Harry and Louise Havemeyer (see NEW YORK, METROPOLITAN MUSEUM), who in the 1880s began to heed the advice of their discerning adviser Mary *Cassatt as to what they should buy, and the eccentric millionaire Albert C. Barnes, who acquired works by *Renoir, Cézanne, and Chaim *Soutine in bulk beginning in 1912.

See Académie Royale, École des Beaux-Arts, Salon, and Salon d'Automne under PARIS. JG

Mainardi, P., *The End of the Salon: Art and the State in the Early Third Republic* (1993).

Pomian, K., *Collectors and Curiosities: Paris and Venice, 1500–1800* (1991).

Schnapper, A., *Curieux du Grand Siècle* (1994).

suppression of monasteries in Italy gave him a pretext for going there to collect a group of early paintings, beginning with a *Cimabue *Maestà* from Pisa.

After the defeat of Napoleon Vivant-Denon did his best to keep the plunder but the majority of the most famous works still in Paris were eventually surrendered. Some of the allied negotiators were, however, prepared to write off a surprising amount of material, so that the Louvre kept about 100, mostly Italian, paintings (with as many again left in the provincial museums).

With the Restoration the Louvre became the direct responsibility of the monarch and both Charles X and Louis-Philippe opened up new exhibition space in it. Louis-Philippe had a particular enthusiasm for *Spanish art and built up a huge Spanish collection (see SPANISH ART, PATRONAGE AND COLLECTING), rich in works by *Zurbarán and *Goya, as a result of Baron Taylor's prospecting throughout Spain. From 1838 to 1848 this collection was displayed in the Louvre but it was returned to the Orléans family by the Second Republic and was eventually sold in London in 1853. The next decisive time of expansion was under Napoleon III, when the enormous northern wing (albeit given over to the Ministry of Finance) was added along the Rue de Rivoli, and three huge painting galleries were added alongside the Grande Galerie to the south. With the Third Republic in 1871 the Louvre reverted to being France's national museum, and acquisition policy was placed under the Réunion des Musées Nationaux in 1895.

The period between 1815 and 1870 was when the Louvre acquired most of its ancient *Greek sculptures. The *Venus de Milo* was bought from the local Turkish authorities as soon as it was discovered in 1820, while the *Nike* of Samothrace was found by French excavators in 1863. Meanwhile, the pieces that Napoleon had bought from Camillo Borghese in 1807 continued to form the nucleus of the collection of ancient *Roman sculpture.

Although the encouragement and acquisition of French art was a major state objective throughout the 19th century, the authorities were slow to appreciate the kind of works that are now universally regarded as making the period one of the glories of French cultural history. No work by *Courbet, for example, was accepted for the Louvre before 1878, and when *Caillebotte bequeathed 60 Impressionist paintings in 1894, it took three years to persuade the Musées Nationaux to accept 40 of them. By the 1920s, however, a great deal of 19th-century French work was entering the Louvre through gifts and purchases, and it was progressively highlighted in the displays. From 1947 the Impressionist work was shown separately in the pavilion of the Jeu de Paume.

The 'Grand Louvre', which opened in 1993, was one of the prestige projects taken forward in Paris under President François Mitterrand. The museum almost doubled its

space by taking over the Second Empire north wing, within which vast glazed sculpture courts were constructed; much 19th-century painting and sculpture was transferred to the new Musée d'Orsay (which was devoted to the period 1848–1914); and a new entrance complex was built in the Cour Napoléon under the transparent pyramid designed by I. M. Pei (1917–). No other country has a central museum on such overwhelming scale. It is no accident that the south wing has been named after Vivant-Denon.

See Musée d'Orsay under PARIS. AJL

Gould, C., *Trophy of Conquest* (1965).

PARIS, MUSÉE DE CLUNY (Musée National du Moyen Âge; Thermes de Cluny), a rich collection of (mostly French) medieval art in a flamboyant *Gothic palace in the Latin Quarter. It is itself a monument to 19th-century *Romanticism. Alexandre du Sommerard (1779–1842) was a successful lawyer who had a passion for the Middle Ages before that taste was fashionable. To house his accumulation of art and curiosities he bought the *hôtel* of the abbots of Cluny that had been built in the flamboyant Gothic style around 1500. By 1832 he was exhibiting his collection, which included a very free re-creation of 'the room of François I', in a state of studied disorder.

Under the Revolution a museum of French monuments had been established at the Petits Augustins. This was closed in 1817, and pressure mounted to replace it with a sculpture museum in the ruins of the Gallo-Roman baths (*thermes*) that adjoined the Hôtel de Cluny. The city of Paris acquired the baths for this purpose in 1836 but when du Sommerard died in 1842 a new state museum combining the two sites was rapidly approved. In ceding their part of the museum the city made it a condition that du Sommerard's son Edmond should be the first curator of the new institution and he was, in fact, in charge of it from its inception in 1843 until his death in 1885, acquiring an enormous number of works of art of every kind, including the famous Flemish *Unicorn* tapestries (1484–1500).

After the Second World War the crowded displays of the du Sommerard years were pruned and reorganized and a further substantial thinning-out took place when the *Renaissance material was transferred to the new Musée National de la Renaissance at Écouen. AJL

Erlaine-Brandenburg, A., *Musée National du Moyen Âge: Thermes de Cluny* (1993).

PARIS, MUSÉE D'ORSAY, the national museum of fine and applied arts 1848–1914, including film and *photography, opened in 1986 by President Mitterrand; the greatest and most comprehensive collection of 19th-century French art. The nucleus of the permanent collection was created by bringing together the superb *Impressionist and *Post-Impressionist paintings formerly housed at the Jeu de Paume, 19th-century works from the Louvre, and decorative art from other state collections. It now includes over 2,000 paintings and 1,500 sculptures which are displayed chronologically over three floors. *Courbet's *The Painter's Studio* (1855), *Millet's *The Angelus* (1859), *Manet's *Déjeuner sur l'herbe* (1863), and *Carpeaux's *Dance* (1869) are among the many masterpieces in the museum.

The museum is housed in the former Gare d'Orsay and its attached *hôtel*, designed by Victor Laloux, in an eclectic *Neoclassical style, in 1898 and opened in 1900. After the closure of the railway in the 1940s the building had several temporary users, including a theatre company and an auction house, and was threatened with demolition until 1973 when the museum was conceived. ACT Architecture won an open competition for the structural alterations and the Italian designer Gae Aulenti (1927–) was responsible for the interior. The conversion is notable for its sensitive treatment of the original building, which incorporated works by contemporary artists including Fernand Cormon (1845–1924) and Benjamin-Constant (1845–1902). DER

PARIS, SALON. The official French art exhibition in Paris took its name from the Salon Carré of the Louvre, where from 1737 recent works by the members of the Académie Royale de Peinture et de Sculpture were shown. The Salon Carré succeeded various other venues for this exhibition, including the Louvre's Grande Galerie. At first irregular, with no exhibition sometimes for several years, from 1774 to 1792 the Salon was held biennially. In the 18th century it provided a competitive forum for artists to display their work in the search for both public and private commissions. The exhibition was visited by a surprisingly wide cross-section of society, many of whom bought the *livret* or official catalogue. It was also the focus from mid-century of a growing body of art criticism, most famously that of Denis *Diderot. The hanging of the paintings, always a contentious issue, was supervised for many years by *Chardin. After the replacement of the Académie Royale by the École des Beaux-Arts in 1795 the Salon was thrown open to all artists, though it was some years before it was established as an annual event. In the mid-19th century the exhibition was moved from the Louvre to the Palais de l'Industrie, but retained its traditional name. The process by which works were chosen and the composition of the jury that selected entries and awarded prizes were two of the most controversial issues in the 19th-century art world, the degree of open-mindedness and democracy reflecting the complexions of the various political regimes which succeeded one another in France. The dissatisfaction of progressive artists with a system that by and large favoured the more conservative and academic over the new and challenging culminated in the famous Salon des Refusés of 1863. This was arranged by the government of Napoleon III so that the public might judge for itself the quality of the art which had been rejected from the official Salon. Pictures included *Manet's *Déjeuner sur l'herbe*, the scandal caused by which led to the closure of the exhibition. In 1881 the École des Beaux-Arts gave up its control of the exhibition and a number of competing shows were established, quickly undermining what prestige the Salon still retained.

See Académie Royale, École des Beaux-Arts, and Salon de Refusés under PARIS. MJ

Boime, A., *The Academy and French Painting in the Nineteenth Century* (1971).

Crow, T. E., *Painters and Public Life in Eighteenth-Century Paris* (1985).

Delaborde, H., *L'Académie des Beaux-Arts* (1891).

Vitet, L., *L'Académie Royale de Peinture et de Sculpture: étude historique* (1861).

PARIS, SALON D'AUTOMNE, an annual exhibition held in Paris which was founded in 1903 as an alternative to both the official Salon and the Salon des Indépendants. *Bonnard, *Rouault, *Matisse, and *Marquet were among the founder members. The Salon d'Automne achieved notoriety in 1905 when Matisse and his associates showed the violently coloured works which earned them the sobriquet Les *Fauves (wild beasts). Also of importance in the development of modern art were the memorial exhibitions of *Gauguin (1903), *Manet (1905), and *Cézanne (1907) which brought their work to a wide audience.

See Salon and Salon des Indépendants under PARIS. DER

PARIS, SALON DES INDÉPENDANTS, the annual exhibitions held in Paris of the Société des Artistes Indépendants, an association formed in 1884 by Georges *Seurat, Paul *Signac, and others in opposition to the official Salon (see under PARIS). It was a jury-free exhibition, open to all on payment of a hanging fee. Thus both professional and amateur artists could show together, an opportunity seized by Le Douanier *Rousseau who exhibited regularly among the *Post-Impressionists. It was a major event in the Parisian artistic year until the First World War. DER

PARIS, SALON DES REFUSÉS, an exhibition held in Paris in 1863 to show works that had been rejected by the jury of the official Salon. Vociferous protests by excluded artists were heeded by Napoleon III (1808–73), who ordered this special exhibition. It drew huge crowds, who came mainly to ridicule, and *Manet's *Déjeuner sur l'herbe* was subjected to particular abuse. Other major artists in the exhibition included *Whistler, *Cézanne, and Camille *Pissarro. Despite its controversial nature (it was never repeated) the Salon des Refusés played an important role in undermining the importance of the official Salon and thus reducing its financial stranglehold on painters. It also created a precedent for the *Impressionist exhibition in 1874 and the unofficial Salons, like the Salon des Indépendants (1884), which emerged in the later years of the century.

See Salon and Salon des Indépendants under PARIS.　　　　DER

PARIS, SALON DU CHAMP DE MARS (Salon de la Nationale), an annual exhibition in *Paris founded in 1890 as the Société Nationale des Beaux-Arts by *Puvis de Chavannes, Eugène *Carrière, and Auguste *Rodin among others who seceded from the official Salon organized by the Société des Artistes Français. It takes its more familiar name from the area surrounding the Eiffel Tower, Le Champ de Mars, the venue for the exhibitions.

See Salon under PARIS.　　　　DER

PARIS, SCHOOL OF. See ÉCOLE DE PARIS.

PARLER FAMILY (active mid-14th century). German architects and sculptors, widely influential in southern Germany. The name is close to 'Parlier' or foreman of a building site. The relationship between the various branches and members is established through inscriptions and the use of a twice-broken staff motif as mason's mark and on their seals. Some described themselves as 'von Gmünd' or 'von Freiburg'. The Parlers acted as masters of the works at several sites, but seem also to have trained large numbers of masons, who became known as the *Junker von Prag* (the young men of Prague), after the workshop at Prague Cathedral, run by Peter Parler, the most famous member of the family.

Peter Parler (1333?–99) was the son of **Heinrich** (d.1371), master mason at the Cathedral of the Holy Cross, Schwäbisch-Gmünd, an influential hall church with net vaulting. In 1356 Peter was summoned by Emperor Charles IV to take over the work on S. Vitus' Cathedral, Prague, where he introduced revolutionary star vaulting, curvilinear tracery, and greater spatial unity in the church as a whole. Sculptured busts of Peter and

Heinrich, along with portrayals of the royal family and leading ecclesiastics, appear in the choir triforium; these are attributed to Peter, together with funeral effigies and possibly two figured consoles. Peter also built (1373) the Charles bridge and the Old Town Bridge Tower in Prague, and the choir of S. Bartholomew, Kolin (from 1360).

The only other documented sculptor was **Heinrich von Gmünd** (c.1354–after 1387), possibly the nephew of Peter Parler. Two attributed early works, *Christ Carrying the Cross* and the *Man of Sorrows*, in the Cathedral of the Holy Cross, Schwäbisch-Gmünd, suggest that he was trained there under Heinrich Parler. In 1373 he carved the statue of *S. Wenceslas* in the S. Wenceslas chapel of Prague Cathedral and later made two effigies, and a bust in the choir triforium. Work at Cologne has also been attributed to Heinrich, who seems to have influenced the development of the soft style of late medieval German sculpture; he and his workshop may have developed the type of the 'Beautiful Madonnas' (*Schöne Madonnen*).　　　　NC

Legner, A. (ed.), *Die Parler und die schöne Stil, 1350–1400*, exhib. cat. 1978 (Cologne, Schnütgen Mus.)

PARMIGIANINO, (Francesco Mazzola) (1503–40). Italian painter, draughtsman, and printmaker, born in Parma. He was a precocious talent; aged 16 he painted a *Baptism* (1519; Berlin, Gemäldegal.) which reveals his study of *Correggio, the only local painter who was aware of the new artistic developments in Rome. The softness, both of colouring and lighting, in the two frescoed chapels in S. Giovanni Evangelista, Parma, of the early 1520s, and the frescoes of *Diana and Actaeon* in the Rocca Sanvitale at Fontanellato (c.1523), also show Parmigianino's early debt to Correggio.

In 1524 Parmigianino left for Rome, where he was introduced to the newly elected Pope Clement VII, to whom he subsequently presented, among other items, his celebrated *Self-Portrait in a Convex Mirror* (Vienna, Kunsthist. Mus.). In Rome Parmigianino was profoundly affected by Raphael's works and also by the dramatic style of his contemporaries: *Perino del Vaga, *Rosso Fiorentino, and *Polidoro da Caravaggio. In his most outstanding work from the period, the *Vision of S. Jerome* (1526–7; London, NG), the hard-edged brilliance of the contours and the sculptural monumentality of the figures show his adherence to the new Roman manner. Forced to flee from the Sack of Rome in 1527 Parmigianino settled in Bologna for three years. In this period he produced a series of startlingly original large-scale religious works, notably the *Conversion of S. Paul* (Vienna, Kunsthist. Mus.), in which the horse's neck is so extended that it was later identified as a giraffe. The smaller-scale commissions executed

during this period, such as the celebrated *Virgin of the Rose* (Dresden, Gemäldegal.), share the same qualities of exaggerated refinement and sophistication. In 1530 the artist returned to Parma where he was commissioned the following year to decorate the vault and apse of the church of the Steccata. Progress on the painting was slow, and in 1539 he was arrested and imprisoned. Fleeing the city he went to Castelmaggiore. During this period he painted the unfinished *Madonna of the Long Neck* (1534–40; Florence, Uffizi), perhaps the most famous of all *Mannerist paintings, in which the elongation of the figures is taken to the extreme. Parmigianino's elegant line and exquisite detailing were also suited to portraits, two of the finest of which are the *Turkish Slave* (Parma, Gal. Nazionale) and the *Count of San Secondo* (c.1540; Madrid, Prado).

Parmigianino was a superb draughtsman who, unlike most of his contemporaries, drew for his own pleasure, exemplified in studies made from the life such as the *Man Holding a Pregnant Bitch* (1535–40; London, BM). Through his etchings and the prints after his designs Parmigianino's style had an international following.　　　　HCh

Gould, C., *Parmigianino* (1995).
Popham, A. E., *Catalogue of the Drawings of Parmigianino* (1971).

PARODI, FILIPPO (1630–1702). Italian sculptor. He probably trained in Rome and it is the influence of the Roman *Baroque style that permeates his early work in his native Genoa, such as the allegorical figures of *Faith*, *Hope*, and *Charity* on the altar of the Virgin in S. Maria delle Vigne or the characters from Ovid's *Metamorphoses* now in the Palazzo Reale (all c.1661). The more robust style of Pierre *Puget, who was in Genoa for much of the 1660s, is evident in some of Parodi's work of this decade, whereas the sculpture he executed in Venice in the 1680s, especially the tomb of Francesco Morosini (finished 1683; Venice, S. Nicolo dei Tolentini), is inspired by the dramatic later works of *Bernini. Although not a particularly original artist, Parodi had a sound understanding of how to put to best use the most fashionable sources of his time.　　　　MJ

Genova nell'età barocca, exhib. cat. 1992 (Genoa, Palazzo Reale and Palazzo Spinola).
Rotondi Briasco, P., *Filippo Parodi* (1962).

PARROCEL, JOSEPH (1646–1704). French painter. Although known to posterity chiefly as a *battle painter specializing in lively scenes of Louis XIV's later campaigns (e.g. *Crossing the Rhine*, 1699; Paris, Louvre), he was also an innovative painter of religious pictures. His *Preaching of S. John the Baptist* (1694; Arras, Mus. des Beaux-Arts) is unusual for its time in the drama of its lighting and the richness of its colouring, which recall

*Tintoretto and Salvator *Rosa rather than any of the artists sanctioned by the Académie Royale (see under PARIS) or by the opposing Rubéniste tendency. Parrocel's Provençal origins may explain his idiosyncratic Italianate predilections. Seen from this perspective he was an interesting contributor to the anti-classical spirit of French painting in the last years of the 17th century. MJ

Parrocel, E., *Monographie des Parrocel* (1861).
Schnapper, A., 'Deux Tableaux de Joseph Parrocel au Musée de Rouen', *Revue du Louvre*, 2 (1970).
Schnapper, A., 'Quelques Œuvres de Joseph Parrocel', *Revue de l'Art*, 4–5 (1959).

PARS, WILLIAM (1742–82). English topographical artist. Pars studied and later taught at Shipley's Drawing School in the Strand, London, where his brother Henry (1734–1806) later became principal. In 1764 he was employed by the Society of Dilettanti on Richard Chandler's (1738–1810) archaeological expedition to Asia Minor and Greece. His drawings and watercolours of views and antiquities, like *The Theatre at Miletus* (c.1765; London, BM), are accurate and detailed and were later published in *Ionian Antiquities* (1769) and *Antiquities of Athens* (1789). In 1770 he was commissioned by Henry Temple, 2nd Viscount Palmerston (1739–1802), to accompany him to Switzerland to record the landscape. The resulting watercolours, when exhibited at the RA, *London, in 1771, were the first record of Alpine scenery to be seen in England. Although geologically correct, paintings like *A Bridge near Mont Grimsel* (London, BM), with hints of *sublimity, prefigure *picturesque Romanticism. In 1775 Pars, who was among the first Associates of the RA in 1770, was nominated by the Academy to travel to Rome on a Dilettanti Society bursary. He died there, of pleurisy supposedly caused by standing in water to paint the Falls of Tivoli. DER

Wilton, A., *William Pars: Journey through the Alps* (1979).

PARTHENON SCULPTURES (447–432 BC). These adorn the temple of Athena Parthenos on the Acropolis at *Athens. They constitute the most profuse and coherent decorative programme of any mainland Greek temple. Much of the architectural sculpture, carved of local Pentelic marble, survives, albeit in a damaged state: two pediments each originally contained some 20–5 figures carved in the round (the east depicting the *Birth of Athena*; west *Athena's Contest with Poseidon*); 92 high-relief panels (metopes) of the external Doric frieze expounded themes of *hubris* and *nemesis* and the triumph of civilization over barbarism, allegorizing Athenian victories against the Persians (east *Gigantomachy*; west *Amazonomachy*; north *Sack of Troy*; south *Centauromachy*); and a low-relief Ionic frieze (perhaps the Panathenaic procession) ran continuously for some 160 m (525 ft) high atop the *cella* wall inside the colonnade where it would have been difficult to see despite optical refinements in its carving and the polychromy and metal accoutrements that were also present elsewhere. All this, however, was subordinate to *Phidias' lost chryselephantine statue of *Athena Parthenos*, c.12.75 m (42 ft) tall, inside the temple, of which only base blocks and floor cuttings remain. Detailed descriptions in ancient literature and numerous representations in other media (e.g. Athens, Nat. Arch. Mus.) nonetheless allow reconstruction of this figure and its lavish subsidiary iconography: the goddess, with golden drapery and ivory flesh, stood at ease, fully armed, a winged Victory (*Nike*) alighting on her extended right hand; her left rested on the rim of the shield at her side, within which was coiled the snake-bodied hero Erichthonius; a spear leant against her left shoulder. Athena wore an elaborate triple-crested helmet, and her Etruscan-style sandals bore images of the *Centauromachy*, recapitulating the narratives of the temple's metopes as did the *Amazonomachy* and *Gigantomachy* decorating her shield. The *Birth of Pandora* adorned the statue's base, and a shallow pool cut into the temple's floor not only reflected the image, but also served to humidify the *cella* and thus preserve its ivory. The statue's gold, allegedly removable, weighed some 1,135 kg (2,500 lbs). Its later history is uncertain, but Phidias' statue appears to have been replaced after a fire gutted the temple, perhaps in AD 267. The architectural sculptures were damaged by the building's conversion into a church (dated to perhaps 6th century AD) and *iconoclasm. In 1674, the sculptures in situ were fortunately sketched by an artist (thought to be Jacques Carrey) in the French ambassador's retinue, for the Parthenon was struck by Venetian artillery in 1687, and the horses of the west pediment subsequently destroyed in a botched attempt to lower them. In 1801–3 Lord Elgin's agents removed most of the best preserved statuary, which was acquired by the British Museum, London, in 1816. (The remaining carvings have all gradually been transferred to the Acropolis Museum.) From their arrival in England the 'Elgin Marbles' had a revolutionary impact on European taste, and the Parthenon sculptures are still considered to mark the apogee of Greek art. Although often ascribed to the hand of Phidias, the marbles are, in fact, high-quality workshop products, though the unity of conception they share with the *Athena Parthenos* indicate that Phidias may well have participated in their design. KDSL

Boardman, J., and Finn, D., *The Parthenon and its Sculptures* (1985).
Jenkins, I., *The Parthenon Frieze* (1995).
Leipen, N., *Athena Parthenos: A Reconstruction* (1971).
Palagia, O., *The Pediments of the Parthenon* (1994).
Tournikiotis, P. (ed.), *The Parthenon and its Impact in Modern Times* (1994).

PASITELES (1st century BC). Greek sculptor best known as the author of five volumes entitled *Noble Works of Art throughout the World* (Pliny, *Natural History* 1. 34; 36. 39). His own work is known only through anecdotal tales in the ancient sources and a single signed marble statue strut (Verona, Mus. Romano). Pliny (*Natural History* 36. 39) mentions an ivory *Jupiter* in the temple of the god in the Portico of Metellus in Rome. The signed works of his students Stephanus (*Stephanus Athlete*; Rome, Villa Albani) and Menelaus (*Orestes and Electra*; Rome, Mus. Naz. Romano) have led optimistic scholars to reconstruct a 'neoclassical' school. The emphasis in the sources on his making of clay models led some scholars to associate him with the development of an ancient version of the *'pointing machine', a theory now discredited. His insistence on sketching from life put his life in jeopardy, if the ancient sources are to be believed. L-AT

Kleiner, D. E. E., *Roman Sculpture* (1992).
Stewart, A., *Greek Sculpture: An Exploration* (1990).

PASMORE, VICTOR (1908–98). British painter and maker of constructions who is unusual in having achieved equal eminence as both a figurative and an abstract artist. He was born at Chelsham (Surrey), and from 1927 to 1937 worked as a clerk for the London County Council, while attending evening classes at the Central School of Arts and Crafts. From 1930 he exhibited with the *London Group (he became a member in 1934) and in 1934 he exhibited with the Objective Abstractionists at the Zwemmer Gallery. His work at this time was still figurative, in a freely handled, *Fauve-influenced style, but the work of his fellow exhibitors at the Zwemmer Gallery led him to experiment with abstraction. He soon reverted to naturalistic painting, however, and in 1937 combined with William Coldstream and Claude Rogers in founding the Euston Road School (see under LONDON). Characteristic of his work at this time and in the early 1940s are some splendid female nudes and lyrically sensitive Thames-side landscapes that have been likened to those of *Whistler (*Chiswick Reach*, 1943; Ottawa, NG Canada). In 1948 he underwent a dramatic conversion to pure abstraction, and by the early 1950s he had developed a personal style of geometrical abstraction. As well as paintings, he made abstract reliefs, partly under the influence of

Ben *Nicholson and partly under that of Charles Biederman's book *Art as the Evolution of Visual Knowledge* (1948), lent to him in 1951 by Ceri *Richards. His earlier reliefs had a handmade quality, but later—through the introduction of transparent perspex—he gave them the impersonal precision and finish of machine products (examples London, Tate). Through work in this style he came to be regarded as one of the leaders of *Constructivism in Britain. Later his paintings became less austere and more organic.

Pasmore was an influential teacher and was much concerned with bringing abstract art to the general public. He taught at Camberwell School of Art, 1943–9, the Central School of Art and Design, 1949–53, and King's College, Newcastle upon Tyne (now Newcastle University), as head of the painting department, 1954–61. The 'basic design' course that he taught at Newcastle (based on *Bauhaus ideas) spread to many British art schools. He won many honours, and Kenneth *Clark described him as 'one of the two or three most talented English painters of this century'. IC

PASSAROTTI, BARTOLOMMEO (1529–92). Italian painter, who, except for some early years in Rome, worked in his native town of Bologna. There he had a large studio, which became the focal point of the city's artistic life, and in the 1570s he was its leading painter. His early altarpieces, such as the *Virgin and Child with Saints* (1564–5; Bologna, S. Giacomo Maggiore), are indebted to *Correggio and *Parmigianino, while his portraits blend courtly elegance with a sharper realism, indebted to *Moroni, and brilliant Venetian colour. Several of his sitters hold precious objects, reminiscent of his celebrated museum of fragments of ancient sculpture, medals, drawings, and curiosities. His most novel works are his *genre paintings, which he began in the 1570s. The *Merry Company* (1577; priv. coll.) and the *Butcher's Shop* (Rome, Barberini Gal.), painted with a broad, bold touch, are burlesque works, with grotesquely caricatured figures. Their roots lie in Netherlandish genre, and they intended, through ridicule, to condemn human folly and vice. HL

PASSERI FAMILY. Giovanni Battista (1610/16–79) was a mediocre Italian painter, almost nothing of whose work survives, but an important biographer of contemporary artists. His *Vite*, not published until 1772, contains a mainly accurate account of the lives of 36 artists active in Rome, who died between 1641 and 1673. It opens with *Domenichino and ends with Salvator *Rosa. A pupil of Domenichino, he was most in sympathy with *classical art, but he also appreciated the *Baroque, and enriched his

narratives with anecdote and vivid detail. His nephew, **Giuseppe** (1654–1714), a painter and distinguished draughtsman, trained with him and then with Carlo *Maratti. He painted frescoes and altarpieces, developing from the Baroque drama of the *Incredulity of S. Thomas* (1675–86; Rome, S. Croce in Gerusalemme) to the freer, more *Rococo style of his most famous work, the decoration of the chancel of Viterbo Cathedral (c.1690). HL

Passeri, G. B., *Vite de' pittori, scultori ed architetti che hanno lavorato in Roma, morti dal 1641 fino al 1673*, ed. J. Hess (1934).

PASTE PRINTS. See MANIÈRE CRIBLÉE.

PASTEL. See CHALK.

PASTORAL, a genre of painting whose subject is the idealized life of shepherds who sing, make love, and graze their flocks in an ideally beautiful landscape; such works represent the courtier's or city-dweller's dream of escape, and the genre suggests longing for a past Golden Age or a remote Arcadia. The *Idylls* of Theocritus, whose themes were elaborated in Virgil's *Eclogues*, established the literary pastoral, and created an idyllic landscape which found expression in *Hellenistic reliefs and in Roman wall painting (see ROMAN ART, ANCIENT: PAINTING). In paintings from the villa at Boscotrecase (c.11 BC; New York, Met. Mus.) small vignettes of travellers, goatherds, and rustic shrines beneath leafy trees convey nostalgia for a lost simplicity. Ignored in the Middle Ages, the pastoral was reborn in the *Renaissance, and *Sannazaro's prose romance *Arcadia* (1504) stimulated its development in Venetian painting. The *Concert champêtre* (Paris, Louvre), variously attributed to *Giorgione or *Titian, with its evocative music, shady trees, clear water, perfectly suggests the *locus amoenus*, or lovely place, of classical poetry. Venetian painters also created harder pastorals, and the woodcuts of Titian, and the paintings of Jacopo *Bassano, indebted to Virgil's *Georgics* rather than his *Eclogues*, celebrate country labour. Religious pastorals showed the Holy Family in a lush landscape, or S. Jerome or S. Francis living in harmony with the natural world. The genre was developed in 17th-century Rome, most richly by *Claude Lorrain, whose pastorals, set in the Roman Campagna, create an enchanted mood, and Arcadian themes became popular in 17th-century Holland, where there was a vogue for three-quarter-length paintings of shepherds and shepherdesses. In 1708 de *Piles distinguished between two kinds of landscape, the heroic, and the pastoral, which shows nature simple and unadorned, and which he associated above all with *Rubens. *Watteau, in the 18th century, drew on

the Venetian tradition in his magic *fêtes galantes*, while *Boucher exploited the fashion for his version of elegant eroticism. There are echoes of the pastoral in *Gainsborough's landscapes and subject pictures, and 18th-century English artists idealized the innocent pleasures of country life. This tradition died with the French Revolution, but a dream of pastoral escape was again powerful in the 20th century, and was most movingly conveyed by *Picasso and *Matisse's celebration of a timeless Mediterranean world, by the earthly paradise of *Bonnard, and by the bucolic imagery of many Catalan painters. HL

Cafritz, R., Gowing, L., and Rosand, D., *Places of Delight* (1988).
Freedman, L., *The Classical Pastoral in the Visual Arts* (1989).

PATCH, THOMAS (c.1720×5–82). English painter working in Italy. Patch, who was born in Exeter, lived in Italy from 1747, first in Rome, where he appears to have worked with C.-J. *Vernet. He painted topographical views for a clientele taken almost exclusively from English *Grand Tourists. In 1755, having been expelled from Rome for reasons which remain obscure, he settled in *Florence under the protection of Sir Horace Mann, the English consul. Here he expanded his tourist-oriented practice to include *picturesque seascapes. Two Italian port scenes, *Sunrise and Sunset* (1770; Exeter, AG), are Romantic evocations in the manner of Vernet. He also painted fashionable *caricature conversation pieces: *A Caricature Group in Florence* (c.1760; Exeter, AG) includes a depiction of Mann. He may have been influenced by *Reynolds, who included Patch in his parody of *The School of Athens* (1751; Dublin, NG Ireland), but the genre derives from P. L. *Ghezzi. In 1770 Patch published some timely engravings of the *Masaccio/*Masolino frescoes in the Brancacci chapel of S. Maria del Carmine which were badly damaged by fire the following year. DER

Watson, F. J. B., 'Thomas Patch', *Walpole Society*, 28 (1940).

PATEL, PIERRE, THE ELDER (c.1605–c.1676). French landscape painter. Born in Picardy, Patel was admitted to the Académie de S. Luc in Paris in 1635 and seems to have spent his entire career in that city. His early works, like *Landscape* (Cherbourg, Mus.), show Flemish influence and his mature style was highly influenced by *Claude with whom his work is sometimes confused, an example being *Landscape with a Column and Figures* (Dulwich, Gal.). His highly finished imaginary landscapes and subject paintings frequently contain classical ruins, as in *The Flight into Egypt* (Sheffield, AG), which anticipate the *picturesque. He was associated with the

architect Louis Le Vau (1612–70), decorating the Cabinet de l'Amour in the magnificent interior of the Hôtel Lambert, Paris (1639–44), with inserted panels (Paris, Louvre). His detailed painting of Le Vau's splendid *Garden Front of the Palace of Versailles* (1668; Versailles), the only remaining painting of a series of royal palaces, provides a valuable record of its appearance before alteration. His son Pierre-Antoine the younger (1648–1708) painted landscapes and topographical works in his father's manner. DER

Blunt, A., *Art and Architecture in France, 1500–1700* (rev. edn., 1988).

PATER, JEAN-BAPTISTE-JOSEPH (1695–1736). French painter. He was *Watteau's only pupil, working with him around 1713 before Watteau, a difficult and moody man, quarrelled with him. His career was based on imitations of both Watteau's *fêtes champêtres* and his military scenes. He carried out his work with grace but no inspiration and his pictures are to be found in many collections of French art. MJ

Ingersoll-Smouse, F., *Pater* (1928).

PATER, WALTER (1839–94). English writer and critic. Pater, a bachelor don who lived with his two spinster sisters, was the unlikely standard-bearer for the cult of *aestheticism in Victorian England. He spent much of his life in Oxford, initially as an undergraduate at Queen's College and from 1864 as a fellow of Brasenose. His intention to become ordained was thwarted when he was exposed as an agnostic and his religious scepticism caused suspicion in the university. His espousal of the doctrine of 'art for art's sake', adopted from *Gautier, was first expressed in a review of William Morris's poetry in the *Westminster Review* in 1868 and gained notoriety with the publication of *Studies in the History of the *Renaissance* in 1873. This book, which included studies on *Botticelli, *Michelangelo as a poet, and *Winckelmann, is renowned for the beauty of its prose style, and exhorted the reader to search for and savour sensation. An essay on *Leonardo was possibly intended as a refutation of *Ruskin, whose emphasis on the moral value of art Pater directly opposed. *The Renaissance* had a profound influence on *Wilde, after whose trial in 1895 Pater, although dead, was tainted by association. DER

Levey, M., *The Case of Walter Pater* (1978).

PATINA. The colour of *bronze and other metals may be altered in a number of ways: by heat, by exposure to the atmosphere, by the application of a colour to the surface, or, if buried, by oxidation and decay, though this procedure is normally slow and covers the bronze with a protective hard surface. A natural patina is formed either by a copper carbonate from carbonic acid in the atmosphere, which produces a greenish colour, or copper sulphate from sulphur, producing a brownish black colour. Natural patinas found on classical bronzes have been highly prized since the *Renaissance, despite the fact that originally these were highly polished, and these effects have been sought by artificial means, such as ammonia or liver of sulphur or some organic substance. Homer refers to the patination of armour and shields in the *Iliad* (book 18). During the medieval period various alchemical procedures, using acids, sulphites, and salts, were employed, and codified in the 12th-century manuscript *De diversis artibus* by *Theophilus. A variety of surface patinas and varnishes were favoured in the Renaissance in Italy, including dark brown or black for Tuscan bronzes, translucent red varnish over golden bronze used by *Giambologna and his studio, or the denser blackish colour favoured for Venetian bronzes. Green patination was used to simulate the effect of natural patination on ancient bronzes. In the 19th century increasingly pigments were used to add colour to the surfaces of bronze rather than through natural patinas, and these were finished with varnishes. The French sculptor Antoine-Louis *Barye made a particular study of the various sorts of coloured bronze patinas, and *Rodin favoured a distinctly greenish patina for his bronze sculpture.

Patina in copper was often intended to form a contrast for silver and gold inlay. In Greek metalwork (see GREEK ART, ANCIENT) 'Corinthian bronze', a copper alloy with inlay, was supposed to have been created by plunging the hot bronze into water to create the patination. Silver can be oxidized to give the effect of tarnish, and this coloration was popular in Europe and North America during the 19th century, when it was also produced by using sulphurs. HO/AB

Hughes, R., and Rowe, M., *The Colouring, Bronzing and Patination of Metals* (1982).

PATINIR, HERRY. See BLES, HERRI MET DE.

PATINIR (also Patinier, Patenier), JOACHIM (*c.*1475×80–1524). Painter from the Meuse river valley who is considered the first known *landscape specialist in European art. He was a master in the Antwerp painters' guild in 1515. Before that he may have spent some time in the workshop of Gerard *David in Bruges. Two basic landscape constructions can be associated with him: (1) the landscape is depicted from a high viewpoint (bird's-eye perspective) and recedes without a break to the distant horizon (the so-called *Weltlandschaft* or panoramic landscape) (*Landscape with Charon's Boat,* *c.*1520–4; Madrid, Prado); (2) the composition is vertically divided in two; in one half the landscape stretches to the horizon, in the other half it is filled with tall, fantastic rock formations blocking the view into the distance (*Flight into Egypt,* before 1515; Antwerp, Koninklijk Mus. voor Schone Kunsten). In both types of landscapes, a system of brown foreground, green middle ground, and blue background simulates the effects of *aerial perspective. Figures and other narrative details are inserted into the landscape (Patinir painted no pure landscapes), sometimes supplied by another master, for example Quentin *Massys. Patinir's landscapes became the model for generations of Netherlandish artists. KLB

Falkenburg, R. L., *Joachim Patinir* (1988).

PATRONAGE. *See opposite.*

PATTERN BOOK, or model book, a collection of pages, sometimes bound, filled with clearly outlined pen and ink *drawings, frequently of animals and human figures, that performed the function of exemplum in the medieval and 15th-century painter's workshop. The model book provided material from which a pupil received his initial training and from which workshop members could extract elements for new compositions. Early pattern books contained ornaments and drawings related to the applied arts, initials and capital letters, human figures from a biblical context, and animals in the style of the traditional *bestiary. One 14th-century survival, the so-called sketchbook of Giovannino de *Grassi (Bergamo, Mus. Civico), cannot only be related to completed paintings by the artist but also shows the way successive owners added to the drawings. In 15th-century collections, mostly on paper in portfolios, religious and profane elements intermingle. Pattern books came to be seen as the master's personal property, and were eliminated from the creative process when a sketch was made for every commission. Model books continued to be used as collections of examples for artisans and decorative artists. Survival of pattern books is limited. MFC

Scheller, R., *Exemplum: Model-Book Drawings and the Practice of Artistic Transmission in the Middle Ages* (1995).

PAUSANIAS (active mid-2nd century AD). Greek writer from Asia Minor. Pausanias' comprehensive account of his travels in Greece is one of the few surviving examples of the *Periegesis*. He states that his aim was to record 'all things Greek', reflecting an interest in the Hellenic past characteristic of the Greek-speaking inhabitants of the Roman Empire in this period. Pausanias' descriptions of sites give information about monuments and works of art which no longer

continued on page 549

· PATRONAGE ·

1. Before 1500

THE Middle Ages evolved different theories about how works of art came into existence, most of which gave absolute priority to the patron. The 8th-century Byzantine Patriarch Nicephorus of Constantinople listed no fewer than five causes of an image, the poetic, organic, formal, material, and final, in which emphasis was given to the patron (the poetic cause) and not the artist (the organic). This outlook pertained throughout the Middle Ages in the Latin West. It is embodied in one later medieval meaning of the term *patron*, i.e. model. This hierarchy showed signs of weakening only in the 13th century, when in Italy monumental inscriptions on paintings and sculptures began to glorify the role of the artist and not solely the patron in their manufacture; French master masons also saw a significant increase in their status at this time. But throughout the period the most significant Greek and Latin accounts of art production are primarily laudatory accounts of the great works of patrons, not artists, often informed by literary commonplaces of classical type: Procopius' 6th-century account of Justinian's buildings (*c.*558), Abbot *Suger's treatises on his own work at S. Denis near Paris (1140s), and the monk Gervase's descriptions of the works at 12th-century Canterbury are all notable. Such texts reveal that patrons sought to emulate earlier exemplars (Suger refers to Justinian's Hagia Sophia in Constantinople); magnificent art patronage was thus understood to be the attribute of the great man, and in rulers (e.g. Louis IX of France, d. 1270) was seen as a political virtue. But the patron's desire for the salvation of his or her soul through the performance of good works, of which art patronage was one, ranked far higher in this period than at any other. Thousands of medieval and early Renaissance buildings and artefacts were produced by patrons of differing social station for this reason. Though other factors—the desire for display being one—were also important, art was thought of in an instrumental way rather than as an end in itself; it is only by the 14th and 15th centuries that a self-conscious attitude to the collection of works of art (panel painting, illuminated manuscripts, precious metalwork) for their own sake emerged.

The means by which patronage was effected are well understood only from the 12th and 13th centuries when increasing quantities of surviving documentation enable us to trace the social, economic, and professional relationship of patrons and artists. Early isolated references (e.g. Gregory of Tours's 6th-century account of a patroness at Clermont who read Bible histories to her painters as a guide for their work) suggest the kind of dynamic intervention that may have become typical of later Frankish and Ottonian imperial patrons. Images of patrons as donors or recipients of works of art (Emperor Charles the Bald's 8th-century depiction as recipient in the Vivian Bible, the 12th-century Cluniac Henry of Blois's enamel plaques) are common. Patrons also tended to give priority to precious media: thus Abbot Suger mentions the gilded bronze doors on the façade of his church, but not their accompanying, and revolutionary, stone portal sculptures. But it is only by the 13th century that the processes of patronage become clearly documented. The surviving Chancery records from the long reign of Henry III of England (1216–72) offer detailed evidence of the King's own specifications for images and buildings commissioned by him from court artists, and pinpoint a demanding, spendthrift, and impatient patron with his own circle of artistic advisers. More information survives about the commissioning processes used by secular clergy in the construction of Gothic cathedrals (e.g. the Troyes Cathedral documents). While court painters were bound to patrons by formal offices (e.g. *valet de chambre* at the 14th-century French court), those who worked for non-royal patrons, like the Sienese painter *Duccio, were increasingly obliged by a relatively new form of document, the written contract: that between Duccio and the clerk of works of Siena Cathedral (1308) specifies all terms of employment, Duccio's personal obligations, and the fact that the patron provided him with materials as a bond. Whereas patrons formerly modelled themselves on earlier patrons, contracts increasingly indicate the importance of existing works of art as exemplars for new commissions. The increasing importance of highly finished architectural drawings, which emerge in the 13th century at cathedral sites at Reims and Strasbourg, points to a new role for preliminary designs in guiding tendering and costs; and this may in turn suggest the growing importance of committees. Detailed minutes of the deliberations of the works committee of the cathedral at Milan from 1386 expose a richly politicized world of sophisticated technical and aesthetic argument. It is also known that fresco cycles whose content had official importance, such as the life of S. Francis in the upper church of S. Francesco at *Assisi, were disseminated within the Franciscan order by means of large-scale tracings, to preserve their authorized contents.

The rise of entirely new types of patron in the Middle Ages, of which the mendicant orders (Franciscans and Dominicans), the Italian city-states, and the urban middle classes represent three, reminds us that the accidents of survival of written evidence and works of art have tended to skew our knowledge of the history of patronage. Early written sources, usually biographical or historical in nature, mostly inform us about clerical and especially

monastic patronage at such centres as Jarrow, Hildesheim, Fleury, Montecassino, and Bury St Edmunds. But this does not mean that all art in the medieval period was produced solely for, or by, monks. It remains nevertheless true that only by the 13th century were cathedral churches, headed by ambitious bishops and chapters, displacing major monastic centres in the commissioning of art and architecture in the Gothic style. Gothic architecture had begun in northern France in Benedictine and Cistercian circles, but was developed most spectacularly thereafter by the powerful class of bishops. Indeed by the 13th century royal and aristocratic patrons were also playing an increasingly prominent role with the consolidation of royal power across much of northern Europe. Under Philippe Auguste and his successors, *Paris, already the cultural capital of western Europe and effective birthplace of the Gothic style in building, had developed a flourishing figurative arts industry, supported not only by the prestige of the Crown but also by the demands for illuminated books for the University of Paris. The reigns of Louis IX (d. 1270) and Philip the Fair (d. 1314) saw the consolidation of the royal palace as a centre of artistic activity in a way not seen since the *Carolingian emperors and the Norman kings in Sicily, up to the end of the 12th century. Works like the S. Chapelle, erected by Louis IX in Paris after 1239 to house the relic of the Crown of Thorns, testify by their enormous impact on other patrons (e.g. Henry III at Westminster and the Archbishop of Cologne) to the authority of Parisian models of patronage in this period. Correspondingly, by the 14th century the most powerful Italian city-states were commissioning cycles of frescoes and sculptures which celebrated a new and sophisticated sense of civic ideals: of these the Fontana Maggiore in Perugia by Nicola *Pisano (1278), the frescoes in the Palazzo Pubblico in Siena by Ambrogio *Lorenzetti (late 1330s), and the decorations of the Palazzo della Ragione in Padua (14th and 15th centuries) are the most significant. Yet in many of these instances the mythology of older types of patronage remained crucial: the S. Chapelle resembles contemporary descriptions of the palace chapel at Constantinople which had originally housed the Crown of Thorns; and older Ciceronian and Roman republican ideals informed the frescoes at Siena. The same holds true of the brief but fertile phase of papal patronage under Nicholas III (d. 1279) and Nicholas IV (d. 1292) in *Rome; both popes were Italians facing a period of mounting French influence over the papacy, and both sought to recover something of the splendour of Apostolic Rome either by redecorating the early Christian basilicas of S. Peter's and S. Paul's or by commissioning major new *mosaic and fresco cycles in their spirit (Rome, S. Maria Maggiore). Yet when French popes such as Urban IV commissioned buildings in both France and Italy, local styles were tactfully chosen in each case. Tradition was thus a major constraint on the way that specific types of patron developed specific styles, and though it is sometimes helpful to point to 'Cistercian' styles of building, or 'mendicant' styles of painting, exact correspondences of style and patronage are usually hard to define. Generally speaking, the higher the patron, the more diverse were the resources at his disposal and the more eclectic his art.

*Giotto's career may have begun under Nicholas IV, and his celebrated ability to forge close links with well-placed patrons reminds us of the essentially personal relationships involved in art patronage and commissioning. At a time when urban patronage was growing in importance, Giotto was employed by a wide variety of patrons, civic, mendicant, banking (the Arena chapel frescoes at Padua were executed c.1305–13 for Enrico Scrovegni), and royal. In the Arena chapel's image of Enrico presenting a model of his chapel to the Virgin Mary, Giotto provides us with one of the first true portrait likenesses of a patron in an essentially traditional, supplicant, role. *Simone Martini was also evidently in demand from a similar range of personalities. The role of patrons in taking a close personal interest in the well-being of favoured artists is demonstrated by John, Duke of Berry (d. 1416), who not only provided one of his illuminators with a wife duly kidnapped for the purpose, but tolerated the numerous pranks his artists played on him, notably the presentation to him of a mocked-up illuminated manuscript as a New Year's present. Giotto is also held to have jested with the King of Naples.

Patronage and commissioning were affected above all by the gradual changes in the role and relative importance of artists in the later Middle Ages, and by the diversification that patronage itself underwent. By the 14th and 15th centuries, throughout most of western Europe, art production was in the hands of craftsmen whose specializations reflected the urban economic basis of their work; no longer were art production or the production of writing about art dominated by the isolated cloister, if indeed they ever had been. Artists produced beautifully finished commodities which possessed high cultural capital, and it is scarcely surprising that it is in this period that the notion of self-conscious art *collecting can first be traced. This can usually be done through surviving household and treasury inventories, notably the English royal wardrobe accounts and the inventories of books, panel paintings, tapestries, and jocalia or precious wares associated with Charles V of France (d. 1380), his brother John, Duke of Berry, and John, Duke of Bedford (d. 1435). PB

Branner, R., S. Louis and the Court Style in Gothic Architecture (1965).

Frisch, T. G., Gothic Art 1140–c.1450: Sources and Documents (1971).

Hamel, C. de, A History of Illuminated Manuscripts (1986).

Martindale, A., The Rise of the Artist in the Middle Ages and Early Renaissance (1972).

Meiss, M., French Painting in the Time of Jean de Berry, 1: The Late Fourteenth Century and the Patronage of the Duke (2 vols., 1967).

Panofsky, E. (ed. and trans.), Abbot Suger on the Abbey Church of S. Denis and its Art Treasures (2nd edn., 1979).

White, J., Art and Architecture in Italy 1250–1400 (2nd edn., 1979).

2. From 1500 to 1800

THE words patronage, and patron, had and have many connotations in art history; much is in the eye of the beholder of the relationship past and present, whether that of the patron, the client (not necessarily the same person or institution), or the providing artist. The patron might be a benign and indulgent figure of prestige furthering the career of the artist beyond buying a work of art, acting as propagandist, protector, godfather, or welfare officer; providing houses or opportunities to travel. Alternatively he was a dictatorial, even malign, figure whose taste (or lack of it) cramped the artist's own ideas and style, and whose protection might be cast off once an artist had achieved a reputation. For most artists of repute some form of patronage was both necessary and desirable. Most artists wanted to work to commission, knowing the person or institution ordering the work, whether for himself or for a third party (the head of a family commissioning an altarpiece or tomb complex for a large church). They would want that commissioning patron to recommend the artist to others, or protect him when in trouble. A court artist might have to balance a certain lack of freedom and the burden of non-artistic duties, against advantages of salaries and perks beyond the payment for particular commissions, and even securing noble status. Rising artists, or those who never made a reputation, might paint and sculpt with no known target, and hope to put the work on and in the market for direct sale. Salvator *Rosa was highlighting new attitudes when he alienated and disdained important Roman patronage sources, rejected various offers of court patronage, as notably in Sweden (1652), Innsbruck (1661), and France (1665), and insisted on propagating his 'genius', whether the paintings were liked or not. By the later 18th century this anti-patronage attitude was more prevalent.

The early modern period from the 15th to the 18th century added to the complexities of the types of relationship, and types of patrons, affected by a spread of wealth, a greater stability of main courts in capital cities heading more centralized states, and the rising status of artists. Whatever the vagaries of the general economies through the early modern period, it was an age of increasing conspicuous consumption, in which open display of wealth, the ebullient visual celebrations of the virtues, merits, and strengths of a religious and civil cause, an institution or an individual and his family, was more praised than condemned by a few puritans. Once the Roman Catholic, Anglican, and some Lutheran churches went onto the offensive greater opportunities for religious commissions followed. Painters' work expanded in scale, but in some ways there was a greater impact on the roles and public prestige of sculptors in stone, wood, and stucco as their work spilled all over church interiors, as with Alessandro *Algardi in Rome or Grinling *Gibbons in London.

The rising status of the artist from the 15th century, affected in part by *humanist attitudes, changed patronage relationships. If an artist achieved wide fame, it redounded to the credit of the patron and his perspicacity (or at least supposed generosity). If being a painter, even a sculptor, was as prestigious as being a poet, then personal relations with the artist and involvement in his work might be more worthy, and exciting, for the patron, as Popes Urban VIII (ruled 1623–44) and Alexander VII (ruled 1655–67) found with *Bernini, or Charles I with *Rubens, or Philip IV with *Velázquez. Pope Alexander's cryptic diaries show his delight as 'we' planned building and sculptural decoration with Bernini and Pietro da *Cortona. A well-recognized artist might use his prestige to secure more favours from a patron, as Antonio *Verrio seemingly did at Burghley House in the late 1680s.

Early modern patronage came as before from courts, churches, aristocratic, and merchant families, from religious orders and confraternities. In the post-Reformation period some church patronage was clearly lost, and artists had to develop new genres and subject matter, encouraging more prestige for landscapes, still lifes, domestic scenes (with or without moralizing messages), as notably in the Netherlands. After some puritanism in the face of Protestant and Catholic reformers' criticism in the mid-16th century, Catholic leaders patronized the visual arts to a greater extent, and more flamboyantly, for educational and rhetorical purposes. As territorial states were consolidated from the 16th century, some smaller city courts became less important, but the princely courts based on capital cities and recreational country palaces or villas spent more on the arts; from lavish decorated rooms, to image-boosting portraits and statues. Competitive bidding for political and cultural prestige through artists characterized papal Rome and *Madrid (and environs) throughout the period, Florence under the Medici grand dukes, Paris and *Versailles notably under Louis XIV, *Prague with Rudolf II, Copenhagen under Christian IV, Vienna with Leopold II, *London under the Stuarts, and even *St Petersburg with Catherine the Great, who realized the value of Western style portraiture for promotional ends.

Below the level of the major courts, secular and papal, there were many wealthy patrons intent on enhancing the prestige of family, city, or church, emphasizing their virtue, or delighting their senses. Image making for families like the Farnese, Gonzaga, Barberini, Cecils, Herberts, even the house of Orange, did wonders for artistic commissions as did the competition between new religious orders such as the Jesuits, Oratorians, and Theatines, or lay confraternities in *Venice, Rome, or Perugia. Religious revivals in the enlightened 18th century generated the *Rococo multi-dimensional splendours of Bavarian Benedictine abbeys, or G. B. *Tiepolo's vibrant ceilings and altarpieces in the Veneto.

As in the *Renaissance period there was a huge amount of minor individual patronage, with mixed motivations, if with increasing secular aspects. Exciting and stimulating for artists was the rise, notably from the turn of the 16th–17th century, of the connoisseur collector-patron, led by

Vincenzo Giustiniani (1564–1637/8), Cassiano dal Pozzo (1588–1657), Lord and Lady Arundel (1585–1646 and c.1590–1654), Paul Fréart de Chantelou (1609–94). Samuel Pepys's (1633–1703) involvement in the art scene is instructive of the role of a minor commissioning patron and art purchaser. His diary (1660–9) shows him commissioning three portraits of himself from increasingly better-known artists (the obscure Savill(e), John Hayls, and Samuel *Cooper), at times putting pressure on the artist to change, and interpolating not very well-informed criticism until he learned more. His commissioning also led to portraits of relatives and friends in his social network. He admired Sir Peter *Lely's portraits (in the houses of his more aristocratic associates), but could not really afford him at this stage. He descended into the market to buy already completed Dutch scenic paintings to decorate his house, as well as commissioning landscapes from H. Danckerts to insert into his panelling. The expanding number of new patrons through into the 18th century forced artists to concentrate more on portraiture and scenery (earlier awarded lower status by many Italians at least).

Among female patrons Isabella d'Este has been recognized as one of the most adventurous and demanding; and unusual in commissioning erotic female nudes (from *Correggio). Recent scholarship has stressed the role of non-court women as patrons, with married women and widows using their control over their dowries and legacies to promote major works, such as *Raphael's *Entombment* (1507; Rome, Borghese Gal.) or Correggio's *Virgin and Child with SS Jerome and Mary Magdalene* (1523/8; Parma, Gal. Nazionale). Women actively controlled the creation of funerary monuments (if mainly to celebrate male egos), but also commissioned works for their own lay confraternities, and nuns had their views and tastes implemented in the construction and decoration of convents and chapels, as in 16th–17th-century Rome. The male patronage of the few major women artists raises debates as to whether they were patronized as curiosities, gender-defying *virtuose*, or in their own right as genuinely first rate, as Sofonisba *Anguissola, Lavinia *Fontana, Artemesia *Gentileschi, and Elisabetta Sirani are now judged.

Patron–artist relationships could be distant, or very familiar, ranging from servitude to the friendship of near equals. Artists might live in a patron's household, as lowly servant or close companion. *Caravaggio benefited from happy and protected living in the del Monte household, or Orazio *Gentileschi with the Duke of Buckingham; but Guido *Reni rebelled against the restrictions of Borghese household patronage—and demands for speed painting as if racehorses, as he put it. Salvator Rosa, disdaining court patronage, benefited from ambivalent friendship/patron relations: friends who bought his works, provided hospitality in villas, gave him ideas for subject matter, spread knowledge about his paintings, etchings, and poetry.

Major artists, backed by appreciative patrons, could develop a sub-patronage system, spreading well beyond any studio, such that a painter, sculptor, or decorator attached to *Vasari, Bernini or Rubens would have their artistic opportunities and employment networking expanded. Those who fell out with such entrepreneurs could lose commissions. Major patrons might use artists in international diplomacy, recommending them for commissions at another court, though there could be mixed results when the recommended artist was troublesome and undiplomatic, as with *Cellini at François I's court, or Bernini with Louis XIV's ministers, courtiers, and French architects. Rubens as painter-diplomat may have been closest to the ideal painter–patron relationship, with several rulers and ministers.

Under the best conditions of patronage an artist had somebody who paid well for a work, aesthetically appreciated it, passed on recommendations for other commissions, offered friendship in good and bad times, acted as marriage broker, or spiritual supporter. Artists in serious trouble (Cellini, Caravaggio, G. B. *Gaulli, Bernini) were rescued and evaded the legal consequences of violent and murderous actions by the interventions of popes, dukes, and other powerful patrons. Such support could also restrict the freedom of artists to work for other patrons, as Cellini found at times with Paul III and Duke Cosimo, and Bernini with Urban VIII. The art was to have the benefit and prestige of court patronage, but freedom for other commissions, as Raphael, *Holbein, Rubens, and *Spranger realized.

If patronage were rejected or unavailable artists could try selling in the market place, sell or at least advertise through exhibitions, work through studio partners and friends, or use agents (who might also be painters). The major Sicilian collector-patron Antonio Ruffo (1610–78) obtained works by *Poussin, Rosa, *Rembrandt, *Guercino, Artemisia Gentileschi, and many others through agents in Rome and Naples, though he also directly patronized, in two senses, Artemisia, trying to get her works on the cheap as a female, as she protested in letters to him. There were many intermediaries, agents, facilitators, and friends to link patrons and artists, get commissions spread around; the poet Pietro Aretino (1492–1556) boosted his friend *Titian, diplomats like Sir Dudley Carleton or Joseph Smith both collected and promoted the works of Rubens and *Canaletto. Scholars, religious and secular, helped patrons and artists with the most complex ceilings, as with *Michelangelo's Sistine ceiling or those of Pietro da Cortona in Roman and Florentine palaces. By the 18th century there were bankers like Pierre Crozat (1665–1740) and society hostesses like Mme Geoffrin guiding, allegedly dictating, the taste of patrons in France and further afield. Such influences, and the decline of court patronage of living artists, stimulated onslaughts by artists and literati against 'patronage' itself. CFB

Careri, G., 'The Artist', in *Baroque Personae*, ed. R. Villari, trans. L. G. Cochrane (1995).

Foss, M., *Man of Wit to Man of Business: The Arts and Changing Patronage 1660–1750* (2nd edn., 1988).

Haskell, F., 'Patronage', in *Encyclopedia of World Art*, vol. 9 (1966).

Haskell, F., *Patrons and Painters: A Study in the Relations between Italian Art and Society in the Age of the Baroque* (2nd edn., 1980).

Hollingsworth, M., *Patronage in Sixteenth Century Italy* (1996).

King, C. E., *Renaissance Women Patrons: Wives and Widows in Italy c.1300–1550* (1998).

Trevor-Roper, H., *Princes and Artists: Patronage and Ideology at Four Habsburg Courts, 1517–1633* (1976).

Warnke, M., *The Court Artist: On the Ancestry of the Modern Artist*, trans. D. McLintock (1993).

survive, like *Phidias' chryselephantine statue of *Zeus* at *Olympia or paintings by *Polygnotus which were still visible in *Athens and *Delphi. His main interest was in the remains of the *Classical Greek past but this did not prevent him from recording buildings set up in his own period. He is also a precious source of information on local cults and records the myths and legends he heard in various parts of Greece. RW

Arafat, K. W., *Pausanias' Greece: Ancient Artists and Roman Rulers* (1996).

Habicht, C., *Pausanias' Guide to Ancient Greece* (1985).

PEALE, CHARLES WILLSON (1741–1827). American painter. Peale was apprenticed to a saddler and being naturally entrepreneurial established a thriving business before taking up painting in the mid-1760s. From 1767 to 1769 he studied in London, under *West, and developed a workaday portrait style modelled on *Reynolds. He fought (1775–8) in the War of Independence and on settling in Philadelphia in 1778 served on the State Assembly until 1780. In 1782 he opened a gallery to display his patriotic portraits including George Washington, who was to sit to him seven times. *Washington at Princeton* (1779; Philadelphia, Pennsylvania Academy of Fine Arts) is an assured full-length in Reynolds's manner. In 1786 he founded the Peale Museum which included art, science, nature, and religion. His painting *Exhuming the First American Mastodon* (1806–8; Baltimore, Peale Mus.) records his discovery of the bones in 1801. The museum was a family business involving his four artist sons Raphaelle (1774–1825) and Titian (1799–1881), whom he painted in a celebrated *trompe l'œil*, *The Staircase Group* (1795; Philadelphia Mus.), Rubens (1784–1865), and Rembrandt (1778–1860). It was from Rembrandt, who studied in Paris (1808–10), that Peale learned the French *Neoclassical finish of his later portraits. DER

Sellers, C., *Charles Willson Peale* (2 vols., 1947).

PECHSTEIN, MAX (1881–1955). German painter and graphic artist, born in Zwickau. He studied in Dresden 1900–2 and in 1906 became a member of Die *Brücke. He was one of the founders of the Neue *Sezession in Berlin in 1910. In 1912 he was expelled from Die Brücke because of his refusal to leave the Neue Sezession. In common with other *Expressionists, and with *Gauguin, Pechstein was fascinated by what he perceived as the primitive lives of village and small island communities. In 1909 he began a series of annual visits to the village of Nidden in east Prussia, and in 1913–14 he went to the Palau Islands in the Pacific, painting the fishermen in a near-*Fauvist manner. His other subjects included nudes, landscapes, portraits, and flower pieces. In 1918 he was one of the founders of the Novembergruppe and he taught in the Berlin Academy from 1923, being dismissed as degenerate by the Nazis in 1933 and reinstated in 1945. He was the most French in spirit of the German Expressionists, and was the first of Die Brücke to achieve success and general recognition, due primarily to his technical skill. His work drew heavily on the innovations of others and his reputation has subsequently diminished. He was dismissed by *Kirchner as a *'Matisse-Imitist'. OPa

Moeller, M. (ed.), *Max Pechstein*, exhib. cat. 1996 (Munich).

PEEPSHOW BOX, an enclosed cabinet in which scenes are painted on the interior walls and ceiling so that when these are viewed through an aperture or magnifying eyepiece, at one or either end of the cabinet, there is an illusion of depth and three-dimensional reality. *Alberti may have been the inventor of the peepshow, for some such device is ascribed to him in a contemporary anonymous biography. Other references to peepshows can be found in *perspective books by Vignola (1583) and du Breuil (1649). John Evelyn records one which he saw in London in 1656: 'was shew'd me a prety [sic] Perspective and well represented in a triangular box, the greate Church at Haarlem in Holland, to be seene thro a small hole at one of the Corners.' Only six of these boxes still survive and the best example is that by the 17th-century Dutch artist Samuel van *Hoogstraten (London, NG). CFW

Brown, C., et al., 'Samuel van Hoogstraten: Perspective and Painting', *National Gallery Technical Bulletin*, 11 (1987).

The Diary of John Evelyn, ed. E. S. De Beer, vol. 3 (1955).

PEETERS, BONAVENTURA, THE ELDER (1614–52). Flemish marine painter, draughtsman, and etcher. He came from a family of artists which included his two brothers Gillis and Jan, his sister Catharina, and his nephew Bonaventura the younger. Bonaventura the elder is the best known of the five. Nothing is known of his training. In 1634 he joined the guild of S. Luke in Antwerp. His early work, for example *Sailing Ships near a Pier* (1637; Budapest, Szépmüvészeti Mus.) is influenced by Dutch painters such as Hendrick *Vroom and Salomon van *Ruysdael. He also seems to have followed Vroom in painting views of coastal cities full of realistic detail. Works such as *Port of Archangel* (1644; London, National Maritime Mus.) may have been inspired by voyages to northern ports. He also specialized in storms and shipwrecks, imaginary, but notable for their dramatic skies and light effects, such as *Stormy Sea with Shipwreck* (Vienna, Kunsthist. Mus.). Peeters seems to have anticipated the future developments of Dutch Italianate painters, with his exotic port and coastal scenes such as *Dutch Men-of-War in the West Indies* (1648; Hartford, Conn., Wadsworth Atheneum). CFW

Sutton, P. (ed.), *The Age of Rubens*, exhib. cat. 1993 (Boston, Mus. of Fine Arts).

PEETERS, CLARA (1589–after 1657). Flemish still-life painter, recorded in Amsterdam in 1612, The Hague in 1617, and still alive in 1657. There is a scarcity of documentary evidence and only 30 paintings are known. Her compositions are stark arrangements of simple food and objects against a dark background. *Still Life* (c.1612; Karlsruhe, Kunsthalle) is a more sumptuous example of a careful and symmetrical arrangement of gold vessels, flowers, coins, and shells placed against a dark background. Reflected in the silver gilt cup is the artist, holding her palette. CFW

Chadwick, W., *Women, Art and Society* (1990).

PELLEGRINI, GIOVANNI ANTONIO (1675–1741). Venetian *history painter who established his reputation in England and subsequently travelled widely in Europe. After an inauspicious start—he trained in Venice under P. Pagani (1661–1716) and accompanied him to Moravia and Vienna in 1690—he first made his mark with a series of frescoes in the Foresteria Alessandri in Mira on the Brenta (1702–8). In 1708 he was invited by Charles Montagu, later 1st Duke of Manchester, to return with him to England together with Marco *Ricci with whom he had just collaborated on a painting of the *Plague*

of Serpents in S. Moisè, Venice (1707). In London he decorated the stairwell of Lord Manchester's London home at Arlington Street (destr.), worked as a theatrical scene painter at the Haymarket with Ricci, and designed sets (1709) for Scarlatti's opera *Pirro e Demetrio*. In the same year he was at Castle Howard (North Yorks.), where Charles, 3rd Earl of Carlisle, commissioned him to paint the cupola, staircases, and entrance hall of Vanbrugh's creation (these were seriously damaged by fire). The following year he was at Lord Manchester's country seat, Kimbolton Castle (Cambs.), where he painted *Minerva* on the ceiling, scenes of the *Triumph of a Roman Emperor* on the walls of the stairwell, and a gallery with musicians playing a fanfare in a triangular space on the upper stairs. Painted in oil on plaster, as opposed to true fresco, this is his most important surviving British achievement, with a spaciousness of designs and a radiance of colour that anticipates *Tiepolo. He also painted a large canvas of *Hector and Andromache* (now Leeds, Temple Newsam). His other major project (*c*.1709–10) was a series of paintings from ancient history, the Bible, and *Orlando furioso*, now set into the rooms of the principal saloon at Narford (Norfolk), possibly a gift from Richard Boyle, 3rd Earl of Burlington, to Sir Andrew Fountaine.

Pellegrini left England in 1713 (shortly after the arrival of Sebastiano *Ricci) and for the next three years was employed by Johann Wilhelm, Elector of the Palatinate, at Schloss Bensberg near Düsseldorf, where he painted the *Fall of the Giants* and the *Fall of Phaeton* for the stairwells (*in situ*). For the same castle he also executed a series of allegorical canvases celebrating the Elector's rule (now at Schleissheim Staatsgal.) which mark the pinnacle of his achievement as a history painter. Pellegrini went on to work all over Europe, at Antwerp, The Hague, Würzburg, Dresden, Mannheim, and Vienna. In Venice he painted a radiant altarpiece of the *Martyrdom of S. Andrew* for S. Stae (1722) but only settled down in his home city *c*.1730 after more than 20 years of foreign travel. By now the taste for *Rococo decoration in Britain had been brushed aside in the face of the new-found fashion for Palladian architecture. In Venice and across Germany, on the other hand, Pellegrini's art would exercise great influence. HB

Knox, G., *Antonio Pellegrini* (1995).

PEN (Latin *penna*: feather). Some six main types of pen have been developed over several centuries. The oldest is the reed pen which was used for writing in Antiquity and was not employed as an instrument for *drawing until the *Renaissance. Remarkable variations in width of line are possible and among the greatest exponents of the reed pen are *Rembrandt and van *Gogh. Quill pens were generally cut from the outer hollow wing feathers of swans or geese but feathers from eagles, crows, and turkeys were also found to be suitable. Since the plucked feathers were soft at the shaft end they were cured (hardened) by being placed in pots of hot sand before they were cut as quills.

Such points allowed great flexibility of line and hence quills were widely used in drawing from the 15th century until the end of the 19th. Although metal nibs are recorded as early as the 16th century they were not much used until the last quarter of the 19th when they began to replace quills. A great variety of nib shapes soon became available and these were able to withstand greater wear than quills. Such pens also tended to produce fewer blots than quills but a drawback was the constant refilling or 'dipping' which they demanded. For this reason they were often referred to as 'Dip' pens. They remained in use as writing instruments in schools and offices at least until the 1960s. Fountain pens, with their own reservoirs of ink, invented in the 19th century, are occasionally used for drawing by artists today.

The ballpoint pen, patented in 1939 by László Biró, uses viscous ink in an open-ended capillary tube. There is a replaceable ink reservoir filled with a viscous fluid of either spirit-soluble or oil-soluble dyes. The ink reaches the paper through the ball point and drawing is assisted by the smoothness of application and the flexibility which is made possible. Unfortunately the dyes used in ballpoint ink often fade swiftly. Felt or nylon tip pens popular today control ink flow by a tip of felt or bundle of nylon fibres instead of a traditional nib. Although such instruments are flexible and simple to use, their ink leaves a deep and ineradicable stain. PHJG

PENCIL. The word found in both Latin and Old French originally meant an artist's paintbrush, usually made of camel hair or sable. By the beginning of the 17th century, however, its meaning seems to have changed to denote instead an instrument, probably of wood, intended both for *drawing and writing which could hold pieces of *graphite, *chalks of various colours, or *charcoal. Within 50 years its definition shifted again, this time to indicate more specifically a strip of graphite enclosed in a softwood cylinder or in a metal case with a tapering end (a *porte-crayon*). It is this final meaning which is generally understood today. Graphite pencils became popular at the end of the 18th century when natural black chalks became increasingly difficult to obtain. PHJG

PENCZ, GEORG (*c*.1500–50). German painter and printmaker. He was in *Dürer's workshop in 1523, though he did not paint murals in Nuremberg Town Hall after Dürer's designs, as has long been claimed. In 1525, together with the brothers Sebald and Barthel *Beham, Pencz was expelled from the city for anarchism and atheism, but was readmitted later in the same year. In 1550, he was named court artist to Duke Albrecht of Prussia in Königsberg; he died on his way to accept the appointment. Pencz's paintings show the influence of Dürer and Italy, which he visited several times. They are cool and rather dispassionate, tending to planar compositions which emphasize contour. His importance today lies in his portraits which, after 1540, reflect knowledge of *Bronzino (*Portrait of an Artist*, 1549; Dublin, NG Ireland), and in his illusionistic ceiling decorations, which show him to have been familiar with the work of *Giulio Romano at Mantua (e.g. the great hall of the Hirschvogelhaus, for which Peter *Flötner supplied the interior decoration; destr. 1945). His prints, which are tiny, belong to the group termed *Little Masters. KLB

Gothic and Renaissance Art in Nuremberg, exhib. cat., 1986 (New York, Met. Mus.).

PENNI, GIOVANNI FRANCESCO (1496?–*c*.1528). Italian painter and draughtsman; one of *Raphael's heirs. He acted as Raphael's secretary (hence his nickname of 'Il Fattore') and he probably controlled the use of the *cartoons in the workshop and translated Raphael's sketches into detailed working drawings. Many finished drawings connected with the Vatican Loggias and other workshop projects have been ascribed to him. According to *Vasari he was responsible for much work on the cartoons (1515–16; London, V&A) for the Sistine chapel tapestries, especially in their borders. After Raphael's death he collaborated with *Giulio Romano on completing existing commissions in Rome, and did some work at the Palazzo del Te in Mantua. He died in Naples.

He absorbed Raphael's style so completely that the extent of his contribution to several late Raphael paintings is unsettled, and he produced some works of his own in a correct Raphael style. The most famous such picture now attributed to Penni is the *Madonna del Passeggio* (Duke of Sutherland Coll., on loan, Edinburgh, NG Scotland). Unlike Giulio Romano, however, he never emerged from Raphael's overwhelming shadow, and he was incapable of operating as an independent artistic personality. AJL

Briganti, G., *La pittura in Italia: il cinquecento* (1989).

PENNY, EDWARD (1714–91). English painter. After training under Thomas *Hudson, Penny travelled to Rome in the early 1740s and studied under the decorative painter Marco *Benefial. In 1743 he returned

to England and by 1748 was an established portrait painter. In 1765 he exhibited the first of his paintings illustrating virtuous behaviour, *Lord Granby Relieving Distress* (Oxford, Ashmolean) at the Society of Artists. This was well received and was followed, in 1768, by *The Generous Behaviour of the Chevalier Bayard* (untraced), which proved equally popular and was widely distributed as an engraving. Although he continued to paint portraits Penny's reputation rests on these works of moral genre which reflected the shift from reason to sentiment exemplified in the work of the French painter *Greuze. In 1768 he became a founder member of the RA (see under LONDON), where he exhibited, in 1774, *The Virtuous Comforted by Sympathy and Attention* and its pendant *The Profligate Punished by Neglect and Contempt* (New Haven, Yale Center for British Art). His pupil William Redmore Bigg (1755–1828) adopted his subjects as did many Victorian *genre painters.　　DER

Wind, E., *Hume and the Heroic Portrait* (1986).

PEPO, CENNI DI. See CIMABUE.

PEREDA, ANTONIO (1611–78). Spanish painter, born in Valladolid. He moved to Madrid in 1627/8, where his precocious talent was recognized by G. B. Crescenzi, Italian nobleman and architect in Philip IV's court. Pereda's first dated work is *The Relief of Genoa* (1634; Madrid, Prado), painted for the Salón de Reinos of the Buen Retiro Palace. After his protector's death in 1635, he worked only for religious institutions and private patrons.

Pereda's refined technique and detailed transcription of reality are at their best in his large and abundant *Vanitas* of *c.*1634 (Vienna, Kunsthist. Mus.). Later still lifes (1651; Lisbon, Mus. Nacional de Arte Antiga; 1652; St Petersburg, Hermitage) also forsake the austere simplicity and isolation of the component elements typical of Spanish *bodegones, interlocking instead numerous objects in dynamic compositions. Pereda's religious paintings also display an intense observation of nature. His *S. Jerome* (1643; Madrid, Prado) achieves its expressive force through the realism with which the aged saint and his attributes are rendered. From the 1650s until his death, Pereda's style did not undergo major changes.　　NAM

Brown, J., *The Golden Age of Painting in Spain* (1991).
Mallory, N. A., *El Greco to Murillo: Spanish Painting in the Golden Age: 1556–1700* (1990).

PEREDVIZHNIKI, a Society of Travelling Art Exhibitions (Wanderers; Itinerants) and Russia's first independent artistic association. It was formed in 1870 by a group of Moscow artists headed by Grigory Myasoyedov (1834–1911) and Nikolay Ge (1831–94) and was joined by members of the Artists' Cooperative ('Artel') (which had seceded from

the Imperial Academy in 1863), notably Ivan Kramskoy (1837–87), who with the critic Vladimir Stasov (1824–1906) became its principal ideologue. Established against a background of academic autocracy, state censorship, and fierce controversy over Russia's cultural destiny, the Peredvizhniki held 48 exhibitions 1871–1923, realizing the aspirations of the liberal intelligentsia for a progressive, national school of art, and addressing contentious issues in a critical manner. It also widened the social audience for art by touring its brand of accessible realism to the provinces, stimulating artistic debate and spurring the establishment of art schools and galleries. Much Peredvizhnik art, like Nikolai Yaroshenko's (1846–1898) *Convict* (1878; Moscow, Tretyakov Gal.) or Sergey Ivanov's (1864–1910) *Death of a Migrant Peasant* (1889; Moscow, Tretyakov Gal.) was broadly reformist, addressing political and social inequalities, but the school was far from programmatic. Depictions of the harsh lives of the peasantry (from which many of its members came), the fate of political activists, images of the nation's cultural reformers, such as Kramskoy's *Portrait of Leo Tolstoy* (1873; Moscow, Tretyakov Gal.), and historical canvases professing critical analogies to the present, sat incongruously with the nationalist sentiments embodied in Russian landscapes and the Romanticism, myth, and folklore of the Neo-Slavic movement. Stylistically the school adhered to an academic realism; its innovation lay in the treatment of new and frequently controversial themes, although many of its chief practitioners, such as *Repin, Vasiley Surikov (1848–1916), Valentin Serov (1848–1916), and Isaak Levitan (1860–1900), also proved themselves alive to aesthetic experimentation. Eclipsed by the *avant-garde during the early Revolution, the Peredvizhniki were revived and repackaged by Stalinist commentators as precursors of Soviet Socialist Realism, an historical misrepresentation from which this bold, progressive, and genuinely popular school still suffers.　　DJ

Nesterova, E., *The Itinerants* (1997).
Valkenier, E. K., *Russian Realist Art* (1991).

PEREIRA, MANUEL (1588–1683). Portuguese sculptor active chiefly in Spain. Born in Oporto, Portugal, the sculptor first appears in Spain in 1624 at Alcalá de Henares. He worked both in wood and stone, producing figures for retables and façades, but he seldom carved reliefs or designed the architecture for his projects. Although many of his important pieces are now destroyed, the substantial number which survive attest to his extensive output. Among his most famous works are the four crossing figures for S. Plácido (Madrid) and two versions of S.

Bruno (*c.*1635; Burgos, Charterhouse of Miraflores; 1652; Madrid, Academia de S. Fernando). Clothed in graceful draperies, these elongated figures with fine, delicate features show Pereira working at his best. The images of S. Bruno, lost in profound meditation, are among the most striking examples of Spanish *Baroque religious art, and, according to *Palomino, Philip IV would always stop to admire the version in Madrid as he passed by.　　PL

Martín González, J. J., *Escultura barroca en España 1600–1770* (1983).

PERFORMANCE ART, a term which arose in the late 1960s in an attempt to account for an increasingly diverse range of forms taken by art in that decade. Performance art combined elements of theatre, music, and the visual arts; its deliberate blurring of previously distinct aesthetic categories was intended to focus attention on the relationships between artist, work, and spectator, and to question critical judgements about what does or does not constitute art. In its hostility towards *formalism, Performance art related to other contemporary movements, including *Conceptual art and *Environmental art. It was also closely connected with 'happenings' (the two terms are sometimes used synonymously), but Performance art was usually more carefully planned, and generally did not involve audience participation.

The origins of Performance art can be traced back to movements such as *Futurism, *Dada, and *Surrealism, whose members often staged humorous or provocative events to promote their works and ideas. Other precedents for Performance art include the activities of Georges Mathieu (1921–), who painted in front of audiences in the 1950s, and of Yves *Klein, who directed nude models smeared with paint in the early 1960s. However, it was from the later 1960s onwards that the term gained currency, soon covering an extremely wide variety of applications, ranging from the stage shows of contemporary composers such as Laurie Anderson (1947–) and Frank Zappa (1940–93), to enormous works of *Land art such as *Wrapped Coast* (1969) by *Christo.

Despite this diversity, common theoretical principles can be discerned amongst many manifestations of Performance art. The most important of these is the negation of any distinction between artist and work of art. Examples of this include: *How to Explain Pictures to a Dead Hare* (1965; Düsseldorf, Schmela Gal.), by Joseph *Beuys, in which the artist sat with a dead hare cradled in his arms, his face covered in gold leaf; and *The Singing Sculpture* (1969; various locations) by *Gilbert and George, in which, their faces also covered in gold paint, the artists sang 'Underneath the Arches' non-stop for eight hours. This work

gained much of its effect from another important aspect of Performance art, which was the foreseen—and often extreme—discomfort of the performer, another example of which was *Twenty-Four Hours* (1965; various locations), by Beuys. In this piece, he stood on a white box for 24 hours, performing a complicated series of actions with objects held out at arm's length. OPa

PERGAMUM. The Attalid kings made Pergamum an important centre for the production and collection of art, especially sculpture, casting their city as the protector of Hellenic culture and heir to Classical Athens (to which they provided multiple benefactions, e.g. the Stoas of Attalus and Eumenes). To commemorate triumphs over invading Celts (also known as Gauls, Galatians), they erected multiple monuments both at home and throughout Greece, seeking to inscribe their victories into the nexus of traditional mythological and historical exploits. They also commissioned portraits of famous men, copies of Classical works, and collected 'old master' paintings and mosaics.

Original Pergamene bronze sculpture is lost, but many works are mentioned by ancient writers, who praise their creators, both locals and foreigners, who are also named on fragmentary inscribed stone bases. Excavations on the Pergamene acropolis from 1878, however, have recovered much of the so-called Great Altar of Zeus, erected by Eumenes II c.180 BC, now partially reconstructed in Berlin (Pergamum Mus.). Surmounted by an Ionic colonnade, the monument was dominated by a marble frieze, 120 m (394 ft) long and over 2.3 m (7½ ft) high, depicting the *Gigantomachy*, a traditional theme in which the Olympian gods, with the help of Hercules, father of Pergamum's founder Telephus, suppress the revolt of the monstrous race of giants, thus embodying the triumph of stability and reason over crude nature and wanton arrogance, and providing an allegory for Attalid victories. The disposition of Olympians apparently follows genealogical principles, perhaps derived from allegorical interpretations of Homer and Hesiod developed by Crates of Mallus, a scholar resident at the Attalid court. Inscriptions identify both divinities and giants (and also preserve the names of fifteen sculptors). The frieze is one of the finest examples of so-called *'Hellenistic baroque'*, its figures, some derived from earlier models, carved in extremely high relief dramatizing the turmoil of battle through bulging, strained musculature, violent movement, light and shadow, and expressive countenances that contrast with the serene dignity of the Classical style. Attention was also paid to details of costume, metalwork, and diverse textures, especially the feathers and scales of the winged and snake-and fish-tailed giants. The action of the conflict is closely integrated with the architectural setting as giants appear to climb the stairs leading to the altar platform, around which a smaller frieze, 1.58 m (5 ft) high, presents episodes from the life of Telephus. Here figures are carved to varying depths, while landscape elements and architectural details define the distinct settings of individual narrative scenes.

The exuberant Pergamene 'baroque' style is also apparent in several later marbles found throughout the Mediterranean. These attest to the widespread appeal of Attalid art and are often considered to reflect the appearance of lost bronze originals. The heavily restored Roman group of a suicidal barbarian chieftain supporting the dead body of his wife (Rome, Mus. Naz. Romano, ex-Ludovisi Coll.) and other expiring figures, e.g. the *Dying Gaul* (Rome, Capitoline Mus.) and under-life-size Amazons, giants, and Persians in Naples (Mus. Arch. Naz.), Venice (Mus. Arch.), and elsewhere are often (and perhaps over-optimistically) thought to copy Attalid monuments exactly. Pergamene art, like that of Classical Athens before it, however, was widely disseminated and came to be adopted and adapted by later artists, including the Rhodian carvers of the *Laocoön* (Vatican Mus.) and the Athenian Glycon (who signed the *Farnese Hercules*; Naples, Mus. Arch. Naz.), to suit the diverse needs of their own patrons, Romans in particular, to whom it appealed for its political connotations and appropriate subject matter, as well as aesthetic power. KDSL

Dreyfuss, R. (ed.), *Pergamon: The Telephos Frieze from the Great Altar* (1996).

Hansen, E. V., *The Attalids of Pergamon* (2nd edn., 1971).

Pollitt, J. J., *Art in the Hellenistic Age* (1986).

Marvin, M., 'The Ludovisi Barbarians: History in the Grand Manner', in E. Gazda (ed.), *The Ancient Art of Emulation: Studies in Originality and Tradition from the Present to Classical Antiquity* (2000).

PERINO DEL VAGA (1501–47). Florentine painter, a pupil of *Raphael who worked principally in Rome and Genoa. After studying in Florence Perino left in about 1517 for Rome, where he worked in Raphael's studio on the decoration of the Vatican Loggias. Raphael's influence, as well as that of *Michelangelo, is particularly evident in early works of the 1520s, such as the frescoed vaults of the Pucci chapel in S. Trinità dei Monti. During a brief stay in Florence (1522–3) his cartoon of the *Martyrdom of the Ten Thousand*, now lost, but known through a preparatory drawing (Vienna, Albertina), caused a sensation as an example of the new Roman manner. Following the Sack of Rome he moved to *Genoa (1528–33), where he worked mainly for Andrea Doria decorating the family palace with scenes of classical history and mythology. In the Sala Paolina in the Castel S. Angelo, completed shortly before his death, Perino brilliantly evokes the imagined grandeur of Antique Roman decorations, with scenes from the life of Alexander painted as if cast in bronze, among richly coloured columns and illusionistic sculptures. HCh

Armani, E. P., *Perino del Vaga l'annello mancante* (1986).

PERIODIZATION denotes the division of history into periods, and art historians have imposed order on the flux of time by such traditional periodizations as medieval, *Renaissance, *Baroque, *Romantic, and modern. In the early 20th century such classifications tended to depend on formal analysis, and on the establishment of the hallmarks of a period style that seemed homogeneous and autonomous. In recent years there has been a greater emphasis on diversity, on contextual issues, and on socioeconomic patterns. HL

PERMEKE, CONSTANT (1886–1952). Belgian artist, born in Antwerp. He studied at the Academies of Bruges and Ghent, where he met the painters de *Smet and van den *Berghe. Living in Laethem-St-Martin 1909–12, he became a member of the Second Laethem Group of Flemish *Expressionists. He was wounded in the First World War, and evacuated to England, where, from 1916, he painted his first major Expressionist works, for example *L'Étranger* (1916; Brussels, Mus. Royaux). Returning to Belgium in 1918, he lived first in Antwerp and then in Ostend. In 1929 he built himself a house in Jabbeke, near Bruges, which he named De Vier Windstreken (The Four Corners of the Earth). In 1935 he took up sculpture, and in 1959 his house was converted into the Permeke Museum. His subjects were taken mainly from the life of the coastal towns of Belgium, studies of sailors, fishermen, and peasants, conveyed with a massiveness and solidity that appears to express elemental forces, and to emphasize the pathos of the human condition. Permeke was a dominant figure in Belgian Expressionism and gained international recognition as one of the world's greatest Expressionist artists. OPa

Avermaete, R., *Permeke* (1970).

PERMOSER, BALTHASAR (1651–1732). German sculptor best known for his contribution to the decoration of the Zwinger Palace in Dresden. He trained in Florence with Giovanni Battista *Foggini, making small works in ivory as well as large-scale stone statues. In 1690 he went to Dresden to work for the Elector of Saxony. He remained there for the rest of his career, supplying small-scale sculptures, models in the *Rococo style for the Meissen porcelain factory,

and collaborating with the court goldsmith Dinglinger, as well as working on monumental figures. Although little of the vibrant and graceful late *Baroque sculpture at the Zwinger (from 1712) was actually carved by Permoser, his was the invention, since he supplied drawings and models to the team of craftsmen responsible. Permoser's collaboration with Pöppelmann on the Zwinger was one of the happiest in its results of any between a sculptor and an architect. MJ

Asche, S., *Balthasar Permoser: Leben und Werk* (1978). *Barok in Dresden*, exhib. cat. 1986 (Dresden, Staatliche Kunstsammlungen; Essen, Villa Hügel).

PERRÉAL, JEAN (c.1450×60–1530). Painter, illuminator, designer, and architect, the most renowned French artist of his time. He was painter and *valet de chambre* to three French kings, Charles VIII, Louis XII, and François I. He was an acclaimed and sought-after portraitist, even commissioned by Francesco II Gonzaga, Marquis of Mantua, by 1499; his skill and naturalism in this field can best be seen in the portrait of the poet Pierre Sala that decorates a collection of Sala's verses (c.1500; London, BL, Stowe MS 955, fo. 17ʳ). Perréal wrote poetry himself that was highly praised by his contemporaries and he provided an allegorical miniature to accompany his verse on alchemy (c.1515; Paris, Bib. S. Geneviève, MS 3220) dedicated to François I. Like many artists in the employment of rulers, Perréal designed the decorations for festivities and ceremonies. He visited Italy several times, studied Roman remains, and the influence of Antiquity and his knowledge of contemporary Italian painting modified his style. His interests, including astronomy, were recorded by *Leonardo da Vinci, while Jean Lemaire de Belges praised his topographical studies and surveying skills. In 1514 he was sent to England to negotiate the marriage of Louis XII to Mary Tudor and to check on Mary's fashion sense. Perréal had collaborated with Michel *Colombe on the tomb for the parents of Anne of Brittany and he was initially involved in Margaret of Austria's project to build a foundation at Brou. Throughout his life he undertook the inspection and restoration of buildings. KC

Sterling, C., 'Une peinture certaine de Perréal enfin retrouvée', *L'Œil* (1963).

PERRONNEAU, JEAN-BAPTISTE (1715–83). French portrait painter. He usually worked in pastels and it is unfortunate that he came to maturity when Maurice-Quentin de *La Tour dominated the Paris scene. Perronneau's pastels are less obviously virtuosic than La Tour's in execution and though he has sometimes been accused of lacking insight into character this would be better glossed as his having less of a predilection for quirks of expression. Such pastels as *Mme Chevotet* (Orléans, Mus. des Beaux-Arts) convey a convincing substantiality of human presence. His skills as a painter in oils have also been misunderstood because of the ubiquity of reproductions of his rather sentimental *Girl with a Kitten* (1745; London, NG). He is better judged by the penetrating Dublin *Portrait of a Man* (1766; NG Ireland), which has been compared to the portraits of *Goya. No doubt it was the difficulty of competing with La Tour which sent him on journeys to Holland and to Russia. HO/MJ

Vaillat, L., and Ratouis de Limay, P., *J.-B. Perronneau, sa vie et son œuvre* (1923).

PERSPECTIVE (1) *Introduction;* (2) *The meaning of the word;* (3) *The scientific basis of the perspective image;* (4) *The psycho-physiological basis of perspective illusion;* (5) *Clues for the perception of depth;* (6) *Some facts and definitions for the theory of central perspective, given for the vertical position of the picture plane;* (7) *The perspective constructions of Brunelleschi and Alberti;* (8) *Principal types of perspective, scientific and otherwise;* (9) *Measuring in perspective;* (10) *Marginal distortions;* (11) *The theory and the role of vanishing points and Desargues's Theorem;* (12) *The distance point or three-point construction;* (13) *Spherical perspective;* (14) *Perspective in Antiquity;* (15) *Classical optics: Euclid on perspective phenomena;* (16) *Euclid's Proposition 8;* (17) *Perspective in Byzantine art;* (18) *Perspective in post-classical and medieval Western painting;* (19) *The revival of perspective;* (20) *Medieval optical studies;* (21) *Brunelleschi;* (22) *Perspective in the North;* (23) *Perspective in modern times*

1. INTRODUCTION
In the context of pictorial and scenic art the term 'perspective' may refer to any graphic method, geometrical or otherwise, that is concerned with conveying an impression of spatial extension into depth, whether on a flat surface or with form shallower than that represented (as in *relief sculpture and theatre scenery). (See also AERIAL PERSPECTIVE.) Perspective representation or composition results when the artist adopts a visual approach to drawing and consequently portrays perspective phenomena such as the diminution in size of objects at a distance and the convergence of parallel lines in recession from the eye. Western painting started to develop along optical lines first in Greece and received a geometrical bias from its early association with the optics of classical Antiquity. The illusion of the dimension of depth has been its distinguishing characteristic and to this end geometrical perspective one of its principal aids. The idea of the single static focus of *Renaissance perspective and the characteristic system of central convergence (see below) owed much to the recurrence of themes demanding the representation of interiors. The only other highly developed pictorial tradition in which spatial values are paramount, i.e. the Chinese, evolved on the other hand principally from landscape and took for granted a travelling eye. Hence Chinese artists with rare exceptions adopted the convention of parallelism when they represented buildings, a system which, although denying the optical principle of the convergence of receding parallels, yet had the virtue of allowing the eye to glide easily from scene to scene.

2. THE MEANING OF THE WORD
The word 'perspective' derives from the Latin (*ars) perspectiva*, a term adopted by the Roman philosopher Boethius (d. AD 524) when translating Aristotle to render the Greek *optiki* (optics). In the 15th century 'perspective' came to mean seeing through a transparent plane on which the scene is traced from a single fixed eye-point. It then became in Latin *perspectiva artificialis* or *perspectiva pingendi* to distinguish it from the older science *perspectiva naturalis* or *communis*.

3. THE SCIENTIFIC BASIS OF THE PERSPECTIVE IMAGE
Scientific perspective, known variously as central projection, central perspective, or picture plane or Renaissance or linear or geometrical perspective, may be regarded as the scientific norm of pictorial representation. The story of its development belongs as much to the history of geometry as to that of painting. It is the perspective of the pin-hole camera and (with certain reservations as regards lens distortion) of the *camera obscura and the photographic camera. It derives from geometrical optics and shares with that science its basis in physics: the rectilinear propagation of light rays. In central perspective the picture surface is regarded as a transparent vertical screen (the picture plane), placed between the artist and his subject, on which he traces the outlines as they appear from a single fixed viewpoint. Ideally such a picture, suitably coloured and seen with one eye from the correct point, should evoke the illusion of the real scene viewed through a window. 'Perspective', wrote *Leonardo, 'is nothing else than seeing a *place* (sito) behind a pane of glass, quite transparent, on the surface of which the objects which lie behind the glass are to be drawn. They can be traced in pyramids to the point in the eye and these pyramids are intersected by the glass plane.' The 'pyramids' are composed of the light rays which link the visible surfaces of objects to the eye by straight lines called *visual rays*. Their points of intersection with the transparent plane (the picture plane) form the perspective image.

4. The psycho-physiological basis of perspective illusion

The eyeball is a little dioptric camera and receives projected images of the outside world upon its interior surface. This is a light-sensitive membrane called the retina. Images are formed by the projective action of light. When light passes through a small hole the rays behave like straight lines intersecting in a point. The images of the pin-hole camera, the camera obscura, the photographic camera, and the eye all depend on this phenomenon. The image-screen intercepts the rays. No point of it receives light from more than a single point of the object. When the hole is enlarged to admit more light and give brighter images, a divergent beam of light from each object point enters the camera. It is the function of the lens to correct this divergence and to concentrate the beam onto the screen or retina.

We may assume for our purpose that each object point is linked to its representation on the retina by one straight line, called a *direction line* or *line of sight*. Although in normal circumstances the eye moves continuously in its orbit, when a number of object points are involved all the direction lines may for practical purposes be considered to cross at a nodal point within the eye, very near the centre of rotation. This point is the 'eye' or *centre of projection* of perspective.

Fig. 3

When a luminous point A moves along a direction line, its perspective on the picture plane (A′) and its retinal image (a) all remain in coincidence provided the head is kept still, even though the retinal image continuously moves over the surface of the retina. Thus the point A′ on the picture plane is the perspective of every point in the same direction line AA, and all points on AA give equal stimuli

and hence give rise to identical perceptions. This is why the eye can be deceived and is the basis of perspective illusion. There is ambiguity inherent in all images. In order that a three-dimensional object be correctly represented to the beholder he must know what the object is.

5. Clues for the perception of depth

The retinal image is two-dimensional and can convey to the brain only directional messages about the location of objects in space. The points of stimulation can tell us nothing directly about distance or absolute size. But in binocular vision *the fusion* of two dissimilar images presents to consciousness a three-dimensional pattern that gives us very accurate judgements of distance quite impossible of achievement with one eye. Stereoscopic perception, however, ceases at a certain distance from the eyes. In monocular vision, and in binocular vision at distances in excess of about 15 m (50 ft), the perception of depth depends upon indirect factors. These are *clues for the third dimension*, which may be grouped into nine classes. Five of them are used by painters to create an impression of depth by their flat pictures: overlapping contours; linear perspective; aerial perspective; distributions of light and shade (the direction of light being known); interpretation of size (the judgements of absolute size and distance are interrelated). Four other clues work against the impression of depth in pictures: parallactic movements; muscular efforts of accommodation and of convergence; stereoscopic influence of dissimilar images.

6. Some facts and definitions for the theory of central perspective, given for the vertical position of the picture plane

In Fig. 4:

E is the eye: the centre of perspective or projection.

PP (i.e. the plane AZRT) is the *picture plane*. It is of indefinite extent (as are the other principal planes), and in its usual position is perpendicular to the ground plane.

GP is the horizontal *ground plane*. The 'height' and 'distance' of the eye are measured from these two planes.

GL, the *ground line*, is the *intersection line* in which the picture plane and the ground plane meet.

HL, the *horizon line*, is the line in which the horizontal plane containing the eye meets the picture plane. It is the *vanishing line* of the ground plane and of all other horizontal planes and is the locus of the vanishing points of all horizontal lines.

C is the *central or principal vanishing point*: the point of convergence of the perspectives of all *orthogonals*, i.e. horizontal parallel straight lines of indefinite extent that meet the picture plane at right angles, such as L, Q, M, N. (Orthogonals are parallels that are objectively perpendicular to the picture plane. Their perspectives converge to a point exactly opposite the eye of the artist.)

S is the *station point*.

EC is the *central ray* from the eye drawn perpendicular to the picture plane and therefore parallel to the orthogonals.

C and D are examples of *vanishing points*, of which there can be an indefinite number. They are found by drawing a line from the eye parallel to the given line or system of parallels. Thus EC and ED are drawn parallel to AQ and AB respectively.

In order to draw the perspective of a given line of indefinite extent, it is sufficient to know its vanishing point, such as C or D, and the point in which it meets the picture plane, such as A, Y, Z. These points are called the *intersection points* or near ends of the given lines. In perspective each group of parallels is drawn to a single, particular vanishing point.

DD are *distance points*. They are the vanishing points of horizontal straight lines that make angles of 45° with the picture plane, such as the line AB, whose perspective is contained in AD, and are the same distance from C as the eye: hence their name. They are traditionally used for measuring in perspective along orthogonals and may be regarded as the earliest *measuring points*.

7. The perspective constructions of Brunelleschi and Alberti

*Brunelleschi is generally acknowledged to have been the originator of the first construction of scientific perspective. Of his actual construction, which must date from about 1420, there is no detailed contemporary record. From *Vasari's life of Brunelleschi we learn only that he invented an ingenious system that included a plan and elevation and an intersection and that by the aid of this he painted the two famous panels (now lost) representing the Florentine baptistery of S. Giovanni and the Signoria. This was presumably similar to the construction given in Fig. 5. It is a mechanical system based exclusively on the principle that visual rays are straight lines. These are represented in plan and elevation by the lines joining selected points of

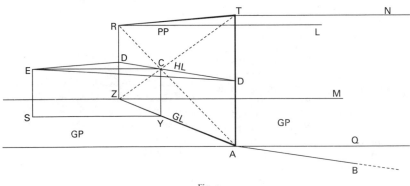

Fig. 4

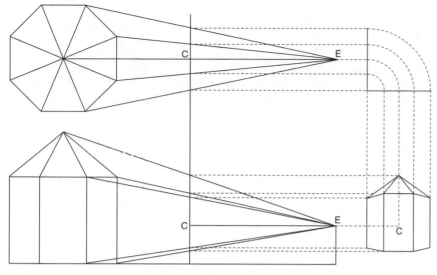

Fig. 5

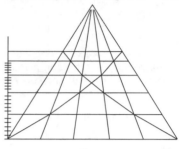

Fig. 7

by drawing a diagonal across the foreshortened grid to show that the diagonals of the individual squares formed into continuous straight lines (Fig. 6), just as in a real chequerboard. For if an artist drew the foreshortening by some arbitrary method, such as that of making each successive space between transversals a constant fraction of the preceding one (Fig. 7), the diagonals would not

lie in straight lines. 'Those who would do thus would err,' wrote Alberti. Perhaps this is why Alberti's system is usually known as the *costruzione legittima*, a term of modern Italian origin. Some authors, however, apply this term also to Brunelleschi's construction. Alberti's construction is most commonly found in the abbreviated form in which the two diagrams are combined into one (Fig. 8). (For

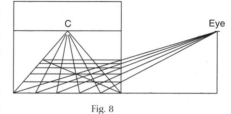

Fig. 8

an example of curved diagonals see the tiled floor in Giovanni di Paolo's painting *The Presentation* (c.1448; Siena, Pin.).)

8. PRINCIPAL TYPES OF PERSPECTIVE, SCIENTIFIC AND OTHERWISE

(a) *Parallel perspective*
The term may refer to parallelism, i.e. the representation of parallels as parallel (Fig. 9),

Fig. 9

which is a non-scientific form and when found in early painting may be regarded as an *ideoplastic element. In combination with the high viewpoint it is a traditional convention of Chinese painting. It is also a convention of modern stereometry. The term may

the object to the eye. The points of intersection which form the image of the visual rays with the picture plane are first found on the plan and the side elevation and from there are transferred to some part of the paper representing the picture surface by the method of rectangular co-ordinates. The mechanical principle of Brunelleschi's construction is exemplified in *Dürer's woodcut *Draughtsmen Drawing a Lute* (1525). The ring in the wall is the 'eye' and the mobile thread serves for the visual rays. While one artist directs the ray to the selected points on the lute, his companion notes the points in which the ray passes through the frame, i.e. the picture plane, and transfers them one by one to the drawing board. The plan and elevation construction with visual rays was particularly suitable for drawing individual architectural or geometrical forms of some complexity and was used for this purpose notably by *Uccello and *Piero della Francesca. The latter applied it also to the drawing of heads. It did not include the use of vanishing points.

Shortly after Brunelleschi made his perspective demonstrations his fellow architect *Alberti devised a perspective construction for the special use of painters, which he described in detail in his famous treatise *Della pittura* (1436), written first in Latin (1435) and then immediately in Italian for his friend Brunelleschi and the avant-garde artists of

Florence (Fig. 6). This is the first known written account of a fully scientific perspective construction. He chose for demonstration a simple squared floor or chequerboard pavement that became in perspective the ground plane of the picture and could be extended, he wrote, 'almost to infinity'. Furthermore, it could easily be elaborated into a three-dimensional grid for measuring heights in perspective. Its primary aim was to enable the history painter to locate and measure in perspective all the figures and objects in his picture, which would then appear to the spectator placed at the predetermined viewpoint as a real scene viewed through an open window: for 'he who looks at a picture done as I have described', wrote Alberti, 'will see a certain cross-section of the visual pyramid'. Alberti's method included the use of a vanishing point for the orthogonals, his 'centric point' (C). This enabled him to dispense with a ground plan. The artist could set to work straightaway on his panel, mark in the squares along the base line, and join up the orthogonals to the centric point, placed centrally at the height of a man represented in the picture standing on the base line. For regulating the measurements in depth, i.e. for spacing his transverse parallels, he drew, like Brunelleschi, a separate side elevation with visual rays and vertical intersection. Finally he proved his perspective to be correct

Fig. 6

also refer to the case in scientific perspective when the picture plane is parallel to a principal surface of the object (Fig. 10), as is commonly found in Renaissance pictures. Then none of the parallels of the frontal surface

Fig. 10

converge, but if the object is rectangular, for example a house or room, the parallels in depth become orthogonals and converge to a central vanishing point.

(b) *Angular or oblique perspective*

A term of scientific perspective used when a rectangular form is represented at an angle to the plane of the picture such that its horizontal parallels recede into depth to the left and the right, thus requiring two vanishing points, but its verticals remain parallel to the picture plane (Fig. 11).

Fig. 11

(c) *Three-point or inclined picture plane perspective*

A term of scientific perspective used with regard to a rectangular form placed so that none of its sides is parallel to the picture plane and the three groups of parallels vanish each to its respective vanishing point (Fig. 12). Three-point perspective may also refer to the distance point construction.

Fig. 12

(d) *Axial perspective*, also called *vanishing* or *vertical axis perspective*

This is the earliest systematic form of punctual convergence and is much in evidence before the invention of scientific perspective.

Fig. 14

In its original form it is simply the symmetrical convergence of parallels to points on a central vertical axis taken mirror-like right and left in pairs, and as such is a form of parallelism (Fig. 13*a*). Early examples are to be seen in the drawing of the parallel beams of

Fig. 13a Fig. 13b

ceilings. They are first found on Apulian Greek vases (see GREEK ART, ANCIENT) of the 4th century BC. There are variations of this construction which persist through Antiquity and the Middle Ages and even survive the Renaissance. In many cases the central pair of beams meets unrealistically on the posterior border of the ceiling in a V, and sometimes artists disguised this with a *cartouche or a nimbus. Often the central meeting point was placed out of sight and some degree of convergence was given to the outside parallels (Fig. 13*b*). But always the spacing of the central section was unrealistic. The same principle was applied to the drawing of walls and floors, and led in this case to an inconvenient encroachment upon one another of neighbouring planes.

Why was this method universally preferred to the simpler device of the single vanishing point? Indeed, central convergence is

virtually never found before the 15th century except in one brief period of *Pompeian painting and then only in the upper parts of the pictures. The answer to this question may be found in the way in which we actually perceive parallels. Recent experiments have proved that we do not normally perceive more than two objective parallels as though they are directed towards a common point. The more a pair of parallels is situated towards the left or right the less the degree of apparent convergence will be, a fact that agrees with modifications of the axial construction as found in some pictures. This principle was presumably known to artists in a general way through direct observation, and it deterred them from using one single convergence point for the whole group of parallels until central convergence was demonstrated with the aid of a projection plane and a fixed eyepoint and shown to be 'scientific'. There may also have been a theoretical justification for the axial construction in the Euclidean theory of visual angles (see below). If the visual rays are projected onto subtended arcs and dimensions transferred from the arcs or their chords to the picture plane, the resulting perspective of a centrally viewed rectangular interior approximates to a vertical axis construction (Fig. 14).

(e) *Inverted perspective*

For the representation of rectangular foreground objects 'inverted perspective' is the common rule in pre-Renaissance painting (Fig. 15). Although it contradicts scientific

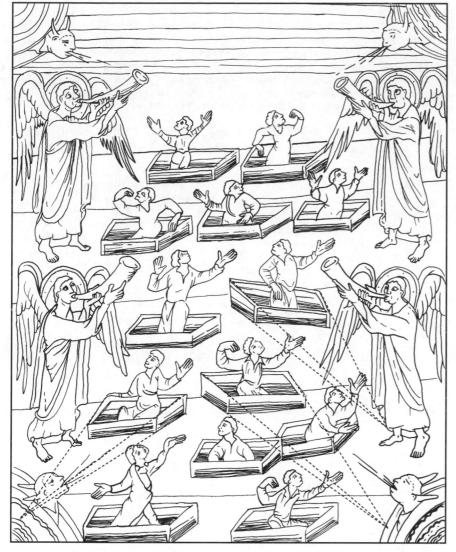

Fig. 16. *Last Judgement*. Tracing of an Ottonian miniature from the *Book of Pericopes* of Henry II (Bayerische Staatsbibliothek, Munich, early 11th century). Dotted perspective lines added

Fig. 17. Illustration from *Underweyssung der Messung* (1525), Albrecht Dürer

the purpose of drawing a diagonal floor-grid (Fig. 18). It is a system without a central vanishing point and is thought to be a workshop

Fig. 18

tradition associated with the *Giottesque perspective of the trecento. It is the construction given by Pomponius *Gauricus in his *De sculptura* (printed in Florence, 1504). A famous example may be seen in the *sinopia* (in *Frescoes from Florence*, exhib. cat. 1969, London, Hayward) of Uccello's *Nativity* fresco at Florence (S. Martino della Scala). It may also refer to the examples of angular perspective given by Viator (Jean Pélerin) in his *De artificiali perspectiva* (1505), the first treatise on perspective printed in Europe and called by him *perspectiva cornuta* or *diffusa*.

9. MEASURING IN PERSPECTIVE

There can be no measuring in perspective in the strict sense of the term (i.e. the establishment of a two-way metrical relationship between a given object and its representation on the picture plane) unless the relative positions of the eye, the picture plane, and the object to be represented are given. In Fig. 19

Fig. 19

the problem is set out in two dimensions. E is the eye, AB the object, EB and EA are visual

Fig. 15

perspective and seems wrong to modern eyes, there is a basis for it in experience. The fact that we do not easily see convergence in foreground objects but rather parallelism or even divergence of parallels can easily be verified by observation. But experience may have been reinforced by a naive interpretation of the visual ray theory. The divergent construction is abundantly exemplified in an Ottonian early 11th-century *Last Judgement* (Fig. 16). (Munich, Staatsbib.). The universal acceptance of central convergence belongs essentially to the age when science acquired overriding authority.

(f) Negative perspective
A term used to describe the application of lines of sight to the adjustment of proportions in large-scale decorations, paintings, or statuary in order to counteract the perspective effect of the more remote parts. In Dürer's example (Fig. 17) all the letters will appear equal to an observer placed at the viewpoint because they have been designed to subtend equal angles at the eye. Plato refers to such a procedure employed by Greek artists of his time (*Sophistes* 236).

(g) Bifocal perspective
This is a term for an empirical construction that uses two vanishing points placed symmetrically on the margins of the picture for

rays, and *Ab* is the perspective measurement of AB. It is clear that this situation could not exist before the invention of the picture plane (by Brunelleschi, as far as is known). Examples have been found, however, both in Pompeian painting and in the work of Giotto, in which the representation of a coffered ceiling appears to have been correctly *foreshortened* (not the same as *measured* in the strict sense). The artist may have arrived at his result from a drawing in plan by means of a simple intuitive development. This could proceed in four steps (similar to Fig. 20) once he had decided to converge his orthogonals to a central point. Such a drawing might appear to be the result of a distance point construction, since the protracted diagonal

(1) (2)

(3) (4)

Fig. 20

would meet the horizon line in a point coincident with a distance point, given a certain position for the eye. But there is no evidence to justify the conclusion that the perspective of either Giotto or the Pompeian artists was other than intuitive.

There are basically two methods of measuring in perspective, (i) by the visual ray and section system of Brunelleschi and Alberti; and (ii) by the modern method of measuring points, a simple geometrical device of great utility which first appears in print in *La Perspective spéculative et pratique du Sieur Aléaume*, edited by Étienne Migon (1643). Both Migon and Aléaume were professional mathematicians. Distance points are the measuring points for orthogonals and are a particular case of the general rule as described in all modern handbooks.

10. MARGINAL DISTORTIONS

In geometrical optics the apparent sizes of objects are shown to be proportional to the visual angles they subtend at the eye. Because of this objects appear to decrease in size in all directions as they recede from the eye. An angle is measured by its subtending arc, but perspective produces flat projections on a plane. This inevitably leads to discrepancies between angular size and projected size. But when a flat projection is viewed

from the projection centre the angular dimensions are restored by the natural foreshortening of the picture plane. This is the principle of *anamorphosis. Two well-known paradoxes arise from this situation. Planes parallel to the picture plane have unforeshortened perspectives however far they recede from the eye. Suppose A and B (Fig. 21)

Fig. 21

to be a plan or elevation of two equal windows in a wall parallel to the picture plane, with the eye at E. B is seen under a smaller angle than A, yet the perspective projection B is equal to that of A, because it forms similar triangles. This is why the façade of a building drawn frontally in perspective is a true elevation. The second paradox concerns solids. A and B (Fig. 22) are two solids seen from E. B

Fig. 22

produces the greater intersection yet it is seen under a smaller angle than A. Such discrepancies are particularly noticeable in the case of objects of known regularity: par excellence the sphere, which in perspective retains its familiar circular outline only when its centre coincides with the central vanishing point. If A and B were two spheres the perspective of B would be elliptical in outline. Some painters have been in doubt whether they should draw in conformity with the plane projections or with the visual angles. Figure 23 (opposite) is from a 17th-century French manual which insists that in order to avoid a double foreshortening of the image the former should be the case (A. *Bosse, Traité des pratiques géométrales et perspectives*, 1665). In *Raphael's *School of Athens*, a famous example, the architecture is drawn from a central viewpoint while the figures have in each case been drawn from a viewpoint in front of them, in fact possibly from life studies. This shifting of viewpoint is particularly observable in the case of the sphere held by the astronomer Ptolemy which, although eccentrically placed, shows no sign of marginal distortion. This method is a practical solution to the perspective problem of large-scale wall paintings.

In order to keep discrepancies within tolerable limits it has always been the practice

amongst artists to work within a narrow angle of vision whenever possible: ideally between 30° and 60° or so. Most paintings are designed to be viewed from a distance of not less than their major dimension, giving a viewing angle of about 60°. When the angle of vision is small every visual ray will be nearly perpendicular to the picture plane. Then the perspective projections will most nearly correspond to the subtending arcs and marginal distortions be minimized.

11. THE THEORY AND THE RULE OF VANISHING POINTS AND DESARGUES'S THEOREM

The perspective of a given line is normally considered to be contained between its intersection point or 'near end' (the point which is its own image) and its vanishing point. The validity of these two points is established respectively in two theorems of theoretical solid geometry: the Vanishing Point Theorem and Desargues's Theorem. These form the basis of perspective geometry.

The theory of vanishing points may be explained in simple terms as follows: In Fig. 24

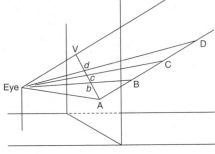

Fig. 24

the eye is looking through a sheet of glass at two parallels. The upper parallel produced through the glass passes through the eye and therefore appears as a point at V on the glass. A plane containing our two parallels will obviously intersect the glass in the line VA and if we take a series of points B, C, D, etc., on the lower line, these will appear as a series of points b, c, d, etc., where the lines joining B, C, D, etc., to the eye meet AV. As the points on the lower line recede from A they will appear to approach V on the glass and if we conceive of a point on our line at a very great distance from A it will appear on the glass so inconceivably close to V as to be coincident with it, so that V is called the vanishing point of that line. And similarly for any other line parallel to A and V.

From this we have the useful rule: the vanishing point of a given line is that point where the line from the eye drawn parallel to the given line meets the picture plane. 'Vanishing point' is a modern term and a misleading one, for it is not the point on the picture plane that vanishes but the point that it represents. In general usage the term has

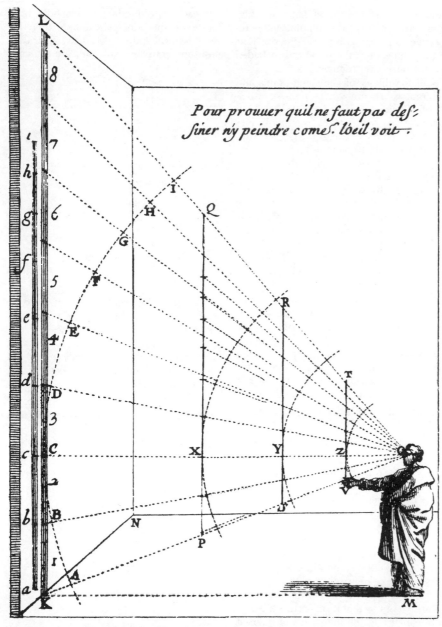

Pour prouuer quil ne faut pas def=
finer ný peindre come^c löeil voit .

Fig. 23. Illustration from *Traité des pratiques géometrales et perspectives* (1665), A. Bosse

an elaborate application of the theory of similar triangles.

The 15th century named only the *centre point*, to which the 16th century added *distance points* and *particular* or *accidental points*. The true antecedent of the modern vanishing point is the *punctum concursus* (point of concurrence) of Marquis Guidobaldo del Monte of Pesaro. This distinguished man of science, pupil of Federigo Commandino, the famous translator of Euclid, was first to formulate the general rule (*Perspectivae libri sex*, 1600). To Guidobaldo goes the distinction of being first to see that the line through the eye parallel to a given line is in the same plane with the given line and is the common line of intersection of all the planes containing the eye and the given parallels. But his exposition was repetitive and diffuse. It was the French mathematician and engineer Girard Desargues of Lyon, friend of Descartes, who first stated this important theory in clear, axiomatic terms. It was first printed in his *Méthode universelle* (1636). At the end of this pamphet (which describes an ingenious but mathematically unimportant perspective construction), Desargues appended in the manner of an afterthought a few paragraphs addressed not to the artists but to 'les contemplatifs' in which the vanishing point theory is expressed in terms that make a break with the past and herald the projective geometry of the modern age. The following extract deals with the case in which the given parallels are not parallel to the picture plane: 'When the given lines are parallel and the line from the eye is not parallel to the picture plane, the perspectives of the given lines all tend towards the point in which the line from the eye meets the picture plane, inasmuch as each of these lines is in a same plane with the line from the eye in which all these planes intersect as in their common axis and all these planes are cut by another plane, the picture plane' (Fig. 25).

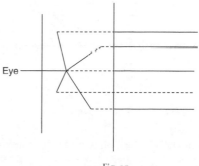

Eye

Fig. 25

Shortly after this Desargues enunciated the theorem that bears his name. And again, in 1639, he broke new ground when he defined a group of parallels as a pencil of lines whose vertex is at infinity. Desargues's Theorem states that when plane figures are in perspective corresponding lines are either parallel or

varied meanings. It may refer to a mere operational point of convergence in a picture. Furthermore there is no separate term for the 'natural' vanishing point—that imaginary point in the distance towards which receding parallels may appear to converge, or that 'point of diminution' (Leonardo's term) to which remote objects tend to diminish.

Brook Taylor, fellow of the Royal Society and famed amongst mathematicians for Taylor's Theorem, coined the English term 'vanishing point', which first appears in his *Linear Perspective* (1715). This is the first perspective handbook in the English language to be entirely founded on the principles of projective geometry. During the 18th century some excellent manuals were written based on 'Dr Brook Taylor's Method'.

Before 1600 there was no general theory and no general term for vanishing points. The points of convergence used by the Renaissance pioneers of perspective were operational points. They were without a theoretical proof and were used as postulates. Arguments in support of their validity were based on the direct experience of the eyes or on the visual ray theory: as an object recedes it subtends an ever smaller angle at the eye. For 'vision makes a triangle', wrote Alberti, and 'from this it is clear that a very distant quantity seems to be no larger than a point'. The results of the constructions using vanishing points were proved to be correct by empirical demonstration, for example by using the drawing frame or geometrically by

meet in a straight line (*Traité de la section perspective*, 1636). Corresponding lines are pairs of lines of which the one is the perspective of the other. The points in which they meet are called their intersection points and the line in which they meet is the intersection line of the picture plane and the object plane, i.e. the plane containing the plane figure (e.g. the ground plane) (see Fig. 26).

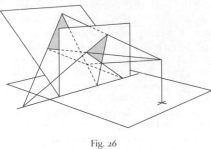

Fig. 26

Desargues's Theorem and its converse are of the first importance to mathematicians by reason of their complete generality. But in the limited field of pictorial perspective its conclusions tend to be self-evident and the perspective practitioner can afford to ignore it. It is, of course, foreshadowed in the type of construction that shows the ground plane 'hinged' to the picture plane along the ground line: for example in Guidobaldo's construction (see below), although in fact Desargues's Theorem had not yet been formulated. Guidobaldo's book contains the earliest constructions to be effectively based on these two theorems.

Fig. 27 is Guidobaldo's *First Method* and

Fig. 27

shows how a given triangle may be drawn in perspective by means of vanishing points and intersection points. The ground plane, containing the plan of the given triangle, has been rotated into the plane of the picture as though hinged on the ground line. The eye, and the parallels drawn from the eye that determine the vanishing points, are also represented in plan. The vanishing points in plan are transferred to the picture plane by

elevating them to eye level. Lines are then drawn from the intersection points to the respective vanishing points. The intersections of these lines form the perspective (shaded area) of the original triangle.

Both the theory of vanishing points and Desargues's Theorem are printed in A. Bosse's *Manière universelle de M. Desargues pour pratiquer la perspective* (1648). This book does not, however, make use of the general vanishing point construction in its practical examples. The theoretical advances in perspective did not reach the popular, vernacular handbooks until the 18th century, the age in which the classical ideal of beauty based on a mathematical order was already in the process of being challenged and the authority of perspective undermined. The quasi-empirical methods of the 15th and 16th centuries (summed up in Vignola's *Le due regole della prospettiva pratica*, 1583), lacking, as they did, the general rule for vanishing points, were entirely satisfactory for the needs of painters. And it is very doubtful if the *Baroque owed anything at all to Desargues and Guidobaldo. For example, the great *trompe-l'œil* ceiling of Andrea *Pozzo in the church of S. Ignazio at Rome was designed by the aid of 15th-century methods clearly described by the artist in his *Perspectiva pictorum et architectorum* (1693).

12. THE DISTANCE POINT OR THREE-POINT CONSTRUCTION
This is historically the most important construction after Alberti's *costruzione legittima* and is by far the best known. It is an interesting case of practice preceding theory and provides an easy way of measuring in depth along the orthogonals and of drawing a chequerboard of squares in parallel perspective.

A distance point is the vanishing point of lines that make angles of 45° with the picture plane. When a perspective line is drawn to a distance point so that it cuts across a pair of orthogonals (Fig. 28) the points of intersection define two diagonally opposed corners

Fig. 28

of a square drawn in parallel perspective. This is the key to a useful system for measuring into depth (Fig. 29) and is the easiest way of drawing a chequerboard.

Fig. 29

In each vanishing line, of which the horizon line is the principal example, there are two distance points placed symmetrically about its centre (Fig. 30). They are the same

Fig. 30

distance from this point as the eye; hence the origin of the term. Because the position of the distance point predetermines the distance of the eye and vice versa, the artist must choose the distance with discretion as it affects the character of the perspective drawing (Figs. 31*a* and *b*).

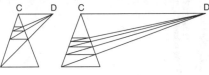

Fig. 31a Fig. 31b

The modern analysis shows that the lines from the eye, EC, ED (given in plan in Fig. 32),

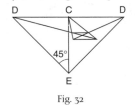

Fig. 32

which determine the vanishing points of the orthogonals and diagonals of the given square, form right-angled isosceles triangles with the picture plane, making EC=CD. But without knowledge of the vanishing-point theory it is not possible to furnish this simple proof. Hence Renaissance theorists were in difficulty when they wished to show that the distance-point rule was in accordance with geometry.

The distance-point construction is of uncertain origin. It first appears in literature in Piero della Francesca's *De prospectiva pingendi* (c.1480), briefly and only once, as a control for another construction, and the reader is referred to a *costruzione legittima* diagram for an explanation. Some authorities regard this isolated example as having been added by a later hand.

The widespread popularity of the distance-

point construction started in France. There Jean Pélerin, called Viator, in his *De artificiali perspectiva* (1505) presented it as the basic construction. Viator was a canon of the Benedictine abbey church at Toul and secretary to Louis XI. Being an amateur of perspective drawing he dispensed with geometrical proofs. His book, written in parallel French and Latin texts, was illustrated with many fine woodcuts and went into four editions in his lifetime. In Vignola's words 'it was more copious in drawings than in text' and his rule 'more difficult to understand than to execute'.

Viator ('The Traveller') called his distance points 'tiers points'. They should be placed 'equidistant from the centre: closer in near and further in distant views'. He presumably came across this construction in the course of his many travels north of the Alps, where it may have become established as a workshop tradition. It does not appear in Italian texts before Viator's time, except in the isolated example mentioned above. Yet it is unlikely that the Italians were previously unaware of its existence. Their reticence on the subject is perhaps accountable to their greater concern for theory than the more empirical northerners.

A confusion arose amongst theorists over the identity of the operative diagonals. Were they graphic lines of the same nature as the orthogonals, or were they visual rays? They may have been prompted by the experiment of observing the orthogonals in a mirror which are seen to converge towards the reflection of the observer's eye (Fig. 33). *Filarete recommends using a mirror for

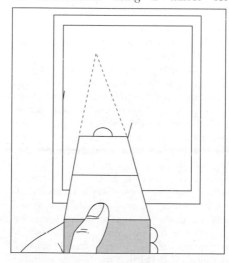

Fig. 33

examining the convergence of parallels (*Trattato di architettura*, 1461–4). If the diagonals were visual rays, the construction could be shown to be sound, being basically the same as Alberti's construction. For this to be so, diagonal and visual rays should coincide and this happened only in the special case where

the centre point and the vertical intersection were brought together as in Fig. 34; and there

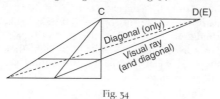

Fig. 34

were practical disadvantages in this arrangement. In the normal arrangements of the *costruzione legittima* the centre point and the vertical intersection are apart and then the diagonal and the ray do not coincide (Fig. 35). To some this was evidence enough that the distance-point construction was faulty. Yet the greater economy of this construction made it popular with practitioners.

Vignola set out in his treatise *Le due regole della prospettiva pratica* (printed in Rome, 1583)

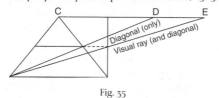

Fig. 35

to demonstrate that both the distance-point construction and Alberti's construction were equally sound. But he could only succeed in showing that if a square, frontally placed, is drawn in perspective by means of the *costruzione legittima*, its protracted diagonals meet in the distance points and that these points are the same distance from the centre point as the 'eye' of the *costruzione legittima* is from the vertical line of intersection (Fig. 36). In the

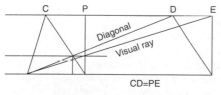

CD=PE

Fig. 36

absence of a general theory of vanishing point, this quasi-empirical demonstration was the nearest Vignola could come to a geometrical proof.

Dürer, who journeyed to Bologna in October 1506 to receive instruction in the art of 'secret perspective' and who afterwards at home must have come across the 1509 Nuremberg pirate edition of Viator, was inevitably confused over the relationship between the Italian and the French constructions. When he came to write his perspective treatise, printed first in 1525 as a section of his *Underweyssung der Messung*, he gave in addition to the Italian plan and elevation construction his own version of the distance-point rule, which he called his 'näherer Weg' or 'shorter way'. This was a *costruzione legittima* with the

centre moved over to the vertical line, an arrangement which causes the Albertian and the French constructions to coincide. It has the practical disadvantage of doubling the total angle of vision and of increasing the marginal distortions. In Dürer's *S. Jerome* engraving, 1514, the total angle is about 108°, which results from placing the centre of vision at the side instead of near the centre. A close examination of Dürer's works reveals that apart from the *S. Jerome* engraving and the *Melancolia* bearing the same date, he never again used a consistent perspective construction throughout a picture.

13. SPHERICAL PERSPECTIVE

The idea that apparent magnitudes depend exclusively on the visual angles so that their relation has to be expressed in terms of arcs, not in terms of sections on a straight line, has led some people to maintain that our visual field approximates to a projection on a concave spherical surface centred in the eye. On this basis some theorists have held that plane perspective is unsatisfactory not only because of the wide-angle distortions inherent in every plane projection but also because it consistently represents objective straight lines as straight whereas they maintain that in natural vision some of them would appear curved.

There are some strong arguments against this view. Vision is by no means exclusively conditioned by the geometry of light rays. Visual perception is partly an acquired faculty in which pre-knowledge and recognition play an important role. Most people do not see objective straight lines as curved except in unusual circumstances. If they habitually do, they will also see the picture plane as curved. When an impression of curvature is experienced it can usually be attributed to the movements of the eyes. For example, when the eyes are made to travel along a high horizontal straight line, the impression is very distinct that the point of vision glides along a line which is not straight but concave to the eye. On the other hand, as soon as the eye is arrested and caused to gaze steadily at some point on the line, the portion of the line in the vicinity of the point of fixation will appear to be horizontal and straight as it really is.

Partisans of the curved visual space theory draw support from the ancient Greeks. Euclid wrote that 'planes elevated above the eye appear to be concave' (*Optics*, Prop. 10). And Vitruvius, writing on Greek architecture, stated that the architect must take steps to counteract the 'false judgements of the eyes': for example, the apparent concavity of a horizontal stylobate (*De architectura* 3. 4, 5. 9, 6. 2). The well-known entasis of columns (also explained by Vitruvius), and other subtle

curvatures built into Doric temples, also testify to the sensitivity of the ancient Greeks to subjective curvatures.

The concavity of the retina is another fact adduced in favour of the theory that our visual space is curved. There are, of course, no straight lines in the retinal image. But as we do not see our retinal images, this fact is quite irrelevant. The retinal images have to be left out of account in localizing objects; they are only means by which the rays of light from one object point are focused on one nervous fibre.

Practising artists may run up against the problem of a curved visual field when they measure the scene they are drawing by the traditional method of holding a pencil or brush handle at arm's length at right angles to the line of vision and sighting across it with one eye. The measurements thus gained are the angular proportions of the scene and theoretically they are incapable of being projected onto a plane surface (in practice this method works very well when the total angle of view is fairly small). It may be objected that the attempt to transfer these measurements made on the arc to the flat picture will produce a double foreshortening of the image because of the natural foreshortening of the picture plane.

It is a mathematical truism that a spherical surface cannot be developed into a plane. Nevertheless, over the years, several systems have been devised that set out to give an approximate solution to this problem. Guido Hauck's system is the best known (*Die subjektive Perspektive und die horizontalen Curvaturen des dorischen Styls*, 1879). It has been claimed that Leonardo was first to invent such a system and that before him the first artist in postclassical times to represent optical curvatures in his paintings was the 15th-century French painter Jean *Fouquet. But Leonardo does not appear to have used curved perspective in his paintings.

Methods of perspective incorporating a curved projection surface may be of some help to an artist who is confronted with the problem of representing a wide-angled view. But they have never had many followers. They disrupt the system of vanishing points and tend to be complicated to use. Furthermore, they produce curved images of objective straight lines (unless the lines pass through the centre of vision).

The multiplicity of systems of curvilinear perspective is witness to the impossibility of arriving at a completely satisfactory solution. In practice artists have generally preferred to employ the much simpler plane perspective and to make the necessary adjustments by eye.

14. PERSPECTIVE IN ANTIQUITY

In the Greek red-figure vases of about 500 BC (see GREEK ART, ANCIENT) we find expressed for the first time the beginning of a completely new approach to drawing: a gradual break from the conceptual or ideoplastic towards a visual or optical attitude. This change in art is part of the general breakaway from age-long habits of thought that the Greeks achieved in the 5th century BC. The beginnings of perspective belong to this period.

Perspective in ancient Greece and Rome (see ROMAN ART, ANCIENT) was known as *skenographia*, a term that covered all devices to regulate the effects of space between the observer and the thing seen and included the application of the rules of optics to painting, sculpture, and architecture. It was first applied in the Theatre of Dionysus at Athens in the second half of the 5th century BC, when drama began to require more elaborate scenic arrangements. Vitruvius writes that the painter *Agatharchus of Samos was the inventor of scenography and that he first applied it when he 'made the scene' for a tragedy by Aeschylus (525–456 BC) given at Athens, probably at a revival in the 430s, and that he wrote a commentary on his method. Furthermore certain scientist-philosophers took up the subject and also wrote about it, working out rules of perspective. They showed how 'if a fixed centre is taken for the outward glance of the eyes and the projection of the rays, we must follow these lines in accordance with a natural law, such that from an uncertain object certain images may give the appearance of buildings in the scenery of the stage, and how what is figured on vertical and plane surfaces can seem to recede in one part and to project in another'. We can only gather from this description that optical rules were applied to illusionistic scenery from the start, though we cannot deduce precisely in what manner. None of these treatises on scenography survives. But they were perhaps the prototypes of Euclid's *Optics*. Here, as in many other fields, practical recipes preceded theoretical investigations.

Although virtually nothing remains of classical Greek painting, the figured vases give some indication of development in practical perspective. By c.500 BC artists were beginning to experiment with foreshortening and with drawing untypical aspects—a shield from the side, a foot from the front. Soon too artists drawing architectural forms employed a rudimentary perspective in the representation of planes and lines in depth. Convergence was still unsystematic and was applied only, if at all, to individual planes and never to the picture as a whole. The receding parallel edges of solid objects, such as tables in the foreground, were mostly drawn parallel or divergently. Central convergence is used fairly consistently only in one short phase of the Antique painting that has come down to us: in the illusionistic wall decorations of the Architectural (or so-called second) *Pompeian style dating from about 80–30 BC, examples of which have been excavated in and near Rome and Pompeii, the best preserved being from Boscoreale. These corroborate Vitruvius' statements on wall decoration in his own time as well as his brief and somewhat obscure definition of scenography as used by architects: 'Scenography is the sketching of the front and the retreating sides and the correspondence of all the lines to the centre of a circle.' This seems to confirm that some kind of functional system of central convergence was in use during the 1st century BC, at least amongst architects. In the following generation the fashion changed to a more decorative and fanciful mode in which the perspective was less systematic.

The question remains, did the Greeks have a theory of central perspective? Did they at any time conceive of a painting as a transparent projection plane with a theoretically fixed eye-point? It used to be thought that they did not, until H. G. Beyen discovered that some mural paintings in Pompeii, Rome, and Boscoreale showed a construction with a point that functionally corresponded with the vanishing point of central perspective. The lower parts of these paintings do not, however, show the same regard for central convergence and are more haphazard in their perspective treatment. It has been suggested that this may be because the artists who drew these pictures were not original masters, but copied more or less accurately pictures they had seen on the stage. As on the raised platform the lower part of such a construction was missing, they therefore had to fill in this deficiency from their own resources and made use of the more common parallel perspective.

Our familiar pair of railway lines that 'vanish' to a point have an equivalent in ancient literature. Lucretius (*De rerum natura* 4) describes how a colonnade may appear to vanish into the obscure point of a cone. But the geometrical principle of vision did not receive universal acknowledgement in Antiquity. It had a popular rival in the Epicurean theory of images, according to which objects are continually throwing off *eidola* or surface films of very fine texture that traverse the air at infinite speed. These impinge upon our eyes and give us vision by direct contact. This theory of vision led to the paradoxical belief that the heavenly bodies are the size they appear. Perhaps Euclid wrote his *Optics* to combat such views. We may believe that the ancients possessed a system of perspective which had close resemblance in its effects to Renaissance perspective, but it is not certain that this was a system of central projection. The first complete rationalization of the picture space

seems to have been the achievement of the 15th century AD.

15. CLASSICAL OPTICS: EUCLID ON PERSPECTIVE PHENOMENA

The oldest extant book on geometrical optics is by the great Greek mathematician Euclid of Alexandria, written about 300 BC. It consists of 58 theorems (20 belong to optics proper and 38 deal with perspective phenomena) preceded by twelve definitions or postulates. Euclid's *Optics* laid the foundations upon which geometrical optics could be developed to its present high level. It exerted a great influence upon medieval writers on optics and indirectly was of great consequence in the evolution of Renaissance perspective. The following are the first four definitions. Let it be assumed

(i) That straight lines proceeding from the eye diverge through a space of great extent. (Euclid adhered to the centrifugal theory of visual rays.)

(ii) That the form of space included within our vision is a cone with its apex in the eye and its base at the limits of what is seen.

(iii) That those things upon which the visual rays fall are seen and that those things upon which they do not fall are not seen.

(iv) That those things seen within a larger angle appear larger and those things seen within a smaller angle appear smaller, and those things seen within equal angles appear to be of the same size.

The purpose of the *Optics* is to express in geometrical propositions the exact relation between the real quantities found in objects and the apparent quantities that constitute our visual image. Euclid connected, in pairs, object points with image points as is done in modern constructions. He shows the apparent size of objects to be directly proportional to the visual angle subtended at the eye. He deals geometrically with common deceptions of vision on the basis of the visual angle theory. The following are some of the propositions which have a bearing upon perspective.

Prop. 6. Parallel lines seen from a distance seem to be an unequal distance apart (Fig. 37).

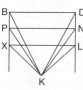

Fig. 37

The proof follows logically from Def. iv. BD is seen within a smaller angle than PN; the angle PKN is smaller than the angle XKL. The intervals then between parallels do not appear equal but unequal.

Prop. 10. Of a horizontal plane situated below the observer's eye those parts which are further away appear to be the more elevated (Fig. 38).

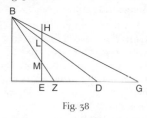

Fig. 38

In the proof the eye at B is connected with Z, D, and G of the horizontal ground plane. The connecting lines intersect the perpendicular EH. H is more elevated than L, etc.

Similar proofs deal with planes above eye level that appear to descend as they recede, with planes on the left that appear to move to the right, and planes on the right that appear to move to the left.

Prop. 36 deals with an example of foreshortening, explaining why chariot wheels appear oval when seen obliquely.

Of particular interest is Prop. 10 since it shows that Euclid knew the principle that lies at the foundation of central perspective, namely that the objects are projected by the eye upon the picture plane. Yet there is no evidence to show that Euclid ever thought of his proof in this way. He wrote about perspective phenomena, but the etymological synonymity of optics and perspective has often led to the misconception that he wrote about perspective constructions.

It is noteworthy that in Prop. 6 Euclid does not conclude that parallels if produced indefinitely will ever appear to meet in a point. The 13th-century writer on optics, Witelo, who followed similar lines in discussing this theorem, concluded that parallel lines are never seen to meet in a point because the interspace between them will always subtend some angle at the eye. Nowadays one would say that at infinity the subtended angle is zero. But in the 15th century the concept of limit was not yet accepted by mathematicians in their proofs. Witelo's qualification may indicate the existence of two opposing schools of thought as regards the geometrical validity of vanishing points and go some way towards explaining the tardy adoption of the central vanishing point for orthogonals by the artists of that time.

16. EUCLID'S PROPOSITION 8

Something must be said about Euclid's Prop. 8, which has often caused confusion in the minds of those who study the history of perspective. This theorem states that 'equal and parallel magnitudes unequally distant from the eye do not appear (inversely) proportional to their distances from the eye'. Euclid wished to discover whether there existed a simple geometrical proportionality between the apparent size of equal and parallel lines and their distances from the eye. He found that this simple relationship did not exist. E is the eye; A and G are the two parallel magnitudes. A is twice as far from the eye as G but the angle it subtends is appreciably greater than one-half of the angle subtended by G (Fig. 39).

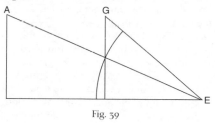

Fig. 39

The confusion has arisen because Leonardo wrote: 'A second object as far away from the first as the first is from the eye will appear half the size of the first, though they be the same size really.' In other words, if you double the distance you halve the apparent size: hence apparent size and distance are inversely proportional. The apparent contradiction does not in fact exist because Euclid is speaking about the visual angles of natural perspective, which are measured by their subtending arcs, while Leonardo has the picture plane in mind, which produces straight projections and forms a series of similar triangles with the visual rays.

By considering the projections on the picture plane with regard to their proportional relationships Leonardo (and Alberti and Piero della Francesca before him) was introducing the *classical concept of proportionality*, with its cosmological and aesthetic connotations, into the theory of perspective. Leonardo goes on to affirm that the same proportional intervals obtain in perspective space as in music. (See PROPORTION.)

17. PERSPECTIVE IN BYZANTINE ART

The post-classical age was a period of regression for perspective. After the division of the Roman Empire and the break-up of the West, Constantinople became the artistic centre of Christendom and conserved for 1,000 years and more much of the classical heritage of drawing, though in a much schematized form, while in the West the taste for abstraction and ornament led to the complete transformation of classical models and the breakdown of perspective schemata. The *Byzantine artist, in common with the rest of the post-classical world, did not follow any consistent system of perspective. To start with, Constantinople copied 3rd-century official Roman art, the tendency of which was already to turn away from classicism and illusionism. But whereas the art of the West went through many changes between the collapse of the empire and the Renaissance, Byzantine art soon settled into a comparatively rigid style. Official Byzantine art was from the start hieratic and anti-illusionistic.

Yet artists never ceased to draw upon classical sources. *Hellenistic illuminated manuscripts provided them with a rich quarry of classical forms, which at times they imitated freely, as for example the *Joshua* Rotulas (Vatican Mus.), executed at Constantinople in the 10th century, in which we find a use of shadow and *aerial perspective almost unique in medieval art.

The *Optics* of Euclid was current in the Byzantine world through Pappus and Theon of Alexandria, and Proclus (AD 412–85), in commenting on Euclid, describes scenography as the branch of optics which 'shows how objects at various distances and of various heights may be so represented that they will not appear out of proportion and distorted in shape'. Byzantine painting never became a window opening onto a world outside in the manner of illusionistic Hellenistic art and the Renaissance conception initiated by the *stil nuovo* of Giotto. At most the pictures create the appearance of a boxlike space or niche in the wall which they occupy. Byzantine wall painting was primarily a functional adjunct to architecture and some authorities have maintained (though not all accept this interpretation) that the picture space was characteristically that of the church or room in which the picture was placed (and in which the observer stood), the perspective opening out into the actual room space. One device sometimes used for suggesting depth of picture space is an 'inverted perspective' in which the viewpoint of the picture might be taken to be behind the scene, not in front of it, figures being smaller in proportion to their distance from the viewpoint. This system of perspective fits naturally to the Euclidean theory of vision, which supposes rays to proceed from the eye to the object. On the assumption that equal sizes subtend equal angles at the eye, an artist who had misunderstood Euclid might assume that a more remote figure or object should be drawn larger than a nearer one since it would span a wider part of the visual pyramid. In the later period a high viewpoint is often used so that the scene is visualized as it would appear from above. Very often different systems or different viewpoints are combined in one composition and the same structure is made to carry planes belonging to successive acts of vision. The idiosyncrasies of Byzantine perspective have been attributed to the fact that Byzantine art derived from two irreconcilable traditions: Greek illusionism and oriental schematic abstraction. Furthermore in the 8th century it suffered the doctrinal severities of *Iconoclasm. In the last phase of Byzantine art there is evidence of cross-fertilization between the East and the Gothic West and of a movement towards spatial unity: witness the *mosaics and frescoes in the church of Christ in Chora, Istanbul. It is only during the late 12th to the early 15th centuries that the representation of functional space became a dominant concern of Byzantine artists both in panel and wall paintings and in mosaics.

18. PERSPECTIVE IN POST-CLASSICAL AND MEDIEVAL WESTERN PAINTING

The shift of art to the transcendental and the symbolic that began during the break-up of the Roman Empire produced in the West many vicissitudes of style. Between the *early Christian and the late *Gothic periods regional differences were at times very marked, but everywhere perspective was in low esteem. In Italy, much under Byzantine influence, painting preserved more of the classical tradition than elsewhere, but on the borders of the Roman Empire the classical heritage was submitted to the disintegrating pressure of barbaric traditions. Artists trained in a style of abstract linear pattern and who knew nothing of narrative painting could not immediately interpret and assimilate the representational forms of Mediterranean origin which they tried to copy. In certain phases of medieval painting the third dimension was virtually eliminated. Examples may be found in *Celtic, *Mozarabic, *Ottonian, and high *Romanesque illumination. The Carolingian attempt to revive the classical tradition was short-lived and it was not until the Gothic period that Western art turned finally towards naturalism. In Gothic illumination figures and objects again acquired relief and were set in a shallow stage space.

Spatial inconsistencies are a common feature in medieval painting. They testify to its disregard for material values. To modern eyes they are a part of its charm. One of the most characteristic is the drawing of pillars as discontinuous. This was done to avoid overlapping in the interest of the overriding demand for narrative clarity. In certain cases such spatial non sequiturs may have been intended to underline the universal validity of the religious scene by introducing transcendental values. In medieval painting there was often a return to ideoplastic elements. Table tops were drawn as though vertical with the utensils sliding off them. Disproportion between figures and their surroundings was the rule. Symbols were preferred to descriptive realism. Knowledge of geometry and geometrical optics virtually died in the West until the revival of the 12th century. A unique and important document in the history of medieval drawing is the sketchbook (c.1235) of *Villard de Honnecourt. This includes four pages of 'the elements of portraiture' with the preface: 'Here begins the art of the elements of drawing, as the discipline of geometry teaches it, so explained as to make the work easy.' But the precepts do not include any instruction in perspective and when the author himself draws buildings he has seen on his travels (and there are several in his sketchbook) the lack of such knowledge is visibly a handicap. Figure 40 shows his drawing of a clocktower, which although admirably observed in all its parts appears unstable because the horizontals are not related to an eye level. It shows how necessary was the seemingly naive perspective rule given by the Italian Cennino *Cennini in his *Il libro dell'arte*, written in the 1390s: 'And you put the buildings in by this uniform system: that the mouldings that you make at the top of the building should slant downwards . . . the moulding in the middle should be quite level and even; the moulding at the base must slant upward, in the opposite sense to the upper moulding.' Cennini's book was a late product of the Byzantine tradition—the *maniera greca*—which survived in Italy right through the Middle Ages. Cennini epitomizes the medieval attitude when, on the first page of his book, he states that the purpose

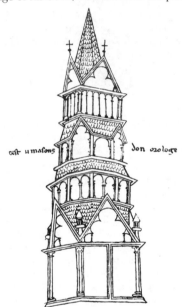

Fig. 40. A clock-tower. Pen-and-ink drawing by Villard d'Honnecourt. (Bib. nat., Paris, c.1235)

of painting is to 'discover things not seen, hiding themselves under the shadow of natural objects'. These words make a vivid contrast with one of the opening statements of another famous book on painting written a generation later by that pioneer of the Renaissance movement Leon Battista Alberti: 'No one would deny that the painter has nothing to do with the things that are not visible. The painter is concerned solely with representing what can be seen.'

19. THE REVIVAL OF PERSPECTIVE

The beginnings of a return in the West to three-dimensional realism and to the drawing of architectonic space are to be found in 13th-century Rome, whose early churches

still preserved many pictorial examples of the late Antique style, for example the 5th-century mosaics of S. Maria Maggiore. The greatest of the Roman early realists was Pietro *Cavallini. His mosaics in S. Maria in Trastevere from the late 1290s such as the *Annunciation*, the *Birth of the Virgin*, and the *Presentation* show that he possessed a firm grasp of vertical axis perspective. Nearly all of his frescoes have been destroyed. He used a unified focus for each separate structure or main architectural part, though not for the whole picture. For example, the two interior rooms that form the background of the *Birth of the Virgin* are each drawn to a separate central axis, implying two distinct viewpoints. The three aedicules in the *Presentation* are represented from high and low viewpoints alternately, as in the traditional Byzantine manner. Cavallini was by no means without immediate predecessors in Rome. Elaborate architectural backgrounds can still be glimpsed in the much-damaged 11th-century frescoes in the lower basilica of S. Clemente, by an unknown hand. And the fresco cycles in the portico of S. Lorenzo fuori le mura, painted between the 1260s and 1280s by painters only known as 'Paulus and his son Filippus', constitute a veritable pattern book of architectural forms. It was in Rome through the art of late Antiquity that the Italian painters first rediscovered perspective space.

The two greatest monuments of the rapid advance made in spatial realism in Italy at the turn of the century are the great fresco cycles of the upper church of S. Francesco at *Assisi and of the Arena chapel at Padua. The clerestory frescoes of the south wall of the nave at Assisi are of the Roman school and show some of the earliest convincing interiors. (Early interiors are always seen from the outside. The real interior seen from within does not appear in painting before the 1440s.) The 29 frescoes of the *S. Francis* cycle at Assisi are traditionally ascribed to Giotto, although doubts have been cast on this attribution; they were painted no later than 1307 and perhaps before 1300. Giotto painted the frescoes of the Arena chapel, Padua, in or about 1306. Striking examples are to be found there of empirical perspective. The two little Gothic chapels painted at eye level on the walls of the chancel arch, on the right- and the left-hand side as one looks towards the altar, are drawn towards a common vanishing point, indicating that Giotto aimed at an illusionistic piercing of the walls. His fresco of the *Suitors Praying* has a ceiling that appears to have been drawn to a central point and to an empirical distance point. Nevertheless Giotto's perspective, in common with the whole of the trecento, was intuitive and practical rather than scientific.

The floor-plane, which was to become the key feature of the Renaissance picture space,

was the last to be brought under perspective control during this empirical phase. The Sienese of the trecento made a habit of introducing tiled floors into their designs. Two early examples may be compared from *Duccio's *Maestà* (1311) (Siena, Mus. dell'Opera del Duomo): the scene representing *Christ amongst the Doctors* has a floor whose squares are barely foreshortened, while the *Temptation of Jesus on the Temple* displays a strip of chequered floor that leads the eye deep into the interior of the building. In the final phase before the formulation of scientific perspective the works of the *Lorenzetti brothers are outstanding. The architecture in Ambrogio Lorenzetti's big fresco of *The Effects of Good Government on the City and Country* (1338; Siena, Palazzo Pubblico) is a strikingly realistic portrait of the town. No less remarkable for its perspective is Pietro Lorenzetti's *Birth of the Virgin* (1342; Siena, Mus. dell'Opera del Duomo) with its three architectural bays drawn to a single focus, while Ambrogio's *Annunciation* (1344; Siena, Pin.) contains what is said to be the first example of a floor drawn to a central vanishing point. The foreshortening of the tiles, however, is not geometrically controlled. After a period of standstill caused by the Black Death, further advances were made in the last quarter of the century at Padua by *Altichiero, and Giusto de' *Menabuoi.

20. MEDIEVAL OPTICAL STUDIES
Euclid's studies in optics had been carried further by Greek and Arab mathematicians in Egypt, notably by Claude Ptolemy (active 2nd century AD) and Alhazen (d. 1038). By about 1200 some of the treatises had become available to the West through Latin translations made from the Arabic in Spain and Sicily and these stimulated great interest in the subject, besides providing material for further treatises by the scholastics in the 13th century (Robert Grosseteste, Bishop of Lincoln; Roger Bacon; John Peckham, Archbishop of Canterbury; Witelo) whose works were consulted up to the time of Kepler. This revival of optics in the West coincides with the return of naturalism in art. The two events were not directly connected yet both were part of the widespread movement that combined the revival of learning with a growing interest in the natural world and a belief in the importance of mathematics and experimental science.

21. BRUNELLESCHI
In Florence of the 15th century and elsewhere these optical treatises were much studied (witness Lorenzo *Ghiberti's *Commentarii*, the third of which is composed of extracts taken from the better-known optical works). It seems that Filippo *Brunelleschi was already acquainted with them when he made his famous perspective experiments early in the century. His first demonstrations are described by his biographer, Antonio Manetti

(*Vita di Filippo Brunnelleschi*, c.1480; English trans. H. Saalman, 1970). Brunelleschi placed himself just inside the central doorway of the Cathedral of Florence and from there he made a picture of the baptistery 'showing as much as could be seen at one glance'. It was a panel about 30 cm (1 ft) square, painted with the precision of a miniature, and the sky was represented by burnished silver that was to reflect the real sky and the passing clouds. Having completed his panel, Brunelleschi bored a hole through it at that point in the view which had been exactly opposite his eye when he painted it: that is at the centre of vision. The spectator was instructed to look through the hole from the back, at the same time holding up a mirror on the far side in such a way that the painting was reflected in it. 'When one looked at it thus,' says Manetti, 'the burnished silver, the perspective of the piazza, and the fixing of the point of vision made the scene absolutely real.'

This was the first recorded centrally projected image in the history of painting. The question remains: how did Brunelleschi make it? He might have used a burnished silver ground as a mirror and traced the lines of the reflected buildings on its surface, thus producing a reversed image. (This would explain why the spectator was asked to look at the painting in a mirror.) If this was Brunelleschi's procedure he may have started from a suggestion found in Ptolemy's *Optics*, where an experiment of marking the reflection of an object on the surface of a mirror is described and accompanied by a geometrical diagram. Perhaps the next stage was to make diagrams of the whole experiment, complete with plan and side elevation, showing where the visual rays intersect the picture plane. Such an order of events would reconcile the opinion of the 15th-century Florentine architect Antonio Filarete, who believed that Brunelleschi discovered perspective while considering reflections in a mirror, with Vasari's statement that Brunelleschi proceeded with the aid of a plan and elevation 'and by means of the intersection'.

The earliest painting in which the architectural perspective is exactly based on Brunelleschi's rules is the fresco of the *Trinity* in S. Maria Novella, Florence, by his friend *Masaccio, painted c.1425. But Brunelleschi's influence is already apparent in the reliefs of *S. George and the Dragon* (Florence, Or San Michele, c.1415–20) and *Salome* (Siena baptistery, c.1423–5), both by *Donatello who was his close friend and perhaps the first to share the discovery. It is also strong in other works of the time: Uccello's fresco of *Sir John Hawkwood* (Florence Cathedral, 1436), and panels of Ghiberti's Gates of Paradise (1425–52) for the Florence baptistery. Shortly after Brunelleschi made his perspective demonstrations Alberti devised his perspective construction for the special use of painters (see above), which he

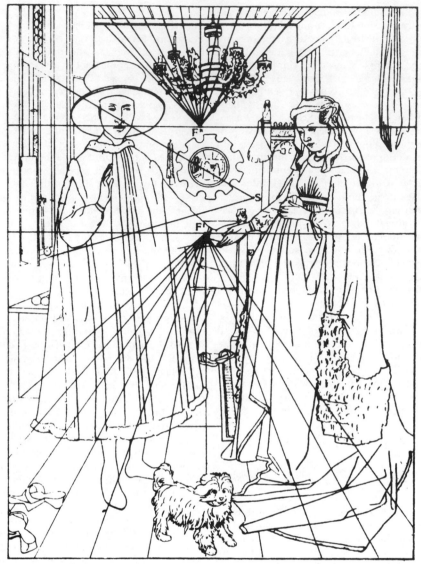

Fig. 41. The perspective of Jan van Eyck's *Arnolfini and his Wife* (N.G., London, 1434). Illustration from
Die Grundzüge der Linear-Perspektivischen Darstellung (1904), G. J. Kern

Today most artists who paint representational pictures acquire their perspective empirically and possess only the rudiments of theory. In 1827 *Delacroix was using the perspectivist Thénot to work on *The Death of Sardanapalus* (Paris, Louvre). Already in the 1860s no less a painter than Jean-François *Millet was enquiring after a professional 'perspecteur' to help him with the perspective of his ceiling painting for the Hôtel Thomas. And *Degas told *Sickert that he had to employ a 'perspecteur' for his *Miss Lola* (London, NG) hanging by her teeth from a trapeze near the ceiling (marginal note in Sickert's hand in his copy of A. Sensier's book on Millet (1881), now in the library of University College, London). Through photography we become so habituated to the perspective image that artists acquire a sense of perspective almost unconsciously, and even make efforts to find new ways of representation. Recent investigations made by experimental psychologists suggest that geometrical perspective provides an inadequate account of our visual perceptions, which are found to be strongly influenced by size, shape, and colour constancy. Moreover, objects in close proximity to the eye do not follow the laws of scientific perspective—a fact that has been exploited by many modern artists since *Cézanne and was no doubt observed by artists before the rule of science took over. Nevertheless it is wrong to call perspective a 'convention'. It may be a convention to paint pictures according to strict geometrical perspective, but perspective itself is not a convention: it is a part of the theory of central projection. And it is a fallacy to suppose that the 'visual truth' may be represented by a flat image, if by 'visual truth' is meant the way we see the world through our two moving eyes forming successive perceptions conditioned by 'constancy'. The perception of representational paintings—or photographs—is usually a very different process from the perception of the actual scenes in depth. Finally, pictures may be regarded as an arrangement of symbols for reality. Central perspective is unique in so far as it enables the picture to send to the eye of the beholder, who respects its conditions, the same distribution of light as the objective scene. HO

Abbott, W., *The Theory and Practice of Perspective* (1950).

Doesschate, G. ten, *Perspective* (1964).

Helmholtz, H. van, *Handbuch der physiologischen Optik* (1867; English trans. J. Southall, repr. 1962).

Panofsky, E., *Die Perspektive als 'symbolische Form'* (1927).

Panofsky, E., *Idea* (1924, edn. 1960).

Schuritz, H., *Die Perspektive in der Kunst Albrecht Dürers* (1919).

White, J., *The Birth and Rebirth of Pictorial Space* (1957).

described in his famous treatise *Della pittura* (1436). In the same work he explained the drawing frame which he claimed as his own invention.

22. PERSPECTIVE IN THE NORTH
The new Italian discoveries took some time to reach the North. There the advance towards realism was achieved without central perspective. Jan van *Eyck's *Virgin and Child in a Church* (Berlin, Gemäldegal.), is not drawn in central perspective, though it was perhaps painted about the same time as Masaccio's *Trinity*. Nor is his *Arnolfini Portrait* (London, NG) drawn to a central point, but ceiling, floor, and walls each to separate points (Fig. 41). Evidently it is not easy to tell without a minute examination whether a systematic

construction has been used. None of the Flemings used central convergence consistently, i.e. for the whole picture, until Petrus *Christus as seen for instance in the *Virgin and Child with S. Francis and S. Jerome* (1457; Frankfurt, Städelsches Kunstinst.). Geometrically controlled foreshortening did not appear north of the Alps until the next century, after the treatises by Viator (1505) and by Dürer (1525) had become widely known.

23. PERSPECTIVE IN MODERN TIMES
Over the ages many great names in art and science have been linked with the story of perspective. Perhaps the last great painter to be learned in this subject was J. W. M. *Turner, who was professor in perspective to the RA (see under LONDON) from 1807 to 1828.

PERUGINO (Pietro Vannucci) (c.1450–1523). Italian painter from Umbria, whose calm and orderly style had a profound influence on his pupil *Raphael. He was in Florence in the late 1460s where he probably trained in the workshop of *Verrocchio. Returning to Perugia, he achieved considerable local success for the sophisticated technique and balanced design of his altarpieces. In 1479 he was called to Rome where he undertook several frescoes in the restored Sistine chapel including *Christ Giving the Keys to S. Peter*, his most important and influential work. There was little that was new in this fresco but the clear organization of the perspective and the simple but effective composition imbued the quattrocento conventions with a new serenity. Thereafter, Perugino enjoyed a great reputation in Florence and north Italy, undertaking many important commissions such as the decoration of the Collegio del Cambio in Perugia and the altarpiece of the Certosa at Pavia (1499; London, NG). After 1500 his work became more repetitive, a fact made all the more obvious by the dramatic developments of the younger generation of artists in Florence and Rome. *Michelangelo dismissed Perugino as an 'artistic clodhopper' which indicates how quickly his somewhat sentimental religious art fell from favour. He was much admired by the *Pre-Raphaelites. PSt

PERUZZI, BALDASSARE (1481–1536). Sienese painter, architect, draughtsman, and stage designer. After *Michelangelo and *Raphael, he was the most important and variously creative artist of the Roman High *Renaissance. He spent his formative years in Siena, and in 1503 he was in Rome, where he worked in the Vatican Stanze and in S. Onofrio (1504–6) on the *Life of Mary*, frescoes characterized by crisp contours and incisive line. Exposure to *Antique art, Raphael's painting, and Bramante's architecture resulted in a more classicizing style, expressed in his architectural designs of the Villa Farnesina (c.1506) and its internal decorations. The grisaille frieze on Ovidian themes in the Sala del Fregio (c.1511) displays vibrant, energetic figures with clearly drawn forms. Upstairs, in the frescoes for the Sala delle Prospettive (c.1516), his monumental illusionistic devices create startling effects. His interest in *illusionism reappears in the fresco of the *Presentation of the Virgin* (1523; Rome, S. Maria della Pace), which also combines Raphaelesque spatial complexities. As architect in his final years he worked on S. Peter's and designed the Palazzo Massimo alle Colonne (1532). FB

Fagiolo, M., et al., *Baldassarre Peruzzi: pittura, scena e architettura nel cinquecento* (1987).

PESELLINO, FRANCESCO DI STEFANO (1422–57). Florentine painter. In his own day he was held in high regard for his narrative compositions in small, well-executed panels. Orphaned at the age of 5, he lived with his grandfather, the painter Pesello. By 1442 he was collaborating with Filippo *Lippi, in whose shop he may have trained, and he executed five predella panels (Florence, Uffizi; Paris, Louvre) for Lippi's altarpiece of the *Virgin and Child with Four Saints* (Florence, Uffizi). Lippi's influence can be detected in Pesellino's graceful, well-designed figures covered in heavy fabrics with clearly defined folds. These same scenes, characterized by clarity of expression and psychological truth, testify to Pesello's own skills in narrative design. In 1455 he received the commission for his only known large-scale altarpiece, the *Trinity* (London, NG). Unfinished at his death, work was completed in Lippi's shop. The landscape setting, probably designed by Pesellino, is characterized by a vibrant naturalism which is also to be seen in his *cassone panels of Petrarch's *Trionfi* (Boston, Isabella Stewart Gardner Mus.). FB

PETRARCH (Francesco Petrarca) (1304–74). Italian poet, scholar, and humanist. One of the first writers of the post-classical age to show an active interest in the visual arts. He was acquainted with *Altichiero (who portrayed him), and with *Giotto and *Simone Martini. If we are to believe sonnets 77–8 of his *Canzoniere*, he commissioned a portrait of his poetic lady Laura from Simone Martini in 1336; he certainly had a frontispiece for his Virgil painted by him c.1338–43. He also owned a Madonna by Giotto and at least one other contemporary religious picture. From his letters we learn that he looked at works of art, a polychrome stucco image of S. Ambrose in Milan, and the bronze horses of S. Mark's in Venice, and admired them for their verisimilitude, and that he studied the images of Roman emperors on coins. But his most important contribution to the literature of art criticism, revealing, as do his letters, his reliance upon classical sources and *Pliny in particular, is two dialogues on paintings and sculptures in the first book of his *De remediis utriusque fortune* of 1366 (1. 40–1), where moral concerns predominate over aesthetic ones. Two of his works (*De viris illustribus* and *Trionfi*) were to prove major sources of inspiration for *Renaissance artists. NM

Baxandall, M., *Giotto and the Orators* (1971).
Mann, N., *Petrarch* (1984).

PETTORUTI, EMILIO (1892–1971). Argentine painter. Pettoruti won a scholarship in 1913 and spent ten years studying and befriending the *avant-garde in Europe. In Florence he met the Italian *Futurists, yet, unlike them, he was less interested in speed and movement than in the effects of colour and light in his work. In Paris he turned to *Cubism after meeting Juan *Gris and was also influenced by *Picasso and the work of the *Purists. Returning to Argentina in 1924, Pettoruti formed part of the *modernist *martinfierrista* group. His exhibition at the Galería Witcomb in Buenos Aires in 1924 initially caused a scandal and was criticized as 'futurist and subversive' but his work soon became well known in Argentina and abroad. His early style is obviously Cubist but his colours are lively and pleasing and his iconography, as well as having European references, includes Argentine subjects such as tango musicians. His later style of the 1940s is more abstract and colour becomes the most important factor. In 1953 he settled in Paris until his death. CC

Pontual, R., *Arte brasileira contemporânea* (1976).

PEVSNER, ANTOINE (1886–1962). Russian-born painter and sculptor, like his brother Naum *Gabo one of the chief exponents of *Constructivism. After an academic training at Kiev and St Petersburg, Pevsner made lengthy trips to Paris (1911–14) where he associated with *Archipenko and *Modigliani. Following a sojourn in Norway (1915–17) with Gabo, the brothers returned to Russia enticed by the auspices of the Revolution. Pevsner became professor at the Academy of Fine Arts, Moscow, where *Malevich and *Kandinsky also taught. In 1920 he co-signed Gabo's *Realistic Manifesto* which set forth the brothers' Constructivist ideals, and in 1922 he helped organize a major exhibition of Soviet art in Berlin. Bolshevik disapproval of *abstract art caused his definitive departure for Paris in 1923 (he became a French national in 1930). In this period he turned his efforts from painting to sculpture, producing pieces like the waggish *Portrait of Marcel Duchamp* (1926; New Haven, Yale University AG). In 1931 he was a founder member of *Abstraction-Création and gained recognition as a leader of non-figurative and constructional sculpture, exhibiting widely in his later years. AA

Giedion-Welcker, C., and Peissi, P., *Antoine Pevsner* (1961).

PEYRON, JEAN-FRANÇOIS-PIERRE (1744–1814). French *history painter. Although his reputation has been almost completely overshadowed by that of his contemporary *David, he was at one point his greatest rival and made an important contribution to the development of *Neoclassicism in the 1780s. Peyron was trained first in his native Provence and then in Paris with Louis *Lagrénée. In 1773, much to the defeated David's chagrin, he won the *Prix de Rome. In Rome from 1775 to 1782 he studied *Antiquity, but also the work of *Poussin and

*Caravaggio. He won much praise at the 1782 Salon with *The Death of Miltiades* (Paris, Louvre), which blended these three influences impressively. His magnificent *Alceste Dying* (Paris, Louvre), dignified, moving, and beautifully painted, was rivalled at the 1785 *Paris Salon by David's *Oath of the Horatii*, which moved Neoclassicism onto an altogether new and more compelling plane. The rout was completed at the 1789 Salon at which both artists chose to exhibit pictures of *The Death of Socrates*. Although Peyron continued to exhibit until his death he received few official commissions. At the end David was brought to acknowledge the debt he owed to his one-time rival, pronouncing over his grave, 'il m'a ouvert les yeux'. MJ

Rosenberg, P., and Sandt, U. van de, *Pierre Peyron 1744–1814* (1983).

PFORR, FRANZ (1788–1812). German painter. Pforr came from Frankfurt to the Vienna Academy, where he became friendly with *Overbeck. Together they rebelled against the dogmatic *Neoclassicism there, and in 1809 founded the Lukasbund (to become known as *Nazarenes). While in Vienna, Pforr produced a set of illustrations for Goethe's medieval play *Götz von Berlichingen*, based on the work of *Dürer whom he greatly admired.

Pforr was strongly influenced by the writings of the German *Romantics, especially Tieck and Goethe. His *Entry of the Emperor Rudolf of Habsburg into Basle, 1273* (1810; Frankfurt, Städelsches Kunstinst.) demonstrates his desire to revive the spirit of the Middle Ages through a romanticized and hybrid historicism, based on the eclectic inspiration of woodcuts and engravings from various periods, and an exaggerated *primitivism. *Shulamit and Maria* (1811; Schweinfurt, AG), from a 'legend' written by Pforr himself, uses a self-conscious simplicity of isolated forms in shallow space in an allegory of his friendship with Overbeck. Pforr's emotional intensity inspired the early years of the Nazarenes in Rome; regarded as their leader, his early death from tuberculosis effectively ended their religious isolation. JH

Andrews, K., *The Nazarenes* (1964).

PHENOMENOLOGY, an approach to philosophy that takes the appearances (Greek *phainomena*) of things to consciousness as the primary data for consideration, and which in this way tries to describe the human experience of being in the world. The approach was developed by Edmund Husserl (1859–1938) from the thinking of his teacher Franz Brentano (1838–1917), who introduced the concept of intentionality—that is, of the way that mental experiences are characteristically *of* an object of thought,

an object upon which they are intent. Husserl proposed to focus on this quality by suspending what he called 'the natural attitude', the everyday manner in which we pass through the world noting its particulars chiefly for the way they impinge on our practical concerns. We may isolate groups of these particulars for defined ends, such as mathematics or science, while beyond them lies our vague awareness of the world 'spread out in space endlessly'. But if we can attend specifically to the quality of consciousness of appearance, we may arrive at 'a piece of pure description, prior to all theories'.

This attempt to isolate the specific quality of experience as such parallels some explorative aspects of *modernist painting—for instance in the work of *Monet, *Cézanne, or *Bonnard. It was adapted by Martin Heidegger (1889–1976) to adumbrate a philosophy of 'being in the world', a quality Heidegger believed van *Gogh was able to reveal in his painting of *Boots*. Heidegger and Husserl stimulated the phenomenological interests of, respectively, Jean-Paul *Sartre and Maurice *Merleau-Ponty; another notable writer in this line of speculation was Mikel Dufrenne. JB

Dufrenne, M., *Phenomenology of Aesthetic Experience* (1953; English edn., 1973).

PHIDIAS (active c.465–425 BC). Athenian sculptor, son of Charmides, the most renowned artist of classical Antiquity. He reputedly began his career as a painter, was trained by Hageladas and/or Hegias, and produced at least some of the bronze statues at *Delphi commemorating the Athenian victory at Marathon. Thereafter he won other state commissions, including the monumental bronze *Athena Promachos* on the Acropolis (see ATHENS) (c.460–450 BC). He is celebrated for his magnificent chryselephantine (gold and ivory) statues of *Athena Parthenos* (see PARTHENON SCULPTURES) (completed in 438) and *Zeus Olympios* (see OLYMPIA), both c.12.75 m (40 ft) tall, the latter one of the *Seven Wonders of the ancient world. Now lost, both were described in detail by ancient authors, and depictions of them can be recognized on ancient coins, gems (e.g. New York, Met. Mus.), pots (e.g. St Petersburg, Hermitage; Berlin, Altes Mus.), and in other media; marble representations of the *Parthenos* have survived in considerable quantity, both in relief and in the round, notably in Athens (Nat. Arch. Mus.) and Piraeus (Arch. Mus.). Ancient authors, who praise the grandeur of Phidias' work, associate him closely with Pericles, and Plutarch anachronistically makes him overseer of the entire Parthenon project. According to a garbled ancient tradition he was tried for embezzlement and/or impiety at Athens or Olympia (where his workshop has been excavated) and was executed or died in exile. None of

his work survives, but among the other statues ascribed to him by ancient authors are an *Athena Lemnia* and *Apollo Parnopios* at Athens, pseudo-chryselephantine *Athena Areia* at Plateia (of marble and gilded wood), *Amazon* at Ephesus, and chryselephantine *Aphrodite Ourania* at Elis. Scholars have attempted to associate Roman marbles with these lost originals, but consensus remains elusive. KDSL

Harrison, E. B., 'Pheidias', *Yale Classical Studies*, 30 (1996).

Stewart, A., *Greek Sculpture* (1990).

PHILADELPHIA MUSEUM OF ART. The founding of an art museum emerged from the enthusiasm engendered by the International Exposition held in Philadelphia in 1876, the first in the USA. In 1928 the collection moved to its permanent home, a handsome Greek revival building, nicknamed the 'Greek garage'. A number of specific influences are reflected in the museum's collections. The collection is not only one of painting but like its model, the V&A in *London, represents a comprehensive collection of objects demonstrating the skills of hand and machine. The strong holding of *American art symbolizes the position of Philadelphia in the early history of the founding of America. Lastly the character of the museum and its collection reflects the wide-ranging interests of Fiske Kimball, the energetic architectural historian who became its director in 1925. The museum's holdings of European art have been enhanced by private bequests; that of John G. Johnson in Italian and northern Renaissance artists, or Louise and Walter Arensberg in early 20th-century artists such as *Picasso and *Duchamp. Mrs Thomas Eakins's gift of her husband's work has established the museum as a centre of studies of *Eakins's work. CFW

PHILOSTRATUS, the name of a family of Greek rhetoricians active in the 2nd–3rd or 4th centuries AD. Two of the Philostrati, grandfather and grandson, composed descriptions of paintings entitled *Eikones* or *Imagines*. The elder Philostratus claims to have seen the works he describes in a private villa in Naples where he was staying after attending a competition. The work of the younger Philostratus is introduced by a discussion of the role of the imagination and the connections between literature and the visual arts. The elder Philostratus makes occasional comments about artistic technique, paying particular attention to effects of perspective and to the portrayal of emotion and character. The descriptions invite the audience to become involved in the narrative depicted in the painting, recreating the subject matter so

that it is often difficult to identify the particular moment illustrated. The *Eikones* were first published in 1503 by Aldus Manutius and were read in translation by 16th-century artists, patrons, and theorists. Some of the elder Philostratus' *Eikones* were translated back into paint by *Titian, *Giulio Romano, and Fra *Bartolommeo. The illustrated edition of Blaise de Vigenere's French translation of the complete *Eikones* enjoyed great popularity in 17th-century France. *Goethe also translated the text and considered it a source of information on ancient painting. The authenticity of the descriptions remains a subject of debate although it seems clear that they reflect artistic conventions and may provide some idea of contemporary responses to the visual arts.
RW

Anderson, G., *Philostratus, Biography and Belles Lettres in the Third Century A.D.* (1986).

Philostratus, *Imagines*, and Callistratus, *Descriptions*, trans. A. Fairbanks (1931).

PHOTOGRAPHY AND ART. The relationship of photography to art, notably painting and graphic media, has a long and problematic history. Changing concepts of art and practices of photography have drawn the urgency from earlier debates about their relative status, but the cultural issues concerning ways of viewing and constructing images remain of interest. The nature of the projected photographic image was known from early times, but the principles of the *camera obscura, a term equally applicable to a darkened room or a small box, rendering the three-dimensional world in two, were explored in parallel with those of *perspective during the 16th century. The developments of the next century in lens technology for telescopes and microscopes extended the experience of vision and produced improved and various versions of the camera. The demand for reproducible imagery of all kinds increased among the emerging professional and middle classes throughout the 18th century. The copper plate used for *etching and engraving (see LINE ENGRAVING) was not adequate for the long runs of impressions demanded and other means of picture production were sought. Modern photography shares its history with contemporary developments in graphic art, such as *lithography, and the term 'plate' remains in use.

The camera had many applications but artists found it a valuable adjunct to perspective devices. While it seems clear that *Vermeer was acquainted with the camera image and deployed some of its effects, recent debate has moved away from the idea of his dependence on the camera.

Vermeer's associations with optical scientists and the nature of his compositions and painting techniques suggest close observation of the image thrown by a camera, not simple tracing or copying. This was not just a technical matter but was intimately related to the 17th-century concern with light as a philosophical and religious phenomenon. Even then camera images had to be modified to meet conventions. In the 18th century some of Vermeer's pictures were seen as demonstrating camera distortion, something that became acceptable and naturalized in the 19th and 20th centuries.

While it is possible to draw or make notes from the various kinds of early apparatus the image presented is one of varying tone and it is only sharply delineated objects, architectural or topographical, that readily lent themselves to graphic exploitation. For topographical artists faced with the task of depicting the cities of Europe the camera offered a valuable 'notebook' for recording relative position and proportion. Examination of sketches purported to be made by *Canaletto with the camera and of his complex London and Venetian views reveals how many other skills were employed. Study of an almost intact original site, the Piazza S. Martino in Lucca, reveals that *Bellotto's photographic, instantaneous view (*c.*1742–6; York, AG) is not explicable in camera terms alone, but represents manipulation of perspective. It is authoritative but is not realizable through either the camera lens or the human eye. Lesser topographical draughtsmen and the many minor artists supplying the increasing demand for landscape views were arguably more dependent on the camera, but even they had to adapt the scope of the view to the format of the copper plate, something the camera does not easily accommodate.

Portrait painters could have made some use of the camera for the tracing of physiognomy. Sir Joshua *Reynolds's camera, tellingly disguised as a large bound volume (London, Science Mus.), reveals that it would be impossible to paint directly on the projected image in the dark tent structure. Whether or not it was used to draft likenesses of sitters in an age of idealization is debatable.

The more portable cameras were undoubtedly used, along with *Claude glasses, by the amateur. Developments in light-fixing chemistry led the amateur artist, but knowledgeable scientist, W. H. Fox Talbot (1800–77) to develop the first practicable system of making an infinite number of image copies without loss of quality. While Fox Talbot was a member of the scientific establishment others, like the showman Louis Daguerre (1789–1851), approached the photograph from the world of spectacular entertainment, such as the diorama and panorama.

Although modern photography emerged with the publication of successful methods of fixing the camera image, that image was made in accordance with the photographer's understanding of historical and contemporary pictorial construction. The camera was designed to confront the world in terms of traditional perspective views, with a painter's relation of horizontals and verticals. The cumbersome nature of early equipment assured that this format was rarely departed from until the arrival later in the 19th century of lighter, hand-held cameras that could convey more flexible impressions.

Once photography was in the public domain its appearance and aesthetic possibilities were seen as various. The granular quality of the early calotypes lent itself to a continuation of the *picturesque aesthetic, while the grainless, mirror quality of the daguerreotype offered an illusion of unmediated reality.

Despite the connotations of art in the title, Fox Talbot's *Pencil of Nature* (1844–6) demonstrated the wide scope and applications of photography. The early years of the medium saw a battle between those who, like *Baudelaire, decried the artistic pretensions of photography and those who sought to make genre photographs that could stand comparison with, and enjoy the same status as, paintings. Some saw photography as a threat. *Delaroche's famous dictum 'From today painting is dead' is often quoted. Less often quoted is his view of 1839 that the invention of photography 'has rendered an immense service to the arts'. This double view informed much thinking about the status of photography. In practice artists were influenced by the photographic image in an astonishing variety of ways.

Artists practising in both the minute style of the *Pre-Raphaelites and the broader modes of *Impressionism found support in photography. *Delacroix was enthusiastic about the medium but, like others, believed that it should not be used slavishly. Matters were complicated as photographers sought the status of artists and photography began, by the 1860s, to be presented as art. O. Rejlander (1813–75) and H. P. Robinson (1830–1901) were among those who created composite pictures from a number of negatives to emulate exhibition paintings. Julia Margaret Cameron (1815–79) costumed, posed, lit, and defocused her sitters to create pictures rivalling the ideal art of G. F. *Watts. The popular audience enjoyed posed scenes, serious and comic, mass produced for the stereoscope and for magic lantern projection.

Photography supplied artists with foreign views and provided a stock of images lending authenticity to orientalist and historicist paintings. It began to support the development of art history with reproductions of works of art from all times and places. Art imitated photography and, as with the Pictorialists of the late 19th century, photography imitated art. The range of printing

papers and processes available to the photographer, many of them offering tints and strong graphic effects, burgeoned. The framed exhibits of the London-based Linked Ring and the American Photo-Secession, dominated by Alfred Stieglitz (1864–1946), were designed to be appreciated as works of art as much as any painting. Stieglitz went on to publish the enormously influential *Camera Work* between 1902 and 1917.

Faster film emulsion allowed the analysis of movement hitherto invisible. After Muybridge's work from the late 1870s onwards the depiction of a racing horse had to follow photographic analysis, not artistic convention. *Degas combined an interest in the accidental effects of photo-composition with the Japanese print to produce monumental images of modern life with the appearance of spontaneity. The development of lighter, more mobile cameras broke the constraints of the vertical and horizontal that characterize most early plate photography. Colour, new lenses, and better techniques of mass reproduction allowed more experimental work, not bound by earlier photographic conventions or camera angle. Marcel *Duchamp coolly appropriated the work of analytical photographers for his mechanistic *Nude Descending a Staircase* (Philadelphia Mus.) of 1912. The *Futurists followed less coolly. In 1917 Alvin Langdon Coburn (1882–1966) experimented with Vortographs. By the 1920s *Constructivist artists like *Rodchenko and *Lissitzky were equally expressive in photographic and fine art media. At this time the influence of the cinema began to influence both still photography and painting.

Photography was a gift to the *Surrealists, who inverted old values by producing photographic paintings (*Dalí) and artwork entirely photographic (*Man Ray). For popular use fashion and theatre photographers like Cecil Beaton (1904–80) and Angus McBean (1904–90) appropriated the appearances of Surrealism with verve.

*Photomontage, particularly in the hands of John *Heartfield, subverted the seamless authority of the single image to create satirical, and frequently political, pictures. In the post-war years the old debates about art and photography were over, if not quite dead. The discipline of painting was still expounded, but the diverse uses of photo imagery, from *Bacon to *Hockney, witnessed the vitality of the continuing dialogue. The practices of *Pop art finally fused the media as demonstrated by the ironic uses of the photographic image by Richard *Hamilton and Andy *Warhol. The *Photo-realists followed, but without the irony.

Photography gave material form to *Conceptual Art, the most bodiless of 20th-century movements, and enabled the exhibiting of works and ideas of artists and sculptors like Richard *Long and Andy Goldsworthy to be viewed in gallery conditions. The medium has been used to effect where artists need to appear within their own works. *Gilbert and George synthesize photography, paint, and print and Cindy Sherman (1954–) stars in her long series of imaginary film stills and art historical pastiches.

The evaluation of photography, in both aesthetic and market terms, rose sharply in the 1960s. Photographic work from the past was increasingly shown in major art galleries. This further confused the boundaries between the media, and even documentary photography, once presented as the antithesis of art, acquired art status. Limited editions and fine prints were promoted by dealers and auction houses and photographers like Edward Weston (1886–1958) and Ansel Adams (1902–84) achieved something akin to old master status.

The now complicated relations between the medium of photography and ideas about art are extended by developments in laser holography, *computer graphics, film, and *video. Where once there was anxiety about an artist's dependence upon what were seen as mechanical devices, the modern artist, and critic, treats all of these processes as valid means to the creation of art. PLe

Hyde, R., *Panoramanias* (1988).

Scharf, A., *Art and Photography* (1968).

PHOTOMONTAGE, the assemblage of photographic material, sometimes incorporating other media, to produce a composite image. This includes *collage, rephotographed to render the edges inconspicuous, and prints made by superimposing two or more negatives. Both techniques were developed in the 19th century, but photomontage gained greater popularity after its adoption during the First World War by members of the Berlin *Dada group, inspired by *Cubist collage. Noted exponents were John *Heartfield and the *Surrealist Max *Ernst. Photomontage is now much used in posters and advertising, and has become ubiquitous in magazine layouts. AA

Frizot, M., *Photomontage* (1991).

PHOTO-REALISM, also known as Super-realism, was a style of painting (and sometimes sculpture) which emerged principally in the USA and Britain in the late 1960s, characterized by the extraordinary detail and precision with which subjects were depicted. The furthest extent of this style is represented in the paintings of Richard Estes (1936–) and Chuck Close (1940–), which were copied from colour slides projected onto the canvas, and whose subjects—for example multiple reflections in shop windows—were often chosen for their combination of visual complexity and emotional neutrality. In the sense of heightened clarity produced by such works, photo-realism has been compared to *magic realism, and to *Pop art, with which it shares a preference for ostensibly banal subject matter. However, Photo-realism can be distinguished from other movements by its apparent rejection of the painterly and formal qualities by which individual artists' styles may be recognized, and by its establishment of the photographic image as a subject for painting. Other American Photo-realist painters include Don Eddy (1944–) and Audrey Flack (1931–), and, in Britain, Michael English (1943–), Michael Leonard (1933–), and Graham Dean (1951–). OPa

PIAZZETTA, GIOVANNI BATTISTA (1682–1754). Italian painter. He was the son of a woodcarver and a feeling for sculptural form is always present in his pictures, emphasized by a strong play of light and shade. After preliminary training in Venice he worked under G. M. *Crespi in Bologna, where he was impressed by the early works of *Guercino with their rich colours and dramatic storytelling. He returned to Venice in 1705 and executed a number of commissions, including the robust and realistic *S. James the Greater Led to Martyrdom* (1722; Venice, S. Stae) with its dramatic chiaroscuro; and the *Glory of S. Dominic* (1727; Venice, SS Giovanni e Paolo). During this period his style became more dramatic and intense as a result of his interest in works executed much earlier by *Liss, *Strozzi, and *Fetti and many of his compositions follow closely after theirs. Piazzetta was a slow worker, and often painted the same subject several times with subtle modifications. He was not without wealthy patrons, such as the English impresario Owen MacSwinny, who commissioned the *Allegorical Tomb of Lord Somers* (1725; Birmingham, Mus. and AG), a collaborative effort also involving *Canaletto and Giovanni Battista Cimaroli (active from c.1700); and Francesco *Algarotti who commissioned *The Standard Bearer* (1743; Dresden, Gemäldegal.). Above all Johann Matthias von der Schulenburg imaginatively commissioned two elegant rustic genre scenes where the artist establishes a new pastoral mode (1740; Chicago, Art Inst.; 1745; Cologne, Wallraf-Richartz-Mus.). The Venetian aristocracy also provided valuable patronage but usually for *history painting, notably the Pisani, for whom Piazzetta provided *The Death of Darius* (1745; Venice, Ca' Rezzonico) as a companion to the celebrated *Veronese *The Family of Darius* (London, NG).

He produced numerous drawings and book illustrations, including illustrations for Albrizzi's 1745 edition of Tasso's *Gerusalemme liberata*. His presentation drawings, portraits, and character heads, usually made in charcoal or white chalk, were also in wide demand from discerning collectors. In 1750 he was made director of the Venice Academy of

Fine Arts but in his last years was eclipsed by the new generation, including G. B. *Tiepolo.

HB

Knox, G., *Giambattista Piazzetta* (1992).

PICABIA, FRANCIS (1879–1953). French artist. After painting in an *Impressionist manner, c.1912 he came under the influence of *Cubism (see also SECTION D'OR), participating in the movement known as *Orphism. In 1913 he visited the USA, exhibiting at New York in the *Armory Show. During a second stay in New York (1915–16), he collaborated with Marcel *Duchamp and contributed to the magazine *291*. Anarchistic, subversive, and highly individualistic by temperament, he was one of the most active and original members of the *Dadaist movement both in the USA and Europe. At Barcelona in 1917 he founded the Dada periodical *391*, which continued to appear irregularly until 1924, while in Zurich he was associated with the group of Tristan *Tzara and Hans *Arp. During this time he published Dadaist poems, as well as producing paintings and drawings that represent ostensibly human subjects as irrational combinations of mechanistic forms, exemplified by *Child Carburettor* (1919; New York, Guggenheim). Although briefly he was close to the *Surrealists, he broke away c.1924, later creating the highly enigmatic *Transparencies* (1927–31), which consist of superimposed figures ironically quoted from celebrated old master paintings. Although unwilling to tie himself to any artistic group, he was among the most influential of 20th-century artists.

CJM

Canfield, W., *Francis Picabia: His Art, Life and Times* (1977).

PICASSO, PABLO (1881–1973). Spanish artist. Born in Malaga to Maria Picasso y López and José Ruiz Blasco, an art teacher and minor painter, Picasso became the most famous and influential artist of the 20th century. Intellectually restless and relentlessly inventive, his brilliant draughtsmanship underpinned all that he undertook and his creative mastery extended all the technical processes he employed. He desired to be 'Le peintre de la vie moderne' and once he had achieved the reputation of being the leading painter of his age, he jealously and competitively guarded it. His capacity to transfigure the realities of the visual world around him into revolutionary new forms required a refined eye, an extraordinary imagination, and great daring; he was not found wanting. Nor was he a stranger to the shock tactic; a taste for the barbaric accompanied the wit, the vitality, and the dynamism. To much of his contemporary audience his sudden changes in direction and style seemed wilful and bewildering, yet, with time and an overview, it is possible to recognize a logic in the rapid, developmental achievements of his inventions, where new forms were created to solve new problems, and to admire his ability to inform all his works, great and small, with the originality and grandeur of his genius. Picasso never abandoned completely the phenomenal world as a source for his inspiration but he did abjure the artistic conventions of the traditions he inherited and created a conceptual form of art rather than recording the appearance of a perceived world, where images could be subjected to objective criteria in their evaluation. He released works of art from being representations of things seen and gave each work independence in its own reality, requiring the spectator, in his subjective response, to come to terms with newly devised forms conceived to express the artist's own subjective experience. Much of the history of 20th-century art is a record of this challenge.

Picasso's early studies were with his father and at the Schools of Art in Corunna and Barcelona to which cities his family had moved. He showed early mastery of academic technique and exhibited his first large canvas in 1896, *First Communion* (Barcelona, Mus. Picasso). At the café Els Quatre Gats in Barcelona he moved among bohemian artists and in 1900 visited Paris with one of them, Carlos Casagemas (1880–1901), whose suicide a little later affected Picasso deeply. For four years he alternated between Barcelona and Paris, painting and engraving alienated, melancholy images of maternity, circus themes, and people in poverty. Since most of the paintings are in a cool, blue hue, this became known as the Blue Period: *La Vie* (1903; Cleveland, Mus. of Art).

In 1904 Picasso moved to Paris, into the 'Bateau-Lavoir' in Montmartre, where he established an avant-garde artists' circle. He already knew the poet Max Jacob (1876–1944) and now met Guillaume *Apollinaire, André Salmon (1881–1969), and Marie *Laurencin. A seven-year relationship with Fernande Olivier from 1905 coincided with the beginning of the Rose Period which lasted almost three years. The predominance of blue gave way to warmer hues in paintings mostly of harlequins, dancers, and acrobats: *Family of Saltimbanques* (1905; Washington, NG). He now made the acquaintance of important collectors, such as the Americans Leo and Gertrude Stein, the Russian S. I. Shchukin (see MOSCOW), and the dealer Ambroise Vollard (see PARIS), who bought most of the Rose Period canvases.

In 1906, Picasso saw the early Iberian sculptures which had been excavated at Osuna and felt a national, personal affinity with them. Also, he met *Matisse and *Derain and the latter urged him to visit the Trocadéro to see the African sculptures there. He began work on the painting André Salmon was to call *Les Demoiselles d'Avignon* (1907; New York, MoMa). Influenced by *Cézanne, who had recently died, and inspired by his new-found enthusiasm for African masks and figure sculpture, Picasso produced the painting which was, even for the few artist friends who saw it, so ugly and shocking that the big canvas remained rolled up and hidden for several years in a private collection, making its public debut in 1916. It is now widely regarded as the century's principal milestone, a signpost pointing away from the conventions of the past. It revolted against *Impressionism and ignored the decorative colour experiments of the *Fauves, embracing distortion as a source of expressive power and pointing towards what *Braque was to call 'the materialization of the new space', which he and Picasso would formulate and explore in the movement called *Cubism. Picasso and Braque together departed from natural representation that used spatial illusions constructed by Renaissance *perspectival models, creating between 1910 and 1914 the works which are identified with 'analytic' and 'synthetic' Cubism. Keeping to monochromatic earth colours, eschewing sensuality and all illusions, they constructed images born out of conceptions, heightening the spectator's awareness of what is real by using materials advancing from the picture surface and involving textures normally foreign to painting. Collage was introduced and the *papier collé invented. Accepting space as a two-dimensional reality and depicting objects as they are known, not as they appear in a particular context, allowed for a variety of viewpoints within the same picture. Picasso turned to sculpture during this time to exploit the inherent dynamism emerging from the planar fragmentation of the forms: *Woman's Head* (1909; Buffalo, Albright-Knox Gal.). After meeting Diaghilev in 1916, Picasso agreed to design the decor for *Parade*, the first of his ballet designs. He travelled to Rome in 1917 to work on the decor and there met *Bakst, Igor Stravinsky (1882–1971), and the ballerina Olga Koklova, whom he married in 1918. Their son Paolo was born three years later. Images of children, mothers, and women bathers began to emerge, classical in style, inspired by *Poussin and *Ingres but mixed with some residual Cubism. *Neoclassicism engaged Picasso 1920–5, involving monumental figures expressing *joie de vivre*: *Mother and Child* (1921; Chicago, Art Inst.).

Picasso met the poet and *Surrealist theorist André *Breton in 1923, a year before the *Manifeste du Surréalisme* was published, and he was included in the first issue of *La Révolution surréaliste*. A year later, the first reproduction of *Les Demoiselles d'Avignon* appeared in Breton's *Le Surréalisme et la peinture*. Although Picasso had been an inspiration to the group, his involvement with it was more an expression of Breton's desire to include him than a turn by the artist towards dreams, chance,

psychopathology, irrational behaviour, and its imagery.

The end of the 'classical' period of Picasso's output coincided with the breakdown of his marriage and the beginning of his relationship with Marie-Thérèse Walter. It is possible to find a correlation between the positive and the negative charges in his work and relationships with lovers, since he was able to harness and give form to the energy released. There is a rhythmic rise and fall as the passion turns from joy in its newness, for instance *Olga in an Armchair* (1917; Paris, Mus. Picasso), to the guilt, anger, and frustration in its deterioration: *Self-Portrait and Monster* (1929; priv. coll.). The 'studio' theme began in 1926 and in the early 1930s the minotaur appeared in his work; tenderness was contrasted with gloom, anger, and violence. He turned to sculpture again, learning to weld in 1928 in the studio of Julio *González, and began *etching, producing work for Vollard and Skira. In 1933, he collaged a cover for the first issue of *Minotaure* and in 1935 his *Minotauromachy* revealed his mastery of the *etching craft.

The foreboding and sense of doom which haunted his themes were fully realized in 1936 with the outbreak of the Spanish Civil War. Picasso, aligned with the Republicans, was named director of the Prado Museum and requested to provide a mural for the Spanish Pavilion at the World's Fair in Paris. His outburst of rage in 1937 when German aircraft bombed the Basque town of Guernica provided him with his subject. *Guernica* (1937; Madrid, Centro de Arte Reina Sofía) was the outcome, one of the century's greatest images. With techniques that had earlier seemed hermetic and indecipherable to many, Picasso constructed, in monochrome, a painting of nightmarish violence, horror, fear, and loss using visual metaphors derived from late Cubism. Gathering together themes from his recent work, the bull, the dying horse, the weeping woman, he composed a huge, unified expression of outrage. During the Second World War, Picasso remained at work in Paris, a shortage of materials being overcome by refashioning found objects, metamorphosed into assemblages full of style and wit. He joined the Communist Party in 1944 and attended Peace Congresses each year from 1948 to 1951, his lithograph *The Dove* (1949) becoming the Peace symbol, and he was twice awarded the Lenin Peace Prize.

After the war, Picasso moved to the south of France with his new muse and lover Françoise Gilot, whom he had met in 1943. Since draughtsmanship was the foundation of all his art, engravings, etchings, *lithographs, linocuts, and drawings poured from him in astonishing quantity and quality. Picasso rightly regarded the history of art as a tradition and source of learning and inspiration, taking what he needed. He decorated ceramics with verve, an eye on ancient Greece, and painted fifteen variations on *Delacroix's *Les Femmes d'Alger* (1954–5) and 44 variations on *Velázquez's *Las meninas* (1957). Some critics saw these acts as plunder but they can be seen more as declarations of homage. His profound interest in earlier masters may be seen as early as 1934 when he included an etching, *Rembrandt and the Two Women*, in the Vollard Suite. Picasso continued making sculptures, producing (1960–3) cut-and-folded paper maquettes for huge sheet-metal versions and a model (1964) for the giant sculpture at Chicago's Civic Centre (1967).

Few figures from the history of art can be compared to Picasso. The range of his creativity, the depth of his imagination, and the breadth of his technical virtuosity continue to amaze and many of the revolutionary developments of the 20th century can be attributed to him. JL

Pablo Picasso: A Retrospective, exhib. cat. 1980 (New York, MoMA).

Richardson, J., *A Life of Picasso* (2 vols., 1991–6).

PICTURESQUE. Although seldom used today with anything akin to a well-defined meaning the word picturesque is soon confronted when studying the ways in which *landscape was appreciated in Britain in the late 18th and early 19th centuries. The word is found everywhere, usually qualifying an actual view of nature or a painted landscape. Picturesque views became the stock in trade of almost all landscape painters in one way or another. Many artists were drawing masters who published instructional manuals illustrated with 'progressive studies', providing lessons in picturesque composition. Such volumes contained pages of rustic figures and animals, rural pursuits, waterfalls, bridges, and Gothic ruins, some or all of which could be brought together in a carefully articulated landscape setting adjusted to suit weather effects and particular times of day. The heyday of such publications was from 1800 to 1840 and such was the power of the picturesque that its formulas were taken up again by landscape photographers of the 1840s onwards.

That the picturesque became so widespread resulted from a combination of factors, not the least of which was the rise of middle-class tourism and the craze for landscape sketching for which guidance was eagerly sought. One of the most prominent names in the not inconsiderable literature of the picturesque was the Revd William Gilpin (1724–1804) whose accounts of his sketching trips in England, Scotland, and Wales between 1769 and 1776 sold very well when they appeared in print from 1782, having circulated in manuscript form prior to that. Illustrated with tinted oval *aquatints in imitation of (in his own words) his 'slight' and 'diminutive' monochrome landscape sketches Gilpin endeavoured to provide characteristic images rather than exact portraits of actual scenes. His ideas and methods were easily adapted by his fellow amateur sketchers. His was an interventionist approach. He proposed what he termed 'a new object of pursuit': 'that of not barely examining the face of a country; but of examining it by the rules of picturesque beauty; that of not merely describing; but of adapting the description of natural scenery to the principles of artificial landscape; and of opening the sources of those pleasures, which are derived from the comparison' (*Observations on the River Wye . . . Relative Chiefly to Picturesque Beauty*, 1782).

The measure of landscape appreciation came from comparing natural scenery with those 'artificial' examples so beloved of British art collectors, namely Dutch and Italian landscapes from the 17th century, widely known in the form of engravings. Gilpin's constant references to 'picturesque beauty' indicate where his ideas need to be placed. 'The picturesque' formed a category roughly midway between the *sublime and the beautiful. It was a book published in 1757 by Edmund *Burke, with many subsequent editions, which also encouraged other 18th-century writers on taste to assign particular aesthetic qualities to forms in nature ranging from the vast to the small (*A Philosophical Enquiry into the Origin of our Ideas of the Sublime and Beautiful*, 1757).

Gilpin termed his combination of touring and sketching a 'rational and agreeable amusement'. It was largely free of any utilitarian purpose but had an element of moral uplift by concerning itself with the natural scene and God's creation well beyond the more base amusements of urban life.

With the Continent closed to foreign travel during Napoleon's reign the tourist-cum-amateur sketcher as well as the professional artist was restricted to seeking out new sites and experiences in Britain which could approximate to the grandeur found abroad. Thus north Wales, the Lakes, and Scotland were added to the picturesque itinerary as well as key historic sites, particularly ruined monasteries and abbeys. The fashionable context for picturesque travel can be found reflected in the literature of Jane Austen as well as in more obviously comic publications such as James Plumptre's *The Lakers* (1798), and *The Tour of Dr Syntax in Search of the Picturesque* (1809), written by William Combe and illustrated by Thomas *Rowlandson. In a series of immensely popular hand-coloured aquatints, he depicted the reverend doctor's

misadventures in his quest for the picturesque.

Serious publications dealing with topography and antiquarian research were also influenced by the cult of the picturesque. Here the great pioneer was John Britton, who was responsible for training a new generation of early 19th-century architectural draughtsmen who provided him with illustrations for a vast array of important publications over some 30 years or more. His own interpretation in 1830 of the significance of the term 'picturesque' is worth quoting: 'It has not only become popular in English literature, but as definite and descriptive as the terms grand, beautiful, sublime, romantic and other similar adjectives ... about scenery and buildings it is a term of essential and paramount import' (*Picturesque Antiquities of the English Cities*, 1830). Whilst evidently acutely aware of the picturesque, Britton's publications, and many others of the 1820s and 1830s, espoused a more objective use of picturesque composition. Steel-engraved views (replacing the earlier use of copper) made possible finer detail and more atmospheric effects.

The earlier sense of 'discovering' the landscape turned more to recording it and its picturesque ruins for posterity in a changing environment in which time-honoured sites were being endangered by new developments catering for a fast-growing population which had little concern for the aesthetic preferences and judgements of the leisured classes, or for the historic interests of the antiquarian artist. Then as now progress and nostalgia came into conflict.

There is no doubt that Gilpin had been the acknowledged pioneer of the picturesque sketch, but this had been restricted chiefly to mountainous and lake scenery, as had his publications. As well as his tours he published various essays expounding his ideas and methods. These included works on *Picturesque Beauty, Picturesque Travel*, and *Sketching Landscape* (1792) and *Two Essays on the Principles on which the Author Made his Drawings; and the Mode of Executing Them* (1804). The publications of 1792 coincided with the death of Sir Joshua *Reynolds, who did not approve of Gilpin's preference for the sketchy, something which Reynolds censured in public at the Royal Academy, *London, when he criticized *Gainsborough for his 'undeterminate manner' and 'uncertain and doubtful beauty' (*Eighth Discourse*, 1778).

Gainsborough's openly sketchy style might have offended Reynolds but it greatly appealed to others. His wonderfully fluid landscape sketches, done for his own amusement, became very influential when many were later engraved in facsimile and their style adopted by picturesque sketchers, *Constable among them, who sought for inspiration in rustic wooded landscapes rather than the lakes and mountains so beloved by Gilpin.

In the 1790s a vigorous debate was conducted in print over the merits and qualities of the picturesque. The writings of Sir Uvedale *Price and Richard Payne *Knight injected a new dimension which had greater bearing on how professional artists responded to the aesthetic debate about the wider issues of landscape painting and sketching. Unlike Gilpin, a clergyman and schoolmaster, both Price and Knight were landed gentlemen with country estates in Herefordshire, at Foxley and Downton respectively. Thus their interests in scenery and its relation to art were compounded by their ownership of both as well as their wider interest in politics and the politics of taste. Their own landscaped grounds and managed estates echoed in microcosm a well-ordered society at large and could thus be seen as symbols of national and patriotic pride, as Price made clear: 'Picturesque composition seeks to reconcile the virtues of variety and imaginative freedom with a frame of order, in a fit image of the perfect constitution.'

Price published his *Essay on the Picturesque* in 1794 and it appeared in two further editions, most fully in 1810 (*Essays on the Picturesque, as Compared with the Sublime and the Beautiful; and on the Use of Studying Pictures, for the Purpose of Improving Real Landscape*). Using the earlier writings of both Burke and Gilpin, Price endeavoured much more precisely to define what 'the picturesque' consisted of. The qualities he sought in real landscape could be found in existing art, in the landscapes of Gainsborough and in Dutch examples from the 17th century. Essentially these qualities were a roughness and variety of texture, and an intricacy of forms, combined with darks and lights bringing them to life. Trees exemplified these qualities, with 'the rugged old oak or knotty wych elm' being especially picturesque, especially if 'rough, mossy, with a character of age, and with sudden variations in their form'. Payne Knight, a wealthy collector and connoisseur, dedicated to his friend Price his own *The Landscape: A Didactic Poem* (1794). Both men disliked the kind of smoothly regular landscape parks made popular by 'Capability' Brown (1716–83). Knight's poem illustrates a 'before' and 'after', picturesque and non-picturesque, park scene, in two engravings after the artist and antiquarian Thomas *Hearne, himself a brilliant exponent of the picturesque. Knight developed his ideas in his *Analytical Inquiry into the Principles of Taste* (1805). In this a more psychological approach is evident in which ways of seeing and looking are more significant than objects themselves. Inherent characteristics are not as significant as the association of ideas, in which an acquired knowledge of art and literature enhances the visual and sensual pleasure found in the study of real landscape scenery. This more dynamic approach proved beneficial to the new landscape artists who were to become the leading exponents of *Romanticism, such as *Turner and Constable, both of whom passed through a formative picturesque phase in their early work.

One of the most influential writers on association theory was the Revd Archibald Alison (1757–1839), a Scottish clergyman and writer on aesthetics, whose *Essays on the Nature and Principles of Taste* (1790) had a more long-lasting influence, through its many 19th-century editions, than the other more restrictive writings on the picturesque. Constable found his notions appealing in confirming his own appreciation of landscape poetry and its rich vein of association of ideas, with natural objects and forms giving rise to thoughts of God, nationality, and the cycle of nature.

The whole concept of the picturesque has been debated anew in recent years from a wide range of theoretical stances. That this has happened is in part evidence of the diversity of the original explorations and their still relevant bases for our own early 21st-century appreciation of the landscape and our relationship to it. **MP**

Andrews, M. (ed.), *The Picturesque: Literary Sources and Documents* (3 vols., 1994).

PIERO DELLA FRANCESCA (c.1415–92). One of the most important Italian painters of the 15th century. He was also a mathematical theorist, and his monumental, architectonic compositions and simplified figures reflect his interest in geometry and *perspective as well as in *colour and light. He was born in Borgo Sansepolcro, a small town near Arezzo, where painting was dominated by the Sienese. His training is not known, but he is documented working locally between 1432 and 1438. By 1439 he was in Florence, working with *Domenico Veneziano on an important fresco cycle (destr.) in S. Egidio. The influence of Domenico's carefully ordered compositions and rational use of light is apparent in Piero's early altarpiece the *Baptism of Christ* (London, NG), with its columnar figures set in a Tuscan landscape. His stylistic development was enriched by the experience of Florentine art, particularly *Donatello, and in the *Misericordia* altarpiece (1445–62; Sansepolcro, Pin.), the massive Madonna, sheltering the donors under her cloak, has a sculptural solidity reminiscent of *Masaccio. Commissions from courtly patrons included frescoes (destr.) for the Este in Ferrara, where he doubtless encountered examples of Flemish painting in oil, with its emphasis on naturalistic detail. By 1450 he was painting frescoes for Sigismondo Malatesta in Rimini, including an elegant profile portrait of the tyrant with his patron saint

and hounds, combining heraldic and religious imagery. The pilasters in the fresco echo its setting, the remarkable *Renaissance temple designed for Malatesta by *Alberti. Albertian architecture also appears in the *Flagellation* (Urbino, Palazzo Ducale), an exquisitely painted panel in which colour, light, and perspective are synthesized in his mature style. Its meaning is mysterious: the three sumptuously dressed foreground figures seem unaware of the scourging of Christ in the background, perhaps indicating that the two scenes are not contemporaneous. His major surviving work, the fresco cycle of the *Legend of the True Cross* in S. Francesco, Arezzo, was begun about 1452. The story of the wood from the Garden of Eden that became Christ's cross includes a great variety of scenes—courtly interiors, landscapes, crowded battles, and solitary sleepers—all lucidly composed, with figures, landscape, and architecture depicted in the same vocabulary of monumental forms. In his powerful fresco of the *Resurrection* (Sansepolcro, Mus. Civico), the figure of Christ, his sepulchral pallor set off by a shroud of tender pink, confronts the viewer with awesome directness. Increasing Flemish influence, particularly from Jan van *Eyck, is apparent in his late works, notably the distant landscapes in the profile portraits of Federigo da Montefeltro and his wife (c.1472; Florence, Uffizi). Federigo also appears in the *Virgin and Child with Saints* (mid-1470s; Milan, Brera), which is set in an elaborate vaulted niche that appears to continue the actual architecture of the chapel, a concept also used in contemporary Venetian altarpieces. By the 1480s he seems to have concentrated on theoretical writing, including a treatise on perspective. Like the Neoplatonists, Piero believed that natural beauty was based on perfection of form, and the noble simplicity of his work appeals to admirers of artists such as *Vermeer and *Seurat.　　LH

Bertelli, C., *Piero della Francesca* (1992).
Lightbown, R., *Piero della Francesca* (1992).

PIERO DI COSIMO (c.1462–1521?). Florentine painter. There are no documented works; all his paintings are attributed. The only source for his life is *Vasari's entertaining account, which suggests an eccentric, bohemian personality.

Apart from assisting his master, Cosimo *Rosselli, with frescoes in the Sistine chapel, Rome (c.1481), Piero produced altarpieces, and secular decorative panels for furniture and wainscoting in the palaces of Florentine patrons. He designed *trionfi*, or public spectacles, including the famous *Triumph of Death* of 1506, and painted striking portraits, such as *Simonetta Vespucci* (Chantilly, Mus. Condé).

His stylistic sources range from Rosselli and Filippino *Lippi to the muscularity of

*Signorelli, the intricate landscapes of *Leonardo, and eventually the simpler classicism of Fra *Bartolommeo, his pupil. In spite of this eclecticism, his paintings are original and imaginative, inspired by his preoccupation with natural themes and the emotional effects of light and landscape, as in the *Forest Fire* (Oxford, Ashmolean). His mythological subjects are fantastic, often disturbing visions such as the *Battle of the Lapiths and Centaurs* (London, NG) and the mysterious so-called *Death of Procris* (London, NG).　　MS

Bacci, M., *L'opera completa di Piero di Cosimo* (1976).
Fermor, S., *Piero di Cosimo: Fiction, Invention and Fantasia* (1993).

PIERRE, JEAN-BAPTISTE (1714–89). French painter. A pupil of *Natoire and de *Troy, he won the *Prix de Rome in 1734 and spent the next five years in Italy. His first exhibited pictures were *genre scenes, but attacks by the critics on the 'unworthiness' of such subject matter turned him exclusively towards history painting, with which he was to earn both fame and fortune. His *Beheading of S. John the Baptist* (Avignon, Mus. Calvet), which was exhibited at the 1761 *Paris Salon, is a good example of his solemn and academic style. From about 1763 Pierre virtually stopped painting to concentrate on his career as an official. As First Painter to the King (from 1770) and director of the Académie Royale (see under PARIS) (from 1778) he was one of the most influential figures in the art world in the last years of the *ancien régime*. He used his powers to promote government funding of large-scale *history painting, an important condition for the triumph of *Neoclassicism in France in the 1780s.　　MJ

Halbout, M., 'Œuvres de J.-B. Pierre', *Études de la Revue du Louvre*, vol. 1 (1980).

PIETÀ, a devotional image showing the grieving Virgin with the body of her dead son, newly taken from the cross, lying over her knees. Not an event from biblical narrative, the subject is dealt with in numerous medieval texts emphasizing the Virgin's empathy for the sufferings of Christ and, therefore, her suitability as an intercessor for man. The earliest examples appear to be German (13th-century) but from the 14th to 17th centuries the subject was popular throughout northern Europe and Italy, in painting and in sculpture, in large scale for public veneration and small scale for private devotion: for example an early 14th-century carving in Naumberg Cathedral, the *Pietà of Villeneuve-lès-Avignon* by Enguerrand *Quarton (c.1455; Paris, Louvre), Giovanni *Bellini's *Pietà* (Venice, Accademia), and *Michelangelo's marble group (1497–1500; Rome, S. Peter's). For the sake of realism and ease of composition the dead Christ was sometimes placed on the ground at the feet of the mourning Virgin by

later painters: for example *Sebastiano del Piombo in the *Pietà* for Viterbo (c.1513; Mus. Civico).　　MLS

PIETRO D'ANGELO, JACOPO DI. See QUERCIA, JACOPO DELLA.

PIGALLE, JEAN-BAPTISTE (1714–85). French sculptor. A pupil of *Lemoyne who went on to study in Rome, he was with *Falconet the foremost sculptor of mid-18th-century France. Though he was a past master of *Baroque composition, he combined this with a *naturalism that gives much of his work a distinctive Enlightenment flavour, sometimes—as in his statue of the elderly Voltaire nude (1776; Paris, Louvre)—with startling results. Pigalle was equally at home with allegory, sentimental genre, and monumental sculpture. Although he made few portrait busts they are among the most vivid and technically vigorous of their time, and include a notable self-portrait in the Louvre (c.1780). His first mature work, a crouching statue of *Mercury* (terracotta version of 1742; New York, Met. Mus.), became so famous that *Chardin included it in a painting and a marble version was sent by Louis XV to Frederick the Great. Pigalle's allegories include the sentimental statue of *Mme de Pompadour as Friendship* (1753; Paris, Louvre), while the great bronze figure of *The Happy Citizen* (1765), on the pedestal of the Louis XV monument in Reims, reinterprets the Baroque device of the captured slave in a rational and naturalistic idiom. His most spectacular work is the bronze and marble funerary monument for the Maréchal de Saxe (1753–77) in S. Thomas, Strasbourg, the last great piece of Baroque theatre in France and in a Protestant church at that.　　MJ

Gaborit, J.-R., *J.-B. Pigalle 1714–1785: sculptures du Musée du Louvre* (1985).
Réau, L., *J.-B. Pigalle* (1950).

PIGMENTS. Paint is generally composed of two components: the pigments that constitute the colouring matter and a vehicle or *medium which acts to bind the paint into a coherent film and to the *support. Artists' pigments are not generally soluble in the medium but mixed with it, although they may, to some degree, interact chemically with the binder. The type of medium with which a pigment is combined is fundamental to the optical qualities of the paint film: the closer in value the scattering power for light of pigment and medium, the more translucent will be the paint film. When a pigment has a high scattering power in relation to the medium, the paint will be dense and opaque in appearance. Certain qualities are desirable in materials chosen as pigments: self-evidently, colour is fundamental, but the intensity and purity of colour are also

important. The colour of a pigment is dictated by the way it absorbs certain parts of the spectrum that make up visible light and reflects others. The high density or opacity of a pigment might be valued: others are chosen for their translucency and consequent suitability for paint *glazes. Pigments should be as stable as possible chemically, and also not affected by light, moisture, and any other factor to which they might be exposed. Certain pigments react chemically with one another, but are perfectly stable on their own. The cost and availability of artists' pigments have always influenced the choices of their users.

A great variety of coloured materials have found application as pigments. Before the 19th century, the bulk of these were drawn from the natural world, whether as mineral materials, that is, naturally occurring inorganic substances, or dyes and coloured resins from plant and animal sources, classed chemically as organic materials. Before inventions of the 19th century, manufactured or artificial pigments were all inorganic compounds, some of which were the synthetic equivalents of minerals (for example, artificial vermilion is chemically identical to cinnabar vermilion); others had no natural counterpart, such as the early manufactured pigments, lead white, verdigris, and Egyptian (Pompeian) blue.

Many of the traditional pigments utilizing naturally occurring dyestuffs were prepared in the form of an important general class of pigments known as lakes. Lake pigments, most usually made in a range of red hues or browns and yellows, are transparent when bound in oil media and were often used as glazing pigments, although they all show a tendency to a greater or lesser degree to fade under the action of light. The process of lake formation involves affixing the coloured dyestuff from solution onto a colourless or white inorganic base material, such as chalk or alumina, often by co-precipitation, to form a solid pigment. Gypsum or a white clay were also used to absorb the dyestuff. Red dyes for lakes were extracted traditionally from scale insect sources such as lac and kermes, and, rather later, from cochineal, and also from plant sources such as brazilwood and madder. In the 19th century, the red colouring matter from madder (alizarin) was isolated, analysed, and prepared for the first time artificially (1868). Roughly at this time a number of new synthetic dyes, the first of which was made from coal tar by William Perkin, a purple known as mauveine (1856), were being prepared and many came to be used to make new brightly coloured lakes, some very fugitive. Red lakes made from synthetic alizarin became common alongside the lakes derived from natural madder dyes.

Some of the earliest pigments employed in painting were natural earth colours, which occur in a great variety of colours and types and at many locations. Virtually all contain one or other natural iron oxide and varying proportions and kinds of mineral impurities, which influence the colour of the deposit and the translucency of the earth when used as a pigment. Natural ochres, siennas, and umbers are found in a range of colours from red, orange, yellow, and brown to virtually black. Names applied to these pigments often indicated their geographical origin, as in Oxford ochre, but frequently this terminology implies a colour quality and relative translucency rather than a source, as in Indian red, Venetian red, Spanish brown, and so on. Natural earths have found application in painting from the earliest times, are suitable for virtually all techniques including true fresco, and are still in use today. Artificial types of iron oxide pigment, so-called Mars colours, were first made in the 18th century. Both the natural and synthetic iron oxide pigments are very stable. A dull green-coloured earth, *terre verte*, different in constitution from the other iron oxide earths, although also iron-containing, was an important pigment in the under-modelling of flesh tones in early Italian panels painted in egg tempera, but not used widely thereafter, except perhaps for foliage greens in 17th- and 18th-century landscape painting.

Most black pigments derive from natural sources, although some processing or preparation might be involved. The majority are based on elemental carbon: charcoals from a variety of wood and plant types (willow, beech, vine twigs, peach stones, and so on); carbonized bone and ivory blacks; mineral forms of carbon such as coal, black chalk, and graphite; and lampblack, essentially soot. Many are ancient in their use; all are very stable.

Other than the earths, which can be dull in tone, coloured minerals historically have been important constituents of the artist's palette. The brilliant pure blue of genuine ultramarine, obtained from crushed lapis lazuli, was a pigment used in Europe from the early 15th century when the method of extraction was perfected. Its striking royal blue colour and great permanence in many media—egg tempera, illuminated manuscripts, oil, and gouache techniques—guaranteed it was highly prized by painters. However, the cost was very high, since before the 19th century only one source of lapis lazuli was known: this was at famous mines at Badakshan (Afghanistan) and the mineral had to be imported into Europe from there. The labour-intensive extraction method added to its cost and scarcity. Another mineral blue, natural azurite, fulfilled early painters' needs for a strong blue, either in place of ultramarine, or beneath it as an underpaint. Azurite requires to be coarsely

ground for use, otherwise it loses some of its colour, which often is of a distinctly greenish blue tone; it commonly darkens dramatically in egg tempera and oil media. Azurite was widely used in easel painting, particularly in northern Europe and Spain, until the later part of the 17th century, when supplies from one of the main sources, Hungary, became uncertain. Germany was another important European source. Synthetic types of azurite were also known. A green mineral, malachite, similar to azurite in constitution and often found with it, was pulverized to form a strong mid-green pigment, particularly in tempera techniques; there was also a synthetic type. Natural cinnabar yielded on grinding the mineral form of bright red vermilion, but the artificial variety was also well known after the transmission to Europe from the Islamic world in the 9th century of the method of synthesis. Orpiment and realgar are yellow and orange mineral species of arsenic sulphide, used in 16th-century Venetian painting particularly, but at various other times also.

Early synthetic pigments varied in their constitution and method of preparation. Lead white, made as a pure flake-like white corrosion crust on metallic lead when it is exposed in closed vessels to sour wine (acetic acid) in the presence of carbon dioxide, was known to the Chinese and to the Greeks. It is undoubtedly the most important white in easel painting of all periods up to the 20th century, when it has been displaced by non-poisonous whites made from zinc oxide, introduced in the 19th century, but not greatly used in the fine arts immediately, and by titanium oxide whites. Lead white acts as a drier for oil paint and its high density to X-rays is largely responsible for the clear results of X-radiography of easel paintings. Deep green verdigris was made in a roughly similar manner from early times, metallic copper replacing lead in the preparation. This was used as a pigment in its own right and as the basis for a rich green glaze in an oil and resin medium, known in modern terminology as 'copper resinate'. Several other manufactured pigments based on lead were also widely used in painting from medieval times and later. Lead-tin yellow, which was prepared in two distinct types: an early form which appeared around 1300 deriving from tin-opacified yellow glass, and a modified form which was a by-product of ceramic glaze technology, introduced probably in the early or mid-15th century. Both types of lead-tin yellow were employed by Venetian painters concurrently in the 16th century. Similar pigments containing antimony, in addition to tin, or later, in place of it, became important from the 17th century. The 18th-century lead antimony yellow was usually described as Naples yellow. A manufactured blue glass, known as smalt, also became common in the

16th and 17th centuries, although it was available rather earlier. The blue colour of smalt derives from the addition of cobalt oxide to a potash glass melt during manufacture. The pigment is the crushed glassy product; it is not particularly stable and often becomes greyish or brown in oil paint films. It was widely used, nonetheless, presumably because of its low cost and ready availability in many different grades of quality.

Colour change in artists' pigments over time is common. Fading (loss of colour) of dyestuff-containing lakes and other organic pigments such as indigo as a result of the bleaching action of light is, perhaps, the most usual form of discoloration, but others, including darkening, also occur. Vermilion can blacken, particularly in egg tempera; azurite darkens in oil and tempera; and 'copper resinate' can become an opaque brown on exposure to light. Lead pigments, particularly lead white, will darken in aqueous media, but not in oil.

Few early pigments have clear dates of introduction. The earliest secure date is the accidental discovery between 1704 and 1710 of Prussian blue by a colourmaker, Diesbach, working in Berlin. The circumstances of discovery and subsequent history of manufacture are well documented. Prussian blue was the first synthetic pigment in a modern sense and a key development in artists' materials, since it finally severed the painters' dependence on costly, unstable, or otherwise poor-coloured traditional blue pigments. Its date of introduction is important in establishing a *terminus post quem* for paint that contains it, and it was extensively used in 18th-century and later painting throughout Europe and elsewhere.

Many pigment introductions of the 19th century have established dates of discovery and first manufacture; many resulted from improved chemical science and technology in the 19th century and were the subject of patent protection and considerable commercial exploitation, notably in France, Germany, and England. The discoverers, dates of invention, and first introduction, where known, are given here for some of the more important developments. Cobalt blue (Thénard, 1802; 1803); chrome yellows, chrome orange (Vauquelin, 1809; c.1818); emerald green (copper acetoarsenite) (discovered 1814); artificial (French) ultramarine (Guimet/ Gmelin, 1827; 1828); cadmium yellow and orange (Stromeyer, 1818; 1840s); viridian (Pannetier, 1838; 1840s); cobalt violet (Salvétat, 1859). The 20th century provided painters with cadmium red (1892; c.1910); titanium white (c.1916–19); manganese blue (Mühlberg, c.1935); phthalocyanine blue (c.1935); phthalocyanine green (1935; 1938); the quinacridone pigments (synthetic translucent organic reds, browns, purples) (c.1955). The majority of the 19th-century pigments and those introduced as artists' pigments in the 20th century are more stable and more permanent than certain of the materials available to painters traditionally.　　　　AR

PILES, ROGER DE (1635–1709). An amateur painter, friend of painters, and spy for Louis XIV in Holland, de Piles is best known for his writings on art published during the years 1668–1708. His annotated translation into French in 1668 of C. A. Dufresnoy's *De arte graphica* went into numerous editions during the following 100 years and first appeared in English translation in 1695. In this work de Piles argued that the principal emotion underlying the subject of a painting should be immediately obvious from the arrangement of its forms and colours. For de Piles a painting should express itself primarily in visual terms and not, as then current academic doctrine held, primarily as a story to be read with characters to be interpreted. He continued to insist on the importance of how a picture appealed to the first glance ('le premier coup d'œil'), both for conveying its essential nature and for attracting the viewer. Nevertheless, although emphasizing painting's visual qualities, de Piles did not deny the importance of a picture's subject—for him *history paintings continued to rank higher than, say, *still life. In his final and perhaps most widely read work, *Cours de peinture par principes* (1708), de Piles said that the success of a painting could be measured by the immediacy with which the spectator grasped the painter's state of mind, with only a few moments more than needed to understand the subject matter. However, this intuitive approach to painting did not catch on with 18th-century history painters and critics. These saw form and colour not as expressive in themselves, but more as an aid to understanding a picture's subject matter, which was to be primarily expressed through gesture and *expression.　　　HW

PILLEMENT, JEAN-BAPTISTE (1727–1808). French painter and designer. As a painter of decorative landscape his work was often derivative from *Boucher, though such works as *Shipping in the Tagus* (1783; priv. coll.) show a freshness of observation that is reminiscent of *Vernet. He was an exquisite draughtsman and prints made from his drawings were popular throughout Europe, helping to spread the *Rococo taste. He was particularly important in the spread of *chinoiserie. He travelled to London and Vienna, as well as to Lisbon, where he was one of a group of lesser French artists who influenced the course of painting in 18th-century Portugal.　　　HO/MJ

Mitchell, P., 'Jean Pillement Revalued', *Apollo*, 117 (1983).
Pillement, J., *Jean Pillement* (1945).

PILO, CARL GUSTAF (1711–93). Swedish portrait painter who migrated in 1740 to Copenhagen and then became the leading artist in his field. His portraits are accomplished provincial variants on 18th-century north Italian and Austrian models, owing little to fashionable French style. Examples are the pair of portraits of *Frederick V of Denmark* and *Queen Louisa* (1746; Copenhagen, Statens Mus. for Kunst). In 1772 Pilo returned to Sweden where his most ambitious work was a huge, unfinished painting of *The Coronation of Gustavus III* (1782; Stockholm, Nationalmus.).　　　HO/MJ

PILON, GERMAIN (c.1528–90). French sculptor and medallist whose major works were executed for the Valois court. He created a highly emotional form of *Mannerism. *Modelling in clay was the basis of his technique, which his father taught him, enabling him to give his elongated figures supple elegance in movement, enhanced by crisp, fluid patterns of drapery. Pilon achieved in his sculpture the closest parallel to *Primaticcio's drawings, and worked with him for Catherine de Médicis on the monument to the heart of Henri II (*The Three Graces*, 1560–6; Paris, Louvre) which reuses *Raphael's design for a perfume-burner for François I. Pilon made most of the bronze and marble figures for the tomb of Henri II and Catherine de Médicis (1560–73; Paris, S. Denis) including gisants of remarkable naturalism. This was the focal point of the Rotonde des Valois (destr.), designed to celebrate the last generations of the dynasty. In the Louvre are figures connected with this project, in Pilon's studio at his death: a monumental unfinished *Resurrected Christ with Two Soldiers* and a large *terracotta model of the *Virgin Mourning* (marble now Paris, S. Paul–S. Louis), all reminiscent of *Michelangelo. Pilon's *S. Francis* (Paris, S. Jean des Arméniens) was also part of this group.

In 1572 he became Controller-General of the Mint and designed medals for the court. His medal of *Chancellor René de Birague* (Paris, Bib. Nat., Cabinet des Médailles) is a powerful, sharply observed profile, with subtly modelled surfaces and lively, varied chasing. These qualities are equally evident in the full-size bronze of the same subject (1584/5; Paris, Louvre) and the marble relief of his wife *Valentine Balbiani* as a *transi* (bashful lover) (1573/4; Paris, Louvre). These are all that remains of the elaborate Birague tombs, which were broken up in the late 18th century and, like many others, saved from destruction at the Revolution by Alexandre *Lenoir, who displayed them in his Museum of French Monuments. Pilon's *Lamentation* relief, possibly from the Birague tombs, is often compared with that of *Goujon (both Paris, Louvre). Pilon's exquisitely chased bronze is

the more overtly intense and pictorial. LL

Bresc-Bautier, G., et al., *Germain Pilon et les sculpteurs français de la Renaissance* (1993).

PILOTY, KARL THEODOR VON (1826–86). German history painter. Piloty was born in Munich and received his early training from his father Ferdinand (1786–1844), a lithographer. He entered the Munich Akademie in 1838 and from 1840 studied under *Schnorr von Carolsfeld. In 1844, on his father's death, he left to run the family business but returned to his studies in 1846. He was influenced by the colourful and elaborate *history paintings of the Antwerp artist Louis Gallait (1810–87) and by the less frenetic work of the Frenchman Paul *Delaroche. An ambitious artist, he preferred to work on a grand scale with vibrant colour and virtuoso brushwork and was noted for his treatment of costume and the accuracy of his settings. His success was assured with the rapturous reception of his *Seni by the Body of Wallenstein* (1855; Munich, Neue Pin.) and he was ennobled in 1860. His subjects are almost entirely historical and frequently tragic. He was an influential teacher, and, as professor (1856) and director (1874) of the Munich Akademie, established Munich as the chief centre of history painting. His successful pupils included *Makart. DER

Ludwig, H., 'Karl Theodore von Piloty', *Die Weltkunst*, 49 (1979).

PINO, PAOLO (active 1535–65). Venetian painter and art theorist. He is remembered for the *Dialogo di pittura* (1548), in which he claimed *Savoldo as his master; his three surviving paintings show the influence of Bergamese painting. The *Dialogo*, one of the first pieces of art theory in Venice, takes the form of a discussion between two painters, a Tuscan and a Venetian. The Venetian espouses the cause of colour against the rigour of the Tuscan's emphasis on *disegno* (see DISEGNO E COLORE), but he does so in a genial and relaxed way; the debate had not yet become as intemperate as it was to do with *Boschini in the next century. The dialogue concludes that painting is entitled to an honoured place in the liberal arts and is ruled by *disegno*, *invenzione*, and *colore*; the perfect painter would combine the *disegno* of *Michelangelo and the *colore* of *Titian. AJL

Rosand, D., *Painting in Cinquecento Venice* (1982).

PINPRICKT PICTURES, lacelike designs pricked into paper with pins. Lines were drawn, more accurately and economically, by using wheels with evenly spaced tines around the edge. The size of the holes varied and the paper was pierced from both the front and back to achieve greater variety of texture. The fashion for pinprickt pictures in England began in the late 18th century and was originally confined to religious subjects, being largely practised in Roman Catholic girls' schools. By the early 19th century it had become a popular pastime for young ladies and was enthusiastically recommended by annuals and other periodicals. Lay subjects were usually exotically costumed figures with faces, hands, and other details painted in watercolour against an opaque, dark, neutral wash background. The origins of the technique are obscure but it probably derived from either embroidery or, more likely, the pricking out of designs, in paper, to transfer the image to another surface. It does not appear to have attracted professional artists. DER

Ayres, J., *British Folk Art* (1977).

PINTURICCHIO, BERNARDINO DI BETTO (c.1452–1513). Italian painter of the Umbrian School whose most important work in Rome and Siena celebrated the renewed authority of the papacy. Trained in Perugia, he accompanied his master *Perugino to Rome in 1481 where he assisted in the decoration of the Sistine chapel. In 1492 Pinturicchio was commissioned to decorate the private apartments of the newly elected Pope Alexander VI, a scheme which exalted the Borgia family and established the artist's reputation. In 1502 he was commissioned by Cardinal Piccolomini to decorate the library adjoining Siena Cathedral with scenes from the life of the patron's uncle, the *humanist Aeneas Silvius Piccolomini (Pope Pius II). Despite the classical elements, derived from the recently discovered *Domus Aurea*, these frescoes are in a conventional 15th-century manner. The vivid colour and curious settings have ensured their popularity. However, *Vasari was critical of the cycle because of its conservatism at a time when art in Rome was undergoing a revolution and suggested that *Raphael might have had a hand in the designs. In his last years Pinturicchio's powers as a decorator were in decline but he produced several interesting panel paintings before his death in poverty at Siena. PSt

PIPER, JOHN (1903–92). English painter. A pupil of Henry *Moore at the Royal College, London, Piper embraced *modernism in the 1930s, producing geometric abstracts related to Ben *Nicholson, a fellow member of the 7 & 5 Society (1919–35). However in his work as a *war artist (1940–2) he revealed his innate Romanticism in a series of dramatic wash drawings of devastated buildings. He continued to produce architectural drawings and prints after the war, the finest being those of *Renishaw Hall* (1941; Renishaw, Sitwell Coll.). Piper was also an accomplished stage and stained-glass designer (1962; Coventry Cathedral). DER

Russell, J., Jenkins, D. F., et al., *John Piper*, exhib. cat. 1983 (London, Tate).

PIRANESI, GIOVANNI BATTISTA (1720–78). Although one of the supreme exponents of topographical engraving (his corpus comprises over 1,000 separate *etchings), his lifelong preoccupation with architecture is central to an understanding of his wide-ranging achievements. The son of a stonemason and master builder, he spent his first 20 years in Venice training in architecture and stage design, with strong influences from the local tradition of topographical art, represented by *Canaletto, and the graphic fantasies of Marco *Ricci and G. B. *Tiepolo. Moving in 1740 to Rome, where he spent the rest of his life, a lack of practical architectural commissions led him to develop skills in etching souvenir views for the *Grand Tour market. His main creative energies, meanwhile, were concentrated on developing the architectural fantasy, or *capriccio, as a vehicle for formal experiment and architectural reform, expressed in his first publication, *Prima parte di architetture e prospettive* (1743), as well as the celebrated suite of arcane prison compositions, *Carceri d'invenzione* (first state, c.1745). By this means he was to exercise a seminal influence on European *Neoclassicism through his personal contact with visiting artists, architects, and patrons in Rome over the course of nearly four decades. From 1748 onwards he began his magisterial *Vedute di Roma*; 135 plates, issued individually or in groups throughout the rest of his career. Pushing the boundaries of etching techniques to extremes and exploiting scenographic perspective, he combined remarkable flights of imagination with a strongly practical understanding of ancient technology. These images generated a highly charged emotional perception of the past which radically effected the art of topography and left an indelible perception of Roman Antiquity. Archaeology became of increasing concern to Piranesi during the 1750s. His treatise *Le antichità romane* (1756), which revolutionized the methods and range of technical illustration, swiftly won him international recognition and embroiled him, as a fervent protagonist of Rome, in the furious controversy provoked by the Greek revival. With the election of the Venetian Pope Clement XIII, the 1760s represented a golden age of patronage for Piranesi with financial support for a series of lavishly produced polemical folios (*Della magnificenza ed architettura de' romani*, 1761; *Il Campo Marzio dell'antica Roma*, 1762) and idiosyncratic designs for architecture, interiors, chimney pieces, and furniture, later illustrated in his highly influential *Diverse maniere d'adornare i cammini* (1769). In the course of controversy

his graphic style developed from a subtle *Rococo linearity to the powerful tonal contrasts of the *sublime, represented, somewhat ironically, by his critical contribution to the Greek revival through the powerful etchings of the Doric temples at Paestum (1778). His greatest legacy, however, was to be the inspiration provided by the powerfully revised plates of the *Carceri* (2nd state 1761) which have continued to provide visual metaphors for the endless processes of the creative imagination for writers, poets, and musicians as much as artists, designers, and film directors

JW-E

Wilton-Ely, J., *G. B. Piranesi: The Complete Etchings* (1994).
Wilton-Ely, J., *The Mind and Art of Piranesi* (1978).

PISANELLO (Antonio Pisano) (c.1395–c.1455). Italian painter, draughtsman, and medallist, one of the most celebrated artists of his day. Born in Pisa or Verona he collaborated with *Gentile da Fabriano on frescoes for the Doge's palace in Venice (1415–20; destr.) and later completed Gentile's frescoes at the Lateran basilica in Rome (1431–2; destr.). From this time he was in great demand and was probably regarded as the successor to Gentile in the *International Gothic style. Of his paintings, only three frescoes and a handful of panel paintings have survived. The frescoes are *The Annunciation* (1424–6; Verona, S. Fermo), *S. George and the Princess of Trebizond* (1437–8; Verona, S. Anastasia), and the *Scenes of War and Chivalry* (1447; Mantua, Palazzo Ducale). The smaller paintings include a profile portrait of *Lionello d'Este* (1441; Bergamo, Gal. Accademia Carrara) and two paintings in the National Gallery, London— *Vision of S. Eustace* (c.1435) and *Virgin and Child with SS Anthony and George* (1447). Pisanello is considered the most brilliant Italian master of the International Gothic, turning it to original uses and giving evidence of a keen and penetrating power of observation and a lively fantasy within the decorative scheme. The wellspring of his art was his superb draughtsmanship, demonstrated in the Codex Valardi (Paris, Louvre), a great sequence of drawings that served as a visual record and source for many of his paintings. The fastidious and enchanting studies of birds, hunting animals, costumes, and even hanged criminals confirm his keen and alert eye for detail. Pisanello was the originator of the Renaissance *medal and in the brilliance of his cutting and majesty of design he set a standard that has not been surpassed. His first medal, portraying the *Emperor John VIII Palaeologus* (1439–40), established the basic format which has changed little to the present day. Thereafter, portrait medals in emulation of ancient Roman practice became popular as gifts and mementoes amongst the *humanist patrons of Italy. Pisanello produced several sets for ruling families such as the Visconti of Milan, the Gonzagas of Mantua, and Alfonso of Aragon, King of Naples.

PSt

Paccagnini, G., *Pisanello* (1973).

PISANO, FATHER AND SON. 1. Italian sculptors. The work of the Pisani was of decisive importance for the development of early *Renaissance art. Especially significant is their creative use of both classical and recent *Gothic sources. **Nicola** (active 1258–78) signed his Pisa baptistery pulpit (1260) as 'Nicola Pisanus'. Other records reveal he came from Apulia, site of the classical revival under the patronage of the Holy Roman Emperor, Frederick II (ruled 1212–50). The pulpit's significance rests chiefly on Nicola's own use of classical forms, based on the great collection of *Antique sculpture assembled in Pisa. Borrowings from these are found in the five narrative reliefs and in the archivolt figure of a nude *Fortitude*. Nicola's *classicism is no mere imitation: the seated figure borrowed for the Virgin of the *Adoration of the Magi* from a *Hippolytus* sarcophagus (Pisa, Camposanto) has a plastic weight quite beyond that of its source. Other aspects of Nicola's classicism, like the triple columns separating the reliefs, may have been derived from French sources, and the impact of Gothic sculpture, already apparent in the later reliefs at Pisa, is pervasive in Nicola's Siena Cathedral pulpit of 1265–8. The architectural mouldings of this octagonal structure are richer, the reliefs separated by figures and carved with a density of incident markedly different from the monumental clarity of Pisa. Nicola's son **Giovanni** (active c.1265–1314) worked with him at Siena and on his last work, the Fontana Maggiore in Perugia (1278). From 1284 Giovanni worked independently on the façade sculpture of Siena Cathedral. The expressive tension and theatrical relationship between sculpture and setting are echoed in the dramatically twisting archivolt figures of Giovanni's own first pulpit, for S. Andrea in Pistoia (s.d. 1301 by 'the son of Nicola and blessed with higher skill'). The design, with pointed arches, is fundamentally Gothic but the deeply cut reliefs indivisibly combine the density of antique battle sarcophagi with the fluidity of northern sculpture. The tragic vehemence of the *Massacre of the Innocents* can scarcely be matched in the history of Italian sculpture. Giovanni's second pulpit, for Pisa Cathedral (1302–10), is the largest of the four and the most elaborately classical in architectural terms. A creative tension between classical and Gothic styles informs supporting figures like the angular *Hercules* and the *Prudence*, based on a Venus Pudica type. Throughout his career Giovanni carved a series of very fine Madonnas and other smaller pieces. His last major work was the tomb of Margaret of Luxembourg of which a number of dramatic fragments survive (1311–13; Genoa, Palazzo Bianco).

JR

Pope-Hennessy, J., *Italian Gothic Sculpture* (4th edn., 1996).

PISANO, FATHER AND SON. 2. Italian sculptors. **Andrea d'Ugolino Nini da Pisa** (active c.1330–c.1349) is first documented in 1330, when he began a pair of bronze doors for the Florentine baptistery, completed in 1336. The 28 reliefs, in quatrefoil frames and partly gilt, comprise *Virtues* and scenes of S. John the Baptist. They combine the Gothic style of Pisan sculpture with the monumental clarity of *Giotto's paintings. The Arena chapel style informs the *Visitation*, but it is to Giotto's Florentine frescoes that Andrea most obviously responds, and *The Birth of the Baptist* reflects Giotto's Peruzzi chapel version of the subject (Florence, S. Croce). The pulpit by Giovanni *Pisano (no relation) in the Duomo, Pisa, was another source of inspiration. After Giotto's death in 1337 Andrea took over supervision of the marble relief decoration of the campanile. Of those reliefs attributable to Andrea himself some may reflect initial designs by Giotto. In 1347 Andrea was *capomaestro* of Orvieto Cathedral, where he was succeeded by his son **Nino** (active 1349–68). Nino's major work is the tomb of Doge Marco Cornaro (d. 1367) in SS Giovanni e Paolo, Venice. His many standing figures, finished and elegant, show little of the intellectual adventurousness of Andrea's work.

JR

Pope-Hennessy, J., *Italian Gothic Sculpture* (4th edn., 1996).

PISSARRO, FATHER AND SON. French painters and graphic artists. **Camille** (1830–1903) was born at St Thomas in the Danish West Indies. In 1855 he entered the École des Beaux-Arts, *Paris, and fell under the influence of *Corot. At the Académie Suisse he met *Monet, and became a leading member of the *Impressionist group. He exhibited in all the eight Impressionist exhibitions. In the late 1860s and 1870s he lived and painted in Pontoise and the Parisian suburb of Louveciennes, apart from the years of the Prussian invasion (1870–1), when he joined Monet in London. His first pictures are horizontal, large, and solidly constructed, but from 1869 he began to paint smaller, more spontaneous works. His themes are rural, and in paintings of quiet country roads, orchards, and vegetable gardens he explored varied effects of light, weather, and season; his *Diligence at Louveciennes* (1870; Paris, Mus. d'Orsay) captures the atmosphere of a moist autumn evening. From 1884 Pissarro lived at Éragny, near Gisors, and there met *Signac, and came to know *Seurat. He became less interested in fleeting effects of

light, and concerned rather to restore a sense of deep meaning to landscape painting. He flirted with the methods of the Neo-Impressionists under Seurat's influence, but found this unsatisfactory; instead he looked back to the art of *Millet, and began to paint increasingly monumental peasant paintings, which revive a sense of the timeless beauty of country labour. Pissarro was a convinced anarchist, and his *Harvest at Éragny* (1901; Ottawa, NG Canada), with its ritualized gestures, and friezelike composition, suggests a Golden Age harmony. In his final years Pissarro turned to urban scenes; he painted insistently modern views of industrial Rouen; and in a series of paintings of Parisian streets, seen from a high viewpoint, explored the same motif under different conditions of light and atmosphere. These apparently detached works convey the essence of contemporary Paris, with its Haussmannian architecture and steep perspectives of wide, straight streets. The sharply characterized figures capture a whole social era. Pissarro was a distinguished graphic artist, and a revered teacher, fundamental to the development of *Gauguin and *Cézanne. His son **Lucien** (1863–1944) was taught by his father at Éragny, where he painted Impressionist rural scenes, and experimented with *Neo-Impressionism. In 1890 he settled in England; here he associated with the circle of Charles Ricketts, and founded the Éragny Press; his wood engravings began to show a *Pre-Raphaelite influence which disturbed his father. He played a part in the formation of the Fitzroy and Camden Town (see under LONDON) groups, and helped to spread an understanding of Impressionism and *Post-Impressionism in England. HL

Lloyd, C., *Camille Pissarro* (1981).
Thorold, A. (ed.), *The Letters of Lucien to Camille Pissarro* (1993).

PITLOO, ANTONIO (Anton Sminck Pitloo) (1791–1837). Dutch painter working in Italy. Pitloo was born in Arnhem and studied there (1803–7) before winning a scholarship to study architecture in Paris. Whilst in Paris (1808–11) he also trained under the landscape painter Jean-Victor Bertin (1755–1842) before travelling to Rome as a prize-winner in 1811. Here he gravitated to the resident Dutch and Flemish landscape painters and soon attracted patrons for his topographical views of Roman monuments, a type of painting which utilized his architectural grounding. On the fall of Napoleon in 1815 he moved to Naples where he remained, apart from visits to Switzerland and Sicily in 1819, for the rest of his life. His Neapolitan landscapes, influenced by *Turner and *Bonington, proved successful and with his pupils Giacinto Gigante (1806–76) and Achille Vianelli (1803–94) he established the School of Posillipo, characterized by local views

painted on the spot *en plein air*, which were particularly popular with wealthy tourists. His later works, like *Baia* (1836; Sorrento, Mus. Correale Terranova), reveal an awareness of the work of *Corot, a fellow, although later, pupil of his master Bertin. DER

Causa, R., *Pitloo* (1956).

PITOCCHETTO, IL. See CERUTI, GIACOMO.

PITTONI, GIAMBATTISTA (1687–1767). Italian history painter from Venice. He trained under his uncle, Francesco Pittoni (c.1654–1728), whom he may have accompanied to Paris in 1720. Influenced by Sebastiano *Ricci and other Venetian artists, and possibly by the French experience, he developed a distinctive *Rococo manner, with a light and broken style of brushwork. Particularly in his early years he painted erotic mythologies, notably *Diana Bathing* (c.1723; Vicenza, Pin.) He had previously found early patronage for *history painting (*Death of Agrippa* and *Death of Seneca*; 1713; destr.) from Friedrich August I, Elector of Saxony. And he was one of the Venetian painters (see also RICCI FAMILY) involved in Owen MacSwinny's series of imaginary allegorical tombs to commemorate British heroes, painting the figures for four of these, including *Isaac Newton* (c.1727–30; Cambridge, Fitzwilliam). He also supplied altarpieces for churches in Venice and throughout north Italy, including Vicenza, Verona, and Bergamo; a notable example is *The Apotheosis of S. Jerome with S. Peter of Alcantara* for the church of S. Maria dei Miracoli, Venice (now Edinburgh, NG Scotland), which was probably painted c.1730 and is recorded by *Zanetti in 1733. Pittoni continued to find important patrons abroad, especially in Dresden, Cologne, Poland, Bohemia, and Spain. Altarpieces by him are still to be found at the castle of Bad Mergentheim, Germany, at Schloss Schönbrunn, Vienna, and the church of S. Mary, Cracow. Pittoni was an accomplished draughtsman, and produced large numbers of lively chalk drawings while preparing his pictures. HB

Binyon, A., *I disegni di Giambattista Pittoni* (1983).
Zava Boccazzi, F., *Pittoni: L'opera completa* (1979).

PLACE, FRANCIS (1647–1728). Amateur printmaker and landscape draughtsman who was at the centre of a group of virtuosi in York. As a young man he worked with *Hollar, but his style of *etching was freer, and his drawings more atmospheric, with loosely applied touches of wash. His drawing of *Knaresborough, the Dropping Well* (London, BM) gives a very good idea of his powers. He also made some fine *mezzotints, including a portrait of his fellow virtuoso William Lodge, and he was a keen potter. RGo

Tyler, R., *Francis Place* (1971).

PLAMONDON, ANTOINE (1804–95). Canadian painter. Born in Ancienne-Lorette, near Quebec City, he was apprenticed to Joseph Légaré (1795–1855), assisting him in copying and restoring paintings (1819–25). He studied in Paris (1826–30) under Paulin Guérin (1783–1855), a pupil of *David, and returned to Quebec City to open his own studio, painting accurate likenesses of the French-speaking upper middle classes, the clergy, and Augustinian nuns. His best-known painting is *Sister S. Alphonse* (1841; Ottawa, NG Canada), in which he has absorbed the lessons of *Ingres and the classicism then fashionable in Europe: blended tones, full modelling, attention to textures and detail, and a precise drawing that often incorporates a slight elongation.

Plamondon also undertook religious commissions, the most notable being a series of *Stations of the Cross* (1837–9) for Notre-Dame, Montreal. He retired to a farm in Neuville in 1851, but continued to paint and uphold his essentially conservative values. An irascible bachelor, he was often vitriolic in his criticism of the work of other artists, and jealous of their successes. KM

Porter, J., *Antoine Plamondon: Sœur Saint-Alphonse/ Sister Saint-Alphonse* (1975).

PLAQUETTE, a small sculptural relief in metal, usually bronze or lead, which originated in the mid-15th century in Italy and became popular throughout Europe in the 16th century. They feature an image on one side only. Once considered to be purely decorative, mounted on mugs, inkstands, sword-hilts, caskets, or lamps, it is now recognized that they were objects of art in themselves, to be suspended, on the person or in a room, or to lie flat in a drawer or casket. Vittore *Carpaccio's *S. Augustine in his Study* (c.1502; Venice, Scuola di S. Giorgio degli Schiavoni) shows a range of plaquettes, lying or suspended from shelves. Although they were usually made of bronze, silver and gold versions were also cast; almost always by the *cire-perdue* process, and new editions could be made from the wax image of an existing example. Very few were struck like coins. After *casting, the best plaquettes were usually chiselled and chased, and either finished with a patina or gilt.

Plaquettes developed in Italy in the 1440s as an effective way to replicate ancient engraved gems. Pope Paul II was largely responsible for this trend, setting up a private bronze foundry in 1455, nine years before he became pope. The plaquette soon developed as an independent medium and featured a variety of subjects from the devotional to scenes from biblical history or classical mythology. Padua was the main centre of production and *Donatello, during his time there in 1444–5, designed some plaquettes,

such as the *Virgin and Child* (c.1450–6; Washington, NG). Few other major Italian artists tried their hand at plaquettes. Many makers borrowed their designs from contemporary engravings, drawings, and paintings. Andrea *Riccio, a supreme bronzeworker, based his plaquettes on the work of Andrea *Mantegna. The artist known only by his signature as Moderno is considered the greatest plaquette maker. He was active in Verona and Venice 1490–1510. His œuvre comprises 45 designs showing great delicacy and energy, for example, the *Flagellation* (1506–9; Vienna, Kunsthist. Mus.). After a century of popularity, the plaquette, which did not conform to late 16th- and 17th-century taste, died out in Italy. In the north, however, it gained popularity only at the beginning of the 16th century and flourished for another 200 years. In Germany the main centres of production were Nuremberg and Augsburg. Unlike in Italy, plaquettes were used as decoration of silverware and furniture. As plaquette makers did not belong to guilds and rarely signed their work, very few northern plaquette makers are known; the exceptions are Peter *Flötner and Hans Peisser (1500×5–after 1571). During the brief period in which plaquettes flourished, being so easily transportable, they were copied both in their country of origin and abroad, not only by plaquette makers, but also by sculptors. Like the engravings of which they are the plastic counterpart, they helped to disseminate the taste of the *Renaissance. KC

Luches, A., *Italian Plaquettes*, Studies in the History of Art 22 (1989).

Norris, A. S., and Weber, I., *Medals and Plaquettes from the Molinari Collection at Bowdoin College* (1976).

Radcliff, A., *The Thyssen-Bornemisza Collection: Renaissance and Later Sculpture Including Objects in Bronze* (1922).

Weber, I., *Deutsche, niederländische und französische Renaissanceplaketten* (1975).

PLASTER CASTS can be made either from clay models or from metal or stone statuary in two or three dimensions. The casts can serve as workshop aids for the production of sculpture. Alternatively, they can function as works of art in their own right, set up in display contexts.

The tradition of taking terracotta or plaster casts seems to date back at least to the classical period. A series of small-scale terracotta rather than plaster casts from metalwork (Athens, Agora Mus.), some of which come from 5th- and 4th-century BC contexts, could have served as moulds for bronze originals or for clay casts. The majority of them, however, come from *Hellenistic and *Roman contexts and thus are contemporary with similar plaster casts preserved in Memphis (late 4th–1st century BC) and Begram (1st century BC).

There is also literary and archaeological evidence for the existence of larger-scale plaster casts from the classical period onwards. The 4th-century BC sculptor Lysistratus, the brother of *Lysippus, is said to have been the first artist to use plaster life masks for the production of portraits (Pliny, *Natural History* 35. 153). Pliny also ascribes to him the invention of taking casts of statuary. The 2nd-century AD writer *Lucian (*Zeus Tragoidos* 33) describes the statue of *Hermes Agoraios* in the Agora at Athens as 'all over pitch; that is what comes of being moulded every day by the sculptors'. Interestingly, the plaster models of the 1st-century BC sculptor Arcesilaus are said by Pliny (*Natural History* 35. 155–8) to have cost more than the finished works of other artists. The find from *Baiae represents the most complete surviving evidence for plaster casts in the Roman period (early 1st century AD). It has plausibly been proposed that the casts were taken directly from the Greek originals. Thus, on the cast of the head of Aristogeiton, the wax used to protect the eyelashes of the original bronze is replicated in the cast.

The literary and archaeological evidence makes clear that these casts could serve two functions within the sculptor's workshop. They could be used as workshop aids for the production of copies. Most studies have focused on the use of plaster casts for the production of Roman copies. It is noteworthy, however, that there is strong evidence to suggest that the twofold function of these casts in the workshop of Lysistratus, for both portraiture and sculpture production, continued in the Roman period. Thus, *punti* used in the *pointing process for the transfer of measurements from the model are found more frequently on portraits than on Roman copies and ideal sculpture.

The practice of making plaster casts seems to have died out in the late Antique period and was not revived until the *Renaissance. According to *Vasari, *Verrocchio revived the taking of plaster casts of parts of the human body so that the artist could use them 'for the more convenient imitation of them in his works'. The painter *Squarcione is said to have had copies of Antique statuary made using plaster casts. Vasari also dates the reintroduction of *death masks to the same period. The first large-scale project for the copying of Antique sculpture is associated with François I and the court artist *Primaticcio in the 1540s for the decoration of the royal palace at *Fontainebleau. Plaster casts were taken directly from the most famous antiquities in Rome, such as the *Cleopatra* and the *Laocoön. These were then cast in bronze at a foundry set up for this purpose near Fontainebleau. The sculptor Leone *Leoni later obtained these moulds for the production of copies for Queen Mary of Hungary. According to Vasari, this artist had an extensive collection of plaster casts that no doubt included casts made from the moulds originally made for Fontainebleau. Other casts were taken directly from the originals in Rome after the granting of a special papal licence.

Tantalizingly, Giovanni Battista Armenini's treatise on painting of 1586 promotes drawing from casts of the well-known statues of the Vatican Belvedere court. He suggests that casts were readily available and inexpensive. The reality must have been somewhat different, with extensive cast collections found only in a few cities, such as Turin, Bologna, and Venice. By the end of the 16th century and the beginning of the 17th, casts had made their way into the academies. Thus, the Accademia di S. Luca in *Rome received a cast collection in 1598; the casts of Leone Leoni made their way, via Federico Borromeo, to the Milanese Academy in 1620. The use of plaster casts was to find its fullest expression in the French Academy at Rome, established in 1666. The holders of the *Prix de Rome could then produce copies in marble or plaster casts of the famous works available in the city. Few of these plaster casts, however, made their way to the Académie Royale de Peinture et de Sculpture in *Paris; the majority remained in the royal collection. Thus, the original educational purpose of the casts for the training of French artists was lost.

The penchant of the royals for the production of bronze copies of antiquities using plaster casts continued in the 17th century in the British and French courts. In 1651, the Spanish court painter *Velázquez returned from Rome with a set of plaster casts and some bronze copies of famous antiquities. These collections of bronze or marble copies and plaster casts were restricted to royalty; only a few copies or plaster casts made their way into private collections in this period. The 18th century was characterized by an important shift as ancient statuary became available through the selling off of important Roman collections and the new excavations at numerous sites including Hadrian's Villa at *Tivoli and the Vesuvian cities of *Pompeii and *Herculaneum. At the same time, a new industry for the production of plaster casts and lead garden sculptures proliferated in England from the 1710s onwards. Perhaps the best-known manufacturer of these pieces was John Cheere (1709–87). These pieces decorated British houses such as Holkham Hall (Norfolk), Kedleston (Derbys.), and Syon House (Twickenham, London). By the end of the century, large collections of plaster casts had found their way to New York and Philadelphia.

The second half of the 18th century was also characterized by developments in sculptural technique and in particular with the introduction of the pointing machine. The possibility of creating exact copies by mechanical means resulted in the depreciation of

copies and the birth of the concept of the primacy of the original. Over the course of the last century, plaster-cast collections have been relegated to the back rooms of art academies and the basements of museums where they have gradually deteriorated. Recently, however, there has been a resurgence of interest in cast collections with the establishment of large collections in Munich, Frankfurt, and elsewhere. L-AT

Haskell, F., and Penny, N., *Taste and the Antique* (1981).

PLASTER OF PARIS is a powder made by the calcination or dehydration of gypsum, and named after the extensive gypsum quarries situated in Montmartre in Paris and the surrounding area. When mixed into a slurry with water it sets rapidly into a uniform, solid, inert mass. It is one of the most important materials for sculptors since it is one of the most universal and satisfactory casting media. However, plaster of Paris has a dull, matt, lifeless surface, and while this can be coloured, waxed, or treated with shellac or varnish, it can never acquire the lively appearance of marble or other stones.

Plaster is used to make negative moulds which are ancillary features of many processes, both commercial (for instance in dentistry work) and artistic. Positive casts are also made of plaster of Paris. One of the commonest and most ancient uses is for the life mask or *death mask, when the living or dead human face is cast in its natural size in order to perpetuate a record of a person's appearance. Casts have also been made of other parts of the human body, for instance, limbs or torsos, for use as models by sculptors who work in stone or other materials. Sometimes sculptors in stone or marble first produce their sculpture in clay and from this make a plaster cast, which is then reproduced more or less mechanically by *pointing in the required material, in the process known as the indirect method of *stonecarving.

Plaster of Paris is well adapted for all sculptural processes which involve reproduction of existing forms, because it sets in a compact mass of even consistency. It is capable of reproducing fine surface detail since it expands slightly in setting and so fills out the negative mould, preserving even the finest shapes. However, it is completely inelastic and therefore involves difficulties where there is undercutting. For this reason complex subjects require more or less elaborate piece-moulds which can be removed piecemeal from the finished cast or else the mould must be chipped away and ruined in the process.

Plaster was sometimes used by the Greeks as a modelling medium over a core or armature. The process is sometimes used today, but chiefly for sculptural work of a temporary nature. Blocks of plaster may also be carved and chiselled, but it is fragile compared to stone and prone to fractures and chipping. The complete absence of grain and texture makes carving difficult and unrewarding.

When plaster is to be modelled, size or glue is added to the moisture, and this slows down the setting process so that the modeller has time to work, as well as making the final product harder. In plaster, as in clay modelling, an armature or skeleton framework is necessary for a free-standing figure. The plaster mixture is applied with spatulas in successive layers, or simply thrown on and allowed to drip and streak. This may be exploited by the sculptor for artistic effect, though others may prefer the smooth and highly finished surfaces obtainable with this medium through the use of abrasives and files after the plaster has set. HO/AB

Mills, J., *The Encyclopedia of Sculpture Techniques* (1990).

PLASTER PRINTS, a 20th-century method of printmaking whereby an etched or engraved plate is inked normally before being surrounded by a frame into which plaster of Paris is poured. By this means a cast of the intaglio plate is obtained, with the black lines in relief. RGo

PLATERESQUE, vaguely defined descriptive term referring to late Gothic/early Renaissance architecture and architectural decoration in Spain. The word is based on the Spanish word for silversmith, *platero*, for the intricate detail of the architectural ornament is reminiscent of the minutely scaled elements of the silversmith's art. The early phase of this style is now more commonly refered to as Isabelline, in homage to the taste of the Queen who commissioned architecture, sculpture, and objets d'art such as chalices in a florid style combining late *Gothic elements with references to the continued Moorish strain in Spanish design called *mudéjar*. The Isabelline style marks the last decades of the 15th century, principally in Castile. The developing early *Renaissance style in Spain during the first half of the 16th century is also called plateresque, but in this later phase the builders were influenced by Italian designs and the architectural decoration, though often far more lavishly applied than in Italy, was based on a classical vocabulary rather than a late Gothic one. Plateresque ornament typical of this later phase may be seen on the façades of the universities of Salamanca (completed 1529) and Alcalá de Henares (completed 1553). SS-P

PLATO (late 5th–4th centuries BC). Greek philosopher. In his *Republic*, Plato introduces the concept of the perfect Form, created by God. What exists on earth is only an imperfect imitation of this ideal; art as secondary *mimesis* is necessarily even further removed from this 'Form'. This theory is developed further in his *Sophist* where sculptors are attacked for ignoring truth. Thus, Plato was important for the development of an art criticism based on 'moralistic' aesthetics. This aesthetic is tied in turn to a dual conception of the concept of imitation. Mimesis can either be 'literal imitation' or 'imitation by psychological association'. These themes are further explored and refined by *Aristotle. L-AT

Janaway, C., *Images of Excellence: Plato's Critique of the Arts* (1995).
Pollitt, J. J., *The Ancient View of Greek Art* (1974).

PLEIN AIR is the term used for painting (especially oil painting) done out of doors, in direct observation of the fall of light. There is a long history of this method being used for sketches and studies. Salvator *Rosa and *Claude are recorded as painting in this way in the 17th century, and in the early 1780s Thomas *Jones and *Valenciennes were doing vivid *plein air* oil sketches in Naples and Rome respectively. Valenciennes (whose finished work was markedly classical) recommended open-air sketching in a treatise of 1800, and the tradition remained strong in Rome at the time of *Corot's first visit (1825–8), when he made sketches that are among the most evocative impressions of Italy ever recorded. From the 1830s many *Barbizon painters worked extensively out of doors. John G. Rand's invention of paint tubes in 1841 made it more practicable to paint outside but, if nothing else, the physical dimensions of a painting always remained a constraint. *Daubigny's *Villerville-sur-Mer* (1864; The Hague, H. W. Mesdag Mus.) was claimed to be the first large exhibition picture entirely executed out of doors and *Monet was unable to achieve his aim of finishing the monumental *Women in the Garden* (1866; Paris, Mus. d'Orsay) without resort to the studio. Monet, and many other *Impressionists, did take smaller paintings to an advanced stage of completion in the open air, and the heyday of Impressionism was indeed the only moment when *plein air* approached being the norm for finished work. By the early 20th century Corot's Italian sketches were recognized as complete in themselves; Thomas Jones's sketches were similarly acclaimed on their rediscovery in the 1950s.

AJL

PLEYDENWURFF, HANS (d. 1472). German painter who established one of the first major workshops in Nuremberg, where he had moved from Bamberg c.1450. His work is typical of the kind of painting produced in Nuremberg before *Dürer, which is characterized by a new realism derived from

Netherlandish art, against the elegant and decorative style of the previous generation. It has been suggested that Pleydenwurff travelled to the Netherlands, but the features in his paintings derived from Rogier van der *Weyden and *Bouts can be explained as a natural response to the general wave of Netherlandish influences that flowed across Germany during the second half of the century. A large *Crucifixion* (c.1470; Munich, Alte Pin.) is representative of his style. The composition is based on Netherlandish types, with many figures under the cross and a sprawling landscape. When Pleydenwurff died, his assistant Michael *Wolgemut married his widow Barbara and inherited the workshop. Hans's son Wilhelm (c.1460–94) trained under his stepfather; and in 1486 the young Dürer entered the workshop.　　KLB

Gothic and Renaissance Art in Nuremberg, exhib. cat. 1986 (New York, Met. Mus.).

PLINY THE ELDER, Gaius Plinius Secundus (AD 23/4–79). Roman writer best known for his *Natural History*, an encyclopedia in 37 books of the natural world. Books 34 and 36 focus on bronzes and marbles respectively; painting is the subject of book 35. Although it is erroneous to term these sections Pliny's 'Chapters on the History of Art', his work has proved invaluable for the reconstruction of the works of the great masters of the ancient world. Pliny's particular interest was in the process of production and the pedigrees ascribed to works of art. He also provided a bibliographical index to each of his books and thus the indexes to books 34–6 constitute a virtual guide to ancient art criticism. The majority of the sources are Greek artists such as Xenocrates of Sicyon (late 4th century BC), Antigonus of Carystus (late 3rd, early 2nd century BC), and *Pasiteles, a Greek based in Rome (c.108–48 BC); Marcus Terentius Varro (116–28 BC), a Roman statesman and scholar, is the primary Latin source.　　L-AT

Beagon, M., *Roman Nature* (1992).
Isager, J., *Pliny on Art and Society: The Elder Pliny's Chapters on the History of Art* (1991).

POELENBURCH, CORNELIS VAN (c.1595–1667). One of the most distinguished of the first generation of Dutch *landscape painters who worked in Rome. Born in Utrecht, he studied there with *Bloemaert, and worked in Italy, in Rome, and at the Medici court in Florence, c.1617–25/7. Here, inspired both by Paul *Bril and by the naturalism of *Elsheimer and *Filippo Napoletano, he created a new type of idyllic ruin landscape, painted on small panels or copper. Such works as *Caprice with Ruins* (1620; Paris, Louvre) are fantasies, with ruins from the Forum and the Palatine, set against soft

distances, and embellished by pastoral figures. Caverns and bizarrely shaped, twisting rocks were a favourite motif. By 1627 he was back in Utrecht, where, apart from a period (1658–41) in the service of Charles I in London, he conducted a highly successful career. His Arcadian landscapes, smoothly painted, often with female bathers, or with saints, or the gods of Olympus, were popular; he painted portraits, and *The Seven Children of the Winter King and Queen* (1628; Budapest, Szépmüvészeti Mus.) sets a refined group portrait within an Italianate landscape.　　HL

POESIA (Italian: poetry), a genre of painting based on the myths and legends familiar from such poets as Ovid. There are 15th-century *poesie*, such as *Botticelli's *Primavera* (Florence, Uffizi), but the genre flourished mainly in the Italian 16th century. The *poesia* was not a precise illustration of a text, but rather allowed the artist a free play of the imagination, and an opportunity to display all the power of his art in rendering anatomy and emotion. *Titian's *Venus and Adonis* and *Danaë* (Madrid, Prado), in which the artist exhibits variety in the handling of the female nude, are among a famous series of paired *poesie* painted for Philip II of Spain. This pairing of *poesie* which contrast in both composition and theme became common in the 16th century.　　HL

POINTILLISM. A technique of painting which is described by Maitland Graves (*Colour Fundamentals*, 1952) as follows: 'Pointillism is the method whereby the chromatic light beams reflected by tiny, juxtaposed dots of paint . . . are additively mixed [see COLOUR] by the eye and fused into one solid colour. This fusion occurs only when the chromatic dots are too small to be resolved by the eye, or when they are viewed at sufficient distance.' The method was developed systematically by *Seurat, first in his painting *La Grande Jatte* (1884–6; Chicago, Art Inst.), where dots of pure pigment of uniform size are superimposed on fundamental underlying painting in longer brush strokes or *balayé*, and afterwards in *Les Poseuses* (1887–8; Merion, Pa., Barnes Foundation) and later paintings as a fundamental structural technique. The use of a stippled technique in painting to secure additive mixture of colours was proposed by the theorists Charles Blanc (*Grammaire des arts du dessin*, 1867) and Ogden N. Rood (*Modern Chromatics*, 1879), whose writings were studied by Seurat. Rood referred to *Ruskin and also to Dr Jean Mile, whose method of securing optical mixture of colours by a stippled technique he described as follows: 'Another method of mixing coloured light seems to have been first definitely contrived by Mile in 1839, though it had been in practical use by artists a long time

previously. We refer to the custom of placing a quantity of small dots of two colours very near each other, and allowing them to be blended by the eye placed at the proper distance . . . This method is the only practical one at the disposal of the artist whereby he can actually mix, not pigments, but masses of coloured light.'

In reference to Seurat's *La Grande Jatte* the critic Félix *Fénéon spoke of 'peinture au point' ('Les Impressionistes', *La Vogue*, June 1886) but Seurat himself and also *Signac preferred the word 'Divisionism'. Seurat found anticipations of the method in many of the earlier masters, notably in *Watteau, *Delacroix, *Murillo, and the *Impressionists. Seurat's use of the method was defended under attack both as a means to achieve a greater luminosity and as a means of securing more delicate control of hue, a means whereby the tonality could be slowly and carefully changed according to the representational effect desired by the artist.　　HO

POINTING, a method used by sculptors for transferring the proportions of a model in two or three dimensions to a block of stone; the same technique is used for the production of copies with the measurements taken either directly from the original or from a *plaster cast. The basic principle involves the fixation of three points on the model in a triangular configuration. Other points can then be determined in relation to these three fixed points using callipers to measure the respective distances. Proportional callipers can be used to produce reliefs or statues of smaller or larger scale. Three distinctive techniques, all variations on the basic technique using a system of triangulation, are known: triangulation, the use of a scaled frame with plumb lines, and a 'pointing machine'.

Preserved evidence on unfinished Greek and Roman statuary demonstrates that the first two techniques were used in Antiquity. *Punti*, small raised bosses for the positioning of callipers, are found on Hellenistic and Roman portraits, ideal sculpture, and copies. Two *punti* are preserved on the head of the Roman copy of Myron's *Doryphorus* in the Capitoline Museum, *Rome; a third would have been on the chin. A slightly different system with only two fixed points has been postulated for the sculpture workshops at *Aphrodisias. Bosses used for the attachment of plumb lines survive on the pedimental sculpture and reliefs of the temple of Zeus at *Olympia (c.460 BC). Measurements would then have been taken with callipers, using the plumb lines as points of reference. An ancient version of the 'pointing machine', once reconstructed by scholars on the model of the 18th-century version, has recently been rejected in favour of these older methods.

During the *Renaissance, a system similar to the ancient system using a scaled frame with plumb lines is mentioned by *Alberti, *Cellini, and *Vasari. Vasari also ascribes to *Michelangelo a variant of this technique, in which the model is placed in a vat of water with the raised areas gradually measured off as the water level drops.

This basic technique continued to be used into the 18th and 19th centuries. Thus, a drawing by Chiaruttini of 1786 demonstrates that *Canova used this form of pointing with a scaled frame and plumb lines for the production of his monument to Clement XIV. This method is also that illustrated in the manual on sculpture production by Francesco Carradori (1802). In the second half of the 18th century, however, the 'pointing machine' was introduced, most probably by the British sculptor John *Bacon (c.1763). Francis *Chantrey is said to have improved on it; he presented a drawing of his version to Canova in 1818. Another contemporary of Canova, Gottfried *Schadow, published a description of a pointing machine in 1802. Indeed, the use of the modern pointing machine is often associated with the workshop of Canova. Alternatively, it is tied to the holders of the *Prix de Rome at the French Academy and contemporary restorers such as *Cavaceppi, who are said to have evolved a pointing machine for the reproduction and restoration of Antique statuary.

A metal apparatus with extendible arms, the pointing machine could be fitted with either a pointed end to take measurements or a drill that would be used to drill to the corresponding depth on the copy. It permitted the mass of the removal of the marble from the block to be carried out by workmen, thereby allowing the 'master' to concentrate on the surface finishing. At the same time, the production of an exact copy of an Antique statue was painstaking and required a massive expenditure in labour. Hundreds and even thousands of points had to be taken to ensure a meticulously exact copy.

By rendering mass production possible, the 'pointing machine' provoked an important shift in art production and connoisseurship by introducing the concept of the primacy of the original, and the consequent denigration of copies. The low esteem accorded to the products of mechanical copying also influenced perceptions of the work of creative artists of the period, as contemporary accounts of Canova's studio, which suggest that much of the work was done by workmen and lacked the hand of the 'master', vividly demonstrate. L-AT

Honour, H., 'Canova's Studio Practice—I: The Early Years', Burlington Magazine, 114 (1972).

POLIAKOFF, SERGE (1906–69). Russian-born painter of the *Ecole de Paris. Poliakoff, who trained as a professional musician, moved to Paris in 1923 and became a French citizen in 1962. He began to paint in 1930, studying in both Paris and London, where he attended first Chelsea School of Art and then the Slade (1935–7). He was an abstract painter, inspired initially by *Kandinsky, whom he met in 1937, and influenced by the colour theories of Robert *Delaunay. His interest in colour and technique led him to abandon commercially prepared pigments for his own preparations. Poliakoff arrived at his mature style in the late 1940s and was sufficiently successful to be able to paint full-time from 1952. His canvases seem purely abstract exercises, comprising flat areas of colour, neither truly organic nor geometric, with a strong overall structure learned from his study of *Cézanne; their intensity however links him to the *Abstract Expressionists. His works are seldom titled other than as Compositions, for instance Abstract Composition (1954; London, Tate); there are examples in museums throughout Europe and America. MF

Brutsch, F., Serge Poliakoff (1993).

POLIDORO DA CARAVAGGIO (Polidoro Caldara) (c.1500–43?). Italian painter. He came from Caravaggio, near Milan, and by 1517–18 he was working in *Raphael's team on the Vatican Loggias. After Raphael's death he worked for a time with *Giulio Romano. By 1524 he had developed the speciality of frescoing the façades of Roman palaces with vigorously inventive monochrome friezes, figures in niches, and architectural elements, saturated with references to the *Antique. Little now remains of any of these celebrated works except the restored example (1524–5) on the Palazzo Ricci, though others are known from drawings and engravings. Around 1525 he painted murals of scenes from the life of the Magdalene and of S. Catherine of Siena in the Roman church of S. Silvestro al Quirinale. These are virtually pure landscapes which must reflect knowledge of Antique models. While they had no immediate impact on Roman painting, they were influential for *Claude and *Poussin in the following century.

After the Sack of Rome (1527) he left Rome for Naples, and then settled in Messina, where his works (mostly altarpieces) became increasingly personal and violently emotional. According to *Vasari he was murdered for his money in Messina in 1543. AJL

Briganti, G., La pittura in Italia: il cinquecento (1987).

POLISH ART. Poland was probably settled by Slavonic tribes during the first millennium, but it was not until the reign of the Piast Duke Mieszko I (960–92) that Christianity was established. In 1025, Boleslas I Chrobry (the Brave), Duke Mieszko's son, was crowned king and Poland began to acquire an independent unity. Trade brought about a rapid expansion of towns and villages and bishoprics were founded at Poznań, Cracow, Wrocław, Kołobrzeg, with the archbishopric at Gniezno. These developments brought about links with the Latin West which are discernible in some of the earliest surviving sculptural remains of the 12th and 13th centuries, for example columns with their remarkable relief sculptures of the virtues and vices (1170; Strzelno, Holy Trinity church) or the Bronze Doors of Gniezno Cathedral (1175), depicting scenes from the life of S. Wojciech (Adalbert) of Prague. Wooden figures from the 13th century seem also to be related to Western art, in particular the Rhineland, such as the Christ Crucified (1322; Wrocław, S. Martin).

After a period of political upheaval, the coronation of Władysław I Lokietek (the Short) in 1320 provided stability and the reign of his son, Kazimierz III Wielki (the Great) (1333–70) saw an economic and artistic resurgence. Cracow became the seat of government and a university was founded there in 1364. *Gothic influences from France, Italy, and Bohemia permeated aspects of royal patronage. The contribution of Polish sculptors can be seen in a series of canopy tombs, such as Władysław I and Kazimierz III (1370–80; Cracow, Wawel Cathedral). Wood-carving flourished and the 'Beautiful' or *International Gothic style spread from the workshop of Peter *Parler in Prague in the later 14th century and culminated in outstanding works such as the Kruzlowa Madonna (1420; Cracow, Szolayski Mus.).

Cracow remained the artistic capital of Poland during the 15th and 16th centuries under the Jagiellonian dynasty, founded in 1386 by Władysław III. The dynasty ruled Poland until 1572, when one of Poland's greatest *Renaissance patrons, King Zygmunt II August, died without heirs. Tombs remain the most important monumental sculpture of this period, for example that of Władysław Jagiello (1440; Cracow, Wawel Cathedral), culminating in the superb tomb by Veit *Stoss of Kazimierz IV Jagiellonian (1492; Cracow, Wawel Cathedral). Stoss, although a German from Nuremberg, settled in Cracow 1477–96 and his masterpiece, the altarpiece of The Virgin Mary (Cracow, church of S. Mary), made a revolutionary impact on late medieval art in Poland. Until the second half of the 15th century, when a distinctive style of Polish painting developed in Cracow, artists were strongly influenced by Bohemian models. Painted and carved altarpieces were produced in large numbers by largely anonymous local painters, such as the Trinity altarpiece (Cracow, Wawel Cathedral).

However, influences from Renaissance Italy and the *humanist culture fostered by Cracow University gave new impetus to the

arts in Cracow under Zygmunt I (the Old), who rebuilt Wawel Castle and added the Kaplica Zygmunowska (1519–33) to the cathedral, one of the finest pieces of Renaissance decoration outside Italy. Italian architects and sculptors were imported, including Bartolommeo Berecci and Giovanni Maria Padovano. He also invited the German painters Hans Dürer and Hans von *Kulmbach to his court. The greatest Polish artist at this time was Stanisław Samostrzelnik (active 1519–41), a Cistercian monk from Mogila, who worked as a muralist and miniature painter, for example *Liber geneseos* (Kórnik Lib.)

In 1569, with the unification of Lithuania with Poland, the capital was transferred from Cracow to Warsaw and Zygmunt III of the new Swedish Waza dynasty was elected by the nobility to the Polish throne. Zygmunt III (1587–1632) acquired a collection of paintings from Italy and the Netherlands through agents and during his own visit, when he was painted by *Rubens. He invited the Venetian Tomaso Dolabella to his court. Collections of various noble families, such as the Radziwiłł, Ossolinski, and Lubormirski, began to rival those of the king.

The Swedish Wars of the mid-17th century brought decline and setbacks to this flourishing situation, but later in the century a more peaceful period ensued and, with it, the development of a mature *Baroque style. A uniquely Polish characteristic of 17th-century art is the emergence of the aristocratic cult of Sarmatism, best exemplified in a type of portrait painting of series of ancestors characterized by realistic likeness, hieratic poses, and a flat linear style, painted in vivid contrasting colours, with jewels and symbols of station, for example *King Stephan Barthory* by Marcin Kober from Wrocław (1583; Cracow, formerly monastery of the Missionary Congregation) or *John III Sobieski* by Jan Tretico (d. 1692) (1677; Cracow, Mus. of Jagiellonian University). Another particularly Polish contribution was so-called 'coffin' portraits, painted usually on metal, octagonal or hexagonal in shape, by mainly anonymous travelling artists, such as *Portrait of Ewa Bronikowski* (d. 1672; Miedzyrzecz, Hexagon Mus.).

In north Poland, Dutch *Mannerism was strong, with the influence of artists such as Vredeman de Vries and Isaac van den Blocke. They influenced Bartlomiej Strobel from Silesia. Another Silesian, Daniel Schultz, was educated in the Netherlands and became court painter to John Kazimierz, whom he portrayed informally without a wig (Cracow, Wawel Castle). The work of Franciszek Lekszycki (d. 1668) reveals the influence of *Rubens, for example the *Crucifixion* (Cracow, Benedictine church). Under King John Sobieski, Italian artists, such as Martino Altomonte (1657–1745) from Naples, were imported to provide large-scale murals in the new Counter-Reformation spirit.

In the last half of the 18th century and coinciding with the reign of the last Waza king, Stanisłaus Augustus Poniatowski (1764–95), elected through the influence of the powerful Polish noble family of Czartoryski, the arts in Poland saw a revival of royal patronage, although political upheavals prevented the completion of various royal schemes, such as the rebuilding of the royal castle in Warsaw. Nevertheless the King invited foreign artists such as Marcello Bacciarelli from Rome to create a school of *history painting and the sculptor André Jean LeBrun, a pupil of *Pigalle, from Paris. One of the most important foreign artists was Bernardo *Bellotto, who was in Poland by 1767 and who painted outstanding views of the city, influencing Polish painters such as Zygmunt Vogel, whose topographical views, together with those of Bellotto, were of inestimable help in rebuilding Warsaw after the Second World War. Jean-Pierre Norblin (1745–1830) arrived in Poland from France in 1774 for the remainder of his career, introducing scenes of aristocratic Polish rural life in the manner of *Watteau. Franciszek Smuglewicz (1745–1807) was sent to Rome in 1763 to study under Anton von *Maron and at the Accademia di S. Luca (see under ROME). He mixed in antiquarian circles, copied Antique frescoes, and painted a celebrated portrait of the Scottish cicerone James Byres and his family (Edinburgh, Scottish NPG). On his return he founded the Royal 'Wilno Academy'. Aleksander Kucharski (1741–1819) went to Paris and painted there the last portrait of Marie-Antoinette.

The demise of an independent Polish kingdom and the partitioning of Poland (1815) did not have an entirely detrimental effect, although public commissions tended to be given to the Berlin sculptor Christian Daniel Rauch or the Danish sculptor Bertel *Thorvaldsen. Nevertheless, a number of Polish artists came to the fore, particularly Piotr Michalowski (1800–55), a talented nobleman-amateur, and Henryk Rodakowski (1823–94). An increasing spirit of nationalism imbues the highly individual work of Jan Matejko (1836–93), whose many scenes of Polish history, such as *Prussian Homage* (Cracow, Sukiennice Mus.), with its visionary reconstruction of the past, did much to arouse and fortify national feeling. Rather more informal and with a greater degree of realism, but no less Polish, are the everyday scenes in Warsaw by Aleksander Gierymski (1850–1901). Towards the end of the 19th century such trends culminated in the formation of a group of artists, writers, and musicians known as Mloda Polska (Young Poland), based in Cracow. A dominating figure of this group was Stanisław Wyspiański (1869–1907), whose wide-ranging abilities encompassed murals and stained glass in the Franciscan church, Cracow, theatre designs, portraits,

landscapes, and pastels in a museum dedicated to him there. Other remarkable late 19th-century painters show an awareness of European styles, such as French *Impressionism in the work of Władysław Podkowinski (1866–95) and *Art Nouveau in the strange visionary canvases of Jozef Mhoffer (1869–1946): *Strange Garden* (1903; Warsaw, National Mus.). A Romantic nationalism and dreamy symbolism infuse the work of Jacek Malczewski (1854–1929), as in *Melancholy* (1894; Poznań, National Mus.). The outstanding sculptor of this period was Xawery Dunikowski (1875–1914), who turned to concerns of form as in *Ewa I* (wood; Warsaw, National Mus.).

After the First World War, groups of Polish artists espoused various international modernist styles. In 1917 artists such as Zbigniew Pronaszko (1885–1958) and Tytus Czyżewski (1880–1945), called themselves the Polish Expressionists. Influenced more by *Cubism, they later renamed themselves the Polish Formists. Dominant artists of the 1920s were Leon Chwistek (1884–1944), whose work inclined towards *Futurism, and the novelist and painter Stanisław Ignacy Witkiewicz (1885–1939), whose work, for example, *Temptation of S. Anthony* (Cracow, NG), has a surreal and unsettling quality. In 1924 the Blok group was formed in Warsaw, whose members included the *Constructivist Mieczysław Szczuka (1898–1927). *Abstract art in Poland, influenced by *Malevich, is expressed in the work of Władysław Strzeminski and his wife Katarzyna Kobro (1889–1951). Ties with France remained strong and Tadeusz Makowski (1882–1932) settled in Paris, painting themes of children and folklore. Whereas Łódź and Warsaw were the centre of avant-garde developments, Cracow became the centre of Polish Colourism during the 1930s, with the work of Karol Larisch (1902–35), Wojciech Kossak (1856–1942), Tadeusz Pruszkowski (1888–1942), Boleslaw Cybis (1895–1957), and Jan Zamoyski (1901–86).

The terrible events of the Second World War made post-war artistic regeneration slow. Some of the most remarkable works of sculpture have been monuments to concentration camp victims, such as the Treblinka Monument (1964) by Franciszek Duszenko (1925–) and Adam Haupt (1920–). More recent events have continued the tradition of monumental sculpture, with the Monument to the Shipyard Workers (1980; Gdańsk) by Bogdan Pietruszka and others. During the Communist period, efforts to impose *Socialist Realism with works such as *Pass Me a Brick* by Aleksander Kobzdej (1920–72) were short-lived. Stalin died in 1953, and at the 1955 *Exhibition of Modern Polish Art* in the Warsaw Arsenal, artists declared an official break with Socialist Realism and abstract art became dominant, following European and

American developments. CFW

A Thousand Years of Polish Art, exhib. cat. 1970 (London, RA).

Klimaszewski, B. (ed.), *An Outline History of Polish Culture* (1983).

POLLAIUOLO BROTHERS. Antonio (c.1432–98) and **Piero** (c.1441–before 1496) together ran a busy Florentine workshop as sculptors, goldsmiths, painters, and printmakers. Their collaboration has caused difficulties in distinguishing their individual hands, but Antonio was probably trained as a goldsmith under Bartoluccio Ghiberti, father of Lorenzo *Ghiberti, and practised primarily as a sculptor and bronze caster. Piero was active chiefly as a painter and contributed three of the *Seven Virtues* in the Uffizi Florence (c.1469/70), which depend stylistically on the work of Fra Filippo *Lippi. The most important of Antonio's handful of paintings is the *Martyrdom of S. Sebastian* (1475; London, NG) in which the mirrored poses of the archers display his inventive powers and a knowledge of human anatomy, a feature characterizing his bronze statuette of *Hercules and Antaeus* (c.1475–80; Florence, Bargello). Antonio's spontaneous drawing style anticipated *Leonardo's, as did his interest in landscape painting. The distinctively sinewy calligraphic style is exemplified in the engraving of the *Battle of the Ten Nudes*, a virtuoso display of human pose and gesture. Most significant of his monumental bronze commissions were the tomb of Sixtus IV (1484–93) and the tomb of Innocent VIII (c.1495; both Rome, S. Peter's), whose sophisticated designs and the inclusion of the papal effigy established the model for subsequent papal tombs. The series of coloured embroidery panels for the Florence baptistery unifies all his artistic skills. HO/AB

Ettlinger, L. D., *Antonio and Piero Pollaiuolo* (1978).

POLLOCK, JACKSON (1912–56). American painter. Born Cody, Wyo., he had his first art training at Manual Arts College, Los Angeles, and became involved with the followers of Krishnamurti, Hindu mysticism, and Jungian psychology. In 1931 he moved to New York and studied at the Art Students' League under Thomas Hart *Benton, then worked on the *Federal Art Project in the 1930s. In 1943 he had his first one-man show at Peggy Guggenheim's New York gallery Art of This Century, showing *Guardians of the Secret* (1943; San Francisco, Mus. of Modern Art). A core member of the *Abstract Expressionist group, he became famous for the paintings of 1948–52, which were dripped or poured on unstretched canvas laid on the floor, rather than painted: *Blue Poles* (1952; Canberra, Australian NG). He and his wife Lee *Krasner moved to Spring, East Hampton, in 1945. For the last two years of his life he found it almost impossible to work and he was killed in a car crash in 1956. RJP

Naifeh, S., and Smith, G. H., *Jackson Pollock: An American Saga* (1990).

POLYCHROME SCULPTURE. The modern eye is unaccustomed to polychrome sculpture, that is, to either the complete or the partial covering of surfaces with pigment. The taste for unpainted, pure white surfaces of marble, or the rich tones of polished natural wood, arises out of a *Neoclassical misconception that the sculpture being unearthed, uncoloured, in archaeological excavations had always lacked any surface colour. *Michelangelo is said to have detested surface treatments, preferring his sculpture to convey ideas by form alone. Yet until the mid- to late 16th century there is clear evidence that all sculpture was painted to a greater or lesser extent, the tradition having been established in Greek (see GREEK ART, ANCIENT) sculpture. The tradition continued unabated through the Hellenistic and Roman periods. The evidence is best preserved on terracotta or limestone, which retains the paint better. Paint has also been found on everything from the Archaic limestone pediments from the Acropolis in Athens to the *Prima Porta Augustus* (Rome). Roman imperial portraits and ideal sculpture preserve evidence for painted hair and gilding.

*Cennini's treatise describes methods for polychromy which can be recognized in surviving medieval polychromed sculpture, and generally its function was to add naturalistic colour to sculptures. Architectural stone sculpture was traditionally highlighted with paint and remains survive, for instance, in the tympanum of the basilica of S. Madeleine in Vézelay, France, or on the façade of Conques. Small-scale carvings in ivory also merited polychromy; for instance, the remains of blue pigment and gilding can be seen on the Chalandon *Angel of the Annunciation* (c.1280–1300; Paris, Louvre). Terracotta was also polychromed, for instance the *Lamentation* groups made in Bologna and Naples during the 15th and 16th centuries, or decorated with coloured tin glazes, especially in the works of Luca della *Robbia and his workshop in Florence. German *limewood sculpture was certainly polychromed according to the same manner as recounted in contemporary painters' handbooks, and even the supposedly monochrome sculptures of Tilman *Riemenschneider had tinted glazes applied to their surface. The tradition for polychrome wood sculpture in Germany and Austria persisted until the 18th century, and the marvellously preserved paint on *Christ at the Column* (1725; Detroit, Inst. of Arts) by Ignaz *Günther displays the subtle polychrome effects that could be reproduced by that date. The polychromy and *gilding used in such profusion in architectural sculpture in southern *Baroque churches and palaces lent these interiors a brilliantly effervescent character.

Major centres for polychrome sculpture throughout the *Renaissance and Baroque periods were Spain and Portugal. There the veristic tradition of carved statues of Christ and the saints promoted the most realistic development of this art, using the *estofado technique in tableaux of life-sized figures wearing actual costumes, such as the scenes from the Passion of Christ by F. Zarcillo (1707–81; Murcia, Ermita de Jesús), or in *Montañés's *Immaculate Conception* (Toledo Cathedral). The Spanish technique involves covering the ground of the figure with gilding, and over this painting on a design or scratching through the paint layer (in the sgraffito manner), to reveal the gilt surfaces below. This was used especially on brocade surfaces of drapery and robes.

By the 19th century the taste for polychrome sculpture had decreased, especially in response to *Winckelmann's theories about the purity of form, as demonstrated by Antonio *Canova's sculptures. However, John *Gibson's *Tinted Venus* (1851–6; Liverpool, Walker AG) caused a scandal by its verisimilitude, though its colour in fact owes much to classical ideals. Later, consciously reviving Greek polychrome techniques, Jean-Léon *Gérôme added colour and tinted wax to his marble figures, for instance in the *Seated Woman* (c.1890–5; Detroit, Inst. of Arts), though the final results are closer to *Symbolist painting than to Antique prototypes. During the 20th century polychromy was added in *Expressionist and *abstract sculpture, and the concept also relates to the coloured *mobiles of Alexander *Calder.

HO/AB

Blühm, A., Drost, W., et al. (eds.), *The Colour of Sculpture 1840–1910*, exhib. cat. 1996 (Amsterdam, Van Gogh Mus.; Leeds, Henry Moore Inst.).

Penny, N., *The Materials of Sculpture* (1993).

POLYCHROMY in sculpture applies not only to pigmented decoration and naturalistic painting, but also to the addition of gilding, glass, incised decoration, and other punched effects. The sculptural surface to be polychromed must also be protected from the penetration of binder pigments by an animal glue or size. Occasionally an intermediate layer of cloth might be applied to add a further barrier against the leaching of pigment into the wood. Over this a surface of gesso, made up of clay, chalk, and size, would be applied in successive layers, and smoothed before paint and gilding was applied. Paint, made up of a binding medium (oil or tempera) and pigments, would be applied both in single and in multiple layers. The gilded areas might also include punched

and incised decoration, which either might be modelled in the gesso, or moulded and fixed to the sculpture. Passages of textile, flesh, or hair would be differentiated to suggest various textures. The stripped altarpieces and figures that are familiar to the present museum-goer have succumbed to the tastes of 18th- and 19th-century collectors who preferred the effect of bare wood or marble (see POLYCHROME SCULPTURE), and unfortunately give no sense of the richness of their original appearance. HO/AB

Penny, N., *The Materials of Sculpture* (1993).

POLYCLITUS or Polykleitos (5th-century BC). Argive (or Sicyonian?) sculptor renowned for his chryselephantine *Hera* at Argos and male figures in bronze, especially the *Doryphorus* (Spear-Bearer), which apparently exemplified his *Canon* (Rule), a treatise on ideal male beauty as embodied in a system of precise mathematical proportions. Only tantalizing fragments of this text survive (e.g. 'perfection comes about little by little through many numbers'), and variations among numerous ancient copies of the statue of a muscular nude youth (e.g. Vatican Mus.; Naples, Mus. Arch. Naz.; Minneapolis, Inst. of Arts), which was also widely adapted by the Romans, preclude definitive recovery of Polyclitus' principles. These were evidently based in a series of binary oppositions (*contrapposto) and the commensurability of parts (*symmetria*): 'the proportion of finger to finger, of fingers to palm and wrist, of these to forearm, . . . of all parts to the whole', according to later quotations from the *Canon*. The *Diadoumenus* (Athlete Crowning Himself) and *Amazon*, which allegedly won a contest at Ephesus, have also been recognized in Roman copies (e.g. *Diadoumenus*: Athens, Nat. Arch. Mus.; *Amazon*: New York, Met. Mus.; Rome, Capitoline Mus.); attempts to identify other works mentioned by ancient authors remain moot. KDSL

Moon, W. G. (ed.), *Polykleitos, the Doryphoros, and Tradition* (1995).

POLYDORUS. See HAGESANDER, ATHENADORUS, AND POLYDORUS.

POLYGNOTUS (active mid-5th century BC). Greek painter. Originally from Thasos, he befriended the Athenian leader Cimon, and received Athenian citizenship in recognition of his paintings in *Athens. Most famously, between *c*.470 and 447, he decorated the Painted Stoa, Theseion, and Anakeion (shrine to Castor and Pollux) in Athens; and, at *Delphi, the Cnidian Lesche. In the latter, he painted the *Sack of Troy* and the *Underworld*; other paintings included *Odysseus after killing the suitors* (in Plataea). None of Polygnotus' work survives, but *Pausanias describes his Delphi paintings at length, and a

series of vase paintings of the mid-5th century may reflect his importance in introducing a varied groundline and spatial distribution of figures. *Pliny (*Natural History* 35. 58) includes among his innovations the representation of women with transparent drapery, and the depiction of expression by bared teeth. The latter observation is consistent with *Aristotle and *Lucian, who also praised his unprecedentedly lively and expressive faces. His figures were often characterized by *ethos* (character). He is said not to have used shading. Pliny says Polygnotus was also a sculptor, although less successfully. KWA

Kebric, R., *The Paintings in the Knidian Lesche at Delphi* (1983).
Stansbury-O'Donnell, M., 'Polygnotus's *Iliupersis*: A New Reconstruction,' *American Journal of Archaeology*, 93 (1989).
Stansbury O'Donnell, M., 'Polygnotus's *Nekyia*: A Reconstruction and Analysis', *American Journal of Archaeology*, 94 (1990).

POMPEII. Since its rediscovery in 1748, the buried city of Pompeii near Naples has exercised a powerful influence on the collective memory, with constant reminders of the frailty of human life and touching conservation of the accoutrements of daily life in the ancient Roman world. The 5–6 m (16–20 ft) of volcanic ash from the eruption of Vesuvius that entombed the 'modest provincial town' and many of its luckless inhabitants on 24 to 25 August AD 79 preserved a hitherto undreamed-of microcosm of Roman life. Since the 18th century, the excavations at Pompeii and Herculaneum have been seen as significant precisely for the possibility of reconstructing entire cities and thus urban life. Public buildings vie in their decoration with private homes and tombs of the Pompeians. A glimpse of social realities results from the juxtaposition of massive residences of the wealthy with minute shops and squalid living quarters on the second storey for the less affluent in their street-fronts.

The private patron of art is most visible in the ruins of Pompeii. A culture of social climbing and grandiose political gestures was expressed visually in the decoration of domestic space with elaborate painted wall schemes, bronze and marble sculpture, and extravagant minor arts. The house of the Roman aristocrat was yet another stage for his political and social aspirations and domestic accoutrements had to match his actual or presumed social status. Recent scholarship suggests that house decoration reflected the hierarchy of Roman society with the 'public' atrium, tablinum, and peristyle of the house equipped with paintings and sculpture to impress the masses while the real 'treasures' of the private core of the house were accessible only to close associates.

The painted decoration at Pompeii may be divided into four styles. Although a loose chronology is evident in the development from one style to another, earlier styles of wall painting were renewed in later periods. Repairs after damage sustained in an earthquake traditionally dated to AD 62 have preserved precious evidence of workshop technique and materials. Mosaic floors were, by comparison, relatively modest; most were black and white with an occasional coloured emblemata. A notable exception is the *Alexander* mosaic from the House of the Faun with its depiction of the historic battle of Issus between Alexander the Great and the Persian King Darius. In sculpture, the norm at Pompeii was for under-life-size busts and statues in bronze or marble, Dionysiac figures for the garden, ancestor busts for the atrium, and images of the gods for the *lararia* (household shrines). The sole exception, a life-size copy of the *Doryphorus* of *Polyclitus, comes from public space, the Samnite Palaestra. Minor arts are represented in large numbers by bronze and ivory attachments for furniture, dining services in precious metals, marble tables decorated at times with mythological figures. L-AT

Clarke, J. R., *The Houses of Roman Italy* (1991).
Wallace-Hadrill, A., *Houses and Society in Pompeii and Herculaneum* (1994).
Ward-Perkins, J., and Claridge, A., *Pompeii AD 79*, exhib. cat. 1976 (London, RA).

PONT-AVEN, SCHOOL OF, a loose grouping of artists associated with *Gauguin who worked for shorter or longer periods in this picturesque Breton town. When the advent of the railway made southern Brittany accessible to tourism, Pont-Aven became a favourite locale of an international colony of artists exploiting it for marketable rural scenes. Gauguin stayed there in 1886; 1888–90 when in the company of *Bernard he made a decisive stylistic shift from Impressionism to *Cloisonnism and *Symbolism; and 1894, before returning definitively to Tahiti. Following the Café Volpini exhibition in Paris in 1889 Pont-Aven acquired a special cachet as the cradle of pictorial symbolism. Younger artists came to seek Gauguin's advice, which he meted out in his own paradoxical way. This international band of followers included at different times Paul *Sérusier, Charles Filiger (1863–1928), Armand Séguin (1869–1903), Jacob Meyer de Haan (1852–98), Jan Verkade (1868–1946), Jens Ferdinand *Willumsen, Cuno Amiet (1868–1961), Robert Bevan (1865–1925), and Roderic *O'Conor; each sought a more expressive, simplified art for which the 'primitive' associations of Brittany provided a ready stimulus. BT

Boyle-Turner, C., *Gauguin and the School of Pont-Aven: Prints and Paintings* (1986).

PONTE, DA. See BASSANO FAMILY.

PONTORMO, JACOPO DA (1494–1556). The outstanding Florentine painter of the mid-16th century and the most original of the early exponents of *Mannerism. The visionary intensity of his paintings reflects his highly idiosyncratic personality, obsessed with his work and the condition of his bowels. Born in Pontormo, hence his nickname, Jacopo Carucci trained in Florence with masters including *Leonardo da Vinci and *Piero di Cosimo, another notable eccentric. Around 1512, in the workshop of *Andrea del Sarto, the leading painter in Florence, he encountered *Rosso Fiorentino, who was also influential in the development of the new Mannerist style. Pontormo's firm grounding in the High *Renaissance *classicism of del Sarto and Fra *Bartolommeo is evident in his early frescoes, such as the *S. Catherine of Alexandria* (1512; Florence, Uffizi) and the dramatic *Visitation* (c.1515; Florence, SS Annunziata). His introduction of more intensely expressive elements, reminiscent of *Donatello, is particularly apparent in the *Virgin and Child* (1518; Florence, S. Michele Visdomini), in which the balance and harmony of the classical compositional model is disrupted by fragmented forms and an irrational spatial structure. There is further evidence of experimentation in three early panel paintings of the *Story of Joseph* (1515–18; London, NG), which were part of the decoration of the Borgherini bridal chamber. The latest of the panels, *Joseph in Egypt*, is crowded with human figures and disconcertingly lifelike statues in an irrational, dreamlike architectural setting. Pontormo's long association with the Medici began in this period, and his portraits include a remarkably vital posthumous depiction of the founder of the dynasty, *Cosimo il Vecchio* (1519; Florence, Uffizi). His approach to his subjects was perhaps too personal and expressive to suit official portraits, however, and unlike his pupil *Bronzino he did not become a court artist. For the Medici villa at Poggio a Caiano he executed fresco decorations (1520–1; *in situ*) including a delightful pastoral scene with the Roman gods Vertumnus and Pomona. The influence of north European prints, particularly those by *Dürer, is apparent in his religious frescoes of the mid-1520s, such as the *Supper at Emmaus* (Florence, Uffizi), in which the sense of the viewer's participation in the scene anticipates *Caravaggio. In the work generally regarded as his masterpiece, the *Deposition* (1525–8; Florence, S. Felicità), the luminous colours recall *Michelangelo's, but the grace and poignancy are unmistakably his own. The major project of his late years, frescoes commissioned by the Medici for S. Lorenzo, Florence, was destroyed, but preparatory sketches are among his nearly 400 surviving drawings. LH

Berti, L., *Pontormo e il suo tempo* (1993).

PONZ, ANTONIO (1725–92). Spanish writer, administrator, and clergyman. Educated by the Jesuit order in Segorbe (Castellón), he moved to Madrid in 1746 to study painting and was in Rome from 1751 to 1759. In 1769, following the expulsion of the Jesuits from Spain, he was commissioned by the Crown to make a survey of property, including works of art, that had been confiscated from the Jesuits. It was as a result of the extensive travel in Spain made to complete this survey that he also prepared his monumental *Viage de España* (1772–94), the first detailed account of monuments and works of art in Spain. Eighteen volumes of this unfinished project had been completed at the time of his death. It remained an essential source for travellers in Spain, including pioneering British writers such as Richard *Ford and Sir William *Stirling-Maxwell, well into the 19th century. HB

POP ART, a term used to describe a movement which began in the late 1950s and flourished until the 1970s, independently but simultaneously, in Britain and America. It included artists working in totally different styles whose subject matter embraced and celebrated popular commercial culture including advertising, photography, comics, and the entertainment industry. The phrase was coined by the British critic, Lawrence Alloway (1926–90), of the *Independent Group which included the artists Eduardo *Paolozzi and Richard *Hamilton, to describe the imagery of popular culture and technology which they explored in the mid-1950s. This phase of British Pop pioneered the use of commercial imagery in fine art (Hamilton, *Hommage à Chrysler Corps*, 1957) but was distinctly more cerebral than later manifestations.

Further developments appeared in the work of painters who graduated from the Royal College of Art London in 1956 and 1957 and took much of their early inspiration from America; Peter *Blake (*Self Portrait with Badges*, 1961; London, Tate) and Richard *Smith (*Package*, 1962; Lisbon, Gulbenkian).

Closely following on Blake's heels came a new group of Royal College graduates, including David *Hockney, Allen Jones (1937–) and Peter Phillips (1939–), whose work shared a brashness and accessibility to a public which had previously considered contemporary art to be exclusive. From now on Pop artists played a significant role, along with pop music (with which they had a symbiotic relationship), in the media-contrived phenomenon of the swinging sixties.

Although British and American Pop shared related themes and subjects, the development of Pop in America was significantly different as it arose in part as a reaction to *Abstract Expressionism and many of its principal figures strove to achieve impersonality in subject and technique. The pioneers were Robert *Rauschenberg, Jim *Dine, and Claes *Oldenburg. Rauschenberg, taking *Dada as his inspiration, began to incorporate real objects into his Combine paintings of the mid-1950s (*Odalisque*, 1958; Cologne, Ludwig Mus.), a technique developed by Dine and later artists. All three collaborated in happenings (see PERFORMANCE ART) from 1958 and Oldenburg's *Store* (1961), in which painted plaster replica food was exhibited, derived from these events whilst also heralding his giant soft-sculptures: *Dual Hamburger* (1962; New York, MoMA).

American Pop came of age in the early 1960s with exhibitions by Roy *Lichtenstein and Tom Wesselmann (1931–), both of whom had previously worked in an Abstract Expressionist idiom, and Jasper *Johns, Andy *Warhol, and James *Rosenquist, who shared a background in commercial art. The use of *silk screen printing, pioneered by Rauschenberg in the 1950s, and commercial reproductive techniques were further factors in ensuring Pop art's wide appeal. DER

Osterwold, T., *Pop Art* (1991).

POPOVA, LIUBOV (1889–1924). Popova, who was from a wealthy family, studied in Moscow (1907–8) and worked in Paris, with *Le Fauconnier and *Metzinger, in 1912–13. On her return to Moscow, using *Tatlin's studio, she combined *Cubist techniques with Russian *folk art to make *collages, paintings, and *constructions. Popova took part in *avant-garde exhibitions, notably *Knave of Diamonds (Moscow) in 1914 and 1916. In 1918 she became a teacher at the newly founded Svomas (Free State Art Studios) and in 1920 joined the progressive Institute of Artistic Culture under whose aegis she exhibited 'Laboratory Art' in the 5×5 = 25 show in 1921. Her experimental abstract works, the *Painterly Architectonics* of 1916–20 (an example of 1918 is in New Haven, Yale University AG), show a strong interest in colour, like *Malevich, but avoiding his violent contrasts for a softer intersection of tones and planes. She also avoided any hint of perspective, seeing painting as essentially two-dimensional. In 1922–3 she designed for the stage and she spent her last year designing mass-produced clothing for the First State Textile Print Factory. GS

Yablonskaya, M., *Women Artists of Russia's New Age, 1900–1935* (1990).

POPPI (Francesco Morandini) (1544–97). Italian painter. Francesco Morandini was generally called Poppi after his birthplace, a small mountain village between Florence and Arezzo. He was mainly active in Florence, where he was a pupil of Giorgio *Vasari, with whom he collaborated on decorations at the Palazzo Vecchio. His own independent work for the palace includes the ceiling frescoes of the *studiolo* of Francesco I de' Medici, representing allegories of *Prometheus and Nature* and the *Elements*. He also made small panel paintings of *Alexander Giving Campaspe to Apelles* (1571; in situ) and the *Bronze Foundry* (1572; in situ). A small panel of the *Golden Age* (c.1567; Edinburgh, NG Scotland) is based on a drawing by Vasari (1567; Paris, Louvre) that reflected a programme written c.1565–7 by Vincenzo *Borghini. Poppi's style was influenced by Giovan Battista Naldini (c.1537–91), another of Vasari's assistants, as well as by the earlier generation of Florentine *Mannerists, especially *Pontormo and *Rosso Fiorentino. His later work, from the mid-1570s onwards, was often more restrained, and in his religious paintings, for instance the *Last Supper* (c.1586; Castiglion Fiorentino, Chiesa del Gesù), he reverted to High *Renaissance *classicism and the naturalism of *Santi di Tito.　HB

Berti, L., *Il principe dello studiolo* (1967).

POPPYSEED OIL. See MEDIUM.

PORCELLIS, FATHER AND SON. Dutch *marine painters. **Jan** (1580/4–1632) was born in Ghent but migrated to Holland, where he worked in many Dutch cities. His paintings mark the change from the strong local colour and scrupulous ship portraiture of the first generation of Dutch *marine painters, such as *Vroom, to monochromatic paintings which are essentially studies of sea, sky, and atmospheric effects. His overriding concern with atmospheric effects was very probably a main influence on the tone painting that dominated Dutch landscape in the 1630s. A favourite theme was a modest fishing boat making its way through a choppy sea near the shore; many paintings, such as *Shipwreck on a Beach* (1631; The Hague, Mauritshuis), represent storms or shipwrecks and it is likely that they had an emblematic significance analogous to that of the *vanitas* theme in still-life painting. His son **Julius** (1609–45) was also a marine painter.　AJL

The Mirror of Empire: Dutch Marine Art of the 17th Century, exhib. cat. 1990 (Minneapolis, Inst. of Arts).

PORDENONE, GIOVANNI ANTONIO DE' SACCHIS (c.1483–1539). Friulian painter, whose deeply expressive and dramatic work in fresco anticipates the art of *Tintoretto. His sources are diverse, and he skilfully adapted influences from *Michelangelo, *Raphael, and other exponents of Roman *classicism with the lessons he had learned earlier from *Mantegna, *Carpaccio, and *Giorgione. In 1520–1 he worked on a set of frescoes for Cremona Cathedral. The scene of the *Crucifixion (in situ)* displays an intensely dramatic style based on an expressive use of light and shade, and on the depiction of passionate movements and deep-felt, almost violent emotion. In 1529–30 he decorated the Pallavicini chapel of the Franciscan church of Cortemaggiore (Piacenza) with a vibrant mass of figures who are contained within painted architectural forms that mirror the actual architecture. A growing sense of refinement in the figures and a more confident use of illusionistic effects suggest contact with *Correggio's work. In 1535 he moved to Venice, where he worked in the Palazzo Ducale in 1535–8; his paintings for the Sala del Maggior Consiglio perished in a fire in 1577.　FB

Furlan, C., *Il Pordenone* (1988).

PORPHYRY, a hard igneous stone, difficult to carve and polish, varying in colour from red or green, often with flecks of feldspar. The porphyry used by the ancient sculptors was a very hard, durable stone of a deep purplish red and the only known source was at Mons Porphyrites in Egypt. Purple was the royal colour of the Ptolemies and the quarries were a royal possession: the porphyry busts, stelae, sarcophagi, and other works of sculpture that have survived from Ptolemaic times were made, it appears, only at the ruler's command or with his consent. When Cleopatra died (30 BC) Egypt became a Roman province and the Roman emperors took possession of the quarries and control of the stone, since purple was the imperial colour. Large numbers of Roman works in porphyry have been preserved—gems, vases, urns, sarcophagi, busts, and statues, some of the last having only the clothing in porphyry and the flesh parts in some other stone. The Eastern emperors in Byzantium used porphyry, often despoiling Roman monuments to get at it, as when columns were taken from Rome and set up in Hagia Sophia. In the medieval period circles of porphyry set into *'Cosmati' inlaid floors were cut from the cylinders of Roman columns. During the Italian *Renaissance this costly stone of the ancients (*porfido rosso antico*) came into favour once again, especially at the grand ducal court in Florence, when Cosimo I de' Medici revived the working of the stone through his patronage of the Florentine sculptor Francesco di Giovanni *Ferrucci del Tadda, who specialized in cutting it. His figure of *Justice* (c.1581), set on top of the ancient Roman column on Piazza S. Trinita in Florence, represents one of the first full-size porphyry monuments to be carved since Antiquity. Porphyry is also found in Älvdalen in Dalecarlia in Sweden, and in Russia, and during the early 18th and early 19th century factories produced ornamental objects, such as urns and vases for the fashionable interior.　HO/AB

Butters, S., *The Triumph of Vulcan: Sculptors' Tools, Porphyry and the Prince in Ducal Florence* (1996).

PORTER, FAIRFIELD (1907–75). American painter, printmaker, and writer. After studying art history at Harvard, Porter went to New York and worked under Thomas Hart *Benton at the Art Students' League. In 1927 he travelled to Russia and met Trotsky, a formative experience for him; he continued to travel until 1932 when he began work as editor of the short-lived socialist journal *Arise*. During this period he began to write art criticism, contributed to the *Nation* and worked as associate editor of *ARTnews* from 1951. His own painting reflects his attraction to the colour of *Bonnard and particularly *Vuillard. In the early 1930s he painted a number of street scenes but soon turned to domestic scenes and figure studies. *Anne* (1939; New York, Parrish Art Mus.) is a good example of the intimate, realist style of his earlier work. The use of broad areas of often very bright colour became more pronounced in later work, such as *Lawrence at the Breakfast Table No. 4* (1953; New York, Parrish Art Mus.).　MF

Spike, J., *Fairfield Porter: An American Classic* (1992).

PORTINARI, CÂNDIDO (1903–62). Brazilian painter. He trained at the National School of Fine Arts in Rio de Janeiro 1918–21 and in 1928 was awarded a scholarship to study in Europe. Best known for his murals, Portinari's realistic portrayals of life in the hinterland of Rio de Janeiro met with instant success. His mural *Coffee* (1935; Rio de Janeiro, Mus. Nacional de Belas Artes) won a prize at the Carnegie International Exhibition in 1935. From 1937 to 1947 he painted a series of murals for the Ministry of Education in Rio de Janeiro depicting the regional occupations of Brazil. He also executed *Discovery of the New World* (1942) in the Library of Congress, Washington, and *War and Peace* (1953) for the United Nations, New York. Initially influenced by *Rivera, he soon moved on to develop his own more stylized manner, and although his subject matter often features the indigenous life and people of Brazil, the aesthetic effect is of a higher priority than the political and social message. In 1957 he was awarded the Guggenheim National Award.　CC

Fari, R., *150 anos de pitura brasileira, 1820–1970* (1979).

PORTRAITURE. See opposite.

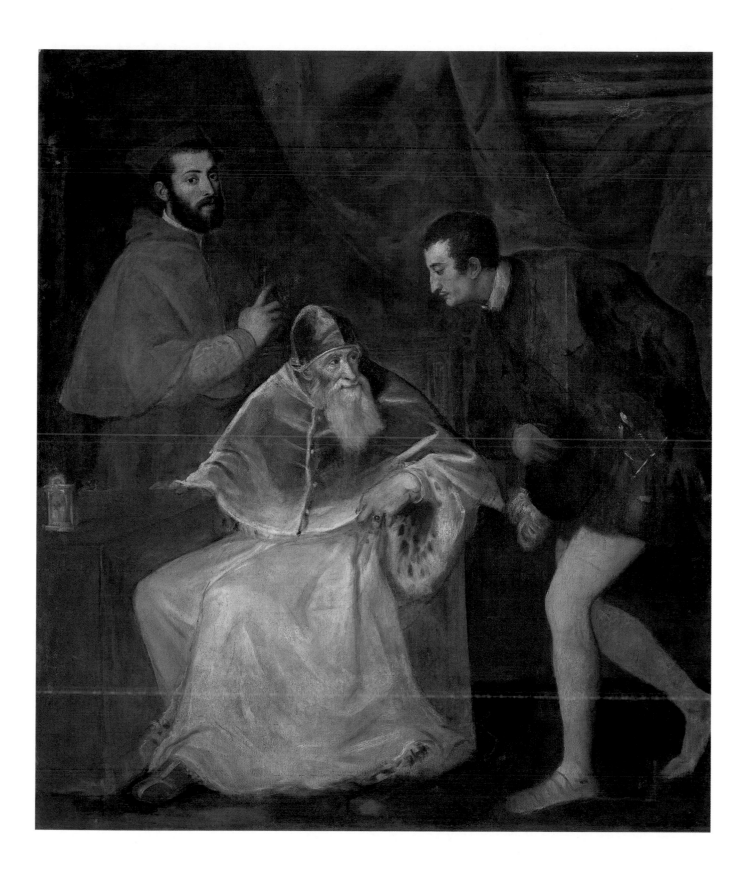

Titian, *Paul III and his Grandsons* (1546), oil on canvas, 210×174 cm (82¾×68½ in), Naples, apodi–monte.

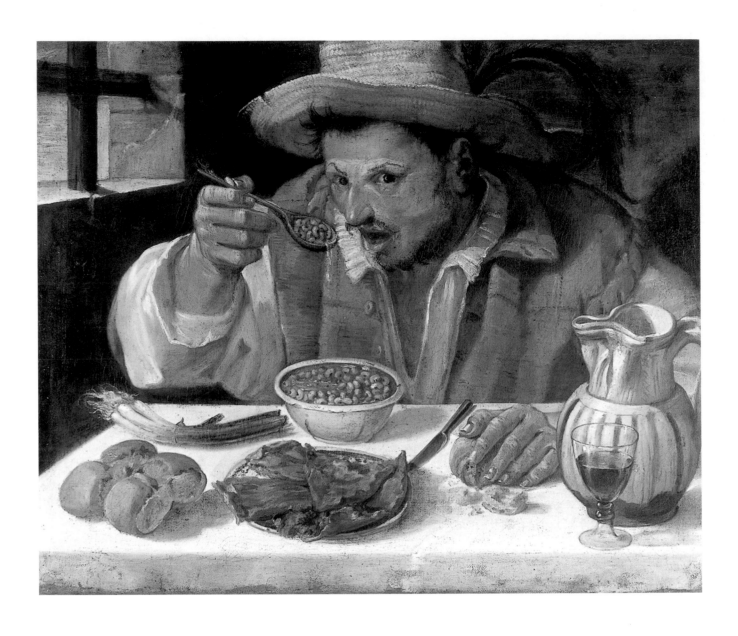

Annibale Carracci (1560–1609), *Bean Eater*, oil on canvas, 57×68 cm (22½×26¾ in), Rome, Galleria Colonna.

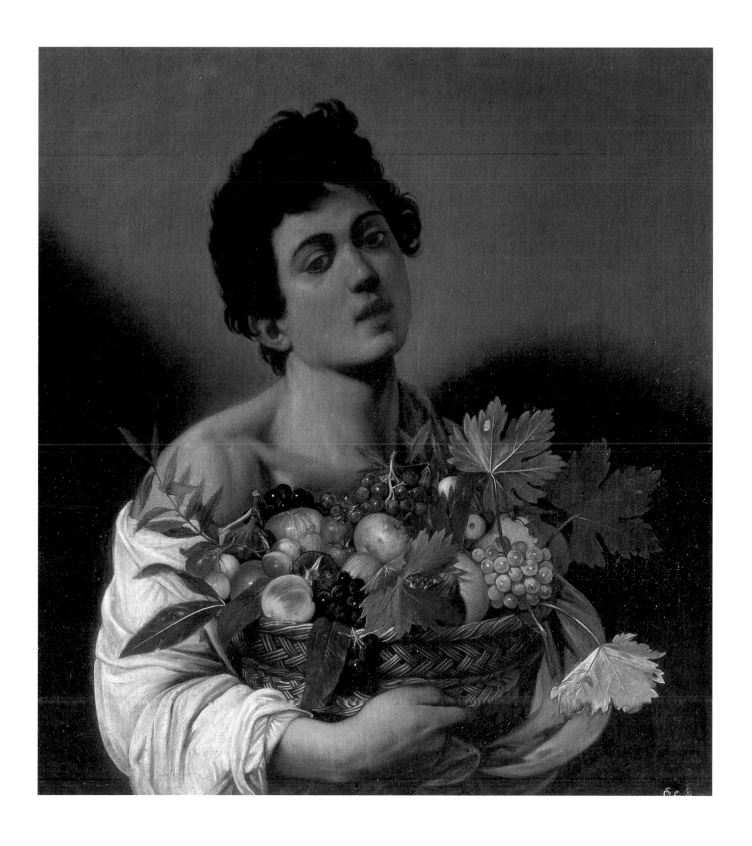

Caravaggio (1571–1610), *Boy with a Basket of Fruit*, oil on canvas, 70×67 cm (27 ½ × 26 ⅜ in), Rome, Borghese Gallery.

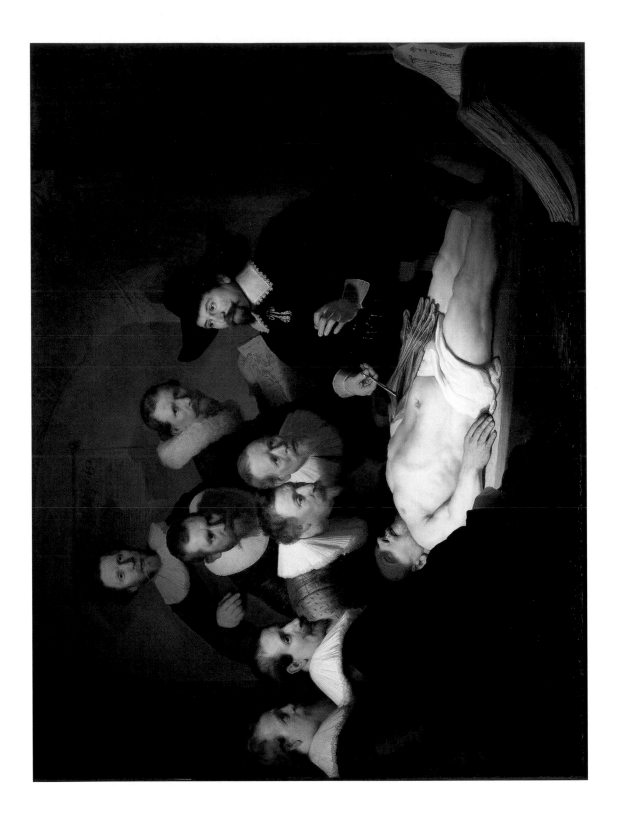

Rembrandt van Rijn, *The Anatomy Lesson of Dr Nicolaes Tulp* (1632), oil on canvas, 1.7×2.17 m (67× 85¼in), The Hague, Mauritshuis.

Anthony van Dyck (1599–1641), *Princess Elizabeth and Princess Anne*, study for 1637 painting, oil sketch, 29.8 × 41.8 cm (11¾ × 16½in), Edinburgh, Scottish National Portrait Gallery.

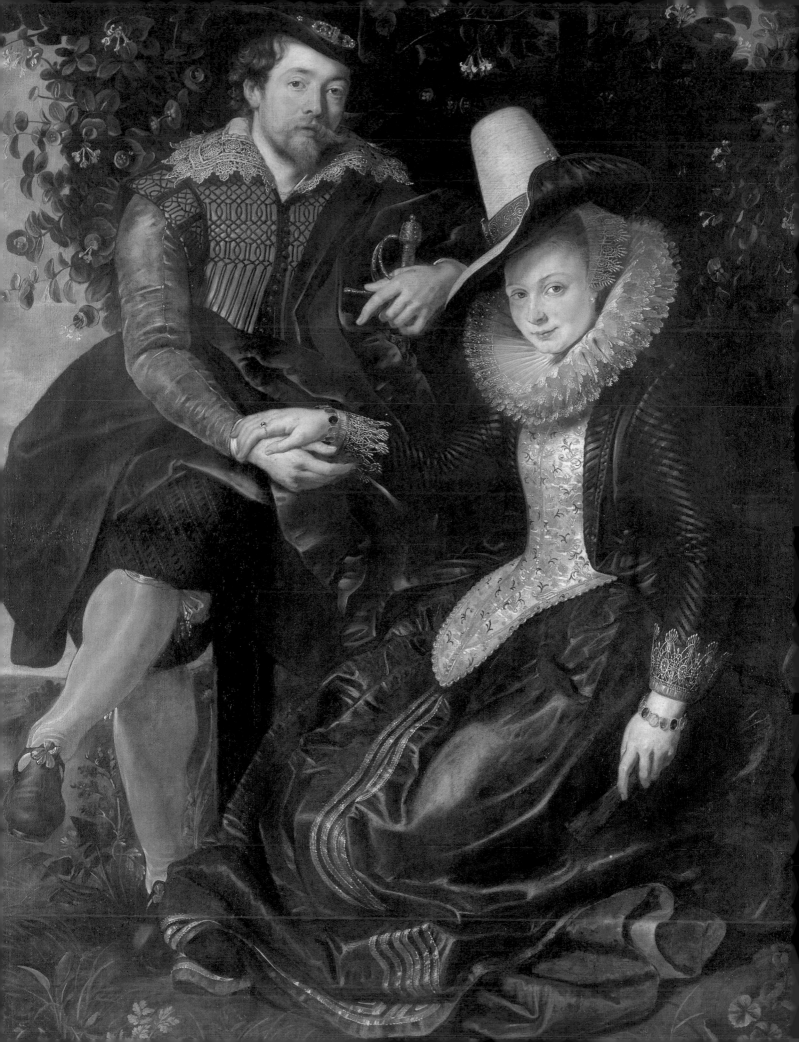

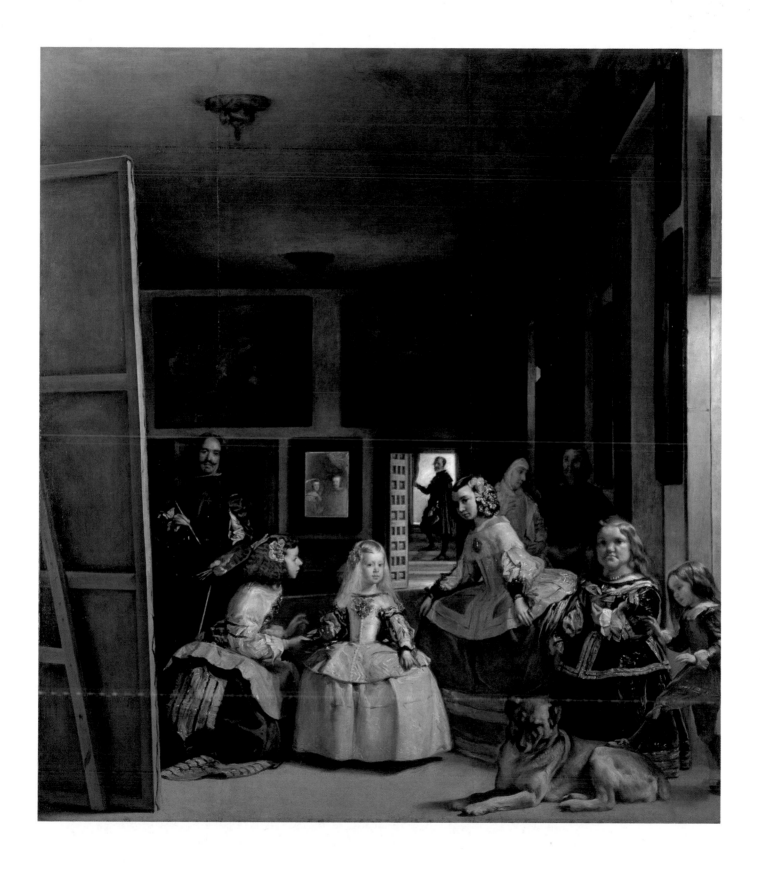

Diego Velázquez, *Las meninas* (1656), oil on canvas, 3.21×2.81 m (10 ft 8½ in ×9 ft 4 in), Madrid, Prado.

Peter Paul Rubens (1577–1640), *The Artist and his first wife Isabella Brant in the Honeysuckle Bower*, oil on canvas–covered panel, 178 × 136.5 cm (70⅛ × 53¾ in), Munich, Alte Pinakothek.

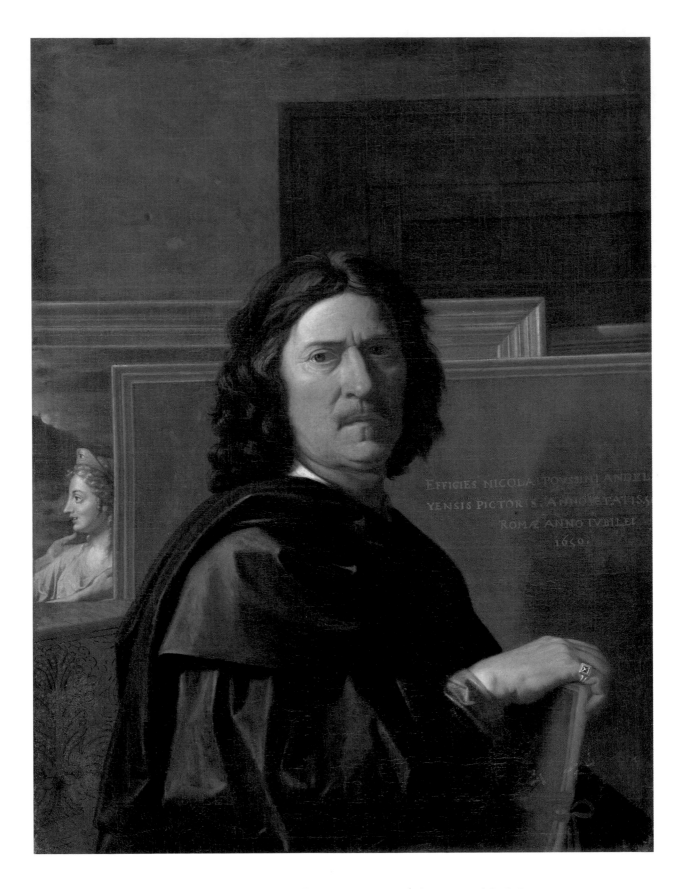

Nicolas Poussin, *Self-Portrait* (1650), oil on canvas, 98×74 cm (38⅔×29⅛ in), Paris, Louvre.

· PORTRAITURE ·

PLINY'S story of Dibutade tracing the outline of her lover's shadow onto a wall, which became a frequent theme in Neoclassical history painting, is in many ways more appropriate as a paradigm for the art of portraiture than as simply a prototype of the origin of painting. The lamp that cast the shadow had to be so positioned that the maximum information about the lover's profile was recorded, in order that it be easily recognizable. Thus two elements that have been more or less constant in the making of portraits are present: the need to fix accurately the lineaments of the face of the individual, so that it becomes a 'likeness'; and the importance, if not the absolute requirement, that this tracing, or fixing, process should be carried out by direct observation of the subject. There is another important element present in the story of Dibutade and her lover—that the features and figure so recorded can become a kind of substitute for the individual—in the story the lover was about to set off on a journey from which he might not return. These concepts find expression in the terms coined in that greatest age of portraiture, 17th-century Holland: *naer het leven*, from the life, and *conterfeytsel*, an imitation, or, a counterfeit.

Two other notions are suggested by the myth. The first is that the portrait is in some degree the reflection of a social situation. A patron may be involved, but, most importantly, the portrait is in some way the outcome of the interaction between the creator and the subject as they face each other, an equation that exists in no other form of art. The second notion is that the portrait will memorialize something. This is encapsulated in a remark made by the exiled Earl of Ancram in Amsterdam in 1652 about his portrait by Jan *Lievens (Edinburgh, Scottish NPG). The portrait is to be sent to his family home in Scotland where it is to be hung 'as a memorial to my so long being there'. It would also hang alongside a portrait of Ancram's old friend the poet John Donne (priv. coll.), which he had commissioned many years before as a memorial to their friendship.

The link between individual 'likeness' and the memorializing function of portraiture has varied in strength, but it has tended to be associated with the *humanism of the *Renaissance. Individual likeness, however, has its origins in the classical world. It is difficult to find a more palpable sense of individuality at any time in the history of portraiture than in the painted portraits of the Romano-Egyptian world of the 1st and 2nd centuries. These tonal portraits, although painted for the lids of mummy cases, have such a distinct liveliness (and even modernity) that they must have been painted before the subject's death. So strong is the sense of a credible individual that they raise, even at this early date, the virtually unanswerable question that is posed in any discussion of Western portraiture—what qualities of the individual personality can the portrait reveal?

It was Roman civilization (see ROMAN ART, ANCIENT) that was first particularly concerned with the matter of likeness, as their funerary busts and life-size portrait sculpture attest. Although these busts may have been concerned with beliefs about the preservation of the soul, they have a quality of realism that is almost mundane. As memorials of the lineaments of the face, it is likely that death casts (see DEATH MASKS) were taken as the first stage in the sculptural process (one of the many mechanical aids, ranging through *pointing machines, grids, *camera lucidas, to the modern camera, that portraitists have used throughout the ages in their attempts to arrive at some kind of objective truth). However, the use of such an aid is more difficult to imagine in the preceding Greek world where portraiture was far more generalized (see GREEK ART, ANCIENT). Here the concern was with the *idea, or the ideal, formal beauty rather than information. This approximate division between the two visions of the individual has always been present in portraiture, the idealized view eliding with the notion of flattery.

Flattery as a reaction to vanity is something that must always be kept in mind in any consideration of Western portraiture, particularly state portraiture, from the Renaissance onwards. Curiously, though, there are cases that demonstrate the precise opposite, most famously *Goya's searingly honest portraiture of the Spanish royal family, which is also an example of the unpredictability of the sitter's reaction, always a bugbear to portraitists. The kind of self-regard that may be assumed to lie at the root of much portraiture has not, of course, necessarily meant the smoothing out of blemishes—Cromwell's remark to Sir Peter *Lely that he wanted to be depicted with 'pimples warts and everything as you see me' has become equally famous. That vanity did not always require flattery is nowhere clearer than in the portraits of donors in early Renaissance Italian and Netherlandish altarpieces, where the subjects, unidealized in appearance, are virtual interlopers in Adorations or Crucifixions or among congregations of saints—sometimes correctly scaled so that they appear to be at least a credible part of the action (as in Hugo van der *Goes's *Trinity* altarpiece of 1478; Edinburgh, NG Scotland), or sometimes so underscaled as to appear inhabitants of a different universe (as in the same artist's Portinari altarpiece; Florence, Uffizi).

The unflattering gravity that is the essence of these donor portraits was the norm in 15th-century northern, individual portraiture—in a variety of scales but usually less than life size. At this time information written on the picture began to play a role: one of the most famous examples is Jan van *Eyck's *Arnolfini Portrait* (London, NG) which is inscribed 'Johannes de Eyck fuit hic'(. . . was present). This kind of information was more than a mere signature, acting as a kind of accreditation. More com-

monly, documentation of this sort concerned the identity of the subject, often including age and date. Such forms were common until the end of the 17th century, part of the role played by the portrait in family or dynastic history.

On the other hand the informality and predilection for life-size portraiture that developed during the Italian Renaissance became the norm of the European portrait tradition until the mid-19th century. This type grew from the civic group portrait, the subjects demanding that the focus be turned on them as individuals. Thus the great portrait tradition that would permeate the whole of Europe over the next 300 years was established by *Raphael in Rome, and, most influentially, by *Titian in Venice. These artists created the standard formats: the head and shoulders portrait, with or without hands; a three-quarter-length view of the subject, usually seated at an angle to the picture plane and cut off just below the knees; and the full-length. But they also played wonderful variations on them: Raphael's *Julius II* (Florence, Pitti) could become his *Pope Leo X with Two Cardinals* (Florence, Pitti) or Titian's *Paul III* could evolve into the disturbing complexity of his portrait of the same pope with Alessandro and Ottavio Farnese added (Naples, Capodimonte)—a precursor of the *conversation piece of the 18th century.

Inscribed information also appeared in Italian portraiture, though to a lesser extent. The portraits of the Bergamesque painter G. B. *Moroni contain identifications, mottoes, and other information. In his posthumous portrait of the poet Giovanni Bressani (Edinburgh, NG Scotland) an inscription on an inkwell actually states that the normal expectation that a portrait be from life has not been fulfilled, and writing on a manuscript remarks that the portrait depicts his body, but not his spirit. This is a disclaimer that many portrait painters would not have allowed themselves. The portrait also contains sheets of simulated verse to emphasize that Bressani specialized in *terza rima* and *ottava rima*.

The kind of portrait developed by Raphael and Titian (and *Leonardo) had a powerful effect on the north of Europe—almost immediately on *Dürer and *Holbein, and, later, on the great triumvirate of 17th-century portrait artists, *Velázquez, *Rembrandt, and *Rubens. The tradition was taken to England by van *Dyck, where, particularly, the elegant full-length form (now frequently and rather meaninglessly termed 'the swagger portrait') went through endless variations in the work of *Ramsay, *Reynolds and *Gainsborough, and on until the time of John Singer *Sargent.

It is not surprising that a society so concerned with property and the creation of wealth as Holland should have used portraiture as a mirror of its success. Dutch materialism created an obsession with recording the everyday details of that society, including themselves. Among the vast number of competent portrait painters Rembrandt stands out as an exceptional figure. With him, uniquely, we can come closer to believing that the portrait is able to reveal something of the inner workings of the mind. This is nowhere better exemplified than in his portrait of *Jan Six* (Amsterdam, Six Coll.), who looks briefly at the artist before pulling on his gloves and walking from the room (Rembrandt's studio or his own house) into the viewer's awareness.

During the 18th century England became equally conscious of its own wealth, so much so that portraiture became virtually the English art. Artists who had what they considered to be grander pretensions were weighed down by the burden of endlessly producing portraits. Reynolds managed to infuse his portraiture with some of his classical ideals, but Ramsay and Gainsborough were generally more 'natural' in their manner. Ramsay, however, found himself embroiled in making state portraits for George III and Queen Charlotte and had to set up a virtual production line manned by assistants. Portraiture is an art unusually bedevilled by duplicates and copies.

So strong was the British portrait tradition, and its effects elsewhere, that a reasonable level of accomplishment was assured until the end of the 19th century. By then, however, the tradition had begun to disintegrate, almost certainly because of the invention of *photography. This did not mean that great portraits ceased to be painted—witness the very different portraits of *Ingres, *Courbet, and *Degas in France—but that a decent, if humdrum, portrait could no longer be taken for granted. The insidious effects of photography on run-of-the-mill artists who were exclusively portraitists led to the imitation of photographic tonalities and, not infrequently, the overpainting of photographic images that had been printed on the canvas. It is even arguable that the smooth, mirror-like effects of the late portraits of Ingres owed something to the mirror surfaces of the daguerreotype. Ultimately this would lead to the 'boardroom' portrait, of a bland literalness, and the flashy society portrait, where in both cases there was a complete divergence from the mainstream of painting. The death of the tradition is nowhere more evident than in the annual exhibitions of the Royal Society of Portrait Painters in London, even now events of great social significance but of no interest at all in aesthetic terms.

This does not mean that portraits that represent the struggle with the eternal problems of representing the individuality of the individual who has sat, or stood, within breathing distance of the other individual in the equation, the artist, have not continued to be created in the modern period. Indeed, since the birth of *Romanticism and the onset of an era of uncertainty about the nature of individuality and the individual's relation to society, great portraits have raised questions rather than answered them—witness the portraits of, for example, van *Gogh, *Munch, *Kokoschka, and *Giacometti. This expressionist fracturing of the great tradition continues unpredictably into the present, in clear opposition to the failed attempts to keep the tradition alive. DT

Campbell, L., *Renaissance Portraits: European Portrait Painting in the 14th, 15th and 16th Centuries* (1990).
Gibson, R., *The Portrait Now*, exhib. cat. 1993 (London, NPG).
Pope-Hennessy, J., *The Portrait in the Renaissance* (1966).

PORTUGUESE ART. The earliest Portuguese works of art of European importance are the sculptured tombs of Ines de Castro (d. 1361) and King Pedro I (d. 1367) at Alcobaça and the *S. Vincent* polyptych attributed to Nuno *Gonçalves (Lisbon, Mus. Nacional de Arte Antiga) dating from a century later. Jan van *Eyck's visit of 1428–9 exercised no perceptible influence; but during the first half of the 16th century it was to the Netherlands that Portuguese painters looked for inspiration. Panels were imported from Antwerp and several Netherlandish masters emigrated to Portugal. Under this influence native schools developed. At Lisbon the circle of court painters included Jorge *Afonso and Gregorio *Lopes. To the local school of Viseu belonged Vasco *Fernandes and Gaspar Vaz (d. c.1568). The prolific output of these so-called Portuguese primitives is to be seen in the museums at Lisbon, Viseu, and Lamego. Their work is characterized by a realism not devoid of sentiment, exceptional skill in portraiture, and a predilection for brilliant colour schemes.

Parallel with these Luso-Flemish schools of painting there appeared in the early 16th century the first indigenous style of architectural decoration, known as Manueline (a term invented by the poet Almeida Garrett c.1825), in which buildings of *Gothic construction were overlaid and transformed by a new and original type of sculptural ornament, the most spectacular example being the window surrounds on the west wall of the church of the convent of Christ at Tomar (begun 1510).

According to *Vasari, Andrea *Sansovino spent some years in Portugal in the 1490s, but no work of his there has been convincingly identified. A taste for *Renaissance art should have been instilled by the importation of small works of art from Italy. For example King Manuel (ruled 1495–1521) possessed a masterpiece of illumination, the seven-volume Jerónimos Bible, ordered by his predecessor King João II in 1494 from the Florentine shop of *Attavante. Eventually the highly decorated Renaissance style (originally developed in northern Italy in the 15th century) known in Spain as *plateresque, and in northern Europe as *Holbeinesque, was introduced into Portugal by French sculptors, the first of whom was Nicolau *Chanterene. These versatile artists carved statues, tombs, pulpits, altars, and reredoses throughout central Portugal.

The art theory of the High Renaissance, modified to some extent by *Mannerism, was expressed by Francisco de *Holanda, friend of *Michelangelo, in his famous treatise *Da pintura antigua* (On the Art of Antiquity, 1548). In another treatise, *Do tirar polo natural* (On Taking Portraits from Life, 1549), Holanda promoted the idea of the state or court portrait, which was soon thereafter introduced by Anthonis *Mor van Dashorst who spent most of the year 1552 in Portugal painting the royal family. Anthonis Mor, aided by Alonso *Sánchez Coello, set up a studio in which assistants, both Portuguese (Cristóvão de Morais, Cristóvão Lopes) and foreign (Jooris van der Straeten), were employed for several years copying the master's portraits and painting others.

Between the accession of King Sebastian (1572) and that of King João V (1706) royal patronage of the arts virtually ceased; and although religious patronage continued, even the best altarpieces of the leading painters, such as Francisco Venegas (active c.1573–90), Diogo Teixeira (documented 1565–97), and Simão Rodrígues (active 1585–1629), seldom rise above mediocrity.

Considerably more remarkable than the altar paintings are the reredoses or retables (*retablos*) of carved and gilded wood (*talha dourada*) into which the paintings were inserted. From the last quarter of the 16th century these woodcarved structures are often of outstanding quality (e.g. those of Gaspar and Domingos Coelho in Portalegre Cathedral dating from 1582–96). They became increasingly elaborate and sculptural over the next two centuries, reflecting changing artistic styles from late Renaissance through *Baroque to *Rococo and *Neoclassical. In the monastery of Alcobaça during the years 1669–90, woodcarved statues were superseded by terracotta figures, occasionally painted and some larger than life. Attributed to an otherwise unknown Frei Pedro, they convey a strong religious emotion, which, combined with their striking elegance, seems to adumbrate the art of *Serpotta or Ignaz *Günther.

Royal patronage revived in the reign of King João V (ruled 1706–50), financed by discoveries of gold in Brazil. During the early years, Italian Baroque painters dominated the field, notably the Savoyard portraitist G. D. Duprà (active in Portugal 1719–30) and the *trompe l'œil painters Vincenzo Bacherelli (1672–1745, active in Lisbon c.1705–20) and Niccolò Nasoni (at Oporto from 1725). The strong Italian influence continued but it was not long before Portuguese artists began to compete for commissions, among the most successful being the sculptor José de *Almeida, and later his more famous pupil Joaquím *Machado de Castro, together with the painter Francisco *Vieira de Matos.

João V's most ambitious undertaking was the monastery-palace of Mafra, begun in 1717. In 1732–33 more than 50 marble statues, mostly larger than life size, by leading Roman sculptors, were imported for installation in the monastery church, making Mafra an incomparable museum of late Baroque Italian sculpture. In 1753 the Italian Alessandro *Giusti set up a school of sculpture and architecture at Mafra which influenced subsequent development of the arts, including the decoration of the royal palaces of Queluz (begun 1747) and Ajuda (begun 1802). None of these palaces was injured by the earthquake of 1755 which destroyed central Lisbon and seriously depleted the country's artistic patrimony.

Portuguese *fin de siècle* *Romanticism had a talented representative in Francisco Vieira, known as Vieira Portuense (1765–1805), who spent the twelve years 1789–1801 first in Italy and then in England. His *Angelica *Kauffmann Painting* is in the Lisbon museum. Romantic art reached its climax in the allegorical sculpture of Antonio *Soares dos Reis.

During most of the 18th century there was a Portuguese Academy of Fine Arts at Rome. In 1836 academies of fine arts were established at Lisbon and at Oporto, the former absorbing schools of fine arts that dated back to 1609. From these institutions many gifted artists have graduated to become respected practitioners, though no 20th-century Portuguese-born artist except Maria Helena Vieira da Silva has achieved a worldwide reputation. JBB

Bury, J. B., 'Introduction to the Art and Architecture of Portugal', in *Blue Guide Portugal* (4th edn., 1996).

França, J. A., Morales, J. L., and García, W. R., *Arte portugués*, Summa Artis XXX (1986).

Smith, R. C., *The Art of Portugal 1500–1800* (1968).

POSADA, JUAN GUADALUPE (1852–1913). Mexican graphic artist. Founder of the satirical print tradition in Latin America, Posada was a freelance engraver whose work featured in adverts, posters, children's books, and mostly in the popular penny press during the pre-revolutionary years in Mexico. His witty and skilfully executed prints illustrated topical ballads, verses, and sensational news items such as murders, accidents, catastrophes, and freakish occurrences, all infused with characteristic Mexican black humour. He is most renowned for his *calaveras*: macabre but comical skeletons dancing, singing, playing instruments, cycling, or dressed as actors or politicians, which were initially published in broadsheets and sold on the Mexican Day of the Dead. Although much of his work centres on social and political satire, his allegiances were entirely dictated by commercial interests; the subject matter being dependent on his employers' wishes. Posada's original audience were the poor and illiterate. However, soon after his death his work became highly sought after, as it assumed a central place in the Mexican renaissance promoted by the Muralists who hailed Posada's prints as a cornerstone in Mexico's rich heritage of popular art. CC

Rothenstein, J., *Posada: Messenger of Mortality* (1989).

POST, FRANS (c.1612–80). Dutch land-scape painter. He was born and trained in Haarlem but travelled to Brazil in 1637 in the retinue of the newly appointed governor-general of the then Dutch colony, Prince John Maurice of Nassau-Siegen. Post stayed in Brazil for seven years and became the first European painter to depict the landscape of the New World. His paintings of this period (São Francisco River and Fort Maurice; Paris, Louvre) are naive but effective in their vivid-ness and direct observation. On his return to Haarlem in 1644 Post settled down to making a career from book illustrations and paint-ings of Brazil, but without the stimulation of immediate experience his work progres-sively became more stereotyped, usually taking the form of well-balanced composi-tions of a broadly *Claudean nature, with a fine display of Brazilian plants, fruit, and ani-mals in the foreground. Even his Sacrifice of Manoah (1648; Rotterdam, Boymans-van Beuningen Mus.) incorporates this exotic scene setting and features a prominent ar-madillo. AJL

Sousa Leão, J. de., Frans Post (1612–1680) (1973).

POSTER. Printed posters, designed solely to convey information, were known in Antiquity, but as a form of art their history does not begin until the second half of the 19th century. Improvements in printing pro-cesses, particularly *lithography, invented by Aloys Senefelder in 1798, and chromolithog-raphy (1827), which made printing in colour a realistic proposition, were largely respon-sible for this development. The French pion-eered artist-designed posters; some, like Jules *Chéret, who designed over 1,000 posters, worked almost solely in this medium whereas others, like *Manet and *Toulouse-Lautrec, probably the greatest and certainly the best-known poster designer, saw it as a profitable sideline. The majority of the French posters were designed for the enter-tainment industry, music, theatre, and circus. Chéret made his reputation with a series of posters for the Circus Rancy in the mid-1860s which, like many later examples, featured at-tractive young women. Lautrec's work of the 1890s was closely associated with cabaret, for example Jane Avril (1893), and the majority of designs by the Czech-born Alphonse *Mucha, a master of sinuous *Art Nouveau, were done for Sarah Bernhardt. Inspired in part by Japanese prints and aware of the need to be immediately striking, the French artists quickly developed a style which in-corporated simple but assertive forms, strong outlines, and large areas of flat colour, a style that was to prevail internationally into the 1920s and beyond and is still signifi-cantly influential. From the start these posters had the double function of being both ephemeral advertisements and collect-able works of art, several of Mucha's, for ex-ample, being printed on silk. Whereas the artist-designer treated text and illustration as an entity, each enhancing the other, this was not the case with many commercial enter-prises which purchased paintings to incorp-orate in their advertising, the most famous example being Pears's use of *Millais's Bubbles (1886).

French posters inspired the work of Eng-lish designers like William *Nicholson and James *Pryde, (under the pseudonym of the Beggarstaff Brothers) and Aubrey *Beardsley, whose posters were confined to the adver-tisement of books, plays, and magazines. Simple lines and flat colours may still be seen in pre-First World War railway posters and those for popular resorts, the most famous of which, Skegness is so bracing, was designed by John Hassall (1868–1948) in 1909.

In the 20th century posters took on the additional role of political propaganda, both specific, as in Alfred Leete's (1882–1933) Your Country Needs You (1914) and Norman *Rock-well's Second World War version; and gen-eral like *Picasso's Dove of peace. Polemical posters played an important part in the de-velopment of several artistic movements, though often in the form of *woodcuts or typography, including *Dada which, in the person of John *Heartfield, produced a major political satirist; German *Expressionism; and Russian *Constructivism. The latter movement produced highly effective social-ist posters like El *Lissitzky's Beat the Whites with the Red Wedge (1919), but after 1928 Soviet propaganda favoured *Socialist Realism. The international *modernist style pioneered by the Russians was widely adopted and may be seen in the work of the British-based Ameri-can painter and designer E. McKnight *Kauffer who worked extensively for the London Transport Board under its inspired director Frank Pick (1878–1941).

Photographic developments in the 1920s and 1930s saw the rise of the graphic designer as an independent professional who largely replaced the fine artist in the production of posters and the growth of an international style which drew upon the elements and idioms of contemporary art often in the form of pastiche. The arrival of *Pop art in the early 1960s and its symbiotic relationship to cin-ema and pop music saw a return to individu-alism and a refreshing amateurism and led to an explosion in the number of posters de-signed purely for purchase and personal dis-play. The underground or psychedelic poster, usually advertising music and musicians, was a popular form of student interior dec-oration. Among these were a few by painters inspired by the democratic intention to make work by established artists affordable, Peter *Blake's enamel Babe Rainbow (1966) being notably successful. Pop artists, particularly Richard *Hamilton and Eduardo *Paolozzi, embraced commercialism, using packaging and advertising as source material. Fittingly several American Pop artists, including Roy *Lichtenstein, were inspired by commercial billboards and both James *Rosenquist and Andy *Warhol began their careers as com-mercial artists. Developments in computers and the growth of desktop publishing in the 1990s have vastly increased the possibilities of amateur poster production by removing technical restraints. DER

Barnicoat, J., A Concise History of Posters (1972).

POST-IMPRESSIONISM. See opposite.

POSTMODERNISM. The epithet first came to prominence to describe a new eclectic mood in the 1970s work of architects like Robert Venturi, and was then used in the titles of wide-ranging cultural diagnoses by Jean-François Lyotard (1979) and Fredric Jameson (1984). Another cultural theorist, Jean Baudrillard, has also helped shape understandings of postmodernism: but con-sensus on the subject has always been weak, with ever-broader usage leading to ever-looser connotations.

As a term contrasted to *modernism, its meaning gathers strength from definitions of its opposite. Thus in art criticism, modernist work between 1960 and 1970 might be char-acterized as keeping its distance from famil-iar representations of the world and seeking out essences of visual experience; while the 'postmodernist' art that followed is seen as embracing all manner of given representa-tions and styles, while querying all notions of essence. Such art supposedly responds to the collapse of modernist notions of pro-gress, and to a global condition in which subjects are bound to experience the world as consumers surfeited with a plurality of processed images and packaged information, among which no narrative can establish privilege. The debated possibility that post-modern art might, like its predecessor, main-tain a critical stance towards society depends on its deployment of 'irony' and, in Lyotard's writings, of 'the *sublime'. The postmodern attitude in art, by definition pervasive in the 1980s and 1990s, may arguably be traced back to 1960s *Pop art and behind that to the work of Robert *Rauschenberg. JB

Krauss, R., The Originality of the Avant-Garde (1983).

POST-PAINTERLY ABSTRACTION, term introduced by the American critic Clement *Greenberg as the title for an exhib-ition of contemporary painting which he ar-ranged at the Los Angeles County Museum in 1964. He took the word 'painterly' (in Ger-man malerisch) from Heinrich *Wölfflin, who had discussed it in his book Principles of Art History (1915). Greenberg defined it as 'the

continued on page 594

· POST-IMPRESSIONISM ·

THE term 'Post-Impressionism' invented in 1910 by Roger *Fry and adopted by Clive *Bell and others to denote the modern French masters—notably *Cézanne, *Gauguin, and van *Gogh—and the so-called movement with which they were associated. When Fry coined the title for an exhibition he had selected for the Grafton Galleries, London, *Manet and the Post-Impressionists*, it was intended as a catch-all categorization for those contemporary foreign artists whom he judged to have made a concerted effort towards style. The artist from whom they took their inspiration, in his view, was Cézanne. In 1912, in the preface to the catalogue of the second Post-Impressionist exhibition, Roger Fry remarked that the distinguishing feature of the artists represented was 'the markedly Classic spirit of their work' and explained that they did not seek to imitate natural forms but to create form. For Clive Bell the term became synonymous with anti-Impressionism and denoted a conscious shift away from representation.

Post-Impressionism was subsequently adopted as a convenient label by academic art history and the museum world, but its stylistic and chronological scope has altered over time. Whereas Fry's second Post-Impressionist exhibition included British, French, and Russian artists, and gave prime place to the works of *Matisse, *Picasso, and the *Cubistic experiments of their associates and admirers, today Cubism and *Futurism are generally treated as separate movements. On the other hand whereas Fry barely recognized the existence of Neo-Impressionism, today this is an integral part of what is understood by the term.

Post-Impressionism continues to be a useful description of the period of assimilation at the end of the 19th and turn of the 20th century, during which there was a vacuum of new ideas but a need to absorb the welter of novel techniques and possibilities opened up by the Impressionists in the 1870s and 1880s. Clumsy and at times confusing, the term seems to describe a unified reaction to the earlier art form, Impressionism, when there was in fact little unity of aim or practice among the artists concerned. Some *Post-Impressionists*, notably Cézanne, did not come after the Impressionists but exhibited with them. It was only with hindsight that his work came to be seen as in a sense apart from theirs.

The 1880s saw two main group developments out of and away from Impressionism, which endured into the 1890s and beyond: Divisionism (see NEO-IMPRESSIONISM), led by Georges *Seurat, and Synthetism, led by Paul Gauguin. These artists were reacting not so much against individual exemplars of Impressionist painting, whose qualities they admired, but rather against the trope of Impressionism as an unthinking practice whose logical development seemed to threaten the intellectual basis of art, blurring the distinction between artist and nature and between preparatory work and finished painting. Impressionism's haste to capture impermanent and superficial effects had devalued composition, it was judged. Such charges were levelled both at the original Impressionists such as *Monet and *Renoir and at those who borrowed impressionistic techniques (loose brushwork, *alla prima* execution) and transposed them into the realm of Salon painting and portraiture, artists such as Albert Besnard or John Singer *Sargent. In the 1880s, there was a growing demand among critics associated with literary Symbolism for contemporary art to explore areas beyond the surface of material reality and the more traditionalist and *Symbolist tendencies within the work of *Puvis de Chavannes, Seurat, Gauguin, or *Redon were singled out for praise.

A characteristic of Post-Impressionist art is the reassertion of the artist's role and the clearer demarcation of distance from the subject—be the subject an aspect of nature or an imaginary invention. At the same time, though to variable degrees, the distinction between preparatory and finished work was once more made clear.

One of the ways in which Post-Impressionist artists imposed a time lag and emotional distance between themselves and the subject was in renewing the importance of drawing as a preliminary stage in the creative process. It was exemplified at its most extreme by Seurat who insisted on traditional method: oil sketches preceding drawn studies of isolated elements within an overall composition, leading to the final canvas. As a result his finished pictures, for example *Une baignade, Asnières* (1883–4; London, NG) or *Un dimanche d'été à l'Île de la Grande Jatte* (1884–5; Chicago, Art Inst.), were not fresh impressions but mature syntheses of his observations of nature.

The painter-theorist Maurice *Denis analysed the sea change of stylistic approach that had occurred in the 1880s in terms of the two distortions, or *déformations*: he argued that, whereas subjective distortion was instinctively practised by any artist, Impressionist or no, in front of a given subject, the newly added ingredient was objective distortion (i.e. deliberate calculated distortion for the sake of the picture's decorative effect). Thus when van Gogh or Cézanne deployed characteristic rhythmic brush strokes in predetermined harmonies of colour, they were not simply expressing in an instinctive way subjective feelings before nature, but deliberately imposing style. Fry, who gleaned much, notably about Cézanne, from Denis's writings, emphasized the reappearance in Post-Impressionist art of the traditional values of composition and form, characterized as a return to *classicism and the reassertion of plastic over imitative values.

In recent usage, the term Post-Impressionism no longer has the exclusive emphasis on Cézanne that it had when first applied by Fry and Bell. It has been applied both more narrowly in a stylistic and chronological sense, yet at the same time more broadly, allowing for the

international dimensions of the movement. BT

Post-Impressionism: Cross Currents in European Art, exhib. cat. 1979–80 (London, RA).

Rewald, J., *Post-Impressionism from van Gogh to Gauguin* (rev. edn., 1978).

blurred, broken, loose definition of colour and contour' ('Modernist Painting', *Art and Literature*, 4, 1965). The term Post-Painterly Abstraction was applied to a generation of artists who, despite a wide variety of individual styles, appeared united in their rejection of *Abstract Expressionism. They had in common the repudiation of such painterly qualities as expressive brush strokes and personalized facture. Certain paintings, such as those of Jules Olitski (1922–), have been interpreted partly as ironic imitations of Abstract Expressionism.

Precedents for the formal qualities of Post-Painterly Abstraction can be found in the Suprematist works of Kasimir *Malevich, the series of paintings *Homage to the Square* by Josef *Albers begun in 1950, and the colour field paintings of Barnett *Newman. Typical examples are *Mao* (1967; New York, Andre Emmerich Gal.) by Al Held (1928–), and *Two Panels, Yellow and Black* (1968; New York, Sidney Janis Gal.) by Ellsworth Kelly (1923–). These paintings, characterized by hard-edged, geometrically arranged areas of flat colour, possess an assertiveness which appears to deny the ambiguity of much abstract art. Tactile and illusionistic qualities have been suppressed; instead the paintings seem to express nothing except their own physical presence.

Although some British artists, such as Tess Jaray (1937–) and Robyn Denny (1930–), were producing closely comparable contemporaneous works, Post-Painterly Abstraction was specifically American in its rejection of the European influence under which Abstract Expressionism was thought to labour. In its assertion of the straightforwardness of pictorial form, Post-Painterly Abstraction can be related to *Precisionism. OPa

POSTSTRUCTURALISM. See STRUCTURALISM AND POSTSTRUCTURALISM.

POT, HENDRIK GERRITSZ. (c.1585–1657). Dutch painter of small-scale genre scenes, who may have received his training from Karel van *Mander. He seems to have spent his early career in Haarlem, moving to Amsterdam in 1648, where, according to *Houbraken, Willem *Kalf became his pupil. His early works are small merry company and guardroom scenes recalling the work of Haarlem contemporaries such as Willem *Buytewech and Dirck *Hals. *Merry Company at a Table* (1630; London, NG) shows an airy setting of muted and restrained tones, enlivened by the bright colours of the clothes and clear even lighting. His work has sometimes been confused with Jacob Duck (c.1600–67), Anthonie Palamedesz (1601–73), or Simon Kick (1603–52) and an early group portrait, *Officers of the Militia of the Kloveniers of Haarlem* (c.1630; Haarlem, Frans Hals Mus.), is reminiscent of Frans *Hals. His work as a portrait painter is small in scale and varies from a detailed miniaturist technique to pictures which are more broadly painted. His later portraits are mainly of single, full-length figures standing or seated at a table. CFW

POTTER, PAULUS (1625–54). Precocious Dutch painter and printmaker who excelled at depictions of animals in landscape, particularly cows, horses, and sheep. He was baptized in Enkhuizen, and probably first trained as an artist with his father, who had settled in Amsterdam by 1631. The style of some of his pictures suggests that he may have also studied with Claes Moeyaert. In 1646 Potter became a member of the artists' guild in Delft. He subsequently moved on to The Hague and then Amsterdam, where he died. Potter's most celebrated work is the life-size painting of a *Young Bull* of 1647 in the Mauritshuis, The Hague. The unrelenting attention to detail in this work creates an impression of extraordinary and somewhat overwhelming naturalism. The scale of the picture is highly unusual, and Potter more frequently painted much smaller works. He also made a number of etchings of animals, and worked as a portraitist. The most important of his works in this latter genre is the very large *Equestrian Portrait of Dirk Tulp* of 1633 (Amsterdam, Six Coll.). CB

van Westrheene, T., *Paulus Potter* (1867).

POUNCE. This was a fine powder, often coloured, which was used in the transference of the main outlines of a drawing (almost invariably a *cartoon) to another surface such as another sheet of paper or a wall. This powder was usually derived from pumice. Tiny prick holes were made in the sheet along the lines and the dust was rubbed or 'pounced' through the holes leaving an outline in dots on the support beneath. PHJG

POURBUS FAMILY. Three generations of Flemish artists who all distinguished themselves as portrait painters. **Pieter** (c.1523–84) settled in Bruges by 1544. He worked in Bruges for the remainder of his life as a surveyor and cartographer as well as a painter. He was active in public life, repeatedly being appointed an officer in the painters' guild. His early training is uncertain but his style is reminiscent of Jan van *Scorel and is characterized by a cool Italianate conservatism as in *The Last Judgement* (1551; Bruges, Stedelijk Mus.). His son and pupil **Frans the elder** (1545–81) entered the Antwerp guild in 1569. As a portrait painter, he has a competent, formal style with an eye for details of costume and setting, for example *The Hoefnagel Wedding Portrait* (Brussels, Mus. Royaux). **Frans the younger** (1569–1622) trained with his grandfather in Bruges, before moving to Antwerp, then Brussels, where he spent a year at the court of the archdukes in 1599. He was appointed painter to the *Mantuan court; then, in 1609, he moved to Paris, becoming court painter to Louis XIII in 1616. CFW

Le Siècle de Rubens, exhib. cat. 1965 (Brussels, Mus. Royaux).

POUSSIN, GASPARD. See DUGHET, GASPARD.

POUSSIN, NICOLAS (1594–1665). French painter and draughtsman who worked mainly in Italy. He was born in Normandy and probably received his early training from Quentin Varin (c.1570–1634) at Les Andeleys. From 1612 to 1623 he was in Paris and may have studied with Ferdinand Elle (c.1580–1649) and Georges Lallemant (c.1580–1636) and was strongly influenced by the *bella maniera* of the Second School of *Fontainebleau, with its emphasis on slender figures and graceful contours. His first patron appears to have been the Italian poet Marino for whom he made a series of drawings on mythological themes (Windsor Castle, Royal Coll.). Executed with considerable assurance and control they reflect the artist's response to the stylized unreality of the art of Fontainebleau. Human passions are filtered through mythological fables and nature is held at arm's length and explored for its poetic effects. It may well have been Marino who persuaded Poussin to leave Paris, still a relatively provincial artistic centre, and move to Rome. He finally arrived there via Venice, in March 1624. Shortly after his arrival he was fortunate to obtain an important commission from Cardinal Barberini who had returned to Rome from Paris in 1625 with an enthusiasm for French culture, and in the same year ordered *The Sack and Destruction of the Temple of Jerusalem* (1626; Jerusalem, Israel

Mus.). It is close in style to three other battle paintings, at least two of which were probably painted speculatively in 1625 while Barberini was abroad (St Petersburg, Hermitage; Moscow, Pushkin Mus.). Each of these works, with its crowded design and contorted figures, suggests an artist still locked in a *Mannerist style, although there are hints of his fruitful study of *Veronese and *Lanfranco. Poussin's other source of patronage was Cassiano dal Pozzo, a learned but far from wealthy lay patron who had accompanied Francesco Barberini on official missions but devoted his main energies to science, natural history, and the systematic study and copying of the antiquities of Rome for his paper museum, Museum Chartaceum. Dal Pozzo employed Poussin as a draughtsman on the project but also encouraged him and other artists in his circle, such as Pietro *Testa, to paint mythological subjects, evoking the spirit of classical literature, in a highly imaginative manner far removed from their more pedestrian duties as copyists. Among the early pictures painted for dal Pozzo are the *Cephalus and Aurora* (c.1624; Hovingham, North Yorks.), the *Venus and Adonis with a View of Grottaferrata* (c.1625–6; Montpellier, Mus. Fabre; a fragment priv. coll. USA), and *Landscape with Sleeping Satyr* (Montpellier, Mus. Fabre). In each of these paintings (the small scale of which suited Poussin well at this early stage of his career) there is a strong emphasis on the landscape; indeed, they appear to be conceived in the tradition of Venetian Renaissance *poesie*. There is also anecdotal evidence that Poussin was exploring the Roman Campagna alongside *Claude Lorrain and Gaspard *Dughet, and making spirited sketches and wash drawings out of doors, although fierce controversy surrounds the identification of his graphic work in this naturalistic genre. In any case Poussin's early landscape paintings never convey the sense of detailed observation of nature that invariably characterizes Claude's work. His interest was primarily in light and shade as it affected the structure rather than the surface of the landscape; and in the sense of transience and changes of mood evoked by the rising and setting sun, reflected in the sombre *Venus and Adonis* (c.1627; Caen, Mus. des Beaux-Arts), and the unsettling *Acis and Galatea* (c.1627; Dublin, NG) where the gloomy light foreshadows the tragedy that lies ahead. Dal Pozzo also commissioned a religious work, a nocturnal scene of the *Agony in the Garden* painted on copper (c.1626–7; New York, Wildenstein) which must have impressed Cardinal Barberini since he appears to have ordered a variant version for himself (c.1627; priv. coll.). Characteristically, Poussin does not repeat his original design but rethinks the composition; the figure of Christ,

originally shown in profile, is now turned towards the viewer to enhance the emotional impact.

In 1627 Poussin received another commission for a large-scale history painting from Francesco Barberini, the *Death of Germanicus* (1628; Minneapolis, Inst. of Arts). It is his first epic masterpiece and serves to remind us of the enormous progress he had made since arriving in Rome. Even if we discount some of the relatively feeble work Poussin produced on speculation to earn a living at this time, for instance *Nymph and Satyr Drinking* (Dublin, NG Ireland; second version Madrid, Prado; both c.1626–7) and exclude from consideration works over-optimistically attributed to him in recent years (for instance *The Fall of Giants*; priv. coll.) one would be forced to conclude that the young Poussin still had much to learn when he arrived in Rome and found protection under Cassiano dal Pozzo. Indeed, even some of the earlier pictures painted for dal Pozzo are surprisingly heavy-handed, albeit rigorous in conception, for instance *Hannibal Crossing the Alps on an Elephant* (c.1625; on loan, Cambridge, Mass., Fogg Art Mus.) and *Rebecca at the Well* (1625–6?; New York, Wildenstein). That Poussin learned his lessons well and developed with astonishing precocity is amply demonstrated by the *Death of Germanicus*, a heroic deathbed scene of considerable gravity and emotional intensity. Its clear design, with the emphatic gestures of the mourners inspired by *Antique relief sculptures of the *Death of Meleager*, and the controlled but expressive use of an enclosed interior space for the dramatic action, mark a clear advance from the Mannerist confusion and empty rhetoric of the *Sack and Destruction of the Temple of Jerusalem*, painted less than two years earlier. Yet notwithstanding its classical restraint, the *Death of Germanicus* also consciously reflects, from a strictly formal and stylistic point of view, the contemporary *Baroque idiom with overlapping figures and an absence of clearly defined forms. A similar finely turned balance between the classical and Baroque characterizes the large-scale *Triumph of Flora* (c.1627; Paris, Louvre). Conceived in a more lyrical mood, it represents a festive procession of figures whose fate, as described in Ovid's *Metamorphoses*, determined that they should be turned into flowers. Richly coloured figures move laterally from the right through a sumptuous Venetian style landscape, but are arrested by a small group of more monumental figures, reclining in the left foreground, that impedes any avalanche of cavorting forms.

Poussin's growing prestige led to more conventional commissions for church altarpieces: the *Martyrdom of S. Erasmus* (1628–9; Vatican Mus.) commissioned for S. Peter's, and the *Virgin Appearing to S. James* (Paris, Louvre), painted in 1629–30 for a church in

Valenciennes in the Spanish Netherlands. The astonishing power of over-life-size figures moving in interlocking groups, and the relatively bright-toned clear colours employed in the execution of these designs, may reflect the influence and even the personal advice of *Bernini, who was a moving force and artistic adviser at S. Peter's. A further possible indication of this friendship is a small, quickly executed, and informally conceived portrait, supposedly of Poussin, by Bernini (York, AG), and probably dating from this moment.

The necessity of painting overlapping groups of human figures on an enlarged scale for these early public commissions, paradoxically, may have also stimulated Poussin to formulate a new and more classicizing artistic objective: to invest the individual figures in his designs with their own inner momentum, emotional strength, and allegorical significance, over and above their secondary dramatic role in a wider narrative context. For instance, in the *Inspiration of the Epic Poet* (c.1629; Paris, Louvre) the monumental figures express, perhaps for the very first time in Poussin's career, a quality of serenity that owes more to the forms of Greek and Roman statuary than to the effects of light and colour. And this new preoccupation with separating, hardening, and defining the contours of individual figures and with freezing their movements and gestures into clearly articulated forms is also apparent in some of Poussin's *poesie* from the period of the *Martyrdom of S. Erasmus*, such as the *Bacchanal with Guitar-Player* (c.1628; Paris, Louvre). However the most deeply felt expression of emotion through the articulation of human forms is the *Massacre of the Innocents* (c.1628; Chantilly, Mus. Condé), where Poussin both for symbolic and emotional effect isolates one individual act of violence.

By 1632 Poussin had become a member of the Accademia di S. Luca (see under ROME) and was drawn into the stylistic debates about *classical and *Baroque principles of composition. He himself was now moving decisively towards a classical style, based on a unified conception of dramatic narrative. Figures in pictures such as the *Plague of Ashdod* (1631; Paris, Louvre) or *The Saving of Pyrrhus* (1634; Paris, Louvre) are no longer isolated in close focus for their individual expressive power. Instead they are disposed like actors on a stage within an enclosed space and express their emotions with appropriate rhetorical gestures, as formulated by the classical orators.

This concept of the *affetti*, the link between physical movement and gesture, on the one hand, and inward emotion and mental attitude on the other, had already been explored by *Alberti and *Leonardo, but a more immediate exposition of this approach was to

be found in *Domenichino's fresco of the *Flagellation of S. Andrew* in the oratory of S. Gregorio al Celio, Rome. However, Poussin arrives at his solution by very different working methods from those of Domenichino. Whereas Domenichino planned his designs in the Bolognese tradition of making careful figure studies in black chalk, as well as compositional drawings, often squared for transfer, Poussin made drawings in pen and wash which have a Baroque energy and sense of flux which he only brought under formal control in the final picture; the drawing for the *Saving of Pyrrhus* (Windsor Castle, Royal Coll.) is a particularly vivid example of this working method and of Poussin's individual style as a draughtsman. Poussin's mastery of this theoretical language of gesture and emotion was consolidated in *The Rape of the Sabines* (c.1637; Paris, Louvre), only here there is a new element of timeless abstraction; the women and their assailants appear to be participating in some Antique ritual and transitory emotions are frozen into masklike expressions and symbolic gestures. The artist is no longer concerned with creating an illusionistic effect. His picture is an autonomous invention, with its own mathematical logic and artificial *perspective, based on three vanishing points.

A more human quality is evident in Poussin's most important and challenging commission from the late 1630s, the series of *Seven Sacraments*, painted for Cassiano dal Pozzo (*Baptism*; Washington, NG; *Penance* destr.; five others Belvoir, Leics.). They were to be interpreted as historical narrative, emphasizing the origin of these practices in the early years of the Christian Church in Rome and at the same time conveying the emotion of the participating individuals at the most critical moments of any human life. Far more than even *Raphael in his tapestry designs for the *Acts of the Apostles*, or Annibale *Carracci in his small-scale late paintings such as the *Domine, quo vadis?* (London, NG), Poussin here achieves an intimate language of expression that informs his carefully choreographed storytelling. The emotionally affective choreography was rehearsed through the use of a shadow box or model stage filled with wax figures, enabling the artist to experiment with lighting and the projection of shadows, a procedure probably inspired by the study of Leonardo and the writings of Matteo Zaccolini preserved in the Barberini Library. Poussin's drawings for these pictures, many probably made with the use of the shadow box, show how relief is obtained without line through contrasts of light and shade; and this in its turn may have led him to see *colour too as a property of light. This enabled him to move on from his earlier use of colour for atmospheric and emotional effects, in the tradition of Renaissance Venice.

Poussin's development during the period 1624 to 1640, before he returned briefly to Paris, was marked by a desire to establish an equilibrium between dramatic storytelling and the expression of extreme states of human emotion on the one hand and the formal harmony of designs based on the beauty and precision and affective power of human forms. His ultimate achievement, from this point of view, was the *Israelites Gathering Manna* (Paris, Louvre), painted in 1638–9 for Paul Fréart Sieur de Chantelou. As Charles *Le Brun realized, in his analysis of the picture at the French Academy (5 Nov. 1667), the artist not only successfully captures the *affetti* of the individual Israelites, but also embodies expression in the very nature of their forms as defined by Greek ideals. As Charles Dempsey has observed: 'Such a response is in essence psychological and precedes rational analysis of dramatic plot as orchestrated by the portrayal of the *affetti*. The *affetti* emblematize emotion but do not embody expression, according to which the viewer's primary response derives from an instinctive virtually empathetic identification with the characters and forms of the figures themselves.... From this moment a rationalist Italian theory of the *affetti* begins to be replaced by the critical concept called *expression* by the French. The distinction is a subtle one, but it is also fundamental. The concept of expression is at heart psychological in that it is based on an emerging awareness of pure and unmediated sensory response to forms in and of themselves.'

Poussin's summons to Paris by Louis XIII to decorate the Grande Galerie of the Louvre interrupted the natural development of his art. He quickly became frustrated and made excuses to return to Rome in December 1642. From 1644 to 1648 he was much preoccupied with a further commission from Chantelou for a second series of *Seven Sacraments* (Duke of Sutherland Coll., on loan Edinburgh, NG Scotland). These pictures lack much of the vivacity and variety and narrative interest of the earlier series, painted for dal Pozzo, but assume a new level of gravity and emotional concentration and show a far greater degree of stylistic consistency and homogeneity of tone. They reflect a more deliberate, scientific, but also expressive system of colour, based on careful manipulation of light and patterns of chiaroscuro, prompting the patron to complain that they lacked charm and Poussin to reply with an explanation likening the appropriate treatments for different themes in painting to the various modes recorded by Antique writers on music.

However it was in his sequence of open landscapes, dating from around 1648, that Poussin gave his most vivid demonstration of the concept of painting as an expression of mood. Here he sought the underlying order of nature, not in its naturalistic detail or its

changing aspect, as the daylight progresses from dawn to dusk, but in its fundamental structure. While owing an obvious debt to Domenichino in this respect, Poussin penetrates far deeper, looking for parallels between the virtue of man and the harmony of nature; and he explored these philosophical notions in the *Funeral of Phocion* (Earl of Plymouth; on loan Cardiff, National Mus. Wales) and the *Ashes of Phocion* (Liverpool; Walker AG), and even in the somewhat later *Landscape with Diogenes* (?1657; Paris, Louvre). Man remains dominant, even in death or adversity. However in Poussin's final landscapes, dating from c.1660 onwards, mankind is finally diminished, and the artist's compositional rigour is relaxed (*Hercules and Cacus*; Moscow, Pushkin Mus.; *Four Seasons*; Paris, Louvre; *Hagar and the Angel*; Rome, Barberini Gal.). Poussin now embraces a pantheistic vision of the universe, rooted in a sense of the fertility of nature, the fecundity of man, and the destructive power of the elements.

From his earliest days as an artist in Paris to his last days in Rome when he struggled in vain to complete a painting of *Apollo and Daphne* (Paris, Louvre) Poussin displayed an inimitable capacity to give visual form to his imaginative study of the poetry and pagan mysteries of the Antique world. He brought a similar historical empathy and imaginative antiquarian spirit to his work on Christian themes, above all in two series of *Seven Sacraments* and innumerable pictures on the life of Moses and other biblical themes. The devotional requirements of Roman churches on the other hand interested him far less. The gulf between pagan and Christian art that had grown during the Italian Renaissance is reconciled by Poussin's strong sense of historical continuity, until in his final works it amounts to a pantheistic sense of the grandeur of nature as a manifestation of the divine. Anthony Blunt, after a lifetime studying the intellectual content of Poussin's art, characterized him as 'a pure example of the Christian Stoic' who lived in harmony with nature and reason. The great French 19th-century antiquarian Séroux d'Agincourt, who once described Poussin as *pictor philosophus* (letter to Monsieur Castellan, 1813), suggested that the artist's designs were 'primarily inspired by a desire to give visible expression to certain ideas which while not deserving the name of a philosophy in any technical sense, represent a carefully thought out view of ethics, a consistent attitude to religion, and towards the end of his life a complex, almost mystical conception of the universe' (cited by Blunt). Artists have responded quite differently. For Bernini and later *Delacroix Poussin was an incomparable storyteller; for the academician Le Brun, his art was an intellectual and rational statement, directed primarily at the mind; *Ingres, Gavin *Hamilton,

*Flaxman, even the German *Nazarenes responded to the purity of the lyrical classical figures Poussin had derived from Greek sculpture and vases; *Degas, *Cézanne, and *Picasso toyed with his designs in an abstract form and Roger *Fry (1926) claimed that the subject matter of his mature work, in particular *Achilles Delivered among the Daughters of Lycomedes* (Boston, Mus. of Fine Arts), was 'merely a pretext for a purely formal construction'. Poussin still defies categorization, and both the French and Italians (and sometimes one suspects the British, who collected his work avidly in the 18th and 19th centuries) claim him as their own. HB

Blunt, A., *Nicolas Poussin*, A. W. Mellon Lectures (1967).

Blunt, A., *The Paintings of Nicolas Poussin: A Critical Catalogue* (1966).

Dempsey, C., 'The Greek Style and the Prehistory of Neo-classicism', in E. Cropper (ed.), *Pietro Testa*, exhib. cat. 1988 (Philadelphia Mus.).

Mahon, D., *Nicolas Poussin: Works from his First Years in Rome* (1999).

Merot, A. (ed.), *Nicolas Poussin: actes du colloque* (1994) (1996).

Rosenberg, P., and Prat, L.-A., *Nicolas Poussin*, exhib. cat. 1994 (Paris, Grand Palais).

Thuillier, J., *Nicolas Poussin* (1994).

Verdi, R., *Nicolas Poussin*, exhib. cat. 1995 (London, RA).

POWERS, HIRAM (1805–73). He was the first American sculptor to win international fame. Powers began his career in Cincinnati modelling life-size wax figures for tableaux from Dante's *Inferno*. Something of the disturbing naturalism of the waxwork found its way into his early portrait of *President Andrew Jackson* (c.1835; Washington, National Mus. of American Art), and sits incongruously with a conventional composition taken from classical sculpture. In 1837 Powers went to Florence, then dominated by Lorenzo Bartolini. He remained in Italy for the rest of his life, assimilating completely the *Neoclassical style developed by *Canova and *Thorvaldsen. His most famous work, then and now, is *The Greek Slave*, first created in plaster in 1843 and later made in several marble examples also (one is in New Haven, Yale University AG). This statue of a nude, chained female combines an almost aggressively chilly Neoclassicism with a strong erotic frisson, much like the contemporary painted nudes of *Ingres. A version was exhibited at the Great Exhibition in London in 1851 and another toured the United States attracting paying crowds for several years. The character of the *Greek Slave* has been connected with both the Greek War of Independence and the sculptor's Swedenborgianism. MJ

Reynolds, D. M., *Hiram Powers and his Ideal Sculpture* (1977).

Wunder, R. P., *Hiram Powers: Vermont Sculptor, 1895–1873* (2 vols., 1991).

POYET, JEAN (active 1483–97). French illuminator and painter active in Tours. Poyet was obviously well regarded during his lifetime; he was included in two contemporary accounts of famous painters and carried out work for the Queen, Anne of Brittany, including 23 illuminations for a *petites heures*. Despite documented commissions it has not been possible to link these accounts with any surviving work and the reconstruction of his œuvre depends upon matching a likely group of works with the known circumstances of this contemporary and fellow *tourangeau* of *Bourdichon. It is suggested that Poyet is, in fact, the artist of the Heinemann Hours (c.1500; New York, Pierpont Morgan Lib., MS H. 8), an exquisite manuscript, known for its radiant colours, sophisticated composition, and high drama. The Tillot Hours (London, BL, Yate Thompson MS 5) which closely resembles the Heinemann Hours, is also considered to be one of the works produced by Poyet when he was at the peak of his career as an illuminator and, although he had no official position, his work was greatly in vogue at court. KC

Avril, F., and Reynaud, N., *Les Manuscrits à peintures en France 1440–1520* (1993).

Kren, T. (ed.), *Renaissance Painting in Manuscripts: Treasures from the British Library*, exhib. cat. 1983–4 (Los Angeles, Getty Mus.; New York, Pierpont Morgan Lib.; London, BL).

POYNTER, SIR EDWARD (1836–1919). English painter. The son of an architect, Poynter single-mindedly pursued an artistic career from childhood. In Rome in 1853, aged 17, he was inspired by *Michelangelo and *Leighton whose studio he visited. In 1856, finding English training inadequate, he enrolled at Charles Gleyre's Academy in Paris for three years and was later immortalized in George du Maurier's *Trilby* (1894) as the industrious 'Lorrimer'. In 1867 and 1868 his exhibits at the Royal Academy, London, *Israel in Egypt* (London, Guildhall) and *The Catapult* (Newcastle on Tyne, Laing AG) were praised for their archaeological and anatomical accuracy (he was considered to be the finest academic draughtsman of his day). However the former owes a compositional debt to Leighton and his later work, overwhelmingly classical genre, is virtually interchangeable in subject and sentiment with that of *Alma-Tadema.

In 1875 he became art director of the South Kensington Museum, London (now V&A), a post that revealed his considerable administrative skills which were fully recognized by his appointment as director of the National Gallery (1894–1904) and election as president of the RA, a post he held for 22 years, in 1896. DER

Monkhouse, C., *Poynter* (1897).

POZZO, ANDREA (1642–1709). Italian painter, architect, and stage designer. Born in Trent, he became a Jesuit lay brother in 1665 and was a noted *trompe l'œil* specialist by the late 1670s. He was brought to Rome in 1681 to work on the commemorative scheme surrounding S. Ignatius Loyola's rooms adjoining the Gesù, and was engaged on Jesuit projects in and near Rome for the next 20 years.

His ceiling frescoes in S. Ignazio, Rome (1688–94), fused the real architecture of the church and the teeming heavenly scene in an overwhelming display of *quadratura illusionism which marked an important step in the development of the *Baroque. The work was financed by sales of his immensely successful treatise *Perspectiva pictorum et architectorum* (vol. 1, 1693).

After designing the important altars of S. Ignatius (1695; Gesù) and S. Luigi Gonzaga (1697–9; S Ignazio), Pozzo left Rome in 1702 for Vienna. There, in addition to work for the Jesuits, he decorated the villa of the Prince of Liechtenstein (1704–8). This secular cycle had a strong influence on Austrian and German *Rococo. AJL

Gregori, M., and Schleier, E. (eds.), *La pittura in Italia: il seicento* (1988).

POZZOSERRATO, LODOVICO. See TOEPUT, LODEWIJCK.

PRAGUE: PATRONAGE AND COLLECTING. Prague is the largest city of Bohemia, formerly the capital of Czechoslovakia, and since 1993 the capital of the Czech Republic. Prague has enjoyed four periods of artistic brilliance: under Charles IV in the 14th century, under the Emperor Rudolf II in the late 16th century, under the Habsburgs in the 18th century and lastly in the late 19th century.

The first dynasty, the Přemyslids, under Prince Bořivoj, established a citadel in the late 9th century and Prague was made a bishopric in 973. The Přemyslid dynasty died out in 1306 when Wenceslaus III was murdered. His daughter Elizabeth married John of Luxembourg, son of the German King Heinrich VII. Their son, Charles IV, became King of Bohemia (1346), King of Germany (1347), and Holy Roman Emperor (1355). To this day, Prague bears his stamp as an extraordinary patron of the arts.

Little survives in Prague today from before the reign of Charles IV with the exception of some fragments of wall paintings in the *Romanesque convent church of S. George and the much restored sculptural decoration of S. Agnes convent. When Charles IV decided to make Prague the capital of his empire, he began extensive ecclesiastical and secular building projects. Substantial additions were made to Prague Castle. A new stone bridge

was constructed across the river forming a permanent link with the Old Town where building of the Týn church and the Charles University was begun. Although Charles had been educated in France, he called upon craftsmen from all over Europe. A French architect, Matthias of Arras, was appointed to begin the new Cathedral of S. Vitus, his place being taken later by the German Peter *Parler, whose workshop were responsible for almost all of the architectural projects in Prague as well as designing a series of portrait busts for the triforium of the cathedral. Mosaicists from Venice made a large mosaic of the *Last Judgement* for the north door of S. Vitus's Cathedral and the Italian painter Tomaso da *Modena painted at least one altarpiece for the chapel of the Holy Cross in Karlštejn Castle. Italian influences are discernible in the wall paintings in the cloister of the Emmaus monastery. However the most outstanding painter of Charles's reign seems to have been a Bohemian, Master *Theodoric, whose workshop produced over 100 portrait panels of saints, bishops, and leading contemporaries for the Emperor's chapel at nearby Karlštejn (*in situ*). These large, richly coloured forms were influential on later painters, such as the anonymous master of the *Archbishop Očko* panel (Prague, Mus. of Bohemian Art) and the *Master of the Třeboň Altarpiece (*Resurrection*; Prague, Národní Gal.).

During the reign of Charles's son Wenceslaus IV, the Hussite rebellion caused turmoil and the decline of Prague as an artistic centre. Nevertheless he was a considerable patron of manuscript scriptoria. Illuminated manuscripts produced for him, such as the Wenceslaus Bible, were taken by the Habsburgs to Vienna and very little is left in Prague.

It was not until the reign of Emperor Rudolf II (1552–1612) that Prague, once again the imperial capital, became an artistic centre of international importance (see PRAGUE SCHOOL). His court in Prague Castle became a focus for new ideas, artistic and scientific, reflecting his unusual and individualistic taste as a patron. He invited to his court *Mannerist painters including the Italian Giuseppe *Arcimboldo, the Fleming Bartholomäus *Spranger, the Germans Josef *Heinz and Hans von *Aachen as well as the sculptor Adriaen de *Vries. His scientific enthusiasm impinged upon art and led to an interest in the new subjects of *landscape and *still life. He sent Roelandt *Savery to study Alpine landscape and Jan *Brueghel worked for him. Paulus van *Vianen produced some remarkable landscape drawings as well as fine works as a goldsmith.

From the 17th to the end of the 19th century Prague was ruled from Vienna by a Habsburg bureaucracy. The work of painters such as Karel Škréta and Petr Brandl and Jan Kupecký or the sculptors Matthias Braun and Ferdinand *Brokof have Baroque characteristics, showing their awareness of developments elsewhere in Europe. The Habsburg aristocracy commissioned the decoration of churches and palaces, for example the entrance portal of the Clam Gallas Palace (Matthias Braun 1714–16).

By the early 19th century Czech nationalism had began to permeate the arts, as seen in the work of Antonín Mánes and František Horčička. An Academy of Fine Arts (1799) and a National Museum were established in 1818. By the end of the century a Czech nationalist style is discernible in two extensive building projects, the historicist National Theatre (1885) and the *Art Nouveau Obecni Dum (1912). These provided an opportunity for artists, sculptors, and glassmakers such as František Ženíšek, Václav Brožík, Josef Myslbek, and Alphonse *Mucha.

Significant in the 20th century was the founding of art groups, such as the Devětsil (1920) and Surrealist groups (1934), through which artists made contact with contemporary European art. Joint exhibitions were held of Czech and foreign artists such as *Rodin. Social realism dominated sculpture and painting after 1948. CFW

PRAGUE, SCHOOL OF, a term used to describe more than 25 artists, some notable sculptors, goldsmiths, and stonecutters, who were attracted to the imperial court at Prague under the patronage of the fascinating and elusive personality of the Habsburg Emperor Rudolf II (1552–1612). In Prague, more than any other artistic centre around 1600, the art produced was notable for its diversity and novelty of subject matter, style, and cosmopolitan character. It is partly the personality and character of Rudolf himself which acted as a catalyst for the distinctive features of the art produced during the comparatively short period of his reign. The term 'Rudolfine' is also one which is often applied to describe the highly individualistic contribution of Prague court artists throughout Europe.

Rudolf II moved his court from Vienna to Prague in 1583 and devoted the following years to adapting the medieval castle there to accommodate his already large and rich collection of paintings by Italian and northern Renaissance artists, which may well have numbered several thousand and included works by *Dürer, Pieter *Bruegel the elder, *Leonardo da Vinci, *Titian, and *Correggio. As in the case of other princely patrons of the period, Rudolf also established a *Kunstkammer or small cabinet intended to display his diverse collection of manuscripts, clocks, coins, cameos, shells, and a host of other scientific and artistic curiosities, including skeletons, fossils, and astronomical instruments. His interests extended to an enthusiastic study of mathematics, the natural sciences, and studies of alchemy and natural magic. Rudolfine Prague became not only a centre of artistic production, but a focal point for many of the leading scientists and philosophers of the day, including Tycho Brahe, Johannes Kepler, and John Dee.

The multifarious diversity so characteristic of Prague court patronage helps to explain the almost contradictory and very varied nature of the art produced by the School of Prague. New subjects of landscape and flower painting by the Flemish artists Pieter Stevens (c.1567–after 1624) and Roelandt *Savery exist alongside the detailed drawings of animals and insects by Joris *Hoefnagel and his son Jacob (1575–c.1630), as well as the more usual mythological and religious themes. Such contradictions are exemplified through two portrayals of Rudolf. A bronze relief by the Dutch-born, but Italian-trained, sculptor Adriaen de *Vries (1609; Windsor Castle, Royal Coll.) represents Rudolf II in traditional Renaissance style. He is portrayed in the guise of a Roman general trampling personifications of the vices under his horse's hooves, while leading figures symbolizing the arts into Bohemia. The other portrait (Sweden, Skokloster Castle) is by the Italian artist Giuseppe *Arcimboldo, who depicted Rudolf as Vertumnus, the Etruscan-Roman god of the seasons, using realistic representations of various fruits, flowers, and vegetables which, combined together, form this striking anthropomorphic portrait.

Mythological subject matter is particularly characteristic of the Prague court artists of whom the leading exponents are the Fleming Bartholomäus *Spranger, the German Hans von *Aachen and the Swiss Joseph *Heinz. Spranger's work, for example *Hercules, Deianira and Nessus* (Vienna, Kunsthist. Mus.), transforms the imagery of late 16th-century Italian *Renaissance art into a particularly individualistic *Mannerist idiom, which was to have a strong impact beyond central Europe through the prints of Spranger's drawings made by Hendrik *Goltzius. For example, Spranger's stylish convoluted figure compositions inspired artists in Utrecht and Haarlem, and even Indian Moghul miniatures exist that are copies of Spranger's work. By comparison with Spranger, Hans von Aachen's work is small in scale, often on copper, such as the *Assembly of the Gods* (London, NG). This reflects the contemporary taste for highly detailed, almost miniature works, painted in jewel-like colours in a glossy smooth technique, which formed an important part of a *Kunstkammer* such as that created by Rudolf.

Joseph Heinz's life-size and usually full-length Habsburg portraits, such as that of the *Archduchess Konstanze* (Williamstown, Mass., Art Inst.), are fine examples of another important demand made of court artists of the

School of Prague. Although these are generally characteristic of late 16th-century court portraiture, they exemplify in the smooth, almost enamel-like paint surface and concern with the sheen of fabrics and finely wrought jewels the distinctive traits of Prague artists. Such traits are also apparent in the work of a German painter from Nuremberg, Hans Hoffmann (c.1530–c.1592), whose rare work includes religious subjects but also particularly detailed studies of animals, inspired by Dürer, such as *Hare among Plants in a Forest Clearing* (priv. coll.).

It is not surprising that the Dutch painter-historian Karel van *Mander, writing in his *Schilderboeck* of 1604, urges the art connoisseur to travel to Prague rather than any other European city at the time, describing the Emperor Rudolf II as the greatest art patron in the world and the Prague collections as containing 'a remarkable number of outstanding and precious, interesting, unusual, and priceless works of art'. CFW

Kaufmann, T. D., *The School of Prague* (1988).

PRAXITELES (active c.375–340 BC). Athenian sculptor, probably the son of Cephisodotus, celebrated for his *Aphrodite* of Cnidus (Roman copy Vatican Mus.). He evidently paid great attention to the final surface of his works, predominantly in marble, but an anecdote reported by *Pliny (*Natural History* 35. 133) indicates that he was not alone responsible for their ultimate appearance: when asked which of his statues he preferred above all, he replied 'those painted by Nicias'. Ancient authors attribute to him numerous statues, mostly of divinities and other mythological figures, but only inscribed bases survive (e.g. Athens, Agora Mus.). The *Hermes and Infant Dionysus* (Olympia Mus., whence moderns have reconstructed his style, is now considered a later work). Other statues known from Roman copies have, perhaps over-optimistically, been attributed to him: e.g. the languorous *Apollo Sauroctonos* (Lizard-Slayer; Paris, Louvre), *Pouring Satyr* (Palermo, Mus. Regionale Arch.), and more than one *Eros* (e.g. Paris, Louvre). His famous association with the courtesan Phryne, who reputedly modelled for multiple Aphrodites and portrait statues, is likely to be exaggerated by ancient sources. KDSL

Ajootian, A., 'Praxiteles', *Yale Classical Studies*, 30 (1996).
Ridgway, B. S., *Fourth-Century Styles in Greek Sculpture* (1997).
Stewart, A., *Greek Sculpture* (1990).

PRECISIONISM, a movement in American art from 1915 whose distinguishing feature was the application of a quasi-Cubist method of depiction to a limited range of subjects: urban and rural landscapes— usually industrial—and still life. The paintings are often characterized by a sense of hallucinatory clarity, for example *Buildings Abstraction, Lancaster* (1931; Detroit, Inst. of Arts) by Charles *Demuth. The sharp linearity of such works, rather than being genuinely *Cubist, has a specific function as an indicator of pictorial modernity, which is intended to complement that of the objects depicted.

In their formal lucidity, Precisionist paintings are comparable to those of the contemporary English artists Edward *Wadsworth and Tristram *Hillier. However, the objects in a Wadsworth still life have a deeply mysterious quality, whereas those in a painting such as *Upper Deck* (1929; Cambridge, Mass., Fogg Art Mus.) by Charles Sheeler (1883–1965) appear more straightforwardly to have been consciously endowed with a contemporary, heroic character. OPa

Precisionism in America 1915–41: Re-ordering Reality, exhib. cat. 1994 (New Jersey, Montclair Art Mus.).

PREDELLA, an altar-step, and hence a picture on the vertical fall of this. It is especially used to refer to the series of paintings beneath polyptychs of the 14th and 15th centuries. In the latter usage, the term applies to a horizontal band of wood, usually cut from a single plank, placed at the bottom of an *altarpiece. They often had a structural function and by raising the altarpiece made it more easily visible. The earliest surviving predella scenes of certain date are those from *Duccio's *Maestà* for Siena Cathedral (1311). AM

Salvini, R., and Traverso, T., *The Predella from the XIIIth to the XVIth Centuries* (1960).

PREDIS (Preda), DE. Family of Milanese painters and illuminators. **Cristoforo** (c.1440–before 1486) was among the most important illuminators to work for the Sforza court in the 1470s. Known as Il Muto (the mute), he was employed by the Borromeo family 1471–4, and it may have been in these years that he illuminated the Borromeo Book of Hours (Milan, Bib. Ambrosiana). His refined style and the fantasy of his designs are indebted to the elegance of late *Gothic imagery and Franco-Flemish traditions. The initials of the Borromeo Hours therefore display a variety of vivid colours, and his landscapes reflect the influence of Flemish detail and Lombard naturalism. In his later *Leggendario* (Turin, Bib. Nazionale, MS 124), dated 1476, Cristoforo's style is characterized by a greater awareness of Italian *Renaissance innovations in space and form, and by the more widespread use of classicizing motifs. Similar developments in style are noticeable in the contemporary illuminations for Bishop Marliani's Choir Book (Varese, S. Maria del Monte).

Giovanni Ambrogio (c.1455–after 1508), half-brother of Cristoforo, was in the service of the Sforza and was closely associated with *Leonardo. Born into a family of artists, he is first mentioned as an illuminator, working on books of hours for the Borromeo family; he may have trained in this art with Cristoforo. Subsequently he was employed by the Milanese mint, and from 1482 he worked for Ludovico il Moro, executing a number of portraits for the Sforza court. From 1483 until the 1490s he collaborated with Leonardo, whose influence is evident in Giovanni Ambrogio's portrait of *Francesco di Bartolomeo Archinto* (London, NG), especially in the use of chiaroscuro and the interest in psychological introspection. The clear drawing of this work also features in the portrait of *Emperor Maximilian* (1502; Vienna, Kunsthist. Mus.), his only known signed and dated work. Compared to the London picture, the latter portrait follows the more conservative model of the profile against a dark background and is inferior in quality and finish. FB

Pirovano, C. (ed.), *Pinacoteca di Brera: scuola lombarda e piemontese, 1300–1535* (1988).

PREISSLER FAMILY. Extensive German dynasty of painters and engravers. Although **Daniel** (1627–65) was mostly active in Nuremberg as a painter of altarpieces and portraits, his descendants are better known as engravers. His posthumous son **Johann Daniel** (1666–1737) published suites of ornament and drawings for copying by students and amateurs. **Johann Justin** (1698–1771), the eldest of Johann Daniel's eleven children, succeeded him as director of the Nuremberg Academy and was a portrait and history painter (e.g. Nuremberg, Germanisches Nationalmus.), as well as continuing the family tradition of ornamental and reproductive engraving. His brother **Johann Martin** (1715–94) and the latter's son **Johann Georg** (1757–1831) both studied engraving in Paris and worked in succession for the Danish court in Copenhagen. MJ

PRENDERGAST, MAURICE (1859–1924). American painter. Generally considered to be the first American *modernist, Prendergast was born in Boston and spent his early life as a clerk in a department store. From 1891 to 1895 he lived in France and he was in Italy in 1898–9 painting brightly coloured and freely handled watercolours like *Piazza di S. Marco* (c.1898; New York, Met. Mus.). Similar works, full of *joie de vivre*, were produced on his return to America: *The East River* (1901; New York, MoMa). His mature style was established by the time he exhibited with The *Eight in 1908; decorative, colourful, and patterned, with no attempt at illusionistic space, based on lessons learned from his study of works by the *Nabis, particularly *Vuillard,

during his first stay in France and subsequent visits. In paintings such as the *Promenade* (1913; New York, Whitney Mus.) Prendergast, unlike the other artists of The Eight, reveals his total understanding of French *Post-Impressionism. He continued to paint in the same vein for the rest of his career, ignoring new developments and gradually becoming accepted by the more adventurous American patrons. DER

Clark, C. (ed.), *Maurice Brazil Prendergast, Charles Prendergast: A Catalogue Raisonné* (1990).

PRE-RAPHAELITE MOVEMENT. The Pre-Raphaelite Brotherhood was founded in late 1848 by three young painters, Holman *Hunt, *Millais, and *Rossetti. The latter rapidly enlisted his brother William, James Collinson (1825–81), a painter who was engaged to Rossetti's sister Christina, and the sculptor Thomas Woolner (1825–92). Hunt retaliated by electing his pupil F. G. Stephens (1828–1907) and the brotherhood was complete. Their avowed aim was to reject sterile and formulaic academicism, which they perceived to have descended from the Bolognese followers of *Raphael, and to return to nature for their inspiration. Sentimental and vulgar subjects were to be avoided and, ever literary, they turned initially to the Bible, Shakespeare, and Keats for their sources. Their paintings of 1849, which included Rossetti's *Girlhood of Mary Virgin* (London, Tate) and Millais's *Lorenzo and Isabella* (Liverpool, Walker AG), were well received but the following year, when the existence of this impertinent brotherhood was known, their works were violently attacked by the critics and it was only the intervention of *Ruskin, in 1851, which saved their careers. In the same year they published four issues of their short-lived journal, the *Germ*, intended to publicize their ideas. In fact they had no clear manifesto although for a brief period (1848–50) they shared a common style of elongated linear drawing, derived in part from their study of *Führich's engravings, and they did paint *en plein air*, in bright colours given further intensity by using a wet white ground. From 1852 they shared an interest in 'modern' subjects, comments on contemporary mores, which resulted in Hunt's moralizing *Awakening Conscience* (1853–4; London, Tate); and *Work* (1852–65; Manchester, AG), the masterpiece of their close associate Madox *Brown. Rossetti's attempt, *Found* (1852– ; Wilmington, Delaware Art Mus.), was never finished. Collinson resigned in 1850, Woolner emigrated to Australia in 1852, and when Millais was elected ARA in 1853 the brotherhood was effectively over. Only Hunt, who made the first of several journeys to Palestine in 1854 to paint the extraordinary *Scapegoat* (1854; Port Sunlight, Lady Lever Gal.), remained true to Pre-Raphaelite ideals but his work was to become obsessively religious and highly mannered. However, their work had a significant effect on other English artists, particularly the landscape painters John *Brett and John William Inchbold (1830–88).

The term Pre-Raphaelite is more loosely applied to a group of painters, which included *Hughes, William Morris, and principally, *Burne-Jones, who were associated with Rossetti from 1855 and worked with him on the ill-fated attempt to decorate the Oxford Union in 1856. DER

Hilton, T., *The Pre-Raphaelites* (1970).

PRESENTATION DRAWING. The term was invented in the 1950s by Johannes Wilde to describe a number of highly finished drawings by *Michelangelo. The artist made them as gifts for close friends and he clearly regarded them as independent works of art. Today finished drawings by other artists which are not preparatory for other projects are often referred to as 'presentation drawings'. PHJG

PRETI, MATTIA (Il Cavaliere Calabrese) (1613–99). Italian painter active at Rome, Naples, and in Malta, who created a colourful *Baroque style derived both from *Caravaggesque naturalism and chiaroscuro and the opulence of Venetian Renaissance painting, especially *Veronese. Born at Taverna, Calabria, he had probably moved to Rome by 1630 and was a member of the Accademia di S. Luca from 1632. His early work shows the influence not only of Caravaggio but also the circle around *Manfredi, both in style and choice of subject matter, for instance the *Draught-Players* (Oxford, Ashmolean). He also responded to the *classicizing tradition in Rome, in his altarpiece of *S. Andrew* (1642; Lucerne, Hofkirche) and his fresco of *The Charity of S. Carlo* (1642; Rome, S. Carlo ai Catinari). In 1641 he was made a Knight of Malta and during this decade he appears to have travelled widely and to have studied Venetian and Emilian painting. In 1649 he painted a two-sided banner for the Confraternità del SS Sacramento in S. Martino al Cimino, Viterbo (*in situ*). In 1650 he was commissioned to paint in fresco three scenes of the martyrdom of S. Andrew for S. Andrea della Valle, Rome (1651; *in situ*) but failed to match the impact of *Domenichino's and *Lanfranco's earlier work there. He moved to Naples *c*.1653 and quickly established himself as the only artist capable of reinvigorating the realistic tradition of Caravaggio and *Ribera, who had just died in 1652. Preti's first major Neapolitan commission was for a series of ten pictures for S. Pietro a Maiella (1659; *in situ*). He then travelled to Valletta in Malta to paint a *Martyrdom of S. Catherine* for the convent of S. Caterina (1659; *in situ*). Eventually he settled in Valletta in 1661 and took on the enormous task of decorating (in oil on stone) the vault and apse of S. John, with scenes from the life of S. John the Baptist. He was duly rewarded by the Knights of Malta with the high rank of Knight of Justice (1662). Toward the end of his career, Preti's use of colour became more restrained and this is apparent in his seven paintings for the Sarria Church in Floriana (1667–8) and in his undocumented but signed *Triumph of Time* (Burghley House, Lincs.) which may date from the 1680s. During this decade Preti returned to his birthplace, Taverna, to decorate the churches of S. Barbara and S. Domenico. HB

Spike, J., *Mattia Preti* (1999).

PRICE, SIR UVEDALE (1747–1829). Leading English writer on the *picturesque. Developing his ideas from Edmund *Burke's theories of the 'sublime' and 'beautiful' and from William Gilpin's (1724–1804) notions of 'picturesque beauty' he sought to clarify the term 'picturesque' in its own right. *Variety* and *intricacy* were two key components seen in such things as old winding and rutted tracks, Gothic ruins, old barns, mills, and cottages. Things regular and utilitarian were not picturesque. His estate at Foxley in Herefordshire Price remodelled on lines set out in his *Essays on the Picturesque* of 1794. His neighbour the connoisseur Richard Payne *Knight replied with his own *The Landscape: A Didactic Poem* of 1795, and the landscape gardener Humphrey Repton (1752–1818) also responded; he supported the designs of 'Capability' Brown (1716–83), who used smooth and regular forms which were opposed by Price, who took many of his preferences from 17th- and 18th-century painters including *Ruisdael and *Gainsborough. In 1810 Price published Repton's letter to him, together with his own reply, in an expanded version of his *Essay*. MP

PRIEUR, BARTHÉLEMY (*c*.1536–1611). French *Mannerist sculptor. After a period in Turin he settled in Paris, where he worked mainly for the court. His large bronze female allegorical figures (before 1573; Paris, Louvre), originally part of the monument for the heart of Constable Anne de Montmorency, are typical of his elegantly proportioned, finely detailed statues with their echoes of the *Fontainebleau style. After the accession of Henri IV Prieur was appointed a court sculptor and provided decorative work for both the interior and the exterior of the Louvre as well as being responsible for the restoration of the well-known Antique statue *Diana with a Hind* (1602; Paris, Louvre). The high quality of his numerous small bronzes, the finest of their period in France, suggests that he was famil-

iar with the output of *Giambologna's Florentine workshop. There are examples in the Louvre, the Metropolitan Museum, New York, and the Ashmolean Museum, Oxford.
MJ

Beaulieu, M., *Description raisonné des sculptures du Musée du Louvre: la Renaissance française* (1978).

PRIMARY COLOURS. See COLOUR.

PRIMATICCIO, FRANCESCO (1504–70). Italian painter, draughtsman, stuccoist, and architect, who with *Rosso Fiorentino and *Cellini carried the Italian *Mannerist style to France, where he was one of the leading artists of the First School of *Fontainebleau. He trained in Bologna but his most important formative influence was *Giulio Romano, with whom he worked at the Palazzo del Te in Mantua in 1526. It was on that project that he began to develop the elaborate style of stucco decoration combining figures and ornament that he took to France when invited to the Château de Fontainebleau by François I in 1532. There he worked alongside Rosso on the huge undertaking of decorating the main rooms, though it is difficult now to assign particular aspects of the development of the sumptuous and sophisticated Fontainebleau style to either artist individually. Primaticcio's most ambitious undertaking, the Galerie d'Ulysse—worked on throughout the 1540s and 1550s with the assistance of *Nicolò dell'Abbate—was destroyed in the 18th century. But it is still possible to get a flavour of its quirky magnificence, with distant echoes of *Michelangelo and *Correggio as well as Giulio Romano, from the surviving frescoes and stuccoes of the Chambre de la Duchesse d'Étampes (1541–4). Late in his career Primaticcio seems to have designed a number of royal buildings. The Grotte des Pins and the Belle Cheminée wing at Fontainebleau have both been attributed to him, as has the first design of the unfinished Valois chapel at S. Denis.
MJ

Béguin, S. (ed.), *L'École de Fontainebleau*, exhib. cat. 1972 (Paris, Grand Palais).
Blunt, A., *Art and Architecture in France, 1500–1700* (rev. edn., 1988).
Dimier, L., *Le Primatice* (1928).

PRIMING. See GROUND.

PRIMITIVE. Today the term is most commonly used to describe aspects of Western art which refer to, or manifest, forms and values derived from African and Oceanic tribal objects celebrating ancestral and regenerative qualities. The term implies a Western viewpoint, whereby ethnic art—historically posited as 'other'—is subjected to formal study, originally by ethnologists and later by artists and art historians.

In recent times, the term has been derided for its earlier ethnocentric and pejorative usage, which is why it is often placed within quotation marks. Towards the end of the 19th century, it was used in an 'evolutionist' sense to denote the cultural artefacts of those peoples deemed to fall outside the influence of Western civilization, such as the African Negroes south of the Sahara, the Eskimos, and the inhabitants of the Pacific islands. The conceptual complexity and aesthetic subtlety of the best of these artefacts were not then appreciated, regarded as they were as the mere fetish objects of barbaric peoples whose cultures were thought to be in a formative or degenerative phase. *Modernist artists were the first to use 'primitive' in an admiring sense, and it is now well established as a term of praise within an artistic context.

A second meaning of the term is one used by art historians and connoisseurs to describe early phases within the historical development of painting and sculpture in various European countries. This usage originally carried the implication that these earlier artists were attempting unsuccessfully to achieve—particularly in the field of naturalistic or illusionistic representation—what was achieved by the artists of the so-called mature period. From the middle of the 19th century, the term was applied to the art of western Europe prior to the *Renaissance, an art which was considered 'primitive' because it pre-dated scientific *perspective and *anatomy. Its freedom from sophisticated and complex devices of illusionistic lighting and perspective was thought a quality to be praised by members of the *Pre-Raphaelite movement, who appreciated the work of *Cimabue and *Giotto for its simplicity and sincerity. Today, however, this use of the term is applied to early art more regularly for descriptive rather than evaluative purposes.

A third meaning of the term denotes a range of other art forms perceived as alien to the academic, traditional, or *avant-garde styles of the day. This work is characterized by a highly idiosyncratic naivety in its interpretation and treatment of subject matter, which often lends it an untutored, childlike quality as seen in the work of Henri *Rousseau. In the case of 'outsider' artists, such unconventional rendering is attributed to mental illness, lack of training, or marginalization in society. These works, often labelled under the category *Art Brut, have provided source material for professional artists such as Jean *Dubuffet and Paul *Klee.
MT

PRIMITIVISM. The term originated in 19th-century French usage and formally entered the language as an art historical term in the seven-volume *Nouveau Larousse illustré* published between 1897 and 1904, to mean 'imitation of primitive art'. This narrow meaning partly persists, even though the identity of the 'primitives' has changed at various times, to include pre-Renaissance Italian artists and most non-Western peoples excluding courtly hieratic societies, such as the ancient Egyptian and Colombian dynasties, as well as today's meaning of mainly tribal African and Oceanic artefacts.

'Primitive' art has been sought occasionally by Western artists as a fresh source of primal inspiration to jolt the seemingly teleological progress of artistic development, rejuvenating art with a vital creative impulse. Theories about both the 'primitive' state of being and the exotic visual spectacle of the arts of 'primitive' peoples imply that they are to be envied and respected. 'Primitivism' is then the wholly Western phenomenon of the way the primitive 'other' impacts on its own creative output.

The 'myth of the primitive' replaced the 'myth of the Antique' in the 19th-century movements of *Romanticism and Orientalism, with their nostalgic quest for a return to an earlier state of grace free from the adulteration of European urban life. This 'cultural primitivism' inspired the journeys by *Gauguin to the ancient folk society of Brittany and later to Tahiti and the Marquesas Islands, where he thought himself to have discovered a way of life free, in its apparent unity with nature, from spiritual decay. His art, in its eclectic use of the 'primitive' sources of medieval Breton stonecarving, Polynesian woodcuts, and the religiosity of *'Cloisonnist' art, was considered to effect in its primitive style a synthesis of a directly felt response to his environment with formal inspiration. In his wish to emulate 'the primitive' Gauguin attempted to adopt a more instinctive, untrammelled state of mind which later, in the case of van *Gogh, became associated with madness and in the early 20th century with schizophrenia, neurosis, and the naive outlook of the child. All these states were considered to indicate an 'animistic sensibility' or more intuitive way of seeing, and after 1920 attracted *Surrealist artists such as *Ernst, *Wols, and *Klee as a more authentic alternative to the rational perspective of the industrialized world.

Early 20th-century *modernist artists redefined 'primitivism' through the multiplicity of references to tribal objects found in their work. Previously viewed merely as curiosities, ethnic objects suddenly became aesthetically relevant due to a shift in artistic developments, away from the perceptual realism of *Impressionism (which also informed *Post-Impressionism) to a more conceptual vision. African artefacts taught artists to conceptualize the human figure with new volumetric expressiveness, for example *Gaudier-Brzeska's *Red Stone Dancer* (1914; London, Tate); whilst from Pacific art were taken bold juxtapositions of colour and

601

materials which defied Western traditions (e.g. Die *Brücke). *Picasso's *Les Demoiselles d'Avignon* (1907; New York, MoMa) was one of the first paintings which reflected the lessons of formal compression and the articulation of interior spaces from ethnic objects, as well as daring curvatures of the body, all intrinsic to the development of *Cubism.

A study of the subject is one of influence, yet it is difficult to proceed in this area because of the immediate complications. Artists readily absorb all manner of imagery without noting down their sources for posterity; a situation further obscured by the apparent anonymity and interchangeability of much non-Western art. In some works where 'primitivist' influences are most detectable, there has often been a straightforward borrowing of visual form. Such superficial visual influences were the hallmark of *style nègre*, the fashionable 'primitivism' which flourished in the 1920s: *Giacometti's *The Couple* (1926; priv. coll.). This contrasts with works which appropriate not the visual form so much as the transformative powers of 'primitive' art, where the work becomes an emblem of vitality and psychic communion, as in the case of Giacometti's *Spoon Woman* (1927; priv. coll.), where the form of the spoon becomes imbued with the power of the female womb.

Since the Second World War, artists have looked less to individual works of tribal art for inspiration. Primitivism has taken on a more oblique, intellectualized presence as artists have focused less on their relationship with the objects and more on the ways in which the objects themselves functioned in the societies from which they came. This conceptual primitivism has led to the creation of hybrid objects, earthworks, Environments, happenings, which have been derived in part from notions of the artist as shaman and the totemic power of the object (see LAND ART, ENVIRONMENTAL ART, and PERFORMANCE ART). Such ideas were often formulated from the writings of Bataille and the anthropologist Lévi-Strauss.　　　MT

Rhodes. C., *Primitivism and Modern Art* (1994).
'Primitivism' in the 20th Century, exhib. cat. 1984 (New York, MoMa).

PRINTS. *See opposite*

PRIX DE ROME, the prize awarded annually between 1666 and 1968 by the French Académie Royale and its successor the École des Beaux-Arts to its most outstanding pupils in the categories of history painting and ideal sculpture. The winner received a bursary to enable the study in Rome for three years of the best examples of *Antique and *Renaissance art while lodging at the French Academy there. Competition for the prize was intense since it was considered a major step on the ladder to success within the academic system and a guarantee of state patronage in the future. The zenith of the Prix de Rome was in the late 17th century and again in the late 18th and early 19th centuries, periods when *classicism and the power of the academy were in the ascendant, and the majority of successful artists had won it. In the mid-19th century an attempt was made to liberalize the system by the introduction of a prize for historical landscape painting, but the relevance of the Prix de Rome seemed increasingly doubtful to many younger artists. The Rome prize competition and the conservative academic system it epitomized lingered on until abolished by André Malraux in 1968.

See Académie Royale and École des Beaux-Arts under PARIS).　　　MJ

Grunchec, P., *Les Concours des Prix de Rome de 1797 à 1863* (2 vols., 1983 9).
Les Cinquante Derniers Premiers Grands Prix de Rome, exhib. cat. 1977 (Antibes, Mus. Picasso).
Saunier, C., *Les Grands Prix* (1896).

PROCACCINI BROTHERS. Italian painters. **Camillo** (c.1555–1629) was born in Bologna, trained under his father, Ercole (1520–95), and developed a clear and direct narrative style of painting, that was well suited to the didactic requirements of Counter-Reformation art. He went to Rome c.1580 and studied the work of Taddeo *Zuccaro, and also visited Parma c.1585 to study *Correggio. In 1585 he was commissioned to decorate the apse of S. Prospero, Reggio Emilia, but by the end of 1587 had moved to Milan with the rest of his family, at the instigation of the Milanese collector Pirro Visconti, who wished him to decorate his villa at Lainate. Visconti was instrumental in obtaining commissions for Camillo at the cathedral of Milan, including three sets of imposing organ shutters, commissioned 1592, 1597, and 1600. Camillo also undertook the decoration of the vault of the choir at S. Angelo, Milan, probably in the late 1590s, and later decorated the chapel of S. Diego of Alcalá in the same church. He was much esteemed for his drawings, his etchings, most notably *The Transfiguration* (c.1587–90) and the *Rest on the Flight to Egypt* (1593), and for small cabinet pictures, such as the *S. George Killing the Dragon* (Rome, Barberini Gal.).

Giulio Cesare (1574–1625) was also born at Bologna but his career only began after the family moved to Milan. He appears to have trained initially as a sculptor in the workshop of Francesco Brambilla (d. 1599) and was active in the workshop of Milan Cathedral. He also made two relief sculptures for the façade of S. Maria presso S. Celso, commissioned in 1595. The physical labour associated with stonecarving did not apparently appeal to Procaccini and he turned instead to painting. His earliest recorded work as a painter is in the church of S. Maria presso S. Celso, Milan, where he began to paint the frescoes in the vault of the chapel of the Pietà in 1602. Then in 1604 he delivered an altarpiece of the *Pietà* for the same chapel. Other important paintings which can be firmly dated include: *The Martyrdom of S. Nazaro and S. Celso* (1606), also in S. Maria presso S. Celso; *The Deposition from the Cross*, signed and dated 1606, in the Capuchin Church at Appenzell, Switzerland; the six large *Miracles of S. Carlo* (1610) in the Cathedral, Milan; the *Holy Family*, the *Annunciation*, and the *Visitation* (1612) in S. Antonio Abate, Milan; the *Circumcision* now in the Estense Gallery, Modena, commissioned in 1613 and delivered early in 1616; *The Death of the Virgin* in the Cremona Museum, commissioned on 12 June 1616; and the *Constantine Receiving the Instruments of the Passion*, commissioned in 1605 but dated in 1620, now in the Castello Sforzesco, Milan.

G. C. Procaccini's work up to c.1616 is strongly influenced by Parmesan artists, such as Correggio and *Parmigianino, and to a lesser extent by Cremonese artists, such as Camillo Boccaccino (1504/5–1546) and the *Campi. Many of his pictures from this period are characterized by figures in shallow relief and with finely faceted draperies; ironically they show how Procaccini, now at the height of his powers as a painter, might have developed as a sculptor. However, in the second half of the decade, his paintings show greater balance in composition and more breadth and vigour in handling, probably in response to *Rubens, whose work he had seen in Genoa no later than 1618, when according to his biographer, Raffaele Soprani (1612–72), he stayed in that city.

From as early as 1611, the Genoese Gian Carlo Doria appears to have been his principal and most imaginative patron. A sequence of inventories of the collection list not only large-scale paintings but also numerous freely and hastily executed oil sketches and *bozzetti*, for instance the *S. Agatha* (Florence, Longhi Foundation). These works were evidently appreciated for their spontaneity and appear to anticipate the oil sketches of *Castiglione and Valerio *Castello. A similar virtuosity characterizes many of Procaccini's drawings, often executed in a brilliant variety of coloured washes, with remarkable bravura and sense of fantasy.　　　HB

Berra, G., *L'attivita scultorea di Giulio Cesare Procaccini* (1991).
Brigstocke H., 'Giulio Cesare Procaccini Reconsidered', *Jahrbuch Berliner Mus.* 17 (1976).
Brigstocke, H., 'G. C. Procaccini et D. Crespi: nouvelles découvertes', *Revue de l'art*, 48 (1980).
Brigstocke, H., 'Giulio Cesare Procaccini: ses attaches génoises . . .', *Revue de l'art*, 85 (1989).
Neilson, N., *Camillo Procaccini: Paintings and Drawings* (1979).

· PRINTS ·

1. Methods and techniques

PRINTMAKING techniques fall into four main groups, with a number of individual techniques peripheral to these.

(a) Relief method
Those parts of the wooden block or metal plate that are intended to be printed are left in relief, while the areas around them are cut or gouged away. A roller is used to apply printing ink to these surfaces, and an impression is taken by vertical pressure in a press, or sometimes by hand. This is the oldest and simplest of Western printing techniques.

The main techniques are the *woodcut, *wood engraving, and *linocut, while the less important techniques of *metal cut, *manière criblée, and *relief etching are printed similarly.

(b) Intaglio methods
*Intaglio is the reverse principle to relief methods, since the polished flat surface of the plate does not print, the ink being retained instead in the engraved or etched furrows and lines. Copper, zinc, or steel are the metals mainly used, the working side being first highly polished to eliminate accidental scratches or other marks. To prepare the plate for printing the whole surface is inked up using rags. The surface is then wiped clean, so that the ink remains only in the etched or engraved lines. The plate is laid on the bed of a roller press and covered with a sheet of moistened paper. The paper and plate together are covered by felt blankets, and then run through the press. The tremendous pressure forces the ink into the inked lines, transferring the ink from the plate to the paper to create an impression, in reverse, of the artist's design.

There is a great variety of intaglio methods, the oldest being engraving (see LINE ENGRAVING), as well as *etching, *drypoint, *soft-ground etching, *aquatint, *mezzotint, *stipple engraving, and the crayon manner. These last four are essentially tonal methods. Frequently these methods have been combined on one plate, when the result is sometimes called a mixed method.

(c) Surface, or planographic methods
*Lithography and its variants. This is based on the fundamental antipathy of grease and water. The design is drawn on the surface of a polished block of limestone with a greasy crayon. During printing the design retains the ink, which is rejected by the rest of the stone.

(d) Stencil methods
A simple principle whereby holes are cut in a protective sheet, which is laid over the surface, and the ink applied through the holes. *Silk-screen printing is the main modern method, but the use of stencils to colour prints goes back to the beginnings of the history of woodcuts.

Certain characteristics distinguish one type of print from another. In the intaglio methods the paper is forced round the edges of the plate during printing, creating an indentation known as the platemark. No such mark is to be found in relief methods, as the paper is not forced round the edge of the block. A further characteristic of an intaglio print is that the lines will be in very slightly raised relief. In a relief print the lines are flat, but indentations are embossed into the paper and can be seen on the back of the sheet.

2. Proofs, states, inscriptions, editions, and watermarks

(a) Proofs
Much importance attaches to the different stages or states of a print. An impression taken while the work is still unfinished and the artist wants to check the progress of his work is known as a working proof, and sometimes shows additions and corrections made by hand in ink or pencil.

A proof print is an example taken when the work is incomplete or not ready for publication. It may thus lack signature and engraved title, or descriptive text, publisher's name, and other details. Proofs are by their nature early and fine examples before the plate or woodblock begins to wear. For this reason they have always been at a premium for collectors, and printmakers have sometimes capitalized on this. *Dürer published quite large numbers of his woodcut series in proofs before text on the reverse of the sheet. In the 18th century *mezzotints were issued in a highly artificial and codified manner—proofs before all letters, proofs with scratched letters—and aimed therefore at a sophisticated collecting fraternity.

In more recent times an impression taken before a regular edition is made is known as an artist's proof.

(b) States
The successive states of a print record the changes made to a plate by the printmaker, and progressive changes made to the lettering by different publishers. *Rembrandt's etchings in particular go through many states, enabling us to follow the creative subtlety of the artist's mind. A portrait print such as Rembrandt's *Jan Lutma*

(1656) goes through three states: first with the work nearly complete, but before signature; second, with more work and the addition of signature and date; third, with additional work below. It should be remembered, however, that many copper plates survived the death of an artist such as Rembrandt, and were retouched and republished by various persons, in some cases for centuries. These posthumous changes constitute states, but do not reflect the artist's intentions.

A more academic type of state change is in the alteration of lettering, particularly of publisher's names, that reflects the changing ownership of a plate.

(c) Inscriptions

Inscriptions in the blank strip at the bottom of a print afford vital information about the authorship and subject of a print. They were frequently made in Latin, usually abbreviated in a codified way to form an internationally understood language: *pinxit* (*pinx*) means painted, *sculpsit* (*sculp*) engraved, *excudit* (*exc*) published. Thus an engraving after a painting by Rubens might bear the inscriptions 'Rubens *pinx*—Pontius *sculp*—Visscher *exc.*'

Another frequently used word is *fecit* (*fec* or simply *f*), which means made, and can refer equally to an etcher or engraver, though the former can distinguish his craft by using the words *aqua fortis* (strong water). A draughtsman's work is designated by *delineavit* (*del*), meaning drawn.

Such inscriptions, to which were often added dates and titles, and sometimes Latin verses, were often executed by professional writing engravers.

(d) Editions

An edition is a uniform print run produced at a specific time and place. Until the 19th century there is very little evidence as to how many impressions were taken from particular plates or blocks. Artists such as Dürer and their subsequent publishers sought in general to obtain as many impressions as possible, whilst many *etchings, and fugitive techniques such as *drypoints may only have yielded a handful of impressions. From the 19th century, when *lithographs and steel plates could print thousands of impressions, the publisher might make an announcement that the edition would, for example, consist of 100 proofs and 2,000 ordinary impressions. In the 20th century the limited edition was the norm, with 50 or perhaps 200 impressions being printed, each with numeration and the artist's signature in pencil below.

(e) *Watermarks

These are designs or formations of letters visible in the *paper when viewed against the light. They are created by the manipulation of individual wires within the wire-mesh on which pulp is placed during the making of paper. All paper before the late 18th century is laid paper, namely paper made from a mesh with rag pulp. Watermarks are a crucial means of identifying the age of paper, and thus the probable date of printing of individual examples.

3. Collecting and connoisseurship

FROM the end of the 16th century, and probably before, the connoisseurship of prints was well developed, encouraged by their availability, and by the opportunities for collectors to see different impressions of the same print—such comparisons being the basis of connoisseurship. Collectors sought for early impressions, crisply printed and in good condition. Certainly by the time of Rembrandt they also attempted to assemble different states of the same print, and in the case of such artists as *Dürer, *Callot, *Hollar, and Rembrandt, to possess their work in its entirety. Many collectors from the 17th century to the 19th assembled their prints in albums, often trimming the prints to the platemark before glueing them in. Such albums were arranged in different ways, sometimes by artist, but more usually by subject, as in the Pepys Collection at Magdalene College, Cambridge. A typical late 17th-century library might contain scores of albums illustrating such themes as classical architecture or the lives of the saints, with perhaps a handful of albums devoted to the most celebrated artists such as Dürer or Rembrandt. The work of other artists might thus be absorbed in the subject albums, which served more as a visual resource of knowledge than as a collection of fine prints.

Over the centuries almost all such albums have been disassembled by dealers, auction houses, and museums.

Prints by such artists as Rembrandt and Dürer were avidly collected from the beginning, and have never gone out of fashion, with the consequence that it is likely that a very high proportion of prints made in their own lifetime still survive. Many prints however were bought to be used, and must have had a very short life. Flemish pictures of the 15th century often show devotional woodcuts fixed to a wall with sealing wax, and already flyblown and curling up. Popular prints, particularly woodcuts, were treated in such a way well into the 19th century, and survive only by accident. In the 17th century large varnished prints and maps are frequently shown on a wall, attached at top and bottom to wooden rods. These too were unlikely to last long in the smoke-filled interiors of the time.

The greater cheapness of glass in the 18th century led to many more prints being framed and displayed, although these were often decorative prints after *Boucher, or so-called furniture prints by such artists as Francesco Bartolozzi (1727–1815). By the middle of the 19th century many households could afford large framed and glazed prints, although the poor quality of the paper destroyed many.

To this day collectors of old master prints still store their prints in boxes, but in recent years the overwhelming tendency of printmakers has been to produce large works intended for the wall.

Collector's marks

These are a small device or symbol printed by means of a little stamp onto the front or back of a print to denote ownership. The initials or name of the collector might also

be printed, or inscribed by hand. A fairly common practice from the 17th century to the early years of this century, but now rather uncommon.

4. Art historical uses

UNTIL its replacement by *photography, printmaking was an indispensable aid to early art historians, particularly in the publication of sets or sequences of prints, sometimes issued in book form, which recorded particular collections or cycles of paintings or drawings. These could often be something of an advertisement for the owner, such as the prints after *Teniers illustrating the collections of Archduke Leopold Wilhelm (1660). They could also serve as an epic scholarly and patriotic venture like the great *Recueil d'estampes d'après les plus beaux tableaux, et d'après les plus beaux dessins qui sont en France dans le Cabinet du Roy et dans celui du Duc d'Orléans, et dans autres cabinets* (begun in 1721). This record of the Orléans collection, Paris, was commissioned by a group of wealthy connoisseurs including Pierre Crozat, and employed many of the leading engravers in Paris. The project as it developed grew more and more ambitious, and may be seen as a product of the Enlightenment, intended as a series of cohesive volumes for libraries across Europe, grand and early forms of reference volumes. It is the type of project that is peculiarly wearisome to the modern, photography-trained, eye, but its importance and that of other ventures cannot be exaggerated.

Many other important sets were issued, including those devoted to single artists such as *Watteau or *Raphael, and great collections in England, such as Sir Robert Walpole's collection at Houghton, were recorded in series of prints.

Perhaps the most significant series of the 19th century, executed under the very shadow of photography, were the lithographs of Johann Strixner (1782–1850) after German and Flemish pictures at Munich, *Die Sammlung altnieder- und ober-deutscher Gemälde* (1820–36), which served not only as records, but images to promote the virtues of a national school.

Haskell, F., *The Painful Birth of the Art Book* (1987).

5. Technical treatises

ALTHOUGH technical guides to printmaking formed a part of some books in the 16th century it was the publication of the engraver Abraham *Bosse's book *Traité des manières de graver* (1645) that launched a tradition of detailed technical recipe books, which were very important in spreading a knowledge of printmaking across Europe. A slightly shortened translation of this, *The Art of Graveing and Etching* (1662), was written by the English engraver William Faithorne. Such works contained engraved illustrations showing tools and methods, and described the various subtleties of stopping out, biting, the composition of acid, and other details. As different techniques developed so were books published describing them, frequently with such success that they appeared in several editions. Perhaps the most celebrated and important technical and historical book in the English language is John Evelyn's *Sculptura* (1662 and subsequent editions), which describes the new method of *mezzotint as practised by Prince Rupert, and includes one of his own mezzotints, the *Small Head of an Executioner*, after a painting then attributed to *Ribera. Later books describing developing techniques of mezzotint include J. C. Le Blon's *Coloritto* (c.1723), which describes his revolutionary method of printing in colour, and *The Handmaid to the Arts* (1758) by Robert Dossie, which is also very illuminating on other techniques.

*Woodcut and *wood engraving were described in several books, perhaps the most interesting being John Baptist Jackson's *Essay on the Invention of Engraving in Chiaroscuro* (1754), a self-advertising text that describes his elaborate method of printing from several blocks. An epic technical and historical work is John Jackson's *Treatise on Wood Engraving* (1839).

The most important book on early *lithography is *A Complete Course of Lithography* (1819) by Frederic von Schlichtegroll (English translation 1819), which is especially important for its description of the work of Aloys Senefelder, the inventor of lithography.

Twentieth-century books on printmaking techniques are legion, but a particularly influential work was *New Ways of Gravure* (1955) by Stanley William Hayter (1901–88), which extols the virtues of continual experimentation.

RGo

Levis, H. C., *A Descriptive Bibliography of the Most Important Books in the English Language Relating to the Art and History of Engraving* (1912).

PROCESS ART, a movement which emerged mainly in the USA and Britain in the 1960s. Its function was to demonstrate the effects on certain objects of a variety of natural and artificial processes, such as burning, melting, and organic decomposition. Early exponents of such art include: Peter Dockley (1942–), whose *Wax Event* (1971) used empty shop premises to show gradually melting wax figures which, containing food, were then eaten by rats; Hans Haacke (1936–), who made photographic records of grass growing in *Grass Cube* (1967) and of the self-explanatory *Chickens Hatching* (1969); Allan Kaprow (1927–); Gustav Metzger (1926–); and Dennis Oppenheim (1938–). The extremely wide range of materials used in Process art means that it has often overlapped with other types. *Spiral Jetty* (1970) by Robert *Smithson, although commonly categorized as *Land art, can be interpreted as

Process art in its anticipation of eventual submersion. In locating both the purpose and aesthetic elements of a work of art within its gradual disintegration, Process art offered a rejection of the commodification of art objects by rendering them impossible to own; it may thus be regarded as a form of *Conceptual art. OPa

Fig. 42. Plato's Five Regular Solids

PROPORTION (1) Introduction; (2) Canons of proportion

1. INTRODUCTION

The idea of proportion derives from that of ratio, which is the simple quantitative comparison between two things of the same kind. In its most general sense proportion is the measure of relative quantity; in its mathematical sense it is a similitude or equivalence of two or more ratios. True proportion therefore necessarily involves at least three terms. Several types of mathematical proportion are distinguished, the best known of which are geometric, arithmetic, and harmonic proportion. All types have the essential characteristic that each successive ratio is linked to the next by a constant ratio which is common to the whole sequence (called the analogical invariant). Thus a mathematical proportion exemplifies the principle of unity amongst a variety of ratios by virtue of a constant ratio which makes them all analogous.

When associated with ideas of beauty 'proportion' usually refers to a harmonic relationship among the parts and between any part and the whole of an object, such as a building or a body. It has often been linked with the notion of cosmic harmony. Thus when *Leonardo wrote (Trattato 32) that the beauty of a beautiful face consists in 'the divine proportionality in the composition of its members', he was thinking in terms of a universal harmony of which proportion in particular things is an intellectually apprehensible reflection. This sort of view was general, though not unopposed or alone in the field, until it gave way to a more subjective conception in the 17th and 18th centuries. Thus Plotinus, for example, said that: 'Practically everybody asserts that visible beauty is produced by symmetry of the parts towards each other and towards the whole' (Enneads, 1. 6). He himself, however, refutes this view on the ground that if beauty consists in the proportion of the parts, the simple parts of a beautiful object cannot themselves be beautiful; and this he is not prepared to accept. Furthermore he argues that the idea of proportion cannot be extended to moral and intellectual beauty. Thomas Aquinas (c.1225–74) names 'due proportion or harmony' as one of the three ingredients necessary to beauty (Summa theologiae). And the cosmic or theological extension given to the mathematical idea of proportion is evident in the following scholastic definition of the

Trinity as 'Three Persons co-ordinate in a marvellous harmony, the Son being the image of the Father and the Holy Ghost the link between them' (Ulrich Engelbert, De pulchro). *Alberti, who believed that beauty depended on a rational order, nevertheless admitted that 'there are some who . . . say that men are guided by a variety of opinions in the judgement of beauty . . . and that the forms of structures must vary according to every man's particular taste'. *Dürer, who worked out more systems of proportion than any other great artist, tells how in his youth he heard of a canon of ideal human proportion from Jacopo de' *Barbari and from this and Vitruvius (1st century BC) set himself to work out the ideal canon.

Evidence of the change from an objective idea of mathematical beauty to a subjective notion of beauty based upon feeling and sentiment is to be found, for example, in The Principles of Painting (1708; English trans. 1743) by de *Piles, where he writes: 'But according to general opinion there is no definition of the beautiful: Beauty they say is nothing real; everyone judges of it according to his own taste, and 'tis nothing but what pleases.' *Burke in his Philosophical Enquiry (1756) prefaces his detailed attack on the 'proportion' theory of beauty by defining beauty (in contrast to the intellectualist notions which had been general until his time) as the quality or qualities in things which cause 'that satisfaction which arises to the mind upon contemplating anything beautiful'. He rejects proportion as the source of beauty on the ground that it is 'a creature of the understanding, rather than a primary cause acting on the senses and imagination'. A new idea of beauty, based on feeling and the senses, has been substituted in his definitions. Though the subjective conception of beauty has prevailed, the idea that the cause of the special sort of satisfaction which a beautiful thing imparts may reside in its proportions has still not finally disappeared.

The origin of theory of proportion is traditionally ascribed to the Pythagorean philosophers of the 6th century BC, who saw in the tuning of the musical scales the unity of variety and the agreement of opposites. The Pythagoreans are said to have been the first to make the famous experiment which showed that if a resonant string is stopped at half its length and sounded, it produces a note an octave higher than that given off by the

whole string, that two-thirds of the string gives the fifth and three-quarters the fourth. Thus the principal aural consonances were shown to be linked with the first four numbers and the three main intervals to be expressible by the three types of proportion or 'means' known to them, namely the arithmetic (in which each term is greater than its predecessor by the same amount, as $1:2:3:4$), the geometric (which they called proportion par excellence and which is an equivalence of two or more ratios, as $1:2::2:4$), and the more subtle harmonic proportion (in which three terms are so related that the two extremes are separated from the mean by the same fraction of their own quantity, as $6:8:12$).

The Pythagoreans, conceiving numbers spatially (e.g. 4 as the square, 3 as the triangle, etc.), believed number to be the origin of all things and that forms, or the heavenly shapes and essences of things, are numbers or ratios of numbers. They were not, however, able to cope with incommensurable relationships, such as that of the diagonal to the side of the square, and it was *Plato who, in the cosmological system developed in the Timaeus, succeeded by his theory of the Five Regular Solids (Fig. 42) in incorporating the irrationals into the ultimate elements of which the cosmos is constructed. For although an infinite number of regular polygons may be postulated in the two-dimensional plane, only five regular figures exist in three-dimensional space. These were called by Plato the most perfect bodies and he invested them with cosmological significance. The first four solids, tetrahedron etc., formed the 'atoms' of the four elements, fire, water, earth, and air. God fashioned them out of primordial chaos 'by form and number' and made them as far as possible the 'fairest and best'. The fifth solid (the solid composed of twelve regular pentagons which subsequently acquired heavenly connotations) gave form to the cosmos: 'There was yet a fifth combination which God used in the delineation of the heavens.' In order to unite these different elements into one harmonious whole God used proportion, for 'the fairest bond is that which makes the most complete fusion of itself and the things which it combines; and proportion is best adapted to effect such a union'. Thus 'the body of the world was created, and it was harmonized by proportion, and therefore

has the spirit of friendship'. But before making the visible and tangible world in this way God created the 'world soul'. First out of the indivisible and the divisible (symbolized by the Pythagoreans by the first two integers) he created an essence. 'When he had mingled them with the essence and out of the three made one, he then divided the whole into as many portions as was fitting' according to the proportions of the Pythagorean Tetractys and Diatonic scale (Fig. 43). Thus 'the soul partakes of reason and harmony'.

Fig. 43. The Pythagorean Tetractys

The influence of Plato's cosmological myth continued into the Middle Ages mainly through Roman writers (Cicero, Seneca, Boethius) or through Byzantine and Arab sources. Most medieval libraries of any standing possessed a copy of Chalcidius' Latin version of the *Timaeus* made about AD 350 (which however stops at the section on the geometrical figures). Another work of great importance for theory of proportion, as for mathematics in general, was Euclid's *Elements*, which appeared shortly after Plato's death and was a product of his school. It first became accessible to the West through a Latin translation made in the 12th century and it is sometimes supposed that this is reflected in the geometrical designs of *Gothic cathedrals. In the systems of proportion which arose during the *Renaissance Pythagoras and Plato are constantly quoted as

Fig. 44. Kepler's solar system based on an arrangement of the five Platonic solids. From his *Mysterium cosmographicum* (1596)

authorities, and the persistence of the Platonic habit of thought may be seen even in Kepler (1571–1630), the founder of modern astronomy (Fig. 44). Kepler wrote: 'Nature loves these proportions in everything which is capable of proportion, so does the human understanding love them which is the image of the Creator.' Moreover the association of proportion with mathematics was kept alive by the place held by theory of music in the *quadrivium* of liberal arts throughout the Middle Ages, which received a new impetus from the humanist movement of the Renaissance. The analogy between musical harmony and proportion in the visual arts was assumed on a philosophical and mystical level, as in the following words of Alberti (*De re aedificatoria*): 'the same numbers, by means of which the agreement of sounds affects our ears with delight, are the very same which please our eyes and mind. And therefore we shall borrow all our rules for the finishing our proportions from musicians, who are the greatest masters of this sort of numbers.' The fusion of the practical with the metaphysical was assisted by new discoveries in *perspective which showed that Pythagoreo-Platonic harmonies exist in optical space. By the early 16th century proportionality had become a catchword. As *Panofsky observed: 'the proportions of the human body were praised as a visual realization of musical harmony, they were reduced to general arithmetical or geometrical principles, they were connected with various classical gods. *Filarete, Luca Pacioli (see GOLDEN SECTION), and *Lomazzo were among the many who discussed proportion in this spirit.

2. CANONS OF PROPORTION
The object of a canon of human (or animal) proportions is to establish an ideal of a beautiful body whether in nature or in artistic reproduction. The aesthetic assumption implicit in the use of such canons in classical Antiquity, diametrically opposed to the aesthetic outlook of the 20th/21st centuries, is that by exactly reproducing the proportions of a beautiful living body and transferring them to stone or bronze (with some compensation in certain cases for distortions of optical perspective) the artist will produce a beautiful work of art. This assumption is present even in Isaiah (44: 13): 'The carpenter stretcheth out his rule; he marketh it [the image] out with a line; he fitteth it with planes and he marketh it out with the compass, and marketh it after the figure of a man according to the beauty of a man.'

The first canons of which we have any exact knowledge are those of Egyptian art. Effigies, which were to be dwelling places for the spirits of the dead, had to be made according to certain proportions. Their purpose was purely constructional. All the

craftsman needed to know was the mechanical rules governing the relationship between the grid and the human body; that is, in which squares the different parts of the body were fixed. Diodorus Siculus describes how two sculptors using the Egyptian method were able to work on separate parts of the same statue, one in Samos and one in Ephesus, and nevertheless secure that the parts fitted so perfectly when brought together that they seemed to have been made by one man.

The influence of the Egyptian method is probably to be seen in Archaic Greek sculpture (see GREEK ART, ANCIENT), but in the 5th century BC, when statues began to show organic movement, the Egyptian system would no longer suffice. The Greeks had a natural bias towards mathematical modes of thought and it is traditionally maintained that they evolved various canons of proportion. The purpose of these must have been simply to provide a scale of the comparative measurements of a normal or a beautiful figure, to be used as a point of departure for the innumerable variations produced by movement. This being so, it is impossible to gain exact information about the Greek canons by measuring the works themselves. We can only infer their general nature from the references in ancient literature. In a key passage Galen (AD 130–200) (*Usefulness of the Parts of the Body*) describes the so-called *Canon* (manual) of *Polyclitus: 'Chrysippus . . . holds that beauty does not consist in the elements but in the harmonious proportion of the parts, the proportion of one finger to the other, of all the fingers to the rest of the hand, . . . in fine, of all parts to all others, as it is written in the canon of Polyclitus.' Unfortunately the interpretation of this passage is obscure. Some have taken it to mean that the proportions of the body (or statue) were expressed in terms of a module which was itself a part of the body. This accords with Vitruvius, the only ancient writer who has recorded actual data regarding ideal proportions of the human body. He formulates them as common fractions of the length of the figure: for instance the face from hairline to chin is one-tenth of the total height. But a module expressed in terms of a part of the figure has no more aesthetic significance than a module expressed in terms of inches or centimetres, and the adjustments made by the Greeks for movement would have been made by eye and were not inherent in the canon. On the other hand the language of Chrysippus is consistent with the view that the canon was a true proportion, i.e. a relation among ratios, and laid down a common or similar relation of parts to parts and to the whole. Such a canon might have aesthetic significance, as ancient writers asserted, as helping to ensure an organic unity among the parts and in the whole.

As the Roman Empire declined the classical ideal of naturalistic beauty was abandoned. Late pagan and *early Christian art adapted classical models to easily recognizable images whose symbolic function was best served by schematic formulas. But even in this flat and schematic art some simple rule of thumb was useful. Two such schemes are known, the *Byzantine and the *Gothic. Of the two the Byzantine was nearer to the classical tradition, for it broadly recognized the articulation of the limbs and their relative proportions in nature. Details of it are recorded in the *Painter's Manual of Mount Athos*, which has come down in an 18th-century edition, and similar proportions are given in *Il libro dell'arte* of Cennino *Cennini, written in the 1390s and deriving from the Byzantine tradition. The Byzantine canon was not an aid to the appreciation of human proportions, but rather a simple practical routine in which the proportions of nature had been modified to fit into a scale of measurements. Simple units were multiplied, such as the length of the nose (for the head) or the length of the face (for the whole figure). This system is easily traceable in heads done in the Byzantine tradition. The frontal view of a head with its halo was proportioned by means of three circles having a common centre at the root of the nose (Fig. 45). The innermost circle, with a radius of one

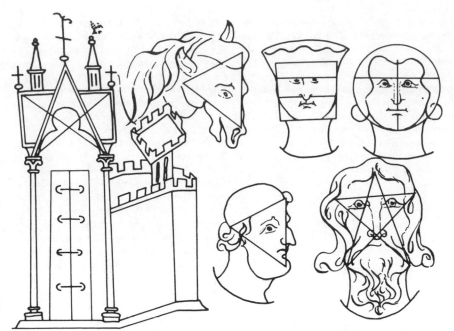

Fig. 46. Rule-of-thumb precepts of proportion from the sketch book of Villard d'Honnecourt

Fig. 45. Byzantine scheme of proportion for representing head with halo

nose-length, gave the tip of the nose and the top of the forehead; the next circle, with a radius of two nose-lengths, gave the outline of the hair; and the outermost circle, with three nose-lengths, gave the outline of the halo. Obviously the representation of foreshortening or natural movement would be restricted by such a method.

The Gothic system was not concerned with relative measurements, and it practically ignored the structure of the body, limiting itself

almost exclusively to determining the outlines and the directions of movement. A unique record of it has been handed down in the notebooks of the French architect *Villard de Honnecourt, whose sketchbook (written between 1243 and 1251) provided the artist with handy geometrical aids 'pour légèrement ouvrier', such as would help him to draw animal and human heads and figures (Fig. 46). Villard's system is not a modular system or even metrical: the measurements are to be supplied by the artist to suit the task in hand. The late Gothic artists of the 14th and 15th centuries seem to have rejected constructional aids altogether. The trend was towards movement and *naturalism, and they relied more and more on observation and personal judgement.

The intense interest in proportion during the *Renaissance led many artists of the 15th and 16th centuries to devise canons for the figure. In Florence the artists of the new movement, led by *Brunelleschi, saw themselves as the heirs of classical Antiquity and sought to rival it not so much by direct imitation of Antique remains as by an attempt to understand the principles underlying the classical ideal. With this purpose in view they made measurements of ancient statues in Rome, and in their search for a rational basis for beautiful forms they applied the same scientific method to living models. The first notable canon was the product of *Alberti's ingenious system of measurement which he called *Exempeda*. He divided the whole length of the figure into 600 *minuta*. This gave him an accurate and practical scale for making and recording measurements, and his canon, recorded in his treatise on sculpture (1464), was the result of measuring

a considerable number of persons. *Leonardo produced tables and analyses of equine as well as human forms. He also broke entirely new ground by investigating the *anatomical processes by which the dimensions of the body are altered in movement. Both he and *Piero della Francesca studied proportion in relation to perspective. *Dürer, the first artist in the North to take up these studies, was obsessed throughout his life by the search for ideal proportion. He not only prepared a treatise on human proportions but produced more systems than any other great artist; indeed he carried his interest so far beyond the bounds of artistic usefulness that his researches, like some of Leonardo's, may rather be seen as the beginnings of such sciences as anthropometry and biometry.

Though the High Renaissance exploited the classical canons in one way or another, it was inherent in the precepts of *Mannerism to disregard them. Nevertheless the *academies, from the late 16th century onwards, taught canons of proportion, together with perspective, as part of the discipline of *drawing. Books of engravings for the edification of students were published which not only reproduced all the most famous classical statues but also gave a careful analysis of their proportions. Their purpose was to familiarize the young artist with correctly drawn figures so that he would no longer need to construct them mathematically. With *Romanticism the artist's individual conception rather than a universal ideal became the subject of the work of art, and therefore systems of any kind were looked upon with abhorrence as obstructions to the creative urge. Nevertheless vestiges of the traditional

canons survived: students of drawing were still taught to relate forms—for instance the size of hands to that of heads—and many of the books on 'how to draw' give rudimentary rules of proportion.

In modern times some artists and aestheticians have revived an interest in mathematical principles of proportion which were neglected through the Romantic period. Artists have usually tried to apply proportion directly to the construction of a picture rather than to the natural objects to be reproduced in the work of art. Interest in principles and theories of proportion has not been restricted to *abstract artists such as *Kandinsky or *Mondrian but has been shown by many others, as for example Giorgio *de Chirico and the *Orphists. It is no longer generally believed that anything of use to the creative artist is likely to result from investigations into historical theories of proportion apart from a reaffirmation of the general principles of design expressed in terms of unity, variety, and balance. But it is accepted that 'a sense of proportion'—in some meaning of the term—is one of the artist's most important assets. On the other hand much work on the mathematical aspects of organic forms, and forms in crystallography and molecular physics, has stimulated a widespread interest in new sorts of analogy between artistic form and the natural forms in which the modern scientist is interested with common features of proportion in both. HO

de Sausmarez, M., *Basic Design: The Dynamics of Visual Form* (1964).
Ivins. W. M., *Art and Geometry* (1946).
Wehl, H., *Symmetry* (1952).
Whyte, L. (ed.), *Aspects of Form* (1951).

PROUST, MARCEL (1871–1922). French novelist, author of *A la recherche du temps perdu*, published 1913 to 1927. Proust's grasp of the visual arts is reflected in the wide range of references throughout the novel, often at key points (e.g. the death of the writer Bergotte while gazing at 'the little patch of yellow wall' in *Vermeer's *View of Delft* (c.1658; The Hague, Mauritshuis)). The idea of artistic creation regaining lost time is, indeed, one of the major axes around which the great work revolves, and it contains many interrelated meditations on creativity in the contexts of music, painting, and literature. The art of painting is personified by the character Elstir who owes most to *Monet and (as his name indicates) to *Whistler, but who also shows traces of *Manet, *Degas, Paul Helleu, *Moreau, and other late 19th-century French painters. Proust's descriptions of Elstir's paintings whose 'charm lay in a sort of metamorphosis of the things represented in them, analogous to what in poetry we call metaphor' are, in fact, the most deeply felt and keenly penetrating analyses that have been

written on late *Impressionist painting (*Within a Budding Grove*, part 2, trans. C. K. Scott Moncrieff, 1924). AJL

Butor, M., *Les Œuvres d'art imaginaires chez Proust* (1963).

PROVOST, JAN (c.1465–1529/32). South Netherlandish painter born in Bergen-Mons in the Hainaut. He came into contact with Simon *Marmion, painter and illuminator from Valenciennes, whose widow he married before 1491. In 1493 he became a master in the Antwerp guild, but in the next year he moved to Bruges, where he spent the rest of his life. Provost's work shows the influence of northern French painting in its precision and soft colouring and of Antwerp, specifically of Quentin *Massys. He was iconographically inventive, as is clear from the various versions of the *Last Judgement* of which the finest is the one commissioned for the council chamber of the town hall (1525; Bruges, Groeningemus.; the ornamental frame, still partly original, may have been designed by Lancelot *Blondeel). Both Provost and Blondeel introduced a new spirit to their respective generations in Bruges. They also worked as cartographers, engineers, and architects, making them early exponents of the universality that typified the age of *humanism. In 1520 Provost met *Dürer in Antwerp and was his host the following year in Bruges. KLB

Martens, M. P. J. (ed.), *Bruges and the Renaissance: Memling to Pourbus*, exhib. cat. 1998 (Bruges, Memlingmus.).

PRUD'HON, PIERRE-PAUL (1758–1823). French painter and draughtsman who modified the robust *Neoclassicism of *David and his followers with a Rousseauist (see ROUSSEAU, JEAN-JACQUES) sentiment in his subjects and a soft chiaroscuro in his facture inspired by *Leonardo and *Correggio. Much of his output consisted of large-scale decorative projects, including two ceilings for the Louvre (*Study Guiding the Flight of Genius*, 1801, is one). He also contributed, less happily, to the patriotic modern history subjects demanded by Napoleon. His most famous subject picture is the sinister but effective *Justice and Divine Vengeance Pursuing Crime* (1808; Paris, Louvre), painted for the Palais de Justice in Paris. His less public paintings include the gentle and poetic *Venus and Adonis* (1812; London, Wallace Coll.), while his late *Crucifixion* (1822; Paris, Louvre), painted for Metz Cathedral, has been described as one of the great religious masterpieces of the 19th century. Most attractive to modern taste are Prud'hon's portraits. These range from the fresh and naturalistic *Mme Anthony and her Children* (1796; Lyon, Mus. des Beaux-Arts) to his yearning and Romantic portrayal of *Empress Josephine* seated on a rock in the woods at

Malmaison (1805; Paris, Louvre). He prepared his work with numerous black and white chalk drawings on coloured paper. It is, perhaps, in these rather than in the paintings, many of which have darkened because of the unstable mixture of drying agents that he used, that both the strength of his imagination and the delicacy of his style can best be appreciated. MJ

Grappe, G., *P.-P. Prud'hon* (1958).

PRYDE, JAMES (1866–1941). Scottish-born painter and designer. Pryde, who was born in Edinburgh, studied at the Royal Scottish Academy School and, briefly, under *Bouguereau in Paris. In 1893 he collaborated with his brother-in-law William *Nicholson, designing posters under the pseudonym of the Beggarstaff Brothers. Their work, which relied upon *papier coupé for its strong silhouettes and simplified forms, owed a debt to French designers. During their brief partnership (1894–6) they designed posters for Henry Irving including the influential *Don Quixote* (1895; London, V&A). After a short dalliance with acting, in Gordon Craig's Company in 1895, Pryde resumed painting and in 1905, with *The Murder House*, established his characteristic style. His subjects, whether decaying architectural fantasies (*The Slum*, Oxford, Ashmolean), menacing ragged beggars (*The Untouchables*, 1929–40; York, AG), or deserted gloomy interiors usually dominated by a vast four-poster, were macabre and sinister. A strong element of the theatrical pervades his work in both theme and technique, for they resemble stage sets, and the relationship with Craig (1872–1966), who was himself a designer, was probably one of mutual influence. He ceased painting c.1929.

DER

Hudson, D., *James Pryde* (1949).

PSALTER, a book containing the 150 Psalms of the Old Testament which praise the Lord and ask for his mercy. Psalters were extremely popular from the 12th to the 14th centuries and were used by the laity as well as the clergy; they were the most popular book used for private devotion before the books of hours. Psalters are used in the divine office and are divided into eight sections in accordance with the Benedictine rule that monks must recite the Psalms in full every week. In a psalter the Psalms are often preceded by a calendar and contain ancillary texts such as canticles, creeds, a litany of saints, and other individual prayers, hymns, and occasionally even the hours of the Virgin. As the Psalms have no obvious narrative, the text did not adapt easily for illustration and illustrative cycles vary greatly from manuscript to manuscript. Full-page miniatures may be placed between the Psalms and the calendar. The earliest extant psalter

illustration dates from the 8th century and features a picture of King David, the author of the Psalms (London, BL, Cotton MS Vespasian A. I). Such prefatory pictures of David or Christ were later expanded into series of Old and New Testament scenes, for example in the S. Albans Psalter (c.1120; Hildesheim Cathedral) and the Queen Mary Psalter (c.1310–35; London, BL, Royal MS 2. B. VII). Cycles of the life of the Virgin, Christ, or of David also appear frequently. In the 12th century an illustrative cycle was developed in England in which historiated initials headed each one of the eight sections of the text (Psalms 1, 26, 38, 52, 68, 80, 97, 104 of Vulgate). This scheme became standard by the following century. During the 14th century, after which its popularity as a personal devotional tool declined, the decoration expanded out of the initial to cover the margins of the page and often featured fantastical drolleries (c.1350; Oxford, Bodleian Lib., MS Liturg. 198). KC

Hamel, C. de, *A History of Illuminated Manuscripts* (1986).

Sandler, L. F., *The Psalter of Robert de Lisle in the British Library* (1983).

PSYCHEDELIC ART, a form of art which emerged in the mid-1960s, characterized by intense, swirling patterns and the use of bright, often sharply contrasting colours. This style was intended to duplicate and complement the effects of hallucinogenic drugs such as LSD; it was usually created specifically for posters advertising rock concerts, and might therefore be more precisely categorized as a type of graphic design. The invention of offset lithography—which enabled multicoloured prints to be produced very cheaply—was important in defining the style of such images. Prominent among early exponents of Psychedelic art were Michael English (1943–) and Martin Sharp (1945–), both of whom contributed regularly to the underground magazines *It* and *Oz*. The paintings of *Op artists like Bridget *Riley and Victor *Vasarely, although often sharing identical formal characteristics with Psychedelic art, have generally been interpreted purely as experiments with optical effects, rather than with those of drugs. Psychedelic art was to a large extent dependent on the cultural atmosphere of the late 1960s. Its production declined steadily throughout the 1970s, and by the early 1980s it had ceased to exist. OPa

PUBLIC WORKS OF ART PROJECT. See FEDERAL ART PROJECT.

PUCELLE, JEAN (active by 1319, d. 1334). French illuminator and designer. He is first documented in accounts of the confraternity of the Hôpital de S. Jacques-aux-Pèlerins in Paris (1319–24), for which he designed the great seal (known from an engraving). His name next appears in a breviary made for Jeanne de Belleville (1323–6; Paris, Bib. Nat.), though it is unclear whether he himself contributed to it, or was only responsible for organizing others (three are named in the manuscript) to undertake the decorative programme, in the devising of which he probably played some part. The Byllying Bible (1327; Paris, Bib. Nat), named after its scribe, unambiguously refers to Pucelle as its illuminator, though since two others are mentioned, his precise contribution is unclear. That Pucelle was a celebrated artist is suggested from records of his name in documents post-dating his death. Indeed he is perhaps the earliest north European painter to have had a reputation which significantly outlasted his lifetime. Thus the will of Queen Jeanne d'Évreux (d. 1371) mentions a very small book of hours 'that Pucelle illuminated', bequeathed to Charles V, and subsequently prized by the Duke of Berry (d. 1416). This most refined of manuscripts, probably made for Jeanne during her marriage to Charles IV (1325–8; New York, Met. Mus. Cloisters), gives a reliable indication of the characteristics which made him so admired until c.1410 and has formed the basis of further attributions, suggesting his particular popularity with female members of the French royal family. Its minute scale and delicate draughtsmanship show an exceptional brilliance, especially eye-catching through his development of a monochrome technique for modelling (grisaille). Although the elegant figure style derives from French traditions, his lively compositions owe much to Sienese art (particularly *Duccio), presumably seen during an undocumented trip to Italy c.1320. This experience enabled him to introduce for the first time in French illumination a convincing sense of space in architectural settings. His page layout, featuring large miniatures for sacred scenes and imagery derived from secular sources for margins and *bas-de-pages*, made a lasting impression: drolleries by him were still being copied into the Duke of Berry's *Grandes Heures* c.1409 (Paris, Bib. Nat. MS lat. 919). Other iconographic innovations—his juxtaposition of infancy scenes with those from the Passion, the sophisticated programme of images associated with him in the Belleville Breviary, and his introduction of carefully observed birds, insects, and plants into the borders of the same manuscript—contributed to the appeal of his work and the degree of his influence on later generations. TT

Morand, K., *Jean Pucelle* (1962).

Sterling, C., *La Peinture médiévale à Paris* (1987).

PUGET, PIERRE (1620–94). French sculptor, painter, and architect. His bust faces that of Nicolas *Poussin at the entrance to the École des Beaux-Arts, *Paris, tribute to his position as the greatest sculptor of 17th-century France. Like Poussin, most of Puget's career unrolled away from the French court and his few direct contacts with it were antagonistic or disappointing. Born in Marseilles, he worked for Pietro da *Cortona in Rome and Florence before taking a post as a ship's decorator in the naval yards at Toulon. By the 1650s he was well known as a sculptor and as a painter of altarpieces in Toulon, Marseilles, and Aix-en-Provence. Puget's magnificent stone portal for the Toulon Town Hall (1656–7; now at the Mus. Naval), with its balcony supported by struggling male torsos, provided a model for many similar doorways throughout Provence. In the 1660s and 1670s he divided his time between Provence and Genoa, where a number of his more flamboyant works remain, including a statue of *The Blessed Alessandro Sauli* (S. Maria Assunta di Carignano). The marble statue of the *Gallic Hercules* (1663–8; Paris, Louvre) was bought by Louis XIV's minister Colbert. Loosely based on the *Ludovisi Mars* (Rome, Mus. delle Terme) it is Puget's most classical work. Thereafter he reverted to a robust Italian *Baroque-inspired style that found little favour at court. He was not helped to obtain royal commissions by his difficult and demanding personality. Such works as the marble groups *Milo of Crotona Attacked by a Lion* (1670–82) and *Perseus Freeing Andromeda* (1675–84), both in the Louvre, are among the most vigorous and original sculptures of the 17th century. But although the Crown was eventually persuaded to buy them they were installed in remote parts of the park at *Versailles, and Puget's last years were overshadowed by his attempts to obtain payment for them. His architectural works include the Hospice de la Charité at Marseilles. Puget's paintings, such as the *Salvator Mundi* of 1655 in the Musée des Beaux-Arts, Marseille, though reminiscent of both Pietro da Cortona and the young *Guercino, have a distinctive character with their thick and aggressive brushwork and dark palette. Like his sculpture they were far from the mainstream of court painting, but proved very influential throughout Provence. MJ

Gloton, M.-C., *Pierre et François Puget, peintres baroques* (1985).

Herding, K., *Pierre Puget* (1970).

Walton, G., *The Sculpture of Pierre Puget* (1967).

PULPIT (Latin *pulpitum*: platform). Raised platform for the preaching of sermons; it is surrounded by a parapet and reached by steps or stairs. Early Christian churches had no pulpits other than the ambos where scriptures could be read. In the later Middle

Ages, when services regularly included sermons, the pulpit came into use distinct from the ambo. Either free standing or attached to a northern nave pier, pulpits were made of a variety of materials. In Italy stone and marble, in northern Europe painted sandstone, in England limestone and alabaster were popular. Several pulpits of precious metal encrusted with gems still exist, such as *Nicholas of Verdun's panels for the Klosterneuburg Abbey pulpit (1181; Klosterneuburg Abbey, near Vienna). One of the oldest surviving examples is the pulpit of S. Ambrogio, Milan (c.1130; in situ). Not only do many of Italy's pulpits still survive, but they also influenced Spanish and Portuguese designs. In the 12th century pulpits were generally rectangular, and decorated with carvings of the symbols of the Evangelists. The most remarkable and influential group of Italian pulpits are those produced by the sculptors Nicola and Giovanni *Pisano, this splendid series of free-standing, iconographically rich polygonal pulpits featured Gospel scenes in high relief (1260; Pisa baptistery; 1302–10; Pisa Cathedral; c.1298–1300; Pistoia, S. Andrea). The caskets of these pulpits are supported by columns resting on lions' backs, often with grouped figures around the base. As preachers sometimes addressed great crowds in the open air, certain pulpits were designed for exterior use, such as *Donatello's pulpit for the west façade of Prato Cathedral (1434–8). The life of Christ and Passion cycles were the most common, but not the only, subjects depicted. Benedetto da *Maiano's pulpit in S. Croce, Florence (1485; in situ), displays scenes from the life of S. Francis, whilst Donatello's Prato pulpit features dancing, singing, and playing putti. The Counter-Reformation led to a renewed emphasis on the pulpit, since the new orders such as the Jesuits laid great stress on preaching. Examples from the 17th and 18th centuries follow the general trend of interior decoration, but a special development took place in Flanders, where lavishly sculpted wooden pulpits combining trees with figures and a wide sounding board with flying angels were made for many churches (1659 40; Lier, S. Gummaruskerk). Elaborate pulpits, carved and gilt, and enriched with figure sculpture in stucco, also appear in the *Rococo churches of southern Germany such as the pulpit of Vierzehnheiligen (c.1748; Vierzehnheiligen, near Banz). The paramount importance of preaching in the Reformed churches had its own impact on pulpits and in the Lutheran churches of Holland the pulpit rather than the aisle was the dominant feature of the interior. Such pulpits were always of wood and were, of course, without religious imagery; for example Pieter Cornelisz. Kunst's (see under ENGELBRECHTSZ., CORNELIS) pulpit in Leiden (c.1515; Leiden, S. Pieterskerk). Their English counterparts, however, especially in Wren's churches, have decorative carving (c.1675; London, S. Magnus the Martyr). KC

Cox, J. C., Pulpits, Lecterns and Organs (1915).
Poscharsky, P., Die Kanzel, Erscheinungsform in Protestantismus bis zu Ende des Barock (1963).
Randall, G., Church Furnishings and Decoration in England and Wales (1980).

PURBECK MARBLE, a limestone formed from densely packed fossil water-snail shells, which can be very highly polished. The seams are found only on the south range of the Purbeck hills in Dorset. It was initially used in the 12th century as a substitute for Tournai marble, but during the 13th century its decorative potential was realized; it was widely used throughout England, both for architectural details (notably at Westminster Abbey) and for tomb effigies, including the first royal *tomb in England, that of King John in Worcester Cathedral. The coastal location of the quarries at Corfe meant that large-scale items such as columns and capital could be supplied direct by sea, although London soon became a major distribution centre. Marble was delivered there by the shipload, cut, and redistributed. Increase in demand, however, and the considerable skill required to cut the marble led eventually to it being replaced by cheaper materials. Its continued use was confined largely to the monumental brass trade which was controlled by the marblers' guild until well into the 16th century. AS

Stone, L., Sculpture in Britain: The Middle Ages (1972).

PURISM, a movement launched in France in 1918 with the book and exhibition Après le Cubisme. Its authors, the painter Amédée *Ozenfant and painter and architect *Le Corbusier, saw *Cubism as having failed to arrive at its logical conclusions, which they aimed to deliver. Their ambitious project for the construction of a co-operative epoch of order was highly classical and puritanical in tone. Clarity and objectivity were their theme, and they championed the intellect, precision, and the beauty of functional efficiency. However, despite a revolutionary tervour in their proclamations they rejected the extremism of the comparable movements, including De *Stijl and *Constructivism. They cast their functionalism in humanist terms and it was in this light that their still lifes depicted simple objects such as glasses and bottles, which they felt acted in harmony with man (these they termed 'objet types'). They also saw paintings as important in terms of utility, in fulfilling a basic human need for art which must appeal to the senses. However, colour was always subordinated to line to safeguard the integrity of forms, which retain a clarity lacking in Cubist fragmentation. It was only effectively through Le Corbusier's architecture that the movement's aims gained international recognition. The movement lasted seven years (1918–25), its demise coinciding with that of its journal, L'Esprit nouveau. MF

Green, C., Cubism and its Enemies (1987).

PUTTO, an Italian word for 'boy' used to refer to the chubby, naked infants—often winged—that were widely used in Roman art and were revived in the Italian *Renaissance. The iconographic significance of putti depends on their context, but the two main connotations, both in classical and modern times, are those of angelic or divine spirit and harbinger of profane love. Early Christians adopted the putto as the type of angel in catacomb painting and sarcophagi, but in the Middle Ages angels were depicted as grown figures. The putto reappeared very early in the Renaissance, as in those holding garlands on the sarcophagus of Jacopo della *Quercia's monument to Ilaria del Carretto (1406; Lucca Cathedral) and it became conventional until the end of the *Rococo period both as attendant angel and as personification of erotic love. *Titian's Worship of Venus (1518–19; Madrid, Prado) is a faithful depiction of the Erotes, in the form of putti, described by *Philostratus in the sixth book of the Immagini. In the 17th century *Duquesnoy was renowned for his reliefs of putti, as in the Vryburgh memorial slab (1628–9; Rome, S. Maria dell'Anima). AJL

PUVIS DE CHAVANNES, PIERRE (1824–98). French painter, born in Lyon. Convalescing in Florence in 1846 he determined to become a painter and studied briefly under *Delacroix and *Couture in 1847 before returning to Italy. Inspired by Italian masters and Théodore *Chassériau he decided to become a muralist, painting on canvas, later fixed to the wall, rather than in fresco. He developed a personal style characterized by economy of line, pale colour, and simplicity of composition and achieved considerable success with decorative schemes including the Childhood of S. Genevieve (1874–8; Paris, Pantheon). Puvis's smaller works met a mixed reception and it was not until the 1880s that his easel paintings were truly appreciated and hailed as *Symbolist by, among others, Joséphin Péladan (1859–1918). Despite attempts to distance himself from Symbolism, Puvis became a hero to *Seurat, *Signac, and *Gauguin in the 1890s and works like The Poor Fisherman (1881; Paris, Louvre), initially dismissed as ugly and naive, were critically reassessed and praised for their powerful and symbolic imagery, thus vindicating his claim to paint subjects 'not from Nature but parallel to Nature'. DER

d'Argencourt, L., and Foucart, J., Puvis de Chavannes (1976).

PYNACKER, ADAM (1622–73). An elegant Dutch landscape painter, who principally worked in the Netherlands, but fell under the spell of Italy. Pynacker, who was the son of a wine merchant, was born near Rotterdam, and probably first trained in Delft with Abraham Pick. He was a Catholic and is thought to have spent three years in Italy, probably 1645–8; his works were certainly inspired by the Italianate landscapes of artists such as Jan *Both, although they make an original contribution to the genre. They are often suffused with a gentle, warm Mediterranean light, and are distinguished by the graceful, calligraphic way in which he defines details of vegetation such as reeds, thistles, and birch trees, and invariably contrast cool greens and greys in shaded areas with the warmth of the skies. A characteristic example is his *Landscape with Cattle*, from the early 1660s (London, Wallace Coll.), which is ornately signed. His earliest dated pictures are from the outset of the 1650s; subsequently Pynacker is recorded in Lenzen, Schiedam, and Amsterdam, where he died. CB

Harwood, L. B., *Adam Pynacker* (1988).

PYNAS BROTHERS. Jan (*c*.1581/2–1631) and his brother **Jacob** (*c*.1592/3–after 1650) played a part in bringing the new naturalism of *Elsheimer, in both history paintings and landscape, to northern Europe. Jan, born in Alkmaar, was in Italy, with *Lastman, 1605–7, and again *c*.1616–17; here he responded both to Elsheimer and to Paul *Bril, whose new, naturalistic *landscape inspired Pynas's early drawing style. Jan settled in Amsterdam, where, with Lastman, he contributed to a new school of *history painting, producing small-scale works, such as *Joseph's Cloak Being Shown to Jacob* (1618; St Petersburg, Hermitage), set in Italianate landscapes, which emphasize a vivid and clear narrative. Some of his subjects were unusual, and reflect a close relationship with contemporary theatre. Jacob, born in Amsterdam, was perhaps Jan's pupil there; he also painted history paintings related to Lastman, such as *Paul and Barnabas at Lystra* (New York, Met. Mus.); his figures are less elongated than those of Jan. He also made landscapes with small biblical or mythological scenes which suggest the influence of Bril and Elsheimer. HL

PYXIS, or **pyx** (plural pyxides), a covered cylindrical box, in classical times made of boxwood (Greek *pyxos*: box tree), but later of metal (copper or silver) or ivory. Originally a toilet box, jewel casket, or container for incense, it was adopted as early as the 4th century to hold the reserved Host, and carry it in procession or to the sick. Since a section of elephant tusk lends itself to this form, most *early Christian pyxides were of ivory.

A 4th-century pyxis in the British Museum carved with pastoral subjects and a 6th-century example (New York, Met. Mus.) with Bacchic figures indicate that the secular use of this type of box continued throughout the early Christian period. However, the celebrated pyxis in Berlin (Staatliche Mus.), perhaps originating from Antioch in the 4th century, represents Christ teaching and Abraham's sacrifice, and was probably made to contain the Host. A 6th-century example from Egypt (London, BM) represents the martyrdom and veneration of S. Menas. Similar but secular ivory boxes reappeared in Muslim Spain and Sicily from the 10th to the 14th centuries. These examples are either carved in flat conventional patterns of foliage and animals (London, V&A), or have been painted (New York, Met. Mus.).

As a result of the Crusades, both early Christian and Muslim pyxides found their way into Western churches in the 12th century. There were, however, few attempts to copy them, since the small *champlevé* enamel copper pyxides with conical covers produced in large numbers in Limoges, France, so popular throughout the 13th and 14th centuries, were already beginning to take their place. Others were made of crystal, enabling the Host to be seen. Grand pyxides could be made in silver, such as the Swinburn Pyx, *c*.1310 (London, V&A), a parcel-gilt cylindrical box originally decorated with *basse-taille* enamel. Another manifestation of the term is 'the Trial of the Pyx', the ceremony dating from the 12th century at which the goldsmiths' company of London assay sample coins to ensure they are of the correct fineness. The pyx is the strong-box in which the coins are delivered to the jury. PS

QUADRATURA, illusionistic painting of walls or ceilings usually in fresco in which architectural or sculptural details are painted to give the illusion of reality. CFW

QUADRO REPORTATO (Italian: carried or transferred painting), describing an easel painting placed on the ceiling as part of a decorative scheme. This can either be an actual painting on canvas such as Annibale *Carracci's *Choice of Hercules* (Naples, Capodimonte; formerly Rome, Palazzo Farnese, Camerino) or an illusion of one created in fresco, either framed in stucco as in Guido *Reni's *Aurora* (Rome, Casino Rospigliosi) or completely in fresco as in Annibale Carracci's most complex scheme in the Galleria of the Palazzo Farnese, Rome. CFW

QUARTON (or Charonton), EN-GUERRAND (*c.*1420–66?). French painter from Laon, active in Provence. His œuvre may be reconstructed from two surviving documented altarpieces, both painted in Avignon. The *Madonna of Mercy* (Chantilly, Mus. Condé), executed in collaboration with Pierre Villate (1452), shows a preference for bold, brightly coloured forms and a knowledge of works by artists as disparate as Jan van *Eyck and *Piero della Francesca. In the magnificent *Coronation of the Virgin by the Trinity* (Villeneuve-lès-Avignon, Mus. Municipal), an immense representation of Christian dogma (including scenes of the Crucifixion, purgatory, and hell), Quarton's interest in the light and landscape of Provence are evident. Many details of this altarpiece were stipulated in the contract (1453), the most extended document of its kind to survive. Among attributed works, the impressive *Pietà* (Paris, Louvre) indicates an unrivalled ability at portraying pathos. A record of 1444 associates Quarton, then in Aix-en-Provence, with the painter Barthélemy d'*Eyck. A book of hours in New York (Pierpont Morgan Lib.,

MS M.358) may be a product of their collaboration at this time. TT

Sterling, C., *Enguerrand Quarton: le peintre de la Pietà d'Avignon* (1983).

QUATREMÈRE DE QUINCY, ANTOINE-CHRYSOSTHÔME (1755–1849). French art theorist. Abandoning legal studies to train as a sculptor, Quatremère de Quincy was one of a number of late 18th-century French artists to receive a classical education. He came to prominence during the French Revolution, both overseeing the transformation of the church of S. Geneviève into a mausoleum for national heroes (the Pantheon), and, more memorably for his *Considérations sur les arts* (1791). In this tract he followed *Winckelmann in his praise of ancient Greek art but added his own radical ideas on arts administration. In particular he argued that the sole function of the Académie Royale de Peinture et de Sculpture should be teaching, and that its members should cease to have a monopoly in respect of state commissions and of the right to exhibit works of art. The *Considérations* were influential in the decision made later that year that the right to exhibit at the Paris Salon should be open to all. Five years later he published his opposition to the widespread removal of Italian art treasures to Paris in the wake of French military victories. He regarded it as morally wrong to exercise rights of conquest, but also argued that works of art should not be taken out of the context for which they had been created. Imprisoned during the Terror in 1794, his increasingly committed royalism led to his exile in 1797–1800. Although he returned to public life in 1804 as an elected member of the Institut de France, by 1816, when he was made *secrétaire-perpétuel* of the École des Beaux-Arts, his espousal of Greek art was ceasing to appeal to younger artists. He became increasingly disenchanted with *Romanticism in both art and literature. In

his *Essai sur la nature* (1823), he was particularly scathing about the indifference to *history painting and what he claimed was a preference for sordid subjects.

See Académie Royale, École des Beaux-Arts, and Salon under PARIS. HW

QUELLINUS, ARTUS, THE ELDER (1609–68). Flemish sculptor. He was the son of the sculptor Erasmus Quellinus the elder (c.1548–1640) and brother of the painter and collaborator of *Rubens, Erasmus Quellinus the younger (1607–78). He trained with his father and later in Rome with François *Duquesnoy, whose moderate *Baroque style vies with the more animated influence of Rubens in his work. Quellinus' principal undertaking was the sculptural decoration of the Amsterdam Town Hall (now royal palace), where from 1648 he led a team that included Rombout *Verhulst, Gabriel Grupello, and his cousin Artus Quellinus the younger (1625–1700). Artus the younger's son, also called Artus (1653–after 1686), worked in London in the 1680s as a collaborator of Grinling *Gibbons. MJ

Gabriels, J., *Artus Quellinus de Oude* (1930).
La Sculpture au siècle de Rubens, exhib. cat. 1977 (Brussels, Mus. Royaux).

QUERCIA, JACOPO DELLA (or Jacopo di Pietro d'Angelo) (c.1371×4–1438). Italian sculptor, born in Siena. He was a contemporary of *Ghiberti, against whom he unsuccessfully competed for the Florentine baptistery doors commission in 1401. The marble tomb of Ilaria del Carretto (c.1405–7/8;

Lucca Cathedral) is one of his early masterpieces and its design remains unique in Tuscany. This combines classical motifs in the putti arranged around the bier supporting swags, with a *Gothic treatment of the recumbent effigy. His Fonte Gaia in Siena (1408–19; now in the Palazzo Pubblico) is a more *classicizing work, and the solemn figures, placed along the rim of the rectangular basin decorated with reliefs, depend partly on Roman models, but also illustrate a familiarity with Burgundian sculpture. His relief of the *Annunciation to Zacharias* for the Siena baptistery font (1419–30), on which he collaborated with Ghiberti and *Donatello, shows a debt to the latter's relief, with its prominent use of architecture and the grave profiles of the protagonists. In 1425 della Quercia received his last important commission for the reliefs from the Old and New Testaments for the portal of S. Petronio in Bologna. The strength of these economically designed reliefs had a considerable impact on *Michelangelo, who reinterpreted motifs from them in the Sistine ceiling. HO/AB

Beck, J., *Jacopo della Quercia* (2 vols., 1991).

QUESNEL, FATHER AND SON. There were six painters of this French family working in the 16th and early 17th centuries, of whom two are worthy of note. **Pierre** (c.1502×4–c.1580) came to Holyrood, Edinburgh, c.1536 to work for James V and Mary of Guise. Later he is recorded in Paris designing stained glass for the church of the Augustins (destr.). His son **François** (1543–1619) was born in Edinburgh but worked in Paris, where he appears in the royal accounts from

1571 as a decorative artist. He designed coins and tapestries, but specialized in portrait drawings (many Paris, Bibl. Nat.) in the manner of *Clouet but with richer use of red chalk and wash, creating a greater effect of luminosity. The oil of *Henri III Wearing the Blue Ribbon of the Order of the S. Esprit* (Paris, Louvre) is ascribed to him, and *Mary Ann Waltham* (Althorp, Spencer Coll.) has his monogram and the date 1572. LL

QUINTILIAN (active second half of 1st century AD). Roman orator and teacher of rhetoric. In his *Institutions of Rhetoric*, a comprehensive overview of the training necessary for an orator, Quintilian illustrates his discussion of rhetorical style by drawing analogies with the concept of style in the visual arts (12. 10). He explains that styles of rhetoric differ just as Etruscan sculpture differs from Greek and that individual artists display different talents. The comparison also serves to illustrate his notion of development. Just as the primitive early painters and sculptors gave way to the grandeur and naturalism of *Zeuxis, Parrhasius, or *Phidias and to the vivid realism of Theon of Samos and Demetrius, so Roman rhetoric developed from its early beginnings to the polished eloquence of *Cicero. The same practice of drawing stylistic analogies between the visual arts and rhetoric can be found in the work of Dionysius of Halicarnassus, a Greek critic of the 1st century BC, who compared the grand and solemn style of Isocrates to *Polyclitus and *Polygnotus while Lysias was compared to the more delicate work of Calamis and Callimachus. RW

Kennedy, G. A., *Quintilian* (1969).

RAEBURN, SIR HENRY (1756–1823). Scottish portrait painter. He was born in Edinburgh where he was apprenticed to a jeweller in 1772. His first commissioned oil (Dunfermline town council) was painted in 1776 but he had previously painted some miniatures. Although apparently self-taught he knew David Martin (1737–98), who introduced him to the work of *Ramsay and *Reynolds. After a fortunate marriage in 1778, he travelled to Italy (1784–6), via London, where he met Reynolds, who was to be a major influence. His Italian stay had little direct influence upon his work but the Italian light may have inspired his dramatically backlit works of the 1790s, among which is the masterly and hauntingly atmospheric *Sir John and Lady Clerk of Penicuik* (Dublin, NG Ireland). By the late 1790s, working in Edinburgh, he had established his characteristic style, painting directly onto canvas with a square brush with emphatic broad strokes and a warm, almost ruddy palette, which produced a lively immediacy and naturalness. Most of his half-lengths, of Edinburgh professionals and Lowland lairds and their wives, are frontally lit against sombre perfunctory backgrounds; but he also excelled at the heroic, when Reynolds's influence is most marked, in his full lengths of be-tartanned Highland chieftains, like the magnificent *MacDonell of Glengarry* (1812; Edinburgh, NG Scotland). Raeburn was the first Scottish painter to earn an international reputation while working in his native country and undoubtably benefited from the Romantic interest in Scotland generated by the novels of Walter Scott, whom he painted in the 1820s, and the espousal of George IV, who knighted him in 1822. DER

Thomson, D., *Raeburn: The Art of Sir Henry Raeburn, 1756–1823* (1997).

RAGGI, ANTONIO (1624–86). Italian *Baroque sculptor and stuccoist. From 1645 he was assistant in Rome to *Algardi and then for many years chief assistant to *Bernini, carrying out numerous statues and reliefs to his designs. Among his many contributions to Bernini's output are the colossal statue of the *River Danube* (1650–1) on the Four Rivers Fountain in Piazza Navona and the *Angel Carrying the Column* (1668–9) on the Ponte S. Angelo. His independent works include a marble relief of *The Death of S. Cecilia* (1662–6; Rome, S. Agnese in Agone) and the monument to Lady Jane Cheyne (1671; London, Chelsea Old Church), as well as the magnificent stucco decorations surrounding *Gaulli's frescoes of 1672–9 on the ceiling of the Gesù, Rome. MJ

Nava, A., 'Scultura barocca a Roma: Ercole Antonio Raggi', *L'Arte*, 40 (1937).
Wittokower, R., *Art and Architecture in Italy 1600–1750* (rev. edn., 1984).

RAIBOLINI, FRANCESCO. See FRANCIA.

RAIMONDI, MARCANTONIO (c.1480–c.1534). The most important engraver of the Italian *Renaissance. He trained in Bologna, and between 1505 and 1509 was in Venice where he engraved the enigmatic *Raphael's Dream*. In 1506 *Dürer complained about Raimondi's unauthorized engraved copies of his *woodcut series *The Life of the Virgin*. From about 1510 he was in Rome, where he spent the most productive part of his career. Although he engraved many original works, his fame rests on his reproductive prints. He made an interesting copy of *Michelangelo's *Bathers* where the landscape is based on *Lucas van Leyden, and also engraved many drawings by *Peruzzi. His most fruitful partnership was with *Raphael whose contemporary reputation owed much to such prints as the *Massacre of the Innocents*, and the *Judgement of Paris*, where his use of crisp, lucid engraved lines is at its best. His work was greatly prized by collectors until the end of the 19th century, and he is the

founding father of reproductive engraving.
RGo

Shoemaker, I., and Broun, E., *The Engravings of Marcantonio Raimondi* (1981).

RAINER, ARNULF (1929–). Austrian painter, printmaker, photographer, and collector, born in the spa town of Baden, near Vienna. He had virtually no formal instruction in art (he stayed for a total of less than a week at the two art schools he attended in Vienna in 1949–50), and his technical procedures are often unconventional. His early works, mainly drawings and prints, were inspired by the fantastic vein of *Surrealism, and after a visit to Paris in 1951 he was influenced by *Abstract Expressionist and *Art Informel paintings that he saw there. Although he met André *Breton in Paris, he soon moved away from Surrealism, and in the mid-1950s he began producing Overpaintings, in which he took as a basis a painting, drawing, or photograph (either his own work or someone else's) and partially obliterated the image with monochromatic colour. A similar concern with reworking surfaces occurs in many of his prints, in which he sometimes uses the same plates again and again. Overpaintings dominated Rainer's work for about a decade, until the mid-1960s, but he also produced a series of cruciform pictures during this period (*Black Cross*, 1956; Munich, Lenbachhaus). In 1963 he began collecting *Art Brut and the following year he began experimenting with hallucinogenic drugs—indications of his interest in extreme emotional states. From 1973 he sometimes painted with his fingers.
IC

RAMSAY, ALLAN (1713–84). Scottish portrait painter. The eldest son of the identically named poet, Ramsay was born in Edinburgh. He studied in London, c.1730, under the Swede Hans Hysing (1678–1752/3), Rome (1736–7), with *Imperiali, and Naples under *Solimena, from whom he learned the elements of European *Baroque style. On returning to London in 1739, he was singularly cosmopolitan and, as his confident *Self-Portrait* (c.1739; London, NPG) reveals, able to compete with both native and émigré portrait painters working in London. Aided by his patron, the influential Dr Richard Mead (whose magisterial, Baroque, full-length portrait he painted in 1747; London, Foundling Hospital), he soon established a thriving practice in which aristocratic Scots predominated. His European traits, remarked by *Vertue in 1739, were strengthened by a further Italian stay (1754–7) during which he studied the *Antique and *Batoni's portraits. *The Artist's Wife* (1754/5; Edinburgh, NG Scotland) shows an awareness of contemporary French painters, particularly *Perronneau, which introduced increased sublety and

delicacy into his work after 1755. Once back in London his intellectual interests predominated, his *Dialogue on Taste* (1754) was republished in 1762, and his friend David Hume commissioned his penetrating portrait of *Jean-Jacques Rousseau* (1766; Edinburgh, NG Scotland). Success continued (he employed assistants from the late 1740s) and he was appointed painter to George III in 1760, much to the chagrin of *Reynolds. After 1773 he ceased painting but made further visits to Italy (1775–7, 1782–4) to pursue antiquarian interests.
DER

Smart, A., *Allan Ramsay* (1992).

RAPHAEL (Raffaello Sanzio) (1483–1520). Italian painter whose work along with that of his older contemporaries *Leonardo and *Michelangelo defined the High *Renaissance style in central Italy. Raphael was born in *Urbino, the son of a competent painter, Giovanni *Santi, who was employed as the court artist of Duke Guidobaldo da Montefeltro. Raphael's social poise, which was later to facilitate his progress at the papal court, was doubtless founded on his early exposure to court life in Urbino. He probably received his earliest training from his father, who died in 1494 when Raphael was 11 years old. Although *Vasari's account of Raphael becoming a pupil of *Perugino before his father's death is probably a fiction, he unquestionably worked in some capacity in the older artist's studio during his youth. Perugino was at this period one of the most admired and influential painters working in Italy, and Raphael's familiarity with Perugino's manner, both in style and technique, is evident from the altarpieces he painted for churches in his native Umbria, such as the *Crucifixion* (c.1503; London, NG), the *Coronation of the Virgin* (c.1503; Vatican Mus.), and the *Marriage of the Virgin* (1504; Milan, Brera). The paintings include many of Perugino's characteristic mannerisms—the slender physique of the figures whose grace is exaggerated by their often balletic poses; the sweetness of the facial expressions; and the formalized landscape backgrounds populated by trees with impossibly slender trunks. Raphael was clearly a prodigy, as is shown by the request by *Pinturicchio, then one of the leading artists in Italy, for Raphael to supply detailed compositional drawings, of which two survive (1502–3; Florence, Uffizi; New York, Pierpont Morgan Lib.), for frescoes in the Piccolomini Library in Siena.

Despite his success as a painter of altarpieces and of smaller courtly paintings, such as the *Dream of a Knight* (c.1504; London, NG) and the *S. George* (c.1505; Washington, NG), Raphael clearly felt the need to leave Umbria in order to widen his experience of contemporary painting. Armed with a letter of recommendation dated October 1504 from the

Duke's sister-in-law Giovanna della Rovere to Piero Soderini, the ruler of Florence, he probably arrived in the city soon afterwards. He was to remain in Florence for four years, and during this time he gradually familiarized himself with the new style being developed by Florentine artists, notably Leonardo and Michelangelo whose cartoons for the proposed frescoes of *battle scenes in the Palazzo della Signoria date from this period. With characteristic energy of purpose Raphael set about mastering the new requirements of Florentine art: the depiction of figures in movement, the expression of emotional state through expression and gesture, and the creation of complex narrative. This process of assimilation is best appreciated through his drawings of the period. His course of rigorous study is reflected in the drawings of *Donatello's *S. George* (Oxford, Ashmolean), Leonardo's lost *Leda* (Windsor Castle, Royal Coll.), and Michelangelo's *David* (London, BM), as well as a series of drawings of fighting nudes (Oxford, Ashmolean).

In the paintings of the Virgin and Child which are the chief product of his Florentine period he experimented with new compositional forms and figural motifs. In the *Madonna of the Meadow* (1505; Vienna, Kunsthist. Mus.) and *La Belle Jardinière* (1507; Paris, Louvre) Raphael employs a pyramidal structure derived from Leonardo, while in the *Bridgewater Madonna* (c.1506; on loan to Edinburgh, NG Scotland) the diagonal movement of the Christ child is inspired by Michelangelo's sculpted figure in his Taddei Tondo (c.1504–7; London, RA). The spiralling movement and the sophisticated psychological interplay between the figures in Raphael's *Canigiani Holy Family* (c.1507; Munich, Alte Pin.) display his new-found command of the modern Florentine style; at least in compositions of relative simplicity.

Raphael painted a few portraits in Florence, the best documented of which (they are mentioned by Vasari) are those of *Agnolo Doni* and *Maddalena Doni* (c.1507–8; Florence, Pitti). Further proof of his rapid development is furnished by the series of preparatory drawings for the *Entombment* (1507; Rome, Borghese Gal.) painted for a church in Perugia, which show how he began with a static composition based on Perugino but ended up with one in which all the figures are in movement. The studied quality of the final composition betrays this radical shift in conception, though there are passages, such as the contrast between the living flesh of the Magdalene's hand and that of the dead Christ, which are painted with great sensitivity.

In 1508 he was summoned to Rome by Julius II, and he was to remain in the city serving successive popes until his death. His first commission was the decoration of the Stanza della Segnatura, a room almost certainly

used by the Pope as a library. The function of the room is reflected in the subjects of the frescoes—Theology, Poetry, Philosophy, and Jurisprudence, which correspond to the classification of books according to the faculties. In the frescoes Raphael shows a genius for finding simple pictorial means to convey these complex abstract concepts. In the most celebrated of all the frescoes, the *School of Athens*, a group of philosophers with Plato and Aristotle at the centre are shown beneath a majestic vaulted building which probably reflects Bramante's plan for S. Peter's. The brooding figure of the philosopher inserted in the foreground of the composition is the first evidence of Raphael's study of Michelangelo's recently unveiled Sistine chapel ceiling. The various preparatory drawings related to the *Disputa*, the first fresco to be painted, show Raphael's painstaking process in establishing a harmonious composition, in which the mass of figures is divided into smaller groups linked by gesture and pose.

The Stanza della Segnatura frescoes were completed by 1512 and soon after he began work on the Stanza d'Eliodoro which was completed in two years. The frescoes treat historical and legendary themes sharing the theme of divine intervention on behalf of the Church. The differences between the two rooms is marked, as the dramatic nature of the two principal frescoes, the *Expulsion of Heliodorus* and the *Repulse of Attila*, demanded scenes of tumultuous action. Pope Julius did not live to see their completion, and the features of Leo X are substituted for those of his belligerent predecessor in the *Repulse of Attila*. Leo continued the programme of decoration and the Stanza dell'Incendio was painted between 1514 and 1517. The pressure of Raphael's growing number of commissions meant that much of the work is painted by studio hands following his designs. In the finest of the scenes, the *Fire in the Borgo*, after which the room is named, the flames are a minor element of the composition but the devastation is registered through the varying emotions of the fleeing crowd in the foreground. Preparation for part of the decoration of the largest of the suite of rooms, the Sala di Costantino, was already in hand on Raphael's death, and the frescoes were painted largely by *Giulio Romano guided, at least in part, by drawings by the master.

Other papal projects included the design of ten *tapestries with scenes from the Acts of the Apostles to hang in the Sistine chapel. The tapestries were woven in Brussels from cartoons of which seven survive (c.1515–16; London, V&A on loan from Royal Coll.). Sensitive to the pictorial limitations of tapestry, Raphael took care that the expressions and gestures of the figures in the compositions are bold and direct. The cartoons themselves are visually something of a disappointment largely because they are mostly the work of

Raphael's well-organized and highly productive workshop. This included young artists of talent like Giulio Romano, *Penni, *Perino del Vaga, and decorative specialists such as *Giovanni da Udine, to whom Raphael entrusted the execution under his supervision, and in some cases part of the design, of major projects, such as Leo X's Loggia in the Vatican Palace (1518–19) which was decorated with *all'antica* stucco and painted ornament, and Old Testament scenes in the vault.

Throughout the period he was working in the Vatican Raphael also managed to work on other commissions. These included major altarpieces, the earliest of which is the *Madonna di Foligno* (c.1512; Vatican Mus.) painted for the Franciscan church of S. Maria in Aracoeli. Venetian elements in the painting, such as the shimmering landscape and a greater subtlety in colouring, may be due to Raphael's contact at this time with *Sebastiano del Piombo. The atmospheric handling of chalk and the choice of blue paper in Raphael's study for the Virgin and Child (London, BM) are also typically Venetian. In probably the most famous of all his altarpieces, the visionary *Sistine Madonna* (c.1512–14; Dresden, Gemäldegal.), painted for a church in Piacenza, the Virgin and Christ child appear to be floating forwards out of the painting. The figures of the Virgin and Child appear to be as weightless as the clouds on which they stand while at the same time they convey a strong sense of corporeality. From the same period he painted for a Bolognese church the *S. Cecilia* altarpiece (c.1513–16; Bologna, Pin.) which introduced an ideal of classical beauty that inspired Emilian artists from *Parmigianino to *Reni. In his last altarpiece, the *Transfiguration* (1518–20; Vatican Mus.), originally planned for Narbonne Cathedral, he included two contrasting episodes—the transfigured Christ in a blaze of light in the upper section, and in the darkness below the apostles who are unable to cure the possessed boy. The expressive heads and the dark overall tone depend on Leonardo's unfinished *Adoration of the Magi* (1481; Florence, Uffizi).

Unlike in Florence Raphael seldom had time to paint small devotional works in Rome, but he did manage to execute two—the *Madonna Alba* (c.1511; Washington, NG) and the *Madonna della Sedia* (c.1514; Florence, Pitti). In both works Raphael brilliantly exploits their circular format (see TONDO). In the Washington painting the circular form gives impetus to the strong diagonal movement of the Virgin and Child, while in the later painting it tightly encompasses the figures, adding to the sense of tender intimacy.

Raphael worked extensively for the rich Sienese banker Agostino Chigi in both secular and ecclesiastical commissions. The earliest of these is the classicizing mythological fresco of *Galatea* (c.1512), which was painted

for his villa on the banks of the Tiber, now known as the Farnesina. In 1512–13 Raphael painted above the entrance arch of the Chigi chapel in S. Maria del Popolo a fresco with sibyls and prophets. The twisting movement of the sibyls is markedly Michelangelesque, but the figures have an ideal feminine beauty perhaps best appreciated (the frescoes are damaged) in Raphael's superb red chalk studies (London, BM; Oxford, Ashmolean). A year or two later he also supplied designs for sculpture, architecture, and mosaic in Chigi's lavish chapel in S. Maria del Popolo. In 1518 Raphael's workshop decorated the loggia of Chigi's villa with scenes from the life of Cupid and Psyche. Giulio Romano and Giovanni Francesco Penni, who were responsible for the figurative parts of the scheme, were such faithful interpreters of Raphael's style that it is hard to establish if they or their master drew the red chalk figure studies related to the loggia.

Raphael continued to work as a portrait painter, but even for important clients he sometimes relied on studio help, as in *Joanna of Aragon* (1518; Paris, Louvre). His portraiture exhibits a sense of psychological penetration new to the genre. In the *Julius II* (c.1512; London, NG) the Pope is shown half-length seated in a chair diagonal to the picture plane, and this spatial dissociation from the viewer adds to the sense of the sitter's self-absorption. The sensual feel of the contrasting textures of velvet and silk in the Pope's costume is even more of a feature in the sumptuous portrait of Leo X with his nephews (1518; Florence, Uffizi). Raphael also painted portraits of his circle of friends: *Baldassare Castiglione* (c.1514–15; Paris, Louvre), *Andrea Navagero and Agostino Beazano* (before Apr. 1516; Rome, Doria Pamphili Gal.), and the presumed self-portrait with a friend, often called *Raphael and his Fencing Master* (c.1518; Paris, Louvre). These portraits actively engage the viewer's attention either through the intensity of the sitter's gaze, as in the *Castiglione*, or more directly as with the outstretched pointing hand in the *Fencing Master*. The sitter of the *Donna velata* (c.1514; Florence, Pitti), one of the few Roman period female portraits, is unknown but the gesture of her hand pointing to her heart would be appropriate for a matrimonial portrait. The *Fornarina* (c.1518; Rome, Barberini Gal.), said to be a portrait of Raphael's mistress, is despite the signature on a bracelet around her arm probably not autograph. The hardness of handling in the rendering of flesh is characteristic of Giulio.

Raphael was quick to see the value of engraving in the dissemination of his work, and through his collaboration with the Bolognese reproductive engraver Marcantonio *Raimondi his reputation and influence spread throughout Europe. Raphael seems to have mainly given him drawings related to

his painted projects, but some of Raimondi's more elaborate plates—for example, the *Massacre of the Innocents* and *Il Morbetto*—were probably made from drawings especially intended for the purpose.

Raphael died at the age of 37 in Rome at the height of his powers. His artistic legacy was immense and it is hard to appreciate his originality because his inventions have been plundered by generations of artists. In the modern era Raphael's past canonical status has counted against him and he has inevitably been compared, often unfavourably, to Leonardo and Michelangelo, whose personalities and artistic expression more readily accord with 20th-century sensibilities.

HCh

Dussler, L., *Raphael: A Critical Catalogue of his Pictures, Wall-Paintings and Tapestries* (1971).

RATGEB, JÖRG (c.1480–1526). German painter active in Stuttgart, Heilbronn, and Frankfurt am Main. As a journeyman he may have spent some time in the workshop of Hans *Holbein the elder at Augsburg. His largest surviving work comprises two sets of folding wings with scenes from the life of the Virgin and the Passion of Christ which, together with a sculptural corpus, made up the high altarpiece for the church of Our Lady at Herrenberg (1518–19; Stuttgart, Staatsgal.). Ratgeb's style is characterized by a strong individuality and expressiveness, in part derived from *Grünewald. He also worked as a fresco painter (part of his murals survive in the Carmelite cloister at Frankfurt). Like the sculptor Tilman *Riemenschneider, Ratgeb sympathized with the peasants in their revolt of 1524–5, possibly encouraged by his marriage to a serf of the Duke of Württemberg. He was executed for treason. KLB

RAUSCHENBERG, ROBERT (1925–). American painter, printmaker, designer, and experimental artist; with his friend Jasper *Johns, whom he met in 1954, he is regarded as one of the most influential figures in the move away from the *Abstract Expressionism that had dominated American art in the late 1940s and early 1950s. Rauschenberg was born in Port Arthur, Tex., and became interested in art after a chance visit to a gallery while serving in the US Navy as a neuropsychiatric technician, 1942–5. He said of his work in the navy: 'This is where I learned how little difference there is between sanity and insanity and realized that a combination is essential.' After leaving the navy he studied at Kansas City Art Institute, 1946–8, the Académie Julian, Paris, 1948, *Black Mountain College, 1948–9, and the Art Students' League of New York, 1949–52. Black Mountain College made the greatest impact on him and he returned several times in the early 1950s. The people he met there included the

composer John Cage (1912–92) and the dancer Merce Cunningham (1919–), both of whom influenced him greatly (he was designer for Cunningham's dance company from 1955 to 1965).

Rauschenberg had his first one-man show (coolly received) at the Betty Parsons gallery, New York, in 1951. At this period his work included minimalist monochromatic paintings. In the mid-1950s he began to incorporate three-dimensional objects into what he called 'combine paintings'. The best-known example is probably *Monogram* (1955–9; Stockholm, Moderna Mus.), which features a stuffed goat with a rubber tyre around its middle, splashed with paint in a manner recalling *Action Painting. Other objects he used included Coca-Cola bottles, fragments of clothing, electric fans, and radios, and because of his preoccupation with such consumer products he has been hailed as one of the pioneers of *Pop art. In 1958 he was given a one-man show at the Leo Castelli gallery, New York, and from this time his career began to flourish. By the early 1960s he was building up an international reputation, and in 1964 he was awarded the Grand Prize at the Venice Biennale.

In the 1960s Rauschenberg returned to working on a flat surface and was particularly active in the medium of screen printing. He has been interested in combining art with new technological developments and in 1966 he helped to form EAT (Experiments in Art and Technology), an organization to help artists and engineers work together. 'I am, I think, constantly involved in evoking other people's sensibilities. My work is about wanting to change your mind. Not for the art's sake, not for the sake of that individual piece, but for the sake of the mutual coexistence of the entire environment.' In line with these beliefs, in 1985 he launched Rauschenberg Overseas Cultural Interchange (ROCI), an exhibition dedicated to world peace that toured the world and included works created specifically for each place visited. Since 1971 Rauschenberg has lived mainly on Captiva Island off the coast of Florida. IC

RAY, MAN. See MAN RAY.

READ, SIR HERBERT (1893–1968). English critic. A persuasive and prolific interpreter of modern art to British audiences, he combined experience of museum work and journalism with far-ranging interests in psychology, biology, and politics. Encounters with German theorists of form development, such as Wilhelm Worringer (1881–1965), helped shape the arguments he brought to bear in favour of artists like Piet *Mondrian, Naum *Gabo, Henry *Moore, and Barbara *Hepworth during the 1930s; his sympathies

encompassed the *Constructivist and *Surrealist thinking of the time. Anarchist ideals and psychoanalytic thought informed the influential treatise *Education through Art* (1943). From 1947 to 1968 Read headed the Institute of Contemporary Arts in London, aiming at once to bring a mass audience into contact with art and to develop connections between artistic and scientific thinking about form.

JB

Read, H., *Art Now* (1933).
Read, H., *The Forms of Things Unknown* (1960).

READY-MADE, a term coined by Marcel *Duchamp to describe work which consisted of mass-produced objects selected and displayed as works of art. Ready-mades differ from *objets trouvés in that they are always mass-produced (i.e. not unique) objects, and no aesthetic criteria should be used in their selection, restrictions to which objects trouvés are not subject. Duchamp's first ready-made was *Bicycle Wheel* (1913), and its many successors included *Bottle Rack* (1914), *In Advance of the Broken Arm* (1915) (a snow shovel), and, most notoriously of all, *Fountain* (1917), a gentleman's urinal embellished with the date and the signature R. Mutt (all originals lost). Ready-mades were paramount in Duchamp's crusade against taste and aesthetics, an active form of criticism which both challenged and sent up traditional notions of refined and hand-crafted art. Despite the furore still provoked by Duchamp's actions, the war on taste has not been won: in 1962 he commented, 'When I discovered ready-mades I thought to discourage aesthetics . . . I threw the bottle rack and the urinal in their faces and now they admire them for their aesthetic beauty.' AA

Duve, T. de, *Résonances du readymade* (1987).

REALISM. See opposite.

RECCO, GIUSEPPE (1634–95). Italian still-life painter from Naples. He specialized in painting fish, fruit, flowers, and kitchen scenes, with an intensity of light and texture that matches the style of *Ruoppolo, who was working in Naples at the same time. He sometimes collaborated with other artists when figures were required. For instance *Giordano appears to have been involved in a picture of a *Fisherman with a Still Life of Fish* (s.d. 1668; priv. coll.) painted for Marquis de Noja, and a *Marine Still Life with Neptune and Two Nereids* (New York art market) from the Buen Retiro, Madrid. Another artist, possibly from the circle of *Solimena, may have painted the figures for two exceptionally ambitious large-scale *Still Lifes with Flowers* which were commissioned in 1685 through the British consul, George Davies, by the 5th Earl of Exeter who had just visited Naples the previous year (Burghley House, Lincs.). These

continued on page 620

· REALISM ·

ALTHOUGH the term 'realism' is widely associated with mid-19th-century painting in France, and especially with the work of *Courbet, its meanings in the 19th century were complex and often contradictory. Apparently first applied to painting by the critic Gustave Planche during the 1830s, it came to be widely used before 1848 to characterize the modest genre paintings of artists such as Adolphe Leleux, which treated themes of peasant life, rejecting the rhetoric and artifice of much contemporary exhibition painting. In reviewing the *Paris Salon after 1848, critics increasingly adopted the term to describe paintings that made a more ambitious, programmatic attempt to paint contemporary life, by Courbet, *Millet, and Jules Breton among others, and in 1855 Courbet appropriated it for himself by giving the title 'Realism' to the preface of a catalogue of an exhibition of his art. But even after this its meanings were much contested.

Two issues were fundamental in these debates: the definition of 'reality' itself, and the role of the artist. Courbet's notion of the 'real' was based on the material existence of objects; but many thinkers in mid-19th-century France held a Neoplatonic view of 'reality', locating it in the realm of essential and perfect forms, in contrast to the imperfections of the physical world. On this argument, many critics viewed the handsome, ennobled peasant figures painted by Breton from 1855 onwards as representing the true form of 'realism', in contrast to the imperfections of Courbet's figures. Beyond this, pictures such as Courbet's The Stonebreakers (1849–50; destr., formerly Dresden) were criticized for giving the figures no more significance than the stones they break, whereas the Neoplatonic world view placed man at the summit of a hierarchy of significance and stones at the bottom.

Courbet's preface stated that his basic intention was 'to translate the customs, ideas and appearance of my epoch, as I see them'. It was widely agreed that the individual, personal vision of the artist played a central role in all types of 'realism', whatever view of the 'real' they presented. In this sense French 19th-century 'realism' can be seen as a development from *'Romanticism', though it marked a rejection of other aspects of 'Romanticism', notably its celebration of the imaginative and the visionary. The essential subjectivity attributed to 'realist' works distinguishes them from the apparent objectivity and 'ethnographic' qualities cultivated by painters such as Jean-Léon *Gérôme, especially in their canvases of the 'Orient'. Though recent scholarship has stressed the value-laden choices involved in Gérôme's images of the 'Orient', many 19th-century viewers saw his detailed observation and precise, unassertive execution as guarantees of the objectivity of his vision.

Technique was another marker of the 'realist' painter's individual temperament. Courbet's broadly handled paint surfaces, often applied with a palette knife, emphasised the uniqueness of his pictorial vision. Likewise *Manet's simplified sketchlike handling and especially his bold individual touches (taches) of colour were very distinctive; for his opponents, this revealed his technical incompetence, but his supporters saw his brushwork as an essential ingredient in his personal and distinctively modern vision of the world. At the other extreme, the meticulous itemization of details in the paintings of the English *Pre-Raphaelites might be seen as a form of 'realism'. The Pre-Raphaelite works included in the 1855 Paris Exposition Universelle attracted much discussion in these terms, though the historical and literary subjects of most of their works excluded them from 'realism' as it was generally understood.

The choice of explicitly contemporary subject matter was a crucial element in debates about 'realism', but 'realist' paintings need also to be viewed in relationship to fine art and its history. Painters such as Courbet and Manet consistently sought to exhibit their most ambitious canvases at the Paris Salon, and conceived them in relation to the conventional categories, or genres, by which paintings were habitually classified. Sometimes a 'realist' painting might seek to subvert a category; Courbet originally gave his huge A Burial at Ornans (1849–50; Paris, Mus. d'Orsay) the subtitle 'history of a burial at Ornans', although its serried ranks of static figures made a mockery of the heroic action expected in *history painting. Other pictures might take up the traditional genres in a more positive way, and reinterpret them in contemporary terms. At the same time, artists, critics, and historians re-explored the art of the past, finding precedents and sanctions for 'realism' especially in 17th-century painting, in the work of painters as diverse as *Rembrandt, *Caravaggio, *Velázquez, and the *Le Nain brothers.

The term 'realism' has also been used to describe various moments in 20th-century art at which painters have returned to subject matter from contemporary life. The diversity of these moments, ranging from *Neue Sachlichkeit in Germany during the 1920s to the *Mexican Muralists of the 1930s and the painting of Lucien *Freud, highlights the impossibility of finding a comprehensive definition of one of the most complex terms in the art criticism of the 19th and 20th centuries.

Beyond this, the terms 'realism' and 'realistic', like 'naturalism' and 'naturalistic', are often loosely used to describe works of art from all periods that seem to depend on direct observation. In whatever context such terms are used, it remains essential to define the notions of 'reality' and 'nature' that the works expressed, and the ways in which their makers transformed their raw material into art. JHo

elaborate works, the flowers placed in vases decorated with reliefs of Perseus and Andromeda and of Lapiths and Centaurs (which might also be by another hand), have a complexity and sophistication which indicates that the artist had assimilated all the most recent developments of European still-life painting, including the work of Abraham Breughel (1631–80?) and J.-B. *Monnoyer.

HB

Brigstocke, H., et al., *Italian Paintings from Burghley House*, exhib. cat. 1995 (Pittsburgh, Frick Art Mus. and other locations).

REDON, ODILON (1840–1916). French painter, lithographer, and etcher who produced an essentially imaginative œuvre inspired by both personal experience and the novelties of science. Born at Bordeaux, Redon spent a solitary, sickly childhood on his family's estate in the Landes. His father had prospered in Louisiana and married a young Creole before returning to his native region. He was taught by Jean-Léon *Gérôme and later by the engraver Rudolph *Bresdin. He was introduced to *lithography by *Fantin-Latour and produced nearly 200 lithographs of dreamlike scenes populated by weird amoeboid creatures, including series entitled *Dans le rêve* (1879), *A Edgar Poe* (1882), *Hommage à Goya* (1885), and *L'Apocalypse de S. Jean* (1899). He was taken up by the literary *Symbolists and was a friend of J.-K. *Huysmans and *Mallarmé. In 1884 he was briefly president of the newly formed Société des Artistes Indépendants.

In the 1890s he turned to colour, producing poetic studies in pastel and oils of flowers, dreaming heads, etc. In 1904 he was given a room in the Salon d'Automne (see under PARIS) and in 1913 was well represented at the *Armory Show in New York. *Surrealist artists regarded him as one of the precursors of their movement.

BT

Druick, D. W., *Odilon Redon*, exhib. cat. 1994 (Chicago, Art Inst.; Amsterdam, Van Gogh Mus.; London, RA).

REGIONALISM, a term applied to a group of American artists, Regionalists, prominent during the 1930s and early 1940s who concentrated on the realistic depiction of scenes and life of the midwest and deep south. Their motivation, like that of the urban scene painters, derived from a patriotic desire to establish a genuine *American art freed from European influence. To this end, although there were considerable stylistic differences among the artists dubbed Regionalists, abstraction and other 'imported' styles were shunned and their work was largely conservative, designed to appeal to popular sensibility. In addition they were moved by a nostalgic desire to record rural and small town America threatened by growing industrial urbanization, and it was this which made their work so popular. Regionalists included the politically committed and vociferous Thomas Hart *Benton, Grant *Wood, whose *American Gothic* (1930; Chicago, Art Inst.), despite its element of satire, may be seen as the movement's icon, Andrew *Wyeth, Edward *Hopper, and John Steuart *Curry. Their portrayal of their subject matter was not always uncritical, Hopper, in particular, revealed the insularity and drabness typical of much small town life.

DER

REGNAULT, GUILLAUME (d. 1534). French sculptor, *valet de chambre* of Queen Anne of Brittany. He worked at Tours in close association with Michel *Colombe, whose niece he married and whose studio he inherited. They collaborated with the Florentine Girolamo da Fiesole on the tomb of François II of Brittany (1502–7; Nantes Cathedral) which *Perréal designed. Here, new Italian ideas (arcaded niches with prophets, Renaissance arabesques) were combined with the traditional French gisants. All three sculptors worked on the exquisitely decorated tomb of the children of Charles VIII (1506; Tours Cathedral). In 1521, Regnault and Guillaume Chaleveau were commissioned to carve the tomb of Louis de Poncher and Roberte Legendre (Paris, Louvre). The gisants have the serenity of Colombe's late Gothic, and suggest that Regnault may have worked on some of the figure sculpture of the tomb of King Louis XII and Anne of Brittany (Paris, S. Denis) with Jean *Juste.

LL

REGNAULT, JEAN-BAPTISTE (1754–1829). French *Neoclassical painter. As a child he accompanied his teacher Jean Bardin (1732–1809) to Rome where he met *Mengs and his circle. On his return to Paris in 1773 he was taught by *Vien, winning the *Prix de Rome in 1776 and returning to Italy for several years. His style was flexible, changing to suit his subject matter, from the elegantly classical *Education of Achilles* (1783; Paris, Louvre) to the *Descent from the Cross* (1789; Paris, Louvre), with its reminiscences of *Jouvenet and *Restout, and *The Three Graces* (before 1799; Paris, Louvre), which recalls the mannerism of the *Fontainebleau School. In the latter part of his long career he was a professor at the École des Beaux-Arts, *Paris, teaching *Guérin among others.

MJ

De David à Delacroix, exhib. cat. 1974 (Paris, Grand Palais; New York, Met. Mus.).

RÉGNIER, NICOLAS (1591–1667). Flemish painter who spent much of his career in Italy, where he was known as Niccolò Renieri. He trained in Antwerp with Abraham *Janssens, one of the first Flemish painters to introduce the tenebrist manner of *Caravaggio. Like other young northern artists Régnier fell under the spell of Caravaggio's dramatic and naturalistic style. For a decade from around 1615 he was in Rome working in the circle of Bartolomeo *Manfredi. Pictures from this period include some of his best, among them *The Fortune-Teller* (Paris, Louvre) and *David with the Head of Goliath* (Rome, Gal. Spada). From about 1625 Régnier lived in Venice. There, inspired by the tradition of *Veronese and the art of the contemporary Bolognese School, his palette lightened and became more colourful while his style became more elegant and superficial (e.g. *Allegory of Sculpture*; Berlin, Schloss Charlottenburg). He was also active as a collector and dealer.

MJ

Nicolson, B., *Caravaggism in Europe* (1989).

REINHARDT, AD (1913–67). American painter. Born in Buffalo, he studied with Meyer *Schapiro at Columbia University, New York, 1931–5, then at the National Academy of Design 1936–7. Reinhardt is linked with *Abstract Expressionism, but his art is cool, controlled, and represents 'art-as-art-as-art' as he called it, rather than expression or apocalypse. His work moved towards such a degree of simplicity that it appears almost non-existent. The last paintings, rejecting asymmetries and colour, are usually around 1.5 m (5 ft) square and divided into nine equal squares, each black. No brush strokes are apparent. It is work that is impossible to reproduce, although the actual works have a baffling fascination as the eye strains to pick up the exceedingly fine gradations: *Abstract Painting no. 5* (1962; London, Tate).

RJP

Lippard, L., *Ad Reinhardt* (1981).

RELIEF, or relievo (Italian *rilievo*), the term for a work of sculpture in which form stands out from a plane or curved surface and the dimension of depth is reduced beyond other dimensions. Reliefs can be created by carving into wood, stone, or marble, by modelling, or by casting in a mould, in terracotta, stucco, or metal. The word is derived from the Italian *rilievo*, from *rilevare*, to raise. *Alto rilievo*, or high relief, is used when the scale of projection (the dimension of depth) is half or more than half the other dimensions, and there may be substantial undercutting. The complex high- and low-relief compositions of *Ghiberti's bronze relief panels for the doors of the baptistery in Florence (the so-called Gates Doors of Paradise; 1425–52) were cast from moulds and chased and chiselled after casting. The term is sometimes incorrectly applied to architectural sculpture carved fully in the round (i.e. where the dimension of depth is equal to other dimensions), but the figures are cut off

midway or attached to an architectural background. Such sculpture is not properly relief carving (for instance, the figures of gods and giants on the Great Altar of Zeus of Pergamum; Berlin, Pergamum Mus.), though the frieze and metopes from the *Parthenon (London, BM) show ancient Greek relief sculpture at its most inventive. *Mezzo rilievo* is used when the dimension of depth is roughly half the scale of the other two dimensions: *Trajan's Column in Rome typifies the skill of ancient Roman sculptors in this technique. *Basso relievo*, low relief or bas-relief, is used when the scale of projection is very much less than that of the other dimensions and there is no undercutting at all. The term intaglio is used when the design is incised and sunk beneath the surface of the block and is moulded in reverse, which strictly speaking is not really a relief but the reverse of relief, and is often used for gemstone carvings. The term *rilievo schiacciato* (or *stiacciato*) is used to describe a very low relief, whose composition barely penetrates the planes of the relief's surface and in some cases is literally scratched in. *Donatello's *Christ Handing the Keys to S. Peter* (c.1430; London, V&A) is a major example of this technique, also practised by his follower *Desiderio da Settignano. Relief sculpture continued to be made in the 16th and 17th centuries, especially for narrative panels for tomb monuments. In his terracotta reliefs, the French 18th-century sculptor *Clodion combined elements of this 'drawing' of the design into the malleable clay with more fully modelled figures. A resurgence of interest in architectural relief sculpture is notable in the later 19th and 20th centuries, and works by Eric *Gill or early Henry *Moore depend on stylized *Romanesque patterns or reflect contemporary Art Deco styles. HO/AB

RELIEF ETCHING, a technique of etching lines by relief, instead of the usual *intaglio process. The design is drawn on the plate with acid-resistant varnish. The plate is then immersed in acid, which eats away the unprotected parts, leaving the protected lines standing out in relief. The plate is then inked and printed by vertical pressure like a *woodcut. The method was pioneered in the 18th century by *Blake, notably in the ecstatic designs for his illuminated book *Jerusalem*, but he had no imitators of his technique.

In the 20th century the technique was used and expanded by S. W. Hayter (1901–88) and Joan *Miró, who often combined it with intaglio etching. They frequently printed in colour by inking the etched lines with one colour, while using a roller to ink the raised lines with another. RGo

RELIQUARY (also shrine, chasse, and monstrance), a container for relics, usually the physical remains of, or items associated with, a saint or holy person. Relics, perceived to have miraculous powers of intercession, seem to have become liturgically important from the 4th century AD, and were an obvious response to the emergence of cults of specific saints. They were set on the altar, and carried in procession for veneration. Forms of reliquary varied from simple boxes to elaborate receptacles in the shape of the relevant part of the body; usually they are richly decorated. The earliest were either box shaped, or architectural in form with simple gabled or barrel-shaped covers. Also known as shrines or chasses, they were made in wood or base or precious metal. Reliquaries in the shape of crosses became popular from the 9th century, initially for fragments of the True Cross. Usually very magnificent, they had a wooden core embellished with gold or silver sheet, enamels, and precious stones, for example the Cross of Desiderius (c.757–74; Brescia, Mus. Civico Cristiano). Portable altars were also often sanctified by the inclusion of relics. From the end of the 10th century, reliquaries were produced that echoed the form of the relic they contained, for example the head reliquary of Pope Alexander (1145; Brussels, Mus. Royaux). The chasse continued to be popular during the 11th to 13th centuries, often with elaborate iconographical programmes and embellished with figural sculpture of saints around the sides. One of the finest, the Shrine of the Three Kings, was from the workshop of *Nicholas of Verdun (c.1180; Cologne Cathedral) but many survive that were produced in the enamel workshops of Limoges, for example the Becket Chasse, a manifestation of the cult of S. Thomas Becket (c.1180; London, V&A). Two later introductions were the monstrance, where the relic was housed in a rock crystal (later glass) capsule mounted on a silver stem enabling it to be displayed to the faithful, and the exquisite containers for tiny relics that took the form of jewellery, such as the enamelled reliquary of the Holy Thorn (c.1340; London, BM). The striking inventiveness and proliferation of reliquaries continued into the 16th century, when challenges to the Catholic Church from humanism and Martin Luther brought about the mass desecration and destruction of many of them. Nonetheless, reliquaries and monstrances continued to be made, the former usually as caskets with glass sides, although traditional forms also survived into the 18th and 19th centuries. The veneration of relics, and thus the need for reliquaries, continues to be significant in Catholic countries today. PS

Lasko, P., *Ars sacra 800–1200* (2nd edn., 1994).

REMBRANDT HARMENSZ. VAN RIJN (1606–69). The most versatile, innovative, and influential Dutch painter of the 17th century; known primarily by his given name. This usage, initiated by Rembrandt with his signature, marks his stature in the history of Western art, which introduced it for the High Renaissance artists *Michelangelo, *Raphael, and *Titian.

Rembrandt was born in Leiden to well-off, Protestant mill owners. He attended Leiden's Latin school and, briefly in 1620, its university, but then was apprenticed for about three years to the *history painter Jacob van Swanenburgh, who must have taught him basic workshop practice. More indicative of Rembrandt's ambitions was his apprenticeship in 1624 with Pieter *Lastman, who was the leading history painter of his generation in Amsterdam. From Lastman, Rembrandt learned a theatrical and colourful mode of history painting dependent on clear compositions and gestures as well as evocative costumes and settings. Back in Leiden Rembrandt painted his first independent works in this style (*The Stoning of S. Stephen*, 1625; Lyon, Mus. des Beaux-Arts). But within two years his palette became more monochrome, his attention to surface texture more precise, his light more nuanced in its range from deep darkness to daylight (*The Miser from the Parable*, 1627; Berlin, Gemäldegal.). Rembrandt forged this mode in creative competition with Jan *Lievens, synthesizing elements of Lastman's style, of monochrome still-life painting popular in Leiden, and of *Caravaggist chiaroscuro practised in Utrecht.

Rembrandt soon received critical attention from Constantijn Huygens, the polymathic secretary to Stadholder Frederick Henry. About 1630, Huygens wrote glowingly of Rembrandt's *Judas Returning the Silver Pieces* (1629; priv. coll.), singling out the emotional characterization of Judas. Rembrandt was at the time experimenting with facial expressions, producing small *etchings of his face in emotional states ranging from curiosity and annoyance to anger and surprise. These reproducible works also let Rembrandt advertise his ability to render the human passions, a capacity essential for history painting as well as *portraiture. Although Rembrandt tried his hand at almost every pictorial subject, these two genres became the mainstay of his career. In the early 1630s, through Huygens's mediation, Rembrandt received both portrait and history commissions from the Stadholder and his wife.

Despite the promise of his early career, Rembrandt must have recognized the prospects of *Amsterdam, the liveliest port and financial centre of northern Europe. At the encouragement of Hendrick Uylenburgh, an art dealer and broker of portrait commissions, he moved to Amsterdam c.1631–2. He

immediately received the prestigious commission for *The Anatomy Lesson of Dr Tulp* (1632; The Hague, Mauritshuis), a group portrait of Amsterdam's college of surgeons. By arranging the likenesses into the story of Dr Tulp's demonstration of the workings of the human hand, Rembrandt diverged from the static tradition of such portraits. Rembrandt's portraits of individual sitters are similarly energetic, emphasizing faces, hands, and dynamic silhouettes at the expense of costumes and settings. They made him the city's leading portraitist until *c*.1650.

Rembrandt's large history paintings of the 1630s became more spectacular. Composed along sweeping diagonals, they acknowledge the Italian and Flemish *Baroque (*The Feast of Belshazzar*, *c*.1636; London, NG). The dramatic scale, subjects, and gestures are in the grand manner, but the protagonists look down-to-earth and the rich colouring has a narrow tonal range. Rembrandt's success in this decade brought him numerous pupils and associates, of whom Govaert *Flinck, Ferdinand *Bol, and Gerbrand van den *Eeckhout were particularly accomplished.

In 1634 Rembrandt married Saskia Uylenburgh, Hendrick's niece. The couple had four children, of whom only Titus survived infancy. Rembrandt's personal life is of particular interest because he represented himself and his family members in widely varied guises. Around 1629 he had begun to paint *self-portraits, the first in a lifelong autobiographical sequence of which 80 survive. The most informal amongst them proved fertile ground for experimentation; on one small panel, Rembrandt cast his face in daring shadow and scratched his lightest hairs through the paint with the butt end of the brush (*c*.1629; Amsterdam, Rijksmus.). Saskia and the children appear in quickly characterized, informal drawings that blur the boundaries between portraiture and domestic genre. Rembrandt's paintings of Saskia are difficult to interpret: was *Saskia as Flora* (1635; London, NG) a picture of the goddess for a collector, a portrait for her family, or a personal response to Saskia's fertile status in the mid-1630s? Even more problematic is the *Self-Portrait with Saskia* (1635; Dresden, Gemäldegal.), in which Rembrandt painted himself as Prodigal Son, whoring with his wife. The picture has been seen variously as a straightforward painting of the Prodigal Son, as Rembrandt thumbing his nose at the staunch middle class to which the couple belonged, as a flaunting of new wealth, and as a pious confession of sinfulness.

By 1639, Rembrandt's success allowed him to buy a large house in a prosperous neighbourhood. He eventually filled the house with a collection of paintings, prints, naturalia, and other curiosities. Although much of the collection constituted his workshop's artistic capital or his stock (Rembrandt dealt in art), collecting was also a genteel pastime. The elegant *Self-Portrait* of 1640 (London, NG) bespeaks his respectable and artistic status by evoking portraits of exemplary gentlemen by Titian and Raphael.

In 1642 Rembrandt completed *The Nightwatch* or *Militia Company of Frans Banning Cocq* (Amsterdam, Rijksmus.). This militia portrait broke radically with tradition. Captain Banning Cocq is striding towards the viewer while he commands his lieutenant to get the company marching. As the men organize themselves in an undulating movement before a dark arch, few of the officers stand out clearly. Allegorical figures comment on the company's role. Because of Rembrandt's blend of narrative and portraiture, later generations believed that the sitters had rejected the painting and thereby plunged the artist's career into decline. The historical evidence is more complex. The painting was accepted and well remunerated, and 17th-century writers expressed admiration for its unusualness. Yet they also registered discomfort at Rembrandt's wilful contrasts of light and dark. The painting's strong *chiaroscuro, soon muddied by yellowing varnish, was ultimately responsible for the title it received around 1800. At that time, militia companies indeed carried out nightwatch duties, which they did not have in Rembrandt's time.

The myth of Rembrandt's decline after *The Nightwatch* was spurred by Saskia's death in 1642, even though he soon found a lifelong companion in Hendrickje Stoffels. Yet if 1642 did not yield instant failure, Rembrandt's production after about 1640 did change in tone as his patronage and friendships shifted. Rembrandt's biblical pictures of the 1640s favour quiet human relevance over awesome divine spectacle (*The Holy Family behind a Curtain*, 1646, Kassel, Schloss Wilhelmshöhe). Whereas his previous portraits were primarily paintings of merchants and preachers, he now made more intimate etchings of professionals, artists, and gentleman-scholars such as Jan Six (1647). Rembrandt began to experiment with landscape, recording the countryside around Amsterdam in limpid drawings and etchings and painting imaginary realms. His etchings became more technically intricate and thematically inventive, even hermetic (*Faust*, *c*.1652). The *Hundred Guilder Print* (*c*.1642–9), named for its fabled price around 1700, fuses aspects of Matthew 19 into a bustling scene whose unshakeable centre is Christ. These works were made for or must have appealed to Six and other connoisseurs; many, including *The Hundred Guilder Print*, visualize an inward spirituality Protestant in character.

The quiet mode of these small works also pervaded Rembrandt's monumental canvases after 1640. Historical figures appear in still actions or pensive moments (*Aristotle*, 1653; New York, Met. Mus.; *The Prodigal Son*, *c*.1665; St Petersburg, Hermitage); richly luminous paint renders portrait sitters introspective (*The Jewish Bride*, *c*.1665; Amsterdam, Rijksmus.). Rembrandt further simplified narratives and poses by what contemporaries called a 'rough' paint handling. Bodies, costumes, reflections are blocked out and built up in bold strokes (*Jan Six*, 1654; priv. coll.). Fundamentally indebted to Titian, Rembrandt's dragged paints and shiny glazes still fool the eye but also call attention to his handiwork.

Although Rembrandt continued to receive commissions, his late style of broad brushwork yet complex layers was partly eclipsed by a new preference for smoothly finished, classically composed, and decorously conceived paintings. Rembrandt's *Conspiracy of Claudius Civilis* (*c*.1661; Stockholm, Nationalmus.), painted for the new town hall, was probably a victim of taste, for the artist soon had to take it back. The authorities may well have objected to Rembrandt's characterization of the heroic ancestors of the Dutch as rough-hewn conspirators pledging a sword oath to their half-blind leader.

Rembrandt's grave, quiet, yet unidealizing mode may have been unsuitable for large historical works, but it was indispensable to the weight of his last self-portraits. These heavily worked paintings manifest Rembrandt's awareness that his style offended prevailing tastes, for in them he confronts the viewer directly, in working garb or vintage imaginary costume, laughing or with steadfast melancholy (*Self-Portrait*, *c*.1661; London, Kenwood House).

It is unclear to what extent Rembrandt's notorious financial difficulties were caused by waning patronage. His expensive house and trade losses were responsible in part. In 1656, Rembrandt declared a *cessio bonorum*, a form of bankruptcy under which he had to sell his house and much of its contents. To protect Rembrandt from further claims, Titus and Hendrickje formed a company that employed him. In 1658, Rembrandt made his final move to a rented house in a modest middle-class quarter. Although he kept painting, the onus of insolvency must have reduced his elite patronage.

Soon after his death Rembrandt came to be seen as a leading anticlassical painter. The theatre critic Andries Pels derided his penchant for painting tattered costumes and the garter marks of models. Because of such violations of decorum, Rembrandt's reputation remained mixed throughout the 18th century, until, in the course of the 19th, he became the archetypal *Romantic genius, a free spirit ahead of his time. Neither the anticlassical nor the genius label acknowledges Rembrandt's historical complexity, yet each was conditioned by his art. From his early *Self-Portrait as Beggar* (etching, 1630) to his late self-portraits as painter, Rembrandt cast

himself in defiant roles. He repeatedly jested with the classics, turning *Ganymede* into a crybaby without bladder control (1635; Dresden, Gemäldegal.). His *Large Nude*, garter marks and all (etching, c.1631), makes mockery of the smooth nudes of Titian, the fleshy heroines of *Rubens. Rembrandt's unconventional, occasionally grotesque renderings of the body may in part be ascribed to a Protestant aesthetic. The cruel *Blinding of Samson* (1636; Frankfurt, Städelsches Kunstinst.) offers the picture of a body fallen by its sinful desire.

But Rembrandt's ability to capture bodies, actions, and emotions in unidealized terms is not easily identified with one ideological stance. His earthy approach is an early, versatile expression of the modern preoccupation with the everyday, embodied in his drawings of people in kitchens, in streets, even on gallows, and in his affecting renderings of biblical stories. Rembrandt's economic suggestion of the character of his sitters and heroes accounts for the sustained appeal of his art. In a rare written statement, Rembrandt praised this characteristic in his New Testament paintings for Frederick Henry, noting that he had represented them 'with the most natural movement'—a visible movement inseparable from the emotion it pictures. MW

Chapman, H. P., *Rembrandt's Self-Portraits: A Study in Seventeenth-Century Identity* (1990).

Rembrandt: The Master and his Workshop, exhib. cat. 1991–2 (Berlin, Altes Mus.; Amsterdam, Rijksmus.; London, NG).

Schwartz, G., *Rembrandt: His Life, his Paintings* (1985).

White, C., *Rembrandt* (1984).

REMINGTON, FREDERIC (1861–1909). American painter and illustrator. Remington was born in Canton, NY, and studied at the newly established School of Fine Art at Yale University (1878–80). In 1881 he travelled in the Dakotas, Montana, Arizona, and Texas recording frontier life in sketches which he finished back in New York. He sold his first drawing to *Harper's Weekly* in 1882 and, with the exception of a brief period as a Kansas City bar owner in the early 1880s, began a successful career as an illustrator of books and magazines including his own short stories. Remington specialized in the Wild West of cowboys and Indians, gathering his authentic material on short visits to the western states. Despite the drama of many of his compositions, including his famous *A Dash for the Timber* (1899; Fort Worth, Amon Carter Mus.), his drawings and paintings provide a valuable source for the history of life in the west. From 1895 Remington also worked in sculpture, creating figurines of mounted Indians and cowboys which were highly popular and replicated in thousands. His work is largely responsible for the archetypes of ranchers, rustlers, and Red Indians immortalized by Hollywood. DER

Hassrick, P., and Webster, M., *Frederic Remington: A Catalogue Raisonné* (2 vols., 1996).

RENAISSANCE. *See overleaf.*

RENI, GUIDO (1575–1642). Italian painter, draughtsman, and etcher; together with Annibale *Carracci and *Caravaggio one of the most famous and successful of the 17th century. His contemporary biographer, *Malvasia, suggests he was a modest and neurotic man of limited education but deeply religious. He was a compulsive gambler; had a pathological dislike of women, apart from his mother, of whom he painted a sensitive portrait (Bologna, Pin. Naz.), and was prone to conflict with teachers, patrons, and other figures of authority. Notwithstanding these personal difficulties, as an artist he achieved, through study of the *Antique, *Raphael, and *Parmigianino, a pure and ideal beauty in his figure style that places him apart from other classicizing artists. His early training in Bologna was under Denys *Calvaert, where he worked alongside *Domenichino and *Albani. Like them he also transferred to the Carracci Accademia degli Incamminati in 1594–5, and trained under Ludovico and Agostino, before quarrelling and leaving c.1598. His paintings from this period include the *Coronation of the Virgin* (Bologna, Pin. Naz.) and the *Assumption of the Virgin* (Pieve di Cento, parish church). By 1601 he had moved on to Rome where he enjoyed much patronage from the Borghese family. For them he painted the fresco of *S. Andrew Led to Martyrdom* (1609; Rome, oratory of S. Andrea at S. Gregorio Magno); the decoration of the chapel of the Annunciation in the Palazzo del Quirinale (1610); and the ceiling fresco of *Aurora* (1614) in the garden pavilion of the Palazzo Rospigliosi-Pallavicini. These are all characterized by a lucid and refined classical grace, distinct from the more expressive and naturalistic style of Annibale Carracci and the more concentrated dramatic narrative to which Domenichino aspired. The *Aurora* in particular recreates the spirit of Antique wall painting.

Earlier, encouraged by the *Cavaliere d'Arpino, Reni had briefly experimented with a more realistic Caravaggesque manner in his *Crucifixion of S. Peter* (1604–5; Vatican Mus.) as well as his *David with the Head of Goliath* (Paris, Louvre). In contrast, in his equally violent *Massacre of the Innocents* (Bologna., Pin. Naz.) commissioned for S. Domenico, Bologna, but probably painted in Rome c.1610–11, he moves on to a style inspired by the idealized but frozen forms of Graeco-Roman sculpture and the internal equilibrium of Raphael's frescoes in the Vatican.

In 1614 Reni returned to Bologna, where he painted some of his most successful large-scale oil paintings, a technique he preferred to fresco. His work included the *Pietà dei Mendicanti* (1613–16; Bologna, Pin. Naz.), the *Samson* (Bologna, Pin. Naz.), the *Annunciation* (1616–17; Genoa, S. Ambrogio), *Atlanta and Hippomenes* (1618–19; Madrid, Prado), the Cappuccini *Crucifixion* (Bologna, Pin. Naz.), the four paintings associated with the feats of Hercules (1617–21; Paris, Louvre), and *Bacchus and Ariadne* (1619–20; Los Angeles, County Mus.). These were followed by the large-scale and much admired *Trinity* for S. Trinità dei Pellegrini, Rome, which he sent from Bologna in 1626; and the *Pala della Peste* (1630; Bologna, Pin. Naz.) which was conceived as a votive banner painting. This marked a change in style; the artist's rich saturated colours and solid firm brushwork are replaced by a much lighter tonal range and thinner, less assertive handling. At the same time Reni's popularity, combined with his growing financial difficulties which resulted from his gambling, led to a proliferation of studio productions which have sometimes impeded a proper evaluation of his artistic achievement. In his final years, Reni produced a number of highly personal sketch-like canvases, in which the dark reddish ground is brought into play for spatial effect and the figures are defined with minimal modelling and sparse but delicate silvery-toned brushwork. These range from his *Anima Beata* (Rome, Capitoline Mus.) of c.1640–2, and his *Moses with Pharaoh's Crown* (Edinburgh, NG Scotland), which are to all intents and purposes complete, to other pictures such as the *Lucretia* and the *Cleopatra* (Rome, Capitoline Mus.) which have been taken little beyond the underpainting stage but are admired today for their spontaneity, delicacy, and lack of finish. HB

Pepper, S., *Guido Reni* (1984).

Spear, R., *The Divine Guido: Religion, Sex, Money and Art in the World of Guido Reni* (1997).

RENIER (or Rainer, Renerus) OF HUY (active 1125). South Netherlandish metalworker known from a reference to one 'Renerus aurifaber' in a charter dated 1125 of Albero I, Prince-Bishop of Liège, and thought to have been responsible for the magnificent brass baptismal font made for Notre-Dame-aux-Fonts, the baptistery of Liège Cathedral (now Liège, S. Barthélemy). Two medieval chronicles state that he was the craftsman. The font, decorated with five baptismal scenes, including the *Baptism of Christ*, rests on feet in the form of cattle. Its cover vanished during the Revolution. It is of exceptional technical quality and is stylistically important because of its classical inspiration. Stylistic similarities with the font have led to the attribution to Renier of a cast copper-alloy Crucifix figure (1120s; Cologne, Schnütgen

continued on page 628

· RENAISSANCE ·

A retrospective term, 'Renaissance' describes a period, a style, and certain associated values ('Renaissance man'). Opening the 'modern' or 'early modern' period, the Renaissance period succeeded the Middle Ages and was succeeded by the *Baroque period, following a slightly varying chronology according to point of view, but within the frame of the 14th or 15th to the 17th century. In practice the 'early' Renaissance spans the 15th century, the 'High' Renaissance is located in the first quarter of the 16th, and the Renaissance as a whole is deemed to have finished its work by 1600, though in its original French usage, and as the late-starting 'English Renaissance' in current parlance, it is a phenomenon of the 17th century. As a style of architecture, art, and ornament the Renaissance originated in Italy and spread rapidly to the rest of Europe after the French invasions of the peninsula in the 1490s. Most obviously and outright in ornament and architecture, fairly clearly in sculpture, rather more obscurely and indirectly in painting, the Renaissance is marked by a return to classical form (see CLASSICISM), and displaces *Gothic. Renaissance values are largely synonymous with *humanism, although in today's terms, filtered through Jacob *Burckhardt, a 'Renaissance' man is a polymath, bridging the gap between art and science which indeed did not then exist.

Above all the Renaissance signifies a break with the Middle Ages. However, despite attestations that the term depends on a *rinascita* or rebirth of which its own age was conscious, Renaissance-period people in fact perceived no such break until well after it was meant to have happened. Recent scholarship continues to demonstrate that in every sphere—art, literature, philosophy, technology—development was continuous through from the later Middle Ages and even earlier. For example, the paper technology that made possible the explosion of publishing due to the invention of printing in the 1460s—and also the rise of the status of the drawing among 16th-century artists—began to evolve in the 12th century. The Renaissance mastery of cannon, to such a degree that rather suddenly in the last years of the 15th century every castle and city in the world became indefensible, initiating a new era of fortification in the 16th century that had a profound effect on urban development, depended on the introduction of gunpowder much earlier and on a steadily evolving tradition of warfare. Even humanism cannot be so sharply distinguished from scholasticism as once it was: return to the original text of *Aristotle, for example, was already advocated by Roger Bacon, and the Greek scholars of the 15th and 16th centuries never equalled the achievement of the Italian Barlaam of Seminara (c.1290–1348), who, in Greek, argued the case of Latin theology in Constantinople (though he was said by the Greeks to have been worsted). The 'lost' classical manuscripts rediscovered by Poggio Bracciolini—in an enterprise often regarded as symbolic of the new spirit—were not late *Antique exemplars but much later copies. So, too, in art, 'Renaissance' is etymologically not much more accurate a term than 'Gothic'.

There are of course differences between the Renaissance and earlier periods, but those between the 14th and 15th centuries are hardly greater than those between the 15th and 16th (or between the periods 1350–1450 and 1450–1550). The Renaissance period was indeed one of transition and of progress. The changes are perhaps more strikingly quantitative than qualitative, more an acceleration than a change of direction. With the important exception of manuscript illumination, there is a vastly greater amount of cultural material surviving from the Renaissance than from the Middle Ages, one which accidental rates of survival can hardly explain; and it is more individuated and articulate—artists' careers in particular are much better documented. Though the tendency to improve written records has a long history, what earlier anywhere can compare with the fulsome surviving archives of the Gonzaga rulers of Mantua? In Italy this expansion becomes almost exponential in the second half of the 15th century and continues until the second half of the 16th, with which there ensues a period of recensionism and codification, even restriction—'neo-feudalist' tendencies in society, Tridentine 'reforms', academicism, and, in painting if not in drawing or sculpture, comparative sterility.

The overall goal of art in the Renaissance remained what it long had been: the perfection of naturalism. In work by such as *Leonardo or *Raphael, this goal might even seem to contemporaries to have been achieved. It was attained in the 16th century with increasing confidence and with the *sprezzatura*, or art of making accomplishment look easy, of Baldassare *Castiglione's ideal courtier. And the scope of naturalism was greatly enlarged, beyond 'a thing of birds and flowers only', as Walter *Pater dismissed medieval art. The Antique, though some have believed it an essential stimulus to Renaissance art, was studied by artists more as a means to this naturalism than as an end itself; it was not directly copied, even in fakes, but was emulated. Classical statuary, once it began to be collected and displayed, increasingly became a repertoire from which to borrow, but its role was obviously passive: formative influences on the young *Michelangelo were *Bertoldo di Giovanni and *Ghirlandaio, possibly Tullio *Lombardo, but not the *Apollo Belvedere or *Belvedere Torso. The older view seems more accurate that the Renaissance was, rather, an 'age of discovery' which took as its domain the Antique no less than the Atlantic. The Renaissance adoption of a 'classical language' of art was a work of synthesis undertaken not out of a passion for the past, but because it could be realized as a suitable vehicle for contemporary ideals or agenda.

Various attempts have been made to pinpoint the

moment at which supposedly the *Zeitgeist* turned from old to new. With exceptional crudity John *Ruskin decided (*The Stones of Venice*, 3 vols., 1851–3) that in Venice the Renaissance—in his perspective, of course, a period of decline—'set in' following the death of Doge Carlo Zeno in 1418. Aby *Warburg (*Sandro Botticellis 'Geburt der Venus' und 'Frühling': eine Untersuchung über die Vorstellungen von der Antike in der italienischen Frührenaissance*, 1893), who saw the Renaissance as embodying a new sensibility or *Einfühlung* expressed in terms of movement, epitomized by the fluttering hem of an Antique nymph's shawl or frock, pointed to successive versions of a mid-15th-century Florentine print in which the costume of a woman changes from a style deriving from the Burgundian court to that of such a nymph. He emphasized the pathos that the Italian Renaissance saw again in Antique art, but Italians appreciated more explicitly the emotional clangour of such 15th-century Netherlandish art as Passion scenes by Rogier van der *Weyden. Erwin *Panofsky (*Renaissance and Renascences in Western Art*, 1960) believed that the earlier, medieval reuses of classical forms or figures (or 'renascences') were fundamentally different from the 'real' Renaissance use of them because, by contrast, classical figures in medieval art never carried their original meanings. It is a naive mistake, however, to suppose that the Renaissance restored or reintegrated classical culture, or in any sense reunited classical signifiers with their classical signifieds. On the contrary, what seems to occur in the 14th and 15th centuries is that writers (notably *Boccaccio) begin to state clearly that the classical gods are only ciphers. Acknowledged as allegories, the classical gods and myths posed no threat to the Christian religion and for this reason from the end of the 15th century became available as the vehicle of a largely new moral and psychological repertoire. But if no single strand or moment can fix the switch from medieval to Renaissance, we surely can assert that printing, introduced from 1460, accelerated and consolidated the process and impact of the mix of changes affecting Renaissance Europe irreversibly.

In Giorgio *Vasari's *Lives of the Most Excellent Artists, Sculptors, and Architects* (1550; 2nd edn. 1568) and in other sources in its wake the Renaissance gave an account of its own artistic development which, consolidated over the intervening period, has been subject to revision by 20th-century art history but not shifted. It is a nice tale. In its first phase or 'manner' Latin artists, turning to nature, let drop the naivety or clumsiness of the prevailing *Greek (or *Byzantine) and Frankish (or Gothic) styles, setting their figures on the ground rather than on their toes in a rational *perspective. The pioneers of this movement were the sculptors Nicola and Giovanni *Pisano and the painter *Giotto. After these artists' heritage had been somewhat dissipated by their followers in the later 14th century, in the early 15th century *Donatello and *Masaccio led the reform of art and refounded this second manner on the study of the Antique and a still more 'scientific' perspective. Their efforts were continued by subsequent generations in a period of almost constant forward

progress, lacking however the accomplishment, grace, and virtuosity of the third phase, inaugurated by Leonardo in the later 15th century and consolidated by Raphael, Michelangelo, *Titian, and several other artists of genius in the 16th. For Vasari and other Florentine commentators Michelangelo's 'divine' achievement was a peak no one else could match; elsewhere in Italy and Europe Raphael of Urbino was preferred, or Titian of Venice. Describing Michelangelo's Sistine chapel ceiling (Vatican), Vasari stated his anachronistic belief that the oak garlands held by the artist's celebrated *ignudi* could be read as emblems of the Golden Age in which they were painted (in fact they are blazons of Pope Julius II's family name, della Rovere (= of the oak)). Still today the 'High' Renaissance is believed to have achieved an outstanding balance and synthesis that fractured after the death of Raphael in 1520. Indeed there are no commentaries from before Vasari offering rival schedules, and the pre-eminence of the High Renaissance was reiterated not only in theory but in imitative practice in the early 17th century by the *Carracci and their school.

It is obviously incorrect, however, to depict the early Renaissance as a sequence of steps leading to the High Renaissance landing, especially when the only treads and risers used are the happy accidents of survival. It is a distortion to begin one's account with the series of monumental *pulpits produced by Nicola Pisano and his workshop in the Papal States at the end of the 13th and beginning of the 14th century, ignoring, for example, the mutilated fragments some 50 years earlier of the statuary programme of Frederick II's Gate at Capua—though the former are prominently displayed, intact, on established tourist routes in hospitable Tuscany, and the latter languish headless in an unfrequented museum in a suburb of Naples. The art of Frederick's court may offer a plausible link connecting the earlier 13th-century style of Reims and other northern cathedrals to the Pisani, emphasizing in particular that the strain of classicism one may have hoped to isolate at the beginning of the Renaissance retreats indefinitely back into the Middle Ages.

It was, too, a medieval context that stimulated the development of the kind of narrative painting with which Giotto is associated, both in *altarpieces and, predominantly, on church walls (we know little of contemporary palace decoration)—a context determined by the politics and economics of the rising medieval city-states and by the emergence of the preaching orders of Franciscans and Dominicans. This narrative painting, moving away from the abstraction of *icon painting towards a naturalism comparable perhaps to contemporary theatre, gradually acquired, through the 14th century, ever greater sophistication in the work of *Duccio, Giotto, *Simone Martini, Ambrogio *Lorenzetti, *Tomaso da Modena, *Altichiero, and others. Again artists working outside the Papal States (with the exception of Giotto at the Arena chapel in Padua) are less well known and appreciated, although these painters, like contemporary sculptors, were often peripatetic. Many of these artists developed individual

styles, moving generally towards a more incisive portraiture, a more convincing *mise-en-scène* (at least the equal of sculptural tableaux), and a more accurate perspective. They initiated a development, for instance, in which the originally discrete, almost token figures of polyptych retables would eventually, in the next century, be united in a single, ordered space in a dynamic interrelationship—the *sacra conversazione* altarpiece.

In the early 15th century Filippo *Brunelleschi in Florence achieved a decisive break with the past by preferring against the prevailing Gothic in architecture a deliberate revival of the local *Romanesque, as represented in particular by the navel of Florence, the cathedral baptistery, which has such a highly classicizing ornament that it is extremely difficult to date. Initiated in the portico of the Foundling Hospital (1419), the new idiom was guaranteed success by Filippo's achievement in vaulting the gaping space above the cathedral's recklessly expanded tribuna (though the famous dome itself is not so obviously a 'Renaissance' work). Translated by Leon Battista *Alberti into a principle of ornament that approximated more closely to classical examples, this new style of architecture took hold even outside Florence and, undergoing continual refinement or adaptation and codification, became the heritage of all Europe; it was not restricted to architecture proper but soon became the standard of every kind of ornament. Of course, Renaissance classical architecture did not consist in the imitation or revival of classical building types, but the adaptation of what was soon perceived as a language of ornament to modern requirements. Churches, for example, remained of Gothic dimensions rather than reverting to late Antique proportions, though the difficult attempt was made to front them in a 'temple' or 'triumphal arch' fashion and to constitute their elements of classicizing parts. Brunelleschi was also responsible for an experiment in which, looking through a pin-hole, the viewer could see the scene depicted on a panel exactly as it was in reality: with this, one might want to say, the goal of perspective shifted from an ancillary role enhancing the realism of a representation (medieval) to that of comprehensive *illusionism (Renaissance). This illusionism, traceable through *Mantegna, *Melozzo da Forlì, *Bramante, *Correggio, *Giulio Romano, *Veronese, and many others, was associated from the beginning with a classicizing ornament.

The Renaissance, or humanist, ability to borrow from the past (or to invent on the basis of a mere hint from it) not simply occasional motifs or effects but whole organisms or procedures is also apparent in Alberti's short but fundamental treatise *De pictura* (1436), adapting the form of a rhetorical manual to a new subject area. Even if, in demanding a kind of dramatic unity for painting, involving for example single-point perspective and consistent mapping of lightfall and shadow, he was updating medieval paradigms, more important still he was articulating them, and by the end of the century attitudes had altered to such a degree that painting, sculpture, and architecture had become widely accepted as equals beside the traditional seven liberal arts. To a lesser degree artists were also gaining in status in northern Europe, though there is no contemporary appreciation of such consummate practitioners as Jan van *Eyck or Rogier van der Weyden as great as is recorded in Italy; the effects they achieved with oil paint (such as glistening highlights, deeply saturated and resonant colours, or infinitesimally gradated shadows) were accompanied by perspectival inscenations actually more complex than those of the Italians (and notably more successful in landscape, for instance)—but, even if they were written up, it was never printed.

Later in the century, the tragic vividness and poignancy that Hugo van der *Goes could achieve has parallels with the work of *Perugino in central Italy or Giovanni *Bellini in Venice (both using oils). However, if these artists seem to found their emotional transmittal in a static naturalism, others, in contrast to the Netherlanders, became increasingly adept in the handling of the movement, or the kinetic energy of their figures—*Pollaiuolo, *Botticelli, Giovanni Antonio Amadeo. This is already present in the expressionism, so to call it, of Donatello, and a factor may be the study of classical art, although Donatello's borrowings from classical material are full of solecism and barbarism, and Mantegna's more disciplined 'classicizing' style is, though powerful, drier. This quest to depict energy was tempered in the next century into a more rhetorical, heroic style by such artists as Fra *Bartolommeo, Raphael, Titian, and Michelangelo.

One incongruous result of the *ex post facto* view of 14th- and 15th-century art is that those earlier artists who did not take a 'classicist' or High Renaissance direction when it was 'offered' by their immediate predecessors—such as later 14th-century artists after Giotto, or Fra *Angelico or Filippo *Lippi after Masaccio—tend to be placed, confusingly, in an implicitly non-progressive 'late Gothic' camp. One may note that the figures for Donatello's and *Michelozzo's tomb for Bartolommeo Aragazzi in Montepulciano (1427–38, dismantled; fragments in Montepulciano Cathedral and London, V&A) seem almost to mimic an early Classical Greek style, but this almost 'pure' classicism was immediately discarded by these artists themselves. The art of *Piero della Francesca, whose reputation has stood very high since his virtual rediscovery in the late 19th century, is not Gothic, is not classicist, does not lead 'on' in any obvious way to the High Renaissance. The Italian early Renaissance is notable for a proliferation of strongly individual, strongly localized 'schools' (to use a later term), based around its numerous autonomous courts or cities. As these centres became politically agglomerated in the 16th century, variations on what soon became virtually an artistic canon became more solely individual than regional.

Leonardo da Vinci's depiction of an archetype of the Renaissance interest in proportions, 'Vitruvian Man', has come to stand, in its satisfactory resolution of a man's outstretched body into a square and a circle, for the High Renaissance itself, just as he himself has become the

archetype of a 'Renaissance man', indeed of a 'modern' genius. In painting Leonardo was most influential in rather a local way, in Lombardy after he had moved to Milan, but many artists emulated that subtlety of tonal gradation (*sfumato*) of which Leonardo was the master; meanwhile Leonardo's caricatural drawings and Madonna and Child compositions are early instances of Italian figuration making an impact on Netherlanders—paralleling that of the prints of Mantegna and his followers upon *Dürer. Leonardo's influence is also clear on Fra Bartolommeo and Raphael, and the parallel direction of Michelangelo's early work (the Doni Tondo; Florence, Uffizi; the *Pietà*; Rome, S. Peter's) should not be underestimated.

Though extremely accomplished, northern artists of the early 16th century such as *Gossaert tend to be overlooked, or rather eclipsed by the patronage and Europe-wide reception of the artists who were successful in the Rome of Popes Julius II (ruled 1503–13), Leo X (ruled 1513–21), and Clement VII (ruled 1523–34). Their achievement (and ambition) is enshrined primarily in the frescoes they carried out in the Vatican, but also in altarpieces, portraits, or other works sought after equally in other Italian courts and in the French king's. Michelangelo was conceded a heroic—or martyric—status unprecedented for an artist in history (even Leonardo, much of whose 'genius' is a late modern rediscovery), but also, in a backlash that focused around his *Last Judgement* in the Sistine chapel (1536–41; Vatican), he was held responsible for unleashing a school of artists captivated by aspects rather than by the full accomplishment of his style, and seduced by opportunities of their 'demonstrating their skill' away from traditional narrative paradigms. From Raphael's circle, too, there were released, onto an Italy of which the political structure was being violently dislocated and reset, a school of artists supremely accomplished in composition but not very certain of getting the job they wanted. This, the period following Raphael's death in 1520 and the sack of Clement VII's Rome by Charles V in 1527, is the era of *Mannerism. It was not exclusively an Italian phenomenon or under Italian influence—the *'Antwerp Mannerists' are quite reasonably so called—and it is difficult to define, partly because, like the term Renaissance itself, it is meant to circumscribe a period, designate a style, and represent certain values, all at once.

*Venice, too, felt the pull of High Renaissance Rome, *Sebastiano del Piombo emigrating to the household of the papal banker Agostino Chigi, a lasting association with Michelangelo, and eventually the curia. Titian, merging all the colourism, and more, that Giovanni Bellini had learned from his own heritage and from Netherlandish art with a 'classicist' form emulating that of Fra Bartolommeo and Raphael—to this extent fusing *disegno* and *colore*—consolidated his international reputation by obtaining the patronage in 1530 of Charles V, the monarch who three years earlier had upset the careers of so many of his peers. From the vantage of 'neutral' Venice, he effectively became a court artist without ties of attendance—well might it be rumoured that Charles stooped to pick up his brush. Around him the local school flourished and even attracted foreign artists, the Veneto still offering plenty of 'local dignitary' patronage; in central Italy, and even for north Italian artists lacking the right kind of social skills (such as Lorenzo *Lotto), patronage was less stable.

The High Renaissance was a watershed. Much in the way that the humanists, on the underpinning of a Latinate grammar, elevated the Tuscan dialect of past masters (*Petrarch, Boccaccio) into a literary vernacular, or that Aldus Minutius translated the *cancelleresca* or 'chancery' hand into what we call italic typeface, High Renaissance artists set a standard—*la buona maniera*, as Vasari called it—which could be deviated from but not unlearned. Indeed this constructed 'classical' style of the Renaissance (though it is often, rather confusingly, called Mannerism) conquered Europe in the 16th century, whether by export or by migration—*Rosso and *Primaticcio to France; numerous northern artists to Italy. It spread increasingly through the means of prints, even emblem books, emanating especially from the Netherlands after the mid-16th century—although, ironically, Dürer well after his death became a source of inspiration to many Mannerists both in Italy and in the north.

The diffusion of the Renaissance in northern Europe should be sought not simply in the assimilation of Italianate styles, but also in the application of Renaissance principles to a native culture—as was done perhaps for the first time at the court of Maximilian I, for whom, for example, Dürer, *Burgkmair, and other artists created in a consciously northern medium, the *woodcut, a massive 'triumphal arch' parading imperial values. The Elizabethan court in England was resistant, perhaps, to some of the outward forms of the current Renaissance style (usually called the 'Mannerist' style) but its artistic patriotism presupposes some assimilation and effect of humanism. PHo

Hale, J., *The Civilization of Europe in the Renaissance* (1993)

Holberton, P., 'Of Antique and Other Figures: Metaphor in Renaissance Art', *Word and Image*, I/1 (1986).

Hollingsworth, M., *Patronage in Renaissance Italy* (1994).

Panofsky, E., *Renaissance and Renascences in Western Art* (1960).

Pope-Hennessy, J., *Italian Gothic Sculpture* (4th edn., 1996).

Pope Hennessy, J., *Italian High Renaissance and Baroque Sculpture* (4th edn., 1996).

Pope-Hennessy, J., *Italian Renaissance Sculpture* (4th edn., 1996).

Mus.), but an incense vessel bearing his name is now thought to be too late to be from the workshop. In view of the importance ascribed to him by contemporary chroniclers, it is curious that so little is known of his work, and in fact it has recently been suggested that the Liège font may have been cast in the imperial foundry at Constantinople in the second half of the 10th century. PS

Lasko, P., *Ars sacra 800–1200* (2nd edn., 1994).

RENOIR, PIERRE-AUGUSTE (1841–1919). Prominent member of the French *Impressionist group of painters. Renoir's art is a celebration of the beauty of women and nature; his images both of modern Parisian life and of idealized figures in a timeless landscape suggest an enchanted and radiant world. He trained initially as a porcelain painter and in 1861 entered the studio of Charles Gleyre (1808–74) where he met *Sisley, *Bazille, and *Monet. His early canvases, indebted to *Courbet, are sombre, but in 1869 he painted with Monet at the fashionable bathing establishment La Grenouillère on the Seine, where he developed the dappled light effects and broken brush strokes of Impressionism. He exhibited at the first three Impressionist exhibitions (1874, 1876, and 1877) and throughout this decade painted both loose and unstructured landscapes, of bright city streets, sunlit meadows, and gardens, and more highly finished scenes of the charm of modern Parisian life, such as *Ball at the Moulin de la Galette* (1876; Paris, Mus. d'Orsay). But he also won success at the *Paris Salon with his *Portrait of Mme Charpentier and her Children* (1878; New York, Met. Mus.) and enjoyed the support of wealthy patrons. In 1881 Renoir, troubled by the limitations of Impressionism, visited Italy, where he studied ancient *Roman and *Renaissance art, and sought a new grandeur and simplicity. The *Umbrellas* (1880s; London, NG), in which soft, vibrant touches contrast with a new emphasis on line and form, marks a change of direction, and from the mid-1880s Renoir abandoned Impressionist spontaneity and modern subject matter. His landscapes, such as *The Grape Pickers at Lunch* (c.1888; Los Angeles, Armand Hammer Coll.), suggest a rural Arcadia, and look back to the enchantment of French 18th-century art. But above all Renoir painted the nude, and in a series of monumental *Bathers* he sought to renew his links with the traditions of European figure painting. His *Bathers* (1884–7; Philadelphia Mus.) is tightly designed, with an emphasis on line and a pale, fresco-like surface. From 1903 Renoir was based at Cagnes, on the Mediterranean coast, and here his palette became warmer, his touch more fluid, and his forms, now reminiscent of *Titian and *Rubens, more voluptuous and massive;

both his nudes, and his images of women at their toilet, are painted in brilliant reds and oranges, evocative of the timeless landscape of the warm south. In his final years, when he was ill, and with his hands paralysed, Renoir's assistants, closely supervised by the painter, realized his massive female nudes as bronze sculptures. HL

Distel, A., and House, J., *Renoir*, exhib. cat. 1985 (London, Hayward).

REPIN, ILYA (1844–1930). Russian painter, the leading exponent of critical realism. He studied at the Imperial Academy, St Petersburg 1864–76 where he painted *Barge-Haulers on the Volga* (1870–3; St Petersburg, Russian State Mus.), a quintessential image of hard labour which established his reputation as a documenter of social and political inequalities. He was in Paris 1873–6 and again in 1883, becoming acquainted with contemporary trends, including *Manet and the *Impressionists. In 1878 he joined the *Peredvizhniki, later producing some of the key works of the Russian realist school: *Religious Procession in Kursk Province* (1880–3; Moscow, Tretyakov Gal.), a gritty portrayal of rural poverty; *They Did Not Expect Him* (1884–8; Moscow, Tretyakov Gal.), a dishevelled political exile returning to his unsuspecting family; and *Ivan the Terrible* (1885; Moscow, Tretyakov Gal.), a harrowing image of murder, banned from exhibition due to its bloody analogy with the assassination of Alexander II. A member of the *Abramtsevo colony, he participated in the Slavic revival, out of which grew his huge ethnographic celebration of national heritage, *The Zaporozhye Cossacks* (1880–91; St Petersburg, Russian State Mus). A gifted portraitist, he painted sharply observed images of nameless peasants and cultural luminaries; his portrait of the terminally ill Mussorgsky (1881; Moscow, Tretyakov Gal.) is an impressive fusion of documentary observation and compassion. From 1892 he taught at the reformed Academy but resigned in 1907 disillusioned at its lack of development. During the 1890s he pioneered progressive teaching methods, organizing an experimental exhibition of younger artistic talent in 1896, and was briefly involved with Diaghilev's World of Art group. After his death he became an unwitting but obvious role model for Soviet artists. Of mercurial but undeniably abundant talent, Repin alternately espoused the tendentious or aesthetic primacy of art, never fully reconciling himself to either but excelling in both, though the latter aspect of his genius continues to receive less recognition. DJ

Sternin, G., *Ilya Efimovitch Repin: Painter of Russian History* (1996).
Valkenier, E. K., *Ilya Repin and the World of Russian Art* (1990).

REPRESENTATION. The term has taken on increasingly complex connotations in 20th-century discussions of visual art. It is primarily used for the way in which something made may stand for, or bring to mind, some other thing—most typically, for the way in which flat pictures may bring to mind solid bodies. Works of art which do this are said to be 'representational', rather than abstract or decorative in character. In this sense, representation is the contemporary term that translates the Greek word *mimesis*, used by *Plato and *Aristotle to describe the making of likenesses. Their attention to this aspect of art led to the doctrine, widely accepted in Europe from classical times until the arrival of abstract art c.1910, that 'the imitation of nature' was the defining quality, or at least the minimal requirement, of the fine arts of painting and sculpture.

Confusingly, however, representation may be contrasted to imitation. *Braque proposed that his *Cubist painting might 'represent an object, without imitating it'. Behind his phrasing lies the thought that an object may be represented either by copying its appearance to the eyes, imitatively, or else through visible symbols which make us think of the object because we have learned the code that assigns them customary significances. Exploring and playing with such codes of symbolic representation was a widely shared interest among 20th-century artists, ranging from the Cubists to *Klee to *Pop artists like Richard *Hamilton.

Meanwhile, a leading concern of art theorists was to relate these seemingly contrasted modes of representation, the symbolic and the 'pictorial' or imitative. Erwin *Panofsky's proposition that *perspective could be seen as a symbolic form, Ernst Gombrich's doctrine that 'making comes before matching', and Nelson Goodman's radical assault on the whole notion that pictures might resemble objects, all gave priority to the idea of symbolization. Art, a common argument might run, stems from humans assigning symbolic meanings to products, within systems of signification that are comparable to languages (see also SEMIOTICS). Such a linguistic model for visual representation was heavily emphasized not only by Goodman but by *structuralist and poststructuralist theorists from the 1960s to the 1990s, and influenced much *Conceptual practice of the era. It relates uneasily, however, to ongoing scientific analyses of visual processes, applied to visual art in the writing of John Willats. JB

Gombrich, E., *Art and Illusion* (1960).
Goodman, N., *Languages of Art* (1968).
Willats, J., *Art and Representation* (1997).

REPRODUCTION REPRODUCTIVE PRINTS. A reproduction is in its broadest sense a *photograph of a painting, print,

drawing, and other techniques, used as an illustration in a book or with an independent function such as a postcard or poster. It is thus to be distinguished from a reproductive print, which is a hand-crafted work, such as a *mezzotint or engraving (see LINE ENGRAVING), in which an engraver copies—sometimes with variations—a painting or drawing by another artist. Thus *Rubens had a whole school of engravers to copy his work, and the great bulk of 18th-century French and English prints are copies of paintings. The term has sometimes taken on slightly pejorative connotations, and in 18th-century England engravers were barred from full membership of the Royal Academy and considered merely as 'ingenious meckanicks'. The art of engraving from paintings reached its apotheosis in the mid-Victorian period, with vast steel engravings after such artists as *Frith and *Millais. And the chromolithographs (see LITHOGRAPHY) published by the *Arundel Society provided cheap colour reproductions of early Italian frescoes. A reproduction is thus mechanical and impersonal, whereas in a reproductive print the personality of the engraver can still be asserted.

A reproduction can be of any size; however a photographic facsimile may be printed the same size as the original work of art, with the purpose of actually simulating, to the point of deceptiveness, the appearance of the original. A photographic facsimile can be particularly effective in the case of prints, drawings, and watercolours, but as yet there is no means of simulating the impasto and texture of an oil painting.

The development of photography between 1825 and 1840 was eventually to render the engraver's profession obsolete, and to encourage painter-etchers to emphasize the originality of their work by signing prints in pencil. Architecture, sculpture, and other inanimate works of art were early subjects for the photographer, and rapidly the discipline of art history was revolutionized by the ready availability of good photographs. These also served as very useful reference tools for artists. A principal method from the end of the 19th century was the half-tone process, based on a relief printing surface of small separate raised dots. A higher, and more expensive, process is collotype printing, in which the photographic image is transferred to a gelatine-covered glass plate which accepts printing ink in different and subtle degrees. Both these methods can be adapted to colour printing by the use of three or four blocks which superimpose the primary colours. Until about 1945 black and white reproductions were the norm, but since then colour has become more and more in demand.

In modern times the supremacy of the printed photographic reproduction is challenged by the ubiquitous computer screen, and the rapid worldwide spread of the Internet, whereby whole archives and collections may be retrieved and studied at the press of a button. RGo

REREDOS. See ALTARPIECE.

RESIN. Natural resins are sticky, water-insoluble materials, which exude from trees and plants, typically as a result of tapping or damage. The chemistry and composition of natural resins is diverse. Some trees or plants produce resins which solidify by evaporation of the essential oil component (oil of turpentine). Examples include pine resin from the genus *Pinus* (Common or Bordeaux turpentine, when still fluid; colophony or rosin when solidified) and larch resin, particularly that from the European *Larix decidua* Miller, the source of a semi-liquid resin known as Venice turpentine. These resins, when dry, tend to be brittle, dissolve readily in essential oils, and can be incorporated relatively easily with drying oils, for use as oil varnish or paint *media, by gentle warming. They are called 'soft' resins and have no chemical units within them that tend to join together to form chains (polymerize) to any great extent.

Other resins do have polymerizable components and dry by a combination of essential oil loss and polymerization. These 'harder' resins include Strasbourg turpentine (olio d'abezzo) from the European silver fir, *Abies alba* and sandarac resin, from *Tetraclinis articulata* (Vahl) and, possibly, from some *Juniperus* species. As such, they required stronger solvents (like alcohol) to effect solution and were likely to be employed as spirit varnishes. They do not combine with drying oils so readily and require quite severe heat treatment if they are to be incorporated with a drying oil, for the production of a varnish. They are less brittle as dry films than pine or spruce resins.

Copal is a general term for very hard, insoluble resins, where the polymer is usually cross-linked to form a tough matrix. These resins must be 'run'—heated strongly to partially decompose the polymer—and then are mixed with hot drying oil to produce tough, durable varnishes. The term copal is derived from copalli, an Aztec name for resins of any kind.

The botanical sources of copals are various and confused. For the most part such resins were known by their commercial names, which often indicated merely their port or area of assembly for export. Some originate from conifer trees of the Araucariaceae, particularly trees of the genus *Agathis*. The 'semi-fossilized' resin of *Agathis australis*, abundant in New Zealand and known as kauri resin, came to be highly prized for the production of durable varnishes in the 19th century. Certain softer qualities of Manila copal, such as 'melengket' or 'loba' tapped directly from *Agathis dammara* (also called *A. Alba*), and the older, more polymerized, and harder specimens 'pontianak' and 'boea' were also prized for varnish production. Small amounts of such varnishes were recommended and have been determined, analytically, to have been added to drying oil paint media in the latter part of the 19th century; partly this was done to increase the gloss and potential for colour saturation of such paints as well as to modify the rheological properties (handling characteristics) of such paints and, possibly, in the belief that the drying characteristics of the paint would be improved. In fact, any such improvement conferred on the paint medium was probably due to the incorporation of driers into the oil used in the varnish production.

The hardest and greatest variety of copal resins are produced by trees of the botanical family known as the Leguminosae. Resins of this group, the African copals, those of South America too, are—for the best part—very hard, highly polymerized resins, which may often be confused with ambers (fossil resins). They can only be incorporated into paint media and varnishes by 'running'. Some African copals, such as East African or Zanzibar copal (*Hymenaea verrucosa*), are known to have been in commerce by the Arab traders with Europe from the 11th century AD. Many of the names of African copals refer to the port of sorting or export, not to a botanical source. South American species of the genus *Hymenaea* (Brazil copal from *Hymenaea courbaril*, for instance) are, for the most part, the source of copals from the New World. Copaiba balsam is produced as a rich free-flowing liquid, by various trees of *Copaifera* species. It has been used to 'nourish' oil paintings and was also used as an additive to their oil media by artists in the 18th and 19th centuries.

Dammars and mastic are relatively soft resins. Mastic (often called 'gum mastic') is the product of a group of trees of the genus *Pistacia* (Anacardiaceae family). The resin has been known from Antiquity and that collected as pealike droplets of hardened resin comes almost exclusively from the tree-form of *Pistacia lentiscus*, found exclusively in the southern half of the island of Chios. Its use in varnish, often toughened by the addition of a little drying oil, was common.

The dammars are resins collected from a wide range of broad-leaf, tropical trees of the sub-family Dipterocarpoideae of the family Dipterocarpaceae. It is likely that resins from only a few genera have been exported to Europe. The Dutch were aware of the widespread collection and use of such material by the natives in the Dutch East Indies and it

was available in quantity at their ports. It is difficult to believe that it was not exported by the Dutch to Europe from the 17th century. Nevertheless, dammar's use as a varnish is said to have been first recorded in an 1842 edition of Lucanus (G. H. Lucanus, *Vollständige Anleitung zur Erhaltung, Reinigung und Wiederherstellung der Gemälde zur Bereitung der Firnisse . . .* , 1842), referring to a thirteen-year experience. Spirit varnishes based on the better qualities of dammar, mostly from the Malayan/Indonesian genera *Hopea*, *Shorea*, and *Balanocarpus*, are prized for their gloss, colour saturation, lack of colour (when reasonably fresh), and transparency. Balsamic resins, such as Sumatra and Siam benzoins (from *Styrax benzoin* Dryander and *Styrax tonkinensis* (Pierre) Craib *ex* Hartwich, respectively), have found application as spirit varnishes. Some resins are coloured, such as dragon's blood, from trees of the genera *Dracaena* (Liliaceae) and *Daemonorops* (Palmae).

Resins are different from natural lacquers—such as Oriental lacquer—because they are produced as an oil/water emulsion by tapping. RWh

RESTORATION OF PAINTINGS. See CON-SERVATION AND RESTORATION.

RESTOUT, JEAN (1692–1768). French history painter who was trained by his uncle Jean *Jouvenet and became a member of the Académie Royale (see under PARIS) in 1720. Although he painted a number of mythologies and genre scenes he specialized in large-scale religious works. He conceived these pictures with a seriousness of intention rare for his time and perhaps only matched by *Subleyras, working in Rome. Among his more notable works is *The Death of S. Scholastica* (1730; Tours, Mus. des Beaux-Arts), which combines grace and austerity in a remarkably potent way. MJ

Rosenberg, P., and Schapper, A., *Jean Restout*, exhib. cat. 1970 (Rouen, Mus. des Beaux-Arts).

REST-STICK. See STUDIO EQUIPMENT (PAINT-ING).

RETABLE (Latin *retabulum*: rear table), term in Christian church art for a decorated panel or screen positioned above and to the back of the altar table. It is sometimes loosely referred to as an *altarpiece. Retables originated as shelves placed above the back of the altar, used for storing liturgical objects. These shelves appeared around the 10th century, at a time when the clergy adopted a new position for celebrating Mass, moving from behind the altar to the front. The shelves were later embellished and elaborated as they developed into a backdrop for the clergy as they celebrated Mass. Retables

varied greatly in size and form. The most expensive were made of precious metals, such as gold, and applied with gems, for example the Pala d'Oro of S. Mark's, Venice (dating from 1109, reassembled in the 14th century). Some of these precious altarpieces were originally *frontals that had been moved to a less exposed position on top of the altar, such as the *Carolingian altar frontal used as a retable by Abbot *Suger at S. Denis in the 12th century (destr., but clearly visible in the picture by the *Master of S. Giles of *The Mass of S. Giles*, c.1500; London, NG). Retables were also made of gilt-bronze and applied with enamelled panels, such as the retable with matching frontal made for Lisbjerg (c.1140; Copenhagen, Nationalmus.) or that made for S. Castor, Koblenz (c.1155–60; Paris, Mus. Cluny).

The other main type of retable was made of wooden panels with painted niches, such as *Margarito of Arezzo's retable (c.1260s; London, NG). Some incorporated elaborately carved and gilded frames (for example the Westminster retable, c.1270–90; London, Westminster Abbey). Occasionally retables reached giant proportions and incorporated a *predella along their base (e.g. *Duccio's *Maestà*, for Siena Cathedral, 1308–11, now dismantled, or the Spanish retable attributed to *Marzal de Sax, c.1400; London, V&A). Painted retables usually depicted the Madonna and Child, as well as a variety of saints, with the titular saint of the church frequently dominating the design.

The retable suffered differing fates in different parts of Europe. On the Continent, particularly in Italy, it developed into the full-blown Renaissance altarpiece, whereas in England retables were destroyed during the Reformation (the Westminster retable, for example, was torn down and reused as part of a packing case, and was only rediscovered in the 19th century). TJH

RETHEL, ALFRED (1816–59). German painter. Rethel was born in Diepenbend, near Aachen, and studied at the Düsseldorf Akademie (1829–c.1834) and under Philipp *Veit in Frankfurt, in 1836, becoming a highly competent *history painter. In about 1839 he received a commission for four paintings of Roman emperors for the Altes Rathaus in Frankfurt and in the following year won a competition to decorate the Rathaus in Aachen with a cycle of frescoes from the life of Charlemagne which was to be his greatest work. In 1844–5, in preparation, he visited Rome to study *Raphael's Vatican frescoes and returned there in 1852–3. He began the Charlemagne frescoes in 1847 and continued to work on them until overtaken by insanity in 1853; they were completed later by the less talented Josef Kehren (1817–80). Painted on an enormous scale and showing *Nazarene influence, his frescoes were greatly admired.

He was also an accomplished draughtsman. The Dresden revolution of 1848 inspired his lively *Holbein-influenced *Another Dance of Death* (1849), a subject he returned to with two further *woodcuts *Death as a Strangler* and *Death as a Friend*, published in 1852. DER

Feldbusch, H., *Alfred Rethel*, exhib. cat. 1959 (Aachen, Suermondt-Ludwig Mus.)

RETROUSSAGE, a printing technique used in *etching and engraving (see LINE ENGRAVING) in which a muslin cloth is passed lightly over the warm inked plate, dragging some of the ink out of the lines and onto the surface to produce a soft atmospheric effect. RGo

RETZSCH, (FRIEDRICH AUGUST) MORITZ (1799–1857). German painter and draughtsman. Born in Dresden, Retzsch studied at the Dresden Kunstakademie from 1797. Although he practised as a portrait and subject painter his fame lies in his illustrations to the poems and plays of the German *Romantics established with his drawings for Goethe's *Faust* (1816). An English translation was published in 1820 and its warm reception encouraged him to publish *Retsch's Outlines to Shakespeare* (1828–46), 106 etchings in eight volumes. These outline drawings of dramatic incidents, executed with a strong and even line, were highly influential, on *Rossetti among others, and his reputation in England briefly exceeded that of *Flaxman. They were less popular in his native Germany, where he had a successful career as a teacher, becoming a professor at the Kunstakademie in 1824. DER

Vaughan, W., *German Romanticism and English Art* (1979).

REYNOLDS, SIR JOSHUA (1723–92). English painter. Although his experimental techniques proved to be disastrous, Reynolds, who became the first president of the RA (see under LONDON) in 1768, was the most influential English artist of his day, establishing, in his *Discourses* (1769–90), the principles of the *Grand Manner. He was born in Plympton, Devon, a clergyman's son, and in 1740 was apprenticed to the fashionable London portrait painter Thomas *Hudson. From 1744 he practised in London and Devon and in 1749 met Augustus Keppel with whom he sailed to Minorca, en route for Italy. Most of his Italian stay was spent in Rome, studying *Antique sculpture and old and modern masters which provided him with inspiration and prototypes for the rest of his career. By 1753 he was in London where his portrait of *Keppel* (1752; London, National Maritime Mus.) established his reputation. Keppel was the first of a series of portraits of military men, endowed with heroic qualities, culminating in the dynamic *Colonel Tarleton*

(1782; London, NG). By 1760 he was sufficiently prosperous, through unremitting work and shrewd self-advancement, to move to a splendid house in Leicester Fields where he entertained a distinguished circle of friends including Johnson, Goldsmith, and Garrick. *Garrick between Tragedy and Comedy* (1762; priv. coll.) is an allegorical portrait, a type, possibly adopted from France, which Reynolds usually reserved for female sitters, the most famous being *Mrs Siddons as the Tragic Muse* (1784; San Marino, Calif., Huntington AG). From 1769, in his RA lectures, he formulated his theory of the Grand Manner. Many of his ideas had been expressed before, but Reynolds was the first to combine them in an elegant synthesis. Simply put, he exhorted artists to learn from past masters (he was unapologetic about his own borrowings) and idealized nature, and to devote themselves to morally elevating subjects. Practising what he preached, he exhibited *Count Ugolino and his Children* (Knole, Kent) in 1773, but his only commissioned *history was *The Infant Hercules* (1787; St Petersburg, Hermitage) painted for Catherine II of Russia, which was praised by *Fuseli and *Barry for its *sublimity. A more profitable sideline from the 1770s was the painting of *fancy pictures, which sometimes, as in *Cupid as Link-Boy* (1774; Buffalo, Albright-Knox Gal.), exhibit a slightly sinister eroticism.

In 1784, Reynolds suceeded *Ramsay as painter to George III but his state portraits of the *King* and *Queen Charlotte* (1780; London, RA) are undistinguished. Far better is his informal but swagger *George IV with a Servant* (1787; Arundel, Sussex) painted for the Prince Regent. DER

Penny, N. (ed.), *Reynolds*, exhib. cat. 1986 (London, RA).

REYSSCHOOT FAMILY. Flemish painters. **Petrus Johannes** (1702–72) spent the early part of his career in England as a portrait painter before returning to his native Ghent in the mid-1740s. His brother **Emannuel Petrus Franciscus** (1713–72) was a painter of religious works but also an original designer of temporary decorations in the tradition of *Rubens. The best-known member of the family is Emannuel's son **Petrus Norbertus** (1758–95), whose *grisaille paintings give an elegant *Rococo sculptural quality even to his numerous religious scenes. More attractive, perhaps, to modern taste are his Frenchified decorative mythologies *en grisaille*, such as *Putti Playing* (c.1780; Ghent, Mus. voor Schone Kunsten), inspired by the paintings of *Boucher and the reliefs of *Bouchardon. MJ

Frédéricq-Lilar, M., *Gand au XVIIIe siècle: les peintres van Rÿschoot* (1992).

RIACE BRONZES (mid-5th century BC; Reggio di Calabria, Mus. Nazionale). These two bronze statues, found in 1972 off the coast of Riace, Italy, are spectacular examples of *Classical Greek bronze statuary. Over-life-size male nudes originally with spears and shields, they probably formed part of a larger group of honorific statues. *Inscriptions on the base would have identified the specific figures portrayed. Onatas of Aegina's group at *Olympia (c.470–460 BC) and the Phidian group dedicated by the Athenians at *Delphi (450 BC) have optimistically been proposed. The only hints of their original identity are provided by the diadem and wreath of Statue A and the Corinthian helmet (now lost) of Statue B. The expressiveness of the face of Statue A led some scholars wrongly to postulate a Roman date. The treatment of the musculature is sensitive, with veins, sinews, and tendons clearly depicted.

The production of the statues is of particular interest. They were cast from a single model, belying earlier suggestions that placed Statue B later chronologically. Clear distinctions were obtained through variations on the wax working model, demonstrating a range of styles within the same workshop. Using the indirect method of bronze *casting, each statue was cast in at least eleven pieces, with a large central section including the torso and legs and smaller piece casts for the head, arms and hands, genitals, front halves of the feet, and middle toe of each foot. The nipples and lips are of copper; the teeth of silver. The curls of Statue B are solid cast. Bronze analysis of the right arm and left forearm of Statue B has revealed an alloy characteristic of the *Hellenistic and Roman (see ROMAN ART, ANCIENT) periods, indicating later restorations. L-AT

Stewart, A., *Greek Sculpture: An Exploration* (1990).

RIBALTA, FRANCISCO (1565–1628). Spanish painter, active in Valencia, who developed a distinctive naturalistic style. He was trained in Madrid and was influenced by the Spanish and Italian artists decorating the *Escorial. His *Crucifixion* (St Petersburg, Hermitage) dates from this period, c.1582–6. Following the death of King Philip II in 1598 he abandoned any hopes of employment in royal circles and had returned to Valencia by early 1599. His first major commission (1603) was to paint the altarpiece for S. Jaime Apostol, Algemesí, a scheme that incorporated nineteen paintings of which six survive, notable particularly for their dependence on prototypes seen at the Escorial. Ribalta's *Vision of Father Francisco Jeronimó Simó* (1612; London, NG) was inspired by *Sebastiano del Piombo's *Christ Carrying the* Cross (1530; Madrid, Prado), which was then in the Vich Collection, Valencia. Around 1620 he worked for

the Capuchins at the Convento de la Sangre de Cristo, Valencia. His last important commission was the high altar of the Cartuja de Porta-Coeli, Bétera, Valencia: *Christ Embracing S. Bernard* (1625–7; Madrid, Prado), recorded there in the prior's cell, successfully combines a sense of physical naturalism and a spirit of expressive mysticism, with a simplicity and concentration that is in marked contrast to the cluttered and tentative Mannerist designs of his early work. HB

Kowal, D., *The Life and Art of Francisco Ribalta* (1981).

RIBERA, JUSEPE DE (Lo Spagnoletto) (1591–1652). Spanish painter and printmaker, born, Játiva, Valencia, who worked in Italy throughout his life. He was established at Naples by 1616, although he is first recorded in Parma in 1611 and was in Rome 1613–16 when he painted his earliest surviving works—the series of five *Senses* (two priv. coll.; others known from copies), in which he used working-class models and a system of light and shade derived from *Caravaggio and the Utrecht Caravaggists. Yet Ribera's immediate response to Caravaggesque tenebrism was soon moderated by a more painterly approach, inspired by the rich impasto and warm colouring of Venetian *Renaissance painting. This tendency is already apparent in his *Crucifixion* for the Duke of Osuna, Viceroy of Napels (1618; Osuna, Mus. de Arte Sacro) and the *Drunken Silenus* (1626; Naples, Capodimonte) painted for the Flemish merchant Gaspar de Roomer, who had brought Flemish pictures to Naples; and it leads on to the emotional intensity of the *Martyrdom of S. Bartholomew* (1634; Washington, NG) in which the saint is confronted by his executioner. Ribera's mature style, as seen in this picture, combines Caravaggio's sense of drama and his penetrating eye for detail with a new, more lyrical approach to the surface design of the composition, inspired by Bolognese classical masters such as Guido *Reni and *Domenichino. Although the executioner is coarse and uncompromising, and belongs to the same world as the protagonists in Caravaggio's *Flagellation of Christ* (Naples, S. Domenico Maggiore), he nevertheless expresses tenderness and compassion as he regards his victim. The figure of the saint is equally realistically rendered but transcends his physical circumstances with visionary concentration. The two strongly contrasting figures are placed in a timeless setting united by the sombre lighting originating from outside the picture. Thus Ribera, without morbidity or melodrama, communicates the essence of the subject with compassion and dignity. Five years later Ribera painted the magical *Dream of Jacob* (1639; Madrid, Prado), where one finds a comparable fusion of realism and poetic vision; the uncompromising

naturalistic observation of a sleeping man, and the magical evocation of his dream that the heavens would open so as to allow angels to pass through. Ribera soon attracted official notice in Naples and was invited to participate in the decoration of the Certosa di S. Martino, where his work eclipsed the contributions of native Neapolitan artists including *Caracciolo and *Stanzione. His altarpiece of the *Pietà* (1637) and his three-quarter-length figures of *Moses* and *Elijah*, together with a series of over-life-size prophets set in the spandrels of the nave arcades (1638), testify to his capacity for heroic naturalism. Yet he was also equally at ease painting intimate portraits of ordinary people such as the *Girl with Tambourine* (1637; priv. coll.) and the *Boy with a Club Foot* (1642; Paris, Louvre). Ribera's response during the 1640s to classical influences, absorbed from Bolognese artists, culminates in the *Communion of the Apostles* (1651; Naples, Certosa di S. Martino), where he achieved a narrative clarity within an architectural framework and clearly defined space in the tradition of *Raphael's tapestry cartoons (London, V&A).

HB

Spinosa, N., et al., *Jusepe de Ribera*, exhib. cat. 1992 (Naples, Castel S. Elmo).

RICCI FAMILY. Italian painters from Belluno. **Sebastiano** (1659–1734) was a successful decorator active at the end of the *Baroque era, who developed the achievement of *Veronese into a spirited *Rococo style. He was also responsive to a wide variety of 17th-century influences, including Annibale *Carracci, Pietro da *Cortona and *Gaulli. He often collaborated with his nephew **Marco** (1676–1730), who became a specialist in decorative landscape painting. Sebastiano, after early training in Venice under the little known Federico Cervelli and in Bologna under Giovanni Gioseffo dal Sole (1654–1719), received his first major commission in 1685: the decoration of two cupolas in the nave and choir of the oratory of the Madonna del Serraglio in S. Secondo Parmense. He moved to Rome in 1691 and the following year was invited to paint a large fresco of the *Battle of Lepanto* for the Palazzo Colonna. He was in Milan in 1694–6 but by 1696 he was back in Venice and found regular employment in the region, most notably the decoration of the nave ceiling in S. Marziale with illusionistic frescoes of the *Legends of S. Martial*. He was also called to *Florence to work for the Grand Duke Ferdinand de' Medici: a *Crucifixion* for S. Francesco de' Macci, commissioned in 1704 and a ceiling fresco of *Venus and Adonis*, with further scenes from Ovid on the walls, for the Palazzo Pitti c.1707–8. Both in Milan and Florence he appears to have collaborated with Anton Peruzzini (1646/7–1724), an artist specializing in landscape.

Marco, who had accompanied his uncle to Florence, was also drawn into the close-knit circle of artists associated with the Grand Duke, including *Magnasco, Bianchi di Livorno, and Nicola van Houbraken and together they produced a remarkable jointly signed painting of *Hermits in a Landscape*, last recorded in the della Gherardesca Collection, at Bolgheri (Livorno). A *Landscape with Monks* (Edinburgh, NG Scotland, acquired from the Gerini Coll., Florence), which is often regarded as a collaborative effort by Sebastiano, imitating Magnasco's figure style, and Marco, may also date from the period around 1705.

In 1711 the two Riccis went together to England. They both received patronage from Richard Boyle, 3rd Earl of Burlington. Sebastiano was engaged to paint four large canvases (c.1713–14) for the staircase at Burlington House, London (now RA). *Diana and her Nymphs Bathing* harks back to Veronese but there are also reminders of *Pellegrini in the treatment of the freely sketched foreground nymph. *The Triumph of Galatea* echoes the spirit of *Giordano while the *Meeting of Bacchus and Ariadne* is inspired by Annibale Carracci's ceiling decoration of the Palazzo Farnese, Rome. Two further paintings now at Chatsworth (Derbys.), one signed and dated 1713, may also have been commissioned by Lord Burlington, whose daughter married the 2nd Duke of Devonshire's grandson. *The Flight into Egypt* evokes the spirit of Jacopo *Bassano; *The Presentation in the Temple* recalls Veronese. The two Riccis left England in 1716, having failed to secure the commission to decorate the dome of S. Paul's, a task assigned to the English artist Sir James *Thornhill.

For the remainder of his life Sebastiano, whose international reputation was now assured, lived in style at Venice. However he accepted a commission to decorate the ballroom of the Palazzo Gabrielli (now Taverna), in Rome, with a sumptuous cycle of paintings on the *Loves of the Gods* (1717). And he continued to receive patronage from England. He collaborated with Marco to produce two paintings from a large series of imaginary monuments dedicated to recent English heroes, a project conceived by the Irish playwright and opera producer Owen MacSwinny: the *Allegorical Tomb of the 1st Duke of Devonshire* (Birmingham, Barber Inst.) and the *Allegorical Tomb of Sir Cloudesley Shovell* (Washington, NG). The two artists also joined forces to produce a series of seven scenes from the life of Christ (1724–30; London, Royal Coll.) for the Venetian palazzo of the consul Joseph Smith (see also under CANALETTO).

Marco Ricci's reputation rests more on his skills as a landscape painter than on his prestigious collaborative ventures with his uncle. Following his visit to Florence c.1704–8, he developed a style which reflects the influence of Salvator *Rosa, Gaspard *Dughet, Pandolfo Reschi (c.1640–96) and Crescenzio Onofri (after 1632–after 1712) and which found fulfilment when he was commissioned in 1709 by Charles Howard, 3rd Earl of Carlisle, to produce some 50 paintings for Castle Howard (North Yorks.). Marco had left Venice for England in 1708, together with Pellegrini, in the retinue of Charles Montagu, 1st Duke of Manchester. In London he decorated Montagu's house in Arlington Street, and found employment as a scene painter at the Haymarket Theatre. He designed the set for Scarlatti's *Pirro and Demetrio* and would have met Owen MacSwinny, who was the English librettist. At Castle Howard he appears to have been required to paint overdoors and overmantels, architectural capricci, seascapes, and a remarkable sequence of wild Romantic landscapes. He also painted an unusually precise topographical *View of the Mall in St James Park* that anticipates the London views that *Canaletto would paint on his visit to England 40 years later. And it was almost certainly at this time that he produced his *Hogarthian *The Rehearsal of an Opera* which depicts prominent figures in the London musical world and which he repeated in several variant versions for other clients.

Marco returned to Venice in 1710 but, as we have noted, went back to England with his uncle the following year. It was almost certainly after he finally returned home for the second time in 1716 that he began to paint the remarkable series of landscapes in tempera on leather, over 30 of which were acquired by Consul Smith, and which are now in the Royal Collection, having been bought by King George III. Here, above all, is evidence of Marco Ricci's intense and individual response to the countryside around Belluno and Venice, evidence too of Smith's capacity for imaginative patronage.

HB

Croft Murray, E., *Decorative Painting in England*, vol. 2 (1970).

Daniels, J., *Sebastiano Ricci* (1976).

Rizzi, A., *Sebastiano Ricci*, exhib. cat. 1989 (Udine, Villa Manin di Passariano).

Succi, D., and Delneri, A., *Marco Ricci e il paesaggio veneto del Settecento*, exhib. cat. 1993 (Belluno, Palazzo Crepadona).

RICCIO, ANDREA BRIOSCO, also called Il Riccio (1470–1532). Italian sculptor. So-called because of his curly hair, Riccio may have been born in Trent, but his main centre of activity was Padua, where he trained in bronze and terracotta sculpture under one of *Donatello's assistants, Bartolomeo Bellano. Typical of his workshop's production are *all'antica* bronze statuettes and objects which were endlessly copied. His most important autograph bronze statuette

is the tense *Shouting Horseman* (c.1505–10; London, V&A). His masterpiece, both technically and iconographically, is the bronze Paschal Candelabrum for the Santo in Padua (1507–16). The series of *classicizing friezelike bronze reliefs for the della Torre tomb in S. Fermo in Verona (now Paris, Louvre) show his classical erudition, the result of contacts with Paduan *humanist circles. Less well known, but probably as important, was his terracotta sculpture, for instance the *Virgin and Child* (c.1520; Madrid, Thyssen Mus.), in which his capacity for tender, but solemn monumental sculpture is well illustrated.

AB

Hope, C., and Martineau, J. (eds.), *The Genius of Venice*, exhib. cat. 1983 (London, RA).

RICHARDS, CERI (1903–71). British painter, printmaker, designer, and maker of reliefs, born at Dunvant, near Swansea, into a Welsh-speaking family (he did not learn English until he was about 5 or 6). From his father, a tin-plate worker, he inherited a love of music and poetry, which often inspired his work. Richards was apprenticed as an electrician before studying at Swansea School of Art, 1921–4, and the Royal College of Art, London, 1924–7. He lived in London for the rest of his life except during the Second World War, when he was head of painting at Cardiff School of Art (earlier he had taught at Chelsea School of Art and later he taught successively at Chelsea, the Slade School, and the RCA until 1960). In 1934 he exhibited with the Objective Abstractionists and in 1936 at the International *Surrealist Exhibition in London. He said that Surrealism 'helped me to be aware of the mystery, even the "unreality", of ordinary things', and at this time he was also strongly influenced by *Picasso, notably in a series of semi-abstract relief constructions begun in 1933. After the Second World War his painting drew inspiration from the large exhibition of Picasso and *Matisse at the V&A, London, 1945. His best-known works include the *Cathédrale engloutie* series, based on a Debussy prelude (which Richards used to play on the piano), and *Do not go gentle into that good night* (1956; London, Tate), based on a poem by Dylan Thomas (whom he once met). Richards's work also included book illustrations, theatre designs, mural decorations for ships of the Orient line, and designs for stained glass and furnishings for the Blessed Sacrament chapel in Liverpool Roman Catholic Cathedral (1965). He received numerous awards and distinctions, including a gold medal at the Royal National Eisteddfod of Wales in 1961.

His wife Frances Richards, née Clayton (1903–85), a fellow student at the RCA whom he married in 1929, was a painter, printmaker, illustrator, and pottery designer (she came from Stoke-on-Trent, heart of the British pottery industry). She taught at Camberwell School of Art, 1928–39, and Chelsea School of Art, 1947–59.

IC

RICHARDSON, JONATHAN (1665–1745). English painter, writer, and collector. He trained as a painter under John *Riley and by 1731 was described by *Vertue as one of the three foremost painters of his day with Charles Jervas (c.1675–1739) and Michael *Dahl. He was an excellent draughtsman, and produced a sequence of chalk drawings of friends and family, including his son Jonathan (London, Courtauld Inst. Gal.) and his pupil and future son-in-law Thomas *Hudson. He was perhaps more influential as a writer and published one of the first works of artistic theory by an Englishman, *An Essay on the Theory of Painting* (1715), which he subsequently developed further in *An Essay on the Whole Art of Criticism as it Relates to Painting and an Argument on Behalf of the Science of a Connoisseur* (1719). He claimed for painting an intellectual quality and regarded it as equal or superior to poetry; this applied not only to *history painting but also to *portraiture, which he likened to the history of a life rather than a copy of external appearances. For him the art of painting consists of Invention, Expression, Composition, Colouring, Handling, Grace, and Greatness (i.e. Sublimity). In 1722 he published with his son the even more influential book *An Account of Some of the Statues, Bas-Reliefs, Drawings and Pictures in Italy*. This was based on Jonathan the younger's (1694–1771) tour of Italy in 1721 to study ancient classical art and Italian painting. It is one of the first *Grand Tour guides which offers serious visually acute *connoisseurship of old master paintings, particularly those of *Raphael and *Michelangelo, Annibale *Carracci, and N. *Poussin, as opposed to literary nostalgia at the classical sites for their association with the mythology of the ancient world. He also made a splendid collection of nearly 1,000 old master drawings, including works by Raphael, Michelangelo, *Rubens, van *Dyck, and *Rembrandt, which was sold over eighteen days at Cock's, London, from 22 January 1747.

HB

Gibson Wood, C., 'Jonathan Richardson and the Rationalism of Connoisseurship', *Art History*, 7/1 (1984).

RICHIER, GERMAINE (1904–59). French sculptor. Richier had a thorough academic training at the École des Beaux-Arts, Montpellier (1922–5), and in the studio of *Bourdelle, in Paris (1925–9). However, from c.1940, she abandoned carving for *cast bronze sculpture and evolved a highly individual style somewhat influenced by *Giacometti. Her figures, which combined human, animal, vegetable, and particularly insect features, became attenuated, with strange limbs or fibrils, and her treatment of the surface suggested decomposition and decay, as in *The Bat* (1952; reproduced in H. Read, *Concise History of Modern Sculpture*, 1964). The forms were often opened up, by vents or ribs, and she is seen as a pioneer of sculpture in which the inner space equals the solid material in importance. Richier gained an international reputation after the Second World War and won the Sculpture Prize at the São Paulo Bienale in 1951.

DER

Crispolti, E., *Germaine Richier* (1968).
Germaine Richier: Retrospective, exhib. cat. 1996 (São Paulo, Fondation Maeght).

RICHIER, LIGIER (c.1500–67). French sculptor of St Mihiel, Lorraine, who worked in a powerful and intense style. Little documented work survives, but he is considered to have carved the gisant of Philippe de Gueldre, wife of René II of Lorraine (d. 1547; Nancy, Mus. Historique). The figure, of waxed and polychromed stone, has deeply cut, expressive features with strongly accentuated eyelids, a feature of Richier's technique. He also carved the skeleton of René de Chalon (d. 1544; Bar-le-Duc, S. Étienne), who stands, wormeaten flesh hanging from his bones, lifting his heart in his hand, a brutally naturalistic symbol of the Resurrection. Richier's life-size *Sepulchre* group (St Mihiel, S. Étienne) is an example of a sculptural type which originated in eastern France. Unusually, Joseph and Nicodemus rest the body of Christ on their knees as the tomb is prepared. The narrative is clear and intense, the figures a combination of *Sluter's realism and Italianate drapery patterns. By 1564 Richier, a Calvinist, had left for Geneva where he died.

LL

Zerner, H., *L'Art de la Renaissance en France* (1996).

RICHTER, HANS (1888–1976). German artist, born in Berlin. He first came into contact with modern art movements through the *Blaue Reiter and the *Sturm exhibitions in Berlin, and had a one-man exhibition in Munich in 1916. He went to Zurich in 1917 and became an active member of the *Dada group there. From this time he began abstract work, though he continued to do *woodcuts and linocuts of an *Expressionist character. In 1918 he began a long association with the Swedish painter Viking Eggeling (1880–1925); they worked on abstract 'scroll' drawings based on musical rhythms and counterpoint. In 1920 he came into contact with *Neo-plasticism and *Constructivism, and from 1921 was active as a pioneer in the development of abstract films. From 1923 to 1926 he worked on the Constructivist periodical *G* (*Gestaltung*), which he founded with the architect Mies van der Rohe and the critic Werner Graeff. He moved to Paris in 1933 and

in 1941 went to America, where he taught at the City College of New York. In his last works, which were executed mainly in shades of black, white, and grey, he attempted to express rhythmic effects of movement over large canvases.　　OPa

Richter, H., *Autobiography* (1965).

RICO Y ORTEGA, MARTÍN (1833–1908). Spanish landscape painter. He was initially trained by his brother Bernardino (1825–94), an engraver, and later at the Madrid Academy, under Federico de *Madrazo. An outstanding student, he won a bursary to study in Paris in 1862. Whilst in France he also visited England and Switzerland, recording his travels in a series of *Turneresque sketches (New York, Hispanic Society of America). In Paris he was influenced by the *Barbizon painters, particularly *Daubigny, reflected in works like *Laundresses of Varenne: The Banks of the Seine* (c.1865; Madrid, Prado). In 1870 he travelled in southern Spain and settled in Venice a year later. His palette lightened and works like the *View of Venice* (c.1872; Madrid, Prado) sparkle with reflected light. This change was partly due to the effect of Venetian light and water but also reveals an awareness of the palette and technique of his slightly younger fellow countrymen and ex-patriates *Fortuny y Marsal and *Rosales y Martínez. His undoubted skill and attractive undemanding subjects won him much success including medals at the Paris Expositions Universelles of 1878 and 1889.　　DER

Rico, M., *Recuerdos de mi vida* (1906).

RIDOLFI, CARLO (1594–1658). Italian art historian, collector, and painter. He is best known as the author of *Le meraviglie dell'arte* (1648), a collection of biographies of Venetian artists, but he trained as a painter in Venice and painted some undistinguished altarpieces, and history paintings and portraits for private collectors. The *Meraviglie* celebrates 16th-century Venetian art, perhaps in response to *Vasari's commitment to Florence. It includes his still invaluable *Life of Tintoretto* (1642), important references to *Giorgione, and many compelling and clear accounts of paintings. Ridolfi was also a collector, and three volumes of his drawings are at Oxford, Christ Church.　　HL

Ridolfi, C., *Le meraviglie dell'arte ovvero delle vite degli illustri pittori veneti e dello stato*, ed. D. F. von Hadeln (2 vols., 1914–24).

RIEGL, ALOIS (1858–1905). Austrian art historian. Riegl became full professor of art history at the University of Vienna in 1897, after having worked for a period of eleven years as keeper of textiles in the Österreichisches Museum für Kunst und Industrie. His first major book, *Stilfragen: Grundlagen zu einer Geschichte der Ornamentik* (1893), was based in part on his intimate knowledge of textiles and represents a turning point in the historiography of art. Criticizing the materialistic notion that the production of art was solely determined by material, technique, and purpose (a view wrongly attributed to Gottfried Semper), the book introduces the concept of artistic intention (*Kunstwollen*), a transcendental force comparable to *Hegel's world spirit, which generates artistic change and directs the development of art towards formal order. Riegl's study *Spätrömische Kunstindustrie* (1901) testifies to his continuing preoccupation with finding universal rules for art historical enquiry. The book sets out to analyse works of art in terms of binary opposites (tactile or 'haptic', and optic), an approach that would have a profound influence on the theoretical outlook of Heinrich *Wölfflin.　　AT

Iversen, M., *Alois Riegl: Art History and Theory* (1993).

RIEMENSCHNEIDER, TILMAN (c.1460–1531). German wood- and stonecarver who had a large workshop in Würzburg. With Veit *Stoss, Riemenschneider was the most outstanding representative of the last generation of *Gothic sculptors in southern Germany. He also held a number of offices with the city council, serving as mayor 1520–1, but in 1525 he was imprisoned and probably tortured, expelled from the city council, and fined for his support of the peasants' revolt (see also RATGEB, JÖRG). Riemenschneider was probably trained in *alabaster sculpture in his native Thuringia, and in *limewood carving in Ulm, perhaps with Michel *Erhart. He is the first of the limewood sculptors who produced altarpieces finished not in *polychrome but with a brown glaze. This practice was perhaps too modern for the tastes of his patrons since ten years after the installation of the altarpiece of the *Magdalene* in the parish church in Münnerstadt (1490–2; now dismantled and dispersed, the image of the *Magdalene with Six Angels* in Munich, Bayerisches Nationalmus.), Stoss was called in to paint and gild the sculptures. Riemenschneider's style has been called the 'florid style' of late Gothic sculpture. His figures, placed in richly carved shrines, crowned with pinnacles and spires, distinguish themselves by restless drapery and agitated gestures.　　KLB

Baxandall, M., *The Limewood Sculptors of Renaissance Germany* (1980).

RIGAUD, HYACINTHE (1659–1743). French portrait painter, the rival of *Largillierre and the outstanding court portraitist at the end of Louis XIV's reign. He was born in Perpignan and trained in Montpellier and Lyons. He arrived in Paris in 1681 and by 1688 had gained an influential clientele at court. Using patterns derived from van *Dyck (and ultimately from *Titian) he developed a style of sumptuous dignity that remained the norm for formal portraiture up until the Revolution and which was revived for royal images at the Bourbon Restoration. His most famous work of this kind is the full-length state portrait of the elderly Louis XIV (1701; Paris, Louvre). To modern eyes this throughly *Baroque image, so cruelly mocked in a caricature by Thackeray, epitomizes all that is most false in a tradition that places the symbols of rank above the personality of the individual. Nevertheless, within the bounds of decorum, Rigaud had a good eye for character, as is clear from one of his most spectacular portraits, *Cardinal de Bouillon* (1709; Perpignan, Mus. Rigaud). Like his contemporary the sculptor *Coysevox, Rigaud also made alongside his official portraits a number of intimate studies of friends and family, which have a *Rembrandtesque truthfulness about them. They include the double portrait *Marie Serre, the Artist's Mother* (1695; Paris, Louvre), which was, in fact, made for a bust by Coysevox.　　HO/MJ

Colomer, C., *Hyacinth Rigaud* (1973).

RILEY, BRIDGET (1931–　). British painter and designer, rivalled only by *Vasarely as the most celebrated exponent of *Op art. She was born in London and studied there at Goldsmiths' College, 1949–52, and the Royal College of Art, 1952–5. Her interest in optical effects came partly through her study of the *Neo-Impressionist technique of Pointillism, but when she took up Op art in the early 1960s she worked initially in black and white. She turned to colour in 1966. By this time she had attracted widespread attention (one of her paintings was used for the cover to the catalogue of the exhibition *The Responsive Eye* at the Museum of Modern Art, New York, in 1965, the exhibition that put Op art on the map), and the seal was set on her reputation when she won the international painting prize at the Venice Biennale in 1968.

Riley's work shows a complete mastery of the effects characteristic of Op art, particularly subtle variations in size, shape, or placement of serialized units in an overall pattern. It is often on a large scale and she frequently makes use of assistants for the actual execution. Although her paintings often create effects of vibration and dazzle, she has also designed a decorative scheme for the interior of the Royal Liverpool Hospital (1983) that uses soothing bands of blue, pink, white, and yellow and is reported to have caused a drop in vandalism and graffiti. She has also worked in theatre design, making sets for a ballet called *Colour Moves* (first performed at the Edinburgh Festival in 1983); unusually, the sets preceded the composition of the music and choreography. Riley has travelled

widely (a visit to Egypt in 1981 was particularly influential on her work, as she was inspired by the colours of ancient Egyptian art) and she has studios in London, Cornwall, and Provence. She writes of her work: 'My paintings are not concerned with the Romantic legacy of *Expressionism, nor with Fantasies, Concepts or Symbols. I draw from Nature, although in completely new terms. For me Nature is not landscape, but the dynamism of visual forces—an event rather than an appearance—these forces can only be tackled by treating colour and form as ultimate identities, freeing them from all descriptive or functional roles.' IC

RILEY, JOHN (1646–91). English portraitist. A pupil of Isaac Fuller (c.1606–72) and Gerard Soest (c.1600–81), he later taught Jonathan *Richardson the elder, amongst others. He collaborated with, as his drapery painters, John Baptist Gaspars and John Closterman (1660–1711). The Scullion (Oxford, Christ Church) is perhaps his finest work, but some of his formal portraits, including those of royal sitters, show an inequality between the face and other parts of the picture. Riley was appointed principal painter, with *Kneller, to William and Mary, and established a club for artists in 1689. KH

Rogers, M., 'John and John Baptist Closterman', Walpole Society, 49 (1983).

RILKE, RAINER MARIA (1875–1926). German poet and art critic. The foremost lyric poet of 20th-century Germany was also a sensitive and idiosyncratic writer about art. At the turn of the century he was associated with the artists' colony at Worpswede near Bremen, marrying the sculptor Clara Westhoff in 1901. In 1902 he published a book about Worpswede, though notably failing to discuss the art of Paula *Modersohn-Becker. His 1903 monograph on *Rodin displays a poet's sensitivity to the sculptor's creative process. The friendship that resulted from Rilke's research for the book led to his becoming *Rodin's secretary in 1905–6. His published letters to Rodin testify to the warmth of the relationship and provide further insights into Rodin's working method and into Rilke's intensely personal response to art. The collection Neue Gedichte (New Poems, 1907–8) shows the influence of Rodin. In 1907 Rilke visited the retrospective of *Cézanne's painting at the *Paris Salon d'Automne. His letters to his wife about the exhibition are a remarkable early tribute to the power of Cézanne's art and the tenacity of his personality. Some of Rilke's writings on art have been translated into English. MJ

Prater, D., A Ringing Glass: The Life of Rainer Maria Rilke (1986).
Rilke, R. M. Briefe an August Rodin (1928).
Rilke, R. M., Letters on Cézanne (1988).
Rilke, R. M., Rodin and Other Prose Pieces (1986).

RIMMER, WILLIAM (1816–79). British-born American sculptor. Rimmer was born in Liverpool but emigrated, aged 2, and never returned to Europe. Brought up in great poverty, he managed to teach himself carving, painting, music composition, and, above all, anatomy which infused his sculpture and helped his practice as a doctor in the Boston area from the late 1840s to the early 1860s. His first known work, Despair (1831; Boston, Mus. of Fine Arts), a nude youth, which is almost *Expressionist in its vulnerable awkwardness, was carved in gypsum when he was 15. For Rimmer the male nude became symbolic of heroic struggle and it appears in many of his pieces including the famous Falling Gladiator (1861; Washington, National Mus. of American Art), characteristically muscular. He is best remembered as a teacher; he lectured on *anatomy for artists in the 1860s and 1870s in Boston and New York and was director of the Women's School of Design at Cooper Union, New York, 1866–70. His highly illustrated textbooks Elements of Design (1864) and Art Anatomy (1877) were influential into the 20th century. DER

William Rimmer, exhib. cat. 1985 (Brocton, Mass., Art Mus.).

RINGERIKE, a phase of Viking-age art, named after the geological area near Oslo providing the carved stones on which the characteristic animals entwined with leafy scrolls were first defined. Decorative animals are typical of the whole period: the Ringerike phase, which belongs to the 11th century, is characterized by the dominant foliate scrolls and tendrils which enmesh or sprout from creatures sometimes identifiable as lions, birds, snakes, or dragons; or there may be a combat between a large beast and a snake, as on the tomb slab from S. Paul's Churchyard (London, Mus. of London). Animals are depicted in profile, with body ornament of spiral hip-joints, and exaggerated facial features, with large almond-shaped eye and sharply pointed tooth on upper or lower jaw. The decorative effect of these swirling contorted forms is powerful, whether carried out in stone, wood, bone, or metalwork; the distribution extends from the Scandinavian homelands to the colonies of England and Ireland. Despite the pagan origins of Viking animal ornament, these motifs also occur in fully Christian contexts, suggesting that their symbolism has successfully adapted to the new religion. CMH

Wilson, D., and Klindt-Jensen, O., Viking Art (1980).

RIO, ALEXIS-FRANÇOIS (1797–1874). A French Catholic writer of Breton origin and royalist sympathies who regarded religious sentiment as the principal criterion for evaluating art and who played a seminal role in the 19th-century rediscovery of early Italian painting. He was a friend of another French Catholic writer, Count Charles de Montalembert, who introduced him to the German Catholic philosophers in Munich: they included Friedrich Wilhelm von Schelling (1775–1854), whose theory of transcendental idealism in art, and the idea of truth revealed through the unconscious medium of the artist, particularly caught Rio's imagination. In Germany Rio was also stimulated by Karl Friedrich von *Rumohr's pioneering study of early Italian art, Italienische Forschungen (1827–31). He had a British wife, Apollonia Jones, from an old Welsh Catholic family, whom he had married in 1833; and later he was on intimate terms with the Puseyites and the leaders of the Oxford movement. In Florence he was a close friend of Félicie de Fauveau, the French sculptress, who as a royalist was living in exile; she too was an enthusiast for early Italian art and helped him with his books. His principal work De la poésie chrétienne, first published in 1836 and reissued in a greatly expanded four-volume edition as De l'art chrétien (1861–7), as well as in an English translation, had, from the outset, a profound effect on English art historical writers, especially Lord *Lindsay and John *Ruskin. Writers before Rio had not usually attempted to distinguish the individual merits of the early Italian artists, except in antiquarian terms or as an early stage in the technical progression towards the ultimate achievement of *Raphael. Rio, on the other hand, was concerned above all with the artist's inner spirit and the expression of religious feelings.

He regarded with contempt the art of *Byzantium, and traces the revival of Christian art to the Germano-Christian tradition established under Charlemagne. In Italy he contrasts the decadence of the Romano-Christian school with the artistic renewal in Siena during the 13th century, with the Camposanto in Pisa, with *Giotto, and the cult of S. Francis in *Assisi, and then goes on to praise *Orcagna in 14th-century Florence, as well as early Bolognese painters such as *Vitale da Bologna and Jacopo *Avanzi. In the 14th century Rio draws a sharp moral distinction between those Florentine artists such as *Masaccio and *Uccello who succumbed to naturalistic or renewed classical influences, and those more retardataire artists, such as Fra *Angelico, Benozzo *Gozzoli and Botticelli, *Francia in Bologna, and certain later Umbrian painters, particularly *Perugino, whose inspiration was thought to be strictly Catholic. A firm division is then established between the purity of Raphael's early Umbrian style and the latent *Mannerism of his Roman period. Equally in Venice Rio greatly admired G. *Bellini, *Cima, and *Carpaccio, but not *Giorgione, *Titian, or *Tintoretto. Rio attributes much of the pagan

quality of Renaissance art to the ill effects of Medici patronage and we are left in no doubt that his own sympathies were with the Dominican friar Savonarola, who had preached the message that a truly Christian society would only be restored when men turned their eyes back to the ideals of an era uncontaminated by progressive ideas. HB

RIVERA, DIEGO (1886–1957). Mexican painter. Principally known as a central figure in the Mexican Muralist movement, Rivera also executed numerous easel paintings, such as *Portrait of Lupe Marín* (1938; Mexico City, Mus. de Arte Moderno). He studied at the S. Carlos Academy in Mexico City, after which he travelled on a scholarship to Madrid and Paris, where he came into contact with modernist currents and befriended the avant-garde. Influenced by *Gris and *Picasso, his first paintings were in the *Cubist style, but uniquely incorporated Mexican revolutionary iconography, as in *Zapatista Landscape* (1915; Mexico City, Mus. Nacional de Arte). Commissioned by the Mexican Education Minister José Vasconcelos, he returned to Mexico in 1921 to take part in a post-revolutionary cultural reform programme which aimed to educate Mexico's illiterate masses about their national heritage (the programme also served as propaganda for Alvaro Obregón's regime). Inspired partly by early Renaissance frescoes he saw during a trip to Italy in 1920, Rivera painted monumental public murals depicting Mexican history from ancient to modern times at the National Preparatory School (1922), the National Palace (1929–35), and the Ministry of Health (1929) in Mexico City, the University of Chapingo (1924–7), and the Palace of Cortés, Cuernavaca (1929–30). These depict indigenous and pre-Columbian themes in a romantic manner, representing them as part of Mexico's heroic heritage, and attempting to dispel the image of the indigenous as 'primitive'. In accordance with his political sympathies, his work displays obvious Communist ideology. Due to political conflict with Mexico's left wing during the 1930s, Rivera executed various murals in the USA which focus mainly on industry and labour themes. CC

Diego Rivera: A Retrospective, exhib. cat. 1986 (Detroit Inst. of Arts).

RIZI BROTHERS. Spanish painters. **Juan Andrés** (1600–82) and **Francisco Rizi** (1608–85) were sons of Antonio Ricci of Ancona, who came to Spain with Federico *Zuccaro in 1585. The elder son became Fray Juan Rizi when he joined the Benedictine order in 1627/8. He was briefly at the court in Madrid as drawing instructor to Prince Balthasar Carlos, but mostly he worked as a painter for his order. His most ambitious undertaking was the high altarpiece for the monastery of S. Millán de la Cogolla (*c*.1563; *in situ*), where his essentially conservative style lends sincerity to his visionary subjects. Fray Juan Rizi's manuscript treatise *Tratado de la pintura sabia* was published in 1930. Francisco Rizi's early works reflect the sober style of his teacher, Vicente *Carducho. However, commissions for the court introduced him to the high *Baroque style of *Rubens, whose loose brushwork and brilliant colour Francisco quickly imitated, as in his depiction of *The Virgin and Child with SS Philip and Francis* (1650; El Pardo, Capuchinos). Francisco Rizi mastered architectural illusionism, which he applied to his work as a fresco painter (1678; Madrid, Descalzas Reales), as a designer of theatre settings for the court, and as a designer of ephemeral decorations. His command of architectural perspective is evident in one of his best-known (though anomalous) paintings, the *Auto de Fe de 1680* (1683; Madrid, Prado). SS-P

Brown, J., *The Golden Age of Painting in Spain* (1991).

RIZZO, ANTONIO (active 1465–99/1500). Italian sculptor and architect, probably born in Verona. Moving to Venice before 1464, he became one of the foremost sculptors in the city. His first works are three altars for S. Mark's (completed 1469), which show a knowledge of Florentine architectural sculpture. His most significant commission is the tomb of Doge Niccolò Tron (1476; Venice, Frari), a profusion of niches, free-standing figures, and reliefs arranged on five tiers, which reflects new moves in Venetian sculpture to absorb classical motifs, but not wholly successfully. Likewise, though exciting contemporary fame, his *Adam* and *Eve* statues for the Arco Foscari at the Palazzo Ducale in Venice have not fully incorporated classical proportions and their sinewy and tapered silhouettes owe something to contemporary painters like *Mantegna. Appointed *protomagister* of the ducal palace, in 1498 Rizzo was accused of embezzlement and fled Venice, eventually dying in Foligno. AB

Pope-Hennessy, J., *Italian Renaissance Sculpture* (4th edn., 1996).

ROBBIA, DELLA. Family of Florentine sculptors active in Italy and France well into the 16th century. **Luca** (1400–82), the senior member, was regarded by contemporaries as one of the leading innovative artists in Florence alongside *Donatello and *Masaccio, and associated with the learned circle around the Medici. He is credited with the invention of the tin-glazed *terracotta sculpture characteristic of the family workshop, and contributed to the sweet style of Florentine sculpture which combined lively humanity with *Antique motifs.

He initially worked on *Ghiberti's baptistery doors, then appears to have been influenced by Donatello's *schiaciatto* ('low') reliefs, as in his *Virgin and Child with Angels* (1429; Oxford, Ashmolean). He and Donatello gained commissions for a pair of marble organ lofts for Florence Cathedral, Luca's installed in 1438 (now Mus. dell'Opera del Duomo). This features ten panels of youthful angelic musicians, framed by *all'antica* architecture. The figures are based on Antique prototypes, possibly from Pisa, and display a cheerful realism very different from that of Donatello's more deeply cut, energetic dancers.

Little stylistic change occurred after this point, but technical innovation began with the marble Tabernacle of the Sacrament (1441; now S. Maria a Peretola), to which colour is added in the form of an inlay of glazed terracotta. Monumental and narrative use of this material followed in more works for Florence cathedral—*Resurrection* and *Ascension* lunettes, and a pair of white candle-bearing angels (1448), the first use of the medium for free-standing figures.

The vitreous glaze of this material gives it a luminosity and intensity of colour, well suited to church interiors, while its durability made it ideal for external decoration. It was used for the roundels of the *Apostles* in the Pazzi chapel, S. Croce, Florence, and those on the external façade of the Foundling Hospital (1460s; probably by Andrea della Robbia).

Luca's other popular sculptural form was the half-length Madonna and Child in glazed white on a blue ground, a charming and intimate maternal image. These could be reproduced quite cheaply by casting (e.g. London, V&A). This reduced individuality and sometimes quality, but contributed to the workshop's prosperity.

Luca's nephew **Andrea** (1435–1525) took over in *c*.1470, producing more complex and ornate pieces. His first documented work is a tabernacle (1475; Florence, Bargello), followed by major Franciscan commissions, including the realistic and expressive *Crucifixion with SS Francis and Jerome* (1481; La Verna, Convento delle Stimmate). Tin-glazed works remained popular, the technique imitated by other artists. Andrea's five sons, in particular **Giovanni** (1469–after 1529), continued the expansion from workshop to industry, producing a wide range of *polychromed decorative items and church furnishings, as well as work for the French court. MS

Gentilini, G., *I della Robbia* (1992).
Pope-Hennessy, J., *Luca della Robbia* (1980).

ROBERT, HUBERT (1733–1808). French landscape painter and draughtsman. With Claude-Joseph *Vernet he satisfied the

late 18th-century taste for *picturesque landscape painting. Where Vernet specialized in coastal scenes, Robert used the buildings of ancient and modern Rome, often combined in fantastical arrangements, to evoke both classical grandeur and a proto-*Romantic sense of the depredations of time. Robert spent the years 1753–65 in Italy, where he knew *Piranesi and *Panini and was a close friend of *Fragonard. He made innumerable drawings that served as the basis of his paintings after he returned to Paris in 1766. His nickname 'Robert des Ruines', coined by *Diderot, derives from his fondness for them as subjects in his paintings (The Temple of Jupiter at Rome, Triumphal Arch at Orange, and The Maison Carrée at Nimes are examples; Paris, Louvre). Under Louis XVI he was Keeper of the King's Pictures, and though he was briefly imprisoned during the Revolution he was afterwards appointed one of the first curators of the new Louvre museum (see under PARIS). He devised many schemes (recorded in some of his most satisfying paintings) for turning the palace's Grande Galerie into a suitable public gallery to display the former royal collection. HO/MJ

Cuzin, J. P., J.-H. Fragonard e H. Robert a Roma, exhib. cat. 1990 (Rome, Académie de France).
Nolhac, P. de, Hubert Robert (1910).

ROBERTI, ERCOLE (D'ANTONIO) DE' (Grandi, Ercole de) (c.1455/6–1496). Italian painter and draughtsman active mainly in Ferrara and Bologna. Like *Cossa and *Tura he worked for the Ferrara court, designing ceremonial items and decorative schemes. He shared, too, their use of strong line, cool colour, and fanciful decoration. He may have been Cossa's pupil and worked with him on the frescoes for the Palazzo Schifanoia, Ferrara, and the Griffoni altarpiece (c.1476; Bologna, Pin.).

Ercole's earliest major work is the Portuense altarpiece of 1480 (Milan, Brera), a monumental *sacra conversazione, dignified and *classicizing in the manner of Giovanni *Bellini, and free of much of the nervous decoration of some earlier works. The sacred group is elevated upon a pedestal, below which appears a distant landscape. This visionary background is echoed in the small Pietà (Liverpool, Walker AG), which demonstrates vividly Ercole's portrayal of emotional and narrative drama in the black-clad, grieving Virgin set against the barren monotone of Golgotha.

Several drawings are attributed to Ercole (Windsor Castle, Royal Lib.), some derived from *Mantegna's engravings, and from 1494 he designed for sculptural schemes in Ferrara. MS

Manca, J. P., The Life and Art of Ercole de Roberti (1986).
Salmi, M., Ercole de Roberti (1960).

ROBERTS, WILLIAM (1895–1980). Roberts escaped from a working-class Cockney background by winning a scholarship to the Slade School, London (1910–13). He travelled in France and Italy before working, briefly, for the *Omega workshops, of which he was later dismissive, in 1913. At around the same time he met Wyndham *Lewis and became associated with the *Vorticists, signing their manifesto in the first issue of Blast (1914–15). Although Roberts later denied Lewis's importance, claiming that continental *Cubism was his inspiration, his paintings from 1914 until the 1920s are undeniably Vorticist in style. The Diners (1919; London, Tate) with its streamlined, angular figures and dynamic diagonal composition owes a clear debt to Lewis. In the 1920s Roberts developed his mature and original style by fleshing out his stylized figures so that bodies and limbs become virtually cylindrical, contained in clearly defined outlines. At the same time he took as his principal subject working-class and everyday life in the London, as in The Char (1923; London, Tate), and continued on the same theme for the rest of his career. DER

William Roberts, exhib. cat. 1965 (London, Tate).

ROBILLON, JEAN-BAPTISTE (d. 1782). French sculptor, architect, and decorator active in Portugal. After bankruptcy in 1748 he left Paris for Portugal. There he was instrumental in introducing French styles in the royal palaces, which were being transformed with the money from taxes on the colonial wealth of Brazil. He is particularly associated with the palace of Queluz in Estremadura, where between 1758 and 1770 he remodelled interiors, exterior, and gardens in the manner of the châteaux of Versailles and Marly. MJ

Pires, A. C., História do Palácio Nacional de Queluz (2 vols., 1924–6).
Réau, L., Histoire de l'expansion de l'art français: le monde latin (1933).

ROBUSTI, JACOPO. See TINTORETTO.

ROCAILLE. In its original meaning from the mid-16th century onwards the word denotes fancy rockwork and shellwork for fountains and grottoes. But from about 1730 it began to acquire a wider connotation, being applied to the bolder and more extravagant flights of the *Rococo style. Indeed, it preceded the word 'Rococo' itself as an indication of style. It was used by Victor Hugo as a general term for the style we now call Rococo and this usage has often been adopted by French art historians who have disliked the implications associated until recently with 'Rococo'. HO

ROCKER, a tool with a serrated edge which is worked mechanically across a copper plate to roughen it for *mezzotint engraving. RGo

ROCKWELL, NORMAN (1894–1978). American painter and illustrator. He studied at the Chase Art School, the National Academy of Art, and the Art Students' League, all in New York. Rockwell also studied for a time in Paris in 1923 where he became acquainted with the European abstract avant-garde, yet he always remained a realist in the 19th-century tradition. He is most famous as a magazine illustrator, particularly for the Saturday Evening Post, for which he began work in 1916. At the time he also specialized in pictures for corporate calendars, and illustrations for the burgeoning youth magazine market. His often punchy and affecting pictures encapsulated the concerns and aesthetic predilections of middle-class America and he was often derided and dismissed by the highbrow. In 1963 he left the Saturday Evening Post to work for Look, and his subjects, such as that of racial segregation in The Problem We All Live With (Look, 14 Jan. 1964), began to reflect the political clashes of the 1960s. MF

Buechner, T. S., Norman Rockwell: Artist and Illustrator (1970).

ROCOCO, style of art and decoration characterized by lightness, grace, playfulness, and intimacy that emerged in France around 1700 and spread throughout Europe in the 18th century. By extension the term is often used simply as a period label—'the age of Rococo', referring to the first half of the 18th century. The word was apparently coined in the 1790s by *David's students, wittily combining *rocaille and barocco (i.e. *Baroque), to refer disparagingly to the taste fashionable under Louis XV. Thus, like so many stylistic labels, it began as a term of abuse, and it long retained its original connotations, implying an art that was, in the words of the Oxford English Dictionary, 'excessively or tastelessly florid or ornate'. The word was used as a formal term of art history from the middle of the 19th century in Germany, where those followers of Jacob *Burckhardt who tried to establish a rhythmic periodicity for the phases of artistic development applied it to the closing and therefore decadent period of any phase. With more recent changes in aesthetic taste the Rococo has come to be seen as one of the major contributions of French designers and artists to the history of European art.

The Rococo style was unlike both the academic, monumental, and plastic art of the age of Louis XIV that preceded it, and the archaeological, formalistic, and rigorously classicizing art of the *Neoclassical period

that succeeded it. In the applied arts, which were the style's first and most characteristic manifestation, Rococo designers were concerned with colourfully fragile decoration, supple curves, anti-architectonic forms, and spirited elegance. In painting and sculpture artists moved away from the high seriousness of subject matter, the emphasis on drawing at the expense of colour and the huge scale of the official art of the French academy of the 17th century, towards an art suited in scale, temper, and form to the metropolitan, cultured, fashion-conscious, and essentially domestic society of Louis XV's Paris, so evocatively depicted in the smart genre scenes of Jean-François de *Troy and François *Boucher. Fiske Kimball, the chief historian of the style, has called the Rococo 'an art essentially French in its grace, its gaiety and its gentleness'. From a postmodern perspective it is now possible to see not only the historical particularity of the style, but also the liberating modernity and the civilized, comfortable, and light-hearted qualities that appealed to a society in reaction against the suffocating formality, solemnity, and discomfort of the 17th century. As Parisian society in the age of Louis XV and Mme de Pompadour, with its emphasis on civilized living, elegant manners, and witty discourse, became the model for metropolitan society across Europe, so the art of the Rococo, whether interior decoration, furniture, silver, porcelain, painting, or sculpture, came to be regarded as the appropriate setting for good society. Even in England, with its Palladian architectural preferences and a certain hostility to the manners and morals of its ancient rival, the Rococo style made an impact on the visual arts.

The Rococo was both a development from and a reaction to the weightier Baroque style, and it was initially expressed mainly in decoration. It shared with the Baroque a love of complexity of form, but instead of a concern for mass, there was a delicate play on the surface, and sombre colours and heavy gilding were replaced with light pinks, blues, and greens, with white also being prominent. Elegance and convenience rather than grandeur were the qualities demanded by a society tired by the excesses of *Versailles. Painters' palettes began to adapt to the pastel tones of the decorators, their forms and compositional rhythms to the fluid curves and S-scrolls of the designers, and they began to repudiate the more solemn scenes of classical and national history for the loves of the gods and pastoral poetry. The predominant trend was for easel paintings to be reduced to a scale appropriate to domestic settings and for decorative paintings to be shaped to fit into the curving forms of Rococo panelling. While monumental sculpture continued to be in demand for the decoration of gardens

and façades, the characteristic scale of Rococo sculpture was adapted to domestic display, and many artists found their most lucrative employment in modelling for porcelain factories.

The early masters of the style in France were engravers such as *Audran and *Bérain, and *Watteau is generally regarded as the first great Rococo painter. Boucher and *Fragonard are the painters who most completely represent the spirit of the mature Rococo, but it is noteworthy that the works of such early 18th-century *history painters as Noël *Coypel and François *Lemoyne share many of the same stylistic characteristics. A similar situation may be found among the sculptors of the first half of the 18th century. *Falconet is, perhaps, the quintessential sculptor of the style, with his svelte, boudoir-scaled marble *baigneuses* and his work for the Sèvres porcelain factory. Yet the same emphasis on fashionable elegance may be found in the monumental fountain sculptures and tombs of Lambert-Sigisbert *Adam.

From Paris the Rococo was disseminated by French artists working abroad and by engraved publications of French designs. In Spain the presence on the throne of a Bourbon monarch was a natural explanation for an addiction to all things French. In Prussia and Russia the aristocracy followed a similar path in language, manners, and art, to the neglect of any native traditions. In England, the presence of many French Huguenot craftsmen expelled from their native country ensured the spread of Rococo forms and decoration in silks, porcelain, and silverware, for instance. The pre-eminent sculptor of the mid-century, *Roubiliac, was French in origin, and there are clear reflections of the style even in the work of so xenophobic a painter as *Hogarth, as well as in that of less combative artists, such as *Hayman and *Gainsborough. In each country the Rococo took on a national character, and in addition many local variants may be distinguished. In northern Italy Marco and Sebastiano *Ricci, *Guardi, *Longhi, and *Tiepolo are often regarded as Rococo artists. Yet Tiepolo, in particular, was heir to a distinctive Italian Baroque tradition of large-scale fresco painting, which he adapted with great originality to the new international taste for the elegant and worldly, with little reference to specifically French models. Outside France the Rococo had its finest and most distinctive flowering in southern Germany and Austria, where it merged with a still vital Baroque tradition. In churches such as Vierzehnheiligen (1743–72) by Balthasar Neuman, the Baroque qualities of spatial variety and of architecture, sculpture, and painting working together are taken up in a breathtakingly light and exuberant manner. The decorative painters *Holzer and *Zimmermann, the painters and sculptors of the *Asam family, as

well as the sculptor Kändler, who provided models for the Dresden porcelain factory, contributed to a distinctive central European Rococo style that continued to flourish in the late 18th century, long after the tide of taste in France and elsewhere had turned towards the solemnity of Neoclassicism, beginning in the 1760s.

Rococo first came under sustained attack in the country that had invented it. In the age of the Enlightenment, a style that had no intellectual underpinning was vulnerable not just to the natural changeability of fashionable taste, but also to attacks from the new breed of art critics and theorists. Already in the mid-1750s, the engraver *Cochin had published his *Supplication to the Goldsmiths*, deriding the love of curves, scrolls, and ornaments which threatened to undermine the dignity of design. He was followed not only by the influential writings of historians of classical art, among them *Caylus and *Winckelmann, but also by the art criticism of those such as *Diderot who saw in the paintings and personalities of Rococo artists like Boucher a frivolity and degeneracy that undermined what he regarded as the essentially didactic purpose of painting and sculpture. The fate of Fragonard is instructive. His room decorations on the theme of *The Pursuit of Love* (New York, Frick Coll.), now regarded as his masterpieces, were returned to him in 1773 by his patron Mme du Barry, one of Louis XV's mistresses, who had decided to substitute for them Neoclassical canvases by *Vien. Fragonard's style was evidently already considered out of date in court circles, and by the end of his career he was virtually forgotten.
HO/MJ

Hempel, E., *Baroque Art and Architecture in Central Europe* (1965).

Kimball, F., *The Creation of the Rococo* (1943).

Levey, M., *Painting and Sculpture in France, 1700–1789* (1993).

Snodin, M. (ed.), *Rococo Art and Design in Hogarth's England*, exhib. cat. 1984 (London, V&A).

RODCHENKO, ALEXANDER (Aleksandr) (1891–1956). Russian *Constructivist, photographer, and designer. Impelled by *Futurism and the functionalism of Communist Russia, his *Impressionist painting style gave way to pure *abstractions drawn with compass and ruler. He was greatly impressed by *Malevich's fanatical nonobjectivity, for instance *White on White* (1918), and countered it with his famous 'black' paintings, including *Non-objective Painting: Black on Black* (1918; New York, MoMa). After meeting *Tatlin, he extended his ideas into constructions which hung against a wall or from the ceiling like *Oval Hanging Construction No. 12* (c.1920; Moscow, Tretyakov Gal.) and these characterized his work from 1916. Abandoning fine art in 1921, he, his wife *Stepanova, and the playwright Aleksei Gan

formed the first Working Group of Constructivists, to produce mainly official photography, propaganda posters, and Soviet design projects. His photographs of the new Russia, with their striking perspectives and tonal contrasts, were perhaps his most original works. Rodchenko returned to easel painting in 1930. At his death, the state overlooked all but his propaganda work, but an archive has since been preserved in his Moscow studio. YJ

Khan-Magomedov, S. O., *Rodchenko: The Complete Work* (1986).

RODIN, AUGUSTE (1840–1917). French sculptor renowned for his expressive handling and themes. Having failed the exam to the École des Beaux-Arts, *Paris, three times, Rodin began his artistic career as an artisan. He studied with Antoine-Louis *Barye and Horace Lecoq de Boisbaudran whose techniques of drawing from life and memory were to remain a part of Rodin's practice throughout his career. He worked as an ornamental mason, as an assistant to Albert Ernest Carrier-Belleuse, and for the Sèvres porcelain manufactures. A trip to Italy in 1875 introduced Rodin to *Michelangelo.

Rodin's art inspired controversy; *The Age of Bronze* (bronze; London, Tate) was initially condemned as cast from life and then admired and purchased by the state in 1878. In his doors for the proposed Musée des Arts Décoratifs, *The Gates of Hell* (plaster; Paris, Mus. d'Orsay), Rodin transformed *Ghiberti's Gates of Paradise (Florence baptistery) into a tumultuous *fin de siècle* vision of Dante's journey through the circles of hell in *The Divine Comedy*. Many of Rodin's free-standing works derive from this ensemble, including *The Thinker*, *The Kiss*, and *Carnal Love*. Many versions of his sculptures exist; *The Burghers of Calais*, a monument to commemorate the 14th-century liberation of the city from the English, was installed both in Calais in 1895 and in Victoria Tower Gardens, London, in 1913.

Rodin was asked to produce many commemorative statues of important artistic figures: the authors Victor Hugo and Honoré de Balzac (both plasters were rejected by their literary society commissioners); and the pictorial artists *Puvis de Chavannes, *Claude Lorrain, and Jules *Bastien-Lepage. He was also inspired by music and dance, in particular by Hanako, a Japanese dancer who performed at the 1889 Exposition Universelle, and by Nijinsky, whose performance of Debussy's *L'Après-midi d'un faune* in Paris in 1912 Rodin greatly admired. His fragment sculptures, often no more than an isolated limb, have particularly intrigued contemporary scholars.

Themes of sexuality and creativity inspired much of Rodin's œuvre and are expressed through physical torsion and explicit studies both in life drawings and in sculptures like *Iris* and the auto-erotic *Balzac*. These aesthetic engagements with passion have filtered into the mythology of the artist's personality, evocatively constructed in Rainer Maria *Rilke's monograph. Rodin was to influence generations of sculptors, including assistants, like Émile-Antoine *Bourdelle. There were more fraught relationships with women artists including Camille Claudel and Gwen *John. Rodin employs expressive techniques of modelling and composition eloquently embodying the passion and anxiety of the *fin de siècle*. CIRO'M

Elsen, A., *Rodin Rediscovered*, exhib. cat. 1981. (Washington, NG).
Rilke, R. M., *Rodin* (1903).

ROELAS, JUAN DE (c.1558×60–1625). Spanish painter, first mentioned in Valladolid in 1598, where he may have been born and was then working. His style does not draw from late 16th-century Castilian painting, and was probably formed in Valladolid in contact with the pictures in the royal collection. He was ordained as a priest and obtained a prebend in the Sevillian village of Olivares in 1603. From that year on he would reside in Olivares and Seville, with a hiatus of at least two years between 1614 and 1621, spent in Madrid.

Venetian painting—particularly *Veronese and the *Bassano family—has been suggested as a source for Roelas's style, but his physical types and compositions, as seen in his *Santiago at the Battle of Clavijo* (1609; Seville Cathedral), *Martyrdom of S. Andrew* (Seville, Mus. Provincial), and *Transit of S. Isidore* (1613; Seville, S. Isidoro), owe little to such influences. His use of *sfumato* and his figure types seem closer to the art of Lorenzo *Lotto. NAM

Brown, J., *The Golden Age of Painting in Spain* (1991).
Mallory, N. A., *El Greco to Murillo: Spanish Painting in the Golden Age: 1556–1700* (1990).

ROGER OF HELMARSHAUSEN (active first quarter of the 12th century). German goldsmith. His only surviving documented work is the portable altar dedicated to SS Killian and Liborius (Paderborn, Diözmus. und Domschatzkammer) commissioned by the Bishop and produced around 1120. He was recorded at Helmarshausen Abbey as a respected writer, as well as a goldsmith, and his identification as *Theophilus, the author of the most important and widespread manual on medieval crafts, is often debated. KS

ROHLFS, CHRISTIAN (1849–1938). German painter and draughtsman. Rohlfs was born in Niendorf, the son of a farmer, and studied at Weimar, where he later taught, from 1874. His painting was conventional, with impressionistic overtones, until 1902 when he was profoundly influenced by a van *Gogh exhibition in Hagen, Westphalia, where he had come to teach in 1901. Van Gogh's example, and the encouragement of *Nolde, with whom he painted in 1905–6, led Rohlfs to adopt brighter colours and a broader brush stroke, as seen in the freely painted *Beech Forest* (1907; Essen, Folkwang Mus.). Further technical freedom came with his adoption of watercolour as his chosen medium, c.1911, and a more expressionistic approach to his subjects, whether visionary, landscape, or still life. From 1927 to 1937 he was mainly based in Ascona, Lago Maggiore, and it was there that he painted, late in life, the delicate semi-abstract flower pieces that are his best-known works. DER

Vogt, P., *Christian Rohlfs* (1956).

ROKOTOV, FYODOR (1735–1808). Russian portrait painter. Of peasant stock, he may have trained in St Petersburg with the court painter Pietro Rotari (1707–62), from whom he would have learned the Frenchified international style of fashionable portraiture, that made him one of the most successful native-born artists of the 18th century. His portraits of the Russian nobility range from his rather stiff state portrait of *Catherine the Great* (1763; St Petersburg, Pavlovsk Palace) to such charming and informal works as *Barbara Novosiltseva* (1780; Moscow, Tretyakov Gal.), which could stand comparison with similar works by *Drouais and *Vigée-Lebrun. MJ

Mikhaylova, K., *Rokotov* (1971).

ROLDÁN, PEDRO (1624–99). Spanish sculptor active in Seville and father of Luisa Roldán (c.1656–c.1704), also a sculptor. Although born in Seville, he travelled to Granada in 1638 to train in the workshop of Alonso de Mena; there he also met and worked with Pedro de *Mena. Roldán returned to Seville in 1647 where he established himself as the most important sculptor after Martínez *Montañés and maintained good relations with local painters such as *Valdés Leal and *Murillo. The former frequently polychromed Roldán's statues, while the latter invited him to serve as a professor in the short-lived Academy in Seville. Roldán's reputation for powerful and emotionally extrovert works led to commissions throughout Andalusia—Cadiz, Jerez, Cordoba, and Jaén—thereby spreading his influence further. Although he created important single figures, his greatest achievements are found in large multi-figural reliefs, such as the *Descent from the Cross* (1666; Seville, Sagrario) or ensembles that combine fully

carved figures with relief, such as the *Entombment* (1670–2; Seville, Hospital de la Caridad).

PL

Bernales Ballesteros, J., *Pedro Roldán* (1992).

Martín González, J. J., *Escultura barroca en España 1600–1770* (1983).

ROMAN ART, ANCIENT (1) *Introduction*; (2) *Inscriptions*; (3) *Painting*; (4) *Mosaics*; (5) *Sculpture*; (6) *Patronage and collecting*

1. Introduction

Roman art enters the scene almost ready made. There is little evidence of experimentation in technique or representation. Rather, from its earliest beginnings, Roman art appropriated the visual traditions of the many cultures with which Rome's expanding empire brought it into contact. The earliest recorded sculptors and painters are *Etruscans and Greeks (see GREEK ART, ANCIENT), both from cultures with a developed visual language. As Virgil tells the Romans in the *Aeneid* 6. 847–53, 'others with greater subtlety will hammer out breathing images from bronze (this, at least, I believe), and will, from marble, draw forth the faces of living men.' The history of Roman art is articulated by Roman reception and adaptation of diverse visual traditions, whether Egyptian, Greek, or Etruscan. And yet, the result is not a mishmash of styles, exactly copied but dry and academic. Rather the Romans succeeded, through an insistence on the response of these divergent traditions to Roman needs, in creating art that was distinctly 'Roman'.

Yet it would be incorrect to read Roman art in its most restricted sense as including only the most 'Roman' of Roman art, historical relief and portraiture, thereby excluding Roman copies and painting and mosaics. Instead, each genre took over earlier prototypes and reshaped them to serve specific Roman needs. Thus, although the Romans are renowned for portraiture, here too they were elaborating on an earlier *Hellenistic tradition developed for the portrayal of Hellenistic dynasts. Even the harsh 'veristic' style of the Republic finds parallels in the Hellenistic fascination with the depiction of set types, with an emphasis on old age and the portrayal of emotion. Likewise, the genre of historical reliefs builds on a Hellenistic penchant for the recording of the deeds of the Hellenistic kings, whether in battle or in hunt scenes. Roman art follows also the Hellenistic pattern of the association of specific styles with themes and genres.

L-AT

2. Inscriptions

Roman culture was literate from probably before 600 BC. The earliest inscriptions on art date back even further, if we accept Dionysius of Halicarnassus' account that a statue dedicated by Romulus (753 BC) was inscribed in Greek. Greek continued alongside Latin in inscriptions throughout the Roman period.

The choice of language may reflect the ethnicity of the dedicator or artist or a conscious choice of the patron. Bilinguals are also possible. Inscriptions could be painted, or incised onto the work of art or a base; alternatively plaques could be hung on statues or attached to statue bases.

The inscription on Romulus' statue probably followed the normal pattern of inscriptions on works of art. They could be labels, identifying the person or subject portrayed, dedications to the gods or honorific inscriptions, or signatures or maker's marks.

Labels appeared on paintings, mosaics, relief sculpture, shafts of herm portraits, silverware and its ceramic counterparts, and gems. Labelling gone mad is represented by the *tabulae iliacae* that depict scenes from the Homeric cycles complete with labels and brief synopses in Greek. Greek labels on the painted *Odyssey* frieze (1st century BC; Vatican Mus.) and the *Nile* mosaic from Palestrina (2nd century BC; Palestrina, Mus. Arch.) suggest that, in some cases, inscriptions were copied from the original model.

Latin signatures are attested from at least the 4th century BC. The Ficoroni Cista is signed by its maker, Novius Plautius (late 4th century BC; Rome, Villa Giulia Mus.). Greek signatures are well attested on sculpture; copyists sign their names rather than those of the original sculptors. The inclusion of ethnics and sometimes the father's name provides essential evidence for workshop organization. In the Roman period, signatures traditionally inscribed on bases moved to the body of the statue or struts in response to the transportation of sculpture from various centres of production. A single signed historical relief survives (Paris, Louvre). Roman portraits are sometimes signed in the Greek East; in the West, signatures seem to occur only when portraits are joined with Greek body prototypes. Signatures on wall painting were also rare; the surviving example is in Latin, in *Pompeii (House of D. Octavianus). Inscriptions on minor arts were more common, relating the name of the workshop (Arretine ware, terracotta architectural reliefs) or the maker (gems).

L-AT

Harris, W. V. (ed.), *The Inscribed Economy* (1993).

3. Painting

Roman painting is known chiefly from the remains of mural decorations of the late republican and the early imperial periods found in the houses of Pompeii and *Herculaneum and the other towns buried by the ashes of Vesuvius in AD 79. Further wall paintings survive in Rome and *Ostia, carrying through to late Antiquity; and increasingly large numbers of examples are being recovered in the Roman provinces, thanks to the patient reassembling of hundreds of small fragments. Of pictures painted on panels of wood (or other materials) we

have few remains, apart from an impressive series of portraits set in mummy cases from Roman Egypt; but the loss may be less serious than at first sight appears, because there is evidence that the major effort of painters in the Roman period was devoted to wall decorations. *Pliny the elder, writing in AD 79 (*Natural History* 35. 118), specifically deplores the switch in fashion from painting panels to painting walls. Other forms of painting, on glass vessels for instance, are of minor importance. The first manuscript illuminations, including those of two codices of Virgil's *Aeneid*, belong to the 5th century AD.

The formal evolution of Roman wall painting can be traced in broad outline from the 2nd century BC to the 4th century AD. The Pompeian material is today conventionally grouped into four successive styles, and, though both the validity and the chronological basis of the sequence have frequently been questioned, this classification continues to provide a useful frame of reference.

The first Pompeian style was a variant of a form of decoration developed in the Greek world during the 4th and 3rd centuries BC. Rather than painting on a flat surface, it consisted of plasterwork raised in relief to produce the effect of monumental ashlar masonry, or alternatively of marble wall veneer such as Vitruvius (*De architectura* 2. 8. 10) describes in the palace of King Mausolus (d. 353 BC) at Halicarnassus (modern Bodrum, Turkey). The blocks were painted in bright colours and often variegated to suggest the veins of marble or alabaster.

In the second style, which came into fashion during the first decades of the 1st century BC, a true architectural illusion was achieved by pictorial means upon flat plaster. The coloured blockwork of the first style was retained, but the impression of relief was supplied by painted shadows and highlights. In the foreground there were screens of columns standing on a projecting podium and supporting an entablature. The *trompe l'œil* effects, exploiting a combination of shading and perspective, became increasingly elaborate, with three or more planes of architecture and exotic motifs such as broken pediments, arches carried by columns, and jutting entablatures; and the upper part of the wall was opened to reveal a colonnaded courtyard, sometimes with a rotunda in the middle. Such grand schemes, in which columns were frequently rendered in coloured stone with gilded and jewel-encrusted enrichments, were designed to evoke the imagined splendour of Hellenistic palaces and may have emerged from the quasi-monarchical aspirations of the Roman elite. There may also have been some influence from painted scenery used in the theatre. Theatrical masks were often hung or otherwise disposed within the architectural framework, and Vitruvius (*De architectura* 7. 5.

2) tells us that paintings 'in open spaces such as *exedrae*' reproduced 'stage-fronts in the tragic, comic, or satyric manner'.

In the last years of the second style, the architectural elements became less solid and the element of fantasy more prominent. Columns sprouted vegetal forms or were replaced by candelabra; pediments gave way to winged heads; half-plant and half-animal forms (the first 'grotesques') or figures seated on plants now populated the wall. Most important was the introduction of a framed picture in the central position. Initially taller than it was wide, this was set within a columnar pavilion which emphasized its importance; it showed mythological or other scenes set within buildings or a natural landscape, and in many cases reflected compositions derived from famous panel paintings of Greek times.

The third style, which superseded the second during the last two decades of the 1st century BC, emphasized the central picture still further by reducing the architectural elements to bean-pole columns and delicate bands of polychrome ornament within broad expanses of flat colour. The favoured colours were not only red, long favoured in the second style, but also black, light blue, and eventually green. Overall the illusionistic piercing of the wall was replaced by a respect for the surface, now solid and impenetrable; even the mythological and landscape paintings which dominated the schemes had a non-spatial quality, with figures ranged parallel to the surface plane, their forms delineated in clear, hard colours without highlights, and the background reduced to a more or less neutral foil.

The fourth style, which emerged around the middle of the 1st century AD, swung the pendulum back towards architectural illusionism, but instead of the solid, believable structures of the second style painters retained the spindly proportions and fantasy forms of the third, now rendered in warm golden colours and stacked up in breathtaking visions of infinite space and recession. Their schemes were once more populated by plant-animal hybrids, most famously in Nero's *Domus Aurea* in Rome where the overwhelming exuberance of the paintings was reinforced by the incorporation of tiny figures and ornaments in stucco relief, by the application of gold leaf, and by inset 'gems' of coloured glass. Central pictures continued to be a feature, though the panels were generally reduced in size and acquired a square format, and tended to appear as if hung upon great coloured tapestries (for which yellow and red were now the preferred colours) rather than framed by pavilions. A favourite scheme offered a rhythmic alternation of these picture-bearing 'tapestries' and visual openings containing perspectival

architecture upon a white ground. Alternatively the entire wall was opened up to create a framework of architecture in which groups of figures played out scenes from well-known myths, like actors in some kind of baroque stage set.

With the end of the fourth style, probably 10–20 years after the destruction of Pompeii, the most innovative period of Roman painting came to an end. From now on painters tended to go back to formulas explored in earlier phases, often putting them together in less clear and coherent ways. At the same time, perhaps as a result of the diffusion of wall painting to an ever wider clientele of different social classes, there was a general decline in standards of workmanship. In the 2nd century AD architectural schemes remained popular, but the architecture was less clearly structured and three-dimensional effects were sacrificed to plays of colours. Central pictures became less common; figured subjects on walls were increasingly confined to single figures or vignettes at the middle of coloured fields, while panels containing groups of figures were more usually found on vaults and ceilings. It was on vaults and ceilings, indeed, that the more inventive and adventurous work was now produced, with various curvilinear and centralized schemes which, under the influence of new forms of vaulting, notably groined cross-vaults and 'umbrella' domes, placed emphasis on the diagonals and radii of the surface. Other decorations imitated the coffering of ceilings in wood or stucco, or created traceries of vegetal and floral ornament similar to the patterns of modern wallpaper.

High-quality polychrome paintings were still being produced in the 4th century, but there was a gradual hardening of forms, with greater emphasis placed on flat colours and strong outlines. This trend led into the hieratic style of *early Christian art, where pictorial illusion was less important than putting over clear messages.

At any given time the elaboration of wall paintings naturally varied. Polychrome decorations with mythological picture panels were at the top of the scale, appearing in the more luxurious houses, or in the more important rooms of second-rank houses. Below them came a range of possibilities: polychrome schemes with landscape panels, white-ground schemes with landscapes or still lifes, white-ground schemes with isolated birds or animals, or simple white walls with fields outlined by coloured stripes. These variations are found throughout the Roman world and testify to the existence of a sliding scale of prices based on the degree of expertise and the cost of the materials needed for each decor. Simple striped decorations were normally relegated to subsidiary rooms; only in very modest dwellings whose

owners could afford no more did they acquire a higher status. During the 3rd century, however, a 'red and green linear style', with isolated figures and animals in a spider's web of panels on a white ground, enjoyed a vogue which extended beyond purely economic considerations. It was widely employed in the decoration of the early catacombs.

The painters themselves seem to have operated in groups, no doubt with a master craftsman who designed and executed the main figures and figure scenes, and apprentices who did all the other jobs from applying the background colours and secondary ornaments down to preparing materials. Just such a team is illustrated on a well-known grave relief from Sens in France, which shows a plasterer and painter working on a scaffolding while an assistant mixes plaster on the pavement and the master sits on a flight of steps consulting a pattern book. A similar unit is attested by a graffito on a 4th-century wall decoration found under the church of S. Sebastiano outside Rome ('Musicus with his workmen Ursus, Fortunio, Maximus, Eusebius'). The use of pattern books is corroborated by references in ancient literature, and can be inferred in any case from close iconographic correspondences between figure compositions in far-flung parts of the empire. Specialization within the painters' workshops is confirmed by the wages laid down in Diocletian's Price Edict (AD 301): the figure painter (*pictor imaginarius*) was allowed to earn up to 150 denarii per day, plus subsistence, while the ordinary wall painter (*pictor parietarius*) was restricted to 75.

The principal technique of Roman *wall painting was *buon fresco*, as Vitruvius makes clear. Close observation of surviving decorations reveals the seams between the *giornate di lavoro*, the areas of fresh plaster laid for each session's painting; and half-finished decorations at Pompeii demonstrate that work usually proceeded from top to bottom in three zones, each of which was painted before the surface plaster for the next was applied. There are also examples of *sinopie* similar to those of the Renaissance—drawings in red ochre carried out on the plaster undercoat to guide the painter before the final surface coat was laid. All this conforms broadly to practice in later times. More unusual is the number of layers of plaster employed for the better-quality work—as many as six or seven in certain wall decorations of the 2nd and 1st centuries BC, such as those of the so-called House of Livia in Rome. The point of building up a thick plaster was to prolong the drying process so as to allow painters ample time to operate and to ensure that the pigments, once applied, were securely fixed. Further assurance on this score was achieved by burnishing the surface after the first colours were applied, a practice

which gave the frescoes a distinctive sheen. The plaster remained soft even after the burnishing, and pressure exerted at selected points brought further lime-saturated water to the surface to fix ornaments painted over the background colours.

The basic colours used were the earth pigments: red ochre, yellow ochre, green earth, and white from chalk or the like. Blue was blue frit, or Egyptian blue, an artificially produced pigment consisting of copper calcium silicate in a glassy matrix. Black was carbon, obtained from soot or charcoal, which had to be mixed with size to make it compatible with the fresco technique. Other pigments belonged to the category that *Pliny (*Natural History* 35. 30) terms 'florid'. Being expensive, these were not held in stock by the painters, and clients had to order them specially. Most important was cinnabar, which produced a deep lustrous red, but which had to be regularly treated with wax and oil to guard against discoloration. For this reason it was sparingly used, being found only in the most important rooms of the best appointed houses. Even rarer were certain organic dyes, such as indigo or purple, which had to be impregnated in chalk or the like to make them fast.

The influence of Roman painting has been considerable in recent centuries, particularly in the wake of major new discoveries. In the Italian Renaissance, artists were inspired by the decorations of Hadrian's Villa at *Tivoli and, more importantly, by those of Nero's *Domus Aurea* in Rome. The design of the so-called Volta Dorata ('gilded vault'), found in one of the principal rooms of the *Domus Aurea*, was adapted by *Pinturicchio for at least two ceiling paintings at Siena, and the general style of the grotesques set a fashion widely used by *Raphael's school for their decorations in Rome, including those of the Vatican Loggias and the Villa Madama. In the 18th and 19th centuries a new wave of influence followed the discoveries in the Vesuvius region. Individual paintings, such as the *Love Seller* from Stabiae, were reproduced in various media, while interior decorations in the Pompeian manner graced the mansions of contemporary potentates, such as Napoleon's brother Jérôme, who had a Pompeian house constructed in Paris, and Ludwig I of Bavaria, who built a replica of the House of the Dioscuri at Aschaffenburg near Frankfurt. RJL

Ling, R., *Roman Painting* (1991).

4. MOSAICS

The Romans brought the medium of floor mosaic, invented by the Greeks, to maturity, and began the practice of applying mosaics to walls and vaults. The inevitable bias of the surviving evidence means that we are best informed about floors, where a flourishing tradition had already emerged in the Hellenistic period. Many of the earliest examples in Italy (late 2nd and 1st centuries BC) clearly demonstrate their Greek pedigree, using cubes (tesserae) of different coloured stone or terracotta to achieve elaborate pictorial illusions, including perspectival meanders and dentils, imitations of coffered ceilings, vegetal scrolls, and central figure scenes (often imported ready made in stone or terracotta trays). Alongside Greek-style mosaics, a simpler local tradition, perhaps first developed in Carthage, favoured patterns of dispersed tesserae or irregular fragments of stone set in mortar; and in the 1st century BC, as wall paintings became more complex, illusionism tended to desert floors altogether, giving way to abstract and geometric patterns, principally in black and white tesserae.

During the imperial period geometric mosaics were the commonest form of decorative paving throughout the Roman world; they used an ever greater range of schemes and ornamental motifs, and by the 3rd century AD were rendered almost universally in colour. Figure work took different forms in different regions. In central Italy and areas under Italian influence the figures were in black silhouette, with inner detail rendered by white lines, all on a continuous white background. In the eastern Mediterranean there were polychrome pictures, often placed centrally within a surrounding geometric pattern in the traditional Hellenistic manner. In the northern and western provinces, polychromy was again preferred, but figure subjects were dispersed within geometric frameworks, usually in more or less equally weighted panels, each with one or two figures on a white background. In North Africa, alongside these polychrome 'carpet' mosaics, there developed a tradition of coloured figure scenes spreading in a free composition over the whole floor surface. Here, in contrast to the predominance of mythological subjects in other regions, there was a marked predilection for genre subjects: hunt scenes, scenes of rural life, the games of the circus and amphitheatre.

Wall and vault mosaics represent a separate development. From the incrustation of fountain niches with shells and pieces of pumice during the 1st century BC to the soaring mosaic vault decorations of imperial bath buildings in the 3rd and 4th centuries AD, this new medium (*opus musivum*) enjoyed a spectacular success. In contrast to floor mosaics, it employed a large proportion of glass tesserae and the surface was left unsmoothed so that the many different facets of the tesserae created a scintillating effect, well suited to contexts where water played. Backgrounds were generally coloured with the rich dark blue and gold hues which later became characteristic of the early Christian mosaics at Ravenna and elsewhere. RJL

Dunbabin, K. M. D., *The Mosaics of the Greek and Roman World* (1999).

Ling, R., *Ancient Mosaics* (1998).

5. SCULPTURE

According to the ancient sources, honorific portraits of mortals pre-dated the representation of the gods in the Roman world. This emphasis on the individual and self-representation propels the entire history of Roman sculpture. Even monuments of official art, erected by the Senate and the Roman people, couch the security of the empire in the hands of single individuals. The cult of the emperor is the most extreme example of this phenomenon; images of these divine mortals are found in even the most remote corners of the empire. For the private individual, competition in the political arena is reflected in dedications in public spaces, the erection of buildings such as temples, baths, theatres, and the elaborate fitting out of the public areas of their houses and villas.

As more public arenas for self-representation were restricted to the emperor and imperial family in the course of the early empire, aristocratic competition focused on the funerary realm, where ordinary men could utilize the iconography of emperors and gods, representing themselves as heroes, philosophers, and deities. The emphasis is on the offices or profession of the deceased, their virtues, and social ambitions, whether articulated through scenes of daily life or through mythology and allegory. Inscriptions further eulogized the deceased. Local traditions are seen most clearly here, for example, the mummy portraits of Roman Egypt, local Palmyrene portrait types, or tombstones in Roman Britain.

(a) Early Roman sculpture

The terracotta material of the earliest surviving Roman sculpture betrays its connection to *Etruscan art; for instance the *Apollo* from Veio (6th century BC; Rome, Villa Giulia Mus.). In marble-poor Italy prior to the opening of the quarries at Carrara in the time of Julius Caesar (mid-1st century BC), a sophisticated tradition of terracotta statuary following Etruscan and Greek models developed. Two 6th-century BC pedimental groups and an architectural frieze are preserved from the temples of S. Omobono (Rome, Capitoline Mus.). Iconographically and stylistically they are comparable to *Archaic limestone sculpture from the Athenian Acropolis. Of particular interest is a group showing Hercules' introduction to Olympus. Terracotta statues and other architectural decoration (c.500 BC) found on the Palatine have been associated with the temple of Victory. Again the polychrome terracottas reflect contemporary Greek style. The discovery of a terracotta cult statue of *Zeus Meilichios* (3rd century BC; Naples, Mus. Arch.

Naz.) at Pompeii demonstrates that this phenomenon was not restricted to Rome.

The development of Roman portraiture has also been tied to Etruscan and Greek influence. Part of the difficulty rests in the absence of datable material before the early 1st century BC. The so-called *Brutus* (Rome, Capitoline Mus.), a bronze bust portrait, has been variously dated from the 4th to the 1st century BC; prevailing opinion leans toward the later date (1st century BC) and reads the image as a 'manufactured' posthumous portrait of a famous Roman. For earlier evidence, we must rely on the mid 2nd-century BC Greek historian Polybius, whose description of contemporary Roman funerary customs includes information of the tradition of preserving faithful images of the deceased in household shrines. These same images or masks were worn in funerary processions by their ancestors. Pliny confirms Polybius' account, further defining the masks as made of wax. The literary record of Polybius and Pliny has led some scholars to attribute the origins of Roman portraiture to this Italic tradition. These scholars focus on the 'naturalism' of Republican portraiture. Others point to the datable material from *Delos (88–64 BC), where portraits in a harsh, 'warts and all' style have been associated with Roman merchants trading there (e.g. portrait of *Gaius Ofellius Ferus*; Delos Mus.). In fact, the Roman tradition of portraiture is marked by an emphasis on certain elements of characterization; baldness, the wrinkles and sunken cheeks of older age, and distinguishing marks such as bulbous noses and warts predominate. Rather than naturalistic, Roman portraits have more properly been defined as veristic. This verism is a manifestation of the cultural values of the Romans with its concentration on the wisdom and authority of older age. The Hellenistic tradition of the characterization of age and of genre figures was adapted to express their Roman values.

An excellent example of the genre is the *Barberini togatus*, a Roman aristocrat (head does not belong) draped in the voluminous toga of the Augustan period, who holds the portrait busts of his ancestors in either hand (50–25 BC; Rome, Capitoline Mus.). The portrait of *Pompey the Great* introduces a new element, the combination in a single image of Hellenistic and veristic style (mid-1st century BC; Copenhagen, Ny Carlsberg Glyptothek). The pudgy face with its pouting mouth and small 'piggy' eyes is crowned by the lionlike mane of Alexander the Great. The interchange of cultural traditions in the late Republic also led to the creation of images that seem strange to modern eyes. These portrait statues place veristic portrait heads atop Greek idealized athletic bodies in Classical style, thereby presenting two different ideals: the authority of the aged politician

and the athletic prowess of a youthful general. The earliest surviving example bridges these two traditions quite precisely. Scholarly opinion is evenly divided on the identification of the bronze *Terme Ruler* as a portrait of either a Hellenistic prince, brought to Rome from the Hellenistic East as booty, or a Roman general, perhaps a dedication in Rome by the defeated Greeks (180–150 BC; Rome, Mus. Naz. Romano). In late Republic Rome, the stark nudity of figures such as these must have seemed shocking at first. Nude and half-draped statues were reserved for the gods; mortal men were dressed in their civil or military garb. A more traditional figure is exemplified by the *Arringatore*, an honorific statue of one of the leading men of Perusina, Aule Metele, c.80 BC; the broad borders of his toga and tunic and his footwear characterize him as a local aristocrat (Florence, Mus. Arch.). Nonetheless, these combination figures become popular, as evidenced by a naked figure with a veristic head from Chieti (c.70–40 BC; Chieti, Mus. Arch.) and the half-draped statue of the *Tivoli General* (c.70–50 BC; Rome, Mus. Naz. Romano).

The genre of historical relief demonstrates a similar interaction between Hellenistic traditions of visual representation and Roman social and political values. The victory Monument of Aemilius Paullus in *Delphi represents the most blatant convergence of these two intentions. As the victor over the Hellenistic King Perseus V in 167 BC, this Roman general appropriated Perseus' monument and added a frieze depicting events from the battle (Delphi Mus.). Aemilius Paullus was following a tradition for representations of battles well attested in the courts of the Hellenistic kings. The existence of similar painted records of battles (see BATTLE PAINTING) in the Roman world is documented by the painting from a tomb on the Esquiline (2nd century BC; Rome, Capitoline Mus.). Triumphal processions included these panel paintings; images of the triumph itself could then be dedicated in temples. The Romans expanded on the Hellenistic tradition, focusing on the depiction of 'historical' events while retaining the Greek penchant for allegorical figures and personifications.

The so-called Altar of Domitius Ahenobarbus represents a similar case of Roman appropriation and reuse of Greek monuments (late 2nd, early 1st century BC; Paris, Louvre; Munich, Glyptothek). Three marble panels depict a marine marriage in Hellenistic 'baroque' style; it is probable that these reliefs were taken as booty to Rome. The style of the fourth relief is more restrained and sombre; a Roman census-taking is recorded along with the traditional sacrifice to the god Mars. Once connected to the temple of Neptune dedicated by Domitius Ahenobarbus, most recently the reliefs have been associated with

Marcus Antonius, the censor in 99–97 and grandfather of Mark Antony. A marble historical relief of this grandson has been recognized in a naval scene complete with crocodile (37–32 BC; Vatican Mus.).

The influx of booty into Rome as the result of Roman conquests in Italy and the Greek East led to an explosion of visual images in the public and private buildings of Rome and Roman Italy. The masses of statues, in bronze, silver, gold, and marble, accustomed the Romans to this kind of visual display and to Hellenistic luxury. Statues of deities were rededicated in temples; porticoes and other public buildings erected to commemorate the general's triumph could be filled with sculpture taken from the defeated foe. Thus, Metellus displayed the *Lysippic group of Alexander and his comrades at the battle of Granicus in his portico. The setting up of trophies outside the house of the triumphant general was extended by the display of booty within the house.

The diaspora of Greek artists to Rome following the decisive defeat of the Greeks in 146 BC opened up a new market in Roman copies after Greek originals or simply in Greek style. Reassessment of the copying industry has argued for a more subtle reading of the interaction between Roman intent and Greek production of these copies. Traditional scholarship ascribed to the Romans the development of an ancient version of the *'pointing machine', capable of producing copies exact in style and detail. Variations in details and deviation from the originals were thought to be the result of the use of fewer measuring points or the inaccessibility of the originals. New research rejects the existence of an ancient pointing machine and suggests that Roman requirements were more varied. Both close copies and broad adaptations (and an entire range in between) coexist as an indication of the equally broad spectrum of Roman reception of the Greek visual tradition. Measurements were transferred from the model or original to the copy using calipers in a three- or two-point configuration.

The best-known workshop of this period is that of *Pasiteles, the favoured sculptor of the collector Asinius Pollio and the author of a five-volume text entitled *Noble Works of Art throughout the World* (Pliny, *Natural History* 1. 34, 36. 39). None of Pasiteles' works survives but the signed works of his pupils have led scholars to assume that they all worked in a classicizing style. Pasiteles' pupils, Stephanus and Menelaus, are unusual in that rather than giving their father's name, they define themselves as pupils of Pasiteles and Stephanus respectively. Perhaps the transfer of artists to Italy disrupted the usual transmission of skills from father to son. The so-called *Orestes and Electra* group of Menelaus is a good example of their eclectic classicizing creations (1st century BC; Rome, Mus. Naz. Romano).

Other copies include the so-called 'Neo-Attic' reliefs that imitate and adapt motives taken primarily from Classical relief sculpture. These sculptors signed their works with their ethnic; 'Athenian' predominates. Examples include marble fountain vases such as the Rhyton of Pontius with dancing maenads from the gardens of Maecenas (c.1st century BC; Rome, Capitoline Mus.) and a large-scale panel after the Victories leading a bull to sacrifice from the parapet of the Athena Nike temple in Athens (1st century BC; Florence, Uffizi); both adapt images from late 5th-century BC Athenian monuments. Greek artists were also called upon to create new cult images for Caesar's extensive building programme; Arcesilaus produced the image of Venus Genetrix for his new Forum (Pliny, *Natural History* 35. 155).

For funerary art of the earlier Republican period, the most elaborate preserved tomb is that of the family of the Scipii in Rome. The façade of the tomb is decorated with statues in niches; the sarcophagus of Cornelius Scipio Barbatus adopts the form of contemporary Greek altars (early 3rd century BC; Vatican Mus.). Late Republican aristocrats and even freedmen erected monumental tombs. Examples include the tomb of a freedman baker in front of Porta Maggiore in Rome with its historical reliefs showing the bakery in operation and portrait statues of Eurysaces and his wife (c.40–30 BC) and the round mausoleum of Caecilia Metella on the Via Appia in Rome, decorated with a frieze in Greek marble of ox-heads and garlands as well as a large panel with military trophies in relief (c.30 BC).

(b) Imperial Roman Sculpture

As the first Roman emperor, Augustus exerted an enormous impact on the visual language of Roman art (27 BC–AD 14). Recognizing the power of images in the struggle against Mark Antony, he changed his own portrait type several times in accordance with changes in his self-representation. Moreover, he introduced the custom of disseminating the imperial portrait image throughout the empire in the form of marble copies and casts; more than 250 examples of his portrait survive as a result. The majority of Augustan portraits are of the so-called 'Prima Porta' type, named after a marble statue of the Emperor from the villa of Livia, his wife, at Prima Porta. Along with the *Ara Pacis this statue, the *Prima Porta Augustus*, has become a byword for Augustan art. It is thought to be a copy of a bronze original that stood in Rome; the marble copy was painted and gilded. The statue is dated to c.20 BC on the basis of the image depicted on his breastplate, the return of the Parthian standards (Vatican Mus.). Thus, the statue is both portrait and historical relief, a complete expression of Augustan iconography. In the

settlement of 27 BC, Octavian gave up all of his emergency powers and 'restored the republic'. As a response to his beneficence, the Senate gave him the new name, Augustus, by which he is commonly known. To celebrate his new position as 'first among equals', a new portrait type was introduced that rejected the earlier portrayal as a Hellenistic dynast. Rather, the Classical style of 5th-century BC Greece was used to emphasize the establishment of a new 'Golden Age' founded by Augustus. He was to use this image for the majority of his 41-year rule. The head of Augustus is idealized and ageless; his body follows the model of *Polyclitan athlete figures. The scene on his breastplate sets the return of the Parthian standards within a cosmic realm, approved by the gods who frame the scene: Heaven, Mother Earth, Apollo and Diana, Sol and Luna. The diplomatic victory is also flanked by representations of the empire, defeated barbarians. The Cupid at his feet alludes to his descent from the goddess Venus. The bare feet of the statue, more appropriate to a god, may suggest that this copy is posthumous.

Some of the same iconography is repeated on the Ara Pacis. Here too the Classical style of the parapet reliefs refer to Augustus' new 'Golden Age'. The altar was erected by the Senate to celebrate Augustus' safe return and the new-found peace in the empire. The Emperor is surrounded by his family, Roman priests, and officials as he prepares to sacrifice; the procession occupies the two long sides of the monument. Two relief panels set the reign of Augustus within the context of Roman myth-history: the suckling of the twins Romulus and Remus, and the sacrifice of Aeneas. On the other two panels, the goddess Roma, the warrior goddess through whom peace is achieved, is juxtaposed with the figure of Mother Earth, an expression of the prosperity of the Augustan period, repeated from the breastplate of the *Prima Porta Augustus*. Fecundity is also celebrated in the lush acanthus scrolls of the bottom tier of the decoration and in the garlands of the interior.

The myth-history of Rome is also depicted on an extensive marble frieze from the Basilica Paulli (Aemilia) in the Roman Forum (14 BC; Rome, Forum Antiquarium). Parallel scenes are represented in a tomb painting from a *columbarium* (dovecote tomb) of Caesarean or early Augustan period (Rome, Mus. Naz. Romano), again demonstrating the overlapping of iconography in sculpture and painting. It has recently been argued that the historical reliefs preserved in miniature on the Boscoreale silver cups represent another important Julio-Claudian monument celebrating the victories of Augustus and Tiberius (Paris, Louvre).

The appropriation of Greek monuments

and statuary continued. Greek temple pediments were stripped bare and the sculpture set into the pediments of temples in Rome. Augustus' temple of Apollo on the Palatine is said to have contained an Archaic pedimental group. An *Amazonomachy* from a Classical Greek temple was displayed in the pediment of Sosius' temple dedicated to the same god, beside the Theatre of Marcellus (20s BC; Rome, Capitoline Mus.). The historical relief displayed on the interior of this temple commemorated the triple triumph of Augustus in 29 BC, a fitting gesture of appeasement from Sosius, who found himself on the wrong side at the battle of Actium.

The copying industry expanded with the influx of marble from the quarries at Carrara. No doubt sculptors were as engaged in producing copies of the imperial image as in producing copies in Greek style for house and villa decoration. Large sculpture collections did exist, such as that of Asinius Pollio in Rome, known only from literary accounts, and of the owner of the Villa of the Papyri at Herculaneum, preserved by the eruption of Vesuvius. The Villa of the Papyri is filled with a mixture of bronze and marble statuary, all made as an ensemble in the 20s BC (Naples, Mus. Arch. Naz.). In addition to the usual villa equipment, a large series of portraits of Hellenistic kings was recovered; many are known only from this site and it has been suggested that they were one-offs made specifically for the patron of this villa. Two bronze pairs, runners and deer, were made as matching sets for the villa. A group of bronze female statues may quote the *Danaids* from Augustus' temple of Apollo in Rome. Finally, a bronze bust after the *Doryphorus* of *Polyclitus is signed by the copyist, Apollonius the Athenian.

Styles of imperial portraiture influenced both male and female private portraiture. Young men adopted the Classicism of Augustus' images; Livia's hairstyles were copied by women. Funerary reliefs, set into the façades of tombs of freedmen of the period, introduce a new element (85% of Augustan date). These men appropriated the veristic style of late republican aristocrats and visualized the enfranchisement of their sons into Roman citizenship. Along the main roads out of the city, these freedmen tombs proclaimed the position of this new emerging social class within Roman society.

The Julio-Claudian emperors (AD 14–64), intent on maintaining power after the death of Augustus, all retained a recognizable 'Julio-Claudian' portrait type as a means of reinforcing continuity from the first emperor. The Classicism of Augustan portraiture was combined with careful attention to the arrangement of the hair. Portrait cycles of the imperial family were set up in diverse cities

in the empire; the series at Lanuvium included a colossal portrait of Claudius as Jupiter (Vatican Mus.), as well as portraits of Tiberius and Drusus Major (Rome, Mus. Naz. Romano).

The imperial cult was also the focus of the *Vicomagistri* relief (1st half of 1st century BC; Vatican Mus.). The offices of the freedmen *vicomagistri* were expanded under Augustus to include not only the public lares or household gods, but also the Augustan lares and the *genius* of the Emperor. In this sacrificial procession, statuettes of the lares and of the Emperor are held by three of the figures on the left. A sacrifice scene also appears on another important historical relief of the Claudian period, once associated with the Ara Pietatis (mid-1st century BC; Rome, Villa Medici). The positioning of the classicizing procession against an architectural backdrop adds a new element; the detail is precise enough for Ovid's (*Fasti* 5. 533) description of the decoration of the pediment of the Augustan temple of Mars Ultor to be confirmed by its depiction here.

For villa decoration, this period is characterized by an emphasis on the grandiose and colossal. Colossal marble statuary groups depicting scenes from the Homeric cycle in Hellenistic style decorated the dining area of Tiberius' villa at *Sperlonga (Sperlonga Mus.). This interest in Hellenistic originals is also seen in two figures, perhaps Niobids, from the villa of Nero at Subiaco (Rome, Mus. Naz. Romano). For the entrance to his imperial villa in Rome, the *Domus Aurea* or Golden House, Nero had the Greek sculptor Zenodorus produce a gilded bronze colossus of the sun god Helius 30.3 or 35.5 m (99 or 116 ft) high. The masses of statuary within were said to have been moved by Vespasian to his new forum, the Templum Pacis. A taste for Egyptian sculpture is seen in the colossal portrait statue in pink granite commissioned by Caligula for the funerary pavilion of his sister Drusilla; the statue was joined by two Egyptian originals, depicting Ptolemy Philadelphus and Arsinöe (284–246 BC; Vatican Mus.). For the exportation of Julio-Claudian imperial imagery, the best evidence comes from the city of *Aphrodisias in Asia Minor (Aphrodisias Mus.). On one relief from the Sebasteion, the Emperor Claudius is depicted as conqueror of Britannia; in another, Augustus rules over land and sea. A mixture of styles is evident in both the historical and mythological reliefs from the three-storeyed portico leading to the temple dedicated to the imperial cult. Imperial iconography was also utilized in Roman funerary art as seen in the decoration of ash urns of the Julio-Claudian period. Private portraiture followed the lead of the emperor and his family in both style and coiffeurs.

The art of the Flavian dynasty (AD 64–96) is characterized by divergent official styles and imagery. Vespasian and his sons Titus and Domitian were intent on signalling a break with the excesses of Nero. Vespasian's images hark back to harsh styles of veristic portraiture of the late Republic (e.g. Rome, Mus. Naz. Romano; Copenhagen, Ny Carlsberg Glyptothek). In Rome, the construction of the largest amphitheatre in the Roman world, the Colosseum, reclaimed the centre of Nero's *Domus Aurea* for the Roman people. A funerary monument of the period, the Tomb of the Haterii (Vatican Mus.), records the sculpture installed in the arcades of the building; a copy of the *Farnese Hercules* of *Lysippus is clearly visible.

The elaborate carving and an emphasis on chiaroscuro in architectural decoration is contrasted with the strict Classicism of preserved relief sculpture, such as the triumphal panels from the Arch of Titus (see TRIUMPHAL ARCHES) in the Roman forum (post AD 81) and the frieze depicting female virtues from the portico of Domitian's Forum Transitorium in Rome (AD 81–96). Most impressive are the so-called Cancelleria Reliefs, with depictions of the arrival of Vespasian in AD 70 on one panel and the setting out of Domitian (head recut as Nerva) on a military campaign (Vatican Mus.). As on the panels of the Arch of Titus, historical figures are joined by personifications such as Roma, the genius of the Senate, and that of the Roman People.

Colossal statuary decoration in the imperial palaces continues. Pliny records the presence of the *Laocoön in the palace of Titus; a colossal *Hercules* and *Dionysus* in Egyptian green basalt have been recovered from the audience hall of Domitian's palace (Parma, Mus. Naz.). In private portraiture, nonimperial women adopt the elaborate wigs of the women of the imperial family. A striking portrait of a Flavian woman as Venus demonstrates both this type of hairstyle and the extension of the combination of Greek ideal bodies and Roman portrait heads to female portraiture (late 1st century AD; Rome, Capitoline Mus.). On the reliefs of the tomb of the Haterii, the depiction of the figures, with their disregard for proportion and relative size, has been called 'non classical' (Vatican Mus.).

Trajanic art reflects the Spanish Emperor's great force as a military campaigner (AD 98–117). The image of the Emperor appears more than 60 times on the scrolled historical narrative of *Trajan's Column in Rome. The bland Classicism of Julio-Claudian imperial portraiture is taken up again as evidenced by his portrait bust in London (BM) and a statue from *Ostia (Ostia Mus.) with scenes of Victories killing bulls, a motif copied from the Athena Nike parapet (late 5th century BC; Athens), on his breastplate.

Innovation is reserved to the realm of historical relief sculpture, particularly on Trajan's Column and the Great Trajanic Frieze (on the Arch of Constantine). These two monuments present a more sophisticated approach to the depiction of narrative and battle episodes. On the column, the scenes of setting up camp and of the besieging of cities are interspersed with scenes in which the Emperor addresses his troops or receives barbarian prisoners. Colossal figures of Dacians adorned Trajan's Forum; another eight similar statues now stand on the attic of the Arch of Constantine. A provincial monument at Adamklissi (Romania) also commemorates the Dacian Wars (reliefs; Bucharest, National Mus. of Romania). Trajan's civic duties are portrayed on the static reliefs of the Anaglypha Traiana in Rome (AD 117–20; Rome, Curia) and the Arch of Trajan at Beneventum (*c.* AD 114–17). On the arch, imperial historical reliefs of the Emperor dispensing largesse and sacrificing stand above and below relief panels showing Victories killing bulls; the same motif decorates the interior frieze of the Basilica Ulpia in Trajan's Forum. The Trajanic period also sees the introduction of sarcophagi in response to a change in funerary custom from cremation to inhumation burials.

The byword of art of the Hadrianic age (AD 117–38) is Classicism. Although a Spaniard like Trajan, Hadrian saw himself much as the direct heir of Augustus and fashioned himself and his art after the first emperor. Like Augustus, Hadrian was fascinated by the possibilities of self-representation for political purposes. He toyed with various images before settling on a bearded image that portrayed him as a Greek philosopher type, appropriate for the emperor nicknamed 'Greekling' (AD 117–38; e.g. Athens, Nat. Arch. Mus.). The surface of marble sculpture was emphasized through a studied contrast between heavy drillwork in the hair and beard and the polished surface of the face; the marking of the pupil and iris through incision also began in the Hadrianic period.

His wife Sabina is associated on coins with a statue of Venus Genetrix type associated with late 5th-century BC prototypes (Paris, Louvre). This image seems to represent a new ideal of female beauty; it may have been created for the Trajanic/Hadrianic restorations of the temple of the goddess in Caesar's Forum in Rome. In her late surviving portraits, a bust in Rome and her image in the scene of her apotheosis, an idealized Sabina appears with a Classical hairstyle and diadem (AD 117–34; Rome, Mus. Naz. Romano; 136–38; Rome, Capitoline Mus.). The iconography of the numerous portraits of Hadrian's Bithynian lover Antinous, set up throughout the empire after his death and divinization, is more complex. A classicizing portrait appears on a statue of the youth in Delphi (*c.* AD 130–8; Delphi Mus.) and on the relief from Hadrian's Villa that portrays him as the god Silvanus, signed by the Aphrodisian sculptor

Antonianus (AD 130–8; Rome, Banca Naz. Romana). A different image is presented by the series of Egyptianizing statues from the Serapeion of the same villa (c.130–8; Vatican Mus.).

Historical relief of the Hadrianic period survives in a different group of marble reliefs, now dissociated from their original monument. Eight Hadrianic roundels, reused on the Arch of Constantine, depict the Emperor in classicizing hunt and bucolic sacrifice scenes that draw on the Near Eastern royal tradition.

Hadrian's villa at *Tivoli was filled with copies of sculpture after Classical and Hellenistic prototypes. The Canopus was flanked by copies of the Erechtheion *caryatids (Tivoli, Hadrian's Villa), while the Serapeion was fitted out with Egyptian statuary in what has been suggested was a recreation of the upper and lower Nile (Vatican Mus.). The Piraeus shipwreck, filled with panel relief copies after the shield of the *Athena Parthenos* (see PARTHENON SCULPTURES) and other Athenian relief sculpture, also dates to the Hadrianic period (Piraeus, Arch. Mus.). Attic sarcophagi with mythological reliefs and Asiatic column sarcophagi with single figures or groups framed against an architectural backdrop were shipped to various parts of the empire. The Antonine emperors (AD 138–92) are easily identified through their adoption of the portrait style of Hadrian with curly hair and beards. The best-known image is the gilded bronze equestrian statue of *Marcus Aurelius* that miraculously survived destruction at the hands of the Christians because they mistook the figure for a portrait of Constantine (c. AD 165; Rome, Capitoline Mus.). This statue is one of the few preserved examples of a large genre of imperial statuary; another, of Augustus, has recently been recovered from outside Athens (Nat. Arch. Mus.). Here, the Emperor is depicted in civilian dress, addressing the Roman people. Equally striking in its own fashion is the contrived marble portrait bust of Marcus Aurelius' son Commodus, as Hercules (AD 180–92; Rome, Capitoline Mus.).

Panels with personifications of provinces and trophies in relief may come from the temple of Divine Hadrian in Rome (Rome, Mus. Naz. Romano and Capitoline Mus.). These reliefs fit within a well-established Roman tradition; we might compare the *ethne* from the Sebasteion at Aphrodisias (mid-1st century AD), the trophy panels on the base of Trajan's Column, and the frieze from the Basilica Ulpia (AD 112; Rome, Mus. of the Imperial Fori). The Column of Marcus Aurelius, modelled on that of Trajan, narrates the events of the Emperor's German and Sarmatian campaigns; expressing the horror of war and nobility of the barbarians.

The Aurelian reliefs, some of which were reused on the Arch of Constantine, also commemorated these Danubian Wars.

On the base of the Column of Antoninus Pius two distinct style of representation are operative (Vatican Mus.). The apotheosis of the Emperor and Faustina Minor is depicted in classicizing style; the scene of the funerary military parade on the short sides, however, uses mixed perspective and squat proportions. Further afield, on the Great Antonine Altar from *Pergamum the active battle scenes are contrasted with the more static images of the imperial family (c. AD 140; Vienna, Neue Hofberg). These elements have led some scholars to date the beginnings of the late *Antique period to the reign of Marcus Aurelius.

The establishment of the Severan dynasty (AD 193–235) by the North African Septimius Severus witnessed a further shift away from traditional Roman forms. The portraits of Septimius emphasized continuity with the Antonines, yet a new element appears in the corkscrew beard modelled after the god Serapis. An excellent example is preserved in the bronze naked statue of the Emperor from Cyprus (AD 200–10; Nicosia, Cyprus Mus.). The later Severans, such as Caracalla and Severus Alexander, adopt a harsher style with short cropped hair (c. AD 211–17; Rome, Mus. Naz. Romano; c. AD 220; Rome, Capitoline Mus.).

The Arch of Septimius Severus (AD 203) in the Roman Forum with its panel reliefs of the Parthian campaigns contains echoes of the composition and style of both the Column of Marcus Aurelius and the base of the Column of Antoninus Pius. A second triumphal arch was erected in Septimius' home town of Leptis Magna. The schematization of representation is more evident here, with a static procession of frontal figures in two tiers (AD 203–4; Tripoli Mus.).

The tradition of Roman copies in colossal scale is represented by the *Farnese Hercules* and *Farnese Bull* from the Baths of Caracalla (AD 211–16; Naples, Mus. Arch. Naz.). The head of the Colossus of Nero, transformed into Hercules by Commodus, regained its original iconography as Helius, and became a symbol of the permanence of the dynasty.

The death of Severus Alexander resulted in a 50-year period of military unrest as at least eighteen emperors came to a too-often short-lived power. The iconography of the period focuses on battle sarcophagi and the portraits hurriedly created to commemorate these emperors. The imperial images of Maximinus Thrax (c. AD 235; Copenhagen, Ny Carlsberg Glyptothek) and Philip the Arab (AD 224–49; Vatican Mus.) demonstrate the uncompromising style with short cropped hair and beard that harks back to late republican and Flavian portraiture as well as the images of Caracalla.

The Ludovisi Battle Sarcophagus is an excellent example of a new form of sarcophagus, in massive scale and no doubt made to commission (c. AD 250; Rome, Mus. Naz. Romano). The battle rages in a confused mass of Romans and barbarians; the bare-headed deceased appears astride his horse in the centre of the relief.

The same harshness of representation is seen in the portraits of the tetrarchs (AD 284–324), along with a stronger emphasis on abstraction as uniformity reinforced the solidarity of the empire. Their porphyry statues in S. Mark's Square in Venice are so similar that only the beards of one figure in each pair distinguish them; the beards may be intended to identify the figures as the older *Augusti*, the reigning emperors. A very different image is presented by the marble portrait of Diocletian from Asia Minor that presents a more modelled Hellenistic-type portrait (c. AD 284–305; Istanbul, Arch. Mus.).

The influence of east Greek artists is also seen in the reliefs of the Arch of Galerius in Thessaloniki (c. AD 300). Tiers of battle scenes, processions, and rows of frontal figures are joined by motifs taken from Asiatic sarcophagi, such as Victories in architectural niches. The colossal marble portrait of Constantine (AD 312–37), a pseudo-chryselephantine acrolith modelled on *Phidias' *Zeus Olympios* (see OLYMPIA) articulates a new confidence in the power of the Emperor and the security of the empire (Rome, Capitoline Mus.). The Arch of Constantine in Rome, with its incorporation of spoils from earlier imperial monuments, commemorates his triumph at the Milvian bridge and his entry into Rome. The combination of diverse styles is evident as well in the Constantinian reliefs, where the Classicism of the *Sol* and *Luna* roundels contrasts with the abstraction and strict frontality of the historical reliefs. L-AT

Elsner, J., *Imperial Rome and Christian Triumph* (1998).
Kleiner, D. E. E., *Roman Sculpture* (1992).
Ridgway, B. S., *Roman Copies of Greek Sculpture* (1984).
Strong, D. E., *Roman Art* (2nd edn., rev. R. Ling, 1988).
Strong, D. E., *Roman Imperial Sculpture* (1961).
Walker, S., *Memorials to the Roman Dead* (1985).
Zanker, P., *The Power of Images in the Age of Augustus* (1988).

6. PATRONAGE AND COLLECTING

Although much is made of the fact that, in contrast to the Greeks, Roman had a word for 'art', art in the Roman world is as functional as Greek art; the functions simply changed over time. The display of art in the Roman world is concentrated in three main areas: public dedications of statues of gods and men in temples, theatres, and fora; private display in the Roman house; funerary gifts and commemorative images.

Public display focused on statuary of various sorts: honorific monuments decorated with sculpture in relief (columns, arches),

free-standing and relief sculpture in temples, theatres, baths, and other public places. Cult statues largely followed the prototypes of the Greeks; the sole exception was the image of the sun god Mithras, with its eclectic mix of Eastern and Greek elements, but even here, the original prototype may hark back to the Victories killing bulls on the parapet of the temple of Athena Nike on the Athenian Acropolis. The establishment of the imperial cult, on the model of that of Hellenistic dynasts, led to the production of masses of imperial images for dissemination throughout the empire; more than 250 portraits of the Emperor Augustus alone survive. For honorific statues of emperors and mortals, Romans could be portrayed in togas, in military garb, as naked or half-draped figures after Greek prototypes, or on horseback in equestrian statues.

Recent scholarship on sculpture production has led to a reconsideration of the traditional view of the development of a copying industry in Rome. The abandonment of the notion of an ancient 'pointing machine' modelled on the modern copying device once postulated for ancient copying has resulting in a reassessment of the intent of Roman copyists and collectors. Rather than seeking exact copies of Greek originals, the Romans required a range of copies from quite precise copies to broad adaptations that reflected the diverse iconographic, religious, and social characteristics of their society. *Cicero's letters ordering sculpture from Athens by the boat-load demonstrate just this sort of response. He is concerned with the appropriateness of the material chosen to its Roman setting and to its nature. Roman copies of Greek sculpture were made in massive quantities to satisfy the needs of the Roman patrons. But rather than serving as museum collections in which Classical style could be contrasted with the *Hellenistic 'baroque' or the works of Lysippus compared to those of Phidias, the focus was on a restricted repertoire of statuary that one would see in every city in the Roman Empire, embellishing the theatres, baths, fora, and other public buildings.

In the private sphere, the Romans inherited the Hellenistic custom of decorating their houses with paintings and statuary. Yet the role of the house in the Roman political sphere imbued display in a private context with greater significance. Like the size of the house, its decoration was meant to serve as an indication of and as an enhancer of the social status of the owner. Styles of sculpture were often closely connected to themes, with Hellenistic satyrs and classicizing athlete statues standing side by side in garden settings. Portraits of famous Greek and Roman poets, orators, and statesmen filled libraries and peristyles. Images of the emperor and his family inhabited the household shrines.

Wall painting marked out the various areas of the house and their functions; marble revetment largely replaced painted walls in the grand villas by the Hadrianic period (AD 117–38).

Connoisseurship in a modern sense seems to have been largely confined to the collecting of panel paintings on wood, gems, and small-scale Corinthian statuettes and metalware. Julius Caesar was known as a collector of gemstones, panel paintings, sculpture, and other objects (Pliny, Natural History 37. 11; Suetonius, Divine Julius 47). Pliny also notes that many only pretended to be experts, being in fact incapable of distinguishing true Corinthian bronzes from fakes (Natural History 34. 5–7).

For the display of art in private contexts, we are limited to the ancient literary sources and to archaeological finds. For Rome, the horti of Rome, urban villas of late Republican aristocrats that passed into imperial hands early on, provide the best evidence. Pliny (Natural History 36. 33) records the sculpture collection of Asinius Pollio that was unusual for the predominance of works by contemporary sculptors, such as Pasiteles, Cleomenes, and Stephanus. The material from the Horti Sallustiani and Horti of Maecenas exhibits a rich mixture of Greek originals, Roman copies adapted to Roman taste, and portrait statuary (e.g. Rome, Capitoline Mus.; Copenhagen, Ny Carlsberg Glyptothek). A broader socio-economic range is preserved in the buried Vesuvian cities. The Villa of the Papyri at Herculaneum included an enormous inventory of bronze and marble statues (Naples, Mus. Arch. Naz.). Many are of well-known types, such as the herm busts of the Doryphorus of Polyclitus and an Amazon, busts and free-standing statues of Greek philosophers and poets, and small-scale Dionysiac fountain statuettes; unique, however, is the collection of portraits of Hellenistic rulers. The majority of Pompeian houses were much more modest, with small-scale statues or painted versions in lieu of the real thing. It has been suggested that, both architecturally and in terms of decorations, these houses imitated their grander neighbours.

*Funerary monuments expressed both hopes for a better afterlife and a desire to articulate social standing. Massive tombs (e.g. the Tomb of the Scipii, Mausoleum of Augustus in Rome) with painted and sculpted decoration, ash urns, and sarcophagi became a form of social competition. An extended trade developed in different types of sarcophagi from centres in Greece and Asia Minor.

Petronius' portrait of Trimalchio in his Satyricon provides a parody of Roman artistic patronage. Everything from his misquoting of the Homeric frescoes in his house to his description of the elaborate arrangements for his funerary monument can be paralleled in the archaeological remains. L-AT

Gold, B. C. (ed.), Literary and Artistic Patronage in Ancient Rome (1982).

Ridgway, B. S., Roman Copies of Greek Sculpture (1984).

Vermeule, C. C., Greek Sculpture and Roman Taste (1977).

Walker, S., Memorials to the Roman Dead (1985).

Wallace-Hadrill, A. (ed.), Patronage in Ancient Society (1989).

ROMANESQUE. See overleaf.

ROMANINO, GEROLAMO (1484×7–c.1560). Italian painter, based in Brescia. Much of his early work is influenced by *Titian but in the Passion scenes (1519–20; Cremona, Duomo) he adopted a harshly vigorous narrative style owing much to northern artists, especially *Dürer. It went down badly; Romanino was replaced on the project by *Pordenone and returned to Brescia. His hauntingly *Giorgionesque Portrait of a Gentleman (Budapest, Szépmüvészeti Mus.) was probably painted around this time. Between 1521 and 1524 he collaborated with *Moretto at S. Giovanni Evangelista, Brescia, and moved closer to Moretto's calmer monumental Lombard style. In 1531–2 he worked on the decorative schemes at the Castello di Buonconsiglio, Trent, producing secular scenes of a strongly German character. This continued to be evident in his powerful Passion scenes for S. Maria della Neve, Pisogne (before 1534). To the end of his life he maintained a huge practice from Brescia, producing his final startling masterpiece Christ Preaching (Modena, S. Pietro) as late as 1557. His vast output was uneven and highly eclectic but at his best he was among the most fascinating north Italian painters of the 16th century. AJL

Le Siècle de Titien, exhib. cat. 1993 (Paris, Grand Palais).

ROMANISTS, Netherlandish artists who travelled to Rome in the 16th century and whose paintings and drawings show the influence of the Italian *Renaissance. Artists include Jan *Gossaert, Frans *Floris, Jan van *Scorel, Lambert *Lombard, and Maerten van *Heemskerck. Bernaert van *Orley did not visit Italy but is generally counted among them because of the strong impact of the Italian Renaissance on his work, not only through influences from returning artists, but also through the presence of the *Raphael cartoons in Brussels from 1516. Influences from classical monuments and sculpture, as well as from contemporaries, such as *Michelangelo, Raphael, and the *Mannerists, feature prominently in their work. CFW

Coessens, P., et al., Fiamminghi a Roma 1508–1608, exhib. cat. 1995 (Brussels, Rome).

· ROMANESQUE ·

THIS term applies to the art and architecture of western Europe in the period AD 1050 to 1200. The earliest and latest manifestations vary according to region and medium, with a different sequence of development in each area: it has even been suggested that the Romanesque might be regarded as a collection of trends rather than a coherent style. However, various distinctive features can be recognized emerging in the middle of the 11th century, followed by a phase of consolidation and maturity in the period approximately 1080–1180, sometimes referred to as the 12th-century Renaissance. By the last quarter of the 12th century, artists in some areas were working in the emerging *Gothic style; elements of Romanesque and Gothic existed in tandem for a considerable time, but with a general move by the beginning of the 13th century to more naturalistic forms and a revival of *classical sources. The only exception is in parts of Germany, where craftsmen worked in a conservative manner until the middle of the century.

The word Romanesque means 'in the manner of the Romans'. It originated as an architectural descriptor in the early 19th century, was subsequently extended to cover other arts of the period, and is now also used in a chronological sense. Its original application referred to all the derivatives of Roman architecture which developed in the West between the collapse of the Roman Empire and the beginnings of Gothic, from AD 500 to 1200. And it was somewhat pejorative, implying what was felt to be simply direct drawing on earlier, specifically Italianate sources. However, as knowledge of the period grew and its complexities became better appreciated, the term was reserved for the major building style of the 11th and 12th centuries, characterized by the thick-walled, vaulted, stone masonry which had been employed by the Romans, but excluding the earlier buildings now more specifically attributed to the *Carolingian and *Ottonian periods.

The geographical distribution of buildings and other works in the style and manner recognized as Romanesque can be paralleled by the extent to which the term 'Romance' is applied to the parts of Europe whose languages and literature are derived from Latin. In French, the name is *roman*, in German *romanisch*, and in Italian and Spanish *romanico*. But these acknowledgements to Rome both underestimate the originality of the works produced and exclude other contributory sources, particularly the *Byzantine Greek component, assimilated by direct contact with the eastern Mediterranean world, and via Ottonian art, already imbued with such influences.

The causes inspiring the growth and spread of new artistic forms must of course be sought in the wider political and social contexts. The commissioning of massive church building projects throughout Europe also involved decorative programmes of sculpture, stained glass, and wall paintings, as well as their often luxurious fittings and contents, including manuscripts and metalwork. Technological developments improved both the quality and quantity of the various works produced: for example, the stonemason's shift from axe to the stronger and subtler chisel resulted in more crisp and detailed carving (see STONECARVING).

The impetus for extensive new commissions first came from the Church, through the *patronage of the great monastic orders, who built hundreds of monasteries throughout Europe from the 11th century onwards; earlier reform movements had provided the necessary organizational skills and wealth for such ambitious undertakings. The ability to overrun the political boundaries of the gradually centralizing states and kingdoms of Europe demonstrated the power of the Church. Indeed, the exceptionally powerful and influential order of Cluny, centred in Burgundy but spreading rapidly to central and northern France, and then the rest of Europe, from England to the Holy Land, answered only to the Pope. The Cluniac order stressed the splendour and magnificence of worship, and positively promoted art through its complex liturgical rituals involving music, decoration, and visual symbolism: it was believed that worship in a beautiful setting enhanced spirituality, as well as showing the greatest honour to God. There was an extreme reaction against this view by Bernard of Clairvaux, who founded the Cistercian order, which also spread through parts of western Europe; it adopted the most simple and restrained art and architecture, requiring non-figural manuscripts, plain windows and walls, and wood instead of gold or bronze.

Not all patronage was monastic. Royal and noble families commissioned works, as symbols of dynastic or political status as well as guarantees of eternal salvation. Increased political stability during the period led to the expansion of towns and trade. The resulting changes in society tended eventually to diminish the absolute power of Church and Crown.

Another factor helping to disseminate new types of building and decoration was the movement of pilgrims over the vast network of routes linking churches housing prestigious holy relics and shrines. Four major routes led through France, on which were located many architecturally important churches, culminating in Santiago de Compostela in Spain. These roads not only improved the mobility of the spiritual tourists, but also of craftsmen— regional workshops of sculptors moved to work on one new building after another, spreading the latest designs and devices. Rome, the centre of the Christian world, and Jerusalem, the fount of Christianity, were also popular destinations.

There was also the common language of Latin, and the common cause of the Crusades, providing an axis

between the West and the East, represented by Jerusalem and Constantinople. The foundation of many universities during the 12th century also encouraged mobility, as well as stimulating learning and a new humanism, expressed in theological studies and in the growth of secular and vernacular literature.

There is some documentary evidence for the making and commissioning of works of art, from which it is also possible to glean some aesthetic attitudes. *On Diverse Arts* is an artist's manual compiled around 1100 by *Theophilus, a German monk who was also a skilled craftsman, which describes the techniques of stained glass, fine metalwork, and jewellery. The ambitious Abbot *Suger wrote no fewer than three acounts of his rebuilding and furnishing of the abbey of S. Denis, just north of Paris, in the 1140s, which provide unique insights into the motivation of an influential patron, including his justification of the Cluniac attitude to lavish embellishment.

While it was the patron who would normally select the subject matter of new commissions, it was the artists and craftsmen who were responsible for the detailed interpretation. A master craftsman would supervise a large-scale project, with a strictly ranked team working under him. Workshops could be mobile and temporary, set up on the site where their products were to be installed. The names of many individual masters are known, their fame resulting not just from their outstanding artistic skills but also because of their status and responsibility for the project. Such names include the sculptors *Gislebertus of Autun, and *Wiligelmo of Modena, and the goldsmiths *Roger of Helmarshausen and *Nicholas of Verdun. Although some craftsmen were monks, attached to particular monastic centres, there were also many lay and itinerant artists, who therefore contributed to the spreading of new ideas.

Through the assimilation and transformation of varied sources, Romanesque artists created a unified and original style which was the first truly international one. They drew upon the arts of the past—of the Roman, Carolingian, and Ottonian empires—but also absorbed those of the contemporary, powerful Byzantine and Islamic worlds, the former derived from ultimately classical sources, the latter contributing more abstract and decorative features. With such an eclectic range, there is no recognizable pattern of diffusion or clear point of origin, although some commentators have claimed particular areas. Regions excelled in different media, with architectural sculpture achieving its finest expression in France, metalwork and ivory carving in Germany, and manuscript decoration in England.

The style reflects the society producing it: like the hierarchical nature of the emerging feudal system, Romanesque is characterized by an ordered structure of main and subordinate but interdependent parts. Line and symmetry are emphasized, and there is an interest in pattern and ornament for their own sake. The idealized naturalism of *Antique art was deliberately abandoned, and artists were now concerned with expressing the human figure according to new rules—treated as a decorative form, with strongly defined outlines, and the substitution of angular or zigzagging lines which have no weight for the classical treatment of drapery, which emphasized the solid body beneath. The frame rigorously controls the designs within it, and the compositions are confidently two-dimensional, unlike artists' earlier attempts to suggest depth or background. This demonstrates the growing concern to express spiritual and emotional values rather than naturalistic ones, with the very forms of nature itself being freely translated into linear designs.

The *iconography of Romanesque art also expresses these transcendental qualities. Christian theology encompassed the whole universe, with the world and its external manifestations depicted as subject to the power of God, represented on earth by the Church. Although the biblical themes devised by *early Christian artists continued to play a major role, many new scenes and subjects were created which placed much more emphasis on symbolic values. Much of the sacred imagery which had previously been concentrated on the inside of a church, as in the mosaics or wall paintings in apse or sanctuary, was now shifted to the outside in the form of relief sculpture, with the result that church façades, particularly the great portals, presented complex iconographic programmes. The key figure was Christ, interpreted as a massive and awe-inspiring judge, presiding over tiers of subordinate tiny figures, whether Evangelists, apostles, prophets, or apocalyptic visions. The narrative sequence of the Passion was extended, and specific comparisons devised to demonstrate how the Old Testament predicted the New, through the juxtaposition of theologically related scenes. Increased prominence was given to Mary, shown in the Byzantine manner as Theotokos, powerful Mother of God. New imagery was devised to fit the burgeoning cult of saints, who could be depicted individually, accompanied by distinctive attributes, or in cycles of narrative scenes telling of their lives, martyrdom, and miracles. For example, Thomas à Becket was the subject of a series of enamelled 'Limoges' caskets, and of stained-glass windows in Canterbury Cathedral, the site of his martyrdom. The development of narrative sequences of related scenes, in manuscripts, stone sculpture, and stained glass, was attributable to various literary sources which included the secular epic and contemporary drama, in the form of mystery plays.

Another striking feature of the new visual language was a fascination with animals, both real and fantastic, and frequently turned into decorative or distorted forms. Their role was to contribute to the universal scheme in which everything played its allotted part, a means of showing the richness of God's creation, but with each animal also having its own symbolic function. These had a specific source in texts which sought to reconcile the allegedly factual information of classical natural histories with Christian teaching, developing into the popular *bestiary. Artists demonstrated their skills in the invention of monsters and other grotesques whose role was to

remind the spectator of the chaos that could ensue if God's works were deformed. This creativity also extended to plant life, with even the most ornamentally treated scrolls of foliage representing a form of spiritual entwinement.

Without the new architecture, there would have been no decoration. The larger buildings were marked by an increasingly complex structure with, for the first time, attempts to subordinate all the parts to an overall system, a characteristic feature of all Romanesque art. It was the liturgical and functional needs of the reformed and prosperous monasteries which posed new building requirements. But the particular solution to these needs, including new ways of articulating space, and the orderly grouping of elements, cannot be explained solely in functional terms. Aesthetic considerations and the urge to create architectural symbols expressive of the monastic Christian view of the world also played their part.

The sculpture on these buildings also played a major part, and its decorative and functional roles are almost impossible to distinguish. The period is marked by the revival of monumental architectural sculpture, which had been almost dormant in Europe for 600 years, but which now became for the first time an integral and coherent part of the system. The carving is subordinate to the architecture only in the sense that it is confined within the frameworks provided by the structural elements of the building, but the subject matter turns the church itself into a Bible depicted in stone, a means of mass communication with a largely illiterate public, and a reinforcement of the power and influence of the clergy.

The many regional differences in architectural sculpture throughout Europe arise from the preceding traditions of each area, ranging from more abstract treatment of northern sculptors, where Viking or Anglo-Saxon motifs and linear patterns survived, to the direct impact of the classical remains still visible in the south of France and Italy. But almost all architectural sculpture shares the common principles of the unity of interdependent forms, of figures being subordinated to pattern and distorted to fit their frames.

The earliest examples of architectural carving were column capitals embellished with simple shapes, at first imitating the foliate patterns of the prototype Corinthian order, then incorporating human and animal figures; examples dating from the first decades of the 11th century are at S. Bénigne, Dijon, and Bernay Abbey, Normandy. Then figures became more elaborate, often ornamentally distorted to fit the frames available, although still mainly as self-contained motifs. A further development was a sequence of linked, narrative, or 'historiated' capitals illustrating Old or New Testament themes. Twelfth-century sculptors made increasing use of the portal as a focal point for Christian imagery: the semicircular tympanum over the door opening took on the significance of the mosaic-decorated apses of early Christian and Byzantine churches. The great triple doorways at the west end of churches, the entry point for pilgrims and liturgical processions, frequently had a massive figure of Christ on the tympanum itself, looking down upon those entering his house, attended and supported by much smaller figures of Evangelists or apostles, and framed by hierarchical tiers of Old Testament elders and prophets; beyond them on the voussoirs and archivolts were further examples of the harmonies of creation in the form of signs of the zodiac, labours of the months, or bestiary animals, all opportunities for the sculptor to create a world of fantastic but always symbolic creatures. And the shafts on either side of the doorways turned into figures representing the Old or New Testament, so that the Word of the Bible literally supported these entrances to church or cathedral. A popular subject for the west portal was the Last Judgement, depicting the graphic torments of sinners in hell to those entering the church. The movement towards Gothic, when sculptors were concerned with more accurate representations of the external world, can be recognized in a transitional monument such as the west front at Chartres, of c.1140–50, where the column figures become more detailed and correctly proportioned, thereby starting to abandon their structural integration with the building itself.

Among the many regional styles of sculpture, one of the most influential originated in the great monastic centre of Cluny, in Burgundy. Its far-reaching effects were due to the extent of Cluniac patronage. Beginning at the end of the 11th century, as expressed in the chancel capitals of Cluny Abbey (Cluny, Mus. du Farinier), the style reached its zenith in the tympana and capitals of Autun, Vézelay, Anzy-le-Duc, and Charlieu, in the years between 1120 and 1150. These apocalyptic tympana with their majestic central image of Christ, surrounded by vigorous complex designs involving humans, animals, and plants treated with the utmost freedom but without destroying the shapes they decorate, are exemplified in the work of Gislebertus at Autun.

Another important school in France was that of Languedoc, centred on Toulouse, a major stopping point on the pilgrimage route, with sculptural programmes in S. Sernin and the cathedral. The tympana of Moissac and Souillac, of c.1120–30, are carved with visionary interpretations of the Apocalypse, so massive that they have to be supported by a central pillar, or *trumeau*, its functional nature masked in the extraordinarily angular and twisted figures of men and beasts.

In western France, architectural carving was of a more ornamental nature, lacking complex tympana, but characterized by richly decorated surfaces, with arches, niches, and friezes; the western façade of Notre-Dame-la-Grande, Poitiers (1130–45), is carved with tiers of holy figures under ornate arcades, all in fairly shallow relief. The strongest classical survival is in Provence where the direct influence of Roman architecture and ornament can be seen in S. Gilles-du-Gard, whose western portal (1150–1200) recalls a Roman *triumphal arch, with the life of Christ in the three tympana, interspersed with apostles arranged as if in a narrative frieze.

In Spain, the two 12th-century portals of Santiago de Compostela, the culminating point of the pilgrimage routes, appear to be influenced by the Toulouse School, but other works, such as the cloisters of S. Domingo at Silos, have the exaggerated linear structures of local *Mozarabic manuscript painting or intricate designs of ivory carving.

The presence of Roman remains in Italy made sculptors the most aware of Antique styles. They created façades which presented figures in well-rounded relief in settings recalling classical architecture; but at the same time there was also an emphasis on the decorative treatment of external surfaces, and a love of display which often overrides the subordination of parts to the whole. There were distinctive regional schools; that of Lombardy in the north influenced western France, Germany, England, and even Scandinavia. The names of a number of distinguished craftsmen are known, including the innovative Wiligelmo, who worked on Modena Cathedral in the first quarter of the 12th century, Niccolò, at Ferrara Cathedral in Emilia, c.1135, and *Antelami at Parma, in the late 12th century, whose works typify the classicizing elements in Italian Romanesque. It is perhaps in free-standing monuments such as the *pulpit made for Pisa Cathedral (now in Cagliari Cathedral) by Guglielmo, c.1160, and the font, of the same date, carved by Robertus for S. Frediano, Lucca, that Italian sculptors achieved the greatest heights and established the more *humanistic style which would lead rapidly from Gothic to *Renaissance.

Art and architecture in England is sometimes described as Anglo-Norman, after the architectural style originally imported from Normandy, but the more correct term is English Romanesque. The first impetus is Norman, for example in the capitals of the crypt of Durham Castle chapel, of c.1072, but during the 12th century, sculptors and patrons synthesized a range of sources, including Germany, north Italy, and west France. There was little of the epic, monumental sculpture or complex theological schemes of the great French church portals, but a continuing concern with surface pattern and decorative effects: relief sculpture on *Anglo-Saxon churches had no functional role, and the traditions of free-standing stone crosses and slabs remained powerful. By the second half of the 12th century, a number of regional schools can be defined. The most distinctive is in Herefordshire, which has been attributed to the influence of a patron who was seeking to recreate the ornament of churches on the pilgrimage road to Santiago. The most remarkable carvings from this workshop can be seen at Kilpeck, of around 1140. Some carvings from the second half of the 12th century develop more monumental, emotional qualities, like the porch reliefs at Malmesbury Cathedral, while the frieze of Old and New Testament scenes at Lincoln Cathedral may be the best surviving evidence for a once widespread English tradition.

Romanesque sculptors in Germany produced fine works in the form of three-dimensional figures in wood or metalwork, but one unusual example of relief carving is the rock face at Externsteine, Horn, dating from c.1115. This shows themes from the Deposition of Christ, part of a deliberate attempt to build up a local pilgrimage centre and shrine, through the recreation of the holy places of Jerusalem. Wood panels were carved in relief and then brightly painted to decorate the late 11th-century doors of S. Maria im Kapitol, Cologne, with scenes from the life of Christ. Free-standing figures in the round also followed advanced *Ottonian prototypes, continuing to be supported by court and episcopal patronage for fine metalwork. Among the most accomplished works in the round are the once silver- and gem-clad, wooden-cored 'Imad' Madonna (Paderborn, Diözesan-Mus.), the almost life-size bronze candle-bearing figure in Erfurt Cathedral, the polychrome wooden lectern supported by the Evangelists as caryatid figures (Freudenstadt), and the energetic bronze lion erected by Henry the Lion in 1166 in Brunswick outside his castle as a public monument.

The stylistic unity of a Romanesque church resulted from the relationship between external and internal decoration, not only in the didactic or scriptural subject matter but in the formal connections between the different media involved. On entering the building, the spectator was intended to be overwhelmed and spiritually uplifted by the emotional impact of the coloured windows, painted walls, glittering liturgical metalwork, and vivid hangings. It is difficult to realize in their present state that the interiors of Romanesque churches were once so brightly coloured. Wall paintings in particular, once so abundant, have succumbed to decay, destruction, or covering over with whitewash. Enough survive, however, to give some idea of their general qualities. The large smooth wall surfaces of Romanesque buildings provided scope for fresco painters to illustrate scenes from the Bible and saints' lives in a variety of styles. Figures appear flat, linear, weightless, shadowless, and highly stylized. Programmes and scenes are designed for particular locations within the church, with huge figures of Christ or the Virgin in the apse, Old and New Testament scenes along the north and south nave walls, and frequently a Last Judgement at the west end, a layout which is paralleled in the external stone carving, and in the stained-glass windows. The Romanesque love of ornament is apparent in the richly patterned clothes of many of the figures and in the decorative borders that frame the scenes.

In France, there are good surviving murals at S. Savin-sur-Gartempe, Tavant, Brinay, and Berzé-la-Ville. In Italy, where Byzantine influence was strong, the best examples are at S. Clemente, Rome, and S. Angelo in Formis, Capua, establishing a tradition which led rapidly to the precocious beginnings of Renaissance painting, through the early 14th-century frescoes of *Cimabue and *Giotto. Byzantine influence also extended further north, as evidenced by the figure of S. Paul in S. Anselm's chapel, Canterbury Cathedral, c.1140, which has the distinctive 'dampfold', a way of turning drapery folds into exuberant ridges, originating in Byzantine art, and also adopted in other media. In Spain, the wall paintings of the Catalan

school have the strong contours and rich glowing colours of Mozarabic art, representing the fusion of two cultures, Islamic and Christian: typical examples, from S. Climent de Taull, have been transferred to the Museu Nacional d'Art de Catalunya, Barcelona.

An alternative to wall painting was *mosaic, the covering of wall surfaces with small cubes of glass or coloured stones whose deliberately uneven setting caught and reflected light, providing awe-inspiring and other-worldly effects to the majestic figures of Christ, the Virgin, and saints. This form of decoration was mainly confined to Italy, and was probably undertaken by Byzantine craftsmen from Constantinople, where mosaic had been an integral part of building design from the 6th century onwards. Schemes survive in Rome (S. Clemente, and S. Maria in Trastevere), Venice (S. Mark's), and Sicily (cathedrals of Cefalù and Monreale, palace of Palermo), where Norman rulers replaced Byzantine ones but retained their artists and designers.

The metaphysical properties of light and colour, which were an essential part of 11th- and 12th-century religious writings, were given their finest expression in *stained glass. This brought a new dimension to massive and potentially dark buildings, whose window openings were very small in relation to their wall spaces. The earliest scheme still in situ is the row of Old Testament figures in Augsburg Cathedral, of c.1100, whose frontality and solemnity suggest a well-established style. Although now dispersed, many of the windows installed in S. Denis by Abbot Suger in the 1140s show the development of complex iconographies, including the Tree of Jesse, and the deliberate juxtaposition of Old and New Testament scenes. In Poitiers Cathedral, the Crucifixion window of c.1150 includes the donors Henry II and Eleanor of Aquitaine; the dominant tones are red and blue, and the figures are elegantly elongated and stylized.

The interconnectedness of different media, which is such a striking feature of the period, can be seen in the smaller-scale, portable products of scribes, goldsmiths, and *enamellers, commissioned for use in sumptuous cathedral or humble parish church, as well as in secular settings for the display of status or private devotion. These luxury products are decorated with the same simplification, stylization, and subordination of separate elements to the overall design as the larger works being made.

Indeed, the caskets and shrines which held the precious relics that were the focus of pilgrimage were given architectural forms, thus imitating and symbolizing the holy buildings which housed them: the lavish embellishment of *reliquaries by the institutions owning them provided evidence of devotion and was a means of further impressing the pilgrims whose donations provided a vital source of revenue for the Church. So the products of metalworkers were as highly prized as sculpture and painting, with the skills of the craftsmanship appreciated as much as the costly materials. There were various regional schools and styles.

The group of enamelled caskets and plaques described as 'Limoges' were distributed over southern France and north Spain from the mid-12th century for the pilgrimage market. Made in the champlevé technique of enamel panels inlaid against gilt backgrounds, their vivid colours and lively ornament show the influence of Islamic art. The occasional use of secular subject matter is in contrast to the more liturgical nature of the enamels produced in the Mosan region, centred on Liège. The exceptional quality of the luxury arts in this and other parts of Germany also extends to ivories and manuscripts as well as gold- and bronzework. The names of distinguished craftsmen include Reiner of Huy, who made the cast-bronze font showing the Baptism of Christ, supported by twelve oxen, of c.1107–18 (Liège, S. Barthélemy), and Roger of Helmarshausen, working in Saxony in the early 12th century; he drew on Byzantine models, using the dampfold motif to create solid forms, as in the engraved silver portable altar in Paderborn Cathedral. Working in a contrasting manner was Nicholas of Verdun, whose masterpieces included the altar frontal of 1181 (Klosterneuburg Abbey) with its 45 enamelled panels in a more classicizing style which suggests the transition to Gothic art. Other important German centres included Aachen and Cologne.

In England also the influence of Ottonian metalwork has been recognized in the design of the great bronze candlestick commissioned for Gloucester Abbey in 1110 (London, V&A), whose stem of entwined creatures enmeshed in foliage can be compared to drawings made by the contemporary Canterbury manuscript school. Ornamental metalwork was also used as door furniture, like the bronze sanctuary doorknocker at Durham Cathedral, of c.1130.

*Illuminated manuscripts played an essential role in worship and in the dissemination of learning. Large illustrated bibles were commissioned for public display in churches and monasteries, psalters and saints' lives were for more private worship. The extensive monastic libraries also housed copies of many classical texts. Romanesque illuminators paid particular attention to the elaboration of the initial, which might contain a narrative scene, or be richly decorated with fantastically distorted human or animal figures. Many of these motifs served as inspiration for sculptured capitals. Manuscript production reached great heights in England in such monastic scriptoria as Winchester, Canterbury, and St Albans, and the best painters achieved an entirely harmonious fusion between text and ornament. A work such as the Bury St Edmunds Bible, of 1130–40 (Cambridge, Corpus Christi College), demonstrates the English transformation of Byzantine style. In Spain, the illustrators of the texts of Beatus' commentaries on the Apocalypse showed, through vivid colours and flat, distorted images, the impact of the Islamic cultures of southern Spain which is also recognized in other media. In Germany, the linearity and ornamental quality of manuscript paintings can be compared to contemporary metalwork.

Carved *ivory, whether of elephant or walrus tusks, or whalebone, often had an interchangeable function with

metalwork, in the role of relief carvings as book covers or altar panels, while the subject matter was also closely linked to manuscript painting. Because of its portable nature, it remained a crucial means of transmitting Byzantine influences into Western art, and had served to keep sculptural traditions alive while monumental stone-carving had been in decline. Discrete items included crucifixes, liturgical combs, and the set of chess pieces from the Isle of Lewis (London, BM).

The Bayeux Tapestry (Bayeux, Mus. de la Tapisserie) represents an almost miraculous survival from what must have been the widespread medium of textiles. It is a 70-m (231-ft) long linen hanging, embroidered with coloured wools. Probably made in the 1070s in England for Bishop Odo of Bayeux, the half-brother of William the Conqueror, it is a subtle piece of propaganda presenting the Norman justification for the conquest of England. The designer has drawn on an extensive range of sources, including Anglo-Saxon, Ottonian, and Norman manuscripts, as well as Persian and Byzantine silks. Despite a long connection with Bayeux Cathedral, it was probably made for a secular context such as a great hall.

Romanesque art, like many other great non-naturalistic styles of the past, has had to wait for the revolution in taste brought about by *modernism in order for its expressionistic distortion and stylization of natural forms to be widely appreciated. Instead of being merely the forerunner to the Gothic, the Romanesque is at last recognized as a major style in its own right. CMH

Cahn, W., *Romanesque Manuscripts: The Twelfth Century* (1996).
Dodwell, C. R., *The Pictorial Arts of the West* (1993).
Focillon, H., *The Art of the West*, 1: *Romanesque* (1963).
Grabar, A., *Romanesque Painting, Eleventh to Thirteenth Century* (1958).
Hearn, M., *Romanesque Sculpture* (1981).
Nicholas, S., *Romanesque Signs: Early Medieval Narrative and Iconography* (1996).
Petzold, G., *Romanesque Art* (1995).
Zarnecki, G., *Romanesque* (1989).

ROMANTICISM IN THE VISUAL ARTS.

Romanticism is a complex phenomenon which can be seen either as a historical movement or as a recurring attitude. Its manifestation is pervasive but hard to define; so much so, in fact, that historians and critics with materialistic or positivistic tendencies are inclined to dismiss the phenomenon out of hand. It cannot be dispensed with so lightly, however, and it is hard to make much sense of the cultural history of the last two centuries without paying attention to it.

As an attitude, romanticism can be described as a tendency to favour the spiritual and oppose materialism. For some people, it is a phenomenon as old as man, which can be witnessed at least as early as the writings of *Plato, and might be said to incorporate all tendencies towards the mystical and a belief in a reality beyond observable phenomena. In the last two centuries such a view has been central for supporting the visual arts as spiritually enlightening and a means of maintaining imagination and creativity increasingly under threat in the modern world. While it can be an agent for redemption, however, romanticism has its darker side. Its promotion of the irrational and instinctive has encouraged some of the most hideous aspects of Western society in the last two centuries—in particular racism and myopic and aggressive forms of nationalism. It is hardly surprising, therefore, that those who believe in the possibility of a rationally ordered secular society have been amongst its greatest opponents.

Romanticism as a historical movement can be seen principally in terms of reaction. Its origins and course are endlessly disputed; but most observers would agree that it began somewhere in the later 18th century and persisted until the mid-19th. It started first as a literary and philosophical movement and only gradually involved the other arts, explicitly around 1800. It was only around 1800, too, that the word 'Romantic' began to be used to describe contemporary culture. In the visual arts it was largely played out by 1850, but in music it persisted for another generation.

The figure who symbolizes the crusading spirit in Romanticism most powerfully is the Swiss French philosopher Jean-Jacques *Rousseau. He preached a radical philosophy in which sentiment played as large a part as reason. He argued that man was nobler in his primitive state than in the modern world, and that he had become corrupted and enslaved by society. In one memorable statement, in his book *The Social Contract* he declared: 'Man is born free, but everywhere he is in chains.' Such thinking was highly important for the revolutionary movements of the late 18th century and the pursuit of democratic and nationalistic claims. Paradoxically Romantic attitudes were manifested by supporters of both the extreme left and the extreme right in the period. Perhaps this is because it was essentially a movement of reaction, which could function as a protest against both the stultifying conservatism of authority, and the soulless materialism of modernity. Romanticism was fundamentally a movement of yearning, of regret at what *Baudelaire called 'an irretrievable sense of loss'. This sense unites what might be seen as the three major topics of the movement; the reperception of the nature of man—emphasizing individualism and inwardness; yearning for the past; and a longing for nature. In the visual arts these tendencies encouraged a new and more ironic form of figurative painting, a revival of historical styles—in architecture and design as much as in painting and sculpture—and a new celebration of nature evident in a wide variety of phenomena ranging from landscape gardening and the *'picturesque' tour to *landscape painting. In all these movements artists followed closely developments in literature and philosophy. Indeed, one of the changes that Romanticism brought about was that of the visual artist thinking of himself or herself in the same terms as the literary 'genius'—as a person to be valued first and foremost for trenchant originality and imaginative force, rather than as the traditional professional painter or craftsman.

The emphasis on originality in literature found direct connections in the visual arts in the late 18th century. The Swiss painter Henry *Fuseli was inspired by the German early Romantic 'Storm and Stress' (*Sturm und Drang*) to develop an art form of dramatic extremes and psychological disturbance, notably in his picture *The Nightmare* (1781; Detroit, Inst. of Arts). But it was an admirer of his, William *Blake, who exemplified most of all the union of the arts. An engraver by profession, he was equally gifted in the visual arts and in poetry and produced a series of illuminated prophetic books which showed a renewed sense of the power of the visionary in art. Blake's statement 'Talent thinks, genius sees' epitomized the new emphasis on synthetic perception that underlay the movement. There were many other artists of this generation who developed—often in

relative privacy—new and disturbing visions. One of the most striking is *Goya in Spain. While working as court painter he produced on his own savage drawings and etchings that exposed the malaises of contemporary society (Los caprichos, 1799) and the horrors of war (The Disasters of War, begun 1810). In Germany Philipp Otto *Runge created a highly personal mythologized landscape. The work of these artist should also be seen in the context of the Napoleonic Wars which plunged Europe into crisis until 1815. After this date the tendency towards Romantic self-questioning could be seen emerging in France, notably in the works of *Géricault. This artist's Raft of the Medusa (1819; Paris, Louvre) explored the dark mood of people in the depths of despair.

None of these would have seen themselves as Romantics. But they were a powerful inspiration to a later generation of artists who were familiar with the self-styled movement. This was most clearly associated with painters of historical subjects who moved away from severe, stoical, classically inspired subjects (such as those by the great French Neoclassical painter *David) towards a more sensuous use of paint and more ironic or unheroic subject matter. While tendencies in this direction can be seen in both England and France as early as the 1770s, it is really in the post-Napoleonic period that this movement gained ascendancy. Its greatest proponent was the French artist Eugène *Delacroix, who shocked the Parisian public in the 1820s with scenes of sensuousness, violence, and dissipation—notably his Death of Sardanapalus (1827; Paris, Louvre). This picture also represented another theme common to the Romantics—the interest in the exotic and the non-Western which is seen most strongly in the interest in the Orient. Delacroix painted one of the most brilliant orientalist works of the period: The Women of Algiers (1834; Paris, Louvre). Yet while styled by contemporaries the 'leader' of the Romantics, Delacroix characteristically rejected the claim.

The medieval revival is perhaps the most identifiable part of Romanticism—signalled by the fact that the very name was derived from the 'romances' of the Middle Ages. From the middle of the 18th century there had been a revival of medieval and traditional literary forms—such as the ballad and the folk tale. This was accompanied from the start by a revival of medieval styles in architecture. As early as 1748 the English writer and dilettante Horace *Walpole had begun to remodel his house, Strawberry Hill in Twickenham near London, in a fanciful 'Gothick' style that has become a byword for the playful early stage of the revival. Significantly he was also an innovator of the 'Gothic Novel'— a new genre in fantasy that drew on the wildness of the Middle Ages. But if the

*Gothic revival could be seen as something of a rich man's plaything in the 18th century it took on deep national seriousness in the early 19th century, when it began to be exploited as a symbol of nationalism by France, Germany, and Britain. This was in line with the Romantic view of the nation as a kind of organic, innate entity—one of the most dangerous legacies of the movement. In Germany Gothic became the symbol under which freedom from France was fought during the Napoleonic Wars. Later it became an image of German unification—most strikingly in the completion of Cologne Cathedral according to its original medieval plans. In Britain the Gothic became so closely identified with a sense of nation that when the Houses of Parliament were rebuilt (1840–60), it was stipulated that this central national institution should be in the 'Gothic or Elizabethan' style. The neo-Gothic Big Ben has subsequently become one of the most clichéd images of national style. Medievalism also encouraged certain artists to revert to a medieval style. The earliest systematic example of this was the German *Nazarene group. Established in 1808, they adopted medieval dress as well and lived a quasi-monastic existence for a time. In Britain the most influential medievalizing group was the *Pre-Raphaelite Brotherhood, established in 1848. Although primarily painters, their influence spread into the world of design, particularly through the work of a younger follower, William Morris. Morris, inspired by the art critic John *Ruskin, gave the medieval revival a radical political dimension, using the ideal of the medieval craftsman to promote a return to pre-industrial means of production and social responsibility.

As with the medieval revival, the renewed interest in nature followed a literary movement. It can be seen developing from the early 18th century in a growing taste for more informal landscape gardens. While this was largely an aristocratic phenomenon, the bourgeoisie increasingly participated in the taste for nature through making tours through natural scenery. The term 'picturesque tour' came into vogue at this time, indicating a tour largely to appreciate the beauties of nature. There was a vigorous literature on the subject—notably the Picturesque Tours of Britain described by William Gilpin (1770–1808). This taste also proved to be a great stimulus for landscape painting, which grew into one of the most powerful artistic forms of the period—notably in the hands of British artists *Turner and *Constable, and the German Caspar David *Friedrich. For all these artists, however, landscape painting was far more than the satisfaction of the tastes of bourgeois tourists. It was, like poetry, the means of exploring the spiritual depths of man's response to nature. It was on

the one hand fantastic and on the other hand exploratory. With the Romantic generation of landscapists there emerged a new and more intensive form of the study of nature, epitomized in the *plein air sketch, in itself a harbinger of *Impressionism. The obsession with atmosphere led to new and vibrant, near-abstract forms of painting, particularly such works by Turner as Rain, Steam, and Speed (1844; London, NG). Romanticism—while being an intensely literary and 'subject-oriented' movement, also promoted through its intensive quality an exploration of the inner nature of artistic form. This encouraged a dramatic painterliness in many artists—such as Delacroix and Turner—and made it into a precursor of *modernism in this as in many other aspects. WV

Eitner, L., Neo-classicism and Romanticism (1970).
Honour, H., Romanticism (1979).
Vaughan, W., Romanticism and Art (2nd edn., 1994).

ROMBOUTS, THEODOOR (1597–1637). Flemish history and genre painter. Born in Antwerp, where he was a pupil of Abraham *Janssens, he went to Italy in 1616. Back in his home town in 1625, he became a master there. He painted genre and religious subjects with strong chiaroscuro effects in a *Caravaggesque manner (The Toothpuller, c.1627/8; Madrid, Prado). In common with so many artists he later inclined towards the softer and more atmospheric style of *Rubens. KLB

Sutton, P. C., The Age of Rubens, exhib. cat. 1993 (Boston, Mus. of Fine Arts; Toledo, Oh., Mus.).

ROME, ANCIENT. Rome was the political and cultural centre of a vast empire from the mid-2nd century BC through to the definitive transfer of the capital of the Roman Empire to the 'New Rome' in Constantinople in AD 410. As a showpiece of Roman power and cultural supremacy, it incorporated all of the best of the sculpture, wall painting, and other arts that the conquest of empire brought with it. From its earliest origins, Rome was marked by a mixed cultural heritage, echoed in the myth-history of the foundation of the city in 753 BC by Romulus, descendant of the Trojan Aeneas. At least two of the early kings of Rome are clearly identifiable as Etruscan. It is to *Etruscans and *Greeks that the earliest images, sculpted and painted, in Rome are attributed. The most important temple of the *Archaic city, the temple of Jupiter on the Capitoline, was decorated with terracotta four-horse chariots by the late 6th- to early 5th-century BC Etruscan artist Vulca; the same artist produced the cult statue. The iconography of the temple pediments of the 6th-century BC temples of Fortuna and Mater Matuta traditionally associated with Servius Tullius (578–534 BC) recall the themes of the pediments of Archaic

buildings on the *Athenian Acropolis. Throughout its history, Roman art appropriated elements from diverse cultural traditions and created a unique mixture of imitative and innovative artistic production.

As in the centre of the Greek Empire, Athens, the majority of art was connected to the gods or to honorific dedications in the public spaces of the city. *Pliny (Natural History 34. 15–16) dates the first bronze image of a god, in this case the goddess Ceres, to 585 BC. According to the ancient sources, portrait statues were introduced much earlier, connected with Romulus and the early kings. Romulus is said to have erected a four-horse chariot in bronze and a statue inscribed in Greek (Dionysius of Halicarnassus, Antiquitates Romanae 4. 40. 7). Pliny (Natural History 34) records an entire series of bronze statues in the city beginning with that of the tyrannicide Junius Brutus (509 BC); he dates the earliest *equestrian statues to the late 4th century BC. Hundreds of bronze statues are recorded by the late Republic. The tradition of dedicating honorific statues was so extensive that in 158 BC a clearing of the Forum of all private dedications was ordered (Pliny, Natural History 34. 30).

The wars of conquest and expansion brought a deluge of works of art into Rome from the 4th century onwards. The gods of defeated foes were stripped from their temples and rededicated in Rome. Triumphal processions included statues, painted panels, gold and silver vessels. Fabius, the conqueror of Tarentum in 209, dedicated a colossal statue of Hercules by *Lysippus on the Capitoline (Pliny, Natural History 34. 40). Metellus transported 34 bronze statues by Lysippus to Rome following his conquest of Macedonia in 148 BC; the sculpture group depicting Alexander the Great and his comrades at the battle of Granicus was set up in the portico that Metellus built as a victory monument (Velleius Paterculus 1. 11. 2–5). Booty was rededicated in temples, porticoes, and other public spaces in the city; other art made its way into the private context of the houses of the triumphant generals. In the late Republic, the display of booty and the construction of public buildings from the rewards of conquest became a potent form of aristocratic competition.

Conquest brought the Romans into direct contact with Greek art, as works of art, such as sculpture, panel painting, and minor arts, were joined by Greek artists after the defeat of Corinth 146 BC provoked a movement of artists towards Rome. These artists produced a range of art for their new patrons: from portraits in an uncompromising veristic style to those more reflective of the idealizing style of Hellenistic dynasts, from close copies to broad adaptations of Greek originals, for public and private display. At the same time, Greek originals continued to enter the city through conquest and expansion.

The rise to power of Augustus changed the face of Rome and yet many republican traditions of artistic display continued. From the time of the foundation of the empire, building and artistic display became centred on the emperor and his family. Augustus' building programme amplified the more modest programmes of his predecessors. He dedicated booty in his new buildings: Classical Greek cult statues of Apollo by Scopas, Diana by Timotheus, Latona by Cephisodotus in his temple of Apollo (Propertius 2. 31); paintings by *Apelles in his Forum (Pliny, Natural History 35. 37, 35. 93). The Forum of Augustus was designated as the place to which all booty was taken. Later imperial fora served the same purpose, as places for the deposition of the treasure of Jerusalem (Templum Pacis), the spoils of the Dacian Wars (Trajan's Forum), etc. Aristocratic competition in domestic decoration was superseded by the construction of grandiose imperial palaces filled with wall painting embellished with jewels, and sculpture. The magnificent public amenities provided in the name of the emperor, baths, theatres, amphitheatres, were fitted out with innumerable statues, and other works of art. L-AT

Claridge, A., Rome (1998).
Richardson, L., A New Topographical Dictionary of Ancient Rome (1992).

ROME: PATRONAGE AND COLLECTING. *See overleaf.*

ROME, ACCADEMIA DI S. LUCA, one of the first artists' academies, serving as a model for France and other countries. The academy was established in 1577 by Pope Gregory XIII. In 1593 the ludicrously self-important painter Federico *Zuccaro was elected president and statutes were drawn up, providing for learned debates and prizes as well as teaching for young artists. The Accademia's authority in the Roman art world was strengthened under Urban VIII, whose nephew Cardinal Francesco Barberini became its protector and paid for its church of SS Martina e Luca to be rebuilt by Pietro da *Cortona. At this time it was given power to tax all artists and art dealers in Rome, and its approval was supposed to be required for public commissions. These measures (which were not fully observed and which were eventually repealed) may have helped the Accademia with its perennial concern to raise artists' status, but the practical organization seems to have been quite inefficient until *Maratti first became president in 1664, with *Bellori becoming secretary in 1671. The Accademia then entered its period of greatest power, firmly identified with the classical *Grand Manner and closely allied with French official thinking. Although practice on the matter had been flexible, the statutes did not provide for practitioners of minor painting genres to be admitted until the 18th century.

Benedict XIV established the Accademia del Nudo for life drawing, under the main academy, in 1754. In 1814 the all-powerful *Canova became life president. In 1873 the Accademia del Nudo became a separate art school, leaving the Accademia di S. Luca as a purely honorific institution.

The Accademia's Galleria is a miscellaneous collection of presentation pieces and other paintings, including a few quattrocento works. It includes Zuccaro's self-portrait and a group of portraits of the *Grand Tour period. The main collection of academicians' portraits and prizewinning works is, however, kept separately in the Accademia's private chambers. AJL

Haskell, F., Patrons and Painters (1963).

ROME, BARBERINI GALLERY (Galleria Nazionale d'Arte Antica a Palazzo Barberini), a collection of mainly 16th- and 17th-century Italian paintings from many sources, in a major Roman palace. The Palazzo Barberini was begun in 1627 by Carlo Maderno (1555/6–1629) for Taddeo Barberini, nephew of Pope Urban VIII. *Bernini took over the project on Maderno's death in 1629. The salone contains Pietro da *Cortona's huge ceiling fresco (1633–9), celebrating Urban VIII as the agent of divine providence. In comparison with this early manifestation of full-blooded *Baroque illusionism and colour *Sacchi's neighbouring ceiling of Divine Wisdom (1629–31) looks distinctly anaemic.

The National Gallery of Rome was founded in 1893 on the basis of the Corsini Collection which had been given to the state in 1883. The Palazzo Corsini became increasingly unable to accommodate the growing collection and in 1949 the Palazzo Barberini was acquired as an additional site. In 1984 the collection was rearranged to assemble the Corsini paintings in their original location, while the rest of the collection was displayed in a consistent chronological presentation in the Palazzo Barberini. The old Barberini Collection was dispersed in 1934 and the collection now in the Palazzo Barberini contains pictures from the Torlonia, Herz, and Chigi collections as well as other acquisitions. It is, therefore, essentially a modern museum collection. AJL

ROME, BORGHESE GALLERY (il Museo e la Galleria Borghese), a rich collection that projects the personality of its founder, Cardinal Scipione Borghese, nephew of Pope Paul V (ruled 1605–21). A passionate love of art featured prominently in Scipio's hedonist lifestyle, and he built up

continued on page 658

· ROME: PATRONAGE AND COLLECTING ·

PATRONAGE, collecting, and the art market in Rome have been largely shaped by the significance assumed at different periods by the city's roles as the ruined capital of the classical world, the spiritual and pilgimage centre of the Catholic Church, and the seat of the pope's court as a major European ruler.

After prolonged turbulence, several major church decoration projects were taking place in the late 13th century, shared between the papacy and members of patrician Roman families such as the Stefaneschi brothers, who commissioned work by *Cavallini and *Giotto. The removal of the popes to Avignon in 1305 ended this phase. When, in 1420, the papacy returned definitively to Rome after the Council of Constance only about 17,000 people lived in the wreckage of the ancient city. Creating an impressive capital became a continuing priority, and many subsequent popes encouraged private building as well as initiating their own development schemes.

The re-established papacy soon transferred its court to the Vatican Palace. The most celebrated artists in Italy were obtained for this politically vital site, and teams were brought in from Tuscany and central Italy. Julius II took this to a peak of achievement by employing *Michelangelo for the Sistine chapel ceiling (1508–12), *Raphael for the Stanze (1509–17), and Bramante for the construction (from 1503) of the vast Belvedere court, modelled on ancient imperial villas. It was here that Julius displayed the finest *Antique sculptures that had been recovered at that time, encouraging the formation of the antiquarian *humanist collections for which Rome became famous over the following decades.

The implied identification of the papal regime with that of ancient Rome continued under the Medici popes after Julius II and was a major factor in the *classicizing nature of their projects, such as the Villa Madama, that were saturated with references to ancient prototypes. This luxury classicism was emulated by the entourage of the court, and the cardinals of this period competed unrestrainedly in palace building and ostentatious spending. One of the most lavish patrons, however, was the papal banker Agostino Chigi, who employed Raphael to decorate his villa and to design his burial chapel. Artists were attracted to Rome from all over Italy until the Sack of Rome in 1527 wrecked the city and temporarily stalled the economy.

During the last decades of the 16th century official patronage in Rome was consciously redeployed to implement the Counter-Reformation agenda. Confraternities that gave the citizenry a role in public ritual became important patrons. The reformed orders (Jesuits, Oratorians, Theatines) found rich patrons to finance their new mother churches in Rome, and tended to allow wealthy bourgeois to establish family chapels in them. Teams of painters were constantly at work on didactic fresco cycles. Eucharistic and conversion themes were common, nudity in art was frowned on, and clarity of narrative became paramount. The missionary Jesuit order developed a speciality in clinical depictions of torturous martyrdoms. The campaign to restore ancient churches signalled the clear aim that the New Rome should be a modern version of the early Christian Church's city, not that of the pagan emperors.

Fine paintings—especially portraits—had always figured in the prized possessions of wealthy families. However, it was only towards the end of the 16th century that a broad range of genres of painting emerged in Rome, together with a new kind of art connoisseur, intellectually involved in art theory and keen to own a personal selection of contemporary and 16th-century work. Two notable Roman collectors of this kind were the Grand Duke of Tuscany's representative Cardinal del Monte and the rich Genoese banker Marchese Vincenzo Giustiniani. However, the most ostentatious of all collectors was the hedonistic Cardinal Scipione Borghese. He was nephew of Pope Paul V (1605–21), and the most extreme example of many papal nephews in the 17th century who returned to earlier traditions of conspicuous display, in which picture galleries now featured prominently. All three connoisseurs were passionate collectors of the revolutionary paintings of *Caravaggio, who was enormously famous between the unveiling of his paintings in the Contarelli chapel, S. Luigi dei Francesi, in 1600 and his flight from Rome in 1606, after killing a man in a street fight.

Although Caravaggio's work aroused enthusiasm in collecting circles, and his religious paintings in a handful of Roman churches created a sensation, the greatest impact on painting in Rome in the first three decades of the 17th century was made by Bolognese artists, led by Annibale *Carracci. Unlike Caravaggio, these painters were not limited to working in oils and were capable of executing large fresco cycles of *history painting, which was conventionally seen as being the highest form of the art. They also painted altarpieces and easel paintings for collectors, and developed genres such as *landscape.

Annibale Carracci was brought to Rome by Cardinal Oduardo Farnese in 1594 to decorate the main reception rooms of the Palazzo Farnese. The family had become enormously wealthy and powerful under Pope Paul III (ruled 1534–49), who had carved out the duchy of Parma and Piacenza for his descendants. Annibale's decorative scheme (1597–1604) in the Galleria of the palace is a richly exuberant mythological celebration of the theme of all-conquering love, startlingly out of keeping with current Counter-Reformation orthodoxy. It may be that one motive of the Farnese patrons was to thumb their noses at the austere Aldobrandini reigning pope, Clement VIII, with whose family they were at loggerheads.

Annibale had run an academy in Bologna which fos-

tered his vigorous reinterpretation of Raphael and Antiquity. Many of the Bolognese artists who came to Rome in the wake of his success had studied there. One of these was Guido *Reni, who was soon taken up by Scipione Borghese and whose lyrical and elegant classicism became, in effect, the official style of the Borghese papacy for some years, displacing the chilly academic late *Mannerism of the *Cavaliere d'Arpino that had previously been in favour.

When Reni returned to Bologna in 1614 his place as the leading painter in Rome was taken by the much more rigidly classicizing *Domenichino, who was a close friend of Cardinal Pietro Aldobrandini's secretary Monsignor *Agucchi, an influential classical theorist. *Guercino, who came from Cento, and the Parmesan painter *Lanfranco both painted in a broader style. Between them, this group of Bolognese and Emilian painters were responsible for most of the important schemes in both palaces and churches. Under the Ludovisi Pope Gregory XV (ruled 1621–3), who came from Bologna, they virtually enjoyed first refusal for any major commission, and Domenichino and Guercino were particularly favoured by Cardinal Lodovico Ludovisi, the papal nephew.

Under the papacy of the Barberini Pope Urban VIII (ruled 1623–44) official art emerged in the form of fully-fledged high *Baroque theatrical statements, often bringing together elements of architecture, sculpture, and colourism, as in *Bernini's work at S. Peter's. These techniques were not confined to religious art; Pietro da *Cortona's stupendous ceiling (1633–9) in the Barberini Palace celebrates Urban VIII with as much splendour as the name of Jesus itself is celebrated in the illusionistic ceiling paintings by *Gaulli and *Pozzo that crowned the two main Jesuit churches later in the century.

Nevertheless, very different tastes could coexist literally under the same roof. The da Cortona ceiling in the Barberini Palace, for which Cardinal Francesco Barberini was responsible, was begun immediately after the nearby ceiling painting of *Divine Wisdom* (1629–31) which had been commissioned from the Roman painter Andrea *Sacchi, who was championed by the other papal nephew Cardinal Antonio Barberini. While da Cortona's ceiling is superbly confident and expansive, Sacchi's is almost agonizingly restrained in its cerebral severity. Also, the new kind of connoisseurship typically provided patronage for many kinds of easel paintings. Cardinal Francesco Barberini did not pursue his early patronage of *Poussin but his friend the learned collector Cassiano dal Pozzo went on to own 50 of Poussin's paintings. One of *Claude's early patrons was Urban VIII himself and his idealized landscapes were much patronized by French diplomats and the Italian aristocracy. Socially reassuring *Bamboccianti scenes of Roman low life by northern painters were highly prized by noble collectors such as Cardinal Bernadino Spada.

Until the end of the 17th century, at least, the art market was essentially structured on traditional lines, with painters and sculptors aiming to establish their own studios,

usually working on commission, and hoping to attract influential patrons and protectors. Shady picture dealers had congregated round the Piazza Navona since before Caravaggio's time, but they probably only had significance for struggling young painters and impecunious buyers. The Accademia di S. Luca, concerned to raise the status of art and artists, forbade its members from dealing. Nevertheless, there were always 'gentleman dealers'—intellectuals and connoisseurs who moved in the world of literature, art, and collecting, and who used their contacts to make some money.

The spectacularly effective public art of the 17th century had, in fact, projected an image of papal power that was not sustained by the reality. Throughout the 17th century the political importance of the papacy had been draining away, and by the end of the century public commissions were greatly reduced. Tourism revenue therefore assumed more importance during the 18th century and the popes' art policy priority turned towards the new Capitoline and Vatican museums that were intended to retain and display the city's patrimony of antiques. Great private collections were nevertheless still being formed. Cardinal Alessandro Albani sold his first accumulation of sculpture to form the basis of the Capitoline collection, but he went on to build up another collection and to employ *Winckelmann as his librarian. The Villa Albani (now Villa Torlonia) with its Anton Raphael *Mengs ceiling painting of *Parnassus* (1761) was the recognized centre of the *Neoclassical movement and was frequented by artists such as Angelica *Kauffmann.

As the 18th-century *Grand Tour became established, the Roman art market looked abroad for custom. Thus *Batoni turned from history painting to specialize in souvenir portraits, while *veduta* specialists like *Panini developed elegant compilation records of the most evocative sites. At the same time, a great market grew up in topographical prints, which *Piranesi invested with a uniquely suggestive power.

By the second half of the century the Roman art market was effectively managed by resident British entrepreneurs. The dominant figure was Thomas Jenkins, a protégé of Cardinal Albani and a banker and de facto British government representative as well as being an excavator and dealer in pictures, gemstones, and Antique sculptures. Jenkins dealt in individual paintings but also bought some famous collections and sold them piecemeal. The trade in ancient marbles was carried on by dubious consortia involving Jenkins, James Byres, Gavin *Hamilton, and restorers such as Bartolomeo Cavaceppi and Piranesi himself. Although the Grand Tour was definitely not an exclusively British phenomenon, the British were the wealthiest collectors in Europe during this period. It is also relevant that the papacy was attempting to pursue a policy of rapprochement with the United Kingdom following the British success in the Seven Years War, and one result of this was the relative ease with which British antiquarians could obtain excavation licences.

The Napoleonic occupation weakened the old Roman families yet further by high taxation, and old collections continued to be broken up and sold to foreign agents during the 19th century. For much of this period Rome maintained its position as the one place that any aspiring artist had to visit, and several hundred young foreign artists lived and maintained studios in the traditional area north of the Piazza di Spagna. The eclectic Roman art market may well have been the busiest in the world at this time though the Grand Tour had been replaced by early mass tourism.

Several 20th-century art movements were centred on Rome, but it is not now generally seen as very significant for contemporary art. It does, however, hold its place as an entry point for old works into the art market in spite of extremely restrictive rules on export.

For information on patronage and collecting in ancient Rome, see ROME, ANCIENT. AJL

Haskell, F., *Patrons and Painters* (1963).
Hollingsworth, M., *Patronage in Sixteenth Century Italy* (1996).
Wilton, A., and Bignamini, I., *Grand Tour*, exhib. cat. 1996 (London, Tate).

a spectacular display of painting and sculpture, including marbles taken from the atrium of the old S. Peter's basilica. He was ruthlessly unprincipled, flagrantly stealing *Raphael's *Deposition* from a church in Perugia, and imprisoning the painter *Cavaliere d'Arpino to extort his collection from him. Nevertheless, he was an inspired patron; the collection's early works by *Bernini that he commissioned show many of the interests of the dawning *Baroque period.

Scipione was an early admirer of *Caravaggio and owned six of his works. Otherwise, he seems to have had an omnivorous appetite for fine painting of all kinds, with a taste for Dosso *Dossi and contemporary Emilian painters. The collection was soon expanded when Olimpia Aldobrandini married Paolo Borghese, bringing with her paintings from the collections of Lucrezia d'Este and Cardinal Salviati. It was acquired by the state in 1902.

The collection is displayed in the casino that was built for it on the Pincio by Flaminio Ponzio and Giovanni Vasanzio (1608–17). The ground floor contains sculpture, including *Canova's celebrated portrait statue (1805) of Napoleon's sister Pauline Borghese, whose impoverished husband Camillo Borghese sold the collection's finest Antique sculpture to his imperial brother-in-law. Most of the paintings are hung in the gallery on the first floor, where the ceiling of the main room was frescoed by *Lanfranco (1624). Some of the richness of the original display has survived the 1998 rearrangement. AJL

Haskell, F., *Patrons and Painters* (1963).

ROME, **CAPITOLINE MUSEUMS,** the city's collection of antiquities and paintings, and the oldest such civic collection in the world. The museums are housed in the Palazzo dei Conservatori and the Palazzo Nuovo which occupy two sides of the Capitol (Campidoglio) as remodelled by *Michelangelo. The collection began in 1471 when Sixtus IV presented the Conservators, the city's chief municipal officers and magistrates, with several ancient bronzes (including the *She-Wolf* and the *Spinario*) previously displayed at the papal Lateran Palace. Sixtus's gift was 'to the Roman people' and he clearly intended a political statement by restoring to the city the symbols of its ancient birthright. The popes continued to present sculptures to the Conservators, and in 1538 Paul III transferred the bronze equestrian statue of *Marcus Aurelius* from the Lateran to the Campidoglio, where it stood in the piazza until it was moved into the museum in 1990. In 1566 the austere Dominican Pope Pius V presented several, mostly undistinguished, sculptures. (Pius, who had been determined to strip the Vatican of its pagan works of art, concealed the masterpieces in the Belvedere sculpture garden behind wooden shutters and was only persuaded to retain them on condition that there should be no access to them.)

By the 18th century concern was developing about the export of works of art from Rome, and in 1733 the nature of the Capitoline collection was transformed when Clement XII bought the entire sculpture collection of Cardinal Alessandro Albani, and made it the nucleus of the new Capitoline Museum, open to the public, that he established in the Palazzo Nuovo. The next pope, Benedict XIV, founded the museum's picture gallery (Pinacoteca Capitolina), which he endowed with a gift of paintings, including several important works by Pietro da *Cortona, which he bought from the Sacchetti Collection in 1748. Two years later he made a further substantial gift of paintings bought from the Pio di Savoia family. AJL

Haskell, F., and Penny, N., *Taste and the Antique* (1981).

ROME, **DORIA PAMPHILI GALLERY.** This holds the best collection of old masters still in private hands in Italy. The Pamphili family fortune was made when Giambattista Pamphili was elected as Pope Innocent X in 1644. The Pope himself, whose appearance is vividly preserved in the famous portrait by *Velázquez and the bust by *Bernini (both in the gallery), was no great collector but his nephew Camillo soon set about building an art collection, and this was much increased when he married Olimpia Aldobrandini in 1647. Olimpia was heir to Cardinal Pietro Aldobrandini and she brought with her many important paintings by *Raphael, *Titian, *Parmigianino, and *Beccafumi, together with the palace on the Corso where the collection remains. At the beginning of the century Cardinal Aldobrandini had had the palace chapel decorated by Annibale *Carracci and others with the 'Aldobrandini lunettes', including Annibale's *Landscape with the Flight into Egypt*, and these were later taken into the Pamphili Collection. Even before his marriage Camillo owned three *Caravaggios and at least one sumptuous *Guercino, and he went on to specialize in collecting Bolognese work and landscape. In addition to landscapes by Bolognese painters such as *Domenichino he owned a large number of works by *Claude and Gaspard *Dughet, as well as many paintings by Flemish and Dutch painters working in Rome.

In 1760 the direct Pamphili line became extinct and the family possessions passed to the Doria Pamphili branch from Genoa who brought with them some fine portraits. In the second half of the 19th century some quattrocento paintings were acquired, reflecting the contemporary taste for 'primitives'. The paintings are displayed in the gallery that was made for them around a courtyard in the palace by Gabriele Valvassori in 1731–4. The gallery's fine *Rococo decoration includes the magnificent Gallery of Mirrors with ceiling frescoes by Aureliano Milani. In 1996 the display was reorganized in strict accordance with the late 18th-century arrangement, of which a detailed record survives.

 AJL

Cappelletti, F., et al., *Nuova guida alla Galleria Doria Pamphilj* (1996).

ROME, **MUSEO NAZIONALE ROMANO,** founded in 1889; one of the largest and most important museums of ancient art in the world, incorporating renowned Renaissance private collections (e.g.

Kircheriano, Boncompagni-Ludovisi) and material excavated in Rome since 1870. Recent restructuring has resulted in the opening of four separate sites for the display of its vast collections. Palazzo Massimo alle Terme, Palazzo Altemps, Terme di Diocleziano, and Crypta Balbi. Division of the material into different display sites is based on function, or alternatively grouped by provenance, excavation, or collection.

The Palazzo Massimo alle Terme holds important sculpture from the late republican to the imperial period. The exhibition commences with an extraordinary colossal statue of *Minerva* in coloured marbles (1st century BC). A succession of late republican veristic portraits (e.g. *Tivoli General*) is followed by a visual chronology of imperial portraits of changing style and iconography (e.g. *Augustus as Pontifex Maximus* from the Via Labicana, bust of *Septimius Severus* from *Ostia). Greek originals imported to Rome in Antiquity are represented by masterpieces such as the *Niobe* from the Horti Sallustiana (5th century BC). Works of art from aristocratic luxury villas include bronze and marble Roman copies of famed Greek originals (e.g. marble *Crouching Aphrodite*). Alternatively, Greek models were reproduced in terracotta as evidenced by the splendid *Head of Apollo*. On the second floor, the visitor enters or peers into the reconstructed painted rooms of the Villa of Livia at Prima Porta and Agrippa's Villa Farnesina (1st century BC). Contemporary mosaics complete the scene setting.

The Ludovisi and other early collections of ancient statuary are displayed in the 15th-century Palazzo Altemps. The material visually articulates the reception of ancient art from the Renaissance onwards. The main collection has in some sense returned to its original home; Ludovico Ludovisi acquired Villa Altemps in 1621. The centrepiece is the Ludovisi Throne, a mid-5th-century BC original from Magna Graecia, excavated in the Villa Ludovisi from a republican temple dedicated to Venus. Another important piece found in excavations in the Villa Ludovisi is the *Barbarian Chieftain and his Wife*, thought to copy a Pergamene (see PERGAMUM) monument (c.220s BC). The massive battle sarcophagus, the Ludovisi Sarcophagus, dates to the mid-3rd century AD.

The Terme di Diocleziano, sited in the early 4th-century AD bath complex built by the emperor Diocletian, is destined to house several important themes: the formation and early development of the city, figurative art in the republican period, art and social classes, history of Latin and writing. To mark the re-opening of the museum, a temporary exhibition on Romulus and Remus and the foundation of Rome displays for the first time the marble frieze of the Basilica Paullii (Aemilia) from the Roman forum with its sculpted narrative of the early history of Rome. Significant bronze and marble statues from imperial bath complexes have found a new setting in the ex-Planetarium, a circular room of the bath complex. The *Terme Ruler* and *Terme Boxer* demonstrate in bronze two diverse styles of *Hellenistic representation; the heroic style of the portrait statue of a Hellenistic prince or Roman general contrasts with the interest in characterization evident in the genre statue of the boxer.

The Crypta Balbi stands on the site of the Theatre and Portico of Balbus, dedicated in 13 BC. Excavations begun in 1981 brought to light extraordinary evidence for production and trade during the so-called 'Dark Ages' of Rome. The exhibition is divided into two sections. The first section, on the ground floor, explores the transformation of the site from Antiquity to the 20th century. The second section, on the first and second floors, presents the evolution of Rome between the 5th and 10th centuries. Material from the Crypta Balbi, that served as a centre of production and trade in luxury and non-luxury goods in this period, is juxtaposed with contemporary finds from other urban sites, both from recent excavations and permanent collections.

L-AT

ROME, SPADA GALLERY, a fascinating survival of a 17th-century Roman connoisseur's art collection, housed in a magnificent 16th-century palace. Cardinal Bernadino Spada was an ardent art enthusiast and a protégé of Pope Urban VIII, and he set about building up a collection of paintings soon after he acquired the palace in 1631. The cardinal's brother Virgilio Spada was an Oratorian who was more interested in architecture, and he employed Borromini to build the celebrated illusionistic arcade in the palace garden.

The pictures are crowded on the walls of the gallery's four rooms in 17th-century style and the entire collection gives a vivid impression of the taste of a wealthy avant-garde collector of the Roman *Baroque period. In addition to portraits and history paintings by leading Italian painters such as *Reni, *Guercino, and *Testa, the collection also includes works by the Italian *Caravaggisti, and there is also a good deal of the genre work that was so popular at the time, including several paintings by van *Laer and *Cerquozzi. Perhaps the most striking work in the collection is Cerquozzi's painting of the *Revolt of Masaniello* (c.1648), which is an astonishingly non-heroic and objective depiction of the popular revolt against Spanish rule in Naples in 1647.

AJL

Haskell, F., *Patrons and Painters* (1963).

ROME, VATICAN MUSEUMS. These comprise the papacy's main collections of *Antique sculpture, paintings, and other works of art. When the papacy returned from Avignon in 1420 Rome was run-down and dilapidated and the artistic patrimony was meagre. The popes soon evolved into *humanist Renaissance princes, using artistic commissions as a political tool. Nevertheless, there was no deliberate attempt to establish a papal collection of art objects at the Vatican until the reign of Julius II (1503–13).

Julius was overwhelmingly concerned to strengthen the temporal power and authority of the papacy, and his reign coincided with a period of fervent interest in excavation, and euphoria at the quality of many of the Antique sculptures that were being recovered. He brought these themes together by establishing the Belvedere sculpture garden behind the Vatican Palace. Here a select group of the very finest antiques were brought together, both to epitomize the papacy's position as the successor to the rulers of ancient Rome and to exercise a massive influence on European taste. Under Julius the display included the *Apollo Belvedere* (which had been discovered on his estates before he became pope), the *Laocoön*, and the so-called *Cleopatra*. Succeeding popes added to the display in the Belvedere garden until the last space was filled in the mid-1540s under the Farnese Pope Paul III, who then felt free to turn his collecting energies to the benefit of the Farnese family rather than the papacy. Soon, however, the austere Counter-Reformation Pope Pius V brought the papal collecting of pagan art to a halt, and even the statues in the Belvedere garden came within a hair's breadth of being removed.

Despite the extensive papal art patronage in Rome during the 17th century none of the popes during this period was much concerned to increase the collections at the Vatican; many of them, in fact, were active in expanding their own family collections in the way the Farnese had done. By the 18th century there was widespread concern at the export of the artistic heritage from Rome, and in 1733 this motivated Clement XII to buy Cardinal Albani's entire collection of Antique sculpture and to present it to the Conservatori on the Capitol (see ROME, CAPITOLINE MUSEUMS). Succeeding popes continued to use the Conservatori, rather than the Vatican, as the custodians of excavated or purchased Antique sculptures until there was a change of policy under Clement XIV (ruled 1769–74) and Pius VI (ruled 1775–99), who decided that this was a function for the papacy itself. Under their rule the Museo Pio Clementino was constructed by Michelangelo Simonetti, to take the Belvedere sculptures into a new display and to make room for the frantic new collecting of antiquities on which the papacy embarked, which soon required the additional accommodation of the Galleria dei Candelabri. Pius VI also

established the Museo Profano of small objects in ivory and stone, while the Museo Sacro of miscellaneous Christian artefacts had already been set up in 1756. It is paradoxical that the foundation of all these collections coincided with a drastic weakening of the papacy's political importance.

Once the papacy was committed to centralized conservation, the collections rapidly expanded in the form of different museums on the Vatican site. Between 1807 and 1810 *Canova directed the establishment of the Museo Chiaramonti, to display both pagan and Christian Antique sculpture; and by 1822 a large new gallery, the Braccio Nuovo, was required. The Egyptian Museum and the Etruscan Museum were set up under the pontificate of Gregory XVI (1831–46), and are together known as the Gregorian Museums. Gregory XVI also founded the Museo Gregoriano Profano of Greek and Roman sculpture and inscriptions, while the Museo Pio Cristiano of material from the catacombs and early Christian churches was established by Pius IX in 1854. These last two museums were originally set up at the Lateran Palace, but were moved to a striking modern gallery at the Vatican in 1970.

The pictures in the picture gallery (Pinacoteca Vaticana) mainly consist of paintings from S. Peter's itself and from the papal palaces, together with a number of paintings taken by the French from the Papal States during the Napoleonic Wars, and brought back to the Vatican largely through Canova's efforts. The collection was assembled in its present purpose-built gallery in 1932, and is now complemented by a, distinctly uneven, Museum of Modern Religious Art. AJL

Haskell, F., and Penny, N., *Taste and the Antique* (1981).

ROMNEY, GEORGE (1734–1802). British painter—portraitist by profession but historical painter by inclination—who was born, trained, and began his career in the north of England. In 1762, he moved to London, where he exhibited at the Society of Arts and later at the Free Society and the Society of Artists, though never at the RA (see under LONDON). He was an assiduous student of prints after old masters and casts after the Antique; moreover, from 1773 to 1775 he was in Italy studying and copying old master paintings and classical sculptures in the original. These endeavours bore fruit in his portraits, which often contain discreet echoes of classical poses and draperies and of compositions by such painters as *Raphael and *Poussin. As he was more inclined to *Neoclassicism than most British 18th-century portraitists, Romney's figures have long flowing contours and simple forms, which

combined well with the demands of contemporary fashion, so that his sitters almost always appear elegant and beautiful: *Sir Christopher and Lady Sykes* (1786; Sledmere, Yorks.).

Romney's 'other' life as a historical painter is reflected in his friendships with such radical and intense figures as *Flaxman and the poet William Haley; in 1790, he went with the latter to Paris, where they admired the latest works by Jacques-Louis *David and met the painter. Romney's own successes as a history painter were limited (his finest is the large *Milton when Blind Dictating to his Daughters*, 1794; Southill, Beds., Whitbread Coll.), but he made many hundreds of wild pen and wash drawings illustrating subjects from the classics, Shakespeare, and Milton. Extravagantly over-valued for his flimsiest portraits 100 years ago, Romney is now seriously understudied. MK

Drawings by George Romney, exhib. cat. 1977 (Cambridge, Fitzwilliam).
Romney, J. (son), *Memoirs of the Life and Works of George Romney* (1830).

RONCALLI, CRISTOFERO (1552–1626). Italian painter, mainly of religious frescoes and altarpieces, who was one of the most respected artists in Rome in the years around 1600. Born in Pomerance, near Volterra, of a Bergamese family, he trained in Florence, and began his career in Siena; he was probably in Rome by 1578, and from the 1580s was busy with both public and private commissions, among them a vast fresco of the *Baptism of Constantine* (1597; Rome, S. John Lateran), and many works for S. Peter's. His style is eclectic, indebted to both Tuscan *Mannerism and Roman *classicism, and he favoured balanced and solemn compositions, which convey the pietistic mood of the Counter-Reformation; he was the favourite artist of the Oratorians, and his scenes from the life of S. Philip Neri (1596–9; Rome, S. Maria in Vallicella) are characterized by a greater naturalism and severity. His most celebrated work is the frescoed decoration (1605–9) of the new sacristy of the sanctuary at Loreto, with scenes from the life of the Virgin set in a rich gilt stucco surround. In 1606 he interrupted this work to make a tour of northern Europe with the collector Vincenzo Giustiniani. HL

Chiappini di Sorio, I., 'Cristofero Roncalli detto il Pomerancio', in *I pittori bergameschi: il seicento* (1983).

ROOD-SCREEN, term in Christian church architecture for a wall erected between the nave and choir, incorporating an image of Christ on the cross (the rood). The primary function of the screen was to exclude the

laity from the immediate vicinity of the high altar, particularly during the celebration of Mass. In early Christian churches this separation was not deemed necessary, with the space between the nave and altar being divided, if at all, by a row of columns. In *Byzantine churches such columns were joined by a low parapet to form an *iconostasis, on which numerous *icons were hung. These structures developed into the more formal separation of space between the altar and nave as a result of religious reform in the 10th and 11th centuries, which emphasized the divide between the laity and the clergy.

The rood-screen was a symbolic frontier between the temporal and spiritual worlds, and the rood represented the essential link between the two; a visible proclamation of Christ's sacrifice. The screen, usually made of wood, was often elaborately carved, and could also include a subsidiary altar for the laity, which was particularly associated with the Mass of the Dead. Late medieval screens were frequently carved in an exuberant *Gothic style with fretted tracery, pinnacles, and arcades. They were generally painted with images of saints. In England particularly fine examples can be seen at York and Canterbury, while on the Continent those at Albi and Troyes cathedrals in France and at Halberstadt in Germany are also noteworthy.

In England many rood-screens were torn down during the Reformation. Although in some parts of Europe they were still being erected well into the 16th century, they were soon regarded as an archaic feature that quickly went out of fashion. Many were destroyed during the 18th century and their fragments reused in different architectural contexts. HO/TJH

ROPS, FÉLICIEN (1855–98). Belgian printmaker and painter. Rops settled in Paris in 1874, and rapidly established himself as an illustrator of esoteric and erotic literature. He was admired by many of the leading *Symbolist writers, including J. K. *Huysmans and, most importantly, *Baudelaire, who was responsible for launching him into the Parisian art world. Rops's art developed from Symbolism towards *Surrealism in his metamorphic depictions of obscene and blasphemous monsters. He also explored the darker aspects of Satanism and the occult. His best works are the illustrations he produced for Baudelaire's *Fleurs du mal*, and Joséphin Péladan's *Le Vice suprême*, and a series of etchings, *Les Sataniques*, which exploit his talent for the depiction of contemporary evil and his hostility to women to devastating effect, as in *Pornokrates* (1896; etching). Hailed as the leader of 'Dark Symbolism', he rejected the lyrical aspects of the movement in favour

of deliberately shocking images and juxtapositions, perverse, erotic, and bizarre. JH

Pierard, L., *Félicien Rops* (1949).

ROSA, SALVATOR (1615–73). Italian painter and printmaker, poet and actor, most celebrated for a new kind of wild and rocky *landscape. Immensely ambitious, and inordinately vain, Rosa claimed a new kind of artistic independence, and came to symbolize the *Romantic concept of unfettered genius. Born in Naples, he studied with his brother-in-law Francesco Fracanzano (1612–?56) and with Aniello Falcone (1607–56); his earliest works are genre scenes and *battle paintings, close to those of Falcone. He is said to have sketched landscapes directly from nature, in oil on paper, and with Micco *Spadaro contributed to a developing school of naturalistic landscape in Naples. He was in Rome 1635–9, and in Florence 1640–9, where he was patronized by Giancarlo de' Medici, and painted landscapes, vast harbour and coastal scenes, and battle pieces. Such works as *The Mill* (Corsham, Methuen Coll.) and *Landscape with a Bridge* (Florence, Pitti) are indebted to Dutch and Flemish landscape artists, and to *Claude Lorrain, and suggest a Tuscan taste for the charms of country life. But his stern and condemnatory *Self-Portrait* (early 1640s; London, NG) conveys a darkening vision, which found expression in his satirical poetry, whose theme was the corruption of courtly life, in paintings of the harshest Cynic and Stoic philosophers of Antiquity, and in macabre scenes of witchcraft. In 1649 Rosa, avid for fame, left for Rome, where he wished to cast off his reputation for genre and landscape, and to be accepted as a learned painter of large-scale *history paintings. He chose unusual, pessimistic subjects, which suggest the vanity of human endeavour, such as *Democritus in Meditation* (1650; Copenhagen, Statens Mus. for Kunst) and *Humana fragilitas* (c.1656; Cambridge, Fitzwilliam), a new kind of philosophizing allegorical picture. His works of the early 1660s, whose relief-like compositions are indebted to *Poussin and *Raphael, are increasingly *Classical, and a series of large etchings was intended to spread his fame as a history painter. The late 1660s saw a return to a more *Baroque style, and a renewed interest in macabre subjects. But his landscapes remained more successful, and Rosa painted both large, heroic works, such as *Landscape with the Baptism of Christ* (mid-1650s; Glasgow, AG) and smaller paintings, with dead branches and craggy rocks, enlivened by bandits (an etched series of *Figurine* (1656) were particularly popular) and anchorite saints. These are landscapes of withdrawal, and in the 18th century the landscapes of Rosa and Claude came to typify the *sublime and the beautiful. HL

Kitson, M., Langdon, H., Mahoney, M., and Wallace, R., *Salvator Rosa*, exhib. cat. 1973 (London, Hayward).

Scott, J., *Salvator Rosa* (1996).

ROSALES Y MARTÍNEZ, EDUARDO (1836–73). Spanish painter. Rosales was born in Madrid and studied philosophy before training at the Academia de S. Fernando (see under MADRID) under Federico de *Madrazo. He was orphaned before he was 20 and poverty and bohemianism undermined his health and curbed his ambitions. In 1857 he visited Rome where he was inspired by *Raphael's Vatican frescoes and the *Nazarenes whose influence may be seen in *Tobias and the Angel* (1860; Madrid, Prado). Often hospitalized and tubercular, Rosales was awarded a state pension which enabled him to complete *The Testament of Isabella the Catholic* (1863; Madrid, Prado), the finest example of Spanish 19th-century *history painting, which won him the Legion of Honour and a gold medal when shown in the Paris Exposition Universelle in 1867. From 1866 to 1871 he worked on *The Death of Lucretia* (Madrid, Prado) in a looser painterly style developed from his study of *Velázquez, which received an unenthusiastic reception. Disappointed by this, Rosales departed for Murcia, where he painted *plein air landscapes until his untimely death, shortly before taking up the directorship of the Spanish Academy in Rome. DER

Revilla Uceda, M., *Eduardo Rosales en la pintura española* (1982).

ROSENQUIST, JAMES (1933–). American painter, born in Grand Falls, N. Dak., one of his country's leading *Pop artists. After studying at the Minneapolis School of Art and the University of Minnesota, he won a scholarship to the Art Students' League, New York (1955–6), where he met Robert Indiana (1928–), Jasper *Johns, and Robert *Rauschenberg. During the 1950s he supported himself for several years as a commercial artist and billboard painter, and he later recalled his excitement on entering an advertising factory for the first time in 1954 and seeing 'sixty-foot long paintings of beer glasses and macaroni salads sixty-feet wide. I decided I wanted to work there.' He was the only major Pop artist who knew this part of the advertising world as an insider. In 1962 he had his first one-man exhibition (at the Green Gallery, New York), in which he adapted the imagery of his advertising work. Rosenquist has sometimes incorporated objects such as mirrors and neon lights in his paintings, and in the 1970s he began experimenting with printmaking, but he has continued to produce his characteristic billboard-style works. IC

ROSICRUCIANS, an esoteric order of artists associated with the Decadent and *Symbolist movements. The so-called Ordre de la Rose-Croix du Temple et du Graal was revived in the 1880s by the art critic and impresario Sâr Joséphin Péladan. The codified aims of the order were in tune with the mystical, Wagnerian preoccupations of the *fin de siècle*, notably the resolutions to 'destroy *Realism and to bring art closer to Catholic ideas, to mysticism, to legend, myth, allegory, and dreams'. Rose-Croix Salons were held 1892–7.

Participation was by invitation and the opening exhibition at Durand-Ruel's gallery, dominated by the work of Alexandre Séon and Carlos Schwabe, included work by *Pont-Aven artists Charles Filiger and Émile *Bernard as well as the Swiss artists Ferdinand *Hodler and Félix *Vallotton. An androgyne *Pre-Raphaelite form of beauty was favoured. The movement was short-lived, largely because many of the notable artists deemed worthy of inclusion—Gustave *Moreau, *Puvis de Chavannes, Odilon *Redon, *Burne-Jones, Maurice *Denis—declined to take part. BT

Pincus-Witten, R., *Occult Symbolism in France: Joséphin Péladan and the Salons de la Rose-Croix* (1976).

ROSLIN, ALEXANDRE (1718–93). Swedish portrait painter mainly active in France. From 1745 until 1752, when he settled in Paris, Roslin travelled through Germany and Italy painting the local notables in the cities he visited. In Paris he built up a flourishing business as one of the more successful society painters in the generation after *Nattier. He had a particular talent for conveying good breeding and the colours and textures of silk, velvet, and hair powder. His 1761 portrait of the *Marquis de Marigny* (Versailles), minister of the arts under Louis XV, is a good example of his attractive but superficial style. That he could convey a deeper sense of character with a less elevated sitter is demonstrated by his oval portrait painted in 1760 of his fellow painter *François *Boucher (Versailles). MJ

Lundberg, G. W., *Roslin Liv och Verk* (1957).

ROSSELLI, COSIMO (1439–1507). Member of a Florentine family of artists. Cosimo reflects many of the tendencies in Tuscan art of the later 15th century although his work lacks the distinctiveness or innovation of contemporaries like *Verrocchio, *Pollaiuolo, or *Botticelli. His early style suggests that he trained in the circle of Benozzo *Gozzoli but the surviving frescoes in the churches of SS Annunziata and S. Ambrogio in Florence demonstrate his grasp of *perspective and rectilinear design. By 1481 he was sufficiently prominent to be invited to

Rome where he undertook four of the frescoes in the lower part of the Sistine chapel alongside Botticelli, *Perugino, and *Ghirlandaio. Cosimo's contribution to this scheme is widely regarded as the weakest of the group, although *The Crossing of the Red Sea* has some notable features. In the latter part of his career he concentrated mainly on altarpieces for Florentine families and confraternities in which the fine modelling and elegance of the figures helped to soften the dull compositions. From the evidence of his pupils, Cosimo must have been a good teacher; *Piero di Cosimo and Fra *Bartolommeo both trained in his studio.　　　　　　　　　PSt

Ettlinger, L. D., *The Sistine Chapel before Michelangelo: Religious Imagery and Papal Primacy* (1965).

R OSSELLINO BROTHERS. Italian sculptors from Settignano. **Bernardo** (1409–64), a sculptor and architect, with his brother **Antonio** (1427–79) ran one of the most important workshops in Florence during the middle of the 15th century. Bernardo's early works in sculpture include three tabernacles, for the abbey of SS Fiora and Lucilla in Arezzo (1435; destr.) and the Badia in Florence (1436), and for S. Egidio in Florence (1450). His sculptural masterpiece is the tomb of Leonardo Bruni (1446–8; Florence, S. Croce), which incorporates the recumbent effigy of Bruni on a severe classical bier, perched on a sarcophagus, and the whole framed within a niche whose design is derived from *Brunelleschi's entrance to the choir of the Old Sacristy in S. Lorenzo. The tomb became a model for niche tombs for the next century. His purely architectural activity includes the interiors of the Palazzo Rucellai in Florence, and the design and building of the cathedral and the Palazzo Piccolomini in Pienza 1461–3.

Antonio's sculptural style was more decorative, and several of his Madonna and Child groups (e.g. London, V&A) display a warm humanity and sweetness of expression. His major commission was the monument of the Cardinal of Portugal in S. Miniato al Monte (Florence; 1461–6), which forms part of a rich complex of painted and sculptural chapel decoration. Antonio's portrait sculptures demonstrate an acuity of vision, particularly in the *Giovanni Chellini* (c.1456; London, V&A), which is a virtuoso exercise in representation. His numerous Christ child and S. John the Baptist busts may be disguised portraits of Florentine children.　　　　　　　　　HO/AB

Pope-Hennessy, J., *Italian Renaissance Sculpture* (4th edn., 1996).

R OSSETTI, DANTE GABRIEL (1828–82). English poet and painter, born in London. Rossetti was a precocious, charismatic, but ill-disciplined student who left the RA Schools (see under LONDON) in 1848 for a brief pupillage with Ford Madox *Brown. In the same year he was a founder member of the *Pre-Raphaelite Brotherhood and he exhibited *The Girlhood of Mary Virgin* (London, Tate) in 1849. In 1850 he painted his first subject from the works of Dante, who remained a lifelong inspiration. From 1854 he prospered under the patronage of John *Ruskin and produced his finest work, a series of highly individual and enigmatic watercolours, including *The Tune of Seven Towers* (1857; London, Tate), in 1856 and 1857. These were partly influenced by a passing interest in Arthurian subjects fuelled by his association, as mentor, with William Morris and Edward *Burne-Jones who joined him in an ill-fated attempt to decorate the Oxford Union in 1857. In 1859 he abandoned Pre-Raphaelite principles to paint *Bocca baciata* (Boston, Mus. of Fine Arts), a bust portrait of his mistress Fanny Cornforth, the prototype for much of his popular and lucrative later work in which beautiful women are posed in exotic surroundings under fanciful titles. After the suicide of his wife and pupil Elizabeth Siddal in 1862, he lived in great style, with a menagerie of animals, in Cheyne Walk. From 1868 until the mid-1870s he conducted an affair with Jane Burden, the wife of William Morris, which may have contributed to his breakdown and attempted suicide in 1872 and his subsequent depression and paranoia. She remained his principal muse until his death and he immortalized her in such works as *Proserpine* (1874; London, Tate).　　　　　DER

Rodgers, D., *Rossetti* (1996).
Surtees, V., *The Paintings and Drawings of Dante Gabriel Rossetti* (2 vols., 1971).

R OSSO FIORENTINO (1494–1540). Italian painter, one of the founders of *Mannerism in *Florence, he was also influential in its introduction to France through his work at *Fontainebleau. As his nickname indicates, Giovanni Battista di Jacopo Rosso was born in Florence, where he worked in the studio of *Andrea del Sarto. With del Sarto's pupil *Pontormo, he developed an intensely expressive style derived from the *classicism of del Sarto and Fra *Bartolommeo. Rosso's individual vision is already evident in the clashing colours and eccentric forms of his 1516–17 fresco of the *Assumption of the Virgin* for SS Annunziata, Florence (*in situ*). The fresco was not well received, and subsequent commissions were also controversial. According to *Vasari, his altarpiece of the *Virgin and Child* (1518; Florence, Uffizi) was rejected because the attendant saints, who appear to be quarrelling, were deemed 'devilish'. With prospects uncertain in Florence, and after a legal dispute involving his pet baboon, Rosso withdrew to Volterra. There he continued his reputation for controversy with the colourful and indecorous *Deposition of Christ* (1521; Volterra, Pin. Comunale), which suggests north European influence, possibly prints by *Dürer. In Rome from 1524, he was much affected by the monumental figures of *Michelangelo, as is clear from the sensual and idealized *Dead Christ* (c.1526; Boston, Mus. of Fine Arts). After the Sack of Rome in 1527, Rosso worked his way north, eventually accepting an invitation to join *Primaticcio and other artists at the court of the French King François I. The voluptuous elegance of his most important project there, the decoration (1536–9) of the Grande Galerie at the Château de *Fontainebleau with allegorical paintings in elaborate stucco surrounds, became widely influential through engravings.　　　LH

Franklin, D., *Rosso in Italy* (1994).

R OSSO, MEDARDO (1858–1928). Italian sculptor. Born in Turin, Rosso trained as a painter before studying sculpture briefly at the Brera Academy, Milan. From 1884 to 1885 he worked in *Dalou's studio in Paris and from 1889 spent most of his career there. Rosso knew *Rodin, whom he was to accuse of plagiarism, and shared his interest in fluidly *impressionistic sculpture, attempting to catch the immediate impact and freshness of direct vision in which changing atmospheric effects break up the permanent identity of the object. In works like the virtually abstract bronze *Conversazione in giardino* (1893; Rome, Gal. Nazionale d'Arte Moderna) he far exceeded Rodin's impressionism. A modeller, rather than a carver, his experimental techniques included wax over plaster, as in *Ecce Puer* (1906–7; Detroit, priv. coll.) which emphasized the transitory nature of appearances, and the incorporation of real objects into sculptures. His use of everyday subjects, like *The Bookmaker* (1894; New York, MoMa), was also revolutionary. By 1900 he had an international reputation and *Apollinaire considered him 'the greatest living sculptor'. Later his work was praised by the *Futurists who adopted and developed many of his ideas.　　　　　　　　　DER

Caramel, I., et al., *Medardo Rosso*, exhib. cat. 1994 (London, Whitechapel AG).

R OTHKO, MARK (Marcus Rothkovich) (1903–70). Russian-born American *Abstract Expressionist and an important pioneer of *colour field painting. Largely self-taught, he began painting as a social realist, and progressed to Expressionist and abstract *Surrealist works such as *Baptismal Scene* (1945; New York, Whitney Mus.), before beginning the colour field paintings for which he is known (c.1947). In these paintings, Rothko sought the simplest means to achieve clarity of purpose. Using one or more horizontal cloudlike rectangles, hovering above each other, he painted or stained his canvases to create extraordinarily evocative images,

sometimes vibrant as in *Number 10* (1950; New York, MoMa), and sometimes menacing, as in later works like the series *Black on Maroon* and *Red on Maroon* (1958–9; London, Tate). Their large size and his staining technique suggest a debt to his experience as a theatrical scene painter. Rothko considered the murals painted in 1967–9, for a chapel in Houston, Texas (now the Rothko chapel), his masterpieces. With *Baziotes, *Motherwell, and *Newman, he founded Subjects of the Artist, an art school dedicated to a search for simplicity (1948/9). Troubled by depression, he committed suicide. YJ

Mark Rothko: 1903–1970, exhib. cat. 1987 (London, Tate).

ROTTENHAMMER, JOHANN (Hans) (1564–1625). German painter and draughtsman. One of several northern artists who travelled to Italy in the late 16th century, where he was commissioned by leading patrons, such as Emperor Rudolf II (see PRAGUE) and the Gonzagas (see MANTUA), Rottenhammer specialized in small-scale and meticulously painted mythological subjects on copper, in which landscape plays a prominent role. Son of a court equerry in Munich, he was apprenticed in 1582/3 to the court painter, Hans Donauer. In 1591/2 he is documented in Rome, where he met and collaborated with Paul *Bril on two copies (1596; Treviso, Mus. Civico) of lost works by Jacopo *Bassano. By the mid-1590s, Rottenhammer was working in Venice, where he was commissioned to paint an *Anunciation* (*in situ*) for S. Bartolomeo to replace *Dürer's *Virgin of the Rose Garlands* (Prague, Národní Gal.). Venetian art made a lasting impact upon Rottenhammer. *The Coronation of the Virgin* (London, NG) is stylistically indebted to *Veronese and *Tintoretto. His workshop in Venice became a focus for other visiting northern artists such as *Elsheimer. In 1606, he moved to Augsburg, where he remained until his death, carrying out a number of larger altarpieces for German churches. CFW

Bosque, A. de, *Mythologie et maniérisme* (1985).

ROTTMAYR, JOHANN MICHAEL (1654–1730). Austrian Baroque painter. He was one of the foremost exponents of decorative fresco painting in the Austro-Hungarian Empire in the early 18th century. He trained in Venice in the studio of the German painter Johann Carl Loth (1632–98), but was also influenced by the large-scale works of Pietro da *Cortona and *Rubens. These two masters remained the inspiration behind Rottmayr's sumptuous and grandly composed, illusionistic decorative schemes throughout his career. Among them are ceiling frescoes in S. Matthew, Wrocław (completed 1706), and the Liechtenstein

Gartenpalais, Vienna (1706–8). MJ

Hubala, E., *J. M. Rottmayr* (1981).

ROUAULT, GEORGES (1871–1958). French painter. Born in Paris, Rouault was first apprenticed to a painter of stained glass, whose glowing colours and strong black lines remained with his student throughout his life. In 1891 Rouault became a pupil at the École des Beaux-Arts, *Paris, studying under Gustave *Moreau. Despite associating with *Matisse and *Marquet, he was influenced by Moreau's *Symbolist-inspired religious work but soon abandoned this style, and under a new strength of religious conviction began painting violent denunciations of a fallen world, full of judges, clowns, and prostitutes, for example *Head of a Tragic Clown* (1904; Zurich, Kunsthaus). In 1906 he began a long association with the dealer Vollard with whom he later collaborated on a number of editions of prints. During the German occupation he was important as an elder figure in the patriotic, French, Catholic group of artists Les Jeunes Peintres de la Tradition Française. His work gained a new serenity after the war, and brighter colours returned in such pieces as *Teresina* (1947; priv. coll.) MF

Courthion, P., *Georges Rouault* (1962).

ROUBILIAC, LOUIS-FRANÇOIS (1702–62). The most accomplished sculptor to work in England in the 18th century and a major innovator in the *Rococo style. He was born in Lyon and trained in Dresden with Balthasar *Permoser and in Paris, perhaps with Nicolas *Coustou. By 1735 he was settled in London among the French Huguenot community and his first independent commission was a statue of *George Frederick Handel* (1738; London, V&A) for Vauxhall Gardens. This work, informal and more up to date in concept than anything conceived by such established sculptors as *Rysbrack or *Scheemakers, was not immediately followed by any more large works. Roubiliac had to content himself instead with building up a practice as a maker of portrait busts. In his aptitude for capturing the character of his sitters with naturalism and grace as well as in his ever-inventive treatment of the head-and-shoulders format he was easily the equal of his compatriots Jean-Baptiste *Lemoyne and, later, *Houdon. Through his career he modelled or carved a brilliant gallery of his contemporaries, including *Alexander Pope* (1738; Leeds, Temple Newsam House); *William Hogarth* (*c*.1740), and *David Garrick* (*c*.1758; both London, NPG); as well as posthumous busts of eminent Englishmen such as the Jacobean scholar *Sir Edward Cotton* (1757; Cambridge, Trinity College). With his first important metropolitan tomb, that for John, Duke of Argyll (1745–9), in Westminster

Abbey, Roubiliac introduced a lively and Frenchified version of the Italian Baroque *funerary monument to England. This was an immediate success and more commissions followed, culminating in the drama of those to General William Hargrave (1757) and to Joseph and Elizabeth Nightingale (1761), both at Westminster Abbey. The former has the classically draped general rising from his sarcophagus, while around him the pyramid of Eternity crumbles and the figure of Time breaks his scythe. The latter, to a lady who died of a miscarriage after a flash of lightning, has a memorable *Berniniesque skeletal figure of Death emerging from a door beneath the main group, armed with the fatal bolt. These are the most suave and accomplished sculptures of their kind ever produced in England, yet in the last analysis it must be acknowledged that, unlike Roubiliac's portrait busts, they lack the degree of integration in their composition that would make them equal to similar contemporary French monuments by Michel-Ange *Slodtz or *Pigalle. The same may be said of the small number of standing figures carved by Roubiliac, though one, the *Sir Isaac Newton* (1755; Cambridge, Trinity College), is outstanding by any standards, embodying as it does all the sculptor's imaginative insight as a portraitist. A number of Roubiliac's terracotta and plaster sketch models may be seen at the V&A, London, throwing valuable light on his working methods. HO/MJ

Bindman, D., and Baker, M., *Roubiliac and the Eighteenth-Century Monument: Sculpture as Theatre* (1995).
Esdaile, K. A., *The Life and Works of Louis-Francis Roubiliac* (1928).
Whinney, M., *Sculpture in Britain 1530–1830* (rev. edn., 1988).

ROULETTE, an engraving tool with at its end a small toothed wheel which is used to puncture the plate with regular dots, for the purpose of *stipple engraving, or the more linear crayon manner. It was first used in the 18th century, primarily in England and France. RGo

ROUSSEAU, ÉTIENNE-PIERRE-THÉODORE (1812–67). French landscape painter. Born in Paris, Rousseau received a conventional academic training but devoted himself to landscape painting. He visited the mountainous Auvergne in 1830 and exhibited at the *Paris Salon in the following year. Success seemed inevitable when his *Ruisdael-inspired *Forest of Compiègne* was bought by the Duke of Orléans in 1834 but his pioneering practice of painting direct from nature and growing objectivity was sufficiently unorthodox to cause regular rejection from the Salon for the next decade. From 1836 he worked mainly in the forest of Fontainebleau, specializing in woodland

scenes such as *Edge of a Forest, Sunset* (1850–1; Paris, Louvre). In 1848 he settled in the village of Barbizon where he was joined in 1849 by his friend J.-F. *Millet. The latter was never a member of the *Barbizon School, the group of landscape painters, including *Diaz and Constant Troyon (1810–65), who were loosely associated with Rousseau and shared his preoccupation with directly observed landscape and atmospheric effects. He achieved success in the 1850s despite his earlier disappointment, and was highly prolific. His late works, after 1863, were influenced by Japanese woodcuts. DER

Schulman, M., *Théodore Rousseau* (1997).

ROUSSEAU, HENRI-JULIEN-FÉLIX, also called Le Douanier (1844–1910). French late 19th-century *naive painter. Henri Rousseau served in the infantry in Angers before becoming a member of the Parisian toll service at the gates of the city. He developed an interest in painting late in life and was self-taught through copying in the Louvre. Rousseau, on Paul *Signac's advice, submitted a work which was exhibited at the Salon des Indépendants in 1886; and he exhibited there for the rest of his life. This venue was to provide a vital arena for more unconventional art production.

Rousseau was inspired by a variety of subjects, especially portraits, landscapes, and exotic themes. His portraits have a certain stillness and awkwardness which is arresting: artistic friends, like the painter Marie *Laurencin and the poet Guillaume *Apollinaire, the novelist Pierre Loti, and family members, especially strange, monumental children. *Myself, Portrait-Landscape* (1890; Prague, Národní Gal.) is typical of the stark contrasts of scale and the symbolic settings of Rousseau's portraits. The artist in beret, palette in hand, stands on the quais of his beloved Seine with the Eiffel Tower (a controversial symbol of modernity for some, of delight to Rousseau who was fascinated by the 1889 Exposition Universelle) asserting his identity as a 'modern master'.

Rousseau's submission to the 1905 Salon d'Automne, *The Hungry Lion* (priv. coll.), may have inspired Louis Vauxelles's famous epithet *'Fauve' (*Gil Blas*, 17 Oct. 1905). Drawn to exotic climes and creatures in his imagination, but not, despite the mythology, in actual experience, Rousseau derived his portrayal of jungle flora and fauna from visits to Paris's Jardin des Plantes. The enigmatic sexuality and strange juxtapositions of a work like *The Dream* (New York, MoMA) have been claimed as precursors to *Surrealism.

Although Rousseau did not achieve fame in official circles, failing in his three entries to the public competitions for the decoration of Parisian town halls, he was greatly admired by young writers and artists. Champions and friends of Rousseau included Alfred Jarry and Rémy de Gourmont, founders of the journal *L'Ymagier* which celebrated *folk art; the painter Pablo *Picasso, who held a banquet for Rousseau, Robert *Delaunay, and Wassily *Kandinsky; and the dealer William Uhde, who wrote the first monograph.

See Louvre, Salon d'Automne, and Salon des Indépendants under PARIS. CIRO'M

Henri Rousseau, exhib. cat. 1985 (New York, MoMa). Uhde, W., *Henri Rousseau* (1911).

ROUSSEAU, JEAN-JACQUES (1712–78). French philosopher of Swiss birth. Despite his training as an engraver, the visual arts had little appeal to Rousseau and he had little to say about them. Nevertheless his anticlassicist ideas and the elevation of nature over culture that lies at the heart of his writings from *Julie, ou la nouvelle Héloïse* (1761) to the famous *Contrat social* (1762) were crucial to the development of the intellectual and moral climate in which *Romanticism flourished in 19th-century Europe and North America. Opposed to the rules and certainties of the *Neoclassicists, Rousseau put forward divinely created nature, rather than man-made culture, as the condition to which all art should aspire. It is above all in *landscape art that Rousseau's ideas were influential. This was most obviously, and ironically, the case with the gardens at Ermenonville, near Paris, laid out with exquisite care and great expense by Rousseau's patron Louis-René Girardin, to conform with those described in *Julie*. But, more importantly, Rousseau's ghost haunts naturalist landscape painting through to *Barbizon and perhaps beyond. MJ

Cranston, M., *The Noble Savage: Jean-Jacques Rousseau, 1754–1762* (1991).
Robinson, P. E. J., *Rousseau's Doctrine of the Arts* (1984).

ROWLANDSON, THOMAS (1757–1827). English caricaturist and draughtsman. Rowlandson trained at the RA Schools (see under LONDON), leaving in 1778 to practise as a watercolour painter specializing in attractive young women, in the manner of *Wheatley, and grotesque subjects which owe a debt to *Mortimer. The elegance of his style reveals the influence of both *Gainsborough and French *Rococo painters whose work he knew from engravings. In 1784 he made the first of several British tours making sketches which were intended for publication, exhibited the masterly *Vauxhall* (London, V&A), and received the patronage of the Prince of Wales who purchased *The English Review* and *The French Review* (1786; Windsor Castle, Royal Coll.) from the RA. His satires on Georgiana, Duchess of Devonshire, also done in 1784, are among his few political *caricatures and lack the savagery of *Gillray. In 1789 he received an inheritance which he had dissipated by 1793 when, despite great productivity, he was living in poverty. Fortunately in 1797 he was employed by the print dealer Rudolph Ackermann (1764–1834) who published, among other works, the *Fish Market, Amsterdam* from his watercolour of 1794 (Bolton, AG). Ackermann commissioned *The Microcosm of London*, a collaboration between Rowlandson and A. C. Pugin (1762–1832), in 1808 and published most of his later prints. The highly popular adventures of *Dr Syntax*, which satirize *picturesque pretension, were issued as books from 1812 to 1821. In the early 1820s Rowlandson visited Italy and resumed his studies of the *Antique. His vast output, including the erotica that damaged his later reputation, is uneven but works like *The 'Stare-case', Somerset House* (c.1800; New Haven, Yale Center for British Art) reveal a masterly talent. DER

Hayes, J., *Rowlandson* (1972).

RUBENS, SIR PETER PAUL (1577–1640). Flemish artist, one of the greatest painters of his age. He was born in Siegen, Westphalia, the son of Jan Rubens, a Protestant lawyer from Antwerp, who had left his home town to escape religious persecution. Most of Peter Paul's childhood, however, was spent in Cologne, where he and his elder brother Philip were encouraged by their learned father to develop their considerable intellectual gifts. In 1589, two years after the death of Jan Rubens, his widow and their children returned to Antwerp, having first officially reconverted to the Catholic faith.

In Antwerp Peter Paul attended a well-known grammar school, leaving in 1590 to become a page to the Countess de Ligne-Arenberg at Oudenarde. Life at this provincial court must have been frustrating to the young man, but it may have taught him lessons in etiquette and diplomacy which were to be valuable in his later career. In 1591 Rubens began his training as a painter: with a kinsman, the landscape artist Tobias Verhaeght (1561–1631); from 1592 with Adam van Noort (1562–1641), also the teacher (and later father-in-law) of Jacob *Jordaens; and from c.1594/5 with the erudite Otto van *Veen, the most influential of his three teachers and one of the most distinguished artists in Antwerp. The few identified works from this period show the style of van Veen as well as a knowledge of Italian Renaissance prints.

In 1598 Rubens became a master in the Antwerp painters' guild, and in 1600 he left for Italy where he spent eight formative years. Nominally in the service of the Duke of *Mantua, he travelled to other cities where he studied the art of classical *Antiquity and of his Italian predecessors and contemporaries, and accepted commissions from individual patrons and church authorities. In 1603

he was sent to Spain by the Duke with presents for Philip III and his court. His most important commission in Spain, and his most successful early work, is the *Equestrian Portrait of the Duke of Lerma* (Madrid, Prado), which set the standard for future portraits of this type. Similarly, on visits to *Genoa, he painted a series of full-length portraits of the local aristocracy, which were to inspire van *Dyck on his visit to that city in 1621 (Washington, NG).

But unlike his northern compatriots, known in Italy primarily for their landscapes and portraits, Rubens established himself successfully as a history painter. At Mantua, he decorated a room with scenes after Virgil's *Aeneid* (1602, fragments only; Prague, Castle Mus.; Paris, Louvre) and executed three large altar paintings for the new Jesuit church (1604–5; *Baptism of Christ*; Antwerp, Koninklijk Mus. voor Schone Kunsten; *Transfiguration*; Nancy, Mus. des Beaux-Arts; *Gonzaga Family Adoring the Trinity*, fragments only; Mantua, Palazzo Ducale; Vienna, Kunsthist. Mus.). In Rome, he was commissioned twice for altarpieces, first for S. Croce in Gerusalemme (1601–2; now Grasse, chapel of the Municipal Hospital) and then for S. Maria in Valicella (1607; first version in Grenoble, Mus. des Beaux-Arts; 1608; second version *in situ*).

In 1608 Rubens returned home. *Antwerp, at this time, had lost its position as a powerful international centre of trade, but it had become instead the cultural headquarters of the Counter-Reformation in Flanders. It had a lively artistic community and its wealthy burghers, together with the Church and the court at Brussels, provided patrons. This was a desirable setting for an artist of Rubens's stature and talents. In 1609 he was appointed painter to the Archduke Albert of Austria and his wife the Infanta Isabella, the rulers of the Southern Netherlands by appointment from Spain. By his own wish, he did not live at court but established his workshop in Antwerp. In the same year he married Isabella Brant, daughter of one of the city's secretaries. The portrait he painted of himself and his young wife sitting in a honeysuckle bower (Munich, Alte Pin.) reveals something of the intimate side of his life.

Rubens's public activity is attested by an astonishing series of commissions during the years 1609–21. They included two major altarpieces for Antwerp churches, the triptychs with the *Raising of the Cross* and the *Descent from the Cross*, the latter for the cathedral (now both Antwerp Cathedral); *The Miraculous Draught of Fishes* for the church at Malines; the designs for a series of tapestries of the history of Decius Mus, to which van Dyck and Jan *Wildens, who were members of Rubens's workshop, contributed (Vaduz, Liechtenstein Coll.); altarpieces and sketches for 39 ceiling paintings for the new Jesuit church at Antwerp. The church was destroyed by fire in 1718 and all the ceiling paintings, which were

largely executed by van Dyck, were lost, but the small oil sketches survive, mainly in the Vienna Academy, the Courtauld Institute Galleries, and the Ashmolean Museum, Oxford. Although Rubens continued to paint autograph pictures—portraits of the Regents, of his family and friends, collectors' pictures on biblical or mythological themes, or of exotic animal hunts (for example Munich, Alte Pin.)—many of the public commissions were executed by the studio, working from coloured oil sketches by the master, such as those for the Jesuit ceiling. In 1622 Rubens published *Palazzi di Genova*, an architectural pattern book of plans and façades to show his countrymen how to replace what he termed their 'barbaric or Gothic' style of architecture with one that conformed 'to rules of the ancient Greeks and Romans'. The house he built for himself in Antwerp helped to popularize the style.

For the Jesuit church Rubens had created not only altarpieces but an entire, and quite novel, interior decoration based on Venetian models, specifically those of *Titian and *Veronese. In 1622–5 he executed, again with studio aid, a large cycle of paintings glorifying the life of the Queen Mother of France, Marie de Médicis, for her new palace of the Luxembourg (now Paris, Louvre). This was to be paired with a series of paintings extolling Marie's late husband Henri IV, which was never completed (e.g. Florence, Uffizi). The pictorial language Rubens created for the Médicis series—a combination of narrative and allegory—is demonstrated again, this time in a sacred context, in his designs for tapestries representing the *Triumph of the Eucharist* for the Infanta Isabella's favoured convent in Madrid, the Descalzas Reales (1625–7; tapestries, Madrid, Descalzas Reales; sketches, Chicago, Art Inst.; Cambridge, Fitzwilliam; Bayonne, Mus. Bonnat; Madrid, Prado; and other collections). At this time, he also painted two important altarpieces for Antwerp churches: the *Assumption of the Virgin* for the high altar in the cathedral and the *Madonna and Child Enthroned with Saints* for the church of S. Augustine. Both works, in their greater luminosity and vibrancy, betray the influence of Titian, who was to become the overwhelming artistic experience of Rubens's last years.

In 1626 Rubens's wife Isabella Brant died and the artist became increasingly involved in diplomatic work to promote the reunification of the Netherlands and peace in Europe. Initially sent on secret missions on behalf of the Infanta, he soon found himself in the role of full-fledged diplomat with orders from the Spanish court (see MADRID). His political missions—to Spain in 1628, and to England in 1629–30—resulted not only in a peace treaty between these two countries (though his ultimate goal, the reunification of the Netherlands, was never achieved), but

also brought him major decorative commissions from the art-loving monarchs Philip IV and Charles I (see LONDON): for the ceiling of Inigo Jones's Banqueting Hall in Whitehall (completed 1634; London, *in situ*), and for Philip's hunting lodge near Madrid, the Torre de la Parada, a series of mythological paintings based on Ovid's *Metamorphoses* (completed, almost entirely by assistants, c.1636–8; ensemble destr.; remaining paintings Madrid, Prado; autograph sketches Brussels, Mus. Royaux; Bayonne, Mus. Bonnat; Rotterdam, Boymans-van Beuningen Mus.; and others). Most significant for Rubens however was his encounter with the works of Titian in the Spanish collections, especially the mythologies the latter painted for Philip II, of which Rubens made painted copies (Madrid, Prado; Knowsley Hall, Merseyside).

The third major cycle on which Rubens worked during the 1630s was the festive decorations he designed for the entry into Antwerp on 17 April 1635 of the Cardinal-Infante Ferdinand, the new Regent of the Southern Netherlands. Closer to his heart than either of the large royal commissions, Rubens took the opportunity to plead on behalf of his city's stricken economy in images traditionally reserved for princely flattery (recorded in engravings by Theodoor van *Thulden, published 1642, and preserved in a series of oil sketches). His political ideals are more famously evoked in two allegories on the subject of war and peace: *Minerva Protecting Peace from Mars* (1629–30; London, NG), painted in England for Charles I, and *The Horrors of War* (c.1637; Florence, Pitti), sent to the Medici court.

In 1630 Rubens remarried, to the young Helena Fourment. She was the epitome of all Rubensian models and appears in many of his late works, not only in portraits but in the guise of various saints and deities. Many of these paintings, especially the portraits and mythologies, are of a more intimate nature than much of Rubens's previous work. Meanwhile he continued to receive public commissions. Besides the great cycles already referred to, he painted altarpieces for churches at home and abroad, among them the altarpiece of S. Ildefonso, with its portraits of the Archduke and the Infanta (c.1631–2; Vienna, Kunsthist. Mus.) But here also one finds the boundaries between the public and the private becoming less distinct as Rubens uses public commissions, such as the decorations for the entry of Ferdinand, to express his personal concerns for the city of Antwerp and his country.

The last four years of his life Rubens spent in quasi semi-retirement in the newly purchased country manor Het Steen (London, NG). Here he painted for his own pleasure an astonishing series of pictures. Especially remarkable are his landscapes with their pioneering observations of light and reflections,

weather and atmosphere (London, NG, Wallace Coll., Courtauld Inst. Gal.; Oxford, Ashmolean). His genre scenes are variations on rustic themes first popularized by Pieter *Bruegel the elder (the so-called *Kermesse flamande*, Paris, Louvre), and fantasies on courtly or pastoral love which were the source of the 18th-century *fête galante* (*The Garden of Love*; Madrid, Prado).

Rubens's genius encompassed every branch of the visual arts common in the 17th century: he executed singly or with the help of the studio altarpieces and large-scale mural and ceiling decorations for churches or palaces; he painted individual canvases and panels for patrons, the art market, or himself; he furnished designs for tapestries, sculpture, silverwork, and prints (mainly title-pages). His subject matter is far-reaching. Primarily a *history painter, he also executed *portraits, *landscapes, and, to a lesser degree, genre scenes; only still lifes are absent from his œuvre. At the basis of his art as well as his immense production lies draughtsmanship. He came to draw with the brush as with the chalk or pen. The accuracy of his designs enabled assistants to work from them; the assurance and vibrancy of his strokes brings his compositions to life, whether in their preliminary stages or the large canvases and panels executed by studio assistants and retouched by him. The other keystone of his genius was the luminosity of his colour, which was influenced by the Venetians, especially Titian, but inspired by the earlier Flemish tradition. His manner of juxtaposing primary and complementary colours anticipated French 19th-century developments.

Though one of the greatest painters of his age, Rubens did not content himself with painting only. His diplomatic work has already been mentioned, as has his interest in architecture. He was also scholarly, an insatiable reader, collector of books, antiquities, and other works of art. He corresponded on all manner of subjects with the most erudite people in Europe. His letters, as well as the testimony of his contemporaries, present a man of independent mind, strong conviction, impeccable tact, and, in the few surviving personal documents, warm affections. The high degree to which Rubens was valued by his princely patrons is witnessed by the honours and privileges bestowed on him: Archduchess Isabella made him her adviser and confidant; Philip IV appointed him secretary of the Spanish privy council; Charles I knighted him, as did Philip IV. These honours were, of course, connected to his diplomatic activities. Yet it is as painter that Rubens's fame endured throughout the centuries. His work affected not only countless contemporaries but also successive generations of artists even into the 20th century.

His portraits became the standard for aristocratic portraiture; his landscapes revolutionized the genre. But is is, above all, his power of conveying energy and emotion through the brilliancy of his colour, the fluency of his brush strokes, and the mastery of his compositions that has proved universal. KLB

Lohse Belkin, K., *Rubens* (1993).

White, C., *Peter Paul Rubens, Man and Artist* (1987).

RUBLEV (or Rublyov), ANDREI, S. (1360?–c.1430). Considered to be among the greatest Russian religious painters. A monk at the Trinity-S. Sergei Monastery at Sergeev Posad, and also the Andronnikov Monastery (now the Andrei Rublev Museum, Moscow), he is recorded as painting, with *Theophanes the Greek, of whom he was a pupil, and Prokhor Gorodtskii, at the cathedral of the Annunciation of the Moscow Kremlin in 1405; three *icons from here have been attributed to him. In 1408 he painted at the Cathedral of the Dormition at Vladimir with Daniil Chernyi. Other documented works are largely destroyed. In 1422 he returned to the Trinity-S. Sergei Monastery where he painted the *Old Testament Trinity* (Moscow, Tretyakov Gal.), showing the three archangels enjoying the hospitality of Abraham, and, in collaboration with Chernyi, the *iconostasis of the Trinity Cathedral. His painting represents an extension of the *Byzantine tradition and was a major influence in the development of the Moscow and consequently other Russian schools of icon painting. PCo

Sergeev, V. N., *Rublev* (1981).

RUBRIC, explanatory or introductory heading or phrase opening a text or section of text in a manuscript or printed book. So called from the Latin for red, because they were written in red to distinguish them from the text itself. KS

RUDE, FRANÇOIS (1784–1855). French sculptor of the *Romantic generation. He won the *Prix de Rome in 1812, but there were no government funds to send him to Italy. An enthusiastic Bonapartist, he fled to Belgium after the final defeat of the Emperor in 1815. He worked there until his return to Paris in 1827, exhibiting his first memorable work at the 1831 Salon. This was the *Neapolitan Fisherboy* (Paris, Louvre), a seated nude figure of startling naturalism for its time. Two years later Rude was given the commission for one of the four huge groups decorating the Arc de Triomphe in Paris. Completed in 1836, *The Departure of the Volunteers of 1792* (popularly known as 'The Marseillaise') is not only one of the most dynamic and exciting pieces of Romantic sculpture, but one of the most famous nationalist images in France, rivalled only by *Delacroix's *Liberty Leading the People*. Its combination of classical costume and allegory with a vigorous and pungent naturalism (the female Genius of Liberty which tops the group was accused by one conservative critic of resembling a fishwife) is extremely potent. It is continued in gentler vein, combined with an increasing awareness of French *Renaissance sculpture by Germain *Pilon and others, in such later masterpieces as *Napoleon Reawakening to Immortality* (1845–7; Fixin, Parc Noisot) and the tomb figure of the republican, politician Godefroy Cavaignac (1845–7; Paris, Montmartre Cemetery). His last work, a curiously truncated and moving torso of *Christ on the Cross* (1855; Paris, Louvre), was inspired by a fragment of the 14th-century sculptor Claus *Sluter's ruined *Calvary* in Rude's native Dijon. MJ

Fourcauld, L. de, *François Rude, sculpteur: ses œuvres et son temps* (1904).

Quarre, P., *La Vie et l'œuvre de François Rude* (1947).

Pingeot, A. (ed.), *La Sculpture française au XIXe siècle*, exhib. cat. 1986 (Paris, Grand Palais).

RUISDAEL, JACOB VAN (1628/9–82). Widely considered the most accomplished and inventive of all Dutch *landscape painters of the 17th century. Ruisdael was born in Haarlem, where he is thought to have been trained by his father Isaac Jacobsz. van Ruisdael (a painter, frame-maker, and dealer) and his uncle Salomon van *Ruysdael. He seems also to have been influenced by the work of the local painter Cornelis *Vroom. His earliest dated pictures are from 1646, but curiously he is not recorded as a member of the painters' guild in Haarlem until two years later. In 1650 Ruisdael visited Bentheim in Germany probably with his friend the painter Nicolaes *Berchem, who sometimes collaborated with him and painted the figures in his landscapes. By 1657 he had settled in Amsterdam, where he probably died, although he was buried in Haarlem.

Ruisdael seems to have been an idiosyncratic, isolated figure, who had an ability to convey a sense of deep melancholy and yearning through much of his work. He produced distinguished drawings, paintings, and etchings, all of which are sensitive to subtle variations of light and spatial recession. His view of the natural world involved exploring its variety and nobility; recurring motifs in his work include mysterious trees in dark, ancient forests, waterfalls and torrents, and fields of golden corn transfixed by sunlight. The waterfalls start to appear in his work particularly from the 1650s onwards, and seem to have been inspired by the paintings of Allart van *Everdingen, who had visited Scandinavia.

The cycles of nature and the themes of

growth, decay, and mortality are most brilliantly explored in Ruisdael's *The Jewish Cemetery*, which is known in two versions (Dresden, Gemäldegal.; Detroit, Inst. of Arts). In these works the tombstones and ruins which indicate the finite nature of human endeavour contrast with the enduring power of nature's capacity for regeneration.

Ruisdael inspired many other artists; among the most distinguished of his pupils was *Hobbema. CB

Slive, S., and Hoetink, H. R., *Jacob van Ruisdael*, exhib. cat. 1981–2 (The Hague, Mauritshuis; Cambridge, Mass., Fogg Art Mus.).

R UMOHR, KARL FRIEDRICH VON (1785–1843). German critic and art historian. As a scholar of considerable independent means, Rumohr was able to study the arts of Italy at leisure and for a long time lived in Florence and Rome. He was also an art collector and a key figure in the museum politics of Berlin, Dresden, and Copenhagen. His crucial work, the *Italienische Forschungen* (1827–31), focuses on the Italian High *Renaissance and can be considered as one of the first truly empirical pieces of art historical literature. Breaking away from the often doctrinal outlook of classicist art criticism, but also from the subjectivism of the *Romantics, the study is primarily based on Rumohr's first-hand knowledge of the monuments and on a critical assessment of scrupulously collected archival material. The book was widely acknowledged by his contemporaries as being authoritative and formed one of the principal sources for the more descriptive parts of Hegel's *Aesthetics*. Amongst Rumohr's other published works are a cookery book (1822), a manual on etiquette (1834), and a fable in rhymed verse (1835). AT

R UNGE, PHILIPP OTTO (1777–1810). German Romantic painter of symbolic subjects. His mystical approach resembles that of his older British contemporary William *Blake. His painting style, however, is far more naturalistic. He was also a theorist and published an important treatise on colour (*Der Farbenkugel*, 1810). Born in Pomerania, he studied first in Copenhagen and then in Dresden. Inspired by such Romantic writers as Novalis and Ludwig Tieck he planned a cycle of the *Times of Day*, publishing a series of four outline engravings of the scheme in 1803. This project preoccupied him for the rest of his short life. In 1806 he went to live with his brother Daniel, a merchant in Hamburg. By the time of his death he had only one picture in the cycle near completion, *Morning* (1810; Hamburg, Kunsthalle). This shows a fascinating combination of allegory and intense naturalistic effect. Runge was also a penetrating portraitist, particularly of

children, as can be seen in his *Hülsenbeck Children* (1806; Hamburg, Kunsthalle). WV

Traeger, J., *Philipp Otto Runge und sein Werk* (1975).
Vaughan, W., *German Romantic Painting* (2nd edn., 1994).

R UOPPOLO FAMILY. Neapolitan *still-life painters. **Giovanni Battista** (1629–93) was the leading still-life painter in Naples in the second half of the 17th century and his work reflects the stylistic developments in that school. His early work, such as *Still Life with Celery and Guelder Roses* (early 1650s; Oxford, Ashmolean), shows the weighty plasticity and naturalism that had characterized previous Neapolitan still life, under Spanish and *Caravaggesque influence. In the 1660s he expanded his repertoire to include, for example, vivid paintings of fish in the manner of Giuseppe *Recco. He later turned to baroque compositions of fruit, flowers and vegetables which, after 1675, reflect the presence in Naples of Abraham Breughel. Despite the increasing emphasis on decorative aspects, however, his work kept its vigour and amplitude until the paintings of his last years. According to de *Dominici, he was the uncle of the still-life painter **Giuseppe Ruoppolo** (d. 1710). The latter still remains a shadowy figure, though his accepted works tend to confirm the fairness of de Dominici's comment that he was infelicitous in composition though he painted with great truthfulness. AJL

Volpe, C., in *Painting in Naples from Caravaggio to Giordano*, exhib. cat. 1982 (London, RA).

R USCONI, CAMILLO (1658–1728). Italian sculptor who was one of the last exponents of the heroic *Baroque style. He worked briefly in Rome with Ercole *Ferrata before embarking on an independent career. Typical of his work are the four over-life-size marble statues of apostles that he contributed to Borromini's redecoration of the nave of S. John Lateran. *S. Andrew, S. John, S. Matthew*, and *S. James* (1708–18) were boldly interpreted from designs by Carlo *Maratti. Among his many tombs the best known is that in S. Peter's to Gregory XIII (1715–23). While this maintains the compositional type established by the earlier papal monuments of *Bernini and *Algardi, Rusconi introduced a note of elegant intimacy into the work, announcing the lighter touch of his *Rococo successors. MJ

Enggass, R., *Early Eighteenth-Century Sculpture in Rome* (1976).

R USIÑOL I PRATS, SANTIAGO (1861–1931). Spanish (Catalan) painter and writer. Rusiñol was born in Barcelona where he studied under Tomás Moragas (1837–1906). His first exhibition, of conventional academic paintings, was held c.1878. In 1889

he went to Paris, where he lived with his friend and fellow Catalan Ramón Casas (1866–1932). They exhibited their *Impressionist-influenced Parisian scenes at the Sala Pares, Barcelona, in 1890 and 1891, which established them at the forefront of the newly emergent Catalan Modernisme, a movement which included writers, musicians, architects, and designers. An intellectual, Rusiñol was a founder of the Moderniste festivals at Sitges in 1892. The performance of *La intrusa* by the Belgian Symbolist playwright Maurice Maeterlinck (1862–1949) at the second festival (1893) signalled Modernisme's move from Impressionism to *Art Nouveau and *Symbolism, exemplified by Rusiñol's paintings *Music, Painting*, and *Poetry* of 1894 (Sitges, Mus. Cau Ferrat). From 1897 Rusiñol was associated with the artists and intellectuals centred on the café Els Quatre Gats which included the young *Picasso, who soon rebelled against the decorative symbolism of Rusiñol's generation. Later he specialized in painting gardens and achieved success as a playwright. DER

Santiago Rusinol, exhib. cat. 1981 (Barcelona, Mus. d'Art Modern).

R USKIN, JOHN (1819–1900) English writer. Ruskin, who was born in London to wealthy, indulgent parents, was a precocious child who studied voraciously. From 1833 he made frequent continental journeys before entering Oxford in 1837. In 1840 Ruskin, who was himself a skilful amateur artist, met J. M. W. *Turner, whose work he knew from engravings, eulogized him in volume 1 of *Modern Painters* (1843), and became his patron and executor. On leaving Oxford his writings and lectures on art and society soon established him as the pre-eminent critic of his times. In 1851 he championed the embattled *Pre-Raphaelites, who had themselves been influenced by his insistence on 'Truth to Nature'. *The Seven Lamps of Architecture* (1849), which extolled the virtues of *Gothic, and *The Stones of Venice* (1851–3), which claimed art as the manifestation of the moral state of society, presaged his later political writings and the idealistic Guild of S. George, which he founded in 1871, and inspired William Morris (1834–96). In 1878 he suffered the first of several mental breakdowns and was insane for the last decade of his life. DER

Hewison, R., et al., *Ruskin, Turner and the Pre-Raphaelites*, exhib. cat. 2000 (London, Tate).
Hunt, J. D., *The Wider Sea* (1982).

R USSELL, MORGAN (1886–1953). American painter, active mainly in Paris; with Stanton *MacDonald-Wright he was the founder of *Synchromism, one of the earliest abstract art movements. Russell was born in New York, the son of an architect. Originally

he intended following his father's profession, but on a visit to Paris in 1906 he was overwhelmed by the *Michelangelo sculptures he saw in the Louvre and decided to become a sculptor. After returning to New York he studied sculpture at the Art Students' League and painting under Robert *Henri. In 1908 he settled in Paris, where he met the American collectors Gertrude and Leo Stein and through them *Matisse, at whose art school he briefly studied. By 1910 Morgan was turning away from sculpture and devoting himself increasingly to painting, and in 1911 he met MacDonald-Wright, with whom he developed theories about the analogies between colours and musical patterns. In 1913 they launched Synchromism, and Russell's *Synchromy in Orange: To Form* (1913–14; Buffalo, Albright-Knox Gal.) won him considerable renown in Paris. His later work, in which he reintroduced figurative elements, was much less memorable than were his pioneering abstract paintings. From about 1930 much of his work consisted of large religious pictures. He lived in Paris until 1946, then returned to the USA. IC

RUSSIAN ART. From the conversion of Russia to Orthodox Christianity in 988, until the reign of Peter the Great (ruled 1682–1725), art on Russian soil was essentially an importation of ecclesiastical models, chiefly *icons, derived from *Byzantine art. Practised first in Kiev, and after the Mongol invasion of 1237 in the northern centres of Pskov, Suzdal, Vladimir, and Novgorod, this was a sacred and hieratic form of visual culture, undesirous of change and painted to strict prescription in terms of style and subjects. The merit of iconic art resided chiefly in its function, as an integral part of religious devotion, for which aesthetic calibre, acknowledgement of authorship, or evolution of style were unimportant. A timeless and unworldly quality, unaffected by the flux of material life, was sought, for which unchanging models served successfully. As art in the modern, secular sense, icons, frescoes, and their related ecclesiastical decorative arts were not granted serious consideration until the early 20th century, particularly at the 1913 *Exhibition of Early Russian Art* in Moscow, when newly cleaned and restored artefacts were greeted with great acclaim. It remains a source of great offence to many Orthodox believers that icons should be traded and debated as objects of aesthetic pleasure, but despite the search for an eternal form of visual expression modifications to the Byzantine tradition are observable. The Novgorod School of the 13th century shows the influence of folk traditions and introduction of local colour schemes, whilst at the close of the 14th century we hear of the first of the renowned masters of icon painting operating within the Moscow School, *Theophanes the Greek. His

best work was surpassed only by his pupil, the monk Andrei *Rublev, now regarded as the greatest of all Russian masters, whose *Old Testament Trinity* (early 15th century; Moscow, Tretyakov Gal.) for the Cathedral of the Trinity at the Trinity-S. Sergei Monastery is perhaps the most famous of Russian images. A more expressionistic insistence on elongation of form and refined coloration marks the work of the 15th-century master Dionisy (c.1440–after 1502–3). Despite fierce resistance on the part of the Church to check secular portraiture and the advent of foreign stylistic influences a growing interest in Western art can be discerned in the work of Simon Ushakov (1626–86) in the 17th century, particularly his use of perspective for architectural forms. The parsuna, an early form of secular portrait painted with iconic techniques and stylistic influence, but with expressive individuality replacing schemata, appears at this time when the tsars were perhaps content to allow temporal images to curb the theocratic aspirations of the Church. Symptomatic of this period of transition are the products of the late 16th-century northern workshops on the wealthy Stroganov estates: small, bright, intricately decorated icons conceived with minute detail and stylized naturalism which may be regarded as a significant move towards secularization of art. Peter the Great proved the catalyst to propelling Russian art from native, religious customs to a secular, wholesale adoption of the Western academic tradition. Foreign architects, painters, and sculptors were imported to build and decorate the new capital, St Petersburg, whilst at the same time promising young Russians were sent abroad to complete their studies. By the 18th century the works of Ivan Nikitin (c.1688–1741), Alexei Antropov (1716–95), and Andrei Matveyev (1701–39) show that Russian artists had assimilated the styles, subjects, and techniques of the West. Peter's successors were like-minded. Empress Elizabeth established Russia's first Imperial Academy of Arts in 1757, which was opened in 1764 by Catherine the Great. This inculcated a thorough technical training, aimed at producing proficient and well-educated artists who would be a credit to the nation. Emphasis was placed on biblical, historical, and classical subjects. Many artists excelled in portraiture, of whom Dmitry Levitsky (1735–1822), Fyodor *Rokotov, and Vladimir Borovikovsky (1757–1825) were the chief exponents. The grand manner of *history painting was introduced by Anton Losenko (1737–73) whose *Vladimir and Rogneda* (1770; St Petersburg, Russian State Mus.) was the first significant national subject which, though treated in a purely academic manner, marked an innovative attention to historical accuracy. This was also a fine period for sculpture, both free standing and decorative;

masters such as Fedot *Shubin and Ivan Martyos (1754–1835) proved that Russia could match the West for technical efficiency and expressive dexterity. Painting in the first half of the 19th century followed a similar *Neoclassical course with occasional influence from *Romanticism, as with Orest Kiprensky's (1782–1826) psychologically introspective or dashingly heroic portraits embodied in his suave image of the poet-soldier E. D. Davydov (1809, St Petersburg, Russian State Mus.). A Romantic approach is evident also in the singular talent of Ivan Aivazovsky (1817–1900), whose breathtakingly luminous seascapes are conceived with audacious coloration and technical daring. A fashion for huge academic historical and religious canvases, facilitated by increased state patronage under Nicholas I, found its most successful exponent in Karl *Bryullov, who gained an international reputation for his heady mix of classicism, Romanticism, and archaeological authenticity. A more traditional but technically impressive academic master was Fyodor Bruni (1799–1875), who specialized in large, complicated historical melodramas. His *Death of Camilla* (1824; St Petersburg, Russian State Mus.) retains the classical purity of *David, whilst *The Brazen Serpent* (1826–41; St Petersburg, Russian State Mus.) shares affinities with the theatricality and emotional intensity of *Géricault. A subversion of academic canon was provided by Aleksandr *Ivanov who adopted an experimental attitude towards the recording of natural phenomena. His invention contributed to a growing proficiency in landscape painting as artists such as Silvestr Shchedrin (1791–1830) similarly broke with convention to paint indigenous scenes from nature. A slow but steady interest in contemporary Russian scenes is observable from the 18th century in the works of Ivan Argunov (1727–1807), Mikhail Shibanov, and I. A. Ermenev (1746–c.1790), which in varying ways addressed the concerns of ordinary working people. *Genre painting gained its legitimacy during the early 19th century, especially with Vasiley Tropinin (1776–1857), who painted faithful and highly popular portraits of professional types surrounded by the accessories of their trade. This work was furthered by Alexei Venetsianov (1780–1847), who democratized subject matter by addressing contemporary peasant life with an authenticity of dress and place, and by Pavel Fedotov (1815–52), who specialized in *Hogarthian satires attacking the abuses of bureaucracy and excesses of the urban bourgeoisie. The 1860s saw the first flowering of critical realism, the works of Vasiley Perov (1833–82), such as *The Drowned Woman* (1867; Moscow, Tretyakov Gal.) answering calls by the intelligentsia for art to expose the social inequalities of autocratic Russia and to seek a

morally reproving and politically regenerative end. Vasiley Pukirev's (1832–90) *The Unequal Marriage* (1862, Moscow, Tretyakov Gal.) showing the wedding of an aged wealthy groom to an impoverished beauty reputedly effected a decline in such unions. The pre-eminence of the Imperial Academy, a bulwark of conservative reactionism, was formally challenged in 1863 when thirteen students seceded from the prestigious gold medal competition on the grounds of lack of artistic freedom. This act of creative independence proved the precedent for the formation in 1870 of the *Peredvizhniki, Russia's first independent school of art, firmly establishing *realism as the dominant artistic force, as practised by its prominent members: *Repin, Ivan Kramskoy (1837–87), Nikolai Yaroshenko (1846–98), and Vladimir Makovsky (1846–1920). Elements of stylistic experimentation were not alien to the society but tended to come from the minority of its members, notably Repin, Isaak Levitan (1860–1900), Vasiley Surikov (1848–1916), Valentin Serov (1865–1911), and the hugely inventive Mikhail Vrubel (1856–1910), who, though never a member of the school, was close to Repin and Serov, existing on the margins of its activity. Vrubel also produced strikingly original works in diverse media at the *Abramtsevo and Talashkino colonies, to which Viktor Vasnetsov (1848–1926) and Mikhail Nesterov (1862–1942) made significant contributions. The remarkable landscape school of the Peredvizhniki, headed by Ivan Shishkin (1832–98), Alexei Savrasov (1830–97), Levitan, and Arkhip Kuindzhi (1842–1910), introduced a fresh and stylistically diverse approach to native scenery. Kuindzhi's formally experimental work, carried forward by pupils such as Nikolai Roerikh (1874–1947), made a decisive impact on early modernism in Russia. The Peredvizhniki held great influence for several decades but the late 19th–early 20th century saw the emergence of several modernist trends unconcerned with art as a reflection of external reality, which challenged their creative monopoly. These included a *Symbolist strain influenced by *Borisov Musatov, but most successfully Sergei Diaghilev's 'World of Art' (Mir Iskusstva) which, whilst not overtly original, wielded enormous influence and international significance during the late 1890s–early 1900s. A loose grouping of young aesthetes, including *Bakst and Alexandre *Benois, they shared eclectic concerns but sought to unite the fine and decorative arts, particularly music, dance, and theatre, whilst stressing the autonomous aesthetic existence of art in place of its social utility. The phenomenally successful Ballets Russes was a synthesis of their various concerns. The rise of a Russian *avant-garde, which was to assume international significance, found its origins in a bewildering diversity of trends by the early 1900s, with much stylistic influence coming also from the West, particularly *Post-Impressionism, German *Expressionism, *Cubism, and the *Fauves. These were augmented with indigenous influences from folk traditions, resulting in the Neo-primitivism of Mikhail Larionov and *Goncharova, exemplified by the *Knave of Diamonds group formed in 1910. Like its Italian counterpart the iconoclasm of *Futurism made a big impact in Russia, glorifying in the celebration of speed, energy, and contemporaneity of the machine age with an antipathy towards 'High Culture'. *The Knife Grinder* (1912; New Haven, Yale University AG) by *Malevich is an early and impressive treatment in this vein. The trend towards abstract, purely formal works is frequently accredited to *Kandinsky, though the Rayonism of Mikhail Larionov (1881–1964), first seen at the *Donkey's Tail* exhibition of 1912, is also a contender. *Suprematism, launched by Malevich in 1915 at the *0.10* exhibition was posited as a purely metaphysical art based solely on abstract, geometrical forms. *Constructivism meanwhile adapted modernist aesthetic concerns to more pragmatic ends, seeking to serve a social function via a move into industrial production, though the visionary nature of many designs, such as the Monument to the Third International projected by *Tatlin, frequently proved impracticable. What characterized a welter of movements too diverse to number, and often in fierce opposition to one another, was a shared sense of utopianism, the desire to move away from representing the world, and to transform it, without reference to moribund artistic language. This revolutionary spirit was initially favoured by the new Soviet state; and for a brief period, following 1917, the avant-garde gained an artistic hegemony in its willingness to serve the Communist regime through propagandistic activities. Constructivist influence was particularly prominent as mass-produced, factory-based art was considered intrinsically proletarian. Many leading proponents of modernism, such as Kandinsky, David Shterenberg (1881–1948), *Rodchenko, and *Chagall, also held influential office or had responsibilities within Narkompros, which, under the progressive leadership of Lunacharsky, Commissar for Popular Enlightenment, was in charge of cultural affairs. With the continued search by the state for a truly proletarian art form, however, the various strands of non-objective art soon began to slip from official approval. The products of the avant-garde were not appreciated by Lenin and the Bolshevik leadership, and as early as 1918 more conservative and legible variations of modernist styles were chosen for Lenin's Decree on Monumental Propaganda. Throughout the 1920s the avant-garde were steadily ousted by the Party in a series of decrees aimed at tightening up the political probity of the visual arts and making them accessible to a mass audience. Many, such as Chagall and Kandinsky, emigrated, whilst others, such as *Mayakovsky, sought refuge in the theatre and in agitational art where their styles were sustained for longer. The *Suprematist-inspired poster of 1920, *Beat the Whites with the Red Wedge* by El *Lissitzky, became a key image of early Soviet propaganda. Much modernist work, however, was greeted with indifference or hostility by a bemused public, and by the early 1920s many artists returned voluntarily to figurative art. OSt (Society of Easel Painters), which included *Deineka, was influential in promoting contemporary figurative art of a formally experimental nature which received Lunacharsky's endorsement. The more virulently pro-Communist AKhRR (Association of Artists of Revolutionary Russia), which included Isaac Brodsky (1884–1939), returned to conventional realism to depict the evolving revolution, stressing modernity of subject over style, and in the process finding favour with both public and the large commissioning powers of the Red Army and trade unions. Though the state increasingly embraced realism as the proper language for the visual arts the process was neither crude nor sudden, official sanction making itself known gradually through pronouncements of Lenin's tastes, increasingly critical reviews of formalist art, and by building on a genuine antipathy on the part of the public and many artists towards non-objective art forms. The official transition to Soviet *Socialist Realism was marked by the 1932 April Decree which dissolved existing artistic groups, instituting one union for each of the professions and effectively establishing the political, centralized control of the arts. This was followed by the influential 1934 First All-Union Congress of Writers, which endorsed Socialist Realism as the only acceptable method of cultural production, the ratified tenets of which were to be applicable to all Soviet arts. The style this 'method' was to adopt, however, was unclear and largely defined by default as the persecution during the 1930s of numberless 'formalists' such as *Klucis, who were condemned as class enemies, meant artists were made painfully aware of what Socialist Realism did not entail. Until the death of Stalin in 1953 the resulting homogeneity of Soviet art, conceived in a purely realist style, with its relentless stress on the cult of the leader, industrial advancement, physical perfection, and above all boundless optimism, exemplified in the works of Stalin's favourite painter Aleksandr Gerasimov (1881–1963), or the gargantuan statues to Stalin by Sergei Merkurov (1881–

1952), was rarely contravened, though a collective rather than individual ethic was a consistent part of state policy. Deineka, *Konenkov, and Vera Mukhina (1889–1953), whose steel colossus *Worker and Woman Collective-Farmer* (1937; entrance to the Exhibition of Economic Achievements, Moscow) has ironically become emblematic of a style to which it does not strictly adhere, are amongst the exceptions as artists working successfully within Socialist Realist confines whilst retaining a stylistic identity and genuine creative dynamism. A terminal date for Socialist Realism remains elusive. Stalin's death undermined its continuation, though in varying degrees it lived on until the Glasnost period of the mid-1980s and still has its adherents and practitioners today. As an artistic philosophy it remains problematic, misunderstood, and wilfully misrepresented, and still awaits a cogent and rational analysis. In some respects too the Socialist Realist and modernist ideologies were very similar. The avant-garde saw their work not as contemplative, but as projects for the restructuring of life, and actively endeavoured to silence all opposition to this enterprise. It has been conjectured that the avant-garde project was accomplished, in reality, by Stalin, albeit using different means and more questionable methods. DJ

Cullerne Bown, M., *Art under Stalin* (1991).
Hamilton, G. H., *The Art and Architecture of Russia* (1983).
Sarabyanov, D. V., *Russian Art from Neoclassicism to the Avant-Garde* (1990).

RUYSCH, RACHEL (1664–1750). Dutch still-life painter. Daughter of a renowned Amsterdam anatomist and amateur painter, Ruysch was apprenticed to Willem van *Aelst in 1679. She became one of the most famous and best-paid *flower painters, celebrated by contemporary poets and her biographer Jan van Gool. After her marriage in 1693 to the portrait painter Juriaen Pool, they both moved to The Hague, where they joined the painters' guild in 1701. Ruysch was appointed court painter to the Elector Palatine in Düsseldorf. On his death in 1716, she returned to Amsterdam, working vigorously until the age of 83. Her compositions are of two kinds. A typical early work is *Forest Floor* (1687; Oxford, Ashmolean). Red flowers, fungi, and a butterfly are asymmetrically arranged and glow in the darkness at the bottom of a tree-trunk on the forest floor. Later compositions are almost exclusively floral bouquets, characterized by sumptuous or sometimes simple, curvaceous arrangements, placed on a ledge, also against a dark background. Colours can be rich or pastel tones of great subtlety as in *Flowers in a Vase* (London, NG). CFW

Harris, A. Sutherland, and Nochlin, L., *Women Artists* (1984).

RUYSDAEL, SALOMON VAN (c.1600–70). The uncle of Jacob van *Ruisdael and father of Jacob Salomonsz. van Ruysdael, Salomon was a prolific and important Dutch landscape painter in his own right. He was born in Naarden, and is recorded as a member of the painters' guild in Haarlem in 1623. He lived in this city throughout his life, and his earliest dated painting is of 1626. Who Ruysdael's master was has not been established, but he clearly came under the influence of Esaias van de *Velde, who is known to have been in Haarlem between 1610 and 1618. There are also stylistic links between his painting and that of Jan van *Goyen. In the 1620s and 1630s Salomon van Ruysdael developed a monochrome style, although he later changed direction and worked in a more colourful and broader manner. He often concentrated on views of rivers or estuaries with a strong diagonal axis, and also occasionally painted seascapes. CB

Stechow, W., *Salomon van Ruysdael* (2nd edn., 1975).

RYDER, ALBERT PINKHAM (1847–1917). American painter. Ryder was born in New Bedford, Cape Cod, and was self-taught before arriving in New York c.1870, where he studied, briefly, at the National Academy of Design. He first exhibited in 1873 and in 1877 was a founder of the Society of American Artists. He remained, however, totally independent of both American and, despite several visits between 1877 and 1896, European artistic movements. His paintings were the product of a fertile imagination, love of the sea, and the transcendental aspirations common to several 19th-century American painters. As he wrote, 'I am trying to find something out there beyond the place on which I have a footing.' The mystical element in his work, whether simple seascape, like *Toilers of the Sea* (pre-1884; New York, Met. Mus.), or grandiose literary subject, like *Jonah* (c.1890; Washington, Smithsonian), was achieved through the simplification of form into essence, eerie lighting, and unnatural colour. His paintings had a long gestation and longer execution during which the paint surface was built up by palette knife into a thick impasto. A reclusive and eccentric figure whose unorthodox technique was sometimes disastrous, Ryder is now seen as a great original whose formal reductionism foreshadowed contemplative abstraction. DER

Broun, E., *Albert Pinkham Ryder* (1989).

RYEPIN, ILYA. See REPIN, ILYA.

RYSBRACK, MICHAEL (1694–1770). English sculptor of Flemish birth. The son of an Antwerp landscape painter, he trained with Michiel van der Voort, inheriting a bold *Baroque manner derived ultimately from *Rubens. He settled in London around 1720 and executed *funerary monuments designed by the architect James Gibbs, including that in Westminster Abbey to the poet Matthew Prior (1721; the bust is by *Coysevox). He also began to specialize in portraits of his contemporaries, rapidly becoming the most fashionable portrait sculptor of the day. Among his sitters were *James Gibbs* (1726; London, S. Martin-in-the-Fields), *Sir Robert Walpole* (1738; London, NPG), and *Alexander Pope* (1757; Cambridge, Fitzwilliam). These works, formal, frontal, and often in classical dress, show the influence of *Antique sculpture, solemnizing Rysbrack's Baroque style in a way that suited the temper of Augustan England. Rysbrack was also much in demand for chimney pieces, decorative reliefs, and tombs. His marble monuments to Sir Isaac Newton (1731; Westminster Abbey) and the Duke of Marlborough (1733; Blenheim, Oxon.) are the best in 18th-century England before the arrival of *Roubiliac, while the bronze *equestrian statue of *William III* in Bristol (1736) eschews the dynamism of contemporary French examples for a calm dignity inspired by the Antique statue of *Marcus Aurelius* in Rome. Although Roubiliac and, to some degree, *Scheemakers provided competition from the 1740s Rysbrack continued to be the choice of more conservative patrons. HO/MJ

Eustace, K., *Michael Rysbrack*, exhib. cat. 1982 (Bristol, AG).
Webb, M. I., *Michael Rysbrack* (1954).

RYSSELBERGHE, THÉO VAN (1862–1926). Belgian painter, graphic artist, and designer, born in Ghent. He was a founder of the avant-garde Groupe des *Vingt (XX), which was formed in 1883 to encourage interest in innovative art, mainly through contact with France. He was considered in his time to be the leading Belgian artist of the *Neo-Impressionist School, playing a particularly important role in the field of portraiture. In 1898 he moved to Paris, where he met *Seurat and adopted his system of Divisionism; he was also associated with the *Symbolist circle of artists and writers. His painting *A Reading* (1903; Ghent, Mus. voor Schone Kunsten) shows several leading literary figures, including André Gide and Maurice Maeterlinck. In 1910 he settled in Provence, where he abandoned Neo-Impressionism for a broader style of painting. OPa

Pogu, G., *Théo van Rysselberghe* (1963).

SACCHI, ANDREA (1599–1661). Italian painter and draughtsman. The pupil of *Albani and master of *Maratti, he was the leading representative of the classical tradition in Roman painting in the mid-17th century. He profoundly admired *Raphael and in his best work emulated harmonious spirit of Raphael's compositions and his portrayal of individual emotions. In the debates at the Accademia di S. Luca (see under ROME) around 1636 he supported the classical theories of pictorial design against Pietro da *Cortona's desire for more crowded, complex, and animated *Baroque compositions. His ceiling fresco of the *Allegory of Divine Wisdom* (c.1629–31) in the Palazzo Barberini, although not, in the final analysis, a successful work, initiated a new type of allegorical decoration that was conceived to create the illusion that a miraculous vision had appeared in the open sky. It was later overshadowed by Pietro da Cortona's more spectacular *Allegory of Divine Providence* (c.1632–9) in the Gran Salone of the same palace. His most famous altarpiece, the *Vision of S. Romuald* (1631), was painted for the Camaldolese order (now Vatican Mus.). It is a sensitive and contemplative work, painted with muted and unemphatic colour, the white-robed monks set against a cool landscape; it would later inspire *Mola when he painted the *Vision of S. Bruno* (c.1662–3; Los Angeles, Getty Mus.). A similar delicacy and even greater intimacy characterizes the *Hagar and Ishmael in the Wilderness* (c.1633; Cardiff, National Mus. Wales). In 1639 he was commissioned to direct the redecoration of the Lateran Baptistery (S. Giovanni in Fonte) although the execution of the frescoes was entrusted to other artists, including Maratti. In 1649 he completed another intimate and emotionally affective altarpiece, the *Death of S. Anne* (Rome, S. Carlo ai Catinari). Sacchi also painted a number of successful portraits ranging from the relaxed demeanour of *Monsignore Clemente Melini* (Rome, Borghese Gal.) to the nervous intensity of *Cardinal Francesco Barberini* (Cologne, Wallraf-Richartz-Mus.).

Although Sacchi lacked *Poussin's intellectual depth and did not share his preoccupation with classical *Antiquity, he was in many respects a kindred spirit, seeking the same kind of reflective morality in his approach to painting. According to his biographer G. B. Passeri, Sacchi, who was an accomplished draughtsman, allowed Poussin to frequent his studio to draw from the nude. And Poussin's painting style may, momentarily, c.1630, reflect a response to the calm dignity and restrained palette of Sacchi's work; this influence is perhaps seen in his light toned and delicate *Muses on Parnassus* (c.1630–2; Madrid, Prado). HB

Schaar, E., and Sutherland Harris, A., *Die Handzeichnungen von Andrea Sacchi und Carlo Maratti: Kataloge der Kunstmuseums Düsseldorf* (1967).
Sutherland Harris, A., *Andrea Sacchi* (1977).

SACRA CONVERSAZIONE (Italian: sacred conversation), a type of religious painting in which the Virgin and Child and several saints respond to one another within a unified space and lighting scheme. The term has come to describe the new form of *altarpiece developed in Italy during the 15th and 16th centuries replacing the late medieval triptych or polyptych. The *sacra conversazione* placed the Virgin and Child along with a selection of saints into an illusionistic space, usually defined by a continuous ground plane and an architectural setting that exploited the techniques of linear *perspective. The Florentine painters of the 1430s and 1440s, notably Fra *Angelico and *Domenico Veneziano, were among the first to explore this new type. *Piero della Francesca's Brera altarpiece of the *Virgin and Child* (c.1475; Milan, Brera) is a fine example in which the pictorial space of the painting is linked to the real space of the spectator to extend the illusion. The *sacra conversazione* saw further development in Venice in the circle of Giovanni *Bellini and it proved to be a very flexible and expressive

form for *Raphael in the evolution of the High *Renaissance style in Rome. PSt

Kemp, M., and Humfrey, P. (eds.), *The Altarpiece in the Renaissance* (1990).

SACRO MONTE (Italian: holy mountain), a mountainside where a series of chapels, each containing thematically linked tableaux of life-size sculptures and *illusionistic frescoes, leads the pilgrim to a monastery at its summit. The wild scenery, and the sense that the mountain is a setting for divine revelation, add to the aesthetic impact. The first was at Varallo (from 1486), where in the *Crucifixion* chapel (1520–6) Gaudenzio *Ferrari established a theatrical and emotionally charged style. The chapel is filled with strikingly realistic terracotta sculptures, their realism heightened by naturalistic colour, glass eyes, real hair, and fragments of fading drapery. Space is extended by the background frescoes, and the pilgrim, who peers at the scene through a grille, seems, with startling suddenness, to be present at a scene of extreme brutality. *Morazzone and *Tanzio also worked at Varallo, which inspired other sanctuaries in Lombardy and Piedmont, an Alpine region where art was the tool of a Counter-Reformation Catholicism profoundly threatened by the Protestant north. *Sacri monti* also appeared, in the 16th and 17th centuries, in Spain, Portugal, and the Americas. HL

Wittkower, R., 'Montagnes sacrées', *L'Œil*, 59 (1959).

SADELER FAMILY. Antwerp printmakers, print publishers, and art dealers active throughout Europe. The most important members were **Jan Sadeler I** (1550–1600), his brother **Raphael I** (1560/1–1628/32), and their nephew **Aegidius II** (c.1570–1629), the most gifted of the family. They worked in Cologne, Frankfurt, Munich, Venice, and Prague. Jan and Raphael collaborated on most of their work. They were known for their engraved portraits and reproductions of figural scenes and landscapes designed by other artists, such as the *Solitudo* series, after drawings of hermits by Marten de *Vos (c.1587). Aegidius surpassed his uncles both in talent and in his accomplishments as engraver to three Habsburg emperors. In 1597 he was appointed imperial engraver by Rudolf II at Prague, and after Rudolf's death he continued to serve his successors Matthias and Ferdinand II. Joachim von *Sandrart was his pupil. As an engraver (see LINE ENGRAVING), Aegidius was one of the most important artists of his time, particularly for the spread of Rudolfine imagery. Among his most famous works are three allegorical prints after designs by Bartholomäus *Spranger (*Triumph of Wisdom*, c.1600) KLB

Ramaix, I. de, *Les Sadeler*, exhib. cat. 1992 (Brussels, Bib. Royale).

SAENREDAM, PIETER JANSZ. (1597–1665). A pioneer and specialist painter of Dutch church interiors, which he depicted with great precision and delicacy. Unlike most of his predecessors, Saenredam made careful paintings of identifiable buildings, usually the vast, calm spaces within whitewashed Gothic churches. He was born in Assendelft, the son of an engraver. He became a pupil of Frans Pietersz. de Grebber in Haarlem and remained in his studio for ten years before being registered as a member of the painters' guild there in 1623. Saenredam painted buildings in Assendelft, Haarlem, Utrecht, Amsterdam, Alkmaar, 's-Hertogenbosch, and Rhenen. The preparation for his pictures was meticulous. He made drawings with sophisticated *perspectival schemes that are inscribed with the hour and day they were made, and concentrate on innumerable subtleties of variation in colour and tone. Above all his paintings and drawings give a convincing impression of the enormity and luminosity of the church interiors he clearly admired, most notably in *The Interior of S. Bavo's church, Haarlem* (1648; Edinburgh, NG Scotland). CB

Schwartz, G., and Bok, M. J., *Pieter Saenredam: de schilder in zijn tijd* (1989).

SAFTLEVEN, CORNELIS (1607–81). Member of a Dutch family of artists from Rotterdam. Cornelis and his brother Herman II (1609–85) probably trained under their father Herman I. Cornelis was the more versatile artist and his 200 surviving paintings and 500 drawings include portraits, rural interiors, peasant scenes, and illustrations of proverbs as well as biblical and mythological scenes. A work such as *Barn Scene* (1635; Prague, Národní Gal.) shows the impact of *Brouwer and *Teniers. His brother Herman gained a reputation for topographical drawings and small, highly finished painted views of the Moselle and Rhine. CFW

Schulz, W., *Cornelis Saftleven (1607–1681)* (1978).

SAGE, KAY (1898–1963). American painter. Sage was born at Albany, NY, and self-taught as a painter. She lived in Italy 1900–14 and 1919–37 and in the latter period was heavily influenced by the work of *de Chirico. In 1937 she moved to Paris where she associated with the *Surrealists, exhibiting with them at the Salon des Surindépendants in 1938. In 1940 she returned to the USA with Yves *Tanguy, whom she married. She participated in the International Surrealist Exhibition, New York, in 1942 and had a successful career, culminating in a retrospective exhibition at the Catherine Viviano Gallery, New York, in 1960. Her American work is free of Chirico's influence and has more in common with Tanguy, although less biomorphic. Her best-known paintings frequently show upright jagged shapes, reminiscent of half-furled sails, of ambiguous material and construction, set against smoothly painted backgrounds of imaginary desert landscapes or the sea. Sometimes, as in *Tomorrow is Never* (1955; New York, Met. Mus.), she incorporates draperies from which ghostly faces and figures emerge. DER

Suther, J., *A House of her Own: Kay Sage, Solitary Surrealist* (1997).

SAGRERA, GUILLEM (Guillermo) (active 1397–1454). Spanish architect and sculptor born in Mallorca to a family of artists. His first work was in architecture, beginning at the Cathedral of Palma de Mallorca (1397). In 1410 he was in Perpignan, working on the reconstruction of the cathedral; in 1416 he was named Master of the Works. A visit to Dijon during these years is suggested by the Burgundian influence of Claus *Sluter on Sagrera's earliest sculptural commissions such as the figure of *S. Peter* on the Portal del Mirador of the cathedral in Palma (1422). Sagrera supervised the construction of the Llotja (Exchange) of Palma de Mallorca where he carved some of the decorative sculpture (1425–45), but he is best known as an architect. In 1447 he moved to Naples to rebuild the royal Castel Nuovo—his masterpiece—and also worked there as a sculptor. SS-P

Alomar, G., *Guillem Sagrera y la arquitectura gótica del siglo XV* (1970).

SAINT-AUBIN, DE. Family name of four French brothers, draughtsmen, engravers, and designers in the *Rococo manner. The eldest, **Charles-Germain** (1721–86), worked on embroidery designs, wrote a treatise on embroidery, and was patronized by the ladies of the court. **Gabriel-Jacques** (1724–80) was the best known of the four and an etcher of some distinction who satisfied the public taste for anecdotal depiction of daily life in its most elegant and appealing aspects. His views of picture sales and of the Salons are valuable documents for the art historian (e.g. *An Auction*; Bayonne, Mus. Bonnat; *Salon of 1765*; Paris, Louvre). **Louis-Michel** (1731–79), less talented, was attached to the Sèvres factory. **Augustin**, the youngest (1736–1809), was a draughtsman of considerable charm (*Young Lady*; Vienna, Albertina) but lacked the *brio* of Gabriel. He had a large output as an engraver of the

works of *Boucher, *Greuze, and *Fragonard.
HO/MJ

Dacier, E., *Gabriel de Saint-Aubin* (1929).
Moureau, A., *Les Saint-Aubin* (1894).
Prints and Drawings by Gabriel de Saint-Aubin, exhib.
cat. 1975 (Baltimore, Walters AG).

SAINT-GAUDENS, AUGUSTUS (1848–1907). American sculptor. He was the son of a French father and an Irish mother who brought him to New York as a child. He worked as a carver of cameos before going to Paris in 1867, where he entered the École des Beaux-Arts and worked under François Jouffroy. He was well aware of the anticlassical, neo-Florentine tendencies of his French contemporaries and made a study of early *Renaissance sculpture when he went to Italy during the Franco-Prussian War of 1870. The influence of this can be seen in the series of fresh and and characterful portraits in very low relief that he made on his return to the United States, among them that of *Robert Louis Stevenson* (1887). Saint-Gaudens's elongated, nude statue of *Diana the Huntress*, designed in 1892 as a weathervane for Madison Square Garden, New York (now Philadelphia Mus.), was another anticlassical gesture, while the bronze figure of a mourner for the tomb of Mrs Henry Adams (1886–91) at Rock Creek cemetery, Washington, attempts to express a sense of Buddhist resignation within the Western formal tradition of the tomb weeper. He is perhaps best known for his series of ambitious monuments to heroes of the American Civil War. Among them are *Admiral Farragut* (1876–81) in New York, *Robert Gould Shaw* (1884–97) in Boston, and *General Sherman* (unveiled 1903) in New York. Saint-Gaudens's combination of naturalism with simplicity and an urge towards the *Symbolist make him one of the most important figures in later 19th-century American art. His studio in the Cornish Hills of New Hampshire contains a collection of casts from his work. HO/MJ

Dryfhout, J. H., *The Work of Augustus Saint-Gaudens* (1982).

ST IVES SCHOOL. The longest lasting of the many turn-of-the-century art communities, the St Ives School has existed, changing and evolving, through more than 100 years. *Sickert and *Whistler visited the Cornish coastal village in 1883–4, and artists have been attracted ever since by the mild climate, rugged coastal scenery, and luminous clarity of light and atmosphere. In 1890 the St Ives Art Club was formed, and the community grew rapidly, although it was always more loose-knit than the *Newlyn colony, focused around the place rather than any leading artist. Initially painters followed the *plein air* *Impressionism of *Bastien-Lepage, but from the 1920s there existed a parallel naive tradition, influenced by self-taught fisherman-painter Alfred Wallis (1855–1942), and developed by Ben *Nicholson and Christopher *Wood, who visited in 1928. From 1927 the St Ives Society of Artists held regular exhibitions, increasing mutual influence among members; the potter Bernard Leach (1887–1979), arrived in 1920 and broadened the range of St Ives School art.

Nicholson returned in 1939 with the sculptor Barbara *Hepworth, shortly followed by Naum *Gabo, leader of the *Constructivists, laying the foundations of a characteristic St Ives style of *modernism. The Society of Artists yielded to the more avant-garde Penwith Society of Arts in Cornwall from 1949, and during the 1950s Peter Lanyon (1918–64), Bryan Wynter (1915–75), Terry Frost (1915–), and Roger *Hilton developed a form of abstraction based on motifs drawn directly from the interactions of land, sky, and sea. This distinctive reconciliation of abstraction and figuration continues in the work of Patrick Heron (1922–99). St Ives remains a vital artistic centre; the opening of the Tate, St Ives, in 1993 confirms the importance of a community which has provided a breeding ground for the British avant-garde of all eras. JH

Whybrow, M., *St Ives 1883–1993: Portrait of an Art Colony* (1993).

ST PETERSBURG: PATRONAGE AND COLLECTING. Eighteenth-century St Petersburg was a honeypot for artists, art dealers, and craftsmen, rather as *New York has become in the latter half of the 20th century. This was especially true of the reign of Catherine the Great (1762–96), who used the spectacular aquisition of works of art as a political tool, a means of demonstrating her importance to the other sovereigns of Europe. In 1779, at a time when British dominions stretched from North America to India, she scooped up the magnificent collection of paintings formed by Britain's first prime minister, Sir Robert Walpole, which the British were ineffectually trying to turn into a national gallery, thus demonstrating the financial superiority of Russia. In 1772 she bought the incomparable paintings of the French collector Pierre Crozat (1664–1740) (see also PARIS)—eight *Rembrandts, six van *Dycks, three *Raphaels, a *Giorgione, to name only a few—while she was precariously negotiating the partition of Poland on her western flank and fighting the Turks in the south.

Catherine bought some 4,000 old master paintings, an even larger number of drawings and prints, the libraries of Voltaire and Diderot, a good number of *Antique sculptures, and the most important ever collection of engraved gems, as well as commissioning porcelain, silver, and furnishings from all the greatest craftsmen of Europe on an imperial scale—she had a 3,000-piece silver dinner service made by Roettiers in Paris for her lover Count Grigory Orlov.

But Catherine was not the first St Petersburg collector. Peter the Great, who ordained the construction of his new capital on a windswept northern marsh after capturing the territory from the Swedes in 1703, was himself a notable collector. He favoured the *Kunstkammer* approach, combining scientific specimens, curiosities, and art. He opened Russia's first museum in the mansion of a friend he had recently executed—the Kikin Mansion—in 1718. He imported classical sculpture from Rome, decreed the acquisition of Scythian gold from the public purse, and recruited architects and sculptors from Paris.

Alexander Menshikov, Peter's protégé and friend, and the first governor of St Petersburg, was the city's first non-imperial art collector. After his exile for treason in 1728 his works of art were confiscated and merged with the imperial collection and are now hard to identify. His palace, the first to be built in St Petersburg, is an out-station of the Hermitage Museum.

Thereafter most of the great aristocratic families took to art collecting. Ivan Shuvalov, the Empress Elizabeth's lover *en titre*, was a great patron of the arts, founding the St Petersburg Academy of Art to which he gave his painting collection; Catherine the Great bought his Antique sculptures. The Stroganovs, who built the finest non-imperial palace of St Petersburg, designed by Rastrelli, the architect of the Winter Palace, spawned several generations of great collectors.

The 19th century saw the construction of the Hermitage Museum at the back of the Winter Palace—now known as the New Hermitage, since the museum has expanded to fill the whole imperial palace complex—where the cream of the imperial collection could be shown to the public; it opened its doors in 1852. This was the brain child of Nicholas I (ruled 1825–55), a passionate builder and interior decorator, amateur artist, and connoisseur of dictatorial but erratic taste.

The taste of his subjects tended towards the antiquarian rather than the purely decorative, and their collecting interest widened to embrace traditional crafts, archaeology, and oriental art. A host of small museums sprang up in St Petersburg in the second half of the century with a variety of specialist interests, ranging from *icons, to Russian crafts, to *Barbizon paintings. The most magnificent was the Stieglitz Museum, founded by Baron Alexander Stieglitz, a merchant and banker to the court, as a decorative arts museum on the lines of the V&A in London. Its

collections were incorporated into the Hermitage after the Revolution.

The 1917 Revolution was a watershed and put paid to traditional collecting. After a brief period when a plethora of aristocratic palaces were opened as museums, their collections were confiscated, along with those of other private citizens, and either allocated to major museums, such as the Hermitage and the Russian Museum, or put in store. Many such artefacts, along with some important museum exhibits, were sold to the West by Stalin in the late 1920s and early 1930s when he was desperate for foreign exchange. Andrew Mellon, the First Secretary of the US Treasury, managed to obtain 21 great old masters from the Hermitage, which now grace the National Gallery, Washington, and cost him some $7 million.

Collecting then went underground. But behind the double doors that keep the bitter winter draughts out of small St Petersburg apartments, some extraordinary collections of 18th- and 19th-century decorative arts, old and modern paintings, were formed—through scavenging garbage tips, bartering for vodka or food, and inexpensive purchases. Collecting was dangerous in the Soviet years; it could lead to arrest and imprisonment. GN

Burrus, C., Les Collectionneurs russes d'une révolution à l'autre (1992).

Norman, G., The Hermitage: The Biography of a Great Museum (1997).

Piotrovski, M., and Neverov, O., Hermitage Collections and Collectors (1997).

SALIMBENI BROTHERS. Italian painters whose spirited narrative style marks the full flowering of early 15th-century late *Gothic painting in the Marches. Four signed and dated works by **Lorenzo** (1374–1420) survive from the years 1400–7, for instance a triptych (1400; S. Severino, Pin. Civica); a *Crucifixion* (1407; S. Severino, S. Lorenzo in Doliolo). In these he reveals an interest in rhythmic outline, incidental detail, and, sometimes, dramatic expression, all of which were probably influenced by exposure to Bolognese, Lombard, and transalpine miniature painting. In 1416 Lorenzo collaborated with his brother **Iacopo** (active 1416–27) on frescoes for the oratory of S. Giovanni Battista in Urbino; their individual contribution is difficult to establish however. All that is best in their art is expressed there in the great scene of the *Crucifixion*, which is spontaneous in its presentation of daily life and individual types. Equally remarkable is the rich and varied display of costume, which is interesting documentation for the history of dress. These same characteristics are to be found in the brothers' signed but undated frescoes on the life of S. John the Baptist (after 1416?) in

the old cathedral in S. Severino. FB

Zampetti, P., Pittura nelle Marche dalle origini al Rinascimento, vol. 1 (1988).

SALLINEN, **TYKO** (1879–1955). Finnish painter. Sallinen was born at Narmes, the son of a tailor who belonged to the puritanical religious sect of the Hihhulit. His unhappy childhood (he fled aged 14) later formed the basis for some of his pictures including the harshly medieval *The Hihhulit* (1918; Helsinki, Ateneumin). After several years working as an itinerant tailor in Sweden, he studied art in Helsinki and in 1909 went to Paris where he was influenced by the *Fauves, particularly van *Dongen. On his return to Finland he painted the harsh landscape and peasant life of the province of Karelia using a brilliant but tightly controlled palette. *Expressionism prevails in his first important work, *Washerwomen* (1911; Helsinki, Ateneumin), which was criticized for its savagery. In 1917, following the proclamation of national independence, Sallinen founded the November Group (see NOVEMBERGRUPPE) of avant-garde Finnish artists who shared a common interest in nationalism and Expressionism, and soon rose to prominence as the leading Finnish painter, with an international reputation. After the 1920s he painted many landscapes, less colourful than his earlier work, which reveal a structural debt to *Cézanne. DER

Smith, J. B., Modern Finnish Painting (1970).

SALONS. See under PARIS.

SALVIATI, **FRANCESCO** (Francesco de' Rossi) (1510–63). Florentine *Mannerist painter known for his large-scale decorative projects. Initially trained as a goldsmith, Salviati briefly studied with *Andrea del Sarto. In 1531 he went to Rome where he entered into the service of Cardinal Giovanni Salviati, from whom he took his name. In his finest surviving early Roman work, the frescoed *Visitation* in the Oratorio di S. Giovanni Decollato of 1538, Salviati shows his allegiance to his adopted city: the monumental figures derive from *Michelangelo, while the decorative elegance and sinuous line are indebted to the younger generation of Mannerists, notably *Perino del Vaga and *Parmigianino. Peripatetic throughout his career, Salviati worked in Venice (1541) and Rome (1541–3), before returning to Florence in 1543 where he was commissioned by Duke Cosimo de' Medici to fresco the Sala dell'Udienza, in the Palazzo Vecchio in Florence with the story of Furius Camillus. The densely packed and brilliantly coloured compositions have a relentless energy heightened by the bewildering density of surface detail. Salviati's conception, particularly in the play between the decorative

elements and the main compositions, was startling in its originality. In comparison, *Perino del Vaga's near contemporary decorations in the Sala Paolina in the Castel S. Angelo, Rome, seem, for all their grandeur, somewhat staid. During his period in Florence he also painted smaller-scale works of great refinement, such as the *Christ Carrying the Cross* (Florence, Uffizi), and made designs for tapestries.

In 1548 he returned to Rome where he worked on a number of ecclesiastical commissions, including more frescoes in the Oratorio di S. Giovanni Decollato (1550–1) and the *Feast at Cana* in S. Salvatore in Lauro of c.1552–3. His secular fresco decorations in the Palazzo Farnese with episodes from the history of the family (probably begun c.1552, and continued after Salviati's short, and unsuccessful, period in France from 1556 to 1557/8), and the scenes from the life of David in the *salone* of the Palazzo Ricchi Sacchetti (c.1552–4) develop from his work in Palazzo Vecchio. But in both, the witty interplay between the main scenes and the overlapping and superimposed elements of allegorical figures, feigned tapestries, swags, and suspended paintings is of even greater complexity and sophistication.

Salviati was a brilliant and prolific draughtsman. His pen and ink studies, in particular, convey a sense of his rapid and seemingly inexhaustible inventive powers. In his portraits, such as that of a unknown young man (Milan, Mus. Poldi Pezzoli), Salviati's elegant line is combined with a delicacy of colouring, perhaps inspired by Venetian models. HCh

Mortari, L., Francesco Salviati (1992).

SALVIATI, **GIUSEPPE** (Giuseppe Porta) (c.1520×5–c.1575). Tuscan-born painter who worked in Venice. Born north of Lucca, Porta was taken to Rome in 1535 where he studied with Francesco *Salviati, whose name he later adopted. In 1539 he followed his master to Venice, and he remained there. The influence of Francesco Salviati is most apparent in the early painting of the *Raising of Lazarus* (c.1540/5; Venice, Cini Coll.), and in the mannered elegance of his drawings. Gradually the gracefulness and decorative artifice of his master's painting style disappeared from his work, although a concern for sculptural solidity remained. Porta received a number of commissions for Venetian churches, the finest of which is probably the *Pala Valier* (c.1548) painted for S. Maria Gloriosa dei Frari. The austere clarity of paintings such as the *Redeemer and Saints* (Venice, S. Zaccharia) shows his continued loyalty to the Roman manner, and in 1562–5 he returned to the city to paint two frescoes in the Sala Regia in the Vatican, only one of

which, *Frederick Barbarossa Submitting to Pope Alexander III*, was completed. HCh

McTavish, D., *Giuseppe Porta Called Giuseppe Salviati* (1981).

S AMBIN, HUGUES (*c.*1520–1601). Extravagantly ornamental French carver, designer, and architect, recorded at *Fontainebleau in 1544, where *Primaticcio's stuccoes and the Florentine sculptor Niccolò *Tribolo's marble many-breasted *Nature* influenced him. In 1547 he was in Dijon, making decorations for fêtes and official entries to the town, including in 1551 designs for statues after the *Antique. In 1572 his *Œuvre de la diversité des termes* was published in Lyon, using the five orders plus one he invented. These fantastic *Mannerist combinations of figures, satyrs, fruit, flowers, and masks owe much to the engraver and writer Jacques Androuet du Cerceau (*c.*1515–85) and were used enthusiastically by Burgundian carvers and furniture-makers. The preface stresses his status as an architect. A Protestant, he left Dijon 1572–4, protected by Léonor de Chabot, Count of Charny, to whom the book of terms was dedicated. In 1582 he designed the Hôtel de Ville at Besançon and a triumphal column dedicated to the Catholic Duke of Mayenne, followed in 1585 by the Palais de Justice, Dijon (doors now Dijon, Mus. des Beaux-Arts). LL

Hugues Sambin, vers 1520–1601, exhib. cat. 1989 (Dijon, Mus. des Beaux-Arts).

S ÁNCHEZ COELLO, ALONSO (*c.*1531/2–88). Spanish painter of Portuguese origin, born in Valencia but raised and trained in Lisbon. In 1550 he went to Brussels with Anthonis *Mor, who had been in the Portuguese court (see PORTUGUESE ART) portraying the royal family, and remained with him until 1554. That year he returned to Spain and Philip II named him court painter.

In technical perfection and minuteness of detail, Sánchez Coello's courtly portraits are comparable to those of the best contemporary Netherlandish masters. In early portraits (*Margaret of Parma*, *c.*1555; Brussels, Mus. Royaux; *Isabella of Valois*, *c.*1560; Vienna, Kunsthist. Mus.), the ornamental potential of the sitter's apparel is given full play. In later portraits (*Infante Don Diego*, 1577; England, priv. coll.; *Infanta Isabella Clara Eugenia*, 1579; Madrid, Prado) the garments, symbols of the sitters' status, are still described in detail, but given less substance and subordinated to the heads. These works embody perfectly the aristocratic ideal of composure and reserve characteristic of Philip II's court.

Sánchez Coello also painted religious pictures, among them eight altarpieces with paired saints for the basilica of El *Escorial (1580–2). NAM

Brown, J., *The Golden Age of Painting in Spain* (1991).
Mallory, N. A., *El Greco to Murillo: Spanish Painting in the Golden Age: 1556–1700* (1990).

S ÁNCHEZ COTÁN, JUAN (1560–1627). Spanish *still-life painter. He came from Toledo and was a famous painter of still lifes there by 1603 when he professed as a lay brother in the Carthusian order and moved to Granada. His still lifes, which are amongst the earliest in Europe, all depict vegetables, fruit, and sometimes dead birds, arranged against a plain blank niche representing a *cantarero* (a simple cool larder). Cotán, however, suppresses any perception of the humble objects as foodstuff and invests them with other-worldly, sacramental importance by arranging them with mathematical exactitude and by hyper-realist depiction of their texture and volume. In his masterpiece *Still Life with Quince, Cabbage, Melon and Cucumber* (*c.*1600; San Diego, Mus. of Art) the sparse objects are even arranged in a pure hyberbolic curve, implying that the laws of geometry are in some sense themselves the subject of the painting. By contrast, the large figure paintings that he executed for the charterhouses of Granada and El Paular, near Segovia, are comparatively bland and conventional and have little of the austere spirituality of his still lifes. AJL

Bryson, N., *Looking at the Overlooked* (1990).

SANDARAC. See RESIN.

S ANDRART, JOACHIM VON (1606–88). German painter and writer on art, born in Frankfurt. He studied engraving and painting with various masters, most prominently Gerrit van *Honthorst in Utrecht. Here he met *Rubens in 1627, whom he accompanied on a journey through Holland. In 1628 he went with his master to the court of Charles I in London; 1629–35 he worked in Rome, and in 1637 he settled in Amsterdam, where he made a name as a portraitist (*Civic Guard Company of Captain Cornelis Bicker*, 1640; Amsterdam, Historical Mus., on loan to the Rijksmus.). In 1645 he returned to Germany, where he received many commissions for altarpieces. In 1674/5 Sandrart was instrumental in founding the earliest art academy in Germany, at *Nuremberg, and it is for this body that he wrote his major work, the *Teutsche Academie der Bau-, Bild- und Mahlerey-Künste* (1675). Its most valuable part consists of biographies of artists. This contains, in addition to material borrowed from *Vasari and van *Mander, also original material, in particular about German artists of the 15th and 16th centuries and his northern European compatriots working in Rome, among them *Claude Lorrain, *Poussin, Pieter van *Laer, and *Duquesnoy. KLB

Klemm, C., *Joachim von Sandrart: Kunst-Werke und Lebens-Lauf* (1986).

S ANNAZARO, JACOPO (1457–1530). Of noble birth, Sannazaro was a Neapolitan poet, connoisseur, and collector, whose immensely successful romance *Arcadia*, (1504) revived the pastoral poetry of classical Antiquity, and influenced European culture for many centuries. *Arcadia* evokes a sensuously beautiful landscape, enriched by tombs and temples, where shepherds lament lost love; its vitality is expressed by nymphs, satyrs, and woodland gods. It contains descriptions of imaginary paintings, which influenced the pastoral aesthetic of 16th-century Venetian artists and of 17th-century ideal landscape painters. Dolce suggests that *Titian's *Pardo Venus* (Paris, Louvre) was inspired by it. It was famous in northern Europe, and van *Mander's *Den Grondt* describes the sweet pastoral poetry of the *Arcadia*. Sannazaro also wrote five piscatorial eclogues, a new genre, evoking an idyllic seashore life. In Naples he studied archaeology and escorted visitors around the Phlegrean fields; he commissioned Giovanni da Nola (*c.*1488–1558) to carve a *Nativity* for his family chapel, S. Maria del Parto. His tomb is there, a site much visited by *Grand Tourists. Sannazaro's portrait appears in *Raphael's *Parnassus* (Vatican Stanze). HL

Kidwell, C., *Sannazaro and Arcadia* (1993).

S ANO DI PIETRO (1405–81). Sienese painter and illuminator who was a successful figure in early *Renaissance Siena. He is thought to have trained with *Sassetta, whose art was a major influence on the development of Sano's style. In 1444 Sano executed his early masterpiece, the Gesuati Polyptych (Siena, Pin.); this work demonstrates his ability to manipulate form and colour with much sophistication, and to create jewel-like surfaces and precious textures. As his Pienza Cathedral altarpiece (1462) testifies, much of his surviving work from after 1450 shows signs of widespread workshop intervention and, consequently, inconsistencies in quality and finish. Nonetheless, the Pienza work displays a simple and well-balanced composition, a successful handling of space, and restrained gestures; these all contribute to a general feeling of serenity. His work as an illuminator in this same period is of a high standard. In 1459–63 he decorated three psalters (Chiusi Cathedral) for the abbot of Monte Oliveto Maggiore; these are characterized by a spirited narrative style and fresh, vibrant colours. FB

Christiansen, K., in *Renaissance Painting in Siena*, exhib. cat. 1989 (New York, Met. Mus.).

SANSOVINO, ANDREA (*c*.1467–1529). Italian sculptor and architect, named after his birthplace, Monte San Savino, though his family name was Contucci. He trained under *Pollaiuolo and *Bertoldo, first working in terracotta before settling on marble sculpture. In 1491 Lorenzo de' Medici sent him to the court of King João II of Portugal, where he remained intermittently until 1500, though his activity there is unknown. His marble *Baptism* group for the east doors of the Florence baptistery (1502–5) was later completed by Vincenzo *Danti (1568). His fame depends largely on his work outside Florence, in particular his two tombs of Cardinals Ascanio Sforza and Girolamo Basso della Rovere (1505–9; Rome, S. Maria del Popolo), which established a much copied design for tomb architecture, with their triumphal arch, relief and figure sculpture, and the reclining figures of the deceased. His *Virgin and Child with S. Anne* (1512; Rome, S. Agostino) is a solemn yet tender representation of the subject. Between 1513 and 1529 he was occupied as architect and sculptor on the shrine of the Holy House in Loreto, contributing marble narrative reliefs and supervising a team of younger sculptors. Other architectural works are at Jesi (1519) and Monte San Savino (*c*.1523).　　　　AB

Huntley, G., *Andrea Sansovino* (1935).

SANSOVINO, JACOPO (Jacopo Tatti) (1486–1570). Italian sculptor and architect born in Florence. He trained as a sculptor under Andrea *Sansovino, whose name he adopted. Around 1506 he went to Rome where he joined Bramante's circle, also studying the *Antique. Returning to Florence *c*.1510, his works during that period include the joyful *Bacchus* (Florence, Bargello). He also practised as an architect, designing palaces both in Florence and Rome, usually for Florentine patrons. After the Sack of Rome (1527) he travelled to Venice, where he spent the remainder of his career. In 1529 he was appointed chief architect to the Procurators of S. Mark's, and his architectural contributions to the replanning of S. Mark's include the Library and Public Mint (*c*.1537), whose regular arcading reflects the Doge's palace opposite. The Loggetta at the base of the campanile incorporates reliefs and figural sculpture in a completely novel way for Venice, and its niche figures were to have an important impact on the development of Venetian small-scale bronze sculpture. Sansovino also designed the Palazzo Corner at S. Maurizio (*c*.1545), the first truly classical palace in Venice. Concurrently with his architectural projects, he executed bronze reliefs of the *Miracle of the Maiden Carilla* for S. Anthony's shrine in the Santo in Padua (1536–63), and designed a series of reliefs for the tribunes in S. Mark's

(1537–41). These were the first truly *Mannerist relief compositions in Venice, while the bronze sacristy doors for S. Mark's incorporate motifs from *Ghiberti's Florence Baptistery doors. His colossal *Neptune* and *Mars* on the Doge's palace staircase (1554–66) lack the grace of his small-scale sculpture. For Tommaso Rangone, in addition to his tomb, he designed a tympanum relief of Rangone seated between the terrestrial and celestial globes, both for S. Giuliano. His *tomb designs, such as the one for Doge Francesco Venier (1555–61; Venice, S. Salvatore), combine the Venetian idiom of the wall tomb, with influences from Roman early 16th-century tomb design. Together with Pietro *Aretino and *Titian, he dominated artistic life in Venice during the mid-16th century and formed an important school of followers, including *Vittoria.　　　　AB

SANTI, GIOVANNI (*c*.1440–94). Italian painter and writer who spent much of his life in contact with the vibrant Montefeltro court at *Urbino. He was a respected portrait painter and in 1493 was employed as such by Isabella d'Este in Mantua. Santi, a modest craftsman compared to his son *Raphael, was of relative importance for the local school of Urbino. He effectively assimilated influences from Flemish and Venetian sources and, in turn, blended them with the styles of *Melozzo da Forlì, *Piero della Francesca, and *Perugino. Among his most successful paintings is the Oliva altarpiece (1489; Frontino, convent of Montefiorentino), which displays a rigorously constructed composition filled with volumetric figures covered in sharply modelled drapery. The more graceful figure types and the luminous landscape of the slightly later *Visitation* (Fano, S. Maria Nuova) result from contact with Perugino's art. His greatest literary feat, the *Cronaca*, was composed in honour of Federigo da Montefeltro (1480s) and was presented to Duke Guidobaldo (*c*.1492); it is famous for its valuable comments on contemporary artists.　　　　FB

Martelli, F., *Giovanni Santi e la sua scuola* (1984).

SANTI DI TITO (1536–1602). Florentine painter. Born in Sansepolcro, he studied in Florence with *Bronzino, and from 1558 was in Rome, associated with Taddeo *Zuccaro and painting decorations in the Casino of Paul IV (Vatican) and elsewhere. Back in Florence by 1564, he was soon involved in *Vasari's projects, though painting in a more restrained and monumental style than Vasari's extreme *Mannerism. By the mid-1570s his work was increasingly concerned with naturalism and with Venetian light and colour (*Supper at Emmaus*, 1574; Florence, S. Croce). During the final decades of the 16th century he developed a religious art that

epitomized the precepts of the Counter Reformation and was built on clarity of narrative, purity of feeling, and the creation of a persuasive space that invited the viewer to participate. This phase of his work is summed up by the *Vision of S. Thomas Aquinas* (1593; Florence, S. Marco). He became the recognized leader of the reforming movement in Florentine art, was a greatly admired teacher, and had many pupils.　　　　AJL

Hall, M. B., *Renovation and Counter-Reformation* (1979).

SANVITO, BARTOLOMEO (*c*.1435–1512). Paduan scribe and illuminator, considered to be one of the greatest calligraphers of the *Renaissance. He spent his formative years in the vibrant *humanist centre of Padua, where his love of classical culture and art was nurtured in the city's antiquarian circles. From the late 1450s he worked for important Venetian clients, including Bernardo Bembo; for the latter he produced a copy of Solinus' *Polystoria* in 1457 (Oxford, Bodleian Lib., Canon. Class. 161). Sanvito strove to revive the classical codex with his influential cursive script and his exquisitely designed epigraphic capitals in the most vivid colours. From 1464 to 1501 he was based mostly in Rome, but he remained in contact with Bembo, for whom he copied Eusebius of Caesarea's *Chronica* (1485–8; London, BL, Royal MS 14. C. III). Sanvito is sometimes credited with the illumination of this work, which includes an architectural frontispiece and other motifs derived directly from *Antique art. At the end of his life he returned to Padua, where he was canon of Monselice.　　　　FB

Alexander, J. J. (ed.), *The Painted Page: Italian Renaissance Book Illumination, 1450–1550*, exhib. cat. 1994 (London, RA).

SARACENI, CARLO (*c*.1579–1620). Italian painter who specialized in small-scale paintings, often on a copper support, depicting biblical and mythological subjects against meticulously observed landscape backgrounds. He also painted altarpieces on a larger scale and in a *Caravaggesque style and occasionally worked in fresco. He was born in Venice and may have been influenced there by north Italian artists with a capacity for naturalistic observation, such as Jacopo *Bassano, *Savoldo, and *Romanino. He had moved to Rome by *c*.1598 and was quick to respond to the precise technique and closely observed realism of the German painter *Elsheimer, who arrived at Rome in 1600. This is apparent in Saraceni's series of six scenes from Ovid, painted on copper *c*.1606 (Naples, Capodimonte). The stories are set against asymmetrical and naturalistic unidealized landscapes that totally engulf the

mythological figures who inhabit them, creating dramatic tension and stimulating poetic imagination. Saraceni continued to work in this intimate mode and attracted the attention of many of the foreign artists in Elsheimer's circle, including *Lastman and Jacob *Pynas. He also attracted a French following including Jean Leclerc (c.1587/8–1633) from Lorraine and probably Guy François (before 1580–1650), and his work would later inspire *Claude.

In his larger-scale work, particularly church altarpieces, Saraceni also responded to the more vigorous naturalism of *Caravaggio and his followers, including Orazio *Gentileschi, and especially to their tenebrist lighting and immediacy of expression. In 1612 he completed the Death of the Virgin for S. Maria della Scala, Rome, to replace Caravaggio's controversial picture of the subject (Paris, Louvre). Other successful works in this style include S. Benno Receiving the Keys of Meissen and the Martyrdom of S. Lambert (both 1616–18; Rome, S. Maria dell'Anima) and S. Carlo Borromeo and the Holy Nail (c.1619; Rome, S. Lorenzo in Lucina). He painted works in a similar manner for provincial churches in Gaeta, Palestrina, and Cesena.

In 1616 Saraceni collaborated with Agostino *Tassi, Marcantonio Bassetti (1586–1630) and others to decorate in fresco the Sala Regia in the Palazzo del Quirinale, Rome. He also decorated the Cappella Ferrari in S. Maria in Aquiro, Rome, with scenes from the life of the Virgin (1616–17) but here he worked in oil, directly onto the plasterwork. In 1619 he returned to Venice to decorate rooms at the Palazzo Ducale, but died the following year. His large canvas of Doge Enrico Dandolo Campaigning for the Crusade was completed by Jean Leclerc, who had accompanied him to Venice. HB

Ottani, A., Carlo Saraceni (1968).

SARGENT, JOHN SINGER (1856–1925). American painter. Born in Florence, he trained in Paris, under Carolus-Duran (1838–1917) who introduced him to direct painting on the canvas, plein air painting, and the art of *Velázquez, which remained influential. An outstanding pupil, he painted Carolus-Duran in 1879 (Williamstown, Mass., Art Inst.) and soon established a *portrait practice. In 1884 his portrait of Mme Gautreau (New York, Met. Mus.) was vilified and from 1885 he worked and lived primarily in England. In the late 1880s he was influenced by his friend *Monet towards *Impressionism but by the 1890s had established a highly successful formula for society portraits. These works, with bravura brush strokes influenced by *Hals, tonality taken from Velázquez, and 18th-century poses, lack the characterization of earlier portraits like Vernon Lee (1881; London, Tate)

and he was criticized for superficiality. However, he could still invest his sitters with considerable presence, as in Lord Ribblesdale (1902; London, Tate), the epitome of aristocratic hauteur. After 1906 he devoted much of his time to drawings and sparkling landscape sketches. In 1918 he worked as a *war artist and from 1890 until c.1925 he painted murals for Boston Library and Museum. DER

Ormond, R., Sargent (1970).

SARRAZIN (Sarazin), JACQUES (1592–1660). French sculptor. After training in Paris, he spent the years 1610–28 in Rome, working for *Maderno and *Domenichino, acquiring a *classicizing style that was the sculptural equivalent of *Poussin's in painting and François Mansart's in architecture. He returned to Paris at about the same time (1627) as Simon *Vouet, with whom he collaborated on the high altar of S. Nicolas-des-Champs, helping to introduce the sonorous classical forms that eventually developed into the official style of the Louis XIV period. Much of his work has been destroyed, but among what survives is the beautiful tomb of Henri de Bourbon, Prince de Condé (begun 1648), now at the Château de Chantilly, as well as the sculptural decoration of Lemercier's Pavillon de l'Horloge at the Louvre, Paris (1639–42). Sarrazin was a founder member of the Académie Royale, *Paris, and a formative influence on such key sculptors of the Versailles generation as *Girardon. MJ

Bresc-Bautier, G., and La Moureyre, F. de (eds.), Jacques Sarazin, sculpteur du roi, 1592–1660, exhib. cat. 1992 (Noyon, Mus. des Beaux-Arts).
Digard, M., Jacques Sarrazin (1934).

SARTO, ANDREA DEL. See ANDREA DEL SARTO.

SARTRE, JEAN-PAUL (1905–80). French philosopher. A leading exponent of the *existentialism that flourished in Paris after the Second World War, his accounts of imagination and freedom have important implications for art. In Psychology of the Imagination (1940), Sartre argues that when we look at a pictorial image (e.g. a *Cézanne mountainscape), the ultimate object of our attention is not the picture itself (the small, flat, painted picture-mountain) but rather the absent world that it makes present to us (the actual mountain seen from Cézanne's viewpoint). Although the painter's brush strokes make this possible, nonetheless the more we gaze, the more the painting itself seems to 'disappear' before the absent world (real or fictional) that it conjures up in all its fullness. In Existentialism and Humanism (1948), Sartre proposes that there is no pre-given 'essence' of human nature and its value. Rather

we bring our being into existence by freely choosing it and taking responsibility for the consequences. This led him to the view that artists should work from an 'engaged' rather than a detached political position. Sartre wrote appreciatively about the work of *Wols and *Giacometti. NMcA

SASSETTA (Stefano di Giovanni) (c.1400–50). Italian painter and the most original artist of 15th-century Siena. While keeping alive the religious ideals of the trecento masters and the poetic feeling of the late Middle Ages, he made his own use of the *International Gothic decorative style and of contemporary Florentine movements, combining them into a personal manner expressive of his own mystical imagination. His first recorded work is the Arte della Lana altarpiece (dispersed) commissioned c.1423 by the guild of wool merchants for their chapel in S. Maria del Carmine in Siena. His Madonna of the Snow (1432; Florence, Pitti) forms a link between the medieval *Maestà and the Renaissance *sacra conversazione. His talent found its most lyrical expression in the smaller panels of an altarpiece completed in 1444 for the church of S. Francesco at Borgo Sansepolcro. Seven of these panels, illustrating the legend of S. Francis, are now in the National Gallery, London, and one in the Musée Condé, Chantilly. Here Sassetta's synthesis of traditional and contemporary elements is further animated by acute observation of detail and compositional flair, making them a unique expression of the Sienese School. PSt

Christiansen, K., in Painting in Renaissance Siena 1420–1500, exhib. cat. 1988 (New York, Met. Mus.).

SASSOFERRATO (Giovanni Battista Salvi) (1609–85). Italian painter. Born at Sassoferrato in the Marches, he may have worked with *Domenichino at Naples before receiving a commission for S. Francesco di Paolo, Rome, in 1641. His only other securely documented major public commission was in 1643 for his masterpiece, the rigid, symmetrically composed, Madonna del Rosario (Rome, S. Sabina). He also did a number of paintings for S. Pietro, Perugia, including a Judith (in situ; preparatory drawing Windsor Castle, Royal Coll.), though the dating of these is problematic. After the S. Sabina altarpiece he seems to have concentrated on portraits and, especially, on the private devotional paintings of the Virgin or Virgin and Child with which he is particularly associated. These images of the Counter-Reformation Marian cult exist in numerous variants and replicas. Like his altarpieces, they are meticulously crafted with strong saturated colours and are characterized by a severe, anachronistic, archaizing *classicism not unlike that of the *Nazarenes. His work is highly eclectic, appropriating motifs and

compositions not only from his most obvious models—*Raphael and *Perugino—but from many schools and periods. AJL

Haskell, F., *Patrons and Painters* (1963).

SATURATION. See COLOUR.

SAVERY, JACOB (c.1565–1603). Flemish still-life and landscape painter and draughtsman. His work is rare because of his early death from plague in Amsterdam. He was an important intermediary in the late 16th century between Flemish and Dutch landscape developments. His training is uncertain but a strong Flemish influence suggests Hans *Bol as his master. Typical of his work is *Panorama of a City by a Lake* (1586; Dresden, Gemäldegal.), an expansive landscape, despite its almost miniature size, meticulously painted and jewel-like. An expert *etcher, a number of his delicate landscape drawings were also engraved by other artists. CFW

Hand, J. O., *The Age of Brueghel*, exhib. cat. 1986 (Washington, NG).

SAVERY, ROELANDT (1576–1639). Dutch painter, draughtsman, and *etcher. Of Flemish birth, Savery emigrated with his parents to the Northern Netherlands. He made important developments as a landscape and flower painter in the late 16th century, when these themes were emerging as independent subjects. His brother Jacob Savery seems to have been his teacher by 1591, when the two brothers were living in Amsterdam. In 1603 Roelandt travelled to *Prague, probably to enter the employment of Emperor Rudolf II. Nearly all his surviving paintings and drawings date to the productive ten years which he spent in central Europe. He was sent to the Tyrol in 1606/7 and the spectacular landscape which he sketched remained an enduring theme as in *Mountain Landscape with Woodcutters* (Vienna, Kunsthist. Mus.). The Emperor's menagerie was a favourite theme and his drawings of animals were among the first of their kind in Dutch art. Similarly, his rare and exquisite flower paintings, for example *Flowers in a Vase* (1612; Vaduz, Liechtenstein Coll.), together with those by Ambrosius *Bosschaert, were highly influential on Dutch flower painters of the next generation. He returned to the Netherlands in 1613, eventually settling in Utrecht. CFW

Kauffmann, T. DaCosta, *The School of Prague* (1988).

SAVOLDO, GIOVAN GEROLAMO (active 1506–48). Italian painter. He probably came from Brescia and may have been trained there, though that is not documented. He was at Parma in 1506 and Florence in 1508; by 1521 he was settled in Venice. At some time between 1530 and 1535 he was patronized by the Duke of Milan. He produced a few altarpieces including the ponderous *Madonna in Glory with Saints* (after 1524; Milan, Brera) but his most characteristic works are easel paintings containing single, or few, figures painted with massive weight and filling the picture frame. He hauntingly combined the solid verism of Lombard painting with the glowing colours of *Giorgione and *Titian and a striking ability to render the surface of rich fabrics, and he often introduced nocturnal and artificial light effects. All these qualities are displayed in the *S. Matthew and the Angel* (1530–5; New York, Met. Mus.) in which the main lighting is provided by an oil lamp in the foreground, while two subsidiary scenes are lit by different kinds of light; this kind of painting may have influenced *Caravaggio. The *Man in Armour* (c.1525; Paris, Louvre) has the subject reflected in two mirrors, and is clearly a sophisticated response to the *paragone argument about the primacy of painting or sculpture. Savoldo's pupil Paolo *Pino wrote that the artist had spent his life painting few works with little honour; yet in this century a body of about 40 works has been attributed to him and he is now recognized as a highly individual and major talent. AJL

Giovanni Girolamo Savoldo, exhib. cat. 1990 (Brescia, monastery of S. Giulia).

SAVONAROLA, GIROLAMO (1452–98). Italian preacher and theologian whose fundamentalist ideas had a huge impact on the politics and art of Florence during the 1490s. Born into a Ferrarese family of physicians and authors, he took religious orders in 1475 at the Dominican priory at Bologna. Thereafter he attracted considerable attention for his charismatic preaching and in 1490 was transferred to the convent of S. Marco in Florence at the request of Lorenzo de' Medici. Over the next few years his sermons railing against political corruption, materialism, and the worldly character of much religious art drew large crowds, leading to occasional outbursts of purification in the form of *bruciamenti delle vanità* (bonfires of the vanities) where books, paintings, jewellery, and expensive clothes were burned in public. Savonarola was particularly critical of the papacy of Alexander VI and this led to his excommunication in 1497. The following year he was arrested, tortured, and burned as a heretic in the Piazza della Signoria, the ashes being disposed of to avoid a posthumous cult. Nevertheless, he continued to have a profound influence on the artistic life of Florence and his views can be detected in the work of *Botticelli, Fra *Bartolommeo, and even *Michelangelo. PSt

Steinberg, R. M., *Fra Girolamo Savonarola* (1977).

SCANDINAVIAN ART (1) *Introduction*; (2) *Danish art*; (3) *Finnish art*; (4) *Icelandic art*; (5) *Norwegian art*; (6) *Swedish art*

1. INTRODUCTION

The earliest surviving art in Scandinavia is prehistoric rock carving, for example carving from Tanum, Bohuslan, Sweden. A number of picture stones from the 8th to the 12th centuries have survived, one of the more famous, from Gotland, Sweden, being that of *Sleipnir*, the god Odin's eight-legged horse (Stockholm, Statens Historiska Mus.). In the 9th to 11th centuries, the period known as the Viking age, Scandinavian art flourished, primarily decorative and based on animal ornament, the different styles derive their names from the sites where important examples have been found. The earliest is known as the Oseberg style, one of the motifs of which is the gripping beast which may be seen on early 9th-century gilt bronze bridle mounts from a grave at Broa, in Gotland (Stockholm, Statens Historiska Mus.). This was followed by two new styles, the Borre style named after the burial barrow at Borre in Vestfold, Norway, characterized by the ring chain, and the Jellinge style which flourished from the late 9th to 10th century. The latter is named after the ornament on a silver cup (Copenhagen, Nationalmus.) found in the royal burial mound at Jelling in Jutland, Denmark. Its chief motif is an animal with a ribbon-shaped body. Following the Jellinge style came the Mammen style, popular in the 10th to 11th centuries, named after a silver inlaid axe (Copenhagen, Nationalmus.) found at Mammen in Jutland. Its main characteristics are stylized animals with more realistic proportions and the use of plant motifs. The *Jelling Stone*, erected by King Harald Bluetooth in the 10th century, is among the most significant examples, having a *Crucifixion* on one side and animal ornamentation on the other. The next style, the Ringerike, named after the geological term for sandstone beds in Oslo, also used plant ornament, with elongated tendrils and lobes, and animals, beasts, and snakes. Carving in this style is found on the *Flatatunga* panels from Iceland (Reykjavik, National Mus. Iceland) and on the weathervane from Heggen Church, Norway. The final style was the Urnes style, named after the decoration of a small church, built c.1060 at Urnes in Norway, and characterized by interlacing animal motifs.

Following the Viking age, from the 12th century to the Reformation, Christian art flourished. A significant number of wall paintings have survived; among them are those in a church at Fanefjord, Denmark (c.1490), 12th-century paintings in a church at Vä, Sweden, the walls and ceilings of Dädesjö church, Småland, Sweden, which were painted in the 13th century by Master Sigmundr, late 13th-century examples in

churches on the Åland Islands, Finland, and the interiors of Norwegian stave churches built from the 11th century onwards. Following the Reformation it is simpler to record the art of each country individually.

2. DANISH ART

In the 16th century Danish art was influenced by royal patronage and many of the successful painters were foreign. Frederik II (ruled 1559–88) commissioned portraits from foreign artists but also, like his predecessor Christian III (ruled 1534–59), patronized the Danish painter Melchior Lorck (c.1526–c.1588). In the reign of Christian IV (ruled 1588–1648) the post of royal painter was dominated by Dutch and Germans, Morten Steenwinckel (1595–1646) being one of the few Danes to hold the post. The Dutch artist Abraham Wuchters (1608–82) painted Christian in 1638 (Hillerød, Frederiksborg Slot) and the King also commissioned Adam van Breen. Portraiture, initially confined to the royal family, spread to other classes as shown by the portraits of rich merchants painted by Karel van Mander III (c.1610–70) who came to Denmark from Holland in 1623, and the ecclesiastical sitters of Elias Fiigenschoug (active 1600–61). Decorative art flourished in the 18th century under Frederik IV (ruled 1699–1730), who commissioned ambitious schemes for the royal palaces, and French influence supplanted that of Germany and the Low Countries. During the reign of Christian VI (ruled 1730–46) works by *Boucher and *Lancret were acquired for the Christiansborg Palace. By the late 18th century Danish artists were rising to prominence; the *Neoclassical history painter Nicolai *Abildgaard collaborated with the internationally renowned sculptor Bertel *Thorvaldsen in decorating one of the Amalienborg palaces. Abilgaard's pupil Christoffer Wilhelm *Eckersberg, 'the Father of Danish art', who had also studied under *David, was an influential teacher at the Copenhagen Academy and taught many of the leading artists of the 'Golden Age' of Danish painting, 1820–50, including *Købke. The century saw the stylistic development from Neoclassicism through *Romanticism to *plein air* realism influenced by developments in France. The Parisian-trained Peder Severin *Krøyer introduced *Impressionism to the group of painters who formed an artists' colony at Skagen from 1882. By the early 20th century the majority of the leading Danish painters studied in France and *modernism was well established by 1914. Later developments included *Surrealism, in the 1930s, *Abstract Expressionism, particularly in the work of Asger *Jorn, from the late 1940s, and Pop art, introduced by Per Kirkeby (1938–) in the 1960s.

3. FINNISH ART

Finland, although allowed considerable autonomy, was under Swedish rule from the 13th century until 1809 when it was annexed by Russia, finally gaining independence in 1917, although from 1939 until 1947 it was subject to both Russian and German occupations. During the medieval and Renaissance periods what little art there was, mainly painted church interiors, was influenced by north German artists operating in the Baltic ports, notably Lübeck, and they also dominated Scandinavian art in general. During the 17th century, art, which had previously been largely ecclesiastical, embraced lay portraiture, which remained the dominant genre into the 18th century, the principal portrait painter being the *Rococo-influenced Isak Wacklin (1720–58). From 1809 Neoclassicism predominated in sculpture, architecture, and decorative painting, heavily influenced by contemporary developments in Russia. Easel painters, however, received their training in Stockholm, but by the mid-19th century, like many of their fellow Scandinavians, studied in Germany. Magnus von Wright (1805–68), who with his brother Ferdinand (1822–1906) painted Finnish landscapes, studied in Dresden in 1858. The best-known 19th-century landscape and genre painter Albert *Edelfelt, who trained in Paris, introduced the realism of *Bastien-Lepage to his native country. Wilhelm Ekman (1808–73), a painter of reredoses and portraits, anticipated the growth of Finnish nationalism by painting subjects from the great Finnish epic the *Kalevala*, first collected and published in the 19th century, which inspired the work of the greatest 20th-century Finnish artist Akseli *Gallen-Kallela, generally considered to be the originator of a truly national art. Tyko *Sallinen further advanced modern Finnish painting with his harsh Expressionist paintings of peasant reality. The Parisian-trained Helene *Schjerfbeck, a painter of increasingly simplified interiors and figures, although largely ignored after the 1890s has since been recognized as a major 20th-century Finnish artist. Internationalism prevailed after the First World War and pioneers of abstract art include Birgir Carlstedt (1907–75), who turned to abstraction in the 1940s, and Sam Vanni (1908–).

4. ICELANDIC ART

National art in Iceland developed in the late 19th century, coinciding with the independence movement led by Jon Sigurdsson (1811–79), 'the father of Iceland's independence', which led to the granting of limited home rule by Denmark in 1874. The harsh climatic conditions of the country ensured that very little early art survived with the exception of some woodcarvings and manuscripts. In the 19th century most Icelandic artists trained in Copenhagen but by the first decades of the 20th century had ventured to Paris and Germany: Jón Stefánsson (1881–1962), a landscape painter, studied with *Matisse and was inspired by *Cézanne; Finnur Jónsson (1892–1993) trained in Germany (1921–5) and was influenced by *Expressionism. International styles predominated after 1918, most recently *Pop art, seen in the work of the artist known as Erro (Gudmundur Gudmundsson, 1932–).

5. NORWEGIAN ART

From 1380 until 1814 Norway was a province of Denmark and it is not overly dismissive to suggest that Norwegian art before the 19th century had much in common with Danish art, although usually it was more provincial. Before the 1840s the majority of Norwegian artists studied in Copenhagen but from 1845 to 1860 Düsseldorf attracted many Norwegian painters and German influence may be seen in both technique and subject, as peasant genre scenes and Romantic landscapes began to predominate. Among them was Adolph *Tidemand, who remained in Germany whilst seeking inspiration during frequent trips to his homeland. The popularity of Tidemand's sentimentalized view of Norwegian rusticity was in part due to the pioneering work of the older painter J. C. *Dahl, who had also worked in Germany, at Dresden, and was a friend of *Friedrich. Dahl was largely responsible for a renaissance in Norwegian landscape painting and his deep feeling for the natural wonders of his native country was a factor in the new spirit of patriotism which entered Norwegian art in the mid-19th century. The French-trained realists Erik Werenskiold (1855–1938) and Christian *Krøhg were both strongly nationalistic, the former illustrating folk tales in Asbjornsen and Moe's *Norwegian Fairy-Tales* (1879–87). By the 1880s, in common with their fellow Scandinavians, many Norwegian painters were studying in Paris, were influenced by *plein air* painting, and returned to Norway to establish summer art colonies. Edvard *Munch, arguably the most influential of Norwegian painters, was in Paris 1889–92, where he was influenced by *Symbolist artists in particular, although he is more closely associated with Berlin, where he worked from 1892 to 1907 developing his highly individual proto-Expressionist style. French influence continued into the 20th century. Jean Heiberg (1884–1976) studied at Matisse's Academy in 1908 and *Cubism was an important factor on Norwegian art after the First World War, particularly on the work of the muralist Per Krøhg (1889–1965), Christian's son. Expressionism, Constructivism, and other international styles dominated until the 1950s when Abstraction first appeared, in the work of Jakob Weidemann (1923–), among others.

6. SWEDISH ART

As in Denmark, Swedish 16th- and 17th-century art was dominated by royal patronage. By the second half of the 16th century

portraiture flourished but the leading practitioners were foreign. In 1561 the Netherlandish painter Steven van der Meulen (active 1543–68) painted a full-length portrait of *Erik XIV* (Mariefred, Gripholms Slott) and foreigners like the German David Klöcker Ehrenstrahl (1628–98), who arrived in Sweden in 1651, prospered with portraits, genre, and allegorical works. Although most of the alien painters were Dutch or German, the Frenchman Sébastien *Bourdon became court painter to Queen Christina (ruled 1632–54) in 1652 and painted her equestrian portrait (Madrid, Prado). By the 18th century the majority of Sweden's leading painters studied abroad, the portrait painters Gustaf Lundberg (1695–1786) and Alexandre *Roslin were both influenced by stays in Paris and Rococo elements may be seen in the work of Carl Gustaf *Pilo, whose best-known work, *The Coronation of Gustavus III* (1792, unfinished; Stockholm, Nationalmus.), is considered one of the masterpieces of Swedish painting. By the second half of the century there was a thriving school of landscape painters, among them Elias *Martin, who had worked in England, and Johan Sevenbom (1721–84). The 19th century saw increasing internationalism in Swedish art and by the last quarter of the century French influence was again dominant. The landscape painter Alfred Wahlberg (1834–1906) was influenced by the *Barbizon School and in the 1880s a group of artists including Carl Larsson (1853–1919) and Karl Nordström (1855–1923) established a summer colony in Grez-sur-Loing near the forest of Fontainebleau, where they concentrated on *plein air* painting which they later applied to their native landscape. French art continued to influence Swedish artists into the 20th century, some studied at Matisse's Academy, and Fauvism may be seen in the work of Leander Engstrom (1886–1927). Karl Isaksson (1878–1922), who studied in Paris in 1913–14, introduced the ideas of Cézanne and Cubism to Swedish painting. By the 1920s a number of naive artists, including Hilding Linnqvist (1891–1984) and Axel Nilsson (1889–1981), were prominent. Abstract painting appeared in the 1940s, most notably in the work of Olle Baertling (1911–81). HC

Andersson, A., and Anker, P., *The Art of Scandinavia* (2 vols., 1970).
Askeland, J., *A Survey of Norwegian Painting* (1963).
Bonsdorff, B. von, 'Finnish Painting from 1840–1940', *Apollo*, May (1982).
Gardberg, C. J., 'Finnish Medieval Art', *Apollo*, May (1982).
Lindgren, M., et al., *A History of Swedish Art* (1987).
Scavenius, B. (ed.), *The Golden Age in Denmark: Art and Culture 1800–1850* (1994).
Smith, J. B., *Modern Finnish Painting & Graphic Art* (1970).
Varnedoe, K., *Northern Light & Nordic Art at the Turn of the Century* (1988).
Wilson, D. M., and Klindt-Jensen, O., *Viking Art* (2nd edn., 1980).

SCAUPER. See scorper.

SCHADOW, JOHANN GOTTFRIED (1764–1850). German sculptor. Schadow's first teacher was the *Baroque portrait sculptor Jean-Pierre-Antoine Tassaert (1727–88) who had a lasting influence on his pupil's work which was otherwise *Neoclassical in style. Schadow was in Rome 1785–7 where he was a friend and admirer of *Canova. In 1788 he settled in *Berlin as court sculptor, remaining there for the rest of his life and becoming head of the Academy in 1816. In 1791–2 he travelled in Russia and Scandinavia, meeting the Swedish sculptor Johan *Sergel and *Houdon, whose example encouraged his attempts to infuse Neoclassical decorum with Baroque energy. Schadow's first major work was a funeral monument to Count von der Mark (1790; Berlin, Dorotheenstadtische Kirche) which encouraged further funerary commissions including the memorial to Frederick the Great (1793; Stettin, Standehaus). His best-known monumental sculpture is the quadriga (four-horse chariot) which surmounts the Brandenburg Gate in Berlin, executed in 1793; it was badly damaged during the Second World War. His portrait busts, which included those of *Goethe and *Kant, were much admired; that of the *Princesses Luise and Fredericke of Prussia* (1795–7; Berlin, Schinkelmus.) is a charming example of his ability to combine natural detail with classical grace. A skilful carver in relief, his numerous works show greater liveliness and delicacy than his free-standing sculptures; the Brandenburger Tor and the Mint in Berlin have good examples. JH

Friedlander, H., *Gottfried von Schadow: Aufsatze und Briefe nebst einem Verzeichnis seiner Werke* (1890).

SCHAFFNER, MARTIN (1477/8–c.1547). German painter from Ulm. Though trained in the workshop of Jörg Stocker in Ulm, he was more strongly influenced by the Augsburg painters Hans *Holbein the elder and Hans *Burgkmair. He produced some of the most outstanding altarpieces of the *Renaissance for Ulm and surrounding cities, in collaboration with local woodcarvers. After the Reformation and with it the loss of commissions for altarpieces, Schaffner increased his activity as a portraitist. His main surviving work consists of the wings of the altar of the *Holy Kinship* made for Lucas Hutz in 1521 (now the high altar in Ulm Cathedral). KLB

Höfler, J., 'Schaffner, Martin', in *The Dictionary of Art* (1996).

SCHAPIRO, MEYER (1904–96). American art historian. A Lithuanian Jewish immigrant to New York, he combined a deep respect for aesthetic expression with abiding socialist convictions. Schapiro's scholarly work concentrated on *Romanesque art. His investigations deployed 20th-century conceptual tools, but with a discretion that made them exemplary demonstrations of art historical method. Schapiro's contributions to discussions of modern art were equally distinguished: they opened questions as to social motives in its choice of imagery, and included a controversy with the German philosopher Martin Heidegger over the latter's remarks on van *Gogh. JB

Schapiro, M., *Modern Art: 19th and 20th Centuries* (1978).
Schapiro, M., *Romanesque Art* (1977).

SCHÄUFELEIN, HANS (c.1480×5–1539/40). German painter and designer of woodcuts and stained glass; follower of *Dürer, whose workshop he entered c.1503/4. At the time of Dürer's second trip to Italy, Schäufelein seems to have held a responsible position in the shop, for he painted, partly from Dürer's designs, the *Passion* altarpiece for the Schlosskirche at Wittenberg (Vienna, Dom- und Diözesanmus.; five of Dürer's drawings survive in the Frankfurt Städelsches Kunstinst. Schäufelein left Nuremberg c.1507, first for Augsburg, where he may have worked with Hans *Holbein the elder, then for the Tyrol. In 1515 Schäufelein moved to the Swabian city of Nördlingen and quickly obtained citizenship. This began a decade of great productivity, which saw several painted commissions, such as the *Last Supper* (1515; Ulm Minster), the *Lamentation* altarpiece for Nikolaus Ziegler (1521; Nördlingen, S. Georgskirche) and numerous *woodcuts for projects ordered by Emperor Maximilian I, such as the *Triumphal Procession* (1522). In all his works, the influence and example of Dürer remained the most important factor. KLB

Gothic and Renaissance Art in Nuremberg, exhib. cat. 1986 (New York, Met. Mus.).

SCHEDONI, BARTOLOMEO (1578–1615). Italian painter and draughtsman. He was born at Formigine, near Modena, the son of a mask-maker employed by the Este at Modena and the Farnese at Parma. In 1595 Bartolomeo went to Rome at the instigation of Ranuccio I, Duke of Parma, to study under Federico *Zuccaro. His subsequent training is not documented, but he was clearly influenced by the art of *Correggio and *Parmigianino and he was aware of the stylistic innovations of the *Carracci at Bologna. His early career was interrupted by various short spells in prison for violent behaviour. He worked for Cesare d'Este at Modena and his paintings in that city included ceiling decorations for the Sala del Consiglio Vecchio of the Palazzo Comunale, c.1602–7. In 1607 he was engaged to work exclusively for Duke Ranuccio I at Parma. His two masterpieces *The Entombment* and the *Three Maries* (Parma,

Gal. Nazionale), on which his reputation now largely depends, were painted for the convent church at Fontevivo. The style of these pictures, with angular forms and draperies, theatrical gestures, dramatic lighting, and intense colours, is highly individual and distinctive, but reflects the influence of Ludovico *Carracci and *Lanfranco.　　HB

Miller, D., in the *Age of Correggio and the Carracci*, exhib. cat. 1986–7 (Bologna, Pinc. Nazionale; Washington, NG; New York, Met. Mus.).

S **CHEEMAKERS, PETER** (1691–1781). Belgian sculptor. He was the son of a *Baroque sculptor in *Antwerp. He settled in England before 1720, having probably been to Rome. He collaborated on a number of *funerary monuments with his fellow Fleming Laurent Delvaux (1695–1778) before they went to Rome together in 1728. Scheemakers returned to London in 1730, deeply influenced by the *Antique and bringing with him casts of famous ancient statues, which were subsequently copied as garden sculpture. He quickly became a rival to *Rysbrack both as a portrait and tomb sculptor, undercutting his prices. His work, though good, is not as inspired as Rysbrack's, as can be seen from his bust of *Viscount Cobham* (c.1733; London, V&A), which lacks a flair for characterization. The success of his monument to Shakespeare (1740) in Westminster Abbey, which has an uncharacteristically *Rococo insouciance, brought him many commissions and his studio was one of the busiest in mid-18th-century England, producing church monuments ranging from small tablets to big multi-figure compositions. He returned to Antwerp in 1771, but his son Thomas (1740–1808) remained in England. His brother Henry (d. 1748) also worked in England, up to 1733 in collaboration with Henry *Cheere.　　HO/MJ

Roscoe, I., *Peter Scheemakers*, Walpole Society 61 (1999).

Whinney, M., *Sculpture in Britain 1530–1830* (rev. edn., 1988).

S **CHEERRE, HERMAN** (active late 14th early 15th century). Painter active in England. An illuminator who signed his name 'hermannus scheere me fecit' in the background of a miniature of *S. John the Evangelist* in a missal (London, BL, Add. MS 16998) may be the same as the 'herman youre meke seruant' whose name appears twice in the magnificent book of hours illuminated for John, Duke of Bedford, shortly after 1414 (London, BL, Add. MS 42131). Herman of Cologne, a *lymnour* (illuminator), witnessed a will in London in 1407, and Herman Scheerre's identifiable works show very strong connections with Cologne painting of the time, particularly that of the S. Veronica *Master. An equally strong *Burgundian influence may be explained by the recorded employment, 1401–5, of one Herman of Cologne by Jean *Malouel, court painter to Philip the Bold. An artist with a truly international training, Herman Scheerre was one of the key figures responsible for the transformation of English illumination from about 1400, and his workshop remained active for the first quarter of the century.　　AS

Rickert, M., *Painting in Britain: The Middle Ages* (1965).

S **CHEFFER, ARY** (1795–1858). Dutch painter active in France. He trained with his parents and then in Paris with the Neoclassical painter *Guérin. After a false start in his master's style he began a series of large pictures with themes drawn from French history painted in an eclectic manner. One of these, *Gaston de Foix Dying on the Battlefield* (Versailles) won him acclaim at the *Paris Salon of 1824 as a leader of the *Romantic movement. Yet compared with his contemporary from Guérin's studio, Eugène *Delacroix, he never justified this claim, either through innovation in style, warmth of feeling, or in his choice of subject matter. He found particular favour as an official painter under the regime of Louis-Philippe (1830–48), contributing several enormous canvases to the historical gallery at Versailles. Much of Scheffer's later output was religious work of mawkish sentiment, such as his *SS Augustine and Monica* (1845; London, NG), and *Baudelaire's hostile criticisms seem fully justified.　　MJ

Ewals, L. J. I., *Ary Scheffer: sa vie et son œuvre* (1987).

S **CHELLING, FRIEDRICH** (1775–1854). German philosopher. A major proponent of *Romanticism, he studied alongside *Hegel and the poet Friedrich Hölderlin, made the acquaintance of *Goethe, Schiller, and Friedrich von *Schlegel, and influenced Coleridge with his early, pantheistically inclined philosophy. This thinking, set out in the *System of Transcendental Idealism* (1800) and the *Philosophy of Art* (1802–3), was directed against *Kant's separation of the thing-in itself and its appearance to us, Schelling asserted a continuity between the knowing subject and nature. In this context, he ascribed great importance to art, arguing that it could provide direct access to the Absolute—not by presenting it as an encompassable object (which would be to deny its absoluteness), but by uniting our unconscious apprehensions with conscious awareness, and so revealing the Absolute as the ground of infinite meanings and manifestations. Science and art, he said, spring from the same kind of activity and both disclose the oneness of the world. Schelling was the first to write a comprehensive philosophy of art, a move that influenced the development of *aesthetics. His later writings moved away from Romanticism to posit that great art is the product of right social conditions.　　DC

S **CHIAVONE, ANDREA** (c.1510–63). Dalmatian painter and etcher who had established himself in Venice by c.1530. He was influenced by *Parmigianino and other central Italian *Mannerist artists in the formulation of his figure style, but quickly developed his own distinctive technique, in both the painterly execution of his oil paintings and the exceptional freedom of his *etchings. His Mannerist compositions and the lack of definition and finish in his paintings, which pushed decorum to its limits, had a significant influence on *Tintoretto and Jacopo *Bassano; while his prints display a degree of technical experimentation otherwise associated with 17th-century etchers such as *Castiglione. Highly regarded in the seventeenth century by M. *Boschini, among others, Schiavone has received less recognition than he probably deserves.　　HB

Richardson, F., *Andrea Schiavone* (1980).

S **CHIELE, EGON** (1890–1918). Austrian painter. Schiele showed a precocious drawing talent, and at 16 entered the Vienna Academy of Fine Art. Impatient of the conservative regime, he soon joined the Vienna *Sezession, encouraged by *Klimt. In 1908 he held his first exhibition, and in 1909 set up a studio. Drawing and painting Viennese slum children, he developed a style of highly erotic immediacy and ugliness related to his fascination with *Freudian psychology: *Standing Nude Girl* (1910) and *Coitus* (1915; both Vienna, Albertina). In 1911 his drawings were seized and he spent some weeks in prison, convicted of pornography and corruption. The experience was traumatic, but his popularity with the Viennese *avant-garde and the rising *Expressionist movement was unaffected: in 1916 the Expressionist periodical *Die Aktion* published an 'Egon Schiele' issue. His reputation was officially recognized in 1917, when he was released from army duties and provided with painting materials. The main participant in the 49th Sezession exhibition (1918), he received constant commissions for portraits and mural projects. His most important works, however, are his obsessive paintings of family groups and self-portraits, such as *The Family* (1918; Vienna, Österreichische Gal.); establishing him in the vanguard of the Expressionist preoccupation with psychological exploration.　　JH

Kallir, J., *Egon Schiele: The Complete Works* (1990).

S **CHILDERSBENT** (Dutch: band of painters), a fraternal organization founded in 1623 for social intercourse and mutual assistance by a group of Netherlandish artists living in Rome. One of its early leaders was Pieter van *Laer. The society had no written

laws and no fixed programme. Its members called themselves *Bentvueghels* or 'birds of a feather'. They lived riotously, dedicating themselves to Bacchus in an initiation ceremony which involved a burlesque procession to the church of S. Costanza, believed to be an ancient temple of Bacchus. A drawing (Rotterdam, Boymans-van Beuningen Mus.), attributed to Jan van Bijlert (1597?–1671), shows a group of Netherlandish painters rendering homage to Bacchus, who is seated on a globe. They tended to live around S. Trinità dei Monti, then as now the centre of bohemian Rome. In 1720 the Schildersbent was dissolved and prohibited by papal decree because of its Bacchic irregularities.　　HL

SCHJERFBECK, HELENE (1862–1946). Finnish painter. In the 1880s, Schjerfbeck was one of many Scandinavian artists to take their inspiration from France. She studied at the Atelier Colarossi, Paris, where she made friends with Marianne Preindlsberger (Stokes) (1855–1927), who persuaded her to visit Brittany. During her three visits there in 1881, 1883–4, and 1887–8 she concentrated on small-scale, intimate interiors and landscapes, rather than the more usual scenes from local history and peasant life. During the same period, again accompanied by Preindlsberger, she also stayed in St Ives, Cornwall, drawing fishermen three or four times a week at Adrian *Stokes's evening classes. Her enthusiasm for the Cornish environment and people culminated in her most ambitious St Ives painting, *The Convalescent* (1888; Helsinki, Ateneumin), which gained a gold medal at the Paris Exposition Universelle, 1889. Another, less conventional, work from this period is *The Bakery* (1887; Vasa, Hedmanska Samlingarna, Osterbottens Mus.) which in its subtle, near-abstract simplification and careful colour prefigures both her own later work and that of St Ives artists of the 1920s and 1930s. From about 1900 she lived a solitary life, the result of ill health, and was largely forgotten until the 1940s.

　　GS

SCHLEGEL, FRIEDRICH VON (1772–1829). German philosopher, poet, and critic. Together with his brother August Wilhelm (1767–1845) he profoundly influenced the development of *Romantic aesthetics in Germany. Whilst working as a private tutor and scholar in Jena, Berlin, and Paris, Schlegel moved in the intellectual circles of Novalis, Schleiermacher, and *Schelling. He also edited the journals *Athenäum* (1798–1800) and *Europa* (1803–5), two mouthpieces of the Romantic movement. His early studies still bear witness to a classicist fascination with the art and culture of *Antiquity, but later, particularly after converting to Catholicism in 1808, he developed an increasing interest in the expressive and imaginative qualities of medieval art and architecture. His later publications promote early Italian art and, especially, the early German masters, as sources for a national renewal of painting, and praise the unadulterated purity of their religious symbolism. His views were diametrically opposed to the classicism of *Goethe, but greatly affected the aesthetic ideals of the *Nazarene School of painting.　　AT

Schanze, H. (ed.), *Friedrich Schlegel und die Kunsttheorie seiner Zeit* (1985).

SCHLEMMER, OSKAR (1888–1943). German artist and designer. Born in Stuttgart, Schlemmer studied there at the Academy under the modernist Adolph Holzel (1853–1934) 1909–14 and 1918–19, spending the war (1914–18) as a military cartographer. In 1919 he exhibited at the Sturm Gallery, Berlin, and showed his first sculpture of a formalized human figure. Although he rejected pure abstraction, Schlemmer thought that the essential inner vision and unity with nature could only be achieved through simplification and in both painting and sculpture reduced the human figure to mechanistic manikins of extreme formality. In works like *Abstrakte Rindplastik* (1921; Munich, Neue Pin.) both human and technological elements may be discerned within an overall abstraction. From 1920 to 1929 he was an influential teacher at the *Bauhaus in the metalwork and sculpture classes and, particularly, the school of stage design. His theatrical works, created 1926–9, which he named 'architectonic dances' combined colour, light, movement, and music with puppet-like human figures as the protagonists. In 1929 he moved to Breslau as a professor and also taught briefly in Berlin before being dismissed by the Nazis in 1933 and declared a degenerate artist.　　DER

Maur, K. von, *Oskar Schlemmer* (2 vols., 1980).

SCHLÜTER, ANDREAS (1659?–1714). German sculptor and architect who was a principal contributor to the development of the *Baroque style in Prussia. He worked in Warsaw and Gdańsk before going to *Berlin to work for the Elector Friedrich III, later first king of Prussia. There he contributed architectural sculpture to various official projects before embarking on a series of monumental works of which the best known is the bronze equestrian statue of *Friedrich Wilhelm, the 'Great Elector'* (1696–1700) at Schloss Charlottenburg. He was then asked to rebuild the Königliches Schloss (1698–1716; destr. 1945), a successful piece of Baroque grandiloquence combining Italian and French models. For a time he worked on both architectural and sculptural projects, including the inventive marble pulpit in the Marienkirche (1703). But the threatened collapse of two of his new royal buildings in 1706/7 and the consequent demolition of one of them led to a cessation of architectural commissions and a nervous breakdown. Schlüter spent the last year of his life in the recently founded St Petersburg as architectural adviser to Peter the Great.

　　MJ

Andreas Schlüter und die Plastik seiner Zeit, exhib. cat. 1964 (Berlin, Bode-Mus.).
Keller, F. E., 'Andreas Schlüter', in W. Ribbe (ed.), *Baumeister-Architekt-Stadtplaner* (1987).

SCHMIDT-ROTTLUFF, KARL (1884–1976). German painter and founder member of Die *Brücke. He studied architecture in Dresden, where he met *Kirchner through his school friend *Heckel, founding Die Brücke with them in 1905. His bold, angular style was best suited to graphic work, and he produced a famous series of religious prints, *Nine Woodcuts*, in 1918. He was influenced by the African and Oceanic art in the ethnological museums of Dresden and Berlin, and by *Cézanne, *Gauguin, van *Gogh, and *Munch, towards a powerfully primitivistic and symbolically emotional style. His paintings show a clear link with his graphic works in their angular depictions of a unified man and nature.

By the time of Die Brücke's move to Berlin in 1911, Schmidt-Rottluff had found his unadulterated *Expressionist voice and reached the apotheosis of his colouristic brilliance. His work returned to a renewed seriousness of mood by 1914; throughout the war he chiefly produced graphic works, such as *Self-Portrait* (1916), an intense and powerfully primitivistic self-examination. After the war Schmidt-Rottluff returned to Berlin, where his work moved towards a more spiritual and abstract idiom. He was officially forbidden to paint under the National Socialist regime.　　RRAM

Grohmann, W., *Karl Schmidt-Rottluff* (1956).

SCHNITZALTAR, a variant of a winged altarpiece, demonstrating the leading role *woodcarving played in the decoration of late *Gothic *altarpieces. They flourished from the 1470s up to the beginning of the 16th century not only in Germany and the Netherlands but also in north Italy, Austria, and in non-German-speaking areas: Hungary, Transylvania, Poland, and Bohemia. In the spacious central shrine there are numerous, often larger-than-life-size painted and gilded wooden sculptures and carved ornaments, with smaller figures in the tall openwork pinnacles in the crowning superstructure (*Gesprenge*) and reliefs against gilt backgrounds on the inside of the wings. There may also be reliefs or small figures on or in the *predella. The shrine statues are usually represented frontally but the most advanced contain an active, narrative scene.

The entire altarpiece was a small architectural edifice which fitted harmoniously into the monumental space of a Gothic church: see for instance Michael *Pacher's *Coronation of the Virgin* altarpiece (1471–81; S. Wolfgang) and Veit *Stoss's *Death of the Virgin* (1477–89; Cracow, S. Mary's). GyT

Baxandall, M., *The Limewood Sculptors of Renaissance Germany* (1980).

S CHNORR VON CAROLSFELD, JULIUS (1794–1872). German painter. Schnorr was born in Leipzig. His elder brother Ludwig (1788–1853) was a painter and he was taught by his father Johann (1764–1841) before attending the Vienna Akademie 1811–15, where he excelled at landscape sketches (examples Vienna, Albertina). In 1818 he joined the *Nazarenes in Rome and illustrated scenes from *Orlando furioso* for the Ariosto room in the Casa Massimo al Laterano, Rome (1821–7; in situ), setting his *Raphaelesque figures against precise and detailed landscapes. In 1826 he visited Sicily to make studies for *The Odyssey*, a mural commission for Ludwig I of Bavaria, but on his return to *Munich the volatile monarch demanded scenes from the *Nibelungen*, which occupied Schnorr until 1867 (Munich, Residenz). By 1846 he was a professor at the Dresden Akademie and director of the gallery, administrative posts which alleviated problems with his eyes. He visited London in 1851 and in 1861 was commissioned to design a stained-glass window, *The Conversion of S. Paul*, for S. Paul's Cathedral (destr.; cartoon in London, V&A). In 1860 he published his *Bilder Bible*, 240 wood engravings from drawings made throughout his career. DER

Andrews, K., *The Nazarenes* (1964).

S CHÖNFELD, JOHANN HEINRICH (1609–84). German painter and etcher, mainly of elegant and theatrical scenes from ancient history, the Old Testament, and mythology, but whose works also include horrific subjects. He left his native southern Germany for Rome in 1633; from 1637/8–c.1648 he was in Naples; after a further stay in Rome, he returned to Germany in 1651. In Rome he mixed with other northern painters, and was influenced by *Poussin and *Castiglione. In Naples his crowded biblical scenes and battles, with elongated, elegantly gesticulating figures, set in landscapes enriched with classical ruins, suggest a response to *Micco Spadaro and to the prints of *Callot. Here too he developed an interest in the macabre, often, as in *Chronos* (Augsburg, Städtische Kunstsammlungen), painting eerie night scenes with skeletons and sombre classical tombs which suggest the transience of earthly life. Their darker colours and melancholy grace reflect the art of *Cavallino. In Rome the art of Salvator *Rosa encouraged

his interest in magic and witchcraft, and after Schönfeld's return to Germany Rosa remained a powerful influence. In Germany Schönfeld was active mainly in Augsburg and painted altarpieces and some portraits. HL

Pée, H., *Johann Heinrich Schönfeld* (1971).

S CHONGAUER, MARTIN (c.1430–91). German painter and engraver who worked in Colmar, where his greatest painting, *Madonna in the Rose Garden*, is still preserved. His fame has resided in his engravings, however, which he always signed with his initials, and which spread his influence across Europe. It was to Schongauer's studio that the young *Dürer travelled in 1492 only to find the master deceased. His work reflects the influence of Rogier van der *Weyden, and other Flemish painters, but with a typically Germanic and *Gothic engrossment with line, also found in his pen drawings. His subjects are principally religious, and often composed with deceptive simplicity, as in the *Madonna and Child in a Courtyard*, but he also engraved ornament with virtuoso flourishes of line, and his large still life of the *Censer* is one of his best works. His engravings were probably printed in large numbers, and posthumous impressions are known, but good early examples are surprisingly scarce. RGo

Falk, T., and Hirthe, T., *Martin Schongauer* (1991).

S CHWIND, MORITZ VON (1804–71). Austrian painter. Schwind studied in his birthplace, Vienna (1821–3), before going to Munich in 1828 to work under *Cornelius. Unable to make a living by painting, he proved to be a versatile and prolific illustrator of contemporary, literary, and religious subjects and romantic chivalric stories. His eclectic style was inspired by artists as diverse as *Dürer and *Raphael. In 1832 he was commissioned to decorate the Residenz in *Munich with classical, religious, and fairytale subjects. Success followed, including a huge classical scheme for Karlsruhe (1840–4), but Schwind resented being confined to decorative work. In 1844 he became professor of history painting at Frankfurt am Main and in 1846 professor of art in Munich. He continued to paint narrative cycles including the dramatic *Story of Cinderella* (1852–5; Munich, Neue Pin.) and, in 1853, received an enormous commission to decorate Wartburg Castle. This scheme (1853–5; Wartburg, in situ), painted in a decorative style incorporating both *Nazarene and *Neoclassical elements, is probably his most successful. In total contrast to his official works Schwind painted many personal pictures, *Reisebilder*, of everyday life (1848–64), in a charming *Biedermeier style, like *The Morning Hour* (1858; Munich, Schack-Gal.). DER

S CHWITTERS, KURT (1887–1948). German artist, best remembered as a *Dadaist. Schwitters's most famous works are his *Cubist-inspired *assemblages, which he began to produce around 1918. Composed of bits of wood, newspaper, and other debris, and often nailed or glued together, they emanated, according to the artist, from a desire to created anew from the shattered remains of the pre-war world. *Das Unbild* (1919; Stuttgart, Staatsgal.) is a typical example. Schwitters expanded his principles of assemblage to encompass other art forms, including poetry and performance, and coined the term *Merz* as a generic for his œuvre. It was through his association with Der *Sturm that he established contact with Dadaists, although he never officially joined the movement after feuding with Richard Huelsenbeck (1892–1974), who excluded him from the Berlin wing. After 1923 his work was influenced by De *Stijl and *Constructivism. That same year he began his magnum opus, the extraordinary *Merzbau* (destr.), an architectonic assemblage which gradually overwhelmed his Hanover home. Forced to flee Nazi persecution in 1937, he moved first to Norway and then in 1940 to Britain, where he later died in obscurity. AA

Elderfield, J., *Kurt Schwitters* (1985).

SCIENTIFIC EXAMINATION. *See overleaf.*

S COREL, JAN VAN (1495–1562). Netherlandish painter who travelled extensively and who is the first Netherlandish artist to have brought the ideals of the Italian *Renaissance to the Northern Netherlands. He was born in the village of Schoorl, near Alkmaar, the son of a priest. His first teacher is said to have been Cornelis Buys, tentatively identified with the *Master of Alkmaar. He was the assistant of Jacob *Cornelisz. van Oostsanen in Amsterdam before he went to Utrecht, c.1515–17, to study with Jan *Gossaert. In 1518/19 he travelled to Venice where he joined a pilgrimage to the Holy Land—an experience reflected in a drawing of Bethlehem (London, BM) and the topographic cityscape in the background of *Christ's Entry into Jerusalem* (1526–7; Utrecht, Centraal Mus.). Upon his return to Italy he was appointed by the Dutch Pope Adrian VI to supervise the *Antique collections of the Vatican (see under ROME). In 1524 Scorel resettled in Utrecht, where he was made a canon and ran a large workshop of painters. His clerical appointment apparently did not prevent him from taking a mistress and fathering six children. Famous throughout the Netherlands, he was called in 1550 to Ghent to restore van *Eyck's Ghent altarpiece (together with Lancelot *Blondeel). Among Scorel's pupils were

continued on page 687

· SCIENTIFIC EXAMINATION ·

1. Paintings

SCIENTIFIC and technical examination of paintings is usually carried out to provide information on their structure and materials. This physical evidence can then be used to elucidate condition, date, the status of doubtful layers, or other questionable features of a picture, and also establishes the nature of the technique used by the painter. Methods of technical examination can be divided broadly into those described as non-destructive (or non-invasive), that is no material need be removed from the painting for study or analysis, and methods which involve sampling for analysis. All photographic and imaging methods, such as recording X-ray photographs (radiographs) and infra-red images, fall in the first category. *Pigment and *medium analyses in paint samples are clearly studies of the second type.

A few methods have been evolved to date paintings by scientific means, but these are helpful only in particular cases. Dendrochronological dating (tree-ring dating) has been applied to determining the dates of wood panels used for paintings, particularly for those on oak, although some success has been achieved also for supports of lime-wood and beech. Poplar wood panels, used for the great majority of Italian paintings of the 13th–16th centuries, are not datable by this method. Dendrochronology provides only the felling date for the tree from which the panel was made; assumptions must then be made, for example the length of time the wood was seasoned, in order to calculate the date for the panel painting. A more direct method of dating involves determination of the amount of residual radioactive carbon in a sample—carbon-14 dating—by correlating it with the point in time when this form of carbon was taken up by the material from carbon dioxide in the atmosphere. It can only be applied to materials that came originally from living organisms: wood and canvas fall in this category. So do the traditional binding media in easel paintings: egg tempera, oils, and animal glue. Radiocarbon dates are not highly accurate, but recent refinements in the technique, particularly the use of mass-spectrometry to separate carbon isotopes, have reduced considerably the sizes of samples required. Because of the inherent imprecision in the method, carbon-14 dating has not been used frequently for paintings, but it is widely applied to archaeological materials.

Imaging methods are employed both to study and to record paintings. Photography using a variety of types of films and photography of details, without and with magnification, are some of the most widely used forms of documentation. Computerized digital recording of paintings involving high-resolution colour imaging, in which no film is used, is becoming increasingly important, particularly since the images can be regarded as immutable (unlike film), are of very high colour precision, and capable also of manipulation (image processing) as well as transmission between computers.

The use of X-rays to investigate paintings is almost as old as the discovery by Roentgen in 1895 of this penetrating radiation. X-ray photographs are usually made by allowing X-rays to pass the entire structure of a painting, on top of which sheets of photographic film have been laid. The principle is that different materials exhibit differing capacities to absorb and block the passage of the radiation and so an image is formed on the film (which is blackened by X-rays) according the extent to which the radiation passes through different parts of the painting. Materials containing light atoms, for example wood, canvas, glues, organic pigments, paint binding media, and varnishes, have a low absorbency for X-rays, allowing them to pass readily, while pigments based on iron, copper, lead, and zinc have a moderate blocking effect. Pigments containing lead, such as lead white and lead-tin yellow, or mercury, principally vermilion, have a very high absorbency for X-rays and their presence registers as white or as light areas on an X-ray photograph (radiograph). The very widespread use of lead white in easel paintings up to the 20th century is the fortuitous reason for the success of X-radiography of paintings, since its presence provides strong photographic contrast with surrounding areas where lead-containing materials are absent or more thinly applied. X-radiographs can provide images of the wood-grain of panels, the structure and weave of canvas, the thickness, method of application, and materials of ground layers and paint layers, the structure of brush strokes, and, perhaps most importantly, the presence of changes in composition, not accessible by other means, made during the course of painting (pentimenti). In rare cases, complete compositions beneath the surface of a later work can be recorded by X-rays. X-ray photographs provide a superimposed image of all layers in a structure and as a result can be difficult to interpret; reading them is not an exact science. A uniform thick ground containing lead white can produce a virtually blank radiograph, while X-ray absorbent layers on the backs of paintings, thick panel constructions, particularly cradles on panels, and double-sided paintings can render X-ray photographs uninformative. X-ray photographs are commonly used by conservators to determined the degree of paint loss or damage in easel paintings beneath restored or overpainted surfaces.

A highly specialized method of imaging structures, particularly the paint layers, known as neutron autoradiography also employs X-ray film. The method involves

exposing a painting to a beam of neutrons, produced by a nuclear reactor, causing the atoms of a variety of types of pigment in the paint layers to become radioactive temporarily. As radioactive decay occurs, and the radioactivity diminishes, X-ray film is used to record images of these radioactive components to determine whether they lie at the surface or beneath it. Usually, a sequence of images is taken over a period of about 50 days detecting different materials as they decay and revert to their non-radioactive forms. Neutron autoradiographs are complementary to X-rays, since they provide images of layers within the structure of the painting that contain light elements. The technique is not widely used for reasons of its high cost and the need for specialized facilities, but it has been used particularly to study the paintings of *Rembrandt and van *Dyck.

A second type of penetrating radiation—infra-red light—is also used to image paintings. Generally the painting is illuminated from the front with infra-red light (heat radiation) and the painting photographed with film that responds to infra-red radiation, or it is imaged with a specialized television camera equipped with an infra-red sensitive tube (vidicon). In both methods, infra-red radiation reflected from the painting is recorded: the vidicon method, developed in the 1960s by van Asperen de Boer, is known as infra-red reflectography. The principal use is to reveal and record the presence of *underdrawings beneath paint layers, since infra-red can penetrate many kinds of overlying paint, even when it is fairly thick, and is then absorbed by certain types of common drawing materials such as *charcoal, black *chalk, *ink, and so on. If the ground on which the underdrawing lies reflects infra-red light, the drawing can be detected by its absorption, appearing as a dark image. White chalk and gesso grounds with black underdrawing on top provide particularly clear results, and the technique has been used with great success for large numbers of early *Renaissance panel paintings from both Italy and northern Europe. Increasingly, infra-red reflectograms are recorded as digital images on computer and small sub-images assembled as larger mosaics to present a complete underdrawings. Study of underdrawing has become a significant attributional tool.

Interest in the identification of the materials of painting by analysis of samples dates to 1800 with published work by John Haslam on the *wall paintings of S. Stephen's chapel, Westminster. Other early pigment analyses were published in France by Jean Chaptal (1809), Désormes and Clément (1806), and in England by Humphrey Davy (1814), who had examined samples of excavated frescoes in Rome and *Pompeii. First attempts, particularly to identify pigments, involved examination of small paint samples under the microscope, comparison with known materials, and microchemical investigation, that is chemical tests applied on a minute scale viewed under magnification. Many pigments are identifiable from their colour, particle form, and optical properties by methods known as optical mineralogy using the polarized light microscope (PLM). A single pigment particle can be identified by this means in favourable cases. These methods remain current practice. Techniques for pigment identification for obvious reasons have relied on very small (micro-scale) samples for their success. Microscopic paint samples are also used to investigate the layer structure of paintings by preparing them as cross-sections. Minute fragments of paint from a selected sample site, often including all paint layers and the ground, are embedded in clear synthetic resin blocks, one face of which is ground away and polished to expose the sample edge on. The layer structure can then be viewed under the microscope at magnifications ranging from around 40 to 1,000x. In this way the sequence of paint layers can be determined, their constitution recorded, particularly the pigment content, and the relationship of one paint layer to another can be assessed. The method is commonly used to explore the way a composition was evolved, often in conjunction with X-ray images, and to investigate the materials used in a painting. Cross-sections are used by conservators to detect and prove the presence of later repaints, or other non-original features, by reference to the layer structure and the presence of intermediate films of varnish or of anachronistic materials contained within the structure.

Electron microscopy applied to samples from paintings, makes use of a beam of electrons to probe paint structures, paint surfaces, pigment particles, canvas fibres, and so on, and provides higher magnification and a more three-dimensional view of microsamples than optical (light) microscopy can achieve. Magnifications up to 80,000x and above are possible in the scanning electron microscope (SEM), but the images can only be monochromatic since they are formed by electrons scattered from the sample, captured and processed in the instrument to generate a video picture. Scanning electron micrographs can show the detailed topography of paint surfaces, the internal texture and microstructure of paint layers, or the three-dimensional shapes of pigment particles. X-ray spectrometers are attached routinely to scanning electron microscopes and these provide elemental analyses of samples in the SEM and are a powerful means for pigment identification. The most common technique is called EDX (or EDS) spectrometry—energy dispersive X-ray microanalysis. The method allows small areas of a sample to be analysed selectively, whether as an individual layer in a paint cross-section or a single pigment particle. The resulting spectra show whether the sample contains lead, copper, iron, cobalt, chromium, and so on, but not what the actual component pigments are. The data must be interpreted in conjunction with examination of the sample under the optical microscope in order to specify the pigments present. These forms of analysis do not destroy the specimen, which can be retained in an archive of paint samples for future examination or further analysis.

A non-destructive method that can be used on the surface of a painting without taking a sample—X-ray fluorescence analysis (XRF)—provides elemental analytical

information of a similar type to EDX, although it is not possible to undertake layer by layer analysis within the internal structure of a picture. The technique is suitable for pigment identification in single-layered paintings such as *watercolours, *illuminated manuscripts, and other painted surfaces with a simple structure, for example true fresco.

A number of newer methods of pigment analysis in samples have been developed in recent years based on spectroscopic techniques linked to microscopy: infra-red microscopy and laser Raman spectroscopy are examples of this trend. These are capable of identifying materials at the molecular, rather than elemental, level and can be applied to paint binding media as well as to pigments. The spectra of known standards are often required as an aid to identifying unknown samples. Progress has been made in turning these methods into non-destructive analytical tools.

The identification of the organic constituents of paintings—principally the binding media in paint—presents quite different problems to the analyst. In general samples must be taken and the various components of the media separated and chemically treated before analysis. These analyses are challenging because the chemistry of the natural products from which materials used in painting are extracted can be very complex, yielding chemically mixed substances such as drying oils and other fats, waxes, resins, proteinaceous materials, gums, and so on. Furthermore, these materials have often aged and changed, particularly by oxidation and through the effects of light; the quantities to be analysed are also extremely small. The most effective methods for the identification of specific materials, for example being able to determine the use of linseed oil in a painting rather than just a drying oil, or pine resin rather than simply paint containing resin, rely on instrumental methods to separate the mixtures of chemical components that these materials contain, and on identifying these individually as a characteristic pattern of chemical composition, often by comparing known standards of aged natural materials. The instrumental methods employed are based principally on different forms of chromatography, in essence a range of chemical separation techniques. Gas-chromatography (GC) has been applied very successfully to the analysis of drying oils and of egg tempera; (high performance) liquid-chromatography to the identification of the dyestuffs present in lake pigments (HPLC). Auxiliary instruments are often attached to chromatographs in order to provide more precise identifications of the components separated by the chromatographic technique. Thus a mass-spectrometer linked to a gas-chromatograph (GC-MS) enables detailed analyses of aged oils, resins, waxes, and other materials to be made and their sources identified. By these high-technology methods, mixtures of media become apparent, for example oil and egg tempera combined, as well as the initial preparation of painting media, such as the heat-bodying (thickening) of drying oils before their use by the painter. AR

2. Sculpture

THE use of scientific methods in the study of sculpture has developed greatly in the last few decades, both as technological advances allow ever more sophisticated investigations to be undertaken, and in response to the increasing demand for technical information in conjunction with preservation and conservation efforts. Scientific examination of sculpture is undertaken for a number of reasons: to identify the physical constituents of a piece of sculpture, as part of the preparatory stages of a programme of conservation or consolidation, or to determine its age or geographic origin through identification of its materials and technique.

The scientific examination of sculpture typically begins with a photographic survey. The physical characteristics of the piece may be examined using a variety of non-destructive techniques. Examination of the surface under ultraviolet light may reveal the presence of dissimilar materials or areas of repair. Tool marks may be revealed under magnification. The recesses and interior areas of an object may be viewed using video microscopy, employing an optical fibre and camera probe. X-radiography is frequently used to study sculpture since it can reveal useful information about the condition, construction, interior armature, previous repairs, and, to some extent, the materials comprising the piece. Though conventionally employed for medical analysis, techniques such as computer-assisted tomography (CAT) and magnetic resonance imaging (MRI) may be employed in special cases to reveal the internal structure of an object. X-ray fluorescence (XRF) spectroscopy can be used to determine the elemental composition of a sculpture's surface, and is particularly valuable in identifying the alloy composition of metal sculpture or the pigments in *polychrome sculpture.

Although the non-invasive techniques described above can provide general information regarding the materials, construction, and condition of an object, it is sometimes necessary to remove small samples in order accurately to identify the materials, pigments, or corrosion products present. X-ray diffraction (XRD) is used to identify crystalline compounds, such as pigments, minerals, stone materials, and metal corrosion products. If multiple layers are present, as in polychrome sculpture, information regarding the composition and structure of the layers only can be obtained by removing a small sample for cross-section analysis. Scanning electron microscopy coupled with energy-dispersive X-ray spectroscopy (SEM-EDS) can be used to determine elemental compositions on a microscopic scale. For example, SEM-EDS can be used to identify the elemental composition of individual pigment layers in a polychrome sculpture or the various metallographic phases or corrosion products present in a bronze. For stone objects, chemical and petrographic analysis of small removed samples may yield information regarding the nature of the stone, which, for example, may be used

to determine whether two fragments come from the same sculpture.

Another area of scientific examination is the dating of works of art. *Dendrochronology is used to date wooden artefacts by comparing the pattern of rings in the heartwood (the area beneath the bark and the sapwood) to the ring pattern of trees known to be from a similar time period and geographic region. Another dating procedure is radiocarbon, or carbon-14 dating (see above). This technique can be used for any material that once formed part of the biosphere (e.g. ivory, bone, leather, and wood). It is most accurate for samples at least 1,000 years old, and has been used to date samples as old as 50,000 years. Dating of fired *clay materials can be achieved by thermoluminescence. When clay is fired, the energy stored within it is released. The fired clay will then begin to reaccumulate energy from natural radiation sources that exist everywhere. To determine the time since the object was last fired, a sample of around 30 mg is removed and heated to 500 °C, which releases the stored energy in the form of light—this is thermoluminescence. This 'natural' thermoluminescence is measured and compared to that obtained when the same sample is subsequently exposed to known quantities of radiation and heated in a similar manner, from which the time since the object was last fired can be calculated. This technique is often used in the identification of fakes, and can be accurate to within 50 years.

Other approaches to the technical examination of sculpture depend on common sense and historical knowledge. Sometimes, for example in the case of stone sculpture, the information gleaned through non-invasive examination may be as important as an accurate identification of the type of stone. The two approaches thus must go hand in hand to arrive at a satisfactory result: the physical evidence revealed by scientific examination must be considered together with the historical and cultural context of the piece. HO/KT

Gilardoni, A., Orsini, R. A., and Taccani, S., X-rays in Art (1977).
Lang, J., and Middleton, A. (eds.), Radiography of Cultural Material (1997).
Marble: Art Historical and Scientific Perspectives on Ancient Sculpture, conference papers, J. P. Getty Centre (1990).
Tite, M. S., Methods of Physical Examination in Archaeology (1972).
Young, William J. (ed.), Application of Science to the Dating of Works of Art (1974).

Maerten van *Heemskerck, Anthonis *Mor, and Lambert *Sustris. KLB

Filedt Kok, J. P., et al. (eds.), Kunst voor de beeldenstorm, exhib. cat. 1988 (Amsterdam, Rijksmus.).

SCORPER, a tool used in *wood engraving for gouging away large areas of the block, or for engraving very broad lines. Its cutting section is usually rounded, occasionally square. RGo

SCORZA, SINIBALDO (1589–1631). Italian painter. He was born at Voltaggio, but trained in Genoa under *Paggi. He was the earliest of the Genoese specialists in naturalistic *landscape in the Flemish mode, often including animals. The Landscape with Philemon and Baucis and the Landscape with Latona and the Peasants (both Edinburgh, NG, Scotland) strongly reflect the influence of such northern artists as Abraham *Bloemaert and Paul *Bril, whose work he could have seen in Genoa. In 1617 he painted an Immacolata for the oratory of S. Giovanni Battista, in his home town of Voltaggio; this and a Jesus Comforted by Angels (Voltaggio, Convento dei Cappuccini) are his only known religious works. Two years later he moved to Turin at the invitation of the Duke of Savoy, probably on the recommendation of the poet Marino, whose Galleria (1620) contains poems in praise of pastoral pictures by Scorza, representing the shepherd Apollo and Orpheus. He was then in Rome c.1625–7; and left a signed picture of the Piazza del Pasquino (Rome, Barberini Gal.) in a realistic genre style close in spirit to the work of the *Bambocciati painters. His later works, such as the Entry of the Animals into Noah's Ark, inscribed 1630 (Genoa, Palazzo Spinola), had considerable influence on *Castiglione. HB

Gavazza, E., and Terminello, G., Genova nell'età Barocca, exhib. cat. 1992 (Genoa, Palazzo Spinola and Palazzo Reale).

SCOTTISH ART. Scotland has had a distinct artistic tradition since the Dark Ages, but our knowledge of art from the centuries before the Reformation is only fragmentary as in the Scottish Reformation the iconoclasts were more thorough than most. Nevertheless in proportion to the country's wealth, Scottish churches and cathedrals were as richly furnished as anywhere else. Survivals from the earliest centuries of Christianity were also revered among their treasures. The tiny 7th-century Monymusk Reliquary (Edinburgh, Mus. of Scotland) and the monumental S. Andrews Sarcophagus (St Andrews Cathedral) are examples of this. The high standards they reveal are reflected, too, in the High Crosses on Iona, in the Book of Kells (Dublin, Trinity College), itself a product of Iona, the S. Ninians Treasure (Edinburgh, Mus. of Scotland), or the great sculptured stones of the Picts such as the Hilton of Cadboll Stone (Edinburgh, Mus. of Scotland), or the stones at Aberlemno.

In the 11th century S. Margaret brought the Scottish Church into the Roman fold, and though *Celtic traditions persisted in the west till the late Middle Ages, art thereafter generally reflected contemporary north European fashions. S. Margaret's own Gospels (Oxford, Bodleian Lib.) are *Anglo-Saxon and there are other books like the 12th-century Iona Psalter (Edinburgh, National Lib. of Scotland), the 13th-century Murthly Hours (Marquess of Bute), or the 15th-century Talbot Hours (Edinburgh, National Lib. of Scotland) which all have close associations with Scotland, but were produced elsewhere. But there were also native scriptoria and sculpture workshops producing work of quality like the 14th-century tomb of the Earl and Countess of Mentieth (Incholm Abbey), the 15th-century sculptured decoration of Melrose Abbey, or the illuminated Scotichronicon from c.1425 at Corpus Christi College, Cambridge.

James III, IV, and V were true Renaissance princes who understood the power of art. The Trinity College altarpiece commissioned by James III from Hugo van der *Goes in the 1470s (Edinburgh, NG Scotland), the Book of Hours commissioned by James IV from Simon *Bening as a wedding present for his Queen, Margaret Tudor, in 1503 (Vienna, Staatsbib.), or the architecture and decoration of the royal palaces completed by James V at Edinburgh, Linlithgow, Stirling, and Falkland reveal the standards they expected. Nor were they alone. Bishop Kennedy of St Andrews was not royal, but the S. Salvator's College mace (University of St Andrews) that he commissioned in Paris in 1461 is an outstanding example of contemporary European goldsmith's work.

The Reformation saw the end of royal and ecclesiastical patronage of religious art, but

until 1603 and its removal to England the court continued to employ artists such as Arnold Bronckhorst (active 1565/6–83) and Adrian Vanson (active 1581–1602). Lively painted decoration was also a feature of Scottish houses until the 1640s, but the first native-born artist whose work we can clearly identify was George Jamesone (1589/90–1644). His portraits are sensitive and in his *Self-Portrait* (Edinburgh, Scottish NPG) he presents himself as a man of professional standing. Later the Flemish painter John Medina (1659–1710) established a successful practice in Edinburgh, but William Aikman (1682–1731), John *Smibert, and John Alexander (1686–c.1766) all travelled to Italy to study, an example followed by artists for the rest of the 18th century. Aikman inherited Medina's practice, but as with Smibert, the collapse of patronage after the Union of 1707 forced him to move south. Smibert later emigrated to America and played a key role in the development of American painting.

The 18th century was the age of the Scottish Enlightenment which had profound implications for visual art. Allan *Ramsay was a close friend of David Hume and his portrait painting was a branch of the same study of human nature that Hume professed. For Ramsay, too, truth to his observations was as firm a principle as it was for Hume in his philosophy. In his use of drawing Ramsay also shared common ground with pioneering surgeons and anatomists like Alexander Munro, William Hunter, or Charles Bell, for whom it was an aid to their investigations. With Robert Strange and William Lizars engraving also flourished in this environment. But as for Adam Smith and the philosophy of moral sense, sympathy and imagination were the basis of society, so Ramsay's own vision was social: empiricism ameliorated by sympathy seen memorably in his portrait of his second wife, *Margaret Lindsay* (Edinburgh, NG Scotland).

By the same logic of moral sense, Thomas Blackwell, Hugh Blair, and Adam Ferguson all argued that imagination flourished more freely in primitive societies. Following this primitive ideal, in Rome Gavin *Hamilton turned to the inspiration of Homer as a primitive, natural poet; and in *Ossian's Hall* in Penicuik House (1772, destr.) Alexander Runciman (1736–85) sought the modern qualities of expressive spontaneity at the expense of correctness. Henry *Raeburn studied briefly with Runciman and spontaneity also characterizes his portraiture. But though it is often grand, like Ramsay's it is also profoundly social, reflecting directly the way we see each other in ordinary social intercourse.

Landscape was important in Runciman's Ossian pictures. He and his contemporary Charles Steuart (active 1762–90) and their younger associates Jacob More (1740–93) and Alexander Nasmyth (1758–1840) established the iconography of the Scottish landscape that is with us still. David *Allan cultivated naivety in his paintings of the inhabitants of this same landscape and in his illustrations of Scots songs produced in collaboration with Robert Burns. Allan and Burns were David *Wilkie's first inspiration and he combined their ideals with the empirical strand of Scottish thought represented by Allan Ramsay and by Charles Bell's study of expression. Wilkie's first success in England was as a comic painter, but he was determined to be recognized as a serious artist, undertaking in *Distraining for Rent* (1815; Edinburgh, NG Scotland) the first social realism and in *The Chelsea Pensioners* (1822; London, Apsley House) the first example of what Baudelaire later called the painting of modern life. Like Walter Scott, Wilkie's psychological narrative had a far-reaching influence, but his religious compositions such as *John Knox Preaching at St Andrews* (1852, London, Tate) reflected his concern for the developing crisis in the Scots Kirk, also seen in the work of artists like George Harvey (1806–76), but most remarkably in the calotype portraits of D. O. Hill (1802–70) and Robert Adamson (d. 1848), commemorating the Disruption of the Kirk in 1843. Among the very first art *photographs, they also continue the portrait tradition of Raeburn.

Scott's influence is seen in the history paintings of William Allan (1782–1850), Thomas Duncan (1807–45), Robert Scott Lauder (1803–69), and others, and in the *Romantic landscapes of John Thomson of Duddingston (1778–1840), Horatio McCulloch (1805–67), and Sam Bough (1822–78). Wilkie's example still informs the narrative style of later painters like W. Q. *Orchardson and John Pettie (1839–93), but William McTaggart (1835–1910) was the outstanding painter of this generation. Ahead of their time, his spacious, freely painted landscapes are more *Expressionist than *Impressionist. Arthur Melville's (1855–1904) brilliant watercolours are equally exceptional in the late 19th century. French and Dutch influences were important for the colourful realism of the Glasgow Boys, James Guthrie (1859–1930), W. Y. Macgregor (1855–1923), and others, but Melville was also an important example to them as to the Scottish Colourists, S. J. Peploe (1871–1935), J. D. *Fergusson, Leslie Hunter (1879–1931), and F. C. B. Cadell (1883–1937).

The Colourists also continued the link with French painting. Indeed as a member of the Salon des Indépendants, *Paris, alongside *Matisse, J. D. Fergusson was really the only British artist to participate directly in the birth of *modernism in Paris. While Muirhead Bone (1876–1953), D. Y. Cameron (1865–1945), and James McBey (1883–1959) took a leading role in the *etching revival of the late 19th century, under the leadership of Patrick Geddes Arts and Crafts ideals were also important. Encouraged by Geddes, Phoebe Traquair's (1852–1936) mural paintings in the S. Mary's Song School, Edinburgh (1882–9), and elsewhere were among the first major works by a professional woman artist in Britain and this tradition was continued by women painters and designers like Jessie M. King (1875–1949) and Cecile Walton (1891–1956). Women sculptors also took a leading role in the Scottish National War Memorial (1927) designed by Sir Robert Lorimer, one of the most ambitious public art schemes of the time.

In the inter-war years the Scots Renaissance, a literary movement led by Hugh MacDiarmid, promoted a more self-consciously Scottish stance. In visual art William Johnstone (1897–1981) interpreted these ideas with great originality, drawing on the inspiration of *Surrealism and American painting and also providing an important example to younger artists like Alan Davie (1920–) and Eduardo *Paolozzi who with William Gear (1915–97) and William Turnbull (1922–) were the first British artists to reconnect with modernism in France and America after the war, leaving an enduring mark on British art. But with William Gillies (1897–1973), William Wilson (1905–1972), James McIntosh Patrick (1907–98), and others, a more intimate and domestic kind of painting came to be seen as the national style. Though part of this, Anne Redpath (1895–1965) and Joan *Eardley were bolder in their response to *Tachisme and *Abstract Expressionism. Eardley's seascapes painted at the end of her life are outstanding, though they look back, too, to William McTaggart.

In the 1960s, the ideal of a distinctive Scottish tradition inspired the symbolist figure paintings of John Bellany (1942–). But at the same time, with the establishment of the Edinburgh Festival, the Scottish Arts Council, and the increasing internationalism of art generally, it became more possible for Scottish artists to take their place on a world stage without needing to identify themselves as Scottish. Ian Hamilton *Finlay did this with great success, becoming a major international figure without ever leaving his extraordinary poetic garden, Little Sparta, high in the Lanarkshire hills. In the early 1980s figurative artists like Steven Campbell (1953–) or Adrian Wiszniewski (1958–) followed his example to claim an original position in the art of their time. Since then, through the work of artists like Elizabeth Blackadder (1931–) or Will Maclean (1941–), or in the younger generation 1996 Turner Prize winner Douglas Gordon (1966–), Scottish artists have continued to

enjoy wide recognition. DM

Calwell, D. H. (ed.), *Angels, Nobles and Unicorns*, exhib. cat. 1982 (Edinburgh, National Mus. of Antiquities of Scotland).

Hardie, W., *Scottish Art from 1837 to the Present* (1990).

Hartley, K., *Scottish Art since 1900*, exhib. cat. 1988 (Edinburgh, Scottish NG of Modern Art).

Irwin, D., and Irwin, F., *Scottish Painters at Home and Abroad 1700–1900* (1975).

Macmillan, D., *Scottish Art 1460–1990* (1990).

Macmillan, D., *Scottish Art in the Twentieth Century* (1994).

Pearson, F., *Virtue and Vision: Sculpture and Scotland 1540–1990*, exhib. cat. 1990 (Edinburgh, NG of Scotland).

SCRAPING/SCRATCHING OUT, a method of removing pigment with a pointed instrument such as a reversed brush, knife, or fingernail. While this may be used in order to make corrections it became a favoured technique with 19th-century watercolourists who employed it to reveal the paper to produce highlights. *Turner was perhaps its greatest exponent and he apparently grew his thumbnail especially long in order to scratch out in his watercolours.

PHJG

SCREEN PRINTING. See SILK-SCREEN PRINTING.

SCRIPT. Until print came into use from the late 15th century onwards (and after that date for many luxury volumes) books were handwritten. By the end of the Roman Empire a hierarchy of scripts had arisen based upon form and function: the script used for a shopping list was not appropriate for a major literary or scriptural text. Higher-grade scripts were initially majuscule (similar to 'upper-case' letters and confined within two lines—'bilinear script') and lower-grade minuscule ('lower-case' with ascender and descender strokes, as in *d* and *q*, and confined within four lines—'quattrolinear script'). The formality of a script was further determined by its 'aspect' (overall appearance) and its *ductus* (the number of strokes used to form letters and the care and speed of execution). Scripts which employ a more formal *ductus*, with many letter strokes and pen-lifts, are termed 'set'; those with fewer pen-lifts, and perhaps with time-saving devices such as linking of letters and loops, are termed 'cursive'; cursive scripts with a high degree of speed and informality may be termed 'current'. Abbreviations were also introduced to save time and space and included symbols (*notae*) borrowed from the shorthand systems of *Antiquity (such as that of Tiro, Cicero's secretary). Punctuation enjoyed limited use in Antiquity, which favoured *scriptura continua* without word separation designed for oral reading, but clerical silent reading led to the introduction of word separation and more punctuation symbols (promoted initially in Ireland as part of the process of learning Latin as a foreign language). The *Carolingians, the medieval scholars attached to cathedral schools and universities, and the *humanists all contributed to the development of punctuation.

The Roman system of scripts ran from around 50 BC to AD 600 and was to influence the subsequent history of scripts, with certain elements being periodically revived. High-grade book scripts were angular square capitals suited to inscriptions and the chisel, more fluid rustic capitals, and rounded uncials suited to the pen. Cursives were used for administrative and less formal purposes and were initially rapidly written versions of capitals. Speed of writing changed the appearance of many letters, however, and along with the introduction by the 4th century of loops and linking of letters this formed the basis for the development of minuscule scripts. The fusion of the two ends of the production spectrum—formal and informal—gave rise to one of the most popular book scripts of late Antiquity, half-uncial.

In the post-Roman world the successor states evolved their own scripts, many of a highly localized character (such as Luxeuil minuscule) and drawing to varying degrees upon the different Roman scripts. Uncial continued to be used for high-grade books, especially in Italy and Gaul, but throughout much of the West minuscules emerged influenced by Roman cursive, with attendant problems of lack of consistency and legibility. Certain areas developed distinctive solutions to these problems, notably Visigothic minuscule and Beneventan minuscule, whilst the Insular world (Britain and Ireland) reinvented a whole hierarchy of scripts within which Roman influence was increasingly apparent. This complemented their schools, which from around 600 to 800 were the envy of the West.

From the late 8th century onwards a new script, Caroline minuscule, swept throughout Europe along with the Carolingian Empire. Based upon the minuscules of Gaul (especially of Corbie) and influenced by Roman half-uncial and the Insular scripts, Caroline was promoted by the Emperor Charlemagne and his circle as part of a campaign to ensure textual (and to some extent cultural) uniformity throughout a disparate series of territories. Only those areas which were not under Carolingian rule and which had already developed good script solutions of their own withstood its introduction, with much of Spain resisting until the 12th century, the duchy of Benevento in southern Italy until around 1300 (and later in some centres). Insular scripts continued to be used in Ireland into the 20th century and also continued in Anglo-Saxon England until the ecclesiastical reforms of the later 10th century, conducted under continental Benedictine influence, which led to the introduction of Caroline, but only for Latin texts, with *Anglo-Saxon minuscule continuing to be used for Old English.

Caroline minuscule, especially in its calligraphic English form, formed the basis of Protogothic (*Romanesque) book script, practised in areas under Norman and Angevin influence from the late 11th to early 13th century. The round aspect of Caroline became more oval, with some lateral compression. Cursive features also crept back into document hands in the prolific Angevin bureaucracy.

This transitional phase paved the way for the *Gothic system of scripts (late 12th to 16th centuries) in which a form/function hierarchy was reintroduced. Caroline letter forms continued to form the basis of formal Gothic book script (*textualis/textura* or 'blackletter'), with a squarer aspect and much compression which, with an increasingly elaborate treatment of strokes, can hinder legibility. Grades of *textualis* were used for different grades of book and are classified according to the degree of elaboration in the treatment of the feet of letter strokes which equated to time and money in production. Such considerations assumed increased importance from around 1200 with the rise of the towns and universities, when much book production shifted from the monastic scriptorium to specialist lay craftspeople whose work was often co-ordinated and subcontracted out by stationers. By the 13th century England had reinvented cursive script for documents (*cursiva anglicana*), joined in the early 14th century by French 'secretary'. From the late 13th century cursives became acceptable for cheaper books and from this point onwards a predictable contamination of formal and cursive scripts occurred, expressed by terms such as 'hybrida', 'bastard *anglicana*', 'bastard secretary', and its most formal expression *bâtarde*. By the 15th century the histories, romances, and other literary volumes owned by the wealthy were written in *bâtarde* or another of the bastard scripts, rather than in Gothic *textualis*, which was virtually limited to liturgical volumes.

Italian script reflected much of the Gothic system, but always remained rounder and broader. From the mid-14th century a distillation of purer, ultimately Caroline, forms from Gothic *textualis* began (its inception attributed to Petrarch) and from the end of the 14th century this crystallized into the humanistic system of scripts, promoted by scholar/author/scribes such as Bracciolini, Niccoli, and Salutati. This was conceived as a cultural manifesto aimed at overturning Gothic/Germanic imperial ascendancy in favour of a reassertion of the Antique and of Italian identity. Ironically, it was to Caroline

minuscule, initially developed as part of an imperial programme, that the humanists looked for inspiration, as preserved in 12th-century Italian volumes. Humanistic book script (*littera antiqua* or *humanistica textualis*) and humanistic cursive (*humanistica cursiva*, along with its more elaborate manifestation, *cancellaresca*) gradually spread from their cradle, Florence, and other humanistic centres such as Rome to influence most of the West, and inspired the development of the 'roman' and 'italic' typefaces.　　　　MPB

A Palaeographer's View: Selected Writings of Julian Brown, ed. J. Bately, M. P. Brown, and J. Roberts (1993).
Bischoff, B., *Latin Palaeography* (English trans., 1990).
Brown, M. P., *A Guide to Western Historical Scripts from Antiquity to 1600* (rev. edn., 1994).

SCROTS, GUILLIM (active 1537–54). Portrait painter. Scrots, also recorded as 'Guillim Stretes', entered the employ of Mary of Hungary in 1537, and probably painted the youthful *Maximilian* and *Ferdinand of Austria* (both *c.*1544; Vienna, Kunsthist. Mus., exhibited at Schloss Ambras, Innsbruck). By 1545 he was in England working for Henry VIII. He apparently remained as official portraitist to the boy King Edward VI, of whom two full-lengths on panel have been plausibly linked with a payment to Scrots in 1551 (Paris, Louvre; Rouanne, Mus. Joseph-Dechelette; further versions Hampton Court, Royal Coll., and Los Angeles, County Mus.). All these works show him to be an accomplished exponent of the Habsburg court style, using dramatic lighting and hard flesh tones. An anamorphic profile image of *Edward VI* (1546; London, NPG) is also thought to be his work.　　　　KH

Auerbach, E., *Tudor Artists* (1954).

SCUMBLE. See GLAZE.

SEBASTEION. See APHRODISIAS.

SEBASTIÁN DE ALMONACID (Sebastián de Toledo) (active 1475–1500). Spanish sculptor, perhaps trained in the Southern Netherlandish style by Cueman *Egas. In 1494 Sebastián did some carving at the church of El Parral, Segovia; the document related to that comission gives his name as Almonacid. In 1489 he was commissioned to carve the tombs of the parents-in-law of Iñigo López de Mendoza, second Duke of Infantado. The resulting recumbent figures of Don Álvaro de Luna and Doña Juana de Pimentel (Toledo Cathedral) are among the finest examples of sculpture created in late 15th-century Toledo. Sebastián was also responsible for several other sculptured tombs, including that of Don Rodrigo de Campuzano (d. 1488; Guadalajara, S. Nicolás).　　SS-P

SEBASTIANO DEL PIOMBO, properly Sebastiano Luciani (*c.*1485–1547). Italian Renaissance painter who established his reputation in Venice as a young man with altarpieces, and later as a mature artist in Rome with mythological *poesie* (*Death of Adonis*; Florence, Uffizi) and portraiture (*Ferry Carondelet and Companions*; Madrid, Thyssen Mus.). Sebastiano began as a lutenist, before embarking on an apprenticeship with Giovanni *Bellini. None of Sebastiano's surviving works are Bellinian, but, unlike *Giorgione and *Titian, he was always a strong draughtsman and his forms retained a clarity of outline. Much more apparent is the impact of his subsequent master Giorgione, with whom his works have often been confused even in the earliest sources, such as the *Judgement of Solomon* (*c.*1506–9; Kingston Lacy, Dorset) and the S. Cristostomo altarpiece (*c.*1507–9; Venice, S. Crisostomo). Sebastiano left Venice for Rome in 1511 with the Sienese banker Agostino Chigi for whom he executed mythological frescoes in the Farnesina Palace in his Venetian style. *Vasari knew the artist in Rome and his biography is especially reliable, particularly in his discussion of how *Michelangelo adopted Sebastiano as his *compagno*, after the completion of the Sistine ceiling when Michelangelo was increasingly isolated from *Raphael and his school. Further evidence of their friendship is to be found in Michelangelo's correspondence; and Michelangelo executed drawings that were preparatory ideas for Sebastiano's most important commissions between 1512 and 1520. According to Vasari, Michelangelo provided a *cartoon for Sebastiano's nocturnal *Pietà*, 1516/17 (Viterbo, Mus. Civico), a statement confirmed by surviving preparatory drawings by Michelangelo (Vienna, Albertina). A similar collaboration is apparent in the *Flagellation of Christ*, commissioned by the rich banker Pierfrancesco Borgherini for S. Pietro in Montorio, Rome, 1524, and in the large, complex masterpiece the *Raising of Lazarus* (London, NG), completed for Cardinal Giulio de' Medici by 1520 for Narbonne Cathedral. Between 1525 and 1527 Sebastiano produced his greatest portraits, representations of Aretino (Arezzo, Palazzo Comunale), Andrea Doria (Rome, Doria Pamphili Gal.), and Anton Francesco degli Albrizzi (Houston, Mus. Fine Arts). In 1531 he was elected to the office of Piombatore, a reward for his loyalty to Clement VIII, whose features he often portrayed (Naples, Capodimonte), and for whom he executed *The Holy Family with the Baptist* (Prague, Národní Gal.). In his last decade he produced sublime half-length figures of Christ (St Petersburg, Hermitage; Budapest, Szépművészeti Mus.) which were to furnish inspiration for religious painting in the future. His last Roman masterpieces, an altarpiece for Agostino Chigi's funerary chapel in S. Maria del Popolo and the *Visitation* in S. Maria della Pace, were left unfinished.　　JA

Hirst, M., *Sebastiano del Piombo* (1981).
Lucco, M., *Sebastiano del Piombo* (1980).

SECCO. See WALL PAINTING.

SECONDARY COLOURS. See COLOUR LANGUAGE.

SECTION D'OR, group of French painters who worked in loose association between 1912 and 1914, when the First World War brought an end to their activity. The members included *Delaunay, *Duchamp, *Duchamp-Villon, *Gleizes, *Gris, *Léger, *Metzinger, *Picabia, and *Villon. Their common stylistic feature was a debt to *Cubism. The name of the group, which was also the title of a short-lived magazine it published, was suggested by Villon. It refers to a mathematical proportion known as the *Golden Section in which a straight line or rectangle is divided into two parts in such a way that the ratio of the smaller to the greater part is the same as the greater to the whole (roughly 8 : 13). The proportion has been studied since Antiquity and has been said to possess inherent aesthetic value because of an alleged correspondence with the laws of nature or the universe. The choice of this name reflected the interest of the artists involved in questions of proportion and pictorial discipline. They held one exhibition, the *Salon de la Section d'Or*, at the Galerie la Boétie, Paris, in October 1912; *Apollinaire gave a lecture here at which he is said to have introduced the term *Orphism to describe the work of several of the members of the group. Although *Kupka's name is not included in the catalogue, there is some evidence that he showed work at the exhibition and he is generally included among the Orphists.　　IC

SEDILIA, fixed seats, usually stone, but sometimes wooden, placed on the south side of a church altar, for the priest, deacon, and sub-deacon officiating at Mass. Established in England by the 12th century, sedilia are rare elsewhere in Europe. There are usually three seats, set into the wall of an aisle-less chancel, but in an aisled building they are backed by a canopied screen. From the 13th century onwards sedilia could be handsomely decorated with sculpture and painting. The early 14th-century wooden sedilia of Westminster Abbey are painted with figures associated with the building and its symbolism. At Heckington (Lincs.) and Hawton (Notts.) the sedilia form an ensemble with the piscina, tomb of Christ, and patron's tomb,

all carved with foliage and figures. The sedilia at Exeter Cathedral are part of a splendid but partly destroyed set of liturgical fittings made 1316–24; they are surmounted by complex, tiered arches, which originally linked with the reredos of the high altar (destr.). NC

Binski, P., *Westminster Abbey and the Plantagenets* (1995).

Swanton, M. (ed.), *Exeter Cathedral: A Celebration* (1991).

SEGAL, GEORGE (1924–). American sculptor, born in New York. His career was slow to mature. He studied at various art colleges and took a degree in art education at New York University in 1950, but until 1958 he worked mainly as a chicken farmer, painting *Expressionist nudes in his spare time. In 1958 he made his first sculpture and in 1960 he began producing the kind of work for which he has become famous—life-size unpainted plaster figures, usually combined with real objects to create strange ghostly tableaux. Examples are *The Gas Station* (1963; Ottawa, NG Canada), *Cinema* (1963; Buffalo, Albright-Knox Gal.), and *The Restaurant Window* (1967; Cologne, Wallraf-Richartz-Mus.). The figures are made from casts taken from the human body; he uses his family and friends as models. In the 1970s he began to incorporate sound and lighting effects in his work. Segal has been classified with *Pop art and *Environment art, but his work is highly distinctive and original, his figures and groups dwelling in a lonely limbo in a way that captures a disquieting sense of spiritual isolation. From the late 1970s he has also made public monuments, notably *The Holocaust* (1982; San Francisco, Lincoln Park), in which the figures are cast in bronze. IC

SEGANTINI, GIOVANNI (1858–99). Italian painter. His early work, often influenced by the *Barbizon School, attracted considerable attention, thanks largely to the efforts of the dealer Vittore Grubicy de Dragon. Segantini did not, however, develop a truly individual style until his move in 1886 from Milan to the area of St Moritz in Switzerland. Despite his limited artistic training, he evolved a method akin to Divisionism (see NEO-IMPRESSIONISM) for representing the brilliant mountain light. His final works have a pronounced emblematic quality, exemplified by the unfinished *Triptych of Nature* (1898–9; St Moritz, Mus. Segantini), in which the solemnity of the human figures is brilliantly enhanced by their sombre Alpine settings. CJM

Quinsac, A., *Segantini: catalogo generale* (2 vols., 1982).

SEGHERS, DANIEL (1590–1661). Flemish Jesuit flower painter. He was born in Antwerp and brought up as a Protestant in Holland, but in 1610 he returned to Antwerp, where he became Jan *Brueghel's pupil, converted to Catholicism, and became a lay brother in the Jesuit order in 1614. In 1625 he took his final vows and was sent to Rome, but he returned to Antwerp in 1628. He became enormously famous and received gifts and visits from all sorts of distinguished people. Most of his paintings are garlands or swags of flowers around religious figure paintings by other artists (*Cartouche with the Virgin and Child and S. Anne*; Dulwich, Gal.) but there are also a few bouquets in glass vases. He did not have Jan Brueghel's fluency but his colours are pure and luminous and he introduced new ways of unifying his compositions by the use of foliage and stalks. Jan Philips van Thielen (1618–1667) was his only pupil, but his widespread influence included de *Heem in Antwerp and *Arellano in Madrid. AJL

Mitchell, P., *European Flower Painters* (1973).

SEGHERS, GERARD (1591–1651). Flemish painter, dealer, and collector. The identity of the artists with whom Seghers trained in Antwerp is disputed but Abraham *Janssens, Caspar de *Crayer, and Hendrik van *Balen have been variously suggested. In 1608 Seghers became a master in the Antwerp guild and in 1613 he travelled to Italy. In Rome he came into contact with the followers of *Caravaggio, in particular Bartolomeo *Manfredi and possibly Gerrit van *Honthorst. In *The Denial of S. Peter* (Raleigh, North Carolina Mus.) the impact of these artists is shown in Seghers's realistic treatment of the figures and dramatic contrasts of light. Seghers then travelled to Spain, where he entered the service of Philip III. By 1620 he had returned to Antwerp. During the 1630s Seghers's work began to reveal the influence of his contemporary *Rubens. In Seghers's *Adoration of the Kings* (1630; Bruges, Onze Lieve Vrouwkerk), the monumental figures, sweeping diagonals, and pulsating colour all bear the stamp of Rubens's work of the previous decade. Seghers also collaborated with flower painters to produce illusionistic sculptural niches surrounded by flower garlands, such as *Flower Cartouche with Statue of the Virgin* (1645; The Hague, Mauritshuis). CFW

Vlieghe, H., *Flemish Art and Architecture 1585–1700* (1998).

SEGHERS (or Segers), HERCULES PIETERSZ. (1589/90–1633×8). Dutch painter and printmaker whose extraordinary experimental *etchings, using coloured papers and inks, have no parallel in the 17th century. He studied under Gillis van *Coninxloo in Amsterdam, and was thereafter working in Utrecht, and from 1633 in The Hague where he was also active as a picture dealer.

His paintings are few in number, the most important being the *Rocky Landscape* (Florence, Uffizi). He etched bleak and fantastic rocky landscapes, ruined buildings, and stormy seas, his colours sometimes obscuring etched lines of an almost morbid sensibility. They are of the greatest rarity, and each impression was treated as a unique work. The largest collection is in the Rijksmuseum, Amsterdam. He was much admired by *Rembrandt, who owned the copper plate of *Tobias and the Angel*, which he reworked and converted into a *Flight into Egypt*. Rembrandt and other Dutch artists were also much influenced by his panoramic views. Little is known of his life, but it was clearly troubled, and a sense of melancholy and desolation is characteristic of all his work. RGo

Haverkamp-Begemann, E., *Hercules Seghers: The Complete Etchings* (1973).

SEGNA DI BONAVENTURA (active 1298?–1326×31). Italian painter who emerged from *Duccio's shop or circle in Siena. He is almost certainly identifiable with a painter mentioned in 1298 in connection with a commission from a Sienese city official. According to 17th-century sources, he was paid for work on a panel for the convent of Lecceto in 1317. In 1319 he is documented in Arezzo, where he painted a *Crucifix* (Badia). This appears to be a later work than his *Crucifix* in Moscow (c.1315, signed; Pushkin Mus.) on account of the greater emphasis on expression in the figures and the more dramatic lighting. Among his four surviving signed works is a *Maestà* (c.1320; Castiglion Fiorentino, Collegiata), which might reflect the composition of Duccio's lost 1302 *Maestà*. Segna's work, Ducciesque in inspiration, is characterized by sharply delineated drapery forms with areas of vigorous shading and grave facial expressions. He is mentioned as dead in a document relating to his son Niccolò di Segna, also a painter, in 1331. FB

Stubblebine, J. H., *Duccio di Buoninsegna and his School*, vol. 1 (1979).

SEISENEGGER, JACOB (1505–67). Court portraitist to the Habsburg Emperor Ferdinand I, he journeyed with the court to Bologna, Madrid, and the Netherlands, but was active mainly in Vienna. Towards the end of his life, he settled in Linz in upper Austria, where he died. Seisenegger's best-known work is the portrait of *Charles V with his Dog*, which he painted in Bologna in 1532 (Vienna, Kunsthist. Mus.). It served as a model for *Titian's more famous likeness in the Prado. It is one of his many official Habsburg portraits,

adopting the formula of the full-length likeness evolved by Lucas *Cranach the elder and Hans *Holbein the younger. Although a competent portraitist, it is through Titian's copy that this portrait type became widespread in Europe. KLB

Löcher, K., *Jakob Seisenegger* (1962).

SEITER, DANIEL (1647–1705). Austrian painter active in Italy. He was born in Vienna but after a duel fled to Venice and trained there under Johann Carl Loth (1632–98) until *c*.1680 when he transferred to Rome. By 1683 he was a member of the Accademia dei Virtuosi al Pantheon, and in 1686 he was elected to the Accademia di S. Luca, *Rome, confirming his high standing among Roman collectors and his fellow artists. He gravitated to the circle of artists associated with *Maratti, including *Chiari and Giacinto Calandrucci (1646–1707), and probably received commissions through his mentor. An erotic, brightly toned *Venus Cupid, Ceres and Bacchus* (Burghley House, Lincs.) is based on a Maratti drawing and with its pendant, a *Sleeping Venus* (s.d. 1684), was bought in Rome by the 5th Earl of Exeter, a regular client of Maratti's. In 1688 Seiter took up an invitation to work for Victor Amadeus II, Duke of Turin (ruled 1675–1730). He undertook an extensive programme of decoration at the Palazzo Reale, most notably the *Apotheosis of Victor-Amadeus II*, with further pictures of *Apollo and Aurora*, in the newly named Galleria di Daniele (1690–3). In 1696 he was made principal court painter. His presence in *Turin marked a new phase of Grand Manner painting in the city. HB

Kunze, M. (ed.), *Daniel Seiter Zeichnungen*, exhib. cat. 1995 (Salzburg, Barockmus.).

SELF-PORTRAITURE. The forms of self-portraiture are related to the forms of artists' portraits of others, but the motivation is likely to be experimental to an unusual degree and patronage is often absent. The evidence suggests that virtually every painter has at some stage in his career made a portrait of himself. This is certainly the case in the 20th century, including the recent past where many artists have moved away from traditional forms and into film, *video, manipulated photographic imagery, and a whole variety of conceptual forms. Here they have used their own likeness or their own body to deal with concerns not necessarily connected with self, but may tackle, for example, issues of gender or sexuality.

The experimental aspect of self-portraiture has usually concerned the processes of seeing and depicting. It has also involved attempts to extend the borders of the artist's place in society. One of the most emphatic statements of this sort is the series of self-portraits of *Rubens, where he draws attention not only to his wealth but to his diplomatic and courtly status. So notable was this presentation of self that a number of artists painted self-portraits in which they attempted to make themselves look like Rubens.

This kind of testimony of society's relation to the individuality of the artist begins throughout Europe in the early 15th century when artists start to introduce themselves, perhaps surreptitiously, as players in the action of altarpieces and frescoes. Sometimes the artist is easily recognized as a highly individualized S. Luke at work within the work; in other instances the presence can be surmised where one actor draws attention to himself by the fixity of his stare into the eyes of the viewer. The presence becomes, in a sense, the signature. Corroboration is often provided by other portraits and sometimes by inscriptions. Perhaps the most famous example is *Raphael's inclusion of himself in the fresco of the *School of Athens* (Vatican Stanze). It is a form that persisted well into the 17th century.

The portrait of the artist by himself with some of the accoutrements of his trade (see STUDIO EQUIPMENT)—palette, brushes, easel, mahlstick, paintings by himself—may at one level have been little more than a shop sign, but at another it was an expression of the high seriousness of art. The most elaborate of all manifestations of this type is *Velázquez's *Las meninas* (Madrid, Prado), where the Spanish royal family and courtiers are so orchestrated by the artist that they virtually become extensions of his existence.

The element of self-portrayal in *Las meninas* is bound up with the problems and mechanics of depiction, and the frequency of much self-portraiture is a consequence of the visual artist's obsession with these problems. Since scrutiny is, as it were, the reason for his being, the act of scrutiny assumes a special significance—so that the scrutineer becomes the subject. Where there is no clear practical function for a self-portrait, both this concern with the nature of scrutiny and a consequent urge to experiment are likely to be present. One of the most intriguing examples is *Parmigianino's self-portrait of *c*.1523 (Vienna, Kunsthist. Mus.), where the image represents the artist reflected from a convex surface, his right hand (or is it his left?) at the bottom limit of the image enormously enlarged. This has no doubt been done to emphasize that a mirrored surface is required to make a self-portrait and that the reflection—all the artist will ever know of his own appearance—is not lacking in ambiguities: the image is the reverse of reality, right becoming left, and is always reduced to 50% of perceived reality, so that it has a more condensed quality. Reversal can, of course, be 'corrected' by the use of a second mirror, so that the resultant image is of a reflection reflected. This kind of 'correction' has always been common and would obviously be of most importance if the artist's hands, brushes, and palette were included. Self-portraits done in order to be engraved do not, of course, require this kind of correction.

Apart from questions of identity, status, and technical challenge, self-portraits may be seen as analogous to a writer's journal—either as a form of relaxation or as a means of releasing energy that external demands may have stultified. There is a good deal of evidence that artists' portraits of themselves are often of a higher quality aesthetically than their portraits of others. This self-indulgence leads to the notion of self-portraiture as visual autobiography, not necessarily as clear intention, but as the result of grappling with the problems described. This is illustrated in the portraits of Albrecht *Dürer and, perhaps most remarkably, in those of *Rembrandt. In Rembrandt's case it is virtually possible to follow the progress of his life from the cheerful optimism of youth through various statements of mid-life accomplishment to the profound resignation of old age. This kind of confrontation, not only with a reflected image, but with states of mind and the core of existence, has been a significant theme in recent art, notably in the series of self-portraits by van *Gogh, Lucian *Freud, and Avigdor *Arikha. They all raise the unavoidable, but virtually unanswerable, question of how much information the portrait can convey about the inner individual. DT

Borzello, F., *Seeing Ourselves: Women's Self-Portraits* (1998).
Goldscheider, L., *Five Hundred Self-Portraits* (1937).
Kelly, S., and Lucie-Smith, E., *The Self-Portrait: A Modern View* (1987).

SEMIOTICS, the analysis of signs, and of cultural phenomena as types of sign. It may be seen as an aspect of semiology, a general study of signs that aims to describe all systems by which meaning is conveyed; but the two terms have become virtually interchangeable. The prominent cultural presence achieved by this area of thought in the later 20th century was founded on the work from 1866 of the American philosopher Charles Sanders Peirce (1839–1914), and on the posthumous *General Course of Linguistics* (1916) by the Swiss Ferdinand de Saussure (1857–1913). Peirce elaborated a system of signs, units of representation, by distinguishing the 'icon', which refers to something by resembling it (e.g. a portrait likeness), from the 'index', which refers to it by pointing the attention back towards it as its origin (e.g. a personal signature), and from the 'symbol', which refers purely by virtue of an agreed system of relations (e.g. that of English-

speakers that the word 'dog' denotes a certain animal).

Saussure, concerned solely with this last 'symbolic' system of language, explained its working by separating *parole*, the word or unit of signification, from *langue*, the encompassing system of differences within which it achieves distinctive significance. When this idea was taken up by French thinkers in the 1950s and 1960s (see STRUCTURALISM AND POSTSTRUCTURALISM; BARTHES, ROLAND), its implications were expanded to cover every type of cultural phenomenon. Not only dress, behaviour, and the stuff of the mass media could be illumined in terms of general, structural systems of convention within which meaning was produced, but the same approach could be applied to works of art—as in the writings of Louis Marin and Norman Bryson. The impulse to treat art entirely in semiotic terms coincided with the attempt of the American philosopher Nelson Goodman to banish the idea of 'iconic' resemblance from pictorial representation, which he claimed depended on a system of agreed equivalences that was thoroughly linguistic or 'symbolic' in nature. This proposal and the innovations of French thought ensured that semiotics took an important place in the *new art history of the late 20th century, whether as a useful investigative tool or as a contentious doctrinaire approach. JB

Bryson, N., *Vision and Painting* (1986).
Eco, U., *A Theory of Semiotics* (1979).
Goodman, N., *Languages of Art* (1968).
Marin, L., *Portrait of the King* (1981).

SEQUEIRA, DOMINGOS ANTÓNIO DE (1768–1837). Portuguese painter and designer. Sequeira studied in Rome, 1788–95, where he absorbed the prevailing *Neoclassical style which typifies much of his work. Appointed painter to the Portuguese court in 1802, he established a prolific practice in Lisbon painting both portraits of courtiers, like the *Count of Farrobo* (1813; Lisbon, Mus. Nacional de Arte Antiga), and religious and *history paintings. During the French occupation of Lisbon (1807–8) under General Andoche Junot (1771–1813), Sequeira spent six months in prison for painting his Goyaesque satirical allegory *Lisbon Sheltered by Junot* (1808; Oporto, Soares dos Res Mus.) and after the French withdrawal he was commissioned by the Regent, Dom João VI, to design the immense silver table setting which a grateful Portugal presented to the Duke of Wellington (1812–16; London, Apsley House), an extravagant but somewhat vapid exercise in Neoclassicism. After 1823, considering himself unappreciated in his native country, he lived and worked in Paris and Rome. DER

Dos Santos, R., *Sequeira y Goya* (1929).

SÉRAPHINE DE SENLIS (1864–1934). French naive painter. Séraphine spent her youth as a farmhand before entering domestic service in Senlis. In 1912 she was discovered by the critic Wilhelm *Uhde and under his patronage her career flourished. One of the most original of naive artists, she painted fantastic compositions of fruit, flowers, and foliage in minute detail, with visionary intensity. Her use of gold to create an iridescent effect, as in *Tree of Paradise* (Paris, Mus. d'Art Moderne de la Ville de Paris), was much admired but the secrets of her technique died with her. GS

Uhde, W., *Cinq Maîtres primitifs* (1949).

SERGEL, JOHAN TOBIAS (1740–1814). Swedish Neoclassical sculptor. He trained with a French sculptor working for the Swedish Crown and spent 1758 in Paris. His early work is late *Baroque in style, but in 1767 he went to Rome on a government stipend, later claiming to have been so struck by the first-hand experience of *Antique sculpture that he had to abandon the 'abominable French manner'. Nevertheless, most of his artistic contacts were at first at the French Academy in Rome and included *Houdon and *Clodion. It may have been in this milieu that he began to develop his *Neoclassical style, although his severe but emotionally somewhat exaggerated Roman work has been compared with the art of Henry *Fuseli, whom he came to know later in what proved to be an eleven-year sojourn in the Eternal City. Representative in its heady blend of Antiquity with *Michelangelo is his statue of *Diomedes* (1771–4; Stockholm, Nationalmus.). With great reluctance Sergel returned to Stockholm in 1778 to take up the position of court sculptor. There he was mostly busy as a portraitist (e.g. herm bust of *Gustavus III*, 1792; Stockholm, Nationalmus.) and few of his ideal works got beyond the stage of terracotta models. His many drawings, which include caricatures, reflect his volatile and melancholy temperament. MJ

Johan Tobias Sergel, 1740–1814, exhib. cat. 1976 (Copenhagen, Thorvaldsens Mus.).

SERIGRAPHY. See SILK-SCREEN PRINTING.

SERODINE, GIOVANNI (1600–30). Italian painter and stuccoist; his family originated from Ascona on Lake Maggiore but he may have been born at Rome. After a tentative start to his career as a stuccoist and decorator at Spoleto in 1624, he appears to have turned to oil painting in a naturalistic *Caravaggesque style c.1625. His earliest paintings may be *The Calling of the Sons of Zebedee* and *Christ at Emmaus* (Ascona, parish church).

These were probably followed by two pictures for S. Lorenzo fuori le mura, Rome: the *Almsgiving of S. Lawrence* (now Casamari, parish church) and the *Beheading of S. John the Baptist* (in situ). His private clients at Rome included Duke Asdrubale Mattei, a patron of *Caravaggio, for whom he painted the *Tribute Money* (Edinburgh, NG Scotland) and the *Meeting of S. Peter and S. Paul* (Rome, Barberini Gal.), both first recorded in an inventory of 1631. These naturalistic easel pictures, together with a *Christ among the Doctors* (Paris, Louvre) of similar dimensions and horizontal format, all broadly painted with great immediacy and rich impasto, are distinct in technique from both Caravaggio's and *Manfredi's far more restrained and tightly controlled style. Serodine continued in this manner up to the *Coronation of the Virgin* (1630; Ascona, parish church), which narrowly preceded his premature death. HB

Chiappini, R., *Serodine: la pittura oltre Caravaggio*, exhib. cat. 1987 (Locarno, Pin. Casa Rusca; Rome, Capitoline Mus.).
Longhi, R., *Giovanni Serodine* (1955).

SÉROUX D'AGINCOURT, JEAN-BAPTISTE (1730–1814). French art historian and collector. He was a habitué of Mme Geoffrin's salon in Paris, where he met the leading thinkers, artists, and collectors of the *ancien régime*. The antiquary the Count de *Caylus seems to have inspired his interest in *Antique and medieval art, the latter a rare taste for the 18th century. In 1778 Séroux undertook a *Grand Tour to the ancient sites of southern Italy and to Rome, where he settled. There he explored the early Christian catacombs and began to collect ancient terracottas. He devoted much of the rest of his life to compiling a vast and pioneering history of art from the end of the classical world to the Renaissance. Curiously, his scrupulous dedication to the recording, analysis, and understanding of medieval art was not accompanied by any corresponding aesthetic enthusiasm. His viewpoint remained that of the Enlightenment and he was convinced that art had reached a high point with the Greeks (see GREEK ART, ANCIENT) and Romans (see ROMAN ART, ANCIENT) to be revived only with the rediscovery and implementation of classical principles in the early 16th century. When the six folio volumes of *Histoire de l'art par les monumens, depuis sa décadence au IVème siècle jusqu'à son renouvellement au XVIème siècle* were finally published in 1811–23, Seroux was dismayed to find that a younger generation of artists and collectors were led by his book to a love for 'primitive' art. MJ

Loyrette, H., 'Séroux d'Agincourt et les origines de l'art médiéval', *Revue de l'art*, 48 (1980).
Previtali, G., *La fortuna dei primitivi: dal Vasari ai neoclassici* (1964).

SERPOTTA, GIACOMO (1656–1732). One of an extensive family of Sicilian sculptors and stuccoists, he is rightly celebrated for his fantastical late *Baroque decoration in the churches of Palermo. These range from the elaborately detailed stucco reliefs of *The Battle of Lepanto* and *The Mysteries of the Rosary* of c.1695 in the oratory of SS Rosario di S. Cita, to the elegant statues in the Gesù, carved in marble from his models. Serpotta is an outstanding example of an artist working in a highly personal style with only tangential contact with the Roman mainstream of the day. MJ

Garstang, D., *Giacomo Serpotta and the Stuccatori of Palermo* (1984).

SERRA BROTHERS. Three brothers who painted in Barcelona in the second half of the 14th century: **Francesc** (documented 1350–62), **Jaume** (active 1358–89), and **Pere** (active 1357–1406). In the 1350s Francesc painted altarpieces for the chapel of SS. Jaume and Francese in the monastery of S. Pere de les Puelles, the convent of S. María de Jonqueres, and the church of S. María del Pi, all in Barcelona. Francesc's 1360 contract for the main altarpiece of the monastery of S. Pere de les Puelles stipulated the participation of his brother Jaume Serra. When Francesc died, Jaume seems to have formed a workshop with his brother Pere; during the 1370s the two of them received important commissions, such as the main altarpiece for the monastery of Pedralbes (Barcelona). In 1385 Jaume Serra contracted alone for the altarpiece dedicated to S. Stephen in the monastery of S. María in Gualter (La Noguera). The scenes from the life of the saint, especially those set in austere landscapes with trees stiff as broccoli florets against gilded skies, reflect the Italianate style introduced to painting in the kingdom of Aragon in the second quarter of the century. Pere Serra's independent undertakings, including graceful Italianate images of the Virgin and Child, such as that painted for the Cathedral of Tortosa (c.1375–90; Barcelona, Museu Nacional d'Art de Catalunya), with their sinuous contours and utterly charming faces, suggest that Pere was the most gifted member of the Serra family. SS-P

Cathalonia: arte gótico en los siglos XIV–XV, exhib. cat. 1997 (Madrid, Prado).

SÉRUSIER, PAUL (1864–1927). French painter and theorist. Sérusier excelled as a student at the Lycée Condorçet and then at the Académie Julian (1885–90) in Paris, showing a keen intellect. The naturalistic style of his early *Breton Weaver* (1888; Senlis, Mus. of Art and Archaeology) quickly changed when he met *Gauguin in *Pont-Aven in 1888. Under Gauguin's instruction he produced the startling abstract landscape *Bois d'amour* (1888; Paris, Mus. d'Orsay), which became known as *The Talisman* due to its importance as an example of Gauguin's 'Synthetism'. Following this lead, artists grouped around Sérusier at the Académie Julian and adopted the name the *'Nabis'. In the 1890s Sérusier moved to Brittany and painted historic Breton subject matter in the manner of Gauguin. However, this *Symbolist style later evolved into one informed by the angular, decorative forms of medieval art: *The Spinners* (c.1918; Paris, Mus. d'Orsay). Sérusier's early interest in philosophy continued throughout his life in his attempts to develop a coherent theoretical framework for his work. He recorded his ideas about *colour and Symbolist art in *ABC de la peinture* (1921). MF

Boyle-Turner, C., *Paul Sérusier* (1983).

SERVAES, ALBERT (1883–1966). Belgian painter. Servaes was born in Ghent and, with the exception of evening classes at the Ghent Academy, was self-taught. In 1905 he settled in the artists' colony of Laethem-St Martin, where he associated with the sculptor Georg *Minne and the proto-Expressionist landscape painter Valerius de Saedeleer (1867–1941). Servaes painted landscapes, rural life, and, following a religious crisis, biblical subjects with heavy figures painted in sombre earth colours. The *Expressionist tendencies in his work may be seen in the literally earthy *Potato Planters* (1909; Brussels, Mus. Royaux). He remained alone at Laethem during the First World War painting increasingly gloomy and tortured religious paintings, derived in spirit from early German masters such as *Grünewald. The *Expressionist intensity of his versions of the Stations of the Cross and the *Pietà* drew critical acclaim but proved uncomfortable to the Catholic authorities and following a public condemnation in 1921 most of them were withdrawn from Belgian churches. From 1944, when he moved to Switzerland, Servaes concentrated on painting mountainous landscapes. DER

Schoonbaert, L., *A. Servaes* (1984).

SEURAT, GEORGES (1859–91). French painter, the founder of *Neo-Impressionism. Seurat enrolled at the *École des Beaux-Arts, *Paris, in 1878 and worked under Henri Lehmann, an academic artist and a pupil of *Ingres, until 1879. Following military service Seurat worked independently, sharing the studio of Edmond Aman-Jean. He experimented in a variety of styles: in drawing he concentrated on producing tenebrist effects by using soft black Conté on textured paper; in painting he looked to Colourists, *Delacroix, the *Barbizon School, and the *Impressionists. Among contemporary artists he was chiefly attracted by *Puvis de Chavannes. He studied the technical and aesthetic treatises of Michel *Chevreul, Charles Blanc, O. N. Rood, and others and set himself to systematize the methods used empirically by *Corot and the Impressionists. His first major painting, *Une baignade, Asnières* (1883–4; London, NG), was rejected by the *Paris Salon in 1884 but exhibited by the newly formed Groupe des Artistes Indépendants. The picture's theme—boys bathing and relaxing on the banks of the Seine—owed something to Impressionist precedent but it differed in style, not only because of the more systematic use of palette and technique but due to the classically rooted, monumental composition, carefully planned from preparatory studies.

In 1884 Seurat met *Signac and Henri-Edmond *Cross, fellow exhibitors with the Groupe des Artistes Indépendants, who collaborated with him in developing the method of Divisionism which was exemplified in his next major painting *Un dimanche d'été à l'île de la Grande Jatte* (Chicago, Art Inst.), exhibited at the last Impressionist exhibition in 1886. Seurat's Divisionist technique, dismissively dubbed *'Pointillism' by critics, was a form of optical painting involving short lozenge-shaped dashes or dots of complementary colours, intended to obtain the optimum degree of luminosity and brilliance. He increasingly used it as a dominant structural element, even incorporating the frame. In his pamphlet *Les Impressionnistes en 1886*, which gave a lucid explanation of this technique, the critic Félix *Fénéon defended Seurat's Divisionism, dubbing it 'Neo-Impressionism'.

Seurat's habit was to spend summers on the Normandy coast painting beautiful, serene, and often unpeopled seascapes, and winters concentrating on a complex, often satirical figure painting on an urban theme to be exhibited the following spring. After 1887 Seurat became increasingly concerned with the problem of expressing specific emotions through pictorial means and under the influence of the aesthetician Charles Henry he tried to systematize the academic theory of emotional expression using directional lines. Major pictures painted during this period were *Chahut* (1889–90; Otterlo, Kröller-Müller), *Parade de cirque* (1887–8; New York, Met. Mus.), and *Cirque* (1890–1; Paris, Mus. d'Orsay). BT

Thomson, R., *Seurat* (1985).

SEVEN WONDERS OF THE ANCIENT WORLD, a list of 'sights' impressive for their size, beauty, and grandeur that reflects, both chronologically and geographically, the world of *Hellenistic Greece. Contemporary Hellenistic monuments as well as those of the recent and more distant past are included in the canonical seven 'wonders'. The earliest

list appears in the 2nd century BC in the *Laterculi Alexandrini* and an epigram of Antipater of Sidon. The monuments are: Great Pyramid of Cheops at Giza, city walls of Babylon, Hanging Gardens in the same city, statue of *Zeus* by *Phidias at *Olympia, temple of Artemis at Ephesus, *Mausoleum at Halicarnassus, Colossus at Rhodes. These seven also appear in a late Antique guide to the 'wonders' by Philon of Byzantium. Roman and Christian authors revised the list, eventually extending the number to sixteen. The canonical seven, with the exclusion of Roman and Christian monuments, was reverted to in the Renaissance period. ILH

Clayton, P. A., and Price, M. J., *The Seven Wonders of the Ancient World* (1988).

S EVERINI, GINO (1883–1966). Italian painter, born in Cortona. In 1901 he moved to Rome, where he met *Balla, who gave him lessons in Divisionism (see NEO-IMPRESSIONISM), and *Boccioni. He moved to Paris in 1906, becoming friendly with such figures as *Picasso, *Apollinaire, and Max Jacob (1876–1944). While living in Paris, he remained in close contact with his Italian associates, joining the *Futurist movement in 1910. Although much of his Futurist work is still influenced by Divisionism, from c.1912 his work showed a strong awareness of *Cubism, whose innovations he recommended to his fellow Futurists. Despite his debt to the figurative style of the Cubists, some of his work at this time is completely abstract, with patches of pure colour arranged into dynamic rhythmic patterns. From 1915 he devoted himself to studies of *proportion in an attempt to arrive at a more objective and classical art, which would nonetheless take account of modern artistic developments. He also concentrated on more traditional subjects, producing in 1922 a series of frescoes at the Palazzo Monteguofoni in Tuscany, which represent scenes from the *commedia dell'arte*. During the 1920s and 1930s he also executed commissions for religious murals and mosaics in Switzerland. His post-war work, however, includes some paintings that are hard to distinguish from those of the Futurist period. CJM

Fonti, D., *Gino Severini: catalogo ragionato* (1988).

S EZESSION, a name adopted by several groups of artists in Germany and Austria who in the 1890s broke away ('seceded') from the established academies, which they regarded as too conservative, and organized their own, more avant-garde exhibitions. The first of these groups was formed in Munich in 1892, its leading members being Franz von *Stuck and Wilhelm Trübner (1851–1917). There were Sezessionen also in Vienna (1897), with Gustav *Klimt as first president, and Berlin (1899), led by Max *Liebermann. When

in 1910 a number of young painters were rejected by the Berlin Sezession—among them members of Die *Brücke—they started the Neue Sezession under the leadership of Max *Pechstein. IC

S FUMATO (Italian *fumo*: smoke), used to describe the softly modelled, somewhat blurred, and scarcely perceptible divisions between areas of colour in a painting. The term was first applied to the tonal and subtly rounded figures in paintings by *Leonardo da Vinci and *Giorgione. According to *Vasari this 'smoky' quality distinguished the work of these 16th-century masters from the precise and hard outlines characteristic of earlier Italian *Renaissance artists. Later in 1681 *Baldinucci described these transitions as being like smoke dissolving in the air. CFW

Baldinucci, F., *Notizie de' professori del disegno* (1681).

SGRAFFITO. See GRAFFITO.

SHADE. See COLOUR.

S HAFTESBURY, ANTHONY ASHLEY COOPER, 3RD EARL OF (1671–1713). British moral philosopher and aesthetician. Having been instructed by his guardian John Locke in the classical languages, Shaftesbury developed a lifelong interest in the thought and culture of *Antiquity. His aesthetic outlook was shaped by Neoplatonic thought, in which the soul of man mirrors the divine ordering of the universe. In this close relationship the artist occupies a pivotal position, since he is gifted with the ability to recognize divine principles in nature and recreate these in his works. In his *Characteristics* (1711) Shaftesbury therefore confers on the artist the title of a 'second God'. Like his teacher Locke, he placed great emphasis on education, arguing that, as a reflection of the divine, the work of art could serve as an instructive vehicle to contemplate the higher principles of beauty and truth. His ideas profoundly influenced French and German aesthetic theory of the 18th century. *Kant for example relied heavily on Shaftesbury's notion of 'disinterested pleasure', a term which signifies the calm and reflective state of the soul essential for the recognition and contemplation of beauty. AT

S HAHN, BEN (1898–1969). American artist. He came with his Lithuanian Jewish family to New York in 1906 where he worked as a *lithographer until 1930, the year of his first solo exhibition. His style always retained the linear bias of a draughtsman, which was effective in his often satirical depictions of

social types. His series of pictures of the trial of the anarchists Sacco and Vanzetti, for instance *The Passion of Sacco and Vanzetti* (1931–2; New York, Whitney Mus.), did much to establish his reputation and led to further series centred around noted trials with political implications. In the 1930s he produced a number of murals, including one with Diego *Rivera for the Rockefeller Center, New York, and worked as a photographer for the *Federal Art Project. Later, during the war, he produced strident posters for the Office of War Information. Meanwhile, in his painting, his style grew fantastic and allegorical, *Italian Landscape* (1943; Minneapolis, Walker Art Center), a sombre depiction of a funeral, prefigures the new air of melancholy and loneliness which would inflect his post-war work. MF

Pohl, F. K., *Ben Shahn* (1993).

S HEELER, CHARLES (1883–1965). American painter and photographer, the best-known exponent of *Precisionism. He was born in Philadelphia, where he studied at the Philadelphia School of Industrial Art (1900–3) and at the Pennsylvania Academy of the Fine Arts (1903–6) under William Merritt *Chase. Between 1904 and 1909 he made several trips to Europe (the final one in company with his friend Morton Schamberg), and he gradually abandoned the bravura handling of Chase for a manner influenced by European modernism—the paintings he exhibited at the *Armory Show in 1913, for example, were much indebted to *Cézanne. In 1912 Sheeler took up commercial photography for a living while continuing to paint, and in 1918 he moved to New York. He worked for a while in fashion photography, but his shy and undemonstrative personality was not suited to that world, and he concentrated more on very mundane subjects such as plumbing fixtures. The clarity needed in such work helped to transform his style of painting to a meticulous smooth-surfaced manner that was the antithesis of his early approach. He began to paint urban subjects in about 1920 and over the next decade shifted from simplified compositions influenced by *Cubism (on 'the borderline of abstraction' in his own words) to highly detailed photograph-like images. In 1927 he was commissioned to take a series of photographs of the Ford Motor Company's plant at River Rouge, Mich. (he also made paintings of the plant). His powerful photographs, presenting a pristine view of American industry, were widely reproduced and brought him international acclaim (he was invited to photograph factories in Russia, but declined the offer). Increasingly, also, he was recognized as the finest painter in the Precisionist style, his work

standing out as much for its formal strength as for its technical polish (*American Landscape*, 1930; New York, MoMa).

Sheeler's paintings continued in this realistic vein in the 1930s, but in the mid-1940s his style changed dramatically; he began using multiple viewpoints and bold unnaturalistic colours, although his brushwork remained immaculately smooth (*Architectural Cadences*, 1954; New York, Whitney Mus.). In 1959 he suffered a stroke and had to abandon painting and photography. His work is represented in many major American collections. IC

S HUBIN, FEDOT (1740–1805). Russian sculptor. From peasant stock, he first worked in bone and mother of pearl. He studied at the Imperial Academy, St Petersburg, 1761–7 under the French sculptor Nicholas-François Gillet (1712–91), in Paris under *Pigalle 1767–70, in Italy 1770–2, and briefly with *Nollekens in London 1773. He executed free-standing sculptures, architectural decoration, and most notably portrait busts of Russia's aristocracy. A consummate technician in plaster and marble, Shubin was the pre-eminent Russian exponent of an elegant if formulaic *Neoclassicism, to which he added a vivid physiognomic realism, as in *A. M. Golitsyn* (1775; Moscow, Tretyakov Gal.). He was made professor at the Imperial Academy 1794. DJ

F. I. Shubin, 1740–1805, exhib. cat. 1991 (Moscow, Tretyakov Gal.).

S IBERECHTS, JAN (1627–*c*.1703). Flemish painter, active first in Antwerp, then in England. The son of a sculptor, Siberechts was apprenticed to Adrian de Bie, becoming a master in the Antwerp guild in 1648. His earliest dated works, such as *Italian Landscape* (1653; Berlin, Gemäldegal.), show the impact of Dutch Italianate painters like Nicolaes *Berchem. During the 1660s Siberechts developed a highly individual style, as in *The Flooded Roadway* (1664; Hanover, Niedersächsische Landesgal.), where prominent rustic figures and animals are further emphasized by patches of bright colour and dramatic lighting effects. In about 1627 Siberechts was invited to England by George Villiers, 2nd Duke of Buckingham, whom he had met two years before in the Netherlands. Siberechts travelled extensively throughout England, painting topographical views of country houses for an aristocratic clientele. These were to have an influence on early British landscape artists. *Longleat House, Wiltshire* (1675; Longleat House, Wilts.) is a fine example of Siberechts's ability to combine an accurate observation of topographical and architectural detail with a sensitive appreciation of the landscape of the extensive gardens and sweeping vistas of the surrounding countryside. CFW

Sutton, P., et al. (eds.), *The Age of Rubens*, exhib. cat. 1993 (Boston, Mus. of Fine Arts).

S ICIOLANTE DA SERMONETA, GIROLAMO (1521–75). Late *Mannerist painter working in Rome. He studied with *Perino del Vaga in Rome, and the latter's influence is evident in Siciolante's earliest recorded work, the *Virgin and Child with Saints* (1541; Sermoneta, Castello Caetani). However Siciolante's work gradually evolved in a direction away from Perino's high Mannerist style towards a sober, more monumental manner derived from late *Michelangelo, and *Sebastiano del Piombo. This change was also influenced by the *Raphaelesque painting style that still dominated in Bologna where Siciolante worked in the late 1540s, as is evident from the deliberately archaic feel of his altarpiece in S. Martino Maggiore in the city (1547–8). The sculptural monumentality of his figures and the deliberately restrained emotional tenor of his work were qualities well suited to the changed artistic atmosphere of the Counter-Reformation, and Siciolante worked extensively in Roman churches. The austere grandeur of his finest works, such as the frescoes in the Fugger chapel (*c*.1560–3; Rome, S. Maria dell'Anima) or the *Crucifixion* (1573; Rome, S. John Lateran), are suggestive of the new mood of piety and introspection that characterized the period. HCh

Hunter, J., *Girolamo Siciolante pittore da Sermoneta (1521–1575)* (1996).

S ICKERT, WALTER RICHARD (1860–1942). English painter. Born in Munich, of Danish and Anglo-Irish descent, he came to England from Dieppe in 1868 and remained cosmopolitan all his life. Classically educated, he spent some years in repertory theatre (1878–81), then attended the Slade School, London (1881–2), and worked in *Whistler's studio, learning *etching and a characteristic subtlety of tonal painting. Between 1883 and 1885 he was in close contact with *Degas and the *Post-Impressionists, in Paris and Dieppe. In Venice from 1895, he returned to England in 1905, becoming the main link between English and continental painting. His north London studios became the centre for several artistic groups, including the Camden Town Group and the *London Group; a member of the New English Art Club from 1888, he became ARA in 1924 and RA in 1934, although he resigned in 1935. He was an inspired teacher, at Westminster Art School until 1918, and thereafter at various short-lived establishments of his own. Unsystematic but articulate in his theories of art, he gained a reputation as critic and commentator and his writings were published posthumously in *A Free House!* (1947), edited by Osbert Sitwell.

Eclectic and highly personal, Sickert's style changed throughout his career: the low-toned naturalism of his Camden Town period (*La Hollandaise*, 1906; *Ennui*, 1914; both London, Tate); the free impressionism of his architectural studies in Venice, Dieppe, and Bath; the bright lights and strange angles of his music hall paintings; and his late works, frequently based on photographs, light in colour with a drier, broader touch. A self-declared maverick, fascinated by all aspects of human life and emotion, he stands at the beginning of the modern movement in British art; a crucial influence on his own and subsequent generations.

See Camden Town Group and New English Art Club under LONDON. JH

Baron, W., *Sickert* (1973).

S IGNAC, PAUL (1863–1935). French *Neo-Impressionist painter, chiefly of landscapes. Self-taught, his early works were *Impressionist; he met *Seurat in 1884, and in the same year helped to found the Société des Artistes Indépendants (see PARIS, SALON DES INDÉPENDANTS). In 1886 he adopted a Pointillist technique, and in the next years painted modern suburban subjects, such as *The Railway Junction at Bois-Colombes* (1886; Leeds, AG), set in the outskirts of Paris and in the small villages along the Seine. In 1892 he moved to St Tropez on the Mediterranean, where his approach became less analytical, his touch broader, and his colour more brilliant; his small studies in oil and watercolour capture form and colour with a new and fresh immediacy. He was a convinced anarchist, like others of the Neo-Impressionist group, and his *In the Time of Harmony* (1895; priv. coll.) is a classic anarchist depiction of a rural utopia in a tranquil coastal setting. In 1899 he published *From Delacroix to Neo-Impressionism*, a manifesto in defence of the Neo-Impressionist movement. HL

Cachin, F., *Paul Signac* (1971).

SIGNIFICANT FORM. See BELL, CLIVE.

S IGNORELLI, LUCA (*c*.1450–1523). Italian painter and draughtsman regarded by *Vasari as the last of the quattrocento artists and, therefore, at the threshold of the High *Renaissance. Born in Cortona and trained by *Piero della Francesca in Umbria, he worked mostly in the provincial centres of Tuscany. He was, however, abreast of current developments in Florentine art and his sculptural treatment of form and animated figure designs bear close affinities with artists such as *Pollaiuolo and *Verrocchio. *The*

Court of Pan (*c*.1484; Berlin, destr.), a 'pagan altarpiece' commissioned by Lorenzo de' Medici, offers an interesting comparison with *Botticelli's *Birth of Venus* (Florence, Uffizi), the latter's elegance contrasting with Signorelli's angular figures in harsh lighting. His greatest work is the fresco cycle of the *Last Judgement* or *End of the World* in Orvieto Cathedral, 1499–1503, where his vigorous draughtsmanship is given full rein describing a collection of muscular devils tormenting the hapless damned. These harrowing scenes, suggesting new and dramatic possibilities for the nude figure in art, were much admired by *Michelangelo.

PSt

Riess, J., *The Renaissance Antichrist: Signorelli's Orvieto Frescoes* (1995).

SIGNORINI, TELEMACO (1835–1901). Italian painter. A leading member of the *Macchiaioli, Signorini brilliantly captured the colours and light of Liguria and Tuscany, his native region, while never shrinking from recording the grimmer realities of working-class life.

Signorini was born in Florence on 18 August 1835, the son of the artist Giovanni Signorini (1808–62), under whom he studied. During the 1850s he co-founded the Macchiaioli group, developing a style characterized by luminous patches of colour and bold tonal contrasts, exemplifed by such rural scenes as *Little Donkey Being Suckled* (*c*.1860; Piacenza, Gal. d'Arte Moderna Ricci Oddi). These qualities also appear in his paintings of the Italian War of Unification, recording his own experiences in the artillery, which he joined in 1859.

Signorini's radical views are also reflected in the social criticism of *The Room of the Insane Women at S. Bonifazio in Florence* (1865; Venice, Gal. d'Arte Moderna), partly inspired by the socialist theories of Pierre-Joseph Proudhon. He also fell under the influence of artists in France and England, particularly *Degas (whom he first met in Florence in 1856) and *Whistler. Like these contemporaries, he was inspired by the colours and compositions of Japanese prints, while never really abandoning Western techniques of perspective. These features can be seen especially clearly in his later paintings, which are mostly delicate landscapes, although he sometimes recalled the sombre realism of his early work, as in *Prison Bath at Portoferraio* (1894; Florence, Pitti).

While celebrated principally for his paintings, Signoroni also produced memorable photographs of Tuscan life and scenery, as well as writing numerous reviews for Italian periodicals, an illustrated book of sonnets, and the evocative, autobiographical *Caricaturisti e caricaturati al Caffè Michelangiolo*. His crucial role in the art life of his day was further demonstrated by a retrospective at the Turin Quadriennale, a year after his death, in Florence, on 11 February 1901.

CJM

Monti, R., et al., *Telemaco Signorini, una retrospettiva*, exhib. cat. 1997 (Florence, Pitti).

Signorini, T., *Caricaturisti e caricaturati al Caffè Michelangiolo* (1893).

SILHOUETTE. All forms of monochrome painting or paper cut out, dark against light or vice versa, bounded by a sharp outline are designated by this term. The word is taken from the name of Étienne de Silhouette (1709–67), French minister of finance in 1759. He was not, as is commonly supposed, an amateur practitioner of this art, but a reforming politician whose stern fiscal policies gave rise to 'à la Silhouette' as a sobriquet for anything mean or frugal. The method is found in many periods of art from the silhouettes of hands in palaeolithic cave paintings, in Egyptian art, and on Greek vases. But the great vogue of silhouette portraits (more often known in England as 'shades') came between 1750 and 1850. Silhouettists offered the quickest and cheapest method of portraiture (their art has been called 'the poor man's miniature'), and their popularity was fostered by the *Neoclassical taste and given intellectual prestige by J. C. Lavater's *Essays on Physiognomy*, which were held in great respect throughout Europe, notably by *Goethe, and which relied on silhouettes for the exposition of their theme. Of miniature size (often reduced by mechanical processes), the earlier ones in England (*c*.1780–1800) were usually painted in black on white plaster or card; the most subtle practitioner was John Miers. The usual format was a head profile, but the range extended even to conversation pieces. After 1800 a greater variety of techniques was developed and silhouettes cut out freehand from paper became especially popular in the hands of the French virtuoso Augustin Édouart, who worked mainly in England but also in America. The strength of the silhouette was, however, vitiated by the introduction of colour, gilding, and fancy backgrounds; its death-blow, like that of the miniature, was dealt by the popularization of photography about 1850, and the art survived only as a curiosity on fairgrounds and piers, although interesting experiments, such as L. Reiniger's animated silhouette cartoon films, made in the 1930s, have been attempted.

HO

Jackson, E. N., *Silhouettes: A History and Dictionary of Artists* (1981).

McKechnie, S., *British Silhouette Artists and their Work, 1760–1860* (1978).

SILK-SCREEN PRINTING, or serigraphy, is a technique whereby a cut stencil is attached to a silk screen of very fine mesh stretched on a wooden frame. By the use of an oblong squeegee the ink is forced through the unmasked areas of the screen onto the paper below. The stencil can also be dispensed with, by the substitution of varnish or opaque glue painted onto the screen.

In the 20th century the technique was much used for commercial textile printing, and from the 1930s was used in America by artists exploiting its suitability for achieving effects of broad and brilliant colour. However its heyday came in the 1960s when it was the chosen medium of such *Pop artists as *Warhol and *Rauschenberg. They often transferred photographic imagery, and appreciated the large scale attainable by the method, and its flat impersonal surface. Brilliant technicians in England and America contributed to the medium's popularity with artists, amongst whom Eduardo *Paolozzi was ready to recognize the importance of the printers. Warhol also used screen printing to establish the imagery on many of his canvases, and is perhaps the artist most associated with the modern technique in such icons as *Jackie*, or the ubiquitous *Marilyn*.

RGo

SILOE, DE. Father and son whose work represents the end of the *Gothic and beginning of the *Renaissance in Spain. **Gil** (active *c*.1485–d. 1500), like many sculptors then active in Castile, came from northern Europe. In 1486 he designed the alabaster tombs in the monastery of Miraflores (Burgos) commissioned by Queen Isabella for her parents and brother. Between 1496 and 1499 with his workshop he created the enormous *polychromed altarpiece that rises behind the tombs of the royal couple. The intricately carved surfaces of Gil's work, enhanced by gilding and polychromy, offered the sumptuous impression favoured by Isabella and members of the Spanish nobility. Gil's son **Diego** (active 1517–63) worked as both architect and sculptor, first contributing to the carved altarpiece of *S. Anne* in the chapel of the Constable (Burgos Cathedral). Following a stay in Italy, he returned to Burgos in 1519, perfectly suited to carve the alabaster funerary monument of Bishop Acuña (Burgos Cathedral) in the up-to-date Roman style requested by the family. After further commissions for the Cathedral of Burgos, including the famous Escalera Dorada, richly decorated with Renaissance ornament, Diego de Siloe moved to Granada. From that time, he was mainly active in southern Spain. His work as a sculptor in Granada includes four carved portals of the cathedral, notably the Puerta del Perdón, where Faith and Justice are accompanied by a rich variety of classical motifs including nude athletes, garlands, and dolphins. As an architect, he designed the cathedral and other churches in Granada,

and worked at the cathedrals of Seville, Malaga, Guadix, and Plasencia. SS-P

Levenson, J. A. (ed.), *Circa 1492: Art in the Age of Exploration*, exhib. cat. 1992 (Washington, NG).

SILVERPOINT. See METALPOINT.

SIMONE CAMALDOLESE, DON (active 1379–1405). Italian illuminator. He was a Camaldolese monk originally from Siena but mainly active in Florence. His earliest surviving signed and dated work, the Antiphonary (1381; Florence, Bib. Laurenziana, Cod. Cor. 39) for the Vallombrosan monastery of S. Pancrazio, shows the clear influence of Sienese artists of the preceding generation. An unusual number of signed, documented, or dated works attributable to him have survived, demonstrating the course of his career illuminating manuscripts—predominantly choir books—for various Florentine monasteries and churches. An initial with the *Resurrection* (New York, Bernard H. Breslauer Coll.), which is also signed and dated (1388), shows the more developed figure style of his mature period. The contained simplicity of his forms and the weightier immobility of his figures distinguishes his style from that of his fellow Camaldolese illuminators Don Silvestro dei *Gherarducci and *Lorenzo Monaco, who were residents of S. Maria degli Angeli, an important centre of manuscript production in Florence. Nonetheless it has been suggested that the latter may have trained as an illuminator with Don Simone. KS

Kanter, L., in *Painting and Illumination in Early Renaissance Florence 1300–1450* (1994).

SIMONE DEI CROCEFISSI (c.1330–99). Immensely prolific Bolognese painter. He probably studied with *Dalmasio, who married his sister, and was subsequently a collaborator with *Vitale da Bologna, in the frescoes of S. Maria dei Servi, Bologna, c.1359, and friend and associate of the leading Bolognese illuminator, *Niccolò da Bologna, with whom he shares distinctive artistic and iconographic features. The neat figural forms of his early work reflect Dalmasio's; he acquired greater variety of colour and expression from Vitale and from Venetian polyptych design. Despite a wider range of technical resources than other Bolognese artists Simone is striking for his serial production of large and small panels, often showing the *Coronation of the Virgin* in a highly emotive manner. He strikingly adapted the quality of painting technique and materials to different budgets. Representative paintings include four major Crucifixes, and the early and late polyptychs *Urban V* and the *Madonna of Giovanni da Piacenza* (1378; Bologna, Pin.). RG

Gibbs, R., 'Two Families of Painters', *Burlington Magazine*, 121 (1979).

SIMONE MARTINI (c.1284–1344). Italian painter. Simone was one of the leading painters of Siena after *Duccio, in whose circle he may have been initially trained. His exceptional lyrical and decorative gifts, the refinement of his draughtsmanship and colour, have tended to dominate past assessments of him at the expense of intellectually tougher and more adventurous aspects of his style. His first major work, the large *Maestà* fresco in the Sala del Mappamondo of the Palazzo Pubblico in Siena (c.1315), reinvents the composition of Duccio's great altarpiece of 1308–11 as a Gothic court scene, but set in a fully illusionistic 'window' border reflecting the work of *Giotto and the painters of *Assisi. The altarpiece of *S. Louis of Toulouse* (1317; Naples, Capodimonte), of exquisite jewel-like craftsmanship, like all Simone's panels, is also iconographically and pictorially inventive: an existing juristic format adapted to show the Franciscan S. Louis renouncing his earthly crown in favour of his brother Robert of Naples; the five *predella scenes precociously grouped round a central perspectival axis. The S. Caterina altarpiece of 1319–20 (Pisa, Mus. Nazionale) is the definitive prototype of the micro-architectural polyptych format followed by all subsequent trecento painters. Other works in fresco are controversial: as to date with the chapel of S. Martino in the lower church of S. Francesco in Assisi; as to date and authenticity in the case of the equestrian profile of *Guidoriccio da Foliagno* in the Palazzo Pubblico in Siena. The *S. Martin* frescoes, full of genre detail, may have been painted before 1319. The *Guidoriccio*, an extraordinary image of a mercenary, facing Simone's *Maestà*, is probably much later, close in date to Simone's masterpiece, the *Annunciation with Saints* (Florence, Uffizi) for the altar of S. Ansano in Siena Cathedral, which he and his brother-in-law Lippo *Memmi signed in 1333. The sinuous form-creating lines translate into entirely personal pictorial terms the emotive power of sculptors like Giovanni *Pisano, who had worked in Siena. The sharply twisting figure of the recoiling Virgin is one of trecento painting's most memorable images. In 1334 or 1335 Simone moved to Avignon, temporary seat of the papacy, where he remained until his death. This phase of his career is represented by fragments of the frescoes and *sinopia* drawings of the portal of the cathedral at Avignon, perhaps done soon after his arrival, (Avignon, Mus. du Petit Palais); a number of small panels, like the signed and dated *Holy Family* (1342; Liverpool, Walker AG); and the frontispiece to a copy of Virgil's poems owned by Simone's friend Petrarch (Milan, Bib. Ambrosiana). JR

Martindale, A., *Simone Martini* (1988).

SINGERIES. The conceit of *babouineries*—figures of monkeys aping human occupations and sports—goes back to medieval manuscript decorations. But the word singeries (French *singe*: ape or monkey) is usually restricted to a particular phase of *chinoiserie during the French Régence period. The 18th-century singeries go back to Jean *Bérain, who first hit on the idea c.1695 of replacing the classical fauns and statues of Renaissance grotesques by figures of monkeys. But the origin of the singerie as a distinct genre is usually attributed to Claude *Audran, who in 1709 painted an arbour with monkeys seated at table for the Château de Marly. Later *Watteau, who had worked under Audran at Marly, painted *Les Singes-peintres* (destr.) for the Regent as a pendant to Pieter *Bruegel the elder's *La Musique des chats*. The fantasy was further developed by Christophe Huet (d. 1759) in his *Grand Singerie* painted in the Château de Chantilly (c.1735) and for the Hôtel de Rohan (1745). In these paintings mandarins and monkeys are so mingled that it is often difficult to tell which an individual figure represents. While the monkeys of Bérain, Audran, and Watteau were attired as fashionable if mischievous Parisians, in the third decade of the 18th century they began to appear in Chinese robes and to ape the airs of the mandarin. Other exponents of the style were Claude Gillot and Jean Oppenord.

HO/MJ

Guérinet, A., *Le Château de Chantilly: les singeries* (1904).

SINOPIA. See WALL PAINTING.

SIQUEIROS, DAVID ALFARO (1896–1974). Mexican painter. The most politically active of the 'Three Great' Mexican Muralists. Like *Rivera and *Orozco, he studied at the Academy of S. Carlos in Mexico City. He fought as a captain in the Mexican revolutionary army, and in 1919 he was sent to Madrid and then Paris as military attaché where he moved in avant-garde circles and met Rivera, whose ideas for a politicized, monumental public art coincided with his own. In 1922 he was asked to join the post-revolutionary educational programme in Mexico for which he painted murals at the National Preparatory School (1922–3) and the University of Guadalajara (1925). His political activity as secretary both to the Mexican Communist Party and to the Revolutionary Union of Technical Workers, Painters, and Sculptors caused him to be imprisoned several times. During his exile from Mexico (1932–40) he fought with the Republican army in the Spanish Civil War 1937–9. In 1936

he founded the Experimental Workshop in New York, teaching many *Abstract Expressionists, including Jackson *Pollock, to explore industrial materials and 'accidental methods' of artistic creation, with the aim to 'create art for the people'. Siqueiros's work is violently powerful, its overriding message being the oppression of the Mexican lower classes. His harsh, aggressive strokes, his bold colours, and scenes of destruction, suffering, and violence all express the epic struggle of mankind, as in *Echo of a Scream* (1937; New York, MoMa). Though present, his use of pre-Hispanic images is less obvious than Rivera's and Orozco's, and his historical murals such as *From Porfirio to the Revolution* (1957–66; Mexico City, National Mus. of History) give more importance to anti-capitalist ideology. CC

Stein, P., *Siqueiros: His Life and Works* (1989).

S ISLEY, ALFRED (1839–99). Born in Paris of English parents, Sisley, a landscape painter, was a leading member of the *Impressionist group. In c.1860 he entered the studio of Charles Gleyre (1808–74), and in this decade, influenced by *Corot, he worked in the forest of Fontainebleau. In the 1870s he painted the villages by the Seine near Paris, where he developed a fully Impressionist style, distinguished by a delicate touch and masterly sense of tone, and by the subtle poetry of unassuming and tranquil motifs. Some works suggest the romantic isolation of *Daubigny's river scenes, while others are touched by modernity, and show the working life of the river. He was attracted by effects of light which transform the everyday world, as in a series of pictures of the floods at Port Marly, and in his scenes of snow and frost which evoke the desolation of winter. From 1880 to 1899 he worked at the more remote Moret-sur-Loing, where such works as *The Small Meadows in Spring* (1882–5; London, Tate) again suggest Corot. He liked painting in series, and in 1893–4 concentrated on the church at Moret, under different conditions of weather and atmosphere. HL

Shone, R., *Sisley* (1992).

SIZE. See MEDIUM.

SLATE. See SUPPORTS.

S LEVOGT, MAX (1868–1932). German painter. Slevogt was born in Landshut, Bavaria, and studied at the Munich Academy (1885–9) and at the Académie Julian, Paris, in 1889. His early paintings were in a sombre naturalistic style akin to that of *Leibl but from 1900 they became increasingly colourful and together with *Corinth and *Liebermann, whom he joined in Berlin, where he taught, in 1901, he is regarded as one of the leading German *Impressionists. His work comprised portraits, landscapes, including brightly painted Egyptian scenes (1913–14), and bravura decorative schemes of historical subjects for which he was much in demand. He was also a prolific and successful draughtsman, working for magazines from 1896 and illustrating many books including *Ali Baba and the Forty Thieves* (1903) and *The Iliad* (1907). His last work, the fresco of *Golgotha* (1932) in the Friedenskirche at Ludwigshaven, is generally considered to be his masterpiece. Although he used a typical late Impressionist technique, with reminiscences of the *plein air* school of painting, there are anticipations of *Expressionism in his work, particularly in some of the illustrations. DER

Imiela, H., *Max Slevogt* (1968).

S LOAN, JOHN (1871–1951). American painter. Born and trained as an artist in Philadelphia, Sloan first worked as an artist-reporter while learning painting from Robert *Henri. In 1904 he followed Henri to New York where he exhibited with The *Eight and was a member of the *Ashcan School of social realists. Sloan himself concentrated on depictions of activity in New York's seamier districts; *Election Night in Herald Square* (1907; New York, University of Rochester AG) is typical of his dark palette, lively crowd scenes, and loose, dynamic handling. He was influential in promoting modern realism in the USA but criticized by social realists in the 1930s for refusing to turn this to more directly political causes; for this reason he resigned as art editor of the *Masses*, where he had worked since 1911. Following the *Armory Show in 1913 his interests became more formal, concentrating on colour theories. In the 1920s he developed a new emphatic use of cross-hatched line to characterize volume and became interested in painting the nude: *Nude, Four Seasons* (1939; Wilmington, Del., John Sloan Trust). MF

Scott, D., *John Sloan* (1975).

S LODTZ FAMILY. French sculptors and decorators in the *Rococo manner, originating in Antwerp. The three sons of **Sébastien** (1655–1726), **Sébastien-Antoine** (c.1695–1754), **Paul-Ambroise** (1702–58), and **René-Michel** (called Michel-Ange; 1705–64), were the principal designers and suppliers of decorations for ceremonial events at the court of Louis XV, succeeding *Meissonier at the department of the Menus-Plaisirs du Roi. Their brief extended to weddings, funerals, firework displays, opera, and ballet. Although by its nature ephemeral, much of the most extravagant and scenic architecture and interior decoration of the 18th century was constructed for such events and is only dimly evoked in surviving drawings and engravings, of which there are many in the Bibliothèque Nationale, Paris. Paul-Ambroise was also active as a sculptor in more permanent materials, while Michel-Ange was mainly a sculptor, having studied from 1728 at the French Academy in Rome, remaining in the city until 1747. His fine tomb in S. Sulpice, Paris, for its curé Languet de Gergy (erected 1753) is a good example of the theatrical style that he brought to monumental sculpture from the family's decorative tradition. HO/MJ

Souchal, F., *Les Slodtz, sculpteurs et décorateurs du roi* (1967).

S LUTER, CLAUS (active c.1379–1406). Netherlandish sculptor. Sluter was born in Haarlem and was named in the Brussels masons' list of 1379. His maturity was spent in Dijon, working for Philip the Bold, Duke of Burgundy, whose service he entered in 1385. Initially employed as assistant to Jean de Marville, Sluter worked independently from 1390 on a series of major commissions for the Duke's foundation of the Charterhouse at Champmol. Collectively these mark him as the major sculptor of his age and one of the seminal masters of the northern *Renaissance, as important for the development of Netherlandish and German painting as for late *Gothic sculpture. The first of these Champmol commissions was the portal (1390–3), in which Sluter transformed the whole notion of architectural sculpture. A standing *Madonna and Child* on the trumeau, in a highly active pose, is flanked on either side of the portal by life-size kneeling figures of *Philip the Bold* and his Duchess *Margaret of Flanders*, presented by SS John the Baptist and Catherine respectively. The articulation of the lower façade by means of large figures engaged in active dialogue across the intervening door spaces marks a revolutionary advance in the liberation of monumental sculpture from its architectural context. In 1395 Sluter began work on a central fountain, now known as the *Well of Moses*, for the Charterhouse cloister. Of the upper-level *Calvary* group only the head and torso of Christ survives. The supporting hexagonal pier remains intact, flanked by six life-size *Prophets*. A figure like Moses, once fully *polychromed, displays Sluter's blend of detailed realism with a quite overwhelming sense of plastic weight, expressed in massive drapery folds. The figures' domination of their architectural setting, virtually eclipsing the niches against which they are set, builds on the achievements of the portal ensemble. This quality of monumental realism informs Sluter's work on the Duke's tomb (now Dijon, Mus. des Beaux-Arts). This was commissioned from Jean de Merville in 1381. Sluter's chief contribution (c.1391) consists of the alabaster weepers of the sarcophagus arcades. Comparison with earlier Gothic equivalents confirms the extent to which Sluter had

again reinvented the given format. The figures inhabit a clearly defined space within the arcade. Individually they are pungently characterized, and of monumental cowl-swathed grandeur, for all their smaller scale. Sluter retired to the abbey of S. Étienne in Dijon in 1404, leaving his nephew Claus de Werve to complete the Duke's (largely destroyed) effigy. JR

Morand, K., *Claus Sluter* (1991).

SLUYTERS, JAN (Johannes Carolus Bernardus) (1881–1957). Dutch painter. Sluyters was born in 's-Hertogenbosch and trained in Amsterdam at the Teachers' Training College (1897–1900) and the Academy of Art (1901–4). He won the *Prix de Rome at the Academy and spent 1904 travelling in Italy, Spain, Portugal, and France. His early works owe a debt to van *Gogh and *Breitner, the Dutch *Impressionist. However, in about 1906, inspired by his exposure to contemporary French painting, he adopted a *Fauvist palette and technique. This too changed, after 1914, under the influence of Henri *Le Fauconnier, the French Cubist-Expressionist, who spent the years 1914–18 in the Netherlands where he played an important role in the development of northern *Expressionism. Working among the Calvinist peasantry in Staphorst, a village near Amsterdam, Sluyters adopted a sombre Expressionist style to depict the puritanical austerity of their lives. From 1916, working in Amsterdam and in contact with the Belgian Expressionists de *Smet and van den *Berghe, he reverted to his earlier, brighter colours and developed a personal Expressionist style which he named 'Colourism', best seen in the paintings of nudes, which brought him a considerable reputation. DER

Wessem, J. van, *Jan Sluyters* (1966).

SMET, GUSTAVE DE (1877–1943). Belgian painter. De Smet was born in Ghent where he studied at the Ghent Academy. In about 1910 he settled at Laethem-S. Martin, where a group of artists, including *Servaes, had painted local life and landscapes since c.1900, together with his brother Léon and Frits van den *Berghe. Inspired by nature and the realities of peasant life his *Impressionistic style gradually evolved towards *Expressionism, a trend consolidated by contact with German Expressionism during the First World War which he spent, with the others, as an internee in the Netherlands. In 1918 the group returned to Laethem where they were joined by *Permeke. De Smet became involved with the Brussels gallery and review *Selection*, founded in 1920, exhibiting circus and pastoral subjects, like the *Village Fair* (c.1930; Ghent, Mus. voor Schone Kunsten). During his internment he had also met Henri *Le Fauconnier and *Cubist influence may be seen in some post-war paintings, such as *La Loge* (1928; Brussels, Mus. Royaux). His work was highly influential on Belgian painting in the inter-war years. DER

Gustave de Smet, exhib. cat. 1961 (Antwerp, Koninklijk Mus. voor Schone Kunsten).

SMETHAM, JAMES (1821–89). English painter. Smetham was born in Pately Bridge (Yorks.), the son of a Methodist minister. He was articled to the Gothic Revivalist architect Edward Willson (1787–1854), in Lincoln, leaving after three years to become a painter. He painted portraits in Shropshire before entering the RA Schools (see under LONDON) in 1843 where he met *Rossetti. From 1851 to 1877 he was a drawing master at the Wesleyan Normal College, Westminster. In 1854 he met *Ruskin, who championed his work which already, as in *The Eve of S. Agnes* (1858; London, Tate), showed elements of the mystical intensity which characterized his later paintings. However he was never to be successful. In the late 1850s he was briefly influenced by *Pre-Raphaelite realism and subjects and *The Knight's Bridal* (1865; London, BM) owes much to Rossetti's watercolours of 1857 which he greatly admired. His mysticism led Rossetti to compare him with *Blake, an artist Smetham loved and whose *Life*, by Gilchrist (1863), he reviewed in the *Quarterly* of January 1869. Smetham, who first suffered a nervous breakdown in 1857, developed severe religious mania and insanity from 1877, only alleviated by Rossetti's financial and practical assistance. DER

Casteras, S., *James Smetham* (1995).

SMIBERT, JOHN (1688–1751). Scottish-born American painter. Smibert was born in Edinburgh and went to London, c.1709, to study, supporting himself by coach painting. From 1717 to 1720 he travelled in Italy and on his return to London founded a portrait practice popular with Scottish patrons. In 1728 he accompanied Dean Berkeley's Bermuda expedition. Landing at Newport, RI, in 1729, Smibert painted his finest work, the ambitious *Bermuda Group* (New Haven, Yale University AG), including his self-portrait. In 1730 he settled in Boston (the expedition had been abandoned) and exhibited the painting to great acclaim, for nothing so sophisticated had previously been seen in America. Smibert, the intended professor of art at Berkeley's aborted college, had brought over engravings, casts, and copies and with these, and his own work, established a gallery and shop in Boston which was a mecca for younger artists including *Copley. His own work, at its best sub-*Kneller Baroque, deteriorated, as may be seen in the wooden *Sir Richard Spry* (c.1747; Portsmouth, NH, Athenaeum), but his influence on the early development of New England portraiture cannot be overemphasized. DER

Foote, H., *John Smibert* (1950).

SMITH, DAVID (1906–65). American sculptor. Born in Indiana, Smith spent time assembling metal parts in a factory after leaving school, which gave him a strong socialist conviction and a feeling for industrial materials. He came to New York in 1926 and studying at the Art Students' League became interested in *abstraction and met other *modernists through John Graham (1881–1961). Impressed by Julio *González's welded sculpture he began to concentrate on sculpture in 1935, experimenting with *Cubist and *Constructivist ideas. By 1940 he was becoming a major critical success. Around 1945 he moved away from smaller-scale pieces to sculpture with a very private symbolism, similar to that being developed by the emerging *Abstract Expressionists to whom he was soon seen to be allied. In the 1950s he developed from rod and wire 'drawings-in-space,' such as *Australia* (1951; New York, MoMa), to a more monumental style with more concentration on abstract formal arrangement, exemplified by his final works, the *Cubi* series of 1961–5: *Cubi XIX* (1964; London, Tate). MF

Wilkin, K., *David Smith* (1984).

SMITH, SIR MATTHEW (1879–1959). Smith attended the Slade School, London (1905–7), before going to France in 1908, studying briefly under *Matisse (1910) before returning in 1913. His passion for *Post-Impressionism, particularly *Cézanne, and exposure to *Fauvism shaped his future work. Initially Matisse's influence predominated, as in *Apples on a Dish* (1919; London, Tate), but during the 1920s he developed the intuitive, spontaneous style he was to retain. The bold impasto brush strokes of Smith's sensuous mature nudes and still lifes, painted in hot colours in which red predominates, belie his lifelong self-doubt and nervous debility. DER

Keene, A., *The Two Mr Smiths: The Life and Work of Sir Matthew Smith, 1879–1959* (1995).

SMITH, RICHARD (1931–). British painter, born at Letchworth (Herts.). He studied at the Luton School of Art, 1948–50, and, after doing National Service in Hong Kong, at St Alban's School of Art, 1952–4, and at the Royal College of Art, London, 1954–7. Since 1957 he has spent a good deal of his time in the USA and his early work was influenced by both the vigorous handling of *Abstract Expressionism and the brash imagery of American advertising. It was essentially abstract but contained allusions to packaging, creating an individual type of *Pop art (he was a member of the *Independent Group, the cradle of British Pop). His

work was often very large in scale and in the early 1960s he formed a link between the new figuration of Pop and the pure abstraction of the Situation painters. From about 1963 he experimented with shaped canvases, which he sometimes made project from the wall, turning the picture into a three-dimensional object. This led to further experimentation with the support, and some of his most characteristic paintings use a kite-like format in which the canvas is stretched on rods that are part of the visual structure of the work (*Mandarino*, 1973; London, Tate). In these the colouring is usually much more subdued and soft than in his Pop phase, sometimes with a watercolour-like thinness of texture and vague allusions to nature. Smith has probably taken the concept of the shaped, projecting, and suspended canvas further than anyone else.

SMITHSON, ROBERT (1938–73). American artist. Born in New Jersey, Smithson studied at the Art Students' League in New York (1953–5) and at the Brooklyn Museum School. He began painting in an expressionistic style and produced *collages, combining elements drawn from popular culture with his interests in European history, religion, and *Byzantine art. In 1963 he married the American sculptor Nancy Holt and began to write and sculpt himself. His first pieces drew on *Minimalist approaches, often employing mirrors. Toward the end of the decade he became more interested in the environment, creating a series of *Non-sites* which introduced photographs and objects into galleries, like *A Nonsite, Franklin, New Jersey* (1968; Chicago, Mus. of Contemporary Art). These works made him central to the development of *Land art and he went on to work on major outdoor projects, called Earthworks, the most famous being *Spiral Jetty* (1970), a construction of earth, rock, and salt in Utah's Salt Lake. He died in a plane crash while documenting another earthwork, the *Amarillo Ramp* in Texas. MF

Hobbs, R., *Robert Smithson: Sculptures* (1981).

SNYDERS, FRANS (1579–1657). Flemish painter of animals, hunting scenes, and still lifes. Born in Antwerp, he studied with Pieter *Brueghel II and may subsequently have studied with Hendrik van *Balen, the teacher of van *Dyck. He became a master in the painters' guild in 1602. In 1608 he is documented in Italy, returning to Antwerp in 1609. In 1611 he married the sister of the painters Cornelis and Paul de *Vos. Snyders was a close friend and working partner of *Rubens from c.1610 until the latter's death in 1640. He collaborated with Rubens on a number of pictures, most famously the *Prometheus Bound* of c.1611 (Philadelphia Mus.), and through him received commissions

from Philip IV for the decorations of the Torre de la Parada near Madrid. Inspired by Rubens, Snyders's still lifes exhibit a *Baroque vitality and grandeur far removed from the miniature-like precision of his predecessors. Above all, he excelled in the representation of animals. He popularized the subject of the Aesopic fable and he invented the animal genre scene (*Two Dogs and a Cat in a Kitchen*, c.1631–6; Madrid, Prado). KLB

Koslow, S., *Frans Snyders* (1995).

SOARES DOS REIS, ANTONIO (1847–89). Portuguese sculptor. Trained at the Oporto Academy, he continued his studies in Paris (1869–70) and Rome (1870–1) where he began his most famous work, *O desterrado* (The Exile). This highly *Romantic allegorical figure, patently inspired by *Antique sculpture, symbolizes the uniquely Portuguese sentiment of *saudade* or nostalgic yearning. Appointed professor of sculpture at the Oporto Academy in 1881, his efforts to reform the teaching system aroused strong opposition, melancholia set in, and he shot himself in 1889. His work, including *O desterrado*, and severely realistic portrait sculpture, is well represented in the museum at Oporto named after him (which was inaugurated in 1942) and in the Museum of Modern Art, Lisbon. JBB

SOCIALIST REALISM, the art produced in accord with the propagandist purposes of the Soviet Communist dictatorship from 1932. It was proclaimed the officially approved artistic idiom in 1934 at the First All-Union Congress, but no clear stylistic guidelines were given. Rather it was defined negatively, in opposition to the 'formalism' and 'intuitivism' of contemporary movements. These influences were defined as foreign and alien to Marxist theory, particularly during the patriotic aftermath of the Second World War. Typical subjects included large-scale factories, the new collectivist farms, and heroic representations of Stalin as found in *The Morning of our Motherland* by Fyodor Shurpin (1948, Moscow, Tretyakov Gal.). Such paintings were often on a monumental scale, with easily identifiable figures painted in a superficially naturalistic mode. Idealized depiction was intended to convey to the proletariat the idea that the Soviet dictatorship had succeeded in extinguishing all societal evils. This form of cultural control diminished in Russia after Stalin's death in 1953 but resemblances were later to be found under similar regimes in South-East Asia. MT

Elliott, D., *New Worlds: Art and Society in Russia, 1900–1937* (1986).

SOCIAL REALISM, term used to describe 19th- and 20th-century painting and sculpture which is not only realistic in the

sense of being representational but has a specific political or social content. The term originated in the context of the 1848 revolutions in Europe, which encouraged aspirations for a shift in the balance of power in favour of the workers. For artists sympathetic to this, the harsh lives of both the rural and urban poor became recurrent themes. The French painters Gustave *Courbet, Jean-François *Millet, and Honoré *Daumier were the first to focus on 'social realist' topics, but theirs was not necessarily a realism of form. Courbet often used a palette knife to create rough, ambiguous textures and painted inconsistent patterns of light, as in *The Painter's Studio* (1854–5; Paris, Mus. d'Orsay), while Daumier frequently used *caricatures to mock establishment figures. Such formal liberties were intended to jolt the viewer out of complacency into a fresh social outlook. A realism of factual reporting was more apparent in the paintings of the later English 'social realist' artists like Luke *Fildes and Hubert von *Herkomer, whose *illustrations frequently appeared in the *Graphic* during the 1870s. These engravings were closely studied by van *Gogh, whose early work, particularly, focused on peasant life. Paintings like Herkomer's *On Strike* (1891; London, RA) and Fildes's *Applicants for Admittance to a Casual Ward* (1874; Egham, Royal Holloway College) were close to current philanthropic movements in spirit, appealing to Victorian sentimentalism in portraying the deprived as working-class heroes. The term broadened its applications in the 20th century, but is frequently associated with left-wing artists like the American Ben *Shahn or the Italian Renato *Guttuso. MT

Shapiro, D., *Social Realism: Art as a Weapon* (1973).

SOCIETY OF ARTISTS. See under LONDON.

SODOMA (Giovanni Antonio Bazzi) (1477–1549). Painter born at Vercelli in northern Italy but who worked chiefly in and around Siena. His first dated works are the frescoes in the convent of S. Anna in Camprena, Pienza (1503–4), and those in Monteoliveto Maggiore (1505–8), in which his Piedmontese training fused with the Umbrian style of *Pinturicchio and *Signorelli. Another formative influence upon him was that of *Leonardo, seen both in the *sfumato* technique and in borrowed arrangements and postures. Sodoma worked in Rome 1508–10, working in the Stanza della Segnatura in the Vatican. His most celebrated Roman work was at Agostino Chigi's Farnesina: frescoes depicting the story of Alexander and Roxana (c.1516). The influence of *Raphael combined with a *Mannerist taste to produce an attractive, decorative style seen at its best in the fresco cycle of *The Life of*

S. *Catherine* (1526; S. Domenico, Siena), particularly the scene of the saint receiving the stigmata, set in a poetic landscape. In his time Sodoma was considered the leading artist in Siena but later critics have come to rank *Beccafumi above him. HO/HB

SOFT ART, a term which emerged in the 1960s to describe a type of sculpture characterized by its use of pliable, rather than rigid, materials, such as cloth, rubber, and vinyl. Such art can be traced back to Marcel *Duchamp's exhibition of a typewriter cover mounted on a stand in 1916, although this is more precisely categorized as a *'ready-made'. The earliest examples of specifically soft sculpture are the giant replicas of pieces of food made from vinyl and canvas by Claes *Oldenburg. By the mid-1960s, Oldenburg was constructing giant soft versions of hard objects, such as *Soft Drainpipe* (1967; London, Tate), whose materials appeared incongruous in relation to their subjects, as well as to the medium of sculpture itself. Other artists have used a variety of materials in many different ways, all of which might be labelled Soft art. These include works by Arman (1928–), *Christo, Robert *Rauschenberg, Richard Serra (1939–), and Antoni *Tàpies. The term was brought into wider use after an exhibition held in Munich in 1979.

OPa

Feddersen, J., *Soft Sculpture and Beyond* (1993).

SOFT-GROUND ETCHING, an 18th-century technique designed to simulate the texture of crayon or graphite lines. The copper plate was prepared with a soft, sticky, resinous mixture, akin to an ordinary wax etching ground, but sticky enough to adhere to anything pressed onto it. A sheet of paper was laid onto this prepared surface, and the artist drew directly onto the paper with a pencil. Wherever the pencil touched, the ground adhered to the paper, so that when it was peeled off the wax on the paper was removed, exposing the copper. The plate was bitten and printed in the same manner as an *etching, but the lines produced reproduce the texture of the original paper used, producing an effect very close to an actual drawing. The effect is similar to the crayon manner, but softer and freer.

It was naturally used extensively for drawing manuals, before it was largely superseded by *lithography. A number of English artists did however make very original soft-ground etchings, including *Gainsborough and *Cotman, the former combining it with *aquatint. Curiously, though, the most beautiful soft-ground etchings were made by *Stubbs in some compositions of dogs.

In the 20th century the technique was expanded and changed. Textures, such as muslin, can pressed into the ground to create textural effects, and the potential of the medium for abstract work has been exploited. A direct way of drawing has been to dispense with the paper, and to draw directly into the ground with a wooden stylus, thus exploiting the possibilities of spontaneity inherent in the technique. RGo

SOFT STYLE, a term used to describe a type of painting fashionable during the late 14th and early 15th centuries. It has much in common with, and indeed can be confused with, *International Gothic, but is more localized within Germany and central Europe (the name is a translation from the German *weiche Stil*). Its artists (among them *Conrad von Soest, and the *Master of S. Veronica) depict a courtly and refined world, where the atmosphere is tranquil; features are delicately modelled, softly coloured robes elegantly draped, and the interest in spatial definition negligible. At its best, as in the work of the *Master of the Třeboň Altarpiece, it can convey a profound mysticism; at its worst, a somewhat banal prettiness. Although the term is generally used to describe painting, its characteristic features can be found in the contemporary and equally fashionable sculpted figures of the Virgin and Child, the so-called 'Beautiful Madonnas'. AS

SOLARIO (Solari), ANDREA (b. *c*.1465; d. before 1524). Italian painter. The Lombard painter Andrea Solario's work has often been confused with that of *Luini and *Boltraffio, and his entire œuvre remains unclear. He was a brother of the Lombard sculptor Cristoforo Solari, which may account for the sculptural style of some of his own paintings. In the early 1490s he probably travelled to Venice with Cristoforo, where he may have seen works by *Antonello da Messina, whose influence can be detected subsequently in his Virgin and Child and Ecce Homo compositions (examples in Milan, Brera, and Poldi Pezzoli Mus.), and in the *Christ Blessing* (*c*.1515; New York, Met. Mus.). He worked again in Milan from around 1495, before travelling to France, where he was in the service of Cardinal Georges I d'Amboise at his château at Gaillon, between 1507 and 1509, though his work there was destroyed in the French Revolution.

His portraits, including the grand *Portrait of Chancellor Morone* (after 1522; Milan, priv. coll.), look forward to *Lotto's portrait style. His most tender works, and which show the strongest influence from *Leonardo, are the Virgin and Child compositions, foremost among which is the exquisite *Madonna of the Green Cushion* (*c*.1509; Paris, Louvre). AB

Brown, D. A., *Andrea Solario* (1987).
Cogliati, L., *Andrea Solario* (1965).

SOLIMENA, FRANCESCO (1657–1747). Italian painter who dominated the artistic life of Naples and introduced a more classical style in the wake of *Giordano's exuberant *Baroque manner. Son of an artist, Angelo Solimena (1629–1716), he was trained by the academic painter Francesco di Maria (d. 1670). His early career blossomed in his work at S. Paolo Maggiore, Naples, where he decorated the sacristy: *Virtues* on the vault and two large frescoes of the *Conversion of Saul* and the *Fall of Simon Magus* on the walls (1689–80). Although boldly executed and brightly coloured in the manner of Giordano they show a far more academic approach to design and dramatic narrative. His *Miracle of S. John of God* for the Ospedale di S. Maria della Pace, Naples, reflects Solimena's response to *Preti's expressive chiaroscuro. Yet the general direction of Solimena's work during the 1690s was towards a more classical preoccupation with clarity of design and expressive gesture. These concerns were further stimulated by a visit to Rome *c*.1701 and are reflected in the *Abduction of Oreithyia* (Rome, Gal. Spada). His most monumental achievement in the classical style was the crowded but lucid composition for the *Expulsion of Heliodorus* in the church of Il Gesù Nuovo, Naples, of 1725, although it was criticized by de *Dominici for its lack of unity and dramatic force. In his later years, Solimena was patronized by Charles III, the Bourbon ruler of Naples and later King of Spain. He was also much in demand for rather grandiloquent portraits of the nobility; none of these however match the commanding presence of his own *Self-Portrait* (1729–30; Naples, Mus. Nazionale di S. Martino). HB

Bologna, F., *Solimena* (1958).
Pavone, M., *Solimena e la pittura napoletana della seconda metà del seicento* (1980).

SOLIS, VIRGIL (1514–62). German printmaker. Little is known of his place of birth, family's origin, or training; he is documented in 1539 in Nuremberg, where he died. After Sebald *Beham, and particularly after that artist's death in 1550, Solis was the leading producer of book illustration in Germany. He worked mostly for the Frankfurt publisher Sigmund Feyerabend, for whom he supplied his finest and most influential *woodcuts, the *Biblische Figuren des Alten und Neuwen Testaments* (1562). He was also one of the most prolific designers of ornamental engravings for the use of goldsmiths and other artisans. Solis ran a large workshop that produced over 2,000 prints. KLB

O'Dell-Franke, I., *Kupferstiche und Radierungen aus der Werkstatt des Virgil Solis* (1977).

SOROLLA Y BASTIDA, JOAQUÍN (1863–1923). Painter born in Valencia. As a student, he spent time in Rome and Paris. Soon, from 1890 to 1900, Sorolla's paintings were seen in all the leading European salons. He painted 500 works for his first one-man show at the Galeries Georges Petit in Paris in 1906, quickly followed by exhibitions in Berlin (1907), London (1908), New York (1909), Chicago, and St Louis (1909). His early works such as *Sad Inheritance* (1899; Valencia, Caja de Ahorros de Valencia) were influenced by the art of Jules *Bastien-Lepage and Adolphe von *Menzel as well as by the social realism championed by his friend the novelist Vicente Blasco Ibáñez. Although these paintings made him well known, Sorolla later found the subjects sentimental. Indeed, his reputation would rest instead with his renderings of Valencia's Mediterranean shore. Painting out of doors, Sorolla vividly captured the sparkling blues of the water and golden sunlight in works such as *The Return from Fishing* (1894; Paris, Mus. d'Orsay). From 1911 to 1919 Sorolla worked on the immense depictions of the landscape, costumes, and popular traditions of the unique regions of Spain commissioned by Archer M. Huntington for the Hispanic Society of America in New York (*in situ*). Sorolla also had a successful career as a *portraitist; his distinguished sitters included King Alfonso XIII of Spain (1907; Madrid, Palacio Real) and American President Taft (1909; Cincinnati, Taft Mus.).

SS-P

Peel, E. (ed.), *The Painter Joaquín Sorolla y Bastida*, exhib. cat. 1989 (Valencia, IVAM Centre Julio González; San Diego, San Diego Mus. of Art).

SOTTO IN SÙ (Italian: from below in upwards). The term is used to describe painted ceilings where the figures or objects are foreshortened in such a way as to give the spectator the illusion of real figures floating above. A famous early example is *Mantegna's late 15th-century Camera degli Sposi in Mantua. In the 16th century further developments are represented in the three ceilings by *Correggio in Parma (Camera di S. Paolo, S. Giovanni Evangelista, and the cathedral). Usually employed to describe frescoed ceilings, the term can also be applied to fresco combined with stucco or even canvases, placed on ceilings and set into gilded stucco frames. These may be a partial illusion as in *Veronese's work (Venice, S. Sebastiano). During the 17th century, particularly in Rome, an even greater complexity characterized the *illusionistic ceilings of *Baroque painters such as Annibale *Carracci (Palazzo Farnese) or Pietro da *Cortona (Barberini Gal.) and later those by Andrea *Pozzo (S. Ignazio) or *Gaulli (Gesù). In the 18th century *di sotto in sù* illusionism was taken to new extremes by the Venetian painter *Tiepolo in

Würzburg (Residenz) and Madrid (Palacio Real). These Italian examples were to be an important influence on the fresco painters and stuccoists of the Baroque and *Rococo buildings of central Europe during the 18th century.

CFW

SOUTH AFRICAN ART. Prehistoric man's earliest cave drawings are found in South Africa, but South African art can only truly be said to have come into existence in April 1993, with the election which gave power to the black majority. Up until then, with the centuries of exploration by white voyagers, and the building of colonial empires, painting reflected the African landscape through European eyes and, before the age of the camera, had to paint pictures of an alien and exotic landscape, peopled with primitive heathen tribes, and report meticulously the topography, flora, and fauna to disbelieving European eyes.

Table Mountain (whose unique shape excited speculation that it was the eighth wonder of the world) and animals with mythic reputation were depicted with flair and accuracy by artists who were primarily travellers, explorers, soldiers, anthropologists, or botanists: the French ornithologist and artist François le Vaillant (1753–1824) (*Travels into the Interior Parts of Africa* and *Histoire naturelle des oiseaux d'Afrique*); the Englishmen Samuel Daniell (1775–1811) (*African Scenes and Animals*); William John Burchell (1781–1869), who in four years, 1811–15, covered 4,500 miles, collected 60,000 natural history specimens, and made 500 drawings for his exemplary *Travels in the Interior of South Africa*; Frederick Timpson I'Ons (1802–87); Captain Sir William Cornwallis Harris (1807–48) (*Wild Sports of South Africa* and *Portraits of Game and Wild Animals of South Africa*); Thomas William Bowler (1813–69), whose 55 lithographic views were issued in four sought-after volumes; Thomas Baines (1820–75); and the Capetonian Abraham de Smidt (1829–1908), whose topographical talents elevated him to the post of surveyor-general of the Cape Colony.

From the mid-19th century, through the Boer War (1899–1902) and the formation of the Union of South Africa (1910) to the advent of the Afrikaner Nationalist government in 1948 with its ethos of white—i.e. European—supremacy, art which was not topographical or reportage was, for the most part, a pale reflection of Dutch, French, German, or English trends. Sculpture neglected the ancient African tradition of clay modelling or carving in wood or stone for bronzes by Anton van Wouw (1862–1945) in the *Rodin or *Maillol tradition, idealizing the noble savage/black African/worker, or Expressionistic woodcarvings by two European sculptor settlers, Moses Kottler (1892–1977) and Lippy Lipshitz (1903–80).

Painting reflected an etiolated vision of

Europe in Africa or an idyllic representation of a purified landscape, typified by the lurid and sentimental paintings of Cape Dutch homesteads—shaded by oaks and nestling beneath majestic Cape mountains—of Tinus de Jongh (1885–1942), a tradition carried on in watered-down fashion by his son Gabriel (1913–) and dignified somewhat by the colourful if sanitized visions of Cape Malay and Cape Coloured ghetto life painted by Gregoire Boonzaaier (1909–).

European and British artists continued to come to South Africa, no longer as visitors but to stay, bringing with them the traditions of their European or British art school training: Dutch-born Frans Oerder (1867–1944), who painted in an intimist, naturalistic style, became South Africa's first war artist with depictions of Boer suffering, which he followed with decades of tasteful, disciplined genre scenes and still lifes. Others reflect the turbulent movements of late 19th- and early 20th-century European art: Pieter Wenning (1873–1921), the South African *Fantin-Latour; Pranas Domsaitis (1880–1965), the South African *Rouault; Wolf Kibel (1903–38), the South African *Soutine; Jean (Hans) Welz (1900–75), a Viennese architect who worked in Paris with *Le Corbusier and who brought *Picasso's Blue Period to the dusty, sunbaked Karoo town of Worcester. Robert Gwelo Goodman, Cecil Higgs, Freida Lock, Dorothy Kay, Maud Sumner, Ruth Prowse, and Florence Zerffi were British artists, trained in Britain or Europe, who all brought a distinctive European vision to South African scenes, as did the many South African-born artists who trained in Europe or Britain. Pieter Hugo Naudé (1869–1941), the South African *Impressionist, trained at the Slade (London) and in Munich and worked with members of the *Barbizon group; Maggie Laubser (1886–1973) learned her bold and gestural style from Karl *Schmidt-Rottluff, a founder of Die *Brücke; Alexis Preller (1911–75), the South African *Dalí, studied with the Bloomsbury artist Mark *Gertler.

Two artists strongly reflected their Africanness: Jacob Hendrik Pierneef (1886–1957) (who trained in Rotterdam and moved from Impressionism and *Post-Impressionism to a highly personal *Cubism) and, particularly, Irma *Stern, the South African German *Expressionist who studied with Max *Pechstein, travelled widely in central Africa, and amassed an impressive collection of tribal art; the frames of many of her most sought-after paintings are fashioned from intricately carved wooden doors, often with Islamic motifs, acquired in Zanzibar.

While white South African artists did their utmost to become European, traditional African art—such as the painted houses of the Ndebele people, their highly coloured walls with intricate symmetries incorporating the mundanities of daily life—was classified as

ethnology; there was a clear distinction between tribal art which, with its inventive use of materials, was a part of daily life, and the rarefied activity of fine artists. Apartheid meant that, while survival was at stake and there was no money for rudimentary education, art education for blacks was practically non-existent. The struggle of black artists to achieve recognition is exemplified by George Pemba (1912– , finally acknowledged in 1997 by a retrospective exhibition at the Johannesburg Art Gallery) and Gerard Sekoto (b. 1913, died 1993 in exile in Paris). Cecil Skotnes (1926–), doyen white artist and the son of Norwegian and Canadian Salvation Army stalwarts, has always used African motifs in his carvings and paintings, and, in 1948, started an art school in Johannesburg to reintroduce to blacks their African heritage.

During the final decade of the Apartheid era, the most significant work produced by black and white artists was classified as resistance or protest art, paintings and sculpture with a message, produced by artist-theorists like David Koloane, Ezrom Legae, Sydney Kumalo, Sue Williamson, Gavin Younge, Pippa Skotnes, and Penny Siopis. Black sculptors who had traditionally produced painted woodcarvings of oxen, elephants, lions, and venerable figures, produced instead stylized and demonized effigies of white politicians, while Coloured artist Willie Bester's collages reflected the violence and squalor of township life. The work of untaught rural or urban black artists like 'Chickenman' (Fanozi Mkize), 'Doctor' Phutuma Seoka, and Johannes Segogela, with their exuberant appropriation of unlikely materials—tin cans, wire, plastic, beads, animal skins, feathers—elevated craft to art.

With the dawn of the new South Africa, and the rush to redress the balance of decades of Eurocentric acquisition, public collections are, paradoxically, in danger of falling victim to politically correct 'affirmative action', Apartheid in reverse, by acquiring work by black artists because of the colour of their skins rather than the colour of their paints; while some white artists, cushioned in comfortable white suburbs with their echoes of California and the Mediterranean, came late to the struggle but have conspicuously reinvented themselves as black African. SL

Alexander, L., and Cohen, E., *150 South African Paintings* (1990).
Arnold, M., *Women and Art in South Africa* (1996).
Art from South Africa, exhib. cat. 1990 (Oxford, Mus. of Modern Art).
Gordon-Brown, A., *Pictorial Africana* (1975).
Loppert, S., 'Art at the Crossroads', *Contemporary Art*, 1/4 (1993).
Ogilvie, G., and Graf, G., *The Dictionary of South African Painters and Sculptors* (1988).
The Neglected Tradition, exhib. cat. 1988 (Johannesburg, Johannesburg AG).

Williamson, S., and Ashraf, J., *Art in South Africa: The Future Present* (1996).
Williamson, S., *Resistance Art in South Africa* (1989).
Younge, G., *Art of the South African Townships* (1988).

SOUTINE, CHAIM (1893–1943). Painter of the *École de Paris. Born into a poor Lithuanian Jewish family, Soutine studied briefly, before arriving in Paris in 1912 where he trained at the École des Beaux-Arts. He always worked in a gestural *Expressionist manner, painting a variety of themes. His still lifes, often of food, reflect the hardships of his youth and first years in Paris. *Still Life with Fish* (c.1918; New York, Met. Mus.) anticipates his violent Expressionism of the 1920s, the sombre tones of his early work giving way to the painting's vibrant dashes of red. Later, the influence of *Rembrandt led him to violent depictions of slaughtered animals: *Carcass of Beef* (c.1925; Buffalo, Albright-Knox Gal.). Between 1919 and 1922 he spent three years at Ceret in Provence, painting his most wildly expressionistic landscapes, such as *View of Ceret* (c.1922; Baltimore, Mus. of Art), which earned him comparisons with van *Gogh. During the 1920s he also painted a number of portraits of young, uniformed men, vigorously depicted in strident contrasts of colour, as in *The Groom* (c.1927; Paris, Centre Georges Pompidou). MF

Werner, A., *Soutine* (1978).

SPAGNOLETTO, LO. See RIBERA, JUSEPE DE.

SPAGNUOLO, LO. See CRESPI, GIUSEPPE MARIA.

SPANISH ART. Throughout its history, Spain experienced disruptive invasions and powerful internal conflicts that complicate the concept of a single 'Spanish' art. As the Roman Empire collapsed in the West, Germanic tribes penetrated the Iberian peninsula during the early 5th century AD, and by the end of the 6th century a Visigothic kingdom was in place. Although the Visigothic transmission of Roman media and vocabulary was important, only scattered architectural fragments survive to record the characteristic preference for flat patterns.

In 711 the peninsula was separated dramatically from the rest of Europe by an invasion of Arabs and Berbers from North Africa. Within a few years, almost all of present-day Spain and Portugal was under Muslim rule. But by 914 Christian kingdoms in the north began seizing Muslim lands, and the last Islamic stronghold fell in 1492. To describe the art produced during centuries of Moorish hegemony, historians attempt distinctions such as Mozarabic (Christians living under Muslim rule), or *mudéjar* (Muslims under Christian rule). It is misleading to assume, however, that these terms indicate clear-cut

differences in either political allegiance or style. The Islamic lions (11th century) now in the Court of the Lions (1354–91; Granada, Alhambra) were originally created for a Jew; the Beatus manuscript (c.940–5; New York, Pierpont Morgan Lib.) was made for a Christian who accepted a heavenly Jerusalem represented by Islamic motifs.

Moorish sculpted decoration can still be seen at the Great Mosque (785–988; Cordoba), but painted cycles such as those at Madinat-al-Zahra' (begun 986; destr. 1010) exist only as ruins. As a result, one is left with the inaccurate impression that all figural painting in medieval Spain was Christian.

In Asturias, the only Christian kingdom to survive the Muslim conquest intact, wall paintings (c.812–42) made for the palatine chapel of Alfonso II at S. Julián de los Prados in Oviedo incorporate late Antique and *trompe l'œil* architectural details that suggest contacts with the *Carolingian Empire. Such references to the Christian arts of Europe often have an Islamic appearance. Though this can be said of medieval art elsewhere, in Spain there is a difference: these citations enact a lived reality in which an Islamic vocabulary is not exotic but is fully native to the local culture.

As military successes shifted the centre of Christian power from Asturias south to León, Ferdinand I (d. 1065) supported religious foundations as well as financing troops; his heirs commissioned sculpture at S. Isidoro (12th century; León), and the portals (before 1119) are important evidence of contact with Cluny. A vital and original contribution to *Romanesque sculpture was made by the portals and capitals in churches along the pilgrimage road that ran from France to Santiago de Compostela (cathedrals, 1st half 12th century at Compostela, and c.1080–1120 at Jaca; cloister at S. Domingo de Silos, Burgos, c.1130 and c.1165–80s).

Different kinds of painting illustrate the diversity of patronage in the Middle Ages. As Catalonia began to detach itself from Frankish rule at the end of the Romanesque period, painted altar frontals and frescoes in remote rural churches asserted a new political identity. Executed in simpler materials than paintings at princely courts, these works appeal to the modern eye in their graphic design and flat colour fields (frescoes from S. Climent de Taull, consecrated 1123, now Barcelona, Mus. Nacional d'Art de Catalunya). Yet aristocratic patronage could also produce images that speak with a vernacular immediacy. From the court of Alfonso X of Castile (ruled 1252–84), the codices of the *Cantigas de S. María* (last half 13th century; Escorial) serve as an anecdotal social archive, detailing the diversions (from hunting to feasting to bullfights), misdeameanours, miracles, and financial transactions of Christians, Jews, and Muslims.

In the 14th and 15th centuries Christians spent new wealth on the decoration of churches. At this point the complex idiom of Spanish art became polyglot in the extreme, as tags like Franco-Gothic, Italo-Gothic, and Hispano-Flemish indicate. Royal marriages linked the children of Ferdinand and Isabella (ruled 1474–1516) with the courts of Burgundy and Vienna; the kings of Aragon ruled Sardinia and Sicily (and after 1442, Naples), and the Italian connection is visible in Ferrer Bassa's *Giottoesque frescos (begun 1346; Pedralbes, Barcelona). Yet fresco in Spain gave way to panel painting, which was better suited to the demands of the increasingly popular *retable. This very Spanish altarpiece, which could be enormous in scale and often housed both painting and sculpture, was to become the cornerstone of church decoration until the 18th century. In Catalonia 15th-century retable panels were made by *Borrassà, *Martorell, *Dalmau, and Jaume *Serra; in Valencia and Tarragona, by *Baço and *Huguet.

The close relations with northern Europe are visible in *Bermejo's S. Domingo de Silos (c.1474; Madrid, Prado) and in Hispano-Flemish panels by *Gallego and *Inglés. Here at the victorious end of the Christian conquest, the infusion of money is played out in sumptuous materials and elaborate gold tooling in both Hispano-Flemish and Italianate paintings. Yet political victory did not produce a national artistic identity, and regional painters like Pedro *Berruguete, *Maçip, *Vargas, *Yáñez, *Machuca, *Juan de Juanes, *Morales, and Alejo *Fernández display very different manners.

In 1469 the marriage of Isabella of Castile and Ferdinand of Aragon united their kingdoms. The subject matter of Spanish art during the siglo de oro or Golden Age (from the reign of their grandson Charles I (1516–56) to the end of the Habsburg dynasty in 1700) would remain overwhelmingly Catholic. Isabella was the more active patron, and when Juan de Flandes executed panels for her retable of Isabella the Catholic (c.1500; mostly Madrid, Palacio Real), his exquisitely detailed scenes exhibit doctrinal correctness via scrupulously traditional iconography. In many ways Isabella simply continued the conservative policies of ecclesiastical commissions of the Middle Ages. Furthermore, during the crusading years of war, princely patrons were more interested in funding military ventures than commissioning art; as a result *Renaissance Spain never developed secular imagery on the scale seen in Italy. Although Spaniards occasionally collected mythological scenes, they were more likely to import them than to buy them from local painters.

The fact that patrons lavished funds on sculpture as well as painting in the early 16th century attracted a new wave of foreign artists from Burgundy and Italy: *Vigarny, *Juni, *Fancelli, and *Torrigiano sculpted tombs and retables from Castile to Granada. The optimistic sense of a grand professional future also encouraged Spaniards to travel. Alonso *Berruguete, *Becerra, Diego de *Siloe, and *Ordóñez all spent time in Italy and obtained substantial commissions upon their return, such as Berruguete's retable of S. Benito (1527–32; Valladolid, Mus. Nacional de Escultura Religiosa). Berruguete brought back a new awareness of the artist's status, expressed by a lawsuit against his patron's foreman in 1556; El *Greco, who had also worked in Italy, was involved in litigation at least three times from 1579 to 1607. *Pacheco's Arte de la pintura (1638) echoed the concern to raise painting to the status of a liberal art.

Although *alabaster was occasionally used for funerary monuments, and Pompeo *Leoni cast bronzes for Philip II at the *Escorial 1579–1600, most sculpture continued to be executed in the traditional medium of *polychromed wood. The two great regional centres were Valladolid and Seville, and at the turn of the century, sculptors joined painters like Bartolomé *Carducho, *Roelas, *Herrera the elder, and *Maino in communicating a new naturalistic sense of corporeal presence. Gregorio *Fernández's Christ Embracing S. Bernard (1613; Valladolid, Las Huelgas) was carved prior to *Ribalta's painting of S. Bernard Embracing Christ (contracted 1622; Madrid, Prado). By the 1660s, however, that initiative had been reversed: *Mena's S. Francis in Ecstasy (1663; Toledo, Cathedral Mus.) followed *Zurbarán's painting (1639; Boston, Mus. of Fine Arts). While sculpture in Italy was increasingly aesthethicized, in Spain it remained deeply devotional. Nowhere is this more visible than in the pasos or processional statues of bleeding Christs and sorrowing Virgins by Martínez *Montañés, Juan de Mesa, the *Moras, and Pedro *Roldán. These provoked intense religious exaltation, as when the 18th-century painter/critic *Palomino reacted to a statue by Luisa Roldán by saying that he was so thunderstruck at its sight that it seemed irreverent not to be on his knees to look at it.

The protocols of court portraiture were established by *Titian's imported canvases, and by portraits made in Madrid by *Mor after 1552, Sánchez *Coello 1559–88, Sofonisba *Anguissola after 1559, and Juan *Pantoja de la Cruz until 1608. Although Fernández de *Navarrete and Luis de Carvajal (c.1555–1607) also executed small canvases for the Escorial between 1576 and 1600, the bulk of the commissions for that huge complex were awarded in the 1580s to the Italians *Cambiaso, Federico *Zuccaro, and *Tibaldi. Not until the early 17th century were native Spaniards in command of major commissions and new trends. The novel genre of still life was supported by Toledo's elite, who collected pictures by *Sánchez Cotán (Still Life with Cardoon, c.1602–5; Granada, Mus. Bellas Artes), and by 1619 still lifes were executed in Madrid by van der *Hamen. These radically simple paintings were often private; except for series of Seasons or Months, they were rarely produced as institutional cycles. The same can be said of the *bodegones or *genre scenes by *Velázquez. Although he took the Walter Carrier of Seville (c.1619; London, Apsley House) with him when he sought a position in Madrid in 1623, such humble subjects, however brilliantly executed, never produced financial rewards on a par with religious paintings or portraiture.

Until Philip II settled in Madrid in the 1560s, Spain had no permanent capital. Regional schools persisted, though after 1600 their most talented members tended to find their way to Madrid. Seville was the gateway to the Americas and produced Velázquez and *Cano. Despite Velázquez's success, his energies were only partially devoted to painting, and his output was comparatively small. Nevertheless he was the 17th century's greatest artist and would remain a point of reference for *Goya and *Picasso, who reprised Las meninas (c.1656; Madrid, Prado) in the Family of Charles IV (1800–1; Madrid, Prado), and Las meninas, de Velázquez (1957; Barcelona, Mus. Picasso). Later in the century, *Murillo produced colourful altarpieces for Seville's brotherhoods and churches, as did *Valdés Leal, *Pereda, and *Herrera the younger. But Seville's prosperity depended on the waning Indies trade, and commissions from religious communities there were also dwindling. Artistic pre-eminence had shifted to Madrid, where commissions were produced even after the fortunes of the nation were clearly in decline. As a Spanish subject, *Rubens painted for the Crown 1629–40; *Mazo, *Antolínez, the *Rizi, Herrera, and *Carreño de Miranda also worked for the court, and *Coello closed out the century with his elaborate Sagrada Forma (1685–90, Escorial).

Upon the death of the last Habsburg in 1700, the crown passed to a French Bourbon, Philip V, and royal commissions were awarded to foreigners. Van *Loo, *Tiepolo, *Giaquinto, and *Mengs kept Spain abreast of continental developments, but their arrival marked the end of the Golden Age of Spanish painting. The only important exception to the marginalization of native artists was Goya, who came to Madrid in 1775, and, despite interruptions during the War of Independence (1808–13), continued working for the Crown until his emigration to France in 1824. In freedom of interpretation, Goya has been hailed as a harbinger of modern art, but

his enormous œuvre is also a summation of typologies inherited from the *siglo de oro*.

In 1752 the Academia de Bellas Artes de S. Fernando was established at *Madrid. A Neo-classical tone appeared in the works of *Bayeu and *Maella, though *Paret and *Meléndez still found clients for landscapes and historical genre scenes. Sculptors now preferred marble.

By the 19th century, patrons were often members of the bourgeoisie rather than the aristocracy. Artistic focus in Europe had shifted to Paris, where José de *Madrazo was a pupil of *David before 1605, and Federico de *Madrazo became acquainted with *Ingres in 1833; *Esquivel also painted portraits in Madrid. Painters of historical scenes (*Fortuny y Marsal, José Maria Casado del Alisal (1831–86), Francisco Lameyer (1825–77)) chose nationalistic subjects, and their orientalizing fantasies rehearsed Spain's own particular history of persecutions of Jews, of *arabismo*, and of crusading monarchs (*Rosales, *Testament of Isabella the Catholic*, 1864; Madrid, Prado). At the turn of the century, *Sorolla still struck a folkloric note in his beach scenes.

In Barcelona the re-examination of the past took the form of the Catalan Renaissance, with a group of painters that included *Rusiñol, Ramón Casas, *Nonell, and the young Pablo *Picasso. Picasso left for Paris in 1900, and he was not the only Spaniard to make the trip. María Blanchard, *Zuloaga, *Gris, *Dominguez, Dalí, and *Miró experimented with *Expressionism, *Surrealism, and *Cubism, and in the 1930s Julio *González forged metal sculptures.

During the Civil War (1936–9), Picasso painted the explicitly political *Guernica* (1937; Madrid, Reina Sofia). The post-war years saw a general focus on abstraction among those who did not expatriate (Modest Cuixart, Manolo Millares, Antonio Saura, Rafael Canogar, Luis Feito, Antoni *Tàpies, Eduardo Chillida), though the realist Antonio López exhibited still lifes and cityscapes. After Franco's death in 1975 and Spain's entry into the European Community in 1986, the recognition of Spanish artists has been facilitated by new museums such as the Centro Reina Sofia in Madrid (1986), and the Guggenheim in Bilbao (1997). GMcK-S

Bozal, V., *Pintura y escultura del siglo XX, Summa Artis*, vols. 36, 37 (2nd edn., 1993).
Brown, J., *The Golden Age of Painting in Spain* (1991).
Dodds, J. (ed.), *Al-Andalus: The Art of Islamic Spain*, exhib. cat. 1992 (New York, Met. Mus.).
Martín González, J. J., *Escultura barroca en España, 1600–1770* (1983).
Pérez Sánchez, A. E., *Pintura barroca en España 1600–1750* (1992).
Reyero, C., *Pintura y escultura en España, 1800–1910* (1995).
Tomlinson, J., *From El Greco to Goya: Painting in Spain 1561–1828* (1997).

Yarza, J., *Arte y arquitectura en España 500–1250* (6th edn., 1990).

SPANISH ART AS OBJECTS OF PATRONAGE AND COLLECTING. *See opposite*

SPANISH FORGER (active *c*.1900). Artist described by William Voelkle as 'one of the most skillful, successful and prolific forgers of all time'. He was first identified by Belle da Costa Green as the author of a panel that had been attributed to Jorge *Inglés, and it was from this attribution that he gained his name. His real identity remains unknown, although he is now thought likely to have worked in Paris at the end of the 19th and beginning of the 20th centuries. Numerous panels, often deliberately aged, and illuminated miniatures or historiated initials, usually on reused leaves from genuine medieval manuscripts, survive and frequently appear on the art market. The Forger's scenes of courtly encounter between sweet-faced, gesturing protagonists set in complex landscapes—incorporating castles perched on promontories and ships on surging seas—perfectly exemplify the romanticized interpretation of medieval life prevalent at the turn of the century. KS

Voelkle, W., *The Spanish Forger* (1978).

SPAZIALISMO. See FONTANA, LUCIO.

SPENCER, SIR STANLEY (1891–1959). English painter, born and lived in the village of Cookham (Berks.). After attending the Slade School, London, 1908–12, he returned there, beginning the series of biblical scenes in everyday village surroundings which preoccupied him throughout his career, as in *Christ Carrying the Cross* (1920; London, Tate).

Spencer recorded his Macedonian War experiences in his murals for the memorial chapel at Burghclere (Hants) (1923–34): climaxing with the *Resurrection of the Soldiers*. Another *Resurrection* is set in Cookham churchyard (1923–7; London, Tate). While working on religious compositions he also painted landscapes and portraits with a *Pre-Raphaelite clarity and realism. During the 1930s Spencer's paintings became progressively distorted in form and erotic in subject. Elected ARA in 1932, he resigned in 1935 when two works, including the powerfully grotesque *S. Francis and the Birds* (London, Tate), were refused exhibition; he was not re-elected until 1950. From 1940 Spencer worked as official *war artist in the Glasgow shipyards. His *Resurrection: Port Glasgow* (1945–50; central panel, London Tate) forms the climax of his later work. Back in Cookham he continued to paint and plan ambitious religious pictures. Knighted in 1958, he remains one of the great originals of the 20th century. JH

Robinson, D., *Stanley Spencer* (1979).

SPERLONGA (ancient Spelunca), best known for the grotto which served as a combination fishpond/dining area for an imperial villa on the east coast of Italy, 95 km (60 miles) south of Rome. By 26 BC, we know that the villa belonged to the Emperor Tiberius; Suetonius records the collapse of part of the cave during a dinner party. The interior is fitted out with four sculpture groups related to the *Odyssey* cycle (Sperlonga Mus.). Flanking the entrance are small-scale copies of groups depicting Odysseus and Diomedes stealing the Palladium of Troy and Odysseus rescuing Achilles' body (or Menelaus and Patroclus). The colossal groups within are marble copies of *Hellenistic 'baroque' originals: Odysseus and his companions putting out the eye of the Cyclops Polyphemus at the back of the grotto; Scylla reaching out to grab the sailors on the hero's passing ship in the centre of the pond. The ship's stern plate is inscribed with the names of the Rhodian sculptors *Hagesander, Athenadorus, and Polydorus, active between 50 BC and AD 25. *Pliny names these same artists as the sculptors of the *Laocoön*. L-AT

Stewart, A., *Greek Sculpture* (1990).

SPINELLO ARETINO (Spinello di Luca Spinelli) (1350×2–1410). Aretine painter whose style influenced the development of late 14th- and early 15th-century painting in Tuscany. He is first documented in Arezzo in 1373 and his earliest works, which manifest an interest in space, form, and outline, suggest that he spent his formative years in Arezzo. In 1383–5 he resided in Lucca and executed at least two altarpieces for the Olivetans: one for the Lucchese convent of S. Ponziano (1385–4) and another for the Roman convent of S. Maria Nuova (1385). These works, with their fresh colours and vigorous modelling, are enriched with a late *Gothic approach to surface decoration, rhythmic design, and anecdotal detail. From the mid-1380s into the 1390s he worked on large fresco cycles in Florence (S. Miniato al Monte, S. Caterina all'Antella, S. Maria del Carmine) and Pisa (Camposanto), and, along with Agnolo *Gaddi and Antonio Veneziano (active 1369–93), he contributed to the renewed interest in narrative mural art and the ideals of *Giottesque painting. Spinello's lively anecdotal fresco cycles are characterized by clarity of gesture and expression. FB

Boskovits, M., *Pittura fiorentina alla vigilia del Rinascimento* (1975).

· SPANISH ART AS OBJECTS OF PATRONAGE AND COLLECTING ·

1. SPAIN
2. ITALY
3. FRANCE
4. GREAT BRITAIN
5. UNITED STATES OF AMERICA

1. Spain

ALTHOUGH the activities of the Spanish royalty and aristocracy in the 16th and 17th centuries are well documented no general survey of artistic patronage and collecting in Spain exists. Prior to the 19th century, there was little demand outside the Iberian peninsula for the works of Spanish painters, and Spanish sculpture historically has never enjoyed much foreign interest.

During the Middle Ages, precious objects, relics, and illuminated manuscripts were accumulated primarily by religious institutions as objects of devotion, expressions of wealth, and evidence of generous patronage. The collections of the Catholic Kings, Ferdinand and Isabella (ruled 1479–1516), reflected a new taste for objects valued for their rarity and beauty, such as precious gems, jewels, and objects from the New World. The notable collections of the Mendoza family and Cardinal Francisco Jiménez de Cisneros (c.1436–1517) exhibited similar preferences for the accumulation of both sacred and exotic treasures. The collection of Charles I (ruled 1517–56) embodied the eclectic taste of *Mannerism in its scientific, aesthetic, and exotic interests, setting the stage for the transition from the accumulative medieval mode to true patronage and collecting as practised elsewhere. Charles's collection of paintings, composed almost exclusively of works by foreign artists, formed the basis for the future royal gallery of painting.

There was a remarkable lack of interest in Spanish artists at court until the reign of Philip II (ruled 1556–98). Philip supported several Spanish painters, including Alonso *Sanchez Coello and Gaspar *Becerra, and collected the works of leading contemporary Spaniards; however, these were predominantly portraiture and religious works. Philip assigned Juan Fernández de *Navarrete, Sánchez Coello, Luis de Cavajal, and Diego de Urbina to paint altarpieces at the *Escorial, but rejected El *Greco, who thereafter worked almost exclusively for ecclesiastical patrons such as Diego de Castilla, dean of Toledo Cathedral, and Pedro Salazar de Mendoza, administrator of the Hospital of S. John the Baptist, Toledo.

Contemporary aristocratic collections emphasized painting, especially the new genres, over other forms of art. In the collection of the dukes of Alcalá, works by Juan de *Roelas, Francisco *Pacheco, Pablo de Céspedes, Luis de *Vargas, and Juan Bautista Vázquez occupied a pre-eminent position. Profane themes as well as portraits and religious works were favoured by wealthy collectors such as the dukes of Villahermosa, the counts of de Benavente, the Duke of Arcos, the Marquis of Poza, Antonio Pérez, Diego Hurtado de Mendoza, and Don Juan de Borja.

Under Philip III (ruled 1598–1621), interest in painting continued, although he did not collect with the zeal of his predecessor. However, the collection of his contemporary, the Duke of Lerma, was one of the most important in Europe, and included works by Vicente *Carducho, Sánchez Coello, *Pantoja de la Cruz, and Blas de Prado.

During the 17th century, the taste for new genres of painting promoted the specialization of Spanish artists, and *bodegones, landscapes, and genre scenes were collected by the Crown and aristocracy, in addition to religious works reflecting the renewed piety of the Counter-Reformation. Under Philip IV (ruled 1621–65), court artists such as *Velázquez, Francisco de *Zurbarán, Juan van der *Hamen, and Antonio *Pereda produced a range of themes from still lifes to mythological scenes. The Salón de Reinos at the Buen Retiro was decorated exclusively by Spanish artists, and the Sala de Comedias in the Alcázar contained works by Félix Castello, Antonio Arias, José Leonardo, and Alonso *Cano. Notable picture collections were amassed by the Marquis of Leganés, whose paintings numbered 1,333 in 1665, and contained five works by Velázquez: a *Self-Portrait*, portraits of the *Queen of Hungary* and the court jesters *Pablillos* and *Calabacillas*, and an image of *S. Francis de Paula* (locations unknown). His son, the Marquis of El Carpio, acquired Velázquez's *Toilet of Venus* (London, NG), and works by Pereda, José Antolínez, Pedro *Orrente, and Juan *Carreño de Miranda. Paintings by Jusepe de *Ribera were found in virtually all aristocratic collections. The Count of Monterrey possessed more than 2,000 paintings, and the collections of the counts of Benavente, Vincencio Juan de Lastanosa, the Duke of Medina, the dukes of Bejar, and the dukes of Alcalá were also of exceptional importance.

Charles II (ruled 1665–1700) employed numerous Spanish artists at court, including Claudio *Coello and Carreño de Miranda; however, he was by no means as active a patron as his predecessor. The contemporary collection of Don Juan de Austria in Madrid included numerous works by Ribera, Jusepe Martínez, and Fernández de Navarrete. In general, however, the number of works by Spanish artists in royal and aristocratic collections during the 16th and 17th centuries was remarkably small compared to the number of works by foreigners.

The primary employers of Spanish artists during the prosperous 16th and 17th centuries were religious institutions. Painters such as El Greco, Zurbarán, and Bartolomé

*Murillo, as well as the sculptors Juan Martínez *Montañés, Gregorio *Fernández, and Pedro *Roldán, worked mostly for religious patrons, especially the religious orders, and many exported works to Spanish colonies. Zurbarán, for example, worked almost exclusively for religious orders such as the Dominicans and Carthusians, while Murillo's patrons were composed of both secular and regular clergy. Confraternities were also significant patrons of Spanish artists, commissioning large quantities of sculpture and painting for devotional purposes. One noteworthy example is the confraternity of Charity in Seville, which commissioned important works from Murillo, Roldán, and Juan *Valdés Leal, to adorn its private chapel.

The Bourbon monarchs were avid collectors, and renewed interest in earlier Spanish schools of painting. Philip V (ruled 1700–46) and his wife Isabella Farnese admired the 17th-century Sevillian school, and acquired major works by Murillo. Charles III (ruled 1759–88) promoted the local production of porcelain and tapestries, and appointed Francisco *Goya as court painter. Charles IV (ruled 1788–1808) continued to patronize Goya and acquired paintings by Murillo, *Ribalta, and *Juan de Juanes. Goya also figured prominently in the collection of the dukes of Osuna. His religious commissions included the spectacular mural cycle in the church of S. Antonio de Padua, Madrid.

The Napoleonic campaigns of the 19th century saw the removal of many works to France. A large number of these were returned during the reign of Ferdinand VII (ruled 1808; 1814–33). When the Museo Real del Prado was inaugurated in 1819, paintings by Velázquez, Ribera, Zurbarán, and Goya were the first to be exhibited. Domestic collections of Spanish art were also amassed by wealthy Spanish businessmen and industrialists. Important religious works were readily available to these collectors as a result of the suppression of the religious orders between 1798 and 1837. Impressive 19th-century collections included those of the Infante Sebastián Gabriel, José Madrazo y Agudo, the Conde Bartolomé Eladio de Santamarca, and Manuel López Cépero. By mid-century, shifting financial fortunes forced the sale of major private collections, including those of the Marquis Las Marismas del Guadalquivír, the Marquis of Salamanca, and the Count of Quinto.

In the 20th century, there was a marked shift in taste toward the collection of precious objects, especially medieval works. The most notable were those of the Infante Sebastián Gabriel, José Lázaro Galdiano, Frederico Marés, Francisco de Asís Cambó y Battle, and Luis Planidura. In the later 20th century, collecting focused primarily on contemporary art. Picasso's *Guernica* (Madrid, Reina Sofía) was executed in 1937 for the Pavilion of the Spanish Republic at the Paris International Exposition; but the majority of his patrons were not Spanish. SVW

Brown, J., *Kings and Connoisseurs* (1994).
Morán, J. M., and Checa, F., *El coleccionismo en España* (1985).

2. Italy

FROM at least the 16th century onwards, Spanish painters travelled to Italy to learn from the *Antique and copy the works of celebrated artists such as *Michelangelo, *Raphael, and *Leonardo da Vinci. Many worked in the studios of the Italian masters, receiving tuition in new skills and styles. Spanish viceroys governed the kingdom of Naples and Sicily, the duchy of Milan, and at various moments, the states of Tuscany, Genoa, and Mantua, and their influence was helpful in obtaining introductions for Spanish artists seeking training. These Spanish painters mostly worked in the style of the Italian artists from whom they were receiving training, assisting in commissions until they eventually received recognition in their own right and were given commissions themselves. Aside from a few notable exceptions, such as *Velázquez, there is no evidence of Italian patrons developing a taste for collecting Spanish paintings as such. However, a number of Spanish painters, most notably *Ribera, were recognized as equals by their Italian contemporaries, and works by Spanish painters are still to be found in Italian churches and convents.

One of the first recorded Spanish artists to make the journey to Italy was Pedro Fernández, from Murcia, who made his way in 1500 to Milan where he made contact with *Solario and *Bramantino. During an eighteen-year stay in Italy, he travelled between Milan and Naples, producing several altarpieces in the style of his masters that later earned him the title of the Pseudo-Bramantino. Other Spanish painters who travelled to Italy at about the same time include Fernando Llanos (active 1506–16) and Fernando *Yáñez de la Almedina, both from La Mancha. The influences of Leonardo and Raphael in their work indicate that both spent time in Florence. A document informs us that Yáñez received payment for assisting Leonardo in his painting of the *Battle of Anghiari* (destr.) in 1505 in the Palazzo Vecchio.

Alonso *Berruguete and Pedro *Machuca resided in central Italy during the years when the *Mannerist style was developing. Berruguete left Spain in 1503 and according to *Vasari was in Rome in 1507, where he made a sculptured copy of the recently rediscovered *Laocoön. After studying with Michelangelo, he produced such works as the tondo of the *Virgin and Child with S. John the Baptist* in the Palazzo Vecchio in Florence. Machuca is recorded as having been in Italy in the 1510s, but little is known of his activities. His paintings do, however, indicate an understanding of the Mannerist style in vogue in Florence.

The Sevillan painter Luis de *Vargas is known to have been in contact with Vasari, and used one of his compositions for an altarpiece now in the Cathedral of Seville. Gaspar *Becerra, from Baeza, worked with Vasari in the mid-1540s, assisting him in the execution of the Hall of 100 Days in the Cancelleria Palace in Rome. He then helped

Daniele da *Volterra with the decoration of the della Rovere chapel in S. Trinità dei Monti in Rome.

The most famous Spanish artist to have settled in Italy was Jose de Ribera, known to the Italians as Il Spagnoletto. Based in Naples from 1616, he remained throughout his career in constant contact with Spain, while supplying paintings for a Neapolitan clientele. Velázquez went to Italy twice, in 1629 and then again in 1648, when he earned praise for his portrait of *Innocent X*, now in the Doria Pamphili collection, Rome. Velázquez was highly appreciated in Rome for his skill as a *portraitist at a time when, aside from *Bernini, in sculpture, and *Gaulli, as a painter, there were no eminent practitioners of the art of portraiture in Rome. According to his biographer *Palomino, Velázquez is known to have done portraits of nine other Italian patrons aside from the Pope, of which only two can now be identified: the portrait of *Monsignor Camillo Massimi*, now at Kingston Lacy in Dorset, and *Cardinal Astalli-Pamphili*, in the collection of the Hispanic Society of New York. Velázquez's enthusiasm for Italy is reflected in his highly personal and spontaneous oil sketches of the gardens of the Villa Medici (Madrid, Prado).

In 1748, Antonio González Velázquez decorated the church of S. Trinità degli Spagnoli with frescoes while studying under *Giaquinto in Rome. Following the foundation of the Academia de S. Fernando, *Madrid, in 1753, artists such as Mariano *Maella and Jose del *Castillo received royal sponsorship to study with the Academy's representative, Francisco Preciado de la Vega, who had been in Rome since 1733 and had studied with Sebastiano *Conca. Preciado also served as secretary to the Accademia di S. Luca, *Rome, and several of his works survive in Rome, including an altarpiece in S. Trinità degli Spagnoli. *Goya went independently to Italy in 1771, taking part in a competition organized by the Academy of Parma. In the 19th century, Mariano *Fortuny spent a great part of his life in Rome, painting for private patrons. XB

3. France

THE constant climate of political conflict between the two nations, which resulted in the virtual impossibility of artistic exchange, meant that despite the esteem in which Spain was held in Parisian culture, the only Spanish paintings to be found in France in the 17th century were there as a result of political exchanges or good fortune. The artist and collector Claude *Vignon does not appear to have brought back anything from his stay in Spain (1622–3). In spite of three Franco-Spanish marriages, the inventories of the royal collections from 1681, 1683, and 1706 mention only a handful of dynastic portraits, a canvas by Bartolomé *Carducho, and the *Burning Bush* by Francisco Collantes (c.1599–1656) (Paris, Louvre). The fact that the Lyons convent of Terceline nuns, founded in 1665, owned *S. Francis Standing* by *Zurbarán (Lyon, Mus. des Beaux-Arts) was

due to the patronage of the Queen Mother of Spain, Mariana of Austria. It is unknown how *Murillo's *S. James of Compostella*, which was the first work by the Seville artist to reach France, came to be in the Château de Bussy-Rabutin (*in situ*) at the end of the century. The acquisition of *Democritus* by *Velázquez (Rouen, Mus. des Beaux-Arts), which came from the del Carpio Collection and which was hung in the Chambre des Comptes at Rouen at the beginning of the 18th century, must have been the result of negotiations between a Spanish dealer and the town.

At the beginning of the 18th century, two factors led to the appearance of Spanish paintings in French collections. The establishment of the Bourbon dynasty in Spain (1700) encouraged large numbers of influential French citizens to cross the Pyrenees, while the expansion of the art trade from *Antwerp to both *Paris and the Iberian peninsula certainly resulted in the arrival in France of the first paintings by Murillo. The example of the connoisseur and writer Roger de *Piles is typical: in 1699 he ignored Spain in his *Abrégé de la vie des peintres*, yet in 1705, according to Pierre-Jean Mariette, he bought around 30 Spanish drawings in Madrid (*Cano, Murillo, *Ribalta), which found their way into Pierre Crozat's collection. Although collectors did not generally look specifically for works from the Spanish School, they did like to enrich their collections of European paintings with a few works by Murillo. Most notable among those which found their way to France are his portraits of children and his street scenes, which may have come from the Antwerp market. Among the 400 paintings owned by the Countess de Verrue, who died in 1737, of particular note are the *Laughing Boy* (London, NG) and the *Flower Girl* (Dulwich, Gal.). The *Marriage at Cana* (Birmingham, Barber Inst.) was the only Murillo in the important gallery of Jean de Julienne. There was a pair of children's portraits in the collection of the Duke de Choiseul (Moscow, Pushkin Mus.; St Petersburg, Hermitage). The sale catalogue after his death in 1772 also mentions two paintings of mythological scenes attributed to Velázquez, in whom some French collectors were beginning to take an interest: the sculptor Edmé *Bouchardon owned *Philip IV at Fraga* (copy; Dulwich, Gal.). While the painter was highly regarded, his work remained little known, which explains why so many prestigious works were attributed incorrectly to him: since at least 1701, the Orléans family had attributed O. *Gentileschi's *The Finding of Moses* (priv. coll.) to Velázquez. This growing taste for Spanish painting which eventually aroused royal interest coincided with a Spanish embargo on the export of Murillos (1779). However agents working on behalf of Louis XVI managed to acquire five Murillo paintings at sales in France between 1782 and 1786. Among them was *The Street Urchin* (Paris, Louvre), which had been a part of the superb collection of Jean de Gaignat, devoted primarily to the northern schools.

During the French Revolution there was obviously a period of stagnation in the formation of collections. It also marked the beginning of the exodus of Spanish paintings from France to England. In 1787, the gallery of the minister

Charles-Alexandre Calonne, which included several Spanish works, was shipped to London and sold in 1795. The dealer Noel Desenfans, who had already acquired several Murillos and a 'Velázquez' in Paris, moved to London; his collection was given to Dulwich College in 1811 (see LONDON, DULWICH PICTURE GALLERY).

Following the British example, French travellers and dealers finally began to explore Spain at the beginning of the 19th century. Although in 1807 Jean-Baptiste Lebrun did not purchase as many Spanish pictures as his English counterparts William Buchanan and George Wallis, he did bring back to France works by artists who were still virtually unknown there, such as *Christ Carrying the Cross* by Zurbarán (Orléans Cathedral) and *S. Peter of Alcantara* by Claudio *Coello, which was sold to Josephine de Beauharnais (Munich, Alte Pin.).

In 1808, the occupation of the Iberian peninsula by Napoleonic forces and the installation of Joseph Bonaparte as King of Spain meant that Spanish treasures became readily available to French officers, especially after the religious orders had been suppressed and their goods seized (1809). Joseph Bonaparte made a collection of Spanish and Italian works using royal funds: *Raphael, *Correggio, but also Velázquez—the *Water Carrier* (London, Apsley House)—as well as landscapes by *Paret and still lifes by Sánchez *Cotán. Many officers assembled superb collections by means of coercion and the abuse of power; and the majority of the generals—Sebastiani, Fabvier, Eble, and Marshal Soult—sought out Spanish art. As the governor of Andalusia from 1810 to 1812, Soult, guided by the five-volume *Diccionario de artistas* of *Céan Bermúdez (1800), took works that had been removed from the abolished religious orders directly from the Alcázar in Seville, or bought them with threats for give-away prices; most notably he dismantled the decorations by Murillo at S. María la Blanca and at the Hospital de la Caridad. In all, he sent 109 paintings, together representing the entire Andalusia School, back to his *hôtel* in Paris.

The passion for Spain that dominated the years 1830–50 in France did not, however, give rise to a real enthusiasm for Spanish painting. In 1826 the Countess de Chinchon was unable to sell *Christ on the Cross* by Velázquez (Madrid, Prado) in Paris. And while Sebastiani and Soult kept together the bulk of their collections until the beginning of the 1850s, many other army officers were intent on selling their pictures. This internal trade, further boosted by the arrival of the first wave of Spanish émigrés, bringing new works with them, attracted neither the museums, which were nevertheless in the process of development, nor French collectors. Those who were interested were either British dealers—for instance Samuel Wooburn bought *Philip IV in Brown and Silver* by Velázquez (London, NG) from the heirs of General Dessoles—or else people with personal links to Spain. Thus Alexandre Aguado (1785–1842), who came originally from Seville, but who had become a Parisian banker whilst retaining business interests in Spain, built up between 1837 and 1840 a collection of more than 250 works, both from sales in Paris—for

instance *The Death of S. Clare* by Murillo (Dresden, Gemäldegal.) was bought at the Febvier sale in 1837—and from dealers from Seville. The Spanish dealers were taking advantage of the recent laws of *desamortización* (1835, closure of religious establishments and seizure of their goods) to acquire works which should have gone to provincial Spanish museums; thus c.1840 the Duke of Padua, part of whose collection can still be seen in the Château de Courson, was able to obtain *The Foundation of the Order of Trinitarians* by *Carreño (Paris, Louvre), which came from a convent in Pamplona.

This *desamortización* greatly facilitated Baron Taylor's mission, initiated in 1835 by King Louis-Philippe, to form a Galerie Espagnole for the French public. In a year and a half, helped by the painters Adrien Dauzats and Pharamond Blanchard, he assembled a collection of almost 500 paintings, many of which had just been confiscated. The Galerie Espagnole, opened at the Louvre (see under PARIS) in January 1838, owed its public success mainly to its extraordinary concentration of 80 paintings by Zurbarán. On the other hand it had no autograph works by Velázquez, but some excellent works by El *Greco, an artist who was still completely unknown to the French. They were no more interested in him than they were in *Goya, who was still only known for his etchings, *Los caprichos*. Taylor had been able to buy eight Goya paintings from Javier, the artist's son, who had owned them since 1812; they included *Les Jeunes* and *Les Vieilles* (Lille, Mus. des Beaux-Arts). The revolution of 1848 led to the closure of the Galerie Espagnole, whose stock had been increased in 1841 by 200 paintings bequeathed to the King by the Francophile British collector Frank Hall Standish. Having been bought by the personal privy purse of the King, the whole collection was returned to his family in England in 1850.

Thus, by the early 1850s, Paris had lost almost all its Spanish paintings. When Louis-Philippe's gallery was sold in London at Christie's in May 1853, it hardly attracted any French presence, with the exception of the Duke de Montpensier, the son of the King, who bought back several masterpieces which he then took to his palace in Seville. The dispersal of the Aguado Collection in 1843 had already attracted British collectors, from the dealer William Buchanan to the Marquess of Hertford (see LONDON, WALLACE COLLECTION), both of whom were again the major buyers at the sales of the galleries belonging to Sebastiani (1851) and Soult (1852). The Louvre, which had already acquired several works of Murillo, had exhausted its financial resources on Soult's *Immaculate Conception* (Madrid, Prado), leaving the Russians and the British to fight over the superb remains of this war booty, while a handful of French aristocrats each bought a canvas. Even if this constant exodus of paintings demonstrates the profound lack of sustained interest among the French for Spanish art, it remained good form for a great Parisian collector to supplement his collection of European paintings with one or two Spanish canvases. The Duke de Morny and Count de Pourtales both believed they owned a Velázquez: *Portrait of the Infanta* (del *Mazo; New York, Met. Mus.) in the

first case, *A Dead Soldier* (Italian; London, NG), in the second. The case of the Pereire brothers, bankers with interests in the construction industry, is quite unusual. Their Parisian collection, which was sold in 1868 and 1872, contained a few Spanish paintings, some even attributed to Velázquez. But the paintings which they were able to buy with such ease whilst building railways in northern Spain served above all as benefactions to advance the donors' prestige and their careers as deputies; they are still scattered today among the churches of Bordeaux (Arcachon).

Paradoxically this was a period of close political and economic ties with Spain, which was in the throes of the Carlist Wars. Among the Spaniards who accompanied Queen Maria Christina during her renewed exile in France (1854–78), Count Javier del Quinto (1810–62) had assembled an impressive collection of paintings which were obtained, like those owned by the Museo de La Trinidad where he was the director, during the *desamortización* of the convents of Madrid and Toledo. It included some important works by El Greco and also some by Goya bought from Madrid collectors. Its dispersal, both in private sales in 1862 and then in a public auction in 1864, allowed John Bowes to create a Spanish gallery which today is the pride of the Bowes Museum at Barnard Castle (Co. Durham). The Marquis of Salamanca, a very wealthy businessman, had acquired, while in temporary exile (1811–33), as part of a highly eclectic collection, an exceptional group of Spanish paintings. It was at their dispersal in 1867 and 1875 that M. de Lasalle bought *Ribera's Baptism of Christ*, which he gave almost straight away to the Musée de Nancy. Other museum benefactors—d'Esplanlard at Le Mans, General Beylié at Grenoble—often bought their works in sales or from Parisian dealers like Eugène and Jules Ferral, who in turn bought them from photographs sent by Spanish dealers. The bequests made to French museums during this period reveal the names of the few remaining collectors of Spanish art. The artist dealer Marcel Briguiboul who bought Goya's *Self-Portrait with Glasses* and *The Junta of the Philippines* (Castres, Goya Mus.) in 1881, and the collection of the painter Léon Bonnat (Bayonne, Mus. Bonnat), also mark the first signs of interest in Goya, the painter whose Black Paintings had gone unnoticed in Paris at the Exposition Universelle of 1878. VGP

Baticle, J., and Marinas, C., *La Galerie Espagnole de Louis-Philippe au Louvre* (1981).

Ressort, C., *Murillo dans les musées français*, exhib. cat. 1983 (Paris, Louvre).

4. Great Britain

THE discovery of Spanish art in Britain had its origins in patronage and collecting by diplomats posted to Madrid and Seville during the 17th and 18th centuries, but essentially it was a 19th-century phenomenon, inspired in part by dealing and speculation during the political, military, and religious upheavals associated with the Peninsular War and in part by the pioneering efforts of travel writers and historians, especially Richard *Ford and William *Stirling. *Pacheco, in his *Arte de la pintura* (1649), records that the future King Charles I was the subject of a portrait by *Velázquez when he visited Madrid in 1623. However, the earliest surviving identifiable portrait of an English sitter by a Spanish artist is the full-length *Portrait of Sir Arthur Hopton*, British ambassador to Madrid, 1638–44, by a still unidentified artist (Dallas, Meadows Mus.). Hopton had gone out to Spain in 1629 with Sir Francis Cottington, who preceded him as ambassador, and after Cottington returned to England in 1631 they corresponded regularly about purchasing and shipping works of art. Their principal concern was to buy still-life paintings for King Charles by Juan Fernández, El Labrador, a little documented artist painting in a stylistically advanced *Caravaggesque manner. Throughout the 18th century diplomats continued to take advantage of their residence in Spain to buy Spanish art. Sir Paul Methuen, posted as ambassador at Madrid in 1714, bought Spanish pictures for Corsham (Wilts.), and Lord Harrington, who became ambassador in 1717, bought high-quality pictures by *Murillo for Belvoir (Leics.). Above all, Sir Benjamin Keene, who worked at Madrid as consul and minister plenipotentiary 1724–39, bought Murillo's *Assumption of the Virgin* (St Petersburg, Hermitage) for Sir Robert Walpole at Houghton (Norfolk). Others outside the diplomatic circle in Madrid occasionally joined the pursuit. Daniel Arthur, an Irish merchant resident in Spain, bought Murillo's *Immaculate Conception* (formerly Fort Worth, Kimbell Mus.) for the Cartwrights of Aynhoe Park (Northants) and a *Flight into Egypt* for the banker Sir Lawrence Dundas (Dublin, NG Ireland).

Velázquez paintings were less readily obtainable during the 18th century; most of his mature works had been royal commissions and did not return to the market. However Alleyn FitzHerbert, Lord St Helens, who was ambassador in Madrid from 1791 to 1794, managed to obtain a striking early Velázquez portrait, painted in Seville in 1620: *The Venerable Mother Jerónima de la Fuente* (priv. coll.). The only other Velázquez brought to Britain at this time, the *Portrait of Juan de Pareja* (New York, Met. Mus.), had been painted in Italy and was acquired there by Sir William Hamilton. It seems likely that Fitzherbert's picture was acquired in Seville. Certainly it was there that he bought en bloc some 60 Murillo drawings from the cathedral library. He also brought home Murillo's painting *The Madonna of the Rosary* (London, Dulwich, Gal.).

The Napoleonic Wars and the suppression of religious houses both provided opportunities for intrepid dealers. Ironically, the first wave of speculative importations of Spanish art into Britain came not from Spain but from Italy. In 1805 we find James Irvine, a Scottish artist acting as agent from the dealer William Buchanan, buying a series of Murillo paintings from the Capuchin convent in Genoa, several of which later found their way to the Wallace Collection, *London. Buchanan was also pressing Irvine to find a Velázquez, but eventually it was his agent in Spain, the artist George Wallis, who had arrived there just

before the Aranjuez uprising, who made the spectacular acquisition of the *Toilet of Venus* (London, NG), which reached Britain by 1813. The British residents were also able to take advantage of this buyers' market. Bartholomew Frere, who arrived in Seville as minister plenipotentiary during the Peninsular War and remained from 1809 to 1810, acquired two exceptionally important Seville period paintings by Velázquez, the *Immaculate Conception* and *S. John on Patmos* (both London, NG). Some three years later, at the battle of Vitoria in 1813, the Duke of Wellington, who had already had his portrait painted by *Goya (London, NG), captured from Joseph Bonaparte the two early Velázquez *bodegones* that are at Apsley House, London. William Bankes, a friend of Byron, was also in Spain at this time, in search of adventure and enlightenment, and visited Wellington's headquarters after the battle of Salamanca in July 1812. He too acquired pictures by Spanish artists, including *Cano, *Morales, *Ribalta, *Orrente, and Jerónimo Jacinto Espinosa (1600–67) that are now in the Spanish room at Kingston Lacy (Dorset). Above all he bought what he believed to be Velázquez's original sketch for *Las meninas*; it is now attributed to *Mazo. His authentic Velázquez *Portrait of Cardinal Massimi*, an Italian work, was bought some six years later, at Bologna, in 1820.

Back in Madrid, the diplomatic community continued to collect and extend the frontiers of taste. Sir William A'Court, Lord Heytesbury, showed considerable perception in his acquisition *c.*1822–4 of several paintings by *Zurbarán, as well as Murillo's unusual *Two Galician Women at a Window* (Washington, NG); Lord Clarendon, minister plenipotentiary at Madrid 1833–9, bought a series of paintings by Francisco *Herrera (now Madrid, Prado; Paris, Louvre). Sir Arthur Aston, in Madrid from 1840 to 1843, acquired one of Zurbarán's most intense religious images, *S. Francis in Meditation* (London, NG). Lord Savile, who was posted to Madrid from 1856 to 1860, bought the Velázquez *Christ at the Column* (London, NG).

Some diplomats went beyond collecting for themselves and indulged in a little art dealing. Sir John Brackenbury, British consul for Andalusia, who was based at Cadiz for 20 years 1825–45, sold Murillo's *Portrait of Andrés de Andrade* (New York, Met. Mus.) to King Louis-Philippe of France in 1835. However the bulk of his collection was only dispersed a year after his death at a sale by Christie's in London in May 1849. Julian Benjamin Williams, unsalaried vice-consul at Seville 1831–56, stands apart from other British diplomats on account of the size and prestige of his collection which appears to have amounted to some 200 paintings, including, unusually at this time, Spanish primitives as well as large portfolios of drawings by Cano and Murillo. Richard Ford, author of the pioneering and highly influential *Handbook to Spain* (1845), described him to Sir Edmund Head, author of Murray's handbook *The Spanish and French Schools of Painting* (1848), as the only person fully to understand Murillo's stylistic development. Williams in his turn sold him a Murillo, *Two Franciscans* (Ottawa, NG Canada), and a Zurbarán, *Martyrdom of S. Serapion* (Hartford, Conn., Wadsworth Atheneum); and also

presented him with an outstanding Murillo drawing *Christ on the Cross* (London, Brinsley Ford Coll.). Williams also sold Murillos to Sir William Eden of Windlestone, Co. Durham, who was in Spain in 1831–3, and to Frank Hall Standish, also from Durham, who spent his later years in Spain writing a guidebook published in 1840. The Standish Collection was bequeathed to King Louis-Philippe of France and was eventually sold in London in 1853.

During the period that followed the Peninsular War Spanish pictures had also been reaching London from Paris in considerable quantity, as some of the French generals decided to realize their newly acquired assets. Alexander Baring, the banker, bought Murillo's *Charity of S. Thomas* (Cincinnati Mus.) from the sale of General Sebastiani's collection in 1814. Murillo's *Portrait of Don Justino de Neve* (London, NG), which had been in Seville in 1810, was imported from Paris to London by the dealer Delahante in 1818. In 1823 Marshal Soult offered to sell eight of his best Murillos to the British nation, through the agency of Buchanan, but at first the suggestion fell on deaf ears. Eventually the Duke of Sutherland bought *The Prodigal Son* (Washington, NG) and *Abraham and the Angels* (Ottawa, NG Canada). George Tomline of Orwell Park took *Christ Healing the Lame* (London, NG). In 1853 the Louis-Philippe Collection (former Galérie Espagnole), together with the Standish pictures, were sent from Paris for sale at Christie's. The National Gallery paid £2,050 for the *Adoration of the Shepherds* optimistically attributed to Velázquez and still today of uncertain attribution and £265 for Zurbarán's *S. Francis in Meditation*, but major works by El *Greco, Zurbarán, and Goya were ignored by British buyers and re-exported.

The most interesting collector to emerge at this juncture was Sir William Stirling, a wealthy Scottish landowner, antiquarian, and scholar who in 1848 had published his three-volume *Annals of the Artists of Spain*. His approach was more that of a historian than a connoisseur and as a collector his principal art historical interest was in acquiring reproductive prints after the paintings of Velázquez and Murillo (culminating in a catalogue published in 1873), although he was also keen to buy portraits, paintings, and drawings of Spanish artists and other figures of historical interest. The Louis-Philippe sale offered the opportunity to acquire many such pictures, including a *Self-Portrait* by V. *Carducho (Glasgow, Pollok House): an El Greco portrait, said to be of the artist's daughter (Pollok House); El Greco's *Pompeo Leoni* (priv. coll.); and putative self-portraits by Juan de *Roelas, Cano, and Zurburán. As a bibliophile and print collector, Stirling was also inspired to make an outstanding collection of Goya prints, mainly during or in the aftermath of his several trips to Spain, where he befriended the celebrated Madrid antiquarian Valentin Carderera (1796–1880) and the bibliophile Pasqual de Gayangos. His Goya acquisitions included two volumes of early proofs of *Los proverbios* (priv. coll.); a working proof after Velazquez's *Las meninas*, a working proof of the frontispiece of the *Caprichos*; and above all 74 working proofs of *The Disasters of War* (all Boston, Mus. of Fine Arts).

If Stirling broke new ground in his acquisition of works

by El Greco and Goya, this taste was then endorsed by a rich cosmopolitan collector of a very different type, John Bowes, son of the 10th Earl of Strathmore, who was forming a large representative collection for display in the Bowes Museum, which he was building at Barnard Castle, Co. Durham, and which finally opened its doors to the public in 1892. During the 1860s Bowes had bought over 70 pictures in Paris from the collection of the recently deceased Count Xavier del Quinto, chamberlain to the Spanish Regent, Queen Maria Cristina: the transaction included El Greco's *Tears of S. Peter*, Goya's *Portrait of Don Juan Antonio Meléndez Valdés*, a Goya *Prison Interior*, and many other Spanish works.

Notwithstanding Bowes's grandiose private ambitions, what was still lacking was a museum curator of vision and courage to take full advantage of the market. Sir Charles *Eastlake was too preoccupied with opportunities to buy early Renaissance art in Italy to give serious attention to Spain, although in 1859, while briefly in Madrid to study Spanish art, he made a half-hearted offer for the Velázquez *Christ at the Column* (London, NG) that had just been bought by the British diplomat John Saville Lumley. Eventually it was Sir J. C. Robinson, superintendent of the Victoria and Albert Museum, *London from 1852, who systematically assessed the opportunities for acquiring works of art in Spain and made several museum-funded journeys there in the 1860s. He also substantially widened the parameters of taste; his principal responsibility at the museum was sculpture, silverwork, and ivories. He travelled widely, filed copious reports, and was responsible for a major campaign to gather casts of notable sculptures such as the Porta della Gloria in Santiago. He commissioned photographs of the principal monuments and in Paris he acquired the great Spanish altarpiece of *S. George* by *Marzal de Sax which had been dismantled into seventeen separate parts during its removal from a church in the north of Spain. He also collected paintings and drawings, advising private buyers such as Sir Francis Cook, and often dealing on his own account. His stock book still survives. In 1895 he presented the National Gallery with its first El Greco, *Christ Driving the Traders from the Temple*, provoking belated official recognition of this artist's genius. However another generation would pass before critics such as Roger *Fry were ready to endorse this taste. By then the centre of gravity for the collecting of Spanish art had moved elsewhere, especially the USA. Many of the collections of Spanish painting formed in Britain during the 18th and 19th centuries would be broken up and dispersed, while new collections were formed elsewhere.

HB

Braham, A., *El Greco to Goya*, exhib. cat. 1981 (London, NG).
Brigstocke, H., 'El descubrimiento del arte español en Gran Bretaña', in *En torno a Velázquez*, exhib. cat. 1999 (Oviedo, Mus. de Bellas Artes de Asturias).

5. United States of America

MURILLO'S *Roman Charity* was taken to Philadelphia by a merchant and US navy agent stationed at Cadiz, when he returned from Spain in 1820. The *Roman Charity* may have been the only authentic painting by a Spanish master in the USA when it perished in a fire in 1845.

However, during the 1880s and 1890s, a number of extremely wealthy Americans began to collect old master paintings in earnest. From the turn of the century until the Great Depression of the 1930s, a multitude of paintings was ferried across the Atlantic to new owners in the USA. Many of the Spanish Golden Age paintings now in public museums were gifts of these early collectors, who sought a wide variety of European art. The exception was Archer Milton Huntington, whose interests focused on Hispanic art and culture.

In 1904 Huntington established the Hispanic Society of America, which still occupies the building he constructed for it in New York City. For the permanent collection of his foundation Huntington bought early Aragonese and Castilian panel paintings, a *Holy Family* by Luis de *Morales, three fine paintings by El *Greco, Alonso *Cano's *Portrait of a Man*, Jusepe de *Ribera's *S. Paul*, *Velázquez's *Portrait of a Little Girl* and *Portrait of Cardinal Camillo Pamphili*, and, among other acquisitions, *Goya's *Portrait of the Duchess of Alba*. Huntington's mother Arabella (Mrs Collis P. Huntington) bought Velázquez's *Portrait of the Count-Duke of Olivares* as a gift to her son's foundation. Huntington also bought works by 19th-century painters such as José de *Madrazo, Mariano *Fortuny, and Martín *Rico. He also championed the Spanish painters of his own day. In 1909 and 1911 he offered huge monographic exhibitions of works by Ignacio *Zuloaga and Joaquín *Sorolla. He bought many of their paintings and promoted their careers in the USA.

Unlike Huntington, most Americans collectors were not, in the years before the disastrous fall of the stock market, amassing permanent collections. Private wealth enabled the purchase of old master paintings which were, more often than not, soon given to the rapidly expanding number of US museums where they could be seen by the public. Benjamin Altman, self-made department store magnate, bought Velázquez's *Portrait of Philip IV* which he later gave to the Metropolitan Museum of Art. H. O. Havemeyer's old master acquisitions, which were all given by bequest to the Metropolitan Museum of Art, included Goya's *Majas on a Balcony*, *Portrait of Doña Narcisa Barañana de Goicoechea*, and *Portrait of Queen María Luisa*, as well as two outstanding works by El Greco, the *Portrait of a Cardinal* and *Landscape of Toledo*. In like manner, museums across the country benefited from the generosity of American collectors. In 1917 the Cincinnati Art Museum was given *Zurbarán's *S. Peter Nolasco Recovering the Image of the Virgin* and, in 1927, Mrs Mary M. Emery donated Murillo's *S.*

Thomas of Villanueva as a Child Dividing his Clothes among Beggar Boys and Velázquez's Portrait of Philip IV. The S. Thomas had once belonged to Lord Ashburton: like so many paintings by Murillo and other Spanish masters now in US collections, it had a British provenance.

During the 1920s, John Ringling, founder of the circus of his name, was fearless in purchasing *Baroque art. This was at a time when Baroque painting, with the exception of a handful of very famous names (Velázquez, *Rembrandt, *Rubens), was not especially popular with collectors and their advisers. The holdings of the John and Mable Ringling Museum in Sarasota, Florida thus include a portrait of Philip IV by Velázquez, but also paintings by less well-known artists such as Velázquez's son-in-law Juan Martínez del *Mazo, Alonso Cano, Francisco Camillo, and Juan *Carreño de Miranda. Ringling's fondness for grand scale is reflected in his purchase of four of the tapestry cartoons (representing the Triumph of the Eucharist) created by Rubens for the royal convent of the Descalzas Reales in Madrid.

During the 1950s Algur Hurtle Meadows spent much time in Spain with engineers and geologists, exploring possibilities for his Texas oil company. Many hours spent in the Prado Museum led to Meadows's idea of a museum of Spanish art in Texas, to which end he avidly bought Spanish paintings. The Meadows Museum of Southern Methodist University in Dallas opened to the public in 1965. The collection, which continues to grow, includes Spanish art from the late 15th century until today. Among the outstanding works from the Golden Age are Murillo's Jacob Laying Peeled Rods before the Flocks of Laban, Jusepe de Ribera's Portrait of a Knight of Santiago, and Juan de *Valdés Leal's Joachim and the Angel.

In more recent years, US museums have directly purchased Spanish paintings to expand the range of their collections, often for prices beyond the means of contemporary private collectors. In fact, the sale at Christiés, London, from the Earl of Radnor's collection, of Velázquez's Portrait of Juan de Pareja to the Metropolitan Museum of Art in 1970 introduced a new, very high standard of valuations for Spanish old master paintings. SS-P

SPORTING PAINTING, a term applied to paintings of blood sports, horse and dog racing, pugilism, and portraits of the animals and individuals involved. Unlike other branches of animal painting, sporting painting is essentially documentary with no allegorical or secondary purpose.

Hunting is among the earliest subjects in art, appearing, for instance, in the cave paintings of Lascaux (c.15000 BC), in Antiquity, and in classical, medieval, and Renaissance art. However it is invariably either non-specific or incidental and not, strictly speaking, sporting painting.

The documentary tradition of sporting painting, which flourished most strongly in England, stemmed, surprisingly, from *Rubens, whose pupil Abraham van Diepenbeeck (1596–1675) was employed by the Duke of Newcastle, a noted equestrian scholar, to paint portraits of his horses in 1629. The first English animal painter, Francis Barlow (1626?–1704), is essentially decorative and the pioneer of English sporting painting is John Wootton (c.1682–1764) who knew Diepenbeeck's work. His William III Stag Hunting (1729; priv. coll.), a pendant to William III Boar Hunting (whereabouts unknown) by the Dutchman Dirk Maas (1659–1717), is among the first examples of panoramic paintings of horses, dogs, and their owners which dominate the genre in the 18th century. His Bloody Shouldered Arabian (c.1724; Cambridge, Anglesey Abbey) established the important practice of animal portraiture. Despite lucrative rewards animal painters were considered inferior by their peers. Wootton probably avoided the stigma but his successor George *Stubbs, resenting his lowly status, wished to be thought of as a history and portrait painter. However his genius lay in his animal portraits like the life-size Hambletonian, Rubbing Down (1800; Mount Stewart House, Co. Down) which is considerably more powerful than his elevated dramatic subjects, also inspired in part by Rubens, like his Horse Attacked by a Lion (c.1762; New Haven, Yale Center for British Art). The same ambition beset James *Ward whose allegories literally ruined him. Less ambitious painters, like James Seymour (c.1702–52), Ben Marshall (1767–1835), John Ferneley (1782–1860), and J. F. Herring Sr. (1795–1865), usually flourished, owing mainly to the popularity of prints after their works.

Ward's French contemporary *Géricault, usually associated with *Romanticism, painted a record of the Derby at Epsom (1821; Paris, Louvre) and racing, treated realistically after the publication of Muybridge's Animal Locomotion (1887), appears in paintings by *Degas, *Manet, and *Lautrec although none are truly sporting painters. Manet also painted bullfights, inspired by *Goya who, in turn, worked in a tradition established by *Velázquez in works like A Royal Boar Hunt (c.1635–7; London, NG). Bullfighting also inspired *Picasso, the bête noire of the last traditional practitioner of English sporting painting Sir Alfred Munnings (1878–1959). DER

Millario, B., British Sporting Painting, 1650–1850 (1974).

SPRANGER, BARTHOLOMÄUS (1546–1611). Antwerp-born painter, active in Italy, Austria, and Bohemia. With Hans von *Aachen and Josef *Heinz he was one of the most important artists at the *Prague court of Emperor Rudolf II. In 1565 Spranger travelled to Italy, staying for some months in Milan and Parma, before going to Rome. There he entered the service of Cardinal Alessandro Farnese, for whom he also worked at Caprarola, and later of Pope Pius V. On the recommendation of his compatriot the sculptor *Giambologna, he took an appointment at the court of the Habsburg Emperor Maximilian II in Vienna (1575). After Maximilian's death in 1576, Spranger was taken into the employ of his successor Rudolf II, and moved with the imperial court to Prague. He painted mythologies and learned allegories, often featuring female nudes, in a refined and mannered style that owed much to the elegant mode of figure drawing of *Correggio and *Parmigianino (Triumph of Wisdom, c.1591; Vienna, Kunsthist. Mus.). While in Rome, Spranger had made the acquaintance of Karel van *Mander, and it was through van Mander that his style was introduced to *Goltzius and thus formed the basis of Haarlem *Mannerism. KLB

Prag um 1600, exhib. cat. 1988 (Essen, Villa Hügel).

SQUARCIONE, FRANCESCO (c.1395–1468) Italian painter and teacher, best known as the unscrupulous master of *Mantegna, whom he adopted to retain the young artist's services in his large studio in Padua. A controversial and enigmatic figure, Squarcione is reported to have used classical fragments in the teaching of his pupils, which gives him a significant role in the *Renaissance rediscovery of the *Antique. According to Scardeone, one of his pupils, he also knew

the principles of *perspective, although this is doubted. There are no pictures reliably attributed to Squarcione but two works are generally associated with his workshop; the *S. Jerome* altarpiece from the Carmine in Padua (Padua, Mus. Civico) and a *Madonna and Child* (Berlin, Gemäldegal.). Both are in a transitional style but reveal some knowledge of Florentine art, possibly through *Donatello and Fra Filippo *Lippi, who had worked in Padua. Squarcione's studio seems to have offered a form of art training that differed from the standard apprenticeship system approved and monitored by the guilds. In this he anticipates some later developments in the academies. Described as the father of painters, he had 137 pupils including Mantegna, Marco *Zoppo, and Giorgio Schiavone (1433?×6–1504). PSt

S QUEEZE, a cast usually in stucco or plaster, taken from another relief in terracotta. This type of process was commonly used in Italy during the 15th and early 16th centuries for reproducing economic multiple versions of popular Virgin and Child compositions by *Donatello or *Ghiberti. AB

S TAËL, NICOLAS DE (1914–55). Russian-born painter of the *École de Paris. The orphan of exiled Russian aristocrats, de Staël fled with his sisters to Brussels where he was brought up and later studied art. He travelled widely throughout his life but acquired French citizenship in 1948 as he rose to fame. He began to work in a representational style but soon adopted an allusive abstraction which refered to the formal organization of real objects. In the 1940s he moved from dynamic juxtapositions of long, thin forms to more stable geometric compositions of small blocks, tightly composed with a heavy impasto, paint being often applied with a palette knife. *The Roofs* (1952; Paris, Centre Georges Pompidou) demonstrates how this later style accommodates both abstraction and representation; in this he was immensely influential in Europe when abstraction came to dominate the mainstream. His later work gained a stronger representational character and the paint became more fluid, the style less geometric, as in *Le Fort-Carré d'Antibes* (1955; Antibes, Mus. Picasso). MF

Dobbels, D., *Staël* (1994).

S TAFFAGE, a German word, derived from Old French, used in Europe, including England, to denote the subordinate figures and animals in a landscape. Seventeenth- and 18th-century landscape painters frequently employed specialist figure painters to populate their works and the practice continued into the 19th century. DER

S TAINED GLASS, general term for the coloured windows which combine architectural, decorative, and narrative functions. Although staining is only one of the colouring techniques involved, the term is accepted as referring to the whole medium.

Glass is made by the molten fusion of silica (sand), potash (woodash), and lime, a process discovered in the ancient Near East, and used for jewellery and vessels. It was not until Roman times that it was mouth-blown into sheets of glass to fill window apertures. The addition of various metallic oxides at the molten stage produces colour-saturated glass, known as pot-metal; to make a window, separate coloured pieces are held together by strips of lead, which also provide the main outlines of the design. True staining, discovered at the beginning of the 14th century, is achieved by the application of silver nitrate, which stains the glass, when fired in a kiln, right through with tones which range from lemon to orange, a way of obtaining different tones on the same piece of glass. Another means of colouring, popular from the 16th century, was the application of different enamel paints onto the surface of the glass, as if it were a painter's canvas, although this undermines the design function of the lead. The relationship between pot-metal glass and lead was rediscovered during the Gothic Revival, and survives today, together with more modern methods, including *dalle de verre* (glass slabs set in concrete), and glass fused together or held by resins.

Glass transmits rather than reflects light, and the effect of painting with coloured light, as stained glass has been described, contributes to the spiritual ambience of a small parish church or a great cathedral. In the Middle Ages, the church symbolized the Holy City; the gemlike, mystical properties of glass were almost as important to medieval theologians as the biblical scenes within it. The illiterate spectators 'read' the stories in the windows as an essential part of their Christian learning. The earliest fragments of such figural windows date from 6th-century Ravenna (S. Vitale); the influence of *early Christian Italy spread to north-west Europe, and there is evidence that the churches of the *Carolingian Empire and *Anglo-Saxon England had didactic window schemes. Surviving *Romanesque windows are marked by their strong colour tones, with red and blue predominant, and stylized figures set in many small medallions within richly decorated borders, like the scenes from the life of Christ in the west front at Chartres Cathedral (c.1150).

The structures of *Gothic architecture generated larger window areas whose elongated openings required lighter colours, with yellows and whites predominating, to depict figures which frequently stand framed by architectural canopies echoing the surrounding sculpture. Rows of saints or Bible figures are surmounted by angels in the complex tracery above. A contrasting, more economical style is the use of grisaille glass—abstract, geometrically patterned windows, such as the *Five Sisters* window in York Minster (c.1260).

With the increasing realism of later medieval art, windows begin to include many details of daily life, and their donors are commemorated by being depicted in contemporary dress, or by the inclusion of their armorial bearings. By the end of the 15th century, the naturalism of Italian *Renaissance painting caused an increasing pictorialism in windows, and painting in enamels contributed to the required effects of perspective and modelling. The windows of King's College Chapel, Cambridge (c.1515–40), represent this culminating phase, with the medieval subject matter of the Old Testament prefiguring the New being depicted in the modern style.

Another cause of change was the Reformation, which meant that in Protestant Europe, major glazing programmes, with their Catholic connotations, virtually ceased to be commissioned; glass painting became confined to small-scale or portable panels, of heraldic, secular, or literary significance, while the few large windows to be made copied contemporary oil paintings.

However, the earlier traditions were revived in the 19th century, when glaziers were commissioned to restore and install medieval panels; by the 1840s, a new generation of stained-glass makers, working for Gothic Revival architects, were producing windows which looked convincingly medieval, through an understanding of the techniques of pot-metal and lead, and the exact copying of styles and subject matter. The ever-increasing demand for windows for the many new churches being built inevitably led to blandness and stereotyping; this inspired William Morris (1834–96), through the firm he founded in 1861, to produce windows which demonstrated a greater understanding of the properties of glass, particularly colour. These principles were followed by the Arts and Crafts movement at the turn of the century, whose windows often employed the richly textured 'slab glass' discovered in 1889.

During the 20th century, stained-glass artists were divided between following or escaping from the lingering medieval tradition. Abstract designs have been used in many secular buildings, including banks and shopping centres; however, the Church has remained an important patron, even though new windows rely on the effects of colour

and form rather than the figural scenes of the past. CMH

Brisac, C., *A Thousand Years of Stained Glass* (1986).
Brown, S., *Stained Glass: An Illustrated History* (1994).
Lee, L., Seddon, G., and Stephens, F., *Stained Glass* (1976).

STANZIONE, MASSIMO, CAVALIERE (1585?–1656?). Italian painter from Naples who together with *Ribera held a dominant position in the city in the 1630s and 1640s and attracted numerous pupils. He studied under Fabrizio Santafede (active 1576–1623) and *Caracciolo and, moving frequently between Naples and Rome, was also influenced by the classical tradition and the work of Annibale *Carracci, *Domenichino, and Guido *Reni. Indeed, he was to become known as 'Il Guido Reni Napoletano'. By the 1630s he had responded to the tenebrist manner of *Caravaggio, and this is evident in his *S. Agatha in Prison* (Naples, Capodimonte) and the *Beheading of S. John the Baptist* (Madrid, Prado); yet he never fully embraced the naturalistic approach that lies at the heart of Caravaggio's style and remained closer both in spirit and technique to Guido Reni, whose luminous palette he also emulated. Stanzione was at his best on large-scale church commissions. He was active at the Certosa di S. Martino, Naples, where he decorated the chapel of S. Bruno (1630–7), and then painted the *Last Supper* and the *Pietà with Carthusian Monks* for the choir (by 1639). The *Pietà*, arguably his masterpiece, reflects concern for the classical tradition of expressive gesture, yet is strikingly original in conception and uncomfortably morbid. From the Certosa he went on to decorate the apse of the Gesù Nuovo (1640); and following Domenichino's death he substituted for him with an altarpiece of *S. Gennaro Healing the Possessed Woman* for the chapel of the treasury of S. Gennaro in the cathedral at Naples, in a rhetorical style that echoes Domenichino. Stanzione's portraits are rare but include *Jerome Bankes* (Kingston Lacy, Dorset). His best pupil was *Cavallino. HB

Whitfield, C., and Martineau, J. (ed.), *Painting in Naples 1606–1705: From Caravaggio to Giordano*, exhib. cat. 1982 (London, RA).

STARNINA, GHERARDO (1354?–c.1413). Florentine painter whose strongly Gothicizing works deeply influenced the development of early quattrocento painting in Florence. On the basis of stylistic and circumstantial evidence, works previously associated with the *Master of the Bambino Vispo are now given to Starnina. He is first mentioned in 1387 when he joined the Florentine Compagnia di S. Luca. He is documented in Spain in 1395–1401, but he returned to Florence before 1404, since in this year he had already completed a fresco cycle (destr.) in the Carmine. Fragments uncovered in the 1930s display an elegantly posed *S.*

Benedict; this figure, designed with a strong sense of individual characterization, is covered in abundantly flowing fabric. In 1409 Starnina decorated a chapel in S. Stefano, Empoli; two fragments from this destroyed cycle have survived (Empoli, Collegiata). By this date the extravagant drapery style, complex rhythms, and vibrant colours of Starnina's Spanish phase had evolved into more restrained and monumental forms. This shift in emphasis probably resulted from his revitalized contact with the Florentine artistic scene. FB

van Waadenoijen, J., *Starnina e il gotico internazionale a Firenze* (1983).

STATES. See PRINTS.

STATIUS (b. mid-1st century AD). Roman poet, born in Naples. Statius composed epic poems, as well as the *Silvae*, a collection of elegant occasional poems for friends, relatives, and patrons. Several of these celebrate various works of art and architecture, from the equestrian statue of the *Emperor Domitian* in Rome, dedicated in AD 91 (1. 1) to a tiny statuette of *Hercules* (known as the *Epitrapezios*) owned by the collector and poet Novius Vindex (4. 6). Other poems in the collection describe opulent villas like that of Manilius Vopiscus at Tibur with its interior decoration of marble, exotic woods, statues, and its unswept floor represented in mosaic (1. 3); a similar appreciation of precious materials is evident in the poem on a bath building (1. 5). The luxurious life style of the wealthy inhabitants of the bay of Naples is evoked in poems on a villa and temple at Surrentum (2. 2 and 3. 1) and the completion of the Via Domitiana, the new coast road linking the area to Rome, is also celebrated (4. 3). These poems represent a unique blend of rhetorical *ekphrasis* with the poetic tradition the epigram. RW

Hardie, A., *Statius and the Silvae: Poets, Patrons and Epideixis in the Graeco-Roman World* (1983).

STEEN, JAN (1626–79). Dutch painter of lively *genre scenes, often with a strongly moralizing content. Son of a Leiden brewer, Steen briefly entered Leiden University before beginning his artistic training in 1647. Various possible teachers have been mentioned in documents, including Jan van *Goyen whose daughter Steen married in 1649, although Adriaen van *Ostade, an early painter of low-life genre in Haarlem, would appear to have been the most influential, particularly on Steen's early work such as *The Lean Kitchen* (Ottawa, NG Canada). By 1653, Steen's compositions had become more complex, for example *Village Wedding* (Rotterdam, Boymans-van Beuningen Mus.), an outdoor scene in which a wide variety of fig-

ures watch the arrival of the bride, a demure figure bathed in sunlight.

By 1654 Steen settled in Delft, where his father had rented a brewery. The business failed; indeed Steen seems to have continued to suffer financial difficulties for the remainder of his career. The move brought Steen into contact with painters not only of Delft, such as Pieter de *Hooch, but also of nearby Dordrecht, such as Nicolaes *Maes. The characteristics of their work are experiments with perspective, spatial effects, and a clear warm light which are present in Steen's own works, such as *The Burgher of Delft and his Daughter* (1655; priv. coll.) or *Young Woman Playing a Harpsichord* (1659; London, NG). In 1661 Steen moved again, this time to Haarlem where his subject matter becomes even more diverse. A favourite and recurring theme is that of *The Doctor's Visit* (London, Apsley House), possibly inspired by Dutch theatre. During the 1660s not only does Steen's work as a genre painter become more prolific and varied than any of his contemporaries, but he also turns to the painting of biblical and mythological subjects such as *Samson and Delilah* (1668; Los Angeles, County Mus.). His later work is characterized by increasingly elegant interiors and dress, smooth and detailed handling of paint, and a range of subtle colours, as in the two very different examples of *The Effects of Intemperance* (London, NG and Apsley House). Steen returned to Leiden for the last decade of his career when war with France increased the precariousness of his financial situation. Although there is some decline in the quality of his artistic output, his late works show interesting new developments involving outdoor compositions of elegant figures, engaged in music-making or mild flirtation, as in *Music-Making on a Terrace* (London, NG). The soft pastel colour and bright, even light anticipate future developments in 18th-century French painting. CFW

Jansen, G. (ed.), *Jan Steen: Painter and Storyteller*, exhib. cat. 1996 (Washington, NG).

STEENWYCK BROTHERS. Seventeenth-century Dutch still-life painters. They were born in Delft, but were trained in Leiden by their uncle David Bailly and became leading exponents of the Leiden school of *vanitas painting that Bailly founded. These are meticulously crafted pictures consisting solely of objects representing mortality and the ephemerality of human achievement; a skull is usually included. **Harmen** (1612–after 1655) was noted for his refined technique, his smooth handling of tones, and his taste for including exotic objects; the *Allegory of the Vanities of Human Life* (London, NG) is typical, and was painted a few years before Harmen returned to Delft in 1644. He also painted still lifes of fish and game. His less talented younger brother **Pieter** (c.1615–after 1654), who became a master in 1642, did pro-

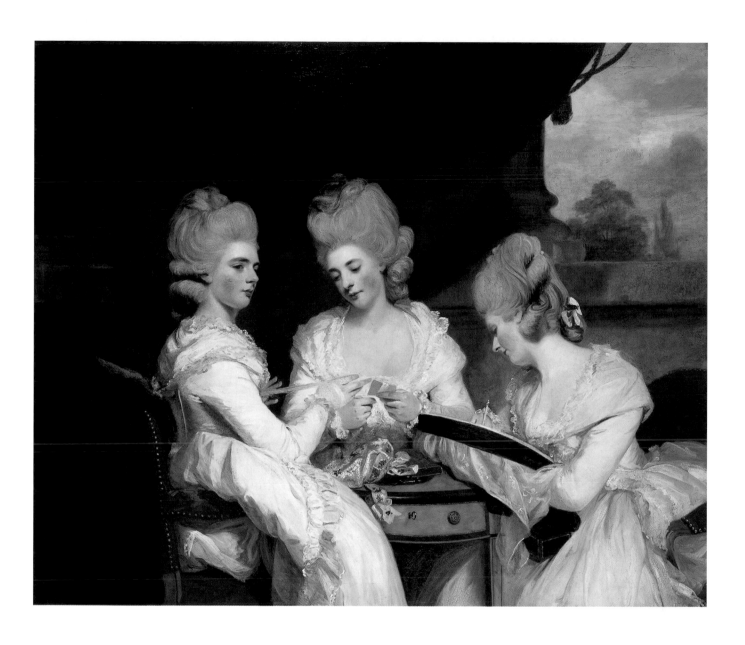

Sir Joshua Reynolds, *The Ladies Waldegrave* (1781), oil on canvas, 143.4×168cm (56½×66in), Edinburgh,
National Gallery of Scotland.

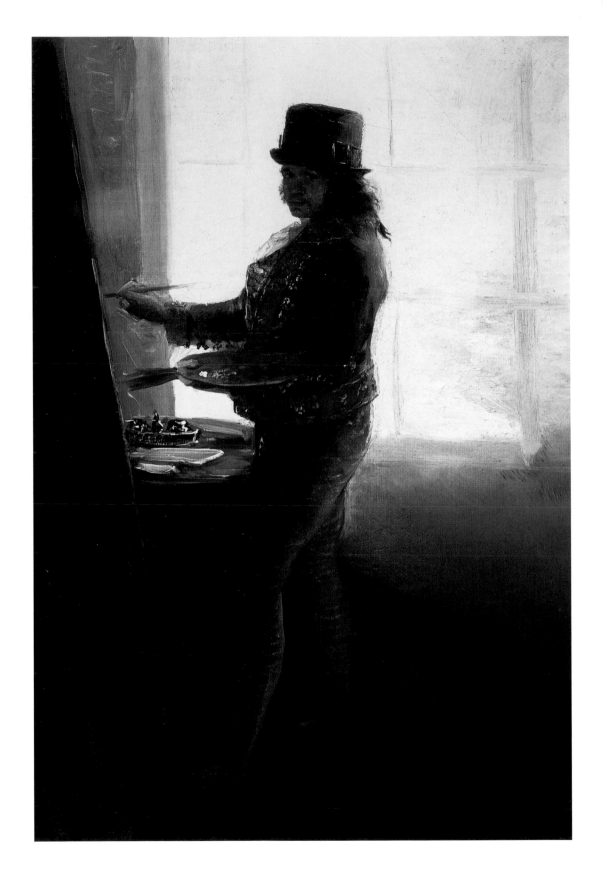

Francisco Goya, *Self-Portrait* (1790–5), oil on canvas, 42×28 cm (16½×11 in), Madrid, Academia de S. Fernando.

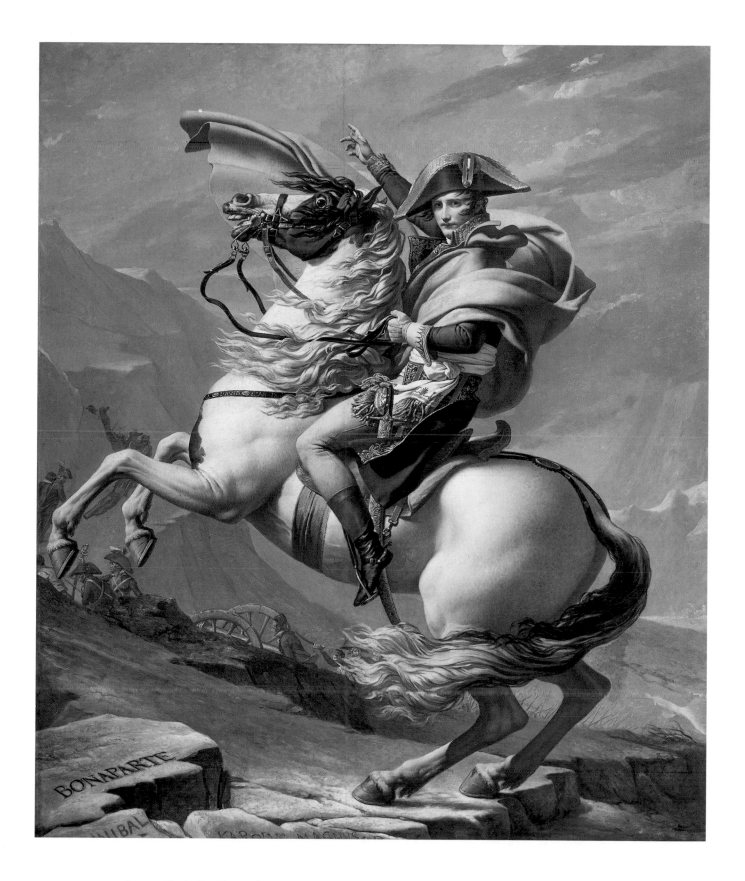

Jacques Louis David, *Napoleon crossing the St Bernard Pass* (1801), oil on canvas, 260 × 221 cm (102 ½ × 87 in), Malmaison, Musée National des Châteaux de Malmaison et Bois–Préau.

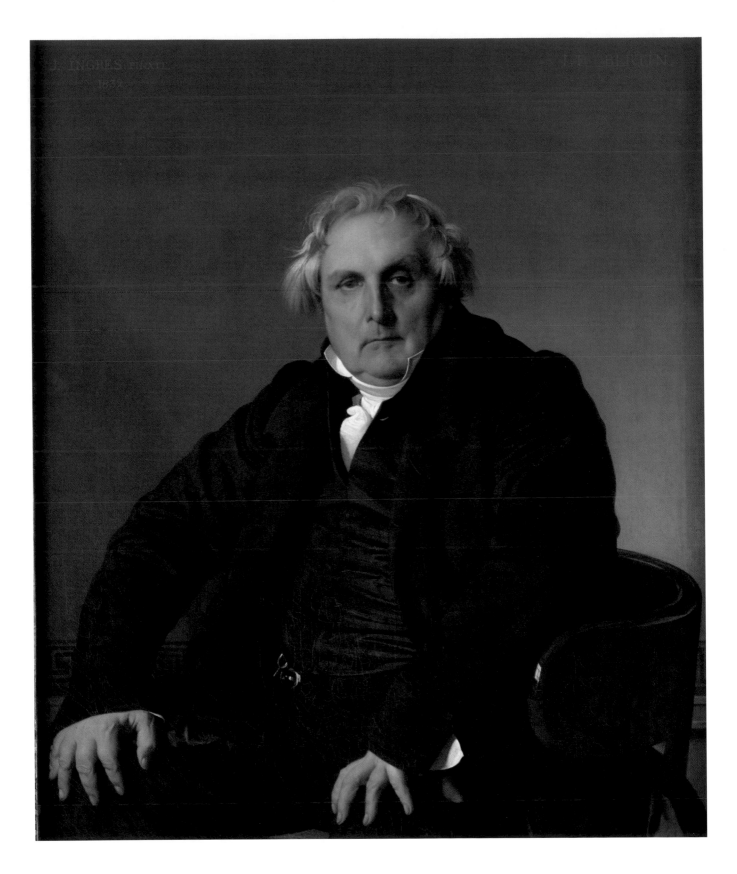

Jean–Auguste–Dominique Ingres, *Louis-François Bertin* (1832), oil on canvas, 116 × 95 cm (45¾ × 37½ in), Paris, Louvre.

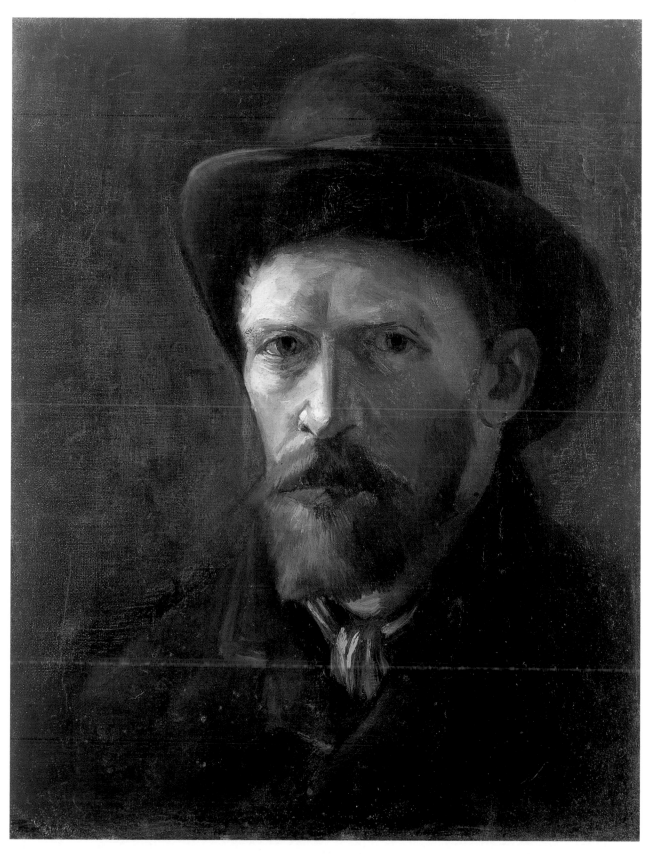

Vincent van Gogh, *Self-Portrait with dark felt hat* (1886), oil on canvas, 41.5 × 32.5 cm (16 ³⁄₈ × 12 ³⁄₄ in), Amsterdam, Van Gogh Museum.

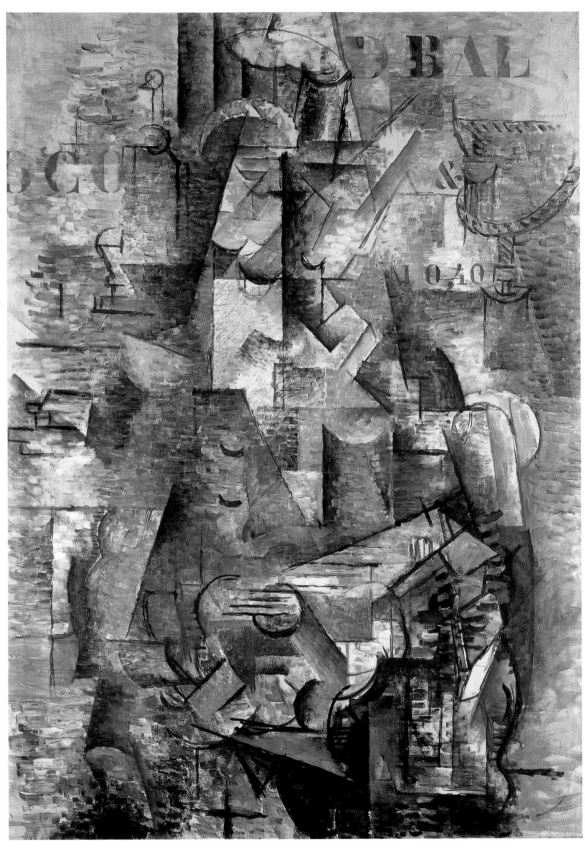

Georges Braque (1882–1963), *The Portuguese*, oil on canvas, 117 × 81 cm (46 × 32 in), Basle, Öffentliche Kunstsammlung Basel, Kunstmuseum.

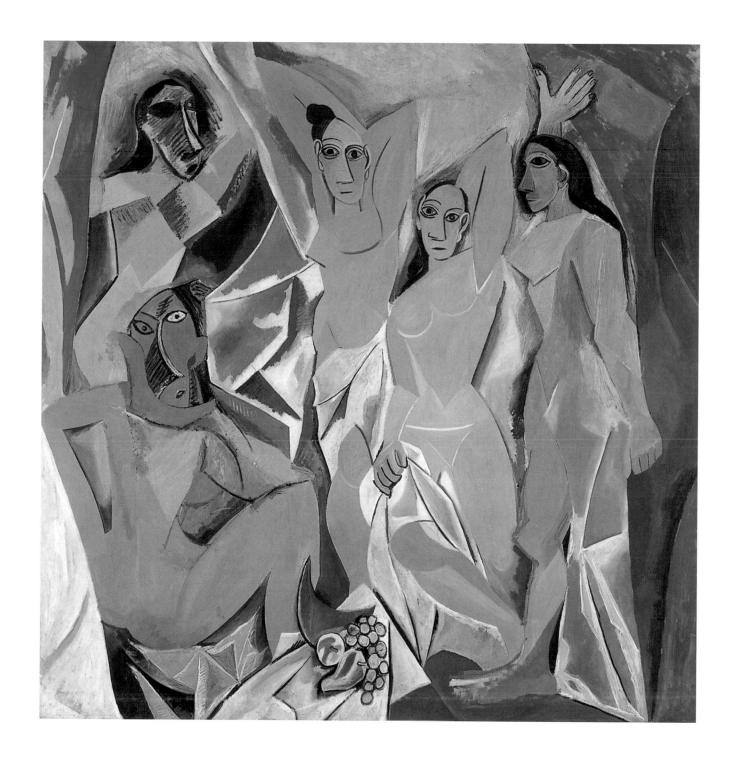

Pablo Picasso, *Les Demoiselles d'Avignon* (1907), oil on canvas, 243.9 × 233.7 cm (96 × 92 in), New York, MoMa.

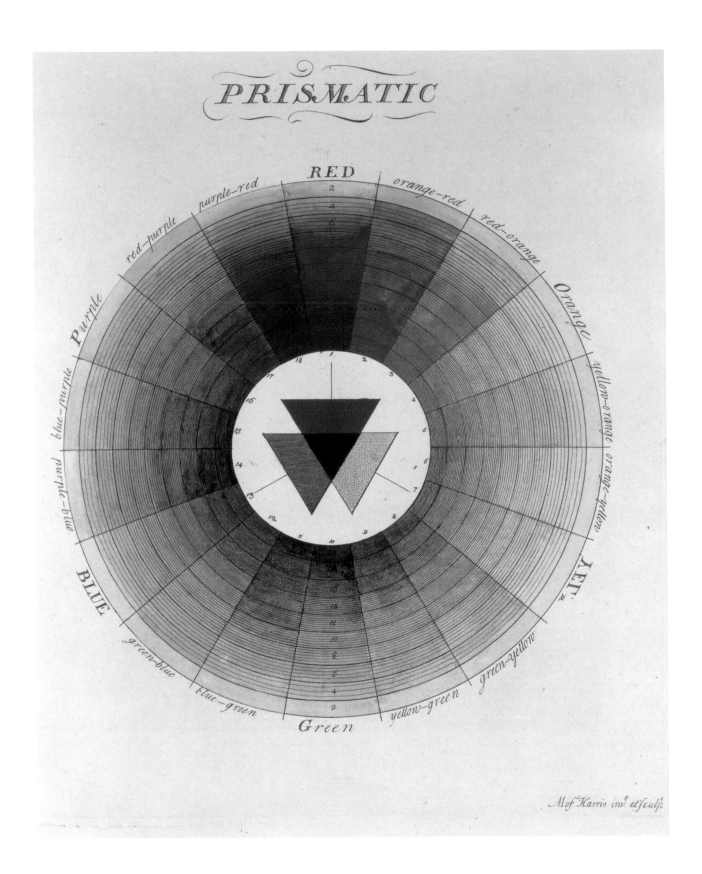

Moses Harris, Prismatic colour wheel, hand–coloured engraving from *The Natural System of Colours* (London, *c*.1770), plate size (not page size) 28.9 × 23.9 cm (11⅓ × 9⅖ in); this is the first known presentation of a colour circle in full hue; London, Royal Academy of Arts Library.

duce one *vanitas* that departed from the genre in an important way. This is the *Allegory on the Death of Admiral Tromp* (c.1653; Leiden, Stedelijk Mus.) which gives the still life a specific commemorative focus by including *trompe l'œil* depictions of a portrait print of the deceased hero, and of the first page of his funeral oration.

AJL

STEER, PHILIP WILSON (1860–1942). British painter. Steer trained in Paris from 1882 to 1884. His early work was influenced by *Whistler. In the late 1880s he adopted *Impressionism and became its leading British exponent, painting lively, summery scenes *en plein air*: *The Beach, Walberswick* (1890; London, Tate). From the mid-1890s he turned his attention to the work of *Constable and *Turner who remained lasting influences. Steer was somnolent by nature and his natural facility and the veneration of his peers led to a certain laziness in his work after the 1920s in which watercolours predominate.

DER

Laughton, B., *Philip Wilson Steer* (1971).

STEFANO DA ZEVIO, or Stefano di Giovanni da Verona (1374/5–c.1438). Painter known only through his life and work in Italy, although he was the son of Jean d'Arbois, painter to Philip the Bold, Duke of Burgundy. Jean d'Arbois is known to have been to Lombardy for the Duke and is believed to have been in Pavia around 1370. Stefano himself was often referred to in documents as 'Stefano of France' and his style, an epitome of the concept *'International Gothic', shows a mixture of northern and Lombard features. It is thought likely that he trained in Lombardy and the influence of *Michelino da Besozzo is particularly obvious, even in a late work such as the signed panel of the *Adoration of the Magi* (?1435; Milan, Brera). There were frescoes by him in Mantua and Verona, where he lived between 1425 and 1433 as a contemporary of *Pisanello.

KS

STELLA, FRANK (1936–). American painter, printmaker, and writer on art, a leading figure of *Post-Painterly Abstraction. He was born in Malden, Mass., a suburb of Boston, and began to paint abstract pictures while he was at school at Phillips Academy, Andover. In 1954–8 he studied history at Princeton University and also attended painting classes. At this time he was influenced by *Abstract Expressionism, but after settling in New York in 1958 he was impressed by the flag and target paintings of Jasper *Johns and the direction of his art changed completely. He began to emphasize the idea that a painting is a physical object rather than a metaphor for something else,

saying that he wanted to 'eliminate illusionistic space' and that a picture was 'a flat surface with paint on it—nothing more'. These aims were first given expression in a series of black 'pinstripe' paintings in which regular black stripes were separated by very thin lines. They made a big impact when four of them were shown at the Museum of Modern Art's *16 Americans* exhibition in 1959, inspiring a mixture of praise and revulsion. Soon after this he began using flat bands of bright colour (*Hyena Stomp*, 1962; London, Tate), then to identify the patterning more completely with the shape of the picture as a whole he started working with notched and shaped canvases. In the 1970s he began to experiment with paintings that included cut-out shapes in relief and he abandoned his impersonal handling for a spontaneous, almost graffiti-like manner (*Guadalupe Island, Caracara*, 1979; London, Tate).

Stella has been an influential figure not only in painting but also on the development of *Minimal sculpture. In 1983–4 he delivered the Charles Eliot Norton lectures at Harvard University, which were published in 1986 as *Working Space*. John Golding writes of this book: 'The Working Space of the title is Stella's plea for the reintroduction of greater spatial expansiveness, expressiveness and experiment into contemporary art: "What painting wants more than anything else is working space—space to grow into and expand into." '

IC

Golding, J., 'Frank Stella's Working Space', in *Visions of the Modern* (1994).

STELLA, JOSEPH (1877–1946). American painter. Born in Italy, Stella emigrated in 1896. Between 1897 and 1901 he studied art in New York, for a time under William Merritt *Chase. He excelled as a draughtsman and published his realist drawings in magazines between 1905 and 1909. Returning to Europe in 1909 he discovered avant-garde *modernism in Paris, though he only finally began to paint in a modernist style around 1913–14, in the painting *Battle of Lights, Coney Island, Mardi Gras* (New Haven, Yale University AG); a fragmented Futurist vision of an amusement park. He went on to employ the languages of *Cubism and *Futurism with great success, in depictions of New York, such as *Brooklyn Bridge* (1918–20; New Haven, Yale University AG). During the 1920s and 1930s he spent much of his time in Italy and France and, responding to the conservative 'call to order' during the inter-war period, he withdrew from abstraction to realism and executed a number of religious works. During the late 1930s he worked for the *Federal Art Project.

MF

Baur, J., *Joseph Stella* (1971).

STEPANOVA, VARVARA (1894–1958). Russian artist. Born at Kovno, Stepanova trained at the Kazan School of Art in 1911, where she met *Rodchenko whom she later married, and the Stroganov Institute for Applied Arts, Moscow (1913–14). In 1914 she contributed to the Moscow Salon but from 1918 onwards was closely associated with the avant-garde, an enthusiast for non-objective art and *Constructivism. In 1921, with Rodchenko and Aleksey Gan (1889/95–1940/2?), she founded a Constructivist group and edited their journal, *Lef*. She now virtually abandoned painting for graphic and stage design and typography, devoting her work to the practical needs of the state. In 1923 she worked as a designer at the First State Textile Print Factory with Rodchenko and *Popova where her most remarkable productions were designs for sports clothes, in which she combined an economy of material with loud contrasts in colour, to enable identification on the sports field, while rejecting as superfluous all ornamental or 'aesthetic' elements.

GS

Yablonskaya, M., *Women Artists of Russia's New Age, 1900–1935* (1990).

STERN, IRMA (1894–1966). South African artist. Stern was born in the Transvaal but spent much of her childhood in Germany where she studied art in Berlin and Weimar. In 1917 she met *Pechstein and exhibited in the Berlin Sezession exhibitions in 1918 and 1920, the year in which she returned to South Africa. From 1927 she lived in The Firs, Capetown, which is now a memorial museum. Stern's prolific œuvre may be divided into European and African subjects, the product of her own multicultural experiences. She painted in an *Impressionistic manner until c.1916, when her work became more *Expressionist, and, after the early 1930s, in an immediate and personal representational style ideally suited to exotic subject matter like *Two Harlots, Madeira* (1932; Stellenbosch, Rembrandt van Rijn Art Foundation). Stern, a liberal intellectual, painted the lives of native Africans in the Congo and Zanzibar as well as in South Africa and attempted to establish a rapport with her subjects; nonetheless her view of Africans was romantic and idealistic and after decolonialization she painted mainly in Europe.

DER

STEVENS, ALFRED (1818–75). English painter and sculptor. Born in Blandford (Dorset), Stevens's precocious talents gained him financial help to study in Italy in 1833. He spent eighteen unhappy months in Naples and the next four years in Florence working as a copyist. From 1840 until his return to England in 1842 he worked in Thorvaldsen's studio in Rome. Although he continued to paint his fame rests on his

sculptural work. After teaching in the Government School of Design (1845–7) he worked for Hoole & Co. of Sheffield, winning a prize at the Great Exhibition, London, (1851). Back in London by 1852 he worked on the British Museum railings and *c*.1856 the dining room of Dorchester House (demolished 1929). The fireplace, with caryatids influenced by *Michelangelo, is in the V&A, London. In 1856 he won the competition for a Wellington memorial in S. Paul's Cathedral which occupied him until death. This ambitious monument, wholly inspired by *Renaissance prototypes, takes the form of a triumphal arch with bronze allegorical groups on the flanking sides. The equestrian figure which surmounts it was completed by John Tweed (active 1894–1950) from Stevens's *modello*, in 1912.

DER

Alfred Stevens, exhib. cat. 1975 (London, V&A).

STEVENS, ALFRED-ÉMILE-LÉOPOLD-VICTOR (1823–1906). Belgian painter. Stevens trained under François-Joseph Navez (1787–1869) in Brussels. He settled in Paris in 1844 and achieved great success after 1860 with his paintings of fashionably dressed coquettish young women in elegant interiors including the occasional church. He painted these with considerable subtlety, influenced by his friend *Manet, and was particularly skilful in rendering the surface and texture of fabrics. He was a friend of *Whistler with whom he shared an interest in Japanese art, which appears in several of his paintings, but only as an exotic accessory, as in *La Dame en rose* (Brussels, Mus. Royaux), in which an elegantly attired young woman examines an oriental figurine. His subjects, whether fashionable or Japanese, greatly influenced *Tissot. Stevens also painted seascapes and coastal scenes in a more *Impressionistic style similar to that of *Boudin and *Jongkind. In 1900 he received the accolade of being the first living artist to be given an exhibition at the École des Beaux-Arts in *Paris but died in penury through his extravagance. One of his pupils was the actress Sarah Bernhardt (1845–1923), whom he also painted on several occasions. DER

Alfred Stevens, exhib. cat. 1977 (Ann Arbor, University of Michigan Mus. of Art).

STIJL, DE, Dutch art periodical founded in Leiden by Theo van *Doesburg in 1917, in collaboration with Piet *Mondrian and edited by him until 1928. A final number was published in 1931. Its title means 'the style' in Dutch. Collaborators saw style not just as surface ornament, but as an essential ordering structure which would function as a sign for an ethical view of society. The single compositional element and the overall configuration of elements symbolized the relationship between the individual and the collective. Earlier issues were characterized by Mondrian's theories on *Neo-plasticism, but it was van Doesburg who disseminated the group's ideas on architecture and the role of primary colours in Europe. Later, in 1924, *Dada influence became apparent in a supplement called *Mecano*. Other painters of the group included Vilmos Huszár (1884–1960), Georges *Vantongerloo (also a sculptor), and Bart van der *Leck. Architects working with the group, such as Gerrit Rietveld (1888–1964), were united in their use of modern materials to achieve smooth surfaces and austere lines which opened up the relationship with the surrounding environment.

MT

De Stijl, exhib. cat. 1982 (Minneapolis, Walker Art Center).

STILE LIBERTY. See ART NOUVEAU.

STILL, CLYFFORD (1904–80). American painter, one of the major figures of *Abstract Expressionism but the one least associated with the New York art scene. He was born in Grandin, N. Dak., and studied at Spokane University (graduating in 1933) and Washington State College, Pullmann, where he taught until 1941. After working in war industries in California, 1941–3, he taught for two years at the Richmond Professional Institute, Va. He then lived briefly in New York (1945–6), where he had a one-man exhibition at Peggy Guggenheim's Art of This Century gallery in 1946. Although he stood somewhat apart from the other Abstract Expressionists, he was friendly with Mark *Rothko (they had met in 1943), the two men sharing a sense of almost mystical fervour about their work. In 1946–50 he taught at the California School of Fine Arts in San Francisco, then lived in New York, 1950–61. By the time he returned to New York Still had created his mature style and had a rapidly growing reputation He was one of the pioneers of the very large, virtually monochromatic painting. But unlike *Newman and Rothko, who used fairly flat, unmodulated pigment, Still used heavily loaded, expressively modulated impasto in jagged forms. His work can have a raw aggressive power, but in the 1960s it became more lyrical.

In 1961 Still moved to Maryland to work in tranquillity away from the art world. Scorning galleries, dealers, and critics, and rarely exhibiting, he considered himself something of a visionary who needed solitude to give expression to his high spiritual purpose, and he gained a reputation for cantankerousness and pretentiousness. He presented large groups of his paintings to the Albright-Knox Art Gallery, Buffalo, the Metropolitan Museum, New York, and the San Francisco Museum of Art, and his work is represented in many other major collections. IC

STILL-LIFE paintings are pictures that are complete works of art in themselves and which depict inanimate things of small or medium size. *Illusionistic painting was highly valued in the ancient world, as is recorded in *Pliny's famous anecdote about *Zeuxis, whose painted grapes deceived the birds that tried to peck them, but who was himself fooled into trying to draw the curtain painted by his rival Parrhasius. Pliny also mentions Piraicus, who only painted genre scenes and foodstuffs, but nevertheless won great esteem. *Philostratus includes two *xenia*, or depictions of foodstuff, in the *ekphrastic descriptions of paintings in his *Imagines*. A number of Roman *xenia* survive, and many of them display an astonishingly modern-looking fresh and direct realism.

Still-life painting did not re-emerge as a fully developed independent genre in Western art until the turn of the 16th and 17th centuries when it became established alongside other newly liberated genres such as *landscape. From the time of *Giotto's naturalistic discoveries, however, passages of illusionistic painting that concentrated on capturing the presence of objects, and which acknowledged their separate identity in the spirit of still life, had appeared as parts of larger schemes, in the formal and emblematic programmes of which they were submerged. Thus, many 15th-century Italian and, especially, Netherlandish religious paintings of scenes such as S. Jerome in his study or the Annunciation include still-life details charged with symbolic meaning. Other relevant traditions were the Italian *trompe l'œil inlaid marquetry pictures (intarsie) and Flemish *manuscript illustrations that included domestic objects in their decorative borders. In the second half of the 16th century painters such as Pieter *Aertsen in Flanders and *Passarotti in Italy produced broadly handled genre scenes of butchers' or fishmongers' shops, or biblical episodes, in which the main point of interest was the mountains of food and utensils piled up in the foreground.

Still life's final emergence as a fully independent form probably happened more or less contemporaneously in Italy, Spain, and Flanders towards the end of the 16th century. It clearly reflected profound changes that were taking place at this late point in the *Renaissance, and there can be no adequate single explanation for cultural shifts of this kind. Among the factors underlying still life, however, have been the urge towards scientific accuracy of describing, the market created by connoisseurs of extreme illusionistic skill, the thought of rivalling the ancients at their own game, and the implied claim that the status of a work of art depends on the vision and skill of its creator and not on its subject matter. Although still life by definition cannot convey a story-line (and was for

that reason ranked as far inferior to *history painting in academic theories of the hierarchy of genres) there have also been continuing traditions of still life meant to be read for its allegorical message, especially on the *vanitas theme of the frailty of human life.

Rooted in the Lombard realist tradition, some of the first Italian still lifes were firmly tactile paintings of fruit by artists like Fede Galizia (1578–1630), Ambrogio Figino (1550–c.1608), and *Caravaggio, who is recorded as saying that it was as much work for him to make a painting of flowers as one of figures. Caravaggio's only surviving independent still life is the small *Basket of Fruit* (c.1595; Milan, Ambrosiana), which has a presence that demands that it should be taken as seriously as any high art. The same status is impliedly claimed by *Sánchez Cotán's cerebrally concentrated still lifes painted in Spain in the early 1600s.

In the Low Countries the first types of still life to emerge were *flower paintings and stiff, meticulous, banquet tables by artists like Floris van Schooten (c.1585–after 1655). Soon, different traditions of foodstuff still life developed in Flanders and in the Netherlands, where huge commercial prosperity, and the absence of traditional patronage from Church and court, were creating an entirely new kind of bourgeois art market. In the hands of Haarlem specialists such as *Claesz. and *Heda the Dutch breakfast piece became a serious, contemplative form in which a few objects were brought into a unified composition by extremely subtle tonal variation within a virtually monochrome palette. Their accuracy of visual analysis and their deliberately understated celebration of a comfortable lifestyle exemplify the Dutch Puritan mind-set, as do the highly crafted *vanitas* ensembles of emblems such as skulls and guttering candles that became a popular type in Leiden and elsewhere. A more lavish Dutch tradition, catering for a patrician clientele, culminated in *Kalf's stupendous displays of luxury objects, the wonder of which is only exceeded by the marvels of technique in the painting itself. In Flanders, still life had from the start been a matter of heroic display. The style set by *Snyders's Rubensian banquet pieces was developed in Antwerp by the Dutchman de *Heem, and it was a major element in the formation of the opulent baroque confections of fruit, flowers, and precious vessels that became a standardized decorative type throughout Europe.

Alongside the general movement towards rich decorative effect, there were always more austere painters. The unrelenting rigour and sacramental quality of Cotán's work, for example, remained a feature of Spanish still life, especially in the few still lifes executed by *Zurbarán. Lubin *Baugin's pared-down compositions epitomize French intellectual clarity and elegance. The resonance of pure formal relationships similarly underlies the paintings of musical instruments by the north Italian painter *Baschenis. A unique painting is *Rembrandt's *Flayed Ox* (1655; Paris, Louvre), which is simultaneously an unforgettable image of the total finality of death and a dazzling display of ruby paint against an endless range of shadow.

Both the great names of 18th-century still life are highly personal painters. *Chardin's modest, welcoming ensembles of simple domestic objects or simple arrangements of fish and game were recognized at the time by the great critic Denis *Diderot as challenging the conventional hierarchy of the genres, through sheer magic of painterly handling. *Meléndez, too, painted ensembles of domestic utensils and foodstuff that demand to be taken as important statements, but they work through a pitiless gaze and detached objectivity that could hardly be more different from Chardin's quiet dialogue with the observer.

In the 19th century many first-rank painters turned to still life in pursuit of widely ranging artistic objectives. *Goya's few still lifes, painted late in his career, are amazingly loosely handled close-ups of poultry, fish, and meat, and have much of the quality of Rembrandt's *Flayed Ox*, in both the tragic resonance of the subject and the phenomenal handling of paint. *Manet's flower pieces and studies of such simple things as a ham on a dish restate 17th-century types with unequalled painterly freedom. *Renoir and *Monet explored the colouristic opportunities of flower painting. Van *Gogh's still-life images manifestly bear an overwhelming weight of meaning.

The most significant 19th-century painter of still life was unquestionably *Cézanne. Although he took for his ostensible subject a more or less familiar kind of grouping of fruit, curtains, and kitchen articles, his concern was not to depict these objects in a naturalistic manner but to recreate their pictorial equivalent, so that for the first time it could truthfully be said that the surface of the painting had itself become the work's subject.

It was precisely because the traditional components of still life were so recognizable, and so drained of any anecdotal content, that they provided the ideal counters for the *Cubists to use in setting their conundrums about perception and illusion. The view that art is essentially about the creation of new orderings of shapes and appearances has remained at the heart of much 20th-century art, and still-life motifs have been reinvented in endless ways from the experiments in colour that concerned *Bonnard and *Matisse to Andy *Warhol's repetitious Campbell's soup cans. Having said that, one of the century's very greatest still-life specialists, *Morandi, painted with a subtlety and communion with his simple subject matter that have much in common with the world of Zurbarán. AJL

Bryson, N., *Looking at the Overlooked* (1990).
Sterling, C., *Still Life Painting from Antiquity to the Twentieth Century* (1981).

STIMMER, TOBIAS (1539–84). Versatile German-Swiss artist who executed portraits as well as decorative frescoes on the façades of houses (1568–70; Schaffhausen, Haus zum Ritter, now Mus.) and ceiling paintings on canvas in the Venetian manner (1578–9; Baden-Baden castle). He was a designer and decorator of clocks (1571–4; Strasbourg Cathedral) and of stained-glass panels. Stimmer's fame however rests on his enormous production of book illustrations: reproductions of portraits of famous men from the humanist Paolo Giovio's museum at Como, 1575, drawn while visiting Italy; woodcuts to a Bible edition in verse form (copied by the young *Rubens) and to the publications of the ancient historians Livy and Flavius Josephus. At a time when engraving was the preferred medium for book illustrations, Stimmer, inspired by *Dürer, revived the woodcut as a serious vehicle for artistic expression. KLB

Geelhaar, C., Koepplin, D., Tanner, P., et al., *Spätrenaissance am Oberrhein: Tobias Stimmer*, exhib. cat. 1984 (Basle, Kunstmus.).

STIPPLE ENGRAVING, a method of puncturing a plate with *roulettes, punches, and other tools so that modelling is achieved with greater or lesser accumulations of dots. It was often used in conjunction with etched line.

Engraved dots and flicks had always been a component of regular *line engraving, but stipple engraving flourished as a specialized technique from the latter part of the 18th century until the early 19th century mainly in France and England. It was used mainly to copy paintings and drawings, often of a soft and decorative nature, vapid even, and rendered more so by the frequent use of red or brown printing inks. It was also a technique well adapted to printing in full colours, the plate being dabbed in different colours by the use of pieces of rag.

Frequently the engraver began by etching the foundation of the design, and then built it up by the use of a special curved burin and by roulettes, punches, and other tools. A variant of stipple engraving, known as the crayon manner, was used to imitate the soft effect of chalk drawings, and many drawings by *Boucher were thus engraved in France.

In England by far the best-known stipple engraver was the Italian Francesco Bartolozzi (1727–1815) who came to England in 1764. He struck up a partnership with *Cipriani and

Angelica *Kauffmann, and their repertoire of bloodless mythological scenes adorned with dimpled putti is synonomous with the art, despite the many portraits engraved in stipple. Such prints, decoratively framed, are known, in a rather derogatory way, as furniture prints, and stipple engravers were openly despised by the elite line engravers—who also despised and envied the *mezzotinters. However, the technique was also used at the highest level of artistic achievment, particularly by George *Stubbs in two large and haunting plates of *Haymakers* and *Reapers* (1791).

Stipple was often a crucial ingredient in the large reproductive steel engravings of the mid-Victorian pictures, particularly in the modelling of soft flesh tones, but it is best seen as an 18th-century manifestation and expression of sentiment and sensibility.

RGo

STIRLING-MAXWELL, SIR WILLIAM

(1818–78). Wealthy Scottish landowner, writer, Hispanophile, and collector. He succeeded to the family estates at Keir (Perthshire) in 1847 and adopted the name Maxwell when he succeeded his uncle to a baronetcy in 1865. In 1848 he published his three-volume *Annals of the Artists of Spain*, encompassing Spanish art and architecture from the Middle Ages to *Goya. Like his friend Richard *Ford, author of the *Handbook to Spain* (1845), a pioneering guidebook, Stirling relied heavily on Spanish sourcebooks for information and documentation; and generally his approach was far more that of a political and social historian than of an art historian preoccupied with style and attribution. From his manuscript travel journals, dating from 1841, 1842, 1845, 1849, and his published work it becomes clear that he looked to Spanish art for an austere but naturalistic alternative to the classical tradition of Italy and France. He shows admirable open-mindedness and curiosity in his approach to still unfashionable artists including El *Greco as well as fascination with the more disturbing and grotesque modes of expression employed by Goya. Nevertheless like most of his contemporaries he was still preoccupied above all with *Velázquez and *Murillo, and in the *Annals* ambitiously attempts to provide a full catalogue of the known works of these two artists. The *Annals* also reflect Stirling's interest in modern methods of reproducing works of art which may have originated from his activities as a print collector. Attached to the three-volume text he issued a limited edition volume (25 copies) of photographic images or Talbotypes, most made from reproductive prints, the frontispieces of books, or drawings of buildings and paintings in Spain or France by Richard Ford, José Roldán, and William Barclay. Among the prints selected for reproduction are several rare Goya

etchings after Velázquez which Stirling had already collected in Spain. He also reproduced original drawings by *Cano and Murillo from Ford's collection, and describes them as 'the only original works of these masters to be copied by the sun'.

A year after the *Annals* was published, Stirling returned to Spain and followed a detailed itinerary provided by Ford. He planned to send on corrections or suggestions for Ford's *Handbook* and also made notes that would be reflected in the second edition of the *Annals*, published posthumously from his manuscript in 1891. It was during this trip that he developed in depth his pioneering interest in Goya and made a memorable visit, recorded in detail in his travel journal, to the house of Goya's son. He also became intimate with Valentin Carderera (1796–1880), a well-respected antiquarian and friend of *Céan Bermúdez. During his lifetime Carderera had acquired around 40 Goya drawings and an unrivalled collection of rare working proofs of Goya's etchings; and in due course he would sell Stirling 74 'duplicates' of Goya's working proofs of the *Disasters of War* from the set of 85, inadvertently including a unique impression of *Infame provecho* (Boston, Mus. of Fine Arts). He also sold Stirling a drawing by Juan Alfaro showing Velázquez on his deathbed.

Stirling's other consuming interest was in manuscript and printed source material. The Madrid bibliophile Pasqual de Gayangos (1809–1897), a friend of Ford, put much in his way including the proof of the frontispiece of Goya's *Caprichos* (Boston, Mus. of Fine Arts) and a copy of Francisco *Pacheco's *Arte de la pintura* (1649). On a visit to the Prince of Anglona Stirling was shown the original manuscript of this book, including the unpublished 'Prologo' which he had copied and inserted in his own copy of the book. Visiting Gallardos at Toledo he saw the original manuscript of Palomino de *Castro y Velasco's *Vidas de los pintores* and in Valencia he bought the same writer's portrait by Juan Battista de Simo (priv. coll.). The principal result of the Spanish tour from an art historian's viewpoint was the small monograph on Velázquez published in 1855, which consists of a more of less completely rewritten version of the chapter on the artist in the *Annals*, followed by a detailed catalogue of all known reproductive prints after Velázquez's paintings. This was based on Stirling's own collection, that of a friend Charles Morse, as well as an intensive search of European print rooms. Clearly the project continued to gather momentum for years after the book was published, to judge from the greatly expanded list of prints in a later catalogue Stirling published in 1873. Here the essay on Velázquez is omitted but a list of prints after Murillo is added. There is evidence that originally (*c*.1860) Stirling and Morse had planned an

illustrated life of Murillo, with photographs by Morse and Luis Masson and an essay by Stirling, but this never materialized.

Stirling also published two major historical works, *The Cloister Life of the Emperor Charles V* (1852), inspired by a visit to S. Yuste in June 1849, which he described in a letter to Ford; and *Don John of Austria* (1883). He also published a catalogue of his comprehensive art historical library entitled *An Essay towards a Collection of Books Relating to the Arts of Design* (1850; 2nd edn. 1860).

Stirling's picture collection (half remains at Pollok House, Glasgow, together with part of his library; the remainder from Keir was dispersed) was formed from both Spanish sources and the London salerooms and reflected his art historical interests. Apart from works by El Greco, including the *Adoration of the Name of Jesus* (London, NG), Cano, *Zurbarán, *Pereda, and Goya, it was remarkable above all for its portraits and self-portraits of artists, including El Greco's *Portrait of Pompeo Leoni Sculpting a Bust of Philip II* (priv. coll.), *Carducho's *Self-Portrait* (Glasgow, Pollok House) and a *Self-Portrait* by Juan de *Roelas (priv. coll.).

HB

Brigstocke, H., 'El descubrimiento del arte Español en Gran Bretaña,' *En torno a Velázquez*, exhib. cat. 1999–2000 (Oviedo, Mus. de Bellas Artes de Asturias).

Harris, E., 'Sir William Stirling and the History of Spanish Art', *Apollo*, 79 (1964).

STOKES, ADRIAN

(1902–72). English writer and painter. He outlined an individual vision of artistic values in a succession of demanding but highly respected books, paralleling his writing with painting from the late 1930s (when he attended the Euston Road School, *London) onwards. This vision was marked by an enraptured fascination with certain aspects of Italian architecture and sculpture, which he characterized in *The Stones of Rimini* (1934) and *The Quattrocento* (1934). In his discussion of them Stokes made an influential contrast between the procedures and values inherent in moulding and those inherent in carving. The distinction, which he metaphorically extended to painting, was made in favour of carving values, seen as a discovery of the inner reality of the material being worked. Stokes's thought, which also extensively addressed modern art, was stimulated by psychoanalysis under Melanie Klein, a pupil of *Freud. Her concepts of 'projection' and 'substitution' were adapted in Stokes's doctrine that art was an externalization of the inner life, connecting it with the life of the world and symbolizing the organization of the self and its experiences. Stokes's work as a painter, done chiefly from life, is marked by a tender and openly explorative touch.

DC/JB

The Critical Writings of Adrian Stokes, ed. L. Gowing (1978).

STONE, NICHOLAS (1587?–1647). The leading English monumental mason and sculptor of the first half of the 17th century. He trained first in England but from 1606 until 1613 he worked for the Amsterdam sculptor Hendrick de *Keyser, bringing back to London a more sophisticated style, blending naturalism and *Mannerism, than that of his contemporaries. He soon built up a large practice in tomb monuments. His early work, such as the tomb of Lady Carey (1617; Stowe-Nine-Churches, Northants.), probably carved by his own hand, proves him to be the most accomplished English sculptor of his time. He introduced a number of new ideas to England, including the seated figure in Roman armour (monument to Frances Holles, after 1622; London, Westminster Abbey) and, in the monument to John Donne (1631; London, S. Paul's Cathedral), the eccentric idea suggested by the poet himself of representing him standing in his shroud. Stone's association with Inigo Jones and the court of Charles I (see LONDON) (he was master mason for the Banqueting House at Whitehall) brought a more *classicizing style to his later work, as may be seen from the varied output of his workshop, ranging from commemorative wall tablets (e.g. monument to John and Thomas Lyttelton, 1634; Oxford, Magdalen College) to tombs with reclining and kneeling figures in architectural settings (e.g. monument to Sir Charles Morison, 1630; Watford, Herts.). His *Notebook* and *Account Book* (London, Soane Mus.) give much valuable information about the organization of his workshop. HO/MJ

Spiers, W. L., 'The Note-Book and Account Book of Nicholas Stone', *Walpole Society*, 7 (1919).
Whinney, M., *Sculpture in Britain 1530–1830* (rev. edn., 1988).

STONE-CARVING. There are two methods of approach to stonecarving, which are known as *indirect* and *direct* carving respectively. In indirect carving the sculpture is first made in some other material—usually a plaster cast taken from a clay model—and this is transferred more or less mechanically into stone by *pointing. Where the indirect method is used the actual cutting of the stone may be done by artisan carvers or workshop assistants and need not be done by the artist himself.

The indirect method of carving is not to be confused with the practice of making a small preliminary figure in *clay, *wax, or a comparable material as a general guide to the sculptor cutting his stone block. The use of preliminary studies allows the sculptor to solve formal and compositional details in a more economical medium, and according to *Pliny the practice of producing a preparatory model originated among the Greeks in the late 4th century BC. A similar method was also described by *Cellini and *Vasari and used by *Michelangelo.

Indirect carving has conflicted with contemporary notions of sculpture and the majority of creative artists use the direct method or *taille directe*. They argue that modelling and carving are different activities in fact and principle, one being the process of building up the form, the other being the process of removing stone, thus releasing the form 'trapped within', as in Michelangelo's classic statement in his 15th sonnet:

> Non ha l'ottimo artista alcun concetto
> Ch'un marmo solo in se non circonscriva
> Col suo soverchio, e solo a quello arriva
> La man, che ubbidisce all'intelletto.

(The greatest artist has no conception which a single block of marble does not potentially contain within its mass, and only a hand obedient to the mind can penetrate to this image.)

Direct carving is thus a process of releasing superfluous material from a block to reveal the shape the artist has conceived as latent within the block. The way in which an artist releases this image depends on his own imaginary conception. If he conceives the form as a set of profiles fitting within the block, he will proceed in one way; if he conceives the form fully in the round from the beginning his approach will necessarily differ. Michelangelo's unfinished marble sculptures of the *Slaves* or figures of the Evangelists intended for the tomb of Julius II can be seen to exemplify this principle (for instance the *S. Matthew*, c.1506; Florence, Accademia).

Different stones require different approaches: thus limestone and sandstone are relatively soft stones which can be easily carved and have softer contours. These are commonly used in French and English sculpture, while grey *pietra serena* is a typical sandstone from near Florence, often used for architectural sculpture. Harder white and coloured marbles will allow for more precise crisp carving and a higher polish. Finally the hardest stones such as granite and *porphyry require the most tempered steel tools.

The tools employed in sculpture have not changed substantially since ancient times. These include the point, the boucharde, claw chisels and fine chisels, drills, rasps, gouges, and abrasives. Most of these were familiar to the early Egyptians. Where very hard stones were carved in ages before iron tools were known greater use was made of abrasive techniques and by drilling with the aid of a wet abrasive. Michelangelo's method of preparation for carving stone may also be typical for most stone sculpture, for he would order stone from the Carrara quarries, sending precise measured drawings detailing the length and width of the block to be carved. In the quarry stone blocks are split during quarrying and by packing holes with wood which has been wetted to cause it to expand, or by inserting steel wedges and tapping with a hammer to force a split. The first major shaping of the block is done at the quarry by sawing large pieces at angles to give the general shape required for the figure to be carved, before it is shipped to the sculptor's studio.

This roughing out of the shape of the figure is done by means of a 'pitcher', 'pick', or 'point' (pointed chisel), which chips off large irregularly shaped pieces of stone. The point is used until a very late stage, and its angle depends on the hardness of the stone. After the point or punch the claw chisel is used, usually in conjunction with a mallet. The claw marks left by the chisel might be left to denote texture, or smoothed out by ever finer chisels and abrasives. For the hard granite a chisel with a less acute angle is employed, and flat chisel is then used to smooth out the final surfaces of the stone and for undercutting. Drills and abrasives can be used for the finer details, and a sculpture such as *Bernini's portrait bust of *Thomas Baker* (1637–9; London, V&A) illustrates the virtuoso use of the drill for the undercutting of the hair and the intricate lace of the collar. The marks of the drill can either be left apparent, or smoothed out to form a continuous channel. Drilling is also used to split hard stones. The different types of drill include the bow or running drill, a jumper drill, or the electric drill. The boucharde, a hammer-shaped tool with diamond point surfaces, can be used in very hard stones such as granite, to wear down the surfaces, but should be avoided for softer stones, since it will bruise a surface such as marble. In contemporary sculpture the use of pneumatic hammers and drills has speeded up the working of stone.

Surfaces can be smoothed down by rasps, files, and rifflers or by carborundum and emery, and the addition of water avoids a build-up of dust. Final polishing will only succeed on the hardest of stones, such as granite, porphyry, and gemstones, and again abrasive materials will be used for this, including abrasive powders or salts.

See also CONSERVATION AND RESTORATION, SCULPTURE. HO/AB

Penny, N., *The Materials of Sculpture* (1993).
Rockwell, O., *The Art of Stoneworking: A Reference Guide* (1993).

STOPPING-OUT VARNISH, the acid-resistant varnish applied to a copper plate, through which the artist scratches his design before the plate is immersed in acid for the process of etching. RGo

STOSS, VEIT (Polish: Wyt Stwosz) (c.1445×50–1533). German sculptor who worked in Nuremberg and Cracow. The style of his works indicates that he was trained in

the area of the upper Rhine valley. He is first recorded in 1477 when he gave up his citizenship in Nuremberg to move to Cracow. There he was employed both by the resident German merchants and the Polish court, his main commission being the monumental polychrome wood retable for the high altar of S. Mary's (1477–89; *in situ*) and the red marble tomb of King Kazimierz IV Jagiellonian in Wawel Cathedral (1492). Stoss's style, which is strongly expressionistic, has sometimes been called 'late Gothic Baroque' in contrast to *Riemenschneider's more refined late Gothic florid manner. In 1496 Stoss returned to Nuremberg. Between 1503 and 1506 he was imprisoned for forging a document, branded on the face, and confined to the city limits. He fled to Münnerstadt, where he painted Riemenschneider's monochrome *Magdalene* retable (all *polychromy subsequently removed). In 1507 Stoss was able to take up residence in Nuremberg again. One of his most familiar works from this period is the *Annunciation of the Rosary*, of polychrome limewood (1517–18; Nuremberg, S. Lorenz).

KLB

Baxandall, M., *The Limewood Sculptors of Renaissance Germany* (1980).

S TREETER, ROBERT (1621–79). English decorative and landscape painter, and etcher. The son of a London artist, Streeter may have trained abroad, being commended in 1658 by W. Sanderson for his skill in painting, etching, and engraving, and appointed Serjeant Painter in 1663. Little of his decorative work survives. His masterpiece is the allegorical painted ceiling to Wren's Sheldonian Theatre, Oxford, *Truth Inspiring the Arts and Sciences*, an ambitious *Baroque composition showing French and Italian influences. His known landscapes, such as *View of Boscobel House* (London, Royal Coll.), are Netherlandish in style.

KH

Edmond, M., 'Limners and Picturemakers', *Walpole Society*, 47 (1980).
Waterhouse, E. K., *Painting in Britain 1530–1790* (5th edn., 1994).

STRETCHER. See SUPPORT.

S TRIGEL, BERNHARD (1460–1528). German painter. Born into a family of artists in Memmingen, in the Allgäu region of southern Germany, it is most likely that he was trained in the family shop. Some of the painted outer wings and the predella of the high altar of the Klosterkirche at Blaubeuren (1493–4) are attributed to him (centre shrine by Michel *Erhart). During this period he was influenced by the Ulm painter Bartholomäus *Zeitblom, who also participated in the Blaubeuren altarpiece. In the course of the 1490s, Strigel became an independent master in Memmingen and began to produce religious

paintings and portraits. In 1515 he left to work in Vienna as court painter to Maximilian I. Here he produced one of the earliest group portraits in Germany, *The Emperor Maximilian and his Family* (1515; Vienna, Kunsthist. Mus.). Though he returned to Memmingen almost immediately, he continued to be patronized by Maximilian. In his last years Strigel seems to have abandoned religious works and devoted himself almost exclusively to portraiture, apparently as a result of his Protestant sympathies.

KLB

Löcher, K., *Germanisches Nationalmuseum Nürnberg: die Gemälde des 16. Jahrhunderts* (1997).

S TROZZI, BERNARDO (1581–1644). Italian painter who was born in Genoa and died in Venice and exercised considerable influence on artistic developments in each of these cities. His career started late, and followed twelve years, 1598–1610, as a Capuchin monk at S. Barnaba, Genoa. His early style was based on study of the Tuscan and Lombard *Mannerists whose work was well represented at Genoa. These influences are readily apparent in his earliest religious paintings, including the *S. Catherine* (Hartford, Conn., Wadsworth Atheneum), with its exotic and violent colour juxtapositions, and the *Pietà* (Genoa, Accademia Ligustica) with its technique of broken contours and heavy impasto, recalling the oil sketches of G. C. *Procaccini, who had come from Milan to Genoa to work for Gian Carlo Doria *c.*1618 or maybe earlier. Similar Mannerist impulses govern Strozzi's fresco paintings from this period before *c.*1620. Much of this work has been destroyed but the Doria commission for the *Marcus Curtius*, *Horatius Cocles*, and *Dido and Aeneas* (all three at Sampierdarena, Villa Centurione-Carpaneto) is sufficient to suggest he lacked the instinct for illusionistic decoration which would preoccupy many Genoese painters of the next generation. Instead Strozzi's capacity for innovation was expressed in pictures such as *The Cook* (Genoa, Palazzo Rosso), based on the Flemish tradition of *still-life painting and such kitchen pictures as Pieter *Aertsen's *The Cook* (Genoa, Palazzo Bianco). Strozzi was also responsive to the naturalism and chiaroscuro of *Caravaggesque artists, many of whom including *Borgianni, O. *Gentileschi, and the Frenchman Simon *Vouet had come to Genoa from Rome. Strozzi's *Calling of S. Mathew* (1617; Worcester, Mass., Art Mus.) apparently echoes elements from *Caravaggio's picture of the same subject in S. Luigi dei Francesi, Rome; yet in his dependence on local colour and surface detail he remains clearly distinct from the Caravaggisti. Some reconciliation of all these Flemish and Roman naturalistic influences is achieved in his *S. Augustine Washing Christ's feet* (Genoa, Accademia Ligustica) with its dramatic concentration, emphatic lighting, and acutely

observed but unobtrusive description of the vessels in the foreground.

Strozzi's predilection for colour and heavily textured brushwork stood him in good stead when he moved to Venice in 1630 and adopted a more exuberant style inspired by *Veronese. This is developed in major religious commissions, including *S. Sebastian Tended by Irene* (Venice, S. Benedetto) and *S. Lawrence Distributing Alms* (Venice, S. Nicolo dei Tolentini), which probably date from the late 1630s. It culminates in his *Rape of Europa* (Poznań, National Mus.), which has a Baroque vitality and decorative opulence that eclipses anything produced by a native Venetian artist at this time. Strozzi was also successful as a portrait painter, working with a relatively extrovert approach in a style that owes more to the *Bassano family and other Venetians than to the Grand Manner portraits that had been painted in Genoa by *Rubens and van *Dyck.

HB

Capaneto da Langasco, C., *Bernardo Strozzi* (1983).
Newcome, M. (ed.), *Kunst in der Republik Genua 1528–1810*, exhib. cat. 1992 (Frankfurt, Schirn Kunsthalle).

S TROZZI, ZANOBI (1412–68). Florentine painter and illuminator associated with Fra *Angelico at the convent of S. Marco. He may have trained under Fra Angelico as a panel painter and his signed *Annunciation* from an altarpiece in S. Salvatore al Monte (London, NG) clearly demonstrates his dependence upon the style and compositions of the older master. It is as a manuscript illuminator that he had the greater success, introducing several new designs and subjects to familiar liturgical book types such as the gradual, the antiphonal, or the book of hours. His most important works are found in the series of illuminated choir books for S. Marco (1446–60; Florence, Mus. S. Marco) in which he combines a lively interest in naturalistic detail with an awareness of the larger designs and architectural settings of contemporary monumental painting. These books exerted a strong influence on Florentine illuminators throughout the later 15th century.

PSt

Gordon, D., 'Zanobi Strozzi's "Annunciation" in the National Gallery', *Burlington Magazine*, 140 (1998).

STRUCTURALISM AND POSTSTRUCTURALISM. *See opposite.*

S TUART, GILBERT (1755–1828). American portrait painter. Born in Narragansett, RI, of Scottish ancestry, his family moved to Newport where, in 1769, he met the Scottish artist Cosmo Alexander (*c.*1724–72), who took him to Edinburgh *c.*1771. On Alexander's untimely death Stuart returned to America but left for London in 1775. A year later he was

continued on page 724

· STRUCTURALISM AND POSTSTRUCTURALISM ·

DEFINITIONS of structuralism have undergone many transformations, but the term is most commonly associated with an intellectual movement that originated in France during the 1950s and 1960s. Its representatives shared the belief that all phenomena of human life are shaped by constant laws of abstract structure. Fundamental to the development of this view was the linguistic model of Ferdinand de Saussure (1857–1913), who claimed to have discovered certain sets of rules underlying spoken language. His theory postulates that words establish their meaning via comparison with other words rather than through a relationship with an extra-linguistic reality. Structuralist scholars subsequently justified their extrapolations from Saussurian linguistics by recourse to the fact that language is central to any culture and present in all forms of discourse. Applications included the structural anthropology of Claude Lévi-Strauss (1908–), which traces the customs and myths of primitive societies back to basic structures of communication, and the psychoanalytic model of Jacques *Lacan, which regards the unconscious as a text to be unravelled. The methodology of structuralism has also been applied to the analysis of social institutions (prisons, clinics, etc.) and their underlying structures of power, specifically by Michel *Foucault, and to the study of signs and their meanings (*semiotics), for example by Umberto Eco (1932–) in *La struttura assente* (1968) and Roland *Barthes in *Éléments de sémiologie* (1964).

While structuralism holds that there are essentially detectable meanings locked in the structure of a given discourse, poststructuralism, reacting against the somewhat totalizing tendencies of the former, challenges the notion of 'structure' altogether and maintains that all meaning is indeterminate and arbitrary. Although deriving its momentum from a variety of sources (including Nietzsche and Wittgenstein), poststructuralist practice is mainly indebted to the critical process of *deconstruction associated with the writings of Jacques Derrida (1930–98). Deconstruction is a method of analysis by which the ambiguity of signs and their meaning in a text or an image is revealed, thereby establishing the relative position of the interpreter. Poststructuralism is therefore less concerned with investigating the actual organization of a system of signs than with its initial creation and subsequent use, for example in order to maintain certain positions of authority.

The methods of structuralism and poststructuralism have been beneficial to the study of visual material in various respects. By virtue of its concern with semiotics and linguistics, structuralism has generally alerted scholars to the signlike character of art and visual culture at large, and directed their attention towards possible relationships between images and texts. It was first brought to bear on the interpretation of visual media by some of the French structuralists themselves, notably by Roland Barthes in various essays on *photography and cinema. His method of reading an image as text is exemplarily set out in his semiotic analysis of a Panzani pasta advertisement poster ('Rhétorique de l'image', *Communications*, 4, 1964).

In the field of art history, scholars have explored the structural analogies between image and text in a number of ways. Most recently, this problem has been discussed in relation to extensive narrative cycles, especially those of medieval stained glass. Jean-Paul Deremble and Colette Manhes have thus attempted to analyse aspects of the glass programme at Chartres Cathedral in terms and metaphors of structural linguistics. While the entire church building is described as a 'book', the windows themselves provide a 'universal narration', which is generated by the 'writing' of the geometrical window frames (medallions, diamonds, etc.), and by the 'language' of light, colour, glass, and the design and composition of the images (*Les Vitreaux légendaires de Chartres: des récits en images*, 1988). In another study devoted to the glass at Chartres, Wolfgang Kemp pleads for the relative independence of pictorial cycles from literary models. Rather than merely reproducing a story, taken for example from a sermon, a coherent sequence of images can produce that story in a new way which is particular to its medium, and which follows grammatical rules comparable to those of textual narrative (*Sermo corporeus: die Erzählung der mittelalterlichen Glasfenster*, 1987; English trans., 1997).

While structuralism can still be concerned with the analysis of individual works of art, poststructuralism has affected the discipline of art history in a somewhat different way, causing a shift of attention away from the art object or artist, and towards a general critique of the way in which both are dealt with in the scholarly discourse so as to become part of art historical canons. Notions such as 'masterpiece', 'genius', or the central importance of the individual artist have thus been called into question. At an even deeper level, *feminist deconstructionists have pointed to the societal dimension of much art historical literature; an analysis of a painting of the Virgin or a female saint might for example contribute towards the perpetuation of notions of apparently gender-specific qualities, such as 'motherhood' or 'hysteria'.

Although mostly associated with French structuralism, structuralist art history had a predecessor in the so-called *Strukturforschung* pioneered in Vienna during the 1920s and 1930s, with Hans Sedlmayr (1896–1984) as its principal exponent. For Sedlmayr, each work of art represented a microcosm, the analysis of which would unravel the broader structures of its creator's mind, and of the society within which it was produced. His views are summed up in *Die Architektur Borrominis* (1930), which moves from a discussion of the structural processes discernible in the

architecture to a reconstruction of Francesco Borromini's (1599–1667) 'personal structure' and world view. The notion that an underlying force connects the structures of artistic phenomena with those of the human psyche, and society on the whole is ultimately derived from Alois *Riegl's concept of 'Kunstwollen'. AT

Barthes, R., *Image, Music, Text* (1977).
Kemp, W., *The Narratives of Gothic Stained Glass* (1997).

assisting *West and exhibiting at the RA (see under LONDON), where the success of *The Skater* (1782; Washington, NG), a masterly full-length, enabled him to establish his own fashionable practice in 1783. Success led to extravagance and he fled his creditors for Dublin in 1787, leaving for America, under similar circumstances, in 1793. In 1794, seeing a commercial opportunity, he painted George Washington. Stuart created three separate formats for his Washington portraits (of which over 100 copies exist): the 'Vaughan' (1795; Washington, NG), looking to the right, the full-length 'Lansdowne' (1796; Philadelphia, Pennsylvania Academy of Fine Arts), and the 'Athenaeum' (1796; Boston, Mus. of Fine Arts), unfinished, looking to the left. A master of characterization, who eschewed flattery, Stuart is regarded as the creator of a distinctly American style of portraiture. DER

McLanathan, R., *Gilbert Stuart: Father of American Portraiture* (1986).

STUBBS, GEORGE (1724–1806). English animal painter and engraver. He was born in Liverpool and, apart from a visit to Rome (1754), lived in the north of England until the late 1750s. Anatomical studies in York (c.1745–51) and Lincolnshire (c.1756–8) resulted, respectively, in his plates for Dr John Burton's *Midwifery* (1751) and *The Anatomy of the Horse* (1766). Around 1758 he moved to London and began painting animals for noble owners. His originality was immediately apparent for he painted not only conventionally, *Molly Long-Legs* (1762; Liverpool, Walker AG), but also dramatically, as in the startling *Whistlejacket* (1762; London, NG). Furthermore he painted their owners, like the sensitive *Milbanke and Melbourne Families* (c.1770; London, NG), and devoted attention to landscape. His wild animals were either scientifically accurate, such as *Zebra* (1763; New Haven, Yale Center for British Art), or *Romantic, as in the much repeated *Horse Attacked by a Lion* (c.1762; New Haven, Yale Center for British Art), a subject he painted in enamels in the late 1760s. By the 1780s his lack of sentiment, shown in the beautiful *Haymakers* (1785; London, Tate), was unfashionable and he devoted his last decade to a comparative anatomy of human, tiger, and fowl. DER

Egerton, J., *George Stubbs*, exhib. cat. 1984 (London, Tate).

STUCCO. Sculptural stucco is dehydrated lime, which is calcium hydroxide, produced from firing and slaking marble or travertine. To strengthen the lime, finely pulverized marble dust, sand, and glue can be mixed in, and it is also sometimes reinforced with hair, of a coarser or finer quality. Stucco differs from *plaster, which is a calcium sulphate, though they are both used for similar functions: sculptural and architectural decoration. This mixture is weather resistant, and can be coloured, though being alkaline, an intervening layer of chalk sand size is needed before colour is applied to stucco. It is especially suitable for the ornamental decoration of walls, both on the interior and exterior of buildings, and for ceilings, and it has been used extensively for sculpted figural decoration. In order to give the stucco a hold on a wooden wall or ceiling reeds are nailed to the surface beforehand, providing a 'key'. As the mixture is comparatively slow in setting the *stuccatore* has time for the free modelling of even complicated shapes. Recurring ornament can be cast in solid box or lead moulds, and affixed to the wall so as to take its place in the general design, but some ornament is done freehand in the semi-dry stucco.

Hellenistic and Roman interiors, for example at *Pompeii and *Herculaneum, and in the catacombs, provide fine examples of stucco design. During the *Renaissance the discovery of ancient Roman stuccowork (see ROMAN ART, ANCIENT) in the *Domus Aurea* in Rome led to a revival of this form of architectural decoration, often called *grotesque, after the *grotte* (caves) in which it was discovered. These techniques and ornamental motifs spread from Italy throughout Europe. The interior of *Fontainebleau by the Italian artists *Primaticcio and *Rosso followed the models established by *Raphael and *Giulio Romano in the Vatican Loggias, in the effective combination of stucco and painted decoration. White stucco ornamentation, often incorporating angels and strapwork patterns, is frequent in churches in Rome, such as S. Maria del Popolo or S. Andrea al Quirinale, and designs often derived from models used in ancient Roman art decorate a number of secular buildings, such as the Villa Madama, Villa Giulia, and Villa Doria in Rome. The example of Italian stuccowork at Fontainebleau was then taken up in Britain, by Nicholas Bellin, who in the 1540s worked at Nonsuch Palace (destr.). Elaborate figurative plasterwork is seen in late 16th- and 17th-century English houses, such as Hardwick Hall (Derbys.) (c.1592) and Blickling Hall (Norfolk) (1620). In Britain, the Netherlands, and Scandinavia, the pattern books of Hans Vredeman de Vries or Cornelis *Floris often provided the designs employed for stucco ornamentation in domestic and church interiors.

From the 17th century onwards Italian *stuccatori*, sometimes called 'Comacini' and often originally from the Ticino area of north Italy, worked in organized teams. The virtuosity of these and central European craftsmen in combining figures with ornamental work may be seen in the Baroque churches of southern Germany, such as those at Diessen, Vierzehnheiligen, and the cloister church of Ottobeuren, all in Bavaria. The delightful decorative interior of the church at Wies in Bavaria resulted from the collaboration of the *Zimmermann brothers with stuccoists from the Benedictine abbey of Wessobrunn.

The lightness of stucco was also used to great effect by the Italian sculptor Giacomo *Serpotta for his decorations in Sicily. In a typical example, the oratory of S. Lorenzo, Palermo, full-size figures, smaller figures, and intricately shaped reliefs are all of white stucco, freely combined in a graceful and attractive way.

By adding large quantities of glue and colour and greater amounts of marble dust and gesso to the stucco mixture, the *stuccatori* were also able to produce a material which could take a high polish and assume the appearance of marble: so-called *scagliola* in Italian, and *Stukkmarmor* in German. The material was extensively used for interior decoration during the 18th century and it is difficult to distinguish from real marble except that it is warmer to the touch.

During the 17th and 18th centuries interiors at *Versailles, at the Louvre (see under PARIS), and in private houses in Paris were enriched with extensive stucco figurative ornament. The *Rococo style of 18th-century France, and England, where it is illustrated in the work of the Artari family at Clandon Park, Surrey, or the *Neoclassical stuccowork in Robert Adam's interiors, demonstrates the varied effects possible from the skilful use of stucco decoration. HO/AB

Penny, N., *The Materials of Sculpture* (1993).
Beard, G., *Stucco and Decorative Plasterwork in Europe* (1983).

STUCK, FRANZ VON (1863–1928). German painter, born in Bavaria. The son of a miller, Stuck was determined to escape the spiritual and material poverty of his origins. In 1881, he enrolled in the School of Arts and Crafts at Munich, where he rapidly acquired a high reputation designing menus, greeting cards, and invitations; he also had two series of designs published as copybooks, and became the chief illustrator of the popular periodical *Fliegende Blätter*. In 1889 he sent two large mythological paintings to the exhibition at the Glass Palace. *The Guardian of Paradise* (Munich, Villa Stuck) won him a gold medal, a substantial cash prize, and overnight fame as the foremost painter of the new generation. His blend of observation and fantasy, decoration and symbol, made him instantly popular and when the Munich *Sezession was formed Stuck was firmly at its head. He designed the exhibition poster for the first Sezession show in 1893, and his image of the head of the Greek goddess of wisdom, Pallas Athena, became the group's hallmark. In 1895 his appointment as professor of painting at the Munich Academy extended his influence into the next generation of artists, including Paul *Klee and Wassily *Kandinsky. JH

Voss, H., *Franz von Stuck 1863–1928* (1973).

STUDIO. The *Renaissance concept of the artist as someone with a liberal education as well as craft training changed not only social status but also the working environment. In 17th-century Italy the word for *study* (as both activity and location) gradually replaced *bottega* (workshop). *Bernini's house had at least two studios: a big street-level room appropriate for heavy marble works and busy with assistants, and an upstairs study where he alone would draw, read, write, and contemplate. Sculpture is inevitably noisy, dusty, and cumbersome—work was also done out of doors—but successful painters made a similar division, especially those working on a large scale. Bernini also had a 'gallery' whose walls he used for life-size charcoal drawings. The eccentric English sculptor John *Bushnell lived and worked in an unfinished London house without floors or staircase.

In 1621 *Rubens received a visitor to Antwerp in his private office, then directed him to a great room where assistants converted his sketches into canvases as high as 5 m (16 ft); this top-lit room is lacking in the modern reconstruction of Rubens's house. His personal work was kept securely in an upstairs studio. Any artist of ambition needed such a band of helpers, producing not only 'studio work'—reductions, enlargements, and replicas to order—but also following the master's style on parts of original works. In some studios the assistants followed full-size *cartoons, but Rubens's qualified helpers, some specializing in landscape, still life, and other accessories of history painting, worked from oil sketches. Bernini likewise employed professional finishers and specialists like *Finelli.

Such assistants inevitably became disciples; *Rembrandt on the other hand took pupils for many years, and their fees augmented his income; the most talented worked so closely with him that it is often difficult to isolate autograph from studio work. Although pupils learned to paint in his manner, the best developed individual styles when they left him. The work of more solitary artists such as *Caravaggio, *Poussin, and *Claude was so commonly replicated in near-contemporary copies and imitations that we must suppose that security was often lax when a studio was both private retreat and public showroom. Collectors prized work from the master's own hand, but artists commonly believed that only they could distinguish it.

The modern painting studio's large north windows were rare before the 19th century. *Leonardo mentioned the north light's shadowless constancy, but recommended weak light to preserve colour relationships; in the studio as in the home, natural illumination levels were lower than nowadays. The Dutch landscapists achieved their astonishing realism in ill-lit studios, working with backs to the light and the outside world, often from a preparatory drawing pinned to the easel. What mattered more was that the picture—like Bernini's marble portraits—should be exhibited in a light similar to that in which it was made; the 'right light' was commonly from the left, so the right-handed painter would not work in his own shadow.

Studios were sparsely and functionally furnished, but contained unfinished or unsold works, also accessories such as busts, musical instruments, and costumes. The actual objects in a *still life were not assembled, but portrayed individually in spaces predetermined for them on the canvas; Jan *Brueghel inserted the various blooms into his marvellous *flower pieces as they came into season. Figure paintings involved a similar degree of artifice. Caravaggio's contemporaries believed that, as an unusual handicap, he could only paint from life, but the essential factor may be that he did not work from preparatory drawings but set out his composition, like a still-life painter, on the canvas and painted each figure from life. This was only the extreme of a common working practice; especially in portraiture it was convenient to paint faces and costumes separately.

Painting from the model was less common than is often supposed, and the term 'from life'—as opposed to imagination—sometimes meant working from sculpture or casts, not live models. Many artists drew from the nude as an exercise rather than in preparation for a picture, and occasional or regular life classes were a feature of the increasingly popular local academies; however, opportunities for private study were numerous enough to be noteworthy. In Rome *Domenichino and *Sacchi retained nude models, offering access to other painters such as Poussin who did not employ his own; hardly any of Poussin's life drawings survive. In Naples good female models were at a premium, while the Florentine painter Francesco Furini (1603–46) attributed his moral downfall to his use of them. In the libertarian Netherlands they were easier to obtain. Drawings from the Rembrandt studio confirm that he ran life classes for his pupils, but although he was a prolific draughtsman his paintings were usually worked out on the panel or canvas.

Many supposed images of the artist at work are either allegories or visual catalogues of studio activities from colour grinding to picture selling. *Self-portraits are often quite artificial, although Rembrandt depicted himself in working clothes and adjusted the mirror image to retain his right-handedness. Famous images by *Vermeer and *Velázquez are equally misleading. In Vermeer's *Art of Painting* (Vienna, Kunsthist. Mus.) an artist is seen from behind, in an elegantly furnished room, painting a woman dressed as the Muse of History. This depicts neither Vermeer nor his studio, and although he used models he would not have started with the headdress on an almost blank canvas; on the other hand similarities between many of his interiors suggest that, although he worked out their perspective on the canvas, they record elements of a real room with tiled floor and numerous small windows whose light could be controlled by shutters. Similar controls can also be seen refracted or reflected in some of Caravaggio's incidental details. Although Velázquez's *Las meninas* (Madrid, Prado) records a room he is known to have used, it is peculiarly empty; an undoubted self-portrait, it is also an allegory of the newly raised status of his art. Philip IV's visits to his studio speak more of this than of the King's love of art. KD

STUDIO EQUIPMENT (PAINTING). The tools, equipment, and props found in a painter's studio are the emblems of his art, frequently used in portraits to indicate his occupation. The artist's studio has long been a popular subject for paintings, some of the earliest in the guise of depicting the patron saint of painters, S. Luke, painting the Madonna. These studio views vary from simple, realistic interiors showing painter, palette, and easel, to elaborate fantasies with no relation to actual artistic practice.

The easel is the main piece of studio equipment associated with painting. It was often the first and most expensive purchase made by an artist in furnishing a studio. The earliest and most basic form was three-legged, into which pegs were inserted to support the painting. The studio easel is more robust and complex, capable of carrying large paintings. The legs of the easel are mounted on a horizontal stand and the painting rests on a ledge, in early versions supported on pegs but subsequently replaced by a geared system to raise or lower the painting by winding a crank. In some modern versions the crank has been replaced by an electric motor.

Less essential than the easel, other items of studio furniture included steps to reach the upper parts of a painting, a chair for the sitter known as a 'throne', sometimes on a raised dais to improve the artist's view, and a four-legged stool with an elongated seat, known as a 'donkey', capable of supporting a drawing board against the stool's vertical neck while the artist sits astride the seat to draw or paint. Until artist's colourmen's shops became relatively common as a source of materials in the late 17th century, the preparation of paint was the responsibility of the artist or his assistant and many depictions of the studio include a table with a slab and muller used for grinding paint by hand. Many studios also contained a cabinet with drawers in which to keep *pigments, *media, and brushes dust-free, with a hinged top which lifts to reveal paints in a tray or paint-box below. A modified version of this was owned by *Whistler, whose cabinet had a slightly sloping top which he used as a palette.

More commonly the palette was designed to be held in the hand, with a hole for the thumb and sometimes with a series of depressions for the paint. Made of any type of non-absorbent material, most usually wood but also ceramic, enamelled metal, glass, marble, or ivory, it was used as a support for laying out paint. Early palettes used for painting in egg tempera tended to be fairly small, reflecting a limited range of pigments and the small amount of tempera used at one sitting. As oil became the dominant medium, so the size of the palette increased, varying from batlike shapes to rectangles and ovals, often varying in thickness from tip to handle to improve the balance. The palette would often have a small metal or ceramic pot known as a 'dipper' attached to one side to contain the diluent for the paint. Closely associated with the palette is the palette knife, a flat, flexible spatula designed to transfer paints from grinding slab to palette, mix pigments with media, and clean the palette after use. Occasionally the blade of the knife would be perpendicular to the handle, although a straight blade was more common, usually made of flexible steel, although non-ferrous materials such as ivory or tortoiseshell were also recommended in treatises on painting. By the 19th century artists such as *Constable used palette knives to apply paint and when put to this use they became known as painting knives.

Almost all depictions of artists or their studios include a selection of paint and varnish brushes. Ancient examples made from palm fibre or twigs survive, but more usually brushes were made from the bristle or hair of mammals, the most common being squirrel, badger, camel, horse, ermine, and hog. In the 20th century synthetic fibres were introduced. Cennino *Cennini in 15th-century Italy gives instructions for making brushes and, until they became commercially available in the 16th century, artists made their own. Smaller brushes of the type used by artists were known in both English and French by the general term 'pencils' and sometimes the larger ones were known as 'tools', but a great many names were given to individual types of brush depending on their material or function, such as sweeteners, softeners, stripers, writers, and riggers, for painting rigging in *marine paintings. Traditionally brushes were round, the brush hairs being inserted into a quill or bound onto a wooden shaft with string, but the invention of the metal ferrule to secure the hairs allowed the manufacture of flat brushes, with implications for brushwork exemplified in the paintings of *Cézanne. The handle of the brush varied in length according to an artist's preference, some portrait painters using brushes with handles 1 m (3 ft) long in order to be able to stand back from their easel and see the sitter while painting. Many artists also used a mahlstick, a long cane with a ball of leather at one end, on which to rest the hand while painting, avoiding the danger of marking slow-drying oil paint.

A studio might also contain *plaster casts taken from life or classical sculpture, skeletons, and anatomical figures to assist in the accurate depiction of the human form. Small-scale to life-size models known as 'lay figures' made of jointed metal, wood, or textile, realistically stuffed to resemble the human body, were used by painters as substitutes for the living model, especially when painting complicated drapery. The studio might be fitted with a stove used to provide heat for artist and model alike, warm varnishes, and often cook the artist's lunch. When natural light was unavailable the studio would have to contain a means of artificial illumination, initially candles, oil or spirit lamps, later gas burners fitted with reflectors or shades to control the light, and ultimately electric lighting. SAW

Ayres, J., The Artist's Craft (1985).
Kemp, M., The Science of Art (1992).

STUMP, a coil of leather, paper, or felt with blunted points at either end which was used for rubbing on drawings made in *graphite, *chalk, pastel, or *charcoal. Sometimes a tapered cork was substituted. The process produced a softer appearance on the sheet. PHJG

STURM, DER, a periodical (1910–32) and a gallery (1912–24), founded in Berlin by the champion of the European avant-garde Herwarth Walden (1878–1941). Both acted as a forum for the leading artists of their day, and the periodical provided a critical framework in which contemporary art could be theorized and debated. Walden was a champion of the German *Expressionists, notably the *Blaue Reiter, who had their first exhibition in his gallery in 1912. Walden famously said 'Expressionism is a Weltanschauung [world view]', thus packaging together all of the diverse artists he promoted in the early decades of the 20th century. RRAM

STYLUS, a drawing instrument generally made of cast metal and often with a point at each end. In ancient times it was used for writing on wax tablets but in drawing its main purpose was to impress lines into paper when an artist was beginning to work out a composition. Since it left no visible mark other than the indentation it avoided the need to erase lines drawn in error. It was also used as a way of transferring the main lines in a composition drawing: in the case of an *etching from the sheet of paper to the copper plate and in fresco from the *cartoon to the plaster. PHJG

SUARDI, BARTOLOMEO. See BRAMANTINO.

SUBLEYRAS, PIERRE (1699–1749). French painter. He trained with Antoine Rivalz (1667–1735) in Toulouse and shared much of his master's antipathy to metropolitan art and the Parisian art world. In 1727 he won the *Prix de Rome and the following year left for Italy, where he spent the rest of his life, mainly in Rome. He worked for the Pope and the religious orders producing portraits and devotional pictures. His style, austere and serious, is in marked contrast to the *Rubéniste flamboyance of *Lemoyne and his pupils. Only Jean *Restout in Paris shared the gravity of his approach to religious art. Something of *Chardin's approach to the handling of paint is apparent also in such works as the portrait of the nun Marie-Claire Baptiste Vernazza (1740; Montpellier, Mus. Fabre), with its variations on white. His canvas The Painter's Studio (after 1740; Vienna, Akademie der Bildenden Künste) is a delightful anthology of his work and includes the sketch for his most famous picture The

Mass of S. Basil, commissioned by Benedict XIV for S. Peter's.　　　　　　　　MJ

Michel, O., and Rosenberg, P., *Subleyras 1699–1749*, exhib. cat. 1987 (Paris, Luxembourg; Rome, Académie de France).

SUBLIME, THE, a term originating with the translation of a treatise by a 2nd-century Greek named Longinus. His *Peri hypsous* was latinized as *De sublima* (On the Sublime); it offered writers stylistic advice, telling them how to compose in a powerful and inspiring way which could elevate the reader into a kind of ecstasy.

The treatise was translated into French in 1674 by Nicolas Boileau (1636–1711). He interpreted the term as 'the extraordinary, the surprising and the marvellous in discourse'. By extension from literature, it came to denote a sensibility, emergent in the late 17th century in paintings like those of Salvator *Rosa, that responded to overwhelming experiences of wild, magnificent, and awe-inspiring natural scenery: rugged mountains, precipices, torrents, storms, vast seas, skies, and deserts, etc. The writings of Lord *Shaftesbury, who viewed the sublime as a species of beauty that through its vastness pointed towards the infinite and its creator, helped to shape the developing concept.

The most influential theorization of the sublime came from Edmund *Burke in 1757. Contrasting it as a quality to beauty, he analysed the psychology that causes people to be drawn to fearful imagery. 'Whatever is fitted in any sort to excite the ideas of pain and danger,' he wrote, 'that is to say, whatever is in any sort terrible, or is conversant about terrible objects, or operates in a manner analogous to terror, is a source of the *sublime*; that is, it is productive of the strongest emotion which the mind is capable of feeling.' He opposes the factors inducing this experience—obscurity, power, privation, emptiness, and greatness of dimension—to the factors inducing the experience of beauty—smoothness, delicacy, smallness, and gradual variation. The sublime is dynamic, immense, and fearful; the beautiful static, well formed, and pleasurable.

Burke's argument met with an echo in an early essay by *Kant (1763), discussing the same contrast and extending it: men are sublime, women beautiful; the sublime moves us, the beautiful charms. A more critical reaction came in 1785 from the Scottish philosopher Thomas Reid (1710–96), who accused Burke of incoherent psychological reasoning: he had fallen for a misleading similarity between dread and admiration, forgetting that 'admiration supposes some uncommon excellence in its object, which dread does not'.

Kant's return to the subject in his *Critique of Judgement* (1790), however, gave it more penetrating consideration. The sublime, he says, is 'that which is absolutely great'. It is unencompassable and overwhelming and 'does violence to the imagination', taxing it beyond bounds. He distinguishes between the mathematically and the dynamically sublime. The former exceeds what can be imagined, yet reason is led towards comprehension of it. The latter is fearful and engulfing, threatening obliteration. The sublime transports us, but at the same time it is a joyous realization of reason's ability to transcend the imagination. Reason, although it cannot contain the boundless sublime, can remain inviolable before it, thereby glimpsing 'the Supersensible', that is, the unknowable that lies beyond ordinary human experience.

This late 18th-century interest in the sublime was reflected in much of the imagery of *Piranesi, Hubert *Robert, and *Wright of Derby, and developed further by painters of the Romantic era like *Turner and Caspar David *Friedrich. Discussion of the concept, however, was only effectively revived in the 1980s, largely through the renewed recourse of the French philosopher Jean-François Lyotard (1924–) to Kant's terminology. Lyotard deployed the idea that the sublime occurs 'when the imagination fails to present an object which might, if only in principle, come to match a concept' to argue that such a quality is delivered by imageless modern paintings like those of Kasimir *Malevich. His *White on White* strives 'to make visible that there is something which cannot be seen'. Art like this, or that of Barnett *Newman, strains at the limits of representation to open it to the unpresentable—with a productively subversive effect on the existent field of discourse. This conception of the sublime has been widely applied in *postmodernist criticism, among other things being invoked to argue for the significance of what is inchoate and fragmentary in late 20th-century art.

　　　　　　　　　　　　　　DC/JB

Burke, E., *A Philosophical Enquiry into the Origin of our Ideas of the Sublime and the Beautiful* (1757).
Lyotard, J.-F., *The Postmodern Condition* (1984).

SUGER, ABBOT (*c*.1081–1151). French patron and writer, abbot of S. Denis Abbey, near Paris, from 1122. Confidant of King Louis VI of France, Suger promoted S. Denis as the 'royal' abbey, substantially rebuilding and decorating the church. The choir is widely seen as the first *Gothic church design, and the west doors had the earliest column statues. The works are dated by Suger's written accounts of the building, which are a rare type of document from the medieval period.

Suger is no longer considered the inventor of Gothic (a claim that belongs more properly to his architect, whom Suger never mentions). He was a model patron in encouraging and promoting the work, but his main preoccupation was with rich adornments to decorate and enhance the shrines of the patron saints of his church: rich stained glass, jewels, liturgical vessels, marble, and bronze. There is little evidence that Suger was influenced by late Antique light metaphysics, as proposed by *Panofsky.　　　　　　NC

Abbot Suger and Saint-Denis: A Symposium, New York, 1981.
Kidson, P., 'Panofsky, Suger and Saint-Denis', *Journal of the Warburg and Courtauld Institutes*, 51 (1987).

SULLY, THOMAS (1783–1872). English-born American portrait painter. Sully was born in Horncastle (Lincs.), but emigrated as a child in 1792. His family settled at Charleston, SC. Sully practised as a portrait painter in New England in 1801 before moving to Philadelphia in 1807. Sponsored by a mercantile consortium he visited England (1809–10), where he was much influenced by *Lawrence, whose *Romantic sophisticated portraiture Sully introduced to America. Although his work lacks Lawrence's genius and panache, portraits like the flattering *Lady with a Harp* (1818; Washington, NG), a fashionable and apparently accomplished American debutante, found a ready market. In 1837 he visited London again to paint the newly crowned *Queen Victoria* for the St George Society of Philadelphia (priv. coll.) and while there painted a three-quarter-length version (1838; London, Wallace Coll.) which suffers from insipidity. Extremely industrious, he painted over 2,000 portraits and more than 500 subject and *history paintings, the best known of which is *Washington Crossing the Delaware* (1819; Boston, Mus. of Fine Arts). His son-in-law John Neagle (1796–1865) was also a portrait painter in a sentimental vein.

　　　　　　　　　　　　　　DER

Fabian, M., *Mr. Sully, Portrait Painter*, exhib. cat. 1983 (Washington, NPG).

SUPER-REALISM. See PHOTO-REALISM.

SUPPORT, the solid substance on which a painting is executed. An ideal painting support would be firm, flat, not too heavy to be impractical, slightly absorbent so that the paint adheres well, but not so absorbent that the *medium is leached out of the paint film. It would not react, either with the paint or the environment, and would not alter or deteriorate over time. Although a great many different supports have been used by artists over the years, none of them conforms in every way to the ideal, meaning that artists have had to adapt their techniques to overcome the various shortcomings of their chosen support. The type of support selected is important because it will affect the look of

the painting and how it deteriorates as it ages.

The two painting supports most commonly used are wood and canvas. The many other materials which have been used can be divided into two broad types: rigid, like wood; and flexible, like canvas. Most supports are prepared with a *ground and may receive additional preparatory layers before painting begins.

Until the early 16th century the most important support for easel paintings was the wood panel. Wood, if carefully chosen, carpentered, and prepared, makes an excellent support on which to paint. Most paintings that survive from the 13th to the early 16th centuries are on wood, and although it began to be replaced in the 17th century by canvas (see below), wood continued to be used through the 17th, 18th, and 19th centuries, especially for small works and those which benefit from having a smooth surface such as *still-life and *flower paintings. It is still used today, although the 20th century has seen an increase in the use of synthetic substitutes such as hardboard and plywood.

The choice of wood type depended mainly on availability. In Italy most artists worked on poplar, a tree that grows to a considerable size, yielding very large planks. However, because of its rapid growth, poplar is a soft, weak wood with erratic grain and many knots. It has to be cut thickly (making individual panels rather heavy) and is prone to warping and damage by woodworm. In spite of these shortcomings it seems that deforestation of Italy left artists working there with little alternative, although occasionally an artist was able to make use of a better-quality wood such as walnut, lime, or cherry. They certainly understood the problems associated with poplar and took steps to minimize their effects; some of the better-made panels have insets of wood replacing knots and areas of irregular grain which could otherwise become loose or cause splits. Northern European artists preferred to use oak, which is a much stronger wood with an even, straight grain and few irregularities, making it ideal as a painting support. Although oak is indigenous to the area, and locally grown oak was used by artists in the more southern parts of Germany, in France, and in Spain, the wood used by Netherlandish and northern German artists has been identified as coming from the Baltic, imported as part of the flourishing trade with the Hansa towns of that region. Artists working further away from the Hanseatic trade routes, and especially in southern Germany and the Alpine regions of Switzerland, Austria, and northern Italy, used a greater variety of locally grown woods such as spruce, pine, fir, and beech. The increase in imports of woods such as mahogany, from outside Europe, in the 18th

and 19th centuries provoked a new interest in painting on wood.

Wood reacts to changes in temperature and humidity in the environment, expanding and contracting quite significantly, especially across the grain. The way the planks are sawn from the log significantly affects the subsequent behaviour of the panel. For optimum dimensional stability planks should be cut so that the rings run as nearly perpendicular to the face of the board as possible. This is achieved by cutting radially, from the centre; tangentially cut boards are more likely to warp. The wood must then be seasoned, allowed to dry out gradually over several years, to discourage splits developing in the finished panels. Small panels can be made from single pieces of wood while larger ones are constructed by joining several planks together. Joins between planks are sometimes reinforced with dowels (cylinders of wood inserted into holes in the thickness of the wood across the join), or other, more complex constructions, but most are simple butt-joins, glued in place. To minimize potential problems, most artists (or their panel makers) took great care to choose the best cuts of wood and align the grain in adjacent planks. One notable exception was *Rubens, who constructed several large panels from up to 20 small planks not always correctly aligned in terms of grain direction.

The second major support for easel paintings is canvas. Strictly speaking, canvas is a woven fabric made from hemp (*Cannabis sativa*), from which the term canvas is derived, but in the context of painting supports the term has become more generally applied to painting on woven fabrics. Most artists' canvases are linen (made from flax, *Linum usitatissimum*), a greyish brown cloth which is strong and hard-wearing. Cotton is naturally off-white and forms a smoother cloth, but is softer and less durable than linen. It is produced in a variety of weights the heavier of which, often called cotton 'duck', are usually used for painting. The lack of durability has made cotton less attractive to artists, but mass production has resulted in cheap cotton canvases being available, which are widely used by amateur painters and students. Some 20th-century artists, such as *Hockney, have chosen to paint on cotton despite its disadvantages. Man-made fibres, although they have the advantage of durability over traditional natural fabrics, have yet to make a big impact on painting.

Canvas is supremely flexible and must be attached to a frame or board to keep it rigid, both for painting and for display. Early artists seem to have laced canvases into a temporary frame to paint on them, only attaching them to their final stretcher or board later. There is evidence that, in the 15th and early 16th centuries, canvas paintings intended for use in *altarpieces were stretched over solid

wood panels before being framed. Since then most canvas paintings have been attached to lightweight wooden frameworks or stretchers. Originally these had fixed corners, but in the 18th century wedges, or keys, were introduced at the corners, which can be driven in to expand the frame slightly. This allows for the slack, which naturally develops as a canvas ages and relaxes, to be taken up and the painting kept taut.

Very few canvas paintings survive from before the 16th century. This does not mean that they were not made. Documentary sources reveal that canvas paintings were common but mostly for less permanent items such as banners, decorations, and theatrical scenery. In the 15th century some Netherlandish and north Italian artists started to use canvas for quality work, producing *Tüchlein* in a water-based paint made with glue. Since canvas is flexible, it is not a successful support for egg tempera, which dries to a rigid film, or for gold, which requires a solid base if it is to be burnished, but with the increased use of oil paint, which is much more flexible when dry, canvas became a very attractive option. In Italy its popularity seems to have started in the north-east; one of the earliest artists whose surviving works include a relatively high proportion of canvases is *Mantegna.

Canvas is lighter than wood, it can also be woven in large pieces, much larger than any individual plank of wood, and if an even greater area is desired it is easy to attach another piece by sewing.

Most canvases have a plain weave. The thickness of the threads and the tightness with which they are woven together affect the handling properties of the cloth, its stability, and texture. The choice of canvas has a profound influence on the final appearance of the painting. Often the choice must have been dictated by availability or other practicalities, such as the need for a strong, robust cloth for a large painting, but some artists seem to have chosen particular fabrics because of their aesthetic qualities. Twill fabrics, for example, because of the nature of the weave, are stronger than plain weave fabrics, which may explain why *Veronese selected them for many of his large works, but they also form distinct surface patterns which he may have found attractive. Certainly, several 18th-century treatises on the art of painting suggest that portraits are better done on a twill canvas because the diagonal patterns are more flattering to the face than the square shapes of a plain weave.

The use of copper as a support for oil paintings dates from the late 16th and early 17th centuries. The popularity of printmaking using copper plates resulted in increased manufacture of the plates and therefore increased availability. Many artists made

*prints as well as paintings and would therefore have had the copper plates in their studios and there are examples of paintings on copper plates which have previously been engraved: the copper support of a painting of *Tobias and the Angel* (London, NG), a mid-17th-century copy after a work by Adam *Elsheimer, has part of a coat of arms engraved on it. Copper gives a flat surface which in many ways is ideal as a painting support since it is not prone to problems of ageing or degradation and is not affected by climate changes. The chief problem for artists working on copper is to persuade the paint to adhere to the very smooth surface. Early treatises advise rubbing the surface with garlic, but more usually the panel was scratched slightly to provide some tooth to which the paint can adhere. Large copper panels are unwieldy, very heavy if thick enough to support themselves, or else requiring additional support, but copper is an excellent support for smaller-scale works, the smooth surface making it particularly suitable for highly detailed works such as those by Paul *Bril and Jan *Brueghel I ('Velvet' Brueghel). Painting on copper is usually very thin, with a minimum of impasto to allow the colour and reflective properties of the copper to be exploited.

Other rigid materials which have been used as painting supports include stone and slate. *Vasari, in his life of *Sebastiano del Piombo, says that the painter introduced a new method for painting on stone which pleased people because the use of stone made paintings less vulnerable to damage. Slate, in particular, was used by Sebastiano for a number of works including his *Madonna del Velo* (Naples, Capodimonte), and by several other artists of the time, including *Michelangelo. The particular interest in slate, which is dark grey, seems to develop in conjunction with artists' moves away from the traditional white ground to painting on darker, coloured grounds. Among the more unusual rigid supports are roof tiles, which were used by Italian artists of the late 16th and early 17th centuries for portable paintings in fresco. Glass has also been used as a support and ivory was employed, especially for miniatures, because of its exceptionally smooth, even surface and creamy colour. More recently, in the 19th and 20th centuries a range of boards have been used: some, such as plywood, hardboard, chipboard, blockboard, and cardboard, products of the building and packaging industries, have been taken up by artists as cheaper and more readily available alternatives to wood; others, such as academy board, pasteboard, millboard, and canvas boards, have been specifically developed for painting.

Returning to flexible supports, other fabrics have been used, including silk and velvet, in addition to canvas. The other two main types of flexible support are *parchment or vellum and paper. Parchment is used as a general term for animal skins, dried and treated to produce a flat sheet for writing or painting on. Vellum is more specifically the skin of a calf treated in this way. The use of parchment is mainly confined to miniatures and books but it is sometimes found, mounted on panel or canvas, as the support for a larger easel painting (for example *Gossaert, *An Elderly Couple*; London, NG). *Paper, because of its relative cheapness and light weight, is an ideal material for sketches and less permanent types of painting but is less often seen as the support for a finished easel painting. There are examples of paper mounted on wood panel or canvas being used as the support for a larger-scale oil painting (for example *Holbein the younger, *Portrait of the Artist's Wife and her Two Oldest Children*; Basle, Kunstmus.) but it is not always clear whether these were intended as finished paintings, or started as sketches which were subsequently worked up. However it is really in the field of *watercolours and prints, which exploit its particular qualities, that paper comes into its own as a support. RB

SUPREMATISM, a Russian art movement launched by *Malevich in 1915, and based on his spiritual beliefs. He asserted that a non-objective and apolitical art, which used only geometric shapes and a limited colour range, was eternally enduring and capable of transcending religion by achieving 'the supremacy of pure emotion'. Its manifesto was published in 1915, and its journal *Supremus* a year later; by 1917, Naum *Gabo described Suprematism as a dominant force among avant-garde artists in Moscow. Malevich expounded his theories in *The Non-objective World* (1928), in which he stated that through Suprematism art was 'attempting to set up a genuine world order, a new philosophy of life'. The exhibition of Malevich's radical paintings *White on White* (1918) effectively marked the end of Suprematism, but its non-objective principles, as distinct from its spiritual ones, were carried on by the *Constructivists and the De *Stijl artists and thus significantly influenced the development of Western art and design. YJ

Russian Constructivism and Suprematism, exhib. cat. 1991 (London, Annely Juda Fine Art).

SURREALISM, an artistic and literary movement, founded in Paris in 1924, whose influence extended for several decades throughout Europe and the Americas. Surrealism was created by a group of Parisian intellectuals, led by the poet André *Breton, who had previously been involved in *Dada. The new movement inherited certain of Dada's qualities, including its revolutionary political stance and contempt for cultural conventions, as well as its use of chance in the production of collages and poems. However, while Dada had intended to subvert the concept of artistic creativity, Surrealism had a more positive aim, seeking to fuse the conventional, logical view of reality with unconscious, dream experience in order to achieve a 'super-reality'. This phrase led to the adoption of the term 'surréalisme', which had in fact been coined by the poet Guillaume *Apollinaire in 1917.

The Surrealists cited a wide range of precursors, ranging from the poets Arthur Rimbaud (1854–91) and Count de Lautréamont (1846–70), to earlier artists such as *Arcimboldo, *Piranesi, *Bosch, *Goya, Félicien *Rops, and Odilon *Redon, as well as to their contemporaries Marc *Chagall and Giorgia *de Chirico. They were also preoccupied with Freudian psychoanalysis, and as a result concentrated initially on expressing the workings of the unconscious mind through the technique of *automatism: drawing or writing executed without any conscious control. Indeed Breton's *First Surrealist Manifesto* (1924) defines Surrealism as 'pure psychic automatism, by which it is intended to express, verbally, in writing, or by other means, the real process of thought. Thought's dictation, in the absence of all control exercised by reason and outside of all aesthetic or moral preoccupations . . . Surrealism rests in the belief in the superior reality of certain forms of associations neglected heretofore; in the omnipotence of the dream, and in the disinterested play of thought.'

While Breton's definition refers primarily to verbal or literary activity, such as the poems of Paul Éluard (1895–1952) and Breton himself, automatism was also practised by such artists as Hans *Arp, André *Masson, and *Miró. Their work was published in the periodical *La Révolution surréaliste* and shown in Surrealist exhibitions, such as those held at the Galerie Surréaliste (opened in 1926). Masson's work included sand paintings, in which sand was poured on glue-covered canvases, creating arbitrary patterns which then suggested to the artist a subject (usually violent or erotic). Max *Ernst also developed procedures based on chance through the invention of *frottage and grattage, the latter technique involving the scraping away of upper layers of paint so as to reveal unexpected forms in the under-layers. Ernst also later practised *decalcomania, a process developed by Oscar *Dominguez around 1936, which involved rubbing paint arbitrarily between two sheets of paper.

Despite these developments, the decline of automatism as a Surrealist technique can be perceived as early as 1930, the date of the *Second Surrealist Manifesto*. By this time such painters as *Tanguy, *Magritte, and *Dalí were attempting to explore the unconscious in highly contrived dreamlike paintings,

executed with the skill of a 19th-century academic painter. Together these works combined the reproduction of dream settings (especially by Tanguy) with suitably irrational juxtapositions of apparently unrelated objects (in the work of Dalí and Magritte). The ambiguity of Dalí's work was enhanced by his predilection for ambivalent images, in which a single form could be interpreted as representing more than one subject, an effect also created by the photographers *Man Ray and Hans *Bellmer.

Throughout the history of Surrealism, an important role was played by sculpture, which ranged from Alberto *Giacometti's disturbing human figures to Arp's biomorphic abstraction. Most of the Surrealists also experimented with the *objet trouvé, producing unsettling, illogical combinations of objects divorced from their normal settings and functions. Although heavily influenced by the Dada assemblages of *Duchamp and *Picabia, the Surrealists' bizarre juxtapositions also demonstrated Lautréamont's concept of beauty as 'the chance encounter of a sewing machine and an umbrella on an operating table'. The Surrealists also regarded such objects as materializing their creators' unconscious desires, which would then be communicated to the spectator, so as to stimulate his own imaginative faculties.

While such avant-garde innovations were coolly received by the Surrealists' supposed allies in the Communist Party, Breton and his colleagues organized highly successful exhibitions in other Western countries, including one held in London in 1936. Moreover, during the Second World War American artists were strongly influenced by Surrealist émigrés in New York, such as Breton, Ernst, and Masson, whose principle of automatism was particularly important in the development of *Abstract Expressionism. Although the disruption of the war effectively destroyed Surrealism as a coherent movement, individual Surrealists continued to work far into the post-war period. Surrealism remains unquestionably one of the most significant phenomena in 20th-century art through its expression of the unconscious, and emphasis on the marvellous and fantastic, in contrast to the purely formal considerations of *Cubism and abstract art. CJM

Ades, D., Dada and Surrealism Reviewed (1978).
Chadwick, W., Myth in Surrealist Painting 1919–39 (1980).
Nadeau, M., Histoire du Surréalisme (1945; English edn., 1967).
Picon, G., Surrealism 1919–1939 (1977).
Rubin, W. S., Dada and Surrealist Art (1969).

S USINI FAMILY. Antonio (active 1580, d. 1624) and his nephew **Francesco** (1584–after 1653) were Italian sculptors and bronze founders. Antonio was one of *Giambologna's assistants and although both uncle and nephew produced independent work they are best known for their exquisite small-scale *Mannerist bronzes. These were cast both from models by Giambologna or from models by the Susini in his style. Signed and dated works, such as Antonio's reduction after the Farnese Bull (1613; St Petersburg, Hermitage), give some clues in disentangling the work of the master and associates such as the Susini and Pietro *Tacca. Nevertheless the attribution of individual small works from Giambologna's workshop continues to give experts enormous problems. MJ

Giambologna: Sculptor to the Medici, exhib. cat. 1979 (Edinburgh, Royal Scottish Museum; London, V&A).

S USTRIS, FATHER AND SON. Italo-Netherlandish painters. **Lambert** (c.1510×15–after 1560) was born and trained in Amsterdam. By the early to mid-1530s he was in Rome, together with Maerten van *Heemskerck. He worked in Venice c.1535 in the studio of *Titian and later independently in Padua. He developed a style of Venetian *Mannerism particularly suitable to narratives in landscapes (Women in a Roman Bath; Vienna, Kunsthist. Mus.). In 1547–8 and 1550–1 he accompanied Titian to Augsburg where he executed portraits. Lambert's son **Federico** (or Friedrich; c.1540–99) was born in Italy. Between 1563 and 1567 he was in Florence, where he participated in the decoration of the Palazzo Vecchio and worked on *Michelangelo's catafalque under the direction of *Vasari. Summoned to Augsburg to decorate interiors in the Fugger mansion, he was recommended by Hans Fugger to Duke Wilhelm V of Bavaria, for whom he worked at Landshut and later *Munich. There Sustris assumed a role similar to Vasari's in Florence, overseeing all artistic projects at court. Among others, he designed scenes from Ovid's Metamorphoses for the new Grottenhof at the Residenz (rebuilt in the 18th century), which were partly executed by Peter *Candid (Phaethon Asks to Drive the Chariot of Apollo, c.1588; Vienna, Albertina). KLB

Dacos Crifò, N., and Meijer, B. W. (eds.), Fiamminghi a Roma, exhib. cat. 1995 (Brussels, Palais des Beaux-Arts).
Geissler, H., Zeichnungen in Deutschland, exhib. cat. 1979 (Stuttgart, Graphische Sammlung).

S UTHERLAND, GRAHAM (1903–80). English painter and printmaker. Sutherland abandoned an engineering career to study *etching at Goldsmiths' College (1921–6). Until 1930 he made his living through etchings, working in the visionary *Romantic style of Samuel *Palmer. The collapse in the print market led him to take up painting in the 1930s; with his first visit to Pembrokeshire in 1934 he began to develop his distinctive landscape vision of 'imaginative paraphrase' and anthropomorphic abstraction, as in Welsh Landscape with Roads (1936; London, Tate). In 1936 he exhibited at the International *Surrealist Exhibition in London. Sutherland was commissioned as a *war artist in 1940, recording the effects of bombing in London, and the work of the Cornish miners. After the war he travelled abroad for the first time, to the south of France; he also began to paint portraits, which were generally acclaimed, although sometimes controversial, for example Somerset Maugham (1949; London, Tate), and Winston Churchill (1954; destr.). Converted to Roman Catholicism in 1926, he also executed a number of religious commissions, including a Crucifixion (1944) for S. Matthew's, Northampton, and a tapestry design, Christ in Glory (1954–7), for Coventry Cathedral. He was awarded the Order of Merit in 1960. JH

Berthoud, R., Graham Sutherland (1982).

S UTTERMANS (Sustermans), GIUSTO (Justus) (1597–1681). Flemish painter, active in Italy. He was trained in Antwerp under Willem de Vos (active 1593–1629) and then in Paris under Frans *Pourbus the younger. In 1620 he went to *Florence as a follower of the Belgian tapestry weaver Pieter Fevère whom Cosimo II de' Medici (ruled 1609–21) had persuaded to leave Paris to direct the Medici tapestry manufactory. His portait of Fevère (Florence, Corsini Coll.) attracted favourable attention and he was nominated court painter. His first known documented work for the Medici is the portrait of Maria Maddalena of Austria, the widow of Grand Duke Cosimo II de' Medici (1622; Brussels, Mus. Royaux). For the next 60 years Suttermans recorded the appearance of virtually all the members of the Medici family. He was also able to travel widely: Vienna (1623); Rome (1627 and 1645); Modena (1649 and several further occasions in the 1650s); Genoa (1649); Parma (1656); Innsbruck (1656–7). His absences from Florence and lack of his personal supervision might account for the excessive proliferation of inferior studio productions which have been associated with his name. If Medici patronage underpinned Suttermann's enormous success in his own lifetime, the family's extinction in the 18th century almost certainly precipitated the decline in his posthumous reputation. HB

Cummings, F., and Chiarini, M., The Twilight of the Medici: Late Baroque Art in Florence 1670–1743, exhib. cat. 1974 (Detroit, Inst. of Arts; Florence, Pitti).
Langedijk, K., The Portraits of the Medici 15th–18th Centuries, 3 vols. (1981–7).

SWART VAN GRONINGEN, JAN (c.1500–c.1560). North Netherlandish printmaker, painter, and designer of stained glass. According to van *Mander, he spent several years in Gouda and travelled to Italy. He may have gone from Venice to Constantinople: a set of five woodcuts of the *Procession of Turkish Riders* (1526) depicts Sultan Süleyman the Great and his entourage. Swart executed *woodcuts continuously 1520–33, when he began to *etch (ten etchings from the life of John the Baptist, of which one is dated 1533). From c.1524 to 1528 he lived in Antwerp, where he provided publishers with woodcut illustrations for books, among them a series of 75 illustrations to the Old Testament published by Willem Vorsterman in 1528. Swart's Italianate figure types with elongated proportions and complex poses set in naturalistic landscapes are linked with Antwerp artists such as Dirck Vellert and Pieter *Coecke van Aelst. Numerous drawings for stained glass exist (for example from the story of Ruth) and a number of paintings have been attributed to him on stylistic grounds, though his authorship is not certain. KLB

Filedt Kok, J. P., et al. (eds.), *Kunst voor de beeldenstorm*, exhib. cat. 1986 (Amsterdam, Rijksmus.).

SWEDISH ART. See SCANDINAVIAN ART.

SWEERTS, MICHIEL (1618–64). Flemish painter born in Brussels. By the mid-1640s he was in Rome, and during 1646–51 is recorded as living in an area of the city densely populated by northern painters. In 1656 he was back in Brussels where he founded a drawing academy. He became a member of the Brussels guild of S. Luke only in 1659. In 1660 he joined the mission of Bishop François Pallu, and in 1662 he set out from Marseilles with the mission for the Far East. Because of his unstable character ('not the master of his own mind') he was dismissed in Isfahan (Iran). He made his way to the Portuguese Jesuit centre at Goa, on the west coast of India, where he died. In Rome Sweerts painted genre scenes in the manner of the *Bamboccianti and *history paintings combining *Caravaggesque *chiaroscuro and realism with a serenity and simplicity related to the works of *Poussin or the *Le Nain. Reflecting his own interest in artistic education, he painted several scenes of artists' studios (e.g. Detroit, Inst. of Arts). His deep religiosity and compassionate interest in social problems is recorded in paintings of the *Acts of Mercy* (Amsterdam, Rijksmus.; New York, Met. Mus.). KLB

Kultzen, R., *Michael Sweerts, Brussels 1618–Goa 1664*, Aetas Aurea XII (1996).

SWISS ART has reflected since the early 16th century both the democratic constitution of the Swiss Confederation and the Calvinist hatred of conspicuous display, which is apparent even in the Italian canton of Ticino. Although external patronage developed with the *Grand Tour in the 18th century, patronage within Switzerland has generally been meagre and many Swiss artists have left the country to make their careers abroad.

In the 15th century the German-born painter Konrad *Witz settled in Basle and brought with him the enquiring spirit of northern *Renaissance naturalism. The accurate landscape near Geneva in his *Miraculous Draught of Fishes* (1444; Geneva, Mus. d'Art et d'Histoire) is one of the first such depictions in Western art.

In 1515 Hans *Holbein the younger also came from Germany to Basle, and he made portraits, altarpieces, and history paintings there before finally leaving for London in 1532, when the impact of the Reformation had made Basle highly unattractive for a major artist with humanist sympathies. Holbein's slightly younger contemporaries Niklaus Manuel *Deutsch and Urs *Graf were wilder artists who had both seen military service at a time when the Swiss Confederation was an important political force. Deutsch sought turbulent, expressive effects in his altarpieces, while Graf's prints and drawings provide the classic image of the swaggering *Landesknechts* who were then the most feared soldiery in Europe.

While there was a steady flow of commissions for the Baroque decoration of Catholic churches in the later 17th and 18th centuries, many of these were executed by artists from Austria and Bavaria, and the local talent was not remarkable. The most celebrated Swiss artist of the 18th century was Angelica *Kauffmann who made her career in London and Rome and whose stardom as a European prodigy owed at least as much to her status as a learned professional woman painter as to her *Neoclassical art itself. *Fuseli, who mainly worked in London, began as a Neoclassical painter, but moved into a neurotic, somewhat ersatz, *Romanticism. A very different painter of the Enlightenment period was Jean-Étienne *Liotard, whose portraits and genre pieces have something of *Chardin's calm tone, as well as Chardin's unblinking accuracy of recording. Two generations later the animal specialist and *Biedermeier genre painter *Agasse showed similarly unpretentious clarity and assurance.

Accuracy was, in fact, the quality that was most prized when 18th-century Swiss artists first began to discover Alpine scenery as promising quasi-scientific subject matter. Alpine peaks, glaciers, and vertiginous gorges soon became recognized as the ultimate manifestation of the sublime and of the sheer power of nature, and the resident Swiss artists who catered for the burgeoning tourist industry relied on these overwhelming Romantic images as well as a vocabulary of happy peasants and quaint townscapes. Printmaking was an important aspect of this souvenir landscape trade, and a speciality (the *Manière Aberli*) developed in lightly engraved Swiss views that were coloured and elaborated by hand in an essentially mass-production enterprise. Even so, artists who aspired to a wider audience had to go abroad. Perhaps the most notable of all Swiss Grand Tour painters was Louis Ducros (1748–1810) who operated a version of the *Manière Aberli* in Rome in collaboration with the engraver Giovanni Volpato (1732–1803) before going on to establish a European reputation in very grand watercolours of Grand Tour sights in Rome, Naples, and Umbria.

One of the last Swiss specialists in pure Romantic landscape was Alexandre Calame (1810–64), whose pupil Arnold *Böcklin developed into a fully-fledged *Symbolist painter. Böcklin, who spent most of his time in Italy, painted scenes of vague, mystical longing for the unknown that brought him huge fame, especially in German-speaking countries. *Hodler, the other major 19th-century Swiss painter, was also a Symbolist who was popular in the Germanic world. He painted heroic, somewhat lugubrious, allegories before turning at the end of his life to expressive mountain scenes done in a vivid *Post-Impressionist manner.

In 1915 Zurich saw the first manifestation of *Dadaism. The most famous Swiss artists of the 20th century have been *Klee, who worked and taught in Germany until he was dismissed by the Nazis, and the sculptor Alberto *Giacometti, who spent his active career in Paris. The witty sculptor Jean *Tinguely has also mainly worked abroad. Major trends in Switzerland have included the Art Concret movement, in which the artist, teacher, and writer Max *Bill played a leading role, and *Tachisme, in which Franz Fedier (1922–) was a notable figure. AJL

SYMBOLISM. The symbolic use of objects to express underlying ideas and emotions came to fascinate certain artists towards the end of the 19th century. Reacting against the growing materialism of the age, and specifically the artistic dominance of *Impressionism and *Realism, they aimed to reconcile matter and spirit through a language of signs and hidden meanings; an esoteric art where the significance of a work implied more than the sum of its apparent parts, revealing its full meanings only to initiates in the loose, unofficial 'brotherhood' of the Symbolists' self-defined dream world. *Burne-Jones spoke of a beautiful land which

'no-one can define or remember, only desire'. This became one aspect of Symbolism; the other, closely allied to the general extravagances of *fin de siècle* culture, was a land of decadent orgies and mysterious fears. The poet Jean Moréas (1856–1910) published a Symbolist manifesto in 1886, declaring that the artist must 'clothe the idea in sensuous form', a conception leading many painters to explore the mystical and the occult. The most extreme manifestations of this quest appeared at the Rose + Croix Salons, established by the flamboyant Joséphin Péladan in 1892.

Burne-Jones, *Rossetti, *Watts, *Beardsley, and Albert *Moore established Symbolist painting in England, while in France *Puvis de Chavannes, Gustav *Moreau, and Odilon *Redon explored the darkly brilliant worlds of *Baudelaire's *Fleurs du mal* (1857), and Rimbaud's *Saison en enfer* (1873). Symbolism also emerged powerfully in Belgium, in the mysterious, evocative paintings of Jean Delville (1867–1953), Fernand *Khnopff, and Lucien Lévy-Dhurmer (1865–1904).

At *Pont-Aven in 1888, Paul *Gauguin and Émile *Bernard formulated Synthetism (also called Cloisonnism). Beginning from natural observation, they used abstract colours and heavy black outlines to make the world around them express emotions and ideas through decorative design. Their discoveries, expounded by the critic Albert *Aurier, in the Symbolist periodical, *Mercure de France* (1891), influenced the *Nabis, whose chief theorist, Maurice *Denis, was among the most articulate exponents of the Symbolist position: 'a belief in the correspondence between external forms and subjective states . . . the work itself should transmit the initial sensation and perpetuate the emotion.'

Propagated by assorted periodicals, including the *Symboliste* (1886), and the *Revue blanche* (1891), Symbolism was widely influential. Symbolist thought and painting inspired the *Fauves and *Expressionists, the Vienna *Sezession artists, and the young *Picasso. The Symbolists did not create a new style, but made eclectic use of traditions of art, religion, and the occult to express their ideas. Although their works can appear clichéd and tasteless, they produced many resonant paintings, and their art represents a vital strand in *modernist aesthetics. JH

Goldwater, R., *Symbolism* (1979).

S YNAESTHESIA (Greek *syn*: union; *aisthesis*: sensation), indicating literally a union of sensation, appears to have provided a source of inspiration to many working within the arts. Science too has flirted with the topic and for the last 150 years has sought to explain the causes of coloured-hearing and the more exotic forms of the condition.

The notion that stimulation to one sensory modality could elicit a perception in another was much promoted by charismatic literary figures in the mid-19th century. Charles *Baudelaire, for example, writes of a mingling of 'perfumes, colours and sounds' in his poem 'Correspondances' (1860). Arthur Rimbaud develops this theme in his 'Le Sonnet des voyelles' (1871), moving beyond mere mingling to direct association between *colour and vowel. What is unclear from these accounts is whether these correspondences constitute direct evocation of colour as the result of auditory stimulation or mere metaphor. This is an important distinction as the former case constitutes a condition in which sound automatically and irrepressibly causes the subject to experience colour.

Scientists from a variety of disciplines have studied the developmental form of synaesthesia over the last two decades and have revealed much about its nature. First, individuals with the condition report having had the condition for as long as they can remember and that the colour–sound correspondence is fixed and unvarying. Further, the vast majority of synaesthetes appear to be women and tend to report having other female relatives with the condition. Evidence also suggests that the condition appears to have a strong genetic component and is considerably more common than was once thought, having a minimum incidence of 1 : 2000.

The techniques used to investigate synaesthesia are modern developments unavailable to scientists working in the late 19th and early to mid-20th centuries. In addition to Baudelaire and Rimbaud, a number of figures from the arts have been attributed with the condition of synaesthesia. Perhaps the most important attribution from the standpoint of Western art is that made to Wassily *Kandinsky.

Kandinsky's source of inspiration appears to have been the efforts made by the Russian composer Alexander Scriabin to imbue his symphonic compositions with a visual dimension. Scriabin achieved this by including in his score for *Prometheus* provision for a 'light organ', an instrument designed to project coloured light. Kandinsky appears to have been much taken with Scriabin's efforts and included in *Der *Blaue Reiter Almanac* (1911) an appraisal of Scriabin's *Prometheus*.

Kandinsky appears to have possessed a certain envy of music as an art form in that music, whilst being almost totally abstract, could successfully conjure visual images. Kandinsky's move toward total abstraction (see ABSTRACT ART) in his work seems to have followed from his desire to imbue his work with a synaesthesic quality. His intention was for his work to possess the quality of evoking sounds (*klangen*) in those who viewed his canvases. This evocation of an auditory dimension to visual representations was a move toward Kandinsky's ultimate aim of creating the *Gesamtkunstwerk* (total art work). In seeking to create this *Gesamtkunstwerk* Kandinsky's logic was simple; the more senses that could be appealed to with a piece of work, the better the chance of touching the inner spirituality within his audience.

The idea of a unity of sensation has provided a clear source of inspiration for poets, composers, artists, and novelists alike. However, the evidence suggest that these individuals did not actually 'see' colour as a result of auditory stimulation as a developmental synaesthete might, but instead made conscious associations between sound and vision. JEH

Baron-Cohen, S., and Harrison, J. E., *Synaesthesia: Classic and Contemporary Readings* (1997).

S YNCHROMISM, a movement whose basic principle was the reliance on colour alone to provide both the form and content of painting. It was developed by two American painters working in Paris, Stanton *MacDonald-Wright and Morgan Russell (1886–1953), who issued their manifesto at joint exhibitions in Munich and Paris in 1913. Their theories developed from *Neo-Impressionist ideas which were themselves based on such scientific analyses as that of Michel-Eugène *Chevreul. Although synchromism was roughly contemporaneous with the *Orphism of Robert *Delaunay, Macdonald-Wright had used colour theory in figurative works before meeting Delaunay; though contact with the latter probably influenced the Synchromist move to abstraction after 1913. Other painters associated with the movement were the expatriate Americans Arthur Frost (1898–1928) and Patrick Bruce (1881–1937). Frost's return to New York in 1914, which coincided with an exhibition by Macdonald-Wright and Russell, disseminated Synchromist ideas in America, influencing Thomas Hart *Benton, Arthur Bowen *Davies, and Joseph *Stella, among others. DER

Synchromism and Related Color Principles in American Painting, exhib. cat. 1965 (New York, Knoedler).

S YRLIN, JÖRG, FATHER AND SON. German woodcarvers active in Ulm. They were formally joiners who however contracted for complexes that included much sculpture. **Jörg the elder** (1420×30–91) engaged to supply in 1469 the choir stalls and in

1473 the high altar retable (destr. 1531) for Ulm Cathedral, though it is unresolved to what extent he participated in the design and execution of the sculptures since Michel *Erhart was certainly involved in the latter and probably in the former. **Jörg the younger** (1455–1523) took over his father's workshop in 1482. He can be documented as the contractor for a large number of altarpieces, such as the altarpiece for the former Benedictine abbey of Ochsenhausen (three surviving figures now in Bellamont, S. Blasius), and other works, some of which he apparently also designed. The sculpture in these works is inconsistent and was executed by several hands. KLB

Baxandall, M., *The Limewood Sculptors of Renaissance Germany* (1980).

TACCA, PIETRO (1577–1640). Italian sculptor and bronze founder, one of the main later exponents of *Mannerism. He trained in *Giambologna's Florentine studio, rapidly becoming his chief assistant, responsible for the execution of monumental bronze sculptures from his master's models. He played a major role in such famous works as the equestrian statues of *Ferdinand I de' Medici* (from 1605; Florence, Piazza SS Annunziata) and *Henri IV of France* (from 1604; formerly Paris, Pont Neuf). After Giambologna's death in 1608 Tacca inherited his workshop and the post of court sculptor to the Medici grand dukes in *Florence. His main personal projects are the four magnificent bronze *Slaves* (completed 1626) on the base of the statue of *Ferdinand I de' Medici* on the quayside at Livorno and the rearing *equestrian statue of *Philip IV of Spain* (begun 1634; Madrid, Plaza de Oriente). The latter is a technical tour de force (on which he was advised by Galileo) not equalled until *Falconet's *Peter the Great* at St Petersburg near the end of the 18th century. As well as monumental sculpture Tacca, like his colleague Antonio *Susini, was also responsible for small bronzes of exquisite refinement cast from Giambologna's models and his own. In every case his works are marked by a high level of technical skill and surfaces of great animation. His son Ferdinando (1619–86) succeeded him as court sculptor. MJ

Torritti, P., *Pietro Tacca di Carrara* (rev. edn., 1984).
Watson, K., *Pietro Tacca, Successor to Giovanni Bologna* (1983).

TACHISME (French *tache*: blot, stain, or spot). The term was originally used, disparagingly, in the late 19th century by critics of the *Impressionists, in France. However it is more usually associated with the French critic Michel Tapie who used it objectively, in his book *Un art autre* (1952), to describe the work of several contemporary non-geometric *abstract painters associated with the *École de Paris. These artists, who included Georges *Mathieu and *Wols, produced work characterized by apparently spontaneous dabs, blotches, and dribbles of paint, similar to American Action Painting but less overtly vigorous. DER

TADDEO DI BARTOLO (c.1362–c.1422). Sienese painter. Though most of his surviving work was done after 1400, Taddeo's artistic roots lie in the trecento. After a period working in Genoa and, perhaps, Padua he returned to Siena in 1399. His signed triptych of the *Assumption and Coronation of the Virgin* (1401; Montepulciano Cathedral) was the largest Sienese altarpiece since *Duccio's *Maestà*. Taddeo's eclectic culture is demonstrated by his frescoes of the *Last Days of the Virgin* (1406–7) in the internal chapel of the Palazzo Pubblico in Siena and the *Roman Gods and Heroes, Virtues* etc. in the antechapel (1413–14). The *Funeral of the Virgin* clothes a densely architectural setting and bulky figure grouping reminiscent of *Altichiero's or Giusto de' *Menabuoi's work in Padua in a more florid texture of draperies and gesture. The antechapel frescoes, important early examples of *humanist civic decoration, reveal Taddeo's taste for challenging foreshortened postures, testimony to his powerful draughtsmanship. JR

Symeonides, S., *Taddeo di Bartolo* (1965).

TAEUBER-ARP, SOPHIE. See ARP, HANS.

TAMAYO, RUFINO (1899–1991). Mexican painter born in Oaxaca. One of the most internationally acclaimed modern Mexican painters, Tamayo was influenced by pre-Columbian art whilst working in the Museum of Anthropology, Mexico City; paintings such as *Animals* (1941; New York, MoMa) show this influence. He placed himself in opposition to the pervasive aesthetic ideology of the revolutionary Mexican

Muralists, believing that painting should be universal rather than nationalistic. His work focuses on the plastic qualities of painting—colour, form, texture, composition—rather than on subject. However, the strongest thematic current within his work is that of the human figure, abstracted and dynamically placed within nature and the cosmos. His years in New York (1926–44 periodically) exposed him to international modernist trends, and the distance from Mexico enabled him to create a particular style drawn from the 'essence' of Mexican culture—its folklore, popular art, geometric form, and, above all, colour. His murals, like his easel paintings, depict universal myths; they include those at Smith College, Northhampton (1943), UNESCO, Paris (1958), and the National Conservatory of Music, Mexico City (1933). CC

Lassaigne, J., and Paz, O., *Rufino Tamayo* (1994).

TANGUY, YVES (1900–55). French painter. Having worked as a merchant sailor for two years, in 1922 Tanguy settled in Paris, where he took up painting, partly as a result of seeing *de Chirico's work in an exhibition of 1923. During this period he also met André *Breton, and joined the *Surrealists in 1925. Tanguy's paintings were characterized by endless, dreamlike settings, recalling deserts or beaches, populated by ambiguous objects with irregular organic forms. The enigmatic nature of these images, combined with their convincing evocation of dream-space, brilliantly expressed the Surrealists' aim of exploring the human unconscious. In 1939 Tanguy emigrated to the USA, where in the following year he married the American painter Kay *Sage. Although some of his American paintings were lurid in colour, others depict sombre, rocklike forms under lowering skies, creating a characteristically disturbing interior landscape. CJM

Breton, A., *Yves Tanguy* (1946).
Yves Tanguy: Retrospective, 1925–1955, exhib. cat. 1982, (Paris, Centre Georges Pompidou).

TANZIO DA VARALLO (Antonio d'Enrico) (1575/80 1632/3). Italian painter. He was born at Varallo and had two brothers who were also artists, Giovanni d'Enrico (c.1560–1646), a sculptor who worked at the *Sacro Monte of Varallo, and Melchiorre d'Enrico, a fresco painter under whom he may have trained, and with whom he went to Rome in 1600. Tanzio's early activity is still a matter of speculation. In Rome he appears to have absorbed the classical tradition of drawing in chalk from the model as well as the naturalism and chiaroscuro of *Caravaggio and his followers. Early works, scattered in the churches of the Abruzzi (Fara San Martino parish church; Pescocostanzo Collegiata) and at Naples, suggest an artist with little sense of artifice or dramatic chore-

ography; an archaic style of composition is enlivened by a keen eye for naturalistic detail and a monastic simplicity that anticipates Spanish artists such as *Zurbarán. On his return to Lombardy he was commissioned (before 1616) to paint *S. Carlo Administering the Sacrament to Victims of the Plague* (Domdossola, parish church), which is in a similar style to his earlier work. From 1616 to 1618 he was more fruitfully engaged, painting *illusionistic frescoes at the Sacro Monte of Varallo, where he worked with his brother Giovanni. In the chapel of Christ before Pilate he also executed ceiling decorations of exuberant flying angels, strongly reminiscent of *Morazzone, for one of which there is a carefully finished preparatory drawing (Varallo, Pin.). He and his brother then moved on to create the chapel of Pilate washing his hands. By 1628 Tanzio had also completed the chapel of Christ before Herod. He was also occupied with the decoration of the chapel of the Guardian Angel at S. Gaudenzio, Novara (1627–9), an ambitious scheme that included his vast oil painting of the *Battle of Sennacherib*. This is a highly theatrical work in which realistic figures, dramatically lit, engage in violent action, but without adequate room for manœuvre, the *horror vacui* in the lower half of the picture juxtaposed with vast areas of empty darkening sky above.

Although Tanzio, in his illusionistic frescoes and large-scale altarpieces, never throws off his vigorous roots in the rustic Lombard tradition of Gaudenzio *Ferrari and Morazzone, he also produced a small number of striking paintings on a smaller scale, often of single figures, such as two pictures of *David with the Head of Goliath* (Varallo, Pin.), *S. Sebastian* (Washington, NG), and *S. John in the Desert* (Tulsa, Okla., Philbrook Art Centre), where a more sophisticated Mannerist artifice, reminiscent of G. C. *Procaccini, is combined almost incongruously with a naturalistic quality reminiscent of Marcantonio Bassetti (1586–1630), an artist from Verona who had studied Caravaggio. Yet in these pictures too there are vivid glimpses of landscape that bring us back firmly to Tanzio's native soil in Valsesia. HB

Testori, G., *Tanzio da Varallo*, exhib. cat. 1959/60 (Turin, Palazzo Madama).

TAPESTRY: TECHNIQUE AND HISTORY. The word 'tapestry' is now used colloquially to describe a range of textiles, but historically and technically it designates a figurative 'weft-faced' textile, woven by hand on a loom. In European practice the loom consists of two rollers, between which plain 'warp' threads (usually wool or linen) are stretched. Depending on the arrangement of the loom the warps run vertically (high-warp) or horizontally (low-warp) but in both cases the weaver works from the back of the textile. The 'weft' threads (usually

wool, but also silk and metallic thread in more expensive products) are wound on bobbins which the weaver passes over one warp and under the next in one direction, and back the other way, until the warps are entirely covered. By varying the colours of the weft the weaver creates a pattern or figurative image, generally copied from a full-scale design known as the *cartoon. With the high-warp loom the cartoon hangs behind the weaver but with the low-warp loom it can be cut into strips and placed directly beneath the warp threads, a proximity that is useful if the design is complex. An additional advantage of the latter is that the 'draw strings' (used by the weaver to divide the even and odd warp threads) are controlled by foot pedals so that both the weaver's hands are free to manipulate the weft, resulting in a faster process. The disadvantage of the low-warp technique is that it reverses the orientation of the cartoon, a factor that the designer needs to take into account. Apart from this, there is little physical distinction between the product of high- and low-warp looms.

The origins of the modern European industry are unclear before 1300. From this date, tapestry-style hangings with decorative motifs are recorded in increasing numbers, and from around 1350 contemporary documentation demonstrates a massive proliferation of figurative tapestries. Much of this production seems to have centred in Paris and Arras, and by the end of the century variants on the term 'arras' were being used around Europe to denote high-quality tapestry hangings. The expansion of the industry seems to have been stimulated by the competitive patronage of the dukes of Burgundy, Berry, and Anjou, whose commissions spurred contemporary workshops to ever more ambitious enterprises. The appeal of tapestry to contemporary patrons is readily evident. Apart from its practical attraction as a portable form of insulation, it was appreciated both as an art form and as a medium for the display of wealth and power. Little of this early production survives but fragments of the *Apocalypse* series made for Louis I d'Anjou during the 1380s (Angers Chateau), demonstrate the scale and monumental style of some of the most ambitious of these early products.

It has often been suggested that large-scale production originated in Paris, became centred in Arras between about 1380 and 1440, and shifted to Tournai 1440–90, but documentary evidence suggests that from the early 15th century there were workshops in many of the South Netherlandish towns. Whatever the case, there is little question of the central role that tapestry played in the art and culture of the 15th century. The Netherlandish workshops flourished under the patronage of the dukes of Burgundy, and

entrepreneurial merchants exported tapestries all over Europe. Indeed, it was through tapestry, as much as any other medium, that the courts of the day shared a common vocabulary of style and subject matter. For example, between 1470 and 1500, the Greniers of Tournai, a rich merchant family, are known to have provided duplicate weavings of an enormous *History of Troy* series to Charles the Bold, Duke of Burgundy, Henry VII, King of England, Charles VIII, King of France, Matthias Corvinus, King of Hungary, and Federigo da Montefeltro, Duke of Urbino (preliminary designs Paris, Louvre; examples, London, V&A; New York, Met. Mus.; Zamora Cathedral).

During the same period, independent workshops are documented in France and Italy, often staffed by weavers with Flemish names. Generally dependent on the funding of one family or patron, such as the manufactories documented in Siena, Ferrara, and Mantua in the course of the 15th century, most were of fairly limited scale and little of their product survives. At the same time, more sizeable production took place in Germany and northern Switzerland. Much of this centred on religious institutions in the Strasbourg and Basle districts, several of which seem to have housed weaving ateliers. Their products are characteristically of modest dimensions, woven in a limited palette of materials and colours (examples, Basle, Historisches Mus.).

From the late 15th century high-quality Netherlandish production increasingly focused on Brussels. Various factors account for this development, particularly the monopoly that the Brussels guild of S. Luke obtained over storiated designs from 1476, and the patronage local ateliers received by virtue of their proximity to the Burgundian (and subsequently the Habsburg) court. Early 16th-century Brussels production was characterized by a conservative style in which the emphasis was on pattern and ornament. Between 1515 and 1540 this was increasingly infused with pictorial values introduced by cartoons and designs sent from Italy. The first and most famous were *Raphael's Acts of the Apostles*, commissioned by Pope Leo X in 1515, painted in 1515–16 (seven of the ten cartoons survive, London, V&A), and woven in Brussels between 1516 and 1521 (Vatican). These were followed by other commissions involving designs by artists like *Perino del Vaga, *Penni, and *Giulio Romano. Flemish masters like van *Orley drew from both traditions; his designs for the *Battle of Pavia* (c.1526–31; Naples, Capodimonte) and the *Hunts of Maximilian* (c.1530–3; Paris, Louvre) combining Flemish narrative and decorative values with Italianate concepts of drama, monumentality, and perspectival illusion. During the 1530s and 1540s,

the varying synthesis of these and other *Renaissance and *Mannerist components by designers such as Pieter *Coecke van Aelst, Michiel *Coxcie, and Jan *Vermeyen resulted in an extraordinarily rich period of tapestry design and innovation. Monarchs like Henry VIII, François I, and Charles V vied in the richness and scale of their collections, while tapestries were also keenly sought by Italian patrons (much of the Habsburg collection survives in Madrid, Patrimonio Nacional, and Vienna, Kunsthist. Mus.; similarly, many of the tapestries purchased by Sigismund August, the Polish King, survive at Cracow, Wawel Castle). The volume and standard of production attained during this period has never been surpassed.

Although Brussels dominated high-quality production throughout the 16th century, many other South Netherlandish towns continued to produce tapestries of lesser quality, while a sizeable industry also developed in Paris. The central role that tapestry played in the art and magnificence of the day also stimulated the creation of various independent workshops. Erik XIV, King of Sweden, established one in Stockholm (active c.1550), François I had one at Fontainebleau (active 1539–47), while the Gonzaga, the Este, and Medici were also to revive or establish workshops in Mantua (active 1539–62), Ferrara (active 1534–82), and Florence (established 1545). Most were short-lived or of limited output, but the Medici manufactory flourished into the 17th century, producing tapestries after designs by artists such as *Bronzino, Francesco *Salviati, Joannes Stradanus (1523–1605), and Alessandro Allori (1535–1607) (Florence, Soprintendenza).

The South Netherlandish dominance of large-volume production was disrupted by the religious troubles that convulsed the country in the 1560s and 1570s. Many of the leading merchants and weavers emigrated to the North Netherlands, or further afield to France, Germany, or Denmark. Of the new enterprises that came into being during these years, the Spiering manufactory in Delft (established 1592) is of particular note (examples, Amsterdam, Rijksmus.). The Brussels industry only began to revive during the late 1590s, aided by the support of the Archdukes Albrecht and Isabella. Subsequently, designs by artists such as *Rubens, *Jordaens, and Anthonis Sallaert (c.1580–1650), introduced the ebullient compositions, monumental figures, and *trompe l'œil borders characteristic of the *Baroque style to the tapestry medium (examples, Madrid, Patrimonio Nacional; Rome, Palazzo del Quirinale).

The revival of the Flemish industry was paralleled by the development of manufactories elsewhere. Of these, the Parisian industry was now to rise to the foremost rank, aided by initiatives instigated during the

early 1600s by Henri IV, with the intention of developing an industry to rival that of the Netherlands. Working from designs by artists like Henri Lerambert, Toussaint *Dubreuil, Rubens, and *Vouet, workshops in Paris, Reims and Amiens produced numerous sets for the French court and the French nobility (examples, Paris, Louvre and Mobilier National). During the early 1660s, Colbert amalgamated several of these independent workshops under the direction of Charles *Le Brun at a Parisian site known as the Gobelins, where their product was henceforth reserved exclusively for Louis XIV. Blending literal representation and allegorical elements, Le Brun's propagandistic designs such as the *L'Histoire du roi* and the *Maisons royales* were executed in a quality that rivalled the greatest products of 16th-century Brussels (Paris, Louvre and Mobilier National; Versailles). In 1664 Colbert also established a new manufactory in Beauvais to make high-quality products for the commercial market, while royal aid was also provided to an industry that had existed in the Aubusson region for more than a century. Numerous products of a variety of grades demonstrate the volume of these manufactories during the late 16th and early 17th centuries (examples, Aubusson, Mus. des Tapisseries; Paris, Louvre and Mobilier National).

If the Netherlands and France dominated high-quality, large-volume production during the 17th century, several new workshops were also created during this period. Following Henri IV's example, James I and Charles, Prince of Wales, established a workshop at Mortlake on the outskirts of London (active 1619–1703). This produced some exquisite tapestries before royal financing collapsed in the 1640s because of the Civil War (examples, Paris, Louvre and Mobilier National; London, V&A; Stockholm, Royal Palace). Although the manufactory revived following the Restoration (1660), it never attained the quality of pre-war production, and during the late 17th century many of the weavers moved to workshops in central London, which enjoyed considerable success between the 1680s and 1740s (examples, London, V&A). Other 17th-century initiatives included an atelier established in Munich under the patronage of Maximilian I, Duke of Bavaria (active 1604–18; examples Munich, Residenz), while Cardinal Francesco Barberini established a workshop in Rome (active 1627–79; examples, New York, Cathedral of S. John the Divine; Philadelphia Mus.; Vatican). The Medici manufactory also enjoyed a new lease of life under Ferdinand II, Grand Duke of Tuscany (examples, Florence, Soprintendenza).

If tapestry formed a crucial component of Baroque interiors, the medium was equally well suited to the decorative styles of the 18th century. The Brussels workshops continued

to enjoy considerable success, producing historical, classical, and genre designs by artists like Jan van Orley (1665–1735) and Victor Janssens (1658–1736) that were particularly sought by German and British patrons. Many survive in the country houses of the period (examples, Houghton Hall; London, V&A; Blenheim Palace, Oxon.). Large volumes of cheaper tapestries were also produced at workshops in Antwerp and Audenaarde for export all over Europe.

The French market continued to be dominated by native manufactories. Royal needs were met by the Gobelins, which produced decorative series designed by artists like Charles *Coypel and Claude III *Audran, and heroic series by, among others, Jean-François de *Troy and Jean *Jouvenet. The Beauvais and Aubusson workshops provided a similar fare for the commercial market. Between 1735 and 1755 François *Boucher produced numerous genre and pastoral scenes for Beauvais, whose subject and palette perfectly embodied the French *Rococo style (examples, Los Angeles, Getty Mus.; New York, Met. Mus.; Paris, Louvre). Their success led to Boucher's transfer to the Gobelins manufactory in the mid-1750s, where his most notable work was a collaboration with Maurice Jacques and Louis Tessier on a series of decorative tromp l'œil ensembles (examples, London, Osterley House; New York, Met. Mus.).

As in the previous century, large-scale production at the principal centres was complemented by that of smaller manufactories. Inspired by the example of the Gobelins, Peter the Great established a manufactory in St Petersburg in 1717 that continued to produce tapestries well into the 18th century under the patronage of Catherine the Great (examples, St Petersburg, Hermitage). In Italy, although the Medici manufactory closed in 1737, the art of tapestry was continued by the S. Michele workshop, established in Rome by Clement XI (active 1710–98; examples, Vatican). New workshops were also established in Turin (1737) under the patronage of Charles Emmanuel III of Savoy, and in Naples by Charles de Bourbon (1737). In Germany, the prince elect, Maximilian-Emmanuel, refounded the Munich manufactory (active 1718–70s), while several new workshops were also established, of which those in Berlin (active 1700–70) and Dresden (active 1713–50) were the most notable. In Spain, Philip V established a royal manufactory in Madrid (1720), whose most memorable products were the courtly and genre scenes produced after designs by José del *Castillo, Francisco *Bayeu, and Francisco *Goya (most survive in the Spanish royal collection).

The scale of the European tapestry industry began to contract rapidly in the last quarter of the 18th century, partly as a result of changing tastes in interior decoration, and partly because of the increasing preoccupation of contemporary patrons with painting collections. The French industry was additionally decimated by the French Revolution and the destruction of its traditional clientele. Although the Gobelins and Beauvais manufactories continued to receive official commissions, first from Napoleon and subsequently under the various republics, production was a fraction of past volume.

Antiquarian interest in tapestry developed during the second quarter of the 19th century, while a strong commercial market was stimulated between 1880 and 1929 by the building boom on both sides of the Atlantic and the associated demand for European antiques. The mid-19th-century interest in the arts and crafts of the past also stimulated a number of more literal initiatives. In England, a tapestry manufactory was established under royal patronage at Windsor (active 1876–90). Emulating the quality of Gobelins production, this enterprise rapidly ran into financial difficulties, but the exhibition of its products at the Chicago trade fair in 1893 stimulated William Baumgarten to found a manufactory in New York (active 1893–1910). William Morris (1834–96) also included a tapestry workshop at Merton Abbey (active 1881–1940), whose most notable products were woven from designs by Edward *Burne-Jones. Deriving inspiration from the linear and decorative forms of medieval tapestries, this work is best exemplified by the Holy Grail series, conceived in 1890 (examples, Birmingham, Mus. and AG).

Production during the 20th century is too multifarious to be discussed in detail here, with new manufactories being established throughout Europe and America. Many of these have been short-lived and of little consequence, but large-scale production enjoyed something of a renaissance in France during the second third of the century. Much of the impetus for this came from the work of Jean Lurçat, who combined Morris's interest in medieval tapestry with 20th-century notions of abstract pattern, to champion a monumental symbolist style that has continued to exert a strong influence over subsequent production. Today, tapestry continues to be woven according to traditional practices at the Dovecot works at Corstorphine near Edinburgh (established 1913), the Gobelins in Paris, at several independent workshops in Aubusson, at the Victorian works in Melbourne, Australia (established 1976), and at numerous small workshops throughout Europe and America. TPC

Bertrand, P.-F., Joubert, F., and Lefébure, A., Histoire de la tapisserie (1995).

Cavallo, A., introductory section in Medieval Tapestries in the Metropolitan Museum of Art (1993).

Heinz, D., Europäische Tapisseriekunst des 17. und 18. Jahrhunderts: die Geschichte ihrer Produktionsstätten und ihrer künstlerischen Zielsetzungen (1995).

TÀPIES, ANTONI (1923–). The best-known Spanish painter to emerge in the period since the Second World War. He was born in Barcelona and grew up in a cultured environment (his father was a lawyer and his mother came from a family of booksellers). From 1943 to 1946 he studied law at Barcelona University and he was largely self-taught as an artist. In 1948 he became a member of the avant-garde group Dau al Set, and in 1950 he had his first one-man exhibition, at the Galeries Laietanes, Barcelona. He lived in Paris 1950–1 on a French government scholarship and has often returned there, but Barcelona has remained the centre of his activities. His early works were in a *Surrealist vein, influenced by *Klee and *Miró, but in about 1953, after turning to abstraction, he began working in mixed media, in which he has made his most original contribution to art. He incorporated clay and marble dust in his paint and used discarded materials such as paper, string, and rags (Grey and Green Painting, 1957; London, Tate). By the end of the 1950s he had an international reputation; in 1958, for example, he won first prize for painting at the Carnegie International in Pittsburgh and the Unesco and David E. Bright prizes at the Venice Biennale. From about 1970 (influenced by *Pop art) he began incorporating more substantial objects into his paintings, such as parts of furniture. He explained his belief in the validity of commonplace materials in his essay Nothing is Mean (1979). Tàpies has travelled extensively and his ideas have had worldwide influence. Apart from paintings, he has also made sculpture, *etchings, and *lithographs. There are examples of his work in many major collections. IC

TASSI, AGOSTINO (1578–1644). Italian quadratura specialist and landscape painter, whose skill in organizing a vast workshop and completing projects speedily and efficiently made him immensely successful. Born in Rome, he entered the service of the Grand Duke of Tuscany perhaps c.1595, and worked in Florence, Livorno, and Genoa, before settling in Rome in 1620. Here he decorated many palaces, often collaborating with Bolognese artists; he painted the architectural setting for *Guercino's Aurora (Rome, Casino Ludovisi). His most original works are the landscape friezes (1617–25) in the Palazzo Lancellotti. In the Sala dei Palafrenieri he painted a continuous landscape frieze, of hills, mountains, ships, glimpsed through *illusionistic architecture, poetic in its effects of light, and evoking the mural decorations of ancient Rome (see ROMAN ART, ANCIENT: PAINTING). In other rooms, and in small oil paintings, he painted fishermen at work, in scenes full of lively social contrast, and *capricci that strikingly look forward to

*Claude's seaports. Claude was his assistant, and may have worked at the Palazzo Lancellotti. Tassi was a cultured but violent man, and his celebrated rape of Artemesia *Gentileschi is only one episode in a stormy career amongst prostitutes and swordsmen that makes *Caravaggio's look pale. HL

Cavazzini, P., *Palazzo Lancellotti* (1998).

TATLIN, VLADIMIR (1885–1953). Russian painter and designer, considered a pioneer of *Constructivism. Tatlin ran away to sea at an early age, and his subsequent artistic training (1902–11) was chequered. By the early 1910s he had developed a lively and idiosyncratic painting style (e.g. *Sailor*, 1911; St Petersburg, Russian State Mus.), expressive of the Constructivist tendencies to come. These are fully apparent in his *Counter-Reliefs* of the late 1910s—totally abstract, suspended constructions. After the Revolution, Tatlin worked for the Soviet state, as both designer and teacher. Responsible for monumental propaganda, he proposed the celebrated Monument to the Third International (1919–20; unexecuted), an enormous spiral tower to house the institutions of a future world state. He developed prototypes for mass-produceable goods, and worked on the quixotic *Letatlin* (1929–32), a design for an ornithopter. Under *Socialist Realism he practised mainly stage design (a lifelong vocation), and died in relative obscurity. Tatlin is generally remembered as a Constructivist, a term he did not invent but willingly adopted. He differed from other Constructivists in his insistence on utility, encapsulated by the slogan 'art into life'. AA

Zhadova, L. (ed.), *Tatlin* (1984).

TATTI, JACOPO. See SANSOVINO, JACOPO.

TEMPERA. See MEDIUM.

TEMPESTA, ANTONIO (1555?–1630). Florentine painter and printmaker, who is chiefly remembered for his hunting scenes and *battle pieces. He was trained in Florence, but spent nearly all his adult working life in and around Rome, where he was occupied with decorative work in the Vatican and other Roman palaces, and at the villas in Caprarola and Tivoli; he also contributed to the fresco cycle of scenes of martyrdom in S. Stefano Rotondo, Rome. After 1589 he became more active as an engraver (see LINE ENGRAVING), creating more than 1,500 prints, among them a great map of Rome (1593); he also produced, for a circle of private collectors, small pictures of landscapes, battles, and hunts on alabaster, stone, copper, and parchment (e.g. Rome, Borghese Gal.). His spirited battle scenes, which lack precise historical subjects, look forward to the 17th-century tradition of small *battle paintings. The vocabulary of decorative art, particularly tapestries, was greatly enriched by his widely diffused prints. HO/HL

TENIERS, FATHER, SON, AND GRANDSON. Flemish artists. Little is known about **David Teniers I** (1582–1649), although many paintings are associated with his name. By contrast, his son and pupil **David Teniers the younger** (1610–90) enjoys far greater renown. He joined the artists' guild in Antwerp in 1632–3, and explored a wide range of genres; his biblical paintings owe a debt to the work of his father-in-law Jan *Brueghel, and his peasant scenes are inspired by the work of *Brouwer. In 1645 he became dean of the Antwerp guild, and was then summoned to *Brussels, to be court painter to Archduke Leopold Wilhelm. He curated the Archduke's art collection, catalogued the pictures, made reduced copies of a number of them, and depicted the galleries in which they were housed. In the early 1650s he visited England, and in 1680 was granted a patent of nobility. His son **David Teniers III** (1638–85) also became a painter. CB

TERRACOTTA (Italian: baked earth). The presence of certain chemicals, such as iron oxide or other organic and mineral impurities, affects the colour of the baked product, and the firing of terracotta may cause the colour to vary from light buff to deep red. The hardness and strength of the baked clay varies according to the temperature at which it has been fired; and it can withstand temperatures up to 1,000°. During firing the clay shrinks by up to one-tenth of its volume, according to its quality and the amount of moisture it contains. Figures and architectural ornaments have been made of it since very early times and it is to these, rather than pottery vessels, that the word 'terracotta' usually refers.

*Clay modelling is described in another article. Certain precautions have to be taken if a clay model is to be fired. It must contain no air bubbles which would expand during the firing and cause it to crack. Very small objects can be modelled solid, but large ones must be made hollow, again to avoid the danger of cracking. One method of preparing a hollow figure is to model a solid one, cut into sections when the clay has half hardened (the 'leather-hard' stage), scrape out the clay from the inside surfaces, and reassemble the sections with diluted clay, known as 'slip'. This can be done even when the model has been built around an *armature, which would cause cracking if it were left in. The armature can be severed and pulled out in sections. Many medieval terracotta figures were made in this way and modern sculptors make use of this technique. Another method of preparing a hollow model is to build it up gradually in rings or coils, a technique related to one method of pottery making. Figures modelled by either of these methods go into the kiln for firing.

If several replicas of the same work are desired, a more complicated process of casting from a mould is employed. The mould may be of plaster or wood and is taken from a clay model. This would consist of one piece for a relief without any undercutting, or two or more pieces (a piece-mould) for a figure in the round. It is also possible to model the mould concavely, but such modelling in reverse is difficult and is seldom done except when very simple architectural ornament is being prepared. All methods require that the mould be fired in the kiln; the mould can then be used again for numerous replicas. Thin layers of soft clay are pressed into the mould, which is then removed, revealing a hollow clay form. Seams caused by the meeting of the piece moulds are retouched, and the figure is ready for firing.

A variation on this technique involves assembling the piece-moulds of plaster, and pouring the slip into the hollow. The plaster sucks away the moisture from the clay and the remaining liquid slip in the hollow is poured out. The mould is removed, and the hollow clay figure is retouched, to hide mould lines, and the figure is fired. Figures with protruding limbs can be cast in parts and reassembled with slip before firing.

Terracotta sculpture goes back to the invention of pottery techniques in neolithic ages. Many terracotta figurines survive from civilizations of the Stone Age, predynastic Egypt, and ancient Crete. The small Greek figurines known as Tanagra statuettes were mass produced from moulds, and reproduce everyday life as well as copies of famous statues (see GREEK ART, ANCIENT: SCULPTURE). Most were originally covered with a white slip and *polychromed, though these layers have usually flaked off. Terracotta was also frequently used in ancient Italy; the light wooden and brick temples of Etruria were given an elaborate decorative facing in terracotta and early *Etruscan sculpture included both small objects buried in tomb chambers and impressive life-size figures such as the *Apollo* from Veii (Rome, Villa Giulia Mus.).

During the Middle Ages a scarcity of stone in the flat plains of northern Germany and the Low Countries encouraged the use of brick for building and terracotta for architectural ornament, but terracotta sculpture declined. In the Renaissance and Baroque periods it not only flourished again as a medium for *bozzetti (sculptor's sketches) but it was also a favourite medium for portraits (such as life masks), plaques, and wall tombs, as a substitute for the more costly marble and bronze. The innovation of applying white and coloured tin glazes to terracotta sculpture, using techniques of glazing, was

first made by Luca della *Robbia in Florence in the early 1440s as a form of architectural decoration, and was eventually used for free-standing figures and reliefs. His Florentine workshop fully realized the potential for the mass production of attractive, and economic, coloured terracotta sculpture, and the popularity of della Robbia's sculpture remains undiminished. The use of terracotta was widespread in sculpture in Reggio Emilia, for instance in the harrowing *Lamentation* group by *Niccolò dell'Arca (c.1463; Bologna, S. Maria della Vita). Though originally terracotta modelling formed part of an academic training as well as part of the creative sculptural process, by the late 16th century and the 17th century these models, especially those produced by *Bernini, were sought after and preserved as collectable objects (an important collection is in London, V&A).

The coloured terracotta figurines and groups of the French 18th-century sculptors *Pigalle and *Clodion were small in scale, and delicate and light in conception. They retain the immediacy of terracotta sketches, and designs are occasionally incised and modelled in very low relief in the clay, as if drawn. *Houdon's portrait busts retain more of the spontaneity of a live sitting than do his more polished marble busts. In England *Roubiliac's and *Rysbrack's models of English tombs, and the latter's full-length terracotta figures (for instance, *John Locke*; Oxford, Christ Church), illustrate their skill at modelling in this medium. During the 19th century Jules *Dalou's terracotta groups (*Woman Reading*, 1872; London, V&A) or Albert-Ernest Carrier-Belleuse's (1824–87) historicizing sculpture continued the French tradition. In the 20th century terracottas by *Maillol, Charles Despiau (1874–1946), Frank *Dobson, *Epstein, and many others are valued products of contemporary sculpture. AB

Avery, C., and Laing, A., *Fingerprints of the Artist* (1979).
Penny, N., *The Materials of Sculpture* (1995).

TESTA, PIETRO (1612–50). Italian painter, draughtsman, etcher, and theorist. He was born in Lucca in 1612 and moved to Rome c.1630. He studied there, first with *Domenichino and then with Pietro da *Cortona. He was employed by Cassiano dal Pozzo to copy sculpture and classical remains for his 'paper museum' (Museum Chartaceum). Testa's fame rests chiefly on his graphic works, and less than 30 of his paintings have been securely identified. In particular his early style as a painter has never been satisfactorily defined. A fresco on the theme of *Liberty and Justice*, commissioned for the Cortile degli Svizzeri, Lucca, probably in 1632, is now so badly damaged as to be virtually invisible. Testa's work from the mid-1630s, which shows the clear influence of Nicolas *Poussin, includes a painting of *Venus and Adonis*,

now in Vienna, (Akademie der Bildenden Künste) and two paintings now in Potsdam (Bildergal.), first recorded in an inventory of the Giustiniani Collection, Rome, in 1638. There is documentary evidence for dating an altarpiece in S. Romano, Lucca, c.1636–7. An altarpiece of the *Vision of S. Angelo* in S. Martino ai Monti, Rome, was paid for between October 1645 and January 1646. Testa died in Rome in 1650, probably by suicide, following the rejection c.1647 of his designs for decorating the apse of S. Martino ai Monti, Rome, and the poor reception, earlier in the 1640s, of his frescoes (now destroyed) for S. Maria dell'Anima, Rome.

During his lifetime Testa compiled a substantial collection of notes in which he defined artistic practice as a habit of the intellect. This concept, reflected also in his etching *Il liceo della pittura*, implied a process in which the artist would progressively acquire intellectual freedom and critical independence, by means of the judicious imitation of nature, the mastering of mathematics and study of the elements, and the analysis and application of chiaroscuro and the organization of colour values. Although ironically it was Poussin, a close associate in dal Pozzo's circle in Rome, who more successfully realized many of these objectives in his paintings, Testa nevertheless did make some important advances, both in style and the language of expression, through his prints and drawings. Late works, such as the drawing c.1648–50 (Paris, Louvre) for the print of *Achilles Dragging the Body of Hector around the Walls of Troy* anticipate the purity and expressive language of the *Neoclassical movement. And in his etching of the *Death of Cato* (1648), where he contrasts the heroism of Cato, who is depicted in the form of the Laocoön (Vatican Mus.), with the disfiguring and irrational grief of his friends, so as 'to direct the spectator to a state of virtuous balance through catharsis and not simply to an extravagant and debasing expense of spirit' (Cropper), Testa raises fundamental questions about the way artistic images should be read or perceived. Thus whereas in Poussin's deathbed scenes, from the *Death of Germanicus* (1627–8; Minneapolis, Institute Fine Arts) to *Extreme Unction* (1644; Duke of Sutherland Coll., on loan Edinburgh, NG Scotland), the dialectical tension has been resolved and the human expressions are concentrated and idealized, with Testa the spectator is left to measure his own response. HB

Brigstocke, H., 'Pietro Testa', exhib. review in *Burlington Magazine*, 131 (Feb. 1989).
Brigstocke, H., 'Poussin et ses amis en Italie' in Boyer, (ed.), *Seicento: la peinture italienne du XVII siècle en France* (1990).
Cropper, E., *The Ideal of Painting: Pietro Testa's Düsseldorf Notebook* (1984).
Cropper, E., et al., *Pietro Testa 1612–1650: Prints and Drawings*, exhib. cat. 1988–9 (Philadelphia Mus.).

THEED, WILLIAM (1804–91). English sculptor. Born in London, he was the son of William Theed, RA (1764–1817), a history painter and sculptor whose *Hercules Taming the Thracian Horses* (c.1816; London, Royal Mews) is among the first British sculptures to show the influence of the Elgin Marbles (see PARTHENON SCULPTURES); he also designed for the Wedgwood ceramic factory. Theed the younger trained under E. H. Baily (1788–1867), and at the RA Schools (see under LONDON). In 1826 he travelled to Rome where he worked as an assistant in the studios of both *Thorvaldsen and *Gibson. He returned to London in 1848 and rapidly established a prolific and successful practice producing competent but unexciting work, in the *Neoclassical tradition, aptly suited for public, portrait, and memorial sculpture. He soon received royal commissions, modelling a bust of *Queen Victoria* (1861; Royal Coll.), providing statues, including *The Prince Consort* (Balmoral Castle), for the royal residences, and carving low reliefs of historical subjects for S. George's chapel, Windsor. His œuvre includes numerous busts, including that of his former master *John Gibson* (c.1868; London, NPG), and monumental groups like *Africa* for the Albert Memorial (1863–76; London, Hyde Park). DER

Read, B., *Victorian Sculpture* (1982).

THEODORIC, MASTER (active third quarter of the 14th century). He had achieved the position of imperial painter to the Emperor Charles IV, King of Bohemia, by 1359, and may be that same Theodoric who was elected master of the Prague Brotherhood of Painters in 1348. In 1367 he was rewarded for his only documented work, the decoration of the chapel of the Holy Cross in the imperial palace of Karlštejn. The chapel was built to house the imperial regalia, and the most important of Charles's collection of relics. The gilded glass globes of the vault, slabs of semi-precious stones set in the dado, frescoed window embrasures, and panels of half-length figures of saints present a dazzling and unique vision of the heavenly Jerusalem. Although it is impossible to identify which paintings were executed by Theodoric himself he must have had overall responsibility for the scheme, and the chapel decoration, with its softly modelled, blunt-featured figures, had a profound influence on much of the court painting in the last part of Charles's reign. AS

Kutal, A., *Gothic Art in Bohemia and Moravia* (1971).

THEOPHANES THE GREEK (Russian: Feofan Grek) (c.1370–c.1405). Byzantine painter active mainly in Russia. According to

documentary evidence Theophanes had worked in Constantinople (Istanbul) and in various cities in the Crimea, but only his work in Russia has survived. Among his earliest works are the frescoes in the cathedral of the Transfiguration at Novgorod painted in 1378, where the images of Christ Pantocrator, the church fathers and prophets, together with the Old Testament Trinity, are the best preserved. The strongly modelled figures are *Byzantine in style but show distinct Russian influences. The same influences are visible in some of the *icons in the Deësis tier of the iconostasis in the cathedral of the Annunciation (Moscow, Kremlin) believed to have been painted c.1390/5, but heavily restored after the fire of 1547. Apart from his work at this cathedral, which he decorated with the help of Russian assistants, including Andrei *Rublev and Daniil Chernyi, Theophanes is recorded as having decorated the cathedrals of the Nativity of the Mother of God and of the Archangel Michael in the Kremlin (no longer extant). He illuminated several manuscripts including a Gospel book that has very original and distinctive initials (late 14th century; Moscow, State Russian Lib.). Renowned in his own time, he had a great influence on the Russian schools of icon painting during the 15th century. PCo

Alpatov, M. V., *Feofan Grek* (rev. edn., 1982).

THEOPHILUS, pseudonym for the author of a treatise instructing artists and craftsmen entitled *De diversis artibus*. The work has been variously dated as early as the 9th and as late as the 13th century; however, C. R. Dodwell, who edited and translated the definitive version of the text in 1961, dates it between 1110 and 1140, and gives it a north-west German origin.

The treatise is one of the earliest surviving medieval works on the arts and is a fundamental source not just for artistic techniques of the period but also for the artist's attitude to his work. The treatise is presented in three parts, the first book dealing with painting, the second with glassworking, and the third, by far the largest and most detailed section, with metalworking. The latter covers many techniques including the refining of precious metals, gilding, how to make tools, the setting of gems, die stamping, chasing and embossing, the design of chalices, patens, and censers as well as altar frontals, book covers, reliquaries, items of furniture, and bell casting.

The detail with which these techniques are described would tend to suggest that the writer was a practising craftsman, and in particular a goldsmith. Internal evidence also suggests that he was a Benedictine monk and priest who was both educated and conversant with scholastic philosophy. We also know that his name in religion was

Roger, and the temptation to identify him with the goldsmith *Roger of Helmarshausen has often proved irresistible. Roger was a monk at the abbey of Helmarshausen, and a renowned goldsmith, whose most famous work was the portable altar dedicated to SS Liborius and Kilian, made c.1100 for the Bishop of Paderborn, Henry of Werl (Paderborn Cathedral treasury). This piece incorporates many of the techniques described in detail in Theophilus' treatise.

The author of *De diversis artibus* was clearly aware of current debates concerning the purpose and function of art. The moral and educative purpose of art is stressed throughout the text, and it is argued that while art may beautify and instruct it should not be worshipped or venerated in itself. This attitude derives from earlier texts, such as the 8th-century *Libri Carolini*, which denied that religious images held any mystical properties. *De diversis artibus* should be read in the context of S. Bernard of Clairvaux's criticism of Cluniacs for their tendency towards lavish decoration, and his disapproval of the use of secular imagery in churches. Many of S. Bernard's criticisms were indirectly addressed by the author of the treatise, as well as in the writings of Abbot *Suger who oversaw the redecoration of the church at S. Denis in the 1140s. TJH

Theophilus, *De diversis artibus*, ed. C. R. Dodwell (1961; reissued as Theophilus, *The Various Arts*, 1986).

THIEME–BECKER, abbreviated reference for what still remains the most authoritative dictionary of artists, the *Allgemeines Lexikon der bildenden Künstler von der Antike bis zur Gegenwart* (37 vols., 1907–50), edited by Ulrich Thieme (1865–1922) and Felix Becker (1864–1928). Whilst Becker withdrew from the enterprise in 1910, Thieme continued to work on the dictionary until his death. His successor Hans Vollmer saw the project through to completion. The dictionary contains contributions from some of the most renowned art historians of the early 20th century, including Aby *Warburg, Max *Dvořák, and Adolfo *Venturi. AT

THOMSON, TOM (1877–1917). Canadian painter. Born near Claremont, Ontario, he was employed as a designer for photoengraving companies in Seattle before moving to Toronto in 1904 to work for various graphic art firms. He soon met J. E. H. MacDonald (1873–1932) and other artists who would later become members of the *Group of Seven. From 1912 he painted extensively in Algonquin Park in northern Ontario, producing brilliantly coloured oil sketches on small wooden panels. He visited the park each spring, supplementing his income as a

guide and fire-ranger, returning to Toronto in autumn.

Thomson's training in design is especially evident in his larger oil paintings. In *The Jack Pine* (1916–17; Ottawa, NG Canada) a single tree on an outcrop in the foreground appears as a flat silhouette through which there is a view of hills on the far shore of a lake.

During a career of only four years, Thomson painted hundreds of sketches and some 30 canvases showing his mastery of decorative effects. In July 1917 he mysteriously drowned in Canoe Lake, Algonquin Park.

KM

Murray, J., *Tom Thomson: The Last Spring* (1994).

THORÉ, THÉOPHILE (1807–69). French art critic, art historian, and polemicist. From the beginning of his career he favoured the avant-garde artists of his time, including *Delacroix and the *Barbizon painters, above those he saw as reactionary, such as *Ingres, or, worse, those whose success he attributed to their pandering to official taste—the painters of the *juste milieu*, such as *Delaroche. Behind his aesthetic preferences lay a lifelong attachment to radical politics and the progress of mankind. He published regular reviews of the Salon (see under PARIS) during the July Monarchy (1830–48) and was for a long period art critic of the liberal newspaper *Le Constitutionnel*. His involvement with the most radical factions of the 1848 Revolution made him *persona non grata* with the new government of Louis-Napoleon (later Napoleon III) and he spent the first ten years of the Second Empire in exile, only returning to France in 1859. It was during this period that he began to research and publish on the northern European schools, most particularly studying Dutch art of the 17th century. His pioneering work, based on extensive archival research and refined *connoisseurship, was published under the pseudonym of 'W. Bürger'. It was Thoré-Bürger who rediscovered *Vermeer and pioneered the reassessment of many other artists. For him Dutch art of the 17th century, with its emphasis on the realistic portrayal of the everyday, was a democratic art which could provide a model for contemporary painters in a way that the idealizing, hierarchical, and exclusive French academic tradition could not. In his Salon criticism of the 1860s Thoré returned with relish to his attack on the mean and mediocre, reserving his praise for such painters as *Courbet, *Manet, *Monet, and *Renoir, who insofar as they painted modern life themes he regarded as *realists. Both as a critic and as an art historian Thoré was one of the most substantial and discerning figures of the 19th century whose pragmatism and range make him as worthy of modern attention as the more ponderous

writers of the German tradition.　　　MJ

Blum, A., *Thoré-Bürger et Vermeer* (1946) (reprints the essay on Vermeer).

Jowell, F. S., *Thoré-Bürger and the Art of the Past* (1977).

Thoré, T., *Salons de Théophile Thoré, 1844–48* (1868).

Thoré, T., *Salons de W. Bürger, 1861–68* (1870).

THORNHILL, SIR JAMES (1675–1754).

English decorative painter. Thornhill was the only English painter successfully to challenge the dominance of immigrant French and Italian artists in the field of large-scale decorative schemes. He originally trained as a portrait painter under *Highmore (a swagger *Self-Portrait* (c.1707) is in the NPG, London), but probably learned decorative painting from *Laguerre and *Verrio, with whom he may have worked at Chatsworth. In 1707 he won the prestigious commission to decorate the Painted Hall at Greenwich Hospital (1707–27), an allegory of the *Protestant Succession* executed in a robust, full-blooded *Baroque style. He was then engaged to paint the grisaille panels of the *Life of S. Paul* (1714–17) for the cupola and drum of S. Paul's Cathedral, seeing off competition from the Italians, S. *Ricci and *Pellegrini; and in 1720 became Serjeant Painter to George I and was knighted. However, by the mid-1720s vast decorative schemes were no longer in vogue and Thornhill spent his last twelve years as MP for Melcome Regis (Dorset), near Thornhill, the family seat that he had managed to repurchase. *Hogarth, his sometime pupil, eloped with his daughter in 1729.　　　HO

Croft-Murray, E., *Decorative Painting in England 1537–1837*, vol. 1 (1962).

THORN PRIKKER, JOHAN (1868–1932).

Dutch artist and designer. Born at The Hague, Prikker studied there at the Koninklijke Academie van Beeldende Kunsten 1881–8. His early paintings were *Hague School landscapes but he moved towards *Symbolism in 1892 when he produced a number of religious drawings. In 1893 he exhibited with the avant-garde group Les *Vingt In Brussels where he met Henri van de Velde (1863–1957), who shared the interest in *Art Nouveau which is manifest in Prikker's masterpiece *The Bride* (1892–3; Otterlo, Kröller-Müller). This extraordinary painting, a disturbing composition of swirling organic forms, is virtually abstract, the bride herself being reduced to the outline of her veil. However Prikker's interest in Symbolism was short-lived and from 1896 he concentrated on applied art, particularly stained glass for which he received many commissions including the windows of Hagen railway station (1910–19).　　　DER

Johan Thorn-Prikker, exhib. cat. 1968 (Amsterdam, Stedelijk Mus.).

THORVALDSEN, BERTEL (1770–1844).

Danish sculptor who became one of the leaders of the international *Neoclassical movement. He was a pupil of the painter Nicolai *Abildgaard at the Royal Academy in Copenhagen and in 1796 won a bursary that took him to Rome. He reached the city on 3 March 1797, a day he henceforth considered his birthday. He remained in Rome until 1838, apart from a short visit to Denmark in 1819–20. Thorvaldsen was much influenced in his attitude to the *Antique by the German painter *Carstens and the Danish archaeologist Georg Zoega, who looked beyond Roman art to that of Greece as a 'purer' model. Like many of his contemporaries who followed this route, Thorvaldsen never went to Greece, and in the early part of his career his experience of Greek sculpture (see GREEK ART, ANCIENT) was derived from late *Hellenistic and Roman copies (see ROMAN ART, ANCIENT). Nevertheless, like *Flaxman and *David he was able to extrapolate a notional Greek style of some severity. This is exemplified by his statue of *Jason* (1802; Copenhagen, Thorvaldsens Mus.), the austere pose and sharp detailing of which contrast with the more svelte and sensuous Neoclassicism of *Canova.

Thorvaldsen's ambition was to make monumental sculpture, particularly with mythological or allegorical themes, though he also made some distinguished portrait busts. After the success of the plaster version of *Jason* (the marble was not finished until 1828), he was quickly perceived as being second only in importance to Canova. From the latter's death in 1822 Thorvaldsen was Rome's most admired artist and his busy studio a place of pilgrimage for visitors to the city. Among his many monumental works are *Mercury about to Kill Argus* (1818; Copenhagen, Thorvaldsen Mus.); *The Three Graces* (1817–19; Copenhagen, Thorvaldsen Mus.); the monument to Pope Pius VII (1824–31; Rome, S. Peter's), that to Prince Joseph Poniatowski (1826–7) for Warsaw, based on the Antique *equestrian statue of *Marcus Aurelius* (Rome, Capitoline Mus.), and the Byron memorial (1835; Cambridge, Trinity College).

Although Thorvaldsen was responsible for the sensitive restoration of the late Archaic sculptures from the temple of Aphaia at Aegina (Munich, Glyptothek), bought by King Ludwig of Bavaria on the advice of *Goethe, and created the statue of *Hope* (1817; Copenhagen, Thorvaldsens Mus.) in homage to them, his ideal remained the Classical Greek style from *Phidias to *Praxiteles. He was able to adapt this effectively even to Christian subjects, as in his statue of *Christ* (begun 1821) for the church of Our Lady in Copenhagen, which became one of the most popular devotional works of the 19th century. In 1838 Thorvaldsen returned to Copenhagen, though his studio in Rome remained active.

He presented the original plasters of his works and his art collection to the city of Copenhagen, where they may still be seen in the Neoclassical building designed to house them and finished shortly after Thorvaldsen's death.　　　HO/MJ

Bertel Thorvaldsen, 1770–1844: scultore danese a Roma, exhib. cat 1988 (Rome, Gal. Nazionale d'Arte Moderna).

Jørnaes, B., and Urne, A. S., *The Thorvaldsen Museum* (1985).

Jørnaes, B., *Billedhuggeren Bertel Thorvaldsens liv og vaerk* (1993).

THULDEN, THEODOOR VAN (1606–69).

Flemish history and portrait painter, draughtsman, and engraver from 's-Hertogenbosch who worked in Antwerp, Paris, The Hague, and his home town. After an apprenticeship in Antwerp and a visit to Paris, he was back in Antwerp by 1634, assisting with the execution of *Rubens's designs for the entry of the Cardinal-Infante Ferdinand into Antwerp which he later engraved for a book (1642). He eventually returned to 's-Hertogenbosch but continued to execute commissions for patrons both north and south. He painted large decorative works for the town hall in 's-Hertogenbosch and the Huis ten Bosch in The Hague. His style, though strongly influenced by Rubens, displays a more graceful elegance (*Perseus Delivering Andromeda*, 1646; Nancy, Mus. des Beaux-Arts).　　　KLB

Roy, Alain, *Theodoor van Thulden*, exhib. cat. 1992 ('s-Hertogenbosch, Noordbrabants Mus.; Strasbourg, Mus. des Beaux-Arts).

TIBALDI, PELLEGRINO (1527–96). Italian

painter, sculptor, and architect. After completing his early training at Emilia he went to Rome (c.1547–53), where he came into contact with *Daniele da Volterra and conceived an admiration for *Michelangelo's work on the ceiling of the Sistine chapel which lasted through his life. It is seen for instance at Bologna in his decoration of two rooms with scenes from the *Odyssey* at the Palazzo Poggi, Bologna University (c.1555). His later life was devoted chiefly to architecture, much of it under the patronage of Carlo Borromeo. Tibaldi's architectural style owed much to Vignola and Sanmicheli, and was competent without originality. In 1586 he went to Madrid to replace Federico *Zuccaro. He took charge of building operations at the *Escorial and did sculpture and paintings for its decoration including the *Martyrdom of S. Lawrence* for the central panel of the high altar, and two of the surrounding panels of the *Nativity* and the *Adoration of the Magi* (all in situ). The 46 large frescoes for the cloisters of the Patio de los Evangelistas with scenes from the life of the Virgin and the Passion and the Last Judgement show the *Mannerist inclination to break down forms into quasi-

geometrical decorative shapes. He returned to Milan in the year of his death. HO

TIDEMAND, ADOLPH (1814–76). Norwegian painter. Born in Mandal, Tidemand trained privately in Copenhagen (1832–5) and at the Akademi (1832–37) under *Eckersberg. In 1837 he moved to Düsseldorf where, influenced by his teacher Theodor Hildebrandt (1804–74), he embarked upon subjects from Nordic history, the first being of the 16th-century Swedish King, Gustav Vasa, shown in 1841. In 1843, after a year in Italy, he returned to Norway where a tour of the remote regions led him to take Norwegian peasantry and folk tradition as his principal subject, as in *The Storyteller* (1844; Oslo, Slott). Despite settling in Düsseldorf in 1845 Tidemand continued to specialize in Norwegian subjects, frequently returning to sketch subjects and seek inspiration for his peasant genre scenes, usually narrative and coloured by sentimentality. His sanitized version of rusticity proved highly popular and in 1848 he was commissioned by Oskar I, King of Sweden and Norway, to paint a series of *Norwegian Peasant Life* for the royal palace of Oscarshall, near Christiania. In the same year he painted *The Haugians*, a Norwegian religious sect, (Düsseldorf, Kunstsammlung Nordrhein-Westfalen), unusually dramatic and generally considered his finest work. DER

TIEPOLO, FATHER AND SON. Italian painters. **Giambattista** (Giovanni Battista) (1696–1770) was the most brilliant and sought after Italian painter of the 18th century, and represents the ultimate achievement of the Venetian tradition of decorative painting in the Grand Manner. He also painted numerous large-scale oil paintings, a wide repertory of oil sketches, and was an accomplished draughtsman and a successful and original etcher (*Capricci* and *Scherzi di fantasia*). He had been trained in Venice in the workshop of Gregorio Lazzarini and brought up to admire the achievements of the great Venetian Renaissance masters, above all *Tintoretto and *Veronese. Thus he was not inhibited by the more restrained classical tradition of ancient Rome and the legacy of the Renaissance, Baroque, and Neoclassical artists active there, from *Raphael and *Michelangelo to Pietro da *Cortona and *Mengs. Yet through his interest in prints he was well aware of the inventive imagery of a wide range of 17th-century Baroque artists active outside Venice, including the Genoese *Castiglione, Salvator *Rosa, Stefano della *Bella, and *Rembrandt, all of whom exercised a strong influence on the range of his visual vocabulary. Through rhetorical gesture and facial expression, a theatrical sense of composition and design, and an imaginative appreciation of the physical context in which his work would be seen, Tiepolo became extremely successful at projecting narrative and telling a story with dramatic effect, whether of religious or secular subject matter. Above all he could enrich and embellish historical and mythological themes by transforming them into poetic fiction, in a manner comparable to an opera by Gluck or Handel. Invariably, in his response both to the natural world and the artistic tradition he inherited, he displayed a sense of fantasy and humour and an exhilarating feeling of joy that had been conspicuous by its absence from so much art of the preceding Baroque era.

His early oil paintings influenced by *Piazzetta, Federico Bencovich (1677?–1753), and Sebastiano *Ricci are notable for their expressive vigour, contorted figures, angular movement, dark and often murky tonality, dramatic lighting, and crowded compositions—for instance the *Sacrifice of Isaac* (Venice, Ospedaletto), the *Martyrdom of S. Bartholomew* (1722–3; Venice, S. Stae), and the *Madonna of Mount Carmel* (1721–2; Milan, Brera). A decisive turning point, and the beginning of Tiepolo's career as a decorator, came with the commission from the Patriarch Dionisio-Dolfin (1663–1734) to decorate the stairwell and *piano nobile* of his palace at Udine. Working for the first time with Girolamo Mengozzi-Colonna, the *quadratura specialist, he painted an illusionistic ceiling of *The Fall of the Rebel Angels* and filled the walls with scenes from the lives of the ancient patriarchs enclosed by *trompe l'œil frames and surrounded by feigned statues in grisaille. Then in the Sala del Tribunale he painted *The Judgement of Solomon*. The frescoes, dating from c.1726, are notable for their brilliant colouring and the juxtaposition of elegant figures in 16th-century dress within a sunny pastoral landscape. Here Tiepolo consciously revives the artistic language of Veronese, not out of nostalgia but as a source of strength and renewal. A series of ten large canvases with scenes from Roman history painted for the Ca' Dolfin on the Rio di Ca' Foscari, Venice, probably also dates from around this time, c.1726–8 (now New York, Met. Mus; St Petersburg, Hermitage; Vienna, Kunsthist. Mus.).

Tiepolo's first important church decoration was at S. Maria del Rosario (Gesuati, Venice), where in 1739 he painted scenes from the life of S. Dominic who had received the rosary as a special gift from the Virgin. At about the same time he painted for S. Alvise, Venice, a large triptych with scenes from the Passion of Christ, *The Way to Calvary*, *Christ Crowned with Thorns*, and *The Flagellation*. This intense and dramatic altarpiece recalls the work of Tintoretto at the Scuola Grande di S. Rocco, Venice.

During the 1740s Tiepolo continued to paint religious works for churches, including the *Martyrdom of S. John, Bishop of Bergamo* (1745; Bergamo Cathedral), and the *Virgin Appearing to Simon Stock* for the ceiling of the Scuola Grande dei Carmini, Venice, 1749. However, his two most spectacular achievements at this time were the brilliantly coloured frescoes at the Villa Cordellina at Montecchio Maggiore (*The Family of Darius before Alexander* and *The Magnaminity of Scipio*, 1743) and the frescoes of the *Meeting of Anthony and Cleopatra* and the *Banquet of Cleopatra* at the Palazzo Labia, Venice, dating from c.1744. Here, working again with Mengozzi-Colonna, Tiepolo fills the entire space of the principal *salone*, so that the sense of illusion (see ILLUSIONISM) is complete and Anthony and Cleopatra appear to be stepping into the room to encounter the viewer.

The success of these projects prompted the invitation Tiepolo received to go to Würzburg, in Germany, in December 1750, to fresco the ceiling and walls of the Kaisersaal of the Residenz for the Prince-Bishop Karl Philipp von Greiffenklau. The ceiling shows *Apollo Conducting Beatrice of Burgundy to the Genius of the German Nation*; the walls illustrate *The Investiture of Bishop Harold* and *The Wedding of Frederick Barbarossa and Beatrice of Burgundy*. Tiepolo also painted two altarpieces for the chapel. He was then retained to decorate the stairwell of the palace, work he completed in 1753: it depicts the *Apotheosis of von Greiffenklau*, with personifications of the four Continents along the borders below. In their virtuosity and daring, and the successful exploitation of the physical setting and multiple viewpoints provided by Balthasar Neumann's architecture, the Würzburg frescoes are arguably Tiepolo's greatest achievement.

On his return to Venice he continued to receive major commissions and in 1756 became president of the Venetian Academy. At the Villa Valmarana, near Vicenza, Tiepolo in 1757 frescoed four rooms with scenes from Homer, Virgil, Ariosto, and Tasso. In 1760 he was commissioned to paint the ballroom in the Villa Pisani at Stra on the Brenta. Then in 1762 he left Italy once again, never to return, to paint three ceilings at the Palacio Real, Madrid, for King Charles III of Spain. This was followed in 1767 by the royal commission to paint seven altarpieces for the Franciscan church of S: Pascual at Aranjuez. These meditative introspective works were completed in 1769 and were then brought to Aranjuez after the artist's death in March 1770 (*Immaculate Conception* and *S. Francis Receiving the Stigmata*, both Madrid, Prado; others at Cincinnati and Detroit; five of the *modelli* London, Courtauld Inst. Gal.). Five years later they would be replaced with pictures by Mengs, *Bayeu, and Salvador *Maella.

Giandomenico (1727–1804), the son of Giambattista, was in his father's studio from

the 1740s. In 1747 he painted a series of four-teen paintings, *The Via Crucis*, for S. Polo, Venice, in which he displays an independent style, simpler and more direct than his father and less exuberant. He was his father's assistant at Würzburg (1750–3), assisted him at the Villa Valmarana, Vicenza (1757), and accompanied him to Madrid (1762–70) but then returned to Venice and worked independently again—for instance *Abraham and the Three Angels* (Venice, Accademia). He was president of the Venetian Academy 1780–3. In the 1790s he produced a sequence of frescoes of Punchinellos, remarkable for their *joie de vivre* and sense of theatre (Venice, Ca' Rezzonico). He was also a successful etcher. In 1749 he published at Würzburg a series of 24 prints of *The Flight into Egypt*. In 1770 he published the *Raccolta di teste*, 60 heads, based on patriarchal images by his father. HB

Alpers, S., and Baxandall, M., *Tiepolo and the Pictorial Intelligence* (1994).

Barcham, W., *The Religious Paintings of Giambattista Tiepolo: Piety and Tradition in Eighteenth-Century Venice* (1989).

Christiansen, K., et al. (eds.), *Giambattista Tiepolo*, exhib. cat. 1996 (Venice, Ca' Rezzonico) and 1997 (New York, Met. Mus.).

Levey, M., *Giambattista Tiepolo: His Life and Art* (1986).

TINGUELY, JEAN (1925–91). Swiss sculptor and experimental artist. He was born in Fribourg and studied at the Basle School of Fine Arts, 1941–5. In 1952 he settled in Paris, then after a year in Düsseldorf moved to New York in 1960. Tinguely's work was concerned mainly with movement and the machine, satirizing technological civilization. His boisterous humour was most fully demonstrated in his Auto-destructive works, which turned *kinetic art into *Performance art. The most famous was *Homage to New York*, presented at the Museum of Modern Art, New York, on 17 March 1960. The object on which the work was based was constructed of an old piano and other junk; it failed to destroy itself as programmed and caused a fire. Tinguely was an innovator not only in his combination of Kineticism with *Junk sculpture, but also in the impetus he gave to the idea of spectator participation, as in his *Cyclograveur*, in which the spectator mounts a saddle and pedals a bicycle, causing a steel nail to strike against a vertically mounted flat surface, and the *Rotozazas*, in which the spectator plays ball with a machine. Such works have been interpreted as ironic ridicule of the practical functions of machines. Tinguely's most famous work is somewhat more traditional—the exuberant Beaubourg Fountain (1980) outside the Pompidou Centre, Paris, done in collaboration with the French artist Niki de Saint Phalle (1930–), with whom he lived for many years; it features fantastic mechanical birds and beasts that spout water in all directions. IC

TINO DI CAMAINO (c.1280–1337). Sienese sculptor and son of Camaino di Crescentino. He produced funerary monuments and tombs for powerful Guelph and Ghibelline patrons. Until 1315 he was chief of the cathedral works in Pisa, and although he would have associated with Giovanni *Pisano's circle, his figure style here recalls the *Romanesque in its blocklike massiveness. This is seen in the remains of the tomb of Emperor Henry VII (1315; Pisa, Camposanto). In 1315 Tino returned to Siena and succeeded his father as chief of works at the cathedral in 1319. Here the tomb of Cardinal Petroni displays a modification of his rigorous style, retaining volume and breadth but incorporating a rhythmic, decorative flow of form deriving from the work of painters such as *Simone Martini.

Monuments in Florence include that to Bishop Orso (cathedral), which bears a seated effigy, a type probably introduced by Tino. From 1324 he was in Naples carving tabernacle tombs for members of the Angevin court, including Charles of Calabria and Mary of Valois (S. Chiara). Alongside *Giotto, also working in Naples, he carried Tuscan developments to southern Italy. MS

Kreytenberg, G., *Tino di Camaino* (1986).

TINT. See COLOUR.

TINT TOOL, a specialized type of burin used by *wood engravers to engrave lines of even thickness, which, set very close and parallel to each other, create the grey tones or 'tints' characteristic of highly worked 19th-century wood engraving.

RGo

TINTORETTO (Jacopo Robusti) (1519–94). Venetian painter. His nickname derives from his father's profession of cloth-dyer (*tintore*). He quickly developed a highly personal and idiosyncratic style and ran a large workshop offering quick turnover at competitive prices. Three of his children became artists and worked in his studio. Domenico (1560–1635) assisted his father on many major projects including the decoration of the Doge's palace but lacked individual artistic personality. Marietta (c.1554–c.1590) appears to have specialized in portraiture (*Self-Portrait*, Florence, Uffizi). Little beyond the bare outlines is known of Tintoretto's life and early training. He is said to have worked briefly in the studio of *Titian, and the style of his early work suggests the influence of *Schiavone, *Pordenone, Paris *Bordone, and Bonifazio de' Pitati (1487–1553). As a man he was quite unlike Titian, and attracted a different kind of patron, middle-class rather than aristocratic. He spent almost all his life in Venice, working largely for religious confraternities (*scuole*). He appears to have been unpopular due to unscrupulous tactics in procuring commissions.

According to his biographer *Ridolfi, Tintoretto was practising as an independent artist by 1539 when he collaborated with *Schiavone and others in the production of *cassone* panels. During the 1540s, he appears to have received commissions for large narrative religious paintings, often intended for secondary positions on the side walls of chapels in Venetian churches. This may have stimulated him to experiment with *perspective to take account of the viewer's position in the central nave—for instance in the *Christ Washing the Feet of the Disciples* (Madrid, Prado), c.1547–8, painted for the right wall of S. Marcuola, Venice. Public recognition appears to have followed his *S. Mark Rescuing the Slave* (1547–8; Venice, Accademia), commissioned for the Scuola Grande di S. Marco. Its disturbing foreshortening and the contorted limbs of the protagonists heralded the advent of a new, more violent *Mannerist style than that displayed by such artists as Schiavone. This was quickly followed by *S. Roch Healing the Victims of the Plague* for S. Rocco, Venice, in 1549, notable above all for its dramatic chiaroscuro. Paintings such as *Cain Killing Abel*, *Creation of the Animals*, *Original Sin* (1550–3; Venice, Accademia), commissioned by the Scuola della Trinità, seem to confirm Ridolfi's assertion that Tintoretto aimed to combine Titian's colour with Michelangelo's *disegno. Roman influence (in particular *Daniele da Volterra) is also apparent in the *Deposition* (Edinburgh, NG Scotland) painted for the Basso chapel, S. Francesco della Vigna.

In the early 1560s Tintoretto was to be found working on the vast choir paintings, including the *Last Judgement*, at the church of the Madonna dell'Orto. At about the same time, in 1562, he was also commissioned to produce three extremely large-scale paintings for the Scuola Grande di S. Marco: the *Removal of the Body of S. Mark from the Funeral Pyre* (Venice, Accademia), the *Finding of the Body of S. Mark* (Milan, Brera); and *S. Mark Saving the Saracen*. It is here that one can best visualize Tintoretto employing the working technique described by his contemporary Marco *Boschini, making small wax models which he arranged on a stage both to set the design and experiment with spotlights for effects of light and shade. The scenes depicted in these canvases appear to be set within deeply foreshortened boxlike spaces with an irrational pattern of light and shadow.

A major turning point in Tintoretto's career is marked by his election in 1565 to the confraternity of the Scuola Grande di S. Rocco and his commission to paint a series of

paintings *in situ* for the Sala dell'Albergo: *The Crucifixion* (1565), followed by the *Road to Calvary, Christ before Pilate* and *Ecce Homo* in *c.*1566–7. According to Vasari, Tintoretto obtained this commission by means of dirty tricks, having pre-empted the competition by donating and installing the ceiling canvas of *S. Roch in Glory* in 1564. The scenes from the Passion, by virtue of their size, uncompromising realism, and rude energy, make an unforgettable impact and would continue to fascinate north Italian artists (the Lombard G. C. *Procaccini for instance) well into the next century. And from 1575 to 1588 Tintoretto would continue to work for the confraternity on a regular basis. He first executed the ceiling of the Sala Superiore—*Brazen Serpent, Moses Striking the Rock, Gathering of the Manna* (1575–7)—and went on to undertake a large series of paintings of the life of Christ for the walls of the same room (1578–81). It would be easy but cynical to suggest that Tintoretto's *fa presto* style was inspired by commercial considerations, after he agreed to produce three pictures each year for an annual stipend of 100 ducats. The predominant stylistic development evident in this series is a further loosening and simplification of human forms, an almost expressionist and summary treatment of landscape, and a roughness of technique and lack of finish that distressed Vasari. Yet this cycle of pictures claims our attention as one of the great monuments of Venetian Renaissance painting, defying all central Italian conventions about *disegno* and decorum, rational perspective or lighting, but achieving a visionary intensity that later, in the mid-19th century, fired the imagination of John *Ruskin, who recognized its spiritual and moral power. Tintoretto concluded his work at the Scuola di San Rocco with a series of paintings of the life of the Virgin for the ground-floor room (1583–7) and an altarpiece of the *Vision of S. Roch* (1588).

Although Tintoretto painted a few pictures for important foreign patrons—*Origin of the Milky Way* (*c.*1577; London, NG) for the Emperor Rudolf II, and the *Nativity* (1583; Madrid, Escorial) for King Philip II of Spain, he did not enjoy the international success of Titian or even receive the aristocratic patronage that sustained *Veronese. This also affected his practice as a portrait painter, which was probably inhibited by the provincial context of most of his commissions, generally pictures of local dignitaries destined to hang in public buildings. At best, as in *Vincenzo Morosoni* (*c.*1580; London, NG), they convey human dignity and frailty as well as the external trappings of power and wealth.

Tintoretto's career in Venice ended on a high note with the commission for the *Paradise* ceiling in the Sala del Maggior Consiglio of the Doge's palace (1588–90); but only after

Veronese, who had won the initial competition in 1579–82, had died without fulfilling the contract. HB

Nicholls, T., 'Tintoretto's Poverty', in F. Ames-Lewis and A. Bendarek (eds.), *New Interpretations of Venetian Renaissance Painting* (1994).
Rosand, D., *Painting in Cinquecento Venice: Titian, Veronese, Tintoretto* (1982).
Valcanover, F., *Jacopo Tintoretto and the Scuola Grande di San Rocco* (1983).

TISCHBEIN, JOHANN HEINRICH WILHELM (1751–1829). German painter. Tischbein studied under his uncle, the portrait painter Johann Heinrich the elder (1722–89), in Hamburg. In 1771 he travelled to Holland to work as a portrait painter but soon returned to Germany and established a successful practice in Berlin. However, after 1777, dissatisfied with portraiture, he studied early German painters in Munich before travelling to Italy in 1779. In 1783 he was painting *history pictures in Rome but met *Goethe in 1786 and accompanied him to Naples, painting, during the journey, his famous portrait of *Goethe in the Roman Campagna* (1786–7; Frankfurt, Städelsches Kunstinst.). In Naples he moved in the circle of Sir William Hamilton (1730–1803) (see GRAND TOUR) and the court painter Philipp *Hackert and under royal patronage became director of the Naples Academy in 1789. From 1791 he supervised the engraving of the important collection of Greek vases amassed by Hamilton which, when published in Naples (1791–5), were an important influence on *Flaxman. Following the flight of the royal family and the French invasion of 1799 he returned to Germany. His entertaining memoirs, *Aus meinen Leben*, were published posthumously in 1861. His cousin Johann Friedrich (1750–1812) was also a successful portrait painter. DER

TISI, BENVENUTO. See GAROFALO.

TISSOT, JAMES (1836–1902). French painter. Tissot, who was born in Nantes, studied in Paris from 1856. His first exhibited works are literary and historical, often, like *Faust and Marguerite* (1860; Paris, Luxembourg), on Faustian themes. Like his friends *Degas and *Whistler he was a pioneer collector of oriental art and although an early japonaiserie, *Japanese Girl Bathing* (1864; Dijon, Mus. des Beaux-Arts), is unconvincing, Japanese compositional devices pervade his later work. In 1864 he abandoned medievalism for modern subjects, painted meticulously and smoothly with great detail, particularly in costume. After the fall of the Commune in 1871 he fled to England where he resumed a successful career painting portraits, like *Colonel Burnaby* (1870; London, NPG), the epitome of languid urbanity and fashionable life. With paintings like *London

Visitors* (1873; Toledo, Oh., Mus.), a Henry Jamesian scene of American tourists, the lack of narrative, which attracted contemporary criticism, links him to the *Aesthetic movement. From 1876 he lived with his muse and mistress Kathleen Newton but after her death in 1882 returned to Paris. Catholic conversion in 1885 led to ambitious religious subjects including his *Life of Christ*, which was phenomenally popular when published in 1896/7. DER

Wentworth, M., *James Tissot* (1984).

TITIAN (Tiziano Vecellio) (*c.*1485–1576). Italian painter, who dominated Venetian art during its greatest period. Like *Giorgione and *Sebastiano del Piombo, he received the more important part of his early training in the studio of Giovanni *Bellini; then, like Sebastiano, he came under the spell of Giorgione. Titian's earliest known work, the votive picture of *Jacopo Pesaro Presented to S. Peter* (Antwerp, Koninklijk Mus. voor Schone Kunsten), hints at both Bellini and Giorgione. His relationship with the latter must have been a close one: he assisted him with the external fresco decoration of the Fondaco dei Tedeschi, Venice, paid for in 1508, and after Giorgione's early death in 1510 it fell to Titian to complete a number of his unfinished paintings.

Titian's first great commission was for three frescoes in Padua (1511; Scuola del Santo), noble and dignified paintings with a firmness and monumentality more generally associated with central Italian artists. After he returned to Venice, Giorgione having died and Sebastiano gone to Rome in 1511, the aged Bellini alone stood in the way of Titian's supremacy. And on Bellini's death in 1516 Titian became official painter to the Republic. Meanwhile he was gradually breaking free from the stylistic influence of Giorgione and developing a manner of his own with an exploratory technique often characterized by substantial pentimenti or changes of design on the canvas. The latest and finest expression of Titian's work in the Giorgione manner was the *Sacred and Profane Love* (*c.*1514; Rome, Borghese Gal.) and *The Three Ages of Man* (*c.*1515; Edinburgh, NG Scotland) pastoral *poesie* in which the romantic landscape lyrically reflects the elegiac mood of the figures.

By this time Titian had already given evidence of his personal style elsewhere: in the altarpiece of *S. Mark Enthroned with Four Saints* (*c.*1511; Venice, S. Maria della Salute), where he had aimed at a grandeur based on a reality quite opposed to Giorgione's poetic visions. A similar sensual vigour is evident in a group of female half-figure pictures painted in the years 1512–15, outstanding amongst which are the *Woman at her Toilet* (Paris, Louvre) and the *Flora* (Florence, Uffizi). A series of great altarpieces opens with the *Assumption* (1516–18;

Venice, Frari) painted on panel, in which the soaring movement of the Virgin, rising from the tempestuous group of apostles towards the hovering figure of God the Father, contradicts the stable basis of quattrocento and High *Renaissance composition and conveys the illusion of a visionary and miraculous event. The strong, simple colours used here, and the artist's evident pleasure in the silhouetting of dark forms against a light background, reappear throughout the work of this period. There followed the *Resurrection* altarpiece (1522; Brescia, S. Nazaro e Celso) with its *Michelangelesque study of a male nude in the figure of S. Sebastian, and the *Pesaro Family* altarpiece (1519–26; Venice, Frari), a bold diagonal composition of great magnificence in which architectural motifs are used to enhance the drama of the scene, but with no clearly defined articulated space, and no stability in the picture plane. Above all, there was the altarpiece of *S. Peter Martyr* (now destroyed but known to us from several copies and engravings), where trees and figures together form a violent centrifugal composition.

These large works, following closely one upon the other, in no way drained Titian's creative imagination. Between 1518 and 1525 he painted three mythological pictures for Alfonso d'Este to hang beside Bellini's the *Feast of the Gods* in Alfonso's *camerino* at Ferrara: the *Bacchanal of the Andrians* (c.1525; Madrid, Prado) was preceded by two commissions that had originally been intended for Fra *Bartolommeo and *Raphael. Although perhaps influenced by the earlier designs by Fra Bartolommeo for the *Worship of Venus* (1519; Madrid, Prado) and by Raphael for the *Bacchus and Ariadne* (1523; London, NG), Titian made these bacchanals his own with his bold use of colour, poetic visionary landscapes, and an imaginative evocation of the spirit of the Antique world which a century later would inspire the young *Poussin.

About 1530, the year in which his wife died, a change in Titian's manner becomes apparent. The vivacity of former years gave way to a more restrained and meditative art. He now began to use related rather than contrasting colours in juxtaposition, yellows and pale shades rather than the primary blues and reds which shouldered each other through his previous work. In composition too he became less adventurous and used schemes which, compared with his many immediately preceding works, appear almost archaic and classical. Thus his large *Presentation of the Virgin* (1534–8; Venice, Accademia) employs a relief-like frieze composition, without movement or dramatic accent; the figures no longer dominate the space through their size or activity but share it in harmony with architecture, landscape, and still life. Thus also his idyllic scene of Jupiter

and Antiope with nymphs, satyrs, and hunters, known as the *Pardo Venus* (Paris, Louvre), is divided into two contrasting balancing halves with little suggestion of movement in depth. During the 1530s Titian's fame spread throughout Europe. In 1530 he first met the Emperor Charles V and in 1533 he painted a portrait of him (Madrid, Prado) based on a portrait by the German Jakob *Seisenegger. By making seemingly slight alterations Titian endowed the portrait with imperial dignity, and the result was so appreciated that Charles appointed him court painter and knighted him. At the same time Titian's works were increasingly sought after by Italian princes; for instance he painted portraits of Francesco Maria I, Duke of Urbino and his Duchess (1536–8; Florence, Uffizi); and for the Duke's son Guidobaldo II della Rovere, the *Venus of Urbino* (c.1538; Florence, Uffizi), choosing for the nude figure a pose almost identical with that of Giorgione's *Venus* (Dresden, Gemäldegal.) but substituting direct sensual appeal and a realistic setting for Giorgione's idyllic remoteness.

Early in the 1540s Titian came under the stylistic influence of central and north Italian *Mannerism. In the *Ecce Homo* (1543; Vienna, Kunsthist. Mus.) his earlier vigour is once more in evidence, but it is now a vigour expressed in crowds and uncomfortable movement, shimmering colours, darker tones, and more summary handling. In the three large ceiling canvases (*Cain and Abel*, *Sacrifice of Isaac*, and *David and Goliath*, c.1543–4) in S. Maria della Salute, Venice, his energy finds outlet in terms of physical violence, while the action is projected at the spectator from above his head. Then, two years after painting a vivid and technically assured portrait of the Farnese Pope Paul III in Bologna (Naples, Capodimonte), he made his first and only journey to Rome in 1545. There he was deeply impressed not only by modern works such as *Michelangelo's *Last Judgement*, but also by the remains of Antiquity. His own paintings aroused much interest: *Danaë* (Naples, Capodimonte), which he probably brought to Rome, being praised for its handling and colour and (according to Vasari) criticized for its inexact drawing by Michelangelo. Titian painted in Rome a further portrait, *Paul III and his Grandsons* (Naples, Capodimonte), notable for its insight into the sitters' characters. The decade closed with further imperial commissions. In 1548 the Emperor summoned Titian to Augsburg, where he painted both a formal equestrian portrait, *Charles V at the Battle of Mühlberg* (Madrid, Prado), and a more intimate one showing him seated in an armchair (Munich, Alte Pin.). He travelled to Augsburg again in 1550 and this time painted portraits of the Crown Prince—the future Philip II of Spain. Titian's last commission from Charles V was for the picture *La Gloria*

(1554; Madrid, Prado), in which the Emperor and his dead wife, surrounded by the saints in heaven, are presented to the Trinity.

For Philip II, who would be his principal patron for the rest of his life, Titian painted a notable series *of poesie*: *Danaë* and *Venus and Adonis* (Madrid, Prado), *Diana and Actaeon* and *Diana and Callisto* (Edinburgh, NG Scotland), *The Rape of Europa* (Boston, Isabella Stewart Gardner Mus.), *Perseus and Andromeda* (London, Wallace Coll.), *The Death of Actaeon* (London, NG). To judge from Titian's correspondence the series proceeded on an entirely ad hoc basis, rather than in accordance with any preconceived iconographic or decorative scheme. Titian's principle seems to have been to present the pictures as pairs, showing the nude figures from different viewpoints. At least six of the pictures were painted between c.1550 and c.1562. Many of the figures were derived from Antique prototypes and Titian appears to have been consciously attempting to evoke an ancient pastoral world.

During the last 20 years of his life Titian's paintings show an increasing looseness in handling, blurring of forms, and a sensitive merging of colours. By the end of his life, according to *Boschini (1660) quoting a statement by Titian's contemporary, *Palma Giovane, he was painting more with his hands than his brush. In the mid-1550s he painted his first night scene, a *Martyrdom of S. Lawrence* (Venice, S. Maria Assunta dei Gesuiti), notable for its complex design, the drama heightened by intense contrasts of light and shade. In 1564 he repeated this design (*Escorial) but now the light became the dominant feature, creating and dissolving forms. A similar development is apparent in the *Crowning of Thorns* (Munich, Alte Pin.) of c.1570 which is based on an earlier version of c.1542 (Paris, Louvre). The sense of metamorphosis, of human forms dissolving and merging into the natural world, is felt most poignantly in *The Flaying of Marsyas* (Kromeriz Castle) and most poetically in the *Shepherd and Nymph* (Vienna, Kunsthist. Mus.) of c.1570, a loosely composed idyll which looks back to Giorgione and Giulio *Campagnola, in which the figures are absorbed into a mosaic of colour and light.

Titian's career closed with the painting of the *Pietà* (1573–6; Venice, Accademia), intended for his own tomb and finished after his death by Palma Giovane. The kneeling figure of S. Jerome is Titian himself, who gazes at the body of the crucified Christ. The remaining figures have scarcely materialized, while the statues have almost come alive.

Titian's genius was reflected in his work alone, in the single-minded act of painting as a physical and imaginative activity. He appears to have been untroubled by theoretical

issues or by other forms of intellectual activity. Yet in his visual conceits and his technique which explored the expressive potential of paint on canvas to the limit, he opened up a whole new way of painting. HB/HO

Hope, C., *Titian* (1980).

Wilde, J., *Venetian Art from Bellini to Titian* (1974).

TIVOLI (ancient Tibur), from the late republican period (1st century BC), a favourite site for country retreats of the Roman aristocracy (e.g. Cassius, Catullus, Augustus). Sixty sculptures from the Villa of Cassius (1st century BC–2nd century AD) demonstrate the eclectic taste of the Roman elite (Vatican Mus.): herm portraits of Greek statesmen, philosophers, and writers, statues of Apollo and the Muses, Dionysus and his followers, Isis and other Egyptianizing statuary.

The same eclecticism is evident in Hadrian's Villa. Constructed AD 118–28 by the Emperor Hadrian, it is the largest (120 ha/300 acres) and most richly ornamented of the imperial villas. According to a 4th-century biographer, Hadrian recreated here many buildings that he admired in his travels: Athens's Painted Stoa and Academy, the Canopus and temple of Serapis of Egyptian Alexandria, and the Cnidian temple of Aphrodite have all been recognized here. Another building, the so-called 'Maritime Villa', has been interpreted as a place of quiet retreat for the Emperor. After Hadrian's death, the villa was used by later emperors throughout the early 3rd century AD. Rediscovered in the mid-15th century, it was a source of inspiration to *Renaissance artists and architects as well as a major quarry of ancient sculpture. Although over 300 statues can be traced back to the villa, only a handful of important pieces remain. Many others made their way through the hands of Gavin *Hamilton and others to public and private collections throughout Europe. Of great importance is the mixture of different styles in the sculptural programme. Thus, the Egyptianizing statues of the Serapeion (Vatican Mus.) contrast with the Classicism of the copies of the Erechtheion *caryatids (Tivoli, Hadrian's Villa) along the Canopus. The villa also documents the change in taste for wall decoration in the 2nd century AD. The use of coloured marble revetment on the walls recalls first-style *Pompeian painting that reproduced in paint the marble revetment of the Hellenistic palaces. Here in Hadrian's Villa the cycle has come full circle. L-AT

Franceschini, M. de, *Villa Adriana* (1991).

Pinto, J. A., and MacDonald, W. L., *Hadrian's Villa and its Legacy* (1995).

TOBEY, MARK (1890–1976). American painter. Born Centreville, Wis., Tobey attended some classes at the Art Institute of Chicago but was largely self-taught. Moving to New York in 1911 he worked as a fashion illustrator, but also had some success as a portrait painter. In 1917 he was greatly moved by a painting by William *Blake and his developing interest in mysticism led him to join the Baha'i faith. In 1922 he taught at the Cornish School in Seattle and travelled extensively in Europe; and, in the 1930s, whilst based at Dartington Hall, Devon, as artist in residence, he also visited the Far East, where he developed a knowledge of mysticism, Zen Buddhism, and through these of calligraphy. Sometimes he travelled with his friend and fellow Baha'i, the potter Bernard Leach. He is best known for his 'white writing' paintings, with calligraphic brush strokes evenly and delicately covering the canvas: *Shadow Spirits of the Forest* (1961; Düsseldorf, Kunstsammlung Nordrhein-Westfalen). He won the International Prize at the Venice Biennale in 1958, and in 1960 settled in Basle. He is regarded as one of the precursors of the *Abstract Expressionists. RJP

Seitz, W. C., *Mark Tobey* (1962).

TOCQUÉ, LOUIS (1696–1772). French portrait painter, pupil, and son-in-law of *Nattier. He had a successful career as a fashionable painter in Paris and worked also at the courts of Russia, Sweden, and Denmark (1756–9), and in 1750 wrote a discourse on the art of portraiture. He was commissioned to paint Louis XV's wife *Marie Leczinska* (1740; Paris, Louvre), but the result lacks the charm and grace of Nattier's depiction of her a few years later. Nor do his allegorical portraits quite come off. On the whole Tocqué's solidly crafted style was better suited to the depiction of men in everyday costume, *Nicolas de Luker* (1743; Orléans, Mus. des Beaux-Arts) being a fine example. HO/MJ

Doria, A., *Louis Tocqué* (1929).

TOEPUT, LODEWIJCK, also called Lodovico Pozzoserrato (c.1550–c.1605). Flemish painter and draughtsman, active in Italy. He may have studied with Marten de *Vos before going to Italy some time after 1573. In Venice he is supposed to have joined the workshop of *Tintoretto. He was in Florence in the late 1570s, and in Rome in 1581. He eventually settled in Treviso, where he died. Toeput's paintings include decorative frescoes, altarpieces for Treviso churches, and religious canvases for the Monte di Pietà in Treviso, as well as easel pictures. He specialized in imaginary landscapes showing spacious vistas full of atmospheric and picturesque effects. While his broken colours and mannered figures recall his experience of Tintoretto and *Veronese, his landscapes attest to his Flemish heritage. His open-air banquets and musical parties (Treviso, Mus. Civico) anticipate the 17th-century Dutch merry company pieces of Willem *Buytewech and others. KLB

Hand, J. O., et al. (eds.), *The Age of Bruegel*, exhib. cat. 1986 (Washington, NG).

TOMASINO DA VIMERCATE (active c.1390–1415). Italian illuminator. He was the most prolific artist at work in Milan in the decades either side of 1400, illustrating manuscripts for both secular and ecclesiastical patrons. He was paid in 1409 for illuminating the first volume of the *Ambrosianae* copied for the Cathedral of Milan from 1406. The survival of this manuscript (Cambridge, Fitzwilliam, CFM 9) allows his identification as author of the body of work otherwise attributed to the Master of the Modena Hours. Although originally named after a book of hours in the Biblioteca Estense (c.1390; MS alpha R. 7. 3, lat. 842) Tomasino's most beguiling work is in the Book of Hours later completed for Isabella of Castile (The Hague, Rijksmus., MS 76 F. 6) where the variety and exuberance of the borders display an unsurpassed playful inventiveness. His style is deeply indebted to the *Master of Latin 757, with whom he may have trained. KS

Sutton, K., 'The Master of the *Modena Hours*, Tomasino da Vimercate, and the *Ambrosianae* of Milan Cathedral', *Burlington Magazine*, 133 (1991).

TOMASO DA MODENA (Tomaso Barisini) (1325/6–c.1379). Major 14th-century Italian painter; his technical brilliance and inventive imagery received recognition from important patrons. The son of a Modenese painter, Tomaso appears to have learned most from *Vitale da Bologna. He lived in Treviso 1348–c.1357: his frescoes of the leading Dominicans (1351–2; Treviso, S. Nicolò, chapter house) are notable for the individual characterization of the saints and the earliest depictions of spectacles and lenses, the later *S. Jerome* for similar details and cast shadows. The intensely dramatic *Legend of S. Ursula*, reflecting the visit of the Empress and the siege of the city by the Hungarians, is celebrated for its depiction of courtly dress (c.1356/7; Treviso, S. Margherita, now in S. Caterina).

Several panel paintings by Tomaso survive, mostly small in scale but remarkable for their innovative *iconography. The diptych and the triptych for the Emperor Charles IV at Karlštejn are large in scale and sumptuously decorated, and were probably a major influence upon *Bohemian painting. Two illuminated fragments of a choir book and frescoes of Madonnas in Modena and Fidenza record various stages of his activity in Modena itself. RG

Gibbs, R., *Tomaso da Modena* (1989).

TOMBS. The tomb occupies an important place in the history of art. The burial of the dead was subject to diverse customs and

great care and expense was often taken in the erection of tombs, which reflect both the beliefs of a particular culture as well as the prevailing tastes and fashions of the age. Tombs can be divided into two very general categories; the first type was constructed as a home for the spirits of the dead and acted as a gateway to the other world. These tombs are typically simple on the outside and highly ornate inside, often richly furnished with grave goods. The second type of tomb was erected as a monument to honour the dead and to preserve their memory. Such tombs are often elaborate in their iconography and frequently incorporate effigies of the departed. These two types were not, however, mutually exclusive and elements of both can be found in the burial customs of many cultures.

The earliest and best example of the first type of burial is the great Pyramids of Ancient Egypt. Built for permanence, their plain, massive exteriors hide a complex network of tunnels and chambers, all elaborately painted and once filled with treasures. Megalithic burial chambers, dating from 2000 to 1500 BC, were the western European equivalent and represent Europe's earliest surviving monuments. They were normally constructed from a series of upright stones and dry masonry, covered by a large slab. Numerous examples can be found throughout northern Europe (e.g. New Grange, Ireland). Typically these burials are accompanied by grave goods for the dead to use in the other world. Tomb markers were first erected by the Greeks (see GREEK ART, ANCIENT). At Mycenae the shaft-graves were marked with 'stelae' (1600–1500 BC) while during the Geometric period, geometric vases could be used to mark tombs. From the Archaic period on, both stelae and freestanding statuary served the same purpose. The stelae erected by the Classical Greeks served primarily as monuments to the dead. Furthermore the great *Mausoleum of Halicarnassus, erected for King Mausolus of Caria by his widow Artemisia c.350 BC, was regarded as one of the *Seven Wonders of the ancient world. This was also the period that produced the sarcophagus, perhaps the most enduring type of tomb. These were frequently carved in stone or marble and decorated with historical or mythological scenes (a fine series dating from the 5th–4th century BC was found at Sidon, now in the Istanbul Mus.). The *Etruscans also used sarcophagi and sometimes carved effigies of the dead on the lids. Sarcophagi became superfluous during the early Roman period, due to the widespread practice of cremation, but the revival of burial customs in the 2nd century AD brought them back into use, the most expensive being made from porphyry and marble. The magnificence of Roman burials (see ROMAN ART, ANCIENT) reached new heights

with the mausolea erected by the Emperors Augustus (Mausoleum of Augustus erected 28 BC) and Hadrian (Mausoleum of Hadrian: begun c. AD 130, completed in 139). Monuments (see FUNERARY MONUMENT) honouring the memory of the dead reached a zenith with such huge structures as *Trajan's Column (dedicated in 113), with its celebratory images commemorating Trajan's victories and achievements.

Early Christian burial acted as a gateway to heaven, and the earliest catacomb burials in Rome are discreet, subterranean chambers, whose walls are painted with symbols of faith and salvation. With the official recognition of Christianity in the 4th century, however, burials followed the Roman fashion and sarcophagi, even those carved with pagan decoration, were viewed as suitable tombs. By the 6th century the normal practice was to locate the burial in or near a church. Churches, in contrast to mausolea, were not designed as specialized burial places, and restrictions on church burial were constantly reiterated, if sporadically enforced throughout the Middle Ages. Graveyards grew up in the consecrated ground surrounding the church, yet the most important tombs (and most interesting from an art historical point of view) continued to be located inside the church, in the form of either tomb chests/sarcophagi or tomb slabs.

The most important medieval tombs were those containing the remains of saints. The chests or reliquaries in which they were buried were often venerated as shrines and could also serve as an altar. In some cases this veneration was at variance with the actual burial itself. S. Cuthbert was buried in the ground in a simple painted wooden coffin (still preserved at Durham Cathedral), yet his tomb was dug up in 687 and displayed as a shrine first at Lindisfarne, and later at Durham, where in 1104 the body was reinterred in a metal chest set on a platform behind the altar.

Medieval rulers still coveted ancient sarcophagi, in spite of their obvious pagan imagery, and Charlemagne (d. 814) was buried in the palatine chapel at Aachen in a late Antonine sarcophagus decorated with the *Rape of Proserpina*. Even popes favoured this form of burial. Gregory V (d. 999), Damasus II (d. 1048), Innocent II (d. 1143), and Anastasius IV (d. 1154) were among those buried in ancient sarcophagi, the latter in a particularly fine porphyry sarcophagus said to have been used for Empress Helena. The magnificence, splendour, and ancient associations of such tombs obviously outweighed the lack of Christian significance in their imagery.

The most common form of medieval tomb, however, was not the chest/sarcophagus, but the tomb slab, which was normally incorporated into the paving of the church. These were made from various materials, including

stone, bronze, enamel, brass, mosaic, marble, and alabaster, and they frequently portrayed an effigy of the deceased. At first these effigies were carved or cast in low relief, but as slabs were raised off the ground for protection (either on chests, or supported by figures of animals), they became more sculpted and lifelike. The use of coloured enamel (e.g. the effigy of Geoffrey Plantagenet, d. 1151; Le Mans, Mus. Tessé) gave the appearance of three dimensions, while the sculpted limestone effigy of Eleanor of Aquitaine (d. 1204) at Fontevrault Abbey depicts the Queen lifelike and reading a book. Bronze *casting also produced realistic effigies such as the stunning figure of Henry III, made by William *Torel in 1291–2, at Westminster Abbey, London.

The later Middle Ages saw increasing elaboration in tomb design; the most important were free standing, mounted with an effigy and covered with a *Gothic canopy. A particularly interesting form developed, known as the 'transi-tomb', which contrasted the idealized effigy of the deceased with a realistic representation of the decaying corpse. This type of tomb emerged around 1400 and was at first reserved for high-ranking clerics (e.g. Archbishop Henry Chichele, whose transi-tomb was erected at Canterbury Cathedral in 1424–6, well before his death in 1443). Spectacular examples were later made for the French royal family in the 16th century (e.g. Louis XII, 1531, François I, 1548, and Henry II, 1573, all at the abbey of S. Denis).

By the end of the Middle Ages, churches such as Westminster Abbey or S. Denis were full of important tombs, and repositioning these monuments became necessary in order to accommodate yet more. By contrast Italian churches had tended to confine tomb monuments to the peripheries, with the wall tomb the most prestigious form of church burial. Such a position proved very amenable to the revival of classical forms, and the deceased was often represented lying on a bier, above a sarcophagus framed within a specialized niche. The height of these monuments meant that effigies were sometimes depicted as alive, either seated or standing, so that they were visible to viewers below. Antonio *Pollaiuolo's tomb for Innocent VIII (1492; Rome, S. Peter's) shows the Pope seated alive, as well as lying in state, and Pietro *Lombardo's tomb for Doge Pietro Mocenigo (1476–81; Venice, SS Giovanni e Paolo) depicts the Doge standing among many figures. Perhaps the most famous of all Renaissance tombs are *Michelangelo's Medici tombs (1521–34; Florence, S. Lorenzo), where the dukes are depicted seated with allegories reclining on the curved cornices. This period also saw the revival of an earlier Roman form of tomb monument, the portrait *bust set on

a plinth, a fine example being Danese Catta-neo's tomb for Pietro Bembo (1547; Padua, Santo).

The late 16th and 17th centuries saw greater emphasis placed on death as a release and tomb decoration reflected this. In some examples the portrait bust of the deceased is borne aloft by angels, such as *Bernini's tomb for Maria Raggi (c.1643; Rome, S. Maria sopra Minerva). Others depict a deathbed scene such as Richelieu's tomb, where the Cardinal is depicted dying on his bier sur-rounded by mourning allegories (1675–7; Paris, Sorbonne). The period saw an increas-ing tendency for dramatic representation of death, culminating in *Roubiliac's great tomb monuments in Westminster Abbey. General William Hargrave is depicted burst-ing forth from his winding sheet into heaven (1757), while the tomb of Joseph and Lady Elizabeth Nightingale portrays Joseph at-tempting to shield his wife from Death's dart (1758–61).

The late 18th century saw the emergence of *Neoclassicism as the pre-eminent style, and it dominated tomb design, in one form or another, for well over 100 years, from An-tonio *Canova's tomb for Pope Clement XIV (1783–7; Rome, SS Apostoli), to Henry Bacon's Lincoln Memorial (1915–22; Washington). In-creases in population during the 19th cen-tury saw the emergence of public cemeteries, such as Père-Lachaise in Paris, 1804, and Kensal Green in London, 1833. Some signifi-cant tomb monuments were still produced (e.g. Jacob *Epstein's monument to Oscar Wilde at Père-Lachaise, 1912); however, most tombs were reduced to a standard grave marker. The trend was accelerated by the in-creasing use of cremation from the 1890s on-wards. During the 20th century the mass killing of the World Wars has led to the erec-tion of war memorials as the only significant form of tomb monument. TJH

Binski, P., *Medieval Death* (1996).
Colvin, H., *Architecture and the After-life* (1991).
Panofsky, E., *Tomb Sculpture: Its Changing Aspects from Ancient Egypt to Bernini* (1964).

TOMÉ, NARCISO (1694–1742). Spanish architect born in Toro (Castile). His father was an architect and his brothers Diego (d. 1732) and Andrés a sculptor and a painter re-spectively. He is first documented in 1715, working on the central portal of the univer-sity in Valladolid under his father's direction. In 1720, the Cathedral of Toledo called in the Tomés to design a large structure behind the high altar retable, the Transparente that houses the Sacrament. Narciso was in control of the project and in 1721 was named chief architect of the cathedral, a post he occupied until his death. His design—an exuberant mixture of architecture, sculpture, and paint-ing, in which natural light plays an import-ant role—was executed by his brothers

under his direction and finished in 1732. The *Transparente's* particular style does not reflect the *Baroque of Pedro de Ribera (1681–1742) or the *Churriguera brothers, and its unique design can only be related to *Bernini's Cath-edra Petri (Rome, S. Peter's) and Cornaro chapel (Rome, S. Maria della Vittoria) (which he may have known through prints), works in which the three arts were integrated to ex-press a single idea. Tomé's architectural works elsewhere did not survive the 19th century. NAM

Mallory, N. A., 'Narciso Tomé's Transparente in the Cathedral of Toledo', *Journal of the Society of Architectural Historians*, 29 (1970).

TOMMASO MANZUOLI. See MASO DA SAN FRIANO.

TOM RING FAMILY. Three generations of German painters and designers from Münster, Westphalia. The first known painter in the family, **Ludger I** (1496–1547), and his eldest son **Hermann** (1521–97) were highly regarded in Münster, not only for their reli-gious panels, portraits, and murals but also for their designs of book illustrations and *woodcuts. Hermann's portrait of a *Musician* (1547; Münster, Westfälisches Landesmus.) is one of the supreme achievements of *Renais-sance portraiture in north-west Germany, reminiscent of Hans *Holbein the younger. Both artists may also have worked as archi-tects, and Ludger I participated in the con-struction of a new astronomical clock for Münster Cathedral (1540; *in situ*). Hermann's younger brother **Ludger II** (1522–84) distin-guished himself painting portraits and still lifes (*Three Peacocks*, 1566; Münster, Westfälis-ches Landesmus.). Unlike his father and brother, Ludger II was a Protestant who eventually settled in Brunswick. Evidence suggests that he was associated with the painter and graphic artist Heinrich *Alde-grever, another Protestant. Hermann's two sons **Nikolaus** (1564–1622) and **Johann** (1571–1604) painted religious works around Münster, in a *Mannerist style influenced by Hendrik *Goltzius and Hans von *Aachen.
 KLB

Lorenz, A., *Die Maler tom Ring*, exhib. cat. 1996 (Münster, Westfälisches Landesmus.).

TONDO (Italian: round), term used to des-ignate paintings or reliefs of circular form. Such works were particularly popular in Tuscany in the 15th century; many ex-amples survive including tondi by *Botticelli (Florence, Uffizi), Luca della *Robbia (c.1428; Oxford, Ashmolean), and *Domenico Vene-ziano (1439–41; Berlin, Gemälde Gal.).

Their importance and use in the Renais-sance home can be partly reconstructed from inventories and prints; for example the reli-gious tondo placed in the bedchamber or

camera in the 1496 Florentine woodcut in Gir-olamo Savonarola's *Predica dell'arte del bene morire* (London, BL, MS 1. A. 27321).

The prevalence of tondi with the Madonna and Child or the Adoration of the Magi is likely to have originated, at least in part, from the *desco da parto*. MLS

TONE. See COLOUR.

TOOROP, JAN (1858–1928). Dutch artist. Toorop was partly Javanese but left the East Indies for Holland as a child. In 1882 he went to Brussels, on a scholarship from the Dutch Academy of Fine Arts, and made con-tact with Les *Vingt, which he joined in 1885. He was influenced by the *Symbolists *Ensor, *Redon, and *Rops and inspired by contem-porary literature, being close to the avant-garde writing circle the Tachtigers and meeting Verlaine and Péladan in 1892. He also visited London in the late 1880s where he was in contact with *Burne-Jones and William Morris, whose socialist sympathies he shared. His Symbolist period was brief but intense, lasting from c.1889 to 1905 when he converted to Catholicism. His characteristic linear, flat, and decorative style is best seen in his masterpiece *The Three Brides* (1893; Otterlo, Kröller-Müller), with its serpentine, coiling composition and exotic imagery with echoes of Javanese art, particularly batik. His admir-ation of Wagner inspired some of his work which itself approaches the musical in his or-ganization of rhythms and motifs. After 1905 he concentrated on religious works includ-ing *stained glass. JH

Knipping, J., *Jan Toorop* (1947).

TOPOGRAPHICAL ART, term for pictor-ial and graphic art which is concerned with the depiction of places, especially towns, buildings, ruins, and natural pro-spects. It may be distinguished from *land-scape by its main object being to convey information, though in practice the distinc-tion is often unclear. The driving forces be-hind topographical art were, on the one hand, interest in travel and foreign places and, on the other hand, the desire to record personal or communal property.

Recognizable topographical features ap-pear in ancient reliefs and in medieval art primarily as a notation to indicate the local-ity of the action. Accurate depictions of buildings do not appear until northern 15th-century art, where there are many extremely accurate examples of landmark buildings, but still in a background role.

The invention of printing was soon ex-ploited to spread information about cities

and countries, the pioneer work being Erhard Reuwich's *woodcuts to Bernhard von Breydenbach's *Peregrinations* (1486), illustrating a pilgimage to Jerusalem. The illustrations to the *Nuremberg Chronicle* (1493) by Hartmann Schedel show that the public did not always expect or get much topographical accuracy, the same blocks being used to illustrate cities as different as Damascus and Ferrara. In the same period, however, there was ambitious and reasonably accurate work such as the magnificent bird's-eye view of Venice attributed to Jacopo de' *Barbari and published in 1500 on four large woodcut sheets.

During the 16th and 17th centuries commercial, military, and political pressures led to an explosion in the production of maps, especially in northern Europe, and these were frequently linked with topographical images. One of the most ambitious publishing ventures of the period was Georg Braun and Frans Hogenberg's *Civitates orbis terrarum* which appeared in five volumes over the years 1572–98 with a sixth volume added in 1617. This project included 546 views and plans of cities in Europe, Asia, Africa, and Mexico, and relied largely on the energy of Joris *Hoefnagel, who executed about 60 views based on drawings made on the spot in several European countries. In the preface to book 3 (1581) Braun explained the appeal of the books to the armchair traveller, who was enabled to gain knowledge of the world in his 'own home, far from all danger'.

The spread of interest in foreign countries and nations is reflected in the large output of engravers (see LINE ENGRAVING) such as Theodore de Bry (1528–98) of Frankfurt and his son-in-law Matthäus *Merian, who founded the great series of German town-books entitled *Topographia Germania*. The views with which de Bry and his sons illustrated their great work, *Collectiones peregrinatum in Indiam orientalem et Indiam occidentalem* (1590–1634), are often fanciful, but they do demonstrate how quickly topographical draughtsmen moved into the new field of exotic geography. Wenceslaus *Hollar, who probably studied under Merian, engraved a great number of topographical views in England and provided plans and views of the naval base in Tangier which had become a British possession in 1662. His survey of English towns and buildings was carried out by Leonard Knyff (1650–1722), Jan *Siberechts, and Francis *Place.

Accurate describing lies at the heart of many of the genres of painting that evolved in the 17th-century Dutch Republic, and it is entirely characteristic that urban topography should have been one of those genres. The first type that emerged, in the first quarter of the century, was the city profile developed by Hendrick *Vroom, which had its roots in

cartographic prints. The ultimate culmination of that line was *Vermeer's *View of Delft* (1658; The Hague, Mauritshuis). In the second half of the century artists like *Berckheyde and van der *Heyden developed a specialist genre of small, architecturally accurate views of Dutch urban areas, peopled by the townsfolk going about their business. Paintings of this kind reflect the perception that the citizens of the new Dutch Republic had of their society, and they celebrate the values of order and good government that underpinned it.

The major art market that developed for view paintings in 18th-century Italy was radically different from the Dutch experience. Instead of a politically confident society producing definitions of itself for its own consumption, a society in political decline was engaged in describing itself for a clientele that was largely external. Wealthy northerners who had experienced Italy in their *Grand Tour required all kinds of recollections of the country. Many of *Canaletto's views of Venice are pictorially ambitious celebrations of the city; *Panini's paintings of Roman antiquities are frequently *capricci in which buildings are incongruously juxtaposed; and *Piranesi's views of both ancient and contemporary Rome are dramatized and romanticized. There was, however, a parallel stream of accurate topographical description, exemplified by *Vanvitelli's work in Rome and Naples at the beginning of the century and the views of Naples by Giovanni Battista Lusieri (1755–1821) at the end of it, and it was common for Grand Tourists to take their own topographical artists with them. Canaletto's work in England was also profoundly influential on the production of realistic townscapes, notably by Samuel Scott (c.1702–1772) and his pupil William Marlow (1740–1813).

The English *watercolour painters had close affinities with topographical art and many of them did such work either as potboilers or more seriously. *Turner, for example, began his career as a topographical artist but his interest in the transient effects of light and atmosphere steadily assumed greater importance than the topographical element.

Throughout the late 18th and early 19th centuries there was a continuous heavy production of topographical prints. English examples are Thomas Malton's *Picturesque Tour through the Cities of London and Westminster* (1792–1801) and the sets of *aquatints of Oxford and Cambridge that Rudolph Ackermann brought out in 1814 and 1815 respectively. By the 1830s European topographic artists were producing work, for home consumption, in the most distant regions of the world. With the invention of

*photography, however, the need for topographical draughtsmen declined and disappeared. HO/AJL

Harvey, P. D. A., *The History of Topographical Maps: Symbols, Pictures and Surveys* (1980).
The Dutch Cityscape in the 17th Century and its Sources, exhib. cat. 1977 (Amsterdam, Historical Mus.).

TOREL, WILLIAM (active 1291–1303). English goldsmith and bronze caster. From 1291 to 1294 he was employed at Westminster in the works associated with the burial of Edward I's wife Eleanor of Castile, and the tomb of Henry III. In a workshop attached to the abbey, Torel cast and gilded bronze effigies (Westminster Abbey) of Henry and Eleanor, and a second effigy of Eleanor (destr.) for the tomb at Lincoln that contained her entrails. The *casting was by the lost-wax process, and although these were not the first such effigies to be cast in England, Torel's technique, based on bell casting, betrayed unfamiliarity with the method. His techniques of wax *modelling, *gilding, and chasing, however, were superb; it may have been Torel who introduced the French style of soft, vertical drapery folds breaking over the foot that was to characterize English sculpture for a generation. He is last recorded as the allegedly innocent receiver of stolen gold rings. NC

Botfield, B., *Manners and Household Expenses of England in the Thirteenth and Fifteenth Centuries*, ed. T. Hudson Turner (1841)
Colvin, H. M. (ed.), *The History of the King's Works*, vol. 1 (1963).

TORRES-GARCÍA, JOAQUÍN (1874–1949). Uruguayan painter. The leading figure in Latin American *Constructivism, Torres-García lived in Europe and the United States for 40 years. He settled in Paris in 1926, joining the group Cercle et Carré, and was allied to International Constructivism. In 1918 he began constructing wooden toys which moulded his whole approach to art, which was that the simplest forms could be built into the most complex of constructions. His paintings are thus compartmentalized and specific symbols are inserted into each box—keys, fish, leaves, clocks, masks—which form part of a personal coded alphabet. In 1940 he returned to Montevideo and started the Asociación de Arte Constructivo and his influential workshop Taller Torres-García where he trained his followers. At this time he formulated a new alphabet based on pre-Columbian images and Phoenician characters. He executed various murals as well as his hieroglyph-covered three-dimensional wall *Cosmic Monument* (1939; Montevideo, Parque Rodo). His important text *Escuela del sur* (1935) calls for traditional

hierarchies of artistic influences to be inverted, starting with Latin America and ending with Europe. CC

Gradowczyk, M., *Joaquín Torres-García* (1985).

TORRIGIANO, PIETRO (1472–1528). Florentine sculptor, whose fame rests both on having broken *Michelangelo's nose, and on having brought the Italian *Renaissance to England. His training is unclear, but he probably studied in the S. Marco garden in Florence, and his *Head of Christ* (c.1520; London, Wallace Coll.) also suggests a familiarity with *Verrocchio's work. He also worked in Rome, perhaps in *Bregno's workshop, and produced a marble *S. Fina* and a terracotta *S. Gregory* (c.1498; S. Gimignano, Ospedale di S. Fina). Also active as a mercenary soldier, in around 1507 Torrigiano came to England via the Netherlands. He was engaged to execute the tomb of Margaret Beaufort, Countess of Richmond (1511; London, Westminster Abbey), a prelude to his magnificent tomb of Henry VII and Elizabeth of York (1512–19; London, Westminster Abbey, Henry VII chapel). His recumbent effigies are based on *death masks; these are surrounded by putti, and with saints and figures in the bronze grilles; the whole is enlivened by contrasting *polychrome marbles. The high altar for the Abbey (1516–22; destr.) included a polychrome terracotta *Head of Christ*. His tomb of Dr John Yonge is now in the museum of the Public Record Office, London. He left England for Spain (c.1520?), abandoning a project for the tomb of Henry VIII. In Seville he produced the powerful *Penitent S. Jerome* and a *Madonna and Child* (both Seville, Mus. des Bellas Artes). Imprisoned by the Inquisition, he died of starvation. HO/AB

Darr, A., 'The Sculptures of Torrigiano: The Westminster Abbey Tombs', *Connoisseur*, 200 (1979).

TORRITI, JACOPO (active c.1290–early 14th century). Late medieval Roman painter and mosaicist. His work is now known only from two highly prominent signed apse *mosaics in the basilicas of S. John Lateran (1291) and S. Maria Maggiore (c.1295), Rome, but he also carried out the façade mosaic for the former and perhaps also the tomb mosaic of Pope Boniface VIII (both destr.). Although the apse mosaic at the Lateran, with standing saints and Pope Nicholas IV as donor, was thoroughly restored in 1894 it shows that Torriti was influenced by the original *early Christian mosaic there. The central subject of the more authentic mosaic in S. Maria Maggiore is the more recently introduced *Coronation of the Virgin*, but the acanthus scrolls that surround it and the Nilotic frieze below again show early Christian origins. Beneath are five scenes from the life of the Virgin, showing more prominent use of classical detail than *Cavallini's cycle in S.

Maria in Trastevere, Rome. Torriti's conservative style must have appealed to the senior ecclesiastical figures who controlled these two prestigious commissions. His success in Rome may well have recommended him to the authorities at the basilica of *S. Francesco, *Assisi, where the style of some of the early frescoes in the *Creation* cycle on the wall of the upper church certainly shows evidence of his presence, or that of close assistants; the work here may thus have followed his mosaic in S. John Lateran of 1291. PH

Tomei, A., *Iacobus Torriti pictor, una vicenda figurativa del tardo duecento romano* (1990).

TOULOUSE-LAUTREC, HENRI DE (1864–1901). French painter and draughtsman, son of the nobleman Count Alphonse de Toulouse-Lautrec Monfa. Raised in the Languedoc, he was a delicate child and his growth was stunted by two adolescent accidents. His early talent for drawing was encouraged by family and friends, notably by the sporting painters René Princeteau and John Lewis Brown. In 1882 he became a pupil of the academic portraitist Léon Bonnat (1833–1922) and in 1883 entered the school of academic painter Fernand Cormon (1845–1924), where he met *Bernard, *Anquetin, and van *Gogh. In 1885, he was given a financial competence and set up studio in Montmartre. He began to draw for the illustrated journals, tackling modern subjects from the streets, theatres, music halls, cafés, and low life of Paris. He collected the etchings of *Goya and admired the work of *Degas. From this period comes *Au bal du Moulin de la Galette* (1889; Chicago, Art Inst.). In 1890 he began to frequent the Moulin Rouge and painted *Au Moulin Rouge: la danse; dressage des nouvelles* (Philadelphia Mus.), which was hung in the foyer of the cabaret. During the next decade he began to produce his brilliant posters and his drawings and paintings of singers, dancers, entrepreneurs, etc.: Aristide Bruant, La Goulue, Jane Avril, Yvette Guilbert, Loie Fuller, and others. He was associated with the *avant-garde journal *Revue blanche*. He also became a habitué of the *maisons closes*, producing numerous drawings, lithographs, and paintings of the girls, whom he treated compassionately, as individuals.

His style, characterized by flat rhythmic patterning and calligraphic use of strong outline, combined an acerbic *realism with the decorative influences of *Cloisonnism, Japanese colour prints, and the poster artist Jules Chéret. Toulouse-Lautrec was keenly interested in colour lithography—notably pioneering the 'crachis' or splatter technique—and was one of the most important influences in rendering both *lithography and the poster major art forms.

As well as exhibiting at venues ranging from the smart Cercle Volney to the Salon des Indépendants, *Paris, in 1893 Toulouse-

Lautrec exhibited alongside Charles Maurin at the Boussod et Valadon Gallery, and had a one-man show at the Goupil Gallery in London in 1898. Despite some praise from critics neither show was a success. In 1922 the Lautrec family presented some 600 of his works to the town of his birth, Albi, where the Musée Lautrec was created to house them.

BT

Toulouse-Lautrec, exhib. cat. 1991–2 (London, Hayward; Paris, Grand Palais).

TOURNIER, NICOLAS (1590–1639). French painter, born at Montbéliard, Doubs, but first recorded as an artist in Rome in 1619 where he is said to have been a pupil of *Valentin. Like Valentin, he belonged to the circle of Caravaggesque artists associated with *Manfredi and specialized in painting half-length pictures of drinkers, gamblers, soldiers, and musicians; indeed his style appears so close to Manfredi that in the absence of documentation the division of works between them is difficult and controversial. Among the pictures attributed to Tournier, and dating from the period 1619–26 when he was in Rome, are the *Banqueting Scene with a Guitar-Player* (St Louis, Art Mus.), and the *Sinite parvulos* (Rome, Gal. Corsini); the latter is a work of profound spiritual power with a gravity and introspective calm far closer in spirit to Valentin than to Manfredi. By 1627 Tournier was back in France at Carcassonne. He had settled at Toulouse by 1632 where he painted several large altarpieces; and his work from this period, which reflects a new predilection for religious and *history painting, can be reliably identified: the *Descent from the Cross* and the *Entombment* (Toulouse, Mus. des Augustins), the *Crucifixion* (Paris, Louvre), and the *Battle of the Red Rocks* (Toulouse, Mus. des Augustins). Here his style is simplified and austere, serious and expressive, and he emancipates himself from Manfredi's early influence. HB

Bréjon de Lavergnée, A., and Cuzin, J., *Valentin et les Caravaggesques français*, exhib. cat. 1974 (Paris, Grand Palais).

Nicolson, B., *Caravaggism in Europe* (2nd edn., 1990).

TOURS SCHOOL, term applied to the artistic products and influence of the *Carolingian scriptorium of the abbey of S. Martin at Tours. Its reputation began under Charlemagne's mentor, the scholar Alcuin, abbot 796–804, reaching its zenith by the middle of the century under the patronage of Lothar I (d. 855). Its chief products included one-volume bibles (pandects) specifically made for export to other centres, thus disseminating the elegant Tours script and decorated initials. Other distinctive features were Gospel illustrations, which developed Evangelist

symbolism and the theme of Christ in Majesty, a sophisticated use of allegory and symbol reflecting contemporary theological debate. While earlier manuscripts followed *Antique prototypes, including late Roman scientific lore, later works, such as the Lothair Gospels (Paris, Bib. Nat.) or the Bible of Count Vivian (Paris, Bib. Nat.), adopted *Byzantine colour schemes, and introduced narrative cycles and ruler portraits.

The ivory covers of these great books were closely related in style. Tours ivory carvers imitated the vivid, distorted drawings of the Utrecht Psalter, and influenced later works at S. Denis and S. Gall. The Tours style also affected crystal carvings and frescoes.　　CMH

Hollander, H., *Early Medieval* (1990).

TOWNE, FRANCIS (1739–1816). English *watercolour painter. Towne was born at Isleworth in 1739. After a seven-year apprenticeship to a coach painter his ambition was to succeed as an oil painter. His move to Exeter (c.1764) cut him off from the metropolis but he became a well-off drawing master with John White Abbott (1763–1851) among his pupils. Towne's reputation rests on his strong, distinctive landscape watercolours with bold pen-outlined forms infilled with bright clear colours. He sketched in Wales (1777) and the Lakes (1786) as well as Devon and Cornwall, but his most imaginative and original work stems from his trip to Italy via Geneva (1780–1). In Rome he worked with John 'Warwick' Smith (1749–1831), carefully noting the time of day and weather effects on his on-the-spot studies. Coming back via the Alps he made two of his most spare and extraordinary watercolours, *The Source of the Arveyron* (London, V&A and Tate). He failed on ten occasions, between 1788 and 1803, to get elected to the RA. Three albums of Italian watercolours were bequeathed to the British Museum.　　MP

Hardie, M., *Watercolour Painting in Britain*, vol. 1 (1966).

TRAJAN'S COLUMN, honorific column dedicated in AD 113 in the Forum of Trajan in Rome. The column served three distinct functions. Its height of 100 Roman feet (29.77 m) marks the height of the hill excavated for the Forum. The base, decorated with relief sculpture of Dacian booty, held the ashes of the Emperor Trajan. Lastly, the sculptural frieze on the exterior of the column shaft provides a visual record of the events of the two Dacian campaigns in 155 scenes which extend for more than 200 m (650 ft). The Emperor appears more than 60 times in this scrolled continuous narrative. A recent theory suggests that the frieze post-dates the death of Trajan in 118 and should be attributed to Hadrian. The colossal bronze statue

of Trajan on top was replaced in the Renaissance (1587) by a statue of S. Peter. The later column of Marcus Aurelius follows the same schemata (after AD 180); nearly 200 years later, Theodosius I (AD 386) and Arcadius (AD 403) erected their own versions at Constantinople.　　L-AT

Claridge, A., 'Hadrian's Column of Trajan', *Journal of Roman Archaeology*, 6 (1993).
Lepper, F., and Frere, S., *Trajan's Column* (1988).

TRANSITIONAL STYLE describes various styles in medieval art in the years between c.1160 and c.1230, when the extreme stylization of *Romanesque was modified, but not yet fully *Gothic. It was tempered by gentle naturalism, as represented by the Master of the Gothic Majesty in the Winchester Bible (Winchester, Cathedral Lib.). *Byzantine painting and ivories influenced works including the paintings (Barcelona, Mus. Nacional d'Art de Catalunya) from Sigena, and were significant in the 'trough fold' or *Muldenfaltenstil*, in which draperies followed the body naturalistically, but the folds were deeply gouged. This appeared in the metalwork of *Nicholas of Verdun (e.g. the enamelled former pulpit at Klosterneuburg, Austria), spreading to the sculpture of Reims Cathedral and such manuscripts as the Ingeborg Psalter (Chantilly, Mus. Condé, MS 9/1195). The style interested *Villard de Honnecourt, who copied examples into his *Portfolio*. Transitional survived until the broad-fold style was introduced into Parisian sculpture in the 1230s.　　NC

Lasko, P., *Ars sacra* (2nd edn., 1994).
Williamson, P., *Gothic Sculpture, 1140–1300* (1995).

TRAUT, WOLF (c.1485–1520). German painter from Nuremberg, who probably was the son or nephew and pupil of Hans Traut (d. 1516). He was in *Dürer's workshop by c.1505, together with Hans *Baldung and Hans *Schäufelein. He collaborated with Dürer on the woodcuts for the *Triumphal Arch of Maximilian I* (1512–15). Not in the same league as Baldung and the talented Hans von *Kulmbach, Traut nevertheless established himself as one of the leading painters of Nuremberg. He painted altarpieces and portraits in a style strongly dependent on Dürer's. The *Holy Kinship* altarpiece (1514; Munich, Bayerisches Nationalmus.), commissioned for the clothmakers' chapel near St Lorenz, recalls in its luminous, clear colours Dürer's *All Saints* altarpiece (Vienna, Kunsthist. Mus.). Traut's portraits also reflect Dürer's style, though he seems to have been familiar with early Netherlandish types (*Portrait of a Man*; Vienna, Kunsthist. Mus.).　　KLB

Gothic and Renaissance Art in Nuremberg, exhib. cat. 1986 (New York, Met. Mus.).
Strieder, P., *Tafelmalerei in Nürnberg* (1993).

TREATISE, a didactic work which expounds in a systematic way all the aspects of a discipline or of a specific topic. Art treatises encompass a large body of literature ranging from medieval handbooks to essays on aesthetics. Their content and scope vary with the character and profession of their authors: amateurs, antiquarians, artisans, cardinals, classicists, collectors, craftsmen, humanists, *letterati*, mathematicians, painters, philosophers, poets, potters, physicians, priests, scientists, and sculptors.

The modern art treatise emerges in 15th-century Italy. By the 17th century the genre had spread to France, Spain, and Germany, following the rise of artistic and literary academies. Although treatises on painting dominated artistic literature they provide many different points of access to *Renaissance and *Baroque visual cultures. They document the way in which their authors conceived the world by laying out their own conception of its representation. Together with love treatises they constitute the main vernacular genre which records, discusses, and sets criteria of beauty and ugliness. They testify to contemporary belief in the power of images and sometimes dwell on their use from the sacristy to the matrimonial chamber. Furthermore their influence extends to a wide range of decorative and applied arts for which painters and sculptors frequently provided drawings: arms and armour, ceramics, dress, goldsmithery, and tapestries.

With the exception of Vitruvius' *De architectura*—which eventually provided the model of the first early modern treatments of architecture—no ancient art treatise survives. The earliest known Western art treatises are medieval handbooks (*De arte illuminandi*; *Theophilus, *De diversis artibus*; Cennino *Cennini, *Libro dell'arte*). They record aspects of the oral tradition through which ideas and techniques were transmitted from master to apprentice in European workshops. They are basically compilations of recipes and instructions for the various stages of the fabrication of images in several media.

Although artists' handbooks continued to circulate throughout the Renaissance and Baroque periods, they remained in manuscript form due to their limited audience. The only aspects of workshop practice treated in print were those connected to the *humanistic curriculum which included drawing and mathematics as part of the education of the nobility. Hence treatises on *perspective, optics, and drawing were steadily published from the mid-16th century onwards.

The humanist and patrician Leon Battista *Alberti wrote the first modern art treatise. His *Della pittura* (1435) follows the conventions of the philosophical handbook and presents painting as a liberal art connected to eloquence and geometry. Its rubrics set the main headings for a long succession of art

treatises extending well into the 17th century. These headings include: a canonical list of classical and post-classical examples and topoi demonstrating the nobility of painting; a definition of the parts of painting based on those of rhetoric (invention, disposition, elocution); a transposition to images of literary criteria (*decorum, copia, varietà*); a discussion and definition of beauty and ideal proportions; advice and precepts to aspiring artists; and the unanimous statement of the intellectual character of painting and sculpture.

A spontaneous generation of treatises surrounds the publication of *Vasari's *Lives* (1550). These include Paolo *Pino's *Dialogo di pittura* (1548), Anton Francesco Doni's *Disegno* (1549), Michelangelo Biondo's *Della nobilissima pittura* (1549), Benedetto *Varchi's *Due lezzioni* (1549), and Lodovico *Dolce's *L'Aretino* (1558). By the 1560s these texts had established the art treatise as a genre and laid the ground in which the Catholic doctrine of images began to coexist with the humanistic theory of painting. Eventually the divergent requirements of religious and lay writers produced two increasingly distinct trends of art literature, one predominantly religious and the other principally secular.

Catholic authors reaffirm the traditional doctrine of the Church threatened by the rise of Protestant iconoclast theology from the 1520s onwards. They advocate images in which the resources of modern painting serve the mnemonic, didactic, and inspirational functions of religious art. In 1564 Gilio's *Dialogo deg'errori de' pittori* initiates a trend soon dominated by Cardinal *Paleotti's monumental *Delle imagini sacre* of 1584, followed by Federico Borromeo's *De pictura sacra* of 1625 and the Jesuit, Giovanni Domenico Ottonelli's and Pietro da *Cortona's *Trattato* of 1652. In Spain the genre blossoms and expands in *Pacheco's influential *Tratado de pintura* (1649) and Ayala's *Pictor christianus* (1730).

Secular art treatises expand throughout the 17th century with Marco *Boschini (1660, 1664), Francesco Scannelli (1657), and Luigi Pellegrino Scaramuccia (1674) in Italy, *Hoogstraten (1641) in Holland, and in France with *Dufresnoy (1667) and Roger de *Piles (1708), whose influence extends to the 18th century. By then the more supple and focused genre of the essay replaces the treatise as a literary forum for the discussion and expression of modern ideas on art. The treatise returns to its didactic function, but this time in the context of the institutional system of art education rather than that of the medieval workshop.

FQ

TREVISANI, FRANCESCO (1656–1746). Italian painter. He was born at Capodistria and trained in Venice under Antonio Zanchi (1631–1722). He moved to Rome in 1678 and worked for Cardinal Flavio Chigi. Major Chigi commissions include the *Christ between S. Philip and S. James* (1687) and the *Martyrdom of the Four Saints* (1688), both painted for Siena Cathedral (*in situ*). His early style was a synthesis of Venetian influences, including *Veronese and Zanchi, and the *classicism of *Maratti and his circle. From the mid 1690s Trevisani also benefited from the influential support of Cardinal Pietro Ottoboni (d.1740) and had his studio at the Palazzo della Cancelleria; his best portrait of his patron is at the Bowes Museum, Barnard Castle. Trevisani's first major project in Rome was the decoration of the chapel of the Crucifix in S. Silvestro in Capite (1695), where a dramatic tenebrism derived from *Lanfranco and *Solimena is tempered by the influence of Guido *Reni's lyrical classicism, especially in the *Road to Calvary*. Reduced autograph versions of Trevisani's work in S. Silvestro were commissioned for Burghley House (1699; *in situ*) by the 5th Earl of Exeter (1648–1700), who also acquired a *Noli me tangere* (*in situ*) in a much brighter toned painterly *Baroque style that apparently anticipates the *Banquet of Anthony and Cleopatra* (1704; Rome, Gal. Spada). Trevisani enjoyed good relations with British visitors to Rome, especially those of Jacobite leanings. He painted portraits of Prince James Stuart (Edinburgh, Royal Coll. Holyrood); of David Murray, 6th Viscount Stormont, and James Murray, titular Earl of Dunbar (both Scone Palace, Perthshire); of Thomas Coke (1697–1739) (Holkham, Norfolk) and Christopher Crowe, British consul at Livorno (Kipling Hall, North Yorks.).

Following the death of Maratti in 1710, Trevisani became the most famous and prolific painter in Rome. Most of his time was devoted to major altarpieces and decorative projects for churches in Rome and at Narni Cathedral. He also worked (1708–17) for Prince-Bishop Lothar Franz von Schönborn: most of these paintings, both religious and mythological, as well as an intimate *Self-Portrait* (1717) remain at the Schloss Weissenstein, Pommersfelden. And in 1735 he painted the *Family of Darius before Alexander* for the throne room at La Granja de S. Ildefonso (near Segovia), in Spain.

HB

Bowron, E. P., and Rishel, J., *Art in Rome in the Eighteenth Century* (2000).

TRIBOLO, NICCOLÒ (Niccolò di Raffaello de' Pericoli; Il Tribolo) (1500–50). Italian sculptor and garden designer. He was trained in Florence first as a woodcarver with Giovanni d'Alesso d'Antonio (c.1490–1546) and then as a sculptor under Jacopo *Sansovino. He appears to have visited Rome and the influence of the *Antique and *Michelangelo is evident in his early work. He collaborated on numerous projects, providing a marble putto for Baldassare *Peruzzi's tomb of Hadrian VI (c.1524; Rome, S. Maria dell'Anima), and completing in 1533 Andrea *Sansovino's marble relief of the *Marriage of the Virgin* at the Santa Casa, Loreto. In 1536 he was employed at Florence by Alessandro de' Medici on various ephemeral decorations. He worked in Bologna to make marble reliefs of the *Assumption of the Virgin* (1537–8; church of the Madonna di Galliera). He then went back to Florence in 1538 to design the allegorical garden at Cosimo I de' Medici's villa at Castello, a project described in detail by *Vasari. His work included two great marble and bronze fountains: the Fountain of the Labyrinth and the Fountain of Hercules, much of which was executed by assistants. He also designed a new garden for the Medici villa at Poggio a Caiano and was responsible for the design of the Boboli Gardens behind the Pitti Palace, in Florence. Increasingly, as his career developed, Tribolo delegated the execution of his sculptural models to assistants. However, a small free-standing *Pan* (1549; Florence, Bargello) is wholly from his hand and confirms that his astute vision was matched by technical skills.

HB

TRISTÁN, LUIS (c.1585–1624). Spanish painter born in the province of Toledo; El *Greco's only distinguished pupil (1603–6). His stay in Italy between 1607 and 1613, where he encountered *Caravaggesque naturalism and tenebrism, was decisive for his art. The *Adoration of the Shepherds*, for the church at Yepes (1616), contrasts radically with El Greco's Adorations. The characters are common types and emphasis is placed on naturalistic details. Each figure, strongly modelled by the light, has a solid, tactile presence. The lessons absorbed in Rome are also evident in the sharply illuminated, naturalistic figures and black background of the large *S. Louis of France Distributing Alms* (1620; Paris, Louvre). Among Tristán's most successful pictures are his portrayals of ascetic, rude saints of firm, simple faith. *S. Pedro de Alcántara* (Madrid, Prado), depicted with Tristán's characteristic harshness and intensity, is typical. Tristán's different versions of *The Holy Trinity*, of c.1624, hark back to El Greco's S. Domingo altarpiece for their formal scheme, but his unidealized figures respond to a different sensibility. Tristán also painted some portraits.

NAM

Mallory, N. A., *El Greco to Murillo: Spanish Painting in the Golden Age: 1556–1700* (1990).

TRIUMPHAL ARCHES. The Arches of Titus, Septimius Severus, and Constantine are important survivals in Rome of a large series of monuments erected to celebrate military victories. From the 2nd century BC onwards, arches were associated with triumphs of late republican generals; the form was then restricted to the commemoration of imperial victory. Arches spread to

every other province in the empire (e.g. Arch of Trajan at Beneventum, Arch of Galerius in Thessaloniki).

The Arch of Titus, post-dating the death of Titus (AD 81), spans the triumphal route in the Roman Forum. Panel reliefs depicting the triumphal procession commemorating the victory of Titus and Vespasian over Jerusalem in AD 71 decorate the central passage of the single arch; a miniature version spans the middle entablature. The Emperor appears in his triumphal chariot in one panel, crowned by Victoria Romana; the display of booty from the capture of Jerusalem is shown on the other relief. Victories carrying military standards decorate the spandrels; in the centre of the coffered ceiling, Titus is carried into immortality by Jupiter's eagle. The inscription on the attic refers to its dedication to Titus by the Senate and Roman people. An impression of the original statue group on top may be gained from the chariot groups on the triumphal arch in the relief on the south.

The Arch of Septimius Severus of more than a century later (AD 203), although in the Roman Forum, is not connected with the triumphal route. The arch celebrated the Parthian victories of Septimius Severus and his sons Geta and Caracalla; Geta's name was erased from the inscription after his murder by Caracalla. Most important are the panel reliefs above the lateral passages that depict in three registers the Parthian campaign. These panels recall the painted versions of battles that Roman generals carried in triumphal processions. The whole was crowned with a gilded bronze or silver six-horse chariot group of the Emperor and his sons with attendants.

Standing beside the Colosseum in Rome, the Arch of Constantine exemplifies late Antique use of *spolia* from older monuments to decorate contemporary constructions. Dedicated on 25 July AD 315 to commemorate the tenth anniversary of his reign, this triple arch incorporates elements from monuments of diverse types and periods. Four panels of the 'Great Trajanic frieze' decorate the attic and the central passageway. Above the lateral arches are four pairs of Hadrianic roundels with hunt and sacrifice scenes. Four Aurelian panel reliefs with scenes of the Emperor as a civil and military leader flank the central inscription in the attic; these reliefs are flanked in turn by eight Dacian prisoners (four on each side). The head of the Emperor is often recut to represent Constantine. The remainder of the relief sculpture has been carved *in situ*. Most important are the friezes that record the major battles of Constantine (Verona, Milvian bridge) and his triumphal entry into Rome. The inscription notes that the Senate and Roman people dedicated the arch

to Constantine as a mark of triumph. L-AT

de Maria, S., *Gli archi onorari di Roma e dell'Italia romana* (1988).

TROMPE L'ŒIL, painting meant to 'trick the eye' into believing that what it represents is solid. More precisely, it teases the eye, by prompting sensations at once of flatness and of depth. *Trompe l'œil* is properly the type of *illusionism that makes objects seem to jut from the picture plane, through effects of light-and-shade and texture, rather than that which opens up illusory spaces. In many *Antique and *Renaissance texts it serves as an exemplar of artistic skill. Flies seeming to settle on a painting's surface, or papers (*cartellini*) pinned to it, flaunted this mastery in 15th-century works. Dutch painters specialized in such rendering of low relief, its potential for visual paradox being furthest explored by Cornelis Gysbrechts in his work for the Danish court in the later 17th century. This reduplication of appearances was critically disparaged from c.1800, when the epithet *trompe l'œil* is first recorded. The genre however has remained popular, particularly in America, where the Philadelphian William *Harnett was a distinguished exponent. JB

Battersby, M., *Trompe l'Œil: The Eye Deceived* (1974).

TROOST, CORNELIS (1696–1750) Dutch painter and printmaker. He was the most famous Dutch painter of the 18th century, but he started out as an actor in the Amsterdam playhouse and he continued to paint stage sets after he had turned to full-time painting in 1723. He quickly scored a great success with his group portrait of *The Inspectors of the Collegium Medicum in Amsterdam* (1724; Amsterdam, Historical Mus.) and thereafter he maintained a flourishing Amsterdam portrait practice, including formal group portraits and conversation pieces as well as single portraits. The lively, anecdotal quality of his portraits is even more pronounced in his humorous pictures of actors in famous roles and in his witty genre scenes. He liked to work in pastel and gouache, as in the famous series of pictures (1740; The Hague, Mauritshuis) that depict the activities of a group of men during the night of a drunken reunion. Unlike that of his contemporary *Hogarth, his social comedy is relaxed and good-natured, without any serious satirical or moral intention. AJL

The Age of Elegance, exhib. cat. 1995 (Amsterdam, Rijksmus.).

TROOSTWIJK, WOUTER JOHANNES VAN (1782–1810). Dutch painter. During his short career he was one of the first landscape painters to work en *plein air*. He combined this experience with a sensitive awareness of the 17th-century Dutch landscape tradition to produce a handful of

works of true originality, among them *Landscape in Gelderland* (c.1808; Amsterdam, Rijksmus.). MJ

Op zoek naar de Gouden Eeuw: Nederlandse Schilderkunst, 1800–1850, exhib. cat. 1986 (Zwolle, Provinciaal Overijssels Mus.).

TROUBADOUR STYLE, a form of historical genre painting popular in France in the first decades of the 19th century. This visual expression of the *Romantic historical literature of the late 18th and early 19th centuries included among its ablest exponents *Ingres, *Delacroix, and *Bonington. As this trio of names indicates, the appellation 'troubadour style' does not necessarily indicate a uniform approach to the manner of design or execution, but rather to the choice of subject matter and its interpretation. A typical 'troubadour' painting is of intimate cabinet size and takes as its theme a real or quasi-fictional event from medieval or *Renaissance history. With a finer attention given to the accurate recreation of costume, architecture, and accessories than to historical probability, the subject chosen is usually pregnant with chivalric, amorous, or pathetic possibilities. Examples are Ingres's *Raphael and La Fornarina* (1813; Baltimore, Walters AG) and Delacroix's *Execution of Doge Marino Faliero* (1826; London, Wallace Coll.). MJ

Le Style troubadour, exhib. cat. 1971 (Bourgen-Bresse, Mus. de l'Ain).

Pupil, F., *Le Style troubadour ou la nostalgie du bon vieux temps* (1985).

TROY, JEAN-FRANÇOIS DE (1679–1752). French painter. He was the son and pupil of the portrait painter François de Troy (1645–1730). After spending the years 1699–1706 in Italy he returned to *Paris and became a member of the Académie Royale, of which his father was director. At the outset of his career it seemed that his versatile talent for *history painting, both religious and mythical, would earn him a place as the leading official painter in early 18th-century France. His accomplished canvases in this vein include *Niobe and her Children* (1708; Montpellier, Mus. Fabre), *An Allegory of Time Unveiling Truth* (1733; London, NG), and a series of tapestry cartoons on the theme of *Jason and Medea* (1748; e.g. Birmingham, Barber Inst.). He found himself in competition, however, with a younger painter, François *Lemoyne, who was appointed to the coveted post of Premier Peintre du Roi. De Troy accepted instead the lesser job of director of the French Academy in Rome, in which city he remained from 1738 until his death. To modern eyes de Troy's most attractive paintings are his elegantly detailed genre scenes of contemporary upper-class Parisian life, such as *A Reading from Molière* (priv. coll; formerly Marchioness of Cholmondeley Collection), which open a

window on the civilized world of the *ancien régime*. MJ

Brière, G., in L. Dimier, *Les Peintres français du XVIIIe siècle* (1930).

Levey, M., *Painting and Sculpture in France 1700–1789* (1993).

TRUMBULL, JOHN (1756–1843). American painter. Born in Lebanon, Conn., to an influential family, Trumbull graduated from Harvard in 1773 before serving in the army (1775–7), where he used his skills to draw maps and sketch British positions. From 1780 to 1781 he attempted to study under *West in London but was arrested in retaliation for the execution of a British spy and was deported. Undeterred, he returned after the war and was deeply influenced by West and *Copley. In 1785, encouraged by Thomas Jefferson, he began a series of paintings of the War of Independence designed to foster American nationalism. The first of these, *The Death of General Warren at Bunker's Hill* (1785), derives from Copley's *Death of Pierson*, and the second, *The Death of General Montgomery at Quebec* (c.1786; both New Haven, Yale University AG), from West's *Death of Wolfe*, but his use of dramatic colour and fluid movement is original. Trumbull completed eight Independence paintings, some of which he reproduced, enlarged and pedestrian, in the Rotunda of the Capitol (1818–24). Trumbull gave his unsold pictures to Yale in 1831 in exchange for an annuity. DER

Prown, J., *American Painting* (1969).

TURA, COSIMO (Cosmé) (1430?–95). Italian painter, active in his birthplace, Ferrara, where he was court painter to the Este family of Ferrara. First recorded in their employment in 1452, he designed for various decorative media although much of his work for them, including portraits, is lost. His contemporary reputation is indicated by his inclusion in Giovanni *Santi's rhyme (*Cronaca*) listing the finest painters of the day.

An *Allegorical Figure* (London, NG), probably an early work painted for one of the Este palaces, demonstrates the influence of *Mantegna in its hard sculptural style and classicizing detail. His mannered works with their exaggerated drapery folds and fantastic forms became progressively stylized, as in the later Roverella altarpiece (central panel London, NG). The lunette of the *Lamentation* from this work (Paris, Louvre) combines dramatic foreshortening, unusual colour contrasts of strong green and deep red, and figures which are emotionally distant despite their exaggerated gestures and agonized faces. *S. Anthony of Padua* (Modena, Gal. Estense) displays such extreme psychological and physical tension as to be almost repellent.

Tura marks the beginning of Ferrara's rise as an artistic centre and inspired the work of *Cossa and Ercole de' *Roberti. MS

Boskovits, M., 'Ferrarese Painting about 1450: Some New Arguments', *Burlington Magazine* (1978).

TURIN: PATRONAGE AND COLLECTING. Turin's art world was moulded by the situation of the duchy of Savoy-Piedmont, between France and Habsburg-controlled Milan, and by the aspirations of its ruling dynasty. Duke Emanuel Philibert (ruled 1553–80) won back the duchy from French control and in 1563 he moved the capital from Chambéry to Turin. Thenceforwards the house of Savoy singlemindedly used art and architecture to support their political agenda. In 1713 they won the kingdom of Sicily (exchanged for Sardinia in 1720), and the great architect Filippo Juvarra (1678–1736) was soon brought to Turin to complete the process of transforming the city into a capital that reflected the status of a powerful absolutist ruler. There were avid collectors and patrons among the noble and cultured circles (such as the dal Pozzo family) surrounding the court, but the ruling dynasty was always dominant and constantly looking beyond Piedmont for the artists that its projects required.

Once Turin was established as the capital Emanuel Philibert began his collections by bulk-buying on the art market. Charles Emanuel I (ruled 1580–1630) started the re-building of the city and between 1605 and 1607 he employed Federico *Zuccaro to organize the decoration of the Grande Galleria (destr.) with emblems and portraits glorifying the house of Savoy. He acquired Venetian paintings, commissioned work from the Milanese painters *Cerano, *Morazzone, and G. C. *Procaccini, and owned several pictures by painters influenced by *Caravaggio, including *Caracciolo, *Ribera, *Manfredi, *Saraceni, and *Valentin. In 1623 Orazio *Gentileschi sent him the beautiful *Annunciation* (Turin, Sabauda Gal.) as a gift, in recognition of earlier commissions and the hope of more. By the time van *Dyck visited Turin in 1622 the prestige of the ducal collections was well established, and their administration recognized as a distinct part of the government bureaucracy.

Victor Amadeus I (ruled 1630–7) continued the patronage of Milanese painters by appointing Francesco *Cairo as his court painter in 1633. Victor Amadeus' widow Maria Cristina, who may have had a hand in his death by poison, also admired Cairo's morbid hothouse work and ennobled him in 1646, by which time his work had sadly declined. Maria Cristina was the daughter of Henri IV of France and in her long rule as regent she brought in French painters such as Charles Dauphin (1620–77) as well as channelling work to various Italian families of decorators. She was also responsible for the political statement of the huge new Palazzo Reale in Turin which would continue to be decorated for more than a century. The Duke's younger brother Cardinal Maurice spent the 1620s and 1630s in Rome collecting fashionable work (largely Bolognese) which eventually ended up in the ducal collection.

Charles Emanuel II (ruled 1638–75) took a major step in glorifying the court's cult of hunting by establishing the hunting palace of Venaria Reale, equipped with paintings by Charles Dauphin and by the facile Roman-trained Fleming Jan *Miel. His widow Maria Giovanna (1644–1724) was a great patron. She supported both the Theatine and Jesuit orders and was instrumental in securing building commissions for the Theatine priest-architect Guarino Guarini (1624–83) as well as Andrea *Pozzo's commission (1678) to decorate the ceiling (destr.) of the Jesuit church SS Martiri. Late in life she obtained the services of Juvarra to build the mighty façade of her palace, the Palazzo Madama, and entrusted its lavish decoration to the Genoese Domenico Guidobono (1668–1746).

In 1688 the eclectic Venetian-trained Austrian Daniel *Seiter was made court painter by Victor Amadeus II (ruled 1675–1730), who also obtained work from the Neapolitan, Venetian, and Roman traditions in the form of *Solimena, Sebastiano *Ricci, and *Trevisani. Victor Amadeus brought Juvarra to Turin and commissioned from him the colossal hunting palace of Stupinigi. Under his successor Charles Emanuel III (ruled 1730–73) the elegant Piedmontese court painter Claudio Francesco Beaumont (1694–1766) and the Frenchman Carle van *Loo were only two of several painters engaged in major schemes in the royal palaces. They were especially challenged by the Neapolitan Francesco de Mura (1696–1782) and by the Venetian G. B. Crosato (c.1697–1758), whose work at Stupinigi and elsewhere would not be totally eclipsed by comparison with his great Venetian contemporary *Tiepolo. Charles Emanuel was an active buyer on the Roman art market and was responsible for obtaining from Vienna in 1741 the famous collection of his cousin Prince Eugène of Savoy, the great Habsburg general, which was particularly strong on Dutch and Flemish work. He was extremely pious and that aspect of his taste is illustrated by his commissioning *S. John Nepomuk Confessing the Queen of Bohemia* from G. M. *Crespi (1743; Turin, Sabauda Gal.).

*Neoclassicism came to Turin under Victor Amadeus III (ruled 1773–96). *Mengs visited the city in 1774, the Reale Accademia di Belle Arti was founded in 1778, and Mengs's associate Laurent Pécheux (1729–1821) was made its director. Following the restoration of the monarchy after the Napoleonic occupation, the Neoclassical style remained in official favour. From 1834 the Bolognese Neoclassicist Pelagio Pelagi made ponderous decorations

in the Palazzo Reale. In Turin, as elsewhere in Italy, an art market developed to supply Romantic landscapes, portraits, and portentous history pieces. When the capital of Italy was established at Florence and then Rome the limelight moved away from the city completely.

Turin can clearly be sensed behind the empty squares and arcaded streets of *de Chirico's painting before the First World War. In 1929 the Sei a Torino group of young painters published a manifesto deploring political (i.e. Fascist) content in art. The classicizing Felice *Casorati was certainly the city's most distinguished painter between the wars. From the 1970s Arte Povera (see MINIMAL ART) became the predominant style in the prosperous Turin galleries. AJL

Briganti, G. (ed.), *La pittura in Italia: il seicento* (1989). Briganti, G. (ed.), *La pittura in Italia: il settecento* (1990).

TURIN, SABAUDA GALLERY, a major Italian picture gallery, based on the collection of the princely house of Savoy. The Savoy Collection was founded by Charles Emanuel I (ruled 1580–1630) and was substantially increased by the purchase of Prince Eugène's collection in 1741. The collection was badly hit by the confiscations of the French in 1798, and several paintings from it still remain in Paris. The remainder were reassembled in 1832 to form a public gallery in the Palazzo Madama, Turin. In 1860 the collection was given to the new Italian state and in 1865 it was transferred to its present site in a former Jesuit college built by Guarino Guarini in 1679. The collection, which had been expanded by various gifts from Piedmontese aristocrats and from Bernard *Berenson, was reorganized in its present form in 1959.

The collection is strong on Venetian, Piedmontese, Lombard Mannerist, and Italian *Caravaggesque work. It also includes a notable section of Dutch and Flemish painting, including many exquisite small works from Prince Eugène's collection by painters such as Jan *Brueghel and Gerrit *Dou. The collection of paintings and objets d'art presented by the lawyer Riccardo Gualino in 1928 is shown as a self-contained section. AJL

TURNER, JOSEPH MALLORD WILLIAM (1775–1851). English painter. Turner, one of the most original and important of all European landscape and marine painters, was born and lived in London. The son of a Covent Garden barber, he was initially self-taught and learned through copying prints and drawings and assisting architectural draughtsmen. He attended the RA Schools, *London, from 1789 and exhibited his first watercolour at the RA in 1790 (*The Archbishop's Palace, Lambeth*; Indianapolis Mus.). He was soon commissioned to make watercolours for collectors and engravers and one connoisseur, Dr Thomas *Monro, supported him by engaging him to copy works by J. R. *Cozens and others. He began exhibiting oils at the RA in 1796 (*Fishermen at Sea*; London, Tate), was elected ARA in 1799 and RA in 1802. Although he occasionally exhibited elsewhere (his own gallery 1804–12; the British Institution), his artistic life—and much of his emotional and social life—centred on the RA and its functions.

Turner derived artistic and intellectual stimulus from an exceptionally wide range of artists, both historical and contemporary, and enjoyed the challenge of competition. The painter who influenced him most profoundly was *Claude Lorrain whose classical seaports and mythological landscapes made him weep with frustration in the 1790s and inspired compositions, themes, and light effects up to his final exhibits in 1850. He often acknowledged his debts openly in his titles which include references to artists as diverse as *Raphael, *Canaletto, Jan van *Goyen, *Watteau, and *Rembrandt.

His early oils are characterized by dark, naturalistic colouring reminiscent of previous painters and his early watercolours similarly conformed to current norms of 'tinted drawings'. From c.1820 his work in both media was marked by a unique luminosity produced by the use of lighter grounds, a brighter palette, and an increasingly elaborate technique involving many separate touches and subtle gradations of tones. His ability to depict aerial phenomena and reflections has never been surpassed, but his revolutionary colours and tendency to dissolve forms in radiant vapour provoked accusations of eccentricity and madness.

Turner elevated English *landscape painting from its inferior position below *history painting and *portraiture and gave it a new expressive role. After initially following topographical watercolour conventions and painting *picturesque and *sublime subjects in oils, he often used his works as vehicles of many-layered meanings or symbolic references derived from his extensive reading and poetical imagination and exhibited them with verses, sometimes from his own unpublished *Fallacies of Hope*. His lectures as professor of perspective at the RA (1807–37) stressed the importance of landscape as much as that of his official subject. He demonstrated both his own versatility and that of landscape itself in the didactic series of 70 prints published in 1807–19 as his *Liber Studiorum* (a title echoing that of Claude's *Liber veritatis*).

From 1791, summer sketching tours lasting several weeks were part of Turner's annual routine. The French wars of 1793–1815 confined his early tours to England, Wales, and Scotland, but the Peace of Amiens enabled him to visit Switzerland in 1802. He returned through Paris where he studied many paintings, including those recently looted from Italy by Napoleon. In 1817 Turner toured the Low Countries and the Rhineland and in 1819 he paid his first visit to Italy. The longest of all his tours, this lasted six months and took him to Venice, Rome, Naples, and Florence. He subjected countless European cities, villages, rivers, mountains, and lakes to intense scrutiny, filling over 300 sketchbooks with detailed records in pencil or watercolour. His sketches from nature provided him with the material for both real and imaginary scenes, some compositions taking years or even decades to mature. His favourite destinations in the 1830s and 1840s were Venice, the German rivers, and Switzerland, the infinitely complex effects of light on water and mountain scenery inspiring him to the last.

Turner was immensely prolific throughout his life, producing some 550 oil paintings and over 1,500 watercolours. His numerous patrons, some of whom became intimate friends, included aristocrats requiring pendants to old master paintings in their collections, country squires who fancied a depiction of their house and park, and industrialists in Manchester and Liverpool who needed oil paintings as symbols of their new wealth and status. A high proportion of Turner's watercolours were commissioned by printsellers or publishers for engraving, often in series. Most of the earlier series, up to and including the 96 *Picturesque Views in England and Wales* (1827–38), were large topographical scenes engraved on copper. During the 1830s, besides the *Rivers of France* series, he also supplied many exquisite illustrations as small-scale embellishments to literary works by contemporary or recent authors including Scott and Byron. Thanks to the invention of steel engraving, these reached a huge public and it was this type of work (for Samuel Rogers's *Italy*, 1830) which captivated the youthful *Ruskin, inspiring him to champion the elderly painter against his critics.

A lifelong bachelor, Turner intended that his unsold finished paintings should belong to the British nation and his considerable fortune be used to build almshouses for needy artists. His philanthropic proposal was frustrated by the intervention of relatives disputing his will but, after many compromises, the so-called 'Turner bequest' of oils, watercolours, and sketchbooks is now housed in the Clore Gallery at the Tate (see under LONDON). CP

Gage, J., *J. M. W. Turner: 'A Wonderful Range of Mind'* (1987).

TURONE DI MAXIO DA CAMENAGO (active c.1350–c.1390). Italian painter. Turone was of Lombard origin, but his career was based in Verona, where his version of the bulky Lombard style partly transformed

Veronese painting in the mid-trecento. His œuvre is based around the signed and dated SS Trinità Polyptych of 1360 (Verona, Castelvecchio), which marks an advance on the generally unambitious work of earlier Veronese painters. A number of frescoes are attributable to Turone and his workshop, most notably the dramatic and crowded *Crucifixion* on the interior façade of S. Fermo Maggiore, Verona. JR

Sandberg-Vavala, E., *La pittura veronese del trecento e del primo quattrocento* (1926).

TWOMBLY, CY (1929–). American abstract painter and draughtsman, born in Lexington, Va. He studied at the school of the Museum of Fine Arts, Boston, 1948–9, the Art Students' League, New York, 1950–1, and *Black Mountain College, 1951–2. In 1957 he settled in Rome. His work is characterized by apparently random scrawls on white or black grounds. In his rejection of traditional ideas of composition, he shows an affinity with the all-over style initiated by Jackson *Pollock, but Twombly's work is looser and more disorganized than Pollock's. He has an international reputation and his paintings fetch huge prices in the saleroom. In the catalogue of the exhibition 'American Art of the 20th Century', Isabelle Dervaux writes that 'While most American artists of his generation sought their inspiration in contemporary popular culture, Twombly turned to the traditional sources of Western art: Greek and Roman antiquity and the *Renaissance. Characters from Classical mythology and Antique figures and sites . . . became the focus of his abstractions. They were evoked by cryptic scraps of words, pictorial metaphors and allusive signs . . . A careful reading of Twombly's images permits the viewer to penetrate an apparent chaos to arrive at their inner silence and the opening of a window on the classical past.'

Joachimides, C. M., and Rosenthal, N. (eds.), *American Art of the 20th Century*, exhib. cat. 1993 (Royal Academy, London).

TYMPANUM (Greek: drum), stone or masonry enclosed by an arch, usually supported by a lintel. Tympana, made from one or more pieces of stone, are normally set in doors, but occur in windows and wall arcades. The word can also be applied to the triangle enclosed by a classical pediment.

Plain tympana were occasionally inserted to create a rectangular doorway within an arch (Pompeii, Porta di Stabia), but their purpose is decorative. Tympana belong essentially to the 12th to 14th centuries, with occasional later examples. Most are found on churches, although there are tympana on secular buildings. Medieval tympana were usually carved and painted; some were flat painted (11th century; Capua, S. Angelo in Formis), or decorated in mosaic (Alesso *Baldovinetti at Pisa Cathedral, 1467). Some Italian 15th-century artists used glazed terracotta sculptures (Luca della *Robbia at Florence Cathedral, 1442–5).

Carved tympana appeared in Burgundy at Cluny Abbey and related churches in the late 11th century. From then on they became a feature of decorated doorways, the sculpture often linked thematically with the carving on other parts of the doorway or façade. Tympana were particularly popular in France and those areas of Spain under French influence; they are less common in other parts of Europe. Depth of relief and *iconographical complexity depend on the region and on the importance of the church. The thematic content reflects the position of the tympanum above the main entrance to the church building: the references are to the Christian story, to Judgement, to the patron saint of the church, or a symbolic representation such as the Tree of Life (Kilpeck, Herefordshire). Outside France, where tympana are usually smaller, simple subjects are much more common: *Samson* at Gurk Cathedral, Austria; *Coronation of Roman Martyrs* at S. Cecilia, Cologne. The Christian story can be presented as narrative (*Infancy of Christ* at Verona Cathedral), or theophany (*Christ in Majesty*, Cluny Abbey and Rochester Cathedral, and *Ascension* themes at Ely Cathedral and S. Sernin, Toulouse). The *Last Supper* at Charlieu Abbey symbolizes the Eucharist; the *Mission to the Apostles* at Vézelay Abbey is a unique expression of Christian purpose. The tympana of the *Last Judgement* at Autun Cathedral and Beaulieu Abbey, and of the *Passion of Christ* at S. Gilles-du-Gard, prefigure the complex subject matter of monumental Gothic doorways.

The wide, shallow plane of the tympanum and the stylized, abstract qualities of *Romanesque art were well suited. Such monumental figures as the Christ at Vézelay Abbey are flattened and twisted sideways to respect the depth of the field; yet small figures, as at Moissac Abbey, are almost three-dimensional. In the *S. George and the Dragon* group at Brinsop (Herefordshire), the saint's flying cloak and the sinuous, snakelike dragon form a pattern that follows the semicircular shape of the tympanum.

Style and iconography were fused most successfully in early Gothic tympana, from S. Denis Abbey c.1140 to the mid-13th century. In the great churches of the Île de France, where the façade could have three doorways, the subject of each door could be read independently, but was also linked to the others. The royal portal at Chartres shows the *Incarnation* and *Ascension* of Christ, beside *Christ in Glory* in the centre tympanum. The message was a reminder of Christian belief and the transitory nature of life on Earth. *Judgement* tympana (Amiens Cathedral) warned the congregation to repent their sins, with graphic illustrations of sinners going to hell.

Although such minatory subjects were produced until after the mid-13th century (Lincoln Cathedral, angel choir), new iconographic trends were discernible by the 1160s, when the *Coronation of the Virgin* was depicted definitively at Senlis Cathedral. A response to the cult of the Virgin, the subject invited contemplation and prayer. It reflected the growing emphasis on intercession, which was also expressed on tympana of saints, and was overt at Notre-Dame, Paris, where intercessors appeared on the tympanum with Christ as Judge.

Smaller tympana continued to show a single subject (*Dormition of the Virgin* at Strasbourg Cathedral) with another scene on the lintel, but from the 13th century, starting in French great churches, large tympana were divided into horizontal bands (five including the lintel on the Calixtus portal, Reims Cathedral). Variant forms occur in Spain, where Christ could be shown in a central mandorla (Ávila Cathedral) and England (Westminster Abbey; Crowland Abbey), where scenes were shown in separate roundels. These new arrangements, which allowed much more space, stressed narrative at the expense of theophany. The mood thus altered, in company with changes towards softer, more naturalistic and graceful styles; narrative was to prevail until the end of the Middle Ages.

With religious changes and developments in other forms of sculpture, tympana ceased to be an important focus of imagery from the 14th century, although an impressive tympanum was carved at S. Thiébaut, Thann, after 1360. The most startling late tympanum is the bronze *Nymph of Fontainebleau* (Paris, Louvre), cast by Benvenuto *Cellini in 1543, and eventually installed at Anet. NC

Sauerlaender, W., *Gothic Sculpture in France, 1140–1270* (1970).
Williamson, P., *Gothic Sculpture, 1140–1300* (1995).

TYPOGRAPHY. *See opposite.*

TYPOLOGICAL CYCLES, pictorial programmes, sometimes allegorical, illustrating biblical stories, often demonstrating the unity of Old and New Testaments. Rich layers of meaning in the relationship between the Old and the New Testaments were identified by Christian commentators and typological exegesis had profound impact on art. In particular the pairing of 'antitypes' (New Testament) and 'types' (Old Testament) often gave structure to pictorial programmes.

The systematic use of typological cycles is difficult to discover in early Christian funerary art and literature, although Prudentius'

continued on page 758

· TYPOGRAPHY ·

A term for the study of printing with movable types and the history of the art of the printed book. Although printing with movable types was practised in China in the 11th century and in Korea from the 13th, the mechanization of casting type allowing easy reproduction was not fully developed. Printing as it is known today began at Mainz where Johann Gutenberg (d. 1468), a metalsmith, invented a method for casting individual letters in metal and adapted a press for imprinting them. Gutenberg was a native of Mainz, active in Strasbourg in the 1430s and early 1440s, and by 1455 had printed, with the financial backing of Johann Fust, the first major work printed in Europe—a Bible commonly called the Gutenberg Bible, also known as the 42-line Bible owing to the number of lines per page. In the earliest surviving eyewitness account, Aeneas Silvius Piccolomini (elected Pope Pius II) wrote to Cardinal Juan de Carvajal that he had seen quires of the Bible exhibited at Frankfurt in October 1454 and that all copies (reportedly either 158 or 180) had been sold even before being completed.

Gutenberg's was a technological invention, drawing on advances in metallurgy, enabling the production of individual letters cut first into a punch and then cast in metal from a matrix in a mould. A complete set of letters and other sorts, uniform in size and style, constitutes a fount of type. From a fount lines of type are set and pages of text built up within metal frames, or formes. These formes are then placed on the printing press, inked, and printed onto sheets of paper or parchment. The type is then cleaned, distributed to the printing case, and ready for reuse. Gutenberg's method remained largely unchanged until the 19th century.

Gutenberg has been credited in recent years with inventing another method, whereby two lines of set type were cast together as a single unit. This would have facilitated reprinting editions and has been posited for the *Catholicon* (Goff B-20) dated 1460, copies of which exist with near-identical type settings but printed on distinct paper stocks, whose production spanned twelve years. This interpretation is disputed. Even if true, the experiment appears not to have been repeated, and its natural development, stereotype printing, was not introduced until the 19th century.

Printing spread quickly, first by associates of Gutenberg, such as Albrecht Pfister at Bamberg (*c.*1460), Johann Mentelin at Strasbourg (*c.*1460), and Berthold Ruppel at Basle (*c.*1468). By the end of the 15th century printing was practised throughout Europe, having been introduced in the following principal cities: 1465 at Subiaco (the printers then moving to Rome in 1467); 1466 at Cologne; 1469 at Venice; 1468 at Basle; 1470 at Paris and Nuremberg; 1473 at Lyon, Utrecht, Louvain, and Barcelona; 1474 at Bruges; 1475 at Cracow; 1476 at Westminster and Rostock; 1477 at Seville; 1478 at Oxford; 1488 at Constantinople; and 1495 at Lisbon.

William Caxton was England's first printer. He had learned to print during stays in Cologne in 1471–2, and printed Le Fevre's *Recuyell of the Histories of Troye* in 1473 at Bruges where he had been Governor to the English Nation. By 1476 Caxton had set up shop at Westminster and in 1477 produced his first book, Chaucer's *Canterbury Tales*.

The new technology of printing invited the mechanization of other parts of book production. Printing headlines, or rubrics in red required each page to go through the press twice; although it had been abandoned in the Gutenberg Bible after the first two quires, printing in red continued to be practised sporadically by numerous printers. A more complex effort in the 1457 Psalter, printed by Fust and Schoeffer (with Gutenberg as an unacknowledged participant), was the provision of elaborate decorated initials printed in contrasting colours. Each major initial consisted of two parts, the letter itself and the decorative flourishes, which were inked separately and printed in one pull. This time-consuming process resulted in a beautiful book, all mechanically produced, but its method was not repeated, and printing in three colours remained rare in the 15th century. Once considered a precursor of printing with movable types, blockbooks represent an entirely separate method of printing and were made predominantly in the Low Countries and Germany in the 1460s–1470s.

*Woodcut illustration was well suited to the printed book, since woodblocks and type both require relief printing and can thus be printed simultaneously. The first illustrated printed book was the *Ackermann von Boehmen* printed at Bamberg by Pfister about 1460. Fifteenth-century woodcut illustration reached its apogee with Schedel's *Nuremberg Chronicle*, printed in Latin and German editions in 1493 by Koberger at Nuremberg. It contains over 1,800 woodcuts, the work of Michael *Wolgemut and Wilhelm Pleydenwurff (*c.*1460–94) and their workshop, which may have included the young Albrecht *Dürer.

Books illustrated with engravings (see LINE ENGRAVING) also began in the 15th century with the Florentine printer Nicolaus Laurentii, first in Antonio Bettinis da Siena's *Monte santo di Dio*, and more notably, in the first illustrated edition of Dante (1481). Engraved illustrations were planned to head each of the 100 cantos but the impracticality of combining on the same page type and engraved plates, the printing of which required opposite processes, dictated the abandonment of the endeavour after the first two or three cantos. A further sixteen plates were printed on separate sheets and pasted into a few copies. Engravings, generally on separate sheets, continued to illustrate books. Improvements in the mechanical processes combined with great artistry in France in the 18th century produced some of the greatest achievements of the illustrated

book, such as La Fontaine's *Fables choisies* illustrated by J.-B. *Oudry and printed at Paris in 1755–9. As other processes of illustration were developed, they too were applied to the printed book. Senefelder developed *lithography in Germany, first applied to music printing in 1798, and its first use in England was in J. T. Smith's *Antiquities of Westminster* (1803); the first book illustrated with photographs was Anna Atkins's *Photographs of British Algae* (1843–53).

Although the overall form and layout of the codex was well established by the time of Gutenberg, its handling by masters of the art has produced works of great beauty in every age. Nicolas Jenson is noted not only for being the second printer at Venice but also for the beauty of his types, particularly celebrated in his edition of Eusebius, *De Evangelica praeparatione* (1470). Aldus Manutius was perhaps the most influential of all 15th-century printers (see ALDINE PRESS). Then, as now, calligraphers have been instrumental in determining the look of the printed page, and it was Francesco Griffo who cut Aldus' immensely successful roman, Greek, and italic founts. Griffo's type became the model for the great 16th-century French type designers Claude Garamond and Robert Granjon. Garamond supplied type to Simon de Colines and, most notably, to Robert Estienne. In addition to his important roman types, Garamond created a remarkable Greek type, *grecs du roi*, for Estienne as royal printer. Granjon supplied types to Jean de Tournes at Lyons and the Plantin press at Antwerp, one of the largest and most important shops of the second half of the 16th century, known for its scholarly and elegant productions, as witnessed in the Polyglot Bible of 1572.

The 17th century was dominated by large printing shops such as the Elzevirs, specializing in small-format books. England rose to prominence as a source of pre-eminent type design in the 18th century with the types of William Caslon. John Baskerville of Birmingham united high-quality materials with good design, culminating in his Bible for Cambridge University Press in 1763. Other 18th-century typographers of importance were Bodoni of Parma and the Didots of Paris.

The 19th century was remarkable for its technological advances in the printing process, with the introduction of linotype, electrotype, stereotype and—in the 20th century—monotype, along with the mechanical manufacture of paper. These served good design in the hands of William Pickering in England and Theodore Low De Vinne in the United States, but it was William Morris who most revitalized the art of the book at the end of the 19th century. His Kelmscott Press books (the Kelmscott Chaucer is but one example) harked back to the medieval book, with fine, handmade paper, ink, and type; his 'Golden' type was inspired by Jenson's roman type of four centuries earlier. Morris's influence was immediate, and private presses producing fine examples of craftsmanship, such as the Ashendene Press, Eragny Press, Essex House, and the Doves Press, all started less than a decade after Morris's first efforts.

Fine printing principles were again applied to commercial use in the 20th century, most notably in Germany by the Insel Verlag, Kurt Wolff, and S. Fischer. Among the typographers they employed were Hermann Zapf, Giovanni Mardersteig, and Gothar de Beauclair. In England the German typographer Jan Tschichold designed Penguin paperback classics; in America and England Bruce Rogers designed books for the Riverside Press, and Harvard and Oxford University Presses; and in 1922 Stanley Morison joined the British Monotype Corporation, producing a range of seminal types, some based on older models, and others designed by contemporary typographers such as Eric *Gill (Perpetua), Bruce Rogers (Centaur), Giovanni Mardersteig (Dante), and Morison's own Times New Roman for the London *Times*.

The private press and fine printing movement continues today, the leading lights of which are the Rampant Lions Press in England, the Officina Bodoni at Verona, the Janus and Gehenna Presses in the United States, and Walter Wilke at T. H. Darmstadt in Germany.　　MLF

Blumenthal, J., *Art of the Printed Book 1455–1955* (1973).

Febvre, L., and Martin, H.-J., *L'Apparition du livre* (1958; English edn., *The Coming of the Book*, 1976).

Gaskell, P., *A New Introduction to Bibliography* (1972).

Dittochaeon (48 quatrains describing 24 episodes from the Old and 24 from New Testament), the programme of mosaics (*c*.547) in the presbytery of S. Vitale in Ravenna, and the cycle of 'paintings brought back from Rome by Benedict Biscop' described by the Venerable Bede (673–735) in *History of the Abbots of Wearmouth and Jarrow*, are early examples of typological cycles proper.

From the second half of the twelfth century onwards typological cycles were produced in large number. Most commonly they depicted episodes from the life of Christ (the golden cross commissioned by Abbot *Suger for S. Denis (consecrated 1147) with 68 enamels from the life of the Saviour, destr. in the 17th century, smaller replica *c*.1170, S.

Omer, Mus. Hôtel Sandelin; Stavelot Portable Altar (*c*.1150–60; Brussels, Mus. Royaux); Alton Towers Triptych (*c*.1150–60; London, V&A); the Averbode Gospels (*c*.1160; Liège, Bib. Générale, MS 363)). The enamelled pulpit made by *Nicholas of Verdun that was commissioned by Provost Wernher for the Augustinian monastery of Klosterneuburg, near Vienna (completed 1181), is one of the greatest medieval typological works; the complex programme, explained in inscriptions, comprises three vertical tiers—the *Life of Christ* in the central register, with parallel episodes drawn from two periods of Jewish history (*ante legem* and *sub lege*) above and below respectively. Nicholas of Verdun employed both traditional (the *Crucifixion* paired

with the *Sacrifice of Isaac*) and ingenious (the *Annunciation* with the *Annunciation of Isaac*) alignments of subject matter.

Illustrated typological manuscripts were a very popular form in the later Middle Ages, for example the *Bible moralisée*, created in Paris in the early 13th century, and the *Biblia pauperum*, composed in south-west Germany in the last quarter of the 13th century. Over 80 manuscripts survive of the latter, produced mainly in central Europe. There were many printed editions, the earliest dated around 1460. However the most ambitious work was the *Speculum humanae salvationis*. This anonymous typological text in verse form was written early in the 14th century and survives in more than 350 manuscripts

and incunabula. The text was generally accompanied by an extensive cycle of illustrations. Another, but less widespread typological work, was Abbot Ulrich of Lilienfeld's (d. 1358) *Concordantia caritatis* (composed after 1351).

These works provided a repertory of imagery that was drawn upon for monumental decorative programmes in all media; for example the stained glass of S. Stephen in Mulhouse, Alsace (1330s) and the wall paintings of Königsberg Cathedral (mid-14th century). Their influence persisted and the traditional types and antitypes were given a fresh interpretation by *Michelangelo in the ceiling for the Sistine chapel (1508–12; Vatican).　　　OI

Esmeijer, J. C., *Divina quarternitas: A Preliminary Study in the Method and Application of Visual Exegesis* (1978).
Henry, A., *Biblia pauperum: A Facsimile and Edition* (1987).
Wilson, A., and Wilson, J. L., *A Medieval Mirror: Speculum humanae salvationis 1324–1500* (1984).

TZARA, TRISTAN, born Samuel Rosenstock (1896–1963). Romanian poet, avant-garde theorist, and founding father of *Dada. A member of the Cabaret Voltaire group in Zürich, from which Dada erupted in 1916, Tzara achieved prominence as a polemicist and energetic publicist for the movement. As well as contributing to the outré antics of his compatriots, he produced copious poetry, plays, and seven Dada manifestos. He also produced and edited the periodical *Dada* (1917–20), and established links with Dada sympathizers abroad, especially in Paris. He moved there in 1919, and was later involved with *Surrealism.　　　AA

Peterson, E., *Tristan Tzara* (1971).

UCCELLO, PAOLO (Paolo di Dono) (*c*.1397–1475). Italian painter, designer, and craftsman. His style combines contrasting aspects of Florentine art, the late *Gothic patterning which he learned in the workshop of *Ghiberti, with the mathematical system of *perspective and geometry formulated by the circle of *Brunelleschi. It is largely his original application of perspective, criticized by *Vasari as excessive, which gives his work individuality. He worked mainly in Florence, and was in Venice 1425–7, where he produced a mosaic for S. Mark's.

The underdrawing for an early fresco of *The Creation* for the Chiostro Verde in S. Maria Novella, Florence, with its suggestion of spacious, atmospheric landscape, foreshadows Uccello's shift from the influence of Ghiberti to that of *Donatello. The later scene of *The Flood* (*c*.1450) confirms this, with its exaggerated perspective and recession, used to dramatic effect, despite incongruities in scale. Prior to this lies the commission for the painted equestrian monument to Sir John Hawkwood (1436; Florence Cathedral), in which an illusion of three-dimensionality and two viewpoints has produced a lively yet sculptural effect. Soon afterwards Donatello himself translated the scheme of hero and trotting horse mounted on a sarcophagus into bronze in his *Gattamelata* monument in Padua.

Three panels depicting the *Battle of S. Romano* (mid-1450s; London, NG; Florence, Uffizi; Paris, Louvre), combine geometric configurations with heraldic patterning, the result suggesting a tournament rather than a real event. They are decorative and tapestry-like, in spite of their scientific method. This dualism exists in a more subtle form in some small late works, like the *Hunt in the Forest* (Oxford, Ashmolean), in which the underlying structure created by fallen branches and receding figures is disguised by scattered detail and bright ribbons of colour.

Uccello's experimental approach and individual perception of reality produced works distinct from the current Florentine style and which are unique examples of decoration and pictorial design.　　　MS

Borsi, F., and Borsi, S., *Paolo Uccello* (1992; English trans., 1994).

UDEN, LUCAS VAN (1595–1672). Flemish landscape painter, draughtsman, and engraver. He became a master in the Antwerp guild of S. Luke in 1626/7, after having been trained, in all probability, by his father, Artus van Uden (1544–1627/8). It has sometimes been asserted that he entered *Rubens's studio, but there is no evidence that he provided Rubens with backgrounds, or that the latter painted staffage into his paintings. There is evidence, however, of Rubens's influence on van Uden, who executed numerous copies and pastiches of the master's works. Painted mostly between 1630 and 1650, van Uden's landscapes typically feature a group of tall, slender trees to one side, and a lush plain opposite stretching away to a distant horizon. A unifying light green hue pervades while yellow and light brown accents punctuate the scene (*Summer Landscape*, *c*.1640–50; Mainz, Landesmus.). Frequently David *Teniers II supplied van Uden with figures.　　　KLB

Mai, E., and Vlieghe, H. (eds.), *Von Bruegel bis Rubens*, exhib. cat. 1992 (Cologne, Wallraf-Richartz-Mus.; Antwerp, Koninklijk Mus. voor Schone Kunsten; Vienna, Kunsthist. Mus.).

UGO DA CARPI (active 1502–32). Italian *woodcut designer active in Venice, Rome, and Bologna. Carpi is known for his ongoing concern with issues relating to authenticity, which not only led him to sign his works, an uncommon practice at the time, but also to apply to the Venetian Senate and Vatican for copyright of all his woodcuts.

Furthermore, he attempted to claim the technique of the *chiaroscuro woodcut as his own and sought the protection of the Venetian Senate over it in 1516. Innovations in technique were certainly his forte, abandoning the traditional method of cross-hatching to create contrasts and developing the use of tones. His high-quality prints were usually produced in tones of green or blue. Carpi was less interested in *iconography and compositional elements, adapting the designs of *Dürer and *Titian as well as often copying well-known paintings such as *Raphael's *Massacre of the Innocents* and *Parmigianino's *Diogenes*, which *Vasari claims to be Ugo da Carpi's masterpiece. He also produced woodcut typefaces and wrote published treatises on writing. KC

Servolini, L., *Ugo da Carpi: i chiaroscuri e le altre opere* (1977).

Zucker, M., 'Early Italian Masters', in *The Illustrated Bartsch*, vols. 24, 25 (1980).

U GOLINO DA SIENA (Ugolino di Nerio) (active 1317–27, d. 1339?). Sienese painter who may have been a pupil of *Duccio, and perhaps collaborated with him and others on the *Maestà*, the double-sided altarpiece of Siena Cathedral. Although he carried out Florentine commissions he was relatively unaffected by *Giotto's monumentality, remaining constant, as *Vasari wrote, to 'la maniera greca'.

Ugolino is documented as running a successful workshop in Siena and produced a number of altarpieces for Franciscan churches. His only surviving authenticated works are the panels from the high altarpiece made for S. Croce, Florence, which once carried his signature. This multi-tiered polyptych, clearly deriving from Duccio's *Maestà*, was probably painted in Siena and assembled *in situ* (dispersed; Berlin, Gemäldegal.; London, NG). The design of the predella panels is based on the equivalent scenes on Duccio's *Maestà*, as is the physiognomy of many of the figures, but there is evidence, too, of Ugolino's originality. While his work is elegant and refined, his figures can display emotional intensity, reinforced by the exaggeration of facial features and the use of angular lines. MS

Bomford, D., et al., *Art in the Making: Italian Painting before 1400*, exhib. cat. 1989 (London, NG).

Stubblebine, J. H., *Duccio di Buoninsegna and his School* (1979).

U HDE, WILHELM (1874–1947). German critic and connoisseur. Uhde studied in Munich and Florence before settling in Paris in 1904. He was among the first to recognize the talents of *Picasso and *Braque and purchased his first painting by Picasso in 1905. In 1908 he organized an important *Impressionist exhibition, which was shown in Basle

and Zurich, and in subsequent years exhibitions of contemporary French art in Berlin and New York. He is best known as the champion of Le Douanier *Rousseau and other French *primitifs* or naive painters (see PRIMITIVE). He first met Rousseau in 1907 and bought several of his paintings including *Walking in the Forest* (c.1886; Zurich, Kunsthaus). Uhde organized the first retrospective exhibition of his works in 1908 which, sadly, proved a fiasco as the address was omitted from the invitations. After Rousseau's death in 1910 he wrote the first of several monographs on the painter, *Henri Rousseau* (1911), and continued to promote his work but also 'discovered' Séraphine de *Senlis in 1912, Camille Bombois (1883–1970) in 1922, and Louis Vivin (1861–1936) in 1925. His book *Cinq Maîtres primitifs: Rousseau, Vivin, Bombois, Bauchant, Séraphine* was translated into English, as *Five Primitive Masters*, in 1949. DER

UNDERDRAWING. *See overleaf.*

UNITED STATES OF AMERICA. See AMERICAN ART OF THE USA.

U NTERBERGER FAMILY. Austrian painters. The brothers **Michael Angelo** (1695–1758) and **Franz Sebald** (1706–76) came from the Italian Tyrol and spent time in Venice before returning to work in the Habsburg territories of central Europe. They painted almost exclusively altarpieces in a dramatic late *Baroque style. Michael Angelo was the more successful of the two and his mature style can best be judged in his *Fall of the Rebel Angels* (1752; Vienna, Michaelerkirche). Their nephews **Christoph** (1732–98) and **Ignaz** (1742?–97) trained with their uncles and then in Rome under the *Neoclassical influence of *Mengs. Christoph remained in Rome where he was partly responsible for the decoration of the Museo Pio-Clementino (1770s) and other papal commissions, while Ignaz had a successful career as a court history and portrait painter in Vienna. MJ

Michel, O., 'Peintres autrichiens à Rome dans la seconde moitié du XVIIIe siècle: 2, Christoph Unterberger', *Römische historische Mitteilung*, 14 (1972).

Rasmo, N., *Francesco Unterberger, pittore* (1977).

Ringler, J., *Die barocke Tafelmalerei in Tirol* (1973).

U RBINO is a small town in a poor area of the Apennines that had a moment of glory as a centre of the highest *humanist culture, admired throughout Italy. Federigo II da Montefeltro (1422–82) became *signore* in 1444 and was soon the most respected *condottiere* in Italy. He was paid almost as much for not fighting as for fighting, and the years of relative quiet resulting from the Treaty of

Lodi (1454) gave him security and an overflowing treasury. He exploited these favourable circumstances in a sustained campaign to project his tiny state as a paradigm of culture, magnificence, and good government, and from the mid-1460s he was spending more on building and art patronage than any other ruler in Italy. In 1474 he was made Duke of Urbino by Pope Sixtus IV.

Amongst the leading artists from all over Italy who came to Urbino under Federigo's encouragement were Luca della *Robbia, Paolo *Uccello, *Melozzo da Forlì, Luca *Signorelli, and *Piero della Francesca, who dedicated his treatise *De prospectiva pingendi* to the Duke. *Alberti was a frequent visitor. Because of Federigo's interest in oil painting, *Joos van Wassenhove was also brought to the city, to be the only Netherlandish artist working in Italy.

In Urbino the main project was the building of the huge ducal palace, which sits unaggressively on the flank of the hill town, making an implied statement that here dwelt a ruler at peace with his subjects. The main architects were Luciano Laurana and then Francesco di Giorgio Martini, whom Federico used on military projects throughout the duchy. The harmony of the palace's proportions and the restraint of its superbly crafted decoration make it universally recognized as one of the supreme exemplars of *Renaissance ideals. The Duke's humanist credentials were on display everywhere, especially in his magnificent library and in his *studiolo*, decorated with intarsia symbols of his accomplishments and with paintings of famous men by van Wassenhove. Federigo was succeeded by his son Guidobaldo (1482–1508) and it is his court in 1506 that Castiglione used as the setting for *Il cortigiano*, where it is described as 'the fairest that was to be found in all Italy'. Guidobaldo was childless and the dukedom passed by adoption to Francesco Maria della Rovere (1490–1538) who moved the court to Pesaro, where he and his successors were much involved in architectural projects. He and his wife Eleonora Gonzaga were keen patrons of *Titian, as was their son Guidobaldo II (1514–74), who commissioned the *Venus of Urbino* (Florence, Uffizi). When the Urbino inheritance passed to the Medici in 1634 the Titians were the most famous objects in the settlement.

The last Duke of Urbino, Francesco Maria II (1549–1631), was the only one to be in a position to patronize a first-rate artist who was native to the duchy. Unlike the Urbino-born architect Donato di Angelo Bramante and *Raphael, Federico *Barocci spent all his life in the city apart from two short visits to Rome, and for the 40 years until his death in 1612 he was befriended, housed, and pro-

continued on page 763

· UNDERDRAWING ·

UNDERDRAWING is the preliminary drawing on the prepared panel or canvas to establish the main elements of the composition before the application of the paint layers. Most artists made some kind of preliminary sketch on their *support but our knowledge of these underdrawings is severely limited by the methods available for studying them. Underdrawing was not usually intended to be visible in the finished painting although it can be seen in unfinished works and in some paintings where the paint has become more transparent with age. The discovery that underdrawing could be made visible in infra-red photographs (see SCIENTIFIC EXAMINATION, PAINTINGS) was a great breakthrough and the development of infra-red reflectography by the Dutch physicist J. R. J. van Asperen de Boer in the 1960s opened up a whole new field of underdrawing research. There are many factors which restrict the success of infra-red techniques but, given the correct circumstances, the infra-red radiation is able to penetrate layers of paint opaque in normal light and reveal underdrawing, but only if it is executed in an infra-red-absorbing material such as carbon black.

Any material used by an artist for sketching or other types of *drawing could be used for underdrawing and indeed paints and *inks of various colours, black, red, and white *chalks, *charcoal, *metalpoints (silver and lead), and *pencil or *graphite have all been identified as underdrawing materials. Most studies focusing on underdrawing to date have concentrated on paintings from the 15th and 16th centuries because their technique—thin layers of paint applied over a white ground, with the drawing often in a black material—makes them ideal subjects for examination with infra-red. *Cennini recommends starting with lightly applied charcoal lines, which can be erased with a feather so that changes can be made, and then fixing the final design using ink and dusting away the remaining charcoal before painting. Evidence for this two-stage approach has not often been found, possibly because dusting away the charcoal would leave too little to be seen with infra-red, but both dry materials, such as charcoal and black chalk, and liquid media (paint or ink) have been found in 15th- and 16th-century underdrawings. One example of an underdrawing where the artist has started in a dry material and then 'fixed the design' using paint is Albrecht *Altdorfer's Christ Taking Leave of his Mother (c.1520; London, NG). Later changes in painting technique, particularly the introduction of dark, coloured *grounds and increased thickness of paint, render infra-red techniques less useful so that our knowledge of underdrawing methods at this time relies more on the study of unfinished pictures and paintings of artists at work. These often show white underdrawing, probably white chalk, or outlines sketched in thin oil paint, either in white or a slightly darker shade of the ground colour. Much less work has been done on post-16th-century paintings but, in cases where later artists have used light-coloured grounds and thinner paint, underdrawing has been found, for example in the works of the Dutch landscape and flower painters such as Salomon van *Ruysdael and Jan van *Os, 18th-century artists such as *Watteau, and 19th-century artists such as Jacques-Louis *David, *Ingres, the *Pre-Raphaelites, and *Degas.

The main purpose of an underdrawing is to establish the positions of the important elements of the composition. The style and extent of the resulting underdrawing can vary enormously, from a few sketchy lines to elaborate hatched drawings, complete in every detail. Some underdrawings show a particular style or handling that can be related directly to the artist's drawings on paper but more usually they are simple, functional drawings, often employing a form of visual shorthand, which provide just enough information for the artist to complete the painting. The 15th-century Cologne artist Stefan *Lochner, for example, developed a highly specific system of hatching and cross-hatching to indicate the shadows in drapery folds, which in some ways is reminiscent of later developments in printmaking, while his shorthand for faces involved the use of simple circles for the eyes and short straight lines for the nose and mouth.

In a busy artist's workshop, the job of transferring the master's design to the support may well have been delegated to assistants. There are examples of underdrawings in a careful, painstaking hand being altered by someone else in a freer more flamboyant style, which suggest an assistant carefully copying a design and the master correcting the errors. Annotations have also been found on underdrawings, usually words or letters referring to particular colours to be used (colour notes), although sometimes other information is given, such as the title of the scene depicted or the identification of a character. These notes may have been used as an aide-mémoire by the artist himself, or possibly as directions to assistants left to finish a work without the master. Evidence in the underdrawing can also reveal other aspects of workshop practice: for example, if small dots show along the lines of underdrawing, then the design was probably transferred using a pounced *cartoon; while a stiff, mechanical-looking drawing in a dry material, especially if it has been reinforced in a freer hand, may indicate that tracing was used to transfer the design.

One of the main reasons for studying underdrawings is that they can often provide an insight into the artist's method of planning a composition. Sometimes artists followed the drawing exactly when they came to paint, but often there are differences between the underdrawing and the final painting. These may only be small—the repositioning of a hand or a change to the tilt of a head—or

they may be more drastic, such as the repositioning of a whole figure or the addition of extra figures in the painting that were not planned in the underdrawing. The study of these changes in comparison with other underdrawings, related paintings, and preliminary drawings—if they exist—can help to chart the development of a composition and may be useful in establishing the relationship of a painting to its copies or in determining external influences on the artist. Occasionally infra-red examination will reveal a surprise in the form of underdrawing for a completely different composition.

The study of underdrawings is a fascinating, but relatively new, field and a great deal of work remains to be done, especially outside the Renaissance period. RB

tected by the Duke. He was seen as bringing glory to the duchy and the Duke was active in getting important commissions for him, as well as using his paintings as political gifts. The Urbino court was known for its refinement until the end, but when the duchy reverted to the papacy in 1631 it soon became a provincial backwater. AJL

Cole, A., *Art of the Italian Renaissance Courts* (1995).
Dennistoun, J., *Memoirs of the Dukes of Urbino* (1855).

UT PICTURA POESIS (Latin: as is painting so is poetry; *Horace, Ars poetica*, l. 361). A *humanistic theory of painting, dominant in European art from the 15th to the 18th centuries, and founded in the belief that the aim of both painting and poetry, the sister arts, is to imitate human nature in its noblest forms. It is rooted in *Aristotle's *Poetics*, Horace's *Ars poetica*, and in a saying of Simonides, that painting is mute poetry, poetry a speaking picture. It was elaborated by many 16th-century writers, most eloquently by *Leonardo da Vinci, with the aim of claiming for painting, as for poetry, the status of a liberal art. The belief that the painter should choose elevated themes from history, the Bible, or ancient poetry, and that his greatest affinity with the poet lay in his power to convey human passion, were fundamental. In the 17th and 18th centuries French and English critics made detailed and over-elaborate formal analogies between the two arts, which were challenged by *Lessing, and destroyed by the increasing subjectivity of *Romanticism. HL

Lee, R. W. (ed.), *Ut pictura poesis* (1967).

UTRILLO, MAURICE (1883–1955). French painter, son of Suzanne *Valadon. Utrillo was encouraged to paint by his mother, as a diversion from his early alcohol addiction, and began to paint townscapes in and around Paris in an *Impressionist style. Between 1909 and 1914 he increasingly used white in his palette, as in *Rue Norvins* (1912; Zurich, Kunsthaus). His style showed an interest in ordered composition and flattened space; his later work developed richer, darker colours. From c.1912 he spent long periods in hospitals and other institutions. MF

Werner, A., *Utrillo* (1981).

VAENIUS, OCTAVIUS. See VEEN, OTTO VAN.

VAILLANT, WALLERANT (1623–1677). Dutch painter and *mezzotint engraver. Born in Lille, he worked for most of his career in Amsterdam, though he was in Paris 1659–65. Well known as a painter of portraits, such as that of *Maria van Osterwijck* (1671; Amsterdam, Rijksmus.) and studio interiors, his chief claim to attention is as the first professional *mezzotint engraver. He met the inventor of the technique, Prince Rupert of the Rhine, in Frankfurt in 1658, and thereafter made more than 200 reproductive prints which achieved great fame well into the following century. Particularly interesting is a group of his prints after wash drawings by Jan de Bisschop, the mezzotint technique lending itself particularly well to the reproduction of these tonal works. Vaillant also reproduced his own pictures and some plates are original designs of his own invention: a portrait of his family and two nocturnal landscapes. MJ

> Hollstein, F. W. H., *Dutch and Flemish Etchings, Engravings and Woodcuts c.1450–1700* (1949).
> Luijten, G., 'Jan de Bisschop and Wallerant Vaillant', *Print Quarterly* (1994).

VALADON, SUZANNE (1865–1938). French painter and printmaker. Born in Bessines, Haute-Vienne, Valadon came to Paris as a baby with her seamstress mother. Early on she learned dressmaking, worked as a circus acrobat, and had a son, Maurice *Utrillo. Her first contact with art came through modelling for *Renoir and *Toulouse-Lautrec. Without formal art training, she began to draw and when Toulouse-Lautrec showed these drawings to *Degas, he was sufficiently impressed to arrange a professional exhibition. The many shows and sales which followed brought Valadon financial security, especially after 1924 when the dealer Bernheim-Jeune showed her work regularly. Between 1927 and 1932 she had four major retrospectives and took part in the Salons of Modern Women Artists 1933–8. As an 'independent', untouched by avant-garde *modernism, her conventional landscapes, still lifes, and flower paintings nevertheless included symbolic, personal references, especially in the 1920s and 1930s. Similarly, though she frequently painted the figure, she avoided conventional voyeurism: for example, her painting *The Blue Room* (1923; Paris, Mus. National d'Art Moderne) shows a self-possessed figure in a vibrant setting. GS

> Rose, J., *Mistress of Montmartre: A Life of Suzanne Valadon* (1997).

VALCKENBORCH (Valkenborgh) FAMILY. Flemish landscape painters. The family was originally from Louvain, but was one of many who, for political or religious reasons, left the Spanish Netherlands and settled in the more tolerant German imperial cities, particularly Frankfurt. Of the fourteen known painters in the family, only four are significant: **Marten I** (1535–1612), his brother **Lucas I** (c.1635–97), and Marten's sons **Frederik** (1566–1623) and **Gillis** (1570–1622). Marten and Lucas were trained in Malines. After an existence disrupted by war and religious persecution, they eventually settled in Frankfurt, where they ran a flourishing workshop. Both brothers worked in the tradition of Pieter *Bruegel the elder, and both favoured the subject of the Tower of Babel. They also painted series of the Seasons, and their winter scenes are especially notable. Lucas's woodlands with pastures (*Cattle Pasture under Trees*, 1573; Frankfurt, Städelsches Kunstinst.) and road views are important precursors of the landscapes of Jan *Brueghel the elder and the generation of Flemish painters around the turn of the century. Frederik and Gillis van Valckenborch were born and trained in Antwerp. In 1586 they moved to Frankfurt with their father Marten. After an extended trip to Italy, both

brothers returned to Frankfurt, where Gillis remained for the rest of his career, whereas Frederik settled in Nuremberg in 1602. Frederik's few known paintings are characterized by dramatic contrasts between light and dark and by dynamic, somewhat fantastic forms (*Landscape with Hunters*, 1612; Antwerp, Koninklijk Mus. voor Schone Kunsten). His drawings, on the other hand, show an acute observation of nature as well as topographical correctness. Gillis worked in close collaboration with his brother until the latter moved to Nuremberg. Their works are sometimes confused. Three signed and dated drawings testify to his Italian sojourn (*Landscape with a Ruin*, 159?; Copenhagen, Statens Mus. for Kunst). KLB

Wied, A., *Lucas and Marten van Valckenborch* (1990).

VALDÉS LEAL, JUAN DE (1622–90). The last great *Baroque religious painter in Andalusia; also active as a sculptor and *etcher. Son of a Portuguese father, he worked at Cordoba c.1644–50 and returned to work on the high altar of the church of the Carmelitas Descalzas, painting above all the *Ascension of Elijah* (1655–8; *in situ*). By 1656 he was established at Seville, where he remained for the rest of his life, executing paintings for the churches and religious houses of the neighbourhood, such as the series of *The Life of S. Jerome* (1657 onwards; three Seville, Mus. de Bellas Artes) and the series of the *Life of S. Ignatius* (1660; Seville, Mus. de Bellas Artes). *The Allegory of the Crown of Life* (York, AG) and the *Vanitas* (Hartford, Conn., Wadsworth Atheneum), two of his finest pictures, also date from 1660. The special characteristics of his style are intense feeling for movement and dramatic use of colour. His most remarkable works are the two large *Allegories of Death* (see also VANITAS) commissioned c.1672 by the Hospital de la Caridad, Seville (*in situ*), which illustrate the latent medievalism of Spanish taste. The two donors portrayed in his *Immaculate Conception* (1661; London, NG) demonstrate his ability as a portrait painter, also evident in his *Don Miguel Mañara Presiding over a Meeting of the Hermandad de la Caridad* (Seville, church of Hospital de la Caridad). In the 1680s he took up fresco painting, working again at the Hospital de la Caridad and in the church of the Hospital de los Venerables Sacerdotes. HB

Valdivieso, E., *Juan de Valdés Leal* (1988).

VALENCIENNES, PIERRE-HENRI DE (1750–1819). French landscape painter and theorist. Although trained in Paris and Rome as a *history painter, the influence of Joseph *Vernet turned him towards landscape, to which he devoted his career as an artist and writer. He regularly exhibited large-scale historical landscapes in the manner of *Poussin, such as *Cicero Uncovering the Tomb of Archimedes* (1787; Toulouse, Mus. des Augustins), and his treatise *Elemens de perspective* (1799) did much to raise the status of landscape painting in France. It was only in 1930, however, that his full stature as a painter became generally appreciated, with the presentation to the Louvre of numerous small oil studies that he had made in the open air. These sketches, many depicting the same object or view in different light conditions, anticipated the effects and techniques of the *Impressionists. Although Valenciennes would not have agreed, regarding them as preparations for his finished classical pictures not as works in their own right, they are his main contribution to the history of art. MJ

Lacambre, G. (ed.), *Les Paysages de Pierre-Henri de Valenciennes, 1750–1819*, exhib. cat. 1976 (Paris, Louvre).
Radisich, P. R., *Eighteenth-Century Landscape Theory and the Work of Pierre-Henri de Valenciennes* (1981).

VALENTIN DE BOULOGNE (Le Valentin) (1591?–1632). French painter who went to Italy and was active at Rome where he was influenced by *Caravaggio and *Manfredi. He was born at Coulommiers-en-Brie, Seine-et-Marne, and his name derives from Boulogne-sur-Mer, Pas de Calais. His father, also a painter of the same name, may have provided his early training but his style was formed in Italy. According to the German writer *Sandrart he was in Rome before 1614, when his compatriot *Vouet arrived, but he is first securely documented there in 1620. By 1624 he was associated with the *Schildersbent, a group of Dutch and Flemish painters living in Rome; and he was also a member of the Accademia di S. Luca (see under ROME). Valentin's early work appears to reflect the same preoccupations, subject matter, and stylistic influences that are associated with other artists from the Manfredi circle: low-life *genre scenes such as the *Cheat* (Dresden, Gemäldegal.) and the *Concert* (Chatsworth, Derbys.) and more dramatic religious subjects, incorporating relatively humble protagonists, such as the *Denial of S. Peter* (Florence, Longhi Foundation) and *Christ Driving the Moneychangers from the Temple* (Rome, Gal. Corsini) which shows the influence of Caravaggio's *Calling of S. Matthew* (Rome, S. Luigi dei Francesi).

He also painted pictures with more overt themes of violence, such as *Judith and Holofernes* (Valletta, Mus. Nazionale) which owes a clear debt to Caravaggio's picture of the same subject (Rome, Barberini Gal.) and matches Artemesia *Gentileschi's style in its unflinching aggression; and the *Martyrdom of S. Processus and S. Martinian* which he was commissioned to paint for S. Peter's (1629; Vatican Mus.). In this respect he already stands apart from other artists in the Manfredi circle, who tended to concentrate only on the more anecdotal aspects of Caravaggio's art.

During the mature phase of his career Valentin's work becomes more refined in execution and less abrupt in mood. There is already a noble grandeur, a fusion of Caravaggism and the classical Baroque in his *Allegory of Rome* (1628; Rome, Institutum Romanum Finlandiae). There is more emphasis on conveying psychological relationships between the protagonists, as in the *Judgement of Solomon* (Paris, Louvre) or the *Fortune-Teller* (Paris, Louvre); also often a more spiritual or introspective quality in the characterization of the figures as in the *Four Ages of Man* (London, NG). He even occasionally painted a portrait, for instance the jester *Raffaello Menicucci* (Indianapolis Mus.). To appreciate the direction of Valentin's development from uncompromising and overt Caravaggesque naturalism to a more probing and emotionally vulnerable sense of the human condition it is instructive to compare two paintings of vertical format painted for the Barberini family, which provided many of Valentin's commissions: a muscular, physically assured *David with the Head of Goliath* (priv. coll.), commissioned in 1627, and a *Samson* (1631; Cleveland, Mus. of Art) where the equally robust figure appears to be lost in thought and disconcertingly troubled. It is this complexity and the capacity to convey tender emotions that elevates Valentin's work beyond the more mundane and self-regarding style of the *Manfrediana methodus*. It may also explain why the artist apparently never attracted close followers or pupils, although by the time of his death the style had in any case fallen out of fashion. HB

Bréjon de Lavergnée, A., and Cuzin, J., *Valentin et les Caravaggesques français*, exhib. cat. 1974 (Paris, Grand Palais).
Mojana, M., *Valentin de Boulogne* (1989).
Nicolson, B., *Caravaggism in Europe* (2nd edn., 1990).
Rosenberg, P., *France in the Golden Age*, exhib. cat. 1982 (Paris, Grand Palais; New York, Met. Mus.).

VALLOTTON, FELIX (1865–1925). Swiss-born printmaker, painter, and critic. Vallotton settled in Paris in 1882 when he came to study at the Académie Julian. He became famous as a printmaker, particularly for his *woodcuts executed in an *Art Nouveau style; these he began in 1892 and they were published internationally. He supported himself initially by making *etchings after the popular masters and worked as the Paris critic for the *Gazette de Lausanne*. He joined the *Nabis group in 1892 and exhibited with them regularly. *Money* (1892; Chicago, Art Inst.) from his second album of interiors, *Intimités*, shows his common subject, the relations between men and women, framed by

contemporary concerns about female sexuality and bourgeois convention. It is also typical of his technique: employing stark contrasts between blocks of black and white, his forms tend to be soft. In his paintings his execution has a schematic, *Symbolist manner and his colours are subdued and harmonious. After 1902 he concentrated on painting interiors, nudes, and landscapes in an evocative, but calm, classicizing manner, an example being *Solitaire (Nude Playing Cards)* (1912; Zurich, Kunsthaus).　　MF

Newman, S. M., *Felix Vallotton* (1991).

VALORI PLASTICI, an art periodical published in Rome from 1918 to 1921 in both Italian and French editions (it was originally a monthly but became bi-monthly). The editor and publisher was Mario Broglio (1891–1948), a critic and painter, who was conservative in outlook. The first number contained articles by *Carrà, *de Chirico, and Alberto Savinio (1891–1952) setting forth the ideals of *Metaphysical painting. Under the Fascist regime *Valori plastici* was one of the few channels that informed the Italian public about current trends elsewhere in Europe (it carried articles on *Cubism and De *Stijl, for example). However, the main tenor of the journal—supported by Carrà and de Chirico—was in favour of a return to the Italian classical tradition of naturalism and fine craftsmanship, and European avant-garde movements were criticized for forsaking the principles of that tradition.　　IC

VANITAS, a title given to a type of *still-life painting which warns against the transience of worldy pleasures and of earthly power and glory; it derives from the pessimistic sentiment of Ecclesiastes 1: 2: 'Vanity of vanities, all is vanity.' All still lifes, of flowers, fruit, and food, carry overtones of transience, but in 17th-century Leiden, a university town, the dense symbolism of still lifes which gather together a variety of objects suggesting both transience and the insubstantiality of wealth and knowledge became popular; characteristic is Harmen *Steenwyck's *Vanitas* (c.1640; Leiden, Stedelijk Mus.) with its flickering candle, burned-out pipes, its history book and precious shell, and, dominating all, the skull. The type was also popular in 17th-century Spain, where such artists as Antonio *Pereda and Juan de *Valdés Leal created grander and more menacing works; in Valdés Leal's two epic *Vanitas* paintings for the Hospital de la Caridad in Seville (1670–2; *in situ*) threatening skeletons and maggot-infested corpses were intended to inspire fear and encourage acts of charity.　　HL

VANNUCCI, PIETRO. See PERUGINO.

VANTONGERLOO, GEORGES (1886–1965). Belgian sculptor and painter. He trained in Antwerp and Brussels. His works were illustrated, along with selected writings, in the De *Stijl journal from July 1918; both demonstrated his faith in geometric *abstraction. Sculptures such as *Interrelation of Volumes* (1919; London, Tate) create an architectonic play of volumes through their interaction of mass and void. In their balance of positive against negative they manifested a three-dimensional realization of the principles of De Stijl. In 1928 Vantongerloo moved to Paris and became involved with the Cercle et Carré and *Abstraction-Création movements.　　MT

VANVITELLI, GASPARO (Gaspar Wittel) (1652–1736). Dutch painter and draughtsman, active in Italy. After training in Amersfoort he went to Rome where he is first recorded in 1675. For the remainder of his life he devoted himself to *topographical view paintings and drawings. He concentrated on showing the city of Rome not as the site of ancient ruins but in its most modern aspect, and took pains to find original vantage points. He also visited Lombardy and Naples. Many of his paintings were produced (in several versions) from drawings, made on the spot and then elaborated and squared up in the studio.　　HB

VARCHI, BENEDETTO (1503–65). Florentine historian, man of letters, and art theorist, whose career suggests the close relationship between literature and art in Medicean Florence. Exiled from Florence, he travelled in north Italy, and in Venice moved in the literary and artistic circles of *Titian and *Aretino. He later won the patronage of Cosimo I, and lectured at Florence on *Dante and *Petrarch at the Accademia Fiorentina; popularizing, for patrons and artists, an awareness of symbol, metaphor, and allegory. In 1547 he delivered two lectures on the arts in Florence, in which he contributed to the *paragone debate. Subsequently, he held an inquiry into the subject (perhaps the first public inquiry into an artistic matter) and received answers from *Vasari, *Bronzino, Niccolò *Tribolo, Giovan Battista Tasso (1500–55), Francesco da Sangallo, *Pontormo, and *Cellini. Varchi published these as *Due lezzioni* (1549), adding his own conclusion that all the arts, since they have the same aim, are one. This he sent to *Michelangelo, who professed, surely ironically, his agreement with this proposition.　　HL

Mendelsohn, L., *Paragoni: Benedetto Varchi's* Due lezzioni *and Cinquecento Art Theory* (1982).

VARGAS, LUIS DE (c.1505–1567). Painter born in Seville who spent many years in Italy; his work demonstrates close contact there with the *maniera* painters *Vasari, F. *Salviati, and *Perino del Vaga. Returned to Seville, Vargas painted eight panels for an altarpiece in the cathedral dedicated to the Nativity (1555); the central image, representing the *Adoration of the Shepherds*, reflects the figure style and rather acid colours of the Italian *maniera* (see MANNERISM). Vargas's best-known painting, the doctrinally and compositionally complex *Allegory of the Immaculate Conception* (1561; Seville Cathedral), is closely based on Vasari's version of the same subject (1541; Florence, SS Apostoli).　　SS-P

Brown, J., *The Golden Age of Painting in Spain* (1991).

VARNISH. See RESIN.

VASARELY, VICTOR (1908–94). Hungarian; active in France from 1930 as a painter, printmaker, and pioneer of *Op art. The patterned forms of some of his early commercial work such as *Zebras* (1933–8) reflect his training with *Moholy-Nagy in Budapest, and signal his later interests. He collaborated with architects as in *Memorial to Malevich* (1954; Caracas University), and experimented with *kinetic art. His dazzling Op art paintings like *Supernovae* (1959–61; London, Tate) significantly influenced contemporary graphic and popular arts. There are Vasarely museums at Aix-en-Provence and Gordes, in France, and Pecs in Hungary. He expounded his theories in *Yellow Manifesto* (1955).　　YJ

Diehl, G., *Vasarely* (1972).

VASARI, GIORGIO (1511–74). Italian painter, architect, and biographer, whose varied interests typify the intellectual artist/designer of the late *Renaissance. He travelled extensively and contributed to the evolving character of court and church decoration in Florence and Rome. One of the earliest collectors of old master drawings, which he mounted in his Libro di Disegno, he was instrumental in the institution of the Florence Accademia del Disegno (1563). He is perhaps best known as the author of the *Lives of the Most Excellent Painters, Sculptors, and Architects*, in which he laid down the foundations of critical art historiography.

Vasari was born in Arezzo, into a family of artists and potters, and he claimed to have received his first drawing lessons from Luca *Signorelli. He was taught painting in Arezzo by Guillaume de Marcillat, an artist familiar with the work of *Michelangelo and *Raphael in the Vatican, and in 1524 went with Cardinal Silvio Passerini to Florence, where he was taught with the young Medici, Alessandro and Ippolito. Here he acquired a knowledge of Latin and classical themes, as well as training with the artists *Andrea del Sarto and *Bandinelli and briefly meeting Michelangelo. When the Medici were expelled from

Florence in 1527 he returned to Arezzo, and met *Rosso Fiorentino, but in 1529 was again in Florence apprenticed as a goldsmith. In 1532 he studied art and architecture in Rome with *Salviati.

From this point he worked successfully as a painter mainly in Florence and Rome, securing commissions from the Medici, for example the posthumous portrait of *Lorenzo il Magnifico* (1534; Florence, Uffizi), and for large-scale court and civic projects like the decorations for the entry of Charles V into Florence in 1536.

Vasari's principal paintings are fresco cycles, evidence of his talent as a decorator and organizer of large workshops, but he executed some significant altarpieces. The *Immaculate Conception* for SS Apostoli, Florence, which derives from a composition by Rosso, is elegant and fluid in style and influenced the interpretation of the subject. His major fresco schemes, while stylistically eclectic, are notable for their learned and mythological references. The '100 Days Fresco' (Rome, Cancelleria) depicts deeds of Pope Paul III within a grandiose setting of fictive architecture, and the lavish decoration of his own house in Florence includes illustrations of *Pliny's anecdotes of the artists of *Antiquity. From 1554 Vasari was responsible for the architectural remodelling and decoration of the Palazzo Vecchio, Florence, as a ducal residence for Cosimo de' Medici. With the help of numerous assistants he produced a historical and allegorical programme which focuses on the contribution of Medici patrons to the rebirth of the arts, and which culminates in the apotheosis of Cosimo I, the personification of Florentine history.

Of Vasari's architectural works, the Uffizi illustrates well his design skills. It housed the various administrative offices of Florence in its two wings, thereby representing civic centralization. However, the arrangement of the offices is clearly indicated on the façades by a series of entrances marked by Doric columns and piers.

The *Lives*, first published in 1550, was dedicated to Cosimo de' Medici, and includes an introduction to the three arts and three sections of biographies, the only living artist included being Michelangelo. Vasari believed that art is primarily the imitation of nature, progress in art consisting of the perfecting of the means of representation. His view was that this perfection had been achieved by the artists of classical Antiquity, and, after a period of decline during the Middle Ages, was gradually restored by the artists of Tuscany. He divided the process of revival into three epochs, a concept familiar in Antique literature and one he also applied in his classification of Antique art. These began with the *primi lumini* *Cimabue and *Giotto, whose imitation of nature was improved by the *augmenti* of the 15th century and culminated in the *perfezione* of Michelangelo and his contemporaries. This chronological perception of stylistic development, based on truth to nature, and the linking of classical with 16th-century art became the basis of subsequent art historical method.

In addition Vasari built on earlier theorists like *Alberti in formulating a method of stylistic analysis, in which he emphasized the fundamental role of *disegno*, for all three arts, and established aesthetic criteria by which art could be judged. Each biography presents the individual artist's character and contribution against this broader background of artistic development and evaluation.

The enlarged edition of the *Lives* (1568) expands on the histories of artistic techniques, describes individual genres, and introduces the classification of artists by region as well as by techniques. There are more biographies, many of them now of living artists, and various private collections are mentioned. A broad picture is thus presented, of the history of taste as well as of style and method. Although Vasari's biographical and anecdotal accuracy can sometimes be questioned, the *Lives* is one of the most valuable sources for the period covered and for the outlook on art which it embodies. MS

Rubin, P. L., *Giorgio Vasari: Art and History* (1995).
Satkowski, L., *Giorgio Vasari, Architect and Courtier* (1993).
Vasari, G., *Le vite de' più eccellenti pittori, scultori e architettori nelle redazioni del 1550 e 1568*, ed. R. Bettarini and P. Barocchi, 6 vols. (1966–87).

VECCHIETTA, IL (Lorenzo di Pietro) (1410–80). Italian painter and sculptor of the Sienese School. He may have trained under *Sassetta, and throughout his career practised both as a painter and a sculptor. His earliest documented work at Siena includes the fresco for the Pellegrinaio of S. Maria della Scala (1441) (where he painted again in 1446–9) and at the baptistery (1450–3). He made several visits to Rome, to work on tomb sculpture and to discuss with Pius II the proposed Logge del Papa for Siena (1460). His sculpture displays a knowledge of the work of *Donatello, who visited Siena between 1457 and 1459, and the influence of contemporary Roman sculpture, resulting in a vigorously modelled and highly charged bronze sculptural style, visible for instance in his *Flagellation* panel (c.1460; London, V&A). Other reliefs including *The Resurrection* (1472; New York, Frick Coll.) and a statue of *The Risen Christ* for the ciborium now on the high altar of Siena Cathedral (1476; Siena, S. Maria della Scala), intended for his own memorial chapel, demonstrate the power of his sculpture. His only works in marble are the *S. Peter* and *S. Paul* for the Loggia della Mercanzia in Siena (1458–62). AB

Pope-Hennessy, J., *Italian Renaissance Sculpture* (4th edn., 1996).
Vigni, G., *Lorenzo di Pietro, detto Il Vecchietta* (1938).

VEDUTA (Italian: view), used to denote a type of *topographical picture—especially of Rome, Venice, and Naples—that flourished between the late 17th century and the Napoleonic Wars. The central characteristic of the genre is accuracy in conveying information about cities and ancient buildings. This reflects both the preoccupations of the Enlightenment and also the fact that *vedute* had a huge export market outside Italy as souvenirs of the *Grand Tour. The organization of *perspective was especially important; *Canaletto and many other *vedutisti* had experience in designing for the théatre. The first fully-fledged *vedute*, as in the work of *Vanvitelli from the 1680s, were firmly descriptive and objective in their focus. As the genre developed a greater range of interpretative response was admitted, as in the high-keyed emotionalism of *Piranesi and the cultivation of atmosphere by Francesco *Guardi. *Eckersberg's paintings of Rome (1813–16) are true *vedute*, though by that late date the *Romantic emphasis on subjective interpretative values had virtually submerged the genre. AJL

Briganti, G., *View Painters of Europe* (1970).

VEEN, OTTO VAN, also called Octavius Vaenius (1556–1629). Flemish painter and humanist, teacher of *Rubens. Born in Leiden of a Catholic family, he left his home town in 1572 when it fell into Protestant hands, first going to Antwerp, later Liège in the Southern Netherlands. There he studied with the humanist and artist Domenicus Lampsonius (1532–99) whose intellectual interests he came to share. In 1574/5 van Veen travelled to Italy; a period in the studio of Federico *Zuccaro, as has been proposed, cannot be proven, though he undoubtedly was exposed to Zuccaro's work. After visits to Prague, Munich, Liège, and Leiden, van Veen entered, c.1587, the service of Alessandro Farnese in Brussels, moving to Antwerp c.1590. Rubens was in his studio c.1594–8, and continued to work with him until he left for Italy in 1600. Van Veen executed altarpieces, *history paintings, allegories, and portraits; he designed prints and emblem books. His earlier works show the animated style of Zuccaro, but he later abandoned *Mannerist complexity for a clearer, more rational *classicism (*Crucifixion of S. Andrew*, 1594–9; Antwerp, Sint-Andrieskerk). Van Veen knew Latin and was part of the intellectual life of Antwerp. His scholarly and literary interests

were of great importance to Rubens.　KLB

Mai, E., and Vlieghe, H. (eds.), *Von Bruegel bis Rubens*, exhib. cat. 1992 (Cologne, Wallraf-Richartz-Mus.; Antwerp, Koninklijk Mus. voor Schone Kunsten; Vienna, Kunsthist. Mus.).

VEHICLE. See MEDIUM.

VEIT, PHILIPP (1793–1877). German painter. He was born in Berlin and became the stepson from 1804 of Friedrich von *Schlegel. Through Schlegel he met many of the leading Romantic writers in Vienna. In 1810 he became a Catholic and in 1815 painted the *Virgin with Christ and S. John* for the church of S. James, Heiligenstadt, Vienna, in a style inspired by *Perugino and early *Raphael. He was in Rome from 1815 to 1830 and became a leading member of the *Nazarenes, a group of German artists in the circle of *Overbeck and *Cornelius. Together they executed fresco decorations for the Casa Bartholdi (now Biblioteca Herziana) in 1816–17. The following year he was commissioned to paint a fresco of *The Triumph of Religion* in the Museo Chiaramonti in the Vatican. At the Casino Massimo, Rome, he painted the ceiling of the Dante room with the *Heavens of the Blessed* and the *Empyrean* (in situ); and at S. Trinità dei Monti he painted a *Maria Immaculata* (1829–30; in situ). A *Self-Portrait* dating from his time in Rome is at Mainz (c.1816; Landesmus.). In 1830 Veit left Rome and became director of the Städelsches Kunstinstitut in *Frankfurt. Here he painted murals that illustrated his ideas on art and history and artistic regeneration, including a fresco *The Introduction of the Arts to Germany through Christendom* (1832–6; in situ). He resigned from the Institute in Frankfurt in 1843 and moved with his pupils into studios in the Deutschordonshaus in Sachsenhausen, Frankfurt. Ten years later he moved to Mainz to design decorations for the cathedral, of which only the *Life of Christ* over the arches in the nave has survived. He painted a further *Self-Portrait* in 1873 (Mainz, Landesmus.).　HB

Andrew, K., *The Nazarenes: A Brotherhood of German Painters in Rome* (1964)

VELÁZQUEZ, DIEGO DE SILVA Y (1599–1660). Spanish painter born in Seville into a family of the lesser nobility and modest means. In 1610 he was apprenticed to Francisco *Pacheco, whose theoretical and *humanistic interests and contacts would be important for his art. Velázquez entered the painters' guild in 1617, and a year later married Pacheco's daughter. His first works were *genre scenes—some of the earliest done in Spain—painted in a naturalistic and tenebrist style that parallels *Caravaggio's and that of artists working in Toledo in the first quarter of the century. His first masterpiece in that genre is the *Old Woman Frying Eggs* (1618; Edinburgh, NG Scotland), which stresses his superior skill in the imitation of nature. Figures and objects, however, are given equal emphasis, and remain isolated entities. In the *Water Carrier of Seville* (1619; London, Apsley House) the figures are dominant and the picture's components are integrated into a well-knit composition, although the characters remain psychologically isolated. As in the early genre pieces, the naturalistic figures of the *Adoration of the Magi* (1619; Madrid, Prado) occupy a shallow stage close to the picture plane, defined almost exclusively by their overlapping bodies. These volumes are compressed into a compact, relief-like mass, where space is of little consequence.

In 1621, Philip IV ascended to the Spanish throne, and the following year Velázquez travelled to Madrid, hoping for employment at the court through the protection of the Count-Duke of Olivares, the King's favourite. His expectations were frustrated, but the death of one of the court painters in 1623 opened up a vacancy and Velázquez returned to Madrid, where he was soon appointed to the post. His first painting for Philip was a full-length portrait, whose pose is reflected in the early *Portrait of Infante Carlos* (Madrid, Prado), which has an even simpler composition; the Prince stands in a space defined exclusively by the meeting lines of the wall and floor planes and the shadow he casts on the floor.

The *Feast of Bacchus*, known as *The Topers* (1628; Madrid, Prado), a mythological scene in the guise of genre, is Velázquez's most important surviving picture painted at the court during the early years. The portrayal of the drinkers surpasses in realism Velázquez's Sevillian works, as does the vivacity of their expressions. The illumination is more generalized and the shadows more transparent, but the composition is still relief-like, with little space between figures, and the landscape merely a backdrop. In 1628 *Rubens visited the Spanish court, and shortly after his departure the following year Velázquez set out for Italy. He travelled around the peninsula for a year and a half, settling in Rome for a long stay. The most relevant work of this period is *The Forge of Vulcan* (Madrid, Prado), and the distance that separates its style and technique from earlier works demonstrates the importance of Rubens's visit and of his own Italian journey. Although the figures are in a group parallel to the picture plane, the intervals between them are as important as their volumes. The deep space of the forge is fully defined, from the picture plane to the fireplace and shadowy figure at the back of the room. The change in Velázquez's representation of light is no less remarkable; a clear light bathes the flesh of the gods and Cyclops, and permeates the space they inhabit. Here, Velázquez attains the illusion of reality by describing the visual world in terms of the impression it makes on the eye of the beholder, rather than of its tactile substance, as before.

After leaving Seville, Velázquez executed only a handful of religious pictures. The most important are a large *Christ on the Cross* (c.1631/5; Madrid, Prado), painted for the nuns of S. Plácido in Madrid, and a sizeable canvas of *S. Anthony Abbot and S. Paul the Hermit* (c.1634/5; Madrid, Prado), done for a hermitage in the Buen Retiro. Its colouring, luminosity, and the handling of the extensive landscape bring out the extent of Velázquez's artistic evolution in the five or six years after his first Italian journey.

Most of Velázquez's activity in the 1630s relates to the decoration of the recently built Buen Retiro Palace and Torre de la Parada. The most important project in the palace was the decoration of the Salón de Reinos, which consisted of twelve large battle pictures celebrating recent Spanish victories, ten pictures of the Labours of Hercules, and five equestrian portraits of the royal family. Velázquez himself executed *The Surrender of Breda* and the equestrian portraits of *Philip IV* and *Prince Baltasar Carlos* (1634; Madrid, Prado). In the *Surrender*, Velázquez highlighted the chivalrous magnanimity of the victors, the Genoese general Ambrogio Spinola and the Spanish troops he commanded. The gestures of the principals and the contrast between the disarray of the Dutch soldiers and the compact mass of the Spaniards and their lances convey with subtlety and apparent naturalness the military and human situation. For the Torre de la Parada, Velázquez painted an original and witty *Mars* in repose, and imaginary portraits of *Menippus* and *Aesop* (Madrid, Prado), as well as three full-length portraits of *Philip*, his brother *Don Fernando*, and *Prince Baltasar Carlos* dressed for the hunt (c.1634/5; Madrid, Prado).

The private apartments of the Buen Retiro housed a number of portraits of the jesters and dwarfs resident at the court, painted by Velázquez in the 1630s and 1640s. These pictures are of special interest as early examples of the psychological portrait; the most powerful and innovative among them are those of *Juan de Calabazas* and *Sebastián de Morra* (Madrid, Prado).

At the end of the 1630s, Velázquez's production began to decrease, and this trend continued in the 1640s and 1650s. He had been named Gentleman of the Bedchamber in 1643 and awarded the office of Chief Chamberlain in 1652, and the responsibilities entailed by his progressive elevation in rank as courtier and servant of the royal household left him ever less time to paint; between 1640 and 1648 Velázquez painted only some portraits, among them Philip IV's only likeness, done at Fraga in 1644 (New York, Frick

Coll.). In this picture he attained brilliant illusionistic effects in the King's costume with what appear at close range to be erratic brush strokes. For reasons of decorum, the King's face is painted more meticulously and smoothly.

In November 1648, Velázquez made a second journey to Italy, mainly to buy works of art for Philip IV's collection. He remained abroad two and a half years, and his stay was a great personal triumph; in Rome he was honoured with membership in the Accademia di S. Luca (see under ROME) and painted numerous portraits of the clergy and aristocracy, the most important one his penetrating characterization of *Innocent X* (Rome, Doria Pamphili Gal.). *The Toilet of Venus* (London, NG), recorded in Madrid in 1651, may have been executed during Velázquez's stay in Rome. The image has a more erotic charge than most of its 'Toilet of Venus' prototypes and, alone among its antecedents, does not reveal the goddess's face directly. The vague mirror reflection of her features remains forever beyond our grasp, a metaphor for the fugitive beauty of the flesh. On his return from Italy in 1651, Velázquez devoted himself to the decoration of the Alcázar and El *Escorial, but also painted more royal portraits than in the previous decade, among them, the first one of *Queen Mariana* in full length (1652; Madrid, Prado).

Velázquez's best studied work is *The Maids of Honour*, known as *Las meninas* (Madrid, Prado), painted in 1656 for the King's study. It is an inspired innovation, a hybrid of group *portraiture and genre painting. Infanta Margarita, first-born child of Queen Mariana, is the centre of a scene of domestic intimacy, peopled by recognizable individuals and set in an identifiable room of the Alcázar. The image that confronts the modern viewer is what Philip IV would have seen had he stood at the entrance to Velázquez's studio on a given occasion. In Velázquez's invention, the presence of the King and Queen, reflected in the mirror at the back of the room, provokes the various reactions of the gathered characters. To achieve his extraordinary recreation of reality, Velázquez utilized all the resources of his art. The variety of brushwork in his rendering of the figures, and the subtle play of light in the space they inhabit, achieve a remarkable illusion of depth and atmosphere. In *Las meninas*, Velázquez also postulates the idea of the nobility of the art of painting through the presence in his workshop, actual and implied, of three members of the royal family, and through the images of artist-gods that appear in the pictures in the background.

Although Velázquez's production was small during the last decade of his life, some of his most important and complex pictures belong to this period. In *The Fable of Arachne*, known as *The Spinners* (c.1658; Madrid, Prado),

Velázquez exploited to the hilt the possibilities of his optical method for describing the visual world, attaining effects of breathtaking realism, such as the motion of the spinning wheel. The most significant part of the narrative in *The Spinners* takes place in a small space in the background, more brightly lit than the foreground, and this inversion of emphasis makes the Ovidian story appear at first to be a genre scene. Its subject is also an apologia for the nobility of the artist and his art. Velázquez had sought admission into one of the knightly orders unsuccessfully for many years, but in 1658 he finally received the prestigious Order of Santiago.

His last portraits of the royal family are of *Infanta Margarita* and *Prince Philip Prosper* (1659; Vienna, Kunsthist. Mus.). The children's environments, which suggest specific rooms, are more elaborate and visually important than in portraits of the 1620s and 1630s.

In June 1660 Velázquez accompanied Philip IV to Fuenterrabía, and little over a month after his return to Madrid became ill and died. He was Spain's greatest *Baroque painter, but his influence in his own century was surprisingly small. The most admired aspect of his painting, his extraordinary technique, was inimitable.　　　　　NAM

Brown, J., *Velázquez: Painter and Courtier* (1986).
Domínguez Ortiz, A., et al., *Velázquez* (1989).
Harris, E., *Velázquez* (1982).

VELDE, VAN DE, FAMILY (Esaias and Jan II). Dutch family of artists. **Esaias** (1587–1630) moved from Haarlem to The Hague by 1618. He painted genre scenes and collaborated with other painters, but is mainly famous as a founder of Dutch *landscape. He possibly trained with *Coninxloo but soon broke away from his conventional high viewpoint and schematic colouring. The *Winter Landcape* (1614; Cambridge, Fitzwilliam) already shows a low horizon and a totally new spirit of matter-of-fact realism in representing Dutch landscape. The large masterpiece *The Ferry* (1622; Amsterdam, Rijksmus.) achieves a convincing presentation of the world by controlled composition and directly observed scenes of quiet social activity rather than by analysis of light and management of tone. Some smaller works, however, are startlingly fresh. Esaias was a key figure in the transition from the unrealistic world of Coninxloo to the tonal explorations of his pupil van *Goyen.

Jan II (1593–1641), Esaias's nephew, was a Haarlem printmaker of landscapes and other subjects. His early *etchings of imposingly composed Dutch landscapes are exceptional. After 1618 he tended to rely on other artists' designs; his beautiful engravings (see LINE ENGRAVING) of night scenes derived from *Elsheimer and Hendrick Goudt (1585–1630)

were especially famous.　　　　　AJL

Fuchs, R. S., *Dutch Painting* (1978).

VELDE, VAN DE, FAMILY (Willem and sons). The family name of an extensive and distinguished group of 17th-century Dutch painters. The most important members of the family were **Willem the elder** (1611–93), and his sons **Willem the younger** (1633–1707) and **Adriaen** (1636–72).

Willem van de Velde the elder specialized as a marine artist, and most of his work consists of pen drawings of ships executed on both panel and canvas, in a style which makes them look at first glance like large engravings. He had settled in Amsterdam by 1636, but visited England in the early 1660s and early 1670s, and it seems probable that he was the first teacher of his son, the younger Willem van de Velde. In 1674 father and son were taken into the service of King Charles II; they subsequently worked for James II, and remained in England for the rest of their lives. They had a studio in the Queen's House at Greenwich, and later lived at Westminster.

According to the biographer *Houbraken the younger Willem van de Velde as well as studying with his father was also a pupil of Simon de *Vlieger. His earlier pictures often show serene seascapes, in which shipping becomes gradually more prominent. Later, when in England, he depicted specific vessels or events, and also produced a number of replicas of his compositions. He was buried in S. James's, Piccadilly, and the style he developed was followed by numerous imitators throughout the 18th century.

By contrast, his younger brother Adriaen concentrated on depicting landscapes, invariably populated with figures and animals, as well as producing a few coastal and winter scenes. He studied with his father, may also have been a pupil of Jan *Wijnants in Haarlem, and was certainly influenced by the work of Philips *Wouverman. Adriaen possibly visited Italy, although this has not been confirmed, and settled in Amsterdam from the mid-1650s onwards. Some of his most distinguished works are landscapes with biblical themes which allowed him to explore his skill at animal painting, such as the monumental *Departure of Jacob from Laban*, of 1663 (London, Wallace Coll.). However, he also successfully and more modestly collaborated with other artists, painting figures and animals in the landscapes of *Ruisdael, *Koninck, and Frederik Moucheron. As well as painting he also worked as an etcher, and a number of accomplished compositional drawings by him survive.　　　　　CB

MacLaren, N., *National Gallery Catalogues: The Dutch School*, rev. C. Brown (1991).

**VENICE: PATRONAGE AND COLLECT-
ING.** *See opposite.*

**VENICE, ACCADEMIA (Galleria dell'-
Accademia di Belle Arti):** constitutes
the world's most comprehensive review of
Venetian painting up to the 18th century. The
Accademia gallery, like the Brera in Milan, is
a creation of the Napoleonic occupation,
with origins closely linked with an academy.
The old Fine Arts Academy of Venice dated
from the mid-18th century, while the Galleria
dei Gessi had since 1767 organized a collec-
tion of casts of Antique statues. In 1807 Na-
poleon ordered these institutions to be
brought together in the 14th-century build-
ing of the Scuola Grande della Carità.

The Academy's original collection largely
consisted of specimens by its former stu-
dents, but by the time the collection opened
to the public in 1817 these had been
swamped by paintings from suppressed re-
ligious foundations and works returned
from confiscation by the French. During the
years of Austrian rule after 1815, the Accade-
mia collection was greatly expanded by be-
quests from the Venetian aristocracy,
including the Molin, Contarini, Renier, and
Manfrin collections. In 1878 the gallery was
split from the Academy and established as a
state art gallery in its own right, and after
1918 a number of works were ceded to it by
the Austrians. The gallery has continued
with an acquisition policy focused on major
Venetian works.

This is an unusually homogeneous collec-
tion, with very few works from outside the
area under the political and artistic domin-
ation of Venice. The collection includes *Ti-
tian's *Presentation of the Virgin* that he painted
for the committee room of the Scuola Grande
della Carità in 1534–8 and which is still *in situ*.
AJL

VENNE, ADRIAEN PIETERSZ. VAN DE
(1589–1662). Dutch painter, draughts-
man, and poet. The son of Flemish immi-
grants to Delft, van de Venne's early life and
training is obscure. His earliest paintings
date from 1614 to 1624 when he was in Mid-
delburg. *Fishing for Souls* (Amsterdam, Rijks-
mus.) is typical of his early work, indebted to
Flemish painters such as Jan *Brueghel. It is a
political allegory composed of many mi-
nutely painted figures set into a sweeping
landscape. As a printmaker and book illus-
trator, his clear and imaginative composi-
tions contributed to the popularity of
emblem books. In 1625 he moved to The
Hague for the remainder of his life, where he
restricted his palette to grisaille, for example
*Winter King and Queen with Frederick Henry and
Amalia van Solms* (1626; Amsterdam, Rijks-
mus.). There is no actual evidence of courtly

patronage but one of his outstanding works
is an album of 105 exquisitely painted mini-
atures (1626; London, BM) celebrating the
Stadholder Frederick Henry's rule and illus-
trating many facets of Dutch life. CFW

Bol, L. J., *Adriaen Pietersz. van de Venne: Painter and
Draughtsman* (1989).

VENTURI, ADOLFO (1856–1941). Italian
art historian. Following an earlier career
as inspector at the Galleria e Museo Estense
in Modena, and at the Ministero della Pub-
blica Istruzione in Rome, Venturi was profes-
sor of art history at the University of Rome
between 1901 and 1931. Chiefly interested in
Italian art, he published numerous mono-
graphs on *Renaissance and *Baroque artists,
including *Raphael (1920) and *Correggio
(1926). He is best known for his monumental
Storia dell'arte italiana (26 parts, 1901–40), which
is still the fullest account of the art history of
any country. AT

VENUS DE MILO (2nd century BC; Paris,
Louvre). This marble statue of a half-
draped Aphrodite was found in 1820 on the
Greek island of Melos and was presented by
Louis XVIII to the Louvre, Paris. An inscribed
block found with it included the signature of
its *Hellenistic sculptor, [Hages]andrus of An-
tioch on the Menander. In order to attribute
it to the famed Classical Greek master *Prax-
iteles, the statue was dissociated from the in-
scribed block. A fragment of a forearm and
hand with an apple, both a common attrib-
ute of Aphrodite and a pun on 'Melos', also
found with the statue, probably belongs. In
contrast to the open sensuality of the *Aphro-
dite* of Cnidus, the use of classicizing style in
pose and features serve to distance the *Venus
de Milo* from the viewer. The armless state of
the preserved figure led to numerous recon-
structions of her pose; nevertheless the
statue was never restored. L-AT

Haskell, F., and Penny, N., *Taste and the Antique*
(1981).
Stewart, A., *Greek Sculpture: An Exploration* (1990).

VERGINA (ancient Aegae), in Macedo-
nia. In 1977, excavation revealed three
4th-century BC tombs of the Macedonian
royal family, with unprecedentedly rich arte-
facts, notably our best-preserved Classical
wall paintings (see GREEK ART, ANCIENT:
PAINTING). The tombs include the first known
Greek barrel vaults, the earliest dating to the
360s. Two tombs were intact, the larger prob-
ably that of Philip II (d. 336). On its façade
(width 5.5 m/18 ft, height 1.16 m/3 ft 9 in) is
painted a lion hunt probably featuring Philip
and his son Alexander the Great. Its use of
landscape finds parallels in Roman copies of
lost Greek works. The smaller tomb (c.340;
width 3.5 m/1½ ft), depicts Hades abducting
Persephone, and a pensive Demeter, in an

expressive style using shading and depth,
and charged with emotion. The same scene,
although treated differently, occurs on the
back of a marble throne found in another
contemporary tomb at Vergina in 1987. Also
found were ivory portrait heads (one almost
certainly of Philip II), as well as ivory furni-
ture attachments, an exceptionally fine and
rare burial cloth of royal purple with gold
patterns, intricate gold jewellery, and elabor-
ate armour. KWA

Andronikos, M., *Vergina* (1984).

VERHULST, ROMBOUT (1624–98).
Flemish sculptor who worked in Hol-
land. He was the most important assistant to
Artus *Quellinus, supervisor of the sculp-
tural decoration made for the town hall (now
royal palace) in Amsterdam. Verhulst finally
settled in The Hague (1663) and became fam-
ous for his portrait busts and tombs. His
magnificent *Baroque monument to Admiral
de Ruyter (1681) is in the Nieuwe Kerk, Am-
sterdam. HO/MJ

Scholten, F. T., *Rombout Verhulst te Groningen* (1983).

VERMEER, JAN (Johannes) (1632–75).
Now one of the most revered of all
Dutch painters, Vermeer was born and
worked in relative obscurity in Delft. His
father was a silk merchant, art dealer, and
tavern keeper. In 1653 he married and en-
tered the local artists' guild and by 1655 had
taken over his father's businesses. Vermeer
left a widow and eleven children. These
sparse facts give little indication of the qual-
ity and deep meditation of his art. There are
only about 35 surviving paintings that are
widely considered to be by him. All are of
outstanding quality, and although they vary
as his style altered they consistently show a
profound preoccupation with the ways in
which light defines form, and a supremely
controlled, meticulous, technique.

Why Vermeer apparently produced so few
works, and how he learned to paint, are
questions which remain largely unresolved.
It is certainly true that the work of Carel
*Fabritius has affinities with Vermeer's ma-
ture style, and he owned three works by this
artist, so there may have been a firm associ-
ation between the two men.

Vermeer's earliest pictures, such as *Christ in
the House of Martha* (Edinburgh, NG Scotland)
and *Diana and her Companions* (The Hague,
Mauritshuis), are quite large *history paint-
ings which owe a debt to Italianate artists
from Utrecht; by contrast the majority of the
works of his maturity are small *genre works
which tend to explore a series of recurring
themes, and sometimes have allegorical
overtones. These themes include the work of
domestic servants (*The Milkmaid*; Amsterdam,

continued on page 772

· VENICE: PATRONAGE AND COLLECTING ·

FOR much of its long history, the patronage of Venetian art closely reflected the unique political and social institutions of the Venetian state. For more than a millennium, until its fall in 1797, the Republic of Venice was governed by an oligarchy, comprising a limited number of patrician families. In contrast with most of the other artistic centres of Italy there was no court, and the opportunities for independent action by the elected head of state, the doge, were strictly limited. Artistic patronage in Venice was typically exercised on a corporate rather than on an individual basis; and although doges of a particularly forceful character, such as Andrea Dandolo in the mid-14th century, or Andrea Gritti in the early 16th, could sometimes exert a decisive influence on cultural policy, direct responsibility for the most important commissions was taken by such bodies as government magistracies, devotional confraternities, and the religious orders. The role of women in the patronage of art was strictly limited, as it was in politics and society.

Government officials took charge of the two central artistic enterprises of the medieval and *Renaissance periods: the decoration in sculpture and mosaic of the basilica of S. Mark's, which lasted for most of the 12th, 13th, and 14th centuries; and the original pictorial decoration of the adjoining Doge's palace, which took place between 1365 and the 1560s, and involved the talents of virtually all the great Venetian Renaissance painters, from Gentile and Giovanni *Bellini to *Titian, *Tintoretto, and *Veronese. When their work there was destroyed by two disastrous fires in 1574 and 1577, it was again a government committee that oversaw its speedy replacement with the extensive late 16th-century decoration, still extant. In the later 1550s, a similar committee commissioned the fashionably Romanizing ceiling decoration for the third major state building in the Piazza di S. Marco, the Library. Apart from the state, the major force in Venetian art patronage before c.1600 was represented by the devotional confraternities, or *scuole*. Governed by non-patrician, but often very wealthy, members of the citizen class, the *scuole* were religious in function but lay in membership. The five (later six) *scuole grandi* owned large and handsome meeting houses, and it became a point of honour to have them decorated with narrative cycles, in emulation of those in the Doge's palace. Of the five, the Scuola di S. Giovanni Evangelista and the Scuola di S. Marco were the most prominent as patrons in the 15th century; but the greatest achievement of *scuola grande* patronage remains the ceiling-to-floor decoration by Tintoretto of the three large rooms of the Scuola di S. Rocco (1565–87; *in situ*). On a more modest scale, many of the numerous smaller confraternities, the *scuole piccole*, also provided a steady source of employment for Venetian painters. Some of these confraternities had their own buildings, in which they sometimes imitated the *scuole grandi* by commissioning narrative cycles; an example is *Carpaccio's *Life of S. Ursula* cycle (1490 c.1498). But more often they commissioned altarpieces for their chapels in the city's churches, or in the case of the 16th-century Scuole del Sacramento, narrative canvases with appropriately Eucharistic subjects.

Until the earlier 16th century, individual Venetians rarely presumed to commission works of art larger in scale than an altarpiece for their family chapels. Thereafter, however, certain leading patrician families, such as the Grimani and the Corner, began to be more assertive in their patronage of painting and sculpture, commissioning for their palaces ceiling paintings and wall canvases of ever-increasing size and cultural pretension. The same period also witnessed the related phenomenon of the rise of art collecting. There is already evidence in the 15th century of collections of small-scale sculptures, coins, and drawings; and later 15th-century Venetians also showed an avid taste for panels imported from the Netherlands, and for the stylistically and technically similar art of the Sicilian *Antonello da Messina. As is demonstrated by the Notebooks of the patrician Marcantonio Michiel, himself a collector, this demand for pictures that were evidently prized as much for their aesthetic qualities as for their practical use as objects of devotion or as visual records had become widespread by the early 16th century. Prominent among the works of art recorded by Michiel in Venetian private houses are pictures by *Giorgione, whose artistic revolution would have been impossible without the emergence of this new market. By the end of the 16th century there probably existed more art collections in Venice than in any other city in Europe.

During the 16th century the difference between patronage and collecting remained blurred, because Venetian collections comprised above all works by living Venetian artists. But by the beginning of the 17th century connoisseurs, both in Venice and abroad, realized that the great age of Venetian painting had passed, and pictures by the old masters became more sought after than contemporary works. It became natural for discerning collectors such as the citizen Bartolomeo della Nave also to become dealers; and similarly, foreign merchants resident in the city such as the German David Ott, or the Fleming Daniel Nys, often became agents for wealthy foreign customers. In 1627–8, for example, Nys brokered the sale of the collection of the Duke of Mantua to Charles I (see LONDON). Venice was to retain its role as a major centre of the international art market for the next two centuries.

By the time of the new flowering of Venetian painting in the 18th century, many of the older types of patronage had lost their earlier importance. Most state buildings were already decorated, and neither the government nor the confraternities played a major role. The religious orders, by contrast, were more active than ever. In the

pre-Reformation period, much of the responsibility for church decoration had been assumed by the laity; but the comprehensive pictorial programmes commissioned by the regular clergy in the later 16th century, such as that undertaken by Veronese for the church of S. Sebastiano (1555–65), provided inspiring models for the ceiling decorations undertaken by G. B. *Tiepolo in the churches of the Gesuati (1738–9), the Scalzi (1745; destr.), and the Pietà (1754), and for the sets of altarpieces provided by Tiepolo, *Piazzetta, and their contemporaries for churches all over the city. A number of local families, now less inhibited about self-glorification, and including old patrician names such as the Pisani as well as the wealthy *arrivistes* Rezzonico, Labia, and Manin, commissioned similarly splendid large-scale decorations for their palaces and mainland villas. But a major development in the 18th century was the internationalization of the patronage of Venetian painters. Already in the 14th and 15th centuries, Venetian painters had created a international market for their altarpieces by using existing trade networks to ship them to distant destinations. In the 16th century, Titian became an international celebrity, extending his circle of patrons beyond Venice first to the north Italian courts, and then to the Emperor Charles V (see MADRID), Pope Paul III and his family, and Philip II of Spain. But while Titian remained exceptional among his contemporaries, the demand for Venetian painting among the crowned heads of 18th-century Europe meant that a majority of artists of the period, including the history painters Sebastiano *Ricci, Tiepolo, and *Pellegrini, the view painter *Canaletto, and the portraitist Rosalba *Carriera, enjoyed international careers that frequently took them for long spells away from the lagoon. The art market continued to thrive, and was even given a boost by the fall of the Republic, when early 19th-century dealers were able to take advantage of the suppression of age-old religious institutions and of the impoverishment of local families, and to make their fortunes by dispersing Venetian art among the newer markets of Paris and London. PBH

Haskell, F., *Patrons and Painters* (1963).
Humfrey, P., *Painting in Renaissance Venice* (1995).
Levey, M., *Painting in Eighteenth-Century Venice* (3rd edn., 1994).
Logan, O., *Culture and Society in Venice 1470–1790* (1972).

Rijksmus.); music-making (*A Lady at the Virginals with a Gentleman*; Royal Coll.); and the writing and receiving of letters (*Woman in Blue Reading a Letter*; Amsterdam, Rijksmus.). Such pictures are by no means simply a technical tour de force; they seem to explore the human condition and reveal tremulous moments of absolute, unselfconscious, privacy.

Two outdoor scenes by the artist survive (*The View of Delft*; The Hague, Mauritshuis; *The Little Street*; Amsterdam, Rijksmus.). And two large allegorical paintings date from the latter part of his career: a view of his studio, called *The Art of Painting* (Vienna, Kunsthist. Mus.) which seems innately to celebrate the intellectual aspects of his calling, and the *Allegory of Faith* (New York, Met. Mus.), which through a complex conjunction of symbolism explores Catholic doctrine.

Vermeer's paintings remained almost entirely unappreciated after his death until they were 'rediscovered' by the French critic Théophile *Thoré, whose seminal monograph was published in the *Gazette des beaux-arts* in 1866. CB

Wheelock, A. K. (ed.), *Johannes Vermeer*, exhib. cat. 1995 (Washington, NG).

VERMEYEN, JAN CORNELISZ. (c.1500–c.1559). North Netherlandish painter, designer of tapestries and engravings. Born near Haarlem, he was trained in the workshop of Bernaert van *Orley in Brussels. His career took place in the service of the Habsburg court, working for the Regent Margaret of Austria and her successor Mary of Hungary, as well as for Charles V. He travelled to Innsbruck and Augsburg and accompanied Charles V on his Tunisian campaign in 1535, making drawings of battle scenes which were later incorporated in a series of tapestries commemorating the expedition (cartoons: Vienna, Kunsthist. Mus.; tapestries: Madrid, Patrimonio Nacional). Vermeyen painted religious panels and portraits, but it is for his portraits, especially of members of the Habsburg court, that he is best known. One characteristic feature of his portraits is the expressive use of hands (*Portrait of Erard de la Marck*, c.1530; Amsterdam, Rijksmus.). His portraits of Mulay Hasan, King of Tunis, and his son Mulay Ahmad later inspired *Rubens to make copies from them (Rubens's *Mulay Ahmad* is in the Museum of Fine Arts, Boston; his *Mulay Hasan* as well as Vermeyen's originals are lost). KLB

Horn, H. J., *Jan Cornelisz. Vermeyen* (1989).

VERNET. French family of artists originating in Avignon in the 18th century, but mainly active in Paris. **Claude-Joseph** (1714–89) was one of the foremost French *landscape painters of the 18th century. After training in his native city he travelled to Rome in 1734, where he spent the next 20 years. Inspired by the landscapes of *Claude, Gaspard *Dughet, and Salvator *Rosa, he began to specialize in idealized views of the Roman Campagna painted for the *Grand Tourist market. He also developed a second theme in *marine pictures set along an Italianate coastline. These are perhaps his best-known contribution. Often painted in pairs or sets of four depicting calm and storm, morning and evening, they are to be found scattered widely through art collections in Europe and North America, a reflection of Vernet's popularity (characteristic examples: London, Wallace Coll.; Paris, Louvre). In 1753 Vernet returned to France to undertake a government commission to paint a series of views of the ports of France. By 1765 he had given up this ambitious task, but not before producing fifteen canvases of outstanding quality (Paris, Louvre and Mus. de la Marine). In them he reconciled superbly the conflicting demands of topography and artistic effect. His later works are a reprise of his earlier imaginary landscapes and seascapes, though perhaps lacking their delicate touch.

Claude-Joseph's son **Carle** (1758–1836) was a notable exponent of lithography, producing many scenes of contemporary manners. Later in his career he became famous as a painter of horses (the young *Géricault was a constant visitor to his studio) and ambitious *battle scenes, of which *The Battle of Marengo* (1806; Versailles) is an example. His son **Horace** (1789–1863) was one of the most lauded and financially successful artists of the 19th century. The dramatic naturalism and the high degree of finish of his paintings found approval with the public and in official circles, though he was attacked for his superficiality by *Baudelaire. He contributed many huge pictures to Louis-Philippe's Galerie des Batailles at Versailles and was one of the earliest exponents of orientalism. His North African subjects, such as the *Arab Story-Teller* (1833; London, Wallace Coll.), proved

immensely popular with a public seeking escapism. MJ

Conisbee, P. (ed.), *Claude-Joseph Vernet 1714–1789*, exhib. cat. 1976 (London, Kenwood House).

Ingersoll-Smouse, F., *Joseph Vernet: peintre du marine* (1926).

Julia, I., 'Antoine-Charles-Horace (called Carle) Vernet', in *French Painting 1774–1830: The Age of Revolution*, exhib. cat. 1973 (Paris, Grand Palais).

Rosenblum, R., et al., *Horace Vernet 1789–1863*, exhib. cat. 1980 (Paris, École des Beaux-Arts).

VERONESE, PAOLO (Paolo Caliari) (1528–88). Italian painter, born at Verona. His father was a sculptor but he was trained in the studio of a local painter, Antonio Badile, and there learned the use of the cool silvery colours and soft yellows which persisted in all his work. He may also have been taught by Gian Francesco Caroto (c.1480–c.1555). By about 1553 he had established himself in Venice and was already popular. His style was compounded of elements drawn from *Titian, *Dürer, and *Parmigianino, whose prints he copied. His first major commission (from c.1555) was for decorations both in oil and fresco in the church and sacristy of S. Sebastiano, Venice. Three large ovals on the nave and ceiling tell the story of Esther and Ahasuerus, vigorously depicted with an astonishing virtuosity in foreshortening. The walls on the north and south sides of the monks' choir have frescoes of the life of S. Sebastian, painted in 1558.

*Ridolfi says that Veronese visited Rome in 1560 but the experience left little mark on his work, although it may have given him the opportunity to study Antique villa decoration. After his return he decorated some of the villas belonging to the Venetian nobility on the mainland. The Villa Barbaro at Maser is a triumph of collaboration between an architect (Andrea Palladio, 1508–80), a sculptor (*Vittoria), and the painter, who together brought into being an ideally harmonious setting for a life of cultured ease. The illusionistic (see ILLUSIONISM) paintings (1561) extend the architecture of the rooms, leading the spectators into idyllic views of landscape and figures, or surprising them with servants appearing through non-existent doors. The intention was to recreate the environment of the patricians of ancient Rome and to celebrate agrarian, pastoral, Christian, and cultured life.

From this time onwards Veronese was inundated with commissions and with the help of a large workshop, including his brother Benedetto Caliari (1538–98) and his own sons Carlo (1567–92×6) and Gabriele Caliari (1568–1631), his output was enormous. The *Marriage Feast at Cana* for the refectory of S. Giorgio Maggiore, Venice (1562–3; Paris, Louvre) is the first of a series of large religious feast scenes with all the sensuous charm and pompous grandeur of a court function. The clear silvery tones of the classical architecture provide a stage set in which to place an assembly of people and the whole scene is suitably enlivened by spectators, dogs, fools, and musicians. As decoration these paintings are unsurpassed. Unfortunately their religious themes were not always felt to be sufficiently respected, and in 1573 Veronese was summoned before the Inquisition on a charge of irreverence in his painting of the *Feast in the House of Levi* (1573; Venice, Accademia), originally painted for the refectory of SS Giovanni e Paolo.

From 1574 onwards Veronese was largely engaged in redecorating the Sala del Collegio in the Doge's palace in Venice after a fire. He produced a great series of decorative canvases that culminated in the magnificent ceiling painting *Venice Enthroned with Justice and Peace, Mars and Neptune*. During the early 1580s he painted a number of splendid mythological scenes which reflect the spirit of the ceiling in the Doge's palace, including *Mars and Venus* (New York, Met. Mus.) and the *Choice of Hercules* and *Allegory of Wisdom and Strength* (New York, Frick Coll.).

Veronese's achievement is not in his emotional impact on the beholder. He is rather the supreme decorator, who enhances the style and enjoyment of living without attempting to move us more fundamentally. The Venetian tradition of gay festive paintings of pageantry and splendour culminates in him, although his art would later profoundly influence G. B. *Tiepolo. HO/HB

Pignatti, T., *Veronese* (1976).

VERRIO, ANTONIO (1639?–1707). Italian decorative painter active in England. Verrio, who was born in Lecce, came to England from France c.1671. His arrival coincided with an architectural renaissance and he was immediately in great demand to decorate halls, ceilings, and staircases with mythical, religious, and historical scenes in a derivative and vapid *Baroque style which nonetheless had considerable novelty in England. It was greatly admired by John Evelyn, who considered him the equal of the greatest masters. In 1675 he received royal commissions for Whitehall Palace and Windsor Castle which occupied him, amid work for other aristocratic patrons, until 1684 when he was appointed Chief Painter to the King (see LONDON). After the Revolution of 1688 he painted large decorative schemes at Chatsworth (Derbys.) and Burghley (Lincs.); his Heaven Room at the latter is probably his finest work. By 1699 he was again under royal patronage working for William III and Mary at Hampton Court. His immense fame was short-lived and by the mid-1730s, in 'Epistle IV' of his *Moral Essays*, Alexander Pope was satirically dismissive in a memorable couplet: 'On painted ceilings you devoutly stare | Where sprawl the saints of Verrio and Laguerre.' DER

Croft-Murray, E., *Decorative Painting in England*, vol. 1 (1962).

VERROCCHIO, ANDREA DEL (Andrea di Michele di Francesco Cioni) (c.1435–88). Italian sculptor and painter, born in Florence. The universality of his talents foreshadows those of his own pupil *Leonardo. He was probably trained initially as a goldsmith, and may then have entered the workshop of either *Desiderio da Settignano or Antonio *Rossellino. He became one of the principal artists at Florence in Medici service, executing, among other commissions, the tomb of Cosimo il Vecchio and the innovative porphyry and bronze *all'antica* tomb of Giovanni and Piero de' Medici (1464–7; both Florence, S. Lorenzo, Old Sacristy). Among Florentine sculptors he appears to have been one of the most responsive to classical sculpture, and this is visible, for instance, in his bronze *David* (c.1465; Florence, Bargello) and the charming *Putto with a Dolphin* (c.1480–5; Florence, Palazzo Vecchio), both clearly inspired by *Antique statues. His *S. Thomas and Christ* (1466–76; Florence, Or San Michele) is a moving interpretation of the religious scene realized in a virtuoso technique of bronze high relief. In his half-length *Lady with Primroses* (c.1470s; Florence, Bargello) Verrocchio introduced a narrative element and a greater sense of movement than had hitherto been seen in Florentine *portraiture. The relief of *The Beheading of S. John the Baptist* for the silver altar for the baptistery (1477–80; Florence, Mus. dell'Opera del Duomo) displays a violently dramatic narrative skill, contrasting with the more serene accompanying reliefs. This dramatic approach is characteristic of his most renowned work, the *equestrian monument to Bartolommeo Colleoni (Venice, Campo SS Giovanni e Paolo), commissioned in 1480, but only finished after his death by the Venetian Alessandro Leopardi (active 1482–1522). Here the imagery of a powerful *condottiere* is manifest in the prancing horse and the rider proudly turning in his saddle, and represents a modern challenge to Antique equestrian monuments.

The evidence of Verrocchio's activity as a painter is more elusive, although he clearly ran a busy workship where talented pupils, including not only Leonardo but also *Lorenzo di Credi, *Perugino, and Domenico *Ghirlandaio, worked on his designs or developed his ideas. He is first recorded as a painter in 1468 when he painted a standard for the Medici *Giostra* in honour of Lucretia de' Donati. Then in 1475 he painted a pennant that Giuliano de' Medici carried in a tournament in honour of Simonetta Vespucci. Both these works are now lost. In c.1476

he was commissioned to paint an altarpiece for the Cathedral of Pistoia which remains *in situ*. It was not quite completed in 1485 and most critics now believe it was executed on Verrocchio's design by his pupils, principally Lorenzo di Credi, to whom it was attributed by *Vasari in 1568. A *Baptism of Christ* now in the Uffizi, Florence, and formerly in the monastery of S. Salvi, has also been attributed to Verrocchio, although, according to Vasari, Leonardo da Vinci painted the angel, holding some clothing, in the left foreground. Leonardo may also have executed parts of the landscape, and possibly the figure of Christ as well. A *Madonna and Child with Saints*, now in Budapest, which is apparently identical with a picture Vasari attributed to Verrocchio, is usually judged to be unworthy of his hand, and has been attributed to Biagio d'Antonio (1446–1516). There is also a group of undocumented pictures representing the Virgin and Child which are generally accepted as works of Verrocchio's immediate circle, since they all show close links with the design of Verrocchio's marble and terracotta relief sculptures on the same theme. A *Virgin Holding the Child*, now in Berlin (Gemäldegal.), is probably the picture most often attributed to Verrocchio himself, although on the basis of stylistic comparison with the Uffizi *Baptism* this attribution is still not conclusive. Other pictures to be considered in this general context include the *Virgin with Standing Child* (also Berlin, Gemäldegal.), a *Virgin and Child with Two Angels* (London, NG), and the *Ruskin Madonna* (Edinburgh, NG Scotland), although clearly they are not all by the same hand. AB/HB

Passavant, G., *Verrocchio* (1969).

VERSAILLES. The first royal building at Versailles, about 30 km (20 miles) from Paris, was a hunting lodge designed by Philibert le Roy for Louis XIII in 1623–4. This was transformed by Louis XIV in three separate building campaigns. In 1661–8 two service wings were added by the architect Louis Le Vau and the gardens were laid out by André Le Nôtre. Almost immediately, in 1668 Le Vau was commissioned to incorporate the old building in a massive new structure that left the old fabric exposed at the main entrance but presented a new front of 25 bays to the garden. In turn, that building was further expanded in 1678–84 by Jules Hardouin-Mansart, who constructed the Galerie des Glaces across the previously open terrace on the garden side and added great wings to the north and south, extending the total front to some 550 m (1,800 ft). The final major feature completed in Louis XIV's reign was Hardouin-Mansart's chapel (1710). The Salon d'Hercule, begun immediately after the chapel, was not completed until 1736.

Changes by later rulers did not involve significant new painting or sculpture, though the celebrated ceremonial Escalier des Ambassadeurs was destroyed in 1752.

The purpose of this vast project (which was accompanied by a more private palace for the monarch at nearby Trianon) was to accommodate the French court, which was officially transferred to Versailles in 1682. Versailles served various political purposes, including the control of the French nobility, but straightforward personal glorification of Louis XIV was the manifest central theme and the palace has always been seen as an epitomizing statement of absolutist rule. This is inherent in the sheer gigantism of the external elevations, though the successive extensions were fatal to the proportions and unity of the architecture. The political motivation of the project is more explicit in the interiors and the programmes of sculpture for the gardens, for all of which the key figure was Charles *Le Brun, the King's First Painter and Chancellor of the Royal Academy.

Throughout the decade from 1671 Le Brun led a team of sculptors, decorators and painters (including René-Antoine Houasse (1645–1710), Gabriel Blanchard (1630–1704), Jean *Jouvenet, and Charles de *La Fosse in a programme to decorate Le Vau's interiors that he controlled down to the smallest detail. These rooms include the Grands Appartements of the King which were decorated on the theme of Louis as Apollo or the Sun. The same iconographic programme underlies the fountains and other features that Le Brun installed in the gardens.

The interiors of Le Vau's palace were intended to be overwhelmingly magnificent and splendid, and they achieve this by the lavish use of costly materials, exceptionally fine detailing, and, in the painted ceilings and insets, a chilly grand manner that is essentially a disciplined and emotionally drained derivation of Roman *Baroque. Le Brun's collaboration with Hardouin-Mansart in the Galerie des Glaces (1678–84) is, however, his greatest achievement. Here he covered the ceiling of the 80-m (260-ft) gallery with compartmentalized scenes which overtly celebrate Louis XIV's battles and other achievements. The two most important later ceilings are further removed from the style of the first decorative programme. Antoine *Coypel's ceiling of the chapel (1710) is an illusionistic exercise based on *Gaulli's ceiling of the Gesù in Rome, while the airiness and gaiety of François *Lemoyne's ceiling of the Salon d'Hercule (1736) looks forward to the *Rococo. The success of this cheerful confection was, however, not enough to prevent Lemoyne from committing suicide the year after it was unveiled.

The sculpture commissioned for the palace reflects the same kind of changing taste as does the painting. During the first phase the dominant figure was François *Girardon, who was close to Le Brun and whose work (e.g. *Apollo and the Nymphs of Thetis*, begun 1666; Versailles) exemplifies the classical teaching of the Academy. Later the more vigorous Antoine *Coysevox was given his head (*Louis XIV Triumphing over his Enemies*, after 1678; Versailles) and for a short period the cantankerous Pierre *Puget who had worked under Pietro da *Cortona in Florence was also in favour (*Milo of Cortona*, 1671–82; Paris, Louvre).

Many Italian paintings from the royal collection were used to decorate the palace. For example, Guido *Reni's celebrated four paintings of incidents from the story of Hercules, now in the Louvre, originally hung in the Salon d'Hercule. Two exceptional Italian works that remain at Versailles are *Bernini's portrait bust of *Louis XIV* (1665) and *Veronese's monumental *Christ in the House of Simon* which the Venetian Republic presented to Louis in 1665.

In 1837 Louis-Philippe established in the palace a museum of French history, dedicated 'to all of France's glories', which still occupies the lateral wings. Among the large number of paintings commissioned for the museum were two by *Delacroix, the *Battle of Taillebourg* (1837; *in situ*) and the seminal *Entry of the Crusaders into Constantinople* (1840; Paris, Louvre). AJL

Blunt, A., *Art and Architecture in France, 1500–1700* (rev. edn., 1988).

VERTUE, GEORGE (1684–1756). English engraver and antiquary. Vertue trained under the engraver Michael van der Gucht (1660–1725) and learned drawing from *Kneller's assistant John Peeters (1667–1727) before establishing his own practice in 1709. In 1704 he was admitted to the Rose and Crown artists' club and was a founder member of Kneller's Academy in 1711. His fame rests not upon his prolific portrait engravings (see LINE ENGRAVING), many after Kneller, and antiquarian subjects (he was engraver to the Society of Antiquaries, 1717–56) but on his erudite, extensive, and disorganized *Notebooks* (London, BM), 40 manuscript volumes in which he recorded the history of English art and artists of his own and earlier times. In 1758 the books were purchased from his widow by his friend Horace *Walpole for £100 and formed the basis, when sympathetically arranged and edited, of Walpole's *Anecdotes of Painting in England* (1765–71) which remains the principal source of our knowledge of English art during and before Vertue's life. His Baroque *Self-Portrait* drawing (1741; London, BM) shows him, seated, with the dual attributes of artist and scholar. DER

Vertue, G., *Notebooks*, Walpole Society vols. 18, 20, 22, 24, 26, 30 (1930–55).

VESICA PISCIS. See MANDORLA.

VESPASIANO DA BISTICCI (1421–98). Florentine bookseller and biographer who, throughout much of his life, ardently searched for rare Greek and Latin manuscripts (once uncovered, the ancient texts were, more often than not, faithfully copied and lavishly bound). He supplied manuscripts to the most discerning collectors of his day including Cosimo de' Medici, Federigo da Montefeltro, Pope Nicholas V, and Alfonso I of Naples. The birth of printing undermined his business interests in the production of manuscript copies and in time he retired to his family property at Antella (near Florence), where during the 1480s he wrote his *Vite d'uomini illustri del secolo XV*, a collection of biographies of eminent prelates, noblemen, men of letters, and statesmen of his day. He was personally acquainted with many of the personalities mentioned in the *Vite* through his bookselling activities, and his comments are filled with valuable insights into their lives. His chapter on Cosimo de' Medici, for example, reveals fascinating details about the relationship between the great Florentine patron and the sculptor *Donatello. FB

Waters, W. G., and Waters, E., *Renaissance Princes, Popes and Prelates: The Vespasiano Memoirs* (1926).

VETH, JAN (1864–1925). Dutch painter and critic. Veth was born in Dordrecht and studied at the Rijksacademie, Amsterdam, where he was associated with the Amsterdam School of painters which included the Dutch Impressionist George Hendrik *Breitner. He soon established himself as a portrait painter, in a realistic but penetrative vein, but championed the avant-garde in a series of critical articles for the magazine *De nieuwe gids* from 1885. From 1886 to 1888 he painted a number of rural peasant scenes, taking tuition from Anton Mauve (1838–88), but soon reverted to portraiture, working in both oils and lithography. The latter, produced for reproduction in magazines 1891–8, included his fellow *Rembrandt scholar, the German museum director *Wilhelm von Bode* (see BERLIN) (1845–1929), drawn in 1898. The intense individual characterization he brought to his subjects was sometimes criticized as verging on caricature. Veth also had an academic career as professor of art history at the University of Amsterdam. His monograph *Rembrandts leven en kunst* (1906) is one of the most perceptive books on the subject. DER

Huizinga, J., *Leven en werk van Jan Veth* (1927).

VIANEN, PAULUS VAN (1570–1613). Dutch goldsmith and landscape artist. From a family of goldsmiths which also included his brother Adam, Paulus was the most gifted and successful. After an apprenticeship with Bruno Ellardsz. van Leydenberch, Paulus left the Netherlands, never to return, for foreign travels during the 1590s. From 1596 to 1601 he worked for the dukes of Bavaria, Wilhelm V and Maximilian I, in *Munich and then 1601–3 entered the service of the Archbishop of Salzburg, Wolf Dietrich von Raitenau, all patrons known for their lavish patronage of goldsmiths. From 1603 until his death he became court goldsmith to the Emperor Rudolf II in *Prague for whom he produced pieces for the Emperor's *Kunstkammer* such as the silver ewer and dish embossed with a relief of *Diana and Actaeon* (1613; Amsterdam, Rijksmus.). He is recorded as a painter but almost nothing survives except some remarkable landscape drawings, for example *Landscape with Two Draughtsmen* (Berlin, Gemäldegal.) which appear to have influenced artists at Rudolf's court such as Roelandt *Savery and even Jan *Brueghel, who visited Prague in 1604. CFW

Fucikova, E., et al. (eds.), *Rudolf II and Prague*, exhib. cat. 1997 (Prague).

VIDEO ART, a form of art which emerged in the 1960s, and which was based around the manipulation of videotaped images and their projection or replay on television screens. Although contemporary with early experiments in computer art, and despite superficial formal similarities, the earliest manifestations of Video art were not characterized by a specific interest in technological exploration, but were informed rather by an intention to subvert the conventional uses of television and film as communicative media. The most famous examples of such art are the films of Andy *Warhol, such as *Sleep* (1963) and *Empire* (1966), both of which last for more than six hours, are silent, and show only one static image.

The origins of Video art are generally attributed to the work of Nam June Paik (1932–), a member of the *Fluxus group. His early works were installations, characterized by their use of rows of television sets which transmitted similar but slightly differentiated images, such as *TV Clock* (1963; New York, Whitney Mus.), and *Moon is the Oldest TV* (1965; Whitney Mus.). Other leading exponents of such art in the 1970s included Bill Viola (1951–), whose installations manipulate natural time sequences, and Gary Hill (1951–), whose work concentrates on the relationship between speech and image.

Exhibited as art, a videotaped image focuses on issues of representation, and is a rejection of aesthetic values based on artistic imagination and craftsmanship. Although video art may be classified as a distinct art form by its exclusive concentration on the technical demands of its medium, the use of videotape has been an important component in many types of art since the 1960s. Examples of this overlapping include its use in recording the activities of *Conceptual artists such as Denis Oppenheim (1938–). It has also been an occasional element in the work of *Performance artists such as Orlan (1947–), who, since the early 1990s, has videotaped the reshaping of her face and body by plastic surgery. The increasing popularity of Video art since the 1960s is partly accounted for by the suitability of the television screen as a symbol of many of the concepts and concerns associated with *postmodernism. In 1996, the Turner Prize in British art was won for the first time by a Video artist, Douglas Gordon (1966–), who creates video installations, such as *24 Hour Psycho* (1996), in which Alfred Hitchcock's film is slowed down to the rate at which it would take a day to watch. OPa

Popper, F., *Art of the Electronic Age* (1993).
Schneider, I. (ed.), *Video Art* (1976).

VIEIRA DE MATOS (also called Vieira Lusitano), FRANCISCO (1699–1783). Portuguese painter, engraver, and poet. He spent thirteen years at Rome between 1712 and 1728, being elected to the Accademia di S. Luca, *Rome. He developed an eclectic style under the influence of Nicolas *Poussin and the Bolognese and Venetian masters whose works he could study in Rome. These influences are visible in, for example, his *S. Augustine* (c.1760; Lisbon, Mus. Nacional de Arte Antiga). In 1733 he was named court painter and in 1744 made a knight of Santiago. He was a successful but strictly academic artist, famous for his altarpieces, though several of the best were destroyed in the 1755 earthquake. His reputation was given a quasi-heroic enhancement by the extraordinary misfortunes that followed his secret marriage to the patrician Dona Ines Helena Lima e Melo, a story that he eventually published in a long autobiographical poem, *O insigne pintor e leal esposo* (1780), into which he inserted much about the artistic circles he frequented in Rome and Lisbon. JBB

VIEN, JOSEPH-MARIE (1716–1809). French *history painter, now chiefly remembered as a teacher of *David and a pioneer of the *Neoclassical style. Vien spent the years 1744–50 in Rome, a period that coincided with the excavations at *Herculaneum and *Pompeii. His support for the ideas of *Winckelmann won him the patronage in Paris of the antiquarian Count de *Caylus. Under the latter's influence he experimented with various techniques thought to have been used in ancient painting and became obsessed with the use of archaeologically

exact accessories in his art. Combining archaeology with memories of the classicizing Bolognese masters and of Poussin, Vien moved away from the *Rococo conceits of *Boucher and the mid-century painters to pioneer an etiolated and rather sentimental Neoclassicism. *The Cupid Seller* of 1763 (Fontainebleau), which is based on a Roman painting discovered in 1759, is his best-known work in this manner. Although Vien received many official honours (he was the last *premier peintre du roi* before the Revolution and was made a count of the Empire by Napoleon), a lack of vigour and imagination makes his works look lightweight and chic beside those of David and his followers.

HO/MJ

Gaehtgens, T., and Lugand, J., *Joseph-Marie Vien* (1988).

VIENNA: PATRONAGE AND COLLECTING. *See opposite.*

VIENNA, KUNSTHISTORISCHES MUSEUM. The Kunsthistorisches Museum (Museum of Art History) has its origins in the collecting activities of members of the house of Habsburg in the 15th and 16th centuries. By about 1800 the collections had assumed substantially their present shape, although important acquisitions were also made in the 19th and 20th centuries. Having originally been displayed at a variety of sites (such as the Stallburg and Schloss Belvedere), most of the collections were housed from 1891 in the building constructed on the Ringstrasse (at Burgring 5) by the architects Gottfried Semper and Karl Hasenauer. With its magnificent decor, including ceiling and wall frescoes by Mihály von Munkácsy (1844–1900), H. *Makart, and G. *Klimt, it is one of the finest museum buildings of the age of historicism.

Picture Gallery. The enormous collection of Rudolf II in *Prague was plundered by the Swedes in 1648, and only those items which had already been moved to Vienna were saved: these include the works by *Bruegel and *Dürer, pictures by Rudolf's court painters, works by *Correggio and *Parmigianino, and some items from the *Kunstkammer* (see below). Archduke Leopold Wilhelm (1614–62) is considered to have been the actual founder of the Picture Gallery. He acquired about 1,400 pictures during his period as Governor of the Netherlands (1647–56), the emphasis being on the great masters of Venetian and north Italian painting of the 15th and 16th centuries and Flemish painting of the 15th to 17th centuries. Today the main attractions of the Picture Gallery are the works by Bruegel and Dürer, the Netherlandish paintings of the 15th and 16th centuries, the *Infantas* of *Velázquez, 36 works by *Rubens, 27 by van *Dyck, and a fine collection of 16th-

century Venetian and other north Italian work.

The *Kunstkammer* includes Florentine early Renaissance sculpture, ornate Mannerist vessels of rock crystal and semi-precious stones, Benvenuto *Cellini's *saliera*, bronze figures by *Giambologna, and *Baroque sculpture in ivory. The collection of tapestries is one of the most important in the world.

AW

VIGARNY (or Bigarny), FELIPE (d. 1543). Sculptor from Langres, Champagne, active in Spain after 1498. Little is known of Vigarny prior to his arrival in Spain, although his work reflects the *Gothic tradition of his native France. His large reliefs of *Christ's Passion*, commissioned in 1498, for Burgos Cathedral mark a departure from local tradition, in their emotionalism and stocky, deeply carved figures. His activity, however, brought him into contact with Alonso *Berruguete and Diego de *Siloe, both of whom inspired him to include *Renaissance motifs. In 1519, he entered a four-year partnership with Berruguete, during which time he carved the principal retable for the royal chapel, Granada. He subsequently collaborated with Siloe on the retable of the *Presentation of Christ*, Burgos Cathedral. In 1539 he found himself paired with Berruguete again when they shared the commission for the choir stalls of Toledo Cathedral. Contemporaries prized Vigarny's work; in his *Medidas del Romano* (1526), Diego de Sagredo praises the sculptor's rule of proportion for the human figure and his Renaissance versatility.

PL

Gómez-Moreno, M., *Renaissance Sculpture in Spain*, trans. Bernard Bevan (1931).

Proske, B. G., *Castilian Sculpture: Gothic to Renaissance* (1951).

VIGÉE-LEBRUN, ÉLISABETH-LOUISE (1755–1842). French portrait painter. She was the pupil first of her father, Louis Vigée (1715–67), a pastellist specializing in portraiture, and then of *Doyen, but also benefited from the advice of family friends Joseph *Vernet and *Greuze. She quickly became the favourite painter of Marie-Antoinette and her circle, and is said to have painted the ill-fated Queen 25 times. Her most spectacular portrait is the full-length of *Marie-Antoinette and her Children* (1787; Versailles), perhaps painted in emulation of her rival with the ladies of Louis XVI's court, Mme *Labille-Guiard. But Vigée-Lebrun's great contribution to French female portraiture of the *ancien régime* was to introduce a Rousseauesque (see ROUSSEAU, JEAN-JACQUES) informality of pose and simplicity of costume that borders on the sentimental. This is best exemplified in her *Self-Portrait with her Daughter* (c.1789; Paris,

Louvre), in which the sitters seem to have escaped from one of the *larmoyante* *genre scenes of *Greuze. At the outbreak of the Revolution she fled Paris with her daughter, fearing to follow the fate of her royal patron and happy to find a way out of her wretched marriage to the rapacious art dealer Jean-Baptiste Lebrun. She travelled in Italy, Russia (1795–1800), Austria, Germany, and England (1802–5), returning to Napoleonic Paris (which she found pretentious and bourgeois) in 1805. In most countries she had great success as a society portraitist, painting the great, the good, and the not so good (including Emma Hamilton in the guise of a bacchante and Mme de Staël as the heroine of her own novel *Corinne*). In advanced old age she dictated her memoirs, which give a lively picture of the Europe of her day as well as of the perils and trials for a woman of making a career as a portrait painter.

MJ

Baillio, J., *Elisabeth-Louise Vigée-Lebrun*, exhib cat. 1982 (Fort Worth, Kimbell Mus.).

Hautecœur, L., *Madame Vigée-Lebrun: étude critique* (1917).

Sheriff, M. D., *The Exceptional Woman: Elisabeth Vigée-Lebrun and the Cultural Politics of Art* (1996).

Vigée-Lebrun, E.-L., *Souvenirs* (1835–7; English trans. G. Shelley, 1926).

VIGELAND, GUSTAV (1869–1943). Norwegian sculptor. Vigeland was born in Mandal, the son of a furniture maker. He was apprenticed to the Oslo sculptor Torsten Fladmoe (1831–6) 1884–6 and attended evening classes in drawing. He first exhibited at the National Art Exhibition of 1889 with a conventionally *Neoclassical group of *Hagar and Ishmael* (Oslo, Vigeland Mus.). A visit to *Rodin in Paris in 1893 and an Italian stay in 1895–6 brought increased realism and expression to his work. From 1900 to 1910 he executed portrait busts, including that of *Hendrik Ibsen* (1903; Oslo, NG Norway), and his first memorial, the allegorical male nudes in memory of Niels Abel (1902–5; Oslo, Slottspark). These nude figures and the earlier *Man Embracing Woman* (1894; Oslo, NG Norway) provide the enduring themes of his later work. In 1921 a contract between Vigeland and the city of Oslo led to the creation of the astonishing Vigeland-Parken, developed on a 30-ha (80-acre) site over 40 years. This huge allegory of birth, life, love, death, and renewal contains almost 200 over-life-size individual works in granite and bronze set in a park which he also designed.

DER

Wikborg, T., *Gustav Vigeland: His Art and Sculpture Park* (1990).

VIGNON, CLAUDE (1593–1670). French painter and distinguished printmaker, who was almost as prolific an artist in his studio as he was at home, as the father of 34 children. He was born in Tours and trained in Paris in the *Mannerist milieu of Jacob Bunel

continued on page 779

· VIENNA: PATRONAGE AND COLLECTING ·

VIENNA has been the capital of the Federal Republic of Austria since 1918. During the course of its history it was the residence both of the Babenberger dynasty (1156–1246) and the house of Habsburg (1273–1918), which ruled over various territories in (today's) Germany, Belgium, Italy, Hungary, Slovenia, Croatia, Bosnia, the Czech Republic, Slovakia, Poland, the Ukraine. Members of the Habsburg and Habsburg-Lorraine dynasty were elected German kings and Holy Roman emperors; thus Vienna was for long periods the *Haupt- und Residenzstadt* (capital and residence) of the Holy Roman Empire until 1806. Between 1804 and 1918 it was the capital of the Austrian (from 1867: Austro-Hungarian) Empire.

The city of Vienna and various monastic orders did indeed have a substantial role to play as patrons of the arts, but until 1918 Vienna owed its reputation as a city of art mainly to the patronage of the ruling dynasty and of a number of aristocratic families connected to the court and the countries under Habsburg rule. Bourgeois patronage, frequently with a Jewish background, first began on a major scale in the 19th century, culminating around 1900/14, a period when Vienna became one of Europe's intellectual centres, a kind of experimental field of modernism. After the collapse of the Habsburg monarchy Vienna, capital of what was now a very small country on the eastern edge of the German-speaking world, was particularly hit by the economic disasters after the First World War. Vienna lost its status as a major city for the visual arts, great collections, and the art market mainly through the sales of collections induced through the post-war economic crashes and the Anschluss of 1938 forcing Jewish patrons and art dealers to emigrate. They had to leave their collections behind, retrieving several of them from Austria after the Nazi defeat. Nevertheless, the performing arts retained their leading role in Vienna. Recovery has taken place only since the 1960s with the formation of important modern art collections (e.g. Rudolf Leopold, Karlheinz Essl), and the subsequent growth of the museum sector—the founding of the Museum of Modern Art in 1962 and its expansion, for instance in the 1980s, through the holdings of the German collector Peter Ludwig; the restructuring of the Kunsthistorisches Museum and the Österreichische Galerie in the Belvedere in the 1980s and 1990s, the building of the Museumsquartier housed in the Baroque Imperial Stables in the late 1990s. Thus the art market has also been able to regain a measure of importance.

Apart from a few earlier exceptions in sculpture and painting, evidence that Vienna was a centre of the visual arts emerged only in the early 14th century; this is especially demonstrated by the sculptures in the Stephansdom and the Minoritenkirche and the paintings executed for the remodelling of *Nicholas of Verdun's

Klosterneuburg pulpit (1331) as a winged altarpiece (Klosterneuburg abbey). The sculptural decoration of the Stephansdom under Duke Rudolf IV (ruled 1358–65) shows the international awareness of art in Vienna. Panel painting around 1400 (examples in the Österreichische Galerie in the Lower Belvedere Palace) is dominated by Bohemian influence, whereas the multi-winged altarpiece, once the main altar of the Schottenkirche (c.1470, Mus. of the Schottenstift), provides the most vigorous evidence of Netherlandish influence on painting in Vienna. The culmination of late *Gothic sculpture is undoubtedly the tomb of Emperor Friedrich III (ruled 1452–93) by Nicolaus *Gerhaerts from Strasbourg (1467; Stephansdom). Notwithstanding Vienna's status as a centre of *humanistic learning after 1500 and the fact that members of the so-called *Danube School of painting such as Lucas *Cranach the elder spent some time in Vienna (c.1500/3), the city fell into decline as a centre of the visual arts (Emperor Maximilian's I eminent patronage is only visible outside Vienna). The situation first changed when Ferdinand I (b. 1503, ruled as Roman Emperor 1558–64) made Vienna his permanent residence. He called in Jacopo Strada (1515–88) as artistic adviser and imperial *antiquarius* (1557). With Ferdinand and his sons Emperor Maximilian II (1527–76) and Archduke Ferdinand II of Tyrol (1529–95), the Habsburgs established themselves as a dynasty of collectors on a grand scale. But as Archduke Ferdinand II extended his famous *Kunstkammer* in Schloss Ambras near *Innsbruck, and Emperor Rudolf II (ruled 1576–1612), son of Maximilian II and Ferdinand's nephew and heir, transferred his residence to *Prague—he gained worldwide renown for his *Kunstkammer* in Prague's castle—Vienna again lapsed into provincialism. The main body of Rudolf's collections was sacked by Swedish troops in 1648; only a smaller part had previously been transferred to Vienna when the imperial residence was again shifted to the capital after Rudolf's death. Finally, at the end of the Thirty Years War after 1648 and the arrival in 1656 of Archduke Leopold Wilhelm's collection, Vienna regained its significance as a city of art which it was never to lose again. Leopold Wilhelm (1614–62), brother of Emperor Ferdinand III, had accumulated his acquisitions as Governor in the Spanish Netherlands 1647–56 mainly through the collapse of the British monarchy in 1648–9. The Archduke transferred his collection to Vienna and left it to his nephew Leopold I (ruled 1658–1705) as inheritance. Leopold Wilhelm's collection is the nucleus of today's Kunsthistorisches Museum painting gallery.

Emperor Leopold's artistic interests were mainly directed towards music and the performing arts. He himself was a good composer, and it is through him and his first wife and niece, the Infanta Margarita Teresa of Spain, *Velázquez's model for three portraits in the painting collection, that the splendour of Vienna's history as a music and

opera centre took root. However, his energies were also absorbed by the Turkish threat, which culminated in the Siege of Vienna, that was successfully crushed in 1683. After 1700 the victory over the Turks brought about an economic boom, Hungary and large parts of the Balkans were conquered, and the happiest time of art production and art patronage in Vienna began. The period associated with Emperors Josef I (ruled 1705–11), Charles VI (ruled 1711–40), his daughter and heiress Queen Maria Theresa (1717–80) and her husband Emperor Franz Stefan I of Lorraine (ruled 1745–65), and in particular with the rich aristocrats at the imperial court, namely the Liechtensteins, Harrachs, Schönborns, also Prince Eugène of Savoy, the supremely successful imperial general, initiated an art patronage of vigorous intensity, which found its highest expression in the decoration of the new palaces in the city of Vienna and of the summer residences in the suburbs. Until around 1720 the majority of commissioned artists came from Italy, particularly from Bologna and Naples: Liechtenstein used Marcantonio Franceschini (1648–1729) and Andrea *Pozzo for the summer palace in the Rossau. Pozzo also decorated the main Jesuit church in Vienna. Harrach, viceroy in Naples 1728–34, commissioned Francesco *Solimena and Nicola Maria Rossi (1690?–1758). For the Belvedere Palace Prince Eugène also employed Solimena as well as Giacomo del Po (1652–1726?) and Martino Altomonte (1657–1745), a Tyrolean trained in Italy. Giuseppe Maria *Crespi and other Bolognese artists were commissioned for the Winter Palace. It was only after around 1720 that native Austrian artists were successful in Vienna (the painters Johann Michael *Rottmayr, Martino Altomonte, Daniel Gran (1694–1757)) and they had mostly been educated in Italy and/or in the recently established Imperial Academy of Fine Arts (first 1692–1714, then from 1725 onwards). Important sculptors were Lorenzo Mattielli (1682×8–1748), Giovanni Giuliani (1663–1744), and above all Georg Raphael *Donner, who was commissioned by the city authorities to do the lead statues of the Providentia Fountain on the Mehlmarkt (1739: the originals now in the Österreichische Gal.). At the same time Emperor Charles VI, intent on promoting his politics via visual propaganda, ordered a new and sumptuous installation of the imperial collections completed in 1728 in the Stallburg, a separate part of the imperial palace.

The major collections were those of Prince Eugène of Savoy (d. 1736; most of the paintings now in Turin; prints and drawings Vienna, Albertina), the Prince of Liechtenstein (since the Second World War Vaduz, Liechtenstein Coll.), and Count Harrach (collections in Castle Rohrau, lower Austria, since the 1970s).

The imperial collections, substantially enriched by acquisitions, particularly *Rubens and van *Dyck, from what were then the Austrian Netherlands, were later transferred by Josef II (ruled 1765–90) to Prince Eugène's Belvedere and opened to the general public in 1781. During the reigns of Franz I, Maria Theresa, and Josef II the substitution of Italian taste in art through French influence gradually became perceptible. Their interests were similar to those of a fair number of contemporary patrons in Vienna, with a predilection for collections with a scientific and historical focus and support for the organization and the establishment of a policy for the arts within the terms of the Enlightenment. They were supported by the Francophile State Chancellor Prince Wenzel Anton Kaunitz-Rietberg (d. 1794), who as protector also reformed the Academy of Fine Arts (1772); unfortunately his highly important collection was dispersed in 1820–9. However, Vienna still has the collection of graphic art assembled by Maria Theresa's son-in-law Duke Albrecht of Saxe-Teschen (d. 1822), which was combined with the imperial collection of prints and drawings after the First World War to form the Graphische Sammlung Albertina. The most successful native painters of the Maria Theresa and Josef II period are Paul Troger (1698–1762) and Franz Anton *Maulbertsch; the court painter Martin van Meytens (a Swede) (1695–1770) was the most prominent portrait painter; mention should also be made of the sculptor *Messerschmidt, who attained fame with the life-size lead sculptures of the imperial couple (1764–6) and the busts of Charakterköpfe (grimacing heads) (after 1770; Österreichische Gal.).

Around the turn of the century new major collections were found: Count Anton Lamberg-Sprinzenstein (d. 1822), a diplomatic ambassador to Turin and Naples and later protector of the Academy of Fine Arts in Vienna, left his highly important holdings of international and Austrian art to this institution, making it the third important public collection in Vienna. Count Jan Rudolph Czernin (d. 1845), a prominent connoisseur and art administrator, began buying around 1800 (one of his major purchases was the Painter in his Studio by Jan *Vermeer, then attributed to Pieter de *Hooch, and since 1945 in the Kunsthistorisches Museum, Vienna). Significant parts of this collection were sold to the Residenz-Galerie in Salzburg in 1974. Czernin took an active part in the art controversies of his day. He was critical of the highly regarded *Nazarene School and the sentimental historicism of contemporary patriotic painting.

Prince Miklós Esterházy (d. 1833), the grandson of Joseph Haydn's protector, moved his collection to Vienna in 1814. Substantially enriched by his son Prince Paul (d. 1866) the collection was open to the public twice a week; it had to be sold in the late 1860s and was subsequently acquired by the Hungarian state in 1870 to form the core of Budapest's Museum of Fine Arts.

*Classicism in painting and sculpture is represented in Vienna by Heinrich Füger (1751–1818), director of the Academy and of the imperial painting collection, and by Franz Anton Zauner (1746–1822). Duke Albrecht of Saxe-Teschen commissioned *Canova to create the imposing funerary monument for his beloved wife, the Archduchess Marie Christine (1798–1805; Vienna, Augustinerkirche). A new 'idealistic' realism in portrait and landscape painting made its appearance from the 1820s. Its most important representatives are Ferdinand Georg Waldmüller (d. 1856), Friedrich Gauermann (d. 1862), Friedrich von

Amerling (d. 1887), and Rudolf von Alt (1812–1905), who during his long carreer became the faithful chronicler of his native Vienna. During the period 1815–48, known as the *Biedermeier period, the political despotism of the Metternich era was instrumental in causing the social withdrawal of many artists (and non-artists as well) into the private sphere. Viennese bourgeois decorative arts, particularly that of furniture, produced objects of extraordinary quality and sober simplicity.

The second half of the century, often called after the long-reigning Emperor Franz Josef (ruled 1848–1916), saw the rising of eclectic historicism. Initially focused on architecture in conjunction with the building, from 1857 onwards, of the Ringstrasse, the monumental avenue around the centre of Vienna which replaced the medieval walls, it went on to be adopted by all other genres. Hans *Makart was the painter whose name is synonymous with the sumptuous, ornate, and large-scale works so typical of this period of economic boom.

The Emperor's own efforts were directed more to the systematization of the scattered Habsburg collections than to direct patronage. The first decorative arts museum on the Continent, the Austrian Museum of Art and Industry (Austrian Museum of Applied Art, MAK), was founded on the Ringstrasse and opened in 1871, with the V&A (see under LONDON) as its direct model. The Kunsthistorischen Sammlungen des Allerhöchsten Kaiserhauses were opened in 1891 in today's Kunsthistorisches Museum. Starting in 1903 the Belvedere Palace was gradually transformed into an Austrian National Museum.

Compared to London or Paris art dealing had little tradition. Nevertheless, there should be mention of the Artaria'sche Kunsthandlung (founded 1770) of Georg Plach, active from 1847 onwards, and of Karl, later Charles, Sedelmeyer, active in Vienna 1860–73. During the flourishing late 19th century the art market began to grow on a larger scale, with H. O. Miethke (1861 onwards), J. C. Wawra (1872/3 onwards), and finally the installation of the Dorotheum as a state auction house (founded in 1707 as a pawnbroker's shop).

The development of Viennese *Jugendstil* (see ART NOUVEAU) art with its starting point in the founding of the Sezession in 1897 marked a decisive break in the history of art in Vienna (G. *Klimt, Wiener Werkstätte from 1903, later *Gerstl, *Schiele, *Kokoschka). In this context it is remarkable that the nobility and upper middle classes promoted a taste which was increasingly conservative. They were led in this by the Crown Prince, Archduke Franz Ferdinand, who fiercely attacked modern art. Jewish bourgeois industrialists and bankers, however, were intellectual in outlook, and mostly favoured progressive tendencies. On the one hand the art trade after the First World War was influenced by the political and economic problems, so that few traditional firms survived this era of decline (e.g. Nebehay, Artaria). On the other hand a few galleries fostered Austrian modern art (e.g. Neue Galerie; its founder, the Schiele scholar Otto Nirenstein-Kallir, had to move to New York in 1938, where he reopened it as Galerie S. Étienne, introducing Austrian modern art to America). WP

DaCosta Kaufmann, T., 'From Treasury to Museum: The Collections of the Austrian Habsburgs', in J. Elsner (ed.), *The Culture of Collecting* (1994).

Frimmel, T. von, *Lexikon der Wiener Gemäldesammlungen*, vol. 1/2 (1913/14).

(1558–c.1614) and Georges Lallemant (c.1580–1636) before going to Rome, probably early in the second decade of the century. He was associated there with *Manfredi, *Valentin, and *Vouet and certainly studied *Caravaggio. These influences are reflected in his early paintings of half-length saints, including the *S. Paul* (Turin; Sabauda Gal.), the *Singer* (Paris, Louvre), the *Martyrdom of S. Matthew* (1617; Arras, Mus. des Beaux-Arts) and the *Adoration of the Magi* (1619; Dayton, Oh., Art Inst.). However Vignon's response to Caravaggio and the *Manfrediana methodus* radically transforms the style from low-key naturalism to a manner that is apparently insouciant, flamboyant, and theatrical; and is closer in spirit to the work of printmakers such as *Bellange and *Callot. In 1623 he returned to Paris, where he was married; and he quickly achieved success at the court of Louis XIII. Some work continues to reflect his Roman experience, including the *S. Ambrose* (1623; Minneapolis, Inst. of Arts) and the *Christ among the Doctors* (1623; Grenoble, Mus. des Beaux-Arts). On the other hand his *Solomon and the Queen of Sheba* (Paris, Louvre) and the *Esther before Ahasuerus* (Greenville, SC, Bob Jones University AG) revert to a highly artificial Mannerism, with exotic combinations of colours in the heavy treatment of the draperies and a figure style that echoes Dutch and German artists such as *Elsheimer and Leonard *Bramer. By now Vignon's output was becoming prolific and ranged from religious and *history painting to genre and portraiture. He was employed by Cardinal Richelieu to decorate the Palais Cardinal, although he failed to secure any of the major decorative schemes in the French capital. Much in demand for churches all over France, he developed a simplified Counter-Reformation style for such works as the *Resurrection* (1635; Toulouse, Mus. des Augustins) and *S. Mamert at the Feet of Christ on the Cross* (1635–42; Orléans, Mus. des Beaux-Arts). His success was confirmed by election to the Académie Royale, *Paris, in 1651. However his increasingly busy studio was responsible for much mediocre work in the last 20 years of his life and his reputation now rests on his early achievements in and immediately after his return from Italy. HB

Bréjon de Lavergnée, A., and Cuzin, J., *Valentin et les Caravaggesques français*, exhib. cat. 1974 (Paris, Grand Palais).

Pacht Bassani, P., *Claude Vignon*, exhib. cat. 1994 (Tours, Mus. des Beaux-Arts).

VILLARD DE HONNECOURT (active c.1220–40) French draughtsman, who compiled a *Portfolio* (Paris, Bib. Nat., MS fr. 19093) of about 250 drawings on parchment of buildings, sculptures, church furnishings, carpentry, mechanical devices, and surveying. He possibly came from Honnecourt-sur-l'Escaut in Picardy, but he is known only from what he wrote in the *Portfolio*. Nothing he drew is datable after 1240, but a later hand added some stereotomical drawings, which persuaded 19th-century scholars that Villard was an architect. He himself made no such claim, nor is there any evidence that he was other than an educated layman of wide, if superficial, interests, who noted down what he saw, either on his travels or in drawings by others.

Villard used leadpoint, pen and ink, with contour washes. Buildings were inaccurately portrayed, but small objects and drapery were competently drawn, the latter showing interest in the 'trough fold' style. He also drew a human figure after the *Antique.

NC

Barnes, Carl F., Jr, 'Le "Problème" Villard de Honnecourt', in Les Bâtisseurs des cathédrales gothiques (1989).
Bowie, T., The Sketchbook of Villard de Honnecourt (3rd edn., 1968).

VILLON, JACQUES (1875–1963). French painter and engraver. Born Gaston Duchamp (brother of Marcel *Duchamp), Villon was initially a newspaper illustrator—hence his pseudonym, adopted to evade his family who preferred him to study law. His anecdotal style underwent a radical change in 1911 after he discovered *Cubism, and he subsequently became the dominant force in the French avant-garde group *Section d'Or 1912–14. Following its conclusions, Villon sought to combine Cubist and *Renaissance principles; M. D. lisant (1913; priv. coll.). After 1930 he became preoccupied with *colour theory. International awards and exhibitions marked the post-war era.

AA

Jacques Villon, exhib. cat. 1975 (Paris, Grand Palais).

VINCKBOONS, DAVID (1576–before 12 Jan. 1633). Flemish-born painter. He emigrated with his Protestant family to Amsterdam after the Spanish occupation of Antwerp in 1586. He does not appear to have had any teacher other than his father, a painter on linen, an art form practised mainly in Malines. Vinckboons was one of the most prolific and popular painters and print designers in Holland. Himself influenced by Pieter *Bruegel I, he was instrumental—together with Hans *Bol and Roelandt *Savery—in the development of *genre painting in the northern Netherlands. He specialized in elegant figures in parklike landscapes (Outdoor Merry Company, 1610; Vienna, Akademie der Bildenden Künste) as well as kermis and other village festivals. His landscapes reflect his contact with fellow émigré Gillis van *Coninxloo. Vinckboons attracted a number of students; among them were Gillis d'*Hondecoeter and probably Esaias van de *Velde. KLB

Sutton, P. C. (ed.), Masters of Seventeenth-Century Dutch Genre Painting, exhib. cat. 1984 (Philadelphia Mus.; Berlin, Gemäldegal.; London, RA).

VINGT, LES. Group of 20 progressive Belgian painters and sculptors who exhibited together from 1884 to 1893. The members included James *Ensor, Jan *Toorop, Fernand *Khnopff and Henry van der Velde (1863–1957). They showed not only their own work, but also paintings by non-Belgian artists such as *Cézanne, van *Gogh, and *Seurat. The group was influential in spreading the ideas of *Neo-Impressionism and became the main Belgian forum for *Symbolism and *Art Nouveau. Although the group dissolved in 1893 its work was carried on by an association called La Libre Esthétique, which ran from 1894 to 1914. Most of the leading Belgian avant-garde artists of the period were members. It was administered by the lawyer and critic Octave Maus (1856–1919), who also founded and ran the weekly periodical L'Art moderne (1881–1914), the leading avant-garde journal of the period. IC

VIRTU, VIRTUOSO. Virtu (Italian virtù, derived from Latin virtus: excellence) signified a knowledge of and enthusiasm for the fine and decorative arts, the latter being described as objects of virtu. It became current in Italy through Baldassare Castiglione's The Courtier (1528; English trans. 1561), in which it is specified as a courtly attribute. Its use in England, however, was largely due to *Lomazzo's Treatise on Painting (1584; English trans. 1598). A virtuoso, a possessor of virtu, was a description applied in the 17th century to collectors and connoisseurs but was also used for men eminent in the sciences. It was further used to denote artists, but only those of the educated upper classes who were seldom professional; the membership of the Society of Virtuosi (1689) included gentlemen-painters, sculptors, and architects. In modern usage it is confined to artists, particularly musicians, of exemplary and advanced technical ability. Virtuosa, a female virtuoso, a term first used in England in the late 17th century, is now obsolete.

DER

VISCHER FAMILY. Nuremberg sculptors and bronze founders: **Hermann the elder** (active 1453–1488); **Peter the elder** (c.1460–1529); **Hermann the younger** (1486–1517); **Peter the younger** (1487–1528); **Hans** (c.1489–1550); **Georg** (1520–92). The Vischer workshop was established by Hermann the elder in 1453. Its outstanding work is the bronze shrine of S. Sebaldus (Nuremberg, Sebalduskirche). The first design, preserved in a drawing of 1488 (Vienna, Akademie der Bildenden Künste), has an elaborate *Gothic *baldacchino towering over the 14th-century sarcophagus. The tomb as built (1507–19) by Peter the elder and his sons only partly reflects the drawing. The workshop had gained a good working knowledge of Italian sculpture, and the design became a fascinating mixture of Gothic and *Renaissance styles, reduced in height, stripped of elaborate tracery, and furnished instead with a host of Italianate details. Both base and canopy are inhabited by biblical, mythological, and decorative figures conceived in a genuine Renaissance spirit. The standing apostles of the middle register have been fined down, perhaps reflecting *Dürer's studies of Italian proportional practice. They mark a period of transition culminating in Peter the elder's figures for the tomb of the Emperor Maximilian I (1513; Innsbruck, Hofkirche), in a style no longer recognizably Gothic at all. JR

Gothic and Renaissance Art in Nuremberg 1300–1550, exhib. cat. 1986 (Nuremberg, New York).

VISENTINI, ANTONIO (1688–1782). Italian painter, engraver, architect, and theorist. He was born in Venice and trained as a painter with Giovanni Antonio *Pellegrini. A volume of his drawings engraved by Vicenzo Mariotti (d. 1734) was published as Iconographia della ducal basilica dell'Evangelista di S. Marco in 1726, and established his reputation. He was active as an engraver (see LINE ENGRAVING) from the late 1720s when Consul Joseph Smith commissioned him to produce prints after *Canaletto, which were first published in 1735 as Prospectus magni canalis Venetiarum and published in an enlarged version by Giambattista Pasquali in 1742–54, as Urbis Venetiarum prospectus celebriores.

Visentini also worked as a painter of *capricci. He was commissioned by Smith to collaborate with *Zuccarelli in the execution of a series of overdoors showing various English Palladian buildings, based on Colen Campbell's Vitruvius Britannicus (1715–25) and William Kent's The Designs of Inigo Jones (1727). And he himself wrote didactic texts which express anti-Baroque ideas and advocate a Neo-Palladian style in architecture. HB

Blunt, A., 'A Neo-Palladian Programme Executed by Visentini and Zuccarelli for Consul Smith', Burlington Magazine, 100 (1958).

VISIGOTHIC, term describing the (western) Gothic peoples who migrated from south Russia via Gaul to rule the Iberian peninsula from the 5th to 8th centuries AD. Their art represents a fusion between Germanic and classical taste: features of pagan decorative metalwork showing the barbarian love of rich inlays (as on their characteristic eagle brooches) were adapted to the requirements of the Christianity imposed by the devout Visigothic rulers, as part of their immersion into Roman culture. A further influence was the *iconography of the early Christian art of the *Byzantines who occupied southern Spain.

Superb examples of Visigothic Christian jewellery survive from the Guarrazar Treasure; this contained a series of remarkable votive crowns and crosses, including those made for King Recceswinth (653–72), crafted of gold set with pearls and sapphires (Paris, Mus. Cluny). This tradition of vivid colours

and angular stylization was to survive into manuscripts such as the Beatus commentaries of the 9th and 10th centuries, products of the brilliant *Mozarabic style which emerged following the the Arabic invasions of Spain in the 8th century. CMH

Hubert, J., Porcher, J., and Volbach, W. F., *Europe in the Dark Ages* (1969).

VITALE DA BOLOGNA (c.1300×9–1359×61). Vitale was the most important fresco painter working in northern Italy in the mid-14th century. His workshop was probably the largest in Bologna from c.1335 and probably the most important source for panel painting outside Venice between 1340 and 1360. His frescoes in Udine Cathedral (S. Niccolò chapel, Old and New Testament cycles in the chancel, 1348) established the iconography and style of most mural painting in the Julian Alps and the north of the kingdom of Hungary.

The roots of his art lie in the work of such Bolognese illuminators as the 1328 Master and Vitale's contemporary, L'*Illustratore: from them and the first major Bolognese panel painter, the 'Pseudo-Jacopino', Vitale developed a highly dramatic narrative style, his figures expressed with simplified anatomy, elegant faces, and often rich fabrics, exemplified by his *S. George* signed on the horse with an anagram of his name that puns on his surname, *de Equis* (c.1340–5; Bologna, Pin. Naz.). His signed and dated *Madonna dei Denti* (1345; Bologna, Palazzo Davia-Bargellini) is a personalized version of *Giotto's Bologna Polyptych of the *Virgin and Child with Saints* (Bologna, Pin. Naz.), Giotto and *Buffalmacco having a recognizable influence on his maturing style and compositions. The S. Salvatore Polyptych (1352; Bologna, S. Salvatore) shows the richness and refinement of his mature panel paintings. RG

Gnudi, C., *Vitale da Bologna* (1962).

VITTORIA, ALESSANDRO (1525–1608). Italian sculptor born in Trent, who moved to Venice in 1543, where he entered Jacopo *Sansovino's workshop. Among his earlier works are the stucco ceiling decoration of the Libreria di S. Marco and the vaulting of the Scala d'Oro in the Doge's palace (1557–9). His *S. Sebastian* (1561–3) from his altar for S. Francesco della Vigna in Venice was subsequently cast in bronze, and is a familiar sculptural feature in contemporary paintings. His *stuccoes for the Villa Barbaro at Maser complement *Veronese's frescoes there. After Sansovino's death Vittoria assumed his supreme position, and developed an even more *Mannerist style. His bronze *Annunciation* (c.1580; Chicago, Art Inst.), executed for Johann Fugger, depends on *Titian's design, and its flickering contours and broad planes look forward to *Baroque reliefs.

Other small bronzes display an inventive mind. Numerous autograph and workshop portrait busts, including the fine bronze bust of *Tommaso Rangone* (c.1575; Venice, Ateneo Veneto), testify to their popularity among the Venetian patriciate, while monumental marble works such as the *S. Jerome* (c.1576; Venice, SS Giovanni e Paolo) illustrate his mastery of anatomy and expression. AB

Bacchi, A., Camerlengo, L., and Leithe-Jasper, M. (eds.), *'La bellissima maniera': Alessandro Vittoria e la scultura veneta del cinquecento*, exhib. cat. 1999 (Trent, Castello del Buonconsiglio).

Cessi, F., *Alessandro Vittoria scultore* (2 vols., 1961–2).

VIVARINI FAMILY. Italian painters of the Venetian School. **Antonio** (active 1415–76×84) worked mostly in collaboration with his brother-in-law Giovanni d'Alemagna (d. 1450), for example on the *Coronation of the Virgin* (1444; Venice, S. Pantalon), and later with his own younger brother **Bartolomeo** (active 1440–1500), as on the polyptych for the Certosa di Bologna (1450; Bologna, Pin. Nazionale). Their pictures usually took the form of large-scale polyptychs with stiff, archaic figures and very elaborate carved and gilded frames in the *Gothic tradition. Bartolomeo, who was trained in Padua, emerges as an independent figure in the 1460s with a linear style influenced by *Mantegna. **Alvise** (c.1445–1503×5), son of Antonio, was trained by Bartolomeo but showed greater awareness of other developments in Venetian art, notably the work of *Antonello da Messina and Giovanni *Bellini. This was not sufficient to establish a separate identity, however, and the Vivarini family as a whole have generally been regarded as exponents of the conventional Gothic tendency in Venice as opposed to the new *Renaissance manner that emerged from the circle of Giovanni *Bellini. PSt

Steer, J., *Alvise Vivarini: His Art and Influence* (1982).

VLAMINCK, MAURICE DE (1876–1958). French painter. Vlaminck worked as a mechanic, and became a racing cyclist and successful violinist before teaching himself painting. In 1901 he was strongly influenced by a van *Gogh exhibition and, developing a loose, exuberantly coloured style, he was soon exhibiting alongside the *Fauves. However, a retrospective of *Cézanne in 1907 led him toward a stronger emphasis on composition; his subject matter remained predominantly landscape, rendered in an abstract, expressionistic manner. He continued to write throughout his career, publishing poems, novels, and commentaries. MF

Vlaminck, exhib. cat. 1987 (Chartres, Mus. des Beaux-Arts).

VLIEGER, SIMON DE (c.1600–53). Dutch painter, mainly important for *marine pieces. He was versatile, and won important public commissions in his birthplace, Rotterdam, and in Delft and Amsterdam, for jobs such as painting organ shutters and designing stained-glass windows; he also did landscape paintings and *etchings. Initially influenced by *Vroom, in the 1630s he adopted the limited, grey palette of *Porcellis, and went on to explore atmospheric effects in a much wider range of silvery tones; such mature works as *Beach Scene* (1643; The Hague, Mauritshuis) render the evocative play of light against a vast expanse of cloudy sky and sea. He painted beach scenes, storms, rocky coastlines, calms, and parade subjects, in which a variety of vessels is shown, often by the device of depicting the arrival of anonymous dignitaries. He had a strong influence on the next generation of marine artists: van de *Cappelle had a huge collection of his drawings and paintings, and van de *Velde the younger was his pupil. AJL

Mirror of Empire: Dutch Marine Art of the Seventeenth Century, exhib. cat. 1990 (Minneapolis, Inst. of Arts).

VOGTHERR, HEINRICH, THE ELDER (1490–1556). German designer of *woodcuts, block-cutter, publisher, writer, and eye specialist. Son of a surgeon and eye doctor of Dillingen, a town on the Danube, Vogtherr probably acquired his interest in medicine from his father. He wrote and printed several medical books, but his main career was as an artist. He may have been trained in the workshop of Hans *Burgkmair in Augsburg and subsequently may have spent time with Hans *Schäufelein in Nördlingen. He later worked in various cities, including Strasbourg and Zurich, before he was called, in 1550, to the court of Ferdinand I in Vienna. Vogtherr was a versatile personality whose career included painting, designing and executing woodcuts and *etchings, and publishing, as well as writing religious tracts, hymns, and medical books and practising ophthalmology. Not of high artistic quality, his output is characterized by diversity of subject matter, from biblical and devotional images to astrological signs and freaks of nature. Today he is best known for his *Kunstbüchlein* (1537), the first printed model book for artists. KLB

VORAGINE, JACOPO DA (c.1230–98). Italian archbishop and writer. Voragine was a Dominican friar who became Archbishop of Genoa in 1292. He is best known for his enormously popular book on the lives of the saints, the *Legenda aurea* or *Golden Legend* written between 1255 and 1266. Containing 182 chapters, it gives colourful accounts of the lives and deaths of the most venerated

saints and holy people. During the 14th and 15th centuries the *Legenda aurea* exerted a considerable *iconographic influence. Its use as a source can be detected in some of the most important religious works of the period, from *Giotto's Arena chapel, Padua, and *Piero della Francesca's *Legend of the True Cross* (Arezzo, S. Francesco) to the *Belles Heures de Jean, Duc de Berry* (c.1408–9; New York, Met. Mus. Cloisters, MS 54.1.1). The non-historic and legendary nature of the *Golden Legend*, intended to inspire the reader to greater piety, led to its harsh criticism in the 16th century. Nonetheless it stands beside the Bible and the 14th-century Franciscan work *Meditations on the Life of Christ* as one of the most important sources for medieval and Renaissance artists. KC

Reames, S. L., *The Legenda aurea: A Re-examination of its Paradoxical History* (1985).

Voragine, Jacopo da, *The Golden Legend*, trans. and ed. G. Ryan (1993).

VORSTERMAN, FATHER AND SON. Flemish engravers who worked as reproductive printmakers. Born in the northern Netherlands, **Lucas the elder** (1595–1675) came to Antwerp, presumably to work in *Rubens's studio. He was in Rubens's service by 1618, making prints from the master's paintings, which were used to disseminate his ideas and to obtain copyrights. In 1624, after a dispute with Rubens, Vorsterman left for England where he worked primarily for the Earl of Arundel in the reproduction of his collection of drawings (the so-called paper museum). After his return to Antwerp c.1630, Vorsterman became the most important collaborator in van *Dyck's Iconography. Technically brilliant and of great sensitivity, Lucas fully matured in Rubens's studio. Initially working in the style of the Haarlem *Mannerists, he was later able to transform Rubens's painterly manner into the medium of print (*Susanna and the Elders*, 1620). **Lucas the younger** (1624–66) was his father's pupil; he became a member of the Antwerp guild of S. Luke in 1651/2. He continued to work for the Earl of Arundel in Antwerp, producing engravings after drawings in the latter's collection. He also made engravings after paintings by contemporary Flemish artists, and supplied numerous reproductive prints for David *Teniers II's *Theatrum pictorium* (1658). A competent engraver, he lacked his father's brilliance. KLB

Faber Kolb, A., 'The Arundels' Printmakers', *Apollo*, 144/414 (1996).

Mai, E., and Vlieghe, H. (eds.), *Von Bruegel bis Rubens*, exhib. cat. 1992 (Cologne, Wallraf-Richartz-Mus.; Antwerp, Koninklijk Mus. voor Schone Kunsten; Vienna, Kunsthist. Mus.).

VORTICISM, English art movement, formed in 1913 by Wyndham *Lewis at his 'Rebel Art Centre' in London. The group included C. R. W. *Nevinson, William *Roberts, David *Bomberg, Frederick Etchells (1886–1973), and Edward *Wadsworth; the sculptors Jacob *Epstein and Henri *Gaudier-Brzeska, and the philosopher T. E. Hulme. The concept of 'the Vortex' came from Lewis's idiosyncratic interpretation of the manifesto of the Italian *Futurists, whose works were exhibited in London in 1912–13. The new movement was announced through the journal *Blast*, of which two numbers appeared in 1914, edited by Lewis, with contributors including Ezra Pound, T. S. Eliot, Rebecca West, and Ford Madox Hueffer. The Vorticists demanded that the artist should celebrate the dynamic spirit of the modern machine age, while recognizing, unlike the Futurists, the darker side of the industrial world. They held an exhibition in 1915, where their works showed a common tendency towards simplification into angular, semi-abstract, machine-like forms. Vorticism did not survive the war; an attempt to reconstitute it as Group X in 1920 failed, as surviving members developed in different directions. But despite its brief existence it is probably the most original English contribution to the avant-garde. JH

Cork, R., *Vorticism and Abstract Art in the First Machine Age* (1976).

VOS, CORNELIS DE (c.1584–1667). Flemish portrait painter and dealer. Born in Hulst, de Vos moved with his family to Antwerp in 1596, where he became a pupil of David Remeeus. In 1608 he became a master in the Antwerp guild, in which he was later to hold official positions. Described in 1616 as a citizen and dealer, by the 1620s he had begun to have considerable success as a portrait painter, especially after the departure of van *Dyck in 1621. He specialized in large, well-balanced family groups, set within restrained but rich interiors, such as *Portrait of Anthony Reyniers and his Family* (1631; Philadelphia Mus.). An even, bright light brings out de Vos's sensitive portrayal of the characters of his sitters and the varied textures of their clothes. Van Dyck's return to Antwerp in 1627 inspired de Vos to paint full-length portraits, with the figure standing in front of architecture and an open landscape, for example, *Anna Maria Schotten* (Boston, Mus. of Fine Arts). During the 1630s, portraiture gave way to biblical and history subjects. Between 1636 and 1638 Vos assisted *Rubens with decorations for Philip IV's hunting lodge at Torre de la Parada, near Madrid, after which his activity as an artist declined. De Vos's sister Margaretha married Frans *Snyders and his brother Paul de Vos was also a painter.
CFW

Sutton, P., et al. (eds.), *The Age of Rubens*, exhib. cat. 1993 (Boston, Mus. of Fine Arts; Toledo, Oh., Mus.).

VOS, MARTEN DE (1532–1603). Flemish history painter and draughtsman, predominantly of designs for prints, active in Antwerp. A supposed apprenticeship to Frans *Floris is not supported by documents. In the 1550s de Vos was in Italy. It is assumed that he visited Rome, Florence, and Venice, where, according to Carlo *Ridolfi, he spent some time in the studio of *Tintoretto. He became a master in the Antwerp guild of S. Luke in 1558, and henceforth established himself as one of the most successful figure painters in the city, especially after the death of Floris in 1570. Predominantly a painter of religious themes, he also executed portraits. In his numerous altarpieces, he abandoned early *Mannerist forms for a clearer and more rational style, better suited to the propagandistic demands of the Counter-Reformation (*Marriage at Cana*, 1597; Antwerp Cathedral). KLB

Zweite, A., *Marten de Vos als Maler* (1980).

VOUET, SIMON (1590–1649). French painter and draughtsman. He was born in Paris, the son of a painter, and appears to have had a precocious talent. He is said to have visited England at the age of 14, and Constantinople in 1611, to execute portrait commissions, but it was in Rome, where he had arrived by 1614, that he consolidated his reputation as a portrait painter. Supported by a pension from the French Crown and patronage from the Barberini family he soon received commissions from aristocratic and ecclesiastical patrons, not only in Rome but also in Genoa and Naples, and by 1624 his success was confirmed by his election as president of the Accademia de S. Luca (see under ROME). At Rome, he was immediately impressed by *Caravaggio's naturalism and tenebrism, and this influence is evident in his overpowering portrait of the great Genoese patron Giancarlo Doria (1621; Paris, Louvre). More spontaneously executed portraits taken directly from life, with broad brush strokes and minimal detail, such as the *Portrait of a Bravo* (Brunswick, Herzog-Anton-Ulrich Mus.), and the putative *Self-Portrait* now at Arles (Mus. Réattu) and the *Self-Portrait* at Lyon (Mus. des Beaux-Arts), also reflect Vouet's association with the followers of *Manfredi, who specialized in this Caravaggesque genre. However it is in Vouet's major religious commissions, notable for their dignified naturalism, that the debt to Caravaggio is most significant: the *Birth of the Virgin* (c.1620; Rome, S. Francesco a Ripa); the *Crucifixion* (1622; Genoa, Church of the Gesù); the

Circumcision (1622; Naples, Capodimonte, ex-S. Angelo a Segno); the *Temptation of S. Francis* and the *Clothing of S. Francis* (1624; Rome, Alaleoni chapel, S. Lorenzo in Lucina).

Yet Vouet never surrendered wholly to the Caravaggesque style and working methods. He was a brilliant draughtsman and as such responded to the classical-Baroque style of Annibale *Carracci and Guido *Reni as well as to the *Baroque illusionism of *Lanfranco. This is apparent in the decoration of the vault of the Alaleoni chapel of S. Lorenzo in Lucina, in the *Appearance of the Virgin to S. Bruno* (1626?; Naples, Certosa di S. Martino); the *Holy Family with S. John the Baptist*, a *Raphaelesque design set against ruins in the open air (1626; San Francisco, Fine Arts Mus.); and *Time Vanquished by Venus, Love, and Hope* (1627; Madrid, Prado), which in its exuberance, with brightly coloured figures dancing in front of a romantic landscape, anticipates Vouet's future career as a large-scale decorator in France.

Vouet had returned to Paris by November 1627 and became Premier Peintre du Roi. He was employed on innumerable projects for the King, including cartoons (now lost) for a series of tapestries illustrating the Old Testament (Paris, Louvre); paintings for the royal palaces at Château Neuf de St Germain-en-Laye, the Château de Fontainebleau, and the Palais Royal, Paris (*Assumption of the Virgin*; Reims, Mus. S. Denis). Most of his decorative work in the Italian *trompe l'œil* style and executed with the help of a large studio for the *hôtels* in Paris has been destroyed but is recorded in reproductive engravings. His religious commissions have fared better and include a *Crucifixion* (1636; Lyon, Mus. des Beaux-Arts) painted for the chapel of the Hôtel Séguier, Paris; *S. Carlo Borromeo Offering his Life to God* (late 1630s; Brussels, Mus. des Beaux-Arts); *The Rest on the Flight into Egypt* (1640, Grenoble, Mus. des Beaux-Arts); and the *Presentation of Jesus in the Temple*, painted *c*.1641 for S. Louis des Jésuites (Paris, Louvre). A *Diana* painted for King Charles I of England (1637; London, Royal Coll.) epitomizes Vouet's lucid classical style at the height of his career in France. Through his tireless efforts as a decorator Vouet brought the *Grand Manner from Italy to France; and although his French work often lacks intellectual profundity or emotional depth, he successfully prepared the ground for the influential French Académie Royale, *Paris, which opened, with his active participation, in 1648, the year before his death.　　HB

Crelly, W., *The Painting of Simon Vouet* (1962).
Thuillier, J., et al., *Vouet*, exhib. cat. 1990 (Paris, Grand Palais).

VRANCX, SEBASTIAN (1573–1647). Flemish painter of *battle and genre scenes. Van *Mander's claim that he was a pupil of Adam van Noort (1562–1641) is possible but otherwise unconfirmed. Vrancx travelled to Italy *c*.1597. He was back in Antwerp by 1600 when he became a master in the guild of S. Luke. In addition to his professional obligations, he was active in civic organizations and in the rhetoricians' chamber *de Violieren*, for which he wrote many farces, comedies, and tragedies (now lost). Vrancx is best known for his depictions of battle scenes and village plunderings (*Attack on a Convoy*, 1616; Windsor Castle, Royal Coll.). He also painted pure landscapes, religious and mythological subjects, allegories of the Seasons and Months, and illustrations of proverbs in the tradition of Pieter *Bruegel I. His landscapes with classical ruins may have been inspired by his Italian sojourn. He collaborated with Hendrik van *Balen, Jan *Brueghel I, Joost de *Momper, and David *Vinckboons. His successor in the southern Netherlands was his pupil Pieter Snayers (1592–1667) and in the north Esaias van de *Velde and Philips *Wouverman.　　KLB

Sutton, P. C., *The Age of Rubens*, exhib. cat. 1993 (Boston, Mus. of Fine Arts; Toledo, Oh., Mus.).

VREL, JACOBUS (active 1654–62). Dutch painter. Vrel is very sparsely documented and nothing certain is known about his life, though he is normally associated with the School of Delft. Of his 30 or so paintings, half are street scenes and half are simple interiors in most of which women are seen going about their daily tasks. The *Woman at a Window* (1654; Vienna, Kunsthist. Mus.) is signed and dated four years earlier than de *Hooch's first dated Delft interior. Whilst Vrel appears to have anticipated de Hooch's interest in this kind of subject matter, and in exploring the effects of light flooding through windows, both his drawing and control of light effects are naive in comparison with de Hooch's mastery. It is possible that he was a 'Sunday painter'. Whatever his technical limitations, however, Vrel's interiors are memorable intimist images of domestic quietism.　　AJL

Kersten, M. C. C., and Lokin, D. H. A. C., *Delft Masters* (1996).

VRELANT, WILLEM (active 1449–d. 1481). Netherlandish illuminator born in Utrecht, but chiefly active in Flanders, where he became a citizen of Bruges in 1456. Records of the Bruges guild of S. John the Evangelist show him as an active and successful member. He worked for several members of the *Burgundian court, including Philip the Good, whom he portrayed twice in the Duke's Breviary (*c*.1467; Brussels, Bib. Royale, MSS 9026 and 9511). He was also commissioned by Philip to illuminate the second part of the *Chronicles of Hainaut* (Brussels, Bib. Royale, MS 9243), which he completed under the reign of Philip's son Charles the Bold. Indeed all attributions to him depend on accepting that Guillaume Wyelant, the name used in documents concerning the commission for the *Chronicles of Hainaut*, was a variant form of Vrelant. He also contributed to the illumination of the famous Book of Hours made for Charles's daughter Mary of Burgundy (Vienna, Österreichische Nationalbib. Cod. 1857). Vrelant's elegant and mannered style was so popular, his workshop so vast, and imitations so numerous that it is often very difficult to distinguish his own hand. After his death in 1481 Vrelant's wife and daughter continued his trade.　　KC

Bousmanne, B., *'Item a Guillaume Wyelant, aussi enluminure . . .'* (1997).

VRIENDT, DE. See FLORIS FAMILY.

VRIES, ADRIAEN DE (*c*.1545–1626). Sculptor born in The Hague. He was one of *Giambologna's most important pupils in Florence, and was instrumental in introducing *Mannerist sculpture to northern Europe. In his early style he reinterpreted the elegant contours and polished surfaces of his teacher's works, notably in the *Mercury and Psyche* (*c*.1593; Paris, Louvre), while his three fountains for Augsburg (1595–1602) are developed from 16th-century Florentine fountain designs. Together with the *Prague court painters, as sculptor to Emperor Rudolf II (1552–1612) he developed a highly artificial and rarefied artistic style, in both religious and secular works. His two bronze portrait busts of the Emperor (1603, 1607; Vienna, Kunsthist. Mus.) and a portrait relief (1609; London, V&A) demonstrate his supremacy in bronze *casting and imaginative skills in ornamental detail. His *Seated Christ* (1607; Vaduz, Liechtenstein Coll.) is a monumental and dignified image of the broken Christ. Together with the fountain from Frederiksborg Slot in Denmark (1615–17), his fountain and garden figures for Albrecht von Waldstein in Prague were plundered by Swedish troops and re-erected at Drottningholm, near Stockholm (now Stockholm, Nationalmus.). These sculptures illustrate the shift in his later style towards a looser, more bizarre figure style.　　AB

Larsson, L. O., *Adrian de Vries* (1967).
Scholter, F. (ed.), *Adriaen de Vries 1556–1626*, exhib. cat. 1998 (Amsterdam, Rijksmus.; Stockholm, Nationalmus.; Los Angeles, Getty Mus.).

VROOM, FATHER AND SON. Dutch painters. **Hendrick Cornelisz.** (1566–1640) was the first specialist Dutch marine painter. After adventures in Poland, Spain, and Italy, where he spent two years in Rome under Medici patronage, and received instruction from Paul *Bril, he settled in Haarlem in 1592. In that year he designed the

enormously successful set of ten tapestries (destr. 1834) that Lord Howard of Effingham had commissioned to commemorate the defeat of the Spanish Armada. Thereafter he became the leading painter of large marine paintings of history subjects, very many of which were commissioned to celebrate the military, commercial, and political events of the rising Dutch Republic. He was especially praised for the consummate accuracy of his portrayal of ships, and he applied the same meticulous observation to his profile views of Dutch cities, often, as in the *View of Hoorn* (1622; Hoorn, Westfries Mus.) combining the two genres in the same painting. By the 1630s his official art was old-fashioned, though he showed a more experimental side in drawings and small beach scenes. He trained his son **Cornelis** (*c*.1591–1661) as a marine painter, but Cornelis soon turned to landscape, painting unassuming scenes of softly wooded river banks, such as *Landscape with River by a Wood* (1626: London, NG). Cornelis also visited Italy. AJL

Russell, M., *Visions of the Sea* (1983).

VUILLARD, ÉDOUARD (1868–1940). French painter, lithographer, and decorator. At the Lycée Condorcet he was contemporary with Aurélian Lugné-Poë, *Denis, and K.-X. Roussel (1867–1944) (who later married Vuillard's sister) and in 1888 he became a member of the *Nabis while studying at the Académie Julian, Paris. He was influenced by *Gauguin (through *Sérusier), *Degas, and Japanese art, producing flattened and patterned intimist interiors in unusual compositions; *Woman in Blue with Child* (1899; Glasgow, AG). With his seamstress mother ('my muse') he shared a small Paris flat, which was often filled with richly patterned materials; these elements form the tonally and chromatically close paintings which, with their subtle abstractions, express a *fin de siècle* claustrophobia and lay claim to a profound, painterly significance. He formed valuable friendships with the Hessels, Bernsteins, and Natansons (*La Revue blanche*) and painted decorations for them, such as *Little Girls Playing* (1894; Paris, Mus. d'Orsay), favouring distemper (a glue size and pigment mixture) on cardboard and canvas, a technique learned in the theatre. After 1900 he concentrated on large decorative ensembles and *haute bourgeoisie* portraits. JL

Russell, J., *Vuillard* (1971).
Thompson, B., *Vuillard* (1988).

WADSWORTH, EDWARD (1889–1949). British painter, printmaker, draughtsman, and designer, born at Cleckheaton (Yorks.), son of a wealthy industrialist. He took up painting while he was studying engineering in Munich, 1906–7, and had his main training at the Slade School, London, 1908–12, winning prizes for landscape and figure painting. In 1913 he worked for a short time at Roger Fry's *Omega Workshops, but he left with Wyndham *Lewis and joined the *Vorticist group (he was a good linguist and published translations from *Kandinsky's writings in the first number of *Blast*, 1914). At this time his work included completely abstract pictures such as the stridently geometrical *Abstract Composition* (1915; London, Tate). This is close in style to Lewis's work of the same date, but there was a great difference in personality between the two men, as Ezra Pound observed: 'Mr Lewis is restless, turbulent, intelligent, bound to make himself felt. If he had not been a vorticist painter he would have been a vorticist something else . . . If, on the other hand, Mr Wadsworth had not been a vorticist painter he would have been some other kind of painter . . . I cannot recall any painting of Mr Wadsworth's where he seems to be angry. There is a delight in mechanical beauty, a delight in the beauty of ships, or of crocuses, or a delight in pure form. He liked this, that or the other, and so he sat down to paint it' ('Edward Wadsworth, Vorticist', *Egoist*, 15 Aug. 1914). Many other critics echoed Pound's belief that Wadsworth was a born painter, for throughout his career his highly finished craftsmanship won admiration even from those who were not usually sympathetic to *avant-garde art.

In the First World War Wadsworth served with the Royal Naval Volunteer Reserve as an intelligence officer in the Mediterranean, then worked on designing dazzle camouflage for ships, turning his harsh Vorticist style to practical use. This experience provided the subject for one of his best-known paintings, the huge *Dazzle-Ships in Drydock at Liverpool* (1919; Ottawa, NG Canada). The lucidity and precision seen in this work were enhanced when Wadsworth switched from oil painting to tempera in about 1922. At the same time his style changed, as he abandoned *Cubist leanings for a more naturalistic idiom. He had a passion for the sea and often painted maritime subjects, developing a distinctive type of highly composed marine still life, typically with a *Surrealistic flavour brought about by oddities of scale and juxtaposition and the hypnotic clarity of the lighting (*Satellitium*, 1932; Nottingham, Castle Mus.). In the 1920s and 1930s he was among the most European in spirit of British artists. He travelled widely on the Continent and in 1933 contributed to the Paris journal *Abstraction-Création*. In the same year he was a founder member of Unit One. Around this time he again painted abstracts (influenced by *Arp), but he reverted to his more naturalistic style in 1934. In the later 1930s he had several commissions for murals, notably two panels for the liner *Queen Mary* in 1938 (these were so large that he painted them in the parish hall at Maresfield (Sussex), the village where he had settled in 1928, as this was the only building in the neighbourhood that could accommodate them).

Wadsworth was an impressive graphic artist as well as a painter. In this field he is best known for his vigorous, angular wood engravings of ships and machinery, which played a part in the revival of the *woodcut after the First World War. The drawings that he published in *The Black Country* (1920, introduction by Arnold Bennett) are comparably bold, but his copper engravings for his other collection in book form, *Sailing Ships and Barges of the Western Adriatic and the Mediterranean* (1926), are delicately executed. For an artist, Wadsworth was 'unusually businesslike, answering letters by return of post and punctiliously fulfilling his commissions' (*DNB*), but he has been aptly described by Sir

John Rothenstein as 'a true poet of the age of machines'. IC

WALBAUM, MATTHIAS (1554–1632). German goldsmith. One of the most celebrated and prolific artists in Augsburg, he specialized in embossed, cast silver and silver gilt secular and devotional objects, small altars and reliquaries for important Catholic patrons, despite being a Protestant himself. In 1569 he was apprenticed for six years to Hans von Tegelen I in Lübeck. Except for the year 1594 when he resided at the Bavarian ducal court, he moved permanently to Augsburg. A silver writing case (Munich, Residenz) may have been one of the objects made for Duke Wilhelm V. The Borghese Altar (Rome, Borghese Gal.), commissioned c.1613 by Cardinal Scipione Borghese for his private chapel, is a characteristic example of Walbaum's work. The altar has a profusion of *Mannerist ornament, pierced scrollwork, vigorous strapwork, combined with many tiny figures, and floral and grotesque motifs. The elaborately detailed Christian IV Altar (Frederiksborg Slot) is dedicated to the Virgin, somewhat unexpectedly in such a Protestant environment. Walbaum seems to have been an entrepreneur of wide-ranging abilities who ran a large and efficient workshop. CFW

Seling, H., *Die Kunst der Augsburger Goldschmeide* (3 vols., 1980).

WALDMÜLLER, FERDINAND (1793–1865). Austrian painter. He trained at the Vienna Academy (1817–20) and also spent many hours copying old master paintings in Viennese collections. After a visit to Italy in 1825 he established a successful portrait practice and received royal patronage with his portrait of *Franz I* (1827; Vienna, Historisches Mus.). A painter of *Biedermeier portraits, which won comparison with those of *Ingres, flower pieces, and contemporary genre, Waldmüller was particularly admired for his landscapes, which exemplify, with their accurately observed and meticulously painted details and luminous atmosphere, his belief that art should be based on a close study of nature. This artistic credo was directly opposed to the idealization of nature espoused by the Vienna Academy and eventually, after much undiplomatic acrimony, brought about his dismissal from the post of professor of painting, which he had held from 1829, in 1857. From c.1840 Waldmüller painted sanitized scenes of Austrian peasant life in which the naturalism of his technique sits uneasily with the sentimentality of his treatment. In 1856, during a stay in London,

he sold 31 pictures to the royal household and court. DER

Grabner, S., *Ferdinand Georg Waldmüller (1793–1865)*, exhib. cat. 1993 (Salzburg, Mus. Carolino Augusteum).

WALL PAINTING. See opposite.

WALNUT OIL. See MEDIUM.

WALPOLE, HORACE, 4TH EARL OF ORFORD (1717–97). English writer and connoisseur. Walpole undertook a *Grand Tour of France and Italy, 1739–41, with his Etonian schoolfellow the poet Thomas Gray (1716–71). At Florence he met Sir Horace Mann (1701–76), the English consul, and their subsequent, voluminous, correspondence provides an unrivalled portrait of contemporary Florentine life. In 1747 he purchased a villa at Twickenham, Strawberry Hill, and proceeded to Gothicize it using a combination of accurate research and his own *Rococo whimsy. Here he assembled a large but indifferent collection of objects of *virtu, prints, and curiosities, several of which were purchased in Italy by Mann, which attracted fashionable attention. In 1757 he established his own press which published, *inter alia*, his *Anecdotes of Painting in England* (5 vols., 1762–5), based on the notebooks of the engraver George *Vertue and his own assiduous attendance at exhibitions. In both Strawberry Hill and his novel *The Castle of Otranto* (1764) he pioneered the *Romantic Gothic style which reached its literal pinnacle in Fonthill Abbey (Wilts.) (1796–1807), the gigantic folly of William Beckford (1760–1844). DER

Ketton-Cremer, R., *Horace Walpole* (1940).

WALTHER FAMILY. Three generations of German sculptors active in Dresden; the most important members were **Christoph I** (d. 1546), his son **Hans II** (1526–86), and his nephew **Christoph II** (1534–84). The four sons of Christoph II—Andreas III (c.1560–96), Christoph IV (active c.1572–1626), Michael (active c.1574–1624), and Sebastian (1576–1645)—carried the family tradition into the third generation. All members were engaged by the court of Saxony, especially Duke Moritz's and his brother August's ambitious palace expansion, and it was with their work that High *Renaissance forms were introduced into an essentially Gothic Dresden. Christoph I supplied relief carvings for the great staircase in the ducal palace in Meissen (*in situ*). In Dresden he was responsible for the façades of the Georgenbau, the new gatehouse of the Residenz. After its completion, the emphasis of his work shifted to the execution of tombs for the Saxon nobility. Hans II, who took over his father's workshop, shared a career as a sculptor with that of mayor of Dresden. Like his father, he

contributed to the sculptural decorations of the palace in Dresden and carved sandstone statues and reliefs for the portal of the palace church (1555). Christoph II initially collaborated with his cousin Hans II, but later established himself successfully as an independent master. His main work is the organ case originally intended for the Schlosskapelle in Dresden, but placed in his *Kunstkammer* by Duke August (1584; Dresden, Historisches Mus., destr. 1945). KLB

Smith, J. Chipps, *German Sculpture of the Later Renaissance* (1994).

WANDERERS, THE. See PEREDVIZHNIKI.

WAR ARTISTS SCHEME. The first official British war artists were appointed in 1916 after pressure from William Rothenstein (1872–1945) and Lord Northcliffe among others, and in response to a similar German initiative. Artists as traditional as *Orpen and as modern as Paul *Nash were employed to record the progress of the Great War. Others, particularly Wyndham *Lewis and *John, who fell foul of War Office bureaucracy, joined the Canadian War Memorial scheme, established by Lord Beaverbrook. Relations between the artists and the military establishment were uneasy and the work produced, which included many fine paintings, like *Nevinson's *French Troops Resting* (1916; London, Imperial War Mus.), was often unappreciated. During the Second World War (1939–45) artists were employed under the aegis of the War Artists Advisory Committee, the brainchild of Kenneth *Clark, whose discerning patronage and urbane diplomacy resulted in major works by *Moore, *Spencer, Nash, and *Sutherland which were later distributed to galleries and museums. Since 1973 individual painters have been commissioned by the Imperial War Museum, in consultation with the Ministry of Defence, to record military life in peace and conflict. DER

Harries, M., and Harries, S., *The War Artists* (1985).

WARBURG, ABY (1866–1929). German art historian. Born into a family of Jewish bankers, he studied at Bonn and Strasbourg and afterwards pursued a career as an independent scholar. Although his literary production was relatively small, Warburg was of crucial importance to the development of art history, not least because of his extensive library, founded at Hamburg and transferred to England in 1933, where it now bears his name as an institute of the University of London. In opposition to the formalist art history advocated by *Riegl and *Wölfflin, Warburg tried to anchor the

continued on page 788

· WALL PAINTING ·

WALL painting can be broadly defined as any painting in which the support is the structure itself—whether a free-standing building, a subterranean tomb, or a rock-cut cave. A monumental art form, wall painting occurs in all of these structural contexts in Western art—from the Sistine chapel, to the numerous tombs of Egypt or Etruria, to the much rarer painted caves of Cyprus or central France. In its simplest form, a wall painting comprises just the paint layer and support, while in its most complex form it may have several layers of plaster, grounds, multiple paint layers, and metal foils, glazes, varnishes, and finally attachments, such as parchment, mirrors, or semi-precious stones.

Typically, surfaces to be painted are finished with one or more layers of plaster, or, if the masonry is of exceptional quality, simply with a sealant and ground. The plaster functions to level and smooth the surface, and, in the case of fresco painting, to bind the paint layer. Painting in true fresco relies on the carbonation of the slaked lime in the fresh plaster to bind the pigments to the surface:

$$
\begin{array}{ccccc}
 & & carbonation & & \\
\text{fresh plaster} & + & \text{air} & \rightarrow & \text{set plaster} & + & \text{water} \\
\text{Ca(OH)}_2 & & \text{CO}_2 & & \text{CaCO}_3 & & \text{H}_2\text{O} \\
\text{calcium} & & \text{carbon} & & \text{calcium} & & \\
\text{hydroxide} & & \text{dioxide} & & \text{carbonate} & &
\end{array}
$$

This irreversible chemical reaction occurs from the surface inward, and imposes two intractable constraints on the painter. First, painting must be carried out quickly while the plaster is fresh, usually the same day; hence the Italian term *giornate*, or day-works, for the resulting individual plaster patches. Second, very few *pigments are suitable for use in fresco; most are either chemically incompatible or require an organic binder (see MEDIUM) for the desired optical effects. For these reasons, true fresco painting is quite rare. Used occasionally by the Egyptians and regularly by the Romans (see ROMAN ART, ANCIENT), its popularity was sporadic during the Middle Ages until the great fresco revival of *Renaissance Italy, culminating in *Michelangelo's technological tour de force in the Sistine chapel, Rome.

Since fresco painting begins at the plastering stage, the decision to paint either in fresco or in *secco*—that is, on set plaster with any of a broad range of organic and inorganic media—is made at the outset. This decision has significant implications for both the materials and methods used. Not only do the pigments and media vary, but also the preparatory techniques, painting sequence, and workshop practice.

Wall paintings are normally executed as large schemes of decoration, requiring the setting out of the geometry of the composition on the architectural surfaces. Setting out methods have changed little in five millennia: with nails, string, and a straight edge even the most elaborate design can be successfully laid out. A nail and string make a serviceable compass, while string dipped in red paint and snapped against the wall between two points produces an accurate guideline. Typically, such setting out leaves a permanent impression, particularly if the plaster is fresh.

Preparatory techniques—methods for controlling and/or transferring the composition during the painting phase—vary depending on whether the painting is fresco or *secco*. For true fresco painting, two methods are traditionally used: either a *sinopia*—a full-scale preparatory drawing executed in red on the penultimate plaster layer—or a *cartoon—a separate full-scale drawing transferred to the painting surface by *pouncing or incision. *Sinopie* are known from at least the Roman period, and the catastrophic fashion of the 1960s for detaching wall paintings led at least to the recovery of scores of 14th- and 15th-century Italian *sinopie*. Characterized by a striking spontaneity and freedom of line very different from the final painting, *sinopie* were generally supplanted by cartoons in the middle of the 15th century. For large workshops with demanding commissions, such as that of *Ghirlandaio where Michelangelo learned mural painting, cartoons offered the considerable advantage of secure control of design and execution. For *secco* painting, cartoons enjoyed a similar history, but replaced an earlier method of preliminary drawing carried out directly on the painting surface. This was typically done in yellow or red paint—often first in yellow then strengthened and corrected in red—or was incised directly into the plaster. Direct incision has a long history; both Greek (see GREEK ART, ANCIENT) and *Etruscan tomb paintings provide stunning examples of incised drawing. Preliminary drawing offered a flexibility, indeed tentativeness, utterly absent in fresco. As in easel painting, pentimenti—divergences from preparatory drawings or cartoons—are common in wall painting.

Yet it is with the paint layer that the techniques of fresco and *secco* painting diverge most dramatically. Painting on set plaster poses no constraints on materials: the range of pigments and media is as extensive as in easel painting. Indeed, the use of lake glazes in mural painting extends back to Antiquity and oil as a medium has been verified at least as early as the 9th century. But painting in *buon fresco* severely limits the palette. The pigments, applied with water as a vehicle, are bound by the carbonation of the slaked lime in the fresh plaster. This results in the formation of a matrix of calcium carbonate throughout the paint layer which both binds it and adheres it to the surface of the plaster. Contrary to an unaccountably persistent popular belief, this forms a discrete paint layer, not a 'stained' plaster.

The palette for fresco painting is traditionally restricted

to earths, lime white, carbon black, ultramarine, and glass. Since they are natural materials, earth colours vary considerably and can also be burnt to alter their hue. Red from Sinope on the Black Sea and green from Verona have long been prized. Lime white—*bianco di san giovanni*—is the single most important pigment used in the fresco palette. It is made by partially carbonating slaked lime; about one-third remains unreacted and therefore also functions as a binder. This allows the thick impasto highlights characteristic of fresco, and provides an auxiliary binder when mixed with other pigments to modify their tone. Among the carbon blacks, that made from burning bone is the finest. Ultramarine, derived from lapis lazuli, is entirely suitable for fresco, its use restricted only by its extraordinary cost. Despite this, it is found widely used in *Romanesque painting across Europe. Finally, glass ground for use as a pigment has a long history. Egyptian blue, with its characteristic pale colour, is found ubiquitously in Roman wall painting, and recent analysis has shown that its use continued into at least the 9th century. Smalt became widely used in the 16th century. Painters extended this limited range of pigments by mixing and layering. A small amount of black added to white makes a convincing blue, and yellow and black a rather less satisfactory green. Tonal variations of the basic colours were produced by adding increasing amounts of lime white, a practice codified by *Theophilus in his early 12th-century treatise.

Few painters, however, chose to limit themselves to true fresco. Even though the restricted palette could be manipulated, the diversity of hue and especially the translucency offered by pigments and colourants unsuitable for fresco was simply too attractive. Moreover, the constraints on planning and execution in this unforgiving medium must also have been decisive. The vast majority of wall paintings are executed primarily in *secco*, and even those few that are fresco invariably have *secco* additions.

Increasing sumptuousness characterizes the development of wall-painting technique during the Middle Ages and well in to the Renaissance. Multiple grounds, complex paint layers, typically culminating in *glazes, and metal foils—gold and silver, as well as tin glazed to imitate more precious material—all become common. Elaborate ornament is either applied to the surface or pressed into the plaster. Examples abound, from the gilt stars and mirrored suns of the chapel of Our Lady Undercroft at Canterbury Cathedral to the semi-precious stones that litter *Pinturicchio's painting in the Vatican apartments for the Borgia Pope Alexander VI. But this is the last gasp of a dying trend. *Alberti, in his *De pictura* of 1435, advocated artifice and illusion and Alexander's successor, Julius II, chose Michelangelo, master of craftsmanship and *illusionism, to paint the Sistine ceiling.

Given his artistic temperament and keen sense of his place in history, Michelangelo's choice of the demanding medium of *buon fresco* for painting the Sistine is not surprising: its difficulty implies considerable virtuosity and it is extraordinarily durable. Execution required decisiveness and physical endurance. Evidence of his preparatory techniques survives in traces of cartoons either pounced or incised into the fresh plaster, but the historian is unprepared for the breathtaking realization that the lunettes were painted entirely *alla prima*, without the aid of cartoons or preliminary drawing. No approach contrasts more sharply with this technical rigour than that of *Leonardo. Experimental, tentative, entirely autograph, Leonardo's painting of the *Last Supper* in S. Maria delle Grazie, Milan, is technically diametrically opposed to that of Michelangelo. He experimented with the plaster, apparently mixing in oil and heating it before application; he worked irregularly, and is recorded as having variously painted furiously or contemplated for hours before adding a single brush stroke. What he produced was entirely his own masterpiece but a technological wreck; within a score of years it was described as a 'ruin'. While Leonardo disregarded the constraints of the demanding art of mural painting, Michelangelo embraced them. While each produced a masterpiece of Western art, Leonardo's survives as a retouched fragment and Michelangelo's in virtually perfect condition. SC

discipline within cultural history as a whole, bringing in areas such as astrology, mythology, and magic. Mainly concentrating on the transformation of classical thought in the Italian quattrocento, he thus examined the hold that religious loyalties and astrological superstition retained in the minds of *Renaissance merchants and princes, indicating that the subject matter of the painting they commissioned was no mere pretext for the display of artistic fancies. Warburg's synthetic approach laid the foundations for the *iconological method, a term which he himself had first used in 1912 in a paper on the frescoes of the Palazzo Schifanoia, Ferrara.

AT

Gombrich, E. H., *Aby Warburg: An Intellectual Biography* (2nd edn., 1986).

WARD, JAMES (1769–1859). English animal painter. Ward was apprenticed to his brother William (1766–1826) to learn the art of *mezzotint engraving which he later practised with considerable skill, becoming painter and engraver to the Prince of Wales in 1794. Soon afterwards he abandoned engraving for painting and specialized in rustic genre in the manner of *Morland, his brother-in-law. Unsatisfied by his success in the lowly field of animal painting, the vainglorious Ward determined to elevate his art by studying and emulating the old masters, particularly *Rubens whose *Château de Steen* (London, NG) was the direct inspiration for *Bulls Fighting* (1803; London, V&A). From 1811, the year he was elected RA, to 1815 he worked on his masterpiece, the gigantic and awe-inspiring *Gordale Scar* (London, Tate), deliberately conceived as an exercise in Burkean *sublimity, whilst exemplifying *Burke's concept of beauty in the contemporaneous *Tabley Lake and Tower* (c.1814; London, Tate). From 1815 to 1821 he struggled unsuccessfully with an ambitious allegory of Wellington's victory at Waterloo (lost) and spent his final decades in bitterness, poverty, and obscurity. DER

Fussell, G., *James Ward* (1974).

WARD, JOHN QUINCY ADAMS (1830–1910). American sculptor. Born near Urbana, Oh., Ward was apprenticed to the New York sculptor Henry Kirke Brown (1814–86) 1849–56. He received a conventional academic training but also gained experience of bronze founding (see CASTING) of which

Brown was an American pioneer. In 1861 he opened his own studio and achieved success in 1866 with his life-size sculpture *The Indian Hunter* (New York, Central Park) based on his drawings of Dakota Indians. Many commissions for public sculpture and memorials followed, including his bronze *equestrian statue of *General George H. Thomas* (1878; Washington), and he developed a highly prolific and successful practice. Ward believed that American artists should devote their talents to native and patriotic subjects, a view that made him a popular president of the National Academy of Design, New York, from 1874, the first sculptor to be appointed to the office. In 1893 he became the first president of the National Sculpture Society. His work combined a thorough academic technique with solid American *naturalism resulting in competent rather than arresting sculptures ideally suited to popular public taste. DER

Sharp, L. I., *John Quincy Adams Ward: Dean of American Sculpture* (1985).

WARHOL, ANDY (1928–87). American *Pop artist. The son of Ruthenian immigrants, Warhol was born in Pittsburgh where he studied art at the Carnegie Institute. He moved to New York in 1949 and became a successful fashion illustrator. In 1960 he painted works inspired by popular comics in a free, somewhat Expressionist manner, but two years later, with painted and screened replica images of Campbell's soup cans and Coca-Cola bottles (*Green Coca-Cola Bottles*, 1962; New York, Whitney Mus.), established his unique personal style. Warhol, the epitome of cool, took artistic impersonality to extremes, choosing banal subjects, including popular icons (*The Twenty-Five Marilyns*, 1962; Stockholm, Moderna Mus.), and executing them mechanistically, usually by *silk screen, using assistants. Occasionally darker subjects appear, accidents and executions, like *129 DIE IN JET* (1962; Cologne, Ludwig Mus.), but they are treated equally objectively. In 1963 he began film-making, progressing from the silent, virtually static *Sleep* (1963) to the bizarre, sexy *Chelsea Girls* (1966) starring the exotic coterie based on The Factory, his New York studio. Warhol's work, undemanding and instantly recognizable, was highly fashionable and he moved in starry circles, the artist as celebrity. DER

Coplans, J., *Andy Warhol* (1970).

WASHINGTON, NATIONAL GALLERY OF ART. Founded in 1937 by a charter passed by the United States Congress, the collection was built up entirely through private donations, facilitated through the untiring efforts of Andrew W. Mellon (1855–1937). A member of the Pittsburgh banking and steel family, Mellon had served as secretary of the Treasury in the 1920s. He travelled regularly to Europe with his friend Henry Clay Frick, purchasing paintings with the idea of donating them to create a national collection which would show the development of art from the 13th to the 19th centuries. He was also persuasive in persuading other collectors such as Samuel Kress, Joseph Widener, and Chester Dale to do the same. The collection is composed of gifts from private patrons, either actual paintings or the funds to purchase them.

The collection of the National Gallery is housed in two buildings, the original West Building opened in 1941 and designed by the classical revival architect John Russell Pope, which is where the bulk of the collection is to be found, and the East Building, opened in 1978, which houses the gallery's collection of 20th-century painting and sculpture and where changing exhibitions are held.

Besides an outstanding collection of European, British, and American artists, there are galleries displaying French furniture and decorative arts, tapestries, medieval artefacts, and superb examples of European sculpture, predominantly of the *Renaissance and *Baroque periods, including works by *Verrocchio, Adriaen de *Vries, and *Bernini. The Gallery possesses remarkable examples of paintings from most periods and schools. Over 30 rooms are devoted to Italian paintings of the Renaissance and Baroque periods. The early Renaissance is represented by a panel from *Duccio's *Maestà*, a *Virgin and Child* by *Giotto, and works by Fra *Angelico, Andrea *Castagno, *Domenico Veneziano, as well as *Leonardo da Vinci's portrait of *Ginevra de' Benci*. Giovanni *Bellini, *Raphael, *Giorgione, and *Titian are superbly represented amongst the numerous 16th-century examples. The collection of German and Netherlandish pictures is also exceptional. The National Gallery's collection of 19th-century French painting is evidence of the collecting enthusiasms for contemporary art of late 19th-century American travellers to Europe.

The East Building is an impressive example of modern architecture, a marble building designed by I. M. Pei, and is intended to present the great European and American movements and masters of the 20th century rather than to speculate on new trends. It houses a rotating exhibition drawn from the permanent collections and also contains an exhibition space for major travelling exhibitions of all periods. CFW

WASHINGTON, SMITHSONIAN INSTITUTE. Thirteen museums and galleries in Washington, the National Zoo, and the Cooper-Hewitt Museum in New York are administered by the Smithsonian Institution. It was founded by an Englishman, James Smithsonian (1765–1829), the illegitimate son of the Duke of Northumberland. Smithsonian, who never set foot in America, bequeathed his estate to the United States to found 'an establishment for the increase and diffusion of knowledge'. After considerable delay, Congress eventually passed a bill in 1846 to establish the Institution. The Smithsonian collections represent all aspects of science and the arts and the Institution's activities began in a building on the Washington Mall, nicknamed the 'Castle', built in 1855 and designed by James Renwick in the fashionable Italian Romanesque revival style. This building still houses a number of the offices of the Institution and one of the nine museums and galleries on the Washington Mall belonging to the Smithsonian. The Institution's activities are wide ranging and its painting and sculpture collections include those of the Hirschorn Museum and Sculpture Garden, the National Portrait Gallery, the National Museum of American Art, and the Freer Gallery of Art. This last was founded by the donation of the collection of Charles Lang Freer (1854–1919), a railway manufacturer. Freer had been an admirer and friend of James McNeill *Whistler, who encouraged him to collect oriental art as well as oils, pastels, prints, and watercolours by Whistler himself. More than 1,000 of these are now housed in a Renaissance-style building paid for by Freer. Of outstanding importance is the Peacock Room, known as *Harmony in Blue and Gold*, created by Whistler for the London home of the Liverpool businessman Frederick Leyland. CFW

WATERCOLOUR (TECHNIQUE). Watercolour is a pigment for which water and not oil is used as a medium and gum arabic is employed as a binder. A watercolour wash is a fluid made up of water in which the colour particles brushed from cakes of pigment are suspended. It must maintain its liquid state for enough time to enable the tiny colour fragments to distribute themselves evenly across the paper. In pure watercolour the translucent nature of the medium permits the white paper surface to be used as the lighting agent. Many watercolour papers have granular surfaces which help provide variations of light and half-light. In order to render watercolour opaque white pigments may be mixed with it. (See BODYCOLOUR; GOUACHE.)

Watercolour is a technique of great antiquity and is found on papyrus rolls in ancient Egypt and on medieval vellum manuscript pages. In the final decade of the 15th century *Dürer became one of the first artists to make use of watercolour as a medium in its own right but it did not reach full development until the 18th century in England when it was perfected notably by artists

such as Francis *Towne and John Robert *Cozens. PHJG

Cohn, M. B., *Wash and Gouache: A Study of the Development of the Materials of Watercolor* (1977).

Meder, J., *The Mastery of Drawing*, trans. and rev. W. Ames (1978).

WATERCOLOUR PAINTING. In its broadest sense this term denotes painting done in *pigments bound with a *medium (generally gum arabic) which is soluble in water. In a more specific sense watercolour proper differs from other kinds of painting with water as a medium, such as *gouache, tempera, and *miniature, by the fact that lighter tones are not obtained by adding white pigment but by thinning with water so that the light is given by the paper or other support showing more strongly through the thinner layers of paint.

Monochrome washes, generally in brown bistre or the lower-toned sepia (which was made from the 'ink' of the cuttlefish), were used by European artists, notably in the 17th century on pen drawings, for figure and landscape compositions, and both *Claude and *Rembrandt achieved remarkable effects of light by this method. Many landscape drawings by minor Dutch artists in this technique are surprisingly successful in the impression they give of space, recession, and atmosphere, these being easier to obtain in monochrome than in full colour.

The use of full colour was, indeed, exceedingly rare in watercolour before the late 18th century, though it was used by *Dürer for a charming series of landscape drawings made on his journey to Italy in 1495, and also by van *Dyck in a group of landscape studies (mainly London, BM) done perhaps in England. The chief development of watercolour painting took place in 18th-century and early 19th-century England. The use of the medium on the Continent has been rare, though in France it was occasionally used, for figure scenes rather than landscape, strengthened with gouache or *bodycolours (i.e. pigment mixed with white), and a few German and Swiss artists, notably *Hackert, a friend of Goethe who worked in Rome in the late 18th century, and Louis Ducros (1748–1810), who worked for Sir Richard Colt Hoare of Stourhead (Wilts.), used fairly full colour and may have had some influence on English painters.

English watercolour painting was at first primarily *topographical or archaeological and grew out of the Dutch monochrome tradition, taking over the effects of light and atmosphere, which are as natural to the English climate as to the Dutch, though with a gradually increasing use of a restricted range of colour added over the monochrome ground. This phase reached its climax after the middle of the 18th century with the work of Paul Sandby (1731–1809), which went beyond the tinted drawing where the outline was first completed in pencil or ink, for he drew in watercolour with the *brush and often reinforced his effects with the addition of bodycolour. Topography continued to be the main interest of a host of English watercolour painters, such as Thomas *Hearne, Michael Angelo Rooker (1746–1801), and Thomas Malton (1748–1804), who supplied drawings for engraved books of the antiquities and scenery of Great Britain. But the drawings of social life by Edward Dayes (1763–1804) and, with a more humorous twist, those of Thomas *Rowlandson reveal another use of the popular medium. Both in the 18th century and in the 19th century proficiency in watercolour was also considered an elegant accomplishment for young ladies.

The lure of Italy, on the other hand, reinforced by the visit of *Canaletto to England, led English artists in watercolours as well as their contemporaries in oils to a more formal, idealized type of composition, influenced chiefly by Claude and Gaspard *Dughet. Alexander *Cozens, some of whose Italian compositions in monochrome have great distinction, was only the first of many artists, among them William Taverner (1703–72), William *Pars, and Francis *Towne, to visit Rome and paint views of the Campagna for the English market, or on their return to see the English countryside through Italian eyes.

Alexander's son John Robert *Cozens played a more important role; for his poetic renderings of mountain scenery, delicately tinted and filled with an admiration for the grandeur of nature, were to have a profound influence on the art of the two great masters of the end of the century, *Girtin and *Turner. The former's early death in 1802 cut short a career of great achievement, during which a break had been made with the monochrome tradition, and the coloured medium used freely and directly, generally on rough white paper, with no underpainting, so that the white surface was left bare, or slightly tinted, for the lights. Turner was to build on this technique for another 50 years, achieving a brilliance and luminosity of colour which rivals his work in oils. The new freedom was further exploited by *Constable, and this fresh approach, so closely bound up with the *Romantic spirit, was to change the entire character of watercolour painting. Having heightened their palette, artists were also to increase their range, and figure subjects by *Bonington, and J. F. *Lewis compete with landscape with or without figures by *Cotman and David Cox (1783–1859), and with architectural subjects with figures by Samuel Prout (1783–1852). Indeed almost the full range of English painting outside the portrait could now be shown in watercolours, and its use for exhibition pictures was confirmed by the founding of the Old Water Colour Society in 1804. Some foreign artists of the Romantic movement, notably Carl Fohr (1775–1818), found watercolour a sympathetic vehicle, and its quick-drying quality is especially suited to sketches, particularly those done in the open air.

The medium was much used in England in the early years of the 20th century, for instance by Wilson *Steer, and John and Paul *Nash, and continued to be used in the second half of the century by such artists as Graham *Sutherland and John *Piper. From the time of the *Neo-Impressionists it became more popular (though still a subsidiary technique) on the Continent and was used by *Cézanne, *Signac, and André Dunoyer de Segonzac (1884–1974), and later in the beach scenes of *Dufy. HO

Reynolds, G., *A Concise History of Watercolours* (1971).

Wilton, A., and Lyles, A., *The Great Age of British Watercolours 1750–1850*, exhib. cat. 1993 (London, RA; Washington, NG).

WATERHOUSE, JOHN WILLIAM (1849–1917). English painter. Born in Rome, he returned to England in 1854. In 1870 he entered the RA Schools (see under LONDON) and first exhibited at the RA in 1874. His early subjects include both contemporary Italian scenes and classical subjects inspired by the success of *Alma-Tadema, like *In the Peristyle* (1874; Rochdale, AG). By the mid-1880s, when *The Magic Circle* (1886) was acquired by the Tate Gallery, he had an international reputation. In 1888 he painted the haunting *Lady of Shalott* (London, Tate) and thus began a series of *Pre-Raphaelite themes which, like those of *Burne-Jones, approach *Symbolism: the enigmatic *Circe* (1892; Adelaide, AG South Australia). He was, however, considerably more painterly in technique than Burne-Jones and, despite his Romantic historical subjects, close to the painters of the *Newlyn School. *Hylas and the Nymphs* (1896; Manchester, AG) the epitome of this hybrid Pre-Raphaelite-*Impressionist style, is particularly notable for the mild eroticism which pervades much of his work. From being a respected teacher and successful painter Waterhouse's reputation plummeted after his death to be rescued from oblivion in the 1960s. DER

Hobson, A., *J. W. Waterhouse* (1989).

WATERMARKS. One of the most distinctive characteristics of European *paper since its earliest days has been the incorporation within the sheet of images, words, letters, and dates. The term watermark is somewhat misleading as water plays no particular part in the formation of these images. The french term *filigrane* or earlier

English terms such as papermark and wire-mark are more accurate descriptions. The marks are created by wires, bent and shaped into the desired form, and sewn down onto the surface of the papermaking mould. During the formation of a sheet the pulp lies in an even thickness on the mould's surface. Variations in the surface, such as the watermark wires, produce differences in the amount of pulp at that point in the sheet. After pressing the sheet appears flat, but the pulp is less dense where the wires are: held up to the light the image shows as lighter lines within the sheet.

The earliest watermarks date from late 13th-century Italy and were all pictorial: images of animals, birds, suns, moons, stars, human figures, coats of arms, pots, hands, waterwheels, even abstract patterns. Various theories have been advanced as to the origins of watermarks: were they trademarks, indications of paper sizes or qualities, symbols of magical and religious significance, or just a convenient method of distinguishing particular pairs of moulds? The answer is probably a mixture of all these reasons. Gradually the initials of individual makers began to be included. Particular makers gained reputations for quality and their marks passed into general use amongst other makers. By the end of the 18th century watermarks were quite simply trademarks.

In laid papers the watermark image is usually centred within one half of the sheet and, by the 18th century, was generally indicative of a particular sheet size: Posthorn (Post or Large Post), Fleur-de-Lys (different designs for Demy, Medium, Imperial), Britannia (Foolscap, Double Foolscap, etc.). The watermark is often accompanied by a countermark, centred in the other half of the sheet, which consists of the maker's name, initials, and often a date. Watermarks in wove papers are usually found along the bottom edge of the sheet, either centred or in the bottom right corner.

The study of watermarks is increasingly used in the dating and attribution of works of art on paper, but great care must be taken in understanding what is seen: watermarks were often copied, even deliberately forged, by other makers, moulds changed hands, dates were not changed for years. Variations in the choice and preparation of the pulp used, the skill of the papermaker, seasonal variations in the speed of drying of paper can all lead to subtle differences in appearance of watermarks in sheets made on the same mould. The lettering styles of watermarks changed, regional and local traditions affected the design, as the form and composition of the papers themselves changed. The study of watermarks in conjunction with the analysis of the make-up of the sheet itself provides powerful evidence for the authenticity or otherwise of works of art on paper.　　　　PAHB

Briquet, C. M., Les Filigranes (4 vols., 1968).
Churchill, W. A., Watermarks in Paper (1935).
Heawood, E., Watermarks, Mainly of the 17th and 18th Centuries (1950).

WATSON, HOMER (1855–1936). Canadian landscape painter. Watson was born in Doon, Ontario. In 1874 he moved to Toronto to work for a photographer but spent his leisure copying paintings at the Toronto Normal School. In 1876 he visited New York where he admired the *Hudson River painters and met George *Inness who encouraged him to paint. Watson returned to Doon in 1877 and worked up his American sketches into finished works some of which were shown at the Ontario Society of Artists exhibition in 1878. Two years later his painting of *The Pioneer Mill* (c.1879; London, Royal Coll.), based on his father's property, was purchased from the Royal Canadian Academy by the Governor-General, the Marquis of Lorne (1845–1914). Oscar *Wilde, who saw his work in Toronto in 1882 and purchased a landscape with sheep in 1888, dubbed him 'The Canadian Constable' and gained him several commissions. In 1887 Watson visited England, taking lessons from *Whistler, and France, where he studied *Barbizon paintings, returning to Canada in 1890. His later works, post-1914, are more freely painted and his concern with light reveals an awareness of *Impressionism.　　　　DER

Homer Watson RCA, 1855–1936, exhib. cat. 1963 (Ottawa, NG Canada).

WATTEAU, JEAN-ANTOINE (1684 1721). Perhaps the greatest painter of pre-revolutionary 18th-century France. The inventor of the *fête galante, he was one of the most imitated yet least understood artists of his time. Although for later generations his name will forever be associated with the light-hearted gaiety of the *Rococo style, his work has a poetic profundity and a tincture of melancholy that none of his successors ever approached, and which has puzzled literal-minded historians to explain.

Watteau was born in Valenciennes, which had passed from the Spanish Netherlands to France only six years earlier. After some kind of training in his native town he went to Paris around 1702. For a time he worked as a copyist in a picture factory before entering the workshop of Claude Gillot, who stimulated his interest in scenes from the contemporary boulevard theatres. By about 1708 he was working for the decorator Claude *Audran, whose post as keeper of the Palais du Luxembourg gave Watteau access to *Rubens's great *Marie de Médicis* cycle. Like others at this time, such as *La Fosse, he was inspired by the fluid brushwork and rich colouring of Rubens and soon began to make a very personal contribution to the Rubéniste tendency that was displacing the classicizing academicism of Louis XIV's reign. In 1709 Watteau entered the *Prix de Rome competition. When he gained only second place he retreated to Valenciennes, and it is probably from this time that his paintings of military life date. These scenes of which that in the Frick Collection, New York, is a good example, like the later *fêtes galantes*, represent moments of repose and social dalliance rather than scenes of the battlefield. Despite the undoubted elegance of their composition, however, they have the air of being inspired by observation: at this time Marlborough's armies were camped only a few miles from the border.

Indeed, it is the combination of natural observation and well-contrived artifice that makes Watteau's paintings so different from those of his many imitators. His chalk drawings from life of figures and heads (examples Paris, Louvre, and New York, Pierpont Morgan Lib.) are among the most beautiful in the history of art and among the most lovingly observed. He rarely made studies for entire compositions, but combined and recombined different figures from his sketchbooks into his inventive landscape and parkland settings. After his death many of these drawings were engraved at the direction of his friend the collector Jean de Jullienne; and were influential on *Boucher, *Gainsborough, and Domenico *Tiepolo, as well as a host of lesser talents.

On his return to Paris from Valenciennes Watteau was introduced by La Fosse to the collector Pierre Crozat, whose house contained paintings and drawings by some of the great Venetian artists of the 16th century. It is conceivable also that Watteau was able to study at first hand in the royal collection the *Concert champêtre* attributed to *Gorgione (Paris, Louvre). It was from exposure to such works, to Rubens, and to the theatre scenes of Gillot and others that emerged Watteau's first paintings of amorous dalliance, with their figures in fashionable costume or fancy dress, sitting, listening to music, walking or dancing in parklike settings. Watteau's paintings are difficult to date, but among the best of these early works is *The Village Bride* (Berlin, Schloss Charlottenburg). By 1717 he had achieved the most ambitious and characteristic statement of the theme of love that preoccupied him—*The Pilgrimage on the Island of Cythera* (versions, Paris, Louvre, and Berlin, Schloss Charlottenburg). This evocation of the stages of love from starry-eyed enchantment to the social duty of procreation he submitted to the Académie Royale in that year as his diploma piece. Impressed by its originality, but unable to fit it into any existing category in the hierarchy of genres, the academicians admitted Watteau to their

ranks as 'peintre de fêtes galantes', a category invented especially for him. Two years later Watteau, who for some time had been suffering from tuberculosis, went to London to visit the famous physician and collector Dr Richard Mead. Mead could do nothing for him and the English winter only worsened his condition. He returned to Paris a dying man. Henceforth he led a restless existence moving from lodging to lodging before deciding to make a never completed journey to Valenciennes to die.

It was not only in his fluid and idiosyncratic handling of paint and in the rich and subtle palette that he employed that Watteau broke with the impersonal and severe tenets of French academic practice. His subject matter also, eschewing Antiquity, the Bible, the allegory of earlier treatments of the garden of love theme, or even for the most part recognizable scenes from contemporary plays, was the opposite of the clearly readable canvases of Charles *Le Brun and his generation. Couched in the language of poetic delight, but serious and melancholy at the same time, the exact meaning of such paintings as *Halt During the Hunt* (London, Wallace Coll.) or *Fêtes vénétiennes* (Edinburgh, NG Scotland) remains elusive and has provoked many conflicting interpretations. Even Watteau's last major work which is, quite unexpectedly, a shop sign for his friend Gersaint (Berlin, Schloss Charlottenburg), and depicts the interior of the premises of a picture dealer, remains mysterious as to its intention and meaning.

It is, perhaps, part of Watteau's undoubted genius and a reflection of the uneasy character of a consumptive to have created for the 18th century a pictorial idiom with all the poetic power and open-endedness of the *poesie* of Giorgione and the young *Titian, leaving the imagination of each viewer to complete the meaning of his paintings according to their temperament and experience. Such profundity was beyond the reach of such imitators as *Pater and *Lancret, and it is a curious fact that Watteau's patrons also bought indifferently the pictures of his followers. Although it is impossible to imagine either *Boucher or *Fragonard without the example of Watteau they were very different painters, Boucher more cheerful and robust, Fragonard romantic and optimistic. Watteau was a unique phenomenon and it was perhaps not until the 19th century that he was fully appreciated. Despite the eclipse of the Rococo style by the *Neoclassicism of *David and the society that produced it by the French Revolution, Watteau's rehabilitation among collectors and connoisseurs had already begun in the 1820s when the painter Baron Schwiter, a close friend of *Delacroix, owned a number of pictures; his works are eagerly sought by the eponymous hero of Balzac's novel *Le Cousin Pons* (1846); and the bulk of the Louvre's collection of his paintings, including the famous *commedia dell'arte* clown *Gilles*, was bequeathed in 1869 by Dr Louis Lacaze, who had spent a lifetime haunting the salerooms. It was the special achievement of the *Goncourt brothers not, as is so often said, to have rediscovered Watteau, but to have enshrined the 19th century's vision of Watteau the poet in the most evocative of their essays on French 18th-century painters, first published in 1844, an appreciation which is still the *locus classicus* of Watteau criticism. MJ

Goncourt, E. de, and Goncourt, J. de, *L'Art du XVIIIème siècle* (1860; English trans as *French XVIIIth Century Painters*, 1948).

Grasselli, M. M., and Rosenberg, P., *Watteau*, exhib. cat. 1984–5 (Washington, NG; Paris, Grand Palais; Berlin, Schloss Charlottenburg).

Levey, M., *Painting and Sculpture in France 1700–1789* (2nd edn., 1993).

Posner, D., *Antoine Watteau* (1984).

Roland Michel, M., *Watteau: An Artist of the Eighteenth Century* (1984).

Vidal, M., *Watteau's Painted Conversations: Art, Literature and Talk in Seventeenth- and Eighteenth-Century France* (1992).

WATTS, GEORGE FREDERICK (1817–1904).

English painter. Watts studied under William Behnes before entering the RA Schools (see under LONDON) in 1835. In 1837 he revealed considerable talent with *The Wounded Heron* (Compton, Watts Gal.) shown at the RA. A £500 prize for the 1843 Westminster Hall Competition financed a visit to Florence, where he remained until 1847 under the patronage of Lady Holland, one of a series of formidable women who provided adulation and comfort throughout his life. Inspired by *Michelangelo, Watts determined to devote himself to grand, universal themes while making his living from portraits. *Hope* (1886), one of eighteen paintings he presented to the Tate in 1897, is the most famous of these allegories, which were renowned during his lifetime. In 1864 he married the 16-year-old Ellen Terry and painted a charming, if allegorical, portrait of her, *Choosing* (1864; London NPG), before separation the following year. The majority of his portraits after 1860 are of eminent men which, with rare exceptions (*Cardinal Manning*, 1882; London, NPG), are uninspired. A major late sculpture, *Physical Energy* (1904; London, Kensington Gardens), is surprisingly modernistic. DER

Wilton, A., Upstone, R., et al., *The Age of Rossetti, Burne-Jones and Watts*, exhib. cat. 1997 (London, Tate).

WAX

is used both for the preparatory stages of sculpture and as a sculptural medium in its own right. The wax used in the sculptor's studio is beeswax or paraffin wax, though in the 1830s a substitute based on petroleum was developed. Beeswax is usually brownish yellow but may be bleached, or coloured by the addition of earth pigments, or by mixing in oil paint while it is hot and liquid. Though initially malleable, wax becomes hard and friable over time and is durable as long as it is kept cool and safe from accident. It is more suited to small rather than large works; does not shrink as clay does; and can be both modelled and cast. Small figures need no internal framework (armature), though large ones are modelled over a core of clay. The hardness of the material and the necessity of using heated tools enforce a certain discipline on the wax modeller. The final product has a sharpness which makes it suitable for *casting in *bronze, and a bronze cast from a wax model is distinguishable by its surface and forms from one cast from a clay model.

A principal use of wax in sculpture is as an auxiliary material, either for preliminary sketches (*maquettes) or for making models to be reproduced in metal. Wax sketches reasonably attributed to *Michelangelo (for instance, *Model for Dying Slave*; London, V&A) show how he worked out his forms as a preparation for carving. *Cellini described the way in which a wax model was used for bronze in the elaborate preparation for the casting of the *Perseus* (1554; Florence, Loggia dei Lanzi). In the horrific *tableaux vivants* (London, V&A) by Gaetano Giulio Zumbo (1656–1701), the naturalistic uses of the medium are fully exploited in scenes of gruesome verisimilitude.

Wax has also been used as a material for permanent works, such as portraits, funeral effigies, and other figures intended to simulate the appearance of life. Not only is its peculiar transparency akin to that of human skin, but it can be modelled very exactly and sensitively, coloured naturalistically, and even have hair and other materials attached to it. The uses of wax for funerary purposes are among the most ancient. From the medieval period and after full-length wax figures were used as substitutes for the bodies of nobles and monarchs in state funerals. Several of these effigies, including that of Elizabeth I, are still preserved at Westminster Abbey. 'Waxworks' in fact had macabre associations long before Mme Tussaud modelled the heads of victims of the Revolution and the craft was brought to England by Huguenot refugees after the Revocation of the Edict of Nantes (1685). Changes of taste and fashion were quickly incorporated in these wax portraits, from the more elaborate examples using bits of lace, glass eyes, seed pearls, and other precious jewels to the simpler and more spirited characterization of the 18th century. The quieter elegance of the *Neoclassical style achieved a cameo-like effect which was finally translated into 'jasper' and 'Basalt' in the Wedgwood potteries. Relief

wax portraiture, by artists such as Samuel Percy (1750–1820) (many examples at London, V&A) flourished until it was superseded by the daguerreotype and the photograph in the 19th century. HO/AB

Clarke, C. D., 'Modelling and Casting for Wax Reproductions', *Technical Studies*, 4 (1975).

Pyke, J., *A Biographical Dictionary of Wax Modellers* (1973).

WEBER, MAX (1881–1961). American painter, sculptor, and photographer. Born in Russia, Weber grew up in Brooklyn, a self-conscious outsider, strongly aware of his Jewish heritage. From 1898 to 1900 he studied in New York under Arthur Wesley Dow. In Paris from 1905 he admired the *Fauves and *Cubists, integrating their influences with memories of Russian religion and folk art. Returning to America in 1909, he explored New York's chaotic rhythms in paintings attacked by critics for their radical fragmentation, such as *Chinese Restaurant* (1915; New York, Whitney Mus.). He also made *lithographs and coloured *woodcuts in a similar decorative, semi-abstract style.

During the 1920s he painted monumental women reminiscent of *Matisse and *Picasso, reflecting his fascination with Negro and central American sculpture, landscapes, and still life. From 1910 he also produced figurative and abstract sculptures, but only fully developed the medium during the late 1950s. Later works expressed his mystical-religious vision, and show an original use of colour, often in disturbing yet dynamically discordant patterns. Weber was also a writer and teacher of art, publishing his first critical collection, *Essays on Art*, in 1916; other publications include *Cubist Poems* (1914) and *Primitives* (1926). JH

Max Weber, exhib. cat. 1968 (Santa Barbara, University of California AG).

WECHTLIN, HANS (c.1480×5–after 1526). German woodcut designer from Strasbourg, also recorded in Nancy (1505) and Wittenberg (1506–7), where he must have met Lucas *Cranach the elder. He is particularly known for his *chiaroscuro woodcuts, the invention of which was once (wrongly) attributed to him (this distinction is now generally given to Hans *Burgkmair). His prints are mainly religious in content; several have compositions deriving from *Dürer (e.g. *The Virgin on a Grassy Bench*; *S. Christopher*). KLB

Strauss, W., *Chiaroscuro: The Clair-obscur Woodcuts by German and Netherlandish Masters of the XVIth and XVIIth Centuries* (1973).

WEIDITZ, HANS II (before 1500–c.1536). Member of a family of artists documented in Freiburg, Strasbourg, and Augsburg from the late 15th to the later 16th century. Only one work can be attributed to him with certainty: the *woodcuts to Otto Brunfels's *Herbarum vivae eicones* (1530–6). Remarkable for their precision and fidelity to nature, they constitute one of the most significant contributions to the foundation of botany as a scientific discipline. It is likely that other woodcuts in books published in Strasbourg were designed by Weiditz, but none is signed and stylistic comparison with botanical illustrations is difficult. It has been suggested that the anonymous master of the woodcuts to the German edition of Petrarch's *De remediis utriusque fortunae* (*Von der Artzney bayder Glück*, 1532) is identical with Hans Weiditz. This artist, the so-called Petrarch Master, was a prolific woodcut designer active in Augsburg between 1515 and 1522, possibly in the workshop of Hans *Burgkmair, with whom he shows close stylistic affinities. The Petrarch illustrations are among the most original 16th-century woodcuts in Germany; whether they are by Hans Weiditz however remains a puzzle. KLB

WELDING. The art of welding in sculpture is related to earlier, often ancient, methods of joining metal sheets together, such as riveting, soldering, and forging. It differs from them, however, in that the welding of two sheets of metal by extreme heat produces a far stronger join than other alternatives. The success and widespread use of this method in 20th-century sculpture has depended on the invention around 1900 of fusion welding using oxyacetylene welding equipment. The French chemist Le Chatelier demonstrated in 1895 that the combustion of acetylene with oxygen produced a far hotter flame. At around the same period a method for producing liquid oxygen was developed, and in 1901 blowtorches were made commercially available, thus allowing controlled use of the oxyacetylene flame.

This method allows very large metal sculpture to be made, and it has been exploited greatly by sculptors. The Spanish sculptor Julio *González was one of the first to use this method in metal sculpture, and the Russian *Constructivists also adopted the techniques for their large constructions. In the United States, David *Smith, inspired by González as well as the Constructivists, adapted the welding techniques he had acquired in a car factory for his large-scale steel sculpture, for instance in an early work, *Agricola Head* (1933; priv. coll.). AB

Balmuth Widman, L., *Sculpture: A Studio Guide* (1989).

WERTINGER, HANS (1465×70–1533). German painter and printmaker. Son of an official at the court of the dukes of Landshut, Wertinger may have received his first training with Sigmund Gleismüller and then Hans Mair, who encouraged him go to Augsburg. By 1491, Wertinger seems to have returned to Landshut, where he became a master and, in 1518, court painter to the ducal court there. One of his earliest works was a series of panels for Prince-Bishop Philipp of Freising, of which the *Life of S. Sigismund* (1498; Freising Cathedral) is the only one to survive. Other early works are glass paintings for windows in S. Jakob church, Staubing, and the Heiliggeistkirche, Landshut. A considerable number of paintings and woodcut designs carried out by Wertinger after 1515 have survived. *Woodcuts include illustrations for a translation of Sallust, presented to Emperor Maximilian. Wertinger's court portraits represent an individual contribution to the genre, for example *Portrait of 'Knight Christoph'* (Madrid, Thyssen Mus.). is an early example of a full-length portrait, whilst that of *Duke Ludwig X* (1516; Munich, Bayerische Nationalmus.) presents the Duke against a landscape background. CFW

WERVE, CLAUS DE (d. 1439). Netherlandish sculptor active in France. He was the nephew of Claus *Sluter, with whom he worked from 1396 as principal assistant on the *Well of Moses*, the Calvary group for the cloister at the Charterhouse of Champmol, near Dijon (completed 1402). His style remained close to that of his uncle. From 1406 (after Sluter's death) he was 'Tailleur d'ymages et varlet de chambre' to Duke John the Fearless and afterwards Duke Philip the Good, of Burgundy. His best-known work is the marble and alabaster tomb of Philip the Bold (1406–10; Dijon, Mus. des Beaux-Arts), a work that had been conceived by Jean de *Marville and Sluter, and started before Sluter's death. In 1408 de Werve was called to Savoy by Duke Amadeus VIII, possibly to work on the S. Chapelle at Chambéry. Later he was in Paris (1411–12) and Grenoble (1436), where he had been sent to find alabaster for the tombs of John the Fearless and Philip the Good. De Werve died before starting work on this project, and the commission passed first to Juan de la *Huerta and then to Antoine *Le Moiturier. One of the few documented works of his later years was the *Trinity*, a stone votive group for the Maison du Miroir, Dijon (1414; destr. 1767). His only signed work is a stone *Calvary* altarpiece (1430; Bessey-les-Citeaux). OI

WEST, BENJAMIN (1738–1820). American painter. West was born in Pennsylvania and had lessons from, among others, Gustavus *Hesselius in Philadelphia. He painted portraits before studying in Italy (1760–3). In Rome he was influenced by the emergent *Neoclassical theories of *Mengs and *Hamilton and although he practised portraiture when he moved to London in 1763, he achieved fame as a *history painter.

Agrippina with the Ashes of Germanicus (1767; New Haven, Yale University AG) brought him the patronage of George III, whose history painter he became in 1772, following the success of his *Death of Wolfe* (1771; Ottawa, NG Canada). *Wolfe* was a seminal painting for, against *Reynolds's advice, West gave his figures contemporary dress, revolutionary for a history painting. He also pioneered the fashion for medieval history subjects with incidents from the life of Edward III (1312–77) for Windsor Castle (1787–9). Later, after succeeding Reynolds as president of the RA in 1792, he anticipated *Romanticism with vast sublime paintings like *Death on a Pale Horse* (1802; Philadelphia Mus.). West's London studio, recorded in Matthew Pratt's (1734–1805) *The American School* (1765; New York, Met. Mus.), was a Mecca for visiting American painters.

DER

Benjamin West: American Painter at the English Court, exhib. cat. 1989 (Baltimore, Mus. of Art).

WEYDEN, ROGIER VAN DER (c.1399–1464). Netherlandish painter, one of the most celebrated and influential artists of the 15th century. He has been referred to as Roger of Tournai, Roger of Louvain, and Rogier of Bruges, the confusion prompting van *Mander to write two biographies, of different painters. His identity, early training, and his œuvre are obscure; there is little documentation of commissions, recorded works are lost, and no paintings are signed.

Rogier was born in Tournai and worked there and in Brussels. It is likely that he is the 'Rogelet de la Pasture' who was apprenticed to Robert *Campin of Tournai (generally acknowledged to be the *Master of Flémalle) in 1427, and who became a master of the painters' guild in 1432. By 1435 he was living in Brussels, and was town painter there in 1436. There is no trace, however, of such civic commissions as the four *Scenes of Justice* which he painted between 1439 and 1450 for the town hall, although a tapestry (Berne, Historisches Mus.) is a modified version. His workshop was probably large, and his prosperity and civic status is evident from records of his investments and charitable gifts. Unlike Jan van *Eyck, he held no position at the Burgundian court, but executed works, including portraits, for Duke Philip the Good. *Cyriac of Ancona and Bartolomeo Facio (Fazio) (before 1410–70), the Italian *humanist writer (*De viris illustribus* 1456) both attest to his European reputation, describing his technical and expressive power, and Facio wrote that Rogier had visited Rome in 1450.

A few of Rogier's works can be authenticated and approximately dated, and from these a chronology and group of attributed works has been assembled, although some of these involve the work of assistants. The triptych of *The Virgin* (Berlin, Gemäldegal.) from the Charterhouse of Miraflores, near Burgos,

seems to continue the Master of Flémalle's refined stylization and spatial clarity, but its fantastic architectural frame, and the illusionistic device of the figures stepping from the frame, is innovative. The *Magdalene Reading* (London, NG), a fragment of a lost altarpiece, may be a little earlier. It too relates to the Master of Flémalle, with its closely observed domestic detail, clear colour, and bright lighting.

This intense realism, and fusion of the everyday with the timeless, recalls van Eyck, whose work Rogier knew, but it gives way to a concern for a more dramatic religious message. This produces a powerful, sculptural figure style, often exaggerated to a degree of abstraction; the best example is the *Deposition* (Madrid, Prado), painted around 1440 for the guild of crossbowmen of Louvain. The artist shows a frieze of interrelated figures, who fill the picture space and are contained in a cramped, boxlike setting. The picture resembles a carved altarpiece, or a reconstruction of a mystery play, brightly lit and enriched with brilliantly coloured and ornamented costumes. A pattern of flowing lines is created from the billowing drapery, outstretched arms, and sagging body of Christ, but this is offset by the sorrowful faces of the mourners, and the poses of the fainting Virgin and the Magdalene.

The combination of the realistic with the imaginary or the artificial is found in other works. *The Seven Sacraments* (Antwerp, Koninklijk Mus. voor Schone Kunsten) depicts a central Christian doctrine enacted in a *Gothic church. The familiar rites which accompany life, from birth to death, encircle the Crucifixion, miraculously located in the crossing, while the patron, Jean Chevrot, Bishop of Tournai, administers Confirmation. Still more dramatic is the *Last Judgement* (Beaune, Hôtel-Dieu), a vision of heaven glowing against a (gilded) background. S. Michael advances towards the viewer, while the damned souls tumble, shrieking, into hell.

In contrast, Rogier's portraits appear introspective in mood and abstract in design, quite unlike the accurate description of physiognomy and personality seen in portraits by the Master of Flémalle and Jan van Eyck. The *Portrait of a Lady* (Washington, NG) emphasizes line and rhythm, the geometric angles and flat planes of the headdress producing a beautiful iconic representation rather than a description of a real person in a real space.

The *Crucifixion* (Escorial) is probably a late work, painted for the Charterhouse of Scheut, and it represents the essentials of Rogier's style. Its simple composition, free of narrative detail, once again resembles a stage set, the cross set in front of a red hanging. Apart from flesh tones other colours are eliminated, the Virgin and S. John clothed, unusually, in neutral drapery. The attention

of the spectator is directed towards their gestures and emotional reaction.

Rogier was an innovative artist in terms of composition and the interpretation of familiar subjects. The popularity of the half-length diptych can be ascribed to him, and in the Miraflores *Pietà* (Berlin, Gemäldegal.) he introduced the powerful image of the diagonally placed corpse. A few of his drawings exist, some being patterns for the use of his workshop, and a *Portrait of a Lady* (London, BM), probably drawn from life, demonstrates his skill as a draughtsman.

Many artists imitated Rogier's style and compositions and major painters including *Bouts and *Memling were directly influenced, but none recreated his distinctive amalgam of rigorous form and dramatic intensity.

MS

Campbell, L., *The Fifteenth-Century Netherlandish Schools*, exhib. cat. 1998 (London, NG).
Campbell, L., *Van der Weyden* (1979).
Delenda, O., *Rogier van der Weyden* (1987).
Rogier van der Weyden, exhib. cat. 1979 (Brussels, Mus. Communal).

WHEATLEY, FRANCIS (1747–1801). English painter. Wheatley trained at Shipley's Academy at the Society of Arts and at the RA Schools (see under LONDON), where he was a founder student in 1769. He began by painting small portraits and conversation pieces in the manner of *Zoffany. From 1779–83 he worked in Dublin, to avoid his English creditors, and gained commissions to paint *The Irish House of Commons* (1780; Leeds, AG) and *A Review of Troops in Phoenix Park* (1781; London, NPG). After returning to England he painted his first full-scale portraits, including *Mrs Pearce* (1786; Wolverhampton, AG), elegant compositions painted in delicate tones with considerable attention to the successful rendering of costume. From the mid-1780s, probably inspired by the fashion for *Greuze and the success of *Penny, he painted a number of sentimental, moral pictures, designed for engraving, the most successful of which was *Mr Howard Relieving Prisoners* (1787; priv. coll.). *The Cries of London* (1793–7), engravings of smiling, sanitized street vendors, far removed from the realistic depictions by *Laroon and *Hogarth, were and remain his greatest popular success.

DER

Webster, M., *Francis Wheatley* (1970).

WHISTLER, JAMES McNEILL (1834–1903). American-born, French-educated, and (mainly) English-domiciled painter and etcher. In 1855, after learning etching as a US navy cartographer, he went to Paris, where he studied under Charles Gleyre (1808–74), and acquired a lasting admiration for *Velázquez, and for oriental art.

He met *Courbet, whose *realism inspired much of his early work, but after settling in London in 1859 freed himself from this dependence. His *Symphony in White No. 1: The White Girl* (1862; Washington, NG) shows a relationship to *Rossetti; in *La Princesse du pays de la porcelaine* (1863–4; Washington, Freer Gal.) this *Pre-Raphaelitism is overlaid with oriental detail, and in a number of subsequent works the figures and poses become less Japanese and more like those of Greek terracotta statuettes. The experiments of his early years found their fulfilment in his work of the 1870s. The *Thames Nocturnes* distil the Japanese elements into a harmonious relationship of tone and colour; and the portrait *Arrangements*, such as *Arrangement in Grey and Black: Portrait of the Painter's Mother* (1872; Paris, Louvre), translate Velázquez into the language of the 19th century, and at the same time foreshadow something of the geometric formalism of the 20th.

No less original was his work as a decorative artist, notably in the Peacock Room (1876–7) (now reconstructed Washington, Freer Gal.), where attenuated decorative patterning anticipated much in the *Art Nouveau style of the 1890s.

In 1877 Ruskin denounced his *Nocturne in Black and Gold: The Falling Rocket* (Detroit, Inst. of Arts) accusing him of 'flinging a pot of paint in the public's face', and the consequent libel action contributed to Whistler's bankruptcy. After a year (1879–80) devoted mostly to making *etchings and pastels in Venice he returned to London, which, apart from 1893–6 when he lived in Paris, remained his base for the rest of his life. He continued to paint large-scale portrait arrangements but the *Nocturnes* were largely replaced by intimate little seascapes, landscapes, townscapes, and interiors in oil and watercolours.

Whistler chose to work in artistic isolation, turning from the realism and the embryonic *Impressionism of the early 1860s to an intuitive kind of *Symbolism in which subject matter is largely eliminated and titles took on a musical or abstract form. The Butterfly symbol, which *c.*1869 he substituted for his signature, suggests both his art and character. A dandy, a wit, an inveterate controversialist, he conducted a series of campaigns against the public and critics in the form of pamphlets, annotated exhibition catalogues, and letters to the press. His aesthetic creed, which had affinities with the *Aestheticism of the 'art for art's sake' movement, is presented in *Ten O'Clock*, a lecture first delivered in 1885. HO/HL

Young, A. M., Macdonald, M. F., Spencer, R., and Miles, H., *The Paintings of James McNeill Whistler* (1980).

WHITE, JOHN (active 1585–93). English draughtsman. Nothing certain is known of White before 1585, when he travelled as the official artist on Sir Walter Raleigh's (1552–1618) unsuccessful first Roanoke expedition, although he may have accompanied the earlier expedition of Sir Martin Frobisher (1535?–93) in 1577. During the 1585 journey White collaborated with the surveyor Thomas Harriot (1560–1621) in charting the Virginian coastline and also recorded the flora, fauna, and native inhabitants in a series of sketches. These were later worked up as sensitive watercolour drawings, some of which were engraved by Theodore de Bry (1528–1598) as illustrations to Harriot's *A Brief and True Report of the New Found Land of Virginia* (1590). White also provided copies for the naturalists John Gerard (1545–1612) and Thomas Penny (*c.*1530–88). Although most valuable as some of the earliest images of North America and its inhabitants, White's drawings possess considerable charm. He sailed on Raleigh's second expedition (1587), as Governor of the proposed settlement, returning to England in August to obtain assistance for the starving settlers whose eventual fate is unknown. His surviving drawings are in the British Museum and British Library, London. DER

Hulton, P., *America, 1585: The Complete Drawings of John White* (1984).

WHITE VINE (white vine-stem; Italian *bianchi girari*), a border and initial decoration composed of elaborately entwined white vine stems, often left as bare parchment against a richly coloured background, found in manuscripts and incunabula. Originally a *Romanesque form, it was revived in Florence at the beginning of the 15th century. *Renaissance artists, mistakenly believing it to be an Antique decoration, saw it as a suitable form of decoration for *humanistic manuscripts. The misunderstanding over its origins notwithstanding, the style spread throughout Italy and was particularly used to decorate humanists' or classical texts: for example the *Collected Works* of the Florentine humanist Poggio Bracciolini with illumination attributed to *Francesco d'Antonio del Chierico (late 1450s; Vatican, Bib. Apostolica MS Urb. lat. 224). OI

WIERIX BROTHERS. Three brothers who were among the most prolific engravers in Antwerp in the late 16th and early 17th century. **Jan** (1549–*c.*1618) and his brother **Jerome** (1553–1619) were enlisted as master engravers in the guild of S. Luke in 1572/3; a third brother, **Anton II** (1555×9–1604), enrolled in 1590/1. All three brothers worked as reproductive engravers (see REPRODUCTION) for various Antwerp publishers, most frequently for Christopher Plantin (1588; Jan Wierix, *Christopher Plantin*, engraving). Much of the Wierix brothers' work was commissioned by Jesuits and other Counter-Reformation religious orders. Their prints played an important role in the recapturing of the southern Netherlands for the Catholic Church (Anton Wierix, *SS Ignatius and Francis Embrace the Heart of Christ*, engraving). Despite this, all three brothers were known for their disorderly conduct and, at some point, Christopher Plantin complained that whoever wanted to employ the Wierix brothers had to go and look for them in the taverns, pay their debts, and recover their tools which they had pawned. KLB

Mauquoy-Hendricks, M., *Les Estampes des Wierix* (1978–83).

WIERTZ, ANTOINE (1806–65). Belgian artist. Born in Dinant, Wiertz trained at the Antwerp Academie before a stay in Paris (1829–32) during which he was influenced by French *Romantic artists, particularly *Géricault. In 1834 he visited Italy, having won the *Prix de Rome in 1832, where he was greatly impressed by *Michelangelo and formed the ambitiously high-minded but doomed intention to combine the merits of Michelangelo and *Rubens in religious and historical compositions. His huge and frenzied *Greeks and Trojans Fighting over the Body of Patroclus* (1835; Brussels, Wiertz Mus.) brought him some renown, particularly in his native country, to which he returned in 1836. The government, anxious to encourage a distinctive Belgian school of art, built him a studio, based on the Doric temples of Paestum, in Brussels in 1850. His melodramatic compositions became increasingly extreme *c.*1848–50 under the influence of dreams, visions, and a feverishly morbid imagination. The macabre and erotic elements of these later paintings, which include *La Belle Rosine* (Brussels, Wiertz Mus.), in which a naked young woman confronts her skeleton, anticipate aspects of *Symbolism but are crudely executed and often bathetic. DER

Beks, M., *Antoine Wiertz, Genie of Charlatan* (1981).

WIJCK, FATHER AND SON. Dutch painters. **Thomas** (1616–77) visited Italy before he was documented as a painter in Haarlem in 1642. During the approximate period 1660–8 he was in England, where Horace *Walpole records that he painted port scenes, marine views, and scenes of alchemists' laboratories (of which several examples exist), in addition to views of London, including some of the Fire of London in 1666. His most individual and successful paintings are Roman genre scenes, presumably of the early 1640s, in which he depicts with great freshness the everyday life of the poor, surrounded by the jumbled relics of the classical and medieval past (*Washerwomen*; Hanover,

795

Niedersächsische Landesgal.). After his return to the Netherlands his Italianate scenes became more generalized and stereotyped, though his fantasy port scenes, featuring elegant voyagers and exotic orientals, do seem to reflect personal experience of Naples and the neighbouring coast. His son **Jan** (1652–1700) made his career in England, where he died. He is noteworthy as an early painter of English hunting scenes, and he also did battle pieces, portraits, and marines. AJL

Briganti, G., Trezzani, L., and Laureati, L., *The Bamboccianti: The Painters of Everyday Life in Seventeenth Century Rome* (1985).

WIJNANTS, JAN (active 1643; d. 1684). Dutch landscape painter, whose works have considerable charm. There is much unresolved debate over the question of when Wijnants was born; however, he seems to have spent his early years in Haarlem. Most of his paintings show the sort of dune scenery which could be seen near this city. He may well have been the son of an art dealer and his earliest-dated pictures appear to date from 1643. Wijnants was betrothed in Amsterdam in December of 1660, and remained there for the rest of his life; in 1672 he was described as a 'painter and innkeeper'. He collaborated with other artists; he would paint the dunescapes, edged by trees and frequently set against a cloudy sky, and then specialists such as J. Lingelbach (1622–74) or Adriaen van de *Velde would supply the figures. He sometimes worked on a very small scale on panel, and pictures of this type became widely appreciated by collectors. CB

MacLaren, N., *National Gallery Catalogues: The Dutch School*, rev. C. Brown (1991).

WILDE, OSCAR (1854–1900). Irish-born writer. Wilde, a literal martyr to the cult of beauty, was England's leading apostle of *Aestheticism until his imprisonment for sodomy in 1895 and subsequent exile. He was educated at Trinity College, in Dublin, his birthplace, and achieved notoriety at Magdalen College, Oxford, before embarking on a literary career in London. His early aesthetic philosophy, delivered in a series of lectures in America in 1882, derived from *Gautier's dictum 'art for art's sake', the Epicureanism of *Pater, and the teachings of William Morris. From 1888 he was a successful writer and from 1892 a renowned comic dramatist and wit. His wide artistic acquaintance included *Burne-Jones, *Whistler, with whom he later quarrelled, and *Beardsley who provided the illustrations for Wilde's *Salome* (1894). The chief principles of Wilde's mature aesthetic, most succinctly expressed in *Intentions* (1891), a collection of critical essays, are that art is divorced from morality and that nature is inferior to art. Wilde, who could never resist an aphorism, frequently undermines the seriousness of his beliefs by his brilliant and paradoxical style. DER

Ellmann, R., *Oscar Wilde* (1987).
Roditi, E., *Oscar Wilde* (1986).

WILDENS, JAN (1585/6–1653). Flemish landscape painter born in Antwerp. He was apprenticed to Pieter Verhulst (d. 1628) before becoming a master in the Antwerp guild of S. Luke in 1604. After a stay in Italy 1613–c.1616, he became the collaborator of *Rubens, painting the landscape backgrounds for the *Decius Mus* tapestry cycle and for other paintings, including the *Rape of the Daughters of Leucippus* (Munich, Alte Pin.). The collaboration seems to have ended in 1620, but Wildens also provided backgrounds for paintings by other artists from Rubens's circle, among them Jacob *Jordaens, Frans *Snyders, Paul de Vos (1591–2/5–1678), Jan Boeckhorst (c.1604–68), Cornelis Schut (1597–1655), and Theodoor *Rombouts. Wildens's earliest landscapes are derived from the bird's-eye perspective and mountain views of Joost de *Momper and Jan *Brueghel I. In Italy his works were influenced by the more open and spontaneous landscapes of Paul *Bril and Adam *Elsheimer. Rubens inspired him to more expansive compositions of rural roads, woodlands, and pastoral scenes, often with tall trees, though his calmer and more ordered images and muted colours lack the passion of the older master (*Landscape with Dancing Shepherds*, 1631; Antwerp, Koninklijk Mus. voor Schone Kunsten). KLB

Adler, W., *Jan Wildens, der Landschaftsmitarbeiter des Rubens* (1980).

WILIGELMO (active c.1100). Chief sculptor of the reliefs on the western façade of Modena Cathedral. His name is immortalized by an inscription on the façade praising his work: 'Among sculptors, your work shines forth, Wiligelmo.' His distinctive style marks the beginning of the revival of figure sculpture in north Italy. The markedly classical mode of a frieze of simple yet voluminous figures placed under arcades shows the influence of *Antique sarcophagi and Roman triumphal reliefs; indeed evidence for the availability of such material is provided by the incorporation of pieces of Roman sculpture elsewhere in the façade.

Wiligelmo's frieze dates from the first decade of the 12th century. It is composed of four panels on either side of the main door, carved with scenes from the Book of Genesis, including *Creation* and *Temptation*, with God in a mandorla and prophets. The frieze itself is an innovative way of presenting biblical subject matter, and another new form is his application of sculpture to rectangular panels on the door jambs. Some comparisons have been made with contemporary or earlier work in Languedoc and Apulia, where he may have been trained. CMH

WILKIE, SIR DAVID (1785–1841). Wilkie, one of the most admired and successful painters of his day, was born in Scotland and trained at the Trustees Academy in Edinburgh. The sale of *Pitlessie Fair* (Edinburgh, NG Scotland) financed his studies at the RA Schools when he arrived in London in 1805. His fortune was assured in 1806 when *Village Politicians* (priv. coll.) was shown at the RA to general acclaim. Over the next 20 years his anecdotal paintings of peasant life, based on a close study of Dutch 17th-century *genre painters, were universally admired. Aristocratic patrons, including the influential Sir George Beaumont, were joined by royalty in 1813 when the Prince Regent purchased *Blind Man's Buff* (London, Royal Coll.) and royal patronage continued until 1837 when he painted *The First Council of Queen Victoria* (London, Royal Coll.). From 1825 to 1828 he travelled in Europe and under the influence of Spanish art and French *Romantic painters his palette became richer, his brushwork bolder, and his repertoire of subjects wider. He died at sea in 1841, while returning from a trip to the Holy Land. DER

Chiego, W. (ed.), *Sir David Wilkie of Scotland (1785–1841)*, exhib. cat. 1987 (New Haven, Yale Center for British Art).
Cunningham, A., *Life of Wilkie* (1843).

WILLAERTS, ADAM (1577–1664). Flemish marine artist who emigrated to the northern Netherlands, possibly via London, settling in Utrecht, where in 1611 he became a founder member of the guild of S. Luke. His early works, such as *A Fleet of the East India Company near an Island off West Africa* (1608; Amsterdam, Historical Mus.) are panoramas of carefully arranged ships on a choppy sea, strongly indebted to Hendrick *Vroom, with whom he has been confused. *Shipwreck off a Rocky Coast* (1614; Amsterdam, Rijksmus.) is a typical example of his early storm scenes in which the high panoramic viewpoint is retained and reds and blue-greens predominate. Willaerts specialized in beach scenes with figures, for example *Wild Duck Hunt on the Coast* (1620; Hamburg, Kunsthalle). In these, the viewpoint and horizon line are lower and more emphasis is placed upon the animated groups of small figures in the foreground, ranged against a light sea and wide sky. Willaerts retained the use of bright colours long after Dutch marine painters had adopted a greater tonalism. His three sons Cornelis, Abraham, and Isaack worked in their father's studio and continued to paint in his style. CFW

Kloek, W., et al., *Dawn of the Golden Age: Northern Netherlandish Art 1580–1620*, exhib. cat. 1993–4 (Amsterdam, Rijksmus.).

WILLIAM DE BRAILES (active mid-13th century). One of the few English illuminators of the early *Gothic period whose work can be positively identified. His name appears beside the picture of a tonsured cleric, twice in a book of hours (London, BL, Add. MS 49999), and plucked from the ranks of the damned by an angel in a *Last Judgement* picture, on a detached page of Bible illustrations from a psalter (Cambridge, Fitzwilliam, MS 330). An illuminator of this name is recorded between 1238 and 1252 living in Catte Street, Oxford, a major centre of book production. From the style of these 'signed' works it is possible to attribute a number of other works to him, or to his assistants; from the variation of hands in the illuminations it seems probable that William was head of an atelier. Although both his figure style, with its sharply defined draperies, and his use of colour are conventional, his work is remarkable for the highly original interpretation of familiar Bible scenes, and for its lurking sense of humour.　　AS

Morgan, N. J., *Early Gothic Manuscripts 1190–1250* (1982).

WILLUMSEN, JENS FERDINAND (1863–1958). Danish painter, sculptor, architect, engraver, potter, writer, and collector. He was born in Copenhagen, where he studied at the Academy. In 1888–9 he visited Paris, and he was again in France between 1890 and 1894, abandoning his early naturalistic style under the impact of *Gauguin (whom he met in Brittany) and *Symbolism. His work became highly individual, notable for its obscure and disturbing subject matter and glaringly bright colours (*After the Tempest*, 1905; Oslo, NG Norway). His sculpture is often polychromatic, using mixed media, showing the influence of *Klinger. Willumsen was also influenced by El *Greco, on whom he wrote a long book (1927). He designed two villas for himself in Denmark, but after the First World War he spent most of his life in the south of France. His later work included numerous portraits. He was one of the leading personalities of his time in Danish art, idolized as a genius by his admirers but decried by others. There is a museum devoted to Willumsen at Frederikssund in Denmark, containing work he collected as well as produced himself.　　IC

WILSON, RICHARD (1713?–82). English painter. From 1729 to 1735 he studied under Thomas Wright (active 1728–37) and began his career, as a portrait painter, in the 1740s. In 1750 he travelled to Venice where he painted a portrait of *Zuccarelli (1751; London, Tate) who encouraged him to paint *landscapes. In Rome, by 1752, he executed many drawings of the city and the Campagna and studied the works of *Poussin, *Claude, *Dughet, and the *Ricci. Commissions included two landscapes with banditti for Lord Wicklow (1752; Cardiff, National Mus. Wales) which reflect an interest in *Rosa. Returning to London c.1756 he established a successful studio with many pupils. His popularity lay in his ability to synthesize actual and ideal landscape, since the latter, firmly rooted in the Arcadian tradition, had a particular appeal to his classically educated clientele. From 1760, when he exhibited *Niobe* (New Haven, Yale Center for British Art) his work included historical landscapes in the *Grand Manner alongside Claudean depictions of English views. *Cader Idris* (c.1765–7; London, Tate) is among a group of landscapes which reflect the fashion for the *picturesque. After 1770 he declined and retired to Wales in 1781.　　DER

Solkin, D., *Richard Wilson*, exhib. cat. 1982 (London, Tate).

WILTON, JOSEPH (1722–1803). English sculptor. Wilton's father, a successful manufacturer of architectural ornaments, paid for a cosmopolitan training in Flanders, under Laurent Delvaux (1695–1778); Paris, under *Pigalle; and in Italy 1747–55. In Rome he made copies after the *Antique including the *Medici Venus and won the Pope's gold medal in 1750. His bust of *Dr Cocchi* (1755; London, V&A), executed in Florence, reveals his study of Roman portrait sculpture, retained in his post-Italian portraits: *Lord Chesterfield* (1757; London, BM). On returning to England with the architect William Chambers (1723–96) Wilton achieved early success, being appointed sculptor to George III, for whom he carved the Coronation Coach (1760), in 1761. An uneven artist, his most famous monument, to General Wolfe (mid-1760s–1772; London, Westminster Abbey), unsuccessfully combines Antique severity with *Rococo flourish, the latter probably influenced by his friend *Roubiliac. He collaborated with Chambers on several projects including Somerset House in the late 1770s by which time, having inherited his father's fortune, he was employing numerous assistants. Extravagant and worldly, he was bankrupt by 1793 but received an honorarium as keeper of the Royal Academy from 1790 until his death.　　DER

Whinney, M., *Sculpture in Britain 1530–1830* (rev. edn., 1988).

WINCKELMANN, JOHANN JOACHIM (1717–68). German scholar of classical *Antiquity, sometimes dubbed 'the father of art history'. Of humble origin, he was educated at Halle and Jena and for a while worked as a tutor and schoolmaster in north German provincial towns. In 1748 he became librarian to the Count of Bünau, whose excellent library at Nöthnitz near Dresden provided him with many opportunities to pursue further his interest in classical Antiquity. In 1755 he moved to Rome, where under the patronage of the collector Cardinal Albani he established himself as a scholar and antiquarian of European renown. He was murdered in 1768, whilst staying at an inn in Trieste.

His first publication, *Gedanken über die Nachahmung der griechischen Werke in der Malerei und Bildhauerkunst* (1755), programmatically formulated the *Neoclassical ideal and was met with instant acclaim. Focusing on the masterpieces of the Belvedere collection (see ROME, VATICAN MUSEUM), the book recommends imitation of the ancients as a means to achieve perfection and true greatness, both aesthetically and in moral terms. In opposition to the formal dichotomy of the *Baroque, contemporary art should attain a completely balanced harmony. Contemplating the *Laocoön group, Winckelmann devised the famous motto 'noble simplicity and calm grandeur', a term epitomizing his aesthetic vision. He amplified his ideas in *Geschichte der Kunst des Altertums* (1764), which introduced in some respects the scientific methodology of modern art history. Rather than following the tradition of artists' biographies, the book aims to present the visual arts in the broader framework of the relevant place, period, and culture, taking into consideration factors such as climate, society, politics, and education. The book also constitutes the first serious attempt to periodize the development of *Greek art. Subscribing to the notion that history developed in cycles of growth and decay, Winckelmann saw the history of ancient art as an organic evolution, distinguishing between four successive periods, each characterized by its own style: the archaic or early style (before *Phidias), the grand or 'high' style (Phidias and his contemporaries), the beautiful style (*Praxiteles to *Lysippus, the painter *Apelles), and the imitative style, which lasted until the decline of the Roman Empire.

Winckelmann's interpretation of Antiquity had profound repercussions on the aesthetic and ethical ideals of German classicism (*Goethe, Herder, *Hegel). He was similarly important to the development of the visual arts, and the style of artists such as *Mengs, *Canova, and *Thorvaldsen owed much to the stimulus of his doctrines.　　AT

Potts, A., *Flesh and the Ideal: Winckelmann and the Origins of Art History* (1994).

WINTERHALTER, FRANZ XAVIER (1805–73). German-born portrait painter. After studying in Munich, Winterhalter practised in Karlsruhe from 1830 where he was appointed court painter in 1834. From 1833 to 1834 he was in Italy and on his return moved to Paris, at the behest of Queen Marie-Amélie (1782–1866), which was

to remain his principal base. In 1841 he received his first commission from Queen Victoria (1819–1901), probably at the suggestion of Prince Albert (1819–61), whose full-length portrait he painted, in military pose against an avalanche of satin Garter Robes, in 1859 (replica, 1867; London, NPG). It was Albert who suggested the virtually blasphemous pose of *The First of May* (1851; London, Royal Coll.), clearly based on an Adoration. Winterhalter's urbane and elegant style was compromised by Victoria's bourgeois domesticity and he is seen at his best in paintings like *The Empress Eugénie and her Ladies* (c.1855; Château de Compiègne), where the young, attractive women float on a cloud of silks and satins in a fairy-tale landscape.　　DER

Levey, M., *Painting at Court* (1971).
Winterhalter, exhib. cat. 1987 (London, NPG).

WIT, JACOB DE (1695–1754). Dutch painter, draughtsman, etcher, and writer. De Wit received his early training first in Amsterdam under Albert van Spiers, pupil of Gérard de *Lairesse, and then in Antwerp under Jacob van Hal. However, the influence of *Rubens and van *Dyck had a far greater impact upon de Wit. In 1711 he copied Rubens's ceiling paintings for the Jesuit church in Antwerp (destr. 1778), working them up into several series of drawings (red chalk series in London, BM). These are an invaluable record of the destroyed Rubens paintings. By 1713 de Wit had returned to his native city of Amsterdam to become the leading painter of decorative interiors in patrician houses there. He is best known for, and indeed gave his name ('Witje') to, a kind of grisaille which gives the illusion of a marble relief, often over a door or chimney piece. A fine example is the ceiling *Apollo and the Muses* (1743; The Hague, Mauritshuis). The central part of the ceiling appears to open to a sky of swirling clouds and is painted in light pastel shades, whilst in the four corner canvases, putti representing music, poetry, comedy, and tragedy appear in de Wit's delicate grisaille technique.　　CFW

Rosenberg, J., Slive, S., and ter Kuile, E. H., *Dutch Art and Architecture 1600–1800* (1997).

WITTE, EMANUEL DE (1617–92). A versatile and distinguished Dutch artist, who excelled as a painter of architectural scenes and figurative subjects. He was born in Alkmaar and entered the artists' guild there in 1636. He is subsequently recorded in Rotterdam, and then in Delft throughout the 1640s. From 1652 until his death he lived in Amsterdam. The biographer *Houbraken says that de Witte committed suicide, and that his body was discovered in a frozen canal eleven weeks after his disappearance.

His early works are of mythological and biblical subjects, but then from the early 1650s onwards de Witte starts to paint the serene church interiors which dominate his output; they show what are often imaginary buildings, and established his reputation for mastery of linear *perspective. Later in his life he also painted market scenes which in some instances include portraits. Although the quality of his mature work varies considerably, he is said to have enjoyed some distinguished patronage and to have painted two works for the King of Denmark.　　CB

Manke, I., *Emanuel de Witte 1617–1692* (1963).

WITTEL, CASPAR VAN. See VANVITELLI.

WITZ, KONRAD (c.1400×10–1445/6). Swiss painter, a native of the German town of Rottweil (Württemberg) who settled in Basle in 1434. Despite his relatively short career, a remarkable number of paintings survive, including those of three major altarpiece commissions. Witz was a highly original and innovative painter. His last known work, the signed and dated altarpiece of S. Peter (1444; central panel lost, wings in Geneva, Mus. d'Art et d'Histoire), included his most famous panel with the *Miraculous Draught of Fishes*. Not only does the landscape realistically represent part of Lake Geneva, but Witz portrayed the different effects of reflected and refracted water in depicting the half-submerged rocky foreground—perhaps the first artist to do so. Equally, the *Freeing of S. Peter* in the other wing of the altarpiece uses cast shadows to represent one of the earliest night scenes in northern European art. In his striving for the appearance of reality, Witz should be identified as a contemporary of the van *Eyck and *Campin generation who abandoned the courtly style of the *International Gothic.　　KLB

Snyder, J., *Northern Renaissance Art* (1985).

WOENSAM, ANTON (1493/6–1541). German painter and graphic artist specializing in *woodcuts. Forty-five paintings and over 500 woodcuts are attributed to him. The family settled in Cologne in 1510 where Anton received an early training from his father Jasper. By 1517 Anton was working as a maker of woodcuts for a book printer. His style was influenced at first by the *Antwerp Mannerists and by local Cologne painters. Later artists such as Bartholomäus *Bruyn, Joos van *Cleve, and *Dürer had a forceful impact upon his mature work. His late compositions from about 1535 onwards, with their emphasis on the human figure and extremes of *perspective, reveal a renewed debt to *Antwerp Mannerism, for example *Holy Kinship* altarpiece (1540; Worms, Kunsthaus Heylshof). A well-known example of Woensam's graphic work is a woodcut of a *View of Cologne*, for the printer Quentel, which was presented to the Emperor Charles V when he entered the city in 1531.　　CFW

Strauss, W. L., *The Illustrated Bartsch*, vol. 13 (1981).

WOLF, CASPAR (1735–85). Swiss painter and draughtsman. Wolf was one of the first landscape painters to study Alpine scenery closely. His dramatic compositions combine topography with a profound observation of nature, infused with a sense of grandeur which anticipates the work of later *Romantic landscape artists. After training with Jakob Anton von Lenz in Konstanz, Wolf worked 1753–9 in Augsburg, Munich, and Passau, before returning to his birthplace of Muri in 1760. Although he came to specialize in landscapes of mountainous scenery, he also painted altarpieces, wallpapers, and stoves. *The Legend of S. Benedict*, part of a decorative scheme in Schloss Horben, is an example of his early work. By 1768 Wolf was in Basle and then he travelled to Paris to spend two years in the studio of de *Loutherbourg. For the remainder of his career, Wolf was to work mainly for a Lucerne collector, J. A. F. Balthasar, and a Berne publisher, Abraham Wagner, producing increasingly Romantic Alpine landscapes from pencil and oil sketches, made from nature. The paintings for Abraham Wagner were reproduced as prints under the title *Merkwürdigen Prospekte aus den Schweizer Gebirge* (1777–8).　　CFW

Rosenblum, R., *Modern Painting and the Northern Romantic Tradition* (1975).

WÖLFFLIN, HEINRICH (1864–1945). Swiss art historian. Between 1893 and 1934 Wölfflin taught consecutively at the universities of Basle, Berlin, Munich, and Zurich. In his declared aim to write an 'art-history-without-names', he was, like Alois *Riegl, concerned with the formal vocabulary of art and strove to find general laws which governed stylistic change. His seminal work was the *Kunstgeschichtliche Grundbegriffe* (1915), which focused, like most of his other studies, on the visual character of *Renaissance and *Baroque art in Italy and northern Europe. Wölfflin explores and analyses here the phenomenon of stylistic development by means of five antithetical pairs of concepts (linear and painterly; flatness and depth; closed and open form; multiplicity and unity; clarity and complexity). For him these polar opposites furnished neutral and descriptive tools which would help the interpreter trace and reconstruct histories of vision for a variety of historical and cultural contexts. Wölfflin's formalism largely neglected social and cultural factors. Although of considerable influence on art historians such

as Paul *Frankl and Nikolaus Pevsner, his approach was criticized by many scholars, including Aby *Warburg and Erwin *Panofsky.
AT

Lurz, M., Heinrich Wölfflin: Biographie einer Kunsttheorie (1981).

WOLGEMUT, MICHAEL (1434–1519). German painter and *woodcut designer. His paintings are insignificant, but the activities of his large Nuremberg workshop in designing woodcuts, particularly for book illustrations, were important and influential. He designed woodcuts for the widely distributed Nuremberg Chronicle (1493) and the Schatzbehalter (1491) which were boldly cut, probably by specialist woodcutters, and markedly *Gothic in style. These were produced after the apprenticeship in his workshop of *Dürer, who studied there 1486–9. There is a fine portrait of Wolgemut in old age by Dürer (Nuremberg, Germanisches Nationalmus.), and it is as Dürer's master that he is best remembered. RGo

Stadler, F., Michael Wolgemut und der nürnberger Holzschnitt im letzten Drittel des XV. Jahrhunderts (1913).

WOLS (Alfred Otto Wolfgang Schulze) (1913–51). German painter and photographer. Born in Berlin, Schulze adopted the working name Wols from telegram fragments. He studied at the *Bauhaus under *Moholy-Nagy in 1932, then moved to Paris, associating with the *Surrealists while working as a society photographer. From 1933 he was in Ibiza and Barcelona, but was imprisoned and deported in 1936. Returning to Paris, he continued photography; after being interned as an alien in 1939, he concentrated on painting and also fell into the alcoholism which contributed to his early death. His watercolours and drawings use biomorphic shapes and jagged lines to convey states of mind through abstracted organic structure. Wols moved to Cassis in 1940. He began oil painting in 1946, becoming a founder of 'Tachisme', random colour blotches interacting to recreate emotional experience. He was also an accomplished graphic artist and 1947–8 illustrated various contemporary writers, including Sartre and Kafka, with drypoint etchings. His photographs, paintings, and graphics, deliberately undated, re-examine the world through alternative realities of line and colour, juxtaposition, and poetic evocation. JH

Inch, P. (ed.), Circus Wols: The Life and Work of Wolfgang Schulze (1978).

WOOD, CHRISTOPHER (1901–30). English painter. Wood trained in Paris, where he was popular in the avant-garde circles of *Picasso, Cocteau, and Diaghilev. He absorbed a variety of influences from *Cubism, *Fauvism, and *Surrealism, and made a reputation for stage design. In 1926 he returned to London, where he joined the 7 & 5 Society, and became friendly with Ben and Winifred *Nicholson. In 1928 they visited St Ives, Cornwall, where Wood encountered the work of Alfred Wallis (1855–1942), an untrained Cornish fisherman, whose naive images of ships and the sea, painted on old pieces of panel, had an immediacy which he found inspiring. From 1928 to 1930 Wood divided his time between France and England, producing much of his best work at the fishing port of Treboul, Brittany. Paintings such as Church at Treboul (1930; London, Tate) have a simplicity and freshness of vision which is not sentimental but expresses a personal vision of a place and people divorced from the turmoil of the modern world. Wood suffered from chronic instability in his personal life, and was heavily addicted to opium. His suicide at the age of 29 cut short a career which showed great promise. JH

Newton, E., Christopher Wood: His Life and Work (1959).

WOOD, GRANT (1891–1942). American painter and designer. Wood came from a rural, conservative background on a farm in Iowa and moved to the growing city of Cedar Rapids aged 10. He travelled and studied sporadically from 1910 to 1916, taking a mixture of art and craft classes which grounded him in a fin de siècle aesthetic. He painted in an eclectic manner throughout the 1920s, often supporting himself as a decorator. By 1930, under the influence of northern *Renaissance masters he turned to a hard-edged realism, which culminated in American Gothic (1930; Chicago, Art Inst.), an overnight success. He soon became the acknowledged leader of the Regionalist style (see REGIONALISM), concentrating on the depiction of historic midwestern subjects. He promoted the style in speeches throughout North America and espoused its ethos in 1930–2 at the Stone City Art Colony, which he set up, and at the University of Iowa. By the end of the 1930s he was being increasingly attacked as a dangerous reactionary, a reputation which stayed with him among many *modernist critics. MF

Dennis, J., Grant Wood (1975).

WOODCARVING. Wood has been an almost universal medium of sculpture for at least 5,000 years, but its poor rate of preservation does not allow an assessment of earlier evidence of its use. It is used both in relief and in three-dimensional work in sculpture.

Wood is relatively light, fibrous, dense, and durable. It is formed by the formation and discarding of cells, called xylem and phloem, which constitute storage cells, fibres, vessels, and ducts. The fibres run in the direction of the tree's grain, that is, vertically, and these conduct water and nutrients. The annual growth rings form concentric circles which include early and late wood and differ from each other in consistency—the earlier having larger vessels and fewer fibres. Rays radiate from the centre of the trunk, and the heartwood—the inner rings—differs from the outer rings, which are called the sapwood. This is younger and contains live cells and water, while the cells of the dead heartwood are full of gum and resin. Cellulose and ligin combine in wood to give it strength and resistance to pressure.

Wood usually has a distinctive structure, determined by its conditions of growth, as well as a grain which will differ from wood to wood. The groups of woods employed for sculpture are generally divided into two: hardwoods, which include box- and fruitwoods and limewood, which have a close grain and which can be highly polished; and softwoods, such as oak, walnut, chestnut, poplar, and pine, which generally have a coarser grain and a less refined surface texture. A dense wood will have proportionally more elasticity and resistance, but also a greater margin of shrinkage and swelling. In northern Europe, in Flanders and the Rhine region, oak and walnut were widely available and employed, while in southern Europe, in Italy and Spain, walnut, poplar, pine, and chestnut were the favoured woods. French sculptors used limewood, walnut, and poplar, both for sculpture and for the applied arts. Limewood was the most common wood used in Europe, especially central and southern Germany. Pine was a cheap and commonly available wood employed for decorative carving in England, especially in the dazzlingly complex forms and undercutting of Grinling *Gibbons's carved swags and architectural decorations. Generally an indigenous wood will be used for sculpture, and the identification of the wood employed in a sculpture can also aid in the attribution of an unidentified sculptor. During the 20th century tropical woods were used for sculpture, though in recent years ecological concerns have halted their use.

Before a wood can be used it will need seasoning, which allows the newly felled tree to dry out, a procedure which will help avoid the warping of the wood during or after the carving stage. Bound water in the microfibrils might be trapped and cause the wood to shrink or expand at a slower rate over time. Because it retains moisture in three different dimensions wood distorts during drying; it can either be dried naturally by air, which can take years, or in a kiln, which is not only much faster but has the advantage of killing infestations.

Being an absorbent and unstable material, wood will continue to respond to changes in

humidity and climate, and its dimensions may alter over time; this is a common cause of conservation problems. To avoid this problem, though not always successfully, craftsmen would often choose to carve smaller pieces of wood. In addition, an artist will try to use wood from the same tree to avoid the variable fluctuations which might occur in the rate of shrinkage between woods from a different source. Being densely textured, oak will warp with age, while a lighter wood, such as limewood, will split. A further measure to avoid violent movement in the final carved sculpture is to remove the heartwood from the log, since it shrinks at a different rate from the outer sapwood. Thus, for this reason it is characteristic to see the reverse of a sculpture hollowed out, and in reality, most supposedly three-dimensional figures are effectively high-relief sculpture.

The direction of the wood grain commonly also determines the general direction of the composition of the carving, though the dense grain of boxwood, which can be carved across the grain, rather like ivory, allows for the inclusion of much finer detail and virtuoso carving displays, such as in Veit *Stoss's *Virgin and Child* (c.1500–10; London, V&A).

A variety of tools are employed for woodcarving, and these include the axe, adze, saw, drill, and hammer, all used in the preliminary stages of roughing out the wood. The tools used for more refined work include gouges, drills, various types of chisel, a mallet, rasps, files, and rifflers, some of which duplicate the tools used in stonecarving and modelling. Chisels are the only tools used in relief sculpture. Finally, burnishing and polishing of the wood is carried out with burnishers and abrasives of varying texture and refinement.

In the medieval and Renaissance periods a fairly rigidly established guild system meant that the various stages of the creation of a carved piece of sculpture would be divided among a clearly defined group of skilled craftsmen. The preparatory stages were normally left to carpenters, who would prepare the wood and rough out the general forms with saws and axes, while carvers would take over the final finishing stages from there. Subsequent work to prepare a figure for *polychromy, for instance, would be carried out by plasterers, painters, and gilders. Surviving 17th-century contracts specify every detail about the types of wood to be employed and the colours to be applied, and the artist guarantees that no cracks will appear afterwards.

If the wood was to be polychromed, its surface would be roughened to provide an appropriate surface for the ground, and faults in the wood would be treated with a paste and often covered with linen cloth.

This linen would also provide a softening effect for the contours of the carving, as well as providing some stability to the movement of the wood itself. A carved wooden figure of *Lucretia* by Jacopo *Sansovino (London, V&A) illustrates how the stiffened linen dipped in a clay slip and gilded could be arranged over the wooden carcase of the figure. If the wood was to be left monochrome, such as in the altarpieces first produced by the Franconian sculptor Tilman *Riemenschneider, the surfaces would nevertheless be treated with a tinted glaze, consisting of egg white and oil mixed with colour. Similarly the monochrome surfaces of 16th- to 18th-century northern Europe boxwood and other fruitwood statuettes exploited these characteristically finely grained woods with their beautifully polished rich colours, which imitate the effects both of ivory and of bronze. In the 20th century, Henry *Moore's unpainted monumental reclining figures have exploited the varied and prominent markings of the grain, for instance in his elmwood *Reclining Figure* (1939; Detroit, Inst. of Arts), and the use of wood for Ernst *Barlach's sculpture was appropriate for his *Expressionist mode.

Wood objects can be kept in good condition by occasionally rubbing with a soft cloth charged with wax. Wood is affected by humidity and heat and should be kept away from direct sources of heat or light, but should this occur the cracks that appear in the surface can be arrested by applying dowels across the fracture. More serious a problem for wood is fungal and pest infestation, which can attack structural timber. Wood-boring insects are a danger to all objects of wood, but these pests can be destroyed by chemical pesticides or through fumigation. Fumigation can be immediately effective, since gases can penetrate where liquids cannot, but wood thus treated may be attacked by the same pests again. Today treatment in an oxygen-starved environment is preferred. HO/AB

Baxandall, M., *The Limewood Sculptors of Renaissance Germany* (2nd edn., 1990).
Wheeler, W., and Hayward, C., *Practical Woodcarving and Gilding* (rev. edn., 1973).

WOODCUT. *See opposite.*

WOOD ENGRAVING, a technique of engraving in wood that is related to the *woodcut, although very distinct in character. Its principal feature is identical, namely that the lines or marks cut away will not print, the ink adhering only to the raised, uncut parts of the wooden block. However, whereas the woodcut designer works with a broad tool to gouge out large chunks around the lines that are to be printed, the wood engraver works with a *burin and other tools common to engraving, working positively to create delicate white lines. The wood engraver uses a hardwood, generally box, sawn across the grain of the wood and highly polished. It is thus described as 'end-grain engraving', as opposed to the 'side-grained' work of the woodcut designer. The hardwood enables the engraver to create very fine lines and delicate modelling, generally denied to the woodcut. A prerequisite of the wood engraver is fine, smooth paper, of a kind that became available towards the close of the 18th century when the history of the medium effectively begins. It is possible, however, to exaggerate slightly the gulf between the two wood techniques. The woodcuts of *Holbein's *Dance of Death* (c.1522–6), for instance, have much of the fineness on a small scale that we associate with wood engraving.

There are a number of Dutch and French references to end-grain engraving in the 18th century but Thomas *Bewick is the first great wood engraver, with his beautiful vignettes of animals and landscape, drawn with a delicate slightly tremulous white line. He had much influence through his own work, and that of his pupils, principally on small-scale book illustrations. The best of his pupils were Luke Clennell (1781–1840), who engraved some good little blocks after Thomas Stothard (1755–1834), and William Harvey (1796–1866), who attempted an ambitious large print after *Haydon's *Death of Dentatus*. The most exhilarating early wood engravings, though, are *Blake's tiny blocks for the *Pastorals* of Virgil (1821), little remarked at the time, save for a handful of tiny and exquisite blocks by his disciple Edward *Calvert, but very influential in the 20th century.

After this handful of exceptional works the entire direction of 19th-century wood engraving was towards reproductive work for illustrated books and journals, whereby professional engravers cut into the wood designs drawn on the block by artists who never handled the engraving tools themselves. The block can be locked up with typeface and printed simultaneously, making it the perfect tool for the book publisher. In this way the celebrated workshop of the Dalziel brothers produced thousands of blocks, ranging from the most elevated biblical illustrations to advertisements for corsetry. Journals such as *Punch* contained scores of engravings after such artists as Keene, while the *Illustrated London News* published engravings of all descriptions, sometimes large designs printed from multiple blocks, each engraved by a different hand. A golden age was in the 1860s when artists as distinguished as *Millais and *Rossetti drew illustrations for Trollope and Tennyson respectively, corrected proofs demonstrating the extraordinary care with which they worked in partnership with their engravers. No nuance of tone or cross-hatching was too little to be modified by the

continued on page 802

· WOODCUT ·

WOODCUTTING is the oldest and simplest of print techniques. Its history is intertwined with the history of the illustrated book as well as the single print. The smooth flat surface of a thick piece of prepared wood acts as the printing surface. Usually the artist draws his design on this flat surface, and either he or his assistant cuts away with knives and gouges the areas which are to remain white in the print, leaving the design standing in relief. The surface of the block is then inked with a roller, and a sheet of sturdy paper is placed over the block. By applying vertical pressure, either by hand or by means of a press, the ink is transferred to the paper, giving an impression in reverse. In general a woodblock is more durable than a copper plate, permitting more satisfactory impressions, and thus making it more appropriate for simple popular prints, or such ephemera as playing cards. However fine lines can rapidly break down, and that implacable enemy of the woodcut, the woodworm, leaves its mark in the small white circles which often denote later impressions of an old cut.

The woodcut is the senior member of the family of relief prints, differing fundamentally from *intaglio methods such as *etching or *line engraving, which are printed from fine lines etched or incised into the plate. Most woods of moderate softness will serve the purpose, but the most frequently used are pear, sycamore, and cherry. The blocks are cut along the length of the tree before being planed down, and the artist is thus obliged to cut through the texture of the wood with very sharp tools. The medium imposes its own restraints upon the artist, and in general it favours a bold, direct approach with a simple and limited syntax of forms and marks. This does not preclude subtlety, however, and from the early prints of *Dürer at the end of the 15th century, notably the series of the *Apocalypse* (1498), until the prints of *Gauguin and *Munch, artists have been able to articulate fine lines and complex textures from the wood.

The roots of the art are not European. Fabrics printed from wood are found in Middle Eastern work of the 5th century AD, and woodcut technique was advanced in China from the 9th century and probably earlier. However, its regular use in European art does not date until the first decades of the 15th century, when paper manufacture was established on a regular basis, particularly in northern countries such as Germany and Switzerland. Early woodcuts are usually simple devotional subjects, often based on some well-known prototype in sculpture or painting, and frequently boldly coloured by hand, or sometimes through the use of stencils. Many now survive in unique, damaged impressions, and many others must have perished very quickly through casual everyday use.

Woodcuts immediately proved a valuable ally to movable type, since the woodblock could be matched to the size of the typeface and printed simultaneously. This gave it an immense advantage over the use of copper plates in book illustration, since they had to be printed in a laborious separate process. The woodcut thus enabled many books to be cheaply and boldly illustrated, a famous example in Germany being *Wolgemut's illustrations to the *Nuremberg Chronicle* (1491–4). Single sheets are rarely found in early Italian art, but book illustrations, such as the exquisite courtly designs for the *Hypnerotomachia Poliphili* (1499), have a linear grace, often complemented by decorative surrounds, that eluded the northern artists.

It was the woodcuts of Dürer that cast off *Gothic conventions and trumpeted a new *Renaissance confidence and sophistication. It is unlikely that Dürer cut many of the blocks himself (although not improbable that he mastered the craft in some early prints), but he insisted on his craftsmen matching the intricate loops and folds of his drawings in the *Life of the Virgin*, or the *Large Passion* (both of 1511). He was also very aware of the collector's market for his work, issuing numerous proofs before the regular editions with text. These woodcuts, even more than his engravings, were widely circulated abroad, influencing artists and craftsmen of every description. A high proportion of great German artists followed in his footsteps in this Golden Age of the woodcut, including *Cranach, *Altdorfer, *Burgkmair, and *Baldung; the last two making brilliant innovations in printing in colour or in *chiaroscuro woodcuts. These artists did much to claim Germany as the true homeland of the woodcut, recording its forested landscape, its superstitions as well as its faith. Some important woodcuts were also made in the Netherlands by *Lucas van Leyden and although Italian production was modest in comparison it could boast such prodigies as Jacobo de' *Barbari's *Bird's-Eye View of Venice*, and numerous large woodcuts after *Titian.

Throughout the 17th and 18th centuries the woodcut fell from favour, and became mainly the province of street vendors selling cheap broadsides or popular prints. A few exceptions sustained the tradition; in Holland some innovative cuts were made by *Lievens and others, and 1739–45 John Baptist Jackson (c.1700–c.1770) made some large chiaroscuro woodcuts after Venetian painters, and later some remarkable colour woodcuts printed from several blocks that anticipate Japanese work in the medium.

Not until the end of the 19th century did the technique enjoy an exhilarating and lasting revival, notably in the free and expressively cut prints of Gauguin and Munch which are often printed in colours from two or more blocks. These were a big influence on the German artists of Die *Brücke, such as *Kirchner, *Nolde, and *Schmidt-Rottluff, whose aggressive work was cut directly into the wood, and strongly affected by primitive art. Their influ-

ence was felt abroad, but the history of the 20th-century woodcut, like its beginnings, emanates from Germany, and most recently the huge woodcuts of *Baselitz have renewed the tradition.

Musper, H. T., *Der Holzschnitt in funf Jahrhunderten* (1964).

RGo

correcting pencil of the artist. If for Millais and Rossetti this was only an occasional activity, for other artists such as Arthur Boyd Houghton (1836–75) it was a life's work.

England was the main home of the wood engraving, but fine work was done in France, notably from the designs of *Doré, and in Germany, particularly in Kugler's *Geschichte Friedrichs des Grossen* (1840–2) illustrated by Adolphe von *Menzel.

Before 1870, however, it was possible to develop *photographs onto the surface of the block, and engravers were soon enable to recreate a photographic tone, by minuscule flurries of parallel lines, incised by new multiple tools. The increasing sophistication of photo-mechanical processes in the 1880s sounded the death knell of large-scale commercial wood engraving. Yet until the end of the 19th century it competed gallantly with the photograph, engravers such as the American Thomas *Cole copying paintings with an extraordinarily skilful system of linework.

Wood engraving enjoyed something of a revival in the 20th century particularly in association with the expensive books of the private press movement, William Morris's Kelmscott Chaucer setting an example in the 1890s. Charles Ricketts (1866–1931) and Charles Shannon (1863–1937) further refined this tradition at their Vale Press. A number of sensitive artists used wood engraving in the 1930s, often in work that is slightly whimsical and pastoral, the work of Eric Ravilious (1903–41) being particularly distinguished. Wood engraving still has many practitioners, especially in England, but their work is usually revivalist in character.

RGo

Jackson, J., and Chatto, W., *A Treatise on Wood Engraving* (1839).

WOOD PANEL. See SUPPORTS.

WOTRUBA, FRITZ (1907–75). Austrian sculptor, born in Vienna. He initially trained as an engraver and took up sculpture as a pupil of Anton Hanak (1873–1934) at the Vienna Academy. In 1938 he emigrated to Switzerland and remained there during the war. He returned to Vienna in 1945 and was made first professor and later rector of the Academy. Wotruba carved directly in stone (see DIRECT CARVING), preferring a hard stone with a coarse texture. His early style was naturalistic, reminiscent of *Maillol; later he moved towards *abstraction by reducing his figures to their bare essentials, having eliminated unnecessary details. Although this was similar to the method used by *Brancusi, Wotruba's works can be distinguished by their rough, implicitly unfinished, state, which was intended to convey suggestions of the primitive and the monumental. In 1964 he executed a large relief frieze for Marburg University; he also designed the church of the Holy Trinity on the outskirts of Vienna (constructed 1974–6). Wotruba brought about a revival of sculpture in Vienna and was the real founder of the new Austrian School of abstract sculpture.

OPa

Fritz Wotruba, exhib. cat. 1967 (Hanover, Kestner-Gesellschaft).

WOUTERS, RIK (1882–1916). Belgian sculptor and painter. Wouters, who was born in Malines, was apprenticed as a woodcarver in his father's furniture workshop and studied modelling and casting at the Académie des Beaux-Arts, Brussels. Between 1907 and 1914 he executed a number of impressionistic bronzes including the portrait of the Belgian Expressionist James *Ensor (1913; Brussels, Mus. Royaux) and his monumental *Mad Virgin* (1912; Antwerp, Koninklijk Mus. voor Schone Kunsten), inspired by the dancer Isadora Duncan. In 1904 he had begun to paint and by 1912, when he exhibited *Fauvist pictures at the Giroux Gallery, Brussels, painting dominated his work. He painted in thin oils with a bright palette in a freely painted technique which allowed the white of the exposed canvas to give added luminosity. After his exhibition, which established him as the leading Belgian Fauve, he visited Paris where he was influenced by *Cézanne; his subsequent paintings, like *Nature morte—humeur sombre* (1915; Brussels, Mus. Royaux) were more solidly constructed. Wouters joined the Belgian army in 1914 and was interned after the fall of Antwerp. He died following an operation for eye cancer.

DER

Avermaete, R., *Rik Wouters* (1962).

WOUVERMAN, PHILIPS (1619–68). Dutch painter, draughtsman, and one of the most skilled painters of horses. After an early training with his father, a contemporary writer Cornelis de Bie (1661) mentioned that Wouverman served an apprenticeship with Frans *Hals, for which there is no evidence. In 1638 he moved to Hamburg where he married, and he worked there in the studio of the history painter, Evert Decker (d. 1647). By 1640 he had returned to Haarlem and joined the painters' guild. His output was exceptionally prolific and his subject matter was wide ranging, including battle and hunting scenes, smithies, landscapes, and army encampments. Influenced by Pieter van *Laer, who had returned from Italy in 1638, Wouverman developed rapidly during the 1640s as can be seen in *A Camp Scene* (London, Wallace Coll.). Later in his career, Wouverman showed a greater interest in landscape. *Stag Hunt* (Munich, Staatsgal., Schleissheim) shows an expansive and imaginary landscape with distant mountains, drenched in a silvery grey light. The light catches groups of elegant figures and gleaming horses in the shady foreground. Such pictures were very popular in the 18th century and widely collected.

CFW

Sutton, P., *Masters of 17th Century Dutch Landscape Painting*, exhib. cat. 1987 (Amsterdam, Boston, Philadelphia).

WRIGHT (OF DERBY), JOSEPH (1734–97). English painter. Wright studied under Thomas *Hudson 1751–7 and soon surpassed him as a portrait painter. His six *Members of the Markeaton Hunt* (1762–3; priv. coll.) reveal his talent for physicality and individuality, a quality shared with *Stubbs, far removed from Hudson's formulaic images. From the early 1770s he also painted small full-lengths including the charming *Mr and Mrs Thomas Coltman* (c.1771–2; London, NG) which first reveal an interest in landscape. Wright had painted candlelight pictures from the early 1760s and his dual interest in science and chiaroscuro culminated with the spectacular *Orrery* (1766; Derby, AG) and *Airpump* (1769; London, NG). *Miravan* (1772; Derby, AG) and *The Old Man and Death* (1773; Hartford, Conn., Wadsworth Atheneum), two macabre *history paintings, were possibly inspired by his friend *Mortimer. From late 1773 to 1775 he was in Italy, principally in Rome and Naples, where he drew from the *Antique and was inspired by the eruption of Vesuvius, which he painted with increasing elaboration after his return (1774; Derby, AG). After an unsuccessful stay in Bath, 1775–7, prompted by *Gainsborough's departure in 1774, Wright returned to his birthplace, Derby. For the next two decades he painted the portraits of his patrons and friends, including the Rousseauist *Sir Brooke Boothby* (1781; London, Tate), an elegant and urbane figure posed incongruously among vernal woods. A series of *picturesque landscapes of

Derbyshire including *Landscape with Dale Abbey* (*c.*1785; Sheffield, AG) combine *Claudean elegance with an almost hallucinatory realism. In 1786 he was asked to contribute to Boydell's *Shakespeare Gallery* and submitted three paintings, one of which, the rejected *Romeo and Juliet in the Tomb*, is in Derby.　DER

Nicolson, B., *Joseph Wright of Derby* (1968).

W TEWAEL, JOACHIM (1566–1638). Dutch painter and draughtsman, one of the Utrecht *Mannerists. After training with his father, a glass painter, he travelled in Italy and France, *c.*1588–92, where he encountered the elegant style at *Fontainebleau. Back in Utrecht, he was admitted to the saddlers' guild, to which painters then belonged. This was to change in 1611 with the establishment of the painters' own guild of S. Luke, of which Wtewael was a founding member. In his paintings Wtewael employed such typical Mannerist formal devices as brilliant colouring, contrived spatial design, and contorted poses. Many of his works are small-scale collectors' pictures of mythological, biblical, and allegorical subjects (*Mars and Venus Surprised by Vulcan*, *c.*1606–10; Los Angeles, Getty Mus.). He also painted kitchen pieces on a larger scale and in a more sober style in the tradition of *Bueckelaer and *Aertsen, frequently with moralizing content. Primarily an artist, Wtewael was also a flax merchant and a politician, who was elected to the Utrecht town council on several occasions.　KLB

Lowenthal, A. W., *Joachim Wtewael and Dutch Mannerism* (1986).

W YETH, ANDREW (1917–　). American painter, son of Newell Convers Wyeth (1882–1945), a highly successful illustrator of children's books. Wyeth had lessons from his father and later learned tempera technique from his brother-in-law Peter Hurd (1904–84), a *Regionalist painter, but he considers himself largely self-taught. His paintings consist almost entirely of depictions of the people and places of the two areas he knows best—the Brandywine Valley around his native Chadds Ford, Pa., and the Port Clyde area of the Maine coast, where he has his summer home. He usually paints in watercolour or tempera with a precise and detailed technique, and often he conveys a sense of loneliness and nostalgia (trappings of the modern world, such as motor cars, rarely appear in his work). He had his first one-man exhibition at the Macbeth Gallery in New York in 1937, when he was only 19. It was a sell-out success, and he became famous with *Christina's World* (1948), which was bought by the Museum of Modern Art, New York, in 1949 and has become one of the best-known American paintings of the 20th century. It depicts a friend of the artist, Christina Olson, who had been so badly crippled by polio that she moved by dragging herself with her arms. She is shown in a field on her farm in Maine, 'pulling herself slowly back towards the house'. The unusual viewpoint and the heavily charged atmosphere are typical of Wyeth's work. Because Christina is seen from the back, some viewers assumed that she was an attractive young girl frolicking in the grass, and were shocked when they saw Wyeth's portraits of the gaunt, middle-aged figure. Many other viewers, however, saw in it a deeper significance; as Sir David Piper wrote, it 'seems to express both the tragedy and the joy of life with such vivid poignancy that the painting becomes a universal symbol of the human condition—and is recognized as such: the picture has had a continuing fan mail from people who have identified with it' (The Mitchell Beazley Library of Art, vol. 3, *New Horizons*, 1981).

Building on the fame of *Christina's World*, Wyeth has gone on to have an enormously successful career. He has won numerous awards and in 1976 was the first native-born living American artist to be honoured with a retrospective exhibition at the Metropolitan Museum, New York; but critical opinion on him is widely divided.　IC

Y

YÁÑEZ DE LA ALMEDINA, FERNANDO (d. 1531). Spanish painter. Yáñez and his collaborator Fernando Llanos are among the foremost figures in the arrival of the Italian High *Renaissance in Spain. The two artists had been in Italy at the beginning of the 16th century, and scholars have associated one of them with documents referring to a Fernando who assisted *Leonardo da Vinci in 1505 on his frescoes in the Palazzo Vecchio, Florence. Upon his return to Valencia in 1506, Yáñez entered a partnership with Llanos, and the two undertook the main retable of the Cathedral of Valencia. These twelve panels depict scenes from the life of Christ in an accomplished High Renaissance style recalling both Leonardo and *Ghirlandaio. The traditional attribution of the paintings, which assigns the more accomplished images to Yáñez, has recently been challenged, suggesting instead that they should be ascribed to his collaborator; but no consensus has yet emerged. By 1513, when their collaboration ended, Yáñez moved on to Barcelona and, later, Cuenca, where in 1525 he painted an altar for the cathedral of that city. PL

Brown, J., and Mann, R. G., *Spanish Paintings of the Fifteenth through Nineteenth Centuries* (1990).
Brown, J., *The Golden Age of Painting in Spain* (1991).

YEAMES, WILLIAM FREDERICK (1835–1918). English painter. Yeames is known today for one notorious painting, *When Did You Last See your Father?* (1878; Liverpool, Walker AG), in which the power of Oliver Cromwell's military dictatorship is brought to bear on a young, vulnerable, but honourable innocent. The subject, which was probably fortuitous, has since symbolized political witch hunts and been a valuable source for cartoonists. However, in his day, he was a respected and successful Academician who specialized in anecdotal historical genre. His painting of *Amy Robsart* (1877; London, Tate) was among the first purchases of the Chantrey bequest. DER

Morris, E., and Milner, F., '*And When Did You Last See Your Father?*', exhib. cat. 1993 (Liverpool, Walker AG.)

YEATS, JACK BUTLER (1839–1922). Irish painter. The son of a painter and brother of the poet W. B. Yeats, he was born in London and studied at Westminster School of Art. Until *c*.1910 he worked as an illustrator and watercolour painter. His oils were initially influenced by *Impressionism but from *c*.1915 he developed a Romantic *Expressionist style using vivid raw colour and free, almost careless brushwork. He painted subjects from Celtic myth, *The Death of Diarmid* (1945; London, Tate), Irish life, *The Two Travellers* (1942; London, Tate), and visionary subjects, '*That We May Never Meet Again*' (*c*.1955; York, AG). DER

Pyle, H., *Jack B. Yeats* (1989).

YSENBRANDT (or Isenbrandt), ADRIAEN (early 16th century–before 21 July 1551). Southern Netherlandish painter, probably from Antwerp, who worked in Bruges where he is recorded as a master of the guild of S. Luke in 1510. The same accounts record his only official pupil, Cornelis van Callenberghe. There are no signed or documented works and many of the paintings attributed to him were once ascribed to Jan *Mostaert and the Master of the Virgin of the Seven Sorrows, named after the panel in Onze Lieve Vrouwkerk in Bruges. He was one of the leading painters in Bruges after the death of Gerard *David and his works show the influence of this artist. Only two works are dated, *Portrait of a Man* (1518; Bruges, Groeningemus.), and *Adoration of the Magi* (1518; Lübeck, Marienkirche; destr. 1942). His

masterpiece is the *Virgin of the Seven Sorrows* (c.1518; right wing, Bruges, Onze Lieve Vrouwkerk; left wing, Brussels, Mus. Royaux). His style is a mixture of *Gothic compositional devices and *Renaissance details. His colours are warm, with an emphasis on reds, and his flesh colours are noted for their use of brown pigment. OI

Friedlander, M. J., *Die altniederlandische Malerei* (1933); English trans. as *Early Netherlandish Painting*, 1974).

ZADKINE, OSSIP (1890–1967). French
sculptor. Born in Smolensk, Zadkine
studied in London, arriving in Paris in 1909.
He worked briefly there, at the École des
Beaux-Arts, establishing his own studio in
1910. From 1911 he began carving wood and
stone. Initially influenced by *Cubist and
*Futurist conceptions of space and dynamics,
he joined the *avant-garde, exhibiting with
the Berlin *Sezession in 1914. He served in the
French army, taking French nationality in
1921. Abandoning Cubist constraints, Zad-
kine achieved a lyrical and expressive free-
dom combining baroque energy and the
hieratic power of African sculpture. In 1941
he left occupied Europe, teaching and exhib-
iting in New York, and returned to Paris in
1945. Awarded the sculpture prize at the 1950
Venice Biennale, in 1953 he completed a me-
morial monument, *The Destroyed City*, in Rot-
terdam. He had a major Paris retrospective in
1958, winning the Sculpture Grand Prix in
1960. In 1961 he completed the Auvers-sur-
Oise van Gogh Monument. Zadkine is
widely represented in public collections. His
strongly individual sculptures exploit the
qualities of wood and metal in figurative
compositions, exploring archetypal fantasies
and the potential of space and mass by unit-
ing substance with symbol. JH

Jianou, I., *Zadkine* (1963).

ZANDOMENEGHI, FEDERICO (1841–
1917). Italian painter. He left his native
Venice in 1859, and soon after became in-
volved in the struggle for Italian unification.
From 1862 to 1866 he lived in Florence, where
he was friendly with the *Macchiaioli and
their champion Diego Martelli. Following
Zandomeneghi's return to Venice (1872),
Martelli persuaded him in 1874 to come to
Paris, where he settled. He soon became as-
sociated with the *Impressionists, with
whom he exhibited on various occasions.
Certainly his work shows some influence

from Impressionism, with broad patches of
colour and unorthodox compositions in
which figures are cut off abruptly at the edge
of the picture, as in *Place d'Anvers in Paris* (1880;
Piacenza, Gal. d'Arte Moderna Ricci Oddi).
He also was a brilliant pastellist and
draughtsman, but was relatively unsuccess-
ful until the latter part of his career. CJM

Dini, F., *Federico Zandomeneghi: la vita e le opere* (1989).

ZANETTI, ELDER AND YOUNGER.
Anton Maria the elder (1679/80–1767),
Venetian draughtsman, printmaker, con-
noisseur, and collector, was an important
link between the cultural life of Venice and
other European cities. His Venetian house
became a lively meeting place for foreign
collectors and dealers, and he befriended
and patronized Venetian artists, among them
Sebastiano and Marco *Ricci, and Gaetano
Zompini (1700–78); his vast collection of
prints inspired Venetian artists. After study in
Venice and Bologna, he travelled in Europe
(1720–2); he bought etchings by *Callot and
*Rembrandt; in Paris he visited the most
eminent connoisseurs, and in London ac-
quired a collection of *Parmigianino draw-
ings from Lord Arundel. In the late 1720s he
published a series of prints, mainly after
these drawings, in which he revived the
technique of *chiaroscuro woodcuts in three
or four colours. His taste embraced both
*classical and *Baroque; he made lively en-
gravings after drawings by *Castiglione,
while his *Delle antiche statue greche e romane*
(begun 1725), and the illustrated catalogue of
his collection of gems, were important to
Venetian *Neoclassicism. The son of his
cousin, **Antonio Maria the younger**
(1706–78), was a distinguished critic. HL

Haskell, F., *Patrons and Painters* (1963).

ZAVATTARI FAMILY. Lombard painters
active from 1406 to the mid-1500s. **Cris-
toforo** (active 1404–9) worked in Milan

Cathedral, as did his son **Franceschino** (active 1414–53). In 1445 Franceschino, alongside his sons **Gregorio** (active 1445–98) and **Giovanni** (active 1445–79), was instructed to finish decorating the Teodolinda chapel, Monza Cathedral. The highly decorative frescoes depicting the *Life of Queen Teodolinda* are considered the finest surviving examples of late *Gothic narrative mural art in Lombardy. As well as a love of ornament, they display keenly observed details of objects and costumes, well-characterized figures, and a lively narrative style; points of contact with the art of *Michelino da Besozzo, *Gentile da Fabriano, and *Pisanello are evident throughout the cycle. **Ambrogio** (active from 1450), another of Franceschino's sons, worked in Pavia with other family members in 1453. The only other surviving secure work by the Zavattari is a fresco of the *Virgin and Child* (1475; Corbetta, Santuario) by Gregorio. Three of Giovanni's sons are recorded as painters, as is Ambrogio's son Giovanni Angelo (active until *c*.1550). FB

Z EITBLOM, BARTHOLOMÄUS, or Bartel (1455×60–*c*.1520). German painter from Nördlingen who settled in Ulm. Though connected, by marriage, to the painters Friedrich *Herlin, of Nördlingen, and Hans Schüchlin (*c*.1430–1505), of Ulm, Zeitblom's work shows no traces of either style. The calm, frozen poses of his figures are closer to sculpture than to late *Gothic paintings. Together with Bernhard *Strigel, who may have been his pupil at the time, Zeitblom participated in painting the wings for the high altar of the former monastery church at Blaubeuren (1493–4), the sculptural corpus of which was done by Michel *Erhart. KLB

Löcher, K., *Germanisches Nationalmuseum Nürnberg: die Gemälde des 16. Jahrhunderts* (1997).

Z ERO, a group of *kinetic artists formed in Düsseldorf in 1957 by Heinz Mack and Otto Piene, who were joined in 1961 by Günther Uecker (there were other members from time to time, but these three formed the core). Their views were put forward in a periodical, also called *Zero* (two numbers appeared in 1958 and a third in 1961). Although they were interested in technology, they stressed the importance of working with nature, rather than against it, and carried out several environmental projects. They also—unlike many kinetic artists—valued the intrusion of the irrational in their work. The group disbanded in 1966. IC

Z EUXIS. Painter, of Heraclea in Lucania (south Italy). He is said to have built on the innovations of Apollodorus by adding highlights to shading and employing subtly differing colours. His painting of a child carrying grapes fooled birds into attacking the grapes; Zeuxis was disappointed that the birds did not find the child sufficiently realistic to be frightened by it. He is said to have been deceived into thinking a curtain painted by his rival Parrhasius was real, and to have conceded the latter's superiority; but he is also characterized as wealthy and arrogant, giving away his paintings since they were priceless. As with other painters, there was a moral element to his work. His *Penelope* was an embodiment of morality, and he was known for *pathos* (emotion), while Aristotle said he lacked *ethos* (character), elsewhere associated with *Polygnotus. Zeuxis' *floruit* is given by *Pliny (*Natural History* 35. 61) as 397 BC, but *Plato portrays him as young and newly arrived in Athens *c*.430. He is known to have painted *Alcmene* for Acragas in Sicily before 406, and for King Archelaus of Macedonia (413–399 BC). KWA

Z ICK, JANUARIUS (1730–97). German painter. He trained with his father the Bavarian *Rococo fresco painter Johann Zick (1702–62), but in 1757 visited Paris and Rome, spending time in *Mengs's studio. On his return to Germany he continued his father's work at Schloss Brüchsal, painting 34 panels for the 'Watteau-Kabinett' (1758; destr. 1945). Although he painted many easel paintings and secular decorations, his main output was fresco decorations for south German churches. Those in the Klosterkirche at Triefenstein are representative of his mature work. Painted in 1786 they are gracefully classicizing in style without completely embracing the rigours of *Neoclassicism. MJ

Metzger, O., *Januarius Zick* (1981).

Z IMMERMAN BROTHERS. German painters and stuccoists. **Johann Baptist** (1680 1758), working closely with his brother **Dominikus** (1685–1766), was the most inventive of the decorators working for the Bavarian court at *Munich, making a major contribution to the creation of the *Rococo style in southern Germany. His masterpiece, executed in collaboration with François Cuvilliés, is the stucco decoration of the Amalienburg at Schloss Nymphenburg, Munich (1734–7). Elsewhere he created schemes that combined stuccowork and fresco in bright and airy fashion, most notably at S. Michael, Berg am Laim (1737–43). He also painted a number of altarpieces. MJ

Bauer, H., and Bauer, A., *Johann Baptist und Dominikus Zimmerman* (1985).
Hitchcock, H.-R., *German Rococo: The Zimmerman Brothers* (1968).

Z OFFANY, JOHANN (1733–1810). German-born painter working in England. He was born at Frankfurt and studied *history painting at Regensburg and portrait painting in Rome, in the late 1750s, under the fashionable Agostino *Masucci. He was in London by 1760 and soon obtained the patronage of David Garrick (1717–79) who made his reputation. Garrick's fame was enormous and Zoffany's theatrical paintings, which include *Garrick in The Farmer's Return* (1762; New Haven, Yale Center for British Art) and *Garrick as Sir John Brute* (1765; Wolverhampton, AG), were widely disseminated as engravings. They revolutionized theatre painting by portraying the cast in dramatic action with considerable detail and accuracy. By 1764 he had obtained commissions for informal portraits of the royal family and his two most remarkable *conversation pieces, *The Academicians of the Royal Academy* (c.1772) and *The Tribuna of the Uffizi* (1772–8; both London, Royal Coll.), were commissioned by George III. Ironically, when he returned to London from Florence in 1778 his work was no longer fashionable. Six years in India (1783–9), painting nabobs and rajas, restored his fortunes. DER

Webster, M., *Johann Zoffany*, exhib. cat. 1977 (London, NPG).

Z OLA, ÉMILE (1840–1902). French novelist, polemicist, and art critic. His first published art criticism was a defence of his childhood friend *Cézanne, which appeared in *L'Événement* in 1866. Having discharged this loyalty he wrote little more about him and their friendship was ruined when Cézanne recognized himself in Claude Lantier, the failed painter of Zola's novel *L'Œuvre* (1886). Although he wrote widely about other avant-garde artists, including *Millet, *Pissarro, and *Monet, his highest praise was reserved for *Manet, of whom he published a study in 1867 and to whose posthumous retrospective in 1884 he contributed a catalogue introduction. Their friendship is recorded in a notable portrait of Zola by Manet (Paris, Mus. d'Orsay). In Manet's devotion to modern life subjects Zola admired an affinity with the *naturalist aesthetic that underlay his own fiction. But he also saw Manet's art as coming closest to his view that 'painting is a corner of creation seen through a temperament'. It was Manet's formal eloquence and the highly personal handwriting of his facture, as well as his willingness to paint the modern urban world, that made him the greatest of contemporary painters for Zola. Curiously, Zola's support for his progressive friends was accompanied by an uncertain visual taste: in his house canvases by his favourite artists had to compete with fake medieval suits of armour and an assortment of other 'artistic' bric-a-brac. In the last analysis his support for Manet and the *Impressionists was not the result of aesthetic commitment (his failure of imagination in the case of Cézanne is evidence of this) but of his crusading journalist's impulse to champion the underdog. Once he judged their

cause won, Zola's artist friends were disappointed to find themselves pushed aside by more pressing themes for anti-establishment polemic, most notably the Dreyfus affair.

MJ

Brookner, A., *The Genius of the Future: Studies in French Art Criticism* (1971).
Zola, É., *Mon Salon; Manet; Écrits sur l'art*, ed. A. Erhard (1970).

ZOPPO, MARCO (c.1432–c.1478). Italian painter whose life and work typify many of the developments in north Italian art during the third quarter of the 15th century. Born near Bologna, Zoppo entered *Squarcione's studio in Padua and in 1455 was adopted by his master. Like *Mantegna, Zoppo soon appreciated the limitations of this agreement and had it annulled. Thereafter he pursued his career in Venice, Padua, and Bologna in a style that owed much to a combination of Squarcione and the Ferrarese School alongside more ambitious features drawn from Mantegna and *Bellini. The development of his work is clarified in the contrast between the large altarpiece of c.1462 in the chapel of the Collegio di Spagna (Bologna, S. Clemente), a traditional polyptych, and the *Virgin and Child with Saints* painted for S. Giovanni Battista, Pesaro (1471; Berlin, Gemäldegal.), which is in the form of a Venetian *sacra conversazione*. An unusually large group of drawings by Zoppo have survived, revealing something of his working methods and the influence of Mantegna's graphic style. PSt

Armstrong, L., *The Paintings and Drawings of Marco Zoppo* (1976).

ZORACH, WILLIAM (1889–1966). American sculptor, painter, and writer of Lithuanian birth. After emigrating with his family at an early age, Zorach went to study in Cleveland, New York, and Paris. Between 1913 and 1916 he painted in a *Fauvist manner inspired by *Matisse and from 1917 moved to a *Cubist style, drawing on primitive African sources. After 1922 he concentrated solely on sculpture, becoming influential in disseminating the modern technique of *direct carving in the USA. His first sculpture, a wooden carved relief, *Waterfall* (1917; priv. coll.), reflects the angular and primitivizing style that dominated his Cubist paintings. However, after 1922 his work became less modern and more classicizing: *Mother and Child* (1927–30; New York, Met. Mus.) is a good example of this predominantly traditional, nude, figurative subject matter. Commonly, his work retains a sense of the original material and its texture, the forms being monumental and simplified. MF

Baur, J. I. H., *William Zorach* (1959).

ZORN, ANDERS (1860–1920). Swedish painter, sculptor, and draughtsman. Born in the remote Mora province, Zorn studied woodcarving in Stockholm from 1875, before entering the Royal Academy of Fine Arts. Poverty forced him to specialize in watercolour, although he later developed a distinctive oil painting technique. During 1881 he toured Europe, especially admiring French *Impressionism. In London 1882–8, he became a popular society portraitist and also began *etching, gaining an international reputation. In 1887 he worked with *Whistler in St Ives, producing his first oil paintings, including *The Fisherman* (1888; Paris, Mus. d'Orsay). An admirer of *Velázquez and *Rembrandt, he combined studies of light on water with finely realized nudes, also painting contemporary genre scenes; his portraits continued to be sought after, especially in America. From 1888 Zorn lived in Paris, frequenting Impressionist circles, and friendly with *Proust and *Rodin; he continued to travel, painting most summers on the Stockholm skerries. Settled in Sweden from 1896, he founded the Homecraft Association of Mora (1900), reflecting his lifelong interest in Swedish folk culture, and based on his collection of textiles and artefacts. *Midsummer Dance* (1897; Stockholm, Nationalmus.), and his only large sculpture, *Gustavus Vasa* (1903; Mora), also express his enthusiastic nationalism. JH

Boethius, G., *Zorn: Swedish Painter and World Traveller* (1961).

ZUCCARELLI, FRANCESCO (1702–88). Italian painter. Although Tuscan by birth, he was associated with the Venetian school of pastoral landscape painting, derived from Marco *Ricci. From his arrival in Venice in 1732 he was, like *Canaletto, patronized by Joseph Smith, and through his pastoral landscapes and city views achieved popularity and exerted great influence in England. When Richard *Wilson (still primarily a portrait painter) visited Venice in 1751 he painted Zuccarelli's portrait and it was partly Zuccarelli's encouragement which induced him to turn his attention to landscape. Between 1752 and 1771 Zuccarelli spent nearly seventeen years in England, where his conception of the *picturesque suited the taste of George III and ensured his popularity. He was made a foundation member of the Royal Academy, *London, in 1768, and on his return to Venice he became president of the Venetian Academy. HB

ZUCCARO BROTHERS. Italian painters from the neighbourhood of Urbino, who dominated Roman painting in the later 16th century. **Taddeo** (1529–66) had early contact with the art of Parma, and his first important commission in Rome, where he settled in 1551, shows *Correggio's influence. This was the decoration of the Cappella Mattei in S. Maria della Consolazione, finished c.1556. Out of a fusion of the *Grand Manner of *Raphael and the power and movement of *Michelangelo with north Italian colour and line, Taddeo created a harmonious manner of history painting which soon became popular. He employed many assistants and trained his younger brother **Federico** (1540×2–1609) to work beside him. Among the brothers' chief commissions were those from the Farnese family for decorative schemes in their palace in Rome and their villa at Caprarola.

Federico stayed for a while in Venice to work for Cardinal Giovanni Grimani in his chapel in S. Francesco della Vigna. In Florence in 1565 he was elected to the Accademia del Disegno and painted festive decorations celebrating Francesco de' Medici's marriage to Joanna of Austria. He returned to Rome in 1566, in which year Taddeo died and Federico took over his studio and commissions, continuing the work at Caprarola and also the decoration of the Sala Regia in the Vatican (begun by Taddeo in 1561). In 1573/4 he travelled to England, where he is said to have painted portraits of the Queen and many courtiers, although only two drawings in the British Museum portraying Elizabeth and Leicester can safely be attributed to him. After more work in Venice, Loreto, and Rome, he was invited by Philip II of Spain to the Escorial, where he painted a number of altarpieces (1585–8). Back in Rome Federico developed a new Counter-Reformation or Counter-Maniera style, under the impact of the Council of Trent (1543–63). Complexity, virtuosity, and metaphor give way to a simpler form of narrative and emotional expression, for instance in his work for the Capella di S. Giacinto in S. Sabina (1600). In the meantime he had been elected first president of the new Accademia di S. Luca (see under ROME), founded in 1593, to which he later gave his home as headquarters. He believed that correct theory would produce good art, and wrote *L'idea de' pittori, scultori, ed architetti*, published some years later at Turin (1607).

HB

Freedberg, S., *Painting in Italy 1500–1600* (rev. edn., 1983).
Gere, J., *Taddeo Zuccaro* (1969).
Mundy, E., *Renaissance into Baroque: Italian Master Drawings by the Zuccari 1550–1600* (1990).

ZUCCHI, JACOPO (c.1540–c.1596). Italian painter and draughtsman, born in Florence. He was a pupil of *Vasari, with whom he worked at the Palazzo Vecchio, Florence, from 1557; and they are recorded working together there with Giovanni Naldini and Joannes Stradanus on the ceiling of the Sala Grande in 1563–5. He again worked with Vasari in Rome at the Vatican, where he painted

frescoes in the chapel of S. Pio V. In 1572 Cardinal Ferdinando de' Medici appointed him artist in residence to the Medici court at Rome and later in the decade Zucchi decorated several rooms in the Villa Medici, Rome. He also painted frescoes for Orazio Rucellai at the Palazza Ruspoli, Rome. Although overshadowed by Vasari, he was a talented individual and independently painted smaller cabinet pictures such as the *Golden Age* (Florence, Uffizi), the *Bathsheba* (Hartford, Conn., Wadsworth Atheneum), and *Cupid and Psyche* (1589; Rome, Borghese Gal.). HB

Barocci, P. (ed.), *Palazzo Vecchio: committenza e collezionismo medicei*, exhib. cat. 1980 (Florence, Palazzo Vecchio).

ZULOAGA, IGNACIO (1870–1945). Spanish painter. The son of Placido Zuloaga, a metalworker and ceramicist, he was born at Eibar in the Basque Country and trained in Rome and at the Académie Julian in Paris where he subsequently spent much of his career. As a student he was influenced by *Manet and he was acquainted with *Rodin, *Gauguin, and *Degas. Fervently Spanish, as may be seen in his *Portrait*, as a torero, by William Rothenstein (1872–1945) (1896; Manchester, AG), Zuloaga took the paintings of *Velázquez and *Goya as his inspiration and corridas, gypsies, and fiestas are prominent among his subjects. After 1900 he had an international career and achieved great success with his portraits of Spanish aristocrats and literati: *Miguel de Unamuno* (1923; New York, Hispanic Society of America). From 1924 he made his permanent home in Spain and his later works show an increasing interest in landscape. Zuloaga was a serious student of painting and was among those who first realized the importance of the long neglected El *Greco in the 1890s. DER

Lafuente Ferrari, E., *La vida y el arte de Ignacio Zuloaga* (1950).

ZURBARÁN, FRANCISCO DE (1598–1664). Spanish painter, born in Extremadura. He started his apprenticeship in Seville in 1614, and established himself in Llerena in 1617, remaining there for the next twelve years. His first documented commission (1626) was for a cycle of paintings for the Dominicans of S. Pablo el Real in Seville, and shows an already well-defined style, with highly naturalistic figures set off from their dark backgrounds by brilliant light (*Crucified Christ*, 1627; Chicago, Art Inst.). Another important early commission was the series painted for the Merced Calzada (1629–30), which involved narrative scenes with simple compositions (*Vision of S. Peter Nolasco*; Madrid, Prado), and single, sculpturesque figures (*Fray Francisco Zumel*; Madrid, Academia de S. Fernando). In 1629, Zurbarán was invited to establish his residence in Seville by its city council, and his first work there was part of a cycle dedicated to S. Bonaventura, painted for the Franciscans.

The calibre of Zurbarán's art is usually highest when he deals with an isolated figure, such as *S. Francis in Meditation* (c.1635–40; London, NG) or a martyred virgin clad in colourful costume (*S. Margaret*, c.1634–40; London, NG). In his still lifes (*Still Life of Cidras, Oranges, Cup, and Rose* (1633; Pasadena, Calif., Norton Simon Foundations), the intense chiaroscuro, isolation of the objects, and frontality and symmetry of their arrangement impart a sacramental flavour to the simple subject.

Zurbarán's only major secular commission was for a large painting of *The Defence of Cadiz* and ten canvases of the *Labours of Hercules* for the Salón de Reinos in Madrid's Buen Retiro Palace (1634; Madrid, Prado). The pictures for the sacristy and adjoining chapel of the monastery of S. Jerónimo in Guadalupe were his last important monastic cycle (1639–40).

Zurbarán's religious pictures are characterized by a blend of realism and spiritual transcendence that made him the favourite painter of the monastic orders in the 1620s and 1630s. After 1640, he stopped receiving major commissions from the monasteries, and none of any kind is documented after 1650. His works after 1650 (*Virgin and Child with the Infant S. John*, 1656; San Diego, Mus. of Art); *S. Francis in Prayer*, 1658; Madrid, Arango Coll.) respond to the change in religious art that took place in the second half of the century; contours, colour, and light are softer, the shadows less opaque. These pictures, nonetheless, although equal in invention and facture to his works of the 1630s, must have seemed old-fashioned compared to those by younger contemporaries. In 1658 Zurbarán moved to Madrid, dying in poverty six years later. After his death, he fell into total oblivion until the 19th century. NAM

Baticle, J., *Zurbarán* (1987).
Brown, J., *Francisco de Zurbarán* (1973).

INDEX OF ARTISTS AND WRITERS ON ART

This is a select index of artists and writers on art mentioned in the course of other entries, but without an entry of their own. A number of other artists and writers on art not indexed here are mentioned in the general entries on the art of the relevant country. The editors did not feel it would be informative enough to index them in that context. The alphabetical sequence of index items relating to anonymous masters follows that outlined in the Note to the Reader at the front of the book.

PICTURE ACKNOWLEDGEMENTS

The publishers wish to thank the following who have kindly given permission to reproduce illustrations as identified by the following inset numbers.

COLOUR PLATES
All pictures are between the pages quoted.
(76–77) 1.1 Scala, Florence. 1.2 The Board of Trinity College, Dublin. 1.3 Scala, Florence. 1.4 © Photo RMN-Gérard Blot. 1.5 Österreichische Nationalbibliothek, Vienna (MS 1857 fol. 14v). 1.6 © Photo RMN-JG Berizzi. 1.7 Index/Tosi. 1.8 Duke of Sutherland Collection, on loan to National Gallery of Scotland.
(204–205) 2.1 © G Dagli Orti, Paris. 2.2 Scala, Florence. 2.3 Scala, Florence. 2.4 Index/Vasari. 2.5 Scala, Florence. 2.6 Scala, Florence. 2.7 Kunsthistorisches Museum, Vienna. 2.8 Kunsthistorisches Museum, Vienna.
(332–333) 3.1 © National Gallery, London. 3.2 Scala, Florence. 3.3 Scala, Florence. 3.4 Scala, Florence. 3.5 © National Gallery, London. 3.6 Samuel H. Kress Collection, © 2000 Board of Trustees, National Gallery of Art, Washington. 3.7 © Photo RMN-Michèle Bellot. 3.8 The J. Paul Getty Museum, Los Angeles.
(460–461) 4.1 Duke of Sutherland Collection, on loan to National Gallery of Scotland. 4.2 © National Gallery, London. 4.3 The Metropolitan Museum of Art, Gift of Mr and Mrs Nate B. Spingold, 1956 (56.231) Photograph © 1986 The Metropolitan Museum of Art. 4.4 © Photo RMN-Hervé Lewandowski. 4.5 Photograph reproduced with the Permission of the Barnes Foundation. All Rights Reserved. BF#811 Main Gallery. 4.6 © Succession H. Matisse/DACS 2000. Photograph reproduced with the Permission of the Barnes Foundation. All Rights Reserved. BF#719 Gallery I. 4.7 © National Gallery, London. 4.8 © ADAGP, Paris and DACS, London 2000. The Museum of Modern Art, New York. Gift of Mrs John D. Rockefeller 3rd. Photograph © 2000 The Museum of Modern Art, New York.
(588–589) 5.1 Scala, Florence. 5.2 Scala, Florence. 5.3 Index/Vasari. 5.4 Royal Cabinet of paintings, Mauritshuis, The Hague (Inv. 146). 5.5 Scottish National Portrait Gallery. 5.6 Alte Pinakothek, Munich/Joachim Blauel-Artothek. 5.7 © Museo del Prado, Madrid. 5.8 © Photo RMN.
(716–717) 6.1 National Gallery of Scotland. 6.2 Scala, Florence. 6.3 © Photo RMN-Daniel Arnaudet. 6.4 © Photo RMN-Gérard Blot. 6.5 Van Gogh Museum, Amsterdam (Vincent Van Gogh Foundation). 6.6 © ADAGP, Paris and DACS, London 2000. Oeffentliche Kunstsammlung Basel, Kunstmuseum Gift Raoul La Roche 1952 (accession nr. 2286) Photo Oeffentliche Kunstsammlung Basel, Martin Bühler. 6.7 © Succession Picasso/DACS 2000. The Museum of Modern Art, New York. Acquired through the Lillie P. Bliss Bequest. Photograph © 2000. The Museum of Modern Art, New York. 6.8 Royal Academy of Arts, London.

LINE DIAGRAMS
Lost-wax process (page 117): © Francesca Bewer

Picture research by Celia Dearing